ART HISTORY

THIRD EDITION

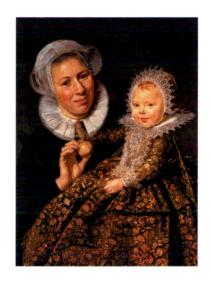

MARILYN STOKSTAD

Judith Harris Murphy Distinguished Professor of Art History Emerita

The University of Kansas

CONTRIBUTORS

David A. Binkley, Claudia Brown, Patricia J. Darish, Patrick Frank, Robert D. Mowry, Sara E. Orel, and D. Fairchild Ruggles

Upper Saddle River, New Jersey 07458

COLLEGE OF STATEN ISLAND LIBRARY

6250955

Library of Congress Cataloging-in-Publication Data

Stokstad, Marilyn,

Art History / Marilyn Stokstad. —3rd ed.

Stokstad, Marilyn

p. cm.

Includes bibliographical references and index.

ISBN 0-13-236854-4 (alk. paper)

1. Art—History. I. Title.

N5300.S923 2008

709-dc22

2006052795

Editor-in-Chief: Sarah Touborg Sponsoring Editor: Helen Ronan

Editor in Chief, Development: Rochelle Diogenes

Development Editors: Jeannine Ciliotta, Margaret Manos,

Teresa Nemeth, and Carol Peters

Media Editor: Anita Castro

Director of Marketing: Brandy Dawson

Executive Marketing Manager: Marissa Feliberty

AVP, Director of Production and Manufacturing: Barbara Kittle

Senior Managing Editor: Lisa Iarkowski Production Editor: Barbara Taylor-Laino Production Assistant: Marlene Gassler Manufacturing Manager: Nick Sklitsis Manufacturing Buyer: Sherry Lewis Creative Design Director: Leslie Osher

Art Director: Amy Rosen

Interior and Cover Design: Anne DeMarinis

Layout Artist: Gail Cocker-Bogusz

Line Art and Map Program Management: Gail Cocker-Bogusz,

Maria Piper

Line Art Studio: Peter Bull Art Studio

Cartographer: DK Education, a division of Dorling Kindersley, Ltd. Pearson Imaging Center: Corin Skidds, Greg Harrison, Robert

Uibelhoer, Ron Walko, Shayle Keating, and Dennis Sheehan

Site Supervisor, Pearson Imaging Center: Joe Conti

Photo Research: Laurie Platt Winfrey, Fay Torres-Yap, Mary Teresa

Giancoli, and Christian Peña, Carousel Research, Inc.

Director, Image Resource Center: Melinda Reo Manager, Rights and Permissions: Zina Arabia

Manager, Visual Research: Beth Brenzel

Manager, Cover Visual Research and Permissions: Karen Sanatar

Image Permission Coordinator: Debbie Latronica Cover Research and Permissions: Rita Wenning

Copy Editor: Stephen Hopkins

Proofreaders: Faye Gemmellaro, Margaret Pinette, Nancy Stevenson,

and Victoria Waters

Composition: Prepare, Inc.

Cover Printer: Phoenix Color Corporation

Printer/Binder: R. R. Donnelley

Maps designed and produced by DK Education, a division of Dorling Kindersley, Limited, 80 Strand London WC2R 0RL. DK and the DK logo are registered trademarks of Dorling Kindersley Limited.

Credits and acknowledgements borrowed from other sources and reproduced, with permission, in this textbook appear on the appropriate page within text or on the credit pages in the back of this book.

Cover Photo:

c. 1620. Oil on canvas, 33% × 25½" (857 × 648 cm). Staatliche Museen zu Berlin, Preussischer Kulturbesitz, Gemäldegalerie. Inv. 801 G. Photo: Joerg P. Anders. Bilarchive Preussischer Kulturbesitz / Art Resource, NY.

Copyright © 2008, 2005 by Pearson Education, Inc., Upper Saddle River, New Jersey, 07458. All rights reserved. Printed in the United States of America. This publication is protected by copyright, and permission should be obtained from the publisher prior to any prohibited reproduction, storage in a retrieval system, or transmission in any form or by any means, electronic, mechanical, photocopying, recording, or likewise. For information regarding permission(s), write to: Rights and Permissions Department.

Pearson Prentice HallTM is a trademark of Pearson Education, Inc.

Pearson® is a registered trademark of Pearson plc

Prentice Hall® is a registered trademark of Pearson Education, Inc.

Pearson Education LTD.

Pearson Education Australia PTY, Limited

Pearson Education Singapore, Pte. Ltd

Pearson Education North Asia Ltd

Pearson Education, Canada, Ltd

Pearson Educación de Mexico, S.A. de C.V

Pearson Education—Japan

Pearson Education Malaysia, Pte. Ltd

Prentice Hall

10987654

ISBN 0-13-236854-4 ISBN 978-0-13-236854-4

BRIEF CONTENTS

CONTENTS iv
PREFACE xiv
WHAT'S NEW xiv
TOOLS FOR UNDERSTANDING ART HISTORY xvi
FACULTY AND STUDENT RESOURCES FOR ART HISTORY xxii
ACKNOWLEDGEMENTS xxiii
USE NOTES xxv
STARTER KIT xxvi
INTRODUCTION xxxii

PREHISTORIC ART IN EUROPE I ART OF THE ANCIENT NEAR EAST 24 ART OF ANCIENT EGYPT 48 AEGEAN ART 82 ART OF ANCIENT GREECE 106 ETRUSCAN AND ROMAN ART 168 JEWISH, EARLY CHRISTIAN, AND BYZANTINE ART 232 ISLAMIC ART 282 ART OF SOUTH AND SOUTHEAST ASIA BEFORE 1200 310 CHINESE AND KOREAN ART BEFORE 1279 342 JAPANESE ART BEFORE 1392 372 1 2 ART OF THE AMERICAS BEFORE 1300 394 13 ART OF ANCIENT AFRICA 420 14 EARLY MEDIEVAL ART OF EUROPE 440 15 ROMANESQUE ART 472 GOTHIC ART OF THE TWELFTH AND THIRTEENTH CENTURIES 512 FOURTEENTH-CENTURY ART

IN EUROPE 552

18 FIFTEENTH-CENTURY ART IN NORTHERN EUROPE AND THE IBERIAN PENINSULA 584 RENAISSANCE ART IN FIFTEENTH-CENTURY ITALY 619 SIXTEENTH-CENTURY ART IN ITALY 658 SIXTEENTH-CENTURY ART IN NORTHERN EUROPE AND THE IBERIAN PENINSULA 706 BAROQUE ART 742 ART OF SOUTH AND SOUTHEAST ASIA AFTER 1200 808 CHINESE AND KOREAN ART AFTER 1279 830 25 JAPANESE ART AFTER 1392 850 ART OF THE AMERICAS AFTER 1300 872 ART OF PACIFIC CULTURES 896

ART OF AFRICA IN THE MODERN ERA 916

EIGHTEENTH-CENTURY ART IN EUROPE

NINETEENTH-CENTURY ART IN EUROPE

AND THE AMERICAS 940

AMERICAS, 1900-1945 1064

SINCE 1945 1124

THE INTERNATIONAL SCENE

AND THE UNITED STATES 984

MODERN ART IN EUROPE AND THE

30

CONTENTS

Preface xiv
What's New xiv
Tools for Understanding Art History xvi
Faculty and Student Resources for Art History xxii
Acknowledgements xxiii
Use Notes xxv
Starter Kit xxvi

Introduction xxxii

PREHISTORIC ART IN EUROPE 1

THE STONE AGE 2

THE PALEOLITHIC PERIOD 2

Shelter or Architecture? 2 Artifacts or Works of Art? 4 Cave Painting 6

THE NEOLITHIC PERIOD 11

Rock-Shelter Art 12
Architecture 13
Sculpture and Ceramics 19

FROM STONE TO METAL 20

The Bronze Age 20 The Proto-Historic Iron Age 21

IN PERSPECTIVE 22 TIMELINE 23

BOXES

THE **OBJECT SPEAKS** Prehistoric Woman and Man 18

ELEMENTS OF ARCHITECTURE Post-and-Lintel and Corbel Construction 14

■ TECHNIQUE

Prehistoric Wall Painting 8 Fiber Arts 17 Pottery and Ceramics 20

■ ART AND ITS CONTEXT
The Power of Naming 5

SCIENCE AND TECHNOLOGY
How Early Art Is Dated 13

2

ART OF THE ANCIENT NEAR EAST 24

THE FERTILE CRESCENT AND MESOPOTAMIA 26

The First Cities 26
The Arts 28

SOUTHERN MESOPOTAMIA 29

Sumer 29 Lagash and Gudea 37 Babylon: Hammurabi's Code 37

THE HITTITES OF ANATOLIA 37 LATER MESOPOTAMIAN ART 40

Assyria 4 Neo-Babylonia 42

IN PERSPECTIVE 46

TIMELINE 47

BOXES

THE **OBJECT SPEAKS** The Code of Hammurabi 38

■ TECHNIQUE

Cuneiform Writing 32

Textiles 44

Coining Money 46

ART AND ITS CONTEXT

Art as Spoils of War-Protection or Theft? 31

3

ART OF ANCIENT EGYPT 48

THE GIFT OF THE NILE 50

EARLY DYNASTIC EGYPT 50

Manetho's List 51
Religion and the State 51
Artistic Conventions 52
Funerary Architecture 55

THE OLD KINGDOM, c. 2575-2150 BCE 56

Architecture: The Pyramids at Giza 57 Sculpture 59 Tomb Decoration 62

THE MIDDLE KINGDOM, c. 1975- c. 1640 BCE 62

Sculpture: Royal Portraits 63
Tomb Architecture and Funerary Objects 63
Town Planning 66

THE NEW KINGDOM, c. 1539-1075 BCE 67

The Great Temple Complexes 67
The Valley of the Kings and Queens 70
Akhenaten and the Art of the Amarna Period 72
The Return to Tradition: Tutankhamun and Rameses I 75
The Books of the Dead 78

LATE EGYPTIAN ART, c. 715-332 BCE 79 IN PERSPECTIVE 80

TIMELINE 81

BOXES

THE **OBJECT SPEAKS** The Temples of Rameses II at Abu Simbel 76

ELEMENTS OF ARCHITECTURE

Mastaba to Pyramid 56

■ TECHNIQUE

Preserving the Dead 55
Egyptian Painting and Sculpture 64
Glassmaking and Egyptian Faience 70

ART AND ITS CONTEXT

Egyptian Symbols 52

Hieroglyphic, Hieratic, and Demotic Writing 78

THE BRONZE AGE IN THE AEGEAN 84 THE CYCLADIC ISLANDS 84

THE MINOAN CIVILIZATION ON CRETE 86

The Old Palace Period, c. 1900–1700 BCE 86
The New Palace Period, c. 1700–1450 BCE 86

THE MYCENAEAN (HELLADIC) CULTURE 95

Helladic Architecture 95
Late Minoan Period (c. 1450–1100 BCE) 101
Metalwork 102
Sculpture 103
Ceramic Arts 104

IN PERSPECTIVE 104

TIMELINE 105

BOXES

THE **OBJECT SPEAKS** The Lion Gate 100

■ TECHNIQUE

Aegean Metalwork 93

ART AND ITS CONTEXT

Pioneers of Aegean Archaeology 88 Homeric Greece 98

THE EMERGENCE OF GREEK CIVILIZATION 108

Historical Background 108 Religious Beliefs and Sacred Places 109 Historical Divisions of Greek Art 111

GREEK ART FROM c. 900-c. 600 BCE 112

The Geometric Period 112
The Orientalizing Period 114

THE ARCHAIC PERIOD, c. 600-480 BCE 114

Temple Architecture 117
Architectural Sculpture 119
Freestanding Sculpture 121
Vase Painting 125

THE CLASSICAL PERIOD, c. 480-323 BCE 128

The Canon of Polykleitos 128
The Art of the Early Classical Period, 480-450 BCE 129

THE HIGH CLASSICAL PERIOD, c. 450-400 BCE 135

The Acropolis 136
The Parthenon 136
The Propylaia and the Erechtheion 142
The Temple of Athena Nike 144
The Athenian Agora 145
Stele Sculpture 147
Paintings: Murals and Vases 148

THE LATE CLASSICAL PERIOD, c. 400-323 BCE 148

Architecture and Architectural Sculpture 149 Sculpture 151

The Art of the Goldsmith 155

Wall Painting and Mosaics 155

THE HELLENISTIC PERIOD, 323-31/30 BCE 156

The Corinthian Order in Hellenistic Architecture 158
Hellenistic Architecture: The Theater at Epidauros 158
Sculpture 160
The Multicultural Hellenistic World 164

IN PERSPECTIVE 165

TIMELINE 166

BOXES

THE **OBJECT SPEAKS** The Parthenon 138

ELEMENTS OF ARCHITECTURE

Greek Temple Plans 116
The Greek Architectural Orders 118

■ TECHNIQUE

Greek Painted Vases 114
The Discovery and Conservation of the Riace Warriors 135

ART AND ITS CONTEXT

Greek and Roman Deities 110
Classic and Classical 128
Who Owns the Art? The Elgin Marbles and the Euphronios Vase 145
Women Artists in Ancient Greece 157

ETRUSCAN AND ROMAN ART 168

THE ETRUSCANS 170

Etruscan Architecture 170
Etruscan Temples and Their Decoration 171
Tomb Chambers 174
Bronze Work 177

THE ROMANS 178

Origins of Rome 179 Roman Religion 179

THE REPUBLIC, 509-27 BCE 179

Sculpture during the Republic 180 Architecture and Engineering 181

THE EARLY EMPIRE, 27 BCE-96 CE 185

Augustan Art 186
The Julio-Claudians 189
The Roman City and the Roman Home 190
Wall Painting 193
The Flavians 199

THE HIGH IMPERIAL ART OF TRAJAN AND HADRIAN 204

Imperial Architecture 205 Mosaics 213 Sculpture 215 Imperial Portraits 216

THE LATE EMPIRE, THIRD AND FOURTH CENTURIES 218

The Severan Dynasty 218
The Third Century: The Soldier Emperors 220
The Tetrarchy 222
Constantine the Great and His Legacy 224

IN PERSPECTIVE 230

TIMELINE 231

BOXES

THE **OBJECT SPEAKS** The Unswept Floor 214

 ELEMENTS OF ARCHITECTURE Arch, Vault, and Dome 172 Roman Architectural Orders 174 Roman Construction 194

■ TECHNIQUE Roman Mosaics 215

Roman Copies 224

ART AND ITS CONTEXT

Roman Writers on Art 179

Color in Roman Sculpture: A Colorized Augustus 186

The Position of Roman Women 198

7

JEWISH, EARLY CHRISTIAN, AND BYZANTINE ART 232

JEWS, CHRISTIANS, AND MUSLIMS 234

Early Jewish Art 234 Early Christian Art 238

IMPERIAL CHRISTIAN ARCHITECTURE AND ART 242

Architecture: The Church and Its Decoration 243

Architecture: Ravenna 247

Sculpture 250

EARLY BYZANTINE ART: THE FIRST GOLDEN AGE 254

The Golden Age of Justinian 254
Objects of Veneration and Devotion 263
Icons and Iconoclasm 266

MIDDLE BYZANTINE ART 267

Architecture and Mosaics 267 The Special Case of Sicily 274

LATER BYZANTINE ART 278

Constantinople 278

Moscow: The Third Rome 278

IN PERSPECTIVE 280 TIMELINE 281

BOXES

THE **OBJECT SPEAKS** The Archangel Michael 276

ELEMENTS OF ARCHITECTURE
 Basilica-Plan and Central-Plan Churches 242
 Pendentives and Squinches 257
 Multiple-Dome Church Plans 275

ART AND ITS CONTEXT
 Early Forms of the Book 251
 Iconography of the Life of Jesus 252

MYTHS AND RELIGION Christian Symbols 238

ISLAMIC ART 282

ISLAM AND EARLY ISLAMIC SOCIETY 284
ART DURING THE EARLY CALIPHATES 285

Architecture 286
Calligraphy 292
Ceramics and Textiles 294

LATER ISLAMIC ART 294

Architecture 295

Portable Arts 300

Manuscripts and Painting 303

THE OTTOMAN EMPIRE 305

Architecture 305

Illuminated Manuscripts and Tugras 306

THE MODERN ERA 307
IN PERSPECTIVE 308
TIMELINE 309

BOXES

THE **OBJECT SPEAKS** A Mamluk Glass Oil Lamp 296

 ELEMENTS OF ARCHITECTURE Mosque Plan 289
 Arches and Mugarnas 292

■ TECHNIQUE Carpet Making 303

■ ART AND ITS CONTEXT
The Five Pillars of Islam 299

9

ART OF SOUTH AND SOUTHEAST ASIA BEFORE 1200 310

THE INDIAN SUBCONTINENT 312
INDUS VALLEY CIVILIZATION 312
THE VEDIC PERIOD 315
THE MAURYA PERIOD 316

THE PERIOD OF THE SHUNGAS AND EARLY ANDHRAS 319

Stupas 319

Buddhist Rock-Cut Halls 321

THE KUSHAN AND LATER ANDHRA PERIODS 322

The Gandhara School 323
The Mathura School 323
The Amaravati School 324

THE GUPTA PERIOD 325

The Early Northern Temple 327
Monumental Narrative Reliefs 330
The Early Southern Temple 333

THE TENTH THROUGH THE FOURTEENTH CENTURIES 333

The Monumental Northern Temple 333
The Monumental Southern Temple 335
The Bhakti Movement in Art 336

ART OF SOUTHEAST ASIA 336

IN PERSPECTIVE 340

TIMELINE 341

BOXES

THE **OBJECT SPEAKS** Shiva Nataraja of the Chola Dynasty 331

■ ELEMENTS OF ARCHITECTURE Stupas and Temples 320 Pendentives and Squinches 257

ART AND ITS CONTEXT

Meaning and Ritual in Hindu Temples and Images 328

MYTHS AND RELIGION

Buddhism 317 Hinduism 318 Mudras 325

vi CONTENTS

THE MIDDLE KINGDOM 344
NEOLITHIC CULTURES 344

Painted Pottery Cultures 344 Liangzhu Culture 345

BRONZE AGE CHINA 346

Shang Dynasty 346 Zhou Dynasty 348

THE CHINESE EMPIRE: QIN DYNASTY 349

HAN DYNASTY 349

Philosophy and Art 351 Architecture 353

SIX DYNASTIES 354

Painting 354 Calligraphy 356

Buddhist Art and Architecture 356

SUI AND TANG DYNASTIES 357

Buddhist Art and Architecture 358 Figure Painting 361

SONG DYNASTY 361

Philosophy: Neo-Confucianism 362 Northern Song Painting 362

Southern Song Painting and Ceramics 365

THE ARTS OF KOREA 366

The Three Kingdon Period 366
The Unified Silla Period 368
Goryeo Dynasty 368

IN PERSPECTIVE 370

TIMELINE 371

BOXES

THE **OBJECT SPEAKS** The Silk Road During the Tang Period 350

ELEMENTS OF ARCHITECTURE Pagodas 361

■ TECHNIQUE
Piece-Mold Casting 347

ART AND ITS CONTEXT
 Chinese Characters 348
 Confucius and Confucianism 355

MYTHS AND RELIGION
Daoism 352

11

JAPANESE ART BEFORE 1392 372

PREHISTORIC JAPAN 374

Jomon Period 374

Yayoi and Kofun Periods 376

ASUKA PERIOD 378

Horyu-ji 379

NARA PERIOD 382

HEIAN PERIOD 383

Esoteric Buddhist Art 383

Pure Land Buddhist Art 384 Calligraphy and Painting 386

KAMAKURA PERIOD 388

Pure Land Buddhist Art 389 Zen Buddhist Art 391

IN PERSPECTIVE 392

TIMELINE 393

BOXES

THE **OBJECT SPEAKS** Monk Sewing 390

■ TECHNIQUE

Joined-Wood Sculpture 387

ART AND ITS CONTEXT

Writing, Language, and Culture 376

Arms and Armor 389

MYTHS AND RELIGION

Buddhist Symbols 381

12

ART
OF THE AMERICAS
BEFORE 1300 394

THE NEW WORLD 396

MESOAMERICA 397

The Olmec 398
Teotihuacan 399
The Maya 402

CENTRAL AMERICA 407

SOUTH AMERICA: THE CENTRAL ANDES 408

The Paracas and Nazca Cultures 410

The Moche Culture 411

NORTH AMERICA 412

The East 412

The Woodland Period 412

The Mississippi Period 412

The North American Southwest 416

IN PERSPECTIVE 418

TIMELINE 419

BOXES

THE **OBJECT SPEAKS** Rock Art 414

■ TECHNIQUE

Andean Textiles 409

ART AND ITS CONTEXT

Maya Record Keeping 403

The Cosmic Ball Game 405

13

ART OF ANCIENT AFRICA 420

THE LURE OF ANCIENT AFRICA 422

AFRICA THE CRADLE OF ART AND CIVILIZATION 422

African Rock Art 424

SAHARAN ROCK ART 424

SUB-SAHARAN CIVILIZATIONS 425

Nok 425

Igbo Ukwu 427 Ife 429 Benin 430

OTHER URBAN CENTERS 432

Jenné 433

Great Zimbabwe 433 Kongo Kingdom 436

IN PERSPECTIVE 438

TIMELINE 439

BOXES

THE **OBJECT SPEAKS** A Warrior Chief Pledging Loyalty 428

■ ART AND ITS CONTEXT
Southern African Rock Art 426

■ DEFINING ART
The Myth of "Primitive" Art 424

14

EARLY MEDIEVAL ART IN EUROPE 440

THE EARLY MIDDLE AGES 442

THE ART OF PEOPLE ASSOCIATED WITH THE ROMAN EMPIRE 443

The Art of People Outside the Roman Sphere of Influence 444
The Coming of Christianity to the British Isles 446

THE MUSLIM CHALLENGE IN SPAIN 449

Mozarabic Art 449

THE CAROLINGIAN EMPIRE 450

Carolingian Architecture 451
The Scriptorium and Illustrated Books 455
Carolingian Goldsmith Work 457

THE VIKING ERA 459

The Oseberg Ship 459
Picture Stones at Jelling 460
Timber Architecture 461
The End of the Viking Era 464

OTTONIAN EUROPE 464

Ottonian Architecture 464 Ottonian Sculpture 468 Illustrated Books 469

IN PERSPECTIVE 470

TIMELINE 471

BOXES

THE **OBJECT SPEAKS** The Doors of Bishop Bernward 466

ART AND ITS CONTEXT

Defining the Middle Ages 444
The Medieval Scriptorium 448

15

ROMANESQUE ART 472

EUROPE ON THE ROMANESQUE PERIOD 474

Political and Economic Life 474 The Church 475 Intellectual Life 476

ROMANESQUE ART 477

ARCHITECTURE 478

The Early Romanesque Style: The "First Romanesque" 479
The "Pilgrimage Church" 479
The Monastery of Cluny in Burgundy 482
The Cistercians 484
Regional Styles in Romanesque Architecture 485
Secular Architecture: Dover Castle, England 493

THE DECORATION OF BUILDINGS 494

Architectural Sculpture 495 Mosaics and Murals 499

THE CLOISTER CRAFTS 502

Portable Sculpture 502 Metalwork 506 Illustrated Books 507

IN PERSPECTIVE 510

TIMELINE 511

BOXES

THE **OBJECT SPEAKS** The Bayeux Tapestry 504

ART AND ITS CONTEXT

Saint Bernard and Theophilus:
Opposing Views on the Art of Their Time 477
The Pilgrim's Journey 480
Relics and Reliquaries 484
The Role of Women in the Intellectual and Spiritual Life of the Twelfth Century 499

16

GOTHIC ART
OF THE TWELFTH
AND THIRTEENTH
CENTURIES 512

THE EMERGENCE OF THE GOTHIC STYLE 514

The Rise of Urban Life 514
The Age of Cathedrals 514
Scholasticism and the Arts 514

GOTHIC ART IN FRANCE 515

Early Gothic Architecture 516
From Early to High Gothic: Chartres Cathedral 518
High Gothic: Amiens and Reims Cathedrals 528
High Gothic Sculpture 532
The Rayonnant Style 535
Illuminated Manuscripts 537

GOTHIC ART IN ENGLAND 538

Architecture 539

GOTHIC ART IN GERMANY AND THE HOLY ROMAN EMPIRE 541

Architecture 541 Sculpture 543

GOTHIC ART IN ITALY 547

Sculpture: The Pisano Family 547
Painting 549

IN PERSPECTIVE 550

TIMELINE 551

BOXES

THE **OBJECT SPEAKS** The Church of St. Francis at Assisi 546

ELEMENTS OF ARCHITECTURE

Rib Vaulting 521 The Gothic Church 522

■ TECHNIQUE

Glass Windows 528

ART AND ITS CONTEXT

Abbot Suger on the Value of Art 516 Master Builders 525

MYTHS AND RELIGION

The Mendicant Orders: Franciscans and Dominicans 524

17

FOURTEENTH-CENTURY ART IN EUROPE 552

EUROPE IN THE FOURTEENTH CENTURY 554

ITALY 557

Florentine Architecture and Sculpture 557 Florentine Painting 550 Sienese Painting 567

FRANCE 572

Manuscript Illumination 572 Sculpture 573

ENGLAND 575

Embroidery: Opus Anglicanum 575 Architecture 576

THE HOLY ROMAN EMPIRE 578

The Supremacy of Prague 578 Mysticism and Suffering 580

IN PERSPECTIVE 582

TIMELINE 583

BOXES

THE **OBJECT SPEAKS** The Triumph of Death 556

■ TECHNIQUE

Cennino Cennini (c. 1370-1440) on Painting 564 Buon Fresco 560

ART AND ITS CONTEXT

A New Spirit in Fourteenth-Century Literature 561

18

FIFTEENTH-CENTURY ART IN NORTHERN EUROPE AND THE IBERIAN PENINSULA 584

HUMANISM AND THE NORTHERN RENAISSANCE 586

ART FOR THE FRENCH DUCAL COURTS 587

Painting and Sculpture for the Chartreuse de Champmol 588 Manuscript Illumination 590 The Fiber Arts 594

PAINTING IN FLANDERS 596

The Founders of the Flemish School 596
Painting at Midcentury: The Second Generation 604

EUROPE BEYOND FLANDERS 609

France 609 Spain and Portugal 611

Germany and Switzerland 613

THE GRAPHIC ARTS 614

Single Sheets 614 Printed Books 615

IN PERSPECTIVE 616

TIMELINE 617

BOXES

THE OBJECT SPEAKS Hans Memling's Saint Ursula Reliquary 608

■ TECHNIQUE

Woodcuts and Engraving on Metal 615

ART AND ITS CONTEXT

Altars and Altarpieces 591

Women Artists in the Late Middle Ages and the Renaissance 592

19

RENAISSANCE ART IN FIFTEENTH-CENTURY ITALY 618

HUMANISM AND THE ITALIAN RENAISSANCE 620

FLORENCE 621

Architecture 623

Sculpture 628

Painting 634

Mural Painting in Florence after Masaccio 638

ITALIAN ART IN THE SECOND HALF OF THE FIFTEENTH CENTURY 640

Urbino 640

Mantua 644

Rome 647

The Later Fifteenth Century in Florence 648

Venice 653

IN PERSPECTIVE 655

TIMELINE 657

BOXES

THE OBJECT SPEAKS The Foundling Hospital 626

■ TECHNIQUE

Brunelleschi, Alberti, and Renaissance Perspective 622 Ceramics 634

ART AND ITS CONTEXT

The Printed Book 652

SIXTEENTH-CENTURY ART IN ITALY 658

EUROPE IN THE SIXTEENTH CENTURY 660

ITALY IN THE EARLY SIXTEENTH CENTURY: THE HIGH RENAISSANCE 662

Three Great Artists of the Early Sixteenth Century 662 Architecture and Painting in Northern Italy 680 Venice and Veneto 682

ART AND THE COUNTER-REFORMATION 687

Art and Architecture in Rome and the Vatican 688

MANNERISM 692

Painting 693

Manuscripts and Miniatures 696

Late Mannerism 698

LATER SIXTEENTH-CENTURY ART IN VENICE AND THE VENETO 699

Oil Painting 699

Architecture: Palladio 703

IN PERSPECTIVE 704 TIMELINE 705

BOXES

THE OBJECT SPEAKS Veronese Is Called Before the Inquisition 700

ELEMENTS OF ARCHITECTURE
 The Grotto 677
 Saint Peter's Basilica 679

■ ART AND ITS CONTEXT
Women Patrons of the Arts 688

■ DEFINING ART
The Vitruvian Man 665

21

SIXTEENTH-CENTURY ART IN NORTHERN EUROPE AND THE IBERIAN PENINSULA 706

THE REFORMATION AND THE ARTS 708

EARLY SIXTEENTH-CENTURY ART IN GERMANY 709

Sculpture 709 Painting 711

RENAISSANCE ART IN FRANCE 720

The Introduction of Italian Art 720 Art in the Capital 722

RENAISSANCE ART IN SPAIN AND PORTUGAL 725

Architecture 725 Painting 725

RENAISSANCE PAINTING IN THE NETHERLANDS 728

Art for Aristocratic and Noble Patrons 728
Antwerp 731

RENAISSANCE ART IN ENGLAND 734

Artists for the Tudor Court 735 Architecture 738

IN PERSPECTIVE 740

TIMELINE 741

BOXES

THE OBJECT SPEAKS Sculpture for the Knights of Christ at Tomar 724

■ TECHNIQUE
German Metalwork: A Collaborative Venture 714

■ ART AND ITS CONTEXT Armor for Royal Games 737

22

BAROQUE ART 742

THE BAROQUE PERIOD 744

ITALY 745

Architecture and Sculpture in Rome 745 Painting 754

THE HABSBURG LANDS 764

Painting in Spain's Golden Age 764 Architecture in Spain and Austria 770

FLANDERS AND THE NETHERLANDS 772

Flanders 774 The Dutch Republic 779

FRANCE 793

Architecture and Its Decoration at Versailles 793 Painting 797

ENGLAND 801

Architecture and Landscape Design 801 English Colonies in North America 805

IN PERSPECTIVE 806

TIMELINE 807

BOXES

THE **OBJECT SPEAKS** Brueghel and Rubens's Allegory of Sight 780

■ ELEMENTS OF ARCHITECTURE French Baroque Garden Design 796

DEFINING ART
 Grading the Old Masters 799

SCIENCE AND TECHNOLOGY
Science and the Changing Worldview 746

23

ART OF SOUTH AND SOUTHEAST ASIA AFTER 1200 808

INDIA AFTER 1200 810

Buddhist Art 810 Jain Art 810 Hindu Art 811

THE BUDDHIST AND HINDU INHERITANCE IN SOUTHEAST ASIA 814

Theravada Buddhism in Burma and Thailand 814
Vietnamese Ceramics 816
Indonesian Traditions 817

MUGHAL PERIOD 817

Mughal Architecture 817 Mughal Painting 818 Rajput Painting 821

INDIA'S ENGAGEMENT WITH THE WEST 825

British Colonial Period 825 The Modern Period 825

IN PERSPECTIVE 828

TIMELINE 829

BOXES

THE **OBJECT SPEAKS** Luxury Arts 827

■ TECHNIQUE

Indian Painting on Paper 820

ART AND ITS CONTEXT

Foundations of Indian Culture 815

MYTHS AND RELIGION

Tantric Influence in the Art of Nepal and Tibet 813

CHINESE AND KOREAN ART AFTER 1279 830

THE MONGOL INVASIONS 832

YUAN DYNASTY 832

MING DYNASTY 835

Court and Professional Painting 836

Decorative Arts 838

Architecture and City Planning 839

QING DYNASTY 843

Orthodox Painting 843 Individualist Painting 844

THE MODERN PERIOD 844

THE ARTS OF KOREA: THE JOSEON DYNASTY TO THE MODERN ERA 845

Joseon Ceramics 845 Joseon Painting 846 Modern Korea 848

IN PERSPECTIVE 848

TIMELINE 849

BOXES

THE OBJECT SPEAKS Poet on a Mountaintop 842

■ TECHNIQUE

Formats of Chinese Painting 806 The Secret of Porcelain 840

ART AND ITS CONTEXT

Foundations of Chinese Culture 834 Marco Polo 836

25

JAPANESE ART AFTER 1392

MUROMACHI PERIOD 852

Ink Painting 852

The Zen Dry Garden 855

MOMOYAMA PERIOD 856

Architecture 857

Kano School Decorative Painting 857

The Tea Ceremony 858

EDO PERIOD 859

The Tea Ceremony 859

Rimpa School Painting 860

Nanga School Painting 863

Zen Painting 863

Maruyama-Shijo School Painting 865

Ukiyo-e: Pictures of the Floating World 866

THE MEIJI AND MODERN PERIODS 868

Meiji 868

Modern Japan 868

IN PERSPECTIVE 870

TIMELINE 871

BOXES

THE **OBJECT SPEAKS** Lacquer Box for Writing Implements 862

ELEMENTS OF ARCHITECTURE

Shoin Design 860

TECHNIQUE

Inside a Writing Box 864

Japanese Woodblock Prints 867

■ ART AND ITS CONTEXT

Foundations of Japanese Culture 854

26

ART OF THE AMERICAS AFTER 1300 618

THE AZTEC EMPIRE 874

Religion 874

Tenochtitlan 874

THE INCA EMPIRE IN SOUTH AMERICA 876

Masonry 877

Textiles 878

Metalwork 879

The Aftermath of the Spanish Conquest 880

NORTH AMERICA 880

The Eastern Woodlands 880

The Great Plains 884

The Northwest Coast 886

The Southwest 887

A NEW BEGINNING 892

IN PERSPECTIVE 893

TIMELINE 895

BOXES

THE **OBJECT SPEAKS** Hamatsa Masks 888

ELEMENTS OF ARCHITECTURE

Inca Masonry 878

■ TECHNIQUE

Basketry 882

ART AND ITS CONTEXT

Navajo Night Chant 890

DEFINING ART

Craft or Art? 893

27

ART OF PACIFIC CULTURES

896

THE PEOPLING OF THE PACIFIC 898

AUSTRALIA 900

Arnhem Land 900

MELANESIA

901

New Guinea 901

New Ireland 903

MICRONESIA 904

POLYNESIA 905

Easter Island 906 Marquesas Islands 909 New Zealand 909 Hawaiian Islands 911

RECENT ART IN OCEANIA 912 IN PERSPECTIVE 914 TIMELINE 915

BOXES

THE **OBJECT SPEAKS** Feather Cloak 908

ART AND ITS CONTEXT
Boats in Oceania 902

ART
OF AFRICA
IN THE
MODERN ERA 916

TRADITIONAL AND CONTEMPORARY AFRICA 918

Living Areas 919
Children and the Continuity of Life 920
Initiation 923
The Spirit World 925
Leadership 928
Death and Ancestors 932

CONTEMPORARY ART 936 IN PERSPECTIVE 938

TIMELINE 939

BOXES

THE **OBJECT SPEAKS** African Art Confronting the West 934

ART AND ITS CONTEXT Foundations of African Cultures 921

■ MYTHS AND RELIGION
Divination among the Chokwe 937

29

EIGHTEENTH-CENTURY ART IN EUROPE AND THE AMERICAS 940

THE ENLIGHTENMENT AND ITS REVOLUTIONS 942 THE ROCOCO STYLE IN EUROPE 943

Architecture and Its Decoration in Germany and Austria 944 Rococo Painting and Sculpture in France 946

ITALY AND THE CLASSICAL REVIVAL 951

Italian Portraits and Views 952

Neoclassicism in Rome: The Albani-Winckelmann Influence 954

REVIVALS AND ROMANTICISM IN BRITAIN 956

Classical Revival in Architecture and Landscaping 956

Gothic Revival in Architecture and Its Decoration 959

Neoclassicism in Architecture and the Decorative Arts 959

Painting 961

LATER EIGHTEENTH-CENTURY ART IN FRANCE 969

Architecture 969

Painting and Sculpture 970

EIGHTEENTH-CENTURY ART OF THE AMERICAS 977

New Spain 977 North America 979

IN PERSPECTIVE 982

TIMELINE 983

BOXES

THE **BJECT SPEAKS** Georgian Silver 962

ELEMENTS OF ARCHITECTURE

Iron as a Building Material 967

ART AND ITS CONTEXT Women and Academies 952

DEFINING ART

Academies and Academy Exhibitions 948

30

NINETEENTH-CENTURY ART IN EUROPE AND THE UNITED STATES 984

EUROPE AND THE UNITED STATES IN THE NINETEENTH CENTURY 986

EARLY NINETEENTH-CENTURY ART: NEOCLASSICISM AND ROMANTICISM 987

Neoclassicism and Romanticism in France 988
Romantic Sculpture in France and Beyond 997
Romanticism in Spain: Goya 998
Romantic Landscape Painting 1000
Orientalism 1005
Revival Styles in Architecture before 1850 1007

ART IN THE SECOND HALF OF THE NINETEENTH CENTURY 1009

Early Photography in Europe 1010 New Materials and Technology in Architecture at Midcentury 1012

French Academic Art and Architecture 1013

Realism 1015

Late Nineteenth-Century Art in Britain 1023

Impressionism 1026

THE BIRTH OF MODERN ART 1038

Post-Impressionism 1038
Symbolism in Painting 1047
Late Nineteenth-Century French Sculpture 1051
Art Nouveau 1053
Late-Century Photography 1057
Architecture 1058

IN PERSPECTIVE 1062

TIMELINE 1063

BOXES

THE **OBJECT SPEAKS** Raft of the "Medusa" 992

ELEMENTS OF ARCHITECTURE

The City Park 1059

TECHNIQUE

Lithography 994

How to be a Famous Artist in the Nineteenth Century 1016

ART AND ITS CONTEXT

Modern Artists and World Culture 1044

DEFINING ART

Art on Trial in 1877 1025

31

MODERN ART IN EUROPE AND THE AMERICAS, 1900–1945 1064

EUROPE AND THE AMERICAS IN THE EARLY TWENTIETH CENTURY 1066

EARLY MODERN ART IN EUROPE 1067

The Fauves: Wild Beasts of Color 1067 "The Bridge" and Primitivism 1070 Independent Expressionists 1072

Spiritualism of the Blue Rider 1073

Cubism in Europe: Exploding the Still Life 1076

Extensions of Cubism 1082

Toward Abstraction in Sculpture 1086

Dada 1088

EARLY MODERN ART IN THE AMERICAS 1091

Modernist Tendencies in the United States 1091 Modernism Breaks out of Latin America 1096

Canada 1098

Early Modern Architecture 1043

EARLY MODERN ARCHITECTURE 1100

European Modernism 1100

American Modern Architecture 1101

ART BETWEEN THE WARS 1105

Utilitarian Art Forms in Russia 1105 Rationalism in the Netherlands 1107

Bauhaus Art in Germany 1110

Art and Politics 1111

Surrealists Rearrange our Minds 1119

IN PERSPECTIVE 1122

TIMELINE 1123

BOXES

THE OBJECT SPEAKS Portrait of a German Officer 1094

ELEMENTS OF ARCHITECTURE

The Skyscraper 1104
The International Style 110

ART AND ITS CONTEXT

Federal Patronage for American Art During the Depression 1116

DEFINING ART

Suppression of the Avant-Garde in Nazi Germany 1112

32

THE INTERNATIONAL SCENE SINCE 1945 1124

THE WORLD SINCE 1945 1126 POSTWAR EUROPEAN ART 1128

Figural Artist 1128

Abstraction and Art Informel 1129

ABSTRACT EXPRESSIONISM 1131

The Formative Phase 1131

Action Painting 1133

Color Field Painting 1137

Sculpture of the New York School 1138

EXPERIMENTS WITH FORM IN BUENOS AIRES 1141

Concrete-Invention 1142

Madí 1142

POSTWAR PHOTOGRAPHY 1142

New Documentary Slants 1143

The Modernist Heritage 1145

MOVING INTO THE REAL WORLD 1145

Assemblage 1145

Happenings 1148

Pop Art 1150

THE FINAL ASSAULT ON CONVENTION, 1960-1975 1154

Op Art and Minimal Art 1154

Arte Povera: Impoverished Art 1158

Conceptual and Performance Art 1160

Earthworks and Site-Specific Sculpture 1161

Feminist Art 1163

ARCHITECTURE: FROM MODERN TO POSTMODERN 1167

Midcentury Modernist Architecture 1167

Postmodern Architecture 1170

POSTMODERN ART 1171

The Critique of Originality 1172

Telling Stories with Paint 1174

Finding New Meanings in Shapes 1179

High Tech and Deconstructive Architecture 1182

New Statements in New Media 1184

IN PERSPECTIVE 1190

TIMELINE 1191

BOXES

THE **OBJECT SPEAKS** The Dinner Party 1168

DEFINING ART

Recent Controversies over Public Funding for the Arts 1183

Contemporary World Map

Glossary 1193

Bibliography 1202

Credits 1214

Index 1220

PREFACE

s I expressed in the Revised Second Edition of *Art History*, I believe that the first goal of an introductory art history course is to create an educated, enthusiastic public for the inspired, tangible creations of human skill and imagination that make up the visual arts—and I remain convinced that every student can and should enjoy her or his introduction to this broad field of study.

Like its predecessors, this book balances formalist analysis with contextual art history to support the needs of a diverse and fast-changing student population. Throughout the text, the visual arts are treated within the real-world contexts of history, geography, politics, religion, economics, and the broad social and personal aspects of human culture.

So . . . What's New in This Edition?

A Major Revision

I strongly believe that an established text should continually respond to the changing needs of its audience. With this in mind, the Third Edition has been revised in several major ways.

Significant Restructuring and Rewriting: In response to the evolving requirements of the text's audience—both students and educators—the changes implemented in this edition result in greater depth of discussion, and for some specific cultures and time periods, a broader scope. I also revamped a number of chapters and sections in a continuing effort to

better utilize chapter organization as a foundation for understanding historic periods and to help explain key concepts.

Improved Student Accessibility: New pedagogical features make this book even more readable and accessible than its previous incarnations. Revised maps and chronologies, for example, anchor the reader in time and place, while the redesigned box program provides greater detail about key contextual and technical topics. At the same time, I have worked to maintain an animated and clear narrative to engage the reader. Incorporating feedback from our many users and reviewers, I believe we have succeeded in making this edition the most student-accessible art history survey available.

Enhanced Image Program: Every image that could be obtained in color has been acquired. Older reproductions of uncleaned or unrestored works also have been updated when new and improved images were available. In some instances, details have also been added to allow for closer inspection. (See, for example, figs. 18–21 and 19–37.) The line art program has been enhanced with color for better readability, and there is a new series of color reconstructions and cutaway architectural images. To further assist both students and teachers, we have sought permission for electronic educational use so that instructors who adopt *Art History* will have access to an extraordinary archive of high quality digital images for classroom use. (SEE P.XXII FOR MORE DETAILS ABOUT THE PRENTICE HALL DIGITAL ART LIBRARY).

WHAT'S NEW

Chapter by Chapter Revisions

Chapter 1 includes a focus on the arts and daily life in prehistoric Europe with enhanced coverage of Neolithic paintings and the village of *Skara Brae*.

Chapter 2 is reorganized to follow a chronological sequence, and the focus on the arts and daily life in this chapter incorporates the sites of *Jericho* and *Catal Huyuk*.

Chapter 3 features an aerial view and reconstruction drawing of *Karnak*, as well as expanded coverage of *Abu Simbel*.

Chapter 4 now offers aerial views combined with reconstruction drawings for the sites of *Knossos* and *Mycenae*, and the "Object Speaks" highlights the *Lions' Gate at Mycenae*.

Chapter 5 is enhanced by the addition of Exekias' vase, *Ajax and Achilles Playing a Dice Game*. There also is a clarification of the ownership status of the *Death of Sarpedon* vase by Euphronios.

Chapter 6 is reorganized to follow a chronological sequence rather an organization by medium. The addition of more "natural" busts such as *Pompey* and a *Middle-aged Flavian Woman* broadens the discussion of Roman portrait. A colorized reproduction of the *Augustus of Prima Porta* is included in a discussion of the use of color in ancient sculpture.

Chapter 7 includes new images of the *Old St. Peter's* interior and the *Hosios Lukas* exterior. New examples of Early Christian sculpture are a sarcophagus with Christian themes, and the carved doors of the church of Santa Sabina.

Chapter 8 heightens its emphasis on the exchanges within the Islamic world and between Islam and its neighbors. A new section on the "Five Pillars" of Islamic religious observance is incorporated. Coverage is extended into the modern period.

Chapter 9 features new material on Southeast Asia, including Thailand, Cambodia, Indonesia, and Sri Lanka.

Chapter 10 has an extensive new section on Korean art, including painting, ceramics, and metalwork. Korean Buddhist works now complement the coverage of Buddhist art in China.

Chapter 11 has updated text and improved illustrations.

Chapter 12 includes a greater emphasis on North America as well as an expanded section on Mayan sculpture.

Chapter 13 now features a discussion of the earliest evidence of art-making in Africa, an expansion of the rock art section, and an added exploration of Igbo-Ukwu culture. A discussion of Kongo art from central Africa is also added. Textiles are introduced as a high art form.

Chapter 14 is reorganized to clarify the complex styles of migrating peoples in the fifth through seventh centuries as well as the contributions of the Vikings in sculpture and architecture. To allow for a more cohesive discussion, eleventh-and twelfth-century work in wood has been moved to this chapter.

Chapter 15 is reorganized chronologically rather than regionally or by medium. It includes a new focus on secular architecture and *Dover Castle*. In sculpture, there is enhanced coverage of cloister reliefs, historiated capitals, and bronze work.

Chapter 16 is reorganized in several significant ways. The chapter incorporates early and high Gothic art and ends at about 1300. The origins and development of Gothic art in France have been reworked, the "hall" church has been reinstated, and the coverage of secular architecture continues with *Stokesay Castle* in England.

Chapter 17 is a new chapter that permits a discussion of the fourteenth century as it unfolded across Europe. An aerial view and illustrated drawing of the *Cathedral in Florence* have been added. A new section on Bohemian art is included.

Chapters 18–21 are a result of a major restructuring. The two chapters formerly devoted to the fifteenth and sixteenth centuries each have been divided into four chapters.

Chapter 18 continues some of the themes and traditions of Gothic and fourteenth-century art outside Italy. *The Ghent Altarpiece* has been reinstated with open and closed views. A closed view of Rogier van der Weyden's *Last Judgment Altarpiece* also is added.

Chapter 19 is devoted to Italian fifteenth-century art. Donatello's *St. George* is now incorporated, as is the *Triumph of Federico and Battista da Montefeltro*. The art and architecture of Venice are given greater emphasis.

Chapter 20 features sixteenth-century Italian art. The sculpture discussion is broadened. Illustrations from *The Farnese Hours* emphasize the continuing tradition of the illuminated manuscript.

Chapter 21 deals with the sixteenth century outside Italy. The "Object Speaks" focuses on Portuguese sculpture and the great *Window at Tomar*. Secular architecture is expanded to include the *Château of Chenonceau* and Tudor *Hardwick Hall*.

Chapter 22 remains regionally organized, but is slightly reordered for better clarity. Spanish colonial sculpture and architecture are moved to chapter 29.

Chapter 23 has new Nepalese and Tibetan material as well as an added segment on Southeast Asia (including Burma, Thailand, and Vietnam). There is enhanced coverage of modern and contemporary India.

Chapter 24 now features a survey of the later art of Korea, including ceramics and painting, with coverage up to the twentieth century.

Chapter 25 includes a Japanese print once owned by Frank Lloyd Wright. Also added are a Nihonga style work by Yokoyama Taikan and a contemporary painting by Takashi Murakami.

Chapter 26 now includes Aztec featherwork and a discussion of the National Museum of the American Indian.

Chapter 27 incorporates a discussion of the importance of the ocean in the culture and art of Oceania. There is an emphasis on shared materials and the commonalities of this vast region.

Chapter 28 now features masquerade, Kuba elite costuming and architectural decoration, and Fon memorial iron sculpture. The contemporary art section is expanded to include artists working on the continent and in the Diaspora.

Chapter 29 includes more historical context in the discussion of artists and works. Colonial Latin American objects are moved to this chapter.

Chapter 30 features a section on Orientalism. The interaction of French political history and art is explored in greater detail, and the discussion relating to the definition and causes of Modern art is rewritten and expanded.

Chapter 31 includes an increased exploration of Primitivism in relation to several movements. There is a key new section on Latin American early Modern art, and the segments relating to Kandinsky's abstract art, Dada, and Surrealism are rewritten.

Chapter 32 has a new discussion of cultural factors such as existentialism, John Cage, and the influence of mass media. There is increased coverage of postwar European art and Latin American art. An expanded discussion of the end of Modernism and the beginnings of Postmodernism is incorporated, as well as new sections relating to some dominant trends in Postmodernism.

Tools for Understanding Art History

Art History offers the most student-friendly, contextual, and inclusive survey of art history.

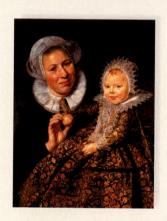

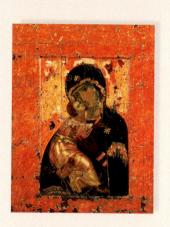

he text provides students with essential historical, social, geographical, political, and religious contexts. It anchors works of art and architecture in time and place to foster a better understanding of their creation and influence. Marilyn Stokstad takes students on a unique journey through the history of art, illustrating the rich diversity of artists, media, and objects.

Key Features of Every Chapter

Art History has always been known for superb pedagogical features in every chapter, many of which have been enhanced for this new edition. These include:

Chapter openers quickly immerse the reader in time and place and set the stage for the chapter. Clear, engaging prose throughout the text is geared to student comprehension.

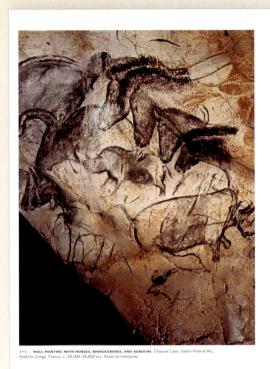

PREHISTORIC ART IN EUROPE

and other structures. In fact, much of what we and other structures. In fact, much of what we contained because the fact of the structure made them. The sheer arrivary and immediacy of the images these tools appear to us. The creation of the images we se-

eastern France (FIG. 1-1) images of horses, deer, mammoths, fishle for the numers have transformed their memories of when and how these works were created they may never be flanks, powerful legs, and dangerous horns or tusks. Using only been created over a very long span of time. The conclusions and

The first contemporary people to explore the painted day survival. They were often painted in areas far from the accessed through long, narrow underground passages, what
vasses but irregular natural rock forms. What we perceive as
they found atounded them and still fascinates us. In the Chau"art" may have been a matter of necessiry to these ancient

next) range to necessary the contract of contract of the contr

Chapter-at-a-glance feature allows students to see how the chapter will unfold.

diating its accumulated pagan idob, while preserving the enigmatic cubical structure itself and dedicating it to God.

The Kaaba is the symbolic center of the Islamic world, the place to which all Muslim prayer is directed and the ultimate pling of these diverse groups of pilgrims has been a primary source of Islamic art's cultural eclecticism

- ART DURING THE EARLY CALIPHATES | Architecture | Calligraphy | Ceramics and Textiles ■ LATER ISLAMIC ART Architecture Portable Arts Manuscripts and Painting

- IN PERSPECTIVE

ISLAM AND EARLY ISLAMIC SOCIETY

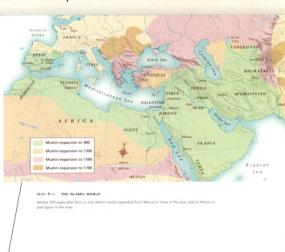

ART DURING THE EARLY CALIPHATES

Easy-to-read color maps use modern country names for ease of reference and point to the sites and locations mentioned in the chapter. ection and that of her customer tell a defperencion, which Manet has curiously as of the mirror were placed at an angle, goward the patron, whose intent gaze the physical and psychological distunce vanished. Exactly what Manet meant to juspointion has been much debated. One warned to contrast the longing for hapin effected miragidike in the mirror, in effected in the place of the properties of the proting of the properties.

OF MODERN ART

OF MODERN ARI

To the control of the

and half of the nuncreasth century, action yelementally to question that transitions for various reasons, which some artists often a stress of the control of the control fation was uniphy used up and that norball with it. Other propaged the transition fast-changing world of urbanization and that period Claude Monte, for example, ment teacher when he urged the class to turn the control of the control of the class to turn the control of the class to the control of the class to turn the control of the class to the control of the class to turn the control of the class to the class to turn the control of the class to the class to turn the class to the class the class to the tent of the class to the tent of the class to the tent of the class to the tent of the class to the class to the class to the class a subject when a machine could do it almost as well? What werther reason, Modern artiss rejected not only the tradition but also the superstructure that came with it in the form of academic training. Salon exhibitions, and the taste of most or public. This choice was a costly one for main of them, who could have had much more lucrative careers it they had created their art in more acceptable modes.

A deeper cause of Modern art was the moderization of soctery. The Indural Revolution created a new public for art in the urban middle classes who flocked to the Salons in search of culture. As we have seen, their taste was cultured and conservative, fovering Academic arries such as Bouguereast. Carpeaus, and Cabanel. Modern arriss had little interest in catering to this cliented, and perferred to carry out and exhibit their experiments in realiso notative the normal conservative.

In place of the "official" are rudners. Modern arrises exsted what has been called an aware-garde. The term was intally used in a military context, designating the forward units of an advancing army that scound terrunny which there so to the troops would soon occupy. This term thus captures the forward-looking aggest of Modern art, and the belief that Modermus are working absend of the public's ability to comprehend, As an art-world social group, the aware-garde consumed of Modern arms, along with a few collectors, art exisises, and are dealer who followed the tarted evolupours and is a martin and the sounders are soon concept, the rejections of tradition and the assume games or the consequence of tradition and the assume games are more important for understanding Moderna and

Despite the agny protestations of conceivance entics, the deposition of traditions do not happen all a core. In fact, the dederin art movement unfolded in a gradual and even liquid, e.g. a attria, questioned and three sou one rich art another su succeeding decades. Modermen was not revolutionary but su succeeding decades. Modermen was not revolutionary but succeeding decades. Modermen was not revolutionary but content and properly "dignified" subject matter. The lungescontent and properly "dignified" subject matter. The lungesments also did that, and addition they break the convention that separated sketch from finished work. Although they may be a support of the tradition perfectly instart. After lungesment fathal to some at the time, both of these momentum from course in the middle 1988, other some negation or in a course in the middle 1988, other some normal course in the middle 1988, other some form of the tradition. To these arisins and someonens we turn not. To these arisins and someonens we turn not.

Post-Impressionism

The English critic Roger Fry contend the term Pos-Improximation in 1990 to identify a board reaction against Improximation in virial-gande painting of the late instructoral and early recentrich centuries. Art Institution recognite Paul Gezame (1887–1990), Cercercus under 1887–1991, Vincercus un Gogh (1885–1990), and Paul Gauguin (1888–1990) as the principal Pose-Improximonis artisis. Each of these painters mose of though an Improximonist artisis. Each of these painters mose of through an Improximonist phase, and each continued to use in his muture work the regist Improximonist place. But each came also to reject.

Impressionism's emphasis on the spontaneous recording of light and color. Some sought to create art with a greater degree of formal order and structure, others moved further from Impressionism and developed more abstract styles that would prove highly influential for the development of Modern painting in the early twentieth century.

CEANME. No article had a genere impact on the next generation of Modern patients than CEANME, when exposed improfessional success until the last few years of his life, when younger artiss and critics began to recognize the immovine qualities of his art. The son of a prospensis banker in the southern Fernels tip of Alicean-Prosecue. Ceanme studied art first in Aix and then in Paris, where he participated in the critic of Relatal serias around Mante. Ceanme's outpieture, somber in color and coursely painted, often depicted Romantic themes of drams and violence, and were commi-

In the early 1870s CEazune changed his syle under the influence of Pissarro and adopted the bright palette, broken brushwork, and everyday subject matter of Impressionism. Like the Impressionisms, with whom he exhibited in 1874 and 1877, CEazune now dedicated himself to the objective transcription of what he called his "sensation" of rature. Unlike the Impressionism, however, he did not seek to scapure transi-

Sequencing Works of Art

4 Homer, The Life Line
4-86 Seurat, A Sunday Afternoon on the Island o
La Grande fatte

1884-89 Rodin, Burghers of Calais 1885-87 Cézanne, Mont Sainte-Victoire 1887-89 Eiffel, Eiffel Tower, Paris van Gogh, The Starry Night

tory effects of light and atmosphere but rather to create a sense of order in nature through a methodical application of color that merged drawing and modeling into a single process. His professed aim was to "make of Impressionism something solid and durable like the art of the magning."

Cézanne's tireless pursuit of this goal is exemplified in his paintings of Mont Sainte-Victoire, a prominent mountain mean this home in Ant that he depicted about thirty times is oil from the mid-1880s to his death. The version here (Willey-Color) when the mountain rising above the Are Villey which is dotted with houses and trees and is traversed at the

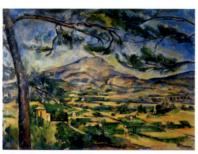

30-62 | Paul Cézanne MONT SAINTE-VICTOIRE c. 1885-87. Oil on canvas, 25% × 32" (64.8 × 92.3 cm). Courtauld Institute of Art Gallery, London. (#1994-5C.55)

THE BIRTH OF MODERN ART

Mini chronologies

provide small in-text sequencing charts related to historic events and works of art.

THE OBJECT SPEAKS

RAFT OF THE "MEDUSA"

mb hodour Caricash's monumental Ref of the Nuban's is history painting that speaks powerfully through a composition in which the vice time 'larghy mode, muscular bodies are organized not round diagnosh. The diagnosh that the same time to be wining figures registers there is the waving figures registers there is the waving figures registers their round pulpers. The diagnosh that begins with the dead main in the lower right and exends through the mass and bibliousing suit, however, directs our attention to a bugs wise. The reasons of the men is not yet assured. They remain and death. Significantly, the required figure darks the principal cardiactic planning reministers in the vigerous figure of laket man, it consists of the principal cardiactic planning reministers in the vigerous figure of laket man, it consists of the principal region of laket man, it is my shareful assuing, by planning reministers are made in many figures.

vivors and giving him the power to save his comrades by signaling to the rescue ship, Gericault suggests metaphorically that freedom for all of humanity will only occur when the most oppressed member

Géricaulé's work was the collemination of extenire study and experimentation. An early pen disawing depicts the survivors' hopeful response to the appearance of the researce ship on the horizon at the extreme left. Their excitement is in contrast with the mountful scene of a man grieving over a dead youth on the right side of the raft. A later pen-and-wash drawing reverses the composition, creates greater unity among the figure, and establishes the modeling of their bod is the strongly light and shade. These developments are those of the strongly light and shade. These developments are the superior of the strongly light and shade. These developments are the superior of the strongly light and shade. These developments are the superior of the

study still lacks the figures of the black man at the apex of the painting and the dead bodies at the extreme left and lower right, which fill out the composition's

many of the figures, as well as studies of actual corpses, severed heads, and dissected limbs supplied to him by friends who worked at a nearby hospital. For several months, according to Géricault's biographer, this studio was a kind of morgue. He kept cadavers there until they were half-decomposed, and insisted on working in this Ahamel-house atmosphere.

cadavers directly in the Raff of the "Mediss." To execute the final painting, he traced the outline of his composition onto a large canwas, then painted each body directly from a living model, gradually

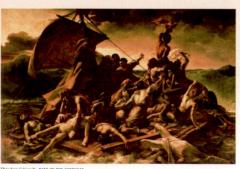

1818-19. Oil on canvas, 16'1" × 23'6" (4.9 × 7.16 m). Musée du Louvre, Paris

992

building up his composition figure by figure. He seems, rather, to have kept the corpses in his studio only to create an atmosphere of death that would provide him with a more authentic understanding of his subject.

Nevertheless, Céricault del not depter he extual physical condition of the survivors on the raft: enhanced, emaciated, he extual physical condition of the survivors on the raft: enhanced, emaciated, engless of the Caral Manner, he gane his men athletic bodies and vigorous poses, vooling the work of Michelangelo and Ruberus (Chapters 20 and 22). He did this to generalize and ennoble his subject, elevating it above the particular of a specific shipwareks on that it could speak to un of more fundamental at could speak to un of more fundamental and could repair to the country of the count

THE SIGHTING OF THE *ARGUS* (TOP) 1818. Pen and ink on paper, 13 % × 16 %* (34.9 × 41 cm). Musée des Beaux-Arts,

THE SIGHTING OF THE *ARGUS* (MIDDLE) 1818.
Pen and ink, sepia wash on paper, 8% × 11 %" (20.6 × 28.6 cm). Musée des Beaux-Arts, Rouen.
STUDY OF HANDS AND FEET (BOTTOM) 1818-19.

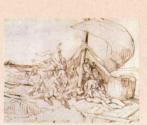

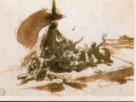

993

The Object Speaks boxes provide in-depth insights on topics such as authenticity, patronage, and artistic intention.

Box program brings an added layer of understanding to the contextual and technical aspects of the discipline:

- The Object Speaks
- Elements of Architecture
 - Technique
 - Defining Art
- Science and Technology
- Religion and Mythology
 - Art and Its Context

Art and Its Context WOMEN AND ACADEMIES

In Perspective is a concluding synthesis of essential ideas in the chapter.

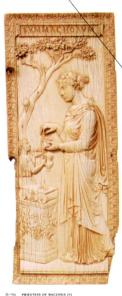

IN PERSPECTIVE

Timelines provide an overview of the chapter time frame

Elements of Architecture THE SKYSCRAPER

ART BETWEEN THE WARS

Diagrams make difficult concepts related to architecture and materials and techniques accessible to students.

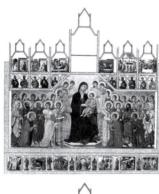

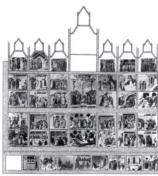

Technique BUON FRESCO

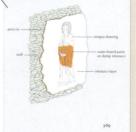

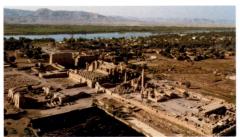

hall and sanctuary. The design was symmetrical and axial that is, all of its separate elements are symmetrically arranged The rooms became smaller, darker, and more exclusive a they neared the sanctuary. Only the pharaoh and the priest

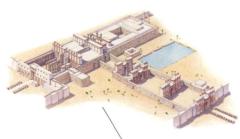

-23 RECONSTRUCTION DRAWING OF THE GREAT TEMPLE OF MUN AT KARNAK, EGYPT

68 CHAPTER THREE ART OF ANCIENT EGYP

Two temple districts consecrated primarily to the worship of Amun, Mut, and Khons arose near Thebes—a huge complex at Karnak to the north and, joined to it by an avenue of sphinxes, a more compact temple at Luxor to the south.

KAMMA. At Karnak, temples were built and rebuilt for order 1,500 years, and the remains of the New Kingdom additions to the Great Temple of Anun still dominate the Indicape (RG, 3–22). Over the nearly 500 years of the New Kingdom, successive kings removated and expanded the Anun temple until the complex covered about 601 acres, an area as large as a dozen football field (RG, 3–23).

access notional teals (see, 2-1).

Access to the heart of the temple, a sanctuary containing the status of Annua, was from the work (on the left side of other reconstruction desaying through a principal contrapt, al. lappose)se half, and a number of smaller halis and cours. Psylons est of tack of these separate elements. Between the Egileteenth and Numeteenth sylusiary regions of Thomsone I (reduced, 1-193-3-193), and Rameste I (rude d. 1-193-3-1193), are 3, this area of the complex underwears a great deal of construction and remeased. The gueen part of Psylon II though you become a surface of the state of the st

In the sunctury, the priest walted the gold vature ever morning and othered it as a new garment. Because the gost was thought to derive nourishment from the spirit of food, it was provided with tempting meds twice a day, which the priests their removed and at themselves. Ordurary people entered the temple precinct only a far as the forecours of the hysosyle halls, where they found themselves surroundee by incerptions and images of kings and the god on column and walts. During religious fourbal, however, they limed the waverways, Jong which status of the golds were carried to exercise the superior of the priests for registers they when the the priests for requests they will be golds to grant.

This Gatz Hai, ar Kossox. Between Pylonis II and III I at Karnak stands the enormous hyposyle ball evered in the regists of the Nineteenth Dynasy rulers Sery I (rule c. 1290–1279 ncc) and his von Rameses II (rule c. 1279–12713 ncs). Called the "Temple of the Spirit of Ser-Belowed of Palin in the House of Annun," it may have bee used for royal consustion ceremonies. Rameses II referred it as "the place where the common people sxat of the rule of it as "the place where the common people sxat of the rule his majors. The hall was 340 feet wide and 170 feet long Its 134 doorly speed columns supported a stepped not of 134 doorly speed a stepped not of 134 doorly speed a stepped not of which now some 20 feet higher from 150 feet from 150

3-24 | RECONSTRUCTION DRAWING OF THE HYPOST

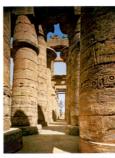

3-25 | FLOWER AND BUD COLUMNS, HYPOSTYLE HALI

THE NEW KINGDOM. c. 1539-1075 act

Reconstructions bring partially destroyed and no longer extant sites to life.

The CAMPORAL. In Florence, the cathedral thomost (1935, 129-4) has a long and complex hostory. The original plan by Armolie (Cambios (c. 1284-1302), was approved in 1294, but polinical unrest in the 1395 brought construction to a last until 1337. Several modifications of the design were made, and the cathedral we see today was built between 1335 and 1338 (The Englew sang sens in venered white and green markle in the mineteenth century to coordinate it with the rest of the building and the next's Baptistry of Star.

Giovanni.)
Sculptors and painters rather than musons were often
responsible for designing Italian architecture, and as the Florence Cathedral reflects, they tended to be more concerned
with pure design than with engineering. The long, square-

the nave and side ailes. Three polygonal apses, each with fix radiating chapels, surround the central space. This winhold Dome of Hearne, where the mini aftic is Ecalest, starts pour from the worldly realm of the congregation in the nave. Bithe great ribbed dome, so fundamental to the planners' conception, was not began until 1420, where the architect Ful pop Brunellecht (1377-1446) solved the engineering problom studied in its commencion for Churse 190.

THE BAPTISTEY DOORS. In 1330, Andrea Pisane (c.1290-1348) was awarded the prestigious commission for a pair of gilded bronze doors for the Florentine Baptistry or San Giovanni. (Although his name means "from Pisa," Andrea was not related to Nicola and Giovanni Pisano, The Baptistry doors were completed within six years and display

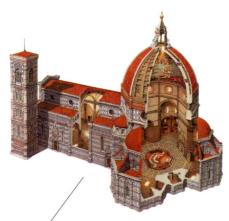

17-3 | FLORENCE CATHEDRAL (DUOMO) Plan 1294, costruction begun 1296, redisegned 1357 and 1366, drum and dome 1420-36

558 CHAPTER SEVENTEEN FOURTEENTH-CENTURY ART IN EUROP

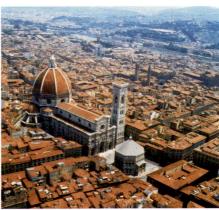

17–4 | Arnolfo di Cambio, Francesco Talenti, Andrea Orcagna, and others
FLORENCE CATHEDRAL (DUOM 1296-1378; drum and dome by Brunelleschi, 1420-36; bell tower (Campanile) by Giotto, Andrea Pisano, and

Francesco Talenti, c. 1334–30.

The Romanesque Baptistry of San Giovanni stands in front of the Dwon

twenty scenes from the life of John the Baptite (San Gisvaum) set above eigh persondication of the Vitruse (Sin-(19-3). The reliefs are framed by quartefuls, the four-lobed decorative frames introduced at the Calestal of Amienta in Transce (Sin 10, 16-21). The figures within the quarteful are in the monumental, classicating syste imprired by Gonton to Carrier (Sin 10, 16-21). The figures within the quarteful adapteries, and a quiet digning of pose particular to Andrea. The individual scenes are elegandly natural. The figures placement, on defellike stages, and their modeling crease a remarkable illusion of three-dimensionality, but the overall effect created by the repeated babelon quartefuls is sow dimensional and decorative, and emphasizes the solidity of the doors. The bronze vine scrolls filled with flowers, fruits, and birds on the linted and jambs framing the door were wided in the mid-fifteenth contrary.

Florentine Paintin

Florence and Siena, trush in so many wasy, each supported flourshing school of painting in the fourteenth century. Both grew out of the Italo-Byzantine wyle of the thirteenth century, modified by local traditions and by the presence of individual artists of genus. The Byzantine influence, also referred to as the manine gene 'Greek manner'), was characterize by dramatic pathos and complex iconography and showe

LY 55

Cutaways assist students in understanding the design and engineering of major buildings.

FACULTY AND STUDENT RESOURCES FOR ART HISTORY

rentice Hall is pleased to present an outstanding array of high quality resources for teaching and learning with Stokstad's Art History.

DIGITAL & VISUAL RESOURCES

The Prentice Hall Digital Art Library: Instructors who adopt Stokstad's Art History are eligible to receive this unparalleled resource. Available in a two-DVD set (ISBN 0-13-232211-0) or a 16-CD set (ISBN 0-13-156321-1), The Prentice Hall Digital Art Library contains every image in Art History in the highest resolution (300-400 dpi) and pixellation (up to 3000 pixels) possible for optimal projection and one-click download. Developed with input from a panel of instructors and visual resource curators, this resource features over 1,200 illustrations in jpeg and in PowerPoint, an instant download function for easy import into any presentation software, along with a zoom feature, and a compare/contrast function, both of which are unique and were developed exclusively for Prentice Hall.

VangoNotes: Students can study on the go with VangoNotes—chapter reviews from the text in downloadable mp3 format. Each

chapter review contains: Big Ideas—Your "need to know" for each chapter; Key Terms: audio "flashcards" to help you review key concepts and terms; and Rapid Review: A quick drill session—use it right before your test. Visit www.vango.com.

OneKey is Prentice Hall's exclusive course management system that delivers all student and instructor resources in one place.

Powered by WebCT and Blackboard, OneKey offers an abundance of online study and research tools for students and a variety of teaching and presentation resources for instructors, including an easy-to-use gradebook and access to many of the images from the book.

Art History Interactive CD-ROM: 1,000 Images for Study & Presentation is a powerful study tool for students. Images are viewable by title, by period, or by artist. Students can quiz them-

selves in flashcard mode or by answering any number of short answer and compare/contrast questions.

Classroom Response System (CRS) In Class Questions: Get instant, class-wide responses to beautifully illustrated chapter-specific questions during a lecture to gauge student comprehension—and keep them engaged. Visit www.prenhall.com/art.

Companion Website: Visit www.prenhall.com/ stokstad for a comprehensive online resource featuring a variety of learning and teaching modules,

all correlated to the chapters of Art History.

Prentice Hall Test Generator is a commercial-quality computerized test management program available for both Microsoft Windows and Macintosh environments.

PRINT RESOURCES

TIME Special Edition, Art: Featuring stories such as "The Mighty Medici," "When Henri Met Pablo," and "Redesigning America," Prentice Hall's TIME Special Edition contains thirty articles and exhibition reviews on a wide range

of subjects, all illustrated in full color. This is the perfect complement for discussion groups, in-class debates, or writing assignments. With TIME Special Edition, students also receive a 3-month pass to the TIME archive, a unique reference and research tool.

Understanding the Art Museum by Barbara Beall-Fofana: This handbook gives students essential museum-going guidance to help them make the most of their experience seeing art outside of the classroom. Case studies are incorporated into the text, and a list of major museums in the United States and key cities across the world is included. (0-13-195070-3)

OneSearch with Research Navigator helps students with finding the right articles and journals in art history.

Students get exclusive access to three research databases: The New York Times Search by Subject Archive, ContentSelect Academic Journal Database, and Link Library.

Instructor's Manual & Test Item File is an invaluable professional resource and reference for new and experienced faculty, containing sample syllabi, hundreds of sample test questions, and guidance on incorporating media technology into your course. (0-13-232214-5)

To find your Prentice Hall representative, use our rep locator at www.prenhall.com.

ACKNOWLEDGEMENTS AND GRATITUDE

Dedicated to my sister, Karen L. S. Leider, and to my niece, Anna J. Leider

preface gives the author yet another opportunity to thank the many readers, faculty members, and students who have contributed to the development of a book. To all of you who have called, written, e-mailed, and just dropped by my office in the Art History Department or my study in the Spencer Research Library at the University of Kansas, I want to express my heartfelt thanks. Some of you worried about pointing out defects, omissions, or possible errors in the text or picture program of the previous edition. I want to assure you that I am truly grateful for your input and that I have made all the corrections and changes that seemed right and possible. (I swear the Weston photograph in the Introduction is correctly positioned in this edition, and that, no, I was not just being witty by showing only the Gallic trumpeter's back side in Chapter 5—that slip has been corrected!)

Art History represents the cumulative efforts of a distinguished group of scholars and educators. Single authorship of a work such as this is no longer viable, especially because of its global coverage. The work done by Stephen Addiss, Chu-tsing Li, Marylin M. Rhie, and Christopher D. Roy for the original edition has been updated and expanded by David Binkley and Patricia Darish (Africa), and Claudia Brown (Asia). Patrick Frank has reworked the modern material previously contributed by David Cateforis and Bradford R. Collins. Dede Ruggles (Islamic), Bob Mowry (Korea), and Sara Orel (Pacific Cultures) also have contributed to the third edition.

As ever, this edition has benefited from the assistance and advice of scores of other teachers and scholars who have generously answered my questions, given recommendations on organization and priorities, and provided specialized critiques. I want to especially thank the anonymous reviewers for their advice about reorganizing and revising individual chapters.

In addition, I want to thank University of Kansas colleagues Sally Cornelison, Amy McNair, Marsha Haufler, Charles Eldredge, Marni Kessler, Susan Earle, John Pulz, Linda Stone Ferrier, Stephen Goddard, and Susan Craig for their insightful suggestions and intelligent reactions to revised material. I want to mention, gratefully, graduate students who also helped: Stephanie Fox Knappe, Kate Meyer, and Emily Stamey.

I am additionally grateful for the detailed critiques that the following readers across the country prepared for this third edition: Charles M. Adelman, University of Northern Iowa; Fred C. Albertson, University of Memphis; Frances Altvater, College of William and Mary; Michael Amy, Rochester Institute of Technology; Jennifer L. Ball, Brooklyn College, CUNY; Samantha Baskind, Cleveland State University; Tracey Boswell, Johnson County Community College; Jane H.

Brown, University of Arkansas at Little Rock; Roger J. Crum, University of Dayton; Brian A. Curran, Penn State University; Michael T. Davis, Mount Holyoke College; Juilee Decker, Georgetown College; Laurinda Dixon, Syracuse University; Laura Dufresne, Winthrop University; Dan Ewing, Barry University; Arne Flaten, Coastal Carolina University; John Garton, Cleveland Institute of Art; Rosi Gilday, University of Wisconsin, Oshkosh; Eunice D. Howe, University of Southern California; Phillip Jacks, George Washington University; William R. Levin, Centre College; Susan Libby, Rollins College; Henry Luttikhuizen, Calvin College; Lynn Mackenzie, College of DuPage; Dennis McNamara, Triton College; Gustav Medicus, Kent State University; Lynn Metcalf, St. Cloud State University: Io-Ann Morgan, Coastal Carolina University: Beth A. Mulvaney, Meredith College; Dorothy Munger, Delaware Community College; Bonnie Noble, University of North Carolina at Charlotte; Leisha O'Quinn, Oklahoma State University; Willow Partington, Hudson Valley Community College; Martin Patrick, Illinois State University; Albert Reischuck, Kent State University; Jeffrey Ruda, University of California, Davis; Diane Scillia, Kent State University;. Stephanie Smith, Youngstown State University; Janet Snyder, West Virginia University; James Terry, Stephens College; Michael Tinkler, Hobart and William Smith Colleges; Reid Wood, Lorain County Community College. I hope that these readers will recognize the important part they have played in this new edition of Art History and that they will enjoy the fruits of all our labors. Please continue to share your thoughts and suggestions with me.

Many people reviewed the original edition of Art History and have continued to assist with its revision. Every chapter was read by one or more specialists. For work on the original book and assistance with subsequent editions my thanks go to: Barbara Abou-el-Haj, SUNY Binghamton; Roger Aiken, Creighton University; Molly Aitken; Anthony Alofsin, University of Texas, Austin; Christiane Andersson, Bucknell University; Kathryn Arnold; Julie Aronson, Cincinnati Art Museum; Michael Auerbach, Vanderbilt University; Larry Beck; Evelyn Bell, San Jose State University; Janetta Rebold Benton, Pace University; Janet Berlo, University of Rochester; Sarah Blick, Kenyon College; Jonathan Bloom, Boston College; Suzaan Boettger; Judith Bookbinder, Boston College; Marta Braun, Ryerson University; Elizabeth Broun, Smithsonian American Art Museum; Glen R. Brown, Kansas State University; Maria Elena Buszek, Kansas City Art Institute; Robert G. Calkins; Annmarie Weyl Carr, Southern Methodist University; April Clagget, Keene State College;

William W. Clark, Queens College, CUNY; John Clarke, University of Texas, Austin; Jaqueline Clipsham; Ralph T. Coe; Robert Cohon, The Nelson-Atkins Museum of Art; Bradford Collins, University of South Carolina; Alessandra Comini; Charles Cuttler; James D'Emilio, University of South Florida; Walter Denny, University of Massachusetts, Amherst; Jerrilyn Dodds, City College, CUNY; Lois Drewer, Index of Christian Art; Joseph Dye, Virginia Museum of Art; James Farmer, Virginia Commonwealth University; Grace Flam, Salt Lake City Community College; Mary D. Garrard; Paula Gerson, Florida State University; Walter S. Gibson; Dorothy Glass; Oleg Grabar; Randall Griffey, The Nelson-Atkins Museum of Art; Cynthia Hahn, Florida State University; Sharon Hill, Virginia Commonwealth University; John Hoopes, University of Kansas; Carol Ivory, Washington State University; Reinhild Janzen, Washburn University; Alison Kettering, Carleton College; Wendy Kindred, University of Maine at Fort Kent; Alan T. Kohl, Minneapolis College of Art; Ruth Kolarik, Colorado College; Carol H. Krinski, New York University; Aileen Laing, Sweet Briar College; Janet Le Blanc, Clemson University; Charles Little, The Metropolitan Museum of Art; Laureen Reu Liu, McHenry County College; Loretta Lorance; Brian Madigan, Wayne State University; Janice Mann, Bucknell University; Judith Mann, St. Louis Art Museum; Richard Mann, San Francisco State University; James Martin,; Elizabeth Parker McLachlan, Rutgers University; Tamara Mikailova, St. Petersburg, Russia, and Macalester College; Anta Montet-White; Anne E. Morganstern, Ohio State University; Winslow Myers, Bancroft School; Lawrence Nees, University of Delaware; Amy Ogata, Cleveland Institute of Art; Judith Oliver, Colgate University; Edward Olszewski, Case Western Reserve University; Sara Jane Pearman; John G. Pedley, University of Michigan; Michael Plante, Tulane University; Eloise Quiñones-Keber, Baruch College and the Graduate Center, CUNY; Virginia Raguin, College of the Holy Cross; Nancy H. Ramage, Ithaca College; Ann M. Roberts, Lake Forest College; Lisa Robertson, The Cleveland Museum of Art; Barry Rubin; Charles Sack, Parsons, Kansas; Jan Schall, The Nelson-Atkins Museum of Art; Tom Shaw, Kean College; Pamela Sheingorn, Baruch College, CUNY; Raechell Smith, Kansas City Art Institute; Lauren Soth; Anne R. Stanton, University of Missouri, Columbia; Michael Stoughton; Thomas Sullivan, OSB, Benedictine College (Conception Abbey); Pamela Trimpe, University of Iowa; Richard Turnbull, Fashion Institute of Technology; Elizabeth Valdez del Alamo, Montclair State College; Lisa Vergara; Monica Visoná, University of Kentucky; Roger Ward, Norton Museum of Art; Mark Weil, Washington University, St. Louis; David Wilkins; Marcilene Wittmer, University of Miami

My thanks also to additional expert readers for this new edition including Susan Cahan, University of Missouri-St. Louis; David Craven, University of New Mexico; Marian Feldman, University of California, Berkeley; Dorothy Johnson, University of Iowa; Genevra Kornbluth, University of Maryland; Patricia Mainardi, City University of New York; Clemente Marconi, Columbia University, Tod Marder, Rutgers University; Mary Miller, Yale University; Elizabeth Penton, Durham Technical Community College; Catherine B. Scallen, Case Western University; Kim Shelton, University of California, Berkeley.

I also want to thank Saralyn Reese Hardy, William J. Crowe, Richard W. Clement, and the Kenneth Spencer Research Library and the Helen F. Spencer Museum of Art of the University od Kansas.

Again I worked with my editors at Prentice Hall, Sarah Touborg and Helen Ronan, to create a book that would incorporate effective pedagogical features into a narrative that explores fundamental art historical ideas. Helen Ronan, Barbara Taylor-Laino, Assunta Petrone, and Lisa Iarkowski managed the project. I am grateful for the editing of Jeannine Ciliotta, Margaret Manos, Teresa Nemeth, and Carol Peters. Peter Bull's drawings have brought new information and clarity to the discussions of architecture. Designer Anne Demarinis created the intelligent, approachable design of this book; she was supported by the masterful talents of Amy Rosen and Gail Cocker-Bogusz. Much appreciation goes to Brandy Dawson, Marissa Feliberty, and Sasha Anderson-Smith in marketing and Sherry Lewis the manufacturing buyer, as well as the entire Humanities and Social Sciences team at Prentice Hall.

I hope you will enjoy this third edition of *Art History* and, as you have done so generously and graciously over the past years, will continue to share your responses and suggestions with me.

Marilyn Stokstad
 Lawrence, Kansas

USE NOTES

he various features of this book reinforce each other, helping the reader to become comfortable with terminology and concepts that are specific to art history.

Starter Kit and Introduction The Starter Kit is a highly concise primer of basic concepts and tools. The Introduction is an invitation to the many pleasures of art history.

Captions There are two kinds of captions in this book: short and long. Short captions identify information specific to the work of art or architecture illustrated:

artist (when known)

title or descriptive name of work

date

original location (if moved to a museum or other site) material or materials a work is made of

size (height before width) in feet and inches, with meters and centimeters in parentheses

present location

The order of these elements varies, depending on the type of work illustrated. Dimensions are not given for architecture, for most wall paintings, or for most architectural sculpture. Some captions have one or more lines of small print below the identification section of the caption that gives museum or collection information. This is rarely required reading.

Long captions contain information that complements the narrative of the main text.

Definitions of Terms You will encounter the basic terms of art history in three places:

IN THE TEXT, where words appearing in boldface type are defined, or glossed, at their first use. Some terms are boldfaced and explained more than once, especially those that experience shows are hard to remember.

IN BOXED FEATURES, on technique and other subjects, where labeled drawings and diagrams visually reinforce the use of terms.

IN THE GLOSSARY, at the end of the volume, which contains all the words in boldface type in the text and boxes. The Glossary begins on page 1193, and the outer margins are tinted to make it easy to find.

Maps and Timelines At the beginning of each chapter you will find a map with all the places mentioned in the chapter. At the end of each chapter, a timeline runs from the earliest through the latest years covered in that chapter.

Boxes Special material that complements, enhances, explains, or extends the text is set off in three types of tinted boxes. Elements of Architecture boxes clarify specifically architectural features, such as "Space-Spanning Construction Devices" in the Starter Kit (page xxxi). Technique boxes (see "Lost-Wax Casting," page xxx) amplify the methodology by which a type of artwork is created. Other boxes treat special-interest material related to the text.

Bibliography The bibliography at the end of this book beginning on page 1202 contains books in English, organized by general works and by chapter, that are basic to the study of art history today, as well as works cited in the text.

Dates, Abbreviations, and Other Conventions This book uses the designations BCE and CE, abbreviations for "Before the Common Era" and "Common Era," instead of BC ("Before Christ") and AD ("Anno Domini," "the year of our Lord"). The first century BCE is the period from 99 BCE to 1 BCE; the first century CE is from the year 1 CE to 99 CE. Similarly, the second century CE is the period from 199 BCE to 100 BCE; the second century CE extends from 100 CE to 199 CE.

Circa ("about" or "approximately") is used with dates, spelled out in the text and abbreviated to "c." in the captions, when an exact date is not yet verified.

An illustration is called a "figure," or "fig." Thus, figure 6–7 is the seventh numbered illustration in Chapter 6. Figures 1 through 25 are in the Introduction. There are two types of figures: photographs of artworks or of models, and line drawings. Drawings are used when a work cannot be photographed or when a diagram or simple drawing is the clearest way to illustrate an object or a place.

When introducing artists, we use the words *active* and *documented* with dates, in addition to "b." (for "born") and "d." (for "died"). "Active" means that an artist worked during the years given. "Documented" means that documents link the person to that date.

Accents are used for words in French, German, Italian, and Spanish only.

With few exceptions, names of museums and other cultural bodies in Western European countries are given in the form used in that country.

Titles of Works of Art Most paintings and works of sculpture created in Europe and North America in the past 500 years have been given formal titles, either by the artist or by critics and art historians. Such formal titles are printed in italics. In other traditions and cultures, a single title is not important or even recognized. In this book we use formal descriptive titles of artworks where titles are not established. If a work is best known by its non-English title, such as Manet's *Le Déjeuner sur l'Herbe (The Luncheon on the Grass)*, the original language precedes the translation.

STARTER KIT

rt history focuses on the visual arts—painting, drawing, sculpture, graphic arts, photography, decorative arts, and architecture. This Starter Kit contains basic information and addresses concepts that underlie and support the study of art history. It provides a quick reference guide to the vocabulary used to classify and describe art objects. Understanding these terms is indispensable since you will encounter them again and again in reading, talking, and writing about art, and when experiencing works of art directly.

Let us begin with the basic properties of art. A work of art is a material object having both form and content. It is also described and categorized according to its style and medium.

FORM

Referring to purely visual aspects of art and architecture, the term form encompasses qualities of *line, shape, color, texture, space, mass* and *volume,* and *composition*. These qualities all are known as *formal elements*. When art historians use the term formal, they mean "relating to form."

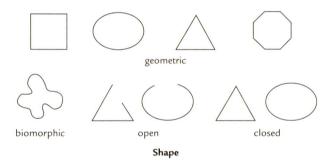

Line and shape are attributes of form. Line is a form—usually drawn or painted—the length of which is so much greater than the width that we perceive it as having only length. Line can be actual, as when the line is visible, or it can be implied, as when the movement of the viewer's eyes over the surface of a work follows a path determined by the artist. Shape, on the other hand, is the two-dimensional, or flat, area defined by the borders of an enclosing *outline*, or *contour*. Shape can be *geometric*, *biomorphic* (suggesting living things; sometimes called organic), *closed*, or *open*. The *outline*, or *contour*, of a three-dimensional object can also be perceived as line.

Color has several attributes. These include *hue*, *value*, and *saturation*.

Hue is what we think of when we hear the word color, and the terms are interchangeable. We perceive hues as the result of differing wavelengths of electromagnetic energy. The visible spectrum, which can be seen in a rainbow, runs from red through violet. When the ends of the spectrum are connected through the hue red-violet, the result may be diagrammed as a color wheel. The *primary hues* (numbered 1) are red, yellow, and blue. They are known as primaries because all other colors are

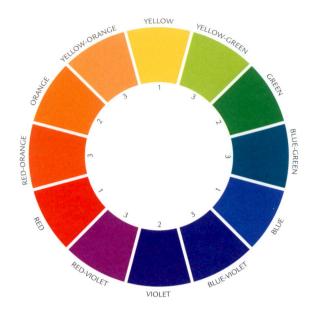

made of a combination of these hues. Orange, green, and violet result from the mixture of two primaries and are known as secondary hues (numbered 2). *Intermediate hues, or tertiaries* (numbered 3), result from the mixture of a primary and a secondary. *Complementary colors* are the two colors directly opposite one another on the color wheel, such as red and green. Red, orange, and yellow are regarded as warm colors and appear to advance toward us. Blue, green, and violet, which seem to recede, are called cool colors. Black and white are not considered colors but neutrals; in terms of light, black is understood as the absence of color and white as the mixture of all colors.

Value is the relative degree of lightness or darkness of a given color and is created by the amount of light reflected from an object's surface. A dark green has a deeper value than a light green, for example. In black-and-white reproductions of colored objects, you see only value, and some artworks—for example, a drawing made with black ink—possesses only value, not hue or saturation.

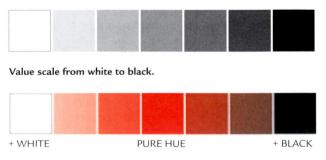

Value variation in red.

Saturation, also sometimes referred to as intensity, is a color's quality of brightness or dullness. A color described as highly saturated looks vivid and pure; a hue of low saturation may look a little muddy or dark.

Intensity scale from bright to dull.

Texture, another attribute of form, is the tactile (or touch-perceived) quality of a surface. It is described by words such as *smooth*, *polished*, *rough*, *grainy*, or *oily*. Texture takes two forms: the texture of the actual surface of the work of art and the implied (illusionistically depicted) surface of the object that the work represents.

Space is what contains objects. It may be actual and threedimensional, as it is with sculpture and architecture, or it may be represented illusionistically in two dimensions, as when artists represent recession into the distance on a wall or canvas.

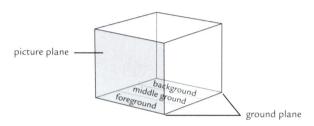

Mass and volume are properties of three-dimensional things. Mass is matter—whether sculpture or architecture—that takes up space. Volume is enclosed or defined space, and may be either

solid or hollow. Like space, mass and volume may be illusionistically represented in two dimensions.

Composition is the organization, or arrangement, of form in a work of art. Shapes and colors may be repeated or varied, balanced symmetrically or asymmetrically; they may be static or dynamic. The possibilities are nearly endless and depend on the time and place where the work was created as well as the personal sensibility of the artist. *Pictorial depth* (spatial recession) is a specialized aspect of composition in which the three-dimensional world is represented in two dimensions on a flat surface, or *picture plane*. The area "behind" the picture plane is called the *picture space* and conventionally contains three "zones": *foreground, middle ground*, and *background*.

Various techniques for conveying a sense of pictorial depth have been devised by artists in different cultures and at different times. A number of them are diagrammed below. In Western art, the use of various systems of *perspective* has created highly convincing illusions of recession into space. In other cultures, perspective is not the most favored way to treat objects in space.

CONTENT

Content includes *subject matter*, which is what a work of art represents. Not all works of art have subject matter; many buildings, paintings, sculptures, and other art objects include no recognizable imagery but feature only lines, colors, masses, volumes, and other formal elements. However, all works of art—even those

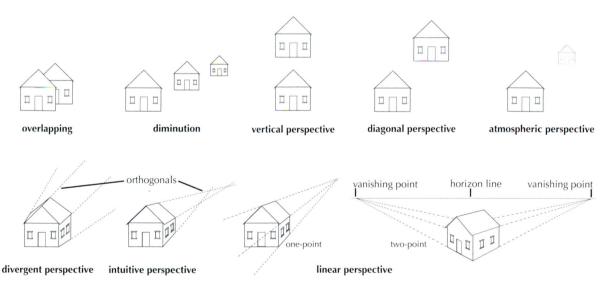

PICTORAL DEVICES FOR DEPICTING RECESSION IN SPACE

The top row shows several comparatively simple devices, including *overlapping*, in which partially covered elements are meant to be seen as located behind those covering them, and *diminution*, in which smaller elements are to be perceived as being farther away than larger ones. In *vertical* and *diagonal perspective*, elements are stacked vertically or diagonally, with the higher elements intended to be perceived as deeper in space. Another way of suggesting depth is through *atmospheric perspective*, which depicts objects in the far distance, often in bluish gray hues, with less clarity than nearer

objects and treats sky as paler near the horizon than higher up. In the lower row, divergent perspective, in which forms widen slightly and lines diverge as they recede in space, was used by East Asian artists. Intuitive perspective, used in some late medieval European art, takes the opposite approach: forms become narrower and converge the farther they are from the viewer, approximating the optical experience of spatial recession. Linear perspective, also called scientific, mathematical, one-point, and renaissance perspective, is an elaboration and standardization of intuitive perspective and was developed

in fifteenth-century Italy. It uses mathematical formulas to construct illusionistic images in which all elements are shaped by imaginary lines called *orthogonals* that converge in one or more vanishing points on a *horizon line*. Linear perspective is the system that most people living in Western cultures think of as perspective. Because it is the visual code they are accustomed to reading, they accept as "truth" the distortions it imposes. One of these distortions is *foreshortening*, in which, for instance, the soles of the feet in the foreground are the largest elements of a figure lying on the ground.

without recognizable subject matter—have content, or meaning, insofar as they seek to convey feelings, communicate ideas, or affirm the beliefs and values of their makers and, often, the people who view or use them.

Content may comprise the social, political, religious, and economic *contexts* in which a work was created, the *intention* of the artist, the *reception* of the work by the beholder (the audience), and ultimately the meanings of the work to both artist and audience. Art historians applying different methods of interpretation often arrive at different conclusions regarding the content of a work of art.

The study of subject matter is *iconography* (literally, "the writing of images"). The iconographer asks, What is the meaning of this image? Iconography includes the study of *symbols* and *symbolism*—the process of representing one thing by another through association, resemblance, or convention.

STYLE

Expressed very broadly, *style* is the combination of form and composition that makes a work distinctive. *Stylistic analysis* is one of art history's most developed practices, because it is how art historians recognize the work of an individual artist or the characteristic manner of several artists working in a particular time or place. Some of the most commonly used terms to discuss *artistic styles* include *period style*, *regional style*, *representational style*, *abstract style*, *linear style*, and *painterly style*.

Period style refers to the common traits detectable in works of art and architecture from a particular historical era. For instance, Roman portrait sculpture created at the height of the Empire is different from sculpture made during the late imperial period, but it is recognizably Roman. It is good practice not to use the words style and period interchangeably. Style is the sum of many influences and characteristics, including the period of its creation. An example of proper usage is "an American house from the Colonial period built in the Georgian style."

Regional style refers to stylistic traits that persist in a geographic region. An art historian whose specialty is medieval art can recognize French style through many successive medieval periods and can distinguish individual objects created in medieval France from other medieval objects that were created in, for example, the Low Countries.

Representational styles are those that create recognizable subject matter. *Realism*, *naturalism*, and *illusionism* are representational styles.

REALISM AND NATURALISM are terms often used interchangeably, and both describe the artist's attempt to describe the observable world. *Realism* is the attempt to depict objects accurately and objectively. *Naturalism* is closely linked to realism but often implies a grim or sordid subject matter.

IDEAL STYLES strive to create images of physical perfection according to the prevailing values of a culture. The artist may work in a representational style or may try to capture an

underlying or expressive reality. Both The *Medici Venus* and Utamaro's *Woman at the Height of Her Beauty* (see Introduction, figs. 7 and 9) can be considered *idealized*.

ILLUSIONISM refers to a highly detailed style that seeks to create a convincing illusion of reality. *Flower Piece with Curtain* is a good example of this trick-the-eye form of realism (see Introduction, fig. 2).

IDEALIZATION strives to realize an image of physical perfection according to the prevailing values of a culture. The *Medici Venus* is idealized, as is Utamaro's *Woman at the Height of Her Beauty* (see Introduction, figs. 7 and 9).

Abstract styles depart from literal realism to capture the essence of a form. An abstract artist may work from nature or from a memory image of nature's forms and colors, which are simplified, stylized, distorted, or otherwise transformed to achieve a desired expressive effect. Georgia O'Keeffe's *Red Canna* is an abstract representation of nature (see Introduction, fig. 5). *Non-representational art* and *expressionism* are particular kinds of abstract styles.

NONREPRESENTATIONAL (OR NONOBJECTIVE) ART is a form that does not produce recognizable imagery. *Cubi XIX* is nonrepresentational (see Introduction, fig. 6).

EXPRESSIONISM refers to styles in which the artist uses exaggeration of form to appeal to the beholder's subjective response or to project the artist's own subjective feelings. Munch's *The Scream* is expressionistic (see fig 30–71).

Linear describes both style and techniques. In the linear style the artist uses line as the primary means of definition, and modeling—the creation of an illusion of three-dimensional substance, through shading. It is so subtle that brushstrokes nearly disappear. Such a technique is also called "sculptural." Raphael's *The Small Cowper Madonna* is linear and sculptural (fig. 20–5)

Painterly describes a style of painting in which vigorous, evident brushstrokes dominate and shadows and highlights are brushed in freely. Sculpture in which complex surfaces emphasize moving light and shade is called "painterly." Claudel's *The Waltz* is painterly sculpture (see fig. 30–75).

MEDIUM

What is meant by medium or mediums (the plural we use in this book to distinguish the word from print and electronic news media) refers to the material or materials from which a work of art is made.

Technique is the process used to make the work. Today, literally anything can be used to make a work of art, including not only traditional materials like paint, ink, and stone, but also rubbish, food, and the earth itself. Various techniques are explained throughout this book in Technique boxes. When several mediums are used in a single work of art, we employ the term *mixed mediums*. Two-dimensional mediums include painting, drawing, prints, and photography. Three-

dimensional mediums are sculpture, architecture, and many so-called decorative arts.

Painting includes wall painting and fresco, illumination (the decoration of books with paintings), panel painting (painting on wood panels) and painting on canvas, miniature painting (small-scale painting), and handscroll and hanging scroll painting. Paint is pigment mixed with a liquid vehicle, or binder.

Graphic arts are those that involve the application of lines and strokes to a two-dimensional surface or support, most often paper. Drawing is a graphic art, as are the various forms of printmaking. Drawings may be sketches (quick visual notes made in preparation for larger drawings or paintings); studies (more carefully drawn analyses of details or entire compositions); cartoons (full-scale drawings made in preparation for work in another medium, such as fresco); or complete artworks in themselves. Drawings are made with such materials as ink, charcoal, crayon, and pencil. Prints, unlike drawings, are reproducible. The various forms of printmaking include woodcut, the intaglio processes (engraving, etching, drypoint), and lithography.

Photography (literally "light writing") is a medium that involves the rendering of optical images on light-sensitive surfaces. Photographic images are typically recorded by a camera.

Sculpture is three-dimensional art that is *carved, modeled, cast,* or *assembled*. Carved sculpture is subtractive in the sense that the image is created by taking away material. Wood, stone, and ivory are common materials used to create carved sculptures. Modeled sculpture is considered additive, meaning that the object is built up from a material, such as clay, that is soft enough to be molded and shaped. Metal sculpture is usually cast (see "Lost-Wax Casting," page xxx) or is assembled by welding or a similar means of permanent joining.

Sculpture is either freestanding (that is, not attached) or in relief. Relief sculpture projects from the background surface of which it is a part. High relief sculpture projects far from its background; low relief sculpture is only slightly raised; and sunken relief, found mainly in Egyptian art, is carved into the surface, with the highest part of the relief being the flat surface.

Ephemeral arts include processions and festival decorations and costumes, performance art, earthworks, cinema, video art, and some forms of digital and computer art. All have a central temporal aspect in that the artwork is viewable for a finite period of time and then disappears forever, is in a constant state of change, or must be replayed to be experienced again.

Architecture is three-dimensional, highly spatial, functional, and closely bound with developments in technology and materials. An example of the relationship among technology, materials, and function can be seen in "Space-Spanning Construction Devices" (page xxxi). Several types of two-dimensional schematic drawings are commonly used to enable the visualization of a building. These architectural graphic devices include plans, elevations, sections, and cutaways.

PLANS depict a structure's masses and voids, presenting a view from above—as if the building had been sliced horizontally at about waist height.

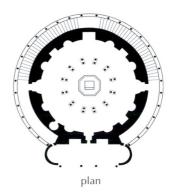

ELEVATIONS show exterior sides of a building as if seen from a moderate distance without any perspective distortion.

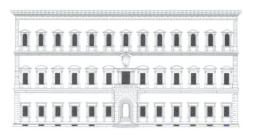

SECTIONS reveal a building as if it had been cut vertically by an imaginary slicer from top to bottom.

elevation

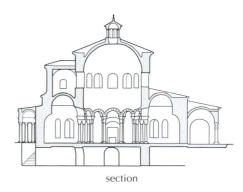

CUTAWAYS show both inside and outside elements from an oblique angle.

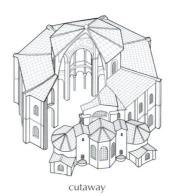

Technique

LOST-WAX CASTING

he lost-wax process consists of a core on which the sculptor models the image in wax. A heat-resistant mold is formed over the wax. The wax is melted and replaced with metal, usually bronze or brass. The mold is broken away and the piece finished and polished by hand.

The usual metal for this casting process was bronze, an alloy of copper and tin, although sometimes brass, an alloy of copper and zinc, was used. The progression of drawings here shows the steps used by the Benin sculptors of Africa. A heat-resistant "core" of clay approximating the shape of the sculpture-to-be (and eventually becoming the hollow inside the sculpture) was covered by a layer of wax having the thickness of the final sculpture. The sculptor carved or modeled the details in the wax. Rods and a pouring cup made of wax were attached to the model. A thin layer of fine, damp sand was pressed very firmly

into the surface of the wax model, and then model, rods, and cup were encased in thick layers of clay. When the clay was completely dry, the mold was heated to melt out the wax. The mold was then turned upside down to receive the molten metal, which is heated to the point of liquification. The cast was placed in the ground. When the metal was completely cool, the outside clay cast and the inside core were broken up and removed, leaving the cast brass sculpture. Details were polished to finish the piece of sculpture, which could not be duplicated because the mold had been destroyed in the process.

In lost-wax casting the mold had to be broken and only one sculpture could be made. In the eighteenth century a second process came into use—the piece mold. As its name implies, the piece mold could be removed without breaking allowing sculptors to make several copies (editions) of their work.

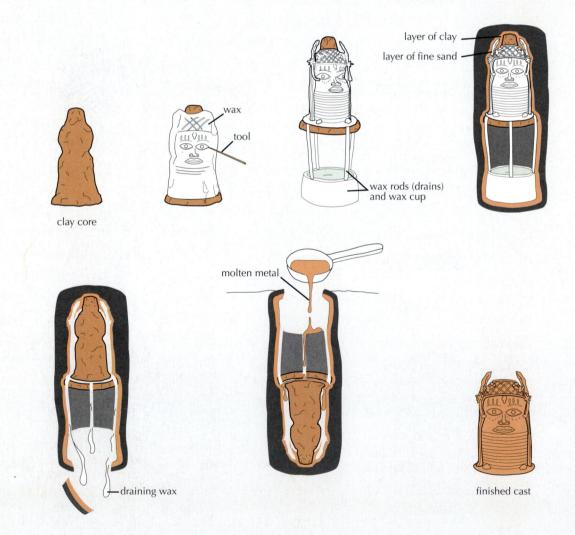

XXX

Elements of Architecture

SPACE-SPANNING CONSTRUCTION DEVICES

ravity pulls on everything, presenting great challenges to architects and sculptors. Spanning elements must transfer weight to the ground. The simplest space-spanning device is **post-and-lintel** construction, in which uprights are spanned by a horizontal element. However, if not flexible, a horizontal element over a wide span may break under the pressure of its own weight and the weight it carries.

Corbeling, the building up of overlapping stones, is another simple method for transferring weight to the ground. Arches, round or pointed, span space. Vaults, which are essentially extended arches, move weight out from the center of the covered space and down through the corners. The cantilever is a

variant of post-and-lintel construction. **Suspension** works to counter the effect of gravity by lifting the spanning element upward. **Trusses** of wood or metal are relatively lightweight spanners but cannot bear heavy loads. Large-scale modern construction is chiefly steel frame and relies on steel's properties of strength and flexibility to bear great loads. When **concrete** is **reinforced** with steel or iron rods, the inherent brittleness of cement and stone is overcome because of metal's flexible qualities. The concrete can then span much more space and bear heavier loads. The **balloon frame**, an American innovation, is based on **post-and-lintel** principles and exploits the lightweight, flexible properties of wood.

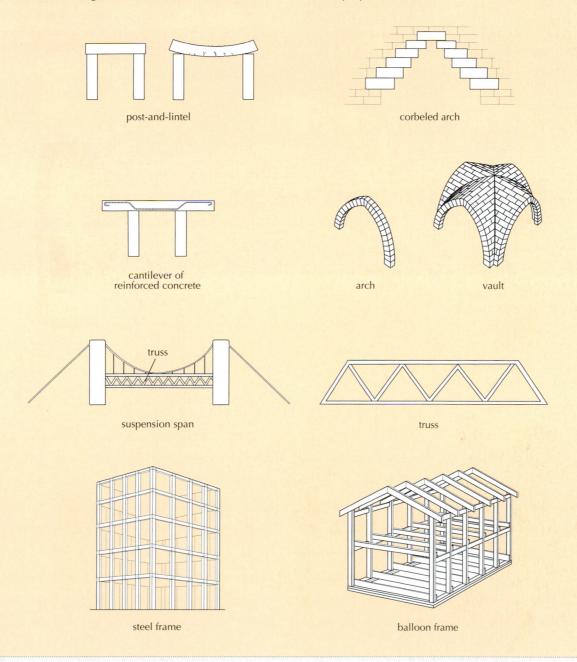

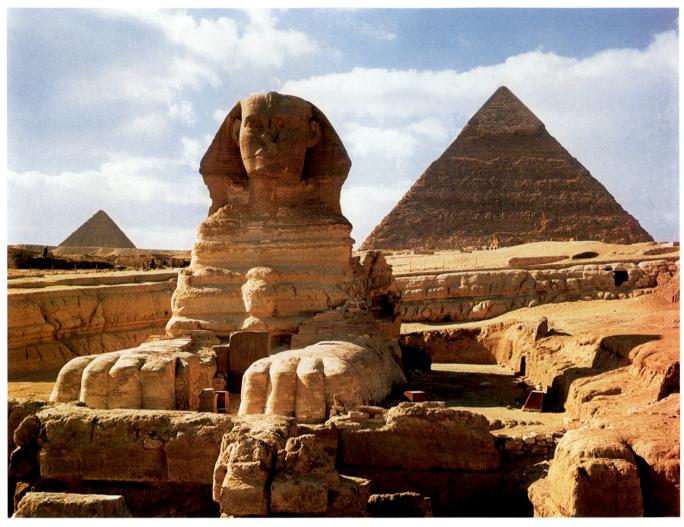

THE GREAT SPHINX, Giza, Egypt Dynasty 4, c. 2613–2494 BCE. Sandstone, height approx. 65' (19.8 m).

INTRODUCTION

Crouching in front of the pyramids of Egypt and carved from the living rock of the Giza plateau, the **GREAT SPHINX** is one of the world's best-known monuments (FIG. 1). By placing the head of the ancient Egyptian king Khafre on the body of a huge lion, the sculptors merged human intelligence and animal strength in a single image to evoke the superhuman power of the ruler. For some 4,600 years, the Sphinx has defied the desert sands; today it also must withstand the sprawl of greater Cairo and the impact of air pollution. In its majesty, the Sphinx symbolizes mysterious wisdom and dreams of per-

manence, of immortality. But is such a monument a work of art? Does it matter that the people who carved the Sphinx—unlike today's independent, individualistic artists—obeyed formulaic conventions and followed the orders of priests? No matter what the ancient Egyptians may have called it, today most people would say, "Certainly, it is art." Human imagination conceived this creature, and human skill gave it material form. Combining imagination and skill, the creators have conceived an idea of awesome grandeur and created a work of art. But we seldom stop to ask: What is art?

WHAT IS ART?

At one time the answer to the question "What is art?" would have been simpler than it is today. The creators of the *Great Sphinx* demonstrate a combination of imagination, skill, training, and observation that appeal to our desire for order and harmony—perhaps to an innate aesthetic sense. Yet, today some people question the existence of an aesthetic faculty, and we realize that our tastes are products of our education and our experience, dependent on time and place. Whether acquired at home, in schools, in museums, or in other public places, our responses are learned—not innate. Ideas of truth and falsehood, of good and evil, of beauty and ugliness are influenced as well by class, gender, race, and economic status. Some historians and critics even go so far as to argue that works of art are mere reflections of power and privilege.

Even the idea of "beauty" is questioned and debated today. Some commentators find discussions of aesthetics (the branch of philosophy concerned with The Beautiful) too subjective and too personal, and they dismiss the search for objective criteria that preoccupied scholars in the eighteenth and nineteenth centuries. As traditional aesthetics come under challenge, we can resort to discussing the authenticity of expression in a work of art, even as we continue to analyze its formal qualities. We can realize that people at different times and in different places have held different values. The words "art history" can be our touchstone. Like the twofold term itself, this scholarly discipline considers both art and history—the work of art as a tangible object and as part of its historical context. Ultimately, because so-called objective evaluations of beauty seem to be an impossibility, beauty again seems to lie in the eye of the beholder.

Today's definition of art encompasses the intention of the creator as well as the intentions of those who commissioned the work. It relies, too, on the reception of the artwork by society—both today and at the time when the work was made. The role of art history is to answer complex questions: Who are these artists and patrons? What is this thing they have created? When and how was the work done? Only after we have found answers to practical questions like these can we acquire an understanding and appreciation of the artwork and, answering our earlier question, we can say, yes, this is a work of art.

ART AND NATURE

The ancient Greeks enjoyed the work of skillful artists. They especially admired the illusionistic treatment of reality in which the object represented appears to actually be present. The Greek penchant for realism is illustrated in a story from the late fifth century BCE about a rivalry between two painters named Zeuxis and Parrhasios as to whom was the better painter. First, Zeuxis painted a picture of grapes so accurately that birds flew down to peck at them. But, when Parrhasios

2 Adriaen van der Spelt and Frans van Mieris FLOWER PIECE WITH CURTAIN

1658. Oil on panel, $18\% \times 25\%$ (46.5 \times 64 cm). The Art Institute of Chicago.

Wirt D. Walker Fund. (1949.585). Photograph © 2005 The Art Institute of Chicago. All rights reserved

took his turn, and Zeuxis asked his rival to remove the curtain hanging over his rival's picture, Parrhasios pointed out with glee that the "curtain" was his painting. Zeuxis had to admit that Parrhasios had won the competition since he himself had fooled only birds, while Parrhasios had deceived a fellow artist.

In the seventeenth century, the painters Adriaen van der Spelt (1630-73) and Frans van Mieris (1635-81) paid homage to the story of Parrhasios's curtain in a painting of blue satin drapery drawn aside to show a garland of flowers. We call the painting simply FLOWER PIECE WITH CURTAIN (FIG. 2). The artists not only re-created Parrhasios's curtain illusion but also included a reference to another popular story from ancient Greece, Pliny's anecdote of Pausias and Glykera. In his youth, Pausias had been enamored of the lovely flowerseller Glykera, and he learned his art by persistently painting the exquisite floral garlands that she made, thereby becoming the most famously skilled painter of his age. The seventeenthcentury people who bought such popular still-life paintings appreciated their classical allusions as much as the artists' skill in drawing and painting and their ability to manipulate colors on canvas. But, the reference to Pausias and Glykera also raised the conundrum inherent in all art that seeks to make an unblemished reproduction of reality: Which has the greater beauty, the flower or the painting of the flower? And which is the greater work of art, the garland or the painting of the garland? So then, who is the greater artist, the garland maker or the garland painter?

MODES OF REPRESENTATION

Many people think that the manner of Zeuxis and Parrhasios, and of van der Spelt and van Mieris—the manner of representation that we call **naturalism**, or **realism**—the mode of

3 CORINTHIAN CAPITAL FROM THE THOLOS AT EPIDAURUS c. 350 BCE. Archaeological Museum, Epidaurus, Greece.

interpretation that seeks to record the visible world—represents the highest accomplishment in art, but not everyone agrees. Even the ancient Greek philosophers Aristotle (384–322 BCE) and Plato (428–348/7 BCE), who both considered the nature of art and beauty in purely intellectual terms, arrived at divergent conclusions. Aristotle believed that works of art should be evaluated on the basis of mimesis ("imitation"), that is, on how well they copy definable or particular

aspects of the natural world. This approach to defining "What is art?" is a realistic or naturalistic one. But, of course, while artists may work in a naturalistic style, they also can render lifelike such fictions as a unicorn, a dragon, or a sphinx by incorporating features from actual creatures.

In contrast to Aristotle, Plato looked beyond nature for a definition of art. In his view even the most naturalistic painting or sculpture was only an approximation of an eternal ideal world in which no variations or flaws were present. Rather than focus on a copy of the particular details that one saw in any particular object, Plato focused on an unchangeable ideal—for artists, this would be the representation of a subject that exhibited perfect symmetry and proportion. This mode of interpretation is known as idealism. In a triumph of human reason over nature, idealism wishes to eliminate all irregularities, ensuring a balanced and harmonious work of art.

Let us consider a simple example of Greek idealism from architecture: the carved top, or capital, of a Corinthian column, a type that first appeared in ancient Greece during the fourth century BCE. The Corinthian capital has an inverted bell shape surrounded by acanthus leaves (FIG. 3). Although the acanthus foliage was inspired by the appearance of natural vegetation, the sculptors who carved the leaves eliminated blemishes and irregularities in order to create the Platonic ideal of the acanthus plant's foliage. To achieve Plato's ideal images and represent things "as they ought to be" rather than as they are, classical sculpture and painting established ideals that have inspired Western art ever since.

4 Edward Weston SUCCULENT
1930. Gelatin silver print,
7½ × 9½" (19.1 × 24 cm).
Center for Creative Photography, The University of Arizona,
Tucson.

Like ancient Greek sculptors, Edward Weston (1886–1958) and Georgia O'Keeffe (1887–1986) studied living plants. In his photograph **succulent**, Weston used straightforward camera work without manipulating the film in the darkroom in order to portray his subject (FIG. 4). He argued that although the camera sees more than the human eye, the quality of the image depends not on the camera, but on the choices made by the photographer-artist.

When Georgia O'Keeffe painted RED CANNA, she, too, sought to capture the plant's essence, not its appearance—although we can still recognize the flower's form and color (FIG. 5). By painting the canna lily's organic energy rather than the way it actually looked, she created a new abstract beauty, conveying in paint the pure vigor of the flower's life force. This abstraction—in which the artist appears to transform a visible or recognizable subject from nature in a way that suggests the original but purposefully does not record the subject in an entirely realistic or naturalistic way—is another manner of representation.

Furthest of all from naturalism are pure geometric creations such as the polished stainless steel sculpture of David Smith (1906–65). His Cubi works are usually called nonrepresentational art—art that does not depict a recognizable subject. With works such as **CUBI XIX** (FIG. 6), it is important to distinguish between subject matter and content. Abstract art like O'Keeffe's has both subject matter and content, or meaning. Nonrepresentational art does not have subject matter but it does have content, which is a product of the interaction between the artist's

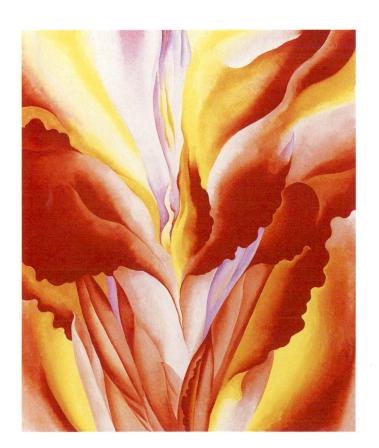

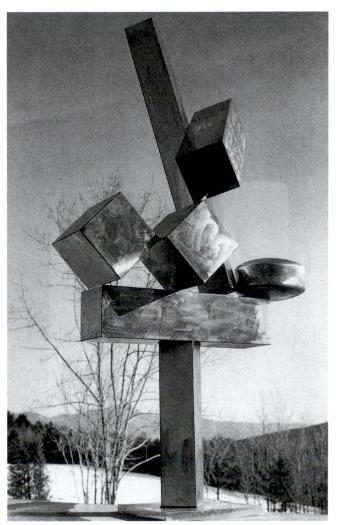

6 David Smith CUBI XIX

1964. Stainless steel, 9'5%" \times 1'9%" \times 1'8" (2.88 x .55 \times .51 m). Tate Gallery, London.

© Estate of David Smith/Licensed by VAGA, New York, NY

intention and the viewer's interpretation. Some viewers may see the Cubi works as robotic plants sprung from the core of an unyielding earth, a reflection of today's mechanistic society that challenges the natural forms of trees and hills.

At the turn of the fifteenth century, the Italian master Leonardo daVinci (1452–1519) argued that observation alone produced "mere likeness" and that the painter who copied the external forms of nature was acting only as a mirror. He believed that the true artist should engage in intellectual activity of a higher order and attempt to render the inner life—the energy and power—of a subject. In this book we will see that artists have always tried to create more than a superficial likeness in order to engage their audience and express the cultural contexts of their particular time and place.

5 Georgia O'Keeffe RED CANNA

1924. Oil on canvas mounted on Masonite, $36\times29\%$ " (91.44 \times 75.88 cm). Collection of the University of Arizona Museum of Art, Tucson.

© 2007 The Georgia O'Keeffe Foundation/Artists Rights Society (ARS), New York

Beauty and the Idealization of the Human Figure

Ever since people first made what we call art, they have been fascinated with their own image and have used the human body to express ideas and ideals. Popular culture in the twenty-first century continues to be obsessed with beautiful people—with Miss Universe pageants and lists of the Ten

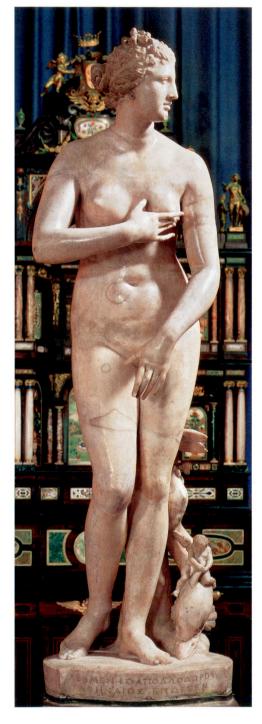

7 THE MEDICI VENUS
Roman copy of a 1st-century BCE Greek statue.
Marble, height 5' (1.53 m) without base. Villa
Medici, Florence, Italy.

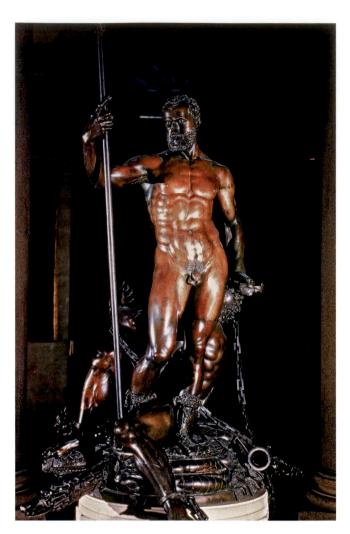

8 Leone Leoni CHARLES V TRIUMPHING OVER FURY, WITHOUT ARMOR

c. 1549–1555. Bronze, height to top of head 5'8'' (1.74 m). Museo Nacional del Prado, Madrid.

Best-Dressed Women and the Fifty Sexiest Men, just to name a few examples. Today the **MEDICI VENUS**, with her plump arms and legs and sturdy body, would surely be expected to slim down, yet for generations such a figure represented the peak of female beauty (FIG. 7).

This image of the goddess of love inspired artists and those who commissioned their work from the fifteenth through the nineteenth century. Clearly, the artist had the skill to represent a woman as she actually appeared, but instead he chose to generalize her form and adhere to the classical canon (rule) of proportions. In so doing, the sculptor created a universal image, an ideal rather than a specific woman.

The *Medici Venus* represents a goddess, but artists also represented living people as idealized figures, creating symbolic portraits rather than accurate likenesses. The sculptor Leone Leoni (1509–90), commissioned to create a monumental bronze statue of the emperor Charles V (ruled 1519–56), expressed the power of this ruler of the Holy Roman Empire just as vividly as did the sculptors of the

Egyptian king Khafre, the subject of the *Great Sphinx* (SEE FIG. 1). Whereas in the sphinx, Khafre took on the body of a vigilant lion, in **CHARLES V TRIUMPHING OVER FURY**, the emperor has been endowed with the muscular torso and proportions of the classical ideal male athlete or god (FIG. 8). Charles does not inhabit a fragile human body; rather, in his muscular nakedness, he embodies the idea of triumphant authoritarian rule. (Not everyone approved. In fact, a full suit of armor was made for the statue, and today museum officials usually exhibit the sculpture clad in armor rather than nude.)

Another example of ideal beauty is the abstract vision of a woman depicted in a woodblock print by Japanese artist Kitagawa Utamaro (1753–1806). In its stylization, woman at the height of her beauty (Fig. 9), reflects a social context regulated by convention and ritual. Simplified shapes depict the woman's garments and suggest the underlying human forms. The treatment of the rich textiles turn the body into an abstract pattern, and pins turn the hair into another elaborate shape. Utamaro rendered the decorative silks and carved pins meticulously, but he depicted the woman's face and hands with a few sweeping lines. The attention to surface detail combined with an effort to capture the essence of form is characteristic of abstract art in Utamaro's time and place, and images of men were equally elegant.

常呼を窓大棚

9 Kitagawa Utamaro WOMAN AT THE HEIGHT
OF HER BEAUTY

Mid-1790s. Color woodblock print, $15\% \times 10''$ (38.5 \times 25.5 cm). Spencer Museum of Art, The University of Kansas, Lawrence.

William Bridges Thayer Memorial, (1928.7879)

Today, when images—including those of great physical and spiritual beauty—can be captured with a camera, why should an artist draw, paint, or chip away at a knob of stone? Does beauty even play a significant role in our world? Attempting to answer these and other questions that consider the role of art is a branch of philosophy called *aesthetics*, which considers the nature of beauty, art, and taste as well as the creation of art.

Laocoön: A Meditation on Aesthetics

Historically, the story of Laocoön has focused attention on the different ways in which the arts communicate. In the *Iliad*, Homer's epic poem about the Trojan War, Laocoön was the priest who forewarned the Trojans of an invasion by the Greeks. Although Laocoön spoke the truth, the goddess Athena, who took the Greeks' side in the war, dispatched serpents to strangle him and his sons. His prophecy scorned, Laocoön represents the virtuous man tragically destroyed by unjust fate. In a renowned ancient sculpture, his features twist in agony, and the muscles of his and his sons' torsos and arms extend and knot as they struggle (FIG. 10). When this sculpture was discovered in Rome in 1506, Michelangelo rushed to watch it being excavated, an astonishing validation of his own ideal, heroic style coming straight out of the earth. The pope acquired it for the papal collection, and it can be seen today in the Vatican Museum.

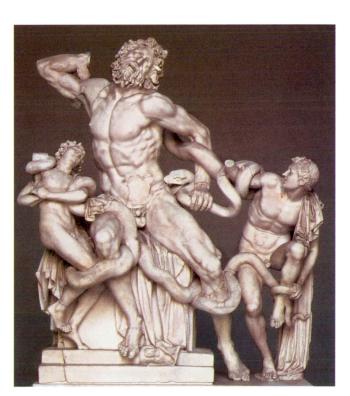

10 Hagesandros, Polydoros, and Athanadoros of Rhodes LAOCOÖN AND HIS SONS

As restored today. Probably the original of 1st century CE or a Roman copy of the 1st century CE. Marble, height 8' (2.44 m). Musei Vaticani, Museo Pio Clementino, Cortile Ottagono, Rome, Italy.

Like other learned people in the eighteenth century, the German philosopher Lessing knew the story of Laocoön and admired the sculpture as well. In fact, he titled his study of the relationship between words and images "Laocoon: An Essay upon the Limits of Painting and Poetry" (1766). Lessing saw literary pursuits such as poetry and history as arts of time, whereas painting and sculpture played out in a single moment in space. Using words, writers can present a sequence of events, while sculptors and painters must present a single critical moment. Seen in this light, the interpretation of visual art depends upon the viewer who must bring additional knowledge in order to reconstitute the narrative, including events both before and after the depicted moment. For this reason, Lessing argued for the primacy of literature over the visual arts. The debate over the comparative virtues of the arts has been a source of excited argument and even outrage among critics, artists, philosophers, and academics ever since.

Underlying all our assumptions about works of art—whether in the past or the present—is the idea that art has meaning, and that its message can educate and move us, that it can influence and improve our lives. But what gives art its meaning and expressive power? Why do images fascinate and inspire us? Why do we treasure some things but not others? These are difficult questions, and even specialists disagree about the answers. Sometimes even the most informed people must conclude, "I just don't know."

Studying art history, therefore, cannot provide us with definitive answers, but it can help us recognize the value of asking questions as well as the value of exploring possible answers. Art history is grounded in the study of material objects that are the tangible expression of the ideas—and ideals—of a culture. For example, when we become captivated by a striking creation, art history can help us interpret its particular imagery and meaning. Art history can also illuminate the cultural context of the work—that is, the social, economic, and political situation of the historical period in which it was produced, as well as its evolving significance through the passage of time.

Exceptional works of art speak to us. However, only if we know something about the **iconography** (the meaning and interpretation) of an image can its larger meaning become clear. For example, let's look again at *Flower Piece with Curtain* (SEE FIG. 2). The brilliant red and white tulip just to the left of the blue curtain was the most desirable and expensive flower in the seventeenth century; thus, it symbolizes wealth and power. Yet insects creep out of it, and a butterfly—fragile and transitory—hovers above it. Consequently, here flowers also symbolize the passage of time and the fleeting quality of human riches. Informed about its iconography and cultural context, we begin to fathom that this painting is more than a simple still life.

WHY DO WE NEED ART?

Before we turn to Chapter 1—before we begin to look at, read about, and think about works of art and architecture historically, let us consider a few general questions that studying art history can help us answer and that we should keep in mind as we proceed: Why do we need art? Who are artists? What role do patrons play? What is art history? and What is a viewer's role and responsibility? By grappling with such questions, our experience of art can be greatly enhanced.

Biologists account for the human desire for art by explaining that human beings have very large brains that demand stimulation. Curious, active, and inventive, we humans constantly explore, and in so doing we invent things that appeal to our senses—fine art, fine food, fine scents, fine fabrics, and fine music. Ever since our prehistoric ancestors developed their ability to draw and speak, we have visually and verbally been communicating with each other. We speculate on the nature of things and the meaning of life. In fulfilling our need to understand and our need to communicate, the arts serve a vital function. Through art we become fully alive.

Self-Expression: Art and the Search for Meaning

Throughout history art has played an important part in our search for the meaning of the human experience. In an effort to understand the world and our place in it, we turn both to introspective personal art and to communal public art. Following a personal vision, James Hampton (1909-64) created profoundly stirring religious art. Hampton worked as a janitor to support himself while, in a rented garage, he built THRONE OF THE THIRD HEAVEN OF THE NATIONS' MILLENNIUM GENERAL ASSEMBLY (FIG. 11), his monument to his faith. In rising tiers, thrones and altars have been prepared for Jesus and Moses. Placing New Testament imagery on the right and Old Testament imagery on the left, Hampton labeled and described everything. He even invented his own language to express his visions. On one of many placards he wrote his credo: "Where there is no vision, the people perish" (Proverbs 29:18). Hampton made this fabulous assemblage out of discarded furniture, flashbulbs, and all sorts of refuse tacked together and wrapped in gold and silver aluminum foil and purple tissue paper. How can such worthless materials turn into an exalted work of art? Art's genius transcends material.

In contrast to James Hampton, whose life's work was compiled in private and only came to public attention after his death, most artists and viewers participate in more public expressions of art and belief. Nevertheless, when people employ special objects in their rituals, such as statues, masks, and vessels, these pieces may be seen as works of art by others who do not know about their intended use and original significance.

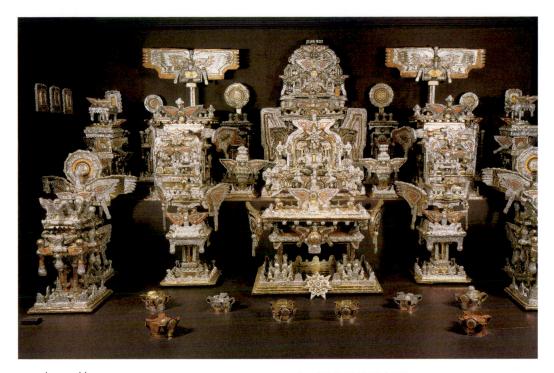

11 James Hampton THRONE OF THE THIRD HEAVEN OF THE NATIONS' MILLENNIUM GENERAL ASSEMBLY

c. 1950–1964. Gold and silver aluminum foil, colored Kraft paper, and plastic sheets over wood, paperboard, and glass, $10'6'' \times 27' \times 14'6'' \ (3.2 \times 8.23 \times 4.42 \ m)$. Smithsonian American Art Museum, Smithsonian Institution, Washington, D.C.

Gift of Anonymous Donors, 1970.353.1

Social Expression: Art and Social Context

The visual arts are among the most sophisticated forms of human communication, at once shaping and being shaped by their social context. Artists may unconsciously interpret their times, but they also may be enlisted to consciously serve social ends in ways that range from heavy-handed propaganda (as seen earlier in the portrait of Charles V, for example) to subtle suggestion. From ancient Egyptian priests to elected officials today, religious and political leaders have understood the educational and motivational value of the visual arts.

Governments and civic leaders use the power of art to strengthen the unity that nourishes society. In sixteenth-century Venice, for example, city officials ordered Veronese (Paolo Caliari, 1528–88) to fill the ceiling in the Great Council Hall with a huge and colorful painting, THE TRIUMPH OF VENICE (FIG. 12). Their contract with the artist survives as evidence of their intentions. They wanted a painting that showed their beloved Venice surrounded by peace, abundance, fame, happiness, honor, security, and freedom—all in vivid colors and idealized forms. Veronese and his assistants complied by painting the city personified as a mature, beautiful, and splendidly robed

Ceiling painting in the Council Chamber, Palazzo Ducale, Venice, Italy. c. 1585. Oil on canvas, $29'8'' \times 19' (9.04 \times 5.79 \text{ m})$.

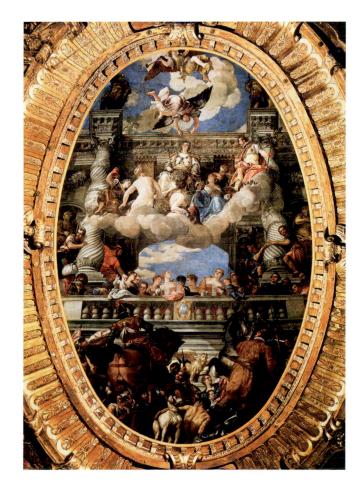

woman enthroned between the towers of the Arsenal, a building where ships were built for worldwide trade, the source of the city's wealth and power. Veronese painted enthusiastic crowds of cheering citizens, together with personifications of Fame blowing trumpets and of Victory crowning Venice with a wreath. Supporting this happy throng, bound prisoners and trophies of armor attest to Venetian military prowess. The Lion of Venice—the symbol of the city and its patron, Saint Mark—oversees the triumph. Although Veronese created this splendid propaganda piece to serve the purposes of his patrons, his artistic vision was as individualistic as that of James Hampton, whose art was purely self-expression.

Social Criticism: Uncovering Sociopolitical Intentions

Although powerful patrons have used artworks throughout history to promote their political interests, modern artists are often independent-minded and astute critics of the powers that be. For example, among Honoré Daumier's most trenchant comments on the French government is his print RUE TRANSON-AIN, LE 15 AVRIL 1834 (FIG. 13). During a period of urban unrest, the French National Guard fired on unarmed citizens, killing fourteen people. For his depiction of the massacre, Daumier used lithography—a cheap new means of illustration. He was not thinking in terms of an enduring historical record, but rather of a medium that would enable him to spread his message as widely as possible. Daumier's political commentary created such horror and revulsion among the public that the government reacted by buying and destroying all the newspapers in which the lithograph appeared. As this example shows, art historians sometimes need to consider not just the historical context of a work of art but also its political content and medium to have a fuller understanding of it.

Another, more recent, work with a critical message recalls how American citizens of Japanese ancestry were removed from their homes and confined in internment camps during World War II. In 1978, Roger Shimomura (b. 1939) painted **DIARY**, which illustrates his grandmother's account of the family's experience in one such camp in Idaho (FIG. 14). Shimomura has painted his grandmother writing in her diary, while he (the toddler) and his mother stand by an open door—a door that does not signify freedom but opens on to a field bounded by barbed wire. In this commentary on discrimination and injustice, Shimomura combines two stylistic traditions—the Japanese art of the color woodblock print and American Pop art of the 1960s—to create a personal style that expresses his own dual culture.

WHO ARE THE ARTISTS?

We have focused so far mostly on works of art. But what of the artists who make them? How artists have viewed themselves and have been viewed by their contemporaries has

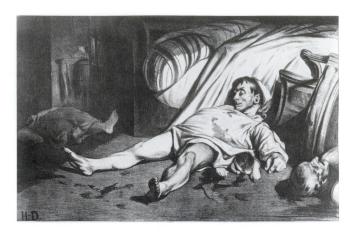

13 Honoré Daumier RUE TRANSONAIN, LE 15 AVRIL 1834 Lithograph, $11'' \times 17\%''$ (28×44 cm). Bibliothèque Nationale, Paris

changed over time. In Western art, painters and sculptors were at first considered artisans or craftspeople. The ancient Greeks and Romans ranked painters and sculptors among the skilled workers; they admired the creations, but not the creators. The Greek word for art, *tekne*, is the source for the English word "technique," and the English words *art* and *artist* come from the Latin word *ars*, which means "skill." In the Middle Ages, people sometimes went to the opposite extreme and attributed especially fine works of art not to human artisans, but to supernatural forces, to angels, or to Saint Luke. Artists continued to be seen as craftspeople—admired, often prosperous, but not particularly special—until the Renaissance, when artists such as Leonardo da Vinci proclaimed themselves to be geniuses with "divine" abilities.

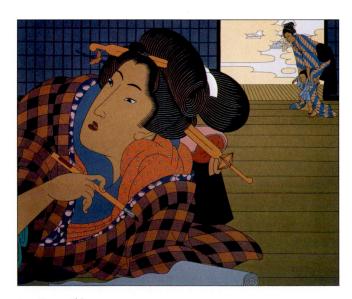

14 Roger Shimomura

DIARY (MINIDOKA SERIES #3)

1978. Acrylic on canvas, 4'11½" x 6' (1.52 \times 1.83 m). Spencer Museum of Art, The University of Kansas, Lawrence. Museum purchase, (1979.51)

Soon after the Renaissance, the Italian painter Guercino (Giovanni Francesco Barbieri, 1591-1666) combined the idea that saints and angels have miraculously made works of art with the concept that human painters have special, divinely inspired gifts. In his painting SAINT LUKE DISPLAYING A PAINTING OF THE VIRGIN (FIG. 15), Guercino portrays the Evangelist who was regarded as the patron saint of artists. Christians widely believed that Luke had painted a portrait of the Virgin Mary holding the Christ Child. In Guercino's painting, Luke, seated before just such a painting and assisted by an angel, holds his palette and brushes. A book, a quill pen, and an inkpot decorated with a statue of an ox (Saint Luke's symbol) rest on a table, reminders of his status as the author of a gospel. Guercino seems to say that if Saint Luke is a divinely endowed artist, then surely all other artists share in this special power and status. This image of the artist as an inspired genius has persisted.

Even after the idea of "specially endowed" creators emerged, numerous artists continued to conduct their work as craftspeople leading workshops, and oftentimes artwork continued to be a team effort. Nevertheless, as the one who conceives the work and controls its execution—the artist is the "creator," whose name is associated with the final product.

This approach is evident today in the glassworks of American artist Dale Chihuly (b. 1941). His team of artist-craftspeople is skilled in the ancient art of glass-making, but Chihuly remains the controlling mind and imagination behind the works. Once created, his multipart pieces may be transformed when they are assembled for display; they can take on a new life in accordance with the will of a new owner, who may arrange the pieces to suit his or her own preferences. The viewer/owner thus becomes part of the creative team. Originally fabricated in 1990, VIOLET PERSIAN SET WITH RED LIP WRAPS (FIG. 16) has twenty separate pieces, but the person who assembles them determines the composition.

How Does One Become an Artist?

Whether working individually or communally, even the most brilliant artists spend years in study and apprenticeship and continue to educate themselves throughout their lives. In his painting **THE DRAWING LESSON**, Dutch artist Jan Steen (1626–79) takes us into a well-lit artist's studio. Surrounded by the props of his art—a tapestry backdrop, an easel, a stretched canvas, a portfolio, musical instruments, and decorative *objets d'art*—a painter instructs two youngsters—a boy apprentice at a drawing board, and a young woman in an elegant armchair (FIG. 17). The artist's pupil has been drawing from sculpture and plaster casts because women were not permitted to work from nude models. *The Drawing Lesson* records contemporary educational practice and is a valuable record of an artist's workplace in the seventeenth century.

Even the most mature artists learn from each other. In the seventeenth century, Rembrandt van Rijn carefully studied

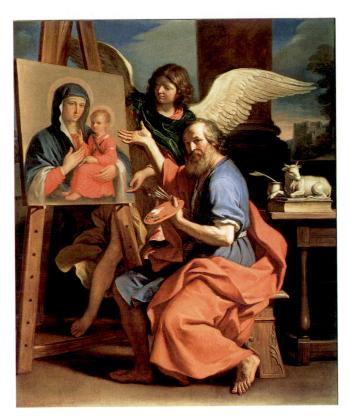

15 Guercino SAINT LUKE DISPLAYING A PAINTING OF THE VIRGIN 1652-1653. Oil on canvas, $7'3'' \times 5'11''$ (2.21×1.81 m). The Nelson-Atkins Museum of Art, Kansas City, Missouri. Purchase (F83-55)

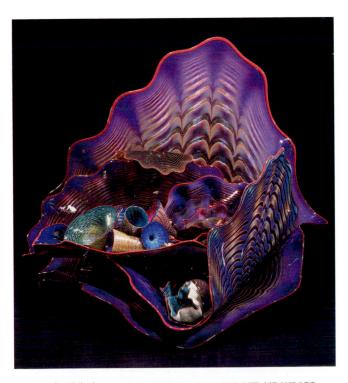

16 Dale Chihuly VIOLET PERSIAN SET WITH RED LIP WRAPS 1990. Glass, $26 \times 30 \times 25''$ ($66 \times 76.2 \times 63.5$ cm). Spencer Museum of Art, The University of Kansas, Lawrence Museum Purchase: Peter T. Bohan Art Acquisition Fund, 1992.2

Leonardo's painting of **THE LAST SUPPER** (FIG. 18). Leonardo had turned this traditional theme into a powerful drama by portraying the moment when Christ announces that one of the assembled apostles will betray him. Even though the men react with surprise and horror to this news, Leonardo depicted the scene in a balanced symmetrical composition typical of the Italian Renaissance of the fifteenth and early sixteenth centuries, with the apostles in groups of three on each side of Christ. The regularly spaced tapestries and ceiling panels lead the viewers' eyes to Christ, who is silhouetted in front of an open window (the door seen in the photograph was cut through the painting at a later date).

Rembrandt, working 130 years later in the Netherlands—a very different time and place—knew the Italian master's painting from a print, since he never went to Italy. Rembrandt copied **THE LAST SUPPER** in hard red chalk (FIG. 19). Then he reworked the drawing in a softer chalk, assimilating Leonardo's lessons but revising the composition and changing the mood of the original. With heavy overdrawing he recreated the scene, shifting Jesus's position to the left, giving Judas more emphasis. Gone are the wall hangings and ceiling, replaced by a huge canopy. The space is undetermined and expansive rather than focused. Rembrandt's drawing is more than an academic exercise; it is also a sincere tribute from one

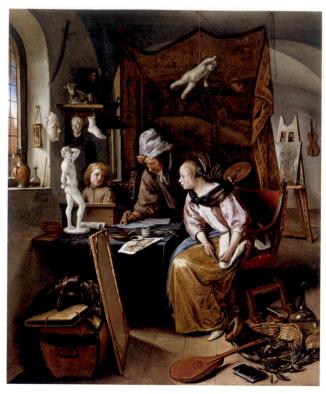

17 Jan Steen **THE DRAWING LESSON** 1665. Oil on wood, $19\% \times 16\%$ (49.3×41 cm). The J. Paul Getty Museum, Los Angeles, California.

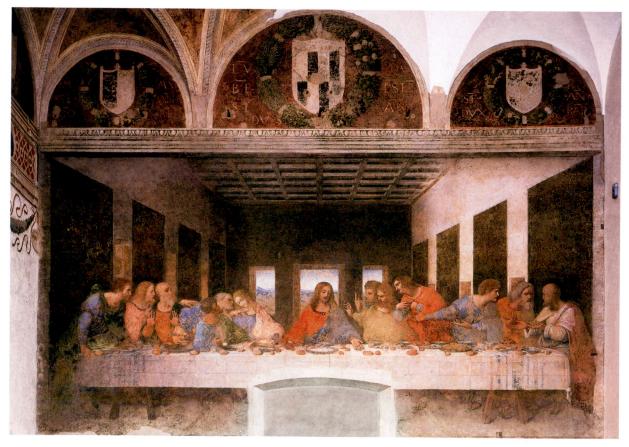

18 Leonardo da Vinci **THE LAST.SUPPER** Wall painting in the refectory, Monastery of Santa Maria delle Grazie, Milan, Italy. 1495–1498. Tempera and oil on plaster, $15'2'' \times 28'10''$ (4.6×8.8 m).

great master to another. The artist must have been pleased with his version of Leonardo's masterpiece because he signed his drawing boldly in the lower right-hand corner.

WHAT ROLE DO PATRONS AND COLLECTORS PLAY?

As we have seen, the person or group who commissions or supports a work of art—the patron—can have significant impact on it. The *Great Sphinx* (SEE FIG. 1) was "designed" following the conventions of priests in ancient Egypt; the monumental statue of *Charles V* was cast to glorify absolutist rule (SEE FIG. 8); the content of Veronese's *Triumph of Venice* (SEE FIG. 12) was determined by that city's government officials; and Chihuly's glassworks (SEE FIG. 16) may be reassembled according to the collector's wishes or whims.

The civic sponsorship of art is epitomized by fifth-century BCE Athens, a Greek city-state whose citizens practiced an early form of democracy. Led by the statesman and general Perikles, the Athenians defeated the Persians, and then rebuilt Athens's civic and religious center, the Acropolis, as a tribute to the goddess Athena and a testament to the glory of Athens. In FIGURE 20, a nineteenth-century British artist, Sir Lawrence Alma-Tadema, conveys the accomplishment of the

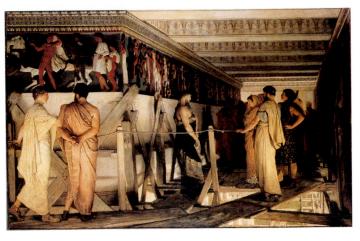

20 Lawrence Alma-Tadema PHEIDIAS AND THE FRIEZE OF THE PARTHENON, Athens 1868. Oil on canvas, $29\% \times 42\%$ (75.3 \times 108 cm). Birmingham City Museum and Art Gallery, England

Athenian architects, sculptors, and painters, who were led by the artist Pheidias. Alma-Tadema imagines the moment when Pheidias showed the carved and painted frieze at the top of the wall of the Temple of Athena (the Parthenon) to Perikles and a group of Athenian citizens—his civic sponsors.

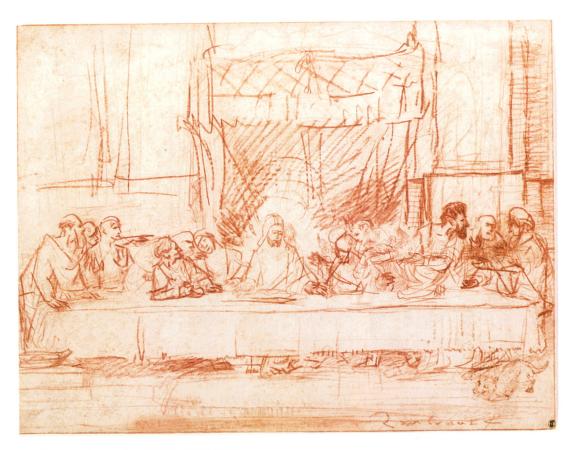

19 Rembrandt van Rijn THE LAST SUPPER After Leonardo da Vinci's fresco. Mid-1630s. Drawing in red chalk, $14\% \times 18\%$ (36.5 \times 47.5 cm). The Metropolitan Museum of Art, New York Robert Lehman Collection, 1975 (1975.1.794)

THE OBJECT SPEAKS

THE VIETNAM VETERANS MEMORIAL

attle die. Kinfolk die. We all die. Only fame lasts," said the Vikings. Names remain. Flat, polished stone walls inscribed with thousands of names reflect back the images of the living as they contemplate the memorial to the Vietnam War's (1964-75) dead and missing veterans. The idea is brilliant in its simplicity. The artist Maya Ying Lin (b. 1959) combined two basic ideas: the minimal grandeur of long, black granite walls and row upon row of engraved namesthe abstract and the intimate conjoined. The power of Lin's monument lies in its understatement. The wall is a statement of loss, sorrow, and the futility of war, and the names are so numerous that they lose individuality and become a surface texture. It is a timeless monument to suffering humanity, faceless in sacrifice. Maya Lin said, "The point is to see yourself reflected in the names."

The VIETNAM VETERANS MEMORIAL, now widely admired as a fitting testament to the Americans who died in that conflict, was the subject of public controversy when it was first proposed due to its severely Minimalist style. In its request for proposals for the design of the monument, the Vietnam Veterans Memor-

ial Fund-composed primarily of veterans themselves-stipulated that the memorial be without political or military content, that it be reflective in character, that it harmonize with its surroundings, and that it include the names of the more than 58,000 dead and missing. They awarded the commission to Maya Lin, then an undergraduate studying in the architecture department at Yale University. Her design called for two 200-foot long walls (later expanded to 246 feet) of polished black granite to be set into a gradual rise in Constitution Gardens on the Mall in Washington, D.C., meeting at a 136 degree angle at the point where the walls and slope would be at their full 10-foot height. The names of the dead were to be incised in the stone in the order in which they died, with only the dates of the first and last deaths to be recorded.

The walls also reflect more than visitors. One wall faces and reflects the George Washington Monument (constructed 1848-84). Robert Mills, the architect of many public buildings at the beginning of the nineteenth century, chose the obelisk, a time-honored Egyptian sun symbol, for his memorial to the nation's founder. The other wall leads the

eye to the Neoclassical-style Lincoln Memorial. By subtly incorporating the Washington and Lincoln monuments into the design, Lin's *Vietnam Veterans Memorial* reminds the viewer of sacrifices made in defense of liberty throughout the history of the United States.

Until the modern era, most public art celebrated political and social leaders and glorified aspects of war in large, freestanding monuments. The motives of those who commissioned public art have ranged from civic pride and the wish to honor heroes to political propaganda and social intimidation. Art in public places may engage our intellect, educating or reminding us of significant events in history. Yet the most effective memorials also appeal to our emotions. Public memorials can provide both a universal and intimate experience, addressing subjects that have entered our collective conscious as a nation, yet remain highly personal. Lin's memorial in Washington, D.C., to the American men and women who died in or never returned from the Vietnam War is among the most visited works of public art of the twenty-first century and certainly among the most affecting war monuments ever conceived.

Maya Ying Lin VIETNAM VETERANS MEMORIAL
1982. Black Granite, length 500' (152 m). The Mall, Washington, D.C.

Although artists sometimes work speculatively, hoping afterwards to sell their work on the open market, throughout history interested individuals and institutions have acted as patrons of the arts. During periods of great artistic vigor, enlightened patronage has been an essential factor. Today, museums and other institutions, such as governmental agencies (for example, in the United States, the National Endowment for the Arts), also provide financial grants and support for the arts.

Individual Patrons

People who are not artists often want to be involved with art, and patrons of art constitute a very special audience for artists. Many collectors truly love works of art, but some collect art only to enhance their own prestige, to give themselves an aura of power and importance. Patrons can vicariously participate in the creation of a work by providing economic support to an artist. Such individual patronage can spring from a cordial relationship between a patron and an artist, as is evident in an early fifteenth-century manuscript illustration in which the author, Christine de Pizan, presents her work to her patron Isabeau, the Queen of France (FIG. 21). Christine—a widow who supported her family by writing-hired painters and scribes to copy, illustrate, and decorate her books. She especially admired the painting of a woman named Anastaise, whose work she considered unsurpassed in the city of Paris. While Queen Isabeau was Christine's patron, Christine in turn was Anastaise's patron; and all the women seen in the painting were patrons of the brilliant textile workers who supplied the brocades for their gowns, the tapestries for the wall, and the embroideries for the bed. Such networks of patronage shape a culture.

Relations between artists and patrons are not always necessarily congenial. Patrons may change their minds or fail to pay their bills. Artists may ignore their patron's wishes, or exceed the scope of their commission. In the late nineteenth century, for example, the Liverpool shipping magnate Frederick Leyland asked James McNeill Whistler (1834–1903), an American painter living in London, what color to paint the shutters in the dining room where he planned to hang Whistler's painting *The Princess from The Land of Porcelain* (FIG. 22).

The room had been designed by Thomas Jeckyll with embossed and gilded leather on the walls and finely crafted shelves to show off Leyland's collection of blue and white Chinese porcelain. While Leyland was away, Whistler, inspired by the Japanese theme of his own painting as well as by the porcelain, painted the window shutters with splendid turquoise and gold peacocks, the walls and ceiling with peacock feathers, and then he gilded the walnut shelves. When Leyland, shocked and angry at what seemed to him to be wanton destuction of the room, paid him less than half the agreed on price, Whistler added a painting of himself and Leyland as fighting peacocks. Whistler called the room HARMONY IN BLUE AND GOLD: THE PEACOCK ROOM.

21 CHRISTINE DE PIZAN PRESENTING HER BOOK TO THE QUEEN OF FRANCE 1410–15. Tempera and gold on vellum, image approx. $5\frac{1}{2}\times6\frac{1}{4}$ " (14 \times 17 cm). The British Library, London.

MS. Harley 4431, folio 3

22 James McNeill Whistler **HARMONY IN BLUE AND GOLD: THE PEACOCK ROOM** northeast corner, from a house owned by Frederick Leyland, London. 1876–1877. Oil paint and metal leaf on canvas, leather, and wood, $13'11\%'' \times 33'2'' \times 19'11\%''$ (4.26 \times 10.11 \times 6.83 m). Over the fireplace, Whistler's *The Princess from The Land of Porcelain*. Freer Gallery of Art, Smithsonian Institution, Washington, D.C. Gift of Charles Lang Freer, (F1904.61)

Luckily, Leyland did not destroy the Peacock Room. After Leyland's death, Charles Lang Freer (1854–1919) purchased the room and the painting of *The Princess*. Freer reinstalled the room in his home in Detroit, Michican, and filled the delicate gold shelves with his own collection of porcelain. When Freer died in 1919, the Peacock Room was moved to the Freer

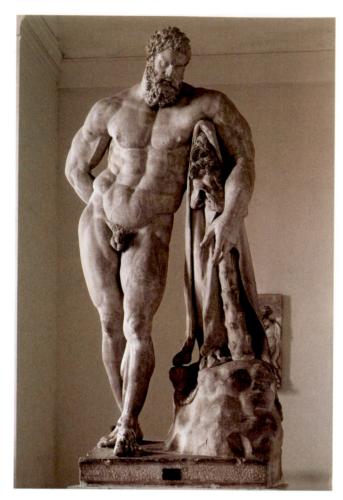

23 THE FARNESE HERCULES

3rd century BCE. Copy of *The Weary Hercules* by Lysippos. Found in the Baths of Caracalla in 1546; exhibited in the Farnese Palace until 1787. Marble, $10\frac{1}{2}$ (3.17 m). Signed "Glykon" on the rock under the club. Left arm restored.

Gallery of Art, which he had founded in Washington D.C., where it remains as an extraordinary example of interior design and late nineteenth-century patronage.

Collectors and Museums

From the earliest times, people have collected and kept precious objects that convey the idea of power and prestige. Today both private and public museums are major patrons, collectors, and preservers of art. Curators of such collections acquire works of art for their museums and often assist patrons in obtaining especially desirable pieces, although the idea of what is best and what is worth collecting and preserving often changes from one generation to another.

Charles Lang Freer, mentioned on the previous page, is another kind of patron—one who was a sponsor of artists, a collector, and the founder of the museum that bears his name. Freer was an industrialist in Detroit—the manufacturer of railway cars—who was inspired by the nineteenth-century ideal of art as a means of achieving universal harmony and of the philosophy "Art for Art's Sake." The leading American exponent of

this philosophy was James McNeill Whistler. On a trip to Europe in 1890, Freer met Whistler, who inspired him to collect Asian art as well as the art of his own time. Freer became an avid collector and supporter of Whistler, whom he saw as a person who combined the aesthetic ideals of both East and West. Freer assembled a large and distinguished collection of American and Asian art, including the *Peacock Room*. (SEE FIG. 22). In his letter written at the founding the Freer Gallery, donating his collection to the Smithsonian Institution and thus to the American people, he wrote of his desire to "elevate the human mind."

WHAT IS ART HISTORY?

Art history became an academic field of study relatively recently. Many art historians consider the first art history book to be the 1550 publication *Lives of the Most Excellent Italian Architects, Painters, and Sculptors*, by the Italian artist and writer Giorgio Vasari. As the name suggests, art history combines two studies—the study of individual works of art outside time and place (**formal analysis** and **theory**) and the study of art in its historical and cultural context (**contextualism**), the primary approach taken in this book. The scope of art history is immense. As a result, art history today draws on many other disciplines and diverse methodologies.

Studying Art Formally and Contextually

The intense study of individual art objects is known as connoisseurship. Through years of close contact with artworks and through the study of the formal qualities that compose style in art (such as the design, the composition, and the way materials are manipulated)—an approach known as formalism—the connoisseur learns to categorize an unknown work through comparison with related pieces, in the hope of attributing it to a period, a place, and sometimes even a specific artist. Today such experts also make use of the many scientific tests—such as x-ray radiography, electron microscopy, infrared spectroscopy, and x-ray diffraction—but ultimately connoisseurs depend on their visual memory and their skills in formal analysis.

As a humanistic discipline, art history adds theoretical and contextual studies to the formal and technical analyses of connoisseurship. Art historians draw on biography to learn about artists' lives; on social history to understand the economic and political forces shaping artists, their patrons, and their public; and on the history of ideas to gain an understanding of the intellectual currents influencing artists' works. Some art historians are steeped in the work of Sigmund Freud (1856–1939), whose psychoanalytic theory addresses creativity, the unconscious mind, and art as an expression of repressed feelings. Others have turned to the political philosopher Karl Marx (1818–83) who saw human beings as the products of their economic environment and art as a reflection of humanity's excessive concern with material val-

ues. Some social historians see the work of art as a status symbol for the elite in a highly stratified society.

Art historians also study the history of other arts including music, drama, and literature—to gain a fuller sense of the context of visual art. Their work results in an understanding of the iconography (the narrative and allegorical significance) and the context (social history) of the artwork. Anthropology and linguistics have added yet another theoretical dimension to the study of art. The Swiss linguist Ferdinand de Saussure (1857-1913) developed structuralist theory, which defines language as a system of arbitrary signs. Works of art can be treated as a language in which the marks of the artist replace words as signs. In the 1960s and 1970s structuralism evolved into other critical positions, the most important of which are semiotics (the theory of signs and symbols) and deconstruction. To the semiologist, a work of art is an arrangement of marks or "signs" to be decoded, and the artist's meaning or intention holds little interest. Similarly the deconstructionism of the French philosopher Jacques Derrida (1930-2004) questions all assumptions including the idea that there can be any single correct interpretation of a work of art. So many interpretations emerge from the creative interaction between the viewer and the work of art that in the end the artwork is "deconstructed."

The existence of so many approaches to a work of art may lead us to the conclusion that any idea or opinion is equally valid. But art historians, regardless of their theoretical stance, would argue that the informed mind and eye are absolutely necessary.

As art historians study a wider range of artworks than ever before, many have come to reject the idea of a fixed canon of superior pieces. The distinction between elite fine arts and popular utilitarian arts has become blurred, and the notion that some mediums, techniques, or subjects are better than others has almost disappeared. This is one of the most telling characteristics of art history today, along with the breadth of studies it now encompasses and its changing attitude to challenges such as preservation and restoration.

WHAT IS A VIEWER'S ROLE AND RESPONSIBILITY?

As viewers we enter into an agreement with artists, who in turn make special demands on us. We re-create the works of art for ourselves as we bring to them our own experiences, our intelligence, our knowledge, and even our prejudices. Without our participation, artworks are merely chunks of stone or flecks of paint. But remember, all is change. From extreme realism at one end of the spectrum to entirely non-representational art at the other, artists have worked with varying degrees of naturalism, idealism, and abstraction. For students of art history, the challenge is to discover not only how those styles evolved, but also why they changed, and

ultimately what significance these changes hold for us, for our humanity, and for our future.

Our involvement with art can be casual or intense, naive or sophisticated. At first we may simply react instinctively to a painting or a building or a sculpture (FIG. 23), but this level of "feeling" about art—"I know what I like"—can never be fully satisfying. Like the sixteenth-century Dutch visitors to Rome (FIG. 24), we too can admire and ponder the ancient marble engraving that depicts his Dutch friends as they ponder, and we can perhaps imagine an artist depicting us as our glance leaps backwards and forwards pondering art history. Because as viewers we participate in the re-creation of a work of art, its meaning changes from individual to individual, from era to era.

Once we welcome the arts into our lives, we have a ready source of sustenance and challenge that grows, changes, mellows, and enriches our daily experience. This book introduces us to works of art in their historical context, but no matter how much we study or read about art and artists, eventually we return to the contemplation of an original work itself, for art is the tangible evidence of the ever-questing human spirit.

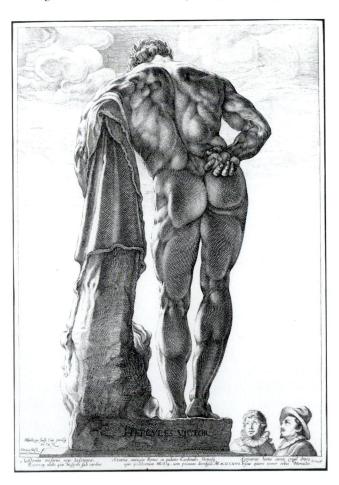

24 Hendrick Goltzius **DUTCH VISITORS TO ROME LOOKING AT THE FARNESE HERCULES** c. 1592. Engraving, $16 \times 11 \frac{1}{2}$ " (40.5 x 29.4 cm). After Goltzius returned from a trip to Rome in 1591–1592, he made engravings based on his drawings. The awe-struck viewers have been identified as two of his Durch friends.

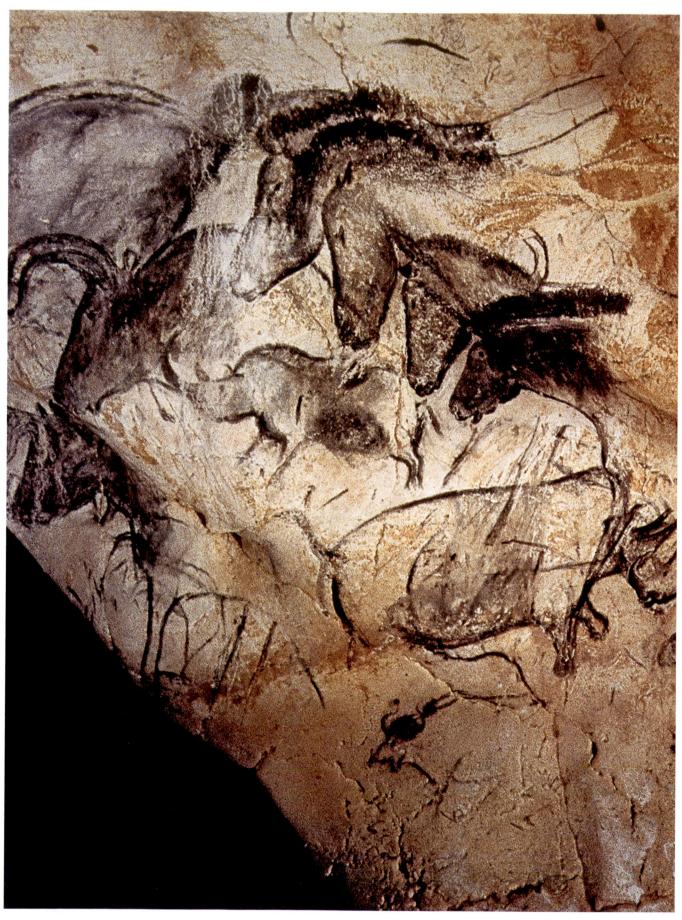

I−I | WALL PAINTING WITH HORSES, RHINOCEROSES, AND AUROCHS Chauvet Cave, Vallon-Pont-d'Arc, Ardèche Gorge, France. c. 30,000–28,000 BCE. Paint on limestone.

CHAPTER ONE

PREHISTORIC ART IN EUROPE

Prehistory includes all of human existence before the emergence of writing, but long before that defining moment, people were carving objects, painting images, and creating shelters and other structures. In fact, much of what we

know about prehistoric people is based on the art they produced. These works are fascinating because they are supremely beautiful and because of what they tell us about those who made them. The sheer artistry and immediacy of the images left by our early ancestors connect us to them as surely as written records link us to those who came later.

The first contemporary people to explore the painted caves of France and Spain entered an almost unimaginably ancient world. Hundreds of yards from the entrances and accessed through long, narrow underground passages, what they found astounded them and still fascinates us. In the Chauvet Cave, located in a gorge in the Ardèche region of southeastern France (FIG. 1-1) images of horses, deer, mammoths, aurochs (extinct ancestors of oxen), and other animals that lived 30,000 years ago cover the walls and ceilings. Their forms bulge and seem to shift and move. The images are easily identifiable, for the painters have transformed their memories of active, three-dimensional figures into two dimensions by capturing the essence of well-observed animals-meat-bearing flanks, powerful legs, and dangerous horns or tusks. Using only the formal language of line and color, shading, and contour, these prehistoric painters seem to communicate with us.

Archaeologists and anthropologists study every aspect of material culture, while art historians usually focus on those things that to twenty-first-century eyes seem superior in craft and beauty. But 30,000 years ago our

ancestors were not making "works of art." They were flaking, chipping, and polishing flints into spear points, knives, and scrapers, not into sculptures, however beautiful the forms of these tools appear to us. The creation of the images we see today on the walls of the Chauvet Cave must have seemed a vitally important activity to their makers in terms of everyday survival. They were often painted in areas far from the cave entrance, without access to natural daylight, and which were visited over many years. The walls were not flat canvasses but irregular natural rock forms. What we perceive as "art" may have been a matter of necessity to these ancient image makers.

For art historians, archaeologists, and anthropologists, prehistoric art provides a significant clue—along with fossils, pollen, and artifacts—to understanding early human life and culture. Although specialists continue to discover more about when and how these works were created, they may never be able to tell us why they were made. The sculpture, paintings, and structures that survive are only a tiny fraction of what must have been created over a very long span of time. The conclusions and interpretations drawn from them are only hypotheses, making prehistoric art one of the most speculative areas of art history.

CHAPTER-AT-A-GLANCE

- THE STONE AGE
- THE PALEOLITHIC PERIOD | Shelter or Architecture? | Artifacts or Works of Art? | Cave Painting | Cave Sculptures
- THE NEOLITHIC PERIOD | Rock-Shelter Art | Architecture | Sculpture and Ceramics
- FROM STONE TO METAL | The Bronze Age | The Proto-Historic Iron Age
- IN PERSPECTIVE

THE STONE AGE

How and when modern humans evolved is the subject of ongoing lively debate, but anthropologists now agree that the species called *Homo sapiens* appeared about 200,000 years ago, and that the subspecies to which we belong, *Homo sapiens sapiens*, evolved about 120,000 to 100,000 years ago. Based on anthropological and archaeological findings, many scientists now contend that modern humans spread from Africa across Asia, into Europe, and finally to Australia and the Americas. Current evidence suggests that this vast movement of people took place between 100,000 and 35,000 years ago.

Scholars began the systematic study of prehistory only about 200 years ago. Nineteenth-century archaeologists, struck by the wealth of stone tools, weapons, and figures found at ancient sites, named the whole period of early human development the Stone Age. Today, researchers divide the Stone Age into the Paleolithic (from the Greek paleo-, "old," and lithos, "stone"), and the Neolithic (from the Greek neo-, "new") periods. The Paleolithic period itself is divided into three phases: Lower, Middle, and Upper, reflecting the relative position of objects found in the layers of excavation. (Upper is the most recent, lower the earliest.) In some places a transitional, or Paleolithic-Neolithic period—formerly called the Mesolithic (from the Greek meso-, "middle")—can also be identified.

Because the glaciers retreated gradually about 11,000 to 8,000 years ago, the dates for the transition from Paleolithic to Neolithic vary with geography. For some of the places discussed in this chapter, the Neolithic period arrived later and lasted until just 2,800 years ago. Archaeologists mark time in so many years ago, or BP ("before present"). However, to ensure consistent style throughout the book, which reflects the usage of art historians, we will use BCE ("before the Common Era") and CE (the Common Era) to mark time.

Much is yet to be discovered in prehistoric art. In Australia, some of the world's very oldest images have been dated to between 50,000 and 40,000 years ago. Africa, as well, is home to ancient rock art in both its northern and southern regions. In all cases, archaeologists associate the arrival of *Homo sapiens sapiens* in these regions with the advent of image making. This chapter explores the rich traditions of prehistoric European art from the Paleolithic and Neolithic periods into the Bronze and Iron ages (MAP I–I). Later chap-

ters will consider the prehistoric art of other continents and cultures, such as the Near East (Chapter 2), the Americas (Chapter 12), and sub-Saharan Africa (Chapter 13).

THE PALEOLITHIC PERIOD

Researchers found that human beings made tools long before they made what today we call "art." *Art*, or image making, is the hallmark of the Upper Paleolithic period. Representational images are seen in the archaeological record beginning around 40,000 years ago in Australia, Africa, and Europe. Before that time, as far back as 2 million years ago during the Lower Paleolithic period in Africa, early humans made tools by flaking and chipping (knapping) flint pebbles into blades and scrapers with sharp edges.

Evolutionary changes took place over time and by 100,000 years ago, during the late Middle Paleolithic period, a well-developed type of Homo sapiens called Neanderthal inhabited Europe. They used many different stone tools and may have carefully buried their dead with funerary offerings. Although Neanderthals survived for thousands of years, Cro-Magnons—fully modern humans like us—overlapped and probably interbred with the Neanderthals and eventually replaced them, probably between 40,000 to 35,000 years ago. Called "Cro-Magnon" after the French site where their bones were first discovered, these modern humans made many different kinds of tools out of reindeer antler and bone, as well as very fine chipped-stone implements. Clearly social beings, Cro-Magnons must have had social organization, rituals, and beliefs that led them to create art. They engraved, carved, drew, and painted with colored ochers, earthy iron ores that could be ground into pigments. These people are our ancestors, and with their sculpture and painting we begin our history of art.

Shelter or Architecture?

The term **architecture** has been applied to the enclosure of spaces with at least some aesthetic intent. Some people object to its use in connection with prehistoric improvisations, but building even a simple shelter requires a degree of imagination and planning deserving of the name "architecture." In the Upper Paleolithic period, humans in some regions used great ingenuity to build shelters that were far from simple. In

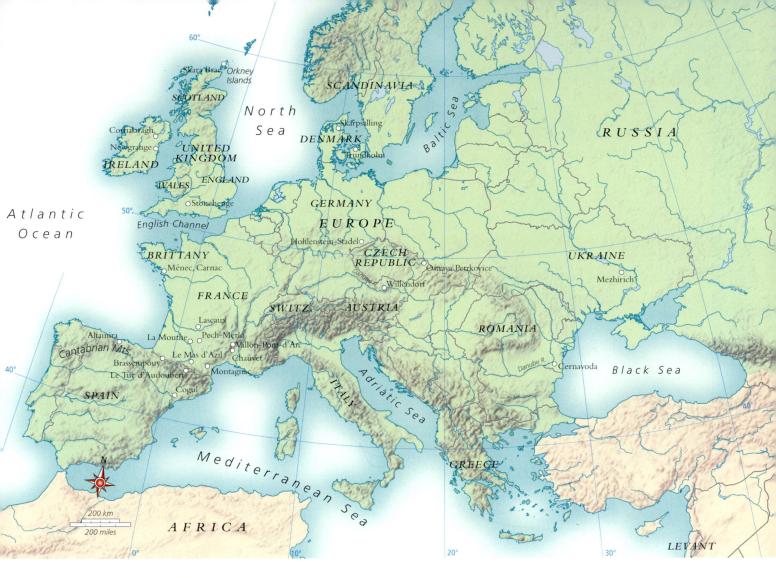

MAP I—I PREHISTORIC EUROPE

As the Ice Age glaciers receded, Paleolithic, Neolithic, Bronze Age, and Iron Age settlements increased from south to north.

woodlands, evidence of floors indicates that circular or oval huts of light branches and hides were built. These measured as much as 15 to 20 feet in diameter. (Modern tents to accommodate six people vary from 10 by 11-foot ovals to 14 by 7-foot rooms.)

In the treeless grasslands of Upper Paleolithic Russia and Ukraine, builders created settlements of up to ten houses using the bones of the now extinct woolly mammoth, whose long, curving tusks made excellent roof supports and arched door openings (FIG. 1–2). This bone framework was probably

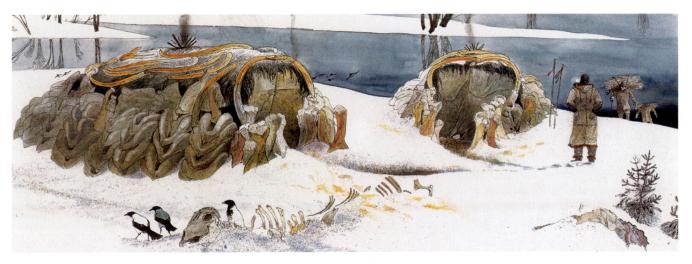

I=2 | RECONSTRUCTION DRAWING OF MAMMOTH-BONE HOUSES Ukraine. c. 16,000-10,000 BCE.

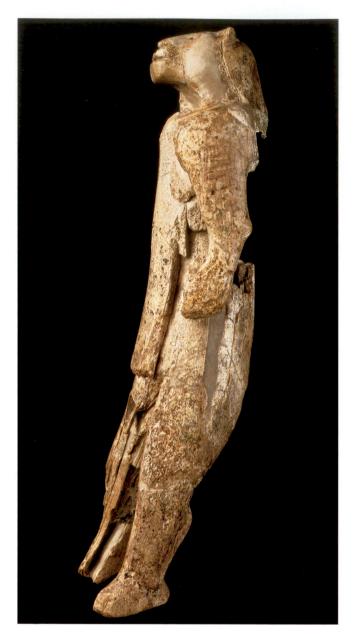

I-3 | LION-HUMAN Hohlenstein-Stadel, Germany. c. 30,000-26,000 BCE. Mammoth ivory, height 11½" (29.6 cm). Ulmer Museum, Ulm, Germany.

covered with animal hides and turf. Most activities centered around the inside fire pit, or hearth, where food was prepared and tools were fashioned. Larger dwellings might have had more than one hearth and spaces set aside for specific uses—working stone, making clothing, sleeping, and dumping refuse. In Mezhirich, Ukraine, archaeologists found fifteen small hearths inside the largest dwelling that still contained ashes and charred bones left by the last occupants. Some people also colored their floors with powdered ocher ranging in color from yellow to red to brown.

Artifacts or Works of Art?

As early as 30,000 BCE small figures, or figurines, of people and animals made of bone, ivory, stone, and clay appeared in Europe and Asia. Today we interpret such self-contained, three-dimensional pieces as examples of sculpture in the round. Pre-historic carvers also produced **relief sculpture** in stone, bone, and ivory. In relief sculpture, the surrounding material is carved away, forming a background that sets off the figure.

THE LION-HUMAN. An early and puzzling example of a sculpture in the round is a human figure—probably male—with a feline head (FIG. 1–3), made about 30,000–26,000 BCE. Archaeologists excavating at Hohlenstein-Stadel, Germany, found broken pieces of ivory (from a mammoth tusk) that they realized were parts of an entire figure. Nearly a foot tall, this remarkable statue surpasses most early figurines in size and complexity. Instead of copying what he or she saw in nature, the carver created a unique creature, part human and part beast. Was the figure intended to represent a person wearing a ritual lion mask? Or has the man taken on the appearance of an animal? One of the few things that can be

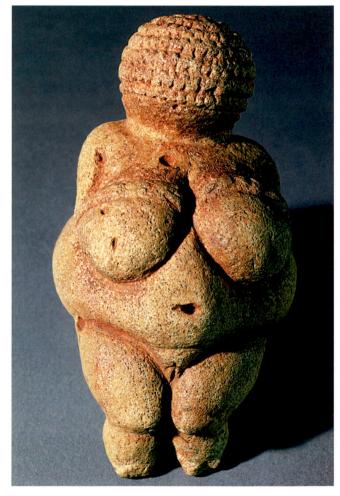

I–4 | WOMAN FROM WILLENDORF Austria. c. 24,000 BCE. Limestone, height 4¾" (11 cm). Naturhistorisches Museum, Vienna.

Art and Its Context

THE POWER OF NAMING

ords are only symbols for ideas. But the very words we invent—or our ancestors invented—reveal a certain view of the world and can shape our thinking. Early people recognized clearly the power of words. In the Old Testament, God gave Adam dominion over the animals and allowed him to name them (Genesis 2:19–20). Today, we still exert the power of naming when we select a name for a baby or call a friend by a nickname. Our ideas about art can also be affected by names, even the ones used for captions in a book. Before the twentieth century, artists usually did not name, or title, their works. Names were eventually supplied by the works' owners or by scholars writing about them and thus may express the cultural prejudices of the labelers or of the times in which they live.

An excellent example of such distortion is provided by the names early scholars gave to the hundreds of small prehistoric

statues of women they found. They called them by the Roman name "Venus." For example, the sculpture in Figure 1-4 was once called the Venus of Willendorf after the place where it had been found. Using the name of the Roman goddess of love and beauty sent a message that this figure was associated with religious belief, that it represented an ideal of womanhood, and that it was one of a long line of images of "classical" feminine beauty. In a short time, most similar works of sculpture from the Upper Paleolithic period came to be known as Venus figures. The name was repeated so often that even scholars began to assume that these had to be fertility figures and mother goddesses, although there is no proof that this was so.

Our ability to understand and interpret works of art creatively is easily compromised by distracting labels. Calling a prehistoric figure a "woman" instead of "Venus" encourages us to think about the sculpture in new and different ways.

said about the **LION-HUMAN** is that it shows highly complex thinking and creative imagination: the ability to conceive and represent a creature never seen in nature.

FEMALE FIGURES. While a number of figurines representing men have been found recently, most human figures from the Upper Paleolithic period are female. The most famous female figure, the **WOMAN FROM WILLENDORF** (FIG. 1–4), from Austria, dates from about 22,000–21,000 BCE (see "The Power of Naming," above). Carved from limestone and originally colored with red ocher, the statuette's swelling, rounded forms make it seem much larger than its actual 4½-inch height. The sculptor exaggerated the figure's female attributes by giving it pendulous breasts, a big belly with deep navel (a natural indentation in the stone), wide hips, dimpled knees and buttocks, and solid thighs. By carving a woman with a well-nourished body, the artist may be expressing health and fertility, which could ensure the ability to produce strong children, thus guaranteeing the survival of the clan.

Another carved figure, found in the Czech Republic, the **WOMAN FROM OSTRAVA PETRKOVICE** (FIG. 1–5), presents an entirely different conception of the female form. It is less than 2 inches tall and dates from about 23,000 BCE. Archaeologists excavating an oval house stockpiled with flint stone and rough chunks of hematite (iron oxide) discovered the figure next to the hearth. The torso and thighs of a youthful, athletic figure of a woman suggest an animated pose, with one angular hip slightly raised and a knee bent as if she were walking. The marks left by the artist's carving tool are visible.

Another remarkable female image, discovered in the Grotte du Pape in Brassempouy, France, is the tiny ivory head

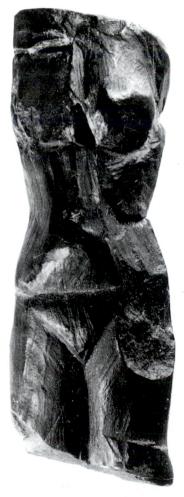

I-5 | WOMAN FROM OSTRAVA PETRKOVICE Czech Republic. c. 23,000 BCE. Hematite, height 1¾" (4.6 cm). Archaeological Institute, Brno, Czech Republic. © Institute of Archaeology, Academy of Sciences of the Czech Republic, Brno

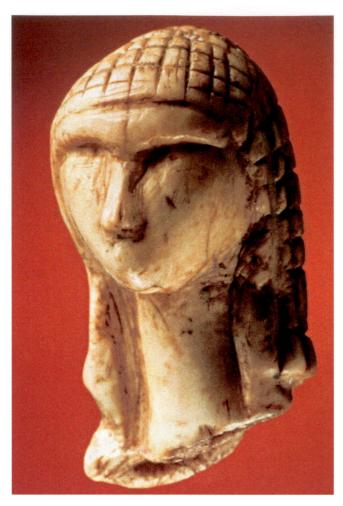

I−6 | WOMAN FROM BRASSEMPOUY
Grotte du Pape, Brassempouy, Landes, France. Probably
c. 30,000 BCE. Ivory, height 1½″ (3.6 cm). Musée des Antiquités
Nationales, St.-Germain-en-Laye, France.

known as the woman from Brassempouy (FIG. 1-6). The finders did not record its archaeological context; however, recent studies declare it to be authentic and date it as early as 30,000 BCE. The carver captured the essence of a head or what psychologists call the memory image—those generalized elements that reside in our standard memory of a human head. An egg shape rests atop a long neck, a wide nose and a strongly defined browline suggest deep-set eyes, and an engraved square patterning may be hair or a headdress. The image is an abstraction (what has come to be known as abstract art): the reduction of shapes and appearances to basic yet recognizable forms that are not intended to be exact replications of nature. The result in this case looks uncannily modern to the contemporary viewer. Today when such a piece is isolated in a museum case or as a book illlustration, we enjoy it as an aesthetic object, but we lose its original cultural context.

Cave Painting

Art in Europe entered a rich and sophisticated phase between about 30,000 and 10,000 BCE, when images were painted on

the walls of caves in central and southern France and northern Spain.

No one knew of the existence of prehistoric cave paintings until one day in 1879, when a young girl, exploring with her father in Altamira in northern Spain, crawled through a small opening in the ground and found herself in a chamber whose ceiling was covered with painted animals (see page 9). Her father, a lawyer and amateur archaeologist, searched the rest of the cave, told authorities about the remarkable find, and published his discovery the following year. Few people believed that these amazing works could have been done by "primitive" people, and the scientific community declared the paintings a hoax. They were accepted as authentic only in 1902, after many other cave paintings, drawings, and engravings had been discovered at other places in northern Spain and in France.

What caused people to paint such dramatic imagery on the walls of caves? The idea that human beings have an inherent desire to decorate themselves and their surroundings—that an aesthetic sense is somehow innate to the human species—found ready acceptance in the nineteenth century. Many believed that people create art for the sheer love of beauty. Scientists now agree that human beings have an aesthetic impulse, but the effort required to accomplish the great cave paintings suggests their creators were motivated by more than simple pleasure. Since the discovery at Altamira, anthropologists and art historians have devised several hypotheses to explain the existence of cave art. Like the search for the meaning of prehistoric female figurines, these explanations depend on the cultural views of those who advance them.

THE MEANING OF CAVE PAINTINGS. Early twentieth-century scholars believed that art fulfills a social function and that aesthetics are culturally relative. They proposed that the cave paintings might be products both of totemistic rites to strengthen clan bonds and increase ceremonies to enhance the fertility of animals used for food. In 1903, French scholar Salomon Reinach suggested that cave paintings were expressions of sympathetic magic (the idea, for instance, that a picture of a reclining bison would insure that hunters found their prev asleep). Abbé Henri Breuil took these ideas further and concluded that caves were used as places of worship and the settings for initiation rites. In the second half of the twentieth century, scholars rejected these ideas and based their interpretations on rigorous scientific methods and current social theory. Andre Leroi-Gourhan and Annette Laming-Emperaire, for example, dismissed the sympathetic magic theory because statistical analysis of debris from human settlements revealed that the animals used most frequently for food were not the ones traditionally portrayed in caves. Their analysis also showed a systematic organization of images.

Researchers continue to discover new cave images and to correct earlier errors of fact or interpretation. A study of the

Altamira cave in the 1980s led Leslie G. Freeman to conclude that these artists faithfully represented a herd of bison during the mating season. Instead of being dead, asleep, or disabled—as earlier observers had thought—the bison were dust-wallowing, common behavior during the mating season.

Although hypotheses that seek to explain cave art have changed and evolved over time, scholars have always agreed that decorated caves must have had a special meaning, because people returned to them time after time over many generations, in some cases over thousands of years. Perhaps Upper Paleolithic cave art was the product of rituals intended to gain the favor of the supernatural. Perhaps because much of the art was made deep inside the caves and nearly inaccessible, its significance may have had less to do with the finished painting than with the very act of creation. Artifacts and footprints (such as those found at Chauvet, below, and Le Tuc d'Audoubert, page 10) suggest that the subterranean galleries, which were far from living quarters, had a religious or magical function. Perhaps the experience of exploring the cave may have been significant to the image makers. Musical instruments, such as bone flutes, have been found in the caves, implying that even acoustical properties may have played a role.

CHAUVET. The earliest known site of prehistoric cave paintings today, discovered in December 1994, is the Chauvet Cave (so called after one of the persons who found it) near Vallon-Pont-d'Arc in southeastern France—a tantalizing trove of hundreds of paintings (SEE FIG. 1–1). The most dramatic of the Chauvet Cave images depict grazing, running, or resting animals. Among the animals depicted are wild horses, bison, mammoths, bears, panthers, owls, deer, aurochs, woolly-haired rhinos, and wild goats (or ibex). Also included are occasional humans, both male and female, many hand-

Sequencing Events PREHISTORIC PERIODS

c.	40,000-8000 все	Upper Paleolithic period; modern man arrives in Europe
c.	10,000 все	Present interglacial period begins
c.	9000-4000 все	Paleolithic-Neolithic overlap (formerly called the Mesolithic period)
c.	6500-1200 все	Neolithic period; farming in Europe
c.	2300-с.800 все	Bronze Age in Europe; trade with Near East increases
c.	1000-50 все	Proto-historic Iron Age in Europe

prints, and hundreds of geometric markings such as grids, circles, and dots. Footprints in the Chauvet Cave, left in soft clay by a child, go to a "room" containing bear skulls. The charcoal used to draw the rhinos has been radiocarbon dated to 32,410 plus or minus 720 years before the present.

PECH-MERLE. A cave site at Pech-Merle, also in southern France, appears to have been used and abandoned several times over a period of 5,000 years. Images of animals, handprints, and nearly 600 geometric symbols have been found in thirty different parts of the underground complex. The earliest artists to work in the cave, some 24,000–25,000 years ago, painted horses (FIG. 1–7) with small, finely detailed heads, heavy bodies, massive extended necks, and legs tapering to almost nothing at the hooves. The right-hand horse's head follows the

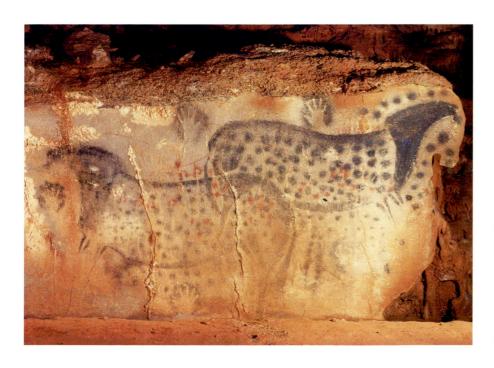

I−7 | SPOTTED HORSES AND HUMAN HANDS

Pech-Merle Cave, Dordogne, France. Horses 25,000–24,000 BCE; hands c. 15,000 BCE. Paint on limestone, individual horses are over 5' (1.5 m) in length. Photograph by Michael Lorblanchet. Redrawing by Rock Art Research Institute, University of the Witwatersrand, Johannesburg.

Technique

PREHISTORIC WALL PAINTING

n a dark cave, working by the light of an animal-fat lamp, an artist chews a piece of charcoal to dilute it with saliva and water. Then he blows out the mixture on the surface of a wall, using his hand as a stencil. In the drawing, cave archaeologist Michel Lorblanchet is showing us how the original makers of a cave painting at Pech-Merle in France created a complex design of spotted horses.

By turning himself into a human spray can, Lorblanchet can produce clear lines on the rough stone surface much more easily than he could with a brush. To create the line of a horse's back, with its clean upper edge and blurry lower one, he blows pigment below his hand. To capture its angular rump, he places his hand vertically against the wall, holding it slightly curved. To produce, the sharpest lines, such as those of the upper hind leg and tail, he places his hands side by side and blows between them. To create the forelegs and the hair on the horses' bellies, he finger paints. A hole punched in a piece of leather serves as a stencil for the horses' spots. It takes Lorblanchet only 32 hours to reproduce the Pech-Merle painting of spotted horses, his speed suggesting that a single artist created the original (perhaps with the help of an assistant to mix pigments and tend the lamp).

Cro-Magnon artists used three painting techniques—the spraying demonstrated by Lorblanchet, drawing with fingers or blocks of ocher, and daubing with a paintbrush made of hair or moss. In some places in prehistoric caves three stages of image creation can be seen—engraved lines using flakes of flint, followed by a color wash of ocher and manganese, and a final engraving to emphasize shapes and details.

shape of the rock. The horse images were then overlaid with bright red dots. Some interpreters see these circles as ordinary spots on the animals' coats, but others see them as representations of rock weapons ritually hurled at the painted horses.

The handprints on the walls at Pech-Merle and other cave sites were almost certainly not idle graffiti or accidental smudges. Some are positive images made by simply coating the hand with color pigment and pressing it against the wall. Others are negative images: The surrounding space rather than the hand shape itself is painted. Negative images were made by placing the hand with fingers spread apart against the wall, then spitting or spraying paint around it with a reed blowpipe or daubing with a paint-covered pad or brush—artist's tools that have been found in such caves (see "Prehistoric Wall Painting," left). In other places, artists drew or incised (scratched) figures onto the cave walls.

LASCAUX. The best-known cave paintings are those found in 1940 at Lascaux, in the Dordogne region of southern France. They have been dated to about 15,000 BCE (FIG. 1–8). Opened to the public after World War II, the prehistoric "museum" at Lascaux soon became one of the most popular tourist sites in France. Too popular, because the visitors brought heat, humidity, exhaled carbon dioxide, and other contaminants. The cave was closed to the public in 1963 so that conservators could battle an aggressive fungus. Eventually they won, but instead of reopening the site, authorities created a facsimile of it. Visitors at what is called Lascaux II may now view copies of the painted scenes without harming the precious originals.

The scenes they view are truly remarkable. The Lascaux artists painted cows, bulls, horses, and deer along the natural ledges of the rock, where the smooth white limestone of the ceiling and upper wall meets a rougher surface below. They also utilized the curving wall to suggest space. Lascaux has about 600 paintings and 1,500 engravings. Ibex and a bear, engraved felines, and a woolly rhinoceros, but no mammoths, have also been found. The animals appear singly, in rows, face to face, tail to tail, and even painted on top of one another. Their most characteristic features have been emphasized. Horns, eyes, and hooves are shown as seen from the front, yet heads and bodies are rendered in profile in a system known as **twisted perspective**. Even when their poses are exaggerated or distorted, the animals are full of life and energy, and the accuracy in the drawing of their silhouettes, or outlines, is remarkable.

Painters worked not only in large caverns, but also far back in the smallest chambers and recesses, many of which are almost inaccessible today. Small stone lamps found in such caves—over 100 lamps have been found at Lascaux—indicate that they worked in flickering light from burning animal fat (SEE FIG. 1–12). (Although 500 grams of fat would burn for 24 hours and animal fat produces no soot, the light created is not as strong as a candle.)

One scene at Lascaux was discovered in a remote setting on a wall at the bottom of a 16-foot shaft that contained a stone

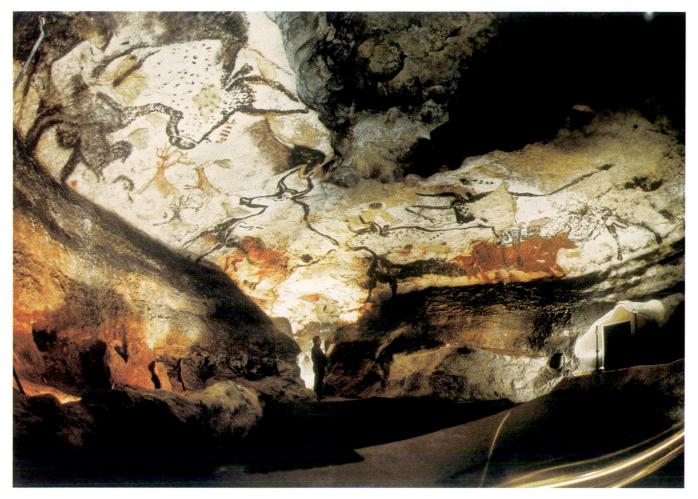

I-8 | HALL OF BULLS Lascaux Cave, Dordogne, France. c. 15,000 BCE. Paint on limestone, length of the largest auroch (bull) 18' (5.50 m).

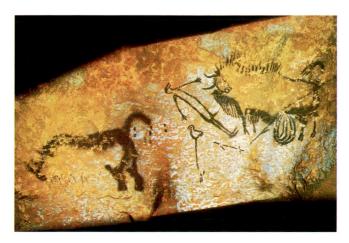

I−9 | BIRD-HEADED MAN WITH BISON Shaft scene in Lascaux Cave. c. 15,000 BCE. Paint on limestone, length approx. 9' (2.75 m).

lamp and spears. The scene is unusual because it is the only painting in the cave complex that seems to tell a story (FIG. 1–9), and it is stylistically different from the other paintings at Lascaux. A figure who could be a hunter, greatly simplified in form but recognizably male and with the head of a bird or wearing a bird's-head mask, appears to be lying on the ground. A great bison looms above him. Below him lie a staff, or baton, and a spear thrower (atlatl)—a device that allowed hunters to throw farther and with greater force—the outer end of which has been carved in the shape of a bird. The long, diagonal line slanting across the bison's hindquarters may be a spear. The bison has been disemboweled and will soon die. To the left of the cleft in the wall a woolly rhinoceros seems to run off.

Why did the artist portray the man as only a sticklike figure when the bison was rendered with such accurate detail? Does the painting illustrate a story or a myth regarding the death of a hero? Is it a record of an actual event? The painting may depict the vision of a *shaman*. Shamans are thought to have special powers, an ability to contact spirits in the form of animals or birds. In a trance they leave their bodies and communicate through spirit guides. The images they use to record their visions tend to be abstract, incorporating geometric

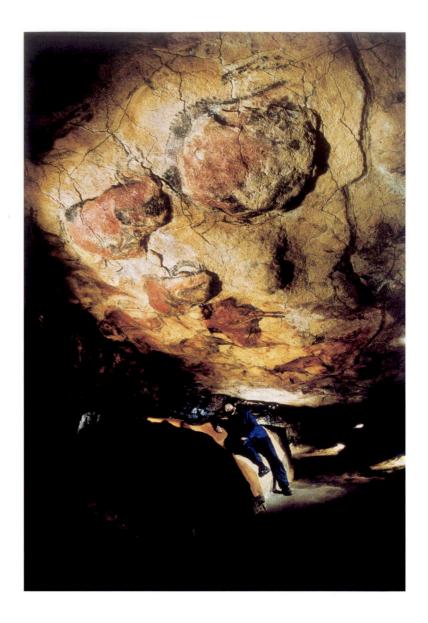

I—IO | BISON
Ceiling of a cave at Altamira, Spain. c. 12,500 BCE.
Paint on limestone, length approx. 8'3" (2.5 m).

figures and combinations of human and animal forms, such as the bird-headed man in this scene from Lascaux or the lionheaded figure discussed earlier (SEE FIG. 1–3).

ALTAMIRA. The cave paintings at Altamira, near Santander in the Cantabrian Mountains in Spain—the first to be discovered and attributed to the Upper Paleolithic period—have been recently dated to about 12,500 BCE. The Altamira artists created sculptural effects by painting over and around natural irregularities in the cave walls and ceilings. To produce the herd of bison on the ceiling of the main cavern (FIG. 1–10), they used rich red and brown ochers to paint the large areas of the animals' shoulders, backs, and flanks, then sharpened the contours of the rocks and added the details of the legs, tails, heads, and horns in black and brown. They mixed yellow and brown from ochers with iron to make the red tones and derived black from manganese or charcoal.

Cave Sculptures

Caves were sometimes adorned with relief sculpture as well as paintings. At Altamira, an artist simply heightened the resemblance of a natural projecting rock to a similar and familiar animal form. Other reliefs were created by modeling, or shaping, the damp clay of the cave's floor. An excellent example of such work in clay from about 13,000 BCE is preserved at Le Tuc d'Audoubert, south of the Dordogne region of France. Here the sculptor created two bison leaning against a ridge of rock (FIG. 1-11). Although these beasts are modeled in very high relief (they extend well forward from the background), they display the same conventions as in earlier painted ones, with emphasis on the broad masses of the meatbearing flanks and shoulders. To make the animals even more lifelike, their creator engraved short parallel lines below their necks to represent their shaggy coats. Numerous small footprints found in the clay floor of this cave suggest that important group rites took place here.

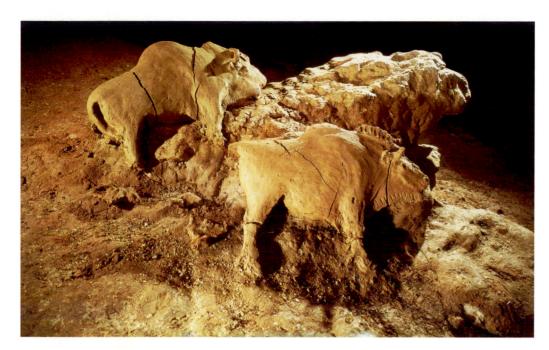

I-II | BISON Le Tuc d'Audoubert, France. c. 13,000 BCE. Unbaked clay, length 25" (63.5 cm) and 24" (60.9 cm).

I-I2 | LAMP WITH IBEX DESIGN La Mouthe Cave, Dordogne, France. c. 15,000–13,000 BCE. Engraved stone.

An aesthetic sense and the ability to express it in a variety of ways are among the characteristics unique to our subspecies, *Homo sapiens sapiens*. Lamps found in caves provide an example of objects that were both functional and aesthetically pleasing. Some were carved in simple abstract shapes; others were adorned with engraved images, like one found at La Mouthe, France (FIG. 1–12). The maker decorated the underside of this lamp with an ibex. The animal's distinctive head is shown in profile, its sweeping horns reflecting the curved outline of the lamp itself. Objects such as the ibex lamp were made by people whose survival depended upon their skill at hunting animals and gathering wild grains and other edible plants. But a change was already under way that would completely alter human existence.

THE NEOLITHIC PERIOD

Today, advances in technology, medicine, transportation, and electronic communication change human experience in a generation. Many thousands of years ago, change took place much more slowly. In the tenth millennium BCE the world had already entered the present interglacial period, and our modern climate was taking shape. However, the Ice Age ended so gradually and unevenly among regions that people could not have known it was occurring.

To determine the onset of the Neolithic period in a specific region, archaeologists look for evidence of three conditions: an organized system of agriculture, the maintenance of herds of domesticated animals, and permanent, year-round settlements. The cumulative effects of warming temperatures were challenging to a settled way of life. Europe underwent a long and varied intermediary period not only of climate change, but also of cultural development.

At the end of the Ice Age in Europe, rising ocean levels dramatically altered the shorelines of the continent, making islands in some places. About 6000 BCE, the land bridge connecting England with the rest of Europe disappeared beneath the waters of what are now known as the North Sea and the English Channel. Most significantly, the retreating glaciers exposed large temperate regions. The heavily forested Mediterranean basin gave way to grassy plains supporting new, edible plants. Great herds of smaller and quicker animals, such as deer, were lured farther and farther west and north into the open areas and forests of central and northern Europe.

At the same time, people responded to these new conditions by inventing new hunting technologies or improving older ones. Hunters now used the bow and arrow much

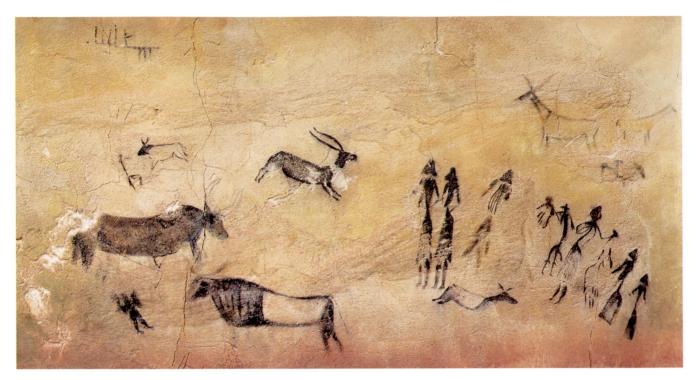

I–I3 | PEOPLE AND ANIMALS

Detail of rock-shelter painting, Cogul, Lérida, Spain. c. 4000–2000 BCE.

more frequently than they did in Paleolithic times. Bows were easier to carry, much more accurate at longer range than spears, and much more effective against the new type of game. The use of dugout boats opened up rich new areas formed by the rising waters of the North Sea for fishing and hunting. Stone tools were now polished to a high gloss instead of being chipped and flaked as in the Paleolithic period. With each advance, the standard of living improved.

The new environment led to a new, more sedentary way of life. Europeans began domesticating animals and cultivating plants. Dogs first joined hunters in Europe more than 10,000 years ago; cattle, sheep, and other animals were domesticated later. Between 10,000 and 5,000 years ago, people along the eastern shore of the Mediterranean began cultivating wild wheat and barley, developing these grasses into productive grains such as bread wheat.

The new farming culture gradually spread across Europe, reaching Spain and France by 5000 BCE. Farmers in the Paris region were using plows by 4000 BCE. As larger numbers of people became farmers, they began to live in villages and produce more than enough food to support themselves—thus freeing some people to attend to other communal needs such as political and military affairs, or ceremonial practices. Over time these early societies became increasingly complex. By the end of the period, villages were larger, trading had developed among distant regions, and advanced building technology had produced awe-inspiring architecture.

Rock-Shelter Art

The period of transition between Paleolithic and Neolithic culture (sometimes called Mesolithic) saw the rise of a distinctive art combining geometric forms and schematic images—simplified, diagrammatic renderings—with depictions of people and animals engaged in everyday activities. Artists of the time preferred to paint and engrave such works on the walls of easily accessible, shallow rock shelters. In style, technique, and subject matter, these rock-shelter images are quite different from those found in Upper Paleolithic cave art. The style is abstract, and the technique is often simple line drawing, with no addition of color. Beginning about 6000 BCE, rock-shelter art appeared in many places near the Mediterranean coast.

At Cogul, in the province of Lérida in Catalonia, the broad surfaces of a rock shelter are decorated with elaborate scenes involving dozens of small figures. The artists now represent men, women, children, animals, even insects, going about daily activities (FIG. 1–13). The paintings date from between 4000 and 2000 BCE (see "How Early Art Is Dated," right). No specific landscape features are indicated, but occasional painted patterns of animal tracks give the sense of a rocky terrain, like that of the surrounding barren hillsides.

In the detail shown here, a number of women are seen strolling or standing about, some in pairs holding hands. The women's small waists are emphasized by skirts with scalloped hemlines revealing large calves and sturdy ankles. All of them have shoulder-length hair. The women stand near several large animals, some of which are shown leaping forward with

legs fully extended. This pose, called a *flying gallop*, has been used to indicate speed in a running animal from prehistory to the present. The paintings are more than a record of daily life: People continued to visit these sites long after their original purpose had been forgotten. Inscriptions in Latin and an early form of Spanish scratched by Roman-era visitors—2,000-year-old graffiti—share the rock wall surfaces with the prehistoric paintings.

Architecture

As humans adopted a settled, agricultural way of life, they began to build large structures to serve as dwellings, storage spaces, and shelters for their animals. After the disappearance of the glaciers in Europe, timber became abundant, and Neolithic people, like their Paleolithic predecessors, continued to construct buildings out of wood and other plant materials. They clustered their dwellings in villages, and built large tombs and ritual centers outside settlements.

DWELLINGS AND VILLAGES. A northern European village of this period typically consisted of three or four long timber buildings, each up to 150 feet long, housing forty-five to fifty people. The structures were rectangular, with a row of posts down the center supporting a ridgepole, a long horizontal beam against which the slanting roof poles were braced (see example 4 in "Post-and-Lintel and Corbel Construction," page 14). The walls were probably made of what is known as wattle and daub, branches woven in a basketlike pattern, then covered with mud or clay. They were probably roofed with thatch, plant material such as reeds or straw tied over a framework of poles. These houses also included large granaries, or storage spaces for the harvest. Similar structures serving as animal shelters or even dwellings can still be seen today. Around 4000 BCE, Neolithic settlers began to locate their communities at defensible sites—near rivers, on plateaus, or in swamps. For additional protection, they also frequently surrounded them with wooden walls, earth embankments, and ditches.

SKARA BRAE. A Neolithic settlement has been wonderfully preserved at Skara Brae in the Orkney Islands off the northern coast of Scotland. It was constructed of stone, which was an abundant building material in this bleak, treeless region. A long-ago storm buried this seaside village under a layer of sand, and another storm brought it to light again in 1850.

Skara Brae presents a vivid picture of Neolithic life in the far north. In the houses, archaeologists found beds, shelves, stone cooking pots, basins, stone mortars for grinding, and pottery with incised decoration. Comparison of these artifacts with objects from sites farther south and laboratory analysis of the village's organic refuse date the settlement to between 3100 and 2600 BCE.

Science and Technology HOW EARLY ART IS DATED

ince the first discoveries at Altamira, archaeologists have developed increasingly sophisticated ways of dating cave paintings and other objects. Today, archaeologists primarily use two approaches to determine an artifact's age. **Relative dating** relies on the chronological relationships among objects in a single excavation or among several sites. If archaeologists have determined, for example, that pottery types A, B, and C follow each other chronologically at one site, they can apply that knowledge to another site. Even if "type B" is the only pottery present, it can still be assigned a relative date. **Absolute dating** aims to determine a precise span of calendar years in which an artifact was created.

The most accurate method of absolute dating is radiometric dating, which measures the degree to which radioactive materials have disintegrated over time. Used for dating organic (plant or animal) materials—including some pigments used in cave paintings—one radiometric method measures a carbon isotope called radiocarbon, or carbon-14, which is constantly replenished in a living organism. When an organism dies, it stops absorbing carbon-14 and starts to lose its store of the isotope at a predictable rate. Under the right circumstances, the amount of carbon-14 remaining in organic material can tell us how long ago an organism died.

This method has serious drawbacks for dating works of art. Using carbon-14 dating on a carved antler or wood sculpture shows only when the animal died or when the tree was cut down, not when the artist created the work using those materials. Also, some part of the object must be destroyed in order to conduct this kind of test—something that is never a desirable procedure to conduct on a work of art. For this reason, researchers frequently test organic materials found in the same context as the work of art rather than in the work itself.

Radiocarbon dating is most accurate for materials no more than 30,000 to 40,000 years old. Potassium-argon dating, which measures the decay of a radioactive potassium isotope into a stable isotope of argon, an inert gas, is most reliable with materials more than a million years old. Two newer techniques have been used since the mid-1980s. Thermo-luminescence dating measures the irradiation of the crystal structure of a material subjected to fire, such as pottery, and the soil in which it is found, determined by the luminescence produced when a sample is heated. Electron spin resonance techniques involve using a magnetic field and microwave irradiation to date a material such as tooth enamel and the soil surrounding it.

Recent experiments have helped to date cave paintings with increasing precision. Radiocarbon analysis has determined, for example, that the animal images at Lascaux are 17,000 years old—to be more precise, 17,070 years plus or minus 130 years.

Elements of Architecture

POST-AND-LINTEL AND CORBEL CONSTRUCTION

f all the methods for spanning space, post-and-lintel construction is the simplest. At its most basic, two uprights (posts) support a horizontal element (lintel). There are countless variations, from the wood structures, dolmens, and other underground burial chambers of prehistory, to Egyptian and Greek stone construction, to medieval timberframe buildings, and even to cast-iron and steel construction. Its

limitation as a space spanner is the degree of tensile strength of the lintel material: the more flexible, the greater the span possible. Another early method for creating openings in walls and covering space is **corbeling**, in which rows or layers of stone are laid with the end of each row projecting beyond the row beneath, progressing until opposing layers almost meet and can then be capped with a stone that rests across the tops of both layers.

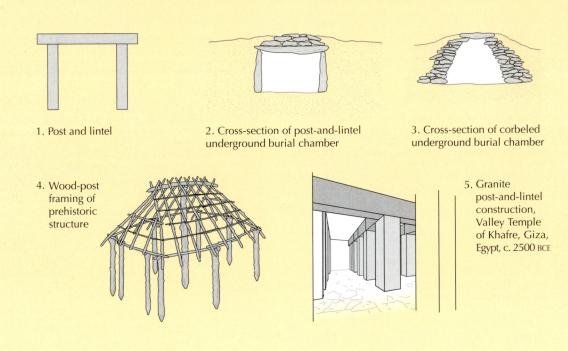

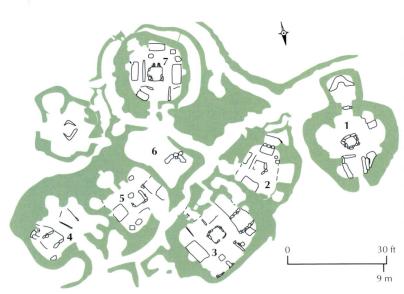

I−I4 PLAN, VILLAGE OF SKARA BRAE
Orkney Islands, Scotland. c. 3100–2600 BCE. (Numbers refer to individual houses.)

The village consists of a compact cluster of dwellings linked by covered passageways (FIG. 1–14). Each of the houses has a square plan with rounded corners. The largest one measures 20 by 21 feet, the smallest, 13 by 14 feet. Layers of flat stones without mortar form walls, with each layer, or course, projecting slightly inward over the one below. This type of construction is called **corbeling** (see example 3 in "Post-and-Lintel and Corbel Construction," above). In some structures, inward-sloping walls come together at the top in what is known as a **corbel vault**, but at Skara Brae the walls stopped short of meeting, and the remaining open space was covered with hides or turf. There are smaller corbel-vaulted rooms within the main walls of some of the houses that may have been used for storage. One room, possibly a latrine, has a drain leading out under its wall.

The houses of Skara Brae were equipped with space-saving built-in furniture. In the room shown (FIG. 1–15), a large rectangular hearth with a stone seat at one end occupies the center of the space. Rectangular stone beds, some engraved with simple designs, stand against the walls on two sides of the

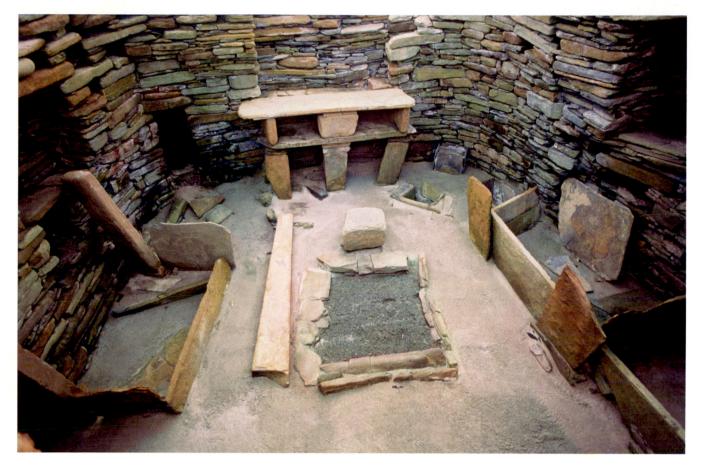

I−I5 HOUSE INTERIOR, SKARA BRAE (House 7 in Fig. 1–14).

hearth. These boxlike beds would probably have been filled with heather "mattresses" and covered with warm furs. In the left corner, a sizable storage room is built into the thick outside wall. Smaller storage niches were provided over each of the beds. A stone tank lined with clay to make it watertight is partly sunk into the floor. This container was probably used for live bait, for it is clear that the people at Skara Brae were skilled fisherfolk. On the back wall is a two-shelf cabinet that is a clear example of what is known as post-and-lintel construction (see "Post-and-Lintel and Corbel Construction," left).

CEREMONIAL AND TOMB ARCHITECTURE. In western and northern Europe, people used huge stones to erect ceremonial structures and tombs. In some cases, they had to transport these great stones over long distances. The monuments thus created are examples of what is known as megalithic architecture, the descriptive term derived from the Greek word roots for "large" (mega-) and "stone" (lithos).

Architecture formed of such massive elements testifies to a complex, stratified society. Powerful religious or political

figures and beliefs were needed to identify the society's need for such structures and dictate their design. Skilled "engineers" were needed to devise methods for shaping, transporting, and aligning the stones. Finally, only strong leaders could have assembled and maintained the labor force required to move the stones long distances.

Elaborate megalithic tombs first appeared in the Neolithic period. Some were built for single burials; others consisted of multiple burial chambers. The simplest type of megalithic tomb was the **dolmen**, built on the post-and-lintel principle. The tomb chamber was formed of huge upright stones supporting one or more tablelike rocks, or *capstones*. The structure was then mounded over with smaller rocks and dirt to form a **cairn** or artificial hill. A more imposing structure was the *passage grave*, which was entered by one or more narrow, stone-lined passageways into a large room at the center.

At Newgrange, in Ireland, the mound of an elaborate passage grave (FIG. 1–16) originally stood 44 feet tall and measured about 280 feet in diameter. The mound was built

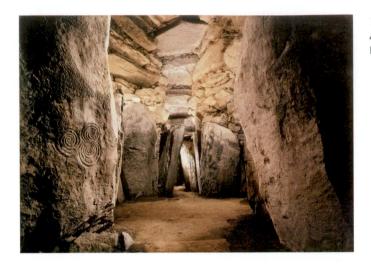

I-16 | TOMB INTERIOR WITH CORBELING AND ENGRAVED STONES

New Grange, Ireland. c. 3000-2500 BCE.

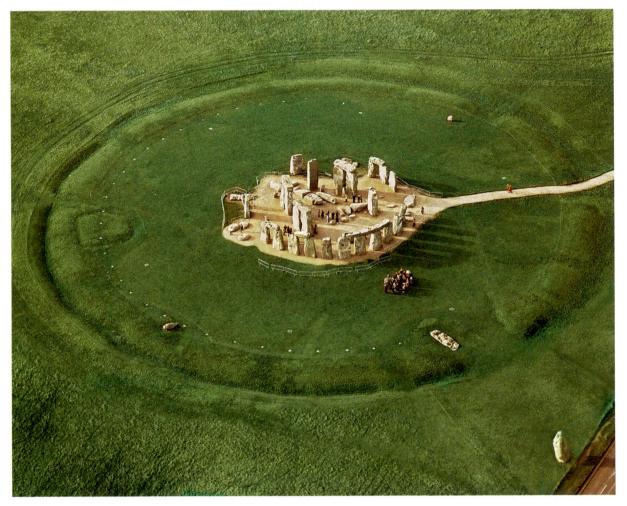

I−I7 | **STONEHENGE**Salisbury Plain, Wiltshire England. c. 2750–1500 BCE.

of sod and river pebbles and was set off by a circle of engraved standing stones around its perimeter. Its passageway, 62 feet long and lined with standing stones, leads into a three-part chamber with a corbel vault rising to a height of 19 feet. Some of the stones are engraved with linear designs, mainly rings, spirals, and diamond shapes. These patterns may have been marked out using strings or com-

passes, then carved by picking at the rock surface with tools made of antlers.

Such large and richly decorated structures did more than honor the distinguished dead; they were truly public architecture that must have fostered communal pride and a group identity. As is the case with elaborate funerary monuments built today, their function was both practical and symbolic.

Technique

FIBER ARTS

eople began working with plant fibers very early. They made ropes, fishing lines, nets, baskets, and even garments using techniques resembling modern macramé and crochet. The actual strings, ropes, and cloth are perishable, but fragments of dried or fired clay impressed with fibers, and even cloth, have been found and dated as early as 25,000 BCE. Fibers were twisted into cording for ropes and strings; netting for traps, fish nets, and perhaps hair nets; knotting for macramé; sprang (a

looping technique similar to making a cat's cradle); and single-hook work or crocheting (knitting with two needles is a relatively modern technique). Work with fibers may have been women's work since women, with primary responsibility for child care, could work with string no matter how frequently they were interrupted by the needs of their families. The creation of strings and nets suggests that women as well as men could hunt for meat; net and trap hunting is common among hunter-gatherers.

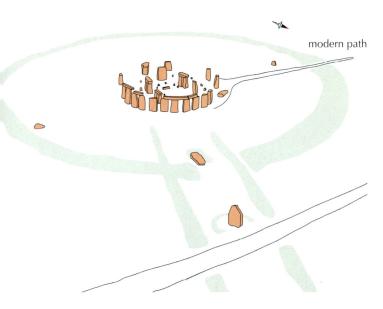

I−I8 | DIAGRAM OF STONEHENGE

STONEHENGE. Of all the megalithic monuments in Europe, the one that has stirred the imagination of the public most strongly is Stonehenge, on Salisbury Plain in southern England (FIGS. I—17, I—18). A henge is a circle of stones or posts, often surrounded by a ditch with built-up embankments. Laying out such circles with accuracy would have posed no particular problem. Architects likely relied on the human compass, a simple but effective surveying method that persisted well into modern times. All that is required is a length of cord either cut or knotted to mark the desired radius of the circle. A person holding one end of the cord is stationed

in the center; a co-worker, holding the other end and keeping the cord taut, steps off the circle's circumference. By the time of Stonehenge's construction, cords and ropes were readily available.

Stonehenge is not the largest such circle from the Neolithic period, but it is one of the most complex. Stones were brought from great distances during at least four major building phases between about 2750 and 1500 BCE. In the earliest stage, its builders dug a deep, circular ditch, placing the excavated material on the inside rim to form an embankment more than 6 feet high. They dug through the turf to expose the chalk substratum characteristic of this part of England, thus creating a brilliant white circle about 330 feet in diameter. An "avenue" from the henge toward the northeast led well outside the embankment to a pointed sarsen megalith—sarsen is a gray sandstone—brought from 23 miles away. Today, this so-called heel stone, tapered toward the top and weighing about 35 tons, stands about 16 feet high. Whoever stood at the exact center of Stonehenge on the morning of the summer solstice 3,260 years ago would have seen the sun rise directly over the heel stone.

By about 2100 BCE, Stonehenge included all of the internal elements reflected in the drawing shown here (SEE FIG. 1–18). Dominating the center was a horseshoe-shaped arrangement of five sandstone *trilithons*, or pairs of upright stones topped by lintels. The one at the middle stood considerably taller than the rest, rising to a height of 24 feet, and its lintel was more than 15 feet long and 3 feet thick. This group was surrounded by the so-called sarsen circle, a ring of sandstone uprights weighing up to 26 tons each and averaging 13 feet 6 inches tall. This circle, 106 feet in diameter, was capped by a continuous lintel. The uprights were tapered slightly toward the top, and the gently curved lintel

THE OBJECT SPEAKS

PREHISTORIC WOMAN AND MAN

or all we know, the artist who created these figures almost 5,500 years ago had nothing particular in mind—people had been modeling clay figures in southeastern Europe for a long time. Perhaps a woman who was making cooking and storage pots out of clay amused herself by fashioning images of the people she saw around her. But because these figures were found in a grave in Cernavoda, Romania, they suggest to us an otherworldly message.

The woman, spread-hipped and bigbellied, sits directly on the ground, expressive of the mundane world. She exudes stability and fecundity. Her ample hips and thighs seem to ensure the continuity of her family. But in a lively, even elegant, gesture, she joins her hands coquettishly on one raised knee, curls up her toes, and tilts her head upward. Though earthbound, is she a spiritual figure communing with heaven? Her upwardly tilted head could suggest that she is watching the smoke rising from the hearth, or worrying about holes in the roof, or admiring hanging containers of laboriously gathered drying berries, or gazing adoringly at her partner. The man is rather slim, with massive legs and shoulders. He rests his head on his hands in a brooding, pensive pose, evoking thoughtfulness, even weariness or sorrow.

We can interpret the Cernavoda woman and man in many ways, but we cannot know what they meant to their makers or owners. Depending on how they are displayed, we spin out different stories about them. When set facing each other, side by side as they are in the photograph, we tend to see them as a couple—a woman and man in a relationship. In fact, we do not know whether the artist conceived of them in this way, or even made them at the same time. For all their visual eloquence, their secrets remain hidden from us.

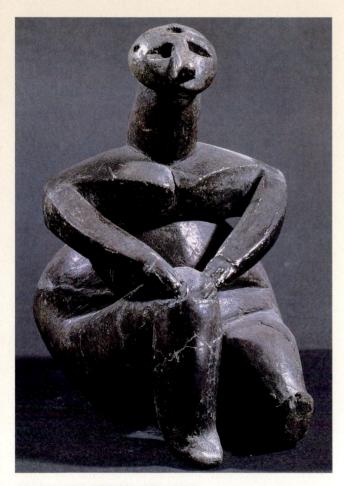

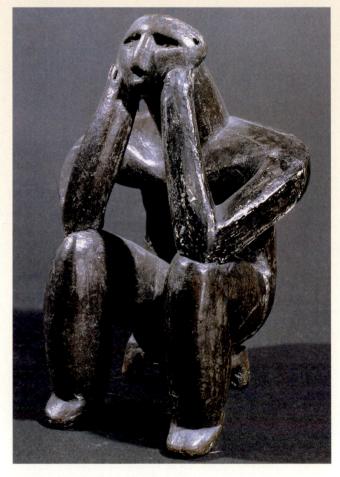

FIGURES OF A WOMAN AND A MAN
Cernavoda, Romania. c. 3500 BCE. Ceramic, height 4½" (11.5 cm). National Historical Museum, Bucharest.

sections were secured by mortise-and-tenon joints, that is, joints made by a conical projection at the top of each upright that fits like a peg into a hole in the lintel.

Just inside the sarsen circle was once a ring of bluestones—worked blocks of a bluish stone found only in the mountains of southern Wales, 150 miles away. Why the builders used this type of stone is one of many mysteries about Stonehenge. Clearly the stones were highly prized, for centuries later, about 1500 BCE, they were reused to form a smaller horseshoe (inside the trilithons) that encloses the so-called altar stone. Calling the horizontal stone an altar is yet another example of misnaming (see "The Power of Naming," page 5).

Through the ages, many theories have been advanced to explain Stonehenge. In the Middle Ages, people thought that Merlin, the magician of the King Arthur legend, had built Stonehenge. Later, the site was incorrectly associated with the rituals of the Celtic Druids (priests). Because its orientation is related to the movement of the sun, some people believe it may have been a kind of observatory. The structure must have been an important site for major public ceremonies. Whatever its role may have been, Stonehenge continues to fascinate visitors. Crowds of people still gather there at midsummer to thrill to its mystery. Even if we never learn the original purpose of megalithic structures, we can understand that the technology developed for building them made possible a new kind of architecture.

Sculpture and Ceramics

Besides working in stone, Neolithic artists also commonly used clay. Their ceramics—wares made of baked clay—display a high degree of technical skill and aesthetic imagination. This art required a remarkable conceptual leap. Sculptors created their work out of an existing substance, such as stone, bone, or wood. To produce ceramics, artists had to combine certain substances with clay—bone ash was a common addition—then subject the objects formed of that mixture to high heat for a period of time, hardening them and creating an entirely new material. Among the ceramic figures discovered at a pottery-production center in the Danube River valley at Cernavoda, Romania, are a seated man and woman who form a most engaging pair (see "Prehistoric Woman and Man," left). The artist who made them shaped their bodies out of simple cylinders of clay but managed to pose them in ways that make them seem very true to life.

One unresolved puzzle of prehistory is why people in Europe did not produce pottery vessels much earlier. Although they understood how to harden clay figures by firing them in an oven at high temperatures as early as 32,000 BCE, it was not until about 7000 BCE that they began making vessels using the same technique. Some anthropolo-

Sequencing Works of Art

с. 30,000-26,000 все	Carved mammoth bone sculp- ture of lion-human from Hohlenstein-Stadel, Germany
с. 25,000-17,000 все	Earliest known cave paintings at Chauvet, France; first human footprints recorded
с. 4000-2000 все	Rock shelter art at Lérida, Spain
с. 3000-2000 все	Ceramic vessels from Denmark
с. 2700–1500 все	Construction of megalithic ceremonial complex at Stone-henge, England
First century BCE	Openwork Celtic box lid from Ireland

gists argue that clay is a medium of last resort for vessels. Compared with hollow gourds, wooden bowls, or woven baskets, clay vessels are heavy and quite fragile, and firing them requires considerable skill. The earliest pots were round and pouchlike and had built-in loops so that they could be suspended on cords.

Excellence in ceramics depends upon the degree to which a given vessel combines domestic utility, visual beauty, and fine execution (see "Pottery and Ceramics," page 20). A group of bowls from Denmark, made in the third millennium BCE, provides only a hint of the extraordinary achievements of Neolithic artists working in clay (FIG. 1–19).

The earliest pieces in the illustration are the globular bottle with a collar around its neck (bottom center), a form perhaps inspired by eggs or gourd containers, and the flask with loops (top). Even when potters began making pots with flat bottoms that could stand without tipping, they often added hanging loops as part of the design. Some of the ornamentation of these pots, including hatched engraving and stitchlike patterns, seems to reproduce the texture of the baskets and bags that preceded them as containers. It was also possible to decorate clay vessels by impressing stamps into the surface or scratching them with sticks, shells, or toothed implements. Many of these techniques appear to have been used to decorate the flat-bottomed vase with the wide, flaring top (bottom left), a popular type of container that came to be known as a funnel beaker.

The large engraved bowl in FIGURE 1–19, found at Skarpsalling, is considered to be the finest piece of northern Neolithic pottery yet discovered. The potter lightly incised its

Technique

POTTERY AND CERAMICS

he terms pottery and ceramics may be used interchangeably—and often are. Because it covers all baked-clay wares, ceramics is technically a more inclusive term than pottery. Pottery includes all bakedclay wares except porcelain, which is the most refined product of ceramic technology.

Pottery vessels can be formed in several ways. It is possible, though difficult, to raise up the sides from a ball of raw clay. Another method is to coil long rolls of soft, raw clay, stack them on top of each other to form a container, and then smooth them by hand. A third possibility is to simply press the clay over an existing form, a dried gourd for example. By about 4000 BCE, Egyptian potters had developed the potter's wheel, a round, spinning platform on which a lump of clay is placed and then formed with the fingers, making it relatively simple to produce a uniformly shaped vessel in a very short time. The potter's wheel appeared in the ancient Near East about 3250 BCE and in China about 3000 BCE.

After a pot is formed, it is allowed to dry completely before it is fired. Special ovens for firing ceramics, called **kilns**, have been discovered at prehistoric sites in Europe dating from as early as 32,000 BCE. For proper firing, the temperature must be maintained at a relatively uniform level. Raw clay becomes porous pottery when heated to at least 500° centigrade. It then holds its shape permanently and will not disintegrate in water. Fired at 800° centigrade, pottery is technically known as earthenware. When subjected to temperatures between 1,200° and 1,400° centigrade, certain stone elements in the clay vitrify, or become glassy, and the result is a stronger type of ceramic called stoneware.

Pottery is relatively fragile, and new vessels were constantly in demand to replace broken ones, so fragments of low-fired ceramics—fired at the hearth, rather than the higher temperature kiln—are the most common artifacts found in excavations of prehistoric settlements. Pottery fragments, or **potsherds**, serve as a major key in dating sites and reconstructing human living and trading patterns.

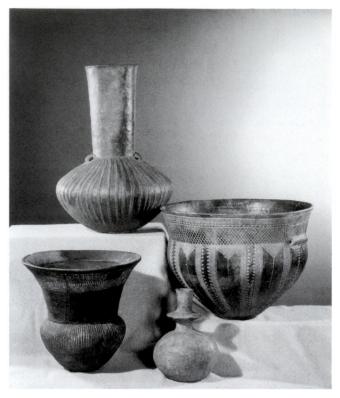

I–I9 | VESSELS Denmark. c. 3000-2000 BCE. Ceramic, heights range 5% to 12% (14.5 to 31 cm). National Museum of Denmark, Copenhagen.

sides with delicate linear patterns, then rubbed white chalk into the engraved lines so that they would stand out against the dark body of the bowl.

FROM STONE TO METAL

The technology of metallurgy is closely allied to that of ceramics. Although Neolithic culture persisted in northern Europe until about 2000 BCE, the age of metals made its appearance in Europe about 2300 BCE. In central and southern Europe, and in the Aegean region, copper, gold, and tin had been mined, worked, and traded even earlier. Smelted and cast copper beads and ornaments dated to 4000 BCE have been discovered in Poland. (Contemporary art from the Mediterranean and ancient Near East and Egypt is discussed in Chapters 2, 3, and 4.)

The Bronze Age

The period that followed the introduction of metalworking is commonly called the Bronze Age. Although copper is relatively abundant in central Europe and in Spain, objects fashioned from it are too soft to be functional. However, bronze—an alloy, or mixture, of tin and copper—is a stronger, harder substance with a wide variety of uses. The introduction of bronze, especially for weapons, changed the peoples of Europe in fundamental ways. Societies dominated

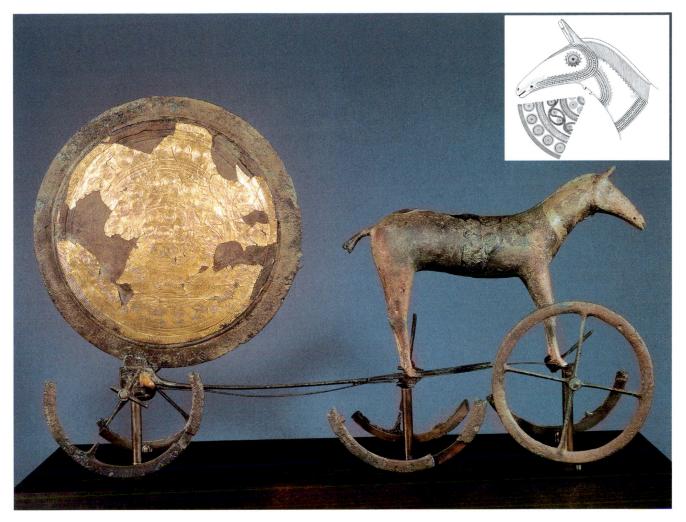

I–20 HORSE AND SUN CHARIOT AND SCHEMATIC DRAWING OF INCISED DESIGN
Trundholm, Denmark. c. 1800–1600 BCE. Bronze, length 23½" (59.2 cm).National Museum, Copenhagen.

by a strong elite came into existence, and trade and intergroup contacts across the continent and into the Near East increased. Exquisite objects made of bronze are frequently found in the settlements and graves of early northern farming communities.

A remarkable bronze sculpture from between 1500 and 1300 BCE was discovered at what is now Trundholm, in Denmark. It depicts a wheeled horse pulling a cart laden with a large, upright disk commonly thought to represent the sun (FIG. 1–20). Horses had been domesticated in Ukraine by about 4000 BCE, but the first evidence of wheeled chariots and wagons designed to exploit the horse's strength dates from about 2000 BCE. Rock engravings in northern Europe show the sun being drawn through the sky by either an animal or a bird—possibly an indication of a widespread sun cult. This horse and sun cart sculpture could have been rolled from place to place in a ritual reenactment of the sun's passage across the sky.

The valuable materials from which the sculpture was made and the great attention devoted to its details attest to its importance. The horse, cart, and sun were cast in bronze. After two faults in the casting had been repaired, the horse was given its surface finish, and its head and neck were incised with ornamentation. Its eyes were represented as tiny suns. Elaborate and very delicate designs were engraved on its body to suggest a collar and harness. The bronze sun was cast as two disks, both of which were engraved with concentric rings filled with zigzags, circles, spirals, and loops. A thin sheet of beaten gold was then applied to one of the bronze disks and pressed into the incised patterns. Finally, the two disks were joined together by an encircling metal band. The patterns on the horse tend to be geometric and rectilinear, but those on the sun disks are continuous and curvilinear, suggestive of the movement of the sun itself.

The Proto-Historic Iron Age

Although bronze remained the preferred material for luxury items, iron was commonly used for practical items because it was cheaper and more readily available. By 1000 BCE, iron technology had spread across Europe. A hierarchy of metals emerged based on the materials' resistance to corrosion. Gold, as the most permanent and precious metal, ranked first,

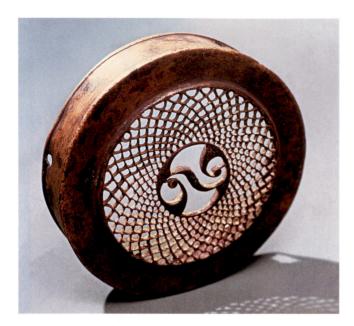

I-21 | OPENWORK BOX LID
 Cornalaragh County Monaghan, Ireland. La Tène period,
 c. 1st century BCE. Bronze, diameter 3" (7.5 cm).
 National Museum of Ireland, Dublin.

followed by silver, bronze, and, finally, practical but rusty iron. The blacksmiths who forged the warriors' swords and the farmers' plowshares held a privileged position among artisans, for they practiced a craft that seemed akin to magic as they transformed iron by heat and hammer work into tools and weapons.

During the Iron Age of the first millennium BCE, protohistoric Celtic peoples inhabited most of central and western Europe. The term *proto-historic* implies that they left no written records but that others wrote about them. Most of their wooden buildings and sculptures and their colorful woven textiles have disintegrated, but their protective earthworks, such as embankments fortifying cities, and funerary goods such as jewelry, weapons, and tableware, have survived.

An openwork box lid, in which space is worked into the pattern, illustrates the characteristic Celtic style and the continuing use of bronze during this period (FIG. 1–21). The pattern consists of a pair of expanding, diagonally symmetrical trumpet-shaped spirals surrounded by lattice. The openwork trumpets—the forms defined by the absence of material—catch the viewer's attention, yet at the same time the delicate tendrils of solid metal are equally compelling. Shapes inspired by compass-drawn spirals, stylized vines, and serpentine dragons seem to change at the blink of an eye, for the

artist has eliminated any distinction between figure and background. In Celtic hands, pattern becomes an integral part of the object itself, not an applied decoration.

The Celtic art of the second and first centuries BCE survived well into the Christian era (see Chapter 14) in Ireland, to be reused in the Middle Ages, in folk art, and as a source for Art Nouveau in the nineteenth century.

IN PERSPECTIVE

The paintings and objects that composed the first art made in Europe held great meaning for the people who made them, but without the aid of writing, we cannot know what that meaning was.

Art emerged about 35,000 years ago during the Upper Paleolithic period with the appearance of Cro-Magnon people. These first modern humans constructed houses made of available materials—branches, hides, even mammoth bones. They carved small figures—many of them depicting women—in bone, ivory, and stone. In the caves of southern France and northern Spain, artists painted images of animals and geometric figures with the aid of animal-fat lamps, using a variety of techniques. They took advantage of natural irregularities of the cave walls to create lifelike effects for their figures, and even modeled clay animals in high relief.

In the transition to the Neolithic period, cave art based on observation was replaced by schematic rock-shelter paintings of people engaged in activities that indicated a more settled way of life. Where timber was plentiful, people built long timber houses. In the northern islands they built in stone with stone furniture. This period in northern Europe is also distinguished by the introduction of a wide variety of ceramics, and of dramatic megalithic architecture. Great tomb and ritual centers built on the post-and-lintel system took the efforts of entire communities. At Stonehenge in England, builders overcame great logistical obstacles to move special stones long distances.

Around 2300 BCE, metalworking was introduced into Europe from the Near East. The period that followed is commonly called the Bronze Age and is a time of fundamental change in technology and trade for the peoples of Europe.

The prehistoric period in European art ends with the Celts. Some of what we know about them was recorded by the Greeks and Romans. Fortunately, their art, like that of other prehistoric people, survives as direct evidence of their culture. In later chapters we will study prehistoric and protohistoric art in other areas of the world.

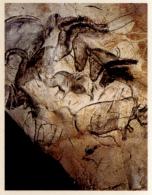

WALL, PAINTING,
CHAUVET
C. 30,000–20,000 BCE

PREHISTORIC ART IN EUROPE

■ Upper Paleolithic 40,000-8000 BCE

■ Last Ice Age 18,000–15,000 BCE

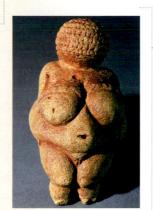

WOMAN FROM WILLENDORF, C. 24,000 BCE

STONEHENGE,

с. 2750-1500 все

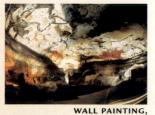

WALL PAINTING,

LASCAUX

C. 15,000 BCE

- Neolithic 6500-1200 BCE
- ▼ Farming in Europe c. 5000 BCE
- Metallurgy c. 5000 BCE
- **Domestication of Horses** c. 4000 BCE
- Plow in Use c. 4000 BCE
- Potter's Wheel in Use c. 3250 BCE
- ✓ Invention of Writing c. 3100 BCE

◄ Iron Age c. 1000 BCE

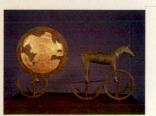

HORSE AND SUN CHARIOT, C. 1800–1600 BCE

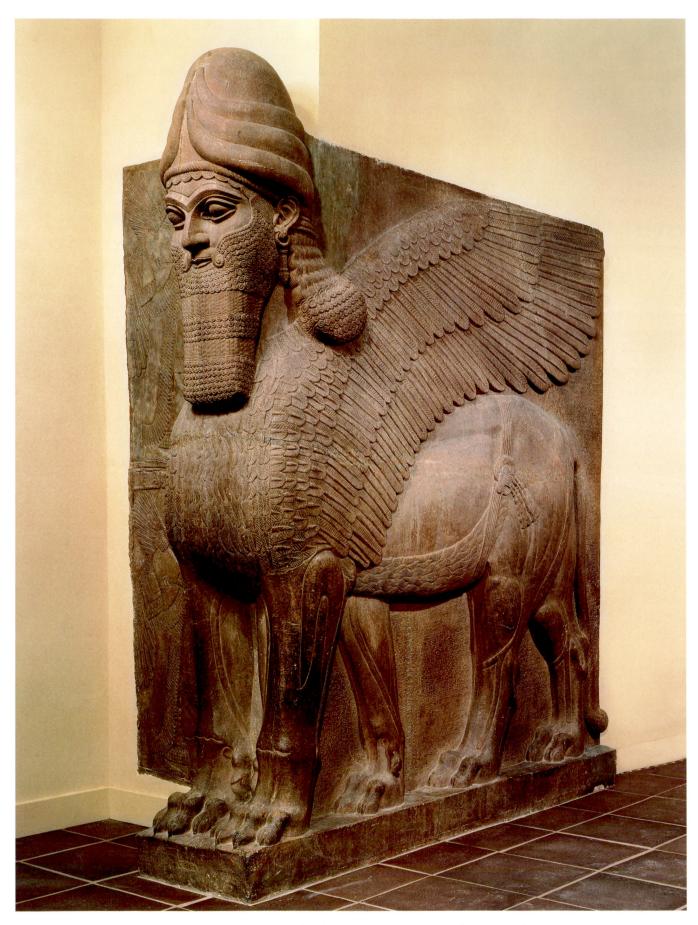

2—I HUMAN-HEADED WINGED LION (LAMASSU) Colossal gateway figure, the palace of Assurnasirpal II, Mesopotamia, Assyria, Kalhu (present-day Nimrud, Iraq). 883–859 BCE. Alabaster, height 10′3½″ (3.11 m). The Metropolitan Museum of Art, New York.

Gift of John D. Rockefeller, Jr., 1932 (32.143.1.-2)

CHAPTER TWO

ART OF THE ANCIENT NEAR EAST

Visitors to capital cities like Washington, Paris, and Rome today stroll along broad avenues among huge buildings, dominating gateways, and imposing sculpture. They are experiencing a kind of civic design that rulers—consciously

or not—have used since the third millennium. In the ninth century BCE, the Assyrians, one of the many groups that rose and fell in the ancient Near East, were masters of the art of impressing and intimidating visitors. Emissaries to the city of Kalhu (later called Nimrud), for example, would have encountered breathtaking examples of this ceremonial urbanism, in which the city itself is a stage for the ritual dramas that reinforce and confirm the ruler's absolute power.

Even from a distance, strangers approaching the city would have seen the high walls and imposing gates and temple platforms where the priest-king acted as intermediary between the people and the gods. Important visitors and ambassadors on the way to an audience with the ruler would have passed sculpture extolling the power of the Assyrian armies and then come face-to-face with lamassus, the

extraordinary guardian-protectors of the palaces and throne rooms. These colossal gate-way figures combined the bearded head of a man, the powerful body of a lion or bull, the wings of an eagle, and the horned headdress of

a god (FIG. 2–1) Because they were designed to be viewed frontally and from the side, lamassus seem to have five legs. When seen from the front, two forelegs are placed together and the creatures appear immobile. But when viewed from the side, the legs are shown as vigorously striding (hence the fifth leg). The sheer size of the lamassus—often twice a person's height—symbolizes the strength of the ruler they defend. Their forceful forms and prominent placement contribute to an architecture of domination. On the other hand, the exquisite detailing of their beards, feathers, and jewels testifies to boundless wealth, which also signifies power. These fantastic composite beasts inspired both civic pride and fear. They are works of art with an unmistakable political mission. In the ancient Near East, the arts played an important political role.

- THE FERTILE CRESCENT AND MESOPOTAMIA | The First Cities | The Arts
- SOUTHERN MESOPOTAMIA | Sumer | Akkad | Lagash and Gudea | Babylon: Hammurabi's Code
- THE HITTITES OF ANATOLIA
- LATER MESOPOTAMIAN ART | Assyria | Neo-Babylonia
- PERSIA Empire Persepolis Persian Coinage
- IN PERSPECTIVE

THE FERTILE CRESCENT AND MESOPOTAMIA

Well before farming communities appeared in Europe, people in Asia Minor and the ancient Near East domesticated grains. This first occurred in an area known today as the Fertile Crescent (MAP 2-1), the outline of which stretches along the Lebanese mountain range on the Mediterranean and then circles the northern reaches of the Tigris and Euphrates rivers (near the present-day borders of Turkey, Syria, and Iraq), down through the Zagros Mountains. A little later, in the sixth or fifth millennium BCE, agriculture developed in the alluvial plains between the Tigris and Euphrates rivers, which the Greeks called Mesopotamia, meaning the "land between the rivers," now in present-day Iraq. Because of problems with periodic flooding, there was a need for large-scale systems to control the water supply. In a land prone to both drought and flood, this need for a system of water management may have contributed to the development of the first cities.

Between 4000 and 3000 BCE, a major cultural shift seems to have taken place. Agricultural villages evolved into cities simultaneously and independently in both northern and southern Mesopotamia. These prosperous cities joined with their surrounding territories to create what are known as city-states, each with its own gods and government. Social hierarchies—rulers and workers—emerged with the development of specialized skills beyond those needed for agricultural work. To grain mills and ovens were added brick and pottery kilns and textile and metal workshops. With extra goods and even modest affluence came increased trade and contact with other cultures.

Builders and artists labored to construct huge temples and government buildings. Organized religion played an important role, and the people who controlled rituals and the sacred sites eventually became priests. The people of the ancient Near East worshiped numerous gods and goddesses. Each city had a special protective deity, and people believed the fate of the city depended on the power of that deity. (The names of comparable deities varied over time and place—for example, Inanna, the Sumerian goddess of fertility, love, and war, was equivalent to the Babylonians' Ishtar.) Large architectural complexes—clusters of religious, administrative, and

service buildings—developed in each city as centers of ritual and worship and also of government.

Mesopotamia's wealth and agricultural resources, as well as its few natural defenses, made it vulnerable to political upheaval. Over the centuries, the balance of power shifted between north and south and between local powers and outside invaders. First the Sumerians controlled the south. Then they were eclipsed by the Akkadians, their neighbors to the north. When invaders from farther north in turn conquered the Akkadians, the Sumerians regained power locally. The Babylonians were next to dominate the south. Later, the center of power shifted to the Assyrians in the north, then back again to the Babylonians (Neo-Babylonian period). Throughout this time, important cultural centers arose outside Mesopotamia, such as Elam on the plain between the Tigris River and the Zagros Mountains to the east, the Hittite kingdom in Anatolia (present-day Turkey), and beginning in the sixth century BCE, the land of the Achaemenid Persians in present-day Iran. The Persians eventually forged an empire that included the entire ancient Near East.

The First Cities

Agriculture made possible the development of large, sustainable communities that required permanent housing for their residents, means of defense from outsiders, and the development of new technologies to sustain everyday life. The earliest of these settlements, in the Fertile Crescent and southeastern Anatolia, reveal architectural solutions impressive for their variety and use of local materials, sculpture that shows well-developed religious practices, sophisticated decorated pottery, and evidence of crafts based on extensive trade.

JERICHO. Jericho (located in today's West Bank territory)—whose walls and towers became part of folklore when the biblical Joshua fought the battle of Jericho and the walls "came a tumblin' down"—has the earliest stone fortifications discovered to date (FIG. 2–2). People had been living there beside an ever-flowing spring in the ninth millennium, and by about 8000 BCE this agricultural village had grown into a town of mud-brick houses (mud bricks are shaped from clay and dried in the sun). The town covered six to ten acres, and by 7500 BCE it may have had a population of 2,000.

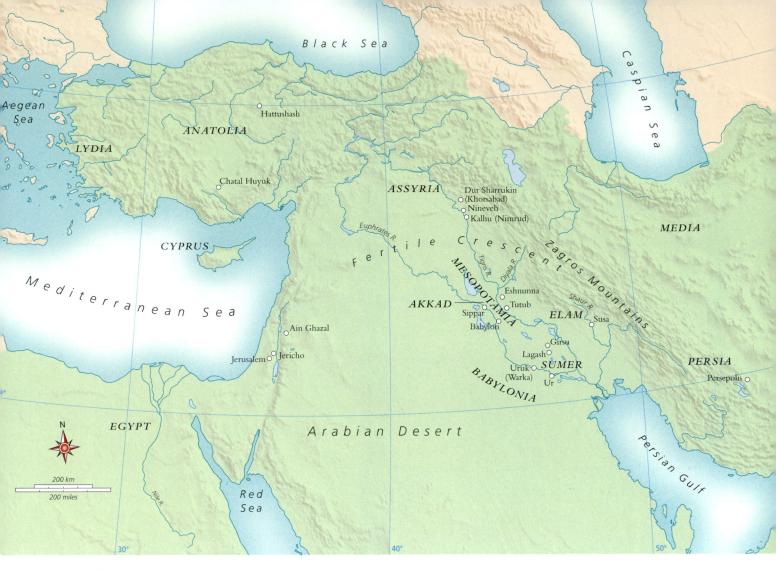

MAP 2-I THE ANCIENT NEAR EAST

Ancient Mesopotamia (present-day Iraq). The Tigris and Euphrates rivers.

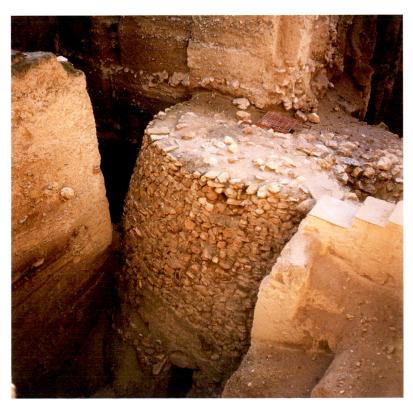

2–2 | WALLS AND TOWER, JERICHO c. 8000–7000 BCE. Mud brick, rubble, stone.

The people of Jericho found they needed protection from their neighbors, or perhaps they were establishing a boundary. For whatever reason, they built a huge brick wall 5 feet thick and nearly 20 feet high, made even higher by a ditch. They also constructed a circular stone tower 28 feet high with a diameter of 33 feet and an inner stair, which required quite sophisticated masonry skills on the part of the builders. Whether this tower was unique or one of several we do not know, but whether one or many, the tower and fortifications of Jericho are a remarkable achievement.

AIN GHAZAL. Another early site, Ain Ghazal ("Spring of Gazelle"), just outside present-day Amman, Jordan, was even larger than Jericho. That settlement, inhabited from about 7200 to 5000 BCE, occupied 30 acres at its maximum extent on terraces stabilized by stone retaining walls. (Its houses, made of stones mortared together with mud, show signs of long occupation, and may have resembled the adobe pueblos built by native peoples in the American Southwest.) The concentration of people and resources in cities such as these was an early step toward the formation of the larger city-states in the ancient Near East.

Снатац Ниуик. Although agriculture appears to have been the economic mainstay of these new permanent communities, other specialized activities, such as crafts and trade, were also important by about 6500 to 5500 все. Chatal Huyuk, a city in Anatolia (present-day Turkey) with a population of about 5,000, developed a thriving trade in obsidian, a rare black volcanic glass that was used from Paleolithic into modern times for sharp blades. The inhabitants of Chatal Huyuk lived in single-story buildings clustered around

shared courtyards, used as garbage dumps. Chatal Huyuk's design, with no streets or open plazas and protected with continuous, unbroken exterior walls, made it easy to defend. Yet the residents could move around freely by crossing from rooftop to rooftop, entering houses through openings in the roofs (FIG. 2–3).

Susa. The strip of fertile plain between the Tigris River and the Zagros Mountains to the east (in present-day Iran), was a flourishing farming region by 7000 BCE. By about 4200 BCE, the city of Susa, later the capital of an Elamite kingdom, was established on the Shaur River. This area, later known as Elam, had close cultural ties to Mesopotamia, but the two regions were often in conflict. For example, in the twelfth century BCE, Elamite invaders did something with which we are all too familiar: They looted art treasures from Mesopotamia and carried them back to Susa (see "Art as Spoils of War—Protection or Theft?" page 31).

The Arts

Among the arts that flourished in these early cities were sculpture, painting, textiles, and pottery.

As in prehistoric art, the sculptures found in these early cities give us hints about the technology and the culture of those who made them. Among the most imposing objects recovered from Ain Ghazal are more than thirty painted plaster figures. Fragments suggest that some figures were nearly life-size (FIG. 2–4). Sculptors molded the figures by applying wet plaster to reed-and-cord frames in human shape. The eyes were inset cowrie shells, and small dots of the black, tarlike substance bitumen—which Near Eastern artists used

2–3 COMPOSITE RECONSTRUCTION DRAWING OF CHATAL HUYUK
Anatolia (present-day Turkey).
c. 6500–5500 BCE.

frequently—formed the pupils. The figures probably wore wigs and clothing and stood upright.

At Chatal Huyuk, the elaborately decorated buildings are assumed to have been shrines. Bold geometric designs, painted animal scenes, actual animal skulls and horns, and three-dimensional shapes resembling breasts and horned animals adorned the walls. In one chamber, a leopard-headed woman—portrayed in a high-arched wall area above three large, projecting bulls' heads—braces herself as she gives birth to a ram.

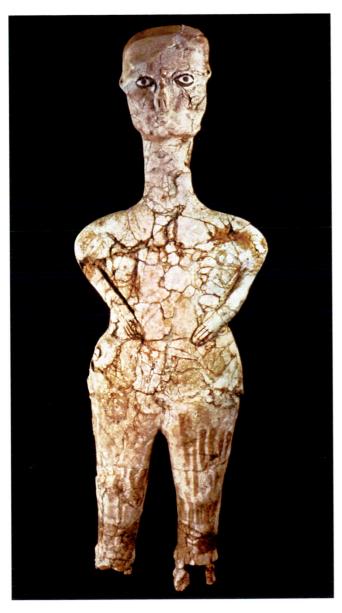

2–4 | HUMAN FIGURE
Ain Ghazal, Jordan. c. 7000-6000 BCE. Fired lime plaster with cowrie shell, bitumen, and paint, height approx. 35" (90 cm). National Museum, Amman, Jordan.

Although this dramatic image suggests worship of a fertility goddess, any such interpretation is risky because so little is known about the culture. Like other early Near Eastern settlements, Chatal Huyuk seems to have been abandoned suddenly, for unknown reasons, and never reoccupied.

SOUTHERN MESOPOTAMIA

Although the stone-free, alluvial plain of southern Mesopotamia was prone to floods and droughts, it served as a fertile bed for agriculture and successive, interlinked societies. The Sumerians, a people about whose origins little is known, first developed this area. They filled their independent citystates with the fruits of new technology, literacy, and impressive art and architecture. The Sumerian states, marked by constant feuds, were eventually unified by another people, the Akkadians, who united Mesopotamia. The Akkadians embraced Sumerian culture, but the unification they accomplished was, in turn, broken by invaders from the northeast. Only one city-state, Lagash, survived and was revived under the ruler Gudea. Mesopotamia remained in turmoil for several more centuries until order was restored by the Amorites, who had migrated to Mesopotamia from the Syrian desert. Under them and their king, Hammurabi, a new, unified society arose with its capital in the city of Babylon.

Sumer

The cities and city-states that developed along the rivers of southern Mesopotamia between about 3500 and 2340 BCE are known collectively as Sumer. The inhabitants, who had migrated from the north but whose origins are otherwise obscure, are credited with important "firsts." Sumerians may have invented the wagon wheel and the plow, and they created a system of writing—perhaps their greatest contribution to later civilizations. (Recent discoveries indicate that writing developed simultaneously in Egypt; see Chapter 3.)

WRITING. Sumerians pressed cuneiform ("wedge-shaped") symbols into clay tablets with a stylus, a pointed writing instrument, to keep business records (see "Cuneiform Writing," page 32). Thousands of Sumerian tablets document the gradual evolution of writing and arithmetic, another tool of commerce, as well as an organized system of justice and the world's first and best-known literary epic. The origins of the *Epic of Gilgamesh* are Sumerian, but the fullest version, written in Akkadian, was found in the library of the Assyrian king Assurbanipal (ruled 669–c. 627 BCE) in Nineveh (present-day Kuyunjik, Iraq). It records the adventures of Gilgamesh, legendary Sumerian king of Uruk, and his companion Enkidu. When Enkidu dies, a despondent Gilgamesh sets out to find the secret of eternal life from a man

and his wife who are the sole survivors of a great flood sent by the gods to destroy the world, and the only people to whom the gods had granted immortality. Gilgamesh ultimately accepts his mortality, abandons his quest, and returns to Uruk, recognizing the majestic city as his lasting accomplishment.

THE ZIGGURAT. The Sumerians' most impressive surviving archaeological remains are their **ziggurats**, huge stepped structures with a temple or shrine on top. The first ziggurats may have developed from the practice of repeated rebuilding at a sacred site, with rubble from one structure serving as the foundation for the next. Elevating the buildings also protected the shrines from flooding.

Whatever the origin of their design, ziggurats towering above the flat plain proclaimed the wealth, prestige, and stability of a city's rulers and glorified its gods. Ziggurats functioned symbolically too, as lofty bridges between the earth and the heavens—a meeting place for humans and their gods. They were given names such as "House of the Mountain" and "Bond between Heaven and Earth."

URUK. Uruk (present-day Warka, Iraq), the first independent Sumerian city-state, had two large architectural complexes in the 1,000-acre city. One was dedicated to

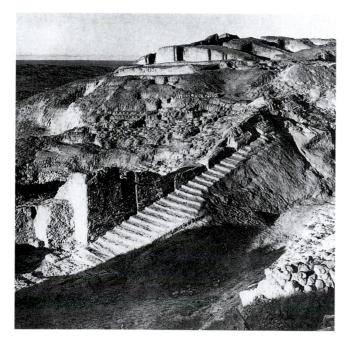

2–5 | RUINS OF THE WHITE TEMPLE
Uruk (present-day Warka, Iraq) c. 3300–3000 BCE.

Many Ancient Near Eastern cities still lie undiscovered. In most cases an archaeological site in a region is signaled by a large mound—known locally as a *tell*, *tepe*, or *huyuk*—that represents the accumulated debris of generations of human habitation. When properly excavated, such mounds yield evidence about the people who inhabited the site.

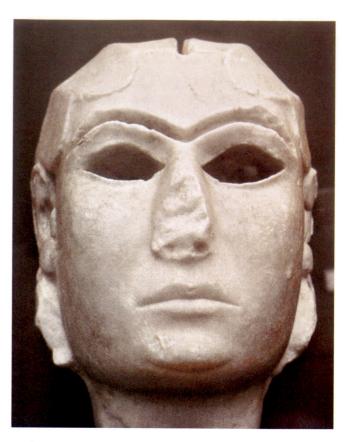

2–6 | FACE OF A WOMAN, KNOWN AS THE WARKA HEAD Uruk (present-day Warka, Iraq). c. 3300–3000 BCE. Marble, height approx. 8" (20.3 cm). Iraq Museum, Baghdad (stolen and recovered in 2003).

Inanna, the goddess of love and war. The Inanna buildings seem to have been an administrative complex as well as serving as temples. The other complex belonged to the sky god Anu. The temple platform of Anu, built up in stages over the centuries, ultimately rose to a height of about 40 feet. Around 3100 BCE, a whitewashed brick temple that modern archaeologists refer to as the White Temple (FIG. 2–5) was erected on top. This now-ruined structure was a simple rectangle oriented to the points of the compass. An off-center doorway on one of the long sides led into a large chamber containing a raised platform and altar; smaller spaces opened off this main chamber.

Statues of gods and donors were placed in the temples. A striking life-size marble face from Uruk may represent a goddess (FIG. 2–6). It could have been attached to a wooden head on a full-size wooden body. Now stripped of its original paint, wig, and inlaid (set-in) brows and eyes, it appears as a stark white mask. Shells may have been used for the whites of the eyes and lapis lazuli for the pupils, and the hair may have been gold. Even without these accessories, the compelling stare and sensitively rendered features attest to the skill of Sumerian sculptors.

Art and Its Context

ART AS SPOILS OF WAR-PROTECTION OR THEFT?

rt has always been a casualty in times of social unrest.

One of the most recent examples is the looting of the head of a woman from Warka, when an angry mob broke into the unguarded Iraq National Museum in April 2003. The delicate marble sculpture was later found, but not without significant damage (compare with FIG. 2-6).

Some of the most bitter resentment spawned by warwhether in Mesopotamia in the twelfth century BCE or in our own time-has involved the "liberation" by the victors of art objects of great value to the people from whom they were taken. Museums around the world hold works either snatched by invading armies or acquired as a result of conquest. Two historically priceless objects unearthed in Elamite Susa, for example-the Akkadian Stele of Naram-Sin (see FIG. 2-14) and the Babylonian Stele of Hammurabi (see "The Code of Hammurabi," page 38)-were not Elamite at all, but Mesopotamian. Both had been brought there as military trophies by an Elamite king, who added an inscription to the Stele of Naram-Sin explaining that he had merely "protected" it. The stele came originally from Sippar, an Akkadian city on the Euphrates River, in what is now Iraq. Raiders from Elam took it there as booty in the twelfth century BCE.

The same rationale has been used in modern times. The Rosetta Stone, the key to deciphering Egyptian hieroglyphics, was discovered in Egypt by French troops in 1799, fell into British hands when they forced the French from Egypt, and ultimately ended up in the British Museum in London (see page 78). In the early nineteenth century, the British Lord Elgin purchased and removed classical Greek reliefs from the Parthenon in Athens with the permission of the Ottoman authorities who governed Greece at the time (see pages 138–139). Although his actions may indeed have protected the reliefs from neglect and damage in later wars, they have remained installed, like the Rosetta Stone, in the British Museum, despite continuing protests from Greece.

The Ishtar Gate from Babylon (see FIG. 2-21) is now reconstructed in Berlin, Germany. Many German collections include

works that were similarly "protected" at the end of World War II and are surfacing now. In the United States, Native Americans are increasingly vocal in their demands that artifacts and human remains collected by anthropologists and archaeologists be returned to them. "To the victor," it is said, "belong the spoils." It continues to be a matter of passionate debate whether this notion is appropriate in the case of revered cultural artifacts.

PHOTO OF FACE OF A WOMAN KNOWN AS THE WARKA HEAD, Displayed by Iraqi authorities on its recovery.

A tall, carved alabaster vase found near the temple complex of Inanna at Uruk (FIG. 2–7) shows how Near Eastern sculptors of the time—and for the next 2,500 years—told their stories with great economy and clarity. They organized the picture space into registers, or horizontal bands, and condensed the narrative, much as modern comic-strip artists do. The stylized figures are shown simultaneously with profile heads and legs and with three-quarter-view torsos, making both shoulders visible and increasing each figure's breadth. The lower register of the vase shows the natural world, beginning with water and plants identified as the date palm and barley or the now extinct silphium (identified by medical historians as a plant used by early people to control fertility). Above the plants, alternating rams

and ewes stand on a solid groundline. In the middle register nude men carry baskets of foodstuffs. In the top register, Inanna stands in front of her shrine and storehouse accepting an offering from the priest-king. Through the doorway we see a display of her wealth as well as two devotees.

The scene is usually interpreted as the ritual marriage between the goddess and a human priest-king during the New Year's festival, a ritual meant to ensure the fertility of crops, animals, and people. The riches of the natural world—the date palms, the rams and ewes, the silphium—placed around the base of the vase literally and visually support the human activity in honor of the goddess. The imagery of the alabaster vase attests to the continued survival of Uruk.

Technique

CUNEIFORM WRITING

umerians invented writing around 3100 BCE, apparently as an accounting system for goods traded at Uruk. The symbols were pictographs, simple pictures cut into moist clay slabs with a pointed tool. Between 2900 and 2400 BCE, the symbols evolved from pictures into *phonograms*—representations of syllable sounds—thus becoming a true writing system. During the same centuries, scribes adopted a stylus, or writing tool, with one triangular end and one pointed end. The stylus could be pressed easily and rapidly into a wet clay tablet to create the increasingly abstract symbols, or characters, of cuneiform writing.

This illustration shows examples of the shift from pictograph to cuneiform writing. The drawing of a bowl, which

means "bread" or "food" and dates from about 3100 BCE, was reduced to a four-stroke sign by about 2400 BCE, and by about 700 BCE to a highly abstract arrangement of vertical marks. By combining the pictographs and, later, cuneiform signs, writers created composite signs; for example, a combination of the signs for "head" and "food" meant "to eat."

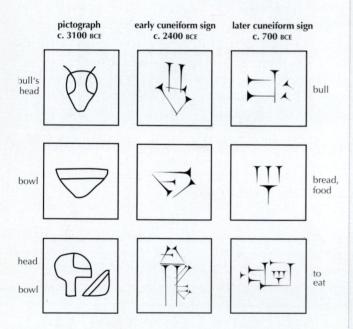

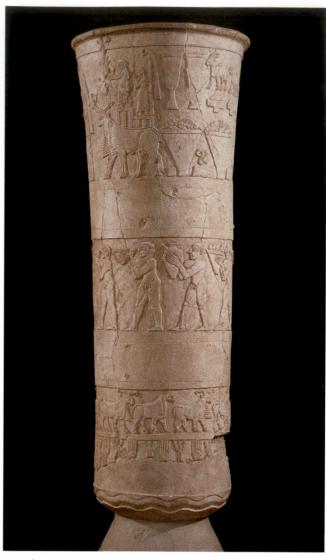

2–7 | CARVED VASE KNOWN AS THE URUK VASE Uruk (present-day Warka, Iraq). c. 3300–3000 BCE. Alabaster, height 36" (91 cm). Iraq Museum, Baghdad (stolen and recovered in 2003).

VOTIVE FIGURES. Limestone statues dated to about 2900–2600 BCE from the Diyala River Valley, Iraq, excavated in 1932–33, reveal another aspect of Sumerian religious art (FIG. 2–8). These votive figures—images dedicated to the gods—are an early example of an ancient Near Eastern religious practice: the placement in a shrine of statues of individual worshipers before a larger, more elaborate image of a god. Anyone who was a donor to the temple might commission a representation of him- or herself and dedicate it in the shrine. Many are figures of women. A simple inscription might identify the figure as "One who offers prayers." Longer inscriptions might recount in detail all the things the donor had accomplished in the god's honor. Each sculpture served as a stand-in, at perpetual attention, making eye contact with the god, and chanting its donor's praises.

The sculptors of the votive figures followed the conventions of Sumerian art—that is, the traditional way of repre-

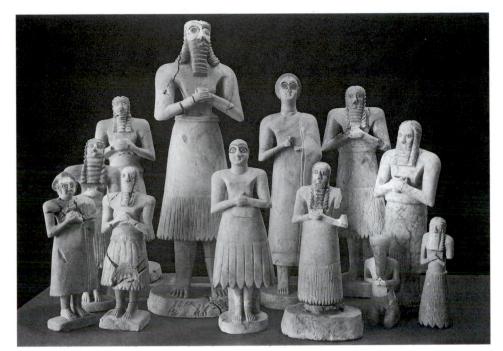

2–8 | **VOTIVE FIGURES**The Square Temple, Eshnunna (present-day Tell Asmar, Iraq). c. 2900–2600 BCE. Limestone, alabaster, and gypsum, height of largest figure approx. 30" (76.3 cm).

The Oriental Institute of the University of Chicago.

senting forms with simplified faces and bodies, and with clothing that emphasized the cylindrical shape. The figures stand solemnly, hands clasped in respect. The wide-open eyes may be explained by cuneiform texts that reveal the importance of approaching a god with an attentive gaze. As with the face of the woman from Uruk, arched brows are inlaid with dark shell, stone, or bitumen that once emphasized the huge, staring eyes. The male figures, bare-chested and dressed in what appear to be sheepskin skirts, are stocky and muscular, with heavy legs, large feet, big shoulders, and cylindrical bodies. The female figures are as massive as the men. One wears a long sheepskin skirt and the other a calf-length skirt that reveals sturdy legs and feet.

South of Uruk lay the city of Ur (present-day Muqaiyir, Iraq). About a thousand years after the completion of the temples at Uruk, the people of Ur built a ziggurat dedicated to the moon god Nanna, also called Sin (FIG. 2–9). Although located on the site of an earlier temple, this imposing mud-brick structure was not the accidental result of successive rebuildings. Its base is a rectangle 205 by 141 feet, with three sets of stairs converging at an imposing entrance gate atop the first of what were three platforms. Each platform's walls slope outward from top to base, probably to prevent rainwater from forming puddles and eroding the mud-brick pavement below. The first two levels of the ziggurat and their retaining walls have been reconstructed in recent years.

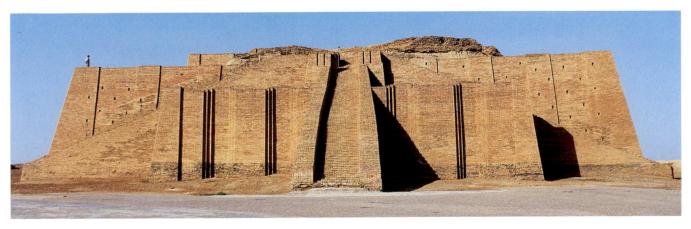

2−9 | NANNA ZIGGURAT Ur (present-day Muqaiyir, Iraq). c. 2100–2050 BCE.

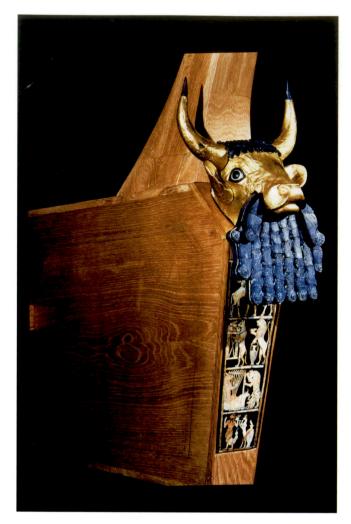

2–10 | THE GREAT LYRE WITH BULL'S HEAD
Royal Tomb, Ur (present-day Muqaiyir, Iraq). c. 2550–2400
BCE. Wood with gold, silver, lapis lazuli, bitumen, and shell, reassembled in modern wood support; height of head 14"
(35.6 cm); height of front panel 13" (33 cm); maximum length of lyre 55½" (140 cm), height of upright back arm 46½" (117 cm).University of Pennsylvania Museum of Archaeology and Anthropology, Philadelphia.

From about 3000 BCE on, Sumerian artisans worked in various precious metals, and in bronze, often combining them with other materials. Many of these creations were decorated with—or were in the shape of—animals or composite animal-human-bird creatures. A superb example of their skill is a lyre—a kind of harp—from a royal tomb (identified as PG789). The harp combines wood, gold, lapis lazuli, and shell (FIG. 2–10). Projecting from the base of the lyre is a sculptured head of a bearded bull, intensely lifelike despite the decoratively patterned blue lapis lazuli beard. (Lapis lazuli, which had to be imported from Afghanistan, is evidence of widespread trade in the region.)

On the front panel of the sound box, four horizontal registers present scenes executed in shell inlaid in bitumen (FIG. 2–II). In the bottom register a scorpion man holds a cylindrical object in his left hand. Scorpion men are associ-

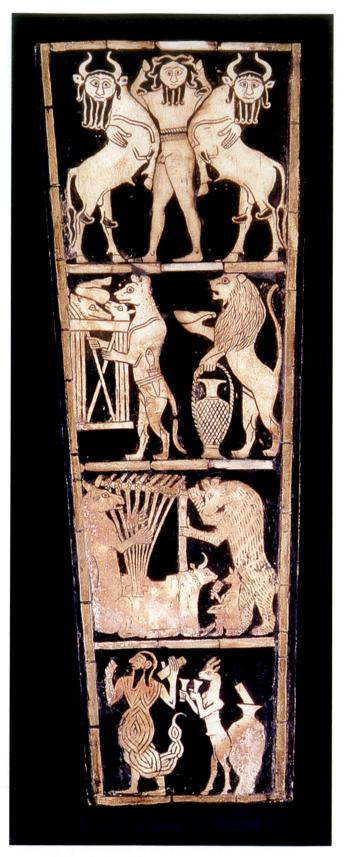

2—II | FRONT PANEL, THE SOUND BOX OF THE GREAT LYRE

Ur (present-day Muqaiyir, Iraq). Wood with shell inlaid in bitumen, height $12\% \times 4\%$ " (31.1 \times 11cm). University of Pennsylvania Museum of Archaeology and Anthropology, Philadelphia.

(T4-29C)

ated with the land of demons, the mountains of sunrise and sunset, which are part of the journey made by the dead. The scorpion man is attended by a gazelle standing on its hind legs and holding out two tall cups, perhaps filled from the large container from which a ladle protrudes. The scene above this one depicts a trio of animal musicians. A seated donkey plucks the strings of a bull lyre—showing how such instruments were played—while a standing bear braces the instrument's frame and a seated animal, perhaps a fox, plays a sistrum (a kind of rattle).

The next register shows animal attendants, also walking erect, bringing food and drink for the feast. On the left a hyena, assuming the role of a butcher with a knife in its belt, carries a table piled high with meat. A lion follows with a large jar and pouring vessel. In the top panel, striding but facing forward, is an athletic man, probably meant to represent the deceased. His long hair and a full beard denote a semidivine status. He is naked except for a wide belt, and he clasps two rearing human-headed bulls. The imagery on the harp may have been inspired in part by the Epic of Gilgamesh, with its descriptions of heroic feats and fabulous creatures like the scorpion man, whom Gilgamesh met as he searched for his friend Enkidu. With the invention of writing we are no longer dealing only with speculation as we did with prehistoric art, and we can begin to study the iconography (the narrative and allegorical meaning) of images.

Because the lyre and others like it were found in royal tombs chambers and were used in funeral rites, the imagery we see here probably depicts a funeral banquet in the realm of the dead. The animals shown are the traditional guardians of the gateway through which the newly dead person had to pass. Cuneiform tablets preserve songs of mourning, which may have been chanted by priests to lyre music at funerals. One begins: "Oh, lady, the harp of mourning is placed on the ground."

Retainers of the deceased ruler seem to have followed them to the tomb, where they committed suicide. In tomb PG789, six soldiers and fifty-seven retainers, mostly women, accompanied the king to the Netherworld. At his death, the legendary Gilgamesh took his wife, child, concubine, minstrel, cup bearer, barber, and courtiers with him into the tomb.

Sequencing Events Ancient Near Eastern Cultures

Uruk (present-day Warka, Iraq)—Sumerian. Settled in c. 5000 BCE; flourished c. 3600-2100 BCE; city occupied until c. 226 CE.

Babylon—Babylonian. First written mention in c. 2200 BCE; capital under Hammurabi (1792–1750 BCE).

Kalhu (present-day Nimrud, Iraq)—Assyrian. Flourished 900-800 BCE; capital under Ashurnarsipal II (ruled 883-859 BCE); sacked c. 614 BCE by the Medes.

Babylon—Neo-Babylonian. Rose to preeminence under Nebuchadnezzar II (ruled 605-562 BCE); declined after 312 BCE.

Persepolis—Persian. Founded c. 515 BCE by Darius I (ruled 521-486 BCE); burned in 330 BCE by Alexander the Great.

CYLINDER SEALS. People in the area of present-day Syria and Turkey first employed simple clay stamps with designs incised (cut) into one surface to stamp textiles or bread. About the time written records appeared, Sumerians developed seals for identifying documents and establishing property ownership. By 3300–3100 BCE, record keepers redesigned the stamp seal as a cylinder. Rolled across soft clay applied to the closure that was to be sealed—a jar lid, the knot securing a bundle, or the door to a room—the cylinder left a raised image of the design. No unauthorized person could then gain access secretly. Sumerian cylinder seals, usually less than 2 inches high, were made of a hard stone, such as marble or lapis lazuli, so that the tiny, elaborate scenes carved into them would not wear away.

The scene in a seal from Ur (FIG. 2–12) includes a human hero protecting rampant bulls from lions in the upper register and five fighting figures in the lower register. Ancient Near Eastern leaders were expected to protect their people from both human and animal enemies, as well as exert control over the natural world. This seal belonged to a queen of Ur named Ninbanda.

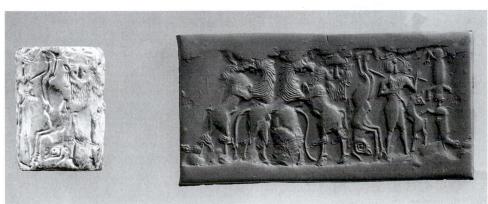

2-I2 | CYLINDER SEAL AND ITS IMPRESSION

Ur (present-day Muqaiyir, Iraq). c. 2550-2400 BCE. Lapis lazuli, height, 1½" (4.1 cm). University of Pennsylvania Museum of Archaeology and Anthropology, Philadelphia.

B16852

Akkad

During the Sumerian period, a people known as the Akkadians had settled north of Uruk. They adopted Sumerian culture, but unlike the Sumerians, the Akkadians spoke a Semitic language (the same family of languages that includes Arabic and Hebrew). Under the powerful military and political figure Sargon I (ruled c. 2332–2279 BCE), they conquered most of Mesopotamia. For more than half a century, Sargon, "King of the Four Quarters of the World," ruled this empire from his capital at Akkad, the actual site of which is yet to be discovered.

HEAD OF A RULER. Few artifacts can be identified with Akkad, making a life-size bronze head thought to date from the time of Sargon especially precious (FIG. 2–13). The head is the earliest major work of hollow-cast copper sculpture known in the Ancient Near East.

The facial features and hairstyle probably reflect a generalized male ideal rather than the appearance of a specific individual, although the sculpture was once identified as Sargon. The enormous curling beard and elaborately braided hair (circling the head and ending in a knot at the back) indicate both royalty and the ideal male appearance. This head was found in the northern city of Nineveh. The deliberate damage to the left side of the face and eye suggests that the head was symbolically mutilated to destroy its power. The ears and the inlaid eyes appear to have been deliberately removed; thus the statue could neither hear nor see.

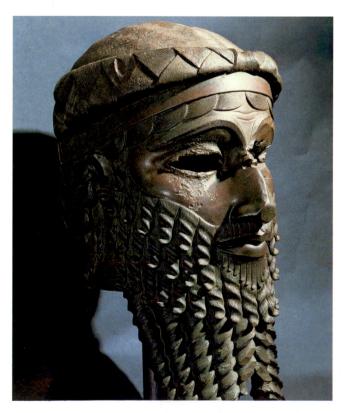

2–13 | HEAD OF A MAN (KNOWN AS AKKADIAN RULER) Nineveh (present-day Kuyunjik, Iraq). c. 2300–2200 BCE. Copper alloy, height 14¾" (36.5 cm). Iraq Museum, Baghdad.

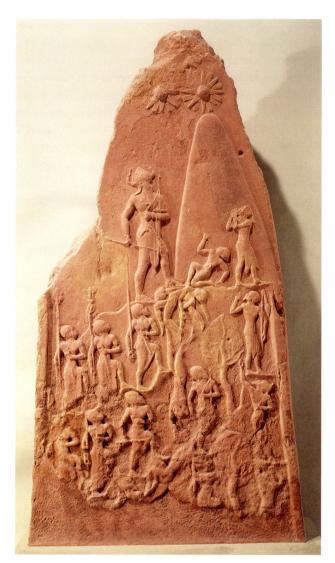

2–14 | **STELE OF NARAM-SIN**Sippar. Found at Susa. c. 2220–2184 BCE. Limestone, height 6′6″ (1.98 m). Musée du Louvre, Paris.

THE STELE OF NARAM-SIN. The concept of imperial authority was literally carved in stone by Sargon's grandson Naram-Sin (FIG. 2-14). A 6½-foot-high stele (an upright stone slab) memorializes one of Naram-Sin's military victories, and is one of the first works of art created to celebrate a specific achievement of an individual ruler. The inscription states that the stele commemorates the king's victory over the people of the Zagros Mountains. Naram-Sin made himself divine during his lifetime—a new concept requiring new iconography. As god-king, Naram-Sin is immediately recognizable by his size. Size was associated with importance in ancient art, a convention known as hieratic scale. Watched over by three solar deities, symbolized by the rayed suns in the sky, he ascends a mountain wearing the horned helmetcrown associated with deities, which he is now entitled to wear. Naram-Sin's importance is magnified by his position at the dramatic center of the scene, closest to the mountaintop and silhouetted against the sky.

The sculptors used the stele's pointed shape to underscore the dynamic role of the carved mountain in the composition. In a sharp break with visual tradition, they replaced the horizontal registers of Mesopotamian and Egyptian art (see Chapter 3) with wavy groundlines. Soldiers (smaller than the king, as dictated by the convention of hieratic scale) follow their leader at regular intervals, passing conquered enemy forces sprawled in death or begging for mercy. Both the king and his warriors hold their weapons triumphantly upright. (Ironically, although this stele depicts Akkadians as conquerers, they would dominate the region for only about another half century.)

Lagash and Gudea

About 2180 BCE, the Guti, a mountain people from the northeast, conquered the Akkadian Empire. The Guti controlled most of the Mesopotamian plain for a brief time before the Sumerian people regained control of the region. However, one large Sumerian city-state remained independent throughout the period: Lagash, whose capital was Girsu (present-day Telloh, Iraq), on the Tigris River. Gudea, the ruler, built and restored many temples, in which he placed votive statues representing himself as governor and embodiment of just rule. The statues are made of diorite, a very hard imported stone. Perhaps the difficulty of carving diorite prompted sculptors to use compact, simplified forms for the portraits. Twenty of these figures survive, making Gudea's face a familiar one in ancient Near Eastern art.

Images of Gudea present him as a strong, peaceful, pious ruler worthy of divine favor (FIG. 2-15). Whether he is shown sitting or standing, he wears a long garment (which provides ample space for long cuneiform inscriptions). His right shoulder is bare, and he is barefooted. He wears a cap with a wide brim carved with a pattern to represent fleece. In one image, Gudea holds a vessel from which life-giving water flows in two streams, each filled with leaping fish. The text says that he dedicated himself, the statue, and its temple to the goddess Geshtinanna, the divine poet and interpreter of dreams. This imposing statue is only $2\frac{1}{2}$ feet tall. The sculptor emphasizes the power centers of the human body: the eyes, head, and smoothly muscled chest and arms. Gudea's face, below the sheepskin hat, is youthful and serene, and his eyes—oversized and wide open, the better to return the gaze of the deityexpress intense concentration.

Babylon: Hammurabi's Code

For more than 300 years, periods of political turmoil alternated with periods of stable government in Mesopotamia, until the Amorites (a Semitic-speaking people from the Syrian Desert, to the west) reunited the region under Hammurabi (ruled 1792–1750 BCE). Hammurabi's capital city was Babylon and his subjects were called Babylonians. Among Hammurabi's achievements was a written legal code that listed the laws of his realm and the penalties for breaking them (see "The Code of Hammurabi," page 38).

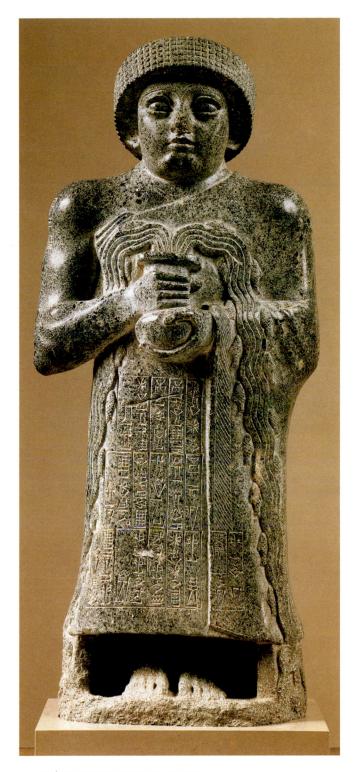

2–15 | VOTIVE STATUE OF GUDEA Girsu (present-day Telloh, Iraq). c. 2090 BCE. Diorite, height 29" (73.7 cm). Musée du Louvre, Paris.

THE HITTITES OF ANATOLIA

Outside of Mesopotamia, other cultures developed and flourished in the ancient Near East. Each had an impact on Mesopotamia. Finally one of them, Persia, overwhelmed them all, but the Hittites of Anatolia were among the most influential.

Anatolia (present-day Turkey) had been home to several independent cultures that resisted Mesopotamian domination.

THE OBJECT SPEAKS

THE CODE OF HAMMURABI

ne of Hammurabi's greatest accomplishments was the systematic codification of his people's rights, duties, and punishments for wrongdoing. This code was engraved on the Stele of Hammurabi, and this black diorite stele speaks to us both as a work of art that depicts a legendary event and as a historical document that records a conversation about justice between god and man.

At the top of the stele, we see Hammurabi standing before a mountain where Shamash, the sun god and god of justice, is seated. The mountain is indicated by three flat tiers on which Shamash rests his feet. Hammurabi, standing in an attitude of prayer, listens respectfully. Shamash sits on a backless throne, dressed in a long flounced robe and crowned by a conical horned cap. Rays rise from his shoulders, and he holds additional symbols of his powerthe measuring rod and the rope circle—as he gives the law to the king, his intermediary. From there, the laws themselves flow forth in horizontal bands of exquisitely engraved cuneiform signs. (The idea of god-given laws engraved on stone tablets is a long-standing tradition in the ancient Near East: Moses, the Lawgiver of Israel, received two stone tablets containing the Ten Commandments from God on Mount Sinai [Exodus 32:19].)

A prologue on the front of the stele lists the temples Hammurabi has restored, and an epilogue on the back glorifies him as a peacemaker, but most of the stele was clearly intended to publish the law guaranteeing uniform treatment of people throughout his kingdom. In the long cuneiform inscription, Hammurabi declared that with this code of law he intended "to cause justice to prevail in the land and to destroy the wicked and the evil, that the strong might not oppress the weak nor the weak the strong." Most of the 300 or so entries that follow deal with commercial and property matters. Only sixty-eight relate to domestic problems, and a mere twenty deal with physical assault.

Punishments are based on the wealth, class, and gender of the parties—the rights of the wealthy are favored over the poor, citizens over slaves, men over women. The death penalty is frequently decreed for crimes such as stealing from a temple or palace, helping a slave to escape, or insubordination in the army. Trial by water and fire could also be imposed, as when an adulterous woman and her lover were to be thrown into the water (those who did not drown were deemed innocent) or when a woman who committed incest with her son was to be burned (an incestuous man was only banished). Although some of the punishments may seem excessive today, we recognize that Hammurabi was breaking new ground in his attempt to create a society regulated by laws rather than the whims of rulers or officials.

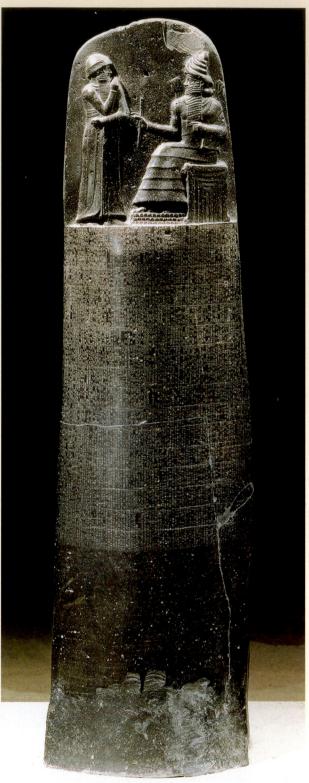

STELE OF HAMMURABI

Susa (present-day Shush, Iran). c. 1792-1750 BCE. Diorite, height of stele approx. 7' (2.13 m); height of relief 28" (71.1 cm). Musée du Louvre, Paris.

The most powerful of them was the Hittite civilization, whose founders had moved into the mountains and plateaus of central Anatolia from the east.

They established their capital at Hattusha (near present-day Boghazkoy, Turkey) about 1600 BCE. (The city was destroyed about 1200 BCE.) Through trade and conquest, the Hittites created an empire that stretched along the coast of the Mediterranean Sea in the area of present-day Syria and Lebanon, bringing them into conflict with the Egyptian Empire, which was expanding into the same region from the south (Chapter 3). They also made incursions into Mesopotamia.

The Hittites may have been the first people to work in iron, which they used for war chariot fittings, weapons, chisels, and hammers for sculptors and masons (see also Chapter 1, page 21). They are noted for the artistry of their fine metalwork and for their imposing palace citadels with double walls and fortified gateways. One of the most monumental of these sites consists of the foundations and base walls of the Hittite stronghold at Hattusha, which date to about 1400–1300 BCE. The lower walls were constructed of stone supplied from local quarries, and the upper walls, stairways, and walkways were finished in brick.

The blocks of stone used to frame doorways at Hattusha were decorated in high relief with a variety of guardian figures—some of them seven feet tall. Some were half-human—half-animal creatures; others were more naturalistically rendered animals like the lions at the Lion Gate (FIG. 2–16). Carved from the building stones, the lions seem

Sequencing Works of Art

с. 8000-7000 все	Early Neolithic —Walls and Towers of Jericho (in present-day Palestine).
с. 3300-2300 все	Sumerian—Votive figures from Eshunna (present-day Tell Asmar, Iraq).
с. 2300-2184 все	Akkadian-Stele of Naramsin.
с. 1400 все	Hittite —Lion Gate at Hattusha, Anatolia (near present-day Borghazkoy, Turkey).
с. 647 все	Assyrian—Assurbanipal and His Queen in the Garden from Nineveh (present-day Kuyunjik, Iraq).
с. 518-460 все	Persian —Apadana of Darius and Xerxes at Persepolis, Iran.

to emerge from the gigantic boulders that form the gate, unlike the later Assyrian guardians (SEE FIG. 2-1) who, while clearly part of the building, seem to stride or stand as independent creatures. The Hittite Lion Gate harmonizes with the colossal scale of the wall. Despite extreme weathering, the lions have endured over the millennia and still possess a sense of both vigor and permanence.

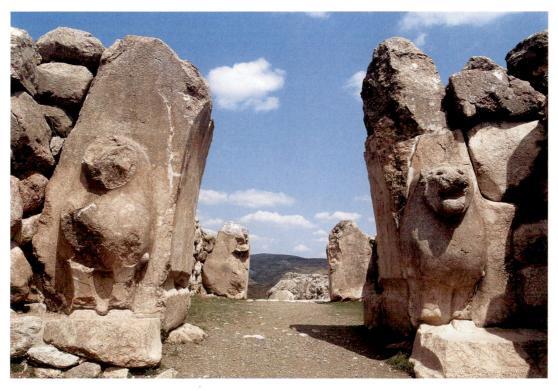

2–16 | LION GATE
Hattusha (near present-day Boghazkoy, Turkey). c. 1400 BCE. Limestone.

LATER MESOPOTAMIAN ART

Assyria

After centuries of struggle among Sumer, Akkad, and Lagash, in southern Mesopotamia, a people called the Assyrians rose to dominance in northern Mesopotamia. They began to extend their power by about 1400 BCE, and after about 1000 BCE started to conquer neighboring regions. By the end of the ninth century BCE, the Assyrians controlled most of Mesopotamia, and by the early seventh century they had extended their influence as far west as Egypt. Soon afterward they succumbed to internal weakness and external enemies, and by 600 BCE their empire had collapsed.

Assyrian rulers built huge palaces atop high platforms inside the different fortified cities that served at one time or another as Assyrian capitals. They decorated these palaces with scenes of battles, Assyrian victories with presentations of tribute to the king, combat between men and beasts, and religious imagery.

Kalhu (Nimrud). During his reign (883–859 BCE), Assurnasirpal II established his capital at Kalhu (present-day Nimrud, Iraq), on the east bank of the Tigris River, and undertook an ambitious building program. His architects fortified the city with mud-brick walls 5 miles long and 42 feet high, and his engineers constructed a canal that irrigated fields and provided water for the expanded population of the city. According to an inscription commemorating the event, Assurnasirpal gave a banquet for 69,574 people to celebrate the dedication of the new capital in 863 BCE.

Most of the buildings in Nimrud were made from mud bricks, but limestone and alabaster—more impressive and durable—were used to veneer walls for architectural decorations. Colossal guardian figures, lamassus, flanked the major portals (SEE FIG. 2–1), and panels covered the walls with scenes

carved in low relief of the king participating in religious rituals, war campaigns, and hunting expeditions.

THE LION HUNT. In a vivid lion-hunting scene (FIG. 2–17), Assurnasirpal II stands in a chariot pulled by galloping horses and draws his bow against an attacking lion that already has four arrows protruding from its body. Another beast, pierced by arrows, lies on the ground. This was probably a ceremonial hunt, in which the king, protected by men with swords and shields, rode back and forth killing animals as they were released one by one into an enclosed area. The immediacy of this image marks a shift in Mesopotamian art away from a sense of timelessness and toward visual narrative.

DUR SHARRUKIN (KHORSABAD). Sargon II (ruled 721–706 BCE) built a new Assyrian capital (FIG. 2–18) at Dur Sharrukin (present-day Khorsabad, Iraq). On the northwest side of the capital, a walled citadel, or fortress, containing several palaces and temples, straddled the city wall. Sargon's palace complex (the group of buildings where the ruler governed and resided) at the rear of the citadel on a raised, fortified platform about 40 feet high, demonstrates the use of art as propaganda to support political power.

Guarded by two towers, it was accessible only by a wide ramp leading up from an open square, around which the residences of important government and religious officials were clustered. Beyond the ramp was the main courtyard, with service buildings on the right and temples on the left. The heart of the palace, protected by a reinforced wall with only two small, off-center doors, lay past the main courtyard. Within the inner compound was a second courtyard lined with narrative relief panels showing tribute bearers that functioned as an audience hall. Visitors would have entered the king's throne room from this courtyard through a stone gate flanked by colossal guardian figures even larger than those at Assurnasirpal (SEE FIG. 2-1).

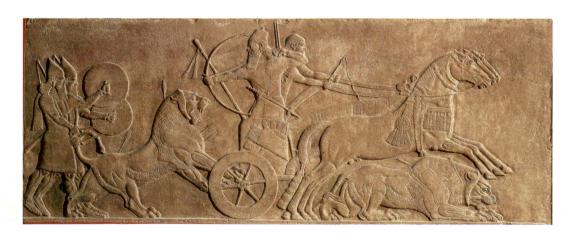

2–17 | ASSURNASIRPAL II KILLING LIONS
Palace complex of Assurnasirpal II, Kalhu (present-day Nimrud, Iraq). c. 850 BCE. Alabaster, height approx. 39" (99.1 cm). The British Museum, London.

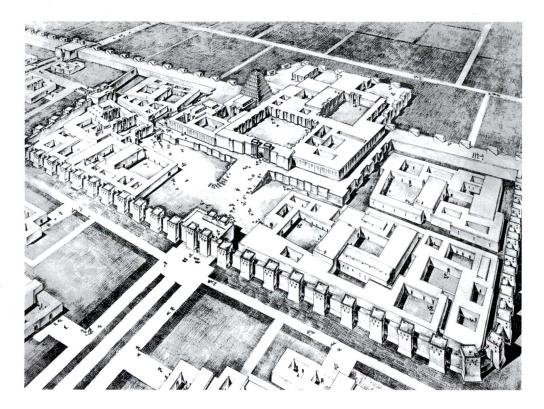

2–18 | RECONSTRUCTION DRAWING OF THE CITADEL AND PALACE COMPLEX OF SARGON II

Dur Sharrukin (present-day Khorsabad, Iraq). c. 721-706 BCE. Courtesy the Oriental Institute of the University of Chicago.

The ziggurat at Dur Sharrukin towered in an open space between the temple complex and the palace, declaring the might of Assyria's kings and symbolizing their claim to empire. It probably had seven levels, each about 18 feet high and painted a different color. The four levels still remaining were once white, black, blue, and red. Instead of separate flights of stairs between the levels, a single, squared-off spiral ramp rose continuously along the exterior from the base.

NINEVEH (KUYUNJIK). Assurbanipal (ruled 669–c. 627 BCE), king of the Assyrians three generations after Sargon II, maintained his capital at Nineveh (present-day Kuyunjik, Iraq).

His palace was decorated with alabaster panels carved with pictorial narratives in low relief. Most show the king and his subjects in battle and hunting, but there are occasional scenes of palace life. An unusually peaceful scene shows the king and queen in a pleasure garden (FIG. 2–19). The king reclines on a couch, and the queen sits in a chair at his feet. Servants arrive with trays of food, while others wave whisks to protect the royal couple from insects.

This apparently tranquil domestic scene is actually a victory celebration. The king's weapons (sword, bow, and quiver of arrows) are on the table behind him, and the severed head of his vanquished enemy hangs upside down from a tree at the far left.

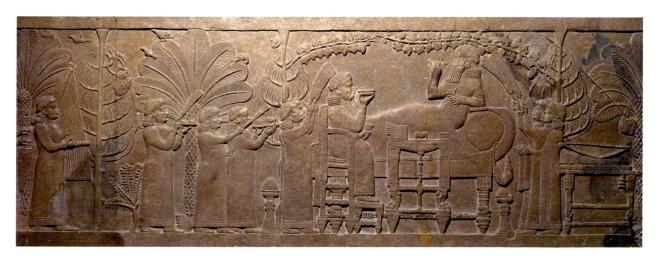

2–19 | ASSURBANIPAL AND HIS QUEEN IN THE GARDEN
The Palace at Nineveh (present-day Kuyunjik, Iraq). c. 647 BCE. Alabaster, height approx. 21"
(53.3 cm). The British Museum, London.

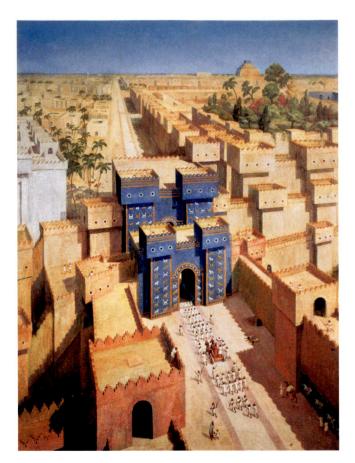

 $2-20 \mid$ reconstruction drawing of Babylon in the 6th century BCE

Courtesy the Oriental Institute of the University of Chicago.

The palace of Nebuchadnezzar II, with its famous Hanging Gardens, can be seen just behind and to the right of the Ishtar Gate, west of the Processional Way. The Marduk Ziggurat looms in the far distance on the east bank of the Euphrates.

Neo-Babylonia

At the end of the seventh century BCE, the Medes, a people from western Iran, allied with the Babylonians and the Scythians, a nomadic people from northern Asia (present-day Russia and Ukraine) invaded Assyria. In 612 BCE, this army captured Nineveh. When the dust settled, Assyria was no more and the Neo-Babylonians controlled a region that stretched from modern Turkey to northern Arabia and from Mesopotamia to the Mediterranean Sea.

Nebuchadnezzar. The most famous Neo-Babylonian ruler was Nebuchadnezzar II (ruled 605–562 BCE), notorious today for his suppression of the Jews, as recorded in the Hebrew (Old Testament) Book of Daniel, where he may have been confused with the final Neo-Babylonian ruler, Nabonidus. A great patron of architecture, he built temples dedicated to the Babylonian gods throughout his realm and transformed Babylon—the cultural, political, and economic

hub of his empire—into one of the most splendid cities of its day. Babylon straddled the Euphrates River, its two sections joined by a bridge.

The older, eastern sector was traversed by the Processional Way, the route taken by religious processions honoring the city's patron god, Marduk (FIG. 2–20). This street, paved with large stone slabs set in a bed of bitumen, was up to 66 feet wide at some points. It ran from the Euphrates bridge, through the temple district and palaces, and finally through the Ishtar Gate, the ceremonial entrance to the city. Beyond the Ishtar Gate, walls on either side of the route were faced with dark blue glazed bricks. The glazed bricks consisted of a film of colored glass placed over the surface of the bricks and fired, a process used since about 1600 BCE. Against that blue background, specially molded turquoise, blue, and gold-colored bricks formed images of striding lions, symbols of the goddess Ishtar.

The Ishtar Gate. The double-arched Ishtar Gate, a symbol of Babylonian power, was guarded by four crenellated towers. (Crenellations are notched walls—the notches are called *crenels*—built as a part of military defenses.) It is decorated with tiers of *mushhushshu* (horned dragons with the head and body of a snake, the forelegs of a lion, and the hind legs of a bird of prey) that were sacred to Marduk, and with bulls with blue horns and tails that were associated with Adad, the storm god.

Now reconstructed inside a Berlin Museum, the Ishtar Gate is installed next to a panel from the throne room in Nebuchadnezzar's nearby palace (FIG. 2–21). In the fragment seen here, lions walk beneath stylized palm trees. Among Babylon's other marvels—none of which have survived—were its fabled terraced and irrigated Hanging Gardens (one of the so-called Seven Wonders of the World), and the Marduk Ziggurat. All that remains of this ziggurat, which ancient documents describe as painted white, black, crimson, blue, orange, silver, and gold, is the outline of its base and traces of the lower stairs.

PERSIA

In the sixth century BCE, the Persians, a formerly nomadic, Indo-European—speaking people, began to seize power in Mesopotamia. From the region of Parsa, or Persis (present-day Fars, Iran), they eventually overwhelmed all of the ancient Near East and established a vast empire. The rulers of this new empire traced their ancestry to a semilegendary Persian king named Achaemenes, and consequently they are known as the Achaemenids.

Empire

The dramatic expansion of the Achaemenids began in 559 BCE with the ascension of a remarkable leader, Cyrus II the Great

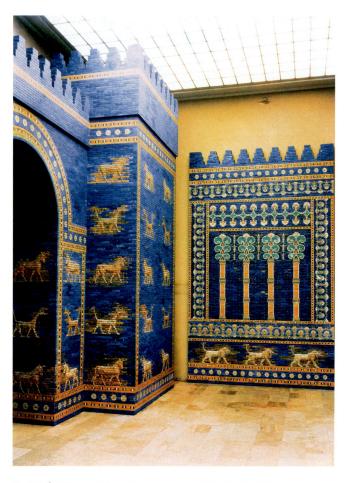

2–21 | ISHTAR GATE AND THRONE ROOM WALL
Reconstructed in a Berlin museum, originally from Babylon
(present-day Iraq) c. 575 BCE. Glazed brick, height of gate
originally 40 feet (12.2 m) with towers rising 100 feet
(30.5 m). Vorderasiatisches Museum, Staatliche Museen zu
Berlin, Preussischer Kulturbesitz.

(ruled 559–530 BCE). By the time of his death, the Persian Empire included Babylonia, Media (which stretched across present-day northern Iran through Anatolia), and some of the Aegean islands far to the west. Only the Greeks stood fast against them (see Chapter 5). When Darius I (ruled 521–486 BCE) took the throne, he could proclaim: "I am Darius, great King, King of Kings, King of countries, King of this earth."

An able administrator, Darius organized the Persian lands into twenty tribute-paying areas under Persian governors. He often left local rulers in place beneath the governors. This practice, along with a tolerance for diverse native customs and religions, won the Persians the loyalty of many of their subjects. Darius also developed a system of fair taxation, issued a standardized currency (SEE FIG. 2-25), and improved communication throughout the empire. Like many powerful rulers, Darius created palaces and citadels as visible symbols of his authority. He made Susa his first capital and commissioned a 32-acre administrative compound to be built there.

Persepolis

In about 515 BCE, Darius began construction of Parsa, a new capital in the Persian homeland in the Zagros highlands. Today this city, known as Persepolis, the name the Greeks gave it, is one of the best-preserved and most impressive ancient sites in the Near East (FIG. 2–22). Darius imported materials, workers, and artists from all over his empire for his building projects. He even ordered work to be executed in Egypt and transported to his capital. The result was a new style of art that combined many different cultural traditions, including Persian, Mede, Mesopotamian, Egyptian, and Greek.

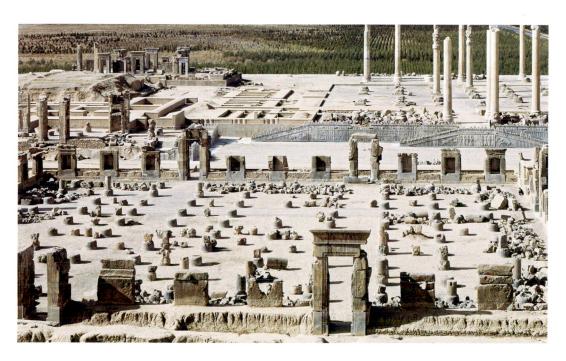

2–22 | AIR VIEW OF THE CEREMONIAL COMPLEX, PERSEPOLIS Iran. 518–c. 460 BCE.

Technique TEXTILES

extiles are usually a woman's art although men, as shepherds and farmers, often produced the raw materials (wool, flax, and other fibers). And as traveling merchants, men sold or bartered the extra fabrics not needed by the family. Early Assyrian cuneiform tablets preserve correspondence between merchants traveling by caravan and their wives. These astute business women ran the production end of the business back home and often complained to their husbands about late payments and changed orders. The woman shown spinning in the fragment from Susa is important-looking, wearing an elegant hairstyle, many ornaments, and a garment with a patterned border. She sits barefoot and cross-legged on a lionfooted stool covered with sheepskin, spinning thread with a large spindle. A servant stands behind the woman, fanning her, while a fish and six round objects (perhaps fruit) lie on an offering stand in front of her.

WOMAN SPINNINGSusa (present-day Shush, Iran). c. 8th-7th century BCE. Bitumen compound, $3\% \times 5\%$ (9.2 \times 13 cm). Musée du Louvre, Paris.

The production of textiles is complex. First, fibers gathered from plants (such as flax for linen cloth or hemp for rope) or from animals (wool from sheep, goats, and camels or hair from humans and horses) are cleaned, combed, and sorted. Only then can the fibers be twisted and drawn out under tension—that is, spun—into the long, strong, flexible thread needed for textiles. Spinning tools include a long, sticklike spindle to gather the spun fibers, a whorl (weight) to help rotate the spindle, and a distaff (a word still used to describe women and their work) to hold the raw materials. Because textiles are fragile and decompose rapidly, the indestructible stone or fired-clay spindle whorls are usually the only surviving evidence of thread making.

Weaving is done on a loom. Warp threads are laid out at right angles to weft threads, which are passed over and under the warp. In the earliest vertical looms, warp threads hung from a beam, their tension created either by wrapping them around a lower beam (a tapestry loom) or by tying them to heavy stones. Although weaving was usually a home industry, in palaces and temples slave women staffed large shops, and specialized as spinners, warpers, weavers, and finishers.

Early fiber artists depended on the natural colors of their materials and on natural dyes from the earth (ochers), plants (madder for red, woad and indigo for blue, safflower and saffron crocus for yellow), and animals (royal purple—known as Tyrian purple after the city of its origin—from marine mollusks). They combined color and techniques to create a great variety of fiber arts: Egyptians seem to have preferred white linen, elaborately folded and pleated, for their garments. The Minoans of Crete created multicolored patterned fabrics with fancy borders. Greeks excelled in the art of pictorial tapestries. The people of the ancient Near East used woven and dyed patterns and also developed knotted pile (the so-called Persian carpet) and felt (a cloth made of fibers bound by heat and pressure, not by spinning, weaving, or knitting).

In Assyrian fashion, the imperial complex at Persepolis was set on a raised platform and laid out on a rectangular **grid**, or system of crossed lines. The platform was 40 feet high and measured 1,500 by 900 feet. It was accessible only from a single approach made of wide, shallow steps that allowed horsemen to ride up on horseback. Darius lived to see the completion of a treasury, the Apadana (audience hall), and a very small palace for himself on the platform. The Apadana, set above the rest of the complex on a second terrace (FIG. 2–23), had open porches on three sides and a square hall large enough to hold several thousand people. Darius's son Xerxes I (ruled 485–465 BCE) added a sprawling palace complex for himself, enlarged the treasury building, and began a vast new public reception space, the Hall of 100 Columns.

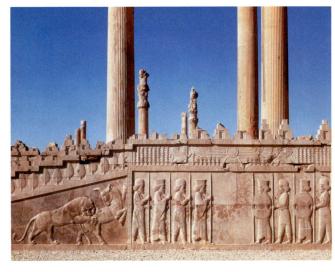

2–23 APADANA (AUDIENCE HALL) OF DARIUS AND XERXES Ceremonial Complex, Persepolis Iran. 518–c. 460 BCE.

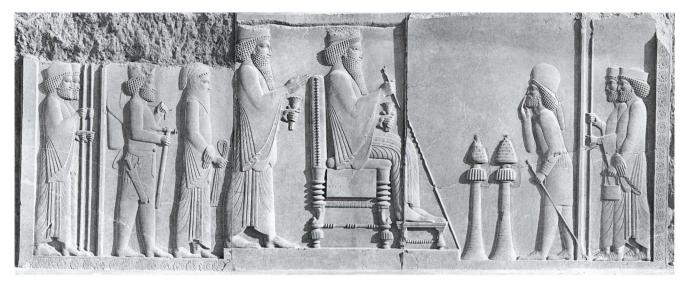

2–24 | **DARIUS AND XERXES RECEIVING TRIBUTE**Detail of a relief from the stairway leading to the Apadana (ceremonial complex), Persepolis, Iran. 491–486 BCE. Limestone, height 8'4" (2.54 m). Courtesy the Oriental Institute of the University of Chicago.

Persian sculpture emphasizes the extent of the empire and its economic prosperity under Persian rule. The central stair of Darius's Apadana displays reliefs of animal combat, tiered ranks of royal guards (the "10,000 Immortals"), and delegations of tribute bearers. Here, lions attack bulls at each side of the Persian generals. These animal combats (a theme found throughout the Near East) emphasize the ferocity of the leaders and their men. Ranks of warriors cover the walls with repeated patterns and seem ready to defend the palace. The elegant drawing, balanced composition, and sleek modeling of figures reflect the Persians' knowledge of Greek art and perhaps the use of Greek artists. Other reliefs throughout Persepolis depict displays of allegiance or economic prosperity. In one example, once the centerpiece, Darius holds an audience while his son and heir, Xerxes, listens from behind the throne (FIG. 2-24). Such panels would have looked quite different when they were freshly painted in rich tones of deep blue, scarlet, green, purple, and turquoise, with metal objects such as Darius's crown and necklace covered in gold leaf (sheets of hammered gold).

Persian Coinage

The Persians' decorative arts—including ornamented weapons, domestic wares, horse trappings, and jewelry—demonstrate high levels of technical and artistic sophistication. The Persians also created a refined coinage, with miniature low-relief portraits of rulers, so that coins, in addition to their function as economic standards, served as propaganda. Persians had learned to mint standard coinage from the Lydi-

ans of western Anatolia after Cyrus the Great defeated Lydia's fabulously wealthy King Croesus in 546 BCE (see "Coining Money," page 46). Croesus's wealth—the source of the lasting expression "rich as Croesus"—had made Lydia an attractive target for an aggressive empire builder like Cyrus.

A Persian coin, the gold daric, named for Darius and first minted during his regime (FIG. 2–25), is among the most valuable coins in the world today. Commonly called an "archer," it shows the well-armed emperor wearing his crown and carrying a lance in his right hand. He lunges forward as if he had just let fly an arrow from his bow.

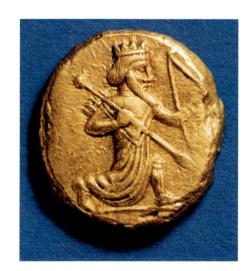

2-25 | DARIC
 A coin first minted under Darius I of Persia. 4th century BCE.
 Gold. Heberden Coin Room, Ashmolean Museum, Oxford.

Technique COINING MONEY

ncient people had long used gold, silver, bronze, and copper as mediums of exchange, but each piece had to be weighed to establish its exact value. In the seventh century BCE, the Lydians of western Anatolia began to produce metal coins in standard weights, adapting the seal—a Sumerian invention—to designate their value. Until about 525 BCE, coins bore an image on one side only. The beautiful early coin shown here, minted during the reign of the Lydian king Croesus (ruled 560–546 BCE), is stamped with the heads and forelegs of a bull and a lion in low relief. The reverse has only a squarish depression left by the punch used to force the metal into the mold.

To make two-faced coins, the ancients used a punch and anvil, each of which held a die, or mold, with the design to be impressed in the coin. A metal blank weighing the exact amount of the denomination was placed over the anvil die, containing the design for the "head" (obverse) of the coin. The punch, with the die of the "tail" (reverse) design, was placed on top of the metal blank and struck with a mallet. Beginning in the reign of Darius I, representations of kings appeared on coins, proclaiming the ruler's control of the coin of the realm—a custom that has continued throughout the world in coins. Because we often know approximately when ancient monarchs ruled, coins discovered in an archaeological excavation help to date the objects around them.

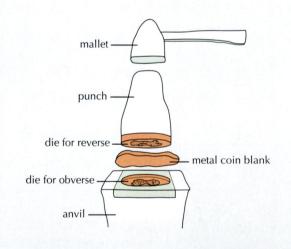

FRONT AND BACK OF A GOLD COIN

First minted under Croesus, king of Lydia. 560-546 BCE. Heberden Coin Room, Ashmolean Museum, Oxford. At its height, the Persian Empire extended from Africa to India. From the Persians' spectacular capital, Darius in 490 BCE and Xerxes in 480 BCE sent their armies west to conquer Greece. Mainland Greeks successfully resisted the armies of the Achaemenids, however, preventing them from advancing into Europe (Chapter 5). And it was a Greek who ultimately put an end to their empire. In 334 BCE, Alexander the Great of Macedonia (d. 323) crossed into Anatolia and swept through Mesopotamia, defeating Darius III and nearly laying waste the magnificent Persepolis in 330. Although the Achaemenid Empire was at an end, Persia eventually revived and the Persian style in art continued to influence Greek artists (Chapter 5) and ultimately Islamic art (Chapter 8).

IN PERSPECTIVE

In the ancient Near East, people developed systems of recordkeeping and written communication. Thousands of clay tablets covered with cuneiform writing document the gradual evolution of writing in Mesopotamia, as well as an organized system of justice and the world's first epic literature. We know a great deal about this ancient society—both from its records and from modern archaeological exploration and excavation. In Sumer, Akkad, Lagash, and Babylonia, agriculture, including the control of the rivers, was improved. Increased food production then made urban life possible. Population density gave rise to the development of specialized skills. Social hierarchies evolved. Priests communicated with the gods; rulers led and governed; warriors defended the greater community and its fields and villages; and artisans and farmers supplied basic material needs.

Art itself became a means of communication. A distinctive architecture arose as people built colorful stepped ziggurats. Sculptors represented these people as compact cylindrical figures animated only by wide staring eyes. By the ninth century, the Assyrians in northern Mesopotamia had built enormous city palaces and fortresses and placed guardian figures at the gates. The walls of corridors and courtyards were covered with low-relief sculptured narratives that told in vivid detail of the Assyrians' daring exploits in nearly constant warfare. Later, Babylon in the south became a luxurious city, whose hanging gardens were considered one of the wonders of the ancient world, and whose temples and ziggurats, palaces and ceremonial avenues, were lined with brilliantly colored images made of glazed bricks.

Finally, the Achaemenid Persians formed a spectacularly rich and powerful empire. Kings Darius and Xerxes built a huge palace at Persepolis (in present-day Iran) where sculptures extolled their wealth and power. Rulers in western Anatolia (present-day Turkey) invented coinage. These lumps of precious metal, stamped with portraits of rulers and symbols of cities or territories, are in fact miniature works of art.

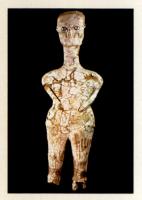

HUMAN FIGURE,
AIN GHIZAL
C. 7000–6000 BCE

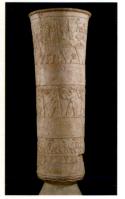

URUK VASE C. 3300–3000 BCE

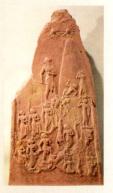

STELE OF NARAM-SIN C. 2220–2184 BCE

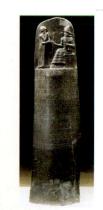

STELE OF HAMMURABI C. 1792–1750 BCE

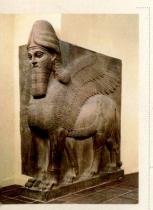

ASSYRIAN GUARDIAN FIGURE C. 883–859 BCE

DARIUS AND XERXES
RECEIVING TRIBUTE
491-486 BCE

9000 BCE

ART OF THE ANCIENT NEAR EAST

- ✓ Paleolithic-Neolithic Overlap c. 9000-4000 BCE
- Growth of Jericho c. 8000-7500 BCE
- **Earliest Pottery** c. 7000 BCE
- Neolithic 6500-1200 BCE
- 5000

- Invention of Writing c. 3100 BCE
 - Akkad c. 2340–2180 BCE

■ Sumer c. 3500-2340 BCE

■ Potter's Wheel in Use c. 3250 BCE

- ◀ Lagash c. 2150 BCE
- Babylonia, Mari, Hammurabi Ruled c. 1792–1750 BCE
- → Hittite (Anatolia) c. 1600-1200 BCE
- Assyrian Empire c. 1000-612 BCE
- Neo-Babylonia c. 612–539 BCE
- Persia c. 559-331 BCE

TOOO

300 BCE

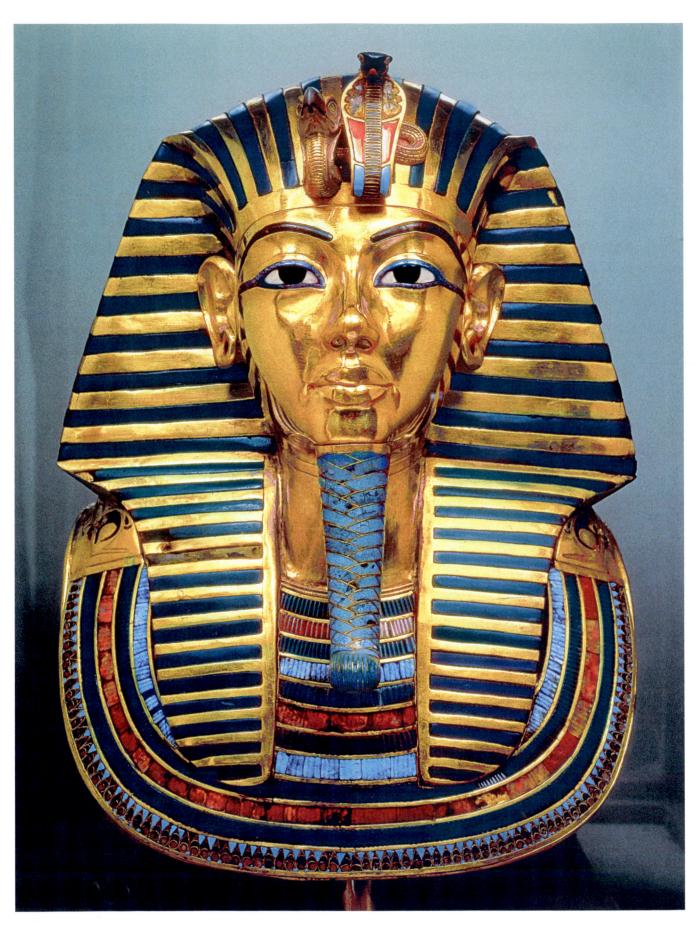

3−I FUNERARY MASK OF TUTANKHAMUN Eighteenth Dynasty (Tutankhamun, ruled 1332–1322 BCE), c. 1327 BCE. Gold inlaid with glass and semiprecious stones. Height 21¼″ (54.5 cm). Weight 24 pounds (11 kg). Egyptian Museum, Cairo.

CHAPTER THREE

ART OF ANCIENT EGYPT

On February 16, 1923, the *Times* of London cabled the *New York Times* with dramatic news of a discovery: "This has been, perhaps, the most extraordinary day in the whole history of Egyptian excavation. Whatever one may have

guessed or imagined of the secret of Tut-ankh-Amen's tomb, they [sic] surely cannot have dreamed the truth as now revealed. The entrance today was made into the sealed chamber of the tomb... and yet another door opened beyond that. No eyes have seen the King, but to practical certainty we know that he lies there close at hand in all his original state, undisturbed." And indeed he did. A collar of dried flowers and beads covered the chest, and a linen scarf was draped around the head. A gold funerary mask (FIG. 3–1) had been placed over the head and shoulders of his mummified body, which was enclosed in three nested coffins, the innermost made of gold (SEE FIG. 3–33, and page 75). The coffins were placed in a yellow quartzite box that was itself encased within gilt wooden shrines nested inside one another.

The discoverer of this treasure, the English archaeologist Howard Carter, had worked in Egypt for more than twenty years before he undertook a last expedition, sponsored by the wealthy British amateur Egyptologist Lord Carnarvon, after World War I. Carter, a former chief inspector of Upper Egypt and draftsman for the Egypt Exploration Fund, had a detailed knowledge of the area to be excavated. He was convinced that the tomb of Tutankhamun, the only Eighteenth Dynasty royal burial place then still unidentified,

lay still hidden in the Valley of the Kings. After fifteen years of digging, on November 4, 1922, Carter unearthed the entrance to Tutankhamun's tomb. His workers cleared the way to the antechamber, which was found to contain

unbelievable treasures: jewelry, textiles, gold-covered furniture, a carved and inlaid throne, four gold chariots. In February 1923, they pierced the wall separating the anteroom from the actual burial chamber. Tutankhamun's tomb had been entered, resealed, and hidden, but the burial chamber had not been disturbed.

Since ancient times, tombs have tempted looters; more recently, they also have attracted archaeologists and historians. The first large-scale "archaeological" expedition in history landed in Egypt with the armies of Napoleon in 1798. The French commander, who went to investigate digging a canal between the Mediterranean and Red seas, must have realized that he might find great riches there, for he took with him some 200 French scholars to study ancient sites. The military adventure ended in failure, but the scholars eventually published thirty-six richly illustrated volumes of their findings, unleashing a craze for all things Egyptian that has not dimmed since.

In 1976, the first blockbuster museum exhibition was born when treasures from the tomb of Tutankhamun began a tour of the United States and attracted over 8 million visitors. Major archaeological finds still make newspaper headlines around the world. In 1987, Kent R. Weeks reopened a huge

burial complex in the Valley of the Kings. Excavations beginning in 1995 revealed the tomb of Rameses II's fifty-two sons. In September 2000, Egyptian archaeologists again made the front pages when they announced the spectacular discovery of more than a hundred mummies—some from about 500 BCE and most from the time of the Roman occupation of Egypt—in a huge burial site called the Valley of the Golden Mummies, about 230 miles southwest of Cairo. The director of excavations for the government of Egypt, Dr. Zahi Hawass, believes that as many as 10,000 mummies will eventually come to light from the Valley. Meanwhile, in 2006, Dr. Hawass announced the discovery of a tomb containing five sarcophagi in the Valley of the Kings, the first tomb to be found there since Tutankhamun's in 1922.

CHAPTER-AT-A-GLANCE

- THE GIFT OF THE NILE
- EARLY DYNASTIC EGYPT | Manetho's List | Religion and the State | Artistic Conventions | Funerary Architecture
- THE OLD KINGDOM, c. 2575-2150 BCE | Architecture: The Pyramids at Giza | Sculpture | Tomb Decoration
- THE MIDDLE KINGDOM, c. 1975-c. 1640 BCE | Sculpture: Royal Portraits | Tomb Architecture and Funerary Objects | Town Planning
- THE NEW KINGDOM, c. 1539–1075 BCE | The Great Temple Complexes | The Valley of the Kings and Queens | Akhenaten and the Art of the Amarna Period | The Return to Tradition: Tutankhamun and Rameses II | The Books of the Dead
- LATE EGYPTIAN ART, c. 715-332 BCE
- **IN PERSPECTIVE**

THE GIFT OF THE NILE

The Greek traveler and historian Herodotus, writing in the fifth century BCE, remarked: "Egypt is the gift of the Nile." This great river, the longest in the world, winds northward from equatorial Africa and flows through Egypt in a relatively straight line to the Mediterranean (MAP 3–1). There it forms a broad delta before emptying into the sea. Before it was dammed in 1970 by the Aswan High Dam, the lower (northern) Nile, swollen with the runoff of heavy seasonal rains in the south, overflowed its banks for several months each year. Every time the floodwaters receded, they left behind a new layer of rich silt, making the valley and delta a fertile and attractive habitat.

By about 8000 BCE, the valley's inhabitants had become relatively sedentary, living off the abundant fish, game, and wild plants. Not until about 5000 BCE did they adopt the agricultural village life associated with Neolithic culture (see Chapter 1). At that time, the climate of North Africa grew increasingly dry. To ensure adequate resources for agriculture, the farmers along the Nile cooperated to control the river's flow. As in Mesopotamia (see Chapter 2), this common challenge led riverside settlements to form alliances. Over time, these rudimentary federations expanded by conquering and absorbing weaker communities. By about 3500 BCE, there were several larger states, or chiefdoms, in the lower Nile Valley.

The Predynastic period, from roughly 5000 to 2950 BCE, was a time of significant social and political transition that

preceded the unification of Egypt under a single ruler. (Egyptian history is divided into dynasties—periods in which members of the same family inherited Egypt's throne.) According to later legend, the earliest Kings of Egypt were gods who ruled on earth. By the last centuries of the Predynastic period, after about 3500 BCE, a centralized form of leadership had emerged in which the rulers were considered to be divine. Their subjects expected their leaders to protect them not only from outside aggression, but also from natural catastrophes such as droughts and insect plagues.

The surviving art of the Predynastic period consists chiefly of ceramic figurines, decorated pottery, and reliefs carved on stone plaques and pieces of ivory. A few examples of Predynastic wall painting—lively scenes filled with small figures of people and animals—were found in a tomb at Hierakonpolis, in Upper Egypt, a Predynastic town of mudbrick houses that was once home to as many as 10,000 people.

We begin our discussion with the art of the early dynastic period, from c. 2950 to c. 2575 BCE, and with Manetho's list, the chronology of Egypt's rulers.

EARLY DYNASTIC EGYPT

Sometime about 3000 BCE, Egypt became a consolidated state. According to legend, the country had previously evolved into two major kingdoms—the Two Lands—Upper

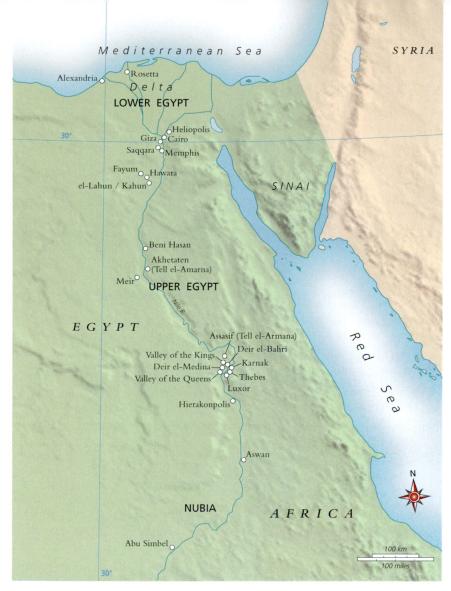

MAP 3-I ANCIENT EGYPT

Upper (southern) Egypt and Lower (northern) Egypt were united about 3100 BCE.

Egypt in the south (upstream on the Nile) and Lower Egypt in the north. But then a powerful ruler from Upper Egypt, referred to in an ancient document as "Menes king-Menes god," finally conquered Lower Egypt.

Manetho's List

In the third century BCE, an Egyptian priest and historian named Manetho used temple records to compile a chronological list of Egypt's rulers since ancient times. He grouped the kings into dynasties and included the length of each king's reign. Although scholars do not agree on all the dates, his chronology is still the accepted guide to ancient Egypt's long history. Manetho listed thirty dynasties that ruled the country between about 3000 and 332 BCE, when Egypt was conquered by Alexander the Great of Macedonia and the Greeks. Egyptologists have grouped these dynasties into larger periods reflecting broad historical developments. The dating system used in this book is that followed by the *Atlas of Ancient Egypt*.

Religion and the State

The Greek historian Herodotus thought the Egyptians the most religious people he had ever encountered. Religious beliefs permeate Egyptian art of all periods. Many of the earliest and most important deities in Egypt's pantheon are introduced in its creation myths.

CREATION MYTHS. One version of the creation myth relates that the sun god Ra—or Ra-Atum—shaped himself out of the waters of chaos, or unformed matter, and emerged sealed atop a mound of sand hardened by his own rays. By spitting—or ejaculating—he then created the gods of wetness and dryness, Tefnut and Shu, who in turn begat the male Geb (earth) and the female Nut (sky). Geb and Nut produced two sons, Osiris and Seth, and two daughters, the goddesses Isis and Nephthys.

Taking Isis as his wife, Osiris became king of Egypt. His envious brother, Seth, promptly killed Osiris, hacked his body to pieces, and snatched the throne for himself. Isis and her sister, Nephthys, gathered up the scattered remains of Osiris

Art and Its Context

EGYPTIAN SYMBOLS

our crowns symbolize kingship: the tall clublike white crown of Upper Egypt (sometimes adorned with two plumes); the flat red cap with rising spiral of Lower Egypt; the double crown representing unified Egypt; and, in the New Kingdom, the blue oval crown, which evolved from a helmet.

A striped gold and blue linen head cloth, known as the **nemes headdress**, having the cobra and vulture at the center front, was commonly used as a royal headdress. The cobra goddess, Meretseger of Lower Egypt ("she who rears up"), was equated with the sun and with royalty and was often included in headdresses. The queen's crown included the feathered skin of the vulture goddess Nekhbet of Upper Egypt.

The god Horus, king of the earth and a force for good, is represented as a falcon or falcon-headed man. His eyes symbolize the sun and moon; the solar eye is called the wedjat. The looped cross, called the ankh, is symbolic of everlasting life. The scarab beetle (khepri, meaning "he who created himself") was associated with creation, resurrection, and the rising sun.

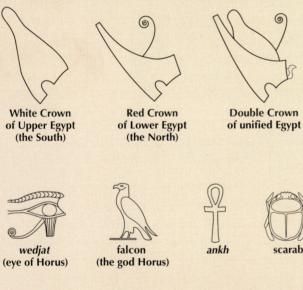

and, with the help of the god Anubis (represented by a jackal), they patched him back together. Despite her husband's mutilated condition, Isis conceived a son—Horus, another power for good, capable of guarding the interests of Egypt. Horus defeated Seth and became king of the earth, while Osiris retired to the underworld as overseer of the realm of the dead (SEE FIG. 3–35).

The myths give different explanations of the creation of human beings. In one, Ra lost an eye but, unperturbed, replaced it with a new one. When the old eye was found, it began to cry, angered that it was no longer of any use. Ra created human beings from its tears. In another myth, the god Khnum created humankind on his potter's wheel.

THE GOD-KINGS. By the Early Dynastic period (2950–2575 BCE), Egypt's kings were revered as gods in human form. A royal jubilee, the *heb sed* or *sed* festival, held in the thirtieth year of the living king's reign, renewed and reaffirmed his power. Kings rejoined their father the sun god Ra at death and rode with him in the solar boat as it made its daily journey across the sky.

To please the gods and ensure their continuing goodwill toward the state, the kings built splendid temples and provided priests to maintain them. The priests saw to it that statues of the gods, placed deep in the innermost rooms of the temples, were never without fresh food and clothing. The many gods and goddesses were depicted in various forms, some as human beings, others as animals, and still others as humans with animal heads. Osiris, for example, regularly appears in human form wrapped in linen as a mummy. His sister-wife, Isis, has a human form, but their son, the sky god Horus, is often depicted as a falcon or falcon-headed man (see "Egyptian Symbols," left).

By the New Kingdom (c. 1539–1075 BCE), Amun (chief god of Thebes, represented as blue and wearing a plumed crown), Ra (of Heliopolis), and Ptah (of Memphis) had become the primary national gods. Other gods and their manifestations included Hathor (cow), goddess of love and fertility; Thoth (ibis), god of writing, science, and law; Maat (feather), god of truth, order, and justice; Anubis (jackal), god of embalming and cemeteries; and Bastet (cat), daughter of Ra.

Egyptian religious beliefs reflect an ordered cosmos. The movements of heavenly bodies, the workings of gods, and the humblest of human activities all were thought to be part of a balanced and harmonious grand design. Death was to be feared only by those who lived in such a way as to disrupt that harmony: Upright souls could be confident that their spirits would live on eternally.

Artistic Conventions

Conventions in art are the customary ways of representing people and the world, generally accepted by artists and patrons. Egyptian artists followed certain well-established conventions: Images are based on memory images and characteristic viewpoints; mathematical formulas determine proportions; importance determines size (hieratic scale); space is represented in horizontal registers; drawing and contours are simplified; and colors are clear and flat. The conventions that govern Egyptian art appear early and continue to be followed, with subtle variations, through its long history.

THE NARMER PALETTE. Being one of the most historically and artistically significant works of ancient Egyptian art, the NARMER PALETTE (FIG. 3–2) was created at the dawn of its history. It is commonly interpreted to announce the unification of Egypt and the beginning of the country's growth as a powerful nation-state. It also exhibits many visual conventions that characterize the art of Egyptian civilization from this point on.

The first king, named Narmer, who may be Menes, is known from this ceremonial palette of green schist found at Hierakonpolis. The ruler's name appears in an early form of hieroglyphic writing at the center top of both sides within a small square representing a palace façade—a horizontal fish (nar) above a vertical chisel (mer). Narmer and his palace are protected by Hathor, depicted as a human face with cow ears and horns and shown on each side of his name.

Palettes, flat stones with a circular depression on one side, were used for grinding eye paint. (Both men and women

Sequencing Events KEY EGYPTIAN PERIODS

c. 5000-2950 BCE Predynastic Period c. 2950-2575 BCE Early Dynastic Period

c. 2575-2150 BCE Old Kingdom

c. 2125-1975 BCE First Intermediate Period

c. 1975-c. 1640 BCE Middle Kingdom

c. 1630-1520 BCE Second Intermediate Period

c. 1630-1520 BCE New Kingdom
c. 715-332 BCE Late Period

painted their eyelids to help prevent infections in the eyes and to reduce the glare of the sun.) The *Narmer Palette*, carved in low relief on both sides, is much larger than most. It was found in the temple of Horus, so it may have had a ceremonial function or been a votive offering.

Narmer dominates the scenes on the palette: Images of conquest proclaim him to be the great unifier, protector, and leader of the Egyptian people. Hieratic scale signals the status of individuals and groups in this highly stratified society; so, as in the *Stele of Naram-Sin* (SEE FIG. 2–14), the ruler is larger than the other human figures. Narmer wears the White

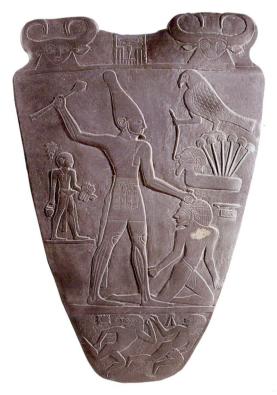

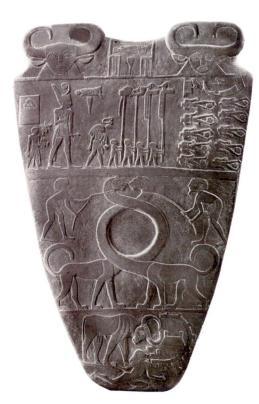

3–2 | THE NARMER PALETTE

Hierakonpolis. Early Dynastic period, c. 2950–2775 BCE. Green schist, height 25" (64 cm).

Egyptian Museum, Cairo.

Crown of Upper Egypt; a ceremonial bull's tail, signifying strength, hangs from his waistband. He is barefoot, and an attendant standing behind him holds his sandals.

He bashes the enemy with a club, and above his kneeling foe, the god Horus—depicted as a falcon with a human hand—holds a rope tied around the neck of a man whose head is attached to a block sprouting stylized papyrus, a plant that grew in profusion along the Nile and was used symbolically to represent Lower Egypt. This combination of symbols makes clear that Narmer has tamed Lower Egypt. At the bottom, below Narmer's feet, two more defeated enemies appear sprawled on the ground.

In the top register on the other side of the palette (FIG. 3–2, right), Narmer wears the Red Crown of Lower Egypt, possibly to indicate he now rules both lands (see "Egyptian Symbols," page 52). With his attendant sandal-bearer, he marches behind his minister of state and four men carrying standards that may symbolize different regions of the country. Before them, under the watchful eye of Horus, decapitated bodies of the enemy are arranged in two neat rows. In the center register, the elongated necks of two feline creatures, each held on a leash by an attendant, curve gracefully around the rim of the cup of the palette. The intertwining of their necks may be another reference to the union of the Two Lands. At the bottom, the king, symbolized as a bull (an animal known for its strength and virility), menaces a fallen foe outside the walls of a fortress.

The images carved on the palette are strong and direct, and although scholars disagree about some of their specific meanings, their overall message is clear: A king named Narmer rules over the unified land of Egypt with a strong hand. For the next 3,000 years, much of Egyptian art was created to meet the demand of royal patrons for similarly graphic and indestructible testimonies to their glory.

TWISTED PERSPECTIVE. Narmer's palette is a very early example of the way Egyptian artists solved the problem of depicting the human form in the two-dimensional arts of relief sculpture and painting. Many of the figures on the palette are shown in poses that would be impossible in real life. By Narmer's time, Egyptian artists, composing their art from memory images (the generic form that suggests a specific object), had arrived at a unique way of drawing the human figure with the aim of representing each part of the body from its most characteristic angle. Heads are shown in profile, to best capture the nose, forehead, and chin. Eyes were rendered frontally. As for the body, a profile head and neck are joined to profile hips and legs by a fully frontal torso. The figure is usually striding to reveal both legs. The result is a formalized version of the twisted perspective we have seen in cave paintings (Chapter 1) and in ancient Near Eastern art (Chapter 2).

This artistic convention was followed especially in the depiction of royalty and other dignitaries. Persons of lesser

social rank engaged in active tasks tend to be represented more naturally (compare the figure of Narmer with those of his standard-bearers).

Similar long-standing conventions governed the depiction of animals, insects, inanimate objects, landscape, and architecture. **Groundlines** establish space as a series of horizontal registers in which the uppermost register is the most distant. A landscape combines the bird's-eye view of a map with the depiction of elements such as trees from the side.

THE CANON OF PROPORTIONS. Egyptian artists also established an ideal image of the human form, following a canon of proportions. The ratios between a figure's height and all of its component parts were clearly prescribed. They were calculated as multiples of a specific unit of measure, such as the width of the closed fist. This unit became the basis of a square grid, the OLD KINGDOM STANDARD GRID (FIG. 3–3). Every body part had its designated place on the grid: Knowing the knee should appear a prescribed number of squares above the groundline, the waist was then x number of squares above the knee, and so on. The whole process was thereby simplified. Since size depended not on the object, but on the amount of space it occupied, even the smallest image possesses the quality of a monumental figure.

3-3 | OLD KINGDOM STANDARD GRID—AN EGYPTIAN CANON OF PROPORTIONS FOR REPRESENTING THE HUMAN BODY

This canon sets the height of the male body from heel to hairline at 18 times the width of the fist, which is 1 unit wide. Thus, there are 18 units between the heels and the hairline. The knees align with the fifth unit up, the elbows with the twelfth, and the junction of the neck and shoulders with the sixteenth.

Technique

PRESERVING THE DEAD

gyptians developed mummification techniques to ensure that the ka, or life force, could live on in the body in the afterlife. No recipes for preserving the dead have been found, but the basic process seems clear enough from images found in tombs, the descriptions of later Greek writers such as Herodotus and Plutarch, scientific analysis of mummies, and modern experiments.

By the time of the New Kingdom, the routine was roughly as follows: The body was taken to a mortuary, a special structure used exclusively for embalming. Under the supervision of a priest, workers removed the brains, generally through the nose, and emptied the body cavity through an incision in the left side. They then placed the body and major internal organs in a vat of natron, a naturally occurring salt, to steep for a month or more.

This preservative caused the skin to blacken, so workers often dyed it later to restore some color, using red ocher for a man, yellow ocher for a woman. They then packed the body cavity with clean linen, soaked in various herbs and ointments, provided by the family of the deceased. They wrapped the major organs in separate packets, putting them in special containers called **canopic jars**, to be placed in the tomb chamber.

Workers next wound the trunk and each of the limbs separately with cloth strips, then wrapped the whole body. They wound it in additional layers of cloth to produce the familiar mummy shape. The linen winders often inserted charms and other smaller objects among the wrappings. If the family supplied a copy of the Book of the Dead, it was tucked between the mummy's legs.

Funerary Architecture

Ancient Egyptians believed that an essential part of every human personality is its life force, or spirit, called the ka, which lived on after the death of the body, forever engaged in the activities it had enjoyed in its former existence. The ka needed a body to live in, and a sculpted likeness was adequate. It was especially important to provide a comfortable home for the ka of a departed king, so that even in the afterlife he would continue to ensure the well-being of Egypt.

The Egyptians developed elaborate funerary practices to ensure that their deceased moved safely and effectively into the afterlife. They preserved the bodies of the royal dead with care and placed them in burial chambers filled with all the supplies and furnishings the *ka* might require throughout eternity (see "Preserving the Dead," above). The quantity and value of these grave goods were so great that even in ancient times looters routinely plundered tombs.

THE MASTABA. In Early Dynastic Egypt, the most common tomb structure—used by the upper level of society, the King's family and relatives—was the mastaba, a flat-topped, onestory building with slanted walls erected above an underground burial chamber (see "Mastaba to Pyramid," page 56). Mastabas were at first constructed of mud brick, but toward the end of the Third Dynasty (c. 2650–2575 BCE), many incorporated cut stone, at least as an exterior facing.

In its simplest form, the mastaba contained a **serdab**, a small, sealed room housing the *ka* statue of the deceased, and

a chapel designed to receive mourning relatives and offerings. A vertical shaft dropped from the top of the mastaba down to the actual burial chamber, where the remains of the deceased reposed in a **sarcophagus** (a coffin), surrounded by appropriate grave goods. This chamber was sealed off after interment. Mastabas might have numerous underground burial chambers to accommodate whole families, and mastaba burial remained the standard for Egyptian elites for centuries.

THE NECROPOLIS. The kings of the Third Dynasty, such as Djoser, devoted huge sums to the design, construction, and decoration of extensive funerary complexes. These structures tended to be grouped together in a necropolis—literally, a "city of the dead"—at the edge of the desert on the west bank of the Nile, for the land of the dead was believed to be in the direction of the setting sun. Two of the most extensive of these early necropolises are at Saqqara and Giza, just outside modern Cairo.

DJOSER'S COMPLEX AT SAQQARA. For his tomb complex at Saqqara, the Third Dynasty King Djoser (c. 2650–2631 BCE) commissioned the earliest known monumental architecture in Egypt (FIG. 3–4). The designer of the complex was Imhotep, the highly educated prime minister who served as one of Djoser's chief advisers. Imhotep is the first architect in history known by name. His name, together with the king's, is inscribed on the base of a statue of Djoser found near the step pyramid.

Elements of Architecture

MASTABA TO PYRAMID

s the gateway to the afterlife for Egyptian kings and members of the royal court, the Egyptian burial structure began as a low rectangular mastaba with an internal *serdab* (the room where the *ka* statue was placed) and chapel. Then a mastaba with attached chapel and *serdab* (not shown) was the custom. Later, mastaba forms of decreasing size were stacked over an underground burial chamber to form the step pyramid. The culmination of the Egyptian burial chamber is the pyramid, in which the actual burial site may be within the pyramid—not below ground—with false chambers, false doors, and confusing passageways to foil potential tomb robbers.

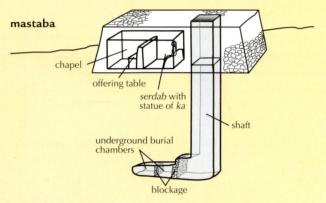

stepped pyramid

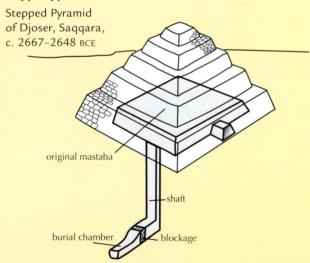

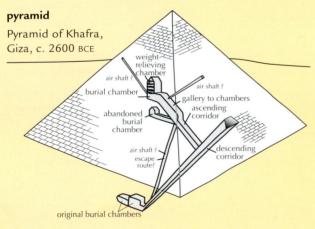

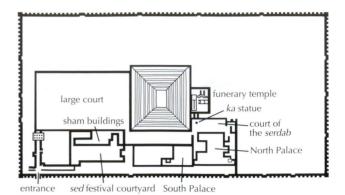

3–4 □ PLAN OF DJOSER'S FUNERARY COMPLEX, SAQQARA Third Dynasty, c. 2630–2575 BCE.

Situated on a level terrace, this huge commemorative complex—some 1,800 feet (544 m) long by 900 feet (277 m) wide—was designed as a replica in stone of the wood, brick, and reed buildings of Djoser's actual palace compound. Inside the wall, the step pyramid dominated the complex. Underground apartments copied the layout and appearance of rooms in the royal palace.

It appears that Imhotep first planned Djoser's tomb as a single-story mastaba, then later decided to enlarge upon the concept (FIG. 3–5). In the end, what he produced was a step pyramid formed by six mastaba-like elements of decreasing size placed on top of each other. Although the final structure resembles the ziggurats of Mesopotamia, it differs in both its intention (as a stairway to the sun god Ra) and its purpose (protecting a tomb). A 92-foot shaft descended from the original mastaba enclosed within the pyramid. A descending corridor at the base of the pyramid provided an entrance from outside to a granite-lined burial vault.

The adjacent funerary temple, where priests performed their final rituals before placing the king's mummified body in its tomb, was used for continuing worship of the dead king. In the form of his ka statue, Djoser intended to observe these devotions through two peepholes in the wall between the serdab and the funerary chapel. To the east of the pyramid, buildings filled with debris represent actual structures in which the dead king could continue to observe the sed rituals that had ensured his long reign. In a pavilion near the entrance to the complex in the southeast corner, his spirit could await the start of ceremonies he had performed in life, such as the running trials of the sed festival. These would take place in a long outdoor courtyard within the complex. After proving himself, the king would proceed first to the South Palace and then to the North Palace, to be symbolically crowned once again as ruler of Egypt's Two Lands.

THE OLD KINGDOM, c. 2575-2150 BCE

The Old Kingdom was a time of social and political stability despite increasingly common military excursions to defend the borders. The growing wealth of ruling families of the period is reflected in the size and complexity of the tomb structures they commissioned for themselves. Court sculptors

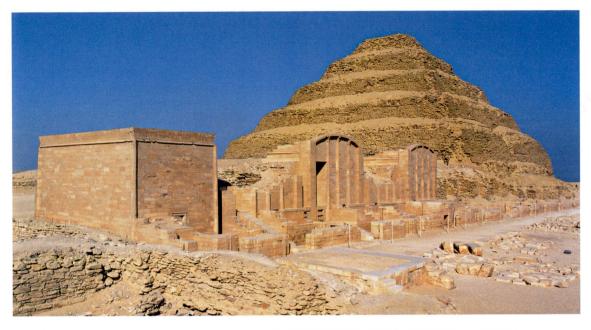

3-5 | THE STEP PYRAMID, AND SHAM BUILDINGS. FUNERARY COMPLEX OF DJOSER, SAQQARA Limestone, height of pyramid 204′ (62 m).

were regularly called on to create life-size, even colossal royal portraits in stone. Kings were not the only patrons of the arts, however. Upper-level government officials also could afford to have tombs decorated with elaborate carvings.

Architecture: The Pyramids at Giza

The architectural form most closely identified with Egypt is the true pyramid with a square base and four sloping triangular faces. The first such structures were erected in the Fourth Dynasty (2575–2450 BCE). The angled sides of the pyramids may have been meant to represent the slanting rays of the sun, for inscriptions on the walls of pyramid tombs built in the Fifth and Sixth dynasties tell of deceased kings climbing up the rays to join the sun god Ra.

Egypt's most famous funerary structures are the three great pyramid tombs at Giza (see Introduction, Fig. 1,; and FIG. 3–6). These were built by the Fourth Dynasty kings Khufu (ruled c. 2551–2528 BCE), Khafre (ruled 2520–2494 BCE), and

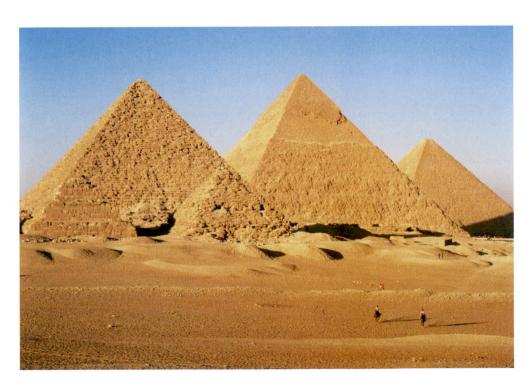

3-6 | GREAT PYRAMIDS, GIZA

Fourth Dynasty, c. 2575-2450 BCE. Erected by (from the left) Menkaure, Khafre, and Khufu. Granite and limestone, height of pyramid of Khufu, 450' (137 m).

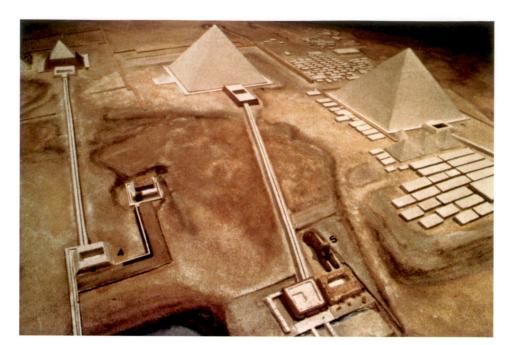

3−7 | MODEL OF THE GIZA PLATEAU

From left to right: the temples and pyramids of Menkaure, Khafre, and Khufu. (Number 4 is the Valley Temple of Menkaure; number 5 is the Valley Temple and Sphinx of Khafre.)

Prepared for the exhibition "The Sphinx and the Pyramids: One Hundred Years of American Archaeology at Giza," held in 1998 at the Harvard University Semitic Museum, Harvard University Semitic Museum, Cambridge, Massachusetts.

Menkaure (ruled c. 2490–2472 BCE). The Greeks were so impressed by these monuments—pyramid is a Greek term—that they numbered them among the world's architectural marvels. The early Egyptians referred to the Giza pyramids as" Horizon of Khufu," "Great is Khafre," and "Divine is Menkaure," thus acknowledging the desire of these rulers to commemorate themselves as divine beings.

Khufu, which covers thirteen acres at its base. It was originally finished with a thick veneer of polished limestone that lifted its apex to almost 481 feet, some 30 feet above the present summit. The pyramid of Khafre, the only one of the three that still has a little of its veneer at the top, is slightly smaller than Khufu's. Menkaure's pyramid is considerably smaller than the other two and had a polished red granite base.

The site was carefully planned to follow the sun's east—west path. Next to each of the pyramids was a funerary temple connected by a causeway, or elevated road, to a valley temple on the bank of the Nile (FIG. 3–7). When a king died, his body was embalmed and ferried west across the Nile from the royal palace to his valley temple, where it was received with elaborate ceremonies. It was then carried up the causeway to his funerary temple and placed in its chapel, where family members presented offerings of food and drink, and priests performed rites in which the deceased's spirit consumed a meal. Finally, the body was entombed in a vault deep inside the pyramid.

The designers of the pyramids tried to ensure that the king and his tomb would never be disturbed. Khufu's builders

placed his tomb chamber in the very heart of the mountain of masonry, at the end of a long, narrow, steeply rising passageway, sealed off after the burial with a 50-ton stone block. Three false passageways further obscured the location of the tomb.

Khafre's funerary complex is the best preserved. In the valley temple, massive blocks of red granite form walls and piers supporting a flat roof (FIG. 3–8). Tall, narrow windows act as a clerestory in the upper walls, letting in light which reflects off the polished alabaster floor (see "Post-and-Lintel and Corbel Construction," page 14).

Constructing the Pyramids. The pyramid was a triumph of engineering and design. Constructing one was a formidable undertaking. A large workers' burial ground discovered at Giza attests to the huge labor force that had to be assembled, housed, and fed. Most of the cut stone blocks—each weighing an average of 2.5 tons—used in building the Giza complex were quarried either on the site or nearby. Teams of workers transported them by sheer muscle power, employing small logs as rollers or pouring water on sand to create a slippery surface over which they could drag the blocks on sleds.

Scholars and engineers have various theories about how the pyramids were raised. Some ideas have been tested in computerized projections and a few models on a small but representative scale have been constructed. The most efficient means of getting the stones into position might have been to build a temporary, gently sloping ramp around the body of the pyramid as it grew higher. The ramp could then be dismantled as the stones were smoothed out or slabs of veneer were laid.

3–8 ↑ VALLEY TEMPLE OF KHAFRE
Giza. Old Kingdom, c. 2570–2544 BCE. Limestone and red
granite. Commissioned by Khafre.

The architects who oversaw the building of such massive structures were capable of the most sophisticated mathematical calculations. They oriented the pyramids to the points of the compass and may have incorporated other symbolic astronomical calculations as well. There was no room for trial and error. The huge foundation layer had to be absolutely level and the angle of each of the slanting sides had to remain constant so that the stones would meet precisely in the center at the top.

Sculpture

Egyptian artists were adept at creating lifelike threedimensional figures. In contrast to the cylindrical images of early Mesopotamian sculpture, their forms—compact, solid, and blocklike—express a feeling of strength and permanence, and address the practical difficulties of carving hard stone such as diorite.

PORTRAIT OF KHAFRE. As was the custom, Khafre commissioned many portraits of himself. His most famous image is the Great Sphinx, just behind his valley temple: a colossal monument some 65 feet tall that combines his head with the long body of a crouching lion (SEE FIG. 1, Introduction). In an over–life-size statue, one of several discovered inside his valley temple, Khafre was portrayed as an enthroned king (FIG. 3–9). sitting erect on a elegant but simple throne. The falcon god Horus perches on the back of the throne, protectively enfolding the king's head with his wings (FIG. 3–10).

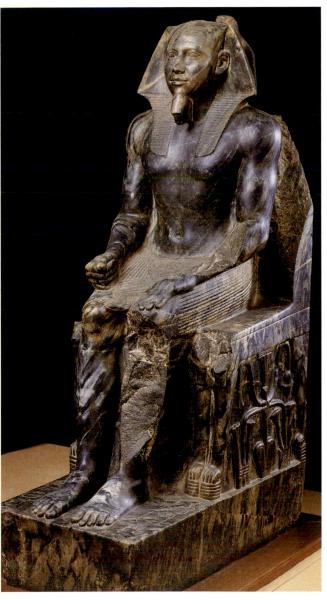

3–9 | KHAFRE Giza, Valley Temple of Khafre. Fourth Dynasty (ruled c. 2520–2494 BCE). Anorthosite gneiss, height 5′ 6¾″ (1.68 m).Egyptian Museum, Cairo.

3-IO | KHAFRE, DETAIL OF HEAD

Lions—symbols of regal authority—form the throne's legs, and the intertwined lotus and papyrus plants beneath the seat symbolize the king's power over Upper (lotus) and Lower (papyrus) Egypt.

Khafre wears the traditional royal costume: a short, pleated kilt, a linen headdress with the cobra symbol of Ra, and a false beard symbolic of royalty (see "Egyptian Symbols," page 52). He holds a cylinder, probably a rolled piece of cloth. The figure conveys a strong sense of dignity, calm, and above all permanence. The arms are pressed tight to the body, and the body is firmly anchored in the block. The statue was carved in an unusual stone: anorthosite gneiss (related to diorite), imported from Nubia. This stone produces a rare optical effect: In sunlight, it glows a deep blue, the celestial color of Horus. Through skylights in the valley temple, the sun would have illuminated the alabaster floor and the figure, creating a blue radiance.

MENKAURE. Dignity, calm, and permanence also characterize the beautiful double portrait of Khafre's heir King Menkaure and a queen, probably Khamerernebty II, discovered in Menkaure's valley temple (FIG. 3–II). The sculptor's handling of the composition of this work, however, makes it far less austere than Khafre's statue. The couple's separate figures, close in size, are joined by the stone out of which they emerge, forming a single unit. They are further united by the queen's symbolic gesture of embrace. Her right hand comes from behind to lie gently against his ribs, and her left hand rests on his upper arm.

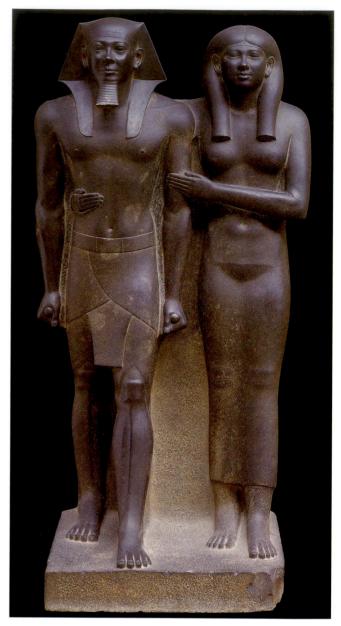

3–II | MENKAURE AND A QUEEN
Perhaps his wife Khamerernebty, from Giza. Fourth
Dynasty (ruled 2490–2472 BCE). Graywacke with traces of red and black paint, height 54½" (142.3 cm). Museum of Fine Arts, Boston.

Harvard University-MFA Expedition

The king, depicted in accordance with the Egyptian ideal as an athletic, youthful figure nude to the waist and wearing the royal kilt and headcloth, stands in a typically Egyptian balanced pose, striding with the left foot forward, his arms straight at his sides, and his fists clenched over cylindrical objects. His equally youthful queen, taking a smaller step forward, echoes his pose. The sculptor exercised remarkable skill in rendering her sheer, close-fitting garment, which clearly reveals the curves of her body. The time-consuming task of polishing this double statue was never completed, indicating that the work may have been undertaken only a few years before Menkaure's death in about 2472 BCE. Traces

of red paint remain on the king's face, ears, and neck (male figures were traditionally painted red), as do traces of black on the queen's hair.

PEPY II AND HIS MOTHER. In the Fifth and Sixth dynasties more generic figures appear, and inscriptions personalize the images. In a statue representing Pepy II (ruled c. 2246–2152 BCE), the king wears the royal kilt and headdress but is reduced to the size of a child seated on his mother's lap (FIG. 3–12). The work pays homage to Queen Ankhnes-meryre, who wears a vulture-skin headdress linking her to the goddess Nekhbet and proclaiming her royal blood. The queen is inscribed "Mother of the King of Upper and Lower Egypt, the god's daughter, the revered one, beloved of Khnum Ankhnesmeryra."

If Pepy II inherited the throne at the age of six, as the Egyptian priest and historian Manetho claimed, then the queen may have acted as regent until he was old enough to rule alone. The sculptor placed the king at a right angle to his mother, thus providing two "frontal" views—the queen fac-

ing forward, the king to the side. In another break with convention, he freed the queen's arms and legs from the stone block of the throne, giving her figure greater independence.

THE SEATED SCRIBE. Old Kingdom sculptors produced figures not only of kings but also of less prominent people. Such works—for example, the *Seated Scribe* from early in the Fifth Dynasty (FIG. 3–13)—are often more lively and less formal than royal portraits. Other early Fifth Dynasty statues found at Saqqara have a similar round head and face, alert expression, and cap of close-cropped hair. This statue was discovered near the tomb of a government official named Kai, and there is some evidence that it may be a portrait of Kai himself.

The scribe's sedentary vocation has made his body a little flabby, a condition that advertised a life freed from hard physical labor. A comment found in a tablet, probably copied from a book of instruction, emphasizes this interpretation: "Become a scribe so that your limbs remain smooth and your hands soft and you can wear white and walk like a man of

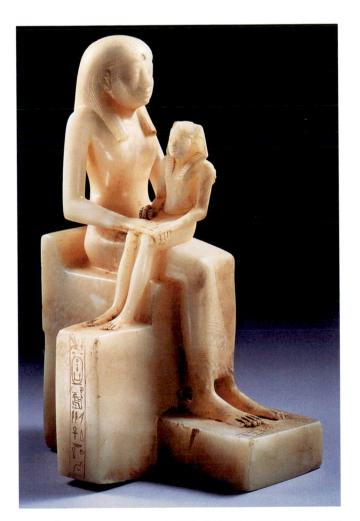

3–12 | PEPY II AND HIS MOTHER, QUEEN ANKHNES-MERYRE Sixth Dynasty, c. 2323–2152 BCE (ruled. c. 2246–2152 BCE). Egyptian alabaster, height $15\% \times 9^{1}\%_6$ " (39.2 \times 24.9 cm). The Brooklyn Museum of Art, New York. Charles Edwin Wilbour Fund (39.119)

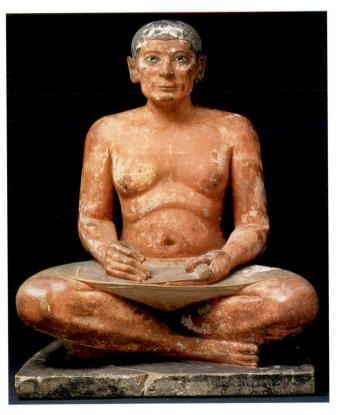

3–13 | SEATED SCRIBE found near the tomb of Kai, Saqqara. Fifth Dynasty, c. 2450–2325 BCE. Painted limestone with inlaid eyes of rock crystal, calcite, and magnesite mounted in copper, height 21" (53 cm). Musée du Louvre, Paris.

standing whom [even] courtiers will greet" (cited in Strouhal, page 216). He sits holding a papyrus scroll partially unrolled on his lap, his right hand clasping a now-lost reed pen, and his face reveals a lively intelligence. Because the pupils are slightly off-center in the irises, the eyes give the illusion of being in motion, as if they were seeking contact.

A high-ranking scribe with a reputation as a great scholar could hope to be appointed to one of several "houses of life," where lay and priestly scribes copied, compiled, studied, and repaired valuable sacred and scientific texts. Completed texts were placed in related institutions, some of the earliest known libraries.

Tomb Decoration

To provide the *ka* with the most pleasant possible living quarters for eternity, wealthy families often had the interior walls and ceilings of their tombs decorated with paintings and reliefs. Much of this decoration was symbolic or religious, especially in royal tombs, but it could also include a wide variety of everyday events or scenes recounting momentous events in the life of the deceased. Tombs therefore provide a wealth of information about ancient Egyptian culture.

TI AND THE HIPPOPOTAMUS HUNT. A scene in the large mastaba of a Fifth Dynasty government official named Ti—a

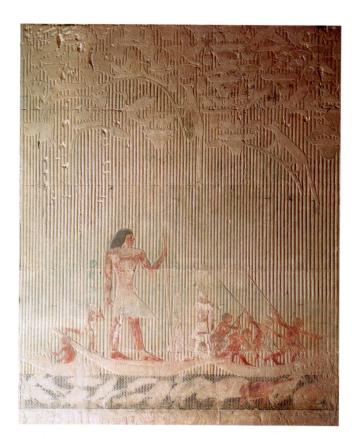

3–14 | **TI WATCHING A HIPPOPOTAMUS HUNT**Tomb of Ti, Saqqara. Fifth Dynasty, c. 2450–2325 BCE.
Painted limestone relief, height approx. 45″ (114.3 cm).

commoner who had achieved great power at court and amassed sufficient wealth to build an elaborate home for his immortal spirit—shows him watching a hippopotamus hunt, an official duty of members of the court (FIG. 3–14). It was believed that Seth, the god of darkness, disguised himself as a hippo. Hippos were thought to be destructive: They wandered into fields, damaging crops. Tomb depictions of such hunts therefore illustrated the valor of the deceased and the triumph of good over evil.

The artists who created this painted limestone relief employed a number of established conventions. They depicted the river as if seen from above, rendering it as a band of parallel wavy lines below the boats. The creatures in the river, however—fish, a crocodile, and hippopotami—are shown in profile for easy identification. The shallow boats carrying Ti and his men skim along the surface of the water unhampered by the papyrus stalks, shown as parallel vertical lines, which choke the marshy edges of the river. At the top of the panel, where Egyptian convention placed background scenes, several animals, perhaps foxes, are seen stalking birds among the papyrus leaves and flowers. The erect figure of Ti, rendered in the traditional twisted pose, looms over all. The actual hunters, being of lesser rank and engaged in more strenuous activities, are rendered more realistically (see "Egyptian Painting and Sculpture," page 64).

THE MIDDLE KINGDOM, c. 1975–c. 1640 BCE

The collapse of the Old Kingdom, with its long succession of powerful kings, was followed by roughly 150 years of political turmoil traditionally referred to as the First Intermediate Period. The provinces grew in power, essentially establishing independent rule, and political and military battles dominated the period. About 2010 BCE, three successive kings named Mentuhotep (Eleventh Dynasty, c. 2010–c. 1938? BCE), gained power from Thebes, and the country was reunited under Nebhepetre Menthutop. He reasserted royal power and founded the centralized Twelfth Dynasty.

The Middle Kingdom was another high point in Egyptian history, a period with a powerful, unified government. Arts and writing flourished, and literary and artistic efforts reflect a burgeoning awareness of the political upheaval the country had undergone. During the Middle Kingdom, Egypt's kings also strengthened the military: They expanded the borders and maintained standing armies to patrol these borders, especially in lower Nubia, south of present-day Aswan. By the Thirteenth Dynasty, however, political authority once again became less centralized. A series of short-lived kings succeeded the strong rulers of the Twelfth Dynasty, and an influx of foreigners, especially in the Delta, weakened the King's control over the nation.

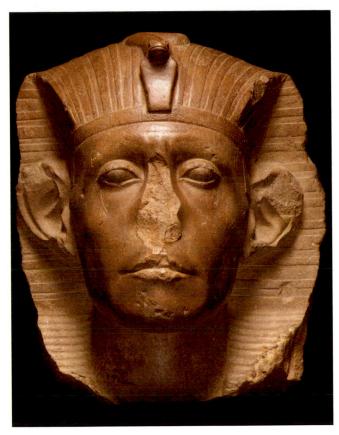

3–15 | HEAD OF SENUSRET III

Twelfth Dynasty, c. 1938–1755 BCE (ruled c. 1836–1818 BCE).

Yellow quartzite, height 17½ × 13½ × 17″ (45.1 × 34.3 × 43.2 cm). The Nelson-Atkins Museum of Art, Kansas City, Missouri.

Purchase: Nelson Trust (62-11)

Sculpture: Royal Portraits

Some royal portraits from the Middle Kingdom express a special awareness of the hardship and fragility of human existence. The statue of **SENUSRET III** (FIG. 3–15), a king of the Twelfth Dynasty, who ruled from c. 1836 to 1818 BCE, reflects this new sensibility. Senusret was a dynamic king and successful general who led four military expeditions into Nubia, overhauled the central administration at home, and did much toward regaining control over the country's increasingly independent nobles. His portrait statue seems to reflect not only his achievements, but also something of his personality and even his inner thoughts. He appears to be a man wise in the ways of the world but lonely, saddened, and burdened by the weight of his responsibilities.

Old Kingdom figures such as *Khafre* (SEE FIG. 3–9) gaze into eternity confident and serene, whereas *Senusret III* shows a monarch preoccupied and emotionally drained. Deep creases line his sagging cheeks, his eyes are sunken, his eyelids droop, and his jaw is sternly set. Intended or not, this image betrays a pessimistic view of life, a degree of distrust similar to that reflected in the advice given by Amenemhat I, Senusret

III's great-great-grandfather and the founder of the Twelfth Dynasty, to his son Senusret I (cited in Breasted, page 231):

Fill not thy heart with a brother,

Know not a friend,

Nor make for thyself intimates, ...

When thou sleepest, guard for thyself thine own heart;

For a man has no people [supporters],

In the day of evil.

Tomb Architecture and Funerary Objects

During the Eleventh and Twelfth dynasties, members of the royal family and high-level officials commissioned a new form of tomb. Rock-cut tombs were excavated in the faces of cliffs, such as those in the necropolis at Beni Hasan on the east bank of the Nile. The chambers and their ornamental columns, lintels, false doors, and niches were all carved out of solid rock (FIG. 3–16). Each one was like a single, complex piece of sculpture that was also usually painted. A typical Beni Hasan tomb included an entrance portico, a main hall, and a shrine with a burial chamber under the offering chapel. Rock-cut tombs at other places along the Nile exhibit variations on this simple plan.

Because the afterlife was always open to danger, ancient Egyptian tombs were equipped with a variety of objects meant to meet not only practical needs—such as actual food, clothing, and furniture—but also reliefs, paintings, and other objects designed to insure the safety and well-being of the individual in perpetuity. Jewelry or amulets with protective or magical functions, figures of deities, and miniature models of buildings, servants, and soldiers all insured that the deceased would experience a life of pleasure and security.

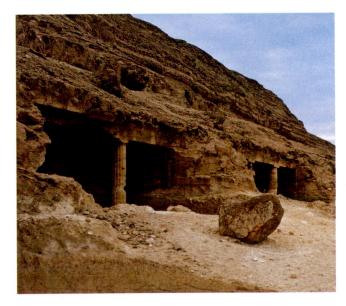

3-16 | ROCK-CUT TOMBS, BENI HASAN Twelfth Dynasty, c. 1938–1755 BCE. At the left is the entrance to the tomb of a provincial governor and the commander-in-chief Amenemhat.

Technique

EGYPTIAN PAINTING AND SCULPTURE

ainting usually relies on color and line for its effect, and relief sculpture usually depends on the play of light and shadow alone, but in Egypt, relief sculpture was also painted. Nearly every inch of the walls and closely spaced columns of Egyptian tombs and temples was adorned with colorful scenes and hieroglyphic texts. Until the Eighteenth Dynasty (c.1539–1292 BCE), the only colors used were black, white, red, yellow, blue, and green. Later, colors were mixed and thinned to produce a wide variety of shades. Modeling might be indicated by overpainting lines in a contrasting color. As more colors were added, the primacy of line was never challenged.

With very few exceptions, figures, scenes, and texts were composed in bands, or registers. Usually the base line at the bottom of each register represented the ground, but determining the sequence of images can be a problem because the registers can run horizontally or vertically.

Surfaces to be painted had to be smooth, so in some cases a coat of plaster was applied. The next step was to lay out the registers with painted lines and draw the appropriate grid (SEE FIG. 3–5). In the unfinished Eighteenth Dynasty tomb of Horemheb in the Valley of the

UNFINISHED RELIEFTomb of Horemheb, 18th Dynasty, Valley of the Kings, west bank of the Nile, Egypt.

Kings, the red base lines and horizontals of the grid are clearly visible. The general shapes of the hieroglyphs have also been sketched in red. The preparatory drawings

from which carvers worked were black. Egyptian artists worked in teams,

and each member had a particular skill. The sculptor who executed the carving seen here was following someone else's drawing. Had there been time to finish the tomb, other hands would have smoothed the surface of this limestone relief, and still others would have made fresh drawings to guide the artists assigned to paint it.

When carving a freestanding statue, sculptors approached each face of the block as though they were simply carving a relief. A master drew the image full face on the front of the block and in profile on the side. Sculptors cut straight back from each drawing, removing the superfluous stone and literally "blocking out" the figure. Then the three-dimensional shapes were refined, surface details were added, and finally the statue was polished and details were painted.

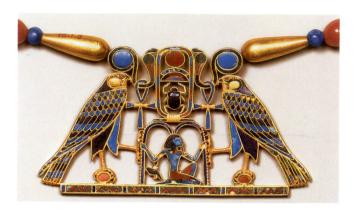

3–I7 | PECTORAL OF SENUSRET II
Tomb of Princess Sithathoryunet, el-Lahun. Twelfth Dynasty, c. 1938–1755 (ruled c. 1842–1837 BCE). Gold and semi-precious stones, length 3¼" (8.2 cm).

THE SENUSRET PECTORAL. Royal dress, especially jewelry,

The Metropolitan Museum of Art, New York.
Purchase, Rogers Fund and Henry Walters Gift, 1916 (16.1.3)

was very splendid, as shown by a pectoral, or chest ornament (FIG. 3–17) found in the funerary complex of Senusret II at el-Lahun, in the tomb of the king's daughter Sithathoryunet. The design, executed in gold and inlaid with semiprecious stones, incorporates the name of Senusret II and a number of familiar symbols. Two Horus falcons perch on its base, and above their heads is a pair of coiled cobras, symbols of Ra, wearing the ankh, the symbol of life. Between the two cobras, a cartouche—an oval formed by a loop of rope—contains the hieroglyphs of the king's name. The sun disk of Ra appears at the top, and a scarab beetle, the hieroglyph *khepri* (a symbol of Ra and rebirth), is at the bottom. Below the cartouche, a kneeling male figure helps the falcons sup-

port a double arch of notched palm ribs, a hieroglyphic sym-

bol meaning "millions of years." Decoded, the pectoral's

combination of images yields the message: "May the sun god

give eternal life to Senusret II."

THE FAIENCE HIPPO. Middle Kingdom art of all kinds and in all mediums, from official portrait statues to delicate bits of jewelry, exhibits the artists' talent for well-observed, accurate detail. A hippopotamus figurine discovered in the Twelfth Dynasty tomb of a governor named Senbi, for example, has all the characteristics of the beast itself: the rotund body on stubby legs, the massive head with protruding eyes, the tiny ears and characteristic nostrils (FIG. 3–18). The figurine is an example of Egyptian faience, with its distinctive lustrous glaze (see "Glassmaking and Egyptian Faience," page 70).

The artist made the hippo the watery blue of its river habitat, then painted lotus blossoms on its flanks, jaws, and head, giving the impression that the creature is standing in a tangle of aquatic plants. Such figures were often placed in tombs, especially of women, since the goddess Taweret, protector of female fertility and childbirth, was a composite fig-

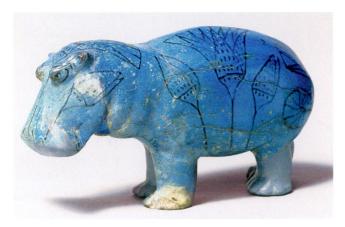

3–18 | HIPPOPOTAMUS
Tomb of Senbi (Tomb B.3), Meir. Twelfth Dynasty, c. 1938–1755 BCE. Faience, length 7½" (20 cm).
The Metropolitan Museum of Art, New York.
Gift of Edward S. Harkness, 1917 (17.9.1)

ure, with the head of a hippo. However, the hippo could also be a symbol of evil, especially in men's tombs (see the discussion of *Ti Watching a Hippotamus Hunt*, FIG. 3–14).

REPRESENTATIONS OF DAILY LIFE. Funeral offerings represented in statues and paintings would be available for the deceased's use through eternity. On a funeral stele of a man named Amenemhat I (FIG. 3–19), a table heaped with food is watched over by a young woman named Hapi. The family sits together on a lion-legged bench. Everyone wears green jewelry and white linen garments, produced by the women in

Sequencing Events KEY EGYPTIAN RULERS

с. 2650-2631 все	Djoser
с. 2551–2528 все	Khufu
с. 2520-2494 все	Khafre
c. 2490-2472 BCE	Menkaure
с. 1836–1818 все	Senusret III
с. 1473–1458 все	Hatshepsut
с. 1353–1336 все	Amenhotep IV (Akhenaten)
с. 1332–1322 все	Tutankhamun (Tutankhaten)
с. 1279-1213 все	Rameses II

the household. Amenemhat (at the right) and his son Antef link arms and clasp hands while Iyi holds her son's arm and shoulder with a firm but tender gesture. The hieroglyphs identify everyone and preserve their prayers to the god Osiris.

Tomb art reveals much about domestic life in the Middle Kingdom. Wall paintings, reliefs, and small models of houses and farm buildings—complete with figurines of workers and animals—reproduce everyday scenes. Many of these models survive because they were made of inexpensive materials of no interest to early grave robbers. One from Thebes, made of

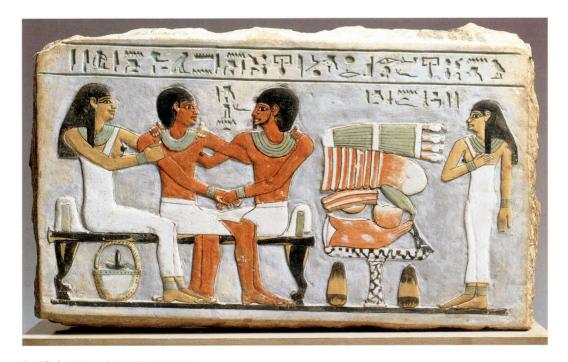

3–19 | STELE OF AMENEMHAT I Assasif. Twelfth Dynasty, c. 1938–1755 (ruled c. 1938–1908 BCE). Painted limestone, $11\times15''$ (30 \times 50 cm). Egyptian Museum, Cairo. The Metropolitan Museum of Art, New York. Excavation 1915–16.

wood, plaster, and copper, from about 1975 to 1940 BCE, depicts the home of Meketre, the owner of the tomb (FIG. 3–20). Colorful columns carved to resemble bundles of papyrus support the flat roof of a portico that opens onto a garden. Trees surround a central pool such as only the wealthy could afford. The shade and water provided natural cooling and the pool was probably stocked with fish.

Town Planning

Although Egyptians used durable materials in the construction of tombs, they built their own dwellings with simple mud bricks, which have either disintegrated over time or been carried away for fertilizer by farmers. Only the foundations of these dwellings now remain.

Archaeologists have unearthed the remains of Kahun, a town built by Senusret II (SEE FIG. 3–17) for the many officials, priests, and workers in his court (FIG. 3–21). The plan offers a unique view of the Middle Kingdom's social structure. Parallel streets laid out with rectangular blocks divided into lots for

homes and other buildings reflect three distinct economic and social levels. The houses of priests, court officials, and their families were large and comfortable, with private living quarters and public rooms grouped around central courtyards. The largest had as many as seventy rooms spread out over half an acre. Workers and their families made do with small, five-room row houses built back to back along narrow streets.

A New Kingdom workers' village which was discovered at Deir el-Medina on the west bank of the Nile near the Valley of the Kings, has provided us with detailed information about the lives of the people who created the royal tombs. Workers lived together here under the rule of the king's chief minister. At the height of activity there were forty-eight teams of builders and artists. During a ten-day week, they worked for eight days and had two days off, and also participated in many religious festivals. They lived a good life with their families, were given clothing, sandals, grain, and firewood by the king, and had permission to raise livestock and birds and to tend a garden. The residents had an elected council, and the

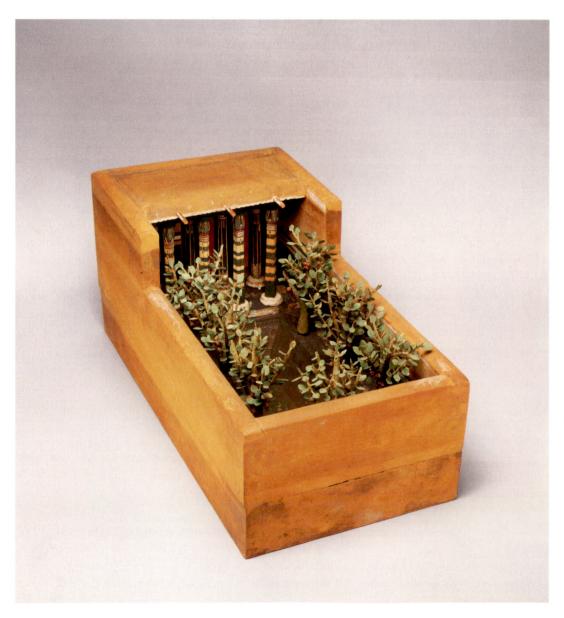

3–20 | MODEL OF A HOUSE AND GARDEN Tomb of Meketre, Deir el-Bahi. Eleventh Dynasty, c. 2125–2055 BCE. Painted and plastered wood and copper, length 33" (87 cm). The Metropolitan Museum of Art, New York.

Purchase, Rogers Fund and Edward S. Harkness Gift, 1920 (20.3.13)

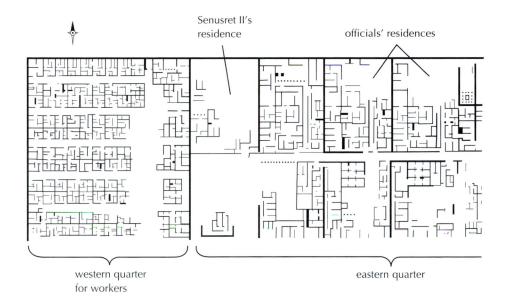

3−21 | PLAN OF THE NORTHERN SECTION OF KAHUN
Built during the reign of Senusret II near Modern el-Lahun. Dynasty 12, c. 1880–1874 BCE.

many written records that survive suggest a literate and litigious society that required many lawyers and scribes. Because the men were away for most of the week working on the tombs, women had a prominent role in the town. The remaining letters, many of which were between women, suggest the women may have been able to read and write.

THE NEW KINGDOM, c. 1539–1075 BCE

During the Second Intermediate period—another turbulent interruption in the succession of dynasties ruling a unified country—an eastern Mediterranean people called the Hyksos invaded Egypt's northernmost regions. Finally, the kings of the Eighteenth Dynasty (c. 1539–1292 BCE) regained control of the entire Nile region from Nubia in the south to the Mediterranean Sea in the north, restoring the country's political and economic strength. Roughly a century later, one of the same dynasty's most dynamic kings, Thutmose III (ruled 1479–1425 BCE), extended Egypt's influence along the eastern Mediterranean coast as far as the region of present-day Syria. His accomplishment was the result of fifteen or more military campaigns and his own skill at diplomacy.

Thutmose III was the first ruler to refer to himself as "pharaoh," a term that literally meant "great house." Egyptians used it in the same way that Americans say "the White House" to mean the current U. S. president and his staff. The successors of Thutmose III continued to use the term, and it ultimately found its way into the Hebrew Bible—and modern usage—as the name for the kings of Egypt.

By the beginning of the fourteenth century BCE, the most powerful Near Eastern kings acknowledged the rulers of Egypt as their equals. Marriages contracted between

Egypt's ruling families and Near Eastern royalty helped to forge a generally cooperative network of kingdoms in the region, stimulating trade and securing mutual aid at times of natural disaster and outside threats to established borders. Over time, however, Egyptian influence beyond the Nile diminished, and the power of Egypt's kings began to wane.

The Great Temple Complexes

At the height of the New Kingdom, rulers undertook extensive building programs along the entire length of the Nile. Their palaces, forts, and administrative centers disappeared long ago, but remnants of temples and tombs of this great age have endured. Even as ruins, Egyptian architecture and sculpture attest to the expanded powers and political triumphs of the builders (FIG. 3–22). Early in this period, the priests of the god Amun at Thebes, Egypt's capital city throughout most of the New Kingdom, had gained such dominance that worship of the Theban triad of deities—Amun, his wife Mut, and their son Khons—had spread throughout the country. Temples to these and other gods were a major focus of royal patronage, as were tombs and temples erected to glorify the kings themselves.

THE NEW KINGDOM TEMPLE PLAN. As the home of the god, an Egyptian temple originally had the form of a house—a simple, rectangular, flat-roofed building preceded by a court-yard and gateway. The temples and builders of the New Kingdom enlarged and multiplied these elements. The gateway became a massive pylon with tapering walls; the semipublic courtyard was surrounded by columns (a peristyle court); the temple itself included an outer hypostyle hall (a vast hall filled with columns), and finally inner rooms—the offering

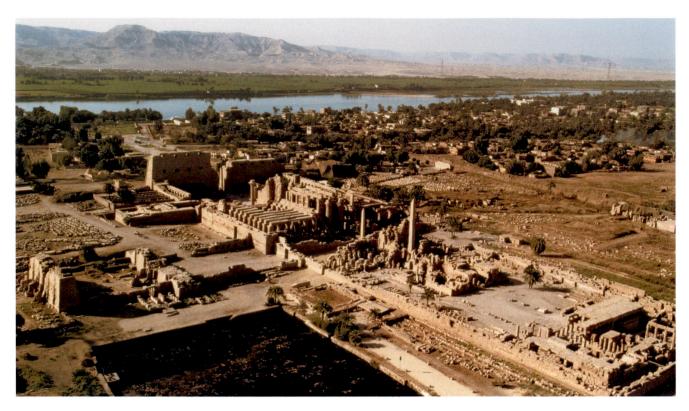

3-22 | THE RUINS OF THE GREAT TEMPLE OF AMUN AT KARNAK, EGYPT

hall and sanctuary. The design was symmetrical and axial—that is, all of its separate elements are symmetrically arranged along a dominant center line, creating a processional path.

The rooms became smaller, darker, and more exclusive as they neared the sanctuary. Only the pharaoh and the priests entered these inner rooms.

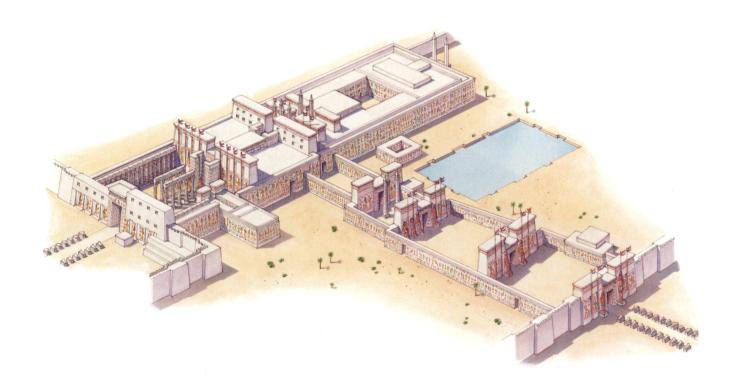

3-23 \perp reconstruction drawing of the great temple of amun at Karnak, egypt New Kingdom, c. 1579–1075 BCE.

Two temple districts consecrated primarily to the worship of Amun, Mut, and Khons arose near Thebes—a huge complex at Karnak to the north and, joined to it by an avenue of sphinxes, a more compact temple at Luxor to the south.

KARNAK. At Karnak, temples were built and rebuilt for over 1,500 years, and the remains of the New Kingdom additions to the Great Temple of Amun still dominate the landscape (FIG. 3–22). Over the nearly 500 years of the New Kingdom, successive kings renovated and expanded the Amun temple until the complex covered about 60 acres, an area as large as a dozen football fields (FIG. 3–23).

Access to the heart of the temple, a sanctuary containing the statue of Amun, was from the west (on the left side of the reconstruction drawing) through a principal courtyard, a hypostyle hall, and a number of smaller halls and courts. Pylons set off each of these separate elements. Between the Eighteenth and Nineteenth dynasty reigns of Thutmose I (ruled c. 1493-? BCE), and Rameses II (ruled c. 1279-1213 BCE), this area of the complex underwent a great deal of construction and renewal. The greater part of Pylons II through VI leading to the sanctuary (modern archaeologists have given the pylons numbers) and the halls and courts behind them were renovated or newly built and embellished with colorful wall reliefs. A sacred lake to the south of the temple, where the king and priests might undergo ritual purification before entering, was also added. In the Eighteenth Dynasty, Thutmose III erected a court and festival temple to his own glory behind the sanctuary of Amun. His great-grandson Amenhotep III (ruled 1390-1353 BCE) placed a large stone statue of the god Khepri, the scarab (beetle) symbolic of the rising sun, rebirth, and everlasting life, next to the sacred lake.

In the sanctuary, the priests washed the god's statue every morning and clothed it in a new garment. Because the god was thought to derive nourishment from the spirit of food, it was provided with tempting meals twice a day, which the priests then removed and ate themselves. Ordinary people entered the temple precinct only as far as the forecourts of the hypostyle halls, where they found themselves surrounded by inscriptions and images of kings and the god on columns and walls. During religious festivals, however, they lined the waterways, along which statues of the gods were carried in ceremonial boats, and were permitted to submit petitions to the priests for requests they wished the gods to grant.

THE GREAT HALL AT KARNAK. Between Pylons II and III at Karnak stands the enormous hypostyle hall erected in the reigns of the Nineteenth Dynasty rulers Sety I (ruled c. 1290–1279 BCE) and his son Rameses II (ruled c. 1279–1213 BCE). Called the "Temple of the Spirit of Sety, Beloved of Ptah in the House of Amun," it may have been used for royal coronation ceremonies. Rameses II referred to it as "the place where the common people extol the name of

his majesty."The hall was 340 feet wide and 170 feet long. Its 134 closely spaced columns supported a stepped roof of flat stones, the center section of which rose some 30 feet higher than the rest of the roof (FIGS. 3–24, 3–25). The columns supporting this higher part of the roof are 66 feet tall and 12 feet in diameter, with massive lotus flower capitals. On each side, smaller columns with lotus bud capitals seem to march off forever into the darkness. In each of the side walls of the higher

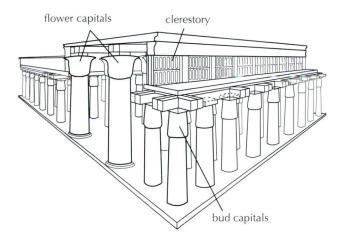

3–24 | RECONSTRUCTION DRAWING OF THE HYPOSTYLE HALL, GREAT TEMPLE OF AMUN AT KARNAK Nineteenth Dynasty, c. 1292–1190 BCE.

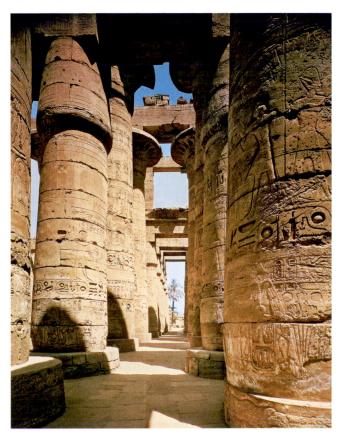

3-25 | flower and bud columns, hypostyle hall, great temple of amun at Karnak

Technique

GLASSMAKING AND EGYPTIAN FAIENCE

eating a mixture of sand, lime, and sodium carbonate or sodium sulfate to a very high temperature produces glass. The addition of other substances can make the glass transparent, translucent, or opaque and create a vast range of colors.

No one knows precisely when or where the technique of glassmaking first developed.

By the Predynastic period, Egyptians were experimenting with **faience**, a technique in which glass paste, when fired, produces a smooth and shiny opaque finish. It was used first to form small objects—mainly beads, charms, and color inlays—but later it was used as a colored glaze to ornament pottery wares and clay figurines. The first evidence of all-glass vessels and other hollow objects dates from the early New Kingdom. The first objects to be made entirely of glass in Egypt were produced with the technique known as **core glass** (see Hippopotamus, FIG. 3–18, on page 65).

A lump of sandy clay molded into the desired shape of the finished vessel was wrapped in strips of cloth, then skewered on a fireproof rod. It was then briefly dipped into a pot of molten glass. When the resulting coating of glass had cooled, the clay core was removed through the opening left by the skewer. To decorate the vessel, glassmakers frequently heated thin rods of colored glass and fused them to the surface in elegant wavy patterns, zigzags, and swirls. In the fish-shaped bottle shown here, an example of core glass from the New Kingdom, the body was created from glass tinted with cobalt, and the surface was then decorated with swags resembling fish scales using small rods of white and orange glass.

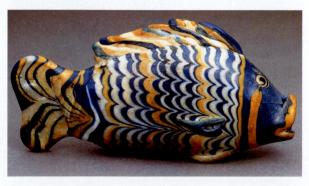

FISH-SHAPED BOTTLE

Akhetaten (present-day Tell el-Amarna). Eighteenth Dynasty, c. 1353–1336 BCE. Core glass, length 5%" (13 cm). The British Museum, London.

center section, a long row of window openings created what is known as a **clerestory**. These openings were filled with stone grillwork, so they cannot have provided much light, but they did permit a cooling flow of air through the hall. Despite the dimness of the interior, artists covered nearly every inch of the columns, walls, and cross-beams with reliefs.

The Valley of the Kings and Queens

Across the Nile from Karnak and Luxor lay Deir el-Bahri and the Valleys of the Kings and Queens. These valleys on the west bank of the Nile held the royal necropolis, and it was near the Valley of the Kings that the pharaoh Hatshepsut built her funerary temple. The dynamic Hatshepsut (Eighteenth Dynasty, ruled c. 1473–1458 BCE) is a notable figure in a

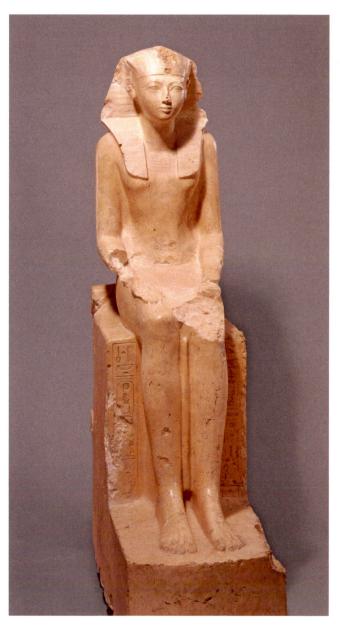

3–26 | HATSHEPSUT ENTHRONED

Deir el-Bahri. Eighteenth Dynasty
(ruled c. 1473–1458 BCE).

The Metropolitan Museum of Art, New York.

period otherwise dominated by male warrior-kings. Besides Hatshepsut, very few women ruled Egypt—they included the little-known Sobekneferu, Tausret, and much later, the notorious Cleopatra VII.

HATSHEPSUT. Of the women rulers who went down in history as "living gods" themselves and not merely "wives of gods," Hatshepsut left the greatest legacy of monuments. Among the reliefs in her funerary temple at Deir el-Bahri, she placed a depiction of her divine birth, just as a male ruler might have done. There she is portrayed as the daughter of her earthly mother, Queen Ahmose, and the god Amun.

The daughter of Thutmose I, Hatshepsut married her half brother, who then reigned for fourteen years as Thutmose II. When he died, she became regent for his underage son—Thutmose III—born to one of his concubines. Hatshepsut had herself declared "king" by the priests of Amun, a maneuver that prevented Thutmose III from assuming the

throne for twenty years. In art, she was represented in all the ways a male ruler would have been, even as a human-headed sphinx, and she was called "His Majesty." Portraits often show her in the full royal trappings; in FIG. 3–26 she wears a kilt, linen headdress, and has a bull's tail hanging from her waist (visible between her legs). In some portraits Hatshepsut even wears the false beard of a king.

HATSHEPSUT'S TEMPLE AT DEIR EL-BAHRI. The most innovative undertaking in Hatshepsut's ambitious building program was her own funerary temple at Deir el-Bahri (FIG. 3–27). The structure was not intended to be her tomb; Hatshepsut was to be buried, like other New Kingdom rulers, in the Valley of the Kings, about half a mile to the northwest. Her funerary temple was magnificently positioned against high cliffs and oriented toward the Great Temple of Amun at Karnak, some miles away on the east bank of the Nile. The complex follows an axial plan (FIG. 3–28).

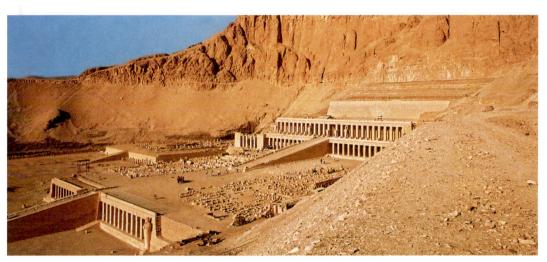

3–27 FUNERARY TEMPLE OF HATSHEPSUT, DEIR EL-BAHRI Eighteenth Dynasty, c. 1473–1458 BCE. (At the far left, ramp and base of the funerary temple of Mentuhotep III. Eleventh Dynasty, c. 2009–1997 BCE.)

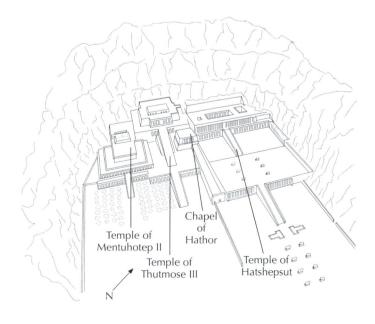

3-28 | plan of the funerary temple of hatshepsut Deir el-Bahri

A raised causeway lined with sphinxes once ran from a valley temple on the Nile to the huge open space of the first court. From there, visitors ascended a long, straight ramp flanked by pools of water to a second court where shrines to Anubis and Hathor occupy the ends of the columned porticos. Relief scenes and inscriptions in the south portico depict Hatshepsut's expedition to the exotic, half-legendary kingdom of Punt (probably located on the Red Sea or the Gulf of Aden), from which rare myrrh trees were obtained for the temple's garden terraces. On the temple's uppermost court, colossal royal statues fronted another colonnade, and behind this lay a large hypostyle hall with chapels dedicated to Hatshepsut, her father, and the gods Amun and Ra-Horakhty—a powerful form of the sun god Ra combined with Horus. Centered in the hall's back wall was the entrance to the innermost sanctuary, a small chamber cut deep into the cliff.

Hatshepsut's funerary temple, with its lively alternating of open garden spaces and grandiose architectural forms, projects an imposing image of authority. Its remarkable union of nature and architecture, with many different levels and contrasting textures—water, stone columns, trees, and cliffs—made it even more impressive in antiquity.

Akhenaten and the Art of the Amarna Period

The most unusual ruler in the history of ancient Egypt was Amenhotep IV, a king of the Eighteenth Dynasty who came to the throne about 1353 BCE. In his 17-year reign (c. 1353–1336 BCE), he radically transformed the political, spiritual, and cultural life of the country. He founded a new religion honoring a single supreme god, the life-giving sun deity Aten (represented by a disk), and changed his own name about 1348 BCE to Akhenaten ("One Who Is Effective on Behalf of Aten"). Abandoning Thebes, the capital of Egypt since the beginning of his dynasty and a city firmly in the grip of the priests of Amun, Akhenaten built a new capital much farther north, calling it Akhetaten ("Horizon of the Aten"). Using the modern name for this site, Tell el-Amarna, historians refer to his reign as the Amarna period.

PORTRAITS OF AKHENATEN. A colossal statue of Akhenaten about 16 feet tall was placed in front of pillars in the new temple to Aten that he built at Karnak when he openly challenged the state gods (FIG. 3–29). He built a huge courtyard (c. 426 by 394 feet) surrounded by porticos, oriented to the movement of the sun. It was here he placed his portraits. The sculpture's strange, softly swelling forms suggest an almost boneless, androgynous figure with long, thin arms and legs, a protruding stomach, swelling thighs, and a thin neck supporting an elongated skull. All the facial features are elongated to the point of distortion. Eyes are slits and slightly downturned, while the nearly smiling and very full lips add to our discomfort. He holds the traditional royal insignia, the flail

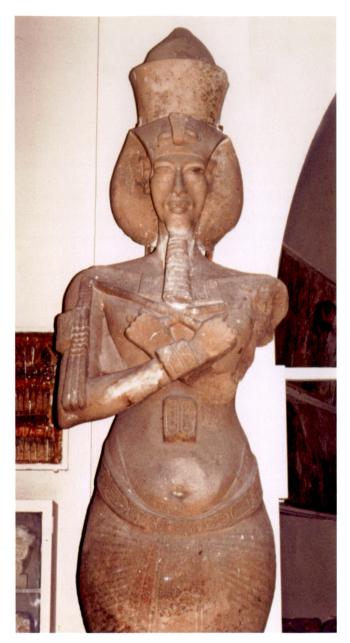

3-29 AKHENATEN, COLOSSAL FIGURE

(symbolizing protection) and the shepherd's crook (the scepter of absolute sovereignty).

THE NEW AMARNA STYLE. The king saw himself as Aten's son, and at his new capital he presided over the worship of Aten as a divine priest. His principal queen, Nefertiti, served as the divine priestess. Temples to Aten were open courtyards, where alters could be bathed in the direct rays of the sun. In art, Aten is depicted as a sun disk sending down long thin rays ending in human hands, some of which hold the *ankh*.

Akhenaten emphasized the philosophical principle of *maat*, or divine truth, and one of his kingly titles was "Living in Maat." Such concern for truth found expression in new artistic conventions. In portraits of the king, artists emphasized his unusual physical characteristics. Unlike his predecessors, and in keeping with his penchant for candor, Akhenaten commanded his artists to portray the royal family in informal situations. Even private houses in the capital city were adorned with reliefs of the king and his family, an indication that he managed to substitute veneration of the royal household for the traditional worship of families of gods, such as Amun, Mut, and Khons.

A painted relief of Akhenaten, Queen Nefertiti, and three of their daughters exemplifies the new openness and a new figural style (FIG. 3–30). In this sunken relief—where the outlines of the figures have been carved into the surface of the stone, instead of being formed by cutting away the background—the king and queen sit on cushioned thrones playing with their children. The base of the queen's throne is adorned with the stylized plant symbol of a unified Egypt (see the throne of Khafre, FIG. 3–9), which has led some historians to conclude that Nefertiti acted as co-ruler with her husband. The royal couple is receiving the blessings of Aten, whose rays end in hands that penetrate the open pavilion and hold ankhs to their nostrils, giving them the "breath of life." Other ray-hands caress the hieroglyphic inscriptions in the center.

SEQUENCING WORKS OF ART

c. 2950 BCE Narmer Palette
c. 2551–2472 BCE Great Pyramids, Giza
c. 2450–2325 BCE Seated Scribe

c. 1473–1458 BCE Funerary temple of Hatshepsut
c. 1332 BCE Funerary mask of Tutankhamun

The king holds one child and lovingly pats her head. The youngest of the three perches on Nefertiti's shoulder and tries to attract her attention by stroking her cheek. The oldest sits on the queen's lap, tugging at her mother's hand and pointing to her father. The children are nude, and the younger two have shaved heads, a custom of the time. The oldest wears the side-lock of youth, a patch of hair left to grow and hang at one side of the head in a braid. The artist has conveyed the engaging behavior of the children and the loving concern of their parents in a way not even hinted at in earlier royal portraiture in Egypt (compare FIG. 3–30 with Pepy II, FIG. 3–12.)

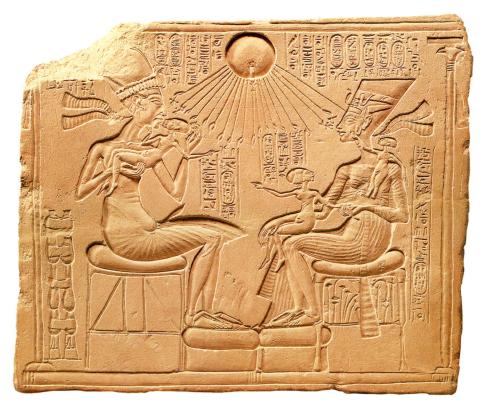

3-30 AKHENATEN AND HIS FAMILY

Akhetaten (present-day Tell el-Amarna). Eighteenth Dynasty, c. 1353–1336 BCE. Painted limestone relief, $12\% \times 15\%$ (31.1 \times 38.7 cm). Staatliche Museen zu Berlin, Preussischer Kulturbesitz, Ägyptisches Museum.

THE PORTRAIT OF TIY. Akhenaten's goals were actively supported not only by Nefertiti but also by his mother, Queen Tiy (FIG. 3–31). She had been the chief wife of the king's father, Amenhotep III (Eighteenth Dynasty, ruled c. 1390–1353 BCE), and had played a significant role in affairs of state during his reign. Queen Tiy's personality emerges from a miniature portrait head that reveals the exquisite bone structure of her dark-skinned face, with its arched brows, uptilted eyes, and slightly pouting lips.

This portrait of Tiy has existed in two versions. In the original, which may been made for the cult of her dead husband, the queen was identified with the funerary goddesses Isis and Nephthys, the sisters of Osiris. She wore a silver headdress covered with gold cobras and gold jewelry. Later, when her son had come to power and established his new religion, the portrait was altered. A brown cap covered with blue glass beads was placed over the funeral headdress. (Blue was the color of Horus, but for Tiy perhaps it was simply royal and a symbol of the sunlit sky.) A plumed crown, perhaps similar to the one worn by Nefertari (SEE FIG. 3–34), rose above the cap (the attachment is still visible). The entire sculpture would have been about one-third lifesize.

THE HEAD OF NEFERTITI. Tiy's commanding portrait contrasts sharply with a head of Nefertiti. The proportions of Nefertiti's refined, regular features, long neck, and heavy-lidded eyes appear almost too ideal to be human (FIG. 3–32). Part of the beauty of this head is the result of the artist's dra-

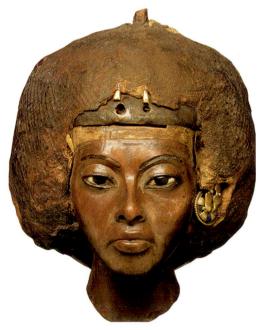

3-31 | QUEEN TIY
Kom Medinet el-Ghurab (near el-Lahun). Eighteenth Dynasty,
c. 1352 BCE. Boxwood, ebony, glass, silver, gold, lapis lazuli,
cloth, clay, and wax; height 3 ¾" (9.4 cm). Staatliche Museen
zu Berlin, Preussischer Kulturbesitz, Ägyptisches Museum.

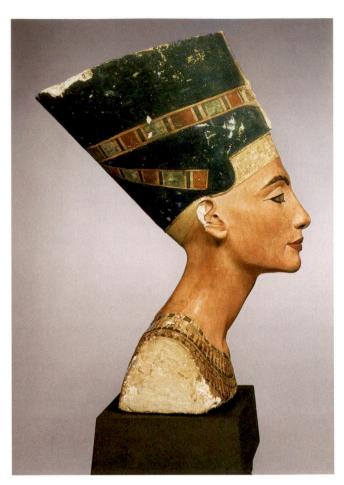

3-32 | NEFERTITI
Akhetaten (modern Tell el-Amarna). Eighteenth Dynasty, c. 1353-1336 BCE. Painted limestone, height 20" (51 cm). Staatliche Museen zu Berlin, Preussischer Kulturbesitz, Ägyptisches Museum.

matic use of color. The hues of the blue headdress and its colorful band are repeated in the rich red, blue, green, and gold of the jewelry. The queen's brows, eyelids, cheeks, and lips are heightened with color, as they no doubt were heightened with cosmetics in real life. Whether or not Nefertiti's beauty is exaggerated, phrases used by her subjects when referring to her—"Beautiful of Face," "Mistress of Happiness," "Great of Love," or "Endowed with Favors"—tend to support the artist's vision. This famous head was discovered in the studio of the sculptor Thutmose in Akhetaten, the capital city. Because bust portraits were rare in New Kingdom art, scholars believe Thutmose may have made this one as a model for sculptures or paintings of the queen.

AMARNA CRAFTS. The crafts also flourished in the Amarna period. Glassmaking, for example, could only be practiced by artists working for the king, and Akhenaten's new capital had its own glassmaking workshops (see "Glassmaking and Egyptian Faience," page 70). A bottle produced there and

meant to hold scented oil was fashioned in the shape of a fish that has been identified as a bolti, a species that carries its eggs in its mouth and spits out its offspring when they hatch. The bolti was a common symbol for birth and regeneration, complementing the self-generation that Akhenaten attributed to the sun disk Aten.

The Return to Tradition: Tutankhamun and Rameses II

Akhenaten's new religion and revolutionary ideas regarding the conduct and the art appropriate for royalty outlived him by only a few years. His successors had brief and troubled reigns, and the priesthood of Amun quickly regained its former power. His son Tutankhaten (Eighteenth Dynasty, ruled c. 1332–1322 BCE) returned to traditional religious beliefs, changing his name to Tutankhamun. He also turned his back on Akhenaten's new city and moved his court back to Thebes.

TUTANKHAMUN. The sealed inner chamber of Tutankhamun's tomb in the Valley of the Kings was never plundered, and when it was found in 1922 its incredible riches were just as they had been left since his interment. His body lay inside three nested coffins that identified him with Osiris, the god of the dead. The innermost coffin, in the shape of a mummy, is the richest of the three, for it is made of over 240 pounds (110.4 kg) of gold (FIG. 3-33). Its surface is decorated with colored glass and semiprecious gemstones, as well as finely incised linear designs and hieroglyphic inscriptions. The king holds a crook and a flail, symbols that were associated with Osiris and had become a traditional part of the royal regalia. A nemes headcloth with cobra and vulture on his forehead covers his head. A blue braided beard is attached to his chin. His necklace indicates military valor. Nekhbet and Wadjyt, vulture and cobra gods of Upper and Lower Egypt, spread their wings across his body. The king's features as reproduced on the coffin and masks are those of a very young man (FIG. 3-1). Even though they may

not reflect Tutankhamun's actual appearance, the unusually full lips and thin-bridged nose suggest the continued influence of the Amarna style and its realistic portraiture.

RAMESES II AND ABU SIMBEL. By Egyptian standards Tutankhamun was a rather minor king. Rameses II, on the other hand, was both powerful and long-lived. Under Rameses II (Nineteenth Dynasty, ruled c. 1279–1213 BCE), Egypt became a mighty empire. Rameses was a bold military commander and an effective political strategist. He also triumphed diplomatically by securing a peace agreement with the Hittites, a rival power centered in Anatolia (Chapter 2) that had tried to expand to the west and south at Egypt's expense. Rameses twice reaffirmed that agreement later in his reign by marrying Hittite princesses.

In the course of a long and prosperous reign, Rameses II initiated building projects on a scale rivaling the Old Kingdom Pyramids at Giza. Today, the most awe-inspiring of his many architectural monuments are found at Karnak and Luxor and at Abu Simbel in Egypt's southernmost region (see "The Temples of Rameses II at Abu Simbel," pages 76–77). At Abu Simbel, Rameses ordered two large temples to be carved in the living rock.

The temples at Abu Simbel were not funerary monuments. Rameses' and his queen Nefertari's tombs are in the Valleys of the Kings and Queens near Deir el-Bahri. The walls of Nefertari's tomb are covered with some of the most beautiful paintings discovered so far. In one of the many wall paintings, Nefertari offers jars of perfumed ointment to the goddess Isis (FIG. 3–34). The queen wears the vulture-skin headdress indicating her position, a royal collar, and a long, semitransparent white linen gown. Isis, seated on her throne behind a table heaped with offerings, holds a long scepter in her left hand, the *ankh* in her right. She wears a headdress surmounted by the horns of Hathor framing a sun disk, clear indications of her divinity.

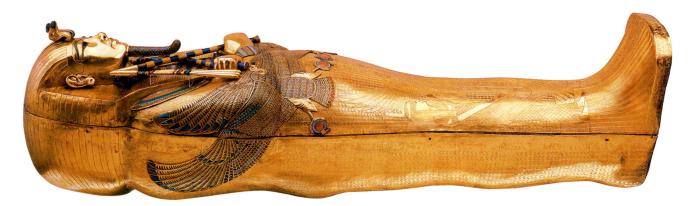

3-33 INNER COFFIN OF TUTANKHAMUN'S SARCOPHAGUS

Tomb of Tutankhamun, Valley of the Kings, near Deir el-Bahri. Eighteenth Dynasty, 1332-1322 BCE. Gold inlaid with glass and semiprecious stones, height 6'%" (1.85 m), weight nearly 243 pounds (110.4 kg). Egyptian Museum, Cairo.

THE OBJECT SPEAKS

THE TEMPLES OF RAMESES II AT ABU SIMBEL

any art objects speak to us subtly, through their beauty or mystery. Monuments such as Rameses II's temples at Abu Simbel, his colossal statues, and his association with the gods also speak across the ages about the religious and political power of this ruler: the king-god of Egypt, the conqueror of the Hittites, the ruler of a vast empire, a virile man with nearly a hundred children. As an inscription he had carved into an obelisk now standing in the heart of Paris says: "Son of Ra: Rameses-Meryamun ['Beloved of Amun']. As long as the skies exist, your monuments shall exist, your name shall exist, firm as the skies."

Rameses built numerous monuments in Egypt, but his choice of Abu Simbel for his

temples proclaims his military and diplomatic success: Abu Simbel is north of the second cataract of the Nile, in Nubia, the ancient land of Kush, which Rameses ruled and which was the source of his gold, ivory, and exotic animal skins. He asserted his divinity in two temples he had carved out of the sacred hills there. The larger temple, carved out of the mountain called Meha, is dedicated to Rameses and the Egyptian gods Amun, Ra, and Ptah. The dominant feature of Rameses' temple is a row of four colossal seated statues of the king himself. At its entrance, four aweinspiring 65-foot statues of Rameses are flanked by relatively small statues of family members, including his principal wife Nefertari, who reaches as high as his leg,

which she affectionately caresses. Inside the temple, eight 33-foot statues of the god Osiris with the face of the god-king Rameses further proclaim his divinity. The corridor they form leads to the seated figures of Ptah, Amun, Rameses II, and Ra. The corridor was oriented in such a way that twice a year the first rays of the rising sun shot through its entire depth to illuminate statues of the king and the four gods placed against the back wall.

About 500 feet away, Rameses ordered a smaller temple to be carved into the mountain called Ibshek, sacred to Hathor, goddess of fertility, love, joy, and music, and to be dedicated to Hathor and to Nefertari. Six statues, 33 feet tall, include two of the queen wearing the headdress

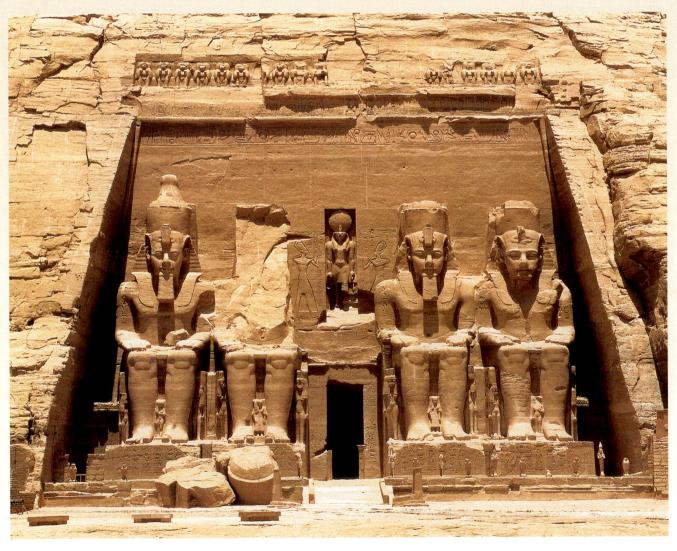

TEMPLE OF RAMESES IIAbu Simbel. Nineteenth Dynasty, c. 1279–1213 BCE.

of Hathor and four of her husband Rameses II. The two temples, together honoring the official gods of Egypt and his dynasty, were oriented so that their axes crossed in the middle of the Nile, suggesting that they may have been associated with the annual life-giving flood.

Ironically, flooding nearly destroyed Rameses' temples at Abu Simbel. Half-buried in the sand over the ages, they were discovered and opened early in the nine-teenth century. But in the 1960s, construction of the Aswan High Dam flooded the Abu Simbel site. Only an international effort and modern technology saved the complex. It was relocated high above the flood levels so that it could continue to speak to us.

TEMPLES OF RAMESES II

(left) and **NEFERTARI** (right) at Abu Simbel. Nineteenth Dynasty, 1279–1213 BCE. (TOP)

DETAIL OF NEFERTARI AND RAMSES'S LEG from Temple of Ramses II. (MIDDLE)

TEMPLE OF RAMESES II, INTERIOR Abu Simbel. Nineteenth Dynasty, c. 1279–1213 BCE. (BOTTOM)

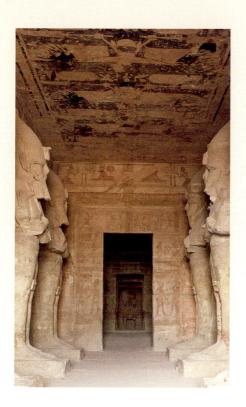

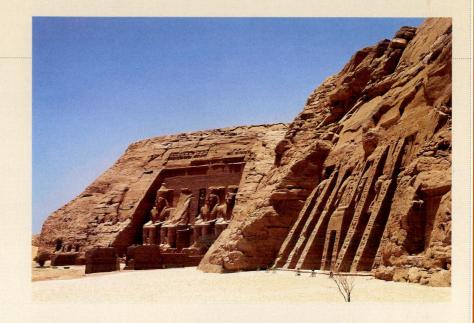

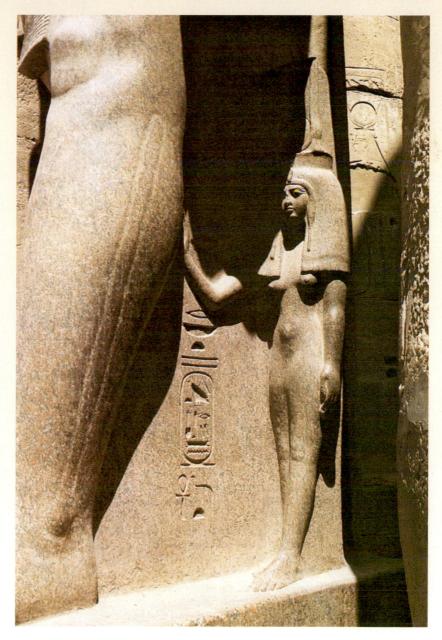

Art and Its Context

HIEROGLYPHIC, HIERATIC, AND DEMOTIC WRITING

ncient Egyptians developed four types of writing that are known today by the names the Greeks gave them. The earliest system employed a large number of symbols called **hieroglyphs** (from the Greek hieros, "sacred," and glyphein, "to carve"). As their name suggests, the Greeks believed they had religious significance. Some of these symbols were simple pictures of creatures or objects, or pictographs, similar to those used by the Sumerians (Chapter 2). Others were phonograms, or signs representing spoken sounds.

The earliest scribes must also have used this system of signs for record keeping, correspondence, and manuscripts of all sorts. In time, however, they developed simplified hieroglyphs that could be written more quickly in lines of script on papyrus scrolls. This type of writing is called **hieratic**, again derived from the Greek word *hieros*, meaning "sacred." Even after this script was perfected, inscriptions in reliefs or paintings and on ceremonial objects continued to be written in hieroglyph.

The third type of writing came into use only in the eighth century BCE, as written communication ceased to be restricted to priests and scribes. It was a simplified, cursive form of hieratic writing that was less formal and easier to master; the Greeks referred to it as **demotic** writing (from *demos*, "the people"). From this time on, all three systems were in use, each for its own specific purpose: religious documents were written in hieratic, inscriptions on monuments in hieroglyph, and all other texts in demotic script. Once the Greeks began to rule over Egypt, the Egyptians adapted their language to be written with Greek characters in a script known as *Coptic*.

After centuries of foreign rule, beginning with the arrival of the Greeks in 332 BCE, the ancient Egyptian language gradually died out. Modern scholars therefore had to decipher four types

ROSETTA STONE
With its three tiers of writing, from top to bottom: hieroglyphic, demotic, and Greek.
196 BCE. The British Museum, London.

of writing in a long-forgotten language. The key was a fragment of a stone stele, dated 196 BCE, which was called the Rosetta Stone (for the area of the Delta where one of Napoleon's officers discovered it in 1799). On it, a decree issued by the priests at Memphis honoring Ptolemy V (ruled c. 205–180 BCE) had been carved in hieroglyphs, demotic, and Greek.

Even with the Greek translation, the two Egyptian texts were incomprehensible until 1818, when Thomas Young, an English physician interested in ancient Egypt, linked some of the hieroglyphs to specific names in the Greek version. A short time later, French scholar Jean-François Champollion located the names Ptolemy and Cleopatra in both of the Egyptian scripts. With the phonetic symbols for P, T, O, and L in demotic, he was able to build up an "alphabet" of hieroglyphs, and by 1822 he had deciphered the two Egyptian texts.

Hieroglyphic signs for the letters P, T, O, and L, which were Champollion's clues to deciphering the Rosetta Stone, plus M, Y, and S: Ptolmys.

The artists responsible for decorating the tomb worked in a new style diverging very subtly but distinctively from earlier conventions. The outline drawing and use of clear colors reflect traditional practices, but quite new is the slight modeling of the body forms by small changes of hue to increase their appearance of three-dimensionality. The skin color of these women is much darker than that conventionally used for females in earlier periods, and lightly brushed-in shading emphasizes their eyes and lips. The tomb's artists used particular care in placing the hieroglyphic inscriptions in order to create a harmonious overall design.

Noble families also had richly painted tombs. Their paintings give us an insight into daily life, much like the models found in earlier tombs (SEE FIG. 3–20).

The Books of the Dead

By the time of the New Kingdom, the Egyptians had come to believe that only a person free from wrongdoing could enjoy an afterlife. The dead were thought to undergo a last judgment consisting of two tests presided over by Osiris, the god of the underworld, and supervised by the jackal-headed god of embalming and cemeteries, Anubis. After the deceased were questioned about their behavior in life, their hearts—

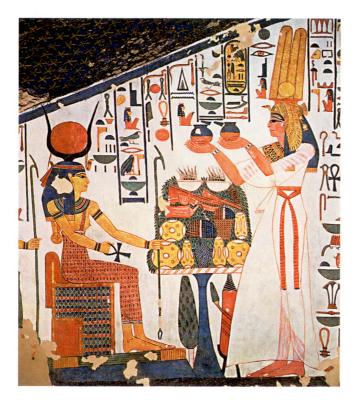

3–34 QUEEN NEFERTARI MAKING AN OFFERING TO ISIS Wall painting in the tomb of Nefertari, Valley of the Queens, near Deir el-Bahri. Nineteenth Dynasty, 1290–1224 BCE.

which the Egyptians believed to be the seat of the soul—were weighed on a scale against an ostrich feather, the symbol of Maat, goddess of truth, order, and justice.

Family members commissioned papyrus scrolls containing magical texts or spells, which the embalmers placed among the wrappings of the mummified bodies to help the

dead survive the tests. Early collectors of Egyptian artifacts referred to such scrolls, often beautifully illustrated, as "Books of the Dead." The books varied considerably in content. A scene created for a man named Hunefer (Nineteenth Dynasty) shows three successive stages in his induction into the afterlife (FIG. 3–35). At the left, Anubis leads him by the hand to the spot where he will weigh his heart, contained in a tiny jar, against the "feather of Truth." Maat herself appears atop the balancing arm of the scales wearing the feather as a headdress. To the right of the scales, Ammit, the dreaded "Eater of the Dead"—part crocodile, part lion, and part hippopotamus—watches eagerly for a sign from the ibis-headed god Thoth, who prepares to record the result of the weighing

But the "Eater" goes hungry. Huncfer passes the test, and Horus, on the right, presents him to the enthroned Osiris, who floats on a lake of natron (see "Preserving the Dead," page 55). Behind the throne, the goddesses Nephthys and Isis support the god's left arm with a tender gesture, while in front of him his four sons, each entrusted with the care of one of the deceased's vital organs, stand atop a huge lotus blossom rising up out of the lake. In the top register, Hunefer, finally accepted into the afterlife, kneels before the nine gods of Heliopolis—the sacred city of the sun god Ra—and the five personifications of life-sustaining principles.

LATE EGYPTIAN ART, c. 715-332 BCE

The Late Period in Egypt saw the country and its art in the hands and service of foreigners. Nubians, Persians, Macedonians, Greeks, and Romans were all attracted to Egypt's riches and seduced by its art. The Nubians conquered Egypt and

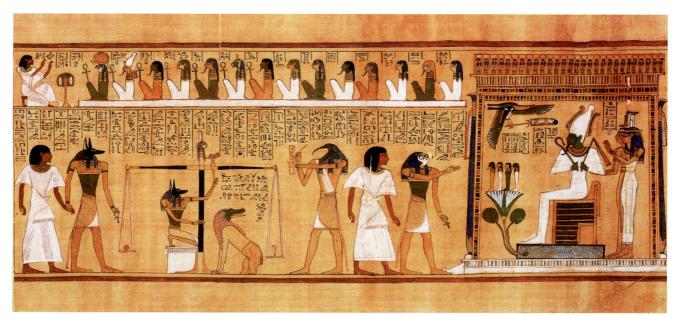

3–35 | JUDGMENT OF HUNEFER BEFORE OSIRIS Illustration from a Book of the Dead. Nineteenth Dynasty, c. 1285 BCE. Painted papyrus, height 15%" (39.8 cm). The British Museum, London.

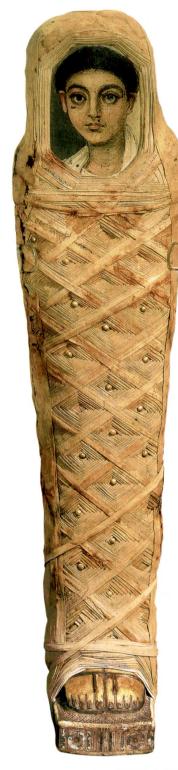

3–36 | MUMMY WRAPPING OF A YOUNG BOY Hawara. Roman period, c. 100–120 CE. Linen wrappings with gilded stucco buttons and inserted portrait in encaustic on wood, height of mummy 53%" (133 cm); portrait $9\frac{1}{2} \times 6\frac{1}{2}$ " (24 × 16.5 cm). The British Museum, London.

re-established capitals at Memphis and Thebes (712–657 BCE). They continued the traditional religious practices and architectural forms, including pyramids.

In 332 BCE the Macedonian Greeks led by Alexander the Great conquered Egypt, and after Alexander's death in 323 BCE, his generals divided up the empire. Ptolemy, a Greek,

took Egypt, declaring himself king in 305. The Ptolemaic dynasty ended with the death of Cleopatra VII (ruled 51–30 BCE), when the Romans succeeded as Egypt's rulers and made it the breadbasket of Europe.

Not surprisingly, painting from this period reflects the conventions of Greek and Roman, not Egyptian, art. The most representative examples of this very late Egyptian art are the so-called Fayum portraits. The tradition of mummifying the dead continued well into Egypt's Roman period. Hundreds of mummies and mummy portraits from that time have been found in the Fayum region of Lower Egypt. The mummy becomes a "soft sculpture" with a Roman-style portrait (FIG. 3–36) painted on a wood panel in encaustic (hot colored wax), inserted over the face in the tradition of the gold mask of Tutankhamun. Although great staring eyes invariably dominate the images, the artists recorded individual features of the deceased. The Fayum portraits link Egyptian art with ancient Roman art (see Chapter 6).

IN PERSPECTIVE

Like the Mesopotamians, the Egyptians brought the prehistoric period to an end when they created hieroglyphic writing (the use of pictures of objects and other signs to represent spoken sounds). They too developed a rich tradition of written history and literature known to us today, thanks to the many surviving texts carved in stone, written on papyrus, and painted on walls.

Egyptian culture included elaborate funerary practices. Rulers devoted huge sums to the design, construction, and decoration of extensive funerary complexes, including the famous pyramids and subterranean tombs. The recovery of this art through the diligent work of archaeologists continues to enlighten and fascinate us.

All cultures have rules for representing both things and ideas, but Egyptian conventions are among the most distinctive in art history. All objects and individual elements are represented from their most characteristic viewpoint, so profile heads are seen on frontal shoulders and stare out at the viewer with eyes drawn in frontal view. Egyptian art is simplified, even geometric, in appearance and often abstract in style.

Egyptian art and history is divided into three principal periods known as the Old, Middle, and New kingdoms. The Old Kingdom was a heroic age of funerary art and architecture whose most famous works—the pyramids and the Great Sphinx—encompass the essence of Egypt to most people. The Middle Kingdom was a slightly decentralized reinstatement of the monarchy with an increase in sensitive and more personal art. In the New Kingdom, rulers devoted extraordinary resources to building temples and expanding the Egyptian empire. During the Eighteenth Dynasty, Akhenaten attempted to change the course of history, religion, and art by introducing a monotheistic religion centered on Aten, the sun. The discovery of the tomb of his successor Tutankhamun ignited an enthusiasm for Egyptian art lasting to this day.

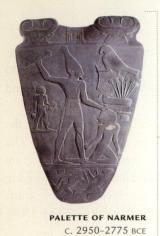

GREAT PYRAMIDS
C. 2575-2450 BCE

c. 1938–1755 BCE

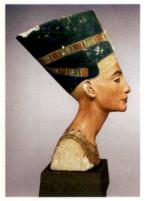

NEFERTITI C. 1353–1336 BCE

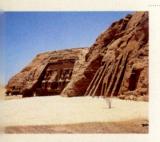

TEMPLE OF RAMESES II

C. 1279–1213 BCE

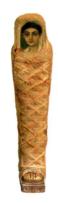

MUMMY WRAPPING
OF A YOUNG BOY
C. 100-120 CE

5500 BCE

3000

2500

2000

1500

1000

500

I CE

ART OF ANCIENT EGYPT

- Predynastic (Neolithic)c. 5000–2950 BCE
- Early Dynastic c. 2950-2575 BCE
- ◆ Old Kingdom c. 2575-2150 BCE
- ▼ First Intermediate c. 2125–1975 BCE
- Middle Kingdom c. 1975–1640 BCE
- Second Intermediate c. 1630–1520 BCE
- New Kingdom c. 1539–1075 BCE
- Amarna c. 1353-1336 BCE
- Third Intermediate c. 1075-715 BCE
- Late Period c. 715-332 BCE
- Nubian c. 712–657 BCE
- Ptolemaic c. 323-30 BCE
- **⋖ Roman** *c.* 30 BCE−395 CE

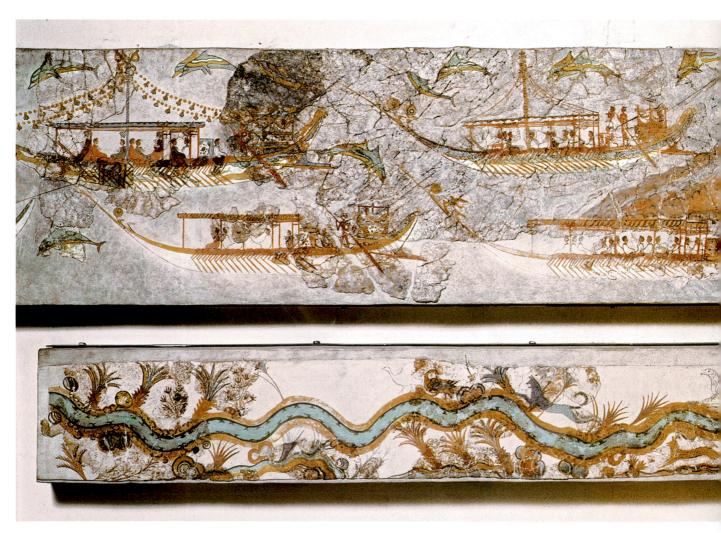

4−I | **"FLOTILLA" FRESCO** from Room 5 of West House, Akrotiri, Thera. New Palace Period, c. 1650 BCE. National Archaeological Museum, Athens.

CHAPTER FOUR

AEGEAN ART

Glorious pink, blue, and gold mountains flicker in the brilliant sunlight. Graceful boats glide on calm seas past islands and leaping dolphins. Picturesque villages line

the shore, with people lounging on terraces and rooftops. These words describe the very old painting you see here (FIG. 4–I): the port of Akrotiri on the island of Thera, one of the Cycladic Islands in the southern Aegean Sea. Today, Thera is a romantic and popular tourist destination called Santorini. Akrotiri and the paradise depicted in this painting ended suddenly more than 3,500 years ago, when the volcano that formed the island erupted and blew the top of the mountain off, spewing pumice that filled and sealed every crevice of Akrotiri—fortunately, after the residents had fled.

The discovery of the lost town of Akrotiri in 1967 was among the most significant archaeological events of the second half of the twentieth century, and excavation of the city is still under way. We have much to learn about the cultures that took root on the Cycladic Islands and elsewhere in the Aegean. Every clue helps, especially because only one of the three written languages used there has been decoded. For now, we depend mainly on works of art and architecture like this painting for our knowledge of life in the ancient Aegean world.

Before 3000 BCE until about 1100 BCE, three early European cultures flourished simultaneously in the Aegean region: on a cluster of small islands called the Cyclades, on Crete and

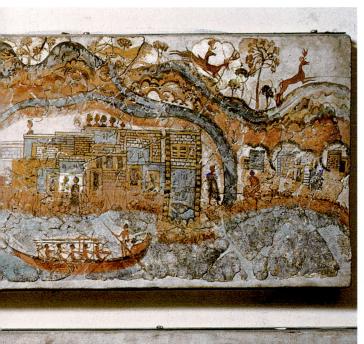

other islands in the eastern Mediterranean, and on the mainland (MAP 4–I). To learn about them, scholars of these cultures have studied shipwrecks, homes and grave sites, and the ruins of architectural complexes. In recent years, archaeologists and art historians have collaborated with researchers in such areas of study as the history of trade and the history of climate change to provide an ever-clearer picture of Aegean society at that time.

CHAPTER-AT-A-GLANCE

- THE BRONZE AGE IN THE AEGEAN
- THE CYCLADIC ISLANDS
- THE MINOAN CIVILIZATION ON CRETE | The Old Palace Period, c. 1900–1700 BCE | The New Palace Period, c. 1700–1450 BCE
- THE MYCENAEAN (HELLADIC) CULTURE | Helladic Architecture | Metalwork | Sculpture | Ceramic Arts
- **IN PERSPECTIVE**

THE BRONZE AGE IN THE AEGEAN

One of the hallmarks of Aegean society during this period was the use of bronze. Bronze, an alloy of copper and tin superior to pure copper for making weapons and tools, gave its name to the period known as the Aegean Bronze Age. (See Chapter 1 for the Bronze Age in Northern Europe.) Using metal ores imported from Europe, Arabia, and Anatolia, Aegean peoples created exquisite objects of bronze that became prized for export.

For the Aegean peoples, the sea provided an important link not only between the mainland and the islands, but also to the world beyond. In contrast to the landlocked civilizations of the Near East, and to the Egyptians, who used river transportation, the peoples of the Aegean were seafarers. So shipwrecks offer vast amounts of information about the material culture of these ancient societies. For example, the wreck of a trading vessel thought to have sunk between 1400 and 1350 BCE and discovered in the vicinity of Ulu Burun, off the southern coast of modern Turkey, carried an extremely varied cargo: metals, bronze weapons and tools, aromatic resins, fruits and spices, jewelry and beads, African ebony, ivory tusks, ostrich eggs, raw blocks of blue glass used for faience, and ceramics from the Near East, mainland Greece, and Cyprus. Among the many gold objects was a scarab associated with Nefertiti, wife of the Egyptian ruler Akhenaten (see Chapter 3). The cargo suggests this vessel cruised from port to port, loading and unloading goods as it went. It also suggests that Egypt and the people of the ancient Near East were especially important trading partners.

The great epics of Homer, the *Iliad* and the *Odyssey*, were both centered on sea voyages, and the places and characters they described roused the interests of two groundbreaking archaeologists of the nineteenth and early twentieth centuries: Heinrich Schliemann located and excavated Homeric Troy in modern western Turkey; Sir Arthur Evans unearthed one of

the great palaces on Crete, and named the civilization Minoan after the mythical king Minos. What archaeologists have since found both substantiates and contradicts Homer.

Probably the thorniest problem in Aegean archaeology is that of dating the finds. Archaeologists have developed a relative dating system for the Aegean Bronze Age, but assigning absolute dates to specific sites and objects continues to be difficult and controversial. One cataclysmic event has helped: A huge volcanic explosion on the Cycladic island of Thera thoroughly devastated Minoan civilization there and on Crete, only 70 miles to the south. Evidence from tree rings from Ireland and California and traces of volcanic ash in ice cores from Greenland put the date of the eruption about 1650–1625 BCE. Outside Thera, archaeologists rely on relative dating, based largely on pottery. Sometimes in this book you will find periods cited without attached dates and in other books you may encounter different dates from those given for objects shown here. You should expect dating to change in the future as our knowledge grows and techniques of dating improve.

THE CYCLADIC ISLANDS

On the Cycladic Islands, late Neolithic and early Bronze Age people had a thriving culture. They engaged in agriculture, herding, some crafts, and trade. They used local stone to build and fortify towns and hillside burial chambers. Because they left no written records and their origins remain obscure, their art is a major source of information about them. From about 6000 BCE on, Cycladic artists used a coarse, poor-quality local clay to make a variety of ceramic objects. Some 3,000 years later, they continued to produce relatively crude but often engaging ceramic figurines of humans and animals, as well as domestic and ceremonial wares. They also produced marble sculptures.

The Cyclades, especially the islands of Naxos and Paros, had ample supplies of a fine and durable white marble. Out of it, sculptors created a unique type of nude figure ranging

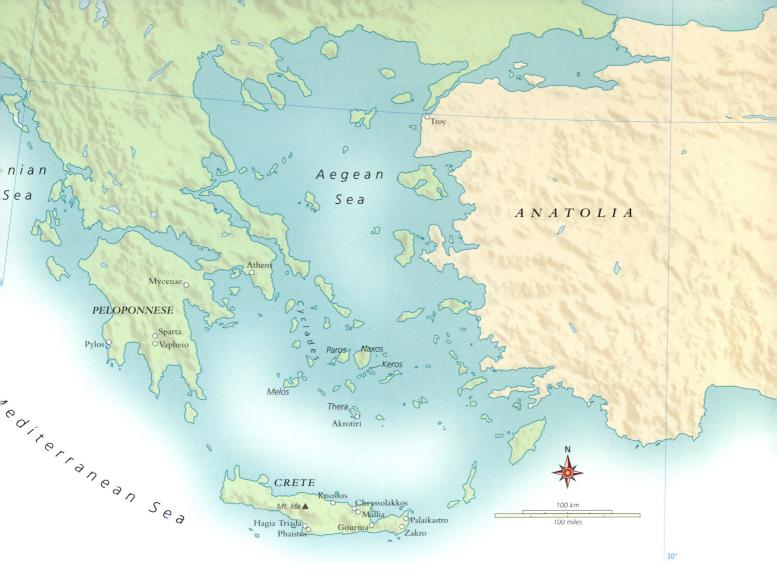

MAP 4-I THE AEGEAN WORLD

The three main cultures in the ancient Aegean were the Cycladic, in the Cyclades; the Minoan, on Thera and Crete; and the Helladic, including the Mycenaean, on the mainland.

from a few inches to about 5 feet tall. The figures are often found lying on graves. To shape the stone, sculptors used scrapers and chisels made of obsidian from the island of Melos and polishing stones of emery from Naxos. The introduction of metal tools may have made it possible for them to carve on a larger scale, but they continued to limit themselves to simple forms, perhaps because the stone fractured easily.

A few male figurines have been found, including depictions of musicians and acrobats, but they are greatly outnumbered by representations of women. The earliest female figures had simple, violinlike shapes. By 2500 BCE a more familiar type had evolved, and it has become the best-known type of Cycladic art (FIG. 4–2). The figures appear as pareddown, elegant renderings of the body. With their simple contours, the female statuettes seem not far removed from the marble slabs out of which they were carved. Tilted-back heads, folded arms, and down-pointed toes suggest that the

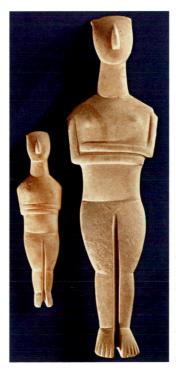

4–2 | TWO FIGURES
OF WOMEN
Cyclades. c. 2500–2200 BCE.
Marble, heights 13" (33 cm)
and 25" (63.4 cm).
Museum of Cycladic Art,
Athens.
Courtesy of the N. P. Goulandris
Foundation.

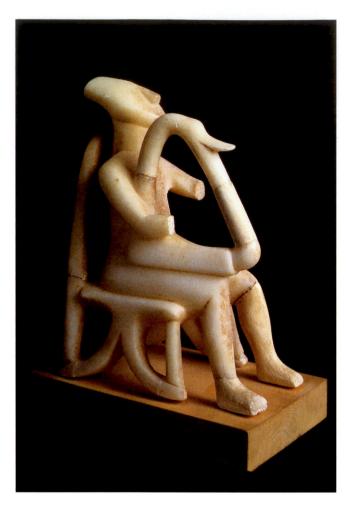

4-3 | SEATED HARP PLAYER

Keros, Cyclades. c. 2700-2500 BCE. Marble, height 11½"
(29.2 cm). Museum of Cycladic Art, Athens.

figures were intended to lie on their backs, as if asleep or dead. Anatomical detail has been kept to a minimum; the body's natural articulations at the hips, knees, and ankles are indicated by lines, and the pubic area is marked with a lightly incised triangle. These statues originally had painted facial features, hair, and ornaments in black, red, and blue.

The **SEATED HARP PLAYER** is a fully developed sculpture in the round (FIG. 4–3), yet its body shape is just as simplified as that of the female figurines. The figure has been reduced to its geometric essentials, yet with careful attention to elements that characterize an actual musician. The harpist sits on a high-backed chair with a splayed base, head tilted back as if singing, knees and feet apart for stability, and arms raised, bracing the instrument with one hand while plucking its strings with the other. So expressive is the pose that we can almost hear the song.

Although some Cycladic islands retained their distinctive artistic traditions, by the Middle and Later Bronze Age, the art and culture of the Cyclades as a whole was subsumed by Minoan and, later, Mycenean culture.

THE MINOAN CIVILIZATION ON CRETE

By 3000 BCE, Bronze Age people were living on Crete, the largest of the Aegean islands, 155 miles long and 36 miles wide. Crete was economically self-sufficient, producing its own grains, olives and other fruits, and cattle and sheep. But because it lacked the ores necessary for bronze production, its people were forced to look outward. With many safe harbors and a convenient location, Crete became a wealthy sea power, trading with mainland Greece, Egypt, the Near East, and Anatolia.

Between about 1900 BCE and 1375 BCE, a distinctive culture flourished on Crete. Its discoverer, the British archaeologist Sir Arthur Evans, named it Minoan from the legend of Minos, a king who had ruled from the capital, Knossos. According to the legend, a half-man, half-bull monster called the Minotaur was the son of the wife of King Minos and a bull belonging to the sea god Poseidon. It lived at Knossos in a maze called the Labyrinth. To satisfy the Minotaur's appetite for human flesh, King Minos ordered the mainland kingdom of Athens to send a yearly tribute of fourteen young men and women. Theseus, son of King Aegeus of Athens, vowed to free his people from this burden by slaying the monster.

Theseus set out for Crete with the doomed young Athenians, promising his father that on the return he would change the ship's black sails to white ones as a signal if he was victorious. With the help of Crete's princess Ariadne, who gave him a sword and a thread to mark his path through the Labyrinth, Theseus defeated the Minotaur. On his way home with Ariadne and the fourteen Athenians, he stopped at the island of Naxos, where he abandoned Ariadne. As he continued on, he forgot to raise the white sails. When King Aegeus saw the black-sailed ship, he threw himself off a cliff and into the sea that now bears his name, Aegean.

Although a number of written records from the period are preserved, the two earliest forms of Minoan writing, called hieroglyphic and Linear A, continue to defy translation. The surviving documents in a third later script, called Linear B (a very early form of Greek imported from the mainland), have proved to be valuable administrative records and inventories that give an insight into Minoan material culture.

Minoan chronology is divided into two main periods, the Old Palace Period, from about 1900 to 1700 BCE, and the New Palace Period, from around 1700 to 1450 BCE.

The Old Palace Period, c. 1900-1700 BCE

Minoan civilization remained very much a mystery until Sir Arthur Evans discovered the buried ruins of the architectural complex at Knossos, on Crete's north coast, in 1900 CE (FIGS. 4–4, 4–5). The site had been occupied in the Neolithic period, then built over with a succession of Bronze Age buildings.

Evans spent the rest of his life excavating and reconstructing the buildings he had found (see "Pioneers of Aegean

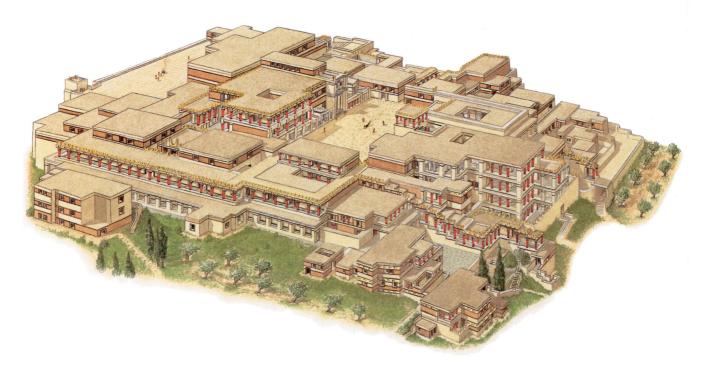

4-4 RECONSTRUCTION OF THE PALACE COMPLEX, KNOSSOS, CRETE

As it would have appeared during the New Palace Period. Site occupied 2000-1375 BCE; complex begun in Old Palace Period (c. 1900-1700 BCE); complex rebuilt after earthquakes and fires during New Palace Period (c. 1700-1450 BCE); final destruction c. 1375 BCE.

Archaeology," page 88). Like nineteenth-century excavators before him, Evans called these great architectural complexes "palaces." But palaces imply kings, and we do not know the sociopolitical structure of the society.

PALACE LAYOUTS. The walls of early Minoan buildings were made of rubble and mud bricks faced with cut and finished

local stone (dressed stone). This was the first use of dressed stone as a building material in the Aegean. Columns and other interior elements were made of wood. Both in palaces and in buildings in the surrounding towns, timber appears to have been used for framing and bracing walls. Its strength and flexibility would have minimized damage from the earthquakes common to the area. Nevertheless, the earthquake at

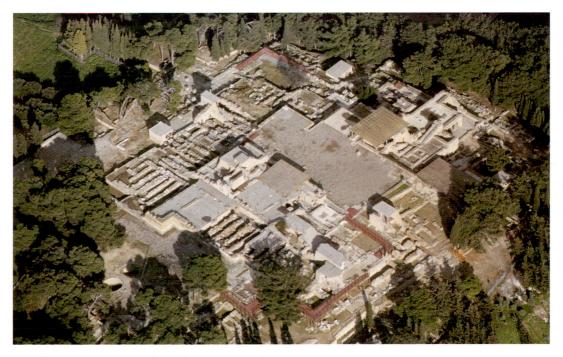

4-5 KNOSSOS, AERIAL PHOTOGRAPH OF THE SITE

Art and Its Context

PIONEERS OF AEGEAN ARCHAEOLOGY

he pioneering figure in the modern study of Aegean civilization was Heinrich Schliemann (1822–90), who was inspired by Homer's epic tales, the *Iliad* and the *Odyssey*. The son of an impoverished German minister and largely selfeducated, he worked hard in America, grew rich, and retired in 1863 to pursue his lifelong dream of becoming an archaeologist. In 1869, he began conducting fieldwork in Greece and Turkey. Scholars of that time considered Homer's stories pure fiction, but by studying the descriptions of geography in the *Iliad*, Schliemann located a multilayered site at Hissarlik, in present-day Turkey, whose sixth level up from the bedrock is now generally accepted as being Homer's Troy.

After this success, Schliemann pursued his hunch that the grave sites of Homer's Greek royal family would be found inside the citadel at Mycenae. But the graves he found were too early to contain the bodies of Atreus, Agamemnon, and their relatives. The discovery of the palace of the legendary King Minos fell to a British archaeologist, Sir Arthur Evans (1851–1941), who led the excavation of the palace at Knossos between 1900 and 1905. Evans gave the name *Minoan* to Bronze Age culture on Crete. He also made a first attempt to establish an absolute chronology for Minoan art, basing his conjectures on datable Egyptian artifacts found in the ruins on Crete and on Minoan artifacts found in Egypt. Later scholars have revised and refined his dating.

the time of the Thera eruption damaged several building sites, including Knossos and Phaistos. The structures were then repaired and enlarged, and the resulting new complexes shared a number of features. Multistoried, flat-roofed, and with many columns, they were designed to maximize light and air, as well as to define access and circulation patterns. Daylight and fresh air entered through staggered levels, open stairwells, and strategically placed air shafts and light wells (FIG. 4–6).

Suites of rooms lay around a spacious rectangular courtyard from which corridors and staircases led to other court-

4–6 | **KNOSSOS INTERIOR** Reconstruction of palace interior staircase.

yards, private rooms and apartments, administrative and ritual areas, storerooms, and baths. Walls were coated with plaster, and some were painted with murals. Floors were plaster, plaster mixed with pebbles, stone, wood, or beaten earth. The residential quarters had many luxuries: sunlit courtyards, richly colored murals, and sophisticated plumbing systems.

Clusters of workshops in and around the palace complexes formed commercial centers. Storeroom walls were lined with enormous clay jars for oil and wine, and in their floors stone-lined pits from earlier structures had been designed for the storage of grain. The huge scale of the centralized management of foodstuffs became apparent when excavators at Knossos found in a single (although more recent) storeroom enough ceramic jars to hold 20,000 gallons of olive oil. There were also workshops that attest to the centralization of manufacturing.

The palace complex itself had a squarish plan and a large central courtyard. Causeways and corridors led from outside to the central courtyard or to special areas such as granaries or storage pits. The complex had a theater or performance area. Around the central court, independent units were made up of eight or nine suites of rooms. Each suite consisted of a forecourt with light well, a hall with a stepped lustral (purification) basin, a room with a hearth, and a series of service rooms. Such suites might belong to a family or serve a special business or government function.

CERAMIC ARTS. During the Old Palace Period, Minoans developed extraordinarily sophisticated metalwork and elegant new types of ceramics, spurred in part by the introduction of the potter's wheel early in the second millennium BCE. One type of ceramic is called Kamares ware, after the cave on Mount Ida overlooking the palace complex at Phaistos, in southern Crete, where it was first discovered. The hallmarks of this select ceramic ware—so sought-after that it was exported as far away as Egypt and Syria—were its extremely

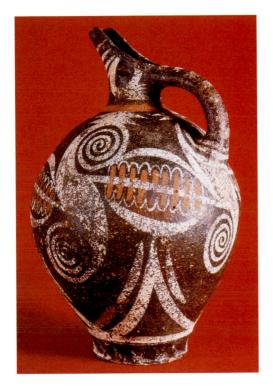

4–7 | KAMARES WARE JUG Phaistos, Crete. Old Palace Period, c. 2000–1900 BCE. Ceramic, height 10 %" (27 cm). Archaeological Museum, Iraklion, Crete.

thin walls, its use of color, and its graceful, stylized, painted decoration. An example from about 2000–1900 BCE has a globular body and a "beaked" pouring spout (FIG. 4–7). Decorated with brown, red, and creamy white pigments on a black body, the jug has rounded contours complemented by bold, curving forms derived from plant life.

METALWORK. Matching Kamares ware in sophistication is early Minoan goldwork (see "Aegean Metalwork," page 93). By about 1700 BCE, Aegean metalworkers were producing objects rivaling those of Near Eastern and Egyptian jewelers, whose techniques they may have adopted. For a pendant in gold found at Chryssolakkos (FIG. 4–8), the artist arched a pair of bees (or perhaps wasps) around a honeycomb of gold granules, providing their sleek bodies with a single pair of outspread wings. The pendant hangs from a spiderlike form, with what appear to be long legs encircling a tiny gold ball. Small disks dangle from the ends of the wings and the point where the insects' bodies meet. The simplified geometric patterns and shapes convey the insects' actual appearance.

Cultural and artistic tradition continued unbroken into the New Palace Period when Minoan civilization reached its highest point.

The New Palace Period, c. 1700-1450 BCE

The "old palace" at Knossos, erected about 1900 BCE, formed the core of an elaborate new one built after the Thera eruption in c. 1650–1625 BCE. The Minoans rebuilt at Knossos and elsewhere, inaugurating the New Palace Period and the

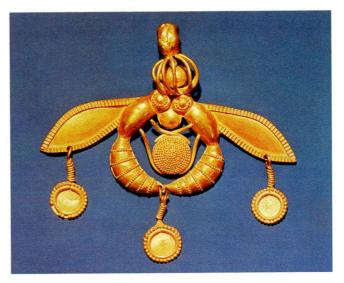

4–8 | PENDANT OF GOLD BEES
Chryssolakkos, near Mallia, Crete. Old Palace Period,
c. 1700–1550 BCE. Gold, height approx. 1 11/16" (4.6 cm).
Archaeological Museum, Iraklion, Crete.

flowering of Minoan art. In its heyday, the palace complex covered six acres (SEE FIG. 4–5).

THE LABYRINTH AT KNOSSOS. Because double-ax motifs were used in its architectural decoration, the Knossos palace was referred to in later Greek legends as the Labyrinth, meaning the "House of the Double Axes" (Greek *labrys*, "double ax"). The layout of the complex seemed so complicated that the word *labyrinth* eventually came to mean "maze" and became part of the Minotaur legend.

The layout provided the complex with its own internal security system: a baffling array of doors leading to unfamiliar rooms, stairs, and yet more corridors. Admittance could be denied by blocking corridors, and some rooms were accessible only from upper terraces. The building was a warren of halls, stairs, dead ends, and suites. Close analysis, however, shows that the builders had laid out a square grid following predetermined principles, and that the apparently confusing layout was caused in part by earthquake destruction and rebuilding over the centuries.

In typical Minoan fashion, the rebuilt Knossos complex was organized around a large central courtyard. A few steps led from the central courtyard down into the so-called Throne Room to the west, and a great staircase on the east side descended to the Hall of the Double Axes, an unusually grand example of a Minoan hall (Evans gave the rooms their misleading but romantic names; see, for example, FIG. 4–6). This hall and others were supported by the uniquely Minoan-type wood columns that became standard in Aegean palace architecture. The tree trunks from which the columns were made were inverted so that they tapered toward the bottom. The top, supporting massive roof beams and a broad flattened capital, was wider than the bottom.

4–9 YOUNG GIRL GATHERING SAFFRON CROCUS FLOWERS
Detail of wall painting, Room 3 of House Xeste 3, Akrotiri, Thera.
Cyclades before 1630 BCE. Thera Foundation, Petros M. Nomikos, Greece.

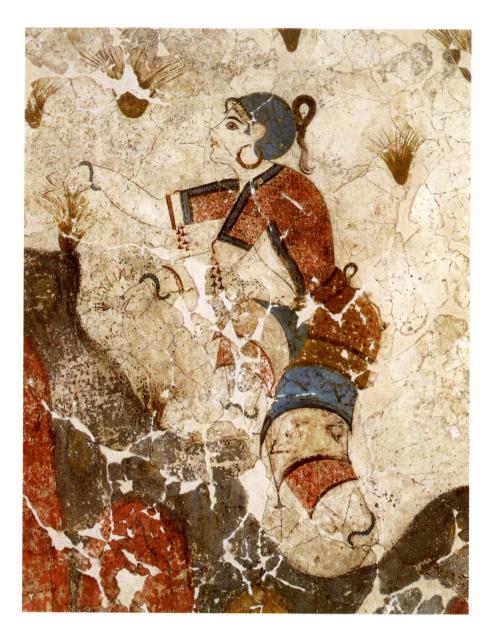

Rooms, following Old Palace tradition, were arranged around a central space rather than along a long axis, as we have seen in Egypt and will see on the mainland. During the New Palace Period, suites functioned as archives, business centers, and residences. Some must also have had a religious function, though the temples, shrines, and elaborate tombs seen in Egypt are not found in Minoan architecture.

Wall Painting at Akrotiri. Minoan painters worked on a large scale, covering the walls of palace rooms with geometric borders, views of nature, and scenes of human activity. Murals can be painted on a still-wet plaster surface (buon fresco) or a dry one (fresco secco). The wet technique binds pigments to the wall, but forces the painter to work very quickly. On a dry wall, the painter need not hurry, but the pigments tend to flake off in time. Minoans used both techniques. Their preferred colors were red, yellow, black, white, green, and blue. Like Egyptian painters, Minoan artists filled in the outlines of their figures and objects with unshaded areas of pure color.

Minoan wall painting displays elegant drawing, linear contours filled with bright colors, a preference for profile or full-faced views, and a stylization that turns natural forms into decorative patterns. Those conventions can be seen in the vivid murals at Akrotiri, on the Cycladic island of Thera (SEE FIG. 4–1). Along with other Minoan cultural influences, the art of wall painting seems to have spread to both the Cyclades and mainland Greece. Thera, for example, was so heavily under Crete's influence at this time that it was virtually an outpost of Minoan culture.

The paintings in residences at Akrotiri demonstrate a sophisticated decorative sense, both in color selection and in surface detail. Some of the subjects at Akrotiri also occur in the art of Crete, but others are new. One of the houses, for example, has rooms dedicated to young women's initiation ceremonies. In the detail shown here, a young woman picks saffron crocus, valuable for its use as a yellow dye, as a flavoring for food, and as a medicinal plant to alleviate menstrual cramps (FIG. 4–9). The girl wears the typically colorful

Minoan flounced skirt with a short-sleeved, open-breasted bodice, large earrings, and bracelets. She still has the shaved head, fringe of hair, and long ponytail of a child, but the light blue color of her scalp indicates that the hair is beginning to grow out.

In another house, an artist has created a landscape of hills, rocks, and flowers (FIG. 4–10). This mural is unlike anything previously encountered in ancient art, the first pure landscape painting. A viewer standing in the center of the room is surrounded by orange, rose, and blue rocky hillocks sprouting oversized deep red lilies. Swallows, represented by a few deft lines, swoop above and around the flowers. The artist unifies the rhythmic flow of the undulating landscape, the stylized patterning imposed on the natural forms, and the

decorative use of bright colors alternating with darker neutral tones, which were perhaps meant to represent areas of shadow. The colors—pinks, blues, yellows—may seem fanciful to us, but sailors today who know the area well attest to their accuracy: The artist recorded the actual colors of Thera's wet rocks in the sunshine. The impression is one of a celebration of the natural world. How different is this art—which captures a zestful joy of life—from the cool, static elegance of Egyptian painting!

BULL LEAPING AT KNOSSOS. One of the most famous and best-preserved paintings at Knossos depicts bull leaping. The restored panel is one of a group of paintings with bulls as subjects from a room in the palace's east wing (the painting is later

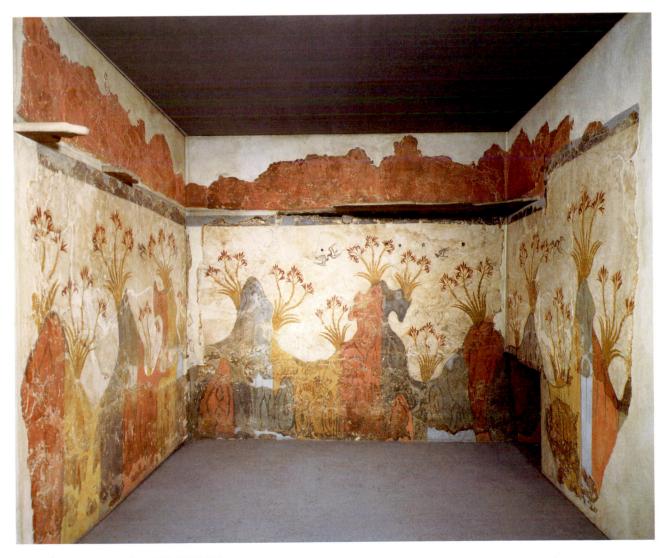

4–10 ↑ **LANDSCAPE (SPRING FRESCO)**Wall painting with areas of modern reconstruction, from Akrotiri, Thera Cyclades. Before 1630 BCE. National Archaeological Museum, Athens.

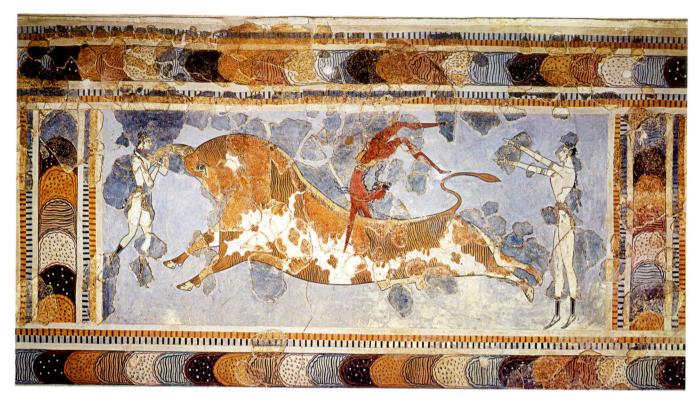

4-II BULL LEAPING

Wall painting with areas of modern reconstruction, from the palace complex, Knossos, Crete. Late Minoan period, c. 1550-1450 BCE. Height approx. 24½" (62.3 cm). Archaeological Museum, Iraklion, Crete.

than the Akrotiri paintings). The action may represent an initiation or fertility ritual. **BULL LEAPING** (FIG. 4–II) shows three scantily clad youthful figures around a gigantic dappled bull, which is charging in the "flying-gallop" pose. The pale-skinned person at the right—probably a woman—is prepared to catch the dark-skinned man in the midst of his leap, and the pale-skinned woman at the left grasps the bull by its horns, perhaps to begin her own vault. The bull's power and grace are masterfully rendered, although the flying-gallop pose is not true to life. Framing the action are overlapping ovals (the so-called chariot-wheel motif) set within striped bands.

Sculpture: The Woman with Snakes. Surviving Minoan sculpture consists mainly of small, finely executed work in wood, ivory, precious metals, stone, and faience. Female figurines holding serpents are among the most characteristic images and may have been associated with water, regenerative power, and protection of the home.

The **woman or Goddess with snakes** from the palace at Knossos is intriguing both as a ritual object and as a work of art (FIG. 4–12). This faience figurine was found with other

4-I2 WOMAN OR GODDESS WITH SNAKES

As restored, from the palace complex, Knossos, Crete. New Palace period, c. 1700-1550 BCE. Faience, height 11%" (29.5 cm). Archaeological Museum, Iraklion, Crete.

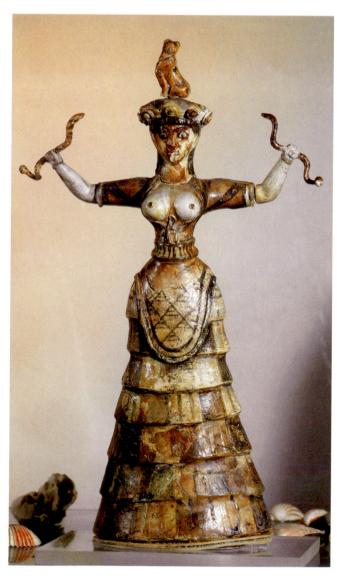

Technique

AEGEAN METALWORK

egean artists created exquisite luxury goods from imported gold. Their techniques included lost-wax casting (see "Lost-Wax Casting," PAGE XXV), inlay, filigree, repoussé (embossing), niello, and gilding. The Vapheio Cup (SEE FIG. 4-16) and the funerary mask (SEE FIG. 4-24) are examples of repoussé, in which the artist gently hammered out relief forms from the back of a thin sheet of gold. Experienced goldsmiths may have done simple designs freehand or used standard wood forms or punches. For more elaborate decorations they would first have sculpted the entire design in wood or clay and then used this form as a mold for the gold sheet.

The artists who created the Mycenaean dagger blade (SEE FIG. 4-25) not only inlaid one metal into another but also

employed a special technique called niello, still a common method of metal decoration. Powdered nigellum—a black alloy of lead, silver, and copper with sulfur—was rubbed into very fine engraved lines in the object being decorated, then fused to the surrounding metal with heat. The lines appear to be black drawings.

Gilding, the application of gold to an object made of some other material, was a technically demanding process by which paper-thin sheets of hammered gold called **gold leaf** (or, if very thin, **gold foil**) were meticulously affixed to the surface to be gilded. This was done with amazing delicacy for the now-bare stone surface of the Harvester Vase (SEE FIG. 4–13) and the wooden horns of the bull's-head rhyton (SEE FIG. 4–14).

ceremonial objects in a pit in one of Knossos's storerooms. Bare-breasted, arms extended, and brandishing a snake in each hand, the woman is a commanding presence. A leopard or a cat (perhaps a symbol of royalty, perhaps protective) is poised on her crown, which is ornamented with circles. This shapely figure is dressed in a fitted, open bodice with an apron over a

typically Minoan flounced skirt. A wide belt cinches the waist. The red, blue, and green geometric patterning on her clothing reflects the Minoan weavers' preference for bright colors, patterns, and fancy borders. Realistic elements combine with formal stylization to create a figure that is both lively and dauntingly, almost hypnotically, powerful—a combination that has led scholars to disagree whether statues such as this one represent deities or their human attendants.

STONE RHYTONS. Almost certainly of ritual significance are the stone vases and rhytons—vessels used for pouring liquids—that Minoans carved from steatite (a greenish or brown soapstone). These pieces were all found in fragments. The HARVESTER VASE is an egg-shaped rhyton barely 4½ inches in diameter (FIG. 4–13). It may have been covered with gold leaf, sheets of hammered gold (see "Aegean Metalwork," above).

A rowdy procession of twenty-seven men has been crowded onto its curving surface. The piece is exceptional for the freedom with which the figures occupy three-dimensional space, overlapping and jostling one another instead of marching in orderly single file across the surface in the manner of Near Eastern or Egyptian art. Also new is the exuberance of this scene, especially the emotions shown on the men's faces. They march and chant to the beat of a *sistrum*—a rattlelike percussion instrument—played by a man who seems to sing at the top of his lungs. The men have large,

4-I3 HARVESTER VASE

Hagia Triada, Crete. New Palace Period, c. 1650-1450 BCE. Steatite, diameter 4½" (11.3 cm). Lower part of vase is reconstructed. Archaeological Museum, Iraklion, Crete.

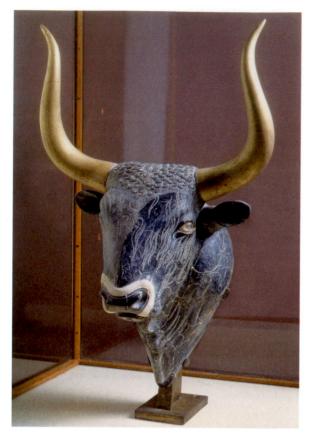

4–14 | BULL'S-HEAD RHYTON
Palace complex, Knossos, Crete. New Palace Period, c.1550–1450 BCE. Steatite with shell, rock crystal, and red jasper, the gilt-wood horns restored, height 12" (30.5 cm). Archaeological Museum, Iraklion, Crete.

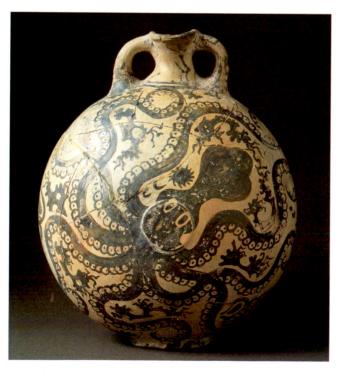

4–15 ↑ **OCTOPUS FLASK**Palaikastro, Crete. New Palace Period, c. 1500–1450 BCE.
Marine style ceramic, height 11" (28 cm).
Archaeological Museum, Iraklion, Crete.

coarse features and sinewy bodies so thin that their ribs stick out. Archaeologists have interpreted the scene in many ways—as a spring planting or fall harvest festival, a religious procession, a dance, a crowd of warriors, or a gang of forced laborers.

Rhytons were also made in the form of a bull's head (FIG. 4–14). Bulls often appear in Minoan art, rendered with an intensity not seen since the prehistoric cave paintings at Altamira and Lascaux (Chapter 1). Although many early cultures associated their gods with powerful animals, neither their images nor later myths offer any proof that the Minoans worshiped a bull god. According to later Greek legend, the Minotaur in King Minos's palace was not an object of religious veneration.

The sculptor of a bull's head rhyton found at Knossos used a block of greenish-black steatite to create an image that approaches animal portraiture. Lightly engraved lines, filled with white powder to make them visible, indicate the animal's coat: short, curly hair on top of the head; longer, shaggy strands on the sides; and circular patterns along the neck suggest its dappled coloring. White bands of shell outline the nostrils, and painted rock crystal and red jasper form the eyes. The horns (restored) were made of wood covered with gold leaf. Additionally, liquid could be poured into a hole in the neck and flowed out from the mouth.

CERAMIC ARTS. Minoan potters also created more modest vessels. The ceramic arts, so splendidly demonstrated in Old Palace Kamares ware, continued throughout the New Palace Period. Some of the most striking ceramics were done in what is called the "Marine style," because of the depictions of sea life on their surfaces. In a stoppered bottle of this style known as the **OCTOPUS FLASK**, made about 1500–1450 BCE (FIG. 4–15), the painter celebrates the sea. Like microscopic life teeming in a drop of pond water, sea creatures float around an octopus's tangled tentacles. The decoration on the Kamares ware jug (SEE FIG. 4–7) reinforces the solidity of its surface, but here the pottery skin seems to dissolve. The painter captured the grace and energy of natural forms while presenting them as a stylized design in harmony with the vessel's spherical shape.

METALWORK. About 1450 BCE, a conquering people from mainland Greece, known as Mycenaeans, arrived in Crete. They occupied the buildings at Knossos and elsewhere until a final catastrophe and the destruction of Knossos about 1375 BCE caused them to abandon the site. But by 1400 BCE, the center of political and cultural power in the Aegean had shifted to mainland Greece.

The skills of Minoan artists, particularly metalsmiths, made them highly sought after in mainland Greece. A pair of magnificent gold cups found in a large tomb at Vapheio, on the Greek mainland south of Sparta, were made sometime between 1650 and 1450 BCE, either by Minoan artists or by locals trained in Minoan style and techniques. One cup is shown here (FIG. 4–16). The relief designs were executed in repoussé—the technique of hammering from the back of the sheet. The handles were attached with rivets, and the cup was then lined with sheet gold. In the scene that circles the cup, men are depicted trying to capture bulls in various ways. Here, a half-nude man has roped a bull's hind leg. The figures dominate the landscape, which literally bulges with a muscular vitality that belies the cup's small size—it is only 3 1/8 inches tall. The depiction of olive trees could indicate that the scene is a sacred grove, and that these may be illustrations of exploits in some long-lost heroic tale rather than commonplace herding scenes.

THE MYCENAEAN (HELLADIC) CULTURE

Archaeologists use the term *Helladic* (from *Hellas*, the Greek name for Greece) to designate the Aegean Bronze Age on mainland Greece. The Helladic period extends from about 3000 to 1000 BCE, concurrent with the Cycladic and Minoan periods. In the early part of the Aegean Bronze Age, Greekspeaking peoples, probably from the northwest, moved into the mainland. They brought with them advanced techniques for metalworking, ceramicware, and architectural design, and they displaced the local Neolithic culture. When Minoan culture declined after about 1450 BCE, people of a late Helladic mainland culture known as Mycenaean, after the city of

Sequencing Events EGYPTIAN, MYCENAEAN, AND MINOAN CULTURES

с. 3000 все	Early Bronze Age in the Cyclades
с. 2200 все	First Palaces at Knossos, Crete
с. 2000 все	First pictographic script, Crete
с. 1900 все	Old Palace Period
с. 1650-25 все	Destruction of Thera, earthquakes and volcanic eruption
с. 1600 все	Mycenaeans rise to power
с. 1450 все	Destruction of Minoan palaces; Knossos occupied by Mycenaeans
с. 1400 все	Knossos burned and not rebuilt
с. 1300 все	Mycenaean walls on acropolis in Athens
с. 1100 все	End of Mycenaean dominance

Mycenae, occupied Crete as well as Greece, and rose to dominance in the Aegean region.

Helladic Architecture

Mycenaean architecture was distinct from that of the Minoans. Mycenaeans built strongholds of megaliths called citadels to protect the palaces of their rulers. These palaces contained a characteristic structure called a *megaron* that was axial in plan. The Mycenaeans also buried their dead in magnificent vaulted tombs, round in shape and crafted of cut stone.

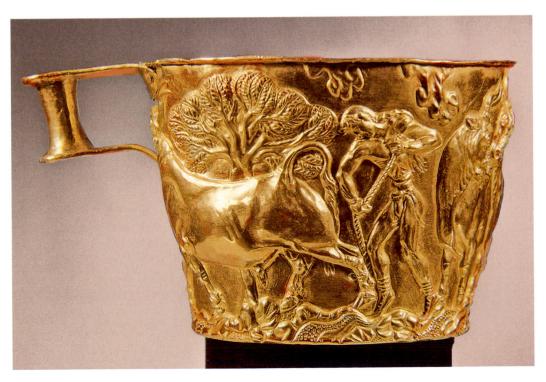

4-16 VAPHEIO CUP Found near Sparta, Greece. c. 1650-1450 BCE. Gold, height 3½" (3.9 cm). Archaeological Museum, Iraklion, Crete.

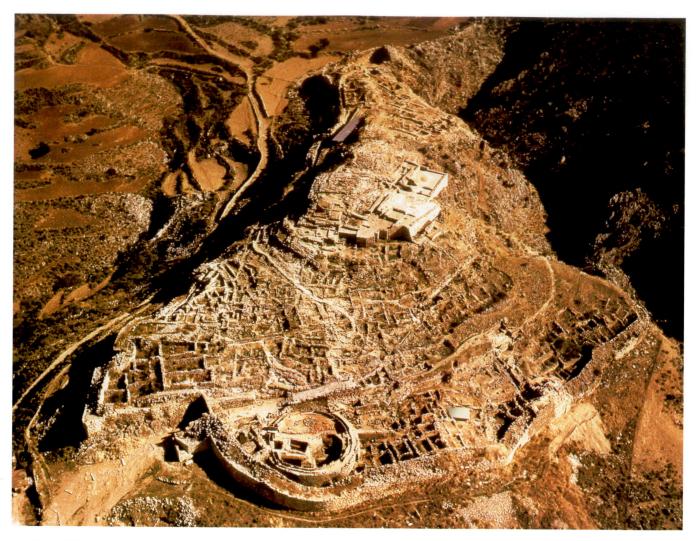

4–17 | CITADEL AT MYCENAE
Greece. Aerial view. Site occupied c. 1600–1200 BCE; walls built c. 1340, 1250, 1200 BCE.

The citadel's hilltop position, the grave circle at the bottom center of the photograph, and the circuit walls are clearly visible. The Lion Gate (see "The Lion Gate," pages 100-101) is at the lower left. The megaron floor and bases of columns and walls are at the top of the hill, at the upper center.

THE CITADEL AT MYCENAE. Later Greek writers called the walled city of Mycenae (FIGS. 4-17, 4-18), located near the east coast of the Peloponnese peninsula in southern Greece, the home of Agamemnon, the leader of the Greek army that conquered the great city of Troy (see "Homeric Greece," page 98). The site has been occupied from the Neolithic period to around 1050 BCE. Even today, the monumental gateway to the citadel at Mycenae is an impressive reminder of the importance of the city. The walls were rebuilt three times—c. 1340 BCE, c. 1250 BCE, and c. 1200 BCE—each time stronger than the last and enclosing more space. The second wall of c. 1250 BCE enclosed the grave circle and was pierced by two gates, the monumental Lion Gate (see "The Lion Gate," pages 100-101) on the west and a small postern gate on the northeast side. The final walls were extended about 1200 BCE to protect the water supply, an underground cis-

tern. These walls were about 25 feet thick and nearly 30 feet high. The drywall masonry is known as **cyclopean**, because it was believed that only the giant Cyclops could have moved such massive stones.

As in Near Eastern citadels, the Lion Gate was provided with guardian figures, which stand above the door rather than in the door jambs. From this gate, the formal entranceway into the citadel, known as the Great Ramp, led up the hillside, past the grave circle, to the king's residence and council room.

The ruler's residence was built on the highest point in the center of the city. Its distinctive feature was a large audience hall called a **megaron**, or "great room." The main courtyard led to a large rectangular building with a porch, a vestibule, and finally the great room—a much more direct approach to the principal room than the complex corridors of a Minoan palace. A typical megaron had a central hearth surrounded by

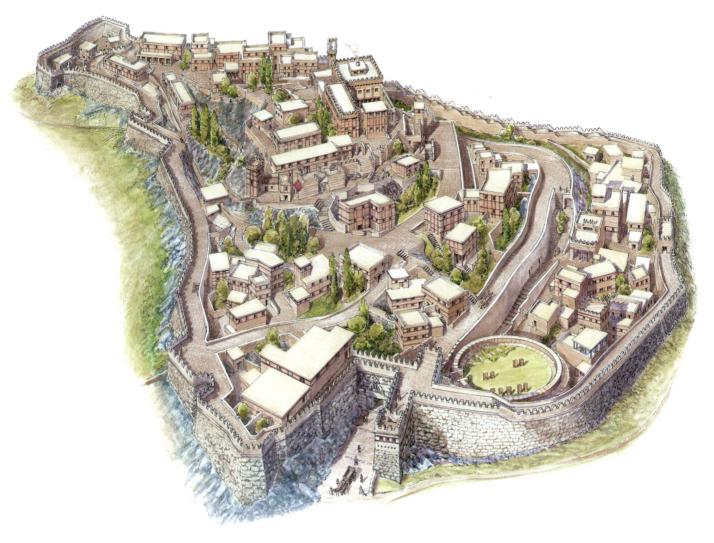

4−18 | RECONSTRUCTION OF CITADEL AT MYCENAE

four large columns that supported the ceiling. The roof above the hearth was raised to admit light and air and permit smoke to escape (FIG. 4–19). Some architectural historians think that the megaron eventually came to be associated with royalty. The later Greeks adapted its form when building temples, which they saw as earthly palaces for their gods.

THE PALACE AT PYLOS. The rulers of Mycenae fortified their city, but the people of Pylos, in the extreme southwest of the Peloponnese, perhaps felt that their more remote and defensible location made them less vulnerable to attack. It may be that the people of Pylos should have taken greater care to protect themselves. Within a century of its construction, the palace at Pylos (c. 1300–1200 BCE) was destroyed by fires, apparently set during the violent upheavals that brought about the collapse of Mycenae.

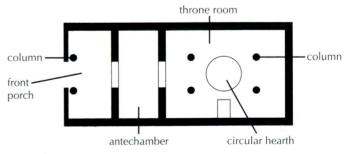

4−19 | **PYLOS PALACE PLAN** c. 1300–1200 BCE.

The palace at Pylos was built on a raised site without fortifications, and it was focused on the ruler's residence and megaron. Set behind a porch and vestibule facing the court-yard, the Pylos megaron was a magnificent display of architectural and decorative skill. The reconstructed view provided

Art and Its Context

HOMERIC GREECE

he legend of the Trojan War and its aftermath held a central place in the imagination of ancient people. Sometime before 700 BCE, it inspired the great epics of the Greek poet Homer—the *Iliad* and the *Odyssey*—and provided later poets and artists with rich subject matter.

According to the legend, a woman's infidelity caused the war. While on a visit to the city of Sparta in the Peloponnese, in southern Greece, young Paris, son of King Priam of Troy, fell in love with Helen, a human daughter of Zeus who was the wife of the Spartan king Menelaus. With the help of Aphrodite, the goddess of love, Helen and Paris fled to Troy, a rich city in northwestern Asia Minor. The angry Greeks dispatched ships and a huge army to bring Helen back. Led by Agamemnon, king of Mycenae and the brother of Menelaus, the Greek forces laid siege to Troy. The two sides were deadlocked for ten years, until a ruse devised by the Greek warrior Odysseus enabled the Greeks to win: The Greeks pretended to give up the siege and built a huge wooden horse to leave behind as a parting gift to the god-

dess Athena. In fact, Greek warriors were hidden inside the wooden horse. After the Trojans pulled the horse inside the gates of Troy, the Greeks slipped out and opened the gates to their comrades, who slaughtered the Trojans and burned the city.

This legend probably originated with a real attack on a coastal city of Asia Minor by mainland Greeks during the late Bronze Age. Tales of the conflict, modified over the centuries, endured in a tradition of oral poetry until finally written down and attributed to Homer.

Archaeologists, including Schliemann, concluded that the remains of the legendary city might be found at the Hissarlik Mound in northwestern Turkey. Excavated first in 1872-90 and again beginning in the 1930s, this relatively small mound—less than 700 feet across—contained the "stacked" remains of at least nine successive cities, the earliest of which dates to at least 3000 BCE. The most recent hypothesis is that so-called Troy 6 (the sixth-level city), which flourished between about 1800 and 1300 BCE, was the Troy of Homeric legend.

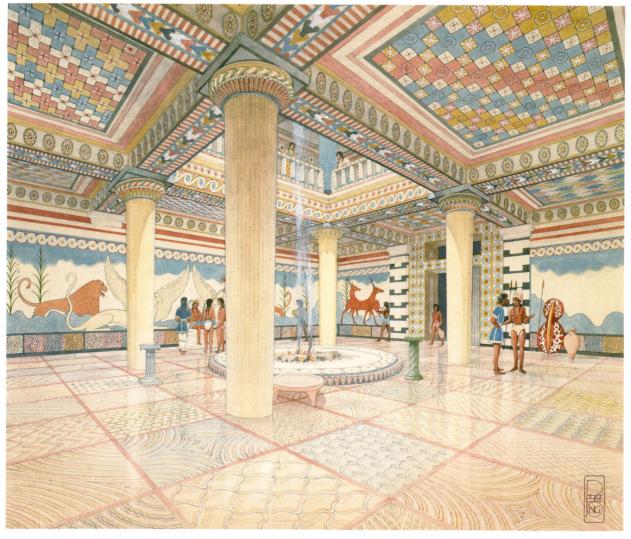

4–20 RECONSTRUCTION DRAWING OF THE MEGARON IN THE PALACE AT PYLOS Greece. c. 1300–1200 BCE. Drawing in Antonopouleion Archaeological Museum, Pylos.

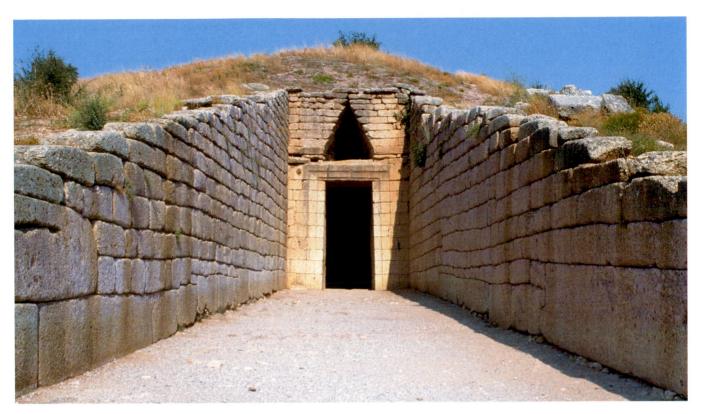

4–21 \mid Tholos, the so-called treasury of atreus Mycenae, Greece. c. 1300–1200 BCE.

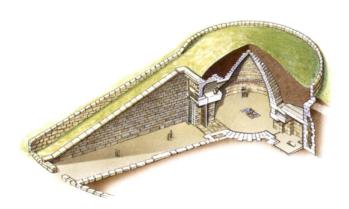

4-22 CUTAWAY DRAWING OF THOLOS

here (FIG. 4–20) shows how the combined throne room and audience hall might have looked. Fluted, upward-swelling Minoan-type columns support heavy ceiling beams. Every inch was painted—floors, ceilings, beams, and door frames were covered with brightly colored abstract designs, and the walls were covered with paintings of large mythical animals and highly stylized plant and landscape forms. The floor was finished with painted plaster.

Clay tablets in Linear B found in the ruins of the palace include an inventory of furnishings that indicates they were as elegant as the architecture. The listing on one tablet reads: "One ebony chair with golden back decorated with birds; and a footstool decorated with ivory pomegranates. One ebony chair with ivory back carved with a pair of finials and

with a man's figure and heifers; one footstool, ebony inlaid with ivory and pomegranates."

MYCENAEAN TOMBS. Tombs were given much greater prominence in the Helladic culture of the mainland than they were by the Minoans, and ultimately they became the most architecturally sophisticated monuments of the entire Aegean period. The earliest burials were in shaft graves, vertical pits 20 to 25 feet deep. In Mycenae, the royal graves were enclosed in a circle of standing stone slabs. In these graves, the ruling families laid out their dead in opulent dress and jewelry and surrounded them with ceremonial weapons (SEE FIG. 4–25), gold and silver wares, and other articles indicative of their status, wealth, and power. It was in shaft grave V that the so-called mask of Agamemnon was found (SEE FIG. 4–24).

By about 1600 BCE, kings and princes on the mainland had begun building large above-ground burial places commonly referred to as **tholos tombs** (popularly known as **bee-hive tombs** because of their rounded, conical shape). More than a hundred such tombs have been found, nine of them in the vicinity of Mycenae. Possibly the most impressive is the so-called **TREASURY OF ATREUS** (FIGS. 4–21, 4–22) which dates from about 1300 to 1200 BCE.

A walled passageway through the earthen mound covering the tomb, about 114 feet long and 20 feet wide and open to the sky, led to the entrance. The original entrance was 34 feet high and the door was $16\frac{1}{2}$ feet high, faced with bronze plaques. It was flanked by engaged, upward-tapering columns

THE OBJECT SPEAKS

THE LION GATE

ne of the most imposing survivals from the Helladic Age is the gate to the city of Mycenae. The gate is today a simple opening, but its importance is indicated not only by the monumental sculptures of guardian beasts, but by the very material of the flanking walls, a conglomerate stone that can be polished to glistening multicolors. Additionally, a corbelled relieving arch above the lintel forms a triangle filled with a limestone panel bearing a grand heraldic composition—a single Minoan column that tapers upward to a large bulbous capital and abbreviated entablature.

An archival photograph shows a group posing jauntily beside, and in, the gate.
Visible is Heinrich Schliemann (standing at

the left of the gate) and his wife and partner in archeology, Sophia (sitting at the right). Schliemann had already "discovered" Troy, and when he turned his attention to Mycenae, he unearthed graves with rich grave goods, including gold masks (see Fig. 4–24). The grave circle he excavated lay just beyond the Lion Gate.

The Lion Gate has been the subject of much speculation in recent years. What are the animals? What does the architectural feature mean? How is the imagery to be interpreted? The beasts supporting and defending the column are magnificent supple creatures rearing up on hind legs. They once must have faced the visitor, but today only the attachment holes indicate the presence of their heads.

What were they—lions or lionesses? One scholar points out that since the beasts have neither teats nor penises, it is impossible to say. The beasts do not even have to be felines. They could have had eagle heads, which would make them griffins, in which case should they not also have wings? They could have had human heads, and that would turn them into sphinxes. Pausanias, a Greek traveler who visited Mycenae in the second century CE, described a gate guarded by lions. Did he see the now missing heads? Did the "object" not only speak, but roar?

Mixed-media sculpture—ivory and gold, marble and wood—was common. One could imagine that if the creatures had the heads of lions, the heads might have resembled the gold cup in the form of a lion that still survives. Such heads would have gleamed and glowered out at the visitor. And if the sculpture were painted, as most sculpture was, the gold would not have seemed out of place.

A metaphor for power, the lions rest their feet on Mycenaean altars. Between them stands the mysterious column, also on an altar base. What does it mean? Scholars do not agree. Is it a temple? A palace? The entire city? Or the god of the place? The column and capital support a lintel or architrave, which in turn supports the butt ends of logs forming rafters of the horizontal roof, so the most likely theory is that the structure is the symbol of a palace or a temple. But some scholars suggest that by extension it becomes the symbol of a king or a deity (just as we say the "White House" when we mean the government of the United States), and that the imagery of the Lion Gate, with its combination of the guardian beasts and divine or royal palace, serves to legitimize the power of the ruler.

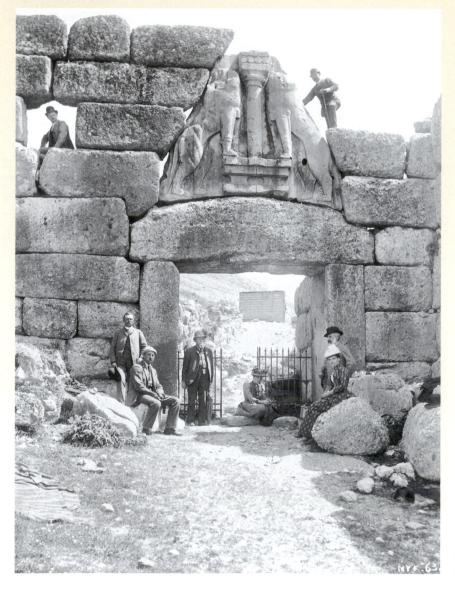

LION GATE, MYCENAE c. 1250 BCE. Historic photo.

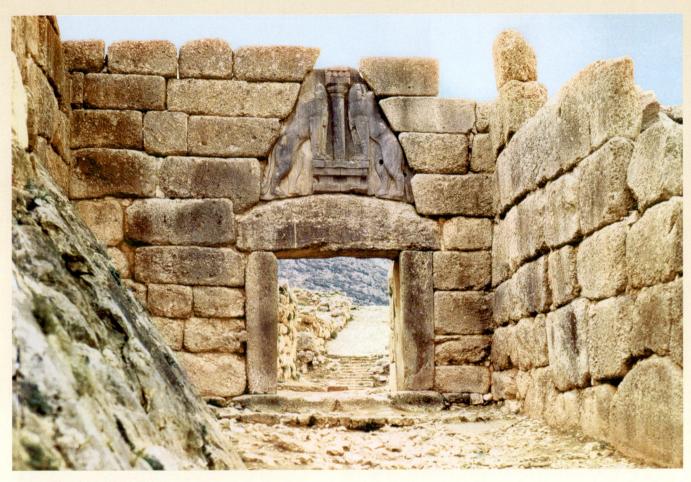

LION GATE, MYCENAE c. 1250 BCE. Limestone relief, height of sculpture approx. 9'6" (2.9 m).

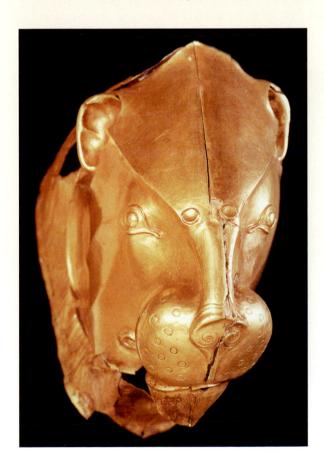

GOLDEN LION'S HEAD RHYTON

Shaft grave IV, south of Lion gate, Mycenae, sixteenth century BCE. National Archaeological Museum, Athens.

4–23 CORBELED VAULT, INTERIOR OF THOLOS Limestone vault, height approx. 43' (13 m), diameter 47'6" (14.48 m).

This great beehive tomb was half buried until it was excavated by Christos Stamatakis in 1878. For more than a thousand years, this Mycenaean tomb remained the largest uninterrupted interior space built in Europe. The first European structure to exceed it in size was the Pantheon in Rome (Chapter 6), built in the first century BCE.

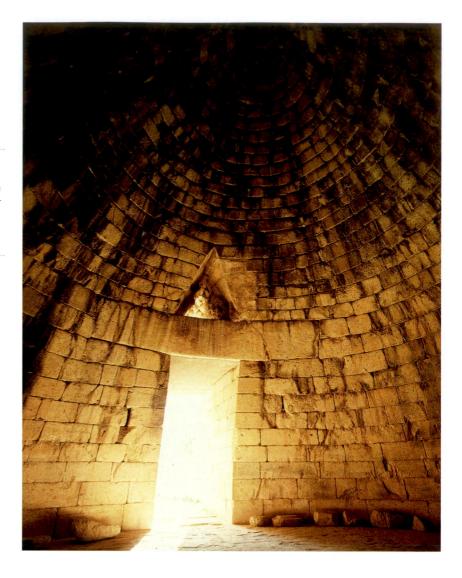

that were carved of green serpentine porphyry found near Sparta and incised with geometric bands and chevrons—inverted Vs—filled with running spirals, a favorite Aegean motif. The section above the lintel had smaller engaged columns on each side, and the relieving triangle was disguised behind a red-and-green engraved marble panel. The main tomb chamber (FIG. 4–23) is a circular room $47\frac{1}{2}$ feet in diameter and 43 feet high. It is roofed with a corbel vault built up in regular courses, or layers, of ashlar—squared stones—smoothly leaning inward and carefully calculated to meet in a single capstone at the peak. Covered with earth, the tomb became a conical hill. It was a remarkable engineering feat.

Metalwork

The *tholos* tombs at Mycenae had been looted long before archaeologist Heinrich Schliemann began to search for Homeric Greece, but he did excavate the contents of shaft graves (vertical pits 20 to 25 feet deep) at the site. Magnificent gold and bronze swords, daggers, masks, jewelry, and drinking cups were found buried with members of the elite.

Schliemann believed the citadel at Mycenae to be the home of Agamemnon, the commander-in-chief of the Greek

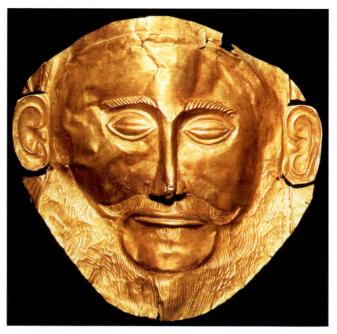

4–24 | "MASK OF AGAMEMNON"
Funerary mask, from the royal tombs, Grave Circle A, Mycenae, Greece. c. 1600–1550 BCE. Gold, height approx. 12" (35 cm). National Archaeological Museum, Athens.

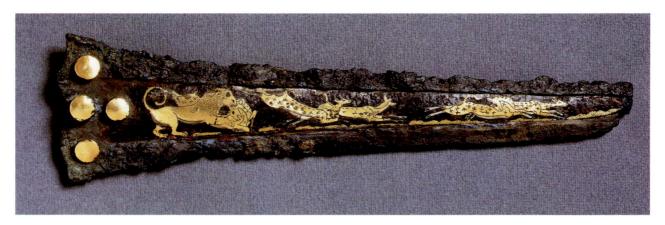

4–25 | DAGGER BLADE WITH LION HUNT
Shaft Grave IV, Grave Circle A, Mycenae, Greece. c. 1550–1500 BCE. Bronze inlaid with gold, silver, and niello, length 9%" (23.8 cm). National Archaeological Museum, Athens.

forces against Troy. Among the 30 pounds of gold objects he found in the royal graves were five death masks, and one of these golden treasures (FIG. 4–24) seemed to him to be the face of Homer's hero. We now know this golden mask has nothing to do with the heroes of the Trojan War. Research shows the Mycenae graves are about 300 years older than Schliemann believed, and the burial practices they display were different from those described by Homer. Still, the mask image is so commanding that we sense it is a hero's face. But the characteristics that make it seem so gallant—such as the handlebar moustache and large ears—have caused some scholars to question its authenticity. This mask is significantly different from the others found at the site, and some scholars contend that Schliemann added features to make the mask appear more heroic to viewers of his day.

Among the other objects found in the graves, the gold lion head rhyton (see "The Lion Gate," page 101) and bronze dagger blade (FIG. 4–25), decorated with inlaid scenes, attest to the wealth of a ruling elite. To form the decoration of the dagger, the Mycenaean artist cut shapes out of different-colored metals—copper, silver, and gold—inlaid them in the bronze blade, and then added the fine details in niello (see "Aegean Metalwork," page 93). In the *Iliad*, Homer's epic poem about the Trojan War, the poet describes similar decoration on Agamemnon's armor and Achilles' shield. The decoration on the blade shown here depicts a lion attacking a deer, with four more terrified animals in full flight. Like the bull in the Minoan fresco (FIG. 4–11), the animals spring forward in the "flying-gallop" pose to indicate speed and energy.

Sculpture

Mainland artists saw Minoan art as it was acquired through trade. Perhaps they even worked side by side with Minoan artists brought back by the conquerors of Crete. They adopted Minoan art with such enthusiasm that sometimes experts disagree over the identity of the artists—were they Minoans working for Mycenaeans or Mycenaeans taught by, or copying, Minoans?

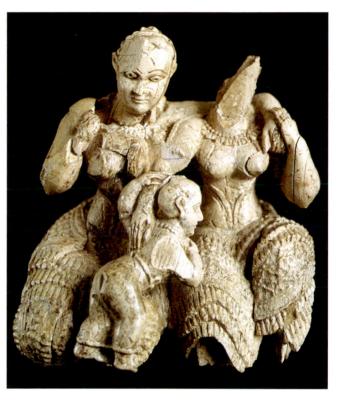

4–26 | TWO WOMEN WITH A CHILD Found in the palace at Mycenae, Greece, c. 1400–1200 BCE. Ivory, height 2%'' (7.5 cm). National Archaeological Museum, Athens.

A carved ivory group of two women and a child (FIG. 4–26), less than 3 inches high and found in the palace shrine at Mycenae, appears to be a product of Minoan-Mycenaean artistic exchange. Dating from about 1400–1200 BCE, the miniature exhibits carefully observed natural forms, an intricately interlocked composition, and finely detailed rendering. The group is carved entirely in the round—top and bottom as well as back and front. It is an object to be held in the hand. Because there are no clues to the identity or the significance of the group, we might easily interpret it as generational—with grandmother, mother, and child. But the figures could just as

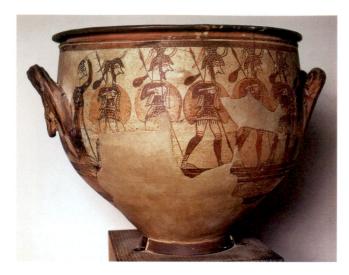

4–27 WARRIOR VASE
Mycenae, Greece. c. 1300–1100 BCE. Ceramic, height 16"
(41 cm). National Archaelogical Museum, Athens

well represent two nymphs or devotees attending a child god. In either case, the mood of affection and tenderness among the three is unmistakable, and, tiny as it is, the sculpture gives an insight into a gentler aspect of Mycenaean art.

Ceramic Arts

In the final phase of the Helladic period, Mycenaean potters created highly refined ceramics. A large **krater**, a bowl for mixing water and wine, used both in feasts and as grave markers, is an example of the technically superior wares being produced between 1300 and 1100 BCE. Decorations could be highly stylized, like the scene of marching men on the **WARRIOR VASE** (FIG. 4–27). On the side shown here, a woman at the far left bids farewell to a group of helmeted men marching off to the right with lances and large shields. The vibrant energy of the *Harvester Vase* or the *Vapheio Cup* has changed to the regular rhythm inspired by the tramping feet of disciplined warriors. The only indication of the woman's emotions is the gesture of an arm raised to her head, a symbol of mourning. The men are seemingly interchangeable parts in a rigidly disciplined war machine.

The succeeding centuries, between about 1100 and 900 BCE, were a "dark age" in the Aegean, marked by political, economic, and artistic instability and upheaval. But a new culture was forming, one that looked back to the exploits of the Helladic warrior-kings as the glories of a heroic age, while setting the stage for a new Greek civilization.

IN PERSPECTIVE

The study of the eastern Mediterranean—the Aegean Sea—is, in some senses, the newest of archeological studies. The culture of Mycenae, home of Agamemnon and the setting of the great Homeric tragedies, was discovered only at the end of the nineteenth century, and Knossos on Crete, the home of the Minotaur as well as King Minos, only at the beginning of the twentieth century.

The legends and myths of the Greeks and the epics of Homer—long part of the Western literary tradition—were at last given material form. The architectural complex of Knossos, with its open courts and sweeping stairs, also included living quarters, workrooms, storehouses, and a large performance area, but no grandiose tombs or temples. Relatively secure in its island location, the palace had few outer walls and watchtowers. Minoan art as reconstructed seems open, colorful, and filled with images of nature.

Three parallel geographical groups existed simultaneously, and the groups flourished at different times. Cycladic civilization peaked first in a Bronze Age culture beginning in 3000 BCE and characterized, as far as monuments in the history of art are concerned, by marble figures of women and musicians. On Crete, the Minoan culture had existed since Neolithic times but flourished in the Old and New Palace periods from about 1900 to about 1450 BCE. Minoan art is characterized by elaborate and lightly fortified architectural complexes (which we call palaces), wall painting, and work in precious and semiprecious materials—gold, ivory, bronze, steatite, ceramics, and textiles. On the mainland of Greece, the Mycenaeans rose to dominance about 1600 BCE with fortified citadels, princely burials, and magnificent gold and bronze equipment. The culture continued until about 1100 BCE, but by the year 1000 BCE this Aegean Age comes to an end.

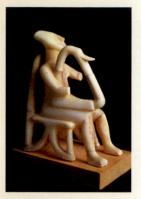

SEATED HARP PLAYER с. 2700-2500 все

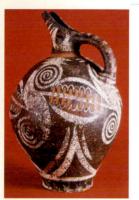

KAMARES WARE JUG с. 2000-1900 все

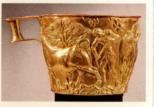

VAPHEIO CUP с. 1650-1450 все

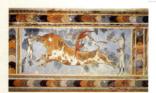

BULL LEAPING с. 1550-1450 все

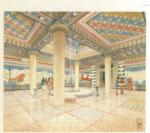

MEGARON IN THE PALACE OF PYLOS с. 1300-1200 все

AEGEAN ART

- Aegean Bronze Age c. 3000-2000 BCE
- Cycladic Culture с. 3000-1600 все
- Bronze Age Culture on Crete c. 3000 BCE
- Helladic Culture 3000-1000 BCE

Minoan Old Palace с. 1900-1700 все

- Minoan New Palace с. 1700-1450 все
- Mycenaean Culture с. 1600-1100 все

■ Late Minoan c. 1450-1100 BCE

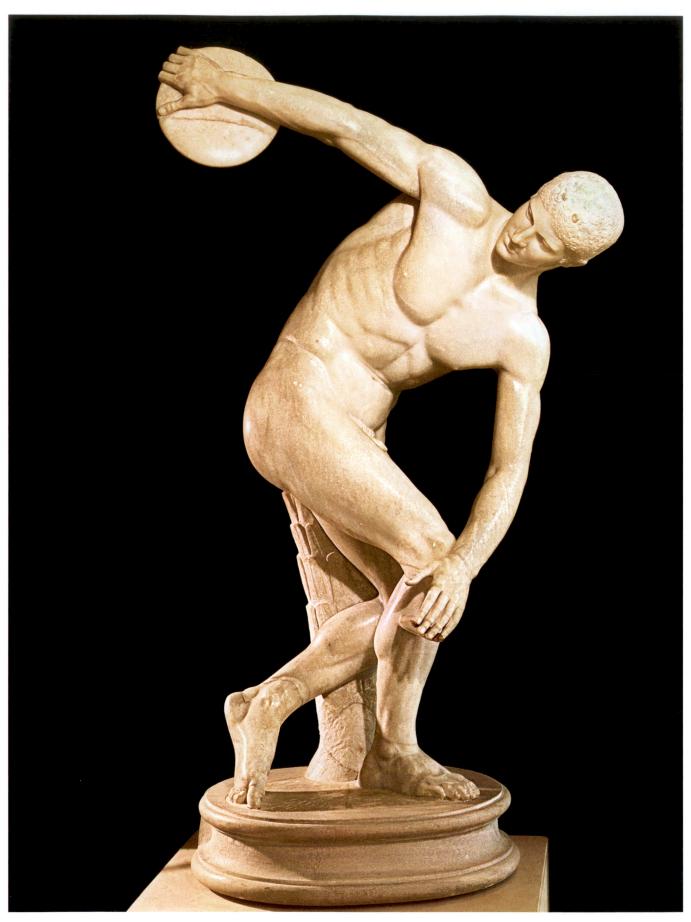

5-I Myron **DISCUS THROWER (DISKOBOLOS)** Roman copy after the original bronze of c. 450 BCE. Marble, height 5'11'' (1.55 m). National Museum, Rome.

CHAPTER FIVE

ART OF ANCIENT GREECE

A sense of awe fills the stadium when the athletes recognized as the best in the world enter. With the opening ceremonies behind them, each has only one goal: to win—to earn recognition as the best, to take home the champi-

5

onship. This competition began more than 2,500 years ago, but the scene seems familiar. Every four years, then as now, the best athletes came together. Attention would focus on physical competition, on the individual human beings who seemed able to surpass even their own abilities—in such feats as running, wrestling, riding, discus throwing, long jumping, boxing, and javelin hurling—in the glorious pursuit of an ideal. Yet beyond those common elements lie striking differences between the Olympian Games of the past and the Olympic Games of the present.

At those first Olympian Games, the contests had a strong religious aspect. The athletes gathered on sacred ground (near Olympia, in present-day Greece) to pay tribute to the supreme god, Zeus. The first day's ceremonies were religious rituals, and the awards were crowns of wild olive leaves from the Sacred Grove of the gods. The winners' deeds were celebrated by poets long after their victories, and the greatest athletes were idealized for centuries in extraordinary Greek sculpture, such as the **DISCUS THROWER (DISKOBOLOS)**, originally created in bronze by Myron about 450 BCE (FIG. 5–I).

The hero Herakles was believed to be the founder of the Olympian Games. According to the ancients, Herakles drew up the rules and decided the size of the stadium. The Olympian Games came to be so highly regarded that the city-states suspended all political activities while the Games were in progress. The Games may have begun in the

ninth century BCE; a list of winners survives from 776 BCE. Games were held every four years until they were banned in 393 CE by the Christian Roman emperor Theodosius I. They did not resume for centuries: The first modern Olympic Games were held in Athens in 1896. The modern Olympics too begin with the lighting of a flame from a torch ignited by the sun at Olympia and carried by relay to the chosen site for a particular year—an appropriate metaphor for the way the light of inspiration was carried from ancient Greece throughout the Western world. But Olympic Games were not the only contribution the Greeks made to world civilization.

"Man is the measure of all things," concluded Greek sages. Supremely self-aware and self-confident, the Greeks developed a concept of human supremacy and responsibility into a worldview that demanded a new visual expression in art. Artists studied the human figure intensely, then distilled their newfound knowledge to capture the essence of humanity—a term that, by the Greeks' definition, applied only to those who spoke Greek; they considered those who could not speak Greek "barbarians."

Greek customs, institutions, and ideas have had an enduring influence in many parts of the world. Countries

that esteem athletic prowess reflect an ancient Greek ideal. Systems of higher education in the United States and Europe also owe much to ancient Greek models. Many important Western philosophies have conceptual roots in ancient Greece. And representative governments throughout the world today owe a debt to ancient Greek experiments in democracy.

CHAPTER-AT-A-GLANCE

- THE EMERGENCE OF GREEK CIVILIZATION | Historical Background | Religious Beliefs and Sacred Places | Historical Divisions of Greek Art
- GREEK ART FROM c. 900 to 600 BCE | The Geometric Period | The Orientalizing Period
- THE ARCHAIC PERIOD, c. 600–480 BCE | Temple Architecture | Architectural Sculpture | Freestanding Sculpture | Vase Painting
- THE CLASSICAL PERIOD, c. 480–323 BCE | The Canon of Polykleitos | The Art of the Early Classical Period, 480–450 BCE
- THE HIGH CLASSICAL PERIOD, c. 450–400 BCE | The Acropolis | The Parthenon | The Propylaia and the Erechtheion | The Temple of Athena Nike | The Athenian Agora | Stele Sculpture | Painting: Murals and Vases
- THE LATE CLASSICAL PERIOD, c. 400–323 BCE | Architecture and Architectural Sculpture | Sculpture | The Art of the Goldsmith | Wall Painting and Mosaics
- THE HELLENISTIC PERIOD, 323–31/30 BCE | The Corinthian Order in Hellenistic Architecture | Hellenistic Architecture: The Theater at Epidauros | Sculpture | The Multicultural Hellenistic World
- **IN PERSPECTIVE**

THE EMERGENCE OF GREEK CIVILIZATION

Ancient Greece was a mountainous land of spectacular natural beauty. Olive trees and grapevines grew on the steep hill-sides, producing oil and wine. But with little good farmland, the Greeks turned to commerce to supply their needs. In towns, skilled artisans provided metal and ceramic wares to exchange abroad for grain and raw materials. Greek merchant ships carried pots, olive oil, and bronzes from Athens, Corinth, and Aegina around the Mediterranean Sea. The Greek cultural orbit included mainland Greece with the Peloponnesus in the south and Macedonia in the north, the Aegean Islands, and the western coast of Asia Minor (MAP 5–1). Greek colonies in Italy, Sicily, and Asia Minor rapidly became powerful independent commercial and cultural centers themselves, but they remained tied to the homeland by common language, traditions, religion, and history.

More than 2,000 years have passed since the artists and architects of ancient Greece worked, yet their achievements continue to have a profound influence. Their legacy is especially remarkable given their relatively small numbers, the almost constant warfare that beset them, and the often harsh economic conditions of the time. Greek artists sought a level of perfection that led them continually to improve upon their past accomplishments through changes in style and technique. The history of Greek art contrasts dramatically with that of Egyptian art, where the desire for permanence and continuity induced artists to maintain artistic conventions for

nearly 3,000 years. In the comparatively short time span from around 900 BCE to about 100 BCE, Greek artists explored a succession of new ideas to produce a body of work in every medium—from painting and mosaics to ceramics and sculpture—that exhibits a clear stylistic and technical direction toward representing the visual world as we see it. The periods into which ancient Greek art is traditionally divided reflect the definable stages in this stylistic progression.

Historical Background

Following the collapse of Mycenaean dominance about 1100-1025 BCE, the Aegean region experienced a period of disorganization during which most prior cultural developments, including writing, were destroyed or forgotten. Greeks in the ninth and eighth centuries BCE developed the citystate (polis), an autonomous region having a city—Athens, Corinth, Sparta—as its political, economic, religious, and cultural center. Each was independent, deciding its own form of government, securing its own economic support, and managing its own domestic and foreign affairs. The power of these city-states initially depended at least as much on their manufacturing and commercial skills as on their military might. In the seventh century BCE, the Greeks adopted two sophisticated new tools, coinage from Asia Minor and alphabetic writing from the Phoenicians, opening the way for success in commerce and literature.

Among the emerging city-states, Corinth, located on major land and sea trade routes, was one of the oldest and

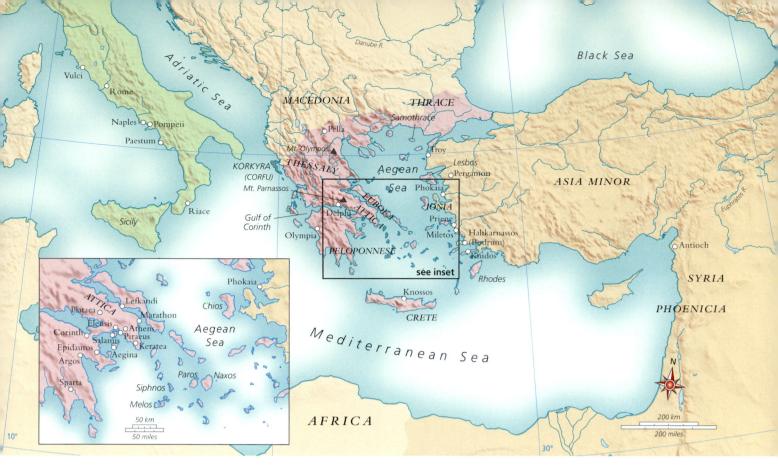

MAP 5-I ANCIENT GREECE

During the Hellenistic period, Greek influence extended beyond mainland Greece to Macedonia, Egypt, and Asia Minor.

most powerful. By the sixth century BCE, Athens, located in Attica on the east coast of the mainland, began to assume both commercial and cultural preeminence. By the end of the sixth century, Athens had a representative government in which every community had its own assembly and magistrates. All citizens participated in the assembly and all had an equal right to own private property, to exercise freedom of speech, to vote and hold public office, and to serve in the army or navy. Citizenship, however, remained an elite male prerogative. The census of 309 BCE in Athens listed 21,000 citizens, 10,000 foreign residents, and 400,000 others—that is, women, children, and slaves. In spite of the exclusive and intensely patriarchal nature of citizenship, the idea of citizens with rights and responsibilities was an important new concept in governance.

Religious Beliefs and Sacred Places

Knowledge of Greek history is important to understanding its arts; knowledge of its religious beliefs is indispensable. According to ancient Greek legend, the creation of the world involved a battle between the earth gods, called Titans, and the sky gods. The victors were the sky gods, whose home was believed to be atop Mount Olympus in the northeast corner of the Greek mainland. The Greeks saw their gods as immortal and endowed with supernatural powers, but more than peoples of the ancient Near East and the Egyptians, they also visualized them in human form and attributed to them human weaknesses and emotions. Among the most important deities were the ruling god and goddess, Zeus and Hera; Apollo, god of healing, arts, and the sun; Poseidon, god of the sea; Ares, god of war; Aphrodite, goddess of love; Artemis, goddess of hunting and the moon; and Athena, the powerful goddess of wisdom who governed several other important aspects of human life (see "Greek and Roman Deities," page 110).

SANCTUARIES. Many sites throughout Greece, called **sanctuaries**, were thought to be sacred to one or more gods. Local people enclosed the sanctuaries and designated them as sacred ground. The earliest sanctuaries had one or more outdoor altars or shrines and a sacred natural element such as a tree, a rock, or a spring. As more buildings were added, a

Art and Its Context

GREEK AND ROMAN DEITIES

ccording to legend, twelve major sky gods and goddesses established themselves on Mount Olympos in northeastern Greece after defeating the earth deities (the Titans) for control of the earth and sky. (The Roman form of the name is given after the Greek name.)

THE FIVE CHILDREN OF EARTH AND SKY

Zeus (Jupiter), supreme deity. Mature, bearded man; holds scepter or lightning bolt; eagle and oak tree are sacred to him.

Hera (Juno), goddess of marriage. Sister/wife of Zeus. Mature woman; cow and peacock are sacred to her.

Hestia (Vesta), goddess of the hearth. Sister of Zeus. Her sacred flame burned in communal hearths.

Poseidon (Neptune), god of the sea. Holds a three-pronged spear; horse is sacred to him.

Hades (Pluto), god of the underworld, the dead, and wealth. His helmet makes the wearer invisible.

THE SEVEN SKY GODS, OFFSPRING OF THE FIRST FIVE

Ares (Mars), god of war. Son of Zeus and Hera. Wears armor; vulture and dog are sacred to him.

Hephaistos (Vulcan), god of the forge, fire, and metal handicrafts. Son of Hera (in some myths, also of Zeus); husband of Aphrodite. Lame, sometimes ugly; wears blacksmith's apron, carries hammer.

Apollo (Phoebus), god of the sun, light, truth, music, archery, and healing. Sometimes identified with Helios (the Sun), who rides a chariot across the daytime sky. Son of Zeus and Leto (a descendant of Earth); brother of Artemis. Carries bow and arrows or sometimes lyre; dolphin and laurel are sacred to him.

Artemis (Diana), goddess of the hunt, wild animals, and the moon. Sometimes identified with Selene (the Moon), who rides a chariot or oxcart across the night sky. Daughter of

Zeus and Leto; sister of Apollo. Carries bow and arrows, is accompanied by hunting dogs; deer and cypress are sacred to her. Also the goddess of childbirth and unwed young women.

Athena (Minerva), goddess of wisdom, war, victory, and the city. Also goddess of handcrafts and other artistic skills. Daughter of Zeus; sprang fully grown from his head. Wears helmet and carries shield and spear; owl and olive trees are sacred to her.

Aphrodite (Venus), goddess of love. Daughter of Zeus and the water nymph Dione; alternatively, born of sea foam; wife of Hephaistos. Myrtle, dove, sparrow, and swan are sacred to her.

Hermes (Mercury), messenger of the gods, god of fertility and luck, guide of the dead to the underworld, and god of thieves and commerce. Son of Zeus and Maia, the daughter of Atlas, a Titan who supports the sky on his shoulders. Wears winged sandals and hat; carries caduceus, a wand with two snakes entwined around it.

OTHER IMPORTANT DEITIES

Demeter (Ceres), goddess of grain and agriculture. Daughter of Kronos and Rhea, Sister of Zeus and Hera.

Persephone (Proserpina), goddess of fertility and queen of the underworld. Wife of Hades; daughter of Demeter.

Dionysos (Bacchus), god of wine, the grape harvest, and inspiration. Shown surrounded by grapevines and grape clusters; carries a wine cup. His female followers are called maenads (Bacchantes).

Eros (Cupid), god of love. In some myths, the son of Aphrodite. Shown as an infant or young boy, sometimes winged; carries bow and arrows.

Pan (Faunus), protector of shepherds, god of the wilderness and of music. Half-man, half-goat, he carries panpipes.Nike (Victory), goddess of victory. Often shown winged and flying.

sanctuary might become a palatial home for the gods, with one or more temples, several treasuries for storing valuable offerings, various monuments and statues, housing for priests and visitors, an outdoor dance floor or permanent theater for ritual performances and literary competitions, and a stadium for athletic events. The Sanctuary of Zeus near Olympia, in the western Peloponnese, housed an extensive athletic facility with training rooms and arenas for track-and-field events. It was here that athletic competitions, prototypes of today's Olympic Games, were held.

Greek sanctuaries are quite different from the religious complexes of the ancient Egyptians (see, for example, the Temple of Karnak, figs. 3–22, 3–23). Egyptian builders dramatized the power of gods or god-rulers by organizing their

temples along straight, processional ways. The Greeks, in contrast, treated each building and monument as an independent element to be integrated with the natural features of the site. It is tempting to draw a parallel between this manner of organizing space and the way Greeks organized themselves politically. Every structure, like every Greek citizen, was a unique entity meant to be encountered separately within its own environment while being closely allied with other entities in a larger scheme of common purpose.

DELPHI. The temple at Delphi, the sacred home of the Greek god Apollo, was built about 530 BCE on the site of an earlier temple (FIG. 5–2). In this rugged mountain site, according to Greek myth, Zeus was said to have released two

eagles from opposite ends of the earth and they met exactly at the site of Apollo's sanctuary. Here too, it was said, Apollo fought and killed Python, the serpent son of the earth goddess Ge, who guarded his mother's nearby shrine. From very early times, the sanctuary at Delphi was renowned as an *oracle*, a place where the god was believed to communicate with humans by means of cryptic messages delivered through a human intermediary, or *medium* (the Pythia). The Greeks and their leaders routinely sought advice at oracles, and attributed many twists of fate to misinterpretations of the Pythia's statements. Even foreign rulers requested help at Delphi.

Delphi was the site of the Pythian Games which, like the Olympian Games, attracted participants from all over Greece. The principal events were the athletic contests and the music, dance, and poetry competitions in honor of Apollo. As at Olympia, hundreds of statues dedicated to the victors of the competitions, as well as mythological figures, filled the sanctuary grounds. The sanctuary of Apollo included the main temple, performance and athletic areas, treasuries, and other buildings and monuments, which made full use of limited space on the hillside.

After visitors climbed the steep path up the lower slopes of Mount Parnassos, they entered the sanctuary by a ceremonial gate in the southeast corner. From there they zigzagged up the Sacred Way, so named because it was the route of religious processions during festivals. Moving past the numerous treasuries and memorials built by the city-states, they arrived

at the long colonnade of the Temple of Apollo. Below the temple was a **stoa**, a columned pavilion open on three sides, built by the people of Athens. There visitors rested, talked, or watched ceremonial dancing. At the top of the sanctuary hill was a stadium area for athletic contests.

Historical Divisions of Greek Art

The names of major periods of Greek art have remained in use, even though changing interpretations have led some art historians to question their appropriateness. The primary source of information about Greek art before the seventh century BCE is pottery, and the Geometric period (c. 900–700 BCE) owes its name to the geometric, or rectilinear, forms with which artists of the time decorated ceramic vessels. The Orientalizing period (c. 700-600 BCE) is named for the apparent influence of Egyptian and Near Eastern art on Greek pottery of that time, spread through trading contacts as well as the travels of artists themselves. The name of the third period, Archaic, meaning "old" or "old-fashioned," stresses a presumed contrast between the art of that time (c. 600-480 BCE) and the art of the following Classical period, once thought to be the most admirable and highly developed. It is a view that no longer prevails among art historians.

The Classical period has been subdivided into three phases: the Early Classical period or transitional style from about 480 to 450 BCE; the High Classical period, from about 450 to the end of the fifth century BCE; and the Late

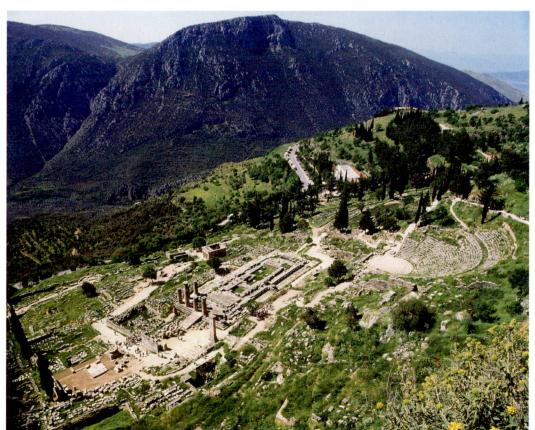

5-2 | SANCTUARY OF APOLLO, DELPHI 6th-3rd century BCE.

Classical, from about 400 to about 323 BCE. High Classical art was once known as the "Golden Age" of Greece. The name of the final period of Greek art, *Hellenistic*, means "Greeklike." Hellenistic art was produced throughout the eastern Mediterranean world as non-Greek people gradually became imbued with Greek culture under Alexander and his successors (323–30 BCE). The history and art of ancient Greece end with the fall of Egypt to the Romans in 31 BCE and the death of Cleopatra one year later.

GREEK ART FROM c. 900 to c. 600 BCE

Around the mid-eleventh century BCE, a new culture began to develop from the ashes of the Mycenaean civilization. A style of ceramic, decorated with organized abstract designs, appeared in Athens and spread to the rest of Greece. This development signaled an awakening that was soon followed by the creation of monumental ceramic vessels embellished with complex geometric designs, the resumption of bronze casting, and perhaps the construction of religious architecture. In this Geometric period, the Greeks, as we now call them, were beginning to create their own architectural forms and were trading actively with their neighbors to the east. By c. 700 BCE, in a phase called the Orientalizing period, they began to incorporate exotic motifs into their native art.

The Geometric Period

The first appearance of a specifically Greek style of vase painting, as opposed to Minoan or Mycenaean, dates to about 1050 BCE. This style—known as Proto-Geometric because it anticipated the Geometric style—was characterized by linear motifs, such as spirals, diamonds, and cross-hatching, rather than the stylized plants, birds, and sea creatures characteristic of Minoan vase painting. The Geometric style proper, an extremely complex form of decoration, became widespread after about 900 BCE in all types of art and endured until about 700 BCE.

CERAMICS. A striking ceramic figure of a half-horse, half-human creature called a centaur dates to the end of the tenth century BCE (FIG. 5–3). This figure exemplifies two aspects of the Proto-Geometric style: the use of geometric forms in painted decoration, and the reduction of human and animal body parts to simple geometric solids, such as cubes, pyramids, cylinders, and spheres. The figure is unusual, however, because of its large size (more than a foot tall) and because its hollow body was formed like a vase on a potter's wheel. The artist added solid legs, arms, and a tail (now missing) and then painted the bold, abstract designs with slip, a mixture of water and clay. The slip fired to dark brown, standing out against the lighter color of the unslipped portions of the figure.

Centaurs, prominent in Greek mythology, had both a good and a bad side and may have symbolized the similar

5-3 | CENTAUR Lefkandi, Euboea. Late 10th century BCE. Ceramic, height 141/8" (36 cm). Archaeological Museum, Eretria, Greece.

dual nature of humans. This centaur, discovered in a cemetery, had been deliberately broken into two pieces that were buried in adjacent graves. Clearly, the object had special significance for the people buried in the graves or for their mourners.

Large funerary vases were used as grave markers (FIG. 5-4). The ancient cemetery of Athens just outside the Dipylon Gate, once the main western entrance into the city, contained many vases with the complex decoration typical of the Geometric style proper (c. 900-700 BCE). For the first time, human beings are depicted as part of a narrative. The krater illustrated here, a grave marker dated about 750 BCE, provides a detailed record of the funerary rituals—including the relatively new Greek practice of cremation—for an important person. The body of the deceased is placed on its side on a funeral bier, about to be cremated, as seen on the center of the top register of the vase. Male and female figures stand on each side of the body, their arms raised and both hands placed on top of their heads in a gesture interpreted as expressing anguish—it suggests that the mourners are literally tearing their hair out with grief. In the bottom register, horse-drawn chariots and foot soldiers, who look like walking shields with tiny antlike heads and muscular legs, form a procession.

The abstract forms used to represent human figures on this pot—triangles for torsos; more triangles for the heads in profile; round dots for eyes; long, thin rectangles for arms; tiny waists; and long legs with bulging thigh and calf muscles—are typical of the Geometric style. Figures are shown in either full-frontal or full-profile views that emphasize flat patterns and outline shapes. No attempt has been made to create the illusion of three-dimensional forms occupying real space. The artist has nevertheless communicated a deep sense of human loss by exploiting the rigidity, solemnity, and strong rhythmic accents of the carefully arranged elements.

Egyptian funerary art reflected the belief that the dead, in the afterworld, could continue to engage in activities they enjoyed while alive. Greek funerary art, in contrast, focused on the emotional reactions of the survivors. The scene of human mourning on this pot contains no supernatural beings, nor any identifiable reference to an afterlife. According to the Greeks, the deceased entered a place of mystery and obscurity that living humans could not define precisely.

Sequencing Events KEY PERIODS IN GREEK ART

с. 1050-900 все	Proto-Geometric Period
с. 900-700 все	Geometric Period
с. 700-600 все	Orientalizing Period
с. 600-480 все	Archaic Period
с. 480-450 все	Early Classical Period
с. 450-400 все	High Classical Period
с. 400-323 все	Late Classical Period
323-31/30 все	Hellenistic Period

METAL SCULPTURE. Greek artists of the Geometric period produced many figurines of wood, ivory, clay, and cast bronze. These small statues of humans and animals are similar to those painted on pots. A tiny bronze of this type, MAN AND CENTAUR, dates to about 750 BCE (FIG. 5–5). (Although there were wise and good centaurs, the theme of battling man and centaur is found throughout Greek art.) The two figures

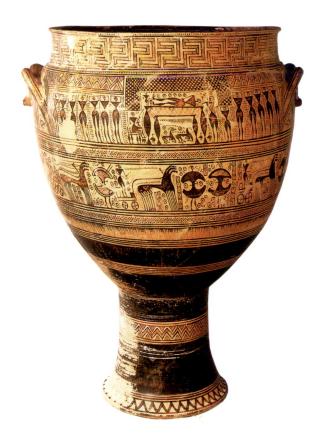

5-4 FUNERARY VASE (KRATER)

Dipylon Cemetery, Athens. c. 750-700 BCE. Attributed to the Hirschfeld Workshop. Ceramic, height 42 %" (108 cm). The Metropolitan Museum of Art, New York. Rogers Fund, 1914 (14.130.14)

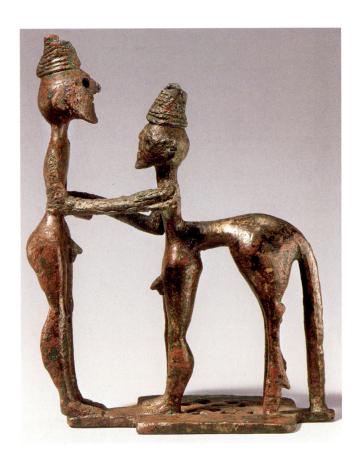

5−5 | MAN AND CENTAUR

Perhaps from Olympia. c. 750 BCE. Bronze, height 4%6'' (11.1 cm). The Metropolitan Museum of Art, New York. Gift of J. Pierpont Morgan, 1917 (17.190.2072)

Technique

GREEK PAINTED VASES

he three main techniques for decorating Greek painted vases were black-figure, red-figure, and white-ground. The painters used a complex procedure that involved preparing a slip (a mixture of clay and water), applying the slip to the vessel, and carefully manipulating the firing process in a kiln (a closed oven) to control the amount of oxygen reaching the ceramics. This firing process involved three stages. In the first stage, oxygen was allowed into the kiln, which "fixed" the whole vessel in one overall shade of red depending on the composition of the clay. Then, in the second (reduction) stage, the oxygen in the kiln was cut back (reduced) to a minimum, turning the vessel black, and the temperature was raised to the point at which the slip partially vitrified (became glasslike). Finally, in the third stage, oxygen was allowed back into the kiln, turning the unslipped areas back to a shade of red. The areas where slip had been applied, which were sealed against the oxygen, remained black. The "reds" varied from dark terra cotta to pale yellow.

In the black-figure technique, artists painted designs—figures, objects, or abstract motifs—with slip in silhouette on the clay vessels. Then using a sharp tool (a **stylus**), they cut through the slip to the body of the vessel, incising linear details within the silhouette. In the red-figure technique, the approach was reversed. Artists painted the background around the figures with the slip and drew details within the figures with the same slip using a brush. In both techniques artists often enhanced their work with touches of white and reddish-purple gloss, pigments mixed with slip. Firing produced the distinctive black (SEE FIG. 5–21) or red (SEE FIG. 5–29) images.

White-ground vases became popular in the Classical period. A highly refined clay slip produced the white ground on which the design elements were painted. After firing the vessel, the artists frequently added details and areas of bright and pastel hues which, because they were added after firing, flaked off easily. Few perfect examples have survived (SEE FIG. 5-46).

confront each other after the man—perhaps Herakles—has stabbed the centaur; the spearhead is visible on the centaur's left side. The centaur must have had a branch or club in his (now missing) right hand. The sculptor reduced the body parts of the figures to simple geometric shapes, arranging them in a composition of solid forms and open, or negative, spaces that makes the piece pleasing from every view. Most such works have been found in sanctuaries, suggesting that they may have been votive offerings to the gods.

THE FIRST GREEK TEMPLES. Greeks worshiped at outdoor altars within sanctuaries where a temple sheltered a statue of a god. Few ancient Greek temples remain standing today. Stone foundations define their rectangular shape, and their appearance has been pieced together largely from fallen columns, broken lintels, and fragments of sculpture lying where they fell centuries ago. Walls and roofs constructed of mud brick and wood have disappeared.

The rectangular building had a door at one end sheltered by a projecting **porch** supported on two sturdy posts. The steeply pitched roof forms a triangular area, or **pediment**, in the **façade**, or front wall that is pierced by an opening directly above the door. The interior followed an enduring basic plan: a large main room called the **cella**, or **naos**, preceded by a small reception area or vestibule, called the **pronaos**.

The Orientalizing Period

By the seventh century BCE, vase painters in major pottery centers in Greece had moved away from the dense linear decoration of the Geometric style. They now created more open compositions built around large motifs that included real and imaginary animals, abstract plant forms, and human figures. The source of these motifs can be traced to the arts of the Near East, Asia Minor, and Egypt. Greek painters did not simply copy the work of Eastern artists, however. Instead, they drew on work in a variety of mediums—including sculpture, metalwork, and textiles—to invent an entirely new approach to vase painting.

The Orientalizing style (c. 700–600 BCE) began in Corinth, a port city where luxury wares from the Near East and Egypt inspired artists. The new style is evident in a Corinthian olpe, or wide-mouthed pitcher, dating to about 600 BCE, which shows silhouetted creatures striding in horizontal bands against a light background with stylized flower forms called rosettes (FIG. 5–6). An example of the blackfigure pottery style, it is decorated with dark shapes of lions, a serpent, and composite creatures against a background of very pale buff, the natural color of the Corinthian clay (see "Greek Painted Vases," above). The artist incised fine details inside the silhouetted shapes with a sharp tool and added touches of white and reddish purple gloss, or clay slip mixed with metallic color pigments, to enhance the design.

THE ARCHAIC PERIOD, c. 600–480 BCE

During the Archaic period, from c. 600 to c. 480 BCE, the Greek city-states on the mainland, on the Aegean islands, and in the colonies grew and flourished. Athens, which had lagged behind the others in population and economic devel-

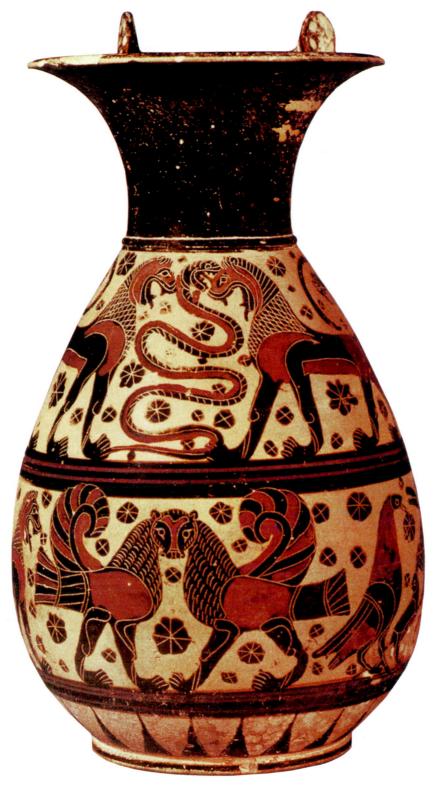

5–6 † PITCHER (OLPE) Corinth. c. 600 BCE. Ceramic with black-figure decoration, height 11½" (30 cm). The British Museum, London.

opment, began moving artistically, commercially, and politically to the forefront.

The Greek arts developed rapidly during the Archaic period. In literature, the poet Sappho on the island of Lesbos was writing poetry that would inspire the geographer Strabo,

near the end of the millennium, to write: "Never within human memory has there been a woman to compare with her as a poet." On another island, the semilegendary slave Aesop was relating animal fables that became lasting elements in Western culture. Artists shared in the growing prosperity of

Elements of Architecture GREEK TEMPLE PLANS

he simplest early temples consist of a single room, the cella, or naos. Side walls ending in attached pillars (anta) may project forward to frame two columns in antis (literally, "between the pillars"), as seen in plan (a). An amphiprostyle temple (b) has a row of columns (colonnade) at the front and back ends of the structure, not on the sides, forming porticos, or covered entrance porches, at the front and

back. If the colonnade runs around all four sides of the building, forming a **peristyle**, the temple is **peripteral** (c and d). Plan (c), the Temple of Hera I at Paestum, Italy, shows a **pronaos** and an **adyton**, an unlit inner chamber. Plan (d), the Parthenon, has an **opithodomos**, enclosed porch, not an adyton, at the back. The **stylobate** is the top step of the **stereobate**, or layered foundation.

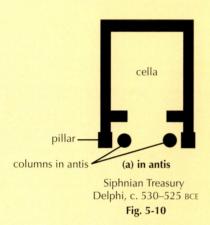

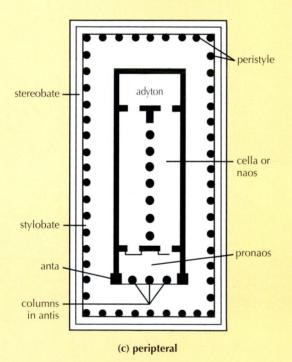

Temple of Hera I, Paestum, Italy, c. 550 BCE **Fig. 5-7**

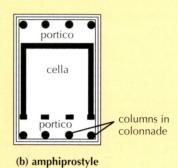

Temple of Athena Nike Athens, c. 425 BCE Fig. 5-41

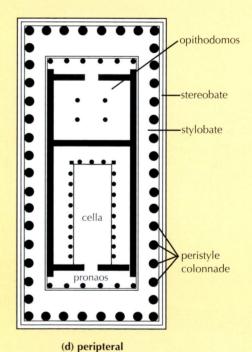

Parthenon, Athens, 447–432 BCE Page 138

the city-states by competing for lucrative commissions from city councils and wealthy individuals, who sponsored the building of temples, shrines, government buildings, monumental sculpture, and fine ceramic wares. During this period, potters and vase painters began to sign their works.

Temple Architecture

As Greek temples grew steadily in size and complexity over the centuries, stone and marble replaced the earlier mudbrick and wood construction. A number of standardized plans evolved, ranging from simple, one-room structures with columned porches to buildings with double porches surrounded by columns (see "Greek Temple Plans," page 116). Builders also experimented with the design of temple elevations—the arrangement, proportions, and appearance of the columns and the lintels, which now grew into elaborate entablatures. Two elevation designs emerged during the Archaic period: the Doric order and the Ionic order. The Corinthian order, a variant of the Ionic order, developed later (see "The Greek Architectural Orders," page 118).

Paestum, the Greek colony of Poseidonia established in the seventh century BCE about 50 miles south of the modern city of Naples, Italy, contains some well-preserved early Greek temples. The earliest standing temple there, built about 550–540 BCE, was dedicated to Hera, the wife of Zeus (FIG. 5–7). It is known today as HERA I to distinguish it from a second temple to Hera built adjacent to it about a century later.

Sequencing Works of Art

с. 580 все	Gorgon Medusa, Temple of Artemis
с. 530-525 все	Battle between the Gods and the Giants, Treasury of the Siphnians
с. 515 все	Euphronios (painter), <i>Death of</i> Sarpedon, red-figure calyx krater
с. 460 все	Apollo with Battling Lapiths and Centaurs, west pediment, Temple of Zeus
с. 447-432 все	Horsemen, from the Procession frieze, Parthenon

Hera I illustrates the early form of the Doric order temple. A row of columns called the **peristyle** surrounded the main room, the cella. A Doric column has a fluted **shaft** and a **capital** made up of the cushionlike **echinus** and the square **abacus**. These columns support an entablature distinguished by its **frieze**, where flat areas called **metopes** alternate with projecting blocks with three vertical grooves called **triglyphs**. Usually the metopes were either painted or carved in relief and then painted. Fragments of terra-cotta decorations painted in bright colors have also been found in the rubble of Hera I.

The builders of Hera I created an especially robust column, only about four times as high as its maximum diameter,

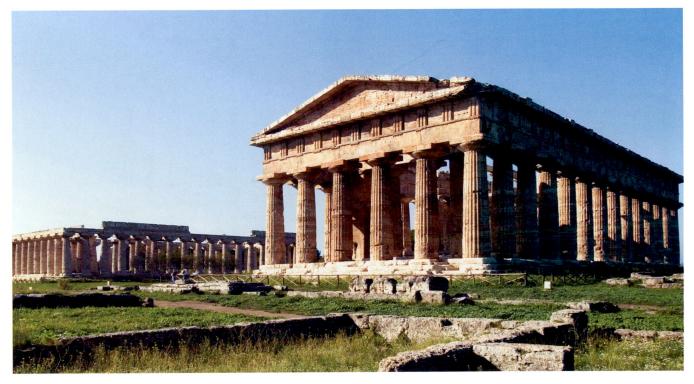

5-7 | **TEMPLE OF HERA I, PAESTUM** (ancient Poseidonia) and **HERA II** (in foreground) Italy. c. 550-540 BCE (Hera I) and c. 470-460 BCE (Hera II).

Elements of Architecture

THE GREEK ARCHITECTURAL ORDERS

he three Classical Greek architectural orders are the Doric, the Ionic, and the Corinthian. Each order is made up of a system of interdependent parts whose proportions are based on mathematical ratios. No element of an order could be changed without producing a corresponding change in other elements.

The basic components of the Greek orders are the **column** and the **entablature**, which function as post and lintel. All types of columns have a **shaft** and a **capital**; Ionic and Corinthian also have a **base**. The shafts are formed of round sections, or **drums**, which are joined inside by metal pegs. In Greek temple architecture, columns stand on the **stylobate**, the "floor" of the temple.

The **Doric order** shaft rises directly from the stylobate, without a base. The shaft is **fluted**, or channeled, with sharp edges. The height of the column ranges from five-and-a-half to seven times the diameter of the base. At the top of the shaft and part of the capital is the **necking**, which provides a transition to the

capital. The Doric capital itself has three parts: the necking, the rounded echinus, and the tabletlike abacus. The entablature includes the architrave, the distinctive frieze of triglyphs and metopes, and the cornice, the topmost, projecting horizontal element. The roofline may have decorative waterspouts and terminal decorative elements called acroteria.

The **lonic order** has more elongated proportions than the Doric, its height being about nine times the diameter of the column at its base. The flutes on the columns are deeper and closer together and are separated by flat surfaces called **fillets**. The **capital** has a distinctive scrolled **volute**; the entablature has a three-panel architrave, continuous sculptured or decorated frieze, and the addition of decorative moldings.

The **Corinthian order** was originally developed by the Greeks for use in interiors but came to be used on temple exteriors as well. Its elaborate capitals are sheathed with stylized **acanthus** leaves that rise from a convex band called the **astragal**.

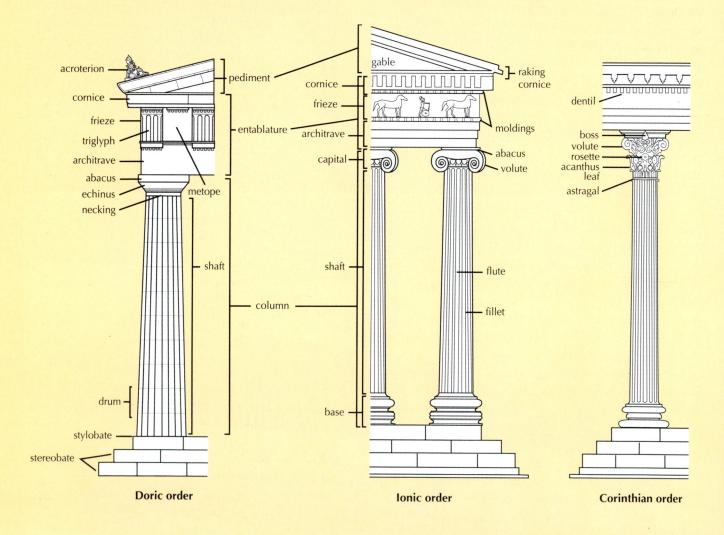

topped with a widely flaring capital. This design creates an impression of great stability and permanence, although it is rather ponderous. As the column shafts rise, they swell in the middle and contract again toward the top, a refinement known as entasis. This adjustment gives a sense of energy and upward lift. Hera I has an uneven number of columnsnine—across the short ends of the peristyle, with a column instead of a space at the center of the two ends. The entrance to the pronaos has three central columns, and a row of columns runs down the center of the wide cella to help support the ceiling and roof. The unusual two-aisle, two-door arrangement leading to the small room at the end of the cella proper suggests that the temple had two presiding deities: either Hera and Poseidon (patron of the city), or Hera and Zeus (her consort), or perhaps Hera in her two manifestations (as warrior and protector of the city and as mother and protector of children).

Architectural Sculpture

As Greek temples grew larger and more complex, sculptural decoration took on increased importance. Among the earliest surviving examples of Greek pediment sculpture are fragments of the ruined Doric order **TEMPLE OF ARTEMIS** on the island of Korkyra (Corfu) off the northwest coast of the mainland, which date to about 600–580 BCE (FIG. 5–8). The figures in this sculpture were carved on separate slabs, then installed in the pediment space. They stand in such high relief from the background plane that they actually break through the architectural frame, which was more than 9 feet tall at the peak.

At the center of the pediment is the rampaging snake-haired MEDUSA (FIG. 5–9), one of three winged female monsters with wings called Gorgons. Medusa had the power to turn humans to stone if they should look upon her face, and in this sculpture she fixes viewers with huge glaring eyes as if to work her dreadful magic on them. Ancient Greeks would have seen the image of Medusa at the center of this pediment as both menacing and protecting the temple. The Greek hero Perseus, instructed and armed by Athena, beheaded Medusa while looking only at her reflection in his polished shield. The Medusa head became a popular decoration for Greek armor (see FIG. 5–22, which shows Achilles' and Ajax's shields.)

The much smaller figures flanking Medusa are the flying horse Pegasus on the left (only part of his rump and tail remain) and the giant Chrysaor on the right. These were Medusa's posthumous children (whose father was Poseidon), born from the blood that gushed from her neck after she was beheaded by Perseus. The felines crouching next to them literally bump their heads against the raking cornices of the roof. Dying human warriors lie at the ends of the pediment,

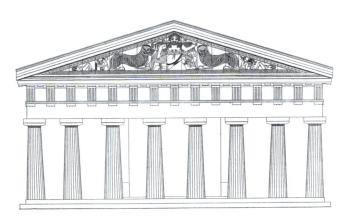

5-8 | reconstruction of the west façade of the temple of artemis, korkyra (corfu)

After G. Rodenwaldt and H. Schleif. c. 600-580 BCE.

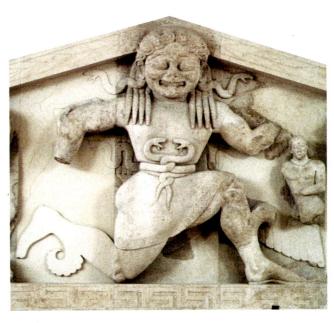

5−9 GORGON MEDUSA

Detail of sculpture from the west pediment of the *Temple of Artemis*, Korkyra. c. 600-580 BCE. Limestone, height of pediment at the center 9'2" (2.79 m). Archaeological Museum, Korkyra (Corfu).

their heads tucked into its corners and their knees rising with its sloping sides. Such changes of scale and awkward positioning are characteristic of Archaic temple sculpture.

TREASURY OF THE SIPHNIANS. An especially noteworthy collaboration between builder and sculptor can still be seen in the small but luxurious TREASURY OF THE SIPHNIANS, built in the sanctuary of Apollo at Delphi between about 530 and 525 BCE and housed today in fragments in the museum at Delphi. Instead of columns, the builders used two caryatids—columns carved in the form of clothed

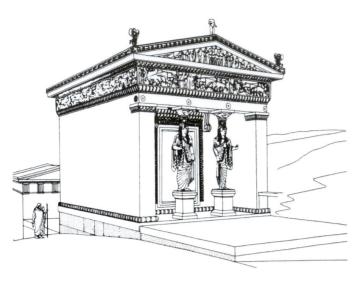

5-10 RECONSTRUCTION DRAWING OF THE TREASURY OF THE SIPHNIANS, DELPHI

Sanctuary of Apollo, Delphi. c. 530-525 BCE.

This small treasury building at Delphi was originally elegant and richly ornamented. The figure sculpture and decorative moldings were once painted in strong colors, mainly dark blue, bright red, and white, with touches of yellow to resemble gold. The people who commissioned this treasury were from Siphnos, an island in the Aegean Sea just southwest of the Cyclades.

women—(FIG. 5–10). The stately caryatids, with their finely pleated, flowing garments, are raised on pedestals and balance elaborately carved capitals on their heads. The capitals support a tall entablature conforming to the Ionic order, which features a plain, or three-panel, architrave and a continuous carved frieze, set off by richly carved moldings (see "The Greek Architectural Orders," page 118).

Both the continuous frieze and the pediments of the Siphnian Treasury were originally filled with relief sculpture. A surviving section of the frieze from the building's north side, which shows a scene from the legendary battle between the Gods and the Giants, is one of the earliest known examples of a trend in Greek relief sculpture toward a more natural representation of space (FIG. 5–II). To give a sense of three dimensions, the sculptor placed some figures behind others, overlapping as many as three of them and varying the depth of the relief. Countering any sense of deep recession, all the figures were made the same height with their feet on the same groundline.

THE TEMPLE OF APHAIA. The long friezes of Greek temples provided a perfect stage for storytelling, but the triangular pediment created a problem in composition. The sculptor of the east pediment of the Doric TEMPLE OF APHAIA at Aegina (FIG. 5–12), dated about 500–490 BCE, provided a creative

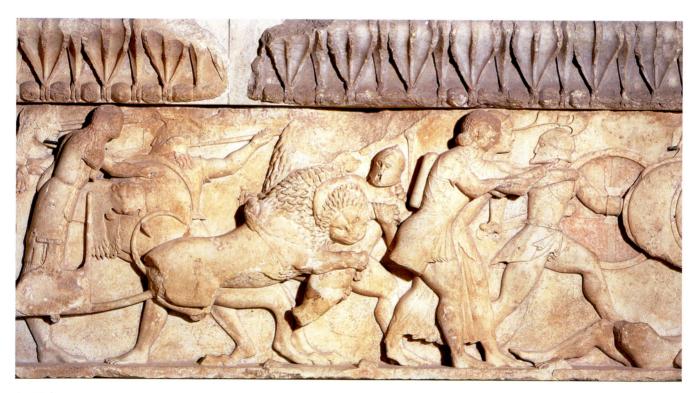

5-II BATTLE BETWEEN THE GODS AND THE GIANTS (TITANS)

Fragments of the north frieze of the Treasury of the Siphnians, from the Sanctuary of Apollo, Delphi. c. 530-525 BCE. Marble, height 26" (66 cm). Archaeological Museum, Delphi.

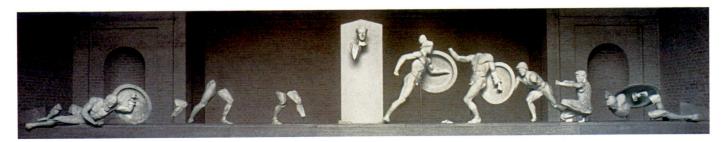

5–12 | EAST PEDIMENT OF THE TEMPLE OF APHAIA, AEGINA c. 490 BCE. Width about 49' (15 m). Surviving fragments as assembled in the Staatliche Antikensammlungen, Munich (early restorations removed).

solution that became a design standard, appearing with variations throughout the fifth century BCE. The subject of the pediment, rendered in fully three-dimensional figures, is an early military expedition against Troy led by Herakles (this is not the Troy of Homer's later epic). Fallen warriors fill the angles at both ends of the pediment base, while others crouch and lunge, rising in height toward an image of Athena as warrior goddess under the peak of the roof. The erect goddess, larger than the other figures and flanked by two defenders facing approaching opponents, dominates the center of the scene and stabilizes the entire composition.

Among the best-preserved fragments from this pediment scene is the **DYING WARRIOR** from the far left corner, a tragic but noble figure struggling to rise, pulling an arrow from his side, even as he dies (FIG. 5–13). This figure originally would have been painted and fitted with authentic bronze acces-

sories, heightening the sense of reality. Fully exploiting the difficult framework of the pediment corner, the sculptor portrayed the soldier's uptilted, twisted form turning in space, capturing his agony and vulnerability. The subtle modeling of the body conveys the softness of human flesh, which is contrasted with the hard, metallic geometry of the shield, helmet, and (now lost) bronze arrow.

Freestanding Sculpture

In addition to decorating temple architecture, sculptors of the Archaic period created a new type of large, freestanding statue made of wood, terra cotta, limestone, or white marble from the islands of Paros and Naxos. Frequently lifesize or larger, these figures usually were standing or striding. They were brightly painted and sometimes bore inscriptions indicating that they had been commissioned

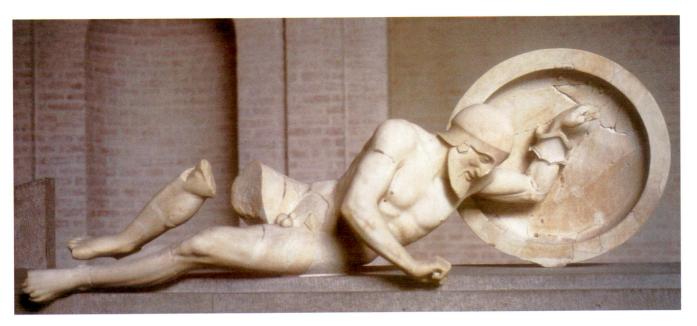

5–13 | **DYING WARRIOR**Sculpture from the left corner of the east pediment of the Temple of Aphaia, Aegina. c. 500–490 BCE. Marble, length 6' (1.83 m). Staatliche Antikensammlungen und Glyptothek, Munich.

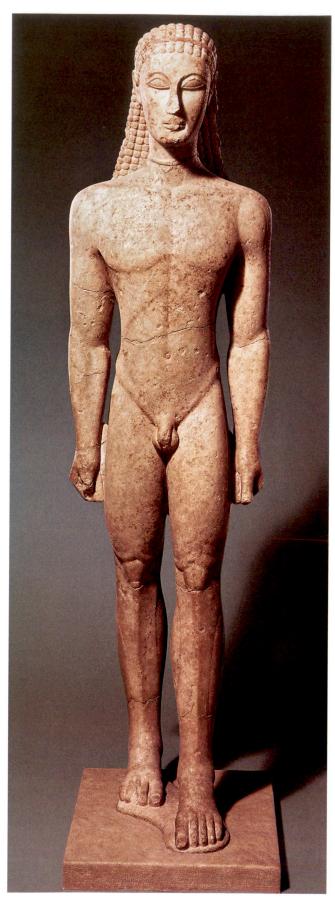

5–I4 | STANDING YOUTH (KOUROS)
Attica. c. 600 BCE. Marble, height 6' (1.84 m).
The Metropolitan Museum of Art, New York.
Fletcher Fund, 1932 (32.11.1)

by individual men or women for a commemorative purpose. They have been found marking graves and in sanctuaries, where they lined the sacred way from the entrance to the main temple.

A female statue of this type is called a kore (plural, koraî), Greek for "young woman," and a male statue is called a kouros (plural, kouroi), Greek for "young man." Archaic korai, always clothed, probably represented deities, priestesses, and nymphs, young female immortals who served as attendants to gods. Kouroi, nearly always nude, have been variously identified as gods, warriors, and victorious athletes. Because the Greeks associated young, athletic males with fertility and family continuity, the kouroi figures may have symbolized ancestors.

Young Man (Kouros). A kouros dated about 600 BCE (FIG. 5–14) recalls the pose and proportions of Egyptian sculpture. As with Egyptian figures such as the statue of Menkaure (SEE FIG. 3–11), this young Greek stands rigidly upright, arms at his sides, fists clenched, and one leg slightly in front of the other. However, Greek artists of the Archaic period did not share the Egyptian obsession with permanence; they cut away all stone from around the body and introduced variations in appearance from figure to figure. Greek statues suggest the marble block from which they were carved, but they have a notable athletic quality quite unlike Egyptian statues.

Here the artist delineated the figure's anatomy with ridges and grooves that form geometric patterns. The head is ovoid, with heavy features and schematized hair evenly knotted into tufts and tied back with a narrow ribbon. The eyes are relatively large and wide open, and the mouth forms a characteristic closed-lip smile known as the **Archaic smile**. In Egyptian sculpture, male figures usually wore clothing associated with their status, such as the headdresses, necklaces, and kilts that identified them as kings. The total nudity of the Greek *kouroi*, in contrast, removes them from a specific time, place, or social class.

The powerful, rounded body of a *kouros* known as the **ANAVYSOS KOUROS**, dated about 530 BCE, clearly shows the increasing interest of artists and their patrons in a more lifelike rendering of the human figure (FIG. 5–15). The pose, wiglike hair, and Archaic smile echo the earlier style, but the massive torso and limbs have greater anatomical accuracy suggesting heroic strength. The statue, a grave monument to a fallen war hero, has been associated with a base inscribed: "Stop and grieve at the tomb of the dead Kroisos, slain by wild Ares [god of war] in the front rank of battle." However, there is no evidence that the figure was meant to represent Kroisos.

Young Woman (Kore). The first Archaic korai are as severe and rigid as the male figures. The Berlin Kore, found in a cemetery at Keratea and dated about 570–560 BCE, stands more than 6 feet tall (FIG. 5–16). The erect, immobile pose and full-bodied figure—accentuated by a crown and thick-

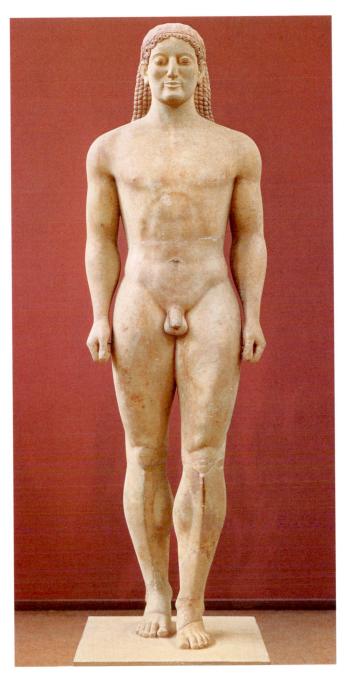

5–15 | ANAVYSOS KOUROS Cemetery at Anavysos, near Athens. c. 530 BCE. Marble with remnants of paint, height 6'4" (1.93 m). National Archaeological Museum, Athens.

soled clogs—seem appropriate to a goddess, although the statue may represent a priestess or an attendant. The thick robe and tasseled cloak over her shoulders fall in regularly spaced, parallel folds like the fluting on a Greek column, further emphasizing the stately appearance. Traces of red—perhaps the red clay used to make thin sheets of gold adhere—indicate that the robe was once painted or gilded. The figure holds a pomegranate in her right hand, a symbol of Persephone, who was abducted by Hades, the god of the underworld, and whose annual return brought the springtime.

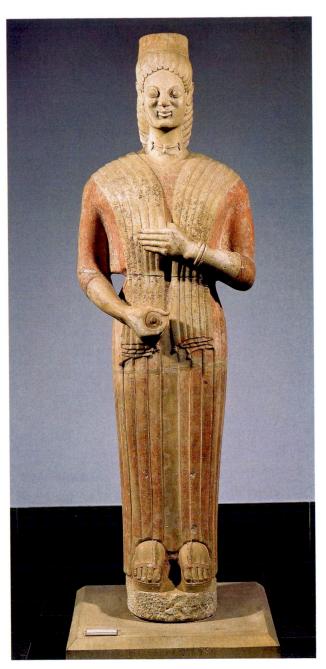

5–16 | BERLIN KORE Cemetery at Keratea, near Athens. c. 570–560 BCE. Marble with remnants of red paint, height 6'3" (1.9 m). Staatliche Museen zu Berlin, Antikensammlung, Preussischer Kulturbesitz, Berlin.

The **PEPLOS KORE** (FIG. 5–17), which dates to about 530 BCE, is named for its distinctive and characteristic garment, called a **peplos**—a draped rectangle of cloth, usually wool, folded over at the top, pinned at the shoulders, and belted to give a bloused effect. The *Peplos Kore* has the same motionless, vertical pose of the earlier *kore*, but is a more rounded, feminine figure. Her bare arms and head convey a greater sense of soft flesh covering a real bone structure, and her smile and hair are somewhat less conventional. The figure once wore a metal crown and earrings and has traces of

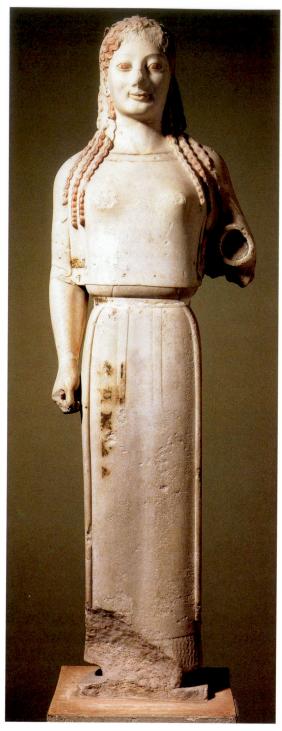

5−17 | **PEPLOS KORE** Acropolis, Athens. c. 530 BCE. Marble, height 4' (1.21 m). Acropolis Museum, Athens.

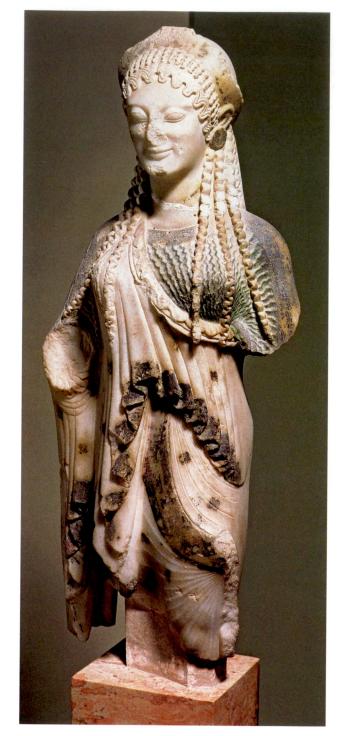

5–18 \dagger KORE Acropolis, Athens (by a sculptor from Chios?). c. 520 BCE. Marble, height 22" (0.55 m). Acropolis Museum, Athens.

encaustic painting, a mixture of pigments and hot wax that left a shiny, hard surface when it cooled. The missing left forearm was made from a separate piece of marble—the socket is still visible—and would have extended forward horizontally. She was probably pouring a libation.

The *Peplos Kore* was recovered from debris on the Acropolis of Athens, where few of the many votive and

commemorative statues placed in the sanctuary have survived. After the Persians sacked the city in 480 BCE and destroyed the sculptures there, the fragments were used as fill in the reconstruction of the Acropolis the following year.

Another *kore* (FIG. 5–18), dating to about 520 BCE and found on the Athenian Acropolis, may have been made by a

sculptor from Chios, an island off the coast of Asia Minor. Although the arms and legs of this figure have been lost and its face has been damaged, it is impressive for its rich drapery and the large amount of paint that still adheres to it. Like the *Anavysos Kouros* (SEE FIG. 5–15) and the *Peplos Kore*, it reflects a trend toward increasingly lifelike anatomical depiction that would peak in the fifth century BCE.

The *kore* wears a garment called a **chiton**; like the *peplos* but fuller, it was a relatively lightweight rectangle of cloth pinned along the shoulders. It originated in Ionia on the coast of Asia Minor but became popular throughout Greece. Over it, a cloak called a **himation** was draped diagonally and fastened on one shoulder. The elaborate hairstyle and abundance of jewelry add to the opulent effect. A close look at what remains of the figure's legs reveals a rounded thigh showing clearly through the thin fabric of the *chiton*.

Vase Painting

Greek potters created vessels that combine beauty with a specific utilitarian function (FIG. 5–19). The artists who painted the pots, which were often richly decorated, had to accommodate their work to these fixed shapes. During the Archaic period, Athens became the dominant center for pottery manufacture and trade in Greece.

BLACK-FIGURE VASES. Athenian painters adopted the Corinthian black-figure techniques (see "Greek Painted Vases," page 114), which became the principal mode of decoration throughout Greece in the sixth century BCE. At first, Athenian vase painters retained the horizontal banded composition that was characteristic of the Geometric period. Over time, they decreased the number of bands and increased the size of figures until a single scene covered each side of the vessel. A mid-sixth-century BCE amphora—a large, allpurpose storage jar-with bands of decoration above and below a central scene illustrates this development (FIG. 5-20). The decoration on this vessel, a depiction of the wine god Dionysos with maenads, his female worshipers, has been attributed to an anonymous artist called the Amasis Painter. Work in this distinctive style was first recognized on vessels signed by a prolific potter named Amasis.

Two maenads, arms around each other's shoulders, skip forward to present their offerings to Dionysos—a long-eared rabbit and a small deer. (Amasis signed his work just above the rabbit.) The maenad holding the deer wears the skin of a spotted panther (or leopard), its head still attached, draped over her shoulders and secured with a belt at her waist. The god, an imposing, richly dressed figure, clasps a large kantharos (wine cup). This encounter between humans and a god appears to be a joyful, celebratory occasion rather than one of reverence or fear. The Amasis Painter favored strong shapes and patterns, generally disregarding conventions for making figures appear to occupy real space. He emphasized

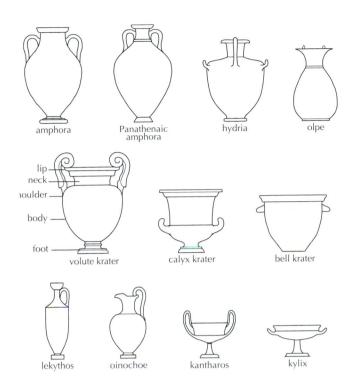

5-19 STANDARD SHAPES OF GREEK VESSELS

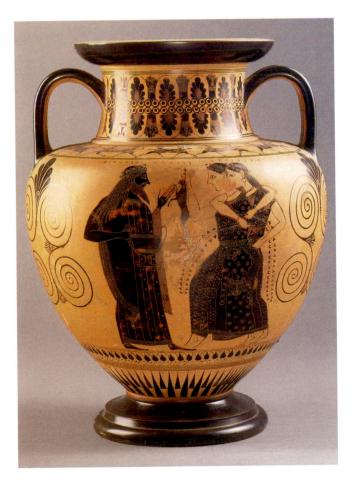

5–20 | Amasis Painter DIONYSOS WITH MAENADS c. 540 BCE. Black-figure decoration on an amphora. Ceramic, height of amphora 13" (33.3 cm). Bibliothèque Nationale de France, Paris.

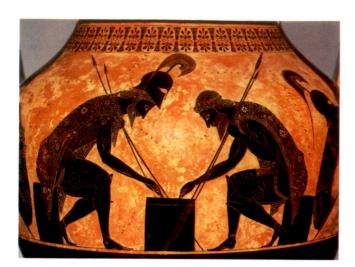

5–21 | Exekias ACHILLES AND AJAX PLAYING A GAME c. 540 BCE. Black-figure decoration on an amphora. Ceramic, height of amphora 2' (61 cm.). c. 540 BCE. Vatican Museums, Rome.

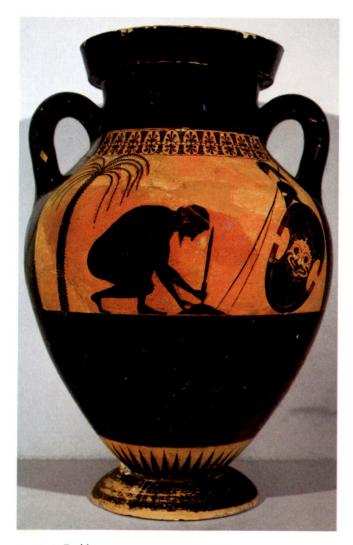

5–22 | Exekias THE SUICIDE OF AJAX c. 540 BCE. Black-figure decoration on an amphora. Ceramic, height of amphora 27" (69 cm). Château-Musée, Boulognesur-Mer, France.

fine details, such as the large, delicate petal and spiral designs below each handle, the figures' meticulously arranged hair, and the bold patterns on their clothing.

EXEKIAS. The finest of all Athenian artists of the Archaic Period, Exekias, signed many of his vessels as both potter and painter. Exekias took his subjects from Greek mythology, which he and his patrons probably considered to be history, such as the hero Achilles and the story of the Trojan War. On the body of an amphora he painted Achilles and his cousin Ajax, a fellow warrior, playing a game of dice (FIG. 5-21). The owner of the amphora knew the story—what had happened and what would happen. Achilles, sulking over an insult, has refused to fight, but eventually returns to battle and is killed. The two men bend over the game board in rapt concentration, wearing their body armor and holding their spears but setting aside their shields. At the moment, Achilles is dominant (he wears his helmet) and is winning the game. He calls "four" to Ajax's "three." (After the battle, Ajax will carry Achilles' lifeless body from the field.) Exekias skillfully matches his painting to the shape of the vase. The triangular shape formed by the two men rises to the mouth of the jar. while the handles continue the line of their shields.

This story continues on another amphora depicting the suicide of Ajax (FIG. 5-22). Ajax was second only to Achilles in bravery, but after the death of Achilles, the Greeks awarded the fallen hero's armor to Odysseus rather than Ajax. Devastated by this humiliation, and mourning his cousin, Ajax killed himself. Other artists showed the great warrior either dying or already dead, but Exekias has captured the story's most poignant moment, showing Ajax preparing to die. He has set aside his helmet, shield, and spear, and he crouches beneath a tree, planting his sword upright in a mound of dirt so that he can fling himself upon it. Two upright elements the tree on the left and the shield on the right-frame and balance the figure of Ajax, their in-curving lines echoing the swelling shape of the amphora and the rounding of the hero's powerful back as he bends forward. The composition focuses the viewer's attention on the head of Ajax and his intense concentration as he pats down the earth to secure the sword. He will not fail in his suicide.

Exekias is a skilled draftsman. He captures both form and emotion, balancing areas of black against fine engraved patterns—for example, the heroes' cloaks and silhouetted figures. These two vessels exemplify the quiet beauty and perfect equilibrium for which Exekias's works are so admired today.

RED-FIGURE VASES. In the last third of the sixth century BCE, while many painters were still creating handsome blackfigure wares, some vase painters turned away from this meticulous process to a new technique called **red-figure** decoration (see "Greek Painted Vases," page 114). This new method,

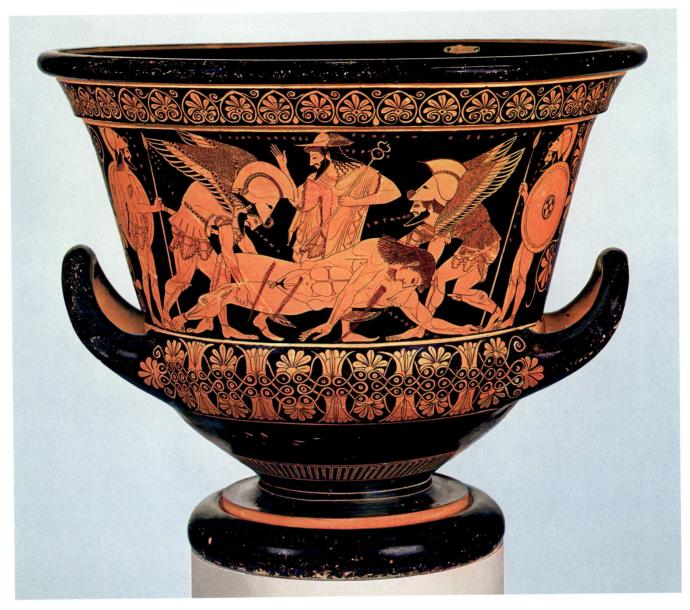

5–23 | Euphronios (painter) and Euxitheos (potter) **DEATH OF SARPEDON**c. 515 BCE. Red-figure decoration on a calyx krater. Ceramic, height of krater 18" (45.7 cm).
The Metropolitan Museum of Art, New York, lent by the Republic of Italy (L.2006.10). Photograph © 1999 The Metropolitan Museum of Art.

The ownership of the Euphronios krater has been the subject of dispute between Italy and the Metropolitan Museum. In 2006 the museum recognized the Italian government's claim.

as its name suggests, resulted in vessels with red figures against a black background, the opposite of black-figure painting. In red-figure wares, the dark slip was painted on as background around the outlined figures, which were left unpainted. Details were drawn on the figures with a fine brush dipped in the slip. The result was a lustrous dark vessel with light-colored figures and dark details. The greater freedom and flexibility of painting rather than engraving the details led artists to adopt it widely in a relatively short time.

One of the best-known artists specializing in the red-figure technique was Euphronios. His rendering of the **DEATH**

OF SARPEDON, about 515 BCE, is painted on a calyx krater, so called because its handles curve up like a flower calyx (FIG. 5–23). According to Homer's *Iliad*, Sarpedon, a son of Zeus and a mortal woman, was killed by the Greek warrior Patroclus while fighting for the Trojans. Euphronios shows the winged figures of Hypnos (Sleep) and Thanatos (Death) carrying the dead warrior from the battlefield, an early use of personification. Watching over the scene is Hermes, the messenger of the gods, identified by his winged hat and *caduceus*, a staff with coiled snakes. Hermes is there in another important role, as the guide who leads the dead to the underworld.

Art and Its Context CLASSIC AND CLASSICAL

ur words classic and classical come from the Latin word classis, referring to the division of people into classes based on wealth. Consequently, classic has come to mean "first class," "the highest rank," "the standard of excellence." Greek artists in the fifth century BCE tried to create ideal images based on perfect mathematical proportions. Roman

artists were inspired by the Greeks, so *Classical* refers to the culture of ancient Greece and Rome. By extension, the word may also mean "in the style of ancient Greece and Rome," whenever or wherever that style is used. In the most general usage, a "classic" is something—perhaps a literary work, a car, or a film—of lasting quality and universal significance.

Euphronios has created a perfectly balanced composition of verticals and horizontals that take the shape of the vessel into account. The bands of decoration above and below the scene echo the long horizontal of the dead fighter's body, which seems to levitate in the gentle grasp of its bearers, and the inward-curving lines of the handles mirror the arching backs of Hypnos and Thanatos. The upright figures of the lance-bearers on each side and Hermes in the center counterbalance the horizontal elements of the composition. The painter, while conveying a sense of the mass and energy of the subjects, also portrayed amazingly fine details of their clothing, musculature, and facial features with the fine tip of a brush. Euphronios created the impression of real space around the figures by foreshortening body forms and limbs—Sarpedon's left leg, for example—so that they appear to be coming toward or receding from the viewer.

THE CLASSICAL PERIOD, c. 480–323 BCE

Over the brief span of the next 160 years, the Greeks would establish an ideal of beauty that, remarkably, has endured in the Western world to this day. This period of Greek art, known as the Classical, is framed by two major events: the defeat of the Persians in 480 BCE and the death of Alexander the Great in 323 BCE. Art historians today divide the period into three phases, based on the formal qualities of the art: the Early Classical period or Transitional style (c. 480–450 BCE); the High Classical period (c. 450–400 BCE); and the Late Classical period (c. 400–323 BCE). The speed of change in this short time is among the most extraordinary characteristics of Greek art (see "Classic and Classical," above).

Scholars have characterized Greek Classical art as being based on three general concepts: humanism, rationalism, and idealism. The ancient Greeks believed the words of their philosophers and followed these injunctions in their art: "Man is the measure of all things," that is, seek an ideal based on the human form; "Know thyself," seek the inner signifi-

cance of forms; and "Nothing in excess," reproduce only essential forms. In their embrace of humanism, the Greeks even imagined that their gods looked like perfect human beings. Apollo, for example, exemplifies the Greek ideal: His body and mind in balance, he is athlete and musician, healer and sun god, leader of the Muses.

Yet as reflected in their art, the Greeks valued reason over emotion. Practicing the faith in rationality expressed by the philosophers Sophocles, Plato, and Aristotle, and convinced that logic and reason underlie natural processes, the Greeks saw all aspects of life, including the arts, as having meaning and pattern. Nothing happens by accident. The great Greek artists and architects were not only practitioners but theoreticians as well. In the fifth century BCE, the sculptor Polykleitos (see below) and the architect Iktinos both wrote books on the theory underlying their practice.

Unlike artists in Egypt and the ancient Near East, Greek artists did not rely on memory images. And even more than the artists of Crete, they grounded their art in close observation of nature. Only after meticulous study did they begin to search within each form for its universal ideal, rather than portraying their models in their actual, individual detail. In doing this, they developed a system of perfect mathematical proportions.

Greek artists of the fifth and fourth centuries BCE established a benchmark for art against which succeeding generations of artists and patrons in the Western world have since measured quality.

The Canon of Polykleitos

Just as Greek architects defined and followed a set of standards for ideal temple design, the sculptors of the Classical period selected those human attributes they considered the most desirable, such as regular facial features, smooth skin, and particular body proportions, and combined them into a single ideal of physical perfection.

The best-known theorist of the Classical period was the sculptor Polykleitos of Argos. About 450 BCE he developed a

set of rules for constructing the ideal human figure, which he set down in a treatise called *The Canon (kanon* is Greek for "measure," "rule," or "law"). To illustrate his theory, Polykleitos created a larger-than-lifesize bronze statue of a standing man carrying a spear—perhaps the hero Achilles (FIG. 5–24). Neither the treatise nor the original statue has survived, but both were widely discussed in the writings of his contemporaries, and later Roman artists made copies in stone and marble of the **SPEAR BEARER (DORYPHOROS)**. By studying these copies, scholars have tried to determine the set of measurements that defined the ideal proportions in Polykleitos's canon.

The canon included a system of ratios between a basic unit and the length of various body parts. Some studies suggest that this basic unit may have been the length of the figure's index finger or the width of its hand across the knuckles; others suggest that it was the height of the head from chin to hairline. The canon also included guidelines for *symmetria* ("commensurability"), by which Polykleitos meant the relationship of body parts to one another. In the statue he made to illustrate his treatise, he explored not only proportions, but also the relationship of weight-bearing and relaxed legs and arms in a perfectly balanced figure. The cross-balancing of supporting and free elements in a figure is sometimes referred to as contrapposto.

The marble copy of the *Spear Bearer* illustrated here shows a male athlete, perfectly balanced with the whole weight of the upper body supported over the straight (engaged) right leg. The left leg is bent at the knee, with the left foot poised on the ball of the foot, suggesting preceding and succeeding movement. The pattern of tension and relaxation is reversed in the arrangement of the arms, with the right relaxed on the engaged side, and the left bent to support the weight of the (missing) spear. This dynamically balanced body pose—characteristic of High Classical standing figure sculpture—differs somewhat from that of the *Kritian Boy* (SEE FIG. 5–28) of a generation earlier. The tilt of the *Spear Bearer's* hipline is a little more pronounced to accommodate the raising of the left foot onto its ball, and the head is turned toward the same side as the engaged leg.

The Art of the Early Classical Period, 480-450 BCE

In the early decades of the fifth century BCE, the Greek city-states, which for several centuries had developed relatively unimpeded by external powers, faced a formidable threat to their independence from the expanding Persian Empire. Cyrus the Great of Persia had incorporated the Greek cities of Ionia in Asia Minor into his empire in 546 BCE. At the beginning of the fifth century BCE, the Greek cities of Asia Minor, led by Miletos (SEE FIG. 5–47), revolted against Persia, initiating a period of warfare between Greeks and Persians. In 490 BCE, at the Greek mainland town of Marathon, the Athenians drove off the Persian army. (Today's marathon races still

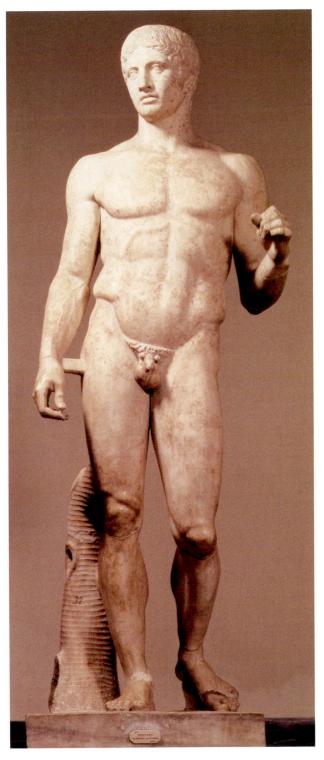

5–24 | Polykleitos | Spear Bearer (Doryphoros), also known as achilles

Roman copy after the original bronze of c. 450-440 BCE. Marble, height 6'11" (2.12 m); tree trunk and brace strut are Roman additions. National Archeological Museum, Naples.

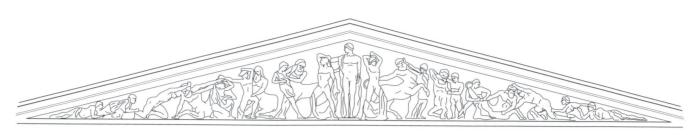

5-25 | reconstruction drawing of the west pediment of the temple of zeus, olympia c. 470-460 BCE.

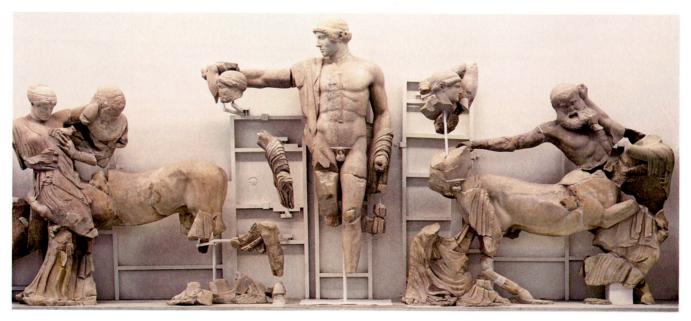

5–26 | APOLLO WITH BATTLING LAPITHS AND CENTAURS Fragments of sculpture from the west pediment of the Temple of Zeus, Olympia. c.470– 460 BCE. Marble, height of Apollo 10'8'' (3.25 m). Archaeological Museum, Olympia.

recall the feat of the man who ran the 26 miles from Marathon to Athens with news of victory and then dropped dead from exhaustion as he gasped out his words.)

In 480 BCE, the Persians penetrated Greece with a large force and destroyed many cities, including Athens. In a series of encounters—at Plataea on land and in the straits of Salamis at sea—an alliance of Greek city-states led by Athens and Sparta repulsed the invasion. By 480 BCE, the stalwart armies and formidable navies of the Greeks had triumphed over their enemies.

Athens emerged from the Persian wars as the leader of the city-states. Not all Greeks applauded the Athenians, however. In 431 BCE, a war broke out that only ended in 404 with the collapse of Athens and the victory of the militaristic state of Sparta. In the fourth century BCE, a new force appeared in the north—Macedonia.

Some scholars have argued that their success against the Persians gave the Greeks a self-confidence that accelerated the development of their art, inspiring artists to seek new and more effective ways to express their cities' accomplishments. In any case, the period that followed the Persian Wars, extending from about 480 to about 450 BCE and referred to as the Early Classical period, saw the emergence of a new style.

ARCHITECTURAL SCULPTURE. Just a few years after the Persians had been routed, the citizens of Olympia in the northwest Peloponnese began constructing a new Doric temple to Zeus in the Sanctuary of Zeus. The temple was completed between 470 and 456 BCE. Today the massive temple base, fallen columns, and almost all the metope and pediment sculpture remain, impressive even in ruins. Although the temple was of local stone, it was decorated with sculpture of imported marble, and, appropriately for its Olympian setting, the themes of its artwork demonstrated the power of the gods Zeus, Apollo, and Athena, and metaphorically, the power of Athens and Greece over the Persians.

The freestanding sculpture that once adorned the west pediment (FIG. 5–25) shows Apollo helping the Lapiths, a clan from Thessaly, in their battle with the centaurs. This leg-

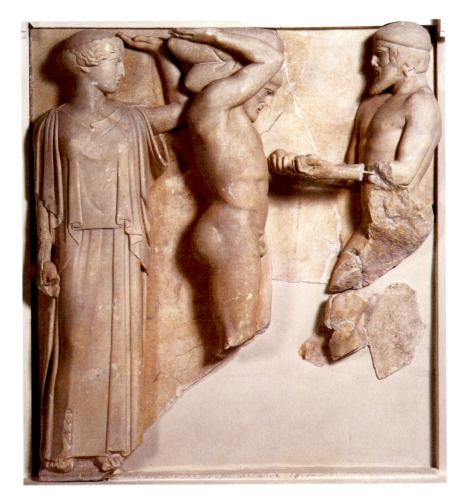

5–27 | ATHENA, HERAKLES, AND ATLAS Metope relief from the frieze of the Temple of Zeus, Olympia. c. 460 BCE. Marble, height 5′3″ (1.59 m). Archaeological Museum, Olympia.

Herakles is at the center with the heavens on his shoulders. Atlas, on the right, holds out the gold apples to him. As we can see, and Atlas cannot, the human Herakles is backed, literally, by the goddess Athena, who effortlessly supports the sky with one hand.

endary battle erupted after the centaurs drank too much wine at the wedding feast of the Lapith king and tried to carry off the Lapith women. Apollo stands calmly at the center of the scene, quelling the disturbance by simply raising his arm (FIG. 5–26). The rising, falling, triangular composition fills the awkward pediment space. The contrast of angular forms with turning, twisting poses dramatizes the physical struggle. The majestic figure of Apollo celebrates the triumph of reason over passion, civilization over barbarism, Greece over Persia.

The metope reliefs of the temple illustrated the Twelve Labors imposed by King Eurystheus of Tiryns on Herakles. One of the labors was to steal gold apples from the garden of the Hesperides, the nymphs who guarded the apple trees. To do this, Herakles enlisted the aid of the Titan Atlas, whose job was to hold up the heavens. Herakles offered to take on this job himself while Atlas fetched the apples for him. In the episode shown here (FIG. 5–27), the artist has balanced the erect, frontal view of the heavily clothed Athena, at left, with profile views of the two nude male figures. Carved in high relief, the figures reflect a strong interest in realism. Even the rather severe columnlike figure of the goddess suggests the flesh of her body pressing through the graceful fall of heavy drapery.

FREESTANDING SCULPTURE. In the remarkably short time of only a few generations, Greek sculptors had moved far from the rigid, frontal presentation of the human figure embodied in the Archaic kouroi. One of the earliest and finest extant freestanding marble figures to exhibit more natural, lifelike qualities is the KRITIAN BOY of about 480 BCE (FIG. 5-28). The damaged figure, excavated from the debris on the Athenian Acropolis, was thought by its finders to be by the Greek sculptor Kritios, whose work they knew only from Roman copies. The boy strikes an easy pose quite unlike the rigid, evenly balanced pose of Archaic kouroi. His weight rests on his left leg, and his right leg bends slightly at the knee. A noticeable curve in his spine counters the slight shifting of his hips and a subtle drop of one of his shoulders. The slight turn of the head invites the spectator to follow his gaze and move around the figure, admiring the small marble statue from every angle. The boy's solemn expression lacks any trace of the Archaic smile—at last the sculptors have mastered the subtle planes of the face.

BRONZE SCULPTURE. The obvious problem for anyone trying to create a freestanding statue is to ensure that it will not fall over. Solving this problem requires a familiarity with the ability of sculptural materials to maintain equilibrium under

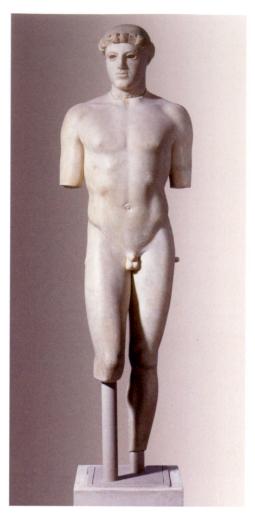

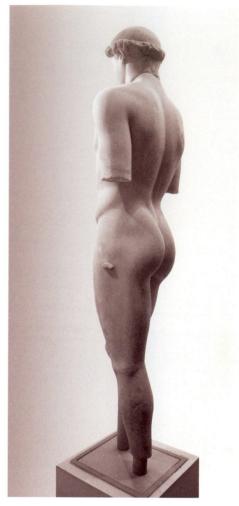

5–28 | KRITIAN BOY From Acropolis, Athens. c. 480 BCE. Marble, height 3'10" (1.17 m). Acropolis Museum, Athens.

various conditions. The **hollow-casting** technique created a far more flexible medium than solid marble or other stone and became the medium of choice for Greek sculptors. Although it is possible to create freestanding figures with outstretched arms and legs far apart in stone, hollow-cast bronze more easily permits vigorous and even off-balance action poses. Consequently, after the introduction of the new technique, sculptors sought to craft poses that seemed to capture a natural feeling of continuing movement rather than an arbitrary moment frozen in time.

Athens was as famous for its metalwork as it was for ceramics. A painted kylix, or drinking cup, illustrates the work in a foundry (FIG. 5–29). The artist, called the Foundry Painter, presents all the workings of a contemporary foundry for casting lifesize and monumental bronze figures. The artist organized this scene within the flaring space that extends upward from the foot of the vessel, using the circle that marks the attachment of the foot to the vessel as the groundline for the figures. The walls of the workshop are filled with hanging tools and other foundry paraphernalia and several sketches. The sketches include a horse, human heads, and human figures in different poses.

On the section shown here, a worker wearing what looks like a modern-day construction helmet squats to tend the furnace on the left. The man in the center, perhaps the supervisor, leans on a staff, while a third worker assembles the parts of a leaping figure that is braced against a molded support. The unattached head lies between his feet. This vase painting provides clear evidence that the Greeks were creating large bronze statues in active poses as early as the first decades of the fifth century BCE.

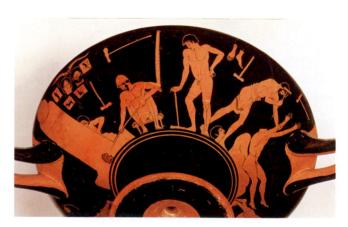

5–29 Foundry Painter A BRONZE FOUNDRY
Red-figure decoration on a kylix from Vulci, Italy. 490–480 BCE. Ceramic, diameter of kylix 12" (31 cm). Staatliche Museen zu Berlin, Preussischer Kulturbesitz, Antikensammlung, Berlin.

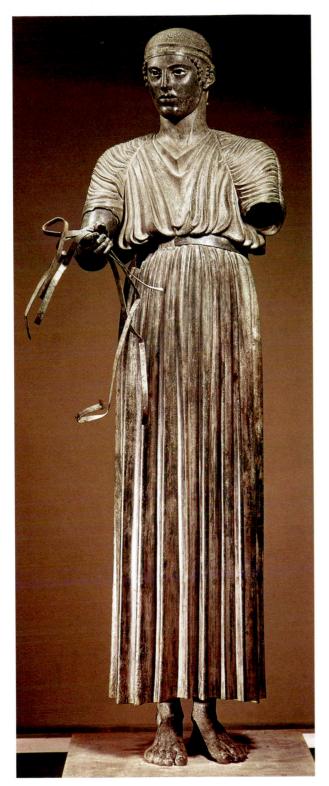

5–30 | **CHARIOTEER**From the Sanctuary of Apollo, Delphi. c. 470 BCE. Bronze, copper (lips and lashes), silver (hand), onyx (eyes), height 5′11″ (1.8 m). Archaeological Museum, Delphi.

The setting of a work of art affects the impression it makes. Today, the charioteer is exhibited on a low base in the peaceful surroundings of a museum, isolated from other works and spotlighted for close examination. Its effect would have been very different in its original outdoor location, standing in a horse-drawn chariot atop a tall monument. Viewers in ancient times, tired from the steep climb to the sanctuary and jostled by crowds of fellow pilgrims, could have absorbed only its overall effect, not the fine details of the face, robe, and body visible to today's viewers.

THE CHARIOTEER. Unfortunately, foundries began almost immediately to recycle metal from old statues into new works, so few original Greek bronzes have survived. A spectacular lifesize bronze, the CHARIOTEER (FIG. 5–30), cast about 470 BCE, was saved only because it was buried after an earthquake in 373 BCE. Archaeologists found it in the sanctuary of Apollo at Delphi, along with fragments of a bronze chariot and horses. According to its inscription, it commemorates a victory by a driver in the Pythian Games of 478 or 474 BCE.

If the *Kritian Boy* seems solemn, the *Charioteer* seems to pout. His head turns slightly to one side. His rather intimidating expression is enhanced by glittering, onyx eyes and fine copper eyelashes. The *Charioteer* stands erect; his long robe with its almost columnar fluting is the epitome of elegance. The folds of the robe fall in a natural way, varying in width and depth, and the whole garment seems capable of swaying and rippling with the charioteer's movement. The feet, with their closely observed toes, toenails, and swelled veins over the instep, are so realistic that they seem to have been cast from molds made from the feet of a living person.

WARRIOR A. The sea as well as the earth has protected ancient bronzes. As recently as 1972, divers recovered a pair of larger-than-life-size bronze figures from the seabed off the coast of Riace, Italy (FIG. 5–31). Known as the RIACE WARRIORS OF WARRIORS A AND B, they date to about 460–450 BCE. Just what sent them to the bottom is not known, but conservators have restored them to their original condition (see "The Discovery and Conservation of the Riace Warriors," page 135).

Warrior A reveals a striking balance between idealized anatomical forms and naturalistic details. The supple musculature suggests a youthfulness belied by the maturity of the face. Minutely detailed touches—the navel, the swelling veins in the backs of the hands, and the strand-by-strand rendering of the hair—are also in marked contrast to the idealized, youthful smoothness of the rest of the body. The sculptor heightened these lifelike effects by inserting eyeballs of bone and colored glass, applying eyelashes and eyebrows of separately cast, fine strands of bronze, insetting the lips and nipples with pinkish copper, and plating the teeth that show between the parted lips with silver. The man held a shield (parts are still visible) on his left arm and a spear in his right hand and was probably part of a monument commemorating a military victory, perhaps against the Persians.

At about the same time, the *Discus Thrower*, reproduced at the beginning of this chapter, was created in bronze by the sculptor Myron (SEE FIG. 5–1). The sculpture is known today only from Roman copies in marble, but in its original form it must have been as lifelike in its details as the *Riace Warriors*. Myron caught the athlete at a critical moment, the breathless instant before the concentrated energy of his body will unwind to propel the discus into space. His muscular torso is

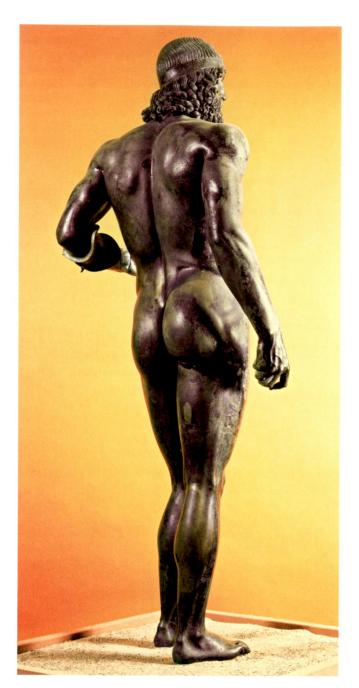

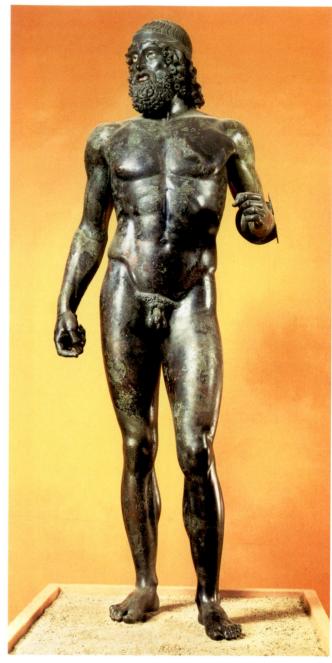

5–31 | **WARRIOR A**Found in the sea off Riace, Italy. c. 460–450 BCE. Bronze with bone and glass eyes, silver teeth, and copper lips and nipples, height 6'9" (2.05 m). National Archeological Museum, Reggio Calabria, Italy.

coiled tightly into a forward arch, and his powerful throwing arm is poised at the top of his backswing. Myron earned the adulation of his contemporaries: It is interesting that he was most warmly admired for a sculpture that has not survived—a bronze cow!

PAINTING. Vase painters continued to work with the redfigure technique throughout the fifth century BCE, refining their styles and experimenting with new compositions. Among the outstanding vase painters of the Early Classical period was the prolific Pan Painter, who was inspired by the less heroic myths of the gods to create an admirable body of red-figure works. The artist's name comes from a work involving the god Pan on one side of a bell-shaped krater that dates to about 470 BCE. The other side of this krater shows **ARTEMIS SLAYING ACTAEON** (FIG. 5–32). Actaeon was punished by Artemis for boasting that he was a better hunter than she, or (in another version) for seducing Semele, who was

Technique

THE DISCOVERY AND CONSERVATION OF THE RIACE WARRIORS

n 1972, a scuba diver in the Ionian Sea near the beach resort of Riace, Italy, found what appeared to be a human elbow and upper arm protruding from sand about 25 feet beneath the sea. Taking a closer look, he discovered that the arm was made of metal, not flesh, and was part of a large statue. He soon uncovered a second statue nearby.

Experienced underwater salvagers raised the statues: bronze warriors more than 6 feet tall, complete in every respect, except for swords, shields, and one helmet. But after centuries underwater, the *Warriors* were corroded and covered with accretions. The clay cores from the casting process were still inside the bronzes, adding to the deterioration by absorbing lime and sea salts. To restore the *Warriors*, conservators first removed all the exterior corrosion and lime encrustations using surgeon's

scalpels, pneumatic drills with 3-millimeter heads, and high-technology equipment such as sonar (sound-wave) probes and micro-sanders. Then they painstakingly removed the clay core through existing holes in the heads and feet using hooks, scoops, jets of distilled water, and concentrated solutions of peroxide. Finally, they cleaned the figures thoroughly by soaking them in solvents, and they sealed them with a fixative specially designed for use on metals.

Since the *Warriors* were put on view in 1980, conservators have taken additional steps to ensure their preservation. In 1993, for example, a sonar probe mounted with two miniature video cameras found and blasted loose with sound waves the clay remaining inside the statues, which was then flushed out with water.

being courted by Zeus. The enraged goddess caused Actaeon's own dogs to mistake him for a stag and attack him. The Pan Painter shows Artemis herself about to shoot the unlucky hunter with an arrow from her bow. The angry god-

dess and the fallen Actaeon each form roughly triangular shapes that conform to the flaring shape of the vessel.

THE HIGH CLASSICAL PERIOD, c. 450–400 BCE

The High Classical period of Greek art, from about 450 to 400 BCE, corresponds roughly to the domination of Sparta and Athens. The two had emerged as the leading city-states in the Greek world in the wake of the Persian Wars. Sparta dominated the Peloponnesus and much of the rest of mainland Greece. Athens dominated the Aegean and became the wealthy and influential center of a maritime empire.

Except for a few brief interludes, Perikles, a dynamic, charismatic leader, dominated Athenian politics and culture from 462 BCE until his death in 429 BCE. Although comedy writers of the time sometimes mocked him, calling him "Zeus" and "The Olympian" because of his haughty personality, he led Athens to a period of great wealth and influence seen later as a "Golden Age." He was a great patron of the arts, supporting the use of Athenian wealth for the adornment of the city and encouraging artists to promote a public image of peace, prosperity, and power.

He brought new splendor to the sanctuaries of the gods who protected Athens and turned the citadel of Athens, the Acropolis, into a center of civic and religious life. Perikles said of his city and its accomplishments: "Future generations will marvel at us, as the present age marvels at us now." It was a prophecy he himself helped fulfill.

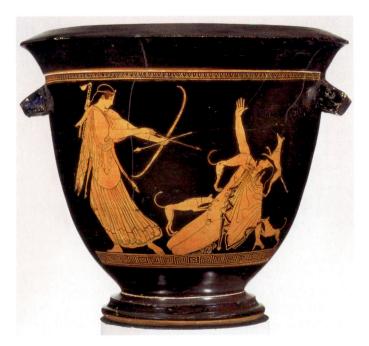

5–32 | Pan Painter ARTEMIS SLAYING ACTAEON c. 470 BCE. Red-figure decoration on a bell krater. Ceramic, height of krater 14%" (37 cm). Museum of Fine Arts, Boston. James Fund and by Special Contribution (10.185).

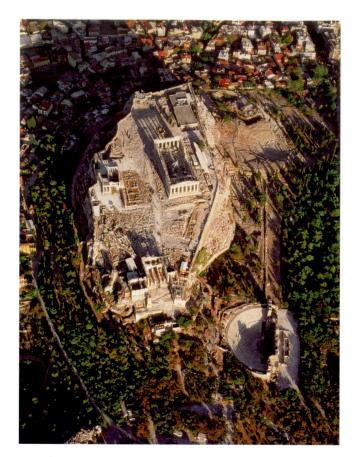

5-33 ATHENS; ACROPOLIS FROM THE AIR

Athens originated as a Neolithic **acropolis**, or "part of the city on top of a hill" (*akro* means "high" and *polis* means "city"). The flat-topped hill that was the original site of the city later served as a fortress and religious sanctuary. As the city grew, the Acropolis became the religious and ceremonial center devoted primarily to the goddess Athena, the city's patron and protector.

The Acropolis

After Persian troops destroyed the Acropolis in 480 BCE, the Athenians vowed to keep it in ruins as a memorial. Later Perikles convinced them to rebuild it (FIG. 5–33). He argued that this project honored the gods, especially Athena, who had helped the Greeks defeat the Persians. But Perikles also hoped to create a visual expression of Athenian values and civic pride that would glorify his city and bolster its status as the capital of the empire he was instrumental in building. He placed his close friend Pheidias, a renowned sculptor, in charge of the rebuilding and assembled under him the most talented artists and artisans in Athens.

The cost and labor involved in this undertaking were staggering. Large quantities of gold, ivory, and exotic woods had to be imported. Some 22,000 tons of marble had to be transported 10 miles from mountain quarries to

city workshops. Perikles was severely criticized by his political opponents for this extravagance, but it never cost him popular support. In fact, many working-class Athenians—laborers, carpenters, masons, sculptors, and the carters and merchants who kept them supplied and fed—benefited from his expenditures.

Work on the Acropolis continued after Perikles' death and was completed by the end of the fifth century BCE (FIG. 5-34). Visitors to the Acropolis in 400 BCE would have climbed a steep ramp on the west side of the hill to the sanctuary entrance, perhaps pausing to admire the small marble temple dedicated to Athena Nike (Athena as the goddess of victory in war), poised on a projection of rock above the ramp. After passing through an impressive porticoed gatehouse called the Propylaia, they would have seen a huge bronze figure of Athena Promachos (the Defender). This statue, designed and executed by Pheidias between about 465 and 455 BCE, showed the goddess bearing a spear. Sailors entering the Athenian port of Piraeus, about 10 miles away, could see the sun reflected off the helmet and spear tip. Behind this statue was a walled precinct that enclosed the Erechtheion, a temple dedicated to several deities.

Religious buildings and votive statues filled the hilltop. A large stoa with projecting wings was dedicated to Artemis Brauronia (the Protector of Wild Animals). Beyond this stoa on the right stood the largest building on the Acropolis, looming above the precinct wall that enclosed it. This was the Parthenon, a temple dedicated to Athena Parthenos (the Virgin). Visitors approached the temple from its northwest corner. The cella of the Parthenon faced east. With permission from the priests, they would have climbed the east steps to look into the cella, seeing a colossal gold and ivory statue of Athena, created by Pheidias and installed and dedicated in the temple in 438 BCE. However, the building was not yet complete and further work on the ornamental sculpture continued until 433/432 BCE.

The Parthenon

Sometime around 490 BCE, Athenians began work on a temple to Athena Parthenos that was still unfinished when the Persians sacked the Acropolis a decade later. Work was resumed in 447 BCE by Perikles, who commissioned the architect Iktinos to design a larger temple using the existing foundation and stone elements. The finest white marble was used throughout, even on the roof, in place of the more usual terra-cotta tiles.

One key to the Parthenon's sense of harmony and balance is an aesthetics of number that was used to determine the perfect proportions—especially the ratio of 4:9, expressing the relationship of breadth to length and also the relationship of column diameter to space between columns. Just as important to the overall effect are subtle refinements of design, including the slightly arched base and entablature, the very subtle swelling of the soaring columns, and the

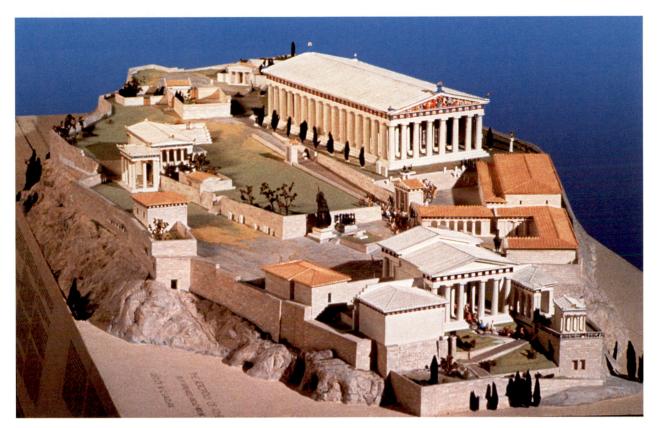

5–34 | MODEL OF THE ACROPOLIS, ATHENS c. 447–432 BCE. Royal Ontario Museum, Toronto.

narrowing of the space between the corner columns and the others in the colonnade. This aesthetic control of space is the essence of architecture, as opposed to mere building. The significance of their achievement was clear to its builders—Iktinos even wrote a book on the proportions of his masterpiece.

The planning and execution of the Parthenon required extraordinary mathematical and mechanical skills and would have been impossible without a large contingent of distinguished architects and builders, as well as talented sculptors and painters. The result is as much a testament to the administrative skills as to the artistic vision of Phidias, who supervised the entire project (see plan (d) of "Greek Temple Plans," page 116). The building and statue of Athena Parthenos were dedicated in 438 BCE. Pheidias designed the ivory and gold sculpture, which was executed in his workshop and finished about 432 .

The decoration of the Parthenon strongly reflects Pheidias's unifying vision. A coherent, stylistic whole, the sculptural decoration conveys a number of political and ideological themes: the triumph of the democratic Greek city-states over imperial Persia, the preeminence of Athens thanks to the favor of Athena, and the triumph of an enlightened Greek civilization over despotism and barbarism (see "The Parthenon," page 138).

THE PEDIMENTS. Like the pediments of most temples, those of the Parthenon were filled with sculpture in the round, set on the deep shelf of the cornice and secured to the wall with metal pins. Unfortunately, much has been damaged or lost over the centuries. Using the locations of the pinholes and weathering marks on the cornice, scholars have been able to determine the placement of surviving statues and infer the poses of missing ones. The west pediment sculpture, facing the entrance to the Acropolis, illustrated the contest Athena won over the sea god Poseidon for rule over the Athenians. The east pediment figures, above the entrance to the cella, illustrated the birth of Athena, fully grown and clad in armor, from the brow of her father, Zeus.

The statues from the east pediment are the best preserved of the two groups (FIG. 5–35). Flanking the missing central figures—probably Zeus seated on a throne with the new-born adult Athena standing at his side—were groups of three goddesses followed by single reclining male figures. In the left corner was the sun god Helios in his horse-drawn chariot rising from the sea. In the right corner was the moon goddess Selene descending in her chariot to the sea. The head of her tired horse hangs over the cornice. The reclining male nude, who fits so easily into the left pediment, has been identified as both Herakles with his lion's skin, or Dionysos (god

THE OBJECT SPEAKS

THE PARTHENON

he Parthenon, a symbol of Athenian aspirations and creativity, rises triumphantly above the Acropolis. This temple of the goddess of wisdom spoke eloquently to fifth-century BCE Greeks of independence, self-confidence, and justifiable pride-through the excellence of its materials and craftwork, the rationality of its simple and elegant post-and-lintel structure, and the subtle yet ennobling messages of its sculpture. Today, we continue to be captivated by the gleaming marble ruin of the Parthenon, the building that has shaped our ideas about Greek civilization, about the importance of architecture as a human endeavor, and also about the very notion of the possibility of perfectibility. Its form, even when regarded abstractly, is an icon for democratic values and independent thought.

When the Parthenon was built, Athens was the capital of a powerful, independent city-state. For Perikles, Athens was the model of all Greek cities; the Parthenon was the perfected, ideal Doric temple.

Isolated like a work of sculpture, with the rock of the Acropolis as its base, the Parthenon is both an abstract form—a block of columns—and at the same time the essence of shelter: an earthly home for Athena, the patron goddess. For the ancient Greeks, the Parthenon symbolized Athens, its power and wealth, its glorious victory over foreign invaders, and its position of leadership at home.

Over the centuries, very different people reacting to very different circumstances found that the temple could also express their ideals. They imbued it with meaning and messages that might have shocked the original builders. Over its long life, the Parthenon has been a Christian church dedicated to the Virgin Mary, an Islamic mosque, a Turkish munitions storage facility, an archaeological site, and a major tourist attraction.

To many people through the ages, it remained silent, but in the eighteenth century CE, in the period known as the Enlightenment, the Parthenon found its

voice again. British architects James Stuart and Nicholas Revett made the first careful drawings of the building in the mid-eighteenth century, which they published as The Antiquities of Athens, in 1789. People reacted to the Parthenon's harmonious proportions, subtle details, and rational relationship of part to part, even in drawings. The building came to exemplify, in architectural terms, human and humane values. In the nineteenth century, the Parthenon became a symbol of honesty, heroism, and civic virtue, of the highest ideals in art and politics, a model for national monuments, government buildings, and even homes.

Architectural messages, like any communications, may be subject to surprising interpretations. On a bluff overlooking the Danube River near Regensburg in Germany, a nineteenth-century Parthenon commemorates the defeat of Napoleon, and in Edinburgh, Scotland ("the Athens of the North") the unfinished façade of Doric columns and entablature (the

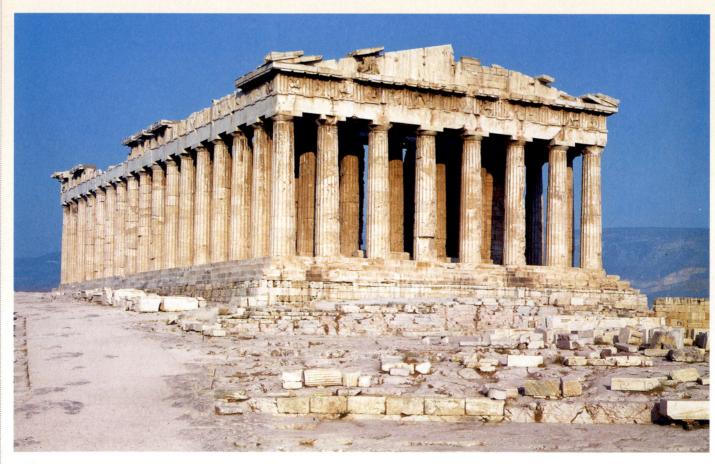

Kallikrates and Iktinos PARTHENON, ACROPOLIS
Athens. 447–432 BCE. View from the northwest. Pantelic marble.

builders ran out of money in 1829) confront the Medieval castle on the opposite hill. Nineteenth century Americans dignified their democratic, mercantile culture by adapting the Parthenon's form to government, business, and even domestic buildings. Not only was the simplicity of the Doric order considered appropriate but it also was the cheapest order to build. In the 1830s and 40s the Greek Revival style spread across the United States, adding a touch of elegance to simple farm houses.

One of the most remarkable reincarnations of the Parthenon can be admired in Nashville, Tennessee, "the Athens of the South." Here a replica of the Parthenon was built for the Centenial exhibition of 1897. So popular was the building that when the structure with its plaster sculpture deteriorated dangerously, the city replaced the building in permanent materials. They rebuilt the Parthenon in concrete on a steel frame. The sculptured pediments were created by the local sculptor Belle Kinney of Nashville, assisted by her husband Leopold Schulz. In 1982 Alan LeQuire created a statue of Athena for the interior. The gigantic figure standing nearly 42 feet tall, made of a compound of gypsum cement and chopped fiberglass supported by a structural steel framework, was unveiled May 20, 1990. In the summer of 2002 the figure was painted to simulate marble and gilded—a sight to behold.

The Athenian Parthenon continues to speak to viewers today. Its columns and pediment have become a universal image, like the Great Pyramids of Egypt, used and reused in popular culture. The Parthenon even has an intriguing half-life in postmodern buildings and decorative arts.

When the notable architect Le Corbusier sought to create an architecture for the twentieth century, he turned for inspiration to the still-vibrant temple of the goddess of wisdom's clean lines, simple forms, and mathematical ratios. Le Corbusier called the Parthenon "ruthless, flawless," and wrote, "There is nothing to equal it in the architecture of the entire world and all the ages . . ." (Le Corbusier, *Vers une architecture*, 1923).

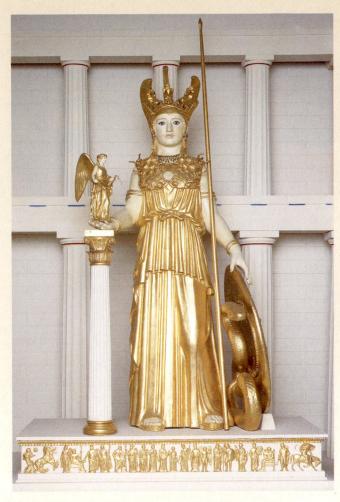

Alan LeQuire ATHENA, THE PARTHENON, NASHVILLE, TENNESSEE

Recreation of Pheidias's huge gold and ivory figure. 1982–1990. Gypsum concrete and chopped fiberglass on structural steel, height 41' 10". Painted to simulate marble with lapis lazuli eyes by Alan LeQuire and gilded under the direction of master gilder Lou Reed, June 3–Sept. 3, 2002. The ancient sculpture was of ivory and gold.

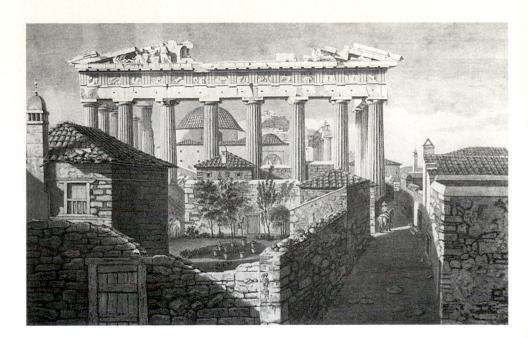

William Pars THE PARTHENON WHEN IT CONTAINED A MOSQUE

Drawing by Nicholas Revett (1765) and published in James Stuart and Nicholas Revett, *The Antiquities of Athens* (London, 1789).

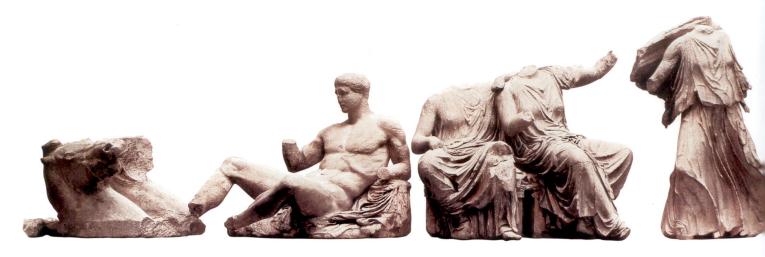

5-35 | PHOTOGRAPHIC MOCK-UP OF THE EAST PEDIMENT OF THE PARTHENON

(Using photographs of the extant marble sculpture) c. 447-432 BCE. The gap in the center represents the space that would have been occupied by the missing sculpture. The pediment is over 90 feet (27.45 m) long; the central space of about 40 feet (12.2 m) is missing.

At the beginning of the nineteenth century, Thomas Bruce, the British Earl of Elgin and ambassador to Constantinople, acquired much of the surviving sculpture from the Parthenon, which was being used for military purposes. He shipped it back to London in 1801 to decorate a lavish mansion for himself and his wife. By the time he returned to England a few years later, his wife had left him and the ancient treasures were at the center of a financial dispute. Finally, he sold the sculpture for a very low price. Referred to as the Elgin Marbles, most of the sculpture is now in the British Museum, including all the elements seen here. The Greek government has tried unsuccessfully in recent times to have the Elgin Marbles returned.

of wine) lying on a panther skin. His easy pose conforms to the slope of the pediment without a hint of awkwardness. The two seated women may be the earth and grain goddesses Demeter and Persephone. The running female figure just to the left of center is Iris, messenger of the gods, already spreading the news of Athena's birth.

The three female figures on the right side, two sitting upright and one reclining, were once thought to be the Three Fates, whom the Greeks believed appeared at the birth of a child and determined its destiny. Most art historians now think that they are goddesses, perhaps Hestia (a sister of Zeus and the goddess of the hearth), Dione (one of Zeus's many consorts), and her daughter, Aphrodite. These monumental interlocked figures seem to be awakening from a deep sleep. The sculptor, whether Pheidias or someone working in his style, expertly rendered the female form beneath the fall of draperies. The clinging fabric both covers and reveals, creating circular patterns rippling with a life of their own over torsos, breasts, and knees and uniting the three figures into a single mass.

THE DORIC FRIEZE. The Athenians intended their temple to surpass the Temple of Zeus at Olympia, and they succeeded. The all-marble Parthenon was large in every dimension. It held a spectacular standing statue of Athena, about 40 feet high. It also had two sculptured friezes, one above the outer peristyle and another atop the cella wall inside (Introduction, see Fig. 20). The Doric frieze on the exterior had ninety-two

metope reliefs, fourteen on each end and thirty-two along each side. These reliefs depicted legendary battles, symbolized by combat between two representative figures: a Lapith against a centaur; a god against a Titan; a Greek against a Tro-

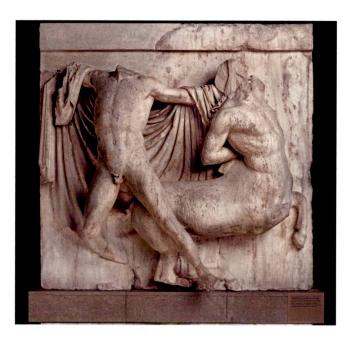

5–36 | LAPITH FIGHTING A CENTAUR

Metope relief from the Doric frieze on the south side of the Parthenon. c. 447–432 BCE. Marble, height 56" (1.42 m).

The British Museum, London.

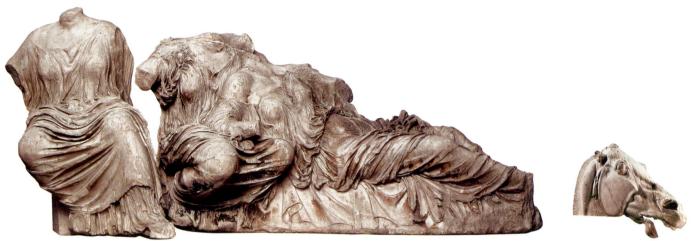

jan; a Greek against an Amazon (Amazons were members of the mythical tribe of female warriors sometimes said to be the daughters of the war god Ares).

Among the best-preserved metope reliefs are those from the south side, including several depicting the battle between the Lapiths and the centaurs. The panel shown here (FIG. 5-36)—with its choice of a perfect moment of pause within a fluid action, its reduction of forms to their most characteristic essentials, and its choice of a single, timeless image to stand for an entire historical episode—captures the essence of High Classical art. So dramatic is the X-shaped composition that we easily accept its visual contradictions.

Like the Discus Thrower (SEE FIG. 5-1), the Lapith is caught at an instant of total equilibrium. What should be a grueling tug-of-war between a man and a man-beast appears instead as an athletic ballet choreographed to show off the

Lapith warrior's muscles and graceful movements against the implausible backdrop of his carefully draped cloak. Like Greek sculptors of earlier periods, those of the High Classical style were masters of representing hard muscles but soft flesh.

PROCESSIONAL FRIEZE. Enclosed within Parthenon's Doric peristyle, the body of the temple consists of a cella, opening to the east, and an unconnected auxiliary space opening to the west. Short colonnades in front of each entrance support an entablature with an Ionic order frieze in relief that extends along the four sides of the cella, for a total frieze length of 525 feet. The subject of this frieze is a procession celebrating the festival that took place in Athens every four years, when the women of the city wove a new wool peplos and carried it to the Acropolis to clothe an ancient wooden cult statue of Athena.

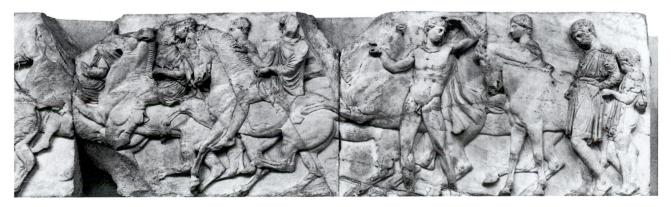

5-37 HORSEMEN Detail of the Procession, from the Ionic frieze on the north side of the Parthenon. c. 447-432 BCE. Marble, height 41¾" (106 cm). The British Museum, London.

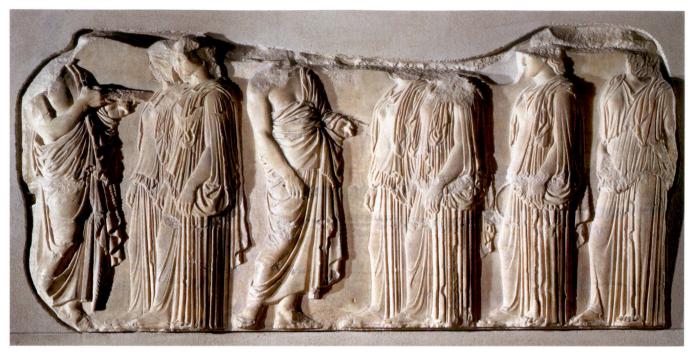

5–38 | MARSHALS AND YOUNG WOMEN
Detail of the *Procession*, from the Ionic frieze on the east side of the Parthenon. c. 447–432 BCE. Marble, height 3'6" (1.08 m). Musée du Louvre, Paris.

The east façade presents a totally integrated program of images—the birth of the goddess in the pediment, her honoring by the citizens who present her with the newly woven *peplos*, and—seen through the doors—the glorious figure of Athena herself.

In Pheidias's portrayal of this major event, the figures—skilled riders managing powerful steeds, for example (FIG. 5–37), or graceful but physically sturdy young walkers (FIG. 5–38)—seem to be representative types, ideal inhabitants of a successful city-state. The underlying message of the frieze as a whole is that the Athenians are a healthy, vigorous people, united in a democratic civic body looked upon with favor by the gods. The people are inseparable from and symbolic of the city itself.

As with the metope relief of the Lapith Fighting a Centaur, (SEE FIG. 5–36) viewers of the processional frieze easily accept its disproportions, spatial incongruities, and such implausible compositional features as all the animal and human figures standing on the same groundline, and men and women standing as tall as rearing horses. Carefully planned rhythmic variations—changes in the speed of the participants in the procession as it winds around the walls—contribute to the effectiveness of the frieze: Horses plunge ahead at full gallop; women proceed with a slow, stately step; parade marshals pause to look back at the progress of those behind them; and human-looking deities rest on conveniently placed benches as they await the arrival of the marchers.

In executing the frieze, the sculptors took into account the spectators' low viewpoint and the dim lighting inside the peristyle. They carved the top of the frieze band in higher relief than the lower part, thus tilting the figures out to catch the reflected light from the pavement, permitting a clearer reading of the action. The subtleties in the sculpture may not have been as evident to Athenians in the fifth century BCE as they are now, because the frieze, seen at the top of a high wall and between columns, originally was completely painted (Introduction, See Fig. 23). The background was dark blue and the figures were in contrasting red and ocher, accented with glittering gold and real metal details such as bronze bridles and bits on the horses.

The Propylaia and the Erechtheion

Upon completion of the Parthenon, Perikles commissioned an architect named Mnesikles to design a monumental gatehouse, the Propylaia (SEE FIG. 5—34). Work began on it in 437 and then stopped in 432 BCE, with the structure still incomplete. The Propylaia had no sculptural decoration, but its north wing was originally a dining hall and later it became the earliest known miseum (meaning "home of the Muses"), the "Pinakotheke" mentioned by Pausanius, which became a gallery built specifically to house a collection of paintings for public view.

The designer of the **ERECHTHEION** (FIG. 5–39), the second important temple erected on the Acropolis under Perikles' building program, is unknown. Work began on the building in 421 BCE and ended in 405 BCE, just before the fall of

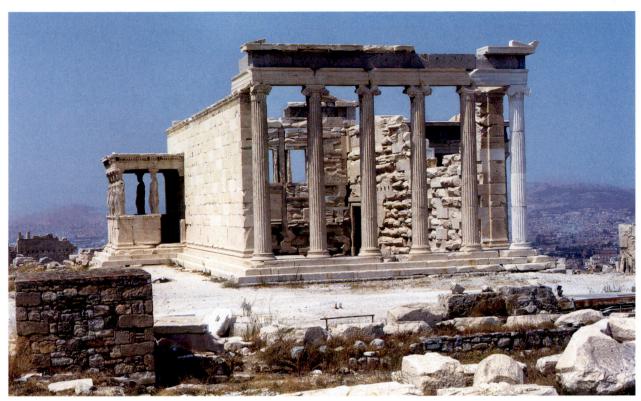

5–39 | **ERECHTHEION** Acropolis, Athens. 421–406 BCE. View from the east. Porch of the Maidens at left; north porch can be seen through the columns of the east wall.

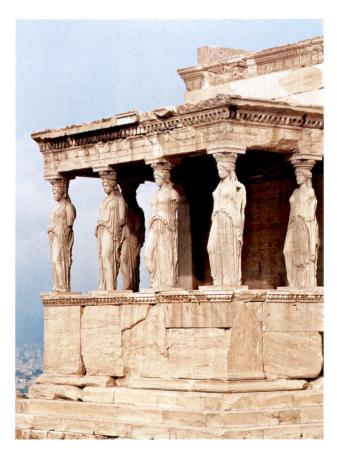

5–40 | PORCH OF THE MAIDENS (SOUTH PORCH), ERECHTHEION
Acropolis, Athens. Temple 430s–406 BCE; porch c. 420–410 BCE.

Athens to Sparta. The asymmetrical plan on several levels reflects the building's multiple functions, for it housed many different shrines, and it also conformed to the sharply sloping terrain on which it was located. The building stands on the site of the mythical contest between the sea god Poseidon and Athena for patronage over Athens. During this contest, Poseidon struck a rock with his trident (three-pronged harpoon), bringing forth a spout of water, but Athena gave the olive tree to Athens and won the contest for the city. The Athenians enclosed what they believed to be this sacred rock, bearing the marks of the trident, in the Erechtheion's north porch. The Erechtheion also housed the venerable wooden cult statue of Athena that was the center of the Panathenic festival.

The Erechtheion had porches on the north, east, and south sides. Later architects agreed that the north porch was the most perfect interpretation of the Ionic order, and they have copied the columns and capitals, the carved moldings, and the proportions and details of the door ever since the eighteenth century. The **PORCH OF THE MAIDENS** (FIG. 5–40), on the south side facing the Parthenon, is even more famous. Raised on a high base, its six stately caryatids support simple Doric capitals and an Ionic entablature made up of bands of carved molding. In a pose characteristic of Classical figures, each caryatid's weight is supported on one engaged leg, while the free leg, bent at the knee, rests on the ball of the foot. The three caryatids on the left have their right legs engaged, and

5−4I THE MONUMENTAL ENTRANCE TO THE ACROPOLIS

The Propylaia (Mnesikles) with the Temple of Athena Nike (Kallikrates) on the bastion at the right. C. 437-423 BCE.

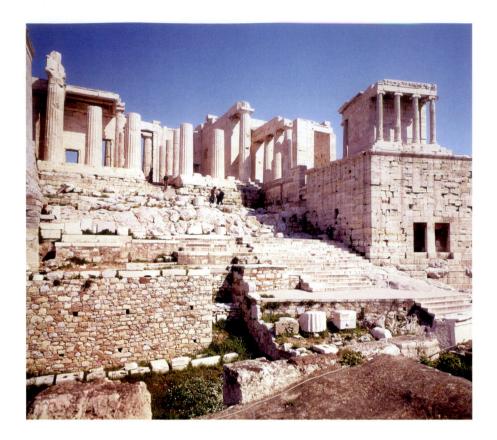

the three on the right have their left legs engaged, creating a sense of closure, symmetry, and rhythm. The vertical fall of the drapery on the engaged side resembles the fluting of a column shaft and provides a sense of stability, whereas the bent leg gives an impression of relaxed grace and effortless support. The hair of each caryatid falls in a loose but massive knot behind its neck, a device that strengthens the weakest point in the sculpture while appearing entirely natural.

The Temple of Athena Nike

The Temple of Athena Nike (victory in war), located south of the Propylaia, was designed and built about 425 BCE, probably by Kallikrates (FIG. 5–41). It is an Ionic temple built on an amphiprostyle plan, that is, with a porch at each end (see plan (c) of "Greek Temple Plans," page 116). Reduced to rubble during the Turkish occupation of Greece in the seventeenth century CE, the temple has since been rebuilt. Its diminutive size, about 27 by 19 feet, and refined Ionic decoration are in marked contrast to the massive Doric Propylaia adjacent to it.

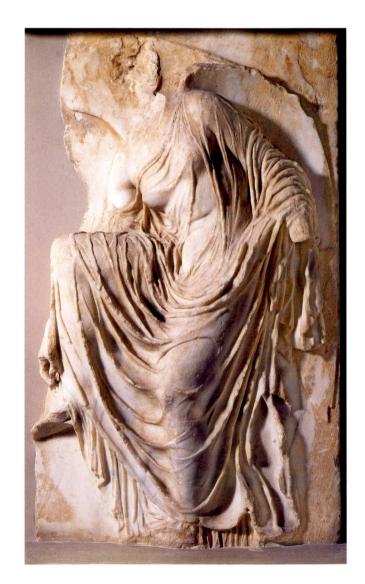

Art and Its Context

WHO OWNS THE ART? THE ELGIN MARBLES AND THE EUPHRONIOS VASE

t the beginning of the nineteenth century, Thomas Bruce, the British earl of Elgin and ambassador to Constantinople, acquired much of the surviving sculpture from the Parthenon, which was being used for military purposes. He shipped it back to London in 1801 to decorate a lavish mansion for himself and his wife. By the time he returned to England a few years later, his wife had left him and the ancient treasures were at the center of a financial dispute. Finally, he sold the sculpture for a very low price. Referred to as the Elgin Marbles, most of the sculpture is now in the British Museum, including all the elements seen in figure 5–35 except the torso of Selene, which is in the Acropolis Museum, Athens. The Greek government has tried unsuccessfully in recent times to have the Elgin Marbles returned.

Recently, another Greek treasure has been in the news. In 1972, a krater (a bowl for mixing water and wine), painted by the master Euphronios and depicting the death of the warrior Sarpedon during the Trojan War, had been purchased by the Metropolitan Museum of Art in New York (FIG. 5–23). Museum officials were told that the krater had come from a private collection, and they made it the centerpiece of the Museum's galleries of Greek vases. But in 1995, Italian and Swiss investigators raided a warehouse in Geneva, Switzerland, where they found documents showing that the vase had been stolen from an Etruscan tomb near Rome. The Italian government wanted the masterpiece back. The controversy—who owns the art—was resolved in 2006. The vase, along with other objects known to have been stolen from other Italian sites, will be returned. Meanwhile, the Metropolitan Museum will display pieces "of equal beauty" on long-term loan agreements with Italy.

Between 410 and 405 BCE, the temple was surrounded by a parapet, or low wall, faced with sculptured panels depicting Athena presiding over her winged attendants, called *nike* (victory) figures, as they prepared for a celebration. The parapet no longer exists, but some of the panels from it have survived. One of the most admired is of **NIKE** (VICTORY) ADJUSTING HER SANDAL (FIG. 5–42). The figure bends forward gracefully, causing her *chiton* to slip off one shoulder. Her large wings, one open and one closed, effectively balance this unstable pose. Unlike the decorative swirls of heavy fabric covering the Parthenon goddesses or the weighty pleats of the robes of the Erechtheion caryatids, the textile covering this *Nike* appears delicate and light, clinging to her body like wet silk, one of the most discreetly erotic images in ancient art.

The Athenian Agora

In Athens, as in most cities of ancient Greece, commercial, civic, and social life revolved around the marketplace, or agora. The Athenian Agora, at the foot of the Acropolis, began as an open space where farmers and artisans displayed their wares. Over time, public and private structures were erected on both sides of the Panathenaic Way, a ceremonial road used during an important festival in honor of Athena (FIG. 5–43). A stone drainage system was installed to prevent flooding, and a large fountain house was built to provide water for surrounding homes, administrative buildings, and shops. By 400 BCE, the Agora contained several religious and administrative structures and even a small racetrack. The Agora also had the city mint, its military headquarters, and two buildings devoted to court business.

In design, the *stoa*, a distinctively Greek structure found nearly everywhere people gathered, ranged from a simple roof held up by columns to a substantial, sometimes architecturally impressive, building with two stories and shops along one side. Stoas offered protection from the sun and rain, and provided a place for strolling and talking business, politics, or philosophy. While city business could be, and often was, conducted in the stoas, agora districts also came to include buildings with specific administrative functions.

In the Athenian Agora, the 500-member *boule*, or council, met in a building called the *bouleuterion*. This structure, built before 450 BCE but probably after the Persian destruction of Athens in 480 BCE, was laid out on a simple rectangular plan with a vestibule and large meeting room. Near the end of the fifth century BCE, a new *bouleuterion* was constructed to the west of the old one. This too had a rectangular plan. The interior, however, may have had permanent tiered seating arranged in an ascending semicircle around a ground-level **podium**, or raised platform. Such an arrangement was typical of the outdoor theaters of the time.

Nearby was a small, round building with six columns supporting a conical roof, a type of structure known as a **tholos**. Built about 465 BCE, this *tholos* was the meeting place of the fifty-member executive committee of the *boule*. The committee members dined there at the city's expense, and a few of them always spent the night there in order to be available for any pressing business that might arise.

The Priam Painter has given us an insight into Greek city life as well as a view of an important public building. A water jug (*hydria*) attributed to him depicts a Greek fountain

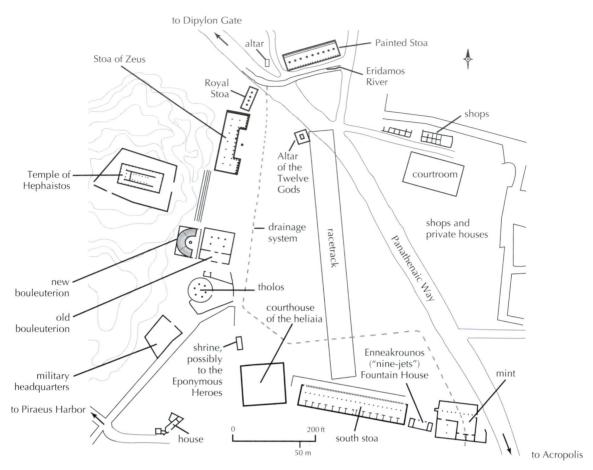

5–43 | PLAN OF THE AGORA (MARKETPLACE) Athens. c. 400 BCE.

house in use (FIG. 5-44). The fountains were truly a public amenity, appreciated by the women and slaves who otherwise would have had to pull up heavy containers from a well. The daily trip to collect water was an important event, since most women in ancient Greece were confined to their homes. At a fountain house, in the shade of a Doric-columned porch, three women fill jugs like the one on which they are painted. A fourth balances her empty jug on her head as she waits, while a fifth woman seems to be waving a greeting to someone. The building is designed like a stoa, open on one side, but having animal-head spigots on three walls. The Doric columns support a Doric entablature with an architrave above the colonnade and a colorful frieze—here black and white blocks replace carved metopes. The circular palmettes (fan-shaped petal designs) framing the main scenes suggest a rich and colorful civic center.

5–44 | Priam Painter WOMEN AT A FOUNTAIN HOUSE 520–510 BCE. Black-figure decoration on a hydria. Ceramic, height of hydria 20%" (53 cm). Museum of Fine Arts, Boston. William Francis Warden Fund (61.195)

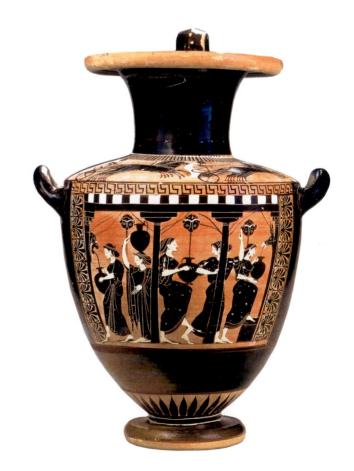

Private houses surrounded the Agora. Compared with the often grand public buildings, houses of the fifth century BCE in Athens were rarely more than simple rectangular structures of stucco-faced mud brick with wooden posts and lintels supporting roofs of terra-cotta tiles. Rooms were small and included a dayroom in which women could sew, weave, and do other chores, a dining room with couches for reclining around a table, a kitchen, bedrooms, and occasionally an indoor bathroom. Where space was not at a premium, houses sometimes opened onto small courtyards or porches.

Stele Sculpture

A freestanding monument that was used in the cemeteries in Greece is an upright stone slab, or **stele** (plural, **stelai**), carved in low relief with the image of the person to be remembered. Instead of images of warriors or athletes used in earlier times, however, the Classical stelai represent departures or domestic scenes that very often feature women. Although respectable

women played no role in politics or civic life, the presence of many fine tombstones of women indicate that they held a respected position in the family.

The **GRAVE STELE OF HEGESO** depicts a beautifully dressed woman seated in an elegant chair, her feet on a footstool (FIG. 5–45). She selects jewels (a necklace indicated in paint) from a box presented by her maid. The composition is entirely inward turning, not only in the gaze and gestures focused on the jewels, but also in the way the vertical fall of the maid's drapery and the curve of Hegeso's chair seem to enclose and frame the figures. Although their faces and bodies are idealized, the two women take on some individuality through details of costume and hairstyle. The simplicity of the maid's tunic and hair, caught in a net, contrasts with the luxurious dress and partially veiled, flowing hair of Hegeso. The sculptor has carved both women as part of the living spectators, space in front of a simple temple-fronted gravestone. The artist does not invade the private world of women: Hegeso's

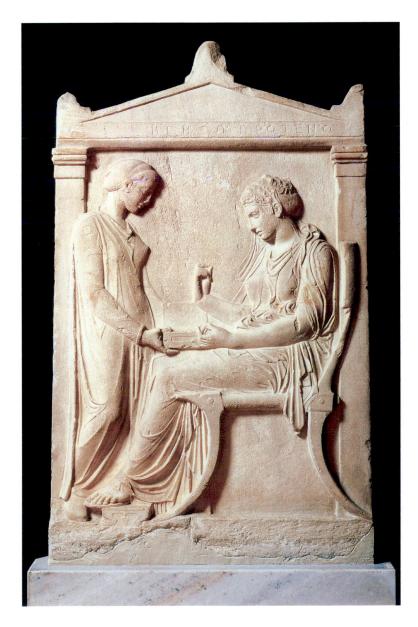

5–45 | GRAVE STELE OF HEGESO c. 410–400 BCE. Marble, height 5′2″ (1.58 m). National Archaeological Museum, Athens.

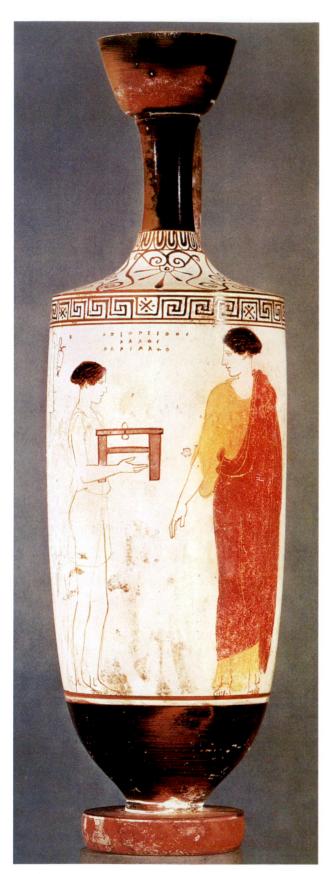

5-46 Style of the Achilles Painter WOMAN AND MAID c. 450-440 BCE. White-ground lekythos. Ceramic, with additional painting in tempera, height of lekythos 15 1/8" (38.4 cm). Museum of Fine Arts, Boston.

Francis Bartlett Donation of 1912 (13.201)

stele and many others like it could be set up in the public cemetery with no loss of privacy or dignity to its subjects.

Painting: Murals and Vases

The Painted Stoa built on the north side of the Athenian Agora about 460 BCE is known to have been decorated with paintings (hence its name) by the most famous artists of the time, including Polygnotos of Thasos (active c. 475–450 BCE). His contemporaries praised his talent for creating the illusion of spatial recession in landscapes, rendering female figures clothed in transparent draperies, and conveying through facial expressions the full range of human emotions. Ancient writers described his painting, as well as other famous works, enthusiastically, but nothing survives for us to see.

Without mural painting, we turn again to ceramics for information. White-ground vase painting must have echoed the style of contemporary paintings on walls and panels. White ground had been used as early as the seventh century BCE, but white-ground vase painting in the High Classical period was far more complex than earlier efforts (SEE "Greek Painted Vases," page 114). Characterized by outlined or drawn imagery, this style was a specialty of Athenian potters. Artists enhanced the fired vessel with a full range of colors using paints made by mixing tints with white clay and also using tempera, an opaque, water-based medium mixed with glue or egg white. This fragile decoration deteriorated easily and for that reason seems to have been favored for funerary, votive, and other nonutilitarian vessels.

A tall, slender, one-handled white-ground lekythos was used to pour liquids during religious rituals. Some convey grief and loss with a scene of a departing figure bidding farewell. Others depict a grave stele draped with garlands. Still others show scenes of the dead person once again in the prime of life and engaged in a seemingly everyday activity, but the images are imbued with signs of separation and loss. A white-ground lekythos, dated about 450-440 BCE and in the style of the Achilles Painter (an anonymous artist known from his painting of Achilles), shows a young servant girl carrying a stool for a small chest of valuables to a well-dressed woman of regal bearing, the dead person whom the vessel memorializes (FIG. 5-46). Like the Grave Stele of Hegeso, the scene contains no overt signs of grief, but a quiet sadness pervades it. The two figures seem to inhabit different worlds, and their glances just fail to meet.

THE LATE CLASSICAL PERIOD. c. 400-323 BCE

After the Spartans defeated Athens in 404 BCE, they set up a pro-Spartan government so oppressive that within a year the Athenians rebelled against it, killed its leader, Kritias, and restored democracy. Athens recovered its independence and

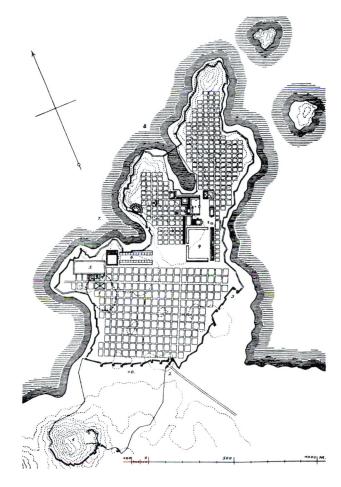

5–47 | PLAN OF MILETOS | Ionia (present-day Turkey), with original coastline.

its economy revived, but it never regained its dominant political and military status. Although Athens had lost its empire, it retained its reputation as a center of artistic and intellectual life. In 387 BCE, the great philosopher-teacher Plato founded a school just outside Athens, as Plato's student Aristotle did later. Among Aristotle's students was young Alexander of Macedon, known to history as Alexander the Great.

In 359 BCE, a crafty and energetic warrior, Philip II, had come to the throne of Macedonia. In 338, he defeated Athens and rapidly conquered the other Greek cities. When he was assassinated two years later, his kingdom passed to his 20-year-old son, Alexander. Alexander rapidly consolidated his power and then led a united Greece in a war of revenge and conquest against the Persians. In 334 BCE, he crushed the Persian army and conquered Syria and Phoenicia. By 331, he had occupied Egypt and founded the seaport he named Alexandria. The Egyptian priests of Amun recognized him as the son of a god, an idea he readily adopted.

That same year, Alexander reached the Persian capital of Persepolis, where his troops accidentally burned down the palace. He continued east until 326 BCE, when he reached the western part of India—now present-day Pakistan. Finally his troops refused to go any farther. On the way home, Alexander died of fever in 323 BCE. He was only 33 years old.

The work of Greek artists during the fourth century BCE exhibits a high level of creativity and technical accomplishment. Changing political conditions never seriously dampened the Greek creative spirit. Indeed, the artists of the second half of the century in particular experimented widely with new subjects and styles. Although they observed the basic Classical approach to composition and form, they no longer followed its conventions. Their innovations were supported by a sophisticated new group of patrons, including the Macedonian courts of Philip and Alexander, wealthy aristocrats in Asia Minor, and foreign rulers eager to import Greek wares and, sometimes, Greek artists.

Architecture and Architectural Sculpture

Despite the political instability, fourth-century Greek cities undertook innovative architectural projects. Architects developed variations on the Classical ideal in urban planning, temple design, and the design of two increasingly popular structures, the *tholos* and the monumental tomb. In contrast to the previous century, much of this activity took place outside of Athens and even in areas beyond mainland Greece, notably in Asia Minor.

CITY PLANS. In older Greek cities such as Athens, buildings and streets developed according to the needs of their inhabitants and the requirements of the terrain. As early as the eighth century BCE, however, builders in some western Greek settlements began to use a rigid, mathematical concept of urban development based on the orthogonal (or grid) plan. New cities or rebuilt sections in old cities were laid out on straight, evenly spaced parallel streets that intersected at right angles to create rectangular blocks. These blocks were then subdivided into identical building plots.

During the Classical period, Greek architects promoted this system as the ideal city plan (FIG. 5–47). Hippodamos of Miletos, a major urban planner of the fifth century BCE, had views on the city akin to those of the Athenian philosophers (such as Socrates) and artists (such as Polykleitos). He believed that humans could arrive at a model of perfection through reason. According to Hippodamos, the ideal city should be limited to 10,000 citizens divided into three classes—artists, farmers, and soldiers—and divided into three zones—sacred, public, and private. The basic Hippodamian plot was a square 600 feet on each side, divided into quarters. Each quarter was subdivided into six rectangular building plots measuring 100 by 150 feet on a side. (This scheme is still widely used in American and European cities and suburbs today.)

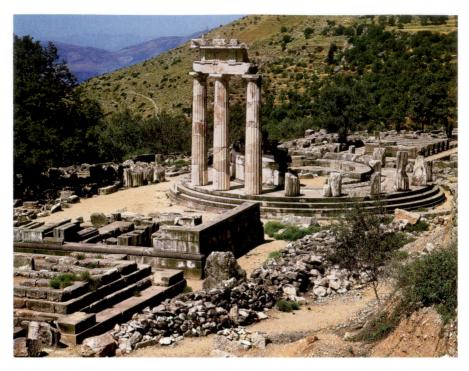

5–48 \perp tholos, sanctuary of athena pronaia, delphi c. 380–370 BCE.

The term *Pronaia* in this sanctuary name simply means "in front of the temples," referring to the sanctuary's location preceding the Temple of Apollo higher up on the mountainside.

Many Greek cities with orthogonal plans were laid out on relatively flat land. Miletos, an Ionian city in Asia Minor, for example, was redesigned by Hippodamos after its partial destruction by the Persians. Later the orthogonal plan was applied on less hospitable terrain, such as that of Priene, another Ionian city, which lies on a rugged hillside across the plain from Miletos. In this case, the city's planners made no attempt to accommodate their grid to the irregular mountainside, so some streets are in fact stairs.

THOLOI AND TOMBS. While most buildings followed a rectilinear plan, buildings with a circular plan also had a long history in Greece, going back to Mycenaean *tholos* tombs (SEE FIG. 4–21). In later times, various types of *tholoi* were erected. Some were shrines or monuments and some, like the fifth-century BCE *tholos* in the Athens Agora, were administrative buildings. However, the function of many, such as a *tholos* built from about 388 to 370 BCE in the Sanctuary of Athena Pronaia at Delphi, is unknown (FIGS. 5–48, 5–49). Theodoros, the presumed archi-

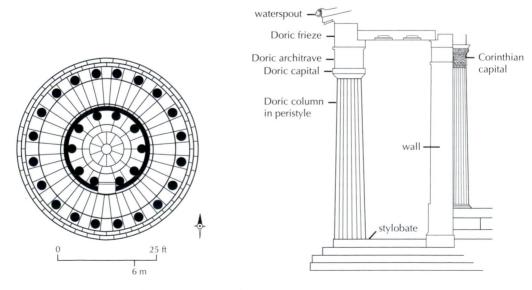

5-49 PLAN AND SECTION OF THE THOLOS, SANCTUARY OF ATHENA PRONAIA, DELPHI.

tect, came from Phokaia in Asia Minor. The exterior was of the Doric order, as seen from the three columns and a piece of the entablature that have been restored. Other remnants suggest that the interior featured a ring of columns with capitals carved to resemble the curling leaves of the acanthus plant (see Introduction, Fig. 3). This type of capital came to be called Corinthian in Roman times (see "The Greek Architectural Orders," page 118). It had been used on roof-supporting columns in temple interiors since the last quarter of the fifth century BCE, but was not used on building exteriors until the Hellenistic period, more than a hundred years later.

Monumental tombs—showy memorials to their wealthy owners—often had circular or square plans. One such tomb was built for Mausolos at Halikarnassos in Asia Minor. Mausolos, whose name has given us the term mausoleum (a large tomb), was the Persian governor of the region. He admired Greek culture and brought the greatest sculptors from Greece to decorate his tomb. The structure was completed after his death in 353 BCE under the direction of his wife, Artemisia, who was rumored to have drunk her dead husband's ashes mixed with wine. The foundation, many scattered stones, and fragments of sculpture are all that remain of Mausolos's tomb.

Sculpture

Throughout the fifth century BCE, sculptors carefully maintained the equilibrium between simplicity and ornament that is fundamental to Greek Classical art. Standards established by Pheidias and Polykleitos in the mid-fifth century BCE for the ideal proportions and idealized forms of the human figure had generally been accepted by the next generation of artists. Fourth-century BCE artists, on the other hand, challenged and modified those standards. The artists of mainland Greece, in particular, developed a new canon of proportions for male figures—now eight or more "heads" tall rather than the six-and-a-half-or seven-head height of earlier works. The calm, noble detachment characteristic of earlier figures gave way to more sensitively rendered images of men and women with expressions of wistful introspection, dreaminess, or even fleeting anxiety. Patrons lost some of their interest in images of mighty Olympian gods and legendary heroes and acquired a taste for minor deities in lighthearted moments. This period also saw the earliest depictions of fully nude women in major works of art. The fourth century BCE was dominated by three sculptors—Praxiteles, Skopas, and Lysippos.

PRAXITELES. Praxiteles was active in Athens from about 370 to 335 BCE or later. According to the Greek traveler Pausanias, writing in the second century CE, Praxiteles carved a "Hermes of stone who carries the infant Dionysos." The sculpture stood in the Temple of Hera at Olympia. Just such a sculpture in marble, depicting the messenger god Hermes teasing the baby Dionysos with a bunch of grapes, was discovered in the ruins of the ancient Temple of Hera in the Sanctuary at Olympia (FIG. 5–50). Archaeologists accepted **HERMES AND**

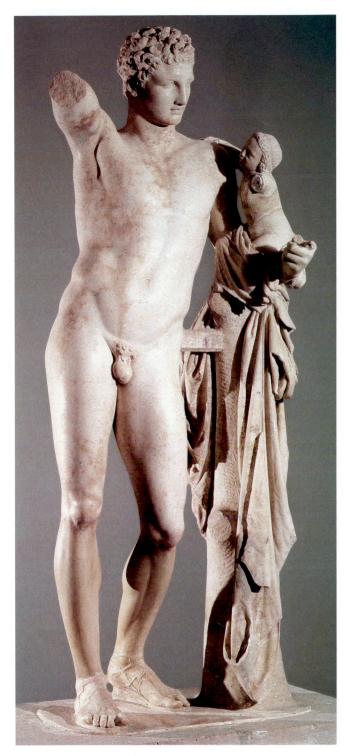

5-50 | Praxiteles or his followers | HERMES AND THE INFANT DIONYSOS

Probably a Hellenistic or Roman copy after a Late Classical 4th-century BCE original. Marble, with remnants of red paint on the lips and hair, height 7'1" (2.15 m). Archaeological Museum, Olympia.

Discovered in the rubble of the ruined Temple of Hera at Olympia in 1875, this statue is now widely accepted as a very good Roman or Hellenistic copy. Support for this conclusion comes from certain elements typical of Roman sculpture: Hermes' sandals, which recent studies suggest, are fourth-century BCE in style; the supporting element of crumpled fabric covering a tree stump; and the use of a reinforcing strut, or brace, between Hermes' hip and the tree stump. Some scholars still attribute the sculpture to Praxiteles.

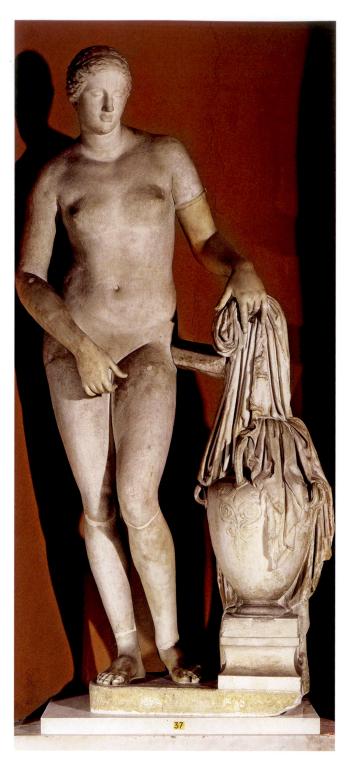

5–51 | Praxiteles APHRODITE OF KNIDOS
Composite of two similar Roman copies after the original marble of c. 350 BCE. Marble, height 6'8" (2.04 m). Vatican Museums, Museo Pio Clementino, Gabinetto delle Maschere, Rome.

The head of this figure is from one Roman copy, the body from another. Seventeenth- and eighteenth-century CE restorers added the nose, the neck, the right forearm and hand, most of the left arm, and the feet and parts of the legs. This kind of restoration would rarely be undertaken today, but it was frequently done and considered quite acceptable in the past, when archaeologists were trying to put together a body of work documenting the appearances of lost Greek statues.

THE INFANT DIONYSOS as an authentic work by Praxiteles until recent studies indicated that it is probably a very good Roman or Hellenistic copy.

The sculpture represents the differences between the fourth and fifth century styles. Hermes has a smaller head and a more youthful body than Polykleitos's Doryphoros (Spear Bearer), his off-balance, S-curve pose, requiring the figure to lean on a post, contrasts clearly with the balance of the earlier work. The sculptor also created a sensuous play of light over the figure's surface. The gleam of the smoothly finished flesh contrasts with the textured quality of the crumpled draperies and the rough locks of hair, even on the baby's head. Praxiteles is also responsible for the humanized treatment of the subject—two gods, one a loving adult and the other a playful child, caught in a moment of absorbed companionship. The interaction of the two across real space through gestures and glances creates an overall effect far different from that of the austere Olympian deities of the fifth century BCE on the pediments and metopes of the Temple of Zeus (SEE FIG. 5-25), near where the work was found.

Around 350 BCE, Praxiteles created a statue of Aphrodite for the city of Knidos in Asia Minor. Although artists of the fifth century BCE had begun to hint boldly at the naked female body beneath tissue-thin drapery, as in Nike Adjusting Her Sandal (SEE FIG. 5–42), this APHRODITE was apparently the first statue by a well-known Greek sculptor to depict a fully nude woman, and it set a new standard (FIG. 5–51). Although nudity among athletic young men was admired in Greek society, among women it had been considered a sign of low character. The eventual wide acceptance of female nudes in large statuary may be related to the gradual merging of the Greeks' concept of their goddess Aphrodite with some of the characteristics of the Phoenician goddess Astarte (the Babylonian Ishtar), who was nearly always shown nude in Near Eastern art.

In the version of the statue seen here (actually a composite of two Roman copies), the goddess is preparing to take a bath, with a water jug and her discarded clothing at her side. Her right arm and hand extend in what appears at first glance to be a gesture of modesty but in fact only emphasizes her nudity. The bracelet on her left arm has a similar effect. Her well-toned body, with its square shoulders, thick waist, and slim hips, conveys a sense of athletic strength. She leans forward slightly with one knee in front of the other in a seductive pose that emphasizes the swelling forms of her thighs and abdomen. According to an old legend, the sculpture was so realistic that Aphrodite herself made a journey to Knidos to see it and cried out in shock, "Where did Praxiteles see me naked?" The Knidians were so proud of their Aphrodite that they placed it in an open shrine where people could view it from every side. Hellenistic and Roman copies probably

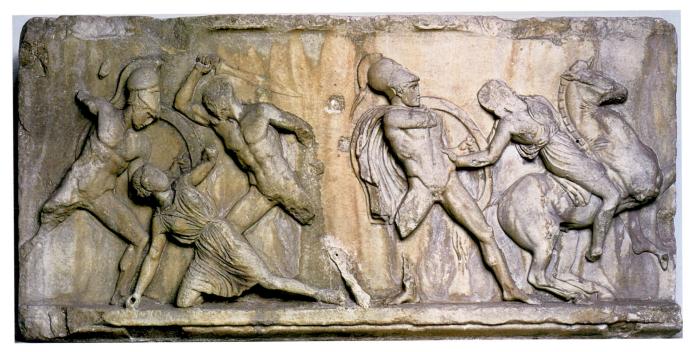

5-52 | Skopas (?) PANEL FROM THE AMAZON FRIEZE, SOUTH SIDE OF THE MAUSOLEUM AT HALIKARNASSOS Mid-4th century BCE. Marble, height 35" (89 cm). The British Museum, London.

numbered in the hundreds, and nearly fifty survive in various collections today (see Introduction Fig. 7).

SKOPAS. According to Pliny, Skopas was one of the sculptors who worked at the mausoleum at Halikarnassos, carving part of the frieze (FIG. 5-52). Skopas was greatly admired in ancient times. He had a brilliant career as both sculptor and architect that took him around the Greek world. Unfortunately, little survives—originals or copies—that can be reliably attributed to him. If literary accounts are accurate, Skopas introduced a new style of sculpture admired in its time and influential in the Hellenistic period. In relief compositions, he favored very active, dramatic poses over balanced, harmonious ones, and he was especially noted for the expression of emotion in the faces and gestures of his figures. The typical Skopas head conveys intensity with its deep-set eyes, heavy brow, slightly parted lips, and a gaze that seems to look far into the future. The squarish heads with deep set eyes, the energetic figures, and the repeated diagonals of the composition all suggest Skopas as the sculptor of the battle scenes of Lapiths against centaurs and Greeks against Amazons.

Lysippos. In contrast to Praxiteles and Skopas, many details of Lysippos's life are known and many copies of his sculpture survive. He claimed to be entirely self-taught and asserted that "nature" was his only model, but he must have received some technical training in the vicinity of his home, near Corinth. He worked from c. 350 to c. 310 BCE. Although he expressed

great admiration for Polykleitos, his own figures reflect a different ideal and different proportions from those of the fifth-century BCE master. For his famous work **THE MAN SCRAPING HIMSELF (APOXYOMENOS)**, known today only from Roman copies (FIG. 5–53), he chose a typical Classical subject, a nude male athlete, but he treated it in an unusual way. Instead of a figure actively engaged in a sport, striding, or standing at ease, Lysippos depicted a young man methodically removing oil and dirt from his body with a scraping tool called a strigil. Judging from the athlete's expression, his thoughts are far from his mundane task. His deep-set eyes, dreamy stare, heavy forehead, and tousled hair may reflect the influence of Skopas.

The Man Scraping Himself, tall and slender with a relatively small head, like Praxiteles' work, makes a telling comparison with Polykleitos's Spear Bearer (SEE FIG. 5-24). Not only does it reflect a different canon of proportions, but the figure's weight is also more evenly distributed between the engaged leg and the free one, with the free foot almost flat on the ground. The legs are also in a wider stance to counterbalance the outstretched arms. The Spear Bearer is contained within fairly simple, compact contours and oriented toward a center front viewer. In contrast, the arms of The Man Scraping Himself break free into the surrounding space, requiring the viewer to move around the statue to absorb its full aspect. Roman authors, who may have been describing the bronze original rather than a marble copy, remarked on the subtle modeling of the statue's elongated body and the spatial extension of its pose.

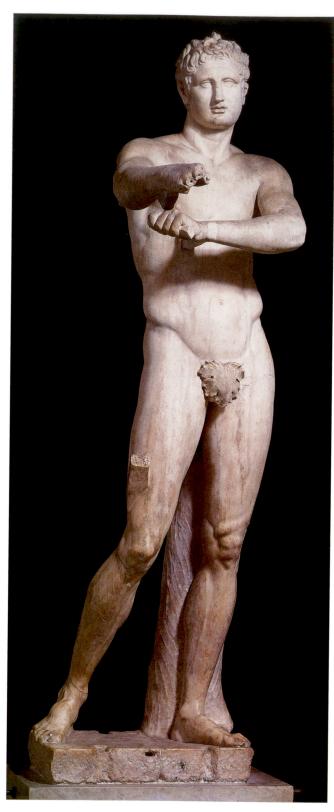

5-53 | Lysippos the man scraping himself (apoxyomenos)

Roman copy after the original bronze of c. $350-325\,$ BCE. Marble, height $6'9''\,(2.06\,\text{m})$. Vatican Museums, Museo Pio Clementino,

Gabinetto dell'Apoxyomenos, Rome.

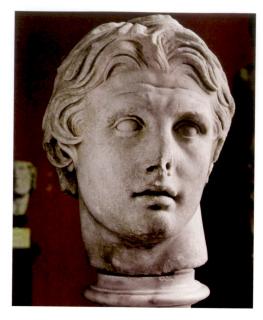

5–54 | Lysippos (?) ALEXANDER THE GREAT Head from a Hellenistic copy (c. 200 BCE) of a statue, possibly after a 4th-century BCE original. Marble fragment, height 16%" (41 cm). Archaeological Museum, Istanbul, Turkey.

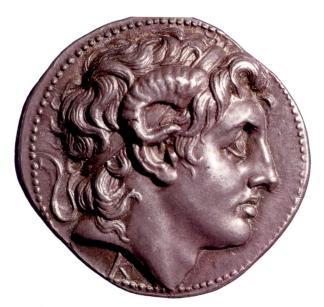

5–55 ALEXANDER THE GREAT
Four drachma coin issued by Lysimachos of Thrace. 306–281
BCE. Silver, diameter 11/8" (30 mm). The British Museum, London.

Lysippos was widely known and admired for his monumental statues of Herakles (see Introduction, Fig. 23) and Zeus. The sculpture of Zeus is lost, but the weary Herakles (Hercules), leaning on his club (resting after the last of his Twelve Labors) and holding the apples of the Hesperides, comes down to us in the imposing Hellenistic sculpture known as the Farnese Hercules, a copy in marble, signed by Glykon, of a bronze by Lysippos. Not surprisingly, the Romans admired this heroic figure; the marble copy stood in the Baths of Caracalla. In the Renaissance the sculpture was part of the Farnese collection in

Rome, where it stood in the courtyard of their palace and was studied by artists from all over Europe.

When Lysippos was summoned to do a portrait of Alexander the Great (ruled 336–323 BCE), he portrayed Alexander as a full-length standing figure with an upraised arm holding a scepter, just as he is believed to have posed Zeus. A head found at Pergamon (located in present-day Turkey) that was once part of a standing figure is believed to be from one of several copies of Lysippos's original of Alexander (FIG. 5–54). It depicts a ruggedly handsome, heavy-featured young man with a large Adam's apple and short, tousled hair. The treatment of the hair may be a visual reference to the mythical hero Herakles, who killed the Nemean Lion as his First Labor and is often portrayed wearing its head and pelt as a hooded cloak. Alexander would have felt great kinship with Herakles, whose acts of bravery and strength earned him immortality.

The Pergamon head was not meant to be entirely true to life, although we see here elements of an individual's distinctive appearance. The artist rendered certain features in an idealized manner to convey a specific message about the subject. The deep-set eyes are unfocused and meditative, and the low forehead is heavily lined, as though the figure were contemplating decisions of great consequence and waiting to receive divine advice.

According to the Roman-era historian Plutarch, Lysippos depicted Alexander in a characteristic meditative pose, "with his face turned upward toward the sky, just as Alexander himself was accustomed to gaze, turning his neck gently to one side" (cited in Pollitt, page 20). Because this description fits the marble head from Pergamon and others like it so well, they have been thought to be copies of the Alexander statue. On the other hand, the heads could also be viewed as conventional, idealized "types" created by Lyssipos. A reasonably reliable image of Alexander is found on a coin issued by Lysimachos, who ruled Thrace from 306 to 281 BCE (FIG. 5–55). It shows Alexander in profile wearing the curled ram's-horn headdress that identifies him as the Greek–Egyptian god Zeus–Amun. The portrait has the same low forehead, high-bridged nose, large lips, and thick neck as the Pergamon head.

The Art of the Goldsmith

The work of Greek goldsmiths, which gained international popularity in the Classical period, followed the same stylistic trends and achieved the same high standards of technique and execution found in the other arts. A specialty of Greek goldsmiths was the design of earrings in the form of tiny works of sculpture. They were often placed on the ears of marble statues of goddesses, but they adorned the ears of living women as well. Earrings designed as the youth Ganymede in the grasp of an eagle (Zeus) (FIG. 5–56), dated about 330—300 BCE, are both a charming decoration and a technical tour de force. Slightly more than 2 inches high, they were hollow-cast

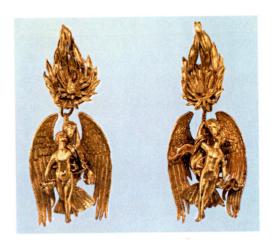

5–56 \parallel EARRINGS c. 330–300 BCE. Hollow-cast gold, height 2%" (6 cm). The Metropolitan Museum of Art, New York. Harris Brisbane Dick Fund, 1937 (37.11.9–10).

using the **lost-wax process**, no doubt to make them light on the ear. Despite their small size, the earrings convey all the drama of their subject. Action subjects like this, with the depiction of swift movement through space, were to become a hall-mark of Hellenistic art.

Wall Painting and Mosaics

Roman observers such as Pliny the Elder claimed that Greek painters were skilled in capturing the appearance of the real world. Roman patrons admired Greek murals and commissioned copies, in paintings or mosaic, to decorate their homes. (Mosaics are created from tesserae, small cubes of colored stone or marble. They provide a permanent waterproof surface that the Romans used for floors in important rooms.) Mosaics and red-figure vases are the best evidence for fourth-century BCE painting. They indicate a growing taste for dramatic narrative subjects. A first-century CE mosaic, ALEXANDER THE GREAT CONFRONTS DARIUS III AT THE BATTLE OF ISSOS (FIG. 5–57), for example, copies a painting of about 310 BCE.

Pliny the Elder mentions a painting of Alexander and Darius by Philoxenos of Eretria; but a new theory claims it was by Helen of Egypt (see "Women Artists in Ancient Greece," page 157). Certainly the scene is one of violent action where radical foreshortening draws the viewer into the scene and elicits an emotional response to a dramatic situation. Astride a horse at the left, his hair blowing free and his neck bare, Alexander challenges the helmeted and armored Persian leader, who stretches out his arm in a gesture of defeat and apprehension as his charioteer whisks him back toward safety in the Persian ranks. The mosaicist has created an illusion of solid figures through modeling, mimicking the play of light on three-dimensional surfaces by highlights and shading.

The interest of fourth-century BCE artists in creating a believable illusion of the real world was the subject of anecdotes repeated by later writers. One popular legend

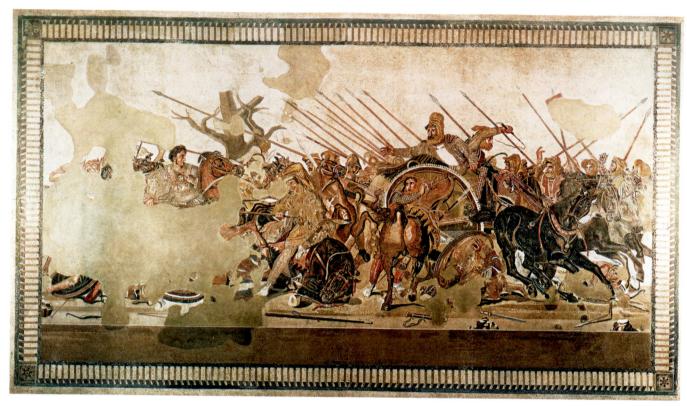

5–57 | ALEXANDER THE GREAT CONFRONTS DARIUS III AT THE BATTLE OF ISSOS Floor mosaic, Pompeii, Italy. 1st-century CE Roman copy of a Greek wall painting of c. 310 BCE, perhaps by Philoxenos of Eretria or Helen of Egypt. Entire panel $8'10'' \times 17'$ (2.7 \times 5.2 m). National Archeological Museum, Naples.

involved a floral designer, a woman named Glykera—widely praised for the artistry with which she wove blossoms and greenery into wreaths, swags, and garlands for religious processions and festivals—and Pausias, the foremost painter of the day. Pausias challenged Glykera to a contest, claiming that he could paint a picture of one of her complex works that would appear as lifelike to the spectator as her real one. According to the legend, he succeeded. It is not surprising, although perhaps unfair, that the opulent floral borders so popular in later Greek painting and mosaics are described as "Pausian" rather than "Glykeran."

A mosaic floor from a palace at Pella (Macedonia) provides an example of a Pausian design. Dated about 300 BCE, the floor features a series of framed hunting scenes, such as the **STAG HUNT** (FIG. 5–58), prominently signed by an artist named Gnosis. Blossoms, leaves, spiraling tendrils, and twisting, undulating stems frame this scene, echoing the linear patterns formed by the hunters, the dog, and the struggling stag.

5-58 Gnosis STAG HUNT

Detail of mosaic floor decoration from Pella (Macedonia), (present-day Greece). 300 BCE. Pebbles, height 10′2″ (3.1 m). Archaeological Museum, Pella. Signed at top: "Gnosis made it."

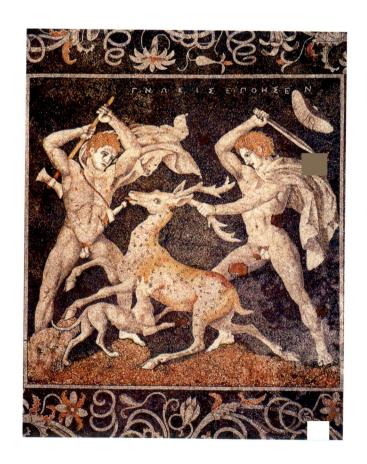

The over-life-size human and animal figures are accurately drawn and modeled in light and shade. The dog's front legs are expertly foreshortened to create the illusion that the animal is turning at a sharp angle into the picture. The work is all the more impressive because it was not made with uniformly cut marble in different colors, but with a carefully selected assortment of natural pebbles.

THE HELLENISTIC PERIOD, 323–31/30 BCE

When Alexander died unexpectedly in 323 BCE, he left a vast empire with no administrative structure and no accepted successor. Almost at once his generals turned against one another, local leaders tried to regain their lost autonomy, and the empire began to break apart. The Greek city-states formed a new mutual-protection league but never again achieved significant power. Democracy survived in form but not substance in governments dominated by local rulers.

By the early third century BCE, three of Alexander's generals-Antigonus, Ptolemy, and Seleucus-had carved out kingdoms. The Antigonids controlled Macedonia and mainland Greece; the Ptolemies ruled Egypt; and the Seleucids controlled Asia Minor, Mesopotamia, and Persia. Over the course of the second and first centuries BCE, these kingdoms succumbed to the growing empire centered in Rome. Ptolemaic Egypt endured the longest, almost two and a half centuries. The Ptolemaic capital, Alexandria in Egypt, a prosperous seaport known for its lighthouse (another of the Seven Wonders of the World, according to ancient writers), emerged as a great Hellenistic center of learning and the arts. Its library is estimated to have contained 700,000 papyrus and parchment scrolls. The Battle of Actium in 31 BCE and the death in 30 BCE of Egypt's last ruler, the remarkable Cleopatra, marks the end of the Hellenistic period.

Alexander's lasting legacy was the spread of Greek culture far beyond its original borders, but artists of the Hellenistic period had a vision noticeably different from that of their predecessors. Where earlier artists sought the ideal and the general, Hellenistic artists sought the individual and the specific. They turned increasingly away from the heroic to the everyday, from gods to mortals, from aloof serenity to individual emotion, and from drama to melodramatic pathos. A trend introduced in the fourth century BCE—the appeal to the senses through lustrous or glittering surface treatments and to the emotions with dramatic subjects and posesbecame more pronounced. Even the architecture of the Hellenistic period largely reflected the contemporary taste for high drama. Building types continued with few changes, but their size and the amount of decoration increased. Greek art continued to influence the art of the Romans, and the Hellenistic style lasted until the Augustan period in the first century CE.

Art and Its Context

WOMEN ARTISTS IN ANCIENT GREECE

Ithough comparatively few artists in ancient Greece were women, there is evidence that women artists worked in many mediums. Ancient writers noted women painters—Pliny the Elder, for example, listed Aristarete, Eirene, Iaia, Kalypso, Olympias, and Timarete. Helen, a painter from Egypt who had been taught by her father, is known to have worked in the fourth century BCE and may have been responsible for the original Greek wall painting of c. 310 BCE of Alexander the Great Confronts Darius III at the Battle of Issos (SEE FIG. 5–57).

Greek women were known to create narrative or pictorial tapestries. They also worked in pottery workshops. The hydria here, dating from about 450 BCE, shows a woman artist in such a workshop, but her status is ambiguous. The composition focuses on the male painters, who are being approached by Nikes (Victories) bearing wreaths symbolizing victory in an artistic competition. A well-dressed woman sits on a raised dais, painting the largest vase in the workshop. She is isolated from the other artists and is not part of the awards ceremony. Perhaps women were excluded from public artistic competitions, as they were from athletics. Another interpretation, however, is that the woman is the head of this workshop. Secure in her own status, she may have encouraged her assistants to enter contests to further their careers and bring glory to the workshop as a whole.

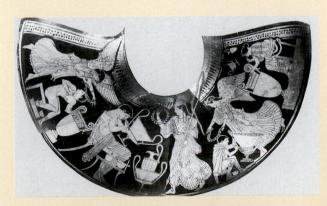

A VASE PAINTER AND ASSISTANTS CROWNED BY ATHENA AND VICTORIES

Composite photograph of the red-figure decoration on a hydria from Athens. c. 450 BCE. Private Collection.

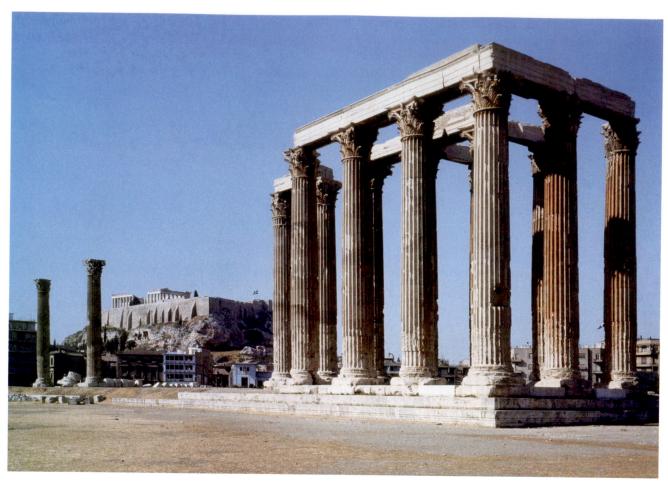

5–59 | TEMPLE OF THE OLYMPIAN ZEUS, ATHENS, ACROPOLIS IN DISTANCE
Building and rebuilding phases: foundation c. 520–510 BCE using the Doric order; temple designed by Cossutius, begun 175 BCE, left unfinished 164 BCE, completed 132 CE using Cossutius's design and the Corinthian order (see FIG. 3, Introduction). Height of columns 55′5″ (16.89 m).

The Corinthian Order in Hellenistic Architecture

During the Hellenistic period, a variant of the Ionic order featuring tall, slender columns with elaborate foliate capitals challenged the dominant Doric and Ionic orders. Invented in the late fifth century BCE and called Corinthian by the Romans, this highly decorative column had previously been used only indoors, as in the tholos at Epidaurus (see Introduction, Fig. 2). Today, the Corinthian variant is routinely treated as a third Greek order (see "The Greek Architectural Orders," page 118). In the Corinthian capital, curly acanthus leaves and coiled flower spikes surround a basket-shaped core. Unlike Doric and Ionic capitals, the Corinthian capital has many possible variations; only the foliage is required. Above the capitals, the Corinthian entablature, like the Ionic, has a stepped-out architrave and a continuous frieze. It also has more bands of carved moldings. The Corinthian design became a symbol of elegance and refinement, and it is still used on banks, churches, and court buildings today.

The Corinthian **TEMPLE OF THE OLYMPIAN ZEUS**, located in the lower city of Athens at the foot of the Acropolis, was designed by the Roman architect Cossutius in the second century BCE (FIG. 5–59) on the foundations of an ear-

lier Doric temple. Work on the Cossutius design halted in 164 BCE and was not completed until three centuries later under the patronage of the Roman emperor Hadrian (see Chapter 6). The temple's great Corinthian columns, 55 feet 5 inches tall, may be the second-century BCE Greek originals or Roman replicas. Viewed through these columns, the Parthenon seems modest in comparison. But in spite of its size and luxurious decoration, the new temple followed long-established conventions. It was an enclosed rectangular building surrounded by a screen of columns standing on a three-stepped base. Its proportions and details followed traditional standards. It is, quite simply, a Greek temple grown very large.

Hellenistic Architecture: The Theater at Epidauros

In ancient Greece, the theater was more than mere entertainment; it was a vehicle for the communal expression of religious belief through music, poetry, and dance. In very early times, theater performances took place on the hard-packed dirt or stone-surfaced pavement of an outdoor threshing floor—the same type of floor later incorporated into religious sanctuaries. Whenever feasible, dramas were also presented

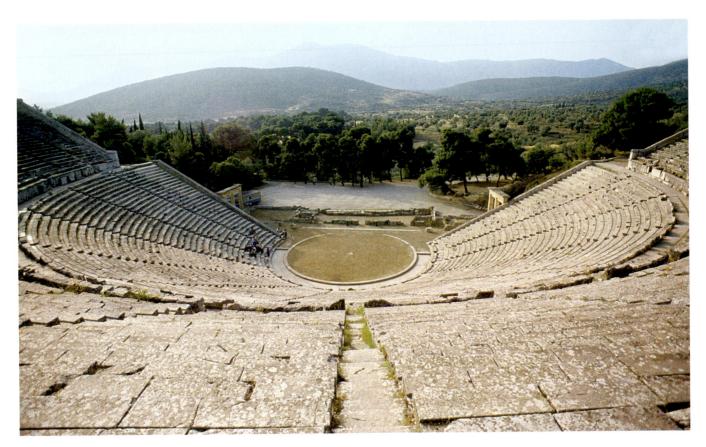

5–60 | THEATER, EPIDAUROS 4^{th} century BCE and later.

facing a steep hill that served as elevated seating for the audience. Eventually such sites were made into permanent openair auditoriums. At first, tiers of seats were simply cut into the side of the hill. Later, builders improved them with stone.

During the fifth century BCE, the plays were usually tragedies in verse based on popular myths and were per-

formed at a festival dedicated to Dionysos. At this time, the three great Greek tragedians—Aeschylus, Sophocles, and Euripides—were creating the dramas that would define tragedy for centuries. Many theaters were built in the fourth century BCE, including those on the side of the Athenian Acropolis and in the sanctuary at Delphi. Because they were

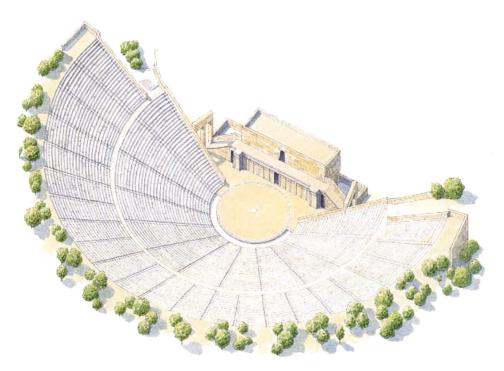

5-61 | RECONSTRUCTION DRAWING OF THE THEATER AT EPIDAUROS

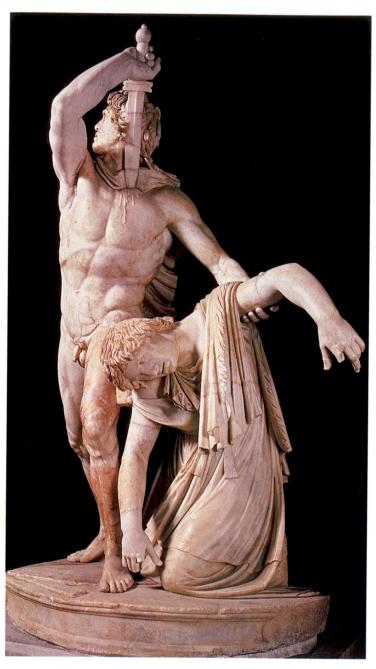

5–62 | GALLIC CHIEFTAIN KILLING HIS WIFE AND HIMSELF Roman copy after the original bronze of c. 220 BCE. Marble, height 6'11" (2.1 m). National Museum, Rome.

used continuously and frequently modified over many centuries, early theaters have not survived in their original form.

The theater at Epidauros, built in the second half of the fourth century, is characteristic (FIGS. 5-60, 5-61). A semicircle of tiered seats built into the hillside overlooked the circular performance area, called the orchestra, at the center of which was an altar to Dionysos. Rising behind the orchestra was a two-tiered stage structure made up of the vertical skene (scene)—an architectural backdrop for performances that also screened the backstage area from view—and the proskenion (proscenium), a raised platform in front of the skene that was increasingly used over time as an extension of the orchestra. Ramps connecting the proskenion with lateral passageways provided access for performers. Steps gave the audience access to the fifty-five rows of seats and divided the seating area into uniform wedge-shaped sections. The tiers of seats above the wide corridor, or gangway, were added at a much later date. This design provided uninterrupted sight lines and good acoustics and allowed for efficient entrance and exit of the 12,000 spectators. No better design has ever been created.

Sculpture

Hellenistic sculptors produced an enormous variety of work in a wide range of materials, techniques, and styles. The period was marked by two broad and conflicting trends. One (sometimes called anti-Classical) led away from Classical models and toward experimentation with new forms and subjects; the other led back to Classical models, with artists selecting aspects of certain favored works by fourth-century BCE sculptors and incorporating them into their own work. The radical anti-Classical style was especially strong in Pergamon and other eastern centers of Greek culture.

PERGAMON. The kingdom of Pergamon, a breakaway state within the Seleucid realm, established itself in the early third century BCE in western Asia Minor. The capital, Pergamon, quickly became a leading center of the arts and the hub of a new sculptural style that had far-reaching influence throughout the Hellenistic period. This new style is illustrated by sculpture from a monument commemorating the victory in 230 BCE of Attalos I (ruled 241–197 BCE) over the Gauls, a Celtic people. The monument extols the dignity and heroism of the defeated enemies and by extension the power and virtue of the Pergamenes.

These figures of Gauls, originally in bronze but known today only from Roman copies in marble, were mounted on a large pedestal. One group depicts the murder-suicide of the Gallic chieftain and his wife (FIG. 5–62) and the slow demise of a wounded soldier-trumpeter (FIG. 5–63). Their wiry, unkempt hair and the trumpeter's twisted neck ring (the Celtic battle dress), identify them as "barbarians." The artist has sought to arouse admiration and pity for his subjects. The chieftain, for example, still supports his dead wife as he plunges the sword

5–63 | Epigonos (?) DYING GALLIC TRUMPETER Roman copy after the original bronze of c. 220 BCE. Marble, height, $36\frac{1}{2}$ (93 cm). Capitoline Museum, Rome.

The marble sculpture was found in Julius Caesar's garden in Rome. The bronze originals were made for the Sanctuary of Athena in Pergamon. Pliny wrote that Epigonos "surpassed others with his Trumpeter."

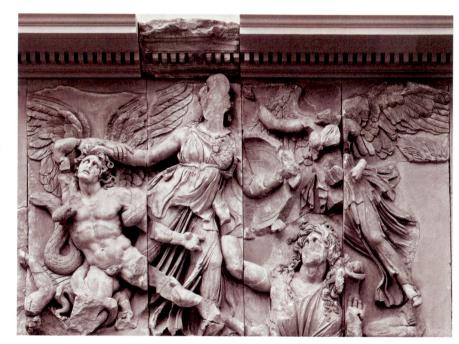

5-65 | ATHENA ATTACKING THE GIANTS Detail of the frieze from the east front of the altar from Pergamon, c. 175-150 BCE. Marble, frieze height 7'7'' (2.3 m). Staatliche Museen zu Berlin, Antikensammlung, Pergamonmuseum, Berlin.

into his own breast. The trumpeter, fatally injured, struggles to rise, but the slight bowing of his supporting right arm and his unseeing downcast gaze indicate that he is on the point of death. This kind of deliberate attempt to elicit a specific emotional response in the viewer is known as **expressionism**, and it was to become a characteristic of Hellenistic art.

The marble copies of these works are now separated, but originally they formed part of an interlocked, multifigured group on a raised base that could have been viewed and appreciated from every angle. Pliny the Elder described a work like the *Dying Gallic Trumpeter*, attributing it to an artist named Epigonos. Recent research indicates that Epigonos

probably knew the early fifth-century BCE sculpture of the Temple of Aphaia at Aegina, which included the *Dying War*rior (SEE FIG. 5–13), and could have had it in mind when he created his own works.

The style and approach of the work in the monument became more pronounced and dramatic in later works, culminating in the sculptured frieze on the base of the Great Altar at Pergamon (FIG. 5–64). The wings and staircase to the entrance of the courtyard in which the altar stood have been reconstructed inside a Berlin museum. The original altar complex was a single-story structure with an Ionic colonnade raised on a high podium reached by a monumental

staircase 68 feet wide and nearly 30 feet deep. The running frieze decoration, probably executed during the reign of Eumenes II (197–159 BCE), depicts the battle between the gods and the Giants (Titans), a mythical struggle that the Greeks are thought to have used as a metaphor for Pergamon's victory over the Gauls.

The frieze was more than 7 feet high, tapering along the steps to just a few inches. The Greek gods fight not only human-looking Giants, but also hybrids with snakes for legs emerging from the bowels of the earth. In a detail of the frieze (FIG. 5–65), the goddess Athena at the left has grabbed the hair of a winged male monster and forced him to his knees. Inscriptions along the base of the sculpture identify him as Alkyoneos, a son of the earth goddess Ge, who rises from the ground on the right in fear as she reaches toward Athena, pleading for her son's life. At the far right, a winged Nike rushes to Athena's assistance to crown her with a victor's wreath.

The figures in the Pergamon frieze not only fill the sculptural space, they break out of their architectural boundaries and invade the spectators' space. They crawl out of the frieze onto the steps, where visitors had to pass them on their way up to the shrine. Many consider this theatrical and complex interaction of space and form to be a benchmark of the Hellenistic style, just as they consider the balanced restraint of the Parthenon sculpture to be the epitome of the High Classical style. Where fifth-century BCE artists sought horizontal and vertical equilibrium and control, the Pergamene artists sought to balance opposing forces in three-dimensional space along diagonal lines.

The Classical preference for smooth surfaces reflecting a clear, even light has been replaced by a preference for dramatic contrasts of light and shade playing over complex forms carved with deeply undercut high relief. The composure and stability admired in the Classical style have given way to extreme expressions of pain, stress, wild anger, fear, and despair. In the fifth century, figures stood remote in their own space. In the fourth century BCE, they reached out into their immediate environment, imposing themselves, often forcefully, on the spectator. Whereas the Classical artist asked only for an intellectual commitment, the Hellenistic artist demanded that the viewer empathize.

THE PERGAMENE STYLE: LAOCOÖN AND NIKE. Pergamene artists may have inspired the work of Hagesandros, Polydoros, and Athenedoros, three sculptors on the island of Rhodes named by Pliny the Elder as the creators of the famed *Laocoön and His Sons* (see Introduction, Fig. 10). This work has been assumed by many art historians to be the original version from the second century BCE, although others argue that it is a brilliant copy commissioned by an admiring Roman patron in the first century CE.

The complex sculptural composition illustrates an episode from the Trojan War. The priest Laocoön warned the Trojans not to take the giant wooden horse left by the Greeks

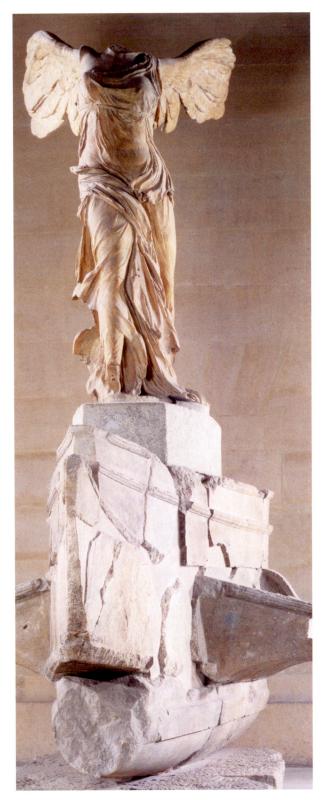

5–66 NIKE (VICTORY) OF SAMOTHRACE
Sanctuary of the Great Gods, Samothrace. c. 180 BCE (?).
Marble, height 8'1" (2.45 m). Musée du Louvre, Paris.

The wind-whipped costume and raised wings of this Victory indicate that she has just alighted on the prow of the stone ship that formed the original base of the statue. The work probably commemorated an important naval victory, perhaps the Rhodian triumph over the Seleucid king Antiochus III in 190 BCE. The Nike (lacking its head and arms) and a fragment of its stone ship base were discovered in the ruins of the Sanctuary of the Great Gods by a French explorer in 1863 (additional fragments were discovered later). Soon after, the sculpture entered the collection of the Louvre Museum in Paris.

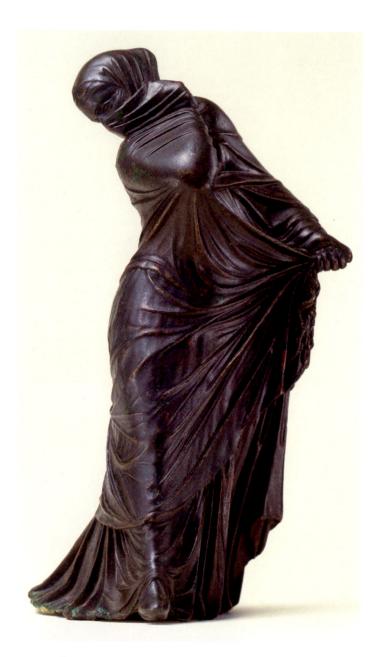

5–67 | **VEILED AND MASKED DANCER** Late 3rd or 2nd century BCE. Bronze, height 8% (20.7 cm). The Metropolitan Museum of Art, New York. Bequest of Walter C. Baker, 1971 (1972.118.95)

inside their walls. The gods who supported the Greeks in the war retaliated by sending serpents from the sea to destroy Laocoön and his sons as they walked along the shore. The struggling figures, anguished faces, intricate diagonal movements, and skillful unification of diverse forces in a complex composition all suggest a strong relationship between Rhodian and Pergamene sculptors. Unlike the monument to the conquered Gauls, the *Laocoön* was composed to be seen from the front, within a short distance. As a result, although sculpted in the round, the three figures resemble the relief sculpture on the altar from Pergamon.

The NIKE (VICTORY) OF SAMOTHRACE (FIG. 5–66) is even more theatrical than the *Laocoön*. In its original setting—in a hillside niche high above the sanctuary of the Greek gods at Samothrace and perhaps drenched with spray from a fountain—this huge goddess of victory must have reminded visitors of the god in Greek plays who descends from heaven to determine the outcome of the drama. The fact that victory in real life does often seem miraculous makes this image of a goddess alighting suddenly on a ship breathtakingly appropriate for a war memorial. The forward momentum of the Nike's heavy body is balanced by the powerful backward thrust of her enormous wings. The large, open movements of the figure, the strong contrasts of light and dark on the deeply sculpted forms, and the contrasting textures of feathers, fabric, and skin typify the finest Hellenistic art.

Although "huge," "enormous," and "larger-than-life" are terms correctly applied to much Hellenistic sculpture, artists of the time also created fine works on a small scale. The grace, dignity, and energy of the 8-foot-tall *Nike of Samothrace* can also be found in a bronze about 8 inches tall (FIG. 5–67). This figure of a heavily veiled and masked dancing woman twists sensually under the gauzy, layered fabric in a complex spiral movement. The dancer is clearly a professional performer. This bronze would have been costly, but many such graceful figurines were produced in inexpensive terra cotta from molds.

The Multicultural Hellenistic World

In contrast to the Classical world, which was characterized by relative cultural unity and social homogeneity, the Hellenistic world was varied and multicultural. In this environment, artists turned from idealism, the quest for perfect form, to realism, the attempt to portray the world as they saw it. Portraiture, for example, became popular during the Hellenistic period, as did the representation of people from every level of society. Patrons were fascinated by depictions of unusual physical types as well as of ordinary individuals.

An old peasant woman on her way to the agora with three chickens and a basket of vegetables may seem to be an unlikely subject for sculpture (FIG. 5–68). Despite the bunched and untidy way the figure's dress hangs, it appears to be of an elegant design and made of fine fabric. Her hair, too,

bears some semblance of a once-careful arrangement. These characteristics, along with the woman's sagging lower jaw, unfocused stare, and lack of concern for her exposed breasts, have led some to speculate that she represents an aging, dissolute follower of the wine god Dionysos on her way to make an offering. Whether an aging peasant, or a Dionysian celebrant, the woman is the antithesis of the *Nike of Samothnace*. Yet in formal terms, both sculptures stretch out assertively into the space around them, both demand an emotional response from the viewer, and both display technical virtuosity in the rendering of forms and textures. They are closer to each other than either is to the *Nike Adjusting Her Sandal* (SEE FIG. 5–42) or the *Aphrodite of Knidos* (SEE FIG. 5–51).

But not all Hellenistic artists followed the trend toward realism and expressionism that characterized the artists of Pergamon and Rhodes. Some turned to the past, creating an eclectic style by reexamining and borrowing elements from earlier Classical styles and combining them in new ways. Certain popular sculptors looked back especially to Praxiteles and Lysippos for their models. This renewed interest in the style of the fourth century BCE is exemplified by the APHRODITE OF MELOS (better known as the Venus de Milo) (FIG. 5-69), found on the island of Melos by French excavators in the early nineteenth century CE. The sculpture was intended by its maker to recall the Aphrodite of Praxiteles (SEE FIG. 5-51), and indeed the head with its dreamy gaze is very like Praxiteles' work. The figure has the heavier proportions of High Classical sculpture, but the twisting stance and the strong projection of the knee are typical of Hellenistic art. The drapery around the lower part of the body also has the rich, three-dimensional quality associated with the Hellenistic sculpture of Rhodes and Pergamon. The juxtaposition of flesh and drapery, which seems about to slip off the figure entirely, adds a note of erotic tension.

By the end of the first century BCE, the influence of Greek painting, sculpture, and architecture had spread to the artistic communities of the emerging Roman civilization. Roman patrons and artists maintained their enthusiasm for Greek art into Early Christian and Byzantine times. Indeed, so strong was the urge to emulate the great Greek artists that, as we have seen throughout this chapter, much of our knowledge of Greek achievements comes from Roman replicas of Greek artworks and descriptions of Greek art by Roman-era writers.

IN PERSPECTIVE

Greek art between the sixth and the fourth centuries BCE reveals that the Greeks had been studying every detail of their surroundings, from an acanthus leaf to the folds of their own clothing. By then, too, builders had evolved standardized temple plans. They had also experimented with the arrangement, proportions, and appearance of their temples until they

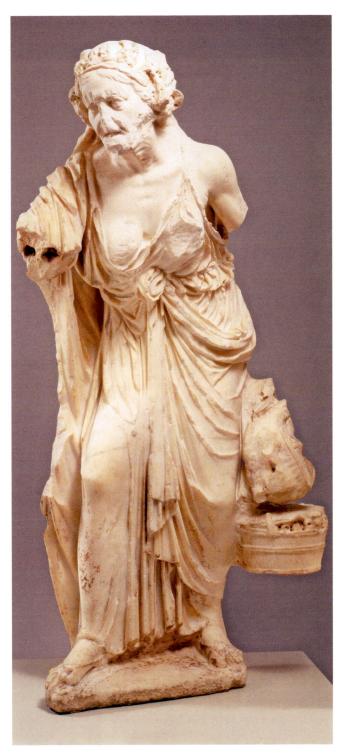

5–68 | OLD WOMAN Roman copy, 1st century CE. Marble, height 49%'' (1.25 m). The Metropolitan Museum of Art, New York. Rogers Fund, 1909 (09.39)

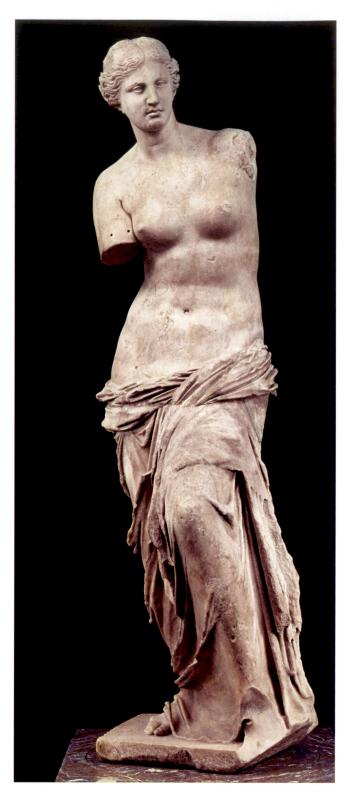

5–69 | APHRODITE OF MELOS (ALSO CALLED VENUS DE MILO) c. 150-100 BCE. Marble, height 6′8″ (2.04 m). Musée du Louvre, Paris.

The original appearance of this famous statue's missing arms has been much debated. When it was dug up in a field in 1820, some broken pieces (now lost) found with it indicated that the figure was holding out an apple in its right hand. Many judged these fragments to be part of a later restoration, not part of the original statue. Another theory is that Aphrodite was admiring herself in the highly polished shield of the war god Ares, an image that was popular in the second century BCE. This theoretical "restoration" would explain the pronounced S-curve of the pose and the otherwise unnatural forward projection of the knee.

perfected two distinct designs—the Doric order and the Ionic order. The Corinthian order became so popular later that today it too is treated as a standard Greek order.

In the fifth century, the Athenians built the Parthenon, a new temple to the goddess Athena in which architectural design and sculptural decoration established a Classical ideal. The Parthenon's extensive program of decoration strongly reflects the ancient Greek vision of unity and beauty.

Studying human appearances closely, the sculptors of the Classical period selected those attributes they considered most desirable and combined them into a single ideal of perfection. These figures also expressed profound political and ideological themes and ideas: the preeminence of Athens and the triumph of an enlightened Greek civilization over despotism and barbarism.

Although later artists continued to observe the basic Classical approach to composition and form, they no longer adhered rigidly to its conventions. Despite the instability of the fourth century BCE, Greek city-states undertook innovative architectural projects. Architects developed variations on Classical ideals in urban planning, temple design, and the construction of monumental tombs and altars. In contrast to the fifth century, much of this activity took place outside of Athens, notably in Asia Minor.

Earlier Greek artists had sought to capture the ideal and often focused on the heroic. Hellenistic artists sought to represent the specific and turned increasingly to the everyday. Since the fourth century BCE, the appeal to the senses through surface treatments and to the emotions through drama had also become more pronounced. Even the architecture of the Hellenistic period largely reflected the contemporary taste for high drama.

CENTAUR, LATE 10TH CENTURY BCE

1000 BCE

ART OF **ANCIENT GREECE**

- ◀ Proto-Geometric с. 1050-900 все
- Geometric c. 900-700 BCE

- Earliest Surviving List of Olympic Game Winners c. 776 BCE
- Orientalizing c. 700-600 BCE
- ✓ Archaic c. 600-480 BCE
- **Early Classical** c. 480–450 BCE
- High Classical c. 450-400 BCE
- Late Classical c. 400–323 BCE

■ Hellenistic c. 323–31 BCE

FUNERARY VASE, с. 750-700 все

BERLIN CORE, с. 570-560 все

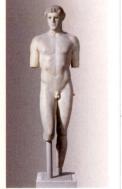

KRITIAN BOY, с. 480 все

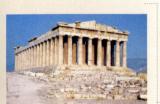

PARTHENON с. 447-432 все

ALEXANDER THE GREAT, с. 306-281 все

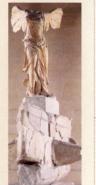

NIKE (VICTORY) OF SAMOTHRACE c. 180

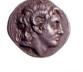

■ Roman Empire 27 BCE-395 CE

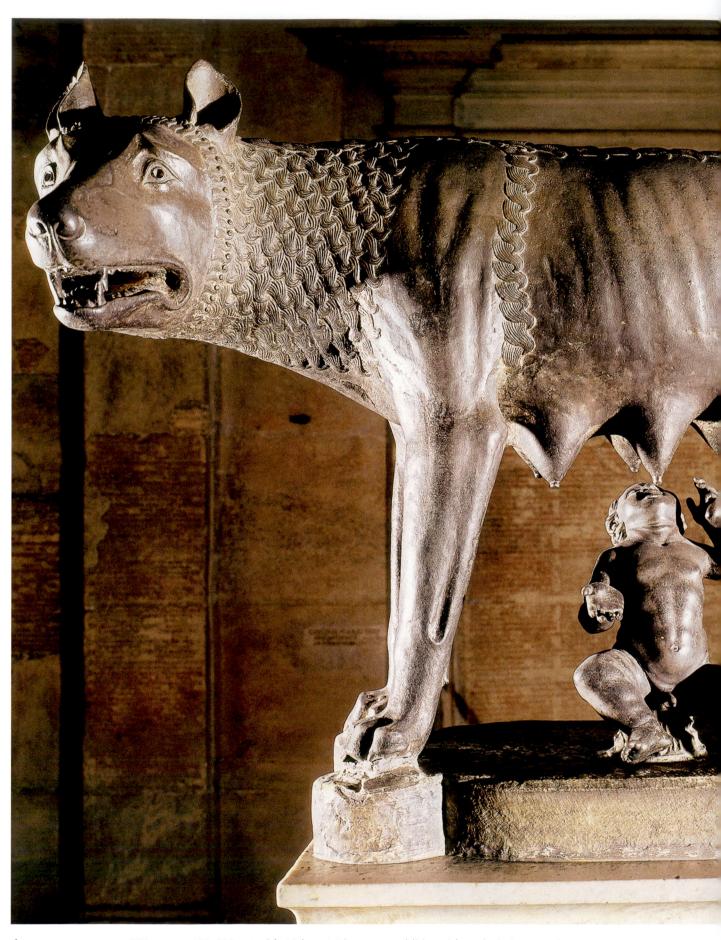

6–I SHE-WOLF c. 500 BCE, or 450–430 BCE with 15th or 16th century additions (the twins). Bronze, glass-paste eyes, height 33½″ (85 cm). Museo Capitolino, Rome.

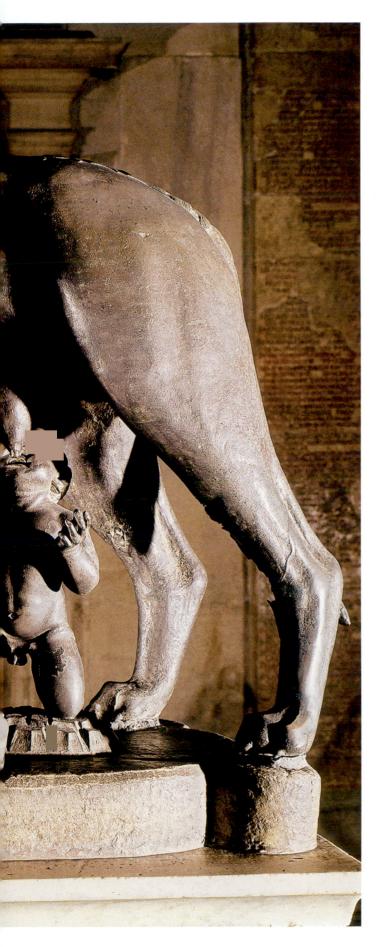

CHAPTER SIX

ETRUSCAN AND ROMAN ART

6

A ferocious she-wolf turns toward us with a vicious snarl. Her tense body, thin flanks, and protruding ribs contrast with her heavy, milk-filled

teats. She suckles two active, chubby little human boys. We are looking at the most famous symbol of Rome, the legendary wolf who nourished and saved the city's founder, Romulus, and his twin brother, Remus (FIG. 6–I). According to a Roman legend, the twin sons, fathered by the god Mars and born of a mortal woman, were left to die on the banks of the Tiber River by their wicked great–uncle. A she–wolf discovered the infants and nursed them in place of her own pups; the twins were later raised by a shepherd. When they reached adulthood, the twins decided to build a city near the spot where the wolf had rescued them, in the year 753 BCE.

This composite sculptural group of wolf and boys suggests the complexity of art history on the Italian peninsula. An early people called Etruscans created the bronze wolf in the fifth century BCE. Later Romans added the sculpture of two children in the late fifteenth or early sixteenth century CE.

We know that a statue of a wolf—and sometimes even a live wolf in a cage—stood on the Capitoline Hill, the governmental and religious center of ancient Rome. But whether the wolf in FIGURE 6–1 is the same sculpture that Romans saw millennia ago is far from certain. According to tradition, the original bronze wolf was struck by lightning

and the damaged figure was buried. The documented history of this statue begins in the tenth century CE, when it was discovered and placed outside the Lateran Palace, the home of the pope. The naturalistic rendering of the wolf's body suggests a mid–fifth-century date and contrasts with the decorative, stylized rendering of the tightly curled, molded, and incised ruff of fur around her neck and along her spine. The glass-paste eyes that add so much to the dynamism of the figure were inserted after the sculpture was finished. At that time, statues of two small men stood under the wolf, personifying the alliance between the Romans and their former enemies from central Italy, the Sabines. In the later Middle Ages, people mistook the figures for children and identified the sculpture with the founding of Rome. During the Renaissance, the Florentine sculptor Antonio del Pollaiuolo (see Chapter 19) added the twins we see here. Pope Sixtus IV (papacy 1471–84 CE) had the sculpture moved from his palace to the Capitoline Hill. Today, the wolf maintains her wary pose in a museum there.

CHAPTER-AT-A-GLANCE

- THE ETRUSCANS Etruscan Architecture Etruscan Temples and Their Decoration Tomb Chambers Bronze Work
- THE ROMANS Origins of Rome Roman Religion
- THE REPUBLIC, 509-27 BCE Sculpture during the Republic Architecture and Engineering
- THE EARLY EMPIRE, 27 BCE-96 CE Augustan Art The Julio-Claudians The Roman City and the Roman Home Wall Painting The Flavians
- THE HIGH IMPERIAL ART OF TRAJAN AND HADRIAN Imperial Architecture Mosaics Sculpture Imperial Portraits
- THE LATE EMPIRE, THIRD AND FOURTH CENTURIES The Severan Dynasty The Third Century: The Soldier Emperors The Tetrarchy Constantine the Great and His Legacy
- IN PERSPECTIVE

THE ETRUSCANS

The boot-shaped Italian peninsula, shielded on the north by the Alps, juts into the Mediterranean Sea. At the end of the Bronze Age (about 1000 BCE), a central European people known as the Villanovans occupied the northern and western regions of the peninsula, and the central area was home to a variety of people who spoke a closely related group of Italic languages, Latin among them. Beginning about 750 BCE, Greeks established colonies on the mainland and in Sicily. Between the seventh and sixth centuries BCE, people known as Etruscans, probably related to the Villanovans, gained control of the north and much of today's central Italy, an area known as Etruria.

Etruscan wealth came from fertile soil and an abundance of metal ore. Both farmers and metalworkers, the Etruscans were also sailors and merchants, and they exploited their resources in trade with the Greeks and with other people of the eastern Mediterranean. Etruscan artists knew and drew inspiration from Greek and Near Eastern sources. They assimilated these influences to create a distinctive Etruscan style. Organized into a loose federation of a dozen cities, the

Etruscans reached the height of their power in the sixth century BCE, when they expanded into the Po River valley to the north and the Campania region to the south (MAP 6-1).

Etruscan Architecture

In architecture, the Etruscans used the plans and post-and-lintel structure seen in Greece and elsewhere. Their pattern of building was later adopted by the Romans. The Etruscan city was laid out on a grid plan, like cities in Egypt and Greece, but with a difference: Two main streets—one usually running north-south and the other east-west—divided the city into quarters. The intersection of these streets was the town's business center. We know something about their domestic architecture within these quarters, because the Etruscans created house-shaped funerary urns and also decorated the interiors of tombs to resemble houses. They built their houses around a central courtyard (or atrium) open to the sky, with a pool or cistern fed by rainwater.

Walls with protective gates and towers surrounded the cities. As a city's population grew, its boundaries expanded and building lots were added outside the walls. The third- to

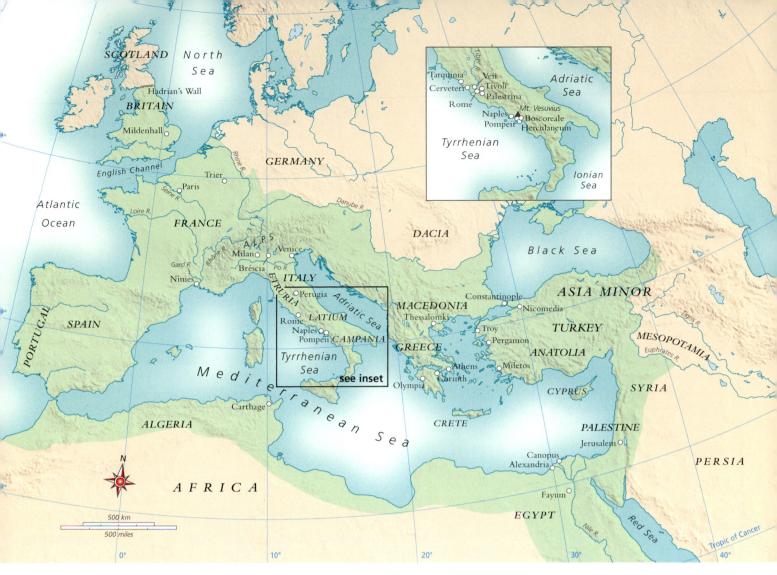

MAP 6-I THE ROMAN REPUBLIC AND EMPIRE

After expelling their Etruscan kings in 509 BCE, Rome became a republic. The Roman Empire, which began in 27 BCE, extended its borders from the Euphrates River to Scotland under Trajan in 106 CE, but was permanently split into the Eastern and Western empires in 395 CE.

second-century BCE city gate of Perugia, called the Porta Augusta, is one of the few surviving examples of Etruscan monumental architecture (FIG. 6–2). A tunnel-like passageway between two huge towers, this gate is significant for anticipating the Roman use of the round arch, which is here extended to create a semicircular barrel vault over the passageway.

The round arch was not an Etruscan or Roman invention, but the Etruscans and Romans were the first to make widespread use of arches and vaults (see "Arch, Vault, and Dome," page 6-6). Unlike the corbel arch, in which overhanging courses of masonry meet at the top, the round arch is formed by precisely cut, wedge-shaped stone blocks called **voussoirs**. In the Porta Augusta, a square frame surmounted by a horizontal decorative element resembling an entablature sets off the arch, which consists of a double row of *voussoirs*

and a molding. The decorative section is filled with a row of circular panels, or **roundels**, alternating with rectangular, columnlike uprights called **pilasters**. The effect is reminiscent of the Greek Doric frieze.

Etruscan Temples and Their Decoration

The Etruscans incorporated Greek deities and heroes into their pantheon. They may also have adapted the use of divination to predict future events from the ancient Mesopotamians. Beyond this and their burial practices (revealed by the findings in their tombs, discussed later), we know little about their religious beliefs. Our knowledge of the temples' appearance comes from the few remaining foundations of Etruscan temples, from ceramic votive models, and from the writings of the Roman architect Vitruvius.

Elements of Architecture

ARCH, VAULT, AND DOME

he first true arch used in Western architecture is the round arch. When extended, the round arch becomes a barrel vault.

The round arch displaces most of the weight, or downward thrust (see arrows on diagrams) of the masonry above it to its curving sides. It transmits that weight to the supporting uprights (door or window jambs, columns, or piers), and from there the thrust goes to the ground. Brick or cut-stone arches are formed by fitting together wedge-shaped pieces, called voussoirs, until they meet and are locked together at the top center by the final piece, called the keystone. These voussoirs exert an outward thrust so arches may require added support, called buttressing, from adjacent masonry elements. Until the keystone is in place and the mortar between the bricks or stones dries, an arch is held in place by wooden scaffolding called centering. The points from which the curves of the arch rise, called springings, are often reinforced by masonry imposts. The wall areas adjacent to the

curves of the arch are **spandrels**. In a succession of arches, called an **arcade**, the space encompassed by each arch and its supports is called a **bay**.

The barrel vault is constructed in the same manner as the round arch. The outward pressure exerted by the curving sides of the barrel vault requires buttressing within or outside the supporting walls. When two barrel-vaulted spaces intersect each other at the same level, the result is a groin vault. Both the weight and outward thrust of the groin vault are concentrated on the four piers, so only the piers require buttressing. The Romans used the groin vault to construct some of their grandest interior spaces.

A third type of vault brought to technical perfection by the Romans is the **hemispheric dome**. The rim of the dome is supported on a circular wall, as in the Pantheon (SEE FIGS. 6-53, 6-55). This wall is called a **drum** when it is raised on top of a main structure. Sometimes a circular opening, called an **oculus**, is left at the top.

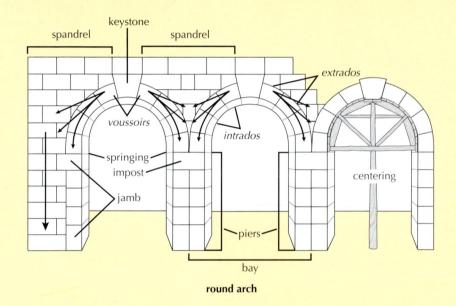

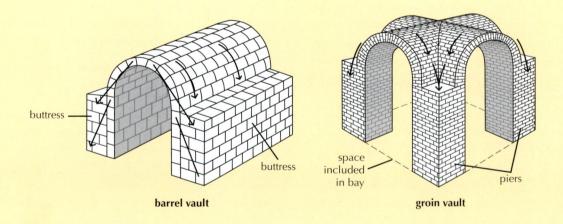

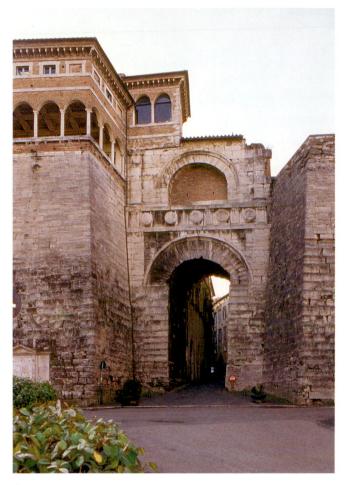

6–2 **PORTA AUGUSTA**Perugia, Italy. 3rd to 2nd century BCE.

Sometime between 33 and 23 CE, Vitruvius compiled descriptions of Etruscan and Roman architecture (see "Roman Writers on Art," page 179). His account indicates that Etruscan temples (FIG. 6–3) were built on a platform called a **podium**, and had, starting from a courtyard or open city square, a single flight of steps leading up to a front porch. This new focus and orientation constitutes an important difference from Greek temples. Columns and an entablature supported the section of

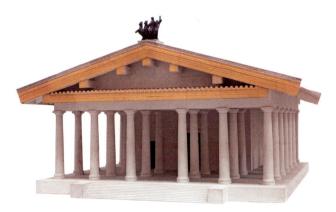

6–3 RECONSTRUCTION OF AN ETRUSCAN TEMPLE Based on archaeological evidence and descriptions by Vitruvius. University of Rome, Istituto di Etruscologia e Antichità Italiche.

roof that projected over the porch. The ground plan was almost square and was divided equally between porch and interior space (FIG. 6–4). Often this interior space was separated into three rooms that probably housed cult statues.

Etruscans built their temples with mud-brick walls. The columns and entablatures were made of wood or a quarried volcanic rock called *tufa*, which hardens upon exposure to air. The column bases, shafts (which were sometimes plain), and capitals could resemble those of the Greek Doric or the Greek Ionic orders, and the entablature might include a frieze resembling that of the Doric order (not seen in the model). Vitruvius used the term **Tuscan order** for the variation that resembled the Doric order, with an unfluted shaft and a simplified base, capital, and entablature (see "Roman Architectural Orders," page 174). Although Etruscan temples were simple in form, they were embellished with dazzling displays of painting and terra-cotta sculpture. The temple roof, rather than the pediment, served as a base for large statue groups.

Etruscan artists excelled at making huge terra-cotta figures, a task of great technical difficulty. A splendid example is a life-size figure of **APOLLO** (FIG. 6–5). To make a large clay sculpture such as this one, the artist must know how to construct the figure so that it does not collapse under its own weight while the clay is still wet. The artist must know how to regulate the temperature in a large kiln for a long period of time. Some of the names of Etruscan terra-cotta artists have come down to us, including that of a sculptor from Veii (near Rome) called Vulca, in whose workshop this Apollo may have been created.

Dating from about 510–500 BCE and originally part of a four-figure scene depicting one of the labors of Hercules (the Greek god Herakles), this *Apollo* comes from the temple dedicated to Minerva and other gods in the sanctuary of Portonaccio at Veii. Four figures on the temple's ridgepole depicted Apollo and Hercules fighting for possession of a deer sacred to Diana,

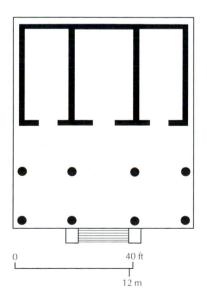

6–4 PLAN OF AN ETRUSCAN TEMPLE Based on descriptions by Vitruvius.

Elements of Architecture

ROMAN ARCHITECTURAL ORDERS

he Etruscans and Romans adapted Greek architectural orders to their own tastes and uses (see Chapter 5, "The Greek Architectural Orders," page 118). The Etruscans modified the Greek Doric order by adding a base to the column. In this diagram, the two Roman orders are shown on pedestals, which consist of a plinth, a dado, and a cornice. The Romans also created the Tuscan order by adding a base to the Doric column and often leaving the shaft unfluted. They elaborated on the Corinthian order with additional moldings and composite capitals that were a combination of lonic volutes placed on the diagonal of all four corners and Corinthian acanthus foliage. Both the Tuscan and the Composite orders were widely used by later architects.

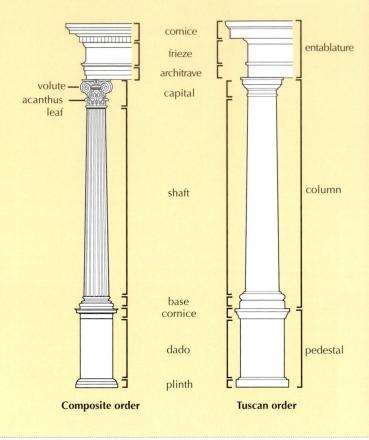

while she and Mercury looked on. Apollo is shown striding forward (to our eyes he seems to have just stepped over the decorative scrolled element that helps support the sculpture). The representation of the god confronting Hercules in vigorous action on the ridgepole of the temple roof defies the logical relationship of sculpture to architecture seen in Greek pediment and frieze sculpture. The Etruscans seemed willing to sacrifice structural logic for lively action in their art.

Apollo's well-developed body and the "Archaic smile" clearly demonstrate that Etruscan sculptors were familiar with contemporary Greek kouroi. Despite those similarities, a comparison of the Apollo and a figure such as the Greek *Anavysos Kouros* (SEE FIG. 5–15) reveals telling differences. Unlike the Greek figure, the body of the Etruscan Apollo is partially concealed by a robe that cascades in knife-edged pleats to his knees. The forward-moving pose of the Etruscan statue also has a vigor that is only hinted at in the balanced stance of the Greek figure. This realistically portrayed energy expressed in purposeful movement is characteristic of Etruscan sculpture and painting.

Tomb Chambers

Like the Egyptians, the Etruscans thought of tombs as homes for the dead. (They did not try to preserve the body but preferred cremation.) The Etruscan cemetery of La Banditaccia at Cerveteri was laid out like a small town, with "streets" running between the grave mounds. The tomb chambers were partially or entirely excavated below the ground, and some were hewn out of bedrock. They were roofed over, sometimes with corbel vaulting, and covered with dirt and stones.

The Etruscan painters had a remarkable ability to suggest that their subjects inhabit a bright, tangible world just beyond the tomb walls. Brightly colored paintings of scenes of feasting, dancing, musical performances, athletic contests, hunting, fishing, and other pleasures decorated the tomb walls. Many of these murals are faded and flaking, but those in the tombs at Tarquinia are well preserved. In a detail of a painted frieze in the **TOMB OF THE TRICLINIUM**, from about 480–470 BCE, young men and women dance to the music of the lyre and double flute (FIG. 6–6). The dancers line the side walls within

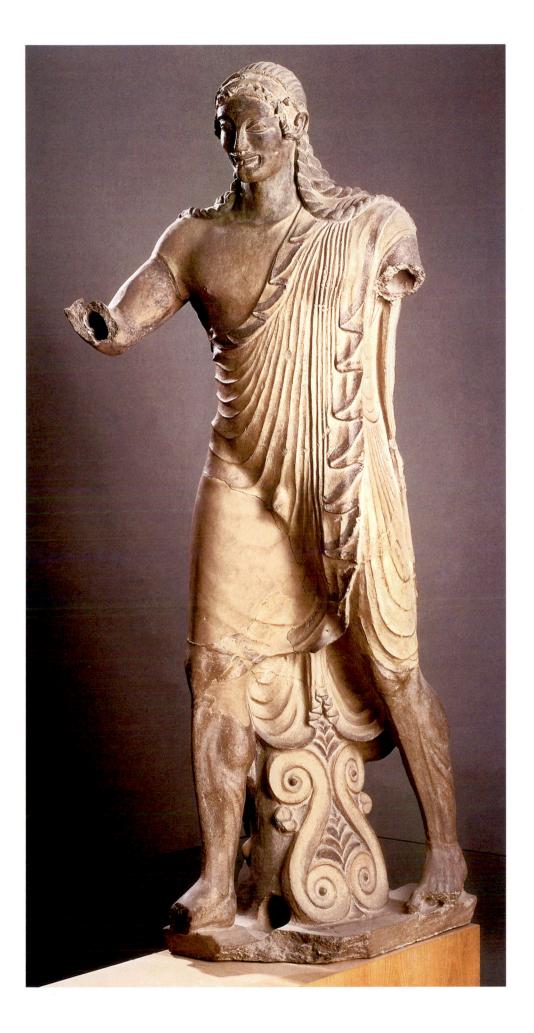

6–5 **APOLLO**Temple of Minerva,
Portenaccio, Veii. Master sculptor Vulca (?). c. 510–500 BCE. Painted terra cotta, height 5'10" (1.8 m). Museo Nazionale di Villa Giulia, Rome.

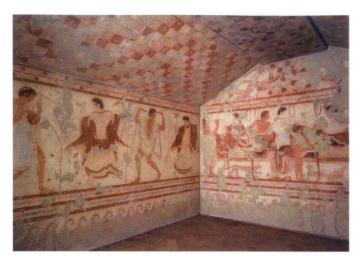

6–6 Burial Chamber, tomb of the triclinium, tarquinia
c. 480–470 BCE.

a carefully arranged setting of stylized trees and birds, while at the end of the room couples recline on couches as they participate in a funeral banquet. Women are portrayed as active participants in the festivities and ceremonies.

Some tombs were carved out of the rock to resemble rooms in a house. The **TOMB OF THE RELIEFS**, for example, seems to have a flat ceiling supported by square stone posts (FIG. 6–7). Its walls were plastered and painted, and it was fully furnished. Couches were carved from stone, and other furnishings were simulated in **stucco**, a slow-drying type of plaster that can be easily molded and carved. Pots, jugs, robes, axes, and other items were molded and carved to look like real objects hanging on hooks. Rendered in low relief at the bottom of the post just left of center is the family dog.

The deceased were placed in urns or sarcophagi (coffins) made of terra cotta. On the SARCOPHAGUS FROM CERVETERI, from about 520 BCE (FIG. 6–8), a husband and wife are shown reclining comfortably on a dining couch. Their upper bodies are vertical and square shouldered, but their hips and legs seem to sink into the couch. Portrait sar-

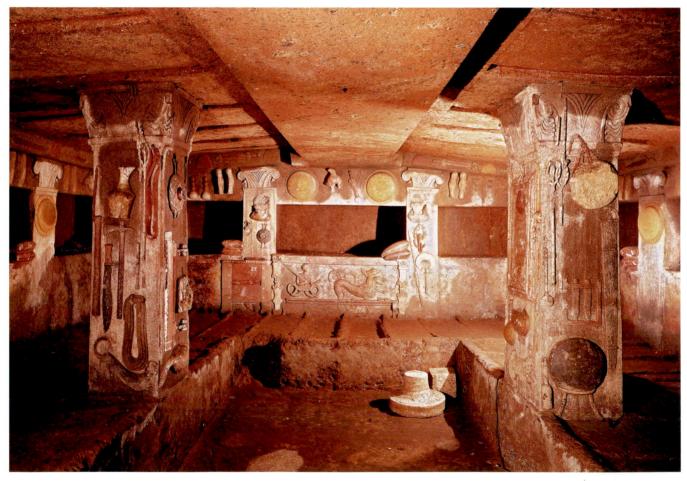

6–7 BURIAL CHAMBER, TOMB OF THE RELIEFS Cerveteri. 3rd century BCE.

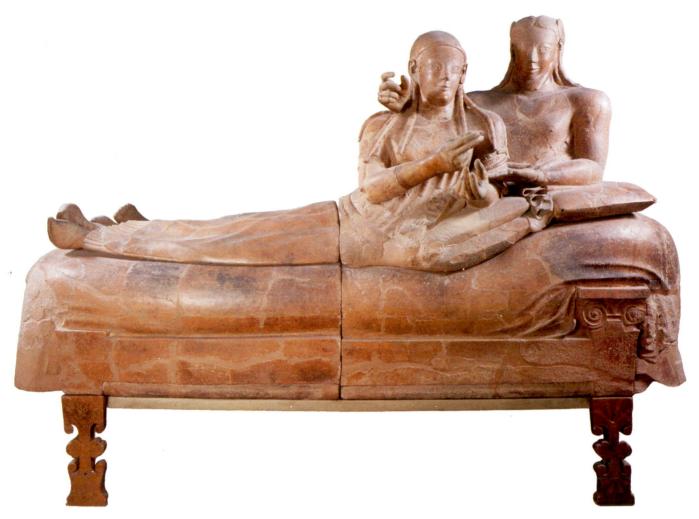

6–8 **SARCOPHAGUS FROM CERVETERI** c. 520 BCE. Terra cotta, length 6'7" (2.06 m). Museo Nazionale di Villa Giulia, Rome.

cophagi like this one evolved from earlier terra-cotta cinerary urns with sculpted heads of the dead person whose ashes they held. Rather than seeing a somber memorial to the dead, we find two lively individuals—the man once raised a drinking vessel—rendered in sufficient detail to convey hair and clothing styles. These genial hosts, with their smooth, conventionalized body forms and faces, their uptilted, almond-shaped eyes, and their benign smiles, gesture as if to communicate something important to the living viewer—perhaps an invitation to dine with them for eternity.

As these details suggest, the Etruscans made every effort to provide earthly comforts for their dead, but tomb decorations also sometimes included frightening creatures from Etruscan mythology. On the back wall of the *Tomb of the Reliefs* is another kind of dog—a beast with many heads—that probably represents Cerberus, the guardian of the gates of the underworld, an appropriate funerary image.

Bronze Work

The most impressive Etruscan metal works are large-scale sculptures in the round like the she-wolf in Figure 6–1.

Etruscan bronze workers created items for both funerary and domestic use, such as a bronze mirror from the early to midfourth century BCE (FIG. 6-9). A mirror had the power to capture an image, hence it was almost magical. Engraved on the back of the mirror is a winged man, identified by the inscription as the Greek priest Calchas, who accompanied the Greek army under Agamemnon to Troy. Here Calchas is shown bending over a table, studying the liver of a sacrificed animal. Greeks, Etruscans, and Romans all believed that the appearance of animal entrails could reveal the future. Perhaps alluding to the legend that Calchas died laughing in his vineyard, the artist has shown him surrounded by grapevines and with a jug at his feet. The complex pose, the naturalistic suggestions of a rocky setting, and the pull and twist of drapery that emphasize the figure's three-dimensionality convey a sense of realism.

Etruscan artists continued to be held in high regard by Roman patrons after the Etruscan cities fell to Rome. Bronze workers and other artists went to work for the Romans, making the distinction between Etruscan and early Roman art difficult. A head that was once part of a bronze statue of a

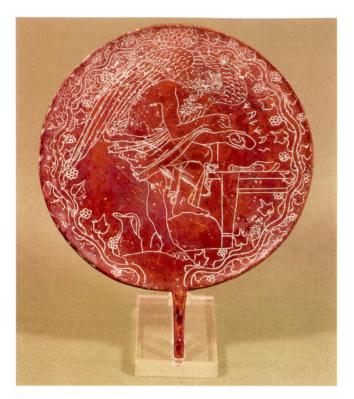

6–9 MIRROR c. 400–350 BCE. Engraved bronze, diameter 6" (15.3 cm). Musei Vaticani, Museo Gregoriano Etrusco, Rome.

One side of the disc was engraved; the other, highly polished to provide a reflecting surface.

man may be an example of an important Roman commission (FIG. 6–IO). Often alleged to be a portrait of Lucius Junius Brutus, a founder and first consul of the Roman Republic, the head traditionally has been dated about 300 BCE (and may even be a more recent work from the first century BCE), long after Brutus's death. Although it may represent an unknown Roman dignitary of the day, it could also be an imaginary portrait of the ancient hero. The rendering of the strong, broad face with its heavy brows, hawk nose, firmly set lips, and wide-open eyes (made of painted ivory) is scrupulously detailed. The sculptor seems also to have sought to convey the psychological complexity of the subject, showing him as a somewhat world-weary man who nevertheless projects strong character and great strength of purpose.

Etruscan art and architectural forms left an indelible stamp on the art and architecture of early Rome that was second only to the influence of Greece. By 88 BCE, when the Etruscans had been granted Roman citizenship, their art had already been absorbed into that of Rome.

THE ROMANS

At the same time as the Etruscan civilization was flourishing, the Latin-speaking inhabitants of Rome began to develop into a formidable power. For a time, kings of Etruscan lineage ruled them, but in 509 BCE the Romans overthrew the kings and formed a republic centered in Rome. Etruscan power was in decline by the fifth century BCE, and they were absorbed by the Roman Republic at the end of the third century, by which time Rome had steadily expanded its territory in many directions. The Romans unified what is now Italy and, after defeating the North African city-state of Carthage, their rival in the western Mediterranean, established an empire that included the entire Mediterranean region (MAP 6–1).

At its greatest extent, in the early second century CE, the Roman Empire reached from the Euphrates River in southwest Asia to Scotland. It ringed the Mediterranean Sea—mare nostrum, or "our sea," the Romans called it. As the Romans absorbed the peoples they conquered, they imposed on them a legal, administrative, and cultural structure that endured for some five centuries—and in the eastern Mediterranean until the fifteenth century CE—and left a lasting mark on the civilizations that emerged in Europe.

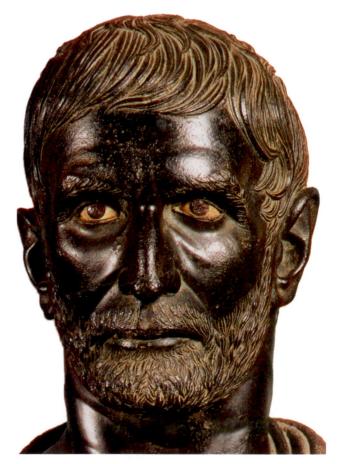

6–10 **HEAD OF A MAN (KNOWN AS BRUTUS)** c. mid-3rd century BCE. Bronze, eyes of painted ivory, height 12½" (31.8 cm). Palazzo dei Conservatori, Rome.

Art and Its Context

ROMAN WRITERS ON ART

nly one book specifically on architecture and the arts survives from antiquity. All our other written sources consist of digressions and insertions in works on other subjects. That one book, Vitruvius's Ten Books on Architecture, written for Augustus in the first century CE, is a practical handbook for builders that discusses such things as laying out cities, siting buildings, and using the Greek architectural orders. His definition of Greek architectural terms is invaluable. Vitruvius argued for appropriateness and rationality in architecture, and he also made significant contributions to art theory, including studies on proportion.

Pliny the Elder (c. 23–79 CE) wrote a vast encyclopedia of "facts, histories, and observations," known as *Naturalis Historia* (*The Natural History*). He often included discussions of art and architecture, and he used works of art to make his points—for example, sculpture to illustrate essays on stones and metals. Pliny's scientific turn of mind led to his death, for he was overcome while observing the eruption of Mount Vesuvius that buried Pompeii. His nephew Pliny the Younger (c. 61–113 CE), a voluminous letter writer, added to our knowledge of Roman domestic architecture with his meticulous description of villas and gardens.

Valuable bits of information can also be found in books by travelers and historians. Pausanias, a second-century CE Greek traveler, wrote descriptions of Greece that are basic sources on Greek art and artists. Flavius Josephus (c. 37–100 CE), a historian of the Flavians, wrote in his *Jewish Wars* a description of the triumph of Titus that includes the treasures looted from the Temple of Solomon in Jerusalem (see Fig. 6–39).

As an iconographical resource, *Metamorphoses* by the poet Ovid (43 BCE-17 CE) provided themes for artists in Ovid's own time, and has done so ever since. Ovid recorded Greek and Roman myths, stories of interactions between gods and mortals, and amazing transformations (metamorphoses)—for example, Daphne turning into a laurel tree to escape Apollo.

Perhaps the best-known—and most pungent—comments on art and artists remain those of the Greek writer Plutarch (c. 46–after 119 CE), who opined that one may admire the art but not the artist, and the Roman poet Virgil (70–19 BCE), who in the *Aeneid* wrote that the Greeks practice the arts, but it is the role of Romans to rule, for their skill lies in government, not art.

Origins of Rome

The Romans saw themselves, not surprisingly, in heroic terms and attributed heroic origins to their ancestors. Two popular legends told the story of Rome's founding: one by Romulus and Remus, twin sons of Mars, the god of war (see the beginning of this chapter); the other, rendered in epic verse by the poet Virgil (70–19 BCE) in the *Aeneid*. In the latter, the Roman people were understood to be the offspring of Aeneas, a Trojan who was the mortal son of Venus. Aeneas and some companions escaped from Troy and made their way to the Italian peninsula. Their sons were the Romans, the people who in fulfillment of a promise by Jupiter to Venus were destined to rule the world.

Archaeologists and historians present a more mundane picture of Rome's origins. In Neolithic times, people settled in permanent villages on the plains of Latium, south of the Tiber River, and on the Palatine, one of the seven hills that would eventually become the city of Rome. The settlements were just clusters of small, round huts, but by the sixth century BCE, they had become a major transportation hub and trading center.

Roman Religion

The Romans adopted the Greek gods and myths as well as Greek art and temple forms. (This chapter uses the Roman form of Greek names.) They assimilated Greek religious beliefs and practices into their state religion. To the Greek pantheon they later added their own deified emperors. Wor-

ship of ancient gods mingled with homage to past rulers, and oaths of allegiance to the living ruler made the official religion a political duty. As an official religion, it became increasingly ritualized, perfunctory, and distant from the everyday life of the average person.

Many Romans adopted the more personal religious beliefs of the people they had conquered, the so-called mystery religions. Worship of Isis and Osiris from Egypt, Cybele (the Great Mother) from Anatolia, the hero-god Mithras from Persia, and the single, all-powerful God of Judaism and Christianity from Palestine challenged the Roman establishment. These unauthorized religions flourished alongside the state religion, with its Olympian deities and deified emperors, despite occasional government efforts to suppress them.

THE REPUBLIC, 509-27 BCE

Early Rome was governed by kings and an advisory body of leading citizens called the Senate. The population was divided into two classes: a wealthy and powerful upper class, the *patricians*, and a lower class, the *plebeians*. In 509 BCE, Romans overthrew the last Etruscan king. They established the Roman Republic as an *oligarchy*, a government by the aristocrats. It was to last about 450 years.

By 275 BCE Rome controlled the entire Italian peninsula. By 146 BCE, Rome had defeated its great rival, Carthage, on the north coast of Africa, and taken control of the western

6–II **AULUS METELLUS**Found near Perugia. c. 80 BCE. Bronze, height 5′11″ (1.8 m). Museo Archeològico Nazionale, Florence.

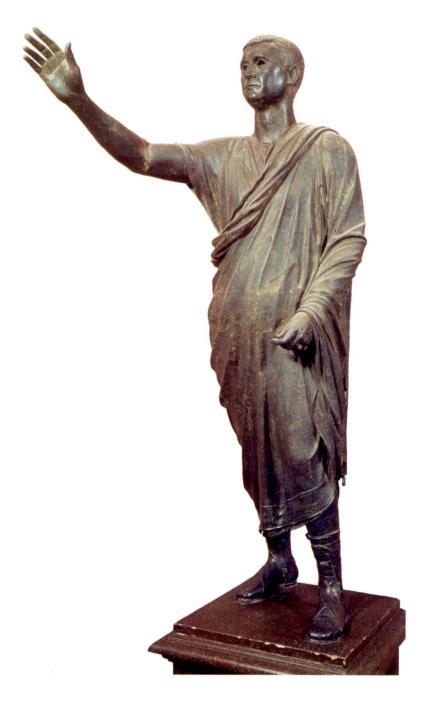

Mediterranean. By the mid-second century BCE, Rome had taken Macedonia and Greece, and by 44 BCE, it had conquered most of Gaul (present-day France) as well as the eastern Mediterranean (SEE MAP 6–1). Egypt remained independent until Octavian defeated Marc Anthony and Cleopatra in the Battle of Actium in 31 BCE.

During the centuries of the Republic, Roman art reflected Etruscan influence, but territorial expansion brought wider exposure to the arts of other cultures. Like the Etruscans, the Romans admired Greek art. As Horace wrote (*Epistulae II, 1*): "Captive Greece conquered her savage conquerors and brought the arts to rustic Latium." The Romans used Greek designs and Greek orders in their architecture, imported Greek art, and employed Greek artists. In 146 BCE,

for example, they stripped the Greek city of Corinth of its art treasures and shipped them back to Rome. Ironically, this love of Greek art was not accompanied by admiration for its artists. In Rome, as in Greece, professional artists were generally considered to be simply skilled laborers.

Sculpture during the Republic

Sculptors of the Republican period sought to create believable images based on careful observation of their surroundings. The desire to render accurate and faithful portraits of individuals may be derived from Roman ancestor veneration and the practice of making death masks of deceased relatives. Roman patrons in the Republican period clearly admired realistic portraits, and it is not sur-

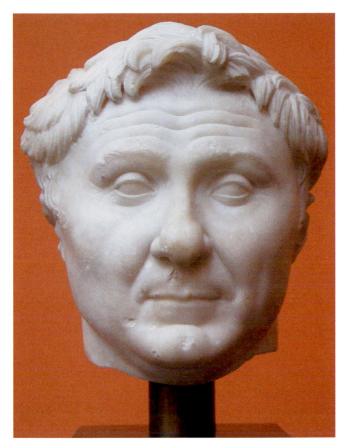

6–12 PORTRAIT OF POMPEY THE GREAT 30 CE. Copy of sculpture of c. 50 BCE. Marble, height 9 1/4" (24.8 cm). Ny Carlsberg Glyptotek, Copenhagen.

prising that for bronze sculpture they often turned to skilled Etruscan artists.

THE ORATOR. The life-size bronze portrait of AULUS METELLUS—the Roman official's name is inscribed on the hem of his garment in Etruscan letters (FIG. 6—II)—dates to about 80 BCE. The statue, known from early times as *The Orator*, depicts a man addressing a gathering, his arm outstretched and slightly raised, a pose expressive of authority and persuasiveness. The orator wears sturdy laced leather boots and the folded and draped garment called a *toga*, dress characteristic of a Roman official. According to Pliny the Elder, large statues like this were often placed atop columns as memorials.

PORTRAIT OF POMPEY. The PORTRAIT OF POMPEY THE GREAT (106–48 BCE), a general and one of the three-man team—along with Caesar and Crassus—who ruled Rome from 60 to 53 BCE, illustrates the realism demanded by Romans (FIG. 6–12). Pompey's fleshy face, too-small eyes, and warts are recorded for posterity. Such meticulous realism, called verism, combines underlying bone structure with surface detail. In the portrait, however, the elegantly tossed hair suggests a more idealized image. The original sculpture was made during Pompey's lifetime (c. 50 BCE), but about 30 CE

his family commissioned the copy seen here. (A statue, perhaps looking like this one, stood in the Theater of Pompey in Rome. When Caesar was assassinated in 44 BCE, he is supposed to have died at the foot of the statue.)

THE DENARIUS OF JULIUS CAESAR. The propaganda value of portraits was not lost on Roman leaders. In 44 BCE, Julius Caesar issued a denarius (a widely circulated coin) bearing his portrait (FIG. 6–13). Like the monumental images of Etruscan and Roman Republican art, this tiny relief sculpture accurately reproduced Caesar's careworn features and growing baldness. This idea of placing the living ruler's portrait on one side of a coin and a symbol of the country or an image that recalls some important action or event on the other was adopted by Caesar's successors. In the case of this denarius, Venus was placed on the reverse, a reference to the Julian family's claim that they were descended from Venus through her mortal son, Aeneas. Consequently, Roman coins give us an unprecedented and personal view of Roman history.

Architecture and Engineering

Roman architects had to satisfy the wishes of wealthy and politically powerful patrons who ordered buildings for the public as well as themselves. They also had to satisfy the needs of ordinary people. To do this, they created new building types and construction techniques that permitted them to erect buildings efficiently and inexpensively.

CONSTRUCTION TECHNIQUES. Among the techniques Roman architects relied on were the round arch and vault, and during the empire, concrete. For example, an ample water supply was essential for a city, and the Roman invention to supply water was the aqueduct, built with arches and

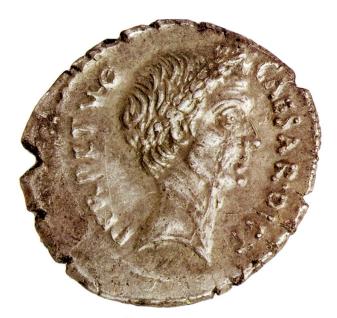

6–13 **DENARIUS WITH PORTRAIT OF JULIUS CAESAR** 44 BCE. Silver, diameter approximately ¾" (1.9 cm). American Numismatic Society, New York.

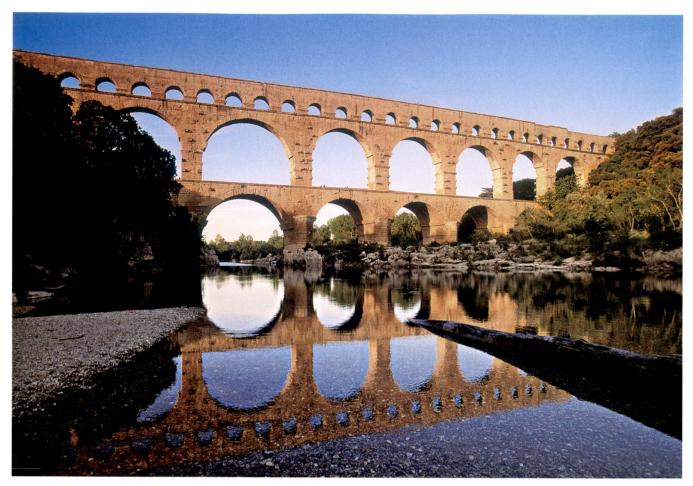

6–I4 PONT DU GARD Nîmes, France. Late 1st century BCE.

The aqueduct's three arcades rise 160 feet (49 m) above the river. The thick base arcade supports a roadbed approximately 20 feet (6 m) wide. The arches of the second arcade are narrower than the first and are set at one side of the roadbed. The narrow third arcade supports the water trough, 900 feet (274.5 m) long on 35 arches, each of which is 23 feet (7 m) high.

using concrete. The Pont du Gard, near Nîmes, in southern France, carried the water channel of an aqueduct across the river on a bridge of arches (FIG. 6–14) (See "Arch, Vault, and Dome," page 172). It brought water from springs 30 miles to the north using a simple gravity flow, and it provided 100 gallons of water a day for every person in Nîmes. Entirely functional, each arch buttresses its neighbors and the huge arcade ends solidly in the hillsides. The structure conveys the balance, proportions, and rhythmic harmony of a great work of art, and fits naturally into the landscape.

THE USE OF CONCRETE. The Romans were pragmatic, and their practicality extended from recognizing and exploiting undeveloped potential in construction methods and physical materials to organizing large-scale building works. Their exploitation of the arch and the vault is typical of their adaptand-improve approach. Their innovative use of concrete, beginning in the first century BCE, was a technological breakthrough of the greatest importance.

In contrast to stone—which was expensive and difficult to quarry and transport—the components of concrete were cheap, relatively light, and easily transported. Building stone structures required highly skilled masons, but a large, semi-skilled work force directed by a few experienced supervisors could construct brick-faced concrete buildings.

Roman concrete consisted of powdered lime, sand (in particular, a volcanic sand called *pozzolana* found in abundance near Pompeii), and various types of rubble, such as small rocks and broken pottery. Mixing in water caused a chemical reaction that blended the materials, which hardened as they dried into a strong, solid mass. At first, concrete was used mainly for poured foundations, but with technical advances it became indispensable for the construction of walls, arches, and vaults for ever-larger buildings. In the earliest concrete wall construction, workers filled a framework of rough stones with concrete. Soon they developed a technique known as *opus reticulatum*, in which the framework is a diagonal web of smallish bricks set in a cross pattern. Concrete-based construction

freed the Romans from the limits of right-angle forms and comparatively short spans. With this freedom, Roman builders pushed the established limits of architecture, creating some very large and highly original spaces, many based on the curve.

Concrete's one weakness was that it absorbed moisture, so builders covered exposed surfaces with a veneer, or facing, of finer materials, such as marble, stone, stucco, or painted plaster. An essential difference between Greek and Roman architecture is that Greek buildings reveal the building material itself, whereas Roman buildings show only the externally applied surface.

The remains of the **SANCTUARY OF FORTUNA PRIMIGE-NIA**, the goddess of fate and chance, were discovered after World War II by teams clearing the rubble from bombings of Palestrina (ancient Praeneste), about 16 miles southeast of Rome. The sanctuary, an example of Roman Republican architectural planning and concrete construction at its most creative (FIG. 6–15), was begun early in the second century BCE and was grander than any building in Rome in its time. Its design and size show the clear influence of Hellenistic architecture, especially the colossal scale of buildings in cities such as Pergamon (SEE FIG. 5–64).

Built of concrete covered with a veneer of stucco and finely cut limestone, the seven vaulted platforms or terraces of the Sanctuary of Fortuna covered a steep hillside. Worshipers ascended long ramps, then staircases to successively higher levels. Enclosed ramps open onto the fourth terrace, which has a

central stair with flanking colonnades and symmetrically placed **exedrae**, or semicircular niches. On the sixth level, **arcades** (series of arches) and **colonnades** (rows of columns) form three sides of a large square, which is open on the fourth side to the distant view. Finally, from the seventh level, a huge, theaterlike, semicircular colonnaded pavilion is reached by a broad semicircular staircase. Behind this pavilion was a small tholos—the actual temple to Fortuna—hiding the ancient rock-cut cave where acts of divination took place. The overall axial plan—directing the movement of people from the terraces up the semicircular staircase, through the portico, to the tiny tholos temple, to the cave—brings to mind great Egyptian temples, such as that of Hatshepsut at Deir el-Bahri (SEE FIG. 3–28).

THE ROMAN TEMPLE. Roman temples followed the pattern of Etruscan and Greek buildings. The Romans built urban temples in commercial centers as well as in special sanctuaries. In Rome, a small rectangular temple stands on its raised platform, or podium, beside the Tiber River (FIG. 6–16). It is either a second-century temple or a replacement of 80–70 BCE and may have been dedicated to Portunus, the god of harbors and ports. With a rectangular cella and a porch at one end reached by a single flight of steps, the temple combines the Greek idea of a colonnade across the entrance with the Etruscan podium and single flight of steps leading to a front porch entrance. The Ionic columns are freestanding on the porch and engaged (set into the wall) around the cella

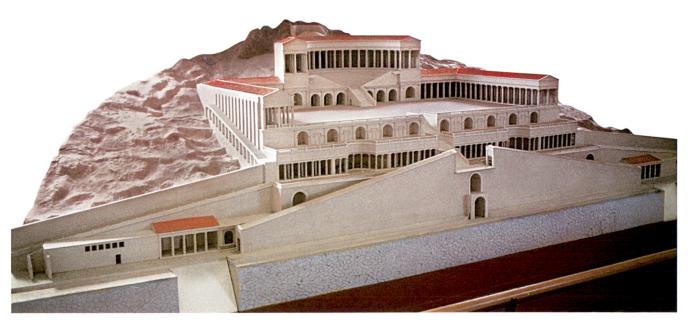

6–15 MODEL OF THE SANCTUARY OF FORTUNA PRIMIGENIA
Palestrina, Italy. Late 2nd century BCE. Museo Archeològico Nazionale, Italy.

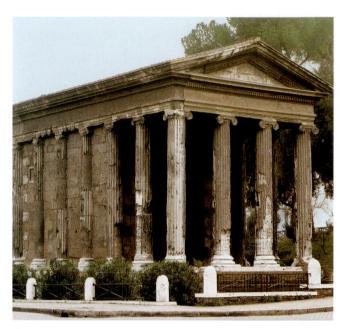

6–16 **TEMPLE, PERHAPS DEDICATED TO PORTUNUS**Forum Boarium (Cattle Market), Rome. Late 2nd century BCE.

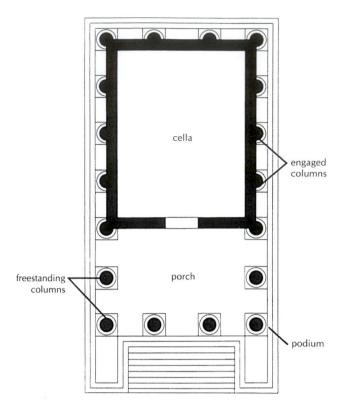

6-17 **PLAN OF TEMPLE**Forum Boarium (Cattle Market), Rome.

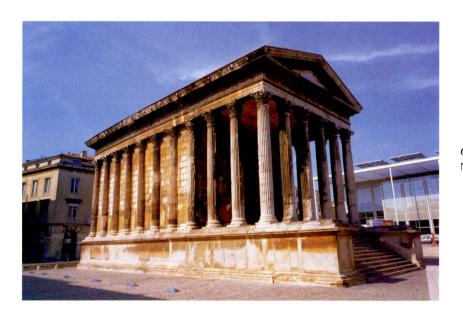

6–18 MAISON CARRÉE Nîmes, France. c. 20 BCE.

(FIG. 6–17). The entablature above the columns on the porch continues around the cella as a decorative frieze. The encircling columns resemble a Greek peripteral temple, but because the columns are engaged, the plan is called pseudo-peripteral. This design, with variations in the orders used with it, is typical of Roman temples.

Early imperial temples, such as the one known as the Maison Carrée (Square House), are simply larger and much more richly decorated versions of the so-called Temple of Portunus. Built in the forum at Nîmes, France, about 20 BCE

and later dedicated to Gaius and Lucius, the adopted heirs of Augustus who died young, the temple was built by their biological father, Marcus Vipsanius Agrippa. The MAISON CARRÉE differs from its prototype only in its size and its use of the opulent Corinthian order (FIG. 6–18). The temple summarizes the character of Roman religious architecture: technologically advanced but conservative in design, perfectly proportioned and elegant in sculptural detail. (These qualities appealed to the future American president and amateur architect Thomas Jefferson, who visited Nîmes and was said

to have found inspiration in the Maison Carrée for his own buildings in the new state of Virginia.)

Although by the first century BCE nearly a million people lived in Rome, the Romans thought of themselves as farmers. In fact, Rome had changed from an essentially agricultural society to a commercial and political power. In 46 BCE, the Roman general Julius Caesar emerged victorious over his rivals, assumed autocratic powers, and ruled Rome until his assassination two years later. The conflicts that followed Caesar's death ended within a few years with the unquestioned control of his grandnephew and heir, Octavian, over Rome and all its possessions. Rome was now an empire.

THE EARLY EMPIRE, 27 BCE-96 CE

The first Roman emperor was born Octavius (Octavian) in 63 BCE. When he was only 18 years old, Octavian was adopted as son and heir by his brilliant great-uncle, Julius Caesar, who recognized qualities in him that would make him a worthy successor. Shortly after Julius Caesar refused the Roman Senate's offer of the imperial crown, early in 44 BCE, he was murdered by a group of conspirators, and the nineteen-year-old Octavian stepped up. Over the next seventeen spectacular years, as general, politician, statesman, and public relations genius, Octavian vanquished warring internal factions and brought peace to fractious provinces. By 27 BCE, the Senate had conferred on him the title of Augustus (meaning "exalted, sacred"). In 12 CE, he was given the title Pontifex Maximus ("High Priest") and so became the empire's highest religious official as well as its political leader.

Assisted by his astute and pragmatic second wife, Livia, Augustus led the state and the empire for nearly sixty years. He proved to be an incomparable administrator who established efficient rule throughout the empire, and he laid the foundation for an extended period of stability, internal peace, and economic prosperity known as the Pax Romana ("Roman Peace"), which lasted over 200 years (27 BCE to 180 CE). When he died in 14 CE, Augustus left a legacy that defined the concept of empire and imperial rule for later Western rulers.

Conquering and maintaining a vast empire required not only the inspired leadership and tactics of Augustus, but also careful planning, massive logistical support, and great administrative skill. Some of Rome's most enduring contributions to Western civilization reflect these qualities—its system of law, its governmental and administrative structures, and its sophisticated civil engineering and architecture.

To facilitate the development and administration of the empire, as well as to make city life comfortable and attractive to its citizens, the Roman government undertook building programs of unprecedented scale and complexity (FIG. 6–19), mandating the construction of central administrative and legal centers (forums and basilicas), recreational facilities (racetracks, stadiums), theaters, public baths, roads, bridges, aqueducts, middle-class housing, and even entire new towns. To accomplish these tasks without sacrificing beauty, efficiency, and human well-being, Roman builders and architects developed rational plans using easily worked but durable materials and highly sophisticated engineering methods. The architect Vitruvius described these accomplishments in his *Ten Books of Architecture* (see "Roman Writers on Art," page 179).

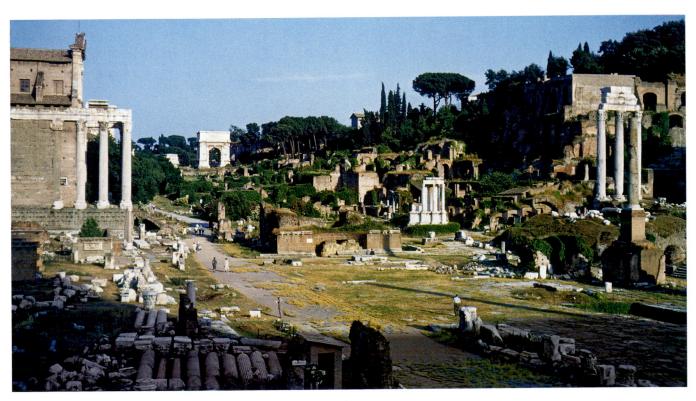

6-19 VIEW OF THE ROMAN FORUM

Art and Its Context

COLOR IN ROMAN SCULPTURE: A COLORIZED AUGUSTUS

ncient sculpture was accentuated by the use of color. A colored reproduction of the Augustus of Primaporta was made based on the research of scholars in the Ny Carlsburg Glyptotek of Copenhagen, Denmark, and the Munich Glyptothek, Germany. In the 1980s, Vincenz Brinkmann of Munich researched the traces of remaining color on ancient sculpture using ultraviolet rays. In addition to aiding the viewer in reading the detailed imagery on Augustus's armor, color also heightens the overall effect of the statue. This painted reproduction may seem shocking to today's viewer, long accustomed to ancient art that has been stripped and scrubbed.

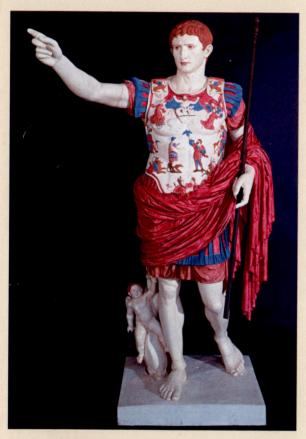

A copy with color restored. Vatican Museum, Rome.

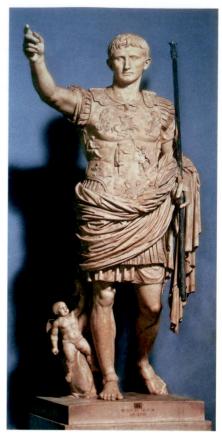

6–20 AUGUSTUS OF PRIMAPORTAEarly 1st century CE. Perhaps a copy of a bronze statue of c. 20 BCE. Marble, originally colored, height 6'8" (2.03 m). Musei Vaticani, Braccio Nuovo, Rome.

To move their armies about efficiently, to speed communications between Rome and the farthest reaches of the empire, and to promote commerce, the Romans built a vast and complex network of roads and bridges. Many modern European highways still follow the lines laid down by Roman engineers, and Roman-era foundations underlie the streets of many cities. Roman bridges are still in use, and remnants of Roman aqueducts need only repairs and connecting links to enable them to function again.

Augustan Art

Drawing inspiration from Etruscan and Greek art as well as Republican traditions, Roman artists of the Augustan age created a new style—a Roman form of idealism that is grounded in the appearance of the everyday world. They enriched the art of portraiture in both official images and representations of private individuals; they recorded contemporary historical events on arches, columns, and mausoleums erected in public places; and they contributed unabashedly to Roman imperial propaganda.

AUGUSTUS OF PRIMAPORTA. The sculpture known as **AUGUSTUS OF PRIMAPORTA** (FIG. 6–20), discovered in Livia's villa at Primaporta, near Rome, demonstrates the creative assimilation of earlier sculptural traditions into a new context. In its idealization of a specific ruler and his prowess, the sculpture also illustrates the use of imperial portraiture for propaganda. The sculptor of this larger-than-life marble statue adapted the orator's gesture of

Aulus Metellus (SEE FIG. 6–11) and combined it with the pose and ideal proportions developed by the Greek Polykleitos and exemplified by the Spear Bearer (SEE FIG. 5–24). To this combination the Roman sculptor added mythological imagery that exalts Augustus's family. Cupid, son of the goddess Venus, rides a dolphin next to the emperor's right leg, a reference to the claim of the emperor's family, the Julians, to descent from the goddess Venus through her human son Aeneas. Although Augustus wears a cuirass (torso armor) and may have held a commander's baton or the Parthian standard, his feet are bare, suggesting to some scholars his elevation to divine status after death.

This imposing statue creates a recognizable image of Augustus, yet it is far removed from the intensely individualized portrait style that was popular during the Republican period. Augustus was in his late seventies when he died, but in his portrait sculpture he is always a vigorous young ruler. Whether depicting Augustus as a general praising his troops or as a peacetime leader speaking words of encouragement to his people, the sculpture projects the image of a benign ruler, touched by the gods, who governs by reason and persuasion, not autocratic power.

THE ARA PACIS. The ARA PACIS AUGUSTAE, OR ALTAR OF AUGUSTAN PEACE (FIG. 6–21), begun in 13 BCE and dedicated in 9 BCE, commemorates Augustus's triumphal return to Rome after establishing Roman rule in Gaul and Hispania. In its original location, in the Campus Martius (Plain of Mars), the Ara Pacis was aligned with a giant sundial that had an Egyptian obelisk as its pointer, suggesting that Augustus controlled time itself. A walled rectangular enclosure surrounded the altar. Its decoration is a thoughtful union of portraiture and allegory, religion and politics, the private and the public. On the inner walls, garlands of flowers are suspended in swags, or loops, from ox skulls. The ox skulls symbolize sacrificial offerings, and the garlands, which unrealistically include flowering plants from every season, signify continuous peace.

Decorative allegory gives way to Roman realism on the exterior side walls, where sculptors depicted the just-completed procession with its double lines of senators and magistrates (on the north) and Augustus, priests, and imperial family members (on the south). Here recognizable people wait for

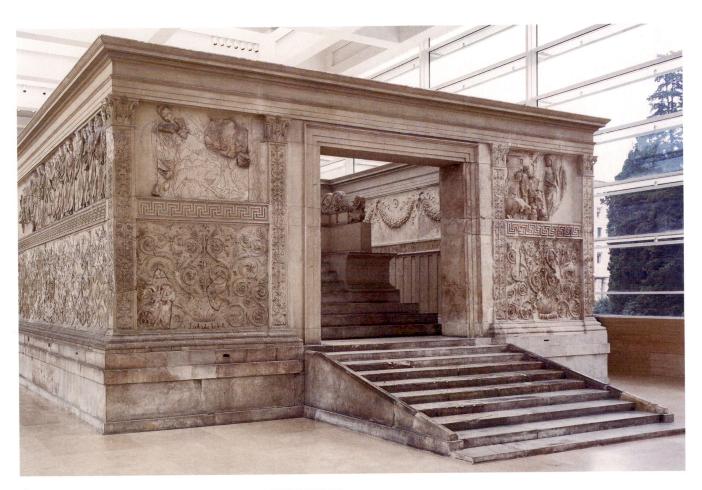

6–21 ARA PACIS AUGUSTAE (ALTAR OF AUGUSTAN PEACE) Rome. 13–9 BCE. Marble, approx. 34'5'' (10.5 m) \times 38' (11.6 m). View of west side.

At the time of the fall equinox (the time of Augustus's conception), the shadow of the obelisk pointed to the open door of the altar's enclosure wall, on which sculptured panels depicted the first rulers of Rome—the warrior-king Romulus and Numa Pompilius. Consequently, the Ara Pacis celebrates Augustus as both a warrior and a peacemaker. The monument was begun when Augustus was 50 (in 13 BCE) and was dedicated on Livia's 50th birthday (9 BCE).

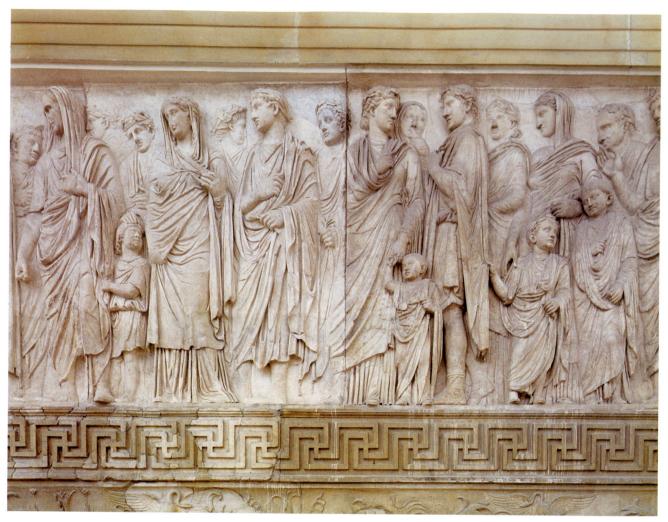

6-22 IMPERIAL PROCESSION

Detail of a relief on the south side of the Ara Pacis. Height 5'2" (1.6 m).

The middle-aged man with the shrouded head at the far left is Marcus Agrippa, who would have been Augustus's successor had he not died in 12 CE. The bored but well-behaved youngster pulling at Agrippa's robe—and being restrained gently by the hand of the man behind him—is probably Agrippa's son Gaius Caesar. The heavily swathed woman next to Agrippa on the right may be Augustus's wife, Livia, followed by Tiberius, who would become the next emperor. Behind Tiberius is Antonia, the niece of Augustus, looking back at her husband, Drusus, Livia's younger son. She grasps the hand of Germanicus, one of her younger children. Behind their uncle Drusus are Gnaeus and Domitia, children of Antonia's older sister, who can be seen beside them. The depiction of children in an official relief was new to the Augustan period and reflects Augustus's desire to promote private family life as well as his potential heirs.

other ceremonies to begin. At the head of the line on the south side of the altar is Augustus (not shown), with members of his family waiting behind him (FIG. 6–22). Unlike the Greek sculptors who created an ideal procession for the Parthenon frieze (SEE FIG. 5–38), the Roman sculptors of the Ara Pacis depicted actual individuals participating in a specific event at a known time. To suggest a double line of marchers in space, they varied the height of the relief, with the closest elements in high relief and those farther back in increasingly lower relief. They draw spectators into the event by making the feet of the nearest figures project from the architectural groundline into the viewers' space.

Moving from this procession, with its immediacy and naturalness, to the east and west ends of the enclosure wall, we find panels of quite a different character, an allegory of Peace and War in two complementary pairs of images. On the west front

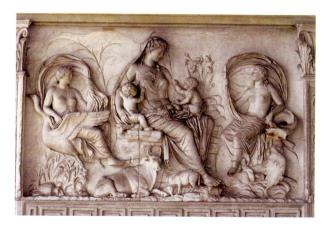

6–23 **ALLEGORY OF PEACE**Relief on the east side of the Ara Pacis. Height 5'2" (1.6 m).

(SEE FIG. 6–21) are Romulus and (probably) Aeneas. On the east side are personifications (symbols in human form) of Roma (the triumphant empire) and Pax (the goddess of peace).

In the best-preserved panel, the **ALLEGORY OF PEACE** (FIG. 6–23), the goddess Pax, who is also understood to be Tellus Mater, or Mother Earth, nurtures the Roman people, represented by the two chubby babies in her arms. She is accompanied by two young women with billowing veils, one seated on the back of a flying swan (the land wind), the other reclining on a sea monster (the sea wind). The sea wind, symbolized by the sea monster and waves, would have reminded Augustus's contemporaries of Rome's dominion over the Mediterranean; the land wind, symbolized by the swan, the jug of fresh water, and the vegetation, would have suggested the fertility of Roman farms. The underlying theme of a peaceful, abundant Earth is reinforced by the flowers and foliage in the background and the domesticated animals in the foreground.

Although the inclusion in this panel of features from the natural world—sky, water, rocks, and foliage—represents a Roman contribution to monumental sculpture, the idealized figures themselves are clearly drawn from Greek sources. The artists have conveyed a sense of three-dimensionality and volume by turning the figures in space and wrapping them in revealing draperies. The scene is framed by Corinthian pilasters

supporting a simple entablature. A wide molding with a Greek key pattern (meander) joins the pilasters and divides the wall into two horizontal segments. Stylized vine and flower forms cover the lower panels. More foliage overlays the pilasters, culminating in the acanthus-covered capitals. The delicacy and the minute detail with which even the ornamental forms are rendered are characteristic of Roman decorative sculpture.

The Julio-Claudians

After his death in 14 CE, the Senate ordered Augustus to be venerated as a god. Augustus's successor was his stepson Tiberius (ruled 14–37 CE), and in acknowledgment of the lineage of both—Augustus from Julius Caesar and Tiberius from his father, Tiberius Claudius Nero, Livia's first husband—the dynasty is known as the Julio-Claudian (14–68 CE). Although the family produced some capable administrators, its rule was marked by suspicion, intrigue, and terror. The dynasty ended with the reign of the despotic, capricious Nero. A brief period of civil war followed Nero's death in 68 CE, until an astute general, Vespasian, seized control of the government in 69 CE.

Exquisite skill characterizes the arts of the first century. A large onyx cameo (a gemstone carved in low relief) known as the **GEMMA AUGUSTEA** glorifies Augustus as triumphant over barbarians and as the deified emperor (FIG. 6–24).

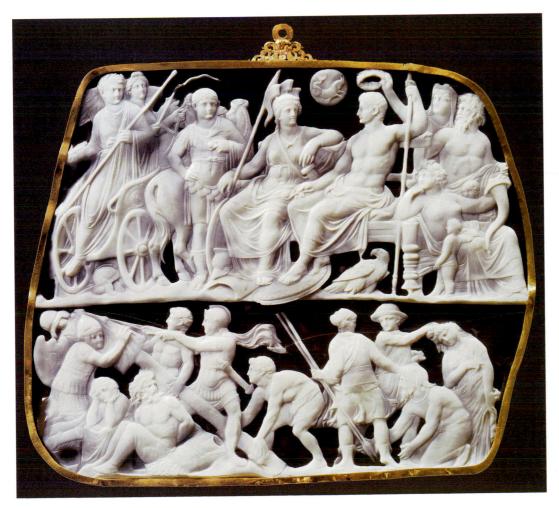

6-24 **GEMMA AUGUSTEA** Early 1st century CE. Onyx, $7\frac{1}{2} \times 9''$ (19 \times 23 cm). Kunsthistorisches Museum, Vienna.

The emperor, crowned with a victor's wreath, sits at the center right of the upper register. He has assumed the identity of Jupiter, the king of the gods; an eagle, sacred to Jupiter, stands at his feet. Sitting next to him is a personification of Rome that has Livia's features. The sea goat in the roundel between them may represent Capricorn, the emperor's zodiac sign.

Tiberius, as the adopted son of Augustus, steps out of a chariot at the left. Returning victorious from the German front, he assumes the imperial throne. Below this realm of godly rulers, Roman soldiers are raising a post or standard on which armor captured from the defeated enemy is displayed. The cowering, shackled barbarians on the bottom right wait to be tied to this post. The artist of the *Gemma Augustea* brilliantly combines idealized, heroic figures characteristic of Classical Greek art with recognizable Roman portraits, the dramatic action of Hellenistic art with Roman realism.

The Roman City and the Roman Home

In good times and bad, individual Romans—like people everywhere at any time—tried to live a decent or even comfortable life with adequate shelter, food, and clothing. Despite their urbanity, as we have noted, Romans liked to portray themselves as simple country folk who had never

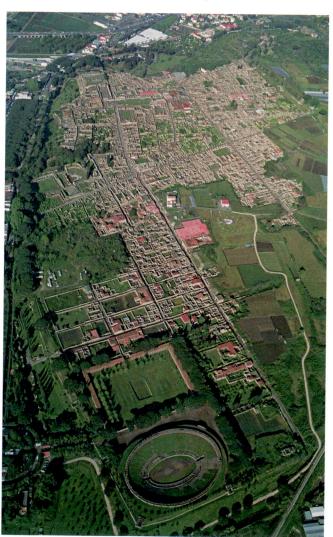

lost their love of nature. The middle classes enjoyed their gardens, wealthy city-dwellers maintained rural estates, and Roman emperors had country villas that were both functioning farms and places of recreation. Wealthy Romans even brought nature indoors by commissioning artists to paint landscapes on the interior walls of their homes. Through the efforts of the modern archaeologists who have excavated them, Roman cities and towns, houses, apartments, and country villas evoke the ancient Roman way of life with amazing clarity.

ROMAN CITIES. Roman architects who designed new cities or who expanded and rebuilt existing ones based the urban plan on the layout of the army camp. These camps were laid out in a grid, but unlike Greek cities such as Miletos, two main streets crossed at right angles dividing the camp—or the city—into quarters. The commander's headquarters, or in a city, the forum and other public buildings, were located at this intersection.

Much of the housing in a Roman city consisted of brick apartment blocks called *insulae*. These apartment buildings had internal courtyards, multiple floors joined by narrow staircases, and occasionally overhanging balconies. City-

6–25 AERIAL VIEW OF THE CITY OF POMPEII 79 CE.

dwellers—then as now—were social creatures who lived much of their lives in public markets, squares, theaters, baths, and neighborhood bars. The city-dweller returned to the insulae to sleep, perhaps to eat. Even women enjoyed a public life outside the home—a marked contrast to the circumscribed lives of Greek women.

The affluent southern Italian city of Pompeii, a thriving center of between 10,000 and 20,000 inhabitants, gives a vivid picture of Roman city life. In 79 CE Mount Vesuvius erupted, burying the city under more than 20 feet of volcanic ash and preserving it until its recovery began in the seventeenth century and rediscovery in the eighteenth century. An ancient village that had grown and spread over many centuries, Pompeii lacked the gridlike regularity of newer, planned Roman cities, but its layout is typical of cities that grew over time (FIG. 6-25). Temples and government buildings surrounded a main square, or forum; shops and houses lined straight paved streets; and a protective wall enclosed the heart of the city. The forum was the center of civic life in Roman towns and cities, as the agora was in Greek cities. Business was conducted in its basilicas and porticoes, religious duties performed in its temples, and speeches presented in its

Sequencing Works of Art

13-9 BCE	Ara Pacis Augustae
c. 10−30 ce	Gemma Augustea
c. 40-60 CE	Wall painting, House of M. Lucretius Fronto
c. 62-79 CE	Peristyle Garden, House of the Vetii, Pompeii
c. 81 CE	Spoils from the Temple of Solomon, Jerusalem, from the Arch of Titus
70-80 CE	Flavian Amphitheater (Colosseum)

open square. For recreation, people went to the nearby baths or to events in the theater or amphitheater.

The people of Pompeii lived in houses behind or above rows of shops (FIG. 6–26). Even the gracious private residences with gardens often had street-level shops. If there was no shop, the wall facing the street was usually broken only by a door, for the Romans emphasized the interior rather than the exterior in their domestic architecture.

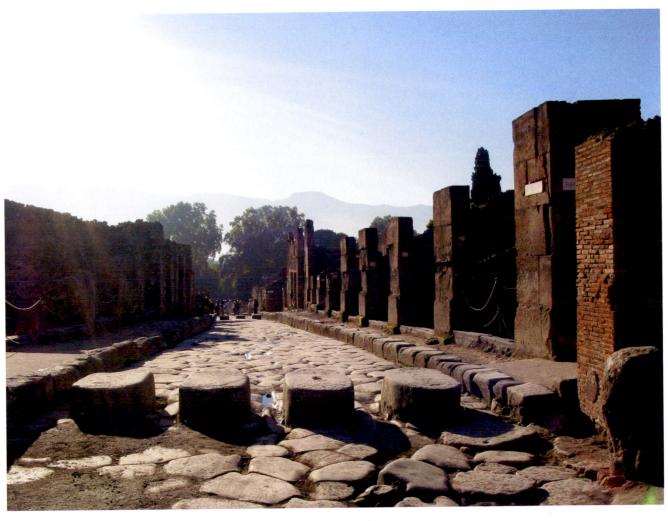

6-26 STREET IN POMPEII

6-27 PLAN OF THE VILLA OF THE MYSTERIES

Pompeii, early second century BCE.

- 1) entrance foyer, 2) peristyle,
- 3) atrium, 4) pool (water basin),
- 5) tablinium (office, official reception room), 6) room with paintings of mysteries, 7) terrace,
- 8) bedroom

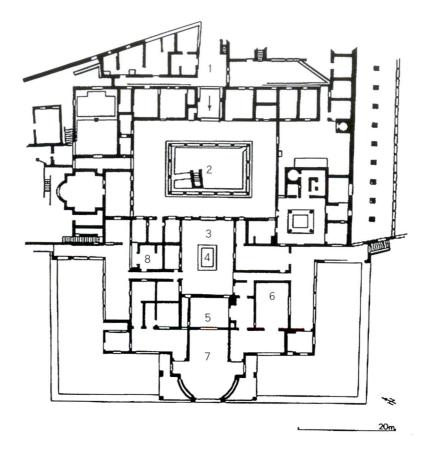

THE ROMAN HOUSE. A Roman house usually consisted of small rooms laid out around one or two open courts, the atrium and the peristyle (FIG. 6-27). The atrium was a large space with a pool or cistern for catching rainwater. The peristyle was a planted interior court enclosed by columns. The formal reception room or office was called the tablinum, and here the head of the household conferred with clients. Portrait busts of the family's ancestors might be displayed there or in the atrium. Rooms were arranged symmetrically. The private areas—such as the family sitting room and bedrooms and the service areas such as the kitchen and servants' quarters—usually were entered from the peristyle. In Pompeii, where the mild southern climate permitted gardens to flourish yearround, the peristyle was often turned into an outdoor living room with painted walls, fountains, and sculpture, as in the mid-first-century CE remodeling of the second-century BCE **HOUSE OF THE VETTII** (FIG. 6–28). The Villa (a country house) combined family living with facilities required by the farm.

THE URBAN GARDEN. The nature-loving Romans softened the regularity of their homes with beautifully designed and planted gardens. Fruit- and nut-bearing trees and occasionally olive trees were arranged in irregular rows. Some houses had both peristyle gardens and separate vegetable gardens. Only the great luxury villas had the formal landscaping and topiery work (fanciful clipped shrubbery) praised by ancient writers.

Little was known about these gardens until the archaeologist Wilhelmina Jashemski began the excavation of the peristyle in the House of G. Polybius in Pompeii in 1973. Earlier archaeologists had usually destroyed evidence of gardens, but Jashemski developed a new way to find and analyze the layout and the plants cultivated in them. Workers first removed layers of debris and volcanic material to expose the level of the soil as it was before the eruption in 79 CE. They then collected samples of pollen, seeds, and other organic material and carefully injected plaster into underground root cavities. When the surrounding earth was removed, the roots, now in plaster, enabled botanists to identify the types of plants and trees cultivated in the garden and to estimate their size.

The garden in the house of Polybius was surrounded on three sides by a portico, which protected a large cistern on one side that supplied the house and garden with water. Young lemon trees in pots lined the fourth side of the garden, and nail holes in the wall above the pots indicated that the trees had been espaliered—pruned and trained to grow flat against a support—a practice still in use today. Fig, cherry, and pear trees filled the garden space, and traces of a fruit-picking ladder, wide at the bottom and narrow at the top to fit among the branches, was found on the site. This evidence suggests that the garden was a densely planted orchard similar to the one painted on the dining-room walls of the villa of Empress Livia in Primaporta (SEE FIG. 6–31).

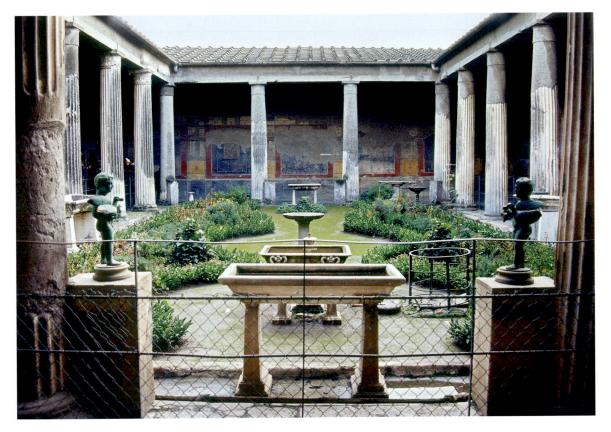

6–28 **PERISTYLE GARDEN, HOUSE OF THE VETTII** Pompeii. Rebuilt 62–79 CE.

An aqueduct built during the reign of Augustus eliminated Pompeii's dependence on wells and rainwater basins and allowed residents to add pools, fountains, and flowering plants that needed heavy watering to their gardens. In contrast to earlier, unordered plantings, formal gardens with low, clipped borders and plantings of ivy, ornamental boxwood, laurel, myrtle, acanthus, and rosemary-all mentioned by writers of the time-became fashionable. There is also evidence of topiary work, the clipping of shrubs and hedges into fanciful shapes. Sculpture and purely decorative fountains became popular. The peristyle garden of the House of the Vettii, for example, had more than a dozen fountain statues jetting water into marble basins (SEE FIG. 6-28). In the most elegant peristyles, mosaic decorations covered the floors, walls, and even the fountains. Some of the earliest wall mosaics, such as the one from a wall niche in a Pompeian garden, were created as backdrops for fountains (FIG. 6-29).

Wall Painting

The interior walls of Roman houses were plain, smooth plaster surfaces with few architectural features. On these invitingly empty spaces, artists painted decorations using pigment in a solution of lime and soap, sometimes with a little wax. After the painting was finished, they polished it with a special metal, glass, or stone burnisher and then buffed the surface with a cloth. Many fine wall paintings have come to light

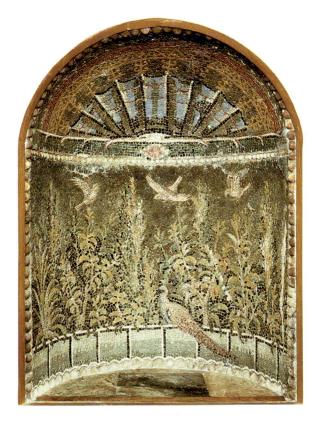

6–29 FOUNTAIN MOSAIC Wall niche, from a garden in Pompeii. Mid-1st century CE. Mosaic, $43\,\% \times 31\,\%$ " (111 \times 80 cm). Fitzwilliam Museum, University of Cambridge, England.

through excavations, first in Pompeii and other communities surrounding Mount Vesuvius, near Naples, and more recently in and around Rome.

In the earliest paintings (200–80 BCE), artists attempted to produce the illusion of thin slabs of colored marble covering the walls, which were set off by actual architectural moldings and columns. By about 80 BCE, they began to extend the space of a room visually with painted scenes of figures on a shallow "stage" or with a landscape or cityscape. Architectural details such as columns were painted rather than made of molded plaster.

ROMAN REALISM: CREATING AN ILLUSION OF THE WORLD. One of the most famous painted rooms in Roman art is in the socalled **VILLA OF THE MYSTERIES** just outside the city walls of Pompeii (FIG. 6–30; SEE PLAN IN FIG. 6–27). The rites of mystery religions were often performed in private homes as well as in special buildings or temples, and this room, at the corner of a suburban villa, must have been a shrine or meeting place for such a cult. The murals depict initiation rites—probably into the cult of Bacchus, who was the god of vegetation and fertility as well as wine. Bacchus (or Dionysus) was one of the most important deities in Pompeii.

The entirely painted architectural setting consists of a "marble" dado (the lower part of a wall) and, around the top of the wall, an elegant frieze supported by pilasters. The action takes place on a shallow "stage" along the top of the dado, with a background of brilliant, deep red—now known as Pompeian red. This red was very popular with Roman

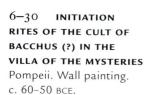

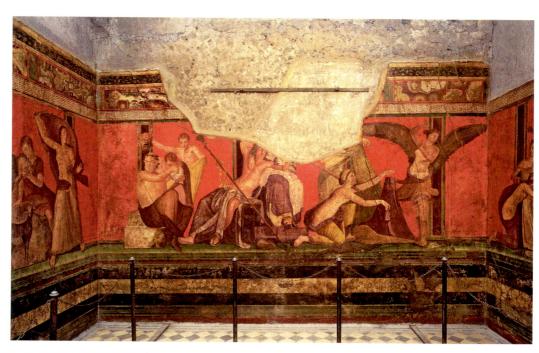

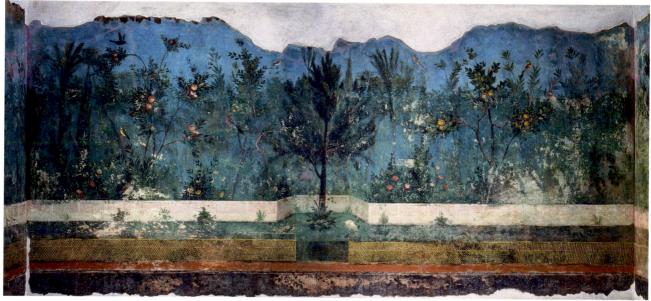

6-31 GARDEN SCENE

Detail of a wall painting from the dining room of the Villa of Livia at Primaporta, near Rome. Late 1st century BCE. Museo Nazionale Romano, Rome.

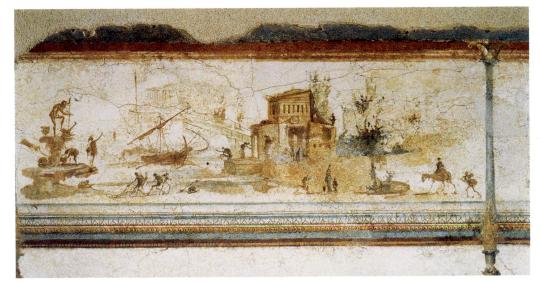

6-32 SEASCAPE AND COASTAL TOWNS
Detail of a wall painting from Villa Farnesina,
Rome. Late 1st century CE.

painters. The scene unfolds around the entire room, perhaps depicting a succession of events that culminate in the acceptance of an initiate into the cult.

The dining-room walls of Livia's Villa at Primaporta exemplify yet another approach to creating a sense of expanded space (FIG. 6–31). Instead of rendering a stage set, the artist "painted away" the wall surfaces to create the illusion of being on a porch or pavilion looking out over a low wall into an orchard of heavily laden fruit trees. These and the flowering shrubs are filled with a variety of wonderfully observed birds.

In such paintings, the overall effect is one of an idealized view of the world, rendered with free, fluid brushwork and delicate color. A painting from the Villa Farnesina, found in excavations in Rome (FIG. 6–32), depicts the *locus amoenus*, the "lovely place" extolled by Roman poets, where people lived effortlessly in union with the land. Here two conventions create the illusion of space: Distant objects are rendered proportionally smaller than near objects, and the colors become slightly grayer near the horizon, an effect called *atmospheric perspective*—that is, the tendency of distant objects to appear hazy and lighter in color.

ELEGANT FANTASIES: BOSCOREALE AND POMPEII. The walls of a room from a villa at Boscoreale near Pompeii (reconstructed in the Metropolitan Museum of Art in New York) open onto a fantastic urban panorama (FIG. 6–33). The wall

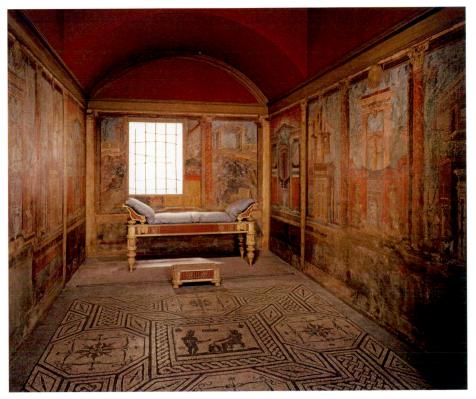

6–33 RECONSTRUCTED BEDROOM House of Publius Fannius Synistor, Boscoreale, near Pompeii. Late 1st century BCE, with later furnishings. The Metropolitan Museum of Art, New York.

Rogers Fund, 1903 (03.14.13)

Although the elements in the room are from a variety of places and dates, they give a sense of how the original furnished room might have looked. The wall paintings, original to the Boscoreale villa, may have been inspired by theater scene painting. The floor mosaic, found near Rome, dates to the second century CE. At its center is an image of a priest offering a basket with a snake to a cult image of Isis. The luxurious couch and footstool, inlaid with bone and glass, date from the first century CE.

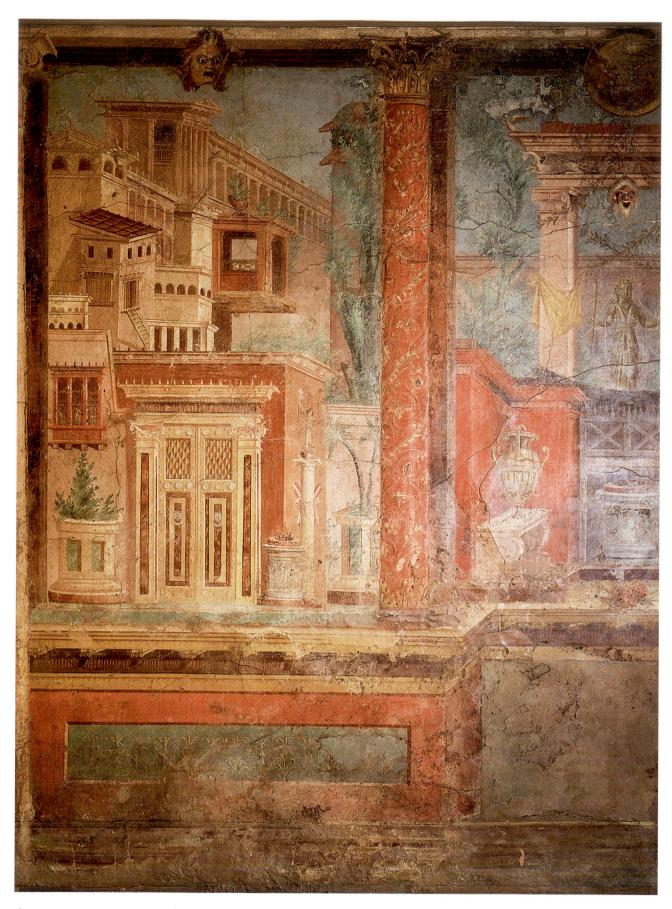

6-34 CITYSCAPE

Detail of a wall painting from a bedroom in the House of Publius Fannius Synistor, Boscoreale. Late 1st century CE. The Metropolitan Museum of Art, New York. Rogers Fund, 1903 (03.14.13)

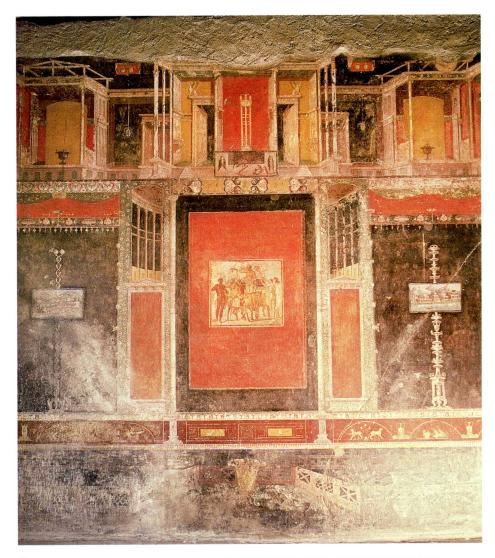

6-35 **DETAIL OF A WALL PAINTING IN THE HOUSE OF M. LUCRETIUS FRONTO** Pompeii. Mid-1st century CE.

surfaces seem to dissolve behind columns and lintels, which frame a maze of floating architectural forms creating purely visual effects, like the backdrops of a stage. Indeed, the theater may have inspired this kind of decoration, as details in the room suggest. For example, on the rear wall, next to the window, is a painting of a grotto, the traditional setting for satyr plays, dramatic interludes about the half-man, half-goat followers of Bacchus. On the side walls, paintings of theatrical masks hang from the lintels.

As one looks more closely, the architecture becomes a complex jumble of buildings with balconies, windows, arcades, and roofs at different levels, as well as a magnificent colonnade (FIG. 6–34). By using an intuitive perspective, the artist has created a general impression of real space. In intuitive perspective, the architectural details follow diagonal

lines that the eye interprets as parallel lines receding into the distance, and objects meant to be perceived as far away from the surface plane of the wall are shown slightly smaller than those intended to appear nearby. The orderly focus of a single point of view, however, is lacking.

As time passed, this painted architecture became increasingly fanciful. Solid-colored walls were decorated with slender, whimsical architectural and floral details and small, delicate vignettes. In the **HOUSE OF M. LUCRETIUS FRONTO** in Pompeii, from the mid-first century CE (FIG. 6–35), the artist painted a room with panels of black and red, bordered with architectural moldings. These architectural elements have no logic, and for all their playing with space, they fail to create any significant illusion of depth. Rectangular pictures seem to be mounted on the black and red panels.

Art and Its Context

THE POSITION OF ROMAN WOMEN

f we were to judge from the conflicting accounts of Roman writers, Roman women were either shockingly wicked and willful, totally preoccupied with clothes, hairstyles, and social events, or they were well-educated, talented, active members of family and society. In ancient Rome, as in the contemporary world, sin sold better than saintliness, and for that reason written attacks on women by their male contemporaries must be viewed with some reservation. Roman women were far freer and more engaged in society than their Greek counterparts (however, to judge from art, so were women in Egypt and Crete). Many women received a formal education, and a well-educated woman was admired. Although many women became physicians, shopkeepers, and even overseers in such male-dominated businesses as shipbuilding, education was valued primarily for the desirable status it imparted.

Ovid (43 BCE-17 CE) advised all young women to read both the Greek classics and contemporary Roman literature, including of course, his own. Women conversant with political and cultural affairs and with a reputation for good conversation enjoyed the praise and admiration of some male writers. A few women even took up literature themselves. Julia Balbilla was respected for her poetry. Another woman, Sulpicia, a writer of elegies, was accepted into male literary circles. Her works were recommended by the author Martial to men and women alike. The younger Agrippina, sister of the emperor Caligula and mother of Nero, wrote a history of her illustrious family.

Women were also encouraged to become accomplished singers, musicians, and even dancers—as long as they did not perform publicly. Almost nothing appears in literature about women in the visual arts, no doubt because visual artists were not highly regarded.

The scene with figures in the center is flanked by two small simulated window openings protected by grilles. The two pictures of villas in landscapes appear to float in front of intricate bronze easels.

ROMAN REALISM IN DETAILS: STILL LIFES AND PORTRAITS.

In addition to landscapes and city views, other subjects that appeared in Roman art included historical and mythological scenes, exquisitely rendered still lifes (compositions of inanimate objects), and portraits. A still-life panel from Herculaneum, a community in the vicinity of Mount Vesuvius near Pompeii, depicts everyday domestic objects—still-green peaches just picked from the tree and a glass jar half filled with water (FIG. 6–36). The items have been carefully arranged on two shelves to give the composition clarity and balance. A strong, clear light floods the picture from right to left, casting shadows, picking up highlights, and enhancing the illusion of real objects in real space.

Portraits, sometimes imaginary ones, also became popular. A first-century tondo (circular panel) from Pompeii contains the portrait YOUNG WOMAN WRITING (FIG. 6–37). The sitter has regular features and curly hair caught in a golden net. As in a modern studio portrait photograph, with its careful lighting and retouching, the young woman may be somewhat idealized. Following a popular convention, she nibbles on the tip of her stylus. Her sweet expression and clear-eyed but unfocused and contemplative gaze suggest that she is in the throes of composition.

The paintings in Pompeii reveal much about the lives of women during this period (see "The Position of Roman

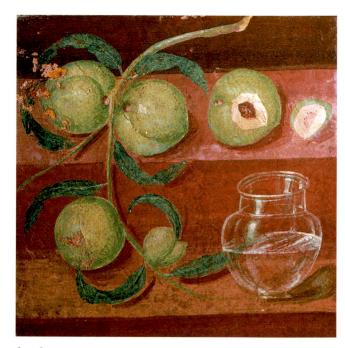

6–36 STILL LIFE Detail of a wall painting from House of the Stags (Cervi), Herculaneum. Before 79 CE. Approx. $1'2'' \times 1' \frac{1}{2}''$ (35.5 \times 31.7 cm). Museo Nazionale, Naples.

Women," above). Some, like Julia Felix, were the owners of houses where paintings were found. Others were the subjects of the paintings. They are shown as rich and poor, young and old, employed as business managers and domestic workers.

The Flavians

The Julio-Claudian dynasty ended with the suicide of Nero in 68 CE, to be replaced by the Flavians, practical military men who restored confidence and ruled for the rest of the first century. They restored the imperial finances and stabilized the frontiers, but during the autocratic reign of the last Flavian, Domitian, intrigue and terror returned to the capital.

THE ARCH OF TITUS. Among the most admirable official commissions during the Flavian dynasty is a distinctive Roman structure, the triumphal arch. Part architecture, part sculpture, the freestanding arch commemorates a triumph, or formal victory celebration, during which a victorious general or emperor paraded through the city with his troops, captives, and booty. When Domitian assumed the throne in 81 CE, for example, he immediately commissioned a triumphal arch to honor the capture of Jerusalem in 70 CE by his brother and deified predecessor, Titus (FIG. 6-38). THE ARCH OF TITUS, constructed of concrete and faced with marble, is essentially a freestanding gateway whose passage is covered by a barrel vault. The arch served as a giant base, 50 feet tall, for a statue of a four-horse chariot and driver, a typical triumphal symbol. Applied to the faces of the arch are columns in the Composite order supporting an entablature. The inscription on the attic story declares that the Senate and the Roman people erected the monument to honor Titus.

Titus's capture of Jerusalem ended a fierce campaign to crush a revolt of the Jews in Palestine. The Romans sacked and

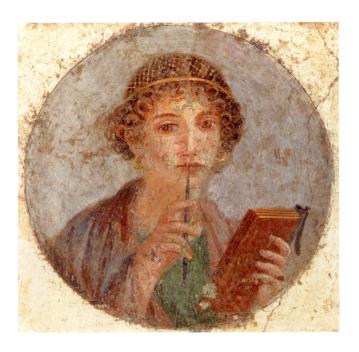

Sequencing Events REIGNS OF NOTABLE ROMAN EMPERORS

The Early Empire	27 все- 96 се
Augustus	27 BCE-14 CE
	14-69 CE
The Julio-Claudians Tiberius	14-37 CE
	37-41 CE
Caligula	
Claudius	41-54 CE
Nero	54-68 CE
The Flavians	69-96 CE
Vespasian	69-79 CE
Titus	79-81 CE
Domitian	81-96 CE
The High Empire	96-192 CE
Nerva	96-98 CE
Trajan	98-117 CE
Hadrian	117-138 се
The Antonines	138-192 CE
Antoninus Pius	138-161 CE
Marcus Aurelius	161-180 CE
Commodus	180-192 CE
The Late Empire	192-476 CE
Septimius Severus	193-211 CE
Caracalla	211-217 CE
Alexander Severus	222-235 CE
Diocletian	284-305 CE
The Tetrarchy (Rule of Four)	293-305/312 CE
Constantine I	312-337 CE
Death of Romulus	
Augustus (last emperor	.=.
in the West)	476 CE

6-37 YOUNG WOMAN WRITING

Detail of a wall painting, from Pompeii. Before 79 CE. Diameter 14%" (37 cm). Museo Archeològico Nazionale, Naples.

The fashionable young woman seems to be pondering what she will write about with her stylus on the beribboned writing tablet that she holds in her other hand. Romans used pointed styluses to engrave letters on thin, wax-coated ivory or wood tablets in much the way we might use a hand-held computer. Errors could be easily smoothed over. When a text or letter was considered ready, it was copied onto expensive papyrus or parchment. Tablets like these were also used by schoolchildren for their homework.

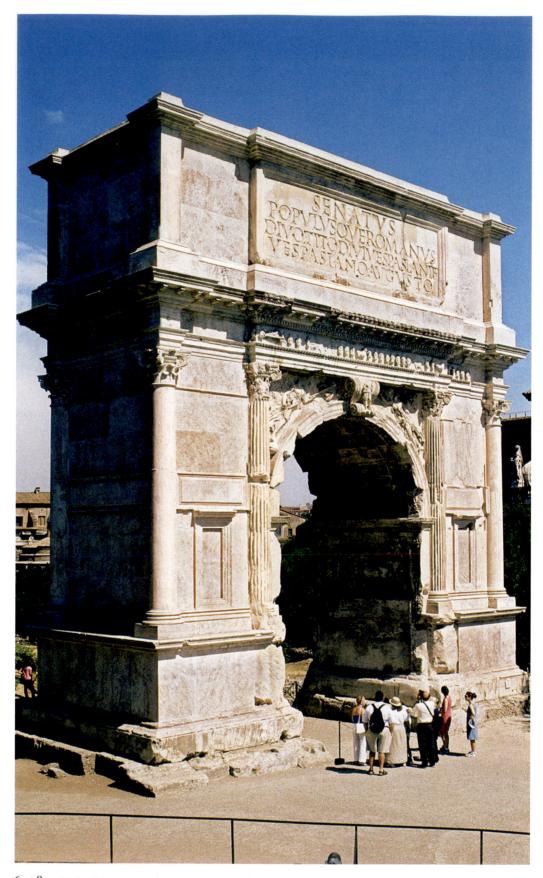

6–38 THE ARCH OF TITUS

Rome. c. 81 CE (Restored 1822–24). Concrete and white marble, height 50′ (15 m).

The dedication inscribed across the tall attic story above the arch opening reads: "The Senate and the Roman People to the Deified Titus Vespasian Augustus, son of the Deified Vespasian." The perfectly sized and spaced Roman capital letters meant to be read from a distance and cut with sharp terminals (serifs) to catch the light established a standard that calligraphers and alphabet designers still follow.

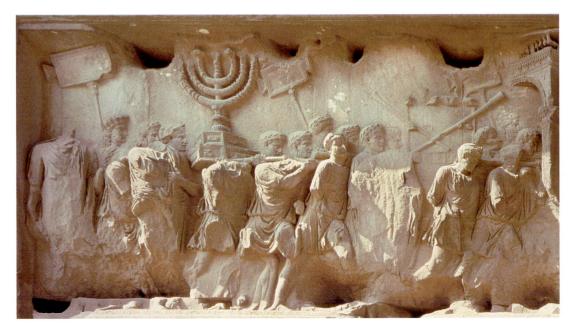

6-39 SPOILS FROM THE TEMPLE OF SOLOMON Relief in the passageway of the Arch of Titus. Marble, height 6'8'' (2.03 m).

destroyed the Second Temple in Jerusalem, carried off its sacred treasures (FIG. 6–39), then displayed them in a triumphal procession in Rome (FIG. 6–40). The reliefs on the inside walls of the arch, capturing the drama of the occasion, depict Titus's soldiers flaunting this booty as they carry it through the streets of Rome. The viewer can sense the press of that boisterous, disorderly crowd and might expect at any moment to hear soldiers and onlookers shouting and chanting.

The mood of the procession depicted in these reliefs contrasts with the relaxed but formal solemnity of the procession portrayed on the Ara Pacis (SEE FIG. 6–21). Like the sculptors of the Ara Pacis, the sculptors of the Arch of Titus

showed the spatial relationships among figures, varying the height of the relief by rendering nearer elements in higher relief than those more distant. A menorah, or seven-branched lampholder from the Temple of Jerusalem, dominates one scene; Titus riding in his chariot as a participant in the ceremonies, the other. Reflecting their concern for representing objects as well as people in a believable manner, the sculptors rendered this menorah as if seen from the low point of view of a spectator at the event, and they have positioned the arch on the right through which the procession is about to pass on a diagonal. On the vaulted ceiling, an eagle carries Titus skyward to join the gods.

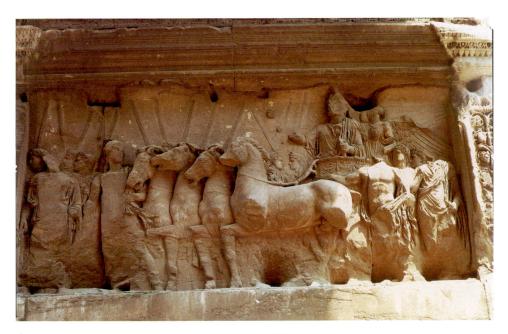

6–40 **TRIUMPHAL PROCESSION, TITUS IN CHARIOT** Relief in the passageway of the Arch of Titus. Marble, height 6'8'' (2.03 m).

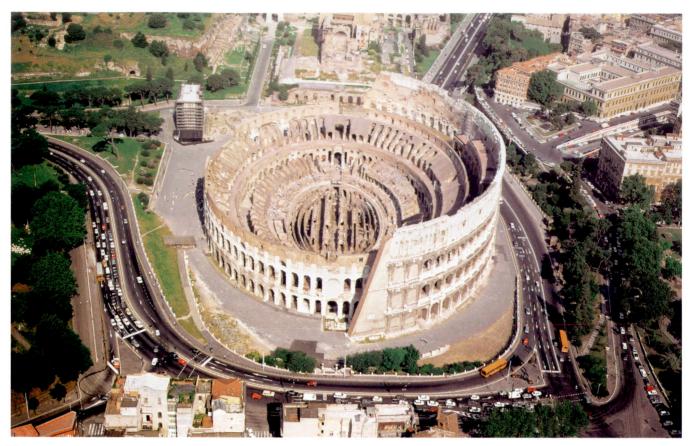

6-41 FLAVIAN AMPHITHEATER (COLOSSEUM) From the air. Rome. 70-80 CE.

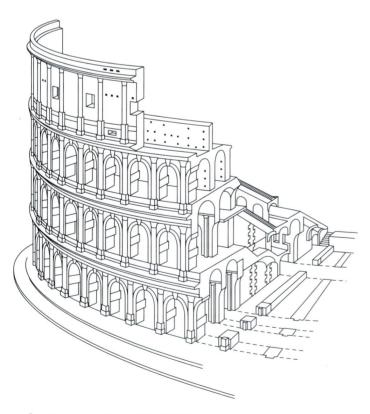

6–42 FLAVIAN AMPHITHEATER Drawing showing vaulted construction.

THE FLAVIAN AMPHITHEATER. In a way, Romans were as sports-mad as modern Americans, and the Flavian emperors catered to their tastes by building splendid facilities. Construction of the FLAVIAN AMPHITHEATER, Rome's greatest arena (FIG. 6-41), began under Vespasian in 70 CE and was completed under Titus, who dedicated it in 80 CE. The Flavian Amphitheater came to be known as the "Colosseum," because a gigantic statue of Nero called the Colossus stood next to it. But "Colosseum" is a most appropriate description of this enormous entertainment center. It is an oval, measuring 615 by 510 feet, with a floor 280 by 175 feet. Its outer wall stands 159 feet high. Roman audiences watched a variety of athletic events and spectacles, including animal hunts, fights to the death between gladiators or between gladiators and wild animals, performances of trained animals and acrobats, and even mock sea battles, for which the arena would be flooded. The opening performances in 80 CE lasted 100 days, during which time it was claimed that 9,000 wild animals and 2,000 gladiators died for the amusement of the spectators.

The floor of the Colosseum was laid over a foundation of service rooms and tunnels that provided an area for the athletes, performers, animals, and equipment. This floor was covered by sand, *arena* in Latin, hence the English term

"arena" for a building of this type. Some 50,000 spectators could move easily through the seventy-six entrance doors to the three levels of seats and the standing area at the top. Each had an uninterrupted view of the spectacle below. Stadiums today are still based on this efficient plan.

The Romans took the form of the Greek theater and enlarged upon it (see Chapter 5, page 159). They constructed freestanding amphitheaters by placing two theaters facing each other to create a central oval-shaped performance area. The amphitheater is a remarkable piece of planning with easy access, perfect sight lines for everyone, and effective crowd control. Ascending tiers of seats were laid over barrel-vaulted access corridors and entrance tunnels that connect the rings of corridors to the ramps and seats on each level (FIG. 6-42). The intersection of the barrel-vaulted entrance tunnels and the ring corridors created groin vaults (see "Arch, Vault, and Dome," page 172). The walls on the top level of the arena supported a huge awning that could shade the seating areas. Sailors who had experience in handling ropes, pulleys, and large expanses of canvas worked the apparatus that extended the awning.

The curving, outer wall of the Colosseum consists of three levels of arcades surmounted by a wall-like attic (top) story. Each arch in the arcades is framed by engaged columns. Entablature-like friezes mark the divisions between levels (FIG. 6–43). Each level also uses a different architectural order, increasing in complexity from bottom to top: the plain Tuscan order on the ground level, Ionic on the second level, Corinthian on the third, and Corinthian pilasters on the fourth. The attic story is broken by small, square windows, which originally alternated with gilded bronze shield-shaped ornaments called cartouches, supported on brackets that are still in place and can be seen in the illustration. Engaged Corinthian pilasters above the Corinthian columns of the third level support another row of corbels beneath the projecting cornice.

All these elements are purely decorative. As we saw in the Etruscan Porta Augusta (SEE FIG. 6–2), the addition of post-and-lintel decoration to arched structures was an Etruscan innovation. The systematic use of the orders in a logical succession from sturdy Tuscan to lighter Ionic to decorative Corinthian follows a tradition inherited from

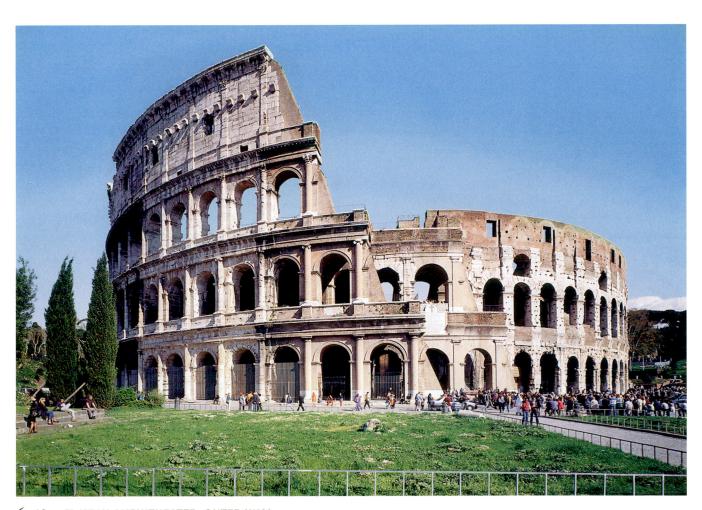

6–43 **FLAVIAN AMPHITHEATER, OUTER WALL** Rome. 70–80 CE.

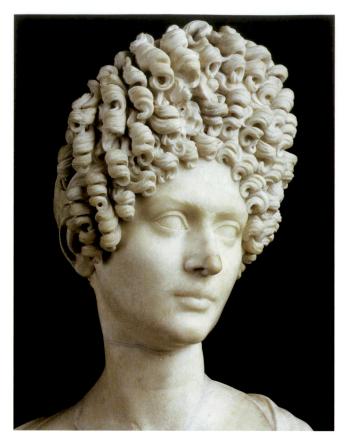

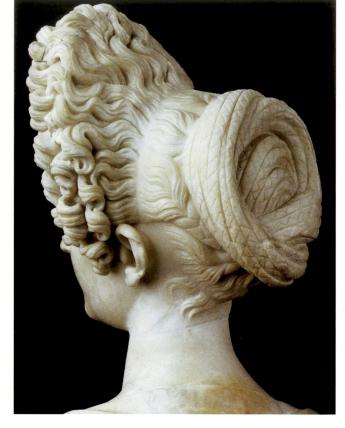

6–44 A YOUNG FLAVIAN WOMAN c. 90 CE. Marble, height 25" (65.5 cm). Museo Capitolino, Rome.

Hellenistic architecture. This orderly, dignified, and visually satisfying way of organizing the façades of large buildings is still popular. Unfortunately, much of the Colosseum was dismantled in the Middle Ages as a source of marble, metal fittings, and materials for buildings such as churches.

PORTRAIT SCULPTURE. Roman patrons continued to demand likenesses in their portraits, but the portrait, A YOUNG FLAVIAN WOMAN (FIG. 6-44), exemplifies the current Roman ideal. Her well-observed, recognizable features—a strong nose and jaw, heavy brows, deep-set eyes, and a long neck-contrast with the smoothly rendered flesh and soft, full lips. (The portrait suggests the retouched fashion photos of today.) Her hair is piled high in an extraordinary mass of ringlets in the latest court fashion. Executing the head required skillful chiseling and drillwork, a technique for rapidly cutting deep grooves with straight sides, as was done here to render the holes in the center of the curls. The overall effect, from a distance, seems very lifelike. The play of natural light over the more subtly sculpted surfaces gives the illusion of being reflected off real skin and hair, yet closer inspection reveals a portrayal too perfect to be real.

A bust of an older woman (FIG. 6–45), reflects a revival of the veristic portraiture popular in the Republican period. The subject of this portrait, though she too wore her hair in the latest style, was apparently not preoccupied with her appearance. The work she commissioned shows her just as she appeared in her own mirror, with all the signs of age recorded on her face.

THE HIGH IMPERIAL ART OF TRAJAN AND HADRIAN

Domitian was assassinated in 96 CE and succeeded by a senator, Nerva (96–98), who designated as his successor Trajan, a general born in Spain and commander of troops in Germany. For nearly a century, the empire was under the control of brilliant administrators. Instead of depending on the vagaries of fate (or genetics) to produce intelligent heirs, the emperors Nerva (96–98), Trajan (98–117), Hadrian (117–138), and Antoninus Pius (138–161) (but not Marcus Aurelius [161–180]) each selected an able administrator to follow him and each thereby "adopted" his successor. Italy and the provinces flourished, and official and private patronage of the arts increased.

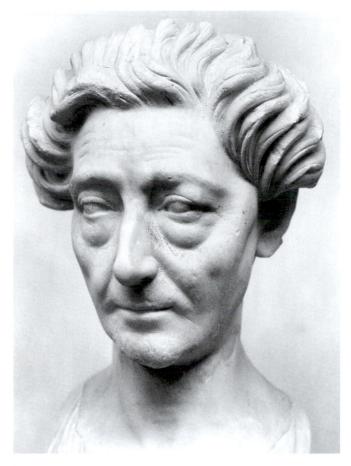

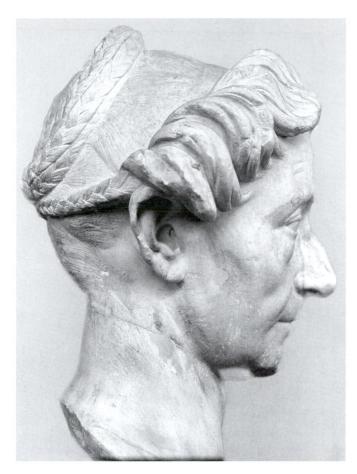

6–45 MIDDLE-AGED FLAVIAN WOMAN Late 1st century CE. Marble, height $9\frac{1}{2}$ " (24.1 cm). Musei Vaticani, Museo Gregoriano Profano, ex-Lateranese, Rome.

Under Trajan, the empire reached its greatest extent. By 106 CE Romans had conquered Dacia, roughly present-day Romania (SEE MAP 6–1). The next emperor, Hadrian, then consolidated the empire's borders and imposed far-reaching social, governmental, and military reforms. Hadrian was well educated and widely traveled, and his admiration for Greek culture spurred new building programs and art patronage throughout the empire. Unfortunately, Marcus Aurelius broke the tradition of adoption and left his son, Commodus, to inherit the throne. Within twelve years, Commodus (180–192) destroyed the government his predecessors had so carefully built.

Imperial Architecture

The Romans believed their rule extended to the ends of the Western world, but the city of Rome remained the nerve center of the empire. During his long and peaceful reign, Augustus had paved the city's old Republican Forum, restored its temples and basilicas, and followed Julius Caesar's example by building an Imperial Forum. These projects marked the beginning of a continuing effort to transform the capital itself into a magnificent monument to imperial rule. While Augustus's claim of having turned Rome into a city of marble is

exaggerated (like most politicians he was speaking metaphorically, not literally), he certainly began the process of creating a monumental civic center. Such grand structures as the Imperial Forums, the Colosseum, the Circus Maximus (a track for chariot races), the Pantheon, and aqueducts stood amid the temples, baths, warehouses, and homes in the city center.

THE FORUM OF TRAJAN. A model of Rome's city center makes apparent the dense building plan (FIG. 6–46). The last and largest Imperial Forum was built by Trajan about 107–113 and finished under Hadrian about 117 CE on a large piece of property next to the earlier forums of Augustus and Julius Caesar (FIG. 6–47). For this major undertaking, Trajan chose a Greek architect, Apollodorus of Damascus, a military engineer. A straight, central axis leads from the Forum of Augustus through a triple–arched gate, surmounted by a bronze chariot group, into a large, colonnaded square with a statue of Trajan on horseback at its center. Closing off the courtyard at the north end was the Basilica Ulpia, dedicated in c. 112 CE, and named for the family to which Trajan belonged.

A basilica was a large, rectangular building with a rounded extension, called an apse, at each end. A general-purpose administrative structure, it could be adapted to

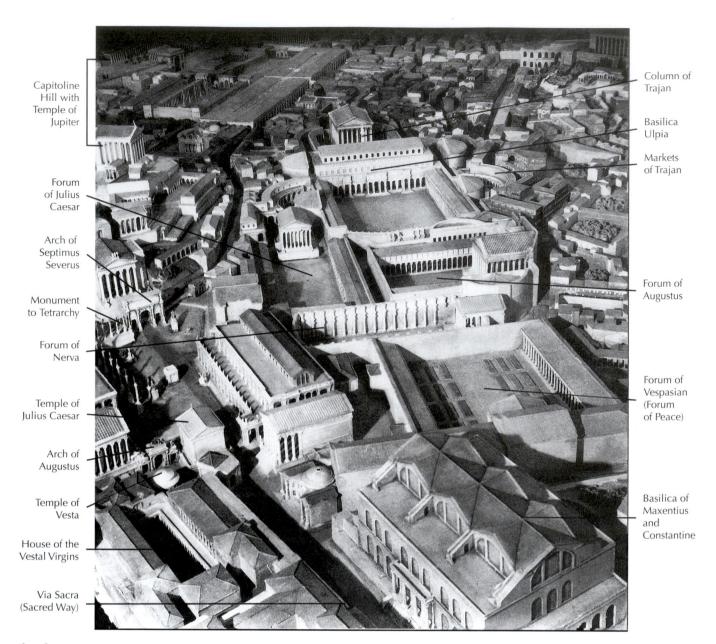

6--46 $\,$ model of the forum romanum and imperial forums Rome. c. 325 Ce.

many uses. The Basilica Ulpia was a court of law, but other basilicas served as imperial audience chambers, army drill halls, and schools. The basilica design provided a large interior space whose many doors on the long sides provided easy access (FIG. 6–48). The Basilica Ulpia was 385 feet long (not including the apses) and 182 feet wide. The interior space consisted of a large central area (the nave) flanked by double colonnaded aisles surmounted by open galleries or by a clerestory, an upper nave wall with windows. The cen-

tral space was taller than the surrounding galleries and was lit directly by an open gallery or clerestory windows. The timber truss roof had a span of about 80 feet. The two apses, one at each end of the building, provided imposing settings for judges when the court was in session.

During the site preparation for the forum, part of a commercial district had to be razed and excavated. To make up for the loss, Trajan ordered the construction of a handsome public market (FIG. 6–49). The market, comparable in size to a large

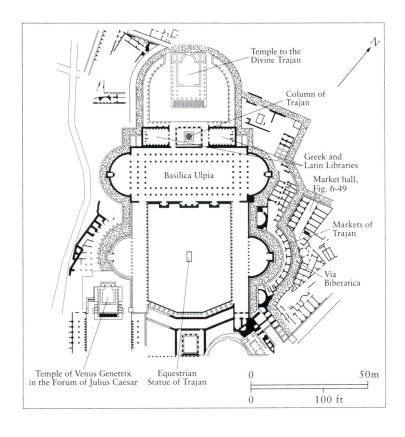

6–47 **PLAN OF TRAJAN'S FORUM** c. 110–113 ce.

6–48 restored perspective view of the central hall

Basilica Ulpia, Rome. c. 112 CE. Drawn by Gilbert Gorski. Trajan's architect was Apollodorus of Damascus.

The building may have had clerestory windows instead of the gallery shown in this drawing. The column of Trajan can be seen at the right.

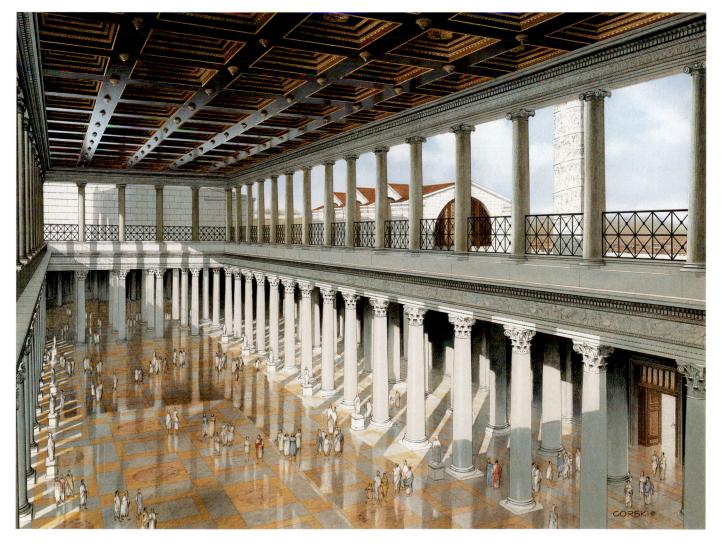

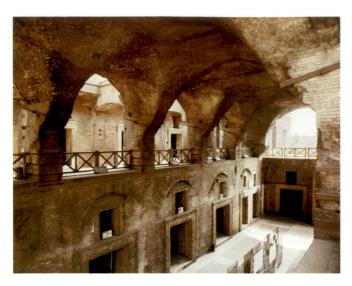

6–49 MAIN HALL, MARKETS OF TRAJAN Rome. 100–12 CE.

modern shopping mall, had more than 150 individual shops on several levels and included a large groin-vaulted main hall. In compliance with a building code that was put into effect after a disastrous fire in 64 CE, the market, like all Roman buildings of the time, had masonry construction—brick-faced concrete, with only some detailing in stone and wood.

Behind the Basilica Ulpia stood twin libraries built to house the emperor's collections of Latin and Greek manuscripts. These buildings flanked an open court and the great spiral column that became Trajan's tomb (Hadrian placed his predecessor's ashes in the base). The column commemorated Trajan's victory over the Dacians and was erected either with the Basilica Ulpia about 113 CE or by Hadrian after Trajan's death in 117 CE. The Temple of the Divine Trajan stands opposite the Basilica Ulpia, forming the fourth side of the court and closing off the end of the forum. Hadrian ordered the temple built after Trajan's death.

THE COLUMN OF TRAJAN. The relief decoration on the COLUMN OF TRAJAN spirals upward in a band that would stretch almost 625 feet if unfurled. Like a giant version of the scrolls housed in the libraries next to it, the column is a continuous pictorial narrative of the Dacian campaigns of 102–103 and 105–106 CE (FIG. 6–50). The remarkable sculpture includes more than 2,500 individual figures linked by landscape, architecture, and the recurring figure of Trajan. The artist took care to make the scroll legible. The narrative band slowly expands from about 3 feet in height at the bottom, near the viewer, to 4 feet at the top of the column, where it is farther from view.

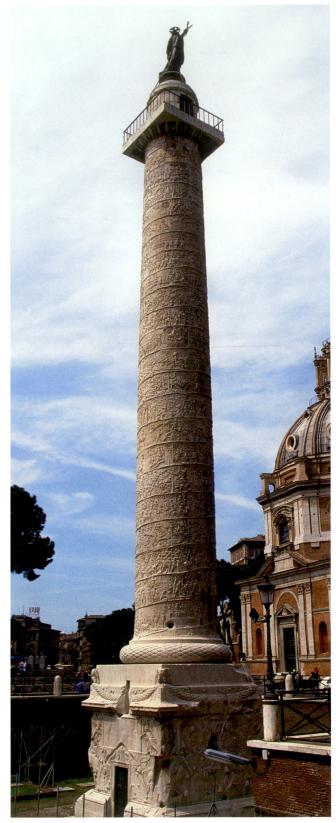

6–50 COLUMN OF TRAJAN

Rome. 113–16 or after 117 CE. Marble, overall height with base 125' (38 m), column alone 97'8'' (29.77 m); relief 625' (190.5 m) long.

The height of the column, 100 Roman feet (97'8", 30 m) may have recorded the depth of the excavation required to build the Forum of Trajan. The column had been topped by a gilded bronze statue of Trajan that was replaced in 1588 CE by order of Pope Sixtus V with the statue of Saint Peter seen today. Trajan's ashes were interred in the base in a golden urn.

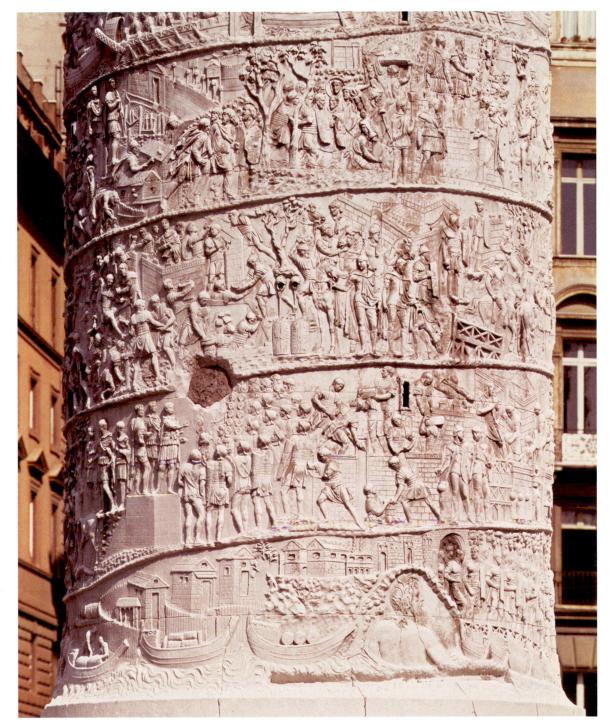

6–51 ROMANS CROSSING THE DANUBE AND BUILDING A FORT

Detail of the lowest part of the Column of Trajan. 113–16 CE, or after 117. Marble, height of the spiral band approx. 36" (91 cm).

The natural and architectural elements in the scenes have been kept small to emphasize the important figures.

On the Column of Trajan, sculptors refined the art of pictorial narrative seen on the Arch of Titus (SEE FIGS. 6–39, 6–40). The scene at the beginning of the spiral, at the bottom of the column, shows Trajan's army crossing the Danube River on a pontoon bridge as the first Dacian campaign of

101 gets under way (FIG. 6–51). Soldiers construct a battle-field headquarters in Dacia from which the men on the frontiers will receive orders, food, and weapons. In this spectacular piece of imperial propaganda, Trajan is portrayed as a strong, stable, and efficient commander of a well-run army, and his barbarian enemies are shown as worthy opponents of Rome.

6–52 PANTHEON Rome c. 118–128 CE.

The approach to the Pantheon is very different today. A huge fountain dominates the square in front of the building. Built in 1578 by Giacomo della Porta, today it supports an Egyptian obelisk placed there in 1711 by Pope Clement XI.

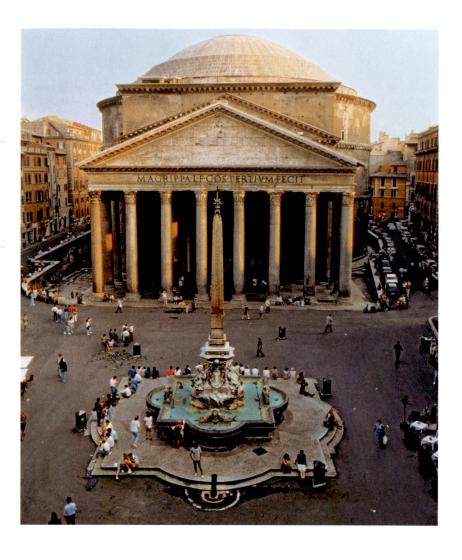

THE PANTHEON. Perhaps the most remarkable ancient building surviving in Rome—and one of the marvels of architecture in any age—is a temple to the Olympian gods called the PANTHEON (literally, "all the gods") (FIG. 6-52). Originally the Pantheon stood on a podium and was approached by stairs from a colonnaded square. (The difference in height of the street levels of ancient and modern Rome can be seen at the left side of the photograph.) Although this magnificent monument was designed and constructed entirely during the reign of the emperor Hadrian, the long inscription on the architrave states that it was built by "Marcus Agrippa, son of Lucius, who was consul three times." Agrippa, the son-in-law and valued adviser of Augustus, was responsible for building on this site in 27-25 BCE. After a fire in 80 CE, Domitian built a new temple, which Hadrian then replaced in 118-128 CE with the Pantheon.

Hadrian, who must have had a strong sense of history, placed Agrippa's name on the façade in a grand gesture to the memory of the illustrious consul, rather than using the new building to memorialize himself. Septimius Severus (see page 218) restored the Pantheon in 202 CE.

The approach to the temple gives little suggestion of its original appearance. Centuries of dirt and street construction

hide its podium and stairs. Attachment holes in the pediment indicate the placement of sculpture, perhaps an eagle within a wreath, the imperial Jupiter. Nor is there any hint of what lies beyond the entrance porch, which resembles the façade of a typical Roman temple. Behind this porch is a giant rotunda with 20-foot-thick walls that rise nearly 75 feet. The walls support a bowl-shaped dome that is 143 feet in diameter and 143 feet from the floor at its summit (FIG. 6-53). Standing at the center of this hemispherical temple (FIG. 6-54), the visitor feels isolated from the outside world and intensely aware of the shape and tangibility of the space itself. The eye is drawn upward over the circular patterns made by the sunken panels, or coffers, in the dome's ceiling to the light entering the 29-foot-wide oculus, or central opening. The sun pours through this opening on clear days; rain falls on wet ones, then drains off as planned by the original engineer; and the occasional bird flies in. The empty, luminous space gives the feeling that one could rise buoyantly upward and escape the spherical hollow of the building to commune with the gods.

The simple shape of the Pantheon's dome belies its sophisticated design and engineering (FIG. 6–55). Marble veneer disguises the internal brick arches and concrete structure. The interior walls, which form the drum that both

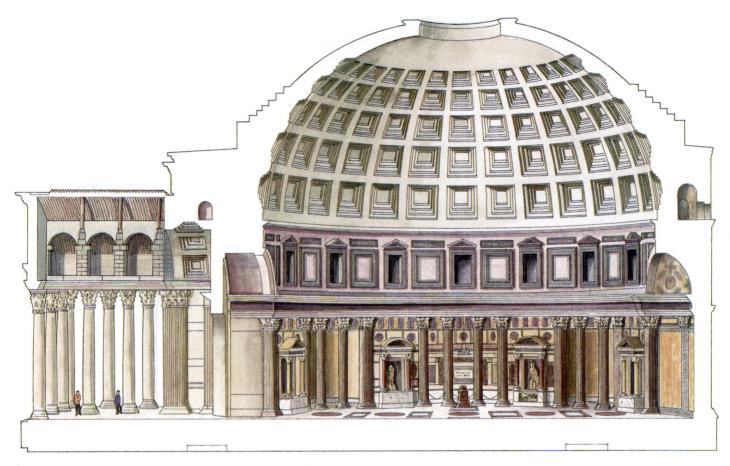

6-53 RECONSTRUCTION DRAWING OF THE PANTHEON

Ammianus Marcellinus described the Pantheon in 357 CE as being "rounded like the boundary of the horizon, and vaulted with a beautiful loftiness." Although the Pantheon has inspired hundreds—perhaps thousands—of faithful copies, inventive variants, and eclectic borrowings over the centuries, only recently have the true complexity and the innovative engineering of its construction been fully understood.

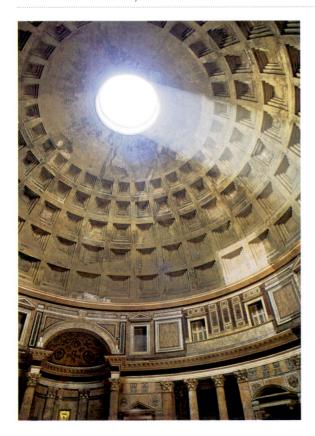

6-54 DOME OF THE PANTHEON

With light from the oculus on its coffered ceiling. 125–128 CE. Brick, concrete, marble, veneer, diameter of dome 143' (43.5 m).

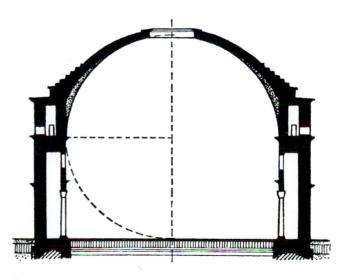

6-55 CIRCLE SECTION OF THE PANTHEON

supports and buttresses the dome, are disguised by two tiers of architectural detail and richly colored marble. More than half of the original decoration—a wealth of columns, pilasters, and entablatures—survives. The wall is punctuated by seven exedrae (niches)—rectangular alternating with semicircular—that originally held statues of gods. This simple repetition of square against circle is found throughout the building. The square, boxlike coffers inside the dome, which help lighten the weight of the masonry, may once have contained gilded bronze rosettes or stars suggesting the heavens. In 609 CE, Pope Boniface IV dedicated the Pantheon as the Christian church of Saint Mary of the Martyrs, thus ensuring its survival through the Middle ages.

HADRIAN'S VILLA AT TIVOLI. To imagine Roman life at its most luxurious, one must go to Tivoli, a little more than 20 miles from Rome. Hadrian's Villa was not a single building but an architectural complex of many buildings, lakes, and gardens spread over half a square mile. Each section had its own inner logic, and each took advantage of natural land formations and attractive views. Hadrian instructed his architects to re-create his favorite places throughout the empire. In his splendid villa, he could pretend to enjoy the Athenian Grove of Academe, the Painted Stoa from the Athenian Agora, and buildings of the Ptolemaic capital of Alexandria, Egypt.

Landscapes with pools, fountains, and gardens turned the villa into a place of sensuous delight. An area with a long reflecting pool, called the **CANOPUS** after a site near Alexandria, was framed by a colonnade with alternating semicircular and straight entablatures (FIG. 6–56). It led to an outdoor dining room with concrete couches facing the pool. Copies of famous Greek statues, and sometimes even the originals, filled the spaces between the columns. So great was Hadrian's

love of Greek sculpture that he even had the caryatids of the Erechtheion (SEE FIG. 5–40) replicated for his pleasure palace.

The individual buildings were not large, but they were extremely complex. Roman builders and engineers exploited to the fullest the flexibility offered by concrete and vaulted construction. Walls and floors had veneers of marble and travertine or exquisite mosaics and paintings.

ARCHITECTURE THROUGHOUT THE EMPIRE. Hadrian traveled widely, since the emperor's appearance in distant lands reinforced his authority there. Hadrian also seemed to be genuinely interested in people and places. The emperor did more than copy his favorite cities at his villa; he also added to them. In Athens, for example, he finished the Temple of the Olympian Zeus and dedicated it in 131/132 CE (SEE FIG. 5–59). He also built a library, a stoa, and an aqueduct for the Athenians, and according to Pausanias, placed a statue of himself inside the Parthenon.

At the other end of the empire he engaged in the construction of functional architecture. During a visit to Britain in 122 CE as part of a review of the western provinces, Hadrian ordered the building of a defensive wall (FIG. 6–57) across the northernmost boundary of the empire.

Hadrian's Wall was built of stone and turf by legionaries and garrisoned by as many as 24,000 auxiliaries from conquered territories. Forts, and fortified towers at mile intervals, were built along its 73-mile length. It was defended by natural sharp drop-offs in the terrain and by a ditch on the north side and a wide open space that allowed easy movement of the troops on the south. Seventeen large camps housed forces ready to respond to any trouble. The wall created a symbolic as well as a physical boundary between Roman territory and that of the "barbarian" Picts and Scots to the north.

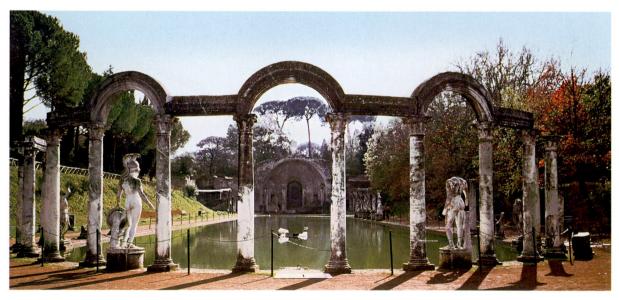

6–56 canopus, hadrian's villa Tivoli. c. 130–35 ce.

6–57 HADRIAN'S WALL Great Britain. 2nd century CE. View from near Housesteads, England.

Mosaics

Pictorial mosaics covered the floors of fine houses, villas, and public buildings throughout the empire. Working with very small *tesserae* (cubes of glass or stone) and a wide range of colors, mosaicists achieved remarkable effects (see "Roman Mosaics," page 215). The panels from a floor mosaic from

Hadrian's Villa at Tivoli illustrate extraordinary artistry (FIG. 6–58). In a rocky landscape with only a few bits of greenery, a desperate male centaur raises a large boulder over his head to crush a tiger that has attacked and severely wounded a female centaur. Two other felines apparently took part in the attack—the white leopard on the rocks to the left

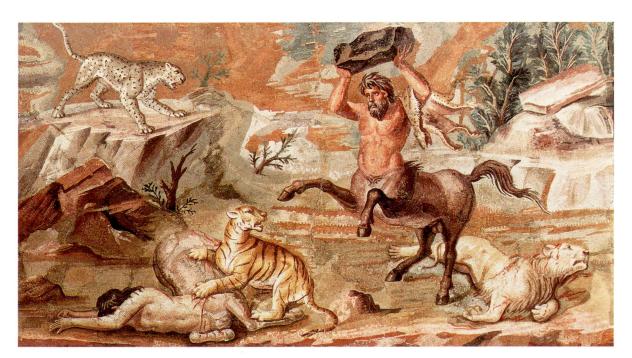

6-58 BATTLE OF CENTAURS AND WILD BEASTS

Hadrian's Villa, Tivoli. c. 118–28 CE. Mosaic, $23\times36''$ (58.4×91.4 cm). Staatliche Museen zu Berlin, Preussischer Kulturbesitz, Antikensammlung, Berlin.

This floor mosaic may be a copy of a much-admired painting of a fight between centaurs and wild animals done by the late fifth-century BCE Greek artist Zeuxis.

THE OBJECT SPEAKS

THE UNSWEPT FLOOR

n his first-century CE work Satyricon, the comic genius and satirist Petronius created one of the all-time wild dinner parties. In Trimalchio's Feast (Cena Trimalchionis, Book 15), the newly rich Trimalchio entertains his friends at a lavish banquet. He shows off his extraordinary wealth, but also exposes his boorish ignorance and bad manners. Unlike the Greeks, whose banquets were private affairs, Romans such as Trimalchio used such occasions to display their possessions. When dishes are broken, Trimalchio orders his servants to sweep them away with the rubbish on the floor.

In *The Unswept Floor* mosaic, the remains of fine food from a party such as Trimalchio's—from lobster claws to cherry pits—seem to litter the floor. In the dining room where this segment was found, mosaics cover almost the entire floor.

Because Romans arranged their dining rooms with three-person couches on three sides of a square table, the family and guests would have seen these fictive remains of past gourmet pleasures under their couches. Such a festive Roman dinner might have had as many as seven courses, including a whole roasted pig (or ostrich, crane, or peacock), veal, and several kinds of fish; the final course may have been snails, nuts, shellfish, and fruit.

If art speaks to and of the ideals of a society, what does it mean that wealthy Romans commemorated their table scraps in mosaics of the greatest subtlety and skill? Is this a form of conspicuous consumption, proof that the owner of this house gave lavish banquets and hosted guests who had the kind of sophisticated humor that could appreciate satires like *Trimalchio's Feast*?

The Romans did in fact place a high value on displaying their wealth and taste in the semipublic rooms and gardens of their houses and villas, and they did so through their possessions, especially their art collections. *The Unswept Floor* is but one of a very large number of Roman copies of Greek mosaics and paintings, such as *Alexander the Great Confronts Darius III* (SEE FIG. 5–57).

In the case of *The Unswept Floor*, Herakleitos, a second-century CE Greek mosaicist living in Rome, made this copy of an original work by the renowned second-century BCE artist Sosos. Pliny the Elder, in his *Natural History*, mentions a mosaic of an unswept floor and another of doves that Sosos made in Pergamon. The guests reclining on their banquet couches could have displayed their knowledge of the notable precedents for the mosaic on the floor.

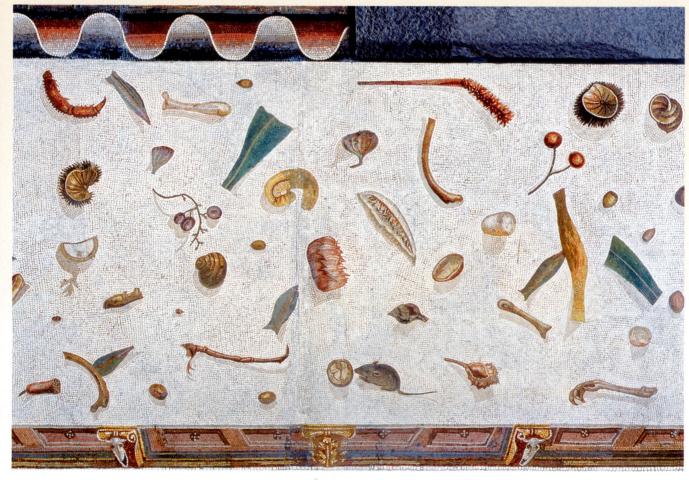

THE UNSWEPT FLOOR Mosaic variant of a 2nd-century BCE painting by Sosos of Pergamon. 2nd century CE. Signed by Herakleitos. Musei Vaticani, Museo Gregoriano Profano, Rome.

Technique

ROMAN MOSAICS

osaics were used widely in Hellenistic times and became enormously popular for decorating homes in the Roman period. **Mosaic** designs were created with pebbles (see Fig. 5–58), or with small, regularly shaped pieces of colored stone and marble, called **tesserae**. The stones were pressed into a kind of soft cement called *grout*. When the stones were firmly set, the spaces between them were also filled with grout. After the surface dried, it was cleaned and polished. At first, mosaics were used mainly as durable, water-resistant coverings on floors. They were done in a narrow range of colors depending on the natural color of the stone—often earth tones or black or some other dark color on a light background. When

mosaics began to be used on walls (see Fig. 6-29), a wide range of colors—and sometimes colored glass—was employed. Some skilled mosaicists even copied well-known paintings. Employing a technique in which very small tesserae, in a wide range of colors, were laid down in irregular, curving lines, they effectively imitated painted brushstrokes.

Mosaic production was made more efficient by the use of emblemata (the plural of emblema, "central design"). These small, intricate mosaic compositions were created in the artist's workshop in square or rectangular trays. They could be made in advance, carried to a work site, and inserted into a floor decorated with an easily produced geometric pattern.

and the dead lion at the feet of the male centaur. The mosaicist rendered the figures with three-dimensional shading, fore-shortening, and a great sensitivity to a range of figure types, including human torsos and powerful animals in a variety of poses.

Artists created these fine mosaic image panels, called emblemata, in their workshops. The emblemata were then set into a larger area already bordered by geometric patterns in mosaic. The mosaic floor in the reconstructed room in the Metropolitan Museum of Art in New York (SEE FIG. 6–33) shows a typical floor with a small image panel and many abstract designs in black and white. Image panels in floors

usually reflected the purpose of the room. A dining room, for example, might have an Unswept Floor (see "The Unswept Floor," page 214), with table scraps re-created in meticulous detail, even to the shadows they cast, and a mouse foraging among them.

Sculpture

Hadrian also used monumental sculpture to publicize his accomplishments. Several large, circular reliefs, or roundels (originally part of a monument that no longer exists and now reused in the Arch of Constantine) contain images designed to affirm his imperial stature and right to rule (FIG. 6–59). In the

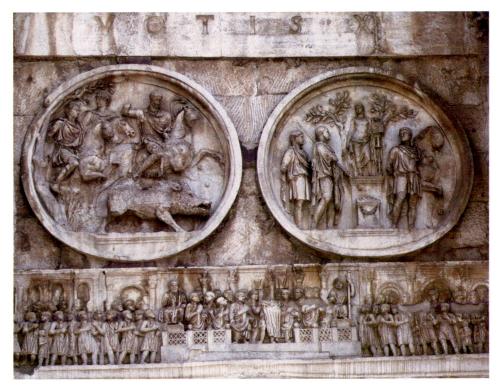

6-59 HADRIAN HUNTING BOAR AND SACRIFICING TO APOLLO

Roundels made for a monument to Hadrian and reused on the Arch of Constantine. Sculpture c. 130-38 CE. Marble, roundel diameter 40" (102 cm). Horizontal panel by Constantinian sculptors 312-315 CE.

In the fourth century CE, Emperor Constantine had the roundels removed from a Hadrianic monument, had Hadrian's head recarved with his own or his father's features, and placed them on his own triumphal arch (SEE FIG. 6–74).

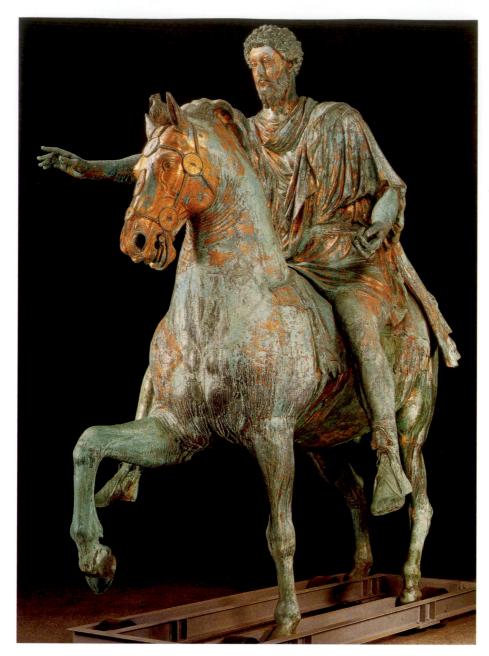

6–60 **EQUESTRIAN STATUE OF MARCUS AURELIUS** c. 176 CE. Bronze, originally gilded, height of statue 11′6″ (3.5 m). Museo Capitolino, Rome.

Between 1187 and 1538, this statue stood in the piazza fronting the palace and church of Saint John Lateran in Rome. In January 1538, Pope Paul III had it moved to the Capitoline Hill. After being removed from its base for cleaning and restoration in recent times, it was taken inside the Capitoline Museum to protect it from air pollution, and a copy has replaced it in the piazza.

scene on the left, he demonstrates his courage and physical prowess in a boar hunt. Other roundels, not included here, show him confronting a bear and a lion. At the right, in a show of piety and appreciation to the gods for their support for his endeavors, Hadrian makes a sacrificial offering to Apollo at an outdoor altar.

Like the sculptors of the Column of Trajan, the sculptors of these roundels included elements of a natural land-scape setting but kept them relatively small, using them to frame the proportionally larger figures. The idealized heads, form-enhancing drapery, and graceful yet energetic move-

ment of the figures owe a distant debt to the works of Praxiteles and Lysippos (Chapter 5). The well-observed details of the features and the bits of landscape are characteristically Roman. Much of the sculpture of the mid-second century CE shows the influence of Hadrian's love of Greek art, and for a time Roman artists achieved a level of idealized figural depiction close to that of Classical Greece.

Imperial Portraits

Imperial portraits contained an element of propaganda. Marcus Aurelius, like Hadrian, was a successful military commander who was equally proud of his intellectual attainments. In a lucky error—or twist of fortune—a gilded bronze equestrian statue of the emperor (FIG. 6–60) came mistakenly to be revered as a statue of Constantine, known in the Middle Ages as the first Christian emperor, and consequently the sculpture escaped being melted down. The emperor is dressed as a military commander in a tunic and short, heavy cloak. The raised foreleg of his horse once trampled a crouching barbarian.

Marcus Aurelius's head, with its thick, curly hair and full beard (a style that was begun by Hadrian) resembles the traditional "philosopher" portraits of the Republican period. The emperor wears no armor and carries no weapons; like Egyptian kings, he conquers effortlessly by the will of the gods. And like his illustrious predecessor Augustus, he reaches out to the people in a persuasive, beneficent gesture. It is difficult to create an equestrian portrait in which the rider stands out as the dominant figure without making the horse look too small. The sculptor of this statue found a balance acceptable to viewers of the time and, in doing so, created a model for later artists.

Marcus Aurelius was succeeded as emperor by his son Commodus, a man without political skill, adminis-

trative competence, or intellectual distinction. The emperor Commodus was not just decadent—he was probably insane. During his unfortunate reign (180-92 CE), he devoted himself to luxury and frivolous pursuits. He claimed at various times to be the reincarnation of Hercules and the incarnation of the god Jupiter. When he proposed to assume the consulship dressed and armed as a gladiator, his associates, including his mistress, arranged to have him strangled in his bath by a wrestling partner. Commodus did, however, attract some of the finest artists of the day for his commissions. A marble bust of the emperor posing as Hercules reflects his character (FIG. 6-61). In this portrait, the emperor is shown adorned with references to the hero's legendary labors: Hercules's club, the skin and head of the Nemean Lion, and the golden apples from the garden of the Hesperides.

The sculptor's sensitive modeling and expert drillwork exploit the play of light and shadow on the figure and bring out the textures of the hair, beard, facial features, and drapery. The portrait conveys the illusion of life and movement, but it

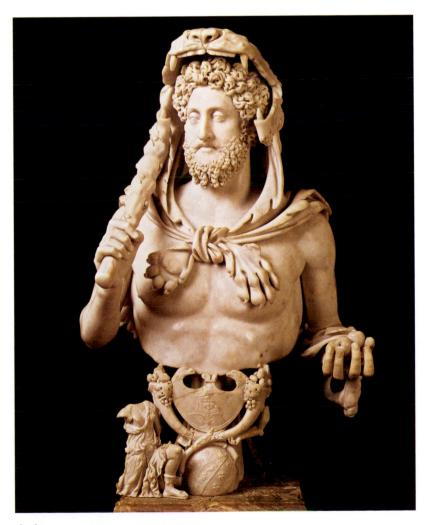

6–61 **COMMODUS AS HERCULES**Esquiline Hill, Rome. c. 191–92 CE. Marble, height 46½" (118 cm).
Palazzo dei Conservatori, Rome.

also captures its subject's weakness. The foolishness of the man comes through in his pretentious assumption of the attributes of Hercules.

THE LATE EMPIRE, THIRD AND FOURTH CENTURIES

The comfortable life suggested by the wall paintings in Roman villas was, within a century, to be challenged by hard times. The reign of Commodus marked the beginning of a period of political and economic decline. Barbarian groups had already begun moving into the empire in the time of Marcus Aurelius. Now they pressed on Rome's frontiers. Many crossed the borders and settled within them, disrupting provincial governments. As perceived threats spread throughout the empire, imperial rule became increasingly authoritarian. Eventually the army controlled the government, and the Imperial Guards set up and deposed rulers almost at will, often selecting candidates from among poorly educated, power-hungry provincial leaders in their own ranks.

The Severan Dynasty

Despite the pressures of political and economic change, at least the arts continued to flourish under the Severan emperors (193–235 CE) who succeeded Commodus. Septimius Severus (ruled 193–211 CE), who was born in Africa, and his Syrian wife, Julia Domna, restored public buildings, commissioned official portraits, and made some splendid additions to the old Republican Forum, including the transformation of the House of the Vestal Virgins, who served the Temple of Vesta, goddess of hearth and home, into a large, luxurious residence. Their sons, Geta and Caracalla, succeeded Septimus Severus as co-emperors in 211 CE. In 212 CE, Caracalla murdered Geta, and then ruled alone until he in turn was murdered in 217 CE.

THE FAMILY OF SEPTIMIUS SEVERUS. A portrait of the family of Septimius Severus provides insight into both the history of the Severan dynasty and early third-century CE painting (FIG. 6–62). The work is in the highly formal style of the Fayum region in northwestern Egypt (SEE FIG. 3–36), and it may be a souvenir of an imperial visit to Egypt. The emperor, clearly identified by his distinctive divided beard and curled moustache, wears an enormous crown. Next to him is the empress Julia Domna, portrayed with similarly recognizable features—full face, large nose, and masses of waving hair. Their two sons, Geta (whose face has been scratched out) and Caracalla, stand in front of them. Perhaps because we know that he grew up to be a ruthless dictator, little Caracalla looks like a disagreeable child.

After murdering his brother, perhaps with Julia Domna's help, Caracalla issued a decree to abolish every reference to Geta. Clearly the owners of this painting complied. The work emphasized the trappings of imperial wealth and power—crowns, jewels, and direct, forceful expressions—rather than

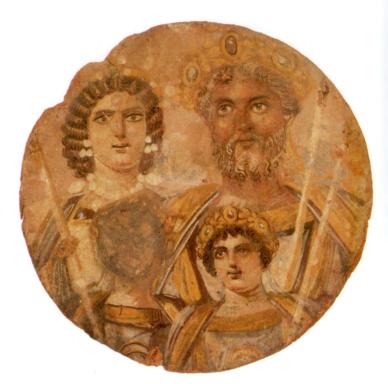

6-62 Septimius Severus, Julia domna, and their Children, geta and caracalla

Fayum, Egypt. c. 200 CE. Painted wood, diameter 14" (35.6 cm). The face of Geta has been obliterated. Staatliche Museen zu Berlin, Preussischer Kulturbesitz, Antikensammlung.

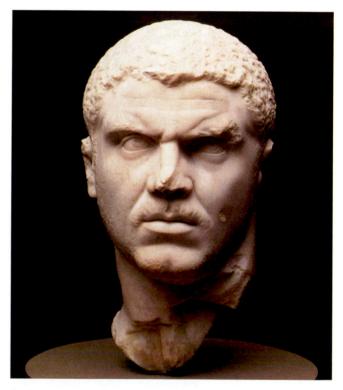

6–63 CARACALLA
Early 3rd century CE. Marble, height 14½" (36.2 cm).
The Metropolitan Museum of Art, New York.
Samuel D. Lee Fund, 1940 (40.11.1A)

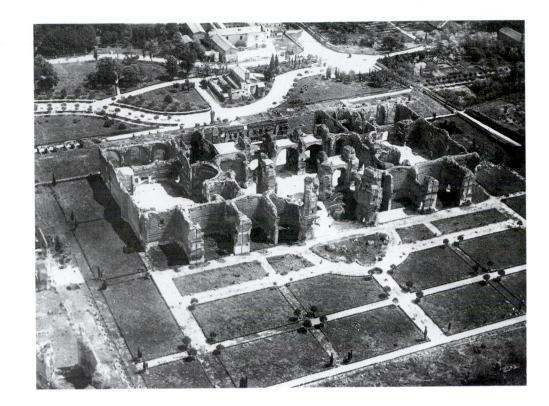

6–64 BATHS OF CARACALLA Rome. c. 211–17 CE.

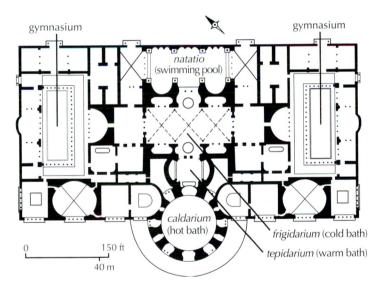

6-65 PLAN OF THE BATHS OF CARACALLA

attempting any psychological study. The rather hard drawing style, with its broadly brushed-in colors, contrasts markedly with the subtlety of earlier portraits, such as the *Young Woman Writing* (SEE FIG. 6–37).

Emperor Caracalla emerges from his adult portraits as a man of chilling and calculating ruthlessness. In the example shown here (FIG. 6–63), the sculptor has enhanced the intensity of the emperor's expression by producing strong contrasts of light and dark with careful chiseling and drillwork. Even the marble eyes have been drilled and engraved to catch the light in a way that makes them glitter. The contrast between this style and that of the portraits of Augustus is a telling

reflection of the changing character of imperial rule. Augustus presented himself as the first among equals: Caracalla revealed himself as a no-nonsense ruler of iron-fisted determination.

THE BATHS OF CARACALLA. The year before his death in 211 CE, Septimius Severus had begun a popular public works project: the construction of magnificent new public baths on the southeast side of Rome. Caracalla completed and inaugurated the baths in 216-17 CE, and they are known by his name. For the Romans, baths were recreational and educational centers in which the brick and concrete structure was hidden under a sheath of colorful marble and mosaic. Even in ruins the great halls soar over the heads of the visitors. The builders covered the space with groin and barrel vaults, which allow the maximum space with the fewest possible supports. (In the early years of the twentieth century, the halls provided architects with the models for major train stations in American cities.) The groin vaults also made possible large windows in every bay. Windows were important, since the baths depended on natural light and could only be open during daylight hours.

The BATHS OF CARACALLA (FIG. 6–64) were laid out on a strictly symmetrical plan. The bathing facilities were grouped in the center of the main building to make efficient use of the below–ground furnaces that heated them and to allow bathers to move comfortably from hot to cold pools and then finish with a swim (FIG. 6–65). Many other facilities—exercise rooms, shops, latrines, and dressing rooms—were housed on each side of the bathing block. The bath buildings alone covered five acres. The entire complex, which included gardens, a stadium, libraries, a painting gallery, auditoriums, and huge water reservoirs, covered an area of 50 acres.

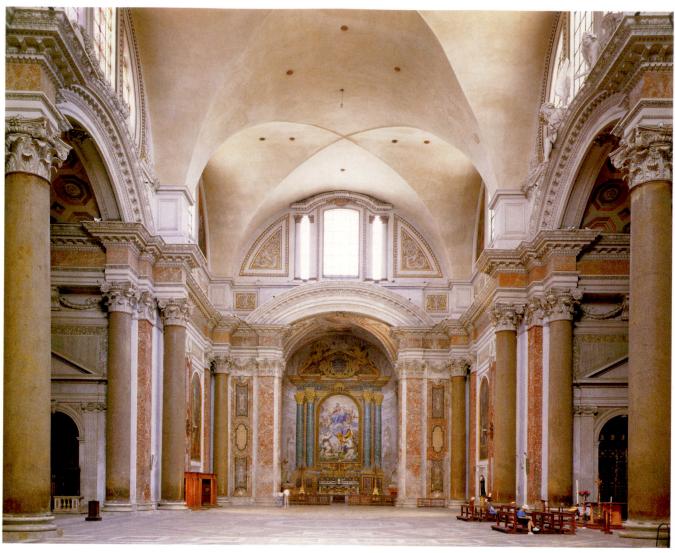

6–66 CHURCH OF SANTA MARIA DEGLI ANGELI (BATHS OF DIOCLETIAN, c. 298–306) Converted into a church by Michelangelo in 1563.

The luxury of these imperial establishments can still be seen in the **CHURCH OF SANTA MARIA DEGLI ANGELI** in Rome (FIG. 6–66), where Michelangelo converted the *frigidarium* of the Baths of Diocletian into a church, thus preserving it. Marble veneers and huge Corinthian columns and pilasters disguise the structural concrete of the building, although the vaults have lost their decoration.

The Third Century: The Soldier Emperors

The successors of the Severan emperors—the more than two dozen so-called soldier-emperors who attempted to rule the empire for the next seventy years—continued to favor the style of Caracalla's portraits. The sculptor of a bust of **PHILIP THE ARAB** (ruled 244–49 CE), for example, only modeled the broad structure of the emperor's head, then used both chisel and drill to deepen shadows and heighten the effects of light in the furrows of the face and the stiff folds of the drapery

(FIG. 6–67). Tiny flicks of the chisel suggest the texture of hair and beard. The overall impact of the work depends on the effects of light and the imagination of the spectator as much as on the carved stone itself.

This portrait does not convey the same malevolent energy as Caracalla's portraits. Philip seems tense and worried, suggesting that this is the portrait of a troubled man in troubled times. What comes through from Philip's twisted brow, sidelong upward glance, quizzical lips, and tightened jaw muscles is a sense of guile, deceit, and fear. Philip had been the head of the Imperial Guard, but he murdered his predecessor and was murdered himself after only five years.

ENGRAVED GOLD-GLASS. During the turmoil of the third century CE, Roman artists emphasized the symbolic or general qualities of their subjects and expressed them in increasingly simplified, geometric forms. Despite this trend toward

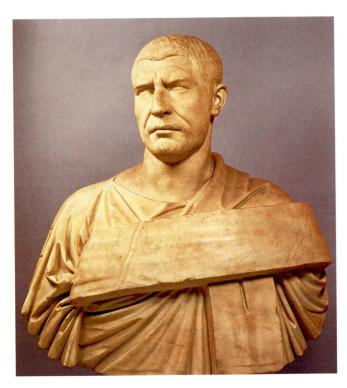

6–67 PHILIP THE ARABRuled 244–49 CE. Marble, height 26" (71.1 cm).
Musei Vaticani, Braccio Nuovo, Rome.

abstraction, the earlier tradition of slightly idealized but realistic portraiture was slow to die out, probably because it showed patrons as they wanted to be remembered. In the engraved gold-glass image of a woman with her son and daughter, the so-called **FAMILY OF VUNNERIUS KERAMUS** (FIG. 6–68), the subjects are rendered as individuals, although the artist has emphasized their great almond-shaped eyes. The work seems to reflect the advice of Philostratus who, writing in the late third century CE, commented:

The person who would properly master this art [of painting] must also be a keen observer of human nature and must be capable of discerning the signs of people's characters even though they are silent; he should be able to discern what is revealed in the expression of the eyes, what is found in the character of the brows, and, to state the point briefly, whatever indicates the condition of the mind. (Quoted in Pollitt, pages 224–25)

The Family Group portrait was engraved and stippled on a sheet of gold leaf sealed between two layers of glass. This fragile, delicate medium, often used for the bottoms of glass bowls or cups, seems appropriate for an age of material insecurity and emotional intensity. The portrait was inserted by a later Christian owner as the central jewel in a Lombard cross (SEE FIG. 14–3).

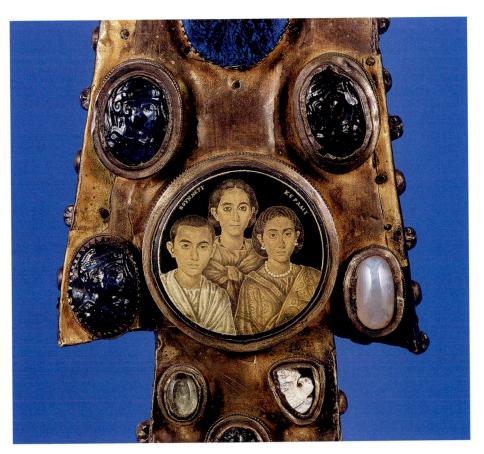

6–68 FAMILY GROUP,
TRADITIONALLY CALLED THE FAMILY OF VUNNERIUS KERAMUS
c. 250 CE. Engraved gold leaf sealed
between glass, diameter 2½" (6 cm).
Museo Civico dell'Età Cristiana,
Brescia.

This gold-glass medallion of a mother, son, and daughter could have been made in Alexandria, Egypt, at any time between the early third and the midfifth centuries CE. The medallion was later placed in a Lombard cross (SEE FIG. 14-3).

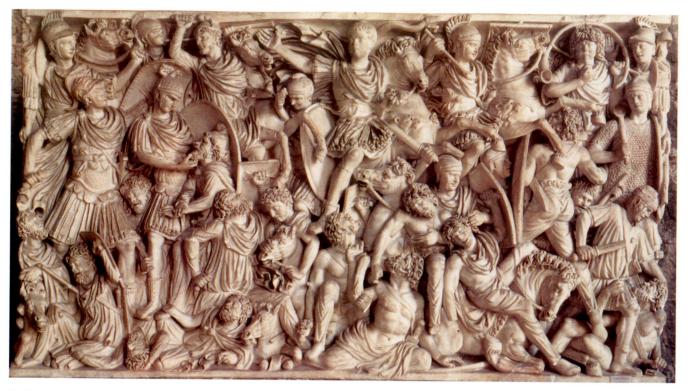

6–69 BATTLE BETWEEN THE ROMANS AND THE BARBARIANS, DETAIL OF THE LUDOVISI BATTLE SARCOPHAGUS Found near Rome. c. 250 CE. Marble, height approx. 5′ (1.52 m). Museo Nazionale Romano, Rome.

FUNERARY SCULPTURE. Although portraits and narrative reliefs were the major forms of public sculpture during the second and third centuries CE, a shift from cremation to burial led to a growing demand for funerary sculpture. Wealthy Romans commissioned elegant marble sarcophagi. Workshops throughout the empire produced thousands of them, carved with reliefs that ranged in complexity from simple geometric or floral ornaments to scenes involving large numbers of figures.

A figured sarcophagus known as the LUDOVISI BATTLE SARCOPHAGUS (after a seventeenth-century owner) dates to about 250 CE (FIG. 6-69) and depicts Romans triumphing over barbarians. The imagery and style has roots in the sculptural traditions of Hellenistic Pergamon (Chapter 5). In contrast to the carefully crafted illusion of earlier Roman reliefs like the Arch of Titus, where figures move in and through naturalistic surroundings, the artist of the Ludovisi squeezed his figures into the allotted space with no attempt to create a realistic environment. The Romans, packed together in orderly rows at the top of the panel, efficiently dispatch the barbarians-clearly identifiable by their heavy, twisted locks of hair and scraggly beards—who fall, dying, or beaten into an unorganized heap at the bottom. The bareheaded young Roman commander with his gesture of victory, who occupies the center top of the composition, recalls the Equestrian Statue of Marcus Aurelius (SEE FIG. 6-60).

The Tetrarchy

The half century of anarchy, power struggles, and inept rule by the soldier-emperors that had begun with the death of Alexander Severus (ruled 222–235 CE), the last in the Severan line, ended with the rise to power of Diocletian (ruled 284–305 CE). This brilliant politician and general reversed the empire's declining fortunes, but he also began an increasingly autocratic form of rule, and the social structure of the empire became increasingly rigid.

To divide up the task of defending and administering the empire and to assure an orderly succession, in 286 CE Diocletian divided the empire in two parts. According to his plan, with the title of "Augustus" he would rule in the East, while another Augustus, Maximian, would rule in the West. Then, in 293 CE, he devised a form of government called a **tetrarchy**, or "rule of four," in which each Augustus designated a subordinate and heir, who held the title of "Caesar."

PORTRAIT OF THE TETRARCHS. Sculpture depicting the tetrarchs, about 300 CE, documents a turn in art toward abstraction and symbolic representation (FIG. 6–70). The four figures—two with beards, probably the senior Augusti, and two clean-shaven, probably the Caesars—are nearly identical. Dressed in military garb and clasping swords at their sides, they embrace each other in a show of imperial unity, proclaiming a kind of peace through concerted strength and

vigilance. As a piece of propaganda and a summary of the state of affairs at the time, it is unsurpassed.

The sculpture is made of porphyry, a purple stone from Egypt reserved for imperial use. The hardness of the stone, which makes it difficult to carve, may have contributed to the extremely abstract style of the work. The most striking features of **THE TETRARCHS**—the simplification of natural forms to geometric shapes, the disregard for normal human proportions, and the emphasis on a message or idea—appear often in Roman art by the end of the third century. The sculpture may have been made in Egypt and moved to Constantinople after 330 CE. Christian Crusaders who looted Constantinople in 1204 CE took the statue to Venice and placed it on the Cathedral of Saint Mark, where it can still be seen.

THE BASILICA AT TRIER. The tetrarchs had ruled the empire from administrative headquarters in Milan, Italy; Trier, Germany; Thessaloniki, in Greece; and Nicomedia, in present-day Turkey. These four capital cities all had imposing buildings. In Trier, for example, Constantius Chlorus (Augustus, 293–306 CE) and his son Constantine fortified the city with walls and a monumental gate which still stand. They built public

6–70 THE TETRARCHS c. 300 CE. Porphyry, height of figures 51" (129 cm). Brought from Constantinople in 1204, installed at the corner of the façade of the Cathedral of Saint Mark, Venice.

amenities, such as baths, and a palace with a huge audience hall, later used as a Christian church (FIGS. 6–71, 6–72). This early fourth-century CE basilica's large size and simple plan and structure exemplify the architecture of the tetrarchs: imposing buildings that would impress their subjects.

The audience hall is a large rectangular building, 190 by 95 feet (200 by 100 Roman feet), with a strong directional focus given by a single apse opposite the door. Brick walls, originally stuccoed on the outside and covered with marble veneer inside, are pierced by two rows of arched windows. The flat roof, nearly 100 feet above the floor, covers both the nave and the apse. In a

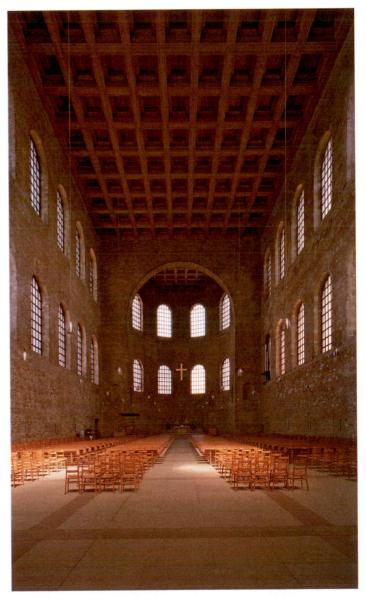

6-71 AUDIENCE HALL OF CONSTANTINE CHLORUS (NOW KNOWN AS THE BASILICA)

Interior. Trier, Germany. Early 4th century. View of the nave. Height of room 100' (30.5 m).

Only the left wall and apse survive from the original Roman building. The hall became part of the bishop's palace during the medieval period.

Technique

ROMAN COPIES

B oth bronze and marble sculpture was often copied in marble (recall the Roman copies of Greek sculpture in Chapter 5). The Romans developed a method of making nearly exact copies using a technique known as "pointing." A stonecutter transferred "points" on the original sculpture to a three-dimensional grid that was used to rough out the form.

Then master sculptors finished the work.

Marble copies of bronze sculpture required extra bracing, such as a tree trunk or column beside a leg or a strut to support an arm. These copies vary considerably in quality, depending on the skill of the copyists.

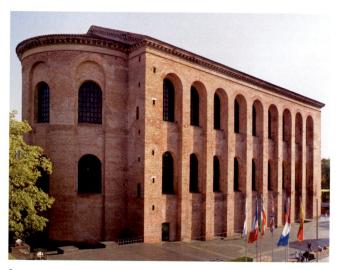

6–72 AUDIENCE HALL (NOW KNOWN AS THE BASILICA) Exterior. Trier, Germany. Early 4th century.

concession to the northern climate, the building was centrally heated with hot air flowing under the floor (a technique used in Roman baths). The windows of the apse create an interesting optical effect. Slightly smaller and set higher than the windows in the hall, they create the illusion of greater distance, so that the tetrarch enthroned in the apse would appear larger than life.

Constantine the Great and His Legacy

In 305 CE, Diocletian abdicated and forced his fellow Augustus, Maximian, to do so too. The orderly succession he had hoped for failed to occur, and a struggle for position and advantage followed almost immediately. Two main contenders emerged in the western empire: Maximian's son Maxentius and Constantine I, son of Tetrarch Constantius Chlorus. Constantine was victorious in 312, defeating Maxentius at the Battle of the Milvian Bridge at the entrance to Rome.

According to tradition, Constantine had a vision the night before the battle in which he saw a flaming cross in the sky and heard these words: "In this sign you shall conquer."

The next morning he ordered that his army's shields and standards be inscribed with the monogram XP (the Greek letters *chi* and *rho*, standing for *Christos*; see "Christian Symbols," page 238). The victorious Constantine then showed his gratitude by ending the persecution of Christians and recognizing Christianity as a lawful religion. (He may also have been influenced in that decision by his mother, Helen, a devout Christian—later canonized.) Whatever his motivation, in 313 CE, together with Licinius, who ruled the East, Constantine issued the Edict of Milan, a model of religious toleration.

The Edict granted freedom to all religious groups, not just Christians. Constantine, however, remained the Pontifex Maximus of Rome's state religion and also reaffirmed his devotion during his reign to the military's favorite god, Mithras, and to the Invincible Sun, Sol Invictus, a manifestation of Helios Apollo, the sun god. In 324 CE Constantine defeated Licinius, his last rival; he ruled as sole emperor until his death in 337. He made the port city of Byzantium the new Rome and renamed it Constantinople (present-day Istanbul, in Turkey). After Constantinople was dedicated in 330, Rome, which had already ceased to be the seat of government in the West, further declined in importance.

PORTRAITURE. Portraiture continued to be an important aspect of imperial propaganda. Constantine commissioned a colossal, 30-foot statue of himself for his new basilica (FIG. 6–73). To create the colossal figure, the sculptor used white marble for the head, chest, arms, and legs, and sheets of bronze for the drapery, all supported on a wooden frame. This statue became a permanent stand-in for the emperor, representing him whenever the conduct of business legally required his presence. The head combines features of traditional Roman portraiture with the abstract qualities evident in *The Tetrarchs* (SEE FIG. 6–70). The defining characteristics of Constantine's face—his heavy jaw, hooked nose, and jutting chin—have been incorporated into a rigid, symmetrical pattern in which other features, such as his eyes, eyebrows, and hair, have been simplified into repeated geometric arcs. The

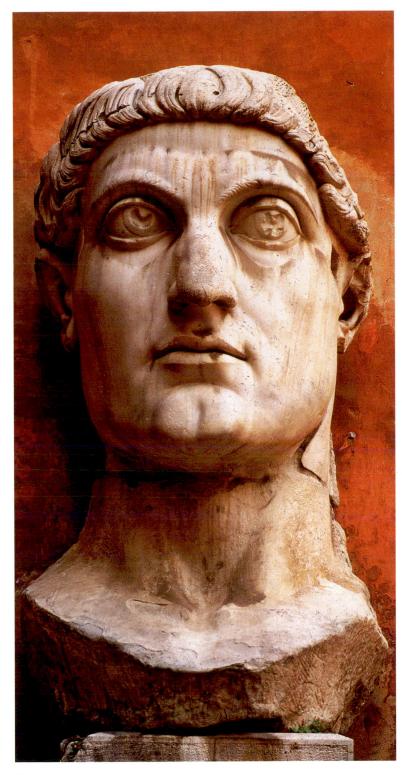

6–73 CONSTANTINE THE GREAT Basilica of Maxentius and Constantine, Rome. 325–26 CE. Marble, height of head 8'6'' (2.6 m). Palazzo dei Conservatori, Rome.

result is a work that projects imperial power and dignity with no hint of human frailty or imperfection. Similar portraits appear in relief sculpture on Constantine's triumphal arch. THE ARCH OF CONSTANTINE. In Rome, next to the Colosseum, the Senate erected a memorial to Constantine's victory over Maxentius (FIG. 6–74), a huge, triple arch that dwarfs the

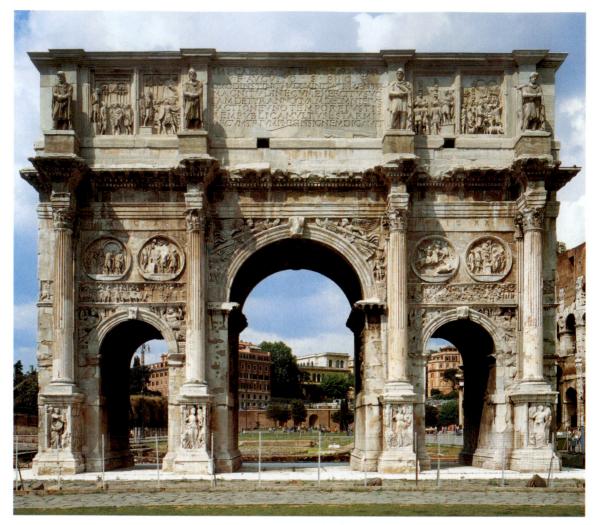

6–74 ARCH OF CONSTANTINE Rome. 312–15 CE (dedicated July 25, 315).

This massive, triple-arched monument to Emperor Constantine's victory over Maxentius in 312 CE is a wonder of recycled sculpture. On the attic story, flanking the inscription over the central arch, are relief panels taken from a monument celebrating the victory of Marcus Aurelius over the Germans in 174 CE. On the attached piers framing these panels are large statues of prisoners made to celebrate Trajan's victory over the Dacians in the early second century CE. On the inner walls of the central arch (not seen here) are reliefs commemorating Trajan's conquest of Dacia. Over each of the side arches are pairs of large roundels taken from a monument to Hadrian (SEE FIG. 6–59). The rest of the decoration is 4th century, contemporary with the arch.

nearby Arch of Titus (SEE FIG. 6–38). Its three barrel-vaulted passageways are flanked by columns on high pedestals and surmounted by a large attic story with elaborate sculptural decoration and a traditional laudatory inscription: "To the Emperor Constantine from the Senate and the Roman People. Since through divine inspiration and great wisdom he has delivered the state from the tyrant and his party by his army and noble arms, [we] dedicate this arch, decorated with triumphal insignia." The "triumphal insignia" were in part looted from earlier monuments made for Constantine's illustrious predecessors, Trajan, Hadrian (SEE FIG. 6–59), and Marcus Aurelius. The reused items visually transferred the old Roman virtues of strength, courage, and piety associated with

these earlier "good" emperors to Constantine. New reliefs made for the arch recount the story of Constantine's victory and symbolize his power and generosity.

Although these new reliefs reflect the long-standing Roman affection for depicting important events with realistic detail, they nevertheless represent a significant change in style, approach, and subject matter. They are easily distinguished from the reused elements in the arch. The stocky, frontal, look-alike figures are compressed by the buildings of the forum into the foreground plane. The arrangement and appearance of the uniform participants below the enthroned Constantine clearly isolate the new emperor and connect him visually with his illustrious predecessors on each side.

This two-dimensional, hierarchical approach and abstract style are far removed from the realism of earlier imperial reliefs. This style, with its emphasis on authority, ritual, and symbolic meaning, was adopted by the emerging Christian Church. Constantinian art thus bridges the art of the Classical world and the art of the Middle Ages (approximately from 476 to 1453 CE).

THE BASILICA NOVA. Constantine's rival Maxentius, who controlled Rome throughout his short reign (ruled 306–12), ordered the repair of many buildings there and had others built. His most impressive undertaking was a huge new basilica, just southeast of the Imperial Forums, called the Basilica Nova, or New Basilica. Now known as the Basilica of Maxentius and Constantine, this was the last important imperial government building erected in Rome. Like all basilicas, it functioned as an administrative center and provided a magnificent setting for the emperor when he appeared as supreme judge.

Earlier basilicas, such as Trajan's Basilica Ulpia (SEE FIG. 6–48), had been columnar halls, but Maxentius ordered

his engineers to create the kind of large, unbroken, vaulted space found in public baths. Such solid masonry construction was less vulnerable to fire, an important consideration in troubled times. The central hall was covered with groin vaults, and the side aisles were covered with lower barrel vaults. These vaults acted as buttresses, or projecting supports, for the central vault and allowed generous window openings in the clerestory areas over the side walls.

Three of these brick-and-concrete barrel vaults still loom over the streets of present-day Rome (FIG. 6–75). The basilica originally measured 300 by 215 feet and the vaults of the central nave rose to a height of 114 feet. A groin-vaulted porch extended across the short side and sheltered a triple entrance to the central hall. At the opposite end of the long axis of the hall was an apse of the same width, which acted as a focal point for the building (FIGS. 6–76, 6–77). The directional focus along a central axis from entrance to apse was adopted by Christians for use in churches.

Constantine, seeking to impress the people of Rome with visible symbols of his authority, put his own stamp on projects Maxentius had started. He may have changed the orientation

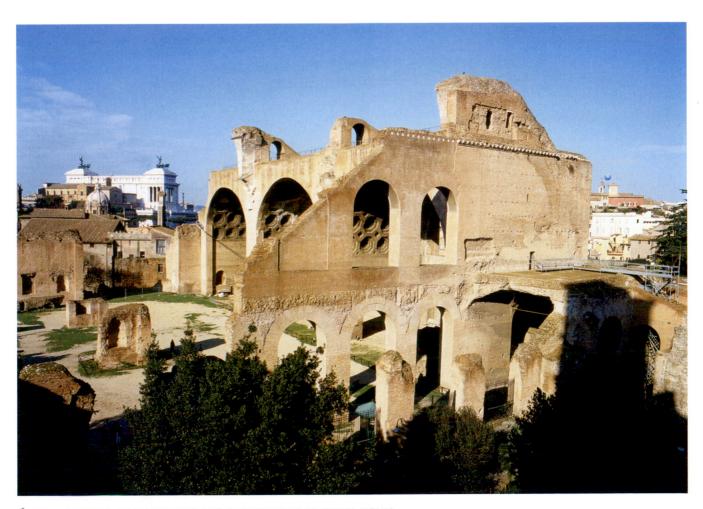

6–75 BASILICA OF MAXENTIUS AND CONSTANTINE (BASILICA NOVA) Rome. 306–13 ce.

apse added by Constantine barrel-vaulte original bays apse FLOOR PLAN **BASILICA OF MAXENTIUS** AND CONSTANTINE original groin-vaulted entrance (BASILICA NOVA). groinvaulted barrel-vaulted porch bays entrance added by Constantine

of the Basilica Nova by adding an imposing new entrance in the center of the long side facing the Via Sacra and a giant apse facing it across the three aisles. (A new theory suggests that the building was designed and built as a single project.)

6 - 76

ROMAN ART AFTER CONSTANTINE. Although Constantine was baptized only on his deathbed in 337, Christianity had become the official religion of the empire by the end of the fourth century CE, and non-Christians had become tar-

gets of persecution. Many people resisted this shift and tried to revive Classical culture. A large silver platter dating from the mid-fourth century CE shows how themes involving Bacchus continued to provide artists with the opportunity to create elaborate figural compositions displaying the nude or lightly draped human body in complex, dynamic poses (FIG. 6-78).

The Bacchic revelers whirl, leap, and sway in a dance to the piping of satyrs around a circular central medallion. In the

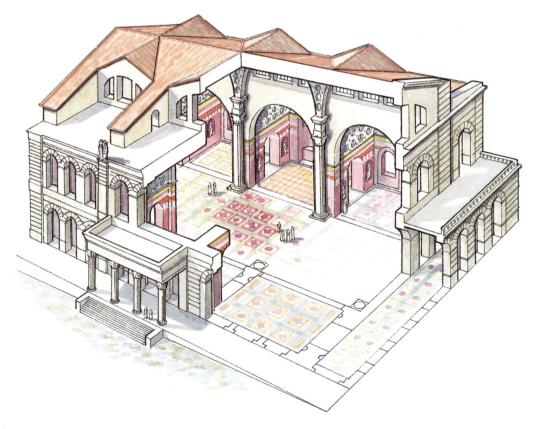

RECONSTRUCTION OF THE BASILICA OF MAXENTIUS AND CONSTANTINE (BASILICA NOVA).

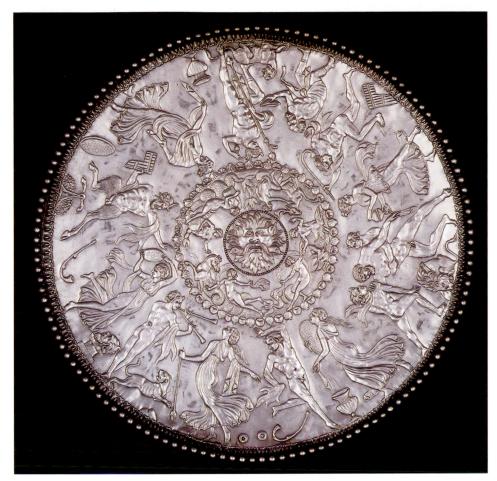

6–78 **DISH**From Mildenhall, England. Mid-4th century CE. Silver, diameter approx. 24" (61 cm). The British Museum, London.

centerpiece, the head of the sea god Oceanus is ringed by nude females frolicking in the waves with fantastic sea creatures. In the outer circle, Bacchus is the one stable element. With a bunch of grapes in his right hand, a krater at his feet, and one foot on the haunches of his panther, he listens to a male follower begging for another drink. Only a few figures away, the pitifully drunken hero Hercules has lost his lion-skin mantle and collapsed in a stupor into the supporting arms of two satyrs. The detail, clarity, and liveliness of this platter reflect the work of a skillful artist. Deeply engraved lines emphasize the contours of the subtly modeled bodies, echoing the technique of undercutting used to add depth to figures in stone and marble reliefs and suggesting a connection between silver working and relief sculpture. The platter was found in a cache of silver near Mildenhall, England. (Such opulent items were often hidden or buried to protect them from theft and looting, a sign of the breakdown of the long Roman peace.)

Among the champions of paganism were the Roman patricians Quintus Aurelius Symmachus and Virius Nicomachus Flavianus. A famous ivory diptych—a pair of panels attached with hinges—attests to the close relationship

between their families, perhaps through marriage, as well as to their firmly held beliefs. One family's name is inscribed at the top of each panel. On the panel inscribed *Symmachorum* (FIG. 6–79), a stately, elegantly attired priestess burns incense at a beautifully decorated altar. On her head is a wreath of ivy, sacred to Bacchus. She is assisted by a small child, and the event takes place out of doors under an oak tree, sacred to Jupiter. The Roman ivory carvers of the fourth century were extremely skillful, and their wares were widely admired. For conservative patrons like the Nicomachus and Symmachus families, they imitated the Augustan style effortlessly. The exquisite rendering of the drapery and foliage recalls the reliefs of the Ara Pacis (SEE FIG. 6–21).

Classical subject matter remained attractive to artists and patrons, and imperial repression could not immediately extinguish it. Even such great Christian thinkers as the fourth-century CE bishop Gregory of Nazianzus (a saint and father of the Orthodox church) spoke out in support of the right of the people to appreciate and enjoy their classical heritage, so long as they were not seduced by it to return to

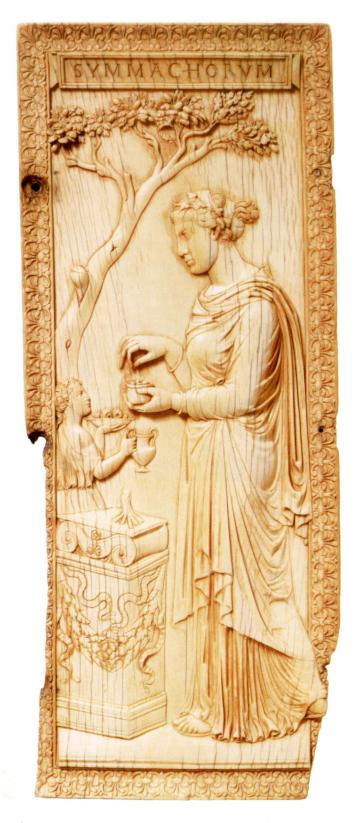

6–79 PRIESTESS OF BACCHUS (?) Right panel of the diptych of Symmachus. c. 390–401 CE. Ivory, 11¼ \times 4¼" (29.9 \times 12 cm). Victoria & Albert Museum, London.

pagan practices. As a result, stories of the ancient gods and heroes entered the secular realm as lively, visually delightful, and even erotic decorative elements.

The style and subject matter of the art reflect a society in transition, for even as Roman authority gave way to local rule by powerful "barbarian" tribes in much of the West, many people continued to appreciate classical learning and to treasure Greek and Roman art. In the East, classical traditions and styles endured to become an important element of Byzantine art.

IN PERSPECTIVE

The Romans, who supplanted the Etruscans and the Greeks, appreciated the earlier art of these peoples and adapted it to their own uses, but they also had their own strengths, such as efficiency and a practical genius for organization. As sophisticated visual propaganda, Roman art served the state and the empire. Creating both official images and representations of private individuals, Roman sculptors enriched and developed the art of portraiture. They also recorded contemporary historical events on commemorative arches, columns, and mausoleums.

Roman artists covered the walls of private homes with paintings, too. Sometimes fantastic urban panoramas surround a room, or painted columns and cornices, swinging garlands, and niches make a wall seem to dissolve. Some artists created the illusion of being on a porch or in a pavilion looking out into an extensive landscape. Such painted surfaces are often like backdrops for a theatrical set.

Roman architects relied heavily on the round arch and masonry vaulting. Beginning in the second century BCE, they also relied increasingly on a new building material: concrete. In contrast to stone, the components of concrete are cheap, light, and easily transported. Imposing and lasting concrete structures could be built by a large, semiskilled work force directed by one or two trained and experienced supervisors.

Drawing artistic inspiration from their Etruscan and Greek predecessors and combining this with their own traditions, Roman artists made a distinctive contribution to the history of art, creating works that formed an enduring ideal of excellence in the West. And as Roman authority gave way to local rule, the newly powerful "barbarian" tribes continued to appreciate and even treasure the Classical learning and art the Romans left behind.

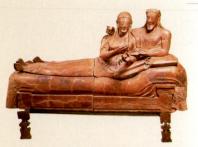

SARCOPHAGUS FROM CERVETERI C. 520 BCE

MIRROR C. 400–350 BCE

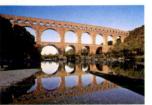

PONT DU GARD
LATE 1ST CENTURY BCE

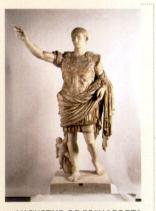

AUGUSTUS OF PRIMAPORTA
EARLY 1ST CENTURY CE

FLAVIAN AMPHITHEATER (COLOSSEUM)
....... 70–80 CE

ARCH OF CONSTANTINE C. 312–15 CE

 700_{BCE}

500

300

100

IOO

300

400

ETRUSCAN AND ROMAN ART

- Etruscan Supremacyc. 700–509 BCE
- Persian Empire
 c. 559-331 BCE
- Roman Republic c. 509-27 BCE
- ◆ Classical Greek Culture

 c. 450-323 BCE

- Julius Caesar Assassinated 44 BCE
- Roman Empire 27 BCE-395 CE
- Conquest of Dacia 106 CE

- Battle of Milvian Bridge 312 CE
- Costantinople Becomes Capital
- Division of Empire 395 CE

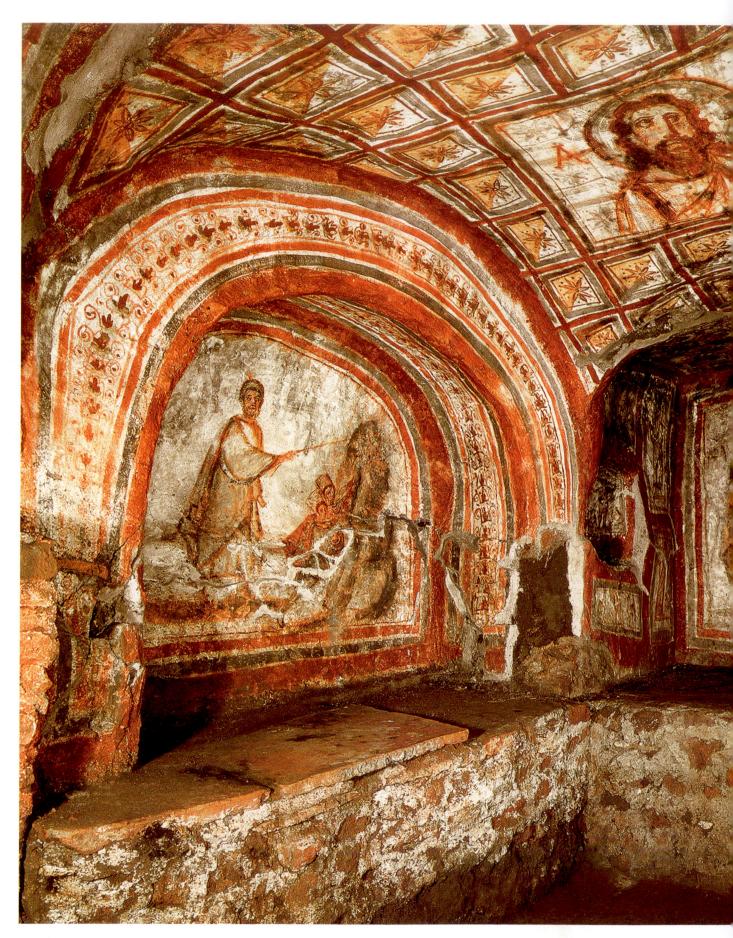

−**I** | **CUBICULUM OF LEONIS, CATACOMB OF COMMODILLA** Near Rome. Late 4th century.

CHAPTER SEVEN

JEWISH, EARLY CHRISTIAN, AND BYZANTINE ART

7

In ancient Rome, gravediggers were the architects of the underground. Where subsoil conditions were right, they tunneled out streets and

houses in a city of the dead—a necropolis—with as many as five underground levels. Working in dark, narrow galleries as much as 70 feet below the surface, they dug out corridors, shelves, and small burial rooms to create catacombs. Aboveground, the gravediggers acted as guards and gardeners. Some of them may have been artists too, for even the earliest catacombs contained paintings—initially very simple inscriptions and symbols.

Burials were always outside the city walls, so that the dead would not defile the city. Catacombs were not secret nor were they ever used as hiding places—such stories spring from the imaginations of nineteenth-century romantic writers. Burial in catacombs became common in the early third century CE and ended by about 500. Although Rome's Christian catacombs are the most famous today, people of other faiths—Jews, devotees of Isis, followers of Bacchus and other mystery religions, pagan traditionalists—were interred in their own communal catacombs, which were decorated with symbols of their faith.

In the third century CE, Christian catacombs were painted with images of salvation based on prayers for the dead. By the fourth century, painting had become even more

elaborate, as in this catacomb which depicts saints having a particular connection to Rome (FIG. 7–1). In the center of a small burial room's ceiling—between alpha and omega—the Greek letters signifying the beginning and end—the head of Christ appears in a circle (a halo). Facing the door is Christ with the Roman martyrs Felix (d. 274) and Adauctus (d. 303). At the right, a painting depicts Peter in the hours before the cock crowed, when he denied that he knew Jesus (Matthew 26:74–75). On the left, Peter miraculously brings forth water from a rock in Rome's Mamertine Prison to baptize his fellow prisoners and their jailers. Here the painter has copied the traditional Jewish scene of Moses striking water from the rock (Exodus 17:1–7). Were it not for the painting's Christian context, it would be indistinguishable from Jewish art.

CHAPTER-AT-A-GLANCE

- JEWS, CHRISTIANS, AND MUSLIMS Early Jewish Art Early Christian Art
- IMPERIAL CHRISTIAN ARCHITECTURE AND ART Architecture: The Church and Its Decoration Architecture: Ravenna Sculpture
- EARLY BYZANTINE ART: THE FIRST GOLDEN AGE The Golden Age of Justinian Objects of Veneration and Devotion Icons and Iconoclasm
- MIDDLE BYZANTINE ART Architecture and Mosaics Objects of Veneration and Devotion The Special Case of Sicily
- LATE BYZANTINE ART Constantinople Moscow: The Third Rome
- IN PERSPECTIVE

JEWS, CHRISTIANS, AND MUSLIMS

Three religions that arose in the Near East dominate the spiritual life of the Western world today: Judaism, Christianity, and Islam. All three are monotheistic—followers hold that only one god created and rules the universe. Jews believe that God made a covenant, or pact, with their ancestors, the Hebrews, and that they are God's chosen people. They await the coming of a savior, the Messiah, "the anointed one." Christians believe that Jesus of Nazareth was that Messiah (the name Christ is derived from the Greek term meaning "Messiah"). They believe that God took human form, preached among men and women, suffered execution, then rose from the dead and ascended to heaven after establishing the Christian Church under the leadership of the apostles (his closest disciples). Muslims, while accepting the Hebrew prophets and Jesus as divinely inspired, believe Muhammad to be the last and greatest prophet of God (Allah), the Messenger of God through whom Islam was revealed some six centuries after Jesus's lifetime.

All three are "religions of the book," that is, they have written records of God's will and words: the Hebrew Scriptures; the Christian Bible, which includes the Hebrew Scriptures as its Old Testament as well as the Christian New Testament; and the Muslim Qur'an, believed to be the Word of God as revealed in Arabic directly to Muhammad through the archangel Gabriel.

Both Judaism and Christianity existed within the Roman Empire, along with various other religions devoted to the worship of many gods. The variety of religious buildings found in present-day Syria at the abandoned Roman outpost of Dura-Europus, a Hellenistic fortress taken over by the Romans in 165 CE, illustrates the cosmopolitan character of Roman society, as well as places of worship, in the second and third centuries. Although Dura-Europus was destroyed in 256-57 CE by the Sassanid Persians, important parts of the stronghold have been excavated, including a Jewish house-synagogue, a Christian house-church, shrines to the Persian gods Mithras and Zoroaster, and temples to Greek and Roman gods, including Zeus, Artemis, and Adonis. The Jewish and Christian structures were preserved because they had been built beside the wall of the southwest rampart. When the desperate citizens attempted to strengthen this fortification in futile preparation for the final attack, they buried these buildings. The entire site was later abandoned and rediscovered in 1920 by a French army officer.

This chapter concentrates on the religions of the Roman Empire: We consider Jewish and Early Christian and Byzantine art, including some of the later art of the Eastern Orthodox Church.

Early Jewish Art

The Jewish people trace their origin to a Semitic people called the Hebrews, who lived in the land of Canaan. Canaan, known from the second century CE by the Roman name Palestine, was located along the eastern edge of the Mediterranean Sea (MAP 7–I). According to the Torah, the first five books of the Hebrew Scriptures, God promised the patriarch

MAP 7-I | JEWISH, EARLY CHRISTIAN, AND BYZANTINE WORLDS

The eastern Mediterranean lands of Canaan and Judaea were centers of Jewish settlement. Rome was a major center of early western Christianity. Byzantine culture took root in Constantinople and flourished throughout the Eastern Roman, or Byzantine, Empire and extended into northern areas such as Russia and Ukraine.

Abraham that Canaan would be a homeland for the Jewish people (Genesis 17:8), a belief that remains important among Jews to this day.

Jewish settlement of Canaan probably began sometime in the second millennium BCE. According to Exodus, the second book of the Torah, the prophet Moses led the Hebrews out of slavery in Egypt to the promised land of Canaan. At one crucial point during the journey, Moses climbed alone to the top of Mount Sinai, where God gave him the Ten Commandments, the cornerstone of Jewish law. The commandments, inscribed on tablets, were kept in a gold-covered wooden box, the Ark of the Covenant.

Jewish law forbade the worship of idols, a prohibition that often made the representational arts—especially sculpture in the round—suspect. Nevertheless, artists working for Jewish patrons depicted both symbolic and narrative Jewish subjects; and as they did so they looked to both Near Eastern and classical Greek and Roman art for inspiration.

SOLOMON: THE FIRST TEMPLE IN JERUSALEM. In the tenth century BCE, the Jewish king Solomon built a temple in Jerusalem to house the Ark of the Covenant. He sent to nearby Phoenicia for cedar, cypress, and sandalwood, and for a superb artisan to supervise construction of the Temple, later known as the First Temple (2 Chronicles 2:2–15). The Temple was the spiritual center of Jewish life. It consisted of court-yards, two bronze pillars, an entrance hall, a main hall, and the Holy of Holies, the innermost chamber that housed the Ark and its guardian cherubim, or attendant angels (perhaps resembling the winged guardians of Assyria, seen in FIG. 2–1).

In 586 BCE, the Babylonians, under King Nebuchadnezzar II, conquered Jerusalem. They destroyed the Temple, exiled the Jews, and carried off the Ark of the Covenant. When Cyrus the Great of Persia conquered Babylonia in 539 BCE, he permitted the Jews to return to their homeland (Ezra 1:1–4) and rebuild the Temple, which became known as the Second Temple. When Canaan became part of the Roman Empire,

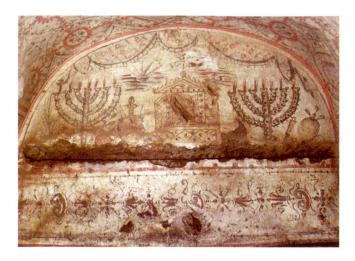

7–2 | MENORAHS AND ARK OF THE COVENANT Wall painting in a Jewish catacomb, Villa Torlonia, Rome. 3rd century. $3'11'' \times 5'9''$ (1.19 \times 1.8 m).

The menorah form probably derives from the ancient Near Eastern Tree of Life, symbolizing for the Jewish people both the end of exile and the paradise to come.

Herod the Great (the king of Judaea, 37–4 BCE), restored the Second Temple. In 70 CE, Roman forces led by the general and future emperor Titus destroyed the Second Temple and all of Jerusalem, an exploit the Romans commemorated on the Arch of Titus (SEE FIG. 6–39). The conspicuous representation of the menorah looted from the Second Temple kept the

memory of the Jewish treasures alive. The site of the Second Temple, the Temple Mount, is also an Islamic holy site, the Haram al-Sharif, and is now occupied by the shrine called the Dome of the Rock (SEE FIGS. 8–2, 8–3).

JEWISH CATACOMB ART IN ROME. Most of the earliest surviving examples of Jewish art date from the Hellenistic and Roman periods. Six Jewish catacombs, discovered in the outskirts of Rome and in use from the first to fourth centuries CE, display wall paintings with Jewish themes. In one example, from the third century CE, two *menorahs* (seven-branched lamps), flank the long-lost Ark of the Covenant (FIG. 7–2).

SYNAGOGUES. Judaism has always emphasized religious learning. Jews gather in synagogues for study and worship, so a synagogue can be any large room where the Torah scrolls are kept and read publicly. Some synagogues were located in private homes or in buildings originally constructed like homes. The first Dura-Europus synagogue consisted of an assembly hall, a separate alcove for women, and a courtyard. After a remodeling of the building, completed in 244–45 CE, men and women shared the hall, and residential rooms were added. Two architectural features distinguished the assembly hall: a bench along its walls and a niche for the Torah scrolls (FIG. 7–3).

Scenes from Jewish history and the story of Moses, as recorded in Exodus, unfold in a continuous narrative around

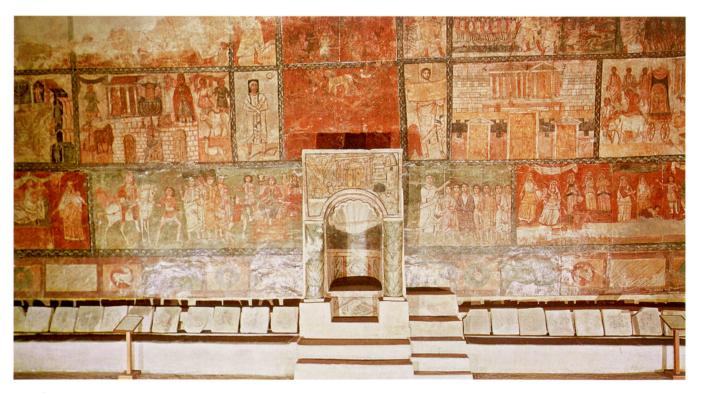

7-3 WALL WITH TORAH NICHE

From a house-synagogue, Dura-Europos, Syria. 244-45. Tempera on plaster, section approx. 40' (12.19 m) long. Reconstructed in the National Museum, Damascus, Syria.

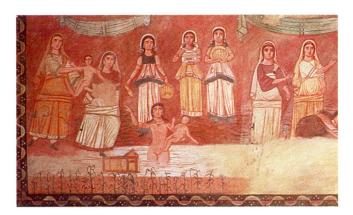

7–4 THE FINDING OF THE BABY MOSES
Detail of a wall painting from a house-synagogue, Dura-Europos, Syria. 244–45. Copy in tempera on plaster.
Dura-Europos Collection. Yale University Art Gallery, New Haven, Connecticut.

the room. This vivid depiction of events follows the Roman tradition of historical narrative. In **THE FINDING OF THE BABY MOSES** (FIG. 7–4), Moses's mother has set him afloat in a reed basket in the shallows of the Nile in an attempt to save him from the pharaoh's decree that all male Jewish infants be put to death (Exodus 1:8–2:10). The pharaoh's daughter finds him and claims him as her own child.

The painting shows the story unfolding in a narrow foreground space. At the right, the princess sees the child hidden in the bulrushes; at the center, she or a servant wades nude into the water to save him; and at the left, she hands him to a nurse (actually his own mother). Individual paintings are inspired by Near Eastern sources. They are done in a style in which static, two-dimensional figures seem to float against a neutral background. The frontal poses, strong outlines, and flat colors are also features of later Byzantine art, an art perhaps derived from the same sources that inspired these images.

In addition to house-synagogues, Jews built synagogues designed on the model of the ancient Roman basilica. A typical basilica synagogue had a central nave; an aisle on both sides, separated from the nave by a line of columns; a semicircular apse in the wall facing Jerusalem; and perhaps an atrium and porch, or narthex. A very grand synagogue might have a mosaic floor.

A fragment of a mosaic floor from a sixth-century synagogue at the site of ancient Menois (present-day Maon) features traditional Jewish symbols along with a variety of stylized plants, birds, and animals (FIG. 7–5). Two lions of Judah flank a menorah. Beneath it is the ram's horn (*shofar*), blown on ceremonial occasions, and three citrons (*etrogs*) used to celebrate the harvest festival of Sukkot. Other Sukkot emblems—including palm trees and the *lulav*, a sheaf of palm, myrtle, and willow branches, and an *etrog*—symbolize the bounty of the earth and unity of all Jews. The variety of

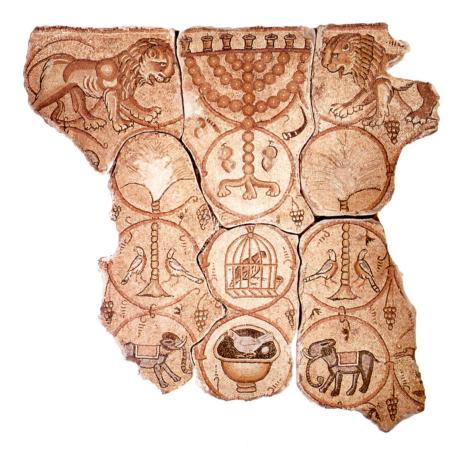

7–5 | SYNAGOGUE FLOOR Maon (ancient Menois). c. 530. Mosaic. The Israel Museum, Jerusalem.

Myth and Religion

CHRISTIAN SYMBOLS

ymbols have always played an integral role in Christian art. Some were devised just for Christianity, but most were borrowed from pagan and Jewish traditions and adopted for Christian use. The Old Testament dove is a symbol of purity, representing peace when it is shown bearing an olive branch. In Christian art, a white dove is the symbolic embodiment of the Holy Spirit. The fish was one of the earliest symbols for Jesus Christ. The first letters of Jesus Christ, Son of God, Savior, spelled "fish" in Greek. Because of its association with baptism in water, it came to stand for all Christians. The lamb, an ancient sacrificial animal, symbolizes Jesus's sacrifice on the Cross as the Lamb of God. A flock of sheep represents the apostles-or all Christians-cared for by their Good Shepherd, Jesus Christ. The Evangelists, who were believed to have written the New Testament Gospels, are traditionally associated with the following creatures: Saint Matthew, a man (or angel); Saint Mark, a lion; Saint Luke, an ox; and Saint John, an eagle.

THE CROSS. The primary Christian emblem, the cross, symbolizes the suffering and triumph of Jesus's Crucifixion and Resurrection. It also stands for Jesus Christ himself, as well as the Christian religion as a whole. Crosses have taken various forms; the two most common are the Latin cross and the Greek cross.

Monograms. Alpha (the first letter of the Greek alphabet) and omega (the last) signify God as the beginning and end of all things. This symbolic device was popular from Early Christian times through the Middle Ages. The initials I and X are the first letters of Jesus and Christ in Greek. The Greek letters XP, known as the *chi rho*, were the first two letters of the word Christos. These emblems are sometimes enclosed by a halo or wreath of victory.

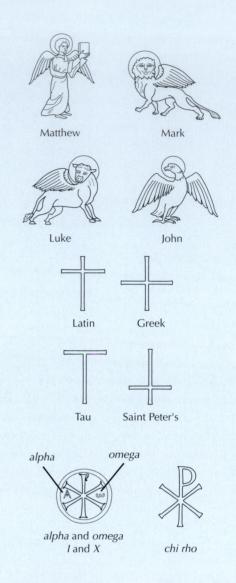

placid animals may represent the universal peace prophesied by Isaiah (11:6–9; 65:25). The pairing of images around a central element—as in the birds flanking the palm trees or the lions facing the menorah—is characteristic of Near Eastern art.

Early Christian Art

Christians believe in one God manifest in three persons: the Trinity of Father (God), Son (Jesus Christ), and Holy Spirit. According to Christian belief, Jesus was the Son of God by a human mother, the Virgin Mary. At the age of 30, Jesus gathered a group of disciples, male and female, and began to preach love and charity, a personal relationship with God, the forgiveness of sins, and the promise of life after death. After his ministry on earth, he was crucified (and after three days he rose from the dead). The core of Christian belief was formalized at the first ecumenical council of the Christian Church, called by Constantine I at Nicaea (present-day Iznik, Turkey) in 325.

THE CHRISTIAN BIBLE. The Christian Bible has two parts: the Old Testament (the Hebrew Scriptures), and the New Testament. The life and teachings of Jesus of Nazareth were recorded between about 70 and 100 CE in the New Testament books attributed to the Four Evangelists: Matthew, Mark, Luke, and John, the order arranged by Saint Jerome, an early Church father who made a translation of the books into Latin. They are known as the Gospels (from an Old English translation of a Latin word derived from the Greek *evangelion*, meaning "good news").

In addition to the Gospels, the New Testament includes an account of the Acts of the Apostles and the epistles, twenty-one letters of advice and encouragement to Christian communities in cities and towns in Greece, Asia Minor, and other parts of the Roman Empire. Thirteen of these letters are attributed to a Jewish convert, Saul, who took the Christian name Paul. The final book is the Apocalypse (the Revelation), a series of enigmatic visions and prophecies concern-

ing the eventual triumph of God at the end of the world, written about 95 CE.

THE EARLY CHURCH. Jesus limited his ministry primarily to Jews; the twelve apostles, as well as followers such as Paul, then took his teachings to non-Jews. Despite sporadic persecutions, Christianity persisted and spread throughout the Roman Empire. The government formally recognized the religion in 313 CE, and Christianity grew rapidly during the fourth century. As well-educated, upper-class Romans joined the Christian Church, they established an increasingly elaborate organizational structure along with ever more sophisticated doctrine.

Christian communities were organized by geographical units, called *dioceses*, along the lines of Roman provincial governments. Senior church officials called *bishops* served as governors of dioceses made up of smaller units, *parishes*, headed by priests. A bishop's church is a *cathedral*, a word derived from the Latin *cathedra*, which means "chair" but took on the meaning "bishop's throne." The bishop of Rome eventually became head of the Western church, with the title *pope*. The bishop of Constantinople became the head, or *patriarch*, of the Eastern church.

In spite of tensions between East and West, the Church remained united until 1054, when the Western pope and Eastern patriarch declared one another to be in error. The Church split in two, with the pope becoming the supreme authority in the Western or Catholic church, and the patriarch, with his metropolitans (equivalent to archbishops), governing the Eastern or Orthodox church.

Communal Christian worship focused on the central "mystery," or miracle, of the Incarnation of Jesus Christ and the promise of salvation. At its core was the ritual consumption of bread and wine, identified as the Body and Blood of Christ, which Jesus Christ had inaugurated at the Last Supper, a Passover meal with his disciples. Around these acts developed an elaborate religious ceremony, or *liturgy*, called the Eucharist (also known as Holy Communion or the Mass). Christians adopted the grapevine and grape cluster of the Roman god Bacchus to symbolize the wine of the Eucharist, and the Blood of Christ (see "Christian Symbols," page 238).

CATACOMB PAINTINGS. Christian rites prompted the development of special buildings—churches and baptistries—as well as specialized equipment. Christians began to use the visual arts to instruct worshipers as well as to glorify God. Almost no examples of specifically Christian art exist before the early third century, and even then it drew its styles and imagery from Jewish and classical traditions.

In this process, known as syncretism, artists assimilate images from other traditions and give them new meanings. The borrowings can be unconscious or quite deliberate. For example, orant figures—worshipers with arms outstretched—can be pagan, Jewish, or Christian, depending on the context in which they occur. Perhaps the most important

Sequencing Works of Art

244-45	Wall with Torah niche, from a house- synagogue, Dura-Europos
c. 270	Sarcophagus from Santa Maria Antiqua
Late 300s	Cubiculum of Leonis, Catacomb of Commodilla
c. 422-32	Church of Santa Sabina
c. 530	Synagogue floor, Maon

of these syncretic images is the Good Shepherd. In pagan art, he was Apollo, or Hermes the shepherd, or Orpheus among the animals. He became the Good Shepherd of the Psalms and Gospels to the Jews and Christians.

Christians, like Jews, used catacombs for burials and funeral services even before Constantine I granted their religion official recognition. In the Christian Catacomb of Commodilla, dating from the fourth century, long rectangular niches in the walls, called *loculi*, each held two or three bodies. Affluent families created small rooms, or *cubicula*, off the main passages to house sarcophagi (SEE FIG. 7–1). The cubicula were hewn out of tufa, soft volcanic rock, then plastered and painted with imagery related to their owners' religious beliefs. The finest Early Christian catacomb paintings resemble murals in houses such as those preserved at Rome and Pompeii (SEE FIGS. 6–34, 6–35). However, the aesthetic quality of the paintings is secondary to the message they convey.

One fourth-century Roman catacomb contained remains, or relics, of Saints Peter and Marcellinus, two third-century Christians martyred for their faith. Here, the ceiling of a cubiculum is partitioned by a central medallion, or round ornament, and four lunettes, semicircular wall areas framed by an arch (FIG. 7–6). At the center is a Good

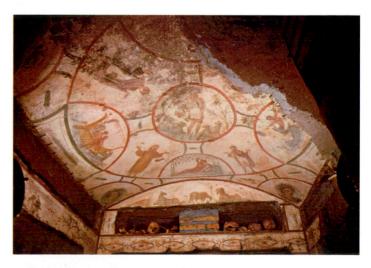

7–6 GOOD SHEPHERD, ORANTS, AND STORY OF JONAH Painted ceiling of the Catacomb of Saints Peter and Marcellinus, Rome. Late 3rd-early 4th century.

Shepherd, whose pose has roots in classical sculpture. In its new context, the image was a reminder of Jesus's promise "I am the good shepherd. A good shepherd lays down his life for the sheep" (John 10:11), as well as the Good Shepherd of the Psalms (Psalm 23:1).

The semicircular compartments at the ends of the arms of the cross tell the Old Testament story of Jonah and the sea monster (Jonah 1–2), in which God caused Jonah to be thrown overboard, swallowed by a monster, and released, repentant and unscathed, three days later. Christians reinterpreted this story as a parable of Christ's death and resurrection—and hence of the everlasting life awaiting true believers—and it was a popular subject in Christian catacombs. On the left, Jonah is thrown from the boat; on the right, the monster spits him up; and at the center, Jonah

reclines in the shade of a vine, a symbol of Paradise. Orant figures stand between the lunettes.

Sculpture. Sculpture that is clearly Christian from before the time of Constantine is even rarer than painting. What there is consists mainly of sarcophagi and small statues and reliefs, many of them Good Shepherd images. A remarkable set of small marble figures, probably made in the third century in Asia Minor, depicts the Good Shepherd (FIG. 7–7). Because it was found with sculptures depicting Jonah, it is probably from a Christian home.

Large workshops devoted to carving tomb chests existed in most urban centers. The sculptors worked on special orders and also kept a supply of finished sarcophagi carved with subjects suitable for a variety of beliefs (FIG. 7–8). Figures of the

7–7 THE GOOD SHEPHERD
Eastern Mediterranean, probably
Anatolia (Turkey). Second half of
the 3rd century. Marble, height
19¼" (50.2 cm), width 16" (15.9
cm). The Cleveland Museum of Art.
John L. Severance Fund, 1965.241

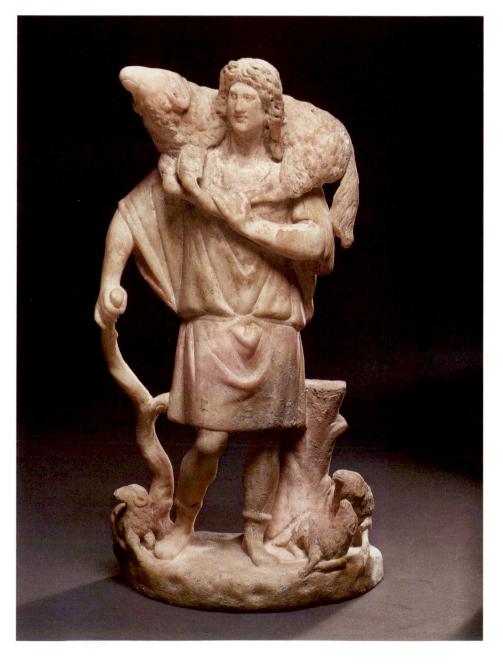

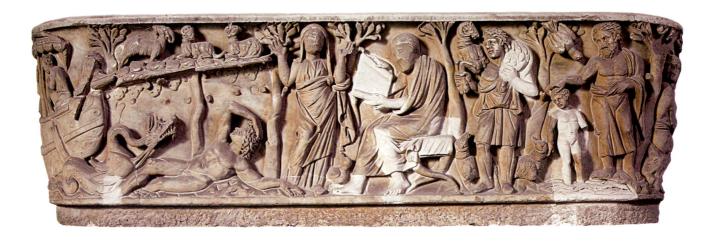

7-8 | SARCOPHAGUS OF THE CHURCH OF SANTA MARIA ANTIQUA Rome. c. 270. Marble. 1'111/4" \times 7'2" (5.45 \times 2.2 m).

deceased needed only to have the individual face carved to complete the work. On the sarcophagus found in the Roman Church of Santa Maria Antiqua the natural poses of the figures, the solid modeling of the figures, and the revealing drapery all indicate the sculpture's classical roots.

The subject of the sculpture would be appropriate for either a pagan or Christian family. In the center stands a figure with hands raised in the age-old gesture of prayer. At one side a bearded man reads a scroll (a teacher or philosopher), a shepherd brings in a sheep, and an older man places his hand on the head of a youth who stands in a river. On the other side, a youth, menaced by a monster, lies under an arbor in the standard classical pose of sleep. Three sheep fill out the landscape, and a ship sails off at the far left. Nothing represented here could offend pagan sensibilities. But to the informed Christian, the orant is the Christian soul, the seated man is the teaching Christ, followed by Christ the Good Shepherd and a scene of baptism. The sleeping youth is Jonah, resting after his ordeal, and the monster is in the classical form of a dog-headed serpent.

HOUSE-CHURCHES. At first, Christians, like Jews, gathered in the homes of members of the community. In Dura-Europus, a house-church stands only about 300 yards from the house-synagogue (SEE FIG. 7–3). The building was a typical Roman house, with rooms around a courtyard and a second-floor apartment for the owner. A small red cross painted above the main entrance alerted Christians that the building was a gathering place. Two of the five ground-floor rooms—a large assembly hall and a room with a water tank—were adapted for Christian use.

The water tank indicates a baptistry, a special place for the baptismal rite. (Baptism washes away sin, leaving the initiate reborn as a member of the community of the faithful.) One end of the room had a niche equipped with a water basin, above which were images of the Good Shepherd and of Adam and Eve (FIG. 7–9). These murals reminded new Christians that humanity fell from grace when the first man and woman disobeyed God and ate fruit from the tree of knowledge, but the Good Shepherd (Jesus Christ) came to earth to carry his sheep (Christians) to salvation and eternal life.

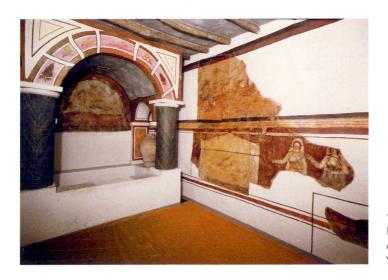

Elements of Architecture

BASILICA-PLAN AND CENTRAL-PLAN CHURCHES

he forms of early Christian buildings were based on two classical prototypes: rectangular Roman basilicas (SEE FIG. 6-48) and round-domed structures—rotundas—such as the Pantheon (SEE FIGS. 6-52, 6-53).

As in Old Saint Peter's in Rome (SEE FIG. 7–10), basilica-plan churches are characterized by a forecourt, the **atrium**, leading to a porch, the **narthex**, which spans one of the building's short ends. Doorways—known collectively as the church's **portal**—lead from the narthex into the **nave**. Rows of columns separate the high-ceilinged nave from the **aisles** on either side. The nave is lit by windows of the **clerestory**, which rises above the side aisles' roofs. At the opposite end of the nave from the narthex is a semicircular **apse**. The apse functions as the building's focal point, where the altar, raised on a platform, is located. Sometimes there is also a **transept**, a wing that crosses the nave in front of the

apse, making the building T-shaped (SEE FIG. 7–10); this is known as the *tau* plan. When additional space (a choir) comes between the transept and the apse, the plan is known as a Latin cross.

Central-plan buildings were first used by Christians as tombs, baptism centers, and shrines to martyrs. The Greek-cross plan, in which two similarly sized "arms" intersect at their centers, is a type of central plan (FIG. 7-44). Like basilicas, central-plan churches generally have an atrium, a narthex, and an apse. But instead of the longitudinal axis of basilica-plan churches, which draws worshipers forward toward the apse, central-plan churches such as Ravenna's San Vitale (SEE FIGS. 7-28, 7-29) have a more vertical axis. This makes worshipers focus on the dome, the symbolic "vault of heaven." The space where the liturgy is performed, containing the central dome, sanctuary, and apse, is called the naos.

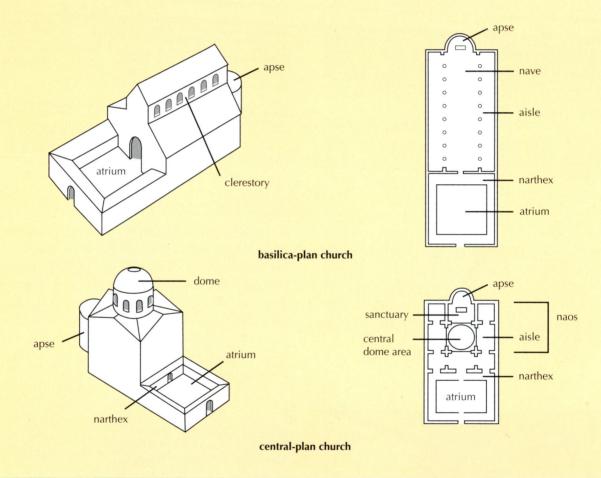

IMPERIAL CHRISTIAN ARCHITECTURE AND ART

In 313, Constantine I issued the Edict of Milan, granting all people in the Roman Empire freedom to worship whatever god they wished. This religious toleration, combined with Constantine's active support, allowed Christianity to enter a

new phase. In the fourth and fifth centuries, a sophisticated philosophical and ethical system developed, using many ideas from Greek and Roman thought. Church scholars edited and commented on the Bible, and the papal secretary who would become Saint Jerome (c. 347–420) undertook a new translation from Hebrew and Greek versions into Latin, the language of the Western church.

Completed about 404, this so-called Vulgate became the official version of the Bible. (The term *Vulgate* has the same root as the word *vulgat*, the Latin *vularis*, meaning "common" or "popular.") Christians also gained political influence in this period. The Christian writer Lactantius, for example, tutored Constantine I's son. Eusebius, bishop of Caesarea, was a trusted imperial adviser from about 315 to 339. These transformations in the philosophical and political arenas coincided with a dramatic increase in the size and splendor of Christian architecture.

Architecture: The Church and Its Decoration

The Christian community had special architectural needs. A Greek or Roman temple served as the house and treasury of the god and formed a backdrop for ceremonies that took place at altars in the open air. In Christianity, as in some of the Mystery religions (SEE FIG. 6–27), the entire community gathered inside the building to participate in the rites. Christians also needed places or buildings for activities such as education, the initiation of new members, private prayer, and burials. The pagan basilica provided a model for the congregational church and the tholos tomb provided a model for the baptistry and martyr's shrine.

THE BASILICA CHURCH. Christian congregations needed large, well-lit spaces for worship, and the Roman basilica provided a perfect model (see "Basilica-Plan and Central-Plan Churches," page 242). But rather than an entrance through

the long side of the building into a columnar hall, with an apse at each end (see the basilica Ulpia, FIG. 6–48), the early Christian basilica had its entrance from an atrium on the short side of the building and a single apse at the opposite end, like the contemporary secular hall in Trier (SEE FIG. 6–71). The place where the altar stood was the place that in a pagan basilica was reserved for the judge or presiding official. The nave with aisles on the two long sides created an ample central space for processions and a place for the congregation. If the clergy needed to partition space, they used screens or curtains around the altar or in the side aisles.

In Rome, Constantine and his family sponsored a vast building program for the Church. For the bishop of Rome (the pope), Constantine built a residence on the site of the imperial Lateran palace as well as a baptistry and a basilican church. The Church of Saint John Lateran remains the cathedral of Rome to this day, although the pope's residence has been the Vatican since the thirteenth century. Perhaps as early as 320, the emperor also ordered the construction of a large new basilica to replace the humble monument marking the place where Christians believed Saint Peter was buried (c. 64 CE).

OLD SAINT PETER'S CHURCH. The new basilica—now known as Old Saint Peter's because it was replaced by a new building in the sixteenth century—would protect the tomb of Peter, and make the site accessible to the faithful (FIG. 7–10). Our knowledge of Old Saint Peter's is based on written descriptions, drawings made before and while it was

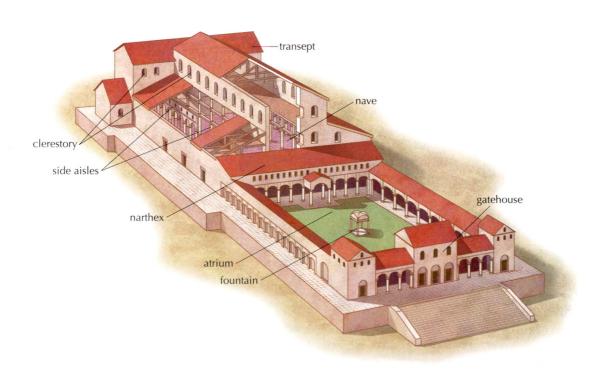

7—IO | RECONSTRUCTION DRAWING OF OLD SAINT PETER'S BASILICA
Rome. c. 320–27; atrium added in later 4th century. Approx. 394' (120 m) long and 210' (64 m) wide.

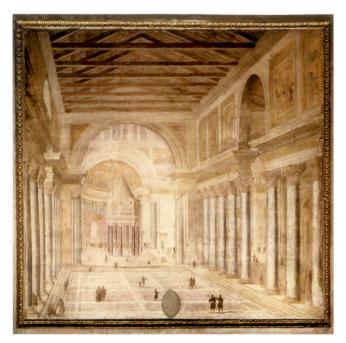

7-II OLD ST. PETER'S, PAINTING OF THE INTERIOR Painting in San Martino ai Monte, Rome. 16th century.

being dismantled, the study of other churches inspired by it, and modern archaeological excavations at the site (FIG. 7–11).

Old Saint Peter's was an unusual basilica church in having double side aisles instead of one aisle on each side of the nave. A narthex across the width of the building provided a place for people who had not yet been baptized. Five doorways—a large, central portal into the nave and two portals on each side—gave access to the church. Columns supporting an entablature lined the nave, forming what is called a nave colonnade. However, the columns dividing the double side aisles supported round arches. In turn, these arches carried the open wood rafters roofing the

nave and aisles. Sarcophagi and tombs also lined the side aisles.

Constantine's architects devised a new element for the basilica plan. At the apse end of the nave, they added a **transept**, a large hall that crossed in front of the apse. It created a T form that anticipated the later Latin-cross church plan, seen in the reconstruction in FIGURE 7–10. This area provided additional space for the large number of clergy serving the church, and it also accommodated pilgrims visiting the tomb of Saint Peter. Transept windows lit the high altar directly.

Saint Peter's bones supposedly lie below the altar, marked by a permanent, pavilionlike structure supported on four columns, called a *ciborium*. A Roman cemetery, partly destroyed and covered by the foundations of Constantine's basilica, lay beneath the church. Eventually a large *crypt*, or underground vault, giving access to the tomb of Peter and providing additional space for important burials, was built on the site. It is still used today for the burial of the popes.

Old Saint Peter's thus served a variety of functions. It was a burial site, a pilgrimage shrine commemorating Peter's martyrdom and containing his relics, and a congregational church. It could hold at least 14,000 worshipers, and it remained the largest Christian church until the eleventh century.

SANTA SABINA. Most early Christian churches have been rebuilt, some many times, but the Church of Santa Sabina in Rome, constructed by Bishop Peter of Ilyria between 422 and 432, appears much as it did in the fifth century (FIG. 7–12). The basic elements of the basilica church are clearly visible inside and out: a nave lit by clerestory windows, flanked by side aisles, and ending in a rounded apse. (Compare the Audience Hall at Trier; SEE FIG. 6–71.)

Santa Sabina's exterior is the typical simple brickwork. In contrast, the church's interior displays a wealth of marble

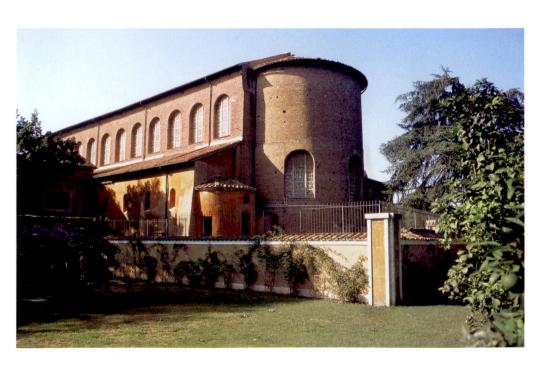

7–12 CHURCH OF SANTA SABINA
Rome. Exterior view from the Southeast.
c. 422–32.

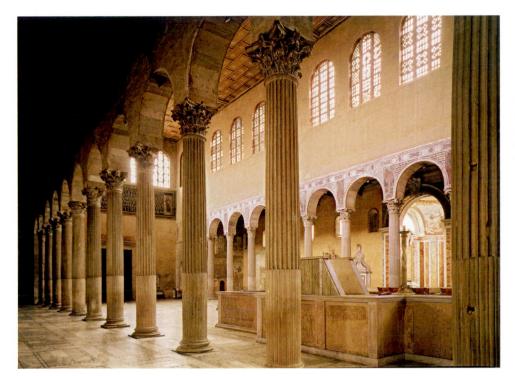

7-13 INTERIOR, CHURCH OF SANTA SABINA
View from the south aisle near the sanctuary to the entrance.
c. 422-32.

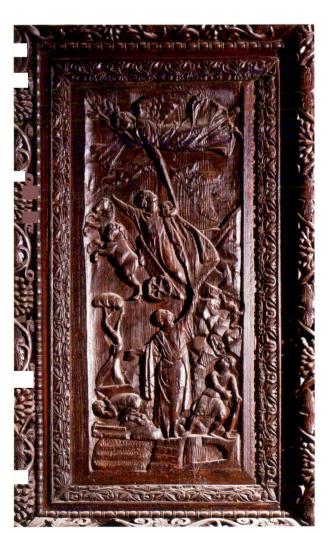

7-14 | THE ASCENSION OF ELIJAH
Panel from the doors of the Church of Santa Sabina.
420s. Cypress wood.

veneer and twenty-four fluted marble columns with Corinthian capitals acquired from a second-century building (FIG. 7–13). (Material reused from earlier buildings is known as *spolia*, Latin for "spoils.") The columns support round arches, creating a nave arcade, in contrast to the nave colonnade in Saint Peter's. The spandrels are inlaid with marble images of the *chalice* (the wine cup) and *paten* (the plate that holds the bread)—the essential equipment for the Eucharistic rite that took place at the altar. The blind wall between the arcade and the clerestory typically had paintings or mosaics with scenes from the Old Testament or the Gospels. The decoration of the upper walls is lost, and a paneled ceiling covers the rafter roof.

Sheltered by the narthex, the principal entrance to the church still has its fifth-century wooden doors (FIG. 7–14), which were in place for the consecration of the church by Pope Sixtus III (432–40 CE). Framed panels are carved with scenes from the Old and New Testaments. Only eighteen out of twenty-eight panels survive, making any analysis of the iconography highly speculative, but some relationship between Old and New Testament themes seems to have been intended. The Ascension of Elijah (2 Kings 2:11) could have been related to the Ascension of Christ, for example. The prophet soars upward in the chariot of fire sent for him by God and guided by an angel, to the amazement of his followers. An angel with a long wand guides his ascent.

SANTA MARIA MAGGIORE. Another kind of decoration, mosaic panels, still survives in the Church of Santa Maria Maggiore, which was built between 432 and 440. The church was the first to be dedicated to the Virgin Mary after the Council of Ephesus in 431 declared her to be Theotokos,

"Bearer of God." The mosaics of the Church of Santa Maria Maggiore reflect a renewed interest in the earlier classical style of Roman art that arose during the reign of Pope Sixtus III. The mosaics along the nave walls, in framed panels high above the worshipers, illustrate Old Testament stories of the Jewish patriarchs and heroes—Abraham, Jacob, Moses, and Joshua—whom Christians believe foretold the coming of Christ and his activities on earth. These panels were not simply intended to instruct the congregation. Instead, as with most of the decorations in great Christian churches from this time forward, they were also meant to praise God through their splendor, to make churches symbolic embodiments of the Heavenly Jerusalem that awaits believers in the afterlife.

Some of the most effective compositions are those in which a few large figures dominate the space, as in the PART-ING OF LOT AND ABRAHAM (FIG. 7–15), a story told in the first book of the Old Testament (Genesis 13:1–12). The people of Abraham and his nephew Lot, dwelling together, had grown too numerous, so the two agreed to separate and lead their followers in different directions. On the right, Lot and his daughters turn toward the land of Jordan, while Abraham and his wife stay in the land of Canaan. Abraham was the founder of Israel and an ancestor of Jesus. (Judaism, Christianity, and Islam are sometimes referred to as Abrahamic religions.)

The toga-clad men share a parting look as they gather their robes about them and turn decisively away from each other. The space between them in the center of the composition emphasizes their irreversible decision to part. Clusters of heads in the background represent their followers, an artistic convention used effectively here. The earlier Roman realistic style can be seen in the solid three-dimensional rendering of foreground figures, the hint of perspective in the building, and the landscape setting, with its flocks of sheep, bits of foliage, and touches of blue sky. To Roman stone and marble mosaics, Christian artists added tesserae of colored glass and clear glass in which gold leaf was embedded. The use of graduated colors creates shading from light to dark, producing three-dimensional effects that are offset by strong outlines. These outlines, coupled with the sheen of the gold tesserae, tend to flatten the forms and emphasize a quality of otherworldly splendor.

SANTA COSTANZA. A second type of ancient building—the *tholos*, a round structure with a central plan and vertical axis—also served Christian builders as a model for tombs, martyrs' churches, and baptistries (see "Basilica-Plan and Central-Plan Churches," page 242). One of the earliest surviving central-plan Christian buildings is the mausoleum of Constantina, the daughter of Constantine. The tomb was built outside the walls of Rome just before 350 (FIG. 7–16). The mausoleum was consecrated as a church in 1256 and is now dedicated to Santa Costanza (the Italian form of Constantina). The building consists of a tall rotunda with an

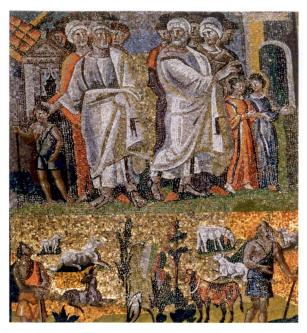

7–I5 | PARTING OF LOT AND ABRAHAM Mosaic in the nave arcade of the Church of Santa Maria Maggiore, Rome. 432–40. Panel approx. $4'11'' \times 6'8''$ (1.2 × 2 m).

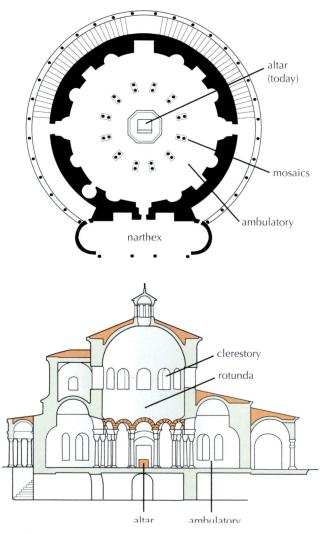

7-16 | Plan and Section, Church of Santa Costanza Rome. c. 350.

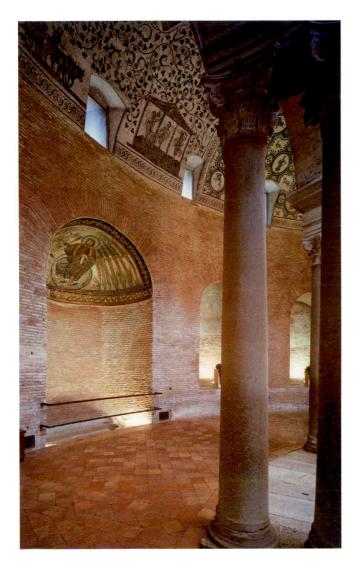

encircling barrel-vaulted passageway called an **ambulatory** (FIG. 7–17). A double ring of paired columns with Composite capitals and richly molded entablature blocks supports the arcade and dome. Originally, the interior was entirely sheathed in mosaics and fine marble.

Mosaics in the ambulatory vault recall the syncretic images in the catacombs. One section, for example, is covered

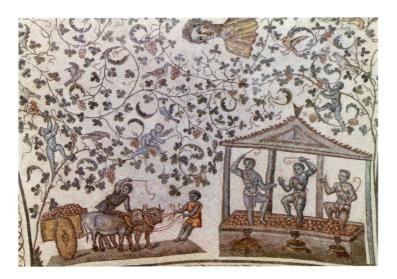

7-17 CHURCH OF SANTA COSTANZA

Rome. c. 350. Ambulatory with harvesting mosaic (see Fig. 7-18). Niche at left with mosaic of Christ. In the apse, the Lord handing over the tablets of the law to Moses (mosaic, later 4th century). Canali Photobank, Capriolo (BS)

with a tangle of grapevines filled with putti—naked male child-angels, or cherubs, derived from classical art—who vie with the birds to harvest the grapes (FIG. 7–18). Along the bottom edges on each side, putti drive wagonloads of grapes toward pavilions housing large vats in which more putti trample the grapes into juice. The technique, subject, and style are Roman, but the meaning has been altered. The scene would have been familiar to the pagan followers of Bacchus, but in a Christian context, the grape juice becomes the wine of the Eucharist. Constantina's pagan husband, however, may have appreciated the double allusion.

Architecture: Ravenna

As Rome's political importance dwindled, that of the northern Italian cities of Milan and Ravenna grew. In 395, Emperor Theodosius I split the Roman Empire into eastern and western divisions, each ruled by one of his sons. Heading the Western Roman Empire, Honorius (ruled 395–423) first established his capital at Milan. When Germanic settlers laid siege to Milan in 402, Honorius moved his government to Ravenna on the east coast. Its naval base, Classis (present-day Classe), had been important since the early days of the empire. In addition to military security, Ravenna offered direct access by sea to Constantinople. Ravenna flourished, and when Italy fell in 476 to the Ostrogoths, the city became one of their headquarters. It still contains a remarkable group of well-preserved fifth- and sixth-century buildings.

THE MAUSOLEUM OF GALLA PLACIDIA. One of the earliest surviving Christian structures in Ravenna is a funerary chapel that was once attached to the narthex of the church of the imperial palace (now Santa Croce, meaning "Holy Cross"). Built about 425–26, the chapel was constructed when

7–18 | HARVESTING OF GRAPES
Ambulatory vault, Church of Santa Costanza,
Rome. c. 350. Mosaic.

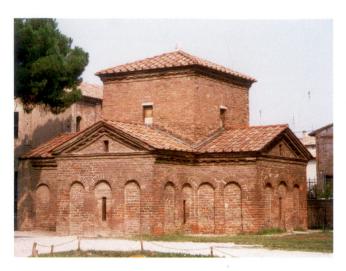

7−**I**9 MAUSOLEUM OF GALLA PLACIDIA Ravenna. *c.* 425–26.

Honorius's half-sister, Galla Placidia, ruled the West (425–c. 440) as regent for her son. The chapel came to be called the **MAUSOLEUM OF GALLA PLACIDIA** because she and her family were once believed to be buried there (FIG. 7–19).

This small building is **cruciform**, or cross-shaped; a barrel vault covers each of its arms, and a **pendentive dome**—a dome continuous with its pendentives—covers the space at the intersection of the arms (see "Pendentives and Squinches," page 257). The interior of the chapel contrasts markedly with the unadorned exterior, a transition designed to simulate the passage from the real world into a supernatural one (FIG. 7–20). The worshiper looking from the western entrance across to the eastern bay of the chapel sees a brilliant, abstract pattern of mosaic that suggests a starry sky filling the barrel vault. Panels of veined marble sheathe the walls below. Bands of luxuriant foliage and floral designs derived from funerary garlands cover the four central arches, and the walls above them are filled with the figures of standing apostles, gesturing like orators. Doves flanking a small fountain between the apostles symbolize eternal life in heaven.

In the lunette below, a mosaic depicts the third-century martyrdom of Saint Lawrence, to whom the building may have been dedicated. The saint holds a cross and gestures toward the fire and metal grill on which he was literally roasted (thereby becoming the patron saint of bakers). At the left stands a tall cabinet containing the Gospels, signifying the faith for which he died (see a detail showing the contents of the cabinet in "Early Forms of the Book," page 251).

Opposite Saint Lawrence, in a lunette over the entrance portal, is a mosaic of the Good Shepherd (FIG. 7–21). A comparison of this version with a fourth-century depiction of the

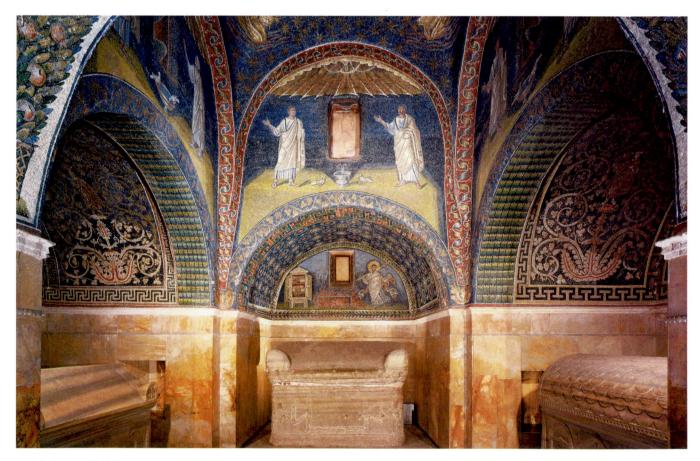

7–20 | MAUSOLEUM OF GALLA PLACIDIA Ravenna. View from entrance, barrel-vaulted arms housing sarchophagi, lunette mosaic of the Martyrdom of Saint Lawrence. c. 425–26.

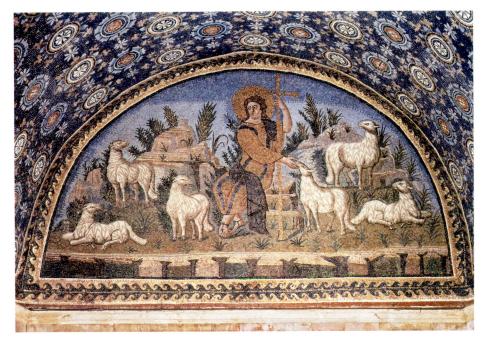

7–21 GOOD SHEPHERD Lunette over the entrance, Mausoleum of Galla Placidia. c 425–26. Mosaic.

same subject (SEE FIG. 7–6) reveals significant changes in content and design. The Ravenna mosaic contains many familiar classical elements, such as shading suggesting a single light source acting on solid forms, cast shadows, and a hint of land-scape in rocks and foliage. The conception of Jesus the Shepherd, however, has changed.

In the fourth-century painting, he was a simple shepherd boy carrying an animal on his shoulders. In the Ravenna mosaic, he is a young adult with a golden halo, wearing imperial robes of gold and purple and holding a long golden staff that ends in a cross instead of a shepherd's crook. The stylized elements of a natural landscape are arranged more rigidly than before. Individual plants at regular intervals fill the spaces between animals, and the rocks are stepped back into a shallow space that rises from the foreground plane and ends in foliage. The rocky band at the bottom of the lunette scene, resembling a cliff face riddled with clefts, separates the divine image from worshipers.

BAPTISTRY OF THE ORTHODOX. Just as the political role of Ravenna changed in the fourth and fifth centuries, so did the religious beliefs of its leaders. The early Christian Church faced many philosophical and doctrinal controversies, some of which resulted in serious splits, called *schisms*, within the Church. When this happened, Church leaders gathered in councils to decide on the orthodox, or official, position, while denouncing other positions as heretical. For example, they rejected Arianism, an early form of Christianity that questioned the doctrine of the Trinity and held that Jesus was not fully divine. The first church council, called by Constantine at Nicaea in 325, made the doctrine of the Trinity the official Christian belief. In 451, the Council of Chalcedon,

near Constantinople, declared Jesus to be of two natures—human and divine—united in one.

In Ravenna, two baptistries, orthodox and Arian, still stand as witness to these disputes. The Baptistry of the Orthodox, constructed next to the cathedral of Ravenna in the early fourth century, is the more splendid of the two. It was renovated and refurbished between 450 and 460 when the original wooden ceiling was replaced with a dome and splendid interior decoration added in marble, stucco, and mosaic (FIG. 7–22). On the clerestory level, a blind arcade frames figures of Old Testament prophets in stucco relief. This arcading suggests that the domed ceiling is a huge canopy tethered to the columns.

In the dome itself, concentric rings of decoration draw the eye upward to a central image: the baptism of Jesus by John the Baptist. The lowest ring depicts fantastic architecture, similar to that seen in ancient secular wall painting. Eight circular niches contain alternating altars holding gospel books and empty thrones that symbolize Christ's Second Coming (Matthew 25:31-36). In the next ring, toga-clad apostles stand holding crowns, the rewards of martyrdom. Stylized golden plant forms divide the deep blue ground between them. Although the figures cast dark shadows on the pale green grass, their cloudlike robes, shot through with golden rays, give them an otherworldly presence. The landscape setting of the Baptism of Jesus in the central tondo—a circular image—exhibits classical roots, and the personification of the Jordan River recalls pagan imagery. The background, however, is not the blue of the earthly sky but the gold of paradise. Already in the mid-fifth century, artists working for the Christian Church had begun to reinterpret and transform Roman realism into an abstract style better suited to their patrons' spiritual goals.

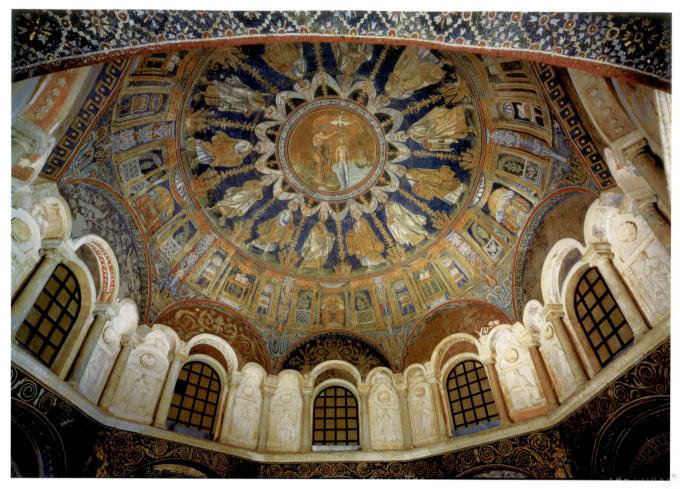

7–22 | CLERESTORY AND DOME BAPTISM OF CHRIST AND PROCESSION OF APOSTLES, GOSPELS AND THRONES, THE PROPHETS. BAPTISTRY OF THE ORTHODOX Ravenna. Italy. Early 5th century; dome remodeled c. 450–60.

Sculpture

In sculpture, as in architecture, Christians adapted Roman forms for their own needs, especially monumental stone sarcophagi such as the elaborately carved **SARCOPHAGUS OF JUNIUS BASSUS** (FIG. 7–23), as imposing as the pagan Roman Battle Sacarphogus (SEE FIG. 6–69). Junius Bassus was a Roman official who, as the inscription here tells us, was "newly baptized" and died on August 25, 359, at the age of 42. On the front panel, columns, entablatures, and gables divide the space into individual scenes. Details of architecture, furniture, and foliage suggest the earthly setting for each scene.

In the center of both registers, columns carved with putti producing wine frame the triumphal Christ. In the upper register, he appears as a teacher-philosopher flanked by Saints Peter and Paul. In a reference to the pagan past, Christ rests his feet on the head of Aeolus, the classical god of the winds, who also represents the Cosmos (shown with a veil billowing behind him). To Christians, Aeolus personified the

skies, so that Christ is meant to be seen as seated in heaven. He is giving the Christian law to his disciples, imitating the Hebrew Scriptures' account of God dispensing the Law to Moses. In the bottom register, the earthly Jesus makes his triumphal entry into Jerusalem like a Roman emperor entering a conquered city. However, he rides on a humble animal.

The earliest Christian art, such as that in catacomb paintings and on the *Sarcophagus of Junius Bassus*, unites the imagery of Old and New Testaments in elaborate allegories; Old Testament themes foreshadow and illuminate events in the New Testament. On the top left, Abraham passes the test of faith and need not sacrifice his son Isaac. Christians saw in this story a sign of God's sacrifice of his son, Jesus, on the cross. Under the triangular gable on the lower right, the Old Testament story of Daniel saved by God from the lions prefigures Christ's Resurrection. The figure of Daniel has been replaced. Originally nude, he balanced the nude Adam and Eve. In the lower left frame on the far left, God tests the faith of Job, who provides a model for the sufferings of Christian

Art in Its Context

EARLY FORMS OF THE BOOK

ince people began to write some 5,000 years ago, they have kept records on a variety of materials, including clay or wax tablets, pieces of broken pottery, papyrus, animal skins, and paper. Books have taken two forms: scroll and codex.

Scribes made **scrolls** from sheets of papyrus glued end to end or from thin sheets of cleaned, scraped, and trimmed sheep- or calfskin, a material known as **parchment** or, when softer and lighter, **vellum**. Each end of the scroll was attached to a rod; the reader slowly unfurled the scroll from one rod to the other. Scrolls could be written to be read either horizontally or vertically.

At the end of the first century CE, the more practical and manageable **codex** (plural, *codices*)—sheets bound together like the modern book—replaced the scroll. The basic unit of the codex was the eight-leaf **quire**, made by folding a large sheet of parchment twice, cutting the edges free, then sewing the sheets together up the center. Heavy covers kept the sheets of a codex flat.

Until the invention of printing in the fifteenth century, all books were manuscripts—that is, written by hand. Manuscripts often included illustrations, called **miniatures**, from *minium*, the Latin word for a reddish lead pigment. Manuscripts decorated with gold and colors were said to be **illuminated**.

The thickness and weight of parchment and vellum made it impractical to produce a very large manuscript, such as an entire Bible, in a single volume. As a result, individual sections were made into separate books. These weighty tomes were stored flat on shelves in cabinets like the one holding the Gospels shown here and visible in the mosaic of Saint Lawrence in the Mausoleum of Galla Placidia.

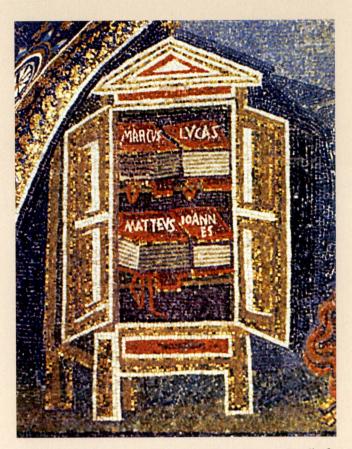

BOOKCASE WITH THE GOSPELS IN CODEX FORM Detail of a mosaic in the eastern lunette, *Mausoleum of Galla Placidia*, Ravenna (FIG. 7-20).

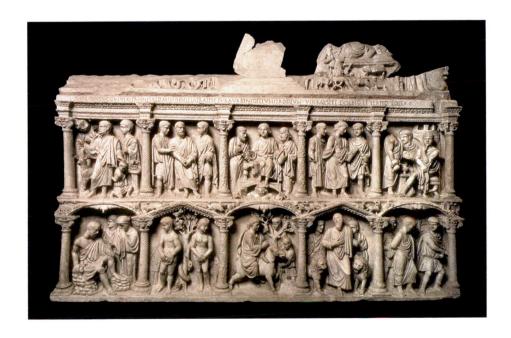

7–23 | SARCOPHAGUS OF JUNIUS BASSUS Grottoes of Saint Peter, Vatican, Rome. c. 359. Marble, $4\times8'$ (1.2 \times 2.4 m).

Myth and Religion

ICONOGRAPHY OF THE LIFE OF JESUS

conography is the study of subject matter in art. It involves identifying both what a work of art represents—what it depicts—and the deeper significance of what is represented—its symbolic meaning. Stories about the life of Jesus, grouped in "cycles," form the basis of Christian iconography. What follows is an outline of those cycles and the main events of each.

The Incarnation Cycle and the Childhood of Jesus

Events surrounding the conception and birth of Jesus.

The Annunciation: The archangel Gabriel informs the Virgin Mary that God has chosen her to bear his son. A dove represents the Incarnation, her miraculous conception of Jesus through the Holy Spirit.

The Visitation: The pregnant Mary visits her older cousin Elizabeth, pregnant with the future Saint John the Baptist. Elizabeth is the first to acknowledge the divinity of Mary's child.

The Nativity: Jesus is born to Mary in Bethlehem. The Holy Family—Jesus, Mary, and her husband, Joseph—is shown in a house, a stable, or, in Byzantine art, a cave.

The Annunciation to the Shepherds and the Adoration of the Shepherds: An angel announces Jesus's birth to humble shepherds who hurry to Bethlehem to honor him.

The Adoration of the Magi: Wisemen from the "East" follow a bright star to Bethlehem to honor Jesus as King of the Jews. They present him with precious gifts: gold (kingship), frankincense (divinity), and myrrh (death). In the European Middle Ages, the Magi were identified as three kings.

The Presentation in the Temple: Mary and Joseph bring the infant Jesus to the Temple in Jerusalem, where he is presented to the high priest. It is prophesied that Jesus will redeem humankind and that Mary will suffer great sorrow.

The Massacre of the Innocents and the Flight into Egypt: An angel warns Joseph that King Herod—to eliminate the threat of a newborn rival king—plans to murder all the male infants in Bethlehem. The Holy Family flees to Egypt.

Jesus among the Doctors: In Jerusalem to celebrate Passover, Joseph and Mary find the twelve-year-old Jesus in serious discussion with Temple scholars, a sign of his coming ministry.

The Public Ministry Cycle

In which Jesus preaches and performs miracles (signs of God's power).

The Marriage at Cana: Jesus turns water into wine at a wedding feast, his first public miracle. Later the event was interpreted as prefiguring the Eucharist.

The Cleansing of the Temple: Jesus, in anger, drives money changers and animal traders from the Temple.

The Baptism: At age thirty, Jesus is baptized by John the Baptist in the Jordan River. He sees the Holy Spirit and hears a heavenly voice proclaiming him God's son. His ministry begins.

Jesus and the Samaritan Woman at the Well: Jesus rests by a spring called Jacob's Well. Jesus and Samaritans did not associate, but Jesus asks a local Samaritan woman for water.

The Miracles of Healing: Jesus performs miracles of healing the blind, the possessed (mentally ill), the paralytic, and lepers. He also resurrects the dead.

The Miraculous Draft of Fishes: At Jesus's command Peter lowers the nets and catches so many fish that James and John have to help him bring them into the boat. Jesus promises that they soon will be "fishers of men."

Jesus Walking on the Water; Storm at Sea: The apostles, in a storm-tossed boat, see Jesus walking toward them on the water. Peter tries to go out to meet Jesus, but begins to sink, and Jesus saves him.

The Calling of Levi (Matthew): Passing the customhouse, Jesus sees Levi, a tax collector, and says, "Follow me." Levi complies, becoming the apostle Matthew.

Raising of Lazarus: Jesus brings his friend Lazarus back to life four days after his death. Lazarus emerges from the tomb wrapped in his shroud.

Jesus in the House of Mary and Martha: Mary, representing the contemplative life, sits listening to Jesus while Martha, representing the active life, prepares food. Jesus praises Mary.

The Transfiguration: Jesus reveals his divinity in a dazzling vision on Mount Tabor in Galilee, as his closest disciples—Peter, James, and John—look on. A cloud envelops them, and a heavenly voice proclaims Jesus to be God's son.

The Tribute Money: Challenged to pay the temple tax, Jesus sends Peter to catch a fish, which has the required coin in its mouth.

The Delivery of the Keys to Peter: Jesus designates Peter as his successor, symbolically turning over to him the keys to the kingdom of heaven.

The Passion Cycle

Events surrounding Jesus's death and Resurrection. (*Passio* is Latin for "suffering.")

Entry into Jerusalem: Jesus, riding an ass, and his disciples enter Jerusalem in triumph. Crowds honor them, spreading clothes and palm fronds in their path.

The Last Supper: During the Passover meal, Jesus reveals his impending death to his disciples. Instructing them to drink wine (his Blood) and eat bread (his Body) in remembrance of him, he lays the foundation for the Christian Eucharist (Mass).

Jesus Washing the Apostles' Feet: After the Last Supper, Jesus washes the apostles' feet to set an example of humility. Peter, embarrassed, protests.

The Agony in the Garden: In the Garden of Gethsemane on the Mount of Olives, Jesus struggles between his human fear of pain and death and his divine strength to overcome them (agon is Greek for "contest"). The apostles sleep nearby, oblivious.

Betrayal (The Arrest): Judas Iscariot, a disciple, accepts a bribe to point Jesus out to his enemies. Judas brings an armed crowd to Gethsemane and kisses Jesus (a prearranged signal). Peter attempts to defend Jesus from the Roman soldiers who seize him.

The Denial of Peter: Jesus is taken to the Jewish high priest, Caiaphas, to be interrogated for claiming to be the Messiah. Peter follows, and there he three times denies knowing Jesus, as Jesus had predicted.

Jesus before Pilate: Jesus is taken to Pontius Pilate, the Roman governor of Judaea, and charged with treason for calling himself King of the Jews. He is sent to Herod Antipas, ruler of Galilee, who scorns him. Pilate proposes freeing Jesus but is shouted down by the mob, which demands that Jesus be crucified. Pilate washes his hands before the mob to signify that Jesus's blood is on their hands, not his.

The Flagellation (The Scourging): Jesus is whipped by his Roman captors.

Jesus Crowned with Thorns (The Mocking of Jesus): Pilate's soldiers torment Jesus. They dress him in royal robes, crown him with thorns, and kneel before him, sarcastically hailing him as King of the Jews.

The Bearing of the Cross (Road to Calvary): Jesus bears the cross from Pilate's house to Golgotha, where he is executed. This event and its accompanying incidents came to be called the Stations of the Cross: (1) Jesus is condemned to death; (2) Jesus picks up the cross; (3) Jesus falls; (4) Jesus meets his grieving mother; (5) Simon of Cyrene is forced to help Jesus carry the cross; (6) Veronica wipes Jesus's face with her veil; (7) Jesus falls again; (8) Jesus admonishes the women of Jerusalem; (9) Jesus falls a third time; (10) Jesus is stripped; (11) Jesus is nailed to the cross; (12) Jesus dies on the cross; (13) Jesus is taken down from the cross; (14) Jesus is entombed.

The Crucifixion: The earliest representations of the Crucifixion show either a cross alone or a cross and a lamb. Later

depictions include some or all of the following details: two criminals (one penitent, the other not) are crucified alongside Jesus; the Virgin Mary, John the Evangelist, Mary Magdalen, and others mourn at the foot of the cross; Roman soldiers torment Jesus—one extends a sponge on a pole with vinegar instead of water for him to drink, another stabs him in the side with a spear, and others gamble for his clothes; a skull identifies the execution ground as Golgotha, "the place of the skull," where Adam was buried, symbolizing the promise of redemption.

The Descent from the Cross (The Deposition): Jesus's followers take his body down from the cross. Joseph of Arimathea and Nicodemus wrap it in linen with myrrh and aloe. Also present are the grief-stricken Virgin, John the Evangelist, and (in some accounts) Mary Magdalen, other disciples, and angels.

The Lamentation (Pietà): Jesus's sorrowful followers gather around his body. An image of the Virgin mourning alone with Jesus across her lap is known as a pietà (from the Latin pietas, "compassion").

The Entombment: Jesus's mother and friends place his body in a nearby sarcophagus, or rock tomb. This is done hastily because the Jewish Sabbath is near.

The Descent into Limbo (The Harrowing of Hell/Anastasis): No longer in mortal form, Jesus, now called Christ, descends into limbo, or hell, to free deserving souls, among them Adam, Eve, and Moses.

The Resurrection: Three days after his death, Christ walks from his tomb while the soldiers guarding it sleep.

The Marys at the Tomb (The Holy Women at the Sepulcher): Christ's female followers—usually including Mary Magdalen and Mary the mother of the apostle James—discover his empty tomb. An angel announces Christ's Resurrection. The soldiers guarding the tomb look on terrified.

Noli Me Tangere ("Do Not Touch Me"), The Supper at Emmaus, and Doubting Thomas: Christ makes a series of appearances to his followers in the forty days between his Resurrection and his Ascension. He first appears to Mary Magdalen as she weeps at his tomb. She reaches out to him, but he warns her not to touch him. Christ tells her to tell the Apostles of his Resurrection. At Emmaus, Christ and his disciples share a meal. Christ invites Thomas, who doubts his Resurrection, to touch the wound in his side in order to convince him.

The Ascension: Christ ascends to heaven from the Mount of Olives, disappearing in a cloud. His disciples, often accompanied by the Virgin, watch.

martyrs. Next, Adam and Eve have set in motion the entire Christian story. Lured by the serpent, they have eaten the forbidden fruit, have become conscious of their nakedness, and are trying to hide their genitals with leaves. This fall from grace will be redeemed by Christ.

On the upper right side are two scenes from Christ's Passion (see "Iconography of the Life of Jesus," page 252), his arrest and his appearance before Pontius Pilate, who is about to wash his hands, symbolizing that he denies responsibility for Jesus's death. The Crucifixion is not represented: It rarely was in early Christian art. After the death of Jesus, the apostle Peter is arrested for preaching. In the last frame, Paul is arrested. The images in the upper central frame are of Paul and Peter, whose martyrdoms in Rome represented the continuing power of Christ and his disciples, and also symbolized the power of the Roman Church.

EARLY BYZANTINE ART: THE FIRST GOLDEN AGE

Byzantine art can be thought of broadly as the art of Constantinople (whose ancient name, before Constantine renamed it after himself, was Byzantium) and the regions under its influence. In this chapter, we focus on Byzantine art's three "golden ages." The Early Byzantine period, most closely associated with the reign of Emperor Justinian I (527-65), began in the fifth century CE and ended in 726, the onset of the iconoclast controversy that led to the destruction of religious images. The Middle Byzantine period began in 843, when Empress Theodora (c. 810-67) reinstated the veneration of icons. It lasted until 1204, when Christian Crusaders from the West occupied Constantinople. The Late Byzantine period began with the restoration of Byzantine rule in 1261 and ended with the empire's fall to the Ottoman Turks in 1453. Russia succeeded Constantinople as the "Third Rome" and the center of the Eastern Orthodox Church. Late Byzantine art continued to flourish into the eighteenth century in the Ukraine, Russia, and much of southeastern Europe.

The Golden Age of Justinian

During the fifth and sixth centuries, while invasions and religious controversy wracked the Italian peninsula, the Eastern Empire prospered. Byzantium became the "New Rome." The city of Constantine was called Constantinople (present-day Istanbul). Constantine had chosen the site of his new capital city well. The small Greek port of Byzantium lay at the crossroads of the overland trade routes between Asia and Europe and the sea route connecting the Black Sea and the Mediterranean.

In the sixth century, Byzantine political power, wealth, and culture reached its height under Emperor Justinian I and his wife, Theodora. Imperial forces held northern Africa, Sicily, much of Italy, and part of Spain. Ravenna became the

Eastern empire's administrative capital in the West. Rome remained under nominal Byzantine control until the eighth century, and the pope remained head of the Western Church. But the pope rejected the Byzantine policy of *caesaropapism*, whereby the emperor was head of both church and state, and the pope was thereby required to pay homage to the powers in Constantinople. As Slavs and Bulgars moved into the Balkan peninsula in southeastern Europe, they too came under Constantinople's influence. Only on the frontier with the Persian Empire to the east did Byzantine armies falter, and there Justinian bought peace with tribute.

Control of land and sea routes between Europe and Asia made many people wealthy. The patronage of the affluent citizenry, as well as that of the imperial family, made the city an artistic center. Greek literature, science, and philosophy continued to be taught in its schools. Influences from the regions under the empire's control—Syria and Palestine—gradually combined to create a distinctive Byzantine culture.

CONSTANTINOPLE: THE WALLS. The secret of Byzantine success was its invulnerable capital. At the beginning of the fifth century, during the reign of Theodosius II, the Byzantines built a new defensive system consisting of a moat and double walls with huge towers (FIG. 7–24). The walls were about 4½ miles long along the city's only vulnerable stretch of land, and the defensive system about 180 feet deep.

An enemy approaching the city encountered a 60-foot stone-lined moat (a water-filled ditch), then a towered wall, a terrace, and finally the powerful inner wall, 36 feet high and

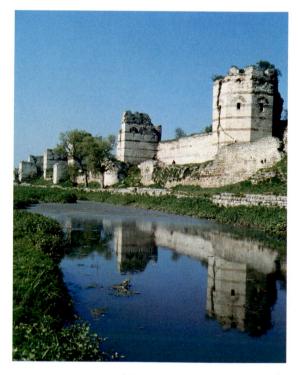

7–24 | LAND WALLS OF CONSTANTINOPLE Begun 412–13. Photo: Josephine Powell, Rome

16 feet wide. The inner wall was high enough that defenders could shoot over the heads of those on the outer wall and even reach the moat with their missiles. The builders used both stone (for strength) and brick (for flexibility) in leveling and bonding the facing to a solid core of rubble and concrete. This masonry created stripes of different colors and textures, an effect that was used decoratively by later builders who copied the walls. Ninety-six huge towers, each an independent unit, defended the inner wall. Double towers flanked the few gateways into the city. For more than a thousand years—from 412–13 to 1453—the people of Constantinople lived secure behind their walls.

CONSTANTINOPLE: HAGIA SOPHIA. Justinian and Theodora embarked on a building and renovation campaign in Constantinople that overshadowed any in the city since the reign of Constantine two centuries earlier. Their massive undertaking would more than restore the city, half of which had been destroyed by rioters in 532. But little now remains of their architectural projects or of the old imperial capital itself.

A magnificent exception is the **CHURCH OF HAGIA SOPHIA**, meaning "Holy Wisdom" (FIG. 7–25). It replaced a fourth-century church destroyed when crowds, spurred on by Justinian's foes, set the old church on fire. The empress Theodora, a brilliant, politically shrewd woman, is said to have goaded Justinian to resist the rioters by saying "Purple makes a fine shroud"—meaning that she would rather die an empress (purple was the royal color) than flee for her life. Taking up her words as a battle cry, imperial forces crushed the rebels and restored order in 532.

To design a church that embodied imperial power and Christian glory, Justinian chose two scholar-theoreticians, Anthemius of Tralles and Isidorus of Miletus. Anthemius was a specialist in geometry and optics, and Isidorus a specialist in physics who had also studied vaulting. They developed a daring and magnificent design. And they had a trained and experienced work force to carry out their ideas. Builders had refined their masonry techniques building the towers and domed rooms within them that were part of the city's defenses. So when Justinian ordered the construction of domed churches, and especially Hagia Sophia, master masons with a trained and experienced work force stood ready to give permanent form to the architects' dreams.

The new Hagia Sophia was not constructed by the miraculous intervention of angels, as was rumored, but by mortal builders in only five years (532–37). The architects, engineers, and masons who built it benefited from the accumulated experience of a long tradition of great architecture. Procopius of Caesarea, who chronicled Justinian's reign, claimed poetically that Hagia Sophia's gigantic dome seemed to hang suspended on a "golden chain from Heaven." Legend has it that Justinian himself, aware that architecture can be a potent symbol of earthly power, compared his accomplish-

ment with that of the legendary builder of the First Temple in Jerusalem, saving "Solomon, I have outdone you."

Hagia Sophia is based on a central plan with a dome inscribed in a square (FIG. 7–26). To form a long nave for

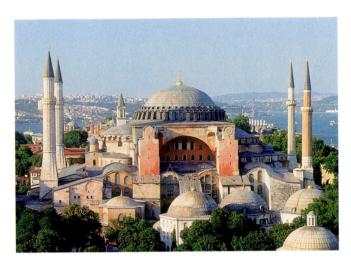

7-25 Anthemius of tralles and isidorus of miletus. Church of hagia sophia

Istanbul. 532-37. View from the southwest.

The body of the original church is now surrounded by later additions, including the minarets built after 1453 by the Ottoman Turks. Today the building is a museum.

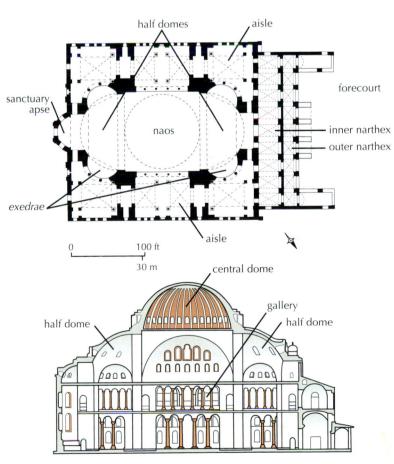

7–26 PLAN AND SECTION OF THE CHURCH OF HAGIA SOPHIA

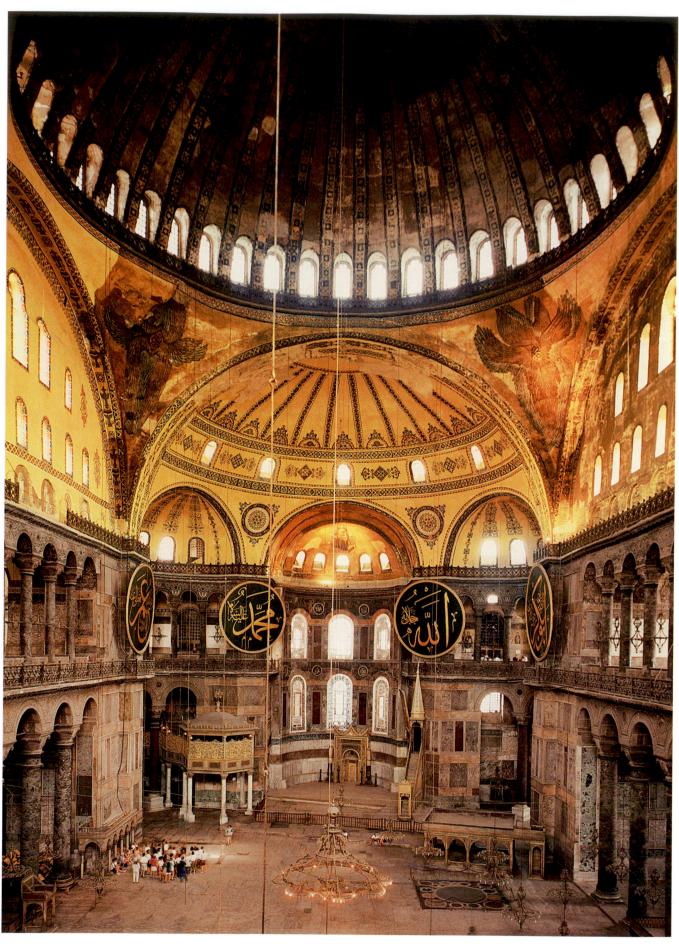

7-27 CHURCH OF HAGIA SOPHIA. INTERIOR

Elements of Architecture

PENDENTIVES AND SQUINCHES

endentives and squinches are two methods of supporting a round dome or its drum over a square space. They convert the square formed by walls or arches into a circle. **Pendentives** are spherical triangles between arches that rise to form openings on which a dome rests (SEE FIG. 7-44). **Squinches** are lintels placed across the upper corner of the wall and supported by an arch or a series of corbeled arches that

give it a nichelike or trumpet shape. Because squinches create an octagon, which is close in shape to a circle, they provide a solid base for a dome. A **drum** (a circular wall) may be inserted between the squinches and the dome or between the pendentives and the dome. Byzantine builders used both pendentives and squinches. Western Europeans and Muslims usually used squinches.

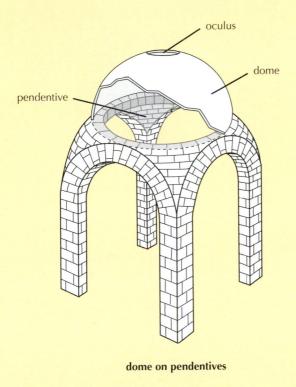

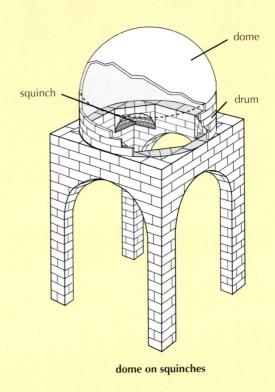

processions, half domes expand outward from the central dome to connect with the narthex on one end and the half dome of the sanctuary apse on the other. Side aisles flank this central core, called the naos in Byzantine architecture; galleries, or stories open to and overlooking the naos, are located above the aisles. The main weight-bearing interior supports in the Hagia Sophia are the piers, which are pushed back into the darkness of the aisles. The massiveness of both piers and walls is minimized by covering them with mosaics and marble veneers. Exterior buttresses give additional support, invisible in the interior.

The main dome of Hagia Sophia is supported on pendentives, triangular curving vault sections built between the

four huge arches that spring from piers at the corners of the dome's square base (see "Pendentives and Squinches," above). The Church of Hagia Sophia represents the earliest use of the dome on pendentives in a major building. Here two half domes flanking the main dome rise above **exedrae** with their own smaller half domes at the four corners of the nave.

Unlike the Pantheon's dome, which rises uninterrupted from the walls to an oculus at the top (SEE FIG. 6–53), Hagia Sophia's dome has a band of forty windows around its base. This daring concept challenged architectural logic by apparently weakening the masonry support, but it created the all-important circle of light that makes the dome appear to float (FIG. 7–27). The architects stretched the building materials to

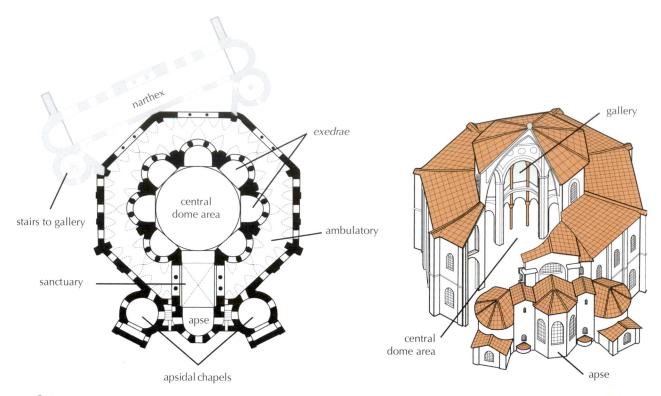

7–28 \mid **PLAN AND CUTAWAY DRAWING, CHURCH OF SAN VITALE** Ravenna. Under construction from c. 520; consecrated 547; mosaics, c. 546–48.

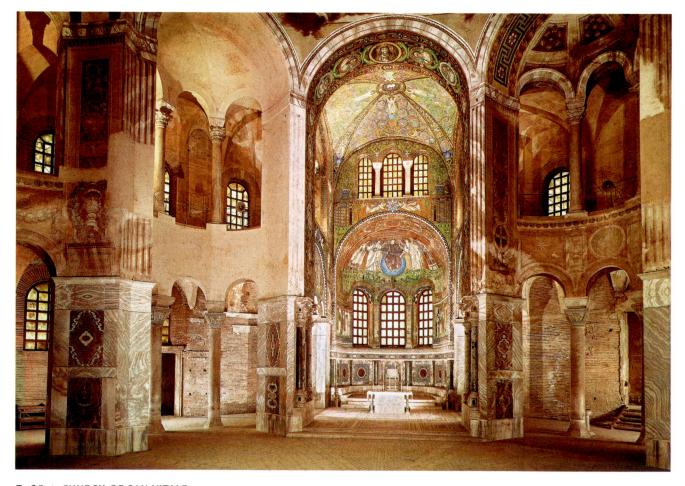

7–29 | **CHURCH OF SAN VITALE**Ravenna. Interior view across the central space toward the sanctuary apse with mosaic showing Christ enthroned, flanked by Saint Vitalis and Bishop Ecclesius. Consecrated 547.

their physical limits, denying the physicality of the building in order to emphasize its spirituality. In fact, when the first dome fell in 558, it did so because a pier and pendentive shifted and because the dome was too shallow and exerted too much outward force at its base, not because of the windows. Confident of their revised technical methods, the architects designed a steeper dome that raised the summit 20 feet higher. They also added exterior buttressing. Although repairs had to be made in 869, 989, and 1346, the church has since withstood numerous earthquakes.

As in a basilica, worshipers moved along a central axis as they entered Hagia Sophia through a forecourt and outer and inner narthexes. Once through the portals, their gaze was drawn upward by the succession of curving spaces to the central dome and then forward to the distant sanctuary. The dome of the church provided a vast, golden, light-filled canopy high above a processional space for the many priests and members of the imperial court who assembled there to celebrate the Eucharist. With this inspired design, Anthemius and Isidorus had reconciled an inherent conflict in church architecture between the desire for a soaring heavenly space and the need to focus attention on the altar and the liturgy.

The liturgy used in Hagia Sophia in the sixth century has been lost, but it presumably resembled the rites described in detail for the church in the Middle Byzantine period. The celebration of the Mass took place behind a screen—at Hagia Sophia a crimson curtain embroidered in gold, in later churches an iconostasis, a wall hung with devotional paintings called icons (meaning "images" in Greek). The emperor was the only layperson permitted to enter the sanctuary; men stood in the aisles and women in the galleries. Processions of clergy moved in a circular path from the sanctuary into the nave and back five or six times during the ritual. The focus of the congregation was on the iconostasis and the dome rather than the altar and apse. This upward focus reflects the interest of Byzantine philosophers, who viewed meditation as a way to rise from the material world to a spiritual state. Worshipers standing on the church floor must have felt just such a spiritual uplift as they gazed at the mosaics of saints, angels, and, in the golden central dome, heaven itself.

RAVENNA: SAN VITALE. In 540, Byzantine forces captured Ravenna from the Arian Christian Ostrogoths who had taken it from the Romans in 476. Much of our knowledge of the art of this turbulent period comes from the well-preserved monuments at Ravenna.

In 526, Ecclesius, bishop of Ravenna, commissioned two new churches, one for the city and one for its port, Classis, as well as other churches and baptistries. Construction began on a central-plan church dedicated to the fourth-century Roman martyr Saint Vitalis (FIG. 7–28) in the 520s, but it was

not finished until after Justinian had conquered Ravenna and established it as the administrative capital of Byzantine Italy.

The design of San Vitale is basically a central-domed octagon extended by exedralike semicircular bays, surrounded in turn by an ambulatory and gallery, all covered by vaults. A rectangular sanctuary and semicircular apse project from one of the sides of the octagon, and in typical Byzantine fashion circular rooms flank the apse. A separate oval narthex, set off-axis, joined church and palace and also led to cylindrical stair towers that gave access to the second-floor gallery. This sophisticated design has distant roots in Roman buildings such as Santa Costanza (SEE FIG. 7–16).

The floor plan of San Vitale only hints at the effect of the complex interior spaces of the church, an effect that was enhanced by the offset narthex, with its double sets of doors leading into the church. People entering from the right saw only arched openings, whereas those entering from the left approached on an axis with the sanctuary, which they saw straight ahead of them. Eight large piers frame the exedrae and the sanctuary. These two-story exedrae open through arches into the outer aisles on the ground floor and into galleries on the second floor. Squinches rather than pendentives support the dome.

The round dome, hidden on the exterior by an octagonal shell and a tile-covered roof, is a light, strong structure ingeniously created out of interlocking ceramic tubes mortared together. The interior is light and airy, a sensation reinforced by the liberal use of gold tesserae in the mosaic surface decoration. The structure seems to dissolve into shimmering light and color (FIG. 7–29).

In the half dome of the sanctuary apse, an image of Christ enthroned is flanked by SaintVitalis and Bishop Ecclesius, who presents a model of the church to Christ (FIG. 7–30). The other sanctuary images relate to its use for the celebration of the Eucharist. Pairs of lambs flanking a cross decorate blocks above the intricately interlaced carving of the marble column capitals. The lunette on the south wall shows an altar table set with a chalice for wine and two patens, to which the high priest Melchizedek on the right brings an offering of bread, and Abel, on the left, carries a sacrificial lamb. Their identities are known from the inscriptions above their heads.

The prophets Isaiah (right) and Moses (left) appear in the spandrels. Moses is shown twice: The lower image depicts the moment when, while tending his sheep, he heard the voice of an angel of God coming from a bush that was burning with a fire that did not destroy it. Just above, Moses is shown reaching down to remove his shoes, a symbolic gesture of respect in the presence of God or on holy ground. In the gallery zone of the sanctuary the Four Evangelists are depicted, two on each wall, and in the vault the Lamb of God, supported by four angels, appears in a field of vine scrolls.

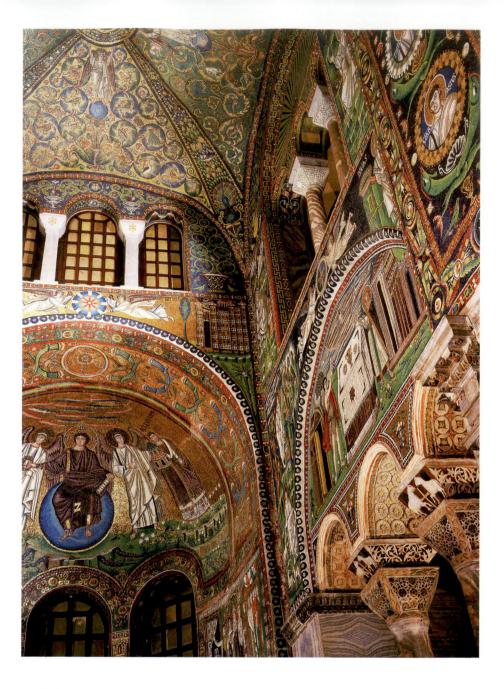

7–30 CHURCH OF SAN VITALE, SOUTH WALL OF THE SANCTUARY Abel and Melchizedek shown in the lunette (at right), and Christ enthroned, flanked by Saint Vitalis and Bishop Ecclesius in the half dome. Consecrated 547.

Justinian and Theodora did not attend the dedication ceremonies for the Church of San Vitale, conducted by Archbishop Maximianus in 547. They may never have set foot in Ravenna, but two large mosaic panels that face each other across its apse still stand in their stead. Justinian (FIG. 7–31), on the north wall, carries a large golden paten for the Host and stands next to Maximianus, who holds a golden, jewelencrusted cross. The priestly celebrants at the right carry the Gospels, encased in a golden, jeweled book cover, symbolizing the coming of the Word, and a censer containing burning incense to purify the altar prior to the Mass.

On the south wall, Theodora, standing beneath a fluted shell canopy and singled out by a gold halolike disk and elaborate crown, carries a huge golden chalice studded with jewels (FIG. 7–32). She presents the chalice both as an offering for the Mass and as a gift of great value for Christ. With it she emulates the Magi (see "Iconography of the Life of Jesus," page 252), depicted in embroidery at the bottom of her purple cloak, who brought valuable gifts to the infant Jesus. A

courtyard fountain stands to the left of the panel and patterned draperies adorn the openings at left and right. Theodora's huge jeweled and pearl-hung crown nearly dwarfs her delicate features, yet the empress dominates these worldly trappings by the intensity of her gaze.

The mosaic decoration in the Church of San Vitale combines imperial ritual, Old Testament narrative, and Christian liturgical symbolism. The setting around Theodora—the implied shell form, the fluted pedestal, the open door, and the swagged draperies—are classical illusionistic devices, yet unlike the ancient Romans, the mosaicists deliberately avoid making them space-creating elements. Byzantine artists accepted the idea that objects exist in space, but they no longer conceived pictorial space the way Roman artists had, as a view of the natural world seen through a "window." In Byzantine art, invisible rays of sight joined eye and image so that pictorial space extended forward from the picture plane to the eye of the beholder and included the real space between them. Parallel lines

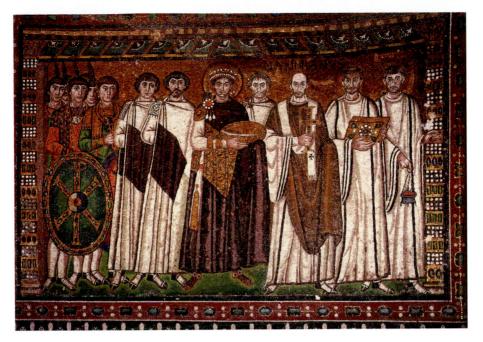

7–31 | EMPEROR JUSTINIAN AND HIS ATTENDANTS, NORTH WALL OF THE APSE Church Of San Vitale. Consecrated 547. Mosaic, $8'8'' \times 12'$ (2.64 \times 3.65 m).

As head of state, Justinian wears a huge jeweled crown and a purple cloak; as head of church, he carries a large golden paten to hold the Host, the symbolic body of Jesus Christ. The church officials at his left hold a jeweled cross and a Gospel book symbolizing Christ and his Church. Justinian's soldiers stand behind a shield decorated with the *chi rho*, the Greek letter monogram for "Christ." On the opposite wall, Empress Theodora, also dressed in royal purple, offers a golden chalice for the liturgical wine (SEE FIG. 7–32).

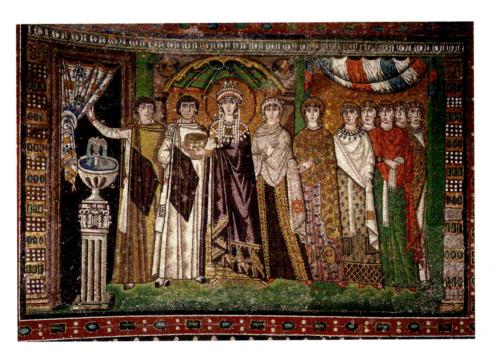

7–32 | EMPRESS THEODORA AND HER ATTENDANTS, SOUTH WALL OF THE APSE Church Of San Vitale. Consecrated 547. Mosaic $8'8'' \times 12' (2.64 \times 3.65 \text{ m})$.

The mosaic suggests the richness of Byzantine court costume. Both men and women dressed in layers, beginning with a linen or silk tunic, over which men wore another tunic and a long cloak fastened on the right shoulder with a *fibula* (brooch) and decorated with a rectangular panel (tablion). Women wore a second, fuller long-sleeved garment over their tunics. Over all their layers, women wore a large rectangular shawl, usually draped over the head. Justinian and Theodora wear imperial purple cloaks with gold-embroidered tablions held by *fibulae*. Embroidered in gold at the hem of Theodora's cloak is the scene of the Magi bringing gifts to Jesus. Her elaborate jewelry includes a wide collar of embroidered and jeweled cloth worn on the shoulders. A pearled crown, hung with long strands of pearls (thought to protect the wearer from diseases) frames her face. Theodora died not long after this mosaic was completed.

appear to diverge as they get farther away and objects seem to tip up in a representational system known as reverse perspective.

THE MOSAICS OF SANT'APOLLINAIRE IN CLASSE. At the same time he was building the Church of San Vitale, Bishop Ecclesius ordered a basilica-plan church in the port of Classis dedicated to Saint Apollinaris, the first bishop of Ravenna. As usual, the basilica's brick exterior gives no hint of the richness within. Nothing interferes visually with the movement forward from the entrance to the raised sanctuary (FIG. 7–33), which extends directly from a triumphal-arch opening into the semicircular apse.

The apse mosaic depicts the Transfiguration—Jesus's revelation of his divinity. An array of men and sheep stand in a

Sequencing Events KEY BYZANTINE PERIODS

526-726	Early Byzantine Period
726-843	Period of Iconoclasm
843-1204	Middle Byzantine Period
1261-1453	Late Byzantine Period

stylized landscape below a jeweled cross with the face of Christ at its center. The hand of God and the Old Testament figures Moses and Elijah appear in the heavens to legitimize the new religion and attest to the divinity of Christ. The apostles Peter, James, and John, who witness the event, are

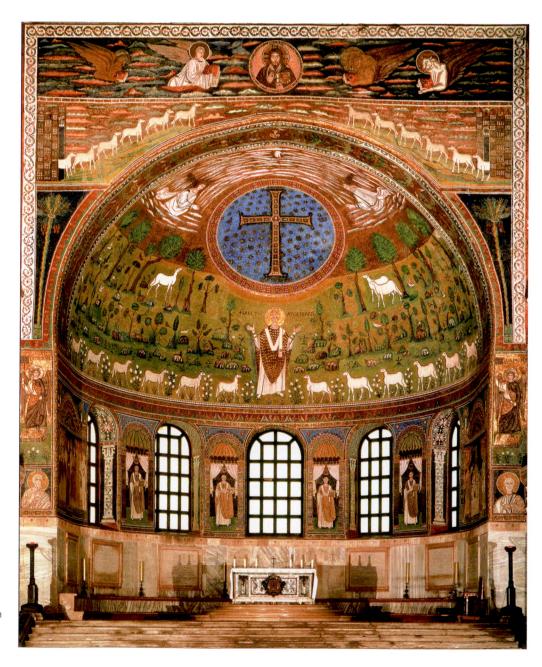

7–33 THE
TRANSFIGURATION OF
CHRIST WITH
SANT'APOLLINARE, FIRST
BISHOP OF RAVENNA
Church of Sant'Apollinare in
Classe. Consecrated 549.
Mosaics: apse, 6th century;
wall above apse, 7th and 9th
centuries; side panels, 7th
century.

represented here by the three sheep with raised heads. Below the cross, Bishop Apollinaris raises his hands in prayer and blessing, flanked by twelve lambs who represent the apostles. Stalks of blooming lilies, along with tiny trees and other plants, birds, and oddly shaped rocks, fill the green mountain landscape. Unlike the landscape in the Good Shepherd lunette of the Mausoleum of Galla Placidia (SEE FIG. 7–21), these highly stylized forms bear little resemblance to nature. The artists eliminated any suggestion of a naturalistic landscape by making the trees and lambs at the top of the golden sky larger than those at the bottom.

In the mosaics on the wall above the apse, which were added in the seventh and ninth centuries, Christ, now portrayed as a man with a cross inscribed in his halo and flanked by symbols representing the Four Evangelists, blesses and holds the Gospels. Sheep (the apostles) emerge from gateways and climb golden rocks toward their leader and teacher.

The formal character of the Transfiguration of Christ mosaic reflects an evolving approach to representation that began with imperial Roman art of the third century. As the character of imperial rule changed, the emperor became an increasingly remote figure surrounded by pomp and ceremony. In official art such as the Arch of Constantine (SEE FIG. 6–74), abstraction displaced the naturalism and idealism of the Greeks. The Roman interest in capturing the visual appearance of the material world gave way in Christian art to a new style that sought to express essential religious meaning rather than exact external appearance. Geometric simplification of forms, an expressionistic abstraction of figures, use of reverse perspective, and standardized conventions to portray individuals and events characterized the new style.

Objects of Veneration and Devotion

The court workshops of Constantinople excelled in the production of gold work, carved ivory, and textiles. The Byzantine elite also sponsored major scriptoria (writing rooms for scribes—professional document writers) for the production of manuscripts (handwritten books).

THE ARCHANGEL MICHAEL DIPTYCH. The commemorative ivory diptych—two carved panels hinged together—originated with Roman politicians elected to the post of consul. The new consuls sent notices of that event to friends and colleagues inscribed in wax on the inner sides of a pair of carved ivory panels. Christians adapted the practice for religious use, inscribing a diptych with the names of people to be remembered with prayers during Mass.

The panel depicting the archangel Michael was half of a diptych (FIG. 7–34). In his beauty, physical presence, and elegant setting, the archangel is comparable to the priestess of Bacchus in the Symmachus panel (SEE FIG. 6–79). His relation to the architectural space and the frame around him, how-

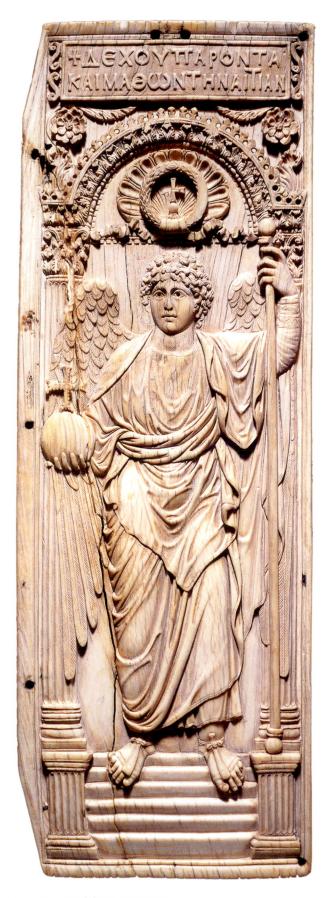

7–34 | ARCHANGEL MICHAEL Panel of a diptych, probably from the court workshop at Constantinople. Early 6th century. Ivory, $17 \times 15 \%$ " (43.3 \times 14 cm). The British Museum, London.

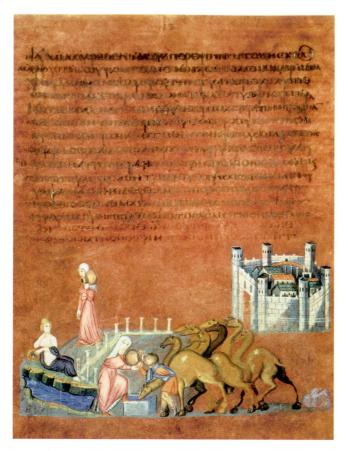

7–35 | REBECCA AT THE WELL Page from the Book of Genesis (known as *The Vienna Genesis*). Syria or Palestine. Early 6th century. Tempera, gold, and silver paint on purple-dyed vellum, $13\frac{1}{2} \times 9\frac{1}{8}$ " (33.7 × 25 cm). Österreichische Nationalbibliothek, Vienna.

ever, has changed. His heels rest on the top step of a stair that clearly lies behind the columns and pedestals, but the rest of his body projects in front of them.

The angel is shown here as a divine messenger, holding a staff of authority in his left hand and a sphere symbolizing worldly power in his right, a message reinforced by repetition: Within the arch is a cross-topped orb, framed by a wreath, against the background of a scallop shell. This image floats in an indefinite space, unrelated to either the archangel or the message. The lost half of this diptych would have completed the Greek inscription across the top, which reads: "Receive these gifts, and having learned the cause . . ." Perhaps the other panel contained the portrait of the emperor or another high official who presented the panels as a gift to an important colleague, acquaintance, or family member.

THE BOOK OF GENESIS. Byzantine manuscripts were often made with very costly materials. Sheets of purple-dyed vellum (a fine writing surface made from calfskin) and gold and silver inks were used in a book known as the VIENNA GENESIS (FIG. 7–35). It was probably made in Syria or Palestine, and the purple vellum indicates that it may have been done for an imperial patron (costly purple dye, made from the shells of murex mollusks, was usually restricted to imperial use). The Vienna Genesis is in codex form and is written in Greek (see "Early Forms of the Book," page 251). Illustrations appear below the text at the bottom of the pages.

The illustration of the story of Rebecca at the Well (Genesis 24) shown here appears to be a single scene, but it actually mimics the continuous narrative of a scroll. Events that take place at different times in the story follow in succession. Rebecca, the heroine of the story, appears at the left walking away from the walled city of Nahor with a large jug on her shoulder to fetch water. She walks along a miniature colonnaded road toward a spring, personified by a reclining pagan water nymph who holds a flowing jar. In the foreground, Rebecca, her jug now full, encounters a thirsty camel driver and offers him water to drink. The man is Abraham's servant, Eliezer, in search of a bride for Abraham's son Isaac. Her generosity leads to her marriage with Isaac. Although the realistic poses and rounded, full-bodied figures in this painting reflect an earlier Roman painting tradition, the unnatural purple of the background and the glittering metallic letters of the text remove the scene from the everyday world.

THE RABBULA GOSPELS. An illustrated Gospel book, signed by a monk named Rabbula and completed in February 586 at the Monastery of Saint John the Evangelist in Beth Zagba, Syria, illustrates a different approach to religious art. Church murals and mosaics may have inspired its illustrations, which are intended not only to depict biblical events, but also to present the Christian story through complex, multileveled symbolism.

A full-page illustration of the Crucifixion provides a detailed picture of Christ's death and the Resurrection (FIG. 7–36). He appears twice, on the cross in the center of the upper register and with the two Marys—the mother of James and Mary Magdalen—at the right in the lower register. In Byzantine art of this period Christ is a living king who triumphs over death. He is shown as a mature, bearded figure, not the youthful shepherd depicted in the catacombs (SEE FIG. 7–6). Even on the cross he is dressed in a long, purple robe that signifies his royal status. (In many Byzantine images he also wears a jeweled crown.)

At his sides are the repentant and unrepentant thieves who were crucified with him. Beside the thief at the left stand the Virgin and John the Evangelist; beside the thief at the right are the holy women. Beneath the cross soldiers

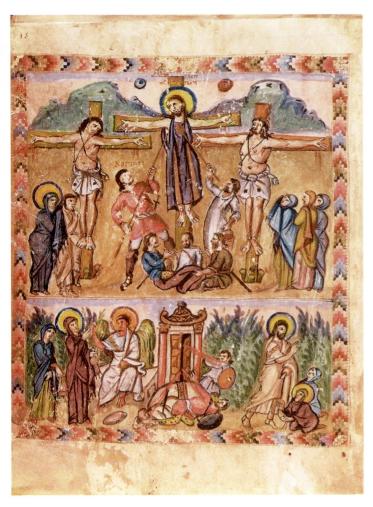

7–36 | THE CRUCIFIXION AND RESURRECTION Page from the *Rabbula Gospels*, from Beth Zagba, Syria. 586. $13\frac{1}{2}\times10\frac{1}{2}$ " (33.7 \times 26.7 cm). Biblioteca Medicea Laurenziana, Florence.

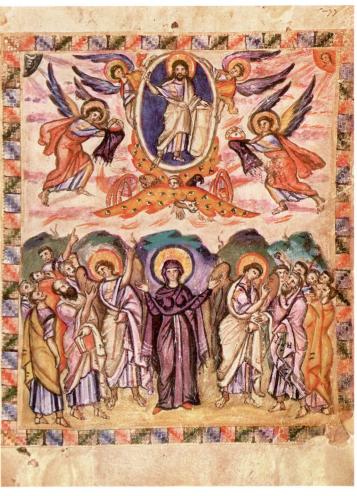

7–37 \perp **THE ASCENSION** Page from the *Rabbula Gospels*, from Beth Zagba, Syria. 586. $13\%\times10\%''$ (33.7 \times 26.7 cm). Biblioteca Medicea Laurenziana, Florence.

throw dice for Jesus's clothes. A centurion stands on either side of the cross. One of them pierces Jesus's side with a lance; the other gives him vinegar to drink from a sponge. The small disks in the heavens represent the sun and moon.

In the lower register, directly under Jesus on the cross, stands his tomb, with its open door and stunned or sleeping guards. The angel reassures the holy women at the left, and Christ himself appears to them at the right. All these events (described in Matthew 28) take place in an otherworldly setting indicated by the glowing bands of color in the sky. The bare mountains behind the crosses give way to the lush foliage of the garden around the tomb.

Another page shows the Ascension of Christ into heaven (FIG. 7–37), which the New Testament describes this way: "[A]s they [his apostles] were looking on, he was lifted up, and a cloud took him from their sight" (Acts of the Apostles 1:9). But now the cloud has been transformed

into an almond-shaped area of light called a mandorla supported by two angels. Two other angels hold victory crowns in fringed cloths. The image directly under the mandorla combines fiery wheels and the four creatures seen by the Hebrew prophet Ezekiel in a vision (Ezekiel 1). Those four, which also appear in the Book of Revelation, are associated with the Four Evangelists: Matthew, an angel; Mark, a lion; Luke, an ox; and John, an eagle. Below this imagery, the Virgin Mary stands calmly in the pose of an orant, while angels at her side confront the astonished apostles. One angel gestures at the departing Christ and the other appears to be offering an explanation of the event to attentive listeners (Acts of the Apostles 1:10-11). The prominence accorded Mary here can be interpreted as a result of her status of Theotokos, God-bearer. She may also represent the Christian community on earth, that is, the Church.

Icons and Iconoclasm

Eastern Christians prayed to Christ, Mary, and the saints while looking at images of them on icons (from the Greek eikon, meaning "image") that were thought to have miraculous powers. The first miraculous image was believed to have been a portrait Jesus sent to King Abgar of Edessa and was known as the Mandylion. It was in Constantinople in the tenth century, and was taken to the West by Crusaders. Later it became identified with the scarf with which Saint Veronica wiped Christ's face as he carried the cross to the execution ground.

Church doctrine toward the veneration of icons was ambivalent. Christianity, like Judaism and Islam, has always been uneasy with the power of religious images. Key figures of the Eastern Church, such as Basil the Great of Cappadocia (c. 329–79) and John of Damascus (c. 675–749), distinguished between idolatry—the worship of images—and the veneration of an idea or holy person depicted in a work of art. The Eastern Church prohibited the worship of icons but accepted them as aids to meditation and prayer, as intermediaries between worshipers and the holy personages they depicted. They were often displayed in churches on a screen called the iconostasis.

Discomfort about the rituals associated with the icons grew into a major controversy in the Eastern Church, and in 726 Emperor Leo III launched a campaign of iconoclasm ("image breaking"). In the decades that followed, Iconoclasts undertook widespread destruction of devotional pictures. Those who defended these images were persecuted. Then in 843 Empress Theodora, widow of Theophilus, last of the iconoclastic emperors, reversed her husband's policy. But it was too late for much of the art: Most early icons were destroyed in the iconoclasm, making those that have survived especially precious.

A few very beautiful examples were preserved in the Monastery of Saint Catherine on Mount Sinai, among them the VIRGIN AND CHILD WITH SAINTS AND ANGELS (FIG. 7-38). As Theotokos, Mary was viewed as the powerful, everforgiving intercessor, appealing to her divine son for mercy on behalf of repentant worshipers. She was also called the Seat of Wisdom, and many images of the Virgin and Child, like this one, show her holding Jesus on her lap in a way that suggests that she represents the throne of Solomon. The Christian warrior-saints Theodore (left) and George (right)—both legendary figures said to have slain dragons, representing the triumph of the Church over the "evil serpent" of paganism-stand at each side. Angels behind them look heavenward. The Christ Child, the Virgin, and the angels were painted with a Roman-derived technique and are almost realistic. The male saints are much more stylized than the other figures; the richly patterned textiles of their cloaks barely hint at the bodies beneath.

Kievan Rus artists (see page 268) copied and recopied icons brought from Constantinople. The revered icon of Mary and Jesus known as the VIRGIN OF VLADIMIR (FIG. 7–39) was such a painting. This distinctively humanized image suggests the growing desire for a more immediate and personal religion. Paintings of this type, known as the Virgin of Compassion, show Mary and the Christ Child pressing their cheeks together and gazing tenderly at each other. It was widely believed that St. Luke was the first to paint such a portrait following a vision he had of the Nativity.

Almost from its creation (probably in Constantinople), the *Virgin of Vladimir* was thought to protect the people of the city where it resided. It arrived in Kiev sometime between

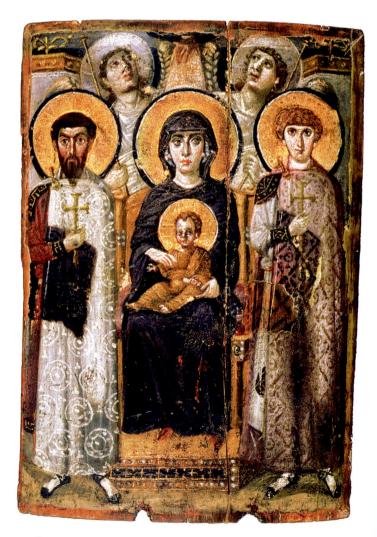

7--38 † VIRGIN AND CHILD WITH SAINTS AND ANGELS Icon. Second half of the 6th century. Encaustic on wood, $27\times18\,\%$ (69 \times 48 cm). Monastery of Saint Catherine, Mount Sinai, Egypt.

7–39 VIRGIN OF VLADIMIR

Icon, probably from Constantinople. Faces,
11th-12th century; the figures have been
retouched. Tempera on panel, height approx.
31" (78 cm). Tretyakov Gallery, Moscow.

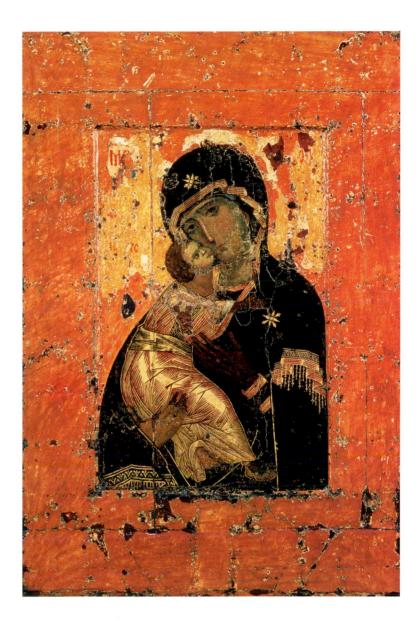

1131 and 1136 and was taken to the city of Suzdal and then to Vladimir in 1155. In 1480 it was moved to the Cathedral of the Dormition in the Moscow Kremlin. Today, even in a museum, it inspires prayers.

MIDDLE BYZANTINE ART

The Virgin of Vladimir belongs to the period now called Middle Byzantine. Early Byzantine civilization had been centered in lands along the rim of the Mediterranean Sea that had been within the Roman Empire. During the Middle Byzantine period, Constantinople's scope was reduced to present-day Turkey and other areas by the Black Sea, as well as the Balkan peninsula, including Greece, and southern Italy. The influence of Byzantine culture also extended into Russia and Ukraine, and to Venice, Constantinople's trading partner in northeastern Italy, at the head of the Adriatic Sea.

Under the Macedonian dynasty (867–1056) initiated by Basil I, the empire prospered and enjoyed a cultural rebirth. Middle Byzantine art and architecture, visually powerful and stylistically coherent, reflect the strongly spiritual focus of the period's autocratic, wealthy leadership. From the mideleventh century, however, other powers entered Byzantine territory. The empire stabilized temporarily under the Comnenian dynasty (1081–1185), extending the Middle Byzantine period well into the time of the Western Middle Ages. Then, in 1204, Western Christian Crusaders seized and looted Constantinople.

Architecture and Mosaics

Comparatively few Middle Byzantine churches in Constantinople have survived intact, but many central-plan domed churches, favored by Byzantine architects, survive in

Ukraine, to the northeast, and in Sicily, to the southwest. These structures reveal the builders' taste for a multiplicity of geometric forms, verticality, and rich decorative effects both inside and out.

KIEVAN RUS: SANTA SOPHIA IN KIEV. Outside Constantinople, the rulers of Ukraine, Belarus, and Russia adopted Orthodox Christianity and Byzantine culture. These lands had been settled by Eastern Slavs in the fifth and sixth centuries, but later were ruled by Scandinavian Vikings who had sailed down the rivers from the Baltic to the Black Sea. In Constantinople, the Byzantine emperor hired the Vikings as his personal bodyguards. In the ninth century, Viking traders established a head-quarters in the upper Volga region and in the city of Kiev, which became the capital of the area under their control, known as Kievan Rus.

The first Christian member of the Kievan ruling family was Princess Olga (c. 890–969), who was baptized in Constantinople by the patriarch himself, with the Byzantine emperor as her godfather. Her grandson Grand Prince

Sequencing Events KEY BYZANTINE EMPERORS

527-65	Justinian I: First Byzantine Emperor
717-41	Leo III: Launches campaign of Iconoclasm in 726
867-86	Basil I: Initiates Macedonian Dynasty
1259-82	Michael VIII Palaeologus: Retakes Constantinople from Crusaders in 1261
1449-53	Constantine XI Palaeologus: Last Byzantine Emperor

Vladimir (ruled 980–1015) established Orthodox Christianity as the state religion in 988. Vladimir sealed the pact with the Byzantines by accepting baptism and marrying Anna, the sister of the powerful Emperor Basil II (ruled 976–1025).

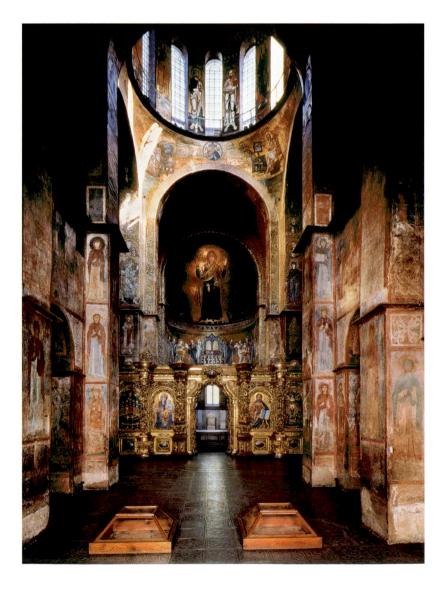

7-40 | interior, cathedral of santa sophia

Kiev. 1037-46. Apse mosaic: *Orant Virgin and Communion of the Apostles*.

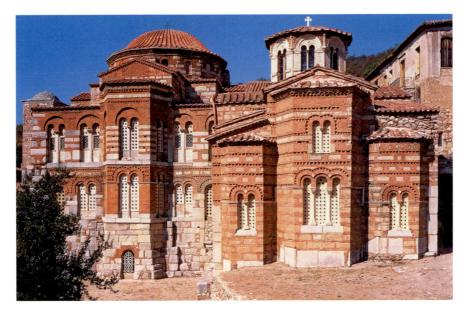

7–4I MONASTERY CHURCHES AT HOSIOS LOUKAS
Greece (view from the east); Katholikon (left) early 11th century, and Church of the Theotokos Cristy. Late 10th century.

Henri Stierlin, Geneva

Vladimir's son Grand Prince Yaroslav (ruled 1036–54) founded the Cathedral of Santa Sophia in Kiev. The church originally had a typical Byzantine multiple-domed cross design, but the building was expanded with double side aisles, leading to five apses. It culminated in a large central dome surrounded by twelve smaller domes. The small domes were said to represent the twelve apostles gathered around the central dome, representing Christ the Pantokrator, Ruler of the Universe. The central domed space of the crossing focuses attention on the nave and the main apse. Nonetheless, the many individual bays create an often confusing and compartmentalized interior.

The walls glow with lavish decoration: Mosaics glitter from the central dome, the apse, and the arches of the crossing. The remaining surfaces are painted with scenes from the lives of Christ, the Virgin, the apostles Peter and Paul, and the archangels.

The Kievan mosaics established a system of iconography that came to be followed in all Russian Orthodox churches. The Pantokrator fills the center of the dome (not visible above the window-pierced drum in FIG. 7–40). At a lower level, the apostles stand between the windows of the drum, with the Four Evangelists in the pendentives. The Virgin Mary, an orant, seems to float in a golden heaven, filling the half dome and upper wall of the apse. In the mosaic on the wall below the Virgin, Christ appears not once, but twice, to offer bread and wine. He celebrates Mass at an altar under a canopy, a theme known as the Communion of the Apostles. Accompanied by angels who act as deacons, he distributes

communion to the apostles, six on each side of the altar. With this extravagant use of costly mosaic, Prince Yaroslav made a powerful political declaration about his own—and the Kievan church's—wealth and importance.

GREECE: HOSIOS LOUKAS. Although an outpost, Greece lay within the Byzantine Empire in the tenth and eleventh centuries and its architecture and art followed the trends toward multiplicity and intricacy seen in the capital. The KATHOLIKON OF THE MONASTERY OF HOSIOS LOUKAS, built a few miles from the village of Stiris, Greece, in the eleventh century, is an excellent example of the architecture of the Middle Byzantine age. It stands next to the ear lier Church of the Theotokos (FIG. 7–41). The church has a compact central plan with a dome, supported by squinches, rising over an octagonal core (see "Basilica-Plan and Central-Plan Churches," page 242, and "Pendentives and Squinches," page 257). On the exterior, the rising forms of apses, walls, and roofs disguise the vaults of the interior.

Outside and in, the buildings revolve around a lofty, central, tile-covered dome on a tall drum. Alternating courses of brick and stone, seen in the defensive walls of Constantinople, bond the wall surface and create an intricate masonry pattern. The Greek builders added to the decorative effect by outlining the stones with bricks set both vertically and horizontally. Ornamental courses of bricks set diagonally form saw-toothed moldings that also enhance the decorative quality rather than the supporting function of the walls. Inside the churches, the high central space of the dome carries the eye

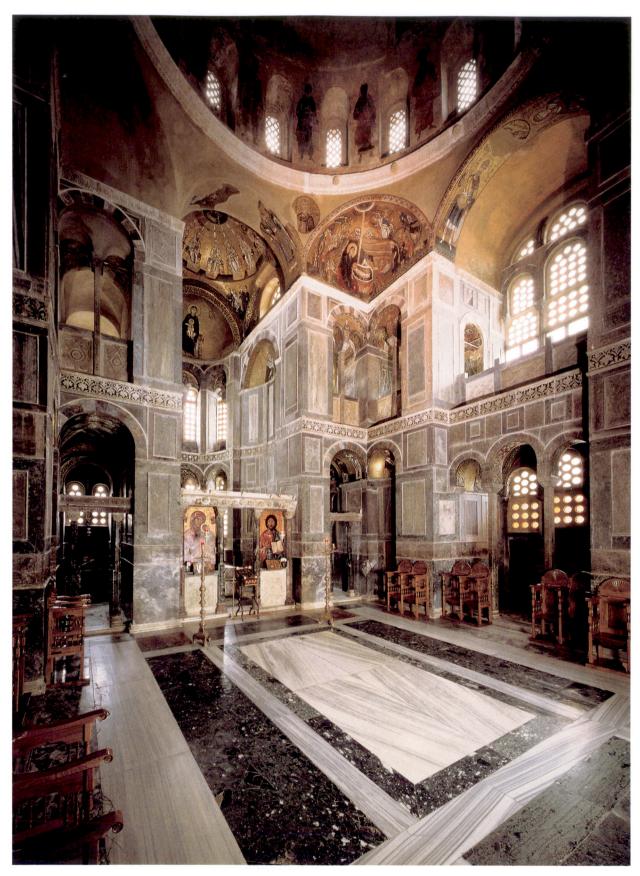

Visible are mosaics of the Virgin and Child Enthroned in the apse; apostles in the sanctuary dome; the Nativity and several standing saints in the vaults. The iconostasis held large paintings of the Virgin and Child (left) and Christ (right). The icons were stolen and have been replaced.

of the worshiper upward into the main dome, which soars above a ring of tall arched windows (FIG. 7–42).

Unlike Hagia Sophia, with its clear, sweeping geometric forms, the Katholikon has a complex variety of forms, including domes, groin vaults, barrel vaults, pendentives, and squinches, all built on a relatively small scale. The barrel vaults and tall sanctuary apse with flanking rooms further complicate the space. Single, double, and triple windows create intricate and unusual patterns of light, illuminating a painting (originally a mosaic) of *Christ Pantokrator* in the center of the main dome. The secondary, sanctuary dome of the Katholikon is decorated with a mosaic of the *Lamb of God* surrounded by the *Twelve Apostles*, and the apse half dome has a mosaic of the *Virgin and Child Enthroned*. Scenes from the Old and New Testaments and figures of saints fill the interior with brilliant color and dramatic images.

GREECE: MOSAICS OF THE CHURCH OF THE DORMITION AT DAPHNI. Eleventh-century mosaicists in Greece looked with renewed interest at models from the past. They conceived their compositions in terms of an intellectual rather than a physical ideal. While continuing to represent the human figure and narrative subjects, artists eliminated all details to focus on the essential elements of a scene to convey its mood and message.

The mosaics of the Church of the Dormition at Daphni. near Athens, provide an excellent example of this moving but elegant style. (Dormition, meaning "sleep," refers to Mary's bodily assumption into heaven.) The mosaic of the CRUCIFIXION (FIG. 7-43), like the Virgin of Vladimir, illustrates the emotional appeal to individuals in Middle Byzantine art: Jesus is shown with bowed head and sagging body, his eyes closed in death. Gone is the alert, living figure in a royal robe seen in the sixth-century Rabbula Gospels (SEE FIG. 7-36); now a nearly nude figure hangs on the cross. Also unlike the earlier scene, where a crowd reacts with anguish, indifference, or hostility, this image shows just two isolated mourning figures, Mary and the young apostle John, to whom Jesus had entrusted the care of his mother. The simplification of contours and the reduction of forms to essentials add to the emotional power of the image. The figures inhabit an otherworldly space, a golden universe anchored to the material world by a few flowers, which suggest the promise of new life.

This interpretation of the Crucifixion unites the Old and New Testaments. The mound of rocks and the skull at the bottom of the cross represent Golgotha, the "place of the skull," the hill outside ancient Jerusalem where Adam was thought to be buried and where the Crucifixion was said to have taken place. To the faithful, Jesus Christ was the new Adam sent by God to save humanity through his own sacrifice from the sins brought into the world by Adam and Eve. The arc of blood and water springing from Jesus's side refers to the rites of the

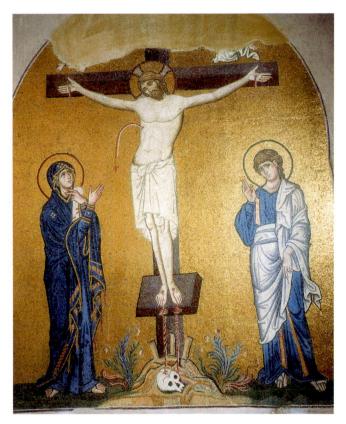

Church of the Dormition, Daphni, Greece. East wall of the north arm, Late 11th century. Mosaic.

Eucharist and the Baptism. As Paul wrote in his First Letter to the Corinthians: "For just as in Adam all die, so too in Christ shall all be brought to life" (1 Corinthians 15:22). The timelessness and simplicity of this image were meant to aid the Christian worshiper seeking to achieve a mystical union with the divine through prayer and meditation.

VENICE: THE CATHEDRAL OF SAINT MARK. The northeastern Italian city of Venice, set on the Adriatic at the crossroads of Europe and Asia Minor, was a major center of Byzantine art in Italy. Venice had been subject to Byzantine rule in the sixth and seventh centuries. Until the tenth century, the city's ruler, the doge, had to be ratified by the emperor. (Doge means "Duke" in the Venetian dialect.) At the end of the tenth century, when Constantinople granted Venice a special trade status that allowed its merchants to control much of the commerce between East and West, the city became very wealthy. Increased exposure to Eastern cultures is reflected in its art and architecture.

Venetian architects looked to the Byzantine domed church for inspiration in 1063, when the doge commissioned a church to replace the palace chapel, which had

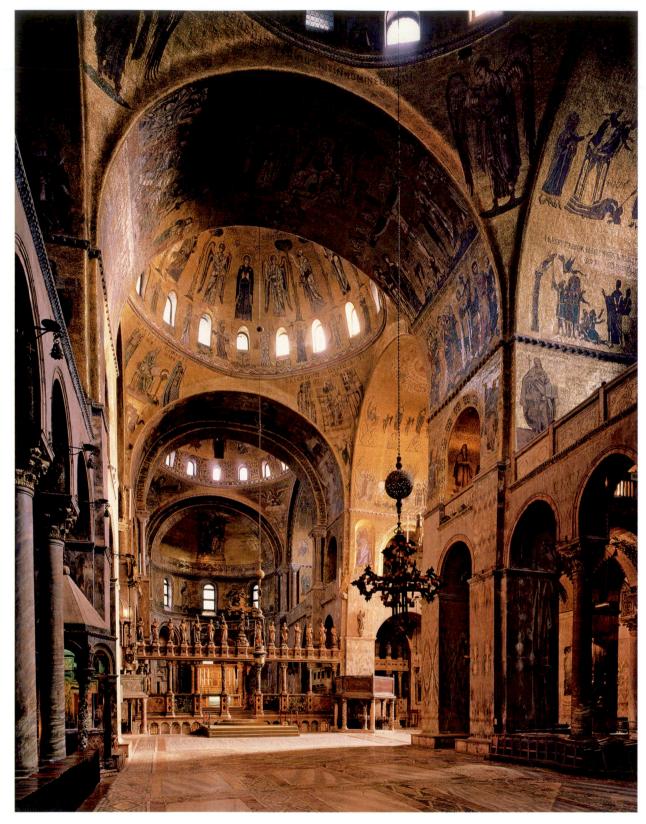

7-44 CATHEDRAL OF SAINT MARK

Venice. Present building begun 1063. View looking toward apse.

This church is the third one built on the site. It was both the palace chapel of the doge and the burial place for the bones of the patron of Venice, Saint Mark. The church was consecrated as a cathedral in 1807. Mosaics have been reworked continually to the present day.

served since the ninth century to hold the relics of Saint Mark the Apostle. The relics had been brought to Venice from Alexandria in 828/29. The Cathedral of Saint Mark has a Greek-cross plan, each square unit of which is covered by a dome, that is, five great domes in all, separated by barrel vaults and supported by pendentives. (See "Multiple-Dome Church Plans," page 275). Unlike Hagia Sophia in Constantinople, where the space seems to flow from the narthex up into the dome and through the nave to the apse, Saint Mark's domed compartments produce a complex space in which each dome has its own separate vertical axis (FIG. 7-44). Marble veneer covers the lower walls, and golden mosaics glimmer above on the vaults, pendentives, and domes. The dome seen in FIGURE 7-44 depicts the Pentecost, the descent of the Holy Spirit on the apostles. A view of Saint Mark's as it would have appeared in premodern times can be seen in a painting by the fifteenth-century Venetian artist Giovanni Bellini (FIG. 19–14).

Objects of Veneration and Devotion

During the second Byzantine golden age, artists of great talent and high aesthetic sensibility produced small luxury items of a personal nature for members of the court as well as for the church. Many of these items were commissioned by rulers and secular and church functionaries as official gifts for one another. They had to be portable, sturdy, and exquisitely refined. In style these works tended to combine classical elements with iconic compositions, successfully joining simple beauty and religious meaning. Ivory carving, gold and enamel work, and fine books were especially prized.

THE HARBAVILLE TRIPTYCH. Dating from the mid-eleventh century, the small ivory devotional piece known as the HAR-BAVILLE TRIPTYCH represents Christ flanked by Mary and Saint John the Baptist, a group known as THE DEËSIS (FIG. 7-45). Deesis means "entreaty" in Greek, and here Mary and John intercede for the people, pleading with Christ for forgiveness and salvation. The Deesis was an important new theme in keeping with personalized religious art. Directly below Christ, Saint Peter stands gesturing toward him. Inscriptions identify Saints James, John, Paul, and Andrew. The figures in the outer panels are military saints and martyrs. All the figures exist in a neutral space given definition only by the small bases under their feet. Although conceived as essentially frontal and rigid, the figures have rounded shoulders, thighs, and knees that suggest physical substance beneath their linear, decorative drapery.

METALWORK. The refined taste and skillful work that characterize the arts of the tenth through twelfth centuries were also expressed in precious materials such as silver and gold. A silver-gilt and enamel icon of the archangel Michael was one of the prizes the Crusaders took back to Venice in 1204, after sacking Constantinople (see "The Archangel Michael," page 276). The icon was presumably made in the late tenth or early eleventh century in an imperial workshop. The archangel appears here in essentially the same frontal pose and with the same idealized and timeless youthfulness with which he was portrayed in a sixth-century ivory panel (SEE FIG. 7–34). His head and hands, executed in relief, are surrounded by intricate relief and enamel decoration. Halo, wings, and garments

7–45 | HARBAVILLE TRIPTYCH Mid-11th century. Ivory, closed 11 \times 9½" (28 \times 24.1 cm); open 11 \times 19" (28 \times 48.2 cm). Musée du Louvre, Paris.

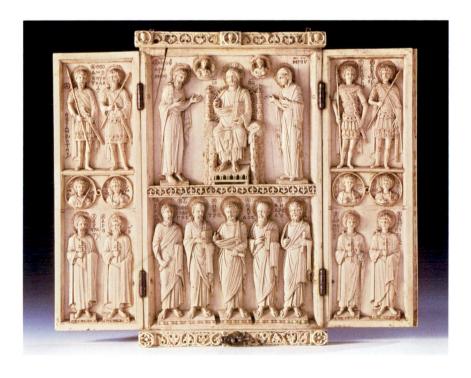

7–46 \perp **DAVID THE PSALMIST**Page from the *Paris Psalter*. Second half of the 10th century. Paint and gold on vellum, sheet size $14 \times 10\%$ " (35.6 \times 26 cm). Bibliothèque Nationale, Paris.

are in jewels, colored glass, and delicate **cloisonné**. (Cloisonné enamel is produced by soldering fine wires in the desired pattern to a metal plate and then filling the resulting spaces, the cells—the *cloisons*—with powdered colored glass. When the plate is heated, the glass powder melts and fuses onto the surface to create small, jewel-like sections.) The outer frame, added later, is inset with enamel roundels.

THE PARIS PSALTER. As was true of the artists who decorated church interiors, the illustrators of luxuriously illustrated manuscripts combined intense religious expression, aristocratic elegance, and a heightened appreciation of rich decoration.

The PARIS PSALTER from the second half of the tenth century was a luxurious production with fourteen full-page paintings (FIG. 7–46). About a third of the Old Testament was written in poetry, and among its most famous poems are those in the Book of Psalms. According to ancient tradition, the author of the Psalms was Israel's King David, who as a young shepherd and musician saved the people by killing the giant Goliath. In Christian times, the Psalms were copied into a book called a psalter, used for private reading and meditation. The words "psalm" and "psalter" refer to the song sung to the harp or to the action of playing a stringed instrument.

Like the earlier *Rabbula Gospels* (SEE FIGS. 7–36, 7–37), the *Paris Psalter* artist framed his scenes on pages without text. The first of the full-page illustrations depicts David seated in a land-

scape playing his harp. The massive, idealized figures occupy a spacious landscape filled with lush foliage, a meandering stream, and a distant city. The image seems to have been transported directly from an ancient Roman wall painting. The ribbon-tied memorial column is a convention in Greek and Roman funerary art, and in the ancient manner, the illustrator has personified abstract ideas and landscape features: Melody, a female figure, leans casually on David's shoulder, while another woman, perhaps the nymph Echo, peeks out from behind the column. The reclining youth in the lower foreground is a personification of Mount Bethlehem, as we learn from his inscription. The image of the dog watching over the sheep and goats while his master strums the harp suggests the classical subject of Orpheus charming wild animals with music. The subtle modeling of forms, the integration of the figures into a threedimensional space, and the use of atmospheric perspective all enhance the classical flavor of the painting.

The Special Case of Sicily

A unique mixing of Byzantine, classical Greek and Roman, Muslim, and western Christian culture took place during this period on the island of Sicily. Sicily had been a Greek colony and then part of the Roman Empire. Muslims had ruled it from 827 to the end of the eleventh century, when it fell to the Normans, descendants of the Viking settlers of northern France. The Norman Roger II was crowned King of Sicily in

Elements of Architecture

MULTIPLE-DOME CHURCH PLANS

he construction of a huge single dome, such as Hagia Sophia's (SEE FIGS. 7-26, 7-27), presented almost insurmountable technical challenges. Byzantine architects found it more practical to cover large interior spaces with several domes. Justinian's architects devised the fivedome Greek-cross plan, which was copied in the West at Saint Mark's in Venice, (a) and see FIGURE 7-44. Middle Byzantine builders preferred smaller, more intricate spaces, and multiple-dome churches were very popular. The five

domes of the Greek cross would often rise over a nine-bay square (b). The most favored plan was the **quincunx**, or cross-in-square, in which barrel vaults cover the arms of a Greek cross around a large central dome, with domes or groin vaults filling out the corners of a nine-bay space (c). Often the vaults and secondary domes are smaller than the central dome. Any of these arrangements can be made into an expanded quincunx (d) by additional domed aisles, as at the Cathedral of Saint Sophia in Kiev (SEE FIG. 7-40).

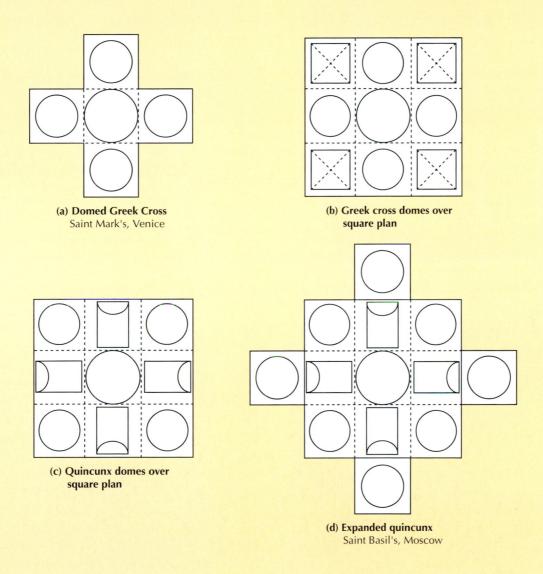

Palermo in 1130 and ruled until 1154. The pope, who assumed ecclesiastical jurisdiction over Sicily for "God and Saint Peter," was forced to endorse his rule while held captive. In the twelfth century, Sicily was one of the wealthiest and most enlightened kingdoms in Europe. Roger extended

religious toleration to a diverse population, which included Western Europeans, Greeks, Arabs, and Jews. He involved all factions in his government, permitted everyone to participate equally in the kingdom's economy, and issued official documents in Latin, Greek, and Arabic.

THE OBJECT SPEAKS

THE ARCHANGEL MICHAEL

cons speak to us today from computer screens—tiny images leading us from function to function in increasingly sophisticated hierarchies. Allusive images formed of light and color, these present-day icons—as with the religious icons (meaning "images" in Greek) that came before—speak to those who almost intuitively understand their suggestive form of communication.

The earliest icons had a mostly religious purpose—they were holy images that mediated between people and their God. Icons in the early Church were thought to be miracle workers, capable of defending petitioners from evil. One icon made more than a thousand years ago, possibly from the front and back covers of a book, depicts the archangel

Michael. The Protector of the Chosen, who defends his people from Satan and conducts their souls to God, Michael is mentioned in Jewish, Christian, and Islamic scriptures. On the front of this icon, Michael blesses petitioners with upraised hand; on the back is a relief in silver of the Cross, symbolizing Christ's victory over death.

When it was created, this icon would have spoken to believers of how archangels and angels mediate between God and humans—as when they announced Jesus's birth or mourned his death. They are not matter: They occupy no space, and their presence is felt, not seen. They are known intuitively, not by human reason.

Intuitive understanding is the core of Christian mysticism, according to the

sixth-century theologian Dionysus the Pseudo-Areopagite. As he explained, humans may, in stages, leave their sensory perception of the material world and rational thought and move to a mystical union with God. In icons, enamels, mosaics, and stained glass, artists tried to convey a sense of the divine with colored light. For them, matter becomes pure color and light as it becomes pure spirit. Believers thus would have interpreted the archangel Michael icon as an image formed by the golden light of heaven-it is his presence that is felt, not his body. When believers then and now behold icons like the archangel Michael, they intuit the image of the Heavenly Jerusalem.

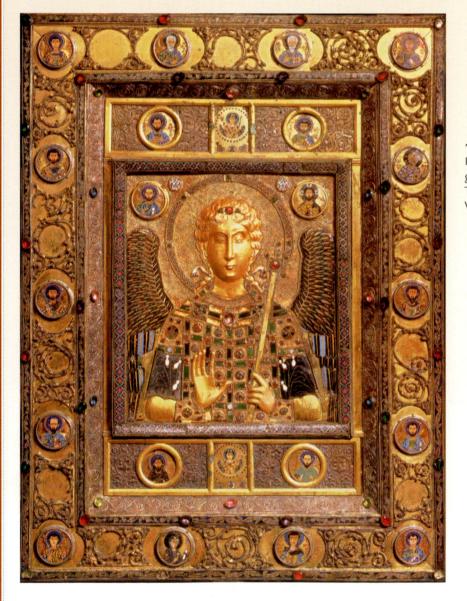

7–43 | ARCHANGEL MICHAEL Icon. Late 10th or early 11th century. Silver gilt with enamel, $19 \times 14''$ (48×36 cm). Treasury of the Cathedral of Saint Mark, Venice.

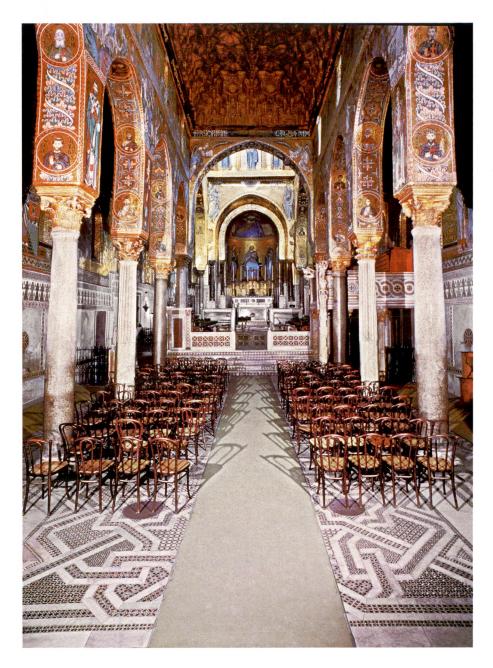

7–47 | PALATINE CHAPEL
Palermo, Sicily. Mid-12th century.
View toward the east.

A rich mixture of influences from East and West define art and architectural forms under his rule. He overtly emulated the culture of Byzantine empire, and his artistic patrimony offers a partial clue to the lost glory of imperial Constantinople in the twelfth century.

PALERMO: THE PALATINE CHAPEL. Roger's court in his capital of Palermo was a brilliant cultural mixture as reflected in the Palatine ("Palace") Chapel. The Western basilica-plan church has a Byzantine dome on squinches over the crossing, and an Islamic timber *muqarnas* ceiling in the nave. Its lower walls and floor are of inlaid marble, and the upper walls are decorated with mosaic. Christ holding an open book fills the half dome of the apse; a Christ Pantokrator surrounded by angels, the dome; the Annunciation, the arches of the crossing. The mosaics in the transept have scenes from the Gospels. The tall, well-proportioned figures are clothed in form-defining garments whose jagged, flying ends bear no relation to gravity. The artists often relied on strong juxtapositions of light and

dark areas instead of modeling forms with subtle tonal gradations. All these elements combine into a colorful, exotic whole (FIG. 7–47).

Palermo: King Roger's Chamber. A room in the Norman Palace at Palermo, made for William I (ruled 1154–66), known as King Roger's chamber, gives an idea of secular Byzantine art (FIG. 7–48). The floor, lower walls, and door frames have individual marble panels framed by strips inlaid with geometric patterns of colored stones. Mosaics cover the upper walls and vault. Against a continuous gold surface are two registers of highly stylized trees and paired lions, leopards, peacocks, centaurs, and hunters. The mosaics in the vault combine Islamic geometric patterns with very stylized vine scrolls and imperial symbols—lions, eagles, and griffons. The interior glistens with reflected light and color. The idea of a garden room, so popular in Roman houses, remains, but the artists have turned it into a stylized fantasy on nature—a world as formalized as the rituals that had come to dominate life in the imperial and royal courts.

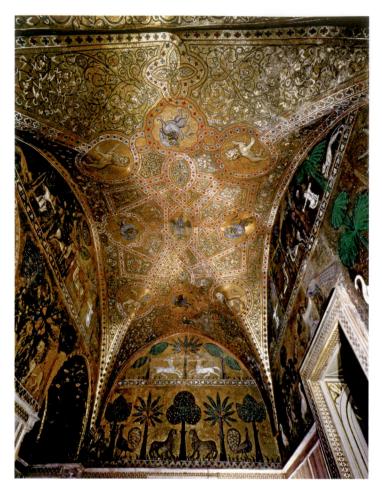

7–48 | CHAMBER OF KING ROGER, NORMAN PALACE Palermo, Sicily. Mid-12th century.

The Palermo palace is especially important because the loss of buildings makes the study of Byzantine domestic architecture almost impossible. Byzantine palaces must have been spectacular. Descriptions of the imperial palace in Constantinople tell of extraordinarily rich marbles and mosaics, silk hangings, and golden furniture, including a throne surrounded by mechanical singing birds and roaring lions. Palaces and houses evidently followed the pattern established by the Romans—a series of rooms around open courts. The great palace of the Byzantine emperors may have resembled Hadrian's Villa, with different buildings for domestic and governmental functions set in gardens, which were walled off from the city.

LATE BYZANTINE ART

The third great age of Byzantine art began in 1261, after the Byzantines expelled the Christian Crusaders who had occupied Constantinople for nearly sixty years, and it lasted until the city fell to the Turks in 1453. Although the empire had been weakened and its realm decreased to small areas of the Balkans and Greece, its arts underwent a resurgence. The

patronage of emperors, wealthy courtiers, and the Church stimulated renewed church building. In this new work, the physical requirements of the clergy and the liturgy took precedence over costly interior decorations. Nevertheless, the buildings reflect excellent construction skills as well as elegant and refined design.

Constantinople

In Constantinople, many small, existing churches were expanded with new ambulatory aisles, narthexes, and side chapels. Among these is the former Church of the Monastery of Christ in Chora, now the Kariye Camii Museum in Istanbul. The expansion of this church was one of several projects that Theodore Metochites, a humanist poet and scientist, and the administrator of the Imperial Treasury at Constantinople, sponsored between c. 1316 and 1321. To its church he added a two-story annex on the north side, two narthexes on the west side, and a funerary chapel on the south side. These structures contain the most impressive interior decorations remaining in Constantinople from the Late Byzantine period.

The funerary chapel is entirely painted with themes appropriate to such a setting (FIG. 7–49). For example, the Last Judgment is painted on the vault of the nave, and the Anastasis, Christ's descent into limbo to rescue Adam, Eve, and other virtuous people from Satan, is depicted in the half dome of the apse. Large figures of the church fathers (a group of especially revered early Christian writers of the history and teachings of the Church), saints, and martyrs line the walls below. Sarcophagi, surmounted by portraits of the deceased, once stood in side niches. Trompe l'oeil ("fool the eye") painting simulates marble paneling in the dado.

In the **ANASTASIS** (FIG. 7–50), Christ appears as a savior in white, moving with a force that is captured by his star-studded mandorla. He has trampled down the doors of hell; tied Satan into a helpless bundle; and shattered locks, chains, and bolts, which lie scattered over the ground. He drags the elderly Adam and Eve from their open sarcophagi with such force that their bodies seem airborne. Behind him are Old Testament prophets and kings, as well as his cousin John the Baptist.

Moscow: The Third Rome

In the fifteenth and sixteenth centuries, architecture of the Late Byzantine style flourished outside the borders of the empire in regions that had adopted Eastern Orthodox Christianity. After Constantinople's fall to the Ottoman Turks in 1453, leadership of the Orthodox Church shifted to Russia, whose rulers declared Moscow to be the "Third Rome" and themselves the heirs of Caesar (the *czar*).

The practice of venerating icons continued in Russia. A remarkable icon from this time is **THE OLD TESTAMENT TRIN- ITY (THREE ANGELS VISITING ABRAHAM)**, a large panel created sometime between 1410 and 1420 by the famed

artist-monk Andrey Rublyov (FIG. 7–51). It was commissioned in honor of the abbot Sergius of the Trinity-Sergius Monastery, near Moscow. This icon clearly illustrates how Late Byzantine artists relied on mathematical conventions to create ideal figures, as did the ancient Greeks. But unlike the Greeks, who based their formulas on close observation of nature, Byzantine artists invented an ideal geometry and depicted human forms and features accordingly.

Here, as is often the case, the circle forms the underlying geometric figure, emphasized by the form of the haloed heads. Despite the formulaic approach, talented artists like Rublyov managed to create a personal, expressive style. Rublyov relied on typical conventions—simple contours, elongation of the body, and a focus on a limited number of figures—to capture the sense of the spiritual in his work, yet distinguished his art by imbuing it with a sweet, poetic ambience. In this artist's hands, the Byzantine style took on new life.

The Byzantine tradition would continue in the art of the Eastern Orthodox Church and is carried on to this day in Greek and Russian icon painting. But in Constantinople, the three golden ages of Byzantine art—and the empire itself—came to an end in 1453. When the forces of the Ottoman sultan Mehmed II overran the capital, the Eastern Empire became part of the Islamic world, with its own very rich aesthetic heritage.

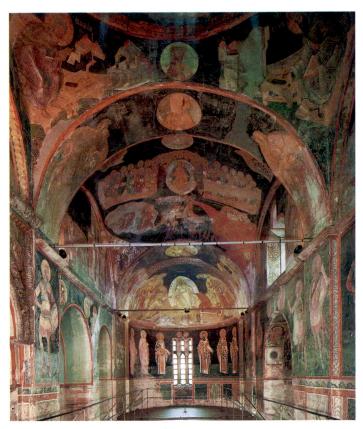

7-49 | FUNERARY CHAPEL, CHURCH OF THE MONASTERY
OF CHRIST

In Chora, Constantinople. (Present-day Kariye Mazesi, Istanbul, Turkey.) c. 1310–21.

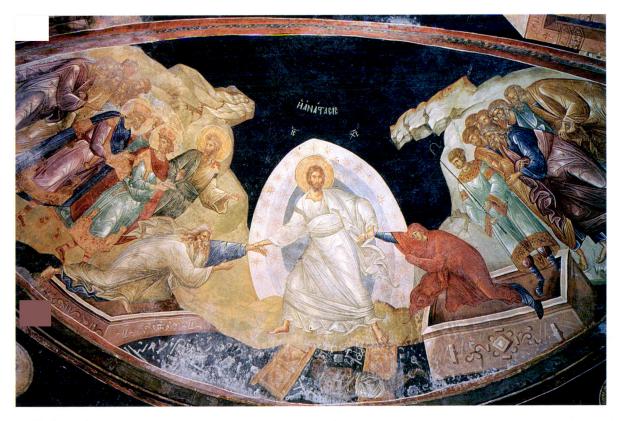

7–50 | ANASTASIS

Apse of the funerary chapel, Church of the Monastery of Christ in Chora. Painting.

Getty Research Library, Los Angeles. Wim Swaan Photograph Collection, 96.P.21

7–51 Andrey Rublyov THE OLD TESTAMENT TRINITY (THREE ANGELS VISITING ABRAHAM) Icon. c. 1410–25. Tempera on panel, 55½ × 44½" (141 × 113 cm).

Representing the dogma of the Trinity—one God in three beings—was a great challenge to artists. One solution was to depict God as three identical individuals. Rublyov used that convention to illustrate the Old Testament story of the Hebrew patriarch Abraham and his wife, Sarah, who entertained three divine messengers in the guise of three strangers.

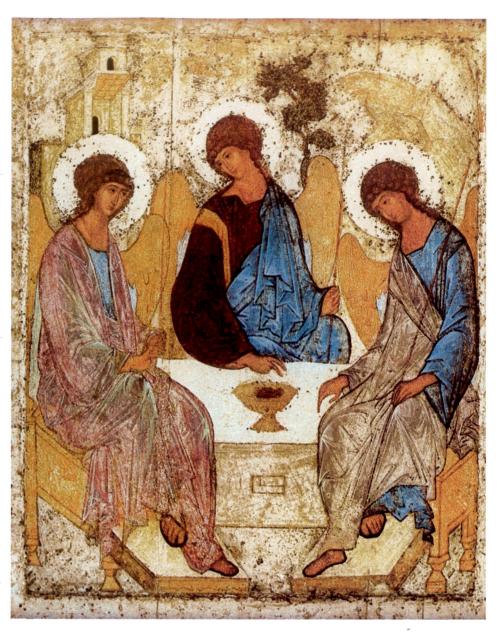

IN PERSPECTIVE

People in widely different times and places have sought answers to the fundamental questions of life and death, and in so doing they have tried to explain their relationship to a spiritual world. The arts reflect such searches for eternal truths. Artists appropriate, adapt, or reject earlier styles as they seek new modes of visual expression appropriate to their beliefs.

Jews, Christians, and Muslims believe in a single god. Jewish law, however, forbade the worship of idols—a prohibition that often made the representational arts suspect. Nevertheless, artists working for Jewish patrons depicted both symbolic and narrative Jewish subjects, and they looked to Near Eastern and classical Greek and Roman art for inspiration. Christians adopted the Jewish Scriptures as their Old Testament. Believing that God came to earth as a man in Jesus

Christ, they created a powerful figurative art using human beings as expressive symbols. Early Christians were Romans, and their art and architecture were essentially Roman in style and technique.

Byzantine art—the art of the Orthodox Church—was centered in Constantinople (present-day Istanbul) and lasted for a thousand years. The Byzantine elite sponsored major scriptoria, or writing rooms, where scribes produced handwritten books, along with workshops for the production of ivory carvings and painted icons. Architects of the Byzantine era perfected churches in which glittering domes formed vast, light-filled canopies. Regardless of a building's appearance, the final product in each case is a reflection and an expression both of the spiritual beliefs and the worldly aspirations of the people who oversaw its construction and who gathered within its walls.

SYNAGOGUE DURA EUROPAS

244-45

GOOD SHEPHERD MOSAIC c. 425-6

ANTHEMIUS OF TRALLES AND ISIDORUS OF MILETUS, HAGIA SOPHIA 532-37

CATHEDRAL OF SAINT MARK 1063

OLD TESTAMENT TRINITY c. 1410-25

IOO

JEWISH, EARLY **CHRISTIAN** AND BYZANTINE ART

- Destruction of Jerusalem 70 CE
- Early Christian 100-6th century CE

- ✓ Imperial Christian 313-476 CE
- Council of Nicaea 325 CE
- Early Byzantine c. 5th century-726 CE
- End of Western Roman Empire 476 CE
- Justinian Emperor 527-65 CE

- Iconoclastic Controversy 726–843 CE
- Middle Byzantine 843-1204 CE
- Russia Becomes Christian 988 CE
- Division of Christian Church into Catholic and Orthodox 1054 CE
- Crusades Begin 1095 CE
- Western Rule of Constantinople 1204-61 CE
- **Late Byzantine** 1261–1453 CE
- Fall of Constantinople to **Turks** 1453 CE

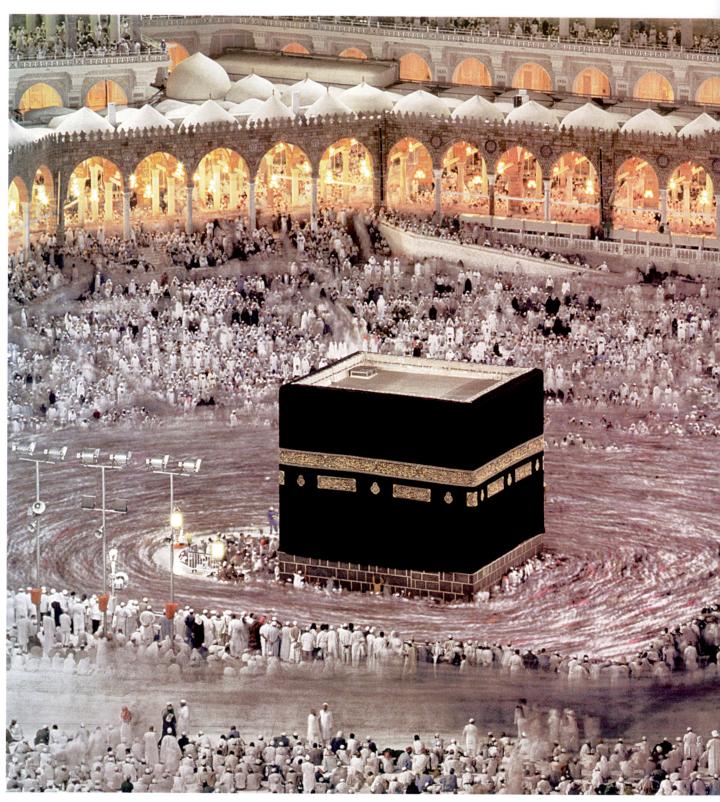

8-i | THE KAABA, MECCA | The Kaaba represents the center of the Islamic world. Its cubical form is draped with a black textile that is embroidered with a few Qur'anic verses in gold.

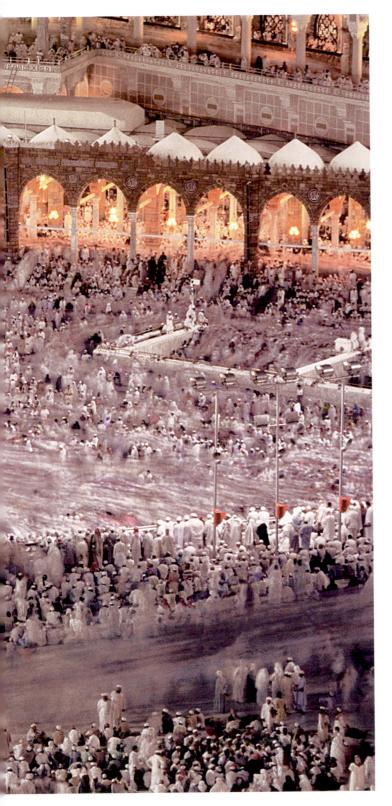

CHAPTER EIGHT

ISLAMIC ART

8

In the desert outside of Mecca in 610 CE, an Arab merchant named al-Amin sought solitude in a cave. On that night, which Muslims call "The

Night of Destiny," an angel appeared to al-Amin and commanded him to recite revelations from God (Allah). In that moment, al-Amin became Muhammad ("Messenger of God"). His revelations form the foundation of the religion called Islam ("submission to God's will"), whose adherents are Muslims ("those who have submitted to God"). For the rest of his life, Muhammad recited revelations in cadenced verses to his followers who committed them to memory. After his death, they transcribed the verses and organized them in chapters called *surahs*, thus compiling the holy book of Islam: the Qur'an ("Recitation").

The first person to accept Muhammad as God's Prophet was his wife, Khadija, followed soon thereafter by other family members. But many powerful Meccans were hostile to the message of the young visionary, and he and his companions were forced to flee in 622. Settling in an oasis town, later renamed Medina ("City"), Muhammad built a house that became a gathering place for the converted and thus the first Islamic mosque.

In 630, Muhammad returned to Mecca with an army of ten thousand, routed his enemies, and established the city

as the spiritual capital of Islam. After his triumph, he went to the Kaaba (FIG. 8–I), a cubical shrine said to have been built for God by the biblical patriarch Abraham and long the focus of pilgrimage and polytheistic worship. He emptied the shrine, repudiating its accumulated pagan idols, while preserving the enigmatic cubical structure itself and dedicating it to God.

The Kaaba is the symbolic center of the Islamic world, the place to which all Muslim prayer is directed and the ultimate destination of Islam's obligatory pilgrimage, the Hajj. Each year, huge numbers of Muslims from all over the world travel to Mecca to circumambulate the Kaaba during the month of pilgrimage. The exchange of ideas that occurs during the intermingling of these diverse groups of pilgrims has been a primary source of Islamic art's cultural eclecticism.

CHAPTER-AT-A-GLANCE

- ISLAM AND EARLY ISLAMIC SOCIETY
- ART DURING THE EARLY CALIPHATES | Architecture | Calligraphy | Ceramics and Textiles
- LATER ISLAMIC ART | Architecture | Portable Arts | Manuscripts and Painting
- THE OTTOMAN EMPIRE | Architecture | Illuminated Manuscripts and Tugras
- **THE MODERN ERA**
- IN PERSPECTIVE

ISLAM AND EARLY ISLAMIC SOCIETY

Seemingly out of nowhere, Islam arose in seventh-century Arabia, a land of desert oases with no cities of great size, sparsely inhabited by tribal nomads. Yet, under the leadership of its founder, the Prophet Muhammad (c. 570–632 CE), and his successors, Islam spread rapidly throughout northern Africa, southern and eastern Europe, and much of Asia, gaining territory and converts with astonishing speed. Because Islam encompassed geographical areas with a variety of longestablished cultural traditions, and because it admitted diverse peoples among its converts, it absorbed and combined many different techniques and ideas about art and architecture. The result was a remarkable eclecticism and artistic sophistication.

Muslims date their history as beginning with the hijira ("emigration"), the flight of the Prophet Muhammad in 622 from Mecca to Medina. In less than a decade Muhammad had succeeded in uniting the warring clans of Arabia under the banner of Islam. Following his death in 632, four of his closest associates in turn assumed the title of caliph ("successor").

Muhammad's act of emptying the Kaaba of its pagan idols confirmed the fundamental concept of aniconism (avoidance of figural imagery) in Islamic art. Following his example, the Muslim faith discourages the representation of figures, particularly in religious contexts. Instead, Islamic artists elaborated a rich vocabulary of nonfigural ornament, including complex geometric designs and scrolling vines

sometimes known as **arabesques**. Islamic art revels in surface decoration, in manipulating line, color, and especially pattern, often highlighting the interplay of pure abstraction, organic form, and script.

According to tradition, the Qur'an assumed its final form during the time of the third caliph, Uthman (ruled 644–56). As the language of the Qur'an, the Arabic language and script have been a powerful unifying force within Islam. From the eighth through the eleventh centuries, Arabic was the universal language among scholars in the Islamic world and in some Christian lands as well. Inscriptions frequently ornament works of art, sometimes written clearly to provide a readable message, but in other cases written as complex patterns simply to delight the eye.

The accession of Ali as the fourth caliph (ruled 656–61) provoked a power struggle that led to his assassination and resulted in enduring divisions within Islam. Followers of Ali, known as Shi'ites (referring to the party or *shi'a* of Ali), regard him alone as the Prophet's rightful successor. Sunni Muslims, in contrast, recognize all of the first four caliphs as "rightly guided." Ali was succeeded by his rival Muawiya (ruled 661–80), a close relative of Uthman and the founder of the Umayyad dynasty (661–750).

Islam expanded dramatically. In just two decades, seemingly unstoppable Muslim armies conquered the Sasanian Persian Empire, Egypt, and the Byzantine provinces of Syria and Palestine. By the early eighth century, under the Umayyads, they had reached India, conquered northern

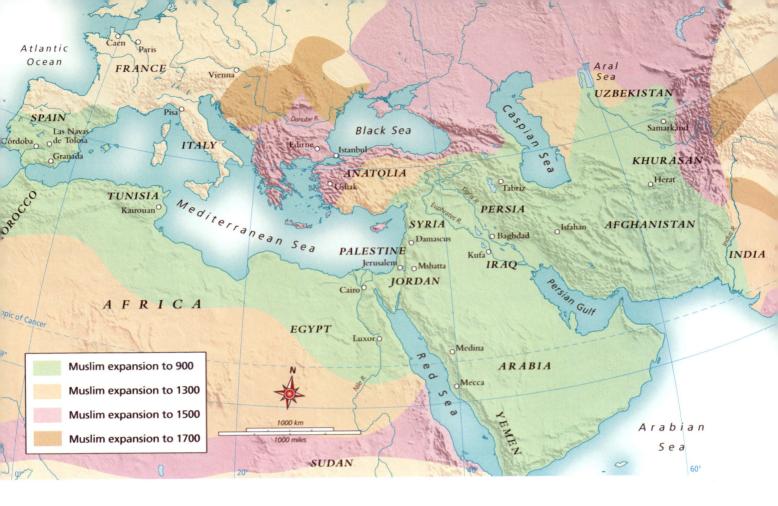

MAP 8-I THE ISLAMIC WORLD

Within 200 years after 622 CE, the Islamic world expanded from Mecca to India in the east, and to Morocco and Spain in the west.

Africa and Spain, and penetrated France to within 100 miles of Paris before being turned back (MAP 8–1). In these newly conquered lands, the treatment of Christians and Jews who did not convert to Islam was not consistent, but in general, as "People of the Book"—followers of a monotheistic religion based on a revealed scripture—they enjoyed a protected status. However, they were also subject to a special tax and restrictions on dress and employment.

Muslims participate in congregational worship at a mosque (masjid, "place of prostration"). The Prophet Muhammad himself lived simply and instructed his followers in prayer at a mud-brick house, now known as the Mosque of the Prophet, where he resided in Medina. This was a square enclosure that framed a large courtyard. Facing the courtyard along the east wall were small rooms where Muhammad and his family lived. Along the south wall, a thatched portico supported by palm-tree trunks sheltered both the faithful as they prayed and Muhammad as he spoke from a low platform. This simple arrangement inspired the design of later mosques.

Lacking an architectural focus such as an altar, nave, or dome, the space of this prototypical mosque reflected the founding spirit of Islam in which the faithful pray directly to God without the intermediary of a priesthood.

ART DURING THE EARLY CALIPHATES

The caliphs of the Umayyad dynasty (661–750), which ruled from Damascus in Syria, built mosques and palaces throughout the Islamic Empire. These buildings projected the authority of the new rulers and reflected the growing acceptance of Islam. In 750 the caliphs of the Abbasid dynasty replaced the Umayyads in a coup d'etat, ruling until 1258 in the grand manner of the ancient Persian emperors. Their capital was Baghdad in Iraq, and their art patronage reflected Persian and Turkic traditions. Their long and cosmopolitan reign saw achievements in medicine, mathematics, the natural sciences, philosophy, literature, music, and art. They were generally

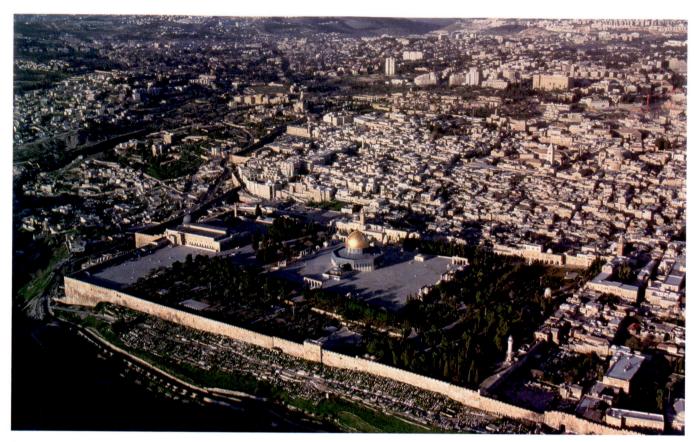

8-2 | AERIAL VIEW OF HARAM AL-SHARIF, JERUSALEM

The Dome of the Rock occupies a place of visual height and prominence in Jerusalem and, when first built, strikingly emphasized the arrival of Islam and its community of adherents in that ancient city.

tolerant of the ethnically diverse populations in the territories they subjugated, and they admired the past achievements of Roman civilization and the living traditions of Byzantium, Persia, India, and China, freely borrowing artistic techniques and styles from all of them.

Architecture

While Mecca and Medina remained the holiest Muslim cities, under the Umayyad caliphs the political center moved away from the Arabian peninsula to the Syrian city of Damascus. Here, inspired by the Roman and Byzantine architecture of the eastern Mediterranean, the Muslims became enthusiastic builders of shrines, mosques, and palaces. The simple congregational mosque with hypostyle columns eventually gave way to new types, such as cruciform and centrally planned mosques. Although tombs were officially discouraged in Islam, they proliferated from the eleventh century onward, in part due to funerary practices imported from the Turkic northeast, and in part due to the rise of Shi'ism with its emphasis on genealogy and particularly ancestry through Muhammad's daughter, Fatima. The Umayyads launched the practice of building both urban palaces and rural estates; under later dynasties such as the Abbasids, the Spanish Umayyads, and

their successors, these were huge, sprawling complexes with an urban infrastructure of mosques, bathhouses, reception rooms, kitchens, barracks, gardens, and road networks.

THE DOME OF THE ROCK. The Dome of the Rock is the first great monument of Islamic art. Built in Jerusalem, it is the third most holy site in Islam. In the center of the city rises the Haram al-Sharif ("Noble Sanctuary") (FIG. 8-2), a rocky outcrop from which Muslims believe Muhammad ascended to the presence of God on the "Night Journey" described in the Qur'an. Jews and Christians variously associate the same site with Solomon's Temple, the site of the creation of Adam. and the place where the patriarch Abraham prepared to sacrifice his son Isaac at the command of God. In 691-2, the Umayyads had completed the construction of a shrine over the rock (FIGS. 8-3, 8-4) using Syrian artisans trained in the Byzantine tradition. By appropriating a site holy to the Jewish and Christian faiths, the Dome of the Rock is the first architectural manifestation of Islam's view of itself as completing the prophecies of those faiths and superseding them.

Structurally, the Dome of the Rock imitates the centrally planned form of Early Christian and Byzantine martyria. However, unlike its models, with their plain exteriors, it is

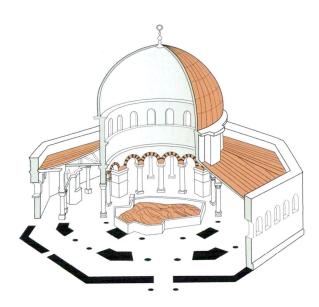

8-3 CUTAWAY DRAWING OF THE DOME OF THE ROCK

crowned with a golden dome that dominates the Jerusalem skyline, and it is decorated with opulent marble veneer and mosaics inside its exterior tiles. The dome, surmounting an octagonal drum pierced with windows and supported by

arcades of alternating piers and columns, covers the central space containing the rock (FIG. 8-3). These arcades create concentric aisles (ambulatories) that permit devout visitors to circumambulate the rock. Inscriptions from the Qur'an interspersed with passages from other texts, including information about the building itself, form a frieze around the inner wall. As the pilgrim walks around the central space to read the inscriptions in brilliant gold mosaic on turquoise green ground, the building communicates both as a text and as a dazzling visual display. These passages of text are especially notable because they are the oldest surviving written Qur'an verses and the first use of monumental Qur'anic inscriptions in architecture. Below the frieze are walls covered with pale marble, the veining of which creates abstract symmetrical patterns, and columns with shafts of gray marble and gilded capitals. Above the calligraphic frieze is another mosaic frieze depicting thick, symmetrical vine scrolls and trees in turquoise, blue, and green, embellished with imitation jewels, over a gold ground. The mosaics are variously thought to represent the gardens of Paradise and trophies of Muslim victories offered to God. The decorative program is extraordinarily rich, but remarkably enough, the focus of the building is neither art nor architecture but the plain rock within it.

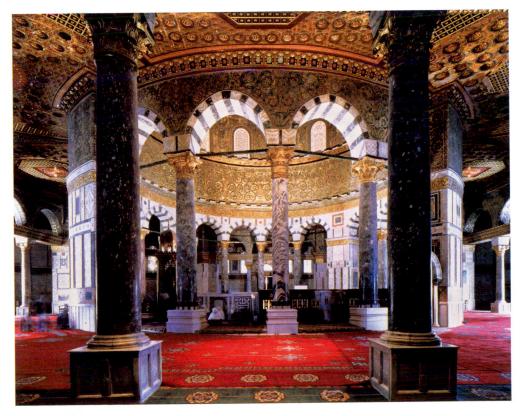

8–4 DOME OF THE ROCK, JERUSALEM 691–2. Interior.

The arches of the inner and outer face of the central arcade are encrusted with golden mosaics. The carpets and ceiling are modern but probably reflect the original patron's intention.

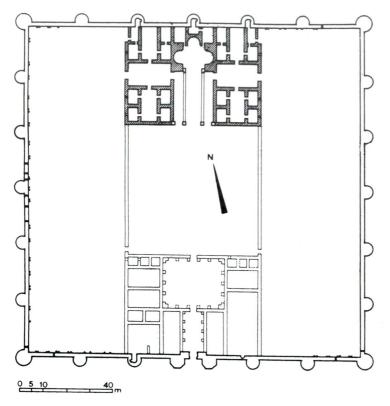

 $8-5 \perp$ plan of the palace at mshatta, jordan 743-4.

MSHATTA PALACE. The Umayyad caliphs built profusely decorated palatial hunting retreats on the edge of the desert where local chieftains could be entertained and impressed. One such palace was built at Mshatta, near present-day Amman, Jordan (probably in 743–4). Although the east and west sides of Mshatta seem never to have been completed, this square, stone-walled complex is nevertheless impressively monumental (FIG. 8–5). It measured 472 feet on each side, and its outer walls and gates were guarded by towers and bastions reminiscent of a Roman fort. Inside, around a large central court, were a mosque, a domed audience hall, and private apartments.

Unique among surviving palaces, Mshatta was decorated with a frieze that extended in a band about 16 feet high across the base of its façade. This frieze was divided by a zigzag molding into triangular compartments, each punctuated by a large rosette carved in high relief (FIG. 8–6). The compartments were filled with intricate carvings in low relief that included interlacing scrolls inhabited by birds and other animals, urns, and candlesticks. Beneath one of the rosettes, two facing lions drink at an urn from which grows the Tree of Life, an ancient Persian motif. However, where the frieze runs across the outer wall of the mosque, to the right of the entrance, animal and bird imagery is conspicuously absent, in close observance of the strictures against icons.

THE GREAT MOSQUE OF KAIROUAN. Mosques provide a place for regular public worship. The characteristic elements of the hypostyle (multicolumned) mosque developed during

the Umayyad period (see "Mosque Plans," right). The Great Mosque of Kairouan, Tunisia (FIG. 8–7), built in the ninth century, reflects the early form of the mosque but is elaborated with new additions. Its large rectangular plan is divided between a courtyard and a flat-roofed hypostyle prayer hall oriented toward Mecca. The system of repeated bays and aisles can easily be extended as the congregation grows in size—one of the hallmarks of the hypostyle plan. New is the huge tower (the minaret, from which the faithful are called to prayer) that rises from one end of the courtyard and that stands as a powerful sign of Islam's presence in the city.

The qibla wall, marked by a centrally positioned mihrab niche, is the wall of the prayer hall that is closest to Mecca. In the Great Mosque of Kairouan, the qibla wall is given heightened importance by a raised roof, a dome over the mihrab, and an aisle that marks the axis that extends from the mihrab to the minaret. The mihrab belongs to the tradition of niches that signify a holy place—the shrine for the Torah scrolls in a synagogue, the frame for the sculpture of a god or ancestor in Roman architecture, the apse in a church.

The maqsura, an enclosure in front of the mihrab for the

 $8\text{--}6 \perp \text{frieze, detail of façade of the palace at mshatta}$

Stone. Staatliche Museen zu Berlin, Preussischer Kulturbesitz, Museum für Islamische Kunst.

Elements of Architecture MOSQUE PLANS

ollowing the model of the Mosque of the Prophet in Medina, the earliest mosques were columnar hypostyle halls. The Great Mosque of Cordoba (SEE FIG. 8–8) was approached through an open courtyard, its interior divided by rows of columns leading, at the far end, to the *mihrab* niche of a *qibla* wall indicating the direction of Mecca.

A second type, the **four-iwan mosque**, such as the Masjid-i Jami at Isfahan, was developed in Iran. The *iwans*—huge barrel-vaulted halls with wide-open, arched entrances—faced each other across a central courtyard; the inner façade of this courtyard was thus given cross-axial emphasis, height, and greater monumentality (SEE FIG. 8–14).

Centrally planned mosques, such as the Sultan Selim Mosque at Edirne (SEE FIG. 8-27), were strongly influenced by Byzantine church plans, such as the Hagia Sophia (SEE FIG. 7-26) and are typical of the Ottoman architecture of Turkey. The interiors are dominated by a large domed space uninterrupted by structural supports. Worship is directed, as in other mosques, toward a *qibla* wall and *mihrab* opposite the entrance.

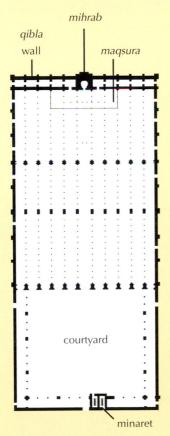

hypostyle mosque Great Mosque, Cordoba, after extension by al-Hakam II

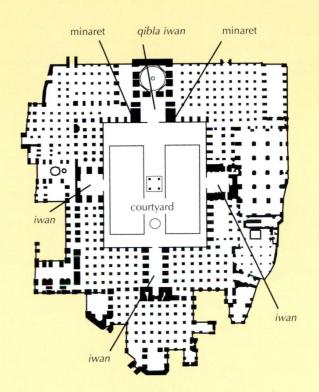

four-iwan mosque
Congregational Mosque, Isfahan

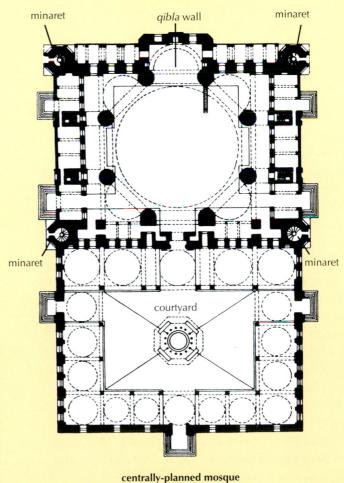

Sultan Selim Mosque, Edirne

(Plans are not to scale)

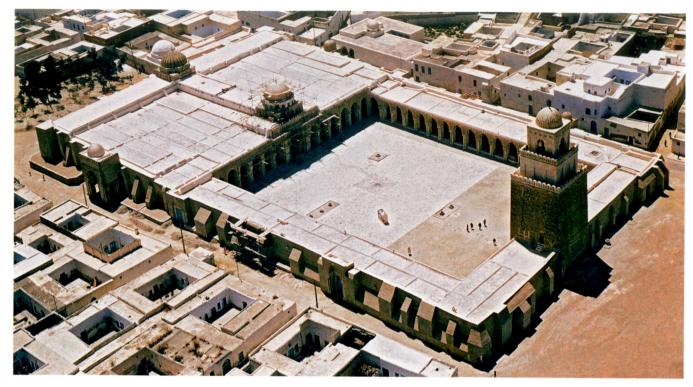

 $8-7 \perp$ the great mosque, Kairouan, Tunisia 836–75.

ruler and other dignitaries, became a feature of the principal congregational mosque after an assassination attempt on one of the Umayyad rulers. The **minbar**, or pulpit, stands by the *mihrab* as the place for the prayer leader and as a symbol of authority (for a fourteenth-century example of a *mihrab* and a *minbar*, SEE FIG. 8–16).

THE GREAT MOSQUE OF CORDOBA. When the Abbasids overthrew the Umayyads in 750, a survivor of the Umayyad dynasty, Abd al-Rahman I (ruled 756–88), fled across North Africa into southern Spain (known as al-Andalus in Arabic) where, with the support of Muslim settlers, he established himself as the provincial ruler, or emir. While the caliphs of the Abbasid dynasty ruled the eastern Islamic world from Baghdad for five centuries, the Umayyad dynasty ruled in Spain from their capital in Cordoba (756–1031). The Umayyads were noted patrons of the arts, and one of the finest surviving examples of Umayyad architecture is the Great Mosque of Cordoba (see "Mosque Plans," page 289).

In 785, the Umayyad conquerors began building the Cordoba mosque on the site of a Christian church built by the Visigoths, the pre-Islamic rulers of Spain. The choice of site was both practical—for the Muslims had already been borrowing space within the church—and symbolic, an appropriation of place (similar to the Dome of the Rock) that affirmed their presence. Later rulers expanded the building three times, and today the walls enclose an area of about 620 by 460 feet, about a third of which is the court-

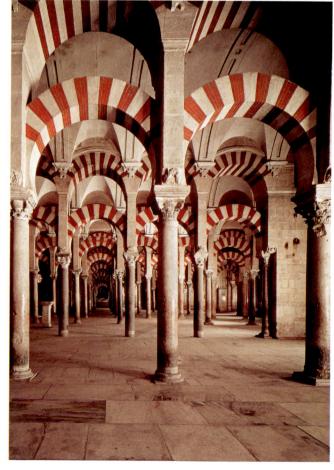

8–8 | **Prayer Hall, Great mosque, cordoba, spain.** Begun 785–86.

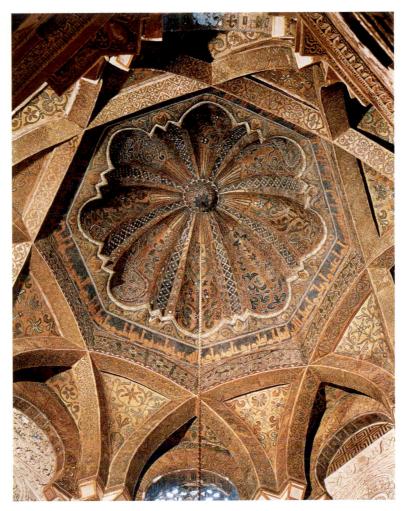

8–9 | DOME IN FRONT OF THE MIHRAB, GREAT MOSQUE 965.

yard. This patio was planted with fruit trees beginning in the early eighth century; today orange trees seasonally fill the space with color and scent. Inside, the proliferation of pattern in the repeated columns and double flying arches is colorful and dramatic. The marble columns and capitals in the hypostyle prayer hall were recycled from the Christian church that had formerly occupied the site, as well as from classical buildings in the region, which had been a wealthy Roman province. Fig. 8-8 shows the mosque's interior with columns of slightly varying heights. Two tiers of arches, one over the other, surmount these columns; the upper tier springs from rectangular posts that rise from the columns. This double-tiered design effectively increases the height of the interior space and provides excellent air circulation as well as a sense of monumentality and awe. The distinctively shaped horseshoe arches—a form known from Roman times and favored by the Visigoths—came to be closely associated with Islamic architecture in the West (see "Arches and Mugarnas," page 292). Another distinctive feature of these arches, also adopted from Roman and Byzantine precedents, is the alternation of white stone and red brick voussoirs forming the curved arch.

In the final century of Umayyad rule, Cordoba emerged as a major commercial and intellectual hub and a flourishing center for the arts, surpassing Christian European cities economically and also in science, literature, and philosophy. As a sign of this new prestige and power, Abd al-Rahman III (ruled 912-61) boldly reclaimed the title of caliph in 929. He and his son al-Hakam II (ruled 961-76) made the Great Mosque a focus of patronage, commissioning costly and luxurious renovations such as a new mihrab with three bays in front of it. The melon-shaped, ribbed dome over the central bay seems to float upon a web of criss-crossing arches (FIG. 8-9). The complexity of the design, which differs from the geometric configuration of the domes to either side, reflects the Islamic interest in mathematics and geometry, not purely as abstract concepts but as sources for artistic inspiration. Lushly patterned mosaics with inscriptions, geometric motifs, and stylized vegetation clothe both this dome and the mihrab below in brilliant color and gold. These were installed by a Byzantine master who was sent by the emperor in Constantinople, bearing boxes of the small glazed ceramic and glass pieces (tesserae). Such artistic exchange is emblematic of the interconnectedness of the medieval Mediterraneanthrough trade, diplomacy, and competition.

Elements of Architecture ARCHES AND MUQARNAS

slamic builders explored structure in innovative ways. They explored the variations and possibilities of the horseshoe arch (SEE FIG. 8–8) (which had a very limited use before the advent of Islam) and the pointed arch (SEE FIG. 8–14). There are many variations of each, some of which disguise their structural function beneath complex decoration.

Unique to Islam, *muqarnas* are small nichelike component that is usually stacked and used in multiples as interlocking, successive, non-load-bearing, vaulting units. Over time they became increasingly intricate (and non-structural) so that they dazzled the eye and confused the rational mind (SEE FIG. 8–18). They are frequently used to fill the hoods of *mihrabs* and portals and, on a larger scale, to vault domes, softening or even masking the transition from the vertical plane to the horizontal.

horseshoe arch

pointed arch

muqarnas

Calligraphy

Muslim society holds calligraphy (the art of fine hand lettering) in high esteem. Since the Qur'an is believed to reveal the word of God, its words must be written accurately, with devotion and embellishment. Writing was not limited to books and documents but was displayed on the walls of buildings, on metalwork, textiles, and ceramics. Since pictorial imagery developed relatively late in Islamic art (and there was no figural imagery at all in the religious context), inscription became the principal vehicle for visual communication. The written word thus played two roles: It could convey verbal information about a building or object, describing its beauty or naming its patron, while also delighting the eye in an entirely aesthetic sense. Arabic script is written from right to left, and each letter usually takes one of three forms depending on its position in a word. With its rhythmic interplay between verticals and horizontals, the system lends itself to many variations. Formal Kufic script (after Kufa, a city in Iraq) is blocky and angular, with strong upright strokes and long horizontals. It may have developed first for carved or woven inscriptions where clarity and practicality of execution were important.

Most early Qur'ans had large Kufic letters and only three to five lines per page, which had a horizontal orientation. The visual clarity was necessary because one book was often shared by multiple readers simultaneously. A page from a ninth-century Syrian Qur'an exemplifies the style common from the eighth to the tenth century (FIG. 8–10). Red diacritical marks (pronunciation guides) accent the dark brown ink; the *surah* ("chapter") title is embedded in the burnished ornament at the bottom of the sheet. Instead of page numbers, the brilliant gold of the framed words and the knoblike projection in the left-hand margin are a distinctive means of marking chapter breaks.

Calligraphers enjoyed the highest status of all artists in Islamic society. Included in their numbers were a few princes and women. Apprentice scribes had to learn secret formulas for inks and paints; become skilled in the proper ways to sit, breathe, and manipulate their tools; and develop their individual specialties. They also had to absorb the complex literary traditions and number symbolism that had developed in Islamic culture. Their training was long and arduous, but unlike other craft practitioners who were generally anonymous in the early centuries of Islam, outstanding calligraphers received public recognition.

By the tenth century, more than twenty cursive scripts had come into use. They were standardized by Ibn Muqla (d. 940), an Abbasid official who fixed the proportions of the letters in each and devised a method for teaching the calligraphy that is still in use today. The Qur'an was usually written on parchment (treated animal skin) and vellum (calfskin or a fine parchment). Paper was first manufactured in Central Asia during the mid-eighth century, having been

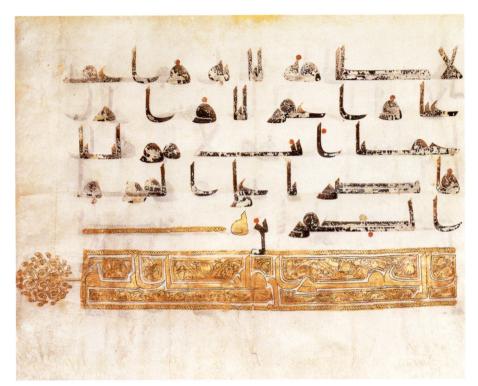

8–10 | PAGE FROM THE QUR'AN (Surah II: 286 and title Surah III) in Kufic script, from Syria, 9th century. Black ink pigments, and gold on vellum, $8\% \times 11\%$ (21.8 \times 29.2 cm). The Metropolitan Museum of Art, New York. Rogers Fund, 1937 (37.99.2)

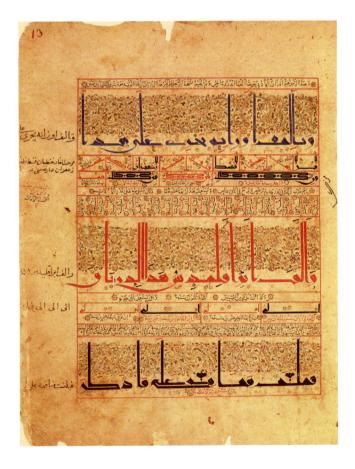

8–II | ARABIC MANUSCRIPT PAGE Attributed to Galinus. Iraq. 1199. Headings are in ornamental Kufic script with a background of scrolling vines, while the text—a medical treatise—is written horizontally and vertically in Naskhi script. Bibliothèque Nationale, Paris.

introduced earlier by Buddhist monks. Muslims learned how to make high-quality, rag-based paper, eventually establishing their own paper mills. By about 1000, paper had largely replaced the more costly parchment, encouraging the proliferation of increasingly elaborate and decorative cursive scripts, which generally superseded Kufic by

the thirteenth century. Of the major styles, one extraordinarily beautiful form, known as *naskhi*, was said to have been revealed and taught to scribes in a vision. Even those who cannot read Arabic can enjoy the flowing beauty of its lines, which are often interlaced with swirling vine scrolls (FIG. 8–II).

Ceramics and Textiles

On objects made of ceramics, ivory, and metal, as well as textiles, calligraphy was prominently displayed. It was the only decoration on a type of white pottery made in the ninth and tenth centuries in and around the region of Khurasan (also known as Nishapur, in present-day northeastern Iran) and Samarkand (in present-day Uzbekistan). Now known as Samarkand ware, these elegant pieces are characterized by the use of a clear lead glaze applied over a black inscription on a white slip-painted ground. In FIG. 8–12 the script's horizontals and verticals have been elongated to fill the bowl's rim. The inscription translates: "Knowledge: the beginning of it is bitter to taste, but the end is sweeter than honey," an apt choice for tableware and appealing to an educated patron. Inscriptions on Samarkand ware provide a storehouse of such popular sayings.

A Kufic inscription appears on a tenth-century piece of silk from Khurasan (FIG. 8–13): "Glory and happiness to the Commander Abu Mansur Bukhtakin. May God prolong his prosperity." Such good wishes were common in Islamic art, appearing as generic blessings on ordinary goods sold in the marketplace or, as here, personalized for the patron. Texts can sometimes help determine where and when a work was made, but they can also be frustratingly uninformative when little is known about the patron, and they are not always

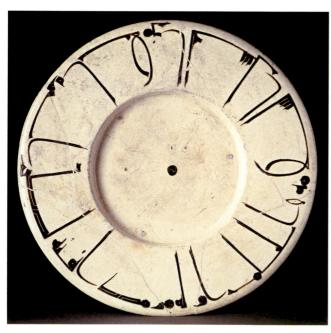

8–12 | BOWL WITH KUFIC BORDER Samarkand, Uzbekistan. 9th–10th century. Earthenware with slip, pigment, and lead glaze, diameter 14½" (37 cm). Musée du Louvre, Paris.

The white ground of this piece imitated prized Chinese porcelains made of fine white kaolin clay. Both Samarkand and Khurasan were connected to the Silk Road, the great caravan route to China (Chapter 10), and were influenced by Chinese culture.

truthful. Stylistic comparisons—in this case with other textiles, with the way similar subjects appear in other mediums, and with other Kufic inscriptions—sometimes reveal more than the inscription alone.

This silk must have been brought from the Near East to France by knights at the time of the First Crusade. Known as the Shroud of Saint Josse, the silk was preserved in the Church of Saint-Josse-sur-Mer, near Caen in Normandy. Textiles were an actively traded commodity in the medieval Mediterranean region and formed a significant portion of dowries and inheritances. Because of this, textiles were an important means of disseminating artistic styles and techniques. This fragment shows two elephants with rich ornamental coverings facing each other on a dark red ground, each with a mythical griffin between its feet. A caravan of two-humped Bactrian camels linked with rope moves up the left side, part of the elaborately patterned borders. The inscription at the bottom is upside-down, suggesting that the missing portion of the textile was a fragment from a larger and more complex composition. The weavers used a complicated loom to produce repeated patterns. The technique and design derive from the sumptuous pattern-woven silks of Sasanian Iran (Persia). The Persian weavers had, in turn, adapted Chinese silk technology to the Sasanian taste for paired heraldic beasts and other Near Eastern imagery. This tradition, with modifications—the depiction of animals, for example, became less naturalistic—continued after the Islamic conquest of Iran.

LATER ISLAMIC ART

The Abbasid caliphate began a slow disintegration in the ninth century, and thereafter power in the Islamic world became fragmented among more or less independent regional rulers. During the eleventh century, the Saljuqs, a Turkic people, swept from north of the Caspian Sea into Khurasan and took Baghdad in 1055, becoming the virtual rulers of the Abbasid Empire. The Saljuqs united most of Iran and Iraq, establishing a dynasty that endured from 1037/38 to 1194. A branch of the dynasty, the Saljugs of Rum, ruled much of Anatolia (Turkey) from the late eleventh to the beginning of the fourteenth century. The Islamic world suffered a dramatic rift in the early thirteenth century when the nomadic Mongols-non-Muslims led by Genghiz Khan (ruled 1206-27) and his successors—attacked northern China, Central Asia, and ultimately Iran. The Mongols captured Baghdad in 1258 and encountered weak resistance until they reached Egypt. There, the young Mamluk dynasty (1250-1517), founded by descendants of slave soldiers (mamluk means "slave"), firmly defeated the Mongols. In Spain, the borders of Islamic territory were gradually pushed back by Christian forces and Muslim rule ended altogether in 1492.

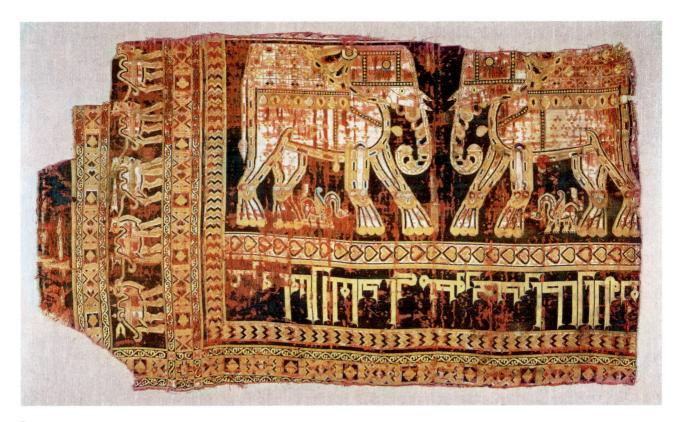

8-13 TEXTILE WITH ELEPHANTS AND CAMELS

Known today as the Shroud of Saint Josse, from Khurasan or Central Asia. Before 961. Dyed silk, largest fragment $20\% \times 37''$ (94 \times 52 cm). Musée du Louvre, Paris.

Silk textiles were both sought-after luxury items and a medium of economic exchange. Government-controlled factories, known as *tiraz*, produced cloth for the court as well as for official gifts and payments. A number of fine Islamic fabrics have been preserved in the treasuries of medieval European churches, where they were used for priests' ceremonial robes, altar cloths, and to wrap the relics of Christian saints.

Although the religion of Islam remained a dominant and unifying force throughout these developments, the history of later Islamic society and culture reflects largely regional phenomena. Only a few works have been selected here and in Chapter 23 to characterize the art of Islam, and they by no means provide a comprehensive history of Islamic art.

Architecture

The Saljuq Dynasty and its successors built on a grand scale, expanding their patronage from mosques and palaces to include new functional buildings, such as tombs, madrasas (colleges for religious and legal studies), public fountains, urban hostels, and remote caravanserais (inns) for traveling merchants in order to encourage long-distance trade. They developed a new mosque plan organized around a central courtyard framed by four large *iwans* (large vaulted halls with rectangular plans and monumental arched openings); this four-*iwan* plan was already being used for schools and palaces.

Furthermore, they amplified the social role of architecture so that multiple building types were combined in large and diverse complexes, supported by perpetual endowments that funded not only the building, but its administration and maintenance. Increasingly, these complexes included the patron's own tomb, thus giving visual prominence to the act of individual patronage and the expression of personal identity.

THE GREAT MOSQUE OF ISFAHAN. The Masjid-i Jami ("Congregational mosque") of Isfahan (the Saljuq capital in Iran) was modified in this period from its original form as a simple hypostyle mosque to a more complex plan. Specifically, two great brick domes were added in the late eleventh century, one of them marking the *mihrab*, and in the twelfth century the mosque was reconfigured as a four-*iwan* plan. The massive *qibla iwan* on the southwest side is a twelfth-century structure to which a vault filled with muqarnas (stacked niches) was added in the fourteenth-century (see "Arches and Muqarnas," page 292). Its twin minarets and the façade of brilliant blue, glazed tile that wraps around the entire

THE OBJECT SPEAKS

A MAMLUK GLASS OIL LAMP

ade of ordinary sand and ash, glass is the most ethereal of materials. The Egyptians produced the first glassware during the second millennium BCE, yet the tools and techniques for making it have changed little since then. During the thirteenth and fourteenth centuries CE, glassmakers in Syria, Egypt, and Italy derived a new elegant thinness through blowing and molding techniques. Mamluk glassmakers especially excelled in the application of enameled surface decoration in gold and various colors.

This mosque lamp was suspended from chains attached to its handles,

although it could also stand on its high footed base. Exquisite glass was also used for beakers and vases, but lamps, lit from within by oil and wick, must have glowed with special richness. A mosque required hundreds of lamps, and there were hundreds of mosques—glassmaking was a booming industry in Egypt and Syria.

Blue, red, and white enamel and gilding cover the surface of the lamp in vertical bands that include swirling vegetal designs and cursive inscriptions interrupted by roundels containing iconic emblems. The inscription on the vessel's flared neck is a Qur'anic quotation (Surah 24:35) commonly found on mosque lamps: "God is the light of the heavens and the earth. His light is as a niche wherein is a lamp, the lamp in a glass, the glass as a glittering star." The emblem, called a blazon, identifies the patron-on this cup, it is the sign of Sayf al-Din Shaykhu al-'Umari, who built a mosque and a Sufi lodge in Cairo. The blazon resembles European heraldry. It was a "symbolic/emblematic language of power [that] passed to Western Europe beginning in the early twelfth century as the result of the Crusades, where it evolved into the genealogical system we know as heraldry" (Redford "A Grammar of Rum Seljuk Ornament," Mésogeois 25-26 [2005]: 288). These emblems, which appear in Islamic glass, metalwork, and architecture, reflect an increasing interest in figural imagery that coincided with the increased production of illustrated books.

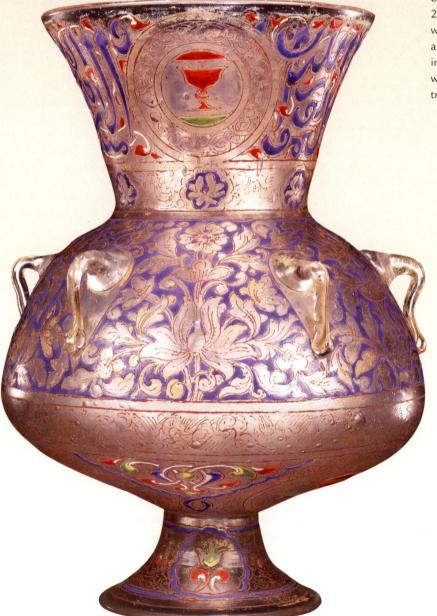

MAMLUK GLASS OIL LAMP

Syria or Egypt. c. 1355. Glass, polychrome enamel, and gold, height 12" (30.5 cm). Corning Museum of Glass, Corning, New York. (52.1.86)

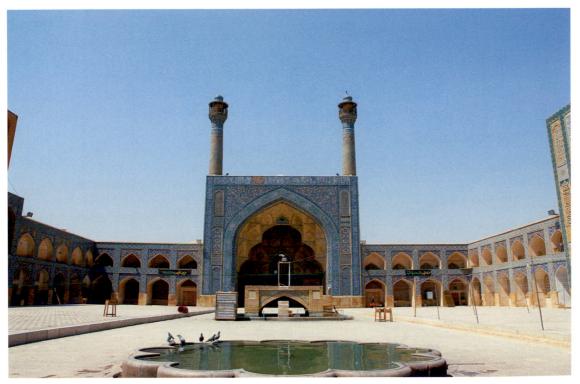

8—I4 | COURTYARD, MASJID-I JAMI, ISFAHAN Iran 11th–18th century. 14th-century *iwan* vault, 17th-century minarets. Courtsey of Abbas Aminmansour

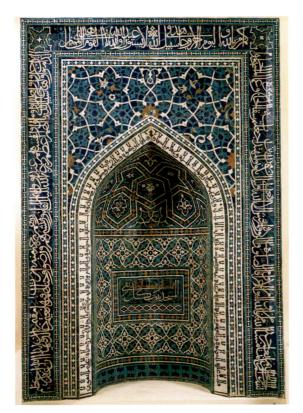

courtyard belong to the seventeenth century (FIG. 8–14). The many changes made to this mosque reflect its ongoing importance to the community it served.

A TILE MIHRAB. A fourteenth-century tile *mihrab*, originally from a *madrasa* in Isfahan but now in the Metropolitan Museum of Art in New York, is one of the finest examples of early architectural ceramic decoration in Islamic art (FIG. 8–15). More than 11 feet tall, it was made by painstakingly cutting each individual piece of tile, including the pieces making up the letters on the curving surface of the niche. The color scheme—white against turquoise and cobalt blue with accents of dark yellow and green—was typical of this type of decoration, as were the harmonious, dense, contrasting patterns of organic and geometric forms. The cursive inscription of the outer frame quotes Surah 9, verses 18–20, from the Qur'an, reminding the faithful of their duties. It is rendered in elegant white lettering on a blue ground, while the Kufic inscription bordering the pointed arch reverses these colors for a pleasing contrast.

8-15 TILE MOSAIC MIHRAB

Madrasa Imami, Isfahan, Iran. Founded 1354. Glazed and cut tiles, $11'3''\times7'6''$ (3.43 \times 2.29 m). The Metropolitan Museum of Art, New York. Harris Brisbane Dick Fund (39.20)

This *mihrab* has three inscriptions: the outer inscription, in cursive, contains Qur'anic verses (Surah 9) that describe the duties of believers and the Five Pillars of Islam. Framing the niche's pointed arch, a Kufic inscription contains sayings of the Prophet. In the center, a panel with a line in Kufic and another in cursive states: "The mosque is the house of every pious person."

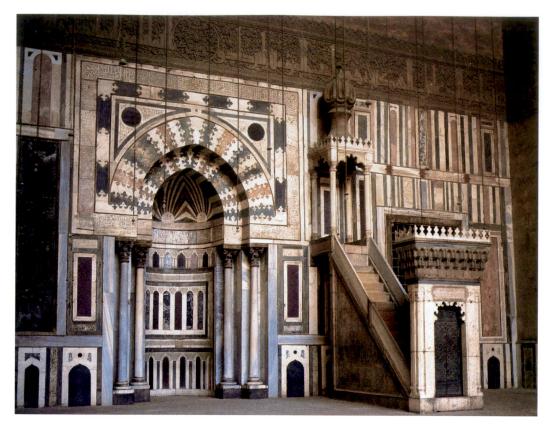

 $8-16 \pm \text{Qibla}$ wall with <code>mihrab</code> and <code>minbar</code>, sultan hasan <code>madrasa-mausoleum-mosque</code> complex

Main iwan (vaulted chamber) in the mosque, Cairo, Egypt. 1356-63.

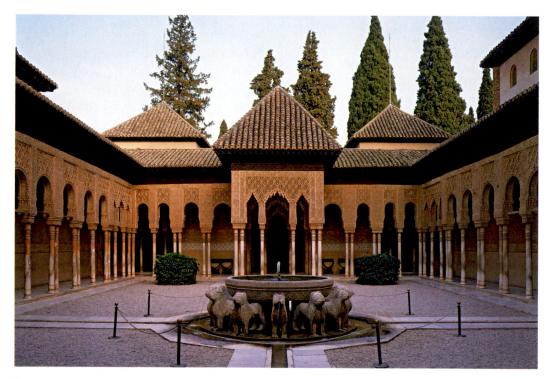

 $8-17 \pm \text{court of the lions, alhambra, granada, spain.} 1354-91.$

An ample water supply had long made Granada a city of gardens. This fountain fills the courtyard with the sound of its life-giving abundance, while channel-lined walkways form the four-part *chahar bagh*. Channeling water has a practical role in the irrigation of the garden, and here it is raised to the level of an art form.

THE MADRASA-MAUSOLEUM-MOSQUE IN CAIRO. Beginning in the eleventh century, Muslim rulers and wealthy individuals endowed hundreds of charitable complexes, including many madrasas. These were public displays of piety as well as personal wealth and status. The combined madrasa-mausoleummosque complex established in mid-fourteenth-century Cairo by the Mamluk Sultan Hasan (FIG. 8-16) is such an example. With a four-iwan plan, each iwan served as a classroom for a different branch of study, the students housed in a multistoried cluster of tiny rooms around each one. Standing just beyond the gibla iwan, the patron's monumental domed tomb attached his identity ostentatiously to the architectural complex. The sumptuous qibla iwan served as the prayer hall for the complex. Its walls are ornamented with colorful marble paneling, typical of Mamluk patronage, that culminates in a doubly recessed mihrab framed by slightly pointed arches on columns. The marble blocks of the arches are ingeniously joined in interlocking pieces of alternating colors called joggled voussoirs. The paneling is surmounted by a wide band of Kufic inscription in stucco set against a background of scrolling vines. Next to the mihrab stands an elaborate thronelike minbar. The Sultan Hasan complex is excessive in its vast scale and opulent decoration, but money was not an object: The project was financed by the estates of victims of the bubonic plague that had raged in Cairo in 1348-50.

THE ALHAMBRA. Muslim architects also created luxurious palaces set in gardens. The Alhambra in Granada, in southeastern Spain, is an outstanding example of beautiful and refined Islamic palace architecture. Built on the hilltop site of a pre-Islamic fortress, this palace complex was the seat of the Nasrids (1232-1492), the last Spanish Muslim (Moorish) dynasty, Islamic territory having shrunk from most of the Iberian Peninsula to the region around Granada. To the conquering Christians at the end of the fifteenth century, the Alhambra represented the epitome of luxury. Thereafter, they preserved the Alhambra as much to commemorate the defeat of Islam as for its beauty. Literally a small town extending for about half a mile along the crest of a high hill overlooking Granada, it included government buildings, royal residences, gates, mosques, baths, servants' quarters, barracks, stables, a mint, workshops, and gardens. Most of what one sees at the site today was built in the fourteenth century or in later centuries by Christian patrons.

The Alhambra was a sophisticated citadel whose buildings offered dramatic views to the settled valley and snow-capped mountains around it, while enclosing gardens within its court-yards. One of these is the Court of the Lions which stood at the heart of the so-called Palace of the Lions, the private retreat of Sultan Muhammad V (ruled 1354–59 and 1362–91). The Court of the Lions is divided evenly into four parts by cross-axial walkways that meet at a central marble fountain held aloft on the backs of twelve stone lions (FIG. 8–17). An Islamic garden divided thus into quadrants is called a *chahar bagh*. The

Art and Its Context

THE FIVE PILLARS OF ISLAM

slam emphasizes a direct, personal relationship with God. The Pillars of Islam, sometimes symbolized by an open hand with the five fingers extended, enumerate the duties required of Muslims by their faith.

- The first pillar (shahadah) is to proclaim that there is only one God and that Muhammad is his messenger. While monotheism is common to Judaism, Christianity, and Islam, and Muslims worship the god of Abraham, and also acknowledge Hebrew and Christian prophets such as Musa (Moses) and Isa (Jesus), Muslims deem the Christian Trinity polytheistic and assert that God was not born and did not give birth.
- The second pillar requires prayer (salat) to be performed by turning to face the Kaaba in Mecca five times daily: at dawn, noon, late afternoon, sunset, and nightfall. Prayer can occur almost anywhere, although the prayer on Fridays takes place in the congregational mosque. Because ritual ablutions are required for purity, mosque courtyards usually have fountains.
- The third pillar is the voluntary payment of annual tax or alms (zakah), equivalent to one-fortieth of one's assets. Zakah is used for charities such as feeding the poor, housing travelers, and paying the dowries of orphan girls. Among Shi'ites, an additional tithe is required to support the Shi'ite community specifically.
- The fourth pillar is the dawn-to-dusk fast (sawm) during the month of Ramadan, the month when Muhammad received the revelations set down in the Qur'an. The fast of Ramadan is a communally shared sacrifice that imparts purification, self-control, and kinship with others. The end of Ramadan is celebrated with the feast day 'Id al-Fitr (Festival of the Breaking of the Fast).
- For those physically and financially able to do so, the fifth pillar is the pilgrimage to Mecca (hajj), which ideally occurs at least once in the life of each Muslim. Among the extensive pilgrimage rites are donning simple garments to remove distinctions of class and culture; collective circumambulations of the Kaaba; kissing the Black Stone inside the Kaaba (probably a meteorite that fell in pre-Islamic times); and the sacrificing of an animal, usually a sheep, in memory of Abraham's readiness to sacrifice his son at God's command. The end of the hajj is celebrated by the festival 'Id al-Adha (Festival of Sacrifice).

The directness and simplicity of Islam have made the Muslim religion readily adaptable to numerous varied cultural contexts throughout history. The Five Pillars instill not only faith and a sense of belonging, but also a commitment to Islam in the form of actual practice.

courtyard is encircled by an arcade of stucco arches supported on single columns or clusters of two and three. Second-floor miradors—windows that frame specifically intentioned views—look over the courtyard, which was planted with aromatic citrus and flowers. From these windows, protected by latticework screens, it is quite likely that the women of the court, who did not appear in public, would watch the activities of the men below. At one end of the Palace of the Lions, a particularly magnificent *mirador* looks out onto a large, lower garden and the plain below. From here, the sultan literally oversaw the fertile valley that was his kingdom.

On the south side of the Court of the Lions, the lofty Hall of the Abencerrajes was designed as a winter reception hall and music room. In addition to having excellent acoustics, its ceiling exhibits dazzling geometrical complexity and exquisitely carved stucco (FIG. 8–18). The star-shaped vault is formed by a honeycomb of clustered *muqarnas* arches that alternate with corner squinches that are filled with more *muqarnas*. The square room thus rises to an eight-pointed star, pierced by eighteen windows, that culminates in a burst of *muqarnas* floating high overhead, perceived and yet ultimately unknowable, like the heavens themselves.

Portable Arts

Islamic society was cosmopolitan, with pilgrimage, trade, and a well-defined road network fostering the circulation of marketable goods. In addition to the import and export of basic foodstuffs and goods, luxury arts brought particular pleasure and status to their owners and were visible signs of cultural refinement. These art objects were eagerly exchanged and collected from one end of the Islamic world to the other, and they were sought by European patrons as well.

METAL. Islamic metalworkers inherited the techniques of their Roman, Byzantine, and Sasanian predecessors, applying this heritage to new forms, such as incense burners and water pitchers in the shape of birds and animals. An example of this delight in fanciful metalwork is an unusually large and stylized griffin, perhaps originally used as a fountain (FIG. 8–19). Now in Pisa, Italy, it is probably Fatimid work from Egypt, and it may have arrived as booty from Pisan victories over the Egyptian fleet in 1087. The Pisans displayed it atop their cathedral from about 1100 to 1828. Made of cast bronze, it is decorated with incised representations of feathers, scales, and silk trappings. The decoration on the mighty creature's thighs includes animals in medallions; the bands across its chest and back are embellished with Kufic lettering and scale and circle patterns.

The Islamic world was administered by educated functionaries who often commissioned personalized containers for their pens, ink, and blotting sand. One such container, an inlaid brass box, belonged to the grand vizier, or chief minister, of Khurasan in the early thirteenth century (FIG. 8–20). The artist cast, engraved, embossed, and inlaid the box with consummate

8–18 | MUQARNAS DOME, HALL OF THE ABENCERRAJES, PALACE OF THE LIONS, ALHAMBRA Built between 1354–91.

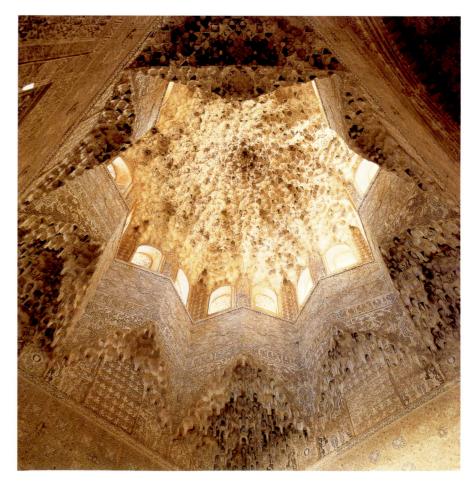

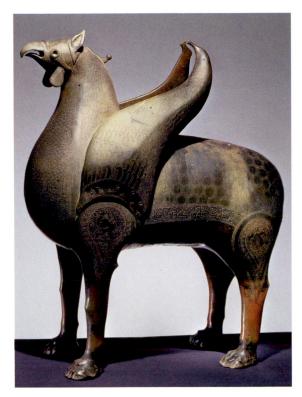

8–19 | GRIFFIN Islamic Mediterranean, probably Fatimid, Egypt. 11th century. Bronze, height 42%" (107 cm). Museo dell' Opera del Duomo, Pisa.

skill. Scrolls, interlacing designs, and human and animal figures enliven its calligraphic inscriptions. A silver shortage in the midtwelfth century prompted the development of inlaid brasswork like this that used the more precious metal sparingly. Humbler brassware was also available to those of lesser rank than the vizier.

8-20 PEN BOX

By Shazi, from Iran or Afghanistan. 1210–11. Brass with inlaid silver, copper, and black organic material; height 2", length 12%", width 2%" (5 \times 31.4 \times 6.4 cm). Freer Gallery of Art, Smithsonian Institution, Washington, D.C. (F1936.7)

The inscriptions on this box include some twenty honorific phrases extolling its owner, al-Mulk. The *naskhi* script on the lid calls him the "luminous star of Islam." The largest inscription, written in animated *naskhi* (an animated script is one with human or animal forms in it), asked twenty-four blessings for him from God. Shazi, the designer of the box, signed and dated it in animated Kufic on the side of the lid, making it one of the earliest signed works in Islamic art. The owner enjoyed his box for only ten years; he was killed by Mongol invaders in 1221.

CERAMICS. In the ninth century, potters developed a technique to produce a lustrous metallic surface on their ceramics. They may have learned the technique from Islamic glassmakers who had produced luster-painted vessels a century earlier. First the potters applied a paint laced with silver, copper, or gold oxides to the surface of already fired and glazed tiles or vessels. In a second firing with relatively low heat and less oxygen, these oxides burned away to produce a reflective shine. The finished lusterware resembled precious metal. At first the potters covered the entire surface with luster, but soon they began to use luster to paint dense, elaborate patterns using geometric design, foliage, and animals in golden brown, red, purple, and green. Lusterware tiles, dated 862–3, decorated the mihrab of the Great Mosque at Kairouan.

The most spectacular lusterware pieces are the double-shell fritware, in which an inner solid body is hidden beneath a densely decorated and perforated outer shell. A jar in the Metropolitan Museum of Art known as **THE MACY JUG** (after a previous owner) exemplifies this style (FIG. 8–21). The black

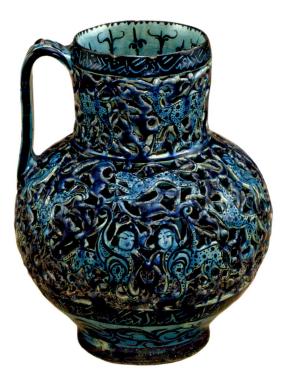

8-21 THE MACY JUG

Iran. 1215–16. Composite body glazed, painted fritware and incised (glaze partially stained with cobalt), with pierced outer shell, $6\% \times 7\%$ " (16.8 \times 19.7 cm). The Metropolitan Museum of Art, New York.

Fletcher Fund, 1932 (32.52.1)

Fritware was used to make beads in ancient Egypt and may have been rediscovered there by Islamic potters searching for a substitute for Chinese porcelain. Its components were one part white clay, ten parts quartz, and one part quartz fused with soda, which produced a brittle white ware when fired. The colors on this double-walled ewer and others like it were produced by applying mineral glazes over black painted detailing. The deep blue comes from cobalt and the turquoise from copper. Luster, a thin, transparent glaze with a metallic sheen, was applied over the colored glazes.

underglaze-painted decoration represents animals and pairs of harpies and sphinxes set into an elaborate "water-weed" pattern. The outer shell is covered with a turquoise glaze, enhanced by a deep cobalt-blue glaze on parts of the floral decoration and finally a luster overglaze that gives the entire surface a metallic sheen. An inscription includes the date AH 612 (1215–16 CE).

TEXTILES. The tradition of silk weaving that passed from Sasanian Persia to Islamic artisans in the early Islamic period (SEE FIG. 8–13) was kept alive in Muslim Spain. Spanish designs reflect a new aesthetic, with an emphasis beginning in the thirteenth century on forms that had much in common with architectural ornament. An eight-pointed star forms the center of a magnificent silk and gold banner (FIG. 8–22). The calligraphic panels continue down the sides and a second panel crosses the top. Eight lobes with gold crescents and white

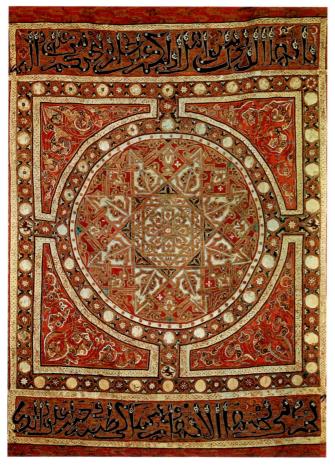

8–22 | **BANNER OF LAS NAVAS DE TOLOSA** Detail of center panel, from southern Spain. 1212–50. Silk tapestry-weave with gilt parchment, $10'9 \%" \times 7'2 \%"$ (3.3 \times 2.2 m). Museo de Telas Medievales, Monasterio de Santa María la Real de Las Huelgas, Burgos, Spain.

This banner was a trophy taken by the Christian king Ferdinand III, who gave it to Las Huelgas, the Cistercian convent outside Burgos, the capital city of Old Castile and the burial place of the royal family. This illustration shows only a detail of the center section of the textile. The calligraphic panels continue down the sides, and a second panel crosses the top.

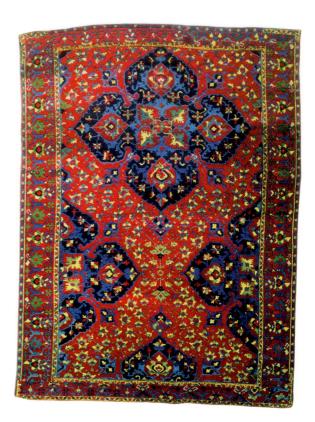

8-23 | MEDALLION RUG, VARIANT STAR USHAK STYLE Anatolia (present-day Turkey). 16th century. Wool, $10'3'' \times 7'6 \ \%'' (313.7 \times 229.2 \ cm)$. The St. Louis Art Museum. Gift of James F. Ballard.

inscribed parchment medallions form the lower edge of the banner. In part, the text reads: "You shall believe in God and His Messenger. . . . He will forgive you your sins and admit you to gardens underneath which rivers flow, and to dwelling places goodly in Gardens of Eden; that is the mighty triumph."

The Qur'an describes paradise as a shady garden with four rivers, and many works of Islamic art evoke both paradisiac and garden associations. In particular, Persian and Turkish carpets were often embellished with elegant designs of flowers and shrubs inhabited by birds. Laid out on the floor of an open-air hall and perhaps set with bowls of ripe fruit and other delicacies, such carpets brought the beauty of nature indoors. Written accounts indicate that elaborate patterns appeared on Persian carpets as early as the seventh century. In one fabled royal carpet, garden paths were rendered in real gold, leaves were modeled with emeralds, and highlights on flowers, fruits, and birds were created from pearls and jewels.

A carpet from Ushak in western Anatolia (Turkey), created in the first half of the sixteenth century, retains its vibrant colors (FIG. 8–23). Large, deeply serrated quatrefoil medallions establish the underlying star pattern but arabesques flow in every direction. This "infinite arabesque," as it is called (the pattern repeats infinitely in all directions), is characteristic of Ushak carpets. Carpets were usually at least three times as long as they were wide; the asymmetry of this carpet may indicate that it was cut and shortened.

Technique

CARPET MAKING

ecause textiles are made of organic materials that are destroyed through use, very few carpets from before the sixteenth century have survived. There are two basic types of carpets: flat-weaves and pile, or knotted, carpets. Both can be made on either vertical or horizontal looms.

The best-known flat-weaves today are kilims, which are typically woven in wool with bold, geometric patterns and sometimes with brocaded details. Kilim weaving is done with a **tapestry** technique called slit tapestry (see diagram a).

Knotted carpets are an ancient invention. The oldest known example, excavated in Siberia and dating to the fourth or fifth century BCE, has designs evocative of Achaemenid art, suggesting that the technique may have originated in Central Asia. In knotted carpets, the pile-the plush, thickly tufted surface-is made by tying colored strands of yarn, usually wool but occasionally silk for deluxe carpets, onto the vertical elements (the warp) of a yarn grid (see diagram b or c). These knotted loops are later trimmed and sheared to form the plush pile surface of the carpet. The weft strand (crosswise threads) are shot horizontally, usually twice, after each row of knots is tied, to hold the knots in place and to form the horizontal element common to all woven structures. The weft is usually an undyed yarn and is hidden by the colored knots of the warp. Two common knot tying techniques are the asymmetrical knot, used in many carpets from Iran, Egypt, and Central Asia (formerly termed the Sehna knot), and the symmetrical knot (formerly called the Gördes knot) more commonly used in Anatolian Turkish carpet weaving. The greater the number of knots, the shorter the pile. The finest carpets can

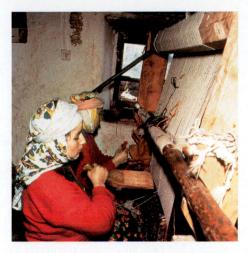

have as many as 2,400 knots per square inch, each one tied separately by hand.

Although royal workshops produced luxurious carpets (SEE FIG. 8–23), most knotted rugs have traditionally been made in tents and homes. Either women or men, depending on local custom, wove carpets. The photograph in this box shows two women, sisters in Çanakkale province in Turkey, weaving a large carpet in a typical Turkish pattern. The woman in the foreground pushes a row of knots tightly against the row below it with a wood comb called a beater. The other woman pulls a dark red weft yarn against the warp threads before tying a knot. Working between September and May, these women may weave five carpets, tying up to 5,000 knots a day. A Çanakkale rug will usually have only 40–50 knots per square inch. Generally, an older woman works with a young girl, who learns the art of carpet weaving at the loom and eventually passes it on to the next generation.

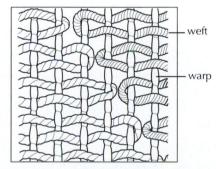

a. Kilim weaving pattern used in flat-weaving

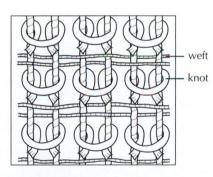

b. Symmetrical knot, used extensively in Iran

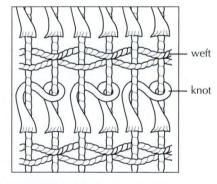

c. Asymmetrical knot, used extensively in Turkey

Rugs have long been used for Muslim prayer, which involves repeatedly kneeling and touching the forehead to the floor before God. While individuals often had their own small prayer rugs, with representations of niches to orient the faithful in prayer, many mosques were furnished with woolpile rugs received as pious donations (see, for example, the rugs on the floor of the Sultan Selim Mosque in FIG. 8–28). In Islamic houses, people sat and slept on cushions and thick mats laid directly on the floor, so that cushions took the place of the fixed furnishings of Western domestic environments.

From the late Middle Ages to today, carpets and textiles are one of the predominant Islamic arts, and the Islamic art form best known in the West. Historically, rugs from Iran, Turkey, and elsewhere were highly prized among Westerners, who often displayed them on tables rather than floors.

Manuscripts and Painting

The art of book production flourished from the first century of Islam. Islam's emphasis on the study of the Qur'an promoted a high level of literacy among both women and men, and calligraphers were the first artisans to emerge from anonymity and achieve individual distinction and recognition for their skill. Books on a wide range of secular as well as religious subjects were available, although hand-copied books—even on paper—always remained fairly costly. Libraries, often associated with *madrasas*, were endowed by members of the educated elite. Books made for royal patrons had luxurious bindings and highly embellished pages, the result of workshop collaboration between noted calligraphers and illustrators. New scripts were developed for new literary forms.

The manuscript illustrators of Mamluk Egypt (1250–1517) executed intricate nonfigural geometric designs for the Qur'ans they produced. Geometric and botanical ornamentation contributed to unprecedented sumptuousness and complexity. As in architectural decoration, the exuberant ornament was underlaid by strict geometric organization. In an impressive frontispiece originally paired with its mirror image on the facing left page, the design radiates from a sixteen-pointed starburst, filling the central square (FIG. 8-24). The surrounding ovals and medallions are filled with interlacing foliage and stylized flowers that provide a backdrop for the holy scripture. The page's resemblance to court carpets was not coincidental. Designers worked in more than one medium, leaving the execution of their efforts to specialized artisans. In addition to religious works, scribes copied and recopied famous secular texts—scientific treatises, manuals of all kinds, stories, and especially poetry. Painters supplied illustrations for these books and also created individual small-scale paintings-miniatures—that were collected by the wealthy and placed in albums.

THE HERAT SCHOOL. One of the great royal centers of miniature painting was at Herat in western Afghanistan. A school of painting and calligraphy was founded there in the early fifteenth century under the highly cultured patronage of the Timurid dynasty (1370-1507). In the second half of the fifteenth century, the leader of the Herat school was Kamal al-Din Bihzad (c. 1450–1514). When the Safavids supplanted the Timurids in 1506-7 and established their capital at Tabriz in northwestern Iran, Bihzad moved to Tabriz and briefly resumed his career there. Bihzad's paintings, done around 1494 to illustrate the Khamsa (Five Poems), written by Nizami, demonstrate his ability to render human activity convincingly. He set his scenes within complex, stagelike architectural spaces that are stylized according to Timurid conventions, creating a visual balance between activity and architecture. In THE CALIPH HARUN AL-RASHID VISITS THE TURKISH BATH (FIG. 8-25), the bathhouse, its tiled entrance leading to a high-ceiling dressing room with brick walls, provides the structuring element. Attendants wash long, blue towels and hang them to dry on overhead clotheslines. A worker reaches for one of the towels with a long pole, and a client prepares to wrap himself discreetly in a towel before removing his outer garments. The blue door on the left leads to a room where a barber grooms the caliph while attendants bring water for his bath. The asymmetrical composition

depends on a balanced placement of colors and architectural ornaments within each section.

An illustrated copy of the Khamsa (FIG. 8-26) from Herat in slightly earlier period shows a romantic scene in a landscape setting. The painting shows the gold-crowned princess Shirin at the moment when she sees a portrait of Khusrau hanging in a tree and falls in love with him. She is shown at the moment of discovery, holding the portrait before her, as one of her dismayed attendants grabs her cloak as if to hold her back from destiny. The background consists of an ochre-colored arid landscape that rises to two ranges of hills from which emerge two trees. Almost hidden in the upper left, a man observes the scene. This is Shapur, the painter of Khusrau's portrait and his friend, but at the same time the inclusion of this figure makes witty reference to the painter of the manuscript page. In contrast to the plain background, in the foreground, a rockbordered stream—its silvery surface now tarnished to gray winds its way through a meadow of flowers and a tree. Overhead, a cloud painted in a Chinese style seems to reflect the agitation in her heart. By the beginning of the seventeenth century, this manuscript was in the hands of the Mughal rulers of India, evidence of the enduring appreciation for Timurid painting and of the cultural exchanges that took place as both artists and art moved to new courts and collections.

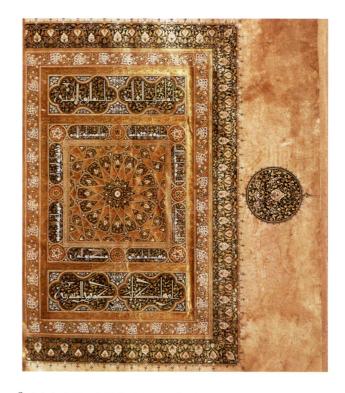

8–24 | **QUR'AN FRONTISPIECE (RIGHT HALF OF TWO-PAGE SPREAD)** Cairo, Egypt. c. 1368. Ink, pigments, and gold on paper, $24 \times 18''$ (61 \times 45.7 cm). National Library, Cairo. Ms. 7.

The Qur'an to which this page belonged was donated in 1369 by Sultan Shaban to the *madrasa* established by his mother. A close collaboration between illuminator and scribe can be seen here and throughout the manuscript.

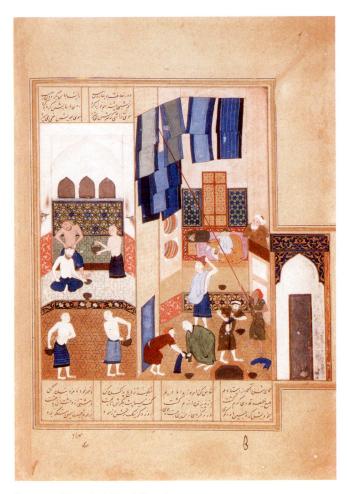

 $8-25 \perp \text{Kamal al-Din Bihzad}$ The Caliph Harun al-Rashid visits the Turkish Bath

From a copy of the 12th-century *Khamsa (Five Poems)* of Nizami. Herat, Afghanistan. c. 1494. Ink and pigments on paper, approx. $7 \times 6''$ (17.8 \times 15.3 cm). The British Library, London. Oriental and India Office Collections (Ms. Or. 6810, fol. 27v)

Despite early warnings against it as a place for the dangerous indulgence of the pleasures of the flesh, the bathhouse (hammam), adapted from Roman and Hellenistic predecessors, became an important social center in much of the Islamic world. The remains of an eighthcentury hammam still stand in Jordan, and a twelfth-century hammam is still in use in Damascus. Hammams had a small entrance to keep in the heat, which was supplied by steam ducts running under the floors. The main room had pipes in the wall with steam vents. Unlike the Romans, who bathed and swam in pools of water, Muslims preferred to splash themselves from basins, and the floors were slanted for drainage. A hammam was frequently located near a mosque, part of the commercial complex provided by the patron to generate income for the mosque's upkeep.

THE OTTOMAN EMPIRE

With the breakdown of Saljuq power in Anatolia at the end of the thirteenth century, another group of Muslim Turks seized power in the early fourteenth century in the northwestern part of that region, having migrated there from their homeland in Central Asia. Known as the Ottomans, after an early leader named Osman, they pushed their territorial boundaries westward and, in spite of setbacks inflicted by the Mongols, ulti-

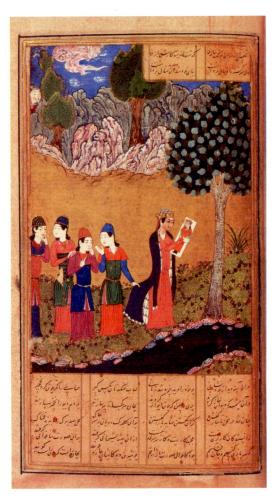

8–26 | SHIRIN SEES KHUSRAU'S PORTRAIT
From a copy of the 12th-century *Khamsa (Five Poems)* of Nizami. Herat, Afghanistan, 1442. Ink, pigments, and gold on paper. The British Library, London.

mately created an empire that extended over Anatolia, western Iran, Iraq, Syria, Palestine, western Arabia (including Mecca and Medina), northern Africa (excepting Morocco), and part of eastern Europe. In 1453, they captured Constantinople, ultimately renaming it Istanbul, and brought the Byzantine Empire to an end. The Ottoman Empire lasted until 1918.

Architecture

Upon conquering Istanbul, the rulers of the Ottoman Empire converted the great Byzantine church of Hagia Sophia into a mosque, framing it with two graceful Turkish-style minarets in the fifteenth century and two more in the sixteenth century (SEE FIG. 7–25). In conformance with Islamic aniconism, the church's mosaics were destroyed or whitewashed. Huge calligraphic disks with the names of God, Muhammad, and the early caliphs were added to the interior in the mid-nineteenth century (SEE FIG. 7–27). At present, Hagia Sophia is neither a church nor a mosque but a state museum.

THE ARCHITECT SINAN. Ottoman architects had already developed the domed, centrally planned mosque (see

"Mosque Plans," page 289), but this great Byzantine structure of Hagia Sophia inspired them to strive for a more ambitious scale. For the architect Sinan (c. 1489–1588) the development of a monumental centrally planned mosque was a personal quest. Sinan began his career in the army and served as engineer in the Ottoman campaign at Belgrade, Vienna, and Baghdad. He rose through the ranks to become, in 1528, chief architect for Suleyman "the Magnificent," the tenth Ottoman sultan (ruled 1520-66). Suleyman's reign marked the height of Ottoman power, and the sultan sponsored a building program on a scale not seen since the days of the Roman Empire. Serving Suleyman and his successor, Sinan is credited with more than 300 imperial commissions, including palaces, madrasas and Qur'an schools, tombs, public kitchens and hospitals, caravanserais, treasure houses, baths, bridges, viaducts, and 124 large and small mosques.

Sinan's crowning accomplishment, completed about 1579, when he was over 80, was a mosque he designed in the provincial capital of Edirne for Suleyman's son Selim II (ruled 1566-74) (FIG. 8-27). The gigantic hemispheric dome that tops this structure is more than 102 feet in diameter, larger than the dome of Hagia Sophia, as Sinan proudly pointed out. The dome crowns a building of extraordinary architectural coherence. The transition from square base to the central dome is accomplished by corner half-domes that enhance the spatial plasticity and openness of the vast interior of the prayer hall (FIG. 8-28). The eight massive piers that bear the dome's weight are visible both within and without—on the exterior they resolve in pointed towers that encircle the main domerevealing the structural logic of the building and clarifying its form. In the arches that support the dome and span from one pier to the next—and indeed at every level—light pours from windows into the interior, a space at once soaring and serene.

In addition to the mosque, the complex housed a *madrasa* and other educational buildings, a cemetery, a hospital, and charity kitchens, as well as the income-producing covered market and baths. Framed by the vertical lines of four minarets and raised on a platform at the city's edge, the Selimiye mosque dominates the skyline.

The interior was clearly influenced by Hagia Sophia—an open expanse under a vast dome floating on a ring of light—but it lacks Hagia Sophia's longitudinal pull from entrance to sanctuary. The Selimiye mosque is truly centrally planned structure and a small fountain covered by a platform (visible in the lower right of Fig. 8–28) emphasizes this centralization.

Illuminated Manuscripts and Tugras

A combination of abstract setting with realism in figures and details characterizes Ottoman painting. Ottoman painters adopted the style of the Herat school (as influenced by Timurid conventions) for their miniatures, enhancing its decorative aspects with an intensity of religious feeling. At the Ottoman court of Sultan Suleyman in Istanbul, the imperial workshops produced even more remarkable illuminated manuscripts.

Following a practice begun by the Saljuqs and Mamluks, the Ottomans put calligraphy to political use, developing the design of imperial ciphers—tugras—into a specialized art form. Ottoman tugras combined the ruler's name and title with the motto "Eternally Victorious" into a monogram denoting the authority of the sultan and of those select officials who were also granted an emblem. Tugras appeared on seals, coins, and buildings, as well as on official documents called firmans, imperial edicts supplementing Muslim law. Suleyman issued hundreds of edicts, and a high court official supervised specialist calligraphers and illuminators who produced the documents with fancy tugras (FIG. 8–29).

8–27 | MOSQUE OF SULTAN SELIM, EDIRNE Turkey. 1568–75.

The minarets that pierce the sky around the prayer hall of this mosque, their sleek, fluted walls and needle-nosed spires soaring to more than 295 feet, are only 12½ feet in diameter at the base, an impressive feat of engineering. Only royal mosques were permitted multiple minarets, and having more than two

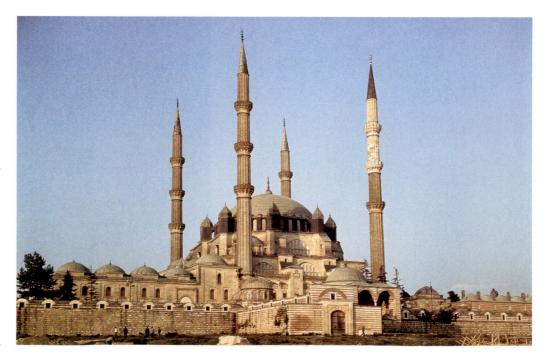

was unusual.

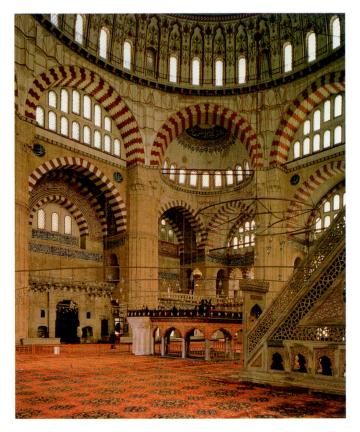

8−28 | INTERIOR, MOSQUE OF SULTAN SELIM

Tigras were drawn in black or blue with three long, vertical strokes (tug means "horsetail") to the right of two concentric horizontal teardrops. Decorative foliage patterns fill the space. Fill decoration became more naturalistic by the 1550s and in later centuries spilled outside the emblems' boundary lines. The rare, oversized tugra in FIG. 8-29 has a sweeping, fluid line drawn with perfect control according to set proportions. The color scheme of the delicate floral inter-

lace enclosed in the body of the *tugra* may have been inspired by Chinese blue-and-white ceramics; similar designs appear on Ottoman ceramics and textiles.

THE MODERN ERA

For many years the largest and most powerful political entity in the Islamic World, the Ottoman Empire lasted until the end of World War I. It was not until 1918 that modern Turkey was founded in Anatolia, the former heart of the empire. The twentieth century saw the dissolution of the great Islamic empires and the formation of smaller nation-states in their place. The question of identity and its expression in art changed significantly as Muslim artists and architects sought training abroad and participated in an international movement that swept away many of the visible signs that formerly expressed their cultural character and difference. The abstract work of the architect Zaha Hadid (SEE FIG. 32-80), who was born in Baghdad and studied and practiced in London, is exemplary of the new internationalism. But earlier, when architects in Islamic countries were debating whether modernity promised opportunities for new expression or simply another form of Western domination, the Egyptian Hasan Fathy (1900-89) asked whether abstraction could serve the cause of social justice. He revived traditional, inexpensive, and locally obtainable materials such as mud brick and forms such as wind scoops (an inexpensive means of catching breezes to cool a building's interior) to build affordable housing for the poor. For architects around the world, Fathy's New Gourna Village (designed 1945-47) in Luxor, Egypt, was a model of environmental sustainability realized in pure geometric forms that resonated with references to Egypt's architectural past (FIG. 8-30). In their simplicity, his watercolor paintings are as beautiful as his buildings.

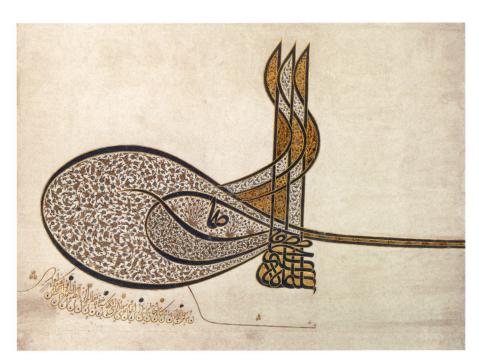

8-29 ILLUMINATED TUGRA OF SULTAN SULEYMAN

Istanbul, Turkey. c. 1555–60. Ink, paint, and gold on paper, removed from a firman and trimmed to $20\% \times 25\%$ " (52 × 64.5 cm). The Metropolitan Museum of Art, New York. Rogers Fund, 1938 (38.149.1).

The tugra shown here is from a document endowing an institution in Jerusalem that had been established by Suleyman's wife, Hurrem.

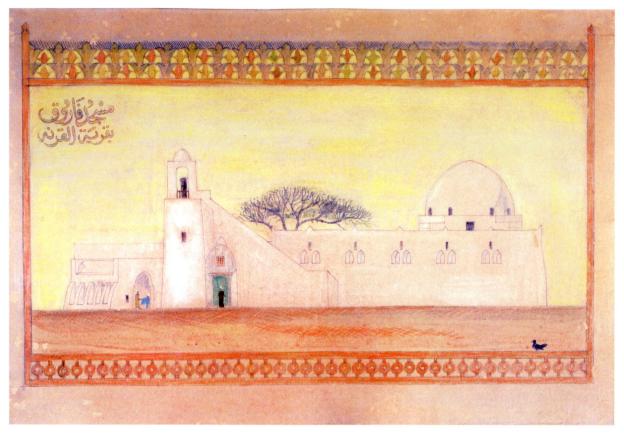

8–30 † HASAN FATHY MOSQUE AT NEW GOURNA Luxor, Egypt, 1945–47. Gouache on paper, $22\% \times 17\%$ (52.8 \times 45.2 cm). Collection: Aga Khan Award for Architecture, Geneva, Switzerland.

One of many buildings designed for the Egyptian Department of Antiquities for a village relocation project. Seven thousand people were removed from their village near pharaonic tombs and resettled on agricultural land near the Nile. Fathy's emphasis on both the traditional values of the community and the individualism of its residents was remarkably different from the abstract and highly conformist character of other modern housing projects of the period.

IN PERSPECTIVE

In Islamic art, a proscription against figural imagery in religious contexts gave rise instead to the development of a rich vocabulary of ornament and pattern using abstract geometrical figures and botanically inspired design. Motifs readily circulated in the Islamic world via portable objects in the hands of pilgrims and traveling merchants. Textiles and carpets especially were widely traded both within the Islamic world and between it and its neighbors. The resulting eclecticism of motif and technique is an enduring characteristic of Islamic art.

As with geometric and floral ornament, writing played a central role in Islamic art. Since the lessons of the Qur'an were not to be presented pictorially, instead the actual words of the Qur'an were incorporated in the decoration of buildings and objects to instruct and inspire the viewer. As a result, calligraphy

emerged as the most highly valued form of art, maintaining its prestige even after manuscript painting grew in importance under court patronage from the thirteenth century onward.

Architecture also played an important role in Islam and reveals the flexibility and innovation of Islamic culture. The mosque began as a simple space for congregational gathering and prayer but grew in complexity. The individual mosque, whether hypostyle, domical, or four-iwan, was eventually combined with other functional types (such as schools, tombs, and public fountains), culminating with the vast complexes of the Ottoman era. The Islamic world's awareness of history is especially evident in its architecture, as for instance in the Mosque of Selim II—an homage to the Hagia Sophia—or as seen in Hasan Fathy's self-conscious evocation of vernacular Egyptian architecture.

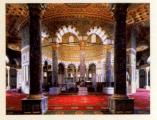

DOME OF THE ROCK BEGUN 691-92

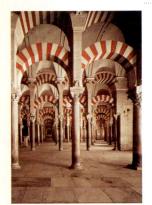

PRAYER HALL, GREAT MOSQUE CORDOBA,
BEGUN 785-86

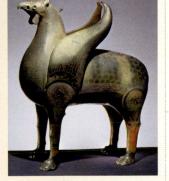

GRIFFIN 11TH CENTURY

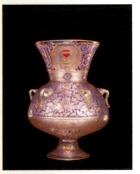

MAMLUK GLASS LAMP C. 1355

of sultan suleyman c. 1555-60

600

800

1000

1200

1400

2000

ISLAMIC ART

- ▼ Founding of Islam 622 CE
- Early Caliphs 633-61 CE
- Umayyad Dynasty c. 661–750 CE
- Abbasid Dynasty c. 750–1258 CE
- Spanish Umayyad Dynasty c. 756-1031 CE

- Fatimid Dynastyc. 909–1171 CE
- Saljuq Dynasty
 c. 1037–1194 CE
- Saljuq Dynasty of Rum late 11th-early 14th century CE

- ✓ Spanish Nasrid Dynasty c. 1232-1492 CE
- ✓ Egyptian Mamluk Dynasty c. 1250–1517 CE
- Ottoman Empire
 c. 1281-1918 CE
- ✓ Timurid Dynasty c. 1370–1507 CE
- ▼ Fall of Constantinople to Ottoman Turks 1453 CE
- Modern Turkey Founded 1918 CE

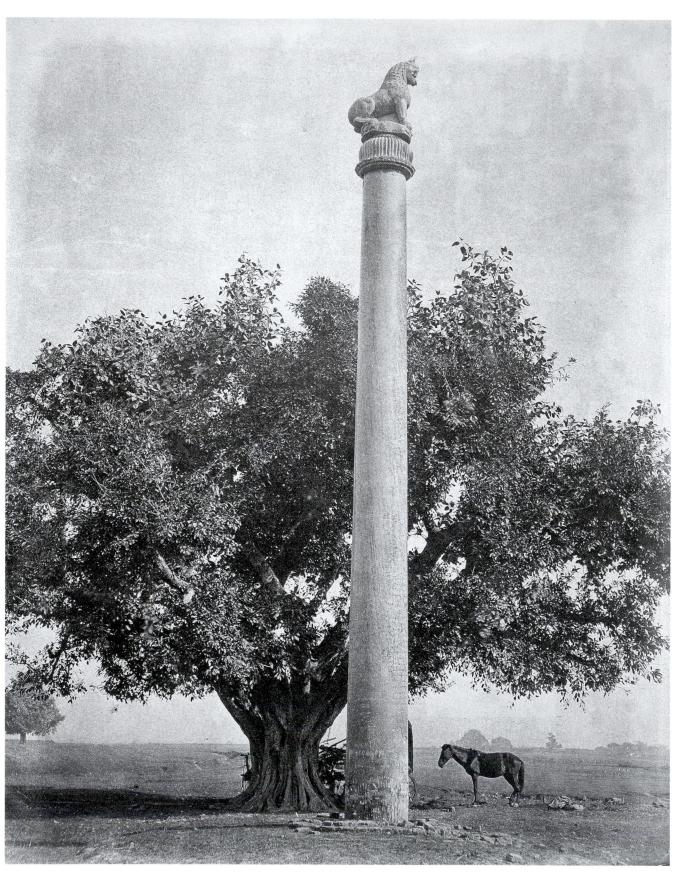

9–I ASHOKAN PILLAR Lauriya Nandangarh, Maurya period. 246 BCE.

CHAPTER NINE

ART OF SOUTH AND SOUTHEAST ASIA BEFORE 1200

According to legend, the ruler Ashoka was stunned by grief and remorse as he looked across the battlefield. In the custom of his dynasty, he had gone to war, expanding his empire until he had conquered many of the

peoples of the Indian subcontinent. Now, in 265 BCE, after the final battle in his conquest of the northern states, he was suddenly—unexpectedly—shocked by the horror of the suffering he had caused. In the traditional account, it is said that only one form on the battlefield moved, the stooped figure of a Buddhist monk slowly making his way through the carnage. Watching this spectral figure, Ashoka abruptly turned the moment of triumph into one of renunciation. Decrying vio-

lence and warfare, he vowed to become a chakravartin ("world-conquering ruler"), not through the force of arms but through spreading the teachings of the Buddha and establishing Buddhism as the major religion of his realm.

Although there is no proof that Ashoka himself converted to Buddhism, he erected and dedicated monuments to the Buddha throughout his empire—shrines, monasteries, sculpture, and the columns known as **ASHOKAN PILLARS** (FIG. 9–I). With missionary ardor, he dispatched delegates throughout the Indian subcontinent and to countries as distant as Syria, Egypt, and Greece. In his impassioned propagation of Buddhism, Ashoka stimulated an intensely rich period of art.

CHAPTER-AT-A-GLANCE

- THE INDIAN SUBCONTINENT
- INDUS VALLEY CIVILIZATION
- THE VEDIC PERIOD
- THE MAURYA PERIOD
- THE PERIOD OF THE SHUNGAS AND EARLY ANDHRAS Stupas Buddhist Rock-Cut Halls
- THE KUSHAN AND LATER ANDHRA PERIODS The Gandhara School The Mathura School The Amaravati School
- THE GUPTA PERIOD Buddhist Sculpture Painting
- THE POST-GUPTA PERIOD The Early Northern Temple Monumental Narrative Reliefs The Early Southern Temple
- THE TENTH THROUGH THE FOURTEENTH CENTURIES The Monumental Northern Temple The Monumental Southern Temple
 The Bhakti Movement in Art
- ART OF SOUTHEAST ASIA
- IN PERSPECTIVE

THE INDIAN SUBCONTINENT

The South Asian subcontinent, or Indian subcontinent, as it is commonly called, is a peninsular region that includes the present-day countries of India, southeastern Afghanistan, Pakistan, Nepal, Bhutan, Bangladesh, and Sri Lanka (MAP 9-1). From the beginning, these areas have been home to societies whose cultures are closely linked and which have maintained remarkable continuity over time. (South Asia is distinct from Southeast Asia, which includes Brunei, Burma [Myanmar], Cambodia [Kampuchea], East Timor, Indonesia, Laos, Malaysia, the Philippines, Singapore, Thailand, and Vietnam.) Present-day India is approximately one-third the size of the United States. A low mountain range, the Vindhya Hills, acts as a kind of natural division that demarcates North India from South India, which are of approximately equal size. On the northern border rises the protective barrier of the Himalayas, the world's tallest mountains. To the northwest are other mountains through whose passes came invasions and immigrations that profoundly affected the civilization of the subcontinent. Over these passes, too, wound the major trade routes that linked the Indian subcontinent by land to the rest of Asia and to Europe. Surrounded on the remaining sides by oceans, the subcontinent has also been connected to the world since ancient times by maritime trade, and during much of the period under discussion here it formed part of a coastal trading network that extended from eastern Africa to China.

Differences in language, climate, and terrain within India have fostered distinct regional and cultural characteristics and artistic traditions. However, despite such regional diversity, several overarching traits tend to unite Indian art. Most evident is a distinctive sense of beauty, with voluptuous forms and a profusion of ornament, texture, and color. Visual abundance is considered auspicious, and it reflects a belief in the generosity and favor of the gods. Another characteristic is the pervasive symbolism that enriches all Indian arts with intellectual and emotional layers. Third, and perhaps most important, is an emphasis on capturing the vibrant quality of a world seen as infused with the dynamics of the divine. Gods and humans, ideas and abstractions, are given tactile, sensuous forms, radiant with inner spirit.

INDUS VALLEY CIVILIZATION

The earliest civilization of South Asia was nurtured in the lower reaches of the Indus River, in present-day Pakistan and in northwestern India. Known as the Indus Valley or Harappan civilization (after Harappa, the first-discovered site), it flourished from approximately 2600 to 1900 BCE, or during roughly the same time as the Old Kingdom period of Egypt, the Minoan civilization of the Aegean, and the dynasties of Ur and Babylon in Mesopotamia. Indeed, it is considered, along with Egypt and Mesopotamia, to be one of the world's earliest urban river-valley civilizations.

It was the chance discovery in the late nineteenth century of some small seals, such as those in FIGURE 9–2, that provided the first clue that an ancient civilization had existed in this region. The seals appeared to be related to, but not the same as, seals known from ancient Mesopotamia (SEE FIG. 2–12). Excavations begun in the 1920s and continuing into the present subsequently uncovered a number of major urban areas at points along the lower Indus River, including Harappa, Mohenjo-Daro, and Chanhu-Daro.

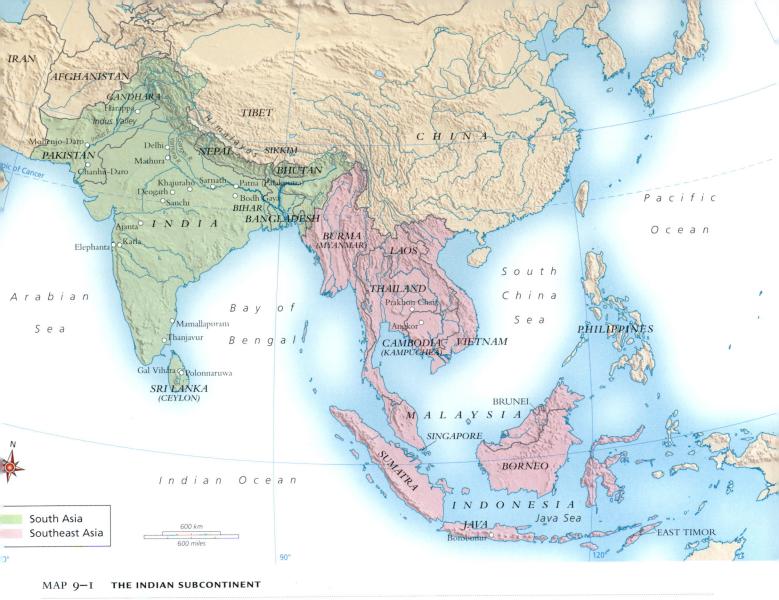

The Vindhya Hills are a natural feature dividing North and South India.

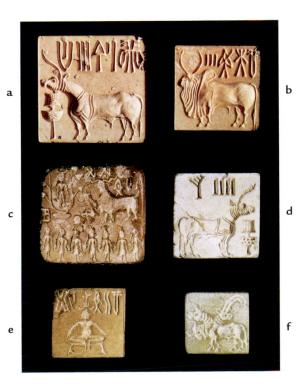

MOHENJO-DARO. The ancient cities of the Indus Valley resemble each other in design and construction, suggesting a coherent culture. At Mohenjo-Daro, the best preserved of the sites, archaeologists discovered an elevated citadel area, presumably containing important government structures, surrounded

9-2 SEAL IMPRESSIONS

a., d. horned animal; b. buffalo; c. sacrificial rite to a goddess (?); e. yogi; f. three-headed animal. Indus Valley civilization, c. 2500-1500 BCE. Seals: steatite, each approx. $1\frac{7}{4} \times 1\frac{7}{4}$ " (3.2 \times 3.2 cm).

The more than 2,000 small seals and impressions that have been found offer an intriguing window on the Indus Valley civilization. Usually carved from steatite stone, the seals were coated with alkali and then fired to produce a lustrous, white surface. A perforated knob on the back of each may have been for suspending them. The most popular subjects are animals, most commonly a one-horned bovine standing before an altarlike object (a, d). Animals on Indus Valley seals are often portrayed with remarkable naturalism, their taut, well-modeled surfaces implying their underlying skeletons. The function of the seals remains enigmatic, and the script that is so prominent in the impressions has yet to be deciphered.

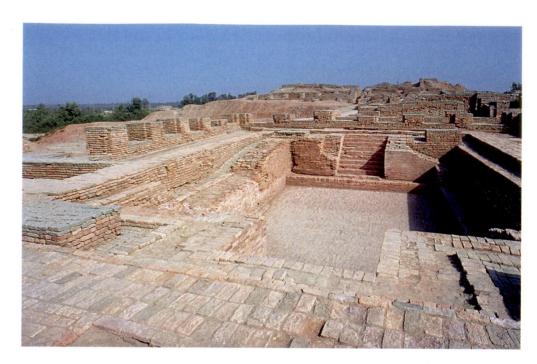

9–3 LARGE WATER TANK Possibly a public or ritual bathing area, Mohenjo-Daro. Indus Valley civilization, Harappan. c. 2600–1900 BCE.

by a wall about 50 feet high. Among the buildings is a remarkable water tank, a large water-tight pool that may have been a public bath but could also have had a ritual use (FIG. 9–3). Stretching out below this elevated area was the city, arranged in a gridlike plan with wide avenues and narrow side streets. Its houses, often two stories high, were generally built around a central courtyard. Like other Indus Valley cities, Mohenjo-Daro was constructed of fired brick, in contrast to the less durable sun-dried brick used in other cultures of the time. The city included a network of covered drainage systems that channeled away waste and rainwater. Clearly the technical and engineering skills of this civilization were highly advanced. At its peak, about 2500 to 2000 BCE, Mohenjo-Daro was approximately 6 to 7 square miles in size and had a population of about 20,000 to 50,000.

INDUS VALLEY SEALS. Although little is known about the Indus Valley civilization, motifs on the seals as well as the few artworks that have been discovered strongly suggest continuities with later South Asian cultures. The seal in FIGURE 9–2E, for example, depicts a man in the meditative posture associated in Indian culture with a yogi, one who seeks mental and physical purification and self-control, usually for spiritual purposes. In FIGURE 9–2C, the persons with elaborate headgear in a row or procession observe a figure standing in a tree—possibly a goddess—and a kneeling worshiper. This scene may offer some insight into the religious or ritual customs of Indus Valley people, whose deities may have been ancient prototypes of later Indian gods and goddesses.

Numerous terra cotta figurines and a few stone and bronze statuettes have been found in the Indus Valley. They reveal a confident maturity of artistic conception and technique. Two main styles appear: One is similar to Mesopotamian art in its motifs

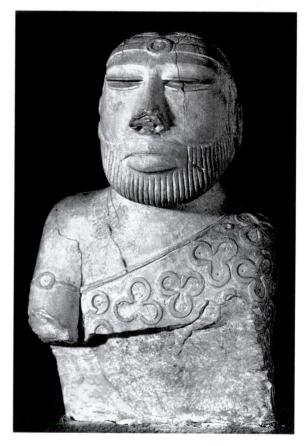

9–4 TORSO OF A "PRIEST-KING" Mohenjo-Daro. Indus Valley civilization, c. 2000–1900 BCE. Steatite, height 6%" (17.5 cm). National Museum of Pakistan, Karachi.

and rather abstract rendering, while the other foreshadows the later Indian artistic tradition in its sensuous naturalism.

"PRIEST-KING" FROM MOHENJO-DARO. The torso of a man, sometimes called the "priest-king," may represent a leader or

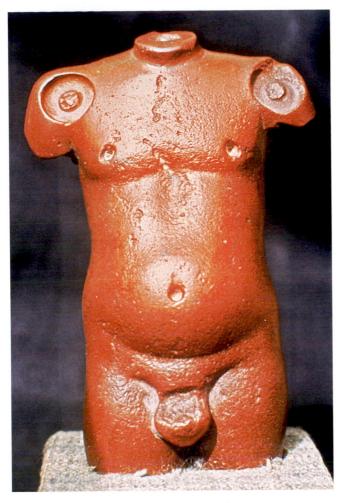

9–5 TORSO Harappa. Indus Valley civilization, c. 2000 BCE. Red sandstone, height 3¼" (9.5 cm). National Museum, New Delhi.

an ancestor figure (FIG. 9–4). Although the striated beard and the smooth, planar surfaces of the face resemble the treatment of the head found in Mesopotamian art, distinctive physical traits emerge, including a low forehead, a broad nose, thick lips, and long slit eyes. The man's garment is patterned with a trefoil (three-lobed) motif. The depressions of the trefoil pattern were originally filled with red paint, and the eyes were inlaid with colored shell or stone. A narrow band with a circular ornament encircles the upper arm and the head. It falls in back into two long strands and may be an indication of rank. Certainly, with its formal pose and simplified, geometric form, the statue conveys a commanding human presence.

NUDE TORSO FROM HARAPPA. Although its date is disputed by some, a nude male torso found at Harappa is an example of a contrasting naturalistic style (FIG. 9–5) of ancient Indus origins. Less than 4 inches tall, it is one of the most extraordinary portrayals of the human form to survive from any early civilization. In contrast to the more athletic male ideal developed in ancient Greece, this sculpture emphasizes the soft

texture of the human body and the subtle nuances of muscular form. The abdomen is relaxed in the manner of a yogi able to control his breath. With these characteristics the Harappa torso forecasts the essential aesthetic attributes of later Indian sculpture.

The reasons for the demise of this flourishing civilization are not yet understood. All we know is that between 2000 and 1750—possibly because of climate changes, a series of natural disasters, and invasions—the cities of the Indus Valley civilization declined, and predominantly rural societies evolved.

THE VEDIC PERIOD

About 2000 BCE nomadic shepherds, the Aryans, entered India from central Asia and the Russian steppes. Gradually they supplanted the indigenous populations and introduced the horse and chariot, the Sanskrit language, a hierarchical social order, and religious practices that centered on the propitiation of gods through fire sacrifice. Their sacred writings known as the Vedas gave the period its name. The earliest Veda consists of hymns to various Aryan gods including the divine king Indra. The importance of the fire sacrifice, overseen by a powerful priesthood, the Brahmins, and religiously sanctioned social classes persisted through the Vedic period. At some point, the class structure became hereditary and immutable, with lasting consequences for Indian society. The Vedic period witnessed the formation of three of the four major enduring religions of India—Hinduism, Buddhism, and Jainism.

During the latter part of this period, from about 800 BCE, the Upanishads were composed. These metaphysical texts examine the meanings of the earlier, more cryptic Vedic hymns. They focus on the relationship between the individual soul, or atman, and the universal soul, or Brahman, as well as on other concepts central to subsequent Indian philosophy. One is the assertion that the material world is illusory and that only Brahman is real and eternal. Another holds that our existence is cyclical and that beings are caught in samsara, a relentless cycle of birth, life, death, and rebirth. Believers aspire to attain liberation from samsara and to unite individual atman with the eternal, universal Brahman.

The latter portion of the Vedic period also saw the flowering of India's epic literature, written in the melodious and complex Sanskrit language. By around 400 BCE, the eighteenvolume *Mahabharata*, the longest epic in world literature, and the *Ramayana*, the most popular and enduring religious epic in India and Southeast Asia, were taking shape. These texts, the cornerstones of Indian literature, relate histories of gods and humans that bring the philosophical ideas of the Vedas to a more accessible and popular level.

In this stimulating religious, philosophical, and literary climate numerous religious communities arose. The most

influential teachers of these times were Shakyamuni Buddha and Mahavira. The Buddha, or "enlightened one," lived and taught in India around 500 BCE; his teachings form the basis of the Buddhist religion (see "Buddhism," page 317). Mahavira (c. 599–527 BCE), regarded as the last of twenty-four highly purified superbeings called pathfinders (tirthankaras), was the founder of the Jain religion. Both Shakyamuni Buddha and Mahavira espoused some basic Upanishadic tenets, such as the cyclical nature of existence and the need for liberation from the material world. However, they rejected the authority of the Vedas, and with it the legitimacy of the fire sacrifice and the hereditary class structure of Vedic society, with its powerful, exclusive priesthood. In contrast, Buddhism and Jainism were open to all, regardless of social position.

Buddhism became a vigorous force in South Asia and provided the impetus for much of the major art created between the third century BCE and the fifth century CE. The Vedic tradition, meanwhile, continued to evolve, emerging later as Hinduism, a loose term that encompasses the many religious forms that resulted from the mingling of Vedic culture with indigenous beliefs (see "Hinduism," page 318).

THE MAURYA PERIOD

After about 700 BCE, cities again began to appear on the subcontinent, especially in the north, where numerous kingdoms arose. For most of its subsequent history, India was a shifting mosaic of regional dynastic kingdoms. From time to time, however, a particularly powerful dynasty formed an empire. The first of these was the Maurya dynasty (c. 322–185 BCE), which extended its rule over all but the southernmost portion of the subcontinent.

YAKSHI FROM DIDARGANJ. The art of the Maurya period reflects an age of heroes. At this time emerged the ideal of upholding *dharma*, the divinely ordained moral law believed to keep the universe from falling into chaos. This heroic ideal seems fully embodied in a life-size statue found at Didarganj, near the Maurya capital of Pataliputra (FIG. 9–6). The statue, dated by most scholars to the Mauryan period, probably represents a *yakshi*, a spirit associated with the productive forces of nature. With its large breasts and pelvis, the figure embodies the association of female beauty with procreative abundance, bounty, and auspiciousness—qualities that in turn reflect the generosity of the gods and the workings of *dharma* in the world.

Sculpted from fine-grained sandstone, the statue conveys the *yakshi*'s authority through the frontal rigor of her pose, the massive volumes of her form, and the strong, linear patterning of her ornaments and dress. Alleviating and counter-

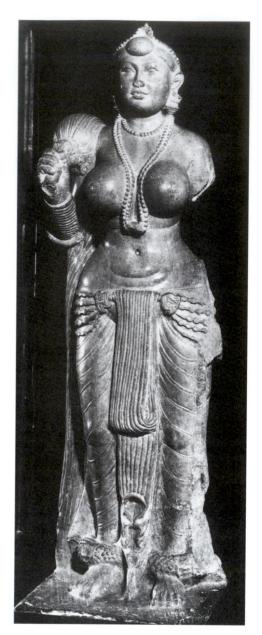

9–6 YAKSHI HOLDING A FLY-WHISK Didarganj, Patna, Bihar, India. Probably Maurya period, c. 250 BCE. Polished sandstone, height 5'4¼" (1.63 m). Patna Museum, Patna.

Discovered near the ancient Maurya capital of Pataliputra, this sculpture has become one of the most famous works of Indian art. Holding a fly-whisk in her raised right hand, the yakshi wears only a long shawl and a skirtlike cloth. The cloth rests low on her hips, held in place by a girdle. Subtly sculpted parallel creases indicate that it is gathered closely about her legs. The ends, drawn back up over the girdle, cascade down to her feet in a broad, central loop of flowing folds ending in a zigzag of hems. Draped low over her back, the shawl passes through the crook of her arm and then flows to the ground. (The missing left side of the shawl probably mirrored this motion.) The yakshi's jewelry is prominent. A double strand of pearls hangs between her breasts, its shape echoing and emphasizing the voluptuous curves of her body. Another strand of pearls encircles her neck. She wears a simple tiara, plug earrings, and rows of bangles. The nubbled tubes about her ankles probably represent anklets made of beaten gold. Her hair is bound in a large bun in back, and a small bun sits on her forehead. This hairstyle appears again in Indian sculpture of the later Kushan period (c. second century CE).

Myth and Religion

BUDDHISM

he Buddhist religion developed from the teachings of Shakyamuni Buddha, who lived from about 563 to 483 BCE in the present-day regions of Nepal and central India. At his birth, it is believed, seers foretold that the infant prince, named Siddhartha Gautama, would become either a chakravartin—a "world-conquering ruler"—or a buddha—a "fully enlightened being." Hoping for a ruler like himself, Siddhartha's father tried to surround his son with pleasure and shield him from pain. Yet the prince was eventually exposed to the sufferings of old age, sickness, and death—the inevitable fate of all mortal beings. Deeply troubled by the human condition, Siddhartha at age 29 left the palace, his family, and his inheritance to live as an ascetic in the wilderness. After six years of meditation, he attained complete enlightenment near Bodh Gaya, India.

Following his enlightenment, the Buddha ("Enlightened One") gave his first teaching in the Deer Park at Sarnath. Here he expounded the Four Noble Truths that are the foundation of Buddhism: (1) life is suffering; (2) this suffering has a cause, which is ignorance; (3) this ignorance can be overcome and extinguished; (4) the way to overcome this ignorance is by following the eightfold path of right view, right resolve, right speech, right action, right livelihood, right effort, right mindfulness, and right concentration. After the Buddha's death at the age of 80, his many disciples developed his teachings and established the world's oldest monastic institutions.

A buddha is not a god but rather one who sees the ultimate nature of the world and is therefore no longer subject to

samsara, the cycle of birth, death, and rebirth that otherwise holds us in its grip, whether we are born into the world of the gods, humans, animals, demons, tortured spirits, or hell beings.

The early form of Buddhism, known as Theravada or Hinavana, stresses self-cultivation for the purpose of attaining nirvana, which is the extinction of samsara for oneself. Theravada Buddhism has continued mainly in southern India, Sri Lanka, and Southeast Asia. Within 500 years of the Buddha's death, another form of Buddhism, known as Mahayana, became popular mainly in northern India; it eventually flourished in China, Korea, Japan, and in Tibet (as Vajrayana). Compassion for all beings is the foundation of Mahayana Buddhism, whose goal is not nirvana for oneself but buddhahood (enlightenment) for every being throughout the universe. Mahayana Buddhism recognizes buddhas other than Shakyamuni from the past, present, and future. One such is Maitreya, the next buddha to appear on earth. Another is Amitabha Buddha, the Buddha of Infinite Light and Infinite Life (that is, incorporating all space and time), who dwells in a paradise known as the Western Pure Land. Amitabha Buddha became particularly popular in East Asia. Mahayana Buddhism also developed the category of bodhisattvas ("those whose essence is wisdom"), saintly beings who are on the brink of achieving buddhahood but have vowed to help others achieve buddhahood before crossing over themselves. In art, bodhisattvas and buddhas are most clearly distinguished by their clothing and adornments: bodhisattvas wear the princely garb of India, while buddhas wear monks' robes.

balancing this hierarchical formality are her soft, youthful face, the precise definition of prominent features such as the stomach muscles, and the polished sheen of her exposed flesh. This lustrous polish is a special feature of Mauryan sculpture.

THE RISE OF BUDDHISM. In addition to depictions of popular deities like the *yakshis* and their male counterparts, *yakshas*, the Maurya period is also known for art associated with the rise of Buddhism, which became the official state religion under the Emperor Ashoka (ruled c. 273–232 BCE), the grandson of the dynasty's founder, and considered one of India's greatest rulers. Among the monuments he erected to Buddhism throughout his empire were monolithic pillars set up primarily at sites related to events in the Buddha's life.

Pillars had been used as flag-bearing standards in India since earliest times. The creators of the Ashokan pillars seem

to have adapted this already ancient form to the symbolism of Indian creation myths and the new religion of Buddhism. The fully developed Ashokan pillar—a slightly tapered sandstone shaft that usually rested on a stone foundation slab sunk more than 10 feet into the ground-rose to a height of around 50 feet (SEE FIG. 9-1). On it were carved inscriptions relating to rules of dharma that Vedic kings were enjoined to uphold, but that many later Buddhists interpreted as also referring to Buddhist teachings or exhorting the Buddhist community to unity. At the top, carved from a separate block of sandstone, an elaborate capital bore animal sculpture. Both shaft and capital were given the characteristic Maurya polish. Scholars believe that the pillars symbolized the axis mundi, or "axis of the world," joining earth with the cosmos. It represented the vital link between the human and celestial realms, and through it the cosmic order was impressed onto the terrestrial.

Myth and Religion

HINDUISM

induism is not one religion but many related beliefs and innumerable sects. It results from the mingling of Vedic beliefs (first appearing around 1500 BCE) with indigenous, local beliefs and practices. All three major Hindu sects draw upon the texts of the Vedas, which are believed to be sacred revelations set down about 1200–800 BCE. The gods lie outside the finite world, but they can appear in visible form to believers. Each Hindu sect takes its particular deity as supreme. By worshiping gods with rituals, meditation, and intense love, individuals may be reborn into increasingly higher positions until they escape the cycle of life, death, and rebirth, which is called *samsara*. The most popular deities are Vishnu, Shiva, and the Great Goddess, Devi. Deities are revealed and depicted in multiple aspects.

Vishnu: Vishnu is a benevolent god who works for the order and well-being of the world. He is often represented lying in a trance or asleep on the Cosmic Waters, where he dreams the world into existence. His symbols are the wheel and a conch shell. A huge figure, he usually has four arms and wears a crown and lavish jewelry. He rides a man-bird, Garuda. Vishnu appears in ten different incarnations, including Rama and Krishna, who have their own cults. Rama embodies virtue, and, assisted by the monkey king, he fights the demon Ravana. As Krishna, Vishnu is a supremely beautiful, blue-skinned youth who lives with the cowherds, loves the maiden Radha, and battles the demon Kansa.

Shiva: Shiva, Lord of Existence, embodies the entire universe; he is both creative and destructive, light and dark, male and female. His symbol is the *lingam*, an upright phallus, which is represented as a low pillar. As an expression of his power and creative energy, he is often represented as Lord of the Dance,

dancing the Cosmic Dance, the endless cycle of death and rebirth, destruction and creation (see "Shiva Nataraja of the Chola Dynasty," page 331). He dances within a ring of fire, his four hands holding fire, a drum, and gesturing to the worshipers. Shiva's animal is the bull. His consort is Parvati; their sons are the elephant-headed Ganesha, God of Prosperity, and the six-faced Karttikeya, God of War.

Devi: Devi, the Great Goddess, controls material riches and fertility. She has forms indicative of beauty, wealth, and auspiciousness, but also forms of wrath, pestilence, and power. As the embodiment of cosmic energy, she provides the vital force to all the male gods. Her symbol is an abstract depiction of female genitals, often associated with the *lingam* of Shiva. When armed and riding a lion (as the goddess Durga), she personifies righteous fury. As the goddess Lakshmi, she is the goddess of wealth and beauty. She is often represented by the basic geometric forms—squares, circles, triangles.

Brahma: Brahma, the creator, once had his own cult. Brahma embodies spiritual wisdom. His four heads symbolize the four cosmic cycles, four earthly directions, and four classes of society: priests (brahmins), warriors, merchants, and laborers.

There are countless other deities, but central to Hindu practice are *puja* (forms of worship) and *darshan* (beholding a deity), generally performed to obtain a deity's favor and in the hope that this favor will lead to liberation from *samsara*. Because desire for the fruits of our actions traps us, the ideal is to consider all earthly endeavors as sacrificial offerings to a god. Pleased with our devotion, he or she may grant us an eternal state of pure being, pure consciousness, and pure bliss.

LION CAPITAL FROM SARNATH. The capital in FIGURE 9–7 originally crowned the pillar erected at Sarnath in northeast India, the site of the Buddha's first sermon. The lowest portion represents the down-turned petals of a lotus blossom. Because the lotus flower emerges from murky waters without any mud sticking to its petals, it symbolizes the presence of divine purity in the imperfect world. Above the lotus is an *abacus* (the slab forming the top of a capital) embellished with low-relief carvings of wheels, called *chakras*, alternating with four different animals: lion, horse, bull, and elephant. The animals may symbolize the four great rivers of the world, which are mentioned in Indian creation myths. Standing on this abacus are four back-to-back lions. Facing the four cardinal directions, the lions may be emblematic of the universal

9-7 LION CAPITAL

Ashokan pillar at Sarnath, Uttar Pradesh, India. Maurya period, c. 250 BCE. Polished sandstone, height 7' (2.13 m). Archaeological Museum, Sarnath.

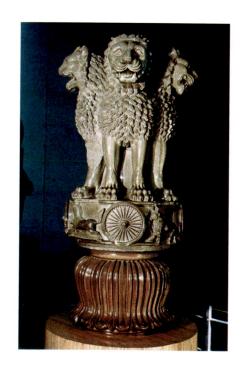

nature of Buddhism. Their roar might be compared with the speech of the Buddha that spreads far and wide. The lions may also refer to the Buddha himself, who is known as "the lion of the Shakya clan" (the clan into which the Buddha was born as prince). The lions originally supported a great copper wheel, now lost. A universal Buddhist symbol, the wheel refers to Buddhist teaching, for with his sermon at Sarnath the Buddha "set the wheel of the law [dharma] in motion."

Their formal, heraldic pose imbues the lions with something of the monumental quality evident in the statue of the *yakshi* of the same period. We also find the same strong patterning of realistic elements: Veins and tendons stand out on the legs; the claws are large and powerful; the mane is richly textured; and the jaws have a loose and fluttering edge.

THE PERIOD OF THE SHUNGAS AND EARLY ANDHRAS

With the demise of the Maurya Empire, India returned to local rule by regional dynasties. Between the second century BCE and the early first century CE, the most important of these dynasties were the Shunga (185–72 BCE) in central India and the early Andhra (73 BCE–50 CE) in South India. During this period, some of the most magnificent early Buddhist structures were created.

Stupas

Religious monuments enclosing relic chambers, called **Stupas** are fundamental to Buddhism (see "Stupas and Temples," page 320). A stupa may be small and plain or large and elaborate. Its form may vary from region to region, but its symbolic meaning remains virtually the same, and its plan is a carefully calculated *mandala*, or diagram of the cosmos as it is envisioned in Buddhism. Stupas are open to all for private worship.

Sequencing Events KEY HISTORIC PERIODS OF INDIAN ART TO 950 CE

с. 322-185 все	Maurya Period
185 BCE-50 CE	Periods of the Shungas and Early Andhras
с. 30 все-433 се	Kushan and Later Andhra Periods
c. 320-486 CE	Gupta Period

The first stupas were constructed to house the Buddha's remains after his cremation. According to tradition, the relics were divided into eight portions and placed in eight reliquaries. Each reliquary was then encased in its own burial mound, called a stupa. Since the early stupas held actual remains of the Buddha, they were venerated as his body and, by extension, his enlightenment and attainment of *nirvana*—liberation from rebirth. The method of veneration was, and still is, to circumambulate, or walk around, the stupa in a clockwise direction. In the mid-third century BCE, King Ashoka opened the original eight stupas and divided their relics among many more stupas, probably including the one at Sanchi.

THE GREAT STUPA AT SANCHI. Probably no early Buddhist structure is more famous than the Great Stupa at Sanchi in central India (FIG. 9–8). Originally built by King Ashoka in the Maurya period, the Great Stupa was part of a large monastery complex crowning a hill. During the mid-second century BCE, the stupa was enlarged to its present size, and the surrounding stone railing was constructed. About 100 years later, elaborately carved stone gateways were added to the railing.

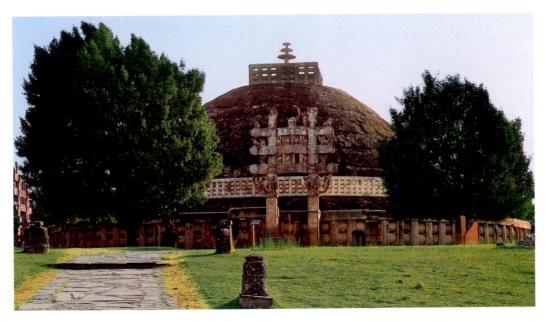

9–8 **GREAT STUPA, SANCHI**Madhya Pradesh, India.
Founded 3rd century BCE, enlarged c. 150–50 BCE.

Elements of Architecture

STUPAS AND TEMPLES

Buddhist architecture in South Asia consists mainly of stupas and temples, often at monastic complexes containing viharas (monks' cells and common areas). These monuments may be either structural—built up from the ground—or rock-cut—hewn out of a mountainside. Stupas derive from burial mounds and contain relics beneath a solid, dome-shaped core. A major stupa is surrounded by a railing that creates a sacred path for ritual circumambulation at ground level. This railing is punctuated by gateways called toranas, aligned with the cardinal points; access is through the eastern torana. The stupa sits on a round or square terrace; stairs lead to an upper circumambulatory path around the platform's edge. On top of the stupa's dome a railing defines a square, from the center of which rises a mast supporting tiers of disk-shaped "umbrellas."

Hindu architecture in South Asia consists mainly of temples, either structural or rock-cut, executed in a number of

styles and dedicated to a vast range of deities. The two general Hindu temple types are the northern and southern styles—corresponding to North India and South India, respectively. Within these broad categories is great stylistic diversity, though all are raised on plinths and dominated by their superstructures, towers called *shikharas* in the North and *vimanas* in the South. *Shikharas* are crowned by *amalakas*, *vimanas* by large capstones. Inside, a series of *mandapas* (halls) leads to an inner sanctuary, the *garbhagriha*, which contains a sacred image. An *axis mundi* runs vertically up from the Cosmic Waters below the earth, through the *garbhagriha*'s image, and out through the top of the tower.

Jain architecture consists mainly of structural and rock-cut monasteries and temples that have much in common with their Buddhist and Hindu counterparts. Buddhist, Hindu, and Jain temples may share a site.

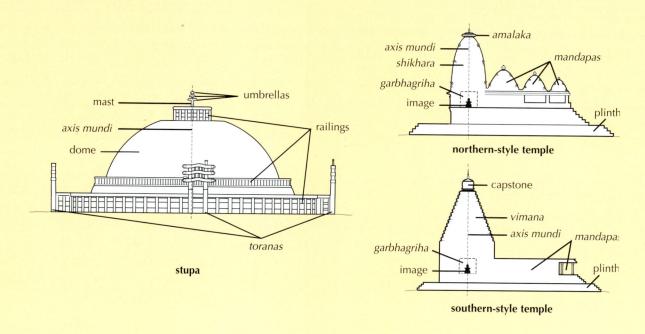

The Great Stupa at Sanchi is a representative of the early central Indian type. Its solid, hemispherical **dome** was built up from rubble and dirt, faced with **dressed stone**, then covered with a shining white plaster made from lime and powdered seashells. The dome—echoing the arc of the sky—sits on a raised base. Around the perimeter is a walkway enclosed by a railing and approached by a pair of staircases. As is often true in religious architecture, the railing provides a physical and symbolic boundary between an inner, sacred area and the outer, profane world. On top of the dome, another stone railing, square in shape, defines the abode of the gods atop the cosmic mountain. It encloses the top of a mast bearing three

stone disks, or "umbrellas," of decreasing size. These disks have been interpreted in various ways. They correspond to the "Three Jewels of Buddhism," the Buddha, the Law, and the Monastic Order, and they may also refer to the Buddhist concept of the three realms of existence—desire, form, and formlessness. The mast itself is an *axis mundi*, connecting the Cosmic Waters below the earth with the celestial realm above it and anchoring everything in its proper place.

A 10-foot-tall stone railing rings the entire stupa, enclosing another, wider, circumambulatory path at ground level. Carved with octagonal uprights and lens-shaped crossbars, it probably simulates the wooden railings of the time.

This design pervaded early Indian art, appearing in relief sculpture and as architectural ornament. Four stone gateways, or toranas, punctuate the railing (FIG. 9-9). Set at the four cardinal directions, the toranas symbolize the Buddhist cosmos. According to an inscription, they were sculpted by ivory carvers from the nearby town of Vidisha. The only elements of the Great Stupa at Sanchi to be ornamented with sculpture, the toranas rise to a height of 35 feet. Their square posts are carved with symbols and scenes drawn mostly from the Buddha's life and the jataka tales, stories of the Buddha's past lives. Vines, lotuses, geese, and mythical animals decorate the sides, while guardians sculpted on the lowest panel of each inner side protect the entrance. The capitals above the posts consist of four back-to-back elephants on the north and east gates, dwarfs on the west gate, and lions on the south gate. The capitals in turn support a three-tiered superstructure in which posts and crossbars are elaborately carved with still more symbols and scenes and studded with freestanding sculptures depicting such subjects as yakshis and vakshas, riders on real and mythical animals, and the Buddhist wheel. As in all known early Buddhist art, the Buddha himself is not shown in human form. Instead, he is represented by symbols such as his footprints, an empty "enlightenment" seat, or a stupa.

Forming a bracket between each capital and the lowest crossbar is a sculpture of a yakshi (FIG. 9-10). These yakshis are some of the finest female figures in Indian art, and they make an instructive comparison with the yakshi of the Maurya period (SEE FIG. 9-6). The earlier figure was distinguished by a formal, somewhat rigid pose, an emphasis on realistic details, and a clear distinction between clothed and nude parts of the body. In contrast, the Sanchi yakshi leans daringly into space with casual abandon, supported by one leg as the other charmingly crosses behind. Her thin, diaphanous garment is noticeable only by its hems, and so she appears almost nude, which emphasizes her form. The band pulling gently at her abdomen accentuates the suppleness of her flesh. The swelling, arching curves of her body evoke this deity's procreative and bountiful essence. As the personification of the waters, she is the source of life. Here she symbolizes the sap of the tree, which flowers at her touch.

The profusion of designs, symbols, scenes, and figures carved on all sides of the gateways to the Great Stupa not only relates the history and lore of Buddhism, but also represents the teeming life of the world and the gods.

Buddhist Rock-Cut Halls

From ancient times, caves have been considered hallowed places in India, for they were frequently the abode of holy ones and ascetics. Around the second century BCE, Buddhist monks began to hew caves for their own use out of the stone plateaus in the region of south-central India known as the Deccan. The exteriors and interiors were carved from top to

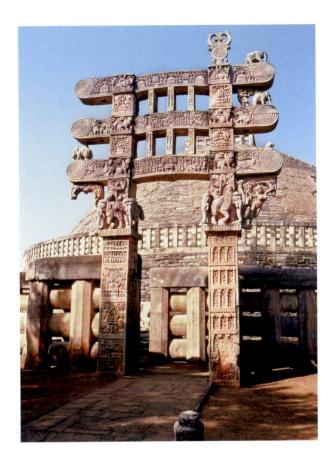

9–9 EAST TORANA OF THE GREAT STUPA AT SANCHI Early Andhra period, mid-1st century BCE. Stone, height 35' (10.66 m).

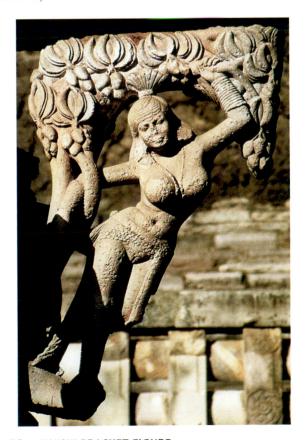

9–10 YAKSHI BRACKET FIGURE
East torana of the Great Stupa at Sanchi. Stone, height approx. 60" (152.4 cm).

bottom like great pieces of sculpture, with all details completely finished in stone. To enter one of these remarkable halls is to feel transported to an otherworldly, sacred space. The energy of the living rock, the mysterious atmosphere created by the dark recess, the echo that magnifies the smallest sound—all combine to promote a state of heightened awareness.

THE CHAITYA HALL AT KARLA. The monastic community made two types of rock-cut halls. One was the vihara, used for the monks' living quarters, and the other was the chaitya, meaning "sanctuary," which usually enshrined a stupa. A chaitya hall at Karla, dating from the first century BCE to the first century CE, is the largest and most fully developed example of these early Buddhist works (FIGS. 9-11, 9-12). At the entrance, columns once supported a balcony, in front of which a pair of Ashokan-type pillars stood. The walls of the vestibule are carved in relief with rows of small balcony railings and arched windows, simulating the façade of a great multistoried palace. At the base of the side walls, enormous statues of elephants seem to be supporting the entire structure on their backs. Dominating the upper portion of the main façade is a large horseshoe-shaped opening called a sun window or chaitya window, which provides the hall's main source of light. The window was originally fitted with a carved wood screen, some of which remains, that filtered the light streaming inside.

Three entrances pierce the main façade. Flanking the entrances are sculpted panels of *mithuna* couples, amorous male and female figures that evoke the harmony and fertility of life. The interior hall, 123 feet long, has a 46-foot-high ceiling carved in the form of a **barrel vault** ornamented with arching wooden ribs. Both the interior and exterior of the hall were once brightly painted. A wide central aisle and two narrower side aisles lead to the stupa in the **apse** at the far end.

The closely spaced columns that separate the side aisles from the main aisle are unlike any known in the West, and

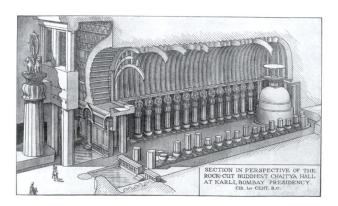

9—II **SECTION OF THE** CHAITYA HALL AT KARLA Maharashtra, India. 1st century BCE to 1st century CE.

they are important examples in the long and complex evolution of the many Indian styles. The base resembles a large pot set on a stepped pyramid of planks. From this potlike form rises a massive octagonal shaft. Crowning the shaft, a bell-shaped lotus capital supports an inverted pyramid of planks, which serves in turn as a platform for sculpture. The statues depict pairs of kneeling elephants, each bearing a *mithuna* couple. These figures, the only sculpture within this austere hall, represent the nobility coming to pay homage at the temple. The pillars around the apse are plain, and the stupa is simple. A railing motif ornaments the base; the dome was once topped with wooden "umbrella" disks, only one of which remains. As with nearly everything in the cave, the stupa is carved from the living rock. Although much less ornate than the stupa at Sanchi, its symbolism is the same.

THE KUSHAN AND LATER ANDHRA PERIODS

Around the first century CE, the regions of present-day Afghanistan, Pakistan, and North India came under the control of the Kushans, a nomadic people forced out of northwest China by the Han. Exact dates are uncertain, but they ruled from the first to the third century CE. The beginning of the long reign of their most illustrious king, Kanishka, is variously dated from 78 to 143 CE. Kanishka's patronage supported the building of many stupas and Buddhist monasteries.

Buddhism during this period underwent a profound evolution that resulted in the form known as Mahayana, or Great Vehicle (see "Buddhism," page 317). This vital new

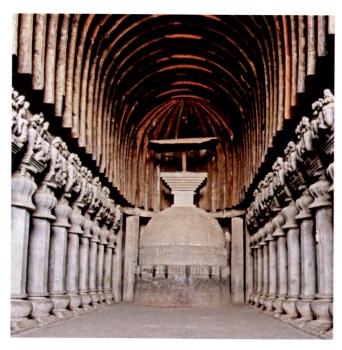

9-12 CHAITYA HALL AT KARLA

movement, which was to sweep most of northern India and eastern Asia, probably inspired the first depictions of the Buddha himself in art. (Previously, as in the Great Stupa at Sanchi, the Buddha had been indicated solely by symbols.) The two earliest schools of representation arose in the Gandhara region in the northwest (present-day Pakistan and Afghanistan) and in the famous religious center of Mathura in central India. Both of these areas were ruled by the Kushans. Slightly later, a third school, known as the Amaravati school after its most famous site, developed to the south under the Andhra dynasty, which ruled much of southern and central India from the second century BCE through the second century CE.

While all three schools cultivated distinct styles, they shared a basic visual language, or iconography, in which the Buddha is readily recognized by certain characteristics. He wears a monk's robe, a long length of cloth draped over the left shoulder and around the body. The Buddha is said to have had thirty-two major distinguishing marks, called lakshana, some of which are reflected in the iconography (see "Buddhist Symbols," page 381). These include a goldencolored body, long arms that reached to his knees, the impression of a wheel (chakra) on the palms of his hands and the soles of his feet, and the urna-a tuft of white hair between his eyebrows. Because he had been a prince in his youth and had worn the customary heavy earrings, his earlobes are usually shown elongated. The top of his head is said to have had a protuberance called an ushnisha, which in images often resembles a bun or topknot and symbolizes his enlightenment.

The Gandhara School

Gandharan art combines elements of Hellenistic, Persian, and native styles. A typical image from the Gandhara school portrays the Buddha as a superhuman figure, more powerful and heroic than an ordinary human (FIG. 9–13). This over—lifesize Buddha dates to the fully developed stage of the Gandhara style around the third century CE. It is carved from schist, a fine-grained dark stone. The Buddha's body, revealed through the folds of the garment, is broad and massive, with heavy shoulders and limbs and a well-defined torso. His left knee bends gently, suggesting a slightly relaxed posture.

The treatment of the robe is especially characteristic of the Gandhara manner. Tight, riblike folds alternate with delicate creases, setting up a clear, rhythmic pattern of heavy and shallow lines. On the upper part of the figure, the folds break asymmetrically along the left arm; on the lower part, they drape in a symmetric U shape. The strong tension of the folds suggests life and power within the image. This complex fold pattern resembles the treatment of togas on certain Roman statues (SEE FIG. 6–12), and it exerted a strong influence on portrayals of the Buddha in Central and East Asia. The Gandhara region's relations with the Hellenistic world may have

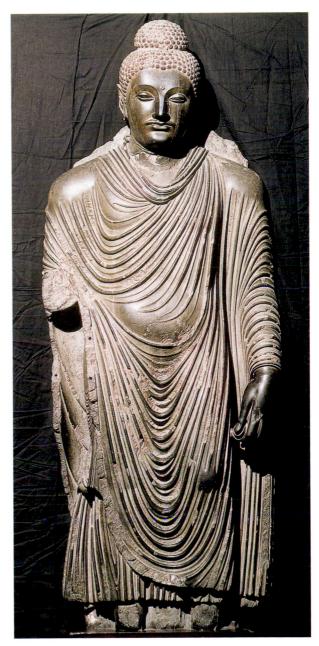

9–13 STANDING BUDDHA
Gandhara, Pakistan. Kushan period, c. 2nd-3rd century CE.
Schist, height 7′6″ (2.28 m). Lahore Museum, Lahore.

led to this strongly Western style in its art. Pockets of Hellenistic culture had thrived in neighboring Bactria (present-day northern Afghanistan and southern Uzbekistan) since the fourth century BCE, when the Greeks under Alexander the Great reached the borders of India. Also, Gandhara's position near the East-West trade routes appears to have stimulated contact with Roman culture in the Near East during the early centuries of the first millennium CE.

The Mathura School

The second major school of Buddhist art in the Kushan period—that found at Mathura—was not allied with the Hellenistic-Roman tradition. Instead, the Mathura style

evolved from representations of *yakshas*, the indigenous male nature deities. Images produced at Mathura during the early days of the school may be the first representations of the Buddha to appear in art.

The stele in FIGURE 9-14 is one of the finest of the early Mathura images. The sculptors worked in a distinctive local sandstone flecked with cream-colored spots. Carved in high relief, it depicts a seated Buddha with two attendants. The Buddha sits in a yogic posture on a pedestal supported by lions. His right hand is raised in a symbolic gesture meaning "have no fear." Images of the Buddha rely on a repertoire of such gestures, called mudras, to communicate certain ideas, such as teaching, meditation, or the attaining of enlightenment (see "Mudras," page 325). The Buddha's urna, his ushnisha, and the impressions of chakras on his palms and soles are all clearly visible in this figure. Behind his head is a large, circular halo; the scallop points of its border represent radiating light. Behind the halo are branches of the pipal tree, the tree under which the Buddha was seated when he achieved enlightenment. Two celestial beings hover above.

As in the Gandhara school, the Mathura work gives a powerful impression of the Buddha. Yet this Buddha's riveting outward gaze and alert posture impart a more intense, concentrated energy. The robe is pulled tightly over the body, allowing the fleshy form to be seen as almost nude. Where the pleats of the robe appear, such as over the left arm and fanning out between the legs, they are depicted abstractly through compact parallel

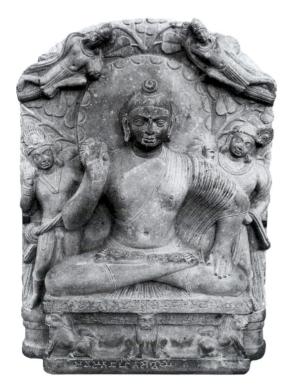

9–14 BUDDHA AND ATTENDANTS
Katra Keshavdev, Mathura, Madhya Pradesh, India. Kushan period, c. late 1st-early 2nd century CE. Red sandstone, height 27¼" (69.2 cm). Government Museum, Mathura.

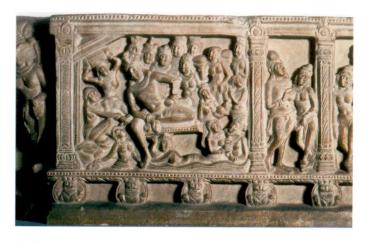

9–15 SIDDHARTHA IN THE PALACEDetail of a relief from Nagarjunakonda, Andhra Pradesh, India. Later Andhra period, c. 3rd century CE. Limestone. National Museum, New Delhi.

In his Buddhacharita, a long poem about the life of the Buddha, the great Indian poet Ashvagosha (c. 100 CE) describes Prince Siddhartha's life in the palace: "The monarch [Siddhartha's father], reflecting that the prince must see nothing untoward that might agitate his mind, assigned him a dwelling in the upper storeys of the palace and did not allow him access to the ground. Then in the pavilions, white as the clouds of autumn, with apartments suited to each season and resembling heavenly mansions come down to earth, he passed the time with the noble music of singing-women." Later, during an outing, a series of unexpected encounters confronts Siddhartha with the nature of mortality. Deeply shaken, he cannot bring himself to respond to the perfumed entreaties of the women who greet him on his return: "For what rational being would stand or sit or lie at ease, still less laugh, when he knows of old age, disease and death?" In this relief, the prince, though surrounded by women in the pleasure garden, seems already to bear the sober demeanor of these thoughts, which were profoundly to affect not only his life, but the world. (Translated by E. H. Johnston).

formations of ridges with an **incised** line in the center of each ridge. This characteristic Mathura tendency to abstraction also appears in the face, whose features take on geometric shapes, as in the rounded forms of the widely opened eyes. Nevertheless, the torso with its subtle and soft modeling is strongly naturalistic.

The Amaravati School

Events from the Buddha's life were popular subjects in the reliefs decorating stupas and Buddhist temples. One example from Nagarjunakonda, a site of the Amaravati school in the south, depicts a scene from the Buddha's life when he was Prince Siddhartha, before his renunciation of his princely status and his subsequent quest for enlightenment (FIG. 9–15). Carved in low relief, the panel reveals a scene of pleasure around a pool of water. Gathered around Siddhartha, the largest figure and the only male, are some of the palace women. One holds his foot, entreating him to come into the water; another sits with legs drawn up on the nearby rock; others lean over his shoulder or fix their hair; one comes into the scene with a box of jewels on her head. The panel is

Myth and Religion

MUDRAS

udras (the Sanskrit word for "signs") are ancient symbolic hand gestures that are regarded as physical expressions of different states of being. In Buddhist art, they function iconographically. *Mudras* also are used during meditation to release these energies. The following are the most common *mudras* in Asian art.

Dharmachakra Mudra

The gesture of teaching, setting the *chakra* (wheel) of the *dharma* (law, or doctrine) in motion. Hands are at chest level.

Dhyana Mudra

A gesture of meditation and balance, symbolizing the path toward enlightenment. Hands are in the lap, the lower representing *maya*, the physical world of illusion, the upper representing *nirvana*, enlightenment and release from the world.

Vitarka Mudra

This variant of *dharmachakra mudra* stands for intellectual debate. The right and/or left hand is held at shoulder level with thumb and forefinger touching.

Abhaya Mudra

The gesture of reassurance, blessing, and protection, this *mudra* means "have no fear." The right hand is at shoulder level, palm outward.

Bhumisparsha Mudra

This gesture calls upon the earth to witness Shakyamuni Buddha's enlightenment at Bodh Gaya. A seated figure's right hand reaches toward the ground, palm inward.

Varada Mudra

The gesture of charity, symbolizing the fulfillment of all wishes. Alone, this *mudra* is made with the right hand; but when combined with *abhaya mudra* in standing *buddha* figures (as is most common), the left hand is also shown in *varada mudra*.

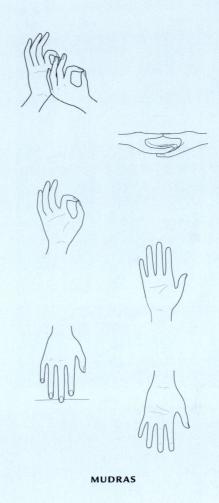

framed by decorated columns, crouching lions, and amorous *mithuna* couples. (One of these couples is visible at the right of the illustration.) The scene is skillfully orchestrated to revolve around the prince as the main focus of all eyes. Typical of the southern school, the figures are slighter than those of the Gandhara and Mathura schools. They are sinuous and mobile, even while at rest. The rhythmic nuances of the limbs and varied postures not only create interest in the activity of each individual but also engender a light and joyous effect.

During the first to third century CE, each of the three major schools of Buddhist art developed its own distinct idiom for expressing the complex imagery of Buddhism and depicting the image of the Buddha. The Gandhara and Ama-

ravati schools declined over the ensuing centuries, mainly due to the demise of the dynasties that had supported them. However, the schools of central India, including the school of Mathura, continued to develop, and from them came the next major development in Indian Buddhist art.

THE GUPTA PERIOD

The Guptas, who founded a dynasty in the eastern region of central India known as Magadha, expanded their territories during the fourth century to form an empire that encompassed northern and much of southern India. Although Gupta power prevailed for only about 166 years (c. 320–486 CE)

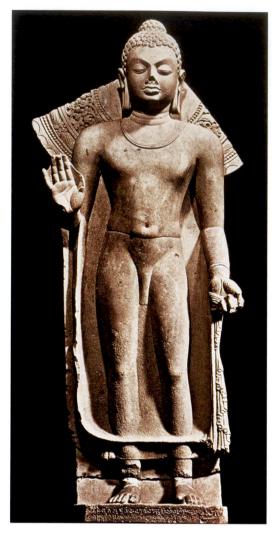

9–16 **STANDING BUDDHA**Sarnath, Uttar Pradesh, India. Gupta period, 474 CE. Chunar sandstone, height 6′ 4″ (1.93 m). Archaeological Museum, Sarnath.

before the dynasty's collapse around 500 CE, the influence of Gupta culture was felt for centuries.

The Gupta period is renowned for the flourishing artistic and literary culture that brought forth some of India's most widely admired sculpture and painting. During this time, Buddhism reached its greatest influence in India, although Hinduism, supported by the Gupta monarchs, began to rise in popularity.

Buddhist Sculpture

Two schools of Gupta Buddhist sculpture reached their artistic peak during the second and third quarters of the fifth century and dominated in northern India: the Mathura, one of the major schools of the earlier Kushan period, and the school at Sarnath.

The standing Buddha in FIGURE 9–16 embodies the fully developed Sarnath Gupta style. Carved from fine-grained sandstone, the figure stands in a mildly relaxed pose, the body

clearly visible through a clinging robe. This plain robe, portrayed with none of the creases and folds so prominent in the Kushan period images, is distinctive of the Sarnath school. Its effect is to concentrate attention on the perfected form of the body, which emerges in high relief. The body is graceful and slight, with broad shoulders and a well-proportioned torso. Only a few lines of the garment at the neck, waist, and hems interrupt the purity of its subtly shaped surfaces; the face, smooth and ovoid, has the same refined elegance. The downcast eyes suggest otherworldly introspection, yet the gentle, open posture maintains a human link. Behind the head are the remains of a large, circular halo. Carved in concentric circles of pearls and foliage, the halo would have contrasted dramatically with the plain surfaces of the figure.

The Sarnath Gupta style reveals the Buddha in perfection and equilibrium. He is not represented as a superhuman presence but as a being whose spiritual purity is evidenced by, and fused with, his physical purity, one whose nature blends the fully enlightened with the fully human.

Painting

The Gupta aesthetic also found expression in painting. Some of the finest surviving works are murals from the Buddhist rock-cut halls of Ajanta, in the western Deccan region of

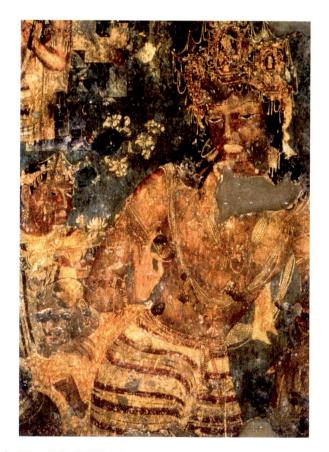

9–17 **BODHISATTVA**Detail of a wall painting in Cave I, Ajanta, Maharashtra, India. Gupta period, c. 475 CE.

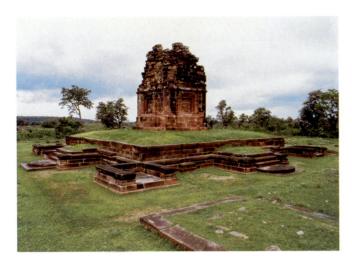

9–18 **VISHNU TEMPLE AT DEOGARH**Uttar Pradesh, India. Post-Gupta period, c. 530 CE.

India (FIG. 9–17). Under a local dynasty, many caves were carved around 475 CE, including Cave I, a large *vihara* hall with monks' chambers around the sides and a Buddha shrine chamber in the back. The walls of the central court were covered with murals painted in mineral pigments on a prepared plaster surface. Some of these paintings depict episodes from the Buddha's past lives. Flanking the entrance to the shrine are two large **bodhisattvas**, one of which is seen in FIGURE 9–17.

Bodhisattvas are enlightened beings who postpone nirvana and buddhahood to help others achieve enlightenment. They are distinguished from buddhas in art by their princely garments. The bodhisattva here is lavishly adorned with delicate ornaments. He wears a complicated crown with many tiny pearl festoons, large earrings, long necklaces of twisted pearl strands, armbands, and bracelets. A striped cloth covers his lower body. The graceful bending posture and serene gaze impart a sympathetic attitude. His spiritual power is suggested by his large size in comparison with the surrounding figures.

The naturalistic style balances outline and softly graded color tones. Outline drawing, always a major ingredient of Indian painting, clearly defines shapes; tonal gradations impart the illusion of three-dimensional form, with lighter tones used for protruding parts such as the nose, brows, shoulders, and chest muscles. Together with the details of the jewels, these highlighted areas resonate against the subdued tonality of the figure and the somber, flower-strewn background seen in FIGURE 9–17. Sophisticated, realistic detail is balanced, in typical Gupta fashion, by the languorous human form. In no other known examples of Indian painting do bodhisattvas appear so graciously divine yet, at the same time, so palpably human. This particular synthesis, evident also in the Sarnath statue, is the special Gupta artistic achievement.

THE POST-GUPTA PERIOD

Although the Gupta dynasty came to an end around 500 CE, its influence—in both religion and the arts—lingered until the mid-tenth century. Although Buddhism had flourished in India during the fifth century, Hinduism, sponsored by Gupta monarchs, began its ascent toward eventual domination of Indian religious life. Hindu temples and sculpture of the Hindu gods, though known earlier, increasingly appeared during the Gupta period and post-Gupta periods.

The Early Northern Temple

The Hindu temple developed many different forms throughout India, but it can be classified broadly into two types: northern and southern. The northern type is chiefly distinguished by a superstructure called a shikhara (see "Stupas and Temples," page 320). The shikhara rises as a solid mass above the flat stone ceiling and windowless walls of the sanctum, or garbhagriha, which houses an image of the temple's deity. As it rises, it curves inward in a mathematically determined ratio. (In mathematical terms, the shikhara is a paraboloid.) Crowning the top is a circular, cushionlike element called an amalaka, a fruit. From the amalaka, a finial (a knoblike decoration at the top point of a spire) takes the eye to a point where the earthly world is thought to join the cosmic world. An imaginary axis mundi penetrates the entire temple, running from the point of the finial, through the exact center of the amalaka and shikhara, down through the center of the garbhagriha and its image, finally passing through the base of the temple and into the earth below. In this way the temple becomes a conduit between the celestial realms and the earth. This theme, familiar from Ashokan pillars and Buddhist stupas, is carried out with elaborate exactitude in Hindu temples, and it is one of the most important elements underlying their form and function (see "Meaning and Ritual in Hindu Temples and Images," page 328).

TEMPLE OF VISHNU AT DEOGARH. One of the earliest northern-style temples is the temple of Vishnu at Deogarh in central India, which dates from around 530 CE (FIG. 9–18). Much of the *shikhara* has crumbled away, so we cannot determine its original shape with precision. Nevertheless, it was clearly a massive, solid structure built of large cut stones. It would have given the impression of a mountain, which is one of several metaphoric meanings of a Hindu temple. This early temple has only one chamber, the *garbhagriha*, which corresponds to the center of a sacred diagram called a *mandala* on which the entire temple site is patterned. As the deity's residence, the *garbhagriha* is likened to a sacred cavern within the "cosmic mountain" of the temple.

The entrance to a Hindu temple is elaborate and meaningful. The doorway at Deogarh is well preserved and an

Art and Its Context

MEANING AND RITUAL IN HINDU TEMPLES AND IMAGES

he Hindu temple is one of the most complex and meaningful architectural forms in Asian art. Age-old symbols and ritual functions are embedded not only in a structure's many parts, but also in the process of construction itself. Patron, priest, and architect worked as a team to ensure the sanctity of the structure from start to finish. No artist or artisan was more highly revered in ancient Indian society than the architect, who could oversee the construction of an abode in which a deity would dwell.

For a god to take up residence, however, everything had to be done properly in exacting detail. By the end of the first millennium, the necessary procedures had been recorded in texts called the *Silpa Shastra*. First, an auspicious site was chosen; a site near water was especially favored, for water makes the earth fruitful. Next, the ground was prepared in an elaborate process that took several years: Spirits already inhabiting the site were invited to leave; the ground was planted and harvested through two seasons; then cows—sacred beasts since the Indus Valley civilization—were pastured there to lend their potency to the site. When construction began, each phase was accompanied by ritual to ensure its purity and sanctity.

All Hindu temples are built on a mystical plan known as a *mandala*, a schematic design of a sacred realm or space—specifically, the *mandala* of the Cosmic Man (Vastupurusha *mandala*), the primordial progenitor of the human species. His body, fallen on earth, is imagined as superimposed on the *mandala* design; together, they form the base on which the temple rises. The Vastupurusha *mandala* always takes the form of a square subdivided

into a number of equal squares (usually sixty-four) surrounding a central square. The central square represents Brahman, the primordial, unmanifest Formless One. This square corresponds to the temple's sanctum, the windowless garbhagriha, or "womb chamber." The nature of Brahman is clear, pure light; that we perceive the garbhagriha as dark is considered a testament to our deluded nature. The surrounding squares belong to lesser deities, while the outermost compartments hold protector gods. These compartments are usually represented by the enclosing wall of a temple compound.

The garbhagriha houses the temple's main image—most commonly a stone, bronze, or wood statue of Vishnu, Shiva, or Devi. In the case of Shiva, the image is often symbolic rather than anthropomorphic. To ensure perfection, the proportions of the image follow a set canon, and rituals surround its making. When the image is completed, a priest recites mantras, or mystic syllables, that bring the deity into the image. The belief that a deity is literally present is not taken lightly. Even in India today, any image "under worship"—whether it be in a temple or a field, an ancient work or a modern piece—will be respected and not taken from the people who worship it.

A Hindu temple is a place for individual devotion, not congregational worship. It is the place where a devotee can make offerings to one or more deities and be in the presence of the god who is embodied in the image in the *garbhagriha*. Worship generally consists of prayers and offerings such as food and flowers or water and oil for the image, but it can also be much more elaborate, including dancing and ritual sacrifices.

excellent example (FIG. 9–19). Because the entrance takes a worshiper from the mundane world into the sacred, stepping over a threshold is considered a purifying act. Two river goddesses, one on each upper corner of the lintel, symbolize the purifying waters flowing down over the entrance. These imaginary waters also provide symbolic nourishment for the vines and flowers decorating some of the vertical jambs. The innermost vines sprout from the navel of a dwarf, one of the popular motifs in Indian art. *Mithuna* couples and small replicas of the temple line other jambs. At the bottom, male and female guardians flank the doorway. Above the door, in the center, is a small image of the god Vishnu, to whom the temple is dedicated.

Large panels sculpted in relief with images of Vishnu appear as "windows" on the temple's exterior. These elaborately framed panels do not function literally to let light *into* the temple; they function symbolically to let the light of the deity *out* of the temple to be seen by those outside. The pan-

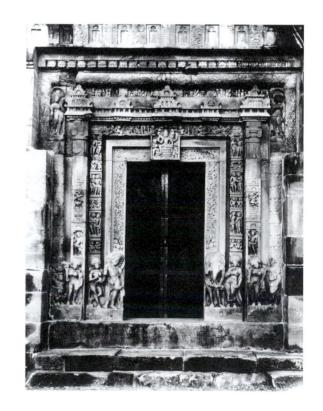

9-19 DOORWAY OF THE VISHNU TEMPLE AT DEOGARH

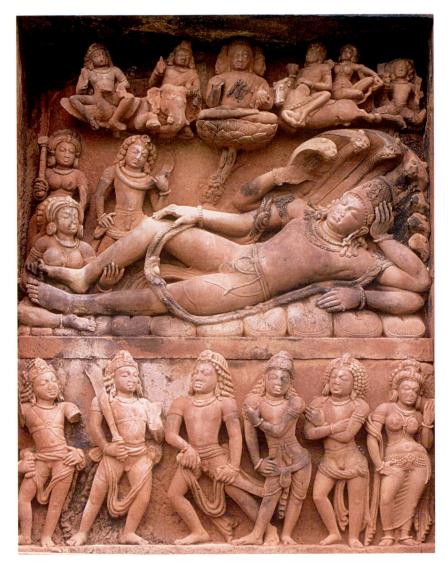

9–20 VISHNU NARAYANA
ON THE COSMIC WATERS
Relief panel in the Vishnu Temple at Deogarh.
c. 530 CE. Stone.

els thus symbolize the third phase of Vishnu's threefold emanation from Brahman, the Formless One, into our physical world. (See "Hinduism," page 318.)

One panel depicts Vishnu lying on the Cosmic Waters at the beginning of creation (FIG. 9–20). This vision represents the second stage of the deity's emanation. Vishnu sleeps on the serpent of infinity, Ananta, whose body coils endlessly into space. Stirred by his female aspect (*shakti*, or female energy), personified here by the goddess Lakshmi, seen holding his foot, Vishnu dreams the universe into existence. From his navel springs a lotus (shown in this relief behind Vishnu), and the unfolding of space-time begins. The first being to be created is Brahma (not to be confused with Brahman), who appears here as the central, four-headed figure in the row of gods portrayed above the reclining Vishnu. Brahma turns himself into the universe of space and time by thinking, "May I become Many."

The sculptor has depicted Vishnu as a large, resplendent figure with four arms. His size and his many arms connote his omnipotence. He is lightly garbed but richly ornamented. The ideal of the Gupta style persists in the smooth, perfected shape of the body and in the lavishly detailed jewelry, including Vishnu's characteristic cylindrical crown. The four rightmost figures in the frieze below personify Vishnu's powers. They stand ready to fight the appearance of evil, represented at the left of the frieze by two demons who threaten to kill Brahma and jeopardize all creation.

The birth of the universe and the appearance of evil are thus portrayed here in three clearly organized registers. Typical of Indian religious and artistic expression, these momentous events are set before our eyes not in terms of abstract symbols, but as a drama acted out by gods in superhuman form. The birth of the universe is imagined as a lotus unfolding from the navel of Vishnu.

Monumental Narrative Reliefs

The Hindu god Shiva was known in Vedic times as Rudra, "the howler." He was "the wild red hunter" who protected beasts and inhabited the forests. Shiva, which means "benign," exhibits a wide range of aspects or forms, both gentle and wild: He is the Great Yogi who dwells for vast periods of time

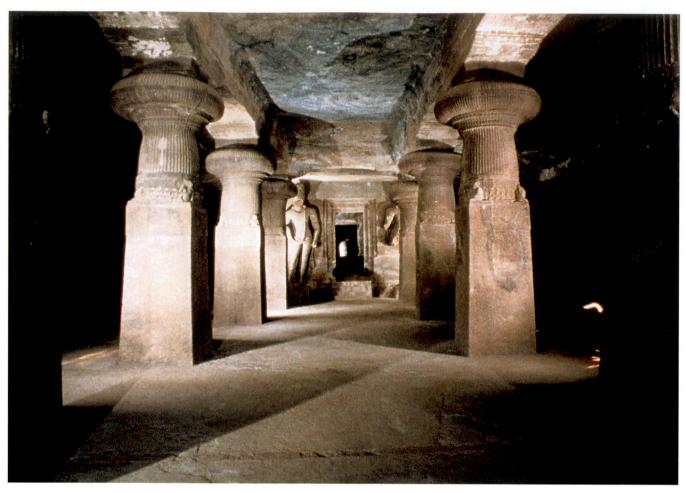

9–21 CAVE-TEMPLE OF SHIVA AT ELEPHANTA

Maharashtra, India. Post-Gupta period, mid-6th century CE. View along the east-west axis to the *lingam* shrine.

in meditation in the Himalayas; he is also the husband par excellence who makes love to the goddess Parvati for eons at a time; he is the Slayer of Demons; and he is the Cosmic Dancer who dances the destruction and re-creation of the world.

TEMPLE OF SHIVA AT ELEPHANTA. Many of these forms of Shiva appear in the monumental relief panels adorning the Cave temple of Shiva carved in the mid-sixth century on the island of Elephanta off the coast of Bombay in western India. The cave-temple is complex in layout and conception, perhaps to reflect the nature of Shiva. While most temples have one entrance, this temple offers three—one facing north, one east, and one west. The interior, impressive in its size and grandeur, is designed along two main axes, one running north-south, the other east-west. The three entrances provide the only source of light, and the resulting cross- and back-lighting effects add to the sense of the cave as a place of mysterious, almost confusing complexity.

Along the east-west axis, large pillars cut from the living rock appear to support the low ceiling and its beams, although, as with all architectural elements in a cave-temple,

they are not structural (FIG. 9-21). The pillars form orderly rows, but the rows are hard to discern within the framework of the cave shape, which is neither square nor longitudinal, but formed of overlapping mandalas that create a symmetric yet irregular space. The pillars are an important aesthetic component of the cave. Each has an unadorned, square base rising to nearly half its total height. Above is a circular column, which has a curved contour and a billowing "cushion" capital. Both column and capital are delicately fluted, adding a surprising refinement to these otherwise sturdy forms. The focus of the east-west axis is a square lingam shrine, shown here at the center of the illustration. Each of its four entrances is flanked by a pair of colossal standing guardian figures. In the center of the shrine is the lingam, the phallic symbol of Shiva. The lingam represents the presence of Shiva as the unmanifest Formless One, or Brahman. It symbolizes both his erotic nature and his aspect as the Great Yogi who controls his seed. The lingam is synonymous with Shiva and is seen in nearly every Shiva temple and shrine.

The focus of the north-south axis, in contrast, is a relief on the south wall depicting Shiva in his second stage of the

THE OBJECT SPEAKS

SHIVA NATARAJA OF THE CHOLA DYNASTY

erhaps no sculpture is more representative of Hinduism than the statues of Shiva Nataraja, or Dancing Shiva, a form perfected by sculptors under the royal patronage of the South Indian Chola dynasty in the late tenth to eleventh century. (For the architecture and painting of the period, see figs. 9-26 and 9-27.) The dance of Shiva is a dance of cosmic proportions, signifying the universe's cycle of death and rebirth; it is also a dance for each individual, signifying the liberation of the believer through Shiva's compassion. In the iconography of the Nataraja, perfected over the centuries, this sculpture shows Shiva with four arms dancing on the prostrate body of Apasmaru, a dwarf figure who symbolizes "becoming" and whom Shiva controls. Shiva's extended left hand holds a ball of fire; a circle of fire rings the god as well. The fire is emblematic of the destruction of samsara and the physical universe as well as the destruction of maya and our ego-centered perceptions. Shiva's back right hand holds a drum; its beat represents the irrevocable rhythms of creation and destruction, birth and death. His front right arm gestures the "have no fear" mudra (see "Mudras," page 325). The front left arm, gracefully stretched across his body with the hand pointing to his raised foot, signifies the promise of liberation.

The artist has rendered the complex pose with great clarity. The central axis, which aligns the nose, navel, and insole of the weight-bearing foot, maintains the figure's equilibrium while the remaining limbs asymmetrically extend far to each side. Shiva wears a short loincloth, a ribbon tied above his waist, and delicately tooled ornaments. The scant clothing reveals his perfected form with its broad shoulders tapering to a supple waist. The jewelry is restrained and the detail does not detract from the beauty of the body.

The deity does not appear selfabsorbed and introspective as he did in the Eternal Shiva relief at Elephanta (see

SHIVA NATARAJA

Thanjavur, Tamil Nadu. Chola dynasty, 12th century CE. Bronze, 32" (81.25 cm). National Museum of India, New Delhi. fig. 9-22). He turns to face the viewer, appearing lordly and aloof yet fully aware of his benevolent role as he generously displays himself for the devotee. Like the Sarnath Gupta Buddha (see fig. 9-16), the Chola Shiva Nataraja presents a characteristically Indian synthesis of the godly and the human, this time expressing the *bhakti* belief in the importance of an intimate relationship with a lordly god through whose compassion one is saved. The earlier Hindu emphasis on ritual and the depiction of the heroic feats of the gods is subsumed into the all-encompassing, humanizing factor of grace.

The fervent religious devotion of the *bhakti* movement was fueled by the sub-lime writings of a series of poet-saints who lived in the south of India. One of them, Appar, who lived from the late sixth

to mid-seventh century CE, wrote this vision of the Shiva Nataraja. The ash the poem refers to is one of many symbols associated with the deity. In penance for having lopped off one of the five heads of Brahma, the first created being, Shiva smeared his body with ashes and went about as a beggar.

If you could see
the arch of his brow,
the budding smile
on lips red as the kovvai fruit,
cool matted hair,
the milk-white ash on coral skin,
and the sweet golden foot
raised up in dance,
then even human birth on this wide earth
would become a thing worth having.

(Translated by Indira Vishvanathan Peterson)

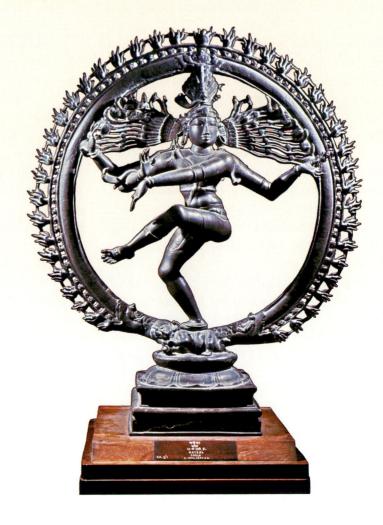

threefold emanation. A huge bust of the deity represents his Sadashiva, or Eternal Shiva, aspect (FIG. 9-22). Three heads are shown resting upon the broad shoulders of the upper body, but five heads are implied: the fourth in back and the fifth, never depicted, on top. The heads summarize Shiva's fivefold nature as creator (back), protector (left), destroyer (right), obscurer (front), and releaser (top). The head in the front depicts Shiva deep in introspection. The massiveness of the broad head, the large eyes barely delineated, and the mouth with its heavy lower lip suggest the god's serious depths. Lordly and majestic, he easily supports his huge crown, intricately carved with designs and jewels, and the matted, piled-up hair of a yogi. On his left shoulder, his protector nature is depicted as female, with curled hair and a pearl-festooned crown. On his right shoulder, his wrathful, destroyer nature wears a fierce expression, and snakes encircle his neck.

Like the relief panels at the temple to Vishnu in Deogarh (SEE FIG. 9–20), the reliefs at Elephanta are early examples of the Hindu monumental narrative tradition. Measuring 11 feet in height, they are set in recessed niches, one on either side of each of the three entrances and three on the south wall. The panels portray the range of Shiva's powers and some of his different aspects, presented in the context of narratives that help devotees understand his nature. Taken as a whole, the reliefs represent the manifestation of Shiva in our world. Indian artists often convey the many aspects or essential nature of a deity through multiple heads or arms—which they do with such convincing naturalism that we readily accept the additions. Here, for example, the artist has united three heads onto a single body so skillfully that we still relate to the statue as an essentially human presence.

The third great Hindu deity is Devi, a designation covering many deities who embody the feminine. In general, Devi represents the power of *shakti*, a divine energy understood as feminine. *Shakti* is needed to overcome the demons of our afflictions, such as ignorance and pride. Among the most widely worshiped goddesses are Lakshmi, goddess of wealth and beauty, and Durga, the warrior goddess.

DURGA RELIEF AT MAMALLAPURAM. Durga is the essence of the conquering powers of the gods. A large relief at Mamallapuram, near Madras, in southeastern India, depicts Durga in her popular form as the slayer of Mahishasura, the buffalo demon (FIG. 9–23). Triumphantly riding her lion, a symbol of her *shakti*, the eight-armed Durga battles the demon. His huge figure with its human body and buffalo head is shown lunging to the right, fleeing her onslaught as his warriors fall to the ground. Accompanied by energetic, dwarfish warriors, victorious Durga, though small, sits erect and alert, flashing her weapons. The moods of victory and defeat are clearly distinguished between the left and right sides of the panel. The

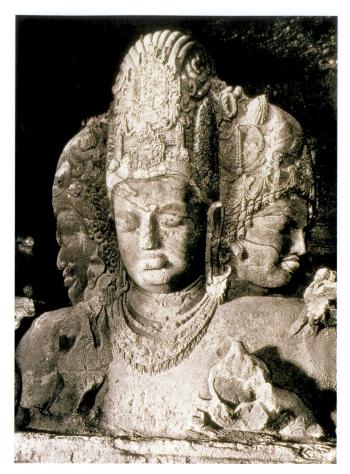

9–22 **ETERNAL SHIVA**Rock-cut relief in the Cave-Temple of Shiva at Elephanta.
Mid-6th century CE. Height approx. 11' (3.4 m).

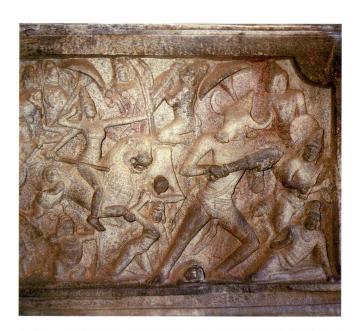

9-23 DURGA MAHISHASURA-MARDINI (DURGA AS SLAYER OF THE BUFFALO DEMON)

Rock-cut relief, Mamallapuram, Tamil Nadu, India. Pallava period, c. mid-7th century CE. Granite, height approx. 9' (2.7 m). artist clarifies the drama by focusing our attention on the two principal actors. Surrounding figures play secondary roles that support the main action, adding visual interest and variety.

Stylistically, this and other panels at Mamallapuram represent a high point of the Indian monumental relief tradition. Here, as elsewhere, the reliefs portray stories of the gods and goddesses, whose heroic deeds unfold before our eyes. Executed under the dynasty of the Pallavas, which flourished in southern India from the seventh to ninth century CE, this panel illustrates the gentle, simplified figure style characteristic of Pallava sculpture. Figures tend to be slim and elegant with little ornament, and the rhythms of line and form have a graceful, unifying, and humanizing charm.

The Early Southern Temple

The coastal city of Mamallapuram was also a major temple site under the Pallavas. Along the shore are many large granite boulders and cliffs, and from these the Pallava stonecutters carved reliefs, halls, and temples. Among the most interesting Pallava creations is a group of temples known as the Five Rathas, which preserve a sequence of early architectural styles. As with other rock-cut temples, the Five Rathas were probably carved in the style of contemporary wood or brick structures that have long since disappeared.

Dharmaraja Ratha at Mamallapuram. One of this group, the Dharmaraja Ratha, epitomizes the early southern-style temple (FIG. 9–24). Though strikingly different in appearance from the northern style, it uses the same symbolism to link the heavens and earth and it, too, is based on a mandala. The temple, square in plan, remains unfinished, and the garbhagriha usually found inside was never hollowed out. On the lower portion, only the columns and niches have been carved. The use of a single deity in each niche forecasts the main trend in temple sculpture in the centuries ahead: The tradition of narrative reliefs declined and the stories they told became concentrated in statues of individual deities, which conjure up entire mythological episodes through characteristic poses and a few symbolic objects.

Southern and northern temples are most clearly distinguished by their superstructures. The Dharmaraja Ratha does not culminate in the paraboloid of the northern *shikhara* but in a pyramidal tower called a *vimana*. Each story of the *vimana* is articulated by a **cornice** and carries a row of miniature shrines. Both shrines and cornices are decorated with a window motif from which faces peer. The shrines not only demarcate each story, but also provide loftiness for this palace for a god. Crowning the *vimana* is a dome-shaped octagonal **capstone** quite different from the *amalaka* of the northern style.

During the centuries that followed, both northern- and southern-style temples developed into complex, monumental forms, but their basic structure and symbolism remained the same as those we have seen in these simple, early examples at Deogarh and Mamallapuram.

THE TENTH THROUGH THE FOURTEENTH CENTURIES

During the tenth through the fourteenth centuries, many small kingdoms and dynasties flourished, giving rise to a number of regional styles. Some were relatively long-lived, such as the Pallavas and Cholas in the south and the Palas in the northeast. Though Buddhism remained strong in a few areas—notably under the Palas—it generally declined, while the Hindu gods Vishnu, Shiva, and the Goddess (mainly Durga) grew increasingly popular. Local kings rivaled each other in the building of temples to their favored deity, and many complicated and subtle variations of the Hindu temple emerged with astounding rapidity in different regions. By around 1000 CE the Hindu temple had reached unparalleled heights of grandeur and engineering.

The Monumental Northern Temple

The Kandariya Mahadeva, a temple dedicated to Shiva at Khajuraho, in central India, was probably built by a ruler of the Chandella dynasty in the late tenth or early eleventh

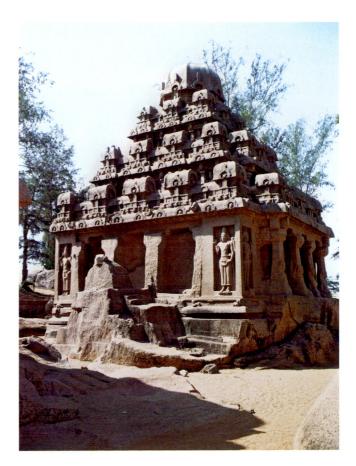

9–24 DHARMARAJA RATHA, MAMALLAPURAM
Tamil Nadu, India. Pallava period, c. mid-7th century CE.

century (FIG. 9–25). Khajuraho was the capital and main temple site for the Chandellas, who constructed more than eighty temples there, about twenty-five of which are well preserved. The Kandariya Mahadeva temple is in the northern style, with a *shikhara* rising over its *garbhagriha*. Larger, more extensively ornamented, and expanded through the addition of halls on the front and porches to the sides and back, the temple seems at first glance to have little in common with its precursor at Deogarh (SEE FIG. 9–18). Actually, however, the basic elements and their symbolism remain unchanged.

As at Deogarh, the temple rests on a stone terrace that sets off a sacred space from the mundane world. A steep flight of stairs at the front (to the right in the illustration) leads to a series of three halls (distinguished on the outside by three pyramidal roofs) preceding the *garbhagriha*. Called *mandapas*, the halls symbolize the deity's threefold emanation. They serve as spaces for ritual, such as dances performed for the deity, and for the presentation of offerings. The temple is built of stone blocks using only **post-and-lintel construction**. Because vault and arch techniques are not used, the interior spaces are not large.

The exterior has a strong sculptural presence, its massiveness suggesting a "cosmic mountain" composed of ornately carved stone. The *shikhara* rises more than 100 feet over the *garbhagriha* and is crowned by a small *amalaka*. The *shikhara* is bolstered by the many smaller *shikhara* motifs bundled around it. This decorative scheme adds a complex richness to the surface, but it also obscures the shape of the main *shikhara*, which is slender, with a swift and impetuous upward movement. The roofs of the *mandapas* contribute to the impression of rapid ascent by growing progressively taller as they near the *shikhara*.

Despite its apparent complexity, the temple has a clear structure and unified composition. The towers of the superstructure are separated from the lower portion by strong horizontal moldings and by the open spaces over the *mandapas* and porches. The moldings and rows of sculpture adorning the lower part of the temple create a horizontal emphasis that stabilizes the vertical thrust of the superstructure. Three rows of sculpture—some 600 figures—are integrated into the exterior walls. Approximately 3 feet tall and carved in high relief, the sculptures depict gods and goddesses, some in erotic postures. They are thought to express Shiva's divine bliss, the manifestation of his presence within, and the transformation of one into many.

In addition to its horizontal emphasis, the lower portion of the temple is characterized by a verticality that is created by protruding and receding elements. Their visual impact is similar to that of engaged columns and buttresses, and they account for much of the rich texture of the exterior. The porches, two on each side and one in the back, contribute to the complexity by outwardly expanding the ground plan, yet their curved bases also reinforce the sweeping vertical movements that unify the entire structure.

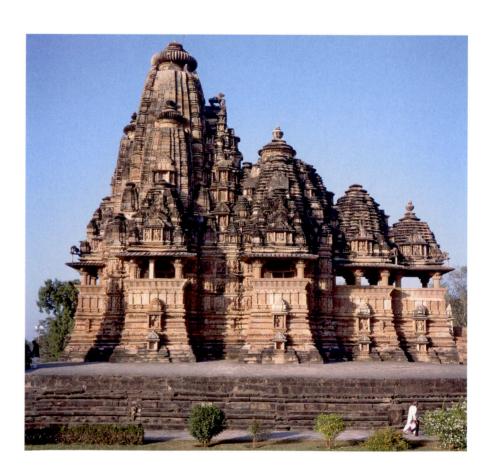

9–25 KANDARIYA MAHADEVA TEMPLE, KHAJURAHO Madhya Pradesh, India. Chandella dynasty, c. 1000 ce.

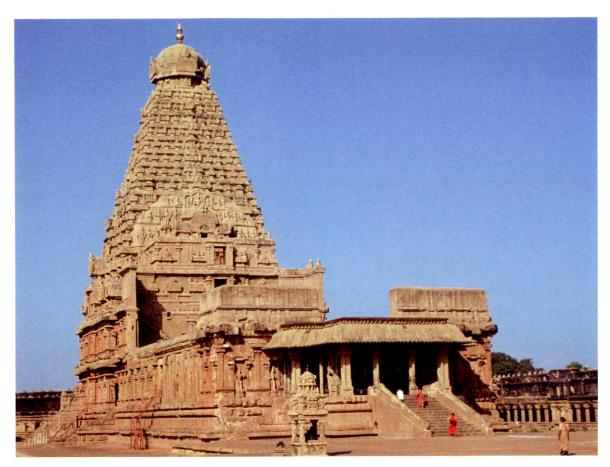

9–26 RAJARAJESHVARA TEMPLE TO SHIVA, THANJAVUR Tamil Nadu, India. Chola dynasty, 1003–10 CE.

The Monumental Southern Temple

The Cholas, who succeeded the Pallavas in the mid-ninth century, founded a dynasty that governed most of the far south well into the late thirteenth century. The Chola dynasty reached its peak during the reign of Rajaraja I (ruled 985–1014 CE). As an expression of gratitude for his many victories in battle, Rajaraja built the Rajarajeshvara Temple to Shiva in his capital, Thanjavur (present-day Tanjore). Known alternatively as the Brihadeshvara, this temple is the supreme achievement of the southern style of Hindu architecture (FIG. 9–26). It stands within a huge, walled compound near the banks of the Kaveri River. Though smaller shrines dot the compound, the Rajarajeshvara dominates the area.

Clarity of design, a formal balance of parts, and refined decor contribute to the Rajarajeshvara's majesty. Rising to an astonishing height of 216 feet, this temple was probably the tallest structure in India in its time. Like the Kandariya Mahadeva temple at Khajuraho, the Rajarajeshvara has a longitudinal axis and greatly expanded dimensions, especially with regard to its superstructure. Typical of the southern style, the *mandapa* halls at the front of the Rajarajeshvara have flat roofs, as opposed to the pyramidal roofs of the northern style.

The base of the *vimana*, which houses the *garbhagriha*, rises for two stories, with each story emphatically articulated

by a large cornice. The exterior walls are ornamented with niches, each of which holds a single statue, usually depicting a form of Shiva. The clear, regular, and wide spacing of the niches imparts a calm balance and formality to the lower portion of the temple, in marked contrast to the irregular, concave-convex rhythms of the northern style.

The *vimana* of the Rajarajeshvara is a four-sided, hollow pyramid that rises for thirteen stories. Each story is decorated with miniature shrines, window motifs, and robust dwarf figures who seem to be holding up the next story. Because these sculptural elements are not large in the overall scale of the *vimana*, they appear well integrated into the surface and do not obscure the thrusting shape. This is quite different from the effect of the small *shikhara* motifs on the *shikhara* of the Kandariya Mahadeva temple (SEE FIG. 9–25). Notice also that in the earlier southern style as embodied in the Dharmaraja Ratha (SEE FIG. 9–24), the shrines on the *vimana* were much larger in proportion to the whole and thus each appeared to be nearly as prominent as the *vimana*'s overall shape.

Because the Rajarajeshvara *vimana* is not obscured by its decorative motifs, it forcefully ascends skyward. At the top is an octagonal dome-shaped capstone similar to the one that crowned the earlier southern-style temple. This huge capstone is exactly the same size as the *garbhagriha* housed thirteen stories directly below. It thus evokes the shrine a final

time before the eye ascends to the point separating the worldly from the cosmic sphere above.

The Bhakti Movement in Art

Throughout this period, two major religious movements were developing that affected Hindu practice and its art: the tantric, or esoteric, and the *bhakti*, or devotional. Although both movements evolved throughout India, the influence of tantric sects appeared during this period primarily in the art of the north (see Chapter 23 for a discussion of their continued development), while the *bhakti* movements found artistic expression mostly in the south.

The *bhakti* devotional movement was based on ideas expressed in ancient texts, especially the *Bhagavad Gita*. *Bhakti* revolves around the ideal relationship between humans and deities. According to *bhakti*, it is the gods who create *maya*, or illusion, in which we are all trapped. They also reveal truth to those who truly love them and whose minds are open to them. Rather than focusing on ritual and the performance of *dharma* according to the Vedas, *bhakti* stresses an intimate, personal, and loving relation with god, and the complete devotion and surrender to god. Inspired and influenced by *bhakti*, southern artists produced some of India's greatest works, as revealed in the few remaining paintings and in the famous bronze works of sculpture (see "Shiva Nataraja of the Chola Dynasty" on page 331).

WALL PAINTING AT RAJARAJESHVARA TEMPLE. Rajaraja's building of the Rajarajeshvara was in part a reflection of the fervent movement of Shiva bhakti that had reached its peak by that time. The corridors of the circumambulatory passages around its garbhagriha were originally adorned with wall paintings. Overpainted later, they were only recently rediscovered. One painting apparently depicts the ruler Rajaraja himself, not as a warrior or majestic king on his throne, but as a simple mendicant humbly standing behind his religious teacher (FIG. 9-27). With his white beard and dark skin, the aged teacher contrasts with the youthful, bronze-skinned king. The position of the two suggests that the king treats the saintly teacher, who in the devotee's or bhakta's view is equated with god, with intimacy and respect. Both figures allude to their devotion to Shiva by holding a small flower as an offering, and both emulate Shiva in their appearance by wearing their hair in the "ascetic locks" of Shiva in his Great Yogi aspect.

The portrayal does not represent individuals so much as a contrast of types: the old and the youthful, the teacher and the devotee, the saint and the king—the highest religious and worldly models, respectively—united as followers of Shiva. Line is the essence of the painting. With strength and grace, the even, skillfully executed line defines the boldly simple forms and features. With less shading and fewer details, these figures are flattened, more linear versions of those in the Gupta paintings at Ajanta (SEE FIG. 9–17). A cool, sedate calm

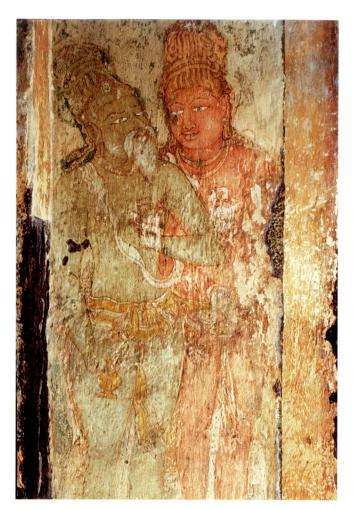

9–27 RAJARAJA I AND HIS TEACHER
Detail of a wall painting in the Rajarajeshvara Temple to
Shiva. Chola dynasty, c. 1010 CE.

infuses the monumental figures, but the power of line also invigorates them with a sense of strength and inner life.

The *bhakti* movement spread during the ensuing centuries into North India. However, during this period a new religious culture penetrated the subcontinent: Turkic, Persian, and Afghan invaders had been crossing the northwest passes into India since the tenth century, bringing with them Islam and its artistic tradition. New religious forms eventually evolved from Islam's long and complex interaction with the peoples of the subcontinent, and so too arose uniquely Indian forms of Islamic art, adding yet another dimension to India's artistic heritage.

ART OF SOUTHEAST ASIA

Trade and cultural exchange, notably by the sea routes linking China and India, brought Buddhism, Hinduism, and other aspects of India's civilization to the various regions of Southeast Asia and the Asian archipelago. Although Theravada Buddhism (see "Buddhism," page 317) had the most lasting impact in the region, other trends in Buddhism, including

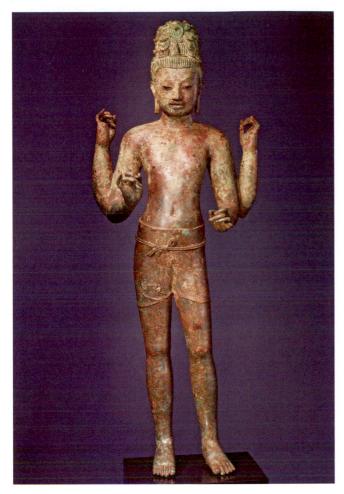

9–28 **BUDDHA MAITREYA**Buriram Province, Thailand, 8th century. Copper alloy with inlaid black glass eyes, 38" (96.5 cm). Asia Society, New York. Mr. and Mrs. John D. Rockefeller 3rd Collection, 1979.063

Mahayana and esoteric (tantric) traditions, also played a role. Elements of Hinduism, including its epic literature, were also adopted in the region.

THAILAND-PRAKHON CHAI STYLE. Even the earliest major flowering of Buddhist art in eighth- and ninth-century Southeast Asia was characterized by distinctly local interpretations of the inheritance from India. For example, a strikingly beautiful style of Buddhist sculpture in Thailand, one with distinct iconographic elements, has been identified based on the 1964 discovery of a hoard of images in an underground burial chamber in the vicinity of Prakhon Chai, Buriram Province, near the modern border with Cambodia. Distinguished by exquisite craftsmanship and a charming naturalism, enhanced by inlaid materials for the eyes, a standing figure of the Buddha Maitreya (FIG. 9-28) exemplifies the lithe and youthful proportions typical of the Prakhon Chai style. The iconography departs from the princely interpretation of the Buddha, presenting instead ascetic elements—abbreviated clothing and a loose arrangement of long hair. The esoteric (tantric) associations of these

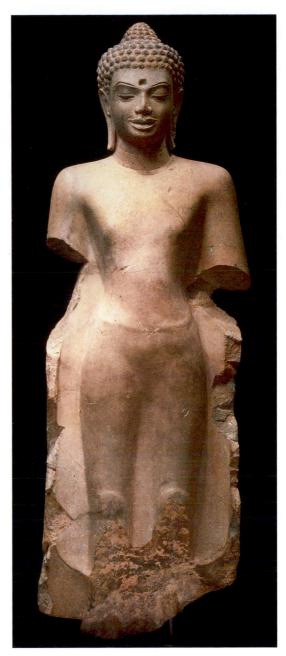

9–29 **BUDDHA SHAKYAMUNI**Mon Dvaravati period, Thailand. 9th century. Sandstone.
Norton Simon Museum, Los Angeles.

features are further emphasized by the multiple forearms, an element which was highly developed in Hindu sculpture and which came to be common in esoteric Buddhist art.

THAILAND—DVARAVATI STYLE. The Dvaravati kingdom, of Mon people, flourished in central Thailand from at least the sixth to the eleventh century. This kingdom embraced Theravada Buddhism and produced some of the earliest Buddhist images in Southeast Asia, based on pre-Gupta period Indian models. During the later centuries, Dvaravati sculptors restated elements of the Gupta style (SEE FIG. 9–16), and introduced Mon characteristics into classical forms inherited from India (FIG. 9–29).

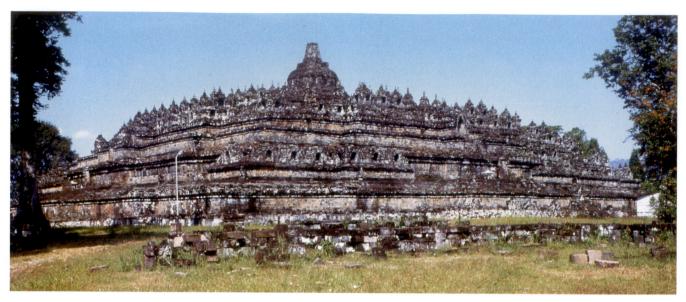

9–30 BOROBUDUR Central Java, Indonesia. c. 800 CE.

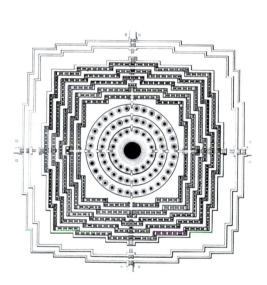

9-31 PLAN OF BOROBUDUR

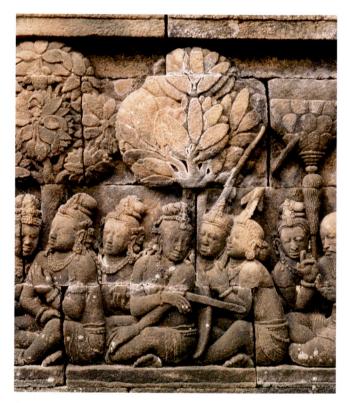

9–32 **COURTLY ATTENDANTS**Detail of a narrative relief sculpture, Borobudur.

JAVA—BOROBUDUR. The most monumental of Buddhist sites in Southeast Asia is Borobudur (FIGS. 9–30, 9–31) in central Java, an island of Indonesia. Built about 800 CE and rising more than 100 feet from ground level, this stepped pyramid of volcanic-stone blocks is surmounted by a large stupa, itself ringed by seventy-two smaller openwork stupas. Probably commissioned to celebrate the Buddhist merit of the Shailendra rulers, the monument expresses a complex range of Mahayana symbolism, incorporating earthly and cosmic

realms. Jataka tales and other Buddhist themes are elaborately narrated in the reliefs of the lower galleries (FIG. 9–32), and more than 500 sculptures of transcendental Buddhas on the balustrades and upper terraces complete the monument, conceived as a *mandala* in three dimensions (SEE FIG. 9–32).

CAMBODIA—ANGKOR VAT. In Cambodia (Kampuchea), Khmer kings ruled at Angkor more than four hundred years from the ninth to the thirteenth century. Among the state

temples, Buddhist as well as Hindu, they built Angkor Vat (FIG. 9-33), the crowning achievement of Khmer architecture. Angkor had already been the site of royal capitals of the Khmer, who had for centuries vested temporal as well as spiritual authority in their kings, long before King Suryavarman II (ruled 1113-1150) began to build the royal complex known today as Angkor Vat. Dedicated to the worship of Vishnu, the vast array of structures is both a temple and a symbolic cosmic mountain. The complex incorporates a stepped pyramid with five towers set within four enclosures of increasing perimeter. Suryavarman's predecessors had associated themselves with Hindu and Buddhist deities at Angkor by building sacred structures. His construction pairs him with Vishnu to affirm his royal status as well as his ultimate destiny of union with the Hindu god. Low-relief sculptures illustrate scenes from the Ramayana, the Mahabharata, and other Hindu texts, and also depict Suryavarman II with his armies (FIG. 9–34).

SRI LANKA. Often considered a link to Southeast Asia, the island of Sri Lanka is so close to India's southeastern coast that Ashoka's son is said to have brought Buddhism there within his father's lifetime. Sri Lanka played a major role in the strengthening of Theravada traditions, especially by pre-

Sequencing Works of Art

c. 800 CE Borobudur, Central Java, Indonesia

1003–10 CE Rajarajeshvara Temple to

Shiva, Thanjavur, India

11th-12th century CE Parinirvana of the Buddha,

Gal Vihara, Sri Lanka

12th century CE Angkor Vat, Angkor,

Cambodia

serving scriptures and relics, and it became a focal point for the Theravada Buddhist world. Sri Lankan sculptors further refined Indian styles and iconography in colossal Buddhist sculptures. The rock-cut Parinirvana of the Buddha at Gal Vihara (FIG. 9–35) is one of three colossal Buddhas at the site. This serene and dignified image restates one of the early themes of Buddhist art, that of the Buddha's final transcendence, with a sophistication of modeling and proportion that updates and localizes the classical Buddhist tradition.

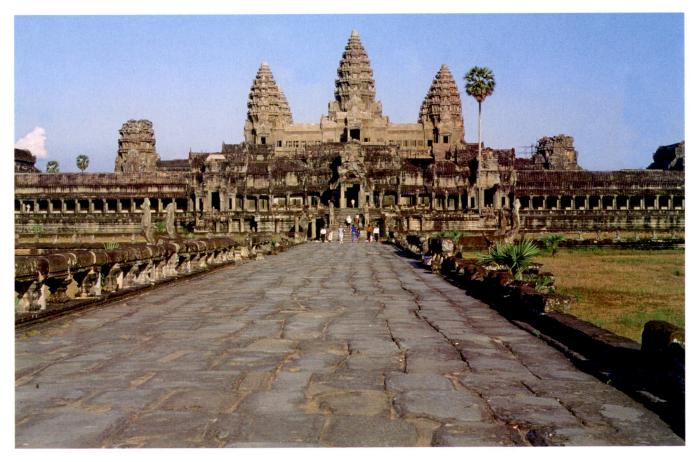

9–33 ANGKOR VAT Angkor, Cambodia. 12th century.

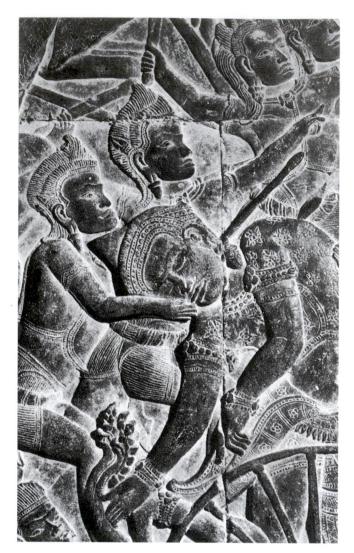

BATTLE SCENE 9 - 34Detail of relief sculpture, Angkor Vat.

IN PERSPECTIVE

The earliest civilization of South Asia arose in the Indus River valley. Like contemporaneous early civilizations in the Aegean, Mesopotamia, and Egypt, this civilization is remarkable for its sophisticated town planning, advanced architectural monuments, and means of record keeping, using seals and a written language. Its distinctive pictorial and sculptural representation established a strong precedent for later Indian art, both in its sensitivity to modeling of the human form and in its symbolic representation of supernatural motifs.

The subsequent rise of Buddhism in India gave Asia a rich pictorial and sculptural tradition. The narratives of the Buddha's life and his previous incarnations provided a major theme for art throughout East Asia and Southeast Asia. The anthropomorphic image of the Buddha himself, which first appeared in the Indian subcontinent during the early centuries of the Common Era, gave expressive form for the veneration of an earthly teacher and served as the basis for the celestial Buddhas envisioned by Mahayana Buddhists everywhere.

The rise of Hinduism surpassed the Buddhist tradition in South Asia. Hindu monuments explored a divine geometry in multitiered roofs and sequenced entrances. Sculptures of Hindu deities combined heroic, superhuman physical attributes with humane grace. Exquisite in proportion and supple in their dancelike poses, these painted and sculpted Hindu divinities set a style that remains classical today.

Southeast Asian art generally expressed the ideals of Theravada Buddhism. Strong traces of a concept of divine kingship were also made manifest by ambitious ruler-patrons, especially in Cambodia and Indonesia, and their influence may still be seen in later centuries. Within that tradition, elements of the sculptural styles originating in India were developed into Southeast Asian works of sublime beauty.

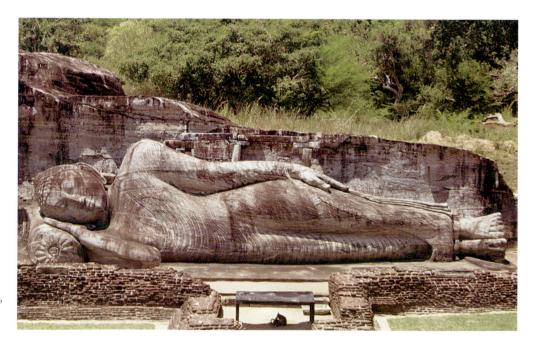

9 - 35PARINIRVANA OF THE BUDDHA Gal Vihara, near Polonnaruwa,

Sri Lanka, 11th-12th century. Stone.

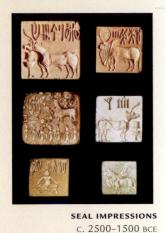

YAKSHI HOLDING A FLY-WHISK
C. 250 BCE

GREAT STUPA, SANCHI C. 150–50 BCE

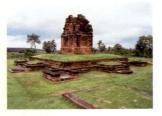

VISHNU TEMPLE AT DEOGARHC. 530 CE

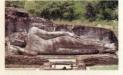

PARINIRVANA OF
THE BUDDHA
11TH–12TH CENTURY CE

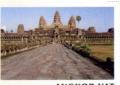

ANGKOR VAT 12TH CENTURY CE

1000

ART OF SOUTH AND SOUTHEAST ASIA BEFORE 1200

- Indus Valley Civilization
 c. 2600–1900 BCE
- ✓ Vedic Period c. 1750–322 BCE
- Shakyamuni Buddha c. 563-483 BCE
- Maurya c. 322–185 BCE
- Shunga 185 BCE-50 CE
- Early Andhra 185 BCE-50 CE
- Kushan 1st century-3rd century CE
- Later Andhra c. 30 BCE-433 CE
- **⋖ Gupta** c. 320–480 CE
- Dvaravati Kingdom
 6th century-11th century CE

- Khmer Rule at Angkor 9th century-13th century CE
- Chola Dynasty
 Mid-9th century-late 13th century CE

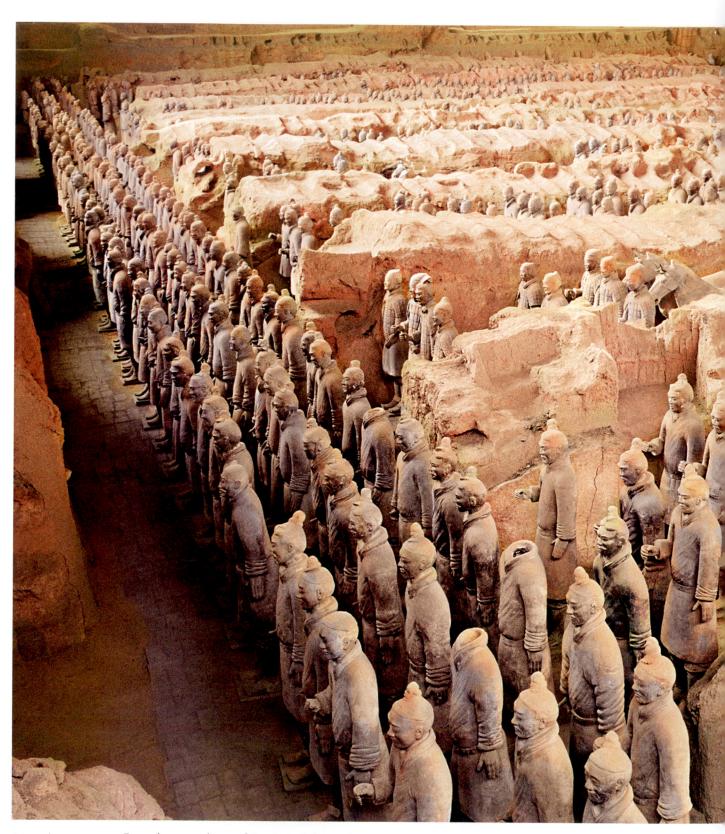

IO—I | **SOLDIERS** From the mausoleum of Emperor Shihuangdi, Lintong, Shaanxi. Qin dynasty, c. 210 BCE. Earthenware, life-size.

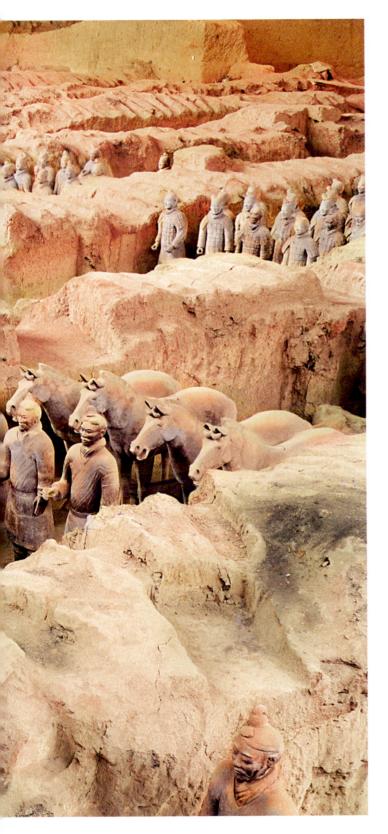

CHAPTER TEN

CHINESE AND KOREAN ART BEFORE 1279

10

As long as anyone could remember, the huge mound in China's Shaanxi province in northern China had been part of the landscape. No one

dreamed that an astonishing treasure lay beneath the surface until one day in 1974 when peasants digging a well accidentally brought to light the first hint of the riches. When archaeologists began to excavate the mound, they were stunned by what they found: a vast underground army of more than 7,000 life-size terra-cotta soldiers and horses standing in military formation, facing east, ready for battle (FIG. 10–1). Originally painted in vivid colors, they emerged from the earth a ghostly gray. For more than 2,000 years, while the tumultuous history of China unfolded overhead, they had guarded the tomb of Emperor Shihuangdi, the ruthless ruler who first united the states of China into an empire, the Qin dynasty.

In 1990, a road-building crew in central China accidentally uncovered an even richer vault, containing perhaps tens of thousands of terra-cotta figures. Although excavations there are barely under way, the artifacts so far uncovered are exceptional both in artistic quality and in what they tell us about life—and death—during the Han dynasty, which is about 100 years later than the Qin dynasty.

China has had a long-standing traditional interest in and respect for antiquity, but archaeology is a relatively young discipline there. Only since the 1920s have scholars methodically dug into the layers of history that lie buried at thousands of sites across the country. Yet in that short period so much has been unearthed that ancient Chinese history has been rewritten many times.

CHAPTER-AT-A-GLANCE

- THE MIDDLE KINGDOM
- NEOLITHIC CULTURES | Painted Pottery Cultures | Liangzhu Culture
- BRONZE AGE CHINA Shang Dynasty Zhou Dynasty
- THE CHINESE EMPIRE: OIN DYNASTY
- HAN DYNASTY Philosophy and Art Architecture
- SIX DYNASTIES | Painting | Calligraphy | Buddhist Art and Architecture
- SUI AND TANG DYNASTIES | Buddhist Art and Architecture | Figure Painting
- SONG DYNASTY | Philosophy: Neo-Confucianism | Northern Song Painting | Southern Song Painting and Ceramics
- **THE ARTS OF KOREA** | The Three Kingdoms Period | The Unified Silla Period | Goryeo Dynasty
- IN PERSPECTIVE

THE MIDDLE KINGDOM

Among the cultures of the world, China is distinguished by its long, uninterrupted development, now traced back some 8,000 years. From Qin, pronounced "chin," comes our name for the country that the Chinese call the Middle Kingdom, the country in the center of the world. Present-day China occupies a large landmass in the center of Asia, covering an area slightly larger than the continental United States. Within its borders lives one-fifth of the human race.

The historical and cultural heart of China—sometimes called Inner China—is the land watered by its three great rivers, the Yellow, the Yangzi, and the Xi (MAP 10-1). The Qinling Mountains divide Inner China into north and south, regions with strikingly different climates, cultures, and historical fates. In the south, the Yangzi River flows through lush green hills to the fertile plains of the delta. Along the southern coastline, rich with natural harbors, arose China's port cities, the focus of a vast maritime trading network. The Yellow River, nicknamed "China's Sorrow" because of its disastrous floods, winds through the north. The north country is a dry land of steppe and desert, hot in the summer and lashed by cold winds in the winter. Over its vast and vulnerable frontier have come the nomadic invaders that are a recurring theme in Chinese history, but caravans and emissaries from Central Asia, India, Persia, and, eventually, Europe also crossed this border.

NEOLITHIC CULTURES

Early archaeological evidence had led scholars to believe that agriculture, the cornerstone technology of the Neolithic

period, made its way to China from the ancient Near East. More recent findings, however, suggest that agriculture based on rice and millet arose independently in East Asia before 5000 BCE and that knowledge of Near Eastern grains followed some 2,000 years later. One of the clearest archaeological signs of Neolithic culture in China is evidence of the vigorous emergence of towns and cities. At Jiangzhai, near modern Xi'an, for example, the foundations of more than 100 dwellings have been discovered surrounding the remains of a community center, a cemetery, and a kiln. Dated to about 4000 BCE, the ruins point to the existence of a highly developed early society. Elsewhere in China, the foundations of the earliest known palace have been uncovered and dated to about 2000 BCE.

Painted Pottery Cultures

In China, as in other places, distinctive forms of Neolithic pottery identify different cultures. One of the most interesting objects thus far recovered is a shallow red bowl with a turned-out rim (FIG. 10–2). Found in the village of Banpo near the Yellow River, it was crafted sometime between 5000 and 4000 BCE. The bowl is an artifact of the Yangshao culture, one of the most important of the so-called Painted Pottery cultures of Neolithic China. Although the potter's wheel had not yet been developed, the bowl is perfectly round and its surfaces are highly polished, bearing witness to a distinctly advanced technology. The decorations are especially intriguing. The marks on the rim may be evidence of the beginnings of writing in China, which was fully developed by the time the first definitive examples appear during the second millennium BCE, in the later Bronze Age.

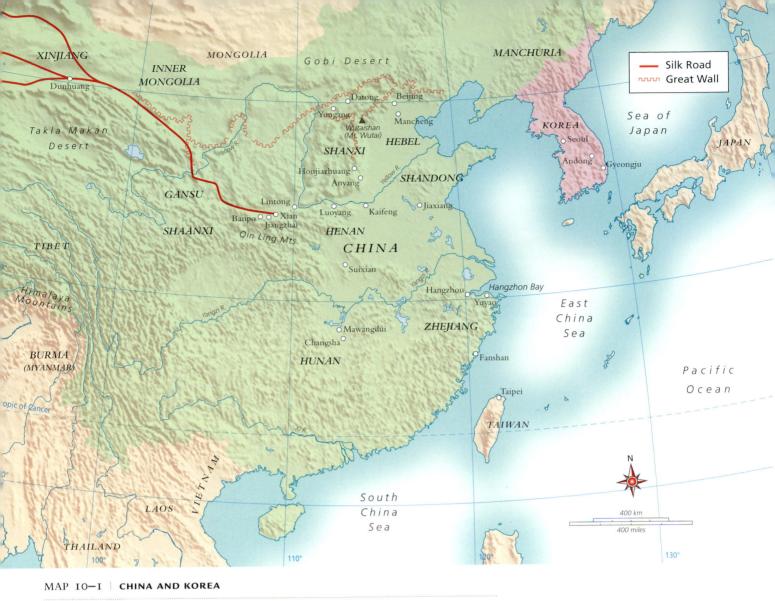

The heart of China is crossed by three great rivers—the Yellow, Yangzi, and Xi—and is divided into northern and southern regions by the Qinling Mountains.

IO-2 | BOWL Banpo, near Xi'an, Shaanxi. Neolithic period, Yangshao culture, 5000-4000 BCE. Painted pottery, height 7" (17.8 cm). Banpo Museum.

Inside the bowl, a pair of stylized fish suggests that fishing was an important activity for the villagers. The image between the two fish represents a human face with four more fish, one on each side. Although there is no certain interpretation of the image, it may be a depiction of an ancestral figure who could assure an abundant catch, for the worship of ancestors and nature spirits was a fundamental element of later Chinese beliefs.

Liangzhu Culture

Banpo lies near the great bend in the Yellow River, in the area traditionally regarded as the cradle of Chinese civilization, but archaeological finds have revealed that Neolithic cultures arose over a far broader area. Recent excavations in sites more than 800 miles away, near the Hangzhou Bay, in the southeastern coastal region, have turned up half-human, half-animal images more than 5,000 years old (FIG. 10–3). Large, round eyes, a flat nose, and a rectangular mouth protrude

IO-3 | IMAGE OF A DEITY Detail from a cong (SEE FIG. 10-4 for schematic of a complete cong) recovered from Tomb 12, Fanshan, Yuyao, Zhejiang. Neolithic period, Liangzhu culture, before 3000 BCE. Jade, $3\frac{1}{2} \times 6\frac{1}{8}$ " (8.8 \times 17.5 cm). Zhejiang Provincial Museum, Hangzhou.

slightly from the background pattern of wirelike lines. Above the forehead, a second, smaller face grimaces from under a huge headdress. The image is one of eight that were carved in low relief on the outside of a large jade cong, an object resembling a cylindrical tube encased in a rectangular block (FIG. 10–4). This cong must have been an object of importance, for it was found near the head of a person buried in a large tomb at the top of a mound that served as an altar. Hundreds of jade objects have been recovered from this mound, which measures about 66 feet square and rises in three levels.

10-4 SCHEMATIC DRAWING OF A CONG

The cong is one of the most prevalent and mysterious of early Chinese jade shapes. Originating in the Neolithic era, it continued to play a prominent role in burials through the Shang and Zhou dynasties. Many scholars believe that the cong was connected with the practice of contacting the spirit world. They suggest that the circle symbolized heaven; the square, earth; and the hollow, the axis connecting these two realms. The animals found carved on many cong may have portrayed the priest's helpers or alter egos.

The intricacy of the carving shows the technical sophistication of this jade-working culture, named the Liangzhu, which seems to have emerged around 3300 BCE. Jade, a stone cherished by the Chinese throughout their history, is extremely hard and is difficult to carve. Liangzhu artists must have used sand as an abrasive to slowly grind the stone down, but we can only wonder at how they produced such fine work.

The meaning of the masklike image is open to interpretation. Its combination of human and animal features seems to show how the ancient Chinese imagined supernatural beings, either deities or dead ancestors. Similar masks later formed the primary decorative motif of Bronze Age ritual objects. Still later, Chinese historians began referring to the ancient mask motif as taotie, but the motif's original meaning had already been lost. The jade carving here seems to be a forerunner of this most central and mysterious image. This would suggest that, despite origins miles apart, various separate Neolithic cultures merged to form a single civilization in China.

BRONZE AGE CHINA

China entered its Bronze Age in the second millennium BCE. As with agriculture, scholars at first theorized that the technology had been imported from the Near East. Archaeological evidence now makes clear, however, that bronze casting using the **piece-mold casting** technique arose independently in China, where it attained an unparalleled level of excellence (see "Piece-Mold Casting," page 347).

Shang Dynasty

Traditional Chinese histories tell of three Bronze Age dynasties: the Xia, the Shang, and the Zhou. Modern scholars had tended to dismiss the Xia and Shang as legendary, but twentieth-century archaeological discoveries fully established the historical existence of the Shang (c. 1700–1100 BCE) and point strongly to the historical existence of the Xia as well.

Shang kings ruled from a succession of capitals in the Yellow River Valley, where archaeologists have found walled cities, palaces, and vast royal tombs. Their state was surrounded by numerous other states—some rivals, others clients—and their culture spread widely. Society seems to have been highly stratified, with a ruling group that had the bronze technology needed to make weapons. They maintained their authority in part by claiming power as intermediaries between the supernatural and human realms. The chief Shang deity, Shangdi, may have been a sort of "Great Ancestor." Nature and fertility spirits were also honored, and regular sacrifices were believed necessary to keep the spirits of dead ancestors alive so that they might help the living.

Shang priests communicated with the supernatural world through **oracle** bones. An animal bone or piece of tortoiseshell was inscribed with a question and heated until it cracked, then the crack was interpreted as an answer. Oracle

Technique

PIECE-MOLD CASTING

he early **piece-mold** technique for bronze casting is different from the **lost-wax** process developed in the ancient Mediterranean and Near East. Although we do not know the exact steps ancient Chinese artists followed, we can deduce the general procedure for casting a simple vessel.

First, a model of the bronze-to-be was made of clay and dried. Then, to create a mold, damp clay was pressed onto the model; after the clay mold dried, it was cut away in pieces, which were keyed for later reassembly and then fired. The original model itself was shaved down to serve as the core for the mold. After this, the pieces of the mold were reassembled around the core and held in place by bronze spacers, which

locked the core in position and ensured an even casting space around the core. The reassembled mold was then covered with another layer of clay, and a sprue, or pouring duct, was cut into the clay to receive the molten metal. A riser duct may also have been cut to allow the hot gases to escape. Molten bronze was then poured into the mold. When the metal cooled, the mold was broken apart to reveal a bronze copy of the original clay model. Finely cast relief decoration could be worked into the model or carved into the sectional molds, or both. Finally, the vessel could be burnished—a long process that involved scouring the surface with increasingly fine abrasives.

bones, many of which have been recovered and deciphered, contain the earliest known form of Chinese writing, a script fully recognizable as the ancestor of the system still in use today (see "Chinese Characters," page 348).

RITUAL BRONZES. Shang tombs reveal a warrior culture of great splendor and violence. Many humans and animals were sacrificed to accompany the deceased. In one tomb, for example, chariots were found with the skeletons of their horses and drivers; in another, dozens of human skeletons lined the approaches to the central burial chamber. The tombs contain hundreds of jade, ivory, and lacquer objects, gold and silver ornaments, and bronze vessels. The enormous scale of Shang burials illustrates the great wealth of the civilization and the power of a ruling class able to consign such great quantities of treasure to the earth, as well as this culture's reverence for the dead.

Bronze vessels are the most admired and studied of Shang artifacts. Like oracle bones and jade objects, they were connected with ritual practices, serving as containers for offerings of food and wine. A basic repertoire of about thirty shapes evolved. Some shapes clearly derive from earlier pottery forms, others seem to reproduce wooden containers, while still others are purely sculptural and take the form of fantastic composite animals.

The illustrated bronze **FANG DING**, a square vessel with four legs, is one of hundreds of vessels recovered from the royal tombs near the last of the Shang capitals, Yin, present-day Anyang (FIG. 10–5). Weighing more than 240 pounds, it is one of the largest Shang bronzes ever recovered. In typical Shang style, its surface is decorated with a complex array of images based on animal forms. The *taotie*, usually so prominent, does not appear. Instead, a large deer's head adorns the center of each side, and images of deer are repeated on each

of the four legs. The rest of the surface is filled with images resembling birds, dragons, and other fantastic creatures. Such images seem to be related to the hunting life of the Shang, but their deeper significance is unknown. Sometimes strange, sometimes fearsome, Shang creatures seem always to have a sense of mystery, evoking the Shang attitude toward the supernatural world.

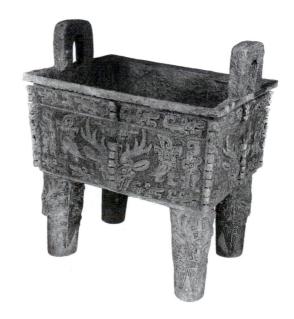

IO-5 | FANG DING Tomb 1004, Houjiazhuang, Anyang, Henan. Shang dynasty, Anyang period, c. 12th century BCE. Bronze, height 24½" (62.2 cm). Academia Sinica, Taipei, Taiwan.

Art and Its Context CHINESE CHARACTERS

ach word in Chinese is represented by its own unique symbol, called a character. Some characters originated as **pictographs**, images that mean what they depict. Writing reforms over the centuries have often disguised the resemblance, but if we place modern characters next to their oracle-bone ancestors, the picture comes back into focus:

Other characters are **ideographs**, pictures that represent abstract concepts or ideas:

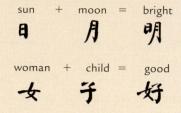

which gives the field of meaning, with a phonetic, which originally hinted at pronunciation. For example, words that have to do with water have the character for "water" abbreviated to three strokes as their radical. Thus "to bathe," pronounced mu, consists of the water radical and the phonetic , which by itself means "tree" and is also pronounced mu. Here are other "water" characters. Notice that the connection to water is not always literal.

Most characters were formed by combining a radical,

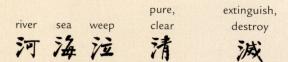

These phonetic borrowings took place centuries ago. Many words have shifted in pronunciation, and for this and other reasons there is no way to tell how a character is pronounced or what it means just by looking at it. While at first this may seem like a disadvantage, in the case of Chinese it is actually a strength. Spoken Chinese has many dialects. Some are so far apart in sound as to be virtually different languages. But while speakers of different dialects cannot understand each other, they can still communicate through writing, for no matter how they say a word, they write it with the same character. Writing has thus played an important role in maintaining the unity of Chinese civilization through the centuries.

Zhou Dynasty

Around 1100 BCE, the Shang were conquered by the Zhou from western China. During the Zhou dynasty (1100–221 BCE) a feudal society developed, with nobles related to the king ruling over numerous small states. (Zhou nobility are customarily ranked in English by such titles as duke and marquis.) The supreme deity became known as Tian, or Heaven, and the king ruled as the Son of Heaven. Later Chinese ruling dynasties continued to follow the belief that imperial rule emanated from a mandate from Heaven.

The first 300 years of this longest Chinese dynasty were generally stable and peaceful. In 771 BCE, however, the Zhou suffered defeat at the hands of a nomadic tribe in the west. Although they quickly established a new capital to the east, their authority had been crippled, and the later Eastern Zhou period was a troubled one. States grew increasingly independent, giving the Zhou kings merely nominal allegiance. Smaller states were swallowed up by their larger neighbors. During the time historians call the Spring and Autumn period (722–481 BCE), ten or twelve states, later reduced to seven, emerged as powers. During the ensuing Warring States period (481–221 BCE), intrigue, treachery, and increasingly ruthless warfare became routine.

Against this background of constant social turmoil, China's great philosophers arose—such thinkers as Confucius, Laozi, and Mozi. Traditional histories speak of China's "one hundred schools" of philosophy, indicating a shift of focus from the supernatural to the human world. Nevertheless, elaborate burials on an even larger scale than before reflected the continuation of traditional beliefs.

BRONZE BELLS. Ritual bronze objects continued to play an important role during the Zhou dynasty, and new forms developed. One of the most spectacular recent discoveries is a carillon of sixty-five bronze bells arranged in a formation 25 feet long (FIG. 10–6), found in the tomb of Marquis Yi of the state of Zeng. Each bell is precisely calibrated to sound two tones—one when struck at the center, another when struck nearer the rim. The bells are arranged in scale patterns in a variety of registers, and several musicians would have moved around the carillon, striking the bells in the appointed order.

Music may well have played a part in rituals for communicating with the supernatural, for the *taotie* typically appears on the front and back of each bell. The image is now much more intricate and stylized, partly in response to the refinement available with the **lost-wax casting** process (see "Lost-Wax Casting," page xxx), which had replaced the older piece-mold technique. On the coffin of the marquis are painted guardian warriors with half-human, half-animal attributes. The marquis, who died in 433 BCE, must have been a great lover of music, for among the more than 15,000 objects recovered from his tomb were many musical instruments.

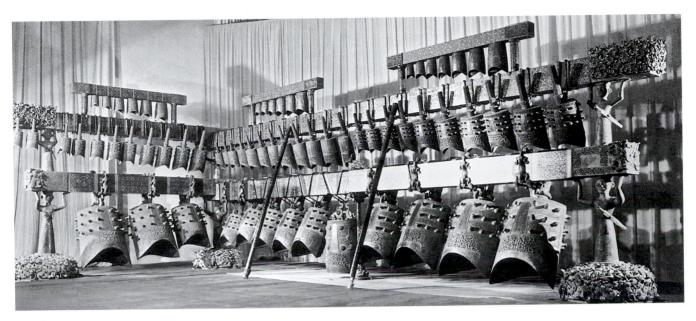

10-6 | SET OF SIXTY-FIVE BELLS

Tomb of Marquis Yi of Zeng, Suixian, Hubei. Zhou dynasty, 433 BCE. Bronze, with bronze and timber frame, frame height 9' (2.74 m), length 25' (7.62 m). Hubei Provincial Museum, Wuhan.

Zeng was one of the smallest and shortest-lived states of the Eastern Zhou, but the contents of this tomb, in quantity and quality, attest to the high level of its culture.

THE CHINESE EMPIRE: QIN DYNASTY

Toward the middle of the third century BCE, the state of Qin launched military campaigns that led to its triumph over the other states by 221 BCE. For the first time in its history, China was united under a single ruler. This first emperor of Qin, Shihuangdi, a man of exceptional ability, power, and ruthlessness, was fearful of both assassination and rebellion. Throughout his life, he sought ways to attain immortality. Even before uniting China, he began his own mausoleum at Lintong, in Shaanxi province. This project continued throughout his life and after his death, until rebellion abruptly ended the dynasty in 206 BCE. Since that time, the mound over the mausoleum has always been visible, but not until an accidental discovery in 1974 was its army of terra-cotta soldiers and horses even imagined (SEE FIG. 10-1). Modeled from clay and then fired, the figures claim a prominent place in the great tradition of Chinese ceramic art. Individualized faces and meticulously rendered uniforms and armor demonstrate the sculptors' skill. Literary sources suggest that the tomb itself, which has not yet been opened, reproduces the world as it was known to the Qin, with stars overhead and rivers and mountains below. Thus did the tomb's architects try literally to ensure that the underworld—the world of souls and spirits—would match the human world.

Qin rule was harsh and repressive. Laws were based on a totalitarian philosophy called legalism, and all other philoso-

phies were banned, their scholars executed, and their books burned. Yet the Qin also established the mechanisms of centralized bureaucracy that molded China both politically and culturally into a single entity. Under the Qin, the country was divided into provinces and prefectures, the writing system and coinage were standardized, roads were built to link different parts of the country with the capital, and battlements on the northern frontier were connected to form the Great Wall. China's rulers to the present day have followed the administrative framework first laid down by the Qin.

HAN DYNASTY

The commander who overthrew the Qin became the next emperor and founded the Han dynasty (206 BCE–220 CE). During this period the Chinese enjoyed a peaceful, prosperous, and stable life. Borders were extended and secured, and Chinese control over strategic stretches of Central Asia led to the opening of the Silk Road, a land route that linked China by trade all the way to Rome. One of the precious goods traded, along with spices, was silk, which had been cultivated and woven in China since at least the third millennium BCE. From as early as the third century BCE, Chinese silk cloth was treasured in Greece and Rome (for more on this topic, see "The Silk Road during the Tang Period," page 350).

PAINTED BANNER FROM CHANGSHA. The early Han dynasty marks the twilight of China's so-called mythocentric age, when people believed in a close relationship between the human and supernatural worlds. The most elaborate and most intact painting that survives from this time is a T-shaped silk

THE OBJECT SPEAKS

THE SILK ROAD DURING THE TANG PERIOD

nder a series of ambitious and forceful Tang emperors, Chinese control once again extended over Central Asia. Goods, ideas, and influence flowed across the Silk Road. In the South China Sea, Arab and Persian ships carried on a lively trade with coastal cities. Chinese cultural influence in East Asia was so important that Japan and Korea sent thousands of students to study Chinese civilization.

Cosmopolitan and tolerant, Tang China was confident and curious about the world. Many foreigners came to the splendid new capital Chang'an (presentday Xi'an), and they are often depicted in the art of the period. A ceramic statue of a camel carrying a troupe of musicians reflects the Tang fascination with the "exotic" Turkic cultures of Central Asia. The three bearded musicians (one with his back to us) are Central Asian, while the two smooth-shaven ones are Han Chinese. Bactrian, or two-humped camels, themselves exotic Central Asian "visitors," were beasts of burden in the caravans that traversed the Silk Road. The stringed lute (which the Chinese called the pipa) came from Central Asia to become a lasting part of Chinese music.

Stylistically, the statue reveals a new interest in naturalism, an important trend in both painting and sculpture. Compared with the rigid, staring ceramic soldiers of the first emperor of Qin, this Tang band is alive with gesture and expression. The majestic camel throws its head back; the musicians are vividly captured in midperformance. Ceramic figurines such as this, produced by the thousands for Tang tombs, offer glimpses into the gorgeous variety of Tang life. The statue's threecolor glaze technique was a specialty of Tang ceramicists. The glazes-usually chosen from a restricted palette of amber, yellow, green, and white-were splashed freely and allowed to run over the surface during firing to convey a feeling of spontaneity. The technique is emblematic of Tang culture itself in its robust, colorful, and cosmopolitan expressiveness.

The Silk Road had first flourished in the second century CE. A 5,000-mile network of caravan routes from the Han capital near present-day Luoyang, Henan, on

the Yellow River to Rome, it brought Chinese luxury goods to Western markets.

The journey began at the Jade Gate (Yumen), at the westernmost end of the Great Wall, where Chinese merchants turned their goods over to Central Asian traders. Goods would change hands many more times before reaching the Mediterranean. Caravans headed first for the nearby desert oasis of Dunhuang. Here northern and southern routes diverged to skirt the vast Taklamakan Desert. At Khotan, in western China, farther west than the area shown in map 10–1,

travelers on the southern route could turn off toward a mountain pass into Kashmir, in northern India. Or they could continue on, meeting up with the northern route at Kashgar, on the western border of the Taklamakan, before proceeding over the Pamir Mountains into present-day Afghanistan. There, travelers could turn off into present-day Pakistan and India, or travel west through present-day Uzbekistan, Iran, and Iraq, arriving finally at Antioch, in Syria, on the coast of the Mediterranean. From there, land and sea routes led on to Rome.

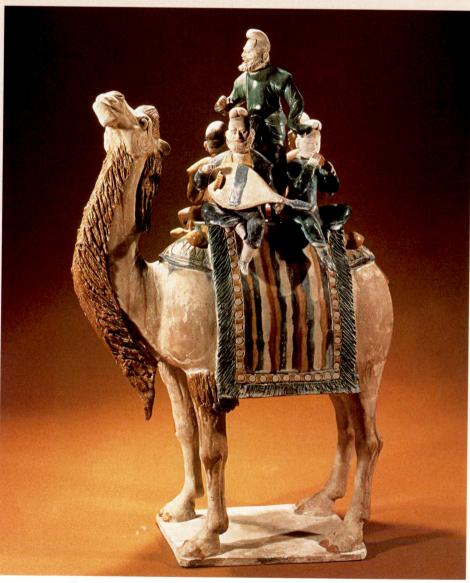

CAMEL CARRYING A GROUP OF MUSICIANS

Tomb near Xi'an, Shanxi. Tang dynasty, c. mid-8th century CE. Earthenware with three-color glaze, height 26½" (66.5 cm). National Museum, Beijing.

banner, which summarizes this early worldview (FIG. 10–7). Found in the tomb of a noblewoman on the outskirts of present-day Changsha, the banner dates from the second century BCE and is painted with scenes representing three levels of the universe: heaven, earth, and underworld.

The heavenly realm is shown at the top, in the crossbar of the T. In the upper-right corner is the sun, inhabited by a mythical crow; in the upper left, a mythical toad stands on a crescent moon. Between them is a primordial deity shown as a man with a long serpent's tail—a Han image of the Great Ancestor. Dragons and other celestial creatures swarm below.

A gate guarded by two seated figures stands where the horizontal of heaven meets the banner's long, vertical stem.

10–7 | PAINTED BANNER
Tomb of the Marquess of Dai, Mawangdui, Changsha, Hunan.
Han dynasty, c. 160 BCE. Colors on silk, height 6'8½" (2.05 m).
National Museum, Beijing.

Sequencing Events CHINESE DYNASTIES TO 1279 CE

с. 1700-1100 все	Shang Dynasty
1100-221 BCE	Zhou Dynasty
221-206 все	Qin Dynasty
206 BCE-220 CE	Han Dynasty
265-589 CE	Six Dynasties Period
581-618 CE	Sui Dynasty
618-907 CE	Tang Dynasty
960-1279 CE	Song Dynasty

Two intertwined dragons loop through a circular jade piece known as a **bi**, itself usually a symbol of heaven, dividing this vertical segment into two areas. The portion above the *bi* represents the earthly realm. Here, the deceased woman and her three attendants stand on a platform while two kneeling figures offer gifts. The portion beneath the *bi* represents the underworld. Silk draperies and a stone chime hanging from the *bi* form a canopy for the platform below. Like the bronze bells we saw earlier, stone chimes were ceremonial instruments dating from Zhou times. On the platform, ritual bronze vessels contain food and wine for the deceased, just as they did in Shang tombs. The squat, muscular man holding up the platform stands in turn on a pair of fish whose bodies form another *bi*. The fish and the other strange creatures in this section are inhabitants of the underworld.

Philosophy and Art

While marking the end of the mythocentric age, the Han dynasty also marked the beginning of a new age. During this dynasty, the philosophical ideals of Daoism and Confucianism, formulated during the troubled times of the Eastern Zhou, became central to Chinese thought. Their influence since then has been continuous and fundamental.

DAOISM AND NATURE. Daoism emphasizes the close relationship between humans and nature. It is concerned with bringing the individual life into harmony with the *Dao*, or the Way, of the universe (see "Daoism," page 352). For some a secular, philosophical path, Daoism on a popular level developed into an organized religion, absorbing many traditional folk practices and the search for immortality.

Immortality was as intriguing to Han rulers as it had been to the first emperor of Qin. Daoist adepts experimented endlessly with diet, physical exercise, and other techniques in the belief that immortal life could be achieved on earth. A popular Daoist legend told of the Isles of the Immortals in

Myth and Religion

DAOISM

aoism is an outlook on life that brings together many ancient ideas regarding humankind and the universe. Its primary text, a slim volume called the *Daodejing*, or *The Way and Its Power*, is ascribed to the Chinese philosopher Laozi, who is said to have been a contemporary of Confucius (551–479 BCE). Later, a philosopher named Zhuangzi (369–286 BCE) took up many of the same ideas in a book that is known simply by his name, *Zhuangzi*. Together the two texts formed a body of ideas that crystallized into a school of thought during the Han period.

A dao is a way or path. The Dao is the Ultimate Way, the Way of the universe. The Way cannot be named or described, but it can be hinted at. It is like water. Nothing is more flexible and yielding, yet water can wear down the hardest stone. Water flows downward, seeking the lowest ground. Similarly, a Daoist sage seeks a quiet life, humble and hidden, unconcerned with worldly success. The Way is great precisely because it is small. The Way may be nothing, yet nothing turns out to be essential.

To recover the Way, we must unlearn. We must return to a state of nature. To follow the Way, we must practice wu wei, or nondoing. "Strive for nonstriving," advises the Daodejing.

All our attempts at asserting ourselves, at making things happen, are like swimming against a current and thus ultimately futile, even harmful. If we let the current carry us, however, we will travel far. Similarly, a life that follows the Way will be a life of pure effectiveness, accomplishing much with little effort.

It is often said that the Chinese are Confucians in public and Daoists in private, and the two approaches do seem to balance each other. Confucianism is a rational political philosophy that emphasizes propriety, deference, duty, and self-discipline. Daoism is an intuitive philosophy that emphasizes individualism, nonconformity, and a return to nature. If a Confucian education molded scholars outwardly into responsible, ethical officials, Daoism provided some breathing room for the artist and poet inside.

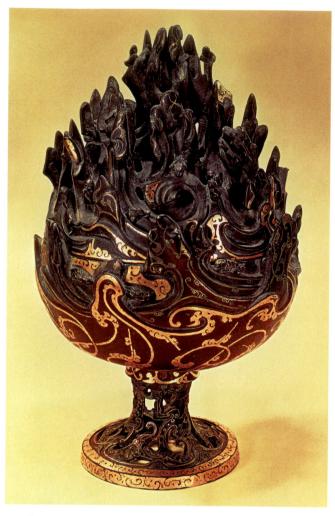

IO-8 | INCENSE BURNER
Tomb of Prince Liu Sheng, Mancheng, Hebei. Han dynasty,
113 BCE. Bronze with gold inlay, height 10½" (26 cm).
Hebei Provincial Museum, Shijiazhuang.

the Eastern Sea, depicted on a bronze incense burner from the tomb of Prince Liu Sheng, who died in 113 BCE (FIG. 10–8). Around the bowl, gold inlay outlines the stylized waves of the sea. Above them rises the mountainous island, busy with birds, animals, and people who had discovered the secret of immortality. Technically, this exquisite piece represents the ultimate development of the long tradition of bronze casting in China.

CONFUCIANISM AND THE STATE. In contrast to the metaphysical focus of Daoism, Confucianism is concerned with the human world, and its goal is the attainment of equity. To this end, it proposes a system of ethics based on reverence for ancestors and the correct relationships among people. Beginning with self-discipline in the individual, Confucianism teaches to rectify relationships within the family, and then, in ever-widening circles, with friends and others, all the way up to the level of the emperor and the state (see "Confucius and Confucianism," page 355).

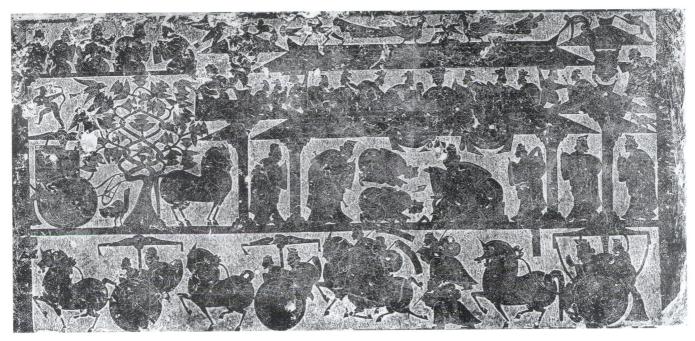

10–9 | DETAIL FROM A RUBBING OF A STONE RELIEF IN THE WU FAMILY SHRINE (WULIANGCI) Jiaxiang, Shandong. Han dynasty, 151 ce, $27\frac{1}{2} \times 66\frac{1}{2}$ " (70 × 169 cm).

Emphasis on social order and respect for authority made Confucianism especially attractive to Han rulers, who were eager to distance themselves from the disastrous legalism of the Qin. The Han emperor Wudi (ruled 141-87 BCE) made Confucianism the official imperial philosophy, and it remained the state ideology of China for more than 2,000 years, until the end of imperial rule in the twentieth century. Once institutionalized, Confucianism took on so many rituals that it too eventually assumed the form and force of a religion. Han philosophers contributed to this process by infusing Confucianism with traditional Chinese cosmology. They emphasized the Zhou idea, taken up by Confucius, that the emperor ruled by the mandate of Heaven. Heaven itself was reconceived more abstractly as the moral force underlying the universe. Thus the moral system of Confucian society became a reflection of the universal order (see "Confucius and Confucianism," page 355).

Confucian subjects turn up frequently in Han art. Among the most famous examples are the reliefs from the Wu family shrines built in 151 CE in Jiaxiang. Carved and engraved in low relief on stone slabs, the scenes were meant to teach Confucian themes such as respect for the emperor, filial piety, and wifely devotion. Daoist motifs also appear, as do figures from traditional myths and legends. Such mixed iconography is characteristic of Han art.

One relief shows a two-story building, with women in the upper floor and men in the lower (FIG. 10–9). The central figures in both floors are receiving visitors, some of whom bear gifts. The scene seems to depict homage to the first emperor of the Han dynasty, indicated by his larger size. The birds and small figures on the roof may represent mythical creatures and immortals, while to the left the legendary archer Yi shoots at one of the sun-crows. (Myths tell how Yi shot all but one of the ten crows of the ten suns so that the earth would not dry out.) Across the lower register, a procession brings more dignitaries to the reception.

When compared with the Han dynasty banner (SEE FIG. 10–7), this late Han relief clearly shows the change that took place in the Chinese worldview in the span of 300 years. The banner places equal emphasis on heaven, earth, and the underworld; human beings are dwarfed by a great swarming of supernatural creatures and divine beings. In the relief of the Wu shrine, the focus is clearly on the human realm (FIG. 10–9). The composition conveys the importance of the emperor as the holder of the mandate of Heaven and illustrates the fundamental Confucian themes of social order and decorum.

Architecture

Contemporary literary sources are eloquent on the wonders of the Han capital. Unfortunately, nothing of Han architecture remains except ceramic models. One model of a house found in a tomb, where it was provided for the dead to use in the afterlife, represents a typical Han dwelling (FIG. 10–10). Its four stories are crowned with a watchtower and face a small walled courtyard. Pigs and oxen probably occupied the ground floor, while the family lived in the upper stories.

Aside from the multilevel construction, the most interesting feature of the house is the **bracketing** system supporting the rather broad eaves of its tiled roofs. Bracketing

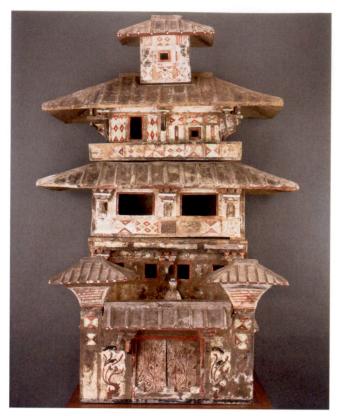

IO—IO \dagger TOMB MODEL OF A HOUSE Eastern Han dynasty, 1st-mid-2nd century CE. Painted earthenware, $52 \times 33\% \times 27''$ (132.1 \times 85.1 \times 68.6 cm). The Nelson-Atkins Museum of Art, Kansas City, Missouri. Purchase, Nelson Trust (33-521)

became a standard element of East Asian architecture, not only in private homes but more typically in palaces and temples (SEE, FOR EXAMPLE, FIG. 10–16). Another interesting aspect of the model is the elaborate painting on the exterior walls. Much of the painting is purely decorative, though some of it illustrates structural features such as posts and lintels. Still other images evoke the world outdoors: Notice the trees flanking the gateway with crows perched in their branches. Literary sources describe the walls of Han palaces as decorated with paint and lacquer and also inlaid with precious metals and stones.

SIX DYNASTIES

With the fall of the Han dynasty in 220 CE, China splintered into three warring kingdoms. In 280 CE the empire was briefly reunited, but invasions by nomadic peoples from Central Asia, a source of disruption throughout Chinese history, soon forced the court to flee south. For the next three centuries, northern and southern China developed separately. In the north, sixteen kingdoms carved out by invaders rose and fell before giving way to a succession of largely foreign dynasties. Warfare was commonplace. Tens of thousands of Chinese fled south, where six short-lived dynasties succeeded

each other in an age of almost constant turmoil broadly known as the Six Dynasties period or the period of the Southern and Northern dynasties (265–589 CE).

In such chaos, the Confucian system lost much influence. In the south especially, many intellectuals—the creators and custodians of China's high culture—turned to Daoism, which contained a strong escapist element. Educated to serve the government, they increasingly withdrew from public life. They wandered the landscape, drank, wrote poems, practiced calligraphy, and expressed their disdain for the world through willfully eccentric behavior.

The rarefied intellectual escape route of Daoism was available only to the educated elite. Far more people sought answers in the magic and superstitions of Daoism in its religious form. Though weak and disorganized, the southern courts continued to patronize traditional Chinese culture, and Confucianism remained the official doctrine. Yet ultimately it was a new influence—Buddhism—that brought the greatest comfort to the troubled China of the Six Dynasties.

Painting

Although few paintings survive from the Six Dynasties, abundant descriptions in literary sources make clear that the period was an important one for painting. Landscape, later a major theme of Chinese art, first appeared as a subject during this era. For Daoists, wandering through China's countryside was a source of spiritual refreshment. Painters and scholars of the Six Dynasties found that wandering in the mind's eye through a painted landscape could serve the same purpose. This new emphasis on the spiritual value of painting contrasted with the Confucian view, which had emphasized art's moral and didactic uses.

Reflections on the tradition of painting also inspired the first works on theory and aesthetics. Some of the earliest and most succinct formulations of the ideals of Chinese painting are the six principles set out by the scholar Xie He (fl.c. 500–535). The first two principles in particular offer valuable insight into the spirit in which China's painters worked.

The first principle announces that "spirit consonance" imbues a painting with "life's movement." This "spirit" is the Daoist *qi*, the breath that animates all creation, the energy that flows through all things. When a painting has *qi*, it will be alive with inner essence, not merely outward resemblance. Artists must cultivate their own spirit so that this universal energy flows through them and infuses their work. The second principle recognizes that brushstrokes are the "bones" of a picture, its primary structural element. The Chinese judge a painting above all by the quality of its brushwork. Each brushstroke is a vehicle of expression; it is through the vitality of a painter's brushwork that "spirit consonance" makes itself felt. We can sense this attitude already

Art and Its Context

CONFUCIUS AND CONFUCIANISM

onfucius was born in 551 BCE in the state of Lu, roughly present-day Shandong province, into a declining aristocratic family. While still in his teens he set his heart on becoming a scholar; by his early twenties he had begun to teach.

By Confucius's lifetime, warfare for supremacy among the various states of China had begun, and the traditional social fabric seemed to be breaking down. Looking back to the early Zhou dynasty as a sort of golden age, Confucius thought about how a just and harmonious society could again emerge. For many years he sought a ruler who would put his ideas into effect, but to no avail. Frustrated, he spent his final years teaching. After his death in 479 BCE, his conversations with his students were collected by his disciples and their followers into a book known in English as the *Analects*, which is the only record of his words.

At the heart of Confucian thought is the concept of ren, or human-heartedness. Ren emphasizes morality and empathy as the basic standards for all human interaction. The virtue of ren is most fully realized in the Confucian ideal of the junzi, or gen-

tleman. Originally indicating noble birth, the term was redirected to mean one who through education and self-cultivation had become a superior person, right-thinking and right-acting in all situations. A *junzi* is the opposite of a petty or small-minded person. His characteristics include moderation, integrity, self-control, loyalty, reciprocity, and altruism. His primary concern is justice.

Together with human-heartedness and justice, Confucius emphasized *li*, or etiquette. *Li* includes everyday manners as well as ritual, ceremony, and protocol—the formalities of all social conduct and interaction. Such forms, Confucius felt, choreographed life so that an entire society moved in harmony. *Ren* and *li* operate in the realm of the Five Constant Relationships that define Confucian society: parent and child, husband and wife, elder sibling and younger sibling, elder friend and younger friend, ruler and subject. Deference to age is clearly built into this view, as is the deference to authority that made Confucianism attractive to emperors. Yet responsibilities flow the other way as well: The duty of a ruler is to earn the loyalty of subjects, of a husband to earn the respect of his wife, of age to guide youth wisely.

in the rapid, confident brushstrokes that outline the figures of the Han banner (SEE FIG. 10–7) and again in the more controlled, rhythmical lines of one of the most important of the very few works surviving from this period, a painted scroll known as *Admonitions of the Imperial Instructress to Court Ladies*. Attributed to the painter Gu Kaizhi (344–407 CE), it alternates illustrations and text to relate seven Confucian stories of wifely virtue from Chinese history.

The first illustration depicts the courage of Lady Feng (FIG. 10–11). An escaped circus bear rushes toward her husband, a Han emperor, who is filled with fear. Behind his throne, two female servants have turned to run away. Before him, two male attendants, themselves on the verge of panic, try to fend off the bear with spears. Only Lady Feng is calm as she rushes forward to place herself between the beast and the emperor.

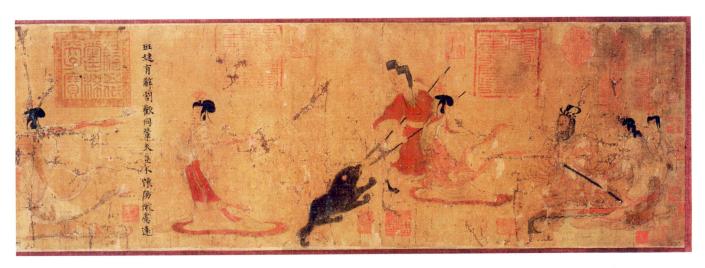

10–11 | Attributed to Gu Kaizhi DETAIL OF ADMONITIONS OF THE IMPERIAL INSTRUCTRESS TO COURT LADIES Six Dynasties period. Handscroll, ink and colors on silk, 9% × 11'6'' (24.8 cm × 3.5 cm). The British Museum, London.

The style of the painting is typical of the fourth century. The figures are drawn with a brush in a thin, even-width line, and a few outlined areas are filled with color. Facial features, especially those of the men, are quite well depicted. Movement and emotion are shown through conventions such as the bands flowing from Lady Feng's dress, indicating that she is rushing forward, and the upturned strings on both sides of the emperor's head, suggesting his fear. There is no hint of a setting; instead, the artist relies on careful placement of the figures to create a sense of depth.

The painting is on silk, which was typically woven in bands about 12 inches wide and up to 20 or 30 feet long. Early Chinese painters thus developed the format used here, the handscroll—a long, narrow, horizontal composition, compact enough to be held in the hand when rolled up. Handscrolls are intimate works, meant to be viewed by only two or three people at a time. They were not displayed completely unrolled as we commonly see them today in museums. Rather, viewers would open a scroll and savor it slowly from right to left, displaying only a foot or two at a time.

Calligraphy

The emphasis on the expressive quality and structural importance of brushstrokes finds its purest embodiment in calligraphy. The same brushes are used for both painting and calligraphy, and a relationship between them was recognized as early as Han times. In his teachings, Confucius had extolled the importance of the pursuit of knowledge and the arts. Among the visual arts, painting was felt to reflect moral concerns, while calligraphy was believed to reveal the style and character of the writer.

Calligraphy is regarded as one of the highest forms of expression in China. For more than 2,000 years, China's "literati," Confucian scholars and literary men who also served the government as officials, have enjoyed being connoisseurs and practitioners of this abstract art. During the fourth century, calligraphy came to full maturity. The most important practitioner of the day was Wang Xizhi (c. 307–365 CE), whose works have served as models of excellence for all subsequent generations. The example here comes from a letter, now somewhat damaged and mounted as part of an album, known as **FENG JU** (FIG. 10–12).

Feng Ju is an example of "walking" or semi-cursive style, which is neither too formal nor too free but is done in a relaxed, easygoing manner. Brushstrokes vary in width and length, creating rhythmic vitality. Individual characters remain distinct, yet within each character the strokes are run together and simplified as the brush moves from one to the other without lifting off the page. The effect is fluid and graceful, yet still strong and dynamic. The walking style as developed by Wang Xizhi came to be officially accepted and learned along with other script styles.

f 10-12 $m \parallel$ WANG XIZHI PORTION OF A LETTER FROM THE FENG JU ALBUM

Six Dynasties period, mid-4th century CE. Ink on paper, $9\frac{7}{4} \times 18\frac{7}{2}$ " (24.7 \times 46.8 cm). National Palace Museum, Taipei, Taiwan, Republic of China.

The stamped characters that appear on Chinese artworks are seals—personal emblems. The use of seals dates from the Zhou dynasty, and to this day seals traditionally employ the archaic characters, known appropriately as "seal script," of the Zhou or Qin. Cut in stone, a seal may state a formal, given name, or it may state any of the numerous personal names that China's painters and writers adopted throughout their lives. A treasured work of art often bears not only the seal of its maker, but also those of collectors and admirers through the centuries. In the Chinese view, these do not disfigure the work but add another layer of interest. This sample of Wang Xizhi's calligraphy, for example, bears the seals of two Songdynasty emperors, a Song official, a famous collector of the sixteenth century, and two Qing-dynasty emperors of the eighteenth and nineteenth centuries.

Buddhist Art and Architecture

Buddhism originated in India during the fifth century BCE (Chapter 9), then gradually spread north into Central Asia. With the opening of the Silk Road during the Han dynasty, its influence reached China. To the Chinese of the Six Dynasties, beset by constant warfare and social devastation, Buddhism offered consolation in life and the promise of salvation after death. The faith spread throughout the country to all social levels, first in the north, where many of the invaders promoted it as the official religion, then slightly later in the south, where it found its first great patron in the emperor Liang Wu Di (ruled 502–549 CE). Thousands of temples and monasteries were built, and many people became monks and nuns.

Almost nothing remains in China of the Buddhist architecture of the Six Dynasties, but we can see what it must have looked like in the Japanese temple Horyu-ji (SEE FIG. 11–6),

which was based on Chinese models of this period. The slender forms and linear grace of Horyu-ji have much in common with the figures in Gu Kaizhi's handscroll, and they indicate the delicate, almost weightless style cultivated in southern China.

ROCK-CUT CAVES OF THE SILK ROAD. The most impressive works of Buddhist art surviving from the Six Dynasties are the hundreds of northern rock-cut caves along the trade routes between Xinjiang in Central Asia and the Yellow River Valley. Both the caves and the sculptures that fill them were carved from the solid rock of the cliffs. Small caves high above the ground were retreats for monks and pilgrims, while larger caves at the base of the cliffs were wayside shrines and temples.

The caves at Yungang, in Shanxi province in central China, contain many examples of the earliest phase of Buddhist sculpture in China, including the monumental **SEATED BUDDHA** in Cave 20 (FIG. 10–13). The figure was carved in the latter part of the fifth century by the imperial decree of a ruler of the Northern Wei dynasty (386–534 CE), the longest-lived and most stable of the northern kingdoms. Most Wei rulers were avid patrons of Buddhism, and under their rule the religion made its greatest advances in the north.

The front part of the cave has crumbled away, and the 45-foot statue, now exposed to the open air, is clearly visible from a distance. The elongated ears, protuberance on the head (ushnisha), and monk's robe are traditional attributes of the Buddha. The masklike face, full torso, massive shoulders, and shallow, stylized drapery indicate strong Central Asian influence. The overall effect of this colossus is remote and austere, less human than the more sensuous expression of the early Buddhist traditions in India.

SUI AND TANG DYNASTIES

In 581 CE, a general from the last of the northern dynasties replaced a child emperor and established a dynasty of his own, the Sui. Defeating all opposition, he molded China into a centralized empire as it had been in Han times. The short-lived Sui dynasty fell in 618 CE, but in reunifying the empire it paved the way for one of the greatest dynasties in Chinese history, the Tang (618–907 CE). Even today many Chinese living abroad still call themselves "Tang people." To them, Tang implies that part of the Chinese character that is strong and vigorous (especially in military power), noble and idealistic, but also realistic and pragmatic.

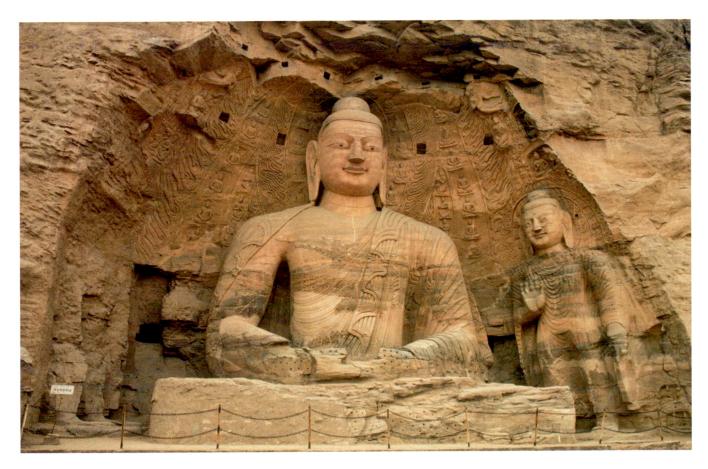

IO—I3 | SEATED BUDDHA, CAVE 20, YUNGANG Datong, Shanxi. Northern Wei dynasty, c. 460 CE. Stone, height 45′ (13.7 m).

Buddhist Art and Architecture

The new Sui emperor was a devout Buddhist, and his reunification of China coincided with a fusion of the several styles of Buddhist sculpture that had developed. This new style is seen in a bronze altar to Amitabha Buddha (FIG. 10–14), one of the many *buddhas* of Mahayana Buddhism. Amitabha dwelled in the Western Pure Land, a paradise into which his faithful followers were promised rebirth. With its comparatively simple message of salvation, the Pure Land sect eventually became the most popular form of Buddhism in China and one of the most popular in Japan (see Chapter 11).

The altar depicts Amitabha in his paradise, seated on a lotus throne beneath a canopy of trees. Each leaf cluster is set with jewels. Seven celestial nymphs sit on the topmost clusters, and ropes of "pearls" hang from the tree trunks. Behind Amitabha's head is a halo of flames. To his left, the bodhisattva Guanyin holds a pomegranate; to his right, another bodhisattva clasps his hands in prayer. Behind are four disciples who first preached the teachings of the Buddha. On the lower level, an incense burner is flanked by seated lions and two smaller bodhisattvas. Focusing on Amitabha's benign

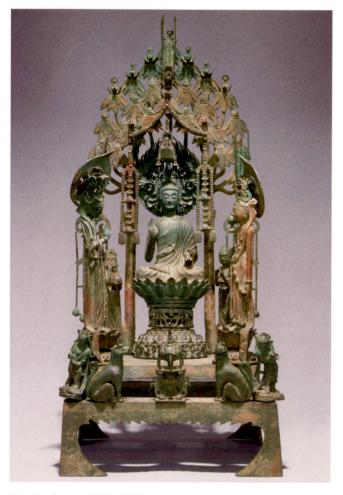

IO-I4 | ALTAR TO AMITABHA BUDDHA
Sui dynasty, 593 CE. Bronze, height 30%" (76.5 cm).
Museum of Fine Arts, Boston.
Gift of Mrs. W. Scott Fitz (22.407) and Gift of Edward Holmes Jackson in memory of his mother, Mrs. W. Scott Fitz (47.1407-1412)

expression and filled with objects symbolizing his power, the altar combines the sensuality of Indian styles, the schematic abstraction of Central Asian art, and the Chinese emphasis on linear grace and rhythm into a harmonious new style.

Buddhism reached its greatest development in China during the subsequent Tang dynasty, which for nearly three centuries ruled China and controlled much of Central Asia. From emperors and empresses to common peasants, virtually the entire country adopted the Buddhist faith. A Tang vision of the most popular sect, Pure Land, was expressed in a wall painting from a cave in Dunhuang (FIG. 10–15). A major stop along the Silk Road, Dunhuang has nearly 500 caves carved out of its sandy cliffs, all filled with painted clay sculpture and decorated with wall paintings from floor to ceiling. The site was worked on continuously from the fourth to the fourteenth century, a period of almost a thousand years. Rarely in art's history do we have the opportunity to study such an extended period of stylistic and iconographic evolution in one place.

In the detail shown here, Amitabha Buddha is seated in the center, surrounded by four *bodhisattvas*, who serve as his messengers to the world. Two other groups of *bodhisattvas* are clustered at the right and left. In the foreground, musicians and dancers create a heavenly atmosphere. In the background, great halls and towers rise. The artist has imagined the Western Paradise in terms of the grandeur of Tang palaces. Indeed, the lavish entertainment depicted could just as easily be taking place at the imperial court. This worldly vision of paradise, recorded with great attention to naturalism in the architectural setting, gives us our best visualization of the splendor of Tang civilization at a time when Chang'an (present-day Xi'an) was probably the greatest city in the world.

The early Tang emperors proclaimed a policy of religious tolerance, but during the ninth century a conservative reaction set in. Confucianism was reasserted and Buddhism was briefly persecuted as a "foreign" religion. Thousands of temples, shrines, and monasteries were destroyed and innumerable bronze statues melted down. Nevertheless, several Buddhist structures survive from the Tang dynasty. One of them, the Nanchan Temple, is the earliest important example of surviving Chinese architecture.

NANCHAN TEMPLE. Of the few structures earlier than 1400 CE to have survived, the Nanchan Temple is the most significant, for it shows characteristics of both temples and palaces of the Tang dynasty (FIG. 10–16). Located on Mount Wutai in the eastern part of Shanxi province, this small hall was constructed in 782 CE. The tiled roof, first seen in the Han tomb model (SEE FIG. 10–10), has taken on a curved silhouette. Quite subtle here, this curve became increasingly pronounced in later centuries. The very broad overhanging eaves are supported by a correspondingly elaborate bracketing system.

Also typical is the **bay** system of construction, in which a cubic unit of space, a bay, is formed by four posts

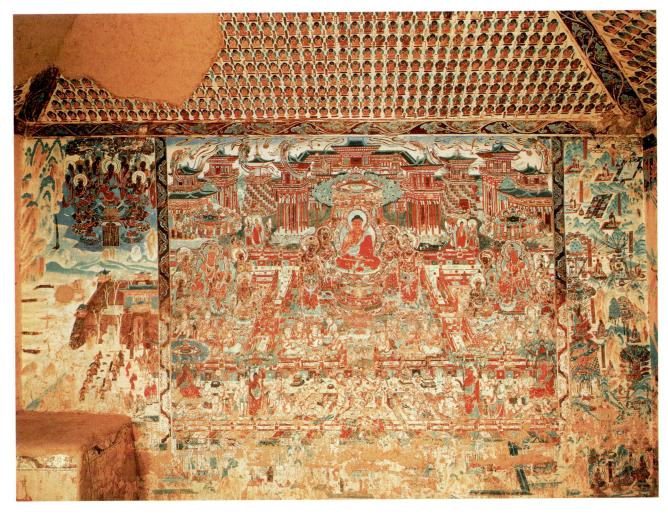

10–15 | THE WESTERN PARADISE OF AMITABHA BUDDHA Detail of a wall painting in Cave 217, Dunhuang, Gansu. Tang dynasty, c. 750 ce. $10'2'' \times 16'$ (3.1 \times 4.86 m).

and their lintels. The bay functioned in Chinese architecture as a module, a basic unit of construction. To create larger structures, an architect multiplied the number of bays. Thus the Nanchan Temple—modest in scope with three bays—gives an idea of the vast, multistoried palaces of

the Tang depicted in such paintings as the one from Dunhuang (SEE FIG. 10–15).

GREAT WILD GOOSE PAGODA. Another important monument of Tang architecture is the Great Wild Goose Pagoda at the

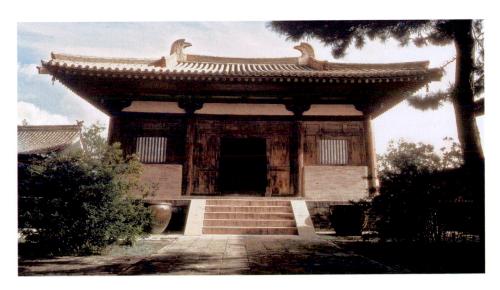

10–16 | NANCHAN TEMPLE, WUTAISHAN
Shanxi. Tang dynasty, 782 CE.

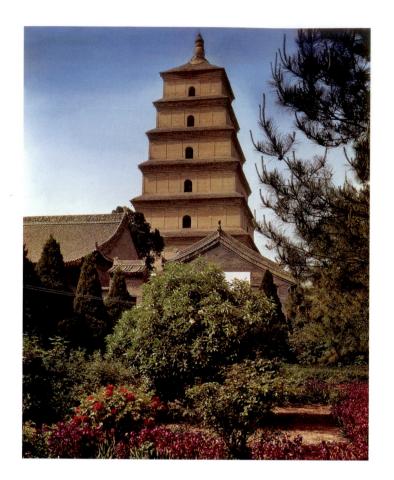

Ci'en Temple in Chang'an, the Tang capital (FIG. 10–17). The temple was constructed in 645 CE for the famous monk Xuanzang (600–664 CE) on his return from a sixteen-year pilgrimage to India. At Ci'en Temple, Xuanzang taught and translated the materials he had brought back with him.

The pagoda, a typical East Asian Buddhist structure, originated in the Indian Buddhist stupa, the elaborate burial mound that housed relics of the Buddha (see "Pagodas," page 361). In India the stupa had developed a multistoried form in the Gandhara region under the Kushan dynasty (c. 50–250 CE). In China this form blended with a traditional Han watchtower to produce the pagoda. Built entirely in masonry, the Great Wild Goose Pagoda nevertheless imitates the wooden architecture of the time. The walls are decorated in low relief to resemble bays, and bracket systems are reproduced under the projecting roofs of each story. Although modified and repaired in later times (its seven stories were originally five, and a new finial has been added), the pagoda still preserves the essence of Tang architecture in its simplicity, symmetry, proportions, and grace.

IO-I7 \perp Great wild goose pagoda at ci'en temple, Chang'an

Shanxi. Tang dynasty, first erected 645 CE; rebuilt mid-8th century CE.

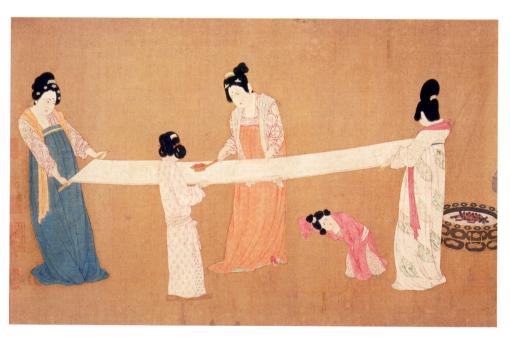

IO–I8 | Attributed to Emperor Huizong DETAIL OF LADIES PREPARING NEWLY WOVEN SILK Copy after a lost Tang dynasty painting by Zhang Xuan. Northern Song dynasty, early 12th century CE. Handscroll, ink and colors on silk, $14\frac{1}{2} \times 57\frac{1}{2}$ " (36 \times 145.3 cm). Museum of Fine Arts, Boston.

Chinese and Japanese Special Fund (12.886)

Confucius said of himself, "I merely transmit, I do not create; I love and revere the ancients." In this spirit, Chinese painters regularly copied paintings of earlier masters. Painters made copies both to absorb the lessons of their great predecessors and to perpetuate the achievements of the past. In later centuries, painters took up the practice of regularly executing a work "in the manner of" some particularly revered ancient master. This was at once an act of homage, a declaration of artistic allegiance, and a way of reinforcing a personal connection with the past.

Figure Painting

Later artists looking back on their heritage recognized the Tang dynasty as China's great age of figure painting. Unfortunately, very few scroll paintings that can be definitely identified as Tang still exist. We can get some idea of the character of Tang figure painting from the wall paintings of Dunhuang (SEE FIG. 10-15). Another way to savor the particular flavor of Tang painting is to look at copies made by later, Song-dynasty artists, which are far better preserved. An outstanding example of this can be seen in LADIES PREPARING NEWLY WOVEN SILK, attributed to Huizong (ruled 1101-1126 CE), the last emperor of the Northern Song dynasty (FIG. 10–18). A long handscroll in several sections, it depicts the activities of court women as they weave and iron silk. An inscription on the scroll informs us that the painting is a copy of a famous work by Zhang Xuan, an eighth-century painter known for his depictions of women at the Tang court. The original no longer exists, so we cannot know how faithful the copy is. Still, its refined lines and bright colors seem to share the grace and dignity of Tang sculpture and architecture.

SONG DYNASTY

A brief period of disintegration followed the fall of the Tang dynasty before China was again united, this time under the Song dynasty (960–1279 CE), which established a new capital at Bianjing (present-day Kaifeng), near the Yellow River. In contrast to the outgoing confidence of the Tang, the mood during the Song was more introspective, a reflection of China's weakened military situation. In 1126 the Jurchen tribes of Manchuria invaded China, sacked the capital, and took possession of much of the northern part of the country. Song forces withdrew south and established a new capital at Hangzhou. From this point on, the dynasty is known as the Southern Song (1127–1279 CE), with the first portion called in retrospect the Northern Song (960–1126 CE).

Although China's territory had diminished, its wealth had increased because of advances in agriculture, commerce, and technology begun under the Tang. Patronage was plentiful, and the arts flourished.

SEATED GUANYIN BODHISATTVA. In spite of changing political fortunes in the eleventh and twelfth centuries, artists continued to create splendid works. No hint of political disruption or religious questioning intrudes on the sublime grace and beauty of the SEATED GUANYIN BODHISATTVA (FIG. 10–19). Bodhisattvas, beings who are close to enlightenment but who voluntarily remain on earth to help others achieve enlightenment, are represented as young princes wearing royal garments and jewelry, their finery indicative of their worldly but virtuous lives. Guanyin is the Bodhisattva of Infinite Compassion, who appears in many guises, in this case as the Water and Moon Guanyin. He sits on rocks by the sea, in

Elements of Architecture PAGODAS

agodas developed from Indian stupas as Buddhism spread northeastward along the Silk Road. Stupas merged with the watchtowers of Han dynasty China in multistoried stone or wood structures with projecting tiled roofs. This transformation culminated in wooden pagodas with upward-curving roofs supported by elaborate bracketing in China, Korea, and Japan. Buddhist pagodas retain the axis mundi masts of stupas. Like their South Asian prototypes, early East Asian pagodas were symbolic rather than enclosing structures; they were solid, with small devotional spaces hollowed out. Later examples often provided access to the ground floor and sometimes to upper levels.

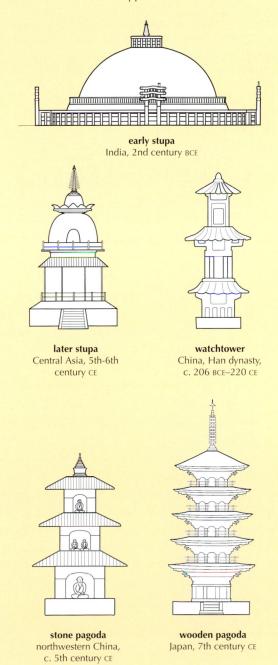

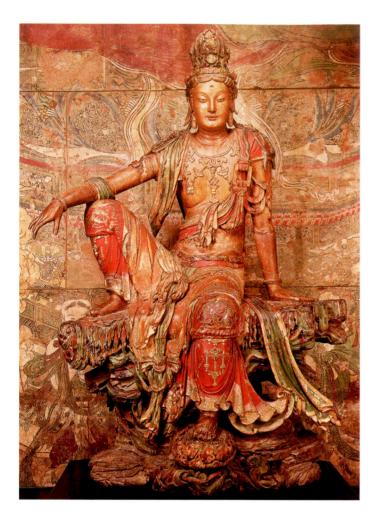

IO–I9 | SEATED GUANYIN BODHISATTVA Liao dynasty, 10th–12th century CE. Wood with paint and gold, $95\times65''$ (241.3 \times 165.1 cm). The Nelson-Atkins Museum of Art, Kansas City, Missouri. Purchase, Nelson Trust (34–10)

the position known as royal ease. His right arm rests on his raised and bent right knee and his left arm and foot extended down, the foot touching a lotus blossom. The wooden figure was carved in the eleventh or twelfth century in a territory on the northern border of Song-dynasty China, a region ruled by the Liao dynasty (907–1125); the painting and gilding are sixteenth century.

Song culture is noted for its refined taste and intellectual grandeur. Where the Tang had reveled in exoticism, eagerly absorbing influences from Persia, India, and Central Asia, Song culture was more self-consciously Chinese. Philosophy experienced its most creative era since the "one hundred schools" of the Zhou. Song scholarship was brilliant, especially in history, and its poetry is noted for its depth. But the finest expressions of the Song are in art, especially painting and ceramics.

Philosophy: Neo-Confucianism

Song philosophers continued the process, begun during the Tang, of restoring Confucianism to dominance. In strengthening Confucian thought, philosophers drew on Daoist and

especially Buddhist ideas, even as they openly rejected Buddhism itself as foreign. These innovations provided Confucianism with a metaphysical aspect it had previously lacked, allowing it to propose a more satisfying, all-embracing explanation of the universe. This new synthesis of China's three main paths of thought is called Neo-Confucianism.

Neo-Confucianism teaches that the universe consists of two interacting forces known as *li* (principle or idea) and *qi* (matter). All pine trees, for example, consist of an underlying *li* we might call "Pine Tree Idea" brought into the material world through *qi*. All the *li* of the universe, including humans, are but aspects of an eternal first principle known as the Great Ultimate, which is completely present in every object. Our task as human beings is to rid our *qi* of impurities through education and self-cultivation so that our *li* may realize its oneness with the Great Ultimate. This lifelong process resembles the striving to attain buddhahood, and if we persist in our attempts, one day we will be enlightened—the term itself comes directly from Buddhism.

Northern Song Painting

The Neo-Confucian ideas found visual expression in art, especially in landscape, which became the most highly esteemed subject for painting. Northern Song artists studied nature closely to master its many appearances—the way each species of tree grew, the distinctive character of each rock formation, the changes of the seasons, the myriad birds, blossoms, and insects. This passion for realistic detail was the artist's form of self-cultivation: Mastering outward forms showed an understanding of the principles behind them.

Yet despite the convincing accumulation of detail, the paintings do not record a specific site. The artist's goal was to paint the eternal essence of "mountain-ness," for example, not to reproduce the appearance of a particular mountain. Painting a landscape required an artist to orchestrate his cumulative understanding of *li* in all its aspects—mountains and rocks, streams and waterfalls, trees and grasses, clouds and mist. A landscape painting thus expressed the desire for the spiritual communion with nature that was the key to enlightenment. As the tradition progressed, landscape also became a vehicle for conveying human emotions, even for speaking indirectly of one's own deepest feelings.

In the earliest times, art reflected the mythocentric worldview of the ancient Chinese. Later, as religion came to dominate people's lives, the focus of art shifted and religious images and human actions became important subjects. Subsequently, during the Song dynasty, artists developed landscape as the chief means of expression, preferring to avoid direct depiction of the human condition and to show ideals in a symbolic manner. The major form of Chinese artistic expression thus moved from the mythical, through the religious and ethical, and finally to the philosophical and aesthetic.

FAN KUAN. One of the first great masters of Song landscape was the eleventh-century painter Fan Kuan (active c. 990–1030 CE), whose surviving major work, TRAVELERS AMONG MOUNTAINS AND STREAMS, is regarded as one of the great monuments of Chinese art (FIG. 10–20). The work is physically large—almost 7 feet high—but the sense of monumentality also radiates from the composition itself, which makes its impression even when much reduced.

The composition unfolds in three stages, comparable to three acts of a drama. At the bottom a large, low-lying group of rocks, taking up about one-eighth of the picture surface, establishes the extreme foreground. The rest of the landscape pushes back from this point. In anticipating the shape and substance of the mountains to come, the rocks introduce the main theme of the work, much as the first act of a drama introduces the principal characters. In the middle ground, travelers and their mules are coming from the right. They are somewhat startling, for we suddenly realize our human scale—how small we are, how vast nature is. This middle ground takes up twice as much picture surface as the foreground, and, like the second act of a play, shows variation and development. Instead of a solid mass, the rocks here are separated into two groups by a waterfall that is spanned by a bridge. In the hills to the right, the rooftops of a temple stand out above the trees.

Mist veils the transition to the background, with the result that the mountain looms suddenly. This background area, almost twice as large as the foreground and middle ground combined, is the climactic third act of the drama. As our eyes begin their ascent, the mountain solidifies. Its ponderous weight increases as it billows upward, finally bursting into the sprays of energetic brushstrokes that describe the scrubby growth on top. To the right, a slender waterfall plummets, not to balance the powerful upward thrust of the mountain but simply to enhance it by contrast. The whole painting, then, conveys the feeling of climbing a high mountain, leaving the human world behind to come face to face with the Great Ultimate in a spiritual communion.

All the elements are depicted with precise detail and in proper scale. Jagged brushstrokes describe the contours of rocks and trees and express their rugged character. Layers of short, staccato strokes (translated as "raindrop texture" from the Chinese) accurately mimic the texture of the rock surface. Spatial recession from foreground through middle ground to background is logically and convincingly handled, if not quite continuous.

Although it contains realistic details, the landscape represents no specific place. In its forms, the artist expresses the ideal forms behind appearances; in the rational, ordered composition, he expresses the intelligence of the universe. The arrangement of the mountains, with the central peak flanked by lesser peaks on each side, seems to reflect both the ancient Confucian notion of social hierarchy, with the emperor

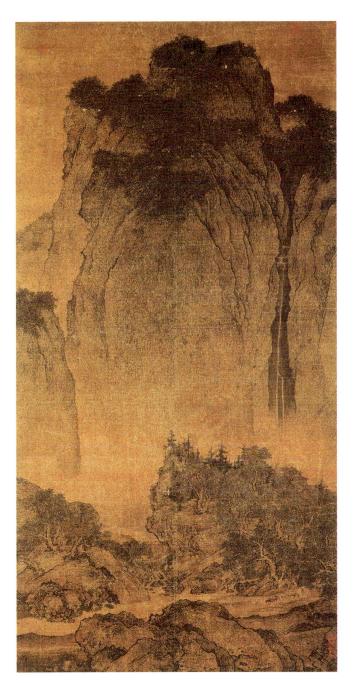

IO—20 | Fan Kuan | TRAVELERS AMONG MOUNTAINS AND STREAMS

Northern Song dynasty, early 11th century CE. Hanging scroll, ink and colors on silk, height 6' 9½" (2.06 m). National Palace Museum, Taipei, Taiwan, Republic of China.

flanked by his ministers, and the Buddhist motif of the Buddha with *bodhisattvas* at his side. The landscape, a view of nature uncorrupted by human habitation, expresses a kind of Daoist ideal. Thus we find the three strains of Chinese thought united, much as they are in Neo-Confucianism itself.

The ability of Chinese landscape painters to take us out of ourselves and to let us wander freely through their sites is closely linked to the avoidance of perspective as it is understood in the West. Fifteenth-century European painters, searching for fidelity to appearances, developed a "scientific"

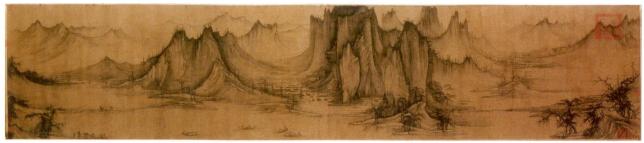

IO-2I+Xu Daoning SECTION OF FISHING IN A MOUNTAIN STREAM Northern Song dynasty, mid-11th century CE. Handscroll, ink on silk, $19'' \times 6'10''$ (48.9 cm \times 2.09 m). The Nelson-Atkins Museum of Art, Kansas City, Missouri.

Purchase, Nelson Trust (33–1559)

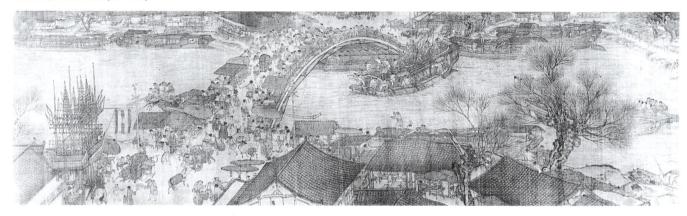

10–22 | Zhang Zeduan | SECTION OF SPRING FESTIVAL ON THE RIVER Northern Song dynasty, early 12th century CE. Handscroll, ink and colors on silk, $9\%'' \times 7'4''$ (24.8 \times 2.28 m). The Palace Museum, Beijing.

system for recording exactly the view that could be seen from a single, fixed vantage point. The goal of Chinese painting is precisely to avoid such limits and show a totality beyond what we are normally given to see. If the ideal for centuries of Western painters was to render what can be seen from a fixed viewpoint, that of Chinese artists was to reveal nature through a distant, all-seeing, and mobile viewpoint.

XU DAONING. The sense of shifting perspective is clearest in the handscroll, where our vantage point changes constantly as we move through the painting. One of the finest handscrolls to survive from the Northern Song is **FISHING IN A MOUNTAIN STREAM** (FIG. 10–21), a painting executed in the middle of the

eleventh century by Xu Daoning (c. 970–c. 1052 CE). Starting from a thatched hut in the right foreground, we follow a path that leads to a broad, open view of a deep vista dissolving into distant mists and mountain peaks. (Remember that viewers observed only a small section of the scroll at a time. To mimic this effect, use two pieces of paper to frame a small viewing area, then move them slowly leftward.) Crossing over a small footbridge, we are brought back to the foreground with the beginning of a central group of high mountains that show extraordinary shapes. Again our path winds back along the bank, and we have a spectacular view of the highest peaks from another small footbridge the artist has placed for us. At the far side of the bridge, we find ourselves looking up into a

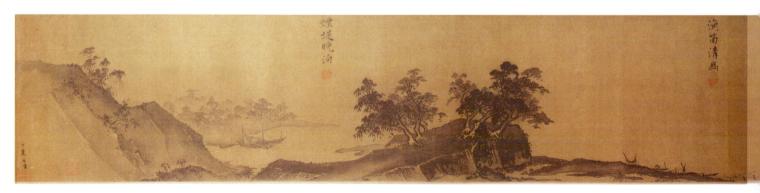

10–23 | Xia Gui TWELVE VIEWS FROM A THATCHED HUT

Southern Song dynasty, early 13th century CE. Handscroll, ink on silk, height 11" (28 cm); length of extant portion 7'7½" (2.31 m). The Nelson-Atkins Museum of Art, Kansas City, Missouri.

Purchase, Nelson Trust (32-159/2)

deep valley, where a stream lures our eyes far into the distance. We can imagine ourselves resting for a moment in the small pavilion halfway up the valley on the right. Or perhaps we may spend some time with the fishers in their boats as the valley gives way to a second, smaller group of mountains, serving both as an echo of the spectacular central group and as a transition to the painting's finale, a broad, open vista. As we cross the bridge here, we meet travelers coming toward us who will have our experience in reverse. Gazing out into the distance and reflecting on our journey, we again feel that sense of communion with nature that is the goal of Chinese artistic expression.

Such handscrolls have no counterpart in the Western visual arts and are often compared instead to the tradition of Western music, especially symphonic compositions. Both are generated from opening motifs that are developed and varied, both are revealed over time, and in both our sense of the overall structure relies on memory, for we do not see the scroll or hear the composition all at once.

ZHANG ZEDUAN. The Northern Song fascination with precision extended to details within landscape. The emperor Huizong, whose copy of *Ladies Preparing Newly Woven Silk* was seen in figure 10–18, gathered around himself a group of court painters who shared his passion for quiet, exquisitely detailed, delicately colored paintings of birds and flowers. Other painters specialized in domestic and wild animals, still others in palaces and buildings. One of the most spectacular products of this passion for observation is **SPRING FESTIVAL ON THE RIVER**. a long handscroll painted in the first quarter of the twelfth century by Zhang Zeduan, an artist connected to the emperor's court (FIG. 10–22). Beyond its considerable visual delights, the painting is also an invaluable record of daily life in the Song capital.

The painting depicts a festival day when local inhabitants and visitors from the countryside thronged the streets. One high point is the scene reproduced here, which takes place at the Rainbow Bridge. The large boat to the right is probably bringing goods from the southern part of China up the

Grand Canal that ran through the city at that time. The sailors are preparing to pass beneath the bridge by lowering the sail and taking down the mast. Excited figures on ship and shore gesture wildly, shouting orders and advice, while a noisy crowd gathers at the bridge railing to watch. Stalls on the bridge are selling food and other merchandise; wine shops and eating places line the banks of the canal. Everyone is on the move. Some people are busy carrying goods, some are shopping, some are simply enjoying themselves. Each figure is splendidly animated and full of purpose; the buildings and boats are perfect in every detail—the artist's knowledge of this bustling world was indeed encyclopedic.

Little is known about the painter Zhang Zeduan other than that he was a member of the scholar-official class, the highly educated elite of imperial China. Interestingly, some of Zhang Zeduan's peers were already beginning to cultivate quite a different attitude toward painting as a form of artistic expression, one that placed overt display of technical skill at the lowest end of the scale of values. This emerging scholarly aesthetic, developed by China's literati, later came to dominate Chinese thinking about art, with the result that only in the twentieth century did *Spring Festival* again find an audience willing to hold it in the highest esteem.

Southern Song Painting and Ceramics

Landscape painting took a very different course after the fall of the north to the Jurchen in 1126, and the removal of the court to its new capital in the south, Hangzhou.

XIA GUI. This new sensibility is reflected in the extant portion of TWELVE VIEWS FROM A THATCHED HUT (FIG. 10–23) by Xia Gui (fl.c. 1195–1235 CE), a member of the newly established Academy of Painters. In general, academy members continued to favor such subjects as birds and flowers in the highly refined, elegantly colored court style patronized earlier by Huizong (SEE FIG. 10–18). Xia Gui, however, was interested in landscape and cultivated his own style. Only the last four of the twelve views that originally made up this long handscroll have survived, but they are enough to illustrate the unique quality of his approach.

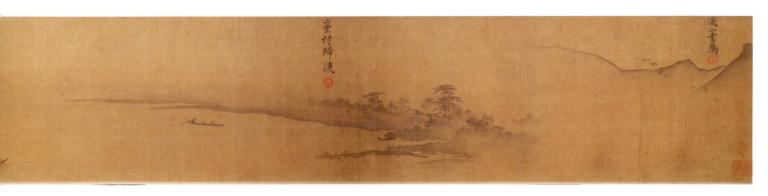

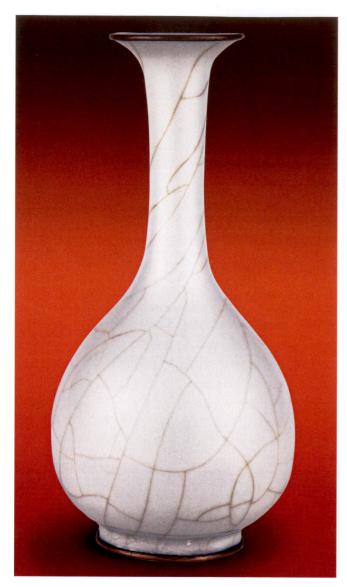

IO-24 | GUAN WARE VASE Southern Song dynasty, 13th century CE. Gray stoneware with crackled grayish blue glaze, height 6%" (16.8 cm). Percival David Foundation of Chinese Art, London.

In contrast to the majestic, austere landscapes of the Northern Song painters, Xia Gui presents an intimate and lyrical view of nature. Subtly modulated, perfectly controlled ink washes evoke a landscape veiled in mist, while a few deft brushstrokes suffice to indicate the details showing through the mist—the grasses growing by the bank, the fishers at their work, the trees laden with moisture, the two bent-backed figures carrying their heavy load along the path that skirts the hill. Simplified forms, stark contrasts of light and dark, asymmetrical composition, and great expanses of blank space suggest a fleeting world that can be captured only in glimpses. The intangible is somehow more real than the tangible. By limiting himself to a few essential details, the painter evokes a deep feeling for what lies beyond.

This development in Song painting from the rational and intellectual to the emotional and intuitive, from the tangible to the intangible, had a parallel in philosophy. During the late twelfth century a new school of Neo-Confucianism

called School of the Mind insisted that self-cultivation could be achieved through contemplation, which might lead to sudden enlightenment. The idea of sudden enlightenment may have come from Chan Buddhism, better known in the West by its Japanese name, Zen. Chan Buddhists rejected formal paths to enlightenment such as scripture, knowledge, and ritual, in favor of meditation and techniques designed to "short-circuit" the rational mind. Xia Gui's painting seems also to suggest this intuitive approach.

The subtle and sophisticated paintings of the Song were created for a highly cultivated audience who were equally discerning in other arts such as ceramics. Building on the considerable accomplishments of the Tang, Song potters achieved a technical and aesthetic perfection that has made their wares models of excellence throughout the world. Like their painter contemporaries, Song potters turned away from the exuberance of Tang styles to create more quietly beautiful pieces.

GUAN WARE. Most highly prized of the many types of Song ceramics is Guan ware, made mainly for imperial use (FIG. 10–24). The everted lip, high neck, and rounded body of this simple vase show a strong sense of harmony. Enhanced by a lustrous grayish blue glaze, the form flows without break from base to lip. The piece has an introspective quality as eloquent as the blank spaces in Xia Gui's painting. The aesthetic of the Song is most evident in the crackle pattern on the glazed surface. The crackle technique was probably discovered accidentally, but came to be used deliberately in some of the most refined Song wares. In the play of irregular, spontaneous crackles over a perfectly regular, perfectly planned form we can sense the same spirit that hovers behind the self-effacing virtuosity and freely intuitive insights of Xia Gui's landscape.

In 1279 the Southern Song dynasty fell to the conquering forces of the Mongol leader Kublai Khan (1215–1294). China was subsumed into the vast Mongol Empire. Mongol rulers founded the Yuan dynasty (1279–1368 CE), setting up their capital in the northeast in what is now Beijing. Yet the cultural center of China remained in the south, in the cities that rose to prominence during the Song, such as Bianjing (Kaifeng) and Hangzhou. This separation of political and cultural centers, coupled with a lasting resentment toward "barbarian" rule, created the climate for later developments in the arts.

THE ARTS OF KOREA

Set between China and Japan, Korea occupies a peninsula in northeast Asia. Inhabited for millennia, the peninsula gave rise to a distinctively Korean culture during the Three Kingdoms period.

The Three Kingdoms Period

Traditionally dated 57 BCE to 668 CE, the Three Kingdoms period saw the establishment of three independent nation-states:

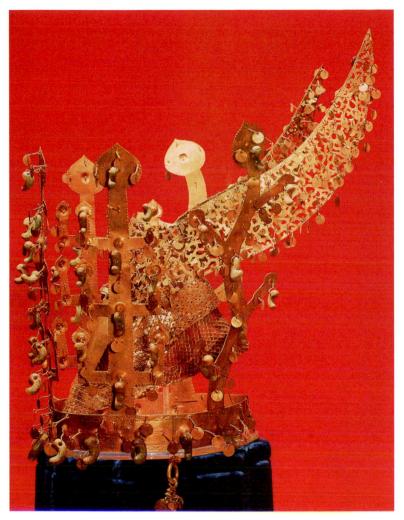

IO-25 | CROWN
Korean. Three Kingdoms
period, Silla kingdom,
probably 6th century.
From the Gold Crown
Tomb, Gyeongju, North
Gyeongsang province.
Gold with jadeite
ornaments, height 17½"
(44.5 cm). National
Museum of Korea,
Seoul, Republic
of Korea.

Silla in the southeast, Baekje in the southwest, and Goguryeo in the north. Large tomb mounds built during the fifth and sixth centuries are enduring monuments of this period.

A GOLD HEADDRESS. The most spectacular items recovered from these tombs are trappings of royal authority (FIG. 10–25). Made expressly for burial, this elaborate crown was assembled from cut pieces of thin gold sheet, held together by gold wire. Spangles of gold embellish the crown, as do comma-shaped ornaments of green and white jadeite—a form of jade mineralogically distinct from the nephrite prized by the early Chinese. The tall, branching forms rising from the crown's periphery resemble trees and antlers. Within the crown is a conical cap woven of narrow strips of sheet gold and ornamented with appendages that suggest wings or feathers.

HIGH-FIRED CERAMICS. These tombs have also yielded ceramics in abundance. Most are containers for offerings of food placed in the tomb to nourish the spirit of the deceased. These items generally are of unglazed **stoneware**, a high-fired ceramic ware that is impervious to liquids, even without glaze.

The most imposing ceramic shapes are the tall stands that were used to support round-bottomed jars (FIG. 10–26).

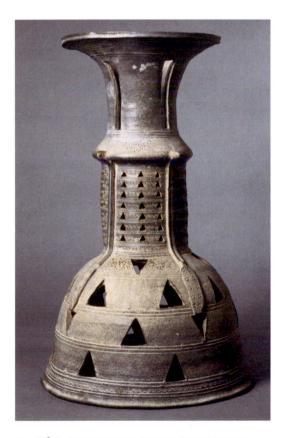

10–26 | CEREMONIAL STAND WITH SNAKE, ABSTRACT, AND OPENWORK DECORATION
Korean. Three Kingdoms period, Silla kingdom, 5th-6th century. Gray stoneware with combed, stamped, applied, and openwork decoration and with traces of natural ash glaze, height 23½" (58.7 cm). Reportedly recovered in Andong, North Gyeongsang province. Arthur M. Sackler Museum, Harvard University, Cambridge, Massachusetts.
Partial gift of Maria C. Henderson and partial purchase through the Ernest B. and Helen Pratt Dane Fund for the Acquisition of Oriental Art [1991.501]

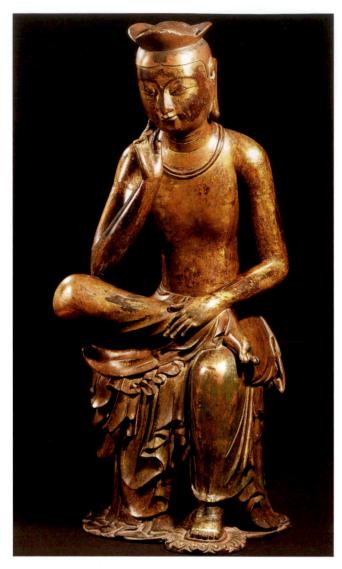

IO-27 | BODHISATTVA SEATED IN MEDITATION
Korean. Three Kingdoms period, probably Silla kingdom, early 7th century. Gilt bronze, height $35\,\%$ " (91 cm). National Museum of Korea, Seoul, Republic of Korea (formerly in the collection of the Toksu Palace Museum of Fine Arts, Seoul).

Such stands typically have a long, cylindrical shaft set on a bulbous base. Cut into the moist clay before firing, their openwork apertures lighten what otherwise would be rather ponderous forms. Although few examples of Three Kingdoms ceramics exhibit surface ornamentation, other than an occasional combed wave pattern or an incised configuration of circles and chevrons, here snakes inch their way up the shaft of the stand.

A BODHISATTVA SEATED IN MEDITATION. Buddhism was introduced into the Goguryeo kingdom from China in 372 and into Baekje by 384. Although it probably reached Silla in the second half of the fifth century, Buddhism gained recognition as the official religion of the Silla state only in 527.

At first, Buddhist art in Korea was a mere imitation of Chinese art. However, by the late sixth century, Korean sculptors had created a style of their own, as illustrated by a magnificent gilt bronze image of a bodhisattva (probably the Bodhisattva Maitreya) seated in meditation that likely dates to the early seventh century (FIG. 10–27). Although the pose links it to Chinese sculpture of the late sixth century, the slender body, elliptical face, elegant drapery folds, and trilobed crown distinguish it as Korean.

Buddhism was introduced to Japan from Korea—from the Baekje kingdom, according to literary accounts. In fact, historical sources indicate that numerous Korean sculptors were active in Japan in the sixth and seventh centuries; several early masterpieces of Buddhist art in Japan show pronounced Korean influence (SEE FIG. 11–8).

The Unified Silla Period

In 660, the Silla kingdom conquered Baekje, and, in 668, through an alliance with Tang-dynasty China, it vanquished Goguryeo, uniting the peninsula under the rule of the Unified Silla dynasty, which lasted until 935. Buddhism prospered under Unified Silla, and many large, important temples were erected in and around Gyeongju, the Silla capital.

SEOKGURAM. The greatest monument of the Unified Silla period is Seokguram, an artificial cave temple constructed under royal patronage atop Mt. Toham, near Gyeongju (FIG. 10–28). The temple is modeled after Chinese cave temples of the fifth, sixth, and seventh centuries, which were in turn inspired by the Buddhist cave temples of India.

Built in the mid-eighth century of cut blocks of granite, Seokguram consists of a small rectangular antechamber joined by a narrow vestibule to a circular main hall with a domed ceiling. More than 11 feet in height, the huge seated Buddha dominates the main hall. Seated on a lotus pedestal, the image represents the historical Buddha Shakyamuni at the moment of his enlightenment, as indicated by his earth-touching gesture, or *bhumisparsha-mudra*. The full, taut forms, diaphanous drapery, and anatomical details of his chest relate this image to eighth-century Chinese sculptures. Exquisitely carved low-relief images of bodhisattvas and lesser deities grace the walls of the antechamber, vestibule, and main hall.

Goryeo Dynasty

Established in 918, the Goryeo dynasty eliminated the last vestiges of Unified Silla rule in 935; it would continue until 1392, ruling from its capital at Gaeseong—to the northwest of present-day Seoul and now in North Korea. A period of courtly refinement, the Goryeo dynasty is best known for its celadon–glazed ceramics.

CELADON-GLAZED CERAMICS. The term **celadon** refers to a high-fired, transparent glaze of pale bluish-green hue, typically applied over a pale gray stoneware body. Chinese potters invented celadon glazes and had initiated the continuous

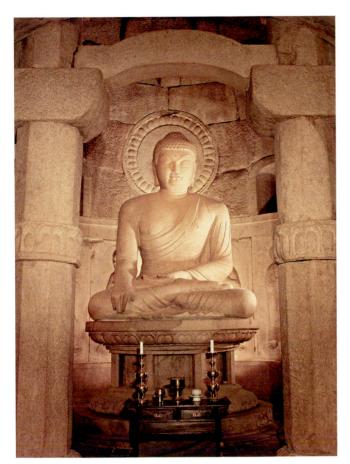

10–28 | SEATED SHAKYAMUNI BUDDHA
With hands in Bhumisparsha mudra (the Earth-Touching Gesture
Symbolizing His Enlightenment), Seokguram Grotto, main
Buddha. Korean. Unified Silla period, c. 751. Near Gyeongju,
North Gyeongsang province. Granite, height of Buddha only
11′ 2½″ (342 cm).

production of celadon-glazed wares as early as the first century CE. Korean potters began to experiment with such glazes in the eighth and ninth centuries; their earliest celadons reflect the strong imprint of Chinese ware. Soon, the finest Goryeo celadons rivaled the best Chinese court ceramics. These wares were used by people of various socioeconomic classes during the Goryeo dynasty, with the finest examples going to the palace, nobles, or the powerful Buddhist clergy.

Prized for their classic simplicity, Korean celadons of the eleventh century often have little decoration, while those of the twelfth century frequently sport incised, carved, or molded decoration, thus generally mimicking the style and ornamentation of contemporaneous Chinese ceramics. By the mid-twelfth century, Korean potters began to explore new styles and techniques of decoration. Most notable among their inventions was inlaid decoration, in which black and white slips, or finely ground clays, were inlaid into the intaglio lines of decorative elements incised or stamped in the body, creating underglaze designs in contrasting colors. This bottle displays three different pictorial scenes inlaid in black and white slips (FIG. 10–29). The scene featured here depicts

Sequencing Works of Art

Seated Buddha, Cave c. 460 CE 20, Yungang, Northern Wei Dynasty, Chinese Early 7th century CE Bodhisattva Seated in Meditation, Three Kingdoms Period, Korean The Western Paradise of c. 750 CE Amitabha Buddha, Dunhuang, Tang Dynasty, Chinese Late 12th-early 13th century CE Maebyeong Bottle, Goryeo Dynasty, Korean Guan ware vase, 13th century CE Southern Song Dynasty, Chinese

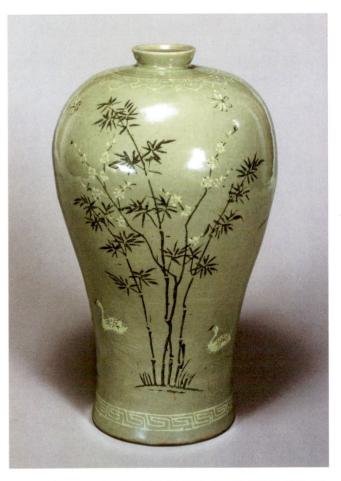

 $10\mbox{--}29$ $\mbox{ }\mbox{ }\mbo$

Korean. Goryeo dynasty, late 12th-early 13th century. Inlaid celadon ware: light gray stoneware with decoration inlaid with black and white slips under celadon glaze, height 13 ¾" (33.7 cm). Tokyo National Museum, Tokyo, Japan. [TG-2171]

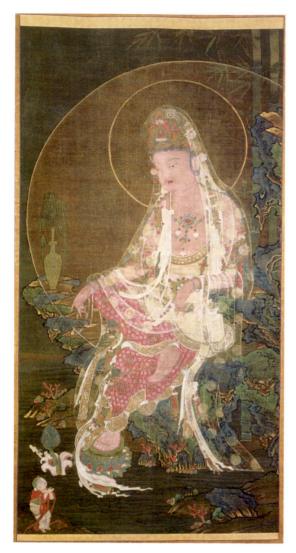

10-30 | SEATED WILLOW-BRANCH GWANSE'EUM BOSAL (THE BODHISATTVA AVALOKITESHVARA)

Korean. Goryeo dynasty, late 14th century. Hanging scroll; ink, colors, and gold pigment on silk, height 62½" (159.6 cm). Arthur M. Sackler Museum, Harvard University, Cambridge, Massachusetts.

Bequest of Grenville L. Winthrop [1943.57.12]

a clump of bamboo growing at the edge of a lake, the stalks intertwined with the branches of a blossoming plum tree (which flowers in late winter, before donning its leaves). Geese swim in the lake and butterflies flutter above, linking the several scenes around the bottle. Called *maebyeong*, which means "plum bottle," such broad-shouldered vessels were used as storage jars for wine, vinegar, and other liquids. A small, bell-shaped cover originally capped the bottle, protecting its contents and complementing its curves.

BUDDHIST PAINTING. Buddhism, the state religion of Goryeo, enjoyed royal patronage; many temples were thus able

to commission the very finest architects, sculptors, and painters. The most sumptuous Buddhist works produced during the Goryeo period were paintings. Wrought in ink and colors on silk, the fourteenth-century hanging scroll illustrated here depicts Gwanse'eum Bosal (whom the Chinese called Guanyin), the Bodhisattva of Compassion (FIG. 10–30). The flesh tones used for the bodhisattva's face and hands, along with the rich colors and gold pigment used for the deity's clothing, reflect the luxurious taste of the period. Numerous paintings of this type were exported to Japan, where they influenced the course of Buddhist painting.

IN PERSPECTIVE

Chinese civilization arose several millennia ago, distinctive for its early advancement in ceramics and metalwork, as well as for the elaborate working of jade. Early use of the potter's wheel, mastery of reduction firing, and the early invention of high-fired stoneware and porcelain distinguish the technological advancement of Chinese ceramics. Highly imaginative bronze castings and remarkably proficient techniques of mold making characterize early Chinese metalworking. Characters inscribed on these ancient bronzes are prototypes of written Chinese. Early China's attainments in so resistant a material as jade reflect not merely a technological competence with rotary tools and abrasive techniques, but moreover a profound passion for refinement and for the subtleties of shape, proportion, and surface texture. The Chinese artistic legacy to the world lies especially in these effects, with its ceramic glazes and monochrome ink paintings standing at the highest level of aesthetic refinement.

Chinese art also explored human relationships and heroic ideals, exemplifying Confucian values and teaching the standards of conduct that underlie social order. Later, China also came to embrace the Buddhist tradition from India, which was in turn transmitted to Korea and Japan, along with other aspects of Chinese culture. In princely representations of Buddhist divinities and in sublime and powerful, but often meditative, figures of the Buddha, China's artists presented the divine potential of the human condition.

Perhaps the most distinguished Chinese tradition, however, is the presentation of philosophical ideals through the theme of landscape. Paintings simply in black ink, depictions of mountains and water, became the ultimate artistic medium for expressing the vastness, abundance, and endurance of the universe.

Chinese civilization radiated its influence throughout East Asia. Chinese learning repeatedly stimulated the growth of culture in Korea, which in turn transmitted influence to Japan.

BEFORE 3000 BCE

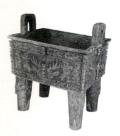

FANG DING
C. 12TH CENTURY BCE

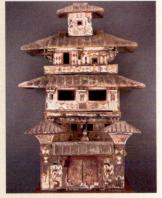

TOMB MODEL OF A HOUSE 1ST-MID-2ND CENTURY CE

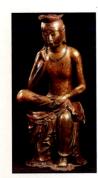

BODHISATTVA SEATED
IN MEDITATION
EARLY 7TH CENTURY CE

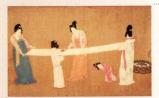

ATTRIBUTED TO EMPEROR
HUIZONG OF LADIES PREPARING
NEWLY WOVEN SILK, DETAIL
EARLY 12TH CENTURY CE

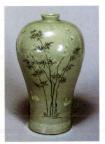

MAEBYEONG BOTTLE
LATE 12THEARLY 13TH CENTURY CE

5000 BCE

2000

1000

CE

500

1000

1500

CHINESE AND KOREAN ART BEFORE 1279

■ Neolithic c. 5000-2000 BCE

■ Liangzhu Culture Emerged c. 3300 BCE

■ Bronze Age c. 1700–211 BCE

■ Shang Dynasty c. 1700–1100 BCE

▼ Zhou Dynasty 1100-211 BCE

■ Warring States Period c. 481-220 BCE

■ Qin Dynasty 221–206 BCE

◀ Han Dynasty 206 BCE-220 CE

▼ Three Kingdoms Period (Korea)
c. 57 BCE-668 CE

▼ Six Dynasties Period c. 265-587 CE

Sui Dynasty 581-618 CE

▼ Tang Dynasty 618-907 CE

■ Unified Silla 668-935 CE

Song Dynasty 960−1279 CE

■ Goryeo Dynasty 918–1392 CE

■ Yuan Dynasty 1279-1368 CE

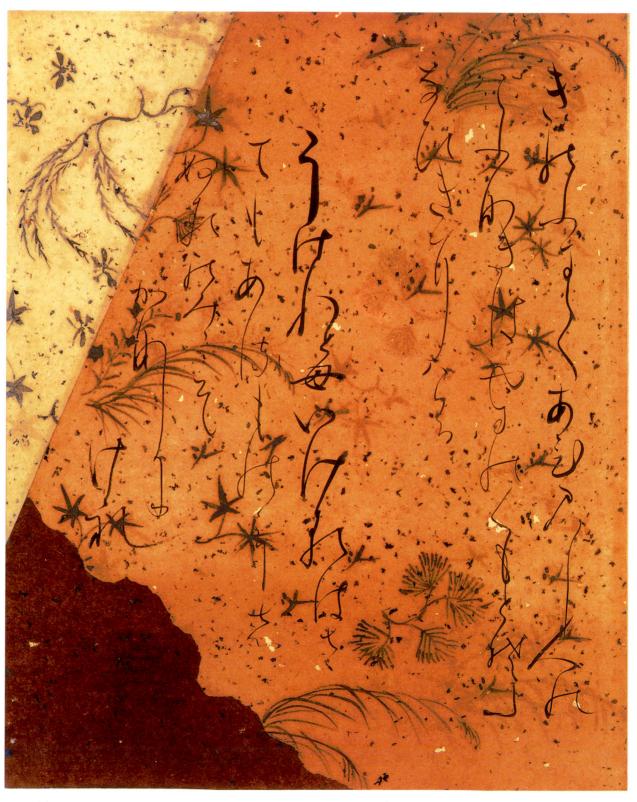

II—I | ALBUM LEAF FROM THE ISHIYAMA-GIRE | Heian period, early 12th century CE. Ink with gold and silver on decorated and collaged paper, $52 \times 17\%$ (131.8 \times 44 cm). Freer Gallery of Art, Smithsonian Institution, Washington, D.C. (F1969.4)

CHAPTER ELEVEN

JAPANESE ART BEFORE 1392

Buddhism pervaded the Heian era (794–1185), and yet a refined secular culture also arose at court. Gradually, over the course of these four centuries, the pervasive influence of Chinese culture gave rise to new, uniquely Japanese

11

developments. Although court nobles continued to write many poems in Chinese, both men and women wrote in the new *kana* script of their native language (see "Writing, Language, and Culture," page 376). With its simple, flowing symbols interspersed with more complex Chinese characters, the new writing system allowed Japanese poets to create an asymmetrical calligraphy quite unlike that of China.

Refinement was greatly valued among the Heian-period aristocracy. A woman would be admired merely for the way she arranged the twelve layers of her robes by color, or a man for knowing which kind of incense was being burned. Much of court life was preoccupied by the poetical expression of human love written in five-line verses called *tanka*. A courtier leaving his beloved at dawn would send her a poem wrapped around a single flower still wet with dew. If his words or his calligraphy were less than stylish, however, he would not be welcome to visit her again. In turn, if she could not reply with equal elegance, he might not wish to repeat

their amorous interlude. Society was ruled by taste, and pity any man or woman at court who was not accomplished in several forms of art.

During the later Heian period, the finest tanka were gathered in anthologies. The poems

in one famous early anthology, the *Thirty-Six Immortal Poets*, are still known to educated Japanese today. This anthology was produced in sets of albums called the *Ishiyama-gire*. These albums consist of *tanka* written elegantly on high-quality papers decorated with painting, block printing, scattered gold and silver, and sometimes paper collage. Sometimes, as in FIG. 11–1, the irregular pattern of torn paper edges adds a serendipitous element. The page shown here reproduces two *tanka* by the courtier Ki no Tsurayuki. Both poems express sadness. Here is one of them:

Until yesterday
I could meet her,
But today she is gone—
Like clouds over the mountain
She has been wafted away.

The spiky, flowing calligraphy and the patterning of the papers, the rich use of gold, and the suggestions of natural imagery match the elegance of the poetry, epitomizing courtly Japanese taste.

CHAPTER-AT-A-GLANCE

- PREHISTORIC JAPAN | Jomon Period | Yayoi and Kofun Periods
- ASUKA PERIOD | Horyu-ji
- NARA PERIOD
- HEIAN PERIOD | Esoteric Buddhist Art | Pure Land Buddhist Art | Calligraphy and Painting
- KAMAKURA PERIOD | Pure Land Buddhist Art | Zen Buddhist Art
- IN PERSPECTIVE

PREHISTORIC JAPAN

The earliest traces of human habitation in Japan are at least 30,000 years old. At that time the four islands that compose the country today were still linked to the East Asian landmass, forming a ring from Siberia to Korea around the present-day Sea of Japan, which was then a lake. With the end of the last Ice Age, some 15,000 years ago, melting glaciers caused the sea level to rise, gradually submerging the lowland links and creating the islands as we know them today (MAP II–I). Sometime thereafter, Paleolithic peoples gave way to Neolithic hunter-gatherers, who gradually developed the ability to make and use ceramics. Recent scientific dating methods have shown some works of Japanese pottery to date earlier than 10,000 BCE, making them the oldest now known.

Jomon Period

The Jomon period (c. 11,000–400 BCE) is named for the patterns on much of the pottery produced during this time, which were made by pressing cord onto damp clay (jomon means "cord markings"). Jomon people were able to develop a sophisticated hunting-gathering culture, unusual for its early production of ceramics, in part because their island setting protected them from large-scale invasions and also because of their abundant food supply. Around 5000 BCE agriculture emerged with the planting and harvesting of beans and gourds. Some 4,500 years later, the Jomon remained primarily a hunting-gathering society that used stone tools and weapons. People lived in small communities, usually with fewer than ten or twelve dwellings, and seem to have enjoyed a peaceful life, giving them the opportunity to develop their artistry for even such practical endeavors as ceramics.

JOMON POTTERY. Jomon ceramics may have begun in imitation of reed baskets, as many early examples suggest. Other early Jomon pots have pointed bottoms. Judging from burn marks along the sides, they must have been planted firmly into the ground, then used for cooking. Applying fire to the sides rather than the bottom allowed the vessels to heat more fully and evenly. Still other early vessels were crafted with

straight sides and flat bottoms, a shape that was useful for storage as well as cooking and which eventually became the norm. Jomon potters usually crafted their vessels by building them up with coils of clay, then firing them in bonfires at relatively low temperatures. Researchers think that Jomon pottery was made by women, as was the practice in most early societies, especially before the use of the potter's wheel.

During the middle Jomon period (2500–1500 BCE), pottery reached a high degree of creativity. By this time communities were somewhat larger, and each family may have wanted its ceramic vessels to have a unique design. The basic form remained straight-sided, but the rim now took on spectacular, flamboyant shapes (FIG. 11–2). Middle Jomon potters made full use of the malleable quality of clay, bending and twisting it as well as **incising** and applying designs. They

II-2 | "FLAME WARE" (KAEN-DOKI) VESSEL
Niigata Prefecture. Middle Jomon phase (c. 2500-1500 BCE),
c. 2500-2400 BCE. Earthenware, height 12½" (30.8 cm).
Kokubunji, Kokununji City, Tokyo.

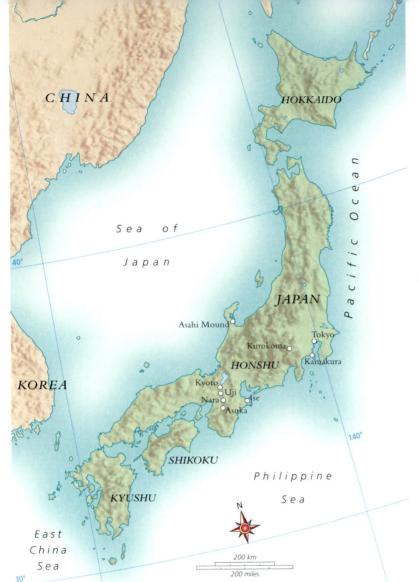

MAP II-I JAPAN

Melting glaciers at the end of the Ice Age in Japan 15,000 years ago raised the sea level and formed the four main islands of Japan: Hokkaido, Honshu, Shikoku, and Kyushu.

favored asymmetrical shapes, although certain elements in the geometric patterns are repeated. Some designs may have had specific meanings, but the vessels also display an abundantly playful artistic spirit.

Dogu. The people of the middle and late Jomon periods also used clay to fashion small humanoid figures. These figures were never fully realistic but rather were distorted into fascinating shapes. Called **dogu**, they tend to have large faces, small arms and hands, and compact bodies. Some of the later *dogu* seem to be wearing round goggles over their eyes. Others have heart-shaped faces. One of the finest, from Kurokoma, has a face remarkably like a cat's (FIG. II-3). The slit eyes and mouth have a haunting quality, as does the gesture of one hand touching the chest. The marks on the face, neck, and shoulders suggest tattooing and were probably incised with a bamboo stick. The raised area behind the face may indicate a Jomon hairstyle.

The purpose of Jomon *dogu* remains unknown, but most scholars believe that they were effigies, figures representing the owner or someone else, and that they manifested a kind

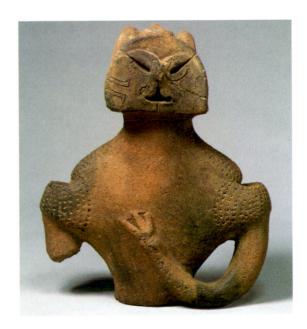

II-3 | DOGU Kurokoma, Yamanashi Prefecture. Jomon period, c. 2500-1500 BCE. Earthenware, height 10" (25.2 cm). Tokyo National Museum.

Art and Its Context

WRITING, LANGUAGE, AND CULTURE

hinese culture enjoyed great prestige in East Asia. Written Chinese served as an international language of scholarship and cultivation, much as Latin did in medieval Europe. Educated Koreans, for example, wrote almost exclusively in Chinese until the fifteenth century CE. In Japan, Chinese continued to be used for certain kinds of writing, such as philosophical and legal texts, into the nineteenth century.

When it came to writing their own language, the Japanese initially borrowed Chinese characters, or *kanji*. Differences between the Chinese and Japanese languages made this system extremely unwieldy, so during the ninth century CE two syllabaries, or *kana*, were developed from simplified Chinese characters. (A *syllabary* is a system of lettering in which each symbol stands for a syllable.) *Katakana*, now generally used for foreign words, consists of mostly angular symbols, while the more frequently used *hiragana* has graceful, cursive symbols.

Japanese written in *kana* was known as "women's hand," possibly because prestigious scholarly writing still emphasized Chinese, which women were rarely taught. Yet Japan had an ancient and highly valued poetic tradition of its own, and women as well as men were praised as poets from earliest times. So while women rarely became scholars, they were often authors. During the Heian period *kana* were used to create a

large body of literature, written either by women or sometimes for women by men.

A charming poem originated in Heian times to teach the new writing system. In two stanzas of four lines each, it uses almost all of the syllable sounds of spoken Japanese and thus almost every *kana* symbol. It was memorized as we would recite our ABCS. The first stanza translates as:

Although flowers glow with color They are quickly fallen, And who in this world of ours Is free from change? (Translation by Earl Miner)

Like Chinese, Japanese is written in columns from top to bottom and across the page from right to left. (Following this logic, Chinese and Japanese narrative paintings also read from right to left.) Below is the stanza written three ways. At the right, it appears in *katakana* glossed with the original phonetic value of each symbol. (Modern pronunciation has shifted slightly.) In the center, the stanza appears in flowing *hiragana*. To the left is the mixture of *kanji* and *kana* that eventually became standard. This alternating rhythm of simple kana symbols and more complex Chinese characters gives a special flavor to Japanese calligraphy.

of sympathetic magic. Jomon people may have believed, for example, that they could transfer an illness or other unhappy experience to a *dogu*, then break it to destroy the misfortune. So many of these figures were deliberately broken and discarded that this theory has gained acceptance, but *dogu* may have had different functions at different times. Regardless of their purpose, the images still retain a powerful sense of magic thousands of years after their creation.

Yayoi and Kofun Periods

During the Yayoi (c. 400 BCE–300 CE) and Kofun (c. 300–552 CE) eras several features of Japanese culture became firmly established. Most important of these was the transformation of Japan into an agricultural nation, with rice cultivation becoming widespread. This momentous change was stimulated by the arrival of immigrants from Korea, who brought with them more complex forms of society and government.

YAYOI. As it did elsewhere in the world, the shift from hunting and gathering to agriculture brought profound social changes, including larger permanent settlements, the division of labor into agricultural and nonagricultural tasks, more hierarchical forms of social organization, and a more centralized government. The emergence of a class structure can be dated to the Yayoi period, as can the development of metal technology. Bronze was used to create weapons as well as ceremonial objects such as bells. Iron metallurgy developed later in this period, eventually replacing stone tools in everyday life.

Yayoi people lived in thatched houses with sunken floors and stored their food in raised granaries. Drawings of their granaries are to be found on bronze artifacts of this period, and these drawings bear a striking resemblance to the architectural design of shrines in later centuries (SEE FIG. 11–5). The sensitive use of wood and thatch in these shrines suggests an early origin of the Japanese appreciation of natural materials noted in later periods and up to the present.

KOFUN. The trend toward centralized government became more pronounced during the ensuing Kofun, or "old tombs," period, named for the large royal tombs that were built then. With the emergence of a more complex social order, the veneration of leaders grew into the beginnings of an imperial system. Still in existence today in Japan, this system eventually equated the emperor (or, very rarely, empress) with deities such as the sun goddess. When an emperor died, chamber tombs were constructed following Korean examples. Various grave goods were placed inside the tomb chambers, including large amounts of pottery, presumably to pacify the spirits of the dead and to serve them in their next life. As a part of a general cultural transfer from China through Korea, fifthcentury potters in Japan gained knowledge of finishing techniques and improved kilns and began to produce a high-fired ceramic ware. Stoneware technology was thus added to the repertory of Japanese ceramic techniques developed in the earthenware of previous periods.

The Japanese government has never allowed the major sacred tombs to be excavated, but much is known about the mortuary practices of Kofun-era Japan. Some of the huge tombs of the fifth and sixth centuries CE were constructed in a shape resembling a large keyhole and surrounded by **moats** dug to protect the sacred precincts. Tomb sites might extend over more than 400 acres, with artificial hills built over the tombs themselves. On the top of the hills were placed ceramic works of sculpture called **haniwa**.

HANIWA. The first *haniwa* were simple cylinders that may have held jars with ceremonial offerings. By the fifth century CE, these cylinders came to be made in the shapes of ceremonial objects, houses, and boats. Gradually, living creatures were added to the repertoire of *haniwa* subjects, including birds, deer, dogs, monkeys, cows, and horses. By the sixth century,

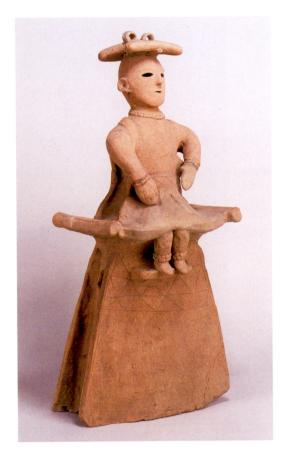

II-4 | HANIWA Kyoto. Kofun period, 6th century CE. Earthenware, height 27" (68.5 cm). Collection of the Tokyo National Museum.

There have been many theories as to the function of haniwa. The figures seem to have served as some kind of link between the world of the dead, over which they were placed, and the world of the living, from which they could be viewed. This figure has been identified as a seated female shaman, wearing a robe, belt, and necklace and carrying a mirror at her waist. In early Japan, shamans acted as agents between the natural and the supernatural worlds, just as haniwa figures were links between the living and the dead.

haniwa in human shapes were crafted, including males and females of various types, professions, and classes (FIG. 11-4).

Haniwa illustrate several enduring characteristics of Japanese aesthetic taste. Unlike Chinese tomb ceramics, which were often beautifully glazed, haniwa were left unglazed to reveal their clay bodies. Nor do haniwa show a preoccupation with technical skill seen in Chinese ceramics. Instead, their makers explored the expressive potentials of simple and bold form. Haniwa are never perfectly symmetrical; their slightly off-center eye slits, irregular cylindrical bodies, and unequal arms impart the idiosyncrasy of life and individuality.

SHINTO. Shinto is considered to be the indigenous religion of Japan, but it is most accurately understood as the various ways that different communities of Japanese, from the

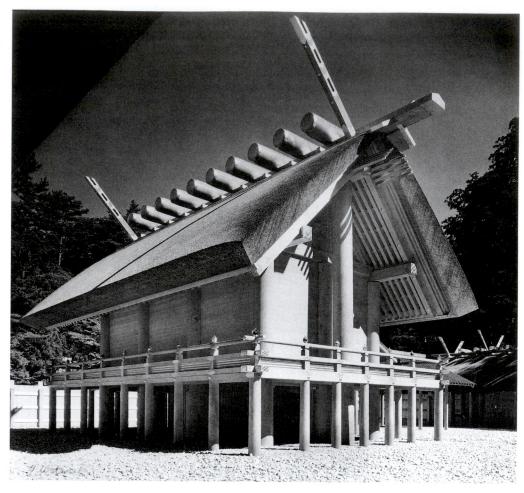

II-5 | MAIN HALL, INNER SHRINE, ISE Mie Prefecture. Last rebuilt 1993.

imperial household to remote villages, have interacted with deities (kami). These kami were thought to inhabit awesome things in the ordinary world, including particularly hoary and magnificent trees, rocks, waterfalls, and living creatures such as deer. Shinto also emphasizes ritual purification of the ordinary world. The term *Shinto* was not coined until after the arrival of Buddhism in the sixth century CE, and as kami worship was influenced by and incorporated into Buddhism it became more systematized, with shrines, a hierarchy of deities, and more strictly regulated ceremonies.

The Ise Shrine. One of the great Shinto monuments is the shrine at Ise, on the coast southwest of Tokyo (FIG. 11–5), dedicated to the sun goddess Amaterasu-o-mi-kami, the legendary progenitor of Japan's imperial family. For nearly 2,000 years, the shrine has been ritually rebuilt, alternately on two adjoining sites at twenty-year intervals (most recently in 1993), by carpenters who train for the task from childhood. After the *kami* is ceremonially escorted to the freshly copied shrine, the old shrine is dismantled. It is believed that the temple accurately preserves features of Yayoi-era granaries, which were its original prototype. Thus—like Japanese culture itself—this exquisite shrine is both ancient and constantly renewed.

The Ise shrine has many aspects that are typical of Shinto architecture, including wooden piles raising the building off the ground, a thatched roof held in place by horizontal logs, the use of unpainted cypress wood, and the overall feeling of natural simplicity rather than overwhelming size or elaborate decoration. Although Ise is visited by millions of pilgrims each year, only members of the imperial family and a few Shinto priests are allowed within the fourfold enclosure that surrounds the sacred shrine. The shrine itself stores the three sacred symbols of Shinto—a sword, a mirror, and a jewel.

ASUKA PERIOD

Japan has experienced several periods of intense cultural transformation. Perhaps the greatest time of change was the Asuka period (552–645 CE). During a single century, new forms of philosophy, medicine, music, foods, clothing, agricultural methods, city planning, and arts and architecture were introduced into Japan from Korea and China. The three most significant introductions, however, were Buddhism, a centralized governmental structure, and a system of writing. Each was adopted and gradually modified to suit Japanese conditions, and each has had an enduring legacy.

Buddhism reached Japan in Mahayana form, with its many buddhas and bodhisattvas (see "Buddhism," page 317). After being accepted by the imperial family, it was soon adopted as a state religion. Buddhism represented not only different gods from Shinto but an entirely new concept of religion itself. Where Shinto had found deities in beautiful and imposing natural areas, Buddhist worship was focused in temples. At first this change must have seemed strange, for the Chinese-influenced architecture and elaborate iconography introduced by Buddhism (see "Buddhist Symbols," page 381) contrasted sharply with the simple and natural aesthetics of earlier Japan. Yet Buddhism offered a rich cosmology with profound teachings of meditation and enlightenment. Moreover, the new religion was accompanied by many highly developed aspects of continental Asian culture, including new methods of painting and sculpture.

Horyu-ji

The most significant surviving early Japanese temple is Horyu-ji, located on Japan's central plains not far from Nara. The temple was founded in 607 CE by Prince Shotoku (574–622 CE), who ruled Japan as a regent and became the most influential early proponent of Buddhism. Rebuilt after a fire in 670, Horyu-ji is the oldest wooden temple in the world. It is so famous that visitors are often surprised at its modest size. Yet its just proportions and human scale, together with the artistic treasures it contains, make Horyu-ji an enduringly beautiful monument to the early Buddhist faith of Japan.

The main compound of Horyu-ji consists of a rectangular courtyard surrounded by covered corridors, one of which contains a gateway. Within the compound are only two buildings, the **kondo**, or golden hall, and a five-story **pagoda**. The

Sequencing Events HISTORIC PERIODS IN JAPANESE ART TO 1392

с. 11,000-400 все	Jomon Period
c. 400 BCE-300 CE	Yayoi Period
c. 300-552 CE	Kofun Period
552-645 CE	Asuka Period
645-794 CE	Nara Period
794-1185 CE	Heian Period
1185-1392 CE	Kamakura Period

simple layout of the compound is asymmetrical, yet the large kondo is perfectly balanced by the tall, slender pagoda (FIG. II–6). The kondo is filled with Buddhist images and is used for worship and ceremonies. The pagoda serves as a reliquary and is not entered. Other monastery buildings lie outside the main compound, including an outer gate, a lecture hall, a repository for sacred texts, a belfry, and dormitories for monks.

Among the many treasures still preserved in Horyu-ji is a shrine decorated with paintings in lacquer. It is known as the Tamamushi Shrine after the *tamamushi* beetle, whose iridescent wings were originally affixed to the shrine to make it glitter, much like mother-of-pearl. There has been some debate whether the shrine was made in Korea, in Japan, or perhaps by Korean artisans in Japan. The question of whether it is, in fact, a "Japanese" work of art misses the point that

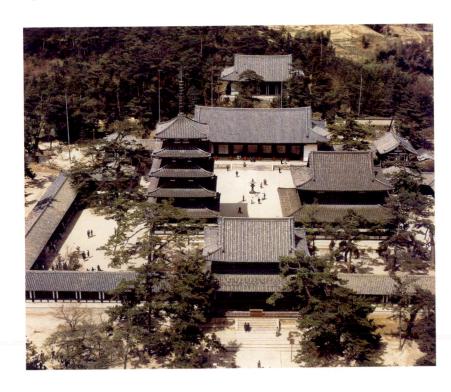

 $_{\rm II-6}$ | aerial view of horyu-ji compound

Pagoda to the west, Golden Hall (Kondo) to the east, Nara Prefecture. Asuka period, 7th century CE.

Photo: Orion Press, Tokyo

Buddhism was so international at that time that matters of nationality were irrelevant.

HUNGRY TIGRESS JATAKA. The Tamamushi Shrine is a replica of an even more ancient palace-form building, and its architectural details preserve a tradition predating Horyu-ji itself. Its paintings are among the few two-dimensional works of art to survive from the Asuka period. Most celebrated among them are two that illustrate jataka tales, stories about former lives of the Buddha. One depicts the future Buddha nobly sacrificing his life in order to feed his body to a starving tigress and her cubs (FIG. 11–7). The tigers are at first too weak to eat him, so he must jump off a cliff to break open his flesh. The anonymous artist has created a full narrative within a single frame. The graceful form of the Buddha appears three times, harmonized by the curves of the rocky cliff and tall sprigs of bamboo. First, he hangs his shirt on a tree, then he dives downward onto the rocks, and finally he is devoured by

the starving animals. The elegantly slender renditions of the figure and the somewhat abstract treatment of the cliff, trees, and bamboo represent an international Buddhist style largely shared during this time by China, Korea, and Japan. These illustrations for the *jataka* tales helped spread Buddhism in Japan.

SHAKA TRIAD. Another example of the international style of early Buddhist art at Horyu-ji is the sculpture called the SHAKA TRIAD, by Tori Busshi (FIG. 11–8). (SHAKA is the Japanese name for Shakyamuni, the historical Buddha.) Tori Busshi was a third-generation Japanese, whose grandfather had emigrated to Japan from the continent as part of an influx of Buddhists and artisans from China and Korea. The Shaka Triad reflects the strong influence of Chinese art of the Northern Wei dynasty (SEE FIG. 10–13). The frontal pose, the outsized face and hands, and the linear treatment of the drapery all suggest that Tori Busshi was well aware of earlier continental

II—7 | HUNGRY TIGRESS JATAKA
Panel of the Tamamushi Shrine, Horyu-ji. Asuka period, c. 650
CE. Lacquer on wood, height of shrine 7' 7½" (2.33 m).
Horyu-ji Treasure House.

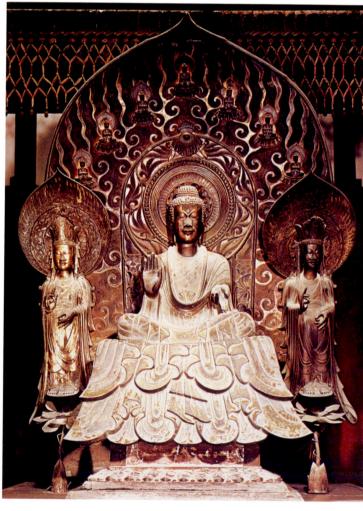

II-8 | Tori Busshi SHAKA TRIAD IN THE KONDO Horyu-ji. Asuka period, c. 623 CE. Gilt bronze, height of seated figure $34\frac{1}{2}$ " (87.5 cm).

Myth and Religion

BUDDHIST SYMBOLS

few of the most important Buddhist symbols, which have myriad variations, are described here in their most generalized forms.

Lotus flower: Usually shown as a white water lily, the lotus (Sanskrit, *padma*) symbolizes spiritual purity, the wholeness of creation, and cosmic harmony. The flower's stem is an **axis** mundi ("axis of the world").

Lotus throne: Buddhas are frequently shown seated on an open lotus, either single or double, a representation of nirvana.

Chakra: An ancient sun symbol, the wheel (*chakra*) symbolizes both the various states of existence (the Wheel of Life) and

the Buddhist doctrine (the Wheel of the Law). A *chakra*'s exact meaning depends on how many spokes it has.

Marks of a buddha: A buddha is distinguished by thirty-two physical attributes (lakshana). Among them are a bulge on top of the head (ushnisha), a tuft of hair between the eyebrows (urna), elongated earlobes, and thousand-spoked chakras on the soles of the feet.

Mandala: Mandalas are diagrams of cosmic realms, representing order and meaning within the spiritual universe. They may be simple or complex, three- or two-dimensional, in a wide array of forms—such as an Indian stupa (SEE FIG. 9–8) or a Womb World mandala (SEE FIG. 11–10), an early Japanese type.

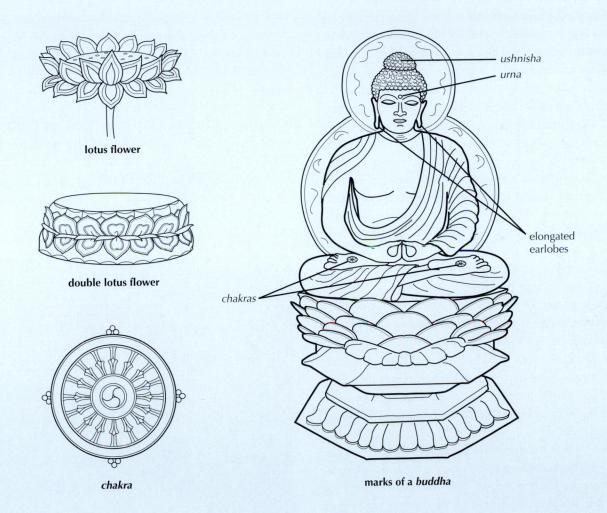

models, while the fine bronze casting of the figures shows his advanced technical skill. The *Shaka Triad* and the Tamamushi Shrine reveal how quickly Buddhist art became an important feature of Japanese culture.

NARA PERIOD

The Nara period (645–794 CE) is named for Japan's first permanent imperial capital. Previously, when an emperor died, his capital was considered tainted, and for reasons of purification (and perhaps also of politics) his successor usually selected a new site. With the emergence of a complex, Chinese-style government, however, this custom was no longer practical. By establishing a permanent capital in Nara, the Japanese were able to enter a new era of growth and consolidation. Nara swelled to a population of perhaps 200,000 people. During this period the imperial system solidified into an effective government that could withstand the powerful aristocratic families that had traditionally dominated the political world.

One result of strong central authority was the construction in Nara of magnificent Buddhist temples and monasteries that dwarfed those built previously. Even today a large area of Nara is a park where numerous temples preserve magnificent Nara-period art and architecture. The grandest of these temples, Todai-ji, is so large that the area surrounding only one of its pagodas could accommodate the entire main compound of Horyu-ji. When it was built, and for a thousand years thereafter, Todai-ji was the largest wooden structure in the world. Not all the monuments of Nara are Buddhist. There also are several Shinto shrines, and deer wander freely, reflecting Japan's Shinto heritage.

Buddhism and Shinto have coexisted quite comfortably in Japan over the ages. One seeks enlightenment, the other purification, and since these ideals did not clash, neither did the two forms of religion. Although there were occasional attempts to promote one over the other, more often they were seen as complementary, and to this day most Japanese see nothing inconsistent about having Shinto weddings and Buddhist funerals.

While Shinto became more formalized during the Nara period, Buddhism advanced to become the single most significant element in Japanese culture. One important method for transmitting Buddhism in Japan was through the copying of Buddhist sacred texts, the *sutras*. They were believed to be so beneficial and magical that occasionally a single word would be cut out from a *sutra* and worn as an amulet. Someone with hearing problems, for example, might use the word for "ear."

Copying the words of the Buddha was considered an effective act of worship by the nobility; it also enabled Japanese courtiers as well as clerics to become familiar with the Chinese system of writing—with both secular and religious results. During this period, the first histories of Japan were written, strongly modeled upon Chinese precedents, and the

first collection of Japanese poetry, the *Manyoshu*, was compiled. The *Manyoshu* includes Buddhist verse, but the majority of the poems are secular, including many love songs in the five-line *tanka* form, such as this example by the late seventh-century courtier Hitomaro (all translations from Japanese are by Stephen Addiss unless otherwise noted):

Did those who lived in past ages lie sleepless as I do tonight longing for my beloved?

Unlike the poetry, most other art of the Nara period is sacred, with a robust splendor that testifies to the fervent belief and great energy of early Japanese Buddhists. Some of the finest Buddhist paintings of the late seventh century were preserved in Japan on the walls of the golden hall of Horyuji until a fire in 1949 defaced and partially destroyed them. Fortunately, they had been thoroughly documented before the fire in a series of color photographs. These murals represent what many scholars believe to be the golden age of Buddhist painting, an era that embraces the Tang dynasty in China (618–907 CE), the Unified Silla period in Korea (668–935 CE), and the Nara period in Japan.

One of the finest of the Horyu-ji murals is thought to represent Amida, the Buddha of the Western Paradise

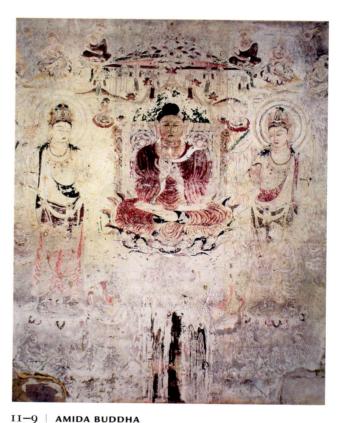

Wall painting in the *kondo*, Horyu-ji. Nara period, c. 710 CE. Ink and colors (now severely damaged), $10'3'' \times 8'6''$ (3.13 \times 2.6 m).

(FIG. 11–9). Delineated in the thin, even brushstrokes known as *iron-wire lines*, Amida's body is rounded, his face is fully fleshed and serene, and his hands form the **dharmachakra** ("revealing the Buddhist law") *mudra* (see "*Mudras*," page 325). Instead of the somewhat abstract style of the Asuka period, there is now a greater emphasis on realistic detail and body weight in the figure. The parallel folds of drapery show the enduring influence of the Gandhara style current in India 500 years earlier (SEE FIG. 9–13), but the face is fully East Asian in contour and spirit.

The Nara period was an age of faith, and Buddhism permeated the upper levels of society. Indeed, one of the few empresses in Japanese history wanted to cede her throne to a Buddhist monk. Her advisers and other influential courtiers became extremely worried at this, and they finally decided to move the capital away from Nara, where they felt Buddhist influence had become overpowering. The move of the capital to Kyoto marked the end of the Nara period.

HEIAN PERIOD

The Japanese fully absorbed and transformed the influences from China and Korea during the Heian period (794–1185 CE). Generally peaceful conditions contributed to a new air of self-reliance on the part of the Japanese. The imperial government severed ties to China in the ninth century and was sustained by support from aristocratic families. An efficient method of writing the Japanese language was developed, and the rise of vernacular literature generated such masterpieces as the world's first novel, Lady Murasaki's *The Tale of Genji*. During these four centuries of splendor and refinement, two major religious sects emerged—first, Esoteric Buddhism and, later, Pure Land Buddhism.

Esoteric Buddhist Art

With the removal of the capital to Kyoto, the older Nara temples lost their influence. Soon two new Esoteric sects of Buddhism, named Tendai and Shingon, grew to dominate Japanese religious life. Strongly influenced by polytheistic religions such as Hinduism, Esoteric Buddhism included a daunting number of deities, each with magical powers. The historical Buddha was no longer very important. Instead, the universal Buddha, called Dainichi in Japanese, meaning "Great Sun," was believed to preside over the universe. He was accompanied by *buddhas* and *bodhisattvas*, as well as guardian deities who formed fierce counterparts to the more benign gods.

Esoteric Buddhism is hierarchical, and its deities have complex relationships to one another. Learning all the different gods and their interrelationships was assisted greatly by works of art, especially mandalas, cosmic diagrams of the universe that portray the deities in schematic order. The Womb World mandala from To-ji, for example, is entirely

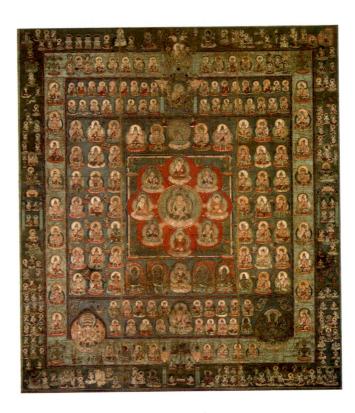

II-IO WOMB WORLD MANDALA

To-ji, Kyoto. Heian period, late 9th century CE. Hanging scroll, colors on silk, $6' \times 5'1\frac{1}{2}''$ (1.83 \times 1.54 m).

Mandalas are used not only in teaching, but also as vehicles for practice. A monk, initiated into secret teachings, may meditate upon and assume the gestures of each deity depicted in the mandala, gradually working out from the center, so that he absorbs some of each deity's powers. The monk may also recite magical phrases called mantras as an aid to meditation. The goal is to achieve enlightenment through the powers of the different forms of the Buddha. Mandalas are created in sculptural and architectural forms as well as in paintings. Their integration of the two most basic shapes, the circle and the square, is an expression of the principles of ancient geomancy (divining by means of lines and figures) as well as Buddhist cosmology.

filled with depictions of gods. Dainichi is at the center, surrounded by *buddhas* of the four directions (FIG. 11–10). Other deities, including some with multiple heads and limbs, branch out in diagrammatical order, each with a specific symbol of power. To believers, the *mandala* represents an ultimate reality beyond the visible world.

Perhaps the most striking attribute of many Esoteric Buddhist images is their sense of spiritual force and potency, especially in depictions of the wrathful deities, which are often surrounded by flames, like those visible in the *Womb World Mandala* just below the main circle of Buddhas. Esoteric Buddhism, with its intricate theology and complex doctrines, was a religion for the educated aristocracy, not for the masses. Its intricate network of deities, hierarchy, and ritual found a parallel in the elaborate social divisions of the Heian court.

Pure Land Buddhist Art

During the latter half of the Heian period, a rising military class threatened the peace and tranquility of court life. The beginning of the eleventh century was also the time for which the decline of Buddhism (*Mappo*) had been prophesied. In these uncertain years, many Japanese were ready for another form of Buddhism that would offer a more direct means of salvation than the elaborate rituals of the Esoteric sects.

Pure Land Buddhism, although it had existed in Japan earlier, now came to prominence. It taught that the Western Paradise (the Pure Land) of the Amida Buddha could be reached through nothing more than faith. In its ultimate form, Pure Land Buddhism held that the mere chanting of a *mantra*—the phrase *Namu Amida Butsu* ("Hail to Amida Buddha")—would lead to rebirth in Amida's paradise. This doctrine soon swept throughout Japan. Spread by traveling monks who took the chant to all parts of the country (SEE FIG. 11–17), it appealed to people of all levels

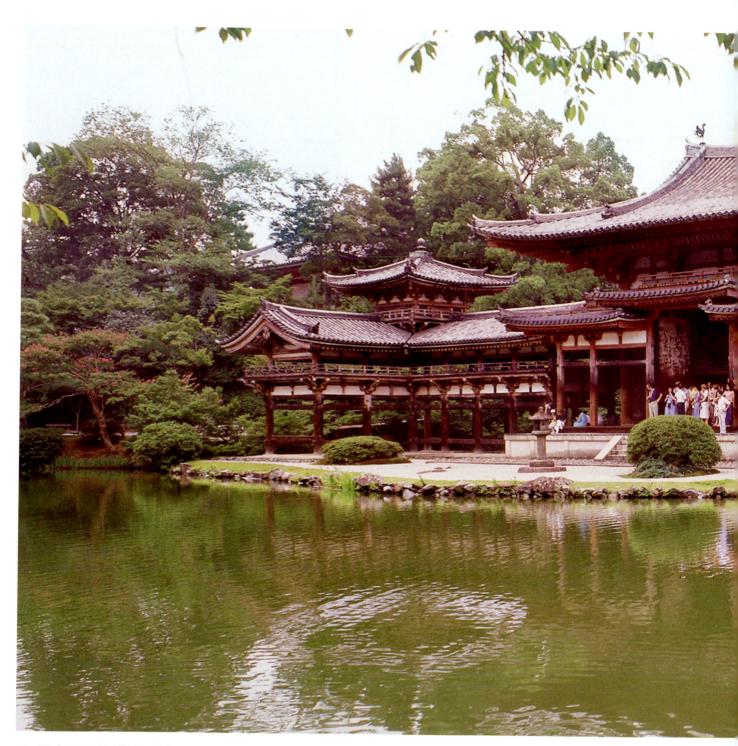

II—II | PHOENIX HALL, BYODO-IN, UJI Kyoto Prefecture. Heian period, c. 1053 CE.

of education and sophistication. Pure Land Buddhism has remained the most popular form of Buddhism in Japan ever since.

Byodo-IN. One of the most beautiful temples of Pure Land Buddhism is the Byodo-in, located in the Uji Mountains not far from Kyoto (FIG. II–II). The temple itself was originally a secular palace created to suggest the palace of Amida in the Western Paradise. It was built for a member of the powerful Fujiwara family who served as the leading counselor to the

emperor. After the counselor's death in the year 1052, the palace was converted into a temple. The Byodo-in is often called Phoenix Hall, not only for the pair of phoenix images on its roof, but also because the shape of the building itself suggests the mythical bird. Its thin columns give the Byodo-in a sense of airiness, as though the entire temple could easily rise up through the sky to Amida's Western Paradise. The hall rests gently in front of an artificial pond created in the shape of the Sanskrit letter A, the sacred symbol for Amida.

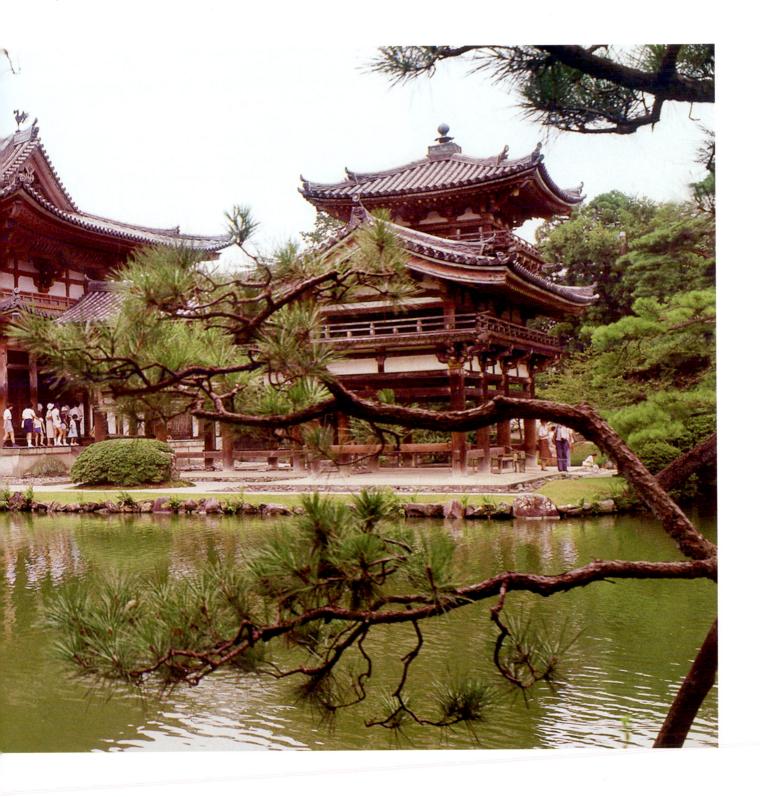

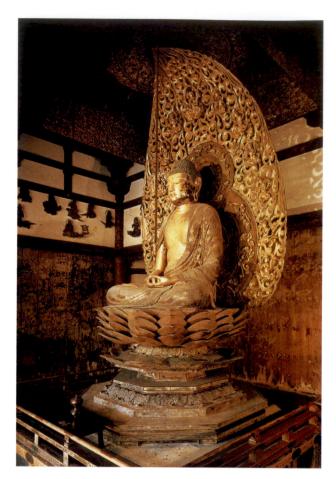

II-I2 | Jocho AMIDA BUDDHA
Phoenix Hall, Byodo-in. Heian period, c. 1053 CE. Gold leaf and lacquer on wood, height 9'8" (2.95 m).

The Byodo-in's central image of Amida, carved by the master sculptor Jocho (d. 1057), exemplifies the serenity and compassion of the Buddha, who welcomes the souls of all believers to his paradise (FIG. 11–12). When reflected in the water of the pond before it, the Amida image seems to shimmer in its private mountain retreat. The figure was not carved from a single block of wood like earlier sculpture, but from several blocks in Jocho's new joined-wood method of construction (see "Joined-Wood Sculpture," page 387). This technique allowed sculptors to create larger but lighter portrayals of buddhas and bodhisattvas for the many temples constructed and dedicated to the Pure Land faith. It also reflects the Japanese love of wood, which during the Heian period became the major medium for sculpture.

Surrounding the Amida on the walls of the Byodo-in are smaller wooden figures of *bodhisattvas* and angels, some playing musical instruments. Everything about the Byodo-in was designed to suggest the paradise that awaits the believer after death. Its remarkable state of preservation after more than 900 years allows visitors to experience the late Heian-period religious ideal at its most splendid.

Calligraphy and Painting

One prominent style of Japanese calligraphy that emerged at this period, such as that seen in the *Ishiyama-gire* (SEE FIG. 11–1), was considered "women's hand." Actually, it is not known how much of the calligraphy of the time was written by women or how widespread the term was in actual use. It is certain, however, that women were a vital force in Heian society. Although the place of women in Japanese society was to decline in later periods, they contributed greatly to the art at the Heian court.

Women were noted for both their poetry and their prose, including diaries, mythical tales, and courtly romances. Lady Murasaki transposed the lifestyle of the Heian court into fiction in the first known novel, *The Tale of Genji*, at the beginning of the eleventh century. She wrote in Japanese at a time when men still wrote prose primarily in Chinese, and her work remains one of Japan's—and the world's—great novels. Underlying the story of the love affairs of Prince Genji and his companions is the Japanese conception of fleeting pleasures and ultimate sadness in life, an echo of the Buddhist view of the vanity of earthly pleasures.

"WOMEN'S HAND" STYLE. One of the earliest extant secular paintings from Japan is a series of scenes from *The Tale of Genji*, painted in the twelfth century by unknown artists in "women's hand" painting style. This style was characterized by delicate lines, strong (but sometimes muted) colors, and asymmetrical compositions usually viewed from above through invisible, "blown-away" roofs. The *Genji* paintings have a refined, subtle emotional impact. They generally show court figures in architectural settings, with the frequent addition of natural elements, such as sections of gardens, that help to represent the mood of the scene. Thus a blossoming cherry tree appears in a scene of happiness, while unkempt weeds appear in a depiction of loneliness. Such correspondence between nature and human emotion is an enduring feature of Japanese poetry and art.

The figures in *The Tale of Genji* paintings do not show their emotions directly on their faces, which are rendered with a few simple lines. Instead, their feelings are conveyed by colors, poses, and the total composition of the scenes. One scene evokes the seemingly happy Prince Genji holding a baby boy borne by his wife, Nyosan. In fact, the baby was fathered by another court noble. Since Genji himself has not been faithful to Nyosan, who appears in profile below him, he cannot complain; meanwhile the true father of the child has died, unable to acknowledge his only son (FIG. 11–13). Thus, what should be a joyful scene has undercurrents of irony and sorrow. The irony is even greater because Genji himself is the illegitimate son of an emperor.

One might expect a painting of such an emotional scene to focus on the people involved. Instead, they are rendered in rather small size, and the scene is dominated by a screen that effectively

Technique

JOINED-WOOD SCULPTURE

ood is a temperamental material because fluctuations in moisture content cause it to swell and shrink. Cut from a living, sap-filled tree, wood takes many years to dry to a state of stability. While the outside of a piece of wood dries fairly rapidly, the inside yields its moisture only gradually, causing a difference in the rates of shrinkage between the inside and the outside, which induces the wood to crack. Natural irregularities in wood, such as knots, further accentuate this problem. Thus, wood with a thinner cross-section and fewer irregularities is less susceptible to cracking because it can dry more evenly. (This is the logic behind sawing logs into boards before drying.) On the other hand, a large statue carved from a single log must inevitably crack as it ages.

An advanced strategy adopted by Japanese sculptors to reduce such cracking in large statues was the **joined-wood** technique. Here the design for a statue was divided into sections, each of which was carved from a separate block. These sections were then hollowed out and assembled. By using multiple blocks, sculptors could produce larger images than they could from any single block. Moreover, statue sections could be created by teams of carvers, some of whom became specialists in certain parts, such as hands or crossed legs or lotus thrones. Through this cooperative approach, large statues (see, for example, FIG. 11-12) could be produced with great efficiency to meet a growing demand.

squeezes Genji and his wife into a corner. This composition deliberately represents how their positions in courtly society have forced them into this unfortunate situation. In typical Heian style, Genji expresses his emotion by murmuring a poem:

How will he respond,

The pine growing on the mountain peak,

When he is asked who planted the seed?

"MEN'S HAND" STYLE. While *The Tale of Genji* scroll represents courtly life as interpreted through the "women's hand" style of painting, Heian painters also cultivated a contrasting

"men's hand" style. Characterized by strong ink play and lively brushwork, it most often depicts subjects outside the court. One of the masterpieces of this style is *Frolicking Animals*, a set of scrolls satirizing the life of many different levels of society. Painted entirely in ink, the scrolls are attributed to Toba Sojo, the abbot of a Buddhist temple, and they represent the humor of Japanese art to the full.

In one scene, a frog is seated as a *buddha* upon an altar while a monkey dressed as a monk prays proudly to him; in other scenes frogs, donkeys, foxes, and rabbits are shown playing, swimming, and wrestling, with one frog boasting of

II-I3 † SCENE FROM THE TALE OF GENJI Heian period, 12th century CE. Handscroll, ink and colors on paper, $8\% \times 18\%$ (21.9 \times 47.9 cm). Tokugawa Art Museum, Nagoya.

Twenty chapters from *The Tale of Genji* have come down to us in illustrated scrolls such as this one. Scholars assume, however, that the entire novel of fifty-four chapters must have been written out and illustrated—a truly monumental project. Each scroll seems to have been produced by a team of artists. One was the calligrapher, most likely a member of the nobility. Another was the master painter, who outlined two or three illustrations per chapter in fine brushstrokes and indicated the color scheme. Next, colorists went to work, applying layer after layer of color to build up patterns and textures. After they had finished, the master painter returned to reinforce outlines and apply the finishing touches, among them the details of the faces.

II—I4 | Attributed to Toba Sojo, DETAIL OF FROLICKING ANIMALS Heian period, 12th century CE. Handscroll, ink on paper, height 12" (30.5 cm). Kozan-ji, Kyoto.

his prowess when he flings a rabbit to the ground (FIG. II-I4). Playful and irreverent though it may be, the quality of the painting is remarkable. Each line is brisk and lively, and there are no strokes of the brush other than those needed to depict each scene. Unlike the *Genji* scroll, there is no text to *Frolicking Animals*, and we must make our own interpretations of the people and events being satirized. Nevertheless, the visual humor is so lively and succinct that we can recognize not only the Japanese of the twelfth century, but perhaps also ourselves.

KAMAKURA PERIOD

The courtiers of the Heian era became so engrossed in their own refinement that they neglected their responsibilities for governing the country. Clans of warriors—samurai—from outside the capital grew increasingly strong. Drawn into the factional conflicts of the imperial court, samurai leaders soon became the real powers in Japan.

A BATTLE HANDSCROLL. The two most powerful warrior clans were the Minamoto and the Taira, whose battles for domination became famous not only in medieval Japanese history but also in literature and art. One of the great painted handscrolls depicting these battles is NIGHT ATTACK ON THE **SANJO PALACE** (FIGS. 11–15, 11–16). Painted perhaps 100 years after the actual event, the scroll conveys a sense of eyewitness reporting even though the anonymous artist had to imagine the scene from verbal (and at best semifactual) descriptions. The style of the painting includes some of the brisk and lively linework of Frolicking Animals and also traces of the more refined brushwork, use of color, and bird's-eye viewpoint of The Tale of Genji scroll. The main element, however, is the savage depiction of warfare (see "Arms and Armor," page 389). Unlike the Genji scroll, Night Attack is full of action: Flames engulf the palace, horses charge, warriors behead their enemies, court ladies try to hide, and a sense of energy and violence is conveyed with great sweep and power. The era of

II—I5 | SECTION OF NIGHT ATTACK ON THE SANJO PALACE Kamakura period, late 13th century CE. Handscroll, ink and colors on paper, $16\% \times 275\%$ " (41.3 \times 699.7 cm). Museum of Fine Arts, Boston. Fenollosa-Weld Collection (11.4000)

The battles between the Minamoto and Taira clans were fought primarily by mounted and armored warriors, who used both bows and arrows and the finest swords. In the year 1160, some 500 Minamoto rebels opposed to the retired emperor Go-Shirakawa carried out a daring raid on the Sanjo Palace. In a surprise attack in the middle of the night, they abducted the emperor. The scene was one of great carnage, much of it caused by the burning of the wooden palace. Despite the drama of the scene, this was not the decisive moment in the war. The Minamoto rebels would eventually lose more important battles to their Taira enemies. Yet Minamoto forces, heirs to those who carried out this raid, would eventually prove victorious, destroying the Taira clan in 1185.

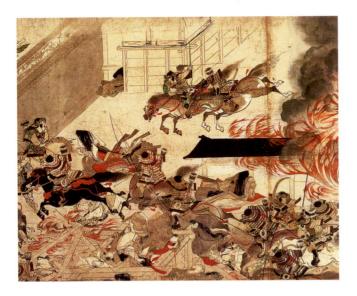

II-I6 DETAIL OF NIGHT ATTACK ON THE SANJO PALACE

poetic refinement was now over in Japan, and the new world of the samurai began to dominate the secular arts.

The Kamakura era (1185–1333 CE) began when Minamoto Yoritomo (1147–99) defeated his Taira rivals and assumed power as shogun (general-in-chief). To resist the softening effects of courtly life in Kyoto, he established his military capital in Kamakura. While paying respect to the emperor, Yoritomo kept both military and political power for himself. He thus began a tradition of rule by shogun that lasted in various forms until 1868.

Pure Land Buddhist Art

Rising militarism, political turbulence, and the excesses of the imperial court marked the beginning of the eleventh century in Japan. To many Japanese of the late Heian and Kamakura eras, the unsettled times seemed to confirm the coming of *Mappo*, a long-prophesied dark age of spiritual degeneration. Japanese of all classes reacted by increasingly turning to the promise of simple salvation extended by Pure Land Buddhism, which had spread from China by way of Korea. The religion held that merely by chanting *Namu Amida Butsu*, hailing the Buddha Amida (the Japanese version of Amitabha Buddha), the faithful would be reborn into the Western (Pure Land) Paradise over which he presided.

A PORTRAIT SCULPTURE. The practice of chanting had been spread throughout Japan by traveling monks such as the charismatic Kuya (903–72 CE), who encouraged people to chant by going through the countryside singing. Believers would have immediately recognized Kuya in this thirteenth-century portrait statue by Kosho (FIG. II–I7): the traveling clothes, the small gong, the staff topped by deer horns (symbolic of his slaying a deer, whose death converted him to Buddhism), clearly identify the monk, whose sweetly intense expression gives this sculpture a radiant sense of faith. As for

Art and Its Context

ARMS AND ARMOR

attles such as the one depicted in *Night Attack on the Sanjo Palace* (SEE FIGS. 11–15, 11–16) were fought largely by archers on horseback. Samurai archers charged the enemy at full gallop and loosed their arrows just before they wheeled away. The scroll clearly shows their distinctive bow, with its asymmetrically placed handgrip. The lower portion of the bow is shorter than the upper so it can clear the horse's neck. The samurai wear a long, curved sword at the waist.

By the tenth century, Japanese swordsmiths had perfected techniques for crafting their legendarily sharp swords. Swordmakers face a fundamental difficulty: Steel hard enough to hold a razor-sharp edge is brittle and breaks easily, but steel resilient enough to withstand rough use is too soft to hold a keen edge. The Japanese ingeniously forged a blade which laminated a hard cutting edge within less brittle support layers.

Samurai armor, illustrated here, was made of overlapping iron and lacquered leather scales, punched with holes and laced together with leather thongs and brightly colored silk braids. The principal piece wrapped around the chest, left side, and back. Padded shoulder straps hooked it together back to front. A separate piece of armor was tied to the body to protect the right side. The upper legs were protected by a skirt of four panels attached to the body armor, while two large rectangular panels tied on with cords guarded the arms. The helmet was made of iron plates riveted together. From it hung a neckguard flared sharply outward to protect the face from arrows shot at close range as the samurai wheeled away from an attack.

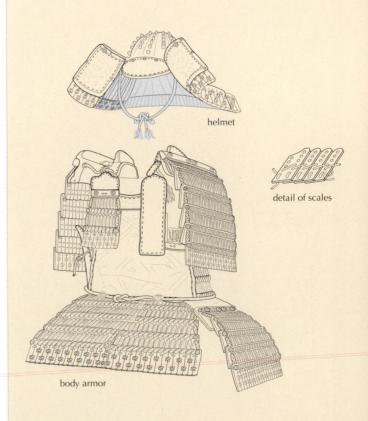

THE OBJECT SPEAKS

MONK SEWING

n the early thirteenth century CE, a statue such as Kosho's Kuya Preaching (SEE FIG. 11–17) epitomized the faith expressed in Pure Land Buddhist art. At the very same time, Zen Buddhism was being introduced into Japan from China, and within a century its art communicated a far different message. Whereas Kuya had wandered the countryside, inviting the faithful to chant the name of Amida Buddha and relying on the generosity of believers to support him, Zen monks lived settled lives in monasteries—usually up in the mountains. They had no need of contributions from the court or from believers.

Then, as today, Japanese Zen monks grew and cooked their own food, cleaned their temples, and were as responsible for their daily lives as for their own enlightenment. In addition to formal meditation, they practiced genjo koan, taking an ordinary circumstance in their immediate world, such as mending a garment, as an object of meditation. Thus, a painting such as MONK SEWING, which bears the seals of the Buddhist priest-painter Kao Ninga (active mid-fourteenth century), would have spoken clearly to viewers of a commitment to a life of simplicity and responsibility for oneself. It was and is still so effective because it has the blunt style, strong sense of focus, and visual intensity of the finest Zen paintings. The almost humorous compression of the monk's face, coupled with the position of the darker robe, focuses our attention on his eyes, which then lead us out to his hand pulling the needle. We are drawn into the activity of the painting rather than merely sitting back and enjoying it as a work of art. This sense of intense activity within daily life, involving us directly with the painter and the subject, is, together with the bold ink brushwork, a feature of the best Zen figure paintings.

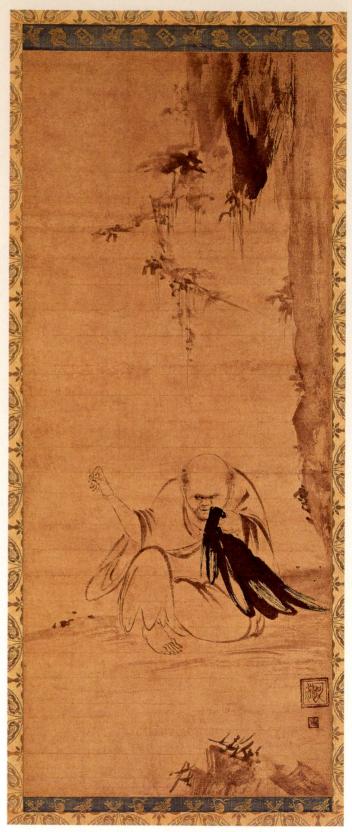

Attributed to Kao Ninga, MONK SEWING Kamakura period, early 14th century. Ink on paper, $31\% \times 13\%$ (83.5 \times 35.4 cm). The Cleveland Museum of Art. John L. Severance Fund (62.163)

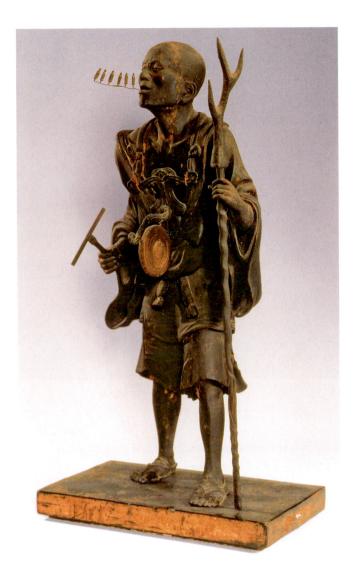

II-I7 Kosho, KUYA PREACHING Kamakura period, before 1207. Painted wood with inlaid eyes, height 46½" (117.5 cm). Rokuhara Mitsu-ji, Kyoto.

Kuya's chant, Kosho's solution to the challenge of putting words into sculptural form was simple but brilliant: He carved six small buddhas emerging from Kuya's mouth, one for each of the six syllables of Na-mu-A-mi-da-Buts(u) (the final u is not articulated). Believers would have understood that these six small buddhas embodied the Pure Land chant.

During the early Kamakura period, Pure Land Buddhism remained the most influential form of religion and was expressed in the new naturalistic style of sculpture as seen in Kuya by Kosho. Just as the Night Attack revealed the political turbulence of the period through its vivid colors and forceful style, Kamakura-era portraiture saw a new emphasis on realism, including the use of crystal eyes in sculpture for the first time. Perhaps the warriors had a taste for realism, for many sculptors and painters of the Kamakura period became expert in depicting faces, forms, and drapery with great attention to naturalistic detail. As we have seen, Kosho took on the more

Sequencing Works of Art

12th century CE Scene from The Tale of Genji

Toba Sojo (attributed), Frolicking Animals

Late 13th century CE

12th century CE

Night Attack on the Sanjo Palace

Kao Ninga (attributed), Early 14th century CE

Monk Sewing

difficult task of representing in three dimensions not only the person of the famous monk Kuya but also his chant.

RAIGO PAINTINGS. Pure Land Buddhism taught that even one sincere invocation of the sacred chant could lead the most wicked sinner to the Western Paradise. Paintings called raigo (literally "welcoming approach") were created depicting the Amida Buddha, accompanied by bodhisattvas, coming down to earth to welcome the soul of the dying believer. Golden cords were often attached to these paintings, which were taken to the homes of the dying. A person near death held on to these cords, hoping that Amida would escort the soul directly to paradise.

Raigo paintings are quite different in style from the complex mandalas and fierce guardian deities of Esoteric Buddhism. Like Jocho's sculpture of Amida at the Byodo-in (FIG. 11-12), they radiate warmth and compassion. One magnificent raigo, a portrayal of Amida Buddha and twenty-five bodhisattvas swiftly descending over mountains, employs gold paint and slivers of gold leaf cut in elaborate patterning to suggest the radiance of their draperies (FIG. 11-18). The sparkle of the gold over the figures is heightened by the darkening of the silk behind them, so that the deities seem to come forth from the surface of the painting. In the flickering light of oil lamps and torches, raigo paintings would have glistened and gleamed in magical splendor in a temple or a dying person's home.

In every form of Buddhism, paintings and sculpture became vitally important elements in religious teaching and belief. In their own time they were not considered works of art but rather visible manifestations of faith.

Zen Buddhist Art

Toward the latter part of the Kamakura period, Zen Buddhism, the last major form to reach Japan, appeared. Zen was already highly developed in China, where it was known as Chan, but it had been slow to reach Japan because of the interruption of relations between the two countries during the Heian period. But during the Kamakura era, both visiting Chinese and returning Japanese monks brought Zen to Japan. It would have a lasting impact on Japanese arts.

In some ways, Zen resembles the original teachings of the historical Buddha. It differed from both Esoteric and Pure Land

II-I $8 \mid$ descent of amida and the twenty-five bodhisattvas

Kamakura period, 13th century. Colors and gold on silk, $57\frac{1}{4} \times 61\frac{1}{2}$ " (145 \times 155.5 cm). Chion-in, Kyoto.

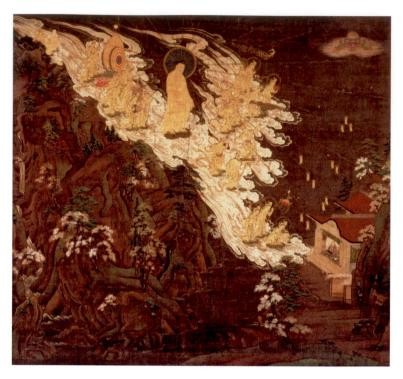

Buddhism in emphasizing that individuals must reach their own enlightenment through meditation, without the help of deities or magical chants. It especially appealed to the self-disciplined spirit of samurai warriors, who were not satisfied with the older forms of Buddhism connected with the Japanese court.

Zen temples were usually built in the mountains rather than in large cities. An abbot named Kao Ninga at an early Zen temple was a pioneer in the kind of rough and simple ink painting that so directly expresses the Zen spirit. We can see this style in a remarkable ink portrait of a monk sewing his robe (see "Monk Sewing," page 390). Buddhist prelates of other sects undoubtedly had assistants to take care of such mundane tasks as repairing a robe, but in Zen Buddhism each monk, no matter how advanced, is expected to do all tasks for himself. Toward the end of the fourteenth century, Zen's spirit of self-reliance began to dominate many aspects of Japanese culture.

As the Kamakura era ended, the seeds of the future were planted: Control of rule by the warrior class and Zen values had become established as the leading forces in Japanese life and art.

IN PERSPECTIVE

The history of Japanese art illuminates an intriguing interplay between native traditions and transmitted culture. In the Japanese archipelago, the Jomon culture produced the world's first ceramics, their early technology developing into a distinctive and long-lived pottery style. Jomon eventually gave way to a new culture, that of the Yayoi, apparently brought by immigrants from the Asian continent. Yayoi and the subsequent Kofun period saw technological developments, includ-

ing new ceramic techniques and the casting of bronze. With the Kofun period, mounded tombs appeared, with *haniwa* figures to guard them. Wooden architecture emerged, with elements that today we think of as distinctively Japanese.

During the Asuka and Nara periods, cultural transmission from China via Korea accelerated bringing a system of writing, the Buddhist religion, and a new tile-roofed architecture. A permanent capital city was established, built on a Chinese model, and Chinese-style government was developed. Magnificent temples were constructed in this city, called Nara, and some of those still stand today.

During the Heian period, the Japanese built upon recent trends in Buddhism imported from the continent, and developed sects of Esoteric Buddhism and Pure Land Buddhism. The artistic legacy of these sects is seen today in mandalas and raigo paintings as well as in portrait sculpture. During this period, a distinctly Japanese writing system and calligraphy were created, with a syllabary of kana to supplement the kanji of Chinese origin. With the use of kana, calligraphic compositions diverged from the regulated Chinese forms into more spontaneous and asymmetrical compositions. Painting too embraced asymmetry and spontaneity, often combining these with gold decoration.

A warrior culture emerged at the end of the Heian period, and with the Kamakura period a long period of rule by military *shoguns* ensued. The *shogun* and *samurai* retainers adopted a new form of Buddhism from China, Chan or Zen, in which they found a self-reliant discipline. Ink painting, also from China, reflected both the restraint and the spontaneity of Zen, and became a highly developed and distinctly Japanese tradition.

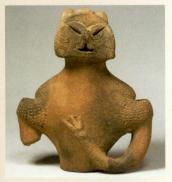

DOGU C. 2500-1500 BCE

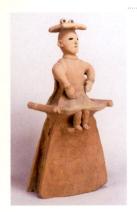

HANIWA 6TH CENTURY CE

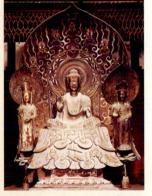

TORI BUSSHI C. 623 CE

BYODO-IN c. 1053 ce

ATTRIBUTED TO
KAO NINGA, MONK SEWING
EARLY 14TH CENTURY

JAPANESE ART BEFORE 1392

12,000 BCE

✓ Jomonc. 11,000-400 BCE

✓ Yayoi
c. 400 BCE-300 CE

Kofunc. 300−552 CE

■ Asuka 552-646 CE

■ Nara 646-794 CE

■ Heian 794-1185 CE

≪ Kamakura 1185-1333 CE

Nambokucho (Period of Rival Northern and Southern) 1336-1392 CE

1200

IIOO

1400

12–1 | **SUN DAGGER SOLAR MARKER AT EQUINOX** Fajada Butte, Chaco Canyon, New Mexico. 850–1250 CE.

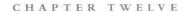

12

On the morning of the summer solstice a streak of light strikes a high cliff in Chaco Canyon. Slowly this "Sun Dagger" descends, and by

noontime it pierces the heart of a large spiral engraved into the rock (FIG. 12-1). The Ancestral Puebloans (formerly called Anasazi) of Chaco Canyon pecked out this spiral, along with a smaller one, on the face of the bluff. The shaft of light forming the Dagger is created by openings between huge slabs of rock, which admit streaks of light that project on the wall. The light moves with the seasonal motion of the sun. Only at the summer solstice in June does the great Dagger appear. At the winter solstice two streaks frame the spiral petroglyph, and at both spring and fall equinoxes a small spike of light hits the center of the small spiral and a large shaft cuts through the large spiral but misses its center. "SunWatchers" may have monitored these events and reported to the community when the time had come to begin special ceremonies or to plant the life-sustaining corn. The rock formation that, together with the moving sun, creates the daggers of light is natural, but the two spirals were located thoughtfully. Nature and art combine, as they do in the work of a modern environmental artist.

Among Ancestral Puebloans spirals were signs for journeys, as well as for wind and water, serpents and snails. The later Zuni call the spiral a "journey in search of the Center."

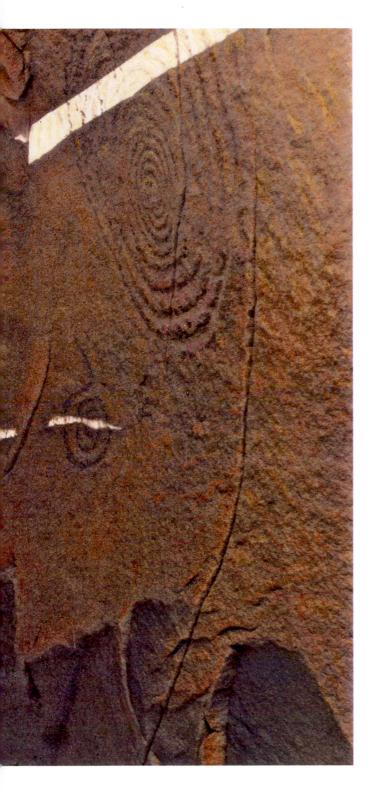

The clocklike workings of the spiral petroglyphs, together with their location on a high point distant from living areas in the canyon, have led to the speculation that the Sun Marker was once a shrine.

The architectural and monumental center of Chaco Canyon is **PUEBLO BONITO** (SEE FIG. 12–25). A complex of rooms and corridors begun in the tenth century CE and enlarged regularly, Pueblo Bonito stood at the hub of a network of wide, straight roads that radiated out to some seventy other communities. Almost invisible today, the roads were discovered through aerial photography. The roads make no detour to avoid topographic obstacles; when they encounter cliffs, they become stairs. Their undeviating course suggests that the roads were more than practical thoroughfares; they may have served as processional ways. Was Pueblo Bonito a gathering place for people in the entire region at specific times of year? Did they assemble there when called by the Sun Watchers?

When the Puebloans of Chaco Canyon were watching for their Sun Dagger, men and women in Europe were also using light, to honor and communicate with God in churches with huge stained glass-windows. Pueblo Bonito is contemporary with the great ceremonial centers like the Abbey of Saint-Denis (FIGS. 16–1 TO 16–3) and the Cathedral of Chartres (FIGS. 16–11 TO 16–14) in Western Europe. In Chaco Canyon, without written texts and without a living tradition, we can speculate but we can never know how Pueblo Bonito and the Chaco Sun Dagger were used. For answers we turn not to texts, but to art and architecture.

CHAPTER-AT-A-GLANCE

- THE NEW WORLD
- MESOAMERICA The Olmecs Teotihuacan The Maya
- CENTRAL AMERICA
- SOUTH AMERICA: THE CENTRAL ANDES | The Paracas and Nazca Cultures | The Moche Culture
- NORTH AMERICA The East The Woodland Period The Mississippian Period The North American Southwest
- IN PERSPECTIVE

THE NEW WORLD

In recent years the question of the original settlement of the Americas has become an area of scholarly debate. The traditional view has been that human beings arrived in North and South America from Asia during the last Ice Age, when glaciers trapped enough of the world's water to lower the level of the oceans and expose a land bridge across the Bering Strait. Although most of present-day Alaska and Canada was covered by glaciers at that time, an ice-free corridor along the Pacific coast would have provided access from Asia to the south and east. Thus, this theory holds that sometime before 12,000 years ago, perhaps as early as 20,000 to 30,000 years ago, Paleolithic hunter-gatherers emerged through this corridor and began to spread out into two vast, uninhabited continents. This view is now challenged by the early dates of some new archaeological finds and by evidence suggesting the possibility of early connections with Europe as well, perhaps along the Arctic coast of the North Atlantic. In any event, between 10,000 and 12,000 years ago, bands of hunters

roamed throughout the Americas; and after the ice had retreated, the peoples of the Western Hemisphere were essentially cut off from the rest of the world until they were overrun by European invaders beginning at the end of the fifteenth century CE.

In this isolation the peoples of the Americas experienced cultural transformations similar to those seen elsewhere around the world following the end of the Paleolithic era. In most regions they developed an agricultural way of life. A trio of native plants—corn, beans, and squash—was especially important, but people also cultivated potatoes, tobacco, cacao, tomatoes, and avocados. New World peoples also domesticated many animals: dogs, turkeys, guinea pigs, llamas, and their camelid cousins—the alpacas, guanacos, and vicuñas.

As elsewhere, the shift to agriculture in the Americas was accompanied by population growth and, in some places, the rise of hierarchical societies, the appearance of ceremonial centers and towns with monumental architecture, and the development of sculpture, ceramics, and other arts. The peo-

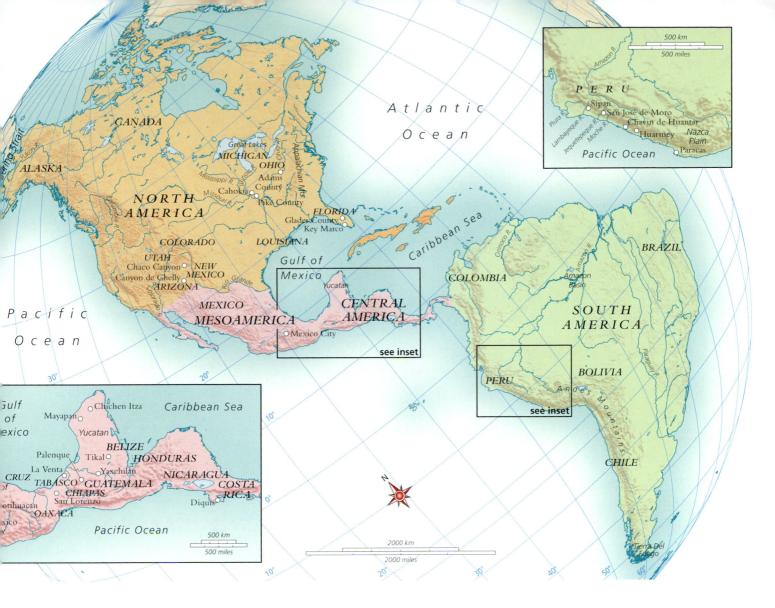

MAP 12-I THE AMERICAS

Paleo-Indians moved across North America, then southward through Central America until they reached the Tierra del Fuego region of South America.

ple of Mesoamerica—the region that extends from central Mexico well into Central America—developed writing, astronomy, a complex and accurate calendar, and a sophisticated system of mathematics. Central and South American peoples had an advanced metallurgy and produced exquisite gold, silver, and copper pieces. The metalworkers of the Andes, the mountain range along the western coast of South America, began to produce metal weapons and agricultural implements in the first millennium CE, and people elsewhere in the Americas made tools and weapons from other materials such as bone, ivory, stone, wood, and, where it was available, obsidian, a volcanic glass capable of a cutting edge five hundred times finer than surgical steel. Basketry and weaving became major art forms (see "Andean Textiles," page 409).

In the American Southwest, Native American people built multistoried, apartmentlike village and cliff dwellings, as well as elaborate irrigation systems with canals. Evidence of weaving in the American Southwest dates to about 7400 BCE. Clearly many extraordinary artistic traditions flourished in many regions in the Americas before 1300 CE. This chap-

ter explores the accomplishments of some of the cultures in five of those regions—Mesoamerica, Central America, the central Andes of South America, the southeastern woodlands and great river valleys of North America, and the North American Southwest.

MESOAMERICA

Ancient Mesoamerica encompasses the area from north of the Valley of Mexico (the location of Mexico City) to present-day Belize, Honduras, and western Nicaragua in Central America (SEE MAP 12–1). The region is one of great contrasts, ranging from tropical rain forest to semiarid mountains. The civilizations that arose in Mesoamerica varied, but they were linked by cultural similarities and trade. Among the shared features of the civilizations that arose in Mesoamerica were a ritual ball game with religious and political significance, aspects of monumental ceremonial building construction, and a complex system of multiple calendars including a 260-day ritual cycle and a 365-day agricultural cycle.

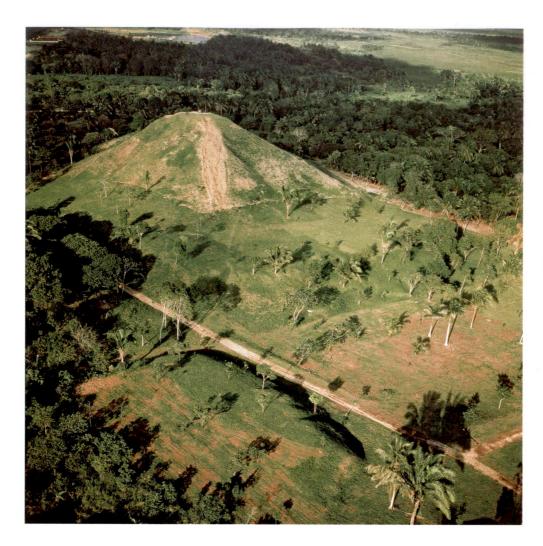

I2−2 | GREAT PYRAMID AND BALL COURT, LA VENTA Mexico. Olmec culture, c. 1000-600 BCE. Pyramid height approx. 100′ (30 m).

Mesoamerican society was sharply divided into elite and commoner classes.

The transition to farming began in Mesoamerica between 7000 and 6000 BCE, and by 3000 to 2000 BCE settled villages were widespread. Customarily the region's subsequent history is divided into three broad periods: Formative or Preclassic (1500 BCE–250 CE), Classic (250–900 CE), and Postclassic (900–1521 CE). This chronology derives primarily from the archaeology of the Maya—the people of Guatemala and the Yucatan peninsula—with the Classic period bracketing the era during which the Maya erected dated stone monuments. The term reflects the view of early scholars that the Classic period was a kind of golden age. Although this view is no longer current—and the periods are only roughly applicable to other cultures of Mesoamerica—the terminology has endured.

The Olmecs

The first major Mesoamerican art style, that of the Olmecs, emerged during the Formative/Preclassic period. In the swampy coastal areas of the present-day Mexican states of Veracruz and Tabasco, the Olmecs cleared farmland, drained fields, and raised earth mounds on which they constructed ceremonial centers. These centers probably housed an elite group of ruler-priests supported by a larger population of

farmers who lived in villages of pole-and-thatch houses. The presence at Olmec sites of goods such as obsidian, iron ore, and jade that are not found in the Gulf of Mexico region but come from throughout Mesoamerica indicates that the Olmecs participated in extensive long-distance trade. They went to great lengths to acquire jade, which they used for ceremonial objects and prized more than gold.

The earliest Olmec ceremonial center, at San Lorenzo, (c. 1200 to 900 BCE, abandoned by 400 BCE), included a possible ball court, an architectural feature of other major Olmec sites and large sculptures. Another center, at La Venta thriving from about 1000 to 400 BCE, was built on high ground between rivers. Its most prominent feature, an earth mound known as the Great Pyramid, still rises to a height of about 100 feet (FIG. 12–2). The Great Pyramid stands at the south end of a large, open court, possibly used as a playing field, arranged on a north-south axis and defined by long, low earth mounds. Many of the physical features of La Venta—including the symmetrical arrangement of earth mounds, platforms, and central open spaces along an axis that was probably determined by astronomical observations—are characteristic of later monumental and ceremonial architecture throughout Mesoamerica.

Although the Olmec developed no form of written language, their highly descriptive art gives us an idea of their

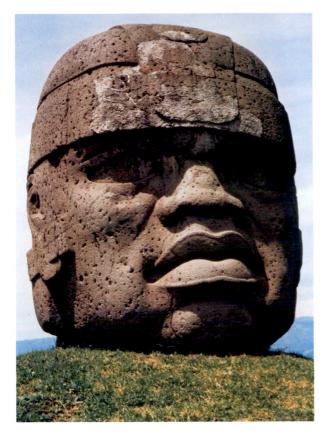

12–3 | COLOSSAL HEAD, SAN LORENZO Mexico. Olmec culture, c. 900–400 BCE. Basalt, height 7'5" (2.26 m).

beliefs. The Olmec universe had three levels: sky, earth surface, and underworld. A bird monster ruled the sky. The earth surface itself was a female deity—apparently La Venta's principal deity—the repository of wisdom and overseer of surface water as well as land. The underworld—ruled by a fish monster—was a cosmic sea on which the earth surface, including its plants, floated. A vertical axis joining the three levels made a fourth element.

At the beginning, religion seems to have centered on shamanistic practices in which a shaman (a priest or healer) traveled in a trance state through the cosmos with the help of animal spirits, usually jaguars but also frogs and birds. Olmec sculpture and ceramics depict humans in the process of taking animal form. As society changed from a hunting base to an agricultural one and natural forces like the sun and rain took on greater importance, a new priest class formed, in addition to the shamans, and they created rituals to try to control these natural forces.

The Olmecs produced an abundance of monumental basalt sculpture, including colossal heads (FIG. 12–3), altars, and seated figures. The huge basalt blocks for the large works of sculpture were quarried at distant sites and transported to San Lorenzo, La Venta, and other centers. Colossal heads ranged in height from 5 to 12 feet and weighed from 5 to more than 20 tons. The heads are adult males wearing close-

fitting caps with chin straps and large, round earspools (cylindrical earrings that pierce the earlobe). The fleshy faces have almond-shaped eyes, flat broad noses, thick protruding lips, and downturned mouths. Each face is different, suggesting that they may represent specific individuals. Twelve heads were found at San Lorenzo. All had been mutilated and buried about 900 BCE, about the time the site went into decline. At La Venta, 102 basalt monuments have been found.

The colossal heads and the subjects depicted on other monumental sculpture suggest that the Olmec elite were pre-occupied with the commemoration of rulers and historic events. This preoccupation was probably an important factor in the development of calendrical systems, which first appeared around 600 to 500 BCE in areas with strong Olmec influence.

By 200 CE, forests and swamps began to reclaim Olmec sites, but Olmec civilization had spread widely throughout Mesoamerica and was to have an enduring influence on its successors. As the Olmec centers of the Gulf Coast faded, the great Classic-period centers in the Maya region and Teotihuacan area in the Basin of Mexico were beginning their ascendancy.

Teotihuacan

Located some thirthy miles northeast of present-day Mexico City, Teotihuacan experienced a period of rapid growth early in the first millennium CE. The city's farmers terraced hillsides and drained swamps, and on fertile, reclaimed land they grew the common Mesoamerican staple foods, including corn, squash, and beans. From the fruit of the spiky-leafed maguey plant they fermented pulque, a mildly alcoholic brew still consumed today. By 200 CE Teotihuacan had emerged as a significant center of commerce and manufacturing, the first large city-state in the Americas. At its height, between 350 and 650 CE, Teotihuacan covered nearly nine square miles and had a population of about 200,000, making it the largest city in the Americas and one of the largest in the world at that time (FIG. 12-4). One reason for its wealth was its control of a source of high-quality obsidian. Goods made at Teotihuacan, including obsidian tools and pottery, were distributed widely throughout Mesoamerica in exchange for luxury items such as the brilliant green feathers of the quetzal bird, used for priestly headdresses, and the spotted fur of the jaguar, used for ceremonial garments.

Teotihuacan's principal monuments include the Pyramid of the Sun and the Pyramid of the Moon. A broad thorough-fare laid out on a north-south axis, extending for more than three miles and in places as much as 150 feet wide, bisects the city (FIG. 12–5). Much of the ceremonial center, in a pattern typical of Mesoamerica, is characterized by the symmetrical arrangement of structures around open courts or plazas. The Pyramid of the Sun is east of the main corridor.

The largest of Teotihuacan's architectural monuments, the Pyramid of the Sun is slightly over 200 feet high and measures about 720 feet on each side at its base, similar in size

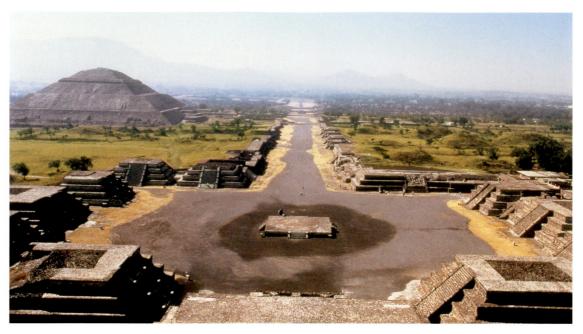

12-4 CEREMONIAL CENTER OF THE CITY OF TEOTIHUACAN

Mexico. Teotihuacan culture, 350-650 CE.

View from the Pyramid of the Moon down the Avenue of the Dead toward the Ciudadela and the Temple of the Feathered Serpent. The Pyramid of the Sun is on the middle left. The avenue is over a mile long.

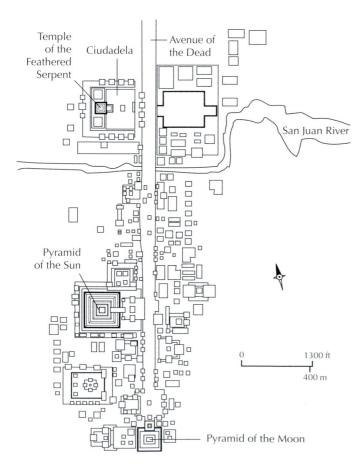

12-5 | PLAN OF THE CEREMONIAL CENTER OF TEOTIHUACAN

Positioned to match photograph of the site shown in FIGURE 12–4, with south at top.

but not as tall as the largest Egyptian pyramid at Giza. It is built over a four-chambered cave with a spring that may have been the original focus of worship at the site and its source of prestige. The pyramid rises in a series of sloping steps to a flat platform, where a two-room temple once stood. A monumental stone stairway led from level to level up the side of the pyramid to the temple platform. The exterior was faced with stone and stucco and was painted. The Pyramid of the Moon, not quite as large as the Pyramid of the Sun, stands at the north end of the main avenue, facing a large plaza flanked by smaller, symmetrically placed platforms.

At the southern end of the ceremonial center, and at the heart of the city, is the Ciudadela (Spanish for a fortified city center), a vast sunken plaza surrounded by temple platforms. The city's principal religious and political center, the plaza could accommodate an assembly of more than 60,000 people. Its focal point was the **TEMPLE OF THE FEATHERED SER-PENT** (FIG. 12–6). This seven-tiered structure exhibits the talud-tablero (slope-and-panel) construction that is a hall-mark of the Teotihuacan architectural style. The sloping base, or talud, of each platform supports a tablero, or entablature, that rises vertically, and is surrounded by a frame, often filled with sculptural decoration. The Temple of the Feathered Serpent was enlarged several times—as was typical of Mesoamerican pyramids—and each enlargement completely enclosed the previous structure like the layers of an onion.

Archaeological excavations of the temple's early-phase tableros and a stairway balustrade have revealed painted heads of the Feathered Serpent, the goggle-eyed Rain or Storm God

12-6 | TEMPLE OF THE
FEATHERED SERPENT
The Ciudadela, Teotihuacan,
Mexico. Teotihuacan culture,

after 350 CE.

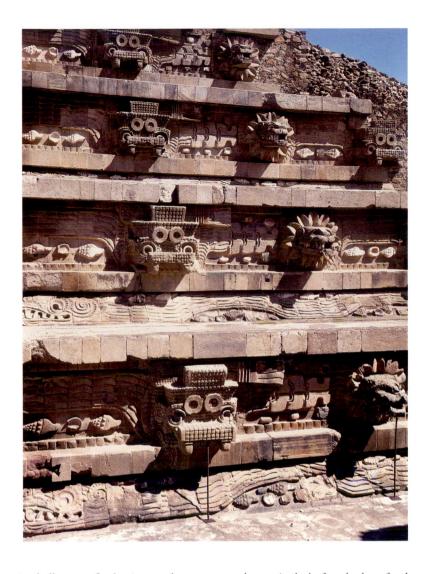

(or Fire God, according to some), and reliefs of aquatic shells and snails. Their flat, angular, abstract style, typical of Teotihuacan art, is in marked contrast to the curvilinear Olmec art. The Rain God has a squarish, stylized head or headdress with protruding upper jaw and huge, round eyes originally inlaid with obsidian, and it is surrounded by once-colored circles, and large, circular earspools. The fanged serpent heads, perhaps composites of snakes and other creatures, emerge from an aureole of stylized feathers. The Storm God and the Feathered Serpent may be symbols of regeneration and cyclical renewal, perhaps representing alternating wet and dry seasons.

The residential sections of Teotihuacan fanned out from the city's center. The large palaces of the elite, with as many as forty-five rooms and seven patios, stood nearest the ceremonial center. Artisans, foreign traders, and peasants lived farther away, in simpler compounds. The palaces and more humble homes alike were rectangular one-story structures with high walls, thatched roofs, and suites of rooms arranged symmetrically around open courts. Walls were plastered and, in the homes of the elite, were covered with paintings.

Teotihuacan's artists worked in a **fresco** technique, applying pigments directly on damp lime plaster. Paint was applied in layers, each layer polished before the next was applied. The style, like the sculpture, was flat, angular, and abstract. Their use

of color is complex—one work may include five shades of red with touches of ocher, green, and blue. A detached fragment of a wall painting, now in the Cleveland Museum of Art, depicts a bloodletting ritual in which an elaborately dressed man enriches and revitalizes the earth (the Great Goddess) with his own blood (FIG. 12-7). The man's Feathered Serpent headdress, decorated with precious quetzal feathers, indicates his high rank. He stands between rectangular plots of earth planted with bloody maguey spines, and he scatters seeds or drops of blood from his right hand, as indicated by the panel with conventionalized symbols for blood, seeds, and flowers. The speech scroll emerging from his open mouth symbolizes his ritual chant. The visual weight accorded the headdress and the speech scroll suggests that the man's priestly office and chanted words are essential elements of the ceremony. Such bloodletting rituals were widespread in Mesoamerica.

Sometime in the middle of the seventh century disaster struck Teotihuacan. The ceremonial center burned, and the city went into a permanent decline. Nevertheless, its influence continued as other centers throughout Mesoamerica and as far south as the highlands of Guatemala borrowed and transformed its imagery over the next several centuries. The site was never entirely abandoned, however, because it remained a legendary pilgrimage center. The much later

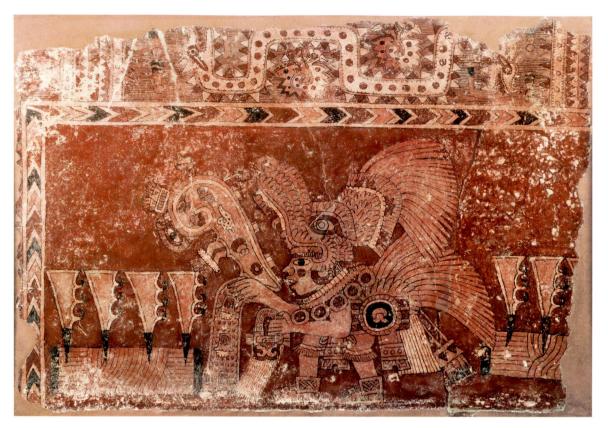

12-7 BLOODLETTING RITUAL

Fragment of a fresco from Teotihuacan, Mexico. Teotihuacan culture, 600–750 CE. Pigment on lime plaster, $32\% \times 45\%$ (82 \times 116.1 cm). The Cleveland Museum of Art. Purchase from the J. H. Wade Fund (63.252)

The maguey plant supplied the people of Teotihuacan with food; fiber for making clothing, rope, and paper; and the precious drink pulque. As this painting indicates, priestly officials used its spikes in rituals to draw their own blood as a sacrifice to the Great Goddess.

Aztec people (c. 1300–1525 CE) revered the site, believing it to be the place where the gods created the sun and the moon. In fact, the name Teotihuacan is actually an Aztec word meaning "Gathering Place of the Gods."

The Maya

The ancient Maya are noted for a number of achievements, including the production of high agricultural yields in the seemingly inhospitable tropical rain forest of the Yucatan. In densely populated cities they built imposing pyramids, temples, palaces, and administrative structures. They developed the most advanced hieroglyphic writing in Mesoamerica and perfected a sophisticated version of the Mesoamerican calendrical system (see "Maya Record Keeping," page 403). Using these, they recorded the accomplishments of their rulers on ceramic vessels, wall paintings, and in books. They studied astronomy and the natural cycles of plants and animals and used sophisticated mathematical concepts such as zero and place value.

An increasingly detailed picture of the Maya has been emerging from recent archaeological research and from advances in deciphering their writing. That picture shows a society divided into competing centers, each with a hereditary ruler and an elite class of nobles and priests supported by a large group of farmer-commoners. Rulers established their legitimacy, maintained links with their divine ancestors, and sustained the gods through elaborate rituals, including ball games, bloodletting ceremonies, and human sacrifice. Rulers commemorated such events and their military exploits on carved steles. A complex pantheon of deities, many with several manifestations, presided over the Maya universe.

Olmec influence was widespread around 1000–300 BCE in what would come to be the Maya area. Maya civilization emerged during the late Preclassic period (250 BCE– 250 CE), reached its peak in the southern lowlands of Guatemala during the Classic period (250–900 CE), and shifted to the northern Yucatan peninsula during the Postclassic period (900–1521 CE).

TIKAL. The monumental buildings of Maya cities were masterly examples of the use of architecture for public display and propaganda. Seen from outside and afar, they would have impressed the common people with the power and authority

Art and Its Context

MAYA RECORD KEEPING

ince the rediscovery of Mayan sites of the Classic period in the nineteenth century, scholars have puzzled over the meaning of the hieroglyphic writing. They soon realized that many of the glyphs were numbers in a complex calendrical system. In 1894, a German librarian, Ernst Forstermann, deciphered the numbering systems, and by the early twentieth century, the Maya calendar had been correlated with the European calendar. The Maya calendar counts time from a starting date now securely established as August 13, 3114 BCE.

Since the late 1950s, scholars have made enormous progress in deciphering Maya writing. Previously, many prominent Mayanists argued that the inscriptions dealt with astronomical and astrological observations, not historical

events. This interpretation accorded with the view that the Maya were a peaceful people ruled by a theocracy of learned priests. But further research suggests that such theories are incorrect. In fact, the inscriptions on Maya architecture and steles appear almost entirely devoted to historical events. They record the dates of royal marriages, births of heirs, alliances between cities, and great military victories, and they tie events to astronomical events and propitious periods in the Maya calendar.

Maya writing, like the Maya calendar, is the most advanced in ancient Mesoamerica. The system combines logographs—symbols representing entire words—and symbols representing syllables in the Maya language.

of the elite class and the gods they served. Tikal (in present-day Guatemala) was the largest Maya city, with a population of as many as 70,000 at its height (FIG. 12–8). Like other Maya cities—yet unlike Teotihuacan, with its grid plan—Tikal conformed to the uneven terrain of the rain forest. Plazas, pyramid-temples, ball courts, and other structures stood on high ground connected by elevated roads, or causeways. One major causeway, 80 feet wide, led from the center of the city to outlying residential areas.

In the ceremonial core of Tikal, the structure whose base is visible on the left in FIGURE 12–8, known as the North Acropolis, dates to the early Classic period. It contained many royal tombs and covers earlier structures that date to the origin of the city, about 500 BCE. The tall pyramid in the center, known as Temple I, faces a companion pyramid, Temple II, across a large plaza. Temple I covers the tomb of Ruler A (formerly called Ah Hasaw, 682–c. 727 CE), who initiated an ambitious expansion of Tikal. Under Ruler A and his successors, Tikal's influence grew, with evidence of contacts that extended from highland Mexico to Costa Rica.

Containing Ruler A's tomb in its limestone bedrock, Temple I rises above the forest canopy to a height of more than 140 feet. Its base has nine layers, probably reflecting the belief that the underworld had nine levels. Priests climbed the steep stone staircase on the exterior to the temple on top, which consists of two long, parallel rooms covered with a steep roof supported by corbel vaults. It is typical of Maya enclosed stone structures, which resemble the kind of poleand-thatch houses the Maya still build in parts of the Yucatan today. The only entrance to the temple was on the long side, facing the plaza and the commemorative stele erected there. The crest that rises over the roof of the temple, known as a roof comb, was originally covered with brightly painted sculpture. Recent archaeological analysis suggests the possibil-

ity that the narrow platforms of the pyramids served as shallow stages for ritual reenactments of mythological narratives.

PALENQUE. Palenque (in the present-day Mexican state of Chiapas) rose to prominence later than Tikal, in the Classic period. Hieroglyphic inscriptions record the beginning of its royal dynasty in 431 CE, but the city had only limited regional importance until the ascension of a powerful ruler, Lord Pakal (Mayan for "shield"), who ruled from 615 to 683 CE. He and his son, who succeeded him, commissioned most of the structures visible at Palenque today. As at Tikal, major buildings are grouped on high ground. A northern complex has five temples, two nearby adjacent temples, and a ball

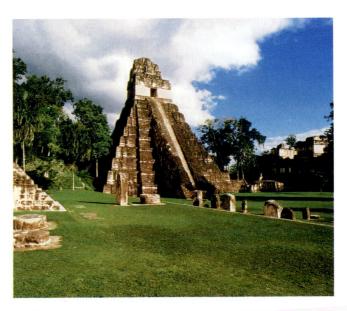

12–8 | BASE OF NORTH ACROPOLIS (LEFT) AND TEMPLE I Tomb of Ruler A, Tikal, Guatemala. Maya culture. North Acropolis, 5th century CE; Temple I, c. 700 CE.

court. A central group includes the so-called **PALACE**, the **TEMPLE OF THE INSCRIPTIONS**, and two other temples (FIG. 12–9). A third group of temples lies to the southeast.

The palace in the central group—a series of buildings on two levels around three open courts, all on a raised terrace—may have been an administrative rather than a residential complex. The Temple of the Inscriptions next to it is a pyramid that rises about 75 feet. Like Temple I at Tikal, it has nine levels. The shrine on the summit consisted of a portico with five entrances and a three-part, vaulted inner chamber surmounted by a tall roof comb. Its façade still retains much of its stucco sculpture. The inscriptions that give the building its name consist of three large panels of text that line the back wall of the outer chamber at the top of the temple.

In 1948 an archaeologist studying the structure of the Temple of the Inscriptions cleared the rear chamber and entered a corbel-vaulted stairway beneath the summit shrine. This stairway zigzagged down 80 feet to a small subterranean chamber that contained the undisturbed tomb of Lord Pakal,

which was finally revealed in 1952 after four years of clearing the stairwell.

SCULPTURE. Lord Pakal lay in a monolithic carved sarcophagus that represented him balanced between the underworld and the earth. His ancestors, carved on the side of his sarcophagus, witness his death and apotheosis. Among them are the Lord's parents, Lady White Quetzal and Lord Yellow Jaguar-Parrot, supporting the contention of some scholars that both maternal and paternal lines transmitted royal power among the Maya.

The stucco **PORTRAIT OF LORD PAKAL** found with his sarcophagus shows him as a young man wearing a diadem of jade and flowers (FIG. 12–10). His features—sloping forehead and elongated skull (babies' heads were bound to produce this shape), large curved nose (enhanced by an ornamental bridge, perhaps of latex), full lips, and open mouth—are characteristic of the Maya ideal of beauty. His long narrow face and jaw are individual characteristics. Traces of pigment indicate that this portrait, like much Maya sculpture, was colorfully painted.

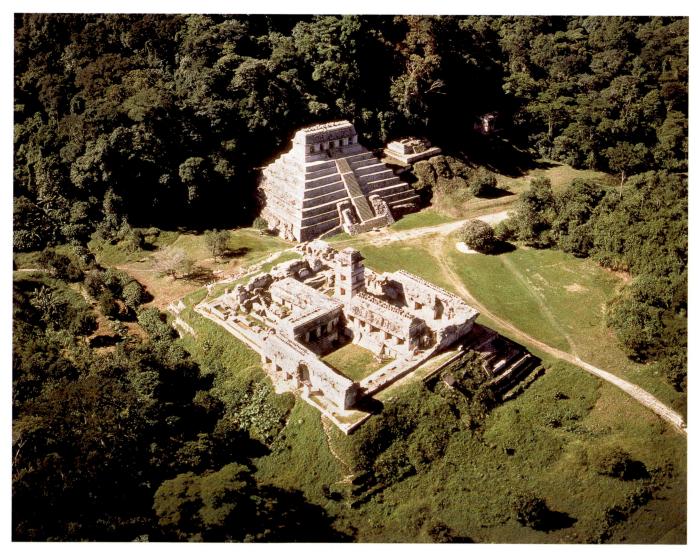

12–9 | PALACE (FOREGROUND) AND TEMPLE OF THE INSCRIPTIONS (TOMB-PYRAMID OF LORD PAKAL), PALENQUE Mexico. Maya culture, late 7th century CE.

Art and Its Context

THE COSMIC BALL GAME

he ritual ball game was one of the defining characteristics of Mesoamerican society. The ball game was generally played on a long, rectangular court with a large, solid, heavy rubber ball. Using their elbows, knees, or hips—but not their hands—heavily padded players directed the ball toward a goal or marker. The rules, size and shape of the court, the number of players on a team, and the nature of the goal varied. The largest surviving ball court at Chichen Itza was about the size of modern football field. Large stone rings set in the walls of the court about 25 feet above the field served as goals.

The game was a common subject in Mesoamerican art. Players, complete with equipment, appear as ceramic figurines and on stone votive sculptures, and the game and its attendant rituals were represented in relief sculpture. The game may have had religious and political significance: The movement of the ball represented celestial bodies—the sun, moon, or stars—held aloft and directed by the skill of the players. The ball game was sometimes associated with warfare. Captive warriors might have been made to play the game, and players might have been sacrificed when the stakes were high.

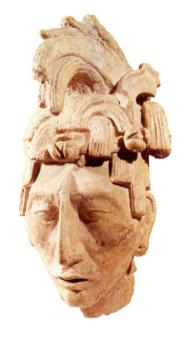

12–10 | PORTRAIT OF LORD PAKAL
Found in his tomb, Temple of the Inscriptions, Palenque, Mexico.
Maya culture, mid-7th century CE. Stucco and red paint, height
16%" (43 cm). Museo Nacional de Antropología, Mexico City.

Sculpture for Lady Xok. Elite men and women, rather than gods, were the usual subjects of Maya sculpture, and most show rulers dressed as warriors performing religious rituals in elaborate costumes and headdresses. Although they excelled at three-dimensional clay and stucco sculpture (SEE FIG. 12–10), the Maya favored low-relief for carving steles and buildings. Three carved lintels of a palace in Yaxchilan are among the masterpieces of Maya art. They formed the lintels of doors in a temple (known as structure 23) dedicated in 726 to Lady Xok, the principal wife and queen of the ruler, Shield Jaguar the Great. The first lintel illustrates a bloodletting ritual in which the queen runs a spiked rope through her tongue and catches the blood on papers in a basket. In the second, pictured here, she conjures up a serpent that spews forth a warrior who aims

his spear at the kneeling queen (FIG. 12–11). In the third, she holds Shield Jaguar's helmet and shield as he arms himself. Although the reliefs seem to tell a story, the events they depict actually happened at different times between 681 and 724. Lady Xok's vision of the monster snake actually took place when Shield Jaguar became the ruler of Yaxchilan in 681. The relief is unusually high, giving the sculptor ample opportunity to display a virtuoso carving technique, for example, in Lady Xok's garments and jewelry. The calm idealized face of the queen recalls the *Portrait of Lord Pakal*. That the queen was

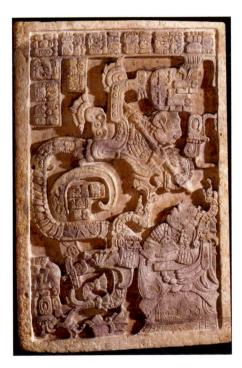

I2-II LADY XOK'S VISION OF A GIANT SNAKE (ACCESSION CEREMONY)

Lintel 25 of a temple (structure 23). Yaxchilan, Chiapas, Mexico. Dedicated in 723 CE and 726 CE. Limestone, $46\frac{1}{2} \times 29\frac{1}{8}$ " (118 \times 74 cm). British Museum. Acquired by the British Museum in 1883.

depicted on a lintel in a temple is an indication of her importance at court, and the role of elite Maya women generally.

PAINTING. Artists had high status in Maya society, reflecting the importance attached to record keeping among the Maya; they chronicled their history in carved and painted inscriptions on stele, ceramic vessels, and walls. And they recorded with hieroglyphic writing and illustrations in codices—books of folded paper made from the maguey plant. Vase painters and scribes were often members of the ruling elite and perhaps included members of the royal family not in the direct line of succession.

Maya painting survives on ceramics and a few large murals; most of the illustrated books have perished, except for a few late examples on astronomical and divinatory subjects. The influence of the books is reflected, however, in vases painted in the so-called codex style, which often show a fluid line and elegance similar to that of the manuscripts.

The codex-style painting on a Late Classic cylindrical vase (FIG. 12–12) may illustrate an episode from a Maya sacred text, *Popol Vuh*, about the creation of the world and the first people. The protagonists, the mythical Hero Twins, overcome death by defeating the lords of Xibalba, the Maya underworld. The vessel shows one of the lords of Xibalba, an aged-looking being known to archaeologists as God L, sitting inside a temple on a raised platform. Five female deities attend him. The god ties a wrist cuff on the attendant kneeling before him. Another attendant, seated outside the temple, looks over her shoulder at a scene in which two men sacrifice a bound victim. A rabbit in the foreground writes in a manuscript. The two men may be the Hero Twins and the bound

Sequencing Works of Art

c. 350-650	Ceremonial center of the city of Teotihuacan
Late 7th century	Temple of the Inscriptions, Palenque
c. 830-1250	Pueblo Bonito, Chaco Canyon
9th to 13th century	Pyramid (el Castillo), Chichen Itza
c. 1070	Great Serpent Mound, Ohio

victim a bystander they sacrifice and then revive to gain the confidence of the Xibalban lords. The inscriptions on the vessel have not been entirely translated. They include a calendar reference to the Death God and to the evening star, which the Maya associated with war and sacrifice.

POSTCLASSIC PERIOD. A northern Maya group called the Itza rose to prominence in the Postclassic period. Their principal center, Chichen Itza, which means "at the mouth of the well of the Itza," grew from a village located near a sacred well. The city flourished from the ninth to the thirteenth century CE, and at its height covered about six square miles.

One of Chichen Itza's most conspicuous structures is a massive nine-level pyramid in the center of a large plaza (FIG. 12–13). There is a stairway on each side of the pyramid leading to a square temple on the pyramid's summit. At the spring and fall equinoxes, the setting sun casts undulating shadows on the stairways, forming bodies for the serpent heads carved at the bases of the balustrades. Many prominent features

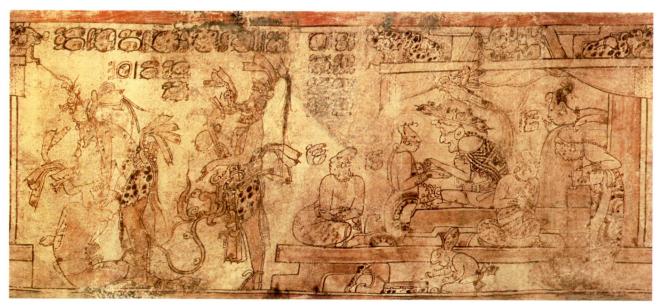

12-12 CYLINDRICAL VESSEL

(Composite photograph in the form of a roll-out.) Maya culture, 600–900 CE. Painted ceramic, diameter $6\frac{1}{2}$ " (16.6 cm); height $8\frac{1}{8}$ " (21.5 cm). The Art Museum, Princeton University, Princeton, New Jersey.

The clay vessel was first covered by a creamy white slip and then painted in light brown washes and dark brown or black lines. The painter may have used turkey feathers to apply the pigments.

I2-I3 | PYRAMID ("EL CASTILLO") WITH CHACMOOL IN FOREGROUND, CHICHEN ITZA

Yucatan, Mexico. Itza (northern Maya) culture, 9th-13th century CE; Chacmool, 800-1000 CE.

Library, Getty Research Institute, Los Angeles. Wim Swaan Photograph Collection (96, p.21)

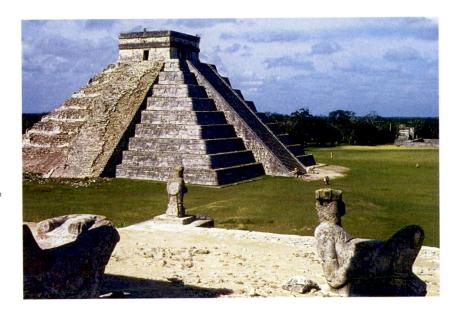

of Chichen Itza are markedly different from earlier sites. The pyramid, for example, is lower and broader than the stepped pyramids of Tikal and Palenque, and Chichen Itza's buildings have wider rooms. Another feature not found at earlier sites is the use of pillars and columns. Chichen Itza has broad, open galleries surrounding courtyards and inventive columns in the form of inverted, descending serpents. Brilliantly colored relief sculpture covered the buildings of Chichen Itza, and paintings of feathered serpents, jaguars, coyotes, eagles, and composite mythological creatures adorned its interior rooms. The surviving works show narrative scenes that emphasize the prowess of warriors and the skill of ritual ballplayers.

Sculpture at Chichen Itza, including the serpent columns and balustrades and the half-reclining figures known as Chacmools, has the sturdy forms, proportions, and angularity of architecture, rather than the curving subtlety of Classic Maya sculpture. The Chacmools probably represent fallen warriors and were used to receive sacrificial offerings.

After Chichen Itza's decline, Mayapan, on the north coast of the Yucatan, became the principal Maya center. But by the time the Spanish arrived in the early sixteenth century, Mayapan, too, had declined (destroyed in the mid-1400s CE). The Maya people and much of their culture would survive the conquest despite the imposition of Hispanic customs and beliefs. The Maya continue to speak their own languages, to venerate traditional sacred places, and to follow traditional ways.

CENTRAL AMERICA

Unlike their neighbors in Mesoamerica, who lived in complex hierarchical societies, the people of Central America lived in extended family groups in towns led by chiefs. A notable example of these small chiefdoms was the Diquis culture (located in present-day Costa Rica), which lasted from about 700 to 1500 CE. The Diquis occupied fortified villages

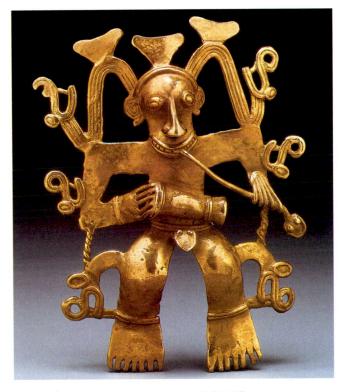

I2–I4 | SHAMAN WITH DRUM AND SNAKE Costa Rica. Diquis culture, c. 13–16th century CE. Gold, $4\frac{1}{4} \times 3\frac{1}{4}$ " (10.8 \times 8.2 cm). Museos del Banco Central de Costa Rica, San José, Costa Rica.

and seem to have engaged in constant warfare with one another. Although they did not produce monumental architecture or sculpture, they created fine featherwork, ceramics, textiles, and objects of gold and jade.

Metallurgy and the use of gold and copper-gold alloys were widespread in Central America. The technique of lost-wax casting probably first appeared in present-day Colombia between 500 and 300 BCE. From there it spread north to the Diquis. A small, exquisite pendant (FIG. 12–14)

illustrates the style and technique of Diquis goldwork. The pendant depicts a male figure wearing bracelets, anklets, and a belt with a snake-headed penis sheath. He plays a drum while holding the tail of a snake in his teeth and its head in his left hand. The wavy forms with serpent heads emerging from his scalp suggest an elaborate headdress, and the creatures emerging from his legs suggest some kind of reptile costume. The inverted triangles on the headdress probably represent birds' tails.

In Diquis mythology, serpents and crocodiles inhabited a lower world, humans and birds a higher one. Their art depicts animals and insects as fierce and dangerous. Perhaps the man in the pendant is a shaman transforming himself into a composite serpent-bird or performing a ritual snake dance surrounded by serpents or crocodiles. The scrolls on the sides of his head may represent the shaman's power to hear and understand the speech of animals. Whatever its specific meaning, the pendant evokes a ritual of mediation between earthly and cosmic powers involving music, dance, and costume.

Whether gold figures of this kind were protective amulets or signs of high status, they were certainly more than personal adornment. Shamans and warriors wore gold to inspire fear, perhaps because gold was thought to capture the energy and power of the sun. This energy was also thought to allow shamans to leave their bodies and travel into cosmic realms.

SOUTH AMERICA: THE CENTRAL ANDES

Like Mesoamerica, the central Andes of South America primarily present-day Peru and Bolivia—saw the development of complex hierarchical societies with rich and varied artistic traditions. The area is one of dramatic contrasts. The narrow coastal plain, bordered by the Pacific Ocean on the west and the abruptly soaring Andes on the east, is one of the driest deserts in the world. Life here depends on the rich marine resources of the Pacific Ocean and the rivers that descend from the Andes, forming a series of valley oases. The Andes themselves are a region of lofty snowcapped peaks, high grasslands, steep slopes, and deep, fertile river valleys. The high grasslands are home to the Andean camelids—llamas, alpacas, vicuñas, and guanacos—that have served for thousands of years as beasts of burden and a source of wool and meat. The lush eastern slopes of the Andes descend to the tropical rain forest of the Amazon basin.

The earliest evidence of monumental building in Peru dates to the third millennium BCE. (With no dated monuments, all dates are approximate.) On the coast, sites with ceremonial mounds and plazas were located near the sea. Coastal inhabitants depended on marine and agricultural resources,

farming the flood-plains of nearby coastal rivers. Their chief crops were cotton, used to make fishing nets, and gourds, used for floats. In the highlands, early centers consisted of multiroomed stone-walled structures with sunken central fire pits for burning ritual offerings.

In the second millennium BCE, herding and agriculture became prevalent in the highlands. On the coast, people became increasingly dependent on agriculture. They began to build canal irrigation systems, greatly expanding their food supply. Settlements were moved inland, and large, U-shaped ceremonial complexes with circular sunken plazas were built. These complexes were oriented toward the mountains, the direction of the rising sun and the source of the water that nourished their crops. The shift to irrigation agriculture coincided with the spread of pottery and ceramic technology in Peru.

Between about 1000 and 200 BCE an art style associated with the northern highland site of Chavin de Huantar spread through much of the Andes. In Andean chronology, this era is known as the Early Horizon, the first of three so-called horizon periods. The political and social forces behind the spread of the Chavin style are not known; many archaeologists suspect that they involved an influential religious cult. The period was one of artistic and technical innovation in ceramics, metallurgy, and textiles. Ceramics, metalware, and textiles have been found in burial sites,

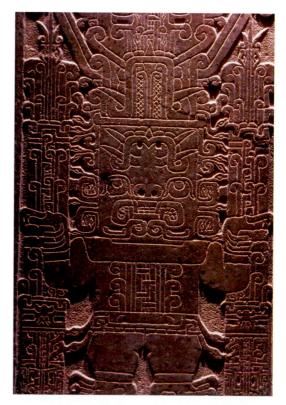

12–15 ↑ **RAIMONDI STONE, CHAVIN DE HUANTAR**Peru, 1000–600 BCE. Height, 6′6″ (2 m). Diorite. Museo
Nacional de Antropología y Arqueología, Lima, Peru.

Technique

ANDEAN TEXTILES

ndean textiles played an important role in both private and public events. Specialized fabrics were developed for everything from ritual burial shrouds and shamans' costumes to rope bridges and knotted cords for record keeping. Clothing indicated ethnic group and social status and was customized for certain functions, the most rarefied being royal ceremonial garments made for specific occasions and worn only once. The creation of textiles, among the most technically complex cloths ever made, consumed a major portion of ancient Andean societies' resources. Weavers and embroiderers used nearly every textile technique known today, some of them the unique inventions of these cultures. Dyeing technology, too, was an advanced art form in the ancient Andes, with some textiles containing dozens of colors.

Cotton was grown in Peru by 3500 BCE and was the most widely used plant fiber. From about 400 BCE on, animal fibers—superior in warmth and dye absorption—largely replaced cotton in the Andes. The earliest Peruvian textiles were made by twining, knotting, wrapping, braiding, and looping fibers. Those techniques continued to be used even after the invention of weaving looms in the early second millennium BCE.

Early Andean peoples developed a simple, portable back-strap loom for weaving in which the undyed cotton warp (the lengthwise threads) was looped and stretched between two poles. One pole was tied to a stationary object and the other strapped to the waist of the weaver. The weaver controlled the tension of the warp threads by leaning back and forth while threading a bobbin, or shuttle, from side to side to create the weft (crosswise threads) that completely covered the warp.

Tapestry weaving appeared in Peru around 900 BCE. In tapestry, a technique especially suited to representational textiles, the weft does not run the full width of the fabric; each colored section is woven as an independent unit. Tapestry was followed by the introduction of embroidery in camelid fibers on cotton. (Camelid fiber—llama, guanaco, alpaca, or vicuña hair—is the Andean equivalent of wool.) As even more complex techniques developed, the production of a single textile might involve a dozen processes

requiring highly skilled workers. Some of the most elaborate textiles were woven, unwoven, and rewoven to achieve special effects that were prized for their labor-intensiveness and difficulty of manufacture as well as their beauty. The finest woven pieces contain an amazing 200 weft threads per square inch (fine European work uses 60-80 threads per square inch).

Because of their complexity, deciphering how these textiles were made can be a challenge, and scholars rely on contemporary Andean weavers—inheritors of this tradition—for guidance. Then, as now, fiber and textile arts were primarily in the hands of women.

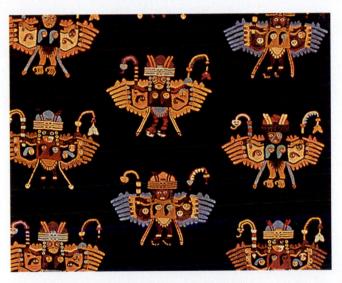

MANTLE WITH BIRD IMPERSONATORS DETAIL

From the Paracas peninsula, Peru. Paracas culture,
c. 200 BCE-200 CE. Camelid fiber, plain weave with stem-stitch
embroidery. Museum of Fine Arts, Boston.

Denman Waldo Ross Collection (16.34a).

reflecting the importance to the Chavin people of burial and the afterlife.

Chavin de Huantar was located on a trade route between the coast and the Amazon basin, and Chavin art features images of tropical forest animals. The relief sculpture on the **RAIMONDI STONE** (named for its discoverer) defies easy interpretation (FIG. 12–15). Found in a ceremonial complex, the huge slab of diorite was carved in low relief with a figure whose headdress completely fills the

rectangular surface. Absolutely frontal and symmetrical, the figure grasps a complex staff in each paw. Easily identifiable are the snakes in the creature's hair filling the top half of the relief and the claws and fangs of a jaguar. The large head resting directly on the shoulders is topped by an extraordinary head/headdress that has three more heads. Compact frontality, flat relief, curvilinear design, and the combination of human, animal, bird, and reptile parts characterize this early art.

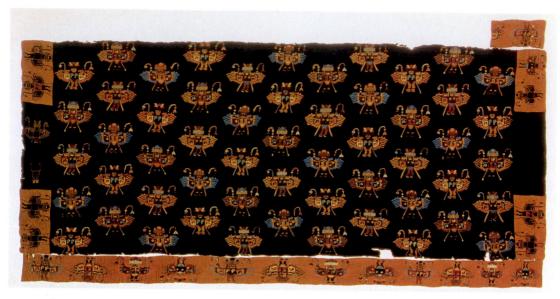

12-16 | MANTLE WITH BIRD IMPERSONATORS

Paracas peninsula, Peru. Paracas culture, c. 200 BCE-200 CE. Camelid fiber, plain weave with stem-stitch embroidery, approx. $40'' \times 7'11''$ (1.01 \times 2.41 m). Museum of Fine Arts, Boston. Denman Waldo Ross Collection (16.34a).

The Paracas and Nazca Cultures

Chavin figures can be seen in the textiles of the Paracas culture on the south coast of Peru, in the art of the Nazca culture there, and in the ceramics and metalwork of the Moche culture on the north coast.

PARACAS. The Paracas culture of the Peruvian south coast flourished from about 1000 BCE to 200 CE, overlapping the Chavin period. It is best known for its stunning textiles, which were found in cemeteries as wrappings in many layers around bodies of the dead. Some bodies were wrapped in as many as 200 pieces of cloth.

Weaving is of great antiquity in the central Andes and continues to be among the most prized arts in the region (see "Andean Textiles," page 409, with detail of FIG. 12–16). Fine textiles were a source of prestige and wealth, and the

production of textiles was an important factor in the domestication of both plants (cotton) and animals (llamas). The designs on Paracas textiles include repeated embroidered figures of warriors, dancers, and composite creatures such as bird-people (FIG. 12–16). Embroiderers used tiny overlapping stitches to create colorful, curvilinear patterns, sometimes using as many as twenty-two different colors within a single figure, but only one simple stitch. The effect of the clashing and contrasting colors and tumbling figures is dazzling.

NAZCA. The Nazca culture, which dominated the south coast of Peru from about 200 BCE to 600 CE, overlapped the Paracas culture. Nazca artisans wove fine fabrics, but they also produced multicolored pottery with painted and modeled images reminiscent of those on Paracas textiles.

I2-I7 | EARTH DRAWING (GEOGLYPH) OF A HUMMINGBIRD, NAZCA PLAIN

Southwest Peru. Nazca culture, c. 100 BCE-700 CE. Length approx. 450' (137 m); wingspan approx. 220' (60.9 m).

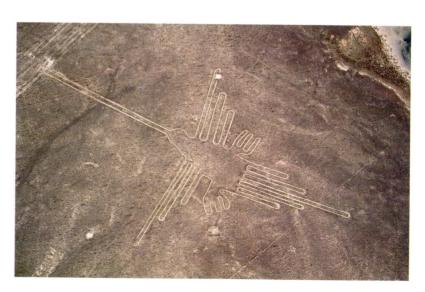

The Nazca are best known for their colossal earthworks. or geoglyphs, which dwarf even the most ambitious twentiethcentury environmental sculpture. On great stretches of desert they literally drew in the earth. By removing dark, oxidized stones, they exposed the light underlying stones, then edged the resulting lines with more stones. In this way they created gigantic images—including a hummingbird, with a beak 120 feet long (FIG. 12-17), a killer whale, a monkey, a spider, a duck, and other birds-similar to those with which they decorated their pottery. They also made abstract patterns and groups of straight, parallel lines that extend for up to 12 miles. Each geoglyph was evidently maintained by a clan. At regular intervals the clans gathered on the plateau in a sort of fair where they traded goods and looked for marriage partners. The purpose and meaning of the glyphs remain a mystery, but the "lines" of stone are wide enough to have been ceremonial pathways.

The Moche Culture

The Moche culture dominated the north coast of Peru from the Piura Valley to the Huarmey Valley—a distance of some 370 miles—between about 200 BCE and 600 CE. Moche lords ruled each valley in this region from a ceremonial-administrative center. The largest of these, in the Moche Valley (from which the culture takes its name), contained the so-called Pyramids of the Sun and the Moon, both built of adobe brick. The Pyramid of the Sun, the largest ancient structure in South America, was originally a cross-shaped structure 1,122 feet long by 522 feet wide that rose in a series of terraces to a height of 59 feet. This site had been thought to be the capital of the entire Moche realm, but evidence is accumulating that indicates that the Moche maintained a decentralized social network.

The Moche were exceptional potters and metalsmiths. Vessels were made in the shape of naturalistically modeled human beings, animals, and architectural structures. They developed ceramic molds, which allowed them to massproduce some forms. They also created realistic portrait vessels and recorded mythological narratives and ritual scenes in intricate fine-line painting. Similar scenes were painted on the walls of temples and administrative buildings. Moche metalsmiths, the most sophisticated in the central Andes, developed several innovative metal alloys.

A ceramic vessel (FIG. 12–18) shows a Moche lord sitting in a thronelike structure associated with high office. He wears an elaborate headdress and large earspools and strokes a cat or perhaps a jaguar cub. Vessels of this kind, used in Moche rituals, were also treasured as special luxury items and were buried in large quantities with individuals of high status.

THE TOMB OF THE WARRIOR PRIEST. A central theme in Moche iconography is the sacrifice ceremony, in which prisoners captured in battle are sacrificed and several elaborately dressed figures then drink their blood. Archaeologists have

Sequencing Events Meso-, Central, and South American Cultures

c. 1200–400 BCE Olmec Culture
c. 200 BCE–600 CE Nazca Culture
c. 1000 BCE–200 CE Paracas Cultures
c. 200 BCE–600 CE Moche Culture
c. 1 CE–750 CE Teotihuacan Culture
c. 250–1521 CE Mayan Culture

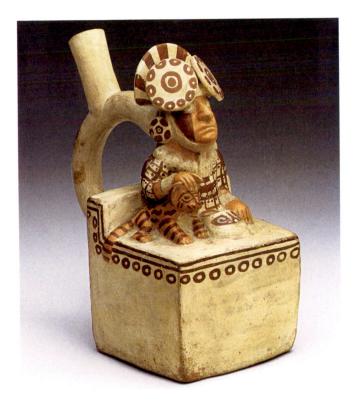

I2–I8 | MOCHE LORD WITH A FELINE Moche Valley, Peru. Moche culture, c. 100 BCE–500 CE. Painted ceramic, height $7\frac{7}{2}$ " (19 cm). Art Institute of Chicago. Buckingham Fund, 1955–2281

Behind the figure is the distinctive stirrup-shaped handle and spout.

labeled the principal figure in the ceremony as the Warrior Priest and other important figures as the Bird Priest and the Priestess. The recent discovery of a number of spectacularly rich Moche tombs indicates that the sacrifice ceremony was an actual Moche ritual and that Moche lords assumed the roles of the principal figures. The occupant of a tomb at Sipan, on the northwest coast, was buried with the regalia of the Warrior Priest. In a tomb at the site of San José de Moro, just south of Sipan, an occupant was buried with the regalia of the Priestess.

Among the riches accompanying the Warrior Priest at Sipan was a pair of exquisite gold-and-turquoise earspools,

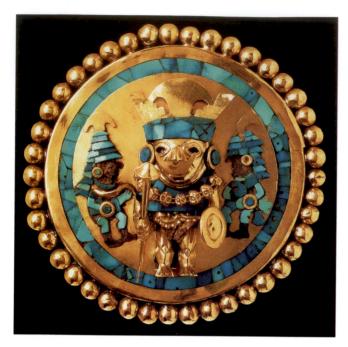

12–19 | **EARSPOOL** Sipan, Peru. Moche culture, 2nd–5th century CE. Gold, turquoise, quartz, and shell; diameter approx. 5" (12.7 cm). Bruning Archaeological Museum, Lambayeque, Peru.

each of which depicts three Moche warriors (FIG. 12–19). The central figure is made of beaten gold and turquoise. He and his companions are adorned with tiny gold-and-turquoise earspools. They wear gold-and-turquoise head-dresses topped with delicate sheets of gold that resemble the crescent-shaped knives used in sacrifices. The central figure has a crescent-shaped nose ornament and carries a gold club and shield. A necklace of owl's-head beads strung with gold thread hangs around his shoulders. Many of his anatomical features have been rendered in painstaking detail.

NORTH AMERICA

Compared with the densely inhabited agricultural regions of Mesoamerica and South America, most of North America remained sparsely populated. Early people lived primarily by hunting, fishing, and gathering edible plants. Agriculture was developed on a limited scale, with evidence of squash cultivation in present-day Illinois dating from around 5000 BCE and maize cultivation in the Southwest around 1000 BCE. In the East and in the lands drained by the Mississippi and Missouri river system, a more settled way of life began to emerge, and by around 1000 BCE—in Louisiana as early as 2800 BCE—nomadic hunting and gathering had given way to more settled communities. People cultivated squash, sunflowers, and other plants to supplement their diet of game, fish, and berries. People across the American Southwest began to adopt a sedentary, agricultural life toward the end of the first millennium BCE.

The East

The culture of eastern North America is only beginning to be understood. Archaeologists have shown that people lived in communities that included both burial and ceremonial earthworks—mounds of earth-formed platforms that probably supported a chief's house, and served as the shrines of ancestors and places for a sacred fire, tended by special guardians. One of the largest, though not the earliest of the ceremonial centers (this distinction goes to Watson Brake, Louisiana, dating to 3400–3000 BCE), is Poverty Point, Louisiana. Between 1800–500 BCE people constructed huge earthen circles three quarters of a mile wide and seven miles long. Scholars have noted that these earthworks are contemporary with Stonehenge in England (SEE FIG. 1–17) and with the Olmec constructions in Mexico.

The Woodland Period

The Woodland period (300 BCE-1000 CE) saw the creation of impressive earthworks along the great river valleys of the Ohio and Mississippi. People built monumental mounds, and buried their leaders with valuable grave goods. Objects discovered in these burials indicate that the people of the Mississippi, Illinois, and Ohio river valleys traded widely with other regions of North and Central America. For example, the burial sites of the Adena (c. 1100 BCE-200 CE) and the Hopewell (c. 100 BCE-550 CE) cultures contained jewelry made with copper from present-day Michigan's Upper Peninsula and silhouettes cut in sheets of mica from the Appalachian Mountains. The pipes the Hopewell people created from fine-grained pipestone have been found from Lake Superior to the Gulf of Mexico. Among the items the Hopewell received in exchange for their pipestone and a flintlike stone used for toolmaking were turtle shells and sharks' teeth from Florida.

The Hopewell carved their pipes with representations of forest animals and birds, sometimes with inlaid eyes and teeth of freshwater pearls and bone. Combining realism and stylized simplification, a beaver crouching on a platform forms the bowl of a pipe found in present-day Illinois (FIG. 12–20). As in a modern pipe, the bowl—a hole in the beaver's back—could be filled with dried leaves (the Hopewell may not have grown tobacco), the leaves lighted, and smoke drawn through the hole in the stem. A second way that these pipes were used was to blow smoke inhaled from another vessel through the pipe to envelop the animal carved on it. The shining pearl eyes suggest an association with the spirit world. Native Americans of the Eastern Woodlands associated white, shiny materials with spirituality well into the post-contact period.

The Mississippian Period

The Mississippian period (c. 700–1550 CE) is characterized by the widespread distribution of complex chiefdoms, both large

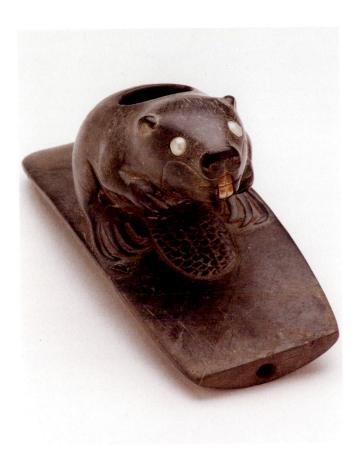

12–20 | BEAVER EFFIGY PLATFORM PIPE Bedford Mound, Pike County, Illinois. Hopewell culture, c. 100–200 CE. Pipestone, river pearls, and bone, length $4\%_{16}\times1\%_{8}\times2''$. Gilcrease Museum, Tulsa, Oklahoma.

and small, that proliferated throughout the region. The people of the Mississippian culture continued the mound-building tradition begun by the Adena, Hopewell, and others.

THE GREAT SERPENT MOUND. One of the most impressive Mississippian period earthworks is the Great Serpent Mound in present-day Adams County, Ohio (FIG. 12–21). Researchers, using carbon-14 radiometric dating, have recently dated the mound at about 1070 CE. There have been many interpretations of the twisting snake form, especially the "head" at the highest point, an oval enclosure that some see as opening its jaws to swallow a huge egg formed by a heap of stones. Perhaps the people who built it, like those who made the petroglyphs and Sun Dagger in Chaco Canyon (SEE FIGURE 12–1), were responding to the spectacular astronomical display of Halley's Comet in 1066. The Bayeaux Tapestry (page 506) shows one European reaction to the comet.

CAHOKIA. The Mississippian people built a major urban center known as Cahokia, near the juncture of the Illinois, Missouri, and Mississippi rivers (now East St. Louis, Illinois). Although the site may have been inhabited as early as c. 3000 BCE, Cahokia, as we know it, was begun about 900 CE, and

Sequencing Events Native North American Cultures

c. 100 BCE-550 CE	Hopewell Culture
c. 200 BCE-1200 CE	Hohokam Culture
c. 700–1550 CE	Mississippian Culture
c. 500-1500 CE	Florida Glades Culture
c. 550 ce-c. 1250 ce	Ancient Puebloan Culture

most construction took place between about 800 and 1500. At its height the city had a population of about 20,000 people, with another 10,000 in the surrounding countryside (FIGS. 12–22 and 12–23).

The most prominent feature of Cahokia is an enormous earth mound called Monk's Mound, covering 15 acres and originally 1200 feet high. A small, conical platform on its summit originally supported a wooden fence and a rectangular building. The mound is aligned with the sun at the equinox and may have had a special use during planting or harvest festivals. Smaller rectangular and conical mounds in front of the principal mound surrounded a large, roughly rectangular plaza. The city's entire ceremonial center was protected by a stockade, or fence, of upright wooden posts-whether to ward off external threats or due to social unrest among the different Mississippian classes is not certain. In all, the walled enclosure contained more than 500 mounds, platforms, wooden enclosures, and houses. The various earthworks functioned as tombs and bases for palaces and temples, and also served to make astronomical observations. One conical burial mound was located next to a platform that may have been used for sacrifices.

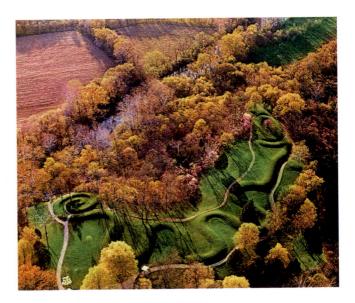

I2-21 | GREAT SERPENT MOUND
Adams County, Ohio. c. 1070 CE. Length approx. 1,254' (328.2 m).

THE OBJECT SPEAKS

ROCK ART

ock art consists of pictographs, which are painted, and petroglyphs, which are pecked or engraved. While occurring in numerous distinctive styles, rock art images include humans, animals, and geometric figures, represented singly and in multifigured murals. In the Great Gallery of Horseshoe Canyon, Utah, the painted human figures have long decorated rectangular bodies and knoblike heads. One large, wide-eyed figure (popularly known as the "Holy Ghost") is nearly 8 feet tall. Previously, archaeologists dated these paintings as early as 1900 BCE and as recently as 300 CE, but some now claim that these paintings may be dated as early as 5400 or even 7500 BCE. The study of the early art of the Americas is filled with debates.

Petroglyphs are often found in places where the dark brown bacterial growths and staining known as "desert varnish" streaks down canyon walls

(SEE FIG. 12-26). To create an image, the artist scrapes or pecks through the layer of varnish, exposing the lighter sandstone beneath.

In Nine Mile Canyon in central Utah, a large human hunter draws his bow and arrow on a flock of bighorn sheep. Other hunters and a large, rectangular armless figure wearing a horned headdress—perhaps a shaman—mingle with the animals. The scene gives rise to the same questions and arguments we have noted with regard to the prehistoric art discussed in Chapter 1: Is this a record of a successful hunt or is it part of some ritual activity to assure success? The petroglyphs are attributed to the Fremont people (800–1300 CE), who were agriculturists as well as hunters.

VISITING PICTOGRAPHS AND PETROGLYPHS

Petroglyphs are found from Kansas and Iowa to California and from Canada to

Mexico, but they are concentrated in the Southwest in the Four Corners states (Colorado, Utah, New Mexico, and Arizona). Although many sites are easily visited, to see some of the finest petroglyphs requires arduous hiking and climbing. When you visit a rock site, certain rules must be observed:

- 1. Get the owner's permission if you venture onto private property.
- 2. Show respect. Remember that rock art has religious associations, especially for Native Americans.
- Do not walk upon or touch rock art. You could permanently damage it, or leave traces of substances that could affect attempts to date the petroglyphs.
- 4. Leave the site as you found it. Do not pull up plants or move rocks.

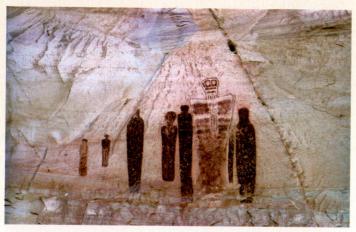

ANTHROPOMORPHS, THE GREAT GALLERY, HORSESHOE (BARRIER) CANYON

Utah. Variously dated. Largest figure about 8' (2.44 m) tall.

The figures may represent shamans and are often associated with snakes, dogs, and other small energetic creatures. Big-eyed anthropomorphs may be rain gods. Painters used their fingers and yuccafiber brushes to apply the reddish pigment made from hematite (iron oxide).

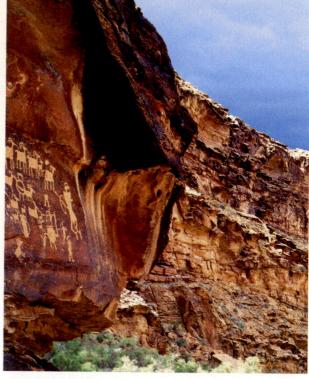

HUNTER'S MURALNine Mile Canyon, Utah, Fremont People, 800-1300 CE.

Postholes indicate that wooden henges (circular areas) were a feature of Cahokia. The largest, with a diameter of about 420 feet (seen to the extreme left in FIGURE 12–23), had forty-eight posts and was oriented to the cardinal points. Sight lines between a forty-ninth post set east of the center of the enclosure and points on the perimeter enabled native astronomers to determine solstices and equinoxes.

FLORIDA GLADES CULTURE. In 1895, excavators working in submerged mud and shell mounds off Key Marco on the west

coast of Florida made a remarkable discovery. Posts carved with birds and animals were found preserved in the swamps. The large mound called Fort Center, in Glades Country, Florida, gives the culture its name: Florida Glades.

In Key Marco painted wooden animal and bird heads, a human mask, and the figure of a kneeling cat-human were found in circumstances that suggested a ruined shrine. Recently carbon-14 dating of these items has confirmed a date of about 1000 CE. Although the heads are simplified, the artists show a remarkable power of observation in

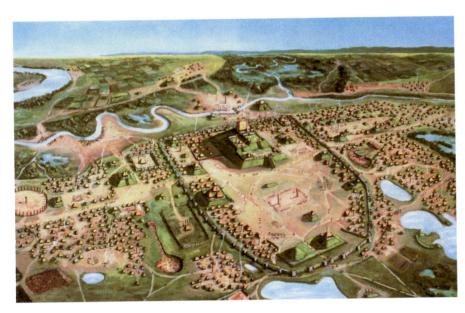

12-22 RECONSTRUCTION OF CENTRAL CAHOKIA, AS IT WOULD HAVE APPEARED ABOUT 1150 CE

East St. Louis, Illinois. Mississippian Culture. East-west length approx. 3 miles (4.5 km), north-south length approx. 2¼ miles (3.6 km); base of great mound, 1,037 × 790′ (316 × 241 m), height approx. 100′ (30 m). Painting by William R. Iseminger

Courtesy of Cahokia Mounds Historic site

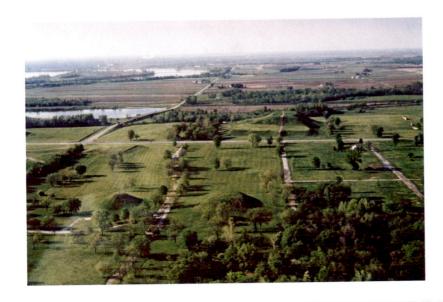

reproducing the creatures they saw around them, such as the pelican (FIG. 12–24). The surviving head, neck, and breast of the pelican are made of carved wood painted black, white, and gray (other images also had traces of pink and blue paint). The bird's outstretched wings were found nearby, but the wood shrank and disintegrated as it dried. Carved wooden wolf and deer heads were also found. Archaeologists think the heads might have been attached to ceremonial furniture or posts. Such images suggest the existence of a bird and animal cult or perhaps the use of birds and animals as clan symbols.

In 1539–43 Hernando De Soto explored the region and encountered Mississippian societies. However, contact between native North American people and Europeans resulted in unforeseen catastrophe. The Europeans introduced the germs of diseases, especially smallpox, to which native populations had had no previous exposure and hence no immunity. In short order, 80 percent of the native population perished, an extraordinary disruption of society, far worse than the Black Death in fourteenth-century Europe.

The North American Southwest

Farming cultures were slower to arise in the arid American Southwest, which became home to three major early cultures. The Mimbres/Mogollon culture, located in the mountains of west-central New Mexico and east-central Arizona, flourished from c. 200 to about 1250 CE. The Hohokam culture, centered in the central and southern parts of present-day Arizona, emerged around 200 BCE and endured until sometime after 1200 CE. The Hohokam built large-scale irrigation systems; they constructed deep and narrow canals to reduce evaporation and lined the canals with clay to reduce seepage. Around 900 CE, they began building elaborate, multistoried structures with many rooms

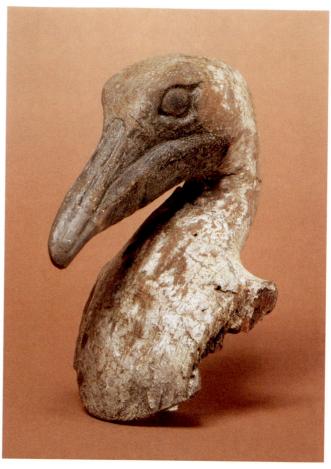

12–24 | **PELICAN FIGUREHEAD** Florida Glades culture, Key Marco, c. 1000 CE. Wood and paint, $4\frac{1}{8} \times 2\frac{1}{8} \times 3\frac{1}{8}$ " (11.2 \times 6 \times 8 cm). The University Museum of Archaeology and Anthropology, Philadelphia. (T4.303)

for specialized purposes, including communal food storage and rituals. The Spaniards called these communities "pueblos," or towns.

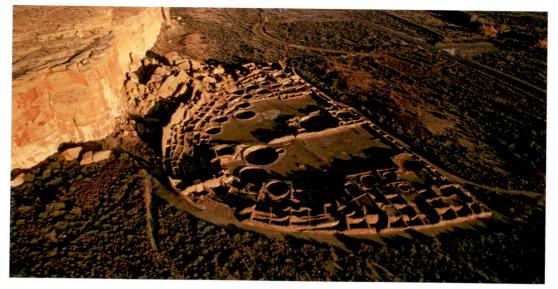

I2-25 | PUEBLO BONITO
Chaco Canyon. New Mexico, 830-1250 CE.

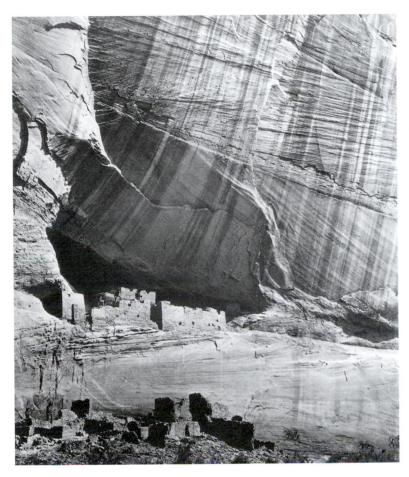

12-26 | Timothy O'Sullivan
ANCIENT RUINS IN THE CANON
DE CHELLEY

Arizona, 1873. Albumen print. National Archives, Washington, D.C.

Timothy O'Sullivan (1840–82) accompanied a geological survey expedition in the western United States. While ostensibly a documentary photograph, his depiction of "The White House," built by 12th century Ancestral Puebloans, is both a valuable document for the study of architecture and an evocative photograph, filled with the Romantic sense of sublime melancholy.

The third southwestern culture, the Ancestral Puebloans emerged around 550 CE in the Four Corners region, where present-day Colorado, Utah, Arizona, and New Mexico meet. The Puebloans adopted the irrigation technology of the Hohokam and began building elaborate, multistoried, apartmentlike "great houses" with many rooms for specialized purposes, including communal food storage. The largest known "great house" is Pueblo Bonito in Chaco Canyon, a New Mexico canyon of about 30 square miles with nine great houses, or pueblos. Interestingly, Pueblo Bonito remained the largest "apartment building" in North America until New York City surpassed it in the nineteenth century. (Calloway, 2004.)

Pueblo Bonito. The most extensive great house in Chaco Canyon, Pueblo Bonito (FIG. 12–25, ALSO SEE FIG. 12–1), was built in stages between the tenth and mid-thirteenth centuries CE. Eventually it comprised over 800 rooms in four or five stories, arranged in a D-shape. Because so many rooms were not needed to house a resident population of the size that the land could support, perhaps the pueblo provided temporary shelter for people assembling there on ritual occasions. Within the crescent part of the D-shape, thirty-two kivas recall the round semisubmerged pit houses of the Ancestral Puebloans. Here men performed religious rituals

and instructed youths in their responsibilities. The top of the kivas formed the floor of the communal plaza. Interlocking pine logs formed a shallow, domelike roof with a hole in the center through which the men entered by climbing down a ladder. Inside the kiva, in the floor directly under the entrance, a square pit—the "navel of the earth"—symbolized the place where the Ancestral Pueblo ancestors had emerged from the earth in the mythic "first times."

About 1150 the pueblo dwellers began to move to more secure places (FIG. 12–26). They built their apartmentlike dwellings on ledges under sheltering cliffs. Difficult as it must have been to live high on canyon walls and farm the valley below, the cliff communities had the advantage of being relatively secure. The rock shelters in the cliffs also acted as insulation, protecting the dwellings from extremes of heat and cold. Like a modern apartment complex, the many rooms housed an entire community comfortably. Communal solidarity and responsibility became part of the heritage of the Pueblo peoples.

Pueblo people found aesthetic expression in their pottery, an old craft perfected over generations and still alive today. Women were the potters in Pueblo society. In the eleventh century they perfected a functional, aesthetically pleasing, coil-built earthenware, or low-fired ceramic. This ceramic tradition continues today among the Pueblo

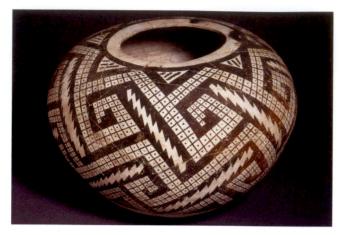

12–27 | **SEED JAR** Pueblo culture, c. 1150 CE. Earthenware and black-and-white pigment, diameter $14\frac{y_2''}{2}$ (36.9 cm). The St. Louis Art Museum, St. Louis, Missouri.

Purchase: Funds given by the Children's Art Bazaar, St. Louis

peoples of the Southwest. One type of vessel, a wide-mouthed seed jar with a globular body and holes near the rim (FIG. 12–27), would have been suspended from roof poles by thongs attached to the jar's holes, out of reach of voracious rodents. The example shown here is decorated with black-and-white dotted squares and zigzag patterns. The patterns conform to the body of the jar, and in spite of their angularity, they enhance its curved shape. The intricate play of dark and light suggests lightning flashing over a grid of irrigated fields.

Though no one knows for certain why the people of Chaco Canyon abandoned the site, the population declined during a severe drought in the twelfth century, and building at Pueblo Bonito ceased around 1250. The Pueblo population of Chaco Canyon may have moved to the Rio Grande and Mogollon River Valleys. Some scholars believe a new religion, based on controlling the rain (the "Katsina phenomenon"), drew the Ancestal Pueblo people to the new population centers. Even today, katsinas remain central to the Pueblo religion.

Throughout the Americas for the next several hundred years, artistic traditions would continue to emerge, develop, and be transformed as the indigenous peoples of various regions interacted. The sudden incursions of Europeans, beginning in the late fifteenth century, would have a dramatic and lasting impact on these civilizations and their art.

IN PERSPECTIVE

Much of American indigenous art has been lost to time and to the disruption of European conquest. Fortunately, during the past century, art history, anthropology, and

archaeology have helped to recover at least some understanding of American art before Columbus. Far from being the vacant wilderness described by some European newcomers, the Americas had been home to a wide variety of peoples since the Ice Age, with cultural traditions dating back at least to the times of Classical Greece. Although art was central to their lives, the indigenous peoples of the Americas designated no special objects as "works of art." Some pieces were essentially utilitarian and others had ritual uses and symbolic associations, but people drew no distinction between art and other aspects of material culture or between the fine arts and the decorative arts. Native Americans, like all people, valued the visual pleasure afforded by objects made with skill and intelligence, and Native artists have always applied a variety of criteria in determining aesthetic value.

Throughout the Americas, some cultures were able to complete monumental undertakings, including vast earthworks, irrigation projects, road systems, and monumental public architecture. Large cities arose at ceremonial centers such as Teotihuacan in Mexico and Cahokia in Illinois. In the rain forests around Tikal in Guatemala and Palenque in Mexico, elaborate stone structures dominated the landscape. Remarkably, these monumental sites were built of quarried stone, cut timber, and transported materials—often from distant locations—without the benefit of wheeled vehicles or metal tools.

Following centuries of neglect, much of what remains of early American art is being preserved and studied. In Mesoamerica, monumental stone sculpture covered buildings and, in the form of gods and goddesses, loomed over the devotees. In the river valleys of North America, people heaped mounds of earth to shape huge serpents, bears, and eagles. On the Nazca Plain in Peru, people scraped away rocks to delineate enormous outlines of birds and insects on the surface of the earth. On the other hand, some of what remains is exquisite and fragile. The masterful textiles of the Paracas culture have been preserved in the desert climate, while in North America delicate Hopewell effigy pipes have survived. Likewise, ceramic vessels in the shape of strikingly realistic portrait heads were made by the Moche of Peru, while equally striking abstraction can be seen in pottery from the Pueblo people of the North American Southwest. Having survived first as "curiosities," then as tourist souvenirs, the arts of the indigenous peoples of the Americas are at last recognized for their own qualities.

Knowledge of indigenous peoples in the Americas constantly requires reevaluation in light of ongoing research. For instance, recent breakthroughs in deciphering inscriptions have led to wholesale revisions in ancient Maya history. Even the origins of indigenous Americans remain a matter of lively debate.

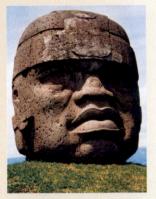

C. 900-400 BCE

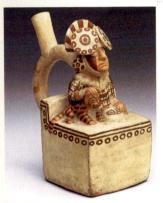

MOCHE LORD WITH A FELINEC. 100 BCE-500 CE

HOPEWELL BEAVER EFFIGY
PLATFORM PIPE
100–200 CE

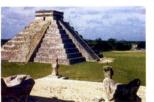

PYRAMID WITH CHACMOOL
CHICHEN ITZA
C. 800-1000 CE

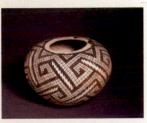

PUEBLO SEED JAR C. 1150 CE

1500 BCI

ART OF THE AMERICAS BEFORE 1300

▼ Formative/Preclassic
c. 1500 BCE -250 CE

✓ Olmec c. 1200–400 BCE

← Chavin c. 1000-200 BCE

■ Paracas c. 1000 BCE-200 CE

■ Maya c. 350 BCE-1521 CE

■ Nazca c. 200 BCE-600 CE

■ Moche c. 200 BCE-600 CE

■ Hohokam c. 200 BCE-1200 CE

■ Hopewell c. 100 BCE-550 CE

⋖ Teothucan c. 1-750 CE

✓ Mimbres/Mogollon c. 200-1250 CE

Classic c. 250−900 CE

■ Ancient Puebloan c. 550-1250 CE

■ Diquis c. 700–1500 CE

✓ Itza c. 800–1200 CE

■ Postclassic c. 900–1521 CE

1000

I

1000

150C

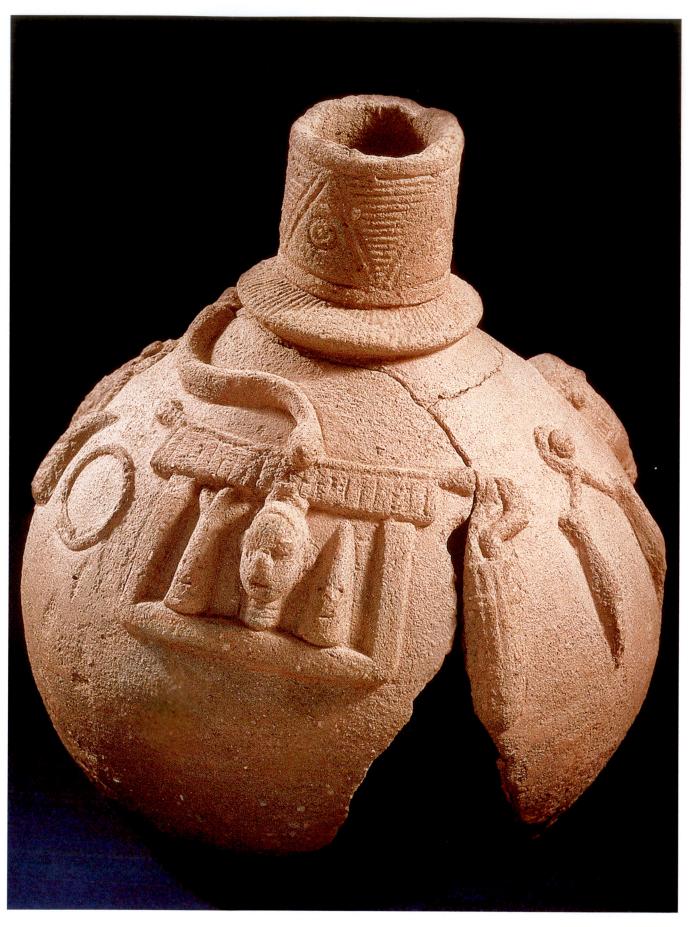

13–1 | RITUAL VESSEL from Ife. Yoruba. 13–14th century. Terra cotta, height 911/16" (24.9 cm). University Art Museum, Obafemi, Awolowo University, Ife, Nigeria.

CHAPTER THIRTEEN

ART OF ANCIENT AFRICA

The Yoruba people of southwestern Nigeria have traditionally regarded the city of Ife (also known as Ile-Ife) as the "navel of the world," the site of creation, the place where kingship originated when Ife's first ruler—the *oni*

Oduduwa—came down from heaven to create earth and then to populate it. By the eleventh century CE, Ife was a lively metropolis and cultural center; today, every one of the many Yoruba cities claims "descent" from Ife.

Ancient Ife was essentially circular in plan, with the oni's palace at the center. Ringed by protective stone walls and moats, Ife was connected to other Yoruba cities by roads that radiated from the center, passing through the city walls at fortified gateways decorated with mosaics created from stones and pottery shards. From these elaborately patterned pavement mosaics, which covered much of Ife's open spaces, comes the name for Ife's most artistically cohesive historical period (c. 1000–1400 CE), the Pavement period.

Just as the *oni*'s palace was located in a large courtyard in the center of Ife, so too were ritual spaces elsewhere in Ife located in paved courtyards with altars. In the center of such a sacred courtyard, outlined by rings of pavement

mosaic, archaeologists excavated an exceptional terra-cotta vessel (FIG. 13–1). The jar's bottom had been ritually broken before it was buried, so that liquid offerings (libations) poured into the neck opening would flow into the earth. The objects so elegantly depicted in relief on the surface of the vessel include what looks like an altar platform with three heads under it, the outer two quite abstract and the middle one almost **naturalistic** in the tradition of freestanding Yoruba portrait heads (SEE FIG. 13–7). The abstraction of the two outside heads may well have been a way of honoring or blessing the central portrait, a practice that survives today among Yoruba royalty.

CHAPTER-AT-A-GLANCE

- THE LURE OF ANCIENT AFRICA
- AFRICA—THE CRADLE OF ART AND CIVILIZATION
- AFRICAN ROCK ART | Saharan Rock Art
- SUB-SAHARAN CIVILIZATIONS | Nok | Igbo-Ukwu | Ife | Benin
- OTHER URBAN CENTERS | Jenné | Great Zimbabwe | Kongo Kingdom
- IN PERSPECTIVE

THE LURE OF ANCIENT AFRICA

"I descended [the Nile] with three hundred asses laden with incense, ebony, grain, panthers, ivory, and every good product." Thus the Egyptian envoy Harkhuf described his return from Nubia, the African land to the south of Egypt, in 2300 BCE. The riches of Africa attracted merchants and envoys in ancient times, and trade brought the continent in contact with the rest of the world. Egyptian relations with the rest of the African continent continued through the Hellenistic era and beyond. Phoenicians and Greeks founded dozens of settlements along the Mediterranean coast of North Africa between 1000 and 300 BCE to extend trade routes across the Sahara to the peoples of Lake Chad and the bend of the Niger River (MAP 13–1). When the Romans took control of North Africa, they continued this lucrative trans-Saharan trade. In the seventh and eighth centuries CE, the expanding empire of Islam swept across North Africa, and thereafter Islamic merchants were regular visitors to Bilad al-Sudan, the Land of the Blacks (sub-Saharan Africa). Islamic scholars chronicled the great West African empires of Ghana, Mali, and Songhay, and West African gold financed the flowering of Islamic culture.

East Africa, meanwhile, had been drawn since at least the beginning of the Common Era into the maritime trade that ringed the Indian Ocean and extended east to Indonesia and the South China Sea. Arab, Indian, and Persian ships plied the coastline. A new language, Swahili, evolved from centuries of contact between Arabic-speaking merchants and Bantu-speaking Africans, and great port cities such as Kilwa, Mombasa, and Mogadishu arose.

In the fifteenth century, Europeans ventured by ship into the Atlantic Ocean and down the coast of Africa. Finally rediscovering the continent firsthand, they were often astonished by what they found (see "The Myth of 'Primitive' Art," page 424). "Dear King My Brother," wrote a fifteenth-century Portuguese king to his new trading partner, the king of Benin in West Africa. The Portuguese king's respect was well founded—Benin was vastly more powerful and wealthier than the small European country that had just stumbled upon it.

As we saw in Chapter 3, Africa was home to one of the world's earliest great civilizations, that of ancient Egypt, and

as we saw in Chapter 8, Egypt and the rest of North Africa contributed prominently to the development of Islamic art and culture. This chapter examines the artistic legacy of the rest of ancient Africa.

AFRICA—THE CRADLE OF ART AND CIVILIZATION

During the twentieth century, the sculpture of traditional African societies—wood carvings of astonishing formal inventiveness and power—found admirers the world over. While avidly collected, these works were much misunderstood. For the past seventy-five years, art historians and cultural anthropologists have studied African art firsthand, which has added to our overall understanding of art-making in many African cultures. However, except for a few isolated examples (such as in Nigeria and Mali), the historical depth of our understanding is still limited by the continuing lack of systematic archaeological research. Our understanding of traditions that are more than one hundred years old is especially hampered by the fact that most African art was made from wood, which decays rapidly in sub-Saharan Africa. Consequently, few examples of African masks and sculpture remain from before the nineteenth century, and scholars for the most part must rely on contemporary traditions and oral histories to help extrapolate backwards in time to determine what may have been the types, styles, and meaning of art made in the past. Nevertheless, the few ancient African artworks we have in such durable materials as terra cotta, stone, and bronze bear eloquent witness to the skill of ancient African artists and the splendor of the civilizations in which they worked.

Twentieth-century archaeology has made it popular to speak of Africa as the cradle of human civilization. Certainly the earliest evidence for our human ancestors comes from southern Africa. Now evidence of the initial stirrings of artistic activity comes from the southern tip of Africa as well. Recently, quantities of ocher pigment thought to have been used for ceremonial or decorative purposes and perforated shells thought to have been fashioned into beads and worn as personal adornment have been found in Blombos Cave on the Indian Ocean coast of South Africa dating to approximately 70,000 years ago. Also dis-

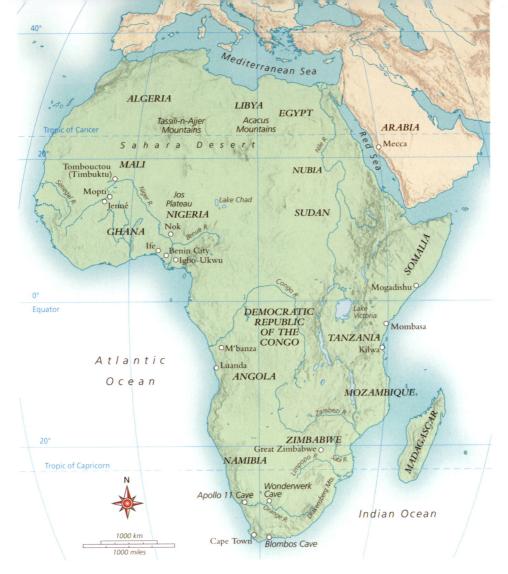

MAP 13-I ANCIENT AFRICA

Nearly 5,000 miles from north to south, Africa is the second-largest continent and was the home of some of the earliest and most advanced cultures of the ancient world.

covered together with these were two small ocher blocks that had been smoothed and then decorated with geometric arrays of carved lines (FIG. 13–2). These incised abstract patterns predate any other findings of ancient art by more than 30,000 years, and they suggest a far earlier develop-

ment of modern human behavior than had been previously recognized.

The earliest known figurative art from the African continent are animal figures dating to c. 25,000 BCE painted in red and black pigment on flat stones found in a cave designated as

13–2 ↑ **INCISED OCHER PLAQUE**Blombos Cave, South Africa.
c. 70,000 BCE. Iron ore ocher stone, length 3" (7.6 cm). Iziko South African Museum, Cape Town, South Africa.

Defining Art

THE MYTH OF "PRIMITIVE" ART

he word *primitive* was once used by Western art historians to categorize the art of Africa, the art of the Pacific islands, and the indigenous art of the Americas. The term itself means "early" or "first of its kind," but its use was meant to imply that these cultures were crude, simple, backward, and stuck in an early stage of development.

This attitude was accepted by Christian missionaries and explorers, who often described the peoples among whom they worked as "heathen," "barbaric," "ignorant," "tribal," "primitive," and other terms rooted in racism and colonialism. Such usages were extended to these peoples' creations, and "primitive art" became the conventional label for their cultural products.

Criteria that have been used to label a people "primitive" include the use of so-called Stone Age technology, the absence of written histories, and the failure to build great cities. Based on these criteria, however, the accomplishments of the peoples of Africa, to take just one example, contradict such prejudiced condescension: Africans south of the Sahara have smelted and forged iron since at least 500 BCE. Africans in many areas made and used high-quality steel for weapons and tools. Many African peoples have recorded their histories in Arabic since at least the tenth century CE. The first European visitors to Africa admired the style and sophistication of urban centers such as Benin and Luanda, to name only two of the continent's great cities. Clearly, neither the cultures of ancient Africa nor the artworks they produced were "primitive" at all.

Until quite recently, Westerners tended to see Africa as a single country and not as an immense continent of vastly diverse cultures. Moreover, they perceived artists working in Africa as craftsworkers bound to styles and images dictated by village elders and producing art that was anonymous and interchangeable. Over the past several decades, however, these misconceptions have crumbled. Art historians and anthropologists have now identified numerous African cultures and artists and compiled catalogs of their work. For example, the well-known Yoruba artist Olowe of Ise (see Chapter 28) was commissioned by rulers throughout the Yoruba region in the early twentieth century to create prestige objects such as palace veranda posts and palace doors or tour de force carvings such as magnificent lidded bowls supported by kneeling figures. Certainly we will never know the names of the vast majority of African artists of the past, just as we do not know the names of the sculptors responsible for the portrait busts of ancient Rome or the monumental reliefs of the Hindu temples of South Asia. But, as elsewhere, the greatest artists in Africa were famous and sought after, while innumerable others labored honorably and not at all anonymously.

Apollo 11, located in the desert mountains of Namibia. These figures are comparable to the better-known European cave drawings such as those from Chauvet Cave (c. 25,000–17,000 BCE) and Lascaux Cave (c. 15,000–13,000 BCE) (see Chapter 1).

AFRICAN ROCK ART

Like the Paleolithic inhabitants of Europe, early Africans painted and inscribed images on the walls of caves and rock shelters. Rock art is found throughout the African continent in places where the environment has been conducive to preservation—areas ranging from small, isolated shelters to great cavernous formations. Distinct geographic zones of rock art can be identified broadly encompassing the northern, central, southern, and eastern regions of the continent. These rock paintings and engravings range in form from highly abstract geometric designs to abstract and naturalistic representations of human and animal forms, including hunting scenes, scenes of domestic life, and costumed figures that appear to be dancing.

Saharan Rock Art

The mountains of the central Sahara—principally the Tassilin-Ajjer range in the south of present-day Algeria and the Acacus Mountains in present-day Libya—contain images that span a period of thousands of years. They record not only the artistic and cultural development of the peoples who lived in the region, but also the transformation of the Sahara from a fertile grassland to the vast desert we know today.

The earliest images of Saharan rock art are thought to date from at least 8000 BCE, during the transition into a geological period known as the Makalian Wet Phase. At that time the Sahara was a grassy plain, perhaps much like the gamepark reserves of modern East Africa. Vivid images of hippopotamus, elephant, giraffe, antelope, and other animals incised on rock surfaces attest to the abundant wildlife that roamed the region. Like the cave paintings in Altamira and Lascaux (Chapter 1), these images may have been intended to ensure plentiful game or a successful hunt, or they may have been symbolic of other life-enhancing activities, such as healing or rainmaking.

By 4000 BCE the climate had become more arid, and hunting had given way to herding as the primary life-sustaining activity of the Sahara's inhabitants. Among the most beautiful and complex examples of Saharan rock art created in this period are scenes of sheep, goats, and cattle and of the daily lives of the people who tended them. One such scene, CATTLE BEING TENDED, was found at Tassili-n-Ajjer and probably dates from late in the herding period, about 5000–2000 BCE (FIG. 13–3). Men and women are gathered in front of their round, thatched houses, the men tending cattle, the women preparing a meal and caring for children. A large herd of cattle, many of them tethered to a long rope, has been

driven in from pasture. The cattle shown are quite varied. Some are mottled, while others are white, red, or black. Some have short, thick horns, while others have graceful, lyreshaped horns. The overlapping forms and the placement of near figures low and distant figures high in the picture plane create a sense of depth and distance.

By 2500–2000 BCE the Sahara was drying and the great game had disappeared, but other animals were introduced that appear in the rock art. The horse was brought from Egypt by about 1500 BCE and is seen regularly in rock art over the ensuing millennia. The fifth-century BCE Greek historian Herodotus described a chariot-driving people called the Garamante, whose kingdom corresponds roughly to present-day Libya. Rock-art images of horse-drawn chariots bear out his account. Around 600 BCE the camel was introduced into the region from the east, and images of camels were painted on and incised into the rock.

The drying of the Sahara coincided with the rise of Egyptian civilization along the Nile Valley to the east. Similarities can be noted between Egyptian and Saharan motifs, among them images of rams with what appear to be disks between their horns. These similarities have been interpreted as evidence of Egyptian influence on the less-developed regions of the Sahara. Yet in light of the great age of Saharan

rock art, it seems just as plausible that the influence flowed the other way, carried by people who had migrated into the Nile Valley when the grasslands of the Sahara disappeared.

SUB-SAHARAN CIVILIZATIONS

Saharan peoples presumably migrated southward as well, into the Sudan, the broad belt of grassland that stretches across Africa south of the Sahara Desert. They brought with them knowledge of settled agriculture and animal husbandry. The earliest evidence of settled agriculture in the Sudan dates from about 3000 BCE. Toward the middle of the first millennium BCE, at the same time that iron technology was being developed elsewhere in Africa, knowledge of ironworking spread across the Sudan as well, enabling its inhabitants to create more effective weapons and farming tools. In the wake of these developments, larger and more complex societies emerged, especially in the fertile basins of Lake Chad in the central Sudan and the Niger and Senegal rivers to the west.

Nok

Some of the earliest evidence of iron technology in sub-Saharan Africa comes from the so-called Nok culture, which arose in the western Sudan, in present-day Nigeria, as early as

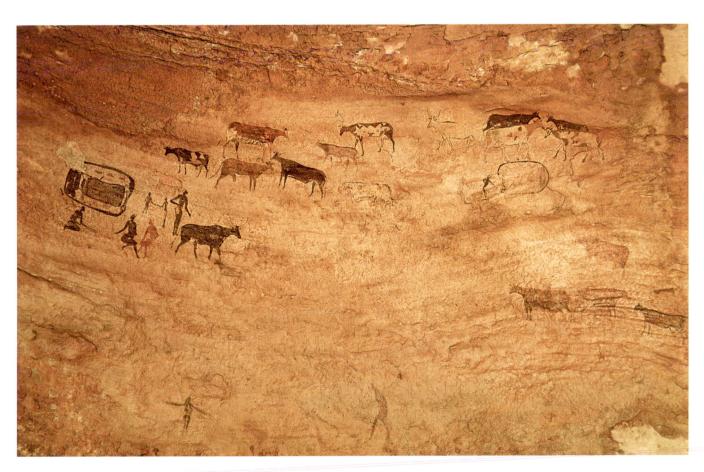

13–3 | CATTLE BEING TENDED
Section of rock-wall painting, Tassili-n-Ajjer, Algeria. c. 5000–2000 BCE.

Art and Its Context

SOUTHERN AFRICAN ROCK ART

ock painting and engraving from sites in southern Africa differ in terms of style and age from those discussed for the Sahara region. Some examples of artworks predate those found in the Sahara, while other found works continued to be produced into the modern era. These works include an engraved fragment found in dateable debris in Wonderwerk Cave, South Africa, which dates back to 10,000 years ago. Painted stone flakes found at a site in Zimbabwe suggest dates between 13,000 and 8000 BCE.

Numerous examples of rock painting are also found in South Africa in the region of the Drakensberg Mountains. Almost 600 sites have been located in rock shelters and caves, with approximately 35,000 individual images catalogued. It is

believed the paintings were produced, beginning approximately 2,400 years ago, by the predecessors of San peoples who still reside in the region. Ethnographic research among the San and related peoples in the area suggest possible interpretations for some of the paintings. For example, rock paintings depicting groups of dancing figures may relate to certain forms of San rituals that are still performed today to heal individuals or to cleanse communities. These may have been created by San ritual specialists or shamans to record their curing dances or trance experiences of the spirit world. San rock artists continued to create rock paintings into the late nineteenth century. These latter works depict the arrival of Afrikaner pioneers to the region as well as British soldiers brandishing guns used to hunt elands.

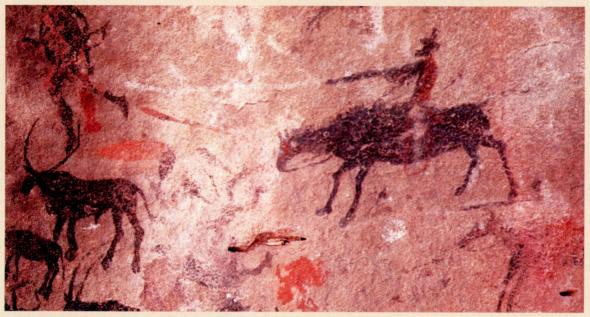

SECTION OF SAN ROCK-WALL PAINTINGSan peoples. n.d. Drakensberg Mountains, South Africa. Pigment and eland blood on rock.

500 BCE. The Nok people were farmers who grew grain and oil-bearing seeds, but they were also smelters with the technology for refining ore. Slag and the remains of furnaces have been discovered, along with clay nozzles from the bellows used to fan the fires. The Nok people created the earliest known sculpture of sub-Saharan Africa, producing accomplished terra-cotta figures of human and animal subjects between about 500 BCE and 200 CE.

Nok sculpture was discovered in modern times by tin miners digging in alluvial deposits on the Jos plateau north of the confluence of the Niger and Benue rivers. Presumably, floods from centuries past had removed the sculptures from their original contexts, dragged and rolled them along, and then deposited them, scratched and broken, often leaving only the heads from what must have been complete human figures. Following archaeological convention, scholars gave the name of a nearby village, Nok, to the culture that created these works. Nok-style works of sculpture have since been found in numerous sites over a wide area.

The Nok head shown (FIG. 13–4), slightly larger than life-size, probably formed part of a complete figure. The triangular or D-shaped eyes are characteristic of Nok style and appear also on sculpture of animals. Holes in the pupils, nostrils, and mouth allowed air to pass freely as the figure was fired. Each of the large buns of its elaborate hairstyle is pierced with a hole that may have held ornamental feathers. Other Nok figures were created displaying beaded necklaces, armlets, bracelets, anklets, and other prestige ornaments. Nok sculpture may represent ordinary people dressed for special occasions or it may portray people of high status, thus reflecting social stratification

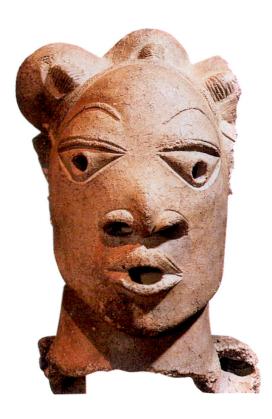

13–4 | **HEAD** Nok, c. 500 BCE-200 CE. Terra cotta, height 14½ (36 cm). National Museum, Lagos, Nigeria.

in this early farming culture. In either case, the sculpture provides evidence of considerable technical accomplishment, which has led scholars to speculate that Nok culture was built on the achievements of an earlier culture still to be discovered.

Igbo-Ukwu

A number of significant sites have been excavated in Nigeria in the mid-twentieth century that increase our understanding of the development of art and culture in West Africa. This includes the archaeological site of Igbo-Ukwu in eastern Nigeria where Igbo peoples reside, one of Nigeria's numerically largest and most politically important populations. The earliest known evidence for copper alloy or bronze casting in sub-Saharan Africa is found at Igbo-Ukwu. This evidence dates to the ninth and tenth century CE. Igbo-Ukwu is also the earliest known site containing an elite burial and shrine complex yet found in sub-Saharan Africa. Three distinct archaeological sites have been excavated at Igbo-Ukwu—one containing a burial chamber, another resembling a shrine or storehouse containing ceremonial objects, and the third an ancient pit containing ceremonial and prestige objects.

The burial chamber contained an individual dressed in elaborate regalia, placed in a seated position, and surrounded by emblems of his power and authority. These included three ivory tusks, thousands of imported beads that originally formed part of an elaborate necklace, other adornments, and a cast bronze representation of a leopard skull (FIG. 13–5). Elephants and leopards are still symbols of temporal and spiritual leadership in Africa today. Ethnographic research among the Nri, an Igbo-related people currently residing in the region, suggests that the burial site is that of an important Nri king or ritual leader called an *eze*.

The second excavation uncovered a shrine or storehouse complex containing ceremonial and prestige objects. These copper alloy castings were made by the **lost-wax technique** (see "Lost-Wax Casting," page xxix) in the form of elaborately decorated small bowls, fly-whisk handles, altar stands, staff finials, and ornaments. Igbo-Ukwu's unique style consists of the representation in bronze of natural objects such as gourd bowls and snail shells whose entire outer surface is covered with elaborate raised and banded decorations. These decorations include linear, spiral, circular, and granular designs, sometimes with the addition of small animals or insects such as snakes, frogs, crickets, or flies applied to the decorated surface. Some castings are further enlivened with the addition of brightly colored beads.

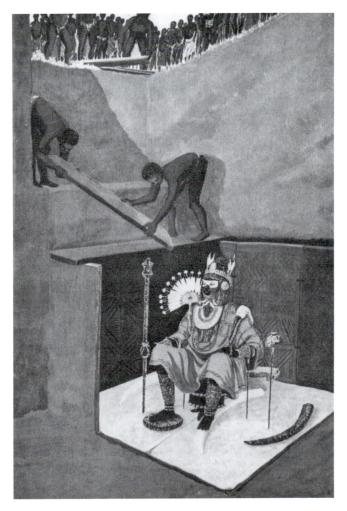

I3-5 | BURIAL CHAMBER Igbo-Ukwu, showing the placement of the ruler and artifacts in the chamber in the 10th century. Reconstruction painting by Caroline Sassoon.

THE OBJECT SPEAKS

A WARRIOR CHIEF PLEDGING LOYALTY

undreds of brass plaques, each averaging about 16 to 18 inches in height, once decorated the walls and pillars of the royal palace of the kingdom of Benin. Produced during the sixteenth and seventeenth centuries, the plaques, numbering approximately 900 examples, were found located in a storehouse by the British during the 1897 Punitive Expedition. Like the brass memorial heads and figure sculpture, the plaques were made following the lost-wax casting process. They illustrate a variety of subjects including ceremonial scenes at court, showing the oba, other court functionaries, and (at times) Portuguese soldiers.

Modeled in relief, the plaques depict one or more figures, with precise details of costume and regalia. Some figures are modeled in such high relief that they appear almost freestanding as they emerge from a textured surface background that often includes foliate patterning representing the leaves employed in certain healing rituals.

This plaque features a warrior chief in ceremonial attire. His rank is indicated by a necklace of leopard's teeth, and coraldecorated cap and collar. He also wears an elaborately decorated skirt with a leopard mask on his hip. The chief is depicted holding a spear in one hand and

an *eben* sword held above his head in the other hand.

The warrior chief is flanked by two warriors holding shields and spears, and two smaller figures representing court attendants. One attendant is depicted playing a side-blown horn that announces the warrior chief's presence, while the other attendant carries a ceremonial box for conveying gifts. The scene recounts a ceremony of obeisance to the *oba*. The warrior chief's gesture of raising the *eben* sword is still performed at annual ceremonies in which chiefs declare their allegiance and loyalty to the *oba* by raising the sword and spinning it in the air.

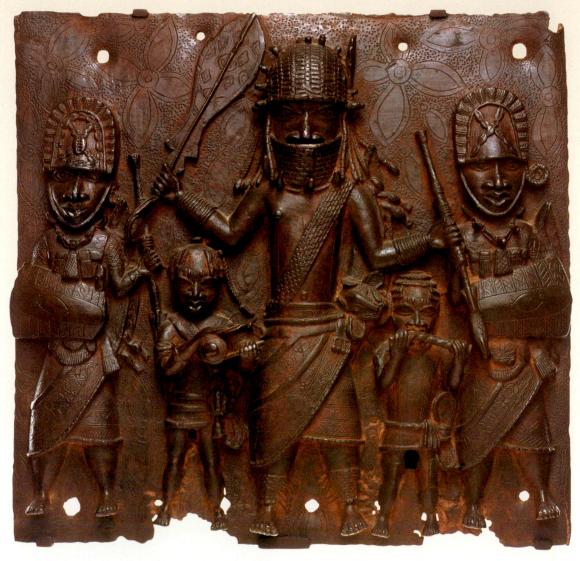

PLAQUE: WARRIOR CHIEF FLANKED BY WARRIORS AND ATTENDANTS Benin, Nigeria. Middle Period, c. 1550–1650 CE. Brass, height $14\%'' \times 15\%''$ (37.5 \times 39.4 cm). The Nelson-Atkins Museum of Art, Kansas City, Missouri. K [58-3]

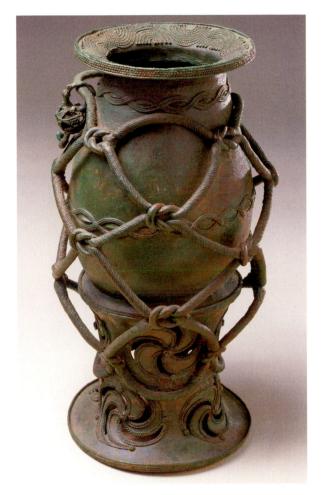

13-6 | ROPED POT ON A STAND Igbo-Ukwu. 9th-10th century. Leaded bronze, height 121/16" (32.3 cm). National Museum, Lagos.

The artifacts include a cast fly-whisk handle topped with the representation of an equestrian figure whose face, like that of a pendant head also found during excavation, is represented scarified in a style similar to the patterning found on some of the terra-cotta and cast heads of rulers at Ife. These markings are similar to markings called *ichi*, which are still used by Igbo men as a symbol of high achievement.

Among the most complex castings found at Igbo-Ukwu is a representation of a water jar resting on a stand and encircled by elaborate rope decoration (FIG. 13–6). This object was cast in several parts, which were then assembled using sophisticated metalworking techniques.

lfe

The naturalistic works of sculpture created by the artists of the city of Ife, which arose in the southwestern forested part of Nigeria about 800 CE, are among the most remarkable in art history.

Ife was, and remains, the sacred city of the Yoruba people. A tradition of naturalistic sculpture began there about 1050 CE and flourished for some four centuries. Although the ancestral line of the current Ife king, or *oni*, continues unbro-

ken, the knowledge of how these works were used has been lost. When archaeologists showed the ancient sculpture to members of the contemporary *oni*'s court, however, they recognized symbols of kingship that had been worn within living memory, indicating that the figures represent rulers.

A life-size head (FIG. 13–7) shows the extraordinary artistry of ancient Ife. The modeling of the flesh is remarkably sensitive, especially the subtle transitions around the nose and mouth. The lips are full and delicate, and the eyes are strikingly similar in shape to those of some modern Yoruba. The face is covered with thin, parallel scarification patterns (decorations made by scarring). The head was cast of zinc brass using the lost-wax method.

Holes along the scalp apparently permitted a crown or perhaps a beaded veil to be attached. Large holes around the base of the neck may have allowed the head itself to be attached to a wooden mannequin for display during

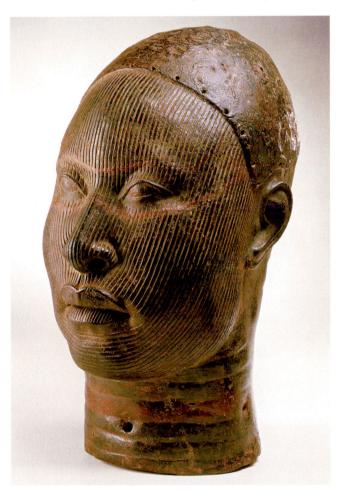

13-7 | **HEAD OF A KING**Ife. Yoruba. c. 13th century CE. Zinc brass, height 11½"
(29 cm). Museum of Ife Antiquities, Ife, Nigeria.

The naturalism of Ife sculpture contradicted everything Europeans thought they knew about African art. The German scholar who "discovered" Ife sculpture in 1910 suggested that it had been created not by Africans but by survivors from the legendary lost island of Atlantis. Later scholars speculated that influence from ancient Greece or Renaissance Europe must have reached Ife. Scientific dating methods, however, finally put such misleading comparisons and prejudices to rest.

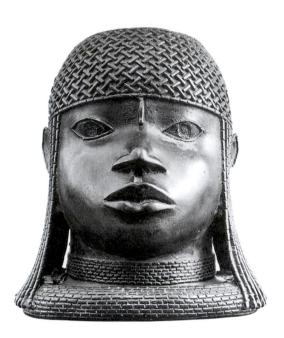

13–8 | HEAD SAID TO REPRESENT THE USURPER LAJUWA Ife. Yoruba. c. 1200–1300 CE. Terra cotta, height 1211/16" (32.8 cm). Museum of Ife Antiquities, Ife, Nigeria.

memorial services for a deceased *oni*. Mannequins with naturalistic facial features have been documented at memorial services for deceased individuals among contemporary Yoruba peoples. The Ife mannequin was probably dressed in the *oni*'s robes; the head probably bore his crown. The head could also have been used to display a crown during annual purification and renewal rites.

The artists of ancient Ife also produced heads in terra cotta. They were probably placed in shrines devoted to the memory of each dead king. One of the most famous was not found by archaeologists but had been preserved through the centuries in the *oni*'s palace. It is said to represent Lajuwa, a court retainer who usurped the throne by intrigue and impersonation (FIG. 13–8).

Scholars continue to debate whether the Ife heads are true portraits. Their realism gives an impression that they could be. The heads, however, all seem to represent men of the same age and embody a similar concept of physical perfection, suggesting that they are **idealized** images. Idealized images of titled individuals are a common feature of sub-Saharan African sculpture, as they are for many other cultures throughout the world.

Benin

Ife was probably the artistic parent of the great city-state of Benin, which arose some 150 miles to the southeast. According to oral histories, the earliest kings of Benin belonged to

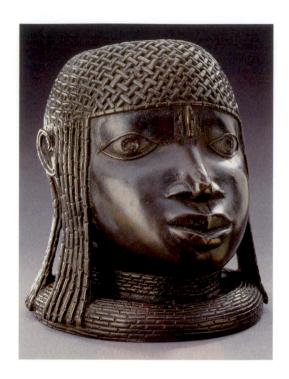

I3-9 | MEMORIAL HEAD OF AN OBA
Benin, Early Period, c. 16th century. Brass, height 9" (23 cm). The Nelson-Atkins Museum of Art, Kansas City, Missouri.
Purchase: Nelson Trust through the generosity of Donald J. and Adele C. Hall, Mr. and Mrs. Herman Robert Sutherland, an anonymous donor, and the exchange of Nelson Gallery Foundation properties [87-7].

This head belongs to a small group of rare Early Period sculptures called "rolled-collar" heads that are distinguished by the roll collar that serves as a firm base for the exquisitely rendered head.

the Ogiso, or Skyking, dynasty. After a long period of misrule, however, the people of Benin asked the *oni* of Ife for a new ruler. The *oni* sent Prince Oranmiyan, who founded a new dynasty in 1170 CE. Some two centuries later, the fourth king, or *oba*, of Benin decided to start a tradition of memorial sculpture like that of Ife, and he sent to Ife for a master metal caster named Iguegha. The tradition of casting memorial heads for the shrines of royal ancestors endures among the successors of Oranmiyan to this day (FIG. 13–9).

Benin came into contact with Portugal in the late fifteenth century CE. The two kingdoms established cordial relations in 1485 and carried on an active trade, at first in ivory and forest products, but eventually in slaves. Benin flourished until 1897, when, in reprisal for the massacre of a party of trade negotiators, British troops sacked and burned the royal palace, sending the *oba* into an exile from which he did not return until 1914. The palace was later rebuilt, and the present-day *oba* continues the dynasty started by Oranmiyan.

The British invaders discovered shrines to deceased *obas* covered with brass heads, bells, and figures. They also found wooden rattles and enormous ivory tusks carved with images of kings, court attendants, and sixteenth-century Portuguese soldiers. The British appropriated the treasure as war booty making no effort to note which head came from which

shrine, thus destroying evidence that would have helped establish the relative age of the heads and determine a chronology for the evolution of Benin style. Nevertheless, scholars have managed to piece together a chronology from other evidence.

The Benin heads, together with other objects, were originally placed on a semicircular platform and surmounted by large elephant tusks, another symbol of power (FIG. 13-10). All of the heads include representations of coral-bead necklaces and headdresses, which still form part of the royal costume. Benin brass heads range from small, thinly cast, and naturalistic to large, thickly cast, and highly stylized. Many scholars have concluded that the smallest, most naturalistic heads with only a few strands of beads around the neck were created during a so-called Early Period (1400-1550 CE), when Benin artists were still heavily influenced by Ife. Heads grew heavier, increasingly stylized, and the strands of beads increased in number until they concealed the chin during the Middle Period (1550–1700 CE). Heads from the ensuing Late Period (1700-1897 CE) are very large and heavy, with angular, stylized features and an elaborate beaded crown. During the Late Period, the necklaces form a tall, cylindrical mass. In addition, broad, horizontal flanges, or projecting edges, bearing small images cast in low relief ring the base of the Late Period heads. The increase in size and weight of Benin memorial heads over time may reflect the growing power and wealth flowing to the *oba* from Benin's expanding trade with Europe.

At Benin, as in many other African cultures, the head is the symbolic center of a person's intelligence, wisdom, and ability to succeed in this world or to communicate with spiritual forces in the ancestral world. One of the honorifics used for the king is "Great Head": The head leads the body as the king leads the people. All of the memorial heads include representations of coral-beaded caps and necklaces and royal costume. Coral, enclosing the head and displayed on the body, is still the ultimate symbol of the *oba*'s power and authority.

The art of Benin is a royal art, for only the *oba* could commission works in brass. Artisans who served the court were organized into guilds and lived in a separate quarter of the city. *Obas* also commissioned important works in ivory.

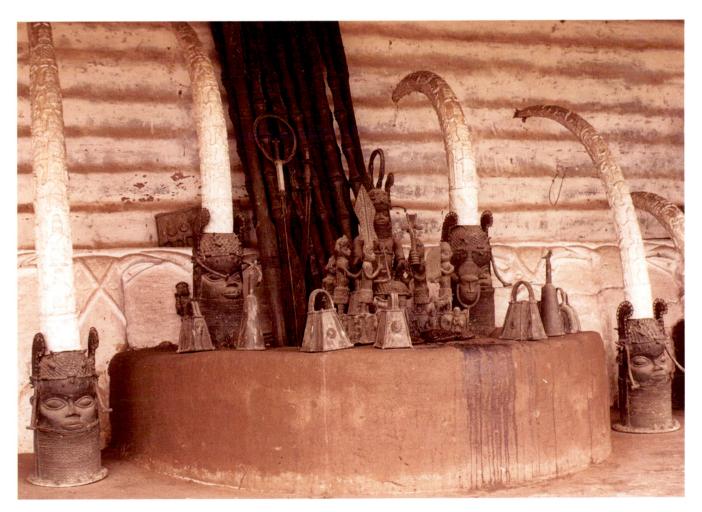

13–10 | ALTAR
Edo Culture, Nigeria. c. 1959. Photo by Eliot Elisofon. The National Museum of African Art, Smithsonian Institution, Washington, D.C.
Eliot Elisofon Photographic Archives 7584

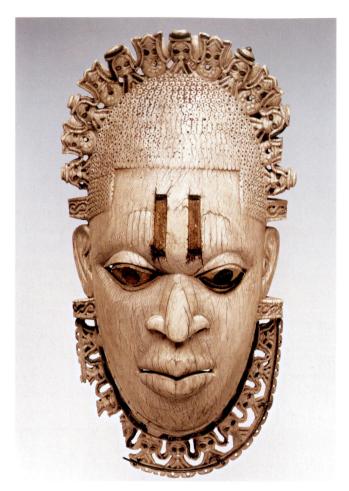

I3—II | HIP MASK
Representing an *iyoba* ("queen mother"). Benin, Middle Period, c. 1550 CE. Ivory, iron, and copper, height 9½" (23.4 cm). The Metropolitan Museum of Art, New York.
The Michael C. Rockefeller Memorial Collection, Gift of Nelson A. Rockefeller, 1972 (1978.412.323)

One example is a beautiful ornamental mask (FIG. 13-11). It represents an iyoba, or queen mother (the Oba's mother), the senior female member of the royal court. The mask was carved as a belt ornament and was worn at the oba's hip. Its pupils were originally inlaid with iron, as were the scarification patterns on the forehead. This particular belt ornament may represent Idia, who was the mother of Esigie, a powerful Oba who ruled from 1504 to 1550 CE. Idia is particularly remembered for raising an army and using magical powers to help her son defeat his enemies. Like Idia, the Portuguese helped Esigie expand his kingdom. The necklace represents heads of Portuguese soldiers with beards and flowing hair. In the crown, more Portuguese heads alternate with figures of mudfish, which symbolize Olokun, the Lord of the Great Waters. Mudfish live near riverbanks, mediating between water and land, just as the oba, who is viewed as semidivine, mediates between the human world and the supernatural world of Olokun.

OTHER URBAN CENTERS

Ife and Benin were but two of the many cities that arose in ancient Africa. The first European visitors to the West African coast at the end of the fifteenth century were impressed not only by Benin, but also by the city of Mbanza Kongo, south of the mouth of the Congo River. Along the East African coastline, Europeans also happened upon cosmopolitan cities that had been busily carrying on long-distance trade across the Indian Ocean and as far away as China and Indonesia for hundreds of years.

Important centers also existed in the interior, especially across the central and western Sudan. There, cities and the states that developed around them grew wealthy from the trans-Saharan trade that had linked West Africa to the Mediterranean from at least the first millennium BCE. Indeed, the routes across the desert were probably as old as the desert itself. Among the most significant goods exchanged in this trade were salt from the north and gold from West Africa. Such fabled cities as Mopti, Timbuktu, and Jenné arose in the vast area of grasslands along the Niger River in the region known as the Niger Bend (present-day Mali), a trading crossroads as early as the first century BCE. They were great centers of commerce, where merchants from all over West Africa met caravans arriving from the Mediterranean. Eventually the trading networks extended across Africa from the Sudan in the east to the Atlantic coast in the west. In the twelfth century CE a Mande-speaking people formed the kingdom of Mali (Manden). The rulers adopted Islam, and by the fourteenth century they controlled the oases on which the traders' caravans depended. Mali prospered, and wealthy cities like Timbuktu and Jenné became famed as centers of Islamic learning.

At a site near Jenné known as Jenné-Jeno or Old Jenné, excavations (by both archaeologists and looters) have uncovered hundreds of terra-cotta figures dating from the thirteenth to the sixteenth centuries. The figures were polished, covered with a red clay slip, and fired at a low temperature. A horseman, armed with quiver, arrows, and a dagger, is a good example of the technique (FIG. 13-12). Man and horse are formed of rolls of clay on which details of the face, clothing, and harness are carved, engraved, and painted. The rider has a long oval head and jutting chin, pointed oval eyes set in multiple framing lids, and a long straight nose. He wears short pants and a helmet with a chin strap, and his horse has an ornate bridle. Such elaborate trappings suggest that the horseman could be a guardian figure, hero, or even a deified ancestor. Similar figures have been found in sanctuaries. But, as urban life declined, so did the arts. The long tradition of ceramic sculpture came to an end in the fifteenth and sixteenth centuries, when rivals began to raid the Manden cities.

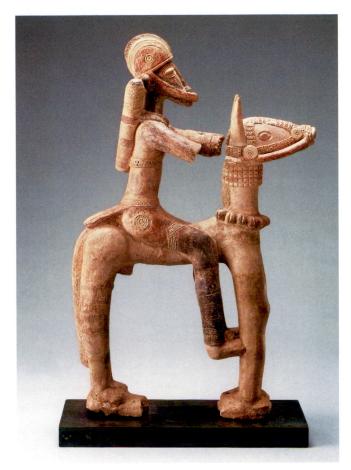

13–12 | HORSEMAN
Old Jenné, Mali. 13–15th century. Terra cotta, height 27¾"
(70.5 cm). The National Museum of African Art, Smithsonian Institution, Washington, D.C.
Museum Purchase, (86-12-2)

Jenné

In 1655, the Islamic writer al-Sadi wrote this description of Jenné:

This city is large, flourishing, and prosperous; it is rich, blessed, and favoured by the Almighty. . . . Jenne [Jenné] is one of the great markets of the Muslim world. There one meets the salt merchants from the mines of Teghaza and merchants carrying gold from the mines of Bitou. . . . Because of this blessed city, caravans flock to Timbuktu from all points of the horizon. . . . The area around Jenne is fertile and well populated; with numerous markets held there on all the days of the week. It is certain that it contains 7,077 villages very near to one another.

(Translated by Graham Connah in Connah, page 97)

By the time al-Sadi wrote his account, Jenné already had a long history. Archaeologists have determined that the city was established by the third century CE, and that by the middle of the ninth century, it had become a major urban center. Also by the ninth century, Islam was becoming an economic and religious force in West Africa, North Africa, and the northern

terminals of the trans-Saharan trade routes that had already been incorporated into the Islamic Empire.

When Koi Konboro, the twenty-sixth king of Jenné, converted to Islam in the thirteenth century, he transformed his palace into the first of three successive mosques in the city. Like the two that followed, the first mosque was built of adobe brick, a sun-dried mixture of clay and straw. With its great surrounding wall and tall towers, it was said to have been more beautiful and more lavishly decorated than the Kaaba, the central shrine of Islam, at Mecca. The mosque eventually attracted the attention of austere Muslim rulers who objected to its sumptuous furnishings. Among these was the early nineteenth-century ruler Sekou Amadou, who had it razed and a far more humble structure erected on a new site. This second mosque was in turn replaced by the current grand mosque, constructed between 1906 and 1907 on the ancient site in the style of the original. The reconstruction was supervised by the architect Ismaila Traoré, the head of the Jenné guild of masons.

The mosque's eastern, or "marketplace," façade boasts three tall towers, the center of which contains the mihrab (FIG. 13–13). The finials, or crowning ornaments, at the top of each tower bear ostrich eggs, symbols of fertility and purity. The façade and sides of the mosque are distinguished by tall, narrow, engaged columns, which act as buttresses. These columns are characteristic of West African mosque architecture, and their cumulative rhythmic effect is one of great verticality and grandeur. The most unusual features of West African mosques are the torons, wooden beams projecting from the walls. *Torons* provide permanent supports for the scaffolding erected each year so that the exterior of the mosque can be replastered.

Traditional houses resemble the mosque on a small scale. Adobe walls, reinforced by buttresses, rise above the roofline in conical turrets, emphasizing the entrance. Rooms open inward onto a courtyard. Extended upper walls mask a flat roof terrace that gives more space for work and living.

Great Zimbabwe

Thousands of miles from Jenné, in southeastern Africa, an extensive trade network developed along the Zambezi, Limpopo, and Sabi rivers. Its purpose was to funnel gold, ivory, and exotic skins to the coastal trading towns that had been built by Arabs and Swahili-speaking Africans. There, the gold and ivory were exchanged for prestige goods, including porcelain, beads, and other manufactured items. Between 1000 and 1500 CE, this trade was largely controlled from a site that was called Great Zimbabwe, home of the Shona people.

The word *zimbabwe* derives from the Shona term *dzimba dza mabwe*, meaning "venerated houses" or "houses of stone." Scholars agree that the stone buildings at Great Zimbabwe were constructed by ancestors of the present-day people of

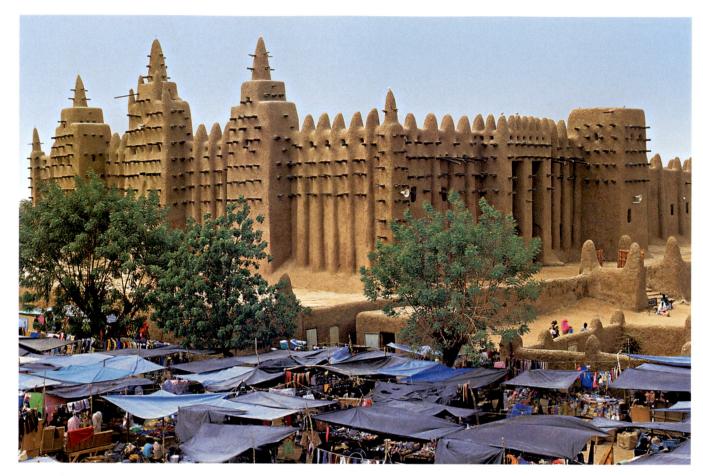

I3-I3 | GREAT FRIDAY MOSQUE
Jenné, Mali, showing the eastern and northern façades. Rebuilding of 1907, in the style of 13th-century original.

The plan of the mosque is not quite rectangular. Inside, nine rows of heavy adobe columns, 33 feet tall and linked by pointed arches, support a flat ceiling of palm logs. An open courtyard on the west side (not seen here) is enclosed by a great double wall only slightly lower than the walls of the mosque itself. The main entrances to the prayer hall are in the north wall (to the right in the photograph).

this region. The earliest construction at the site took advantage of the enormous boulders abundant in the vicinity. Masons incorporated the boulders and used the uniform granite blocks that split naturally from them to build a series of tall enclosing walls high on a hilltop. Each enclosure defined a family's living space and housed dwellings made of adobe with conical, thatched roofs.

The largest building complex at Great Zimbabwe is located in a broad valley below the hilltop enclosures. Known as Imba Huru, or the Great Enclosure, the complex is ringed by a masonry wall more than 800 feet long, up to 32 feet tall, and 17 feet thick at the base. Inside the great outer wall are numerous smaller stone enclosures and adobe platforms. The buildings at Great Zimbabwe were built without mortar; for stability the walls are *battered*, or built so that they slope inward toward the top. Although some of the enclosures at Great Zimbabwe were built on hilltops, there is no evidence that they were constructed as

fortresses. There are neither openings for weapons to be thrust through nor battlements for warriors to stand on. Instead, the walls and structures seem intended to reflect the wealth and power of the city's rulers. The Imba Huru was probably a royal residence, or palace complex, and other structures housed members of the ruler's family and court. The complex formed the nucleus of a city that radiated for almost a mile in all directions. Over the centuries, the builders grew more skillful, and the later additions are distinguished by dressed stones, or smoothly finished stones, laid in fine, even, level courses. One of these later additions is a fascinating structure known simply as the CONICAL TOWER (FIG. 13-14). Some 18 feet in diameter and 30 feet tall, the tower was originally capped with three courses of ornamental stonework. It may have represented the good harvest and prosperity believed to result from allegiance to the ruler of Great Zimbabwe, for it resembles a present-day Shona granary built large.

Among the many interesting finds at Great Zimbabwe is a series of carved soapstone birds (FIG. 13–15). The carvings, which originally crowned tall monoliths (single large stones), seem to depict birds of prey, perhaps eagles. They may, however, represent mythical creatures. Traditional Shona beliefs include an eagle called *shiri ye denga*, or "bird of heaven," who brings lightning, a metaphor for communication between the heavens and earth. These soapstone birds may have represented such messengers from the spirit world. Recently, the birds, and also the crocodiles found decorating such monoliths, have been identified as symbols of royalty,

expressing the king's power to mediate between his subjects and the supernatural world of spirits.

It is estimated that at the height of its power, in the four-teenth century CE, Great Zimbabwe and its surrounding city housed a population of more than 10,000 people. A large cache of goods containing items of such far-flung origin as Portuguese medallions, Persian pottery, and Chinese porcelain testify to the extent of its trade. Yet beginning in the mid-fifteenth century Great Zimbabwe was gradually abandoned as control of the lucrative southeast African trade network passed to the Mwene Mutapa and Kami empires a short distance away.

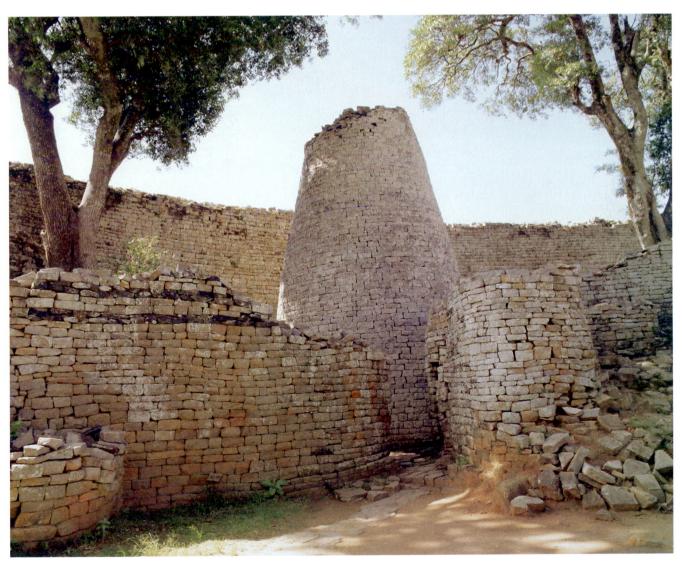

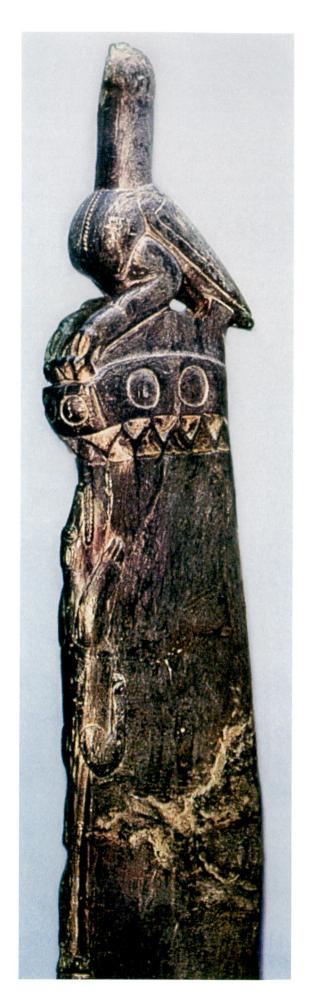

Kongo Kingdom

The Portuguese first encountered Kongo culture in 1482 at approximately the same time contact was made with the royal court of Benin in present-day western Nigeria. They visited the capital of Mbanza Kongo (present-day M'banza Congo) and met the manikongo ("king") who ruled over a kingdom that was remarkable in terms of its complex political organization and artistic sophistication. The kingdom, divided into six provinces, encompassed over 100,000 square miles of present-day northwestern Angola and the western part of the Democratic Republic of the Congo. In 1491, King Nzinga converted to Christianity, as did his successor Afonso I and, later, Afonso's son who was sent to Europe for education. The conversions helped to solidify trade relations with the Portuguese, as trade in copper, salt, ivory, cloth, and, later, slaves brought increased prosperity to the kingdom. Its influence expanded until the mid-seventeenth century when its trading routes were taken over by neighboring peoples including Lunda and Chokwe.

The increase in wealth brought a corresponding increase in the production of specialty textiles, baskets, and regalia for the nobility. Textiles in central Africa, as elsewhere in Africa, are of extreme importance in terms of their value as wealth. Textiles were used as forms of currency before European contact and figure prominently in funerary rituals even to the present day. Kongo-decorated textiles were lauded by the Portuguese from first contact and were accepted as gifts or collected and found their way into European museum collections (FIG. 13–16).

13–15 \dagger BIRD, TOP PART OF A MONOLITH Great Zimbabwe. c. 1200–1400 CE. Soapstone, height of bird 14½" (36.8 cm); height of monolith 5′4½" (1.64 m). Great Zimbabwe Site Museum, Zimbabwe.

13–16 | **DECORATED TEXTILE** Kongo. Early 17th century. Raffia, $9\% \times 28\%$ (24 \times 72 cm). Pitt Rivers Museum, Oxford, England.

This exquisitely embroidered textile employs a special technique that resembles velour to the touch.

Following Portuguese contact in the fifteenth century, Kongolese art increasingly absorbed Western influences, as suggested in a staff finial (FIG. 13–17). While representations of the matrilineal ancestress were a common Kongolese motif symbolizing leadership, this finial also reflects European influences that followed the conversion of the king and the arrival of Catholic missionaries, who brought with them objects such as the monstrance (a highly decorated vessel used to display the consecrated bread or "body" of Christ)

and the crucifix. Made in the Kongo, this cast brass female figure seated within an ornate frame with its foliated decoration seems European in style. Although the figure may appear to be praying, in Kongo iconography, as elsewhere in central Africa, the clapping of hands is a common gesture of respect for another person. As Chapter 28 will show, this complex synthesis of Western and traditional influences would hereafter continue to affect African art in both subtle and overt ways.

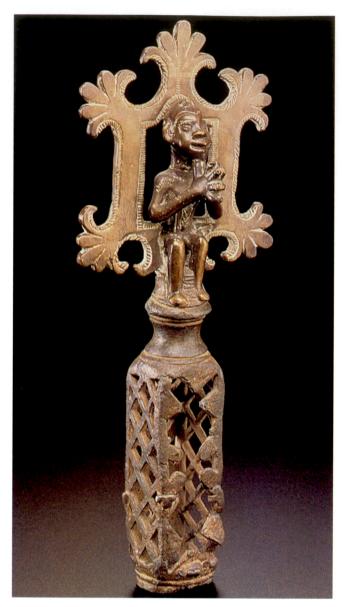

13–17 | STAFF FINIAL Kongo peoples, possibly 17th century. Brass, height 11" (28 cm). Musée Royal de l'Afrique Central, Tervuren, Belgium. RG/Hist. 53.100.1.

IN PERSPECTIVE

Our picture of Africa's ancient history is remarkably incomplete. This is due to a relative absence of archaeological investigation and because much of ancient African art was made of materials that have perished over time. Nevertheless, a tantalizing impression of Africa's ancient past can still be gained from those few objects made of durable materials such as terra cotta, stone, and metal that have been brought to light, and from an extensive record in rock art that has been preserved in sheltered places.

The long record of rock art, extending for thousands of years in numerous places, charts dramatic environmental and social change in the deserts of Africa. Rock art depicting human subjects is also important evidence that the African artistic traditions of mask-making, performance, and body decoration spring from ancient African roots.

The discovery of significant figurative traditions in terra cotta and bronze affords at least a partial reconstruction of the rich cultural heritage in regions of Nigeria. These traditions, including the use of the complicated lost-wax casting technique, seem to have arisen fully realized without evidence of earlier artistic experimentation. They further demonstrate the perennial importance of body decoration and ornamentation as markers of individual status and achievement. The use of animal imagery to suggest the supernatural power of leaders is another enduring tradition seen in some of these artworks.

The pronounced naturalism seen in some Ife sculpture has always sparked avid speculation. While these artworks may be portraits representing distinct individuals, they may also have been intended as idealizations of physical beauty and moral character. Heightened feelings for both naturalism and abstraction have combined distinctively in the aesthetic traditions of Africa since ancient times.

c. 5000-2000 BCE

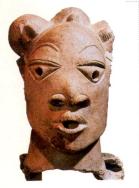

NOK HEAD C.500 BCE-200 CE

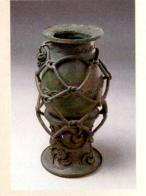

ROPED POT ON A STAND

C. 9TH-10TH CENTURY CE

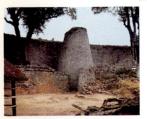

GREAT ZIMBAWE TOWER

C. 1200–1400 CE

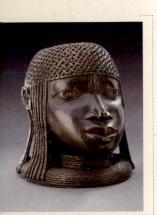

MEMORIAL HEAD OF AN OBA C.16TH CENTURY CE

1500 CE

ART OF ANCIENT AFRICA

8000

✓ Sahara Rock Art c. 8000–500 BCE

Nok
c. 500 BCE−200 CE

■ Djenné c. 200 CE-Present

■ Ghana Empire 600-1100 CE

 Islam introduced mid-Seventeenth century

◀ Ife c. 800 CE-Present

✓ Igbo Ukwu 9th-10th century

■ Great Zimbabwe c. 1000–1500 CE

■ Benin c. 1170 CE-Present

■ Mali Empire 1250-1450 CE

■ Songhay Kingdom 1465–1591 CE

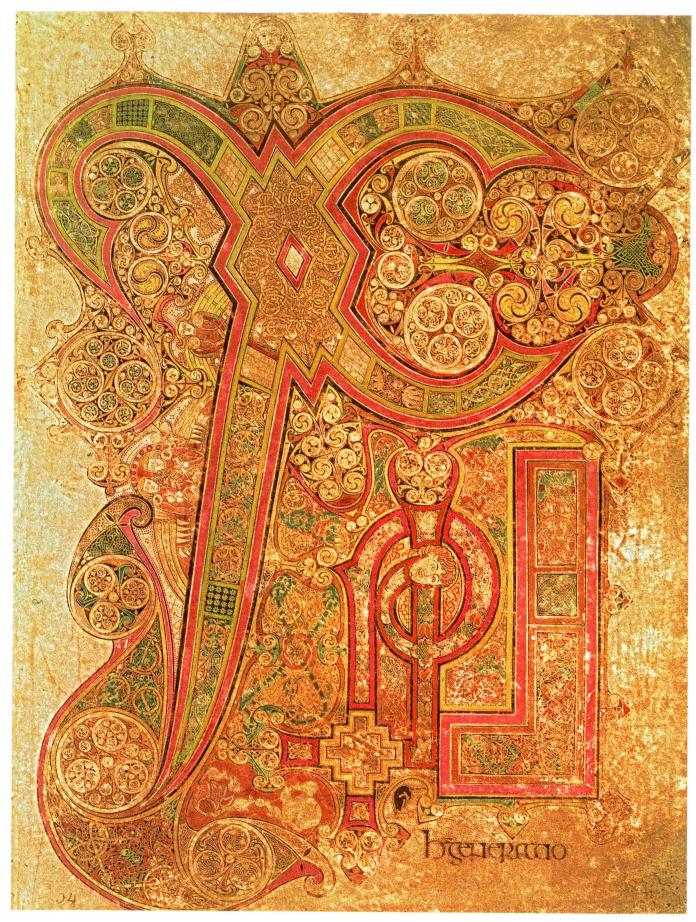

I4–I † CHI RHO IOTA PAGE FROM THE BOOK OF KELLS Matt. 1:18. Probably made at Iona, Scotland. Late 8th or early 9th century. Oxgall inks and pigments on vellum, $12\frac{1}{4} \times 9\frac{1}{2}$ " (325 \times 24 cm). The Board of Trinity College, Dublin.

CHAPTER FOURTEEN

EARLY MEDIEVAL ART IN EUROPE

According to legend, the Irish prince Colum Cille (c. 521–97), scholar, scribe, and churchman, who was canonized as Saint Columba, caused a war by secretly copying a psalter (psalm book). After King Finnian, the owner of the original, found out

and petitioned for possession of the copy, and even after the king ruled, "To every cow its calf, to every book its copy," Colum Cille still refused to relinquish it. Instead he incited his kinsmen to fight for the precious book. Whether fleeing from his enemies or to atone for his actions (the legend is unclear), Colum Cille left Ireland forever in self-imposed exile in 563. He established a monastery on Iona, an island off the western coast of Scotland.

As described by the eighth-century Anglo-Saxon historian Bede, such remote monasteries stood "among craggy and distant mountains, which looked more like lurking places for robbers and retreats for wild beasts than habitation for men." Nevertheless, they became centers of Celtic Christendom—their monks as famous for writing and copying books as for their missionary fervor. But, wealthy, isolated, and undefended, they fell victim to Viking attacks beginning at the end of the eighth century. Only the stormy seas could save the treasures of the monasteries. As one monk wrote:

Bitter is the wind tonight, It tosses the ocean's white hair: Tonight I fear not the fierce warriors of Norway

Coursing on the Irish Sea.

(translated by Kuno Meyer, Selections from Ancient Irish Poetry. London: Constable, 1959 [1911])

In 806, the monks, fleeing Viking raids on Iona, established a refuge at Kells on the Irish mainland. They may have brought with them the Gospel book now known as the **BOOK OF KELLS** (FIG. 14–1). To produce this illustrated

version of the Gospels entailed a lavish expenditure: Four scribes and three major illuminators worked on it (modern scribes take about a month to complete a page comparable to the one illustrated here), 185 calves were slaughtered to make the vellum, and the colors for the paintings came from as far away as Afghanistan.

Throughout the Middle Ages monasteries were the centers of art and learning. While religious services remained their primary responsibility, some talented monks and nuns also spent many hours as painters, jewelers, carvers, weavers, and embroiderers. These arts, used in the creation of illustrated books and liturgical equipment, are often called the "cloister crafts." Few cloisters could claim a work of art like the *Book of Kells*.

The twelfth century priest Gerald of Wales aptly described just such a Gospel book when he wrote:

Fine craftsmanship is all about you, but you might not notice it. Look more keenly at it, and you will penetrate to the very shrine of art. You will make out intricacies, so delicate and subtle, so exact and compact, so full of knots and links, with colors so fresh and vivid, that you might say that all this was the work of an angel, and not of a man.

(cited in Henderson, page 195)

- **THE EARLY MIDDLE AGES** The Art of People Associated with the Roman Empire The Art of People Outside the Roman Sphere of Influence The Coming of Christianity to the British Isles
- THE MUSLIM CHALLENGE IN SPAIN | Mozarabic Art
- THE CAROLINGIAN EMPIRE | Carolingian Architecture | The Scriptorium and Illustrated Books | Carolingian Goldsmith Work
- THE VIKING ERA | The Oseberg Ship | Picture Stones at Jelling | Timber Architecture | The End of the Viking Era
- OTTONIAN EUROPE | Ottonian Architecture | Ottonian Sculpture | Illustrated Books
- **IN PERSPECTIVE**

THE EARLY MIDDLE AGES

As the Roman Empire declined in the fourth century and came to an end in the fifth, its authority was supplanted by "barbarians," people from outside the empire who could only "barble" Greek or Latin.

At this point we have seen these "barbarians" only through Greek and Roman eyes—as the defeated Gauls at Pergamon (FIG. 5–63), on the Gemma Augustea (FIG. 6–24), or on the Ludovisi Sarcophagus (FIG. 6–69). Trajan's Column (FIG. 6–50) shows only Roman triumphs in the barbarians' homeland beyond the Danube River. Hadrian's Wall (FIG. 6–57), built to defend the northern frontier in Britain, marks the extent of the empire. But by the fourth century many Germanic tribes were allies of Rome. In fact, most of Constantine's troops in the decisive battle with Maxentius (page 226) were Germans.

A century later the situation was entirely different. In 410 the Visigoths under Alaric besieged and captured Rome. The adventures of the Byzantine princess Galla Placidia, whom we have met as a patron of the arts (FIG. 7-19), bring the situation vividly to life. She had the misfortune to be in Rome when Alaric and the Visigoths sacked the city (the emperor and pope were living safely in Ravenna). Carried off as a prize of war by the Goths, Galla Placidia had to join their migrations through France and Spain and eventually married the Gothic king, who was soon murdered. Back in Italy, married and widowed yet again, Galla Placidia ruled the Western Empire as regent for her son from 425 to 437/8. She died in 450, before having to endure yet another sack of Rome, this time by the Vandals, in 455. The fall of Rome shocked the Christian world, although the wounds were more psychological than physical. Saint Augustine was inspired to write The City of God, a cornerstone of Christian philosophy, as an answer to people who claimed that the Goths represented the vengeance of the pagan gods on people who had abandoned them for Christianity.

Who were these people living outside the Mediterranean orbit? Their wooden architecture is lost to fire and decay, but their metalwork and use of animal and geometric ornament is well established. The people were hunters and

fishermen, shepherds and farmers living in villages with a social organization based on extended families and tribal loyalties. They engaged in the essential crafts—pottery, weaving, woodwork—and they fashioned metals into weapons, tools, and jewelry. We saw examples of Bronze and Iron Age (Celtic) art in Chapter 1.

The Celts controlled most of Europe, and the Germanic people—Goths and others—lived around the Baltic Sea. Increasing population evidently forced the Goths to begin to move south, into better lands and climate around the Mediterranean and Black Seas, but the Romans had extended the borders of their empire across the Rhine and Danube rivers. Seeking the relative security and higher standard of living they saw in the Roman Empire, the Germanic people crossed the borders and settled within the empire.

The tempo of migration speeded up in the fifth century when the Huns from central Asia swept down on western Europe. Only the death of their leader Attila in 453 saved Europe. The Arian Ostrogoths (Eastern Goths) moved into Italy, and in 476 they deposed the last Roman emperor. They made Ravenna their capital until they were in turn defeated by the Byzantines. The Visigoths (Western Goths) ended their wanderings in Spain. The Burgundians settled in Switzerland and eastern France; the Franks in Germany, France, and Belgium. Meanwhile the Vandals moved through France and Spain, crossed over into Africa, making Carthage their head-quarters, and then returned back to Italy, sacking Rome in 455.

At first Christianity was not a unifying force. As early as 345 the Goths adopted Arian Christianity, beliefs considered heretical by the Church in Rome. Not until 589 did they accept Roman Christianity. In contrast to the Arian Goths, the Franks under Clovis (ruled 481–511), influenced by his Burgundian wife Clotilda, converted to Roman Christianity in 496, beginning a fruitful alliance between French rulers and the popes.

Bewildering as the period seems, the Europe we know today was beginning to take shape. Relationships of patronage and dependence between powerful men and their retainers remained important, ultimately giving rise to a political and economic system based on family and clan ties, on

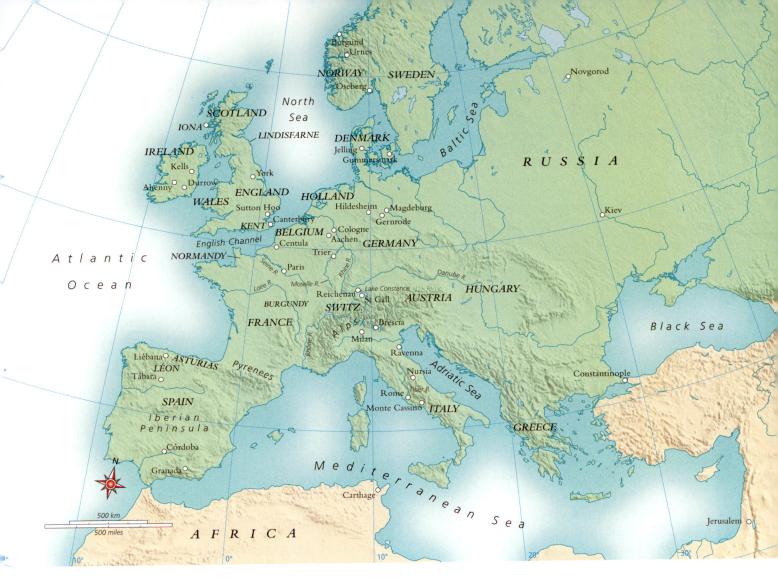

MAP 14-I | EUROPE OF THE EARLY MIDDLE AGES

On this map, modern names have been used for medieval regions in northern and western Europe to make sites of artworks easier to locate.

personal loyalty and mutual support, and on the exchange of personal service and labor for protection. This system became formalized as *feudalism*.

Mutual support also developed between secular and religious leaders. Kings and nobles defended the claims of the Roman Church, and the pope, in turn, validated their authority. As its wealth and influence increased throughout Europe, the Church emerged as the principal patron of the arts to fulfill growing needs for buildings and liturgical equipment, including altars, altar vessels, crosses, candlesticks, containers for the remains of saints (reliquaries), vestments (ritual garments), images of Christian figures and stories, and copies of sacred texts such as the Gospels.

The Art of People Associated with the Roman Empire

As Christianity spread north beyond the borders of what had been the Western Roman Empire, northern artistic traditions similarly worked their way south. Out of a tangled web of themes and styles originating from inside and out of the empire, from pagan and Christian beliefs, from urban and rural settlements, brilliant new artistic styles were born.

THE VISIGOTHS. Among the many people who had lived outside the Roman Empire and then moved within its borders, the Visigoths migrated across southern France and by the sixth century had settled in Spain, where they became an elite group ruling the indigenous population. They adopted Latin for writing, and in 589 they accepted Roman Christianity. Saint Isidore, patron saint of historians (including art historians), was a Visigothic bishop.

Following the same late–Roman–Germanic tradition they shared with other Gothic peoples, the Visigoths were superior metalworkers and created magnificent colorful jewelry. In the eagle brooch (FIG. 14–2), the artist rendered the bird in flight with outspread wings and tail, profile head with curved beak, and large round eye. This brooch displays a rich assortment of gems. Besides the red garnets interspersed with blue and green stones, the circle that represents the eagle's body has a *cabochon* (polished but unfaceted) crystal at the

Art and Its Context

DEFINING THE MIDDLE AGES

he roughly 1,000 years of European history between the collapse of the Western Roman Empire in the fifth century and the Italian Renaissance in the fifteenth are known as the Middle Ages, or the medieval period. These terms reflect the view of Renaissance humanists who regarded the period that preceded theirs as a "dark age" of ignorance, decline, and barbarism, standing in the *middle* and separating their own "golden age" from the golden ages of ancient Greece and Rome. Although we now recognize the Middle Ages as a period of great richness, complexity, and innovation, the term has endured.

Art historians commonly divide the Middle Ages into three periods: Early Medieval (ending in the early eleventh century), Romanesque (eleventh and twelfth centuries), and Gothic (extending from the mid-twelfth into the fifteenth century). We shall look at only a few of the many cultures that make up the Early Medieval period. For convenience, we will use modern geographical names (MAP 14-1)—in fact, the nations we know today did not yet exist.

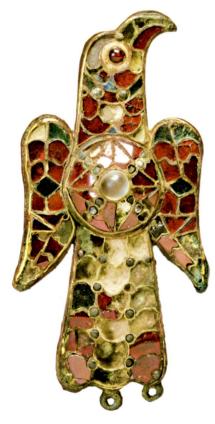

I4–2 | **EAGLE BROOCH** One of a pair. Spain. 6th century. Gilt, bronze, crystal, garnets, and other gems. Height 5% (14.3 cm). The Walters Art Museum, Baltimore.

center. Round amethyst in a white meerschaum frame forms the eyes. Pendant jewels originally hung from the birds' tail. The eagle remained one of the most popular motifs in Western art, owing in part to its continuing significance—first as an ancient sun symbol, then as a symbol of imperial Rome, and later as the emblem of Saint John the Evangelist.

THE LOMBARDS. Among those who established kingdoms in the heart of what had been the Roman Empire in Italy were

the Lombards. The Lombards had moved from their northern homeland into the Hungarian plain and then traveled west into Italy, where they became a constant threat to Rome. Like other migrating people, the Lombards excelled in fine metalwork. The huge jeweled cross in Brescia (east of Milan) shows their skillful use of precious metals and spectacular jewels (FIG. 14-3). The cross has a Byzantine form—equal arms widening at the ends joined by a central disc with a relief figure of Christ enthroned in a jeweled mandorla, indicating divine light emanating from the figure. More than 200 jewels, engraved gems, antique cameos, and glass pseudo-cameos adorn the cross. At the bottom of the cross is a gold glass Roman portrait medallion (SEE FIG. 6-68). According to tradition, the last Lombard king, Desiderius (ruled 757-74), gave the cross to the Church of Santa Giulia in Brescia. Scholars cannot agree on its date; they place the cross somewhere between the late seventh and early ninth centuries.

The patron who gathered this rich collection of jewels and ordered the cross to be made intended it to glorify God with glowing color and was evidently not concerned that nearly all the engraved gems and cameos have pagan subjects. The cross typifies this turbulent period in the Western European history of art. Made for a Western Christian church but having the form associated with the Byzantine East and using engraved jewels and cameos from the ancient world (even when they had to fake some in glass), the makers of the cross achieve an effect of extraordinary splendor.

The Art of People Outside the Roman Sphere of Influence

In Scandinavia (present-day Denmark, Norway, and Sweden), which was never part of the Roman Empire, people spoke variants of the Norse language and shared a rich mythology with other Germanic peoples. In the British Isles, where the Romans had built Hadrian's Wall to mark the boundaries between civilization and the wilds of Scotland, the ancient Celtic culture flourished.

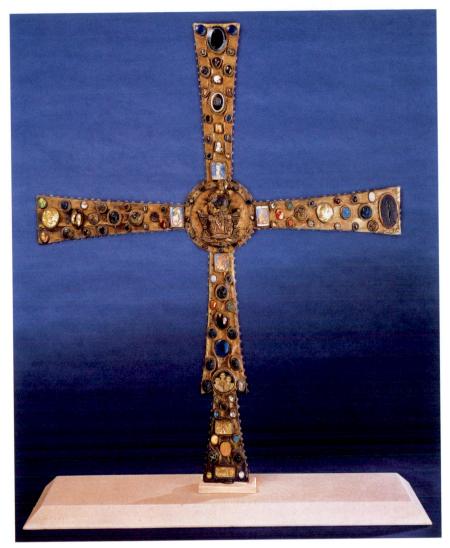

14–3 | **cross** Church of Saint Giulia, Brescia, Italy. Late 7th-early 9th century. Gilded silver, wood, jewels, glass, cameos, and gold-glass medallion of the third century, $50 \times 39''$ (126×99 cm). Museo di Santa Giulia, Brescia.

At the beginning of the fifth century the Roman army abandoned Britain. The economy faltered, and large towns lost their commercial function and declined as Romanized British leaders vied for dominance with the help of Germanic mercenary soldiers from the Continent.

THE NORSE. Scandinavian artists had exhibited a fondness for abstract patterning from early prehistoric times. During the first millennium BCE, trade, warfare, and migration had brought a variety of jewelry, coins, textiles, and other portable objects into northern Europe. The artists incorporated the solar disks and stylized animals on these objects into their already rich artistic vocabulary (SEE FIG. 1–20).

By the fifth century CE, the so-called animal style dominated the arts, displaying an impressive array of serpents, four-legged beasts, and squat human figures, as can be seen in their metalwork. The **GUMMERSMARK BROOCH** (FIG. 14–4), for example, is a large silver gilt pin dating from the sixth century CE in Denmark. This elegant ornament consists of a large, rectangular panel and a medallionlike plate covering the safety pin's catch connected by an arched bow. The surface of the pin seethes with human, animal, and geometric forms. An eye-and-beak motif frames the rectangular panel; a man is compressed between dragons just below the bow; and a pair of monster heads and crouching dogs with spiraling tongues frame the covering of the catch.

Certain underlying principles govern works with animal style design: The compositions are generally symmetrical, and artists depict animals in their entirety either in profile or from above. Ribs and spinal columns are exposed as if they had been x-rayed; hip and shoulder joints are pear-shaped; tongues and jaws extend and curl, and legs end in large claws.

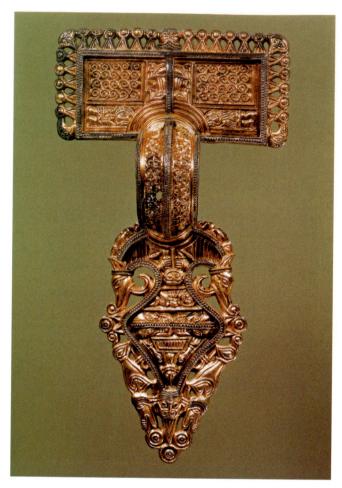

I4–4 | GUMMERSMARK BROOCH
Denmark. 6th century. Silver gilt, height 5¾" (14.6 cm).
Nationalmuseet, Copenhagen.

The northern jewelers carefully crafted their molds to produce a glittering surface on the cast metal, turning a process intended to speed production into an art form of great refinement.

THE CELTS AND ANGLO-SAXONS. After the Romans departed, Angles and Saxons from Germany and the Low Lands and Jutes from Denmark crossed the sea to occupy southeastern Britain. Gradually they extended their control northwest across the island. Over the next 200 years, the arts made a brilliant recovery as the fusion of Celtic, Romanized British, Germanic, and Norse cultures generated a new culture and style of art, known as Hiberno-Saxon (from the Roman name for Ireland, *Hibernia*). Anglo-Saxon literature is filled with references to splendid and costly jewelry and weapons made of or decorated with gold and silver.

The Anglo-Saxon epic *Beowulf,* composed perhaps as early as the seventh century, describes its hero's burial with a hoard of treasure in a grave mound near the sea. Such a burial site was discovered near the North Sea coast in Suffolk at a site called Sutton Hoo (*hoo* means "hill" or "headland"). The

grave's occupant had been buried in a ship whose traces in the earth were recovered by the careful excavators. The wood—and the hero's body—had disintegrated, and no inscriptions record his name. He has sometimes been identified with the ruler Redwald, who died about 625. The treasures buried with him confirm that he was, in any case, a wealthy and powerful man.

The burial ship at Sutton Hoo was 90 feet long and designed for rowing, not sailing. In it were weapons, armor, other equipment to provide for the ruler's afterlife, and many luxury items, including Byzantine silver bowls. Also found was a large purse filled with coins. Although the leather of the pouch and the bone or ivory of its lid have disintegrated, the gold and garnet fittings survive (FIG. 14–5). The artist, using the cloisonné technique (cells formed from gold wire to hold shaped pieces of garnet or glass), frequently seen in Byzantine enamels, created figures of gold, garnets, and blue-checkered glass (known as *millefiore glass*). Polygons decorated with purely geometric patterns flank a central plaque of four animals with long interlacing legs and jaws. Below, large hawks attack ducks, and men are spread-eagled between two rampant beasts.

Themes, techniques, and styles from many places are represented on the purse cover. The motif of a human being flanked by a pair of animals is widespread in ancient Near Eastern art and in the Roman world (as is the motif of the predator vanquishing the prey). The hawks with rectangular eyebrows and curving beaks, twisted wings and square tails are Norse in style, and the interlacing four-legged, long-jawed animals characterize the Germanic animal style. The use of bright color—especially red and gold—reflects an Eastern European tradition. All in all, the purse displays the rich blend of motifs that marks the complex Hiberno-Saxon style that flourished in Britain and Ireland during the seventh and eighth centuries.

The Coming of Christianity to the British Isles

Although the Anglo-Saxons who settled in Britain had their own gods and myths, Christianity survived the pagan onslaught. Monasteries flourished in the Celtic north and west, and Christians from Ireland founded influential missions in Scotland and northern England. Cut off from Rome, these Celtic Christians developed their own liturgical practices, church calendar, and distinctive artistic traditions. Then, in 597, Pope Gregory the Great (ruled 590-604) dispatched missionaries from Rome to the Anglo-Saxon king Ethelbert of Kent, whose Christian wife Bertha was sympathetic to their cause. The head of this successful mission, the monk Augustine (Saint Augustine, d. 604), became the archbishop of Canterbury in 601. The Roman Christian authorities and the Irish monasteries, although allied in the effort to Christianize the British Isles, came into conflict over their divergent practices. The Roman Church eventually triumphed and brought British Christians under its authority. Local traditions, however, continued to influence their art.

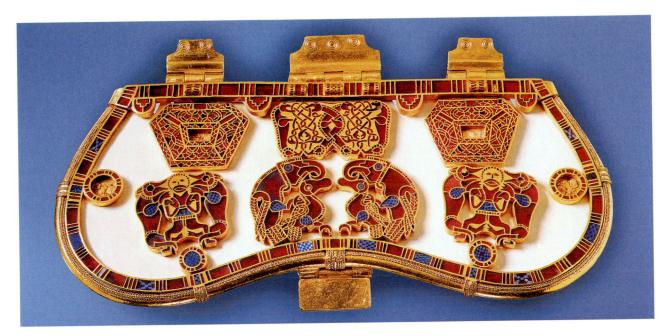

14–5 | PURSE COVER, FROM THE SUTTON HOO BURIAL SHIP
Suffolk, England. First half of 7th century. Cloisonné plaques of gold, garnet, and checked millefiore glass, length 8" (20.3 cm). The British Museum, London.

Only the decorations on this purse cover are original. The lid itself, of a light tan ivory or bone, deteriorated and disappeared centuries ago, and the white backing is a modern replacement. The purse was designed to hang at the waist. The leather pouch held thirty-seven coins, struck in France, the latest dated in the early 630s.

ILLUSTRATED BOOKS. Among the richest surviving artworks of the period were the beautifully written, illustrated, and bound manuscripts, especially the Gospel books. Gospel books were essential for the missionary activities of the Church throughout the early Middle Ages, not only for the information they contained—the "good news" of Christianity—but also as instruments to glorify the Word of God. Often bound in gold and jeweled covers, they were placed on the altars of churches and carried in processions. Thought to protect parishioners from enemies, predators, diseases, and all kinds of misfortune, these books were produced by monks in local monastic workshops called *scriptoria* (see "The Medieval *Scriptorium*," page 448).

One of the many elaborately decorated Gospels of the period is the **GOSPEL BOOK OF DURROW**, dating to the second half of the seventh century (FIG. 14–6). The format and text of the book reflect Roman Christian models, but its paintings are an encyclopedia of contemporary design. Each of the four Gospels is introduced by a page with the symbol of its evangelist author, followed by a page of pure ornament and finally the decorated letters of the first words of the text (the incipit).

I4–6 | PAGE WITH MAN, GOSPEL BOOK OF DURROW
Gospel of Saint Matthew. Probably made at Iona, Scotland, or northern England, second half of 7th century. Ink and tempera on parchment, 9% × 6%" (24.4 × 15.5 cm). The Board of Trinity College, Dublin.

MS 57 fol, 21v.

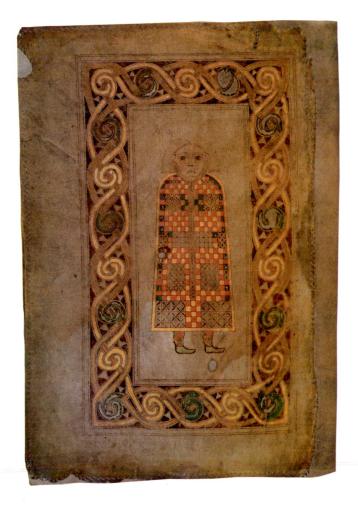

Art in Its Context

THE MEDIEVAL SCRIPTORIUM

oday books are made with the aid of computer software that can lay out pages, set type, and insert and prepare illustrations. Modern presses can produce hundreds of thousands of identical copies in full color. In Europe in the Middle Ages, however, before the invention there of printing from movable type in the mid-1400s, books were made by hand, one at a time, with ink, pen, brush, and paint. Each one was an important, time-consuming, and expensive undertaking. Medieval books were usually made by monks and nuns in a workshop called a scriptorium (plural scriptoria) within the monastery. As the demand for books increased, lay professionals joined the work, and great rulers set up palace workshops supervised by well-known scholars. Books were written on animal skin-either vellum, which was fine and soft, or parchment, which was heavier and shinier. (Paper did not come into common use in Europe until the early 1400s.) Skins for vellum were

cleaned, stripped of hair, and scraped to create a smooth surface for the ink and water-based paints, which themselves required time and experience to prepare. Many pigments—particularly blues and greens—had to be imported and were as costly as semiprecious stones. In very rich books, artists also used gold leaf or gold paint.

Sometimes work on a book was divided between a scribe, who copied the text, and one or more artists, who did the illustrations, large initials, and other decorations. Although most books were produced anonymously, scribes and illustrators signed and dated their work on the last page, called the **colophon** (SEE FIG. 14–9). One scribe even took the opportunity to warn the reader: "O reader, turn the leaves gently, and keep your fingers away from the letters, for, as the hailstorm ruins the harvest of the land, so does the injurious reader destroy the book and the writing" (cited in Dodwell, page 247).

In the Gospel Book of Durrow the Gospel of Matthew is preceded by his symbol, the man, but a man such as to be seen only in jeweled images made by an Irish or Scandinavian metalworker. A colorful checkered pattern resembling the millefiore glass inlays of Sutton Hoo forms the rectangular, armless body. Had the artist seen Byzantine figures wearing colorful brocades, or was he thinking of gold-framed jewels? In Saint Matthew's symbol a startling unshaven face stares glumly from rounded shoulders. The hair framing the man's high forehead follows the tonsure (the ceremonial hairstyle that distinguishes monks from laymen) of the early Celtic church. The figure seems to float with dangling feet against a neutral ground, which is surrounded by a wide border filled with a curling interlacing ribbon. Although the ribbon is continuous, its color changes from segment to segment, establishing yet another pattern. On other pages the ribbons turn into serpents.

The Gospel book known as the *Book of Kells* is one of the most beautiful, original, and inventive of the surviving Hiberno-Saxon Gospel books. A close look at its most celebrated page—the page introducing Matthew (1:18–25) that begins the account of Jesus's birth (SEE FIG. 14–1)—seems at first glance a tangle of colors and lines. But for those who would "look more keenly," there is so much more—human and animal forms—in the dense thicket of spiral and interlace patterns derived from metalwork.

The Kells style is especially brilliant in the monogram page with which we opened this chapter (FIG. 14–1). The artists reaffirm their Celtic heritage with the spirals and trumpet shapes that they combine with Germanic animal

interlaces to embellish the monogram of Christ (the three Greek letters XPI, *chi rho iota*) and the words *Christi autem generatio* ("now this is how the birth of Jesus Christ came about" [Matt. 1:18]). A giant *chi* establishes the basic composition of the page. The word *autem* appears as a Latin abbreviation resembling an *h*; and *generatio* is spelled out.

The illuminators outlined each letter, and then they subdivided the letters into panels filled with interlaced animals and snakes, as well as extraordinary spiral and knot motifs. The spaces between the letters form an equally complex ornamental field, dominated by spirals. In the midst of these abstractions, the painters inserted numerous pictorial and symbolic references to Christ-including his initials, a fish (the Greek word for "fish," ichthus, comprises in its spelling the first letters of Jesus Christ, Son of God, Savior), moths (symbols of rebirth), the cross-inscribed wafer of the Eucharist, numerous chalices and goblets, and possibly in two human faces, one at the top of the page and one at the end of the Greek letter P (rho). Three angels along the left edge of the stem of the Greek letter X (chi) are reminders that angels surrounded the Holy Family at the time of the Nativity, thus introducing Matthew's story while supporting the monogram of Christ.

In a particularly intriguing image, to the right of the Greek letter *chi*'s tail, two cats pounce on a pair of mice nibbling the Eucharistic wafer, and two more mice torment the vigilant cats (FIG. 14–7). As well as being a metaphor for the struggle between good (cats) and evil (mice), the image may also remark upon the perennial problem of keeping the monks' food and the sacred Host safe from rodents.

14–7 | CATS AND MICE WITH HOST, DETAIL OF FIG. 14–1 Chi Rho lota page, Book of Kells, Matt.1:18. Probably made at lona, Scotland. Late 8th or early 9th century. Oxgall inks and pigments on vellum. $12\frac{1}{4} \times 9\frac{1}{2}$ " (325 \times 24 cm). The Board of Trinity College, Dublin. MS 58, fol. 34r.

I4–8 | **SOUTH CROSS, AHENNY**County Tipperary, Ireland. 8th century. Stone.

IRISH HIGH CROSSES. Metalwork's influence is seen not only in manuscripts, but also in the monumental stone crosses erected in Ireland during the eighth century. In Irish high crosses, so called because of their size, a circle encloses the arms of the cross. This Celtic ring has been interpreted as a halo or a glory (a ring of heavenly light) or as a purely practical support for the arms of the cross. The **SOUTH CROSS OF** AHENNY, in County Tipperary, is an especially well–preserved example of this type (FIG. 14–8). It seems to have been modeled on metal ceremonial or reliquary crosses, that is, cross-shaped containers for holy relics. It is outlined with ropelike, convex moldings and covered with spirals and interlace. The large bosses (broochlike projections), which form a cross within the cross, resemble the jewels that were similarly placed on metal crosses.

THE MUSLIM CHALLENGE IN SPAIN

In 711, Islamic invaders conquered Spain, ending Visigothic rule. The invaders brought a new art as well as a new religion and government into Spain (see Chapter 8). Muslim armies swept over the Iberian Peninsula. Bypassing a small Christian kingdom on the north coast, Asturias, they crossed the Pyrenees Mountains into France, but in 732 Charles Martel and the Frankish army stopped them before they reached Paris. The Muslims retreated back across the mountains, and the Christians, led by the Asturians, slowly drove them southward. Even so, the Moors, as they were known in Spain, remained for nearly 800 years, until the fall of the last Moorish kingdom, Granada, to the Christians in 1492.

Mozarabic Art

With some exceptions, Christians and Jews who acknowledged the authority of the new rulers and paid the taxes required of non-Muslims were left free to follow their own religious practices. The Iberian Peninsula became a melting pot of cultures in which Muslims, Christians, and Jews lived and worked together, all the while officially and firmly separated. Christians in the Muslim territories were called Mozarabs (from the Arabic *mustarib*, meaning "would-be Arab").

The conquest resulted in a rich exchange of artistic influences between the Islamic and Christian communities. Christian artists adapted many features of Islamic art, creating a unique, colorful new style known as *Mozarabic*. When the Mozarabic communities migrated to northern Spain, which returned to Christian rule not long after the initial Islamic invasion, they took this Mozarabic style with them.

BEATUS MANUSCRIPTS. One of the most influential books of the eighth century was the *Commentary on the Apocalypse*, compiled by Beatus, abbot of the Monastery of San Martín at Liébana in the northern kingdom of Asturias. Beatus described the end of the world and the Last Judgment of the Apocalypse,

I4-9 | Emeterius and Senior COLOPHON PAGE,
COMMENTARY ON THE APOCALYPSE BY BEATUS AND COMMENTARY ON DANIEL BY JEROME

Made for the Monastery of San Salvador at Tábara, León, Spain. Completed July 27, 970. Tempera on parchment, $14\frac{1}{4} \times 10\frac{1}{4}$ " (36.2 \times 25.8 cm). Archivo Histórico Nacional, Madrid. MS 1079B f. 167.v.

The colophon provides specific information about the production of a book. In addition to identifying himself and Senior on this colophon, Emeterius praised his teacher, "Magius, priest and monk, the worthy master painter," who had begun the manuscript prior to his death in 968. Emeterius also took the opportunity to comment on the profession of bookmaking: "Thou lofty tower of Tábara made of stone! There, over thy first roof, Emeterius sat for three months bowed down and racked in every limb by the copying. He finished the book on July 27th in the year 1008 [970, by modern dating] at the eighth hour" (cited in Dodwell, page 247).

as first depicted in the Revelation to John in the New Testament, which vividly describes Christ's final, fiery triumph.

In 970, the monk Emeterius and a scribe-painter named Senior completed a copy of Beatus's **COMMENTARY** (FIG. 14–9). They worked in the *scriptorium* of the Monastery of San Salvador at Tábara in the Kingdom of León. Unlike most monastic scribes at this time, Mozarabic scribes usually signed their work and occasionally offered the reader their own comments and asides (see "The

Medieval *Scriptorium*," page 448). On the **colophon** (the page at the end of a book with information about its production) is a picture of the five-story tower of the Tábara monastery and the two-story *scriptorium* attached to it, the earliest known depiction of a medieval *scriptorium* and an unusual representation of a bell tower.

The tower and the workshop have been rendered in a cross section that reveals the interior and exterior of the buildings simultaneously. In the *scriptorium*, Emeterius on the right and Senior on the left, identified by inscriptions over their heads, work at a small table. A helper in the next room cuts sheets of parchment or vellum for book pages. A monk standing at the ground floor of the tower pulls the ropes attached to the bell in the turret while three other men climb ladders between the floors, apparently on their way to the balconies on the top level. Brightly glazed tiles in geometric patterns and horseshoearched openings are a common feature of Islamic architecture.

Another copy of Beatus's *Commentary* was produced five years later for Abbot Dominicus. The colophon identifies Senior as the scribe for this project. Emeterius and a woman named Ende (or simply En), who signed herself "painter and servant of God," shared the task of illustration. For the first time in the West, a women artist is identified by name with a specific surviving work of art. Using abstract shapes and brilliant colors recalling Visigothic jewel work, Emeterius and En illustrate a metaphorical description of the triumph of Christ over Satan (FIG. 14–10).

In the illustration, a peacock grasps a red and orange snake in its beak. The text tells us that a bird with a powerful beak and beautiful plumage (Christ) covers itself with mud to trick the snake (Satan). Just when the snake decides the bird is harmless, the bird swiftly attacks and kills the snake. "So Christ in his Incarnation clothed himself in the impurity of our [human] flesh that through a pious trick he might fool the evil deceiver. . . . [W]ith the word of his mouth [he] slew the venomous killer, the devil" (from the Beatus *Commentary*, cited in Williams, page 95). The Church often used such symbolic stories, or allegories, to convey ideals in combinations of recognizable images, making their implications accessible to people at any level of education. Elements of Mozarabic art lasted well into the twelfth century.

THE CAROLINGIAN EMPIRE

During the second half of the eighth century, while Christians and Muslims were creating a rich multicultural art in Spain, a new force emerged in Continental Europe. Charlemagne, or Charles the Great (*Carolus Magnus* is Latin for "Charles the Great"), established a dynasty and an empire known today as "Carolingian." The Carolingians were Franks, a Germanic people who had settled in northern Gaul (parts of present-day France and Germany) by the end of the fifth century. Under Charlemagne (ruled 768–814), the

14-10 | Emeterius and Ende, with the scribe Senior
BATTLE OF THE BIRD AND THE SERPENT, COMMENTARY ON
THE APOCALYPSE BY BEATUS AND COMMENTARY ON DANIEL
BY JEROME, (DETAIL)

Made for Abbot Dominicus, probably at the Monastery of San Salvador at Tábara, León, Spain. Completed July 6, 975. Tempera on parchment, $15\frac{7}{4} \times 10\frac{7}{4}$ " (40×26 cm). Cathedral Library, Gerona, Spain. MS 7[11], fol. 18v.

Carolingian realm reached its greatest extent, encompassing western Germany, France, the Lombard kingdom in Italy, and the Low Countries (present-day Belgium and Holland). Charlemagne imposed Christianity throughout this territory. In 800, Pope Leo III (papacy 795–816) crowned Charlemagne emperor in a ceremony in Saint Peter's Basilica in Rome, declaring him the rightful successor to Constantine, the first Christian emperor. This endorsement reinforced Charlemagne's authority and strengthened the bonds between the papacy and secular government in the West.

Charlemagne sought to restore the Western Empire as a Christian state and to revive the arts and learning. As inscribed on his official seal, Charlemagne's ambition was "the Renewal of the Roman Empire." To lead this revival, Charlemagne turned to the Benedictine monks and nuns. By the early Middle Ages, monastic communities had spread

across Europe. In the early sixth century, Benedict of Nursia (c. 480–547) wrote his *Rule for Monasteries*, a set of guidelines for monastic life that became the model for monastic orders. Benedictine monasticism soon displaced earlier forms, including the Celtic monasticism in the British Isles.

Both the Benedictines and Charlemagne emphasized education, and the Benedictine monks soon became Charlemagne's "cultural army." The court at Aachen, Germany, became one of the leading intellectual centers of Western Europe. Charlemagne's architects, painters, and sculptors looked to Rome and Ravenna for inspiration, but what they created was a new, northern version of the Imperial Christian style.

Carolingian Architecture

Functional plans inspired by Roman and Early Christian architecture were widely adopted by the Carolingian builders. Charlemagne's palace complex at Aachen provides an example of the Carolingian synthesis of Roman, Early Christian, and northern styles. Charlemagne, who enjoyed hunting and swimming, built a headquarters and palace complex amid the forests and natural hot springs of Aachen in the northern part of his empire and installed his court there about 794. The palace complex included a large audience hall and a chapel facing each other across a large square (as seen in a Roman forum), a monumental gateway supporting a hall of judgment, other administrative buildings, a palace school, homes for his circle of advisers and his large family, and workshops supplying all the needs of church and state.

THE PALACE CHAPEL AT AACHEN. Directly across from the royal audience hall on the north-south axis of the complex stood the PALACE CHAPEL (FIGS. 14–11, 14–12). This structure functioned as Charlemagne's private chapel, the church of his imperial court, a place for precious relics, and, after the emperor's death, the imperial mausoleum. To satisfy all these needs, the emperor's architects created a large, central-plan building similar to the Church of SanVitale in Ravenna (FIG. 7–28), which they reinterpreted in the distinctive Carolingian style.

The westwork—church entrances traditionally faced west—is a combined narthex (vestibule) and chapel joined by tall, cylindrical stair towers. The ground-level entrance accommodated the public. On the second level, a throne room opened onto the chapel rotunda, allowing the emperor to participate in the Mass from his private throne room. (The throne is visible through the arch.) At Aachen, this throne room could be reached from the palace audience hall and hall of justice by way of a gallery. The room also opened outside into a large walled forecourt where the emperor could make public appearances and speak to the assembled crowd. Relics were housed above the throne room on the third level. Spiral stairs in the twin towers joined the three levels. Originally designed to answer practical requirements

45 I

I4-II PALACE CHAPEL OF CHARLE-MAGNE

Interior view, Aachen (Aix-la-Chapelle), Germany. 792-805.

Extensive renovations took place in the nineteenth century, when the chapel was reconsecrated as the Cathedral of Aachen, and in the twentieth century, after it was damaged in World War II.

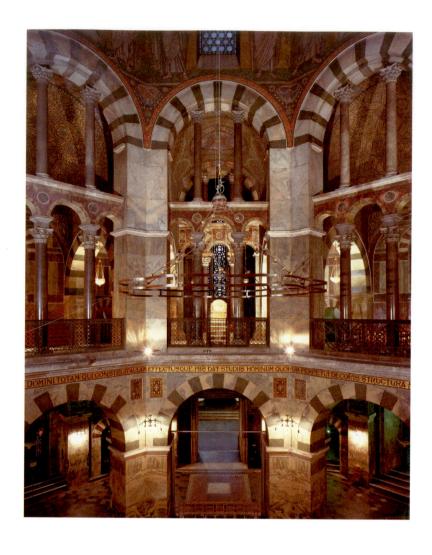

$\begin{array}{c|c} {\bf 14-12} & {\bf RECONSTRUCTION\ DRAWING\ OF} \\ {\bf THE\ PALACE\ CHAPEL\ OF\ CHARLEMAGNE,} \end{array}$

Aachen (Aix-la-Chapelle), Germany. 792-805.

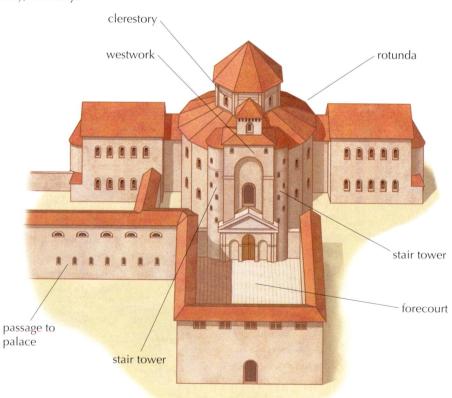

of protection and display, the soaring multitowered westwork came to function symbolically as the outward and very visible sign of an imperial building.

At Aachen, the core of the chapel is an octagon surrounded by an ambulatory and gallery in alternating square and triangular bays that produce a sixteen-sided outer wall. The central octagon rises to a clerestory above the gallery level and culminates in eight curving triangular segments that form an octagonal dome. In contrast, at the Byzantine Church of San Vitale, the central octagon was covered by a round dome and supported by half domes over the eight exedras (SEE FIG. 7-28). The chapel at Aachen has sharply defined spaces created by flat walls and angled piers. Byzantine Ravenna has curving surfaces and flowing spaces. In the gallery at Aachen, two tiers of Corinthian columns in the tall arched openings and bronze grills at floor level create a fictive wall that enhances the clarity and geometric quality of the design. The chapel's interior space is defined by eight panels that create a powerful upward movement from the floor of the central area to the top of the vault. Rich materials, some imported from Italy, and mosaics cover the walls. (The mosaic in the vault depicting the twenty-four Elders of the Apocalypse has been replaced with a modern interpretation.) This use of rich materials over every surface was inspired by Byzantine art, but the emphasis on verticality and the clear division of larger forms into separate parts are hallmarks of the new Carolingian style.

THE CHURCH OF SAINT RIQUIER. The Palace Chapel was a special building. Most Carolingian churches followed the basilican plan, often with the addition of a transept inspired by Old Saint Peter's in Rome. Charlemagne's biographer, Einhard, reported that the ruler, "beyond all sacred and venerable places . . . loved the church of the holy apostle Peter at Rome." Charlemagne's churches, however, were not simply imitations of Roman and Early Christian structures.

The Abbey Church of Saint Riquier, in the monastery at Centula in northern France, illustrates the Carolingian reinterpretation of the Early Christian basilica. Built by Angilbert, a lay abbot (781-814) and Frankish scholar at the court, the church was finished about 799. Destroyed by Viking raids in the ninth century, it is known today from archaeological evidence and a seventeenth-century engraving of a lost eleventhcentury drawing (FIG. 14–13). For the abbey's more than 300 monks, the enclosure between the church and two freestanding chapels evidently served as a cloister—cloisters are arcaded courtyards linking the church and the living and working areas of the monastery. Three kinds of church buildings are represented. Simplest is the small, barnlike chapel (at the right in the print) dedicated to Saint Benedict. The more elaborate structure, a basilica with a rotunda ringed with chapels (lower left), was dedicated to the Virgin Mary and the Twelve Apostles. The interior probably had an altar to the Virgin in the center, an ambulatory, and chapels with altars for each of the apostles against the outside walls.

The principal church, dedicated to Saint Riquier, displays a Carolingian variation of the basilica plan. The nave has side aisles and clerestory windows, and recent excavations have revealed a much longer nave than is indicated in the print. Giving equal weight to both ends of the nave are a multistory westwork including paired towers, a transept, and a crossing tower (at the left in the print), and, at the east end of the church (on the right), a crossing tower, which rises over the transept, and an extended sanctuary and apse.

The westwork served almost as a separate church. The main altar was dedicated to Christ the Savior and used for important church services. The boys' choir sang from its galleries, filling the church with "angelic music," and its ground floor had additional altars with important relics. Later the altar of the Savior was moved to the main body of the church, and the westwork was rededicated to the archangel Michael, whose chapel was usually located in a tower or other high place.

Saint Riquier's many towers would have been the building's most striking feature. The two tall towers at the crossing of the transepts soared upward from cylindrical bases through

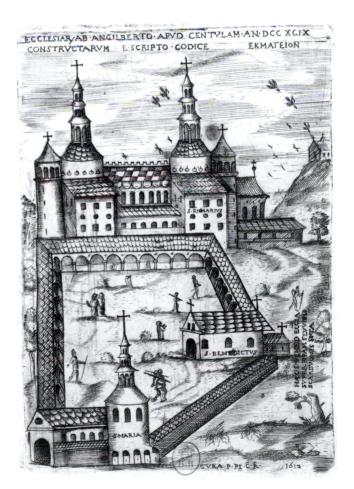

14–13 ABBEY CHURCH OF SAINT RIQUIER, MONASTERY OF CENTULA

France. Dedicated 799. Engraving dated 1612, after an 11th-century drawing. Bibliothèque Nationale, Paris.

three arcaded levels to cross-topped spires. They served a practical function as bell towers and played a symbolic role, designating an important building. Meant to be seen from afar, towers visually dominated the countryside. The vertical emphasis created by integrating towers into the basilican design was a northern contribution to Christian church architecture.

THE SAINT GALL PLAN. Monastic communities had special needs. The life of monks revolved around prayer and service in the church and work for the community. In the early ninth century, Abbot Haito of Reichenau developed an ideal plan for the construction of monasteries for his colleague Abbot Gozbert of Saint Gall near Lake Constance in Switzerland (FIG.14–14). Abbot Haito laid out the plan on a square grid, as with an ancient Roman army camp, and indicated the size and position of the buildings and their uses.

Since Benedictine monks celebrate Mass as well as the eight "canonical" hours every day, they needed a church building with ample space for many altars, indicated in the

plan as standing in the nave and aisles as well as chapels. In the Saint Gall plan, the church had large apses at both the east and west ends of the nave. North of the church were public buildings such as the abbot's house, the school, and guesthouse. The south side was private—the cloister and the complex of monastic buildings surrounding it. The dormitory was built on the east side of the cloister, and for night services the monks entered the church directly from their dormitory. The refectory (dining hall) stood on the south of the cloister, with the kitchen, brewery, and bakery attached. A huge cellar (indicated on the plan by giant barrels) was on the west side. The Saint Gall plan indicates beds for seventy-seven monks in the dormitory and space for thirty-three more elsewhere. Practical considerations for group living include latrines attached to every unit—dormitory, guesthouse, and abbot's house. (The ratio of latrine holes to beds exceeds the standards of the U.S. Army today.) Six beds and places in the refectory were reserved for visiting monks. In the surrounding buildings, monks pursued their individual tasks. Scribes and painters, for example, spent much of their day in the scrip-

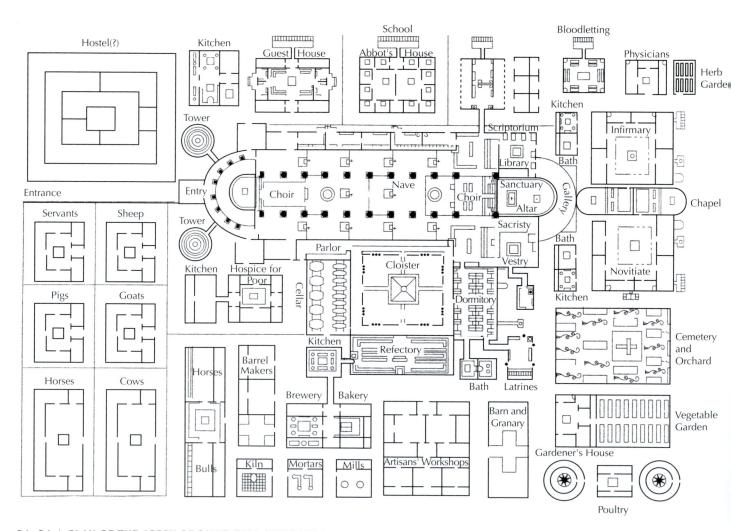

I4–I4 | PLAN OF THE ABBEY OF SAINT GALL (REDRAWN) c. 817. Original in red ink on parchment, $28 \times 44 \%$ (71.1 \times 112.1 cm). Stiftsbibliothek, St. Gallen, Switzerland. Cod. Sang. 1092.

torium studying and copying books, and teachers staffed the monastery's schools and library. Saint Benedict had directed that monks extend hospitality to all visitors, and the large building in the upper left of the plan may indicate the guest-house. The plan also included a hospice for the poor and an infirmary. Around this central core were the workshops, farm buildings, and housing for the lay community. Essentially self-supporting, the community needed barns for livestock, kitchen gardens (grain fields and vineyards lay outside the walls), and, of course, a cemetery. The monastery was often larger than the local villages.

The Scriptorium and Illustrated Books

Books played a central role in the efforts of Carolingian rulers to promote learning, propagate Christianity, and standardize Church law and practice. One of the main tasks of the imperial workshops was to produce authoritative copies of key religious texts, free of the errors introduced by tired, distracted, or confused scribes. The scrupulously edited versions of ancient and biblical texts that emerged are among the lasting achievements of the Carolingian period. The Anglo-Saxon scholar Alcuin of York, whom Charlemagne called to his court, spent the last eight years of his life producing a corrected copy of the Latin Vulgate Bible. His revision served as the standard text of the Bible for the remainder of the medieval period and is still in use.

Generations of copying had led to a shocking decline in penmanship. To create a simple, legible Latin script, the scribes and scholars developed uniform letters. Capitals (majuscules) based on ancient Roman inscriptions were used for very formal writing, titles and headings, and the finest manuscripts. Minuscules (now called lower-case letters, a modern printers' term) were used for more rapid writing and ordinary texts. The Caroline script is comparatively easy to read, although the scribes did not use punctuation marks or spaces between words.

Like the builders who transformed inherited classical types such as the basilican church into the new and different Carolingian monastic church, the scribes and illuminators revived and revitalized the Christian manuscript tradition. The human figure, which was absent or barely recognizable in early medieval books, returned to a central position.

Every monastic *scriptorium* developed its own distinctive forms in harmony with local artistic traditions and the books available as models in the library or treasury. The evangelist portraits (a man seated at a desk writing) in the three Gospel Books discussed here—the **GODESCALC GOSPEL LECTIONARY**, the **CORONATION GOSPELS**, and the **EBBO GOSPELS**—demonstrate the range and variety of Carolingian styles. Although the scribes intended to make exact copies of the texts and illustrations, they brought their own distinctive training to the work and so transformed the images into something new and different.

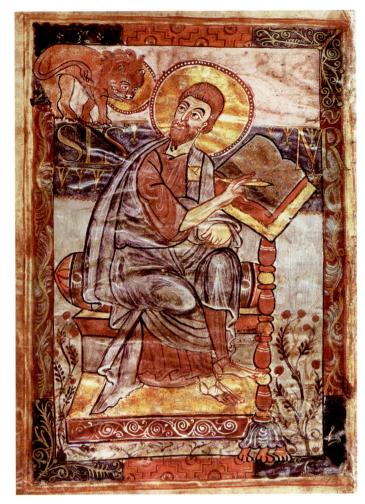

14–15 | PAGE WITH MARK THE EVANGELIST, GODESCALC GOSPEL LECTIONARY

Gospel of Mark. 781–83. Ink, gold, and colors on vellum, $12\frac{1}{2}\times 8\frac{1}{2}$ " (32.1 \times 21.8 cm). Bibliothèque Nationale, Paris. MS lat. 1203, fol. 16.

THE GODESCALC GOSPEL LECTIONARY. One of the earliest surviving manuscripts in the new script produced at Charlemagne's court was the GODESCALC GOSPEL LECTIONARY (FIG. 14–15), a collection of selections from the Gospels to be read at Mass. Commissioned by Charlemagne and his wife Hildegard, perhaps to commemorate the baptism of their sons in Rome in 781, the *Godescalc Gospels* provided a model for later luxuriously decorated Gospel books.

The colophon indicates that the book was finished before the death of Hildegard in 783 and was made by the Frankish scribe Godescalc. This richly illustrated and sumptuously made book, with gold and silver letters on purple-dyed vellum, has a full-page portrait of the evangelist at the beginning of each Gospel. The style of these illustrations suggests that Charlemagne's artists were familiar with the author portraits of imperial Rome, as they had been preserved in Byzantine manuscripts.

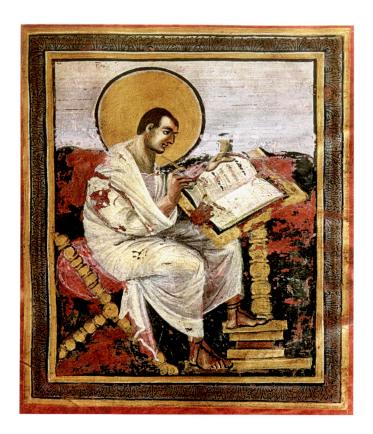

 $\mathbf{14}\text{--}\mathbf{16} + \mathbf{page}$ with saint matthew the evangelist, coronation gospels

Gospel of Matthew. Early 9th century. $12\% \times 9\%$ (36.3 \times 25 cm). Kunsthistorische Museum, Vienna.

THE GOSPELS OF CHARLEMAGNE, KNOWN AS THE CORONATION GOSPELS. Classical Early Christian and Byzantine art seem very close to the style of the CORONATION GOSPELS (FIG. 14–16), in which the Carolingian painters seem to have rediscovered Roman realistic painting. Ways of creating the illusion of figures in space may have been suggested by Byzantine manuscripts in the library, or an artist from Byzantium may have actually worked at the Carolingian court. (Charlemagne had hopes of marrying the Byzantine Empress

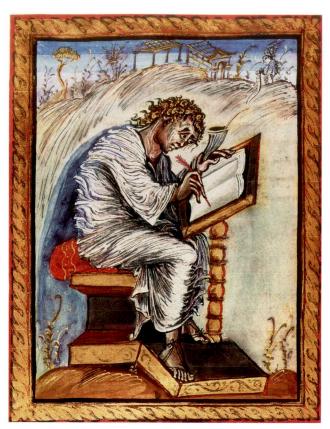

I4–I7 \perp PAGE WITH MATTHEW THE EVANGELIST, EBBO GOSPELS

Gospel of Matthew. Second quarter of 9th century. Ink, gold, and colors on vellum, $10\,\%\times8\,\%$ " (26×22.2 cm). Bibliothèque Municipale, Épernay, France. MS 1, fol. 18v.

Irene. She turned him down—in her eyes he was a barbarian.) Tradition says that the book was placed in the tomb of Charlemagne and that in the year 1000 Emperor Otto III removed it (see page 464). It was used in the coronation of later German emperors. The evangelist portraits in this book show full-bodied, white-robed figures represented in brilliant light and shade and seated in a freely depicted naturalistic landscape. The frame enhances the classical effect of a view through a window.

THE GOSPELS OF ARCHBISHOP EBBO OF REIMS. Patronage of scribes and painters continued under Louis the Pious, Charlemagne's son and successor (ruled 814–840). Louis appointed his childhood friend Ebbo to be archbishop of Reims (ruled 816–35, 840–45). Ebbo was an important patron of the arts. A portrait of Matthew from a Gospel book made for the archbishop, either in Reims or a nearby *scriptorium*, illustrates the unique style associated with Reims (FIG. 14–17). The artist interprets the author's portrait with a frenetic intensity that turns the face, drapery, and landscape into swirling expressive colored lines. The author and his angelic inspiration (the tiny figure in the upper right corner) seem to

AMI FICUMCLAMARI REMINISCENTURITOON OMSTINCUISTERRAE. ADEUMEXAUDIUITME. INCONSPICTUTIUSCA UERTENTURADDNM DENTOMSQUIDESCEN APUDILLAUSMEAINIC UNIVERSIFINESTERRAF DUNTINTERRAM CLISIAMAGNA UOTA GTADORABUNTIN MIARIDDAMINCONS CONSCICTUHUS GTANIMAMEAILLIUI PECTUTIMENTIUEUM UET ETSEMENMEUM UNIVERSAFFAMILIAE EDENTPAUPERESETSA GINTIUM SERVIETICSL QUONIAMONIESTREG TURABUNTUR ETLAU ADNUNCIABITURDNOCE NUM HIPSEDOMINA HERATIOUENTURA HE DABUNTONMQUIRE QUIRUNTIUM 'UI BITURGENTIUM UINTCORDATORUM MANDUCAUIRUNTET tiátius ropuloquinas INSAECULÚSAECULI ADORAUIRUNT CHURQUEHCITONS NSRECITO EET VIBIL INMEDIOUMBRAEMOR MEUSINEBRIANSONAM MIHIDEFRIT INLOCOPAS TIS NONTIMEBOMALA CRAFCIARUSE CULIBIMECOLLOCABIT OMTUMECUMES, ETMISERICORDIATUA UPERAQUÁREFECTIO **UIRCATUATIBACULUSTU** SUBSEQUETURME HISEDUCAUITME ANI US. ITSAMICONSOLATAST: OMNIBUSDIEBUSUI MAMEAMCONVERTIT PARASTIINCONSPECTU IAIMIAE DEDUXITMESUTERSEMI MIOMENSÁ ADUERSÚ CTUTINHABITIMINDO TASIUSTITIAE PROPTER EOSQUITRIBULANTME MODNI INLONGI HOMENSUUM INCINGUASTIINOLIO TUDINIDLIKUM METSIABULAUERO CAPUTMEUM ETCALIX

14-18 | PAGE WITH PSALM 23, UTRECHT PSALTER.

Second quarter of 9th century. Ink on vellum or parchment, $13 \times 9\%$ (33×25 cm). Universiteitsbibliotheek, Utrecht, Holland. MS 32, fol. 13r.

hover over a landscape so vibrant that both threaten to run off the page. Even the golden acanthus leaves in the frame seem windblown.

The artist uses the brush like a pen, focusing attention less on the evangelist's physical appearance than on his inner, spiritual excitement as he transcribes the Word of God coming to him from the distant angel, Matthew's symbol. Saint Matthew's head and neck jut out of hunched shoulders, and he grasps his pen and inkhorn. His twisted brow and prominent eyebrows lend his gaze an intense, theatrical quality. Swept up in Matthew's turbulent emotions, the saint's desk, bench, and footstool tilt every which way, as the top of the desk seems about to detach itself from the pedestal. Gold highlights the evangelist's hair and robe, the furniture, and the landscape. The accompanying text is written in magnificent golden capitals.

THE UTRECHT PSALTER. The most famous Carolingian manuscript, the UTRECHT PSALTER, or Old Testament Book of Psalms, is illustrated with ink drawings that have the same linear vitality as the paintings in Archbishop Ebbo's Gospel book. Psalms do not tell a straightforward story and so are exceptionally difficult to illustrate. The *Utrecht Psalter* artists solved this problem by interpreting individual words and images literally. Their technique can be likened to a game of charades in which each word must be acted out.

The words of the well-known Twenty-third Psalm are illustrated literally (FIG. 14-18). "The Lord is my shepherd; I shall not want" (verse 1): The psalmist (traditionally King David) sits in front of a table laden with food; he holds a cup (verse 5). He is also portrayed as a shepherd in a pasture filled with sheep, goats, and cattle, "beside the still water" (verse 2). Perhaps the stream flows through "the valley of the shadow of death" (verse 4). An angel supports the psalmist with a "rod and staff" and anoints his head with oil (verses 4 and 5). "Thou prepares a table before me in the presence of mine enemies" (verse 5): The enemies gather at the lower right and shoot arrows, but the psalmist and angel ignore them and focus on the table and the House of the Lord. The basilica curtains are drawn back to reveal an altar and hanging votive crown: "I will dwell in the house of the Lord forever" (verse 6). Illustrations like this convey the characteristically close association between text and illustration in Carolingian art.

Carolingian Goldsmith Work

The magnificent illustrated manuscripts of the medieval period represented an enormous investment in time, talent, and materials, so it is not surprising that they were often protected with equally magnificent covers. But because these covers were themselves made of valuable materials—ivory, enamelwork, precious metals, and jewels—they were frequently reused or stolen. The elaborate book cover of gold

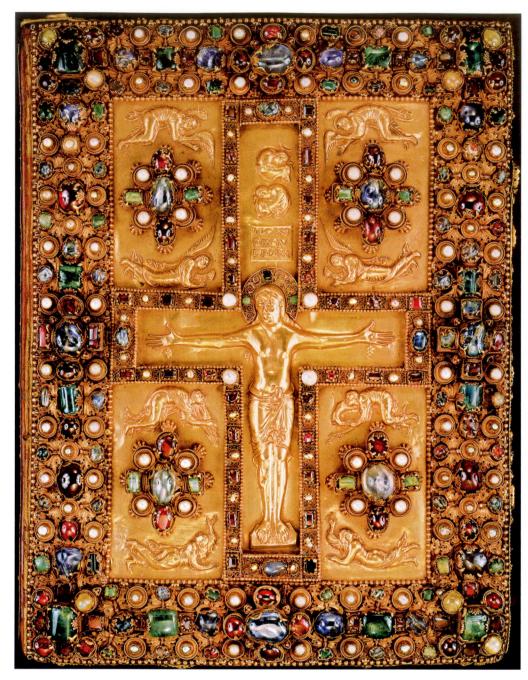

I4–I9 | CRUCIFIXION WITH ANGELS AND MOURNING FIGURES, LINDAU GOSPELS. Outer cover. c. 870–80. Gold, pearls, sapphires, garnets, and emeralds, $13\,\% \times 10\,\%$ (36.9 \times 26.7 cm). The Pierpont Morgan Library, New York. MS 1

and jewels, now the cover of the Carolingian manuscript known as the LINDAU GOSPELS (FIG. 14–19), was probably made between 870 and 880 at one of the monastic workshops of Charlemagne's grandson, Charles the Bald (ruled 840–77). Charles inherited the portion of Charlemagne's empire that corresponds roughly to modern France after the death of his father, Louis the Pious. It is not known what book the cover was made for, but sometime before the sixteenth century it became the cover of the *Lindau Gospels*, prepared at the Monastery of Saint Gall in the late ninth century.

The Cross and the Crucifixion were common themes for medieval book covers. The Crucifixion scene on the front cover of the *Lindau Gospels* is made of gold with figures in *repoussé* (low relief produced by pounding out the back of the panel to produce a raised front) surrounded by heavily jeweled frames. The jewels are raised on miniature arcades. By raising the jewels from the gold ground, the artist allowed reflected light to enter the gemstones from beneath, imparting a lustrous glow. Such luxurious gems are meant to recall the jeweled walls of the Heavenly Jerusalem.

Angels hover above the arms of the cross. Over Jesus's head, hiding their faces, are figures representing the sun and moon. The graceful, expressive poses of the mourners—Mary, John, Mary Magdalene, and Mary Cleophas—who seem to float around the jewels below the arms of the cross, reflect the expressive style of the *Utrecht Psalter* illustrations. Jesus, on the other hand, has been modeled in a rounded, naturalistic style suggesting the influence of classical sculpture. His erect posture and simplified drapery counter the emotional expressiveness of the other figures. Standing upright and wide-eyed with outstretched arms, he announces his triumph over death and welcomes believers into the faith.

In 843, the Carolingian empire was divided into three parts, ruled by three grandsons of Charlemagne. Although a few monasteries and secular courts continued to patronize the arts, intellectual and artistic activity slowed. Torn by internal strife and ravaged by Viking invaders, the Carolingian empire came to a bloody and inglorious end in the ninth century.

THE VIKING ERA

In the eighth century seafaring bands of Norse seamen known as Vikings (*Viken*, "people from the coves") descended on the rest of Europe. Setting off in flotillas of as many as 350 ships, they explored, plundered, traded with, and colonized a vast area during the ninth and tenth centuries. Frequently, their targets were wealthy isolated Christian monasteries. The earliest recorded Viking incursions were two devastating attacks: one in 793, on the religious community on Lindisfarne, an island off the northeast coast of England, and

another in 795, at Iona, off Scotland's west coast. In France they besieged Paris in 845 and later destroyed Centula as they harried the northern and western coasts of Europe.

Norwegian and Danish Vikings raided and settled a vast territory stretching from Iceland and Greenland, where they settled in 870 and 985, respectively, to Ireland, England, Scotland, and France. The Viking Leif Eriksson reached North America in 1000. In good weather a Viking ship could sail 200 miles in a day. In the early tenth century, the rulers of France bought off Scandinavian raiders (the Normans, or North men) with a large grant of land that became the duchy of Normandy. Swedish Vikings turned eastward and traveled down the Russian rivers to the Black Sea and Constantinople, where the Byzantine emperor recruited them to form an elite personal guard. Others, known as Rus, established settlements around Novgorod, one of the earliest cities in what would become Russia. They settled in Kiev in the tenth century and by 988 had become became Orthodox Christians (see Chapter 7).

The Oseberg Ship

Since prehistoric times Northerners had represented their ships as sleek sea serpents, and as we saw at Sutton Hoo they used them for burials as well as sea journeys. The ship of a dead warrior symbolized his passage to Valhalla, and Viking chiefs were sometimes cremated in a ship in the belief that this hastened their journey. Women as well as men were honored by ship burials. A 75-foot-long ship discovered in Oseberg, Norway, and dated 815–20 served as the vessel for two women on their journey to eternity in 834 (FIG. 14–20). Although the burial chamber was long ago looted of jewelry

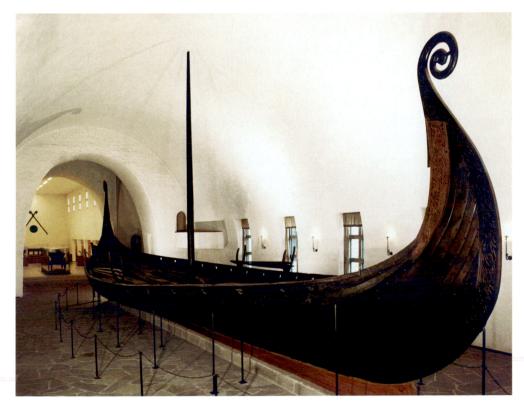

14–20 QUEEN'S SHIP Oseberg, Norway. c. 815–20; burial 834. Wood, length 75'6" (23 m). Vikingskiphuset, Universitets Oldsaksamling, Oslo, Norway.

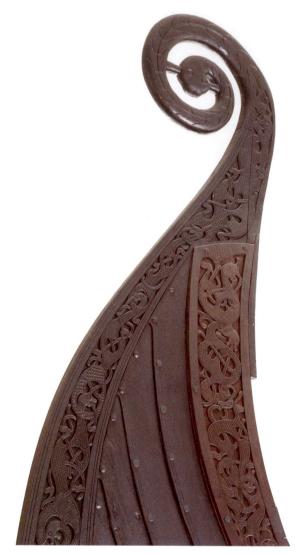

14–21 | GRIPPING BEASTS, DETAIL OF OSEBERG SHIP c. 815–20. Wood. Vikingskiphuset, Universitets Oldsaksamling, Oslo, Norway.

and precious objects, the ship itself and its equipment attest to the wealth and prominence of the ship's owner.

This vessel, propelled by both sail and oars, was designed for travel in the relatively calm waters of fjords (narrow coastal inlets), not for voyages in the open sea. The burial chamber held the bodies of two women—a queen and her companion or servant. At least twelve horses, several dogs, and an ox had been sacrificed to accompany the women on their last journey. A cart and four sleds, all made of wood with beautifully carved decorations, were also stored on board. The cabin contained empty chests that no doubt once held precious goods.

The prow and stern of the Oseberg ship rise and coil, the spiraling prow ending in a tiny serpent's head. Bands of interlaced animals carved in low relief run along the ship's bow and stern. Viking beasts are broad-bodied creatures that clutch each other with sharp claws; in fact, these animals are known as "gripping beasts" (FIG. 14–21). They are grotesque catlike

creatures with bulging eyes, short muzzles, snarling mouths, and large teeth. Their bodies are encrusted with geometric ornament. Images of these strange beasts adorned all sorts of Viking belongings—jewelry, houses, tent poles, beds, wagons, and sleds. Traces of color—black, white, red, brown, and yellow—indicate that the carved wood was painted.

All women, including the most elite, worked in the fiber arts. The Oseberg queen had her spindles, a frame for sprang (braiding), tablets for tablet weaving, as well as two upright looms. Her cabin walls had been hung with tapestries, fragments of which survive. Women not only produced clothing and embroidered garments and wall hangings, but they also wove the huge sails of waterproof unwashed wool that gave the ships a long-distance capability. The entire community—men and women—worked to create the ships, which represent the Viking's most important contribution to world architecture.

Picture Stones at Jelling

Both at home and abroad, the Vikings erected large memorial stones. Those covered mostly with inscriptions are called **rune stones**; those with figural decoration are called **picture stones**. Runes are twiglike letters of an early Germanic alphabet. Traces of pigments suggest that the memorial stones were originally painted in bright colors.

About 980 the Danish king Harald Bluetooth (c. 940–987) ordered a picture stone to be placed near the family burial mounds at Jelling (FIG. 14–22). Carved in runes on a boulder 8 feet high is the inscription, "King Harald had this memorial made for Gorm his father and Thyra his mother: that Harald who won for himself all Denmark and Norway and made the Danes Christians." (The prominent place of women in Viking society is noteworthy.) Harald and the Danes had accepted Christianity in c. 960, but Norway did not become Christian until 1015.

During the tenth century, a new style emerged in Scandinavia and the British Isles, one that combined simple foliage elements and coarse ribbon interlaces with animals that are more recognizable than the gripping beasts of the Oseberg ship. On one face of the Jelling Stone the sculptor carved the image of Christ robed in the Byzantine manner, with arms outstretched as if crucified. He is entangled in a double-ribbon interlace instead of a cross. A second side holds the runic inscriptions, and a third, a striding creature resembling a lion fighting a snake. The coarse, loosely twisting double-ribbon interlace covering the surface of the stone could have been inspired by Hiberno-Saxon art. New to the north, however, are bits of foliage that spring illogically from the animal—the Great Beast's tail, for example, is a rudimentary leaf. The Great Beast symbolizes the Lion of Judah, an Old Testament prefiguration of the militant Christ, and thus is wholly appropriate for a royal monument commemorating the conversion of the Danes and Harald's victorious dynasty.

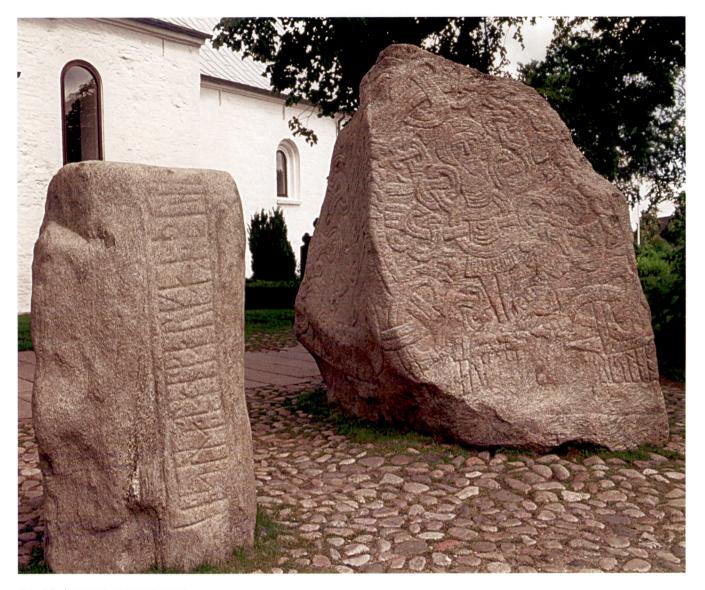

14-22 ROYAL RUNE STONES

Left: Raised by Gorm the Old to honor his wife Thyra. Right: Raised by Harald Bluetooth to honor his parents Gorm and Thyra and to commemorate the conversion of the Danes to Christianity. Jelling, Denmark, 960-985, granite, height of Harald's stone about 8' (2.44 m). The stone church in the background dates c. 1100 and replaces a series of wooden churches on the site.

THE URNES CHURCH PORTAL. The penchant for carved relief decorations seen on the Oseberg ship endured in the decoration of Scandinavia's great halls and later churches. The façades of these structures often teem with intricate animal interlace. A church at Urnes, Norway, although entirely rebuilt in the twelfth century, preserved its original eleventh century doorway (FIG. 14–23), carved with an interlace of serpentine creatures snapping at each other like the vicious little gripping beasts of Oseberg. New in the Urnes style, however, is the satin–smooth carving of rounded surfaces, the contrast of thick and very thin elements, and the organization of the interlace into harmoniously balanced patterns, which have the effect of aesthetic elegance and technical control rather than the wild disarray of earlier carving.

The images on the Urnes doorway panels suggest the persistence of Scandinavia's mythological tradition even as

Christianity spread through the country. The Great Beast standing at the left of the door, fighting serpents and dragons, continued to be associated with the Lion of Judah (as at Jelling) and with Christ, who fought Satan and the powers of darkness and paganism (like the peacock and snake image in Mozarabic art). With Christianity, the Great Beast became a positive, protective force.

Timber Architecture

In Scandinavia vast forests provided the materials for timber buildings of all kinds (FIG. 14–24). Two forms of timber construction evolved: one that stacked horizontal logs, notched at the ends, to form a rectangular building (the still popular log cabin); and the other that stood the wood on end to form a palisade or vertical plank wall, with timbers set directly in the ground or into a sill (a horizontal beam).

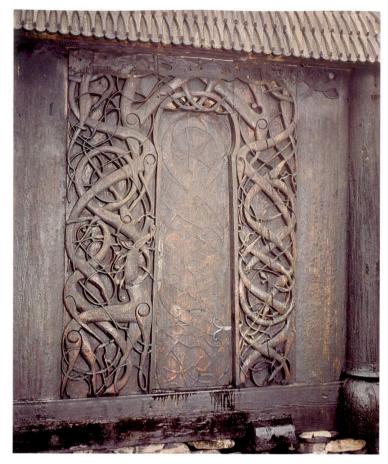

I4–23 \mid PORTAL, SET INTO WALL OF LATER STAVE CHURCH Urnes, Norway. 11th century.

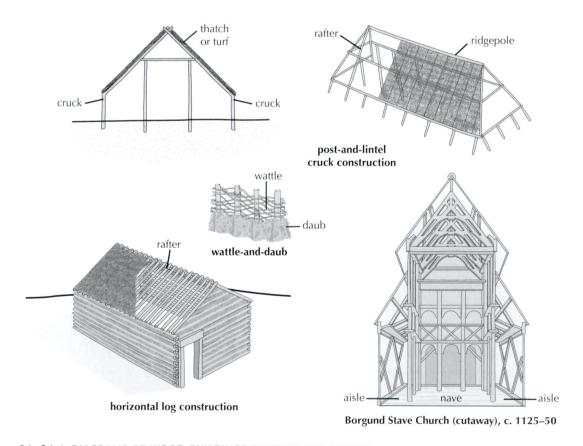

I4–24 | **DIAGRAMS OF WOOD BUILDINGS IN NORTHERN EUROPE**Horizontal log construction; wattle and daub used to plaster between timbers; stave church is a highly crafted version of plank wall construction.

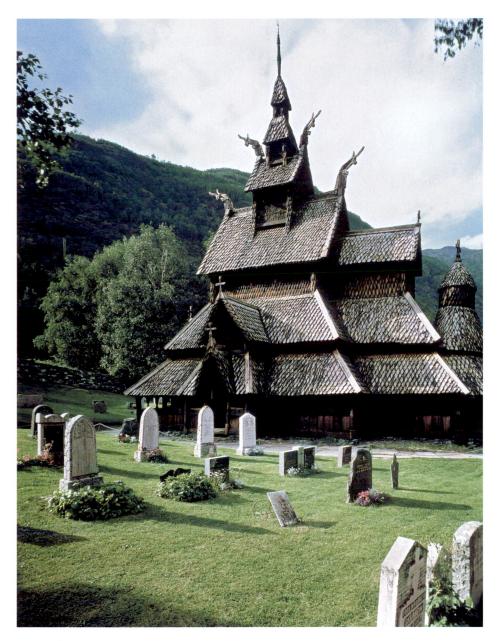

14–25 \parallel stave church, borgund, norway c. 1125–50.

More modest buildings consisted of wooden frames filled with wattle-and-daub (woven branches covered with mud or other substances). Typical buildings had a turf or thatched roof supported on interior posts. The same basic structure was used for almost all building types—feasting and assembly halls, family homes (which were usually shared with domestic animals), workshops, barns, and sheds. The great hall had a central open hearth (smoke escaped through a louver in the roof) and an off-center door designed to reduce drafts. People secured their residences and trading centers by building massive circular earthworks topped with wooden palisades.

THE BORGUND STAVE CHURCH. Subject to decay and fire, early timber buildings have largely disappeared, leaving only post-

holes and other traces in the soil; however, a few timber churches survive in rural Norway. They are called stave churches, from the four huge timbers (staves) that form their structural core. Borgund Church, from about 1125–50 (FIG. 14–25), has four corner staves supporting the central roof, with additional interior posts that create the effect of a nave and side aisles, narthex, and choir. A rounded apse covered with a timber tower is attached to the choir. Upright planks slotted into the sills form the walls. A steep-roofed gallery rings the entire building, and steeply pitched roofs covered with wooden shingles protect the walls from the rain and snow. Openwork timber stages set on the roof ridge create a tower and give the church a steep pyramidal shape. On all the gables are both crosses and dragons to protect the church and its congregation from trolls and demons.

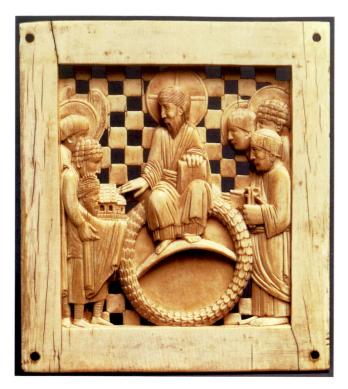

14-26 | otto I presenting magdeburg cathedral to Christ

One of a series of seventeen ivory plaques known as the <code>Magdeburg Ivories</code>, possibly carved in Milan c. 962–68. Ivory, $5\times4\%''$ (12.7 \times 11.4 cm). The Metropolitan Museum of Art, New York.

Bequest of George Blumenthal, 1941 (41.100.157)

The End of the Viking Era

The Vikings were not always victorious. Their colonies in Iceland and the Faeroe Islands survived, but in North America—in Canada—their trading posts eventually had to be abandoned. In Europe, south of the Baltic Sea, a new German dynasty challenged and then defeated the Vikings. During the eleventh century the Viking era came to an end.

OTTONIAN EUROPE

When Charlemagne's grandsons divided the empire in 843, Louis the German took the eastern portion. His family died out at the beginning of the tenth century, and a new Saxon dynasty came to power in lands corresponding roughly to present-day Germany and Austria. This dynasty was called Ottonian after its three principal rulers—Otto I (ruled 936–73), Otto II (ruled 973–83), and Otto III (ruled 994–1002; queens Adelaide and Theophanu had ruled as regents for him, 983–94). The Ottonian armies secured the territory by defeating the Vikings in the north and the Magyars (Hungarians) on the eastern frontier. Relative peace permitted increased trade and the growth of towns, making the tenth century a period of economic recovery. Then, in 951, Otto I gained control of northern Italy by marrying the wid-

owed Lombard Queen Adelaide. He was crowned emperor by the pope in 962, and so reestablished Charlemagne's Christian Roman Empire. The Ottonians and their successors so dominated the papacy and appointments to other high Church offices that in the twelfth century this union of Germany and Italy under a German ruler came to be known as the Holy Roman Empire. The empire survived in modified form as the Habsburg Empire into the twentieth century.

The Ottonian Empire was of necessity a military state. Aware of the threat of the pagan Slavs, in the 960s Otto established a buffer zone on the border with its headquarters in Magdeburg, the site of a frontier monastery. In 968 the pope made Magdeburg his administrative center in the region as well. Otto brought the relics of Saint Maurice from Burgundy, in France, to Magdeburg in 960. Saint Maurice, an African Christian commander in third century Gaul, was executed with all his troops for refusing to sacrifice to pagan Roman gods (as commander of the Theban Legion, Maurice was often represented as an African, SEE FIG. 16–37). The warrior saint became the patron of the Ottonian Empire.

THE MAGDEBURG IVORIES. The unity of church and state is represented on an ivory plaque, one of several that may once have been part of the decoration of an altar or pulpit presented to the cathedral at the time of its dedication in 968. Saint Maurice wraps his arm protectively around Otto I, who with solemn dignity presents a model of the cathedral to Christ and Saint Peter (FIG. 14–26). Hieratic scale demands that the mighty emperor be represented as a tiny, doll-like figure, and that the saints and angels, in turn, be taller than Otto but smaller than Christ. The cathedral Otto holds is a basilica with prominent clerestory windows and rounded apse that are intended to recall the churches of Rome.

Ottonian Architecture

The Ottonian rulers, in keeping with their imperial status, sought to replicate the splendors of the Christian architecture of Rome. German officials knew the basilicas well, since the German court in Rome was located near the Early Christian Church of Santa Sabina. The buildings of Byzantium were another important influence, especially after Otto II married a Byzantine princess, cementing a tie with the East. But while Ottonian patrons saw, envied, and ordered buildings to rival the sophisticated architecture of imperial Rome and Byzantium, the locally trained masons and carpenters could only struggle to comply. They built large timber-roofed basilicas that were terribly vulnerable to fire. Magdeburg Cathedral burned in 1008, only forty years after its dedication; it was rebuilt in 1049, burned in 1207, and rebuilt yet again. In 1009, the Cathedral of Mainz burned down on the day of its consecration. The Church of Saint Michael at Hildesheim was destroyed in World War II. Luckily the convent Church of Saint Cyriakus at Gernrode, Germany, still survives.

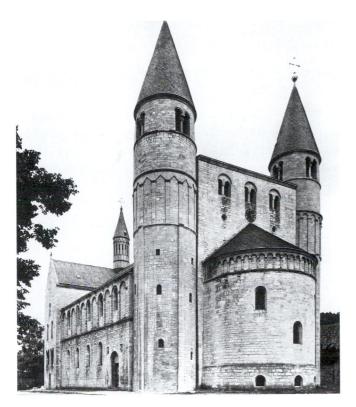

I4-27 | CHURCH OF SAINT CYRIAKUS Gernrode, Germany. Begun 961; consecrated 973.

The apse seen here replaced the original portal of the westwork in the late twelfth century.

THE CHURCH OF SAINT CYRIAKUS, GERNRODE. During the Ottonian Empire, aristocratic women often held positions of authority, especially as the leaders of religious communities. When in 961 the provincial military governor Gero founded the convent and church of Saint Cyriakus, he made his widowed daughter-in-law the convent's first abbess. The church was designed as a basilica with a westwork, an architectural feature that took on greater importance with the increasing elaboration of the liturgy (FIG. 14-27). At Gernrode, the exterior appearance of the westwork was changed in the late twelfth century by the addition of an apse, although the two tall cylindrical towers continue to dominate the skyline. At the eastern end of the church a transept with chapels led to a choir with an apse built over a crypt. This development at both the east and west ends of the nave gave the building the "double-ended" look characteristic of major Ottonian churches. The nuns entered the church from the convent through modest side doors. Pilasters, joined by arches attached to the wall, form blind arcades, and windows also break the severity of the church's exterior.

The interior of Saint Cyriakus (FIG. 14–28) has three levels: an arcade separating the nave from the side aisles, a gallery with groups of six arched openings, and a clerestory. The flat ceiling is made of wood and must have been painted. Galleries over aisles were used in Byzantine architecture but rarely in the West, and their function in Ottonian architecture is uncertain.

Sequencing Events THE TENTH CENTURY-THE STATE OF CHRISTIANITY IN EUROPE 910 William, Duke of Aquitaine, and his wife, Ingelborga, seeking reform in Western monasticism, give the Benedictine Order the town and manor of Cluny The Viking Rolf accepts Christianity and 911 becomes Rollo, Duke of Normandy Muslim ruler Abd-al-Rahman, Caliph of 912-61 Cordoba, pushes back Christians in northern Spain 960 Harald Bluetooth, king of Denmark and Norway, accepts Christianity 962 Supremacy of church over state proclaimed when Christian king Otto I of Germany is crowned emperor by the pope Grand Prince Vladimir in Kiev, Ukraine, 988 accepts Orthodox Christianity

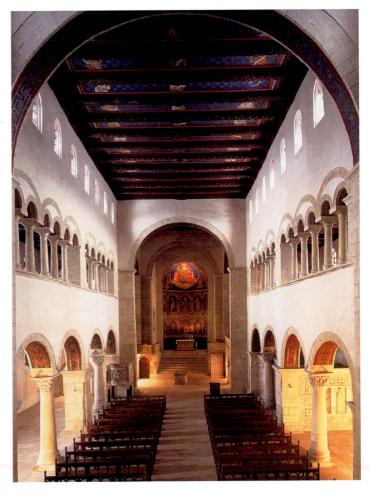

14-28 NAVE, CHURCH OF SAINT CYRIAKUS

THE OBJECT SPEAKS

THE DOORS OF BISHOP BERNWARD

he design of the magnificent doors at Bishop Bernward's abbey church in Hildesheim, Germany, anticipated by centuries the great sculptural programs that would decorate the exteriors of European churches in the Romanesque period. The awesome monumentality of the towering doorsnearly triple a person's height-is matched by the intellectual content of their iconography. The doors spoke eloquently to the viewers of the day and still speak to us through a combination of straightforward narrative history and subtle interrelationships, in which Old Testament themes, on the left, illuminate New Testament events, on the right. Bernward must have designed the iconographical program himself, for only a scholar thoroughly familiar with Christian theology could have conceived it.

The Old Testament history begins in the upper left-hand panel with the Creation and continues downward to depict Adam and Eve's Expulsion from Paradise, their difficult and sorrowful life on earth, and, in the bottom panel, the tragic fratricidal story of their sons, Cain and Abel. The New Testament follows, beginning with the Annunciation at the lower right and reading upward through the early life of Jesus and his mother, Mary, through the Crucifixion to the Resurrection, symbolized by the three Marys at the tomb.

The way the Old Testament prefigured the New in scenes paired across the doors is well illustrated, for example, by the third set of panels, counting down from the top. On the left, we see the Temptation and Fall of Adam and Eve in the Garden of Eden, believed to be the source of human sin, suffering, and death. This panel is paired on the right with the Crucifixion of Jesus, whose suffering and sacrifice redeemed humankind, atoned for Adam and Eve's Original Sin, and brought the promise of eternal life. Another example is the recurring pairing of the "two Eves": Eve, who caused humanity's Fall and Expulsion from Paradise and whose son Cain committed the first murder; and Mary, the "new Eve," through whose son, Jesus, salvation will be granted. In one of the clearest juxtapositions, in the sixth pair down, Eve and Mary are almost identical figures, each holding her first-born son; thus, Cain and Jesus (evil and goodness) are also paired.

DOORS OF BISHOP BERNWARD Made for the Abbey Church of Saint Michael, Hildesheim, Germany. 1015. Bronze, height 16'6" (5 m).

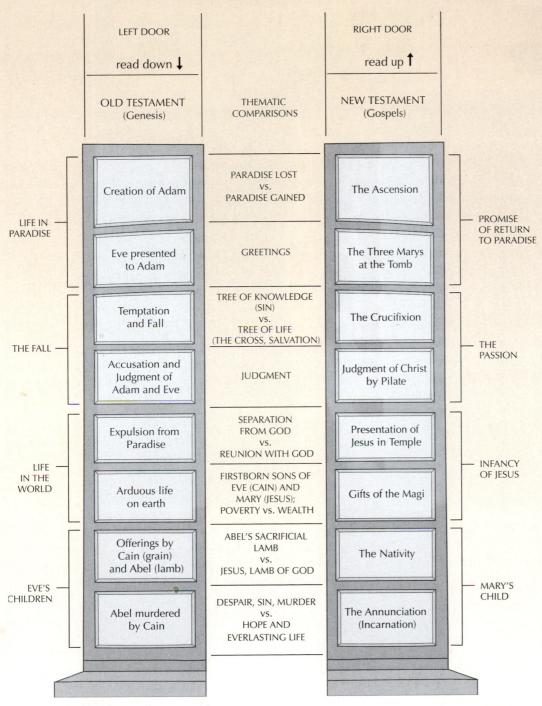

SCHEMATIC DIAGRAM OF THE MESSAGE OF THE DOORS OF BISHOP BERNWARD OF HILDESHEIM

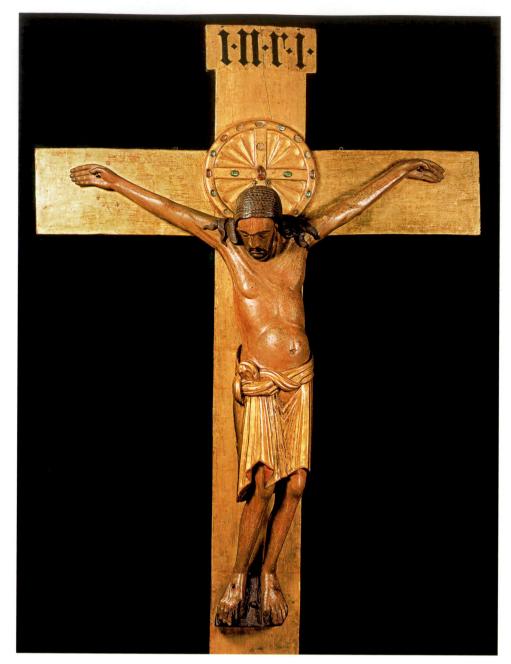

14–29 | GERO CRUCIFIX Cologne Cathedral, Germany. c. 970. Painted and gilded wood, height of figure 6'2" (1.88 m).

This life-size sculpture is both a crucifix to be suspended over an altar and a special kind of reliquary. A cavity in the back of the head was made to hold a piece of the Host, or communion bread, already consecrated by the priest. Consequently, the figure not only represents the body of the dying Jesus but also contains within it the body of Christ obtained through the Eucharist.

They may have provided space for choirs as music became more elaborate in the tenth century. They may have held additional altars. They may have been simply a mark of status.

The alternation of columns and rectangular piers in Saint Cyriakus creates a rhythmic effect more interesting than that of the uniform colonnades of the Early Christian churches. Saint Cyriakus is also marked by vertical shifts in visual rhythm, with two arches on the nave level surmounted by six arches on the gallery level, surmounted in turn by three windows in the clerestory. This seemingly simple archi-

tectural aesthetic, with its rhythmic alternation of heavy and light supports, its balance of rectangular and round forms, and its combination of horizontal and vertical movement found full expression later in the Romanesque period.

Ottonian Sculpture

Ottonian artists worked in ivory, bronze, wood, and other materials rather than stone. Like their Early Christian and Byzantine predecessors, they and their patrons focused on church furnishings and portable art rather than architectural sculpture. Drawing on Roman, Early Christian, Byzantine, and Carolingian models, they created large sculpture in wood and bronze that would have a significant influence on later medieval art.

THE GERO CRUCIFIX. The GERO CRUCIFIX is one of the few large works of carved wood to survive from the early Middle Ages (FIG. 14–29). Archbishop Gero of Cologne (ruled 969–76) commissioned the sculpture for his cathedral about 970. The figure of Christ is more than 6 feet tall and is made of painted and gilded oak. The focus here, following Byzantine models, is on Jesus's suffering. He is shown as a tortured martyr, not as the triumphant hero of the *Lindau Gospels* cover (SEE FIG. 14–19). Jesus's broken body sags on the cross and his head falls forward, eyes closed. The straight, linear fall of his golden drapery heightens the impact of his drawn face, emaciated arms and legs, sagging torso, and limp, bloodied hands. In this image of distilled anguish, the miracle and triumph of the Resurrection seem distant indeed.

THE HILDESHEIM BRONZES. Under the last of the Ottonian rulers, Henry II and Queen Kunigunde (ruled 1002–24), an important artist and patron was Bishop Bernward of Hildesheim. His biographer, the monk Thangmar, described Bernward as a skillful goldsmith who closely supervised the artisans working for him. Bronze doors made under his direction for the Abbey Church of Saint Michael in Hildesheim represented the most ambitious and complex bronze-casting project undertaken since antiquity (see "The Doors of Bishop Bernward," page 466). As tutor for Otto III, the bishop had lived in Rome, where he would have seen the carved wooden doors of the fifth-century Church of Santa Sabina, located near Otto's palace.

The doors' rectangular panels recall not only Santa Sabina (SEE FIG. 7–14) but also resemble the framed miniatures in Carolingian Gospel books. The style of the sculpture is reminiscent of illustrations in manuscripts such as the *Utrecht Psalter*. Animated small figures populate spacious backgrounds. Architectural elements and features of the landscape are depicted in very low relief, forming little more than a shadowy stage for the actors in each scene. The figures stand out prominently, in varying degrees of relief, with their heads fully modeled in three dimensions. The result is lively, visually stimulating, and remarkably spontaneous for so monumental an undertaking.

Illustrated Books

Book illustration in the Ottonian period is not as varied as it is in Carolingian manuscripts, although artists continued to work in widely scattered centers, using different models or sources of inspiration. The **LIUTHAR** (or **AACHEN**) **GOSPELS** (named for the scribe or patron) were made for Otto III around 996 in a monastic *scriptorium* near Reichenau. The dedication page (FIG. 14–30) is a work of imperial propa-

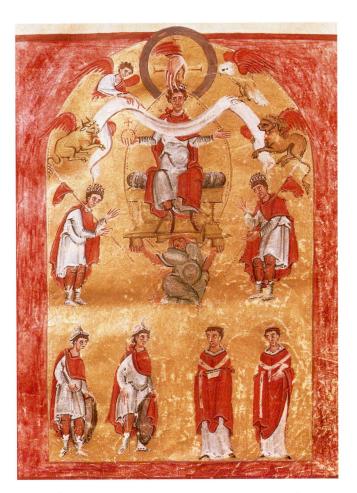

I4–30 | PAGE WITH OTTO III ENTHRONED, LIUTHAR GOSPELS (AACHEN GOSPELS) c. 996. Ink, gold, and colors on vellum, $10\% \times 8\%$ (27.9 \times 21.8 cm). Cathedral Treasury, Aachen.

ganda meant to establish the divine underpinnings of Otto's authority and depicts him as a near-divine being himself. He is shown enthroned in heaven, surrounded by a mandorla and symbols of the evangelists. The hand of God descends from above to place a crown on his head, and Otto holds the Orb of the World surmounted by a cross in his right hand. His throne, in a symbol of his worldly dominion, rests on the crouching Tellus, the personification of earth. In what may be a reference to the dedication on the facing page—"With this book, Otto Augustus, may God invest thy heart"—the evangelists represented by their symbols hold a white banner across the emperor's breast. On each side of Otto, male figures bow their crowned heads as subordinate rulers acknowledging his sovereignty. The bannered lances they hold may allude to the Ottonians' most precious relic, the Holy Lance, believed to be the one with which the Roman soldier Longinus pierced Jesus's side. In the lower register, two warriors face two bishops, symbolizing the union of secular and religious power under the emperor.

A second Gospel book made for Otto III in the same scriptorium illustrates the painters' narrative skill. In an episode

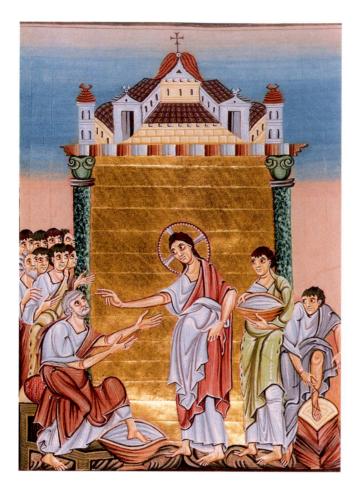

I4-3I \perp PAGE WITH CHRIST WASHING THE FEET OF HIS DISCIPLES, AACHEN GOSPELS OF OTTO III.

c. 1000. Ink, gold, and colors on vellum, approx. $8\times6''$ (20.5 \times 14.5 cm). Staatsbibliothek, Munich. Nr. 15131, Clm 4453, fol 237r.

recounted in Chapter 13 of the Gospel according to John, Jesus, on the night before his Crucifixion, gathered his disciples together to wash their feet (FIG. 14–31). Peter, who felt unworthy, at first protested. The painting shows a towering Jesus in the center extending an elongated arm and hand in blessing toward the elderly apostle. Peter, his foot in a basin of water, reaches toward Jesus with similarly elongated arms. The two figures fix each other with wide-eyed stares. Gesture and gaze carry the meaning in Ottonian painting: A disciple on the far right unbinds his sandals, and another, next to him, carries a basin of water while the other disciples look on. The light behind Jesus has turned to gold, which is set off by buildings suggesting the Heavenly Jerusalem. The painter conveys a sense of spirituality and contained but deeply felt emotion, as well as the austere grandeur of the Ottonian court.

These manuscript paintings summarize the high intellectual and artistic qualities of Ottonian art. Ottonian artists drew inspiration from the past to create a monumental style for a Christian, German-Roman empire. From the groundwork laid during the early medieval period emerged the arts of the Romanesque and Gothic periods in Western Europe.

IN PERSPECTIVE

People living outside the Roman Empire had a heritage of both imaginative abstract art and well-observed animal images. They also had an exceptionally high level of technical skill in the crafts, especially metalwork, and in wooden architecture and sculpture. The Celts, Norse, Goths, and Saxons sought to capture the essence of forms in dynamic, colorful, linear art. From astonishingly complex geometric patterns and interlaces they created imaginary creatures. They loved light and color in the form of gold and jewels. As exchanges of intellectual and artistic influences took place among the diverse groups that populated Europe, an extraordinary amalgam of ancient classical forms and Celtic and Germanic styles took place. The new narrative and figurative art that emerged was also richly decorative and expressive.

As the Western Roman Empire disintegrated, the Christian Church assumed an ever greater social as well as spiritual role. Although the Roman Empire itself was no longer a vital entity, the idea of imperial Rome—both as a secular empire and as the headquarters of the Christian Church—remained strong in people's minds. Twice, charismatic leaders gathered disparate factions together into short-lived but powerful empires—the Carolingians at the end of the eighth and beginning of the ninth centuries, and the Ottonians in the tenth century. The pope in Rome emerged as the supreme leader of the Church, and the Germanic rulers reinforced their power by supporting Rome.

Carolingian artists following ancient models brought together the classical perception of human forms, of weight and mass, with the highly developed decorative sensibility and impeccable craftsmanship of Hiberno-Saxon artisans. The arts provided a splendid and symbolic setting for the Carolingian monarchs and served to advance their imperial ambitions. This flowering of art and scholarship as well as the Christian mission came to a halt during the devastating raids of Viking adventurers. The Vikings had their own cultural and artistic traditions, dating back to their Norse ancestors. Theirs was an animal art very different from the imperial and humanistic Mediterranean arts.

Otto the Great defeated the Vikings and created a new Germanic empire in Germany and Italy. Artists served both the empire and the revitalized Church where spiritual values were considered to be superior to the material world. They created a monumental art, with images of overwhelming solemnity. Their work has a directness that often hides complex meanings. Conservative in their reference to Early Christian, Byzantine, and Carolingian art and innovative in their subordination of earlier northern styles to the new imperial ideal, Ottonian artists reaffirmed the value of art and architecture to carry powerful secular and religious messages. As they brought monumentality, dignity, and grandeur to the art of the West, they paved the way for the mature Christian art in Western Europe.

GUMMERSMARK BROOCH
6TH CENTURY

GOSPEL BOOK OF DURROW,
PAGE WITH MAN
SECOND HALF 7TH CENTURY

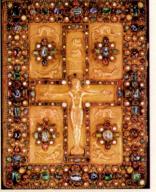

LINDAU GOSPEL COVER C. 870-80

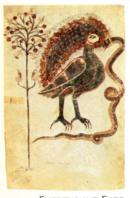

EMERITUS AND ENDE.

BATTLE OF BIRD AND SERPENT,

BEATUS'S COMMENTARY

975

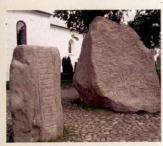

royal rune stone, Jelling c. 980

EARLY MEDIEVAL ART IN EUROPE

500

- Rule of St. Benedict c. 530 CE
- Lombards in Italy c. 568-774 CE
- ✓ Visigoths in Spain Adopt Western Christianity c. 589 CE
- St. Augustine in England 597 CE

700

800

900

1000

IIOO

- Muslims Conquer Spain 711 CE
- Carolingian Empire c. 768-887 CE
- **▼ Viking Raids Begin** 793 CE
- Charlemagne Crowned Emperor by the Pope in Rome 800 CE

- **Cluny Founded** 910 CE
- ◆ Ottonian Empire c. 919–1024 CE
- Viking Settlement in North America 1000 CE

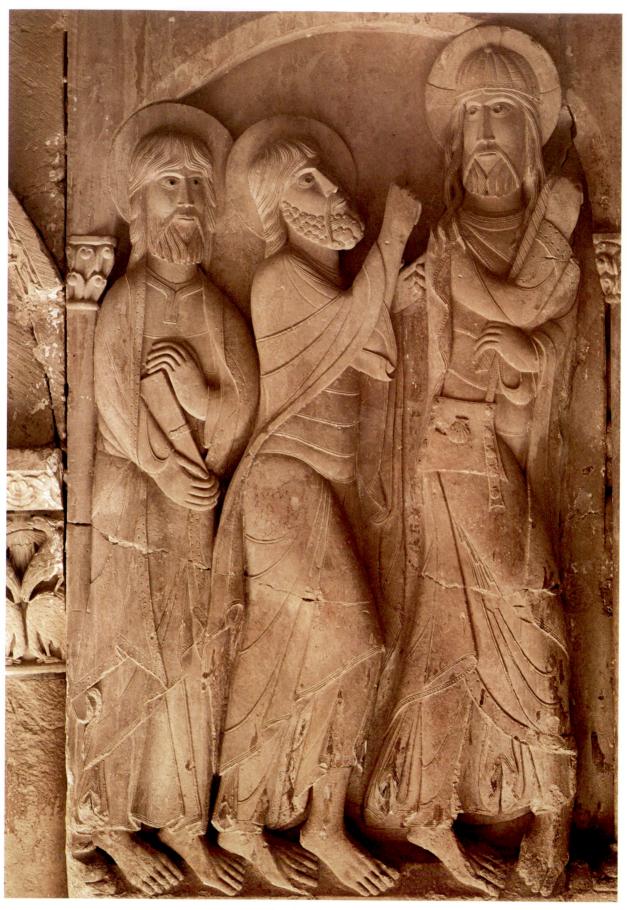

15–I CHRIST AND DISCIPLES ON THE ROAD TO EMMAUS Cloister of the Abbey of Santo Domingo, Silos, Castile, Spain. Pier relief, figures nearly life-size. c. 1100.

CHAPTER FIFTEEN

ROMANESQUE ART

Three men, together under an arch supported by slender columns, seem to glide forward on tip-toe (FIG. 15–1). The leader turns back, reversing their forward movement. The men's bodies seem almost boneless, their legs cross in slow curves

rather than vigorous strides; their shoulders, elbows, and finger joints seem to melt; draperies are reduced to delicate curving lines. Framed by haloes, three bearded faces—foreheads covered by locks of hair—stare out with large wide eyes under strong arched brows. The figures interrelate and interlock without exceeding the limits of the controlling architecture.

Captivated by tranquility, the viewer only gradually realizes that this panel is more than mere decoration. The leader is identified as Christ by his large size and cruciform halo. He wears a ribbed cap and carries a satchel and a short staff. The scene depicts Christ and two disciples on the road from Jerusalem to the village of Emmaus (Luke 24: 13–35). Christ has the distinctive attributes of a pilgrim—a hat, a satchel, and a walking stick. A final surprise rewards a close examination—a scallop shell on Christ's satchel. The scallop shell is the badge worn by the pilgrims to the shrine of Saint James in Santiago de Compostela, Spain. Early pilgrims reaching this destination in the far northwestern corner of the Iberian Peninsula continued to the coast to pick up a shell as evidence of their journey. Soon shells were gathered (or made from metal as brooches) and sold to the

15

pilgrims by authorized persons—a lucrative business for both the sellers and the church. On the return home the shell became the pilgrim's passport.

The Road to Emmaus was carved on a cor-

ner pier in the cloister of the monastery of Santo Domingo de Silos, south of the pilgrimage road across Spain (see "The Pilgrim's Journey," page 480). Santo Domingo was the eleventh century abbot of Silos. The monastery had a flourishing *scriptorium* and metal smithing shops where artists as well as sculptors worked in a Mozarabic style.

The sculpture at Silos is filled with the spirit of the Romanesque. The art is essentially figurative, narrative, and didactic; it is based on Christian story and belief. It develops out of a combination of styles, not only ancient Roman art as the name might suggest. The sculpture is shaped by a new awakening. Pilgrimages to visit the scenes of Christ's life and the tombs of martyrs (those who died for their faith) inspired not only architecture and the arts. The conflict between Christians and Muslims—and the ensuing Christian Crusades to win back conquered territories and gain access to sacred places like Jerusalem—taught more than military tactics. Travel as a Crusader or a pilgrim opened the mind to a world beyond the familiar towns and agricultural villages of home. The distinctive style of the Romanesque signifies a new era in the social and economic life of Europe, an awakening of intellectual exploration.

- EUROPE IN THE ROMANESQUE PERIOD | Political and Economic Life | The Church | Intellectual Life
- ROMANESQUE ART
- ARCHITECTURE | The Early Romanesque Style: The "First Romanesque" | The "Pilgrimage Church" | The Monastery of Cluny in Burgundy | The Cistercians | Regional Styles in Romanesque Architecture | Secular Architecture: Dover Castle, England
- THE DECORATION OF BUILDINGS | Architectural Sculpture | Mosaics and Murals
- THE CLOISTER CRAFTS | Portable Sculpture | Metalwork | Illustrated Books
- IN PERSPECTIVE

EUROPE IN THE ROMANESQUE PERIOD

At the beginning of the eleventh century, Europe was still divided into many small political and economic units ruled by powerful families, such as the Ottonians in Germany (Chapter 14). The nations we know today did not exist, although for convenience we will use present-day names of countries. The king of France ruled only a small area around Paris known as the Ile-de-France. The southern part of modern France had close linguistic and cultural ties to northern Spain; in the north the Duke of Normandy (heir of the Vikings) and in the east the Duke of Burgundy paid the French king only token homage.

When in 1066 Duke William II of Normandy (ruled 1035–87) invaded England and, as William the Conqueror, became that country's new king, Norman nobles replaced the Anglo-Saxon nobility there, and England became politically and culturally allied with Normandy in France. As astute and skillful administrators, the Normans formed a close alliance with the Church, supporting it with grants of land and gaining in return the allegiance of abbots and bishops. Normandy became one of Europe's most powerful feudal domains.

In the eleventh century, the Holy Roman Empire (formerly the Ottonian empire), which encompassed much of Germany and northern Italy (Lombardy), became embroiled in a conflict with the papacy. In 1075, Pope Gregory VII (papacy 1073–85) declared that only the pope could appoint bishops and abbots; the emperor demanded the right for himself. Not only nobles, but cities took sides. In the power struggle between the Holy Roman emperor and the pope, the pope emerged victorious. The conflict persisted in the wars between the great German families, the Welfs of Saxony (known in Italy as the Guelfs), who supported the pope, and the Hohenstaufens of Swabia (or, in Italy, the Ghibellines), who backed the emperor.

Meanwhile, the Iberian Peninsula remained divided between Muslim rulers in the south and Christian rulers in the north. The power of the Christian rulers grew as they joined forces through marriage and inheritance and fought to extend their territory southward. By 1085, Alfonso VI of Castile and León (ruled 1065–1109) had conquered the Muslim stronghold of Toledo, a center of Islamic and Jewish culture in the kingdom of Castile. By this victory he acquired treasures, vast territories, and a skilled work force of Christians, Muslims, and Jews. Catalunya (Catalonia) emerged as a power along the Mediterranean coast.

By the end of the twelfth century, however, a few exceptionally intelligent and aggressive rulers began to create national states. The Capetians in France and the Plantagenets in England were especially successful. In Germany and northern Italy the power of local rulers and towns prevailed, and Germany and Italy remained politically fragmented until the nineteenth century.

Political and Economic Life

Although towns and cities with artisans and merchants gained importance, Europe remained an agricultural society, with land the primary source of wealth and power for a hereditary aristocracy. *Feudalism*, a system of mutual obligation and exchange of land for services that had developed in the early Middle Ages, governed social and political relations, especially in France and England. A landowning lord granted property and protection to a subordinate, called a vassal. In return, the vassal pledged allegiance and military service to the lord.

The economic foundation for this political structure was the manor, a self-sufficient agricultural estate where peasants worked the land in exchange for a place to live, military protection, and other services from the lord. Economic and political power depended on a network of largely inherited but constantly shifting allegiances and obligations among lords, vassals, and peasants.

THE WORCESTER CHRONICLE. The social and economic classes become vividly clear in the WORCESTER CHRONICLE, which depicts the three classes of medieval society: the king and nobles, the churchmen, and the peasant farmers (FIG. 15–2). The book is the earliest known illustrated record of contemporary events in England and was written by John, a monk of Worcester. He described the nightmares of King

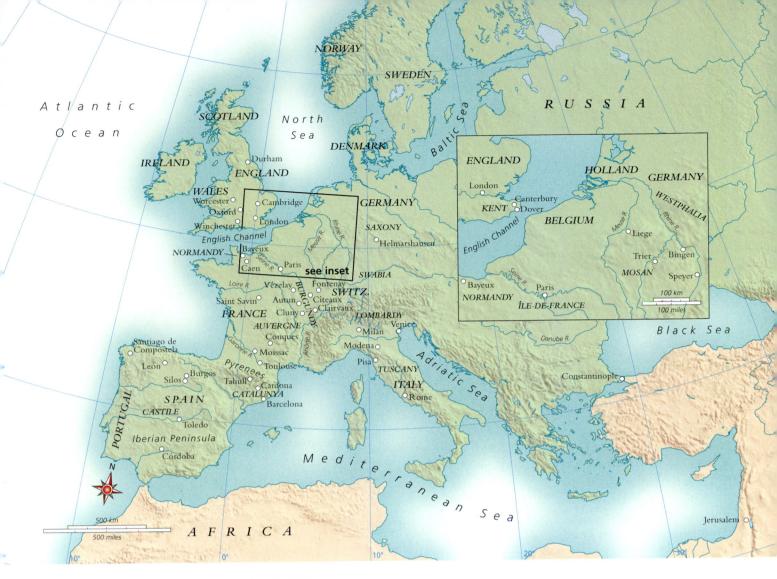

MAP 15-1 | EUROPE IN THE ROMANESQUE PERIOD

Although a few large political entities began to emerge in places like England and Normandy, Burgundy, and Leon-Castile, Europe remained a land of small economic entities. Pilgrimages and crusades acted as unifying international forces. Modern names of countries have been added for convenience.

Henry I (ruled 1100–35) in 1130 in which the people demanded tax relief. On the first night, angry farmers, still carrying their shovels, forks, and scythes, hold up their list of grievances; in the second dream, armed knights confront the king; and then on the third night, monks, abbots, and bishops challenge the sleeping king, who is observed by the royal physician Grimbald. Finally, the king is caught in a storm at sea and saves himself by promising to lower taxes for a period of seven years. Speech is indicated by pointing a finger; sleep, by propping the head on a hand or arm; and royal status, by the crown worn by the sleeping king. Since the goal of the artist was to communicate clearly, not to decorate the text, the illustrations give an excellent idea of the appearance of the people.

The Church

In the early Middle Ages, church and state had forged an often fruitful alliance. Christian rulers helped insure the spread of Christianity throughout Europe and supported monastic communities with grants of land. Bishops and abbots were often their relatives, younger brothers and cousins, who pro-

vided rulers with crucial social and spiritual support and supplied them with educated administrators. As a result, secular and religious authority became tightly intertwined.

PILGRIMAGES. Reinforcing the importance of religion were two phenomena of the period: pilgrimages and the Crusades. Pilgrimages to the holy places of Christendom—Jerusalem, Rome, and Santiago de Compostela—increased, despite the great financial and physical hardships they entailed (see "The Pilgrim's Journey," page 480). As difficult and dangerous as these journeys were, rewards awaited courageous travelers along the routes. Pilgrims could stop to venerate the relics of local saints and visit the places where miracles were believed to have taken place. They also learned about people and places far removed from their isolated village life.

CRUSADES. In the eleventh and twelfth centuries, Christian Europe, previously on the defensive against the expanding forces of Islam, became the aggressor. In Spain, Christian armies of the north were increasingly successful against the

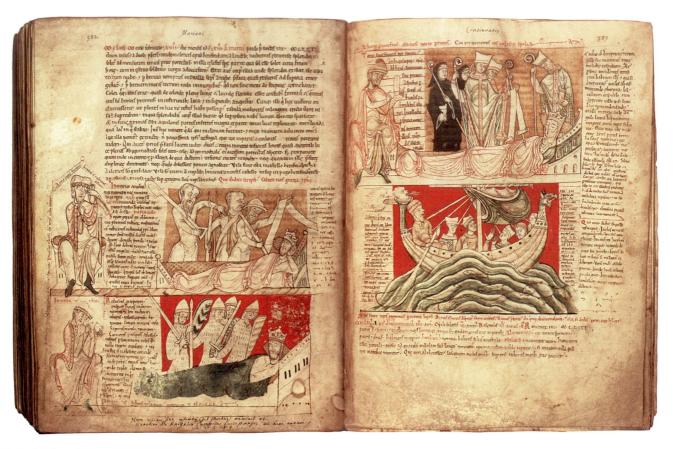

England. c. 1140. Ink and tempera on vellum, each page 12½ \times 9½" (32.5 \times 23.7 cm). Corpus Christi College, Oxford. CCC MS 157, pages 382–83

Islamic south. At the same time, despite the schism within the Church (SEE Chapter 7), the Byzantine emperor asked the pope for help in his war with the Muslims. The Western Church responded in 1095 by launching a series of military expeditions against Islamic powers known as the Crusades. The word *crusade* (from "crux") refers to the cross worn by Crusaders and pilgrims.

This First Crusade was preached by Pope Urban II (a Cluniac monk and pope from 1088 to 1099) and supported by the lesser nobility of France, who had economic and political as well as spiritual goals. The Crusaders captured Jerusalem in 1099 and established a short-lived kingdom. The Second Crusade in 1147, preached by Saint Bernard and led by France and Germany, accomplished nothing. The Muslim leader Saladin united the Muslim forces and captured Jerusalem in 1187, inspiring the Third Crusade, led by German, French, and English kings. (This is the period of Richard Lionheart and Robin Hood.) The Christians recaptured some territory, but not Jerusalem, and in 1192 they concluded a truce with the Muslims, permitting the Christians access to the shrines in Jerusalem. Crusades continued to be mounted against non-Christians and foes of the papacy. Today the word crusade still implies zealous devotion to a cause.

The crusading movement had far-reaching cultural and economic consequences. The Westerners' direct encounters with the more sophisticated material culture of the Islamic world and the Byzantine Empire created a demand for goods from the East. This in turn helped stimulate trade and with it an increasingly urban society during the eleventh and twelfth centuries.

Intellectual Life

The eleventh and twelfth centuries were a time of intellectual ferment as Western scholars rediscovered the classical Greek and Roman texts that had been preserved in Islamic Spain and the eastern Mediterranean. The first universities were established in the growing cities—Bologna (eleventh century) and Paris, Oxford, and Cambridge (twelfth century). Monastic communities continued to play a major role in the intellectual life of Romanesque Europe. Monks and nuns also provided valuable social services, including caring for the sick and destitute, housing travelers, and educating the people. Because monasteries were major landholders, abbots and priors were part of the feudal power structure. The children of aristocratic families who joined religious orders also helped forge links between monastic communi-

Art and Its Context

SAINT BERNARD AND THEOPHILUS: OPPOSING VIEWS ON THE ART OF THEIR TIME

n a letter to William of Saint-Thierry, Bernard of Clairvaux wrote,

But in the cloister, under the eyes of the Brethren who read there, what profit is there in those ridiculous monsters, in that marvellous and deformed comeliness, that comely deformity? To what purpose are those unclean apes, those fierce lions, those monstrous centaurs, those half-men, those striped tigers, those fighting knights, those hunters winding their horns? Many bodies are there seen under one head, or again many heads to a single body. Here is a four-footed beast with a serpent's tail; there, a fish with a beast's head. Here again the forepart of a horse trails half a goat behind it, or a horned beast bears the hinder quarters of a horse. In short, so many and so marvellous are the varieties of divers shapes on every hand, that we are more tempted to read in the marble than in our books, and to spend the whole day in wondering at these things rather than in meditating the law of God. For God's sake, if men are not ashamed of these follies, why at least do they not shrink from the expense?

(from Caecilia Davis-Weyer. Early Medieval Art 300–1150: Sources and Documents. New Jersey: Prentice-Hall, 1971, p. 170.)

"Theophilus" is the pseudonym used by a monk who wrote an artist's handbook, *On Divers Arts*, about 1100. The book gives detailed instructions for painting, glassmaking, and goldsmithing. In contrast to the stern warnings of Abbot Bernard, "Theophilus" assured artists that "God delights in embellishments" and that artists worked "under the direction and authority of the Holy Spirit."

He wrote

most beloved son, you should not doubt but should believe in full faith that the Spirit of God has filled your heart when you have embellished His house with such great beauty and variety of workmanship . . . Set a limit with pious consideration on what the work is to be, and for whom, as well as on the time, the amount, and the quality of work, and, lest the vice of greed or cupidity should steal in, on the amount of the recompense.

(Theophilus, page 43).

ties and the ruling elite. The dominant order had been the Benedictines, but as life in Benedictine communities grew increasingly comfortable, reform movements arose. Reformers claimed to return to the original austerity and spirituality of earlier times. The most important for the arts was the congregation of Cluny founded in the tenth century in Burgundy (in eastern-central France) and the Cistercians in the eleventh century.

ROMANESQUE ART

The word *Romanesque* means "in the Roman manner," and the term applies specifically to eleventh- and twelfth-century European architecture and art. The word was coined in the early nineteenth century to describe European church architecture, which often displayed the solid masonry walls and the rounded arches and vaults characteristic of imperial Roman buildings. Soon the term was applied to all the arts of the period from roughly the mid-eleventh to the late-twelfth century, even though the art reflects influences from many sources, including Byzantine, Islamic, and early medieval European art.

The eleventh and twelfth centuries were a period of great building activity in Europe. Castles, manor houses, churches, and monasteries arose everywhere. As one eleventh-century monk noted, "Each people of Christendom rivaled with the other, to see which should worship in the finest buildings. The world shook herself, clothed everywhere in a white garment of churches" (Radulphus Glaber, cited in Holt, A Documentary History of Art, vol. I, page 18). Increased prosperity in spite of frequent domestic warfare made the resources available to build monumental stone architecture. The desire to glorify the house of the Lord and his saints (whose earthly remains in the form of relics kept their presence alive in the minds of the people) increased throughout Christendom.

Both inside the church and outside, especially around the entrance, sculpture and paintings illustrated important religious themes; they served to instruct as well as fascinate the faithful. These awe-inspiring works of art and architecture had a Christian message and purpose. One monk wrote that by decorating the church "well and gracefully" the artist showed "the beholders something of the likeness of the paradise of God" (Theophilus, page 79). (See "Bernard and Theophilus," above.)

15-3 | INTERIOR, CHURCH OF SANT VINCENC, CARDONA 1020s-30s.

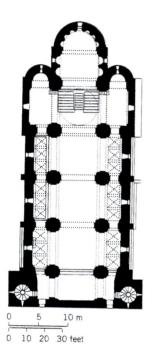

I5-4 | PLAN OF CHURCH OF SANT VINCENC, CARDONA 1020s-30s.

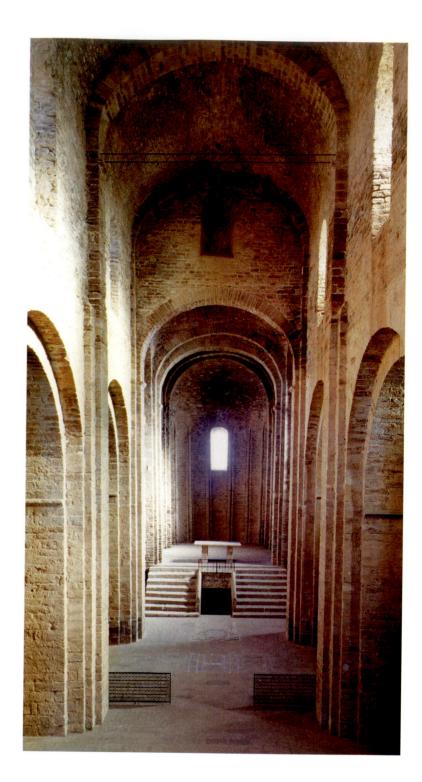

ARCHITECTURE

Romanesque architecture and art are regional phenomena. Romanesque churches were the result of master builders solving the problems associated with each individual project with the resources at hand: its site, its purpose, the building materials, the work force available, the builders' own knowledge and experience, and the wishes of the patrons who provided the funding. The process of building could be slow, often requiring several different masters and teams of masons over the years.

In general, the basic form of the Romanesque church, like that of Carolingian churches, follows the plan arrived at by the

builders of the early Christian basilicas; however, Romanesque builders made several key changes. They added apses or wide projecting transepts, creating complex sanctuaries. A variety of arrangements of ambulatories (walkways) and chapels accommodated the many altars and the crowds of worshipers. Although wooden roofs were still in widespread use, many builders adopted the stone masonry developed by Lombard and Catalan builders. Masonry vaults enhanced the acoustical properties of the building and the effect of the Gregorian chant (plainsong, named after Pope Gregory, papacy 590–604). Masonry also provided some protection against fire, a constant danger from candlelit altars and torchlight processions.

Tall towers marked the church as the most important building in the community. The two-towered west façade, derived in part from traditional fortified gateways, became not only the entrance into the church but also, by extension, the gateway to Paradise.

The Early Romanesque Style: The "First Romanesque"

By the year 1000—by which time the pope had crowned Otto III (page 464) and Radulphus Glaber commented on the rise of church building across the land—patrons and builders in Catalunya (Catalonia) in northeast Spain, southern France, and northern Italy were constructing masonry churches. Based on methods used by late Roman (SEE FIG. 6–71, Trier) and Early Christian (SEE FIG. 7–29, Ravenna) builders, the Catalan and Lombard masons developed a distinctive early Romanesque style. Many buildings still survive in Catalunya where the authorities had introduced the Benedictine Order into their territory.

THE CHURCH OF SANT VINCENC, CARDONA. One of the finest examples of these masonry buildings is the church of Sant Vincenc (Saint Vincent) in the castle of Cardona on the Catalan side of the Pyrenees Mountains (FIGS. 15-3, 15-4). Begun in the 1020s, it was consecrated in 1040. Castle residents entered the church through a two-story narthex into a nave with low narrow side aisles that permitted windows in the nave wall. The transept had two apses and a low crossing tower that emphasized the importance of the choir, large apse, and altar. The sanctuary was raised dramatically over an aisled crypt. The different sizes of the apses, caused by the difference in the widths of the nave and the narrower side aisles, created a stepped outline that came to be called the Benedictine plan. The masons hoped to build practical, sturdy, fireproof walls and vaults. Catalan and Lombard masons used local materials—small split stones, bricks, even river pebbles, and very strong mortar-to raise plain walls and round barrel vaults or groin vaults. Today we can admire their skillful stone work both inside and out, but the builders originally covered their masonry with stucco.

To strengthen the walls and vaults the masons added bands of masonry (called strip buttresses) joined by arches and additional courses of masonry (arched corbel tables) to counter the outward thrust of the vault and to enliven the wall. Late Roman and Early Christian builders had used these techniques, but the eleventh century masons went further. They turned strip buttresses and arched corbel tables into a regular decorative system. On the interior they added masonry strips to the piers and continued these bands across the vault (a transverse arch). They added bands on the underside of the arches of the nave arcade as well. The result was a simple compound pier. The compound piers and transverse

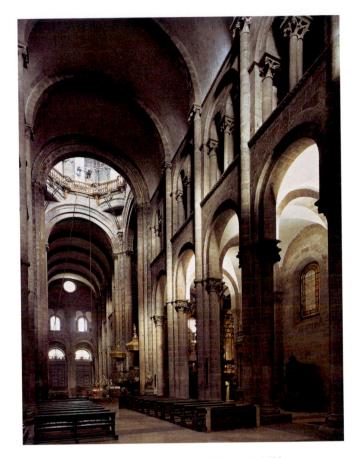

15-5 TRANSEPT, CATHEDRAL OF SAINT JAMES, SANTIAGO DE COMPOSTELA
Galicia, Spain. View toward the crossing, 1078-1122.

arches dividing the nave into a series of bays that clarify and define the space became an essential element in Romanesque architecture.

The "Pilgrimage Church"

The growth of a cult of relics and the desire to visit shrines such as Saint Peter's in Rome or Saint James in Spain inspired people to travel on pilgrimages (see "The Pilgrim's Journey," page 480). Christian victories against Muslims also opened roads and encouraged travel. To accommodate the faithful and instruct them in Church doctrine, many monasteries on the major pilgrimage routes built large new churches and filled them with sumptuous altars and reliquaries.

THE CATHEDRAL OF SAINT JAMES IN SANTIAGO DE COMPOSTELA. One major goal of pilgrimage was the Cathedral of Saint James in Santiago de Compostela (FIG. 15–5), which held the body of Saint James, the apostle to the Iberian Peninsula. Builders of the Cathedral of St. James and other major churches along the roads leading through France to the shrine developed a distinctive church plan designed to accommodate the crowds of pilgrims and give them easy access to the relics (see "Relics and Reliquaries," page 484).

Art and Its Context

THE PILGRIM'S JOURNEY

estern Europe in the eleventh and twelfth centuries saw an explosive growth in the popularity of religious pilgrimages. The rough roads that led to the most popular destinations—the tomb of Saint Peter and the Constantinian churches of Rome, the Church of the Holy Sepulchre in Jerusalem, and the Cathedral of Saint James in Santiago de Compostela in the northwest corner of Spain—were often

Durham ENGLAND **Bury St** Hildesheim. **LCanterbury** Helmarshausen NORMANDY Cologne FRANCE Bingen • Caen Bayeux Danube St. Denis Paris Vézelay Fontenay St. Savin Autun •Cluny ø Poitiers HOLY Conques -- Le Puy ROMAN **EMPIRE** Santiago de Compostela Roncesvalle Moissac St. Gilles du-Gard Puente-la-Reina Toulouse Burgos León Tahull • Silos CORSICA Rome SPAIN SARDINIA Monreale Palermo **AFRICA**

crowded with pilgrims. Their journeys could last a year or more; church officials going to Compostela were given sixteen weeks' leave of absence. Along the way the pilgrims had to contend with bad food and poisoned water, as well as bandits and dishonest innkeepers and merchants.

The stars of the Milky Way, it was said, marked the road to Santiago de Compostela (SEE FIGS. 15-5, 15-6). Still, a guide-

book helped, and in the twelfth century the priest Aymery Picaud wrote one for pilgrims on their way to the great shrine through what is now France. Like travel guides today, Picaud's book provided advice on local customs, comments on food and the safety of drinking water, and a list of useful words in the Basque language. In Picaud's time, four main pilgrimage routes crossed France, merging into a single road in Spain at Puente la Reina and leading on from there through Burgos and León to Compostela. Conveniently spaced monasteries and churches offered food and lodging. Roads and bridges were maintained by a guild of bridge builders and guarded by the Knights of Santiago.

Picaud described the best-traveled routes and most important shrines to visit along the way. Chartres, for example, housed the tunic that the Virgin was said to have worn when she gave birth to Jesus. The monks of Vézelay had the bones of Saint Mary Magdalene, and at Conques, the skull of Sainte Foy was to be found. Churches associated with miraculous cures—Autun, for example, which claimed to house the relics of Lazarus, raised by Jesus from the dead—were filled with the sick and injured praying to be healed.

The great pilgrimage churches in Compostela, Toulouse, Limoges, and Conques became models of functional planning and traffic control. To the aisled nave the builders added aisled transepts with chapels leading to an ambulatory with additional radiating chapels around the apse (FIGS. 15–6, 15–7). This system of continuous aisles and ambulatory allowed worshipers to move around the church, visiting all the chapels and saying their own prayers, without disrupting services at the high altar. An octagonal windowed lantern tower over the crossing flooded the sanctuary with daylight, drawing the people forward to the shrines.

Building usually proceeded from east to west. Individual elements produce a series of simple geometric forms that express the internal arrangements of the church—chapels are attached to aisles and ambulatory; the ambulatory then circles the apse and choir, which in turn lead to the wide transept marked by a tall crossing tower. The nave culminates in western towers, an entrance porch, or a narthex. Each element of the building has a distinct geometric form; added together, they produce the powerful impression and solidity characteristic of Romanesque architecture.

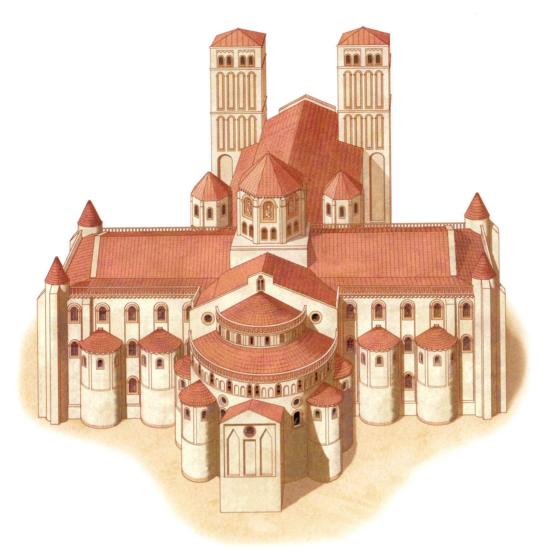

15–6 | RECONSTRUCTION DRAWING (AFTER CONANT) OF CATHEDRAL OF SAINT JAMES, SANTIAGO DE COMPOSTELA 1078–1122, western portions later.

Pilgrims usually entered the church through the large double doors at the ends of the transepts rather than through the western portal, which served ceremonial processions. Pilgrims from France entered the north transept portal; the approach from the town was through the south portal. They found themselves in a transept in which the design exactly mirrored the nave in size and structure. The nave and transept have two stories—an arcade and a gallery. Compound piers with attached half columns on all four sides support the immense ribbed barrel vault. The vaulted gallery over the aisles buttresses the nave vault for its entire length (FIG. 15-8). Quadrant vaults, each with an arc of one-quarter of a circle, strengthen the building by carrying the outward thrust of the high barrel vault to the outer walls and buttresses. The compound piers and transverse ribs give sculptural form to the interior as they mark off individual vaulted bays in which the sequence is as clear and regular as the ambulatory chapels of the choir. Three different kinds of vaults are used: ribbed

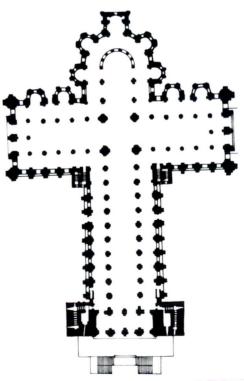

15-7 PLAN OF CATHEDRAL OF SAINT JAMES, SANTIAGO DE COMPOSTELA

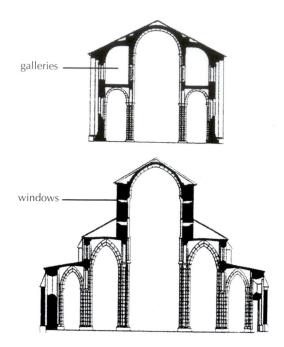

15-8 | cross section of the Cathedral of Saint James, santiago de compostela (drawing after conant)

barrel vaults cover the nave; groin vaults span the side aisles; and half-barrel or quadrant vaults cover the galleries. Without a clerestory, light enters the nave only indirectly, through windows in the outer walls of the aisles and upper-level galleries that overlook the nave.

The building is made of local granite that has weathered to a golden brownish-gray color. In its own time, the cathedral was admired for the excellence of its construction—"not a single crack is to be found," according to the twelfth-century pilgrims' guide—"admirable and beautiful in execution . . . large, spacious, well-lighted, of fitting size, harmonious in width, length, and height . . ."

Pilgrims arrived at Santiago de Compostela weary after weeks of difficult travel through dense woods and mountains. Grateful to Saint James for his protection along the way, they entered a church that welcomed them with open portals. The cathedral had no doors to close—it was open day and night. Its portals displayed didactic sculpture, a notable feature of Romanesque churches. Santiago de Compostela was more than a pilgrimage center; it was a cathedral, the seat of a bishop and later an archbishop and consequently the administrative headquarters of the church in the northwest of the Iberian Peninsula.

The Monastery of Cluny in Burgundy

In 909 the Duke of Burgundy gave land for a monastery to Benedictine monks intent on strict adherence to the original rules of Saint Benedict. They established the reformed congregation of Cluny. From its foundation, Cluny had a special independent status; its abbot answered directly to the pope in Rome rather than to the local bishop or feudal lord. This unique freedom, jealously safeguarded by a series of long-lived and astute abbots, enabled Cluny to keep the profits from extensive gifts of land and treasure. Independent, wealthy, and a center of learning, Cluny and its affiliates became important patrons of the arts.

Cluny was a city unto itself. By the second half of the eleventh century, there were some 200 monks at Cluny and troops of laymen on whom they depended for material support. As we have seen in the Carolingian Saint Gall plan for monasteries (SEE FIG. 14–14), the cloister lay at the center of the community, joining the church with the domestic buildings and workshops (FIG. 15–9). In wealthy monasteries the arcaded galleries of the cloister had elaborate carved capitals as well as relief sculpture on piers (SEE FIG. 15–1). The capitals may even have served as memory devices to direct the monks' thoughts and prayers.

Benedictine monks and nuns observed the eight Hours of the Divine Office (including prayers, scripture readings, psalms, and hymns) and the Mass, which was celebrated after the third hour (terce). Cluny's services were especially elaborate. During the height of its power, the plainsong (or Gregorian chant) filled the church with music twenty-four hours a day. When the monks were not in the choir, they dedicated themselves to study and the cloister crafts, including manuscript production.

The hallmark of Cluny—and Cluniac churches—was their functional design that combined the needs of the monks with the desire of pilgrims to visit shrines and relics, their fine stone masonry with rich sculptured and painted decoration, and their use of elements from Roman and Early Christian art, such as fluted pilasters and Corinthian capitals. Individual Cluniac monasteries were free to follow regional traditions and styles; consequently, Cluny III was widely influential, though not copied exactly.

THE ABBEY CHURCH OF SAINT PETER. The original church, a small barnlike building, was soon replaced by a basilica with two towers and narthex at the west and a choir with tower and chapels at the east. Hugh de Semur, abbot of Cluny for sixty years (1049-1109), began rebuilding for the third time at Cluny in 1088 (FIG. 15-10). Money paid in tribute by Muslims to victorious Christians in Spain financed the building. When King Alfonso VI of León and Castile captured Toledo in 1085, he sent 10,000 pieces of gold to Cluny. The church (known to art historians as Cluny III because it was the third building at the site) was the largest church in Europe when it was completed in 1130. Huge in size—550 feet long-with five aisles like Constantine's churches in Rome, built with superb masonry, and richly carved, painted, and furnished, Cluny III was a worthy home for the relics of Saint Peter and Saint Paul, which the monks acquired from Saint Paul's Outside the Walls in Rome.

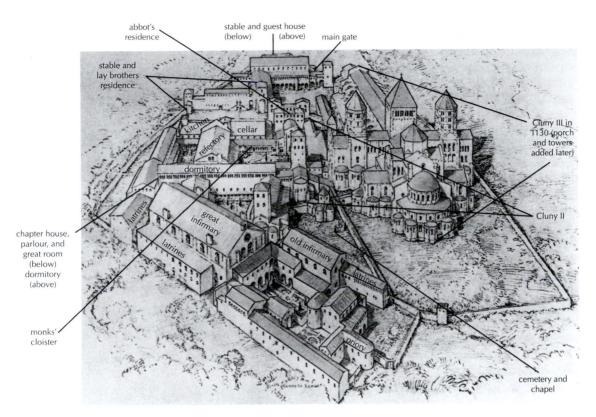

15−9 | **RECONSTRUCTION DRAWING OF THE ABBEY AT CLUNY** Burgundy, France. 1088–1130. View from the east.

The monastery of Cluny expanded to accommodate its increasing responsibilities and number of monks. In this reconstruction, Cluny III, the abbey church (on the right), dominates the complex. Other buildings are loosely organized around cloisters and courtyards. The cloisters link buildings and provide private space for the monks; the two principal cloisters—for choir monks and for novices—lie to the south of the church.

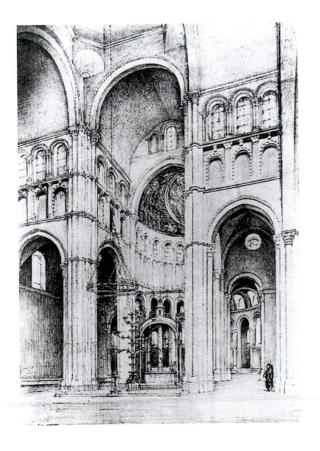

In simple terms, the church was a basilica with five aisles, double transepts with chapels, and an ambulatory and radiating chapels around the high altar. The large number of altars was required by the monks who celebrated Mass daily. Octagonal towers over the two crossings and additional towers over the transept arms created a dramatic pyramidal design at the east end. Pope Urban II, while in Burgundy in 1095 to preach the First Crusade, consecrated the high altar.

The nave of Cluny III had a three-part elevation like Saint Peter's in Rome. In the nave arcade tall compound piers with pilasters and engaged columns supported pointed arches. At the next level a blind arcade and pilasters created a triforium that resembled a classical Roman triumphal arch, and finally triple clerestory windows let sunlight directly into the church. A ribbed vault, which rose to the daring height of 98 feet with a span of about 40 feet, was made possible by giving the vaults a steep profile (rather than being round as at Santiago de Compostela) and slightly decreasing the width of the nave at the top of the wall.

15-10 The church choir from the transept at cluny (drawing after conant)

Art and Its Context

RELICS AND RELIQUARIES

hristians turned to the heroes of the Church, the martyrs who had died for their faith, to answer their prayers and to intercede with Christ on their behalf at the Last Judgment. In the Byzantine church people venerated icons, that is, pictures of the saints, but Western Christians wanted to be close to the actual earthly remains of the saints. Scholars in the church assured the people that the veneration of icons or relics was not idol worship. Bodies of saints, parts of bodies, things associated with the Holy Family or the saints were kept in richly decorated containers called reliquaries. Reliquaries could be simple boxes, but they might also be given the shape of the relic—the head of Saint John the Baptist, the rib of Saint Peter, the sandal of Saint Andrew.

Churches were built in cemeteries, over and around the martyrs' tombs. By the eleventh century, many different arrangements of crypts, chapels, and passageways gave people access to the relics. When the Church decided that every altar required a relic, the saints' bodies and possessions were subdivided. Ingenious churchmen came up with the idea of the *brandea*, a strip of linen that took on the powers of the relic by touching it. In this way relics were multiplied; for example, hundreds of churches held relics of the true cross.

Owning and displaying these relics so enhanced the prestige and wealth of a community that people went to great lengths to acquire relics, not only by purchase but also by theft. In the ninth century, for example, the monks of Conques stole the relics of the child martyr Sainte Foy (Saint Faith) from her shrine at Agent. Such a theft was called "holy robbery," for the new owners insisted that the saint had encouraged them because she wanted to move. In the late ninth or tenth century the monks of Conques encased their relic—the skull of Sainte Foy—in a jewel-bedecked and gilt statue whose head was made from a Roman statue. Over the centuries, added jewels, cameos, and other gifts from pilgrims enhanced the splendor of the statue.

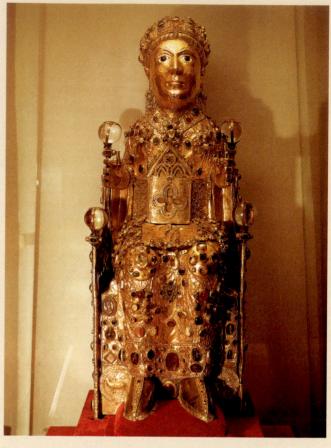

RELIQUARY STATUE OF SAINTE FOY (SAINT FAITH)
Abbey Church of Conques, Conques, France. Late 9th or 10th century with later additions. Silver gilt over a wood core, with added gems and cameos of various dates. Height 33" (85 cm). Church Treasury, Conques, France.

The Church was consecrated in 1130, but building continued at Cluny. A narthex, added at the west end of the nave, was finished at the end of the twelfth century in early Gothic style. The monastery suffered during the French Revolution, and the church was sold and used as a stone quarry. Today the site is an archeological park.

The Cistercians

New religious orders devoted to an austere spirituality arose in the late eleventh and early twelfth centuries. Among these were the Cistercians, who spurned Cluny's elaborate liturgical practices and emphasis on the arts. The Cistercian reform began in 1098 with the founding of the Abbey of Cîteaux (*Cistercium* in Latin, hence the order's

name). Led in the twelfth century by the commanding figure of Abbot Bernard of Clairvaux, the Cistercians advocated strict mental and physical discipline and a life devoted to prayer and intellectual pursuits combined with shared manual labor, although like the Cluniacs, they depended on the work of laypersons. To provide for their minimal physical needs, the Cistercians settled and reclaimed swamps and forests in the wilderness, where they then farmed and raised sheep. In time, their monasteries could be found from Russia to Ireland.

THE ABBEY AND CHURCH OF NOTRE-DAME AT FONTENAY. Cistercian architecture reflects the ideals of the order—simplicity and austerity—in their building. Always practical, the

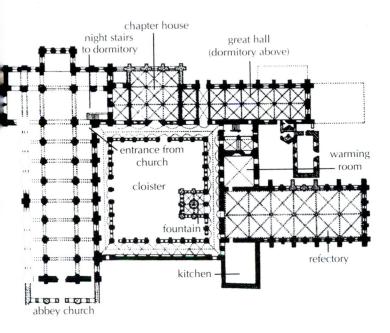

15–11 | PLAN OF THE ABBEY OF NOTRE-DAME, FONTENAY Burgundy, France. 1139–47.

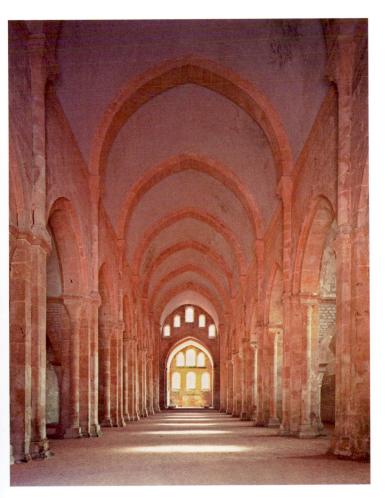

15–12 NAVE, ABBEY CHURCH OF NOTRE-DAME, FONTENAY = 1139-47.

Cistercians made a significant change to the already very efficient monastery plan. They placed key buildings such as the refectory at right angles to the cloister walk so that the building could easily be extended should the community grow. The cloister fountain was relocated from the center of the cloister to the side, conveniently in front of the refectory. The monks entered the church from the cloister into the south transept or from the dormitory by way of the "night stairs."

The Cistercians dedicated all their churches to Mary, to Notre Dame ("Our Lady"). The Abbey Church of Notre-Dame at Fontenay was begun in 1139. It has a simple geometric plan (FIG. 15–11): a long nave with rectangular chapels off the square-ended transept arms and a shallow choir with a straight east wall.

A feature of Fontenay often found in Cistercian architecture is the use of pointed ribbed barrel vaults over the nave and pointed arches in the nave arcade and side-aisle bays (FIG. 15–12). The pointed arch and vault may have derived from Islamic architecture. Pointed arches are structurally more stable than round ones, directing more weight down into the floor instead of outward to the walls. Consequently, they can span greater distances at greater heights without collapsing. Pointed arches have a special aesthetic effect, for they narrow the eye's focus and draw the eye upward, an effect intended to direct thoughts toward heaven.

The Cistercians relied on harmonious proportions and fine stonework, not elaborately carved and painted decoration, to achieve beauty in their architecture. Church furnishings included little else than altars with crosses and candles. The large windows in the end wall, rather than a clerestory, provided light. The sets of triple windows reminded the monks of the Trinity. Situated far from the distractions of the secular world, the building made few concessions to the popular taste for architectural adornment, either outside or inside. In other ways, however, Fontenay and other Cistercian monasteries fully reflect the architectural developments of their time in their masonry, vaulting, and proportions.

This simple architecture spread from the Cistercian homeland in Burgundy to become an international style. From Scotland and Germany to Spain and Italy, Cistercian designs and building techniques varied only slightly. The masonry vaults and harmonious proportions influenced the development of the Gothic style in the years leading to the twelfth century (Chapter 16).

Regional Styles in Romanesque Architecture

The Cathedral of Santiago de Compostela and the Abbey church at Cluny reflect the international aspirations of the pope and the impact of the Crusades and pilgrimages, but Europe remained a land divided by competing kingdoms, regions, and factions. Romanesque architecture reflects this regionalism in the wide variety of its styles and building techniques, only a few of which will be noted here.

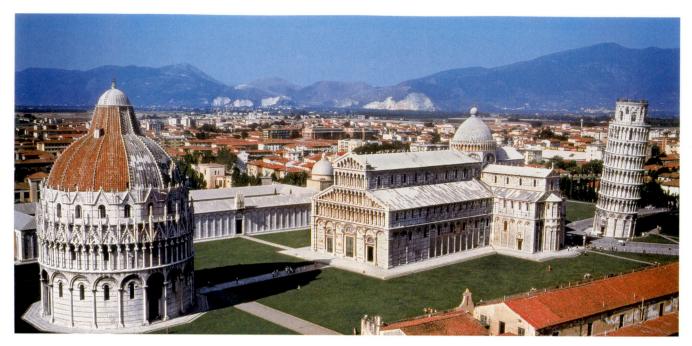

15-13 CATHEDRAL COMPLEX, PISA

Tuscany, Italy. Cathedral, begun 1063; Baptistry, begun 1153; Campanile, begun 1174; Campo Santo, 13th century.

When finished in 1350, the Leaning Tower of Pisa stood 179 feet high. The campanile had begun to tilt while still under construction, and today it leans about 13 feet off the perpendicular. In the latest effort to keep it from toppling, engineers filled the base with tons of lead.

EARLY CHRISTIAN INSPIRATION IN PISA. Throughout Italy artists looked to the still-standing remains of imperial Rome. The influence remained especially strong in Pisa, on the west coast of Tuscany. Pisa became a maritime power, competing with Barcelona and Genoa as well as the Muslims for control of trade in the western Mediterranean. In 1063, after a decisive victory over the Muslims, the jubilant Pisans began an imposing new cathedral dedicated to the Virgin Mary (FIG. 15-13). The cathedral complex eventually included the cathedral building itself, a campanile (a freestanding bell tower-now known for obvious reasons as "the Leaning Tower of Pisa"), a baptistry, and the later Gothic Campo Santo, a walled burial ground. The cathedral was designed by the master builder Busketos, who adopted the plan of a cruciform basilica. A long nave with double side aisles (the fiveaisle building always pays homage to Rome) is crossed by projecting transepts, designed like basilicas with aisles and apses. The builders added galleries above the side aisles, and a dome covers the crossing.

Unlike Early Christian basilicas, the exteriors of Tuscan churches were richly decorated with marble—either panels of green and white marble or with arcades. At Pisa, pilasters, blind arcades, and narrow galleries in white marble adorn the five-story façade. A trophy captured from the Muslims, a bronze griffin, stood atop the building until 1828 (SEE FIG. 8–19).

Other buildings in the complex soon followed the cathedral. The baptistry, begun in 1153, has arcading and galleries on the lower levels of its exterior that match those on the

cathedral (the baptistry's present exterior dome and ornate upper levels were built later). The campanile (bell tower) was begun in 1174 by the Master Bonanno. Built on inadequate foundations, it began to lean almost immediately. The cylindrical tower is encased in tier upon tier of marble columns. This creative reuse of the ancient, classical theme of the colonnade, turning it into a decorative arcade, is characteristic of Tuscan Romanesque art; artists and architects in Italy seem always to have been conscious of their Roman past.

MONTE CASSINO AND ROME; THE CHURCH OF SAN CLEMENTE, ROME.

From 1058 to 1086 Abbot Desiderius ruled Monte Cassino, the mother house of the Benedictine order. At the end of his life he was elected pope, taking the name Victor III. He rebuilt the abbey church at Saint Benedict's monastery of Monte Cassino using Saint Peter's basilica in Rome as his model—with important modifications. Since a monastic church did not have to accommodate crowds of pilgrims, single aisles and a short transept provided sufficient space. A chapel off the transept, facing each aisle, produced a distinctive stepped, triple-apse plan. The eastern portion of the church was raised above the level of the nave to accommodate an open, partially underground crypt. The church, consecrated in 1071, set the pattern for Benedictine churches thereafter.

In the late eleventh century the Benedictines turned to Desiderius's church for technical assistance and inspiration to rebuild the Church of San Clemente in Rome. The new church, consecrated in 1128, was built on top of the previous

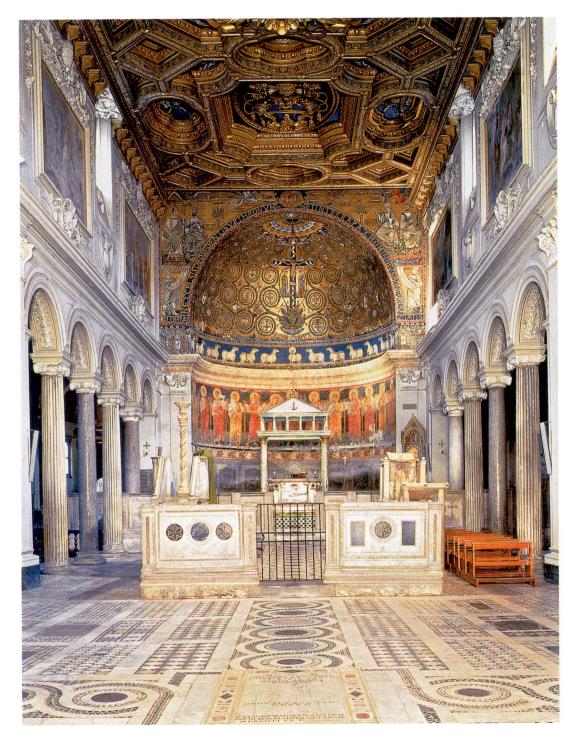

15-14 NAVE, CHURCH OF SAN CLEMENTE, ROME Consecrated 1128.

San Clemente contains one of the finest surviving collections of early church furniture: choir stalls, pulpit, lectern, candlestick, and also the twelfth-century inlaid floor pavement. Ninth-century choir screens were reused from the earlier church on the site. The upper wall and ceiling decoration are eighteenth century.

church (which had been built over a Roman sanctuary of Mithras). Although the architecture and decoration reflect a conscious effort to reclaim the artistic and spiritual legacy of the early church (FIG. 15–14), a number of features mark San Clemente as a twelfth-century building. Early Christian basilicas, for example, have parallel rows of identical columns, which create a strong, regular horizontal movement down

the nave to the sanctuary. In the new church of San Clemente, however, rectangular piers interrupt the line of Ionic columns and divide the nave into bays. (As with the columns of Santa Sabina (SEE FIG. 7–13), the columns in San Clemente are *spolia*; that is, they were taken from ancient Roman buildings.) The church had a timber roof now disguised by an ornate ceiling. The construction of

timber-roofed buildings continued throughout the Middle Ages. Its advantage of being slightly easier and cheaper to build was offset by its vulnerability to fire.

The nave and aisles at San Clemente end in semicircular apses. The central apse was too small to accommodate the increased number of participants in the twelfth-century liturgy. As a result, the choir was extended into the nave and defined by a low barrier made up of ninth-century relief panels saved from the earlier church. In early Christian basilicas, the area in front of the altar had been enclosed by a screen wall (SEE FIG. 7–13, Santa Sabina), and the later builders may have wanted to revive what they considered a glorious early Christian tradition. A **baldachin** (*baldacchino* or *ciborium*), symbolizing the Holy Sepulchre, covers the main altar in the apse.

THE BARREL VAULTED CHURCH OF SAINT-SAVIN-SUR-GARTEMPE. At the Benedictine abbey church in Saint-Savin-sur-Gartempe in western France, a tunnel-like barrel vault runs the length of the nave and choir (FIG. 15–15). Supported directly by tall columns and consequently without galleries or clerestory windows, the nave at Saint Savin approaches the form of a "hall church," where the nave and aisles rise to an equal height. At Saint Savin the vault is unbroken. The continuous vault is ideally suited for paintings (see page 502, FIG. 15–31).

More often in Romanesque churches, transverse arches divide the space into bays, as at the Cathedral of Santigo de Compostela (SEE FIG. 15–5). These transverse arches provide little extra support for the vault once it is in place, but they allow the vault to be constructed in segments. They also enhance the rhythmic and "additive" aesthetic quality of the building.

FOUR-PART RIBBED VAULTS AT SANT'AMBROGIO, MILAN.

About 1080, at the height of the struggles between the pope and the emperor, construction began in the city of Milan in Lombardy on a new Church of Sant'Ambrogio. The church had been founded by the city's first bishop, Saint Ambrose (d. 397), one of the Fathers of the Christian Church. This new church replaced a ninth-century building. Then, following an earthquake in 1117, masons had to rebuild the church again. This time they used a technically advanced system of fourpart rib vaulting (FIG. 15–16). With a nave wider than that of Cluny III, but, at 60 feet, only a little more than half as high, the vault presented a challenge.

Massive compound piers support three huge ribbed groin vaults over the square bays of the nave. The Romans had used groin vaults, and the Romanesque Lombard builders added diagonal and transverse ribs that had supported scaffolds during construction and now also helped to stabilize the vault. Smaller intermediate piers support the small groin vaults over the side-aisle bays, and vaulted galleries buttress the walls and vaults. Since the builders used round arches throughout the construction, in each bay the diagonal ribs had a greater diameter and therefore greater

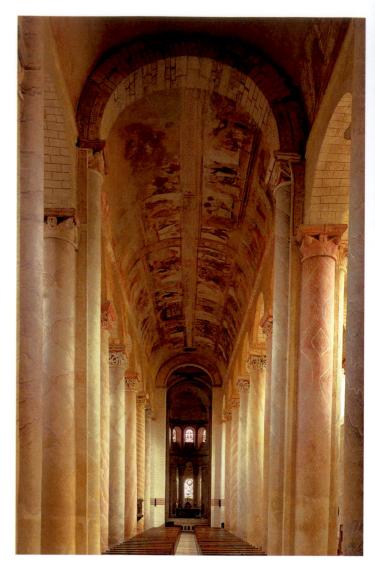

I5−I5 CHURCH OF SAINT-SAVIN-SUR-GARTEMPE, POITOU

France. Choir c.1060-75; nave c. 1095-1115.

height than the transverse and lateral ribs, and each bay rises up into a domical form, emphatically defining each bay. The builders did not risk weakening the structure with window openings, so there is no clerestory. The dimly lit nave makes the light streaming down in front of the altar from the lantern tower all the more dramatic.

THE IMPERIAL CATHEDRAL OF SPEYER. Ties between northern Italy and Germany established by the Carolingian and Ottonian rulers remained strong, and the architecture of Switzerland, southern Germany, and especially the Rhine Valley is closely related to that of Lombardy. The Imperial Cathedral at Speyer in the Rhine River valley was a colossal structure rivalled only by Cluny III. The Ottonian woodenroofed church built between 1030 and 1060 was given a masonry vault c. 1080–1106 (FIG. 15–17). Massive compound piers mark each nave bay and support the transverse ribs of a vault that rises to a height of over 100 feet. These

compound piers alternate with smaller piers that support the vaults of the aisle bays. This rhythmic pattern of heavy and light elements, first suggested for aesthetic reasons in Ottonian wooden-roofed architecture (SEE FIG. 14–27, Gernrode), became an important design element in Speyer. Since groin vaults concentrate the weight and thrust of the vault on the four corners of the bay, they relieve the stress on the side walls of the building. Windows can be safely inserted in each bay (something the builders of Sant' Ambrogio dared not do). The result is a building flooded with light.

The exterior of Speyer Cathedral emphasizes its Ottonian (and even Carolingian) qualities. Soaring towers and wide transepts mark both ends of the building, although a narthex, not an apse, stands at the west. Like the arrangement of the east end first seen at Saint Riquier (SEE FIG. 14–13), a large apse housing the high altar abuts the flat wall of the choir; transept arms project at each side; a large octagonal tower rises over the crossing; and a pair of tall slender towers flanks the choir (FIG. 15–18). A horizontal arcade forms an exterior gallery at the top of the apse and transept wall. Stepped niches follow the line of the choir roof, and arched corbel

Sequencing Events Memorable Abbots and Popes

ruled 1049–1109	Hugh de Semur, Abbot of Cluny, began the Great Church of Cluny III (1088)
ruled 1058-86	Desiderius (Benedictine), Abbot of Monte Cassino, elected Pope Victor III (ruled 1086-87)
ruled 1073–85	Pope Gregory VII (Cluniac) asserted papal authority over political rulers; under his given name of Hildebrand, one of the great papal administrators (1048–1073)
ruled 1088-99	Pope Urban II (Cluniac) preached the First Crusade (1095)
ruled 1115–53	Saint Bernard (Cistercian), Abbot of Clairvaux abbey; writer and preacher; called for Second Crusade (1147)

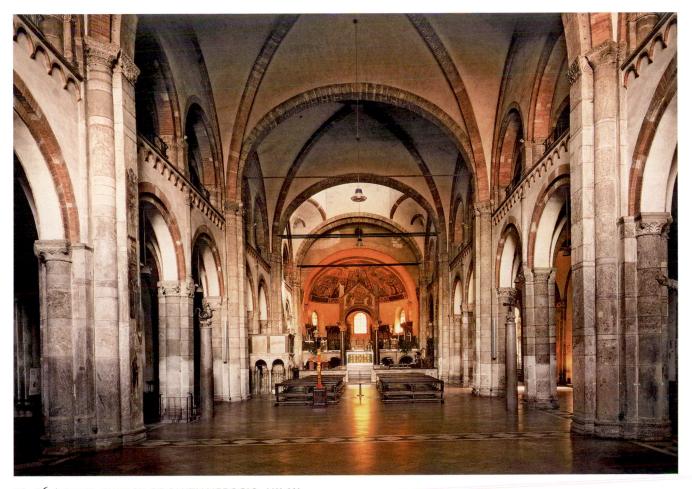

15−16 | NAVE, CHURCH OF SANT'AMBROGIO, MILAN Lombardy, Italy. Begun 1080; vaulted after an earthquake in 1117.

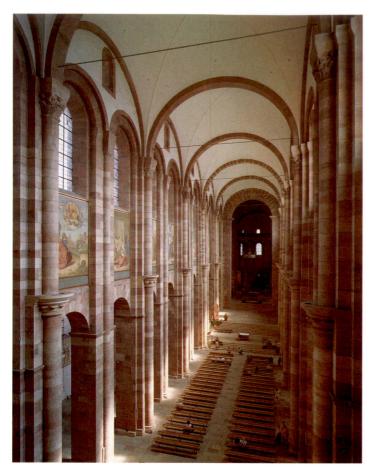

15–17 | INTERIOR, SPEYER CATHEDRAL Speyer, Germany. As remodeled c. 1080–1106.

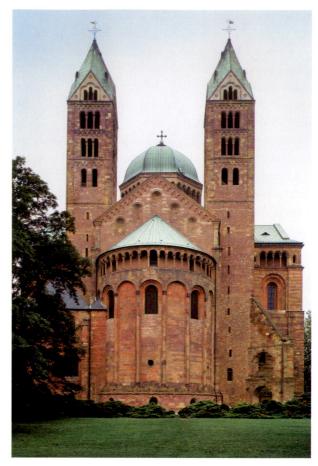

15–18 | EXTERIOR, SPEYER CATHEDRAL c. 1080–1106 and second half of the 12th century.

tables also define the roof line and the stages of the towers. This decorative scheme has been adapted from the Lombard-Catalan builders. (The startling green copper roofs seen in the photograph are modern.)

EXPERIMENTAL VAULTS IN DURHAM. In Durham, a military outpost near the Scottish border, builders were experimenting with masonry vaults. When the British turned from timber architecture to stone and brick, they associated masonry buildings—whether church, feasting hall, or castle—with the power and glory of ancient Rome and to some extent with Charlemagne and the Continental powers. As a practical matter, they also appreciated the greater strength and resistance to fire of masonry walls, although they often continued to use wooden roofs.

In Durham, one man, a count-bishop, had both secular and religious authority. For his headquarters he chose a natural defensive site where the oxbow of the River Wear formed a natural moat. Durham grew into a powerful fortified complex including a castle, a monastery, and a cathedral. The great tower of the castle defended against attack from the land, and an open space between buildings served as the bailey of the castle and the cathedral green.

Durham Cathedral, begun in 1087 and vaulted beginning in 1093, is an impressive Norman church, but like most buildings that have been in continuous use, it has been altered several times (FIG. 15–19). The nave retains its Norman character, but the huge circular window lighting the choir is a later Gothic addition. The cathedral's size and decor are ambitious. Enormous compound piers alternating with robust columns form the nave arcade. The alternating circular and clustered piers establish the typical alternating rhythm. The columns are carved with chevrons, spiral fluting, and diamond patterns, and some have scalloped, cushion-shaped capitals. The arcades have multiple round moldings and chevron ornaments. All this carved ornamentation was originally painted.

Above the cathedral's massive piers and walls rise a new system of ribbed vaults and buttresses. Masons in Santiago de Compostela, Cluny, Milan, Speyer, and Durham were all experimenting with vaults—and reaching different conclusions. Unlike the masons at Sant' Ambrogio, the designers in Durham wanted a unified, well-lit space. In the vault, the Durham builders divided each bay with two pairs of diagonal crisscrossing ribs and so kept the crowns of the vaults close in height to the keystones of the transverse arches (FIG. 15–20).

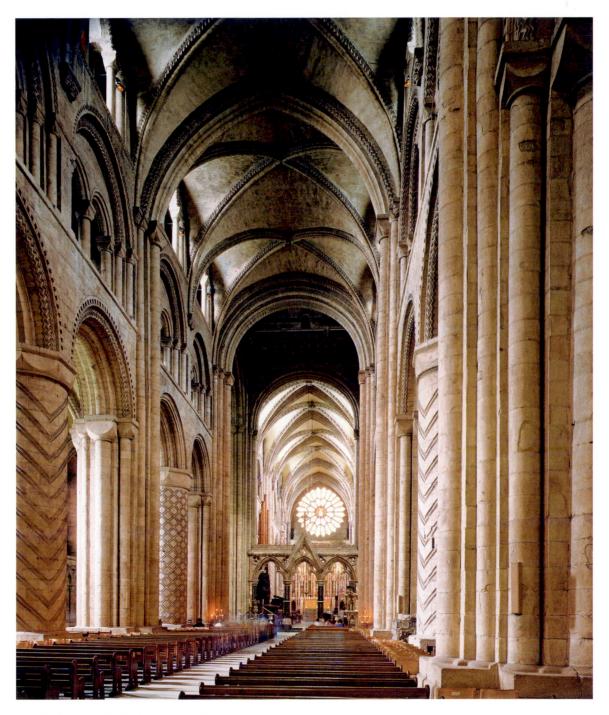

15–19 NAVE, DURHAM CATHEDRAL England. 1087–1133. Original east end replaced by a Gothic choir, 1242–c. 1280. Vault height about 73′ (22.2 m).

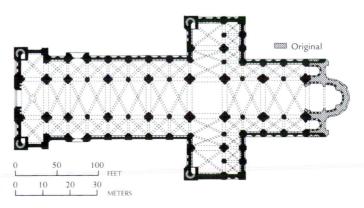

15–20 PLAN OF DURHAM CATHEDRAL Showing original east end.

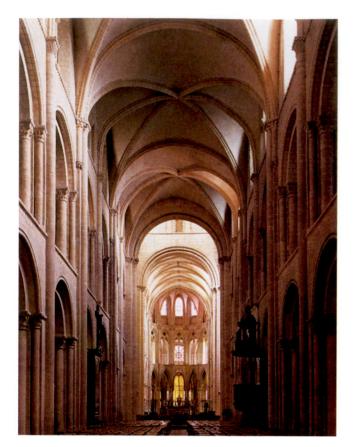

15–21 ∣ **NAVE, CHURCH OF SAINT-ÉTIENNE, CAEN** Normandy, France c. 1060–77; vaulted c. 1130.

The eye runs smoothly down the length of the vault. In the transept, the builders divided the square bays in two to produce four-part ribbed vaults over rectangular bays. They also experimented with buttresses that resembled later Gothic systems (see Chapter 16). Although the buttresses were not a success, the germ of the idea was there.

THE CHURCH OF SAINT-ÉTIENNE, CAEN. The Benedictine abbey church of Saint-Étienne (FIG. 15–21) in Caen was originally built as a wooden-roofed basilica nearly a generation before Durham Cathedral. William the Conqueror, while still only Duke of Normandy, had founded the monastery and had begun the construction of its church before 1066. He dedicated the church in 1077 and was buried there in 1087. His wife, Queen Matilda, established an abbey for women and built a church dedicated to the Trinity.

William's original church provides the core of the building we see today (FIG. 15–22). The nave wall has a three-part elevation (nave arcade, gallery, and clerestory) with exceptionally wide arches both in the nave arcade and the gallery. At the clerestory level, an arcade of three small arches on colonettes runs in front of the windows, creating a passageway within the thickness of the wall. On each pier, engaged columns alternate with columns backed by pilasters. They

run unbroken the full height of the nave, emphasizing its height. The walls seem designed for a masonry vault, but in fact supported a timber roof.

Sometime after 1120—perhaps as late as 1130–35—Saint-Étienne's original timber roof was replaced by a masonry vault. The masons joined two bays to form square bays defined by the heavy piers (that is, the piers with the pilaster-backed columns) and by six-part vaults. The six-part vault combines two systems—transverse ribs crossing the space at every pier and ribbed groin vaults springing from the heavy piers. To accommodate the lower masonry vault under the timber roof, the triple arches of the clerestory were reduced to two.

Soaring height was a Norman architectural goal, and the façade towers continue the tradition of church towers begun by Carolingian builders. This preference for verticality is seen in the west façade of Saint-Étienne, which was designed at the end of the eleventh century, probably about 1096–1100 (FIG. 15–23). Wall buttresses divide the façade into three vertical sections corresponding to the nave and side aisles. Narrow stringcourses (unbroken horizontal moldings) at each window level suggest the three stories of the building's nave elevation. This concept of reflecting the plan and elevation of the church in the design of the façade was later adopted by Gothic builders. Norman builders, with their brilliant techni-

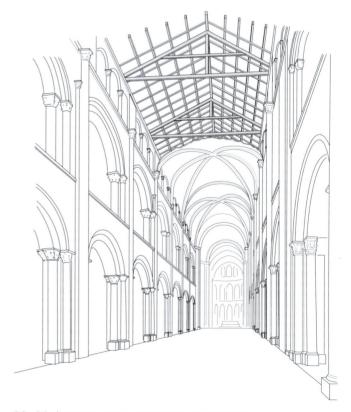

15–22 □ **COMPOSITE DIAGRAM OF CHURCH OF SAINT-ÉTIENNE, CAEN**Showing original 11th-century timber roof and later 12th-century six-part vault inserted under the roof.

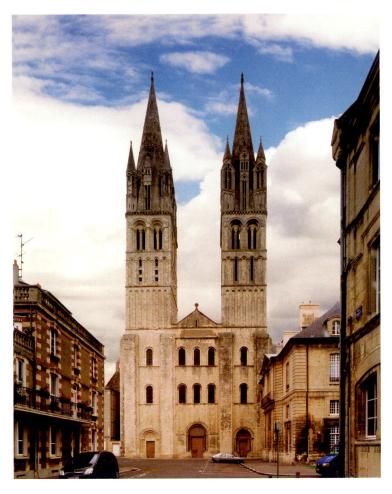

cal innovations and sophisticated designs, prepared the way for the architectural feats accomplished by Gothic architects in the twelfth and thirteenth centuries. The elegant spires topping the tall towers are examples of the Norman Gothic style.

Secular Architecture: Dover Castle, England

The need to provide for personal security in a period of constant local warfare and political upheaval, as well as the desire to glorify the house of the lord and his saints, meant that communities used much of their resources for churches and castles. Fully garrisoned, castles were sometimes as large as cities. In the twelfth century, Dover Castle, safeguarding the coast of England from invasion, was a magnificent demonstration of military power (FIG. 15-24). It illustrates the way in which a key defensive position developed over the centuries. The Romans had built a lighthouse on the point where the English Channel separating England and France narrows. The Anglo-Saxons added a church (both lighthouse and church can be seen behind the tower, surrounded by the remains of earthen walls). In the early Middle Ages, earthworks topped by wooden walls provided a measure of security, and a wooden tower signified an important administrative building and residence. The advantage of fire-resistant walls was obvious, and in the twelfth and thirteenth centuries, military engineers replaced the timber tower and palisades with stone walls. They added the massive stone towers we see today.

The Great Tower, as it was called in the Middle Ages (but later known as a keep in England, and donjon in France), stood in a courtyard (called the bailey) surrounded by additional walls. Ditches outside the walls added to the height of the walls. In some castles, ditches were filled with water to form moats. A gatehouse—perhaps with a drawbridge—controlled the entrance. In all castles the bailey was filled with buildings, the most important of which was the lord's hall, which was used for a court and for feasts and ceremonial occasions. Timber buildings housed troops, servants, and animals. Barns and workshops, ovens and wells were also needed since the castle had to be self-sufficient.

If enemies broke through the outer walls, the castle's defenders retreated to the Great Tower. The landwalls of Constantinople (SEE FIG. 7–24) had demonstrated the value of defense in depth. In the thirteenth century, the builders at Dover doubled the walls and strengthened them with towers, even though the castle's position on cliffs overlooking the sea made scaling the walls nearly impossible. The garrison could be forced to surrender only by starving its occupants.

During Dover Castle's heyday improving agricultural methods and growing prosperity provided the resources for increased building activity in Europe. Churches, castles, halls, houses, barns, and monasteries proliferated. The buildings that still stand—despite the ravages of weather, vandalism, neglect, and war—testify to the technical skills of the builders and the power, local pride, and faith of the patrons.

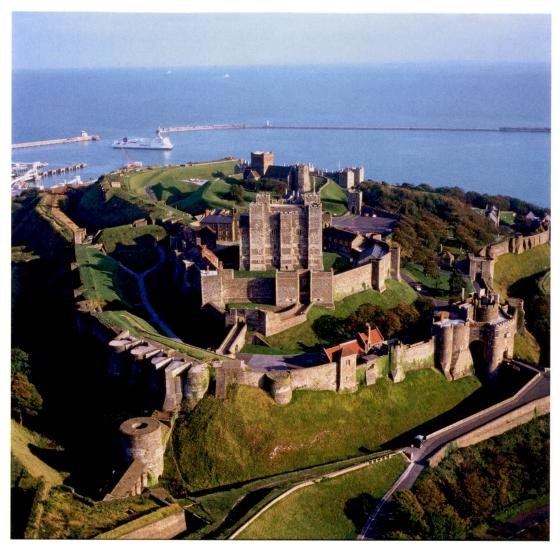

15–24 DOVER CASTLE Dover, England

Air view overlooking the harbor and the English Channel. Center distance: Roman lighthouse tower, rebuilt Anglo-Saxon church, earthworks. Center: Norman Great Tower, surrounding earthworks and wall, twelfth century. Outerwalls, thirteenth century. Modern buildings have red tile roofs. The castle was used in World War II and is now a museum.

THE DECORATION OF BUILDINGS

Like Cluny and unlike the severe churches of the Cistercians, many Romanesque churches have a remarkable variety of painting and sculpture. Christ Enthroned in Majesty in heaven may be carved over the entrance or painted in the half-dome of the apse. Stories of Jesus among the people or images of the lives and the miracles of the saints cover the walls; the art also reflects the increasing importance accorded to the Virgin Mary. Depictions of the prophets, kings, and queens of the Old Testament symbolically foretell people and events in the New Testament, but also represented are contemporary bishops, abbots, other noble patrons, and even

ordinary folk. A profusion of monsters, animals, plants, geometric ornament, allegorical figures such as Lust and Greed, and depictions of real and imagined buildings surround the major works of sculpture. The elect rejoice in heaven with the angels; the damned suffer in hell, tormented by demons; biblical and historical tales come alive, along with scenes of everyday life. All these events seem to take place in a contemporary medieval setting.

Inside the building paintings covered walls, vaults, and even piers and columns with complex imagery that combined biblical narratives and Christian symbolism with legends, folklore, and history.

Architectural Sculpture

Architecture dominated the arts in the Romanesque period—not only because it required the material and human resources of an entire community but because, by providing the physical context for sculpture and painting, it also established the size and shape of images. Sculptured façades and large and richly carved portals with symbolic and didactic images are a significant innovation in Romanesque art.

The most important imagery is usually in the semicircular tympanum directly over the door. Archivolts—curved moldings composed of the wedge-shaped stone voussoirs of the arch—frame the tympanum. On both sides of the doors, the jambs and often a central pier (called the trumeau), which support the lintel and archivolts, may have figures or columns. The jambs form a shallow porch.

WILIGELMUS AT THE CATHEDRAL OF MODENA. The spirit of ancient Rome pervades the sculpture of Romanesque Italy. The sculptor Wiligelmus may have been inspired by ancient sarcophagi still visible in cemeteries when he carved the horizontal reliefs with heavy-set figures across the west façade of Modena Cathedral, c. 1099. Wiligelmus's work is

some of the earliest narrative sculpture in Italy. He took his subjects from Genesis, beginning with the Creation and the Fall of Adam and Eve (FIG. 15–25). On the far left, God, in a mandorla supported by angels, appears in two persons as both the creator and Christ, identified by a cruciform halo. He brings Adam to life, then brings forth Eve from Adam's side. On the right, Adam and Eve cover their genitals in shame as they greedily eat the fruit of the forbidden tree, around which the serpent twists.

Wiligelmus's deft carving gives these low-relief figures a strong three-dimensionality. Adding to their tangibility is Wiligelmus's use of a miniature arcade to establish a stagelike setting. The rocks on which Adam lies, or the fatal tree of Paradise, seem like stage props for the figures. Adam and Eve stand awkwardly, with pot bellies and skinny arms and legs, but they exude a sense of life and personality that gives an emotional depth to the narrative. Bright paint, now almost all lost, increased the impact of the sculpture. An inscription reads: "Among sculptors, your work shines forth, Wiligelmus." This self-confidence turned out to be justified. Wiligelmus's influence can be traced throughout Italy and as far away as the Cathedral of Lincoln in England.

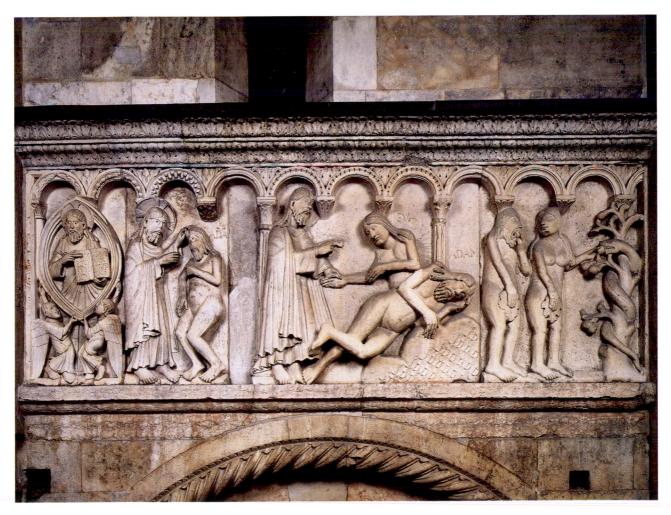

15–25 | Wiligelmus CREATION AND FALL, WEST FAÇADE, MODENA CATHEDRAL Modena, Emilia, Italy. Building begun 1099; sculpture c. 1099. Height approx. 3′ (92 cm).

THE PRIORY CHURCH OF SAINT-PIERRE, MOISSAC. The Cluniac priory of Saint-Pierre at Moissac was a major pilgrimage stop and Cluniac administrative center on the route to Santiago de Compostela. The original shrine at the site was reputed to have existed in the Carolingian period. After joining the congregation of Cluny in 1047, the monastery prospered from the donations of pilgrims and the local nobility, as well as from its control of shipping on the nearby Garonne River. Moissac's monks launched an ambitious building campaign, and much of the sculpture from the cloister (c. 1100) and the church portal and porch (1100-30) has survived. Abbot Ansquetil (ruled 1085-1115) built the cloister and portal, which must have been finished by his death in 1115, and Abbot Roger (c. 1115-31) added a porch with sculpture. The sculpture of the portal represents a genuine departure from earlier works in both the quantity and the quality of the carving.

The image of Christ in Majesty dominates the huge tympanum (FIG. 15-26). The scene combines the description of the Second Coming of Christ in Chapters 4 and 5 of the Book of Revelation with Old Testament prophecies. A

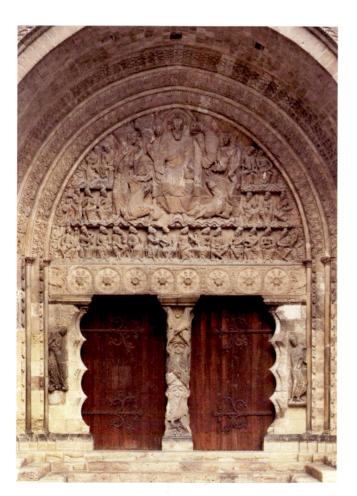

15-26 | SOUTH PORTAL AND PORCH, PRIORY CHURCH OF SAINT-PIERRE, MOISSAC

Tarn-et-Garonne, France. c. 1115.

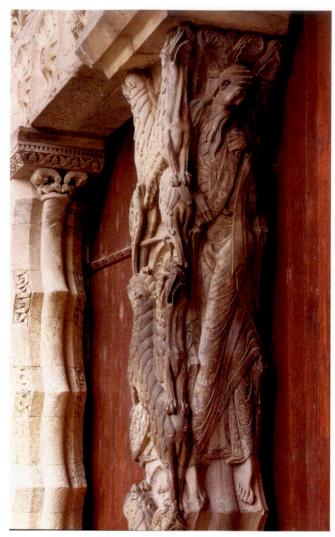

15-27 TRUMEAU, SOUTH PORTAL, PRIORY CHURCH OF SAINT-PIERRE, MOISSAC Tarn-et-Garonne, France. c. 1115.

gigantic Christ, like an awe-inspiring Byzantine Pantokrator, stares down at the viewer as he blesses. He is enclosed by a mandorla, and a cruciform halo rings his head. Four winged creatures symbolizing the evangelists—Matthew the Man (upper left), Mark the Lion (lower left), Luke the Ox (lower right), and John the Eagle (upper right)—frame Christ on either side, each holding a scroll or book representing his Gospel. Two elongated seraphim (angels) stand one on either side of the central group, each holding a scroll. Rippling bands represent the waves of the "sea of glass like crystal" (Revelation 4:6), defining three registers in which twenty-four elders with "gold crowns on their heads" are seated holding either a harp or a gold bowl of incense (Revelation 4:4 and 5:8). According to the medieval view, the elders were the kings and prophets of the Old Testament and, by extension, the ancestors and precursors of Christ.

The figures in the tympanum relief reflect a hierarchy of scale and location. Christ, the largest figure, sits at the top center, the spiritual heart of the scene. The evangelists and angels are smaller, and the elders, farthest from Christ, are roughly one-third his size. Despite this formality and the limitations forced on them by the architecture, the sculptors achieve variety by turning and twisting the gesturing figures, shifting their poses off-center, and avoiding rigid symmetry or mirror images. Foliate and geometric ornament covers every surface. Monstrous heads in the lower corners of the tympanum spew ribbon scrolls, and other creatures appear at each end of the lintel, their tongues growing into ropes encircling acanthus rosettes.

Two side jambs and a central trumeau support the weight of the lintel and tympanum. These elements have scalloped profiles (a motif inspired by Islamic art) that control the design of the sculpture. Saint Peter (holding his attribute, the key to the gates of heaven) and the prophet Isaiah are carved on the jambs. Peter, a tall, thin saint, steps away from the door but twists back to look through it. His shoulder, knees, and

feet reflect the pointed cusps of the scalloped jamb; the vertical folds of his cloak repeat the framing colonettes. The trumeau depicts crisscrossing pairs of lions. A tall, thin figure of Saint Paul is on the left, and an Old Testament prophet, usually identified as Jeremiah, twists toward the viewer, with his legs crossed in the walking pose seen at Silos (FIG. 15-27). The sculptors placed him skillfully within the constraints of the scalloped trumeau; his head, pelvis, knees, and feet fall on the pointed cusps. This decorative scalloping as well as the rosettes, lions, and ribbons reveal a knowledge of Islamic art. Moissac was on the road to Compostella. Furthermore, it was being built shortly after the First Crusade when many Europeans first encountered the Islamic art and architecture of the Holy Land. People from the region around Moissac participated in the Crusade and presumably brought Eastern objects and ideas home with them.

GISLEBERTUS AND THE LAST JUDGMENT AT AUTUN. A different pictorial style is seen in the Last Judgment at Autun on the main portal of the Cathedral of Saint-Lazare (FIG. 15–28).

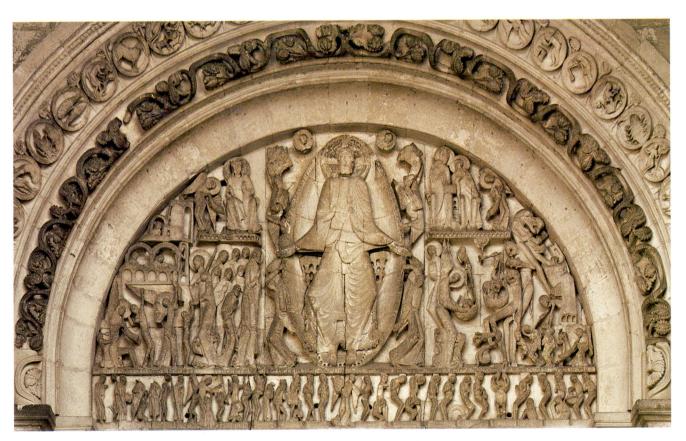

15–28 | Gislebertus LAST JUDGMENT, TYMPANUM ON WEST PORTAL, CATHEDRAL (ORIGINALLY ABBEY CHURCH) OF SAINT-LAZARE, AUTUN Burgundy, France. c. 1120–30 or 1130–45.

I5−29 | CAPITAL: SUICIDE OF JUDAS. CATHEDRAL OF SAINT-LAZARE, AUTUN Burgundy, France. c. 1125.

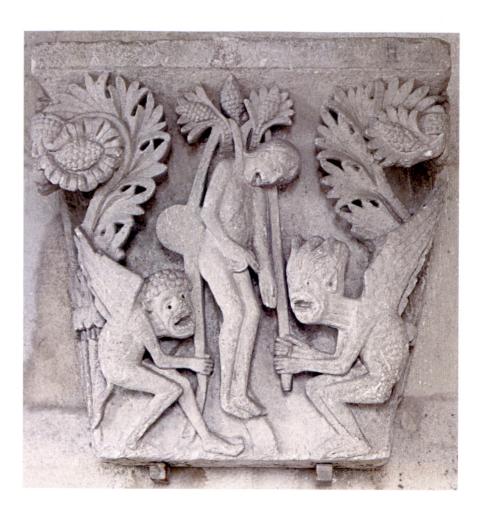

Christ has returned to judge the cowering, naked human souls at his feet. The damned writhe in torment, while the saved enjoy serene bliss. The inscribed message reads: "May this terror frighten those who are bound by worldly error. It will be true just as the horror of these images indicates" (translated by Petzold). A lengthy inscription identifies the Autun tympanum as the work of Gislebertus, who oversaw the sculpture and probably did much of the work himself.

The overall effect of the tympanum is less consciously balanced than the pattern-filled composition at Moissac. Christ dominates the composition, but the surrounding figures are arranged in less regular compartmentalized tiers than seen at Moissac. Thinner and taller, stretched out and bent at sharp angles, the stylized figures are powerfully expressive. They convey the terrifying urgency of the moment as they swarm around the magisterially detached Christ. Delicate weblike engraving on the robes seems inspired by metalwork or manuscript illumination. The scene is filled with human interest. Some angels trumpet the call to the Day of Judgment; others help the souls rise from their tombs and line up to await judgment. In the bottom register, two pilgrims—one to Jerusalem and one to Santiago de Compostela-can be identified by the cross and scallop-shell badges on their satchels. But, ominously, a pair of giant, pincerlike hands scoops up a soul at the far right of the lintel. Above these hands, the archangel Michael competes with devils for souls being weighed on the scale. Michael shelters some souls in the folds of his robe and seems to be jiggling the scales. Another angel boosts a saved soul into heaven, bypassing the gate and Saint Peter. By far the most riveting players in the drama are the grotesquely decomposed, screaming demons grabbing at terrified souls and trying to cheat by pushing down souls and yanking the scales to favor damnation.

HISTORIATED CAPITALS. An important Romanesque contribution to architectural decoration was the ingenious compression of instructive narrative scenes into the geometric confines of column capitals, a feature known as the historiated capital. Gislebertus developed this idea into a series of personalized narratives, such as **THE SUICIDE OF JUDAS** (FIG. 15–29), illustrating the Bible and the lives of the saints.

Corinthian capitals (see Introduction, Fig. 3) from among the ruins of Roman cities inspired the design of Romanesque capitals, on which spiky acanthus leaves and ribbonlike volutes surround an inverted bell shape and support a wide abacus. The Romanesque sculptors such as Gislebertus, however, turned the capital into an educational or symbolic narrative.

Art and Its Context

THE ROLE OF WOMEN IN THE INTELLECTUAL AND SPIRITUAL LIFE OF THE TWELFTH CENTURY

ne would expect women to have a subordinate position in this hierarchical, military society. On the contrary, aristocratic women took responsibility for managing estates in their male relatives' frequent absences during wars or while attending to duties at court. Among peasants and artisans, women and men worked side by side.

Women also achieved positions of authority and influence as the heads of religious communities. Convents of educated women lived under the direction of abbesses such as Hildegard of Bingen and Herrad of Landsberg, abbess of Hohenburg in Alsace. The original illuminated manuscripts containing their writings did not survive the wars of the nineteenth and twentieth centuries, but copies exist.

The Liber Scivias by Hildegard of Bingen (1098-1179) opened with a portrait of the author at work. Born into an aristocratic German family, Hildegard transcended the barriers that limited most medieval women. She began serving as leader of her convent in 1136, and about 1147 she founded a new convent near Bingen. With the assistance of the monk Volmar, she began to record her visions in a book, Scivias (from the Latin scite vias lucis, "know the ways of the light"). The opening page of this copy shows Hildegard receiving a flash of divine insight, represented by the tongues of flame encircling her head. She wrote, "a fiery light, flashing intensely, came from the open vault of heaven and poured through my whole brain." She records her visions on tablets, while Volmar, her scribe, writes to her dictation. Hildegard also wrote on medicine and natural science. A major figure in the intellectual life of her time, she corresponded with emperors, popes, and the Cistercian abbot Bernard of Clairvaux.

Herrad (1130-96), the Abbess of Hohenburg, wrote an encyclopaedia—Hortus Deliciarum (The Garden of Delights)—in which she combined a history of the world from its creation to the Last Judgment with a compendium of all human knowledge, using almost 1200 quotations from scholars as well as sermons

and poems. For example, when she told the story of the Magi following the star to Bethlehem she added a discussion of astronomy and astrology. She also devised a complex scheme of illustrations as part of her educational program. She explained her intentions: "Like a small active bee, I have extracted the sugar of the flowers of divine and philosophical literature. . ." for "my sisters in Jesus." Today, such books guide scholars who try to decode the meaning of medieval artworks.

HILDEGARD AND VOLMAR, LIBER SCIVIAS 1165–75. Facsimile frontispiece.

In the Suicide of Judas from Autun, flat split-leaf acanthus fronds curl up to form volutes and establish the architectural frame. Two demons string up Judas's limp ugly corpse. The strange noose they use has been identified as the bag of money Judas accepted for his betrayal of Christ or as a wrestler's belt, the symbol of useless worldly physical strength. The screaming demons with contorted faces, vicious teeth, and flaming hair embody evil. With scrawny limbs, bloated bodies, and upswept wings they reinforce the shape of the capital. The sculptors achieve a crispness and clarity by slightly undercutting the forms so that the edges are sharpened by shadows. This clarity was important when the capitals had to be seen at a distance.

Mosaics and Murals

Church interiors were not the bare expanses of stone we see today. Throughout Europe colorful murals glowed in flickering candlelight amid clouds of incense. Wall painting was subject to the same influences as the other visual arts; that is, the painters were inspired by illuminated manuscripts, or ivories, or enamels in their treasuries or libraries. Some must have seen examples of Byzantine art; others had Carolingian or even Early Christian models. During the Romanesque period, painted decoration largely replaced mosaics on the walls of churches. This change occurred at least partly because the growing demand by the greater number of churches led to the use of less expensive materials and techniques.

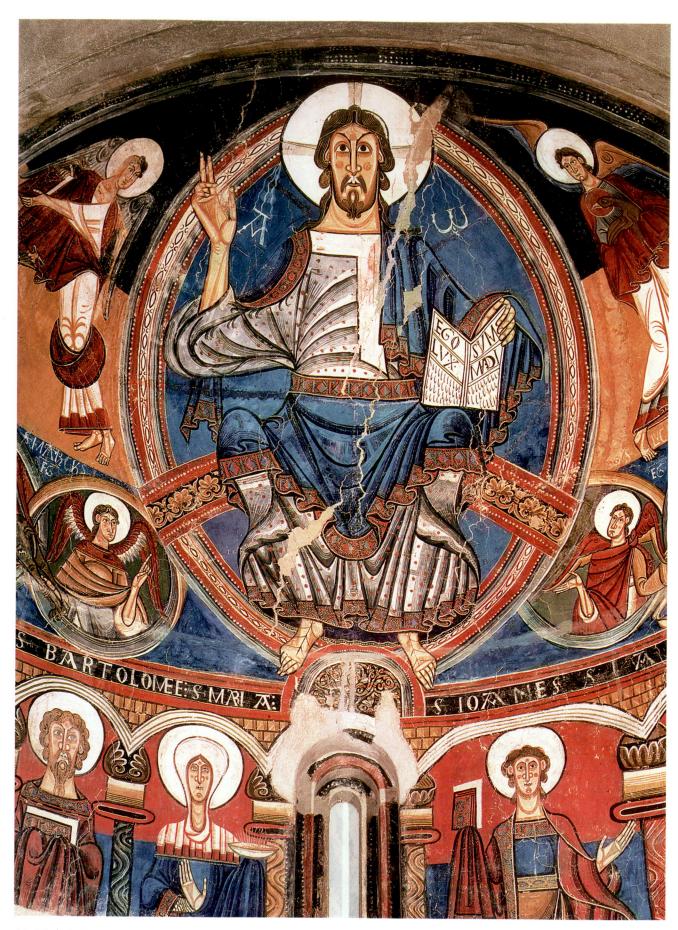

15–30 ∣ **CHRIST IN MAJESTY**Detail of apse, Church of San Climent, Taull, Catalunya, Spain.
1123. Museu Nacional d'Art de Catalunya, Barcelona.

THE MOSAICS OF SAN CLEMENTE, ROME. The apse of San Clemente, richly decorated with colored marbles and a gold mosaic in the semidome, recalls the lost mosaics of the church at Monte Cassino, south of Rome. Abbot Desiderius built a new headquarters Church for the Benedictine Order that he intended should rival the churches of Constantinople. He brought artists from Byzantium to create mosaics and to teach the technique to his most talented monks. In Rome, where Desiderius ruled briefly as Pope Victor III, mosaics were added to a few chapels and churches in spite of the difficulty getting the expensive materials and specialized artists. In the church of San Clemente (SEE FIG. 15-14), the mosaics seem to recapture the past, with the trees and rivers of Paradise, a vine scroll inhabited by figures surrounding the crucified Christ. Mary and Saint John stand below, and twelve doves on the cross and twelve sheep represent the apostles. Stags (symbols of resurrection) drink from streams flowing from the cross, the tree of life in Paradise.

Although the iconography of the mosaic is Early Christian, the style and technique are clearly Romanesque. The artists made no attempt to create an illusion of the natural world. The hard dark outlines and bright flat colors turn the figures into ornamental patterns typical of the twelfth century. The doves on the cross, the repeated circular vine scrolls ending in bunches of leaves and flowers, even the animals, birds, and humans among the leaves are reduced to elements in a formal design. When compared with Early Christian and Byzantine mosaics (see Chapter 7), the mosaic seems evidence of a decline in standards of craftsmanship. However, the irregular setting of tesserai in visibly rough plaster is intentional and actually heightens the color and increases the glitter of the gold. Light reflects off the irregular surface of the apse, causing the mosaic to sparkle.

These rich surfaces continue through the choir and across the pavement in San Clemente. As in other Italian churches of the period, inlaid geometric patterns in marble embellish the floors in an ornamental style known as Cosmati work, after the family who perfected the technique.

MURALS IN TAULL (TAHULL), CATALUNYA, SPAIN. Artists in Catalunya brilliantly combined the Byzantine style with their own Mozarabic and classical heritage. In the Church of San Climent in Taull (Tahull), consecrated in 1123, a magnificently expressive CHRIST IN MAJESTY fills the curve of the half-dome of the apse (FIG. 15–30). Christ's powerful presence recalls the Byzantine depiction of Christ Pantokrator, ruler and judge of the world. The iconography is traditional: Christ sits within a mandorla; the Greek letters alpha and omega hang from strings beside his head. He holds the open Gospel inscribed "Ego sum lux mundi" ("I am the light of the world," John 8:12). Four lively angels, each grasping an evangelist's symbol, appear beside him. In the arcade at Christ's feet are six apostles and the Virgin Mary.

The columns with stylized capitals have wavy lines of paint indicating marble shafts.

The San Climent artist was one of the finest Spanish painters of the Romanesque period, but where he came from and where he learned his art is unknown. His use of elongated oval faces, large staring eyes, and long noses, as well as the placement of figures against flat bands of color and his use of heavy outlines, reflect the Mozarabic style (Chapter 14). At the same time his work shows the prevailing influence of Byzantine art, although he simplified the style. His painting technique-modeling from light to dark—is Byzantine, accomplished through repeated colored lines of varying width in three shades—dark, medium, and light. But instead of blending the colors, he delights in the striped effect. Details of faces, hair, hands, and muscles also become elegant patterns. The intensity of the colors was created by building up many thin coats of paint, a technique called glazing.

MURALS IN THE CHURCH OF SAINT-SAVIN-SUR-GARTEMPE, FRANCE. The paintings in the Church of Saint-Savin (SEE FIG. 15–15) have survived almost intact. The nave vault has scenes from the Old and New Testaments, and the lives of two local saints, Savin and Cyprian, provide imagery for the crypt. The narthex was also painted, as were the columns.

The nave was built c. 1095–1115, and the painters seem to have followed the masons immediately in order to use the same scaffolding. Perhaps this intimate involvement with the building process accounts for the vividness with which they portrayed the biblical story of the **TOWER OF BABEL** (FIG. 15–31).

According to the account in Genesis (11:1-9), God punished the prideful people who tried to build a tower to heaven by scattering them and making their languages mutually unintelligible. The tower in the painting is a medieval structure, reflecting the practice of depicting distant or legendary events in contemporary settings. Workers haul heavy stone blocks to the tower, lifting them to masons on the top with a hoist. The giant Nimrod, on the far right, simply hands over the blocks. The paintings recall the energy and narrative drama of early medieval art. God confronts the people. He steps away from them even as he turns back to chastise them. The scene's dramatic action, large figures, strong outlines, broad areas of color, and simplified modeling all help make it intelligible to a viewer looking up at it in the dim light from far below. The painters did not use the wet-plaster fresco technique favored in Italy for its long-lasting colors, but they did moisten the walls before painting, which allowed some absorption of pigments into the plaster, making them more permanent than paint applied to a dry surface. Several artists, or teams of artists, worked on the church.

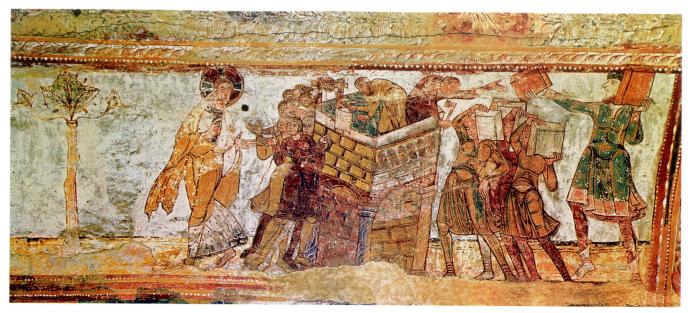

I5-3I | TOWER OF BABEL

Detail of painting in nave vault, Abbey Church of Saint-Savin-sur-Gartempe, Poitou, France. c. 1115.

THE CLOISTER CRAFTS

Monastic *scriptoria* and other workshops continued to dominate the production of works of art, although more and more secular artists could be found producing high-quality pieces in the towns and in workshops attached to courts. The cloister crafts include a wide range of media from illuminated manuscripts to goldsmithing, ivory carving, and embroidery; and the designation "cloister crafts" replaces the term "decorative arts," which suggests less important work. In the Middle Ages small precious objects, as well as works in readily available material like wood, often carried profound meaning. Neither the *Mayestat Batlló* nor the *Mary as the Throne of Wisdom* can be categorized as "decorative."

Portable Sculpture

Painted wood was commonly used when abbey and local parish churches of limited means commissioned statues. Wood was not only cheap, it was lightweight, a consideration since these devotional images were frequently carried in processions.

15-32 | CRUCIFIX (MAJESTAT BATLLÓ)

Catalunya, Spain. Mid-12th century. Polychromed wood, height approx. 37 ¾" (96 cm). Museu Nacional d'Art de Catalunya, Barcelona.

The cross was hung near the entrance or the altar and might be carried in processions.

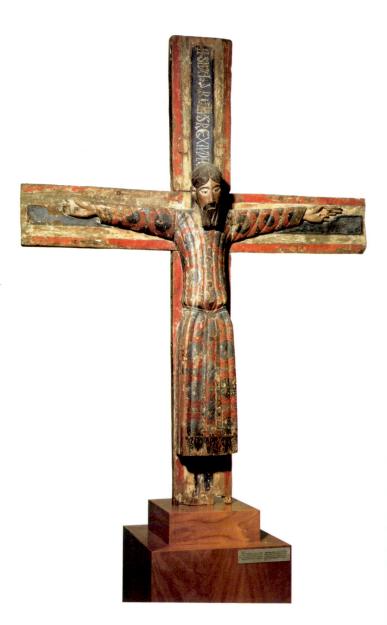

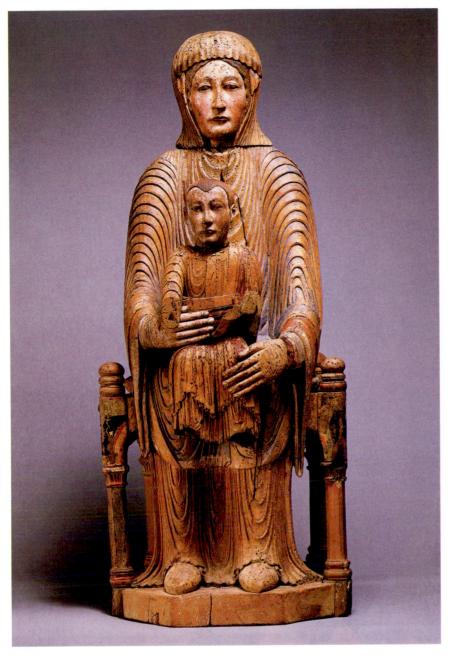

15–33 | VIRGIN AND CHILD
Auvergne region, France. Late 12th century.
Oak with polychromy, height 31"
(78.7 cm).
The Metropolitan Museum of Art,
New York.
Gift of J. Pierpont Morgan, 1916 (16.32.194)

CHRIST ON THE CROSS (MAJESTAT BATLLÓ). Sculptors—image makers—found sources and inspiration in Byzantine art. The image of Jesus in a mid—twelfth-century crucifix from Catalunya, known as the MAJESTAT BATLLÓ (FIG. 15–32), recalls the Volto Santo (Holy Face) of Lucca, thought to have been brought from Palestine to Italy in the eighth century. Legend had it that the sculpture had been carved by Nicodemus, who helped Joseph of Arimathea remove the body of Christ from the cross.

The Byzantine robed Christ, rather than the nude, tortured Jesus of Byzantine Daphni (SEE FIG. 7–43) or the Ottonian Gero Crucifix (SEE FIG. 14–29), inspired the Catalan sculptor. Christ wears royal robes that emphasize his kingship (SEE THE *Rabbula Gospels*, FIG. 7–36), although Jesus's bowed head, downturned mouth, and heavy-lidded eyes con-

vey a sense of deep sadness or contemplation. His long, medallion-patterned tunic has pseudo-kufic inscriptions—designs meant to resemble Arabic script—on the hem, a reminder that silks from Islamic Spain were highly prized in Europe at this time. Islamic textiles were widely used as cloths of honor hung behind thrones and around altars to designate royal and sacred places. They were used to wrap relics and to cover altars with apparently no concern for their Muslim source.

MARY AS THE THRONE OF WISDOM. Any image of Mary seated on a throne and holding the Christ Child on her lap is known as "The Throne of Wisdom." In a well-preserved example in painted wood dating from the second half of the twelfth century (FIG. 15–33), Mother and Child are frontally

THE OBJECT SPEAKS

THE BAYEUX TAPESTRY

arely has art spoken more vividly than in THE BAYEUX TAPESTRY, a strip of embroidered linen that tells the history of the Norman conquest of England. On October 14, 1066, William, Duke of Normandy, after a hard day of fighting, became William the Conqueror, king of England. The story told in embroidery is a straightforward justification of the action, told with the intensity of an eyewitness account: The Anglo-Saxon nobleman Harold initially swears his feudal allegiance to William, Duke of Normandy, but later betraying his feudal vows, he accepts the crown of England for himself. Unworthy to be king, he dies in battle at the hands of William and the Normans.

At the beginning of the Bayeux story, Harold is a heroic figure. Then events overtake him. After his coronation, cheering crowds celebrate—until a flaming star crosses the sky. (We now know that it was Halley's Comet, which appeared shortly after Harold's coronation and evidently reached astonishing brightness.) The Anglo-Saxons see the comet as a portent of disaster; the crowd cringes and gestures at this ball of fire with a flaming tail, and a man rushes to inform the new king. Harold slumps on his throne in the Palace of Westminster. He foresees what

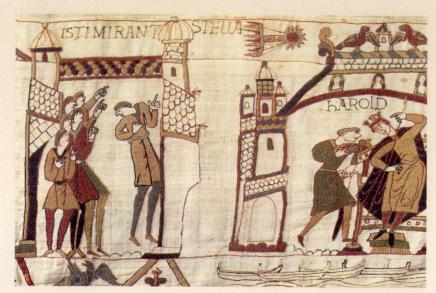

MESSENGERS SIGNAL THE APPEARANCE OF A COMET (HALLEY'S COMET), THE BAYEUX TAPESTRY Norman-Anglo-Saxon embroidery from Canterbury, Kent, England, or Bayeux, Normandy, France. c. 1066-82. Linen with wool, height 20" (50.8 cm). Centre Guillaume le Conquérant, Bayeux, France.

is to come: Below his feet is his vision of a ghostly fleet of Norman ships already riding the waves. William, Duke of Normandy, has assembled the last great Viking flotilla on the Normandy coast.

The designer was a skillful storyteller who used a staggering number of images. In the fifty surviving scenes are

more than 600 human figures; 700 horses, dogs, and other creatures; and 2,000 inch-high letters. Perhaps he or she was assisted by William's half-brother, Bishop Odo, who had fought beside William. As a man of God, he used a club, not a sword, to avoid spilling blood.

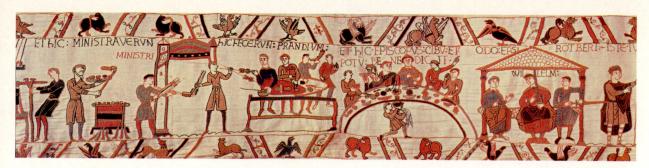

BISHOP ODO BLESSING THE FEAST, THE BAYEUX TAPESTRY

Norman-Anglo-Saxon embroidery from Canterbury, Kent, England, or Bayeux, Normandy, France. c. 1066-82. Linen with wool, height 20" (50.8 cm). Centre Guillaume le Conquérant, Bayeux, France.

Odo and William are feasting before the battle. Attendants bring in roasted birds on skewers, placing them on a makeshift table made of the knights' shields set on trestles. The diners, summoned by the blowing of a horn, gather at a curved table laden with food and drink. Bishop Odo—seated at the center, head and shoulders above William to his right—blesses the meal while others eat. The kneeling servant in the middle proffers a basin and towel so that the diners may wash their hands. The man on Odo's left points impatiently to the next event, a council of war between William (now the central and tallest figure), Odo, and a third man labeled "Rotbert," probably Robert of Mortain, another of William's half-brothers.

Translation of text: ". . . and here the servants (ministra) perform their duty. /Here they prepare the meal (prandium) /and here the bishop blesses the food and drink (cibu et potu). Bishop Odo. William. Robert."

The tragic drama has spoken to audiences over the centuries. It is the story of a good man who, like Shakespeare's *Macbeth*, is overcome by his lust for power and so betrays his king. The images of this Norman invasion also spoke to people during the darkest days of World War II. When the Allies invaded Nazioccupied Europe in June 1944, they took the same route in reverse from England to beaches on the coast of Normandy. The *Bayeux Tapestry* still speaks to us of the folly of human greed and ambition and of two battles that changed the course of history.

EMBROIDERY

The Bayeux Tapestry is really embroidery, not tapestry. In tapestry, colored threads are woven to form the image or pattern; embroidery consists of stitches applied to a woven ground. The embroiderers, probably Anglo-Saxon women, worked in tightly twisted wool that was dyed in eight colors. They used only two stitches: the quick, overlapping stem stitch that produced a slightly jagged line or outline, and the time-consuming laid-and-couched work used to form blocks of color. The embroiderer first "laid" a series of long, parallel covering threads; then anchored them with a second layer of regularly spaced crosswise stitches; and finally tacked all the strands down with tiny "couching" stitches. Some of the laid-andcouched work was done in contrasting colors to achieve particular effects. Some of the coloring was fanciful; for example, some horses have legs in four different colors. Skin and other light-toned areas were represented by the bare linen cloth that formed the ground of the work. The embroiderers of the Bayeux Tapestry probably followed drawings provided by a Norman, who may have been an eyewitness to some of the events depicted.

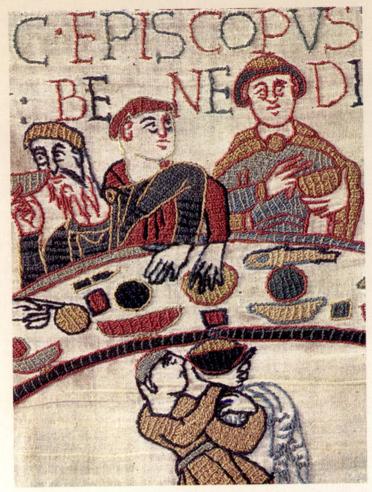

Norman-Anglo-Saxon embroidery from Canterbury, Kent, England, or Bayeux, Normandy, France. c. 1066-82. Linen with wool, embroidery, height 20" (50.8 cm). Centre Guillaume le Conquérant, Bayeux, France.

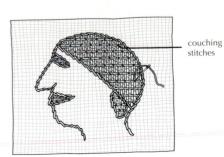

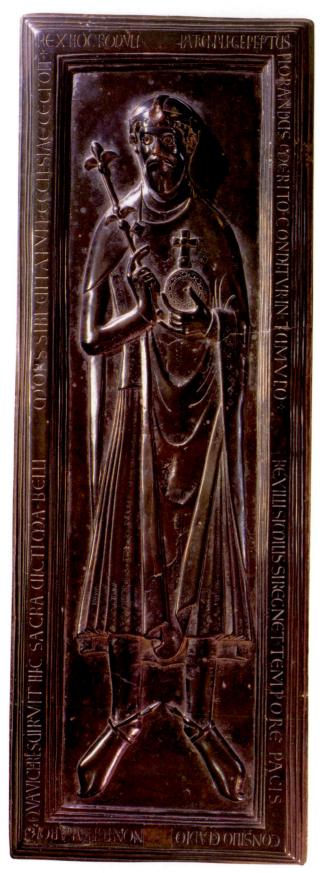

15-34 TOMB COVER WITH EFFIGY OF RUDOLF OF SWABIA

Saxony, Germany. c. 1080. Bronze with niello, approx. $6'5\%\times2'2\%''$ (1.97 \times 0.68 m). Cathedral of Merseburg, Germany.

erect, as rigid as they are regal. Mary's thronelike bench symbolized the lion-throne of Solomon, the Old Testament king who represented earthly wisdom in the Middle Ages. Mary, as Mother and "God-bearer" (the Byzantine Theotokos), gave Jesus his human nature. She forms a throne on which he sits in majesty. She also represents the Church. Although the Child's hands are missing, we can assume that the small but adult Jesus held a book—the Word of God—in his left hand and raised his right hand in blessing.

A statue of the Virgin and Child, like the sculpture here, could have played a role in the liturgical dramas being added to church services at that time. At the Feast of the Epiphany, which in the Western Church celebrates the arrival of the Magi to pay homage to the baby Jesus, participants representing the Magi acted out their journey by searching through the church for the newborn king. The roles of Mary and Jesus were "acted" by the sculpture, which the Magi discovered on the altar. In such simple ways theater and the performing arts returned to the West.

Metalwork

Three geographical areas—the Rhineland, the Meuse River valley, and German Saxony—continued to supply the best metalwork for aristocratic and ecclesiastical patrons. Metalworkers in these areas drew on a variety of stylistic sources, including the work of contemporary Byzantine and Italian artists, as well as classical precedents as reinterpreted by their Carolingian and Ottonian forebears.

Tomb of Rudolf of Swabia. In the late eleventh century, Saxon metalworkers, already known for their large-scale bronze casting, began making bronze tomb effigies (portraits of the deceased). The oldest known bronze tomb effigy is that of KING RUDOLF OF SWABIA (FIG. 15–34), who died in battle in 1080, having sided with the pope against the emperor during the Investiture Controversy. The spurs on his oversized feet identify him as a heroic warrior, and he holds a scepter and cross-surmounted orb, emblems of Christian kingship. Although the tomb is in the Cathedral of Merseburg, in Saxony, the effigy has been attributed to an artist originally from the Rhine Valley. Nearly life-size, it has fine linear detailing in niello, an incised design filled with a black alloy. The king's head has been modeled in high relief and stands out from his body like a detached shield.

Reiner of Huy. Renier of Huy (Huy is near Liège in present-day Belgium) worked in the Mosan region under the profound influence of ancient art as interpreted by Carolingian and Byzantine forebears. He was also influenced by the humanistic learning of Church scholars. Liege was called the "Athens of the North." Artists like Renier created a style that seems classical in its depiction of human figures with dignity, simplicity, and harmony (FIG. 15–35). Between 1107 and 1118 he cast a

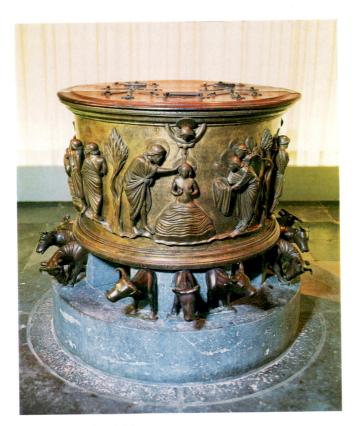

I5−35 | Renier de Huy **BAPTISMAL FONT, NOTRE-DAME-AUX-FONTES** Liege, France. 1107–18. Bronze, Height, 23¾" (60 cm); diameter, 31¼" (79 cm). Now in the Church of St. Barthelemy, Liège.

bronze baptismal font for Notre-Dame-aux-Fonts in Liège (now in the Church of Saint Barthelemy) that was inspired by the basin carried by twelve oxen in Solomon's Temple in Jerusalem (I Kings 7:23-24). Christian philosophers identified the twelve oxen as the twelve apostles and the basin as the baptismal font. On the sides of the font, Renier placed images of Saint John the Baptist, preaching and baptizing Christ, Saint Peter baptizing Cornelius, and Saint John the Evangelist baptizing the philosopher Crato. Renier constructs sturdy idealized bodies-nude or with clinging drapery-that move and gesture with convincing reality. His intuitive understanding of anatomy required close observation of the people around him. These figures also convey a sense of space, however shallow, where landscape is reduced to rippling ground lines, a few miniature trees used to separate the scenes, and waves of water rising (in Byzantine fashion) to discreetly cover nude figures. Renier's bronze sculptures demonstrate the survival of a classical and humanistic art in northern Europe.

Illustrated Books

Illustrated books played a key role in the transmission of artistic styles and other cultural information from one region to another. The output of books increased dramatically in the

Sequencing Works of Art PAINTING IN TWELFTH-CENTURY EUROPE

Early 12th century	The Nun Guda, <i>Book of Homilies,</i> Westphalia, Germany
c. 1100	<i>Tower of Babel</i> , Abbey Church of Saint-Savin-sur-Gartempe, Poitou, France
c. 1123	Christ in Majesty, Church of San Climent, Taull, Catalunya, Spain
c. 1125	Tree of Jesse from the Commentary on Isaiah, Abbey of Cîteaux, Burgundy, France
c. 1150	The Mouth of Hell, Winchester Psalter, Winchester, England

twelfth century, despite the labor and materials involved. Monastic and convent *scriptoria* continued to be the centers of production. The *scriptoria* sometimes also employed lay scribes and artists who traveled from place to place. In addition to the books needed for the church services, scribes produced scholarly commentaries, lives of saints, collections of letters, and even histories (SEE FIG. 15–2). Liturgical works were often large and lavish; other works were more modest, their embellishment confined to initial letters.

SAINT MATTHEW IN THE CODEX COLBERTINUS. The portrait of Saint Matthew from the CODEX COLBERTINUS, in contrast to the Hiberno-Saxon and Carolingian author portraits, is an entirely Romanesque conception. Like the sculptured pier figures of Silos (SEE FIG. 15–1), he stands within an architectural frame that controls his size and form (FIG. 15–36). A compact figure, he blesses and holds his book—rather than writing it. His dangling feet bear no weight. Blocks of color fill in outlines without giving the figure any three-dimensional quality. The evangelist is almost part of the text—the opening lines *Liber Generationes*.

The L of *Liber* (Book) is formed of plants and animals and is called a historiated initial. The L established the size and shape of the figurative panel, just as the architectural elements controlled the figures and composition in historiated capitals. The geometric underpinnings are filled with acanthus leaves and interlacing vines. Dogs or catlike animals and long-necked birds twist, claw, and bite each other and themselves while, in the center, two humans—one dressed and one nude—clamber up the letter. This manuscript was made in the region of Moissac at about the same time that sculptors were working on the abbey church.

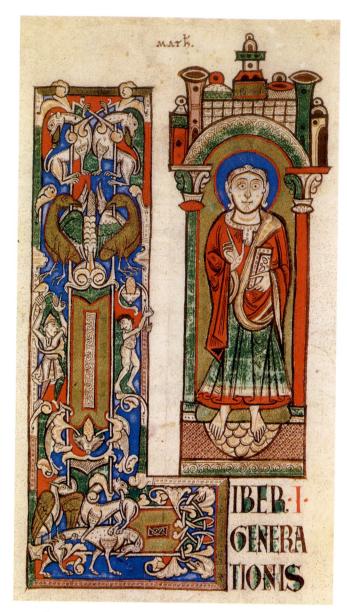

I 5–36 | ST. MATTHEW, FROM THE CODEX COLBERTINUS c. 1100. Tempera on vellum, $7\frac{1}{2} \times 4^n$ (19 \times 10.16 cm). Bibliothèque National Paris.

THE GERMAN NUN GUDA. In another historiated initial, this one from Westphalia in Germany, the nun Guda has a more modest role. In a book of homilies (sermons), she inserted her self-portrait into the letter D and signed it as scribe and painter, "Guda, the sinful woman, wrote and illuminated this book" (FIG. 15–37). A simple drawing with a little color in the background, Guda's self-portrait is certainly not a major work of art. Its importance lies in its demonstration that women were far from anonymous workers in German *scriptoria* in the Romanesque period. Guda's image is the earliest signed self-portrait by a woman in Western Europe. Throughout the Middle Ages, women were involved in the production of books as authors, scribes, painters, and patrons.

THE HELLMOUTH IN THE WINCHESTER PSALTER. Religious texts dominated the work of the *scriptorium*. The **winchester PSALTER**, commissioned by the English king's brother, Henry of Blois, the Bishop of Winchester, contains a dramatic image of hell (FIG. 15–38). The page depicts the gaping jaws of hell, a monstrous head with dragons sprouting from its mane. Hell is filled with a tangled mass of sinners, among whom are kings and queens with golden crowns and monks with shaved heads, a daring reminder to powerful rulers and the clergy of the vulnerability of their own souls. Hairy, horned demons torment the lost souls, who tumble around in a dark void. An impassive and very elongated angel locks the door.

This vigorous narrative style had its roots in the Carolingian art of the *Utrecht Psalter* (SEE FIG. 14–18), a manuscript which was then in an English monastic library. Here, by comparison, the free pen work of the *Utrecht Psalter* has become controlled and hard. The composition of the intricate interlocking forms is carefully worked out using strong framing devices. For all its vicious energy, the page seems dominated by the ornamental frame.

15–37 | The Nun Guda BOOK OF HOMILIES
West, Germany. Early 12th century. Ink on parchment.
Stadtund Universitäts-Bibliothek, Frankfurt, Germany.
MS. Barth. 42, folio 110v

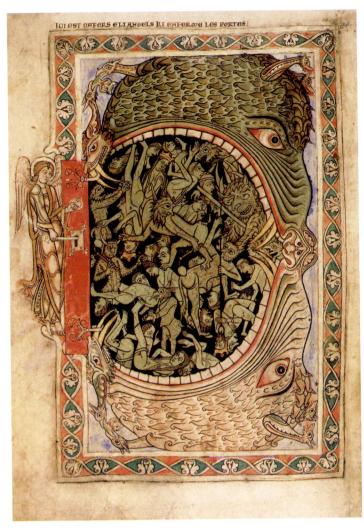

15-38 | THE MOUTH OF HELL, WINCHESTER PSALTER

Winchester, England. c. 1150. Ink and tempera on vellum, $12\frac{1}{4} \times 9\frac{1}{8}$ " (32.5 × 23 cm). The British Library, London.

The inscription reads: "Here is hell and the angels who are locking the doors."

There are fascinating parallels between the images of the mouth of Hell and the liturgical dramas—known in English as "mystery plays"—that were performed throughout Europe from the tenth through the sixteenth century. On stage, voracious Hellmouth props featured prominently, to the delight of audiences. Carpenters made the infernal beast's head out of wood, papier-mâché, fabric, and glitter and placed it over a trapdoor onstage. The wide jaws of the most ambitious Hellmouths, operated by winches and cables, opened and closed on the actors while emitting smoke, flames, foul smells, and loud noises. Hell scenes, with their often scatological humor, were by far the most popular parts of the plays.

Cistercians were particularly devoted to the Virgin and are also credited with popularizing themes such as the Tree of Jesse as a device for showing her position as the last link in the genealogy connecting Jesus Christ to King David. (Jesse, the father of King David, was an ancestor of Mary and, through her, of Jesus.) Saint Jerome's **COMMENTARY ON ISA-IAH**, a manuscript made in the *scriptorium* of the Cistercian mother house at Cîteaux about 1125, contains an image known as the **TREE OF JESSE** (FIG. 15–39).

A monumental Mary, standing on the forking branches of the tree, dwarfs the sleeping patriarch, Jesse, a small tree trunk grows from his body. The Christ Child sits on her veiled right arm. The elongated but still human figure of Mary, emphasized by the vertical lines and V-shaped folds of the drapery and the soft colors, suggests a new sense of humanity. The artist has drawn, rather than painted, with colors, the subtle tints creating an image in keeping with Cistercian restraint. Following late Byzantine and Romanesque convention, Christ is portrayed as a miniature adult with his right hand raised in blessing. His cheek presses against Mary's, a display of affection similar to that shown in Byzantine icons of the time, like the *Virgin of Vladimir* (SEE FIG. 7–39). Mary holds a flowering sprig from the tree—another symbol for Christ.

The building held by the angel on the left equates Mary with the Church, and the crown held by the angel on the right is hers as Queen of Heaven. The dove above her halo represents the Holy Spirit. The jeweled hems of Mary's robes reflect her elevated status as Queen of Heaven. In the early decades of the twelfth century, Church doctrine came increasingly to stress the role of the Virgin Mary and the saints as intercessors who could plead for mercy on behalf of repentant sinners, and devotional images of Mary became increasingly popular during the later Romanesque period.

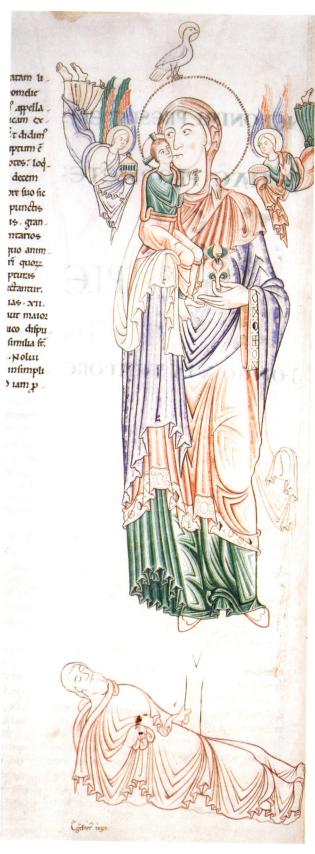

15–39 PAGE WITH THE TREE OF JESSE, EXPLANATIO IN ISAIAM (SAINT JEROME'S COMMENTARY ON ISAIAH) Abbey of Cîteaux, Burgundy, France. c. 1125. Ink and tempera on vellum, $15 \times 4\%$ " (38 \times 12 cm). Bibliothèque Municipale, Dijon, France. MS 129, fol. 4v

IN PERSPECTIVE

Wiligelmus, Roger, Gislebertus, Guda, and many anonymous women and men of the eleventh and twelfth centuries created a new art that—although based on the Bible and the lives of the saints—focused on human beings, their stories, and their beliefs. The artists worked on a monumental scale in painting, sculpture, and even embroidery, and their art moved from the cloister to the public walls of churches.

The sheer size of churches, the austere majesty of their towers, their interior spaces often covered with masonry vaults, their marvelously functional plans and elevations reflect a culture that saw the church as not only the Heavenly Jerusalem but as a bulwark against the ever-present demonic forces of evil. Equally mighty castle walls stood against actual earthly enemies. A source of local and even regional pride, the cathedral, monastic church, or castle required the most creative and highest quality work, and rulers and communities contributed material resources and labor.

Many Romanesque churches have a remarkable variety of painting and sculpture. Christ enthroned in majesty may be carved over the entrance or painted in the half-dome of the apse. Scenes from the life of Christ or images of the lives and the miracles of the saints cover the walls. Romanesque art also reflects the increasing importance accorded to the Virgin Mary. The elect rejoice in heaven; the damned suffer in hell. A profusion of monsters, animals, plants, geometric ornament, and depictions of real and imagined buildings fill the spaces. While the artists emphasized the spiritual and intellectual concerns of the Christian Church, they also began to observe and record what they saw around them. In so doing they laid the groundwork for the art of the Gothic period.

CATHEDRAL COMPLEX,
PISA
CATHEDRAL BEGUN 1063

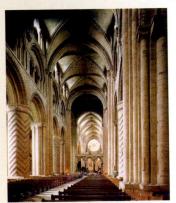

DURHAM CATHEDRAL,
NAVE
1087-1133

RUMEAU SOUTH PORTAL,

c. 1115

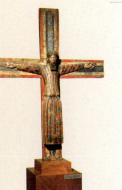

CRUCIFIX (MAJESTAT BATLLÓ)
MID 12TH CENTURY

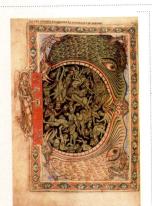

THE MOUTH OF HELL, WINCHESTER PSLATER C. 1150

ART

1050

⊲ н

Henry IV Rules Germany and Holy Roman Empire 1056-1106

ROMANESQUE

- William of Normandy Invades Englandc. 1066
- ✓ Investiture Controversy c. 1075
- First Crusade 1095-99
- Cistercian Order Founded 1098

1100

1120

114C

1150

- Eleonor of Aquitaine Queen of France with Louis VII 1137-52
- Hildegard of Bingen Writes Scivias
 c. 1141-1151
- Second Crusade 1147-49
- Eleanor of Aquitaine Queen of England with Henry II 1154-1189

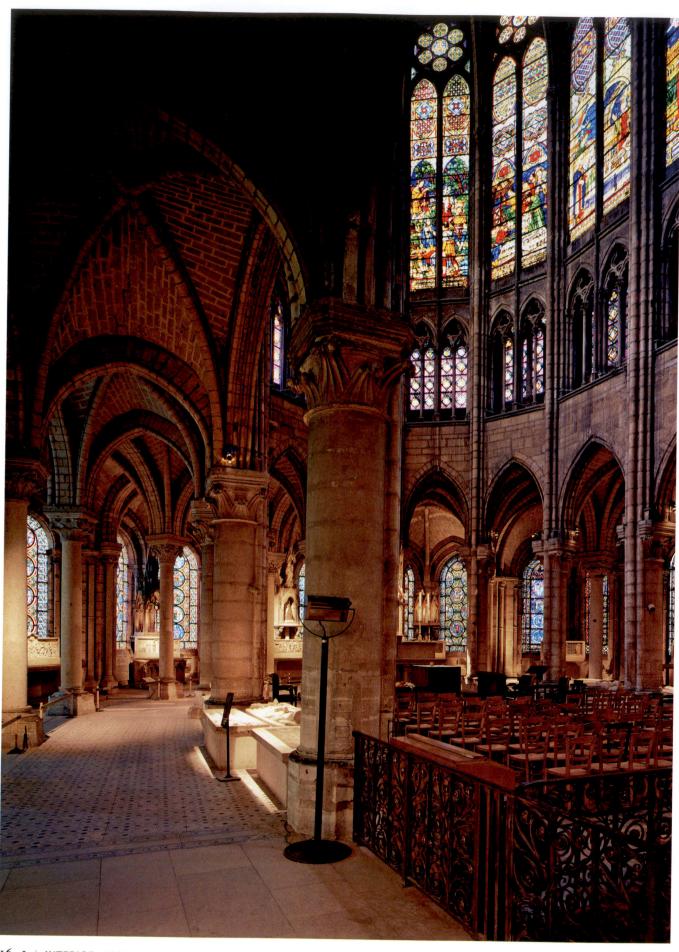

16–1 | Interior, abbey church of saint-denis, choir | France. 1140–44; 1231–81.

CHAPTER SIXTEEN

GOTHIC ART OF THE TWELFTH AND THIRTEENTH CENTURIES

The twelfth-century Abbot Suger of Saint-Denis (1081–1151) was, according to his biographer Willelmus, "small of body and family, constrained by twofold smallness, [but] he refused, in his smallness, to be a small man"

(cited in Panofsky, page 33). Educated at the monastery of Saint-Denis, near Paris, he became a powerful and trusted adviser to kings Louis VI and Louis VII. Suger governed France as regent when Louis VII and Eleanor of Aquitaine were absent from France during the Second Crusade (1147–49). He also built what many consider the first Gothic church in Europe.

After Suger was elected abbot of Saint-Denis, he was determined to build a new church to replace the old Carolingian one. He waged a successful campaign to gain both royal and popular support for his rebuilding plans. The old building, he pointed out, had become inadequate. With a touch of exaggeration, he claimed that the crowds of worshipers had become so great that women were being crushed and monks sometimes had to flee with their relics by jumping through windows.

The abbot had traveled widely—in France, the Rhineland, and Italy, including four trips to Rome—and so he was familiar with the latest architecture and sculpture of Romanesque Europe. As he began planning the new church,

he also turned for inspiration to books in the monastery's library, including the writings of a late fifth-century Greek philosopher known as the Pseudo-Dionysius, who had identified radiant light with divinity (see "Abbot Suger on the

Value of Art," page 516). Seeing the name "Dionysius," Suger thought he was reading the work of Saint Denis, also known as Dionysius the Aeropagite, the first-century convert of Saint Paul (Acts 17:34). Not unreasonably, he adapted the concept of divine luminosity into the redesign of the church dedicated to Saint Denis. In the choir of the new church, he created "a circular string of chapels by virtue of which the whole [church] would shine with the wonderful and uninterrupted light of most luminous windows, pervading the interior beauty" (cited in Panofsky, page 101).

Although Abbot Suger died before he was able to finish rebuilding Saint-Denis, his presence remained: The cleric had himself portrayed in a sculpture at Christ's feet in the central portal and in a stained-glass window in the apse. Suger is remembered not for these portraits, however, but for his inspired departure from traditional architecture in order to achieve a flowing interior space and an all-pervasive, colored interior light. His innovation led to the widespread use of large stained-glass windows that bathed the inside walls of French churches with sublime washes of color (FIG. 16–1).

- THE EMERGENCE OF THE GOTHIC STYLE | The Rise of Urban Life | The Age of Cathedrals | Scholasticism and the Arts
- GOTHIC ART IN FRANCE | Early Gothic Architecture | From Early to High Gothic: Chartres Cathedral | High Gothic: Amiens and Reims Cathedrals | High Gothic Sculpture | The Rayonnant Style | Illuminated Manuscripts
- GOTHIC ART IN ENGLAND | Manuscript Illumination | Architecture
- GOTHIC ART IN GERMANY AND THE HOLY ROMAN EMPIRE | Architecture | Sculpture
- GOTHIC ART IN ITALY | Sculpture: The Pisano Family | Painting
- IN PERSPECTIVE

THE EMERGENCE OF THE GOTHIC STYLE

In the middle of the twelfth century, a distinctive new architecture known today as Gothic emerged in the Île-de-France, the French king's domain around Paris (MAP 16-1). The appearance there of a new style and building technique coincided with the emergence of the monarchy as a powerful centralizing force in France. Soon, the Gothic style spread throughout Western Europe, gradually Romanesque forms while taking on regional characteristics inspired by those forms. The term Gothic was first used by Italians in the fifteenth and the sixteenth centuries when they disparagingly attributed the style to the Goths, the Germanic invaders who had destroyed the classical civilization of the Roman Empire that they so admired. In its own day the Gothic style was simply called the "modern" style or the "French" style.

Gothic architecture sought to express the aspiration for divinity through a quest for height and luminosity. Its soaring stonework and elegance of line, and the light, colors, and sense of transparency produced by its great expanses of glass—all became more pronounced over time. The style was adapted to all types of structures—including town halls, meeting houses, market buildings, residences, synagogues, and palaces—and its influence extended beyond architecture and architectural sculpture to painting and other mediums.

The Rise of Urban Life

The Gothic period was an era of both communal achievement and social change. Although Europe remained rural, towns gained increasing prominence. Some cities were freed from obligations to local feudal lords, and, as protected centers of commerce, became sources of wealth and power for the king. Intellectual life was also stimulated by the interaction of so many people living side by side. Universities in Bologna, Padua, Paris, Cambridge, and Oxford supplanted rural monastic schools as centers of learning. Brilliant teachers like Peter Abelard (1079–1142) drew crowds of students, and in the thirteenth century a Dominican professor from Italy, the theologian Thomas Aquinas (1225–74), made Paris

the intellectual center of Europe. This period saw the flowering of poetry and music as well as philosophy and theology.

As towns grew, they became increasingly important centers of artistic patronage. The production and sale of goods in many towns was controlled by guilds. Merchants and artisans of all types, from bakers to painters, formed these associations to advance their professional interests. Medieval guilds also played an important social role, safeguarding members' political interests, organizing religious celebrations, and looking after members and their families in times of trouble.

A town's walls enclosed streets, wells, market squares, shops, churches, and schools. Homes ranged from humble wood-and-thatch structures to imposing town houses of stone. Although wooden dwellings crowded together made fire an ever-present danger and although hygiene was rudimentary at best, towns fostered an energetic civic life. This strong communal identity was reinforced by public projects and ceremonies.

The Age of Cathedrals

Urban cathedrals, the seats of the ruling bishops, superseded rural monasteries as centers of religious patronage. So many of these churches were rebuilt between 1150 and 1400often after fires—that the period has been called the "Age of Cathedrals." Cathedral precincts functioned almost as towns within towns. The great churches dominated their surroundings and were central fixtures of urban life (SEE FIG. 16-8). Their grandeur inspired admiration; their great expense and the intrusive power of their bishops inspired resentment. In the twelfth century, the laity experienced a decisive growth in religious involvement. In the early thirteenth century members of two new religious orders, the Franciscans and the Dominicans, known as mendicants (beggars) because they were meant to be free of wordly goods, went out into the world to preach and to minister to those in need, rather than secluding themselves in monasteries. (see "The Mendicant Orders: Franciscans and Dominicans" page 524).

Scholasticism and the Arts

The Crusades—which continued throughout the thirteenth century—and the trade that followed these military ventures

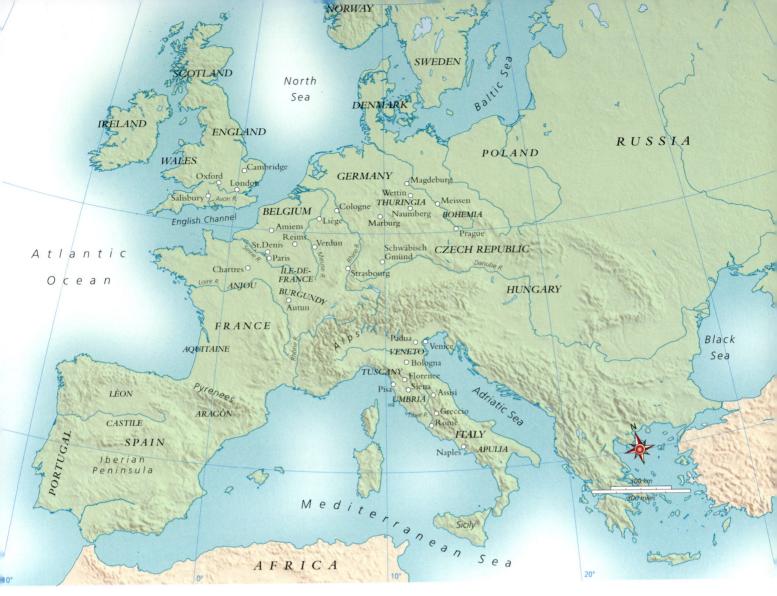

MAP 16-I EUROPE IN THE GOTHIC ERA

The Gothic period witnessed the emergence of England, France, Portugal, and Spain (Castile) as nations, while the pope wielded political as well as religious power throughout the West. The residents of cities rose to challenge the power of landed nobility.

brought Western Europeans into contact with the Byzantine and Islamic worlds, where—unlike in the West—literary works of classical antiquity had been preserved. The "rediscovery" of these works, particularly the philosophy of Aristotle, posed a challenge to Christian theology because they promoted rational inquiry rather than faith as the path to truth, and their conclusions did not always suit Church doctrine.

A system of reasoned analysis known as Scholasticism emerged to reconcile Christian theology with classical philosophy. Scholastic thinkers used a question-and-answer method of argument and arranged their ideas into logical outlines. Thomas Aquinas, the foremost Scholastic, applied Aristotelian logic to comprehend religion's supernatural aspects. His great philosophical work, the Summa Theologica, which attempted to reconcile rationalism with religious faith, has endured as a basis of Catholic thought to this day. Scholastic thinkers applied reasoned analysis to a vast range of subjects. Vincent de Beauvais, a thirteenth-century Parisian Dominican, organized his eighty-volume encyclopedia, the Speculum Maius (Greater Mirror), in which he intended to

encompass all human knowledge, into four categories: the Natural World, Doctrine, History, and Morality.

This all-pervasive intellectual approach had a profound influence on the arts. Like the philosophers, master builders saw divine order in geometric relationships and used these relationships as the underpinnings of architectural and sculptural programs. Sculptors and painters created naturalistic forms that reflected the combined idealism and analysis of Scholastic thought. Gothic religious imagery expanded to incorporate a wide range of subjects from the natural world, and like Romanesque imagery its purpose was to instruct and convince the viewer. In the Gothic cathedral, Scholastic logic intermingles with the mysticism of light and color to create for the worshiper the direct, emotional, ecstatic experience of the church as the embodiment of God's house, filled with divine light.

GOTHIC ART IN FRANCE

The initial flowering of the Gothic style took place in France against the backdrop of the growing power of the French Capetian monarchy. Louis VII (ruled 1137–80) and Philip

Art and Its Context

ABBOT SUGER ON THE VALUE OF ART

rom *De administratione*, Ch. XXVII, Of the Cast and Gilded Doors:

Bronze casters having been summoned and sculptors chosen, we set up the main doors on which are represented the Passion of the Saviour and His Resurrection, or rather Ascension, with great cost and much expenditure for their gilding as was fitting for the noble porch. . . .

The verses on the door are these:

Whoever thou art, if thou seekest to extol the glory of these doors,

Marvel not at the gold and the expense but at the craftsmanship of the work, Bright is the noble work; but being nobly bright, the work Should lighten the minds, so that they may travel, through the true lights,

To the True Light where Christ is the true door, In what manner it be inherent in this world the golden door defines:

The dull mind rises to truth through that which is material And, in seeing this light, is resurrected from its former subversion.

Panofsky, Erwin. Abbot Suger on the Abbey Church of St.-Denis and its Art Treasures. 2nd ed. By Gerda Panofsky-Soergel. Princeton, NJ: Princeton University Press, 1979, pp. 47; 49.

Augustus (ruled 1180–1223) consolidated royal authority in the Île-de-France and began to exert control over powerful nobles in other regions. Before succeeding to the throne, Louis VII had married Eleanor of Aquitaine (heiress to all southwestern France). When the marriage was annulled, Eleanor took her lands and married Henry Plantagenet—count of Anjou, Duke of Normandy—who became King Henry II of England. The resulting tangle of conflicting claims kept France and England at odds for centuries. Through all the turmoil, the French kings continued to consolidate royal authority and to increase their domains and privileges at the expense of their vassals and the Church.

Early Gothic Architecture

The political events of the twelfth and thirteenth centuries were accompanied by energetic church building, often made necessary by the fires that constantly swept through towns. It has been estimated that during the Middle Ages several million tons of stone were quarried to build some eighty cathedrals, 500 large churches, and tens of thousands of parish churches and that within a hundred years some 2,700 churches were built in the Île-de-France region alone. This explosion of building began at a historic abbey church on the outskirts of Paris.

THE ABBEY CHURCH OF SAINT-DENIS. The Benedictine monastery of Saint-Denis, a few miles north of central Paris, had great symbolic significance for the French monarchy (SEE FIG. 16–1). It housed the tombs of the kings of France and their courts, regalia of the French Crown, and the relics of Saint Denis, the patron saint of France, who, according to tradition, had been the first bishop of Paris. In the 1130s, under the direction of Abbot Suger, construction began on a new abbey church (FIG. 16–2).

Suger described his administration of the abbey and the building of the Abbey Church of Saint-Denis in three books (see "Abbot Suger on the Value of Art," above). Suger prized magnificence. Having traveled widely, he combined design ideas from many sources. Suger invited masons and sculptors from other regions, making his abbey a center of artistic exchange. (Unfortunately, Suger did not record the names of the masters he employed, nor did he give information about them.) For the rebuilding, he received substantial annual revenues from the town's inhabitants, and he established free housing on abbey estates to attract peasant workers. For additional funds, he turned to the royal coffers and fellow clerics.

Suger began the rebuilding in 1135, with a new west façade and narthex (SEE FIG. 16–2). The design combined a Norman tripartite façade design, as seen in the abbey church in Caen (SEE FIG. 15–23), with sculptured portals like those at Autun (SEE FIG. 15–28). Two towers, a round window, and narrative sculpture over not one but three portals completed the magnificent composition. Within the narthex Suger's masons built highly experimental ribbed groin vaults over both square and rectangular bays (see "Rib Vaulting," page 521). (Much of the sculpture was destroyed or damaged in the eighteenth century, and the north tower had to be removed after it was struck by lightning in the nineteenth century.)

Suger's renovation of the choir at the east end of the church represented an equally momentous departure from the Romanesque style (SEE FIG. 16–1). Completed in three years and three months (1140–44), timing that the abbot found auspicious, the choir resembled a pilgrimage church, with a semicircular sanctuary surrounded by an ambulatory and seven radiating chapels (FIG. 16–3). Its large stained-glass windows, however, were new. While all the architectural elements of the choir—ribbed groin vaults springing from

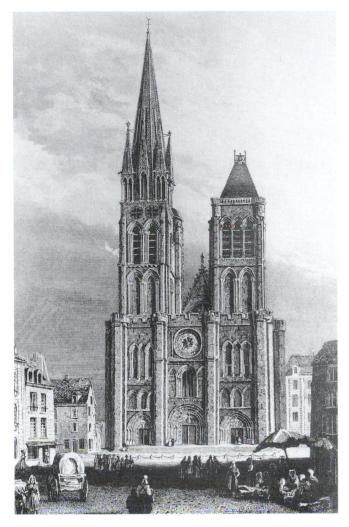

16–2 WEST FAÇADE, ABBEY CHURCH OF SAINT-DENIS France. 1135–44, engraving made before 1837.

round piers, pointed arches, wall buttresses to relieve stress on the walls, and adequate window openings—had already appeared in Romanesque buildings, the achievement of Suger's master mason was to combine these into a fully integrated architectural whole. Sanctuary, ambulatory, and chapels open into one another to create a feeling of open, flowing space. Walls of stained glass replace masonry, permitting colored light to permeate the interior. These effects rely on the masterful use of vaulting techniques, the culmination of half a century of experiment and innovation.

The choir of Saint-Denis represented a new architectural aesthetic based on open spaces rather than massive walls. Suger considered light and color to be a means of illuminating the soul and uniting it with God. For him, the colored lights of stained-glass windows, like the glint of gems and gold in the chalice he gave to his church transfixed the world with the splendor of Paradise

Louis VII and Eleanor of Aquitaine attended the consecration of the new choir on June 14, 1144. Shortly thereafter the Second Crusade became the primary recipient of royal resources, leaving Suger without funds to replace the old nave and transept at Saint-Denis. After Suger died in 1151, his church remained unfinished for another century (see page 536).

The Abbey Church of Saint-Denis became the prototype for a new architecture of space and light based on a highly adaptable skeletal framework constructed from buttressed perimeter walls and pointed arch interior vaulting with masonry ribs. It initiated a period of competitive experimentation in France that resulted in ever larger churches, enclosing increasingly taller interior spaces, walled with ever greater expanses of colored glass. These great churches, with their unabashed decorative richness, were part of Abbot Suger's legacy to France.

AN EARLY GOTHIC CATHEDRAL: NOTRE DAME OF PARIS. The Cathedral of Paris, known simply as Notre Dame ("Our Lady," the Virgin Mary), bridges the period between Abbot Suger's rebuilding of his abbey church and the High Gothic

16–3 ABBEY CHURCH OF SAINT-DENIS, PLAN West façade 1135–40; choir 1140–44; nave 1231–81.

16–4 | CATHEDRAL OF NOTRE-DAME, PARIS
Begun 1163; choir chapels, 1270s; crossing spire, 19th-century replacement. View from the south.

cathedrals of the thirteenth century (FIG. 16–4). As the city and royal court grew, Paris needed a larger cathedral. According to tradition, in 1163, Pope Alexander II laid the cornerstone of a new church.

The nave, with its massive walls and buttresses and sixpart vaults adopted from Norman Romanesque architecture (SEE FIG. 15-19), dates to 1180-1200. The nave had four stories: an arcade surmounted by a gallery and two levels of rather small windows, including both lancets and round "bull's eye" windows (SEE FIG. 16-12). To increase the window size and secure the vault, the builders built the first true flying buttresses. The flying buttress, a gracefully arched, skeletal exterior support, counters the outward thrust of the nave vault by carrying the weight over the side aisles to the ground (see "Rib Vaulting," page 521). Although the nave was huge, it must have seemed very old fashioned by the thirteenth century. After 1225, new masters modernized the building by reworking the two upper levels into the large clerestory windows we see today. The huge flying buttresses rising dramatically to support the 115-foot high vault at Notre Dame are the result of later remodeling. (The 290-foot spire over the crossing is the work of the nineteenth-century architect Eugène-Emmanuel Viollet-le-Duc.)

From Early to High Gothic: Chartres Cathedral

The structural techniques and new conception of space applied at Saint-Denis and Notre Dame in Paris were taken one step further at Chartres Cathedral. It is here that the transition from Early to High Gothic is most eloquently

expressed. The great Cathedral of Notre-Dame in Chartres dominates this town southwest of Paris (SEE FIG. 16–8 and "The Gothic Church," page 522). For many people, Chartres Cathedral is a near-perfect embodiment of the Gothic spirit in stone and glass. Constructed in several stages beginning in the mid-twelfth century and extending into the mid-thirteenth, with additions such as the north spire as late as the sixteenth century, the cathedral reflects the transition from an experimental twelfth-century architecture to a mature thirteenth-century style.

FOUR HUNDRED YEARS AT CHARTRES. Chartres was the site of a pre-Christian virgin-goddess cult, and later, dedicated to the Virgin Mary, it became one of the oldest and most important Christian shrines in France. Its main treasure was a piece of linen believed to have been worn by Mary when she gave birth to Jesus. The so-called Tunic of the Virgin was a gift from the Byzantine Empress Irene to Charlemagne, whose grandson, Charles the Bald, donated it to the church in 876. The relic was kept below the high altar in a huge basement crypt. The healing powers attributed to the cloth made Chartres a major pilgrimage destination, especially as the cult of the Virgin grew in popularity in the twelfth and thirteenth centuries.

The theologians of Chartres tried to present all of Christian history in the sculpture and stained glass of their cathedral. On the west, in the Royal Portal, the sculpture is dedicated to Christ (FIG. 16–5). The north transept portal and the stained glass above it depict the world before Christ, with Saint Anne and the Virgin Mary. On the south transept, the

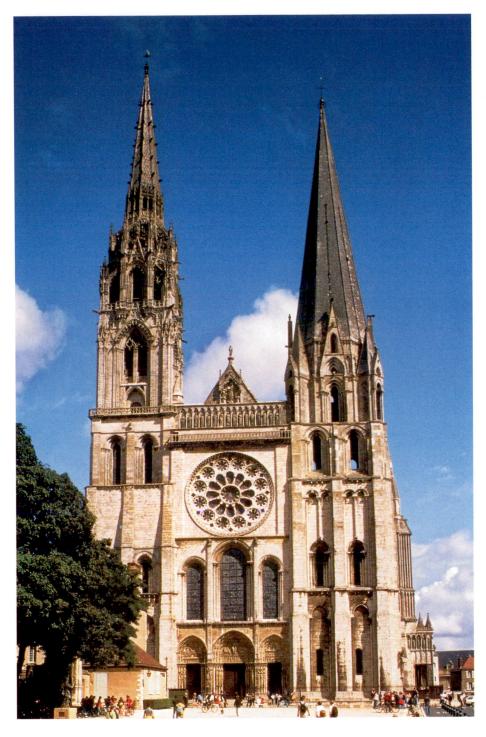

16-5 | WEST FAÇADE, CHARTRES CATHEDRAL (THE CATHEDRAL OF NOTRE-DAME)

Chartres, France. West façade begun c. 1134; cathedral rebuilt after a fire in 1194; building continued to 1260; north spire 1507-13.

viewers learn of later events in Christian history, including the lives of the saints and the Last Judgment.

Chartres' decoration also encompasses number symbolism. The number three represents the spiritual world of the Trinity, while the number four represents the material world (the four winds, the four seasons, the four rivers of Paradise). Combined, they form the perfect and all-inclusive number seven, expressed in the seven gifts of the Holy Spirit. References to three, four, and seven recur throughout the cathedral imagery. On the west façade, for example, the seven liberal arts surround the image of Mary and Jesus.

THE ROYAL PORTAL. From a distance, the most striking features of the west façade, constructed after a fire in 1134, are its prominent rose window—a huge circle of stained glass—and two towers with their spires. But up close, the western façade's three doorways—the so-called Royal Portal, inspired by the portal of the Church of Saint-Denis—capture the attention with their sculpture.

In the center of the west façade, on the central tympanum, Christ is enthroned in royal majesty with the four evangelists (FIG. 16–6). He appears imposing but more benign than at Autun. The apostles, organized into four groups of

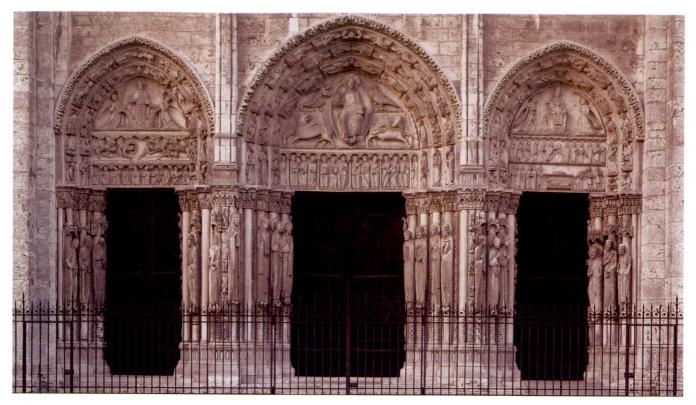

16–6 | ROYAL PORTAL, WEST FAÇADE, CHARTRES CATHEDRAL c. 1145–55.

Right—Tympanum: Mary enthroned with Christ Child (Throne of Wisdom); Lintels: Annunciation, Visitation, Nativity and Shepherds, Presentation; Archivolts: The Liberal Arts. Center—Tympanum: The Second Coming, Christ and the Four Apostles; Lintels: Apostles; Archivolts: The Twenty-Four Elders. Left—Tympanum: Ascension; Lintels: Angels and Apostles; Archivolts: Zodiac and Labors of the Months; Capitals: Life of Christ; Statue Columns: Old Testament Kings and Queens.

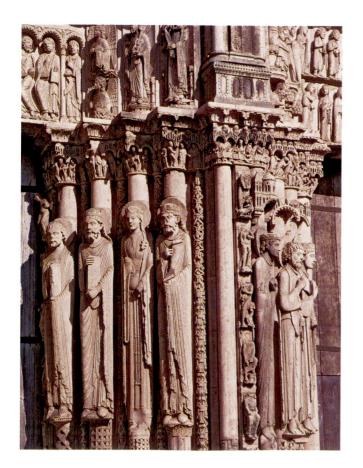

three, fill the lintel, and the twenty-four elders of the Apocalypse line the archivolts. The portal on Christ's left (the viewer's right) is dedicated to Mary and the early life of Christ, from the Annunciation to the Presentation in the Temple. On the left portal, Christ ascends heavenward in a cloud, supported by angels. Running across all three portals, storied capitals depict his earthly activities.

Flanking the doorways are monumental jamb figures (FIG. 16–7) depicting Old Testament kings and queens, the precursors of Christ. These figures convey an important message—just as the Old Testament supports and leads to the New Testament, so too these biblical kings and queens support Mary and Christ in the tympana above. They also lead the worshiper into the House of the Lord. The depiction of Old Testament kings and queens reminded people of the close ties between the Church and the French royal house. During the French Revolution, sculptures of kings and queens were removed from churches and destroyed. The Chartres figures are among the few that survived.

16−7 | ROYAL PORTAL, WEST FAÇADE, CHARTRES CATHEDRAL

Detail: Prophets and Ancestors of Christ (Kings and Queens of Judea). Right side, Central Portal, c. 1145-55.

Jamb figures became standard elements of Gothic church portals. They developed from shaftlike reliefs to fully three-dimensional figures that appear to interact. Earlier sculptors had achieved dramatic effects by compressing, elongating, and bending figures to fit an architectural framework. At Chartres, the sculptors sought to pose their figures naturally and comfortably in their architectural settings. The erect, frontal column statues, with their slender proportions and vertical drapery, echo the cylindrical shafts from which they seem to emerge. Their heads are finely rendered with idealized features. Calm and order prevails in all the elements of the portal, in contrast to the crowded imagery of the Romanesque churches.

REBUILDING CHARTRES. A fire in 1194 destroyed most of the church at Chartres but spared the Royal Portal and its windows and the crypt with its precious relics. A papal representative convinced reluctant local church officials to rebuild. He argued that the Virgin permitted the fire because she wanted a new and more beautiful church to be built in her honor. Between 1194 and about 1260, the chapter and people built a new cathedral (FIG. 16–8).

To erect such an enormous building required vast resources—money, raw materials, and skilled labor. A contemporary painting shows a building site with the masons at work (FIG. 16–9). Carpenters have built scaffolds, platforms, and a lifting machine. Master stone cutters measure and cut the stones, and in many cases sign their work with a "mason's mark." Workmen carry and hoist the blocks by hand or with a lifting wheel. Thousands of stones had to be accurately cut and placed. In the illustration a laborer carries mortar up a ladder to men working on the top of the wall, where the lifting wheel delivers cut stones.

The highly skilled men who carved capitals and portal sculpture were members of the masons' guild. Skilled stone cutters earned more than simple workmen, and the master usually earned at least twice what his men received (see "Master Builders," page 525).

Elements of Architecture

RIB VAULTING

n important innovation of Romanesque and Gothic builders was rib vaulting. Rib vaults are a form of groin vault (SEE "arch, vault, and dome," PAGE 172), in which the ridges (groins) formed by the intersecting vaults may rest on and be covered by curved moldings called ribs. After the walls and piers of the building reached the desired height, timber scaffolding to support the masonry ribs was constructed. After the ribs were set, the web of the vault was then laid on forms built on the ribs. After all the temporary forms were removed, the ribs provided strength at the intersections of the webbing to channel the vaults' thrust outward and downward to the foundations. In short, ribs formed the "skeleton" of the vault; the webbing, a lighter masonry "skin." In late Gothic buildings additional, decorative ribs give vaults a lacelike appearance.

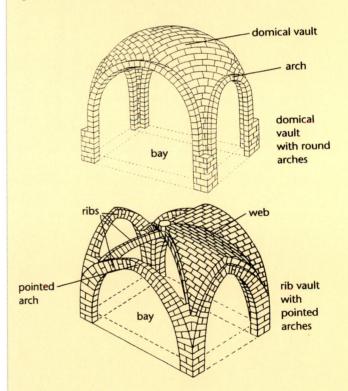

Elements of Architecture

THE GOTHIC CHURCH

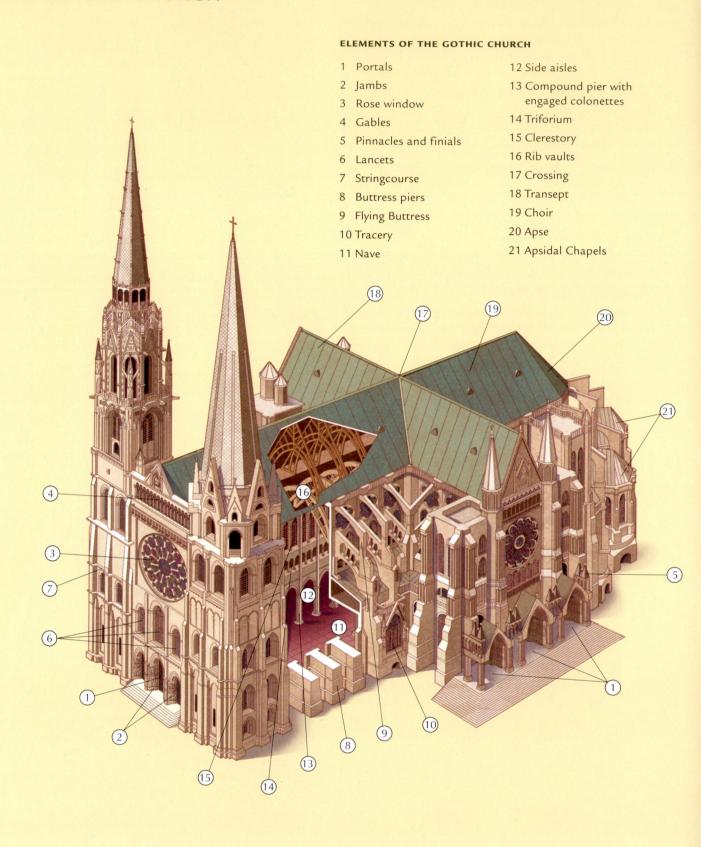

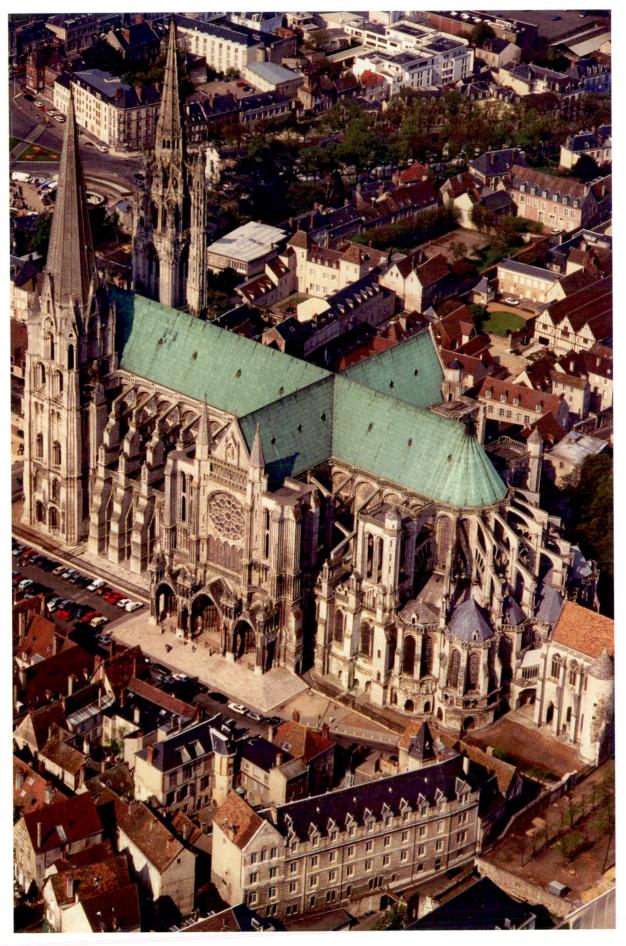

16-8 | CHARTRES CATHEDRAL, AIR VIEW FROM SOUTHEAST

Myth and Religion

THE MENDICANT ORDERS: FRANCISCANS AND DOMINICANS

n the thirteenth century new religious orders arose to meet the needs of the growing urban population. The mendicants (begging monks) lived among the urban poor. They espoused an ideal of poverty, charity, and love, and they dedicated themselves to teaching and preaching.

The first mendicant orders were the Franciscans and Dominicans. Saint Francis (Giovanni di Bernardone, (1182-1226; canonized in 1228) was born in Assisi, the son of wealthy merchants. Sensitive to the misery of others, he gave away his possessions and devoted his life to God and the poor. He was soon joined by others who also dedicated their lives to poverty, service, and love of all creatures. His love of Christ was so intense that the stigmata, or wounds suffered by Christ on the cross, are believed to have appeared on his own body.

Saint Francis wrote a simple rule for his followers, who were called brothers, or friars (from the Latin *frater*, meaning

"brother"). The pope approved the new order in 1209-10. Franciscans can be recognized by their dark gray or brown robes tied with a rope, whose three knots symbolized their vows of poverty, chastity, and obedience.

The Dominican Order was established in 1216 by a Castilian nobleman, Domenico Guzman (1170–1221; canonized in 1234), as the Order of Friars Preachers. The Dominicans held their first general meeting in 1220. In order to combat heresy by combating ignorance, the Dominicans became teachers. Dominicans number among their members some of the greatest scholars of the thirteenth century: Vincent of Beauvais (c. 1190–1264) and Thomas Aquinas (c. 1225–74). Dominicans were also known as Black Friars because they wore a black cloak over a white tunic.

16–9 | MASONS AT WORK Morgan Library, New York. ms. M240 fol. 3

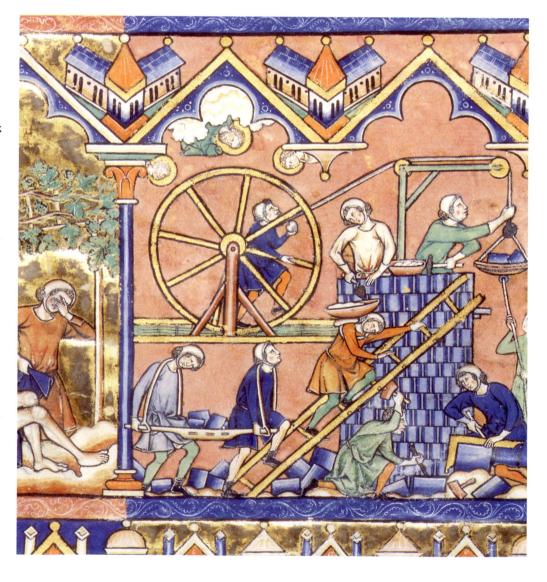

Art and Its Context

MASTER BUILDERS

aster masons oversaw all aspects of church construction in the Middle Ages, from design and structural engineering to decoration. The job presented formidable logistical challenges, especially at great cathedral sites. The master mason at Chartres coordinated the work of roughly 400 people scattered, with their equipment and supplies, at many locations, from distant stone quarries to high scaffolding. This work force set in place some 200 blocks of stone each day.

Funding shortages and technical delays, such as the need to let mortar harden for three to six months, made construction sporadic, so masters masons and their crews moved constantly from job to job, with several masters contributing to a single building. Fewer than 100 master builders are estimated to have been responsible for all the major architectural projects around Paris during the century-long building boom there, some of them working on parts of as many as forty churches. Today the names of more than 3,000 master masons are known to us, and the close study of differences in construction techniques can disclose the participation of specific masters.

Master masons gained in prestige during the thirteenth century as they increasingly differentiated themselves from the laborers they supervised. Their training was rigorous. By the standards of their time they were well read; they traveled widely.

Villard de Honnecourt SHEET OF DRAWINGS WITH GEOMETRIC FIGURES AND ORNAMENTS

From Paris. 1220–35. Ink on vellum, $9\% \times 6''$ (23.5 \times 15.2 cm). Bibliothèque Nationale, Paris.

Lodge books were an important tool of the master mason and his workshop (or lodge). Such books or collections of drawings provided visual instruction and inspiration for apprentices and assistants. Since the drawings received hard use, few have survived. One of the most famous architect's collections is the early thirteenth-century sketchbook of Villard de Honnecourt, a well-traveled master who recorded a variety of images and architectural techniques. A section labeled "help in drawing figures according to the lessons taught by the art of geometry" illustrates the use of geometric shapes to form images and how to copy and enlarge images by superimposing geometric shapes over them as guides.

They knew both aristocrats and high Church officials, and they earned as much as knights. In some cases their names were prominently inscribed in the labyrinths on cathedral floors. From the thirteenth century on, in what was then an exceptional honor, masters were buried, along with patrons and bishops, in the cathedrals they built.

The economy of Chartres revolved around trade fairs, especially cloth fairs held at the times of the church festivals honoring Mary, such as the day of her Assumption, August 15. Both merchants and the Church profited from sales and taxes at the fairs. To build the new cathedral, the bishop and cathedral officials pledged all or part of their incomes for three to five years. Royal and aristocratic patrons joined in the effort. In an ingenious scheme that seems very modern, the churchmen solicited contributions by sending the cathedral relics, including the Virgin's tunic, on tour as far away as England.

As the new structure rose higher during the 1220s, the work grew more costly and funds dwindled. But when the bishop and the cathedral clergy tried to make up the deficit by raising feudal and commercial taxes, the townspeople drove them into exile for four years. This action in Chartres was not unique; people often opposed the building of cathedrals because of the burden of new taxes. The economic privileges claimed by the Church for the cathedral sparked intermittent riots by townspeople and the local nobility throughout the thirteenth century.

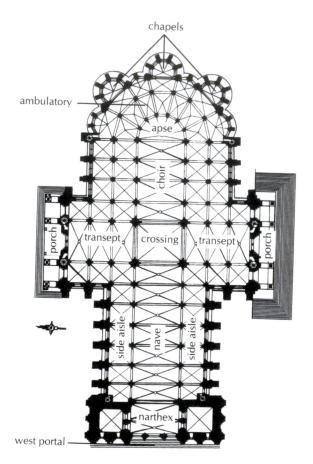

16–10 | **CHARTRES CATHEDRAL, PLAN** c. 1194–1220.

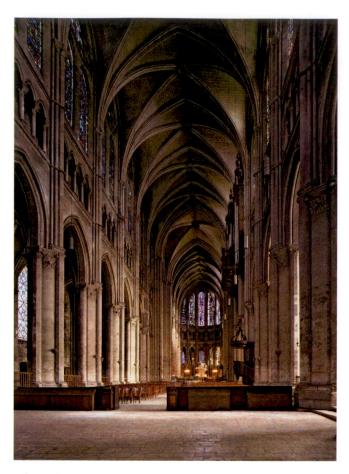

16–11 | NAVE, CHARTRES CATHEDRAL c. 1194–1220.

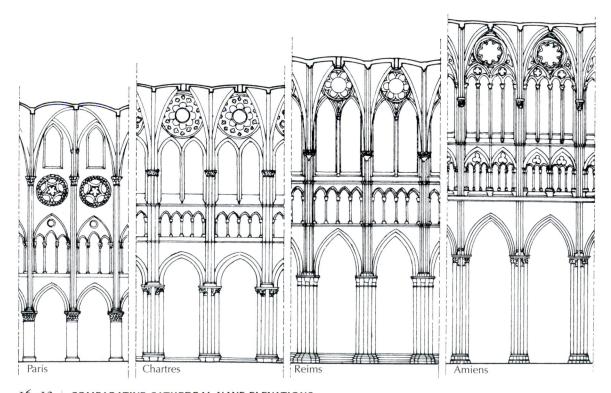

16–12 | **COMPARATIVE CATHEDRAL NAVE ELEVATIONS**From Louis Grodecki, *Gothic Architecture,* New York, 1985. Paris, h. 115' (35 m), w. 40' (12 m); Chartres, h. 120' (37 m), w. 45' 6" (17 m); Reims h. 125' (38 m), w. 46' (14 m); Amiens, h. 144' (44 m), w. 48' (15 m).

HIGH GOTHIC ARCHITECTURE AT CHARTRES, 1194 TO 1260. Building on the concept pioneered at Saint-Denis of an elegant masonry shell enclosing a large open space, the masons at Chartres erected a church over 45 feet wide with vaults that soar approximately 120 feet above the floor. In the plan, the enlarged sanctuary with its ambulatory and chapels, a feature inspired by the church at Saint-Denis, occupied one-third of the building (FIG. 16–10). The actual cross section of the nave is an equilateral triangle measured from the outer line of buttresses to the keystone of the vault. The worshiper's gaze is drawn forward toward the choir where the high altar was situated behind a choir screen and at the same time upward to the clerestory windows and the soaring vaults (FIG. 16–11).

By making the open nave arcade and glowing clerestory nearly equal in height, the architect creates a harmonious elevation (FIG. 16-12). Relatively little interior architectural decoration interrupts the visual rhythm of compound piers with their engaged shafts supporting pointed arches. Fourpart vaulting has replaced more complex systems found in churches such as Durham or Caen (SEE FIG. 15-21). The alternating heavy and light piers typical of Romanesque naves such as that at Speyer Cathedral (SEE FIG. 15–17) become a subtle alternation of round and octagonal compound piers. The gallery, now a narrow arcaded triforium passage, forms a horizontal band running the length of the nave. The large and luminous clerestory is formed by windows whose paired lancets are surmounted by small circular windows, or oculi (bull's-eye windows). The technique used is known as plate tracery; that is, holes are cut in the stone of the wall and filled with stained glass. Glass fills nearly half the wall surface. This lightening of the structure is made possible by the ingenious system of flying buttresses on the exterior.

THE GLORY OF STAINED GLASS. Chartres is unique among French Gothic buildings in that most of its stained-glass windows have survived. Stained glass is an expensive and difficult medium, but its effect on the senses and emotions makes the effort worth-while. The light streaming in through these windows changes with the time of day, the seasons, and the movement of clouds.

Chartres was famous for its glassmaking workshops, which by 1260 had installed about 22,000 square feet of stained glass in 176 windows (see "Stained-Glass Windows," page 528). Most of the glass dates between about 1210 and 1250, but a few earlier windows, from around 1150 to 1170, survived the fire of 1194.

Among the twelfth-century works of stained glass in the west wall of the cathedral is the **TREE OF JESSE** window (FIG. 16–13). The treatment of this subject, much more complex than its depiction in an early twelfth-century Cistercian manuscript (SEE FIG. 15–39), was apparently inspired by a similar window at Saint-Denis. Jesse, the father of King David and an ancestor of Mary, lies at the base of the tree whose trunk grows out of his body, as described by the prophet Isaiah

Sequencing Works of Art

c. 1194-1220	Chartres Cathedral
1220-58	Salisbury Cathedral
1220-88	Amiens Cathedral
1235-83	Saint Elizabeth at Marburg
1243-48	Sainte-Chapelle, Paris

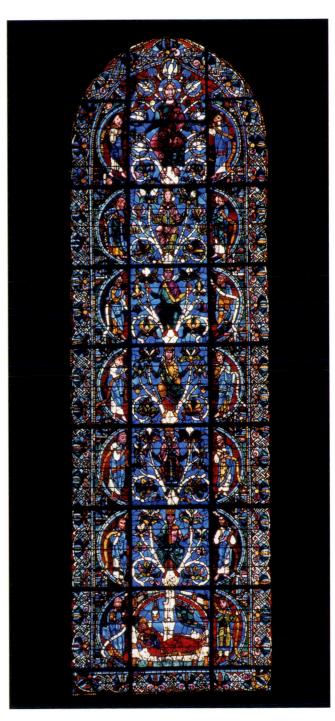

16−13 | TREE OF JESSE, WEST FAÇADE, CHARTRES CATHEDRAL c. 1150-70. Stained and painted glass.

Technique

STAINED-GLASS WINDOWS

he basic technique for making colored glass has been known since ancient Egypt. It involves the addition of metallic oxides—cobalt for blue, manganese for red and purple—to a basic formula of sand and ash or lime that is fused at high temperature. Such "stained" glass was used on a small scale in church windows during the Early Christian period and in Carolingian and Ottonian churches. Colored glass sometimes adorned Romanesque churches, but the art form reached a pinnacle of sophistication and popularity in the cathedrals and churches of the Gothic era.

Making a stained-glass image was a complex and costly process. A designer first drew a composition on a wood panel the same size as the opening of the window to be filled, noting the colors of each of the elements in it. Glassblowers produced sheets of colored glass, and artisans cut individual pieces from these large sheets and laid them out on the wood template. Painters added details with enamel emulsion, and the glass was reheated to fuse the enamel to it. Finally, the pieces were joined together with narrow lead strips, called **cames**. The assembled pieces were set into iron frames that had been made to fit the stonework of the window opening.

The colors of twelfth-century glass—mainly reds and blues with touches of dark green, brown, and orange-yellow—were so dark as to be nearly opaque, and early uncolored glass was full of impurities. But the demand for stained-glass windows stimulated technical experimentation to achieve new colors and greater purity and transparency. The Cistercians adorned their churches with *grisaille* windows, painting foliage and crosses onto a gray glass, and Gothic artisans developed a clearer material onto which elaborate narrative scenes could be drawn.

By the thirteenth century, many new colors were discovered, some accidentally, such as a sunny yellow produced by the addition of silver oxide. Flashing, in which a layer of one color was fused to a layer of another color, produced an almost infinite range of hues. Blue and yellow, for example, could be combined to make green. In the same way, clear glass could be fused to layers of colored glass in varying thicknesses to produce a range of hues from light to dark. The deep colors of early Gothic stained-glass windows give them a saturated and mysterious brilliance. The richness of some of these colors, particularly blue, has never been surpassed. Pale colors and large areas of grisaille glass became increasingly popular from the mid-thirteenth century on, making the windows of later Gothic churches bright and clear by comparison.

(11:1–3). The family tree literally connects Jesus with the house of David (Matthew 1:1–17). In the branches above him appear four kings of Judea (Christ's royal ancestors), then the Virgin Mary, and finally Christ himself. Seven doves, symbolizing the seven gifts of the Holy Spirit, encircle Christ, and fourteen prophets stand in the semicircles flanking the tree. The glass in the *Tree of Jesse* window is set within an iron framework visible as a rectilinear pattern of black lines.

Twelfth-century windows are remarkable for their simple geometric compositions—usually squares and circles and the intensity of the color of the glass. In the color symbolism of the time, blue signified heaven and fidelity; red, the Passion; white, purity; green, fertility and springtime. Yellow as a substitute for gold could represent the presence of God, the sun, or truth; but plain yellow could also mean deceit and cowardice. Stained-glass windows changed the color and quality of light to inspire devotion and contemplations. Their painted narratives also educated the viewers.

Most of the windows in the new church were glazed between 1210 and 1250. In the aisles and chapels where the windows were low enough to be easily seen, there were elaborate narratives using many small figures. Tracery—geometric decorative patterns in stone or wood that filled window openings—became increasingly intricate. In the clerestory windows, glaziers used single figures that could be seen at a distance because of their size, simple drawing, and strong colors. In the north transept, five lancets and a rose window (over 42 feet in diameter) fill the upper wall (FIG. 16–14).

The North transept windows may have been a royal commission, a gift from Queen Blanche of Castile (mother of Louis IX, regent, 1226–34), whose heraldic castles symbolizing the country of Castile (Spain) join the golden lilies of France in the spandrels. In the lancets, Saint Anne and the infant Mary have the place of honor. Saint Anne is flanked by Old Testament figures: the priests Mechizedek and Aaron and the kings David and Solomon. In the center of the rose window, Mary is enthroned with the Christ Child. Radiating from the holy pair are lattice-filled panels displaying four doves (the Gospels) and eight angels, the prophets, and the Old Testament ancestors of Christ.

High Gothic: Amiens and Reims Cathedrals

New cathedrals in other rich commercial cities of northern France reflected both the piety and civic pride of the citizens. The cathedrals of Chartres, Amiens, and Reims were being built at the same time, and the master masons at each site borrowed ideas from one another. Amiens was an important trading and textile-manufacturing center north of Paris. The cathedral housed relics of Saint John the Baptist. When Amiens burned in 1218, church officials devoted their resources to making its replacement as splendid as possible.

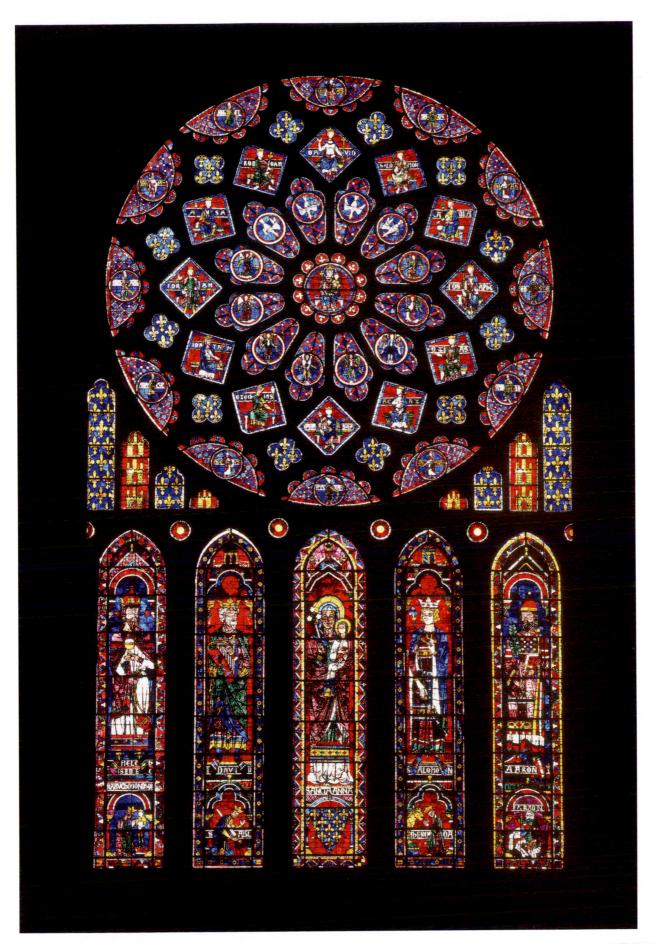

16--14 | chartres cathedral, north transept, rose window and lancets, known as THE "ROSE OF FRANCE"

North transept, Chartres Cathedral. c. 1220, stained and painted glass.

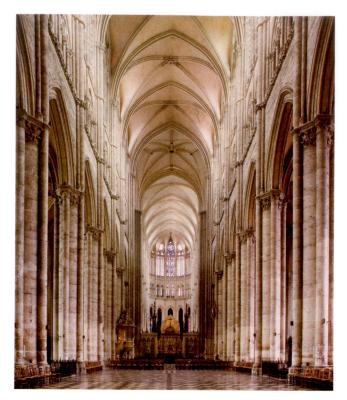

16–15 ↑ **NAVE, AMIENS CATHEDRAL** France. 1220–88; upper choir reworked after 1258.

Their funding came mainly from the cathedral's agricultural estates and from the city's important trade fairs. Construction on the new church began in 1220. The lower parts date from about 1220–36, with major work continuing until 1288. Robert de Luzarches (d. 1236) was the builder who established the overall design. He was succeeded by Thomas de Cormont, who was followed by his son Renaud.

NAVE AND CHOIR: AMIENS CATHEDRAL. The church at Amiens became the archetypical Gothic cathedral (FIG. 16-15). Robert de Luzarches made critical adjustments that simplified, clarified, and unified the plan of Amiens Cathedral as compared with Chartres Cathedral. He eliminated the narthex and expanded the transept and sanctuary (comprising the apse, ambulatory chapels, and choir), thus shortening the nave and creating a plan that seems to balance east and west around the crossing (FIG. 16-16). In the choir, chapels of the same size and shape enhance the clarity of the design. The nave elevation is also balanced and compact. Uniform and evenly spaced compound piers, with engaged half columns topped by foliage capitals, support the arcades. Tracery and colonnettes (small columns) unite the triforium and the clerestory, and together they equal the height of the nave arcade. An ornate floral molding below the triforium runs uninterrupted across the wall surfaces and the colonnettes, providing a horizontal counterpoint to the soaring verticality of the design. This sculptural detail adds an elegant note to the severe architecture.

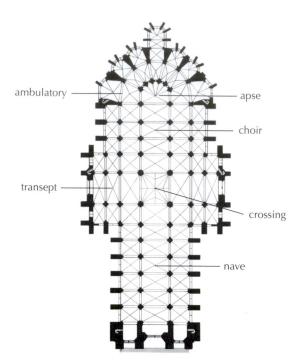

16–16 | Robert de Luzarches, Thomas de Cormont, and Renaud de Cormont PLAN OF CATHEDRAL OF NOTRE-DAME, AMIENS 1220–88.

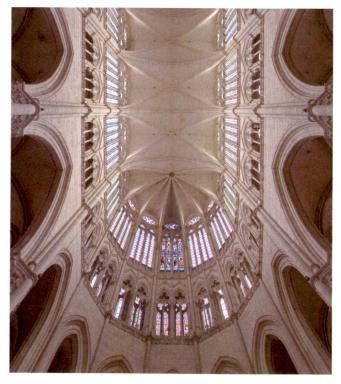

16–17 | **VAULTS, SANCTUARY, AMIENS CATHEDRAL** France. Upper choir after 1258; vaulted by 1288.

Amiens is a supreme architectural statement of the Gothic desire for both actual and perceived height (FIG. 16–17). The nave, only 48 feet wide, soars upward 144 feet; consequently, not only is the nave in fact exceptionally tall, its narrow proportions (3:1, height to width) create an exaggerated sense of

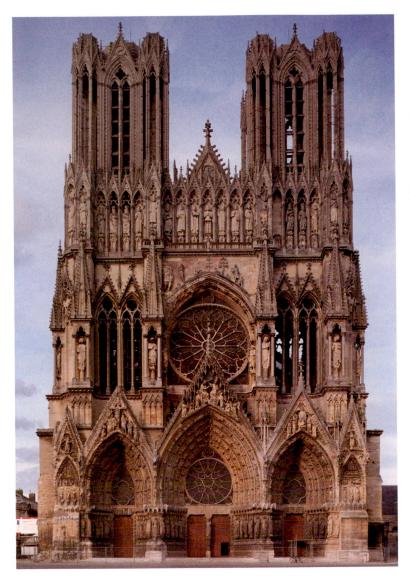

16-18 | West façade, cathedral of notre-dame, reims

France. Rebuilding begun 1211; façade begun c. 1225; to the height of rose window by 1260; finished for the coronation of Philip the Fair in 1286; towers left unfinished in 1311; additional work 1406–28.

The cathedral was restored in the sixteenth century and again in the nineteenth and twentieth centuries. During World War I it withstood bombardment by some 3,000 shells, an eloquent testimony to the skills of its builders.

height. A comparison of Louis Grodecki's nave elevations of the cathedrals of Paris, Chartres, Reims, and Amiens—drawn to the same scale—demonstrates the change in height and design of cathedrals over time (SEE FIG. 16–12).

The lower portions of the church were substantially finished by about 1240. The vault and the light-filled choir date to the second phase of construction, directed by Thomas de Cormont, perhaps after a fire in 1258 (FIG. 16–17). The choir is illuminated by large windows subdivided by bar tracery (in bar tracery, thin stone strips, called mullions, form a lacy matrix for the glass). In the Amiens choir, the tracery divides the windows into slender lancets crowned by trefoils (three-lobed designs) and circular windows.

THE WEST FAÇADE AT REIMS CATHEDRAL. In the Church hierarchy, the bishop of Amiens was subordinate to the archbishop of Reims. Reims, northeast of Paris, was the coronation church of the kings of France and, like Saint-Denis, had been a cultural and educational center since Carolingian times. When in 1210 fire destroyed this vital building, the

community at Reims began to erect a new structure. The cornerstone was laid in 1211, and work on the cathedral continued throughout the century. The expense of the project sparked such local opposition that twice in the 1230s revolts drove the archbishop and canons into exile. At Reims five masters directed the work on the cathedral over the course of a century-Jean d'Orbais, Jean le Loup, Gaucher de Reims, Bernard de Soissons, and Robert de Coucy. If Amiens Cathedral has the ideal Gothic nave and choir, Reims Cathedral's west front takes pride of place among Gothic façades. The major portion of this magnificent structure must have been finished in time for the coronation of Philip the Fair in 1286 (FIG. 16-18). Its tall gabled portals form a broad horizontal base and project forward to display an expanse of sculpture. Their soaring peaks, the middle one reaching to the center of the rose window, unify the façade vertically. Large windows fill the tympana, instead of the sculpture usually found there. The deep porches are encrusted with sculpture that lacks the unity seen at Amiens, reflecting instead 100 years of changes in plan, iconography, and workshops.

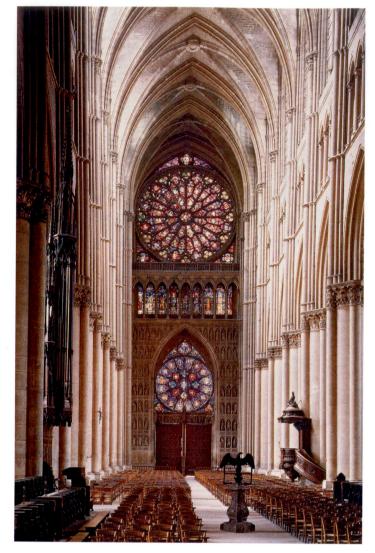

16–19 NAVE, REIMS CATHEDRAL Looking west. Begun 1211; nave c. 1220.

In a departure from tradition, Mary rather than Christ dominates the central portal, a reflection of the popularity of her cult. Christ crowns her as Queen of Heaven in the central gable. The enormous rose window is the focal point of the façade. The towers were later additions, as was the row of carved figures that runs from the base of one tower to the other above the rose window. This "gallery of kings" is the only strictly horizontal element of the façade.

Inside the church, remarkable sculpture and stained glass fill the west wall (FIG. 16–19), which visually "dissolves" in colored light. The great rose window fills the clerestory level; a row of lancets illuminate the triforium; and a smaller rose window replaces the stone of the tympanum of the portal. This expanse of glass was made possible by bar tracery, a technique invented or at least perfected at Reims. The circles of the two rose windows are anchored visually by a masonry grid of tracery and sculpture covering the inner wall of the façade.

Here ranks of carved Old Testament prophets and Christ's royal ancestors serve as moral guides for the newly crowned monarchs who faced them after the coronation ceremonies.

High Gothic Sculpture

Like Greek sculpture, Gothic sculpture evolved from static forms to moving figures, from formal geometric abstraction though an idealized phase, to a surface realism that could be highly expressive. As in ancient art, Gothic sculpture was originally painted and sometimes gilded. The stone surfaces were not entirely covered but subtly colored and decorated to enhance the realism of the figures. Recent cleaning at Amiens and Reims has revealed remarkable amounts of color—borders of garments painted to indicate rich embroidery, gilded angel wings, colored foliage, and chevron-patterned colonettes.

AMIENS. The worshipers approaching the main entrance—the west portals—of Amiens Cathedral encountered an overwhelming array of images. Figures of apostles and saints line the door jambs and cover the projecting buttresses (FIG. 16–20). Most of them were produced by a large workshop in only twenty years, between about 1220 and perhaps 1236/40, making the façade stylistically more coherent than those of many other cathedrals. In the mid-thirteenth century, Amiens–trained sculptors traveled across Europe and carried their style into places like Spain and Italy.

The Amiens central portal is dedicated to Christ and the Apostles, with the Last Judgment in the tympanum above, surrounded by angels and saints in the voussoirs. At the right is Mary's portal, where she is depicted as Queen of Heaven. The left portal is dedicated to local saints with Saint Firmin, the first bishop of Amiens, in the trumeau. At Amiens the master designer introduced a new feature: At eye-level, on the base below the jamb figures, are quatrefoils (four-lobed medallions) containing lively illustrations of good (Virtues) and evil (Vices) in daily life, the seasons and labors of the months, the lives of the saints, and biblical stories (FIG.16–21). At last the natural world enters the ideal Christian vision.

All this imagery revolves around Christ standing in front of the trumeau of the central portal. Known as the **BEAU DIEU**, meaning "Noble (or Beautiful) God," Christ as the teacher-priest bestows his blessing on the faithful (FIG. 16–22). This exceptionally fine sculpture may well be the work of the master of the Amiens workshop himself. The figure establishes an ideal for Gothic figures. The broad contours of the heavy drapery wrapped around Christ's right hip and bunched over his left arm lead the eye up to the Gospel book he holds and, following his right hand, raised in blessing, to his face, which is that of a young king. He stands on a lion and a dragonlike creature called a *basilisk*, symbolizing his kingship and his triumph over evil and death (Psalm 91:13).

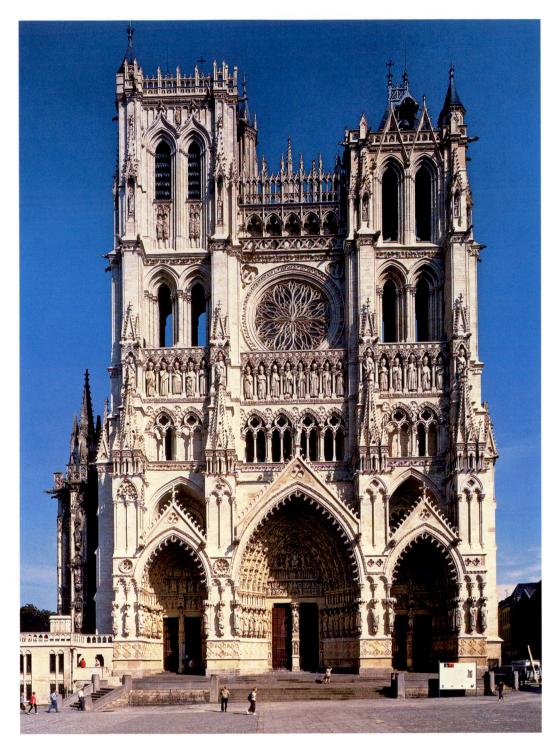

I6−20 | WEST FAÇADE, AMIENS CATHEDRAL c. 1220-36/40 and continued through the 15th century.

With its clear, solid forms, elegantly cascading robes, and interplay of close observation with idealization, the *Beau Dieu* embodies the Amiens style and the Gothic spirit.

REIMS. At Reims, sculptors from major workshops, such as Chartres and Amiens, as well as local sculptors worked together for decades. Most of the sculpture was done in a

twenty-year period between 1230 and 1250, although sculpture in the upper regions of the façade may be as late as 1285.

Complicating the study of the sculpture at Reims is the fact that many figures have been moved from their original locations. On the right jamb of the central portal of the western façade, a group of four figures—depicting the *Annunciation* and the *Visitation*—illustrates three of the characteristic

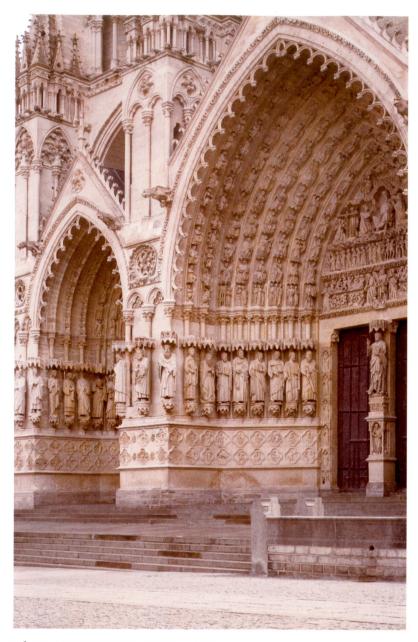

16-21 | west façade, central and north portals. Amiens cathedral.

c. 1220-1236/40. Central portal: tympanum: Last Judgement; trumeau: Christ (Beau Dieu); jambs: Apostles. Height of figures, 7-8'.

Reims styles (FIG. 16–23). Art historians have given names to the styles: the Classical Master (or the Master of Antique Figures), the Amiens Master, and the Master of the Smiling Angels. The pair on the right, the *Visitation*, is the work of the Classical Shop, which was active as early as the 1220s and 1230s. Mary (left), pregnant with Jesus, visits her older cousin Elizabeth (right), who is pregnant with John the Baptist.

The sculptors drew on classical sources—either directly from Roman sculpture (Reims had been an important center under ancient Rome) or indirectly through Mosan metalwork (SEE FIG. 16–35). The heavy figures have a solidity seen in Roman sculpture, and Mary's full face, gently waving hair, and heavy mantle recall imperial portrait statuary. The contrast between the features of the young Mary and the older

Elizabeth recall ancient Roman sculpture (compare the portrait of the Flavian woman in FIG. 6–45). The Classical Master of Reims used deftly modeled drapery not only to provide volume, but also to create a stance in which the apparent shift in weight of one bent knee allows the figures to seem to turn toward each other. The new freedom, movement, and sense of implied interaction inspired later Gothic artists toward ever greater realism.

In the *Annunciation* two other masters were at work, one probably from Amiens and the other a new artist whose antecedents are still unknown. The Amiens Master's Mary is a quiet, graceful figure, with a slender body and restrained gestures—a striking contrast to the bold tangibility of the Classical Master's Mary. The broad planes of simple drapery suggest

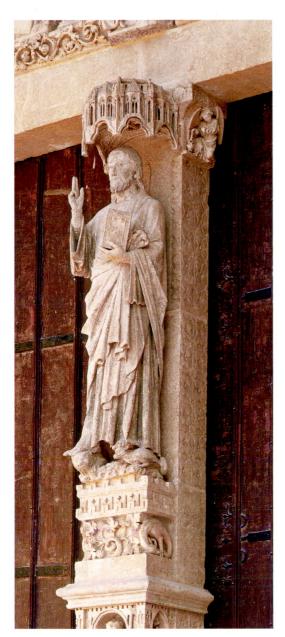

16–22 | CHRIST: BEAU DIEU
Trumeau, central portal, west façade, Amiens
Cathedral. France. c. 1220–36/40.

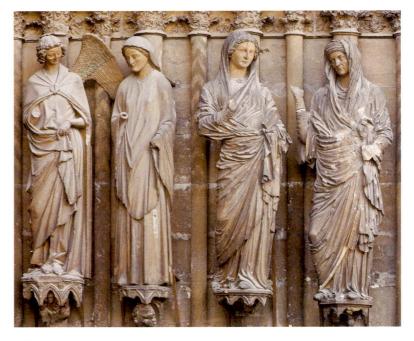

I6-23 | WEST FAÇADE, CENTRAL PORTAL, RIGHT SIDE,
REIMS CATHEDRAL
Annunciation (left pair: Mary [right] c. 1245, angel [left] c. 1255) and
Visitation (right pair: Mary [left] and Elizabeth [right] c. 1230).

the Amiens shop, but her pinched features are the sculptor's personal style. The sculptor here was one of a large team that made most of the other sculptures of the west entrance.

The figure of the angel Gabriel is the work of the Master of the Smiling Angels. This artist created tall, gracefully swaying figures that in body type, features, pose, and gestures suggest the fashionable refinement associated with the Parisian court at mid-century. The angel Gabriel is typical. His small, almost triangular head with a broad brow and pointed chin is framed by wavy hair; his puffy, almond-shaped eyes are set under arching brows; he has a well-shaped nose and thin lips curving into a slight smile. The cocked head, hint of a smile, and mannered gestures as he draws his voluminous drapery into elegant folds suggest aristocratic,

courtly elegance. Later in the century (and during the fourteenth century), artists from Paris to Prague imitated this style, as grace and refinement became a guiding ideal in sculpture and painting (see Chapter 17).

The Rayonnant Style

In the second half of the thirteenth century artists fell under the spell of the Master of the Smiling Angels of Reims as well as the luminous west façade of Reims and choir of Amiens. They created a new variation of the Gothic style of architecture, known today as the Rayonnant (Radiant) or Court Style (referring to the Parisian court). Using this style, they finished older buildings, such as the abbey church of Saint-Denis, and added transepts and chapels to Notre Dame in Paris.

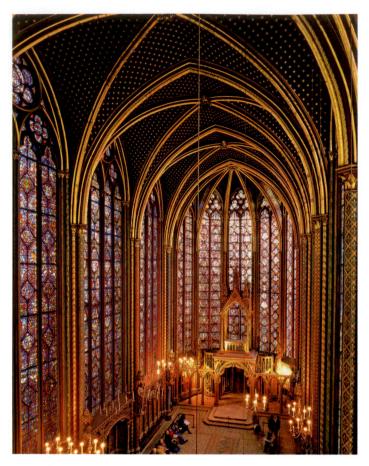

16–24 ↑ **UPPER CHAPEL, SAINTE-CHAPELLE** Paris. 1243–48.

At Saint-Denis (SEE FIG. 16–1), work began in 1231 to complete Abbot Suger's church. The new nave, transept, and upper part of the choir attach seamlessly to the twelfth-century narthex and lower part of the choir (SEE FIG. 16–3). Its glazed triforium and tall clerestory windows filled with bar tracery and stained glass are visually united by the continuous shafts rising from the base of clustered columns to the rib vault. The builders achieved the effects of spatial unity and an interior filled with the jewel-like colored space dreamed of by Suger.

The remodeling and construction of the transepts at Paris, the choir at Amiens, and the façade at Reims all reflect a courtly style characterized by interlocking and overlapping forms, linear patterns, and above all, spatial unity and luminosity. The Rayonnant style continued through the fourteenth and into the fifteenth centuries and influenced the Gothic art of Germany, Italy, and Spain.

THE SAINTE-CHAPELLE IN PARIS. The masterpiece of Rayonnant style is the palace chapel in Paris—the Sainte-Chapelle, or Holy Chapel—ordered by Louis IX (FIG. 16–24). Louis IX (ruled 1226–70) avidly collected relics of Christ's Passion sold to him by his cousin, who was ruling Constantinople after the Fourth Crusade. In 1239 Louis acquired the crown of thorns and in 1241 other relics,

including a bit of the metal lance tip that pierced Christ's side, the vinegar-soaked sponge offered to wet Christ's lips, a nail used in the Crucifixion, and a fragment of the True Cross (or so people believed). He kept these treasures in the palace while he built a chapel to house them. Construction moved rapidly. The building may have been finished in 1246, and it was consecrated in 1248.

The Sainte-Chapelle resembles a giant reliquary, one made of stone and glass instead of gold and gems. Built in two stories, the ground-level chapel is accessible from a courtyard, and a private upper chapel is entered from the royal residence. The ground-level chapel has a nave and narrow side aisles, but the upper level is a single room with a western porch and a rounded east wall. The design of the exterior, with gables and wall buttresses framing huge windows, inspired the artist who created a psalter for the king (discussed on the facing page).

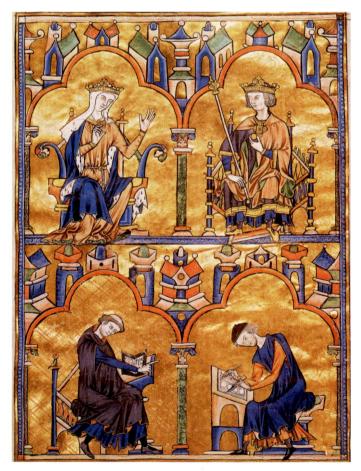

16-25 Queen blanche of castile and louis IX, moralized bible

Paris. 1226–34. Ink, tempera, and gold leaf on vellum, $15\times10\%$ (38 \times 26.6 cm). The Pierpont Morgan Library, New York.

MS. M. 240, f. 8

This page was placed at the end of the manuscript as a colophon (comparable to a title page in a modern book). Thin sheets of gold leaf were painstakingly attached to the vellum and then polished to a high sheen with a tool called a burnisher. Gold was applied to paintings before pigments.

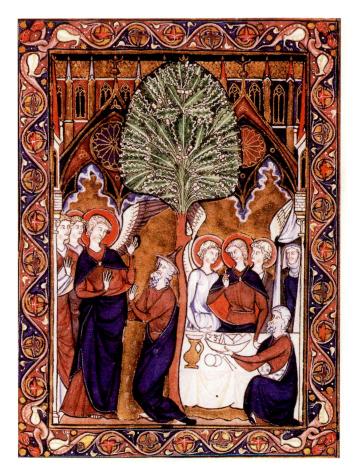

 $16-26 \perp$ abraham, sarah, and the three strangers from the psalter of saint louis

Paris. 1253-70. Ink, tempera, and gold leaf on vellum, $5 \times 3\frac{1}{2}$ " (13.6 \times 8.7 cm). Bibliothèque Nationale, Paris.

Whether entering the upper level, walking through the palace halls, or climbing up the narrow spiral stairs from the lower level, the visitor emerges into a kaleidoscopic jewel box. The walls have been reduced to clusters of slender colonnettes framing tall windows filled with shimmering glass. Bar tracery in the windows is echoed in the blind arcading and tracery decorating the lower walls. The stone surfaces are painted and gilded-red, blue, and gold-so that stone and glass seem to merge in the multicolored light. Painted statues of the twelve apostles stand between window sections, linking the walls and the stained glass. The windows contain narrative and symbolic scenes. Those in the curve of the sanctuary behind the altar and relics, for example, illustrate the Nativity and Passion of Christ, the Tree of Jesse, and the life of Saint John the Baptist. The story of Louis' acquisition of his relics is told, and the Last Judgment appeared in the original rose window on the west.

Illuminated Manuscripts

France gained renown in the thirteenth century not only for its new architecture and sculpture but also for the production

Sequencing Works of Art

c. 1145-55	Prophets and Ancestors of Christ, Royal Portal, Chartres Cathedral
c. 1150-70	Tree of Jesse Window, Chartres Cathedral
c. 1220-36	Beau Dieu, west façade, Amiens Cathedral
c. 1226-34	Queen Blanche of Castile and Louis IX, Moralized Bible, from Paris
c. 1230	Visitation, west façade, Reims Cathedral

of books. The Court Style had enormous influence throughout northern Europe, spread by artists, especially manuscript illuminators, who flocked to Paris from other regions. There they joined workshops affiliated with the Confrérie de Saint-Jean (Guild of Saint John), supervised by university officials who controlled the production and distribution of books. These works ranged from practical manuals to elaborate devotional works illustrated with exquisite miniatures. Women played an important role in book production. Widows continued their husband's businesses; they even took oaths as commercial book producers.

Louis IX and Blanche of Castile. Paris was a major center of book production in the Gothic period, and the royal library in Paris was especially renowned. Not only the king, but his mother, Blanche of Castile, commissioned and collected books (FIG. 16–25). Blanche and the young king appear here seated on ornate thrones against a gold background. Colorful Gothic architecture suggests the royal palace, where the manuscript may actually have been made. Below, a scholar-monk dictates, and the scribe works on a page with a column of circles that will hold the illustrations. This compositional format derives from stained-glass lancets organized as columns of images in medallions. The illuminators show their debt to stained glass in their use of glowing red and blue colors and reflective gold surfaces.

THE PSALTER OF SAINT LOUIS. In the opulence, number, and style of its illustrations, the PSALTER OF SAINT LOUIS defines the Court style in manuscript illumination just as Louis' chapel does the architecture (FIG. 16–26). The book, containing seventy-eight full-page illuminations, was created for the king's private devotions, probably after his return from the Fourth Crusade in 1254. The illustrations fall at the back of the book, preceded by Psalms and other readings. Intricate scrolled borders frame the narratives, and figures are rendered in a style that reflects the sculpture of the Master of the Smiling Angels of Reims.

Depicted here is the Old Testament story of Abraham and Sarah's hospitality to three strangers, that is, God in the three persons (compare the later Byzantine icon, FIG. 7–51). Sarah watches from the entryway of their tent, while the strangers—angels representing God—tell the elderly couple that Sarah will bear a child, Isaac. The story is yet another instance of the Old Testament prefiguring the New. To the medieval reader, the three strangers were symbols of the Trinity, and God's promise to Sarah foreshadowed the angel's annunciation of the Christ Child's birth to Mary.

The architectural frame, depicting gables, pinnacles, and windows modeled on the Sainte-Chapelle, establishes a narrow stage on which the story unfolds. Wavy clouds floating within the arches under the gables indicate an outdoor setting. The oak tree, representing the biblical oaks of Mamre (Genesis 18:1), has stylized but recognizable oak leaves and acorns. The oak establishes the specific location of the story. At the same time, the angel's blessing gesture and Sarah's pres-

ence indicate a specific moment. This new awareness of time and place, as well as the oak leaves and acorns, reflect a tentative move toward the representation of the natural world that will gain momentum in the following centuries.

GOTHIC ART IN ENGLAND

Plantagenet kings ruled England from the time of Henry II and Eleanor of Aquitaine until 1485. Many of the kings, especially Henry III (ruled 1216–72), were great patrons of the arts. During this period, London grew into a large city, but most people continued to live in rural villages and bustling market towns. Textile production dominated manufacture and trade, and fine embroidery continued to be an English specialty. The French Gothic style influenced English architecture and manuscript illumination. However, these influences were tempered by local materials, methods, and artistic traditions such as an expressive use of line and an interest in surface decoration.

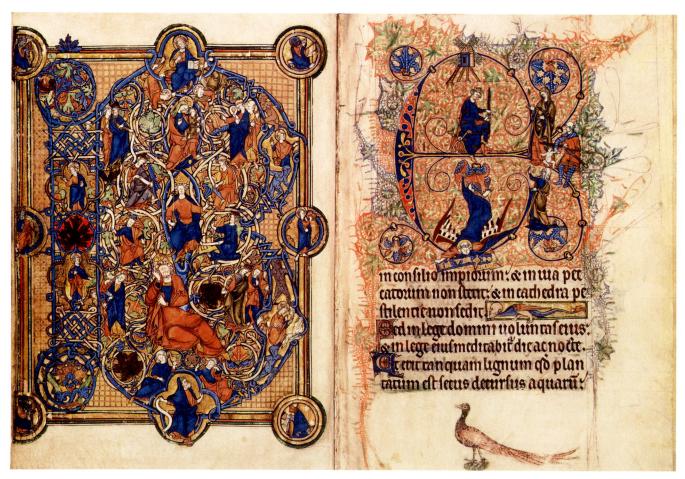

16–27 | **PSALM 1 (BEATUS VIR) FROM THE WINDMILL PSALTER** London. c. 1270–80. Ink, pigments, and gold on vellum, each page $12\frac{3}{4}\times8\frac{3}{4}$ " (32.3 \times 22.2 cm). The Pierpont Morgan Library, New York. M. 102, f. lv-2

Manuscript Illumination

The universities of Oxford and Cambridge dominated intellectual life, but monasteries continued to house active *scriptoria*, in contrast to France, where book production became centralized in the professional workshops of Paris. By the end of the thirteenth century, secular workshops became increasingly active in England, reflecting a demand for books from newly literate landowners, townspeople, and students. These people read books for entertainment and general knowledge as well as for religious enlightenment.

The dazzling artistry and delight in ambiguities that had marked early medieval manuscripts in the British Isles reappear in the **WINDMILL PSALTER** (FIG. 16–27). The elegance of French Gothic visible in the elongated proportions and dainty heads of the figures is combined with the English tradition of draftsmanship visible in the interlaced tendrils and stylized drapery folds.

Psalm 1 begins with the words "Beatus vir qui non abiit" ("Blessed is the man who does not follow [the counsel of the wicked]," Psalm 1:1). The letter B, the first letter of the Psalm, fills the left-hand page, and an E occupies the top at the right. The rest of the opening words appear on a banner carried by an angel at the bottom of the E. The B outlines a densely interlaced Tree of Jesse. The E is formed from large tendrils that escape from delicate background vegetation to support characters in the story of the Judgment of Solomon (I Kings 3:16-27). The story, seen as a prefiguration of the Last Judgment and an illustration to the phrase "his delight is in the law of the Lord" (Psalm 1:2), relates how two women (at the right) claiming the same baby came before King Solomon (on the crossbar) to settle their dispute. The king ordered his knight to slice the baby in half and give each woman her share. This trick revealed the real mother, who hastened to give up her claim in order to save the child's life.

Realistic and surprising images appear everywhere—note how the knight hooks his toe under the cross bar of the *E* to maintain his balance. Visual puns on the text abound. The meaning of the pheasant at the bottom of the page remains a mystery, but the windmill at the top of the letter *E* (which gives the name to the *Windmill Psalter*) is typical of this new realism. It illustrates the verse that tells how wicked people would not survive the Judgment but would be "like chaff driven away by the wind" (Psalm 1:4). The imagery thus encouraged further thought on the text's familiar messages.

Architecture

The Gothic style in architecture appeared early in England under the influence of local Cistercian and Norman builders and by traveling master builders. A typical thirteenth-century English cathedral seems to hug the earth more like a Cistercian monastery (see Fontenay in Burgundy, FIG. 15–12)

than compact and vertical French cathedrals like Chartres (SEE FIG. 16–8). English builders also favored a screenlike façade that does not usually reflect the interior distribution of space, a characteristic that is at odds with the architectural logic of French Gothic.

SALISBURY CATHEDRAL. The thirteenth-century cathedral in Salisbury is an excellent example of English interpretation of the Gothic style. It had an unusual origin. The first Salisbury Cathedral had been built within the castle complex of the local lord. In 1217, Bishop Richard Poore petitioned the pope to relocate the church, claiming the wind on the hilltop howled so loudly that the clergy could not hear themselves sing the Mass. A more pressing concern was probably his desire to escape the lord's control. As soon as he moved, the bishop established a new town, called Salisbury. Material from the old church carted down the hill was used in the new cathedral, along with dark, fossil-filled Purbeck stone from quarries in southern England and limestone imported from Caen. Building began in 1220, and most of the cathedral was finished by 1258, an unusually short period for such an undertaking (FIG. 16-28).

A general comparison between the major features of French High Gothic cathedrals and Salisbury is instructive, for the builders took very different means to achieve their goal of creating the Heavenly Jerusalem on earth. In contrast to French cathedral façades, whose mighty towers flanking deep portals suggest monumental gateways to Paradise, English façades have a horizontal emphasis suggesting the jeweled walls of the celestial city.

At Salisbury, the west façade was completed by 1265. The small flanking towers of the west front project beyond the side walls and buttresses, giving the façade an increased width, underscored by tier upon tier of blind tracery and arcaded niches. Instead of a western rose window floating over triple portals (as seen in France), the English masters placed tall lancet windows above rather insignificant doorways. A mighty crossing tower (the French preferred a slender spire) became the focal point of the building. (The huge crossing tower and its 400-foot spire are a fourteenth-century addition at Salisbury, as are the flying buttresses, which were added to stabilize the tower.) The slightly later cloister and chapter house provided for the cathedral's clergy.

Salisbury has an equally distinctive plan, with wide projecting double transepts, a square east end with a single chapel, and a spacious sanctuary—like a monastic church (FIG. 16–29). The nave interior reflects the Norman building tradition of heavy walls and a tall nave arcade surmounted by a gallery and a clerestory with simple lancet windows (FIG. 16–30). The walls alone are enough to buttress the four-part ribbed vault. The emphasis on the horizontal movement of the arcades, unbroken by colonnettes,

directs worshipers' attention forward toward the altar behind the choir screen, rather than upward into the vaults, as preferred in France (SEE FIG. 16–15). The use of color in the stonework is reminiscent of Romanesque interiors: The shafts supporting the four-part rib vaults are made of dark Purbeck stone that contrasts with the lighter limestone of the rest of the interior. The stonework was originally painted and gilded.

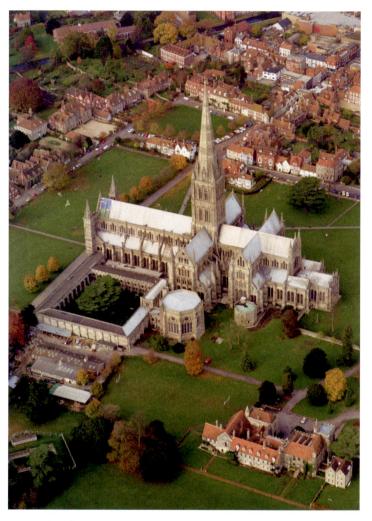

I6–28 | **SALISBURY CATHEDRAL** Salisbury, England. 1220–58; west façade finished 1265; spire c. 1320–30; cloister and chapter house 1263–84.

16-30 NAVE, SALISBURY CATHEDRAL

In the eighteenth century, the English architect James Wyatt subjected the building to radical renovations, during which the remaining stained glass and figure sculpture were removed or rearranged. Similar campaigns to refurbish medieval churches were common at the time. The motives of the restorers were complex and their results far from our notions of historical authenticity today.

16-29 | SALISBURY CATHEDRAL, PLAN

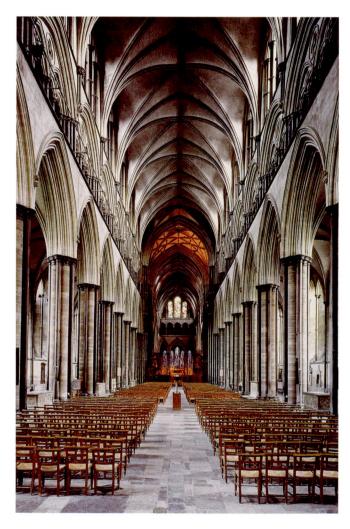

MILITARY AND DOMESTIC ARCHITECTURE. Cathedrals were not the only structures that underwent development during the Early and High Gothic periods. Western European knights who traveled east during the Crusades were inspired by the architectural forms they saw employed in Muslim castles and the mighty defensive land walls of Constantinople (SEE FIG. 7-24). When they returned home, Europeans built their own versions of these fortifications. Castle gateways now became complex, nearly independent fortifications often guarded by twin towers rather than just one. New D-shaped and round towers eliminated the corners that had made earlier square towers vulnerable to battering rams; and crenellations (notches) were added to tower tops in order to provide stone shields for more effective defense. The outer, enclosing walls of the castles were strengthened. The open, interior space was enlarged and filled with more comfortable living quarters for the lord and wooden buildings to house the garrison and the staff necessary to repair armor and other equipment. Barns and stables for animals, including the extremely valuable war horses, were also erected within the enclosure (SEE FIG. 15-24).

STOKESAY CASTLE. Military structures were not the only secular buildings outfitted for defense. In uncertain times, the manor (a landed estate), which continued to be an important economic basis in the thirteenth century, also had to fortify its buildings. A country house that was equipped with a tower and crenellated rooflines became a status symbol as well as a necessity. Stokesay Castle, a remarkable fortified manor house, survives in England near the Welsh border. In 1291 a wool merchant, Lawrence of Ludlow, acquired the property of Stokesay and secured permission from King Edward I to fortify his dwelling—officially known as a "license to crenellate" (FIG. 16–31). He built two towers, including a massive crenellated south tower and a great hall. The defense walls of Stokesay are gone, but the two towers and the great hall survive.

Life in the Middle Ages revolved around the hall. Windows on each side of Stokesay's hall open both toward the courtyard and out across a moat toward the countryside. By the thirteenth century people began to expect some privacy as well as security; therefore at both ends of the hall are two-story additions that provided retiring rooms for the family and workrooms for women to spin and weave. Rooms on the north end could be reached from the hall, but the upper chamber at the south was accessible only by means of an exterior stairway. A tiny window—a peephole—let women and members of the household observe the often rowdy activities in the hall below.

Furnishings defined and dignified the rooms. Of prime importance were textiles in the form of wall hangings, cushions, and coverlets (see *Christine de Pizan and the Queen of France* for an example of a furnished room, Introduction, Fig. 21). In both layout and décor, there was essentially no

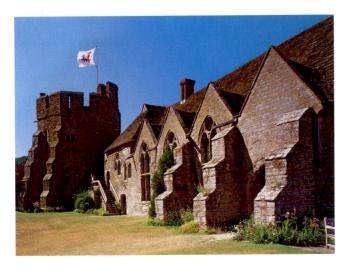

16 - 31 | exterior of the tower and great hall, stokesay castle

Late 13th century. Royal permission to build granted in 1291.

difference between this manor far from the London court and the mansions built by the nobility in the city. A palace followed the same pattern of hall and retiring rooms; it was simply larger than a manor. The great hall was also the characteristic domestic architectural feature on the Continent.

GOTHIC ART IN GERMANY AND THE HOLY ROMAN EMPIRE

The Holy Roman Empire, weakened by internal strife and a prolonged struggle with the papacy, ceased to be a significant power in the thirteenth century. England and France were becoming strong nation-states, and the empire's hold on southern Italy and Sicily ended at midcentury with the death of Emperor Frederick II, who was also king of Sicily. The emperors—who were elected—had only nominal authority over a loose union of Germanic states. After Frederick, German lands increasingly became a conglomeration of independent principalities, bishoprics, and free cities. As in England, the French Gothic style, avidly embraced in the western Germanic territories, shows regional adaptations and innovations.

Architecture

In the thirteenth century, the increasing importance of the sermon in church services led architects in Germany to further develop the hall church, a type of open, light-filled interior space that appeared in Europe in the early Middle Ages but was particularly popular in Germany. The hall church is characterized by a nave and side aisles whose vaults all reach the same height. Large windows in the outer walls create a well-lit interior. The spacious and open design of the hall church provided accommodation for the large crowds drawn by charismatic preachers.

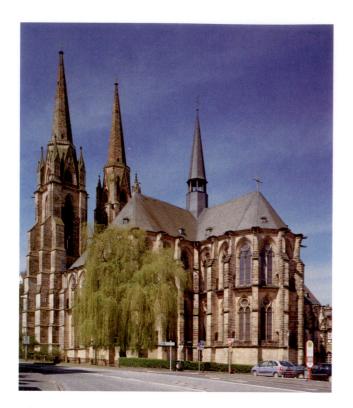

16–32 ↑ **EXTERIOR, CHURCH OF SAINT ELIZABETH** Marburg, Germany. 1235–83.

The plan of the church is an early German form, a trefoil with choir and transepts of equal size. The elevation of the building, however, is new—the nave and aisles are of equal height. On the exterior wall, buttresses run the full height of the building and emphasize its verticality. The two rows of windows suggest a two-story building, which is not the case. Inside, the closely spaced piers of the nave support the ribbed vault and, as with the buttresses, give the building a vertical, linear quality (FIG. 16–33). Light from the two stories of tall windows fills the interior, unimpeded by walls, galleries, or triforia. Both the circular piers with slender engaged columns and the window tracery resemble those of the cathedral of Reims. The hall church design was adopted widely for civic and residential buildings in Germanic lands and also for Jewish architecture.

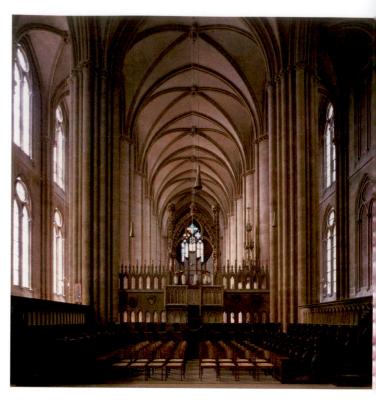

16–33 | INTERIOR, CHURCH OF SAINT ELIZABETH Marburg, Germany. 1235–83.

THE ALTNEUSCHUL. Built in the third quarter of the thirteenth century, Prague's Altneuschul ("Old-New Synagogue") is the oldest functioning synagogue in Europe and one of two principal synagogues serving the Jews of Prague (FIG. 16–34). The Altneuschul demonstrates the adaptability of the Gothic hall-church design for non-Christian use. Like a hall church, the vaults of the synagogue are all the same height. Unlike a basilican church, with its division into nave and side aisles, the Altneuschul has only two aisles, each with three bays. The six bays are supported by the walls and two octagonal piers. The bays have Gothic four-part ribbed vaulting to which a nonfunctional fifth rib has been added. Some say that this fifth rib was added to remove the cross form made by the ribs.

The medieval synagogue was both a place of prayer and a communal center of learning and inspiration where men gathered to read and discuss the Torah. The synagogue had two focal points, the *aron*, or shrine for the Torah scrolls, and a raised reading platform called the *bimah*. The congregation faced the *aron*, which was located on the east wall, in the direction of Jerusalem. The *bimah* stood in the center of the hall, straddling the two center bays, and in Prague it was surrounded by a fifteenth-century ironwork open screen. The single entrance was placed off-center in a corner bay at the west end. Men worshiped and studied in the principal space; women had to worship in annexes on the north and west sides.

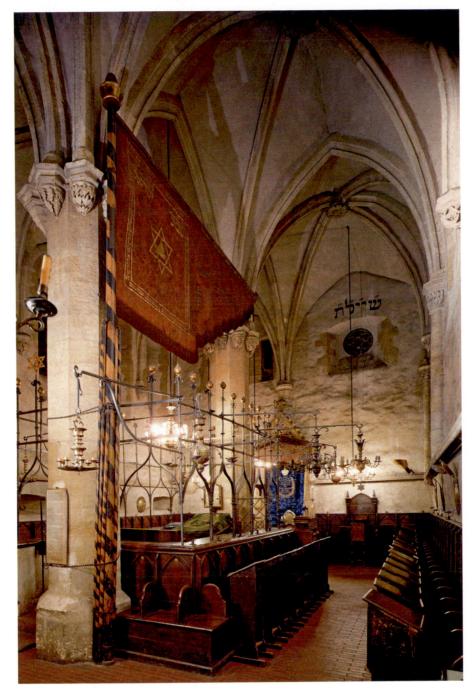

16–34 | INTERIOR, ALTNEUSCHUL Prague, Bohemia (Czech Republic). c. late 13th century; *bimah* after 1483.

Sculpture

Germanic lands had a distinguished tradition of sculpture and metalwork. One of the creative centers of Europe since the eleventh century had been the Rhine River valley and the region known as the Mosan (from the Meuse River, in present-day Belgium), with centers in Liège and Verdun. Ancient Romans built their camps and cities in this area, and classical influence lingered on through the Middle Ages. Nicholas of Verdun was a pivotal figure in the development of Gothic sculpture. He and his fellow goldsmiths inspired a

new classicizing style in the arts. Masters of the Classical Shop at Reims, for example, must have known his work.

SHRINE OF THE THREE KINGS. For the archbishop of Cologne, Nicholas created a magnificent reliquary to hold what were believed to be relics of the Three Magi (c. 1190–1205/10). Called the SHRINE OF THE THREE KINGS, the reliquary has the shape of a basilican church (FIG. 16–35). It is made of gilded bronze and silver, set with gemstones and dark blue enamel plaques that accentuate its architectural

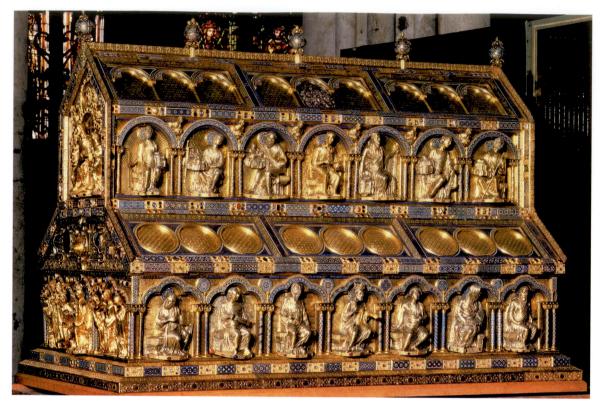

16–35 | Nicholas of Verdun and workshop SHRINE OF THE THREE KINGS Cologne (Köln) Cathedral, Germany c. 1190–c. 1205/10. Silver and gilded bronze with enamel and gemstones, $5'8'' \times 6' \times 3'8''$ (1.73 \times 1.83 \times 1.12 m).

details. Nicholas and other Mosan artists were inspired by ancient Roman art still found in the region. Their figures are fully and naturalistically modeled and swathed in voluminous but revealing drapery. The three Magi and the Virgin fill the front gable end, and prophets and apostles sit in the niches in the two levels of arcading on the sides. The work combines robust, expressively mobile sculptural forms with a jeweler's exquisite ornamental detailing to create an opulent, monumental setting for its precious contents.

STRASBOURG CATHEDRAL. At the cathedral in Strasbourg (a border city variously claimed by France and Germany over the centuries), sculpture in the south transept portal reflects the Mosan style as interpreted by Reims masters. A relief (c. 1240) depicting the death and Assumption of Mary fills the tympanum (FIG. 16–36). While Mary lies on her deathbed surrounded by distraught apostles, Christ has received her soul (the doll-like figure in his arms) and will carry her directly to heaven. The theme is Byzantine, where the subject is known as the Dormition (Sleep) of the Virgin. The apostles are dynamically expressive figures with large heads, their grief vividly rendered. Their short bodies are clothed in fluid drap-

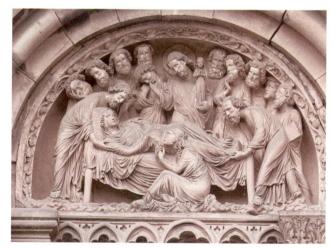

16–36 | DORMITION OF THE VIRGIN
South transept portal tympanum, Strasbourg Cathedral,
Strasbourg, France. c. 1240.

ery. Deeply undercut, each stands out dramatically in the crowded scene. Strasbourg sculpture has an emotional expressiveness unknown earlier, and this depiction of intense emotion became characteristic of German medieval sculpture.

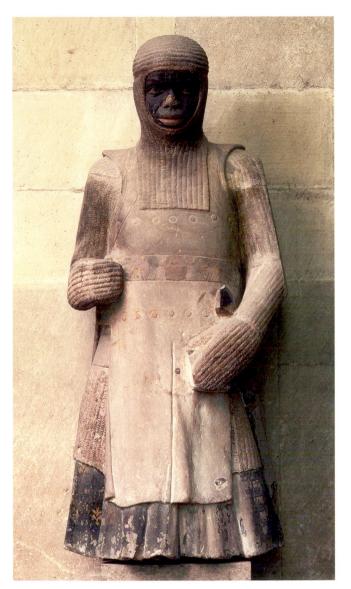

I6–37 | **SAINT MAURICE**Magdeburg Cathedral, Magdeburg, Germany. c. 1240–50.
Dark sandstone with traces of polychromy.

SAINT MAURICE. In addition to emotional expressionism, a powerful current of realism runs through German Gothic sculpture. Some works suggest a living model, among them a statue of Saint Maurice in Magdeburg Cathedral, where his relics were preserved. Carved about 1240–50 (FIG. 16–37), Maurice, the commander of Egyptian Christian troops in the Roman army, was martyred together with his men in 286. As patron saint of Magdeburg, he was revered by Ottonian emperors and became a favorite saint of military aristocrats. Because he came from Egypt, Saint Maurice was commonly portrayed with black African features. Dressed in a full suit of chain mail covered by a sleeveless coat of leather, he represents a distinctly different military ideal (SEE FIG. 14–26).

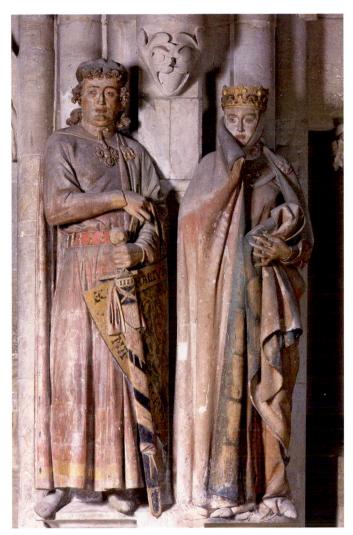

I6–38 | **EKKEHARD AND UTA**West chapel, Naumburg Cathedral, Naumburg, Germany.
c. 1245–60. Stone, originally polychromed, approx. 6'2"
(1.88 m).

NAUMBURG. As portraitlike as medieval figure sculpture sometimes seems, the figures represented ideal types, not actual individuals. Such is the case in the portrayal of the ancestors of the bishop of Wettin, Dietrich II. About 1245 he ordered sculptures for the family funeral chapel, built at the west end of Naumburg Cathedral. Bishop Dietrich had lifesize statues of twelve of his ancestors, who had been patrons of the church, placed on pedestals around the chapel.

In the representations of Margrave Ekkehard of Meissen and his Polish-born wife, Uta (FIG. 16–38), the sculptor created extraordinarily lifelike and individualized figures and faces. The Margrave seems to be a proud warrior and nononsense administrator (a *margrave*—count of the march or border—was a territorial governor whose duty it was to

THE OBJECT SPEAKS

THE CHURCH OF ST. FRANCIS AT ASSISI

hortly after Saint Francis's death, the church in his birthplace, Assisi, was begun (1228). It was nearly finished in 1239 but was not dedicated until 1253. Unusually elaborate in its design with upper and lower sections in two stories and a crypt, it is set into the hillside. Both upper and lower churches have a single nave of four square vaulted bays, and both end in a transept and a single apse. The lower church has massive walls and a narrow nave flanked by side chapels. The upper church is a spacious, well-lit hall designed to accommodate crowds. People went there to listen to the friars preach as well as to participate in church rituals, so Franciscan churches had to provide lots of space and excellent visibility and acoustics. The friars' educational mission utilized visual as well as spoken messages, so their churches had expanses of unbroken wall space suitable for educational and inspirational paintings.

Wall painting became a preeminent art form in Italy. The growing demand

for painting reflected the educational mission of the mendicant orders—the Franciscans and the Dominicans—as well as the new sources of patronage created by Italy's burgeoning economy and urban society. Art proclaimed a patron's status as much as it did his or her piety.

The Church of Saint Francis is much more richly decorated than most Franciscan churches, although the architecture itself is simple. Typical Franciscan churches were barnlike structures with wooden roofs, but in the Church of Saint Francis the nave is divided by slender clustered, engaged columns that rise unbroken to Gothic ribbed vaults. At the window level, the walls are set back to make walkways down the nave. Single two-light windows pierce the upper walls of each bay. Painting covers every surface, even the vaults where large figures float against a bright blue heaven. The amount of decoration is surprising in the mother church of a monastic order dedicated to poverty and service.

On the morning of September 27, 1997, tragedy struck. An earthquake convulsed the small town of Assisi. It shook the Church of Saint Francis, causing great damage to the architecture and paintings. The vault collapsed in two places, causing priceless frescoes to shatter and plunge to the floor. The photographer Ghigo Roli had just finished recording every painted surface of the interior when the sound of the first earthquake was heard in the basilica. As the building shook, the paintings on the vaults fell. "I wanted to cry," Ghigo Roli later wrote.

When such a disaster happens, the whole world seems to respond. Volunteers immediately established organizations to raise money to restore the frescoes, with the hope and intention of paying the costs of repairing and strengthening the basilica, reassembling the paintings from millions of tiny pieces, and finally reinstalling the restored treasures. So successful was the effort that visitors today would not guess that an earthquake had brought down the vaults only a decade ago.

Church of Saint Francis, Assisi, Italy during the 1997 earthquake. (Above) Church of Saint Francis, Assisi, Italy restored. (Right) 1228-53.

Caught by a television camera during the quake, some of the vaults and archivolts in the upper church plunged to the floor, killing four people. The camera operator eventually emerged, covered with the fine dust of the shattered brickwork and plaster, as a "white, dumbfounded phantom."

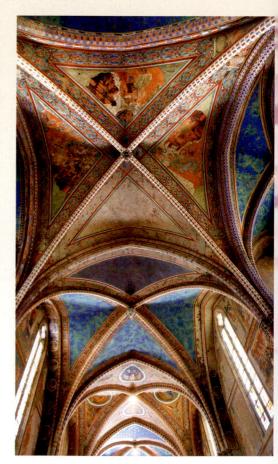

defend the frontier). Uta, coolly elegant and courtly, seems to draw her cloak artfully to her cheek. Traces of color indicate that painting added to the realistic impact of the figures. Such realism became characteristic of German Gothic art and ultimately had a profound impact on later art, both within Germany and beyond.

GOTHIC ART IN ITALY

The thirteenth century was a period of political division and economic expansion for the Italian peninsula. Part of southern Italy and Sicily was controlled by Frederick II von Hohenstaufen (1194–1250), king of Sicily from 1197 and Holy Roman emperor from 1220. Called by his contemporaries "the wonder of the world," Frederick was a politically unsettling force. He fought with a league of north Italian cities and briefly controlled the Papal States. On his death, Germany and the Holy Roman Empire ceased to be an important factor in Italian politics and culture. Instead, France and Spain began to vie for control of parts of the peninsula and the island of Sicily.

In northern Italy, in particular, organizations of successful merchants created communal governments in their prosperous and independent city-states and struggled against powerful families for control of them. Growing individual power and wealth inspired patronage of the arts. Artisans began to emerge as artists in the modern sense, both in their own eyes and the minds of their patrons. They joined together in urban guilds and independently contracted with wealthy clients and with civic and religious groups.

Sculpture: The Pisano Family

During his lifetime, the culturally enlightened Holy Roman emperor Frederick II had fostered a classical revival. He was a talented poet, artist, and naturalist, and an active patron of the arts and sciences. In the Romanesque period, artists in southern Italy had sometimes relied on ancient sculpture for inspiration. But Frederick, mindful of his imperial status as Holy Roman emperor, commissioned artists who turned to ancient Roman sculpture to help communicate a message of power. He also encouraged artists to look anew at the natural world around them. Nicola Pisano (active in Tuscany c. 1258–78), who came from the southern region of Apulia, one of the territories where imperial patronage under Frederick had flourished, became the leading exponent of the style that had developed in southern Italy.

NICOLA PISANO'S PULPIT AT PISA. An inscription identifies the marble pulpit in the Pisa Baptistry as Nicola's work (FIG. 16–39). Clearly proud of his skill, he wrote: "In the year 1260 Nicola Pisano carved this noble work. May so gifted a hand be praised as it deserves." Columns topped with leafy Corinthian capitals support standing figures and Gothic

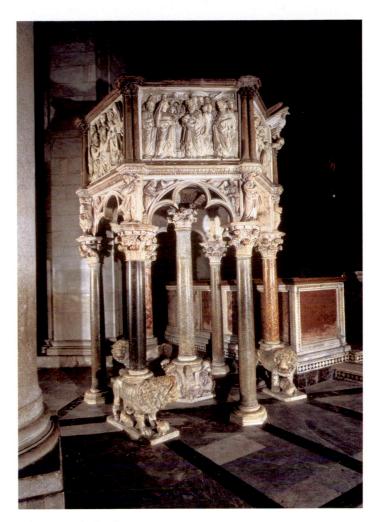

16–39 | Nicola Pisano PULPIT, BAPTISTRY, PISA 1260. Marble; height approx. 15' (4.6 m).

trefoil arches, which in turn provide a base for the six-sided pulpit. The columns rest on high bases carved with crouching figures, domestic animals, and shaggy-maned lions. The panels illustrate New Testament subjects, each framed as an independent composition.

Panels illustrate several scenes in a continuous narrative—the Annunciation, Nativity, and Adoration of the Shepherds. The Virgin reclines in the middle of the composition (FIG. 16–40). The upper left-hand corner holds the Annunciation, and the scene in the upper right combines the annunciation to the shepherds with their adoration of the Child. In the foreground, midwives wash the infant Jesus as Joseph looks on. The viewer's attention moves from group to group within the shallow space, always returning to the regally detached Mother of God. The format, style, and technique of Roman sarcophagus reliefs—readily accessible in the burial ground near the Baptistry (SEE FIG. 15–13)—may have provided models for carving. The sculptural treatment of the deeply cut, full-bodied forms is classically inspired, as are their

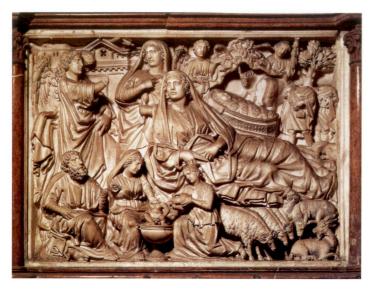

16–40 | Nicola Pisano **NATIVITY** Detail of pulpit, Baptistry, Pisa, Italy. 1260. Marble, $33\frac{1}{2} \times 44\frac{1}{2}$ " (85 \times 113 cm).

heavy, placid faces. The closely packed composition recalls the Ludovisi Battle Sarcophagus (FIG. 6–69), although the shifts in scale are typically Gothic.

GIOVANNI PISANO'S PULPIT AT PISA. Nicola's son Giovanni (active c. 1265–1314) both assisted his father and learned from him, and he may also have worked or studied in France. By the end of the thirteenth century Giovanni emerged as a

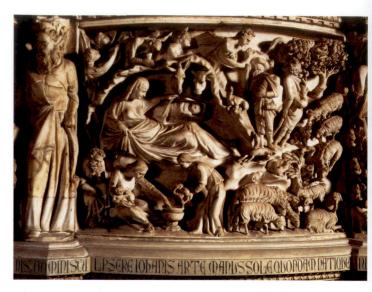

16–41 | Giovanni Pisano **NATIVITY** Detail of pulpit, Pisa Cathedral, Pisa. 1302–10. Marble, $34\% \times 43''$ (87.2 \times 109.2 cm).

versatile artist in his own right. Between 1302 and 1310, he and his shop carved a huge pulpit for Pisa Cathedral that is similar to his father's in conception but significantly different in style and execution. In his **NATIVITY** panel Giovanni places graceful, animated figures in an uptilted, deeply carved landscape (FIG. 16–41). He replaces Nicola's impassive Roman matron with a slender young Mary who, sheltered by a shell-like cave, gazes delightedly at her baby. Below her, the

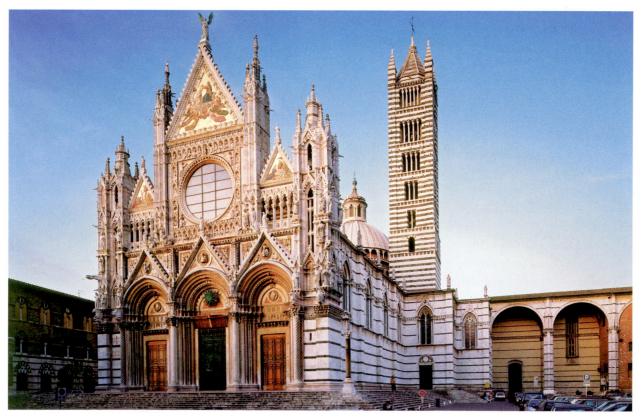

16–42 | SIENA CATHEDRAL Siena, Italy. Lower west façade, 1284–99.

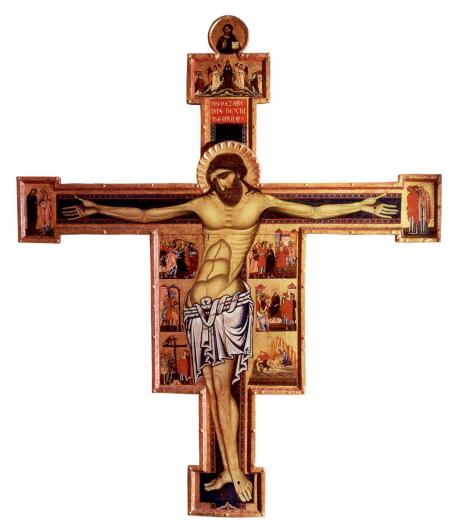

16–43 | Coppo di Marcovaldo **CRUCIFIX** Tuscany, Italy. c. 1250–70. Tempera and gold on wood panel, $9'7\%\% \times 8'1\%\% \times 8$

midwife who doubted the virgin birth has her withered hand restored by the baby's bath water. Sheep, shepherds, and angels spiral up through the trees at the right and more angelic onlookers replace the Annunciation. Giovanni's sculpture is as dynamic as Nicola's is static.

THE CATHEDRAL FAÇADE AT SIENA. Between 1284 and 1299 Giovanni Pisano worked as architect, designer, and sculptor of the façade of the Cathedral of Our Lady in the central Italian city of Siena (FIG. 16–42). He incorporated elements of the French Style, such as Gothic gables with classical columns and moldings, to produce a richly ornamented screen independent of the building behind. High on the façade he placed figural sculptures, including dramatically gesturing and expressive prophets and sibyls. (The sculpture is now in the museum and has been replaced by copies.) Rather than the complex narrative sculptural programs typical of French Gothic façades, in Italy there was often an emphasis on architectural detailing of lintels and on narrative

door panels, as well as on figural sculpture placed across the façade. Inside, the focus was on furnishings such as pulpits, tomb monuments, baptismal fonts, and on paintings (see "The Church of Saint Francis at Assisi," page 546).

Painting

The capture of Constantinople by Crusaders in 1204 that brought relics to France also resulted in an influx of Byzantine art and artists to Italy. The imported style of painting, the *maniera greca* ("in the Greek manner"), influenced thirteenthand fourteenth-century Italian painting in style and technique and introduced a new emphasis on pathos and emotion.

A "HISTORIATED CRUCIFIX." One example, the large wooden crucifix attributed to the thirteenth-century Florentine painter Coppo di Marcovaldo (FIG. 16–43), represents the *Christus patiens*, or suffering Christ: a Byzantine type with closed eyes and bleeding, slumped body that emphasized emotional realism (SEE FIGS. 7–43, 14–29). The cross is also a "historiated

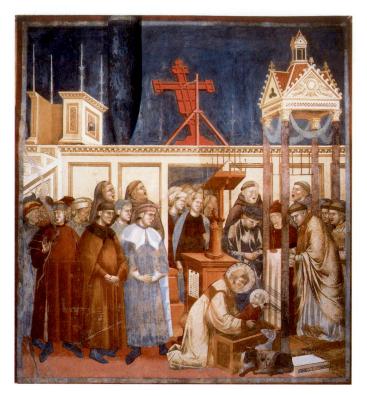

16–44 | LIFE OF SAINT FRANCIS, MIRACLE OF THE CRIB AT GRECCIO
Church of Saint Francis, Assisi, Italy. Fresco, late 13th century?

crucifix," with scenes at each side that tell the Passion story. Such crosses were mounted on the choir screen that separated the clergy in the sanctuary from the lay people in the nave (one can be seen with its wooden bracing in FIG. 16–44).

MURAL PAINTING AT ASSISI. Colorful, educational paintings covered the walls of Italian churches. The *Life of Saint Francis*, a series of narratives depicting the saint's life in the upper church of Saint Francis in Assisi, provides a vivid example of Gothic mural painting. Scholars differ on whether the murals were painted as early as 1290. Many have adopted the neutral designation of the artist as the "Saint Francis Master." THE MIRACLE OF THE CRIB AT GRECCIO (FIG. 16–44) portrays Saint Francis making the first Christmas manger scene in the church at Greccio and also vividly documents the appearance

of an Italian Gothic church. A large wooden crucifix, similar to the one by Coppo di Marcovaldo, has been suspended from a stand on top of a screen separating the sanctuary from the nave. The cross has been reinforced on the back and tilted forward to hover over people in the nave, whom we see through an open door in the choir screen. A pulpit, with stairs leading up to its entrance and candlesticks at its corners, rises above the screen at the left. An elaborate carved *baldacchino* (canopy) surmounts the altar at the right, and an adjustable wooden lectern stands in front of the altar.

Other small but telling touches include a seasonal liturgical calendar posted on the lectern, foliage swags decorating the *baldacchino*, and an embroidered altar cloth. Candles in tall candlesticks stand on the top of the screen and on wire frames above the lectern and altar. Saint Francis, in the foreground, reverently holds the Holy Infant above a plain, box-like crib next to representations of various animals that might have been present at the Nativity. The scene depicts the astonishing moment when, it was said, the Christ Child appeared in the manger. The tableau is recreated at Christmas by many families and communities today.

IN PERSPECTIVE

From its beginnings in France, Gothic art spread throughout Europe. In media as diverse as tiny book illustrations and enormous stained-glass windows, Gothic artists proclaimed the Christian message. These works were both educational and decorative. Inspired by biblical accounts of the jeweled walls of heaven and the golden gates of Paradise, Christian patrons and builders labored to erect glorious dwelling places for God and the saints on Earth. In order to intensify the effects of light and color, they constructed ever-larger buildings with higher vaults and thinner walls that permitted the insertion of huge windows. The glowing, back-lit colors of stained glass and the soft sheen of mural paintings dissolved the solid forms of masonry, while within the church the reflection of gold, enamels, and gems on altars and gospel book covers, on crosses and candlesticks, captured the splendor of Paradise on Earth. Subtle light and dazzling color created a mystical visual pathway to heaven as artists gave tangible form to the unseen and unknowable.

ABBEY CHURCH OF ST. DENIS 1140-44; 1231-81

NICHOLAS OF VERDUN AND WORKSHOP.

SHRINE OF THE THREE KINGS

C. 1190–1205/10

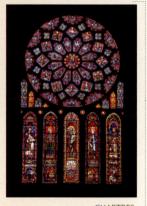

NORTH TRANSEPT, ROSE WINDOW
AND LANCETS
ABOUT 1220

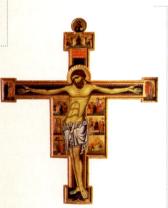

COPPO DI MARCOVALDO.

CRUCIFIX

C. 1250–1270

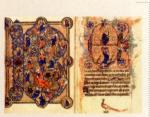

PSALM1 (BEATUS VIR).
WINDMILL PLASTER
C. 1270-80

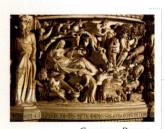

GIOVANNI PISANO.

NATIVITY, DETAIL OF PULPIT

1302–10

114C

GOTHIC ART OF THE TWELFTH AND THIRTEENTH CENTURIES

- Second Crusade 1147-49
- ✓ Plantagenet Dynasty Ruled England 1154-1485
- **◄ Third Crusade** 1188-92
- Fourth Crusade Takes Constantinople
 1204
- ▼ Franciscan Order Founded 1209

1250

- Western Control of Constantinople Ends 1261
- Thomas Aquinas Begins Writing Summa Theologica 1266

1300

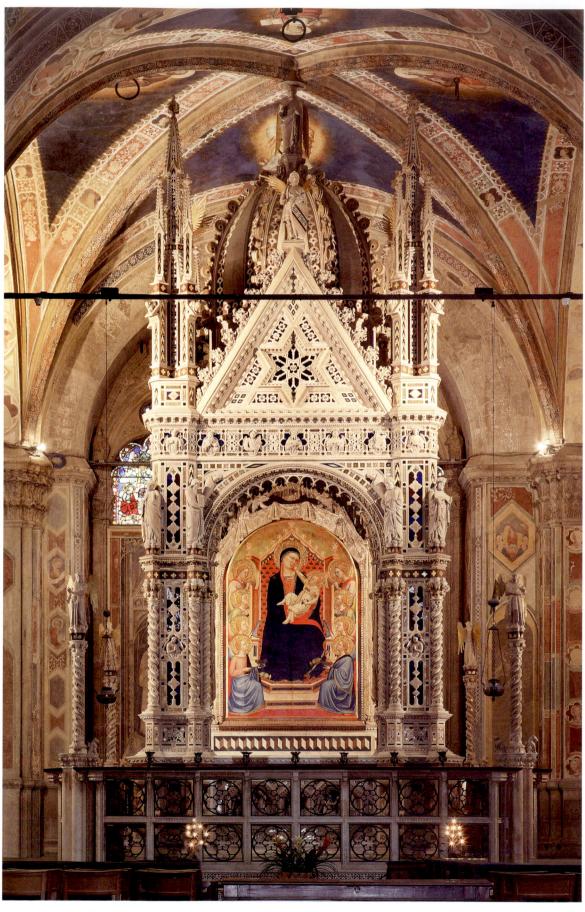

I7-I Andrea Orcagna TABERNACLE Orsanmichele, Florence, Probably begun 1355, completed 1359.
 Marble, mosaic, gold, lapis lazuli.
 Bernardo Daddi MADONNA AND CHILD 1346-7. Tempera and gold on wood panel.

CHAPTER SEVENTEEN

FOURTEENTH-CENTURY ART IN EUROPE

One of the many surprises greeting the modern visitor to Florence is a curious blocky building with statue-filled niches. Originally a loggia (a covered, open-air gallery), today its dark interior is dominated by a huge and ornate taberna-

cle built to house the important MADONNA AND CHILD (FIG. 17–1) by Bernardo Daddi. Daddi was commissioned to create this painting in 1346/47, just before the Black Death swept through the city in the summer of 1348.

Daddi's painting was the second replacement of a late thirteenth-century miracle-working image of the Madonna and Child. The original image had occupied a simple shrine in the central grain market, known as *Orsanmichele* (Saint Michael in the Garden). The original painting may have been irreparably damaged in the fire of 1304 that also destroyed the first market loggia, built at the end of the thirteenth century. A second painting, also lost, was made sometime later, but it was believed that the healing power of the image passed from painting to painting with continued potency.

Florence grew rapidly in the late Middle Ages. By the fourteenth century two-thirds of the city's grain supply had to be imported. The central grain market and warehouse established at Orsanmichele, as insurance against famine, made that site the economic center of the city. The Confraternity (charitable society) of Orsanmichele was created to honor the image of the Madonna and Child and to collect and distribute alms to needy citizens. In 1337 a new loggia

was built to protect the miracle-working image, and two upper stories were added to the loggia to store the city's grain reserves.

Orsanmichele remained Florence's central grain market for about ten years after Daddi

painted the newest miracle-working *Madonna and Child* in 1346/47. As a reflection of its wealth and piety, the Confraternity of Orsanmichele commissioned Andrea di Cione, better known as Orcagna (active c. 1343–68), to create a new and rich tabernacle for Daddi's painting. A member of the stone- and woodworkers guild, Orcagna was in charge of building and decorating projects at Orsanmichele. To protect and glorify the *Madonna and Child*, he created a tour-de-force of architectural sculpture in marble, encrusted with gold and glass mosaics. In Orcagna's shrine, Daddi's *Madonna and Child* seems to be revealed by a flock of angels drawing back carved curtains. Sculpted saints stand on the pedestals against the piers, and reliefs depicting the life of the Madonna occupy the structure's base. The tabernacle was completed in 1359, and a protective railing was added in 1366.

Orsanmichele answered practical economic and social needs (granary and distribution point for alms), as well as religious and spiritual concerns (a shrine to the Virgin Mary), all of which characterized the complex society of the fourteenth century. In addition, Orsanmichele was a civic rallying point for the city's guilds. The significance of the guilds in the life of cities in the later Middle Ages cannot be overestimated. In

Florence, guild members were not simple artisans; the major guilds, composed of rich and powerful merchants and entrepreneurs, dominated the government and were key patrons of the arts. For example, the silk guild oversaw the construction of Orsanmichele. In 1380, the arches of the loggia were walled up. At that time, fourteen of the most important Florentine guilds were each assigned an exterior niche on the ground level in which to erect an image of their patron saint.

The cathedral, the Palazzo della Signoria, and Orsanmichele, three great buildings in the city center, have come to symbolize power and patronage in the Florentine Republic. But of the three, the miraculous Madonna in her shrine at Orsanmichele witnessed the greatest surge of interest in the years following the Black Death. Pilgrims flocked to Orsanmichele, and those who had died during the plague left their estates in their wills to the shrine's confraternity. On August 13, 1365, the Florentine government gathered the people together to proclaim the Virgin of Orsanmichele the special protectress of the city.

CHAPTER-AT-A-GLANCE

- EUROPE IN THE FOURTEENTH CENTURY
- ITALY | Florentine Architecture and Sculpture | Florentine Painting | Sienese Painting
- FRANCE | Manuscript Illumination | Sculpture
- ENGLAND | Embroidery: Opus Anglicanum | Architecture
- THE HOLY ROMAN EMPIRE | The Supremacy of Prague | Mysticism and Suffering
- IN PERSPECTIVE

EUROPE IN THE FOURTEENTH CENTURY

By the middle of the fourteenth century, much of Europe was in crisis. Earlier prosperity had fostered population growth, which by about 1300 had begun to exceed food production. A series of bad harvests then meant that famines became increasingly common. To make matters worse, a prolonged conflict known as the Hundred Years' War (1337–1453) erupted between France and England. Then, in the middle of the fourteenth century, a lethal plague known as the Black Death swept across Europe, wiping out as much as 40 percent of the population (see "The Triumph of Death," page 556). By depleting the labor force, however, the plague gave surviving peasants increased leverage over their landlords and increased the wages of artisans.

The papacy had emerged from its conflict with the Holy Roman Empire as a significant international force. But its temporal success weakened its spiritual authority and brought it into conflict with growing secular powers. In 1309, after the election of a French pope, the papal court moved from Rome to Avignon, in southern France. Italians disagreed, and during the Great Schism from 1378 to 1417, there were two popes, one in Rome and one in Avignon, each claiming legitimacy. The Church provided some solace but little leadership, as rival popes in Rome and Avignon excommunicated each other's followers. Secular rulers took sides: France, Scotland, Aragon, Castile, Navarre, and Sicily supported the

pope in Avignon; England, Flanders, Scandinavia, Hungary, and Poland supported the pope in Rome. Meanwhile, the Church experienced great strain from challenges from reformers like John Hus (c. 1370–1415) in Bohemia. The cities and states that composed present-day Germany and the Italian Peninsula were divided among different factions.

The literary figures Dante, Petrarch, and Boccaccio (see "A New Spirit in Fourteenth-Century Literature," page 561) and the artists Cimabue, Duccio, and Giotto fueled a cultural explosion in fourteenth-century Italy. In literature, Petrarch (Francesco Petrarca, 1304–74) was a towering figure of change, a poet whose love lyrics were written not in Latin but in Italian, marking its first use as a literary language. A similar role was played in painting by the Florentine Giotto di Bondone (c. 1277–1337). In deeply moving mural paintings, Giotto not only observed the people around him, he ennobled the human form by using a weighty, monumental style, and he displayed a new sense of dignity in his figures' gestures and emotions

This new orientation toward humanity, combined with a revived interest in classical learning and literature, we now designate as *humanism*. Humanism embodied a worldview that focused on human beings; an education that perfected individuals through the study of past models of civic and personal virtue; a value system that emphasized personal effort and responsibility; and a physically active life that was directed toward the common good as well as individual

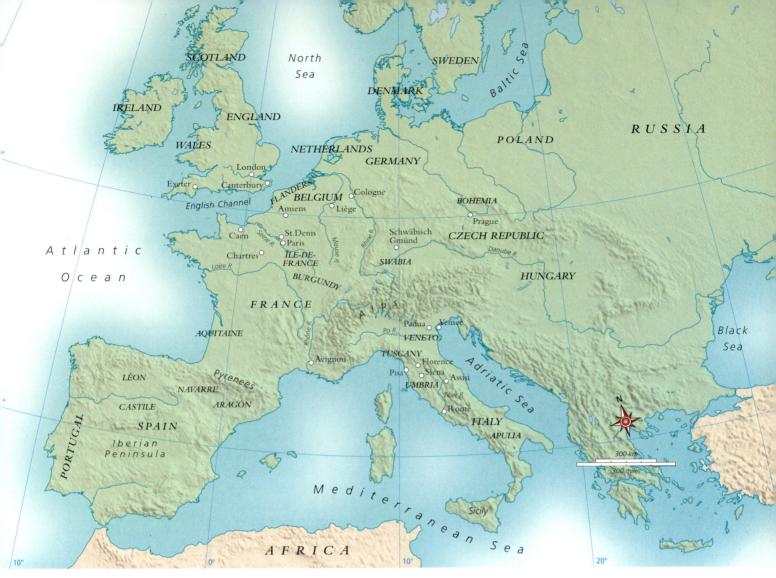

MAP 17-1 | Europe in the Fourteenth Century

Avignon in Southern France, Prague in Bohemia, and Exeter in Southern England joined Paris, Florence, and Siena as centers of art patronage in the late Gothic period.

nobility. For Petrarch and his contemporaries an appreciation of Greek and Roman writers became the defining element of the age. Humanists mastered the Greek and Latin languages so that they could study the classical literature—including newly rediscovered works of history, biography, poetry, letters, and orations.

In architecture, sculpture, and painting, the Gothic style—with its soaring vaults, light, colorful glass, and linear qualities—persisted in the fourteenth century, with regional variations. Toward the end of the century, devastation from the Hundred Years' War and the Black Death meant that large-scale construction gradually ceased, ending the great age of cathedral building. The Gothic style continued to develop, however, in smaller churches, municipal and commercial buildings, and private residences. Many churches were modernized or completed in this late Gothic period.

From the growing middle class of artisans and merchants, talented and aggressive leaders assumed economic and in some places political control. The artisan guilds—organized by occupation—exerted quality control among members and supervised education through an apprenticeship sys-

tem. Admission to the guild came after examination and the creation of a "masterpiece"—literally, a piece fine enough to achieve master's status. The major guilds included cloth finishers, wool merchants, and silk manufacturers, as well as pharmacists and doctors. Painters belonged to the pharmacy guild, perhaps because they used mortars and pestles to grind their colors. Their patron saint, Luke, who was believed to have painted the first image of the Virgin Mary (see Chapter 7, page 266), was also a physician—or so they thought. Sculptors who worked in wood and stone had their own guild, while those who worked in metals belonged to another guild. Guilds provided social services for their members, including care of the sick and funerals for the deceased. Each guild had its patron saint and maintained a chapel and participated in religious and civic festivals.

Complementing the economic power of the guilds was the continuing influence of the Dominican and Franciscan religious orders (see Chapter 16), whose monks espoused an ideal of poverty, charity, and love and dedicated themselves to teaching and preaching. The new awareness of societal needs manifested itself in the

THE OBJECT SPEAKS

THE TRIUMPH OF DEATH

he Four Horsemen of the Apocalypse—Plague, War, Famine, and Death—stalked the people of Europe during the fourteenth century. France, England, and Germany pursued their seemingly endless wars, and roving bands of soldiers and brigands looted and murdered unprotected peasants and villagers. Natural disasters—fires, droughts, floods, and wild storms—took their toll. Disease spread rapidly through a population already weakened by famine and physical abuse.

Then a deadly plague, known as the Black Death, spread by land and sea from Asia. The plague soon swept from Italy and France across the British Isles, Germany, Poland, and Scandinavia. Half the urban population of Florence and Siena—some say 80 percent—died in the summer of 1348. To people of the time the Black Death seemed to be an act of divine wrath against sinful humans.

In their panic, some people turned to escapist pleasures; others to religious fanaticism. Andrea Pisano and Ambrogio Lorenzetti were probably among the many victims of the Black Death. But the artists who survived had work to do—chapels and hospitals, altarpieces and votive statues. The sufferings of Christ, the sorrows as well as the joys of the Virgin, the miracles of the saints, and new themes—"The Art of Dying Well," and "The Triumph of Death"—all carried the message "Remember, you too will die." An unknown artist, whom we call the Master of the Triumph of Death, painted such a theme in the cemetery of Pisa (Camposanto).

The horror and terror of impending death are vividly depicted in the huge mural, THE TRIUMPH OF DEATH. In the center of the wall dead people lie in a heap while devils and angels carry their souls to hell or heaven. Only the hermits living in the wilderness escape the holocaust. At the right, wealthy young people listen to music under the orange trees, unaware of Death flying toward them with a scythe. At the left of the painting, a group on horseback who have ridden out into the wilderness discover three open coffins. A woman recoils at the sight of her dead counterpart. A courtier covers his nose, gagging at the smell,

while his wild-eyed horse is terrified by the bloated, worm-riddled body in the coffin. The rotting corpses remind them of their fate, a medieval theme known as "The Three Living and the Three Dead."

Perhaps the most memorable and touching images in the huge painting are the crippled beggars who beg Death to free them from their earthly miseries. Their words appear on the scroll: "Since prosperity has completely deserted us, O Death, you who are the medicine for all pain, come to give us our last supper!"* The painting speaks to the viewer, delivering its message in words and images. Neither youth nor beauty, wealth nor power, but only piety like that of the hermits provides protection from the wrath of God.

Strong forces for change were at work in Europe. For all the devastation caused by the Four Horsemen, those who survived found increased personal freedom and economic opportunity.

* Translated by John Paoletti and Gary Radke, Art in Renaissance Italy, 3rd ed. Upper Saddle River, New Jersey. Pearson Prentice Hall, 2005. p. 154.

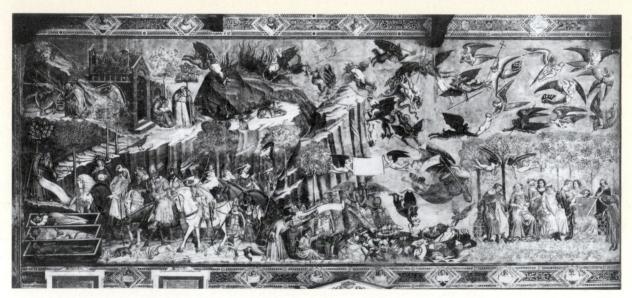

Master of the Triumph of Death (Buffalmacco?) THE TRIUMPH OF DEATH Camposanto, Pisa. 1330s. Fresco, $18'6'' \times 49'2''$ (5.6 \times 15 m).

Reproduced here in black and white, photo taken before the fresco was damaged by American shells during World War II.

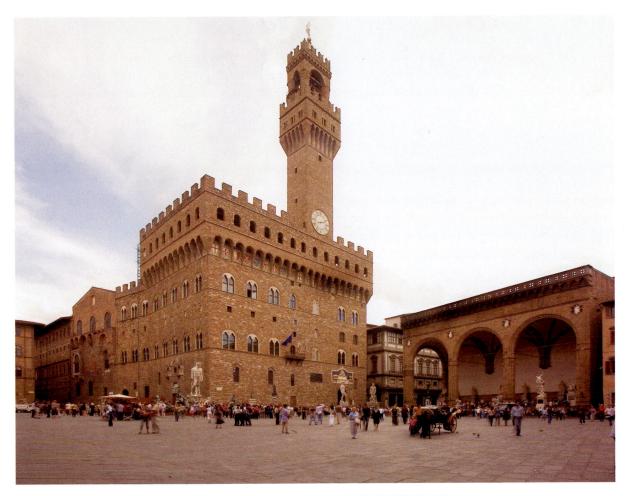

17–2 | PIAZZA DELLA SIGNORIA WITH PALAZZO DELLA SIGNORIA (TOWN HALL)
1299–1310 and LOGGIA DEI LANZI (LOGGIA OF THE LANCERS)
Florence. 1376–82. Speakers' platform and since the sixteenth century a guard station and sculpture gallery.

architecture of churches designed for preaching as well as liturgy, and in new religious themes that addressed personal or sentimental devotion.

ITALY

Great wealth and a growing individualism promoted art patronage in northern Italy. Artisans began to emerge as artists in the modern sense, both in their own eyes and in the eyes of patrons. Although their methods and working conditions remained largely unchanged, artisans in Italy contracted freely with wealthy townspeople and nobles and with civic and religious bodies. Their ambition and self-confidence reflect their economic and social freedom.

Florentine Architecture and Sculpture

The typical medieval Italian city was a walled citadel on a hilltop. Houses clustered around the church and an open city square. Powerful families added towers to their houses both for defense and out of family pride. In Florence, by contrast, the ancient Roman city—with its rectangular plan, major north—south and east—west streets, and city squares—remained the foundation for civic layout. The cathedral stood northeast of the ancient forum. The north—south street joining the cathedral and the Piazza della Signoria followed the Roman line.

THE PALAZZO DELLA SIGNORIA. The governing body of the city (the Signoria) met in the PALAZZO DELLA SIGNORIA, a massive fortified building with a tall bell tower 300 feet (91 m) high (FIG. 17–2). The building faces a large square, or piazza, which became the true civic center. Town houses often had seats along their walls to provide convenient public seating. In 1376 (finished in 1381/82), a huge loggia was built at one side to provide a covered space for ceremonies and speeches. After it became a sculpture gallery and guard station in the sixteenth century, the loggia became known as the LOGGIA OF THE LANCERS. The master builders were Berici di Cione and Simone Talenti. Michelangelo's *David* (SEE FIG. 20–10) once stood in front of the Palazzo della Signoria facing the loggia (it is replaced today by a modern copy).

THE CATHEDRAL. In Florence, the cathedral (duomo) (FIGS. 17–3, 17–4) has a long and complex history. The original plan, by Arnolfo di Cambio (c. 1245–1302), was approved in 1294, but political unrest in the 1330s brought construction to a halt until 1357. Several modifications of the design were made, and the cathedral we see today was built between 1357 and 1378. (The façade was given its veneer of white and green marble in the nineteenth century to coordinate it with the rest of the building and the nearby Baptistry of San Giovanni.)

Sculptors and painters rather than masons were often responsible for designing Italian architecture, and as the Florence Cathedral reflects, they tended to be more concerned with pure design than with engineering. The long, square-bayed nave ends in an octagonal domed crossing, as wide as

the nave and side aisles. Three polygonal apses, each with five radiating chapels, surround the central space. This symbolic Dome of Heaven, where the main altar is located, stands apart from the worldly realm of the congregation in the nave. But the great ribbed dome, so fundamental to the planners' conception, was not begun until 1420, when the architect Filippo Brunelleschi (1377–1446) solved the engineering problems involved in its construction (see Chapter 19).

THE BAPTISTRY DOORS. In 1330, Andrea Pisano (c.1290–1348) was awarded the prestigious commission for a pair of gilded bronze doors for the Florentine Baptistry of San Giovanni. (Although his name means "from Pisa," Andrea was not related to Nicola and Giovanni Pisano.) The Baptistry doors were completed within six years and display

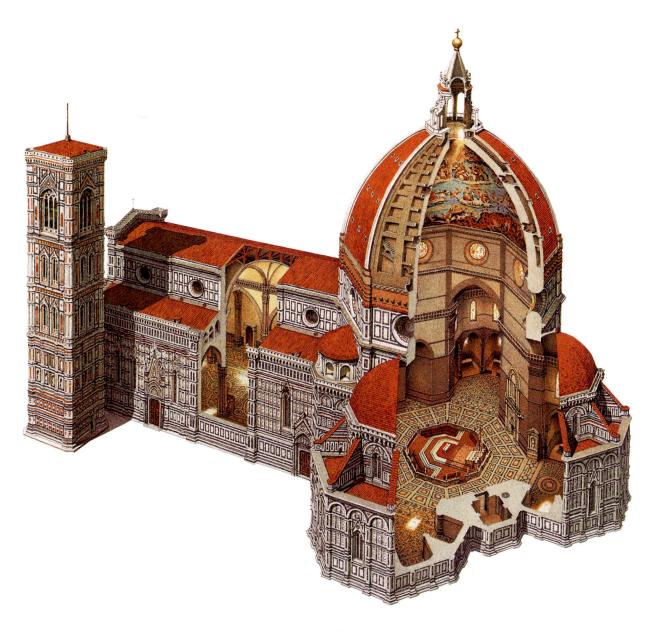

I7-3 | FLORENCE CATHEDRAL (DUOMO)

Plan 1294, costruction begun 1296, redisegned 1357 and 1366, drum and dome 1420–36. Illustration by Philipe Biard in Guide Gallimard Florence © Gallimard Loisirs.

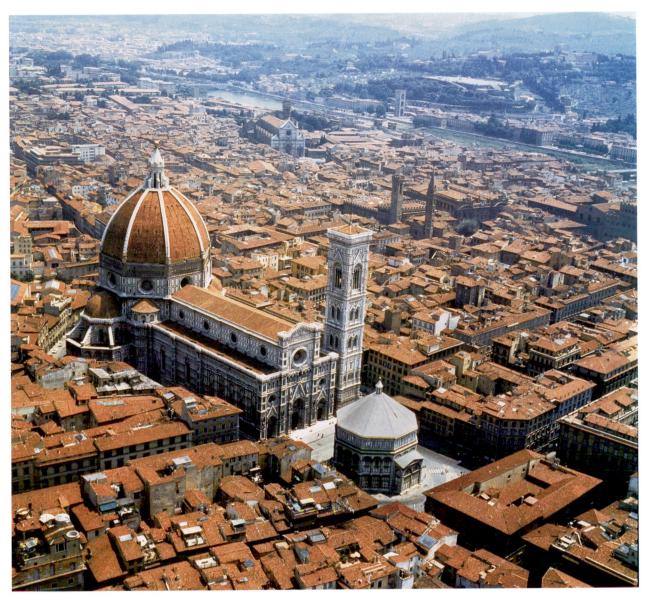

17–4 | Arnolfo di Cambio, Francesco Talenti, Andrea Orcagna, and others FLORENCE CATHEDRAL (DUOMO) 1296-1378; drum and dome by Brunelleschi, 1420–36; bell tower (Campanile) by Giotto, Andrea Pisano, and Francesco Talenti, c. 1334–50.

The Romanesque Baptistry of San Giovanni stands in front of the Duomo.

twenty scenes from the life of John the Baptist (San Giovanni) set above eight personifications of the Virtues (FIG. 17–5). The reliefs are framed by quatrefoils, the four-lobed decorative frames introduced at the Cathedral of Amiens in France (SEE FIG. 16–21). The figures within the quatrefoils are in the monumental, classicizing style inspired by Giotto then current in Florentine painting, but they also reveal the soft curves of northern Gothic forms in their gestures and draperies, and a quiet dignity of pose particular to Andrea. The individual scenes are elegantly natural. The figures' placement, on shelflike stages, and their modeling create a remarkable illusion of three-dimensionality, but the overall effect created by the repeated barbed quatrefoils is two-

dimensional and decorative, and emphasizes the solidity of the doors. The bronze vine scrolls filled with flowers, fruits, and birds on the lintel and jambs framing the door were added in the mid-fifteenth century.

Florentine Painting

Florence and Siena, rivals in so many ways, each supported a flourishing school of painting in the fourteenth century. Both grew out of the Italo-Byzantine style of the thirteenth century, modified by local traditions and by the presence of individual artists of genius. The Byzantine influence, also referred to as the *maniera greca* ("Greek manner"), was characterized by dramatic pathos and complex iconography and showed

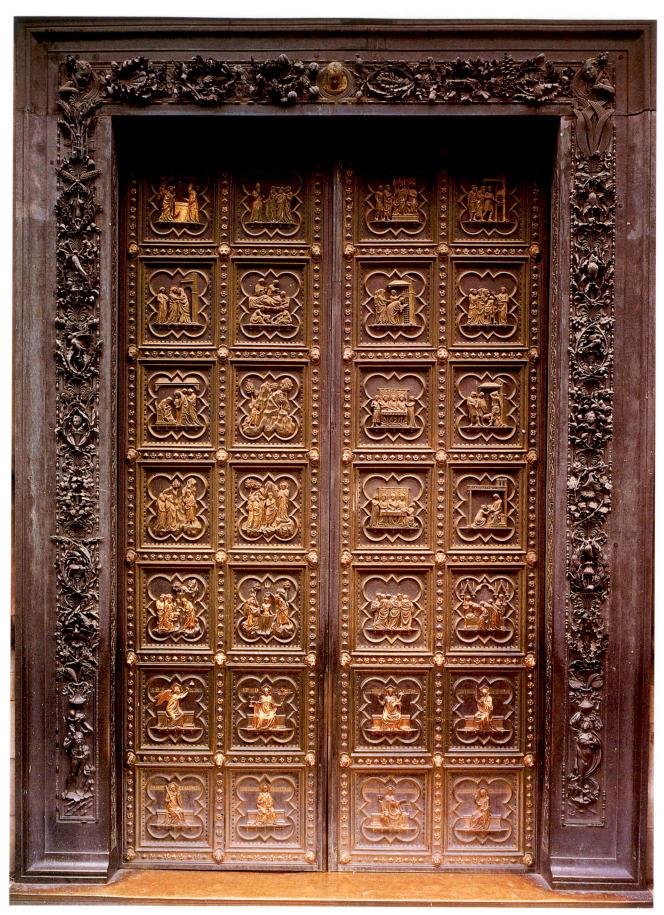

17–5 | Andrea Pisano LIFE OF JOHN THE BAPTIST South doors, Baptistry of San Giovanni, Florence. 1330–36. Gilded bronze, each panel $19\% \times 17''$ (48×43 cm). Frame, Ghiberti workshop, mid-15th century.

itself in such elements as elongated figures, often exaggerated, iconic gestures, stylized features including the use of gold for drapery folds, and striking contrasts of highlights and shadows in the modeling of individual forms. By the end of the fourteenth century, the painter and commentator Cennino Cennini (see "Cennino Cennini [c. 1370–1440] on Painting," page 564) would be struck by the accessibility and modernity of Giotto's art, which, though it retained traces of the "Greek manner," was moving toward the depiction of a humanized world anchored in three-dimensional form.

CIMABUE. In Florence, the transformation of the Italo-Byzantine style began a little earlier than in Siena. About 1280, a painter named Cenni di Pepi (active c. 1272–1302), better known by his nickname "Cimabue," painted the VIRGIN AND CHILD ENTHRONED (FIG. 17–6), perhaps for the main altar of the Church of Santa Trinita in Florence. At almost 12 feet tall, this enormous panel painting set a new precedent for monumental altarpieces. Cimabue uses the traditional Byzantine iconography of the "Virgin Pointing the Way," in which Mary holds the infant Jesus in her lap and points to him as the path to salvation. Mother and child are surrounded by saints, angels, and Old Testament prophets.

A comparison with a Byzantine icon (SEE FIG. 7-51) shows that Cimabue employed Byzantine formulas in determining the proportions of his figures, the placement of their schematic features, and even the tilt of their haloed heads. Mary's huge throne, painted to resemble gilded bronze with inset enamels and gems, provides an architectural framework for the figures. To render her drapery and that of the infant Jesus, Cimabue used the Italo-Byzantine technique of highlighting drapery with thin lines of gold to indicate divinity. The viewer seems suspended in space in front of the image, simultaneously looking down on the projecting elements of the throne and Mary's lap, while looking straight ahead at the prophets at the base of the throne and the angels at each side. These spatial ambiguities, the subtle asymmetries within the centralized composition, the Virgin's thoughtful gaze, and the individually conceived faces of the old men enliven the picture with their departure from Byzantine tradition. Cimabue's concern for spatial volumes, solid forms delicately modeled in light and shade, and warmly naturalistic human figures contributed to the course of later Italian painting.

GIOTTO DI BONDONE. Compared to Cimabue's Virgin and Child Enthroned, Giotto's painting of the same subject (FIG. 17–7), done about 1310 for the Church of the Ognissanti (All Saints) in Florence, exhibits a groundbreaking spatial consistency and sculptural solidity while retaining some of Cimabue's conventions. The central and overtly symmetrical composition and the position of the figures reflect Cimabue's influence. Gone, however, are Mary's modestly inclined head and the delicate gold folds in her drapery. Instead, her face is

Art and Its Context

A NEW SPIRIT IN FOURTEENTH-CENTURY LITERATURE

or Petrarch and his contemporaries—Boccaccio, Chaucer, Christine de Pizan—the essential qualifications for a writer were an appreciation of Greek and Roman authors and an ability to observe and appreciate people from every station in life. Although fluent in Latin, they chose to write in the language of their own daily life—Italian, English, French. Leading the way was Dante Alighieri (1265–1321), who wrote *The Divine Comedy*, his great summation of human virtue and vice, and ultimately human destiny, in Italian. Dante established the Italian language as worthy of great themes in literature.

Francesco Petrarca, called simply Petrarch (1304–74), raised the status of secular literature with his sonnets (love lyrics) to his unobtainable, beloved Laura; his histories and biographies; and his discovery of the ancient Roman writings on the joys of country life. Petrarch's imaginative updating of classical themes in a work called *The Triumphs*—which examines the themes of Chastity triumphant over Love, Death over Chastity, Fame over Death, Time over Fame, and Eternity over Time—provided later Renaissance poets and painters with a wealth of allegorical subject matter.

More earthy, Giovanni Boccaccio (1313-75) perfected the art of the short story in *The Decameron*, a collection of amusing and moralizing tales told by a group of young Florentines who moved to the countryside to escape the Black Death. With wit and sympathy, Boccaccio presents the full spectrum of daily life in Italy. Such secular literature, including the discovery and translation of ancient authors (for some of the tales had a long lineage), written in Italian as it was then spoken in Tuscany, provided a foundation for the Renaissance of the fifteenth century.

In England, Geoffrey Chaucer (c. 1342-1400) was inspired by Boccaccio to write his own series of short stories, *The Canterbury Tales*, told by pilgrims traveling to the shrine of Saint Thomas à Becket (1118?-1170) in Canterbury. Observant and witty, Chaucer depicted the pretensions and foibles, as well as the virtues, of humanity.

Christine de Pizan (1364–c. 1431), born in Venice but living and writing at the French court, became an author out of necessity when she was left a widow with three young children and an aged mother to support. Among her many works are a poem in praise of Joan of Arc and a history of famous women—including artists—from antiquity to her own time. In *The Book of the City of Ladies* she defended women's abilities and argued for women's rights and status. These writers, as surely as Giotto, Duccio, Peter Parler, and Master Theodoric, led the way into a new era.

individualized, and her action—holding her child's leg instead of merely pointing to him—seems entirely natural. This colossal Mary seems too large for the slender Gothic tabernacle, where figures peer through the openings and haloes overlap the faces. In spite of the formal, enthroned image and flat, gold background, Giotto renders the play of light and shadow across these substantial figures to create a sense that they are fully three-dimensional beings inhabiting real space. Details of the Virgin's solid torso can be glimpsed under her thin tunic, and Giotto's angels, unlike those of Cimabue, have ample wings that fold over in a resting position.

According to the sixteenth-century chronicler Vasari, "Giotto obscured the fame of Cimabue, as a great light out-

shines a lesser." Vasari also credited Giotto with "setting art upon the path that may be called the true one [for he] learned to draw accurately from life and thus put an end to the crude Greek [i.e., Italo-Byzantine] manner" (translated by J. C. and P. Bondanella).

Giotto may have collaborated on murals at the prestigious Church of Saint Francis in Assisi (see "The Church of Saint Francis at Assisi," page 546). Certainly he worked for the Franciscans in Florence and reacted to their teaching. Saint Francis's message of simple, humble devotion, direct experience of God, and love for all creatures was gaining followers throughout Western Europe, and it had a powerful impact on thirteenth- and fourteenth-century Italian literature and art.

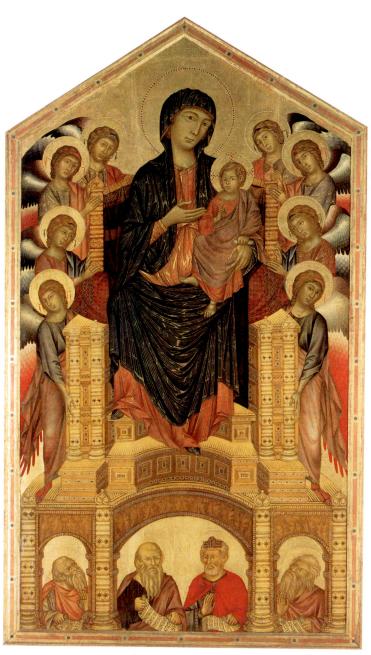

17–6 | Cimabue **VIRGIN AND CHILD ENTHRONED** Most likely painted for the high altar of the Church of Santa Trinita, Florence. c. 1280. Tempera and gold on wood panel, $12'17'' \times 7'$ 4" $(3.53 \times 2.2 \text{ m})$. Galleria degli Uffizi, Florence.

Early in the fourteenth century Giotto traveled to northern Italy. While working at the Church of Saint Anthony in Padua, he was approached by a local banker, Enrico Scrovegni, to decorate a new family chapel. He agreed, and the **SCROVEGNI CHAPEL** was dedicated in 1305 to the Virgin of Charity and the Virgin of the Annunciation. (The chapel is also called the "Arena Chapel" because it and the family palace were built on and in the ruins of an ancient Roman arena.) The building is a simple, barrel-vaulted room (FIG. 17–8). As viewers look toward the altar, they see the story of Mary and Jesus unfolding before them in a series of rectangular panels. On the entrance wall Giotto painted the Last Judgment.

Sequencing Events MARCH OF THE BLACK DEATH

1346	Plague enters the Crimian Peninsula
1347	Plague arrives in Sicily
1348	Plague reaches port cities of Genoa, Italy, and Marseilles, France
1349	First recorded cases of plague in Cologne and Vienna
1350	Plague reaches Bergen, Norway, via England

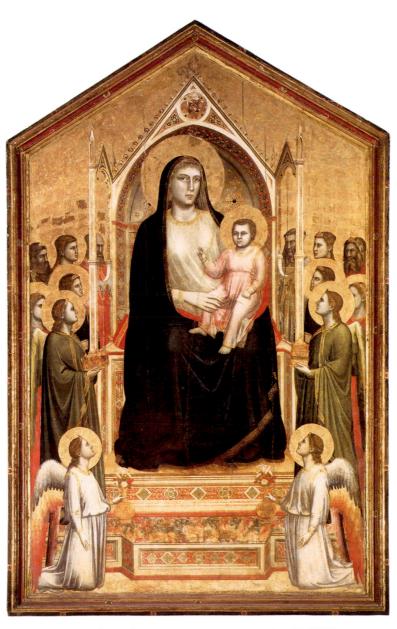

17–7 | Giotto di Bondone VIRGIN AND CHILD ENTHRONED Most likely painted for the high altar of the Church of the Ognissanti (All Saints), Florence. 1305–10. Tempera and gold on wood panel, $10'8'' \times 6'$ 8½" (3.53 \times 2.05 m). Galleria degli Uffizi, Florence.

Technique

CENNINO CENNINI (c. 1370–1440) ON PAINTING

ennino Cennini's *Il Libro dell' Arte (The Book of Art)* is a handbook of Florentine and north Italian painting techniques from about 1400. Cennini includes a description of the artist's life as well as step-by-step painting instructions.

"You, therefore, who with lofty spirit are fired with this ambition, and are about to enter the profession, begin by decking yourselves with this attire: Enthusiasm, Reverence, Obedience, and Constancy. And begin to submit yourself to the direction of a master for instruction as early as you can, and do not leave the master until you have to" (Chapter III).*

The first step in preparing a panel for painting is to cover its surface with clean white linen strips soaked in a **gesso** made from gypsum. Gesso provides a ground, or surface, on which to paint. Cennini specified that at least nine layers of gesso should be applied. The gessoed surface should then be burnished until it resembles ivory. The artist can now sketch the composition of the work with charcoal. At this point, advised Cennini, "When you have finished drawing your figure, especially if it is in a very valuable [altarpiece], so that you are counting on profit and reputation from it, leave it alone for a few days, going back to it now and then to look it over and improve it wherever it still needs something . . . (and bear in mind that you may copy and examine things done by other good masters; that it is no shame to you). The final version of the design should be inked in with a

fine squirrel-hair brush, and the charcoal brushed off with a feather. Gold leaf should be affixed on a humid day, the tissuethin sheets carefully glued down with a mixture of fine powdered clay and egg white, on the reddish clay ground (called bole). Then the gold is burnished with a gemstone or the tooth of a carnivorous animal. Punched and incised patterning should be added to the gold leaf later."*

Italian painters at this time worked in **tempera** paint, powdered pigments mixed most often with egg yolk, a little water, and an occasional touch of glue.

Cennini specified a detailed and highly formulaic painting process. Faces, for example, were always to be done last, with flesh tones applied over two coats of a light greenish pigment and highlighted with touches of red and white. The finished painting was to be given a layer of varnish to protect it and enhance its colors. An elaborate frame, which included the panel or panels on which the painting would be executed, would have been produced by a specialist according to the painter's specifications and brought fully assembled to the studio.

Cennini claimed that panel painting was a gentleman's job, but given its laborious complexity, that was wishful thinking. The claim does, however, reflect the rising social status of painters.

* Cennino Cennini, *The Craftsman's Handbook (Il Libro dell' Arte)*. Trans. by Daniel V. Thompson. New York: Dover, 1960. pp. 3, 16, 75.

A base of faux marble and allegorical *grisaille* (gray monochrome) paintings of the Virtues and Vices support vertical bands painted to resemble marble inlay and carved relief and containing quatrefoil portrait medallions. The central band of medallions spans the vault, crossing a brilliant, lapis blue, star-spangled sky in which large portrait disks float like glowing moons. Set into this framework are the rectangular narrative scenes juxtaposing the life of the Virgin with that of Jesus (FIG. 17–9).

Both the individual scenes and the overall program display Giotto's genius for distilling a complex narrative into a coherent visual experience. The life of the Virgin Mary begins the series and fills the upper band of images. Following in historical sequence, events in the life and ministry of Jesus circle the chapel in the middle band, while scenes of the Passion (the arrest, trial, and Crucifixion of Jesus) fill the lowest band. Read vertically, however, each set of three scenes foreshadows or comments on the others.

The first miracle, when Jesus changes water to wine during the wedding feast at Cana, recalls that his blood will become the wine of the Eucharist, or Communion. The raising of Lazarus becomes a reference to Jesus's Resurrection. Below, the Lamentation over the body of Jesus by those closest

to him leads to the Resurrection, indicated by angels at the empty tomb and his appearance to Mary Magdalen in the *Noli Me Tangere* ("Do not touch me"). The juxtaposition of dead and live trees in the two scenes also becomes a telling detail of death and resurrection. Giotto used only a few large figures and essential props in settings that never distract the viewer by their intricate detail. The scenes are reminiscent of *tableaux vivants* ("living pictures"), in which people dressed in costume re-created poses from familiar works of art—scenes that were played out in the city square in front of the chapel in Padua.

Among Giotto's achievements was his ability to model form with color. He rendered his bulky figures as pure color masses, painting the deepest shadows with the most intense hues and highlighting shapes with lighter shades mixed with white. These sculpturally modeled figures enabled Giotto to convey a sense of depth in landscape settings without relying on the traditional convention of an architectural framework.

In one of the most moving works, **LAMENTATION** (FIG. 17–10), in the lowest **register** (horizontal band) of the Arena Chapel, Giotto focused the composition off center for maximum emotional effect, concentrating on the faces of Mary and the dead Jesus. A great downward-swooping ridge—its barrenness emphasized by a single dry tree, a medieval

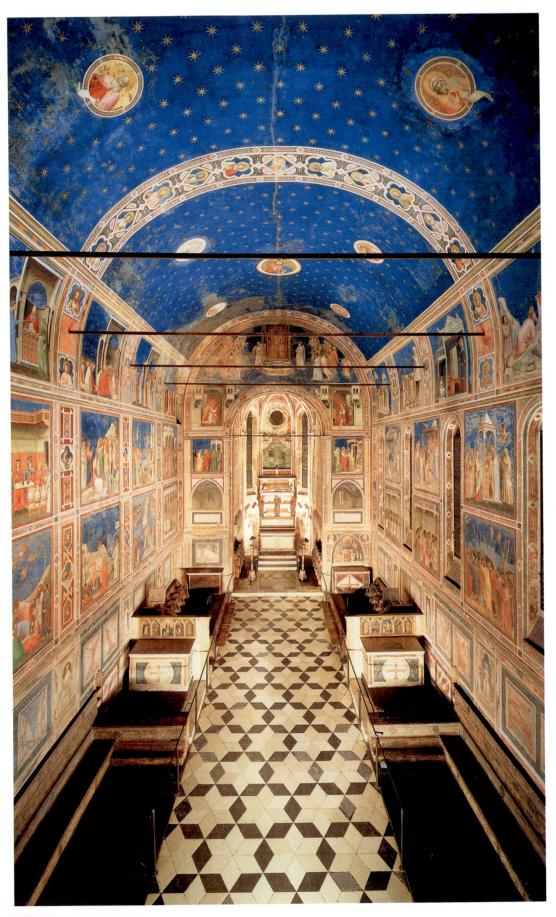

17-8 Giotto di Bondone SCROVEGNI (ARENA) CHAPEL, Frescoes, Padua. 1305-6. View toward east wall.

17–9 ☐ Giotto di Bondone
MARRIAGE AT CANA,
RAISING OF LAZARUS,
RESURRECTION, and NOLI ME
TANGERE and LAMENTATION
Frescoes on north wall of
Scrovegni (Arena) Chapel,
Padua. 1305–6. Each scene
approx. 6′5″ × 6′ (2 × 1.85 m).

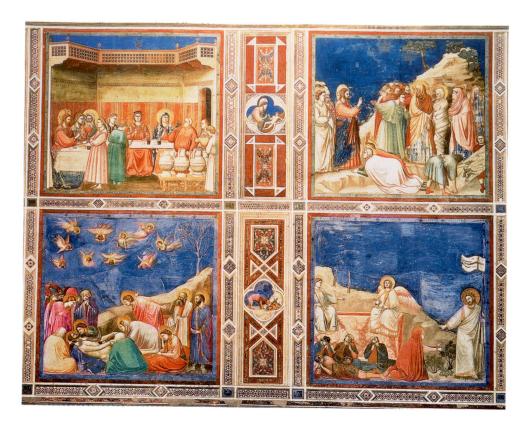

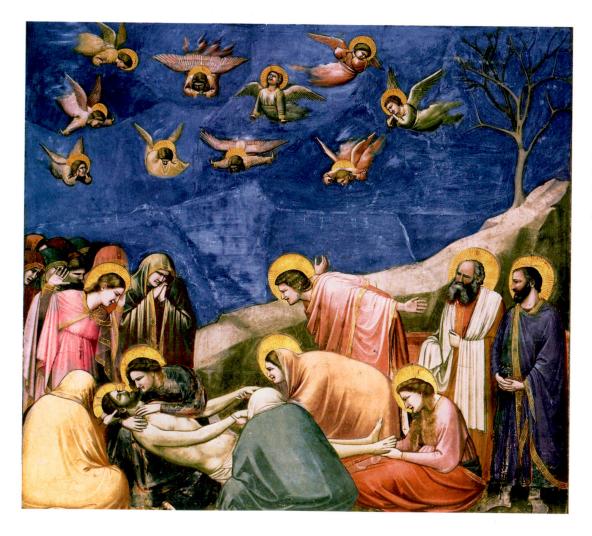

17–10 | Giotto di Bondone LAMENTATION Fresco in the Scrovegni (Arena) Chapel, Padua. 1305–6. Approx. 6′5″ × 6′ (2 x 1.85 m).

symbol of death—carries the psychological weight of the scene to its expressive core. Mourning angels hovering overhead mirror the anguish of Jesus's followers. The stricken Virgin communes with her dead son with mute intensity, while John the Evangelist flings his arms back in convulsive despair and other figures hunch over the corpse. Instead of symbolic sorrow, more typical of art from the early Middle Ages, Giotto conveys real human suffering, drawing the viewer into the circle of personal grief. The direct, emotional appeal of his art, as well as its deliberate plainness, seems to embody Franciscan values.

Bernardo Daddi. Giotto dominated Florentine painting in the first half of the fourteenth century. His combination of humanism and realism was so memorable that other artists' work paled beside his. The artists who worked in his studio picked up the mannerisms but not the essence of his style. Bernardo Daddi (active c. 1312–48), who painted the *Madonna and Child* in Orsanmichele (SEE FIG. 17–1), typifies the group with his personal reworking of Giotto's powerful figures. Daddi's talent lay in the creation of sensitive, lyrical images rather than the majestic realistic figures. He may have

been inspired by courtly French art, which he would have known from luxury goods, such as imported ivory carvings. The artists of the school of Giotto were responsible for hundreds of panel paintings. They also frescoed the walls of chapels and halls (see "Buon Fresco," page 569).

Sienese Painting

Like their Florentine rivals, the Sienese painters at first worked in a strongly Byzantine style. Sienese painting continued to emphasize abstract decorative qualities and a love of applied gold and brilliant colors. Consequently, Sienese art often seems slightly conservative.

Duccio di Buoninsegna. Siena's foremost painter in the later Gothic period was Duccio di Buoninsegna (active 1278–1318). Duccio knew thirteenth-century Byzantine art, with its elongated figures, stacks of angels, patterned textiles, and lavish use of gold. Between 1308 and 1311, Duccio painted a huge altarpiece for the high altar of Siena Cathedral. The MAESTÀ (MAJESTY) was dedicated, like the town itself, to the Virgin (FIGS. 17–11, 17–12).

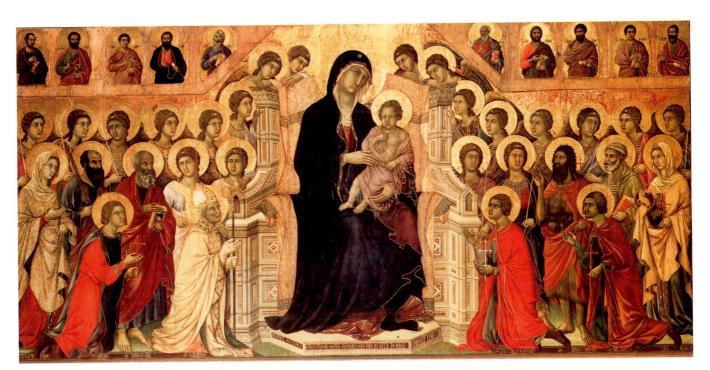

17–11 | Duccio di Buoninsegna VIRGIN AND CHILD IN MAJESTY, Central Panel from Maestà Altarpiece Siena Cathedral. 1308–11. Tempera and gold on wood panel, 7' × 13'6" (2.13 × 3.96 m). Museo dell'Opera del Duomo, Siena.

"On the day that it was carried to the [cathedral] the shops were shut, and the bishop conducted a great and devout company of priests and friars in solemn procession, accompanied by . . . all the officers of the commune, and all the people, and one after another the worthiest with lighted candles in their hands took places near the picture, and behind came the women and children with great devotion. And they accompanied the said picture up to the [cathedral], making the procession around the Campo [square], as is the custom, all the bells ringing joyously, out of reverence for so noble a picture as is this" (Holt, page 69).

I7−I2 | PLAN OF FRONT AND BACK OF THE MAESTÀ ALTARPIECE

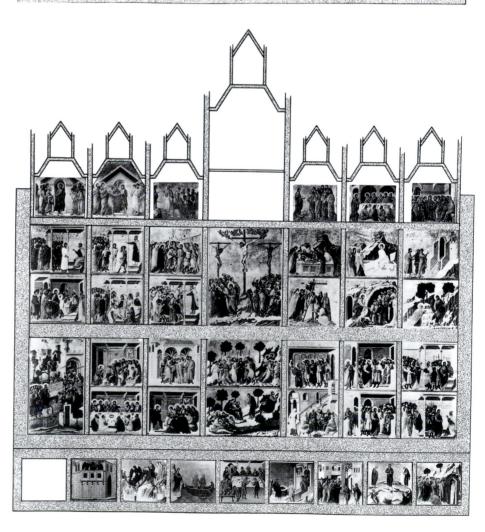

Creating this altarpiece was an arduous undertaking. The central panel alone was 7 by 13 ½ feet, and it had to be painted on both front and back, because it was meant to be seen from both sides. The main altar for which it was designed stood beneath the dome in the center of the sanctuary. Inscribed on Mary's throne are the words, "Holy Mother of God be thou the cause of peace for Siena and, because he painted thee thus, of life for Duccio" (cited in Hartt and Wilkins 4.2, page 104).

Mary and Christ, adored by angels and the four patron saints of Siena—Ansanus, Savinus, Crescentius, and Victor—kneeling in front, fill the large central panel. This *Virgin and Child in Majesty* represents both the Church and its specific embodiment, Siena Cathedral. Narrative scenes from the early life of the Virgin and the infancy of the Christ Child appear below the central image. The **predella** (the lower zone of the altarpiece) was entirely painted with the events in the childhood of Jesus. The back of this immense work was dedicated to scenes of his adult life and the miracles. The entire composition was topped by pinnacles—on the front, angels and the later life of the Virgin, and on the back, events after the Passion.

Duccio created a personal style that combines a softened Italo-Byzantine figure style with the linear grace and the easy relationship between figures and their settings characteristic of French Gothic. This subtle blending of northern and southern elements can be seen in the haloed ranks of angels around Mary's architectonic throne. The central, most holy figures retain a solemnity and immobility with some realistic touches, such as the weighty figure of the child; the adoring saints reflect a more naturalistic, courtly Gothic style that became the hallmark of the Sienese school for years to come. The brilliant palette, which mingles pastels with primary hues, the delicately patterned textiles that shimmer with gold, and the ornate punchwork—tooled designs in gold leaf on the haloes—are characteristically Sienese.

In 1771 the altarpiece was broken up, and individual panels were sold. One panel—the NATIVITY WITH PROPHETS ISAIAH AND EZEKIEL—is now in Washington, D.C. Duccio represented the Nativity in the tradition of Byzantine icons. Mary lies on a fat mattress within a cave hollowed out of a jagged, stylized mountain (FIG. 17-13). Jesus appears twice: first lying in the manger and then with the midwife below. However, Duccio followed Western tradition by placing the scene in a shed. Rejoicing angels fill the sky, and the shepherds and sheep add a realistic touch in the lower right corner. The light, intense colors, the calligraphic linear quality, even the meticulously rendered details recall Gothic manuscripts (see Chapter 16). The tentative move toward a defined space in the shed as well as the subtle modeling of the figures point the way toward future development in representing people and their world. Duccio's graceful, courtly art contrasts with Giotto's austere monumentality.

Technique

BUON FRESCO

he two techniques used in mural painting are buon ("true") fresco ("fresh"), in which paint is applied with water-based paints on wet plaster, and fresco secco ("dry"), in which paint is applied to a dry plastered wall. The two methods can be used on the same wall painting.

The advantage of buon fresco is its durability. A chemical reaction occurs as the painted plaster dries, which bonds the pigments into the wall surface. In fresco secco, by contrast, the color does not become part of the wall and tends to flake off over time. The chief disadvantage of buon fresco is that it must be done quickly without mistakes. The painter plasters and paints only as much as can be completed in a day. In Italy, each section is called a giornata, or day's work. The size of a giornata varies according to the complexity of the painting within it. A face, for instance, can occupy an entire day, whereas large areas of sky can be painted quite rapidly.

In medieval and Renaissance Italy, a wall to be frescoed was first prepared with a rough, thick undercoat of plaster. When this was dry, assistants copied the master painter's composition onto it with charcoal. The artist made any necessary adjustments. These drawings, known as sinopia, have an immediacy and freshness lost in the finished painting. Work proceeded in irregularly shaped sections conforming to the contours of major figures and objects. Assistants covered one section at a time with a fresh, thin coat of very fine plaster over the sinopia, and when this was "set" but not dry, the artist worked with pigments mixed with water. Painters worked from the top down so that drips fell on unfinished portions. Some areas requiring pigments such as ultramarine blue (which was unstable in buon fresco), as well as areas requiring gilding, would be added after the wall was dry using the fresco secco method.

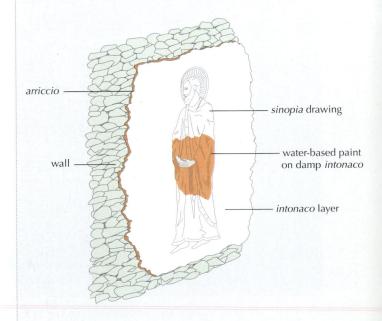

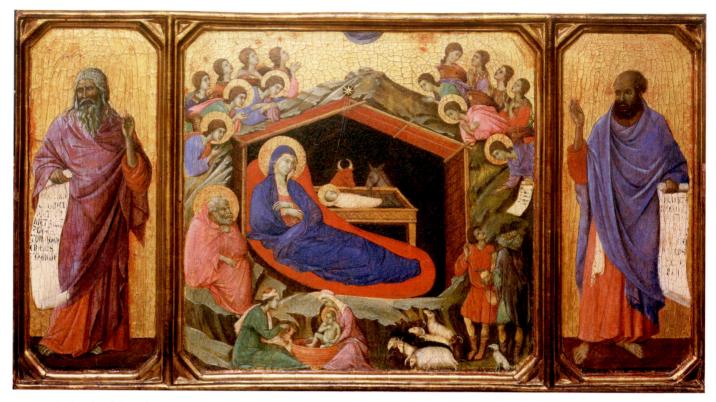

17–13 | Duccio di Buoninsegna NATIVITY WITH PROPHETS ISAIAH AND EZEKIEL Predella of the Maestà Altarpiece, $17\times17\%''$ (44 × 45 cm); Prophets, $17\%''\times6\%''$ (44 × 16.5 cm). National Gallery, Washington, D.C.

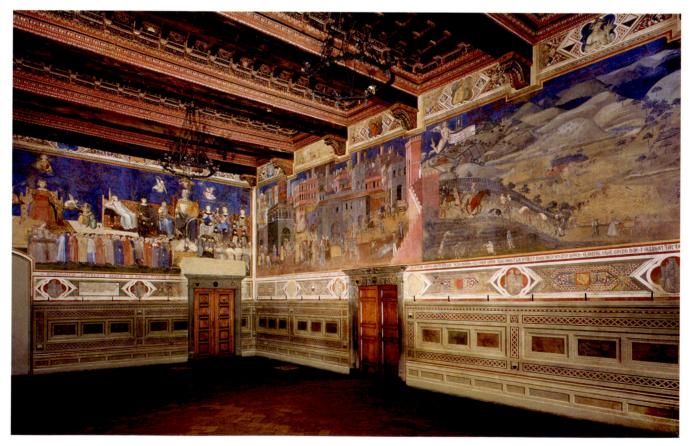

17–14 | Ambrogio Lorenzetti FRESCO SERIES OF THE SALA DELLA PACE, PALAZZO PUBBLICO Siena city hall, Siena, Italy. 1338–40. Length of long wall about 46′ (14 m).

AMBROGIO LORENZETTI. In Siena, a strain of seemingly native realism also began to emerge. In 1338, the Siena city council commissioned Ambrogio Lorenzetti to paint in fresco the council room of the Palazzo Pubblico (city hall) known as the SALA DELLA PACE (CHAMBER OF PEACE) (FIG. 17–14). The murals were to depict the results of good and bad government. On the short wall Ambrogio painted a figure symbolizing the Commune of Siena, enthroned like an emperor holding an orb and scepter and surrounded by the Virtues. Justice, assisted by Wisdom and Concord, oversees the local magistrates. Peace lounges on a bench against a pile

of armor, having defeated War. The figure is based on a fragment of a Roman sarcophagus still in Siena.

Ambrogio painted the results of both good and bad government on the two long walls. For the **ALLEGORY OF GOOD GOVERNMENT,** and in tribute to his patrons, Ambrogio created an idealized but recognizable portrait of the city of Siena and its immediate environs (FIG. 17–15). The cathedral dome and the distinctive striped campanile (see Chapter 16) are visible in the upper left-hand corner; the streets are filled with productive citizens. The Porta Romana, Siena's gateway leading to Rome, divides the city from the country. Over the portal

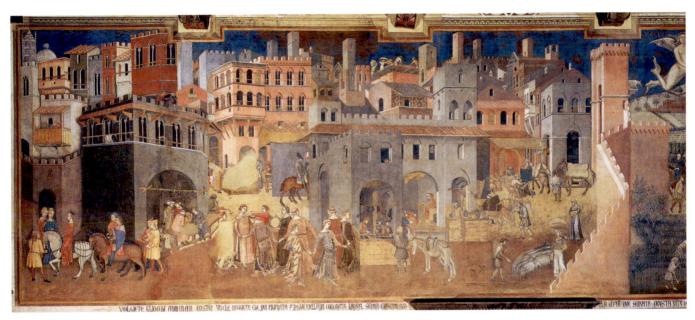

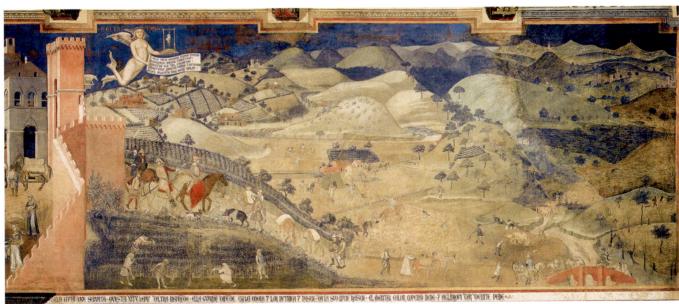

17–15 | Ambrogio Lorenzetti ALLEGORY OF GOOD GOVERNMENT IN THE CITY AND IN THE COUNTRY Sala della Pace, Palazzo Pubblico, Siena, Italy. 1338–40. Fresco, total length about 46′ (14 m).

stands the statue of the wolf suckling Romulus and Remus, the legendary founders of Rome. Representations of these twin boys were popular in Siena because of the legend that Remus's son Senus founded Siena. Hovering above outside the gate is a woman clad in a wisp of transparent drapery, a scroll in one hand and a miniature gallows complete with a hanged man in the other. She represents Security, and her scroll bids those entering the city to come in peace. The gallows is a sharp reminder of the consequences of not doing so.

Ambrogio's achievement in this fresco was twofold. First, despite the shifts in vantage point and scale, he maintained an overall visual coherence and kept all parts of the flowing composition intelligible. Second, he maintained a natural relationship between the figures and the environment. Ambrogio conveys a powerful vision of an orderly society, of peace and plenty, from the circle of young people dancing to a tambourine outside a shoemaker's shop to the well-off peasants tending fertile fields and lush vineyards. Sadly, plague struck in the next decade. Famine, poverty, and disease overcame Siena just a few years after this work was completed.

The world of the Italian city-states—which had seemed so full of promise in Ambrogio Lorenzetti's *Good Government* fresco—was transformed into uncertainty and desolation by epidemics of the plague. Yet as dark as those days must have seemed to the men and women living through them, beneath the surface profound, unstoppable changes were taking place. In a relatively short span of time, the European Middle Ages gave way to what is known as the Renaissance.

FRANCE

At the beginning of the fourteenth century the royal court in Paris was still the arbiter of taste in Western Europe, as it had been in the days of Saint Louis. During the Hundred Years' War, however, the French countryside was ravaged by armed struggles and civil strife. The power of the old feudal nobility, weakened significantly by warfare, was challenged by townsmen, who took advantage of new economic opportunities that opened up in the wake of the conflict. Leadership in the arts and architecture moved to the duchy of Burgundy, to England, and—for a brief golden moment—to the court of Prague.

Gothic sculptors found a lucrative new outlet for their work in the growing demand among wealthy patrons for religious art intended for homes as well as churches. Busy urban workshops produced large quantities of statuettes and reliefs in wood, ivory, and precious metals, often decorated with enamel and gemstones. Much of this art was related to the cult of the Virgin Mary. Architectural commissions were smaller—chapels rather than cathedrals, and additions to already existing buildings, such as towers, spires, and window tracery.

In the second half of the thirteenth century, architects working at the royal court in Paris (see Chapter 16) introduced a new style, which continued into the first part of the fourteenth century. Known as the French Court style, or Rayonnant style or Rayonnant Gothic in France, the art is characterized by elegance and refinement achieved through extraordinary technical virtuosity. In sculpture and painting, elegant figures move gracefully through a narrow stage space established by miniature architecture and elements of land-scape. Sometimes a focus on the details of nature suggests the realism that appears in the fourteenth century.

Manuscript Illumination

By the late thirteenth century, literacy had begun to spread among laypeople. Private prayer books became popular among those who could afford them. Because they contained special prayers to be recited at the eight canonical "hours" between morning and night, an individual copy of one of these books came to be called a Book of Hours. Such a book included everything the lay person needed—psalms, prayers to the Virgin and the other saints, a calendar of feast days, the office of the Virgin, and even the offices of the dead. During the fourteenth century, a richly decorated Book of Hours was worn or carried like jewelry and was among a noble person's most important portable possessions.

THE BOOK OF HOURS OF JEANNE D'EVREUX. Shortly after their marriage in 1325, King Charles IV gave his queen, Jeanne d'Evreux, a tiny, exquisite BOOK OF HOURS, the work of the illuminator Jean Pucelle (FIG. 17–16). This book was precious to the queen, who mentioned it in her will. She named its illuminator, Jean Pucelle, an unusual tribute.

In this manuscript, Pucelle worked in the *grisaille* technique—monochromatic painting in shades of gray with faint touches of color (here, blue and pink). The subtle shades emphasized his accomplished drawing. Queen Jeanne appears in the initial below the *Annunciation*, kneeling before a lectern and reading, perhaps, from her Book of Hours. This inclusion of the patron in prayer within a scene conveyed the idea that the scenes were visions inspired by meditation rather than records of historical events. In this case, the young queen would presumably have identified with Mary's joy at Gabriel's message.

Jeanne d'Evreux's Book of Hours combines two narrative cycles in its illuminations. One, the Hours of the Virgin, juxtaposes scenes from the Infancy and Passion of Christ, a form known as the Joys and Sorrows of the Virgin. The other is dedicated to the recently canonized king, Saint Louis. In the opening shown here, the joy of the *Annunciation* on the

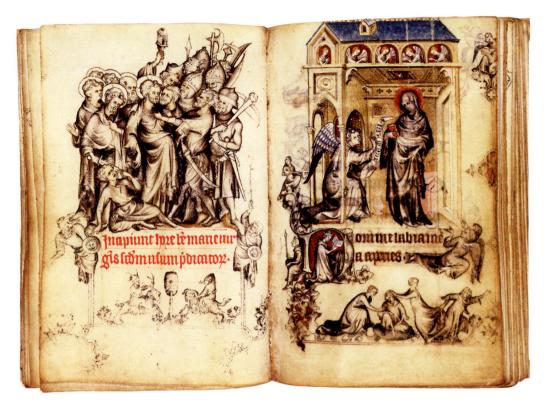

17–16 | Jean Pucelle PAGES WITH BETRAYAL AND ARREST OF CHRIST, folio 15v. (left), and **ANNUNCIATION**, folio 16r. (right), **BOOK OF HOURS OF JEANNE D'EVREUX**Paris c. 1325–28. *Grisaille* and color on vellum, each page $3\frac{1}{2} \times 2\frac{1}{4}$ " (8.9 × 6.2 cm). The Metropolitan Museum of Art, New York. The Cloisters Collection 1954 (54.1.2).

right is paired with the "sorrow" of the Betrayal and Arrest of Christ on the left. In the Annunciation, Mary is shown receiving the archangel Gabriel in a Gothic building, while rejoicing angels look on from windows under the eaves. The group of romping children at the bottom of the page (known as the bas-de-page in French) at first glance seems to echo the joy of the angels. They might be playing "love tag," which would surely relate to Mary as the chosen one of the Annunciation. Folklorists have suggested, however, that the children are playing "froggy in the middle," or "hot cockles," games in which one child was tagged by the others. To the medieval reader the game symbolized the mocking of Christ or the betrayal of Judas, who "tags" his friend, and it evokes a darker mood by foreshadowing Jesus's death even as his life is beginning. In the Betrayal on the opposite page, Judas Iscariot embraces Jesus, thus identifying him to the Roman soldiers. The traitor sets in motion the events that lead to the Crucifixion. Saint Peter, on the left, realizing the danger, draws his sword to defend Jesus and slices off the ear of the high priest's servant Malchus. The bas-de-page on this side shows knights riding goats and jousting at a barrel stuck on a pole, a spoof of the military that may comment on the lack of valor of the soldiers assaulting Jesus.

Pucelle's work represents a sophisticated synthesis of contemporary French, English, and Italian art. From English illuminators he borrowed the merging of Christian narrative with allegory, the use of foliate borders filled with real and grotesque creatures (instead of the standard French vine scrolls), and his lively bas-de-page illustrations. His presentation of space, with figures placed within coherent architectural settings, suggests a firsthand knowledge of Sienese art: The small angels framed by the rounded arches of the attic are reminiscent of the half-length saints who appear above the front panel of Duccio's Maestà. Pucelle also adapted to manuscript illumination the Parisian Court style in sculpture, with its softly modeled, voluminous draperies gathered around tall, elegantly curved figures with curly hair and delicate features.

Sculpture

Sculpture in the fourteenth century is exemplified by its intimate character. Religious subjects became more emotionally expressive. In the secular realm, the cult of chivalry was revived just as the era of the knight on horseback was being rendered obsolete. Tales of love and valor were carved on luxury items to delight the rich, middle class, and aristocracy alike. Precious metals—gold, silver, and ivory—were preferred.

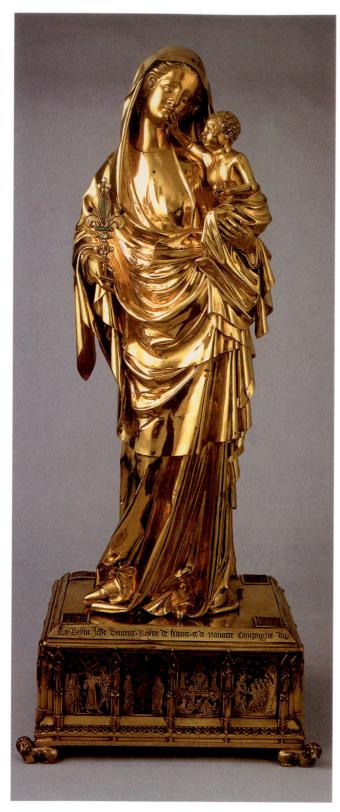

17–17 | VIRGIN AND CHILD c. 1339. Silver gilt and enamel, height 27 1/8" (69 cm). Musée du Louvre, Paris.

Given by Jeanne d'Evreux to the Abbey Church of Saint-Denis, France.

THE VIRGIN AND CHILD FROM SAINT-DENIS. A silver-gilt image of a standing virgin and child (FIG. 17-17) was once among the treasures of the Abbey Church of Saint-Denis (see Chapter 16). An inscription on the base bears the date 1339 and the donor's name, Queen Jeanne d'Evreux. The Virgin holds Jesus in her left arm, her weight on her left leg, creating the graceful S-curve pose that became characteristic of the period. Fluid drapery, suggesting the consistency of heavy silk, covers her body. She originally wore a crown, and she holds a scepter topped with a large enameled and jeweled fleur-de-lis, the heraldic symbol of French royalty. The scepter served as a reliquary for a few strands of Mary's hair. The Virgin's sweet, youthful face and simple clothing, although based on thirteenth-century sculpture, anticipate the so-called Beautiful Mother imagery of fourteenth-century Prague (SEE FIG. 17-25), Flanders, and Germany. The Christ Child reaching out to touch his mother's lips is babylike in his proportions and gestures, a hint of realism. The image is not entirely joyous, however; on the enameled base, scenes of Christ's Passion remind us of the suffering to come.

COURTLY LOVE: AN IVORY BOX. A strong market also existed for personal items like boxes, mirrors, and combs with secular scenes inspired by popular literature and folklore. A box—perhaps a gift from a lover—made in a Paris workshop around 1330–50 provides a delightful example of such a work (FIG. 17–18). In its ivory panels, the God of Love shoots his arrows; knights and ladies throw flowers as missiles and joust with flowers. The subject is the ATTACK ON THE CASTLE OF LOVE, but what the owner kept in the box—jewelry? love tokens?—remains a mystery.

A tournament takes place in front of the Castle of Love. The tournament—once a mock battle, designed to keep knights fit for war—has become a lovers' combat. In the center panel, women watch jousting knights charge to the blare of the heralds' trumpets. In the scene on the left, knights use crossbows and a catapult to hurl roses at the castle, while the God of Love helps the women by aiming his arrows at the attackers. The action concludes in the scene on the right, where the tournament's victor and his lady love meet in a playful joust of their own.

Unlike the aristocratic marriages of the time, which were essentially business contracts based on political or financial exigencies, romantic love involved passionate devotion. Images of gallant knights serving ladies, who bestowed tokens of affection on their chosen suitors or cruelly withheld their love on a whim, captured the popular imagination. Tales of romance were initially spread by the musician-poets known as troubadours. Twelfth-century troubadour poetry marked a shift away from the usually negative way in which women had previously been portrayed as sinful daughters of Eve.

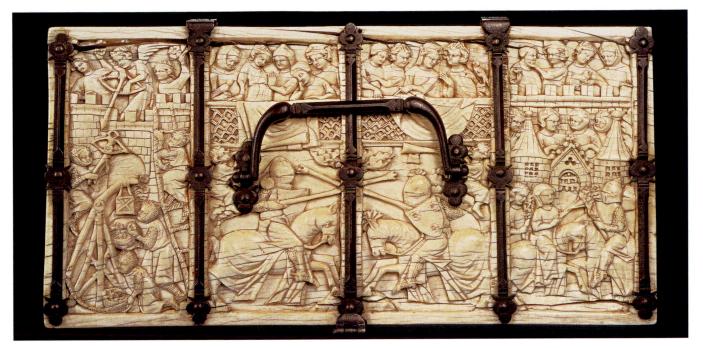

17–18 $\,^{|}$ ATTACK ON THE CASTLE OF LOVE Lid of a box. Paris. c. 1330–50. Ivory box with iron mounts, panel $4\% \times 9\%$ (11.5 \times 24.6 cm). The Walters Art Museum, Baltimore.

ENGLAND

Fourteenth-century England prospered in spite of the ravages of the Black Death and the Hundred Years' War with France. Life in medieval England is described in the rich store of Middle English literature. The brilliant social commentary of Geoffrey Chaucer in the *Canterbury Tales* (see "A New Spirit in Fourteenth-Century Literature," page 561) includes all classes of society. The royal family, especially Edward I—the castle builder—and many of the nobles and bishops were generous patrons of the arts.

Embroidery: Opus Anglicanum

An English specialty, pictorial needlework in colored silk and gold thread, gained such fame that it came to be called *opus anglicanum (English work)*. Among the collectors of this luxurious textile art were the popes, who had more than 100 pieces in the Vatican treasury. The names of several prominent embroiderers are known, but few names can be connected to specific pieces.

Opus anglicanum was employed for court dress, banners, cushions, bed hangings, and other secular items, as well as for the vestments worn by the clergy to celebrate the Mass (see Introduction Fig. 3, Christine de Pizan Presenting a Book to the Queen of France). Few secular pieces survive, since clothing and furnishings were worn out and discarded when fashions changed. But some vestments have survived, stored in church treasuries.

A liturgical vestment (that is, a special garment worn by the priest during mass), the red velvet **CHICHESTER-CONSTABLE** **CHASUBLE** (FIG. 17–19) was embroidered with colored silk, gold threads forming the images as subtly as painting. Where gold threads were laid and couched (tacked down with colored silk), the effect resembles the burnished gold-leaf backgrounds of manuscript illuminations. The Annunciation, the Adoration of the Magi, and the Coronation of the Virgin are set in cusped, crocketed **ogee** (S-shaped) arches amid twisting branches sprouting oak leaves, seed-pearl acorns, and animal masks. Because the star and crescent moon in the Coronation of the Virgin scene are heraldic emblems of Edward III (ruled 1327–77), perhaps he or a family member ordered this luxurious vestment.

During the celebration of the Mass, garments of *opus* anglicanum would have glinted in the candlelight amid treasures on the altar. Court dress was just as rich and colorful, and at court such embroidered garments established the rank and

Sequencing Events		
c. 1307-21	Dante writes The Divine Comedy	
1309-77	Papacy transferred from Rome to Avignon	
1348	Arrival of Black Death on European mainland	
1378-1417	Great Schism in Catholic Church	
1396	Greek studies instituted in Florence; beginning of the revival of Greek literature	

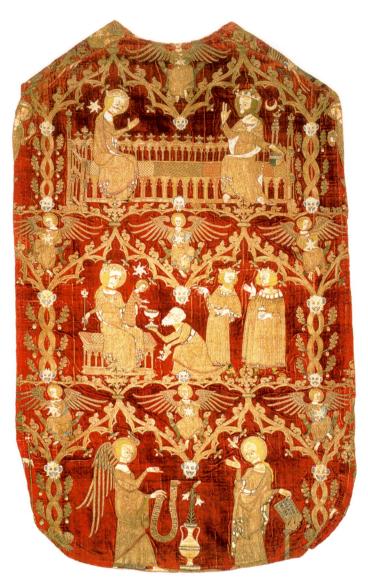

17–19 † Life of the virgin, back of the chichester-constable chasuble

From a set of vestments embroidered in *opus anglicanum* from southern England. 1330–50. Red velvet with silk and metallic thread and seed pearls; length 4'3" (129.5 cm), width 30" (76 cm). The Metropolitan Museum of Art, New York. Fletcher Fund, 1927 (27 162.1).

status of the wearer. So heavy did such gold and bejeweled garments become that their wearers often needed help to move.

Architecture

In the later years of the thirteenth century and early years of the fourteenth, a distinctive and influential style, popularly known as the "Decorated style," which corresponded to the Rayonnant style in France (see Chapter 16), developed in England. This change in taste has been credited to Henry III's ambition to surpass his brother-in-law, Saint Louis (Louis IX) of France, as a royal patron of the arts.

THE DECORATED STYLE AT EXETER. The most complete Decorated style building is the **EXETER CATHEDRAL.** Thomas of Witney began work at Exeter in 1313 and was the master

mason from 1316 until 1342. He supervised construction of the nave and redesigned upper parts of the choir. He left the towers of the original Norman cathedral but turned the interior into a dazzling stone forest of colonnettes, moldings, and vault ribs (FIG. 17-20). From diamond-shaped piers covered with colonnettes rise massed moldings that make the arcade seem to ripple. Bundled colonnettes spring from sculptured corbels (supporting brackets that project from a wall) between the arches to support conical clusters of thirteen ribs that meet at the summit of the vault, a modest 69 feet above the floor. The basic structure here is the four-part vault with intersecting cross-ribs, but the designer added additional ribs, called tiercerons, to create a richer linear pattern. Elaborately carved bosses (decorative knoblike elements) cover the intersections where ribs meet. Large clerestory windows with bartracery mullions (slender vertical elements dividing the windows into subsections) illuminate the 300-foot-long nave. Unpolished gray marble shafts, yellow sandstone arches, and a white French stone, shipped from Caen, used in the upper walls add subtle graduations of color to the many-rayed space.

Detailed records survive for the building of Exeter Cathedral. They extend over the period from 1279 to 1514, with only two short breaks. Included is such mundane information as where the masons and carpenters were housed (in a hostel near the cathedral) and how they were paid (some by the day with extra for drinks, some by the week, some for each finished piece); how materials were acquired and transported (payments for horseshoes and fodder for the horses); and of course payments for the building materials (not only stone and wood but rope for measuring and parchment on which to draw forms for the masons). The bishops contributed generously to the building funds. Building was not an anonymous labor of love as imagined by romantic nineteenth-century historians.

Thomas of Witney also designed the bishop's throne. Richard de Galmeton and Walter of Memburg led a team of a dozen carpenters to build the throne and the intricate canopy, 57 feet high. The canopy is like a piece of embroidery translated into wood, revealing characteristic forms of the Decorated style: S-curves, nodding arches (called "nodding ogee arches" because they curve outward—and nod—as well as upward) lead the eye into a maze of pinnacles, bursting with leafy crockets and tiny carved animals and heads. To finish the throne in splendor, Master Nicolas painted and gilded the wood. When the bishop was seated on his throne wearing embroidered vestments like the *Chichester-Constable Chasuble*, he must have resembled a golden image in a shrine rather than a living man. Enthroned, he represented the power and authority of the Church.

THE PERPENDICULAR STYLE AT EXETER. During years following the Black Death, work at Exeter Cathedral came to a

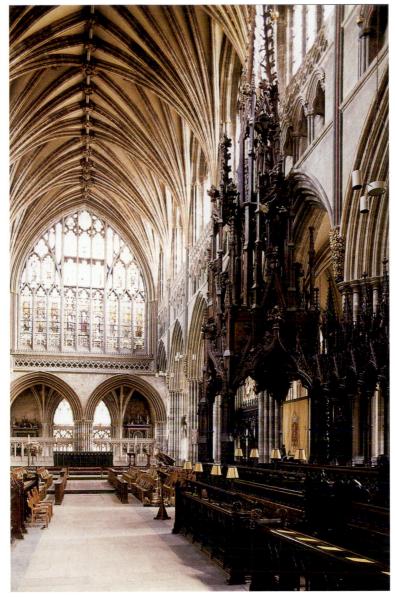

17–20 | **EXETER CATHEDRAL**Exeter, Devon, England. Thomas of Witney, Choir, 14th century and Bishop's Throne, 1313–17; Robert Lesyngham, East Window, 1389–90.

standstill. The nave had been roofed but not vaulted, and the windows had no glass. When work could be resumed, taste had changed. The exuberance of the Decorated style gave way to an austere style in which rectilinear patterns and sharp angular shapes replaced intricate curves, and luxuriant foliage gave way to simple stripped-down patterns. This phase is known as the Perpendicular style.

In 1389–90, well-paid master mason Robert Lesyngham rebuilt the great East Window (FIG. 17–20), and he designed the window tracery in the new Perpendicular style. The window fills the east wall of the choir like a glowing altarpiece. A single figure in each light stands under a tall painted canopy that flows into and blends with the stone tracery. The Virgin with the Christ Child stands in the center over the high altar,

with four female saints at the left and four male saints, including Saint Peter, to whom the church is dedicated, on the right. At a distance the colorful figures silhouetted against the silver *grisaille* glass become a band of color, reinforcing the rectangular pattern of the mullions and transoms. The combination of *grisaille*, silver stain (creating shades of gold), and colored glass produces a cool silvery light.

The Perpendicular style produces a decorative scheme that heralds the Renaissance style (see Chapter 19) in its regularity, its balanced horizontal and vertical lines, and its plain wall or window surfaces. When Tudor monarchs introduced Renaissance art into the British Isles, builders did not have to rethink the form and structure of their buildings; they simply changed the ornament from the pointed cusped and

crocketed arches of the Gothic style to the round arches and ancient Roman columns and capitals of the classical era. The Perpendicular style, used throughout the Late Gothic period in the British Isles, became England's national style. It remains popular today in the United States for churches and college buildings.

THE HOLY ROMAN EMPIRE

By the fourteenth century, the Holy Roman Empire existed more as an ideal fiction than a fact. The Italian territories had established their independence, and in contrast to England and France, Germany had become further divided into multiple states with powerful regional associations and princes. The Holy Roman Emperors, now elected by Germans, concentrated on securing the fortunes of their families. They continued to be patrons of the arts, promoting local styles.

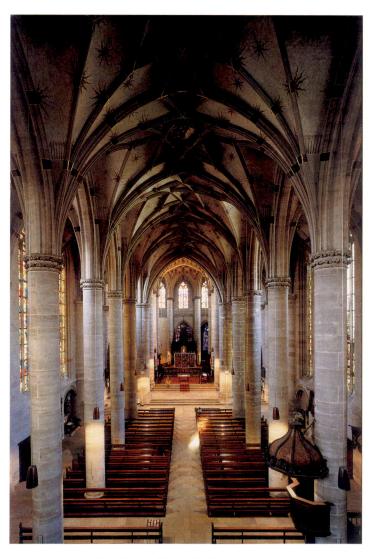

17–21 | Heinrich and Peter Parler CHURCH OF THE HOLY CROSS

Schwäbisch Gmünd, Germany. Interior. Begun in 1317 by Henrich Parler; choir by Peter Parler begun in 1351; vaulting completed 16th century.

The Supremacy of Prague

Charles IV of Bohemia (ruled 1346–75), whose admiration for the French king Charles IV was such that he changed his own name from Wenceslas to Charles, had been raised in France. He was officially crowned king of Bohemia in 1347 and Holy Roman Emperor in 1355.

Charles established his capital in Prague, which, in the view of its contemporaries, replaced Constantinople as the "New Rome." Prague had a great university, a castle, and a cathedral overlooking a town that spread on both sides of a river joined by a stone bridge, a remarkable structure itself.

When Pope Clement VI made Prague an archbishopric in 1344, construction began on a new cathedral in the Gothic style—to be named for Saint Vitus—which would also serve as the coronation church and royal pantheon. At Charles's first coronation, however, the choir remained unfinished. Charles, deeply involved in his projects, brought Peter Parler from Swabia to complete the building. Peter came from a distinguished family of architects.

THE PARLER FAMILY. In 1317 Heinrich Parler, a former master of works on the Cologne Cathedral, designed and began building the **CHURCH OF THE HOLY CROSS** in Schwäbisch Gmünd, in southwest Germany. In 1351, his son Peter (c. 1330–99), the most brilliant architect of this talented family, joined the shop. Peter designed the choir (FIG. 17–21) in the manner of a hall church in which a triple-aisled form was enlarged by a ring of deep chapels between the buttresses

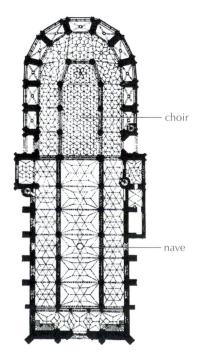

17–22 | PLAN OF CHURCH OF THE HOLY CROSS
Schwäbisch Gmünd.

of the choir. The unity of the entire space was enhanced by the complex net vault—a veritable web of ribs created by eliminating transverse ribs and ridge ribs. Seen clearly in the plan (FIG. 17–22), the contrast between Heinrich's nave and Peter's choir illustrates the increasing complexity of rib patterns, a complexity that in fact finally led to the unified interior space of the Renaissance.

Called by Charles IV to Prague in 1353, Peter turned the unfinished Saint Vitus Cathedral into a "glass house," adding a vast clerestory and glazed triforium supported by double flying buttresses, all covered by net vaults that created a continuous canopy over the space. Photos do not do justice to the architecture; but the small, gilded icon shrine suggests the richness and elaborateness of Peter's work. The shrine stands in the reliquary chapel of Saint Wenceslas (FIG. 17–23)—once a freestanding Romanesque chapel, now incorporated into the cathedral—on the south side of the church. The chapel itself, with walls encrusted with semiprecious stones, recalls a reliquary (c. 1370–71).

Peter, his family, and heirs became the most successful architects in the Holy Roman Empire. Their concept of space, luxurious decoration, and intricate vaulting dominated central European architecture for three generations.

Sequencing Works of Art			
c. 1330	Vesperbild, Germany		
1330-36	Andrea Pisano, Life of Saint John the Baptist, Baptistry, Florence		
1338-40	Ambrogio Lorenzetti, <i>Allegory of Good Government</i> , Sala della Pace, Palazzo Pubblico, Siena		
1330-50	Life of the Virgin, Chichester-Constable Chasuble		
1339	Virgin and Child, Jeanne d'Evreux, France		

Master Theodoric and the "Beautiful Style." At Karlstejn Castle, a day's ride from Prague, the emperor built another chapel and again covered the walls with gold and precious stones as well as with paintings. One hundred thirty paintings of the saints also served as reliquaries, for they had relics inserted into their frames. Master Theodoric, the court painter, provided drawings on the wood panels, and he painted about thirty images himself (FIG. 17–24). These figures are crowded into—and even extend over—the frames,

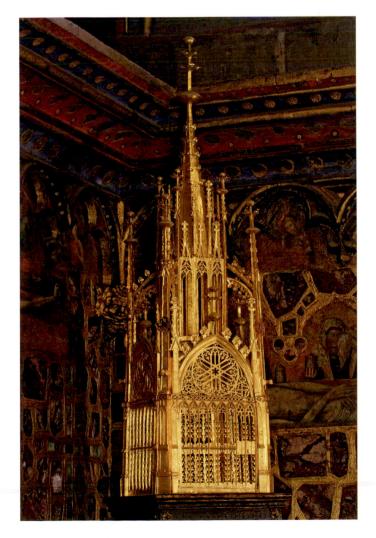

17–23 Peter Parler and workshop SAINT WENCESLAS CHAPEL, CATHEDRAL OF SAINT VITUS

Prague. Begun 1356. In 1370-71, the walls were encrusted with slabs of jasper, amethyst, and gold, forming crosses. Tabernacle, c. 1375: gilded iron. Height 81%" (208 cm).

The spires, pinnacles, and flying buttresses of the tabernacle may have been inspired by Peter Parler's drawings for the cathedral.

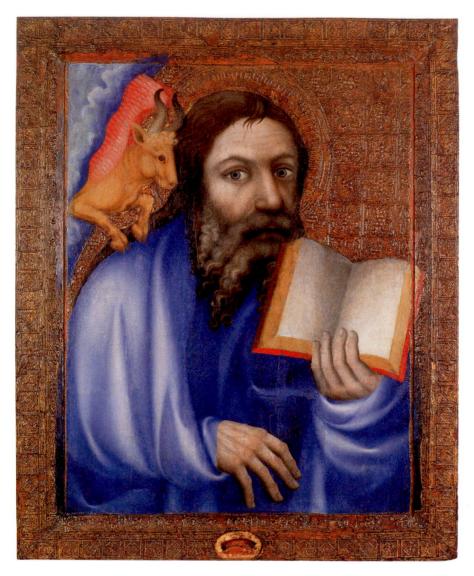

Theodoric SAINT LUKE
Holy Cross Chapel, Karlstejn Castle, near Prague.
1360-64. Paint and gold on panel. 45¼ × 37″
(115 × 94 cm).

emphasizing their size and power. Master Theodoric was head of the Brotherhood of Saint Luke, the patron saint of painters, and his painting of **SAINT LUKE**, accompanied by his symbol, the ox, looks out at the viewer, suggesting that this may really be a self-portrait of Master Theodoric. Master Theodoric's personal style—heavy bodies, oversized heads and hands, dour and haunted faces, and soft, deeply modeled drapery—merged with the French Gothic style to become what is known as the Beautiful style of the end of the century. The chapel, consecrated in 1365, so pleased the emperor that in 1367 he gave the artist a farm in appreciation for his work.

Like the architecture of the Parler family, the style created by Master Theodoric spread through central and northern Europe. Typical of this Beautiful style is the sweet-faced Virgin and Child, as seen in the "BEAUTIFUL" VIRGIN AND CHILD (FIG. 17–25), engulfed in swaths of complex drapery.

Cascades of V-shaped folds and clusters of vertical folds ending in rippling edges surround a squirming infant to create the feeling of a fleeting movement. Emotions are restrained, and grief as well as joy become lost in a naive piety. Yet, this art emerges against a background of civil and religious unrest. The Beautiful style seems like an escape from the realities of fourteenth-century life.

Mysticism and Suffering

The ordeals of the fourteenth century—famines, wars, and plagues—helped inspire a mystical religiosity that emphasized both ecstatic joy and extreme suffering. Devotional images, known as *Andachtsbilder* in German, inspired the worshiper to contemplate Jesus's first and last hours, especially during evening prayers, or vespers (giving rise to the term *Vesperbild* for the image of Mary mourning her son).

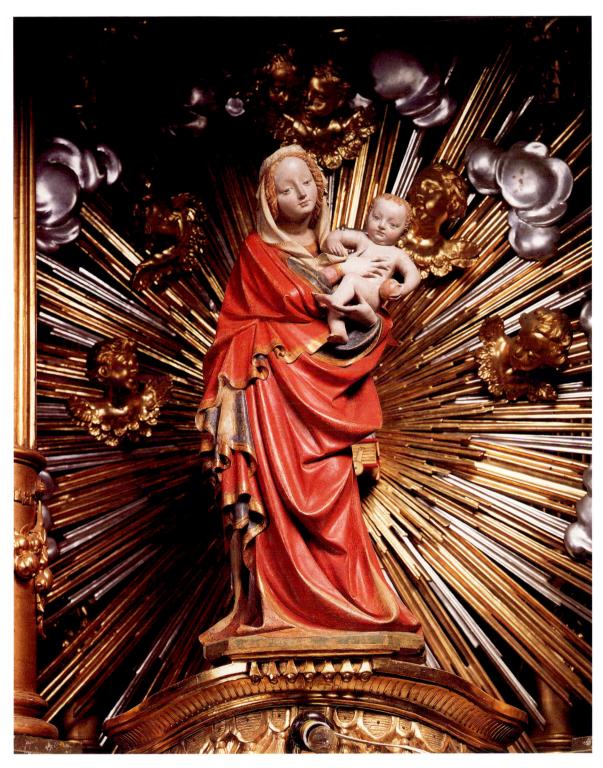

17–25 | "BEAUTIFUL" VIRGIN AND CHILD
Probably from the Church of Augustinian Canons, Sternberk. c. 1390. Limestone with original paint and gilding; height 33%" (84 cm).

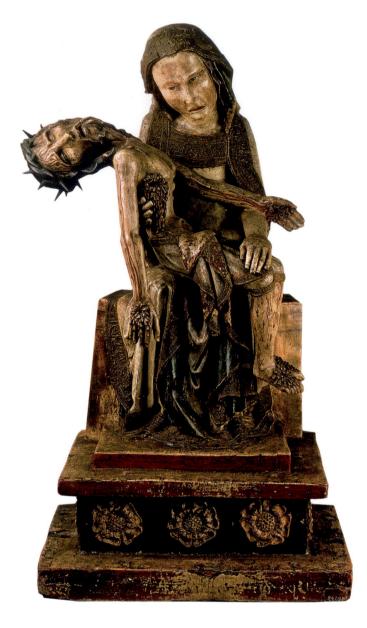

17–26 | VESPERBILD From Middle Rhine region, Germany. c. 1330. Wood, height 34½" (88. 4 cm). Landesmuseum, Bonn.

Through such religious exercises, worshipers hoped to achieve understanding of the divine and union with God. In the well-known example shown here (FIG. 17–26), blood gushes from the hideous rosettes that are the wounds of an emaciated Jesus. The Virgin's face conveys the intensity of her ordeal, mingling horror, shock, pity, and grief. Such images had a profound impact on later art, both within Germany and beyond.

Prague and the Holy Roman Empire under Charles IV had become a multicultural empire where people of different religions (Christians and Jews) and ethnic heritage (German and Slav) lived side by side. Charles died in 1378, and without his strong central government, political and religious dissent overtook the empire. Jan Hus, dean of the philosophy faculty at Prague University and a powerful reforming preacher, denounced the immorality he saw in the Church. He was burned at the stake, becoming a martyr and Czech national hero. The Hussite Revolution in the fifteenth century ended Prague's—and Bohemia's—leadership in the arts.

IN PERSPECTIVE

The emphasis on suffering and on supernatural power inspired many artists to continue the formal, expressive styles of earlier medieval and Byzantine art. At the same time, the humanism emerging in the paintings of Giotto and his school at the beginning of the fourteenth century could not be denied. Painters began to combine the flat, decorative, linear quality of Gothic art with the new representation of forms defined by light and space. In Italy they created a distinctive new Gothic style that continued through the fourteenth century. North of the Alps, Gothic elements survived in the arts well into the fifteenth century.

The courtly arts of manuscript illumination, embroidery, ivory carving, and of jewel, enamel, gold, and silver work flour-ished, becoming ever richer, more intricate and elaborate. Stained glass filled the ever-larger windows, while paintings or tapestries covered the walls. In Italy, artists inspired by ancient Roman masters and by Giotto looked with fresh eyes at the natural world. The full impact of their new vision was not fully assimilated until the beginning of the fifteenth century.

GIOTTO DI BONDONE VIRGIN AND CHILD ENTHRONED 1305-10

AMBROGIO LORENZETTI.

ALLEGORY OF GOOD GOVERNMENT IN THE CITY AND IN THE COUNTRY

SALA DELLA PACE, PALAZZO PUBBLICO, SIENA, ITALY 1338-40

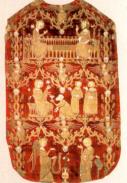

LIFE OF THE VIRGIN BACK OF THE CHICHESTER-CONSTABLE CHASUBLE, SOUTHERN ENGLAND 1330-50

PETER PARLER AND WORKSHOP. ST. WENCESLAS CHAPEL

MASTER THEODORIC ST. LUKE 1360-64

BEGUN 1356

FOURTEENTH-**CENTURY ART** IN EUROPE

■ Papacy resides in Avignon 1309-77

Hundred Years' Wars 1337-1453

Black Death begins 1348

Boccaccio begins writing The Decameron 1349-51

■ Great Schism 1378-1417

 Chaucer starts work on The Canterbury Tales 1387

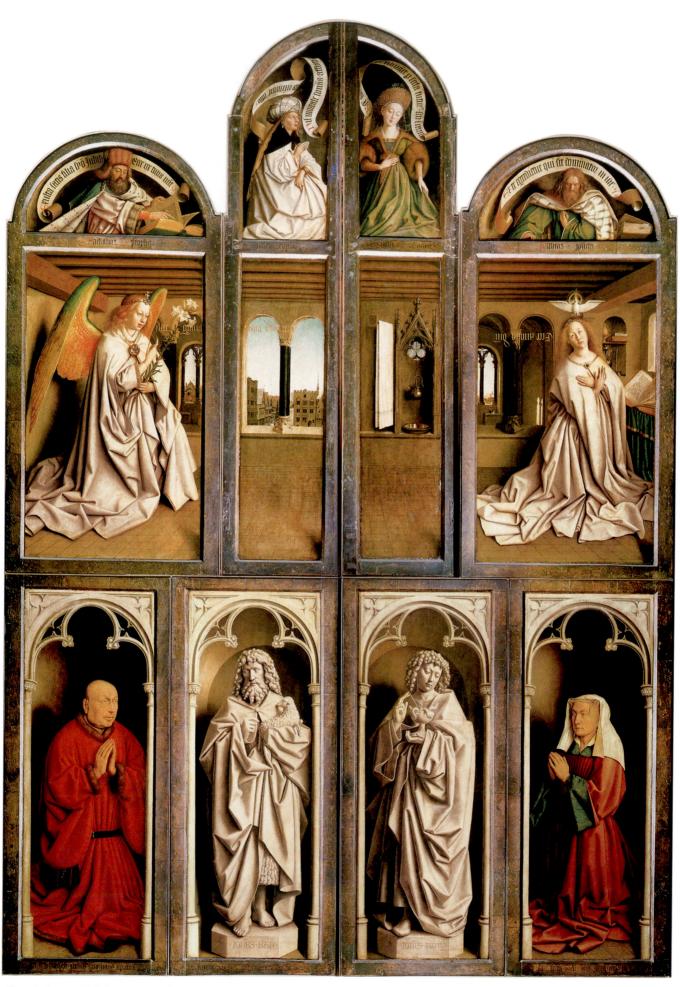

 $\textbf{18-I} \quad | \quad \textbf{Jan and Hubert van Eyck} \quad \textbf{GHENT ALTARPIECE (CLOSED). ANNUNCIATION WITH DONORS } \\ \textbf{Completed 1432. Oil on panel, height } 11'5''. \text{ Cathedral of Saint Bavo. Ghent.}$

CHAPTER EIGHTEEN

FIFTEENTH-CENTURY ART IN NORTHERN EUROPE AND THE IBERIAN PENINSULA

When Philip the Good, duke of Burgundy, entered Ghent in 1458, the entire Flemish city turned out. Townspeople made elaborate decorations and presented theatrical events, and local artists designed banners and made sets for

18

Below, the donors are portrayed beside statues of the church's patron saints, Saint John the Baptist and Saint John the Evangelist, who, although painted to represent stone, seem to acknowledge the presence of their supplicants

dramatic and fascinating example of the union of visual arts and performance, as groups of citizens welcomed Philip with tableaux vivants ("living pictures"). They dressed in costume and stood "absolutely frozen, like statues" to re-create scenes from their town's most celebrated work of art, Jan and Hubert van Eyck's *Ghent Altarpiece* (SEE FIG. 18–11), completed twenty-six years earlier. The altarpiece had an enthroned figure of God, seated between the Virgin Mary and John the Baptist and flanked by angel musicians. Below, a depiction of the Communion of Saints, based on the biblical passage Revelation 14:1, described the Lamb of God receiving the veneration of a multitude of believers. The

the performances. That day in Ghent became an especially

in glance and gesture. Before the altarpiece is even opened, as it was at Easter time, it signals the new interests of the fifteenth century: the intellectual change from religious symbolism to secular and ancient learning, a formal change to detailed realism and awareness of the world, and a social and economic change to middle-class power and patronage.

Closed, as we see it here (FIG. 18–1), the wings of the altarpiece present the **ANNUNCIATION**, with Gabriel and the Virgin on opposite sides of an upper room that overlooks a city. In panels above them, Old Testament prophets and seers from the ancient classical world foretell the coming of Christ.

church fathers, prophets, martyrs, and other saints depicted

in the altarpiece were among those scenes staged that day to

greet Philip.

The vision of the Annunciation takes place in a domestic interior, and a prosperous Flemish city can be seen through the open windows. We are at once made aware of the remarkable rise of the middle class to wealth, power, and patronage. The donors are represented by true-to-life portraits, and the patron saints are sculptured figures on pedestals in niches, not visions. In fact, the two Saint Johns do not present the donors to God. Instead, the donors Jodocus Vijd and Elizabeth Borluut kneel in prayer, just as they must have knelt in front of the altarpiece in life.

Because of its monumental scale, complex iconography, and masterly painting techniques, the *Ghent Altarpiece* has continued to be one of the most studied and respected works of the early Renaissance in Europe since its creation in the early fifteenth century.

- HUMANISM AND THE NORTHERN RENAISSANCE
- **ART FOR THE FRENCH DUCAL COURTS** Painting and Sculpture for the Chartreuse de Champmol Manuscript Illumination
 The Fiber Arts
- PAINTING IN FLANDERS The Founders of the Flemish School Painting at Midcentury: The Second Generation
- EUROPE BEYOND FLANDERS | France | Spain and Portugal | Germany and Switzerland
- THE GRAPHIC ARTS | Single Sheets | Printed Books
- IN PERSPECTIVE

HUMANISM AND THE NORTHERN RENAISSANCE

Revitalized civic life and economic growth in the late four-teenth century gave rise to a prosperous middle class of artisans, merchants, and bankers who attained their place in the world through personal achievement, not inherited wealth. This newly rich middle class supported scholarship, literature, and the arts. Their patronage resulted in the explosion of learning and creativity known as the Renaissance. Though the actual term *Renaissance* (French for "rebirth") was applied by later historians, the characterization has its origins in the thinking of Petrarch and other fourteenth-century scholars, who believed in *humanism*—the power and potential of human beings.

Humanism is also fundamentally tied to the revival of classical learning and literature that appeared in fourteenth-century Italy with Petrarch, Boccaccio, and others (see "A New Spirit in Fourteenth-Century Literature," page 561). Beginning with Petrarch, humanists of the later fourteenth and fifteenth centuries looked back at the thousand years extending from the collapse of the Roman Empire to their own time, and they determined that human achievement of the ancient classical world was followed by a period of decline (a "middle age" or "dark age"). The third period—their own era—saw a revival, a rebirth, a renaissance, when humanity began to emerge from an intellectual and cultural stagnation and scholars again appreciated the achievements of the ancients.

Humanists extended education to the laity, investigated the natural world, and subjected philosophical and theological positions to logical scrutiny. They constantly invented new ways to extend humans' intellectual and physical reach. For all our differences, we still live in the modern era envisioned by these Renaissance thinkers—a time when human beings, their deeds, and their beliefs have primary importance.

The rise of humanism did not signify a decline in the importance of Christian belief, however. An intense Christian spirituality continued to inspire and pervade most European art. But despite the enormous importance of Christian faith, the established Western Church was plagued with problems. Its hierarchy was bitterly criticized for a number of practices, including a perceived indifference to the needs of common

people. Strains within the Western Church exemplified the skepticism of the Renaissance mind. In the next century, these strains would give birth to the Protestant Reformation.

The new intense interest in the natural world manifested itself in the detailed observation and recording of nature. Artists depicted birds, plants, and animals with breathtaking accuracy. They looked at people and objects, and they modeled these forms with light and shadow, giving them three dimensions. In the north, artists such as Jan van Eyck (FIGS. 18–1, 18–11, 18–12, 18–13), Dirck Bouts (FIG. 18–19), and Hugo van der Goes (FIG. 18-20) used an intuitive perspective in order to approximate the appearance of things growing smaller and closer together in the distance. They coupled it with a masterful use of atmospheric or aerial perspective. This technique—applied to the landscape scenes that were a northern specialty—was based on observation that distant elements appear less distinct and less colorful than things close by: The sky becomes paler near the horizon and the distant landscape turns bluish-gray.

Along with the desire for accurate depiction of the world came a new interest in individual personalities. Fifteenth-century portraits have an astonishingly lifelike quality, combining careful—sometimes even unflattering—description with an uncanny sense of vitality. Indeed, the individual becomes important in every sphere. More names of artists survive from the fifteenth century, for example, than in the entire span from the beginning of the Common Era to the year 1400.

The new power of cities in the Flanders region and the greater Low Countries (present-day Belgium, Luxembourg, and the Netherlands; SEE MAP 18–1) provided a critical tension and balance with the traditional powers of royalty and the Church. Increasingly, the urban lay public sought to express personal and civic pride by sponsoring secular architecture, sculptured monuments, or paintings directed toward the community. The common sense values of the merchants formed a solid underpinning for humanist theories and enthusiasms.

But if the *Ghent Altarpiece* donors Jodocus Vijd and Elizabeth Borluut represent the new influence of the middle class, this influence nevertheless remained intertwined with the continuing power of the Church and the royal and noble

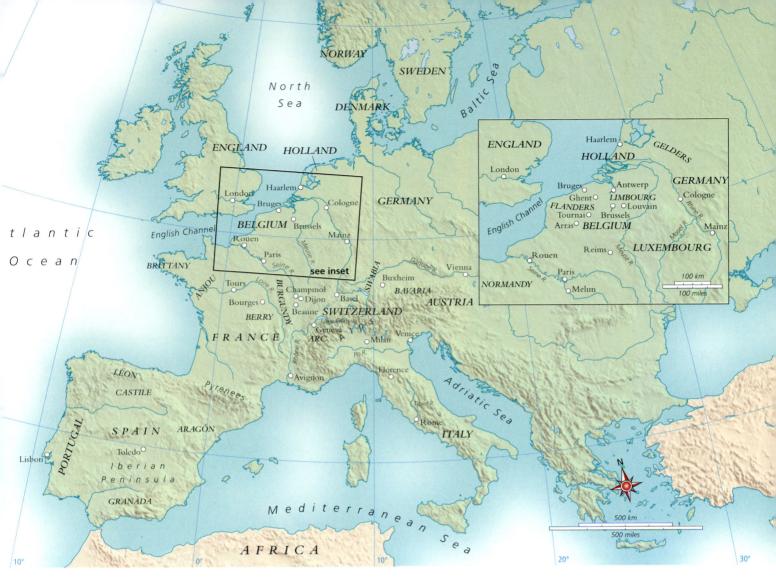

MAP 18-1 | FIFTEENTH-CENTURY NORTHERN EUROPE AND THE IBERIAN PENINSULA

The dukes of Burgundy, whose territory included much of present-day Belgium and Luxembourg, the Netherlands, and eastern France, became the cultural and political leaders of Western Europe. Their major cities of Bruges (Belgium) and Dijon (France) were centers of art and industry as well as politics.

courts. Like other wealthy individuals, Jodocus and Elizabeth sought eternal salvation with their donation to the Church; and though Jodocus eventually became the mayor of Ghent, he also served as a high official to the Burgundian duke Philip the Good (ruled 1419–67).

ART FOR THE FRENCH DUCAL COURTS

The dukes of Burgundy were the most powerful rulers in northern Europe for most of the fifteenth century, and a primary reason for this was their control not only of Burgundy but also of Flemish and Netherlandish centers of finance and trade, including the thriving cities of Ghent, Bruges, Tournai, and Brussels (FIG. 18–2). The major seaport, Bruges, was the commercial center of northern Europe and the rival of the Italian city-states of Florence, Milan, and Venice. In the late fourteenth century, Philip the Good's predecessor Philip the Bold (ruled 1363–1404) had acquired territory in the Nether-

lands—including the politically desirable region of Flanders—by marrying the daughter of the Flemish count. Though dukes Philip the Bold of Burgundy, John of Berry, and Louis of Anjou were brothers of King Charles V of France, their interests rarely coincided. Even the threat of a common enemy, England, during the Hundred Years' War was not a strong unifying factor. Burgundy and England were often allied because of common financial interests in Flanders.

While the French king held court in Paris, the dukes held even more splendid courts in their own cities. The dukes of Burgundy (including present-day east-central France, Belgium, Luxembourg, and the Netherlands) and Berry (central France), not the king in Paris, were arbiters of taste. The painting of the Duke of Berry in his great hall (FIG. 18–3), from an illuminated manuscript, which we will take up in more detail later, shows us how the dukes collected splendid robes and jewels, tapestry, goldsmithing, and monumental stone sculpture. Painting on panel also gained a place of importance, with early enthusiasm appearing in the ducal

18-2 Robert Campin A FLEMISH CITY

Detail of right wing of the Mérode Altarpiece (Triptych of the Annunciation), fig. 18–10. c. 1425–28. Oil on wood panel, wing approx. $25\frac{1}{2} \times 10\frac{1}{4}$ " (64.5 × 27.3 cm). The Metropolitan Museum of Art, New York.

The Cloisters Collection, 1956 (56.70)

The windows in Joseph's carpentry shop open onto a view of a prosperous Flemish city. Tall, well-kept houses crowd around churches, whose towers dominate the skyline. People gather in the open market square, walk up a major thoroughfare, and enter the shops, whose open doors and windows suggest security as well as commercial activity—an ideal to be sure.

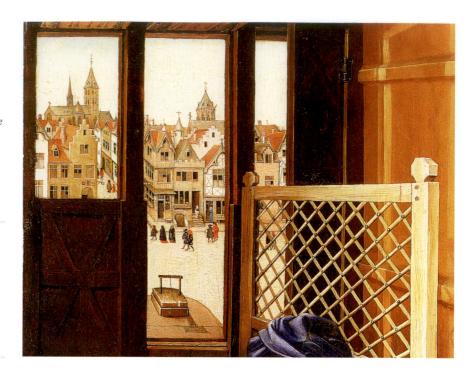

courts under Philip the Bold. The duke commissioned many works from Flemish and Netherlandish painters. Those that survive show a debt to the International Gothic style.

A new, composite style emerged in the late fourteenth century from the papal court in Avignon in the south of France, where artists from Italy, France, and Flanders worked side by side. The International Gothic style, the prevailing manner of the late fourteenth century, is characterized by slender, gracefully posed figures whose delicate features are framed by masses of curling hair and extraordinarily complex headdresses. Noble men and women wear rich brocaded and embroidered fabrics and elaborate jewelry. Landscape and architectural settings are miniaturized; however, details of nature—leaves, flowers, insects, birds—are rendered with nearly microscopic detail. Spatial recession is represented by rising tiled floors in buildings open at the front like stage sets, by fanciful mountains and meadows having high horizon lines, and some diminution in size of objects and lightening of color near the horizon. Artists and patrons alike preferred light, bright colors and a liberal use of gold in manuscript and panel paintings, tapestries, and polychromed sculpture. The International Gothic was so appealing that patrons throughout Europe continued to commission such works well into the fifteenth century.

Painting and Sculpture for the Chartreuse de Champmol

One of Philip the Bold's most lavish projects was the Carthusian monastery, or chartreuse ("chartrehouse"), at Champmol, near Dijon, his Burgundian capital city. Land was acquired in 1377 and 1383 and construction began in 1385. The monastic

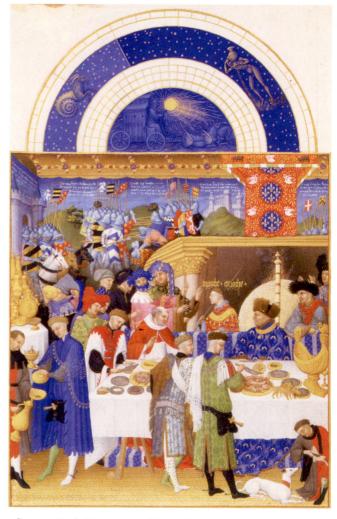

18–3 | Paul, Herman, and Jean Limbourg JANUARY, THE DUKE OF BERRY AT TABLE. TRÈS RICHES HEURES 1411–16. Colors and ink on parchment, $8\% \times 5\%$ " (22.5 × 13.7 cm). Musée Condé, Chantilly, France.

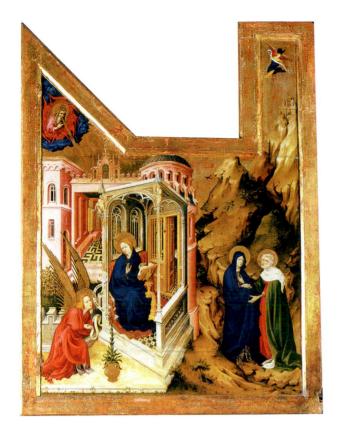

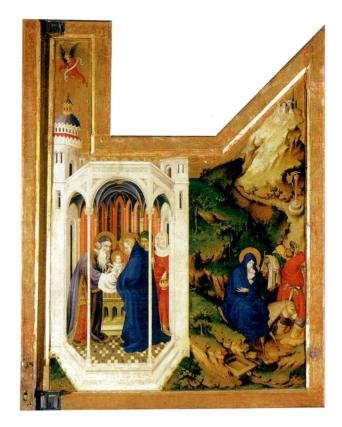

18–4 | Melchior Broederlam CHAMPMOL ALTARPIECE Wings of the altarpiece for the Chartreuse de Champmol. 1393–99. Oil on wood panel, $5'5\%'' \times 4'1\%''$ (1.67 \times 1.25 m). Musée des Beaux-Arts, Dijon.

The paintings depict the Annunciation and Visitation at the left and the Presentation in the Temple and Flight into Egypt on the right. The irregular shape of the paintings was determined by the sculpture they were meant to protect.

church was intended to house the family's tombs, and the monks were expected to pray continuously for the souls of Philip and his family. A Carthusian monastery was particularly expensive to maintain because the Carthusian monks did not provide for themselves by farming or other physical work but were dedicated to prayer and solitary meditation. In effect, Carthusians were a brotherhood of hermits.

MELCHIOR BROEDERLAM. The duke ordered a magnificent carved and painted altarpiece for the Chartreuse de Champmol (see "Altars and Altarpieces," page 591). The altarpiece, of gilded wood carved by Jacques de Baerze, depicts scenes of the Crucifixion flanked by the Adoration of the Magi and the Entombment. The primary interest today, however, is in the protective shutters, painted by Melchior Broederlam (active 1381–1410) with scenes from the life of the Virgin and the infancy of Christ (FIG. 18–4). In a personal style that carries the budding realism of the International Style further toward a faithul rendering of the natural world, Broederlam creates tangible figures in fanciful miniature architectural and landscape settings. Christian religious symbolism is present everywhere.

Under the benign eyes of God, the archangel Gabriel greets Mary with the news of her impending motherhood. A door leads into the dark interior of the tall pink rotunda meant

to represent the Temple of Jerusalem, a symbol of the Old Law. According to legend, Mary was an attendant in the Temple prior to her marriage to Joseph. The tiny enclosed garden and a pot of lilies are symbols of Mary's virginity. In International Gothic fashion, both the interior and exterior of the building are shown, and the floors are tilted up to give clear views of the action. Next, in the Visitation, just outside the temple walls, the now-pregnant Mary greets her older cousin Elizabeth, who is also pregnant and will soon give birth to John the Baptist.

On the right shutter, in the Presentation in the Temple, Mary and Joseph have brought the newborn Jesus to the temple for the Jewish purification rite. The priest Simeon takes him in his arms to bless him (Luke 2:25–32). At the far right, the Holy Family flees to Egypt to escape King Herod's order that all Jewish male infants be killed. The family travels along treacherous terrain similar to that in the Visitation scene. The landscape has been arranged to lead the eye up from the foreground and into the distance along a rising ground plane. Despite the imaginative architecture, fantastic mountains, miniature trees, and solid gold sky, the artist has created a sense of light and air around solid figures. Reflecting a new realism creeping into art, a hawk flies through the golden sky, and Joseph drinks from a flask and carries the family belongings in a satchel over his shoulder. The statue of

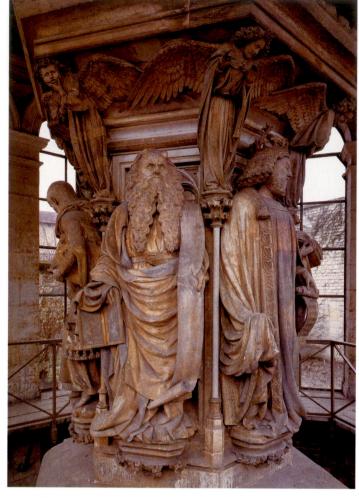

18-5 | Claus Sluter | WELL OF MOSES, DETAIL OF MOSES AND DAVID

The Chartreuse de Champmol, Dijon, France. 1395–1406. Limestone with traces of paint, height of figures about 5'8" (1.69 m).

The sculpture's original details included metal used for buckles and even eyeglasses. It was also painted: Moses wore a gold mantle with a blue lining over a red tunic; David's gold mantle had a painted lining of ermine, and his blue tunic was covered with gold stars and wide bands of ornament.

a pagan god, visible at the upper right, breaks and tumbles from its pedestal as the Christ Child approaches. A new era dawns and the New Law replaces the Old.

CLAUS SLUTER. Philip the Bold commissioned the Flemish sculptor Jean de Marville (active 1366–89) to direct the decoration of the monastery. When Jean died in 1389, he was succeeded by his assistant Claus Sluter (c. 1360–1406), from Haarlem, in Holland. Although the Chartreuse and its treasures were nearly destroyed during the French Revolution, the distinctive character of Sluter's work can still be seen in the surviving parts of a monumental well in the main cloister (FIG. 18–5). Begun in 1395, the **WELL OF MOSES** was unfinished at Sluter's death.

The concept of the *Well of Moses* is complex. A pier rose from the water and supported large freestanding figures of Christ on the cross mourned by the Virgin Mary, Mary Magdalen, and John the Evangelist. Forming a pedestal for this Crucifixion group are life-size stone figures of Old Testament men who foretold the coming of Christ: Moses (prophet and lawgiver), David (king of Israel and an ancestor of Jesus), and the prophets Jeremiah, Zachariah, Daniel, and Isaiah. These images and their texts may have been inspired by contemporary mystery plays such as *The Trial of Jesus* and *The Procession of Prophets*, in which prophets foretell and explain events of the Passion. *Meditations on the Life of Christ*, written between 1348 and 1368, by Ludolph of Saxony, provides another source.

Sluter depicted the Old Testament figures as physically and psychologically distinct individuals. Moses's sad old eyes blaze out from a memorable face entirely covered with a fine web of wrinkles. Even his horns—traditionally given to him because of a mistranslation in the Latin Bible—are wrinkled. A mane of curling hair and a beard cascade over his heavy shoulders and chest, and an enormous cloak envelops his body. Beside him stands David, in the voluminous robes of a medieval king, the personification of nobility.

Sluter looked at the human figure in a new way—as a ponderous mass defined by voluminous drapery. Drapery lies in deep folds falling in horizontal arcs and cascading lines; its heavy sculptural masses both conceal and reveal the body, creating strong highlights and shadows. With these vigorous, imposing, and highly individualized figures of the *Well of Moses*, Sluter introduced a radically new style in northern sculpture. He abandoned the idealized faces, elongated figures, and vertical drapery of the International Gothic style for surface realism and the broad horizontal movement of forms. Nevertheless, Sluter retained the detailed naturalism and rich colors (now almost lost but revealed in recent cleaning) and surfaces preferred by his patrons.

Manuscript Illumination

Of all the family, the duke of Burgundy's older brother Jean, duke of Berry, was the most enthusiastic art collector and bibliophile. In addition to commissioning religious art works for personal salvation and public devotion, he collected illuminated manuscripts, which signified both his worldly status and a commitment to learning.

Besides religious texts, wealthy patrons treasured richly illuminated secular writings such as herbals (encyclopedias of plants), health manuals, and both ancient and contemporary works of history and literature. Workshops in France and the Netherlands produced outstanding manuscripts to fill the demand. A typical manuscript page might have leafy tendrils framing the text, decorated opening initials, and perhaps a small inset picture, such as the illustration of Thamyris in Boccaccio's *Concerning Famous Women* (see "Women Artists

Art and Its Context

ALTARS AND ALTARPIECES

he altar in a Christian church symbolizes both the table of Jesus's Last Supper and the tombs of Christ and the saints. The front surface of a block altar is the *antependium*. Relics of the church's patron saint may be placed in a reliquary on the altar, beneath the floor on which the altar rests, or even within the altar itself.

Altarpieces are painted or carved constructions placed at the back or behind the altar in a way that makes altar and altar-

piece appear to be visually joined. The altarpiece evolved into a large and elaborate architectural structure filled with images and protected by movable wings that function like shutters. An altarpiece may have a firm base, called a **predella**. A winged altarpiece can be a **diptych**, in which two panels are hinged together (SEE FIG. 18–22); a **triptych**, in which two wings fold over a center section (SEE FIG. 18–21); or a **polyptych**, consisting of many panels (SEE FIG. 18–16 AND 18–17).

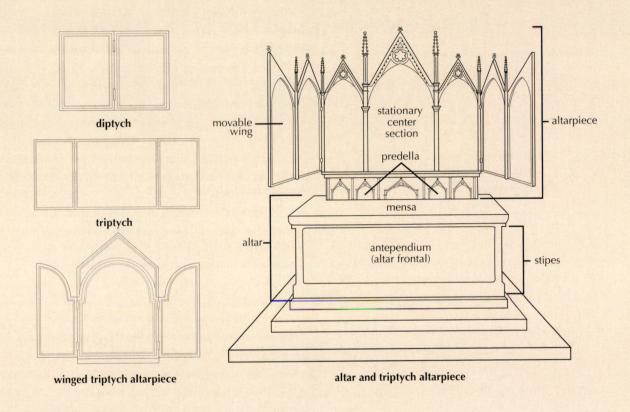

in the Late Middle Ages and the Renaissance," page 592). The illustrations for the books made for the royal family might be large and lavish, as we see in the detail of the page where Christine de Pizan presents her work to the queen of France (Fig. 21, Introduction). Here the glimpse into the queen's private room displays tapestries on the walls and embroidered bed coverings.

The Flemish style that would influence all of fifteenthcentury Europe originated in manuscript illumination of the late fourteenth century, when artists began to create full-page scenes set off with frames that functioned almost as windows looking into rooms or out onto landscapes with distant horizons. Painters in the Netherlands and Burgundy were especially skilled at creating an illusion of reality.

THE LIMBOURG BROTHERS. Among the finest Netherlandish illuminators at the beginning of the century were three brothers—Paul, Herman, and Jean Limbourg—commonly known as the Limbourg brothers, probably referring to their home region.

About 1404 the brothers entered the service of Duke John of Berry (1340–1416), for whom they produced their major work, the so-called *Très Riches Heures (Very Sumptuous Book of Hours)*, between 1413 and 1416 (see figs. 18–3, 18–6). A Book of Hours was a selection of prayers and readings to be

Art and Its Context

WOMEN ARTISTS IN THE LATE MIDDLE AGES AND THE RENAISSANCE

edieval and Renaissance women artists typically learned to paint from their husbands and fathers because formal apprenticeships were not open to them. Noblewomen, who were often educated in convents, learned to draw, paint, and embroider. One of the earliest examples of a signed work by a woman painter is a tenth-century manuscript of the Apocalypse illustrated in Spain by a woman named Ende (SEE FIG. 14–10), who describes herself as "painter and helper of God." In Germany, women began to sign their work in the twelfth century. A collection of sermons was decorated by a nun named Guda (SEE FIG. 15–37), who not only signed her work but also included a self-portrait, one of the earliest in Western art.

Examples abound of women artists in the fourteenth and fifteenth centuries. In the fourteenth century, Jeanne de Montbaston and her husband, Richart, worked together as book illuminators under the auspices of the University of Paris. After Richart's death, Jeanne continued the workshop and, following the custom of the time, was sworn in as a *libraire* (publisher) by the university in 1353. In the fifteenth century, women could be admitted to the guilds in some cities, including the Flemish towns of Ghent, Bruges, and Antwerp, and by the 1480s one-quarter of the members of the painters' guild of Bruges were female.

Particularly talented women received major commissions. Bourgot, the daughter of the miniaturist Jean le Noir, illuminated books for King Charles V of France and Jean, duke of Berry. Christine de Pizan (1365-c. 1430), a well-known writer patronized by Philip the Bold of Burgundy and Queen Isabeau of France, described the work of an illuminator named Anastaise, "who is so learned and skillful in painting manuscript borders and miniature backgrounds that one cannot find an artisan . . . who can surpass her . . . nor whose work is more highly esteemed" (*Le Livre de la Cité des Dames*, I.41.4, translated by Earl J. Richards).

In a French edition of a book by the Italian author Boccaccio entitled *Concerning Famous Women*, the anonymous illuminator shows Thamyris, an artist of antiquity, at work in her studio. She is depicted in fifteenth-century dress, painting an image of the Virgin and Child. At the right, an assistant grinds and mixes the colors Thamyris will need to complete her painting. In the foreground, her brushes and paints are laid out conveniently on a table.

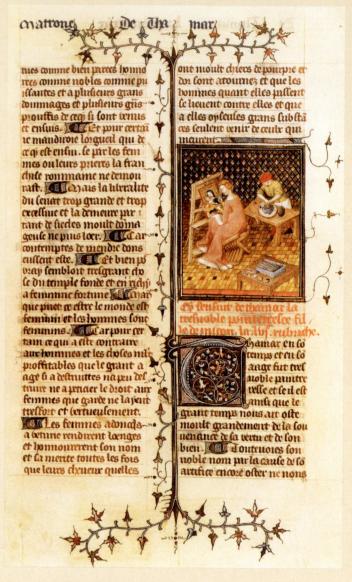

PAGE WITH THAMYRIS

From Giovanni Boccaccio's *De Claris Mulieribus (Concerning Famous Women)*. 1402. Ink and tempera on vellum. Bibliothèque Nationale de France, Paris.

used in daily prayer and meditation, and it included a calendar of holy days. The Limbourgs created full-page illustrations for the calendar in the International Gothic style, with subjects including both peasant labors and aristocratic pleasures. Like most European artists of the time, the Limbourgs showed the laboring classes in a light acceptable to aristocrats—that is, happily working for the nobles' benefit. But they also showed peasants enjoying their own pleasures.

In the **FEBRUARY** page (FIG. 18–6), farm people relax cozily before a blazing fire. This farm looks comfortable and well maintained, with timber-framed buildings, a row of beehives, a sheepfold, and tidy woven wattle fences. In the distance are a village and church. Most remarkably, the artists convey the feeling of cold winter weather: the breath of the bundled-up worker turning to steam as he blows on his hands, the leaden sky and bare trees, the snow covering the

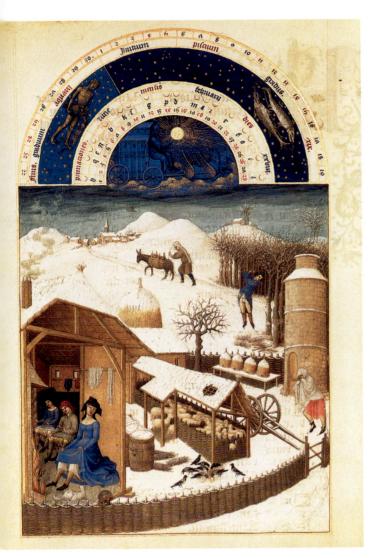

18–6 | Paul, Herman, and Jean Limbourg FEBRUARY, LIFE IN THE COUNTRY. TRÈS RICHES HEURES 1411–16. Colors and ink on parchment, $8\% \times 5\%$ " (22.5 × 13.7 cm). Musée Condé, Chantilly, France.

landscape, and the comforting smoke curling from the farm-house chimney. The painting employs several International Gothic conventions: the high placement of the horizon line, the small size of trees and buildings in relation to people, and the cutaway view of the house showing both interior and exterior. The muted palette is sparked with touches of yellowish-orange, blue, and a patch of bright red on the man's turban at the lower left. The landscape recedes continuously from foreground to middle ground to background. An elaborate calendar device, with the chariot of the sun and the zodiac symbols, fills the upper part of the page.

In contrast, the illustration for the other winter month— January—depicts an aristocratic household (SEE FIG. 18–3). The Duke of Berry sits behind a table laden with food and rich tableware, including a huge gold standing salt. A second

Sequencing Events THE DUKES OF BURGUNDY (VALOIS)

1363-1404	Philip the Bold (acquires Flanders through marriage)
1404-19	John the Fearless
1419-67	Philip the Good; patron of Jan van Eyck
1467-77	Charles the Bold
1477	Mary of Burgundy inherits Burgundy and marries Habsburg heir Maximilian of Austria

table or buffet holds his collection of gold vessels. His chamberlain invites courtiers to approach (the words written overhead say "approach"). John is singled out visually by the red "cloth of honor" with his heraldic arms—swans and the lilies of France—and by a large fire screen that circles his head like a secular halo. Tapestries with battle scenes cover the walls and are rolled up around the fireplace. Rich clothing and jewels, embroidered fabrics and brocades, turbans, golden collars and chains attest to the wealth and lavish lifestyle of this great patron of the arts and brother of King Charles V.

THE MARY OF BURGUNDY PAINTER. By the end of the century, each scene on a manuscript page was a tiny image of the world rendered in microscopic detail. Complex compositions and ornate decorations were commonplace, with framed images surrounded by a fantasy of vines, flowers, insects, animals, shellfish, or other objects painted as if seen under a magnifying glass. Christine de Pizan's preferred artist, Anastaise, probably worked in this mode (see Fig. 21, Introduction).

One of the finest later painters was the anonymous artist known as the Mary of Burgundy Painter—so called because he painted a Book of Hours for Mary of Burgundy, daughter of Charles the Bold. Mary married the Habsburg heir, Maximilian of Austria, in 1477, and her grandson became both King of Spain as Charles I and Holy Roman Emperor as Charles V (see Chapter 20).

Within an illumination in a book only $7\frac{1}{2}$ by $5\frac{1}{4}$ inches, reality and vision have been rendered equally tangible (FIG. 18–7). The painter has attained a new complexity in treating pictorial space. We look not only through the "window" of the illustration's frame but through another window in the wall of the room depicted in the painting. The spatial recession leads the eye into the far reaches of the church interior, past the Virgin and the gilded altarpiece in the sanctuary to two people conversing in the far distance.

Mary of Burgundy appears twice: once seated in the foreground by a window, reading from her Book of Hours; and again in the background, perhaps in a vision inspired by her reading. She kneels with attendants and angels in front of the Virgin and Child. On the window ledge is an exquisite

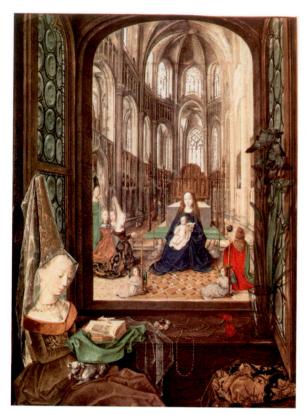

18–7 | Mary of Burgundy Painter MARY AT HER DEVOTIONS, HOURS OF MARY OF BURGUNDY Before 1482. Colors and ink on parchment, size of image $7\frac{1}{2} \times 5\frac{1}{4}$ " (19.1 \times 13.3 cm). Österreichische Nationalbibliothek, Vienna.

still life—a rosary (symbol of Mary's devotion), carnations (flowers symbolizing the nails of the Crucifixion), and a glass vase holding purple irises, representing the Virgin Mary's sorrows over the sacrifice of Christ (SEE FIG. 18–21). The artist has skillfully executed the filmy veil covering Mary's steeple headdress, the transparent glass vase, and the glass of the window (circular panes whose center "lump" was formed by the glassblower's pipe).

The Fiber Arts

The lavish detail with which textiles are depicted in Flemish manuscripts and paintings reflects their great importance in fifteenth-century society. In the fifteenth and sixteenth centuries, Flemish tapestry making was the finest in Europe. Major weaving centers at Brussels, Tournai, and Arras produced these intricately woven wall hangings for royal and aristocratic patrons, important church officials, and even town councils. Among the most common subjects were foliage and flower patterns, scenes from the lives of the saints, and themes from classical mythology and history, such as the Battle of Troy seen hanging on the Duke of Berry's walls. Tapestries provided both insulation and luxurious decoration for the stone walls of castle halls, churches, and municipal buildings.

Often they were woven for specific places or for festive occasions such as weddings, coronations, and other state events. Many were given as diplomatic gifts, and the wealth of individuals can often be judged by the number of tapestries listed in their household inventories.

The price of a tapestry depended on the work required and the materials used. Rarely was a fine, commissioned series woven only with wool; instead, tapestry producers enhanced the weaving with silk, silver, and gold threads. The richest kind of tapestry was made almost entirely of silk and gold. Because silver and gold threads were made of silk wrapped with real metal, people later burned many tapestries to retrieve the precious materials. As a result, few royal tapestries in France survived the French Revolution. Many existing works show obvious signs, however, that the metallic threads were painstakingly pulled out in order to get the gold but preserve the tapestries.

THE UNICORN TAPESTRY. Tapestries often formed series. One of the best-known surviving tapestry series is the *Hunt of the Unicorn*. Each piece exhibits many people and animals in a dense field of trees and flowers, with a distant view of a castle, as in the UNICORN IS FOUND AT THE FOUNTAIN (FIG. 18–8). The unusually fine condition of the tapestry allows us to appreciate its rich colors and the subtlety in modeling the faces, the tonal variations in the animals' fur, and even the depiction of reflections in the water. The unicorn, a mythical horselike animal with cloven hooves, a goat's beard, and a single long twisted horn, was said to be supernaturally swift and, in medieval belief, could only be captured by a virgin, to whom it came willingly. Thus, the unicorn became a symbol of the Incarnation (Christ is the unicorn captured by the Virgin Mary) and also a metaphor for romantic love.

Because of its religious connotations, the unicorn was an important animal in the medieval bestiary, an encyclopedia of real and imaginary animals that gave information of both moral and practical value. For example, the unicorn's horn (in fact, the narwhal's horn) was thought to be an antidote to poison. In the tapestry, the unicorn purifies the water by dipping its horn into the stream. This beneficent act, resulting in the capture and killing of the unicorn, was equated with Christ's death on the cross to save humanity. The prominence of the red roses (symbols both of the Passion and of Mary) growing behind the unicorn suggests that the tapestries may have celebrated Christian doctrine, but they could also have been a wedding gift.

All the woodland creatures included in the tapestry have symbolic meanings. For instance, lions, ancient symbols of power, represent valor, faith, courage, and mercy, and even—because they breathe life into their cubs—the Resurrection of Christ. The stag is another symbol of the Resurrection (it sheds and grows its antlers) and a protector against poisonous serpents and evil in general. Even today

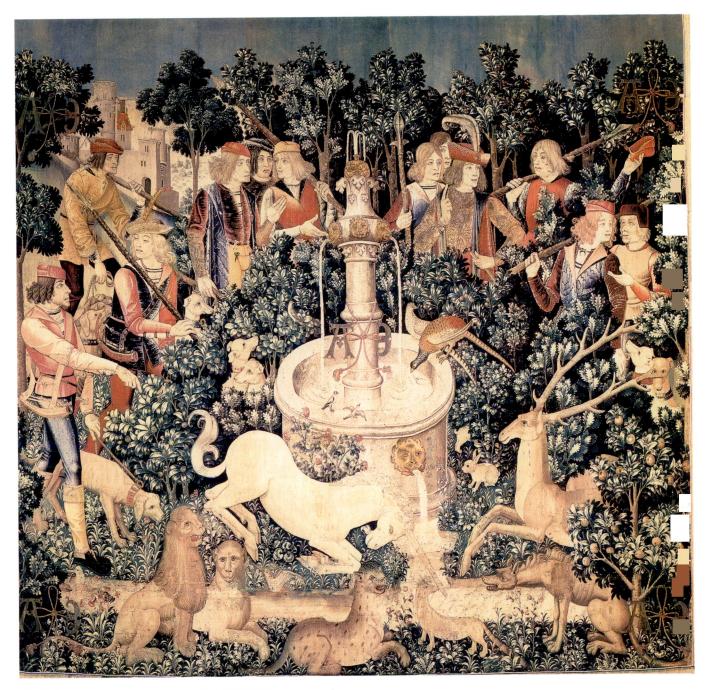

18–8 UNICORN IS FOUND AT THE FOUNTAIN

From the Hunt of the Unicorn tapestry series.

c. 1495–1505. Wool, silk, and silver- and gilt-wrapped thread (13–21 warp threads per inch), 12′1″ × 12′5″ (3.68 × 3.78 m). The Metropolitan Museum of Art, New York.

Gift of John D. Rockefeller Jr., the Cloisters Collection, 1937 (37.80.2)

we expect the rabbits to symbolize fertility, and the dogs, fidelity. The pair of pheasants is an emblem of human love and marriage, and the goldfinch is another symbol of fertility and also of the Passion of Christ. Only the ducks swimming away have no apparent message.

The flowers and trees in the tapestry, identifiable from their botanically correct depictions, reinforce the theme of protective and curative powers. Each has both religious and secular meanings—as explained in herbals (encyclopedias of plants, their uses and significance)—but the theme of marriage, in particular, is referred to by the presence of such plants as the strawberry, a common symbol of sexual love; the pansy, a symbol for remembrance; and the periwinkle, a cure for spiteful feelings and jealousy. The trees include oak for fidelity, beech for nobility, holly for protection against evil, hawthorn for the power of love, and pomegranate and orange for fertility. The parklike setting with its prominent fountain was inspired by the biblical love poem the Song of Songs (4:12, 13, 15–16): "You are an enclosed garden, my sister, my bride, an enclosed garden, a fountain sealed."

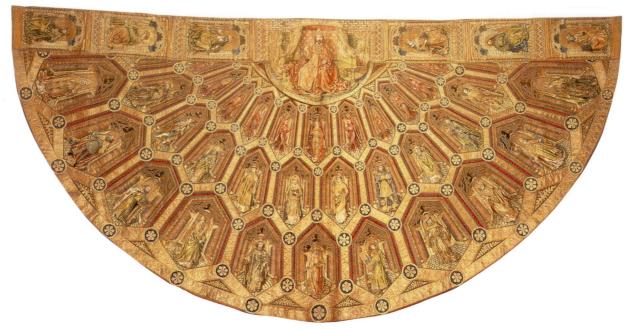

18–9 | COPE OF THE ORDER OF THE GOLDEN FLEECE Flemish, mid-15th century. Cloth with gold and colored silk embroidery, $5'4\%'' \times 10'9\%'' (1.64 \times 3.3 \text{ m})$. Imperial Treasury, Vienna.

COPE OF THE ORDER OF THE GOLDEN FLEECE. Remarkable examples of the Flemish fiber arts are the vestments of the Order of the Golden Fleece. The Order of the Golden Fleece was an honorary fraternity founded by Duke Philip the Good of Burgundy in 1430 with twenty-three knights chosen for their moral character and bravery. Religious services were an integral part of the order's meetings, and opulent liturgical and clerical objects were created for the purpose.

The surface of the sumptuous cope (cloak) in FIGURE 18–9 is divided into compartments filled with the standing figures of saints. At the top of the neck edge, as if presiding over the company, is an enthroned figure of Christ, flanked by scholar-saints in their studies. The embroiderers worked with great precision to create illusionistic effects of contemporary Flemish painting. The particular stitch used here is known as couching, that is, gold threads are tacked down using unevenly spaced colored silk threads to create images and an iridescent effect. (For the effect of a cope when worn, see the angels in the center panel of the *Portinari Alta*rpiece, FIG. 18–20.)

PAINTING IN FLANDERS

A strong economy based on wool, the textile industry, and international trade provided stability and money for the arts to flourish. Civic groups, town councils, and wealthy merchants were also important patrons in the Netherlands, where the cities were self-governing and largely independent of the landed nobility. Guilds oversaw nearly every aspect of their members' lives, and high-ranking guild members served on

town councils and helped run city governments. Even experienced artists who moved from one city to another usually had to work as assistants in a local workshop until they met the requirements for guild membership.

The diversity of clientele encouraged artists to experiment with new types of images—with outstanding results. Throughout most of the fifteenth century, Flemish art and artists were greatly admired; artists from abroad studied Flemish works, and their influence spread throughout Europe, including Italy. Only at the end of the fifteenth century did a general preference for the Netherlandish painting style give way to a taste for the new styles of art and architecture developing in Italy.

The Founders of the Flemish School

Flemish artists were known for their exquisite illuminated manuscripts, tapestries, and stained glass. For works ranging from enormous altarpieces to small portraits, Flemish painters perfected the technique of painting with an oil medium rather than the tempera paint preferred by the Italians. Oil paint provided more flexibility: Slow to dry, it permitted artists to make changes as they worked. Most important, it had a luminous quality. Oil paint applied in thin glazes produced luminous effects that enabled the artists to capture rich jewel-like colors and subtle changes in textures and surfaces. Like manuscript illuminations, the panel paintings provided a window onto a scene, which fifteenth-century Flemish painters typically rendered with keen attention to individual

features—whether of people, objects, or the natural world—in works laden with symbolic meaning.

ROBERT CAMPIN. One of the first outstanding exponents of the new Flemish style was Robert Campin (active 1406–44). His paintings reflect the Netherlandish taste for lively narrative and a bold three-dimensional treatment of figures reminiscent of the sculptural style of Claus Sluter. About 1425–28, Campin painted an altarpiece now known as the MÉRODE ALTARPIECE from the name of later owners (FIG. 18–10). Slightly over 2 feet tall and about 4 feet wide with the wings open, it was probably made for a small private chapel.

By depicting the Annunciation inside a Flemish home, Campin turned common household objects into religious symbols. The treatment is often referred to as "hidden symbolism" because objects are treated as an ordinary part of the scene, but their religious meanings would have been widely understood by contemporary people. The lilies in the majolica (glazed earthenware) pitcher on the table, for example, symbolize Mary's virginity, and were a traditional element of Annunciation imagery. The white towel and hanging waterpot in the niche symbolize Mary's purity and her role as the vessel for the Incarnation of God. Unfortunately, the precise meanings are not always clear today. The central panel may simply portray Gabriel telling Mary that she will be the Mother of Christ. Another interpretation suggests that the painting shows the moment immediately following Mary's

acceptance of her destiny. A rush of wind riffles the book pages and snuffs the candle as a tiny figure of Christ carrying a cross descends on a ray of light. Having accepted the miracle of the Incarnation (God assuming human form), Mary reads her Bible while sitting humbly on the footrest of the long bench. Her position becomes a symbol of her submission to God's will. But another interpretation of the scene suggests that it represents the moment just prior to the Annunciation. In this view, Mary is not yet aware of Gabriel's presence, and the rushing wind is the result of the angel's rapid entry into the room, where he appears before her, half kneeling and raising his hand in salutation.

The complex treatment of light in the *Mérode Altarpiece* is another Flemish innovation. Campin combines natural and supernatural light, with the strongest illumination coming from an unseen source at the upper left in front of the picture plane. The sun seems to shine through a miraculously transparent wall that allows the viewer to observe the scene. In addition, a few rays enter the round window at the left as the vehicle for the Christ Child's descent. More light comes from the window at the rear of the room, and areas of reflected light can also be detected, such as the right side of the brass waterpot.

Campin maintained some of the conventions typical of the International Gothic style: the abrupt recession of the bench toward the back of the room, the sharply uplifted floor and tabletop, and the disproportionate relationship between the figures and the architectural space. In an otherwise

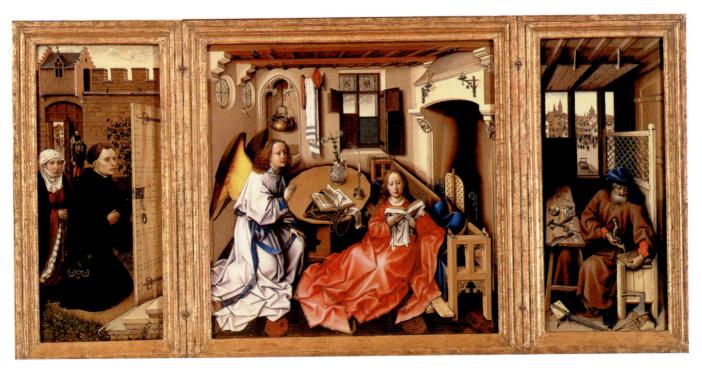

18–10 | Robert Campin | MÉRODE ALTARPIECE (TRIPTYCH OF THE ANNUNCIATION) (OPEN) c. 1425–28. Oil on wood panel, center $25\% \times 24\%$ (64.1 \times 63.2 cm); each wing approx $25\% \times 10\%$ (64.5 \times 27.6 cm). The Metropolitan Museum of Art, New York. The Cloisters Collection, 1956 (56.70)

intense effort to mirror the real world, this treatment of space may be a conscious remnant of medieval style, serving the symbolic purpose of visually detaching the religious realm from the world of the viewers. Unlike figures by such International Gothic painters as the Limbourg brothers (SEE FIGS. 18–3, 18–6), the Virgin and Gabriel are massive rather than slender, and their abundant draperies increase the impression of material weight.

Although in the biblical account Joseph and Mary were not married at the time of the Annunciation, this house clearly belongs to Joseph, who is shown in his carpentry shop. A prosperous Flemish city can be seen through the shop window, with people going about their business unaware of the drama taking place inside the carpenter's home (SEE FIG. 18-2). One clue indicates that this is not an everyday scene: the shop, displaying wooden wares-mousetraps, in this case—would have been on the ground floor, but Campin has the window apparently opening from the second floor. Furthermore, the significance of the mousetraps would have been recognized by knowledgeable people. They could refer to Saint Augustine's reference to Christ as the bait in a trap set by God to catch Satan. Joseph is drilling holes in a small board used as a drainboard for wine making, which would have been understood as symbolic of the Eucharistic wine and Christ's Passion.

Joseph's house has a garden planted with a rosebush; roses allude to both the Virgin and the Passion. Perhaps the man standing behind the open entrance gate, clutching his hat in one hand and a document in the other, is a self-portrait of the artist, but he has also been called the prophet Isaiah. Kneeling in front of the open door to the house are the donors of the altarpiece, Peter Inghelbrecht and his wife. Although they could observe the Annunciation through the door their eyes seem unfocused. Perhaps the scene of the Annunciation is a vision induced by their prayers.

Jan van Eyck. Campin's contemporary Jan van Eyck (active 1420s-41) was a trusted official as well as painter in the court of Philip the Good. His influence would extend through ducal Burgundy and into France, Spain, and Portugal, where he traveled on diplomatic missions for the duke. Duke Philip alluded to Jan's remarkable technical skills in a letter of 1434-35, saying that he could find no other painter equal to his taste or so excellent in art and science. Part of the secret of Jan's "science" was his technique of painting with oil glazes on wood panel. So brilliant were the results of his experiments that Jan has been mistakenly credited with being the inventor of oil painting. Actually, the medium had been known for several centuries, and medieval painters had used oil paint to decorate stone, metal, and occasionally plaster walls. Jan perfected the medium by building up his images in very thin transparent oil layers. This technique permitted a

precise, objective description of what he saw, with tiny, carefully applied brushstrokes so well blended that they are only visible at very close range.

The GHENT ALTARPIECE (FIG. 18–11), which we have already seen in closed form, presents questions of authorship. An inscription on the frame identifies both Jan and Hubert van Eyck as artists, but Hubert died in 1426. Perhaps Hubert left several unfinished panels in his studio when he died and Jan assembled them, repainting and adding to them to bring them into harmony. In addition to the visual evidence, modern scientific analysis—X-ray, infrared reflectography, and chemical analysis—supports this theory.

Dominating the altarpiece by size, central location, and brilliant red and gold color is the enthroned figure of God, wearing the triple crown of Saint Peter (the papal crown) and having an earthly crown at his feet. He is joined in his golden shrine by the Virgin Mary and John the Baptist, each enthroned and holding an open book. This divine trio (in Byzantine art, known as the Deësis) is flanked first by angel musicians and then by Adam and Eve. Van Evck emphasizes humanity's fall from grace by depicting the murder of Abel by Cain, in the upper lunette (semicircular wall area), and Eve, who holds the forbidden fruit. In the upper register, each of the three themes—God with Mary and John, musical angels, and Adam and Eve-is represented in a different space and at a different scale. Angels stand on a tiled floor but against a blue sky. Adam and Eve stand in shallow stone niches.

The five lower panels present a unified field—a vast landscape with meadows, woods, and distant cities against a continuous horizon. All saints—apostles, martyrs, confessors and virgins, hermits, pilgrims, warriors, and judges—gather to adore the Lamb of God as described in the Book of Revelation. The Lamb stands on an altar, blood flowing into a chalice, ultimately leading to the fountain of life.

The three-dimensional mass of the figures, the voluminous draperies as well as the remarkable surface realism, even the faux sculpture, recall the art of Claus Sluter for the Burgundian court in Dijon. The extraordinary painting of brocades and jewels, the facial expressions (especially of the angels), the detailed rendering of plants, including Mediterranean palms and orange trees, and the concern with atmospheric perspective—all suggest Jan's unique contribution. Jan's technique is firmly grounded in the terrestrial world despite his visionary subject.

The portrait of a MAN IN A RED TURBAN of 1433 (FIG. 18–12) projects a strong sense of personality, and the signed and dated frame also bears Jan's personal motto, in Flemish, "As I can" ("The best that I am capable of doing"). This motto, derived from classical sources and written here in Greek letters, is a telling illustration of the humanist spirit of the age and the confident expression of an artist who

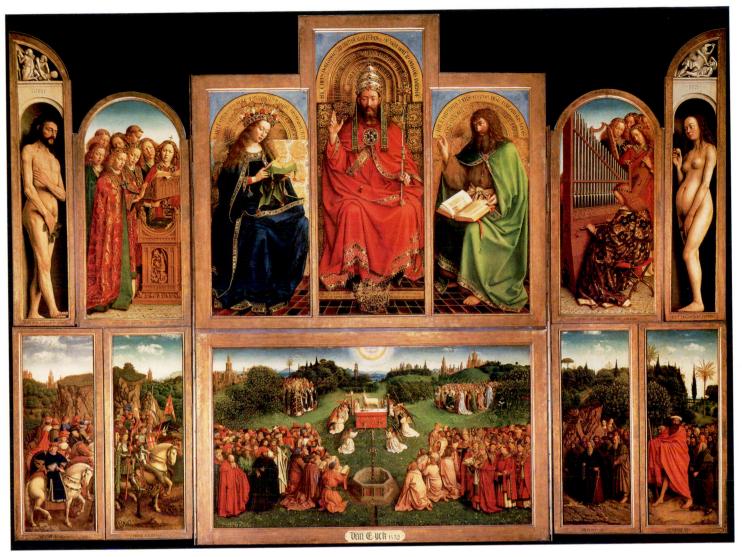

18–11 | Jan and Hubert van Eyck GHENT ALTARPIECE (OPEN), ADORATION OF THE MYSTIC LAMB Completed 1432. Oil on panel, $11'5\%''\times15'1\%''$ (3.5 × 4.6 m). Cathedral of Saint Bavo, Ghent.

On the frame of the altarpiece was written, "The painter Hubert van Eyck, greater than whom no one was found, began [this work]; and Jan, his brother, second in art, having carried through the task at the expense of Jodocus Vijd, invites you by this verse, on the sixth of May, to look at what has been done." (Translation by L. Silver)

knows his capabilities and is proud to display them. The *Man in a Red Turban* is a portrait in which the physical appearance seems recorded in a magnifying mirror. We see every wrinkle and scar, the stubble of a day's growth of beard on his chin and cheeks, and the tiny reflections of light from a studio window in the pupils of the eyes. The outward gaze of the subject is new in portraiture, and it suggests the subject's increased sense of self-confidence as he catches the viewer's eye.

Jan's best-known painting today is an elaborate portrait of a man and woman traditionally identified as **GIOVANNI ARNOLFINI AND HIS WIFE, GIOVANNA CENAMI** (FIG. 18–13). This fascinating work continues to be subject to a number of interpretations, most of which suggest that it represents a wedding or betrothal. One remarkable detail is the artist's inscription above the mirror on the back wall: *Johannes de eyck fuit hic* 1434 ("Jan van Eyck was present, 1434"). Normally, a work of art in fifteenth-century Flanders would have been signed "Jan

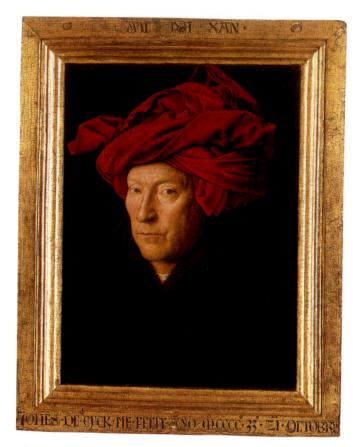

18–12 $^{\dag}$ Jan van Eyck $\,$ MAN IN A RED TURBAN 1433. Oil on wood panel, 13 % \times 10 % (33.3 \times 25.8 cm). The National Gallery, London.

On the frame is written, "Als ich Kan. Joh. de Eyck me Fecit," Jan's personal motto, which translates "As I can."

van Eyck made this." The wording is that of a witness to a legal document, and indeed, two witnesses to the scene are reflected in the mirror, a man in a red turban—perhaps the artist—and one other. The man in the portrait, identified by early sources as Giovanni Arnolfini, a member of an Italian merchant family living in Flanders, holds the hand of the woman and raises his right hand before the two witnesses. In the fifteenth century, a marriage was rarely celebrated with a religious ceremony. The couple signed a legal contract before two witnesses, after which the bride's dowry might be paid and gifts exchanged. However, it has been suggested that the painting might be a pictorial "power of attorney," giving the woman the right to act in her husband's absence. The recent discovery of a document showing that Arnolfini married in 1447, six years after Jan's death, adds to the mystery.

Whatever event or situation the painting depicts, the artist has juxtaposed secular and religious themes in a work that seems to have several levels of meaning. On the man's side of the painting, the room opens to the outdoors, the external "masculine" world, while the woman is silhouetted against a domestic interior, with its allusions to the roles of wife and mother. The couple is surrounded by emblems of

wealth, piety, and married life. The convex mirror reflecting the entire room and its occupants is a luxury object, but it may also symbolize the all-seeing eye of God. The roundels decorating its frame depict the Passion of Christ, a reminder of Christian redemption.

Many other details suggest the piety of the couple: the crystal prayer beads on the wall; the image of Saint Margaret, protector of women in childbirth, carved on the top of a high-backed chair next to the bed; and the single burning candle in the chandelier, a symbol of Christ's presence. The fruits shown at the left, seemingly placed there to ripen in the sun, may allude to fertility in a marriage, and also to the Fall of Adam and Eve in the Garden of Eden. The small dog may simply be a pet, but it serves also as a symbol of fidelity, and its rare breed—affenpinscher—suggests wealth.

The woman wears an aristocratic fur-lined overdress with a long train. Fashion dictated that the robe be gathered up and held in front of the abdomen, giving an appearance of pregnancy. This ideal of feminine beauty emphasized women's potential fertility. The merchant class copied the fashions of the court, and a beautifully furnished room containing a large bed hung with rich draperies was often a home's primary public space, not a private retreat.

Jan delighted in complex symbolism in the guise of ordinary objects. The paintings of his contemporaries and followers seem relatively straightforward by comparison.

ROGIER VAN DER WEYDEN. Little as we know about Jan van Eyck, we know less about the life of Rogier van der Weyden. Not a single existing work of art bears his name. He may have studied under Robert Campin, but this relationship is not altogether certain. At the peak of his career, Rogier maintained a large workshop in Brussels, where he was the official city painter. Apprentices and shop assistants came from as far away as Italy to study with him, adding to modern scholars' difficulties.

To establish the thematic and stylistic characteristics for Rogier's art, scholars have turned to a painting of the **DEPOSITION** (FIG. 18–14), an altarpiece commissioned by the Louvain Crossbowmen's Guild sometime before 1443, the date of the earliest known copy of it by another artist. The copy has wings painted with the four evangelists—Matthew, Mark, Luke, and John—and Christ's Resurrection. Perhaps the *Deposition* was once a triptych too.

The Deposition was a popular theme in the fifteenth century, in part because of its dramatic, emotionally moving nature. Rogier set the act of removing Jesus's body from the cross on a shallow stage closed off by a wooden backdrop that has been covered with a thin overlay of gold like a carved and painted altarpiece. The ten solid, three-dimensional figures seem to press forward into the viewer's space, forcing the viewer to identify with the grief of Jesus's friends—made palpably real by their portraitlike faces and elements of contem-

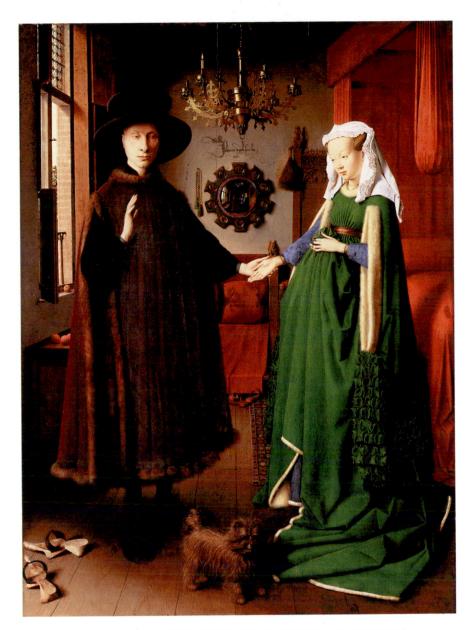

18–13 | Jan van Eyck | DOUBLE PORTRAIT; TRADITIONALLY KNOWN AS GIOVANNI ARNOLFINI AND HIS WIFE, GIOVANNA CENAMI 1434. Oil on wood panel, $33\times22\%$ ($83.8\times57.2~{\rm cm}$). The National Gallery, London.

"Johannes de eyck fuit hic [was present]." According to a later inventory, the original frame was inscribed with a quotation from Ovid, a Roman poet known for his celebration of romantic love.

porary dress—as they tenderly and sorrowfully remove his body from the cross for burial. Rogier has arranged Jesus, the life-size corpse at the center of the composition, in a graceful curve that is echoed in angular fashion by the fainting Virgin, thereby increasing the emotional identification between the Son and the Mother. The artist's compassionate sensibility is especially evident in the gestures of John the Evangelist, who supports the Virgin at the left, and Jesus's friend Mary Magdalen, who wrings her hands in anguish at the right. Rogier's

emotionalism links the Gothic past with the fifteenthcentury humanistic concern for individual expressions of emotion. Although united by their sorrow, the mourning figures react in personal ways.

Rogier's choice of color and pattern balances and enhances his composition. For example, the complexity of the gold brocade worn by Joseph of Arimathea, who offered his new tomb for the burial, and the contorted pose and vivid dress of Mary Magdalen increase the visual impact of the

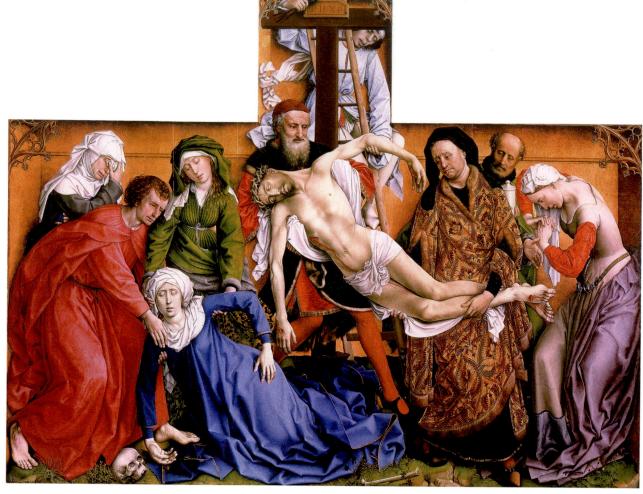

18–14 Rogier van der Weyden DEPOSITION
From an altarpiece commissioned by the Crossbowmen's Guild, Louvain, Belgium. Before 1443, possibly c. 1435–38. Oil on wood panel, 7′2 1/8″ × 8′7 1/8″ (2.2 × 2.62 m). Museo del Prado, Madrid.

right side of the panel and counter the pictorial weight of the larger number of figures at the left. The palette of subtle, slightly muted colors is sparked with red and white accents that focus the viewer's attention on the main subject. The whites of the winding cloth and the tunic of the youth on the ladder set off Jesus's pale body, as the white turban and shawl emphasize the ashen face of Mary.

Rogier painted his largest and most elaborate work, the altarpiece of the LAST JUDGMENT, for the hospital in Beaune, founded by the chancellor of the Duke of Burgundy, Nicolas Rolin (FIGS. 18–15, 18–16). Whether Rogier painted this altarpiece before or after he made a trip to Rome for the Jubilee of 1450 is debated by scholars. He would have known the iconography of the Last Judgment from medieval church tympana, but he could also have been inspired by the paintings and mosaics of the theme in Rome. The tall, straight figure of the archangel Michael, dressed in a white robe and cope, dominates the center of

the wide polyptych as he weighs souls under the direct order of God, who sits on the arc of a giant rainbow above him. The Virgin Mary and John the Baptist kneel at either end of the rainbow. Behind them on each side, six apostles and a host of saints (men at the right side of Christ and women at the left) witness the scene. The cloudy gold background serves, as it did in medieval art, to signify events in the heavenly realm or in a time remote from that of the viewer.

The bodily resurrection takes place on a narrow, barren strip of earth that runs across the bottom of all but the outer panels. Men and women climb out of their tombs, turning in different directions as they react to the call to Judgment. The scales of justice held by Michael tip in an unexpected direction; instead of Good outweighing Bad, the saved soul has become pure spirit and rises, while the damned soul sinks, weighed down by unrepented sins. The damned throw themselves into the flaming pit of hell—no demons drag them

down; the saved greet the archangel Gabriel at the shining gate of heaven, depicted as a Gothic portal.

When the altarpiece's shutters are closed, they show Rogier's debt to Jan and the *Ghent Altarpiece*. The donors, Nicolas Rolin and Guigone de Salins, kneel in prayer before sculptures of the patron saints of the hospital chapel, Saint Sebastian and Saint Anthony. On the upper level the angel Gabriel greets the Virgin Mary, in yet another version of the Annunciation. The high status of the donors is indicated by their coats of arms and the gold brocade on the walls of their room. In contrast, the central images of Mary, Gabriel, and the

two saints are represented in *grisaille* as unpainted stone sculpture set in shallow niches. As on the wings of the *Ghent Altarpiece*, the contrast of living and carved figures is dramatic and interactive. The popularity of *grisaille* in fifteenth-century northern panel painting goes back to Giotto's use of frescoed *grisaille* figures on the fictive marble base of the Arena Chapel (SEE FIG. 17–8), and is at odds with the actual fifteenth-century practice of adding polychromy to stone sculpture before it left the workshop. For Rogier (as for Jan van Eyck), perhaps leaving the stone "unfinished" was more effective and illusionary than depicting painted sculpture.

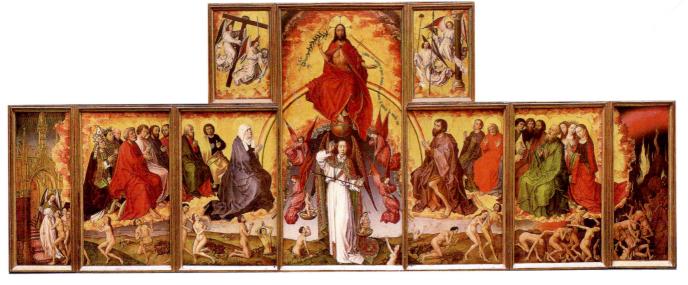

18–15 | Rogier van der Weyden LAST JUDGMENT ALTARPIECE (OPEN) After 1443, c. 1445–48. Oil on wood panel, open: $7'4\%'' \times 17'11''$ (2.25 \times 5.46 m). Musée de l'Hôtel-Dieu, Beaune, France.

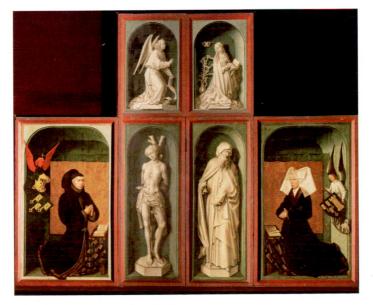

18–16 | Rogier van der Weyden

LAST JUDGMENT ALTARPIECE (CLOSED)

Oil on panel, height 7'4%" (2.28 m). Donors: Nicolas Rolin and Guigone de Salins.

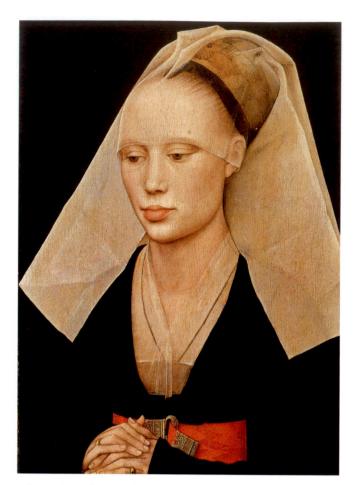

18–17 | Rogier van der Weyden PORTRAIT OF A LADY c. 1455. Oil and tempera on wood panel, $14\% \times 10\%$ (37 \times 27 cm). National Gallery of Art, Washington, D.C. Andrew W. Mellon Collection (1937.1.44)

In his portraits, Rogier balanced a Flemish love of individual detail with a flattering idealization of the features of men and women. In PORTRAIT OF A LADY (FIG. 18-17), painted after his return from Italy, Rogier transformed the young woman into a vision of exquisite but remote beauty. Her long, almond-shape eyes, regular features, and smooth translucent skin appear in many portraits of women attributed to Rogier. He popularized the half-length pose that includes the woman's high waistline and clasped hands. Images of the Virgin and Child often formed diptychs with small portraits of this type. The woman is pious and humble, wealthy but proper and modest; nevertheless, her tense fingers convey a sense of inner controlled emotion. The portrait expresses the complex and often contradictory attitudes of both aristocratic and middle-class patrons of the arts, who balanced pride in their achievements with appropriate modesty.

Painting at Midcentury: The Second Generation

The extraordinary accomplishments of Robert Campin, Jan van Eyck, and Rogier van der Weyden attracted many followers in Flanders. The work of this second generation of Flemish painters was simpler, more direct, and easier to understand than that of their predecessors. These artists produced high-quality work of great emotional power, and they were in large part responsible for the rapid spread of the Flemish style throughout Europe.

PETRUS CHRISTUS. Among the most interesting of the second-generation painters was Petrus Christus (active 1444–c. 1475/76). He came from Holland, but nothing is known of his life before 1444, when he became a citizen of Bruges. He signed and dated six paintings.

In 1449 Christus painted a goldsmith, perhaps Saint Eligius, in his shop (FIG. 18–18). According to Christian tradition, Eligius, a seventh-century ecclesiastic, goldsmith, and mintmaster for the French court, used his wealth to ransom Christian captives. He became the patron saint of metalworkers. Here he weighs a jeweled ring, as a handsome couple looks on. The man wears a badge identifying him as a member of the court of the duke of Gelders; the young woman, dressed in Italian gold brocade, wears a jeweled double-horned headdress fashionable at midcentury (worn by Christine de Pisan and the ladies of the queen of France; see Fig. 21, Introduction).

The counter and shelves hold a wide range of metalwork and jewelry. The coins are Burgundian gold ducats and gold "angels" of Henry VI of England (ruled 1422-61, 1470-71), and on the bottom shelf are a box of rings, two bags with precious stones, and pearls. Behind them stands a crystal reliquary with a gold dome and a ruby and amethyst pelican. Many of the objects on the shelves had a protective function—for example, the red coral and the serpents' tongues (actually fossilized sharks' teeth) hanging above the coral could ward off the evil eye, and the coconut cup at the left neutralized poison. Slabs of porphyry and rock crystal were "touchstones," used to test gold and precious stones, such as the pendant and two brooches of gold with pearls and precious stones pinned to a dark fabric. Rosary beads and a belt end hang from the top shelf, where two silver flagons and a covered cup stand. A bridal belt, similar to the one worn in Rogier's Portrait of a Lady, curls across the counter. Such a combination of pieces suggests that the painting expresses the hope for health and well-being for the couple whose betrothal or wedding portrait this may be. Or perhaps the painting simply advertises the guild's wares.

As in Jan's Giovanni Arnolfini and his wife Giovanna Cenami, a convex mirror extends the viewer's field of vision, in this instance to the street outside, where two men appear. One is stylishly dressed in red and black, and the other holds a falcon, another indication of high status since only the nobility hunted with falcons. Whether or not the reflected image has symbolic meaning, the mirror has a practical value in allowing the goldsmith to observe the approach of a potential customer.

DIRCK BOUTS. Dirck Bouts (active c. 1444–75) is the best storyteller among the Flemish painters, skillful in direct narration rather than complex symbolism. The two remaining panels (FIG. 18–19) from a set of four on the subject of justice illustrate this skill. The town council of Louvain, for whom Bouts was the official painter, ordered these huge paintings for the city hall to be examples and warnings to city officials. The paintings depict an early moral tale, the WRONGFUL **EXECUTION OF THE COUNT**. The empress, seen standing with Emperor Otto III in her palace garden, falsely accuses a count of a sexual impropriety. Otto III has the count beheaded and the countess receives her husband's head, in the presence of the councilors. In the second panel, the countess successfully endures a trial by ordeal to prove her husband's innocence. Unscathed and still holding her husband's head, she lifts up a glowing iron bar before the shocked and repentant emperor. In the far distance, justice is done and the evil empress is executed by burning at the stake.

Dirck Bouts's paintings are notable for his use of spacious outdoor settings and his inclusion of contemporary portraits.

Sequencing Works of Art

1432	Jan van Eyck, Ghent Altarpiece
c. 1450	Jean Fouquet, Étienne Chevalier and Saint Stephen, Melun Diptych
c. 1460	Rogier van der Weyden, Portrait of a Lady
c. 1465-67	Nuno Gonçalves, Saint Vincent and the Portuguese Royal Family
c. 1474-76	Hugo van der Goes, Portinari Altarpiece

He is the first to create an illusion of space that recedes continuously and gradually from the picture plane to the far horizon. To achieve this effect, he employed devices such as walkways, walls, and winding roads along which characters in the scene are placed. His use of atmospheric perspective can be seen in the gradual lightening of the sky and the smoky blue hills at the horizon. Bouts is also credited with inventing

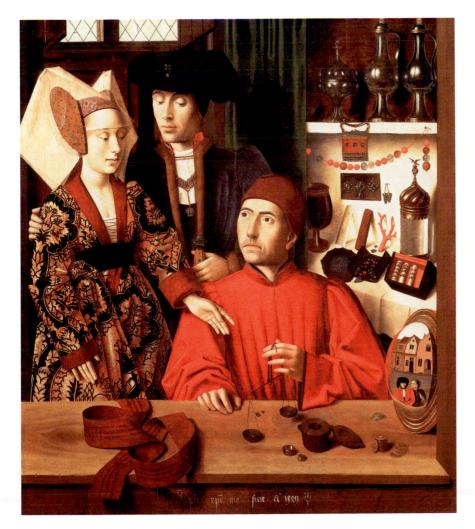

18–18 | Petrus Christus

A GOLDSMITH (SAINT ELIGIUS?)
IN HIS SHOP 1449. Oil on oak
panel, 38 % × 33 ½" (98 × 85 cm).
The Metropolitan Museum of Art,
New York.

Robert Lehman Collection, 1975. (1975.1.110)

The artist signed and dated his work on the house reflected in the mirror.

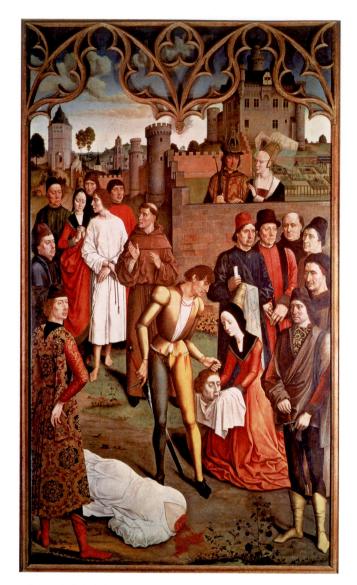

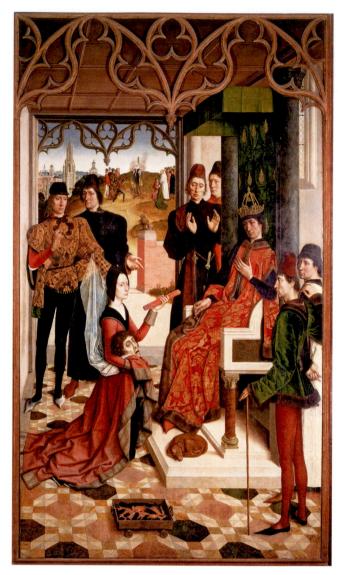

18–19 | Dirck Bouts | WRONGFUL EXECUTION OF THE COUNT (LEFT), JUSTICE OF OTTO III (RIGHT) 1470–75. Oil on wood panel, each $12'11'' \times 6'7 \frac{1}{2}'' (3.9 \times 2 \text{ m})$. Musées Royaux des Beaux-Arts de Belgique, Brussels, Belgium-Koninklijke Musea voor Schone Kunsten van Belgie, Brussels.

the official group portrait in which living individuals are integrated into a narrative scene along with fictional or religious characters. In the Louvain justice panels, the men observing the execution may have been members of the town council. Their impassive faces are realistic but their figures are impossibly tall and slender.

Hugo Van Der Goes. Hugo van der Goes (c. 1440–82), dean of the painters guild in Ghent (1468–75), united the intellectual prowess of Jan van Eyck and the emotional sensitivity of Rogier van der Weyden. Hugo's major work was a large altarpiece of the Nativity (FIG. 18–20). The altarpiece was commissioned by Tommaso Portinari, head of the Medici bank in Bruges. Painted probably between 1474 and 1476, the triptych was sent to Florence and installed in 1483 in the Portinari fam-

ily chapel in the Church of Sant'Egidio. It had a noticeable impact on Florentine painters such as Ghirlandaio, whose own altarpiece in the Sassetti Chapel in the Church of Santa Trinita (SEE FIG. 19–35) reflects his study of Hugo's painting. Tommaso, his wife Maria Baroncelli, and their three oldest children are portrayed kneeling in prayer on the wings. On the left wing, looming larger than life behind Tommaso and his son Antonio, are the saints for whom they are named, Saint Thomas and Saint Anthony. The younger son, Pigello, born in 1474, was apparently added after the original composition was set. On the right wing, Maria and her daughter Margherita are presented by the saints Mary Magdalen and Margaret.

The theme of the altarpiece is the Nativity as told by Luke (2:10–19). The central panel represents the Adoration of the newborn Christ Child by Mary and Joseph, a host of

angels, and the shepherds who have rushed in from the fields. In the middle ground of the wings are scenes invented by Hugo, a part of his personal vision. Winding their way through the winter landscape are two groups headed for Bethlehem. On the left wing, Mary and Joseph travel to their native city to take part in a census ordered by the region's Roman ruler, King Herod. Near term in her pregnancy, Mary has dismounted from her donkey and staggers, supported by Joseph. On the right wing, a servant of the three Magi, who are coming to honor the awaited Savior, asks directions from a peasant. The continuous landscape across the wings and central panel is the finest evocation of cold, barren winter since the Limbourg brothers' *February* (SEE FIG. 18–6).

Hugo's technique is firmly grounded in the terrestrial world despite the visionary subjects. Meadows and woods are painted meticulously. Like Bouts (SEE FIG. 18–19) and many other northern artists at this time, he used atmospheric perspective to approximate distance in the landscape. Although Hugo's brilliant palette and meticulous accuracy recall Jan van Eyck, and although the intense but controlled emotions he depicts suggest the emotional content of Rogier van der Weyden's works, the composition and interpretation of the altarpiece are entirely his own. He shifts figure size for emphasis: The huge figures of Joseph, Mary, and the shepherds are the same size as the patron saints on the wings, in contrast to the much smaller *Portinari* family and still smaller angels. Hugo also uses color, as well as the gestures and gazes of the figures, to focus our eyes on the center panel where the mystery of

the Incarnation takes place. Instead of lying swaddled in a manger or in his mother's arms, Jesus rests naked and vulnerable on the barren ground. Rays of light emanate from his body. The source of this image was the visionary writing of the Swedish mystic Saint Bridget (who composed her work c. 1360–70), which describes Mary kneeling to adore the Christ Child immediately after giving birth.

Hugo was also a master of disguised symbolism (FIG. 18-21). In the foreground the ceramic pharmacy jar (albarello), glass, flowers, and wheat have multiple meanings. The wheat sheaf refers both to the location of the event at Bethlehem, which in Hebrew means "house of bread," and to the Host, or bread, at Communion, which represents the Body of Christ. The majolica albarello is decorated with vines and grapes, alluding to the wine of Communion at the Eucharist, which represents the Blood of Christ. It holds a red lily for the Blood of Christ and three irises—white for purity and purple for Christ's royal ancestry. Every little flower has a meaning. The three irises may refer to the Trinity of Father (God), Son (Jesus), and Holy Ghost. The iris, or "little sword," also refers to Simeon's prophetic words to Mary at the Presentation in the Temple: "And you yourself a sword will pierce so that the thoughts of many hearts may be revealed" (Luke 2:35). The glass vessel symbolizes Mary and the entry of the Christ Child into the Virgin's womb, the way light passes through glass without breaking it. The seven blue columbines in the glass remind the viewer of the Virgin's future sorrows, and scattered on the ground are violets, symbolizing humility.

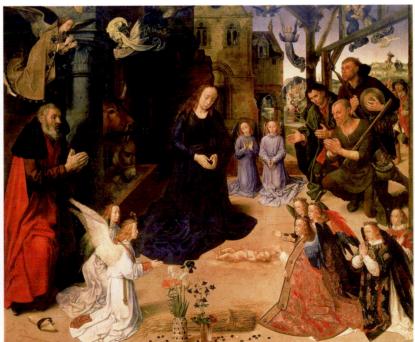

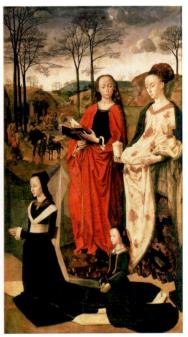

18–20 | Hugo van der Goes PORTINARI ALTARPIECE (OPEN) c. 1474–76. Tempera and oil on wood panel; center $8'3\%'' \times 10'$ (2.53 \times 3.01 m), wings each $8'3\%'' \times 4'7\%''$ (2.53 \times 1.41 m). Galleria degli Uffizi, Florence.

THE OBJECT SPEAKS

HANS MEMLING'S SAINT URSULA RELIQUARY

mong the works securely assigned to Memling is the reliquary of Saint Ursula, a container in the form of a Gothic chapel, made in 1489 for the Hospital of Saint John in Bruges. According to legend, Ursula, the daughter of the Christian king of Brittany, was betrothed to a pagan English prince. She requested a three-year delay in the marriage to travel to Rome, during which time her husband-to-be was to convert to Christianity. On the trip home, she stopped in Cologne, which had been taken over by Attila the Hun and his nomadic warriors from Central Asia. When Ursula rejected an offer of marriage, they killed her with an arrow through the heart and also murdered her companions. The story of Ursula is told on the six side panels of the reliquary. Visible in the illustration are the pope bidding Ursula goodbye in Rome; the murder of her female companions in Cologne harbor; and Ursula's own death. On the reliquary's "roof" are roundels with musical angels flanking the Coronation of the Virgin. At the corners are carved saints, and on the end is Saint Ursula in the doorway of the "chapel," sheltering her followers under her mantle. In early stories, Ursula was accompanied on her trip by ten maidens. By the tenth century, however, she had become the leader of 11,000 young virgin martyrs.

Although the events supposedly took place in the fourth century, Memling has set them in contemporary Cologne: the city's Gothic cathedral, under construction (with the huge lifting wheel still visible), looms in the background of the Martyrdom panel. Memling created this deep space as a foil for his idealized female martyr, a calm aristocratic figure amid menacing men-at-arms. The surface pattern and intricately arranged folds of the drapery draw our attention to her.

Saints continued to play a role in the pre-Reformation Church although the need for personal intercessors began to be questioned by reformers. The possession of relics (remains) of the saints was an important source of prestige for a church, and relics attracted offerings from petitioners. The reliquary was commissioned presumably by the two women dressed in the white habits and black hoods worn by hospital sisters and depicted on the end of the reliquary not visible in the illustration. One hypothesis is that they are Jossine van Dudzeele and Anna van den Moortele, two nuns who were administrators of the hospital of Saint John in the fifteenth century. The reliquary of Saint Ursula, for all the beauty and interest of its paintings, is not a gold and jewel bedecked casket but a simple wooden shrine, an appropriate gift from the women who led the community and the hospital they served.

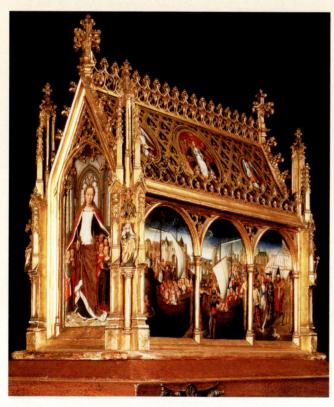

Hans Memling SAINT URSULA RELIQUARY 1489. Painted and gilded oak, $34 \times 36 \times 13''$ ($86.4 \times 91.4 \times 33$ cm). Memling Museum, Hospital of Saint John, Bruges, Belgium.

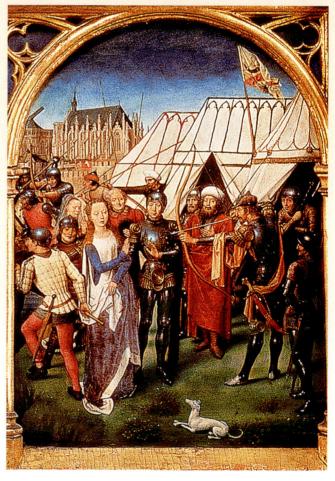

Hans Memling MARTYRDOM OF SAINT URSULA Detail of the Saint Ursula Reliquary. Panel $13\frac{3}{4} \times 10''$ (35×25.3 cm).

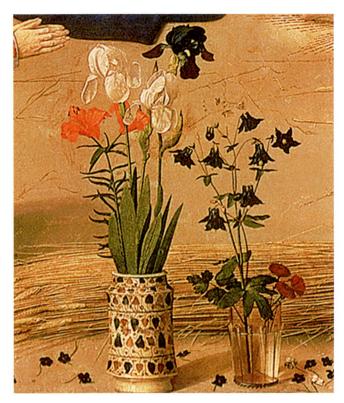

18−21 Hugo van der Goes DETAIL OF STILL LIFE FROM THE CENTER PANEL OF THE PORTINARI ALTARPIECE

Hugo's artistic vision goes far beyond this formal religious symbolism. For example, the shepherds, who stand in unaffected awe before the miraculous event, are among the most sympathetically rendered images of common people to be found in the art of any period. The portraits of the children are among the most sensitive studies of children's features.

HANS MEMLING. The artist who summarizes and epitomizes the end of the era in Flanders is Hans Memling (1430/35–94). Memling combines the intellectual depth and virtuoso rendering of his predecessors with a delicacy of feeling and exquisite grace. A German from the nearby Rhineland, Memling may have worked in Rogier van der Weyden's Brussels workshop in the 1460s, since Rogier's style remained the dominant influence on his art. Soon after Rogier's death in 1464, Memling moved to Bruges, where he developed an international clientele. In 1489 he produced the reliquary of Saint Ursula for the Hospital of Saint John (see "Hans Memling's Saint Ursula Reliquary," page 608). It has the form of a basilican church, and instead of gold, silver, and enamels, it is made of painted wood, modest materials in keeping with a commission from the nuns of the hospital.

EUROPE BEYOND FLANDERS

Flemish art—its complex symbolism, its realism and atmospheric space, its brilliant colors and sensuous textures—delighted wealthy patrons and well-educated courtiers both

inside and outside of Flanders. At first, Flemish artists worked in foreign courts; later, many artists went to study in Flanders. Flemish manuscripts, tapestries, altarpieces, and portraits appeared in palaces and chapels throughout Europe. Soon local artists learned Flemish oil painting techniques and emulated the Flemish style. By the end of the fifteenth century, distinctive regional variations of Flemish art could be found throughout Europe, from the Atlantic Ocean to the Danube.

France

The centuries-long struggle for power and territory between France and England continued well into the fifteenth century. When King Charles VI of France died in 1422, England claimed the throne for the king's nine-month-old grandson, Henry VI of England. The plight of Charles VII, the late French king's son, inspired Joan of Arc to lead a crusade to return him to the throne. Thanks to Joan's efforts Charles was crowned at Reims in 1429. Although Joan was burned at the stake in 1431, the revitalized French forces drove the English from French lands. In 1461, Louis XI succeeded his father, Charles VII, as king of France. Under his rule the French royal court again became a major source of patronage for the arts.

JEAN FOUQUET. The leading court artist of the period in France, Jean Fouquet (c. 1420–81), was born in Tours and may have trained in Paris as an illuminator. He may have visited Italy in about 1445–47, but by about 1450 he was back in Tours, a renowned painter. Fouquet adapted contemporary Italian classical motifs in architectural decoration, and he was also strongly influenced by Flemish realism. He painted Charles VII, the royal family, and courtiers, and he illustrated manuscripts and designed tombs.

Among the court officials Fouquet painted is Étienne Chevalier, the treasurer of France under Charles VII. Fouquet painted a diptych showing Chevalier praying to the Virgin and Child (FIG. 18–22). According to an inscription, the painting was made to fulfill a vow made by Chevalier to the king's much-loved and respected mistress, Agnès Sorel, who died in 1450. Agnès Sorel, whom contemporaries described as a highly moral, extremely pious woman, was probably the model for the Virgin; her features were taken from her death mask, which is still preserved. Fouquet paints the figures of Virgin and angels as stylized, simplified forms, reducing the color to near-grisaille, then surrounds them with amazing jewels in the crown and the throne. The brilliant red and blue cherubs form a tapestrylike background.

In the other wing of the diptych, Fouquet uses a realistic style. Étienne Chevalier, who kneels in prayer with clasped hands and a meditative gaze, is presented to the Virgin by his name saint, Stephen (Étienne in French). Fouquet has followed the Flemish manner in depicting the courtier's ruddy features with a mirrorlike accuracy that is confirmed by other known portraits. Saint Stephen's features are also distinctive enough to

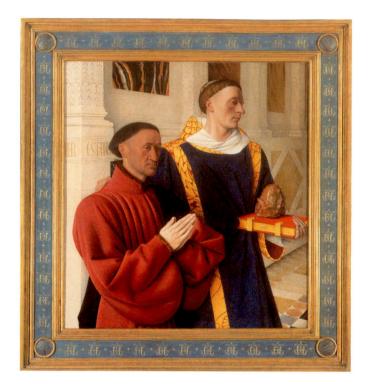

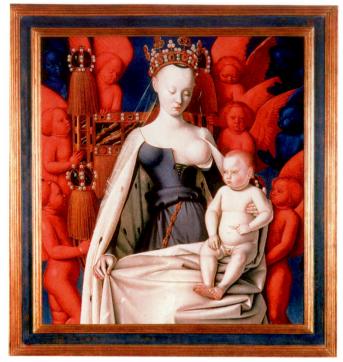

18–22 | Jean Fouquet ÉTIENNE CHEVALIER AND SAINT STEPHEN Left wing of the Melun Diptych c. 1450. Oil on wood panel, $36\frac{1}{2} \times 33\frac{1}{2}$ " (92.7 × 85.5 cm). Staatliche Museen zu Berlin, Preussischer Kulturbesitz, Gemäldegalerie. VIRGIN AND CHILD Right wing of the Melun Diptych c. 1451. Oil on wood panel, $37\frac{1}{4} \times 33\frac{1}{2}$ " (94.5 × 85.5 cm). Koninklijk Museum voor Schone Kunsten, Antwerp, Belgium.

The diptych was separated long ago and the two paintings went to collections in different countries. They are reunited on this page. The original frame was of blue velvet embroidered with pearls and gold and silver thread.

have been a portrait. According to legend and biblical accounts, Stephen, a deacon in the early Christian Church in Jerusalem, was the first Christian martyr, stoned to death for defending his beliefs. Here the saint wears liturgical, or ritual, vestments and carries a large stone on a closed Gospel book as evidence of his martyrdom. A trickle of blood can be seen on his tonsured head (male members of religious orders shaved their heads as a sign of humility). The two figures are shown in a hall decorated with the kind of marble paneling and classical architectural decoration Fouquet could have seen in Italy. Fouquet arranged the figures in an unusual spatial setting; the diagonal lines of the wall and uptilted tile floor recede toward an unseen vanishing point at the right. Despite his debt to Flemish realism and his nod to Italian architectural forms and to linear perspective (discussed in Chapter 19), Fouquet's austere geometric style is uniquely his own.

THE FLAMBOYANT STYLE. The great age of cathedral building that had begun about 1150 was over by the end of the fourteenth century, but the growing urban population needed houses, city halls, guild halls, and more parish churches. The richest patrons commissioned master masons

to build light-filled spacious halls and sculptors to cover their buildings with elaborate Gothic architectural decoration. Like painters, sculptors also turned to the realistic depiction of nature, and they covered capitals and moldings with ivy, hawthorn leaves, and other vegetation. Called the Flamboyant style (meaning "flaming" in French) because of its repeated, twisted, flamelike tracery, this intricate, elegant decoration was used to cover new buildings and was added to older buildings being modernized with spires, porches, or window tracery. The forms often recall the earlier English Decorated style (see Chapter 17).

The **CHURCH OF SAINT-MACLOU** in Rouen, which was begun after a fund-raising campaign in 1432 and dedicated in 1521, is an outstanding example of the Flamboyant style (FIG. 18–23). It may have been designed by the Paris architect Pierre Robin. A projecting porch bends to enfold the façade of the church in a screen of tracery. Sunlight on the flame-shaped openings casts ever-changing shadows across the intentionally complex surface. Crockets—small, knobby leaflike ornaments that line the steep gables and slender buttresses—break every defining line. In the Flamboyant style, decoration sometimes seems divorced from structure. The strength of load-bearing

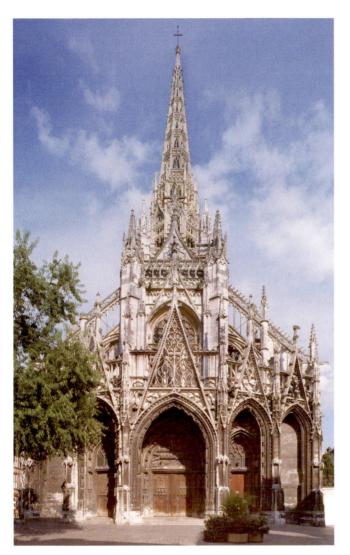

18–23 | Pierre Robin (?)

CHURCH OF SAINT-MACLOU, ROUEN

Normandy, France. West façade, 1432–1521; façade c. 1500–14.

walls and buttresses is often disguised by an overlay of tracery; and traceried pinnacles, gables, and S-curve moldings combine with a profusion of ornament in geometric and natural shapes, all to dizzying effect. The interior of such a church, filled with light from huge windows, can be seen in the *Book of Hours of Mary of Burgundy* (SEE FIG. 18–7).

The **HOUSE OF JACQUES COEUR**, the fabulously wealthy merchant in Bourges, reflects the popularity of the Flamboyant style for secular architecture (FIG. 18–24). Built at great expense between 1443 and 1451, it survives almost intact, although it has been stripped of its rich furnishings. The rambling, palatial house is built around an irregular open courtyard, with spiral stairs in octagonal towers giving access to the rooms. Tympana over doors indicate the function of the rooms within; for example, over the door to the kitchen a cook stirs the contents of a large bowl. Flamboyant decoration enriches the cornices, balustrades, windows, and gables.

Sequencing Events

1416	Death of Jean, Duke of Berry
1431	Joan of Arc burned at the stake in Rouen
1455	Gutenberg prints the Bible
1453	Hundred Years' War ends
1492	Columbus reaches the West Indies and North America

Among the carved decorations are puns on the patron's surname, *Coeur* (meaning "heart" in French). The house was also Jacques Coeur's place of business, so it had large storerooms for goods and a strong room for treasure. (A well-stocked but lesser merchant's shop can be seen in the painting of Petrus Christus, *A Goldsmith in His Shop*; SEE FIG. 18–18.)

Spain and Portugal

Many Flemish and French artists traveled to Spain and Portugal, where they were held in high esteem. Queen Isabella of Castile, for example, assembled a large collection of Flemish paintings and illuminated manuscripts as well as a collection of tapestries, jewels, and gold- and silversmith's work. She was also a patron of architecture. In Toledo,

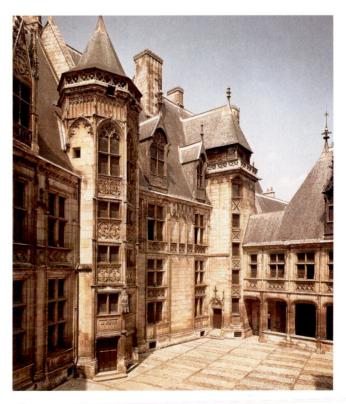

18–24 House of Jacques coeur Bourges. France. Interior courtyard, 1443–51.

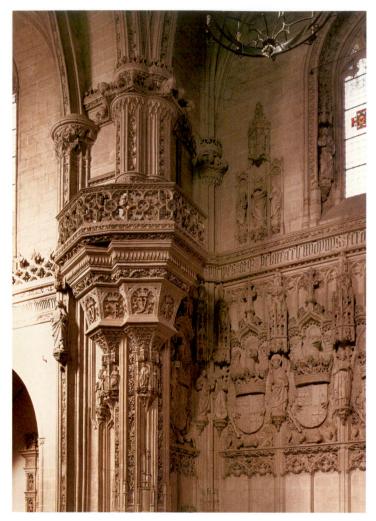

18–25 | Juan Güas SAN JUAN DE LOS REYES Interior, wall with carved coats-of-arms and saints. Toledo, Spain. Begun 1477.

18−26 | Juan Güas PLAN OF SAN JUAN DE LOS REYES Begun 1477.

Isabella built a church for the Franciscans, which she intended to be the royal burial chapel.

SAN JUAN DE LOS REYES. Founded in 1477, SAN JUAN DE LOS REYES (Saint John of the Kings) was never used as intended, since the conquest of Granada in 1492 permitted Ferdinand and Isabella to build their pantheon in the former Moorish capital rather than in Toledo. Nevertheless, the church in Toledo established a new church type known as "Isabellan" (FIGS. 18–25, 18–26). The church had a single nave flanked by lateral chapels built between the wall buttresses, a raised choir over the western entrance (Spanish churches usually had the choir in the nave), and raised pulpits at the crossing. The transept did not extend beyond the line of the buttresses and chapels. A low lantern tower over the crossing focused the light on the space reserved for the tombs, which were never built. This simple compact design allowed ample space for the congregation, and the expanses of wall could be used for educational paintings, sculptures, or tapestries.

Lavish sculptural decoration at San Juan de los Reyes honored Ferdinand and Isabella. Heraldry—an art form in itself—became a major decorative feature in the fifteenth century. Huge shields with the royal coat of arms (chains and bars for King Ferdinand's Aragon and Catalunya and lions and castles for Queen Isabella's Leon and Castile) are held by the gigantic eagles of Saint John. They are flanked by saints standing on pedestals under flamboyant canopies. On moldings and piers the artists, led by Juan Güas, carved plants, insects, and animals as avidly and accurately as painters of manuscripts. Friezes with inscriptions mimic Moorish architectural inscriptions, and the luxurious surface decoration may also reflect the Moorish taste with which the Christians were well informed.

Isabellan art has a special relevance for the Americas. In 1492, when Isabella and Ferdinand entered the Moorish capital city of Granada in triumph, Spanish ships reached the Americas. Soon missionaries were sent to the New World, where they built churches in the Isabellan style, using local materials and workmen. The Mission style of California and the American Southwest (SEE FIG. 29–46) is a simplified version of the Isabellan style of San Juan de los Reyes.

NUÑO GONÇALVES. Local painters and sculptors quickly absorbed the Flemish style. They could have had firsthand experience, since Jan van Eyck, among others, visited Spain and Portugal. Jan was sent by the Duke of Burgundy to paint the portrait of a Portuguese princess who was a candidate for marriage to the duke. A little later Nuño Gonçalves (active 1450–71) painted the members of the Portuguese royal family. Gonçalves reflects Jan's influence in his monumental figures and intense interest in surfaces and rich colors, although the severity of the portraits recalls Dirck Bouts. Perhaps as early as 1465–67, Gonçalves painted a large multipanel altar-

piece for the Convent of Saint Vincent de Fora in Lisbon (FIG. 18–27). The paintings are filled with remarkable portraits of people from all walks of life—the royal family, Cistercians, businessmen, fishermen—most of whom are identifiable. The central panel with the royal family holds a special interest for Americans. Here the painter has included a portrait of Prince Henry the Navigator, the man who inspired and financed Portuguese exploration. Prince Henry sent ships down the west coast of Africa and out into the Atlantic, but he died before Columbus's ships reached the Americas. Dressed in black, he kneels behind his nephew, King Alfonso V.

Saint Vincent, magnificent in red and gold vestments, stands in a tightly packed group of people, with members of the royal family at the front and courtiers forming a solid block across the rear. With the exception of the idealized features of the saint, all are portraits: At the right, King Alfonso V kneels before Saint Vincent, while his young son and his deceased uncle, Henry the Navigator, look on. Alfonso and his son rest their hands on their swords; Henry's hands are tented in prayer. At the left, Alfonso's deceased wife and mother hold rosaries. The appearance of Saint Vincent is clearly a vision, brought on by the intense prayers of the individuals around him.

Germany and Switzerland

Present-day Germany and Switzerland were situated within the Holy Roman Empire, a loose confederation of primarily German-speaking states. Industries, especially metalworking, developed in the Rhine Valley and elsewhere, and the artisan guilds grew powerful. Trade flourished under the auspices of the Hanseatic League, an association of cities and trading outposts, and both trade and manufacture were stimulated by the financial acumen of the rising merchant class. The Fugger family began their spectacular rise from simple textile workers and linen merchants to bankers for the Habsburgs and the popes. The Holy Roman Emperor and the pope continued their disputes, although a church council, held in Constance (1414-18), temporarily settled some of the problems of church-state relations. These problems would resurface, however, and lead to the Protestant Reformation in the next century.

Germanic artists worked in two very different styles. Some, working around Cologne, continued the International Gothic style with increased prettiness, softness, and sweetness of expression. The "Beautiful Style" of the fourteenth century continued, especially in the Rhineland, where artists perfected a soft, lyrical style. Other artists began an intense investigation and detailed description of the physical world. The major exponent of the latter style was Konrad Witz (active 1434–46). Witz, a native of Swabia in southern Germany, moved to Basel (in present-day Switzerland), where he found a rich source of patronage in the Church.

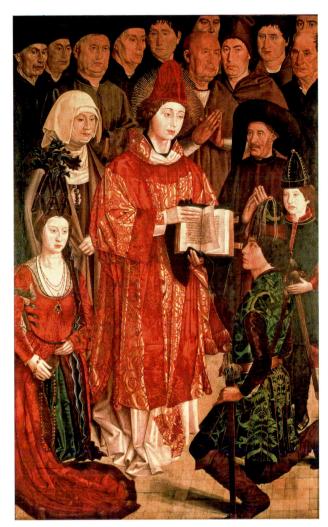

18–27 | Nuño Gonçalves SAINT VINCENT WITH THE PORTUGUESE ROYAL FAMILY Panel from the Altarpiece of Saint Vincent. c. 1465–67. Oil on wood panel, $6'9\frac{1}{4}''\times4'2\frac{1}{8}''$ (2.07 \times 1.28 m). Museu Nacional de Arte Antiga, Lisbon.

Witz's last large commission before his early death in 1446 was an altarpiece dedicated to Saint Peter for the Cathedral of Saint Peter in Geneva. Witz signed and dated his work in 1444. In the MIRACULOUS DRAFT OF FISHES (FIG. 18-28), a scene from the altarpiece which depicts Jesus's calling of the fishermen Peter and Andrew, Witz painted Lake Geneva, not Galilee. He has gone beyond the generic realism of the Flemings to paint a realistic portrait of a specific landscape: the dark mountain (the Mole) rising on the far shore of Lake Geneva and the snow-covered Alps shining in the distance. Witz records every nuance of light and water—the rippling surface, the reflections of boats, figures, and buildings, even the lake bottom. Peter's body and legs, visible through the water, are distorted by the refraction. The floating clouds above create shifting light and dark passages over the water. Perhaps for the first time in European art, the artist captures both the appearance and spirit of nature.

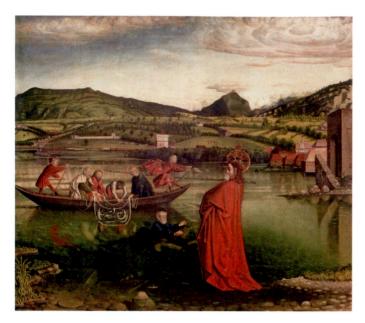

18–28 | Konrad Witz MIRACULOUS DRAFT OF FISHES From an altarpiece from the Cathedral of Saint Peter, Geneva, Switzerland. 1444. Oil on wood panel, $4'3'' \times 5'1''$ (1.29 \times 1.55 m). Musée d'Art et d'Histoire, Geneva.

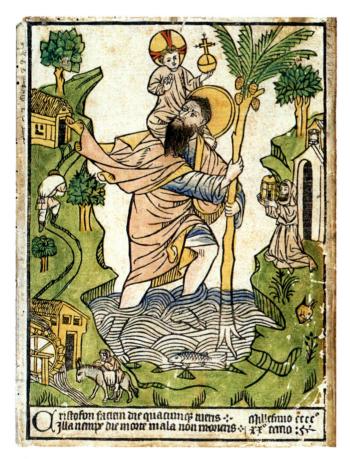

18–29 | THE BUXHEIM SAINT CHRISTOPHER 1423. Hand-colored woodcut, $11\% \times 8\%$ " (28.85 \times 20.7 cm). Courtesy of the Director and Librarian, the John Rylands University Library, the University of Manchester, England.

The Latin verse reads, "Whenever you look at the face of Christopher, in truth, you will not die a terrible death that day." "1423"

THE GRAPHIC ARTS

Printmaking emerged in Europe at the end of the four-teenth century with the development of printing presses and the increased local manufacture and wider availability of paper. The techniques used by printmakers during the fifteenth century were woodcut and engraving (see "Woodcuts and Engravings on Metal," page 614). Woodblocks cut in relief had long been used to print designs on cloth, but only in the fifteenth century did the printing of images and texts on paper and the production of books in multiple copies of a single edition, or version, begin to replace the copying of each book by hand. Both handwritten and printed books were often illustrated, and printed images were sometimes hand colored.

Single Sheets

Single-sheet prints in the woodcut and engraving techniques were made in large quantities in the early decades of the fifteenth century. Initially, woodcuts were made primarily by woodworkers with no training in drawing, but soon artists began to draw the images for them to cut from the block.

THE BUXHEIM SAINT CHRISTOPHER. Devotional images were sold as souvenirs to pilgrims at holy sites. The BUXHEIM **SAINT CHRISTOPHER** was found in the Carthusian Monastery of Buxheim, in southern Germany, glued to the inside of the back cover of a manuscript (FIG. 18-29). Saint Christopher, patron saint of travelers, carries the Christ Child across the river. His efforts are witnessed by a monk holding out a light to guide him to the monastery door, but ignored by the hardworking millers on the opposite bank. Both the cutting of the block and the quality of the printing are very high. The artist and cutter vary the width of the lines to strengthen major forms. Delicate lines are used for inner modeling (facial features) and short parallel lines to indicate shadows (the inner side of draperies). Since the date 1423 is cut into the block, the print was thought to be among the earliest to survive. Recent studies have determined that the date refers to some event and the print was made at midcentury.

MARTIN SCHONGAUER. Engraving may have originated with goldsmiths and armorers, who recorded their work by rubbing lampblack into the engraved lines and pressing paper over the plate. German artist Martin Schongauer (c. 1435–91), who learned engraving from his goldsmith father, was an immensely skillful printmaker who excelled both in drawing and in the difficult technique of shading from deep blacks to faintest grays using only line. He was also a skilled painter. In **DEMONS TOR-MENTING SAINT ANTHONY**, engraved about 1470–75 (FIG. 18–30), Schongauer illustrated the original biblical meaning of temptation as a physical assault rather than a subtle inducement. Wildly acrobatic, slithery, spiky demons lift

Technique

WOODCUTS AND ENGRAVINGS ON METAL

oodcuts are made by drawing on the smooth surface of a block of fine-grained wood, then cutting away all the areas around the lines with a sharp tool called a *gouge*, leaving the lines in high relief. When the block's surface is inked and a piece of paper pressed down hard on it, the ink on the relief areas transfers to the paper to create a reverse image. The effects can be varied by making thicker and thinner lines, and shading can be achieved by placing the lines closer or farther apart. Sometimes the resulting black-and-white images were then painted by hand.

Engraving on metal requires a technique called *intaglio*, in which the lines are cut into the plate with tools called *gravers* or *burins*. The engraver then carefully burnishes the plate to ensure a clean, sharp image. Ink is applied over the whole plate and forced down into the lines, then the plate's surface is carefully wiped clean of the excess ink. When paper and plate are held tightly together by a press, the ink in the lines transfers to the paper.

Woodblocks and metal plates could be used repeatedly to make nearly identical images. If the lines of the block or plate wore down, the artists could repair them. Printing large numbers of identical prints of a single version, called an *edition*, was usually a team effort in a busy workshop. One artist would make the drawing. Sometimes it was drawn directly on the block or plate with ink, in reverse of its printed direction, sometimes on paper to be transferred in reverse onto the plate or block by another person, who then cut the lines. Others would ink and print the images.

In the illustration of books, the plates or blocks would be reused to print later editions and even adapted for use in other books. A set of blocks or plates for illustrations was a valuable commodity and might be sold by one workshop to another. Early in publishing, there were no copyright laws, and many entrepreneurs simply had their workers copy book illustrations onto woodblocks and cut them for their own publications.

Anthony up off the ground to torment and terrify him in midair. The engraver intensified the horror of the moment by condensing the action into a swirling vortex of figures beating, scratching, poking, tugging, and no doubt shrieking at the stoical saint, who remains impervious to all by reason of his faith.

Printed Books

The explosion of learning in Europe in the fifteenth century encouraged experiments in faster and cheaper ways of producing books than by hand-copying them. The earliest printed books were block books, for which each page of text, with or without illustrations, was cut in relief on a single block of wood. Movable-type printing, in which individual letters could be arranged and locked together, inked, and then printed onto paper, was first achieved in the workshop of Johann Gutenberg in Mainz, Germany. More than forty copies of Gutenberg's Bible, printed around 1455, still exist. As early as 1465, two German printers were working in Italy, and by the 1470s there were presses in France, Flanders, Holland, and Spain. With the invention of this fast way to make a number of identical books, the intellectual and spiritual life of Europe—and with it the arts—changed forever.

WILLIAM CAXTON. England got its first printing press as the result of a second career launched by a former English cloth merchant, William Caxton (active c. 1441–91). Caxton had lived for thirty years in Bruges, where he came in contact with the humanist community as well as with local printing ventures. In 1476 Caxton moved back to London, where he

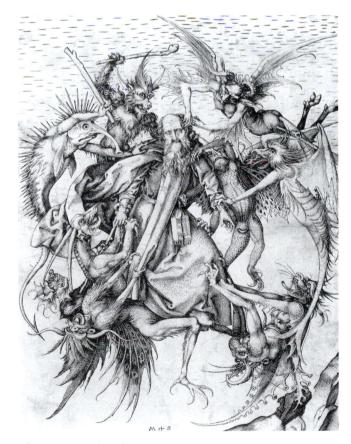

18–30 | Martin Schongauer **DEMONS TORMENTING SAINT ANTHONY** c. 1480–90. Engraving, $12\,\% \times 9''$ (31.1 \times 22.9 cm). The Metropolitan Museum of Art, New York. Rogers Fund, 1920 (20.5.2)

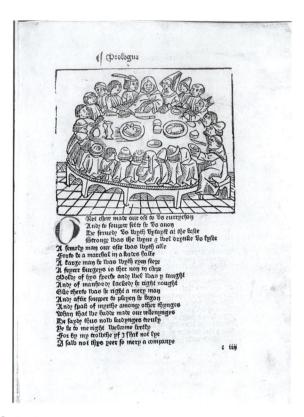

18-31 | page with pilgrims at table, prologue to canterbury tales

By Geoffrey Chaucer, published by William Caxton, London, 1484 (second edition, the first with illustrations). Woodcut, $4\frac{1}{16} \times 4\frac{7}{8}$ " (10.2 \times 12 cm). The Pierpont Morgan Library, New York.

PML 693.

established the first English publishing house. He printed eighty books in the next fourteen years, including works by the fourteenth-century author Geoffrey Chaucer (see "A New Spirit in Fourteenth-Century Literature," page 561).

In the second edition of Chaucer's *Canterbury Tales*, published in 1484, Caxton added woodblock illustrations by an unknown artist (FIG. 18–31). The assembled pilgrims journeying to the shrine of Saint Thomas à Becket are seated around a table. Included in the group of storytellers is an engaging woman, Alice, the Wife of Bath. Some critics see the Wife of Bath as an example of a woman who good women should avoid, but Chaucer put words in the lively

Alice's mouth that are well understood by many women today. Simple woodcut illustrations such as this are typical of the popular art of the time.

New techniques for printing illustrated books in Europe at the end of the fiftheenth century held great promise for the spread of knowledge and ideas in the following century.

IN PERSPECTIVE

The fifteenth century marks the end of the Middle Ages and the beginning of the modern world, our own era. The period has been called the Renaissance, for some people saw it as a period of "rebirth," but in fact Western Europeans built on the accomplishments of the twelfth century—a renaissance in its own right—and on the achievements of the thirteenth and fourteenth centuries. By the fifteenth century thoughtful people focused their attention on human beings and their accomplishments, on life in this world as well as the next. They held a sense of human history, including a new respect for ancient learning.

The fifteenth century saw the growth of a secular spirit, related to the growth of towns into cities where the stimulating hurly-burly of urban life encouraged verbal and intellectual exchange. Whereas towns had once revolved around a court or cathedral, the new cities were industrial and commercial centers. Business joined religion and politics as a powerful motivating force. While the church continued to be a major patron of the arts and architecture, new sources of patronage emerged in the cities.

Architects followed the basic Gothic principles and methods of construction, but they added increasingly elaborate carved decoration that turned solid stone into lacy confections. Sculpture was freed from architecture, and free-standing figures gave the impression of life, vitality, and even possibility of movement. This realism extended into all the arts. Painters and tapestry makers, like writers and sculptors, included images from daily life.

By the middle of the century, a new medium—the graphic arts—came into being. The rapid dissemination of information both in words and pictures now available through the printing press allowed people to read—and see—for themselves. The new empirical frame of mind that characterized the fifteenth century gave rise in the sixteenth century to an explosion of inquiry and new ways of looking at the world.

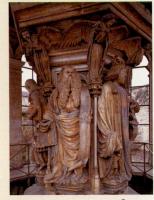

SLUTER.

WELL OF MOSES,
THE CHARTREUSE DE CHAMPMOL, DIJON
1395–1406

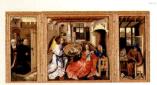

Campin. **MÉRODE ALTARPIECE** c. 1425–28

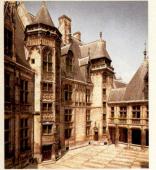

HOUSE OF JACQUES COEUR
BOURGES
1443-51

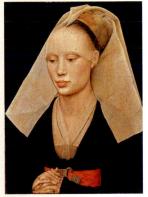

ROGIER VAN DER WEYDEN.

PORTRAIT OF A LADY

C. 1455

Martin Schongauer tons tormenting saint antony c. 1480–90

HUNT OF THE UNICORN
TAPESTRY SERIES
C. 1495–1505

1400

1420

1440

1460

1480

1500

FIFTEENTHCENTURY
ART IN NORTHERN
EUROPE
AND THE IBERIAN
PENINSULA

Great (Western) Schism Ends 1417

 Duke Philip The Good of Burgundy Founds The Order of the Golden Fleece 1430

Habsburgs Begin Rule of Holy Roman Empire 1452

Hundred Year's War Ends 1453

Gutenberg Prints Bible 1455

William Caxton Establishes First
 English Publishing House 1476

Columbus Reaches the West Indies 1492

19–1 Paolo Uccello **THE BATTLE OF SAN ROMANO** 1438–40. Tempera on wood panel, approx. $6' \times 10' \ 7'' \ (1.83 \times 3.23 \ m)$. National Gallery, London.

Reproduced by courtesy of the Trustees

RENAISSANCE ART IN FIFTEENTH-CENTURY ITALY

The ferocious but bloodless battle we see in FIGURE 19–1 could take place only in our dreams. Under an elegantly fluttering banner, the Florentine general Niccolò da Tolentino leads his men

against the Sienese at the Battle of San Romano, which took place on June 1, 1432. In the center foreground, Niccolò holds aloft a baton of command, the sign of his authority. His bold gesture, together with his white horse and fashionable crimson and gold damask hat, ensure that he dominates the scene. The general's knights charge into the fray, and when they fall, like the soldier at the lower left, they join the many broken lances on the ground—all arranged in conformity with the new mathematical depiction of space, one-point (linear) perspective.

The battle rages across a shallow stage defined by the debris of warfare arranged in a neat pattern on a pink ground and backed by a hedge of blooming orange trees and rosebushes. In the cultivated hills beyond, crossbowmen prepare their lethal bolts. A Florentine painter nicknamed Paolo Uccello ("Paul Bird"), whose given name was Paolo di Dono (c. 1397–1475), created this panel painting, housed today in London's National Gallery. It is one of three panels now separated; the other two are hanging in major museums in Florence and Paris.

The complete history of these paintings has only recently come to light. Lionardo Bartolini Salimbeni (1404–79), who led the Florentine city government during the war against Lucca and Siena, probably commissioned the paintings. Uccello's remarkable accuracy when depicting armor from the 1430s, heraldic banners, and even fashionable fabrics and crests surely would have appealed to civic pride.

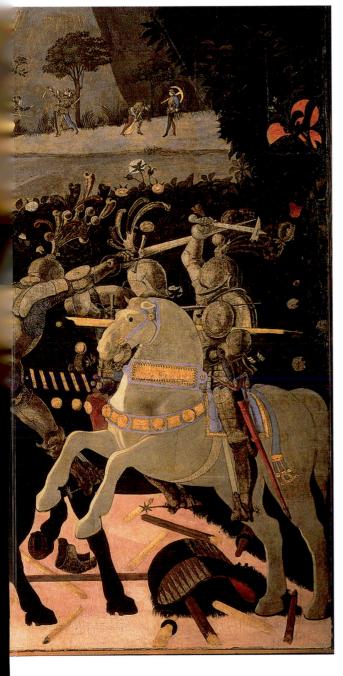

The hedges of oranges, roses, and pomegranates—all ancient fertility symbols—make a tapestry-like background for the action. Lionardo and his wife Maddalena had six sons, two of whom inherited the paintings. According to a complaint brought by one of the heirs, Damiano, Lorenzo de' Medici, the powerful de facto ruler of Florence, "forcibly removed" the paintings from Damiano's house. The paintings were never returned, and Uccello's masterpieces are recorded in a 1492 inventory as hanging in Lorenzo's private chamber in the Medici palace. Perhaps Lorenzo, who was called "the Magnificent," saw Uccello's heroic pageant as a trophy worthy of a Medici merchant prince.

In the sixteenth century, the artist, courtier, and historian Giorgio Vasari devoted a chapter to Paolo Uccello in his book *The Lives of the Most Excellent Italian Architects, Painters, and Sculptors.* He described Uccello as a man so obsessed with the study of perspective that he neglected his painting, his family, and even his beloved birds, until he finally became "solitary, eccentric, melancholy, and impoverished" (Vasari, page 79). His wife "used to declare that Paolo stayed at his desk all night, searching for the vanishing points of perspective, and when she called him to bed, he dawdled, saying: 'Oh, what a sweet thing this perspective is!'" (Vasari, page 83; translation by J. C. and P. Bondanella, Oxford, 1991). Such passion for science is typical of fifteenth-century artists, who were determined to capture the appearance of the material world and to subject it to overriding human logic. Thus a battle scene becomes a demonstration of the science of perspective.

CHAPTER-AT-A-GLANCE

- HUMANISM AND THE ITALIAN RENAISSANCE
- FLORENCE | Architecture | Sculpture | Painting | Mural Painting in Florence After Masaccio
- ITALIAN ART IN THE SECOND HALF OF THE FIFTEENTH CENTURY | Urbino | Mantua | Rome | The Later Fifteenth Century in Florence | Venice
- IN PERSPECTIVE

HUMANISM AND THE ITALIAN RENAISSANCE

By the end of the Middle Ages, the most important Italian cultural centers lay north of Rome in the cities of Florence. Milan, and Venice, and in the smaller duchies of Mantua, Ferrara, and Urbino. In the south, Naples, Apulia, and Sicily were under French and then Aragonese control, Much of the power and influential art patronage was in the hands of wealthy families: the Medici in Florence, the Montefeltro in Urbino, the Gonzaga in Mantua, the Visconti and Sforza in Milan, and the Este in Ferrara. Cities grew in wealth and independence as people moved to them from the countryside in unprecedented numbers. Commerce became increasingly important. In some of the Italian states a noble lineage was not necessary for-nor did it guarantee-political and economic success. Money conferred status, and a shrewd business or political leader could become very powerful. The period saw the rise of mercenary armies led by entrepreneurial (and sometimes brilliant) military commanders called condottieri. Unlike the knights of the Middle Ages, they owed allegiance only to those who paid them well; their employer might be a city-state, a lord, or even the pope. Some condottieri, like

Niccolò da Tolentino, became rich and famous. Others, like Federico da Montefeltro (SEE FIG. 19–29), were lords or dukes themselves, with their own territories in need of protection. Patronage of the arts was an important public activity with political overtones. As one Florentine merchant, Giovanni Rucellai, succinctly noted, he supported the arts "because they serve the glory of God, the honour of the city, and the commemoration of myself" (cited in Baxandall, page 2).

Like their northern counterparts (see Chapter 18), Italian humanists had a new sense of the importance of human thought and action, and they looked to the accomplishments of ages past for inspiration and instruction. For Italians, though, this had added significance. Although politically divided into many small entities, and therefore not resembling the country we know today, Italy existed as a geographic unit with a common heritage descended from ancient Rome. Ancient Rome therefore provided not only a unifying ideal of power and wealth but also a unifying culture based on ethical principles. Humanists sought the physical and literary records of the ancient world—assembling libraries, collecting sculpture and fragments of architecture, and beginning archaeological investigations of ancient Rome. They imagined a golden age of

MAP 19-1 | Fifteenth-century Italy

Powerful families divided the Italian peninsula into city-states—the Medici in Florence, the Visconti and Sforza in Milan, the Montefeltro in Urbino, the Gonzaga in Mantua, and the Este in Ferrara. After 1420 the popes ruled Rome, while in the south Naples and Sicily were French and then Spanish (Aragonese) territories. Venice maintained her independence as a republic.

philosophy, literature, and the arts, which they hoped to recapture. Their aim was to live a rich, noble, and productive life—usually within the framework of Christianity but always adhering to a school of philosophy as a moral basis.

Artists, like the humanist scholars, turned to classical antiquity for inspiration even as they continued to fulfill commissions for predominantly Christian subjects. Secular works other than portraits do not survive in great numbers until the second half of the century. Much has been lost, especially painted home furnishings such as birth trays and marriage chests. Allegorical and mythological themes appeared, as patrons began to collect art for their personal enjoyment. Because few examples of ancient Roman painting were known in the fifteenth century, Renaissance painters looked to Roman sculpture and to literature. The male nude became an acceptable subject in Renaissance art, often justified as a religious image—Adam, Jesus on the cross, and martyrdoms of saints such as Sebastian. Other than representations of Eve or an occasional allegorical or mythological figure such as Venus, female nudes were rare until the end of the century.

Like the Flemish artists, Italian painters and sculptors moved gradually toward a greater precision in rendering the illusion of physical reality. They did so in a more analytical way than the northerners had, with the goal of achieving correct but perfected figures set within a rationally, rather than visually, defined space. Painters and sculptors developed a mathematical system called *linear perspective*, which achieved the illusion of a measured and continuously receding space (see "Brunelleschi, Alberti, and Renaissance Perspective," page 622). Italian architects also came to apply abstract, mathematically derived design principles to the plans and elevations of the buildings.

FLORENCE

In seizing Uccello's battle painting (SEE FIG. 19–1), Lorenzo de' Medici was asserting the role his family had come to play in the history of Florence. The fifteenth century witnessed the rise of the Medici from among the most successful of a newly rich middle class (comprising primarily merchants and

Technique

BRUNELLESCHI, ALBERTI, AND RENAISSANCE PERSPECTIVE

rtists such as Jan van Eyck refined intuitive perspective in order to approximate the appearance of things growing smaller and closer together in the distance, coupling it with atmospheric, or aerial, perspective. In Italy, the humanists' study of the natural world and their belief that "man is the measure of all things" led to the invention of a system of perspective that enabled artists to represent the visible world in a convincingly illusionistic way. This system—known variously as mathematical, linear, or one-point perspective—was first demonstrated by the architect Filippo Brunelleschi about 1420.

Brunelleschi's biographer, writing in the 1480s, describes two perspective panels that the architect created. One of them depicted the front of the Florentine Baptistry as if it were seen by someone standing three *braccia* inside the front door of the cathedral—a total of 60 *braccia* from the Baptistry. (In Florence, a *braccia*—meaning "arm," in Italian—measured about 2 feet.) To obtain this illusion, Brunelleschi pierced a hole in the back of the panel at the center point of the composition and placed a mirror one *braccia* length in front of it. Viewers could peep through the hole and see a reflection of the Baptistry that could be understood in actual space. The illusion was made even more striking

by Brunelleschi's use of a burnished silver background, which reproduced real weather conditions.

Leon Battista Alberti developed and codified Brunelleschi's rules of perspective into a mathematical system for representing three dimensions on a twodimensional surface in his treatise, in Latin, De pictura (On Painting) in 1435. A year later he published an Italian version, Della pittura, making a standardized, somewhat simplified method available to a larger number of draftspeople, painters, and relief sculptors. The goal he articulated is to make an image resemble a "view through a window," the view being the image represented, and the window, the picture plane.

In this highly artificial Italian system, the picture's surface was a flat plane that intersected the viewer's field of vision at a right angle. The system is based on a one-eyed viewer standing a prescribed distance from a

work, dead center. From this fixed vantage point everything would appear to recede into the distance at the same rate, following imaginary lines called **orthogonals** that met at a single **vanishing point** on the horizon. Using orthogonals as a guide, artists could **foreshorten** objects, replicating the effect of perspective on individual objects. Despite its limitations, mathematical perspective seems to extend pictorial space into real space, providing the viewer with a direct, almost physical connection to the picture. It creates a compelling, even exaggerated sense of depth.

Early Renaissance artists relied on a number of mechanical methods. Many constructed devices with peepholes through which they sighted the figure or object to be represented. They used mathematical formulas to translate three-dimensional forms onto the picture plane, which they overlaid with a grid to provide reference points, or they emphasized the orthogonals created by tiled floors or buildings in the composition. As Italian artists became more comfortable with mathematical perspective over the course of the fifteenth century, they came to rely less on peepholes and formulas. Many artists adopted multiple vanishing points, which gave their work a more relaxed, less tunnel-like feeling.

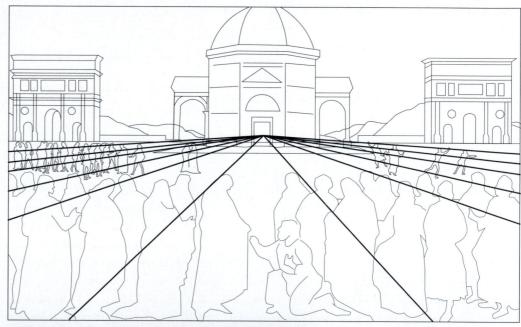

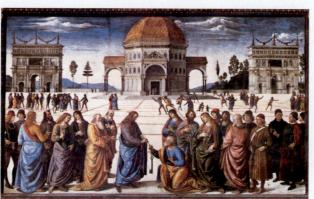

(ABOVE) Perugino THE DELIVERY OF THE KEYS TO SAINT PETER: SCHEMATIC DRAWING SHOWING THE ORTHOGONALS AND VANISHING POINT

(LEFT) Perugino THE DELIVERY OF THE KEYS TO SAINT PETER Fresco on the right wall of the Sistine Chapel, Vatican, Rome. 1481. $11'5\%''\times18'8\%''$ (3.48 \times 5.70 m).

bankers) to become the city's virtual rulers. Unlike hereditary aristocracy, the Medici rose up from obscure roots to make their fortune in banking. The competitive Florentine atmosphere that had fostered mercantile success and civic pride also cultivated competition in the arts and encouraged an interest in the ancient literary texts. These factors have led observers to consider Florence the cradle of the Italian Renaissance. Under Cosimo the Elder (1389-1464), the Medici became leaders in intellectual and artistic patronage. They sponsored philosophers and other scholars who wanted to study the classics, especially the works of Plato and his followers, the Neoplatonists. Neoplatonism distinguished between the spiritual (the ideal or Idea) and the physical (Matter) and encouraged artists to represent ideal figures. Writers, philosophers, and musicians dominated the Medici Neoplatonic circle. Few architects, sculptors, or painters were included, because most of them had learned their craft in apprenticeships and were considered little more than manual laborers. Nevertheless, interest in the ancient world rapidly spread beyond the Medici circle to artists and craftspeople, who sought to reflect the new interests of their patrons in their work. Gradually, artists began to see themselves as more than artisans, and society eventually recognized their best works as achievements of a very high order.

Although the Medici were the de facto rulers, Florence was considered to be a republic. The Council of Ten (headed for a time by Salimbeni, who commissioned Uccello's *Battle of San Romano*) was a kind of constitutional oligarchy where wealthy men formed the government. At the same time, the various guilds wielded tremendous power, and evidence of this is the fact that guild membership was a prerequisite for holding government office. Consequently, artists could look to the church and the state and civic groups—the city and the guilds—as well as private individuals for patronage, and the patrons expected the artists to reaffirm and glorify their achievements.

Architecture

The defining civic project of the early years of the fifteenth century was the completion of the Florence Cathedral with a magnificent dome over the high altar. The construction of the cathedral had begun in the late thirteenth century and had continued intermittently during the fourteenth century (see Chapter 17). As early as 1367, the builders had envisioned a very tall dome to span the huge interior space of the crossing, but they lacked the engineering know-how to construct it. When interest in completing the cathedral revived, around 1407, the technical solution was proposed by a young sculptor-turned-architect, Filippo Brunelleschi.

FILIPPO BRUNELLESCHI. Filippo Brunelleschi (1377–1446), whose father had been involved in the original plans for the cathedral dome in 1367, achieved what many considered impossible: He solved the problem of the dome. Brunelleschi originally had trained as a goldsmith. To further his education

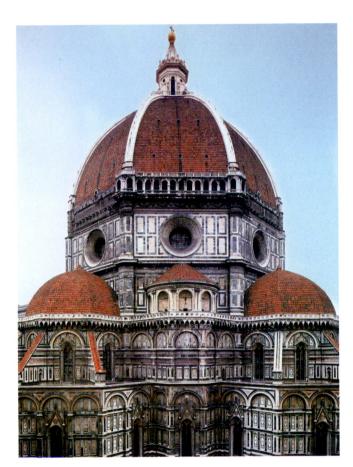

19–2 | Filippo Brunelleschi DOME OF FLORENCE CATHEDRAL

1417-36; lantern completed 1471; the gallery, 1515.

The cathedral dome was a source of immense local pride. Renaissance architect and theorist Leon Battista Alberti described it as rising "above the skies, large enough to cover all the peoples of Tuscany with its shadow."

he traveled to Rome, probably with his friend, the sculptor Donatello. In Rome he studied ancient Roman sculpture and architecture. On his return to Florence, he tackled the problem of the cathedral. First he advised constructing a tall octagonal drum, as a base. The drum was finished in 1412, and in 1417, Brunelleschi was ready to design the dome itself (FIG. 19–2). From 1420 until 1436, workers built the dome. A revolutionary feat of engineering, the dome is a double shell of masonry 138 feet across. The octagonal outer shell is supported on eight large and sixteen lighter ribs. Instead of using a costly and even dangerous scaffold and centering, Brunelleschi devised a system in which temporary wooden supports were cantilevered out from the drum. He moved these supports up as building progressed. As the dome was built up course by course, each portion of the structure reinforced the next one. Vertical marble ribs interlocked with horizontal sandstone rings, connected and reinforced with iron rods and oak beams. The inner and outer shells were linked internally by a system of arches. When completed, this self-buttressed unit required no external support to keep it standing. Unsure of Brunelleschi's still theoretical approach to building, the men responsible for

19–3 Filippo Brunelleschi **OLD SACRISTY, CHURCH OF SAN LORENZO, FLORENCE** 1421–28, approx. $38 \times 38'$ (11.6 \times 11.6 m). Sculpture by Donatello.

Brunelleschi wanted simple architecture and protested the addition of sculpture.

the cathedral also appointed a respected master mason to assist with practical details of construction.

An oculus (round opening) in the center of the dome was surmounted by a lantern designed in 1436. After Brunelleschi's death, this crowning structure, made up of Roman architectural forms, was completed by another Florentine architect, Michelozzo di Bartolomeo (1396–1472). The final touch—a gilt bronzed ball—was added in 1468–71.

Other commissions came quickly after the cathedral dome project, as Brunelleschi's innovative designs were well received by Florentine patrons. From about 1418 until his death in 1446, Brunelleschi was involved in a series of influential projects. In 1419 he designed a foundling hospital for the city (see "The Foundling Hospital," page 626). For the Medici's parish church of San Lorenzo, he designed a sacristy (a room where ritual attire and vessels are kept), which also served as a burial chapel for Giovanni di Bicci de' Medici, who established the Medici fortune, and his wife (FIG. 19-3). Completed in 1428, it is called the **OLD SACRISTY** to distinguish it from the one built in the sixteenth century that lies opposite it on the other side of the church's choir. The Old Sacristy has a centralized plan, like a martyr's shrine in the Early Christian period. Later, Leon Battista Alberti, in his treatise on architecture (see page 622), wrote of the central plan as an ideal, derived from the

humanist belief that the circle was a symbol of divine perfection and that both the circle inscribed in a square and the cross inscribed in a circle were symbols of the cosmos.

The present church of San Lorenzo replaced an eleventh-century basilica. Brunelleschi conceived plans for the new church during the time that he designed and built the sacristy, that is, between 1421 and 1428, but Michelozzo, whose name appears in the construction documents, finished the building after Brunelleschi's death. The façade was never built.

The **CHURCH OF SAN LORENZO** has a basilican plan with a long nave flanked by side aisles that open into shallow lateral chapels (FIG. 19-4). A short transept and square crossing lead to a square sanctuary flanked by additional chapels opening off the transept. Projecting from the left transept, as one faces the altar, are Brunelleschi's sacristy and the older Medici tomb. The Church of San Lorenzo is notable for its mathematical regularity. Brunelleschi based his plan on a square module—a basic unit of measure that could be multiplied or divided and applied to every element of the design. Medieval builders had used modular plans, but Brunelleschi applied the module with greater consistency, and the result was a series of clear, harmonious spaces (FIG. 19-5). Ornamental details, all in a classical style, were carved in pietra serena, a grayish stone that became synonymous with Brunelleschi's interiors. Below the plain clerestory (upper-story wall of windows) with its unobtrusive openings, the arches of the nave arcade are carried on tall, slender Corinthian columns made even taller by the insertion of an impost block between the column capital and the springing of the round arches—one of Brunelleschi's favorite details. Flattened architectural forms in pietra serena repeat the arcade in the outer walls of the side aisles, and each bay is covered by its own shallow domical

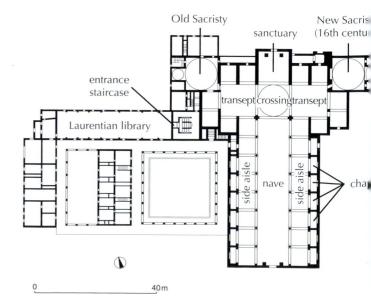

19–4 | Filippo Brunelleschi PLAN OF THE CHURCH OF SAN LORENZO, FLORENCE

Includes later additions and modifications.

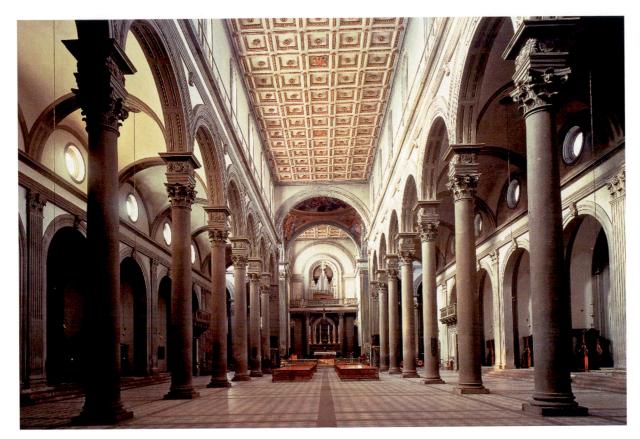

19–5 | Filippo Brunelleschi; continued by Michelozzo di Bartolomeo NAVE, CHURCH OF SAN LORENZO, FLORENCE c. 1421–28, nave (designed 1434?) 1442–70.

vault. The square crossing is covered by a hemispherical dome; the nave and transept by flat ceilings. Brunelleschi's rational approach, unique sense of order, and innovative incorporation of classical motifs inspired later Renaissance architects, many of whom learned from his work firsthand by completing his unfinished projects.

THE MEDICI PALACE. Brunelleschi may have been involved in designing the nearby Medici Palace (now known as the PALAZZO MEDICI-RICCARDI) in 1446. According to sixteenth-century gossip recorded by Giorgio Vasari, Cosimo de' Medici the Elder rejected Brunelleschi's model for the palazzo as too grand (any large house was called a "palace"—palazzo). The courtyards of both buildings were the work of Michelozzo, whom many scholars have accepted as the designer of the building (FIG. 19–6). The austere exterior was in keeping with the republican political climate and Florentine religious attitudes, imbued with the Franciscan ideals of

19–6 │ Attributed to Michelozzo di Bartolomeo FAÇADE, PALAZZO MEDICI-RICCARDI, FLORENCE Begun 1446.

For the palace site, Cosimo de' Medici the Elder chose the Via de' Gori at the corner of the Via Larga, the widest city street at that time. Despite his practical reasons for constructing a large residence and the fact that he chose simplicity and austerity over grandeur in the exterior design, his detractors commented and gossiped. As one exaggerated: "[Cosimo] has begun a palace which throws even the Colosseum at Rome into the shade."

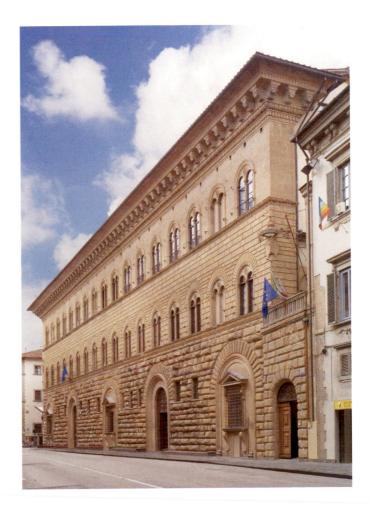

THE OBJECT SPEAKS

THE FOUNDLING HOSPITAL

n 1419 the Guild of Silk Manufacturers and Goldsmiths in Florence undertook a significant public service: It established a large public orphanage and commissioned the brilliant young architect Filippo Brunelleschi to build it next to the Church of the Santissima Annunziata ("Most Holy Annunciation"), which housed a miracle-working painting of the Annunciation. Completed in 1444, the Foundling Hospital, the Ospedale degli Innocenti, was unprecedented in terms of scale and design innovation.

In the Foundling Hospital,
Brunelleschi created a building that paid
homage to traditional forms while introducing what came to be known as the
Italian Renaissance style. Traditionally, a
charitable foundation's building had a
portico open to the street to provide
shelter. Brunelleschi built an arcade of
hitherto unimagined lightness and ele-

gance, using smooth round columns and richly carved capitals-his own interpretation of the classical Corinthian order. The underlying mathematical basis for his design creates a sense of classical harmony. Each bay of the arcade encloses a cube of space defined by the 10-braccia (20-foot) height of the columns and the diameter of the arches. Hemispherical pendentive domes, half again as high as the columns, cover the cubes. The bays at the end of the arcade are slightly larger than the rest, creating a subtle frame for the composition. Brunelleschi defined the perfect squares and circles of his building with dark gray stone (pietra serena) against plain white walls. His training as a goldsmith and sculptor served him well as he led his artisans to carve crisp, elegantly detailed capitals and moldings for the open, covered gallery.

A later addition to the building seems eminently suitable: About 1487, Andrea della Robbia, who had inherited the family firm and its secret glazing formulas from his uncle Luca (see "Ceramics," page 634), created blue-and-white glazed terra-cotta medallions that signified the building's function. The babies in swaddling clothes, one in each medallion, are among the most beloved images of Florence.

The medallions seem to embody the human side of Renaissance humanism, reminding viewers that the city's wealthiest guild cared for the most helpless members of society. Perhaps the Foundling Hospital spoke to fifteenth-century Florentines of an increased sense of social responsibility. Or perhaps, by so publicly demonstrating social concerns, the wealthy guild that sponsored it solicited the approval and support of the lower classes in the cutthroat power politics of the day.

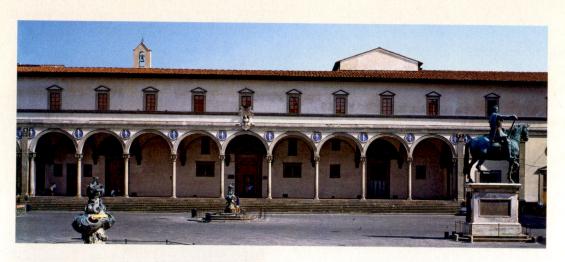

(ABOVE) Filippo Brunelleschi FOUNDLING HOSPITAL, FLORENCE Italy. Designed 1419; built 1421–44.

(LEFT) Andrea della Robbia

DETAIL OF TERRA-COTTA MEDALLION

poverty and charity. Like many other European cities, Florence had sumptuary laws, which forbade ostentatious displays of wealth—but they were often ignored. For example, private homes were supposed to be limited to a dozen rooms; Cosimo, however, acquired and demolished twenty small houses to provide the site for his new residence. The house was more than a dwelling place; it was his place of business, company headquarters. The *palazzo* symbolized the family and underscored the family's place in society. The building is linked to the seat of government, the Palazzo della Signoria (SEE FIG. 17–2), logistically by means of a straight line of connecting streets and symbolically through its imposing massiveness.

Huge in scale (each story is more than twenty feet high—today's builders calculate ten feet per story), the building has harmonious proportions and elegant, classically inspired details. On one side, the ground floor originally opened through large, round arches onto the street, creating in effect a loggia that provided space for the family business. These arches were walled up in the sixteenth century and given windows designed by Michelangelo. The façade of large, rusticated stone blocks—that is, blocks with their outer faces left rough, typical of Florentine town house exteriors—was derived from fortifications. On the façade, the stories are clearly set off from each other by the change in the stone surfaces from very rough at the ground level to almost smooth on the third.

The builders followed the time-honored tradition of placing rooms around a central courtyard. Unlike the still-medieval plan of the House of Jacques Coeur (SEE FIG. 18–24), however, the MEDICI PALACE COURTYARD is square in plan with rooms arranged symmetrically (FIG. 19–7). Round arches on slender columns form a continuous arcade and support an enclosed second story. Tall windows in the second story match the exterior windows. Disks bearing the Medici arms surmount each arch in a frieze decorated with swags in sgraffito work (tinted and engraved plaster). Such classical elements, inspired by the study of Roman ruins, gave the great house an aura of dignity and stability and undoubtedly enhanced the status of its owners. The Medici Palace inaugurated a new monumentality and regularity of plan in residential urban architecture. Wealthy Florentine families soon copied it in their own houses.

LEON BATTISTA ALBERTI. The relationship of the façade to the body of the building behind it was a continuing challenge for Italian Renaissance architects. Early in his architectural career, Leon Battista Alberti (1404–72), a lawyer turned humanist, architect, and author, devised a façade to be the unifying front for a planned merger of eight adjacent houses in Florence acquired by Giovanni Rucellai (FIG. 19–8). Work began about 1455, but the house was never finished, as is obvious on the right side of the view seen here. It has been suggested that Alberti designed a five-bay façade with a central door and that Bernardo Rossellino (1409–64), the builder on record, added two more bays and began the eighth but was unable to finish

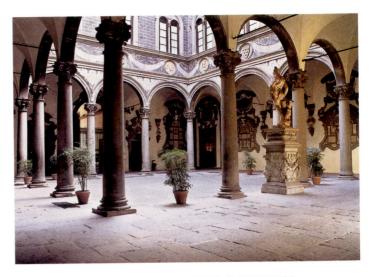

19–7 | COURTYARD WITH SGRAFFITO DECORATION, PALAZZO MEDICI-RICCARDI, FLORENCE Begun 1446.

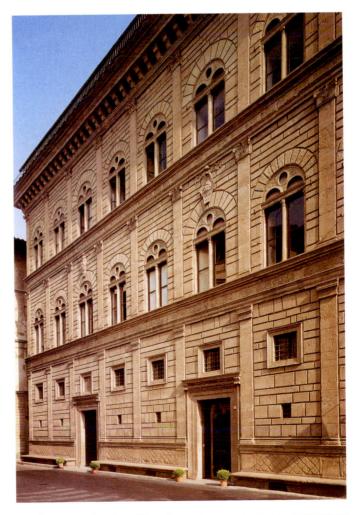

19–8 | Leon Battista Alberti PALAZZO RUCELLAI, FLORENCE Left five bays 1455–58; later extended but never finished.

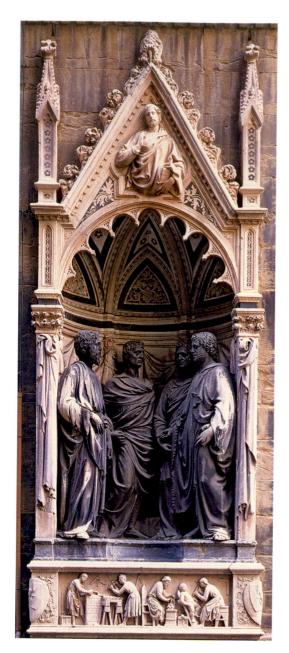

19–9 Nanni di Banco THE FOUR CROWNED MARTYRS c. 1409–17. Marble, height of figures 6' (1.83 m). Orsanmichele, Florence (photographed before removal of figures to museum). The sculpture has been cleaned and restored.

the façade because Rucellai could not acquire the additional land. Alberti's design, influenced in its basic approach by the Palazzo Medici, was a simple rectangular front suggesting a coherent, cubical three-story building capped with an overhanging cornice, the heavy, projecting horizontal molding at the top of the wall. The double windows under round arches were a feature of Michelozzo's Palazzo Medici, but other aspects of the façade were entirely new. Inspired by the ancient Colosseum in Rome, Alberti created systematic divisions on the surface of the lightly rusticated wall with a horizontal-vertical pattern of pilasters and architraves. He superimposed the classically inspired orders on three levels: a novel type of the Doric on the ground floor (the first time this order is employed in Renaissance architecture), a modified version of

the Corinthian on the second floor, and a standard Corinthian on the third. The **PALAZZO RUCELLAI** provided a visual lesson for local architects in the use of classical elements and mathematical proportions, and Alberti's enthusiasm for classicism and his architectural projects in other cities were catalysts for the spread of the Renaissance movement.

Sculpture

The new architectural language inspired by ancient classical form was accompanied by a similar impetus in sculpture. By 1400, Florence had enjoyed internal stability and economic prosperity for over two decades. However, until 1428, the city and its independence were challenged by two great antirepublican powers: the Duchy of Milan and the Kingdom of Naples. In an atmosphere of wealth and civic patriotism, Florentines turned to commissions that would express their self-esteem and magnify the importance of their city. A new attitude toward realism, space, and the classical past set the stage for more than a century of creativity.

In the early fifteenth century the two principal sculptural commissions in Florence included the new set of bronze doors for the Baptistry of Florence Cathedral and the exterior niche decorations of Orsanmichele. Individual commissions for the Orsanmichele sculptures were awarded to a number of different artists. The competitive and distinctive nature of the works produced reveals a great deal about the artistic climate of early Renaissance Florence.

ORSANMICHELE. In the fourteenth century, the city's fourteen most powerful guilds had been assigned the ground floor niches that decorated the exterior of Orsanmichele and were asked to fill them with images of their patron saints (SEE FIG. 17–1). By 1400, only three had fulfilled this responsibility. In the new climate of republicanism and civic pride, the government pressured the guilds to furnish their niches with statuary. The assignment, with some replacements, took almost a century to reach its conclusion. In the meantime, Florence witnessed a dazzling sculptural exposition. Among the most important examples were two early commissions given to the sculptors Nanni di Banco and Donatello.

Nanni di Banco (c. 1385–1421), son of a sculptor in the Florence Cathedral workshop, produced statues for three of Orsanmichele's niches in his short but brilliant career. **THE FOUR CROWNED MARTYRS** was commissioned about 1409 by the stone carvers' and woodworkers' guild, to which Nanni himself belonged (FIG. 19–9). These martyrs, according to tradition, were third-century Christian sculptors who were executed for refusing to make an image of a pagan Roman god. Although the architectural setting resembles a small-scale Gothic chapel, Nanni's figures—with their solid bodies; heavy, form-revealing togas; stylized hair and beards; and naturalistic features—reveal Nanni's interest in ancient Roman sculpture, particularly portraiture, and are testimony to his role in the

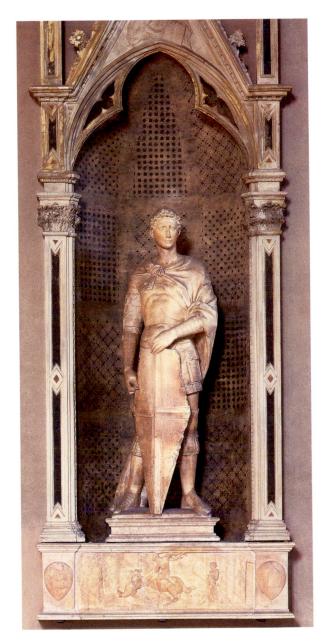

19–10 | Donatello SAINT GEORGE 1415–17. Marble, height 6'5" (1.95 m). Bargello, Florence. Formerly Orsanmichele, Florence.

revival of classicism. The saints convey a new spatial relationship to the building and to the viewer. They stand in a semicircle with forward feet and drapery protruding beyond the floor of the niche. The saints appear to be four individuals talking together, in an open arrangement that involves the passerby. Nanni's sense of a unified geometric composition is based on a circle completed in the space beyond the niche. In the relief panel below the niche, showing the four sculptors at work, Nanni has given the forms a similar solid vigor. He achieved this by deeply undercutting both figures and objects to cast shadows and enhance the illusion of three-dimensionality.

Another sculptor to receive guild commissions for the niches at Orsanmichele was Donatello (Donato di Niccolò di Betto Bardi, c. 1386/87–1466), the great genius of early Italian

Sequencing Events THE MEDICI OF FLORENCE

1360-1429	Giovanni di Bicci de' Medici founded family fortune
1389-1464	Cosimo de' Medici; later known as Pater Patriae ("Father of the Florentine state")
1416-69	Piero the Gouty
1449-92	Lorenzo the Magnificent
1471-1503	Piero the Unfortunate; driven out of Florence by Savonarola in 1494

Renaissance sculpture and one of the most influential figures of the century in Italy. A member of the guild of stone carvers and woodworkers, he worked in both mediums. During his long and productive career, he rethought and executed each commission as if it were a new experiment. Donatello took a remarkably pictorial approach to relief sculpture. He developed a technique for creating the impression of very deep space by improving on the ancient Roman technique of varying heights of relief—high relief for foreground figures and very low relief, sometimes approaching engraving, for the background.

Commissioned by one of Florence's lesser guilds—the armorers and sword makers—to carve their patron saint for their niche, Donatello created a marble figure of **SAINT GEORGE** (FIG. 19–10). As originally conceived, Saint George would have been a standing advertisement for the guild. The figure carried a sword in his right hand and probably wore a metal helmet, a sword belt, and a sheath. The figure is remarkably successful even without these accoutrements. Saint George holds his shield squarely in front of his braced legs; he seems alert and ready as he turns to meet any challenge, yet the expression on his face is tense and worried. His rather sensitive features and wrinkled brow contrast with the serene confidence of medieval knights or aggressive *condottieri* (SEE FIG. 19–1).

The base of the niche, where Saint George is seen slaying a dragon to save the princess, is a remarkable feat of low-relief carving. The contours of the foreground figures are slightly undercut to emphasize their mass, while the landscape and architecture are in progressively lower relief until they are barely incised rather than carved. The result is a spatial setting in relief sculpture as believable as any illusionistic painting.

GATES OF PARADISE. In 1401, a competition was announced in order to determine who would design bronze relief panels for a new set of doors for the east—and most important—side of the Baptistry of San Giovanni. These doors faced the main entrance to the cathedral, and the commission carried enormous prestige—and expense. The commission was awarded to Lorenzo Ghiberti (1381?–1455), a young artist trained as a goldsmith, at the very beginning of

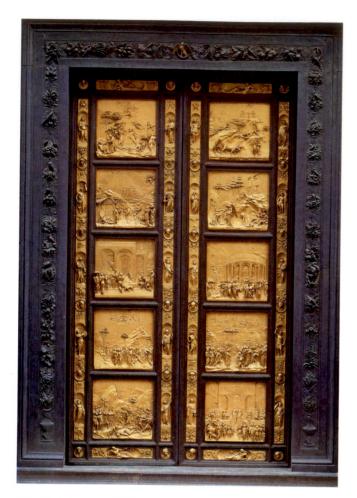

19–11 | Lorenzo Ghiberti GATES OF PARADISE (EAST DOORS), BAPTISTRY OF SAN GIOVANNI, FLORENCE 1425–52. Gilt bronze, height 15′ (4.57 m). Museo dell'Opera del Duomo, Florence.

Ghiberti, whose bust portrait appears at the lower right corner of Jacob and Esau, wrote in his *Commentaries* (c. 1450-55): "I strove to imitate nature as clearly as I could, and with all the perspective I could produce, to have excellent compositions with many figures."

his career. His rival was none other than Brunelleschi, who claimed the competition ended in a tie.

Ghiberti's doors were such a success that in 1425 he was awarded the commission for the third set of doors for the east side of the baptistry, and his first set was moved to the north side. The door panels, commissioned by the Wool Manufacturers' Guild, were a significant conceptual leap from the older schemes of twenty-eight small scenes employed for Ghiberti's earlier doors and those of Andrea Pisano in the fourteenth century (SEE FIG. 17-5). The chancellor of Florence expressed the desire for a magnificent and memorable work. Ghiberti responded to the challenge by departing entirely from the old arrangement: He produced a set of ten Old Testament scenes, from the Creation to the reign of Solomon. Michelangelo reportedly said that those doors, installed in 1452, were worthy of being the GATES OF PARADISE (FIG. 19-11). Overall gilding unites the ten large, square reliefs. Ghiberti organized the space either by a system

of linear perspective, with obvious orthogonal lines approximating the system described by Alberti in his 1435 treatise on painting (see "Brunelleschi, Alberti, and Renaissance Perspective," page 622) or sometimes more intuitively by a series of arches or rocks or trees leading the eye into the distance. Foreground figures are grouped in the lower third of the panel, while the other figures decrease gradually in size, suggesting deep space. The use of a system of perspective, with background and foreground clearly marked, also helped the artist to combine a series of related events within only one frame. In some panels, the tall buildings suggest ancient Roman architecture and illustrate the emerging antiquarian tone in Renaissance art.

The story of Jacob and Esau (Genesis 25 and 27) forms the relief in the center panel of the left door. Ghiberti creates a coherent and measurable space peopled by graceful, idealized figures (FIG. 19-12). He unifies the composition by paying careful attention to one-point perspective in the architectural setting. Squares marked out in the pavement establish the lines of the orthogonals that recede to a central vanishing point under the loggia, and towering arches supported on piers with Corinthian pilasters define the space above the figures. The story from Genesis unfolds in a series of individual episodes and begins in the background. On the rooftop (upper right) Rebecca stands, listening to God, who warns of her unborn sons' future conflict; under the left-hand arch she gives birth to the twins. The adult Esau sells his rights as oldest son to Jacob, and when he goes hunting (center right), Rebecca and Jacob plot against him. Finally, in the

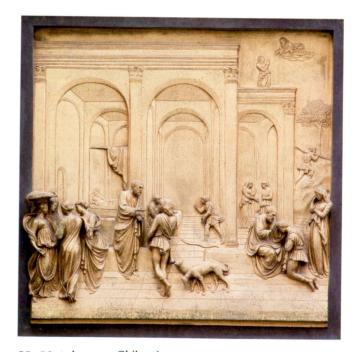

19–12 | Lorenzo Ghiberti JACOB AND ESAU, PANEL OF THE GATES OF PARADISE (EAST DOORS)
Formerly on the Baptistry of San Giovanni, Florence. c. 1435. Gilded bronze, 31¼" (79 cm) square. Museo dell'Opera del Duomo, Florence.

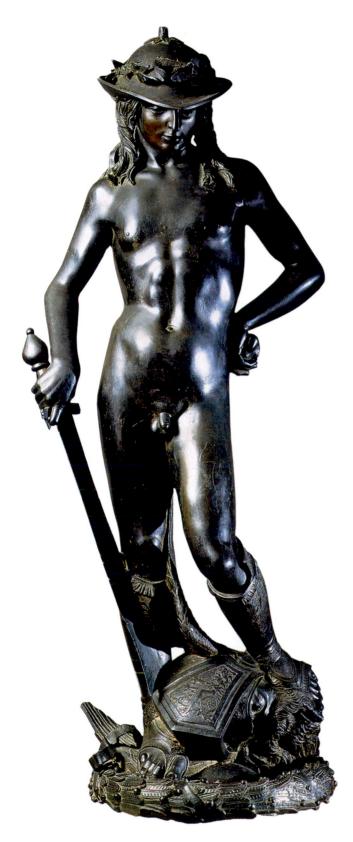

19–13 | Donatello DAVID c. 1446–60(?). Bronze, height 5′ 2½″ (1.58 m). Museo Nazionale del Bargello, Florence.

While still in the Medici courtyard, the base was inscribed:

"The victor is whoever defends the fatherland. All-powerful God crushes the angry enemy. Behold, a boy overcomes the great tyrant. Conquer, O citizens!"

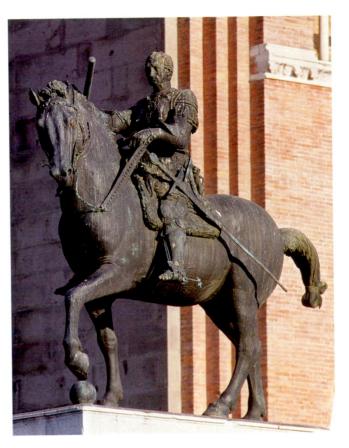

19–14 | Donatello EQUESTRIAN MONUMENT OF ERASMO DA NARNI (GATTAMELATA)
Piazza del Santo, Padua. 1443–53. Bronze, height approx. 12'2" (3.71 m).

right foreground, Jacob receives Isaac's blessing, while in the center, Esau faces his father.

In the Renaissance interpretation, Esau symbolized the Jews and Jacob the Christians. The story explains conflict between the two religions and compositionally balances the panel on the opposite door valve. The vanishing point lies between the two panels. Therefore Jacob, who occupies the right foreground, is near the center of interest for the doors as a whole. Esau and his faithful hound complete the beautiful curve of figures that begins with the trio of women at the far left and shows Ghiberti's debt to the International Gothic. In the spirit of Renaissance individuality, Ghiberti not only signed his work, but also included his self-portrait in the medallion beside the lower right-hand corner of the panel.

DONATELLO: NEW EXPRESSIVENESS. Donatello excelled for three reasons: his constant exploration of human emotions and expressions; his vision and insight in representing the formal problems inherent in his subjects; and his ability to solve the technical problems posed by various mediums, from bronze and marble to polychromed wood. In bronze sculpture, he produced the first life-size male nude, DAVID (FIG. 19–13); one of the first life-size bronze equestrian portraits, GATTAMELLATA (FIG. 19–14); and the first statuettes since antiquity.

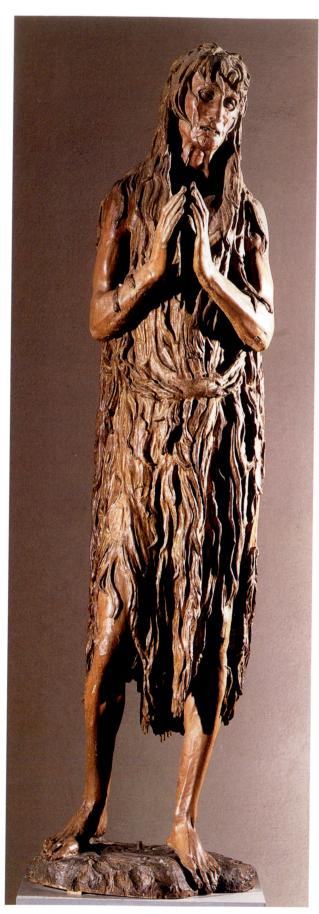

19–15 | Donatello MARY MAGDALEN
1450s(?). Polychromy and gold on wood, height 6'1"
(1.85 m). Museo dell'Opera del Duomo, Florence.

Since nothing is known about the circumstances of its creation, the sculpture of the David has been the subject of continuous inquiry and speculation. Although the statue clearly draws on the classical tradition of heroic nudity, this sensuous, adolescent boy in a jaunty laurel-trimmed shepherd's hat and boots has long piqued interest in its meaning. In one interpretation, the boy's angular pose, his underdeveloped torso, and the sensation of his wavering between childish interests and adult responsibility heighten his heroism in taking on the giant and destroying him. With Goliath's severed head now under his feet, David seems to have lost interest in warfare and now seems to be retreating into his dreams. The sculpture is first recorded in 1469 in the courtyard of the Medici palace, where it stood on a base engraved with an inscription extolling Florentine heroism and virtue. This inscription supports the suggestion that the sculpture celebrated the triumph of the Florentines over the Milanese in 1425. A peace treaty was signed in 1428. It ended the struggle with the despots of Milan, which had endured for over a quarter of a century, and helped give Florence a vision of itself as a strong, virtuous republic.

In 1443, Donatello was probably called to Padua to execute the equestrian statue commemorating the Paduan general of the Venetian army, Erasmo da Narni, nicknamed "Gattamelata" (meaning "Honeyed Cat"—a reference to his mother, Melania Gattelli). If one image were to characterize the selfmade men of the Italian Renaissance, surely the most appropriate examples would be the *condottieri*—the brilliant generals (such as Tolentino, from Uccello's *Battle of San Romano*) who organized the armies and fought for any city-state willing to pay. The very word *chivalry* with all its connotations of honor, courage, and courtesy comes from the French word for "horse"—*cheval*. Italian Renaissance *condottieri* may have seen themselves as chivalric, as guardians of the state, although they were in fact tough, opportunistic mercenaries. But they, too, subscribed to an ideal of military and civic virtue.

Donatello's sources for this statue were two surviving Roman bronze equestrian portraits, one (now lost) in the north Italian city of Pavia, the other of the emperor Marcus Aurelius, which the sculptor certainly saw and probably sketched during his stay in Rome. Equestrian monuments of ancient Roman emperors demonstrated their virtues of bravery, nobility, and authority. Horsemanship was more than a necessary skill before the age of automobiles: It had symbolic meanings. The horse, a beast of enormous brute strength, symbolized the passions and man's physical animal nature. Consequently, skilled horsemanship demonstrated physical and intellectual control—self-control, as well as control of the animal—the triumph of the intellect, of "mind over matter."

Viewed from a distance, Donatello's man-animal juggernaut, installed on a high marble base in front of the Church of Sant'Antonio in Padua, seems capable of thrusting forward at the first threat. Seen up close, however, the man's sunken cheeks, sagging jaw, ropy neck, and stern but sad expression suggest a warrior grown old and tired from the constant need for military vigilance and rapid response.

During the decade that he remained in Padua, Donatello executed other commissions for the Church of Sant'Antonio, including a bronze crucifix and reliefs for the high altar and pulpits. His presence in the city introduced Renaissance ideas to northeastern Italy and gave rise to a new Paduan school of painting and sculpture. The expressionism of Donatello's late work inspired some artists to add psychological intensity even in public monuments. His MARY MAGDALEN, traditionally dated about 1455 (although it may have been executed before his stay in Padua), shows the saint, known for her physical beauty, as an emaciated, vacant-eyed hermit clothed by her own hair (FIG. 19-15). Few can look at this figure without a wrenching reaction to the physical deterioration caused by age and years of self-denial. Nothing is left for her but an ecstatic vision of the hereafter, and yet that is everything. Despite Donatello's total rejection of the classical ideal form in this figure, the powerful force of the Magdalen's personality makes this a masterpiece of Renaissance imagery.

Verrocchio's Condottiere. In the early 1480s, the Florentine painter and sculptor Andrea del Verrocchio (1435–88) was commissioned by the government to produce an equestrian monument honoring the Venetian army general Bartolommeo Colleoni (d. 1475), who left money for a memorial to himself (FIG. 19–16). In contrast to the thoughtful and even tragic over-

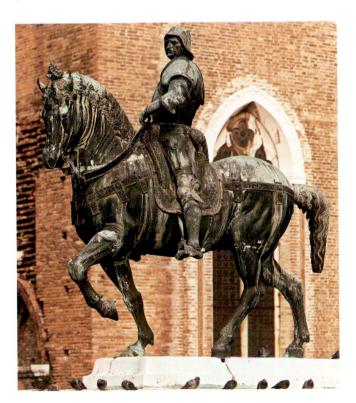

19−16 | Andrea del Verrocchio EQUESTRIAN MONUMENT OF BARTOLOMMEO COLLEONI, CAMPO SANTI GIOVANNI E PAOLO, VENICE

Clay model 1486-88; cast after 1490; placed 1496. Bronze, height approx. 13' (4 m). Bronze cast by Alessandro Leopardi.

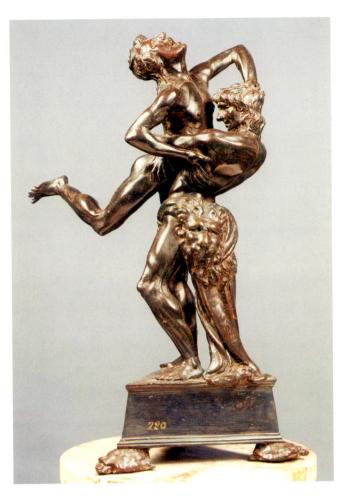

19–17 | Antonio del Pollaiuolo HERCULES AND ANTAEUS c. 1475. Bronze, height with base 18" (45.7 cm). Museo Nazionale del Bargello, Florence.

tones communicated by Donatello's *Gattamelata*, the impression conveyed by the tense forms of Verrocchio's equestrian monument is one of vitality and brutal energy. The general's ferocious determination is expressed in his clenched jaw and staring eyes. The taut muscles of the horse, the fiercely erect posture of the rider, and the complex interaction of the two make this image of will and domination a singularly compelling monument. It still presides over the square of Santi Giovanni e Paolo in Venice.

Poliaiuolo. Sculptors in the fifteenth century worked not only on a monumental scale for the public sphere; they also created small works, each designed to inspire the mind and delight the eye of its private owner (see "Ceramics," page 634). The enthusiasm of European collectors in the latter part of the fifteenth century for small, easily transported bronzes contributed to the spread of classical taste. Antonio del Pollaiuolo, ambitious and multitalented—a goldsmith, embroiderer, printmaker, sculptor, and painter—came to work for the Medici family in Florence about 1460. His sculptures were mostly small bronzes; his HERCULES AND ANTAEUS of about 1475 is one of the largest (FIG. 19–17). This study of complex interlocking figures has an explosive energy that can best be appreciated by viewing it from every angle.

Technique CERAMICS

talian sculptors did not limit themselves to the traditional materials of wood, stone and marble, and bronze. They also returned to **terra cotta**, a clay medium whose popularity in Italy went back to Etruscan and ancient Roman times. Techniques of working with and firing clay had been kept alive by the ceramics industry and by a few sculptors, especially in northern Italy.

Typical of Renaissance ceramics in shape and decoration is the *albarello*, a jar designed especially for pharmacies: The tall concave shape made it easy to remove from a line of jars on pharmacy shelves, and the lip at the rim helped secure the cord that tied a parchment cover over the mouth. Sometimes the name of the owner or the contents of the jar were inscribed on a band around the center (the jar shown held syrup of lemon). The jars were glazed white and decorated in deep, rich colored enamel—orange, blue, green, and purple. The technique for making this lustrous, tin-glazed earthenware had been developed by Islamic potters and then by Christian potters in Spain. It spread to Italy from the Spanish island of Mallorca—known in Italian as Maiorca, which gave rise to the term *maiolica* to describe such wares. The painted decoration of broad scrolling leaves seen here is characteristic of the fifteenth century.

Ceramics were also used to supply the ever-increasing demand for architectural sculpture. Luca della Robbia (1399/1400-1482), although an accomplished sculptor in marble, began to experiment in 1441-42 with tin glazing to make his ceramic sculpture both weatherproof and decorative. As his inexpensive and rapidly produced sculpture gained an immediate popularity, he added color to the traditional white glaze. His

workshop even made molds so that a particularly popular work could be replicated many times. The elegant and lyrical della Robbia style was continued by Luca's nephew Andrea and his children long after Luca's death (see "The Foundling Hospital," page 626).

ALBARELLO
Cylindrical pharmacy jar,
from Faenza. c. 1480. Glazed
ceramic, height 12%"
(31.5 cm). Getty Museum,
Los Angeles.
Getty .84.DE.104

Statuettes of religious subjects were still popular, but humanist art patrons began to collect bronzes of Greek and Roman subjects. Many sculptors, especially those trained as goldsmiths, began to cast small copies after well-known classical works. Some artists also executed original designs all'antica ("in the antique style"). Although there were outright forgeries of antiquities at this time, works in the antique manner were intended simply to appeal to a cultivated humanist taste. Hercules was always a popular figure, as a patron of Florence. He was even used on the city seal. Among the many courageous acts by which Hercules gained immortality was the slaying of the evil Antaeus in a wrestling match by lifting him off the earth, the source of the giant's great physical power. Hercules had been attacked by Antaeus, the son of the earth goddess Ge (or Gaia), on his search for a garden that produced pure gold apples.

An engraving by Pollaiuolo, **THE BATTLE OF THE NUDES** (FIG. 19–18), reflects the interests of Renaissance scholars—the study of classical sculpture and the anatomical research

that leads to greater realism—as well as the artist's technical skill in fine work on a metal plate. Pollaiuolo may have intended this, his only known—but highly influential—print, as a study in composition involving the human figure in action. The naked men, fighting each other ferociously against a tapestry-like background of foliage, seem to have been drawn from a single model in a variety of poses, many of which were taken from classical sources. Like the artist's *Hercules and Antaeus*, much of the engraving's fascination lies in how it depicts muscles of the male body reacting under tension.

Painting

Italian patrons generally commissioned murals and large altarpieces for their local churches and smaller panel paintings for their private chapels. Artists experienced in fresco, mural painting on wet plaster, were in great demand and traveled widely to execute wall and ceiling decorations. At first the Italians showed little interest in oil painting, for the most part

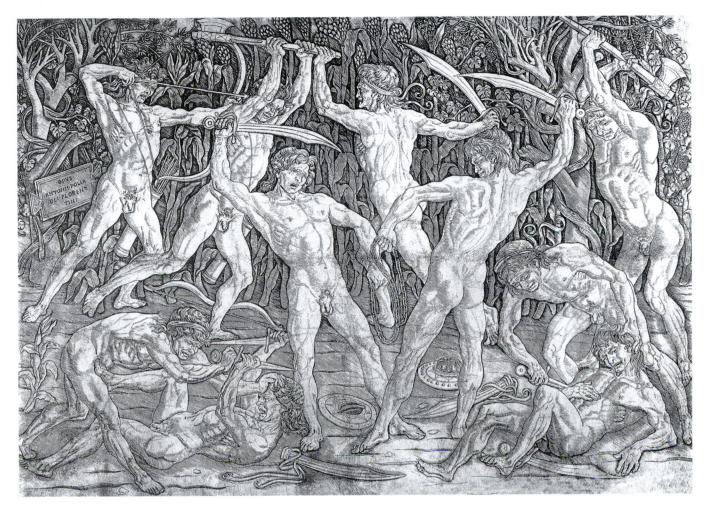

19–18 | Antonio del Pollaiuolo BATTLE OF THE NUDES c. 1465–70. Engraving, $15\% \times 23\%$ (38.3 \times 59 cm). Cincinnati Art Museum, Ohio. Bequest of Herbert Greer French. 1943.118

using tempera even for their largest works. But, in the last decades of the century, Venetians began to use the oil medium for major panel paintings.

MASACCIO. The most innovative of the early Italian Renaissance painters was Tommaso di Ser Giovanni di Mone Cassai (1401–28/29?), nicknamed "Masaccio." In his short career of less than a decade, he established a new direction in Florentine painting, much as Giotto had a century earlier. Masaccio rejected the International Gothic style in favor of monumental forms that occupy rationally defined and unified space. Masaccio's interest in one-point perspective, the new architectural style, and classical sculpture allies him, especially, with his older contemporary Brunelleschi. Masaccio's fresco of the Trinity in the Church of Santa Maria Novella in Florence must have been painted around 1426, the date on the Lenzi family tombstone that was once in front of the fresco (FIG. 19–19). The TRINITY was meant to give the illusion of a stone funerary monument and altar table set below

a deep *aedicula* (framed niche) in the wall. The praying donors in front of the pilasters may be members of the Lenzi family. The red robes of the male donor at the left signify that he was a member of the governing council of Florence.

Masaccio created the unusual *trompe l'oeil* ("fool-the-eye") effect of looking up into a barrel-vaulted niche, made plausible through precisely rendered linear perspective. The eye and level of an adult viewer determined the horizon line on which the vanishing point was centered, just above the base of the cross. The painting demonstrates Masaccio's intimate knowledge of both Brunelleschi's perspective experiments and his architectural style (SEE FIG. 19–5). The painted architecture is an unusual combination of classical orders; on the wall surface, Corinthian pilasters support a plain architrave below a cornice, while inside the niche Renaissance variations on Ionic columns support arches on all four sides. The Trinity is represented by Jesus on the cross, the dove of the Holy Spirit poised in downward flight above his tilted halo, and God the Father, who stands behind the cross on a

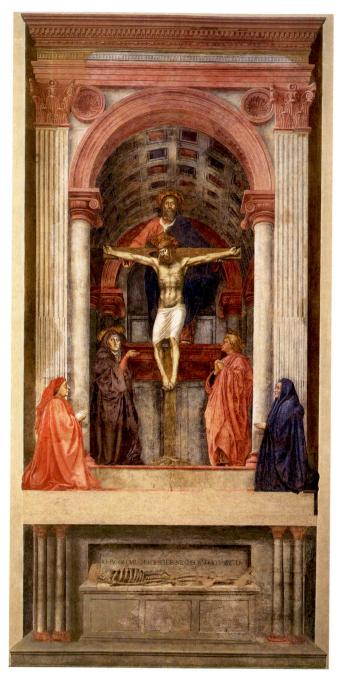

19–19 | Masaccio TRINITY WITH THE VIRGIN, SAINT JOHN THE EVANGELIST, AND DONORS Church of Santa Maria Novella, Florence. c. 1425-27/28. Fresco $21' \times 10'5''$ $(6.4 \times 3.2 \text{ m})$.

high platform apparently supported on the rear columns. The "source" of the consistent illumination modeling the figures with light and shadow lies in front of the picture, casting reflections on the **coffers**, or sunken panels, of the ceiling. As in many scenes of the Crucifixion, Jesus is flanked by the Virgin Mary and John the Evangelist, who contemplate the scene. Mary gazes calmly out at us, her raised hand presenting

the Trinity. Below, in an open sarcophagus, is a skeleton, a grim reminder that death awaits us all and that our only hope is redemption and life in the hereafter through Christian belief. The skeleton represents Adam, on whose tomb the cross was thought to have been set. The inscription above the skeleton reads: "I was once that which you are, and what I am you also will be."

THE BRANCACCI CHAPEL. Masaccio's brief career reached its height in his collaboration with another painter, Masolino (1383–c. 1440), on the fresco decoration of the BRANCACCI CHAPEL in the Church of Santa Maria del Carmine in Florence (FIG. 19–20). The project was ill-fated, however: The painters never finished their work—Masolino traveled to Hungary in 1425–27, and the two painters went to Rome in 1428. Masaccio died in Rome in 1428 or 1429. Felice Brancacci, the patron, was exiled in 1435. Eventually, another Florentine painter, Filippino Lippi, finished painting the chapel in the 1480s. The chapel was dedicated to Saint Peter, and the frescoes illustrate events in his life.

Masaccio combined a study of the human figure with an intimate knowledge of ancient Roman sculpture. In THE EXPULSION FROM PARADISE, he presented Adam and Eve as monumental nude figures (FIG. 19-21). In contrast to Flemish painters, who sought to record every visible hair or scratch (compare Adam and Eve from the Ghent Altarpiece, FIG. 18-11), Masaccio focused on the mass of bodies formed by the underlying bone and muscle structure to create a new realism. He used a generalized light shining on the figures from a single source and further emphasized their tangibility with cast shadows. Ignoring earlier interpretations of the event that emphasized wrongdoing and the fall from grace, Masaccio was concerned with the psychology of individual humans who have been cast mourning and protesting out of Paradise, and he captured the essence of humanity thrown naked into the world.

Adam and Eve lead to THE TRIBUTE MONEY (FIG. 19-22). The painting was done in thirty-one working days. Completed about 1427, it was rendered in a continuous narrative of three scenes within one setting (a medieval compositional technique). The painting illustrates an incident in which a collector of the Jewish temple taxes (the "tribute money") demands payment from Peter, shown in the central group with Jesus and the other disciples (Matt. 17:24-27). Saying "Render unto Caesar that which is Caesar's," Jesus instructs Peter to "go to the sea, drop in a hook, and take the first fish that comes up," which Peter does at the far left. In the fish's mouth is a coin worth twice the tax demanded, which Peter gives to the tax collector at the far right. The tribute story was especially significant for Florentines because in 1427, to raise money for defense against military aggression, the city enacted a graduated tax, based on the value of one's personal property.

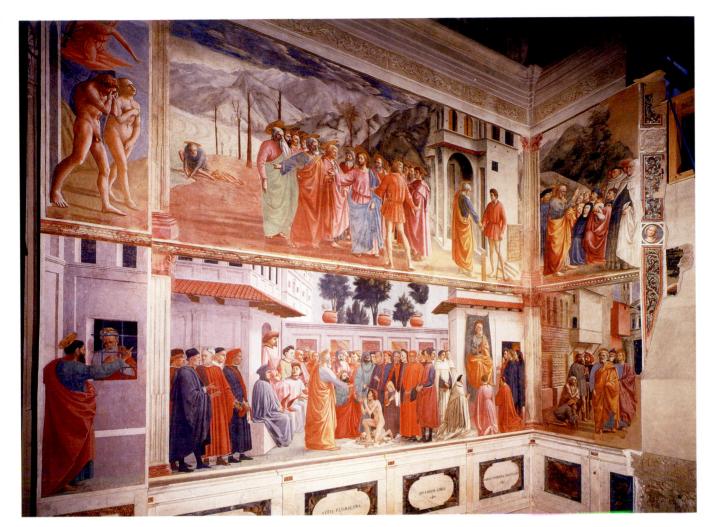

19–20 | INTERIOR OF THE BRANCACCI CHAPEL, CHURCH OF SANTA MARIA DEL CARMINE, FLORENCE Frescoes by Masaccio and Masolino (1426–27) and Filippino Lippi (lower register) (c. 1482–84).

The Tribute Money is remarkable for its integration of figures, architecture, and landscape into a consistent scene. The group of Jesus and his disciples forms a clear central focus, from which the landscape seems to recede naturally into the far distance. To create this illusion, Masaccio used linear perspective in the depiction of the house and then reinforced it by diminishing the sizes of the trees and reducing Peter's size at the left. At the vanishing point established by the lines of the house is the head of Jesus. A second vanishing point determines the steps and stone rail at the right. Masaccio used atmospheric perspective as well as linear perspective in the distant landscape, where mountains fade from grayish green to grayish white and the houses and trees on their slopes are loosely sketched. Green leaves were painted on the branches al secco (meaning "on the dry plastered wall"; see Chapter 17, "Buon Fresco," page 569).

Masaccio modeled the foreground figures with strong highlights and cast their long shadows on the ground toward

the left, implying a light source at the far right, as if the scene were lit by the actual window in the rear wall of the Brancacci Chapel. Not only does the lighting give the forms sculptural definition, but the colors vary in tone according to the strength of the illumination. Masaccio used a wide range of hues-pale pink, mauve, gold, blue green, apple green, peach—and a sophisticated color technique in which Andrew's green robe is shaded with red instead of darker green. All of the figures in The Tribute Money, except those of the temple tax collector, originally had gold-leaf halos, several of which had flaked off before the painting underwent restoration (1982-90). Rather than silhouette the heads against flat gold circles in the medieval manner, Masaccio conceived of the halo as a gold disk hovering in space above each head, and he subjected it to perspective foreshorteningshortening the lines of forms seen head-on to align them with the overall perspectival system—depending on the position of the figure.

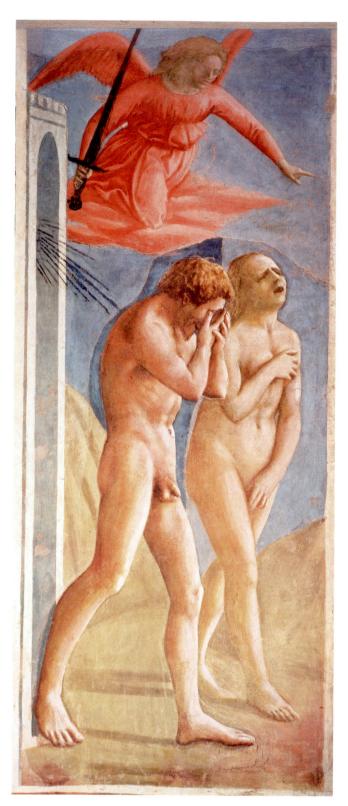

19–21 | Masaccio THE EXPULSION FROM PARADISE Brancacci Chapel. ϵ . 1427. Fresco, $7' \times 2'$ 11" (214 \times 90 cm).

Cleaning and restoration of the Brancacci Chapel paintings revealed the remarkable speed and skill with which Masaccio worked. He painted Adam and Eve in four *giornate* (each *giornata* of fresh plaster representing a day's work). Working from the top down and left to right, he painted the angel on the first day; on the second day, only the portal; the magnificent figure of Adam on the third day; and Eve on the fourth day.

Stylistic innovations take time to be fully accepted, and Masaccio's genius for depicting weight and volume, consistent lighting, and spatial integration was best appreciated by a later generation. Many important sixteenth-century Italian artists, including Michelangelo, studied and sketched from Masaccio's Brancacci Chapel frescoes. In the meantime, painting in Florence after Masaccio's death developed along lines somewhat different from that of *The Tribute Money* or *Trinity*, as other artists such as Paolo Uccello experimented in their own ways of conveying the illusion of a believably receding space (SEE FIG. 19–1).

Mural Painting in Florence After Masaccio

The tradition of covering walls with paintings in fresco continued through the fifteenth century. Walls of churches and chapels provided space for painters to combine Christian themes with local incidents and realistic portraits. Between 1438 and 1445, the decoration of the Dominican Monastery of San Marco in Florence, where Fra Angelico lived, was one of the most extensive projects.

FRA ANGELICO. Guido di Piero da Mugello (c. 1395/1400–55), known as Fra Giovanni da Fiesole, earned the designation "Fra Angelico" ("Angelic Brother") through his piety as well as his painting. He was beatified, the first step toward sainthood, in 1984. He is first documented as a painter in Florence in 1417–18, and he continued to be a very active painter after taking his vows as a Dominican monk (see "The Mendicant Orders," page 524).

Between 1438 and 1445, in the Monastery of San Marco, Fra Angelico and his assistants created a painting to inspire meditation in each monk's cell (forty-four in all), and they also added paintings to the chapter house (meeting room) and the corridors. The paintings were probably commissioned by Cosimo de' Medici. At the top of the stairs in the north corridor Fra Angelico painted the scene of the annunciation (FIG. 19-23). Here the monks were to pause for prayer before going to their individual cells. The illusion of space created by the careful linear perspective seems to extend the stair and corridor out into a second cloister, the Virgin's home and verdant enclosed garden, where the angel Gabriel greets the modest, youthful Mary. The slender, graceful figures wearing flowing draperies assume modest poses. The natural light falling from the left models their forms and casts an almost supernatural radiance over their faces and hands. The scene is a vision that welcomes the monks to the most private areas of the monastery and prepares them for their meditations.

CASTAGNO. Another notable Florentine fresco, THE LAST SUPPER, is the work of Andrea del Castagno (c. 1417/19–57), painted for a convent of Benedictine nuns in 1447 (FIG. 19–24). The Last Supper was often painted in monastic refectories (dining halls) to remind the monks or nuns of

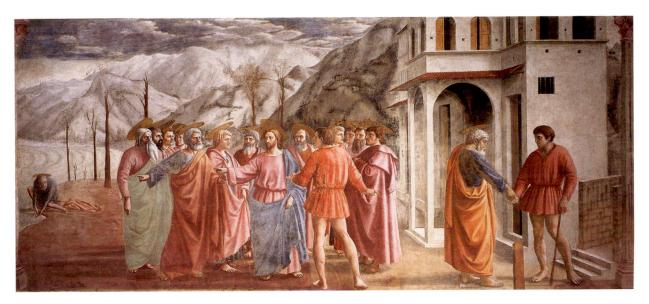

19–22 | Masaccio **THE TRIBUTE MONEY** Brancacci Chapel. c. 1427. Fresco, $8'1'' \times 19'7''$ (1.87 \times 1.57 m).

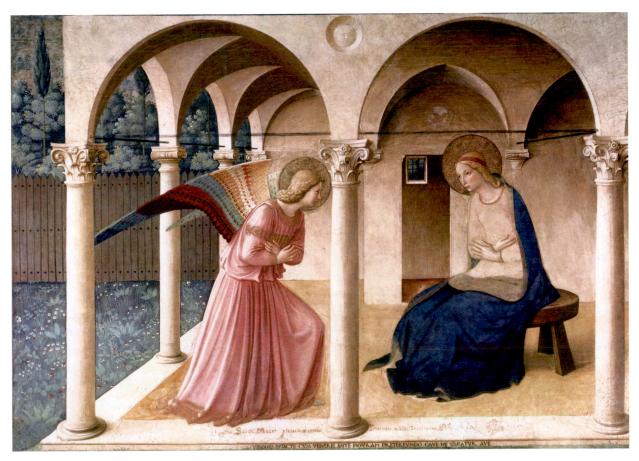

19–23 | Fra Angelico annunciation north corridor, monastery of san marco, florence c. 1438–45. Fresco, $7'\%'' \times 19'6''$ (230 \times 297 m).

The shadowed vault of the portico is supported by a wall on one side and by slender lonic and Corinthian columns on the other, a new building technique being used by Brunelleschi in the very years when the painting was being created.

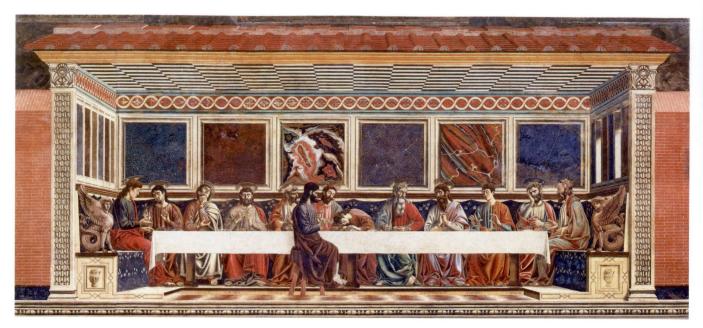

19–24 Andrea del Castagno **THE LAST SUPPER** Refectory, Convent of Sant'Apollonia, Florence. 1447. Fresco, width approx. $16 \times 32'$ (4.6 \times 9.8 m).

Christ's sacrifice and of the bread and wine as his Body and Blood. Here the scene takes place in the "upper room"—the biblical setting—but the humble house described in the Bible has become a great palace with sumptuous marble panels. A brilliantly colored and wildly patterned marble panel frames the heads of Christ and Judas. Judas is separated from the apostles and sits on the viewer's side of the table. Saint John sleeps, head on the table. The strong perspective lines of floor tiles, ceiling rafters, and paneled walls draw the viewer into the scene. The religious would have seen the painting as an extension of their hall. At first, the lines of the orthogonals seem to follow Alberti's perfect logic, but close examination reveals that only the lines of the ceiling converge, below the hands of Saint John; consequently, an uneasy situation is established, and we do not know why. Two windows light the room from the direction of the actual windows, further unifying the painted and actual spaces, and Castagno paints his figures in solid sculptured fashion with clear outlines and strong highlights. He worked quickly, completing the huge mural in at most thirty-two days.

ITALIAN ART IN THE SECOND HALF OF THE FIFTEENTH CENTURY

In the second half of the fifteenth century, the ideas and ideals of artists like Brunelleschi, Donatello, and Masaccio began to spread from Florence to the rest of Italy, combining with local styles. Artists who trained or worked in Florence then traveled to other cities to work, either temporarily or perma-

nently, carrying the style with them. Northern Italy embraced the new classical ideas swiftly, with the ducal courts at Mantua and Urbino taking the lead. The Republic of Venice and the city of Padua, which Venice had controlled since 1405, also emerged as innovative art centers in the last quarter of the century.

Urbino

East of Florence lay another outstanding cultural center, Urbino, where Count (later, in 1474, Duke) Federico da Montefeltro attracted writers, philosophers, and the finest artists of the day to his court. The palace at Urbino would have made a glorious backdrop for the courtly pageantry. The Renaissance book of manners, *The Book of the Courtier*, by Baldassare Castiglione, was written there.

THE PALACE AT URBINO. Construction of Federico's palace had begun about 1450, and in 1468 Federico hired Luciano Laurana (c. 1420/25–1479), who had been an assistant on the project, to direct the work. Among Laurana's major contributions to the palace were closing the courtyard with a fourth wing and redesigning the courtyard façades (FIG. 19–25). The result is a superbly rational solution to the problems of courtyard elevation design, particularly the awkward juncture of the arcades at the four corners. The ground-level portico on each side has arches supported by columns; the corner angles are bridged with piers having engaged columns on the arcade sides and pilasters facing the courtyard. This arrangement avoided the awkward visual effect of two arches springing

from a single column and gave the corner a greater sense of stability. A variation of the composite capital (a Corinthian capital with added Ionic volutes) was used, perhaps for the first time, on the ground level. Corinthian pilasters flank the windows in the story above, forming divisions that repeat the bays of the portico. (The two short upper stories were added later.) The plain architrave was engraved with inscriptions lauding Federico's many virtues. Not visible in the photograph is an exceptionally magnificent monumental staircase leading from the courtyard to the main floor.

The interior of the Urbino palace likewise reflected its patron's embrace of new Renaissance ideas and interest in classical antiquity, seen in carved marble fireplaces and window and door surrounds. In creating luxurious home furnishings and interior decorations for educated clients such as Federico, Italian craft artists found freedom to experiment with new subjects, treatments, and techniques. Among these was the creation of *trompe l'oeil* effects, which had become more convincing with the development of linear perspective. *Trompe l'oeil*, commonly used in painting, was carried to its

ultimate expression in **intarsia** (wood inlay) decoration, exemplified by the walls of Federico da Montefeltro's "**STUDIOLO**," or study, a room for private conversation and the collection of fine books and art objects (FIG. 19–26). The work was probably done by the architect and woodworker Giuliano da Maiano (1432–90) and carries a date of 1476.

The elaborate scenes in the small room are created entirely of wood inlaid on flat surfaces with scrupulously applied linear perspective and foreshortening. Each detail is rendered in *trompe l'oeil*: the illusionistic pilasters, carved cupboards with latticed doors, niches with statues, paintings, and built-in tables. Prominent in the decorative scheme is the prudent and industrious squirrel, a Renaissance symbol of the ideal ruler: in other words, of Federico da Montefeltro. A large window looks out onto an elegant marble loggia with a distant view of the countryside through its arches; and the shelves, cupboards, and tables are filled with all manner of fascinating things—scientific instruments, books, even the Duke's armor hanging like a suit in a closet. On the walls above were paintings of great scholars (whose books Federico

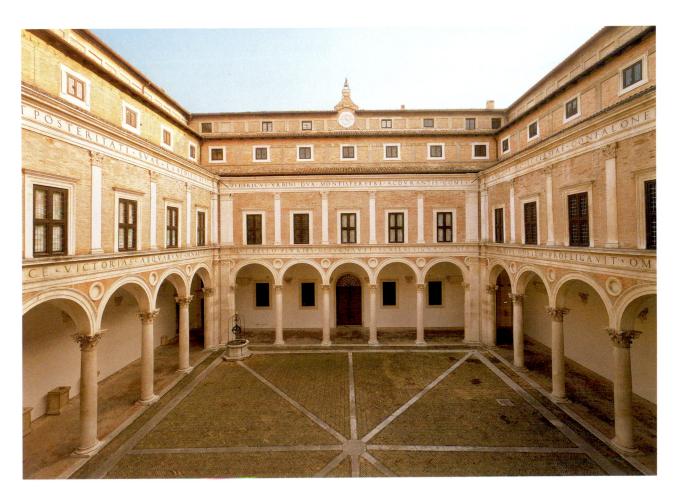

19–25 | Luciano Laurana COURTYARD, DUCAL PALACE, URBINO Italy. Courtyard c. 1467–72; palace begun c. 1450.

The inscription extolling Federico's virtues—Justice, Clemency, Liberality, and Religion—was added in 1476 when he was made Duke of Urbino.

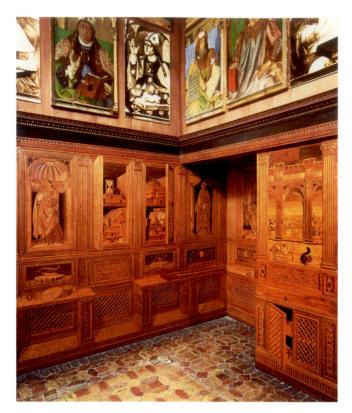

19–26 $\,\mid\,$ studiolo of federico da montefeltro, ducal palace, urbino

1476. Intarsia, height 7'3'' (2.21 m). Woodwork probably by Giuliano da Maiano (1432-90).

owned) by Pedro Berruguete from Spain and Justus of Ghent from Flanders.

In 1472 Federico's wife Battista died, shortly after the birth of her ninth child, a son who would inherit the duchy. She was only 26, and Federico was disconsolate. Leaving the palace unfinished, he turned to building a funeral chapel, the church of San Bernardino, on a neighboring hilltop. The church can be seen in the background of Raphael's *Madonna and Child* (FIG. 20–5).

PIERO DELLA FRANCESCA. One artist Federico brought to Urbino was Piero della Francesca (c. 1415–92). Piero had worked in Florence in the 1430s before settling down in his native Borgo Sansepulcro, a Tuscan hill town under papal control. He knew current thinking in art and art theory—including Brunelleschi's system of spatial illusion and linear perspective, Masaccio's powerful modeling of forms and atmospheric perspective, and Alberti's theoretical treatises. Piero was one of the few practicing artists who also wrote about his own theories. Not surprisingly, in his treatise on perspective he emphasized the geometry and the volumetric construction of forms and spaces that were so apparent in his own work. He traveled widely—to Rome, to the Este court in Ferrara, and especially to Urbino.

From about 1454 to 1458, Piero was in Arezzo, where he decorated the Bacci Chapel of the Church of San Francesco

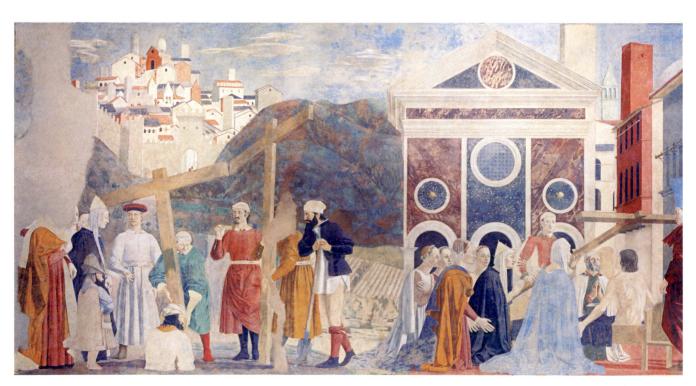

19–27 | Piero della Francesca RECOGNITION AND PROVING OF THE TRUE CROSS San Francesco, Arezzo. 1450s. Fresco, $11'8'' \times 24'6'' (3.56 \times 7.47 \text{ m})$.

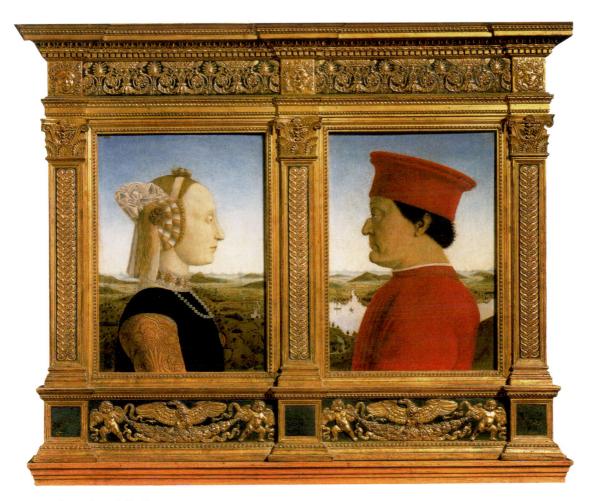

19–28 | Piero della Francesca BATTISTA SFORZA AND FEDERICO DA MONTEFELTRO c. 1474. Oil on wood panel, each $18\frac{1}{2}\times13^{\prime\prime}$ (47 \times 33 cm). Galleria degli Uffizi, Florence.

with a cycle of frescoes illustrating the legend of the True Cross, the cross on which Jesus was crucified. The Cross was buried after the Crucifixion, but Helena (the mother of Constantine, who was believed to be the first Christian Roman emperor) discovered and proved the authenticity of the cross when its touch brings to life a man being carried to his tomb.

In the RECOGNITION AND PROVING OF THE TRUE CROSS, (FIG. 19–27), Piero's analytical modeling and perspectival projection result in a highly believable illusion of space around his monumental figures. He reduced his figures to cylindrical and ovoid shapes and established a geometric patterned setting in marble veneered buildings. The building that forms a background is a brilliant example of the ideal Renaissance façade as designed by Alberti. Few such façades were ever finished. Particularly remarkable are the foreshortening of figures and objects such as the cross at the right and the anatomical accuracy of the revived youth's nude figure. Unlike many of his contemporaries, however, Piero gave his figures no expression of human emotion. They observe the miracle with an indifference born of complete confidence.

In about 1474 Piero painted the portraits of Federico and his recently deceased wife, Battista Sforza (FIG. 19–28). The

small panels, painted in tempera in light colors, resemble Flemish painting in their detail and luminosity, their record of surfaces and textures, and their vast landscapes. In the traditional Italian fashion, the figures are portrayed in strict profile, as remote psychologically from the viewer as icons. The profile format also allowed for an accurate recording of Federico's likeness without emphasizing two disfiguring scars—the loss of his right eye from a sword blow and his broken nose. His good left eye is shown, and the angular profile of his nose seems like a distinctive family trait. Typically, Piero emphasized the underlying geometry of the forms. Dressed in the most elegant fashion (Federico wears his red ducal robe), Battista and Federico are silhouetted against a distant view recalling the hilly landscape around Urbino. The influence of Flemish art (which Piero would have known from Flemish and Spanish painters working with him in Urbino) is also strong in the careful record of Battista's jewels and in the well-observed atmospheric perspective, making the landscape as subtle and luminous as any Flemish panel or manuscript. Piero used another northern European device in the harbor view near the center of Federico's panel: The water narrows into a river that leads the eye into the distant landscape.

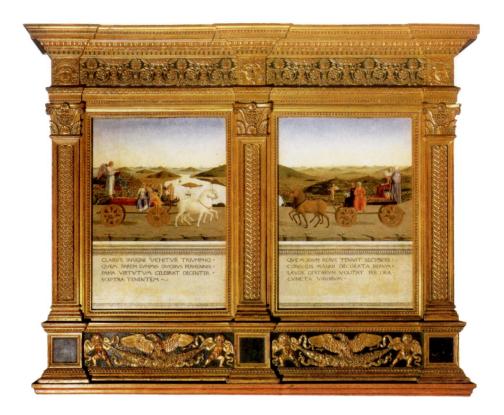

19–29 | Piero della Francesca TRIUMPH OF FEDERICO AND BATTISTA Reverse of FIGURE 19–28.

Federico's inscription can be translated, "He that the perennial fame of virtues rightly celebrates holding the scepter, equal to the highest dukes, the illustrious, is borne in outstanding triumph." Battista had been dead two years when hers was written: "She that kept her modesty in favorable circumstances, flies on the mouths of all men, adorned with the praise of the acts of her great husband." (Translated by John Paolitti and Gary Radke, *Art in Renaissance Italy*. Prentice Hall, 2002, p. 288.)

The painting on the reverse of the portraits reflects the humanist interests of the court (FIG. 19-29). Engraved on the fictive parapets in letters inspired by ancient Roman inscriptions are stanzas praising the couple's respective virtues—Federico's moderation and the fame of his virtue; and Battista's restraint, shining in the reflected glory of her husband. Behind these laudatory inscriptions a wide landscape of hills and valleys appears to be nearly continuous across the two panels. Across the flat top of a jagged cliff in the foreground, triumphal carts roll, and we catch a glimpse of the kind of pageantry and spectacle that must have been enacted at court. The Triumphs of Petrarch—poetic allegories of love, chastity, fame, time, eternity (Christianized as Divinity), and death (see "A New Spirit in Fourteenth-Century Literature," page 561)—inspired many of these extravaganzas. White horses pull Federico's wagon. The Duke is crowned by a winged figureeither Victory or Fortune—and accompanied by personifications of Justice, Prudence, Fortitude, and Temperance. Battista's cart is controlled by a winged putto (nude little boy) driving a team of unicorns. The virtues standing behind her may be personifications of Chastity and Modesty. Seated in front of her are Faith and Charity, who holds a pelican. This bird, believed to feed its young from its own blood, may symbolize the recently deceased Battista's maternal sacrifices.

Mantua

Lodovico Gonzaga, the Marquis of Mantua, ruled a territory that lies on the north Italian plain between Venice and Milan. Like Federico, he made his fortune as a *condottiere*. Lodovico was schooled by humanist teachers and created a court where humanist ideas flourished in art as well as in literature. His relationship with Cosimo de' Medici led to a connection with Florentine artists and architects, including Alberti.

ALBERTI. The spread of Renaissance architectural style beyond Florence was due in significant part to Leon Battista Alberti, who traveled widely, wrote on architecture, and expounded his views to potential patrons. In 1470 Ludovico Gonzaga commissioned Alberti to enlarge the small **CHURCH**

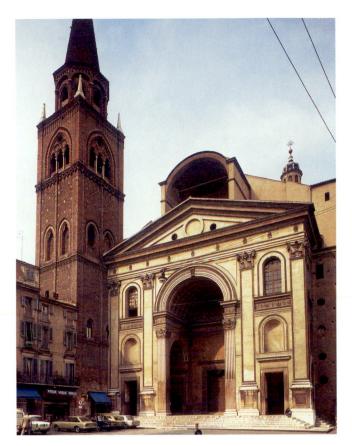

19–30 | Leon Battista Alberti **FAÇADE, CHURCH OF SANT'ANDREA, MANTUA** Designed 1470, begun 1472.

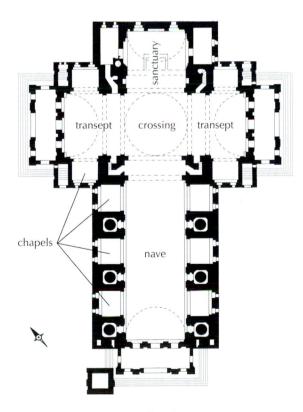

19–31 | Leon Battista Alberti PLAN OF THE CHURCH OF SANT'ANDREA, MANTUA
Designed 1470.

Sequencing Works of Art

1470-72	Leon Battista Alberti, Church of Sant'Andrea, Mantua
1476	Giuliano da Maiano, intarsia decora- tion of the studiolo, ducal palace, Mantua
c. 1480	Giovanni Bellini, Saint Francis in Ecstasy
1481	Perugino, Delivery of the Keys to Saint Peter, Sistine Chapel, Vatican
1500	Botticelli, The Mystic Nativity

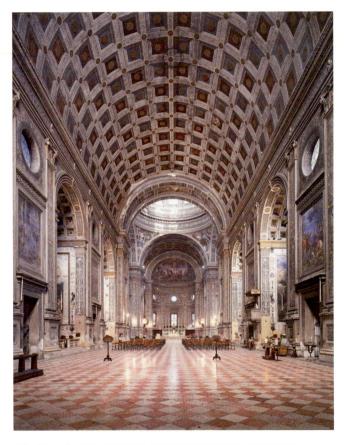

19–32 | NAVE, CHURCH OF SANT'ANDREA, MANTUA Designed 1470. Vault width 60′ (18.3 m).

OF SANT'ANDREA, which housed a sacred relic believed to be the actual blood of Christ (FIG. 19–30). To satisfy his patron's desire for a sizable building to handle crowds coming to see the relic, Alberti proposed to build an "Etruscan temple." Work began on the new church in 1472, but Alberti died that summer. Construction went forward slowly, at first according to his original plan, but it was finally completed only at the end of the eighteenth century. Thus, it is not always clear which elements belong to Alberti's original design.

The Church of Sant' Andrea follows the Latin-cross plan, in which the transept intersects the nave high above the

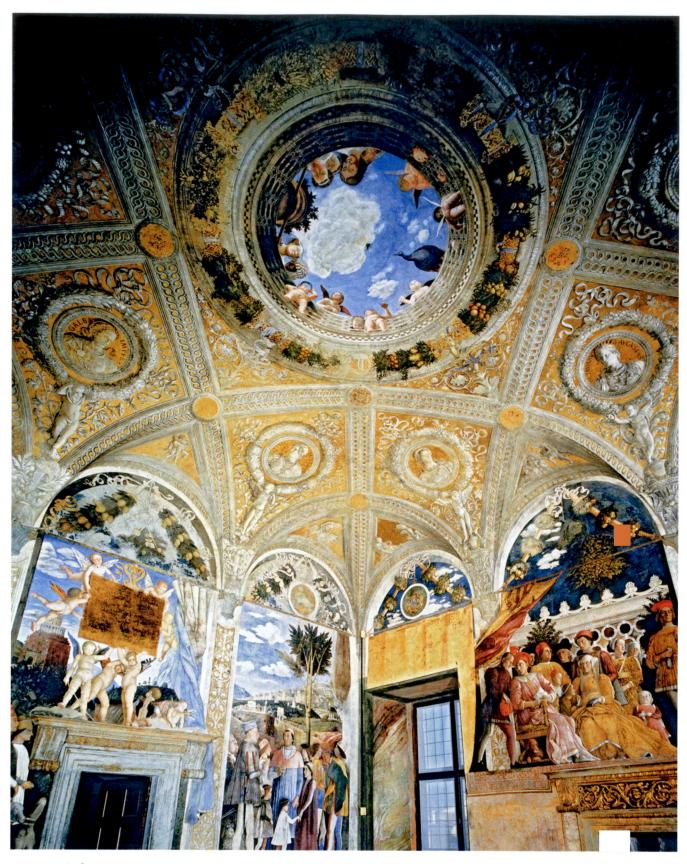

19–33 \perp Andrea Mantegna CAMERA PICTA, DUCAL PALACE, MANTUA 1465–74. Frescoes. Diameter of false oculus 8'9" (2.7 m); room 62' 6" square (8 \times 5 m square).

midpoint of the church. Here, the nave, nearly 60 feet wide, meets a transept of equal width at a square, domed crossing (FIGS. 19–31, 19–32). A rectangular sanctuary on axis with the nave is certainly in keeping with Alberti's ideas. Alberti was responsible, too, for the barrel-vaulted chapels at right angles to the nave that give the appearance of an arcade. Low chapel niches are carved out of the huge piers supporting the barrel vault of the nave. Light enters from chapel windows.

Alberti's design for the façade of Sant'Andrea (SEE FIG. 19–30) integrates two classical forms—a temple front and a triumphal arch with two sets of colossal Corinthian pilasters. The façade now has a clear volume of its own, which sets it off visually from the building behind. Pilasters flanking the barrel-vaulted triumphal-arch entrance are two stories high, whereas the others, raised on pedestals, run through three stories to support the entablature and pediment of the temple form. The arch itself has lateral barrel-vaulted spaces opening through two-story arches on the left and right.

Neither the simplicity of the plan nor the complexity of the façade hints at the grandeur of Sant'Andrea's interior. Its immense barrel-vaulted nave, extended on each side by tall chapels, was inspired by the monumental interiors of such ancient ruins as the Basilica of Maxentius and Constantine in the Roman Forum (SEE FIG. 6–75). This clear reference to Roman imperial art is put to Christian use. Alberti created a building of such colossal scale, spatial unity, and successful expression of Christian humanist ideals that it affected architectural design for centuries.

MANTEGNA. Andrea Mantegna (1431–1506) also worked at the court of Mantua. Mantegna, a painter, was trained in Padua and profoundly influenced by the sculptor Donatello, who arrived in Padua in 1443 and worked there for a decade. Mantegna absorbed such techniques as the Florentine linear perspective system, which Mantegna pushed to its limits with experiments in radical perspective views and foreshortenings. In 1460 Mantegna went to work for Ludovico Gonzaga, and he continued to work for the Gonzaga family for the rest of his life.

Mantegna's mature style is characterized by a virtuoso use of perspective, the skillful integration of figures into their settings, and a love of naturalistic details. His finest works are the frescoes of the CAMERA PICTA ("Painted Room"), a tower chamber in Ludovico Gonzaga's palace, which Mantegna decorated between 1465 and 1474 (FIG. 19–33). Around the walls the family receives its returning cardinal in scenes set in landscapes and loggias. (Ludovico's son, Cardinal Francesco, was head of the Church of Sant'Andrea; SEE FIG. 19–30). The paintings create a continuous scene with figures and countryside behind a fictive arcade. The people are all recognizable portraits of the family and court. On the domed ceiling, the artist painted a tour de force of radical perspective, a tech-

nique called *di sotto in sù* ("from below upwards"). The room appears to be open to a cloud-filled sky through a large oculus in a simulated marble- and mosaic-covered vault. On each side of a precariously balanced planter, three young women and an exotically turbaned African man peer over a marble balustrade into the room below. A fourth young woman in a veil looks dreamily upward. Joined by a large peacock, several *putti* play around the balustrade. The ceiling began a long tradition of illusionistic ceiling painting that culminated in the seventeenth century.

Although Mantegna made trips to Florence and Pisa in the 1460s and to Rome in 1488–90, he spent most of his time in Mantua. There he became a member of the humanist circle, whose interests in classical literature and archaeology he shared. He often signed his name using Greek letters.

Rome

Rome's establishment as a Renaissance center of the arts was enhanced by Pope Sixtus IV's decision to call to the city the best artists he could find to decorate the walls of his newly built chapel, named the Sistine Chapel after him. The resolution in 1417 of the Great Schism in the Western Church had secured the papacy in Rome, precipitating the restoration of not only the Vatican but the city as a whole.

PERUGINO. Among the artists who went to Rome was Pietro Vannucci, called "Perugino" (c. 1445–1523). Originally from near the town of Perugia in Umbria, Perugino worked for a while in Florence and by 1479 was in Rome. Two years later, he was working on the Sistine murals. One of his contributions, **DELIVERY OF THE KEYS TO SAINT PETER** (FIG. 19–34), portrayed the event that provided biblical support for the supremacy of papal authority, Christ's giving the keys of the kingdom of heaven to the apostle Peter (Matt. 16:19), who became the first bishop (pope) of Rome.

Delivery of the Keys is a remarkable work. Its carefully studied linear perspective reveals much about Renaissance ideals. In a light-filled piazza in which banded paving stones provide a geometric grid for perspectival recession, the figures stand like chess pieces on the squares, scaled to size according to their distance from the picture plane and modeled by a consistent light source from the upper left. The composition is divided horizontally between the lower frieze of massive figures and the band of widely spaced buildings above. Vertically, it is divided by the open space at the center between Christ and Peter and by the symmetrical architectural forms on each side of this central axis. Triumphal arches inspired by ancient Rome frame the church and focus the attention on the center of the composition, where the vital key is being transferred. The carefully calibrated scene is softened by the subdued colors, the distant idealized landscape and cloudy skies, and the variety of the

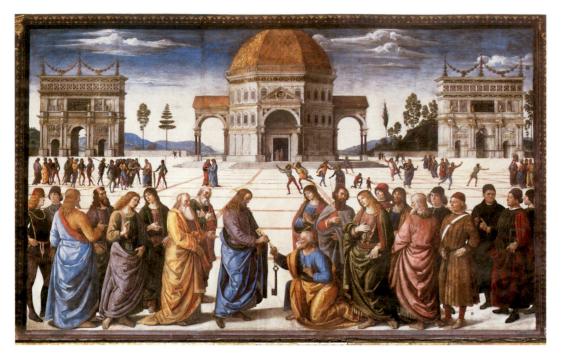

19–34 | Perugino DELIVERY OF THE KEYS TO SAINT PETER
Fresco on the right wall of the Sistine Chapel, Vatican City, Rome. 1481. $11'5\%'' \times 18'8\%'' (3.48 \times 5.70 \text{ m})$.

figures' positions. Perugino's painting is, among other things, a representation of Alberti's ideal city, described in his treatise on architecture as having a "temple" (that is, a church) at the very center of a great open space raised on a dais and separate from any other buildings that might obstruct its view. His ideal church had a central plan, illustrated here as a domed octagon.

The Later Fifteenth Century in Florence

In the final decades of the fifteenth century, Florentine painting was characterized on one hand by a love of material opulence and an interest in describing the natural world, and on the other by a poetic, mystical spirit. The first trend was encouraged by the influence of Netherlandish art and the patronage of citizens who sought to advertise their wealth and position, the second by philosophic circles surrounding the Medici and the religious fervor that arose at the very end of the century.

GHIRLANDAIO. In Florence, the most prolific painting workshop of the later fifteenth century was that of the painter Domenico di Tommaso Bigordi (1449–94), known as Domenico "Ghirlandaio" ("Garland Maker"), a nickname adopted by his father, who was a goldsmith noted for his floral wreaths. A skilled painter of narrative cycles, Ghirlandaio reinterpreted the art of earlier fifteenth-century painters into a popular visual language of great descriptive immediacy.

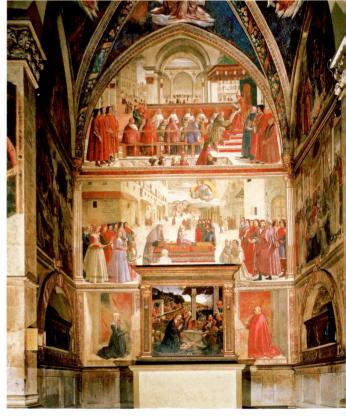

19–35 | Domenico Ghirlandaio VIEW OF THE SASSETTI CHAPEL, CHURCH OF SANTA TRINITA, FLORENCE Frescoes of scenes from the Legend of Saint Francis; altarpiece with Nativity and Adoration of the Shepherds. 1483–86. Chapel: 12'2'' deep \times 17'2'' wide $(3.7 \times 5.25 \text{ m})$.

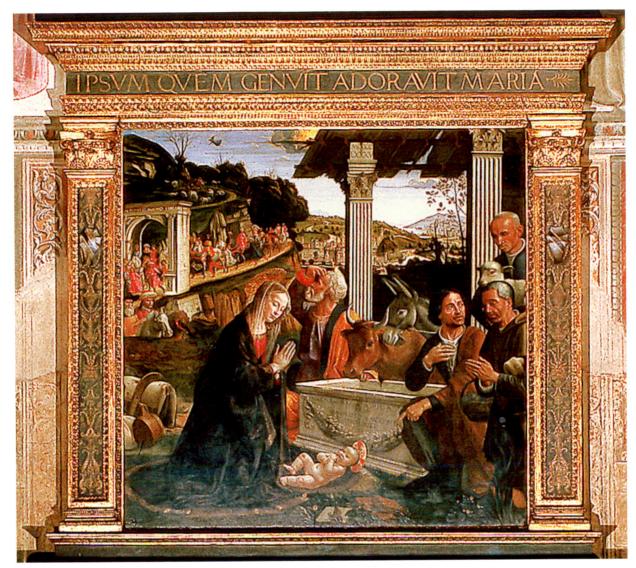

19–36 | Domenico Ghirlandaio | NATIVITY AND ADORATION OF THE SHEPHERDS, SASSETTI CHAPEL PANEL, ALTARPIECE, SANTA TRINITÀ, FLORENCE

1485. 65¾" square (1.67 m square).

The taste for Flemish painting in Florence grew noticeably after about 1450, and works such as Hugo van der Goes's *Portinari Altarpiece* (SEE FIG. 18–20), which Tommaso Portinari had sent home to Florence from Bruges in 1483, had considerable impact on Ghirlandaio's style.

Among Ghirlandaio's most effective narrative programs were frescoes of the life of Saint Francis created between 1483 and 1486 for the Sassetti family burial chapel in the Church of Santa Trinita, Florence (FIG. 19–35). In the uppermost tier of the paintings, Pope Honorius confirms the Franciscan order. The Loggia of the Lancers (see Chapter 17, FIG. 17–2) and the Palazzo della Signoria can be seen in the background. All the figures, including those coming up the stairs, are portraits of well-known Florentines. In the middle register, a small boy who has fallen from an upper window is resurrected by Saint Francis. The miracle is witnessed by contemporary Florentines, including members of the Sassetti family, and the scene takes place in the piazza outside the actual church. Thus, Ghirlandaio transferred the events of the traditional story from thirteenth-century

Rome to the Florence of his own day, painting views of the city and portraits of Florentines, taking delight in local color and anecdotes. Perhaps Renaissance painters represented events from the distant past in contemporary terms to emphasize their current relevance, or perhaps they and their patrons simply enjoyed seeing themselves in their fine clothes acting out the dramas in the cities of which they were justifiably proud.

The Sassetti Chapel altarpiece, NATIVITY AND ADORATION OF THE SHEPHERDS (FIG. 19–36), is still in its original frame and in the place for which it was painted. Ghirlandaio clearly was inspired by Hugo's *Portinari Altarpiece* (SEE FIG. 18–20), which had been placed on the high altar of the church of Sant'Egidio two years earlier in 1483. As in Hugo's painting, Domenico's Christ Child lies on the

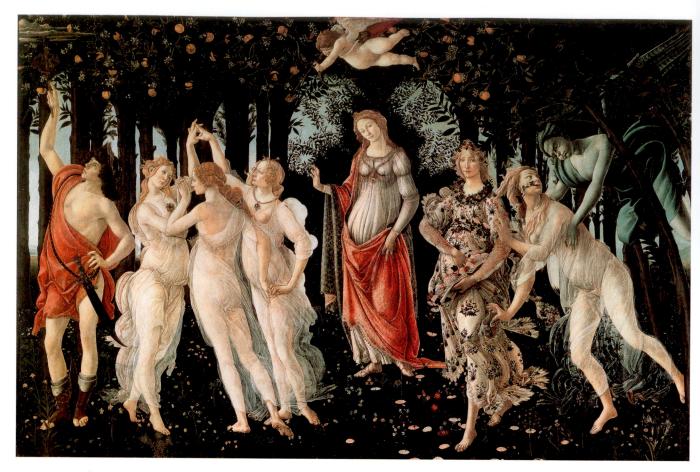

19–37 | Sandro Botticelli PRIMAVERA c. 1482. Tempera on wood panel, $6'8'' \times 10'4''$ (2.03 \times 3.15 m). Galleria degli Uffizi, Florence.

ground, adored by the Virgin while shepherds-rugged countrymen-kneel at the right. He even copies some of Hugo's flowers—although here the iris, a symbol of the Passion, springs not from a vase, but from the earth in the lower right corner. Instead of elaborate late-medieval symbolism, Ghirlandaio includes references to classical Rome. First to catch the eye are the two classical pilasters with Corinthian capitals, one of which has the date 1485. The manger is an ancient sarcophagus with an inscription that promises resurrection (as in the fresco directly above the altarpiece where Saint Francis is reviving a child); and in the distance a classical arch inscribed with a reference to the Roman general Pompey the Great frames the road along which the Magi travel. Domenico replaces the psychological intensity of Hugo's figures with weighty, restrained actors. His mastery of linear perspective is revealed in the manner in which the diagonally placed wooden planks that support the thatched roof of the shed organize the space. A clear foreground, middle ground, and background are joined together in part by the road and in part by aerial perspective, which creates a seamless transition of color, from the sharp details and primary hues of the Adoration to the soft gray mountains in the distance.

BOTTICELLI. Like most artists in the second half of the fifteenth century, Sandro Botticelli (1445–1510) learned to draw and paint sculptural figures that were modeled by light from a consistent source and placed in a setting rendered with strict linear perspective. An outstanding portraitist, he, like Ghirlandaio, often included recognizable contemporary figures among the saints and angels in religious paintings. He worked in Florence, often for the Medici, then was called to Rome in 1481 by Pope Sixtus IV to help decorate the new Sistine Chapel along with Ghirlandaio, Perugino, and other artists.

Botticelli returned to Florence that same year and entered a new phase of his career. Like other artists working for patrons steeped in classical scholarship and humanistic speculation, he was exposed to a philosophy of beauty—as well as to the examples of ancient art in his employers' collections. For the Medici, Botticelli produced secular paintings of mythological subjects inspired by ancient works and by contemporary Neoplatonic thought, including **PRIMAVERA**, or **SPRING** (FIG. 19–37), and *Birth of Venus* (SEE FIG. 19–38).

The overall appearance of *Primavera* recalls Flemish tapestries, which were popular in Italy at the time. The decorative quality of the painting is deceptive, however, for it is a highly complex **allegory** (a symbolic illustration of a concept

or principle), interweaving Neoplatonic ideas with esoteric references to classical sources. In simple terms, Neoplatonic philosophers and poets conceived of Venus, the goddess of love, as having two natures. The first ruled over earthly, human love and the second over universal divine love. In this way the philosophers could argue that Venus was a classical equivalent of the Virgin Mary. Primavera was painted at the time of the wedding of Lorenzo di Pierfrancesco de' Medici and Semiramide d'Appiano in 1482. The theme suggests love and fertility in marriage and provides in the image of Venus a model of the ideal woman. Venus is silhouetted and framed by an arching view through the trees. She is flanked by Flora, the Roman goddess of flowers and fertility, and by the Three Graces. Her son, Cupid, hovers above, playfully aiming an arrow at the Graces. At the far right is the wind god, Zephyr, in pursuit of the nymph Chloris, his breath causing her to sprout flowers from her mouth. At the far left, the messenger god, Mercury, uses his characteristic snake-wrapped wand, the caduceus, to dispel a patch of gray clouds drifting in Venus's direction. He is the sign of the month of May, and he looks out of the painting and onto summer. Venus, clothed in contemporary costume and wearing a marriage wreath on her head, here represents her terrestrial nature, governing wedded love. She stands in a grove of orange trees (a Medici

	and the second		The same	
Seal	uenci	nσ	∟ven	ts

1402	Death of Gian Galeazzo, Duke of Milan; stronghold on Florence and other Italian cities broken
1420	Pope returns to Rome from Avignon
1464	First printing press in Italy
1496-98	Savonarola in power in Florence
1499	France captures Milan

symbol) weighted down with lush fruit, suggesting human fertility; Cupid also embodies romantic desire. As practiced in central Italy in ancient times, the goddess Flora's festival had definite sexual overtones.

Several years later, some of the same mythological figures reappeared in Botticelli's **BIRTH OF VENUS** (FIG. 19–38), in which the central image represents the Neoplatonic idea of divine love and is based on an antique statue type known as the "modest Venus." The classical goddess of love and beauty, born of sea foam, floats ashore on a scallop shell, gracefully arranging her hands and hair to hide—or enhance—her sexuality. Her hair is highlighted with gold. Blown by the

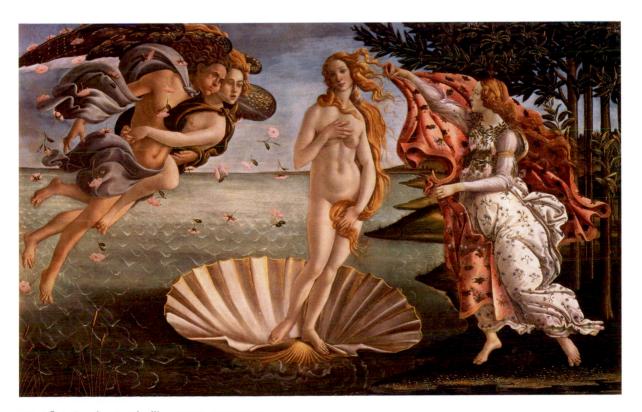

19–38 | Sandro Botticelli BIRTH OF VENUS c. 1484–86. Tempera and gold on canvas, $5'8\%'' \times 9'1\%''$ (1.8 \times 2.8 m). Galleria degli Uffizi, Florence.

Art and Its Context

THE PRINTED BOOK

book entitled Hypnerotomachia Poliphili (The Love-Dream Struggle of Poliphilo) tells of the search of Poliphilo through exotic places for his lost love, Polia. The book, written in the 1460s or 1470s by Fra Francesco Colonna, was published in 1499 by the noted Venetian printer Aldo Manuzio (Aldus Manutius in Latin), who had established a press in Venice in 1490 (known today as the Aldine Press). Many historians of the printed book consider Aldo's Hypnerotomachia to be the most beautiful book ever produced, from the standpoint of type and page design. The woodcut illustrations in the Hypnerotomachia incorporate pseudoclassical structures that would influence future architects and garden designers. The Garden of Love, illustrated here, provides a setting for music, story telling, and romance, while Venus as a fountain discreetly turns her back.

Although woodcuts, constantly refined and increasingly complex, would remain a popular medium of book illustration for centuries to come, books also came to be illustrated with engravings. The innovations in printing at the end of the 1400s held great promise for the spread of knowledge and ideas in the following century.

Fra Francesco Colonna PAGE WITH GARDEN OF LOVE, HYPNEROTOMACHIA POLIPHILI

Published by Aldo Manuzio (Aldus Manutius), Venice, 1499. Woodcut, image $5\% \times 5\%$ (13.5 \times 13.5 cm). The Pierpont Morgan Library, New York. PML 373.

wind, Zephyr (and his love, the nymph Chloris), Venus arrives at her earthly home. She is welcomed by a devotee—sometimes identified as one of the Hours—who holds a garment embroidered with flowers. The circumstances of this commission are uncertain. It is painted on canvas, which suggests that it is a banner or a painted tapestry-like wall hanging. The birth of Venus has been interpreted as the birth of the idea of beauty.

Botticelli's later career was affected by a profound spiritual crisis. While the artist was creating his mythologies, a Dominican monk, Fra Girolamo Savonarola (active in Florence 1490–98), had begun to preach impassioned sermons denouncing the worldliness of Florence. Many Florentines reacted with orgies of self-recrimination, and processions of weeping penitents wound through the streets. Botticelli, too, fell into a state of religious fervor. In a dramatic gesture of repentance, he burned many of his earlier paintings and began to produce highly emotional pictures pervaded by an intense religiosity.

In 1500, when many people feared that the end of the world was imminent, Botticelli painted MYSTIC nativity (FIG. 19-39) his only signed and dated painting. The Nativity takes place in a rocky, forested landscape in which the cave-stable follows the tradition of the Eastern Orthodox (Byzantine) Church, while the timber shed in front recalls the Western iconographic tradition (SEE FIG. 17-13). In the center of the painting, the Virgin Mary kneels in adoration of the Christ Child, who lies on the earth, as recorded in the vision of the fourteenth-century mystic Saint Bridget. Joseph crouches and hides his face, while the ox and the ass bow their heads to the Holy Child. The shepherds at the right and the Magi at the left also kneel before the Holy Family. A circle of singing angels holding golden crowns and laurel branches flies jubilantly above the central scene. Tiny devils, vanquished by the coming of Christ, try to escape from the bottom of the picture.

The most unusual element of the painting is the frieze of wrestling figures below the Holy Family. The men are ancient classical philosophers, who ceremonially struggle with angels. Each of the three pairs holds an olive branch, a symbol of peace, and a scroll—as do the angels circling above, whose scrolls are inscribed (in Greek) with the words: "Glory to God in the Highest; peace on earth to men of good will." (Palm Sunday in fifteenth-century Florence was called Olive Sunday, and olive branches, symbols of peace, rather than palms were carried in processions.) The inscription at the top of the painting (in Greek) begins: "I Alessandro made this picture..." and goes on to reference the Book of Revelation, Chapter 11, which describes woes to come, and Chapter 12, which includes the vision of a woman crowned with stars and clothed by the sun (the woman of Revelations was interpreted by Christians as a portrayal of the Virgin Mary) and the description of the defeat of Satan. Thus, in spite of the troubles Botticelli saw all around him, he believed that Christ would come to save humankind.

Venice

In the last quarter of the fifteenth century, Venice emerged as a major Renaissance art center. Venice was an oligarchy (government by a select few) with an elected duke (doge in the Venetian dialect). The city government was founded at the end of the Roman empire and survived until the Napoleonic era. In building their city the Venetians had turned marshes into a commercial seaport, and they saw the sea as a resource, not a threat. They depended on naval power and on their lagoons rather than city walls. The city turned toward the east, especially after the Crusaders' conquest of Constantinople in 1204. Even earlier the Venetians were investing the Church of Saint Mark, a great Byzantine-inspired building, with the rich color of mosaics and gold liturgical decorations from the Eastern Christian empire. They excelled in the arts of textiles, gold and enamel, glass and mosaic, and fine printing (see "The Printed Book," page 652), as well as book binding.

THE VENETIAN PALACE. Venice was a city of waterways with few large public spaces. Even palaces had only small interior courtyards and tiny gardens, and were separated by narrow alleys. They faced out on canals, whose waters gave protection and permitted the owners to build houses with large portals, windows, and loggias. This presented a sharp contrast to the fortresslike character of most Italian townhouses. But, as with the Florentine great houses, their owners combined in these structures a place of business with a dwelling.

The CA D'ORO (HOUSE OF GOLD), the home of the wealthy nobleman Marino Contarini, has a splendid front with three superimposed loggias facing the Grand Canal (FIG. 19–40). The house was constructed between 1421 and 1437, and its asymmetrical elevation is based on a traditional Byzantine plan. A wide central hall ran from front to back all the way through the building to a small inner courtyard with

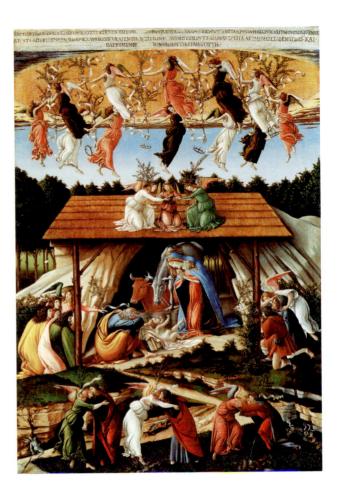

19–39 | Sandro Botticelli MYSTIC NATIVITY 1500. Oil on canvas, $42 \times 29 \frac{1}{2}$ " (106.7 × 74.9 cm). The National Gallery, London.

This is the only work signed and dated by Botticelli; translated from the Greek, his inscription reads: "I Alessandro made this picture at the conclusion of the 1500th year" (National Gallery, London, files).

a well and garden. An outside stair led to the main floor on the second level. The entrance on the canal permitted goods to be delivered directly into the warehouse that constituted the ground floor. The principal floor, on the second level, had a salon and reception room opening on the richly decorated loggia. It was filled with light from large windows, and more light reflected off the polished terrazzo floor. Private family rooms filled the upper stories. In contrast to the massive stone façades of Florentine palaces (SEE FIGS. 19-6, 19-8), Contarini's instructions to his contractors and workers specified that the façade was to be painted with white enamel and ultramarine blue and that the red stones in the patterned wall should be oiled to make them even brighter. Details of carving, such as coats of arms and balls on the crest at the roof line, were to be gilded. Beautiful as the palace is today (it is now an art museum), in the fifteenth and sixteenth centuries it must have been truly spectacular.

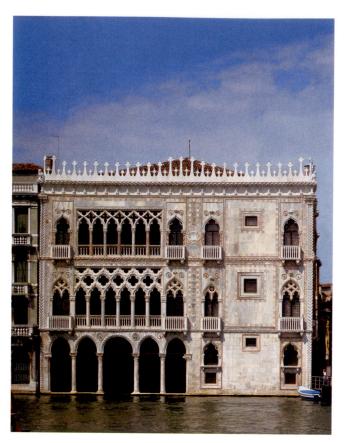

19–40 | **CA D'ORO, VENICE** 1421–37. Contarini Palace, known as the Ca d'Oro.

THE BELLINI BROTHERS. The domes of the Church of Saint Mark dominated the city center, and the rich colors of its glowing mosaics captured painters' imaginations. The love of color encouraged the use of the oil medium. Venetian painters eagerly embraced the oil paint technique for both panel and canvas painting.

The most important Venetian artists of this period were two brothers, Gentile (c. 1429–1507) and Giovanni (c. 1430–1516) Bellini, whose father, Jacopo (c. 1400–70), had also been a central figure in Venetian art. Andrea Mantegna was also part of this circle, for he had married Jacopo's daughter in 1453.

Gentile Bellini celebrated the daily life of the city in large, lively narratives, such as the PROCESSION OF THE RELIC OF THE TRUE CROSS BEFORE THE CHURCH OF SAINT MARK (FIG. 19–41). Every year on the Feast of Saint Mark (April 25) the Confraternity of Saint John the Evangelist carried the miracle-working Relic of the True Cross in a procession through the square in front of the church. Bellini's painting of 1496 depicts an event that had occurred in 1444: the miraculous recovery of a sick child whose father, the man in red kneeling to the right of the relic, prayed for help as the relic passed by. Gentile has rendered the cityscape with great accuracy and detail. The mosaic-encrusted Byzantine Church of Saint Mark (SEE ALSO FIG. 7-44) forms a backdrop for the procession, and the doge's palace and base of the bell tower can be seen at the right. The relic, in a gold reliquary under a canopy, is surrounded by marchers with giant candles, led by a choir and followed at the far right by the doge and other officials. The procession and spectators bring the huge piazza to life.

Gentile's brother, Giovanni, amazed and attracted patrons with his artistic virtuosity for almost sixty years. The **VIRGIN**

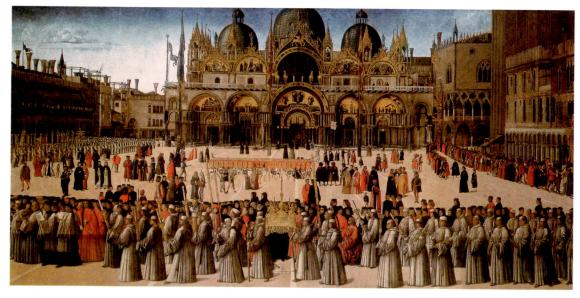

I9–4I | Gentile Bellini | PROCESSION OF THE RELIC OF THE TRUE CROSS BEFORE THE CHURCH OF SAINT MARK 1496. Oil on canvas, $12' \times 24'5''$ (3.67 \times 7.45 m). Galleria dell'Accademia, Venice.

AND CHILD ENTHRONED WITH SAINTS FRANCIS, JOHN THE BAP-TIST, JOB, DOMINIC, SEBASTIAN, AND LOUIS OF TOULOUSE (FIG. 19-42), painted about 1478 for the Chapel of the Hospital of San Giobbe (Saint Job), exhibits a dramatic perspectival view up into a vaulted apse. Certainly, Giovanni knew his father's perspective drawings well, and he may also have been influenced by his brother-in-law Mantegna's early experiments in radical foreshortening and the use of a low vanishing point. In Giovanni's painting, the vanishing point for the rapidly converging lines of the architecture lies at the center, on the feet of the lute-playing angel. Giovanni has placed his figures in a classical architectural interior with a coffered barrel vault, reminiscent of Masaccio's Trinity (SEE FIG. 19-19). The gold mosaic, with its identifying inscription and stylized seraphim (angels of the highest rank), recalls the art of the Byzantine Empire in the eastern Mediterranean and the long tradition of Byzantineinspired painting and mosaics produced in Venice.

Giovanni Bellini also demonstrates the intense investigation and recording of nature associated with the early Renaissance. His early painting of SAINT FRANCIS IN ECSTASY (FIG. 19-43), painted in the 1470s, illustrates his command of an almost Flemish realism. The saint stands in communion with nature, bathed in early morning sunlight, his outspread hands showing the stigmata. Francis had moved to a cave in the barren wilderness in his search for communion with God, but in this landscape, the fields blossom and flocks of animals graze. The grape arbor over his desk and the leafy tree toward which he directs his gaze add to an atmosphere of sylvan delight. True to fifteenth-century religious art, however, Bellini unites Old and New Testament themes to associate Francis with Moses and Christ: The tree symbolizes the burning bush; the stream, the miraculous spring brought forth by Moses; the grapevine and the stigmata, Christ's sacrifice. The crane and donkey represent the monastic virtue of patience. The detailed realism, luminous colors, and symbolic elements suggest Flemish art, but the golden light suffusing the painting is associated with Venice, a city of mist, reflections, and above all, color.

Giovanni's career spanned the second half of the fifteenth century, but he produced many of his greatest paintings in the early years of the sixteenth, when his work matured into a grand, simplified, idealized style. It seems fitting to end our consideration of the first phase of Renaissance painting in Italy with Giovanni Bellini as an important and influential bridge to the future.

IN PERSPECTIVE

In many people's minds the Renaissance and Italy are synonymous—the Renaissance is the Italian Renaissance. Florence is its home, and the Medici family, its patrons. As we have seen, however, the fifteenth century witnessed changes throughout Western Europe—in Bruges as well as Florence.

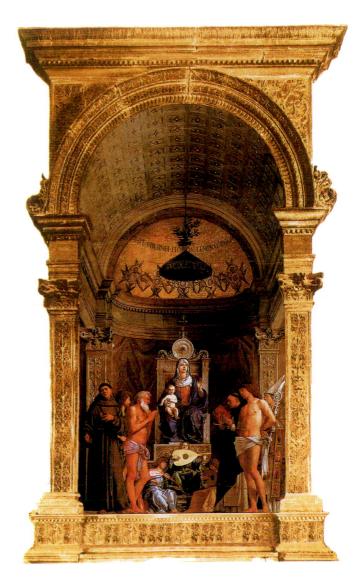

19–42 | Giovanni Bellini VIRGIN AND CHILD ENTHRONED WITH SAINTS FRANCIS, JOHN THE BAPTIST, JOB, DOMINIC, SEBASTIAN, AND LOUIS OF TOULOUSE

(computer reconstruction) Commissioned for the Chapel of the Hospital of San Giobbe, Venice. c. 1478. Oil on wood panel, $15'4'' \times 8'4''$ (4.67 \times 2.54 m). Galleria dell'Accademia, Venice. The original frame is in the Chapel of the Hospital of San Giobbe, Venice. c. 1478.

Art historians have given the special name sacra conversazione ("holy conversation") to this type of composition that shows saints, angels, and sometimes even the painting's donors in the same pictorial space with the enthroned Virgin and Child. Despite the name, no "conversation" or other interaction among the figures takes place in a literal sense. Instead, the individuals portrayed are joined in a mystical and eternal communion occurring outside of time.

The art of the fifteenth century reflects the values and worldview of the new social order. A spirit of inquiry was fueled by the study of classical texts begun in the four-teenth century. The kind of logical discourse formerly reserved for theological debate now was applied to the material world. Theories based on the close observation of

19–43 | Giovanni Bellini

SAINT FRANCIS IN ECSTASY

c. 1470's. Oil and tempera on wood panel, 49 × 55%" (125 × 142 cm).

The Frick Collection, New York.

Copyright the Frick Collection, New York.

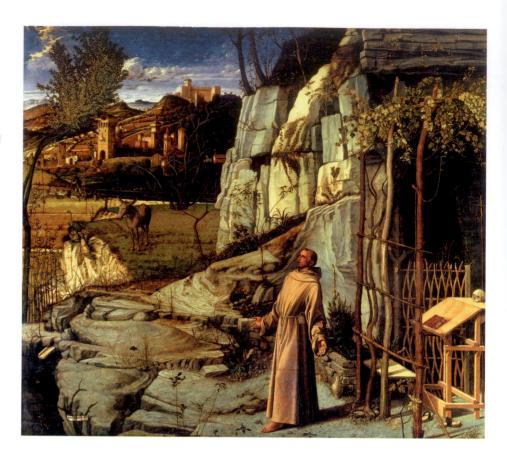

phenomena were put forth to be challenged and defended. During this time individuals gained importance, not only as inquiring minds but as the subject of inquiry. Artists, too, emerged from anonymity and were recognized as distinct personalities.

Patrons wanted to see themselves and their possessions depicted as they were. Fifteenth-century portraits have an uncanny sense of vitality, in part because of their careful, even unflattering, representations of individuals. The patrons' desire for realism extended to their surroundings; they wanted identifiable views of the buildings and countryside where they worked and played, fought and died. Artists tacitly agreed to follow new ways of representing space and visually organizing a scene using linear and atmospheric perspective. By the end of the fifteenth century, the visual mastery of the material

world seemed complete; rational and scientific thought had triumphed in both secular and religious art.

Power was no longer the prerogative of divinely sanctioned elites; it now also lay in the hands of commoners—the merchants and bankers, the leaders of the major guilds and professions. The arts flourished as patronage extended beyond the church and the court to civic, mercantile, and religious associations, as well as to families grown powerful through business and banking.

The last decade of the century saw a sudden reversal of artistic fortunes as the fiery preacher Savonarola spread the fear of damnation and inspired a need for repentance. In great "bonfires of the vanities" people destroyed their finery and great works of art as well. The furor was brief but devastating, a dramatic prelude to the tumultuous sixteenth century.

NANNI DI BANCO FOUR CROWNED MARTYRS C. 1409-17

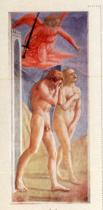

MASACCIO

ION FROM PARADISE,

BRANCACCI CHAPEL

C. 1427

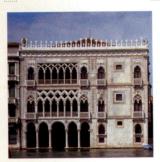

CA D'ORO, VENICE 1421-37

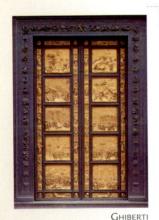

EAST DOORS, FLORENCE
BAPTISTRY COMPLETED
1452

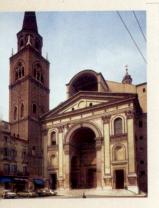

ALBERTI
CH OF SANT'ANDREA DESIGNED
1470

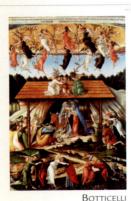

BOTTICELLI MYSTIC NATIVITY 1500

RENAISSANCE ART IN FIFTEENTH-CENTURY ITALY

◀ Great Schism Ends 1417

Alberti Writes De Pictura (On Painting) 1435

■ Ghiberti Writes Commentaries

c. 1450-55

✓ Lorenzo de' Medici Rules Florence 1469-92

Savonarola Executed 1498

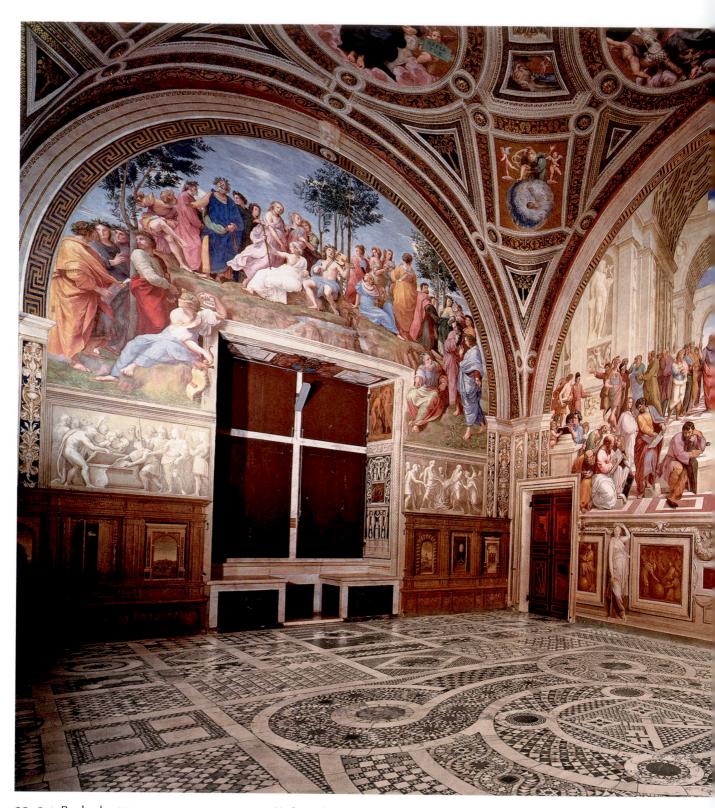

20–I | Raphael STANZA DELLA SEGNATURA Vatican, Rome. Fresco in the left lunette, *Parnassus*; in the right lunette, *School of Athens*. 1510–11. *School of Athens*, $19 \times 27'$ (5.79 \times 8.24 m).

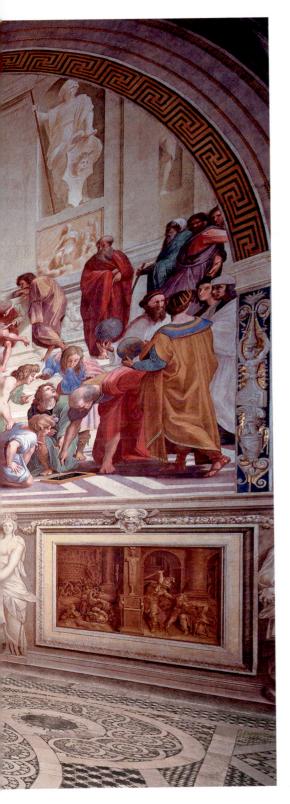

CHAPTER TWENTY

SIXTEENTH-CENTURY ART IN ITALY

20

Two young artists—Raphael (Raffaello Santi) and Michelangelo Buonarroti—although rivals in every sense, were both in the service of Pope Julius II in the early years of the sixteenth century. Raphael was

painting the pope's private library (1509–11) while nearby Michelangelo painted the ceiling of his chapel (1508–12). The pope demanded an art that reflected his imperial vision of a new, worldwide Church based on humanistic ideas. In fulfilling this demand, Raphael and Michelangelo brought early Renaissance principles of harmony and balance together with a new monumentality based on classical ideals, and they knit these separate elements into a dynamic and synthetic whole. Together with the architect Donato Bramante and the multifaceted genius Leonardo da Vinci, they created a style we now think of as the High Renaissance.

Pope Julius II (ruled 1503–13) intended the STANZA DELLA SEGNATURA, or Room of the Signature, to be his library and study (FIG. 20–1). In painting the all-encompassing iconographic program we see here, Raphael created an ideal setting for the activities of a pope who believed that all human knowledge existed under the power of divine wisdom. Raphael based his mural program on the traditional organization of a library into divisions of theology, philosophy, the arts, and justice; and he created allegories to illustrate these themes. On one wall, churchmen discussing the sacraments represent theology, while across the room ancient philosophers debate in the School of Athens, led by Plato and Aristotle. Plato holds his book Timaeus, in which creation is seen in terms of geometry, and in which humanity encompasses and explains the universe. Aristotle holds his Nicomachean Ethics, a decidedly human-centered book concerned with

relations between people. Ancient representatives of the academic curriculum—Grammar, Rhetoric, Dialectic, Arithmetic, Music, Geometry, and Astronomy—surround them. On a window wall, Justice, holding a sword and scales, assigns each his due. Across the room, Poetry and the Arts are represented by Apollo and the Muses, and the poet Sappho reclines against the fictive frame of an actual window. Raphael included his own portrait among the onlookers on the extreme lower right in the School of Athens and signed the painting with his initials—a signal that artists were increasingly aware of their individual significance.

Raphael achieved a lofty style in keeping with the papal ideals of classical grandeur, faith in human rationality and perfectibility, and the power of the pope as God's earthly administrator. But when Raphael died at the age of 37 on April 6, 1520, the grand moment was already passing: Luther and the Protestant Reformation were challenging papal authority.

CHAPTER-AT-A-GLANCE

- EUROPE IN THE SIXTEENTH CENTURY
- ITALY IN THE EARLY SIXTEENTH CENTURY: THE HIGH RENAISSANCE | Three Great Artists of the Early Sixteenth Century | Architecture in Rome and the Vatican | Architecture and Painting in Northern Italy | Venice and the Veneto
- ART AND THE COUNTER-REFORMATION | Art and Architecture in Rome and the Vatican
- MANNERISM | Painting | Manuscripts and Miniatures | Late Mannerism
- LATER SIXTEENTH-CENTURY ART IN VENICE AND THE VENETO | Oil Painting | Architecture: Palladio
- IN PERSPECTIVE

EUROPE IN THE SIXTEENTH CENTURY

The sixteenth century was an age of social, intellectual, and religious ferment that transformed European culture. It was also marked by continual warfare triggered by the expansionist ambitions of the continent's various rulers. The humanism of the fourteenth and fifteenth centuries, with its medieval roots and its often uncritical acceptance of the authority of classical texts, slowly developed a critical spirit that led Europeans to further their exploration of new ideas, nature, and lands. New methods in cartography that took account of the earth's curvature and the degrees of distance undermined traditional views of the world and led to a more accurate understanding of Europe's distinct place in it. The use of the printing press caused an explosion in the number of books available, spreading new ideas through the translation and publication of ancient and contemporary texts. broadening the horizons of educated Europeans and encouraging more people to learn to read. Travel became more common than in earlier centuries; artists and their work became mobile; consequently, artistic styles became less regional and more international.

At the start of the sixteenth century, England, France, and Portugal were nation-states under strong monarchs. Central Europe (Germany) was divided into dozens of principalities, counties, free cities, and other small territories. But even states as powerful as Saxony and Bavaria acknowledged the overlordship of the Habsburg (Holy Roman) Empire—in

theory the greatest power in Europe. Charles V, elected Holy Roman Emperor in 1519, also inherited Spain, the Netherlands, and vast territories in the Americas. Italy, which was divided into many small states, was a diplomatic and military battlefield where, for much of the century, the Italian citystates, Habsburg Spain, France, and the papacy fought each other in shifting alliances. The popes themselves behaved like secular princes, using diplomacy and military force to regain control over central Italy and in some cases to establish family members as hereditary rulers. The popes' incessant demands for money, to finance the rebuilding of Saint Peter's as well as their self-aggrandizing art projects and luxurious lifestyles, aggravated the religious dissent that had long been developing, especially north of the Alps. Early in the century, religious reformers within the established Church challenged beliefs and practices—especially Julius II's sale of indulgences, which entailed a financial contribution to the Church in return for forgiveness of sins and insurance of salvation. Because they protested, these northern European reformers came to be called Protestants. Their demand for reform gave rise to a movement called the Reformation.

Although Italy remained staunchly Catholic, the Reformation had profound repercussions there. It drove the Catholic church not only to launch a fight against Protestantism but also to seek internal reform and renewal—a movement that became known as the Counter-Reformation. The Counter-Reformation would have a profound effect on artists and the works they created.

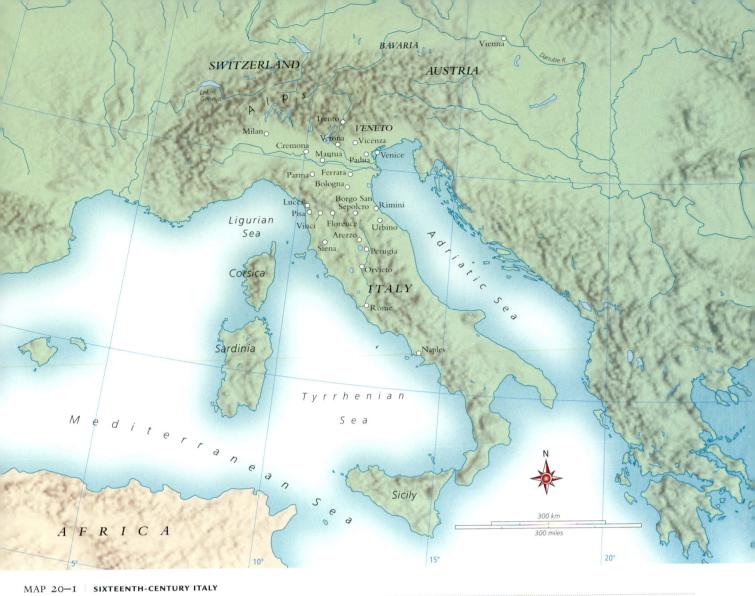

In the 16th century Italy remained a peninsula divided into city-states in the north and the Papal States in the center. In the south Naples and Sicily were part of the vast and powerful Hasburg domains.

The political maneuvering of Pope Clement VII (papacy 1523–34) led to a direct clash with Holy Roman Emperor Charles V. In May 1527, Charles's German mercenary troops attacked Rome, beginning a six-month orgy of killing, looting, and burning. The Sack of Rome, as it is called, shook the sense of stability and humanistic confidence that until then had characterized the Renaissance, and it sent many artists fleeing from the ruined city. Nevertheless, Charles saw himself as the leader of the Catholic forces—and he was the sole Catholic ally Clement had at the time. In 1530 Clement VII crowned Charles emperor in Bologna.

Sixteenth-century patrons valued artists highly and rewarded them well, not only with generous commissions but sometimes even with high social status. Charles V, for example, knighted the painter Titian. Some painters and sculptors became entrepreneurs, selling prints of their works on the side. The sale of prints was a means by which reputations and styles became widely known, and a few artists of stature became international celebrities. With their new fame and independence, the most successful artists could decide which commissions to accept or reject.

Many artists recorded their activities in private diaries, notebooks, and letters that have come down to us. In addition, contemporary writers reported on everything about artists, from their physical appearance to their personal reputation. In 1550, Giorgio Vasari wrote the first survey of Italian art history, Lives of the Best Architects, Painters, and Sculptors. Vasari included more than simple biographical details; he made value judgments on work, commented on the role of patrons, and argued that art had become more realistic and more beautiful over time. He described the art of his own age as the culmination of historical processes, with its fulfillment in the life and work of Michelangelo. From his characterization, in part, stems our notion of this time period as the High Renaissance—that is, as a high point in art since Cimabue and Giotto that marks a balanced synthesis of classical ideals and an ordered naturalism.

During this period, the fifteenth-century humanists' argument that the conception of a painting, sculpture, or work of architecture was not a manual art but a liberal (intellectual) art, which therefore required education in the classics and mathematics, became a topic of intense interest. The

artist could express as much through painted, sculptural, and architectural forms as the poet could with words or the musician with melody. The myth of the divinely inspired creative genius—which arose during the Renaissance—is still with us today.

As with the business side of artistic production, however, the newly elevated status to which artists aspired favored men. Although few artists of either sex had access to the humanist education required for the sophisticated, often esoteric, subject matter used in paintings (most artists depended on outside sources for this aspect of their work), women were denied even the studio practice necessary to draw nude figures in foreshortened poses. Furthermore, it was almost impossible for an artist to achieve international status without traveling extensively and frequently relocating to follow commissions—something most women could not do. Still, women artists were active in European cultural life despite the obstacles to their entering any profession.

ITALY IN THE EARLY SIXTEENTH CENTURY: THE HIGH RENAISSANCE

Italian art from the 1490s to about the time of the Sack of Rome in 1527 has been called the "High Renaissance," the "Imperial style," and the "classical phase" of the Renaissance. It is characterized by a sense of gravity, a complex but balanced relationship of individual parts to the whole, and a deeper understanding of humanism and of ancient classical art than in the previous century. As before, outstanding Italian artists practicing in Rome, Florence, and other Italian cities spread this Italian Renaissance style throughout Europe.

Two important practical developments at the turn of the sixteenth century affected the arts in Italy: Technically, the use of tempera gave way to the more flexible oil medium in painting; and economically, commissions from private sources increased. Artists no longer depended so exclusively on the patronage of the Church, the aristocracy, or civic associations. Some members of the middle class in Italy and other European countries amassed wealth and became avid collectors of classical antiquities, paintings, and small bronzes, as well as coins, minerals, and fossils from the natural world.

Three Great Artists of the Early Sixteenth Century

Florence's renowned artworks and tradition of arts patronage attracted a stream of young artists to that city. The frescoes in the Brancacci Chapel there (SEE FIG. 19–20) inspired young artists, who went to study Masaccio's solid, monumental figures and eloquent facial features, poses, and gestures. For example, the young Michelangelo's sketches of the chapel frescoes clearly show the importance of Masaccio to his developing style. Michelangelo, Leonardo, and Raphael—the three leading artists of the classical phase of the Italian

Renaissance—all began their careers in Florence, although they soon moved to other centers of patronage and their influence spread far beyond that city.

LEONARDO DA VINCI. Leonardo da Vinci (1452–1519) was twelve or thirteen when his family moved to Florence from the Tuscan village of Vinci. He was an apprentice in the shop of the painter and sculptor Verrocchio until about 1476. After a few years on his own, Leonardo traveled to Milan in 1481 or 1482 to work for the ruling Sforza family.

Leonardo spent much of his time in Milan on military and civil engineering projects, including both urbanrenewal and fortification plans for the city, but he also created one of the key monuments of Renaissance art there: At Duke Ludovico Sforza's request, Leonardo painted THE LAST SUPPER (FIG. 20-2, AND Fig. 18, Introduction) in the refectory, or dining hall, of the Monastery of Santa Maria delle Grazie in Milan between 1495 and 1498. In fictive space defined by a coffered ceiling and four pairs of tapestries that seem to extend the refectory into another room, Jesus and his disciples are seated at a long table placed parallel to the picture plane and to the living diners seated in the hall. The stagelike space recedes from the table to three windows on the back wall, where the vanishing point of the one-point perspective lies behind Jesus's head. Jesus forms an equilateral pyramid at the center, his arms uniting the twelve disciples, who are grouped in four interlocking sets of three. As a narrative, the scene captures the moment when Jesus tells his companions that one of them will betray him. They react with shock, disbelief, and horror. Judas recoils, clutching his money bag in the shadows to the left of Jesus. Leonardo was an acute observer of human beings and his art vividly expressed human emotions.

On another level, The Last Supper is a symbolic evocation of both Jesus's coming sacrifice for the salvation of humankind and the institution of the ritual of the Mass. Breaking with traditional representations of the subject, such as the one by Andrea del Castagno (SEE FIG. 19-25), Leonardo placed the traitor Judas in the first triad to the left of Jesus, with the young John the Evangelist and the elderly Peter, rather than isolating him on the opposite side of the table. Judas, Peter, and John were each to play an essential role in Jesus's mission: Judas to set in motion the events leading to Jesus's sacrifice; Peter to lead the Church after Jesus's death; and John, the visionary, to foretell the Second Coming and the Last Judgment in the Apocalypse. By arranging the disciples and architectural elements into four groups of three, Leonardo incorporated a medieval tradition of numerical symbolism. He eliminated another symbolic element—the halo-and substituted the natural light from a triple window framing Jesus's head (compare Rembrandt's reworking of the composition, Fig. 19, Introduction).

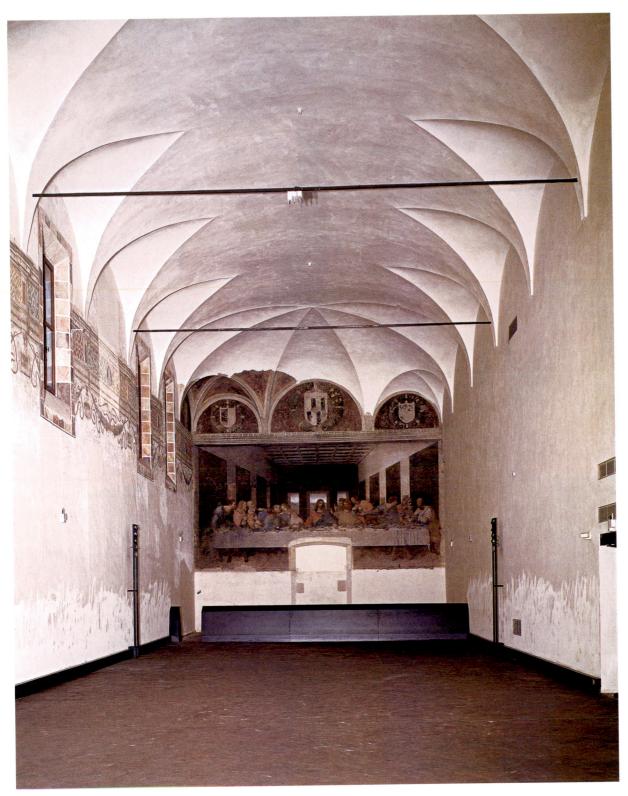

20–2 † Leonardo THE LAST SUPPER Wall painting in the refectory of the Monastery of Santa Maria delle Grazie, Milan, Italy. 1495–98. Tempera and oil on plaster, 15'2" \times 28'10" (4.6 \times 8.8 m). See Introduction, Fig. 18.

Instead of painting in fresco, Leonardo devised an experimental technique for this mural. Hoping to achieve the freedom and flexibility of painting on wood panel, he worked directly on dry *intonaco*—a thin layer of smooth plaster—with an oil-and-tempera paint for which the formula is unknown. The result was disastrous. Within a short time, the painting began to deteriorate, and by the middle of the sixteenth century its figures could be seen only with difficulty. In the seventeenth century, the monks saw no harm in cutting a doorway through the lower center of the composition. Since then the work has barely survived, despite many attempts to halt its deterioration and restore its original appearance. The painting narrowly escaped complete destruction in World War II, when the refectory was bombed to rubble around its heavily sandbagged wall. The coats of arms at the top are those of patron Ludovico Sforza, the Duke of Milan (ruled 1494-99), and his wife, Beatrice.

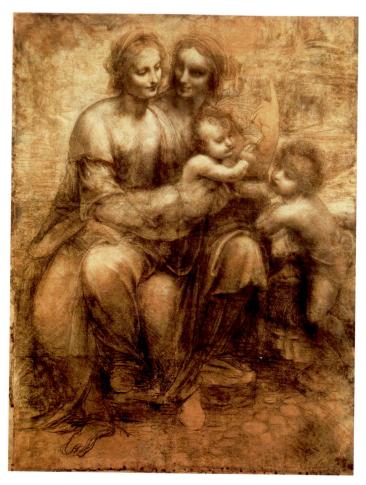

20–3 | Leonardo VIRGIN AND SAINT ANNE WITH THE CHRIST CHILD AND THE YOUNG JOHN THE BAPTIST c. 1500. Charcoal heightened with white on brown paper, $55\frac{1}{2} \times 41$ " (141.5 \times 104.6 cm). The National Gallery, London.

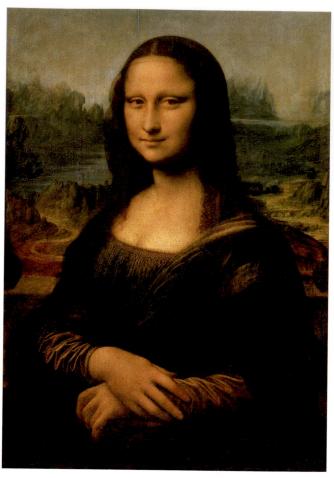

20–4 | Leonardo MONA LISA c. 1503. Oil on wood panel, $30\% \times 21''$ (77 \times 53 cm). Musée du Louvre, Paris.

The painting's careful geometry, the convergence of its perspective lines, the stability of its pyramidal forms, and Jesus's calm demeanor at the mathematical center of all the commotion together reinforce the sense of gravity, balance, and order. The work's qualities of stability, calm, and timelessness, coupled with the established Renaissance forms modeled after those of classical sculpture, characterize the art of the Renaissance at the beginning of the sixteenth century.

Leonardo returned to Florence in 1500, after the French, who had invaded Italy in 1494, claimed Milan. (They defeated Leonardo's Milanese patron, Ludovico Sforza, who remained imprisoned until his death in 1508.) Upon his return, Leonardo produced a large drawing of the VIRGIN AND SAINT ANNE WITH THE CHRIST CHILD AND THE YOUNG JOHN THE BAPTIST (FIG. 20–3). This work may be a full-scale model, called a cartoon, for a major painting, but no known painting can be associated with it. Scholars today believe it to be a finished work—perhaps one of the drawings artists often made as gifts. Mary sits on the knee of her mother, Anne, and turns to the right to hold the Christ Child, who strains away from her to reach toward his cousin, the young John the Bap-

tist. Leonardo created the illusion of high relief by modeling the figures with strongly contrasted light and shadow, a technique called **chiaroscuro** (Italian for "light-dark"). Rather than a central focus, carefully placed highlights create interlocking circular movements that activate the composition; they underscore the individual importance of each figure while making each of them an integral part of the whole. This effect emphasizes the figures' complex interactions, which are suggested by their exquisitely tender expressions, particularly those of Saint Anne and the Virgin.

Between about 1503 and 1506, Leonardo painted the renowned portrait known as MONA LISA (FIG. 20–4). The subject may have been 24-year-old Lisa Gherardini del Giocondo, the wife of a prominent merchant in Florence. Leonardo never delivered the painting and kept it with him for the rest of his life. Remarkably for the time, the young woman is portrayed without any jewelry, not even a ring. The solid pyramidal form of her half-length figure—a significant departure from the traditional portraits, which stopped at the upper torso—is silhouetted against distant mountains, whose desolate grandeur reinforces the painting's mysterious atmosphere.

Defining Art

THE VITRUVIAN MAN

rtists throughout history have turned to geometric shapes and mathematical proportions to seek the ideal representation of the human form. Leonardo da Vinci, and before him Vitruvius, equated the ideal man with both circle and square. Ancient Egyptian artists laid out square grids as aids to design. Medieval artists adapted a variety of figures, from triangles to pentagrams. The Byzantines used circles centered on the bridge of the nose to create face, head, and halo.

The first-century BCE Roman architect and engineer Vitruvius, in his ten-volume *De architectura* (*On Architecture*), wrote: "For if a man be placed flat on his back, with his hands and feet extended, and a pair of compasses centered at his navel, the fingers and toes of his two hands and feet will touch the circumference of a circle described therefrom. And just as the human body yields a circular outline, so too a square figure may be found from it. For if we measure the distance from the soles of the feet to the top of the head, and then apply that measure to the outstretched arms, the breadth will be found to be the same as the height" (Book III, Chapter 1, Section 3). Vitruvius determined that the body should be eight heads high. Leonardo added his own observations in the reversed writing he always used for his notebooks when he created his well-known diagram for the ideal male figure, called the VITRUVIAN MAN.

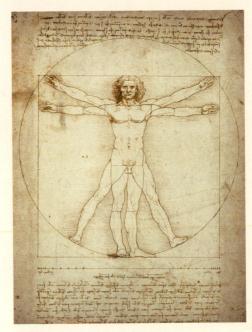

Leonardo VITRUVIAN MAN c. 1490. Ink, 13½ × 9½" (34.3 × 24.5 cm). Galleria dell'Accademia, Venice.

Mona Lisa's expression has been called enigmatic because her gentle smile is not accompanied by the warmth one would expect to see in her eyes. The contemporary fashion for plucked eyebrows and a shaved hairline to increase the height of the forehead adds to her arresting appearance. Perhaps most unsettling is the bold and slightly flirtatious way her gaze has shifted toward the right to look straight out at the viewer. The implied challenge of her direct stare, combined with her apparent serenity and inner strength, has made the *Mona Lisa* one of the most haunting and consequently one of the most popular and best-known works in the history of art.

A fiercely debated topic in Renaissance Italy was the question of the superiority of painting or sculpture. Leonardo insisted on the supremacy of painting as the best and most complete means of creating an illusion of the natural world, while Michelangelo argued for sculpture. Yet in creating a painted illusion, Leonardo considered color to be secondary to the depiction of sculptural volume, which he achieved through his virtuosity in highlighting and shading. He also unified his compositions by covering them with a thin, lightly tinted varnish, which resulted in a smoky overall haze called *sfumato*. Because early evening light tends to produce a similar effect naturally, Leonardo considered dusk the finest time of day and recommended that painters set up their

studios in a courtyard with black walls and a linen sheet stretched overhead to reproduce twilight.

Leonardo's fame as an artist is based on only a few works, for his many interests took him away from painting. Unlike his humanist contemporaries, he was not particularly interested in classical literature or archaeology. Instead, his passions were mathematics, engineering, and the natural world. He compiled volumes of detailed drawings and notes on anatomy, botany, geology, meteorology, architectural design, and mechanics. In his drawings of human figures, he sought not only the precise details of anatomy but also the geometric basis of perfect proportions (see "The Vitruvian Man," above). Leonardo's searching mind is evident in his drawings, not only of natural objects and human beings, but also of machines. His drawings are so clear and complete that modern engineers have been able to construct working models from them. He designed flying machines, a sort of automobile, a parachute, and all sorts of military equipment, including a mobile fortress. His imagination outran his means to bring his creations into being. For one thing, he lacked a source of power other than men and horses. For another, he may have lacked focus and follow-through: His contemporaries complained that he never finished anything and that his inventions distracted him from his painting.

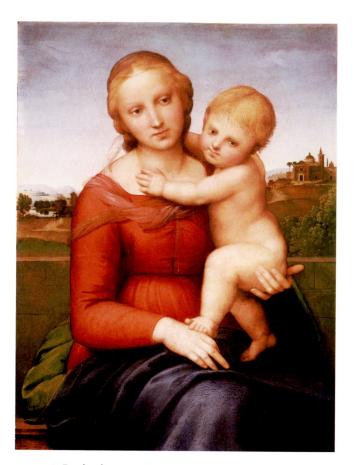

20–5 | Raphael THE SMALL COWPER MADONNA c. 1505. Oil on wood panel, $23\% \times 17\%$ " (59.5 \times 44.1 cm). National Gallery of Art, Washington, D.C. Widener Collection (1942.9.57)

RAPHAEL. About 1505, Raphael (Raffaello Santi or Sanzio, 1483-1520) arrived in Florence from his native Urbino. He had studied in Perugia with the leading artist of that city, Perugino (SEE FIG. 19-34). Raphael quickly became successful in Florence, especially with paintings of the Virgin and Child, such as THE SMALL COWPER MADONNA (named for a modern owner) of about 1505 (FIG. 20-5). Already a superb painter technically, the youthful Raphael shows his indebtedness to his teacher in the delicate tilt of the figures' heads and the tranquil, even mood that pervades the painting. But Raphael must have studied Leonardo's work to achieve the simple grandeur created by these monumental shapes, the pyramid activated by the spiraling movement of the child, and the figure-enhancing draperies of the Virgin. The solidly modeled forms are softened by the clear, even light of the outdoor setting.

In the distance on a hilltop, Raphael has painted a scene he knew well from his childhood, the domed Church of San Bernardino, two miles outside Urbino. The church contains the tombs of the dukes of Urbino, Federico and Guidobaldo da Montefeltro, and their wives (SEE FIG. 19–28). Donato Bramante, whose architecture was key in establishing the High Renaissance style (see page 677), may have designed the church.

Raphael left Florence about 1508 for Rome, where Pope Julius II put him to work almost immediately decorating rooms (stanze, singular stanza) in the papal apartments. In the Stanza della Segnatura—the papal library, which we saw at the beginning of the chapter (SEE FIG. 20–1)—Raphael painted the four branches of knowledge as conceived in the sixteenth century: Religion (the Disputà, depicting the disputation over the true presence of Christ in the Host, the Communion bread), Philosophy (the School of Athens), Poetry (Parnassus, home of the Muses), and Law (the Cardinal Virtues under Justice). The shape of the walls and vault of the room itself inspired the composition of the paintings—for example, the receding arches and vaults in the School of Athens, or the inclusion of the window as part of the rocky mountain in Parnassus.

Raphael's most outstanding achievement in the papal rooms was the **school of athens**, painted about 1510–11 (FIG. 20–6). Here, the painter seems to summarize the ideals of the Renaissance papacy in his grand conception of harmoniously arranged forms in a rational space, as well as in the calm dignity of its figures. The learned Julius II may have actually devised the subjects painted; he certainly must have approved them.

Viewed through a trompe l'oeil arch, the Greek philosophers Plato and Aristotle—placed to the right and left of the compositional vanishing point—are silhouetted against the sky (the natural world) and command our attention. At the left, Plato gestures upward, indicating the "ideal" as impossible to attain on earth. Aristotle, with his outstretched hand palm down, seems to emphasize the importance of gathering empirical knowledge from observing the material world. Looking down from niches in the walls are sculptures of Apollo, the god of sunlight, rationality, poetry, music, and the fine arts; and Minerva, the goddess of wisdom and the mechanical arts. Around Plato and Aristotle are mathematicians, naturalists, astronomers, geographers, and other philosophers debating and demonstrating their theories to onlookers and to each other. The scene, flooded with a clear, even light from a single source, takes place in an immense barrel-vaulted interior, possibly inspired by the new design for Saint Peter's, under construction at the time. The grandeur of the building is matched by the monumental dignity of the philosophers themselves, each of whom has a distinct physical and intellectual presence. The sweeping arcs of the composition are activated by the variety and energy of the poses and gestures of these striking individuals. Such dynamic unity is an expression of the High Renaissance style.

Raphael continued to work for Julius II's successor, Leo X (papacy 1513–21), as director of all archaeological and architectural projects in Rome. Leo was born Giovanni de' Medici, the son of Lorenzo the Magnificent, and his driving ambition was the advancement of the Medici family—who had been exiled from Florence in 1494 and only returned to power there in 1512. Raphael's portrait of Leo X is, in effect,

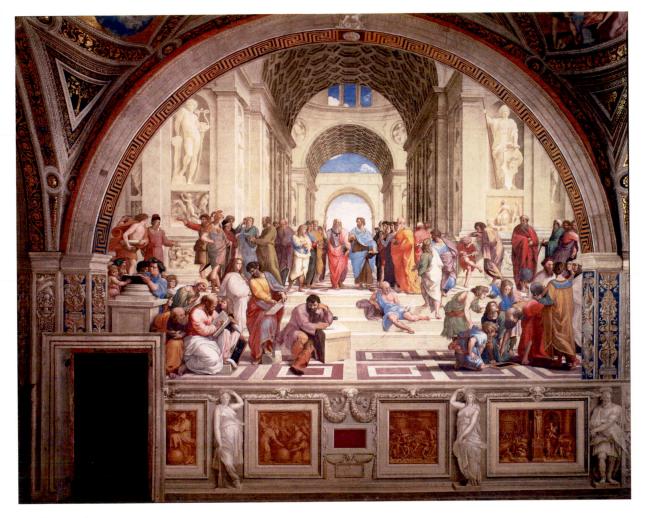

20–6 | Raphael School of Athens Fresco in the Stanza della Segnatura, Vatican, Rome. c. 1510–11. 19 \times 27' (5.79 \times 8.24 m).

Raphael gave many of the figures in his imaginary gathering of philosophers the features of his friends and colleagues. It is speculated that Plato, standing immediately to the left of the central axis and pointing to the sky, was modeled after Leonardo da Vinci; Euclid, shown inscribing a slate with a compass at the lower right, was, according to Vasari, a portrait of Raphael's friend the architect Donato Bramante. Michelangelo, who was at work on the Sistine Chapel ceiling, only steps away from the stanza where Raphael was painting his fresco, may be the solitary figure at the lower left center, leaning on a block of marble and sketching, in a pose reminiscent of the figures of the sibyls and prophets on his great ceiling. Raphael's own features are represented on the second figure from the front group at the far right, as the face of a young man listening to a discourse by the astronomer Ptolemy.

a dynastic group portrait (FIG. 20–7). Facing the pope at the left is his cousin Giulio, Cardinal de' Medici, who governed Florence from 1519 to 1523 and then became Pope Clement VII (papacy 1523–34). Behind Pope Leo stands Luigi de' Rossi, a nephew whom he made a cardinal. Dressed in splendid brocades and enthroned in a velvet chair, the pope looks up from a richly illuminated fourteenth-century manuscript that he has been examining with a magnifying glass. He seems to stare into space, and, curiously, none of the three men look at each other. The mood seems uneasy, disconnected. Raphael carefully depicted the contrasting textures and surfaces in the picture, including the visual distortion caused by the magnifying glass on the book page. The polished brass knob on the

pope's chair reflects the window and the painter himself. In these telling details, Raphael acknowledges his debt—despite great stylistic differences—to fifteenth-century Flemish artists such as Jan van Eyck.

How could a man—even a brilliant artist—accomplish so much? Raphael was only 37 when he died. The answer lies partly in Raphael's genius for organizing his studio, which enabled him to accept numerous commissions. Retaining a flexible method, Raphael was able to assign assistants wherever he felt it was appropriate, even if that meant finishing major figures in a painting or making preparatory drawings—work generally assumed by the master. Raphael thus freed himself to concentrate on what he considered most necessary at any given

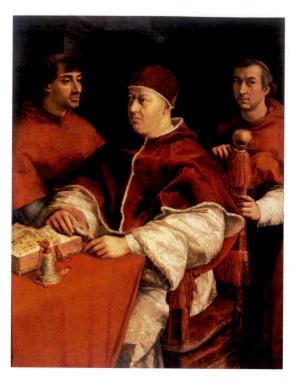

20–7 | Raphael POPE LEO X WITH CARDINALS GIULIO DE' MEDICI AND LUIGI DE' ROSSI c. 1517. Oil on wood panel, 5'\%" \times 3'10\%" (1.54 \times 1.19 m). Galleria degli Uffizi, Florence.

time. This method sometimes resulted in uneven products, especially toward the end of the artist's short life, when he was overwhelmed with work. Yet, even then, Raphael's major pieces show his contribution to be the dominant one.

In 1515–16, Raphael and his shop provided cartoons on themes from the Acts of the Apostles to be made into tapestries to cover the wall below the fifteenth-century wall paintings of the Sistine Chapel (FIG. 20–8). This commission must have suited Raphael's method, accustomed as he was to teamwork. For the production of tapestries, which were woven in workshops in Flanders, artists made full-scale charcoal drawings, then painted over them with glue-based colors for the weavers to match. Pictorial weaving was the most prestigious and expensive kind of wall decoration. With murals by the leading painters of the fifteenth century above and Michelangelo circling over all, Raphael must have felt the challenge. The pope had given him the place of honor among the artists in the papal chapel.

The first tapestry in Raphael's series was the **MIRACULOUS DRAFT OF FISHES** on the Sea of Galilee (Matt. 4:18–22). The fisherman Simon, whom Christ called to be his first apostle, Peter, became the cornerstone on which the papal claims to authority rested. Andrew, James, and John would also become apostles. The two boats establish a friezelike composition, and

20–8 | Shop of Pieter van Aelst, Brussels, after cartoons by Raphael and assistants MIRACULOUS DRAFT OF FISHES

1515–16. From the nine-piece set, the *Acts of the Apostles* series; lower border, two incidents from the life of Giovanni de' Medici, later Pope Leo X. Woven 1517, installed 1519 in the Sistine Chapel. Wool and silk with silver-gilt wrapped threads, 16'1" × 21' (4.9 × 6.4 m). Musei Vaticani, Pinacoteca, Rome.

Raphael's Acts of the Apostles cartoons were used as the models for several sets of tapestries woven in van Aelst's Brussels shop, including one for Francis I of France and another for Henry VIII of England. In 1630, the Flemish painter Peter Paul Rubens (Chapter 22) discovered seven of the ten original cartoons in the home of a van Aelst heir and convinced his patron Charles I of England to buy them. Still part of the British royal collection today, they are exhibited at the Victoria & Albert Museum in London. The original tapestries were stolen during the Sack of Rome in 1527, returned in the 1530s, taken to Paris by Napoleon in 1798, purchased by a private collector in 1808, and returned to the Vatican as a gift that year. They are now displayed in the Raphael Room of the Vatican Painting Gallery.

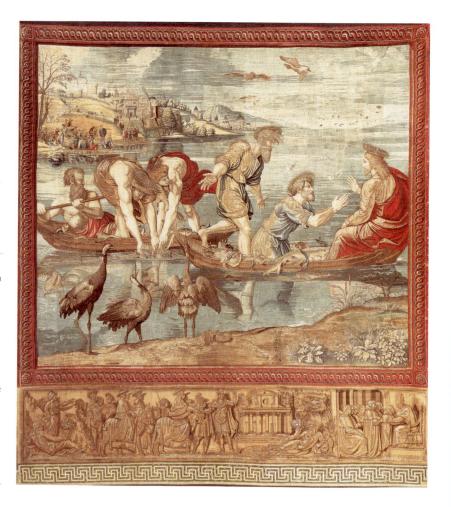

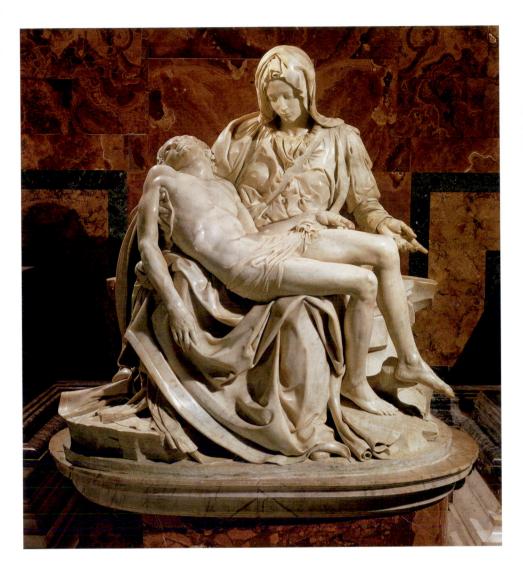

20–9 | Michelangelo PIETÀ c. 1500. Marble, height 5'8½" (1.74 m). Saint Peter's, Vatican, Rome

the huge straining figures remind us that Raphael felt himself in clear competition with Michelangelo, whose Sistine ceiling had been completed only three years earlier. Raphael studied not only his contemporaries' paintings, but also antique sources in his efforts to achieve both monumentality and realism. For example, he copied the face of Christ from a fifteenth-century bronze copy of an ancient emerald cameo, which at the time was thought to be the true portrait of Jesus. The panoramic landscape behind the fishermen includes a crowd on the shore, and the city of Rome with its walls and churches. The three cranes in the foreground were not a simple pictorial device; in the sixteenth century they symbolized the ever-alert and watchful pope. The cranes proved to be a timely addition. When the tapestries were first displayed in the Sistine Chapel on December 26, 1519, papal authority was already being challenged by reformers like Martin Luther in Germany (see Chapter 21).

MICHELANGELO'S EARLY WORK. Michelangelo Buonarroti (1475–1564) was born in the Tuscan town of Caprese into an impoverished Florentine family that laid claim to nobility: a claim the artist carefully advanced throughout his life. He

grew up in Florence, and spent his long career working there and in Rome. At thirteen, he was apprenticed to Ghirlandaio (SEE FIG. 19-36), in whose workshop he learned the rudiments of fresco painting and studied drawings of classical monuments. Soon the talented youth joined the household of Lorenzo the Magnificent, head of the ruling Medici family, where he came into contact with the Neoplatonic philosophers and studied sculpture with Bertoldo di Giovanni, a pupil of Donatello. Bertoldo worked primarily in bronze, and Michelangelo later claimed that he had taught himself to carve marble by studying the Medici collection of classical statues. After Lorenzo died in 1492, Michelangelo traveled to Venice and Bologna, then returned to Florence, where he fell under the spell of the charismatic preacher Fra Girolamo Savonarola (see Chapter 19). The preacher's execution for heresy in 1498 had a traumatic effect on Michelangelo, who said in his old age that he could still hear the sound of Savonarola's voice.

Michelangelo's major early work at the turn of the century was a **pietà** marble sculpture group, commissioned by a French cardinal and installed as a tomb monument in the Vatican basilica of Saint Peter (FIG. 20–9). The pietà—in

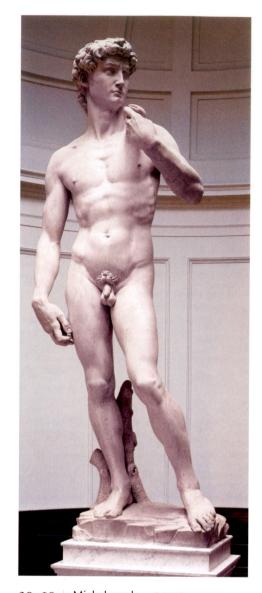

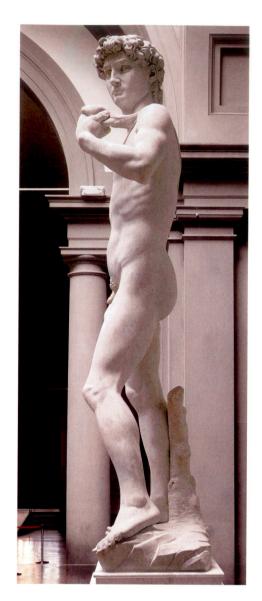

20–10 | Michelangelo DAVID 1501-04. Marble, height 17' (5.18 m) without pedestal. Galleria dell'Accademia, Florence.

Michelangelo's most famous sculpture was cut from an 18-foot-tall marble block. The sculptor began with a small model in wax, then sketched the contours of the figure as they would appear from the front on one face of the marble. Then, according to his friend and biographer Vasari, he chiseled in from the drawn-on surface, as if making a figure in very high relief. The completed statue took four days to move on tree-trunk rollers down the narrow streets of Florence from the premises of the cathedral shop where he worked to its location outside the Palazzo della Signoria (SEE FIG. 17-2). In 1504, the Florentines gilded the tree stump and added a gilded wreath to the head and a belt of twenty-eight gilt-bronze leaves, since removed. In 1873 the statue was replaced by a copy, and the original was moved into the museum of the Florence Academy.

which the Virgin supports and mourns the dead Jesus—had long been popular in northern Europe but was an unusual theme in Italian art at the time. Michelangelo traveled to the marble quarries at Carrara in central Italy himself to select the block from which to make this large work, a practice he was to follow for nearly all of his sculpture. His choice of stone was important, for Michelangelo envisioned the statue as already existing within the marble and needing only to be "set free" from it. Michelangelo was a poet as well as an artist, and later wrote in his Sonnet 15:

"The greatest artist has no conception which a single block of marble does not potentially contain within its mass, but only a hand obedient to the mind can penetrate to this image" (1536–47).

Michelangelo's *Pietà* is a very young Virgin of heroic stature holding the lifeless, smaller body of her grown son. The seeming inconsistencies of age and size are forgotten in contemplating the sweetness of expression, the finely finished surfaces, and the softly modeled forms. Michelangelo's compelling vision of beauty is meant to be seen up close, from

directly in front of the statue and on the statue's own level, so that the viewer can look into Jesus's face. The 25-year-old artist is said to have slipped into the church at night to sign the finished sculpture, to answer the many questions about its creator. It is the only signature of Michelangelo's that has not been disputed.

In 1501, Michelangelo accepted a commission for a statue of one of the symbols of Florence, the biblical DAVID (FIG. 20-10), to be placed high atop a buttress of the Cathedral. When it was finished in 1504, the David was so admired that the city council instead placed it at eye-level in the square next to the Palazzo Vecchio, the seat of Florence's government. There it stood as a reminder of Florence's republican status, which was briefly reinstated after the expulsion of the powerful Medici oligarchy in 1494. Although, in its muscular nudity, Michelangelo's David embodies the athletic ideal of antiquity—particularly of Hellenistic sculptures of Hercules (another symbol of Florence)—the emotional power of its expression and its concentrated gaze is entirely new. Unlike Donatello's bronze David (SEE FIG. 19–13), this is not a triumphant hero with the head of the giant Goliath under his feet. Instead, slingshot over his shoulder and a rock in his right hand, Michelangelo's David frowns and stares into space, seemingly preparing himself psychologically for the danger ahead, a mere youth confronting a gigantic experienced warrior. Here the male nude implies heroic or even divine qualities, as it did in classical antiquity. Traditionally no match for his opponent in experience, weaponry, or physical strength, Michelangelo's powerful David represents the supremacy of right over might—a perfect emblematic figure for the Florentines, who recently had fought the forces of Milan, Siena, and Pisa and still faced political and military pressure.

THE SISTINE CHAPEL. Despite Michelangelo's contractual commitment to the Florence Cathedral for statues of the apostles, in 1505 Pope Julius II, who saw Michelangelo as an ideal collaborator in the artistic aggrandizement of the papacy, arranged for him to come to Rome to work on the spectacular tomb-monument Julius planned for himself. Michelangelo began the new project, but two years later in 1506 the pope put this commission aside and ordered him to paint the SISTINE CHAPEL CEILING instead (FIG. 20–II).

Michelangelo considered himself a sculptor, but the strong-minded pope wanted his chapel painted and paid Michelangelo well for the work, which began in 1508. Michelangelo complained bitterly in a sonnet to a friend: "This miserable job has given me a goiter . . . The force of it has jammed my belly up beneath my chin. Beard to the sky . . . Brush splatterings make a pavement of my face . . . I'm not a painter." Despite his physical misery as he stood on a scaffold, painting the ceiling just above him, he achieved the

Sequencing Events Reigns of the Great Papal Patrons of the Sixteenth Century

1492-1503	Alexander VI (Borgia)
1503-13	Julius II (della Rovere)
1513-21	Leo X (Medici)
1523-34	Clement VII (Medici)
1534-49	Paul III (Farnese)
1585-90	Sixtus V (Peretti)

desired visual effects for viewers standing on the floor far below. His Sistine Chapel ceiling frescoes established a new and extraordinarily powerful style in Renaissance painting.

Julius's initial order for the ceiling was simple: trompe l'oeil coffers to replace the original star-spangled blue ceiling. Later he wanted the twelve apostles seated on thrones to be painted in the triangular walls between the lunettes framing the windows. According to Michelangelo, when he objected to the limitations of Julius's plan, the pope told him to paint whatever he liked. This Michelangelo presumably did, although a commission of this importance probably involved an adviser in theology. Certainly it required the pope's approval. Then, as master painter, Michelangelo assembled a team of expert assistants, who probably continued to work with him under close supervision.

In Michelangelo's final composition, illusionistic marble architecture establishes a framework for the figures on the vault of the chapel (FIG. 20-12). Running completely around the ceiling is a painted cornice with projections supported by short pilasters decorated with putti. Set within this frame are figures of Old Testament prophets and classical sibyls (female prophets) who were believed to have foretold Jesus's birth. Seated on the fictive cornice are heroic figures of nude young men, called ignudi (singular, ignudo), holding sashes attached to large gold medallions. Rising behind the ignudi, shallow bands of fictive stone span the center of the ceiling and divide it into compartments in which are painted scenes of the Creation, the Fall, and the Flood. The narrative sequence begins over the altar and ends near the chapel entrance (FIG. 20-13). God's earliest acts of creation are therefore closest to the altar, the Creation of Eve at the center of the ceiling, followed by the imperfect actions of humanity: the Temptation, the Fall, the Expulsion from Paradise, and God's eventual destruction of all people except Noah and his family by the Flood. The triangular spandrels contain paintings of the ancestors of Jesus; each is flanked by mirror-image nudes in reclining and seated poses.

According to discoveries during the most recent restoration, Michelangelo worked on the ceiling in two

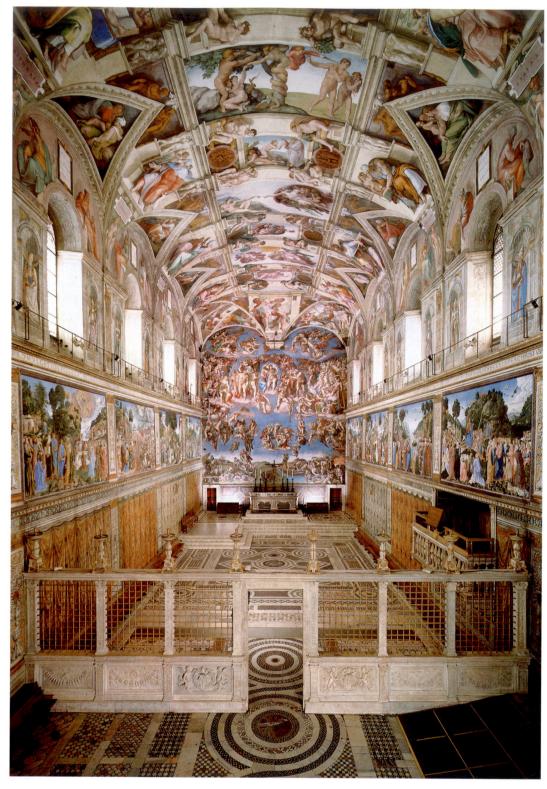

20-II INTERIOR, SISTINE CHAPEL

Vatican, Rome. Built 1475–81; ceiling painted 1508–12; end wall, 1536–41. The ceiling measures $45 \times 128'$ (13.75 \times 39 m).

Named after its builder, Pope Sixtus (Sisto) IV, the chapel is slightly more than 130 feet long and about 143½ feet wide, approximately the same measurements recorded in the Old Testament for the Temple of Solomon. The floor mosaic was recut from the colored stones used in the floor of an earlier papal chapel. The walls were painted in fresco between 1481 and 1483 with scenes from the lives of Moses and Jesus by Perugino (SEE FIG. 19–34), Botticelli, Ghirlandaio, and others. Below these are *trompe l'oeil* painted draperies, where Raphael's tapestries illustrating the Acts of the Apostles once hung (SEE FIG. 20–8). Michelangelo's famous ceiling frescoes begin with the lunette scenes above the windows. On the end above the altar is his *Last Judgment* (SEE FIG. 20–28).

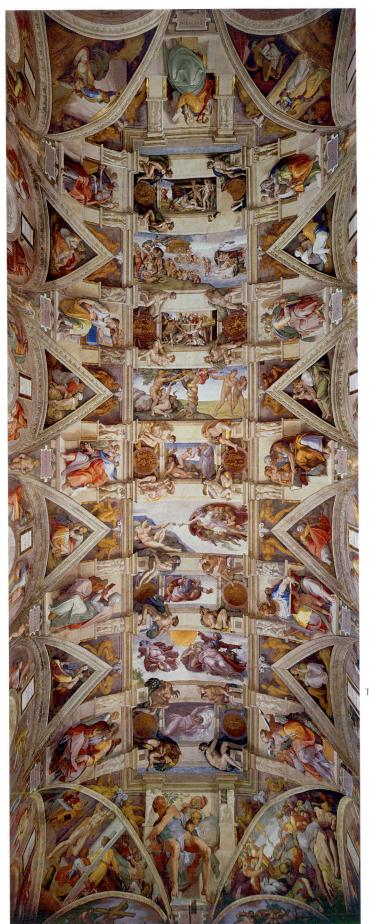

20–12 \mid Michelangelo VIEW OF THE SISTINE CHAPEL CEILING FRESCOES Vatican, Rome. 1508-12. 45' \times 128' (13.75 \times 39 m). Commissioned by Pope Julius II.

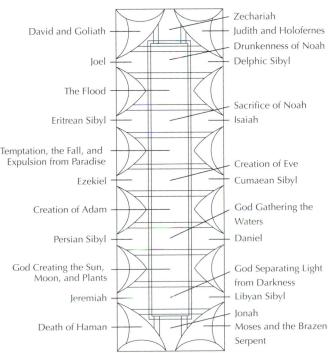

 $20\text{--}13^{-\!-\!-}$ diagram of scenes of the sistine chapel ceiling

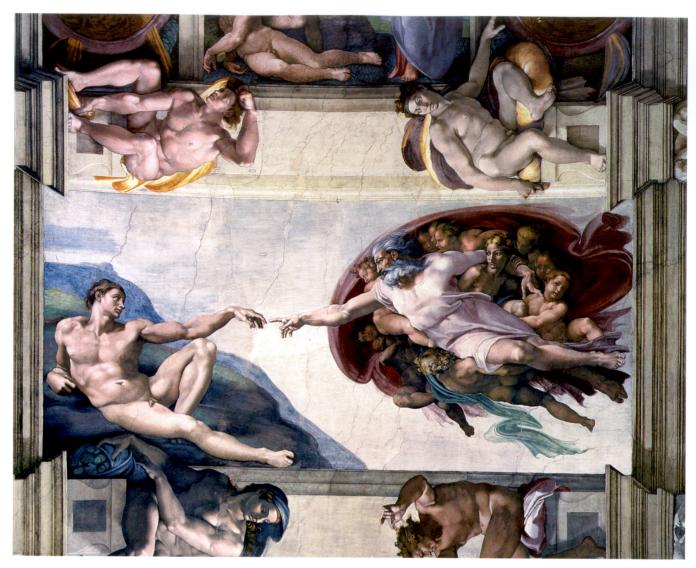

20–14 Michelangelo **CREATION OF ADAM, SISTINE CHAPEL CEILING** 1511–12.

The Creation of Adam, which opens the second stage of Michelangelo's fresco cycle, has the simplified background and the powerful male figures, and nude youths twisting into contrapposto poses characteristic of this phase of his work. Stylus marks above Adam's head show where the artist transferred his design onto the wet plaster.

stages, beginning in the late summer or fall of 1508 and moving from the chapel's entrance toward the altar, in reverse of the narrative sequence. The first half of the ceiling up to the Creation of Eve was unveiled in August 1511 and the second half in October 1512. His style became broader and the composition simpler as he progressed.

Perhaps the most familiar scene on the ceiling is the **CREATION OF ADAM** (FIG. 20–14). Here Michelangelo depicts the moment when God charges the languorous Adam with the spark of life. As if to echo the biblical text, Adam's

heroic body and pose mirror those of God, in whose image he has been created. Directly below Adam is an *ignudo* grasping a bundle of oak leaves and giant acorns, which refer to Pope Julius's family name (della Rovere, or "of the oak") and possibly also to a passage in the Old Testament prophecy of Isaiah (61:3): "They will be called oaks of justice, planted by the Lord to show his glory."

MICHELANGELO'S LATER SCULPTURE. Michelangelo's first papal sculpture commission, the tomb of Julius II, still incomplete at

Julius's death in 1513, was to plague him and his patrons for forty years. In 1505, he had presented his first designs to the pope for a huge freestanding structure crowned by the pope's sarcophagus and covered with more than forty statues and reliefs in marble and bronze. But Julius had halted the tomb project to divert money toward other ends. After Julius died, his heirs soon began to cut back on the expense and size of the tomb. At this time, between 1513 and 1516, and again from 1542 to 1545, Michelangelo worked on the figure of MOSES (FIG. 20-15), the only sculpture from the original design to be incorporated into the final, much-reduced monument to Julius II. No longer an actual tomb-Julius was buried elsewhere—the monument was installed in 1545, after decades of wrangling, in the Church of San Pietro in Vincoli, Rome, where Julius had been the cardinal. In the original design, Moses was to have been one of four seated figures; in the final configuration, however, Moses becomes the focus of the monument and a stand-in for the long-dead pope.

Moses is an inspired figure, a prophet holding the tablets of the Law, which he has just received from God on Mount Sinai. Like the prophets on the Sistine Chapel ceiling, his gigantic muscular figure, swathed in great sheets of drapery, is seated in a restless contrapposto that seems to strain the confines of the niche. Moses's beard is an extraordinary curling, flowing mass that covers his chest. Michelangelo's carving of this beard as it is drawn aside by a finger is a tour de force of marble sculpture.

After the Medici regained power in Florence in 1512, and Leo X succeeded Julius in 1513, Michelangelo became chief architect for Medici family projects at the Church of San Lorenzo in Florence—including a new chapel for the tombs of Lorenzo the Magnificent, his brother Giuliano, and two younger dukes, also named Lorenzo and Giuliano, ordered in 1519. The older men's tombs were never built to Michelangelo's designs, but the unfinished tombs for the younger relatives were placed on opposite side walls of the so-called New Sacristy (FIG. 20–16). The Old Sacristy, by Filippo Brunelleschi, is at the other end of the transept (SEE FIG. 19–3).

In the New Sacristy, each of the two monuments consists of an idealized portrait of the deceased, who turns to face the family's unfinished ancestral tomb. The men are dressed in a sixteenth-century interpretation of classical armor and seated in niches above pseudoclassical sarcophagi. Balanced precariously atop the sarcophagi are male and female figures representing the times of day. Their positions would not seem so unsettling had reclining figures of river gods been installed below them, as originally planned. Giuliano represents the Active Life, and his sarcophagus figures are allegories of Night and Day. Night is accompanied by her symbols: a star and crescent moon on her tiara; poppies, which induce sleep; and an owl under the arch of her leg. The huge mask at her back may allude to Death, since Sleep and Death were said to be the children of Night. Lorenzo, representing the

Sequencing Events GREAT SECULAR PATRONS OF THE SIXTEENTH CENTURY

1452-1508	Ludovico Sforza, Duke of Milan
1474-1539	Isabella d'Este, Marchesa of Mantua
1494-1547	Francis I (Valois), King of France
1500-40	Federigo II Gonzaga, Fifth Marchese and First Duke of Mantua
1500-58	Charles V (Habsburg), King of Spain and Holy Roman Emperor
1519-74	Cosimo I de' Medici, Duke of Florence and Grand Duke of Tuscany

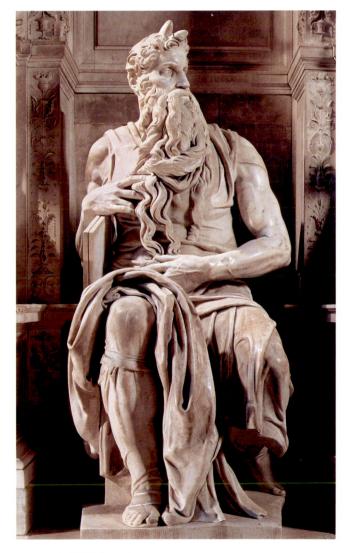

20–15 | Michelangelo MOSES Tomb of Julius II. 1513–16, 1542–45. Marble, height 7'8½" (2.35 m). Church of San Pietro in Vincoli, Rome.

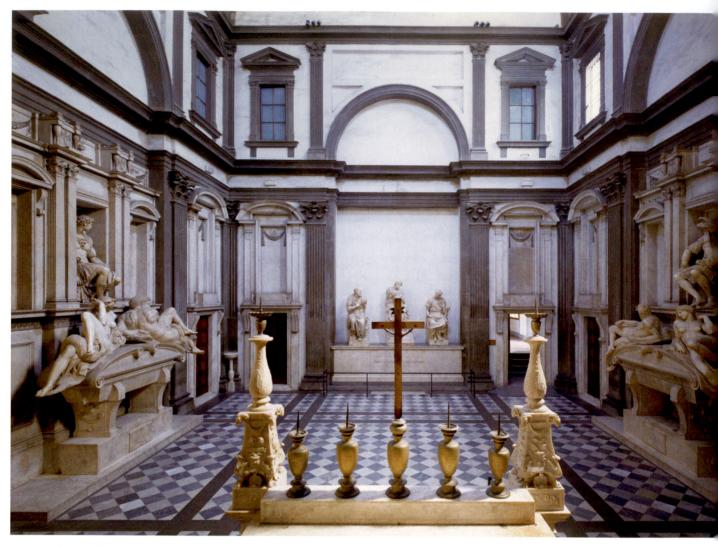

20–16 | Michelangelo NEW SACRISTY (MEDICI CHAPEL) 1519–34. Church of San Lorenzo, Florence.

Looking from the altar, we see on the left the tomb of Giuliano de' Medici, with Giuliano seated in the niche and personifications of Day and Night reclining on the pseudo-classical sarcophagus; on the right, the tomb of Lorenzo with the personifications of Dusk and Dawn. Facing the altar is the unfinished tomb of Lorenzo the Magnificent with the "Medici Madonna" in the center and the Medici patron saints, Sts. Cosmas and Damian, at each side.

Contemplative Life, is supported by Dawn and Evening. The allegorical figures for the empty niches that flank the tombs were never carved. The walls of the sacristy are articulated with Brunelleschian *pietra serena* pilasters and architraves in the Corinthian order.

Ongoing political struggles in Florence interrupted Michelangelo's work. In 1534, detested by the new Duke of Florence and fearing for his life, Michelangelo returned to Rome, where he settled permanently. He had left the Medici chapel unfinished. Many years later, in 1545, his students assembled the tomb sculptures, including unfinished figures of the times of day, into the composition we

see today. The figures of the dukes are finely finished, but the times of day are notable for their contrasting areas of rough unfinished and polished marble. These are the only unfinished sculptures Michelangelo may have permitted to be put in place, and we do not know what his reasons were. Michelangelo specialists call this his *nonfinito* ("unfinished") quality, suggesting that he had begun to view his artistic creations as symbols of human imperfection. Indeed, Michelangelo's poetry often expressed his belief that humans could achieve perfection only in death. The lack of finish may also reflect his belief that the block of marble held the image prisoner within it. Some of

Michelangelo's unfinished sculptures were placed in the Great Grotto of the Boboli Gardens in Florence (see "The Grotto," right).

Michelangelo's style continued to evolve throughout his career in sculpture, painting, and architecture, and he produced significant works until his death in 1564. We will return to him later in this chapter to examine his further development and his direct influence on artists of the later sixteenth century.

Architecture in Rome and the Vatican

The election of Julius II as pope in 1503 crystallized a resurgence of the papal power. France, Spain, and the Holy Roman Empire all had designs on Italy. The political turmoil that beset Florence, Milan, and other northern cities left Rome as Italy's most active artistic and intellectual center. During the ten years of his reign, Julius fought wars and formed alliances to consolidate his power. And in addition to commissioning large painting programs and sculpture projects, he also enlisted the artists Bramante, Raphael, and Michelangelo as architects to carry out his vision of revitalizing Rome and the Vatican, the pope's residence, as the center of a new Christian art based on classical forms and principles.

Inspired by the achievements of their fifteenth-century predecessors as well as the monuments of antiquity, architects working in Rome created a new ideal classical style typified by the architecture of Bramante. The first-century Roman architect and engineer Vitruvius wrote a treatise on classical architecture (see "The Vitruvian Man," page 665) that became an important source for sixteenth-century Italian architects. Although most commissions were for churches, opportunities also arose to build urban palaces and country villas.

Bramante. Donato Bramante (1444–1514) was born near Urbino and trained as a painter, but turned to architectural design early in his career. Earlier in this chapter, we saw a church attributed to him, the Church of San Bernardino near Urbino, in the landscape background of Raphael's Small Cowper Madonna (SEE FIG. 20-5). About 1481, he became attached to the Sforza court in Milan, where he would have known Leonardo da Vinci. In 1499, Bramante settled in Rome, but work came slowly. The architect was nearing sixty when, according to a dedicatory inscription, the Spanish rulers Queen Isabella and King Ferdinand commissioned a small shrine over the spot in Rome where the apostle Peter was believed to have been crucified (FIG. 20-17). In this tiny building, known as the **TEMPIETTO** ("Little Temple"), Bramante combined his interpretation of the principles of Vitruvius and the fifteenth-century architect Leon Battista Alberti, from the stepped base to the Doric columns and frieze (Vitruvius had advised that the Doric order be used for temples to gods of particularly forceful character) to the elegant balustrade. The centralized plan and the tall drum, or

Elements of Architecture

THE GROTTO

f all the enchanting features of Renaissance gardens, none is more intriguing than a grotto, a recess typically constructed of irregular stones and shells and covered with fictive foliage and slime to suggest a natural cave. The fancifully decorated grotto usually included a spring, pool, fountain, or other waterworks. Sculpture of earth giants might support its walls, and depictions of nymphs might suggest the source of the water that nourished the garden. Great Renaissance gardens had at least one grotto where one could commune with nymphs and Muses and escape the summer heat. Alberti recommended that the contrived grotto be covered "with green wax, in imitation of mossy Slime which we always see in moist grottoes" (Alberti, On Architecture, 9.4).

The Great Grotto of the Boboli Gardens of the Pitti Palace in Florence, designed by Bernardo Buontalenti in 1583 and constructed in 1587-93, contained four marble captives (originally conceived for the tomb of Pope Julius II) carved by Michelangelo and, in its inner cave, a 1592 copy of Astronomy (or Venus Urania by Giovanni da Bologna (SEE FIG. 20-41). Flowing water operated fountains, hydraulic organs, and other devices, such as mechanical birds that fluttered their wings and chirped or sang, filling the grotto with noise, if not music. Water jets concealed in the floor, stairs, or crevasses in the rockwork could be turned on by the owner to drench his guests, to the great amusement of all.

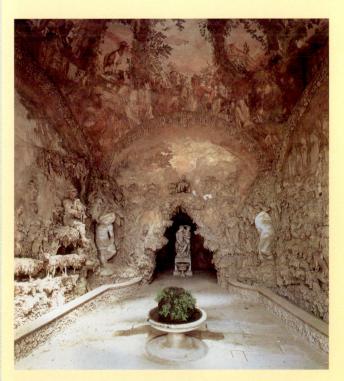

Bernardo Buontalenti **THE GREAT GROTTO, BOBOLI GARDENS, PITTI PALACE, FLORENCE**1583–93. Sculpture by Michelangelo.

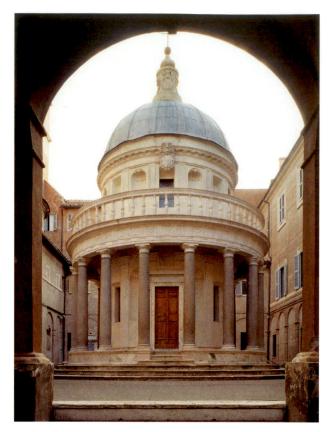

20–17 | Donato Bramante | TEMPIETTO, CHURCH OF SAN PIETRO IN MONTORIO

Rome. 1502-10; dome and lantern were restored in the 17th century.

circular wall, supporting a hemispheric dome recall early Christian shrines built over martyrs' relics, as well as ancient Roman circular temples. Especially notable is the sculptural effect of the building's exterior, with its deep wall niches creating contrasts of light and shadow, and the Doric frieze of carved papal emblems. Bramante's design called for a circular cloister around the church, but the cloister was never built.

Shortly after Julius II's election as pope, he commissioned Bramante to renovate the Vatican Palace. Julius also appointed him chief architect of a project to replace Saint Peter's Basilica (see "Saint Peter's Basilica," right).

THE ROMAN PALACE. Sixteenth-century Rome was more than a city of churches and public monuments. Wealthy families, many of whom had connections with the pope or the cardinals—the "princes of the church"—commissioned architects to design residences to enhance their prestige. For example, Cardinal Alessandro Farnese (who became Pope Paul III in 1534) set Antonio da Sangallo the Younger (1484–1546) the task of rebuilding the PALAZZO FARNESE into the largest, finest palace in Rome (FIG. 20–18). The main façade of the great rectangular building faces a public square—which was created by tearing down blocks of

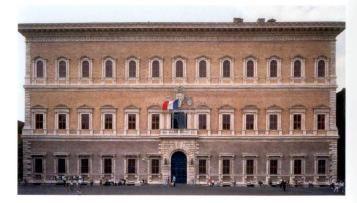

20-18 | Antonio da Sangallo the Younger and Michelangelo PALAZZO FARNESE, ROME

1517-50. When Sangallo died in 1546, Michelangelo added the third floor and cornice.

houses. The massive central door is emphasized by elaborate rusticated stonework (as are the building's corners, where the shaped stones are known as quoins) and is surmounted by a balcony suitable for ceremonial appearances, over which is set the cartouche (a decorative plaque) with the Farnese coat of arms—lilies. The palace's three stories are clearly defined by two horizontal bands of stonework, or stringcourses. Windows are treated differently on each story: on the ground floor, the twelve windows sit on supporting brackets. The story directly above is known in Italy as the piano nobile, or first floor (Americans would call it the second floor), which contains large and richly decorated reception rooms. Its twelve windows are decorated with alternating triangular and arched pediments supported by pairs of engaged halfcolumns in the Corinthian order. The second floor (or American third floor) has windows all with triangular pediments whose supporting Ionic half columns are set on brackets echoing those under the windows on the ground floor. At the back, a loggia overlooks a garden and the Tiber River. Annibale Carracci painted the loggia in 1597-1601 (SEE FIG. 22-13). When Sangallo died, the pope turned work on the palace over to Michelangelo, who added focus to the building by emphasizing the portal and gave it added dignity by increasing the height of the top story, capping the building with a magnificent cornice.

Great patrons of the arts were also great collectors of antiquities, none greater than Farnese, and none more generous to artists wanting to study. The Farnese *Hercules* stood in the courtyard, to impress visitors with the extensive collection of antiquities—and the erudition—of the owner (Figs. 23, 24, Introduction). Imagine walking into the Farnese Palace; then identify with the two "tourists" who come upon the colossal figure. The Farnese *Hercules*, along with the *Laocoön* and other discoveries by sixteenth-century art excavators, created new

Elements of Architecture

SAINT PETER'S BASILICA

he history of Saint Peter's in Rome is an interesting case of the effects of individual and institutional demands on the practical congregational needs of a major religious building. The original church, now referred to as Old Saint Peter's, was built in the fourth century CE by Constantine, the first Christian Roman emperor, to mark the grave of the apostle Peter, the first bishop of Rome and therefore the first pope. Because the site was considered the holiest in Europe, Constantine's architect had to build a structure large enough to house Saint Peter's tomb and to accommodate the crowds of pilgrims who came to visit it. To provide a platform for the church, a huge terrace was cut into the side of the Vatican Hill, across the Tiber River from the city. Here Constantine's architect erected a basilica, with a new feature, a transept, to allow large numbers of visitors to approach the shrine at the front of the apse. The rest of the church was, in effect, a covered cemetery, carpeted with the tombs of believers who wanted to be buried near the apostle's grave. When it was built, Constantine's basilica, as befitted an imperial commission, was one of the largest buildings in the world (interior length 368 feet; width 190 feet), and for more than a thousand years it was the most important pilgrim shrine in Europe.

In 1506, Pope Julius II made the astonishing decision to demolish the Constantinian basilica, which had fallen into disrepair, and to replace it with a new building. That anyone, even a pope, had the nerve to pull down such a venerated building is an indication of the extraordinary sense of assurance of the age—and of Julius himself. To design and build the new church, the pope appointed Donato Bramante. Bramante envisioned

the new Saint Peter's as a central-plan building, in this case a Greek cross (with four arms of equal length) crowned by an enormous dome. This design was intended to continue the tradition of domed and round *martyria* (martyrs' shrines). In Renaissance thinking, the central plan and dome symbolized the perfection of God.

The deaths of pope and architect in 1513 and 1514 put a temporary halt to the project. Successive plans by Raphael, Antonio da Sangallo, and others changed the Greek cross to a Latin cross (with three shorter arms and one long one) to provide the church with a full-length nave. However, when Michelangelo was appointed architect in 1546, he returned to the Greekcross plan. Michelangelo simplified Bramante's design to create a single, unified space covered with a hemispherical dome. The dome was finally completed some years after Michelangelo's death by Giacomo della Porta, who retained Michelangelo's basic design but gave the dome a taller profile (SEE FIG. 20–29).

During the Counter-Reformation, the Church emphasized congregational worship, so more space was needed to house the congregation and allow for processions. To expand the church—and to make it more closely resemble Old Saint Peter's—Pope Paul V in 1606 commissioned the architect Carlo Maderno to change Michelangelo's Greek-cross plan to a Latin-cross plan. Maderno extended the nave to its final length of slightly more than 636 feet and added a new façade, thus completing Saint Peter's as it is today. Later in the seventeenth century, the sculptor and architect Gianlorenzo Bernini changed the approach to the basilica by creating an enormous piazza. In the twentieth century a wide avenue was built joining the piazza and the Tiber River.

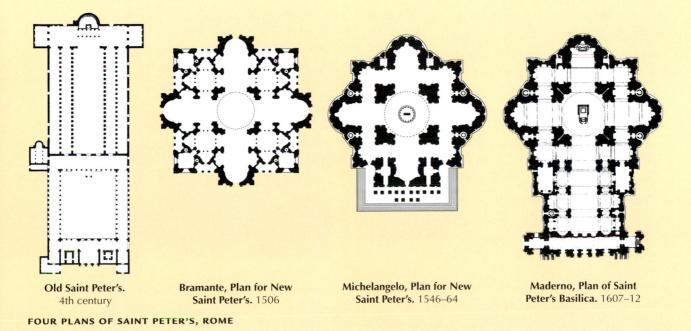

ideals for the contemporary artists. Like our two gentlemen, once having seen these extraordinary muscle men their view of art would be forever changed. Who could return to the bony figure of Jan van Eyck's Adam?

Architecture and Painting in Northern Italy

While Rome ranked as Italy's preeminent arts center at the beginning of the sixteenth century, wealthy and powerful families elsewhere in Italy also patronized the arts and letters, just as the Montefeltro had in Urbino and the Gonzaga had in Mantua during the fifteenth century. Their architects created fanciful structures and their painters developed a new colorful, illusionistic style—witty, elegant, and finely executed art designed to appeal to the jaded taste of the intellectual elite of Mantua, Parma, and Venice.

GIULIO ROMANO. In Mantua, Federigo II Gonzaga (ruled 1519-40) continued the family tradition of patronage when in 1524 he lured a Roman architect and follower of Raphael, Giulio Romano (c. 1499-1546), to Mantua to build a pleasure palace. The PALAZZO DEL TÈ (FIG. 20-19) is not "serious" architecture and was never meant to be. Giulio Romano devoted more space in his design to gardens, pools, and stables than he did to rooms for living—and partying. Federigo and his erudite friends would have known classical orders and proportions so well that they could appreciate this travesty of classical ideals—visual jokes such as lintels masquerading as arches and dropped triglyphs. The building itself is skillfully constructed. Later architects and scholars have studied the palace, with its sophisticated humor and exquisite craft, as a precursor to Mannerism or as Mannerist itself (see page 692).

Giulio Romano continued his witty play on the classics in the decoration of the two principal rooms. One, dedicated to the loves of the gods, depicted the marriage of Cupid and Psyche. The other room is a remarkable feat of *trompe l'oeil* painting in which the entire building seems to be collapsing about the viewer as the gods defeat the giants (FIG. 20–20). Here, Giulio Romano accepted the challenge Andrea Mantegna had laid down in the Camera Picta of the Gonzaga palace (SEE FIG. 19–33), painted for Federigo's grandfather. Like the building itself, the mural paintings display brilliant craft in the service of lighthearted, even superficial, goals: to distract, amuse, and enchant the viewer.

CORREGGIO. At about the same time that Giulio Romano was building and decorating the Palazzo del Tè in Mantua, in nearby Parma an equally skillful master, Correggio, was creating just as theatrical effects through dramatic foreshortening in the Parma Cathedral dome. In his brief but prolific career, Correggio (Antonio Allegri, c. 1489–1534) produced most of his work for patrons in Parma and Mantua. Correggio's great work, the **ASSUMPTION OF THE VIRGIN** (FIG. 20–21),

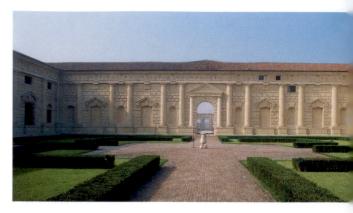

20−19 | Giulio Romano COURTYARD FAÇADE, PALAZZO DEL TÈ, MANTUA 1527-34.

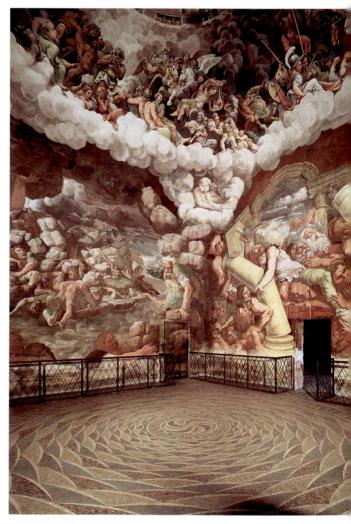

20–20 | Giulio Romano FALL OF THE GIANTS Fresco in the Sala dei Giganti, Palazzo del Tè. 1530–32.

a fresco painted between 1526 and 1530 in the dome of Parma Cathedral, distantly recalls the illusionism of Mantegna's ceiling in the Gonzaga palace. But Leonardo da Vinci also clearly inspired Correggio's use of softly modeled forms,

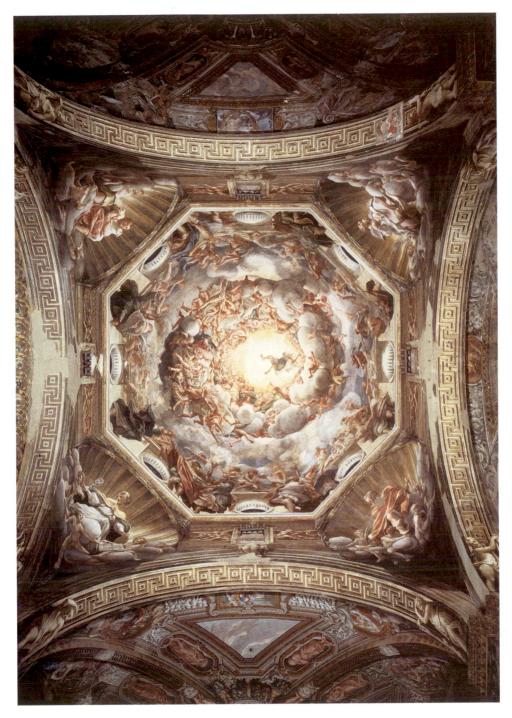

20–21 | Correggio ASSUMPTION OF THE VIRGIN
Fresco in main dome, interior, Parma Cathedral, Italy. c. 1526–30. Diameter of base of dome approx. 36' (11 m).

spotlighting effects of illumination, and a slightly hazy overall appearance (sfumato). Correggio also assimilated Raphael's idealism into his personal style. In the Assumption, Correggio created a dazzling illusion: The architecture of the dome seems to dissolve and the forms seem to explode through the building, drawing the viewer up into the swirling vortex of saints and angels who rush upward, amid billowing clouds, to accompany the Virgin as she soars into heaven. Correggio's

painting of the sensuous flesh and clinging draperies of the figures contrasts with the spirituality of the theme (the Virgin's miraculous transport to heaven at the moment of her death). The viewer's strongest impression is of a powerful, spiraling upward motion of alternating cool clouds and warm, sensuous figures. Illusionistic painting directly derived from this work became a hallmark of ceiling decoration in Italy in the following century.

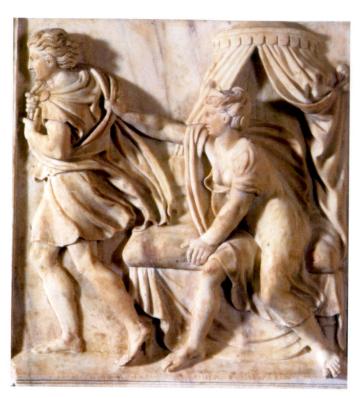

20–22 | Properzia de' Rossi JOSEPH AND POTIPHAR'S WIFE San Petronio, Bologna. 1525–26. Marble, $1'9'' \times 1'11''$ $(54 \times 58 \text{ cm})$. Museo de S. Petronio, Bologna.

Properzia de' Rossi. Very few women had the opportunity or inclination to become sculptors. Properzia de' Rossi (c. 1490-1529/30), who lived in Bologna, was an exception. She mastered many arts, including engraving, and was famous for her miniature carvings, including an entire Last Supper carved on a peach pit! She carved several pieces in marble two sibyls, two angels, and this relief of JOSEPH AND POTIPHAR'S WIFE—for the cathedral of San Petronio in Bologna (FIG. 20-22). The contemporary historian Vasari wrote that a rival male sculptor prevented her from being paid fairly and from getting more commissions. This particular relief, according to Vasari, was inspired by her own love for a young man, which she got over by carving this panel. Joseph escapes, running, as the partially clad seductress snatches at his cloak. Properzia is the only woman Vasari includes in the 1550 edition of the Lives.

Venice and the Veneto

In the sixteenth century the Venetians did not see themselves as rivals of Florence and Rome, but rather as superiors. Their city was the greatest commercial sea power of the Mediterranean; they had challenged Byzantium and now they confronted the Muslim Turks. Favored by their unique geographical situation—protected by water and controlling sea routes in the Adriatic Sea and the eastern Mediter-

ranean—the Venetians became wealthy and secure patrons of the arts. Their Byzantine heritage, preserved by their natural conservatism, encouraged an art of rich patterned surfaces emphasizing light and color.

The idealized style and oil painting technique initiated by the Bellini family in the late fifteenth century (see Chapter 19) were developed further by sixteenth-century painters in Venice and the Veneto region, the part of northeastern Italy ruled by Venice. Venetians were the first Italians to use oils for painting on both wood panel and canvas. Possibly because they were a seafaring people accustomed to working with large sheets of canvas, and possibly because of humidity problems in their walls, the Venetians were also the first to use large canvas paintings instead of frescoes. Because oils dried slowly, errors could be corrected and changes made easily during the work. The flexibility of the canvas support, coupled with the radiance and depth of oil-suspended color pigments, eventually made oil painting an almost universally preferred medium. Oil paint was particularly suited to the rich color and lighting effects employed by Giorgione and Titian, two of the city's major painters of the sixteenth century. (Two others, Veronese and Tintoretto, will be discussed later in this chapter.)

GIORGIONE. The career of Giorgione (Giorgio da Castel-franco, c. 1475–1510) was brief—he died from the plague—and most scholars accept only four or five paintings as entirely by his hand. Nevertheless, his importance to Venetian painting is critical, as he introduced new, enigmatic pastoral themes, known as *poesie* (or painted poems), that were inspired by the contemporary literary revival of ancient pastoral poetry. He is significant for his sensuous nude figures, and, above all, an appreciation of nature in his landscape painting. His early life and training are undocumented, but his work suggests that he studied with Giovanni Bellini. Perhaps Leonardo da Vinci's subtle lighting system and mysterious, intensely observed landscapes also inspired him.

Giorgione's most famous work, called today THE TEM-PEST (FIG. 20-23), was painted shortly before his death. It is an example of the imaginative and sensual (rather than historical and intellectual) aspects of the poesie. Simply trying to understand what is happening in the picture piques our interest. At the right, a woman is seated on the ground, nude except for the end of a long white cloth thrown over her shoulders. Her nudity seems maternal rather than erotic as she nurses the baby at her side. Across the dark, rock-edged spring stands a man wearing the uniform of a German mercenary soldier. His head is turned toward the woman, but he appears to have paused for a moment before continuing to turn toward the viewer. X-rays of the painting show that Giorgione altered his composition while he was still at work on it—the soldier replaces a second woman. Inexplicably, a spring gushes forth between the figures to feed a lake surrounded by

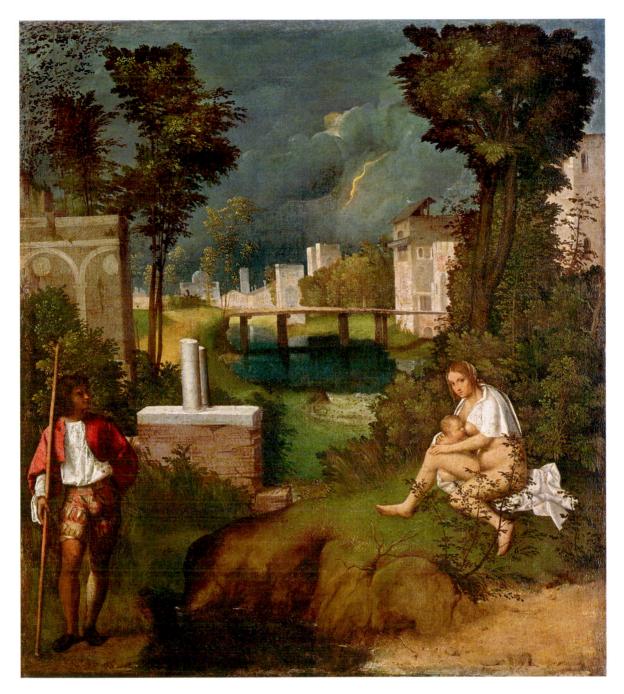

20–23 | Giorgione THE TEMPEST c. 1506. Oil on canvas, $32\times28\%$ (82 \times 73 cm). Galleria dell'Accademia, Venice.

The subject of this enigmatic picture preoccupied twentieth-century art historians, many of whom came up with well-reasoned possible solutions to the mystery. However, the painting's subject seems not to have particularly intrigued sixteenth-century observers, one of whom described it in 1530 simply as a small landscape in a storm with a gypsy woman and a soldier.

substantial houses, and in the far distance a bolt of lightning splits the darkening sky. Indeed, the artist's attention seems focused on the landscape and the unruly elements of nature rather than on the figures. By making the landscape central to the composition, Giorgione gave nature an importance that is new in Western painting.

Although he may have painted *The Tempest* for purely personal reasons, most of Giorgione's known works were of

traditional subjects, produced on commission for clients: portraits, altarpieces, and paintings on the exteriors of Venetian buildings. When commissioned in 1507 to paint the exterior of the Fondaco dei Tedeschi, the warehouse and offices of German merchants in Venice, Giorgione hired Titian (Tiziano Vecellio, c. 1489–1576) as an assistant. For the next three years, before Giorgione's untimely death, the two artists' careers were closely bound together.

20–24 | Titian THE PASTORAL CONCERT OR ALLEGORY ON THE INVENTION OF PASTORAL POETRY c. 1510. Oil on canvas, $41\% \times 54\%''$ (105 \times 136.5 cm). Musée du Louvre, Paris.

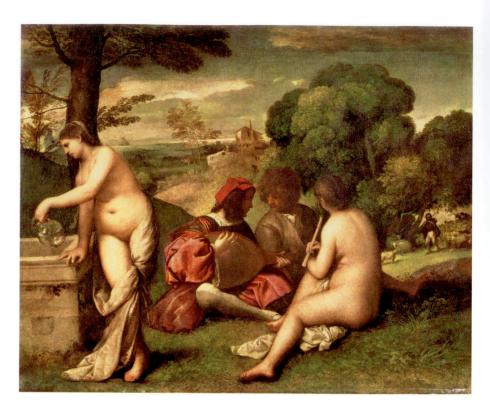

The painting known as THE PASTORAL CONCERT (FIG. 20–24) has been attributed to both Giorgione and Titian, although today scholarly opinion favors Titian. As in Giorgione's The Tempest, the idyllic, fertile landscape, here bathed in golden, hazy late-afternoon sunlight, seems to be the true subject of the painting. In this mythic world, two men-an aristocratic musician in rich red silks and a barefoot, singing peasant in homespun cloth-turn toward each other, ignoring the two women in front of them. One woman plays a pipe and the other pours water into a well, oblivious of the swaths of white drapery sliding to the ground that enhance rather than hide their nudity. Are they the musicians' muses? Behind the figures the sunlight illuminates another shepherd and his animals near lush woodland. The painting evokes a mood, a golden age of love and innocence recalled in ancient Roman pastoral poetry. In fact, the painting is now interpreted as an allegory on the invention of poetry. The Pastoral Concert had a profound influence on later painters—even into the nineteenth century, when Édouard Manet (SEE FIG. 30-49) reinterpreted it.

TITIAN. Everything about Titian's early life is obscure, including his birth, probably about 1489. He supposedly began an apprenticeship as a mosaicist, then studied painting under Gentile and Giovanni Bellini (see page 654). He was about 20 when he began work with Giorgione, and whatever Titian's early work had been, he had completely absorbed Giorgione's style by the time Giorgione died two years later. Titian completed paintings that they had worked on together, and when Giovanni Bellini died in 1516, Titian became the official painter to the Republic of Venice.

In 1519, Jacopo Pesaro, commander of the papal fleet that had defeated the Turks in 1502, commissioned Titian to commemorate the victory in a votive altarpiece for a side-aisle chapel in the Franciscan Church of Santa Maria Gloriosa dei Frari in Venice. Titian worked on the painting for seven years and changed the concept three times before he finally came up with a revolutionary composition—one that complemented the viewer's approach from the left: He created an asymmetrical setting of huge columns on high bases soaring right out of the frame (FIG. 20-25). Into this architectural setting, he placed the Virgin and Child on a high throne at one side and arranged saints and the Pesaro family at the sides and below on a diagonal axis, crossing at the central figure of Saint Peter (a reminder of Jacopo's role as head of the papal forces in 1502). The red of Francesco Pesaro's brocade garment and of the banner diagonally across sets up a contrast of primary colors against Saint Peter's blue tunic and yellow mantle and the red and blue draperies of the Virgin. Saint Maurice (behind Jacopo at the left) holds the banner with the coat of arms of the pope, and a cowering Turkish captive reminds the viewer of the Christian victory. Light floods in from above, illuminating not only the faces, but also the great columns, where putti in the clouds carry a cross. Titian was famous for his mastery of light and color even in his own day, but this altarpiece demonstrates that he also could draw and model as solidly as any Florentine. The composition, perfectly balanced but built on diagonals instead of a vertical and horizontal grid, looks forward to the art of the seventeenth century.

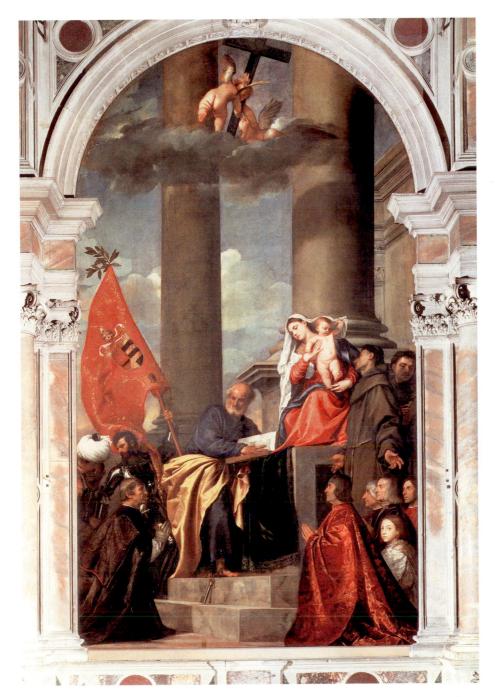

20–25 † Titian PESARO MADONNA 1519–26. Oil on canvas, 16' \times 8'10" (4.9 \times 2.7 m). Side-aisle altarpiece, Santa Maria Gloriosa dei Frari, Venice.

In 1529, Titian, who was well-known outside Venice, began a long professional relationship with Emperor Charles V, who vowed to let no one else paint his portrait. Charles ennobled Titian in 1533. The next year Titian was commissioned to paint a portrait of Isabella d'Este (see "Women Patrons of the Arts," page 688). Isabella was past 60 when Titian portrayed her in 1534–36, but she asked to appear as she had in her twenties. A true magician of portraiture, Titian was able to satisfy her wish by referring to an early portrait by another artist while also conveying the mature Isabella's strength, self-confidence, and energy.

No photograph can convey the vibrancy of Titian's paint surfaces, which he built up in layers of pure colors, chiefly red, white, yellow, and black. A recent scientific study of Titian's paintings revealed that he ground his pigments much finer than had earlier wood-panel painters. The complicated process by which he produced many of his works began with a charcoal drawing on the prime coat of lead white that was used to seal the pores and smooth the surface of the rather coarse Venetian canvas. The artist then built up the forms with fine glazes of different colors, sometimes in as many as ten to fifteen layers. Titian and others had the

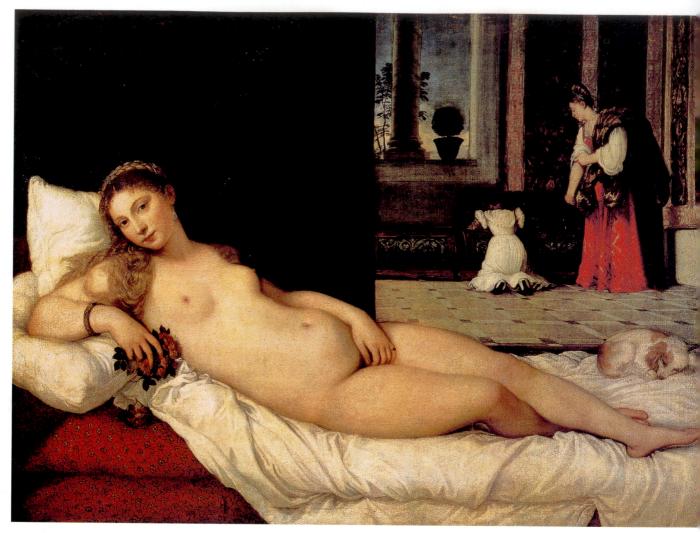

20–26 | Titian **VENUS OF URBINO** c. 1538. Oil on canvas, $3'11'' \times 5'5''$ (1.19 \times 1.65 m). Galleria degli Uffizi, Florence.

advantage of working in Venice, the first place to have professional retail "color sellers." These merchants produced a wide range of specially prepared pigments, even mixing their oil paints with ground glass to increase its glowing transparency. Not until the second half of the sixteenth century did color sellers open their shops in other cities.

According to a contemporary, Titian could make "an excellent figure appear in four brushstrokes." His technique was admirably suited to the creation of female nudes, whose flesh seems to glow with an incandescent light. Paintings of nude reclining women became especially popular in sophisticated court circles, where male patrons could enjoy and appreciate the "Venuses" under the cloak of respectable classical mythology. Typical of such paintings is the Venus Titian painted about 1538 for the Duke of Urbino (FIG. 20–26). The sensuous quality of this work suggests that Titian was as inspired by flesh-and-blood beauty as by any source from mythology or the history of art. Here, a beautiful Venetian courtesan—whose gestures seem deliberately provocative—

stretches languidly on her couch in a spacious palace, white sheets and pillows setting off her glowing flesh and golden hair. A spaniel, symbolic of fidelity, sleeping at her feet and maids assembling her clothing in the background lend a comfortable domestic air. The **VENUS OF URBINO** inspired artists as distant in time as Manet (SEE FIG. 30–50).

Over the course of his lengthy career, Titian continued to explore art's expressive potential. In his late work he sought the essence of the form and idea, not the surface perfection of his youthful works. Beset by failing eyesight and a trembling hand, Titian left the PIETÀ he was painting for his tomb unfinished at his death in 1576 (FIG. 20–27). Against a monumental arched niche, the Virgin mourns her son. Titian painted himself as Saint Jerome kneeling before Christ. The figures emerge out of darkness, their forms defined by the broken brushstrokes that activate the dynamic diagonal of the composition. Titian, like Michelangelo, outlived the classical phase of the Renaissance and his new style profoundly influenced Italian art of the later years of the sixteenth century.

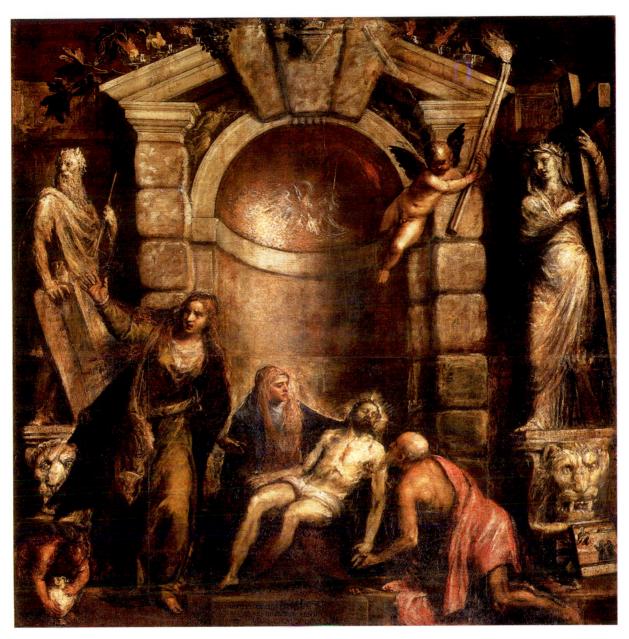

20–27 | Titian (finished by Palma Giovane) PIETÀ c. 1570–76. Oil on canvas, 11'6" × 12'9" (3.5 × 3.9 m). Galleria dell'Accademia, Venice.

ART AND THE COUNTER-REFORMATION

Pope Clement VII, whose miscalculations had spurred Emperor Charles V to attack and destroy Rome in 1527, also misjudged the threat to the Church and to papal authority posed by the Protestant Reformation. His failure to address the issues raised by the reformers enabled the movement to spread. His successor, the rich and worldly Roman noble Alessandro Farnese, who was elected Pope Paul III (papacy 1534–49), was the first pope to grapple directly with the rise of Protestantism and vigorously pursue Church reform. In 1536, he appointed a commission to investigate charges of corruption within the Church. He convened the Council of

Trent (1545–63) to define Catholic dogma, initiate disciplinary reforms, and regulate the training of clerics.

Pope Paul III also addressed Protestantism through repression and censorship. In 1542, he instituted the Inquisition, a papal office that sought out heretics for interrogation, trial, and sentencing. The enforcement of religious unity extended to the arts. Traditional images of Christ and the saints continued to be used to inspire and educate, but art was scrutinized for traces of heresy and profanity. Guidelines issued by the Council of Trent limited what could be represented in Christian art and led to the destruction of some works. At the same time, art became a powerful weapon of propaganda, especially in the hands of members of the Society of Jesus, a new religious order

Art and Its Context

WOMEN PATRONS OF THE ARTS

n the sixteenth century, many wealthy women, from both the aristocracy and the merchant class, were enthusiastic patrons of the arts. The Habsburg princesses Margaret of Austria and Mary of Hungary presided over brilliant humanist courts. The Marchesa of Mantua, Isabella d'Este (1474-1539), became a patron of painters, musicians, composers, writers, and literary scholars. Married to Francesco II Gonzaga at age 15, she had great beauty, great wealth, and a brilliant mind that made her a successful diplomat and administrator. A true Renaissance woman, her motto was the epitome of rational thinking-"Neither through Hope nor Fear." An avid collector of manuscripts and books, she sponsored the publication of an edition of Virgil while still in her twenties. She also collected ancient art and objects, as well as works by contemporary Italian artists such as Mantegna, Leonardo, Perugino, Correggio, and Titian. Her study in the Mantuan palace was a veritable museum for her collections. The walls above the storage and display cabinets were painted in fresco by Mantegna, and the carved wood ceiling was covered with mottoes and visual references to Isabella's impressive literary interests.

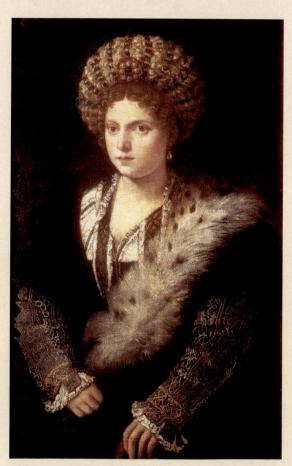

Titian ISABELLA D'ESTE 1534-36. Oil on canvas, $40\% \times 25\%$ (102×64.1 cm). Kunsthistorisches Museum, Vienna.

founded by the Spanish nobleman Ignatius of Loyola (1491–1556) and confirmed by Paul III in 1540. The Jesuits, dedicated to piety, education, and missionary work, spread worldwide from Il Gesù, their headquarters church in Rome (SEE FIG. 20–31). They came to lead the Counter-Reformation movement and the revival of the Catholic Church.

The Reformation and Counter-Reformation inspired the papacy to promote the Church's preeminence by undertaking an extensive program of building and art commissions. Under such patronage, religious art of the Italian late Renaissance flourished in the second half of the sixteenth century.

Art and Architecture in Rome and the Vatican

To restore the heart of the city of Rome, Paul III began rebuilding the Capitoline Hill as well as continuing work on Saint Peter's. His commissions include some of the finest art and architecture of the late Italian Renaissance. His first major commission brought Michelangelo, after a quarter of a century, to the Sistine Chapel.

MICHELANGELO'S LATE WORK. In his early sixties, Michelangelo complained bitterly of feeling old, but he nonetheless began the important and demanding task of painting the LAST JUDGMENT on the 48-foot-high end wall above the chapel altar (FIG. 20–28).

Abandoning the clearly organized medieval conception of the Last Judgment, in which the saved are neatly separated from the damned, Michelangelo painted a writhing swarm of rising and falling humanity. At the left (the right side of Christ), the dead are dragged from their graves and pushed up into a vortex of figures around Christ, who wields his arm like a sword of justice. The shrinking Virgin represents a change from Gothic tradition, where she sat enthroned beside, and equal in size to, her son. To the right of Christ's feet is Saint Bartholomew, who in legend was martyred by being skinned alive. He holds his flayed skin, the face of which may be painted with Michelangelo's own distorted features. Despite the efforts of several saints to save them at the last minute, the rejected souls are plunged toward hell on the right, leaving the elect and still-unjudged in a dazed, almost uncomprehending state. On the lowest level of the mural is the gaping, fiery entrance to hell, toward which Charon, the ferryman of the dead to the underworld, propels his craft. Conservative clergy criticized the painting for its nudity, and after Michelangelo's death they ordered bits of drapery to be added. The painting was long interpreted as a grim and constant reminder to the celebrants of the Massthe pope and his cardinals—that ultimately they would be judged for their deeds. However, the brilliant colors revealed by recent cleaning contrast with the grim message.

Another of Paul III's ambitions was to complete the new Saint Peter's, a project that had been under way for forty years (see "Saint Peter's Basilica," page 679). Michelangelo was well

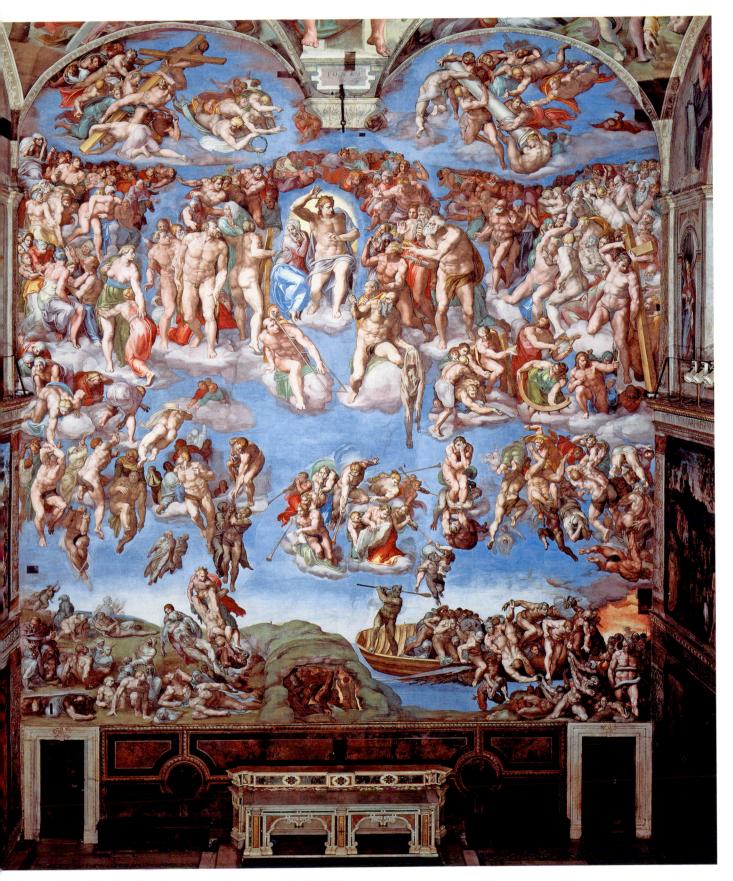

20–28 | Michelangelo LAST JUDGMENT, SISTINE CHAPEL 1536–41 (cleaning finished 1994). Fresco, $48\times44'(14.6\times13.4~\text{m})$.

Dark, rectangular patches left by the restorers (visible, for example, in the upper left and right corners) contrast with the vibrant colors of the chapel's frescoes. These dark areas show just how dirty the walls had become over the centuries before their recent cleaning.

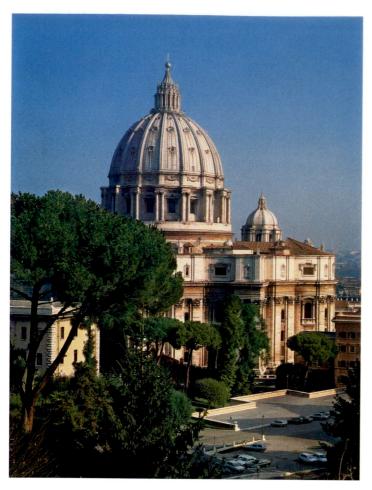

20–29 | Michelangelo SAINT PETER'S BASILICA, VATICAN c. 1546–64; dome completed 1590 by Giacomo della Porta; lantern 1590–93. View from the west.

aware of the work done by his predecessors—from Bramante to Raphael to Antonio da Sangallo the Younger. The 71-yearold sculptor, confident of his architectural expertise, demanded the right to deal directly with the pope, rather than through a committee of construction deputies. Michelangelo further shocked the deputies—but not the pope—by tearing down or canceling parts of Sangallo's design and returning to Bramante's central plan, long associated with Christian martyr shrines. Although seventeenth-century additions and renovations dramatically changed the original plan of the church and the appearance of its interior, Michelangelo's SAINT PETER'S BASILICA (FIG. 20-29) still can be seen in the contrasting forms of the flat and angled walls and the three hemicycles (semicircular structures), in which colossal pilasters, blind windows (having no openings), and niches form the sanctuary of the church. The level above the heavy entablature was later given windows of a different shape. The dome that was erected by Giacomo della Porta in 1588-90 retains Michelangelo's basic design: a segmented dome with regularly spaced openings, resting on a high drum with pedimented windows between paired columns, and surmounted by a tall lantern reminiscent of Bramante's Tempietto (SEE FIG. 20-17). Della Porta's major changes were raising the dome

height, narrowing its segmental bands, and changing the shape of its openings.

Michelangelo—often described by his contemporaries as difficult and even arrogant—alternated between periods of depression and frenzied activity. Yet he was devoted to his friends and helpful to young artists. He believed that his art was divinely inspired; later in life, he became deeply absorbed in religion and dedicated himself to religious works.

Michelangelo's last days were occupied by an unfinished sculpture now known, from the name of a modern owner, as the **RONDANINI PIETÀ** (FIG. 20–30). The *Rondanini Pietà* is the final artistic expression of a lonely, disillusioned, and physically debilitated man who struggled to end his life as he had lived it—working. In his youth, the stone had released the *Pietà* in Saint Peter's as a perfect, exquisitely finished work (SEE FIG. 20–9), but this block resisted his best efforts to shape it. He was still working on the sculpture six days before his death. The ongoing struggle between artist and medium is nowhere more apparent than in this moving example of Michelangelo's *nonfinito* creations. In his late work, Michelangelo subverted Renaissance ideals of human perfectability and denied his own youthful idealism, uncovering new forms that mirrored the tensions in Europe during the second half of the sixteenth century.

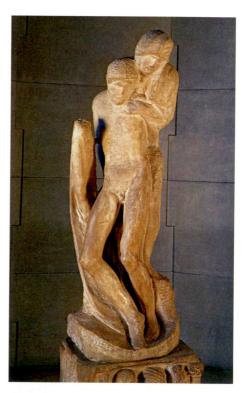

20–30 | Michelangelo PIETÀ (KNOWN AS THE RONDANINI PIETÀ)

1559-64. Marble, height 5'3%'' (1.61 m). Castello Sforzesco, Milan. Intended for his own tomb.

Shortly before his death in 1564, Michelangelo resumed work on this sculpture group, which he had begun some years earlier. He cut down the massive figure of Jesus, merging the figure's now elongated form with that of the Virgin, who seems to carry her dead son upward toward heaven.

The elderly artist Michelangelo, like Titian, secure in the techniques gained over decades of masterful craft, could abandon the knowledge of a lifetime as he attempted to express ultimate truths through art. In his late work, he discovered new stylistic directions that would inspire succeeding generations of artists.

VIGNOLA. Michelangelo alone could not satisfy the demand for architects. One young artist who helped meet the need for new churches was Giacomo Barozzi (1507–73), known as Vignola after his native town. He worked in Rome in the late 1530s surveying ancient Roman monuments and providing illustrations for an edition of Vitruvius. From 1541 to 1543 he was in France with Francesco Primaticcio at the Château of Fontainebleau (see Chapter 21). After returning to Rome, he secured the patronage of the Farnese family.

Vignola profited from the Counter-Reformation program of church building. The Church's new emphasis on individual, emotional participation brought a focus on sermons and music. It also required churches to have wide naves and unobstructed views of the altar instead of the complex interiors of medieval and earlier Renaissance churches. Ignatius of Loyola was determined to build the Jesuit head-quarters church in Rome under these precepts, although he did not live to see his church finished (FIG. 20–31). The cornerstone was laid in 1540, but construction of the CHURCH OF IL GESÙ did not begin until 1568, as the Jesuits had to raise considerable funds. Cardinal Alessandro Farnese (Paul III's namesake and grandson) donated funds to the project in 1561 and selected Vignola as architect. After Vignola died in 1573, Giacomo della Porta finished the dome and façade.

Il Gesù was admirably suited for its congregational purpose. Vignola designed a wide, barrel-vaulted nave, shallow connected side chapels but not aisles, and short transepts that

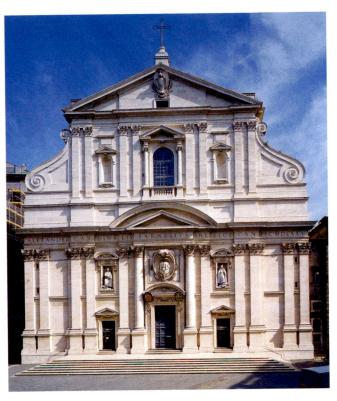

did not extend beyond the line of the outer walls—enabling all worshipers to gather in the central space. A single huge apse and dome over the crossing (FIG. 20–32) directed their attention to the altar. The building fit compactly into the city block—a requirement that now often overrode the desire to orient a church along an east-west axis. The façade design emphasized the central portal with classical pilasters, engaged

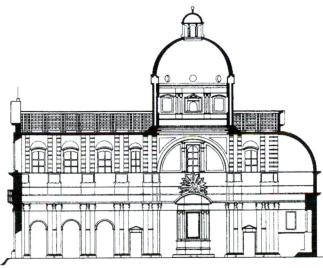

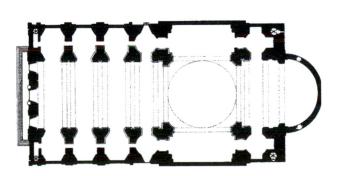

20–32 | Giacomo da Vignola PLAN AND SECTION OF THE CHURCH OF IL GESÙ, ROME Cornestone laid in 1540; Project begun in 1550; Giacomo da Vignola's design begun in 1563; building begun in 1568; completed by Giacomo della Porta in 1584.

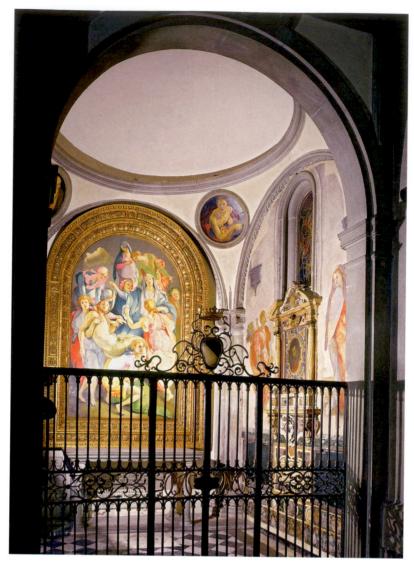

20–33 | CAPPONI CHAPEL, CHURCH OF SANTA FELICITÀ, FLORENCE Chapel by Filippo Brunelleschi for the Barbadori family, 1419–23; acquired by the Capponi family, who ordered paintings by Pontormo, 1525–28.

One of the few surviving early Mannerist interiors—fresco, stained-glass window, and altarpiece in an early Renaissance structure.

columns and pediments, and volutes scrolling out to hide the buttresses of the central vault and to link the tall central section with the lower sides.

As finally built by Giacomo della Porta, the design, in its verticality and centrality, would have significant influence on church design well into the next century. The façade abandoned the early Renaissance grid of classical pilasters and entablatures for a two-story design of paired colossal order columns that reflected and tied together the two stories of the nave elevation. Each of these stories was further subdivided by moldings, niches, and windows. The entrance of the church, with its central portal and tall window, became the focus of the composition. Pediments at every level break into the level above, leading the eye upward to the cartouches

with coats of arms. Both Cardinal Farnese, the patron, and the Jesuits (whose arms entail the initials IHS, the monogram of Christ) are commemorated here on the façade.

MANNERISM

A word that has inspired controversy—sometimes even rancorous debate—among historians of Italian art is *Mannerism*. The term comes from the Italian word *maniera*, used in the sixteenth century to suggest self-aware elegance and grace to the point of artifice. When modern critics began to use the term, some defined it as a style opposed to the principles of High Renaissance art; others treated it as an historical period in art between the early sixteenth-century High Renais-

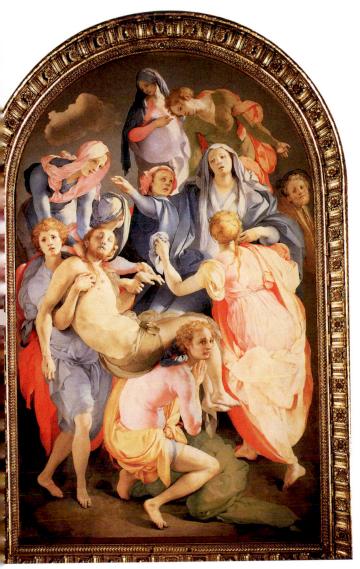

20–34 | Pontormo ENTOMBMENT 1525–28. Oil and tempera on wood panel, $10'3'' \times 6'4''$ (3.1 \times 1.9 m). Altarpiece in Capponi Chapel, Church of Santa Felicità, Florence.

sance and the seventeenth-century Baroque. Today many critics would like to drop the term altogether, but it has entered the standard art historical vocabulary. Certainly one can agree that different styles existed at the same time in sixteenth-century Italy.

Today, in the visual arts, Mannerism has come to mean intellectually intricate subjects, highly skilled techniques, and art concerned with beauty for its own sake. Mannerism is an attitude, a point of view, as much as a "style." Certain characteristics do occur regularly: extraordinary virtuosity; intricate compositions; sophisticated, elegant figures; and fearless manipulations or distortions of accepted formal conventions. Some artists and patrons favored obscure, unsettling, and often erotic imagery; unusual colors and juxtapositions; and

Sequencing Works of Art ITALIAN RENAISSANCE ART IN THE 1530s

1530-32	Giulio Romano, Fall of the Giants, Palazzo del Tè, Mantua
1534-36	Titian, Portrait of Isabella d'Este
c. 1538	Titian, Venus of Urbino
1534-40	Parmigianino, Madonna with the Long Neck
1536-41	Michelangelo, <i>Last Judgment</i> , Sistine Chapel, Vatican

unfathomable secondary scenes. Mannerist artists admired the great artists of the earlier generation, and the late styles of Michelangelo and Titian also became a source of inspiration.

Elements of Mannerism, stimulated and supported by aristocratic, sophisticated, and courtly patrons, began to appear in Florence and Rome at the height of the High Renaissance around 1510. The term has been interpreted as an artistic expression of the unsettled political and religious conditions in Europe. Furthermore, a formal relationship between new art styles and aesthetic theories began to appear at this time—especially the elevation of "grace" as an ideal.

Painting

Examples of early Mannerism are the frescoes and altarpieces painted between 1525 and 1528 by Jacopo da Pontormo (1494-1557) for the hundred-year-old CAPPONI CHAPEL in the Church of Santa Felicità in Florence (FIG. 20-33). Open on two sides, the chapel forms an interior loggia. The altarpiece depicts the ENTOMBMENT (FIG. 20-34), and frescoes depict the Annunciation. The Virgin accepts the angel's message, but the juxtaposition with the altarpiece also seems to present her with a vision of her future sorrow, as she sees her son's body lowered from the cross. Pontormo's ambiguous composition in the altarpiece enhances the visionary quality of the painting. The bare ground and cloudy sky give little sense of physical location. Some figures press into the viewer's space, while others seem to levitate or stand on the smooth boulders. Pontormo chose a moment just after Jesus's removal from the cross, when the youths who have lowered him have paused to regain their hold. The emotional atmosphere of the scene is expressed in the odd poses, and drastic shifts in scale, but perhaps most poignantly in the use of secondary colors and colors shot through with contrasting colors, like iridescent silks. The palette is predominantly blue and pink with accents of olive green, gray, scarlet, and creamy white. The overall tone of the picture is set by the color treatment of the crouching youth, whose skintight bright pink shirt is shaded in iridescent, pale gray-green.

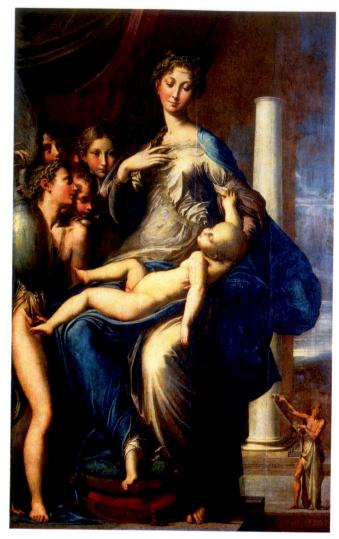

20–35 | Parmigianino MADONNA WITH THE LONG NECK 1534–40. Oil on wood panel, $7'1'' \times 4'4''$ (2.16 \times 1.32 m). Galleria degli Uffizi, Florence.

Parmigianino. Parmigianino (Francesco Mazzola, 1503–40) created equally intriguing variations on the classical style. Until he left his native Parma in 1524 for Rome, the strongest influence on his work had been Correggio. In Rome, Parmigianino met Giulio Romano, and he also studied the work of Raphael and Michelangelo. He assimilated what he saw into a distinctive style of Mannerism, calm but strangely unsettling. After the Sack of Rome in 1527, he moved to Bologna and then back to Parma.

Left unfinished at the time of his early death is a painting known as the MADONNA WITH THE LONG NECK (FIG. 20–35). The elongated figure of the Madonna, whose massive legs and lower torso contrast with her narrow shoulders and long neck and fingers, resembles the large metal vase inexplicably being carried by the youth at the left. The sleeping Christ Child recalls the pose of the pietà, and in the background Saint Jerome unrolls a scroll beside tall white columns that

have no more substance than theater sets in the middle distance. Like Pontormo, Parmigianino presents a well-known image in a manner calculated to unsettle viewers. The painting challenges the viewer's intellect while it exerts its strange appeal to aesthetic sensibility.

BRONZINO. Agnolo di Cosimo (1503–72), whose nickname of "Bronzino" means "Copper-colored" (just as we might call someone "Red"), was born near Florence. About 1522, he became Pontormo's assistant. (He probably helped with the tondos in the corners of the Capponi Chapel.) In 1530, he established his own workshop, though he continued to work occasionally with Pontormo on large projects. In 1540, Bronzino became the court painter to the Medici. Although he was a versatile artist who produced altarpieces, fresco decorations, and tapestry designs over his long career, he is best known today for his courtly portraits. Bronzino's virtuosity in rendering costumes and settings creates a rather cold and formal effect, but the self-contained demeanor of his subjects admirably conveys their haughty personalities. The PORTRAIT

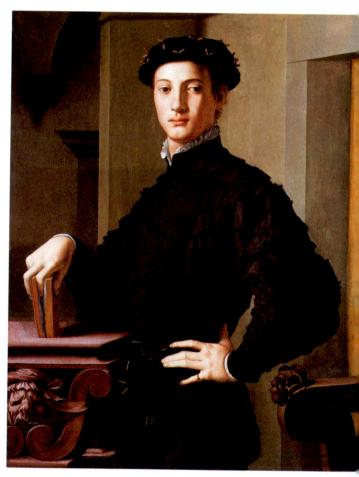

20–36 | Bronzino PORTRAIT OF A YOUNG MAN c. 1540–45. Oil on wood panel, $37\frac{1}{2} \times 29\frac{1}{2}$ " (95.5 × 74.9 cm). The Metropolitan Museum of Art, New York.

The H. O. Havemayer Collection (29.100.16).

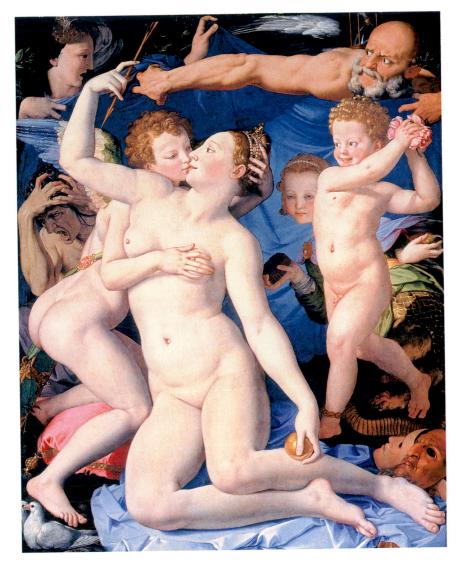

20–37 | Bronzino ALLEGORY WITH VENUS AND CUPID Mid-1540s. Oil on panel, $57\frac{1}{2} \times 46^{\prime\prime}$ (1.46 \times 1.16 m). National Gallery, London. Reproduced by courtesy of the Trustees of the National Gallery, London.

OF A YOUNG MAN (FIG. 20–36) demonstrates Bronzino's characteristic portrayal of his subjects as intelligent, aloof, elegant, and self-assured. The youth toys with a book, suggesting his scholarly interests, but his walleyed stare creates a slightly unsettling effect and seems to associate his portrait with the carved masks surrounding him.

Bronzino's **ALLEGORY WITH VENUS AND CUPID**, one of the strangest paintings in the sixteenth century, contains all the formal, iconographical, and psychological characteristics of Mannerist art (FIG. 20–37). The painting could stand alone as a summary of the period. Seven figures, two masks, and a dove interweave in an intricate formal composition pressed breathlessly into the foreground plane. Taken as individual images, they display the apparent ease of execution and grace of form, ideal perfection of surface and delicacy of color that characterize Mannerist art. Together they become a disturbingly erotic and inexplicable composition.

The painting defies easy explanation for it is one of the complex allegories that delighted the sophisticated courtiers

who enjoyed equally esoteric wordplay and classical references. Nothing is quite what it seems. Venus and her son Cupid engage in lascivious dalliance, encouraged by a putto representing Folly, Jest, or Playfulness, who is about to throw pink roses at them. Cupid kisses his mother and squeezes her breast and nipple while Venus lifts up an arrow from Cupid's quiver, leading some scholars to suggest that the painting's title should be "Venus Disarming Cupid." Venus holds the golden apple of discord given to her by Paris; her dove seems to support Cupid's feet, while a pair of ugly red masks lying at her feet reiterates the theme of duplicity. An old man, Time or Chronos, assisted by an outraged Truth, pulls back a curtain to expose the couple. Lurking just behind Venus a monstrous serpent with a lion's legs and claws and the head of a beautiful young girl crosses her hands to hold a honeycomb and scorpion's stinger. She has been called Inconstancy and Fraud but also Pleasure. In the shadows a screaming head tears its hair—if female, she is Jealousy or Envy, but if male, he would be Pain. The complexity of the painting and the

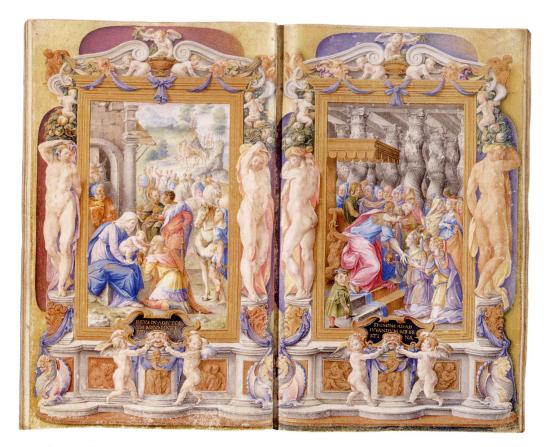

20–38 | Giulio Clovio (Jura Klovic, born in Croatia) THE FARNESE HOURS: ADORATION OF THE MAGI AND THE MEETING OF SOLOMON AND THE QUEEN OF SHEBA 1546. Vellum, each folio $6\times4''$ (17.3 \times 11 cm). The Pierpont Morgan Library, New York. M69 fl 380-3912

possibilities for multiple meanings are typical of the games enjoyed by sixteenth-century intellectuals. Perhaps the allegory tells of the impossibility of constant love and the folly of lovers, which will become apparent in time. But perhaps it is an allegory on sin and a condemnation of vice. In any event, Duke Cosimo ordered the painting himself, and he presented it to King Francis I of France.

Manuscripts and Miniatures

The Farnese Hours. In spite of the increasing use of the printing press (see Chapter 19), luxury manuscripts continued to be made by hand. The Farnese Hours, a book of hours commissioned by Cardinal Alessandro Farnese from Guilio Clovio (1498–1578), is a masterpiece among Italian Renaissance manuscripts (FIG. 20–38). The colophon (at the end of the manuscript) dates it at 1546, and the contemporary historian Giorgio Vasari wrote that Giulio worked for nine years painting the miniatures. Vasari perceptively calls him a "new, if small, Michelangelo." Small indeed, each page measures only 7 by 4 inches, but the paintings encompass every aspect of Mannerist art—the "serpentine figures" in graceful poses and the elongated proportions so noticeable in the nudes support the frames and the extraordinarily elongated figures in the narra-

tives. Brilliant colors combine with pale atmospheric space. The Old Testament supports the New, in a way typical of medieval manuscripts. Thus the Queen of Sheba's visit and homage to Solomon prefigures the Magi's journey with gifts for the Christ Child. King Solomon has the features of the patron, Cardinal Farnese, and beside him is a dwarf in painter's clothes making a typical sixteenth-century visual pun—he is a small man, a "miniature" painter.

ANGUISSOLA. Northern Italy, more than any other part of the peninsula, produced a number of gifted women artists. Sofonisba Anguissola (c. 1532–1625), born into a noble family in Cremona, was unusual as a woman artist in that she was not the daughter of an artist. Her father gave all his children a humanistic education and encouraged them to pursue careers in literature, music, and especially painting. He consulted Michelangelo about Sofonisba's artistic talents in 1557, asking for a drawing that she might copy and return to be critiqued. Michelangelo evidently obliged because Sofonisba Anguissola's father wrote an enthusiastic letter of thanks.

Anguissola was also skilled at miniatures and portraits, an important kind of painting in the sixteenth century, when people had few means of recording a lover, friend, or family

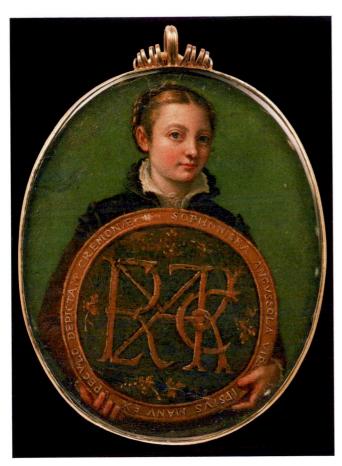

20–39 | Sofonisba Anguissola SELF-PORTRAIT c. 1552. Oil on parchment on cardboard, $2\frac{1}{2} \times 3\frac{1}{2}$ " (6.4 \times 8.3 cm). Museum of Fine Arts, Boston.

member's features. Anguissola painted herself holding a medallion, the border of which spells out her name and home town, Cremona (FIG. 20–39). Such visual and verbal games delighted sixteenth-century viewers. The interlaced letters at the center of the medallion are a riddle; they seem to form a monogram with the first letters of her sisters' names: Minerva, Europa, Elena. Such names are further evidence of the Anguissola family's enthusiasm for the classics.

Contemporaries especially admired Sofonisba Anguissola's self-portraits. One wrote that he liked to show off her painting as "two marvels, one the work, the other the artist" (quoted in Hartt/Wilkins, page 629). In 1560, Anguissola accepted the invitation of the queen of Spain to become a lady-in-waiting and court painter, a post she held for twenty years. In a 1582 Spanish inventory, Anguissola is described as "an excellent painter of portraits above all the painters of this time"—extraordinary praise in a court that patronized Titian.

Cellini (1500–71), who wrote a dramatic—and scandalous—autobiography and a practical handbook for artists, worked in the French court at Fontainebleau, where he made the famous **SALTCELLAR OF KING FRANCIS I** (FIG. 20–40)—a table accessory transformed into an elegant sculptural ornament by fanciful imagery and superb execution. In gold and enamel, the Roman sea god Neptune, representing the source of salt, sits next to a tiny boat-shaped container that carries the seasoning, while a personification of Earth guards the plant-derived

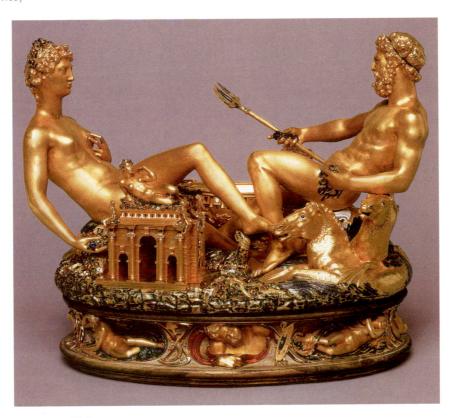

20–40 | Benvenuto Cellini SALTCELLAR OF KING FRANCIS I OF FRANCE 1540–43. Gold and enamel, $10\frac{1}{2} \times 13\frac{1}{8}$ " (26.67 \times 33.34 cm). Kunsthistorisches Museum, Vienna.

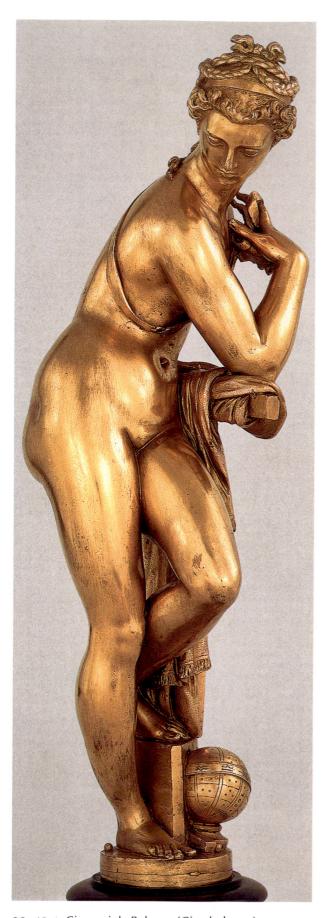

20–41 Giovanni da Bologna (Giambologna)

ASTRONOMY, or VENUS URANIA
c. 1573. Bronze gilt, height 15¼" (38.8 cm). Kunsthistorisches

Museum, Vienna.

pepper, contained in the triumphal arch to her right. Representations of the seasons and the times of day on the base refer to both daily meal schedules and festive seasonal celebrations. The two main figures, their poses mirroring each other with one bent and one straight leg, lean away from each other at impossible angles yet are connected and visually balanced by glances and gestures. Their supple, elongated bodies and small heads reflect the Mannerist conventions of artists like Parmigianino. Cellini wrote, "I represented the Sea and the Land, both seated, with their legs intertwined just as some branches of the sea run into the land and the land juts into the sea. . " (quoted in Hartt/Wilkins, page 669).

Late Mannerism

In the second half of the sixteenth century, probably the most influential sculptor in Italy was Jean de Boulogne, better known by his Italian name, Giovanni da Bologna or Giambologna (1529-1608). Born in Flanders, he settled by 1557 in Florence, where both the Medici family and the sizable Netherlandish community there were his patrons. He not only influenced a later generation of Italian sculptors, he also spread the Mannerist style to the north through artists who came to study his work. Although inspired by Michelangelo, Giovanni was more concerned with graceful forms and poses, as in his gilded-bronze ASTRONOMY, or VENUS URANIA (FIG. 20-41) of about 1573. The figure's identity is suggested by the astronomical device on the base of the plinth. Designed with a classical prototype of Venus in mind, the sculptor twisted Venus's upper torso and arms to the far right and extended her neck in the opposite direction so that her chin was over her right shoulder, straining the limits of the human body. Consequently, Giambologna's statuette may be seen from any viewpoint. The elaborate coiffure of tight ringlets and the detailed engraving of drapery texture contrast strikingly with the smooth, gleaming flesh of Venus's body. Following the common practice for cast-metal sculpture, Giambologna replicated this statuette several times for different patrons.

The northern Italian city of Bologna was especially hospitable to accomplished women. In the latter half of the sixteenth century it boasted of some two dozen women painters and sculptors, as well as a number of women scholars who lectured at the university. There, Lavinia Fontana (1552–1614) learned to paint from her father. By the 1570s, her success was so well rewarded that her husband, the painter Gian Paolo Zappi, gave up his own painting career to care for their large family and help his wife with the technical aspects of her work, such as framing. In 1603 Fontana moved to Rome as an official painter to the papal court. She also soon came to the attention of the Habsburgs, who became major patrons of her work.

While still in her twenties, Fontana painted the **NOLI ME TANGERE** (FIG. 20–42), illustrating the biblical story of Christ

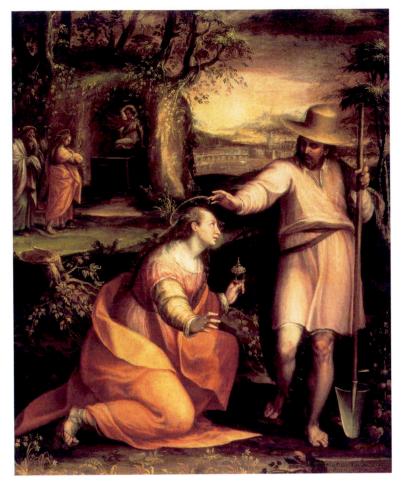

20–42 | Lavinia Fontana NOLI ME TANGERE 1581. Oil on canvas, $47 \% \times 36 \%''$ (120.3 \times 93 cm). Galleria degli Uffizi, Florence.

revealing himself before his Ascension to Mary Magdalen and warning her not to touch him (John 20:17). Christ's costume refers to the passage in the Gospel of John that tells us that Mary Magdalen at first thought Christ was the gardener.

Christ steps forward like a classical god—but dressed in a short tunic and wearing a gardener's hat. His graceful gesture echoes that of the Magdalen. In the middle distance a second confrontation is taking place: the earlier meeting of the women with the angel at the empty tomb. Like a medieval artist, Fontana ignores the sequence of earthly time and contrasts the large foreground figures with the tiny figures at the tomb, creating a striking plunge into depth. This unsettling spatial and temporal disconnect is a typical Mannerist conceit.

LATER SIXTEENTH-CENTURY ART IN VENICE AND THE VENETO

By the second half of the sixteenth century, Venice ruled supreme as "Queen of the Adriatic." Her power was not, however, unchallenged, and the Turks remained a threat to commerce. In 1571, allied with Spain and the pope, the Christian fleet with Venetian ships defeated the Turkish fleet at the Battle of Lepanto and so established Christian power for future generations. Victorious and wealthy Venetians entered on a lavish lifestyle, building palaces and villas, which they hung with lush oil paintings. The *Triumph of Venice* (see Fig. 12, Introduction), commissioned by the city government from the artist Veronese for the Hall of the Great Council in the Doge's palace, captures the splendor of Venice.

Oil Painting

Rather than the cool, formal, technical perfection sought by the Mannerists, painters in Venice expanded upon the techniques initiated there by Giorgione and Titian, concerning themselves above all with color, light, and expressively loose brushwork.

VERONESE. Paolo Caliari (1528–88) took his nickname—"Veronese"—from his hometown, Verona, but he worked mainly in Venice. His paintings are nearly synonymous today with the popular image of Venice as a splendid city of

THE OBJECT SPEAKS

VERONESE IS CALLED BEFORE THE INQUISITION

esus among his disciples at the Last Supper was an image that spoke powerfully to believers during the sixteenth century. So it was not unusual when, in 1573, the highly esteemed painter Veronese revealed an enormous canvas that seemed at first glance to depict this scene. The Church officials of Venice were shocked and offended by the impiety of placing near Jesus a host of extremely unsavory characters. Veronese was called before the Inquisition to explain his painting.

Venice, July 18, 1573. The minutes of the session of the Inquisition Tribunal of Saturday, the 18th of July, 1573. . . . *

- Q: What picture is this of which you have spoken?
- A: This is a picture of the Last Supper that Jesus Christ took with His apostles in the house of Simon . . .
- Q: At this supper of Our Lord have you painted other figures?
- A: Yes, milords.
- Q: Tell us how many people and describe the gestures of each.

(Veronese describes the painting.)

- Q: What is the significance of those armed men dressed as Germans, each with a halberd in his hand?
- A: We painters take the same license the poets and the jesters take and I have represented these two hal-

berdiers, one drinking and the other eating nearby on the stairs. They are placed there so that they might be of service because it seemed to me fitting, according to what I have been told, that the master of the house, who was great and rich, should have such servants

- Q: And that man dressed as a buffoon with a parrot on his wrist, for what purpose did you paint him on that canvas?
- A: For ornament, as is customary . . .
- Q: Who do you really believe was present at that Supper?
- A: I believe one would find Christ with His Apostles. But if in a picture there is some space to spare I enrich it with figures according to the stories.
- Q: Did anyone commission you to paint Germans, buffoons, and similar things in that picture?
- A: No, milords, but I received the commission to decorate the picture as I saw fit. It is large and, it seemed to me, it could hold many figures.
- Q: Are not the decorations which you painters are accustomed to add to paintings or pictures supposed to be suitable and proper to the subject and the principal figures or are they for pleasure—simply what comes to

- your imagination without any discretion or judiciousness?
- A: I paint pictures as I see fit and as well as my talent permits.
- Q: Does it seem fitting at the Last Supper of the Lord to paint buffoons, drunkards, Germans, dwarfs, and similar vulgarities?
- A: No, milords . . .

(The questions continue in this vein.)

The judges decreed that Veronese must change the painting within three months or be liable to penalties. Veronese changed the picture's title so that it referred to another banquet, given by the tax collector Levi. The "buffoons, drunkards . . . and similar vulgarities" remained, and Veronese noted his new source-Luke 5-on the balustrade. That Gospel reads that "Levi gave a great banquet for him [Jesus] in his house, and a large crowd of tax collectors and others were at table with them" (Luke 5:29). In changing the declared subject of the painting, Veronese also had modest revenge on the Inquisitors: When Jesus was criticized for associating with such people, he replied, "I have not come to call the righteous to repentance but sinners" (Luke 5:32).

* E. G. Holt, *Literary Sources of Art History*. Princeton, NJ: Princeton University Press, 1947. pp. 245-48.

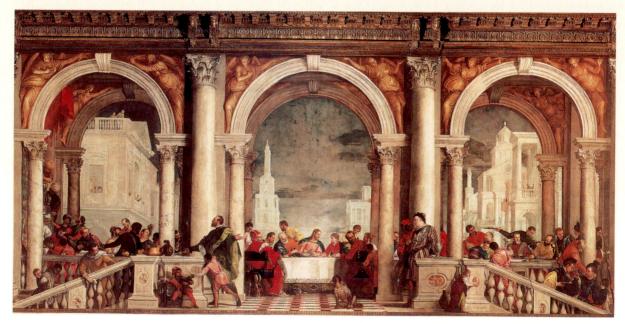

Veronese FEAST IN THE HOUSE OF LEVI

From the refectory of the Dominican Monastery of Santi Giovanni e Paolo, Venice. 1573. Oil on canvas, $18'3'' \times 42'$ (5.56 \times 12.8 m). Galleria dell'Accademia, Venice.

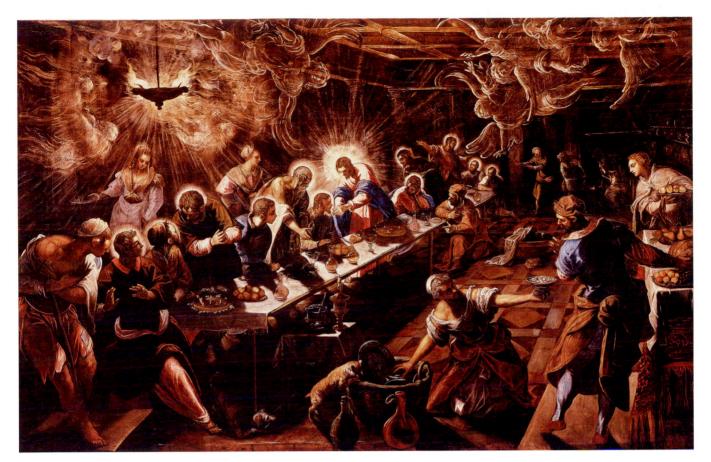

20–43 \dagger Tintoretto THE LAST SUPPER 1592–94. Oil on canvas, 12' \times 18'8" (3.7 \times 5.7 m). Church of San Giorgio Maggiore, Venice.

Tintoretto, who had a large workshop, often developed a composition by creating a small-scale model like a miniature stage set, which he populated with wax figures. He then adjusted the positions of the figures and the lighting until he was satisfied with the entire scene. Using a grid of horizontal and vertical threads placed in front of this model, he could easily sketch the composition onto squared paper for his assistants to copy onto a large canvas. His assistants also primed the canvas, blocking in the areas of dark and light, before the artist himself, free to concentrate on the most difficult passages, finished the painting. This efficient working method allowed Tintoretto to produce a large number of paintings in all sizes.

pleasure and pageantry sustained by a nominally republican government and great mercantile wealth. Veronese's elaborate architectural settings and costumes, still lifes, anecdotal vignettes, and other everyday details, often unconnected with the main subject, proved immensely appealing to Venetian patrons. His vision of the glorious Venice reached an apogee in the ceiling of the council chamber in the ducal palace (Fig. 12, Introduction).

Veronese's most famous work is a Last Supper that he renamed **FEAST IN THE HOUSE OF LEVI** (see opposite), painted in 1573 for the Dominican Monastery of Santi Giovanni e Paolo. At first glance, the subject of the painting seems to be architecture and only secondarily Christ seated at the table. An enormous loggia framed by colossal triumphal arches and reached by balustraded stairs symbolizes Levi's house. Beyond the loggia an imaginary city of white marble gleams. Within this grand setting, realistic figures in splendid costumes assume exaggerated, theatrical poses. The huge size of the painting

allowed Veronese to include the sort of anecdotal vignettes beloved by the Venetians—the parrots, monkeys, and Germans—but detested by the Church's Inquisitors, who saw in them profane undertones.

TINTORETTO. Another Venetian master, Jacopo Robusti (1518–94), called "Tintoretto" ("Little Dyer," because his father was a dyer), worked in a style that developed from, and exaggerated, the techniques of Titian, in whose shop he reportedly apprenticed. Tintoretto's goal, declared on a sign in his studio, was to combine Titian's color with the drawing of Michelangelo. Like Veronese, Tintoretto often received commissions to decorate huge interior spaces. He painted THE LAST SUPPER (FIG. 20–43) for the choir of the Church of San Giorgio Maggiore, a building designed by Palladio (SEE FIG. 20–44). Comparison with Leonardo da Vinci's painting of almost a century earlier is instructive (see Figs. 20–2 and fig. 18, Introduction). Instead of Leonardo's closed

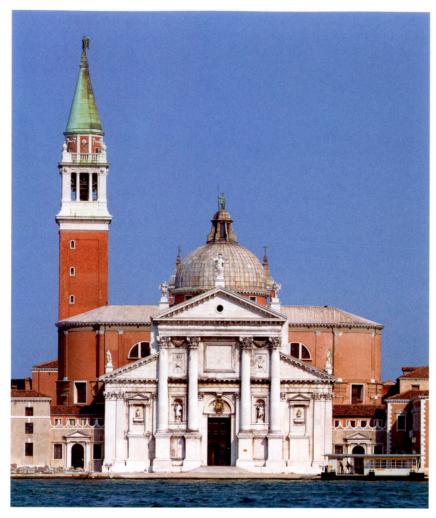

20–44 | Palladio CHURCH OF SAN GIORGIO MAGGIORE, VENICE Plan 1565; construction 1565–80; façade, 1597–1610; campanile 1791. Finished by Vincenzo Scamozzi following Palladio's design.

and logical space with massive figures reacting in individual ways to Jesus's statement, Tintoretto's view is from a corner, with the vanishing point on a high horizon line at the far right side. The table, coffered ceiling, and inlaid floor all seem to plunge dramatically into the distance. The figures, although still large bodies modeled by flowing draperies, turn and move in a continuous serpentine line that unites apostles, servants, and angels. Tintoretto used two light sources: one real, the other supernatural. Light streams from the oil lamp flaring dangerously over the near end of the table; angels seem to swirl out from the flame and smoke. A second light emanates from Jesus himself and is repeated in the glow of the apostles' halos. The mood of intense spirituality is enhanced by deep colors flashed with bright highlights, as well as by the elongated figures—treatments that reflect both the Byzantine art of Venice and the Mannerist aesthetic. The still lifes on the tables and the homey detail of a cat and basket emphasize the reality of the viewers' experience. At the same time, the deep chiaroscuro and brilliant dazzling lights catching forms in near-total darkness enhance the convincingly otherworldly atmosphere. The

interpretation of *The Last Supper* also has changed—unlike Leonardo's more secular emphasis on personal betrayal, Tintoretto has returned to the religious institution of the Eucharist: Jesus offers bread and wine, a model for the priest administering the sacraments at the altar next to the painting.

The speed with which Tintoretto drew and painted was the subject of comment in his own time, and the brilliance and immediacy so admired today (his slashing brushwork was fully appreciated by the gestural painters of the twentieth century) were derided as evidence of carelessness. His rapid production may be attributed to the efficiency of his working methods: Tintoretto had a large workshop of assistants and he usually provided only the original conception, the beginning drawings, and the final brilliant touches on the finished painting. Tintoretto's workshop included members of his family—of his eight children, four became artists. His oldest daughter, Marietta Robusti, worked with him as a portrait painter, and two or perhaps three of his sons also joined the shop. So skillfully did Marietta capture her father's style and technique that today art historians cannot identify her work in the shop.

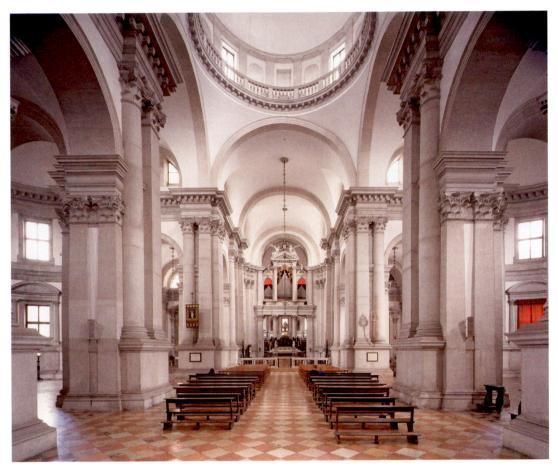

20–45 | NAVE, CHURCH OF SAN GIORGIO MAGGIORE, VENICE
Begun 1566. Tintoretto's *Last Supper* (not visible) hangs to the left of the altar.

Architecture: Palladio

Just as Veronese and Tintoretto expanded upon the rich Venetian tradition of oil painting established by Giorgione and Titian, Andrea Palladio dominated architecture during the second half of the century by expanding upon principles of Alberti and of ancient Roman architecture. His work—whether a villa, palace, or church—was characterized by harmonious symmetry and a rejection of ornamentation. Over the years, Palladio became involved in several publishing ventures, including a guide to Roman antiquities, an illustrated edition of Vitruvius, and books on architecture that for centuries would be valuable resources for architectural design.

Born Andrea di Pietro della Gondola (1508–80), probably in Padua, Palladio began his career as a stonecutter. After moving to Vicenza, he was hired by the nobleman, humanist scholar, and amateur architect Giangiorgio Trissino. Trissino gave him the nickname "Palladio" for the Greek goddess of wisdom, Pallas Athena, and the fourth-century Roman writer Palladius. Palladio learned Latin at Trissino's small academy and accompanied his benefactor on three trips to Rome, where he made drawings of Roman monuments.

SAN GIORGIO MAGGIORE. By 1559, when he settled in Venice, Palladio was one of the foremost architects of Italy. In

1565, he undertook a major architectural commission: the monastery CHURCH OF SAN GIORGIO MAGGIORE (FIG. 20-44). His design for the Renaissance façade to the traditional basilica-plan elevation—a wide lower level fronting the nave and side aisles surmounted by a narrower front for the nave clerestory—is ingenious. Inspired by Alberti's solution for Sant'Andrea in Mantua (SEE FIG. 19-31), Palladio created the illusion of two temple fronts of different heights and widths, one set inside the other. At the center, colossal columns on high pedestals, or bases, support an entablature and pediment that front the narrower clerestory level of the church. The lower temple front, which covers the triple-aisle width and slanted side-aisle roofs, consists of pilasters supporting an entablature and pediment running behind the columns of the taller clerestory front. Palladio retained Alberti's motif of the triumphal-arch entrance. Although the façade was not built until after the architect's death, his original design was followed.

The interior of San Giorgio (FIG. 20–45) is a fine example of Palladio's harmoniously balanced geometry, expressed here in strong verticals and powerful arcs. The tall engaged columns and shorter pairs of pilasters of the nave arcade echo the two levels of orders on the façade, thus unifying the building's exterior and interior.

THE VILLA ROTONDA. Palladio's versatility can best be seen in numerous villas built early in his career. In the 1560s, he started his most famous and influential villa just outside Vicenza (FIGS. 20–46, 20–47). Although traditionally villas were working farms, Palladio designed this one as a retreat for relaxation (a party house). To afford views of the countryside on each face of the building, he placed a porch, with four columns, arched openings in the walls, and a wide staircase. The main living quarters are on this second level, as is usual

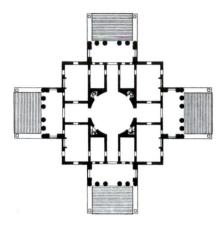

20–46 \mid plan of the villa rotonda c. 1550.

Palladio was a scholar and an architectural theorist as well as a designer of buildings. His books on architecture provided ideal plans for country estates, using proportions derived from ancient Roman structures. Despite their theoretical bent, his writings were often more practical than earlier treatises. Perhaps his early experience as a stonemason provided him with the knowledge and self-confidence to approach technical problems and discuss them as clearly as he did theories of ideal proportion and uses of the classical orders. By the eighteenth century, Palladio's Four Books of Architecture had been included in the library of most educated people. Thomas Jefferson had one of the first copies in America.

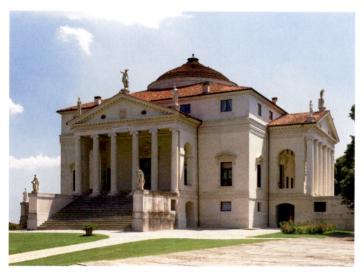

20–47 | Palladio VILLA ROTONDA (VILLA CAPRA), VICENZA Italy. Begun, 1560s.

in European palace architecture, and the lower level is reserved for the kitchen, storage, and other utility rooms. Upon its completion in 1569, the villa was dubbed the VILLA ROTONDA because it had been inspired by another round hall, the Roman Pantheon. After its purchase in 1591 by the Capra family, it became known as the Villa Capra. The villa's plan shows the geometric clarity of Palladio's conception: a circle inscribed in a small square inside a larger square, with symmetrical rectangular compartments and identical rectangular projections from each of its faces. The use of a central dome on a domestic building was a daring innovation that effectively secularized the dome. The Villa Rotonda was the first of what was to become a long tradition of domed country houses, particularly in England and the United States.

IN PERSPECTIVE

In spite of ongoing struggles between the Holy Roman emperor and the pope, and in spite of the scandals beginning to envelop the Church, the early sixteenth century emerged as a golden age for the arts. As sixteenth-century artists built on the past, they carried the investigation of nature, classics, and humanistic learning further than their fifteenth-century predecessors. Art went beyond realism to idealism. Artists not only reproduced the surface appearances, they sought underlying forms. In painting a figure, for example, their study of anatomy had to be more than skin deep; their knowledge of the skeletal and muscular structure of the human body was on display, and the observation of a face led to the study of a personality. The ideal of the dignity of all human beings as creatures made by God, expounded by the philosophers and forcefully elucidated in Michelangelo's paintings in the Sistine Chapel, informed the art of this period.

As classicists, their fascination with the tangible remains of ancient Rome—inscriptions, fragments of architecture and sculpture—turned into full-scale archaeological excavation and the discovery of major pagan artworks such as the *Laocoön*. Like the ancient Greeks (whose sculpture they knew only in Roman copies), the Italian painters of the High Renaissance sought perfection. They, too, developed an ideal canon of proportions and a kind of spiritual geometry that underlies their painting and sculpture. This classical equilibrium in the arts, balancing physical and spiritual forces, proved to be fleeting.

By 1530 change was in the air, and an anticlassical style emerged in works of art that later critics defined as "Mannerist." A high level of technical skill could be assumed and was used to achieve dazzling displays of grace, elegance, and "manner." As complex in their compositions as they were in their subjects, the Mannerist artworks stimulate an uneasy imagination, and today they often defy analysis or explication. Social institutions might be crumbling but artists, secure in their technical achievements and admired by their patrons, continued to paint, carve, and build.

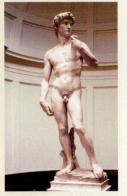

MICHELANGELO

DAVID

1501-4

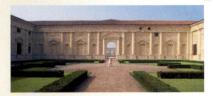

Giulio Romano **courtyard façade** , **palazzo del tè, mantua** 1527–34

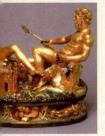

BENVENUTO CELLINI
R OF KING FRANCIS I
OF FRANCE
1540-43

SOFONISBA ANGUISSOLA SELF PORTRAIT C. 1552

TINTORETTO
THE LAST SUPPER
1592-94

SIXTEENTH-CENTURY ART IN ITALY

1500

1520

1540

1560

1580

1600

- Luther Officially Protests Church's Sale of Indulgences 1517
- Charles V Holy Roman Emperor 1519-56
- Charles V Orders Sack of Rome 1527
- ✓ Jesuit Order Confirmed 1540
- Pope Paul III Institutes Inquisition 1542
- **⋖ Council of Trent** 1545-63
- Vasari's Lives Published 1550

■ Veronese Appears Before the Inquisition 1573

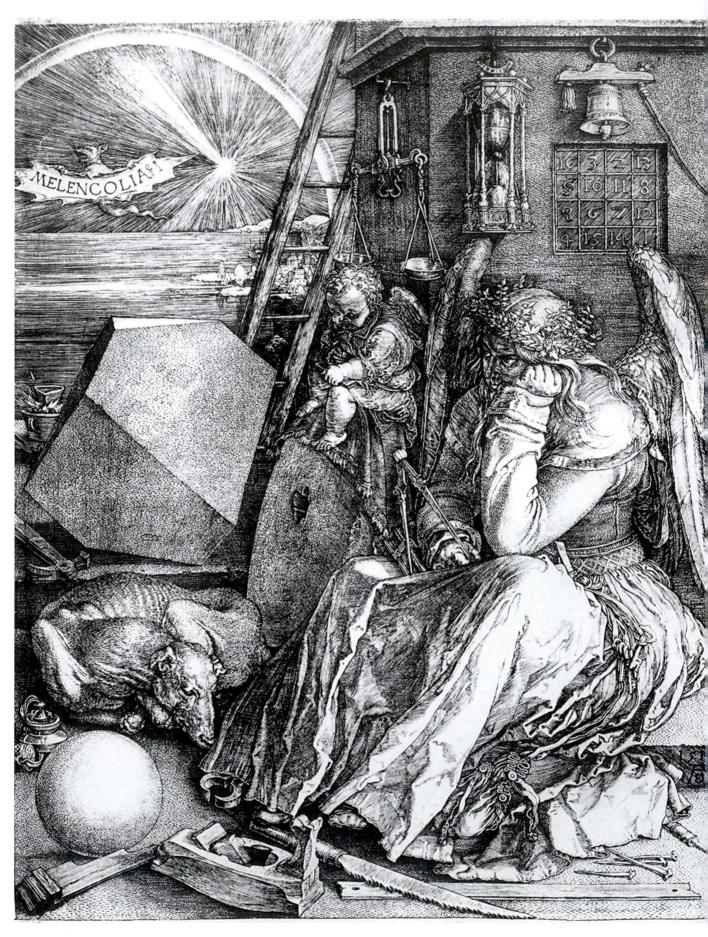

21–1 | Albrecht Dürer | MELENCOLIA I | 1514. Engraving, $9\% \times 7\%$ (23.8 \times 18.9 cm). Victoria & Albert Museum, London.

CHAPTER TWENTY-ONE

SIXTEENTH-CENTURY ART IN NORTHERN EUROPE AND THE IBERIAN PENINSULA

A bat inscribed "Melencolia I" flits through the sky. The flashing light of a comet illuminates a huge winged creature seated below, who seems lost in thought and whose body expresses weariness and even despair, a mood reflected in the

curled figure of a starving dog. Piled on the ground and hanging on the wall is a striking collection of objects, some associated with the mechanical arts and crafts—builders' tools such as a ladder, hammer, spikes, saw, and a plane—and others with intellectual activity—compasses, scales, an hourglass, and a measuring stick, all instruments used to describe the world in terms of geometry. A winged child scribbles mindlessly, but the adult figure seems to have created a perfect sphere, a truncated polyhedron, and a magic number square. Now, though, she sits in an attitude of defeat and frustration. What does this all mean? In his groundbreaking study, the scholar Erwin Panofsky identified the image as the "spiritual self-portrait" of its creator, the artist Albrecht Dürer.

A skilled graphic artist with a brilliant mind, Dürer was a leading figure in the German Renaissance. He was also a social and professional success in Italy, where he traveled in 1494 and 1505. There, he must have noted a certain distinction: Artists like Michelangelo could claim to be divinely inspired creators, but in Dürer's Germany artists were still considered artisans—craftsmen and manual laborers. They were not "humanists," not "intellectuals"; they were skilled and valued members of society, to be sure, but nevertheless people who

21

worked with their hands. Dürer, caught up in the humanist spirit of Renaissance Italy, may have identified with his creation in **MELENCOLIA I** (FIG. 21–1): a superhuman, listlessly brooding figure surrounded by tools and symbols of the arts

and humanities but still unable to act.

The ideas behind Dürer's image seem strange to us today. Renaissance scholars believed that the planets influenced human destiny. Artists, it was thought, were born under the distant and dark planet Saturn (the dog and bat are creatures of Saturn). From Saturn came a divine frenzy that inspired artistic creativity. If that frenzy was not kept in balance with what the discipline of art could reasonably accomplish, however, artists were led to frustration and ultimately inaction. In short, the creative genius was prone to melancholy and despair. Also, according to the Renaissance theory of the four humors (bodily fluids that determined human personality and temperament), the melancholy person had an excess of black bile. Black bile was associated with things dry and cold, with the earth, with endings-evening, autumn, age-and with the vices of greed and despair. As if to reinforce the identification with the melancholy humor, Dürer's winged figure wears a wreath of watercress and ranunculus, plants thought to cure the dryness caused by melancholy. The figure's rumpled purse lies on the ground, perhaps signifying the craving for—but absence of—wealth.

But what is the meaning of the roman numeral "I" after the word "Melencolia"? According to the belief of the time, melancholy took three forms, conceived of as "limitations" that varied by profession. Scientists and physicians, for example, were "limited" by the second form of melancholy, reason; theologians were limited by intuition, the third form. Artists suffered from limitation by imagination, the first form—hence, Melencolia I. We are watching an artist struggling with the burden of the creative imagination.

The other two engravings Dürer made between 1513 and 1514 illustrate the active life—a knight defying death and the devil—and the contemplative life—the scholar Saint Jerome at work in his study. *Melencolia I*, however, shows us a secular genius and reflects the philosophical and social conflict that beset Dürer and many other thoughtful artists, especially in Protestant lands, in the early years of the sixteenth century. In its melancholy, the engraving also foreshadows the effects of the religious turmoil, social upheaval, and civil war soon to sweep northern Europe.

CHAPTER-AT-A-GLANCE

- THE REFORMATION AND THE ARTS
- EARLY SIXTEENTH-CENTURY ART IN GERMANY | Sculpture | Painting
- RENAISSANCE ART IN FRANCE | The Introduction of Italian Art | Art in the Capital
- RENAISSANCE ART IN SPAIN AND PORTUGAL | Architecture | Painting
- RENAISSANCE PAINTING IN THE NETHERLANDS | Art for Aristocratic and Noble Patrons | Antwerp
- RENAISSANCE ART IN ENGLAND | Artists in the Tudor Court | Architecture
- IN PERSPECTIVE

THE REFORMATION AND THE ARTS

In spite of dissident movements that challenged the Christian Church through the centuries, the authority of the Church and the pope ultimately prevailed—until the sixteenth century. Then, against a backdrop of broad dissatisfaction with financial abuses and lavish lifestyles among the clergy (see Chapter 20), religious reformers within the established Church challenged practices and went on to challenge beliefs.

Two of the most important reformers in the early sixteenth century were themselves Catholic priests and trained theologians: Desiderius Erasmus of Rotterdam (1466?–1536) in Holland who tried to reform the Roman Catholic Church from within, and Martin Luther (1483–1546) in Germany who eventually broke with the Church. Indeed, the Reformation may be said to begin in 1517, when Luther issued his Ninety-Five Theses calling for Church reform. Among Luther's concerns were the practice of selling indulgences (the forgiveness of sins and the assurance of salvation) and the excessive veneration of saints and their relics, which he considered superstitious. Luther and others emphasized individual faith and regarded the Bible as the ultimate religious authority. As they challenged the pope's supremacy, it became clear that the Protestants had to break away from Rome. The Church condemned Luther in 1521.

Increased literacy and the widespread use of the printing press aided the reformers and allowed scholars throughout

Europe to debate religious matters and to influence many people. In Germany the wide circulation of Luther's writings—especially his German translation of the Bible and his works maintaining that salvation comes through faith alone—eventually led to the establishment of the Protestant (Lutheran) Church there. In Switzerland, John Calvin (1509–64) led an even more austere Protestant revolt, and in England, King Henry VIII (ruled 1509–47) also broke with Rome in 1534. By the end of the sixteenth century, some form of Protestantism prevailed throughout northern Europe.

Leading the Catholic cause was Holy Roman Emperor Charles V (see Chapter 20). Europe was wracked by religious war from 1546 to 1555 as Charles battled the Protestant forces in Germany. During this turbulent time, the Italian Leone Leoni (1509-90), working for the emperor in Spain, created a life-size bronze sculpture of Charles V Triumphing over Fury (see Fig. 8, Introduction). Yet Leone's portrayal of a victorious Charles proved premature. At a meeting of the provincial legislature of Augsburg in 1555, the emperor was forced to accommodate the Protestant Reformation in his lands. By the terms of the peace, local rulers selected the religion of their subjects-Catholic or Protestant. Tired of the strain of government and prematurely aged, Charles abdicated in 1556 and retired to a monastery in Spain, where he died in 1558. His son Philip II inherited Spain and the Spanish colonies; his brother Ferdinand led the Austrian branch of the Habsburg dynasty.

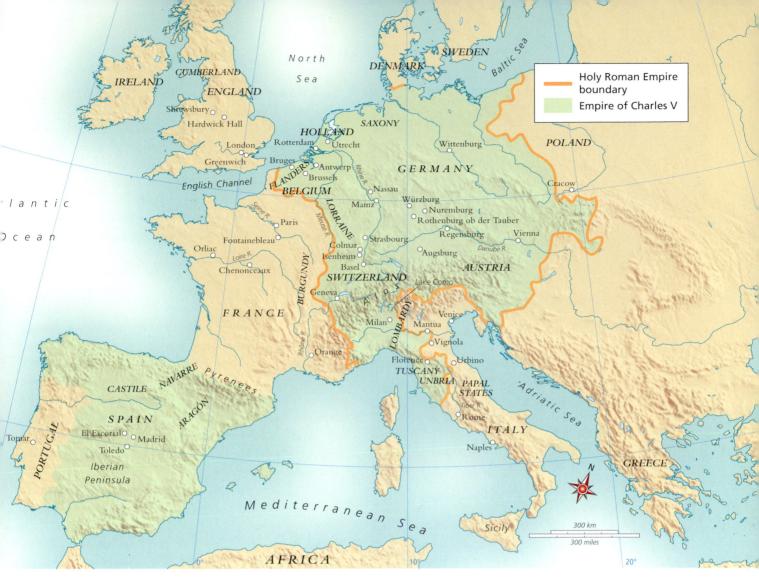

MAP 2I-I | NORTHERN EUROPE AND THE IBERIAN PENINSULA IN THE SIXTEENTH CENTURY

The 16th century saw Europe divided between Protestant and Catholic countries. While France, Spain, Flanders, Belgium, and Italy remained Catholic, Switzerland, the northern Netherlands (the United Provinces), and England became Protestant. By 1555 Emperor Charles V had to permit rulers in his German lands to follow their own religious beliefs.

The years of political and religious strife had a grave impact on artists. Some artists found their careers at an end because of their sympathies for rebels and reformers. Then as Protestantism gained ascendancy, artists who supported the Roman Catholic Church had to leave their homes to seek patronage abroad.

A tragic consequence of the Reformation was the destruction of religious art. In some places, Protestant zealots smashed sculpture and stained-glass windows and destroyed or whitewashed religious paintings to rid the churches of what they considered to be idolatrous images—though Luther, who understood the educational value of art, never directly supported iconoclasm (the smashing of religious images). With the sudden loss of patronage for religious art in the newly Protestant lands, many artists had to find new patrons and new themes. They turned to portraiture and other secular subjects, including moralizing depictions of human folly and weaknesses. Still-life (that is, the painting of objects alone) and landscape painting began to appear. The popularity of these themes stimulated a free art market, centered in Antwerp.

EARLY SIXTEENTH-CENTURY ART IN GERMANY

In German regions the arts flourished until religious upheavals and iconoclastic purges of religious images took a toll at midcentury. The German cities had strong business and trade interests and their merchants and bankers accumulated self-made, rather than inherited, wealth. They ordered portraits of themselves and fine furnishings for their large, comfortable houses. Entrepreneurial artists, like Albrecht Dürer, became major commercial successes.

Sculpture

At the end of the fifteenth century, sculpture gradually changed from the late Gothic to Renaissance style with an increased interest in naturalism. Although, like the Italians, German sculptors worked in stone and bronze, they produced their most original work in wood, especially fine-grained limewood. They gilded and painted these wooden images, until Tilman Riemenschneider began to use natural wood finishes.

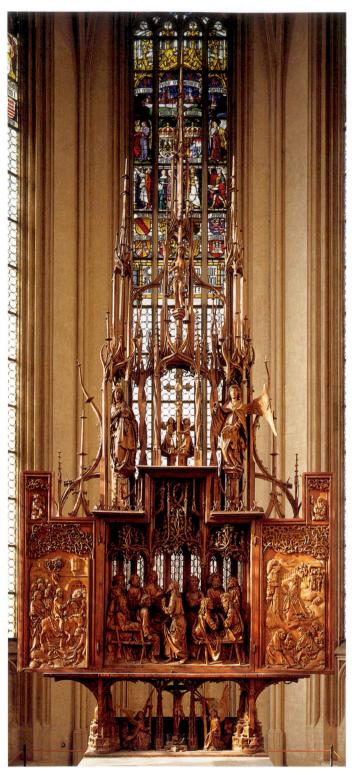

21-2 | Tilman Riemenschneider ALTARPIECE OF THE HOLY BLOOD (WINGS OPEN)

Center, Last Supper. c. 1499-1505. Limewood, glass, height of tallest figure 39" (99.1 cm); height of altar 29'6" (9 m). Sankt Jakobskirche, Rothenburg ob der Tauber, Germany.

TILMAN RIEMENSCHNEIDER. Tilman Riemenschneider (c. 1460–1531) became a master in 1485 and soon had the largest workshop in Würzburg. His shop included specialists in both wood and stone sculpture. Riemenschneider attracted patrons from other cities, and in 1501 he signed a contract with the Church of Saint James in Rothenburg, where a relic said to be a drop of Jesus's blood was preserved. The ALTARPIECE OF THE HOLY BLOOD (FIG. 21–2) is a spectacular limewood construction standing nearly 30 feet high. A specialist in architectural shrines had begun work on the elaborate Gothic frame in 1499. The frame cost fifty florins. Riemenschneider was commissioned to provide the figures and scenes to be placed within this frame, and Riemenschneider was paid sixty florins for the sculpture (a suggestive commentary on the value assigned the work by the patrons).

In the main scene of the altarpiece, the *Last Supper*, Riemenschneider depicted the moment when Christ revealed that one of his followers would betray him. Unlike Leonardo da Vinci, who chose the same moment (see Introduction, Fig. 18), Riemenschneider made Judas the central figure in the composition and placed Jesus off-center at the left. The disciples sit around the table. As the event is described in the Gospel of John (13:21–30), Jesus extends a morsel of food to Judas, signifying that Judas will be the traitor who sets in motion the events leading to the Crucifixion. An apostle points down, a strange gesture until one realizes that he points to the Crucifix in the predella, to the relic of Christ's blood, and to the altar table, the symbolic representation of the table of the Last Supper and the tomb of Christ.

Rather than creating individual images in his sculptures, Riemenschneider repeated a limited number of facial types. In this way he could make effective use of his workshop. His figures have large heads, prominent features, sharp cheekbones, sagging jowls, baggy eyes, and elaborate hair with thick wavy locks and deeply drilled curls. The muscles, tendons, and raised veins of hands and feet are also especially lifelike. His assistants and apprentices copied these faces and figures, either from drawings or from three-dimensional models made by the master. In the altarpiece, deeply hollowed folds and active patterned draperies create strong highlights and dark shadows that unite the figures with the intricate carving of the framework. In the Last Supper the scene is set in a real room with actual benches for the figures, with windows in the back wall glazed with bull's-eye glass. Natural light shining through both the church and altarpiece windows illuminates the scene, creating changing effects depending on the time of day and the weather.

In addition to producing an enormous number of religious images for churches, Riemenschneider was politically active in the city's government, and he even served as mayor in 1520. His career ended during the Peasants' War (1524–26), an early manifestation of the Protestant movement. His support for the peasants led to a fine and imprisonment in 1525, and he died in 1531.

VEIT STOSS. Riemenschneider's contemporary Veit Stoss (1450–1533) spent his early years (1477–96) in Cracow, Poland, where he became wealthy from his sculpture and architectural commissions, as well as from financial investments. After returning to his native Nuremberg, he too began to specialize in limewood sculpture, probably because established artists already dominated commissions in other mediums. He had a small shop whose output was characterized by an easily recognizable realistic style. Following the lead of Riemenschneider and others, Stoss shows in his unpainted limewood sculptures a special appreciation for the wood itself, which he exploited for its inherent colorations, grain patterns, and range of surface finishes.

Stoss carved the **ANNUNCIATION AND VIRGIN OF THE ROSARY** (FIG. 21–3) for the choir of the Church of Saint Lawrence in Nuremberg in 1517–18. Gabriel's greeting to Mary takes place within a wreath of roses symbolizing the prayers of the rosary, which was being popularized by the Dominicans. Disks are carved with scenes of the Joys of the Virgin, to which are added her death (Dormition) and Coronation. Mary and Gabriel are adored and supported by angels. Their dignified figures are encased in elaborate crinkled and fluttering drapery that seems to blend with the delicate angels and to cause the entire work to float like an apparition in the upper reaches of the choir. The sculpture continues the expressive, mystical tradition prevalent since the Middle Ages in the art of Germany, where the recitation of prayers to the Virgin (the rosary) had become an important part of personal devotion.

NIKOLAUS HAGENAUER. Prayer was also the principal source of solace and relief to the ill before the advent of modern medicine. About 1505, the Strasbourg sculptor Nikolaus Hagenauer (active 1493–1530s) carved an altarpiece for the Abbey of Saint Anthony in Isenheim near Colmar (FIG. 21–4). The Abbey's hospital specialized in the care of patients with skin diseases, including the plague, leprosy, and Saint Anthony's Fire (a terrible disease caused by eating rye and other grains infected with the ergot fungus). The shrine includes images of Saint Anthony, Saint Jerome, and Saint Augustine. Three men kneel at the feet of the saints: the donor, Jean d'Orliac, and two men offering a rooster and a piglet. The three are tiny figures, as befits their subordinate status.

In the predella below, Jesus and the apostles bless the altar, Host, and assembled patients in the hospital. The limewood sculpture was painted in lifelike colors, and the shrine itself was gilded to enhance its resemblance to a precious reliquary. Later, Matthias Grünewald painted wooden shutters to cover the shrine (SEE FIGS. 21–5, 21–6).

Painting

German art during the first decades of the sixteenth century was dominated by two very different artists, Matthias Grünewald and Albrecht Dürer. Grünewald's unique style expressed the

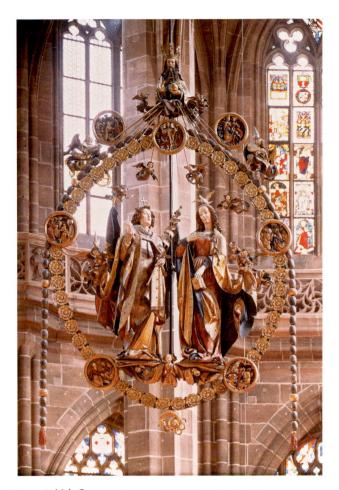

2I-3 | Veit Stoss ANNUNCIATION AND VIRGIN

OF THE ROSARY

1517-18 Painted and gilt limewood 12'2" × 10'6

1517–18. Painted and gilt limewood, $12'2'' \times 10'6''$ (3.71 \times 3.20 m). Church of Saint Lawrence, Nuremberg.

continuing currents of medieval German mysticism and emotional spirituality, while Dürer's intense observation of the natural world represented the scientific Renaissance interest in empirical observation, including mathematical perspective to create the illusion of space, and the use of a reasoned canon of proportions for depicting the human figure.

MATTHIAS GRÜNEWALD. As an artist in the court of the archbishop of Mainz, Matthias Grünewald (Matthias Gothart Neithart, c. 1470/75–1528) was a man of many talents, who worked as an architect and hydraulic engineer as well as a painter. He is best known today for painting the wings of the ISENHEIM ALTARPIECE (SEE FIGS. 21–5, 21–6), built to protect the shrine carved by Nikolaus Hagenauer. In his realism and intensity of feeling, Grünewald may have been inspired by the visions of Saint Bridget of Sweden, a fourteenth-century mystic whose works were published in Germany beginning in 1492. She described the Crucifixion in morbid detail.

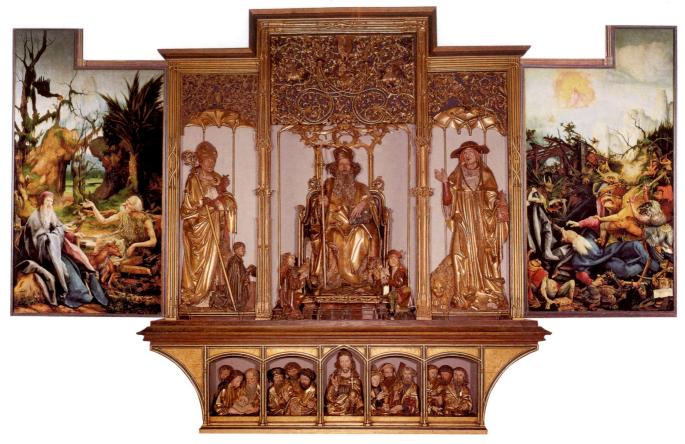

21–4 Nikolaus Hagenauer SAINT ANTHONY ENTHRONED BETWEEN SAINTS AUGUSTINE AND JEROME, SHRINE OF THE ISENHEIM ALTARPIECE (OPEN, SHOWING GRÜNEWALD WINGS.)

From the Community of Saint Anthony, Isenheim, Alsace, France. c. 1500. Painted and gilt limewood, center panel $9'9\%'' \times 10'9''$ (2.98 \times 3.28 m); predella $2'5\%'' \times 11'2''$ (0.75 \times 3.4 m). Wings $8'2\%'' \times 3'\%''$ (2.49 \times 0.93 m). Predella: *Christ and the Apostles*. Wings *Saint Anthony and Saint Paul* (left); *The Temptation of Saint Anthony* (right). 1510–15. Musée d'Unterlinden, Colmar, France.

The altarpiece is impressive in size and complexity. Grünewald painted one set of fixed wings and two sets of movable ones, plus one set of sliding panels to cover the predella. The altarpiece could be exhibited in different configurations depending upon the Church calendar. The wings and carved wooden shrine complemented one another, the inner sculpture seeming to bring the surrounding paintings to life, and the painted wings protecting the precious carvings.

On weekdays, when the altarpiece was closed, viewers saw a shocking image of the Crucifixion in a darkened landscape, a Lamentation below it on the predella, and life-size figures of Saints Sebastian and Anthony Abbot—saints associated with the plague—standing on *trompe l'oeil* pedestals on the fixed wings (FIG. 21–5). Grünewald represented in the most horrific details the tortured body of Jesus, covered with gashes from being beaten and pierced by the thorns used to form a crown for his head. His ashen body, open mouth, and blue lips indicate that he is dead. In fact, he appears already to be decaying, an effect enhanced by the palette of putrescent green, yellow, and purplish red—all described by Saint Bridget; she wrote, "The color of death spread through his flesh. . ." A ghostlike Virgin Mary has collapsed in the arms of an emaciated John the Evangelist, and Mary Magdalen has fallen in anguish to her knees; her

clasped hands with outstretched fingers seem to echo Jesus's fingers, cramped in rigor mortis. At the right John the Baptist points at Jesus and repeats his prophecy, "He shall increase." The Baptist and the lamb, holding a cross and bleeding from its breast into a golden chalice, allude to baptism, the Eucharist, and to Christ as the sacrificial Lamb of God (recalling the *Ghent Altarpiece*; SEE FIG. 18–12). In the predella below, Jesus's bereaved mother and friends prepare his body for burial—an activity that must have been a common sight in the abbey's hospital.

In contrast to these grim scenes, the first opening displays events of great joy—the Annunciation, the Nativity, and the Resurrection—appropriate for Sundays and Church festivals (FIG. 21–6). Praying in front of these images, the patients hoped for miraculous recovery. Unlike the awful darkness of the Crucifixion, the inner scenes are illuminated with clear natural daylight, phosphorescent auras and halos, and the glitter of stars in a night sky. Fully aware of contemporary formal achievements in Italy, Grünewald created the illusion of three-dimensional space and volumetric figures, and he simplified and idealized the forms. Underlying this attempt to arouse a sympathetic emotional response in the viewer is a complex religious symbolism, undoubtedly the result of close collaboration with his monastic patrons.

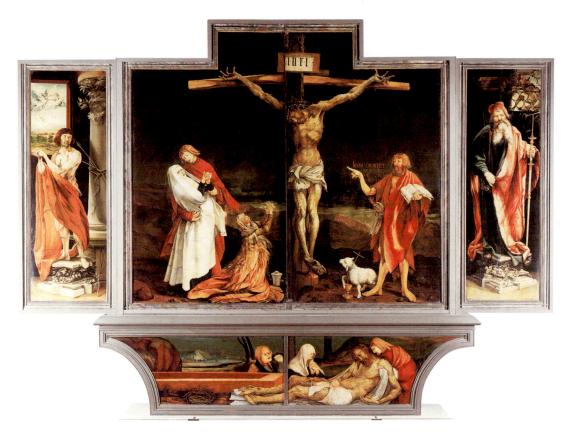

21-5 Matthias Grünewald ISENHEIM ALTARPIECE (CLOSED)

From the Community of Saint Anthony, Isenheim, Alsace, France. Center panels: Crucifixion; predella: Lamentation; side panels: Saints Sebastian (left) and Anthony Abbot (right). c. 1510–15. Date 1515 on ointment jar. Oil on wood panel, center panels $9'9\frac{7}{2}''\times10'9''$ (2.97 \times 3.28 m) overall; each wing $8'2\frac{7}{2}''\times3'\frac{7}{2}''$ (2.49 \times 0.93 m); predella $2'5\frac{7}{2}''\times11'2''$ (0.75 \times 3.4 m). Musée d'Unterlinden, Colmar, France.

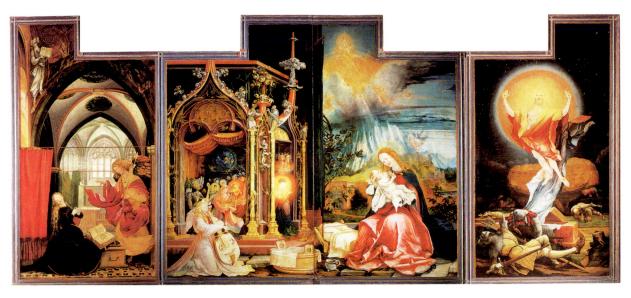

21-6 | Matthias Grünewald ISENHEIM ALTARPIECE (FIRST OPENING)

Left to right: Annunciation, Virgin and Child with Angels, Resurrection. c. 1510–15. Oil on wood panel, center panel $9'9\frac{1}{2}'' \times 10'9''$ (2.97 \times 3.28 m), each wing $8'2\frac{1}{2}'' \times 3'\frac{1}{2}''$ (2.49 \times 0.92 m). Musée d'Unterlinden, Colmar, France.

Materials and Techniques GERMAN METALWORK: A COLLABORATIVE VENTURE

n Nuremberg, a city known for its master metalsmiths, Hans Krug (d. 1519) and his sons Hans the Younger and Ludwig were among its finest gold- and silversmiths. They created marvelous display pieces for the wealthy, such as this silver-gilt apple cup. Made about 1510, a gleaming apple, in which the stem forms the handle of the lid, balances on a leafy branch that forms its base.

The Krug family was responsible for the highly refined casting and finishing of the final product, but several artists worked together to produce such pieces—one drawing designs, another making the models, and others creating the final piece in metal. A drawing by Dürer may have been the basis for the apple cup. Though we know of no piece of goldwork by the artist himself, Dürer was a major catalyst in the growth of Nuremberg as a key center of German goldsmithing. He accomplished this by producing designs for metalwork throughout his career, evidence of the essential role of designers in the metalwork process. With design in hand, the model maker created a wooden form for the goldsmith to follow. The result of this artistic collaboration was a technical tour de force, an intellectual conceit, and a very beautiful object.

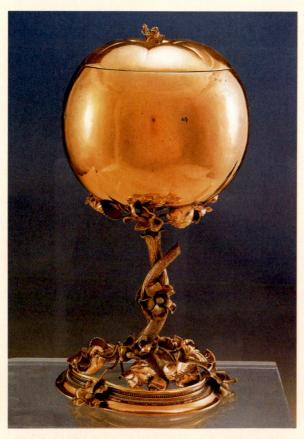

Workshop of Hans Krug (?) APPLE CUP c. 1510–15. Gilt silver, height 8% (21.5 cm). Germanisches Nationalmuseum, Nuremberg.

The *Annunciation* on the left wing may have been inspired by a special liturgy called the Golden Mass, which celebrated the divine motherhood of the Virgin. The Mass included a staged reenactment of the angel's visit to Mary, as well as readings from the story of the Annunciation (Luke 1:26–38) and the Old Testament prophecy of the Savior's birth (Isaiah 7:14–15), which is inscribed in Latin on the pages of the Virgin's open book.

The central panels show the heavenly and earthly realms joined in one space. In a variation on the northern European visionary tradition, the new mother adores her miraculous Christ Child while envisioning her own future as Queen of Heaven amid angels and cherubs. Grünewald portrayed three distinct types of angels in the foreground—young, mature, and a feathered hybrid with a birdlike crest on its human head—and a range of ethnic types in the heavenly realm. Perhaps this latter was intended to emphasize the global dominion of the Church, whose missionary efforts were expanding as a result of European exploration. Saint Bridget describes the jubilation of the angels as "the glowing flame of love."

The panels are also filled with traditional imagery of the Annunciation: Marian symbols such as the enclosed garden, the white towel on the tub, and the clear glass cruet behind it, which signify Mary's virginity; the water pot next to the tub, which alludes both to purity and to childbirth; and the fig tree in the background, suggesting the Virgin Birth, since figs were thought to bear fruit without pollination. The bush of red roses at the right alludes not only to Mary but also to the Passion of Jesus, thus recalling the Crucifixion on the outer wings and providing a transition to the Resurrection on the right wing. There, the shock of Christ's explosive emergence from his stone sarcophagus tumbles the guards about, and his new state of being—no longer material but not yet entirely spiritual—is vibrantly evident in his dissolving, translucent figure.

The second opening of the altarpiece (SEE FIG. 21–4) reveals Hagenauer's sculpture and was reserved for the special festivals of Saint Anthony. The wings in this second opening show Saint Anthony attacked by horrible demons—perhaps inspired by the horrors of the diseased patients—and the meeting of Saint Anthony with the hermit Saint Paul. The meeting of the two hermits in the desert glorifies the monastic life, and in the wilderness Grünewald depicts medicinal plants used in the hospital's therapy. Grünewald painted his self-portrait as the face of Saint Paul, and Saint Anthony is a portrait of the donor and administrator of the hospital, the Italian Guido Guersi, whose coat of arms Grünewald painted on the rock.

Like Riemenschneider, Grünewald's career may have been damaged by his active support of the peasants in the Peasants' War. He left Mainz and spent his last years in Frankfurt and then Halle.

ALBRECHT DÜRER. Studious, analytical, observant, and meticulous—and as self-confident as Michelangelo—

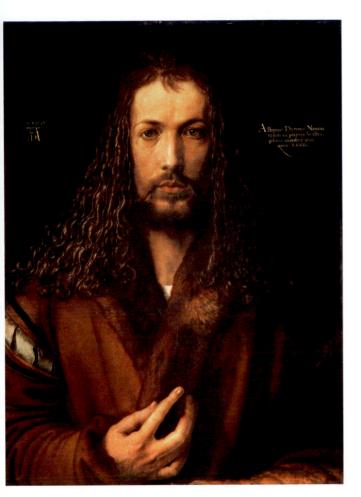

21–7 | Albrecht Dürer SELF-PORTRAIT 1500. Signed "Albrecht Dürer of Nuremberg...age 28." Oil on wood panel, $26\%\times19\%$ " (66.3 \times 49 cm). Alte Pinakothek, Munich.

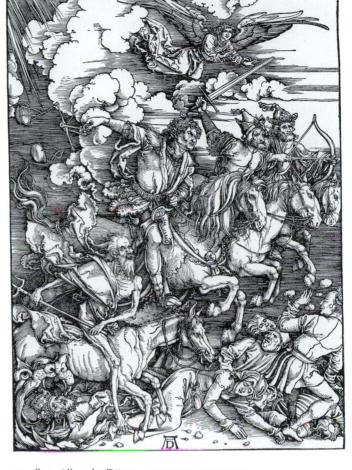

21–8 Albrecht Dürer **FOUR HORSEMEN OF THE APOCALYPSE**From *The Apocalypse*. 1497–98. Woodcut, $15\frac{1}{2} \times 11\frac{1}{8}$ " (39.4 × 28.3 cm). The Metropolitan Museum of Art, New York. Gift of Junius S. Morgan, 1919 (19.73.209)

Albrecht Dürer (1471–1528) was the foremost artist in the northern part of the Holy Roman Empire. He made his home in Nuremberg, where he became a prominent citizen. Its university made Nuremberg a center of learning as well as business, with an active group of humanists and internationally renowned artists. With the new scholarship the city became a leading publishing center.

Dürer's father was a goldsmith and must have expected his son to follow in his trade. Dürer did complete an apprenticeship in goldworking, as well as in stained-glass design, painting, and the making of woodcuts, but it was ultimately as a painter and graphic artist that he found his artistic fame (see "German Metalwork: A Collaborative Venture," p. 714).

In 1490, Dürer began traveling to extend his education. He went to Basel, Switzerland, hoping to meet Martin Schongauer, but arrived after the master's death. Dürer remained in Basel until 1494, providing drawings for woodcut illustrations for books. His first trip to Italy (1494–95) introduced him to Italian Renaissance ideas and attitudes and, as we considered at the beginning of this chapter, to the concept of the artist as an inde-

pendent creative genius. In the **SELF-PORTRAIT** of 1500 (FIG. 21–7), Dürer represents himself as an idealized, almost Christlike, figure in a severely frontal pose, like an icon. He stares directly at the viewer. His rich fur-lined robes and flowing locks create an equilateral triangle, the timeless symbol of unity.

On his return to Nuremberg, Dürer began to publish his own prints to bolster his income, and ultimately the prints, not his paintings, made his fortune. His first major publication, *The Apocalypse*, appeared simultaneously in German and Latin editions in 1497–98. It consisted of a woodcut title page and fourteen full-page illustrations with the text printed on the back of each. The best-known of the woodcuts is the **FOUR HORSE-MEN OF THE APOCALYPSE** (FIG. 21–8), based on figures described in Revelation 6:1–8: a crowned rider, armed with a bow, on a white horse (Conquest); a rider with a sword, on a red horse (War); a rider with a set of scales, on a black horse (Plague and Famine); and a rider on a sickly pale horse (Death). Earlier artists had simply lined up the horsemen in the land-scape. Dürer created a compact overlapping group of wild riders charging across the land and trampling the cowering men.

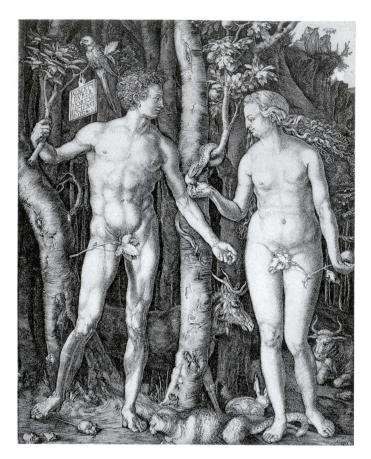

21–9 | Albrecht Dürer ADAM AND EVE 1504. Engraving, $9\% \times 7\%$ (25.1 \times 19.4 cm). Philadelphia Museum of Art. Purchased: Lisa Nora Elkins Fund

Dürer probably did not cut his own woodblocks but employed a skilled carver who followed his drawings faithfully. Dürer's dynamic figures show affinities with Schongauer's *Temptation of Saint Anthony* (SEE FIG. 18–30). He adapted Schongauer's metal engraving technique to the woodcut medium, using a complex pattern of lines to model the forms. Dürer's early training as a goldsmith is evident in his meticulous attention to detail, and in his decorative cloud and drapery patterns. He fills the foreground with large, active figures just as late fifteenth-century artists had done.

Perhaps as early as the summer of 1494, Dürer began to experiment with engravings, cutting the metal plates himself with artistry equal to Schongauer's. His growing interest in Italian art and his theoretical investigations are reflected in his 1504 engraving **ADAM AND EVE** (FIG. 21–9), which represents his first documented use of ideal human proportions based on Roman copies of ancient Greek sculpture. He may have seen figures of Apollo and Venus in Italy, and he would have known ancient sculpture from contemporary prints and drawings. But behind his idealized human figures he represents plants and animals with typically northern European naturalistic detail.

Dürer embedded the landscape with symbolic content reflecting the medieval theory that after Adam and Eve disobeyed God, they and their descendants became vulnerable to imbalances in the body fluids that controlled human temperament. As we saw in Melencolia I (FIG. 20-1), an excess of black bile from the liver produced melancholy, despair, and greed. Yellow bile caused anger, pride, and impatience; phlegm in the lungs resulted in lethargy and disinterest; and an excess of blood made a person unusually optimistic but also compulsively interested in pleasures of the flesh. These four human temperaments, or personalities, are symbolized here by the melancholy elk, the choleric cat, the phlegmatic ox, and the sensual rabbit. The mouse is a symbol of Satan (see the mousetrap in FIG. 18-2), whose earthly power, already manifest in the Garden of Eden, was capable of bringing perfect human beings to a life of woe through their own bad choices. The parrot may symbolize false wisdom, since it can only repeat mindlessly what it hears. Dürer's pride in his engraving can be seen in the prominence of his signature—a placard bearing his full name and date hung on a branch of the tree of life.

Dürer's familiarity with Italian art was greatly enhanced by a second, leisurely trip over the Alps in 1505–06. Thereafter, he seems to have resolved to reform the art of his own country by publishing theoretical writings and manuals that discussed Renaissance problems of perspective, ideal human proportions, and the techniques of painting. Between 1513 and 1515, Dürer used images, not words, to define a philosophy of Christian life. He created what are known today as his master prints—three engravings having profound themes, but also demonstrating his skill as a graphic artist who could imply color, texture, and space by black lines alone.

Dürer admired Martin Luther, but they never met. In 1526, the artist openly professed his Lutheranism in a pair of inscribed panels, the FOUR APOSTLES (FIG. 21-10). On the left panel, the elderly Peter, who normally has a central position as the first pope, has been displaced by Luther's favorite evangelist, John, who holds an open Gospel that reads "In the beginning was the Word," reinforcing the Protestant emphasis on the Bible. On the right panel, Mark stands behind Paul, whose teachings and epistles were particularly admired by the Protestants. A long inscription on the frame warns the viewer not to be led astray by "false prophets" but to heed the words of the New Testament as recorded by these "four excellent men." Below each figure are excerpts from their letters and from the Gospel of Mark warning against those who do not understand the true word of God. In the inscriptions, Dürer used Luther's German translation of the New Testament. The paintings were surely meant to demonstrate that a Protestant art was possible.

Dürer presented the panels to the city of Nuremberg, which had already adopted Lutheranism as its official religion. Dürer wrote, "For a Christian would no more be led to superstition by a picture or effigy than an honest man to commit murder because he carries a weapon by his side. He must

indeed be an unthinking man who would worship picture, wood, or stone. A picture therefore brings more good than harm, when it is honourably, artistically, and well made" (cited in Snyder, 2nd ed., page 333).

Lucas Cranach the Elder. One of Dürer's friends, and Martin Luther's favorite painter, Lucas Cranach the Elder (1472–1553), had moved his workshop to Wittenberg in 1504, after a number of years in Vienna. In addition to the humanist milieu of its university and library, Wittenberg offered the patronage of the Saxon court. Appointed court painter to Elector Frederick the Wise, Cranach created woodcuts, altarpieces, and many portraits.

At the humanistic court Cranach met Italian artists who evidently inspired him to paint female nudes himself. Just how far the German artist's style and conception of the figure differ from Italian Renaissance idealism is easily seen in his NYMPH OF THE SPRING, a painting that characterizes the Renaissance in the north (FIG. 21–11; compare Titian's *Venus of Urbino*, FIG. 20–26). The sleeping nymph was a Renaissance theme, not an ancient one. Cranach was inspired by a fifteenth-century inscription on a fountain beside the Danube. Translated from the Latin, the text reads, "I am the nymph of the sacred font. Do not interrupt my sleep for I am at peace." Cranach records the Danube landscape with northern fidelity and turns his nymph into a highly provocative young woman, who glances

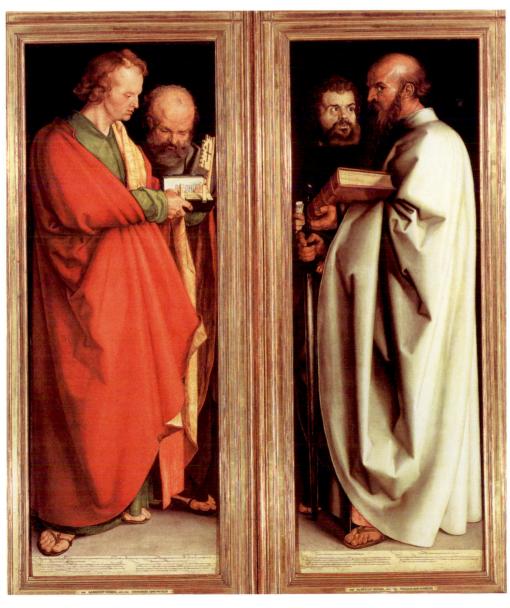

21–10 | Albrecht Dürer FOUR APOSTLES 1526. Oil on wood panel, each panel $7'\%'' \times 2'6''$ (2.15 \times 0.76 m). Alte Pinakothek, Munich.

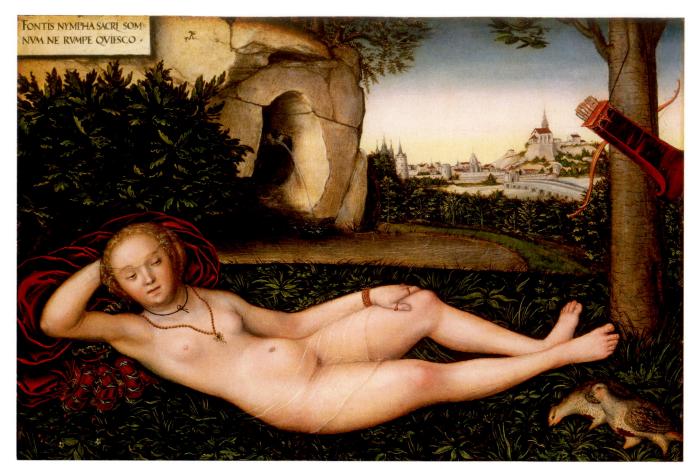

2I–II Lucas Cranach the Elder **NYMPH OF THE SPRING** c. 1537. Oil on panel, $19 \times 28\frac{1}{2}$ " (48.5 \times 72.9 cm). National Gallery of Art, Washington, D.C.

In 1537 Cranach adopted as his device a dragon with folded wings, seen on the rock above the fountain.

slyly out at the viewer through half-closed eyes. She has cast aside a fashionable red velvet gown, but still wears her jewelry, which together with her transparent veil enhances rather than conceals her nudity. Unlike other artists working for Protestant patrons, many of whom looked on earthly beauty as a sinful vanity, Cranach seems delighted by earthly things—the lush foliage that provides the nymph's couch, the pair of partridges (symbols of Venus and married love), and Cupid's bow and quiver of arrows hanging on the tree. The *Nymph of the Spring* seems to depict a beauty from the Wittenburg court rather than a follower of the classical Venus.

ALBRECHT ALTDORFER. Landscape, with or without figures, became a popular theme in the sixteenth century. In the fifteenth century, northern artists had examined and recorded nature with the care and enthusiasm of biologists, but they painted their landscapes as backgrounds for figural compositions, usually with religious themes. In the 1520s, however, religious art found little favor among Protestants. Landscape painting, on the other hand, had no overt religious imagery, although

it could be seen as a reflection or even glorification of God's works on earth. The most accomplished German landscape painter of the period was Albrecht Altdorfer (c. 1480–1538).

Altdorfer probably received his early training in Bavaria from his father; he then became a citizen in 1505 of the city of Regensburg in the Danube River valley. He remained there painting the Danube Valley for the rest of his life. The DANUBE LANDSCAPE of about 1525 (FIG. 21-12) is an early example of pure landscape painting—one without a narrative subject or human figures, and with no religious significance. A small work on vellum laid down on a wood panel, the landscape seems to be a minutely detailed view of the natural terrain, but the forest seems far more poetic and mysterious than Dürer's or Cranach's carefully observed views of nature. The low mountains, gigantic lacy pines, neatly contoured shrubberies, and fairyland castle with red-roofed towers at the end of a winding path announce a new sensibility. The eerily glowing yellowwhite horizon below moving gray and blue clouds in a sky that takes up more than half the composition foretell the Romanticism that will characterize later German landscape painting.

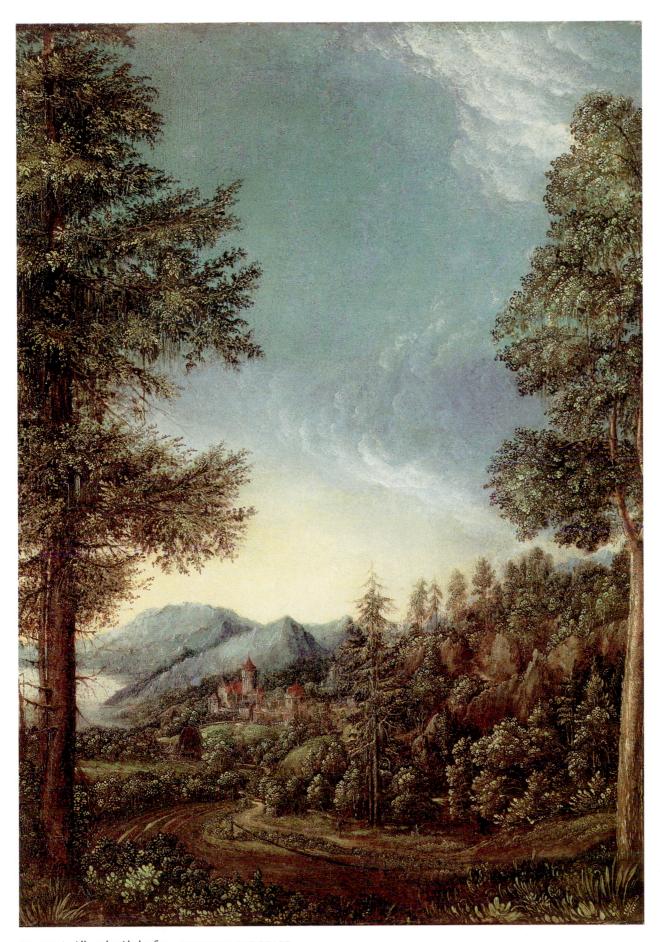

21–12 | Albrecht Altdorfer DANUBE LANDSCAPE c. 1525. Oil on vellum on wood panel, $12\times8\%$ (30.5 \times 22.2 cm). Alte Pinakothek, Munich.

RENAISSANCE ART IN FRANCE

France in the early sixteenth century took a different road than did Germany. Pope Leo X came to an agreement with the French king Francis I (ruled 1515–47) in 1519 that spared the country the turmoil suffered in Germany. Furthermore, whereas Martin Luther had devoted followers among the political leaders as well as the people, the French reformer John Calvin (1509–64) fled to Switzerland in 1534, where he led a theocratic state in Geneva. Nevertheless, wars of religion between political factions favoring either Catholics or Huguenots (Protestants), who each wished to exert power over the French crown, also devastated France in the second half of the century.

In 1560, the devoutly Catholic Catherine de' Medici, widow of Henry II (ruled 1547–59), became regent for her young son, Charles IX. She tried, but failed, to balance the warring factions, and her machinations ended in religious polarization and a bloody conflict that began in 1562. Her successor and third son Henry III (ruled 1574–89) was murdered by a fanatical Dominican friar, and his Protestant cousin, Henry, king of Navarre, the first Bourbon king, inherited the throne. Henry converted to Catholicism and ruled as Henry IV. Backed by a country sick of bloodshed, he quickly settled the religious question by granting toleration to Protestants in the Edict of Nantes in 1598.

The Introduction of Italian Art

The greatest French patron of Italian artists was King Francis I. Immediately after his ascent to the throne, Francis showed his desire to "modernize" the French court by acquiring the versatile talents of Leonardo da Vinci. Leonardo moved to France in 1516, officially to advise the king on royal architectural projects and, the king said, for the pleasure of his conversation. Francis continued to support the arts throughout his reign despite the distraction of continual wars against his brother-in-law, Emperor Charles V. Under his patronage, an Italian-inspired Renaissance blossomed in France.

JEAN CLOUET. The Flemish artist Jean Clouet (c. 1485–c. 1540) found great favor as the royal portrait painter. Clouet was in France as early as 1509, and in 1527 he moved to Paris as principal court painter. In his official portrait of the king (FIG. 21–13), Clouet created a flattering image by modeling Francis's distinctive features with subtle shading, a technique that may have been partially inspired by exposure to the work of Leonardo. At the same time he created an image of pure power. The depiction of the king's thick neck and huge body seems at odds with the nervous movement of his fingers. Elaborate, puffy sleeves broadened his shoulders to more than fill the panel, much as parade armor turned scrawny men into giants. The delicately worked costume of silk, satin, velvet, jewels, and gold embroidery could be painted separately from

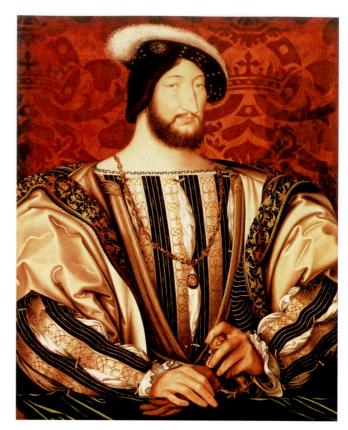

2I–I3 | Jean Clouet FRANCIS I 1525–30. Oil and tempera on wood panel, $37\frac{1}{4} \times 29\frac{1}{8}$ " (95.9 \times 74 cm). Musée du Louvre, Paris.

the portrait itself. The clothing was often loaned to the artist or modeled by a servant to spare the "sitter" the boredom of posing. In creating such official portraits, the artist sketched the subject, then painted a prototype that, upon approval, was the model for numerous replicas made for diplomatic and family purposes.

THE CHÂTEAU OF CHENONCEAU. With the enthusiasm of Francis for things Italian and the widening distribution of Italian books on architecture, the Italian Renaissance style soon appeared in French architecture. Builders of elegant rural palaces, called châteaux, were quick to introduce Italianate decoration to otherwise Gothic buildings, but French architects soon adapted classical principles of building design as well.

One of the most beautiful of these Renaissance palaces was not built as a royal residence, although it soon became one. In 1512 Thomas Bohier, a royal tax collector, bought the castle of Chenonceau on the River Cher, a tributary of the Loire River (FIG. 21–14). He demolished the old castle, leaving only a tower. Using the piers of a water mill on the river bank as part of the foundations, he and his wife erected a new Renaissance home. The plan reflects the classical principles of geometric

regularity and symmetry—a rectangular building with rooms arranged on each side of a wide central hall. Only the library and chapel, which are corbelled out over the water, break the line of the walls. In the upper story, the builders used traditional features of medieval castles—battlements, corner turrets, steep roofs, and dormer windows. The château was finished in 1521. When the owners died soon after, their son gave the château to the king, who turned it into a hunting lodge (see "Chenonceau: The Castle of the Ladies," p. 722).

Later, the foremost French Renaissance architect, the Roman-trained Philibert de l'Orme (d. 1570), designed a gallery on a bridge across the river for Catherine de' Medici. The extension was completed about 1581 and incorporated contemporary Italianate window treatments, wall molding, and cornices that harmonized almost perfectly with the forms of the original turreted building. Chenonceau remains today one of the most important—and beautiful—examples of classical influence on French Renaissance architecture.

FONTAINEBLEAU. Francis I also began renovating royal properties. Having chosen as his primary residence the medieval hunting lodge at Fontainebleau, Francis began transforming it into a grand palace. Most of the exterior structure was altered or destroyed by later renovations, but parts of the interior decoration, the work of artists and artisans from Italy, have been preserved and restored. The first artistic director at

Sequencing Events KEY EVENTS IN THE PROTESTANT REFORMATION

1517	Martin Luther propounds his Ninety- Five Theses at Wittenberg.
1534	Henry VIII of England breaks from Rome; founds Church of England.
1555	Lutheranism recognized in Germany by the Holy Roman Emperor at the Peace of Augsburg.

Fontainebleau, the Mannerist painter Rosso Fiorentino (d. 1540), arrived in 1530. Francesco Primaticcio (1504–70), who had worked with Giulio Romano in Mantua (SEE FIG. 20–19), joined Rosso in 1532 and succeeded him in 1540. Primaticcio worked on the decoration of Fontainebleau from 1532 until his death in 1570. During that time, he also commissioned and imported a large number of copies and casts of original Roman sculpture, from the newly discovered *Laocoön* (see Introduction, Fig. 10) to the relief decoration on the Column of Trajan. These works provided an invaluable visual source of figures and techniques for the northern European artists employed on the Fontainebleau project.

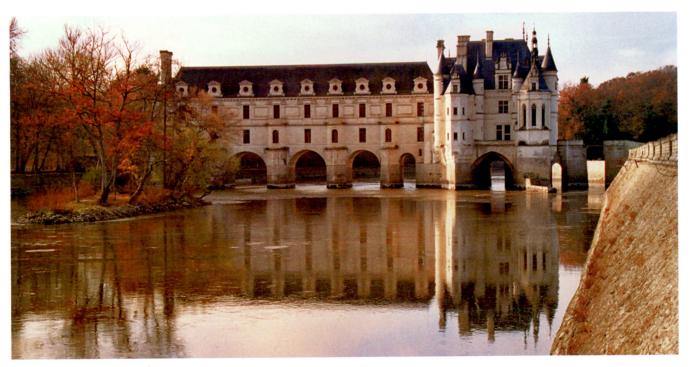

21–14 CHÂTEAU OF CHENONCEAU
Touraine, France. 1513–21; gallery on bridge, finished c. 1581.

Art and Its Context

CHENONCEAU: THE CASTLE OF THE LADIES

omen played an important role in the patronage of the arts during the Renaissance. Nowhere is their influence stronger than in the castle-palaces (châteaux) built in the Loire River valley. At Chenonceau, built beside and literally over the River Cher, a tributary of the Loire, women built, saved, and restored the château. Catherine Briconnet and her husband Thomas Bohier originally acquired the property, including a fortified mill, on which they built their country residence. Catherine supervised the construction, which included such modern conveniences as a straight staircase (an Italian and Spanish feature) instead of traditional medieval spiral stairs, and a kitchen inside the château instead of in a distant outbuilding. When Thomas died in 1524 and Catherine in 1526, their son gave Chenonceau to King Francis I.

King Henry II, Francis's son, gave Chenonceau to his mistress Diane de Poitiers in 1547. She managed the estate astutely, increased revenue, developed the vineyards, added intricately planted gardens in the Italian style, and built a bridge across the Cher. When Henry died in a tournament, the queen Catherine de' Medici (1519-89) appropriated the château for herself.

Catherine, like so many of her family a great patron of the arts, added the two-story gallery to the bridge at Chenonceau, as well as outbuildings and additional formal gardens. Her parties were famous—mock naval battles on the river, fireworks, banquets, dances, and on one occasion two choruses of young women dressed as mermaids in the moat and nymphs in the shrubbery—who were then chased about by young men costumed as satyrs! When Catherine's third son became king as Henry III in 1574, she gave Chenonceau to his wife, Louise of Lorraine.

Louise of Lorraine lived in mourning at Chenonceau after Henry III was assassinated in 1589. She wore only white and covered the walls, windows, and furniture in her room with black velvet and damask. She gave Chenonceau to her niece when she died.

In the eighteenth and nineteenth centuries the ladies continued to determine the fate of Chenonceau. During the French Revolution (1789-93) the owner, Madame Dupin, was so beloved by the villagers that they protected her and saved her home. Then in 1864 Madame Pelouze bought Chenonceau and restored it by removing Catherine de' Medici's Italian "improvements."

Chenonceau continued to play a role in the twentieth century. During World War I it was used as a hospital. During the German occupation in World War II (1940-42), when the River Cher formed the border with Vichy "Free" France, the gallery bridge at Chenonceau became an escape route. In 2000 the Valley of the Loire and its châteaux became a UNESCO World Heritage site.

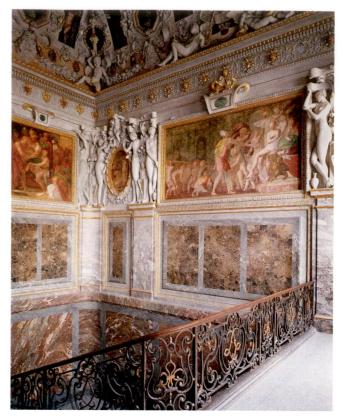

21–15 | Primaticcio STUCCO AND WALL PAINTING, CHAMBER OF THE DUCHESS OF ÉTAMPES, CHÂTEAU OF FONTAINEBLEAU

France. 1540s.

Following ancient tradition, the king maintained an official mistress—Anne, the duchess of Étampes, who lived at Fontainebleau. Among Primaticcio's first projects was the redecoration of Anne's rooms (FIG. 21–15). The artist combined woodwork, stucco relief, and fresco painting in his complex but lighthearted and graceful interior design. The lithe figures of stucco nymphs, with their long necks and small heads, recall Parmigianino's paintings (see fig. 20–35). Their spiraling postures are playfully sexual. The wall surface is almost overwhelmed with garlands, mythological figures, and Roman architectural ornament, yet the visual effect is extraordinarily confident and joyous. The first School of Fontainebleau, as this Italian phase of the palace decoration is called, established a tradition of Mannerism in painting and interior design that spread to other centers in France and into the Netherlands.

Art in the Capital

Before the defeat of King Francis I at Pavia by the Holy Roman Emperor Charles V, and the king's subsequent imprisonment in Spain in 1525, the French court was a mobile unit, and the locus of French art resided outside of Paris in the Loire valley. After 1525, Francis made Paris his bureaucratic seat; and the capital and region around it—the Île de France—took the artistic lead with an attendant shift in style.

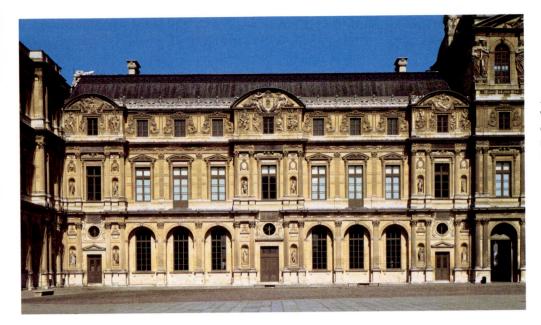

21–16 | Pierre Lescot
WEST WING OF THE
COUR CARRÉ, PALAIS DU
LOUVRE
Paris. Begun 1546.

RENOVATING THE LOUVRE. Paris saw the birth of a French classical style when the kings Francis I and Henry II decided to modernize the medieval castle of the Louvre. The work began in 1546, with the replacement of the west wing of the square court, the cour carré (FIG. 21-16), by the architect Pierre Lescot (c. 1510-78). Working with the sculptor Jean Goujon (1510-68), Lescot designed a building incorporating Renaissance ideals of balance and regularity with classical architectural details and rich sculptural decoration. The irregular roof lines of a château, such as at Chenonceau, gave way to discreetly rounded arches and horizontal balustrades. Classical pilasters and entablatures replaced Gothic buttresses and stringcourses. Pediments topped a round-arched arcade on the ground floor, suggesting an Italian loggia. The sumptuous decoration recalls the French medieval Flamboyant style, but with classical pilasters and acanthus replacing Gothic colonnettes and cusps.

FRENCH GARDENS AND GROTTOS. Gardens played an important role in architectural designs, usually intended to be viewed from the owners' rooms on the principal (second) floor. Elaborate flower beds bordered with clipped evergreen yews were planted in generally symmetrical patterns. Long avenues enlivened by sculpture and sculptured fountains led to witty surprises such as trick waterworks and grottos. One of the most brilliant must have been the grotto created by Bernard Palissy for the Tuileries Palace facing the Louvre.

Bernard Palissy (1510–90) created a false earthenware grotto made of glazed ceramic rocks and shells, to which he added crumbling statues, a cat stalking birds, ferns, garlands of fruits and vegetation, fish and crayfish seeming to swim in the pool, and reptiles slithering or creeping over mossy rocks—all of which glistened with water and surely achieved Alberti's

21–17 Attributed to Bernard Palissy

OVAL PLATE IN "STYLE RUSTIQUE"

1570–80/90 (?). Polychromed tin and glazed earthenware, length 20½" (52 cm). Musée du Louvre, Paris.

ideal Slime (see "The Grotto," page 677). Reportedly, he made all the figures from casts of actual animals and plants. In 1563, Palissy had been appointed the court's "inventor of rustic figurines." A Protestant, he was repeatedly arrested during periods of persecution, and he died in prison. Although his Tuileries grotto was destroyed, we can imagine its appearance from the distinctive ceramic designs attributed to him (FIG. 21–17). Platters decorated in high relief with plants, reptiles, and insects resemble descriptions of the grotto. Existing examples are best called "Palissy-style" works, because their authenticity is nearly impossible to prove.

THE OBJECT SPEAKS

SCULPTURE FOR THE KNIGHTS OF CHRIST AT TOMAR

ne of the strangest-and in its own way most beautifulsixteenth-century sculptures in Portugal seems to float over the cloisters of the Convent of Christ in Tomar. Unexpectedly, in the heart of the castlemonastery complex, one comes face to face with the Old Man of the Sea. He supports on his powerful shoulders an extraordinary growth-part roots and trunk of a gnarled tree, part tangled mass of seaweed, algae, ropes, and anchor chains. Barnacle- and coral-encrusted piers lead the eye upward, revealing a large lattice-covered window, the great west window of the Church of the Knights of Christ.

When in 1314 Pope Clement V disbanded the Templars (a monastic order of knights founded in Jerusalem in 1118 after the First Crusade), King Dinis of Portugal offered them a renewed existence as the Knights of Christ. In 1356, they made the former Templar castle and monastery in Tomar their headquarters. When Prince Henry the Navigator (1394–1460) became the Grand Master of the Order, he invested their funds in the exploration of the African coast and the Atlantic Ocean. The Templar insignia, the squared cross, became the emblem used on the sails of Portuguese ships.

King Manuel I of Portugal (ruled 1495-1521) commissioned the present church, with its amazing sculpture from Diogo de Arruda, in 1510. It reflects the wealth and power of sixteenth-century Portugal and the Knights of Christ. So distinctive is the style developed under King Manuel by artists like the Arruda brothers, Diogo (active 1508-31) and Francisco (active 1510-47), that Renaissance art in Portugal is called "Manueline." Architecture became more and more sculptural; piers and columns were carved to resemble twisted ropes; vaulting ribs multiplied into treelike branches. In the window of Tomar, Manueline sculpture reached the pinnacle of

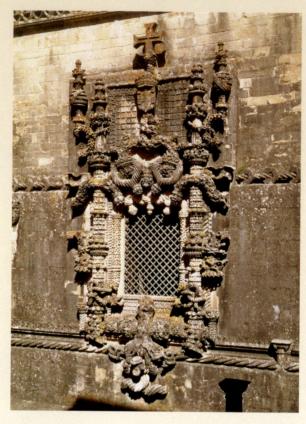

Diogo de Arruda
WEST WINDOW,
CHURCH IN THE CONVENT
OF CHRIST

Tomar, Portugal. c. 1510. Commissioned by King Manuel I of Portugal.

complexity. Every surface is carved with architectural and natural detail associated with the sea. Twisted ropes form the corners of the window; the coral pillars support great swathes of seaweed. Chains and cables drop through the watery depths to the place where the head of a man-some see him as the Old Man of the Sea; others see a self-portrait of Diogo de Arruda-emerges from the roots of a tree. Trees with generations of ancestors seated in their branches became an important theme in Portuguese art. Here, the idea of a male figure as the foundation block recalls the biblical Tree of Jesse.

Above the window more ropes, cables, and seaweed support the emblems of the patron—the armillary spheres and the coat of arms of Manuel I with its Portuguese castles framing the five wounds of Christ.

Topping the composition is the square cross of the Order of Christ—clearly delineated against the wall of the chapel.

The armillary sphere became a symbol of the era. This complex form of celestial globe, with the sun at the center surrounded by rings marking the paths of the planets, acknowledges the new scientific theory that the sun, not the earth, is the center of the solar system. (Copernicus, teaching in Germany at this time, only published his theories in 1531 and 1543.) Although the armillary sphere had no practical value in navigation, it was a teaching device, a way to demonstrate and learn astronomy. King Manuel's continued use of the armillary sphere as his emblem indicates his determination to make Portugal the leader in the exploration of the sea. Indeed, in Manuel's reign the Portuguese reached India and Brazil.

RENAISSANCE ART IN SPAIN AND PORTUGAL

The sixteenth century saw the high point of Spanish political power. The country had been united in the fifteenth century by the marriage of Isabella of Castile and Ferdinand of Aragon. Only Navarre (in the Pyrenees) and Portugal remained outside the union of the crowns (see "Sculpture for the Knights of Christ at Tomar," page 724).

When Isabella and Ferdinand's grandson Charles V abdicated in 1556, his son Philip II (1556–98) became the king of Spain, the Netherlands, and the Americas, as well as ruler of Milan, Burgundy, and Naples. Philip made Spain his permanent residence. From an early age, Philip was a serious art collector, and for more than half a century, he supported artists in Spain, Italy, and the Netherlands. His navy, the famous Spanish Armada, halted the advance of Islam in the Mediterranean and secured control of most American territories. Despite enormous effort and wealth, however, Philip could not suppress the revolt of the northern provinces of the Netherlands, nor could he prevail in his war against the English, who destroyed his navy in 1588. He was able to gain control of the entire Iberian Peninsula, however, by claiming Portugal when the king died in 1580. Portugal remained part of Spain until 1640.

Architecture

Philip built **EL ESCORIAL** (FIG. 21–18), the great monastery-palace complex outside Madrid, partly to comply with his father's direction to construct a "pantheon" in which all Spanish kings might be buried and partly to house his court and government. To build the palace, in 1559 Philip summoned from Italy Juan Bautista de Toledo (d. 1567), who had been Michelangelo's

supervisor of work at Saint Peter's from 1546 to 1548. Juan Bautista's design reflected his indoctrination in Bramante's classical principles in Rome, but the king himself dictated the severity and size of the structure. El Escorial's grandeur comes from its overwhelming size, fine proportions, and excellent masonry. The complex includes not only the royal residence but also the Royal Monastery of San Lorenzo, a school, a library, and a church, its crypt serving as the royal burial chamber. The plan was said to resemble a gridiron, the instrument of martyrdom of its patron saint, Lawrence, who was roasted alive.

In 1572, Juan Bautista's assistant, Juan de Herrera, was appointed architect, and he immediately changed the design, adding second stories on all wings and breaking the horizontality of the main façade with a central frontispiece that resembled superimposed temple fronts. Before beginning the church in the center of the complex, Philip solicited the advice of Italian architects—including Vignola and Palladio (see p. 690 and p. 703). The final design combined ideas that Philip approved and Herrera carried out. Although not a replica of any Italian design, the building embodies Italian classicism in its geometric clarity and symmetry and the use of superimposed orders on the temple-front façade. In its sober and severe character, however, it embodies the austere and deeply religious spirit of the Spanish Philip II.

Painting

The arts continued to be sponsored by the Church and the nobles. Pageantry—including the sign language of heraldry, luxurious armor, and textiles—answered the aesthetic desires of the patrons. Philip II was a great patron of the Venetian painter Titian, and he collected Netherlandish artists such as Bosch (see page 728).

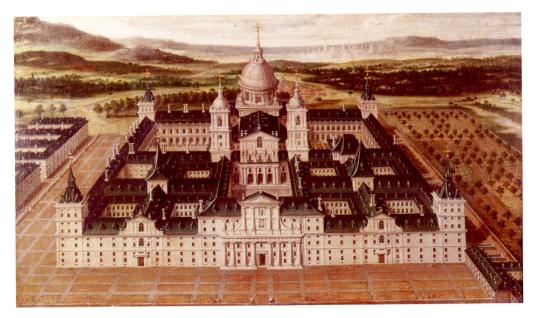

21–18 | Juan Bautista de Toledo and Juan de Herrera EL ESCORIAL Madrid. 1563–84. Detail from an anonymous 18thcentury painting.

EL GRECO. Today the most famous Spanish painter from the last quarter of the sixteenth century is Domenikos Theotokopoulos (1541-1614), who arrived in Spain in 1577 after working for ten years in Italy. "El Greco" ("The Greek"), as he is called, was trained as an icon painter in the Byzantine manner in his native Crete, then under Venetian rule. In about 1566, he went to Venice and entered Titian's studio, where he also studied the paintings of Tintoretto and Veronese. From about 1570 to 1577, he worked in Rome, apparently without finding sufficient patronage, although he lived for a time in the Farnese Palace. Probably encouraged by Spanish Church officials whom he met in Rome, El Greco settled in Toledo, Spain, the seat of the archbishop. He had apparently hoped for a court appointment, but Philip II disliked the painting he had commissioned from El Greco for El Escorial and never gave him work again.

In Toledo, El Greco joined the circle of humanist scholars. His annotations in his own copies of Vitruvius and Vasari demonstrate his concern with the issues of the day. He wrote that the artist's goal should be to copy nature, that Raphael relied too heavily on the ancients, and that the Italians' use of mathematics to achieve ideal proportions hindered their painting of nature. At the same time an intense religious revival was under way in Spain, expressed in the impassioned preaching of Ignatius of Loyola, as well as in the poetry of the two great Spanish mystics: Saint Teresa of Ávila (1515-82), founder of the Discalced ("unshod") Carmelites, and her follower Saint John of the Cross (1542-91). El Greco's style-rooted in Byzantine icon painting and strongly reflecting Venetian artists' rich colors and loose brushwork—expressed in paint the intense spirituality of these mystics.

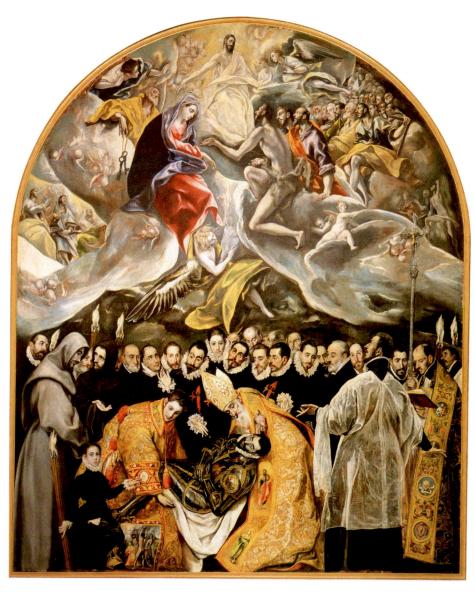

21–19 | El Greco Burial of Count orgaz 1586. Oil on canvas, $16' \times 11'10''$ (4.88 \times 3.61 m). Church of Santo Tomé, Toledo, Spain.

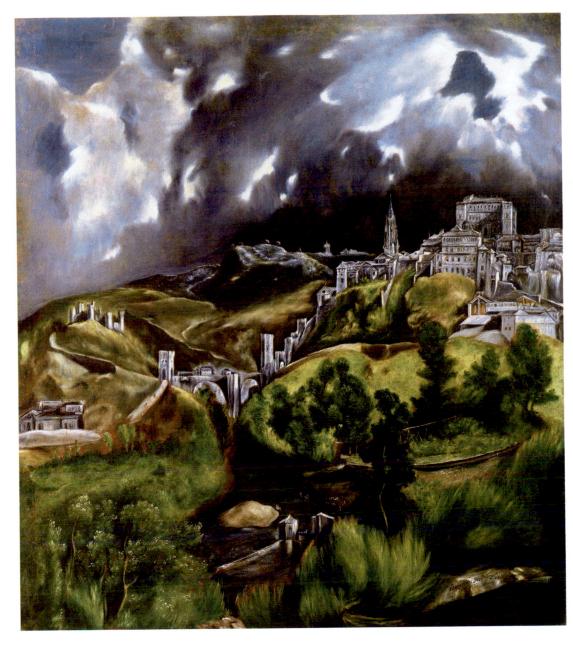

2I-20 | El Greco
VIEW OF TOLEDO
c. 1610. Oil on
canvas, $47\frac{1}{4} \times 42\frac{1}{4}$ "
(121 × 109 cm).
The Metropolitan
Museum of Art,
New York.
The H. O. Havemeyer
Collection. Bequest of
Mrs. H. O. Havemeyer,
1929 (29.100.6)

In 1586, the Orgaz family commissioned El Greco to paint a large altarpiece honoring an illustrious fourteenth-century ancestor. Count Orgaz had been a great benefactor of the Church, and at his funeral in 1323 the saints Augustine and Stephen were said to have appeared to lower his body into his tomb as his soul was seen ascending to heaven. El Greco's painting the BURIAL OF COUNT ORGAZ (FIG. 21-19) reenacts the miraculous burial. An angel lifts Orgaz's tiny ghostly soul along the central axis of the painting through the heavenly hosts toward the enthroned Christ at the apex of the canvas. El Greco filled the space around the burial scene with portraits of the local aristocracy and religious notables. He placed his own eight-year-old son at the lower left next to Saint Stephen and signed the painting on the boy's white kerchief. El Greco may also have put his own features on the man just above the saint's head, the only one who looks straight out at the viewer.

In composing the painting, El Greco used Mannerist devices reminiscent of Pontormo (SEE FIG. 20—34), filling the pictorial field with figures and eliminating specific reference to the spatial setting. Yet he has distinguished between heaven and earth by the elongation of the heavenly figures and the light emanating from Christ, who sheds an otherworldly luminescence quite unlike the natural light below. The two realms are connected, however, by the descent of the light from heaven to strike the priestly figure in the white vestment at the lower right.

Late in his life, El Greco painted one of his rare landscapes, **VIEW OF TOLEDO** (FIG. 21–20), a topographical cityscape transformed into a mystical illusion by a stormy sky and a narrowly restricted palette of greens and grays. This conception is very different from Altdorfer's peaceful, idealized *Danube Landscape* (SEE FIG. 21–12). If any precedent comes to mind, it is the

lightning-rent sky and prestorm atmosphere in Giorgione's *The Tempest* (SEE FIG. 20–23). In El Greco's painting, the precisely accurate portrayal of Toledo's geography and architecture seems to have been overridden by the artist's desire to convey the power of nature. In this, El Greco looks forward to the art of the Baroque period.

RENAISSANCE PAINTING IN THE NETHERLANDS

In the Netherlands the sixteenth century was an age of bitter religious and political conflict. Despite the opposition of the Spanish Habsburg rulers, the Protestant Reformation took hold in the northern provinces. Seeds of unrest were sown still deeper over the course of the century by continued religious persecution, economic hardship, and control by inept governors. A long battle for independence began with a revolt in 1568 and lasted until Spain relinquished all claims to the region eighty years later. As early as 1579, when the seven northern Protestant provinces declared themselves the United Provinces, the discord split the Netherlands, eventually dividing it along religious lines into the northern provinces—United Provinces (present-day Netherlands)—and Catholic Flanders (present-day Belgium).

Even with the turmoil, the Netherlanders found the resources to pay for art, and Antwerp and other cities developed into art centers. The Reformation led artists to seek patrons outside the Church. While courtiers and burghers alike continued to commission portraits, the demand arose for small paintings with interesting secular subjects appropriate for homes. For example, some artists became specialists known for their landscapes or satires. In addition to painting, textiles, ceramics, and sculpture in wood and metal flourished in the Netherlands. Flemish tapestries were sought after, as they had been in the fifteenth century. In Italy fine Netherlandish tapestries were highly prized and leading Italian artists made paintings (cartoons) to be woven. For example, Raphael's cartoons for the tapestries of the Sistine Chapel were woven in Brussels by the workshop of Pieter van Aelst (SEE FIG. 20–8).

The graphic arts emerged as an important medium and provided many artists with another source of income. Pieter Bruegel began his career drawing amusing and moralizing images to be printed and published by At the Four Winds, an Antwerp publishing house. Artists such as Hendrick Goltzius, who traveled sketchbook in hand, turned their experiences to profit when they returned home. Goltzius, who had spent 1591–92 in Rome, recorded the awestruck wonder of his Dutch friends at the sight of the recently discovered 10-foot-tall Hercules displayed in the Farnese Palace (see Fig. 24, Introduction). Surely he meant to inform and amuse—and sell prints.

Netherlandish artists had their biographer. Like Vasari in Italy, Carel van Mander (1548–1606) recorded the lives of his contemporaries in lively stories that mix fact and gossip. He,

too, intended his book *Het Schilderbock (The Painter's Book)* to be a survey of the history of art, and he included material from the ancient Roman writers Pliny and Vitruvius as well as from Vasari, his contemporary. Vasari's revised and expanded *Lives* had been published in 1568 and served as a source and a model for Van Mander and others.

Art for Aristocratic and Noble Patrons

Artistic taste among the wealthy bourgeoisie and noble classes in early sixteenth-century Netherlands was characterized by a striking diversity: the imaginative and difficult visions of Hieronymous Bosch, as well as the more Italian-influenced compositions of Jan Gossaert. In the later years of his life (after 1500), Bosch's membership in a local but prestigious confraternity called the Brotherhood of Our Lady seems to have opened doors to noble patrons such as Count Hendrick III of Nassau and Duke Philip the Fair. His younger contemporary, Gossaert, left the city of Antwerp as a young man to spend the majority of his active years as the court painter for the natural son of Duke Philip the Good. His art also attracted members of the Habsburgs, including Charles V, who were seduced by Gossaert's combination of northern European and Italian styles.

HIERONYMUS BOSCH. One of the most fascinating of the Netherlandish painters to viewers today is Hieronymus Bosch (1450–1516), whose work depicts a world of fantastic imagination more often associated with medieval than Renaissance art. A superb colorist and technical virtuoso, Bosch spent his career in the town whose name he adopted, 's-Hertogenbosch. Bosch's religious devotion is certain, and his range of subjects shows that he was well educated.

Challenging and unsettling paintings such as the triptych GARDEN OF EARTHLY DELIGHTS (FIG. 21–21) have led modern critics to label Bosch both a mystic and a social critic. The subject of the painting seems to be the Christian belief in human beings' natural state of sinfulness. Because only the damned are shown in the Last Judgment on the right, the work seems to caution that damnation is the natural outcome of a life lived in ignorance and folly, that people ensure their damnation through their self-centered pursuit of pleasures of the flesh—the sins of gluttony, lust, greed, and sloth.

In the left wing, God introduces Adam and Eve, under the watchful eye of the owl of perverted wisdom. The owl symbolizes both wisdom and folly. Folly had become an important concept to the northern European humanists, who believed in the power of education. They believed that people would choose to follow the right way if they knew it. Here the owl peers out from a fantastic pink fountain in a lake from which vicious creatures creep out into the world. Their hybrid forms result from unnatural unions. In the central panel, the earth teems with revelers, monstrous birds, and huge fruits, symbolic of fertility and sexual abandon. In hell, at the right, the sensual pleasures—eating, drinking, music, and dancing—become torture in a dark

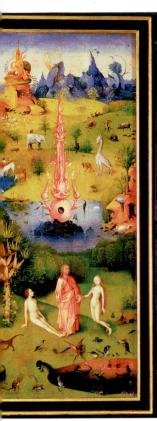

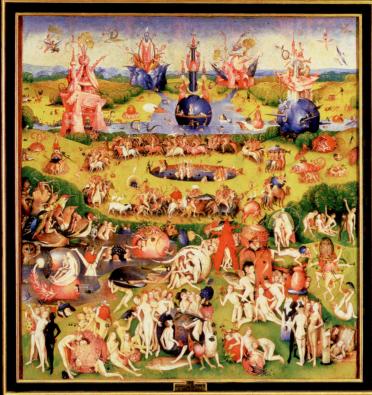

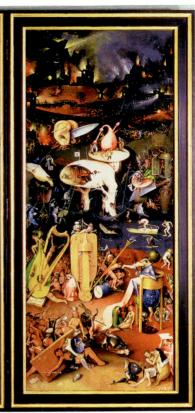

21–21 | Hieronymus Bosch GARDEN OF EARTHLY DELIGHTS c. 1505–15. Oil on wood panel, center panel $7'2\frac{1}{2}''\times6'4\frac{3}{4}''$ (2.20 \times 1.95 m), each wing $7'2\frac{1}{2}''\times3'2''$ (2.20 \times 0.97 m). Museo del Prado, Madrid.

world of fire and ice. A creature with stump legs balanced unsteadily on rowboats watches his own stomach, filled with lost souls in the proverbial "tavern on the road to hell."

One scholar has proposed that the central panel is a parable on human salvation in which the practice of alchemy—the process that sought to turn common metals into gold—parallels Christ's power to convert human dross into spiritual gold. In this theory, the bizarre fountain at the center of the lake in the middle distance can be seen as an alchemical "marrying chamber," complete with the glass vessels for collecting the vapors of distillation. Others see the theme known as "the power of women." In this interpretation the central pool is the setting for a display of seductive women and sex-obsessed men. Women frolic alluringly in the pool while men dance and ride in a mad circle trying to attract them. In this strange garden, men are slaves to their own lust. Yet another critic focused on the fruit, writing (c. 1600) that the triptych was known as The Strawberry Plant because it represented the "vanity and glory and the passing taste of strawberries or the strawberry plant and its pleasant odor that is hardly remembered once it has passed." Luscious fruits having sexual symbolism—strawberries, cherries, grapes, and pomegranates—appear everywhere in the

Garden, serving as food, as shelter, and even as a boat. Is human life as fleeting and insubstantial as the taste of a strawberry? Meaning clearly lies in the eye of the beholder of these very private paintings.

The Garden of Earthly Delights was commissioned by an aristocrat (probably Count Hendrick III of Nassau) for his Brussels town house, and the artist's choice of a triptych format, which suggests an altarpiece, may have been an understated irony. In a private home the painting may have inspired lively discussion and even ribald comment, much as it does today in its museum setting. Despite—or perhaps because of—its bizarre subject matter, the triptych was copied in 1566 into tapestry versions, one for a cardinal (now in the Escorial) and another for the French king Francis I. At least one painted copy was made as well. Bosch's original triptych was sold at the onset of the Netherlands revolt and sent in 1568 to Spain, where it entered the collection of Philip II.

Jan Gossaert. In contrast to the private visions of Bosch, Jan Gossaert (c. 1478–c. 1533) took a conservative line in subject matter and also embraced the new classical art of Italy. Gossaert (who later called himself "Mabuse" after his native

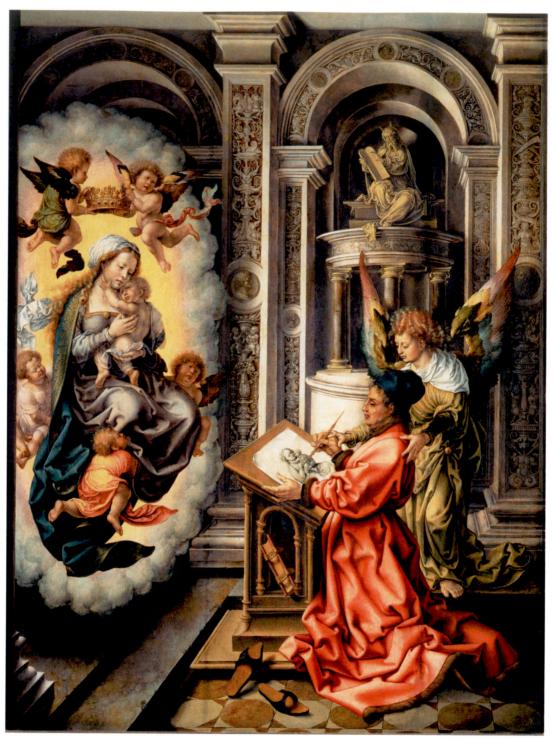

2I–22 | Jan Gossaert SAINT LUKE PAINTING THE VIRGIN MARY 1520. Oil on panel, $43\% \times 32\%''$ (110.2 \times 81.9 cm). Kunsthistorisches Museum, Vienna.

city Maubeuge) entered the service of Philip, the illegitimate son of the Duke of Burgundy. In 1508 he traveled to Italy with Philip, and on their return Gossaert continued to work for Philip—who became archbishop of Utrecht in 1517.

After a period when he had been influenced by Jan van Eyck, Gossaert settled into what has been called a "Romanizing" style, inspired by Italian Mannerist paintings with a strong interjection of decorative details based on ancient Roman art.

In **SAINT LUKE PAINTING THE VIRGIN MARY** (FIG. 21–22), the artist's studio is an extraordinary structure of barrel vaults and classical piers and arches, which are carved with a dense ornament of foliage and medallions. Mary and the Christ Child appear to Saint Luke in a vision of golden light and clouds. The saint kneels at a desk, drawing, his hand guided by an angel. Luke's crumpled red robe recalls fifteenth-century drapery conventions. Behind the saint, seated on a round, columnar

structure, Moses holds the tablets of the Law, having seen the burning bush (which, as with Mary's virginity, was not consumed) on Mount Sinai. Moses removed his shoes in the presence of God's manifestation and so has Saint Luke in the presence of his vision. In short, the artist is divinely inspired. Gossaert, like Dürer before him, emphasizes the divine inspiration of the artist.

Antwerp

In the sixteenth century the city of Antwerp was the commercial and artistic center of the southern Netherlands. Antwerp's deep port made it an international center of trade (it was one of the European centers for trade in spices), and it was the financial center of Europe. Painting, printmaking, and book production flourished in this environment, attracting artists and craftsmen from all over Europe. The demand for luxury goods (including art) fostered the birth of the art market, in which art was transformed into a commodity both for local and international consumption. In responding to this market, many artists became specialists in one area, such as portraiture or landscape. Eventually, art dealers emerged as middlemen, further shaping the nascent art market and the professions it includes.

Sequencing Works of Art THE CLASSICIZING INFLUENCE

1504	Albrecht Dürer, Adam and Eve
1520	Jan Gossaert, Saint Luke Painting the Virgin Mary
1546	Pierre Lescot, west wing of the Cour Carré, Louvre, Paris, begun
1563-84	Juan Bautista de Toledo and Juan de Herrera, El Escorial, Madrid, Spain
1591-97	Robert Smythson, Hardwick Hall, Shrewsbury, England

MARINUS VAN REYMERSWAELE. In contrast to Gossaert's inspired *Saint Luke*, Marinus van Reymerswaele from Zeeland (c. 1493—after 1567) painted "Everyman" going about his daily affairs. In his popular Antwerp workshop he produced secular panel paintings featuring such characters as the universally despised money-lenders and tax collectors. **THE BANKER AND HIS WIFE** (FIG. 21–23), painted in 1540, is

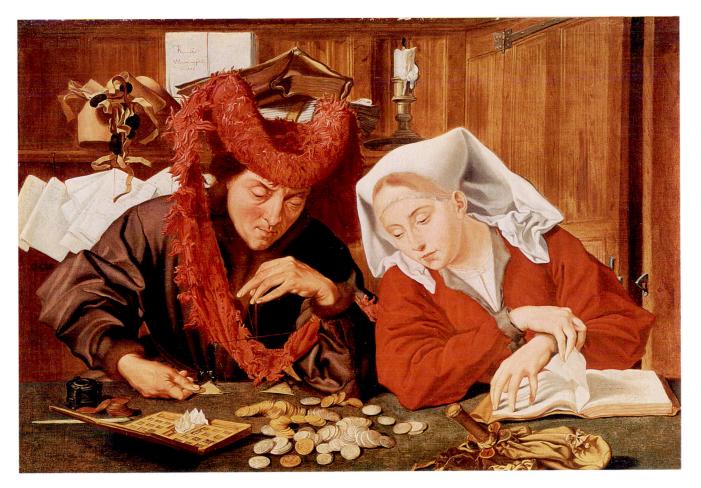

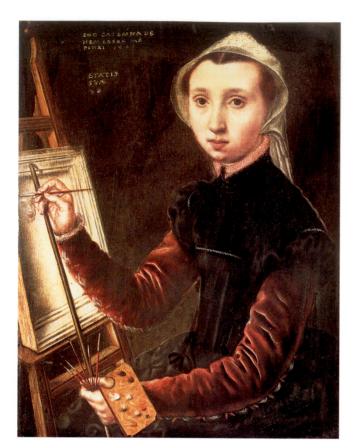

21–24 | Caterina van Hemessen **SELF-PORTRAIT** 1548. Oil on wood panel, $12\frac{1}{4} \times 9\frac{1}{4}$ " (31.1 \times 23.5 cm). Öffentliche Kunstsammlung, Basel, Switzerland.

The panel on the easel already has its frame. Caterina holds a small palette and brushes and steadies her right hand with a mahlstick, an essential tool for an artist doing fine, detailed work.

almost a caricature of *A Goldsmith (Saint Eligius?) in His Shop* by Petrus Christus (SEE FIG. 18–18). In contrast to the pious saint, the banker greedily counts coins, avidly watched by his young wife, whose thin, clawlike fingers turn the pages of the account book. Two other popular themes emerge: "the power of women," a variation of "the world turned upside down," and the "mismatched couple"—the old man with a young wife. Virtuoso painting technique has been applied to a less-than-worthy subject, but the artist probably intended more than mere illustration. The painting recalls the sins of lust and greed—the folly of ill-matched lovers, and the sin caused by the love of money. The cluttered table and filled shelves suggest the emerging specialty of still-life painting—which, along with landscape painting, will become an important theme in the art of the next century.

CATERINA VAN HEMESSEN. As religious art declined in the face of Protestant disapproval, portraits became a major source of work for artists. Caterina van Hemessen (1528–87)

of Antwerp had an illustrious international reputation as a portraitist. She had learned to paint from her father, the Flemish Mannerist Jan Sanders van Hemessen, but her quiet realism and skilled rendering also had its roots in the Italian High Renaissance, whose ideas were brought back to the Netherlands by painters who had visited Italy. To maintain the focus on the foreground subject, van Hemessen painted her portraits against even, dark-colored backgrounds, on which she identified the sitter by name and age, signing and dating each work. The inscription in her **SELF-PORTRAIT** (FIG. 21–24) reads: "I Caterina van Hemessen painted myself in 1548. Her age 20." In delineating her own features, van Hemessen presented a serious young person without personal vanity yet seemingly already self-assured about her artistic abilities.

During her early career in Antwerp, van Hemessen became a favored court artist to Mary of Hungary, sister of Emperor Charles V and regent of the Netherlands, for whom she painted not only portraits but also religious works. In 1554, Caterina married the organist of Antwerp Cathedral, and when Mary ceased to be regent in 1556 (at the time of Charles's abdication), the couple accompanied Mary to Spain.

PIETER BRUEGEL THE ELDER. So popular did the works of Hieronymus Bosch remain that, nearly half a century after his death, Pieter Bruegel (c. 1525-69) began his career by imitating them. Fortunately, Bruegel's talents went far beyond those of an ordinary copyist. Like Bosch he often painted large narrative works crowded with figures, and he chose moralizing or satirical subject matter. He traveled throughout Italy, but, unlike many Renaissance artists, he did not record the ruins of ancient Rome or the wonders of the Italian cities. Instead, he seems to have been fascinated by the landscape, particularly the formidable jagged rocks and sweeping panoramic views of Alpine valleys, which he recorded in detailed drawings. Back home in his studio, he made an impressive leap of the imagination as he painted the flat and rolling lands of Flanders as broad panoramas, even adding imaginary mountains on the horizon (SEE FIG. 21-26).

In 1563, after his first career as a draftsman for the engravers in At the Four Winds publishing house, he moved to Brussels. Bruegel's style and subjects found great favor with local scholars, merchants, and bankers, who appreciated the beautifully painted, artfully composed works that also reflected contemporary social, political, and religious conditions. Bruegel visited country fairs to sketch the farmers and townspeople who became the focus of his paintings, whether religious or secular. He depicted characters not as unique individuals but as well-observed types, whose universality makes them familiar even today. Bruegel presented Flemish farmers vividly and sympathetically while also exposing their very human faults.

Clearly Bruegel knew the classics; he had been a member of the humanistic circles in Antwerp. He could only have

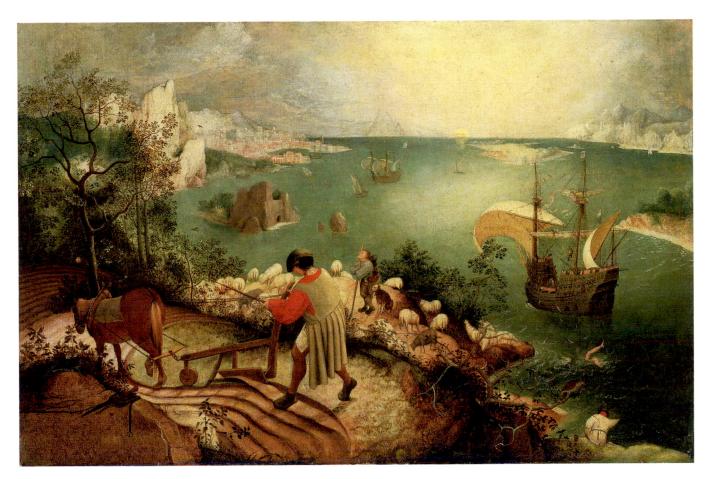

21–25 | Pieter Bruegel the Elder THE FALL OF ICARUS c. 1555–56. Oil on panel transferred to canvas. $29 \times 44\%''$ (73.6 \times 112 cm). Konenklijke Musea voor Schone Kunsten van Belgie, Brussels.

painted **THE FALL OF ICARUS** (FIG. 21–25) after reading Ovid, so closely does he follow the ancient Roman's description of Icarus's fall. Icarus—thrilled by the experience and filled with exuberant self-confidence—ignored his father's warning and flew too near the sun, melting his wings of feathers and wax. As Ovid tells the story, in Book 8 of his *Metamorphoses*, no one noticed as the youth plunged into the sea—neither the fisherman, the shepherd, nor the plowman. Bruegel's painting of these workers indicates a very close observation of real people going about their normal activities. That he was as aware of local folklore as he was of the classics is demonstrated by his inclusion of a half-hidden corpse in the underbrush. A Flemish proverb says, "No plow stops at the death of any man."

But where is Icarus, the fallen hero? Amid rippling waves near the shore two tiny legs thrash madly as the boy plunges to his death. Man's great achievement—flight—and man's pride in accomplishment—and death because of this pride—all are irrelevant to the simple people whose goal is day-to-day survival in the continuous cycle of nature.

Bruegel was not only a great landscape painter, he could depict nature in all seasons and in all moods. His RETURN OF THE HUNTERS (FIG. 21-26) is one of a cycle of six panels, each representing two months of the year. In this December-January scene, Bruegel has captured the atmosphere of the damp, cold winter, with its early nightfall, in the same way that his compatriots the Limbourgs did 150 years earlier in the February calendar illustration (see fig. 18-6). At first, the Hunters appears neutral and realistic, but the sharp plunge into space, the juxtaposition of near and far without middle ground, is a typically sixteenth-century device. The viewer seems to hover with the birds slightly above the ground, looking down first on the busy foreground scene, then suddenly across the valley to the snow-covered village and frozen ponds. The main subjects of the painting, the hunters, have their backs turned and do not reveal their feelings as they slog through the snow, trailed by their dogs. They pass an inn, at the left, where a worker moves a table to receive a pig that others are singeing in a fire. But this is clearly not an accidental image; it is a slice of everyday life

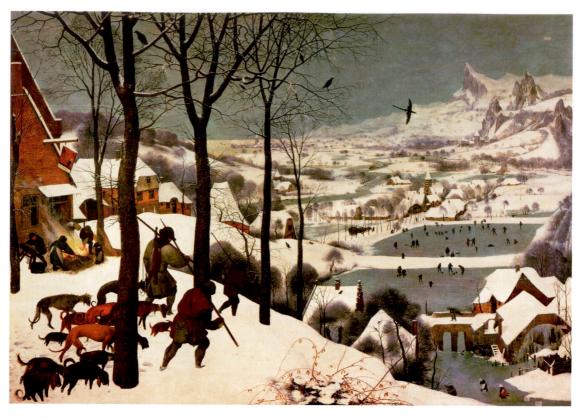

21–26 | Pieter Bruegel the Elder RETURN OF THE HUNTERS 1565. Oil on wood panel, $3'10\%'' \times 5'3\%''$ (1.18 \times 1.61 m). Kunsthistorisches Museum, Vienna.

faithfully reproduced within the carefully calculated composition. The sharp diagonals sweeping into space are countered by the pointed gables and roofs at the lower right as well as by the jagged mountain peaks along the right edge. Their rhythms are deliberately slowed and stabilized by a balance of vertical tree trunks and horizontal rectangles of water frozen over in the distance. As a depiction of Netherlandish life, this scene represents a relative calm before the storm. Three years after it was painted, the anguished struggle of the northern provinces for independence from Spain began.

Pieter the Elder died in 1569, leaving two children, Pieter the Younger and Jan, both of whom became successful painters in the next century. The dynasty continued with Jan's son, Jan the Younger. In the seventeenth century, the spelling of the family name was changed from Bruegel to Brueghel.

RENAISSANCE ART IN ENGLAND

England, although facing the disruption of the Reformation, was economically and politically stable enough to provide sustained support for architecture and the decorative arts during the Tudor dynasty. Music and literature also flourished, but painting was left to foreigners. Henry VIII was known for his love of music (he was himself a composer of considerable

accomplishment), and he also hoped to compete with the wealthy, sophisticated court of Francis I in the visual arts.

As a young man Henry VIII (ruled 1509–47) was loyal to the Church. When he wrote a book attacking Luther in 1520, the pope declared him "Defender of the Faith." But when the pope refused to annul his marriage to Catherine of Aragon, Henry broke with Rome. By action of Parliament in 1534 he became the "Supreme Head on earth of the Church and Clergy of England." He ordered an English translation of the Bible to be put in every church. In 1536 and 1539, he went further and dissolved the monasteries, confiscating their great wealth and rewarding his followers with monastic lands and buildings. Henry's need for money had disastrous effects on the arts as his men stripped shrines and altars of their jewels and precious metals. The final blow to religious art came during the reign of Henry's son EdwardVI when in 1548 all images were officially prohibited and two years later altars were replaced by wooden tables.

During the brief reign of Mary (ruled 1553–58), England officially returned to Catholicism, but the accession of Elizabeth in 1558 confirmed England as a Protestant country. So effective was Elizabeth, who ruled until 1603, that the last decades of the sixteenth century in England are called the Elizabethan Age.

Artists in the Tudor Court

Religious painting had no place in England, but a remarkable record of the appearance of Tudor monarchs survives in portraiture. Because direct contacts with Italy became difficult after Henry's break with the Roman Catholic Church, the Tudors favored Netherlandish and German artists. Thus, it was a Germanborn painter, Hans Holbein the Younger (c. 1497–1543), who shaped the taste of the English court and upper classes, and a Flemish artist who held the title of "King's Painter."

HANS HOLBEIN. Holbein first visited London from 1526 to 1528 and was introduced by the Dutch scholar Erasmus to the humanist circle around the statesman Thomas More. He returned to England in 1532 and was appointed court painter to Henry VIII about four years later. One of Holbein's official portraits of Henry (FIG. 21–27), shown at age 49 according to the inscription on the dark blue-green background, was painted in 1540, although the king's appearance had already been established in an earlier prototype. Henry, who envied the

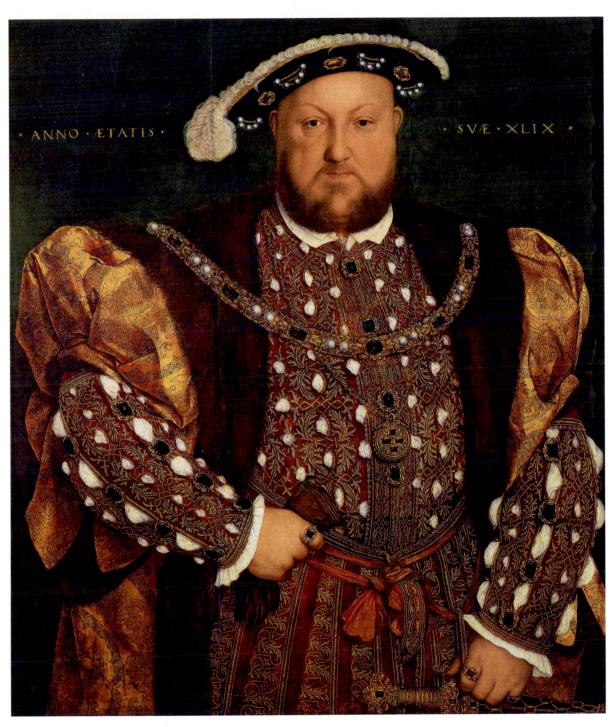

21–27 | Hans Holbein the Younger HENRY VIII 1540. Oil on wood panel, $32\frac{1}{2} \times 29\frac{1}{2}$ " (82.6 × 75 cm). Galleria Nazionale d'Arte Antica, Rome.

21–28 | Attributed to Levina Bening Teerlinc PRINCESS ELIZABETH c. 1559. Oil on oak panel, $42\frac{1}{4} \times 32\frac{1}{4}$ " (109 × 81.8 cm). The Royal Collection, Windsor Castle, England. (RCIN 404444, OM 46 WC 2010)

French king Francis I and attempted to outdo him in every way, imitated French fashions and even copied the style of the French king's beard. Henry's huge frame—he was well over 6 feet tall and had a 54-inch waist—is covered by the latest style of dress: a short puffed-sleeve coat of heavy brocade trimmed in dark fur; a narrow, stiff white collar fastened at the front; and a doublet, encrusted with gemstones and gold braid, which was slit to expose his silk shirt. Holbein used the English king's great size to advantage for this official portrait, enhancing Henry's majestic figure with embroidered cloth, fur, and jewelry to create one of the most imposing images of

power in the history of art. He is dressed for his wedding to his fourth wife, Anne of Cleves, on April 5, 1540.

LEVINA BENING TEERLINC. Holbein was not the highest-paid painter in Henry VIII's court. That status belonged to a Netherlandish woman, Levina Bening Teerlinc. Since Teerlinc worked in England for thirty years, her near-anonymity is an art-historical mystery. At Henry's invitation to become "King's Paintrix," she and her husband arrived in London in 1545 from Bruges, where her father was a leading manuscript illuminator. She maintained her court appointment

Art and Its Context

ARMOR FOR ROYAL GAMES

he medieval tradition of holding tilting, or jousting, competitions at English festivals and public celebrations continued during Renaissance times. Perhaps the most famous of these, the Accession Day Tilts, were held annually to celebrate the anniversary of Elizabeth I's coronation. The gentlemen of the court, dressed in armor made especially for the occasion, held mock battles in the queen's honor. They rode their horses from opposite directions, trying to strike each other with long lances. Each pair of competitors made six passes and the judges rated their performances.

The elegant armor worn by George Clifford, third Earl of Cumberland, at the Accession Day Tilts has been preserved in the collection of the Metropolitan Museum of Art in New York. Tudor roses and back-to-back capital E's in honor of the queen decorate the armor's surface. As the Queen's Champion beginning in 1590, Clifford also wore her jeweled glove attached to his helmet as he met all comers in the tiltyard of Whitehall Palace in London.

Made by Jacob Halder in the royal armories at Greenwich, the 60-pound suit of armor is recorded in the sixteenth-century Almain Armourers' Album along with its "exchange pieces." These allowed the owner to vary his appearance by changing mitts, side pieces, or leg protectors, and also provided backup pieces if one were damaged.

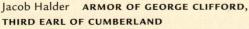

Made in the royal workshop at Greenwich, England. c. 1580–85. Steel and gold, height $5'9\frac{1}{2}''$ (1.77 m). The Metropolitan Museum of Art, New York. Munsey Fund, 1932 (32.130.6)

until her death about 1576, in the reign of Elizabeth I. Because Teerlinc was the granddaughter and daughter of Netherlandish manuscript illuminators, she is assumed to have painted miniature portraits or scenes on vellum and ivory. Certainly, she designed Elizabeth's first official seal of 1559, which included the queen's likeness. One life-size portrait frequently attributed to her—but by no means securely—depicts Elizabeth Tudor as a young princess (FIG. 21–28). Elizabeth's pearled cap, an adaptation of the so-

called French hood popularized by her mother, Anne Boleyn, is set back to expose her famous red hair. Her brocaded outer dress, worn over a rigid hoop, is split to expose an underskirt of cut velvet. Although her features are softened by youth and no doubt are idealized as well, her long, high-bridged nose and the fullness below her small lower lip give her a distinctive appearance. The prominently displayed books were no doubt included to signify Elizabeth's well-known love of learning.

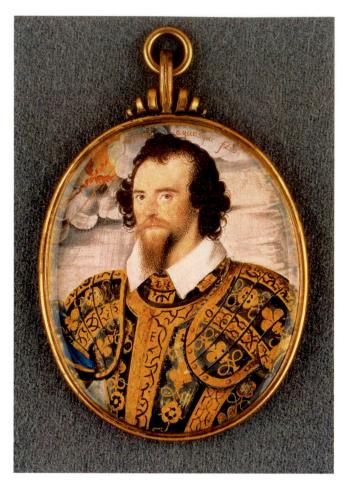

21–29 Nicholas Hilliard GEORGE CLIFFORD, THIRD EARL OF CUMBERLAND (1558–1605)

c. 1595. Watercolor on vellum on card, oval $2\% \times 2\%$ (7.1 \times 5.8 cm). The Nelson-Atkins Museum of Art, Kansas City, Missouri.

Gift of Mr. and Mrs. John W. Starr through the Starr Foundation. F58-60/188

NICHOLAS HILLIARD. In 1570, while Levina Teerlinc was still active at Elizabeth's court, Nicholas Hilliard (1547–1619) arrived in London from southwest England to pursue a career as a jeweler, goldsmith, and painter of miniatures. Hilliard never received a court appointment but worked instead on commission, creating miniature portraits of the queen and court notables, including GEORGE CLIFFORD, THIRD EARL OF CUMBERLAND (FIG. 21–29). Cumberland was a regular participant in the annual tilts and festivals celebrating the anniversary of Elizabeth I's ascent to the throne. In Hilliard's miniature, Cumberland wears a richly engraved and gold-inlaid suit of armor, forged for his first appearance, in 1583, at the tilts (see "Armor for Royal Games," page 737). Hilliard had a talent for giving his male subjects an appropriate air of courtly jauntiness. Cumberland, a man of about thirty with a stylish beard, mustache, and curled hair, is humanized by his direct gaze and unconcealed receding hairline. Cumberland's motto, "I bear lightning and water," is inscribed on a stormy sky, with a lightning bolt in the form of a caduceus (the classical staff with two entwined snakes), one of his emblems. After all, he was that remarkable Elizabethan type—a naval commander and a gentleman pirate.

Architecture

Henry VIII, as the newly declared head of the Church of England, sold or gave church land to favored courtiers. Many properties were bought by speculators who divided and resold them. To increase support for the Tudor dynasty, Henry and his successors also granted titles to rich landowners. To display their wealth and status, many of these newly created aristocrats embarked on extensive building projects. They built lavish country residences, which sometimes surpassed the French châteaux in size and grandeur. At this time, Elizabethan architecture still reflected the Perpendicular Gothic style (SEE FIG. 17–20), with its severe walls and broad expanses of glass, although designers modernized the forms by replacing medieval ornament with classical motifs copied from architectural handbooks and pattern books. The first architectural manual in English, published in 1563, was written by John Shute, one of the few builders who had spent time in Italy. But books by Flemish, French, and German architects were readily available. Most influential were the treatises on architectural design by the Italian architect Sebastiano Serlio.

HARDWICK HALL. One of the grandest of all the Elizabethan houses was HARDWICK HALL, the home of Elizabeth, Countess of Shrewsbury, known as "Bess of Hardwick" (FIG. 21–30). When she was in her seventies, the redoubtable countess—who inherited riches from all four of her deceased husbands—employed Robert Smythson (c. 1535–1614), England's first Renaissance professional architect, to build Hardwick Hall (1591–97).

Smythson's—and Bess's—plan for Hardwick was new. The medieval great hall became a two-story entrance hall, with rooms arranged symmetrically around it—a nod to classical balance. A sequence of rooms leads to a grand stair up to the Long Gallery and **HIGH GREAT CHAMBER** on the second floor (FIG. 21-31), where the countess received guests, entertained, and sometimes dined. The High Great Chamber was designed to display a set of six Brussels tapestries with the story of Ulysses. The room had enormous windows, ornate fireplaces, and a richly carved and painted plaster frieze around the room. The frieze, by the master Abraham Smith, depicts Diana and her maiden hunters in a forest where they pursue stags and boars. In the window bay, the frieze turns into an allegory on the seasons; Venus whipping Cupid represents spring, and the goddess Ceres, summer. Smith based his allegories on Flemish prints. Graphic arts transmitted images from artist to artist and country to country much as photography does today.

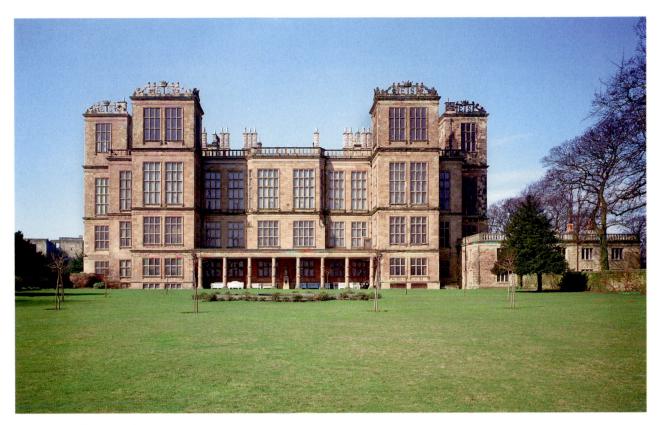

21–30 | Robert Smythson HARDWICK HALL, SHREWSBURY England. 1591–97.

Elizabeth, Countess of Shrewsbury, who commissioned Smythson, participated actively in the design of her houses. She embellished the roofline with her initials, ES, in letters 4 feet tall.

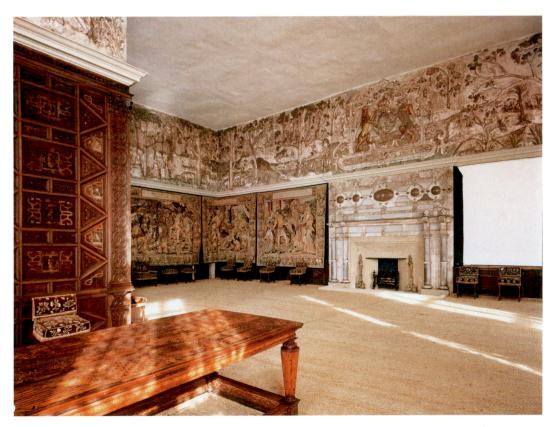

21–31 | Robert Smythson HIGH GREAT CHAMBER, HARDWICK HALL
Shrewsbury, England. 1591–97. Brussels tapestries, 1550s; painted plaster sculpture by Abraham Smith.

IN PERSPECTIVE

In the sixteenth century people faced many challenges—political, religious, and aesthetic. Humanistic learning, based on the written word, was dominant—Germany was, after all, the home of the first printed book—and an increasingly literate public gained access not only to practical information but also to new ideas. Germany was also the center of the Reformation within the Christian Church. In many places, the reformers' zeal led to the destruction first of religious art and then sometimes of all the arts. People worshiped in stark shells of church buildings. With no call to paint religious themes, the artists found new themes and focused on worldly subjects, especially on portraits.

Artists were well aware of the new forces at work across the Alps in Italy, and study tours were an essential part of education. Traveling artists could copy ancient classical art in Rome, study mural painting in Florence, and admire the dazzling lush oil painting in Venice. The idea took hold that artists

could express as much through painted, sculptural, and architectural forms as poets could with words or musicians with melody. The notion of divinely inspired creativity supplanted manual artistry.

Intense religiosity vied with materialistic enterprise early in the century. The crafts also emerged as splendid fine arts, as seen in pictorial tapestries, gold and silver show-piece tableware, and glazed ceramics, among other mediums. All the arts of personal display—cut velvet and brocade gowns and robes, chains and jewels of state—can be studied in portraits.

The Protestants carried on the tradition of using the visual arts to promote a cause, to educate, and to glorify with grand palaces and portraits—just as the Catholic Church had over the centuries used great church buildings and religious art for its didactic as well as aesthetic values. The effects of the Reformation and the Counter-Reformation would continue to reverberate in the arts of the following century throughout Europe and, across the Atlantic, in America.

ANNUNCIATION AND VIRGIN OF THE ROSARY 1517-18

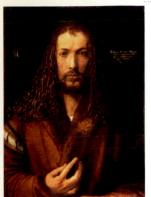

ALBRECHT DÜRER SELF-PORTRAIT 1500

Indulgences 1517 Charles V Holy Roman Emperor 1519-56

Luther Protests Church's Sale of

First Circumnavigation of Earth

Peasants' War 1524-26

Charles V Orders Sack of Rome

 Church of England Separates from Roman Church 1534

■ Council of Trent 1545-63

Elizabeth I Queen of England 1558-1603

 Dutch Unite against Spanish Rule 1579

English Defeat Spanish Navy in Spanish Armada 1588

PIERRE LESCOT WEST WING. COUR CARRÉ, PALAIS DU LOUVRE, PARIS **BEGUN 1546**

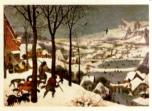

PIETER BRUEGEL THE ELDER RETURN OF THE HUNTERS 1565

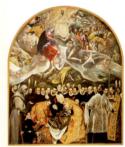

EL GRECO **BURIAL OF COUNT ORGAZ** 1586

ROBERT SMYTHSON EAT CHAMBER, HARDWICK ., SHREWSBURY, ENGLAND 1591-97

1600

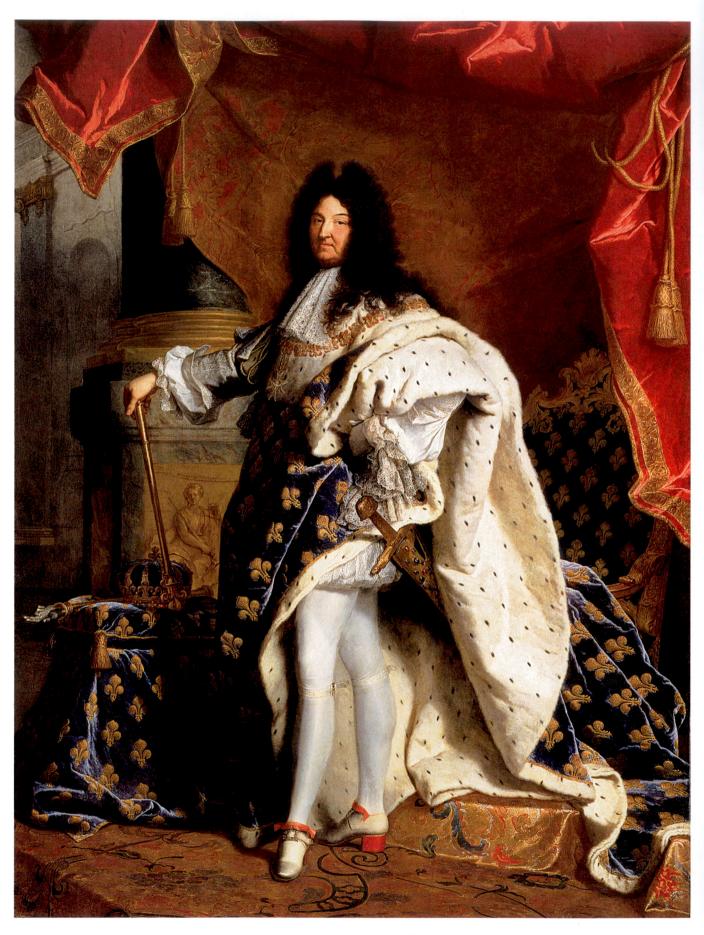

22–I | Hyacinthe Rigaud Louis XIV 1701. Oil on canvas, $9'2'' \times 7'10\%''$ (2.19 \times 2.4 m). Musée du Louvre, Paris.

CHAPTER TWENTY-TWO

BAROQUE ART

In Hyacinthe Rigaud's 1701 portrait of **LOUIS XIV** (FIG. 22–I), the richly costumed monarch known as *le Roi Soleil* ("the Sun King"; ruled 1643–1715) is presented to us by an unseen hand that pulls aside a huge billowing curtain.

Showing off his elegant legs, of which he was very proud, the 63-year-old French monarch poses in an elaborate robe of state, decorated with gold *fleurs-de-lis* and white ermine, and he wears the red-heeled built-up shoes he had invented to compensate for his short stature. At first glance, the face under the huge wig seems almost incidental to the overall grandeur of the presentation. Yet the directness of Louis XIV's gaze makes him movingly human despite the pompous pose and the overwhelming magnificence that surrounds him. Rigaud's genius in portraiture was always to capture a good likeness while idealizing his subjects' less attractive features

Louis XIV had ordered this portrait as a gift for his grandson Philip, but when Rigaud finished the painting, Louis liked it so much that he kept it. Three years later, Louis ordered a copy from Rigaud to give his grandson, now King Philip V of Spain (ruled 1700–46). The request for copies of

and giving minute attention to the virtuoso rendering of tex-

tures and materials of the costume and setting.

22

portraits was not unusual, for the royal and aristocratic families of Europe were linked through marriage, and paintings made appropriate gifts for relatives. Rigaud's workshop produced between thirty and forty portraits a year. His

portraits varied in price according to whether the entire figure was painted from life or whether Rigaud merely added a portrait head to a stock figure in a composition he had designed for his workshop to execute.

Rigaud's long career spanned a time of great change in Western art. Not only did new manners of representation emerge, but, whereas art had once been under the patronage of the Church and the aristocracy, a kind of broad-based commercialism arose that was reflected both by portrait workshops such as Rigaud's and by the thousands of still-life and landscape painters producing works for the middle-class households that could now afford to decorate their homes. These changes of the seventeenth and eighteenth centuries—the Baroque period in Europe—took place in a cultural context in which individuals and organizations were grappling with the effects of religious upheaval, economic growth, colonial expansion, political turbulence, and a dramatic explosion of scientific knowledge.

CHAPTER-AT-A-GLANCE

- THE BAROQUE PERIOD
- ITALY | Architecture and Sculpture in Rome | Painting
- THE HABSBURG LANDS | Painting in Spain's Golden Age | Architecture in Spain and Austria
- FLANDERS AND THE NETHERLANDS | Flanders | The Dutch Republic
- FRANCE | Architecture and Its Decoration at Versailles | Painting
- ENGLAND | Architecture and Landscape Design | English Colonies in North America
- IN PERSPECTIVE

THE BAROQUE PERIOD

The word baroque was initially used in the late 1700s as a derogatory term to characterize the exuberant and extravagant aspects of some of the art of the preceding century and a half. Today, Baroque can designate certain formal characteristics of style, as well as refer to a period in the history of art lasting from the end of the sixteenth into the eighteenth century. Baroque style is characterized by an emotional rather than intellectual response to a work of art and by an interest in exploiting the dramatic moment through choice of subject and style. Artists created open compositions in which elements are placed or seem to move diagonally, expand upward, or overlap their supposed frames. Many artists developed a loose, free technique using rich colors and dramatic contrasts of light and dark, producing what one critic called an "absolute unity" of form. This unified concept extends to the more expansive unity between architecture, sculpture, and painting and the theatrical effects that could be created by what we would term a multimedia approach. Although many of the formal characteristics of the Baroque have been applied to other periods, like Hellenistic Greek styles, the term Baroque will be used here to refer to the complex of styles-including a more restrained, classical stream-that developed against the historical backdrop of the Counter-Reformation, the advancement of science, the expanding world of exploration and trade, and the rise of private patronage in the arts.

By the seventeenth century, the permanent division within Europe between Roman Catholicism and Protestantism had a critical effect on European art. As part of the Counter-Reformation program that came to fruition in the seventeenth century, the Church used art to encourage piety among the faithful and to persuade those it regarded as heretics to return to the fold. Patronage of art in Catholic as well as Protestant countries was spurred by economic growth that helped to support not only the aristocracy, but a large, affluent middle class eager to build and furnish fine houses and even palaces. Buildings ranged from magnificent churches and palaces to stage sets for plays and ballets, while painting and sculpture varied from large religious works and history paint-

ings to portraits, still lifes, and genre paintings (scenes of everyday life). At the same time, scientific advances compelled people to question their worldview. Of great importance was the growing understanding that Earth was not the center of the universe but was a planet revolving around the sun (see "Science and the Changing Worldview," page 746).

Within these historical parameters, artists achieved spectacular technical virtuosity and an impressive ability to produce for their patrons and the market. Painters manipulated their mediums from the thinnest glazes to heavy impasto (thickly applied pigments), taking pleasure in the very quality of the material. A desire for realism led some artists to reach for a verisimilitude that went against the idealization of classical and Renaissance styles. The English leader Oliver Cromwell supposedly demanded that his portrait be painted "warts and all." Leading artists such as Rubens and Rembrandt organized their studios into veritable picture factories. Artists were admired for the originality of a concept or design, and their shops produced paintings on demand—including copy after copy of popular themes or portraits. The respect for the "original," or first edition, is a modern concept.

The role of viewers also changed. Earlier, Renaissance painters and patrons had been fascinated with the visual possibilities of perspective, but even such displays as Mantegna's ceiling fresco at Mantua (SEE FIG. 19-34) remained an intellectual conceit. Seventeenth-century masters, on the other hand, treated viewers as participants in the artwork, and the space of the work included the world beyond the frame. In Catholic countries, representations of horrifying scenes of martyrdom or the passionate spiritual life of a mystic in religious ecstasy inspired a renewed faith (SEE FIG. 22-6). In Protestant countries, images of civic parades and city views inspired pride in accomplishment (SEE FIGS. 22-45, 22-49). Viewers participated in art like audiences in a theater vicariously but completely—as the work of art reached out visually and emotionally to draw them into its orbit. The seventeenth-century French critic Roger de Piles described this exchange when he wrote: "True painting . . . calls to us; and has so powerful an effect, that we cannot help coming near it, as if it had something to tell us" (quoted in Puttfarken, page 55).

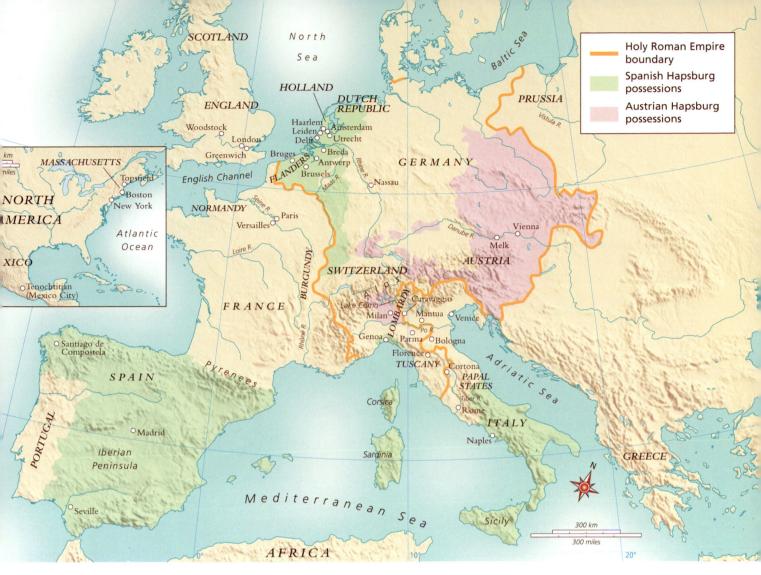

MAP 22-I THE SEVENTEENTH CENTURY IN EUROPE AND NORTH AMERICA

Protestantism dominated in northern Europe, while Roman Catholicism remained strong after the Counter-Reformation in southern Europe.

ITALY

Italy in the seventeenth century remained a divided land in spite of a common history, language, and geography with borders defined by the seas. The Kingdom of Naples and Sicily was Spanish; the Papal States crossed the center; Venice maintained its independence as a republic; and the north remained divided among small principalities. In spite of religious wars raging in Germany and France, churchmen remained powerful patrons of the arts, especially as they recognized the visual arts' role in propaganda campaigns. The popes, cardinals, and their families turned to artists to enhance their status. Additionally, the Church had set down rules for art at the Council of Trent (1563) that went against the arcane, worldly, and often lascivious trends exploited by Mannerism. The clergy's call for clarity, simplicity, chaste subject matter, and the ability to rouse a very Catholic piety in the face of Protestant revolt found a response in the fresh approaches to subject matter and style offered by a new generation of artists.

Architecture and Sculpture in Rome

A major goal of the Counter-Reformation was to properly embellish the Church and its mother city. Pope Sixtus V (papacy 1585-90) had begun the renewal by cutting long straight avenues through the city to link the major pilgrimage churches with one another and with the main gates of Rome. Sixtus also ordered open spaces—piazzas—cleared in front of major churches, marking each site with an Egyptian obelisk. (His chief architect, Domenico Fontana, performed remarkable feats of engineering to move the huge monoliths.) In a practical vein, Sixtus also reopened one of the ancient aqueducts to stabilize the city's water supply. Unchallengeable power and vast financial resources were required to carry out such an extensive plan of urban renewal and to materially fashion Rome-which had been the victim of rapacity and neglect since the Middle Ages—once more into the center of spiritual and worldly power.

The Counter-Reformation popes had great wealth, although eventually they nearly bankrupted the Church with

Science and Technology

SCIENCE AND THE CHANGING WORLDVIEW

nvestigations of the natural world that had begun during the Renaissance changed the way people of the seventeenth and eighteenth centuries—including artists—saw the world. Some of the new discoveries brought a sense of the grand scale of the universe, while others focused on the minute complexity of the microscopic world of nature. As frames of reference expanded and contracted, artists found new ways to mirror these changing perspectives in their own works.

The philosophers Francis Bacon (1561–1626) of England and René Descartes (1596–1650) of France established a new scientific method of studying the world by insisting on scrupulous objectivity and logical reasoning. Bacon proposed that facts be established by observation and tested by controlled experiments. Descartes argued for the deductive method of reasoning, in which a conclusion was arrived at logically from basic premises—the most fundamental example being "I think, therefore I am."

In 1543, the Polish scholar Nicolaus Copernicus (1473-1543) published On the Revolutions of the Heavenly Spheres, which contradicted the long-held view that Earth is the center of the universe (the Ptolemaic theory) by arguing that Earth and other planets revolve around the sun. The Church put the book on its Index of Prohibited Books in 1616, but Johannes Kepler (1571–1630) continued demonstrating that the planets revolve around the sun in elliptical orbits. Galileo Galilei (1564-1642), an astronomer, mathematician, and physicist, developed the telescope as a tool for observing the heavens. His findings provided further confirmation of the Copernican theory, but since the Church prohibited teaching that theory, Galileo was tried for heresy by the Inquisition and forced to recant his views. As the first person to see the craters of the moon through a telescope, Galileo began the exploration of space that eventually led humans to take their first steps on the moon in 1969.

Seventeenth-century science explored not only the vastness of outer space but also the smallest elements of inner space, thanks to the invention of the microscope by the Dutch lens maker and amateur scientist Antoni van Leeuwenhoek (1632–1723). Although embroiderers, textile inspectors, manuscript illuminators, and painters had long used magnifying glasses in their work, Leeuwenhoek perfected grinding techniques and increased the power of his lenses far beyond what those uses required. Ultimately, he was able to study the inner workings of plants and animals and even see microorganisms. Soon, scientists learned to draw, or depended on artists to draw, the images revealed by the microscope for further study

and publication. Not until the discovery of photography in the nineteenth century could scientists communicate their discoveries without an artist's help.

INSECT GENERATIONS AND METAMORPHOSIS IN SURINAM 1719. Hand-colored engraving, $18\% \times 13''$ (47.9×33 cm). National Museum of Women in the Arts, Washington, D.C.

Gift of Wallace and Wilhelmina Holladay Collection, funds contributed by Mr. and Mrs. George G. Anderman and an anonymous donor (1976.56)

Maria Sibylla Merian (1647–1717) was unusual in making noteworthy contributions as both researcher and artist. German by birth and Dutch by training, Merian was once described by a Dutch contemporary as a painter of flowers, fruit, birds, worms, flies, mosquitoes, spiders, "and other filth." At the time, it was believed that insects emerged spontaneously from the soil, but Merian's research on the life cycles of insects proved otherwise, findings she published in 1679 and 1683 as The Wonderful Transformation of Caterpillars and (Their) Singular Plant Nourishment. In 1699, Amsterdam subsidized Merian's research on plants and insects in the Dutch colony of Surinam in South America; her results were published as Dissertation in Insect Generations and Metamorphosis in Surinam, illustrated with sixty large plates engraved after her watercolors. Each plate is scientifically precise, accurate, and informative, presenting insects in various stages of development, along with the plants they live on.

their building programs. Sixtus began to renovate the Vatican and its library. He completed the dome of Saint Peter's and built splendid palaces. The Renaissance ideal of the central-plan church continued to be used for the shrines of saints, but Counter-Reformation thinking called for churches with long, wide naves to accommodate large congregations assem-

bled to hear firm sermons as well as to participate in the Mass. In the sixteenth century, the decoration of new churches had been generally austere, but seventeenth- and eighteenth-century Catholic taste favored opulent and spectacular visual effects to heighten the emotional involvement of worshipers.

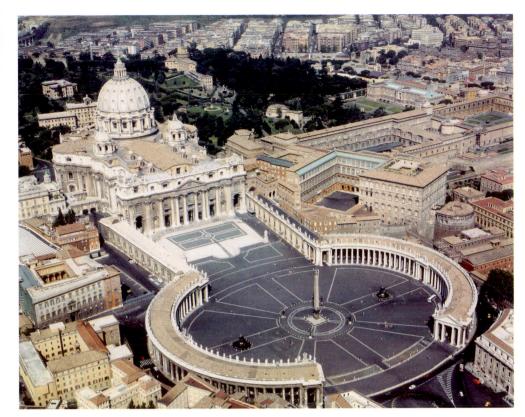

22–2 | SAINT PETER'S BASILICA AND PIAZZA, VATICAN, ROME Carlo Maderno, façade, 1607–26; Gianlorenzo Bernini, piazza design, c. 1656–57.

Perhaps only a Baroque artist of Bernini's talents could have unified the many artistic periods and styles that come together in Saint Peter's Basilica (starting with Bramante's original design for the building in the sixteenth century). The basilica in no way suggests a piecing together of parts made by different builders at different times but rather presents itself as a triumphal unity of all the parts in one coherent whole.

SAINT PETER'S BASILICA IN THE VATICAN. Half a century after Michelangelo had returned Saint Peter's Basilica to Bramante's original vision of a central-plan building, Pope Paul V (papacy 1605-21) commissioned Carlo Maderno (1556-1629) to provide the church with a longer nave and a new façade (FIG. 22-2). Construction began in 1607, and everything but the façade bell towers was completed by 1615 (see "Saint Peter's Basilica," Chapter 20, page 679). In essence, Maderno took the concept of Il Gesù's façade (SEE FIG. 20-31) and enlarged it to befit the most important church of the Catholic world. Maderno's façade for Saint Peter's "steps out" in three progressively projecting planes: from the corners to the doorways flanking the central entrance area, then the entrance area, then the central doorway itself. Similarly, the colossal orders connecting the first and second stories are flat pilasters at the corners but fully round columns where they flank the doorways. These columns support a continuous entablature that also steps out-following the columns-as it moves toward the central door. A triangular pediment provides vertical movement, as does the superimposition of pilasters on the relatively narrow attic story above the entablature.

When Maderno died in 1629, he was succeeded as Vatican architect by his collaborator of five years, Gianlorenzo Bernini (1598–1680). Gianlorenzo was taught by his father,

and part of his training involved sketching the Vatican collection of ancient sculpture, such as *Laocoön and His Sons* and the Farnese Hercules (see Introduction, Fig. 23), as well as the many examples of Renaissance painting in the papal palace. Throughout his life, Bernini admired antique art and, like other artists of this period, considered himself a classicist. Today, we not only appreciate his strong debt to the Renaissance tradition but also consider his art a breakthrough that takes us into a new, Baroque style.

When Urban VIII was elected pope in 1623, he unhesitatingly gave the young Bernini the demanding task of designing an enormous bronze baldachin, or canopy, for the high altar of Saint Peter's. The church was so large that a dramatic focus on the altar was essential. The resulting BALDACCHINO (FIG. 22–3), completed in 1633, stands almost 100 feet high and exemplifies the Baroque artists' desire to combine architecture and sculpture—and sometimes painting as well—so that works no longer fit into a single category or a single medium. The twisted columns symbolize the union of Old and New Testaments—the vine of the Eucharist climbing the columns of the Temple of Solomon. The fanciful Composite capitals, combining elements of both the Ionic and the Corinthian orders, support an entablature with a crowning element topped with an orb (a sphere representing the

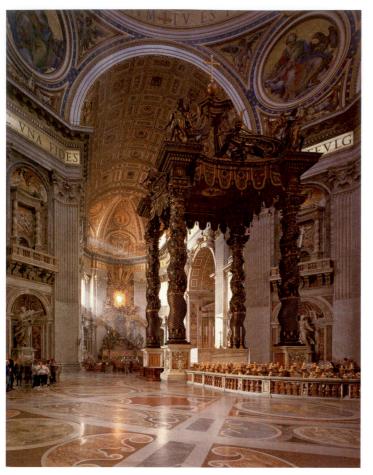

22–3 | Gianlorenzo Bernini BALDACCHINO 1624–33. Gilt bronze, height approx. 100′ (30.48 m). Chair of Peter shrine, 1657–66. Gilt bronze, marble, stucco, and glass. Pier decorations, 1627–41. Gilt bronze and marble. Crossing, Saint Peter's Basilica, Vatican, Rome.

universe) and a cross (symbolizing the reign of Christ). Figures of angels and *putti* decorate the entablature, which is hung with tasseled panels in imitation of a cloth canopy. These symbolic elements, both architectural and sculptural, not only mark the site of the tomb of Saint Peter but also serve as a monument to Urban VIII and his family, the Barberini, whose emblems—including honeybees and suns on the tasseled panels, and laurel leaves on the climbing vines—are prominently displayed.

Between 1627 and 1641, Bernini and several other sculptors, again combining architecture and sculpture, rebuilt Bramante's crossing piers as giant reliquaries. Statues of saints Helena, Veronica, Andrew, and Longinus stand in niches below alcoves containing their relics, to the left and right of the *baldacchino*. Visible through the *baldacchino*'s columns in the apse of the church is another reliquary: the gilded stone, bronze, and stucco shrine made by Bernini between 1657 and 1666 for the ancient wooden throne thought to have

belonged to Saint Peter as the first bishop of Rome. The Chair of Peter symbolized the direct descent of Christian authority from Peter to the current pope, a belief rejected by Protestants and therefore deliberately emphasized in Counter-Reformation Catholicism. In Bernini's work, the chair is carried by four theologians and is lifted even farther by a surge of gilded clouds moving upward to the Holy Spirit, who materializes in the stained-glass window in the form of a dove surrounded by an oval of golden rays. Adoring, gilded angels and gilt-bronze rays fan out around the window and seem to extend the penetration of the natural light—and the Holy Spirit—into the apse of the church. The gilding also reflects the light back to the window, creating a dazzling, ethereal effect that the seventeenth century, with its interest in mystics and visions, would equate with the activation of divinity—and the sort of effect that present-day artists achieve by resorting to electric spotlights.

At approximately the same time that he was at work on the Chair of Peter, Bernini designed and supervised the building of a colonnade to form a huge double piazza in front of the entrance to Saint Peter's (SEE FIG. 22–2). The open space that he had to work with was irregular, and an Egyptian obelisk and a fountain already in place (part of

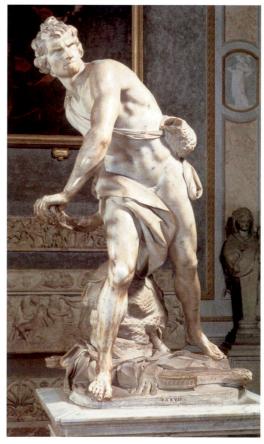

22–4 | Gianlorenzo Bernini DAVID 1623. Marble, height 5'7" (1.7 m). Galleria Borghese, Rome.

Sixtus V's plan for Rome) had to be incorporated into the overall plan. Bernini's remarkable design frames the oval piazza with two enormous curved porticoes, or covered walkways, supported by Doric columns. These curved porticoes are connected to two straight porticoes, which lead up a slight incline to the two ends of the church façade. Bernini spoke of his conception as representing the "motherly arms of the Church" reaching out to the world. He had intended to build a third section of the colonnade closing the side of the piazza facing the church so that pilgrims, after crossing the Tiber River bridge and passing through narrow streets, would suddenly emerge into the enormous open space before the church. Even without the final colonnade section, the great church, colonnade, and piazza with its towering obelisk and monumental fountains-Bernini added the second one to balance the first—are an awe-inspiring vision.

BERNINI AS SCULPTOR. Even after Bernini's appointment as Vatican architect in 1629, he was able to accept outside commissions by virtue of his large workshop. In fact, Bernini first became famous as a sculptor, and he continued to work as a sculptor throughout his career, for both the papacy and private clients. A man of many talents, he was also a painter and even a playwright—an interest that dovetailed with his genius for theatrical and dramatic aspects in his sculpture and architecture.

Bernini's DAVID (FIG. 22-4), made for a nephew of Pope Paul V in 1623, introduced a new type of three-dimensional composition that intrudes forcefully on the viewer's space. Inspired by the athletic figures Annibale Carracci had painted in the Farnese gallery some twenty years earlier (SEE, for example, the Giant preparing to heave a boulder at the far end of the gallery, FIG. 22-13), Bernini's David bends at the waist and twists far to one side, ready to launch the lethal rock. Unlike Michelangelo's cool and self-confident youth (SEE FIG. 20-10), this more mature David, with his lean, sinewy body, is all tension and determination, a frame of mind emphasized by his ferocious expression, tightly clenched mouth, and straining muscles. Bernini's energetic, twisting figure includes the surrounding space as part of the composition by implying the presence of an unseen adversary somewhere behind the viewer. Thus, the viewer becomes part of the action that is taking place at that very moment. This immediacy, the emphasis on the climactic moment, and the inclusion of the viewer in the work of art represent an important new direction for art.

From 1642 until 1652, Bernini worked on the decoration of the funerary chapel of Venetian cardinal Federigo Cornaro (FIG. 22–5) in the Church of Santa Maria della Vittoria, designed by Carlo Maderno earlier in the century. Like Il Gesù (SEE FIG. 20–32), the church had a single nave with shallow side chapels. Santa Maria della Vittoria was built by the order of the Discalced (unshod) Carmelite Friars, and the chapel of the Cornaro family was dedicated to one of the

Sequencing Events GREAT ROYAL AND PAPAL PATRONS OF THE SEVENTEENTH CENTURY

1605-21	Pope Paul V (Borghese)
1623-44	Pope Urban VIII (Barberini)
1625-49	Charles I of England (Stuart)
1643 (61)-1715	Louis XIV of France (Bourbon)
1644-55	Pope Innocent X (Pamphili)
1621-65	Philip IV of Spain (Habsburg)
1655-67	Pope Alexander VII (Chigi)

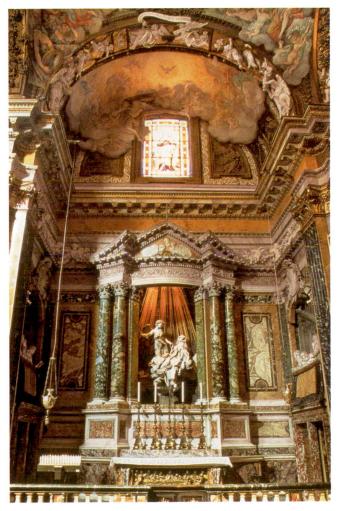

22-5 | Gianlorenzo Bernini CORNARO CHAPEL, CHURCH OF SANTA MARIA DELLA VITTORIA, ROME 1642-52.

order's great figures, the Spanish saint Teresa of Ávila, canonized only twenty years earlier. Bernini designed the chapel to be a rich and theatrical setting in which to portray an event in Teresa's life that contributed to her sainthood. To accomplish this, he covered the walls with colored marble panels

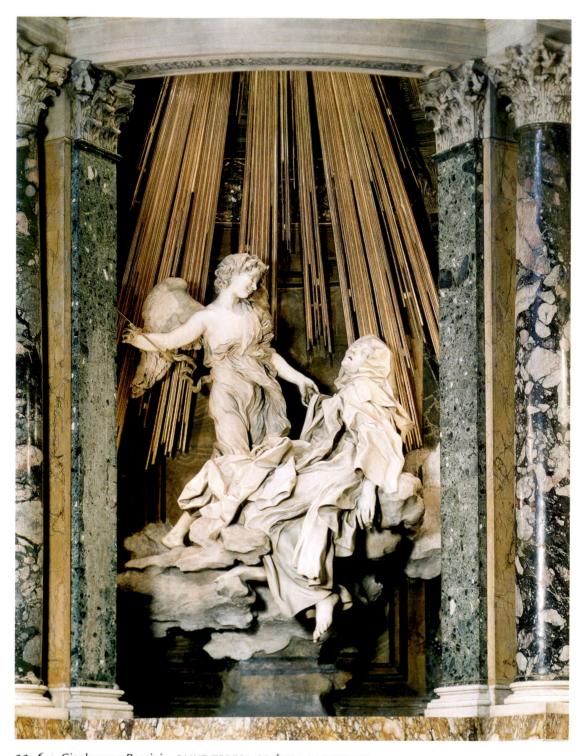

and crowned them with a projecting cornice supported by marble pilasters.

In the center of the chapel and framed by columns in the huge oval niche above the altar, Bernini's marble group **SAINT TERESA OF ÁVILA IN ECSTASY** (FIG. 22–6) represents a vision described by the Spanish mystic in which an angel pierced her body repeatedly with an arrow, transporting her to a state of

indescribable pain, religious ecstasy, and a sense of oneness with God. Saint Teresa and the angel, who seem to float upward on moisture-laden stucco clouds, are cut from a heavy mass of solid marble supported on a hidden pedestal and by hidden metal bars sunk deep into the chapel wall. Bernini's skill at capturing the movements and emotions of these figures is matched by his virtuosity in simulating different textures

and colors in the pure white medium of marble; the angel's gauzy, clinging draperies seem silken in contrast with Teresa's heavy woolen robe, the habit of her order. Yet Bernini effectively used the configuration of the garment's folds to convey the swooning, sensuous body beneath, even though only Teresa's face, hands, and bare feet are actually visible.

As he would later do for the Chair of Peter (SEE FIG. 22-3), Bernini used a directed light source to announce the divine presence that enfolds the saint's ecstasy and spiritual martyrdom. Above the cornice on the back wall, the curved ceiling surrounds a concealed window that mysteriously illuminates the niche that houses Saint Teresa and dissolves the descending rays of gilt bronze, the solid marble figures, and the clouds on which they are suspended into a painterly vision. Kneeling at what appear to be prie-dieux on both sides of the chapel are marble portraits of Federigo, his deceased father (a Venetian doge), and six cardinals of the Cornaro family. The figures are informally posed and naturalistically portrayed. Two read from their prayer books, others exclaim at the miracle taking place in the light-infused realm above the altar, and one leans out from his seat, apparently to look at someone entering the chapel—perhaps the viewer, whose space these figures share. The frescoed vault, above, executed by another artist, depicts the dove of the Holy Spirit hovering over angels and stuccoed scenes of the saint's life.

Gianlorenzo Bernini was deeply religious and held fast to the tenets espoused by the Counter-Reformation. Although he created a "stage" for his subject, his purpose was not to produce a mere spectacle but to capture a critical, dramatic moment at its emotional and sensual height and by doing so guide the viewer to identify totally with the event—and perhaps be transformed in the process.

Bernini's complex, theatrical interplay of media—sculpture, architecture, and painting—and of the various levels of illusion in the chapel—divine, mystical, and actual—invite the beholder to identify with Teresa's experience. His brilliant solution to the problem of transfixing the momentary in physical materials was imitated by sculptors throughout Europe.

BORROMINI'S CHURCH OF SAN CARLO. The intersection of two of the wide straight avenues created by Pope Sixtus V inspired city planners to add a special emphasis, with fountains marking each of the four corners of the crossing. In 1634, the Trinitarian monks decided to build a new church at the site and awarded the commission for SAN CARLO ALLE QUATTRO FONTANE (Saint Charles at the Four Fountains) to Francesco Borromini (1599–1667). Borromini, a nephew of architect Carlo Maderno, had arrived in Rome in 1619 from northern Italy to enter his uncle's workshop. Later, he worked under Bernini's supervision on the decoration of Saint Peter's, and some details of the *Baldacchino*, as well as the structural engineering, are now attributed to him, but San Carlo was his first independent commission. Unfinished at

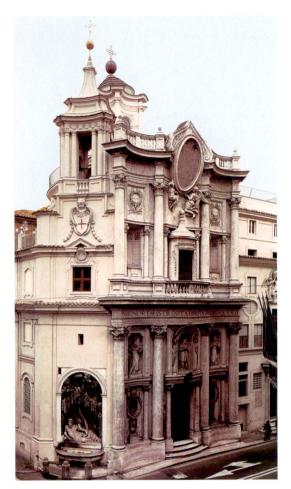

22-7 | Francesco Borromini FAÇADE, CHURCH OF SAN CARLO ALLE QUATTRO FONTANE, ROME 1665-67.

Borromini's death, the church was nevertheless completed according to his design.

San Carlo stands on a narrow piece of land, with one corner cut off to accommodate one of the four fountains that give the church its name (FIG. 22-7). To fit the irregular site, Borromini created an elongated central-plan interior space with undulating walls (FIG. 22-8), whose powerful, sweeping curves create an unexpected feeling of movement, as if the walls were heaving in and out. Robust pairs of columns support a massive entablature, over which an oval dome, supported on pendentives, seems to float. The coffers (inset panels in geometric shapes) filling the interior of the oval-shaped dome form an eccentric honeycomb of crosses, elongated hexagons, and octagons (FIG. 22-9). These coffers decrease sharply in size as they approach the apex, or highest point, where the dove of the Holy Spirit hovers in a climax that brings together geometry used in the chapel: oval, octagon, circle, and—very important—a triangle, symbol of the Trinity as well as of the church's patrons. The dome appears be shimmering and inflating, thanks to light sources placed in the lower coffers and the lantern.

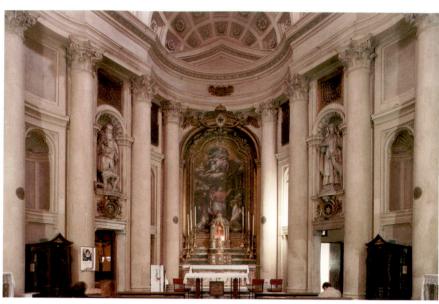

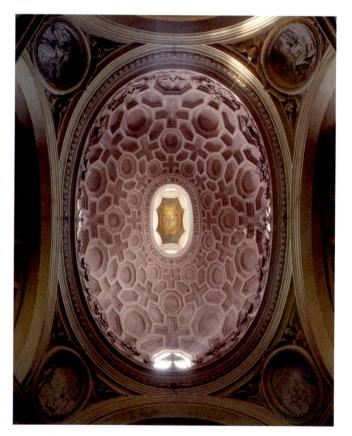

22–9 $^{\parallel}$ dome interior, church of san carlo alle quattro fontane $1638{\text -}41.$

It is difficult today to appreciate how audacious Borromini's design for this small church was. In it he abandoned the modular, additive system of planning taken for granted by every architect since Brunelleschi. He worked instead from an overriding geometrical scheme for the ideal, domed, central-plan church. Borromini looked at his buildings in

terms of geometrical units as a Gothic architect might, subdividing the units to obtain more complex, rational shapes. For example, the elongated, octagonal plan of San Carlo is composed of two triangles set base to base along the short axis of the plan (FIG. 22–10). This diamond shape is then subdivided into secondary triangular units made by calculating the distances between what will become the concave centers of the four major and five minor niches. Yet Borromini's conception of the whole is not medieval. The chapel is dominated horizontally by a classical entablature that breaks any surge upward toward the dome, allowing the eye to play with the rhythm of paired Corinthian columns. Borromini's treatment of the architectural elements as if they were malleable was also unprecedented. His contemporaries understood immediately what an extraordinary innovation the church represented; the Trinitarian monks who had commissioned it received requests for plans from visitors from all over Europe. Although Borromini's invention had little influence on the architecture of classically minded Rome, it was widely imitated in northern Italy and beyond the Alps.

Borromini's design for San Carlo's façade (SEE FIG. 22–7), done more than two decades later, was as innovative as his plan for its interior had been. He turned the building's front into an undulating, sculpture-filled screen punctuated with large columns and deep concave and convex niches that create dramatic effects of light and shadow. Borromini also gave his façade a strong vertical thrust in the center by placing over the tall doorway a statue-filled niche, then a windowed niche covered with a canopy, then a giant, forward-leaning cartouche held up by angels carved in such high relief that they appear to hover in front of the wall. The entire façade is crowned with a balustrade broken by the sharply pointed frame of the cartouche. Borromini's façade was enthusiastically imitated in northern Italy and especially in northern and eastern Europe.

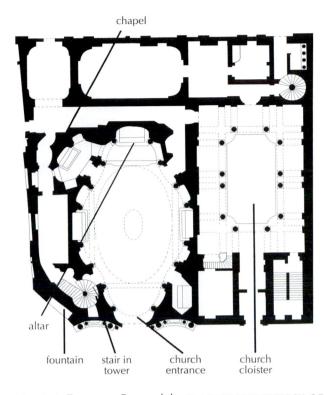

22–IO | Francesco Borromini PLAN OF THE CHURCH OF SAN CARLO ALLE QUATTRO FONTANE, ROME 1638–41.

PIAZZA NAVONA. Rome's PIAZZA NAVONA, a popular site for festivals and celebrations, became another center of urban renewal with the election of Innocent X as pope (papacy 1644–55). Both the palace and parish church of his family, the Pamphilis, fronted on the piazza, which had been the site of a stadium built by Emperor Domitian in 86 CE, and it still retains the shape of the ancient racetrack. The stadium, in ruins, had been used for festivals during the Middle Ages and as a marketplace since 1477. A modest shrine to Saint Agnes stood on the site of her martyrdom.

The Pamphilis enlarged their palace in 1644–50 and in 1652 decided to rebuild their parish church, the Church of Sant'Agnese (Saint Agnes). In 1653–57 Francesco Borromini took the commission, altered the interior, and designed the façade, conceiving a plan that unites church and piazza (FIG. 22–11). The façade sweeps inward from two flanking towers to a monumental portal approached by broad stairs. The inward curve of the façade brings the dome nearer the entrance than usual, making it clearly visible from the piazza. The templelike design of columns and pediment around the door also leads the eye to the steeply rising dome on its tall drum. As the pope had wished, the church truly dominates the urban space.

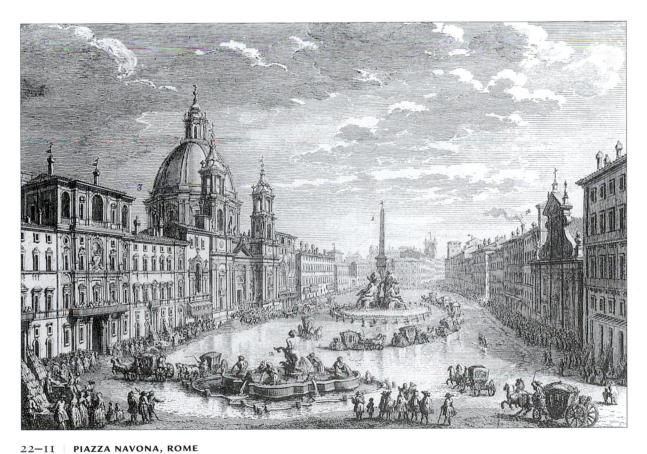

In the middle ground, Gianlorenzo Bernini's Four Rivers Fountain, 1648-51. To the left of the fountain, Franceso Borromini's Church of Sant'Agnese, 1653-57. In the foreground, Giacomo della Porta's fountain of 1576. Giuseppe Vasi, *The Flooding of the Piazza Navona*, 18th century, engraving.

The south end of the piazza was already graced by a 1576 fountain by Giacomo della Porta. The contest for a second monumental fountain in the center of the piazza was meant to celebrate the pope's redirection of one of Rome's main water supplies to the piazza. It was won by Borromini, who originated the fountain's theme of the Four Rivers and who brought in the water supply for it in 1647. Gianlorenzo Bernini, who had been publicly disgraced in 1646 when a bell tower he had begun for Saint Peter's threatened to collapse, had not been invited to compete for the fountain's design. However, after some skillful maneuvering, Pope Innocent X saw Bernini's model for the fountain and transferred the project to him the next year.

Bernini was at his most ingenious in fountain designs (FIG. 22–12). Executed in marble and travertine, a porous stone that is less costly and more easily worked than marble, the now famed **FOUNTAIN OF THE FOUR RIVERS** was completed in 1651. In the center a rocky hill seems to be suspended over an open grotto, within which a hidden collecting pool feeds streams of water signifying the four great rivers of the world. Above the streams recline colossal personifications of the four continents then recognized by contemporary geographers—the Nile (Africa), the Ganges (Asia), the Danube (Europe), and the Rio de la Plata (Americas). In the

center soars a towering ancient Roman imitation of an Egyptian obelisk that Bernini has crowned with a dove: a sign of peace and the Trinity but also the emblem of the pope's family. The towering complex is therefore a dual memorial to the might and reach of the papacy throughout the world as well as the power and status of the Pamphili.

Painting

Painting in seventeenth-century Italy followed one of two principal paths: the classicism of the Carracci or the naturalism of Caravaggio. Although the leading exponents of these paths were northern Italians—the Carracci family was from Bologna, and Caravaggio was apprenticed briefly in Milanthey were all eventually drawn to Rome, the center of power and patronage. The Carracci family as well as Caravaggio were schooled in northern Italian Renaissance realism, with its emphasis on chiaroscuro, as well as in Venetian color and sfumato. They painted with increased realism by using live models. The Carracci quite consciously rejected the difficulties of the Mannerist style and fused their northern roots with the central Italian Renaissance insistence on line (disegno), compositional structure, and figural solidity. They looked to Raphael, Michelangelo, and the models provided by classical sculpture for their ideal figural types. To their

22–12 | Gianlorenzo Bernini and His Shop FOUNTAIN OF THE FOUR RIVERS, THE GANGES (ASIA) 1648–51. Travertine and marble. Piazza Navona, Rome.

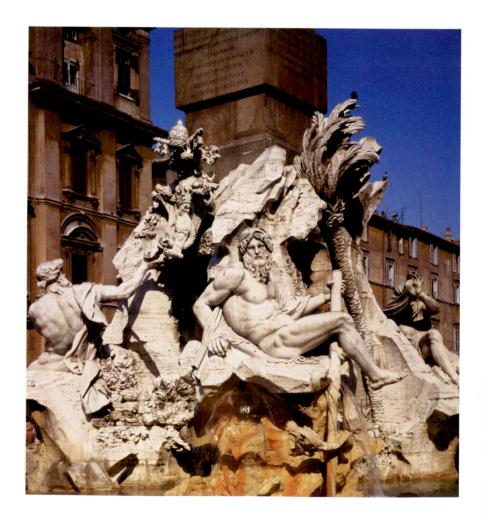

22–13 | Annibale Carracci
CEILING OF GALLERY,
PALAZZO FARNESE, ROME
1597–1601. Fresco, approx. 68 × 21'
(20.7 m × 6.4 m)

contemporaries, the Carraccis' dramatic but decorous style seemed, as one critic wrote, "to intuit the intentions of nature and thereby to close the gap between imagination and reality" (Minor, *Baroque and Rococo Art and Culture*, page 160). Caravaggio, on the other hand, satisfied the Baroque demand for drama and clarity by developing realism in a powerful new direction. He painted less than elevated subjects—the lowlife of Rome—and worked directly from his model without elaborate drawings and compositional notes. Unlike the Carracci, he claimed to ignore the masters. He intended to give the impression of immediacy, although he must have considered and adjusted his compositions carefully.

THE CARRACCI. The brothers Agostino (1557–1602) and Annibale Carracci (1560–1609) and their cousin Ludovico (1555–1619) shared a studio in Bologna. As their reevaluation of the High Renaissance masters attracted interest among their peers, they opened their doors to friends and students and then, in 1582, founded an art academy, where students

drew from live models and studied art theory, Renaissance painting, and antique classical sculpture. The Carracci placed a high value on accurate drawing, complex figure compositions, complicated narratives, and technical expertise in both oil and fresco painting. During its short life the academy had an impact on the development of the arts—and art education—through its insistence on both life drawing (to achieve naturalism) and aesthetic theory.

In 1595, Annibale was hired by the Cardinal Odoardo Farnese to decorate the principal rooms of his family's immense Roman palace. In the long *galleria* (gallery), to celebrate the wedding of Duke Ranuccio Farnese of Parma to the niece of the pope, the artist was requested to paint scenes of love based on Ovid's *Metamorphosis* (FIG. 22–13). Throughout their palace, the Farnese had an important collection of sculpture (see Introduction, Fig. 23). Undoubtedly, Annibale and Agostino, who assisted him, felt both inspiration and competition from the sculpture and architecture in the rooms below.

22–I4 Annibale Carracci **LANDSCAPE WITH THE FLIGHT INTO EGYPT** 1603–04. Oil on canvas, 48 × 90½". Galleria Doria Pamphili, Rome.

The primary image, set in the center of the vault, is *The* Triumph of Bacchus and Ariadne, a joyous procession celebrating the wine god Bacchus's love for Ariadne, a woman whom he rescued after her lover, Theseus, abandoned her on the island of Naxos. Annibale combines the great tradition of ceiling painting of northern Italy-seen in the work of Mantegna and Correggio (FIGS. 19-34, 20-21)—with influences gained by his study of central Italian Renaissance painters and the classical heritage of Rome. Annibale organized his complex theme by using illusionistic devices to create multiple levels of reality. Gold-framed easel paintings called quadri riportati ("transported paintings") "rest" against the actual cornice of the vault and overlap "bronze" medallions that are flanked, in turn, by realistically colored ignudi, dramatically lit from below. The viewer is invited to compare the warm flesh tones of these youths, and their realistic poses, with the more idealized "painted" bodies in the framed scenes next to them. Above, paintings of stucco-colored sculptures of herms (plain shafts topped by human torsos) appear to support the painted framework of the vault, yet many of them also wear human expressions and seem to communicate with one another. Many of Annibale's motifs are inspired by Michelangelo's Sistine Chapel ceiling (FIG. 20-12). The figure types, true to their source, are heroic, muscular, and drawn with precise anatomical accuracy. But instead of Michelangelo's cool illumination and intellectual detachment, the Carracci ceiling glows with a warm light

that recalls the work of the Venetian painters Titian and Veronese and seems buoyant with optimism.

The ceiling was highly admired and became famous almost immediately. The Farnese family, proud of the gallery, generously allowed young artists to sketch the figures there, so that Carracci's masterpiece influenced Italian art well into the following century.

Among those present for the initial viewing of the galleria was the nephew of Pope Clement VIII, Pietro Aldobrandini, who subsequently commissioned the artist to decorate the six lunettes of his private chapel with scenes from the life of the Virgin, sometime between 1603 and 1604. LANDSCAPE WITH THE FLIGHT INTO EGYPT (FIG. 22–14), the largest of the six and one of only two that show Annibale's hand-probably occupied the position above the altar. In contrast to the dramatic figural compositions Annibale created for the Farnese gallery, the escape of the holy family is conceived within a contemplative pastoral landscape filled with golden light in the tradition of Venetian Renaissance painting (SEE FIG. 20-23). The design of the work and its affective spirit of melancholy result, however, in one of the fundamental exercises in Baroque classicism that would influence artists for generations to come. Here is nature ordered by man. Trees in the left foreground and right middle ground gracefully frame the scene; and the collection of ancient buildings in the center of the composition form a stable and protective canopy for the flight of the holy family. Space progresses gradually from foreground to background in diago-

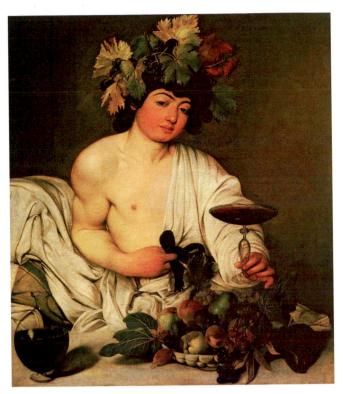

22–15 | Caravaggio BACCHUS 1595–96. Oil on canvas, $37 \times 33\%$ " (94 \times 85.1 cm). Galleria degli Uffizi, Florence.

nal movements that are indicated by people, animals, and architecture. Nothing is accidental, yet the whole appears unforced and entirely natural. The French painter Nicolas Poussin would soon learn lessons from Annibale's work (SEE FIG. 22–62).

CARAVAGGIO. A new powerful naturalism was introduced into painting by the Carracci's younger contemporary Michelangelo Merisi (1571–1610), known as "Caravaggio" after his family's home town in Lombardy. Lombard painters not only favored realistic art with careful drawing, they also had an interest in still life, which had been revived in the sixteenth century but was still unusual at the time. The young painter demonstrated those interests in his first known paintings when, late in 1592, he arrived in Rome from Milan and found work in the studio of the Cavaliere d'Arpino as a specialist painter of fruit and vegetables. When he began to paint on his own, he continued to paint still lifes but also included half-length figures, as in the BACCHUS (FIG. 22–15). By this time, his reputation had grown to the extent that an agent offered to market his pictures.

Caravaggio painted for a small circle of sophisticated Roman patrons. His subjects from this early period include still lifes and low-life scenes featuring fortune-tellers, cardsharps, and street urchins dressed as musicians or mythological figures like Bacchus. The figures in these pictures tend to be large, brightly lit, and set close to the picture plane. His important innovation was the decision to paint directly on the canvas. He

sketched out the figure with a sharp point—perhaps the end of his brush—and the marks can be seen through the paint. in *Bacchus*, Caravaggio painted what he saw: a slightly flabby, undressed youth. The parts of the skin that have been exposed to sun (hands and face) are darker in color than the rest of the body. His half-closed, slightly unfocused eyes look past the viewer even as he offers a glass filled with wine. Caravaggio's skill as a still-life painter is apparent in the bowl of half-rotten fruit and the decanter of wine on the table. Caravaggio's youth may appear to be simply a street tough masquerading as Bacchus, the classical god of wine; however, the painting may also have been meant as an allegory of the sins of lust and gluttony.

Most of Caravaggio's commissions after 1600 were religious, and reactions to them were mixed. On occasion, patrons rejected his powerful, sometimes brutal, naturalism as unsuitable to the subject's dignity. Critics differed as well. An early critic, the Spaniard Vincente Carducho, wrote in his Dialogue on Painting (Madrid, 1633) that Caravaggio was an "omen of the ruin and demise of painting" because he painted "with nothing but nature before him, which he simply copied in his amazing way" (Enggass and Brown, pages 173–74). Others recognized him as a great innovator who reintroduced realism into art and developed new, dramatic lighting effects. The art historian Giovanni Bellori, in his *Lives of the Painters* (1672), described Caravaggio's painting as

... reinforced throughout with bold shadows and a great deal of black to give relief to the forms. He went so far in this manner of working that he never brought his figures out into the daylight, but placed them in the dark brown atmosphere of a closed room, using a high light that descended vertically over the principal parts of the bodies while leaving the remainder in shadow in order to give force through a strong contrast of light and dark....

(Bellori, Lives of the Painters, Rome, 1672, in Enggass and Brown, page 79.)

Caravaggio's approach has been likened to the preaching of Filippo Neri (1515-95), the Counter-Reformation priest and mystic who founded a Roman religious group called the Congregation of the Oratory. Neri, called the Apostle of Rome and later canonized, focused his missionary efforts on ordinary people for whom he strove to make Christian history and doctrine understandable and meaningful. Caravaggio, too, interpreted his religious subjects directly and dramatically, combining intensely observed figures, poses, and expressions with strongly contrasting effects of light and color. His knowledge of Lombard painting, where the influence of Leonardo was strong, must have aided him in his development of the technique now known as tenebrism, in which forms emerge from a dark background into a strong light that often falls from a single source outside the painting. The effect is that of a modern spotlight.

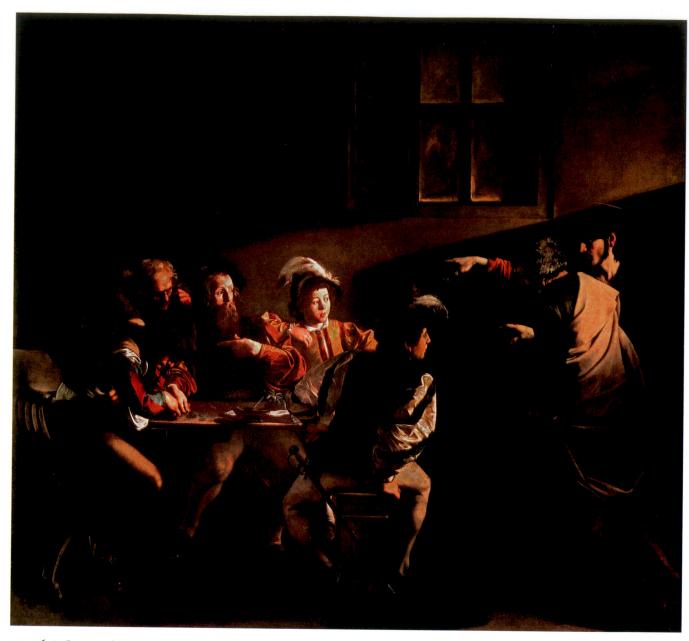

Caravaggio's first public commission, paintings for the Contarelli Chapel in the French community's Church of Saint Louis (Church of San Luigi dei Francesi), included **THE CALLING OF SAINT MATTHEW** (FIG. 22–16), painted about 1599–1600 and meant to suggest conversion, one of the tasks of the Church. The work is painted in oils. (Caravaggio had a very short apprenticeship and never seemed to have mastered the technique of fresco—nor, perhaps, skill in painting figures in depth.) The painting depicts Jesus calling Levi, the tax collector, to join his apostles (Mark 2:14). Levi sits at a table, counting out gold coins for a boy at the left, surrounded by overdressed young men in plumed hats, velvet doublets, and satin shirts. Nearly hidden behind the cloaked apostle Peter, at the right, the gaunt-

faced Jesus points dramatically at Levi, a gesture that is repeated by the tax collector's surprised response of pointing to himself. An intense raking light enters the painting from a high, unseen source at the right, above the altar, and spotlights the faces of the men. The viewpoint of the chapel visitor is the empty space across from Saint Matthew, so that she or he directly participates in the dramatic moment of conversion. For all of his realism and claims of independence, Caravaggio also used antique and Renaissance sources. Jesus's outstretched arm, for example, recalls God's gesture giving life to Adam in Michelangelo's Creation of Adam on the Sistine Chapel ceiling (SEE FIG. 20–14). It is now restated as Jesus's command to Levi to begin a new life by becoming his disciple Matthew.

The emotional power of Baroque realism combines with a solemn monumentality in Caravaggio's ENTOMBMENT (FIG. 22-17), painted in 1603-4 for a chapel in Santa Maria in Vallicella, the church of Neri's Congregation of the Oratory. With almost physical force, the size and immediacy of this painting strike the viewer, whose perspective is from within the burial pit into which Jesus's lifeless body is being lowered. The figures form a large off-center triangle, within which angular elements are repeated: the projecting edge of the stone slab; Jesus's bent legs; the akimbo arm, bunched coat, and knock-kneed stance of the man on the right; and even the spaces between the spread fingers of the raised hands. The Virgin and Mary Magdalen barely intrude on the scene, which, through the careful placing of the light, focuses on the dead Jesus, the sturdy-legged laborer supporting his body at the right, and the young John the Evangelist at the triangle's apex.

Despite the great esteem in which Caravaggio was held by some, especially the younger generation of artists, his violent temper repeatedly got him into trouble. During the last decade of his life, he was frequently arrested, generally for minor offenses such as street brawling. In 1606, however, he killed a man in a fight over a tennis match and had to flee Rome. He went first to Naples, then to Malta, finding work in both places. The Knights of Malta awarded him the cross of their religious and military order in July 1608, but in October he was imprisoned for insulting one of their number, and again he escaped and fled. The aggrieved knight's agents tracked him to Naples in the spring of 1610 and severely wounded him. The artist recovered and moved north to Port'Ercole, where he died of a fever on July 18, 1610, just short of his thirty-ninth birthday. Caravaggio's intense realism and tenebrist lighting influenced nearly every important European artist of the seventeenth century.

GENTILESCHI. One of Caravaggio's most successful Italian followers was Artemisia Gentileschi (1593-c. 1652/53), whose international reputation helped spread the Caravaggesque style beyond Rome. Born in Rome, Artemisia first studied and worked under her father, one of the early followers of Caravaggio. In 1616, she moved to Florence, where she worked for the grand duke of Tuscany and was elected, at the age of twenty-three, to the Florentine Academy of Design. As a resident of Florence, Artemisia was well aware of the city's identification with the Jewish hero David and heroine Judith (both subjects of sculpture by Donatello and Michelangelo), and she painted several versions of Judith triumphant over the Assyrian general Holofernes (FIG. 22-18). Artemisia brilliantly uses Baroque naturalism and tenebrist effects, dramatically showing Judith still holding the bloody sword and hiding the candle's light as her maid stuffs the general's head into a sack. Tension mounts-enhanced by the dramatic use of light—as the women listen for the sounds of guards.

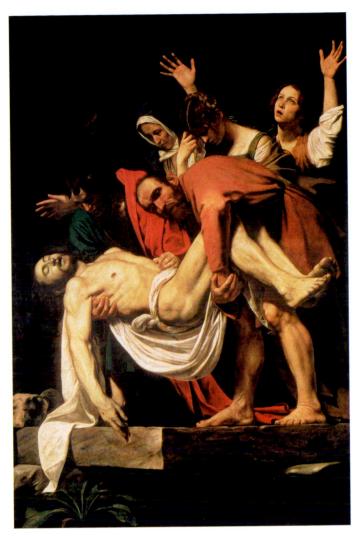

22–17 | Caravaggio ENTOMBMENT Vittrici Chapel, Church of Santa Maria in Vallicella, Rome. 1603–4. Oil on canvas, $9'10\%'' \times 6'7\%'' (3 \times 2.03 \text{ m})$. Musei Vaticani, Pinacoteca, Rome.

The Entombment was one of many paintings confiscated from Rome's churches and taken to Paris during the French occupation by Napoleon's troops in 1798 and 1808–14. It was one of the few to be returned after 1815 through the negotiations of Pius VII and his agents, who were assisted greatly by the Neoclassical sculptor Antonio Canova, a favorite of Napoleon. The decision was made not to return the works to their original churches and chapels but instead to assemble them in a gallery where the general public could enjoy them. Today, Caravaggio's painting is one of the most important in the collections of the Vatican Museums.

Religious subjects have dominated Western art since the medieval period. Beginning in the Renaissance, however, themes drawn from mythology, literature, daily life, and folklore began to play a significant role. Starting with Mannerism, and continuing into the Baroque period, artists and patrons delighted in iconography that was often complex and extremely subtle. A sourcebook, the *Iconologia*, by Cesare Ripa (1593), became an essential tool for creating and deciphering

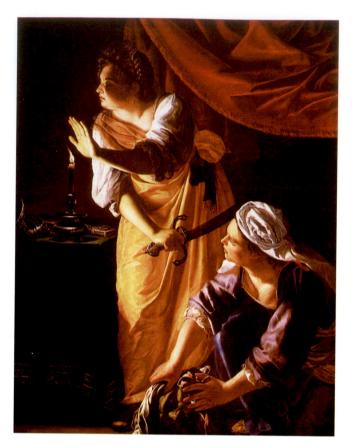

22–18 | Artemisia Gentileschi JUDITH AND MAIDSERVANT WITH THE HEAD OF HOLOFERNES 1625. Oil on canvas, $6'7_2'' \times 4'7''$ (1.84 \times 1.41 m). The Detroit Institute of Arts. Gift of Leslie H. Green, (52.253)

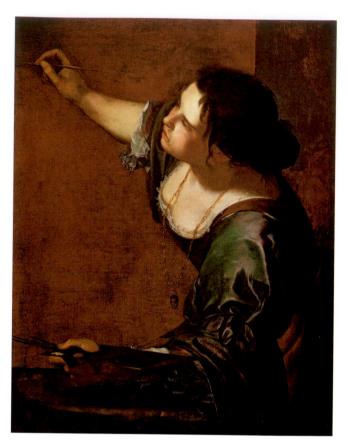

22–19 | Artemisia Gentileschi SELF-PORTRAIT AS THE ALLEGORY OF PAINTING 1630. Oil on canvas, $38 \times 29''$ (96.5 \times 73.7 cm). The Royal Collection, Windsor Castle, England. (RCIN 405551, ML 49 BP 2652)

seventeenth- and eighteenth-century art. Painters and patrons turned to it when they needed detailed instruction or new ways to present a subject or person. Artemisia Gentileschi was no exception. In 1630, she painted self-PORTRAIT AS THE THE ALLEGORY OF PAINTING (FIG. 22–19), personified by a richly dressed woman with palette and brushes. The Iconologia's influence is revealed in the woman's gold necklace with its mask pendant. Ripa writes that the mask imitates the human face, as painting imitates nature, and the gold chain symbolizes "the continuity and interlocking nature of painting, each man learning from his master and continuing his master's achievements in the next generation" (cited in E. Maser, trans. no. 197). Artemisia may have painted her own features as the personification of painting, in which case she not only commemorates her profession but also pays tribute to those who came before.

FOLLOWERS OF THE CARRACCI. The Carracci had many Italian followers and students. Baroque classicism was preferred by patrons and artists for the altarpieces and murals required by the many new churches being built in Rome.

Giovanni Francesco Barbieri (1591-1666), called "Il Guercino" ("The Little Squinter"), responded to developments in classicism, and perhaps also to the work of Ludovico Carracci, during a brief sojourn in Rome in 1621-23. In Guercino's painting of Saint Luke Displaying a Painting of the Virgin (Introduction, Fig. 15) for the high altar of the Franciscan church in Reggio nell'Emilia, near Bologna, his palette has evolved from the pronounced chiaroscuro of his early work to the lighter colors of artists like Guido Reni (SEE FIG. 22-20). In keeping with the desire for greater naturalism and contemporary relevance in religious art, Luke turns to the viewer as if in the middle of a discussion about his painting of the Virgin and Child, a copy of a Byzantine icon believed by the Bolognese to have been painted by Luke himself. Although Protestants ridiculed the idea that paintings by Luke existed, Catholics staunchly defended their authenticity. Guercino's painting, then, is both an homage to the patron saint of painters and a defense of the miracle-working Madonna di San Luca in his hometown. The classical architecture and idealized figures typify Bolognese academic art.

The most important Italian Baroque classicist after Annibale Carracci was the Bolognese artist Guido Reni (1575-1642), who briefly studied at the Carracci academy in 1595. By 1620, Guido Reni had become the most popular painter in Italy.

In 1613-14, during a sojourn in Rome, Reni decorated the ceiling of a palace garden house (casino in Italian) in Rome with his most famous work, AURORA (FIG. 22-20). The fresco emulates the illusionistic mythological scenes in quadro riportato on the Farnese ceiling, although Reni made no effort to relate his painting's space to that of the room. Indeed, Aurora appears to be a framed oil painting incongruously attached to the ceiling. The composition itself, however, is Baroque classicism at its most lyrical. Framed by self-emanating golden light, Apollo, escorted by Cupid and the Seasons, drives the sun chariot. Ahead, the flying figure of Aurora, goddess of the dawn, leads Apollo's horses at a sharp diagonal over a dramatic Venetian sky. The measured, processional staging and idealized forms seem to have been derived from an antique relief, and the precise drawing owes much to Annibale Carracci and academic training. But the graceful figures, the harmonious rhythms of gesture and drapery, and the intense color are Reni's own, demonstrating his close study of models and his skillful combination of the real and ideal.

BAROOUE CEILINGS: CORTONA AND GAULLI. Theatricality, intricacy, and the opening of space reached an apogee in Baroque ceiling decoration. Baroque ceiling projects were complex constructions combining architecture, painting, and stucco sculpture. These grand illusionistic projects were carried out on the domes and vaults of churches, civic buildings, palaces, and villas, and went far beyond even Michelangelo's Sistine Chapel ceiling (SEE FIG. 20-12) or Correggio's dome (SEE FIG. 20-21). In addition to using the device of the quadro riportato, Baroque ceiling painters were also concerned with achieving the drama of an immeasurable heaven that extended into vertiginous zones far beyond the limits of High Renaissance taste. To achieve this, they employed the system of quadratura (literally, "squaring" or "gridwork"): an architectural setting painted in meticulous perspective and usually requiring that it be viewed from a specific spot to achieve the effect of soaring space. The resulting viewpoint is called di sotto in su ("from below to above"), which we first saw, in a limited fashion, in Mantegna's ceiling (FIG. 19-34). Because it required such careful calculation, figure painters usually had specialists in quadratura paint the architectural frame for them.

Pietro Berrettini (1596-1669), called "Pietro da Cortona" after his hometown, carried the development of the Baroque ceiling away from classicism into a more strongly unified and illusionistic direction. Trained in Florence and inspired by Veronese's ceiling in the doge's palace, which he saw on a trip to Venice in 1637, the artist was commissioned in the early 1630s by the Barberini family of Pope Urban VIII to decorate the ceiling of the audience hall of their Roman palace. A drawing by a Flemish artist visiting Rome, Lieven Cruyl (1640-c. 1720), gives us a view of the Barberini's huge palace, piazza, and the surrounding city. Bernini's Trident Fountain stands in the center of the piazza, and his scallop shell fountain can be seen at the right (FIG. 22-21).

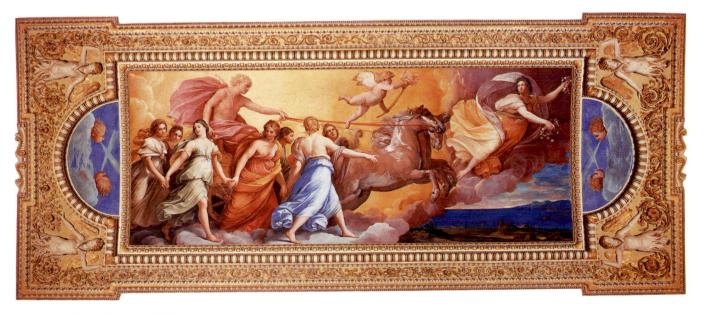

22-20 Guido Reni AURORA Ceiling of the Garden House, Palazzo Rospigliosi-Palavacini, Rome. 1613-14. Fresco.

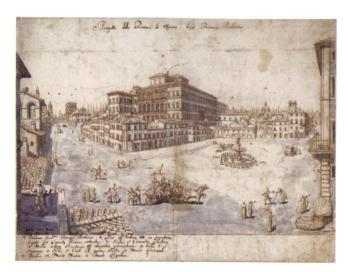

22–2I | BARBERINI PALACE AND SQUARE 1628–36. Drawing by Lieven Cruyl, 1665. Ink and chalk on paper, $15\times19\%''$ (38.2 \times 49.4 cm). The Cleveland Museum of Art, Cleveland, Ohio. Dudley P. Allen Fund 1943.265.

Maderno, Bernini, and Borromini collaborated on the Barberini Palace between 1628 and 1636, and in the 1670s the structure underwent considerable remodeling. The original plan is unique, having no precedents or imitators in the history of Roman palaces. The structure appears as a single massive pile, but in fact it consists of a central reception block flanked by two residential wings and two magnificent staircases. Designed to house two sides of the family, the rooms are arranged in suites allowing visitors to move through them achieving increasing intimacy and privacy. Since Cruyl visited the city during Carnival, a Carnival float with musicians and actors takes center stage among the strollers. The Carnival floats are among the ephemera of art. (Today we might call them "performance art.") Cruyl, who includes his own image at the left, published his drawings as engravings, a set of fifteen plates called *Views of Rome*, in 1665.

Pietro's great fresco, **THE GLORIFICATION OF THE PAPACY OF URBAN VIII**, became a model for a succession of Baroque illusionistic palace ceilings throughout Europe (FIG. 22–22). Cortona structured his mythological scenes around a vault-like skeleton of architecture, painted in *quadratura* that appears to be attached to the actual cornice of the room. But in contrast to Annibale Carracci's neat separations and careful *quadro riportato* framing, Pietro's figures weave in and out of their setting in active and complex profusion; some rest on the actual cornice, while others float weightlessly against the sky. Instead of Annibale's warm, nearly even light, Pietro's dramatic illumination, with its bursts of brilliance alternating with deep shadows, fuses the ceiling into a dense but unified whole.

The subject is an elaborate allegory of the virtues of the pope. Just below the center of the vault, seated at the top of a pyramid of clouds and figures personifying Time and the Fates, Divine Providence (in gold against an open sky) gestures toward three giant bees surrounded by a huge laurel wreath (both Barberini emblems) carried by Faith, Hope, and Charity. Immortality offers a crown of stars, while other figures present the crossed keys and the triple-tiered crown of the papacy. Around these figures are scenes of Roman gods and goddesses, who demonstrate the pope's wisdom and virtue by triumphing over the vices. So complex was the imagery that a guide gave visitors an explanation, and one member of the household published a pamphlet, still in use today, explaining the painting.

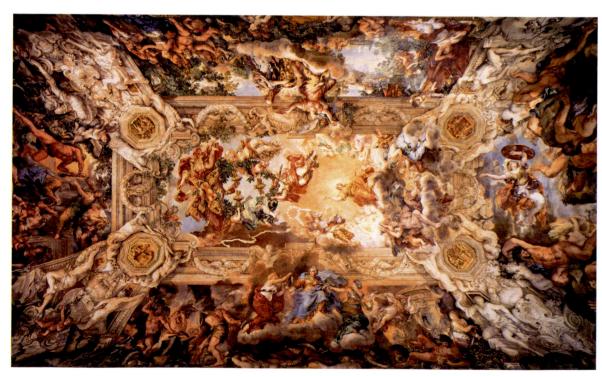

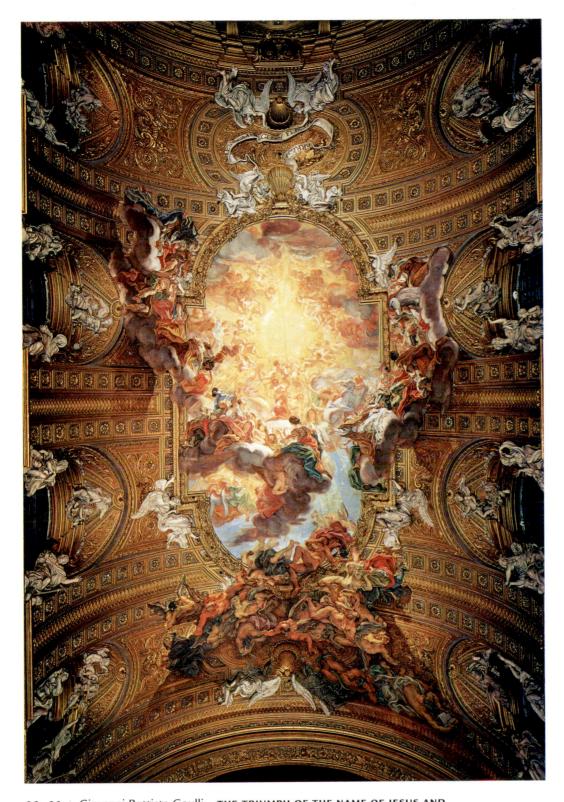

The most spectacular of all, and the ultimate illusionistic Baroque ceiling, is Gaulli's **THE TRIUMPH OF THE NAME OF JESUS AND THE FALL OF THE DAMNED** (FIG. 22–23), which fills the vault of the Jesuit church Il Gesù. In the 1560s, Giacomo da Vignola had designed an austere interior for Il Gesù,

but when the Jesuits renovated their church a century later, they commissioned a religious allegory to cover the nave's plain ceiling. Giovanni Battista Gaulli (1639–1709) designed and executed the spectacular illusion between 1672 and 1685, fusing sculpture and painting to eliminate any appearance of

architectural division. It is impossible to understand which figures are three-dimensional and which are painted, and some paintings are on real panels that extend over the actual architectural frame. Gaulli, who arrived in Rome from Genoa in 1657, had worked in his youth for Bernini, from whom he absorbed a taste for drama and for multimedia effects. The elderly Bernini, who worshiped daily at Il Gesù, may well have offered his personal advice to his former assistant, and Gaulli was certainly familiar with other illusionistic paintings in Rome as well, including Pietro da Cortona's Barberini ceiling.

Gaulli's astonishing creation went beyond anything that had preceded it in unifying architecture, sculpture, and painting. Every element is dedicated to creating the illusion that clouds and angels have floated down through an opening in the church's vault into the upper reaches of the nave. The extremely foreshortened figures are projected as if seen from below, and the whole composition is focused off-center on the golden aura around the letters *IHS*, the monogram of Jesus and the insignia of the Jesuits. The subject is, in fact, a Last Judgment, with the elect rising joyfully toward the name of God and the damned plummeting through the ceiling toward the nave floor. The sweeping inclusion in the work of the space of the nave, the powerful and exciting appeal to the viewer's emotions, and the nearly total unity of visual effect have never been surpassed.

THE HABSBURG LANDS

When the Holy Roman Emperor Charles V abdicated in 1556 (see Chapter 21), he left Spain and its American colonies, the Netherlands, Burgundy, Milan, and the Kingdom of Naples and Sicily to his son Philip II and the Holy Roman Empire (Germany and Austria) to his brother Ferdinand. Ferdinand and the Habsburg emperors who succeeded him ruled their territories from Vienna in Austria, but much of German-speaking Europe remained divided into small units in which local rulers decided on the religion of their territory. Catholicism prevailed in southern and western Germany and in Austria, while the north was Lutheran.

The Spanish Habsburg kings Philip III (ruled 1598–1621), Philip IV (ruled 1621–65), and Charles II (ruled 1665–1700) reigned over a weakening empire. After repeated local rebellions, Portugal reestablished its independence in 1640. The Kingdom of Naples remained in a constant state of unrest. After eighty years of war, the Protestant northern Netherlands—which had formed the United Dutch Republic—gained independence in 1648. Amsterdam grew into one of the wealthiest cities of Europe, and the Dutch Republic became an increasingly serious threat to Spanish trade and colonial possessions. The Catholic southern Netherlands (Flanders), discussed separately below, remained under Spanish and then Austrian Habsburg rule.

What had seemed an endless flow of gold and silver from the Americas to Spain diminished, as precious-metal production in Bolivia and Mexico lessened. Agriculture, industry, and trade at home also suffered. As they tried to defend the Roman Catholic Church and their empire on all fronts, the Spanish kings squandered their resources and finally went bankrupt in 1692. Nevertheless, despite the decline of the Habsburgs' Spanish empire, seventeenth-century writers and artists produced much of what is considered the greatest Spanish literature and art, and the century is often called the Spanish Golden Age.

Painting in Spain's Golden Age

The primary influence on Spanish painting in the fifteenth century had been the art of Flanders; in the sixteenth, it had been the art of Florence and Rome. Seventeenth-century Spanish painting, profoundly influenced by Caravaggio's powerful art, was characterized by an ecstatic religiosity combined with intense realism whose surface details emerge from the deep shadows of tenebrism. This influence is not surprising, since the Kingdom of Naples was ruled by Spanish monarchs, and contact between Naples and the Iberian peninsula was strong and productive.

JUAN SÁNCHEZ COTÁN. Late in the sixteenth century, Spanish artists developed a significant interest in paintings of artfully arranged objects rendered with intense attention to detail. Juan Sánchez Cotán (1561–1627) was one of the earliest painters of these pure still lifes in Spain. In **STILL LIFE WITH**

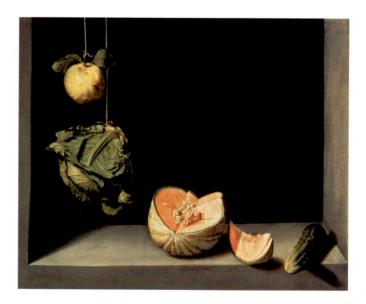

22–24 | Juan Sánchez Cotán STILL LIFE WITH QUINCE, CABBAGE, MELON, AND CUCUMBER c. 1602. Oil on canvas, $27\% \times 33\%$ (68.8 \times 84.4 cm). San Diego Museum of Art. Gift of Anne R. and Amy Putnam

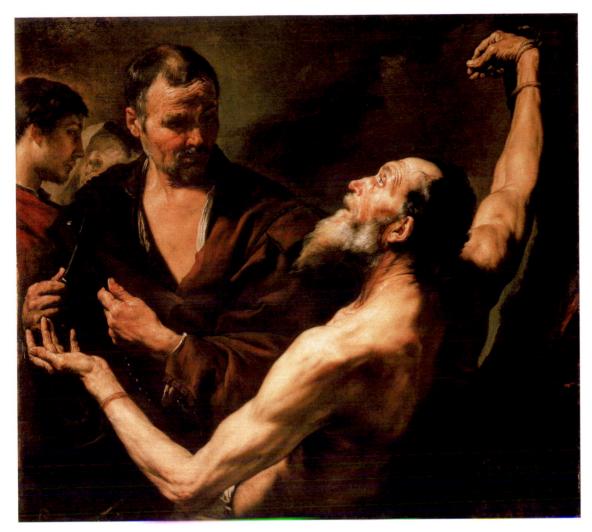

22–25 | Jusepe de Ribera MARTYRDOM OF SAINT BARTHOLOMEW 1634. Oil on canvas, $41\% \times 44\%$ (1.05 \times 1.14 m). National Gallery of Art, Washington, D.C. Gift of the 50th Anniversary Gift Committee (1990.137.1)

QUINCE, CABBAGE, MELON, AND CUCUMBER (FIG. 22–24), of about 1602, he plays off the irregular, curved shapes of the fruits and vegetables against the angular geometry of the ledge. His precisely ordered subjects—two of which are suspended from strings—form a long arc from the upper left to the lower right. It is not clear whether the seemingly airless space is a wall niche or a window ledge or why these objects have been arranged in this way. Set in a strong light against impenetrable darkness, this highly artificial arrangement portrayed in an intensely realistic manner suggests not only a fascination with spatial ambiguity but a contemplative sensibility and interest in the qualities of objects that look forward to the work of Zurbarán and Velázquez.

JUSEPE DE RIBERA. José or Jusepe de Ribera (c. 1591–1652), born in Seville but living in Naples, has been claimed by both Spain and Italy; however, Naples was ruled by Spain, and in Italy he was known as "Lo Spagnoletto" ("the Little Spaniard"). He combined the classical and Caravaggesque styles he had learned in Rome, and after settling in Naples in 1620, he created a new Neapolitan—and eventually Spanish—style. Ribera became the link extending from Caravaggio in Italy to the Spanish masters Zurbarán and Velázquez. Ribera was once thought to epitomize Spanish religiosity.

Scenes of martyrdom became popular as the church—aiming to draw people back to Catholicism—ordered art depicting heroic martyrs who had endured shocking torments as witness to their faith. Others, like Saint Teresa (SEE FIG. 22–6), reinforced the importance of personal religious experience and intuitive knowledge. A striking response to this call for relevance and passion is Ribera's painting of Saint Bartholomew, an apostle who was martyred by being skinned alive (FIG. 22–25). The bound Bartholomew looks heavenward as his executioner tests the knife that he will soon use on his still-living victim. Ribera has learned the lessons of Caravaggio well, as he highlights the intensely realistic aged

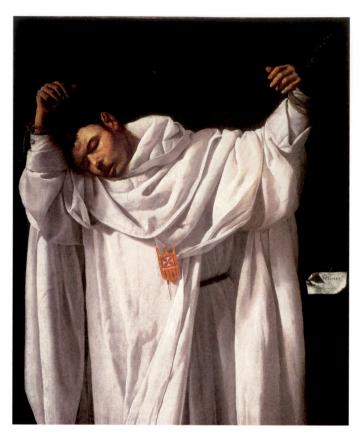

22–26 | Francisco de Zurbarán SAINT SERAPION 1628. Oil on canvas, $47\frac{1}{2} \times 40\frac{1}{4}$ " (120.7 \times 103.5 cm). Wadsworth Atheneum, Hartford, Connecticut. Ella Gallup Sumner and Mary Catlin Sumner Collection Fund

faces with the dramatic light of tenebrism and depicts the aging wrinkled flesh with almost painful naturalism. The compression of the figures into the foreground space heightens their immediacy and horror.

FRANCISCO DE ZURBARÁN. Equally horrifying in its depiction of martyrdom, but represented with understated control, is the 1628 painting of **SAINT SERAPION** (FIG. 22–26) by Francisco de Zurbarán (1598–1664). Little is known of his early years before 1625, but Zurbarán too came under the influence of the Caravaggesque taste prevalent in Seville, the major city in southwestern Spain. His own distinctive style incorporated a taste for abstract design, which some critics see as part of the heritage of centuries of Islamic Moorish occupation.

Zurbarán executed his major commissions for the monastic orders. In the painting shown here, he portrays the martyrdom of Serapion, who was a member of the thirteenth-century Mercedarians, a Spanish order founded to rescue the Christian prisoners of the Moors. Following the vows of his order, Serapion sacrificed himself in exchange for Christian captives. The dead man's pallor, his rough hands,

and the coarse ropes contrast with the off-white of his creased Mercedarian habit, its folds carefully arranged in a pattern of highlights and varying depths of shadow. The only colors are the red and gold of the insignia. This composition, almost timeless in its immobility, is like a tragic still life, a study of fabric and flesh.

DIEGO VELÁZQUEZ. Diego Rodríguez de Silva y Velázquez (1599-1660), the greatest painter to emerge from the Caravaggesque school of Seville, shared this fascination with objects. Velázquez entered Seville's painters' guild in 1617. Like Ribera, he began his career as a tenebrist and naturalist. During his early years, he painted figural works set in taverns, markets, and kitchens and emphasized still lifes of various foods and kitchen utensils. His early water carrier of SEVILLE (FIG. 22-27) is a study of surfaces and textures of the splendid ceramic pots that characterized folk art through the centuries. Velázquez was devoted to studying and sketching from life, and the man in the painting was a well-known Sevillian water seller. Like Sánchez Cotán, Velázquez arranged the elements of his paintings with almost mathematical rigor. The objects and figures allow the artist to exhibit his virtuosity in rendering sculptural volumes and contrasting textures illuminated by dramatic natural light. Light reacts to the surfaces: reflecting off the glazed waterpot at the left and the coarser clay jug in the foreground; being absorbed by the rough wool and dense velvet of the costumes; and reflecting, being refracted, and passing through the clear glass held by the man and through the waterdrops on the jug's surface.

In 1623, Velázquez moved to Madrid, where he became court painter to young King Philip IV, a prestigious position that he held until his death in 1660. The opportunity to study paintings in the royal collection, as well as to travel, enabled the development of his distinctive personal style. The Flemish painter Peter Paul Rubens (see pages 774–777), during a 1628–29 diplomatic visit to the Spanish court, convinced the king that Velázquez should visit Italy. Velázquez made two trips, the first in 1629–31 and a second in 1649–51. He was profoundly influenced by contemporary Italian painting, and on the first trip seems to have taken a special interest in narrative paintings with complex figure compositions.

Velázquez's Italian studies and his growing skill in composition are apparent in both figure and landscape painting. In **THE SURRENDER AT BREDA** (FIG. 22–28), painted in 1634–35,Velázquez treats the theme of triumph and conquest in an entirely new way—far removed from traditional gloating military propaganda. Years earlier, in 1625, the duke of Alba, the Spanish governor, had defeated the Dutch at Breda. In Velázquez's imagination, the opposing armies stand on a hilltop overlooking a vast valley where the city of Breda burns and soldiers are still deployed. The Dutch commander, Justin of Nassau, hands over the keys of Breda to the

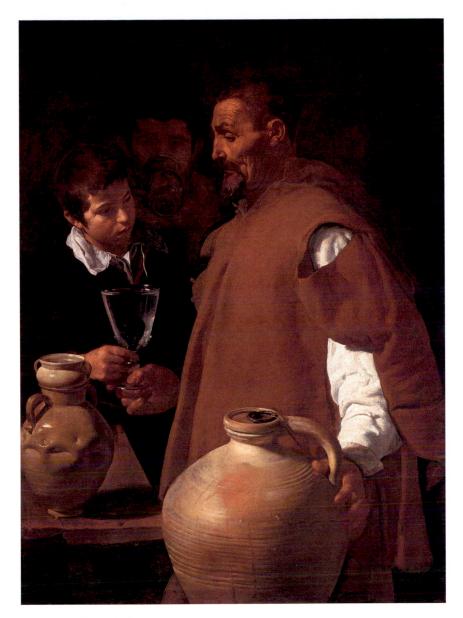

In the hot climate of Seville, Spain, where this painting was made, water vendors walked the streets selling cool drinks from large clay jars like the one in the foreground. In this scene, the clarity and purity of the water are proudly attested to by its seller, who offers the customer a sample poured into a glass goblet. The jug contents were usually flavored with the addition of a piece of fresh fruit or a sprinkle of aromatic herbs.

victorious Spanish commander, Ambrosio Spinola, the duke of Alba. The entire exchange seems extraordinarily gracious; the painting represents a courtly ideal of gentlemanly conduct. The victors stand at attention, holding their densely packed lances upright in a vertical pattern—giving the painting its popular name, "The Lances"—while the defeated Dutch, a motley group, stand out of order, with pikes and banners drooping. The painting is memorable as a work of

art, not as history. According to reports, no keys were involved and the Dutch were more presentable in appearance than the Spaniards. The victory was short-lived: The Dutch retook Breda in 1637.

In *The Surrender at Breda*, Velázquez displays his ability to arrange a large number of figures to tell a story effectively. A strong diagonal starting in the sword of the Dutch soldier in the lower left foreground and ending in the checked banner

on the upper right unites the composition and moves the viewer thematically from the defeated to the victorious soldiers. Portraitlike faces, meaningful gestures, and brilliant control of color and texture convince us of the reality of the scene. The landscape painting is almost startling. Across the huge canvas, Velázquez painted an entirely imaginary Netherlands in greens and blues worked with flowing, liquid brushstrokes. Luminosity is achieved by laying down a thick layer of lead white and then flowing the layers of color over it. The silvery light forms a background for dramatically silhouetted figures and weapons. Velázquez revealed a breadth and intensity unsurpassed in his century; his painting has inspired modern artists such as Manet and Picasso.

Although complex compositions became characteristic of many of Velázquez's paintings, perhaps his most striking and enigmatic work is the enormous multiple portrait, nearly 10½ feet tall and over 9 feet wide, known as LAS MENINAS (THE MAIDS OF HONOR) (FIG. 22–29). Painted in 1656, near the end of the artist's life, this painting continues to challenge the viewer and stimulate debate. Like Caravaggio's *Entombment* (SEE FIG. 22–17), it draws the viewer directly into its action, for in one interpretation, the viewer is apparently standing in the space occupied by King Philip and the queen, whose reflections can be seen in the large mirror on the back

wall. (Others say the mirror reflects the canvas on which Velázquez is working.) The central focus, however, is not on the royal couple or on the artist but on the 5-year-old *infanta* (princess) Margarita, who is surrounded by her attendants, most of whom are identifiable portraits.

The cleaning of *Las Meninas* in 1984 revealed much about Velázquez's methods. He used a minimum of underdrawing, building up his forms with layers of loosely applied paint and finishing off the surfaces with dashing highlights in white, lemon yellow, and pale orange. Velázquez tried to depict the optical properties of light rather than using it to model volumes in the classical time-honored manner. While his technique captures the appearance of light on surfaces, at close inspection his forms dissolve into a maze of individual strokes of paint.

No consensus exists today on the meaning of this monumental painting. Yes, it is a royal portrait; it is also a self-portrait of Velázquez standing at his easel. But more than that, Las Meninas seems to have been a personal statement. Throughout his life, Velázquez had sought respect and acclaim for himself and for the art of painting. Here, dressed as a courtier, the Order of Santiago on his chest (added later) and the keys of the palace in his sash, Velázquez proclaimed the dignity and importance of painting as one of the liberal arts.

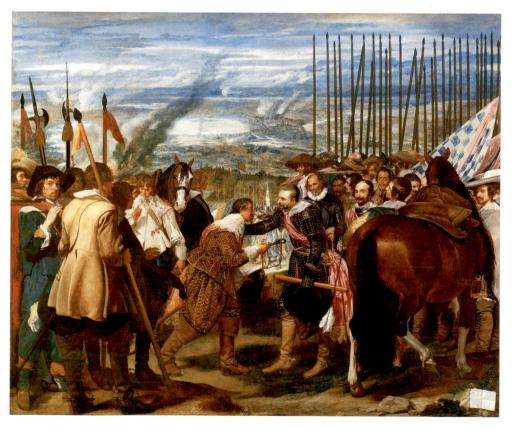

22–28 | Diego Velázquez | THE SURRENDER AT BREDA (THE LANCES) 1634–35. Oil on canvas, $10'\%'' \times 12'\%''$ (3.07 × 3.67 m). Museo del Prado, Madrid.

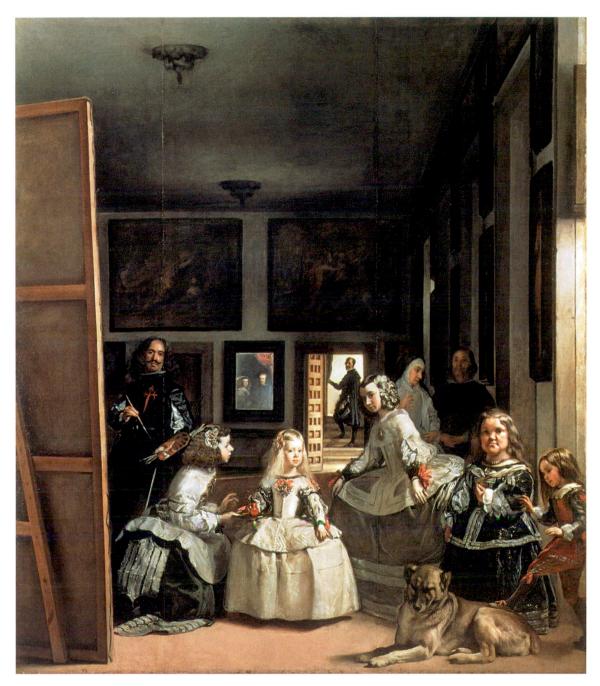

22–29 | Diego Velázquez LAS MENINAS (THE MAIDS OF HONOR) 1656. Oil on canvas, $10'5'' \times 9''2''$ (3.18 \times 2.76 m). Museo del Prado, Madrid.

BARTOLOMÉ ESTEBAN MURILLO. The Madrid of Velázquez was the center of Spanish art; Seville declined after an outbreak of plague in 1649. Still living and working in Seville, however, was Bartolomé Esteban Murillo (1617–82). Seville was a center for trade with the Spanish colonies, where Murillo's work had a profound influence on art and religious iconography. Many patrons wanted images of the Virgin Mary and especially of the Immaculate Conception, the controversial idea that Mary was born free from original sin. Although the Immaculate Conception became Catholic dogma only in

1854, the concept, as well as devotion to Mary, was widespread during the seventeenth and eighteenth centuries.

Counter-Reformation authorities provided specific instructions for artists painting the Virgin: Mary was to be dressed in blue and white, her hands folded in prayer, as she is carried upward by angels, sometimes in large flocks. She may be surrounded by an unearthly light ("clothed in the sun") and may stand on a crescent moon in reference to the woman of the apocalypse. Angels often carry palms and symbols of the Virgin, such as a mirror, a fountain, roses, and lilies, and

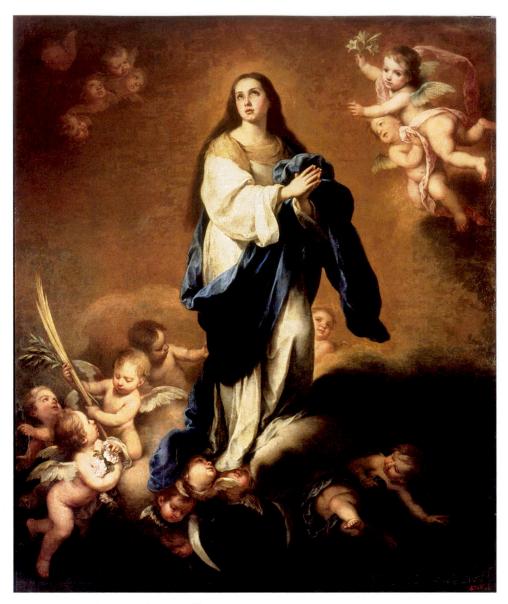

c. 1645-50. Oil on canvas, $7'8'' \times 6'5''$ (2.35 \times 1.96 m). State Hermitage Museum, St. Petersburg, Russia.

they may vanquish the serpent, Satan. Today, Murillo's paintings are admired for his skill as a draftsman and colorist. His version of ideal beauty—in Mary, Jesus, or the cherubs that surround Mary-is never cloying. The Church exported many paintings by Murillo, Zurbarán, and others to the New World. When the native population began to visualize the Christian story, paintings such as Murillo's THE IMMACULATE **CONCEPTION** provided the imagery (FIG. 22-30).

Architecture in Spain and Austria

THE CATHEDRAL OF SANTIAGO DE COMPOSTELA. Turning away from the severity displayed in the sixteenth-century El Escorial monastery-palace (SEE FIG. 21–19), Spanish architects again embraced the lavish decoration that had characterized their art since the fourteenth century. The profusion of ornament typical of Moorish and Gothic architecture in Spain swept back into fashion, first in huge retablos (altarpieces), then in portals (main doors often embellished with sculpture), and finally in entire buildings.

In the seventeenth century, the role of Saint James as patron saint of Spain was challenged by the supporters of Saint Teresa of Ávila and then by supporters of Saint Michael, Saint Joseph, and other popular saints. It became important to the archbishop and other leaders in Santiago de Compostela, where the Cathedral of Saint James was located, to establish their primacy. They reinforced their efforts to revitalize the yearly pilgrimage to the city, undertaken by Spaniards since the ninth century, and used architecture as part of their campaign.

Renewed interest in pilgrimages to the shrines of saints in the seventeenth century brought an influx of pilgrims, and consequently financial security, to the city and the church. The cathedral chapter ordered a façade of almost unparalleled splendor to be added to the twelfth-century pilgrimage church (FIG. 22–31). The twelfth-century portal had already been closed with doors in the sixteenth century and a staircase built that incorporated the western crypt. A south tower was built in 1667–80 and then later copied as the north tower.

The last man to serve as architect and director of works, Fernando Casas y Nóvoas (active 1711–49), tied the disparate elements together at the west—towers, portal, stairs—in a grand design focused on a veritable wall of glass, popularly called "The Mirror." His design culminates in a freestanding gable soaring above the roof, visually linking the towers, and framing a statue of Saint James. The extreme simplicity of the cloister walls and the archbishop's palace at each side of the portal heighten the dazzling effect of this enormous expanse of glass windows, glittering jewel-like in their intricately carved granite frame.

THE BENEDICTINE ABBEY, MELK. The arts suffered in seventeenth-century Germanic lands, including Austria, during and after the Protestant Reformation. Wars over religion ravaged the land. When peace finally returned in the eighteenth cen-

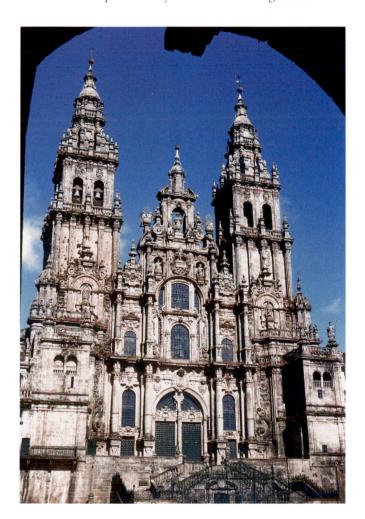

Sequencing Events Key Scientific and Mathematical Discoveries in the Seventeenth Century

1609, 1619	Johannes Kepler (Germany) publishes his three laws of planetary motion
1619	William Harvey (England) announces discovery of the circulation of the blood
1643	Evangelista Torricelli (Italy) invents barometer
1654	Blaise Pascal and Pierre de Fermat (France) develop the theory of probability
1675	Ole Romer (Denmark) establishes that light travels at a determined speed
1687	Isaac Newton (England) publishes his laws of gravity and motion

tury, Catholic Austria and Bavaria (southern Germany) saw a remarkable burst of building activity, including the creation and refurbishing of churches and palaces with exuberant interior decoration. Emperor Charles VI (ruled 1711–40) inspired building in his capital, Vienna, and throughout Austria.

22-31 WEST FAÇADE, CATHEDRAL OF SAINT JAMES, SANTIAGO DE COMPOSTELA, SPAIN.

South tower 1667-1680; north tower and central block finished mid-18th century by Fernando de Casas y Nóvoas.

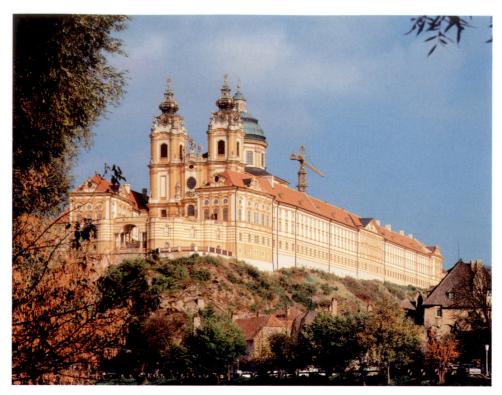

22–32 | Jakob Prandtauer | BENEDICTINE MONASTERY CHURCH, MELK Austria. 1702–36 and later.

Church architecture looked to Italian Baroque developments, which were then added to German medieval forms such as tall bell towers. With these elements, German Baroque architects gave their churches an especially strong vertical emphasis. One of the most imposing buildings of this period is the Benedictine Abbey of Melk, built high on a promontory overlooking the Danube River on a site where there had been a Benedictine monastery since the eleventh century. The complex combines church, monastery, library, and—true to the Benedictine tradition of hospitality—guest quarters that evolved into a splendid palace to house the traveling court (FIG. 22–32). The architect, Jakob Prandtauer (1660–1726), oversaw its construction from 1702 until his death in 1726. The buildings were finished in 1749.

Seen from the river, the monastery appears to be a huge twin-towered church, but it is in fact a complex of buildings. Two long (1,050 feet) parallel wings flank the church; one contains a great hall and the other, the monastery's library. The wings are joined by a curving building and terrace overlooking the river in front of the church. Large windows and open galleries take advantage of the river view. Colossal pilasters and high, bulbous-domed towers emphasize the building's verticality. Its grand and palacelike appearance is a reminder that the monastery was an ancient foundation enjoying imperial patronage.

Spectacular as it is, even the Danube River view does not prepare one for the interior of the church (FIG. 22–33). People descending the spiral staircase from the hall and

library emerge into an amazing yellow and pink confection. Every surface moves. Huge deep red pilasters support a massive undulating entablature. They establish the semblance of a wall behind which the chapels, galleries, and screens curve and disappear in a maze of gilded sculpture. Light from huge clerestory windows, reminiscent of ancient Roman architecture, enhance the effect of detachment. One cannot distinguish actual from fictive architecture. Figures seem to spill out over the architecture which—as in Gaulli's ceiling for Il Gesù (SEE FIG. 22–23)—sometimes is actually built and sometimes is fiction. Overhead white, gold, and pastel colors cause the frescoed vault to seem to float upward, detached from architecture below. The painting is the work of the first great Austrian Baroque muralist, Johann Michael Rottmayr (c. 1654–1750).

FLANDERS AND THE NETHERLANDS

After a period of relative autonomy from 1598 to 1621 under a Habsburg regent, Flanders, the southern—and predominantly Catholic—part of the Netherlands, returned to direct Spanish rule. Led by the nobleman Prince William of Orange, the Netherlands' Protestant northern provinces (present-day Holland) rebelled against Spain in 1568. The seven provinces joined together as the United Provinces in 1579 and began the long struggle for independence, achieved in the seventeenth century. The king of Spain considered the Dutch heretical rebels, but finally the Dutch prevailed. In

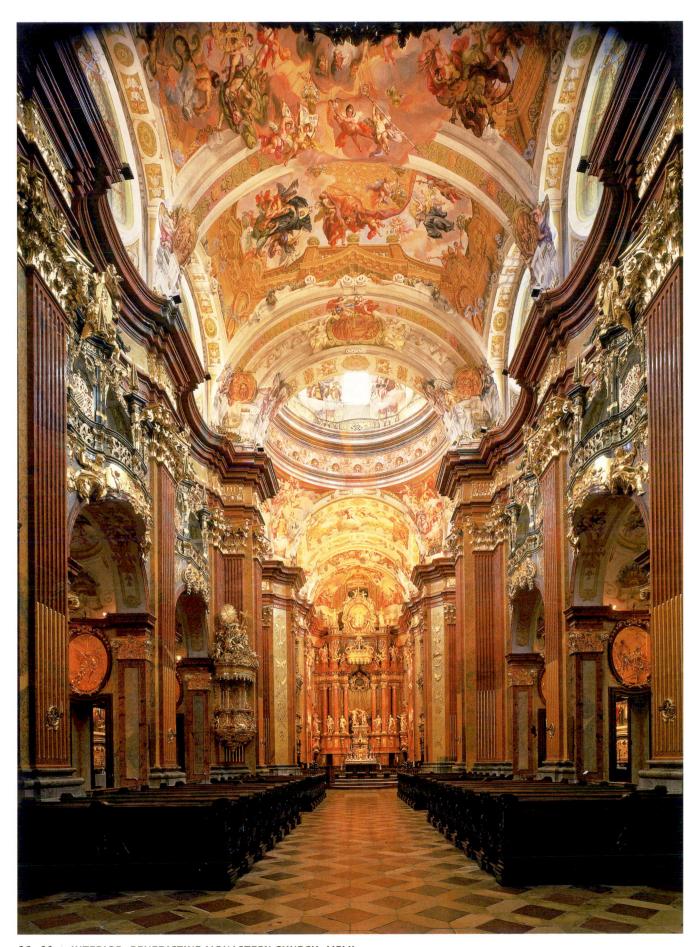

22–33 | INTERIOR, BENEDICTINE MONASTERY CHURCH, MELK Austria. Completed after 1738, after designs by Prandtauer, Antonio Beduzzi, and Joseph Munggenast.

1648, the United Provinces joined emissaries from Spain, the Vatican, the Holy Roman Empire, and France on equal footing in peace negotiations. The resulting Peace of Westphalia recognized the independence of the northern Netherlands.

Flanders

With the southern Netherlands remaining under Catholic Habsburg rule, churches were restored and important commissions went to religious subject matter. As Antwerp, the capital city and major arts center of the southern Netherlands, gradually recovered from the turmoil of the religious wars, artists of great talent flourished there. Painters like Peter Paul Rubens and Anthony Van Dyck established international reputations that brought them important commissions from foreign as well as local patrons.

RUBENS. Peter Paul Rubens (1577–1640), whose painting has become synonymous with Flemish Baroque art, was born in Germany, where his father, a Protestant, had fled from his native Antwerp to escape religious persecution. In 1587, after her husband's death, Rubens's mother and her children returned to Antwerp and to Catholicism. Rubens decided in his late teens to become an artist and at age twenty-one was accepted into the Antwerp painters' guild, a testament to his energy, intelligence, and skill. Shortly thereafter, in 1600,

Rubens left for Italy. In Venice, Rubens's work came to the attention of the duke of Mantua, who offered him a court post. His activities on behalf of the duke over the next eight years did much to prepare him for the rest of his long and successful career. Surprisingly, other than designs for court entertainments and occasional portraits, the duke never acquired an original painting by Rubens. Instead, he had him copy famous paintings in collections all over Italy to add to the ducal collection.

Rubens visited every major Italian city, went to Madrid as the duke's emissary, and spent two extended periods in Rome, where he studied the great works of Roman antiquity and the Italian Renaissance. While in Italy, Rubens studied the paintings of two contemporaries, Caravaggio and Annibale Carracci. Hearing of Caravaggio's death in 1610, Rubens encouraged the duke of Mantua to buy the artist's *Death of the Virgin*, which the patron had rejected because of the shocking realism. The duke eventually bought the painting.

In 1608, Rubens returned to Antwerp, where he accepted employment by the Habsburg governors of Flanders, Archduke Albert and Princess Isabella Clara Eugenia, the daughter of Philip II. Shortly after his return he married and in 1611 built a house, studio, and garden in Antwerp (FIG. 22–34). Rubens lived in a large typical Flemish house. He added a studio in the

22–34 | Peter Paul Rubens RUBENS HOUSE

Built 1610–15. Looking toward the garden: house at left, studio at right. From an engraving of 1684. British Museum, London. The house was restored and opened as a museum in 1946.

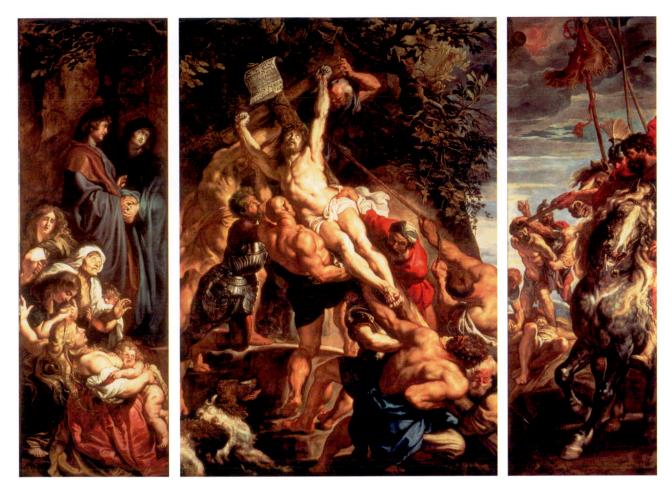

Italian manner across a courtyard, joining the two buildings by a second-floor gallery over the entrance portal. Beyond the courtyard lay the large formal garden, laid out in symmetrical beds. The living room permitted access to a gallery overlooking Rubens's huge studio, a room designed to accommodate large paintings and to house what became virtually a painting factory. The large arched windows provided ample light for the single, two-story room, and a large door permitted the assistants to move finished paintings out to their designated owners. Across the courtyard, one can see the architectural features of the garden, which inspired the architecture of the painting *Garden of Love* (SEE FIG. 22–37).

Rubens's first major commission in Antwerp was a large canvas triptych for the main altar of the Church of Saint Walpurga, **THE RAISING OF THE CROSS** (FIG. 22–35), painted in 1610–11. Rubens continued the Flemish tradition of uniting the triptych by extending the central action and the landscape through all three panels (see Rogier van der Weyden's Last Judgment Altarpiece, FIG. 18–16). At the center, Herculean figures strain to haul upright the wooden cross with Jesus already stretched upon it. At the left, the followers of Jesus join in mourning, and at the right, indifferent soldiers

supervise the execution. All the drama and intense emotion of Caravaggio and the virtuoso technique of Annibale Carracci are transformed and reinterpreted according to Rubens's own unique ideal of thematic and formal unity. The heroic nude figures, dramatic lighting effects, dynamic diagonal composition, and intense emotions show his debt to Italian art, but the rich colors and surface realism, with minute attention given to varied textures and forms, belong to his native Flemish tradition.

Rubens had created a powerful, expressive visual language that was as appropriate for the secular rulers who engaged him as it was for the Catholic Church. Moreover, his intelligence, courtly manners, and personal charm made him a valuable and trusted courtier to his royal patrons, who included Philip IV of Spain, Queen-Regent Marie de' Medici of France, and Charles I of England. In 1621, Marie de' Medici, who had been regent for her son Louis XIII, asked Rubens to paint the story of her life, to glorify her role in ruling France, and also to commemorate the founding of the new Bourbon royal dynasty. In twenty-four paintings, Rubens portrayed Marie's life and political career as one continuous triumph overseen by the ancient gods of Greece and Rome.

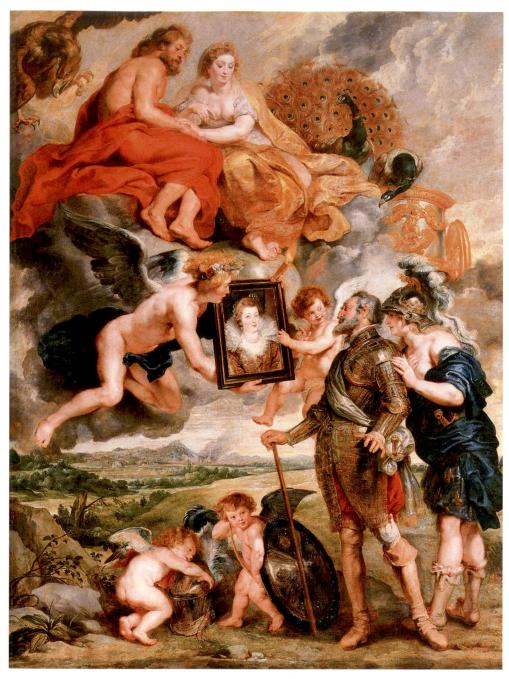

22–36 | Peter Paul Rubens HENRI IV RECEIVING THE PORTRAIT OF MARIE DE' MEDICI 1621–25. Oil on canvas, $12'11\%'' \times 9'8\%''$ (3.94 \times 2.95 m). Musée du Louvre, Paris.

In the painting depicting the royal engagement (FIG. 22–36), Henri IV falls in love at once with Marie's portrait, shown to him—at the exact center of the composition—by Cupid and Hymen, the god of marriage, while the supreme Roman god, Jupiter, and his wife, Juno, look down from the clouds. Henri, wearing his steel breastplate and silhouetted against a landscape in which the smoke of a battle lingers in the distance, is encouraged by a personification of France to abandon war for love, as *putti* play with the rest of his armor. The ripe colors, multiple tex-

tures, and dramatic diagonals give a sustained visual excitement to these enormous canvases, making them not only important works of art but also political propaganda of the highest order.

In 1630, while Rubens was in England on a peace mission, Charles I knighted him and commissioned him to decorate the ceiling of the new Banqueting House at Whitehall Palace, London (SEE FIG. 22–65). There, he painted the apotheosis of James I (Charles's father) and the glorification of the Stuart dynasty.

For all the grandeur of his commissioned paintings, Rubens was a sensitive, innovative painter, as the works he created for his own pleasure clearly demonstrate. His greatest joys seem to have been his home in Antwerp and his home in the country, Castle Steen, a working farm with gardens, fields, woods, and streams.

In GARDEN OF LOVE—a garden reminiscent of his own—Rubens may have portrayed his second wife, Helene Fourment, as the leading lady among a crowd of beauties (FIG. 22–37). Putti encourage the lovers, and one pushes a hesitant young woman into the garden. The couple joins the ladies and gentlemen who are already enjoying the pleasures of nature. The sculpture and architectural setting recall Italian Mannerist conceits. For example, the nymph presses water from her breasts to create the fountain. Herms flank the entrance and columns banded with rough-hewn rings support the pavilion that forms the entrance to the grotto of Venus. All is lush color, shimmering satin, falling water, and sunset sky—the visual and tactile effects so appreciated by seventeenth-century viewers achieved through masterful brushwork.

To satisfy his clients all over Europe, Rubens employed dozens of assistants, many of whom were, or became, important painters in their own right. Using workshop assistants was standard practice for a major artist, but Rubens was par-

ticularly methodical, training or hiring specialists in costumes, still lifes, landscapes, portraiture, and animal painting who together could complete a work from his detailed sketches. Among his friends and collaborators were Anthony Van Dyck and his friend and neighbor Jan Brueghel.

PORTRAITS AND STILL LIFES. One of Rubens's collaborators, Anthony Van Dyck (1599-1641), had an illustrious independent career as a portraitist. Son of an Antwerp silk merchant, he was listed as a pupil of the dean of Antwerp's Guild of Saint Luke at age 10. He had his own studio and roster of pupils at age 16 but was not made a member of the guild until 1618, the year after he began his association with Rubens as a painter of heads. The need to blend his work seamlessly with that of Rubens enhanced Van Dyck's technical skill; his independent work shows an elegance and aristocratic refinement that seems to express his own character. After a trip to the English court of James I (ruled 1603–25) in 1620, Van Dyck traveled to Italy and worked as a portrait painter for seven years before returning to Antwerp. In 1632, he returned to England as the court painter to Charles I (ruled 1625-49), by whom he was knighted and given a studio, a summer home, and a large salary.

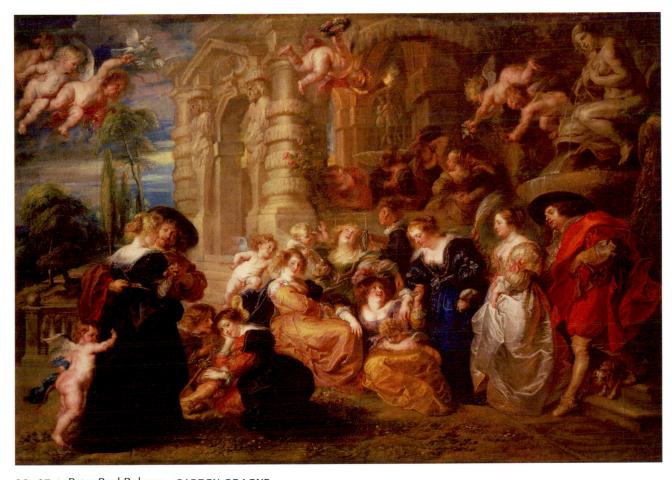

22–37 | Peter Paul Rubens GARDEN OF LOVE 1630–32. Oil on canvas, $6'6'' \times 9'3\%''$ (1.98 \times 2.83 m). Museo del Prado, Madrid.

22-38 | Anthony Van Dyck CHARLES I AT THE HUNT 1635. Oil on canvas, 8'11" × 6'11" (2.75 × 2.14 m). Musée du Louvre, Paris.

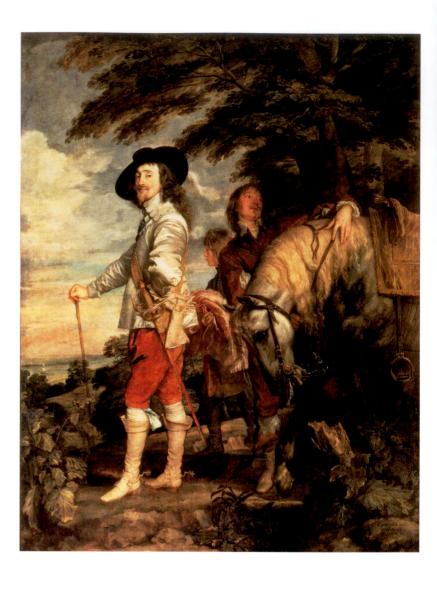

Van Dyck's many portraits of the royal family provide a sympathetic record of their features. In **CHARLES I AT THE HUNT** (FIG. 22–38), of 1635, Van Dyck was able, by clever manipulation of the setting, to portray the king truthfully and yet as a quietly imposing figure. Dressed casually for the hunt and standing on a bluff overlooking a distant view (a device used by Rubens to enhance the stature of Henry IV; SEE FIG. 22–36), Charles is shown as being taller than his pages and even than his horse, since its head is down and its heavy body is partly off the canvas. The viewer's gaze is diverted from the king's delicate and rather short frame to his pleasant features, framed by his jauntily cocked cavalier's hat. As if in decorous homage, the tree branches bow gracefully toward him, echoing the circular lines of the hat.

Yet another painter working with Rubens, Jan Brueghel (1568–1625), specialized in settings rather than portraits. Jan was the son of Pieter Bruegel the Elder; recall that Jan added the "h" to the family name (see Chapter 21). Brueghel and Rubens's allegories of the five senses—five paintings illustrating sight, hearing, touch, taste, and smell—in effect invited the viewer to wander in an imaginary space and to enjoy an amazing collection of works of art and scientific equipment

(see Brueghel and Rubens's *Allegory of Sight*, page 780). This remarkable painting is a display, a virtual inventory, and a summary of the wealth, scholarship, and connoisseurship created through the patronage of the Habsburg rulers of the Spanish Netherlands.

Our term still life for paintings of artfully arranged objects on a table comes from the Dutch stilleven, a word coined about 1650. The Antwerp artist Clara Peeters (1594-c. 1657) specialized in still-life tabletop arrangements. She was a precocious young woman whose career seems to have begun before she was fourteen. Of some fifty paintings now attributed to her (of which more than thirty are signed), many are of the type called "breakfast pieces," showing a table set for a meal of bread and fruit. Peeters was one of the first artists to combine flowers and food in a single painting, as in her STILL LIFE WITH FLOWERS, GOBLET, DRIED FRUIT, AND PRETZELS (FIG. 22-39), of 1611. Peeters arranged rich tableware and food against neutral, almost black backgrounds, the better to emphasize the fall of light over the contrasting surface textures. In a display of decorative arts that must have appealed to her clients, the luxurious goblet and bowl contrast with simple stoneware and pewter, as do the delicate

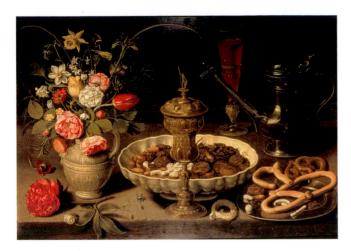

22–39 | Clara Peeters STILL LIFE WITH FLOWERS, GOBLET, DRIED FRUIT, AND PRETZELS 1611. Oil on panel, $20\frac{1}{2} \times 28\frac{1}{4}$ " (52 × 73 cm). Museo del Prado, Madrid.

Like many breakfast pieces, this painting features a pile of pretzels among the elegant tablewares. The salty, twisted bread was called pretzel (from the Latin pretiola, meaning "small reward") because it was invented by southern German monks to reward children who had learned their prayers: The twisted shape represented the crossed arms of a child praying.

flowers with the homey pretzels. The pretzels, piled high on the pewter tray, are a particularly interesting Baroque element, with their complex multiple curves.

The Dutch Republic

The House of Orange was not notable for its patronage of the arts, but patronage improved significantly under Prince Frederick Henry (ruled 1625-47), and Dutch artists found many other eager patrons among the prosperous middle class in Amsterdam, Leiden, Haarlem, Delft, and Utrecht. The Hague was the capital city and the preferred residence of the House of Orange, but Amsterdam was the true center of power, because of its sea trade and the enterprise of its merchants, who made the city an international commercial center. The Dutch delighted in depictions of themselves and their country—the landscape, cities, and domestic life—not to mention beautiful and interesting objects to be seen in still-life paintings and interior scenes or exotic things (like the Farnese Hercules admired by Dutch travelers in Rome; see Introduction, Fig. 24). A well-educated people, the Dutch were also fascinated by history, mythology, the Bible, new scientific discoveries, commercial expansion abroad, and colonial exploration.

Visitors to the Netherlands in the seventeenth century noted the popularity of art among merchants and working

people. Peter Mundy, an English traveler, wrote in 1640 that even butchers, bakers, shoemakers, and blacksmiths had pictures in their houses and shops. This taste for art stimulated a free market for paintings that functioned like other commodity markets. Artists had to compete to capture the interest of the public by painting on speculation. Naturally, specialists in particularly popular types of images were likely to be financially successful, and what most Dutch patrons wanted were paintings of themselves, their country, their homes, and the life around them. The demand for art gave rise to an active market for the graphic arts, both for original compositions and for copies of paintings, since one copperplate could produce hundreds of impressions, and worn-out plates could be reworked and used again.

THE INFLUENCE OF ITALY. Hendrik Goltzius (1558–1617) from Haarlem, the finest engraver in the Netherlands, perhaps in Europe, had visited Florence and Rome in 1590–91. His engravings of antiquities and of Mannerist paintings, which he made on his return, were widely circulated and introduced many people to Italian art (see Introduction, Fig. 24). The fascination continued. Flemish travelers like Leiven Cruyl (1640–1720) published engravings of the views of Rome he made in 1665 (SEE FIG. 22–21).

Hendrick ter Brugghen (1588-1629) had spent time in Rome, perhaps between 1608 and 1614, where he must have seen Caravaggio's works and became an enthusiastic follower. On his return home, in 1616, he entered the Utrecht painters' guild, bringing Caravaggio's style into the Netherlands. Ter Brugghen's saint sebastian tended by saint irene introduced the Netherlandish painters to the new art of Baroque Italy (FIG. 22-40). The suffering and recovery of Saint Sebastian was equated to the Crucifixion and Resurrection of Christ. The sickly gray-green flesh of the nearly dead saint, set in an almost monochromatic palette, contrasts with the brilliant red and gold brocade of his garmentactually the cope of the bishop of Utrecht, which survived the destruction by Protestants and became a symbol of Catholicism in Utrecht. The saint is a heroic figure: His strong, youthful body is still bound to the stake. But Saint Irene (the patron saint of nurses) carefully removes one of the arrows that pierce him, and her maid is about to untie his wrists. In a typically Baroque manner, the powerful diagonal created by Saint Sebastian's left arm dislodges him from the triangular stability of the group: His corpse is in transition and will soon fall forward. The immediacy and emotional effectiveness of the work are further strenghtened by setting all the figures in the foreground plane, an effect strangthened by the low horizon line. The use of tenebrism and dramatic light effects, and realism recalling Caravaggio, made an impact on the Dutch artists who had not had the opportunity to travel to Italy. Rembrandt, Vermeer, and Rubens all admired ter Brugghen's painting.

THE OBJECT SPEAKS

BRUEGHEL AND RUBENS'S ALLEGORY OF SIGHT

n 1599, the Spanish Habsburg princess Isabel Clara Eugenia married the Austrian Habsburg archduke Albert, uniting two branches of the family. Together they ruled the Habsburg Netherlands for the king of Spain. They were patrons of the arts and sciences and friends of artists-especially Peter Paul Rubens. Their interests and generous patronage were abundantly displayed in five allegorical paintings of the senses by Rubens and Jan Brueghel. The two artists were neighbors and frequently collaborated; Rubens painted the figures, and Brueghel created the settings. Such collaboration between major artists was not unusual in Antwerp.

Of the five paintings, the ALLEGORY OF SIGHT is the most splendid: It is like an illustrated catalog of the ducal collection.

Gathered in a huge vaulted room are paintings, sculpture, furniture, objects in gold and silver, and scientific equipmentall under the magnificent double-headed eagle emblems of the Habsburgs. We explore the painting inch by inch, as if reading a book or scanning a palace inventory. There on the table are Brueghel's copies of Rubens's portraits of Archduke Albert and Princess Isabel Clara Eugenia; another portrait of the duke rests on the floor. Besides the portraits, we can find Rubens's Daniel in the Lions' Den (upper left corner), The Lion and Tiger Hunt (top center), and The Drunken Silenus (lower right), as well as the Madonna and Child in a Wreath of Flowers (far right), a popular seventeenth-century subject, for which Rubens painted the Madonna and Brueghel created the wreath. Brueghel

also included Raphael's Saint Cecilia (behind the globe) and Titian's Venus and Psyche (over the door).

In the foreground, the classical goddess Venus, attended by Cupid (both painted by Rubens), has put aside her mirror to contemplate a painting of Christ Healing the Blind. She is surrounded by the equipment needed to see and to study: The huge globe at the right and the armillary sphere with its gleaming rings at the upper left-the Earth and the solar system-symbolize the extent of humanistic learning, an image that speaks to viewers of our day as clearly as it did to those of its own. The books and prints, ruler, compasses, magnifying glass, and the more complex astrolabe, telescope, and eyeglasses may also refer to spiritual blindness-to those who look but do not see.

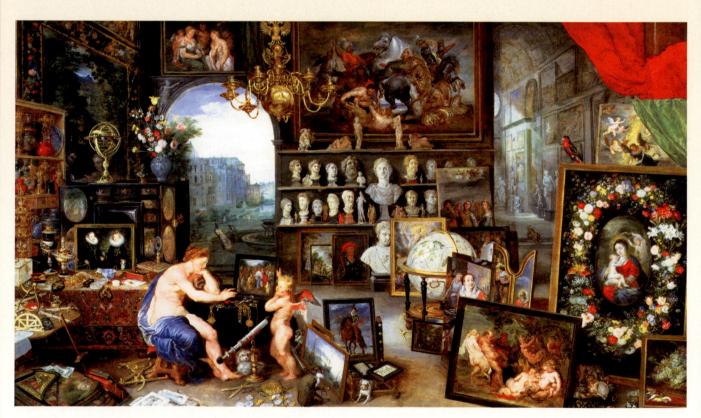

Jan Brueghel and Peter Paul Rubens AlleGORY OF SIGHT From Allegories of the Five Senses. c. 1617–18. Oil on wood panel, $25\% \times 43''$ (65 \times 109 cm). Museo del Prado, Madrid.

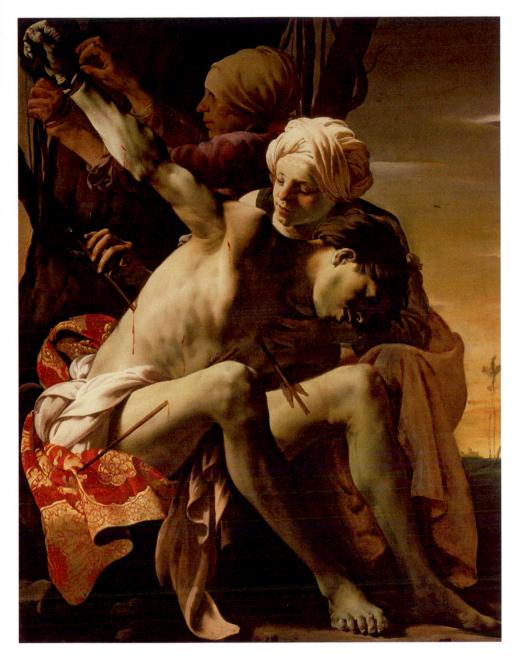

22–40 | Hendrick ter Brugghen SAINT SEBASTIAN TENDED BY SAINT IRENE 1625. Oil on canvas, 58½ 47½" (149.6 × 120 cm). Allen Memorial Art Museum, Oberlin College, Ohio.

PORTRAITS. Dutch Baroque portraiture took many forms, ranging from single portraits in sparsely furnished settings to allegorical depictions of people in elaborate costumes surrounded by appropriate symbols. Although the accurate portrayal of facial features and costumes was the most important gauge of a portrait's success, the best painters went beyond pure description to convey a sense of mood or emotion in the sitter. (We cannot know if it was an accurate representation of their personality in the modern sense, however.) Group portraiture documenting the membership of corporate organizations was a Dutch specialty. These large canvases, filled with many individuals who shared the cost of the commission, challenged

painters to present a coherent, interesting composition that nevertheless gave equal attention to each individual portrait.

Frans Hals (c. 1581/85–1666), the leading painter of Haarlem, developed a style grounded in the Netherlandish love of realism and inspired by the Caravaggesque style introduced by artists such as ter Brugghen. Like Velázquez, he tried to re-create the optical effects of light on the shapes and textures of objects. He painted boldly, with slashing strokes and angular patches of paint. When his work is seen at a distance, however, all the colors merge into solid forms over which a flickering light seems to move. In Hals's hands, this seemingly effortless technique suggests a boundless joy in life.

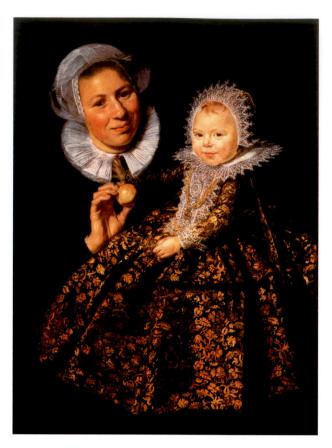

In his painting **CATHARINA HOOFT AND HER NURSE** (FIG. 22–41), of about 1620, Hals captured the vitality of a gesture and a fleeting moment in time. While the portrait records for posterity the great pride of the parents in their child, the painting also records their wealth in its study of rich fabrics, laces, and expensive toys (a golden rattle). Hals depicted the heartwarming delight of a child, who seems to be acknowledging the viewer as a loving family member while her doting nurse tries to distract her with an apple.

In contrast to this intimate individual portrait are Hals's official group portraits, such as his **OFFICERS OF THE HAARLEM MILITIA COMPANY OF SAINT ADRIAN** (FIG. 22–42), of about 1627. Less imaginative artists had arranged their sitters in neat rows to depict every face clearly. Instead, Hals's dynamic composition turned the group portrait into a lively social event. The composition is based on a strong underlying geometry of diagonal lines—gestures, banners, and sashes—balanced by the stabilizing perpendiculars of table, window, tall glass, and striped banner. The black suits and hats make the white ruffs and sashes of rose, white, and blue even more brilliant.

The company, made up of several guard units, was charged with the military protection of Haarlem. Officers came from the upper middle class and held their commissions for three years, whereas the ordinary guards were tradespeople and craftworkers. Each company was organized like a guild, under the patronage of a saint. When the men were not on war alert, the company functioned as a fraternal order, holding archery competitions, taking part in city processions, and maintaining an altar in the local church (SEE ALSO FIG. 22–45.)

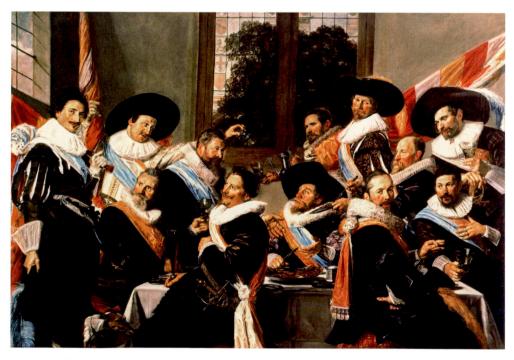

22–42 | Frans Hals OFFICERS OF THE HAARLEM MILITIA COMPANY OF SAINT ADRIAN c. 1627. Oil on canvas, $6' \times 8'8''$ (1.83 \times 2.67 m). Frans Halsmuseum, Haarlem.

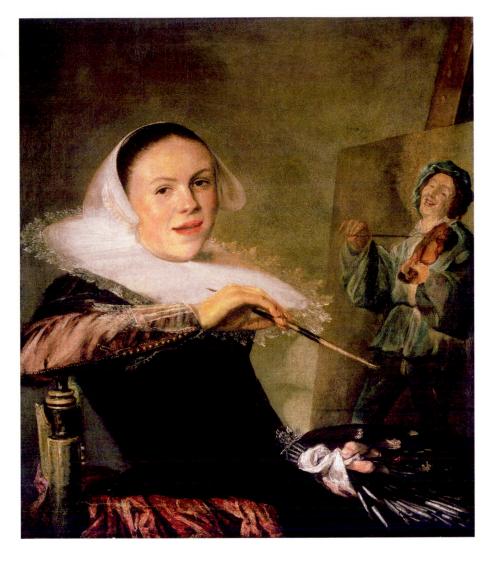

22–43 | Judith Leyster

SELF-PORTRAIT

1635. Oil on canvas, 29 % × 25 %"

(72.3 × 65.3 cm). National Gallery of Art, Washington, D.C.

Gift of Mr. and Mrs. Robert Woods Bliss.

A painting long praised as one of Hals's finest works was recently discovered to be by Judith Leyster (c. 1609-60), Hals's contemporary. A cleaning uncovered her distinctive signature, the monogram JL with a star, which refers to her surname, meaning "pole star." Leyster's work shows clear echoes of her exposure to the Utrecht painters who had enthusiastically adopted Caravaggio's realism, dramatic tenebrist lighting effects, large figures pressed into the foreground plane, and, especially, theatrically presented themes. Since in 1631 Leyster signed as a witness at the baptism in Haarlem of one of Hals's children, it is assumed they were close; she may also have worked in Hals's shop. She entered Haarlem's Guild of Saint Luke in 1633, which allowed her to take pupils into her studio, and her competitive relationship with Frans Hals around that time is made clear by the complaint she lodged against him in 1635 for luring away one of her apprentices.

Leyster is known primarily for her informal scenes of daily life, which often carry an underlying moralistic theme. In her lively **SELF-PORTRAIT** of 1635 (FIG. 22–43), the artist has paused momentarily in her work to look back, as if the viewer had just entered the room. Her elegant dress and the

fine chair in which she sits are symbols of her success as an artist whose popularity was based on the very type of painting underway on her easel. (One critic has suggested that her subject—a man playing a violin—may be a visual pun on the painter with palette and brush.) Leyster's understanding of light and texture is truly remarkable. The brushwork she used to depict her own flesh and delicate ruff is finer than Hals's technique and forms an interesting contrast to the broad strokes of thick paint used to create her full, stiff skirt. She further emphasized the difference between her portrait and her painting by executing the image on her easel in lighter tones and soft, loose brushwork. The narrow range of colors sensitively dispersed in the composition and the warm spotlighting are typical of Leyster's mature style.

REMBRANDT VAN RIJN. The most important painter working in Amsterdam in the seventeenth century was Rembrandt van Rijn (1606–69). Rembrandt, one of nine children born in Leiden to a miller and his wife, enrolled at the University of Leiden in 1620 at age 14 but chose instead to study painting with a local artist. Later he studied briefly under

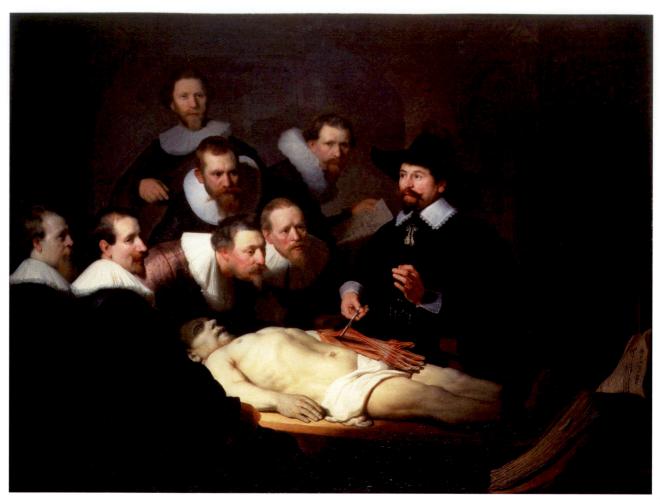

22–44 Rembrandt van Rijn **THE ANATOMY LESSON OF DR. NICOLAES TULP** 1632. Oil on canvas, $5'3\%'' \times 7'1\%''$ (1.6 × 2.1 m). Mauritshuis, The Hague, Netherlands.

Pieter Lastman (1583–1633), the principal painter in Amsterdam at the time. From Lastman, a history painter who had worked in Rome, Rembrandt learned the new styles developed in Rome by Annibale Carracci and Caravaggio: naturalism, drama, and extreme tenebrism. He was back in Leiden by 1626, painting religious and historical scenes as well as fantasy portraits from models likely drawn from his family and acquaintances. Late in 1631 he returned to Amsterdam to work primarily as a portrait painter, although he continued to paint a wide range of narrative themes and landscapes.

In his first group portrait, **THE ANATOMY LESSON OF DR. NICOLAES TULP** (FIG. 22-44) of 1632, Rembrandt combined his scientific and humanistic interests. Frans Hals had activated the group portrait rather than conceiving it as a simple reproduction of figures and faces; Rembrandt transformed it into a dramatic narrative scene. Doctor Tulp, who was head of the surgeons' guild from 1628 to 1653, sits right of center, and the other doctors gather around to observe the cadaver and listen to the famed anatomist. Rembrandt built his composition on a sharp diagonal that pierces space from right to left, uniting the cadaver on the table, the calculated

arrangement of speaker and listeners, and the open book into a climactic event. Rembrandt makes effective use of Caravaggio's tenebrist technique. The figures emerge from a dark and undefined ambience with their faces framed by brilliant white ruffs. Radiant light from an unknown source streams down on the juxtaposed arms and hands, as Dr. Tulp flexes his own left hand to demonstrate the action of the cadaver's arm muscles. Unseen by the viewers are the illustrations of the huge book. It must be an edition of Andreas Vesalius's study of human anatomy, published in Basel in 1543, which was the first attempt at accurate anatomical illustrations in print. Rembrandt's painting has been seen as an homage to Vesalius and to science, as well as a portrait of the members of the Amsterdam surgeons' guild.

Prolific and popular with Amsterdam clientele, Rembrandt ran a busy studio producing works that sold for high prices. The prodigious output of his large workshop and of many followers who imitated his manner has made it difficult for scholars to define his body of work, and many paintings by students and assistants formerly attributed to Rembrandt have recently been assigned to other artists. Rembrandt's

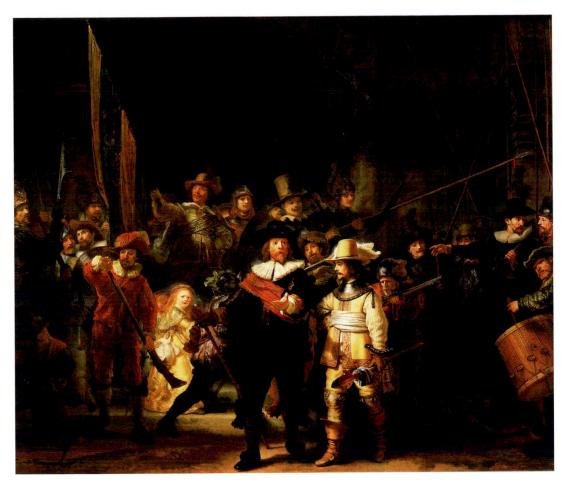

22–45 | Rembrandt van Rijn CAPTAIN FRANS BANNING COCQ MUSTERING HIS COMPANY (THE NIGHT WATCH) 1642. Oil on canvas, $11'11'' \times 14'4''$ (3.63 \times 4.37 m). (Cut down from the original size.)

mature work reflected his cosmopolitan city environment, his study of science and nature, and the broadening of his artistic vocabulary by the study of Italian Renaissance art, chiefly from engravings and paintings. Thanks to prints imported by the busy Amsterdam art market, he could study such works as Leonardo's *Last Supper* (see Introduction, Fig. 18).

Rijksmuseum, Amsterdam.

In 1642, Rembrandt was one of several artists commissioned by a wealthy civic-guard company to create large group portraits of its members for its new meeting hall. The result, Captain Frans Banning COCQ MUSTERING HIS COMPANY (FIG. 22–45), carries the idea of the group portrait as drama even further. Because of the dense layer of grime and darkened varnish on it and its dark background architecture, this painting was once thought to be a night scene and was therefore called "The Night Watch." After cleaning and restoration in 1975–76 it now exhibits a natural golden light that sets afire the palette of rich colors—browns, blues, olive green, orange, and red—around a central core of lemon yellow in the costume of a lieutenant. To the dramatic group composition, showing a company forming for a parade in an Amsterdam street, Rembrandt added several colorful but

seemingly unnecessary figures. While the officers stride purposefully forward, the rest of the men and several mischievous children mill about. The radiant young girl in the left middle ground, carrying a chicken and wearing a money pouch, may be a pun on the kind of guns (klower) that gave the name (the Kloveniers) to the company. Chicken legs with claws (klauw in Dutch) also are part of their coat of arms. She may stand as a kind of symbolic mascot of the militia company.

In his enthusiasm for printmaking as an important art form with its own aesthetic qualities, Rembrandt was remarkably like Albrecht Dürer (SEE FIGS. 21–9, 21–10). He focused on etching, which uses acid to inscribe a design on metal plates. His earliest etchings date from 1627. About a decade later, he began to experiment with making additions to his compositions in the **drypoint** technique, in which the artist uses a sharp needle to scratch shallow lines in a plate. Because etching and drypoint allow the artist to work directly on the plate, the style of the finished print can have the relatively free and spontaneous character of a drawing. Rembrandt's commitment to the full exploitation of the medium is indicated by the fact that in these works he alone

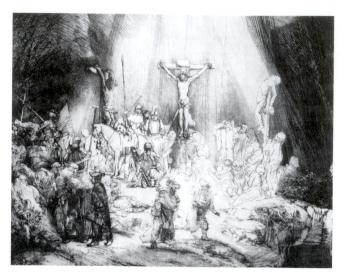

22–46 | Rembrandt van Rijn THREE CROSSES (FIRST STATE) 1653. Drypoint and etching, $15\% \times 17\%$ (38.5 \times 45 cm). Rijksmuseum, Amsterdam.

carried the creative process through, from the preparation of the plate to its inking and printing, and he constantly experimented with the technique, with methods of inking, and with papers for printing.

Rembrandt experienced a deep religious faith that was based on his personal study of the Bible. His deep consideration of the meaning of the life of Christ can be studied in a series of prints, THREE CROSSES, that comes down to us in five states, or stages, of the creative and printing process. (Only the first and fourth are reproduced here.) Rembrandt tried to capture the moment described in the Gospels when, during the Crucifixion, darkness covered the Earth and Jesus cried out, "Father, into thy hands I commend my spirit." In the first state (FIG. 22-46), the centurion kneels in front of the cross while other terrified people run from the scene. The Virgin Mary and John share the light flooding down from heaven. By the fourth state (FIG. 22-47), Rembrandt has completely reworked and reinterpreted the theme. In each version, the shattered hill of Golgotha dominates the foreground, but now a mass of vertical lines, echoing the rigid body of Jesus, fills the space, obliterates the shower of light, and virtually eliminates the former image, including even Mary and Jesus's friends. The horseman holding a lance now faces Jesus. Compared with the first state, the composition is more compact, the individual elements are simplified, and the emotions are intensified. The first state is a detailed rendering of the scene in realistic terms; the fourth state, a reduction of the event to its essence. The composition revolves in an oval of half-light around the base of the cross, and the viewer's attention is drawn to the figures of Jesus and the people, in mute confrontation. In Three Crosses, Rembrandt defined the mystery of Christianity in Jesus's sacrifice, presented in realistic terms but as something beyond rational

22–47 | Rembrandt van Rijn THREE CROSSES (FOURTH STATE)
1653. Drypoint and etching, $15\% \times 17\%$ " (38.5 × 45 cm). The Metropolitan Museum of Art, New York.
Gift of Felix M. Warburg and his family, 1941 (41.1.33)

explanation. In Rembrandt's late works, realism relates to the spirit of inner meaning, not of surface details. The eternal battles of dark and light, doom and salvation, evil and good—all seem to be waged anew.

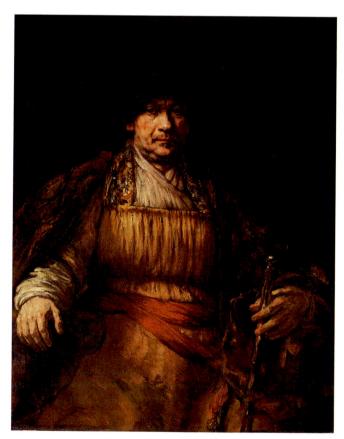

22–48 | Rembrandt van Rijn SELF-PORTRAIT 1658. Oil on canvas, $52\% \times 40\%$ (133.6 \times 103.8 cm). The Frick Collection, New York.

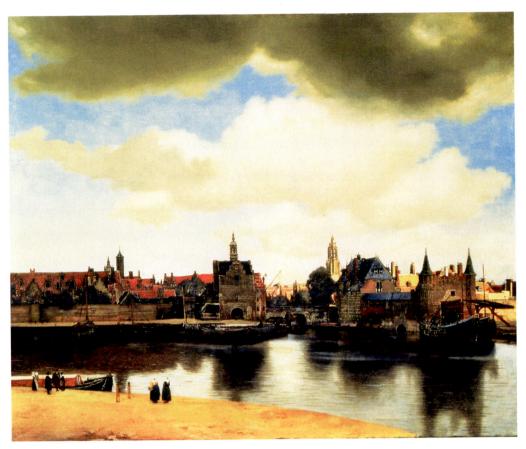

22–49 | Jan Vermeer VIEW OF DELFT c. 1662. Oil on canvas, $38\% \times 46\%$ (97.8 \times 117.5 cm). Mauritshuis, The Hague. The Johan Maurits van Nassau Foundation.

As he aged Rembrandt painted ever more brilliantly, varying textures and paint from the thinnest glazes to thick impasto, creating a rich luminous chiaroscuro, ranging from deepest shadow to brilliant highlights in a dazzling display of gold, red, and chestnut brown. His sensitivity to the human condition is perhaps nowhere more powerfully expressed than in his late self-portraits which became more searching as the artist aged. Distilling a lifetime of study and contemplation, he expressed an internalized spirituality new in the history of art. In this SELF-PORTRAIT of 1658 (FIG 22-48), the artist assumes a regal pose, at ease with arms and legs spread and holding a staff as if it were a baton of command. Yet his face and eyes seem weary, and we know that fortune no longer smiled on him (he had to declare bankruptcy that same year). A few well-placed brush strokes suggest the physical tension in the fingers and the weariness of the deep-set eyes. Mercilessly analytical, the portrait depicts the furrowed brow, sagging flesh, and prematurely aged face of one who has suffered deeply but still retains his dignity.

JAN (JOHANNES) VERMEER. One of the most intriguing Dutch artists of this period is Jan (Johannes) Vermeer (1632–75), who was also an innkeeper and art dealer. He entered the Delft

artists' guild in 1653 and painted only for local patrons. Meticulous in his technique, with a unique compositional approach and painting style, Vermeer produced fewer than forty canvases that can be securely attributed to him; and the more these paintings are studied, the more questions arise about the artist's life and his methods. Vermeer's view of DELFT (FIG. 22-49), for example, is no simple cityscape. Although the artist convinces the viewer of its authenticity, he does not paint a photographic reproduction of the scene; Vermeer moves buildings around to create an ideal composition. He endows the city with a timeless stability by a stress on horizontal lines, the careful placement of buildings, the quiet atmosphere, and the clear, even light that seems to emerge from beneath low-lying clouds. Vermeer may have experimented with the mechanical device known as the camera obscura (see Chapter 30), not as a method of reproducing the image but as another tool in the visual analysis of the landscape. The camera obscura would have enhanced optical distortions that led to the "beading" of highlights (seen here on the harbored ships and dark gray architecture), which creates the illusion of brilliant light but does not dissolve the underlying form.

Vermeer seemed to favor enigmatic scenes of women in their homes, alone or with a servant, who are occupied with some cultivated activity, such as writing, reading letters, or playing a musical instrument. Most of his accepted works are of a similar type—quiet interior scenes, low-key in color, and asymmetrical but strongly geometric in organization. Vermeer achieved his effects through a consistent architectonic construction of space in which every object adds to the clarity and balance of the composition. An even light from a window often gives solidity to the figures and objects in a room.

All emotion is subdued, as Vermeer evokes the stillness of meditation. Even the brushwork is so controlled that it becomes invisible, except when he paints reflected light as tiny droplets of color.

In **WOMAN HOLDING A BALANCE** (FIG. 22–50), perfect equilibrium creates a monumental composition and a moment of supreme stillness. The woman contemplates the balance and so calls our attention to the act of weighing and

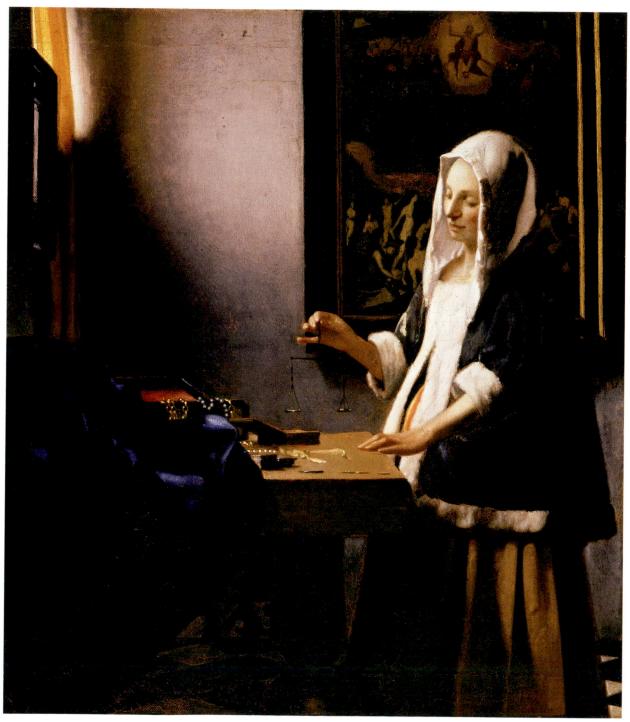

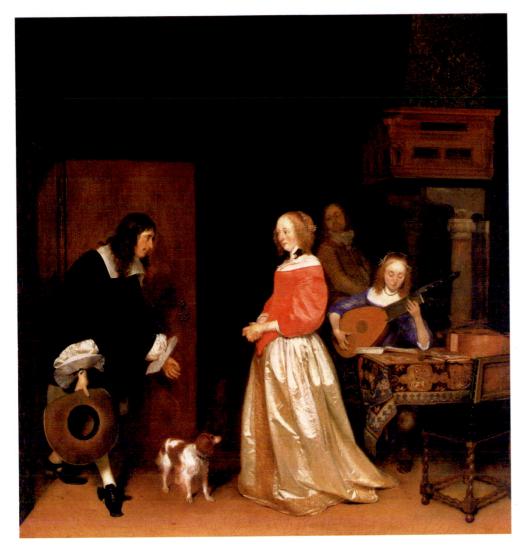

22-51 Gerard ter Borch THE SUITOR'S VISIT c. 1658. Oil on canvas, $32\frac{1}{2} \times 29\frac{1}{8}$ " (82.6 × 75.3 cm). National Gallery of Art, Washington, D.C. Andrew W. Mellon Collection

(1937.1.58).

judging. Her hand and the scale are central, but directly over her head, on the wall of the room, an image of Christ in a gold aureole appears in a large painting of the Last Judgment. Thus, Vermeer's painting becomes a metaphor for eternal judgment. The woman's moment of quiet introspection before she touches the gold or pearls, shimmering with the reflected light from the window, also recalls the vanitas theme of the transience of life, allowing the painter to comment on the ephemeral quality of material things.

LIFE IN THE CITY, GENRE SCENES. Continuing a long Netherlandish tradition, genre paintings of the Baroque period—generally painted for private patrons and depicting scenes of contemporary daily life—were often laden with symbolic references, although their meaning is not always clear. A clean house might indicate a virtuous housewife and mother while a messy household suggested laziness and the sin of sloth. Ladies dressing in front of mirrors certainly could be succumbing to vanity, and drinking parties led to overindulgence and lust.

One of the most refined of the genre painters was Gerard ter Borch (1617-81). In his painting traditionally known as THE SUITOR'S VISIT (FIG. 22-51), from about 1658, a welldressed man bows gracefully to an elegant woman arrayed in white satin, who stands in a sumptuously furnished room in which another woman plays a lute. Another man, in front of a fireplace, turns to observe the newcomer. The painting appears to represent a prosperous gentleman paying a call on a lady of equal social status, possibly a courtship scene. The dog in the painting and the musician seem to be simply part of the scene, but we are already familiar with the dog as a symbol of fidelity, and stringed instruments were said to symbolize, through their tuning, the harmony of souls and thus, possibly, a loving relationship. On the other hand, it has been suggested that the theme is not so innocent: that the gestures here suggest a liaison. The dog could be interpreted sexually, as sniffing around, and the music making could be associated with sensory pleasure. Ter Borch was renowned for his exquisite rendition of lace, velvet, and especially satin, and such wealth could be seen as a symbol of excess. One critic has even suggested that the white satin is a metaphor for the women's skin. If there is a moral lesson, it is presented discreetly and ambiguously.

Another important genre painter is Jan Steen (1626–79), whose larger brushstrokes contrast with the meticulous treatment of ter Borch. Steen painted over 800 (mostly undated) works but never achieved financial success. Most of his scenes used everyday life to portray moral tales, illustrate proverbs and folk sayings, or make puns to amuse the spectator. Steen moved about the country for most of his life, and from 1670 until his death he kept a tavern in Leiden. He probably found inspiration and models all about him. Early in his career Steen was influenced by Frans Hals, and his work, in turn, influenced a school, or circle of artists working in a related style, of Dutch artists who emulated his ever-changing style and subjects. Steen could be very summary or extremely detailed in his treatment of forms. His paintings of often riotous and disorderly interiors gave rise to the saying "a Jan Steen household."

Jan Steen's paintings of children are especially remarkable, for he captured not only their childish physiques but also their fleeting moods and expressions with rapid and fluid brushstrokes. His ability to capture such transitory dispositions was well expressed in his painting **THE DRAWING LESSON** (Introduction, Fig. 17). Here, youthful apprentices—a boy and a well-dressed young woman—observe the master artist correct an example of drawing, a skill widely believed to be the foundation of art. The studio is cluttered with all the supplies the artists need. On the floor at the lower right, objects such as a lute, wine jug, book, and skull also remind the viewer of the transitory nature of life in spite of the permanence art may seem to offer.

Emanuel de Witte (1617-92) of Rotterdam specialized in architectural interiors, first in Delft in 1640 and then in Amsterdam after settling there permanently in 1652. Although many of his interiors were composites of features from several locations combined in one idealized architectural view, de Witte also painted faithful "portraits" of actual buildings. One of these is his PORTUGUESE SYNAGOGUE. AMSTERDAM (FIG. 22-52), of 1680. The synagogue, which still stands and is one of the most impressive buildings in Amsterdam, is shown here as a rectangular hall divided into one wide central aisle with narrow side aisles, each covered with a wooden barrel vault resting on lintels supported by columns. De Witte's shift of the viewpoint slightly to one side has created an interesting spatial composition, and strong contrasts of light and shade add dramatic movement to the simple interior. The caped figure in the foreground and the dogs provide a sense of scale for the architecture and add human interest.

Today, the painting is interesting both as a record of seventeenth-century synagogue architecture and as evidence of Dutch religious tolerance in an age when Jews were often persecuted. Ousted from Spain and Portugal in the late fifteenth and early sixteenth centuries, many Jews had settled first in

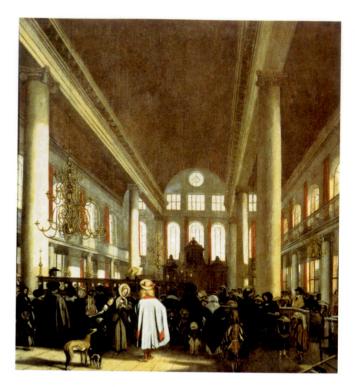

22-52 | Emanuel de Witte PORTUGUESE SYNAGOGUE, AMSTERDAM

1680. Oil on canvas, $43\%\times39''$ (110.5 \times 99.1 cm). Rijksmuseum, Amsterdam. Architect Daniel Stalpaert built the synagogue in 1670–75.

Flanders and then in the Netherlands. The Jews in Amsterdam enjoyed religious and personal freedom, and their synagogue was considered one of the outstanding sights of the city.

LANDSCAPE. The Dutch loved the landscapes and vast skies of their own country, but those who painted them were not slaves to nature as they found it: The concept was foreign to this time period. The artists constructed and refined their work in the confines of their studio and were never afraid to remake a scene by rearranging, adding, or subtracting to give their compositions formal organization or a desired mood. Starting in the 1620s, view painters generally adhered to a convention in which little color was used beyond browns, grays, and beiges. After 1650, they tended to be more individualistic in their styles, but nearly all brought a broader range of colors into play. One continuing motif was the emphasis on cloud-filled expanses of sky dominating a relatively narrow horizontal band of earth below. Painters specialized in the sea, the countryside, the city, and its buildings. Paintings of architectural interiors also became popular and seem to have been painted for their own beauty, just as exterior views of the land, cities, and harbors were.

The Haarlem landscape specialist Jacob van Ruisdael (1628/29–82), whose popularity drew many pupils to his workshop, was especially adept at both the invention of

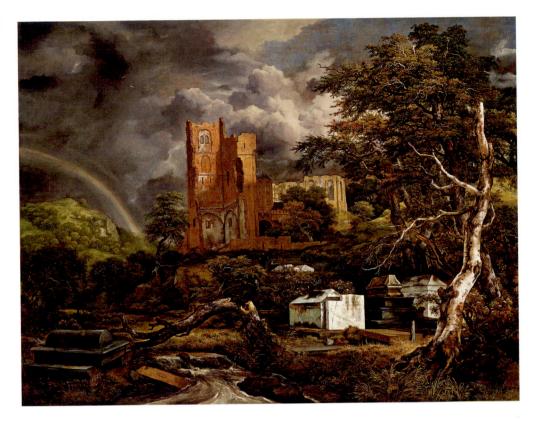

22–53 | Jacob van Ruisdael
THE JEWISH CEMETERY
1655–60. Oil on canvas,
4' 6" × 6'2½" (1.42 × 1.89 m).
The Detroit Institute of Arts.
Gift of Julius H. Haass in memory of
his brother Dr. Ernest W. Haass (24.3)

dramatic compositions and the projection of moods in his canvases. His **JEWISH CEMETERY** (FIG. 22–53), of 1655–60, is a thought-provoking view of silent tombs, crumbling ruins, and stormy landscape, with a rainbow set against dark, scudding clouds. Ruisdael was greatly concerned with spiritual meanings of the landscape, which he expressed in his choice of such environmental factors as the time of day, the weather, the appearance of the sky, or the abstract patterning of sun and shade. The barren tree points its branches at the tombs. Here the tombs, ruins, and fallen and blasted trees suggest an allegory of transience. The melancholy mood is mitigated by the rainbow, a traditional symbol of renewal and hope.

STILL LIFES AND FLOWER PIECES. The Dutch were so proud of their artists' still-life paintings that they presented one (a flower piece by Rachel Ruysch) to the French queen Marie de' Medici when she made a state visit to Amsterdam. A still-life painting might carry moralizing connotations and commonly had a *vanitas* theme, reminding viewers of the transience of life, material possessions, and even art.

One of the first Dutch still-life painters was Pieter Claesz (1596/97–1660) of Haarlem, who, like the Antwerp artist Clara Peeters, painted "breakfast pieces," that is, a meal of bread, fruits, and nuts. In subtle, nearly monochromatic paintings, such as **STILL LIFE WITH A WATCH** (FIG. 22–54), Claesz seems to give life to inanimate objects. He organizes dishes in diagonal positions to give a strong sense of space, and he gives the maximum contrast of textures within a color scheme of

white, grays, and browns. The brilliant yellow lemon provides visual excitement with its rough curling peel, juicy flesh, and soft pulpy inner skin. The tilted silver tazza contrasts with the half-filled glass that becomes a towering monumental presence and permits Claesz to display his skill at transparencies

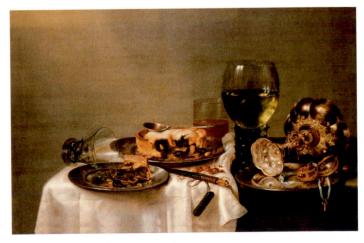

22-54 | Pieter Claesz STILL LIFE WITH A WATCH 1636. Oil on panel, Royal Picture Gallery, Maurithuis, The Hague.

The heavy round glass is a Roemer, an inexpensive, everyday item, as are the pewter plates. The gilt cup (tazza) was a typical ornamental piece. Painters owned and shared such valuable props, and this and other show pieces appear in many paintings.

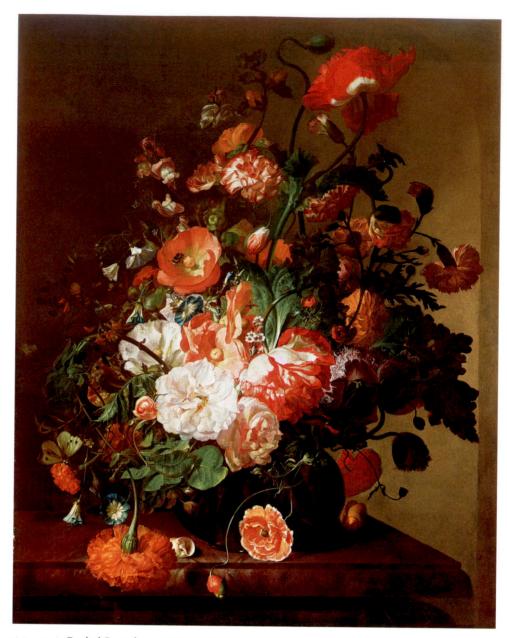

22–55 | Rachel Ruysch | FLOWER STILL LIFE | After 1700. Oil on canvas, $30 \times 24''$ (76.2 \times 61 cm). The Toledo Museum of Art, Ohio. Purchased with funds from the Libbey Endowment. Gift of Edward Drummond Libbey (1956.57)

and reflections. No longer are inanimate objects represented for their symbolic value as in fifteenth-century Flemish painting, yet meaning is not entirely lost, for such paintings suggest the prosperity of Claesz's patrons. The food might be simple, but the lemon is a luxury imported from Mediterranean lands, and the silver ornamental cup graced the tables of only the wealthy. Finally, the meticulously painted timepiece suggests a deeper meaning—perhaps human achievement in science and technology, or perhaps it also becomes a *vanitas* symbol of the inexorable passage of time and the fleet-

ing life of human beings, thoughts also suggested by the interrupted breakfast.

Still-life paintings in which cut-flower arrangements predominate are referred to simply as "flower pieces." Significant advances were made in botany during the seventeenth century through the application of orderly scientific methods and objective observation (see "Science and the Changing Worldview," page 746). The Dutch were major growers and exporters of flowers, especially tulips, which appear in nearly every flower piece in dozens of exquisite

variations. The Dutch tradition of flower painting peaked in the long career of Rachel Ruysch (1664–1750) of Amsterdam. Her flower pieces were highly prized for their sensitive, free-form arrangements and their unusual and beautiful color harmonies. During her seventy-year career, she became one of the most sought-after and highest-paid still-life painters in Europe—her paintings brought twice what Rembrandt's did.

In her **FLOWER STILL LIFE** (FIG. 22–55), painted after 1700, Ruysch placed the container at the center of the canvas's width, then created an asymmetrical floral arrangement of pale oranges, pinks, and yellows rising from lower left to top right of the picture, offset by the strong diagonal of the tabletop. To further balance the painting, she placed highlighted blossoms and leaves against the dark left half of the canvas and silhouetted them against the light wall area on the right. Ruysch often emphasized the beauty of curving flower stems and enlivened her compositions with interesting additions, such as casually placed pieces of fruit or insects, in this case a large gray moth (lower left) and two snail shells.

Flower painting, a much-admired specialty in the seventeenth- and eighteenth-century Netherlands, was almost never a straightforward depiction of actual fresh flowers. Instead, artists made color sketches of fresh examples of each type of flower and studied scientifically accurate color illustrations in botanical publications. Using their sketches and notebooks, in the studio they would compose bouquets of perfect specimens of a variety of flowers that could never be found blooming at the same time. The short life of blooming flowers was a poignant reminder of the fleeting nature of beauty and of human life.

FRANCE

The early seventeenth century in France was marked by almost continuous foreign and civil wars. The assassination of King Henri IV in 1610 left France in the hands of the queen, Marie de' Medici (regency 1610–17; SEE FIG. 22–36), as regent for her 9-year-old son, Louis XIII (ruled 1610–43). When Louis came of age, the brilliant and unscrupulous Cardinal Richelieu became chief minister and set about increasing the power of the Crown at the expense of the French nobility. The death of Louis XIII again left France with a child king, the five-year-old Louis XIV (ruled 1643–1715). His mother, Anne of Austria, became regent, with the assistance of another powerful minister, Cardinal Mazarin. At Mazarin's death in 1661, Louis XIV (SEE FIG. 22–1) began his long personal reign, assisted by yet another able minister, Jean-Baptiste Colbert.

An absolute monarch whose reign was the longest in European history, Louis XIV expanded royal art patronage, making the French court the envy of every ruler in Europe. The arts, like everything else, came under royal control. In 1635, Cardinal Richelieu had founded the French Royal Academy, directing the members to compile a definitive dictionary and grammar of the French language. In 1648, the Royal Academy of Painting and Sculpture was founded, which, as reorganized by Colbert in 1663, maintained strict control over the arts (see "Grading the Old Masters," page 799). Although it was not the first European arts academy, none before it had exerted such dictatorial authority—an authority that lasted in France until the late nineteenth century. Membership in the academy assured an artist of royal and civic commissions and financial success, but many talented artists did well outside it.

Architecture and Its Decoration at Versailles

French architecture developed along classical lines in the second half of the seventeenth century under the influence of François Mansart (1598–1666) and Louis Le Vau (1612–70). When the Royal Academy of Architecture was founded in 1671, its members developed guidelines for architectural design based on the belief that mathematics was the true basis of beauty. Their chief sources for ideal models were the books of Vitruvius and Palladio (see Chapter 20).

In 1668, Louis XIV began to enlarge the small château built by Louis XIII at Versailles, not far from Paris. Louis moved to the palace in 1682 and eventually required his court to live in Versailles; 5,000 aristocrats lived in the palace itself, together with 14,000 servants and military staff members. The town had another 30,000 residents, most of whom were employed by the palace. The designers of the palace and park complex at Versailles (FIG. 22-56) were Le Vau, Charles Le Brun (1619-90), who oversaw the interior decoration, and André Le Nôtre (1613-1700), who planned the gardens (see "French Baroque Garden Design," page 796). For both political and sentimental reasons, the old Versailles château was left standing, and the new building went up around it. This project consisted of two phases: the first additions by Le Vau, begun in 1668; and an enlargement completed after Le Vau's death by his successor, Jules Hardouin-Mansart (1646–1708), from 1670 to 1685.

Hardouin-Mansart was responsible for the addition of the long lateral wings and the renovation of Le Vau's central block on the garden side to match these wings (FIG. 22–57). The three-story elevation has a lightly rusticated ground floor, a main floor lined with enormous arched windows separated by Ionic pilasters, an attic level whose rectangular windows are also flanked by pilasters, and a flat, terraced roof. The overall design is a sensitive balance of horizontals and verticals relieved by a restrained overlay of regularly spaced projecting blocks with open, colonnaded porches.

In his renovation of Le Vau's center-block façade, Hardouin-Mansart enclosed the previously open gallery on the main level, creating the famed **HALL OF MIRRORS** (FIG. 22–58), which is about 240 feet (73 meters) long and

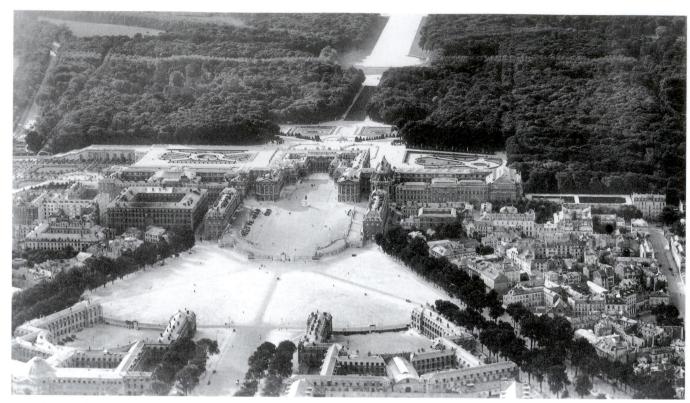

22–56 \mid Louis Le Vau and Jules Hardouin-Mansart PALAIS DE VERSAILLES, VERSAILLES France. 1668–85. Gardens by André Le Nôtre.

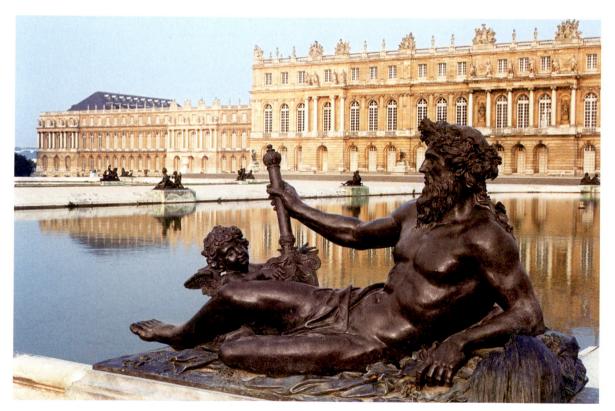

22-57 Central block of the garden façade, palais de versailles

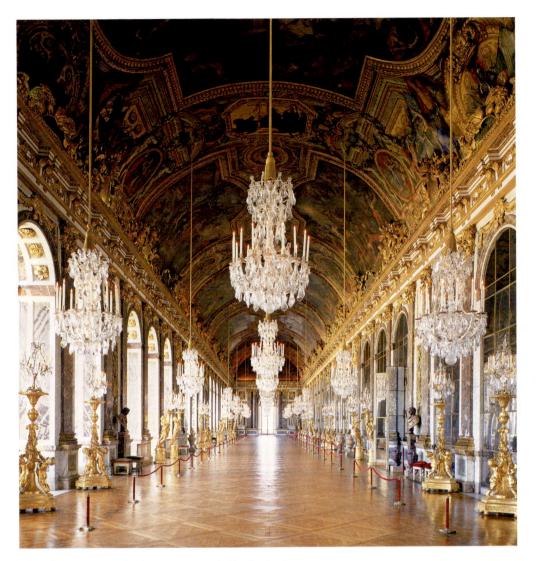

22–58 | Jules Hardouin-Mansart and Charles Le Brun | HALL OF MIRRORS, PALAIS DE VER-SAILLES

Begun 1678. Length approx. 240' (73 cm).

In the seventeenth century, mirrors and clear window glass were enormously expensive. To furnish the Hall of Mirrors, hundreds of glass panels of manageable size had to be assembled into the proper shape and attached to one another with glazing bars, which became part of the decorative pattern of the vast room.

47 feet (13 meters) high. He achieved architectural symmetry and extraordinary effects by lining the interior wall opposite the windows with Venetian glass mirrors the same size and shape as the arched windows. (Mirrors were tiny and extremely expensive in the seventeenth century, and these huge walls of glass were created by fitting eighteen-inch panels together.) The mirrors reflect the natural light from the windows and give the impression of an even larger space; at night, the reflections of flickering candles must have turned the mirrored gallery into a veritable painting in which the king and courtiers saw themselves as they promenaded. Inspired by Carracci's Farnese ceiling (SEE FIG. 22–13), Le Brun decorated the vaulted ceiling with paintings (on canvas, which is more stable in the damp northern climate) glorify-

ing the reign of Louis XIV and Louis's military triumphs, assisted by the classical gods. In 1642, he had studied in Italy, where he came under the influence of the classical style of his compatriot Nicolas Poussin (discussed later in this chapter). As "First Painter to the King" and director of the Royal Academy, Le Brun controlled art education and patronage from 1661/63 until his death in 1690. He tempered the more exuberant Baroque ceilings he had seen in Rome with Poussin's classicism to produce spectacular decorations for the king. The underlying theme for the design and decoration of the palace was the glorification of the king as Apollo the Sun God, with whom Louis identified. Louis XIV thought of the duties of kingship, including its pageantry, as a solemn performance, so it is most appropriate that Rigaud's portrait

Elements of Architecture

FRENCH BAROQUE GARDEN DESIGN

ealthy landowners commissioned garden designers to transform their large properties into gardens extending over many acres. The challenge for garden designers was to unify diverse elements-buildings, pools, monuments, plantings, natural land formations-into a coherent whole. At Versailles, André Le Nôtre imposed order upon the vast expanses of palace gardens and park by using broad, straight avenues radiating from a series of round focal points. He succeeded so thoroughly that his plan inspired generations of urban designers as well as landscape architects.

In Le Nôtre's hands, the palace terrain became an extraordinary work of art and a visual delight for its inhabitants. Neatly contained stretches of lawn and broad,

straight vistas seemed to stretch to the horizon, while the formal gardens became an exercise in precise geometry. The Versailles gardens are classically harmonious in their symmetrical, geometric design but Baroque in their vast size and extension into the surrounding countryside, where the gardens thickened into woods cut by straight avenues.

The most formal gardens lay nearest the palace, and plantings became progressively less elaborate and larger in scale as the distance from the palace increased. Broad, intersecting paths separated reflecting pools and planting beds, which are called embroidered **parterres** for their colorful patterns of flowers outlined with trimmed hedges. After the formal zone of parterres came lawns, large fountains on terraces, and trees planted in thickets to conceal features such as an open-air ball-room and a colonnade. Statues carved by at least seventy sculptors also adorned the park. A mile-long canal, crossed by a sec-

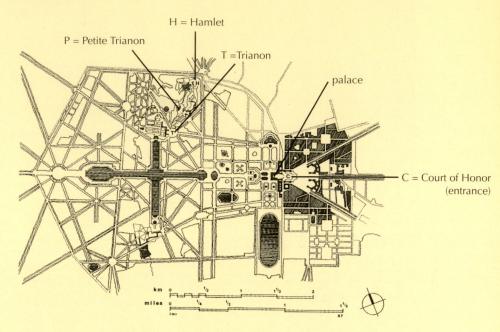

Louis Le Vau and André Le Nôtre PLAN OF THE PALAIS DE VERSAILLES Versailles, France. c. 1661–1785. Drawing by Leland M. Roth after Delagrive's engraving of 1746.

ond canal nearly as large, marked the main axis of the garden. Fourteen waterwheels brought the water from the river to supply the canals and the park's 1,400 fountains. Only the fountains near the palace played all day; the others were turned on only when the king approached.

At the north of the secondary canal, a smaller pavilion-palace, the Trianon, was built in 1669. To satisfy the king's love of flowers year-round, the gardens of the Trianon were bedded out with blooming plants from the south, shipped in by the French navy. Even in midwinter, the king and his guests could stroll through a summer garden. The head gardener is said to have had nearly 2 million flowerpots at his disposal. In the eighteenth century, Louis XV added greenhouses and a botanical garden. The facilities of the fruit and vegetable garden that supplied the palace in 1677–83 today house the National School of Horticulture.

presents him on a raised, stagelike platform, with a theatrical curtain (SEE FIG. 22–1). Versailles was the splendid stage on which the king played this grandiose drama.

In the seventeenth century, French taste in sculpture tended to favor classicizing works inspired by antiquity and the Italian Renaissance. A highly favored sculptor in this classical style, François Girardon (1628–1715) had studied the monuments of classical antiquity in Rome in the 1640s.

He had worked with Le Vau and Le Brun before he began working to decorate Versailles. In keeping with the repeated identification of Louis XIV with Apollo, Girardon created the sculpture group **APOLLO ATTENDED BY THE NYMPHS OF THETIS** (FIG. 22–59), executed about 1666–75, for the central niche of the so-called Grotto of Thetis—a formal, triple-arched pavilion named after a sea nymph beloved by the Sun God. In Girardon's circular grouping, Apollo, after

his long journey across the heavens, is attended by the graceful nymphs of Thetis. As in classical or Renaissance sculpture, the composition is best understood from a fixed viewpoint. The original setting was destroyed in 1684, and in 1776, Louis XVI had the painter Hubert Robert design a "natural" rocky cavern for Girardon's sculpture.

Painting

The lingering Mannerism of the sixteenth century in France gave way as early as the 1620s to Baroque classicism and Caravaggism—the use of strong chiaroscuro (tenebrism) and raking light—and the placement of large-scale figures in the foreground. Later in the century, under the control of the academy and inspired by studies of the classics and the surviving antiquities in Rome, French painting was dominated by the classical influences propounded by Le Brun.

THE INFLUENCE OF CARAVAGGIO. One of Caravaggio's most important followers in France, Georges de La Tour (1593–1652) received major royal and ducal commissions and became court painter to Louis XIII in 1639. La Tour may have traveled to Italy in 1614-16, and in the 1620s he almost certainly visited the Netherlands, where Caravaggio's style was being enthusiastically emulated. Like Caravaggio, La Tour filled the foreground of his canvases with monumental figures, but in place of Caravaggio's detailed naturalism he used a simplified setting and a light source within the picture so intense that it often seems to be his real subject. La Tour painted Mary Magdalen many times. In MARY MAGDALEN WITH THE SMOKING FLAME (FIG. 22-60), as in many of his paintings, the light emanates from a candle. The hand and skull, symbols of mortality, act as devices to establish a foreground plane, and the compression of the figure within the pictorial space lends a sense of intimacy. The light is the unifying element of the painting and conveys the somber mood. Mary Magdalen has put aside her rich clothing and jewels and meditates on the frailty and vanity of human life. She sighs, and the candle flickers.

Something of this same feeling of timelessness pervades the paintings of the Le Nain brothers, Antoine (c. 1588–1648), Louis (c. 1593–1648), and Mathieu (1607–1677). Although the brothers were working in Paris by about 1630, little else is known about their lives and careers. Because they collaborated closely with each other, art historians have only recently begun to distinguish their individual styles. They painted genre scenes imbued with a strange sense of foreboding and enigmatic meaning. **THE VILLAGE PIPER (FIG. 22–61)** of 1642, by Antoine Le Nain, is typical of the brothers' work. Peasant children gather around the figure of a flute player. The simple homespun garments and undefined setting turn the painting into a study in neutral colors and rough textures, with soft young

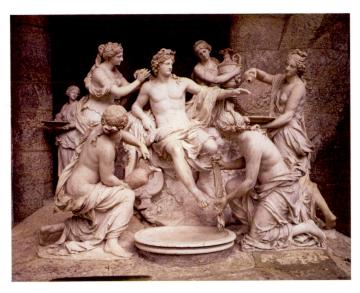

22–59 | François Girardon APOLLO ATTENDED BY THE NYMPHS OF THETIS

From the Grotto of Thetis, Palais de Versailles, Versailles, France. c. 1666-75. Marble, life-size. Grotto by Hubert Robert in 1776; sculpture reinstalled in a different configuration in 1778.

faces that contrast with the old man, who seems lost in his simple music. Why the brothers chose to paint these peasants and who bought the paintings are questions still not resolved.

THE CLASSICAL LANDSCAPE: POUSSIN AND CLAUDE LORRAIN.

The painters Nicolas Poussin (1594–1665) and Claude Gellée (called "Claude Lorrain" or simply "Claude," 1600–82) pursued their careers in Italy although they usually worked for French patrons. They perfected the ideal "classical" landscape and profoundly influenced painters for the next two centuries. Poussin and Claude were classicists in that they organized natural elements and figures into idealized compositions. Both were influenced by Annibale Carracci and to some extent by Venetian painting, yet each evolved an unmistakable personal style that conveyed an entirely different mood from that of their sources and from each other.

Nicolas Poussin, born in Normandy, settled in Paris, where his career as a painter was unremarkable. Determined to go to Rome, he finally arrived there in 1624. The Barberini became his foremost patrons, and Bernini considered Poussin to be one of the greatest painters in Rome. Poussin's landscapes with figures are the epitome of the orderly, arranged, classical landscape. In his **Landscape with Saint John on Patmos** (FIG. 22–62), from 1640, Poussin created a consistent perspective progression from the picture plane back into the distance through a clearly defined foreground, middle ground, and background. These zones are

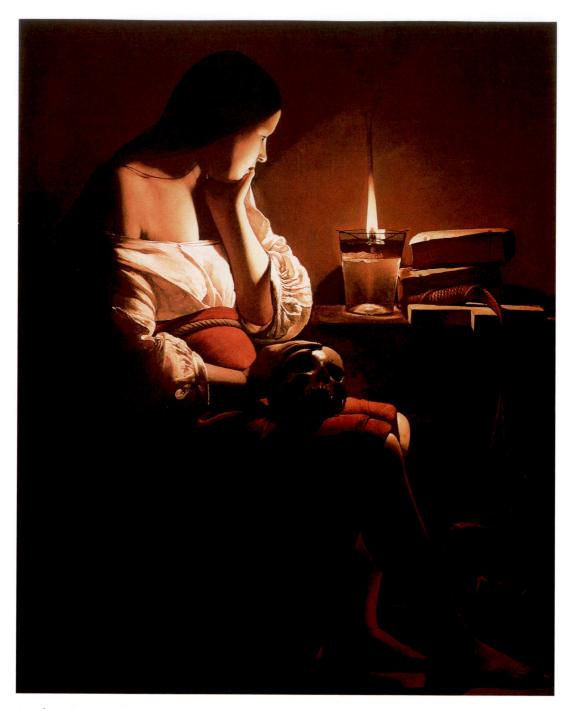

22–60 | Georges de La Tour MARY MAGDALEN WITH THE SMOKING FLAME c. 1640. Oil on canvas, 46% (117 \times 91.8 cm). Los Angeles County Museum of Art. Gift of the Ahmanson Foundation (M. 77.73)

marked by alternating sunlight and shade, as well as by architectural elements. Surrounded by the huge, tumbled ruins of ancient Rome—and by extension all earthly empires—Saint John writes the Book of Revelation, describing the end of the world, the Last Judgment, and the Second Coming of Christ: a renewal of life suggested by the flourishing vegetation. This grand theme is represented in the highly intellectualized format of Poussin's classical composition. In the middle distance are a ruined temple and an obelisk, and the round building in the distant city is

Hadrian's Tomb, which Poussin knew from Rome. Precisely placed trees, hills, mountains, water, and even clouds take on a solidity of form that seems almost as structural as architecture. The reclining evangelist and the eagle, his symbol, seem immobile—locked into this perfect landscape. The triumph of the rational mind takes on moral overtones. The subject of Poussin's painting is not the story of John the Evangelist but rather the balance and order of nature.

In the second half of the seventeenth century, the French Academy took Poussin's paintings and notes on

Defining Art

GRADING THE OLD MASTERS

he members of the French Royal Academy of Painting and Sculpture considered ancient classical art to be the standard by which contemporary art should be judged. By the 1680s, however, younger artists of the academy began to argue that modern art might equal and even surpass the art of the ancients—a radical thought that sparked controversy.

A debate arose over the relative merits of drawing and color in painting. The conservatives argued that drawing was superior to color because drawing appealed to the mind while color appealed to the senses. They saw Nicolas Poussin as embodying perfectly the classical principles of subject and design. But the young artists who admired the vivid colors of Titian, Veronese, and Rubens claimed that painting should deceive the eye, and since color achieves this deception more convincingly than drawing, application of color should be valued over drawing. Adherents to the two positions were called poussinistes (in honor of Poussin) and rubénistes (for Rubens).

The portrait painter and critic Roger de Piles (1635–1709) took up the cause of the *rubénistes* in a series of pamphlets. In *The Principles of Painting*, Piles evaluated the most important painters on a scale of 0 to 20 in four categories. He gave no score higher than 72 (18 in each category), since no mortal artist could achieve perfection. Caravaggio received the lowest grade, a 0 in expression and 6 in drawing for a low of 28, while Michelangelo and Leonardo both got a 4 in color and Rembrandt a 6 in drawing.

Most of the painters we have studied don't do very well. Raphael and Rubens get 65 points, Van Dyck comes close with 55. Poussin and Titian earn 53 and 51, while Rembrandt slips by with 50. Leonardo da Vinci gets 49, and Michelangelo and Dürer with 37 and Caravaggio with 28 all are resounding failures in Piles's view.

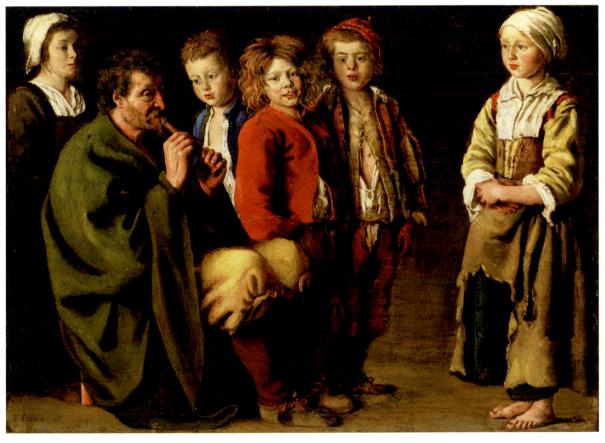

22–61 | Antoine Le Nain THE VILLAGE PIPER 1642. Oil on copper, $8\frac{1}{4} \times 11\frac{1}{2}$ " (21.3 \times 29.2 cm). Detroit Institute of Arts.

painting as a final authority. From then on, whether as a model to be followed or one to be reacted against, Poussin influenced French art.

When Claude Lorrain went to Rome in 1613, he first studied with Agostino Tassi, an assistant of Guercino and a specialist in architectural painting. Claude, however, preferred landscape. He sketched outdoors for days at a time, then returned to his studio to compose his paintings. Claude was fascinated with light, and his works are often studies of the effect of the rising or setting sun on colors and the atmosphere. A favorite and much imitated device was to place one or two large objects in the foreground—a tree, building, or hill—past which the viewer's eye enters the scene and proceeds, often by zigzag paths, into the distance.

Claude used this compositional device to great effect in paintings such as **EMBARKATION OF THE QUEEN OF SHEBA** (FIG. 22–63). Instead of balanced, symmetrically placed elements, Claude leads the viewer into the painting in a zigzag fashion. A ruined building with Corinthian cornice and columns frames the composition at the left; light catching the seashore leads the eye to the right, where a handsome palace with a grand double staircase and garden with trees establishes a middle ground. Across the water the sails and rigging of ships provide extra visual interest. More distant still are the

harbor fortification with town and lighthouse and finally the breakwater (at the left). On the horizon the sun illuminates the clouds in a clearing sky and catches the waves to make a glowing sea path to shore. The small figures—workers and onlookers in the foreground, the queen and her courtiers waiting on the quay and about to board—seem incidental, added to give the painting a subject. Claude's meticulous one-point perspective focuses on the sun with the same driving force with which earlier painters focused on Christ and the saints.

HYACINTHE RIGAUD. Hyacinthe Rigaud (1659–1743), trained by his painter father, won the Royal Academy's prestigious Prix de Rome in 1682, which would have paid his expenses for study at the Academy's villa in Rome, Rigaud rejected the prize, however, and opened his own Paris studio. After painting a portrait of Louis XIV's brother in 1688, he became a favorite of the king himself. His representation of the monarch (SEE FIG. 22–1) reveals a more extravagant style than the restrained classicism of Le Brun. In fact, Louis favored a more theatrical presentation for himself and his court, and Rigaud's representation of the Sun King embodies official portraiture as the height of royal propaganda.

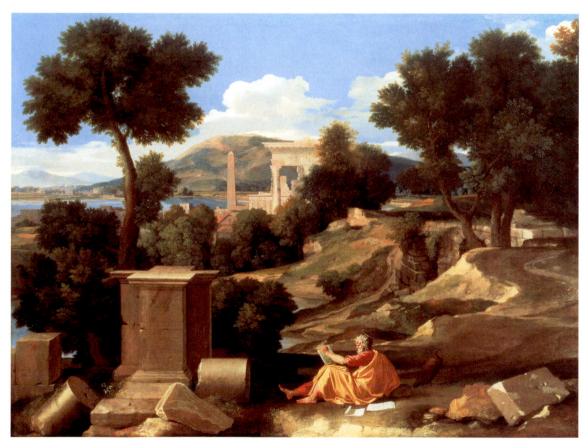

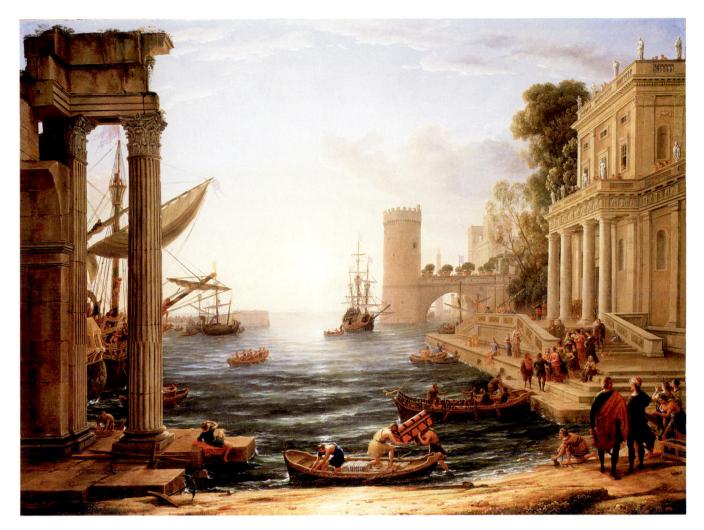

22–63 | Claude Lorrain | EMBARKATION OF THE QUEEN OF SHEBA 1648. Oil on canvas, 4' $10'' \times 6'$ 4" (1.48 \times 1.93 m). National Gallery, London. Reproduced by courtesy of the Trustees of the National Gallery, London

ENGLAND

England and Scotland were joined in 1603 with the ascent to the English throne of James VI of Scotland, who reigned over Great Britain as James I (ruled 1603–25). James increased royal patronage of British artists, especially in literature and architecture. William Shakespeare wrote *Macbeth*, featuring the king's legendary ancestor Banquo, in tribute to the new royal family, and the play was performed at court in December 1606.

Although James's son Charles I was an important collector and patron of painting, religious and political tensions that erupted into civil wars cost Charles his throne and his life in 1649. A succession of republican and monarchical rulers who alternately supported Protestantism or Catholicism followed, until the Catholic king James II was deposed in the Glorious Revolution of 1689 by his Protestant son-in-law and daughter, William and Mary. After Mary's death in 1694, William (the Dutch great-grandson of William of Orange, who had led the Netherlands' independence movement) ruled on his own until his death in 1702. He was succeeded by Mary's sister Anne (ruled 1702–14).

Architecture and Landscape Design

In sculpture and painting, the English court patronized foreign artists. The field of architecture, however, was dominated in the seventeenth century by the Englishmen Inigo Jones, Christopher Wren, and Nicholas Hawkmoor. They replaced the country's long-lived Gothic style with a classical one and were followed in a more Baroque mode by another English architect, John Vanbrugh. Major changes in landscape architecture took place during the eighteenth century, led by the innovative designer Lancelot "Capability" Brown.

INIGO JONES. In the early seventeenth century, the architect Inigo Jones (1573–1652) introduced his version of Renaissance classicism—an architectural design based on the style of the architect Andrea Palladio—into England. Jones had studied Palladio's work in Venice, and he filled his copy of Palladio's Four Books of Architecture (which has been preserved) with notes. Appointed surveyor–general in 1615, Jones was commissioned to design the Queen's House in Greenwich and the Banqueting House for the royal palace of Whitehall.

The BANQUETING HOUSE, WHITEHALL PALACE (FIG. 22-64), built in 1619-22 to replace an earlier hall destroyed by fire, was used for court ceremonies and entertainments such as the popular masques—dance-dramas combining theater, music, and dance in a spectacle in which professional actors, courtiers, and even members of the royal family participated. The west front shown here, consisting of what appears to be two upper stories with superimposed Ionic and Composite orders raised over a plain basement level, exemplifies the understated elegance of Jones's interpretation of Palladian design. Pilasters flank the end bays, and engaged columns subtly emphasize the three bays at the center. These vertical elements are repeated in the balustrade along the roofline. A rhythmic effect was created in varying window treatments from triangular and segmental (semicircular) pediments on the first level to cornices with volute (scroll-form) brackets on the second. The sculpted garlands just below the roofline add an unexpected decorative touch, as does the use of a different-color stone—pale golden, light brown, and white—for each story (no longer visible after the building was refaced in uniformly white Portland stone).

Although the exterior suggests two stories, the interior of the Banqueting House (FIG. 22–65) is actually one large hall divided by a balcony, with antechambers at each end. Ionic pilasters suggest a colonnade but do not impinge on the ideal, double-cube space, which measures 55 feet in width by 110 feet in length by 55 feet in height. In 1630, Charles I commissioned Peter Paul Rubens to decorate the ceiling. Jones had divided the flat ceiling into nine compartments, for which Rubens painted canvases glorifying the reign of James I. Installed in 1635, the paintings show the triumph of the Stu-

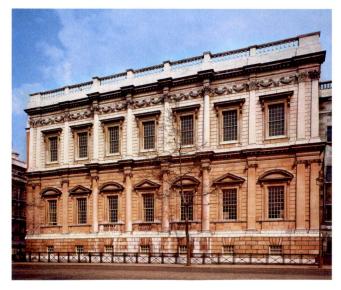

22–64 | Inigo Jones BANQUETING HOUSE, WHITEHALL PALACE
London. 1619–22.

art dynasty with the king carried to heaven in clouds of glory. The large rectangular panel beyond it depicts the birth of the new nation, flanked by allegorical paintings of heroic strength and virtue overcoming vice. In the long paintings on each side, *putti* holding the fruits of the Earth symbolize the peace and prosperity of England and Scotland under Stuart rule. So proud was Charles of the result that, rather than allow the smoke of candles and torches to harm the ceiling decoration, he moved evening entertainments to an adjacent pavilion.

Christopher Wren. After Jones's death, English architecture was dominated by Christopher Wren (1632–1723). Wren began his professional career in 1659 as a professor of astronomy; architecture was a sideline until 1665, when he traveled to France to further his education. While there, he met with French architects and with Bernini, who was in Paris to consult on his designs for the Louvre. Wren returned to England with architectural books, engravings, and a greatly increased admiration for French classical Baroque design. In 1669, he was made surveyor–general, the position once held by Inigo Jones; in 1673, he was knighted.

After the Great Fire of 1666 demolished central London, Wren was continuously involved in rebuilding the city. He built more than fifty Baroque churches. His major project from 1675 to 1710, however, was the rebuilding of SAINT PAUL'S CATHEDRAL (FIG. 22-66). Attempts to salvage the burned-out medieval church on the site failed, and a new cathedral was needed. Wren's famous second design for Saint Paul's (which survives in the so-called Great Model of 1672-73) was for a centrally planned building with a great dome in the manner of Bramante's plan for Saint Peter's. This was rejected, but Wren ultimately succeeded both in satisfying Reformation tastes for a basilica and in retaining the unity inherent in the dome. Saint Paul's has a long nave and equally long sanctuary articulated by small, domed bays. Semicircular, colonnaded porticoes open into short transepts that compress themselves against the crossing, where the dome rises 633 feet from ground level. Wren's dome for Saint Paul's has an interior masonry vault with an oculus and an exterior sheathing of lead-covered wood but also has a brick cone rising from the inner oculus to support a tall lantern. (The ingenuity of the design and engineering remind one that Wren was mathematician and professor of astronomy at Oxford.) The columns surrounding the drum on the exterior recall Bramante's Tempietto in Rome (SEE FIG. 20-17), although Wren never went to Italy and knew Italian architecture only from books.

On the façade of Saint Paul's, two stages of paired Corinthian columns support a carved pediment. The deep-set porticoes and columned pavilions atop the towers create dramatic areas of light and shadow. Not only the huge size of the cathedral but also its triumphant verticality, complexity of form, and chiaroscuro effects make it a major monument of the English Baroque. Wren recognized the importance of the

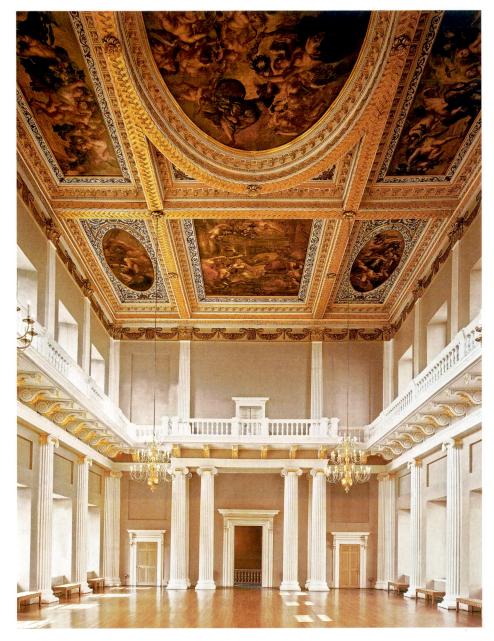

22–65 INTERIOR, BANQUETING HOUSE, WHITEHALL PALACE
Ceiling paintings of the apotheosis of King James and the glorification of the Stuart monarchy by Peter Paul Rubens. 1630–35.

building. On the simple marble slab that forms his tomb in the crypt of the cathedral, he had engraved: "If you want to see his memorial, look around you."

BLENHEIM PALACE. Like Wren, Sir John Vanbrugh (1664–1726) came late to architecture. His heavy, angular style, utterly unlike Wren's, was well suited to buildings intended to express power and domination. Wren's assistant Nicholas Hawksmoor (1661–1736) also worked in a bolder style. Perhaps the most important achievement of the two was **BLENHEIM PALACE** (FIG. 22–67), built in two phases (1705–12 and 1715–25) in Woodstock, just northwest of London. Van-

brugh was an amateur, a soldier and playwright whose architectural designs are indeed theatrical. Hawksmoor was an established professional who understood building and engineering. The two combined to create the imposing and impractical monument to the glory of England—an architectural challenge to Louis XIV and Versailles. Built by Queen Anne, with funds from Parliament, for John Churchill, duke of Marlborough, after his 1704 victory over the armies of Louis XIV at Blenheim, the palace was made a national monument as well as the residence of the dukes of Marlborough. Except for the formal gardens at each side of the center block, the informal and natural landscaping is the work of

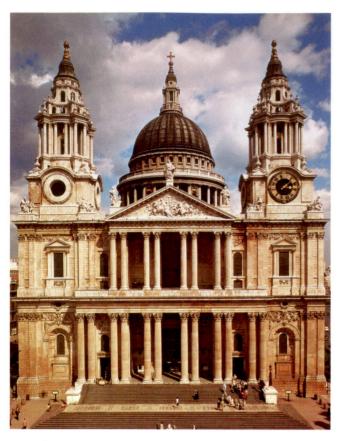

22–66 | Christopher Wren SAINT PAUL'S CATHEDRAL, LONDON
Designed 1673, built 1675–1710.

Lancelot "Capability" Brown. Blenheim's enormous size and symmetrical plan, with service and stable wings flanking an entrance court, recall Versailles as they reach out to encompass the surrounding terrain.

Blenheim's grounds originally comprised a practical kitchen garden, an avenue of elm trees, and another garden. In the 1760s, the grounds were redesigned by Lancelot "Capability" Brown (1716-83) according to his radical new style now called, appropriately, "landscape architecture." In contrast to the geometric rigor of the French and Italian gardens, Brown's designs appeared to be both informal and natural. The "natural" appearance was created by feats of engineering, as the land was reformed to create views inspired by the paintings of Claude Lorrain. In order to accomplish this at Blenheim, Brown dammed the small river flowing by the palace to form two lakes and a rockwork cascade, then created sweeping lawns and vistas with artfully arranged trees. (Gardeners and their patrons thought of the future, as they planted trees that they would never see grow to maturity.) The formal gardens in the French style now seen at each side of Blenheim's center block were added in the twentieth century.

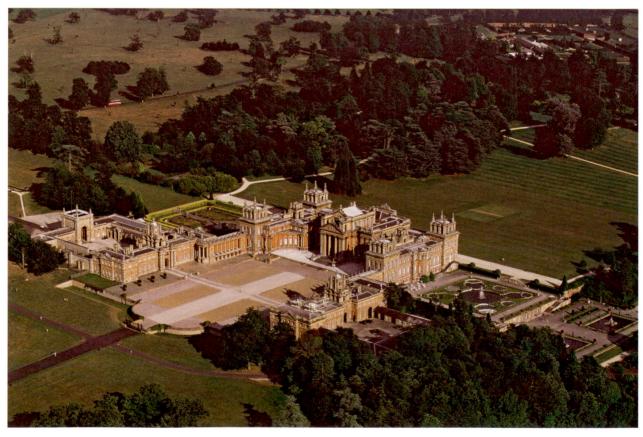

22–67 | John Vanbrugh BLENHEIM PALACE, WOODSTOCK Oxfordshire, England. 1705–12 and 1715–25.

English Colonies in North America

In the seventeenth century, the art of North America reflected the tastes of the European rulers—England on the East Coast, France in Canada and Louisiana, Spain in the Southwest. Not surprisingly, much of the colonial art was the work of immigrant artists, and styles often lagged behind the European mainstream. The rigors of colonial life meant that few people could afford to think of fine houses and art collections. Furthermore, the Puritans, religious dissenters who had left England and settled in the Northeast beginning in 1620, wanted simple, functional buildings for homes and churches. Architecture and crafts responded more quickly than sculpture and painting in the development of native styles. Although by the last decades of the seventeenth century a market for fine furniture and portraits had developed, native artists of outstanding talent often found it advantageous to resettle in Europe.

ARCHITECTURE. Early architecture in the British North American colonies was derived from European timber construction. Wood, so easily obtained in the Northeast, was used to create the same kinds of houses and churches then being built in rural England (as well as in Holland and France, which also had colonies in North America). In seventeenth-century New England, many buildings reflected the adapta-

Sequencing Works of Art

1645-52	Gianlorenzo Bernini, Saint Teresa of Ávila in Ecstasy
1648	Claude Lorrain, Embarkation of the Queen of Sheba
1656	Diego Velázquez, Las Meninas
c. 1656-57	Gianlorenzo Bernini, piazza design for Saint Peter's, Rome
1658	Rembrandt van Rijn, Self-Portrait

tion of contemporary English country buildings, which were appropriate to the severe North American winters—framed-timber construction with steep roofs, massive central fire-places and chimneys, overhanging upper stories, and small windows with tiny panes of glass or parchment screens. Following a time-honored tradition, walls consisted of wooden frames filled with wattle and daub (woven branches packed with clay) or brick in more expensive homes. Instead of leaving this construction exposed, as was common in Europe, colonists usually weatherproofed it with horizontal plank siding, called clapboard. The PARSON CAPEN HOUSE in Topsfield, Massachusetts (FIG. 22–68), built in 1683, is a well-preserved example. The earliest homes generally consisted of a single

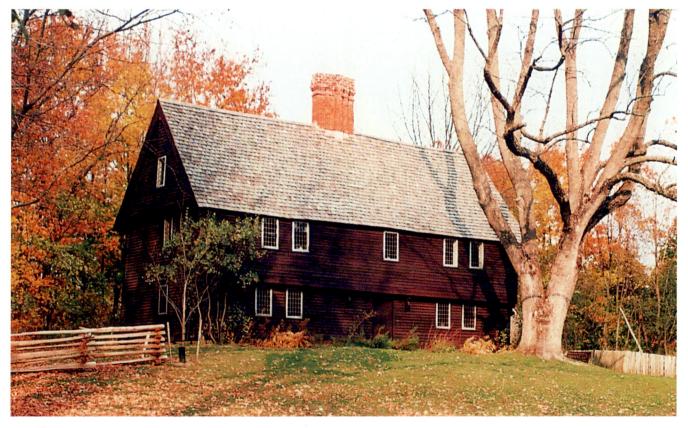

22–68 | **PARSON CAPEN HOUSE** Topsfield, Massachusetts. 1683.

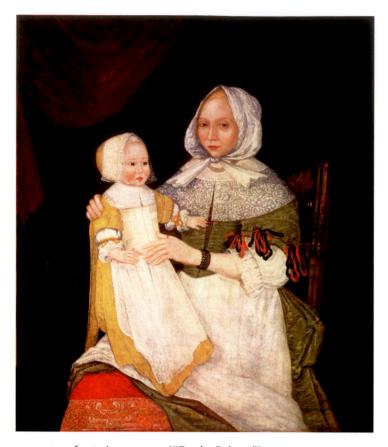

22–69 Anonymous ("Freake Painter") MRS. FREAKE AND BABY MARY c. 1674. Oil on canvas, $42\frac{1}{4} \times 36\frac{1}{4}$ " (108 \times 92.1 cm). Worcester Museum of Art, Worcester, Massachusetts.

Gift of Mr. and Mrs. Albert W. Rice

"great room" and fireplace, but the Capen House has two stories, each with two rooms flanking the central fireplace and chimney. The main fireplace was the center of domestic life; all the cooking was done there, and the firelight provided illumination for reading and sewing.

Painting. Painting and sculpture had to wait for more settled and affluent times in the eastern seacoast colonies. For a long time, the only works of sculpture were carved or engraved tombstones. Painting, too, was sponsored as a necessary part of family record keeping, and portraits done by itinerant "face painters," called **limners**, have a charm and sincerity that appeal to the modern eye. The anonymous painter of MRS. FREAKE AND BABY MARY (FIG. 22–69), dated about 1674, seems to have known Dutch portraiture, probably

through engraved copies that were imported and sold in the colonies. Even though the "Freake Painter" was clearly self-taught and lacked skills in illusionistic, three-dimensional composition, emotionally this portrait has much in common with Frans Hals's *Catharina Hooft and Her Nurse* (SEE FIG. 22–41). Maternal pride in an infant and hope for her future are universal ideals that apply to little Mary as well as to Catharina, even though their worlds were far apart.

IN PERSPECTIVE

Cataclysmic forces unleashed in the sixteenth century came to fruition in the arts only in the seventeenth century, as political and religious factions attacked each other with lethal fanaticism and enlisted art—as well as God—on their side. Spectacular visions, brilliant state portraits, and grandiose palaces and churches proclaimed the power of church and state. In papal Rome, Bernini, Borromini, and Gaulli worked their visual magic while Caravaggio revolutionized painting with his new naturalism. In Spain, France, and England, artists such as Rigaud and Van Dyck created portraits that were miracles of royal propaganda while Velázquez and Rubens glorified political and military victories.

Florence, Venice, and even Antwerp lost their economic and hence cultural advantage while papal Rome, Louis XIV's Paris and Versailles, and the commercial center of Amsterdam became the economic engines of the arts. In the Protestant countries, religious art was replaced by secular subject matter and a strong realistic style as the arts found a new economic basis—the open art market. Artists like Vermeer or Ruisdael painted themes considered "lesser" by the critics but with sales in mind: still lifes, landscapes, and scenes of daily life. As the universities became the centers of intellectual life, curriculum changed from religion and philosophy to science and mathematics. Artists like Maria Sibylla Merian joined scientists in the exploration and recording of nature, and Rembrandt probed the human mind and spirit.

Trade became global, and fortunes were to be made as ships replaced the overland routes between Europe and Asia and new trade routes crossed the Atlantic. The fascinating phenomenon today referred to as "core and periphery"—cultural transference between colonial power and colony—is epitomized by the comparison of two portraits, Hals's *Catharina Hooft* and the "Freake Painter's" *Baby Mary*—as a new art center arose in the New World.

ILL LIFE WITH FLOWERS, GOBLET,
DRIED FRUIT AND PRETZLES
1611

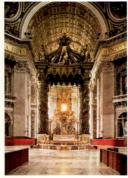

BERNINI

BALDACCHINO

SAINT PETER'S BASILICA, VATICAN

1624–1633

LA TOUR
MARY MAGDALEN WITH
THE SMOKING FLAME
C. 1640

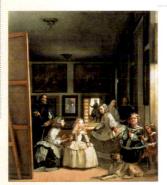

VELAZQUEZ LAS MENINAS 1656

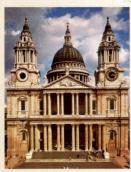

WREN

ST. PAUL'S CATHEDRAL

DESIGNED 1673

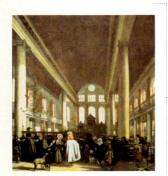

DE WITTE
PORTUGUESE SYNAGOGUE, AMSTERDAM
1680

BAROQUE ART

1600

1620

T610

1660

1680

1700

- Thirty Year's War 1618-48
- Mayflower Lands in North America
 1620
- Galileo Forced to Recant 1633
- Louis XIV of France Ruled 1643-1715
- ▼ French Royal Academy of Painting and Sculpture 1648
- Spanish Habsburgs Recognize
 Independence of United Provinces
 1648
- Charles I of England Beheaded;
 England a Commonwealth 1649
- Restoration of Charles II and Monarchy in England 1660
- Great Fire of London 1666
- French Royal Academy of Architecture 1671

- Newton Publishes Laws of Gravity and Motion 1687
- Glorious Revolution in England 1689
- Steam Engine Invented 1698

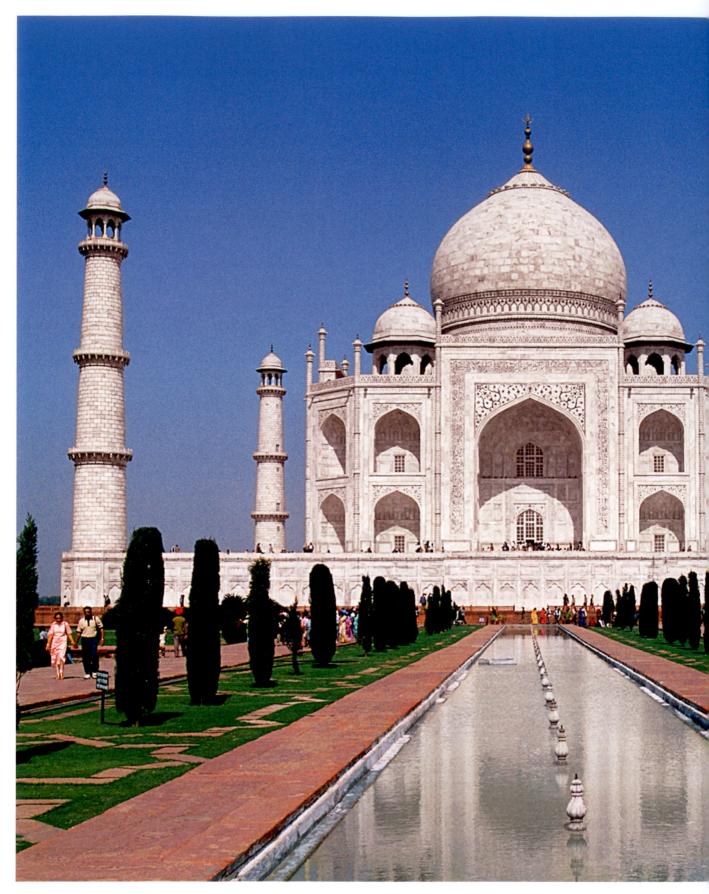

23–I ТАЈ МАНАL Agra, India. Mughal period, reign of Shah Jahan, с. 1631–48.

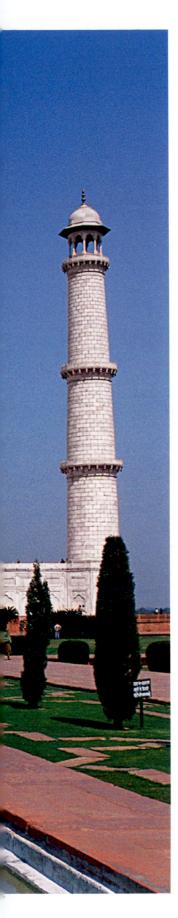

CHAPTER TWENTY-THREE

ART OF SOUTH AND SOUTHEAST ASIA AFTER 1200

23

Visitors catch their breath. Ethereal, weightless, the building before them barely seems to touch the ground. Its reflection shimmers in the pools of the garden meant to evoke a vision of paradise as described in the Qur'an, the holy book of Islam. Its façades are delicately inlaid with inscriptions and arabesques in

semiprecious stones—carnelian, agate, coral, turquoise, garnet, lapis, and jasper. Above, its luminous, white marble dome reflects each shift in light, flushing rose at dawn, dissolving in its own brilliance in the noonday sun. One of the most celebrated buildings in the world, the **TAJ MAHAL** (FIG. 23–1) was built in the seventeenth century by the Mughal ruler Shah Jahan as a mausoleum for his favorite wife, Mumtaz-i-Mahal, who died in childbirth.

Inside, the Taj Mahal invokes the *hasht behisht*, or "eight paradises," a plan named for the eight small chambers that ring the interior—one at each corner and one behind each *iwan*, a vaulted opening with an arched portal. In two stories (for a total of sixteen chambers), the rooms ring the octagonal central area, which rises the full two stories to a domed ceiling that is lower than the outer dome. In this central chamber, surrounded by a finely carved octagonal openwork marble screen, are the exquisite inlaid cenotaphs of Shah Jahan and his wife, whose actual tombs lie in the crypt below.

A dynasty of Central Asian origin, the Mughals were the most successful of the many Islamic groups that established themselves in India beginning in the tenth century. Under their patronage, Persian and Central Asian influences mingled with older traditions of the South Asian subcontinent, adding yet another dimension to the already ancient and complex artistic heritage of India.

CHAPTER-AT-A-GLANCE

- INDIA AFTER 1200 | Buddhist Art | Jain Art | Hindu Art
- THE BUDDHIST AND HINDU INHERITANCE IN SOUTHEAST ASIA | Theravada Buddhism in Burma and Thailand | Vietnamese Ceramics | Indonesian Traditions
- MUGHAL PERIOD | Mughal Architecture | Mughal Painting | Rajput Painting
- INDIA'S ENGAGEMENT WITH THE WEST | British Colonial Period | The Modern Period
- **IN PERSPECTIVE**

INDIA AFTER 1200

By 1200 India was already among the world's oldest civilizations (see "Foundations of Indian Culture," page 815). The art that survives from its earlier periods is almost exclusively sacred, most of it inspired by the three principal religions: Buddhism, Hinduism, and Jainism. These three religions continued as the principal focus for Indian art, even as invaders from the northwest began to establish the new religious culture of Islam.

Buddhist Art

After many centuries of prominence, Buddhism had been in decline as a cultural force in India since the seventh century C.E. By 1200, the principal Buddhist centers were concentrated in the northeast, in the region that had been ruled by the Pala dynasty (c. 750–1199). There, in great monastic universities that attracted monks from as far away as China, Korea, and Japan, was cultivated a form of Buddhism known as Tantric (Vajrayana) Mahayana.

ICONOGRAPHY OF A TANTRIC BODHISATTVA. The practices of Tantric Buddhism, which included techniques for visualizing deities, encouraged the development of images with precise iconographic details such as the gilt-bronze sculpture of the BODHISATTVA AVALOKITESHVARA in FIGURE 23–2. Bodhisattvas are beings who are well advanced on the path to buddhahood (enlightenment), the goal of Mahayana Buddhists, and who have vowed out of compassion to help others achieve enlightenment. Avalokiteshvara, the bodhisattva of greatest compassion, whose vow is to forgo buddhahood until all others become buddhas, became the most popular of these saintly beings in India and in East Asia.

Characteristic of *bodhisattvas*, Avalokiteshvara is distinguished in art by his princely garments, unlike a *buddha*, who wears a monk's robes. Avalokiteshvara is specifically recognized by the lotus flower he holds and by the presence in his crown of his "parent" *buddha*, in this case Amitabha, *buddha* of the Western Pure Land (the Buddhist paradise). Other marks of Avalokiteshvara's extraordinary status are the third eye (symbolizing the ability to see in miraculous ways) and the wheel on his palm (signifying the ability to teach the Buddhist truth).

Avalokiteshvara is shown here in the relaxed pose known as the posture of royal ease. One leg angles down; the other is drawn up onto the lotus seat, itself considered an emblem of spiritual purity. His body bends gracefully, if a bit stiffly, to one side. The chest scarf and lower garment cling to his body, fully revealing its shape. Delicate floral patterns enliven the textiles, and closely set parallel folds provide a wiry, linear tension that contrasts with the hard but silken surfaces of the body. Linear energy continues in the sweep of the tightly pleated hem emerging from under the right thigh, in the sinuous lotus stalks on each side, and in the fluttering ribbons of the elaborate crown. A profusion of details and varied textures creates an ornate effect—the lavish jewelry, the looped hair piled high and cascading over the shoulders, the ripe blossoms, the rich layers of the lotus seat. Though still friendly and human, the image is somewhat formalized. The features of the face, where we instinctively look for a human echo, are treated abstractly, and despite its reassuring smile, the statue's expression remains remote. Through richness of ornament and tension of line, this style expresses the heightened power of a perfected being.

With the fall of the Pala dynasty in the late twelfth century, the last centers of Buddhism in northern India collapsed, and the monks dispersed, mainly into Nepal and Tibet (SEE MAP 23–1). From that time, Tibet has remained the principal stronghold of Tantric Buddhist practice and its arts. The artistic style perfected under the Palas, however, became an influential international style throughout East and Southeast Asia.

Jain Art

The Jain religion traces its roots to a spiritual leader called Mahavira (c. 599–527 BCE), whom it regards as the final in a series of twenty-four saviors known as pathfinders, or *tirthankaras*. Devotees seek through purification to become worthy of rebirth in the heaven of the pathfinders, a zone of pure existence at the zenith of the universe. Jain monks live a life of austerity, and even laypersons avoid killing any living creature.

A Manuscript Leaf from the Kalpa Sutra. As Islamic, or Muslim, territorial control over northern India expanded,

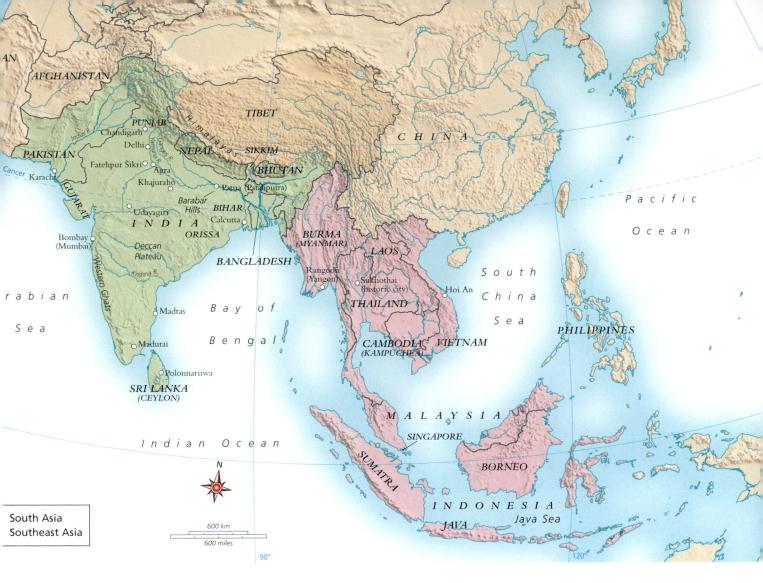

MAP 23-I INDIA

Throughout its history, the Indian subcontinent was subject to continual invasion that caused the borders of its kingdoms to contract and expand until the establishment of modern-day India in the mid-twentieth century.

non-Islamic religions resorted to more private forms of artistic expression, such as illustrating sacred texts, rather than public activities, such as building temples. In these circumstances, the Jains of western India, primarily in the region of Gujarat, created many illustrated manuscripts, such as this *Kalpa Sutra*, which explicates the lives of the pathfinders (FIG. 23–3). Produced during the late fourteenth century, it is one of the first Jain manuscripts on paper rather than palm leaf, the material which had previously been used for written documents.

With great economy, the illustration, inserted between blocks of Sanskrit text, depicts the birth of Mahavira. He is shown cradled in his mother's arms as she reclines in her bed under a canopy connoting royalty, attended by three ladies-in-waiting. Decorative pavilions and a shrine with peacocks on the roof suggest a luxurious palace setting. Everything appears two-dimensional against the brilliant red or blue

ground. Vibrant colors and crisp outlines impart an energy to the painting that suggests the arrival of the divine in the mundane world. Transparent garments with variegated designs reveal the swelling curves of the figures, whose alert postures and gestures convey a sense of the importance and excitement of the event. Strangely exaggerated features, such as the protruding eyes, contribute to the air of the extraordinary. With its angles and tense curves, the drawing is closely linked to the aesthetics of Sanskrit calligraphy, and the effect is as if the words themselves had suddenly flared into color and image.

Hindu Art

Hinduism became the dominant religious tradition of India. With the increasing popularity of Hindu sects came the rapid development of Hindu temples. Spurred by the ambitious building programs of wealthy rulers, well-formulated

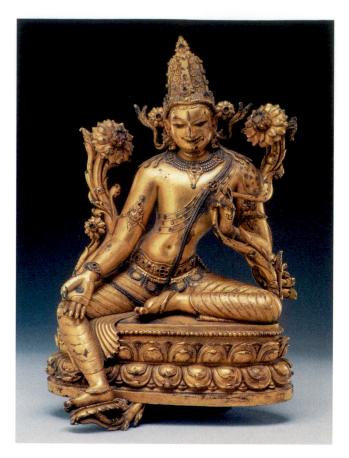

23–2 | **THE BODHISATTVA AVALOKITESHVARA**Kurkihar, Bihar. Pala dynasty, 12th century. Gilt-bronze, height 10" (25.5 cm). Patna Museum, Patna.

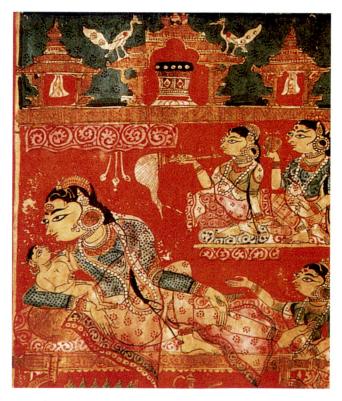

23–3 | **DETAIL OF A LEAF WITH THE BIRTH OF MAHAVIRA** *Kalpa Sutra*. Western Indian school (probably Gujarat), c. 1375–1400. Gouache on paper, $3\frac{1}{6} \times 3^n$ (8.5 \times 7.6 cm). Prince of Wales Museum, Bombay.

regional styles had evolved by about 1000 CE. The most spectacular structures of the era were monumental, with a complexity and grandeur of proportion unequaled even in later Indian art.

Emphasis on monumental individual temples gave way to the building of vast temple complexes and more moderately scaled yet more richly ornamented individual temples. These developments took place largely in the south of India, for temple building in the north virtually ceased with the consolidation of Islamic rule there from the beginning of the thirteenth century. The mightiest of the southern Hindu kingdoms was Vijayanagar (c. 1336–1565), whose rulers successfully countered the southward progress of Islamic forces for more than 200 years. Viewing themselves as defenders and preservers of Hindu faith and culture, Vijayanagar kings lavished donations on sacred shrines. Under the patronage of the Vijayanagar and their successors, the Nayaks, the principal monuments of later Hindu architecture were created.

TEMPLE AT MADURAI. The enormous temple complex at Madurai, one of the capitals of the Nayaks, is an example of this fervent expression of Hindu faith. Founded around the thirteenth century, it is dedicated to the goddess Minakshi (the local name for Parvati, the consort of the god Shiva) and to Sundareshvara (the local name for Shiva himself). The temple complex stands in the center of the city and is the focus of Madurai life. At its heart are the two oldest shrines, one to Minakshi and the other to Sundareshvara. Successive additions over the centuries gradually expanded the complex around these small shrines and came to dominate the visual landscape of the city. The most dramatic features of this and similar "temple cities" of the south were the thousand-pillar halls, large ritual-bathing pools, and especially entrance gateways, called gopuras, which tower above the temple site and the surrounding city like modern skyscrapers (FIG. 23-4).

Gopuras proliferated as a temple city grew, necessitating new and bigger enclosing walls, and thus new gateways. Successive rulers, often seeking to outdo their predecessors, donated taller and taller *gopuras*. As a result, the tallest structures in temple cities are often at the periphery, rather than at the central temples, which are sometimes totally overwhelmed by the height of the surrounding structures. The temple complex at Madurai has eleven *gopuras*, the largest over 160 feet tall.

Formally, the *gopura* has its roots in the *vimana*, the pyramidal tower characteristic of the seventh-century southern temple style. As the *gopura* evolved, it took on the graceful concave silhouette shown here. The exterior is embellished with thousands of sculpted figures, evoking a teeming world of gods and goddesses. Inside, stairs lead to the top for an extraordinary view.

Myth and Religion

TANTRIC INFLUENCE IN THE ART OF NEPAL AND TIBET

he legacy of India's Tantric Buddhist art can be traced in the regions of Nepal and Tibet. Artistic expression of esoteric Buddhist ideals reached a high point in the seventeenth and eighteenth centuries. Indeed, even today, artists worldwide continue to explore aspects of this tradition.

Inlaid Devotional Sculpture. In Nepal, where Hinduism intermingled with Buddhism, sculptors developed a metalwork style in which a traditional artistic use of polished stones became prevalent in devotional sculptures as well. Inlaid gems and semiprecious stones often enlivened their copper or bronze sculptures, which were almost always brightly gilded. Complex representations of deities, often multiarmed and adorned with celestial attributes, predominated, but some themes from early Buddhism were revived. In one particularly fine eighteenthcentury example, Maya, the Mother of Buddha, holds the legendary tree branch while the Buddha emerges from her side. The cast and chased details of the regal costume of Queen Maya, including fluttering scarves, elaborate jewelry, and a large crown, are studded with real jewels, pearls, and semiprecious stones. The tree, also, is richly inlaid, symbolizing the auspicious nature of the event. Both the tree and the figure rise from a pedestal shaped to suggest the blossoming lotus, a reference to

the appearance of the Buddha's purity in the muddy pond of the material world.

Tangka Painting. Buddhism was established relatively late in Tibet but the region has since become almost wholly identified with the religion. With the rule of a lineage of Dalai Lamas established in the seventeenth century and continuing through to the twentieth century, and a related expansion of monasteries, the arts associated with Tantric Buddhism flourished. Wrathful manifestations of deities, mysterious and powerful, were evoked in sculpted and painted forms, with the scroll-like tangka emerging as a major format. A nineteenth-century painting of Achala, one of a group of wrathful deities associated with truth, resolve, and the overcoming of obstacles, exemplifies this major aspect of Tibetan art. The deity exudes brilliant red flames while brandishing a sword and posing as if to strike. Following traditional practice, the artist-or artists, as these may have employed highly specialized craftsmen-positions the terrifying figure on a lotus pedestal, establishing his ethereal nature. The background suggests the green hills and blue sky of the material world as well as the cosmic geometry envisioned in Tantric Buddhism. Repeated representations of the deity emphasize the efficacious function and conspicuous power of the image.

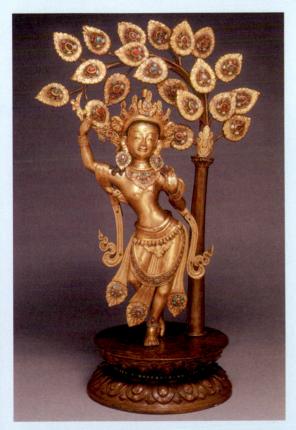

MAYA, MOTHER OF BUDDHA, HOLDING A TREE BRANCH Nepal. 18th century. Gilt bronze with inlaid precious stones, height 22" (56 cm). Musée Guimet, Paris.

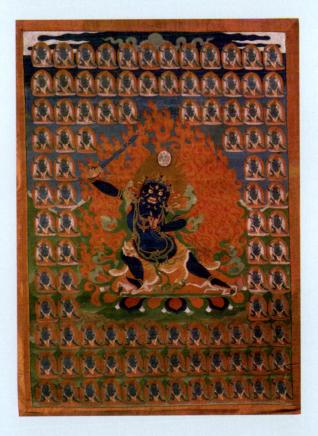

ACHALA

Tibet. 19th century. Gouache on cotton, $33\frac{1}{2} \times 23\frac{1}{3}$ " (85 × 60 cm). Musée Guimet, Paris.

Photo Réunion des Musées Nationaux; Art Resource, New York

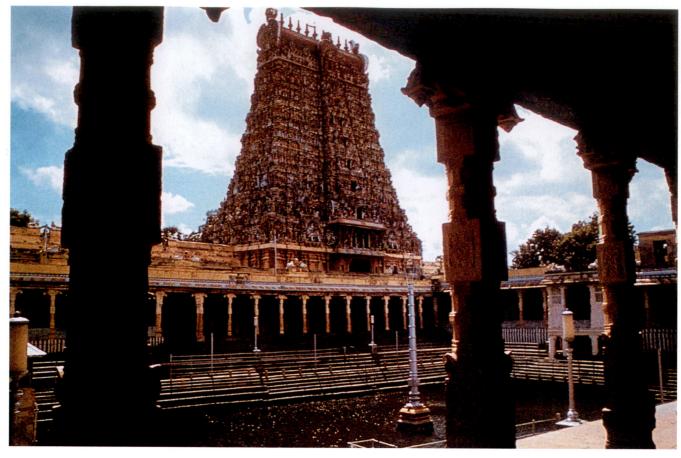

23–4 | **OUTER** *GOPURA* **OF THE MINAKSHI-SUNDARESHVARA TEMPLE**Madurai, Tamil Nadu, South India. Nayak dynasty, mostly 13th to mid-17th century, with modern renovations.

THE BUDDHIST AND HINDU INHERITANCE IN SOUTHEAST ASIA

India's Buddhist and Hindu traditions influenced Southeast Asia (discussed in Chapter 9), where they were absorbed by newly rising kingdoms in the regions now comprising Burma (Myanmar), Thailand, Cambodia (Kampuchea), Vietnam, and Indonesia.

Theravada Buddhism in Burma and Thailand

In northern Burma, from the eleventh to the thirteenth century, rulers raised innumerable religious monuments—temples, monasteries, and stupas—in the Pagan plain, following the scriptures of Theravada Buddhism (or Hinayana Buddhism, see Chapter 9). To the south arose the port city

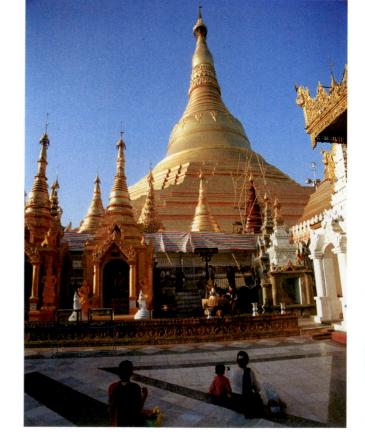

23-5 SHWE-DAGON STUPA (PAGODA)

Terrace, 15th century. Construction at the site from at least the 14th century, with replastering and redecoration continuously to the present.

Art and Its Context

FOUNDATIONS OF INDIAN CULTURE

he earliest civilization on the Indian subcontinent flourished toward the end of the third millennium BCE along the Indus River in present-day Pakistan. Remains of its expertly engineered brick cities have been uncovered, together with works of art that intriguingly suggest spiritual practices and reveal artistic traits known in later Indian culture.

The decline of the Indus Valley civilization during the mid-second millennium BCE coincides with (and may be related to) the arrival from the northwest of a seminomadic warrior people known as the Indo-European Aryans. Over the next millennium they were influential in formulating the new civilization that gradually emerged. The most important Aryan contributions to this new civilization included the Sanskrit language and the sacred texts called the Vedas. The evolution of Vedic thought under the influence of indigenous Indian beliefs culminated in the mystical, philosophical texts called the Upanishads, which took shape sometime after 800 BCE.

The Upanishads teach that the material world is illusory; only Brahman, the universal soul, is real and eternal. We—that is, our individual souls—are trapped in this illusion in a relentless cycle of birth, death, and rebirth. The ultimate goal of religious life is to liberate ourselves from this cycle and to unite our individual soul with Brahman.

Buddhism and Jainism are two of the many religions that developed in the climate of Upanishadic thought. Buddhism (see "Buddhism" page 317) is based on the teachings of Shakyamuni Buddha, who lived in central India about 500 BCE; Jainism was shaped about the same time by the followers of the spiritual leader Mahavira. Both religions acknowledged the cyclical nature of existence and taught a means of liberation from it, but they rejected the authority, rituals, and social strictures of Vedic religion. Whereas the Vedic religion was in the hands of a

hereditary priestly class, Buddhist and Jain communities welcomed all members of society, which gave them great appeal. The Vedic tradition eventually evolved into the many sects now collectively known as Hinduism (see "Hinduism" page 318).

Through most of its history India was a mosaic of regional dynastic kingdoms, but from time to time, empires emerged that unified large parts of the subcontinent. The first was the Maurya dynasty (c. 322-185 BCE), whose great king Ashoka patronized Buddhism. From this time Buddhist doctrines spread widely and its artistic traditions were established.

In the first century CE the Kushans, a Central Asian people, created an empire extending from present-day Afghanistan down into central India. Buddhism prospered under Kanishka, the most powerful Kushan king, and spread into Central Asia and to East Asia. At this time, under the evolving thought of Mahayana Buddhism, traditions first evolved for depicting the image of the Buddha in art.

Later, under the Gupta dynasty (c. 320-486 CE) in central India, Buddhist art and culture reached their high point. However, Gupta monarchs also patronized the Hindu religion, which from this time grew to become the dominant Indian religious tradition, with its emphasis on the great gods Vishnu (the Creator), Shiva (the Destroyer), and the Goddess—all with multiple forms.

After the tenth century, numerous regional dynasties prevailed, some quite powerful and long-lasting. During the early part of this period, to roughly 1200, Buddhism continued to decline as a cultural force, while artistic achievement under Hinduism soared. Hindu temples, in particular, developed monumental and complex forms that were rich in symbolism and ritual function, with each region of India producing its own variation.

of Rangoon (in Burmese Yangon, called Dagon in antiquity), now the nation's capital. Established by Mon rulers (SEE FIG. 9–29) at least by the eleventh century, Rangoon is site of the Shwe-dagon stupa (FIG. 23–5), which enshrines relics of the Buddha. The modern structures of Shwe-dagon (which means "Golden Dagon") rise from an ancient core—fourteenth century or earlier—and reflect centuries of continual restoration and enhancement. The site continues to be a center of Theravada devotion amid symbolic ornamentation—especially lotus elements symbolic of the Buddha's purity—and splendid decoration in gilding and precious stones supplied by pious contributions. Images of

the Buddha, and sometimes his footprints alone, provide focal points for devotion.

In Thailand, the Sukhothai kingdom (mid-thirteenth to late fourteenth century) also embraced Theravada Buddhism, although Hindu shrines were constructed as well in its capital city called Sukhothai (ancient name Sukhodaya). Artisans working under royal patrons developed a classic statement of Theravada ideals in bronze sculptures of the Buddha. Notable was their development of a free-standing walking Buddha. The highest expression of the ascetic simplicity of Theravada Buddhism, however, may be found in their many renditions of the BUDDHA CALLING THE EARTH TO WITNESS (FIG. 23–6).

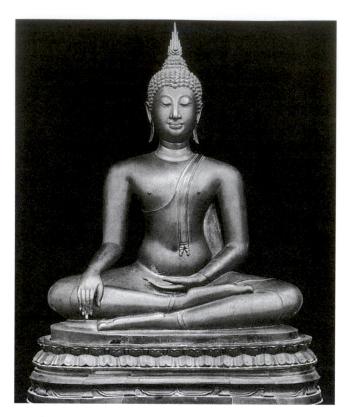

23–6 | BUDDHA CALLING THE EARTH TO WITNESS Sukhothai style. Bronze. Height 37" (94 cm). Collection of H.R.H. Prince Chalermbol Yugala, Bangkok.

Inspired by devotional texts and poetry, and further refined through reference to models from Sri Lanka, the iconographical and stylistic elements reached a height of perfection. The Buddha's cranial protuberance is interpreted as a flame of divine knowledge, and details of his ecclesiastical costume are reduced to a few elegant lines. The *mudras* (see p. 325), or hand gestures, are quietly eloquent.

Vietnamese Ceramics

Both the Burmese and the Thai kingdoms produced ceramics, often inspired by the stonewares and porcelains from China. Sukhothai potters, for example, made green-glazed and brown-glazed wares, called Sawankhalok wares. Even more widespread were the wares of Vietnamese potters. For example, excavation of the Hoi An "hoard" (SEE FIG. 23–7), actually the contents of a sunken ship laden with ceramics for export, brought to light an impressive variety of ceramic forms made by Vietnamese potters of the late fifteenth to early sixteenth century. Painted in underglaze cobalt blue and further embellished with overglaze enamels, these wares were shipped throughout Southeast Asia and beyond, as far east as Japan and as far west as England and The Netherlands.

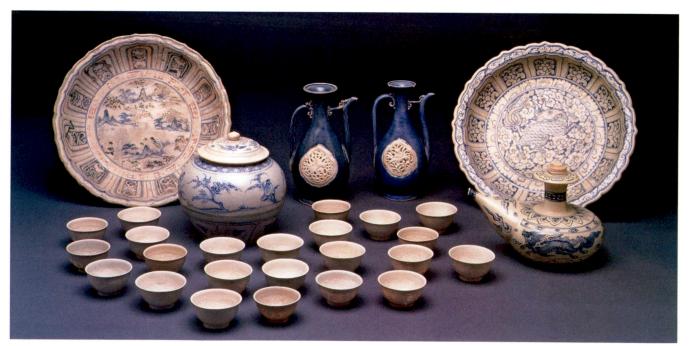

23–7 | GROUP OF CERAMICS FROM THE HOI AN HOARD, VIETNAMESE
Late 15th to early 16th century, porcelain with underglaze blue decoration, barbed-rim dishes: (left) diam. 14" (35.1 cm); (right) diam. 13½" (34.7 cm). Phoenix Art Museum, 2000.105–109.

More than 150,000 blue-and-white ceramics were found in the hold of a sunken ship excavated in the late 1990s under commission from the Vietnamese government, which later sent many of the retrieved items to public auction. Among the works shown here, the twenty-three small cups were found packed inside the jar.

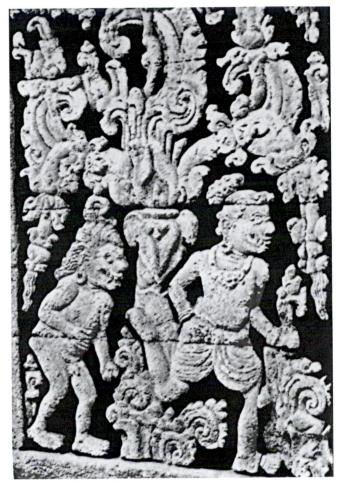

23–8 | RAMAYANA SCENE Candi Panataran, Java. Stone relief, height 29½" (70 cm). Early 14th century.

Indonesian Traditions

Indonesia experienced a Hindu revival in the centuries following its Buddhist period, which came to a close in the eighth or ninth century (see Chapter 9). As a consequence, it has maintained unique traditions that build upon the Hindu epics, especially the Ramayana. Javanese versions of these epics can be found illustrated in narrative reliefs from shrines of the fourteenth century (FIG. 23–8). Here modeling is reduced and rhythmic surface ornamentation increased. This style is often called the *wayang* style because of its similarities to the leather shadow puppets of Indonesia's *wayang* theater, still popular today. During the fifteenth century, Islam spread over Indonesia and subsequent religious monuments avoided figural representation. In their portrayal of botanical motifs and other ornaments, however, Indonesian sculptors preserved some elements of the relief style seen here.

MUGHAL PERIOD

Islam first touched the South Asian subcontinent in the eighth century, when Arab armies captured a small territory near the Indus River. Later, beginning around 1000, Turkic factions from Central Asia, relatively recent converts to Islam, began military campaigns into North India, at first purely for plunder, then seeking territorial control. From 1206, various Turkic dynasties ruled portions of the subcontinent from the northern city of Delhi. These sultanates, as they are known, constructed forts, mausoleums, monuments, and mosques. Although these early dynasties left their mark, it was the Mughal Dynasty that made the most inspired and lasting contribution to the art of India.

The Mughals, too, came from Central Asia. Muhammad Zahir-ud-Din, known as Babur ("Lion" or "Panther"), was the first Mughal emperor of India (ruled 1526–30). He emphasized his Turkic heritage, though he had equally impressive Mongol ancestry. After some initial conquests in Central Asia, he amassed an empire stretching from Afghanistan to Delhi, which he conquered in 1526. Akbar (ruled 1556–1605), the third ruler, extended Mughal control over most of North India, and under his two successors, Jahangir and Shah Jahan, northern India was generally unified by 1658. The Mughal Empire lasted until 1858, when the last Mughal emperor was deposed and exiled to Burma by the British.

Mughal Architecture

Mughal architects were heir to a 300-year-old tradition of Islamic building in India. The Delhi sultans who preceded them had great forts housing government and court buildings. Their architects had introduced two fundamental Islamic structures, the mosque and the tomb, along with construction based on the arch and the dome. (Earlier Indian architecture had been based primarily on post-and-lintel construction. They had also drawn freely on Indian architecture, borrowing both decorative and structural elements to create a variety of hybrid styles, and had especially benefited from the centuries-old Indian virtuosity in stone carving and masonry. The Mughals followed in this tradition, synthesizing Indian, Persian, and Central Asian elements for their forts, palaces, mosques, tombs, and cenotaphs (tombs or monuments to someone whose remains are actually somewhere else).

Akbar, an ambitious patron of architecture and city planning, constructed a new capital at a place he named *Fatehpur Sikri* ("City of Victory at Sikri"), celebrating his military conquests and the birth of his son Jahangir. The palatial and civic buildings, built primarily during Akbar's residence there from about 1572 to 1585, have drawn much admiration from modern and contemporary architects. Akbar's congregational mosque (Jami Masjid), completed about 1571–72, is one of

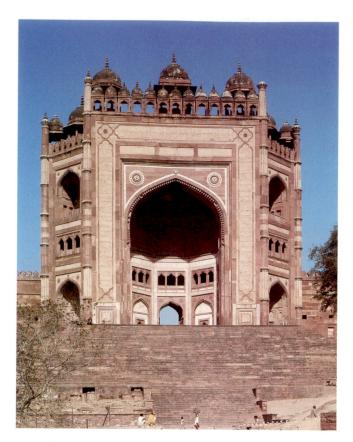

23–9 | BULAND DARVAZA (THE LOFTY GATE)
Fatehpur Sikri, approaching the Congregational Mosque (Jami Masjid), 1573–74.

the largest and most ornately finished mosques in India. Built on a high plinth, its vast central courtyard is approached from the south through the **BULAND DARVAZA (THE LOFTY GATE)**, as seen in FIGURE 23–9. This gateway is dignified in proportion but monumental in scale, rising more than 150 feet above the road below. An inscription dated 1601 cites Akbar's triumphant return from the Deccan; however, many scholars maintain a date in the 1570s or 1580s for the monumental gateway itself.

THE TAJ MAHAL. Perhaps the most famous of all Indian Islamic structures, the Taj Mahal is sited on the bank of the Yamuna River at Agra, in northern India. Built between 1631 and 1648, it was commissioned as a mausoleum for his wife by the emperor Shah Jahan (ruled 1628–58), who is believed to have taken a major part in overseeing its design and construction.

Visually, the Taj Mahal never fails to impress (SEE FIG. 23–1). As visitors enter through a monumental, hall-like gate, the tomb rises before them across a spacious garden set with long reflecting pools. Measuring some 1,000 by 1,900 feet, the enclosure is unobtrusively divided into quadrants planted with trees and flowers and framed by broad walkways and stone inlaid in geometric patterns. In Shah Jahan's time, fruit trees and cypresses—symbolic of life and death, respectively—lined the walkways, and fountains played in the shal-

low pools. One can imagine the melodies of court musicians that wafted through the garden. Truly, the senses were beguiled in this earthly evocation of paradise.

Set toward the rear of the garden, the tomb is flanked by two smaller structures not visible here, one a mosque and the other a hall designed in mirror image. They share a broad base with the tomb and serve visually as stabilizing elements. Like the entrance hall, they are made mostly of red sandstone, rendering even more startling the full glory of the tomb's white marble. The tomb is raised higher than these structures on its own marble platform. At each corner of the platform, a minaret, or slender tower, defines the surrounding space. The minarets' three levels correspond to those of the tomb, creating a bond between them. Crowning each minaret is a chattri, or pavilion. Traditional embellishments of Indian palaces, chattris quickly passed into the vocabulary of Indian Islamic architecture, where they appear prominently. Minarets occur in architecture throughout the Islamic world; from their heights, the faithful are called to prayer.

A lucid geometric symmetry pervades the tomb. It is basically square, but its chamfered, or sliced-off, corners create a subtle octagon. Measured to the base of the finial (the spire at the top), the tomb is almost exactly as tall as it is wide. Each façade is identical, with a central iwan flanked by two stories of smaller iwans. (A typical feature of eastern Islamic architecture, an iwan is a vaulted opening with an arched portal.) By creating voids in the façades, these iwans contribute markedly to the building's sense of weightlessness. On the roof, four octagonal chattris, one at each corner, create a visual transition to the lofty, bulbous dome, the crowning element that lends special power to this structure. Framed but not obscured by the chattris, the dome rises more gracefully and is lifted higher by its drum than in earlier Mughal tombs, allowing the swelling curves and lyrical lines of its beautifully proportioned, surprisingly large form to emerge with perfect clarity.

By the seventeenth century, India was well known for exquisite craftsmanship and luxurious decorative arts (see "Luxury Arts," page 827). The pristine surfaces of the TAJ MAHAL are embellished with utmost subtlety (FIG. 23–10). Even the sides of the platform on which the Taj Mahal stands are carved in relief with a blind arcade motif and carved relief panels of flowers. The portals are framed with verses from the Qur'an inlaid in black marble, while the spandrels are decorated with floral arabesques inlaid in colored semi-precious stones, a technique known by its Italian name, pietra dura. Not strong enough to detract from the overall purity of the white marble, the embellishments enliven the surfaces of this impressive yet delicate masterpiece.

Mughal Painting

Probably no one had more control over the solidification of the Mughal Empire and the creation of Mughal art than the emperor Akbar. A dynamic, humane, and just leader, Akbar

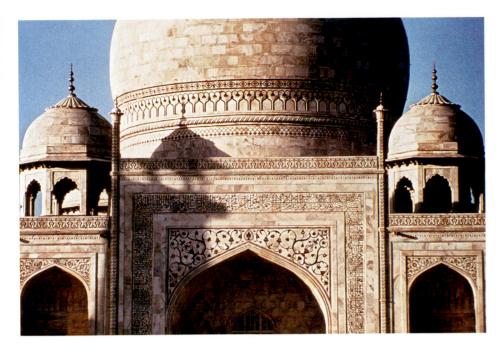

23–10 | TAJ MAHAL Agra, India. Mughal period, reign of Shah Jahan, c. 1631–48.

enjoyed religious discourse and loved the arts, especially painting. He created an imperial atelier (workshop) of painters, which he placed under the direction of two artists from the Persian court. Learning from these two masters, the Indian painters of the atelier soon transformed Persian styles into the more vigorous, naturalistic styles that mark the Mughal school (see "Indian Painting on Paper," page 820). At Akbar's cosmopolitan court, pictorial sources from Europe also became inspiration for Mughal artists.

Painting in the Court of Akbar. Akbar's court painters also produced paintings documenting Akbar's own life and accomplishments in the *Akbarnama*. Among the most fascinating in the series are those which record Akbar's supervision of the construction of Fatehpur Sikri. One painting (FIG. 23–II) documents Akbar's inspection of the stone masons and other craftsmen, and includes an ambitious rendering of the Buland Darwaza (The Lofty Gate), shown above in FIGURE 23–9.

One of the most famous and extraordinary works produced in Akbar's atelier is an illustrated manuscript of the *Hamzanama*, a Persian classic about the adventures of Hamza, uncle of the Prophet Muhammad. Painted on cotton cloth, each illustration is more than $2\frac{1}{2}$ feet high. The entire project gathered 1,400 illustrations into twelve volumes and took fifteen years to complete.

One illustration shows Hamza's spies scaling a fortress wall and surprising some men as they sleep (FIG. 23–12). One man climbs a rope; another has already beheaded a figure in yellow and lifts his head aloft—realistic details are not avoided in paintings from the Mughal atelier. The receding lines of the architecture, viewed from a slightly elevated vantage point, provide a reasonably three-dimensional setting. Yet the

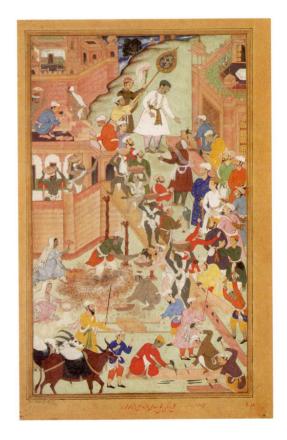

23-II AKBAR INSPECTING THE CONSTRUCTION OF FATEHPUR SIKRI

Akbarnama, c. 1590. Opaque watercolor on paper, $14\%\times10''$ (37.5 \times 25 cm). Victoria & Albert Museum, London. (I.S.2-1896 91/117)

Many of the painters in the Mughal imperial workshops are recorded in texts of the period. Based on those records and on signatures that occur on some paintings, scholars have attributed the design of this work to Tulsi Kalan (Tulsi the Elder), the painting to Bandi, and the portraits to Madhu Kalan (Madhu the Elder) or Madhu Khurd (Madhu the Younger).

Technique

INDIAN PAINTING ON PAPER

Before the fourteenth century most painting in India had been on walls or palm leaves. With the introduction of paper, Indian artists adapted painting techniques from Persia and over the ensuing centuries produced jewel-toned works of surpassing beauty on paper.

Painters usually began their training early. As young apprentices, they learned to make brushes and grind pigments. Brushes were made from the curved hairs of a squirrel's tail, arranged to taper from a thick base to a single hair at the tip. Paint came from pigments of vegetables and minerals—lapis lazuli to make blue, malachite for pale green—that were ground to a paste with water, then bound with a solution of gum from the acacia plant. Paper was made by crushing fibers of cotton and jute to a pulp, pouring the mixture onto a woven mat, drying, and then burnishing with a smooth piece of agate, often achieving a glossy finish.

Artists frequently worked from a collection of sketches belonging to a master painter's atelier. Sometimes, to transfer the drawing to a blank sheet beneath, sketches were pricked with small, closely spaced holes that were then daubed with wet color. The resulting dots were connected into outlines, and the process of painting began.

First, the painter applied a thin wash of a chalk-based white, which sealed the surface of the paper while allowing the underlying sketch to show through. Next, outlines were filled with thick washes of brilliant, opaque, unmodulated color. When the colors were dry, the painting was laid facedown on a smooth marble surface and burnished with a rounded agate stone, rubbing first up and down, then side to side. The indirect pressure against the marble polished the pigments to a high luster. Then outlines, details, and modeling—depending on the style—were added with a fine brush.

Sometimes certain details were purposely left for last, such as the eyes, which were said to bring the painting to life. Gold and raised details were applied when the painting was nearly finished. Gold paint, made from pulverized, 24-karat gold leaf bound with acacia gum, was applied with a brush and burnished to a high shine. Raised details such as the pearls of a necklace were made with thick, white, chalk-based paint, with each pearl a single droplet hardened into a tiny raised mound.

sense of depth is boldly undercut by the richly variegated geometric patterns of the tilework, which are painted as though they had been set flat on the page. Contrasting with the flat geometric patterns are the large human figures, whose rounded forms and softened contours create a convincing sense of volume. The energy exuded by the figures is also characteristic of painting under Akbar—even the sleepers seem active. This robust, naturalistic figure style is quite different from the linear style seen earlier in Jain manuscripts (SEE FIG. 23–3) and even from the Persian styles that inspired Mughal paintings.

Nearly as prominent as the architectural setting with its vivid human adventure is the sensuous landscape in the foreground, where monkeys, foxes, and birds inhabit a grove of trees that shimmer and glow against the darkened background like precious gems. The treatment of the gold-edged leaves at first calls to mind the patterned geometry of the tilework, yet a closer look reveals a skillful naturalism born of careful observation. Each tree species is carefully distinguished—by the way its trunk grows, the way its branches twist, the shape and veining of its leaves, the silhouette of its overall form. Pink and blue rocks with lumpy, softly outlined forms add still further interest to this painting, whose every inch is full of intriguing elements.

Painting in the Court of Jahangir. Painting from the reign of Jahangir (ruled 1605–27) presents a different tone. Like his father, Jahangir admired painting and, if anything, paid even more attention to his atelier. Indeed, he boasted that he could recognize the hand of each of his artists even in collaborative paintings, which were common. Unlike Akbar, however, Jahangir preferred the courtly life to the adventurous one, and paintings produced for him reflect his subdued and refined tastes and his admiration for realistic detail.

One such painting is **JAHANGIR IN DARBAR** (FIG. 23–13). The work, probably part of a series on Jahangir's reign, shows the emperor holding an audience, or *darbar*, at court. Jahangir himself is depicted at top center, seated on a balcony under a canopy. Members of his court, including his son, the future emperor Shah Jahan, stand somewhat stiffly to each side. The audience, too, is divided along the central axis, with figures lined up in profile or three-quarter view. In the foreground, an elephant and a horse complete the symmetrical format.

Jahangir insisted on fidelity in portraiture, including his own in old age. The figures in the audience are a medley of portraits, possibly taken from albums meticulously kept by the court artists. Some represent people known to have died before Jahangir's reign, so the painting may represent a symbolic gathering rather than an actual event. Standing out amid the bright array of garments is the black robe of a Jesuit priest from Europe. Both Akbar and Jahangir were known for their interest in things foreign, and many foreigners flocked to the courts of these open-minded rulers.

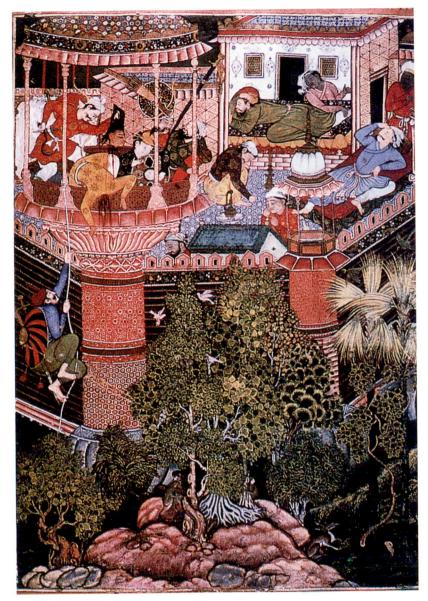

23–12 | **HAMZA'S SPIES SCALE THE FORTRESS** *Hamzanama*, North India. Mughal period, Mughal, reign of Akbar, c. 1567–82. Gouache on cotton, $30 \times 24''$ (76×61 cm). Museum of Applied Arts, Vienna.

The scene is formal, the composition static, and the treatment generally two-dimensional. Nevertheless, the sensitively rendered portraits and the fresh colors, with their varied range of pastel tones, provide the aura of a keenly observed, exquisitely idealized reality that marks the finest paintings of Jahangir's time.

Rajput Painting

Outside of the Mughal strongholds at Delhi and Agra, much of northern India was governed regionally by local Hindu princes, descendants of the so-called Rajput warrior clans, who were allowed to keep their lands in return for allegiance to the Mughals. Like the Mughals, Rajput princes frequently supported painters at their courts, and in these settings, a variety of strong, indigenous Indian painting styles were perpetu-

ated. Rajput painting, more abstract and poetic than the Mughal style, included subjects like those treated by Mughal painters, royal portraits and court scenes, as well as indigenous subjects such as Hindu myths, love poetry, and the Ragamala (illustrations relating to musical modes).

The Hindu devotional movement known as *bhakti*, which had done much to spread the faith in the south from around the seventh century, now experienced a revival in the north. As it had earlier in the south, *bhakti* inspired an outpouring of poetic literature, this time devoted especially to Krishna, the popular human incarnation of the god Vishnu. Most renowned is the *Gita Govinda*, a cycle of rhapsodic poems about the love between God and humans expressed metaphorically through the love between the young Krishna and the cowherd Radha.

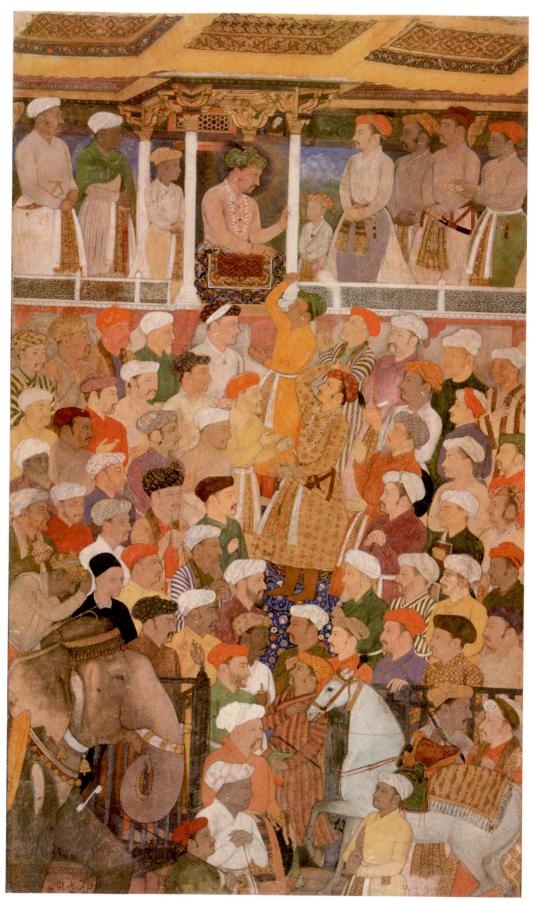

23–13 | Abul Hasan and Manohar Jahangir in Darbar Jahangirnama. North India. Mughal period, Mughal, reign of Jahangir, c. 1620. Gouache on paper, $13\% \times 7\%$ (35 \times 20 cm). Museum of Fine Arts, Boston. Frances Bartlett Donation of 1912 and Picture Fund (14, 654)

The illustration here is from a manuscript of the *Gita Govinda* produced in the region of Rajasthan about 1525–50. The blue god Krishna sits in dalliance with a group of cowherd women. Standing with her maid and consumed with love for Krishna, Radha peers through the trees, overcome by jealousy. Her feelings are indicated by the cool blue color behind her, while the crimson red behind the Krishna grouping suggests passion (FIG. 23–14). The curving stalks and bold patterns of the flowering vines and trees express not only the exuberance of springtime, when the story unfolds, but also the heightened emotional tensions of the scene. Birds, trees, and flowers are brilliant as fireworks against the black, hilly landscape edged in an undulating

white line. As in the Jain manuscript earlier (SEE FIG. 23–3), all the figures are of a single type, with plump faces in profile and oversized eyes. Yet the resilient line of the drawing gives them life, and the variety of textile patterns provides some individuality. The intensity and resolute flatness of the scene seem to thrust all of its energy outward, irrevocably engaging the viewer in the drama.

Quite a different mood pervades **HOUR OF COWDUST**, a work from the Kangra school in the Punjab Hills, foothills of the Himalayas north of Delhi (FIG. 23–15). Painted around 1790, some 250 years later than the previous work, it shows the influence of Mughal naturalism on the later schools of Indian painting. The theme is again Krishna.

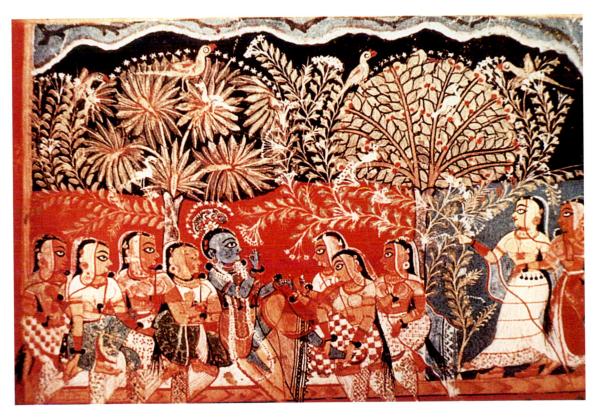

23–14 | KRISHNA AND THE GOPIS From the *Gita Govinda*, Rajasthan, India. Mughal period, Rajput, c. 1525–50. Gouache on paper, $4\frac{7}{8} \times 7\frac{1}{2}$ " (12.3 \times 19 cm). Prince of Wales Museum, Bombay.

The lyrical poem *Gita Govinda*, by the poet-saint Jayadeva, was probably written in eastern India during the latter half of the twelfth century. The episode illustrated here occurs early in the relationship of Radha and Krishna, which in the poem is a metaphor for the connection between humans and god. The poem traces the progress of their love through separation, reconciliation, and fulfillment. Intensely sensuous imagery characterizes the entire poem, as in the final song, when Krishna welcomes Radha to his bed. (Narayana is the name of Vishnu in his role as cosmic creator.)

Leave lotus footprints on my bed of tender shoots, loving Radha!

Let my place be ravaged by your tender feet!

Narayana is faithful now. Love me Radhika!

I stroke your feet with my lotus hand-you have come far.

Set your golden anklet on my bed like the sun.

Narayana is faithful now. Love me Radhika!

Consent to my love. Let elixir pour from your face!

To end our separation I bare my chest of the silk that bars your breast.

Narayana is faithful now. Love me Radhika!

(Translated by Barbara Stoler Miller)

Wearing his peacock crown, garland of flowers, and yellow garment—all traditional iconography of Krishna-Vishnu—he returns to the village with his fellow cowherds and their cattle. All eyes are upon him as he plays his flute, said to enchant all who hear it. Women with water jugs on their heads turn to look; others lean from windows to watch and call out to him. We are drawn into this charming village

scene by the diagonal movements of the cows as they surge through the gate and into the courtyard beyond. Pastel houses and walls create a sense of space, and in the distance we glimpse other villagers going about their work or peacefully sitting in their houses. A rim of dark trees softens the horizon, and an atmospheric sky completes the aura of enchanted naturalism. Again, all the figures are similar in

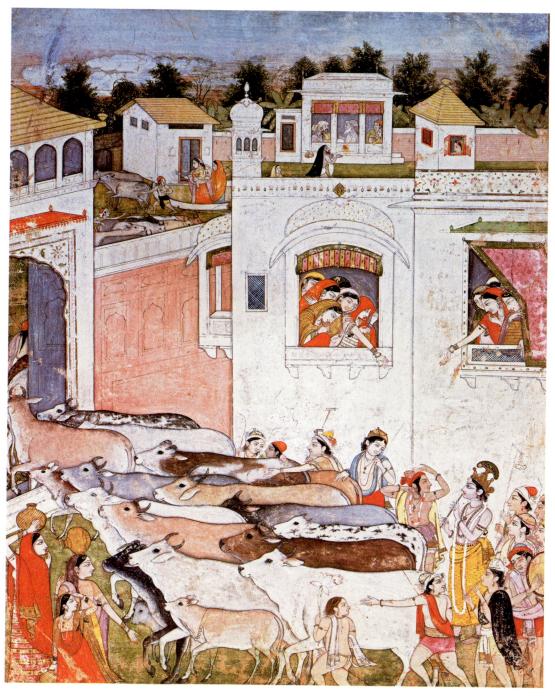

23–15 HOUR OF COWDUST From Punjab Hills, India. Mughal period, Rajput, Kangra school, c. 1790. Gouache on paper, $14\frac{1}{16} \times 12\frac{9}{16}$ " (36 \times 31.9 cm). Museum of Fine Arts, Boston.

type, this time with a perfection of proportion and a gentle, lyrical movement that complement the idealism of the setting. The scene embodies the sublime purity and grace of the divine, which, as in so much Indian art, is evoked into our human world to coexist with us as one.

INDIA'S ENGAGEMENT WITH THE WEST

By the time *Hour of Cowdust* was painted, India's regional princes had reasserted themselves, and the vast Mughal Empire had shrunk to a small area around Delhi. At the same time, however, a new power, Britain, was making itself felt, inaugurating a markedly different period in Indian history.

British Colonial Period

First under the mercantile interests of the British East India Company in the seventeenth and eighteenth centuries, and then under the direct control of the British government as a part of the British Empire in the nineteenth century, India was brought forcefully into contact with the West and its culture. The political concerns of the British Empire extended even to the arts, especially architecture. Over the course of the nineteenth century, the great cities of India, such as Calcutta, Madras, and Bombay (now Mumbai), took on a European aspect as British architects built in the revivalist styles favored in England.

New Delhi. In 1911 the British announced their intention to move the seat of government from Calcutta to a newly constructed Western-style capital city to be built at New Delhi. Two years later, Sir Edwin Lutyens (1869-1944) was appointed joint architect for New Delhi (with Herbert Baker), and was charged with laying out the new city and designing the Viceroy's House (now Rashtrapati Bhavan or President's House). Drawing inspiration from Classical antiquity—as well as from more recent urban models, such as Washington, D.C.—Lutyens sited the Viceroy's House as a focal point along with the triumphal arch that he designed as the All India War Memorial, now called the INDIA GATE (FIG. 23–16). In these works Lutyens sought to maintain the tradition of Classical architecture he developed a "Delhi order" based on the Roman Doric—while incorporating massing, detail, and ornamentation derived from Indian architecture as well. The new capital was inaugurated in 1931.

MOTHER INDIA. Far prior to Britain's consolidation of imperial power in New Delhi a new spirit asserting Indian independence and pan-Asiatic solidarity was awakening. For example, working near Calcutta, the painter Abanindranath Tagore (1871–1951)—nephew of the poet Rabindranath Tagore (1861–1941), who went on to win the Nobel Prize for Litera-

23–16 | Sir Edwin Lutyens INDIA GATE (Originally the All India War Memorial), New Delhi. British Colonial Period, 20th century.

ture in 1913—deliberately rejected the medium of oil painting and the academic realism of Western art. Like the Nihonga artists of Japan (SEE FIG. 25–16) with whom he was in contact, Tagore strove to create a style that reflected his ethnic origins. In **BHARAT MATA (MOTHER INDIA)** he invents a nationalistic icon by using Hindu symbols while also drawing upon the format and techniques of Mughal painting (FIG. 23–17).

The Modern Period

In the wake of World War II, the imperial powers of Europe began to shed their colonial domains. The attainment of self-rule had been five long decades in the making, when finally—chastened by the non-violent example of Mahatma Gandhi (1869–1948)—the British Empire relinquished its "Jewel in the Crown," which was partitioned to form two modern nations: India and Pakistan.

MODERNISM AT CHANDIGARH. After Indian independence in 1947, a modern, internationalist approach was welcomed by the exuberant young nation. One example of this new spirit is the **GANDHI BHAVAN** at Punjab University in Chandigarh, in North India (FIG. 23–18). Used for both lectures and prayer, the hall was designed in the late 1950s by Indian

architect B. P. Mathur in collaboration with Pierre Jeanneret, cousin of the French Modernist architect Le Corbusier (Chapter 31), who had drawn plans for the new city at Chandigarh and whose version of the International Style had become influential in India.

The Gandhi Bhavan's three-part, pinwheel plan and abstract sculptural qualities reflect the modern vision of the International Style. Yet other factors speak to India's heritage. Its robust combinations of angles and curves recall ancient Sanskrit letterforms, while the pools surrounding the building evoke Mughal tombs, as well as the ritual-bathing pools of Hindu temples. Yet the abstract style is free of specific religious associations.

A MODERN INDIAN PAINTER. Artists working after Indian independence have continued to study and work abroad, but often draw upon India's distinctive literary and religious traditions as well as regional and folk art traditions. One example is Manjit Bawa (born 1941), who worked in Britain as a silkscreen artist before returning to India to settle in New Delhi. His distinctive canvases, painted meticulously in oil, juxtapose illusionistically modeled figures and animals against brilliantly colored backgrounds of flat, unmodulated color. The composite result, for example in **DHARMA AND THE GOD** (FIG. 23–19), brings a strikingly new interpretation to the heroic figures of Indian tradition.

826

1905. Watercolor on paper, $10\% \times 6"$ (26.7 \times 15.3 cm). Rabindra Bharati Society, Calcutta.

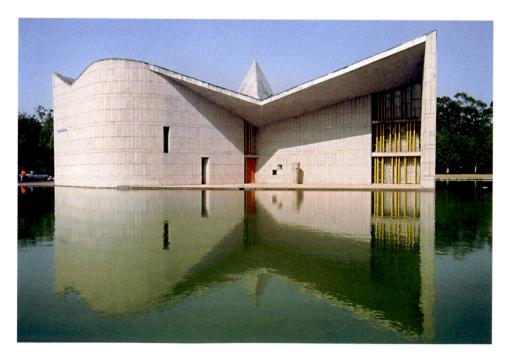

23–18 | B. P. Mathur and Pierre Jeanneret GANDHI BHAVAN Punjab University, Chandigarh, North India. Modern period, 1959–61.

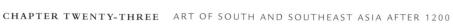

THE OBJECT SPEAKS

LUXURY ARTS

he decorative arts of India represent the height of opulent luxury. Ornament embellishes even the invisible backs of pendants and bottoms of containers. Technically superb and crafted from precious materials, tableware, jewelry, furniture, and containers enhance the prestige of their owners and give visual pleasure as well. Metalwork and work in rock crystal, agate, and jade, carving in ivory, and intricate jewelry are all characteristic Indian arts. Because of the intrinsic value of their materials, however, pieces have been disassembled, melted down, and reworked, making the study of Indian luxury arts very difficult. Many pieces, like the carved ivory panel illustrated here, have no date or records of manufacture or ownership. And, like it, many such panels have been removed from a larger container or piece of furniture.

Frozen in timeless delight, carved in ivory against a golden ground, where openwork, stylized vines with spiky leaves, weave an elegant arabesque; loving couples dally under the arcades of a palace courtyard, the thin columns and cusped arches of which resemble the arcades of the palace of Tirumala Nayak (reigned 1623-59) in Madurai (Tamil Nadu). Their huge eyes under heavy brows suggest the intensity of their gaze, and the artist's choice of the profile view shows off their long noses and sensuously thick lips. Their hair is tightly controlled; the men have huge buns and the women, long braids hanging down their backs. Are they divine lovers? After all, Krishna lived and loved on earth among the cowherd maidens. Or are we observing scenes of courtly romance?

The rich jewelry and well-fed look of the couples indicate a high station in life. Men as well as women have voluptuous figures—rounded buttocks and thighs, abdomens hanging over jeweled belts, and sharply indented slim waists that emphasize seductive breasts. Their smooth flesh contrasts with the diaphanous fabrics that swath their plump legs, and their long arms and elegant gestures seem designed to show off their rich jewelry—bracelets, armbands, necklaces, huge earrings, and ribbons. Such amorous couples symbolize harmony as well as fertility.

The erotic imagery suggests that the panel illustrated here might have adorned a container for personal belongings such as jewelry, perfume, or cosmetics. In any event, the ivory relief is a brilliant example of South Indian secular arts.

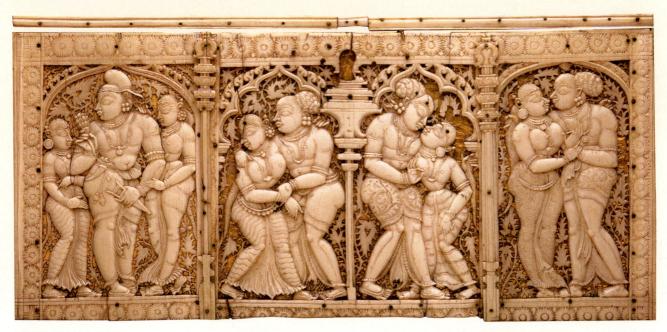

PANEL FROM A BOX

Nayak dynasty, Tamil Nadu, South India. Late 17th-18th century. Ivory backed with gilded paper, $6 \times 12 \frac{1}{8} \times \frac{1}{8}$ " (15.2 \times 31.4 \times 0.3 cm). Virginia Museum of Fine Arts.

The Arthur and Margaret Glasgow Fund. 80.171

23–19 | Manjit Bawa DHARMA AND THE GOD 1984. Oil on canvas, 216 x 185.4 cm. Peabody Essex Museum. Salem, Massachusetts. The Davida and Chester Hervitz Collection

IN PERSPECTIVE

India's voluptuous figurative art, together with her rich religious traditions, had already reached a high point when the Mughals gained control of North India in the sixteenth century, and these traditions continued to thrive under regional patrons throughout the subcontinent. Within the Mughal empire, however, styles introduced from Persia mingled with these sensibilities, and Islamic ideals imparted a new emphasis to nonfigural art forms.

Under their Mughal patrons, architects developed vast building programs based on symmetrical plans and proportionate elevations. The pointed arches and complex vaults in their interiors were matched by the corresponding shapes of their open pavilions and exterior elements, thus providing graceful notes of repetition throughout the imperial complexes. Craftsmen embellished the surfaces of these buildings with intricate inlays of colored, hard stones portraying floral motifs inspired by nature's rhythms, thus perfecting the architectural whole to the pinnacle of refinement.

In the nineteenth century, as the British imposed their rule throughout India, Western academic painting attracted followers in the major cities. Gradually, British architects found opportunity in the construction of civic buildings in India, first in Calcutta and Bombay, and later culminating in the design of the modern capital at New Delhi.

Simultaneously, however, a move for independence from Britain, together with a search for modernity, led artists first to embrace Western artistic ideals and then to modify them, all the while aiming to identify and develop a tradition drawn from India's own history. As elsewhere in Asia, this search for a modern identity occasionally required the conscientious rejection of Western influences. On the one hand, modern Indian artists have drawn inspiration from sources in their "folk art," admired for its directness and the variety of its local characteristics. At the same time, India's sophisticated literary and religious traditions continue to inspire its art at the highest level.

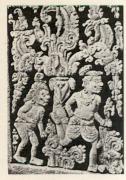

RAMAYANA SCENE, CANDI PANATARAN EARLY 14TH CENTURY

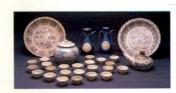

CERAMICS FROM THE HOI AN HOARD
LATE 15TH-EARLY 16TH CENTURY

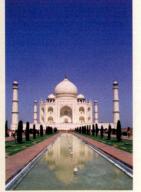

TAJ MAHAL c. 1631-48

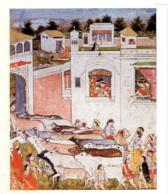

HOUR OF COWDUSTC. 1790

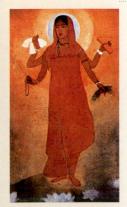

TAGORE

RAT MATA (MOTHER INDIA)

1905

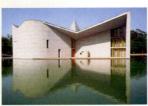

mathur and jeanneret **GANDHI BHAVAN** 1959–61

ART OF SOUTH AND SOUTHEAST ASIA AFTER 1200

▼ Fall of Pala Dynasty c. 1199

1200

1600

1800

- Turkic Dynasties Begin to Rule Portions of Indian Subcontinent c. 1206
- Sukhothai Kingdom, Thailand Mid 13th-late 14th century
- ▼ Vijayanagar Dynasties c. 1336–1565

- Babur, First Mughal Emperor,Begins Rule 1526
- British East India Company Begins Activity in India c. 1600
- Unfied Mughal Empire in Northern India c.1658

- End of Mughal Empire 1858
- Peak of British Imperial Power in India 1858-1947
- Independent India 1947

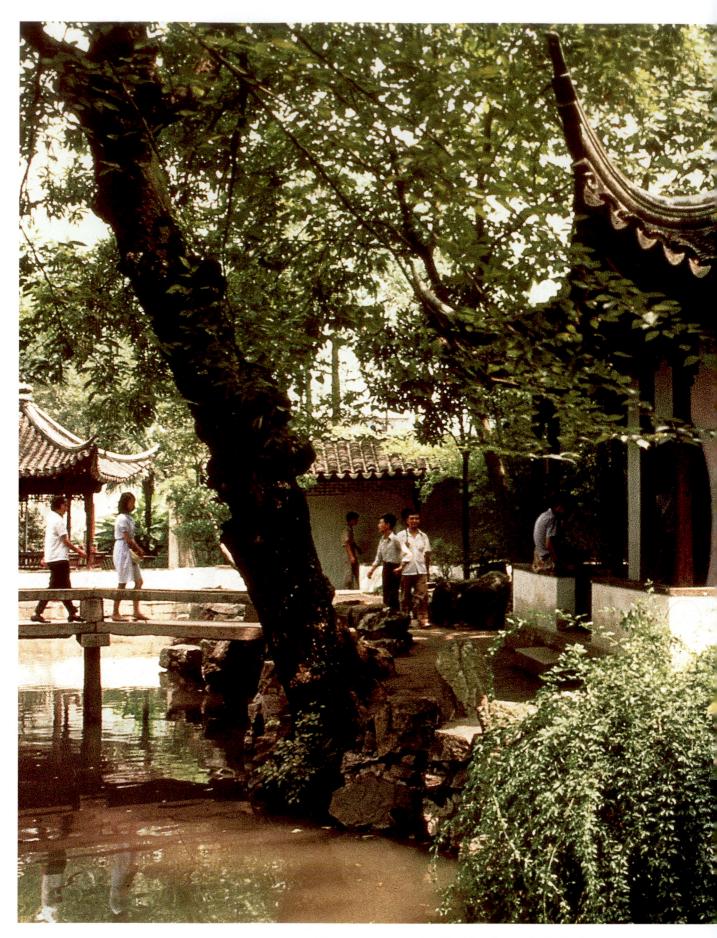

24–I \perp **GARDEN OF THE CESSATION OF OFFICIAL LIFE** (also known as the Humble Administrator's Garden) Suzhou, Jiangsu. Ming dynasty, early 16th century.

CHAPTER TWENTY-FOUR

CHINESE AND KOREAN ART AFTER 1279

24

Early in the sixteenth century, an official in Beijing, frustrated after serving in the capital for many years without promotion, returned to his

home near Shanghai. Taking an ancient poem, "The Song of Leisurely Living," for his model, he began to build a garden. He called his retreat the Garden of the Cessation of Official Life (FIG. 24–1) to indicate that he had exchanged his career as a bureaucrat for a life of leisure. By leisure, he meant that he could now dedicate himself to calligraphy, poetry, and painting, the three arts dear to scholars in China.

The scholar class of imperial China was a phenomenon unique in the world, the product of an examination system designed to recruit the finest minds in the country for government service. Instituted during the Tang dynasty (618–907) and based on even earlier traditions, the civil service examinations were excruciatingly difficult, but for the tiny percentage that passed at the highest level, the rewards were prestige, position, power, and wealth. During the Song dynasty (960–1279) the examinations were expanded and regularized, and more than half of all government positions came to be filled by scholars.

Steeped in the classic texts of philosophy, literature, and history, China's scholars—often called *wenren* or literati—shared a common bond in education and outlook. Their lives typically moved between the philosophical poles of Confucianism and Daoism (see "Foundations of Chinese Culture,"

page 834). Following Confucianism, they became officials to fulfill their obligation to the world; pulled by Daoism, they retreated from society in order to come to terms with nature and the universe: to create a garden, to write poetry, to paint.

Under a series of remarkably cultivated emperors, the literati reached the height of their influence during the Song dynasty. Their world was about to change dramatically, however, with lasting results for Chinese art.

CHAPTER-AT-A-GLANCE

- THE MONGOL INVASIONS
- YUAN DYNASTY
- MING DYNASTY | Court and Professional Painting | Decorative Arts | Architecture and City Planning | The Literati Aesthetic
- QING DYNASTY Orthodox Painting Individualist Painting
- THE MODERN PERIOD
- ARTS OF KOREA: THE JOSEON DYNASTY TO THE MODERN ERA | Joseon Ceramics | Joseon Painting | Modern Korea
- IN PERSPECTIVE

THE MONGOL INVASIONS

At the beginning of the thirteenth century the Mongols, a nomadic people from the steppes north of China, began to amass an empire. Led first by Jenghiz Khan (c. 1162–1227), then by his sons and grandsons, they swept westward into central Europe and overran Islamic lands from Central Asia through present-day Iraq. To the east, they quickly captured northern China, and in 1279, led by Kublai Khan, they conquered southern China as well. Grandson of the mighty Jenghiz, Kublai proclaimed himself emperor of China and founder of the Yuan dynasty (1279–1368).

The Mongol invasions were traumatic, and their effect on China was long lasting. During the Song dynasty, China had grown increasingly introspective. Rejecting foreign ideas and influences, intellectuals had focused on defining the qualities that constituted true "Chinese-ness." They drew a clear distinction between their own people, whom they characterized as gentle, erudite, and sophisticated, and the "barbarians" outside China's borders, whom they regarded as crude, wild, and uncivilized. Now, faced with the reality of barbarian occupation, China's inward gaze intensified in spiritual resistance. For centuries to come, long after the Mongols had gone, leading scholars continued to seek intellectually more challenging, philosophically more profound, and artistically more subtle expressions of all that could be identified as authentically Chinese.

YUAN DYNASTY

The Mongols established their capital in the northern city now known as Beijing (MAP 24–1). The cultural centers of China, however, remained the great cities of the south, where the Song court had been located for the previous 150 years. Combined with the tensions of Yuan rule, this separation of

China's political and cultural centers created a new situation dynamic in the arts.

Throughout most of Chinese history, the imperial court had set the tone for artistic taste; artisans attached to the court produced architecture, paintings, gardens, and objects of jade, lacquer, ceramics, and silk especially for imperial use. Over the centuries, painters and calligraphers gradually moved higher up the social scale, for these "arts of the brush" were often practiced by scholars and even emperors, whose high status reflected positively on whatever interested them. With the establishment of an imperial painting academy during the Song dynasty, painters finally achieved a status equal to that of court officials. For the literati, painting came to be grouped with calligraphy and poetry as the trio of accomplishments suited to members of the cultural elite.

But while the literati elevated the status of painting by virtue of practicing it, they also began to develop their own ideas of what painting should be. Not needing to earn an income from their art, they cultivated an amateur ideal in which personal expression counted for more than "mere" professional skill. They created for themselves a status as artists totally separate from and superior to professional painters, whose art they felt was inherently compromised, since it was done to please others, and impure, since it was tainted by money.

The conditions of Yuan rule now encouraged a clear distinction between court taste, ministered to by professional artists and artisans, and literati taste. The Yuan dynasty continued the imperial role as patron of the arts, commissioning buildings, murals, gardens, paintings, and decorative arts. Western visitors such as the Italian Marco Polo were impressed by the magnificence of the Yuan court (see "Marco Polo," page 836). But scholars, profoundly alienated from the new government, took little notice of these accomplishments, and thus wrote nothing about them. Nor

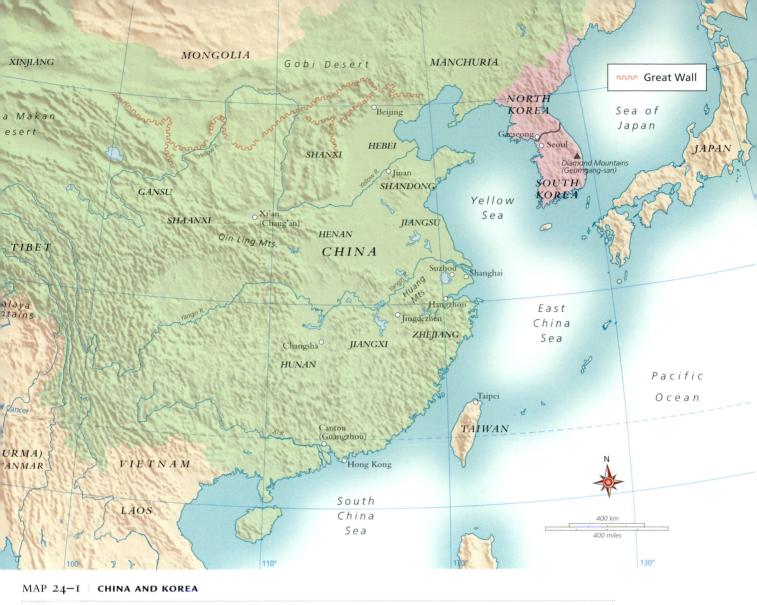

The Qinling Mountains divide China into northern and southern regions with distinctively different climates and cultures.

did Yuan rulers have much use for scholars, especially those from the south. The civil service examinations were abolished, and the highest government positions were bestowed, instead, on Mongols and their foreign allies. Scholars now tended to turn inward, to search for solutions of their own and to try to express themselves in personal and symbolic terms.

ZHAO MENGFU. Typical of this trend was Zhao Mengfu (1254–1322), a descendant of the imperial line of Song. Unlike many scholars of his time, he eventually chose to serve the Yuan government and was made a high official. A painter, calligrapher, and poet, all of the first rank, Zhao was especially known for his carefully rendered paintings of horses. But he also cultivated another manner, most famous in his landmark painting autumn colors on the Qiao and hua mountains (FIG. 24–2).

Zhao painted this work for a friend whose ancestors came from Jinan, the present-day capital of Shandong

province, and the painting supposedly depicts the landscape there. Yet the mountains and trees are not painted in the accomplished naturalism of Zhao's own time but rather in the archaic yet oddly elegant manner of the earlier Tang dynasty (618–907). The Tang dynasty was a great era in Chinese history, when the country was both militarily strong and culturally vibrant. Through his painting Zhao evoked a nostalgia not only for his friend's distant homeland but also for China's past.

This educated taste for the "spirit of antiquity" became an important aspect of **literati painting** in later periods. Also typical of literati taste are the unassuming brushwork, the subtle colors sparingly used (many literati paintings forgo color altogether), the use of landscape to convey personal meaning, and even the intended audience—a close friend. The literati did not paint for public display but for each other. They favored small formats such as **handscrolls**, **hanging scrolls**, or **album leaves** (book pages), which could easily be shown to friends or shared at small gatherings (see "Formats of Chinese Painting," page 837).

Art and Its Context

FOUNDATIONS OF CHINESE CULTURE

hinese culture is distinguished by its long and continuous development. Between 6000 and 2000 BCE a variety of Neolithic cultures flourished across China. Through long interaction these cultures became increasingly similar and they eventually gave rise to the three Bronze Age dynastic states with which Chinese history traditionally begins: the Xia, the Shang (c. 1700–1100 BCE), and the Zhou (1100–221 BCE).

The Shang developed traditions of casting ritual vessels in bronze, working jade in ceremonial shapes, and writing consistently in scripts that directly evolved into the modern Chinese written language. Society was stratified, and the ruling group maintained its authority in part by claiming power as intermediaries between the human and spirit worlds. Under the Zhou a feudal society developed, with nobles related to the king ruling over numerous small states.

During the latter part of the Zhou dynasty, states began to vie for supremacy through intrigue and increasingly ruthless warfare. The collapse of social order profoundly influenced China's first philosophers, who largely concerned themselves with the pragmatic question of how to bring about a stable society.

In 221 BCE, rulers of the state of Qin triumphed over the remaining states, unifying China as an empire for the first time. The Qin created the mechanisms of China's centralized bureaucracy, but their rule was harsh and the dynasty was quickly overthrown. During the ensuing Han dynasty (206 BCE-220 CE), China at last knew peace and prosperity. Confucianism was made the official state ideology, in the process assuming the form and force of a religion. Developed from the thought of Confucius (551-479 BCE), one of the many philosophers of the Zhou, Confucianism is an ethical system for the management of society based on establishing correct relationships among people. Providing a counterweight was Daoism, which also came into its own during the Han dynasty. Based on the thought of Laozi, a possibly legendary contemporary of Confucius, and the

philosopher Zhuangzi (369–286 BCE), Daoism is a view of life that seeks to harmonize the individual with the *Dao*, or Way, the process of the universe. Confucianism and Daoism have remained central to Chinese thought—the one addressing the public realm of duty and conformity, the other the private world of individualism and creativity.

Following the collapse of the Han dynasty, China experienced a centuries-long period of disunity (220–589 CE). Invaders from the north and west established numerous kingdoms and dynasties, while a series of six precarious Chinese dynasties held sway in the south. Buddhism, which had begun to filter over trade routes from India during the Han dynasty, now spread widely. The period also witnessed the economic and cultural development of the south (all previous dynasties had ruled from the north).

China was reunited under the Sui dynasty (581–618 CE), which quickly fell to the Tang (618–907 CE), one of the most successful dynasties in Chinese history. Strong and confident, Tang China fascinated and, in turn, was fascinated by the cultures around it. Caravans streamed across Central Asia to the capital, Chang'an, then the largest city in the world. Japan and Korea sent thousands of students to study Chinese culture, and Buddhism reached the height of its influence before a period of persecution signaled the start of its decline.

The mood of the Song dynasty (960–1279 CE) was quite different. The martial vigor of the Tang gave way to a culture of increasing refinement and sophistication, and Tang openness to foreign influences was replaced by a conscious cultivation of China's own traditions. In art, landscape painting emerged as the most esteemed genre, capable of expressing both philosophical and personal concerns. With the fall of the north to invaders in 1126, the Song court set up a new capital in the south, which became the cultural and economic center of the country.

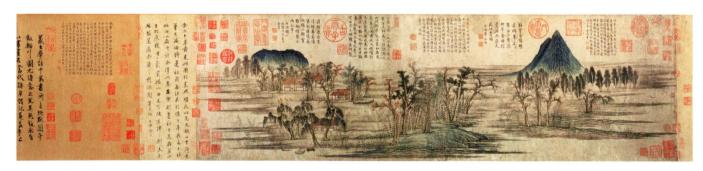

24–2 | Zhao Mengfu Autumn colors on the Qiao and Hua Mountains Yuan dynasty, 1296. Handscroll, ink and color on paper, $11\% \times 36\%$ " (28.6 \times 9.3 cm). National Palace Museum, Taipei, Republic of China.

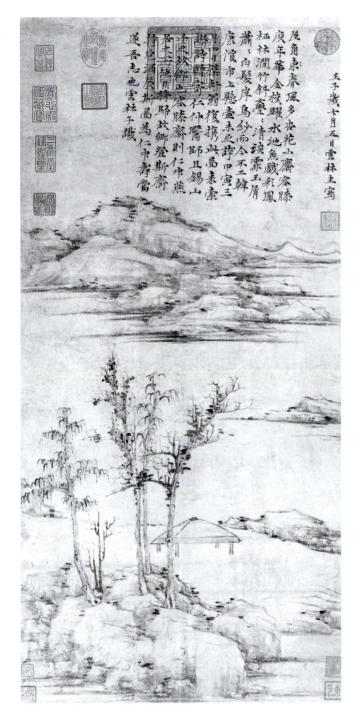

24-3 Ni Zan THE RONGXI STUDIO
Yuan dynasty, 1372. Hanging scroll, ink on paper, height 29%" (74.6 cm). National Palace Museum, Taipei, Republic of China.

The idea that a painting is not done to capture a likeness or to satisfy others but is executed freely and carelessly for the artist's own amusement is at the heart of the literati aesthetic. Ni Zan once wrote this comment on a painting: "What I call painting does not exceed the joy of careless sketching with a brush. I do not seek formal likeness but do it simply for my own amusement. Recently I was rambling about and came to a town. The people asked for my pictures, but wanted them exactly according to their own desires and to represent a specific occasion. [When I could not satisfy them,] they went away insulting, scolding, and cursing in every possible way. What a shame! But how can one scold a eunuch for not growing a beard?" (cited in Bush and Shih, page 266).

Sequencing Events Chinese Dynasties After 1279

1279-1368	Yuan Dynasty
1368-1644	Ming Dynasty
1644-1911	Qing Dynasty
1911-Present	Modern Period

NI ZAN. Of the considerable number of Yuan painters who took up Zhao's ideas, several became models for later generations. One such was Ni Zan (1301–74), whose most famous surviving painting is **THE RONGXI STUDIO** (FIG. 24–3). Done entirely in ink, the painting depicts the lake region in Ni's home district. Mountains, rocks, trees, and a pavilion are sketched with a minimum of detail using a dry brush technique—a technique in which the brush is not fully loaded with ink but rather about to run out, so that white paper "breathes" through the ragged strokes. The result is a painting with a light touch and a sense of simplicity and purity. Literati styles were believed to reflect the painter's personality. Ni's spare, dry style became associated with a noble spirit, and many later painters adopted it or paid homage to it.

Ni Zan was one of those eccentrics whose behavior has become legendary in the history of Chinese art. In his early years he was one of the richest men in the region, the owner of a large estate. His pride and his aloofness from daily affairs often got him into trouble with the authorities. His cleanliness was notorious. In addition to washing himself several times daily, he also ordered his servants to wash the trees in his garden and to clean the furniture after his guests had left. He was said to be so unworldly that late in life he gave away most of his possessions and lived as a hermit in a boat, wandering on rivers and lakes.

Whether these stories are true or not, they were important elements of Ni's legacy to later painters, for Ni's life as well as his art served as a model. The painting of the literati was bound up with certain views about what constituted an appropriate life. The ideal, as embodied by Ni Zan and others, was of a brilliantly gifted scholar whose spirit was too refined for the dusty world of government service and who thus preferred to live as a recluse, or as one who had retired after having become frustrated by a brief stint as an official.

MING DYNASTY

The founder of the next dynasty, the Ming (1368–1644), came from a family of poor uneducated peasants. As he rose through the ranks in the army, he enlisted the help of scholars to gain

Art and Its Context

MARCO POLO

hina under Kublai Khan was one of four Mongol khanates that together extended west into present-day Iraq and through Russia to the borders of Poland and Hungary. For roughly a century, travelers moved freely across this vast expanse, making the era one of unprecedented crosscultural exchange. Diplomats, missionaries, merchants, and adventurers flocked to the Yuan court, and Chinese envoys were dispatched to the West. The most celebrated European traveler of the time was a Venetian named Marco Polo (c. 1254–1324), whose descriptions of his travels were for several centuries the only firsthand account of China available in Europe.

Marco Polo was still in his teens when he set out for China in 1271. He traveled with his uncle and father, both merchants, bearing letters for Kublai Khan from Pope Gregory X. After a four-year journey the Polos arrived at last in Beijing. Marco became a favorite of the emperor and spent the next seventeen years in his service, during which time he traveled extensively throughout China. He eventually returned home in 1295.

Imprisoned later during a war between Venice and Genoa, rival Italian city-states, Marco Polo passed the time by dictating an account of his experiences to a fellow prisoner. The resulting book, *A Description of the World*, has fascinated generations of readers with its depiction of prosperous and sophisticated lands in the East. Translated into almost every European language, it was an important influence in stimulating further exploration. When Columbus set sail across the Atlantic in 1492, one of the places he hoped to find was a country Marco Polo called Zipangu—Japan.

power and solidify his following. Once he had driven the Mongols from Beijing and firmly established himself as emperor, however, he grew to distrust intellectuals. His rule was despotic, even ruthless. Throughout the nearly 300 years of Ming rule, most emperors shared his attitude, so although the civil service examinations were reinstated, scholars remained alienated from the government they were trained to serve.

Court and Professional Painting

The contrast between the luxurious world of the court and the austere ideals of the literati continued through the Ming dynasty.

A typical example of Ming court taste is hundreds of birds admiring the peacocks, a large painting on silk by Yin Hong, an artist active during the late fifteenth and early sixteenth centuries (Fig. 24–4). A pupil of some well-known courtiers, Yin most probably served in the court at Beijing. The painting is an example of the birds-and-flowers genre, which had been popular with artists of the Song academy. Here the subject takes on symbolic meaning, with the homage of the birds to the peacocks representing the homage of court officials to the emperor. The style goes back to Song academy models, although the large format and multiplication of details are traits of the Ming.

A related, yet bolder and less constrained, landscape style was also popular during this period. Sometimes called the Zhe style since its roots were in Hangzhou, Zhejiang province, where the Southern Song court had been located, this manner especially influenced painters in Korea and Japan. A major

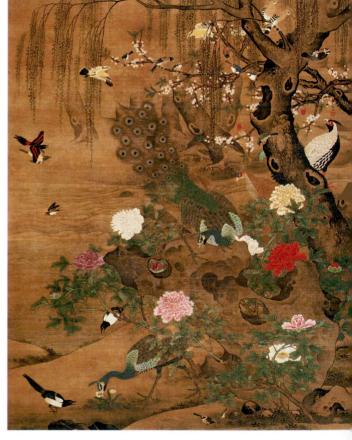

24–4 | Yin Hong HUNDREDS OF BIRDS ADMIRING THE PEACOCKS

Ming dynasty, late 15th-early 16th century. Hanging scroll, ink and color on silk, $7'10\%'' \times 6'5''$ (2.4 \times 1.96 m). The Cleveland Museum of Art.

Purchase from the J. H. Wade Fund, 74.31

Technique

FORMATS OF CHINESE PAINTING

ith the exception of large wall paintings that typically decorated palaces, temples, and tombs, most Chinese paintings were done in ink and water-based colors on silk or paper. Finished works were generally mounted as handscrolls, hanging scrolls, or leaves in an album.

An album comprises a set of paintings of identical size mounted in a book. (A single painting from an album is called an **album leaf**.) The paintings in an album are usually related in subject, such as various views of a famous site or a series of scenes glimpsed on one trip.

Album sized paintings might also be mounted as a hand scroll, a horizontal format generally about 12 inches high and anywhere from a few feet to dozens of feet long. More typically, however, a handscroll would be a single continuous painting. Handscrolls were not meant to be displayed all at once, the way they are commonly presented today in museums. Rather, they were unrolled only occasionally, to be savored in much the same spirit as we might view a favorite film. Placing the scroll on a flat surface such as a table, a viewer would unroll it a foot or two at a time, moving gradually through the entire scroll from right to left, lingering over favorite details. The scroll was then rolled up and returned to its box until the next viewing.

Like handscrolls, hanging scrolls were not displayed permanently but were taken out for a limited time—a day, a week, a season. Unlike a handscroll, however, the painting on a hanging scroll was viewed as a whole, unrolled and put up on a wall,

with the roller at the lower end acting as a weight to help the scroll hang flat. Although some hanging scrolls are quite large, they are still fundamentally intimate works, not intended for display in a public place.

Creating a scroll was a time-consuming and exacting process accomplished by a professional mounter. The painting was first backed with paper to strengthen it. Next, strips of paper-backed silk were pasted to the top, bottom, and sides, framing the painting on all four sides. Additional silk pieces were added to extend the scroll horizontally or vertically, depending on the format. The assembled scroll was then backed again with paper and fitted with a half-round dowel, or wooden rod, at the top of a hanging scroll or on the right end of a handscroll, with ribbons for hanging and tying, and with a wooden roller at the other end. Hanging scrolls were often fashioned from several patterns of silk, and a variety of piecing formats were developed and codified. On a handscroll, a painting was generally preceded by a panel giving the work's title and often followed by a long panel bearing colophons—inscriptions related to the work, such as poems in its praise or comments by its owners over the centuries. A scroll would be remounted periodically to better preserve it, and colophons and inscriptions would be preserved in each remounting. Seals added another layer of interest. A treasured scroll often bears not only the seal of its maker but also those of collectors and admirers through the centuries.

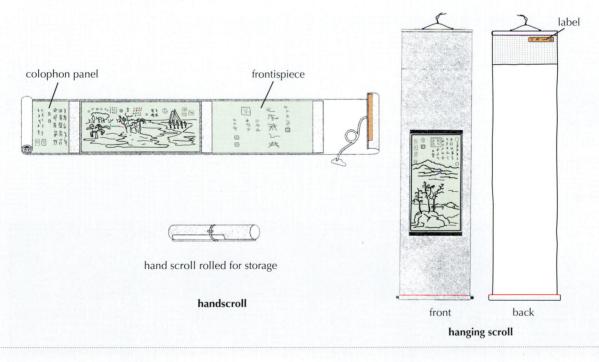

example is **RETURNING HOME LATE FROM A SPRING OUTING** (FIG. 24–5), unsigned but attributed to Dai Jin (1388–1462). This work reflects the Chinese sources for such artists as An Gyeon (SEE FIG. 24–17) and Sesshu (SEE FIG. 25–3).

QIU YING. The preeminent professional painter in the Ming period was Qiu Ying (1494–1552), who lived in Suzhou, a prosperous southern city. He inspired generations of imitators with exceptional works, such as a long handscroll

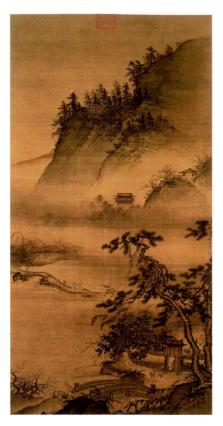

24-5 Dai Jin RETURNING HOME LATE FROM A SPRING OUTING

Ming dynasty. Hanging scroll, ink on silk, 167.9 \times 83.1 cm. National Palace Museum, Taipei, Republic of China.

known as **spring dawn in the han palace** (FIGS. 24–6, 24–7). The painting is based on Tang-dynasty depictions of women in the court of the Han dynasty (206 BCE–220 CE). While in the service of a well-known collector, Qiu Ying had the opportunity to study many Tang paintings, whose artists usually concentrated on the figures, leaving out the background entirely. Qiu's graceful and elegant figures—although modeled after those in Tang works—are portrayed in a setting of palace buildings, engaging in such pastimes as chess, music, calligraphy, and painting. With its antique subject matter, refined technique, and flawless taste in color and composition, *Spring Dawn in the Han Palace* brought professional painting to a new high point.

Decorative Arts

Qiu Ying painted to satisfy his patrons in Suzhou. The cities of the south were becoming wealthy, and newly rich merchants collected paintings, antiques, and art objects. The court, too, was prosperous and patronized the arts on a lavish scale. In such a setting, the decorative arts thrived.

MING BLUE-AND-WHITE WARES. The Ming became famous the world over for its exquisite ceramics, especially porcelain (see "The Secret of Porcelain," page 840). The imperial kilns in Jingdezhen, in Jiangxi province, became the most renowned center for porcelain not only in all of China, but in all the world. Particularly noteworthy are the blue-and-white wares

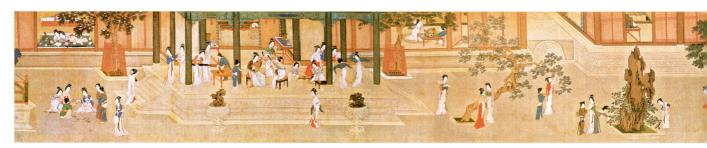

24–6 Qiu Ying SECTION OF SPRING DAWN IN THE HAN PALACE Ming dynasty, first half of the 16th century. Handscroll, ink and color on silk, $1'\times 18'\%''$ (0.30 \times 5.7 m). National Palace Museum, Taipei, Republic of China.

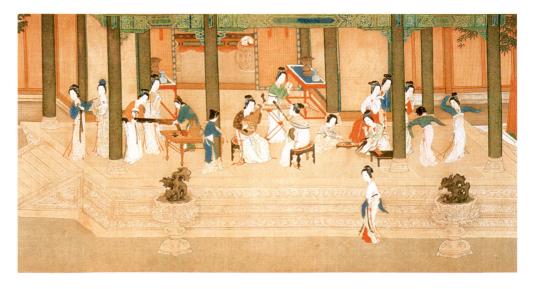

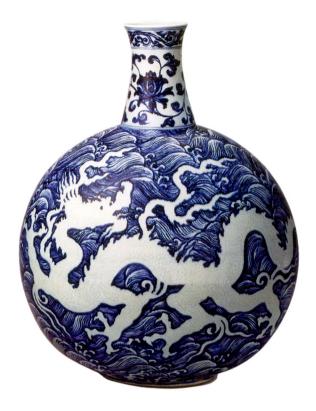

24–8 | FLASK Ming dynasty, 1426–35. Porcelain with decoration painted in underglaze cobalt blue. Collection of the Palace Museum, Beijing.

Dragons have featured prominently in Chinese folklore from earliest times—Neolithic examples have been found painted on pottery and carved in jade. In Bronze Age China, dragons came to be associated with powerful and sudden manifestations of nature, such as wind, thunder, and lightning. At the same time, dragons became associated with superior beings such as virtuous rulers and sages. With the emergence of China's first firmly established empire during the Han dynasty, the dragon was appropriated as an imperial symbol, and it remained so throughout Chinese history. Dragon sightings were duly recorded and considered auspicious. Yet even the Son of Heaven could not monopolize the dragon. During the Tang and Song dynasties the practice arose of painting pictures of dragons to pray for rain, and for Chan (Zen) Buddhists, the dragon was a symbol of sudden enlightenment.

produced there during the ten-year reign of the ruler known as the Xuande Emperor (ruled 1426–35), such as the flask in FIGURE 24–8. The subtle shape, the refined yet vigorous decoration of dragons writhing above the sea, and the flawless glazing embody the high achievement of Ming artisans.

Architecture and City Planning

Centuries of warfare and destruction have left very few Chinese architectural monuments intact. The most important remaining example of traditional Chinese architecture is the Forbidden City, the imperial palace compound in Beijing, whose principal buildings were constructed during the Ming dynasty (FIG. 24–9).

THE FORBIDDEN CITY. The basic plan of Beijing was the work of the Mongols, who laid out their capital city accord-

ing to traditional Chinese principles. City planning began early in China—in the seventh century, in the case of Chang'an (present-day Xi'an), the capital of the Sui and Tang emperors. The walled city of Chang'an was laid out on a rectangular grid, with evenly spaced streets that ran north-south and eastwest. At the northern end stood a walled imperial complex.

Beijing, too, was developed as a walled, rectangular city with streets laid out in a grid. The palace enclosure occupied the center of the northern part of the city, which was reserved for the Mongols. Chinese lived in the southern third of the city. Later, Ming and Qing emperors preserved this division, with officials living in the northern or Inner City and commoners living in the southern or Outer City. Under the third Ming emperor, Yongle (ruled 1403–24), the Forbidden City was rebuilt as we see it today.

The approach to the Forbidden City was impressive. Visitors entered through the Meridian Gate, a monumental gate with side wings (at the center in FIG. 24-9). Inside the Meridian Gate a broad courtyard is crossed by a bow-shaped waterway that is spanned by five arched marble bridges. At the opposite end of the courtyard is the Gate of Supreme Harmony, opening onto an even larger courtyard that houses three ceremonial halls raised on a broad platform. First is the Hall of Supreme Harmony, where, on the most important state occasions, the emperor was seated on his throne, facing south. Beyond is the smaller Hall of Central Harmony, then the Hall of Protecting Harmony. Behind these vast ceremonial spaces, still on the central axis, is the inner court, again with a progression of three buildings, this time more intimate in scale. In its balance and symmetry the plan of the Forbidden City reflects ancient Chinese beliefs about the harmony of the universe, and it emphasizes the emperor's role as the Son of Heaven, whose duty was to maintain the cosmic order from his throne in the middle of the world.

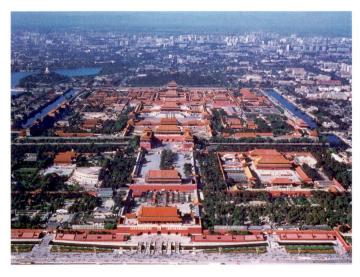

24–9 THE FORBIDDEN CITY

Now the Palace Museum, Beijing

Mostly Ming dynasty. View from the southwest.

Technique

THE SECRET OF PORCELAIN

arco Polo, it is said, was the one who named a new type of ceramic he found in China. Its translucent purity reminded him of the smooth whiteness of the cowry shell, porcellana in Italian. Porcelain is made from kaolin, an extremely refined white clay, and petuntse, a variety of the mineral feldspar. When properly combined and fired at a sufficiently high temperature, the two materials fuse into a glasslike, translucent ceramic that is far stronger than it looks.

Porcelaneous stoneware, fired at lower temperatures, was known in China by the seventh century, but true porcelain was perfected during the Song dynasty. To create blue-and-white porcelain such as the flask in FIGURE 24–8, blue pigment was made from cobalt oxide, finely ground and mixed with water. The decoration was painted directly onto the unfired porcelain vessel, then a layer of clear glaze was applied over it. (In this technique, known as *underglaze painting*, the pattern is painted beneath the glaze.) After firing, the piece emerged from the kiln with a clear blue design set sharply against a snowy white background.

Entranced with the exquisite properties of porcelain, European potters tried for centuries to duplicate it. The technique was finally discovered in 1709 by Johann Friedrich Böttger in Dresden, Germany, who tried—but failed—to keep it a secret.

The Literati Aesthetic

In the south, particularly in the district of Suzhou, literati painting, associated with the educated men who served the court as government officials, remained the dominant trend. One of the major literati figures from the Ming period is Shen Zhou (1427–1509), who had no desire to enter government service and spent most of his life in Suzhou. He studied the Yuan painters avidly and tried to recapture their spirit in such works as *Poet on a Mountaintop* (see "Poet on a Mountaintop," page 842). Although the style of the painting recalls the freedom and simplicity of Ni Zan (SEE FIG. 24–3), the motif of a poet surveying the landscape from a mountain plateau is Shen's creation.

LITERATI INFLUENCE ON FURNITURE, ARCHITECTURE, AND GARDEN DESIGN. The taste of the literati came to influence furniture and architecture, and especially the design of gardens. Chinese furniture made for domestic use reached the height of its development in the sixteenth and seventeenth centuries. Characteristic of Chinese furniture, the chair in FIGURE 24-10 is constructed without the use of glue or nails. Instead, pieces fit together based on the principle of the mortise-and-tenon joint, in which a projecting element (tenon) on one piece fits snugly into a cavity (mortise) on another. Each piece of the chair is carved, as opposed to being bent or twisted, and the joints are crafted with great precision. The patterns of the wood grain provide subtle interest unmarred by any painting or other embellishment. The style, like that of Chinese architecture, is one of simplicity, clarity, symmetry, and balance. The effect is formal and dignified but natural and simple—virtues central to the Chinese view of proper human conduct as well.

The art of landscape gardening also reached a high point during the Ming dynasty, as many literati surrounded their homes with gardens. The most famous gardens were created in the southern cities of the Yangzi River (Chang Jiang) delta, especially in Suzhou. The largest surviving garden of the era

is the Garden of the Cessation of Official Life, with which this chapter opened (SEE FIG. 24–1). Although modified and reconstructed many times through the centuries, it still reflects many of the basic ideas of the original Ming owner. About a third of the garden is devoted to water through artificially created brooks and ponds. The landscape is dotted with pavilions, kiosks, libraries, studios, and corridors. Many

24–10 † ARMCHAIR Ming dynasty, 16th–17th century. Huanghuali wood (hardwood), $39\% \times 27\% \times 20''$ ($100 \times 69.2 \times 50.8$ cm). The Nelson-Atkins Museum of Art, Kansas City, Missouri. Purchase, Nelson Trust (46-78/1)

of the buildings have poetic names, such as Rain Listening Pavilion and Bridge of the Small Flying Rainbow.

Dong Oichang, Literati Theorist. The ideas underlying literati painting found their most influential expression in the writings of Dong Qichang (1555-1636). A high official in the late Ming period, Dong Qichang embodied the literati tradition as poet, calligrapher, and painter. He developed a view of Chinese art history that divided painters into two opposing schools, northern and southern. The names have nothing to do with geography—a painter from the south might well be classed as northern—but reflect a parallel Dong drew to the northern and southern schools of Chan (Zen) Buddhism in China. The southern school of Chan, founded by the eccentric monk Huineng (638-713), was unorthodox, radical, and innovative; the northern school was traditional and conservative. Similarly, Dong's two schools of painters represented progressive and conservative traditions. In Dong's view the conservative northern school was dominated by professional painters whose academic, often decorative, style emphasized technical skill. In contrast, the progressive southern school preferred ink to color and free brushwork to meticulous detail. Its painters aimed for poetry and personal expression. In promoting this theory, Dong gave his unlimited sanction to literati painting, which he positioned as the culmination of the southern school, and he fundamentally influenced the way the Chinese viewed their own

Dong Qichang summarized his views on the proper training for literati painters in the famous statement "Read ten thousand books and walk ten thousand miles." By this he meant that one must first study the works of the great masters, then follow "heaven and earth," the world of nature. These studies prepared the way for greater self-expression through brush and ink, the goal of literati painting. Dong's views rested on an awareness that a painting of scenery and the actual scenery are two very different things. The excellence of a painting does not lie in its degree of resemblance to reality—that gap can never be bridged—but in its expressive power. The expressive language of painting is inherently abstract and lies in its nature as a construction of brushstrokes. For example, in a painting of a rock, the rock itself is not expressive; rather, the brushstrokes that add up to a "rock" are expressive.

With such thinking Dong brought painting close to the realm of calligraphy, which had long been considered the highest form of artistic expression in China. More than a thousand years before Dong's time, a body of critical terms and theories had evolved to discuss calligraphy in light of the formal and expressive properties of brushwork and composition. Dong introduced some of these terms—ideas such as opening and closing, rising and falling, and void and solid—to the criticism of painting.

Sequencing Works of Art

1617	Dong Qichang. The Qingbian Mountains, Chinese
1693	Wang Hui: A Thousand Peaks and Myriad Ravines, Chinese
c. 1700	Shitao. Landscape, Chinese
1734	Jeong Seon. Panoramic View of the Diamond Mountains (Geumgang-san), Korean
Late 18th century	Sin Yunbok. Picnic at the Lotus Pond, Korean

Dong's theories are fully embodied in his painting **THE QINGBIAN MOUNTAINS** (FIG. 24–11). According to Dong's own inscription, the painting was based on a work by the tenthcentury artist Dong Yuan. Dong Qichang's style, however, is quite different from the master's he admired. Although there is some indication of foreground, middle ground, and distant

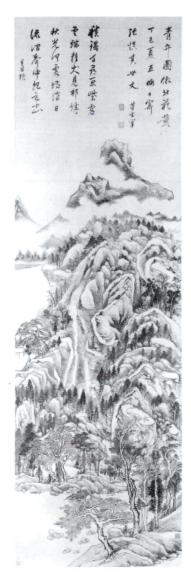

24-II Dong Qichang
THE QINGBIAN
MOUNTAINS

Ming dynasty, 1617. Hanging scroll, ink on paper, $21'8'' \times 7'4\%''$ $(6.72 \times 2.25 \text{ m})$. The Cleveland Museum of Art.

Leonard C. Hanna, Jr., Fund (1980.10)

THE OBJECT SPEAKS

POET ON A MOUNTAINTOP

n earlier landscape paintings, human figures were typically shown dwarfed by the grandeur of nature. Travelers might be seen scuttling along a narrow path by a stream, while overhead towered mountains whose peaks conversed with the clouds and whose heights were inaccessible. Here, the poet has climbed the mountain and dominates the landscape. Even the clouds are beneath him. Before his gaze, a poem hangs in the air, as though he were projecting his thoughts.

The poem, composed by Shen Zhou himself, and written in his distinctive hand, reads:

White clouds like a scarf enfold the mountain's waist;

Stone steps hang in space—a long, narrow path.

Alone, leaning on my cane, I gaze intently at the scene,

And feel like answering the murmuring brook with the music of my flute. (Translation by Jonathan Chaves, *The Chinese Painter as Poet*, New York, 2000, page 46.)

Shen Zhou composed the poem and wrote the inscription at the time he painted the album. The style of the calligraphy, like the style of the painting, is informal, relaxed, and straightforward—

qualities that were believed to reflect the artist's character and personality.

The painting reflects Ming philosophy, which held that the mind, not the physical world, was the basis for reality. With its perfect synthesis of poetry, calligraphy, and painting, and with its harmony of mind and landscape, *Poet on a Mountaintop* represents the essence of Ming literati painting.

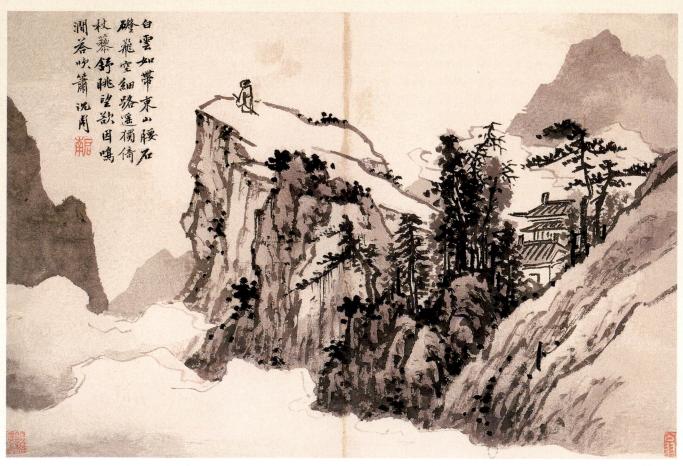

Shen Zhou POET ON A MOUNTAINTOP

Leaf from an album of landscapes; painting mounted as part of a handscroll. Ming dynasty, c. 1500. Ink and color on paper, $15\% \times 23\%$ (40×60.2 cm). The Nelson-Atkins Museum of Art, Kansas City, Missouri. Purchase, Nelson Trust (46-51/2)

mountains, the space is ambiguous, as if all the elements were compressed to the surface of the picture. With this flattening of space, the trees, rocks, and mountains become more readily legible in a second way, as semiabstract forms made of brushstrokes.

Six trees arranged diagonally define the extreme foreground and announce themes that the rest of the painting repeats, varies, and develops. The tree on the left, with its outstretched branches and full foliage, is echoed first in the shape of another tree just across the river and again in a tree farther up and toward the left. The tallest tree of the foreground grouping anticipates the high peak that towers in the distance almost directly above it. The forms of the smaller foreground trees, especially the one with dark leaves, are repeated in numerous variations across the painting. At the same time, the simple and ordinary-looking boulder in the foreground is transformed in the conglomeration of rocks, ridges, hills, and mountains above. This double reading, both abstract and representational, parallels the work's double nature as a painting of a landscape and an interpretation of a traditional landscape painting.

The influence of Dong Qichang on the development of Chinese painting of later periods cannot be overstated. Indeed, nearly all Chinese painters since the early seventeenth century have reflected his ideas in one way or another.

QING DYNASTY

In 1644, when the armies of the Manchu people to the northeast of China marched into Beijing, many Chinese reacted as though their civilization had come to an end. Yet, the Manchus had already adopted many Chinese customs and institutions before their conquest. After gaining control of all of China, a process that took decades, they showed great respect for Chinese tradition. In art, all the major trends of the late Ming dynasty eventually continued into the Manchu, or Qing, dynasty (1644–1911).

Orthodox Painting

Literati painting was by now established as the dominant tradition; it had become orthodox. Scholars followed Dong Qichang's recommendation and based their approach on the study of past masters, and they painted large numbers of works in the manner of Song and Yuan artists as a way of expressing their learning, technique, and taste.

WANG HUI. The grand, symphonic composition a THOUSAND PEAKS AND MYRIAD RAVINES (FIG. 24–12), painted by Wang Hui (1632–1717) in 1693, exemplifies all the basic elements of Chinese landscape painting: mountains, rivers, waterfalls, trees, rocks, temples, pavilions, houses, bridges, boats, wandering scholars, fishers—the familiar and much-loved cast of actors from a tradition now many centuries old. At the upper right corner, the artist has written:

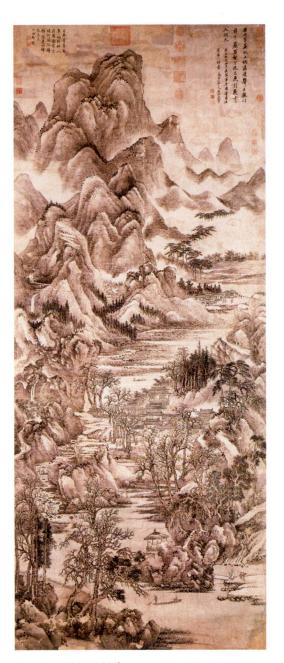

24-I2 | Wang Hui A THOUSAND PEAKS AND MYRIAD RAVINES

Qing dynasty, 1693. Hanging scroll, ink on paper, $8'2\frac{1}{2}'' \times 3'4\frac{1}{2}''$ (2.54 \times 1.03 m). National Palace Museum, Taipei, Republic of China.

Moss and weeds cover the rocks and mist hovers over the water.

The sound of dripping water is heard in front of the temple gate.

Through a thousand peaks and myriad ravines the spring flows,

And brings the flying flowers into the sacred caves. In the fourth month of the year 1693, in an inn in the capital, I painted this based on a Tang-dynasty poem in the manner of [the painters] Dong [Yuan] and Ju[ran].

(Translated by Chu-tsing Li)

This inscription shares Wang Hui's complex thoughts as he painted this work. In his mind were both the lines of a Tang-dynasty poem, which offered the subject, and the paintings of the tenth-century masters Dong Yuan and Juran, which inspired his style. The temple the poem asks us to imagine is nestled on the right bank in the middle distance, but the painting shows us the scene from afar, as when a camera pulls slowly away from some small human drama until its actors can barely be distinguished from the great flow of nature. Giving viewers the experience of dissolving their individual identity in the cosmic flow had been a goal of Chinese landscape painting since its first era of greatness during the Song dynasty.

The Qing emperors of the late seventeenth and eighteenth centuries were painters themselves. They collected literati painting, and their taste was shaped mainly by artists such as Wang Hui. Thus literati painting, long associated with reclusive scholars, ultimately became an academic style practiced at court.

Individualist Painting

The first few decades of Qing rule had been both traumatic and dangerous for those who were loyal—or worse, related—to the Ming. Some committed suicide, while others sought refuge in monasteries or wandered the countryside. Among them were several painters who expressed their anger, defiance, frustration, and melancholy in their art. They took Dong Qichang's idea of painting as an expression of the artist's personal feelings very seriously and cultivated highly original styles. These painters have become known as the *individualists*.

24–13 | Shitao LANDSCAPE One leaf from *An Album of Landscapes*. Qing dynasty, c. 1700. Ink and color on paper, $9\frac{1}{2} \times 11^n$ (24.1 \times 28 cm). Collection C. C. Wang family

SHITAO. One of the individualists was Shitao (1642–1707), who was descended from the first Ming emperor and who took refuge in Buddhist temples when the dynasty fell. In his later life he brought his painting to the brink of abstraction in such works as LANDSCAPE (FIG. 24–13). A monk sits in a small hut, looking out onto mountains that seem to be in turmoil. Dots, used for centuries to indicate vegetation on rocks, here seem to have taken on a life of their own. The rocks also seem alive—about to swallow up the monk and his hut. Throughout his life Shitao continued to identify himself with the fallen Ming, and he felt that his secure world had turned to chaos with the Manchu conquest.

THE MODERN PERIOD

In the mid- and late nineteenth century, China was shaken from centuries of complacency by a series of humiliating military defeats at the hands of Western powers and Japan. Only then did the government finally realize that these new rivals were not like the Mongols of the thirteenth century. China was no longer at the center of the world, a civilized country surrounded by "barbarians." Spiritual resistance was no longer sufficient to solve the problems brought on by change. New ideas from Japan and the West began to filter in, and the demand arose for political and cultural reforms. In 1911 the Qing dynasty was overthrown, ending 2,000 years of imperial rule, and China was reconceived as a republic.

During the first decades of the twentieth century Chinese artists traveled to Japan and Europe to study Western art. Returning to China, many sought to introduce the ideas and techniques they had learned, and they explored ways to synthesize the Chinese and the Western traditions. After the establishment of the present-day Communist government in 1949, individual artistic freedom was curtailed as the arts were pressed into the service of the state and its vision of a new social order. After 1979, however, cultural attitudes began to relax, and Chinese painters again pursued their own paths.

WU GUANZHONG. One artist who emerged during the 1980s as a leader in Chinese painting is Wu Guanzhong (b. 1919). Combining his French artistic training and Chinese background, Wu Guanzhong has developed a semiabstract style to depict scenes from the Chinese landscape. His usual method is to make preliminary sketches on site, then, back in his studio, he develops these sketches into free interpretations based on his feeling and vision. An example of his work, PINE SPIRIT, depicts a scene in the Huang (Yellow) Mountains (FIG. 24–14). The technique, with its sweeping gestures of paint, is clearly linked to Abstract Expressionism, an influential Western movement of the post–World War II years (Chapter 32); yet the painting also claims a place in the long tradition of Chinese landscape as exemplified by such masters as Shitao.

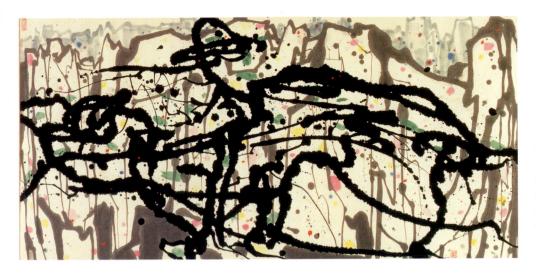

24–14 | Wu Guanzhong
PINE SPIRIT
1984. Ink and color on paper,
2'3%" × 5'3½"
(0.70 × 1.61 m). Spencer
Museum of Art, The University
of Kansas, Lawrence.
Gift of the E. Rhodes and Leonard B.
Carpenter Foundation

Like all aspects of Chinese society, Chinese art has felt the strong impact of Western influence, and the question remains whether Chinese artists will absorb Western ideas without losing their traditional identity. Interestingly, land-scape remains an important subject, as it has been for more than a thousand years, and calligraphy continues to play a vital role. Using the techniques and methods of the West, some of China's artists have joined an international avant-garde (see, for example, Wenda Gu in Chapter 32) while other painters still seek communion with nature through their ink brushstrokes as a means to come to terms with human life and the world.

ARTS OF KOREA: THE JOSEON DYNASTY TO THE MODERN ERA

In 1392, General Yi Seonggye (1335–1408) overthrew the the Goryeo dynasty (918–1392), establishing the Joseon dynasty (1392–1910), sometimes called the Yi dynasty. He first maintained his capital at Gaeseong, the old Goreyo capital, but moved it to Seoul in 1394, where it remained through the end of the dynasty. The Joseon regime rejected Buddhism, espousing Neo-Confucianism as the state philosophy. Taking Ming-dynasty China as its model, the new government patterned its bureaucracy on that of the Ming emperors, even adopting as its own such outward symbols of Ming imperial authority as blue-and-white porcelain. The early Joseon era was a period of cultural refinement and scientific achievement, during which Koreans invented Han'geul (the Korean alphabet) and moveable type, not to mention the rain gauge, astrolabe, celestial globe, sundial, and water clock.

Joseon Ceramics

Like their Silla and Goryeo forebears, Joseon potters excelled in the manufacture of ceramics, taking their cue from contemporaneous Chinese wares, but seldom copying them directly.

Buncheong Ceramics. Descended from Goryeo celadons, Joseon-dynasty stonewares, known as *buncheong* wares, enjoyed widespread usage throughout the peninsula. Their decorative effect relies on the use of white slip that makes the humble stoneware resemble more expensive white porcelain. In fifteenth-century examples, the slip is often seen inlaid into repeating design elements stamped into the body.

Sixteenth-century *buncheong* wares are characteristically embellished with wonderfully fluid, calligraphic brushwork painted in iron-brown slip on a white slip ground. Most painted *buncheong* wares have stylized floral décor, but rare pieces, such as the charming wine bottle in FIGURE 24–15, feature pictorial decoration. In fresh, lively brushstrokes, a bird with outstretched wings grasps a fish that it has just caught in its talons; waves roll below, while two giant lotus blossoms frame the scene.

Japanese armies repeatedly invaded the Korean peninsula between 1592 and 1597, destroying many of the *buncheong* kilns, and essentially bringing the ware's production to a halt. Tradition holds that the Japanese took many *buncheong* potters

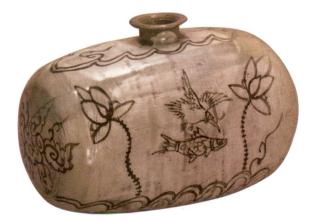

24–15 HORIZONTAL WINE BOTTLE WITH DECORATION OF A BIRD CARRYING A NEWLY CAUGHT FISH

Korean. Joseon dynasty, 16th century. Buncheong ware: light gray stoneware with decoration painted in iron-brown slip on a white slip ground. $6\% \times 9\%$ " (15.5 \times 24.1 cm). Museum of Oriental Ceramics, Osaka, Japan.

Gift of the Sumitomo Group [20773]

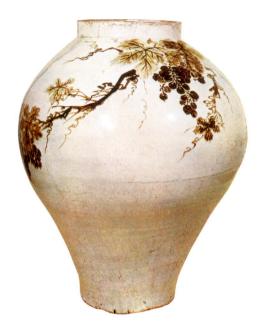

24-16 | BROAD-SHOULDERED JAR

With Decoration of a Fruiting Grapevine. Korean. Joseon dynasty, 17th century. Porcelain with decoration painted in underglaze iron-brown slip. Height 22½" (53.8 cm). Ehwa Women's University Museum, Seoul, Republic of Korea.

Chinese potters invented porcelain during the Tang dynasty, probably in the eighth century. Generally fired in the range of 1300° to 1400° centigrade, porcelain is a high-fired, white-bodied ceramic ware. Its unique feature is its translucency. Korean potters learned to make porcelain during the Goryeo dynasty, probably as early as the eleventh or twelfth century, though few Goryeo examples remain today. For many centuries, the Chinese and Koreans were the only peoples able to produce porcelains.

home with them to produce *buncheong*-style wares, which were greatly admired by connoisseurs of the tea ceremony. In fact, the spontaneity of Korean *buncheong* pottery has inspired Japanese ceramics to this day.

PAINTED PORCELAIN. Korean potters produced porcelains with designs painted in underglaze cobalt blue as early as the

fifteenth century, inspired by Chinese porcelains of the early Ming period (SEE FIG. 24–8). The Korean court dispatched artists from the royal painting academy to the porcelain kilns—located some thirty miles southeast of Seoul—to train porcelain decorators. As a result, from the fifteenth century onward, the painting on the best Korean porcelains closely approximated that on paper and silk, unlike in China, where ceramic decoration followed a path of its own with but scant reference to painting traditions.

In another unique development, Korean porcelains from the sixteenth and seventeenth centuries often feature designs painted in underglaze iron-brown rather than the cobalt blue customary in Ming porcelain. Also uniquely Korean are porcelain jars with bulging shoulders, slender bases and short, vertical necks, which appeared by the seventeenth century and came to be the most characteristic ceramic shapes in the later Joseon period. Painted in underglaze iron-brown, the seventeenth-century jar shown here depicts a fruiting grape branch around its shoulder (FIG. 24–16). In typical Korean fashion, the design spreads over a surface unconstrained by borders, resulting in a balanced but asymmetrical design that incorporates the Korean taste for unornamented spaces.

Joseon Painting

Korean secular painting came into its own during the Joseon dynasty. Continuing Goryeo traditions, early Joseon examples employ Chinese styles and formats, their range of subjects expanding from botanical motifs to include landscapes, figures, and a variety of animals.

Painted in 1447 by An Gyeon (b. 1418), **DREAM JOURNEY TO THE PEACH BLOSSOM LAND (FIG. 24–17)** is the earliest extant and dated Joseon secular painting. It illustrates a fanciful tale by China's revered nature poet Tao Qian (365–427) and recounts a dream about chancing upon a utopia secluded from the world for centuries while meandering among the peach blossoms of spring.

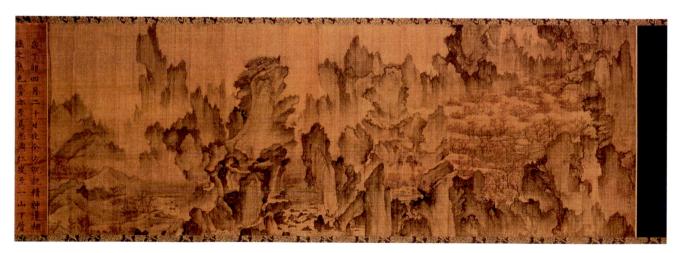

24–17 An Gyeon DREAM JOURNEY TO THE PEACH BLOSSOM LAND Korean. Joseon dynasty, 1447. Handscroll, ink and light colors on silk, $15\% \times 41\%$ (38.7 × 106.1 cm). Central Library, Tenri University, Tenri (near Nara), Japan.

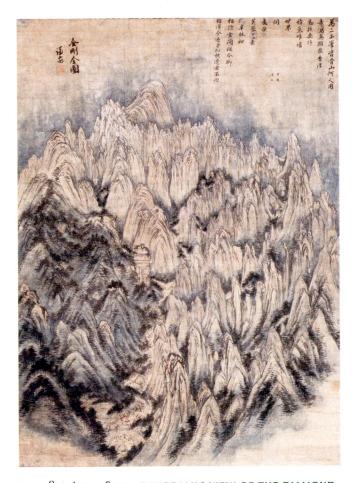

24–18 | Jeong Seon PANORAMIC VIEW OF THE DIAMOND MOUNTAINS (GEUMGANG-SAN) Korean. Joseon dynasty, 1734. Hanging scroll, ink and colors on paper, $40\% \times 37''$ (130.1 \times 94.0 cm). Lee'um, Samsung

Museum, Seoul, Republic of Korea.

The monumental mountains and vast, panoramic vistas of such fifteenth-century Korean paintings, as with their Goryeo forebears, echo Northern Song painting styles. Chinese paintings of the Southern Song (1127–1279) and Ming periods (1368–1644) also influenced Korean painting of the fifteenth, sixteenth, and seventeenth centuries, though these styles never completely supplanted the imprint of the Northern Song masters.

The Silhak Movement. In the eighteenth century, a truly Korean style emerged, inspired by the *silhak*, or "practical learning," movement, which emphasized the study of things Korean in addition to the Chinese classics. The impact of the *silhak* movement is exemplified by the painter Jeong Seon (1676–1759), who chose well-known Korean vistas as the subjects of his paintings, rather than the Chinese themes favored by earlier artists. Among Jeong Seon's paintings are numerous representations of the Diamond Mountains (Geumgang-san), a celebrated range of craggy peaks along Korea's east coast. Painted in 1734, the scroll reproduced here aptly captures the Diamond Mountains' needlelike peaks (FIG. 24–18). The subject is Korean, and so is the energetic spirit and the intensely personal style, with its crystalline mountains, distant clouds of delicate ink wash, and individualistic brushwork.

Among figure painters, Sin Yunbok (b. 1758) is an important exemplar of the *silhak* attitude. Active in the late eighteenth and early nineteenth centuries, Sin typically depicted aristocratic figures in native Korean garb. Entitled **PICNIC AT THE LOTUS POND**, the album leaf illustrated here (FIG. 24–19) represents a group of Korean gentlemen enjoying themselves in the countryside on an autumn day in the

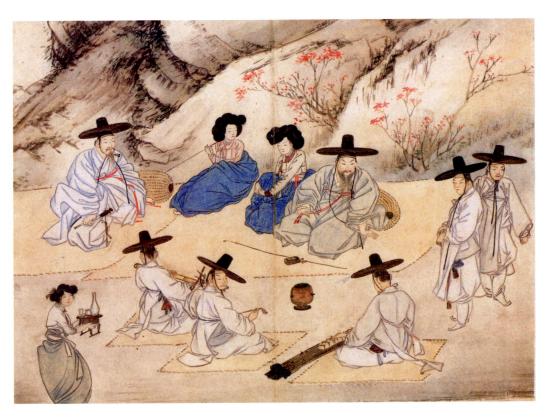

24-I9 | Sin Yunbok PICNIC AT THE LOTUS POND

From an Album of Genre Scenes. Korean. Joseon dynasty, late 18th century. Leaf from an album of thirty leaves; ink and colors on paper, 11 1/8 × 13 1/8" (28.3 × 35.2 cm). Kansong Museum of Art, Seoul, Republic of Korea.

24–20 | Gim Hwangi **5-IV-71**, Korean. 1971. Oil on canvas, $39\% \times 39\%$ " (100 \times 100 cm). Whanki Museum.

company of several *gisaeng*, or female entertainers. The figures are recognizably Korean—the women with their full coiffures, short jackets, and generous skirts, and the men with their beards, white robes, and wide-brimmed hats woven of horse hair and coated with black lacquer. The stringed instrument played by the gentleman seated in the lower right corner is a *gayageum*, or Korean zither, the most hallowed of all Korean musical instruments.

Modern Korea

Long known as "the Hermit Kingdom," the Joseon dynasty pursued a policy of isolationism, closing its borders to most of the world, except China, until 1876. Japan's annexation of Korea in 1910 brought the Joseon dynasty to a close, but effectively prolonged Korea's seclusion from the outside world. The legacy of self-imposed isolation compounded by colonial occupation (1910–45)—not to mention the harsh circumstances imposed by World War II (1939–45), followed by the even worse conditions of the Korean War (1950–53)—impeded Korea's artistic and cultural development during the first half of the twentieth century.

A MODERNIST PAINTER FROM KOREA. Despite these privations, some modern influences did reach Korea indirectly via China and Japan, and beginning in the 1920s and 1930s a few Korean artists experimented with contemporary Western styles, typically painting in the manner of Cézanne or Gauguin, but sometimes trying abstract, nonrepresentational styles. Among these, Gim Hwangi (1913–1974) was influenced by Constructivism and geometric abstraction and would become one of twentieth-century Korea's influential painters. Like many Korean artists after the Korean War, Gim wanted to examine Western modernism at its source. He visited Paris in

1956 and then, from 1964 to 1974, lived and worked in New York, where he produced his best-known works. His painting 5-IV-71 presents a large pair of circular radiating patterns composed of small dots and squares in tones of blue, black, and grav (FIG. 24-20). While appearing wholly Western in style, medium, concept, and even title—Gim Hwangi typically adopted the date of a work's creation as its title—5-IV-71 also seems related to Asia's venerable tradition of monochrome ink painting, while suggesting a transcendence that seems Daoist or Buddhist in feeling. Given that the artist was Korean, that he learned the Chinese classics in his youth, that he studied art in Paris, and that he then worked in New York, it is possible that his painting embodies all of the above. Gim's painting illustrates the paradox that the modern artist faces while finding a distinctive, personal style: whether to paint in an updated version of a traditional style, in a wholly international style, in an international style with a distinctive local twist, or in an eclectic, hybrid style that incorporates both native and naturalized elements from diverse traditions. By addressing these questions, Gim Hwangi blazed a trail for subsequent Korean-born artists, such as the renowned video artist Nam June Paik (1932-2006), whose work can be seen in figure 32-86.

IN PERSPECTIVE

Invading from the steppes of Asia, the Mongols conquered China and established there the Yuan dynasty. While maintaining their foreign connections, Mongol leaders also adopted the values of Chinese dynastic rule, becoming patrons and collectors of art. Scholars educated for government service preserved and further developed the literati ideals that had coalesced during the earlier Song dynasty.

When the Yuan period of foreign rule came to an end, the new Ming ruling house revived the court traditions of the Song, including Southern Song court painting styles, and they commissioned decorated porcelains of exquisite quality. The Ming also became the model for the rulers of Korea's Joseon dynasty, under whose patronage these styles achieved a distinctive and austere beauty.

In the Qing era, China was again ruled by an outside group, this time the Manchus. While maintaining their traditional connections to Tibet and inner Asia through their patronage of Tibetan Buddhism, the Manchu rulers also embraced Chinese ideals, especially those of the literati. Practicing painting and calligraphy, composing poetry in Chinese, and collecting esteemed Chinese works of art, these rulers amassed the great palace collections that can now be seen in Beijing and Taipei.

By the twentieth century, China gradually embraced modern international trends. Chinese artists, and those in neighboring Korea, strove to choose among ideals of Western art, attracted first to its documentary qualities and then to its increasing abstraction, all the while maintaining ties to their own traditions.

NI ZAN THE RONGXI STUDIO 1372

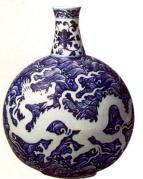

MING FLASK 1426-35

GARDEN OF CESSATION OF
OFFICIAL LIFE
EARLY 16TH CENTURY

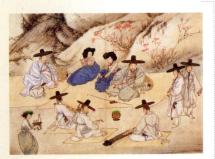

SIN YUNBOK
LATE 18TH CENTURY

Wu Guanzhong PINE SPIRIT 1984

CHINESE AND KOREAN ART AFTER 1279

Yuan Dynasty 1279-1368

Ming Dynasty 1368-1644

Joseon Dynasty, Korea 1392-1910

Qing Dynasty 1644-1911

1600 1700 1800

2000

1400

1500

Korea a Japanese Colony 1910–1945

Republic of China: Mainland

South Korea 1945-Present

■ North Korea 1945-Present

Republic of China: Taiwan 1949-Present

 People's Republic of China 1949-Present

■ Korean War 1950–1953

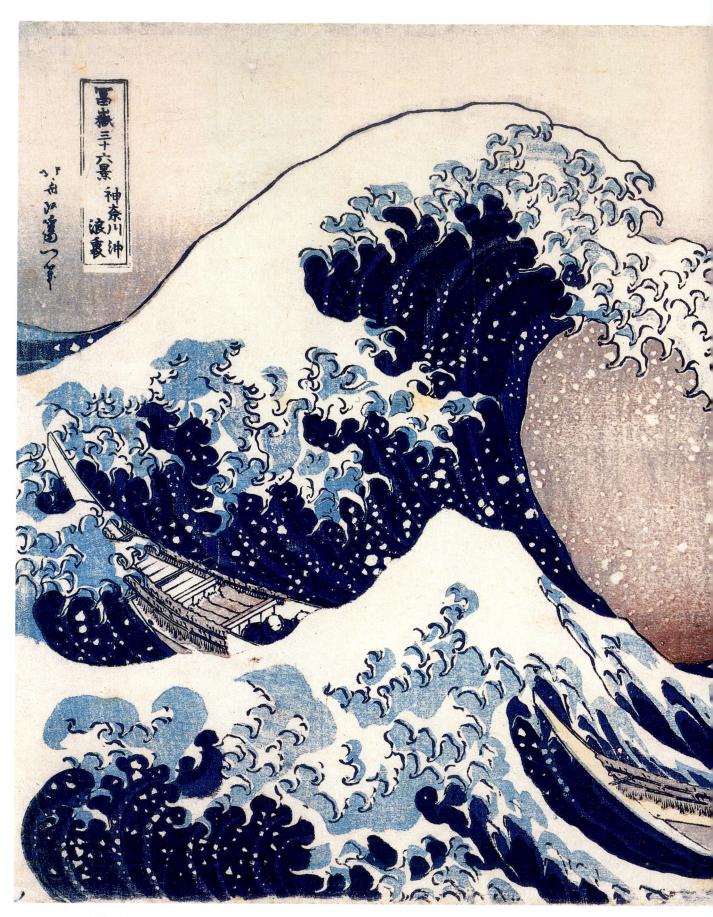

25–I Katsushika Hokusai **THE GREAT WAVE** From *Thirty-Six Views of Mt. Fuji*. Edo period, c. 1831. Polychrome woodblock print on paper, $9 \% \times 14 \%$ " (25 \times 37.1 cm). Honolulu Academy of Arts, Honolulu, Hawaii. James A. Michener Collection (HAA 13, 695)

CHAPTER TWENTY-FIVE

JAPANESE ART AFTER 1392

25

The great wave rears up like a dragon with claws of foam, ready to crash down on the figures huddled in the boat below. Exactly at the point of

imminent disaster, but far in the distance, rises Japan's most sacred peak, Mount Fuji, whose slopes, we suddenly realize, swing up like waves and whose snowy crown is like foam—comparisons the artist makes clear in the wave nearest us, caught just at the moment of greatest resemblance. This woodblock print (FIG. 25–1), known as **THE GREAT WAVE**—from a series called *Thirty-Six Views of Mt. Fuji* by Katsushika Hokusai (1760–1849)—has inspired countless imitations and witty parodies, yet its forceful composition remains ever fresh.

Today, Japanese color woodblock prints of the eight-eenth and nineteenth centuries are collected avidly around the world, but in their own day they were barely considered art. Commercially produced by the hundreds for ordinary people to buy, they were the fleeting secular souvenirs of their era—an era that was one of the most fascinating in Japanese history. When seen in Europe and America, these and other Japanese prints were immediately acclaimed, and they strongly influenced late nineteenth- and early twentieth-century Western art (Chapter 30). Japonisme, or *japonism*, became the vogue, and Hokusai and Hiroshige (1797–1858)

became as famous in the West as in Japan. Indeed, their art was taken more seriously in the West; the first book on Hokusai was published in France, and according to one estimate, by the early twentieth century more than 90 percent of Japanese prints had been sold to Western collectors.

CHAPTER-AT-A-GLANCE

- MUROMACHI PERIOD | Ink Painting | The Zen Dry Garden
- MOMOYAMA PERIOD | Architecture | Kano School Decorative Painting | The Tea Ceremony
- EDO PERIOD | The Tea Ceremony | Rimpa School Painting | Nanga School Painting | Zen Painting | Maruyama-Shijo School Painting | Ukiyo-E: Pictures of the Floating World
- THE MEIJI AND MODERN PERIODS | Meiji | Modern Japan
- **IN PERSPECTIVE**

MUROMACHI PERIOD

By the year 1392, Japanese art had already developed a long and rich history (see "Foundations of Japanese Culture," page 854). Beginning with prehistoric pottery and tomb art, then expanding through cultural influences from China and Korea, Japanese visual expression reached high levels of sophistication in both religious and secular arts. Very early in the tradition, a particularly Japanese aesthetic emerged, including a love of natural materials, a taste for asymmetry, a sense of humor, and a tolerance for qualities that may seem paradoxical or contradictory—characteristics that continue to distinguish Japanese art, appearing and reappearing in ever-changing guises.

By the end of the twelfth century, the political and cultural dominance of the emperor and his court had given way to rule by warriors, or samurai, under the leadership of the shogun, the general-in-chief. In 1338 the Ashikaga family gained control of the shogunate and moved its headquarters to the Muromachi district in Kyoto. In 1392 they reunited northern and southern Japan and retained their grasp on the office for more than 150 years. The Muromachi period after the reunion (1392–1573) is also known as the Ashikaga era.

The Muromachi period is especially marked by the ascendance of Zen Buddhism, whose austere ideals particularly appealed to the highly disciplined samurai. While Pure Land Buddhism, which had spread widely during the latter part of the Heian period (794–1185), remained popular, Zen, patronized by the samurai, became the dominant cultural force in Japan.

Ink Painting

Several forms of visual art flourished during the Muromachi period, but **ink painting**—monochrome painting in black ink and its diluted grays—reigned supreme. Muromachi ink painting was heavily influenced by the aesthetics of Zen, yet

it also marked a shift away from the earlier Zen painting tradition. As Zen moved from an "outsider" sect to the chosen sect of the ruling group, the fierce intensity of earlier masters gave way to a more subtle and refined approach. And whereas earlier Zen artists had concentrated on rough-hewn depictions of Zen figures such as monks and teachers, now Chinese-style ink landscapes became the most important theme. Traditionally, the monk-artist Shubun (active c. 1418–63) is regarded as Japan's first great master of the ink landscape. Unfortunately, no works survive that can be proven to be his. Two landscapes by Shubun's pupil Bunsei (active c. 1450–60) have survived, however. In the one shown here (FIG. 25–2),

Bunsei LANDSCAPE
Muromachi period, mid-15th century.
Hanging scroll, ink, and light colors on paper, 28 ¾ × 13″ (73.2 × 33 cm).
Museum of Fine Arts, Boston.
Special Chinese and Japanese Fund (05.203)

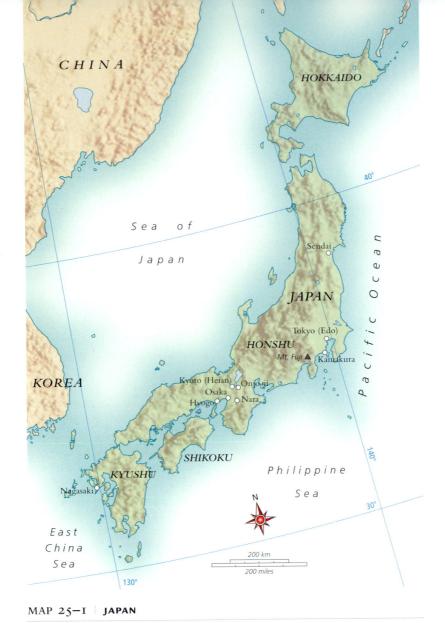

Ideas and artistic influences from the Asian continent flowed to Japan before and after the island nation's self-imposed isolation from the 17th to the 19th century.

the foreground reveals a spit of rocky land with an overlapping series of motifs—a spiky pine tree, a craggy rock, a poet seated in a hermitage, and a brushwood fence holding back a small garden of trees and bamboo. In the middle ground is space—emptiness, the void.

We are expected to "read" the empty paper as representing water, for subtle tones of gray ink suggest the presence of a few people fishing from their boats near the distant shore. The two parts of the painting seem to echo each other across a vast expanse. A depiction of nature echoing the human spirit, the painting illustrates well the pure, lonely, and ultimately serene spirit of the Zen-influenced poetic landscape tradition.

Sesshu. Ink painting soon took on a different spirit. Zen monks painted—just as their Western counterparts illuminated manuscripts—but gave away their artworks. By the turn of the sixteenth century, temples were being asked for so many paintings that they formed ateliers staffed by monks

who specialized in art rather than religious ritual or teaching. Some painters even found they could survive on their own as professional artists. Nevertheless, many of the leading masters remained monks, at least in name, including the most famous of them all, Sesshu (1420-1506). Although he lived his entire life as a monk, Sesshu devoted himself primarily to painting. Like Bunsei, he learned from the tradition of Shubun, but he also had the opportunity to visit China in 1467. Sesshu traveled extensively there, viewing the scenery, stopping at Zen monasteries, and seeing whatever Chinese paintings he could. He does not seem to have had access to works by contemporary literati masters such as Shen Zhou (see Chapter 24), but saw instead the works of professional painters. Sesshu later claimed that he learned nothing from Chinese artists, but only from the mountains and rivers he had seen. When Sesshu returned from China, he found his homeland rent by the Onin Wars, which devastated the capital of Kyoto. Japan was to be torn apart by further civil warfare for the next hundred years. The refined art patronized by a secure society in

Art and Its Context

FOUNDATIONS OF JAPANESE CULTURE

ith the end of the last Ice Age roughly 15,000 years ago, rising sea levels submerged the lowlands connecting Japan to the Asian landmass, creating the chain of islands we know today as Japan (SEE MAP 25-1). Not long afterward, early Paleolithic cultures gave way to a Neolithic culture known as Jomon (c. 11,000-400 BCE), after its characteristic cord-marked pottery. During the Jomon period, a sophisticated hunter-gatherer culture developed. Agriculture supplemented hunting and gathering by around 5000 BCE, and rice cultivation began some 4,000 years later.

A fully settled agricultural society emerged during the Yayoi period (c. 400 BCE-300 CE), accompanied by hierarchical social organization and more centralized forms of government. As people learned to manufacture bronze and iron, use of those metals became widespread. Yayoi architecture, with its unpainted wood and thatched roofs, already showed the Japanese affinity for natural materials and clean lines, and the style of Yayoi granaries in particular persisted in the design of shrines in later centuries. The trend toward centralization continued during the Kofun period (c. 300-552 CE), an era characterized by the construction of large royal tombs, following the Korean practice. Veneration of leaders grew into the beginnings of the imperial system that has lasted to the present day.

The Asuka era (552-645 CE) began with a century of profound change as elements of Chinese civilization flooded into Japan, initially through the intermediary of Korea. The three most significant Chinese contributions to the developing Japanese culture were Buddhism (with its attendant art and architecture), a system of writing, and the structures of a centralized bureaucracy. The earliest extant Buddhist temple compound in Japan—the oldest currently existing wooden building in the world—dates from this period.

The arrival of Buddhism also prompted some formalization of Shinto, the loose collection of indigenous Japanese beliefs and practices. Shinto is a shamanistic religion that emphasizes cere-

monial purification. Its rituals include the invocation and appeasement of spirits, including those of the recently dead. Many Shinto deities are thought to inhabit various aspects of nature, such as particularly magnificent trees, rocks, and waterfalls, and living creatures such as deer. Shinto and Buddhism have in common an intense awareness of the transience of life, and as their goals are complementary—purification in the case of Shinto, enlightenment in the case of Buddhism—they have generally existed comfortably alongside each other to the present day.

The Nara period (645–794 CE) takes its name from Japan's first permanently established imperial capital. During this time the founding works of Japanese literature were compiled, among them an important collection of poetry called the *Manyoshu*. Buddhism advanced to become the most important force in Japanese culture. Its influence at court grew so great as to become worrisome, and in 794 the emperor moved the capital from Nara to Heian-kyo (present-day Kyoto), far from powerful monasteries.

During the Heian period (794–1185) an extremely refined court culture thrived, embodied today in an exquisite legacy of poetry, calligraphy, and painting. An efficient method for writing the Japanese language was developed, and with it a woman at the court wrote the world's first novel, *The Tale of Genji*. Esoteric Buddhism, as hierarchical and intricate as the aristocratic world of the court, became popular.

The end of the Heian period was marked by civil warfare as regional warrior (samurai) clans were drawn into the factional conflicts at court. Pure Land Buddhism, with its simple message of salvation, offered consolation to many in troubled times. In 1185 the Minamoto clan defeated their arch rivals, the Taira, and their leader, Minamoto Yoritomo, assumed the position of shogun (general-in-chief). While paying respects to the emperor, Minamoto Yoritomo kept actual military and political power to himself, setting up his own capital in Kamakura. The Kamakura era (1185–1333) began a tradition of rule by shogun that lasted in various forms until 1868.

peacetime was no longer possible. Instead, the violent spirit of the times sounded its disturbing note, even in the world of landscape painting.

This new spirit is evident in Sesshu's **WINTER LAND-SCAPE**, which makes full use of the forceful style that he developed (FIG. 25–3). A cliff descending from the mist seems to cut the composition in two. Sharp, jagged brushstrokes delineate a series of rocky hills, where a lone figure makes his way to a Zen monastery. Instead of a gradual recession into space, flat overlapping planes fracture the composition into crystalline facets. The white of the paper is left to indicate snow, while the sky is suggested by tones of gray. A few trees cling desperately to the rocky land, and the harsh chill of winter is boldly expressed.

IKKYU. A third important artist of the Muromachi period was a monk named Ikkyu (1394–1481). A genuine eccentric and one of the most famous Zen masters in Japanese history, Ikkyu derided the Zen of his day, writing, "The temples are rich but Zen is declining, there are only false teachers, no true teachers." Ikkyu recognized that success was distorting the spirit of Zen. Originally, Zen had been a form of counterculture for those who were not satisfied with prevailing ways. Now, however, Zen monks acted as government advisers, teachers, and even leaders of merchant missions to China. Although true Zen masters were able to withstand all outside pressures, many monks became involved with political matters, with factional disputes among the temples, or with their reputations as poets or artists. Ikkyu did not hesitate to mock

what he regarded as "false Zen." He even paraded through the streets with a wooden sword, claiming that his sword would be as much use to a samurai as false Zen to a monk.

Ikkyu's calligraphy, which is especially admired, has a spirit of spontaneity. To write out the classic Buddhist couplet "Abjure evil, practice only the good," he created a pair of single-line scrolls (FIG. 25–4). At the top of each scroll—first the right scroll and then the left—Ikkyu began with standard script, in which each stroke of a character is separate and distinct. As his brush moved down a scroll, he grew more excited and wrote in increasingly cursive script, until finally his frenzied brush did not leave the paper at all. This calligraphy displays the intensity that is the hallmark of Zen.

The Zen Dry Garden

Elegant simplicity—profound and personal—was the result of disciplined meditation coupled with manual labor, as practiced in the Zen Buddhism introduced into Japan in the late twelfth century. Zen monasteries aimed at self-sufficiency. Monks were expected to be responsible for their physical as well as spiritual needs. Consequently, the performance of

Sequencing Events Periods in Japanese Art after 1392

1336-1573	Muromachi Period
1568-1615	Momoyama Period
1615-1868	Edo Period

1868-Present Meiji and Modern Periods

simple tasks—weeding the garden, cooking meals, mending garments—became occasions for meditation in the search for enlightenment. Zen monks turned to their gardens not as the focus of detached viewing and meditation but as the objects of constant vigilance and work—pulling weeds, tweaking unruly shoots, and raking the gravel of the dry gardens. This philosophy profoundly influenced Japanese art.

The dry landscape gardens of Japan, *karesansui* (literally "dried-up mountains and water"), exist in perfect harmony with Zen Buddhism. The dry garden in front of the abbot's quarters in the Zen temple of Ryoan-ji is one of the most

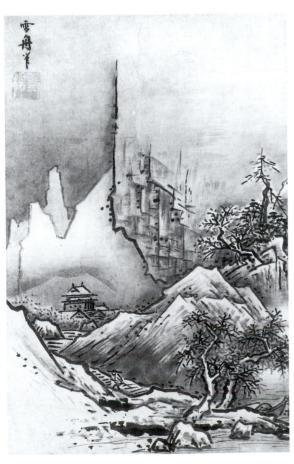

25–3 | Sesshu WINTER LANDSCAPE Muromachi period, c. 1470s. Ink on paper, 18 ½ \times 11 ½" (46.3 \times 29.3 cm). Collection of the Tokyo National Museum.

25–4 | Ikkyu CALLIGRAPHY COUPLET Daitoku-ji, Kyoto. Muromachi period, c. mid-15th century. Ink on paper, each $10'2~\%''\times1'4~\%''$ (3.12 \times 0.42 m).

renowned Zen creations in Japan (FIG. 25–5). A flat rectangle of raked gravel, about 29 by 70 feet, surrounds fifteen stones of different sizes in islands of moss. The stones are set in asymmetrical groups of two, three, and five. Low, plaster-covered walls establish the garden's boundaries, but beyond the perimeter wall, maple, pine, and cherry trees add color and texture to the scene. Called "borrowed scenery," these elements are a considered part of the design even though they grow outside the garden. The garden is celebrated for its severity and emptiness.

Dry gardens began to be built in the fifteenth and sixteenth centuries in Japan. By the sixteenth century, Chinese landscape painting influenced the gardens' composition, and miniature clipped plants and beautiful stones were arranged to resemble famous paintings. Especially fine and unusual stones were coveted and even carried off as war booty, such was the cultural value of these seemingly mundane objects.

The Ryoan-ji garden's design, as we see it today, probably dates from the mid-seventeenth century, since earlier written sources refer only to cherry trees, not to a garden. By the time this garden was created, such stone and gravel gardens had become highly intellectualized, abstract reflections of nature. This garden has been interpreted as representing islands in the sea, or mountain peaks rising above the clouds, perhaps even a swimming tigress with her cubs, or constellations of stars and planets. All or none of these interpretations may be equally satisfying—or irrelevant—to a monk seeking clarity of mind through contemplation. The austere beauty of the naked gravel has led many people to meditation.

MOMOYAMA PERIOD

The civil wars sweeping Japan laid bare the basic flaw in the Ashikaga system, which was that samurai were primarily loyal to their own feudal lord, or *daimyo*, rather than to the central government. Battles between feudal clans grew more frequent, and it became clear that only a *daimyo* powerful and bold enough to unite the entire country could control Japan. As the Muromachi period drew to a close, three leaders emerged who would change the course of Japanese history.

The first of these leaders was Oda Nobunaga (1534-82), who marched his army into Kyoto in 1568, signaling the end of the Ashikaga family as a major force in Japanese politics. A ruthless warrior, Nobunaga went so far as to destroy a Buddhist monastery because the monks refused to join his forces. Yet he was also a patron of the most rarefied and refined arts. Assassinated in the midst of one of his military campaigns, Nobunaga was succeeded by the military commander Toyotomi Hideyoshi (1537-98), who soon gained complete power in Japan. He, too, patronized the arts when not leading his army, and he considered culture a vital adjunct to his rule. Hideyoshi, however, was overly ambitious. He believed that he could conquer both Korea and China, and he wasted much of his resources on two ill-fated invasions. A stable government finally emerged in 1600 with the triumph of a third leader, Tokugawa Ieyasu (1543-1616), who established his shogunate in 1603. But despite its turbulence, the era of Nobunaga and Hideyoshi, known as the Momoyama period (1568-1615), was one of the most creative eras in Japanese history.

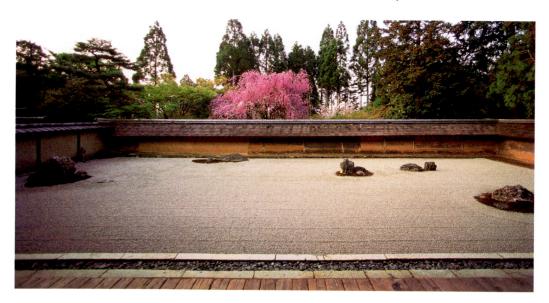

25–5 | ROCK GARDEN, RYOAN-JI, KYOTO Photographed spring 1993. Muromachi period, c. 1480. Photograph by Michael S. Yamashita

The American composer John Cage once exclaimed that every stone at Ryoan-ji was in just the right place. He then said, "And every other place would also be just right." His remark is thoroughly Zen in spirit. There are many ways to experience Ryoan-ji. For example, we can imagine the rocks as having different visual "pulls" that relate them to one another. Yet there is also enough space between them to give each one a sense of self-sufficiency and permanence.

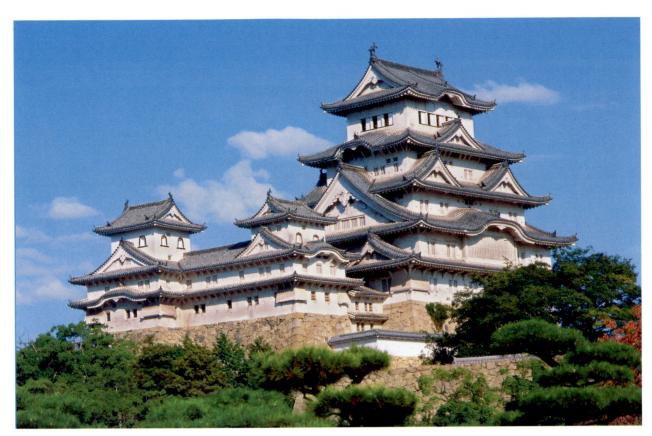

25–6 | **HIMEJI CASTLE** Hyogo, near Osaka. Momoyama period, 1601–09.

Architecture

Today the very word *Momoyama* conjures up images of bold warriors, luxurious palaces, screens shimmering with **gold leaf**, and magnificent ceramics. The Momoyama period was also the era when Europeans first made an impact in Japan. A few Portuguese explorers had arrived at the end of the Muromachi era in 1543, and traders and missionaries were quick to follow. It was only with the rise of Nobunaga, however, that Westerners were able to extend their activities beyond the ports of Kyushu, Japan's southernmost island. Nobunaga welcomed foreign traders, who brought him various products, the most important of which were firearms.

European muskets and cannons soon changed the nature of Japanese warfare and influenced Japanese architecture. In response to the new weapons, monumental fortified castles were built in the late sixteenth century. Some were eventually lost to warfare or torn down by victorious enemies, and others have been extensively altered over the years. One of the most beautiful of the surviving castles is Himeji, not far from the city of Osaka (FIG. 25–6). Rising high on a hill above the plains, Himeji has been given the name White Heron. To reach the upper fortress, visitors must follow angular paths beneath steep walls, climbing from one area to the next past stone ramparts and through narrow fortified gates, all the while feeling as though lost in a maze, with no sense of direction or progress. At the main building, a further climb up a series of narrow ladders leads to the uppermost chamber.

There, the footsore visitor is rewarded with a stunning 360-degree view of the surrounding countryside. The sense of power is overwhelming.

Kano School Decorative Painting

Castles such as Himeji were sumptuously decorated, offering artists unprecedented opportunities to work on a grand scale. Large murals on fusuma—paper-covered sliding doors—were particular features of Momoyama design, as were folding screens with gold-leaf backgrounds, whose glistening surfaces not only conveyed light within the castle rooms but also displayed the wealth of the warrior leaders. Temples, too, commissioned large-scale paintings for their rebuilding projects after the devastation of the civil wars.

The Momoyama period produced a number of artists who were equally adept at decorative golden screens and broadly brushed *fusuma* paintings. Daitoku-ji, a celebrated Zen monastery in Kyoto, has a number of subtemples that are treasure troves of Japanese art. One, the Juko-in, possesses *fusuma* by Kano Eitoku (1543–90), one of the most brilliant painters from the professional school of artists founded by the Kano family and patronized by government leaders for several centuries. Founded in the Muromachi period, the Kano school combined training in the ink-painting tradition with new skills in decorative subjects and styles. The illustration here shows two of the three walls of *fusuma* panels painted when the artist was in his mid-twenties (FIG. 25–7). To the

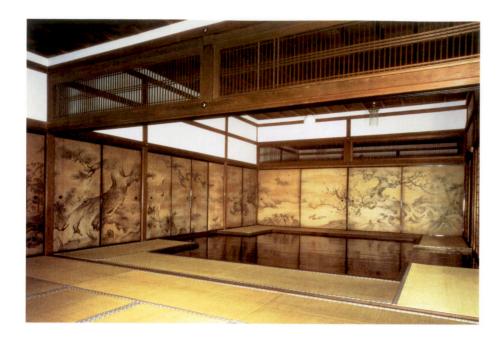

25–7 | Kano Eitoku FUSUMA
Depicting pine and cranes (left) and plum tree (right) from the central room of the Juko-in, Daitoku-ji, Kyoto. Momoyama period, c. 1563–73. Ink and gold on paper, height 5'9 1/8" (1.76 m).

left, the subject is the familiar Kano school theme of cranes and pines, both symbols of long life; to the right is a great gnarled plum tree, symbol of spring. The trees are so massive they seem to extend far beyond the panels. An island rounding both walls of the far corner provides a focus for the outreaching trees. Ingeniously, it belongs to both compositions at the same time, thus uniting them into an organic whole. Eitoku's vigorous use of brush and ink, his powerfully jagged outlines, and his dramatic compositions all hark back to the style of Sesshu, but the bold new sense of scale in his works is a leading characteristic of the Momoyama period.

The Tea Ceremony

Japanese art is never one-sided. Along with castles, golden screens, and massive *fusuma* paintings there was an equal interest during the Momoyama period in the quiet, the restrained, and the natural. This was expressed primarily through the tea ceremony.

The term "tea ceremony," a phrase now in common use, does not convey the full meaning of *cha no yu*, the Japanese ritual drinking of tea, which has no counterpart in Western culture. Tea itself had been introduced to Japan from the Asian continent hundreds of years earlier. At first, tea was molded into cakes and boiled. However, the advent of Zen in the late Kamakura period (1185–1392) brought to Japan a different way of preparing tea, with the leaves crushed into powder and then whisked in bowls with hot water. Zen monks used such tea as a mild stimulant to aid meditation, and it also was considered a form of medicine.

SEN NO RIKYU. The most famous tea master in Japanese history was Sen no Rikyu (1522–91). He conceived of the tea ceremony as an intimate gathering in which a few people would enter a small rustic room, drink tea carefully prepared in front of them by their host, and quietly discuss the tea utensils or a Zen scroll hanging on the wall. He did a great

deal to establish the aesthetic of modesty, refinement, and rusticity that permitted the tearoom to serve as a respite from the busy and sometimes violent world outside. A traditional tearoom is quite small and simple. It is made of natural materials such as bamboo and wood, with mud walls, paper windows, and a floor covered with tatami—mats of woven straw. One tearoom that preserves Rikyu's design is named Tai-an (FIG. 25–8). Built in 1582, it is distinguished by its tiny door (guests must crawl to enter) and its alcove, or *tokonoma*, where a Zen scroll or a simple flower arrangement may be

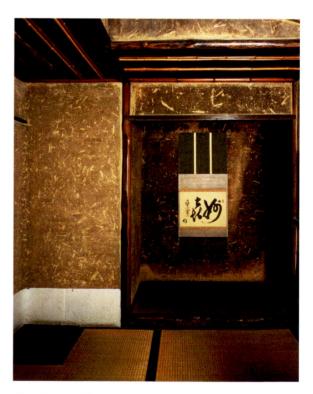

25–8 | Sen no Rikyu TAI-AN TEAROOM Myoki-an Temple, Kyoto. Momoyama period, 1582.

displayed. At first glance, the room seems symmetrical. But the disposition of the *tatami* does not match the spacing of the *tokonoma*, providing a subtle undercurrent of irregularity. A longer look reveals a blend of simple elegance and rusticity. The walls seem scratched and worn with age, but the tatami are replaced frequently to keep them clean and fresh. The mood is quiet; the light is muted and diffused through three small paper windows. Above all, there is a sense of spatial clarity. All nonessentials have been eliminated, so there is nothing to distract from focused attention. The tearoom aesthetic became an important element in Japanese culture, influencing secular architecture through its simple and evocative style (see "Shoin Design," page 860).

EDO PERIOD

Three years after Tokugawa Ieyasu gained control of Japan, he proclaimed himself shogun. His family's control of the shogunate was to last more than 250 years, a span of time known as the Edo period (1615–1868) or the Tokugawa era.

Under the rule of the Tokugawa family, peace and prosperity came to Japan at the price of an increasingly rigid and often repressive form of government. The problem of potentially rebellious *daimyo* was solved by ordering all feudal lords to spend either half of each year or every other year in the new capital of Edo (present-day Tokyo), where their wives and children were sometimes required to live permanently. Zen Buddhism was supplanted as the prevailing intellectual force by a form of neo-Confucianism, a philosophy formulated in Songdynasty China that emphasized loyalty to the state. More drastically, Japan was soon closed off from the rest of the world by its suspicious government. Japanese were forbidden to travel abroad, and with the exception of small Chinese and Dutch trading communities on an island off the southern port of Nagasaki, foreigners were not permitted in Japan.

Edo society was officially divided into four classes. Samurai officials constituted the highest class, followed by farmers, artisans, and finally merchants. As time went on, however, merchants began to control the money supply, and in Japan's increasingly mercantile economy they soon reached a high, if unofficial, position. Reading and writing became widespread at all levels of society. Many segments of the population—samurai, merchants, intellectuals, and even townspeople—were now able to patronize artists, and a pluralistic cultural atmosphere developed unlike anything Japan had experienced before.

The Tea Ceremony

The rebuilding of temples continued during the first decades of the Edo period, and for this purpose government officials, monks, and wealthy merchants needed to cooperate. The tea ceremony was one way that people of different classes could come together for intimate conversations. Every utensil connected with tea, including the waterpot, the kettle, the bam-

Sequencing Works of Art

1582	Sen no Rikyu. Tai-an tearoom, Myoki-an Temple, Kyoto
1601-09	Himeji Castle, Hyogo
17th century	Tawaraya Sotatsu. Matsushima screens
Late 17th-early 18th century	Ogata Korin. Lacquer box for writing implements
Mid-18th century	Suzuki Harunobu. Geisha as Daruma Crossing the Sea

boo spoon, the whisk, the tea caddy, and, above all, the teabowl, came to be appreciated for their aesthetic qualities, and many works of art were created for use in *cha no yu*.

The age-old Japanese admiration for the natural and the asymmetrical found full expression in tea ceramics. Koreanstyle rice bowls made for peasants were suddenly considered the epitome of refined taste, and tea masters urged potters to mimic their imperfect shapes. But not every misshapen bowl would be admired. An extremely rarified appreciation of beauty developed that took into consideration such factors as how well a teabowl fit into the hands, how subtly the shape and texture of the bowl appealed to the eye, and who had previously used and admired it. For this purpose, the inscribed box became almost as important as the ceramic that fit within it, and if a bowl had been given a name by a leading tea master, it was especially treasured by later generations.

One of the finest teabowls extant is named **MOUNT FUJI** after Japan's most sacred peak (FIG. 25–9). (Mount Fuji is

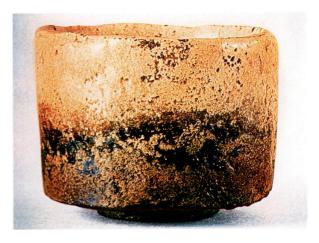

25-9 | Hon'ami Koetsu TEABOWL, CALLED MOUNT FUJI Edo period, early 17th century. Raku ware, height 3 ½" (8.5 cm). Sakai Collection, Tokyo.

Connoisseurs developed a subtle vocabulary to discuss the aesthetics of tea. A favorite term was *sabi* (literally, "loneliness"), which refers to the tranquility found when feeling alone. Other virtues were *wabi* (literally, "poverty"), which suggests the artlessness of humble simplicity, and *shibui*, (literally, "bitter" or "astringent"), meaning elegant restraint, and said to be exemplified by the color of the inside of an old teapot.

Elements of Architecture

SHOIN DESIGN

f the many expressions of Japanese taste that reached great refinement in the Momoyama period, *shoin* architecture has had perhaps the most enduring influence. Shoin are upper-class residences that combine a number of traditional features in more-or-less standard ways, always asymmetrically. These features include wide verandas, wood posts as framing and defining decorative elements, woven straw *tatami* mats as floor and ceiling covering, several shallow alcoves for prescribed purposes, *fusuma* (sliding doors) as fields for painting or textured surfaces, and *shoji* screens—wood frames covered with translucent rice paper. The *shoin* illustrated here was built in 1601 as a guest hall, called Kojo-in, at the great Onjo-ji monastery. *Tatami*, *shoji*, alcoves, asymmetry, and other features of *shoin* are still seen in Japanese interiors today.

In the original shoin, one of the alcoves would contain a hanging scroll, an arrangement of flowers, or a large painted

screen. Seated in front of that alcove, called a **tokonoma**, the owner of the house would receive guests, who could contemplate the object above the head of their host. Another alcove contained staggered shelves, often for writing instruments. A writing space fitted with a low writing desk was on the veranda side of the room, with *shoji* that could open to the outside.

The architectural harmony of *shoin* was based on the proportionate disposition of basic units, or **modules**. In Japanese carpentry, the common module of design and construction is the **bay**, reckoned as the distance from the center of one post to the center of another, which is governed in turn by the standard size of *tatami* floor mats. Although varying slightly from region to region, the size of a single *tatami* is about 3 by 6 feet. Room area in Japan is still expressed in terms of the number of *tatami* mats, so that, for example, a room may be described as an eight-mat room.

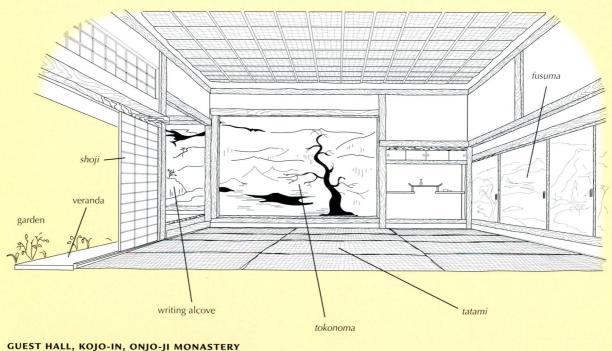

GUEST HALL, KOJO-IN, ONJO-JI MONASTERY Shiga prefecture. Momoyama period. 1601.

depicted in FIGURE 25–1.) An example of raku ware—a hand-built, low-fired ceramic developed especially for use in the tea ceremony—the bowl was crafted by Hon'ami Koetsu (1558–1637), a leading cultural figure of the early Edo period. Koetsu was most famous as a calligrapher, but he was also a painter, lacquer designer, poet, landscape gardener, connoisseur of swords, and potter. With its small foot, straight sides, slightly irregular shape, and crackled texture, this bowl

exemplifies tea taste. In its rough exterior we sense directly the two elements of earth and fire that create pottery. Merely looking at it suggests the feeling one would get from holding it, warm with tea, cupped in one's hands.

Rimpa School Painting

One of Koetsu's friends was the painter Tawaraya Sotatsu (active c. 1600–40), with whom he collaborated on several

magnificent handscrolls. Sotatsu is considered the first great painter of the Rimpa school, a grouping of artists with similar tastes rather than a formal school, such as the Kano school. Rimpa masters excelled in decorative designs of strong expressive force, and they frequently worked in several mediums.

Sotatsu painted some of the finest golden screens that have survived. The splendid pair here depict the celebrated islands of Matsushima near the northern city of Sendai (FIG. 25–10). Working in a boldly decorative style, the artist has created asymmetrical and almost abstract patterns of waves, pines, and island forms. On the right screen (shown here on top), mountainous islands echo the swing and sweep of the waves, with stylized gold clouds in the upper left. The left screen continues the gold clouds until they become a sand spit from which twisted pines grow. Their branches seem to lean toward a strange island in the lower left, composed of an

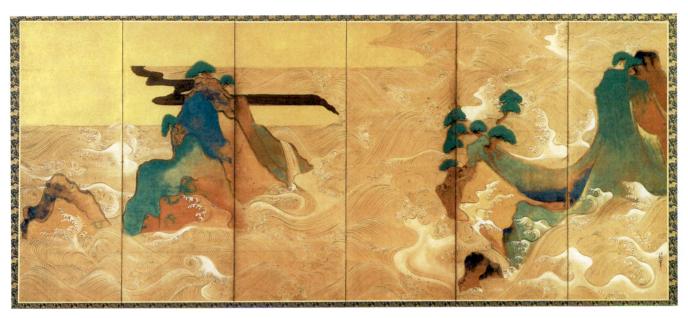

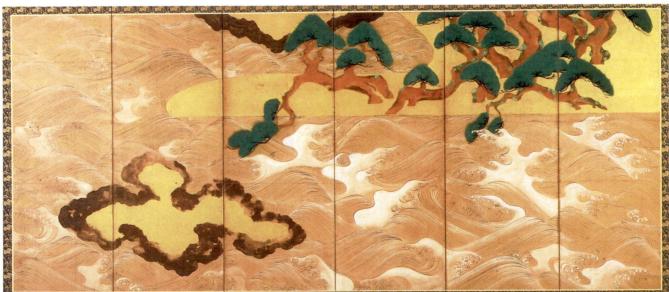

25–IO | Tawaraya Sotatsu PAIR OF SIX-PANEL SCREENS, KNOWN AS THE MATSUSHIMA SCREENS Edo period, 17th century. Ink, mineral colors, and gold leaf on paper; each screen 4'9 $\frac{7}{8}$ " \times 11'8 $\frac{7}{2}$ " (1.52 \times 3.56 m). Freer Gallery of Art, Smithsonian Institution, Washington, D.C. Gift of Charles Lang Freer (F1906.231 & 232)

The six-panel screen format was a triumph of scale and practicality. Each panel consisted of a light wood frame surrounding a latticework interior covered with several layers of paper. Over this foundation was pasted a high-quality paper, silk, or gold-leaf ground, ready to be painted by the finest artists. Held together with ingenious paper hinges, a screen could be folded for storage or transportation, resulting in a mural-size painting light enough to be carried by a single person, ready to be displayed as needed.

THE OBJECT SPEAKS

LACQUER BOX FOR WRITING IMPLEMENTS

gata Korin (1658-1716), another great master of the Rimpa school, originated many remarkable works, including colorful golden screens, monochrome scrolls, and paintings in glaze on his brother Kenzan's pottery. He also designed some highly prized works in lacquer. His writing box is a lidded container designed to hold tools and materials for calligraphy. Korin's design for this black lacquer box sets a motif of irises and a plank bridge in a dramatic combination of mother-of-pearl, silver, lead, and gold lacquer. For Japanese viewers the decoration immediately recalls a famous passage from the tenth-century Tales of Ise, a classic of Japanese literature. A nobleman poet, having left his wife in the capital, pauses at a place called Eight Bridges, where a river branches into eight streams, each covered with a plank bridge. Irises are in full bloom, and his traveling companions urge the poet to write a tanka-a five-line, thirty-one-syllable poem-beginning each line with a syllable from the word for "iris": Kakitsubata (ka-ki-tsu-ba-ta). The poet responds (substituting ha for ba):

Karagoromo kitsutsu narenishi tsuma shi areba harubaru kinuru tabi o shi zo omou. When I remember my wife, fond and familiar as my courtly robe, I feel how far and distant my travels have taken me. (Translated by Stephen Addiss)

The poem brought tears to all their eyes, and the scene became so famous that any painting of a group of irises, with or without a plank bridge, immediately calls it to mind.

Lacquer is derived in Asia from the sap of the lacquer tree, *Rhus Verniciflua*. The tree is indigenous to China, where examples of lacquerware have been found dating back to the Neolithic period. Knowledge of lacquer spread early to Korea and Japan, and the tree came to be grown commercially throughout East Asia.

Gathered by tapping into a tree and letting the sap flow into a container, lacquer is then strained to remove impurities and heated to evaporate excess moisture. The thickened sap can be colored with vegetable or mineral dyes and lasts for several years if carefully stored. Applied in thin coats to a surface such as wood or leather, lacquer hardens into a smooth, glasslike, protective coating that is waterproof, heat- and acid-resistant, and airtight. Lacquer's practical qualities made it ideal for storage containers and vessels for food and drink. In Japan the leather scales

of samurai armor were coated in lacquer, as were leather saddles. The decorative potential of lacquer was developed in the manufacture of expensive luxury items.

The creation of a piece of lacquer is a painstaking process that can take a sequence of specialized artisans several years. First, the item is fashioned of wood and sanded smooth. Next, layers of lacquer are built up. In order to dry properly, lacquer must be applied in extremely thin coats. (If the lacquer is applied too thickly, the exterior surface dries first, forming an airtight seal that prevents the lacquer below from drying.) Optimal temperature and humidity are also essential to drying, and artisans quickly learned to control them artificially. Up to thirty coats of lacquer, each dried and polished before the next is brushed on, are required.

In China, lacquer was often applied to a thickness of up to 300 coats, then elaborately carved. In Japan and Korea, inlay with mother-of-pearl and precious metals was brought to a high point of refinement. Japanese artisans also perfected a variety of methods known collectively as *maki-e* ("sprinkled design"), in which flaked or powdered gold or silver was embedded in a still-damp coat of lacquer.

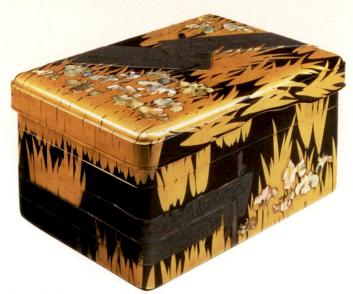

Ogata Korin LACQUER BOX FOR WRITING IMPLEMENTS Edo period, late 17th-early 18th century. Lacquer, lead, silver, and mother-of-pearl, 5 $\% \times$ 10 $\% \times$ 7 %" (14.2 \times 27.4 \times 19.7 cm). Tokyo National Museum, Tokyo.

organic, amoebalike form in gold surrounded by mottled ink. This mottled effect was a specialty of Rimpa school painters.

As one of the "three famous beautiful views of Japan," Matsushima was often depicted in art. Most painters, however, emphasized the large number of pine-covered islands that make the area famous. Sotatsu's genius was to simplify and dramatize the scene, as though the viewer were passing the islands in a boat on the roiling waters. Strong, basic mineral colors dominate, and the sparkling two-dimensional richness of the gold leaf contrasts dramatically with the three-dimensional movement of the waves.

Nanga School Painting

Rimpa artists such as Sotatsu and Korin are considered quintessentially Japanese in spirit, both in the expressive power of their art and in their use of poetic themes from Japan's past. Other painters, however, responded to the new Confucian atmosphere by taking up some of the ideas of the literati painters of China. These painters are grouped together as the Nanga ("Southern") school. Nanga was not a school in the sense of a professional workshop or a family tradition. Rather, it took its name from the southern school of amateur artists described by the Chinese literati theorist Dong

25–II | Uragami Gyokudo GEESE ASLANT IN THE HIGH WIND Edo period, 1817. Ink and light colors on paper, $12 \frac{1}{16} \times 9 \frac{1}{8}$ " (31 × 25 cm). Takemoto Collection, Aichi.

Qichang (Chapter 24). Educated in the Confucian mold, Nanga masters were individualists, creating their own variations of literati painting from unique blendings of Chinese models, Japanese aesthetics, and personal brushwork. They were often experts at calligraphy and poetry as well as painting, but one, Uragami Gyokudo (1745–1820), was even more famous as a musician, an expert on the seven-string Chinese zither called the *qin*. Most instruments are played for entertainment or ceremonial purposes, but the *qin* has so deep and soft a sound that it is played only for oneself or a close friend. Its music becomes a kind of meditation, and for Gyokudo it opened a way to commune with nature and his own inner spirit.

Gyokudo was a hereditary samurai official, but midway through his life he resigned from his position and spent seventeen years wandering through Japan, absorbing the beauty of its scenery, writing poems, playing music, and beginning to paint. During his later years Gyokudo produced many of the strongest and most individualistic paintings in Japanese history, although they were not appreciated by people during his lifetime. **GEESE ASLANT IN THE HIGH WIND** is a leaf from an album Gyokudo painted in 1817, three years before his death (FIG. 25–11). The creative power in this painting is remarkable. The wind seems to have the force of a hurricane, sweeping the tree branches and the geese into swirls of action. The greatest force comes from within the land itself, which mushrooms out and bursts forth in peaks and plateaus as though an inner volcano were erupting.

Zen Painting

Deprived of the support of the government and samurai officials, who now favored neo-Confucianism, Zen initially went into something of a decline during the Edo period. In the early eighteenth century, however, it was revived by a monk named Hakuin Ekaku (1685–1769), who had been born in a small village not far from Mount Fuji and who resolved to become a monk after hearing a fire-and-brimstone sermon in his youth. For years he traveled around Japan seeking out the strictest Zen teachers. After a series of enlightenment experiences, he eventually became an important teacher himself.

In his later years Hakuin turned more and more to painting and calligraphy as forms of Zen expression and teaching. Since the government no longer sponsored Zen, Hakuin reached out to ordinary people, and many of his paintings portray everyday subjects that would be easily understood by farmers and merchants. The paintings from his sixties have great charm and humor, and by his eighties he was creating works of astonishing force. Hakuin's favorite subject was Daruma (Bodhidharma), the semilegendary Indian monk who had begun the Zen tradition in China

Technique

INSIDE A WRITING BOX

he interior of a writing box is fitted with compartments for holding an ink stick, an ink stone, brushes, and paper—tools and materials not only for writing but also for **ink painting**.

Ink sticks are made by burning wood or oil inside a container. Soot deposited by the smoke then is collected, bound into a paste with resin, heated for several hours, kneaded and pounded, and finally pressed into small stick-shaped or cake-shaped molds to harden. Molds are often carved to produce an ink stick (or ink cake) decorated in low relief. The tools of writing and painting are also beautiful objects in their own right.

Fresh ink is made for each writing or painting session by grinding the hard, dry ink stick in water against a fine-grained stone. A typical ink stone has a shallow well at one end sloping up to a grinding surface at the other. The artist fills the well with water from a waterpot. The ink stick, held vertically, is dipped into the well to pick up a small amount of water, then is rubbed in a circular motion firmly on the grinding surface. The process is repeated until enough ink has been prepared. Grinding ink is viewed as a meditative task, time for collecting one's thoughts and concentrating on the painting or calligraphy ahead.

Brushes are made from animal hair set in simple bamboo or hollow-reed handles. Brushes taper to a fine point that responds with great sensitivity to any shift in pressure. Although great painters and calligraphers do eventually develop their own styles of holding and using the brush, all begin by learning the basic position for writing. The brush is held vertically, grasped firmly between the thumb and first two fingers, with the fourth and fifth fingers often resting against the handle for more subtle control.

25–12 | Hakuin Ekaku BODHIDHARMA MEDITATING Edo period, 18th century. Ink on paper, 49 $\frac{1}{2}$ × 21 $\frac{3}{4}$ " (125.7 × 55.3 cm). On extended loan to the Spencer Museum of Art, The University of Kansas, Lawrence.

Hakuin had his first enlightenment experience while meditating upon the koan (mysterious Zen riddle) about mu. One day a monk asked a Chinese Zen master, "Does a dog have the buddha nature?" Although Buddhist doctrine teaches that all living beings have buddha nature, the master answered, "Mu," meaning "has not" or "nothingness." The riddle of this answer became a problem that Zen masters gave their students as a focus for meditation. With no logical answer possible, monks were forced to go beyond the rational mind and penetrate more deeply into their own being. Hakuin, after months of meditation, reached a point where he felt "as though frozen in a sheet of ice." He then happened to hear the sound of the temple bell, and "it was as though the sheet of ice had been smashed." Later, as a teacher, Hakuin invented a koan of his own that has since become famous: "What is the sound of one hand clapping?"

(FIG. 25–12). Here he has portrayed the wide-eyed Daruma during his nine years of meditation in front of a temple wall in China. Intensity, concentration, and spiritual depth are conveyed by broad and forceful brushstrokes. The inscription is the ultimate Zen message, attributed to Daruma himself: "Pointing directly to the human heart, see your own nature and become Buddha."

25–13 | Maruyama Okyo PINE TREE IN SNOW Edo period, 1765. Hanging scroll, ink and color on silk, $48 \% \times 28 \%$ (123 \times 71.75 cm). Tokyo National Museum.

Hakuin's pupils followed his lead in communicating their vision through brushwork. The Zen figure once again became the primary subject of Zen painting, and the painters were again Zen masters rather than primarily artists.

Maruyama-Shijo School Painting

Zen paintings were given away to all those who wished them, including poor farmers as well as artisans, merchants, and samurai. Many merchants, however, were more concerned with displaying their increasing wealth than with spiritual matters, and their aspirations fueled a steady demand for golden screens and other decorative works of art.

MARUYAMA OKYO. One school that arose to satisfy this demand was the Maruyama-Shijo school, formed in Kyoto by Maruyama Okyo (1733–95). Okyo had studied Westernstyle "perspective pictures" in his youth, and he was able in his mature works to incorporate shading and perspective into a decorative style, creating a sense of volume that was new to East Asian painting. Okyo's new style proved very popular in Kyoto, and it soon spread to Osaka and Edo (present-day Tokyo) as well. The subjects of Maruyama-Shijo painting were seldom difficult to understand. Instead of legendary Chinese themes, Maruyama-Shijo painters portrayed the birds, animals, hills, trees (FIG. 25–13), farmers, and townsfolk of Japan. Although highly educated people might make a point of preferring Nanga painting, Maruyama-Shijo works suited the tastes of the emerging upper middle class.

Nagasawa Rosetsu. The leading pupil of Okyo was Nagasawa Rosetsu (1754–99), a painter of great natural talent who added his own boldness and humor to the Maruyama-Shijo tradition. Rosetsu delighted in surprising his viewers with odd juxtapositions and unusual compositions. One of his finest works is a pair of screens, the left one depicting a bull and a puppy (FIG. 25–14). The bull is so immense that it fills almost the entire six panels of the screen and still cannot be contained at the top, left, and bottom. The puppy, white

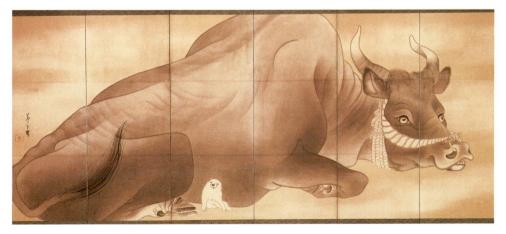

25–I4 Nagasawa Rosetsu **BULL AND PUPPY** Edo period, 18th century. One of a pair of six-panel screens, ink and gold wash on paper, $5'7\,\%\times12'3''\,(1.70\times3.75\,\text{m})$. Los Angeles County Museum of Art, California. Joe and Etsuko Price Collection (L.83.45.3a)

against the dark gray of the bull, helps to emphasize the huge size of the bull by its own smallness. The puppy's relaxed and informal pose, looking happily right out at the viewer, gives this powerful painting a humorous touch that increases its charm. In the hands of a master such as Rosetsu, plebeian subject matter could become simultaneously delightful and monumental, equally pleasing to viewers with or without much education or artistic background.

Ukiyo-E: Pictures of the Floating World

Not only did newly wealthy merchants patronize painters in the middle and later Edo period, but even artisans and tradespeople could purchase works of art. Especially in the new capital of Edo, bustling with commerce and cultural activities, people savored the delights of their peaceful society. Buddhism had long preached that pleasures were fleeting; the cherry tree, which blossoms so briefly, became the symbol for the transience of earthly beauty and joy. Commoners in the Edo period did not dispute this transience, but they took a new attitude: Let's enjoy it to the full as long as it lasts. Thus the Buddhist phrase *ukiyo* ("floating world") became positive rather than negative.

There was no world more transient than that of the pleasure quarters, set up in specified areas of every major city. Here were found restaurants, bathhouses, and brothels. The heroes of the day were no longer famous samurai or aristocratic poets. Instead, swashbuckling actors and beautiful courtesans were admired. These paragons of pleasure soon became immortalized in paintings and—because paintings were too expensive for common people—in woodblock prints known as *ukiyo-e*, "pictures of the floating world" (see "Japanese Woodblock Prints," page 867).

HARUNOBU. At first prints were made in black ink, then colored by hand when the public so desired. The first artist to design prints to be printed in many colors was Suzuki Harunobu (1724–70). His exquisite portrayals of feminine beauty quickly became so popular that soon every artist was designing multicolored *nishiki-e* ("brocade pictures").

One print that displays Harunobu's charm and wit is **GEISHA AS DARUMA CROSSING THE SEA** (FIG. 25–15). Harunobu has portrayed a young woman in a red cloak crossing the water on a reed, a reference to one of the legends about Daruma. To see a young woman peering ahead to the other shore, rather than a grizzled Zen master staring off into space, must have greatly amused the Japanese populace. There was also another layer of meaning in this image because geishas were sometimes compared to Buddhist teachers or deities in their ability to bring ecstasy, akin to enlightenment, to humans. Harunobu's print suggests these meanings, but it also succeeds simply as a portrait of a beautiful woman, with the gently curving lines of drapery suggesting the delicate feminine form beneath.

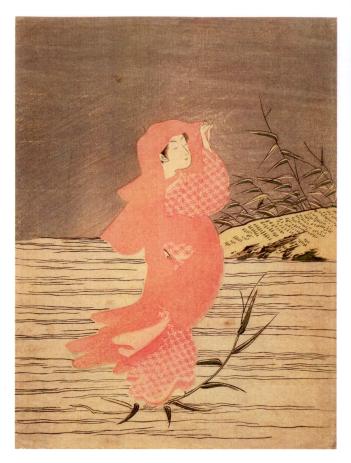

25–15 | Suzuki Harunobu GEISHA AS DARUMA CROSSING THE SEA | Edo period, mid-18th century. Polychrome woodblock print on paper, 10 % × 8 %" (27.6 × 21 cm). Philadelphia Museum of Art.

Gift of Mrs. Emile Geyelin, in memory of Anne Hampton Barnes

The second great subject of *ukiyo-e* were the actors of the new form of popular theater known as *kabuki*. Because women had been banned from the stage after a series of scandalous incidents, male actors took both male and female roles. Much as people today buy posters of their favorite sports, music, or movie stars, so, too, in the Edo period people clamored for images of their pop idols.

HIROSHIGE AND HOKUSAI. During the nineteenth century, landscape joined courtesans and actors as a major theme—not the idealized landscape of China, but the actual sights of Japan. The two great masters of landscape prints were Utagawa Hiroshige (1797–1858) and Katsushika Hokusai (1760–1849). Hiroshige's Fifty-Three Stations of the Tokaido and Hokusai's Thirty-Six Views of Mt. Fuji became the most successful sets of graphic art the world has known. The woodblocks were printed and printed again until they wore out. They were then recarved, and still more copies were printed. This process continued for decades, and thousands of prints from the two series are still extant.

The Great Wave (SEE FIG. 25-1) is the most famous of the scenes from Thirty-Six Views of Mt. Fuji. Hokusai was already

Technique

JAPANESE WOODBLOCK PRINTS

oodblock prints are called *ukiyo-e* in Japanese, which can be translated as "pictures of the floating world." They represent the combined expertise of three people: the artist, the carver, and the printer. Coordinating and funding the endeavor was a publisher, who commissioned the project and distributed the prints to stores or itinerant peddlers, who would sell them.

The artist supplied the master drawing for the print, executing its outlines with brush and ink on tissue-thin paper. Colors might be indicated, but more often they were understood or decided on later. The drawing was passed on to the carver, who pasted it facedown on a hardwood block, preferably cherrywood, so that the outlines showed through the paper in reverse. A light coating of oil might be brushed on to make the paper more transparent, allowing the drawing to stand out with maximum clarity. The carver then cut around the lines of the drawing with a sharp knife, always working in the same direction as the original brushstrokes. The rest of the block was chiseled away, leaving the outlines standing in relief. This block, which reproduced the master drawing, was called the **key block**. If the print was to be **polychrome**, having multiple colors, prints made from the key block were in turn pasted facedown on blocks that

would be used as guides for the carver of the color blocks. Each color generally required a separate block, although both sides of a block might be used for economy.

Once the blocks were completed, the printer took over. Paper for printing was covered lightly with animal glue (gelatin). A few hours before printing, the paper was lightly moistened so that it would take ink and color well. Water-based ink or color was brushed over the block, and the paper placed on top and rubbed with a smooth, padded device called a baren, until the design was completely transferred. The key block was printed first, then the colors one by one. Each block was carved with two small marks called registration marks, in exactly the same place in the margins, outside of the image area-an L in one corner, and a straight line in another. By aligning the paper with these marks before letting it fall over the block, the printer ensured that the colors would be placed correctly within the outlines. One of the most characteristic effects of later Japanese prints is a grading of color from dark to pale. This was achieved by wiping some of the color from the block before printing, or by moistening the block and then applying the color gradually with an unevenly loaded brush-a brush loaded on one side with full-strength color and on the other with diluted color.

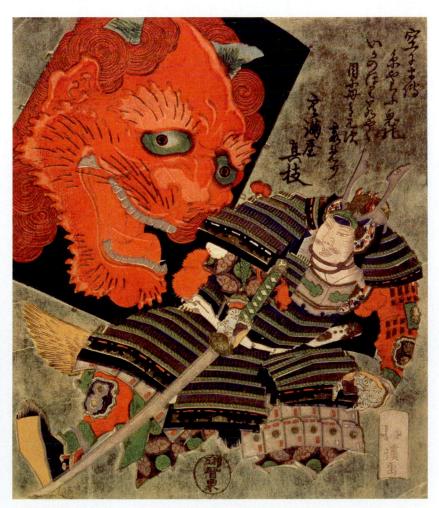

Totoya Hokkei (1780-1850) RAIKO ATTACKS A DEMON KITE

Edo period, c. 1825. Polychrome woodblock print on paper, 8 % × 7 ½" (21.4 × 18.6 cm). Collection of the Frank Lloyd Wright Archives, Scottsdale, Arizona. This print, of a luxurious limited-edition type called *surimono*, celebrates the hero Raiko, legendary slayer of demons, and suggests a message for the new year: vanquishing bad luck and ushering in good. The poem in the print reads:

A demon kite trails its string so high in the sky that even young eyes lose sight of it in the mist

(Translated by John T. Carpenter)

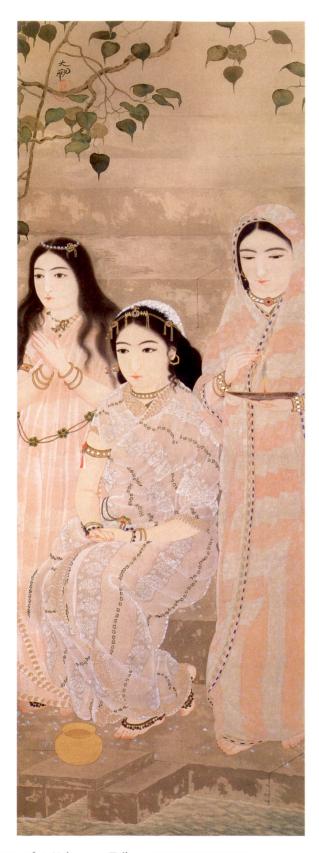

25–16 | Yokoyama Taikan FLOATING LIGHTS Meiji period, 1909. One from a pair of hanging scrolls, ink, colors, and gold on silk, $56 \,\% \times 20 \,\% \,'' \, (143 \times 52 \, \text{cm})$. The Museum of Modern Art, Ibaraki.

in his seventies, with a fifty-year career behind him, when he designed this image. Such was his modesty that he felt that his Fuji series was only the beginning of his creativity, and he wrote that if he could live until he was 100, he would finally learn how to become an artist.

THE MEIJI AND MODERN PERIODS

Pressure from the West for entry into Japan mounted dramatically in the mid-nineteenth century, and in 1853 the policy of national seclusion was ended. Resulting tensions precipitated the downfall of the Tokugawa shogunate, however, and in 1868 the emperor was formally restored to power, an event known as the Meiji Restoration. The court moved from Kyoto to Edo, which was renamed Tokyo, meaning "Eastern Capital."

Meiji

The Meiji period marked a major change for Japan. After its long isolation, Japan was deluged by the influx of the West. Western education, governmental systems, clothing, medicine, industrialization, and technology were all adopted rapidly into Japanese culture. Teachers of sculpture and oil painting were imported from Italy, while adventurous Japanese artists traveled to Europe and America to study.

A Meiji Painter. Ernest Fenollosa (1853–1908), an American who had recently graduated from Harvard, traveled to Japan in 1878 to teach philosophy and political economy at Tokyo University. Within a few years, he and a former student Okakura Kakuzo (1862-1913) began urging artists to study traditional Japanese arts rather than to focus exclusively on Western art styles and media. Yokoyama Taikan (1868–1958) subsequently developed his personal style within the Nihonga (Japanese painting) genre promoted by Okakura. Drawing from Japanese tradition, notably the Rimpa style, Yokoyama avoided outlines and instead defined forms in fields of color. His pictorial space, however, owes something to the Western tradition. Like Okakura, Yokoyama traveled widely. His FLOATING LIGHTS (FIG. 25-16) was inspired by a visit to India in 1903, where he observed women engaged in divination on the banks of the Ganges.

Modern Japan

In the push to become a modern industrialized country, Japan did not lose its sense of tradition, even in the days of the strongest Western influence. In modern Japan, artists still choose whether to work in an East Asian style, a Western style, or some combination of the two. Just as Japanese art in earlier periods had both Chinese style and native traditions, so Japanese art today has both Western and native aspects.

A MODERN CERAMICIST. Perhaps the liveliest contemporary art is ceramics. Japan has retained a widespread appreciation for pottery. Many people still practice the traditional arts of the tea ceremony and flower arranging, both of which require ceramic vessels, and most people own at least one fine ceramic piece. In this atmosphere, many potters earn a comfortable living by making art ceramics, an opportunity not available in other countries. Some ceramicists continue to create raku teabowls and other traditional wares, while others experiment with new styles and new techniques.

Miyashita Zenji (b. 1939), who lives in Kyoto, creates an initial form by constructing an undulating shape out of pieces of cardboard; he then builds up the surface with clay of many different colors, using torn paper to create irregular shapes. When fired, the varied colors of the clay seem to form a landscape, with layers of mountains leading up to the sky. Miyashita's work is modern in shape, yet traditional in its evocation of nature.

Miyashita is representative of the high level of contemporary ceramics in Japan, which is supported by a broad spectrum of educated and enthusiastic collectors and admirers. Objects useful for the tea ceremony or for flower arranging, such as Miyashita's flower vase entitled **WIND** (FIG. 25–17), reflect a continued refinement of traditional taste. There is also strong public interest in contemporary painting, prints, calligraphy, textiles, lacquer, architecture, and sculpture.

A CONTEMPORARY SCULPTOR. One of the most adventurous and original sculptors currently working is Chuichi Fujii (b. 1941). Born into a family of sculptors in wood, Fujii found himself as a young artist more interested in the new materials of plastic, steel, and glass. However, in his mid-

thirties he took stock of his progress and decided to begin again, this time with wood. At first he carved and cut into the wood, but he soon realized that he wanted to allow the material to express its own natural spirit, so he devised an ingenious new technique that preserved the individuality of each log while making of it something new. Fujii first studies the log to come to terms with its basic shape. Next, he inserts hooks into the log and runs wires between them. Every day he tightens the wires, over a period of months gradually pulling the log into a new shape. When he has bent the log to the shape he envisioned, Fujii makes a cut and sees whether his sculpture will stand. If he has miscalculated, he discards the work and begins again.

Here, Fujii has created a circle, one of the most basic forms in nature but never before seen in such a thick tree trunk (FIG. 25–18). The work strongly suggests the *enso*, the circle that Zen monks painted to express the universe, the all, the void, the moon—and even a tea cake. Yet Fujii does not try to proclaim his links with Japanese culture. He says that while his works may seem to have some connections with traditional Japanese arts, he is not conscious of them.

The artist has achieved something entirely new, yet his work also embodies the love of asymmetry, respect for natural materials, and dramatic simplicity encountered throughout the history of Japanese art.

A CONTEMPORARY PAINTER. In the 1990s, art in Japan merged with that in the West, with tradition and creativity playing out in new ways. Takashi Murakami (b. 1962), who lives and works in New York as well as in Japan, is prominent among artists who have taken Japan's *manga* and *anime* art forms, derived from the *ukiyo-e* tradition, as an inspiration for

25–17 | Miyashita Zenji WIND c. 1989. Stoneware, $21\% \times 12\% \times 5\%$ " (55.4 \times 32.4 \times 13 cm). Spencer Museum of Art, The University of Kansas, Lawrence. Gift of the Friends of the Art Museum/Helen Foresman Spencer Art Acquisition Fund

25–18 | Chuichi Fujii UNTITLED '90 1990. Cedar wood, height 7'5 ½" (2.3 m). Hara Museum of Contemporary Art, Tokyo.

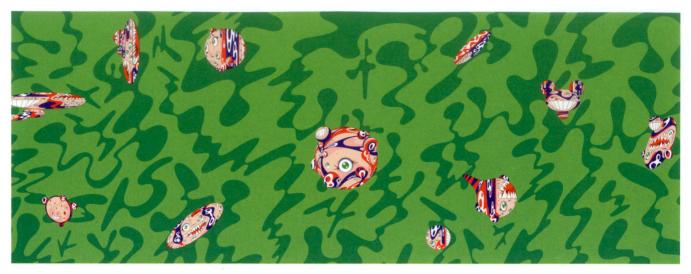

25–19 | Takashi Murakami | MAGIC BALL (POSITIVE) 1999. Seven panels, acrylic on canvas mounted on board, $94 \% \times 248 \% \times 2 \%$ (240 × 630 × 7 cm). Collection: Galerie 20.21. Essen.

painting and sculpture. These forms' close involvement with popular culture has a strong precedent in the *ukiyo-e* tradition. The emphasis on undulating lines and flat forms—to the point of a denial of pictorial space—also has its root in that Edo period style. Murakami's floating motifs (FIG. 25–19) reference *anime* and at the same time satirize its international consumer culture.

IN PERSPECTIVE

Muromachi, Momoyama, and Edo—six hundred years of Japanese culture—saw profound social and political changes. The arts felt these shifts through changing patterns of patronage of arts, yet all the while distinctive aesthetic orientations matured.

Evocative ink landscapes and Zen dry gardens, based on traditions imported from China, developed as the deeply artistic expressions in Japan. In these art forms the bold brushstrokes or subtle washes, and the general aesthetic of monochrome ink complements a strong appreciation of nature, its materials, and its forms. Wood, clay, and straw, or naturally shaped rocks provide patterns and textures with no need of obvious embellishment.

During the same periods, Japanese art inspired exquisite and exacting craftsmanship. Decoration in gold played a distinctive role in the painted screens that defined interior spaces as well as in the ornamentation of lacquer ware and other useful objects. Forms from nature became abstract and stylized patterns. Representation was often distilled to the simplicity of fluctuating line and flat shapes of color.

Japanese art of these periods was also invested with whimsy or even paradox. A sense of humor shows: sometimes easily accessible and at other times in works of art so sophisticated that they could only be understood by those with a deep knowledge of both Japanese and Chinese literature. In Japan, the patronage of art has long reflected a pluralistic cultural atmosphere. With that has come an ability to refine forms to greater and greater subtlety or, in contrast, to startle the viewer with audacious surprises.

Sesshu **WINTER LANDSCAPE** C. 1470s

HIMEJI CASTLE HYOGO 1601-09

Ogata Korin **Lacquer Box** Late 17th–early 18th century

SUZUKI HARUNOBU

GEISHA AS DARUMA

CROSSING THE SEA

MID-18TH CENTURY

CHUICHI FUJII UNTITLED '90 1990

JAPANESE ART AFTER 1392

1300

Muromachi (Ashikaga) 1392-1573

■ Momoyama 1568-1615

Edo (Tokugawa) 1615-1868

1500

✓ Taisho 1912-1926✓ Showa 1926-1989

⋖ Meiji 1868−1912

⋖ Occupation 1945−1952

◀ Heisei 1989-Present

1900

2000

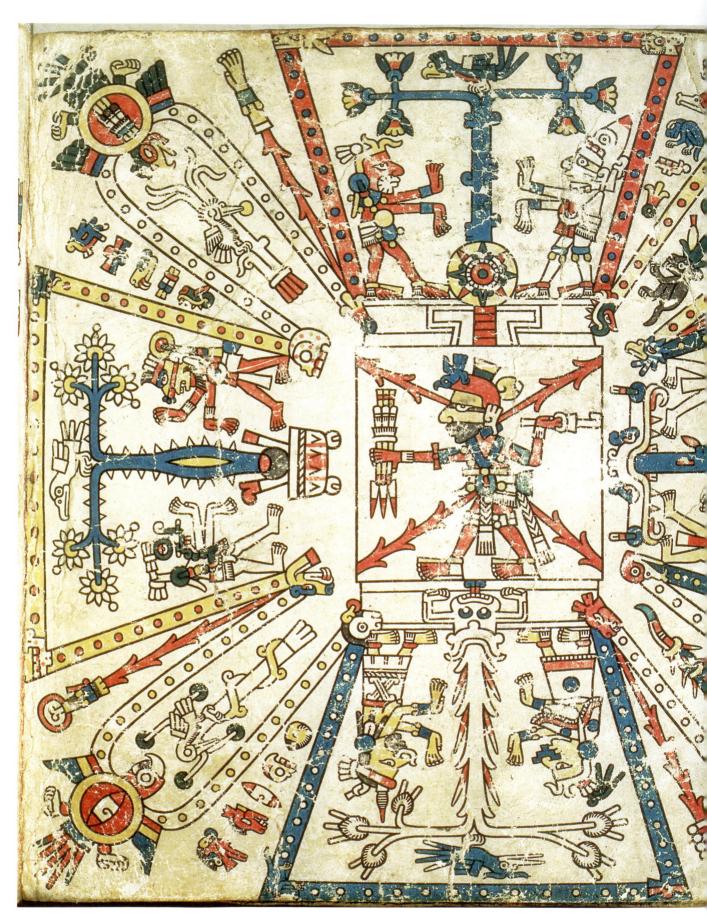

26–I | A VIEW OF THE WORLD | Page from Codex Fejervary-Mayer. Aztec, c. 1400–1519/21. Paint on animal hide, each page $6\% \times 6\%$ (17.5 \times 17.5 cm), total length 13'3" (4.04 m). The National Museums and Galleries on Merseyside, Liverpool, England.

CHAPTER TWENTY-SIX

ART OF THE AMERICAS AFTER 1300

26

Early in November 1519, the army of the Spanish conquistador Hernán Cortés beheld for the first time the great Aztec capital of Tenochtitlan. The shimmering city, which seemed to be floating on the water, was built on islands in the middle of Lake Texcoco in the Valley of Mexico, and linked by broad causeways to the mainland. One of Cortés's companions later recalled

the wonder the Spanish felt at that moment: "When we saw so many cities and villages built on the water and other great towns and that straight and level causeway going towards [Tenochtitlan], we were amazed ... on account of the great towers and [temples] and buildings rising from the water, and all built of masonry. And some of our soldiers even asked whether the things that we saw were not a dream" (cited in Berdan, page 1).

The startling vision that riveted Cortés's soldiers was indeed real, a city of stone built on islands—a city that held many treasures and many mysteries. Much of the period before the conquistadors' arrival remains enigmatic, but a rare manuscript that survived the Spanish conquest of Mexico depicts the preconquest worldview of the native peoples. At the center of the image is the ancient fire god Xiuhtecutli (FIG. 26–1). Radiating from him are the four directions—each associated with a specific color, a deity, and a tree with a bird in its branches. In each corner, to the right of a U-shaped band, is an attribute of Tezcatlipoca, the Smoking Mirror, an omnipotent, primal deity who could see humankind's thoughts and deeds—in the upper right a head, in the upper left an arm, in the lower left a foot, and in the lower right bones. Streams of blood flow from these attributes back to the fire god in the center. Such images are filled with important, symbolically coded information—even the dots refer to the number of days in one aspect of the Mesoamerican calendar—and they were integral parts of the culture of the Americas.

When the first European explorers and adventurers arrived in 1519, the Western Hemisphere was already inhabited from the Arctic Circle to Tierra del Fuego by peoples with long and complex histories and rich and varied cultural traditions. This chapter focuses on the arts of the indigenous peoples of the Americas (MAP 26–1) just prior to, and in the wake of, their encounter with an expansionist Europe.

Two great empires—the Aztec in Mexico and the Inca in South America—had risen to prominence in the fifteenth century at about the same time that European adventurers began to explore the oceans in search of new trade routes to Asia. In the encounter that followed, the Aztec and Inca empires were destroyed.

- THE AZTEC EMPIRE | Religion | Tenochtitlan
- THE INCA EMPIRE IN SOUTH AMERICA | Masonry | Textiles | Metalwork | The Aftermath of the Spanish Conquest
- NORTH AMERICA | The Eastern Woodlands | The Great Plains | The Northwest Coast | The Southwest
- A NEW BEGINNING
- **IN PERSPECTIVE**

THE AZTEC EMPIRE

The Mexica people who lived in the remarkable city that Cortés found in the early sixteenth century were then rulers of much of the land that took their name, Mexico. Their rise to power had been recent and swift. Only 400 years earlier, according to their own legends, they had been a nomadic people living northwest of the Valley of Mexico on the shores of the mythical Aztlan. The term Aztec derives from the word Aztlan.

After a period of migration, the Aztecs arrived in the Valley of Mexico in the thirteenth century. They eventually settled on an island in Lake Texcoco where they had seen an eagle perching on a prickly pear cactus (tenochtli), a sign that their legends told them would mark the end of their wandering. They called the place Tenochtitlan. The city was situated on a collection of islands linked by human-made canals in a grid pattern.

In the fifteenth century, the Aztecs—joined by allies in a triple alliance—began an aggressive campaign of expansion. The tribute they exacted from all over central Mexico transformed Tenochtitlan into a glittering capital. As the Spanish conquistador Hernán Cortés approached Tenochtitlan in November 1519, he and his soldiers marveled at the stone buildings, towers, and temples that seemed from a distance to rise from the water like a mirage.

Religion

Aztec religion was based on a complex pantheon that combined the Aztec deities with more ancient ones that had long been worshiped in central Mexico. According to Aztec belief, the gods had created the current universe at the ancient city of Teotihuacan in the Valley of Mexico (see Chapter 12). The continued existence of the world depended on human actions, including rituals of bloodletting and human sacrifice. The end of each round of fifty-two years in the Mesoamerican calendar was a particularly dangerous time that required a special firelighting ritual. Sacrificial victims sustained the sun god, Huitzilopochtli, in his daily course through the sky. Huitzilopochtli was the son of the Earth mother Coatlicue. When Coatlicue conceived Huitzilopochtli by holding within her chest a ball of hummingbird feathers (the soul of a fallen warrior) that had dropped from the sky, her other children the stars and the moon—jealously conspired to kill her. When they attacked, Huitzilopochtli emerged from his mother's body

fully grown and armed, drove off his half brothers, and destroyed his half sister, the moon goddess Coyolxauhqui. Every day at dawn, the Sun God fights off the darkness, killing the stars (his 400 brothers) and the moon (his sister).

Tenochtitlan

An idealized representation of the city of Tenochtitlan and its sacred ceremonial precinct (FIG. 26–2) was drawn by Aztec scribes for Spanish administrators. It forms the first page of the *Codex Mendoza*, prepared for the Spanish viceroy in the sixteenth century. An eagle perched on a prickly pear cactus—the symbol of the city—fills the center of the page.

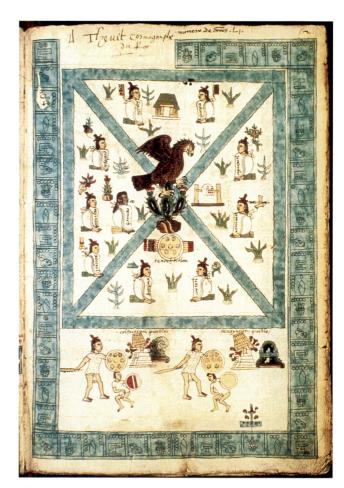

26−2 THE FOUNDING OF TENOCHTITLAN

Page from Codex Mendoza. Aztec, 16th century. Ink and color on paper, $12\% \times 8\%$ " (21.5 \times 31.5 cm). The Bodleian Library, University of Oxford, England.

MS. Arch Selden. A.1.fol. 2r

MAP 26-I THE AMERICAS AFTER 1300

Diverse peoples spread throughout the Americas, each shaping a distinct culture in the area it settled.

Waterways divide the city into four quarters, which are further subdivided into wards, as represented by the seated figures. The victorious warriors at the bottom of the page represent Aztec conquests.

The focal point of the sacred precinct—symbolized in FIGURE 26–2 by the temple or house at the top of the page —was the Great Pyramid, a 115- to 130-foot-high, four-tiered pyramid with two temples on top: a red and black temple dedicated to Huitzilopochtli and a blue temple for Tlaloc, the god of rain and fertility. Two steep staircases led up the west face of the pyramid from the plaza in front. Sacrificial victims climbed these stairs to the Temple of Huitzilopochtli, where priests threw them over a stone, quickly cut open their chests, and pulled out their still-throbbing hearts, hearts whose beating insured the survival of the sun, the gods, and the Aztecs. Their bodies were then rolled down the stairs and dismembered. Thousands of severed heads were said to have been kept on a skull rack in the plaza, represented in FIGURE 26–2 by the rack with a single skull to the right of the eagle.

During the winter rainy season the sun rose behind the Temple of Tlaloc, and during the dry season it rose behind the Temple of Huitzilopochtli. The double temple thus united two natural forces, sun and rain, or fire and water. During the spring and autumn equinoxes, the sun rose between the two temples, illuminating the Temple of Quetzalcoatl, the feathered serpent, an ancient creator god associated with time (the calendar), civilization, and the arts.

Two Goddesses. Sculptures of serpents and serpent heads on the Great Pyramid in Tenochtitlan associated it with the place where the Sun God slew the moon goddess, Coyolxauhqui. A huge circular relief of the dismembered goddess lay at the foot of the temple stairs, as if the enraged and triumphant Huitzilopochtli had cast her there like a sacrificial victim (FIG. 26–3). Her torso is in the center, surrounded by her head and limbs. A rope around her waist is attached to a skull. She has bells on her cheeks and balls of down in her hair. She wears a magnificent headdress and has distinctive ear ornaments composed of disks, rectangles, and triangles. The sculpture is two-dimensional in concept—a flat surface with a deeply cut background.

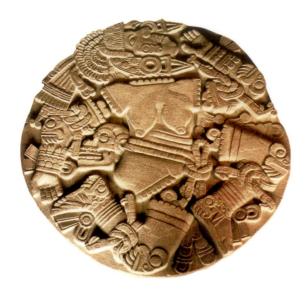

26-3 | The moon goddess coyolxauhqui ("SHE OF THE GOLDEN BELLS")

The Sacred Precinct, now the Museo Templo Mayor, Tenochtitlan. Aztec, 1469 (?). Stone, diameter 10'10" (3.33 m). Museo Templo Mayor, Mexico City.

This disk was discovered in 1978 by workers from a utility company who were excavating in central Mexico City.

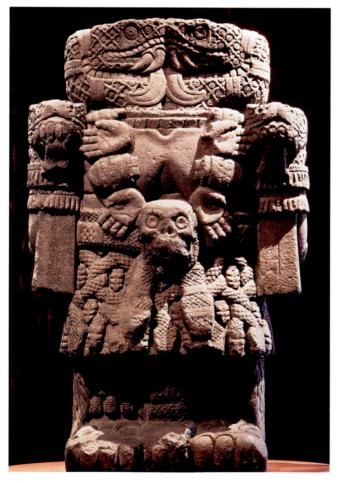

26–4 ↑ **THE GODDESS COATLICUE**Aztec, 1487–1520. Basalt, height 8′6″ (2.65 m). Museo Nacional de Antropología, Mexico City.

Standing high above the disk of the vanquished moon goddess was an imposing statue of Coatlicue, mother of Huitzilopochtli (FIG. 26–4). A sixteenth-century Spaniard described seeing such a statue covered with blood inside the Temple of the Sun. Coatlicue means "she of the serpent skirt," and this broad-shouldered figure with clawed hands and feet has a skirt of twisted snakes. A pair of serpents, symbols of gushing blood, rise from her neck to form her head. Their eyes are her eyes; their fangs, her tusks. The writhing serpents of her skirt also form her body. Around her stump of a neck hangs a necklace of sacrificial offerings—hands, hearts, and a dangling skull. Despite the surface intricacy, the sculpture's simple, bold, and blocky forms create an impression of solidity. The colors with which it was originally painted would have heightened its dramatic impact.

Indeed Aztec art was colorful. An idea of its iridescent splendor is captured in the feather headdress said to have been given by Moctezuma to Cortés, and thought to be the one listed in the inventory of treasures Cortés shipped to Charles V, the Habsburg emperor in Spain in 1519. Featherwork was one of the glories of Mesoamerican art but very few of these extremely fragile artworks survive. "Moctezuma's Crown," as it was called, was originally a conqueror's trophy, and only recognized as "art" in recent times (FIG. 26-5). It is made of brilliant green, red, white, and blue feathers of the quetzal bird, macaw parrot, and other lesser birds, fastened to a reed frame. The feathers were gathered in small bunches, their quills reinforced with reed tubes, and then sewn to the frame in overlapping layers. Featherworkers were esteemed craftspersons. A song in praise of the feather artist says, "He is whole; he has a face and a heart. The good feather artist is skillful, is master of himself; it is his duty to humanize the desires of the people. He works with feathers, chooses them, arranges them, paints them with different colors, joins them together." (Sorge Gruziriski, The Aztecs, Discoveries, New York: Abrams. English translation, 1992, p. 153.)

The Aztec empire was short lived. Within two years of their arrival in Mexico, the Spanish conquistadors overran Tenochtitlan. They built their own capital, Mexico City, over its ruins and established their own cathedral on the site of Tenochtitlan's sacred precinct.

THE INCA EMPIRE IN SOUTH AMERICA

At the beginning of the sixteenth century the Inca Empire was one of the largest states in the world. It extended more than 2,600 miles along western South America, encompassing most of modern Peru, Ecuador, Bolivia, and northern Chile and reaching into present-day Argentina. Like the Aztec Empire, its rise was rapid and its destruction sudden.

The Incas called their empire the "Land of the Four Quarters." At its center was their capital, Cuzco, "the navel of

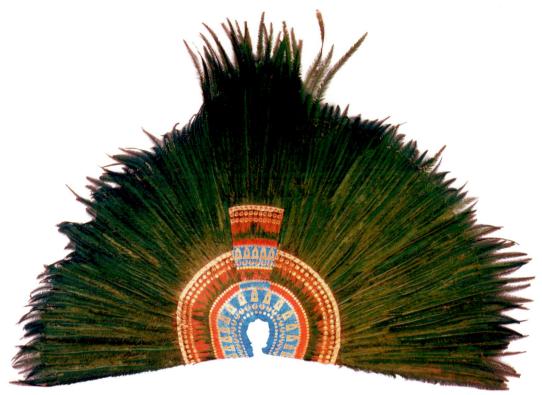

26–5 | FEATHER HEADDRESS OF MOCTEZUMA
Before 1519. Quetzal, macaw, and other feathers on a reed frame.
Museum für Völkerkunde, Vienna.

the world," located high in the Andes Mountains. The Inca state was one of many small competing kingdoms that emerged in the highlands. In the fifteenth century the Incas began to expand, suddenly and rapidly, and had subdued most of their vast domain—through conquest, alliance, and intimidation—by 1500.

To hold this linguistically and ethnically diverse empire together, the Inca ("Inca" refers to both the ruler and to the people) relied on religion, an efficient bureaucracy, and various forms of labor taxation, in which the payment was a set amount of time spent performing tasks for the state. As part of their labor tax, people were required to work the lands of the gods and the state for part of each year. In return the state provided gifts through their local leaders and sponsored lavish ritual entertainments. Men might serve periodically on public-works projects—building roads and terracing hillsides, for example—or in the army. Women wove cloth, a commodity that Inca people considered more precious than gold. The Inca might relocate whole communities to best exploit the resources of the empire. Ranks of storehouses at Inca administrative centers assured the state's ability to feed its armies and supply its workers. No Andean civilization ever developed writing, but the Inca kept detailed accounts on knotted and colored cords, called quipu.

THE INCA ROAD SYSTEM. To move their armies and speed transport and communication within the empire, the Incas built more than 23,000 miles of roads. These varied from 50-

foot-wide thoroughfares to 3-foot-wide paths. Two main north—south roads, one along the coast and the other through the highlands, were linked by east—west roads. Travelers journeyed on foot, using llamas as pack animals. Stairways helped them negotiate steep mountain slopes, and rope suspension bridges allowed river gorge crossings. The main road through the Pacific coastal desert had walls to protect it from blowing sand. All along the roads, storehouses and lodgings—more than a thousand have been found—were spaced a day's journey apart. A relay system of runners could carry messages between Cuzco and the farthest reaches of the empire in about a week.

Masonry

Cuzco, a capital of great splendor, was home to the Inca, ruler of the empire. The city was a showcase of the finest Inca masonry, some of which can still be seen in the present-day city. This masonry has survived earthquakes that have destroyed later structures. Fine INCA MASONRY consisted of either rectangular blocks or irregular polygonal blocks (FIG. 26–6). In both types, adjoining blocks were painstakingly shaped to fit tightly together without mortar (see "Inca Masonry," page 878). Their stone faces might be slightly beveled along their edges so that each block presented a "pillowed" shape expressing its identity, or walls might be smoothed into a continuous flowing surface in which the individual blocks form a seamless whole. In contrast to the massive walls, Inca buildings had gabled, thatched roofs.

Elements of Architecture

INCA MASONRY

orking with the simplest of tools—mainly heavy stone hammers—and using no mortar, Inca builders created stonework of great refinement and durability: roads and bridges that linked the entire empire, built-up terraces for growing crops, and structures both simple and elaborate. At Machu Picchu (SEE FIGS. 26–6, 26–7), all buildings and terraces within its 3-square-mile extent were made of

granite, the hard stone occurring at the site. Commoners' houses and some walls were constructed of irregular stones that were carefully fitted together. Some walls and certain domestic and religious structures were erected using squared-off, smooth-surfaced stones laid in even rows. At a few Inca sites, the stones used in construction were boulder-size: up to 27 feet tall.

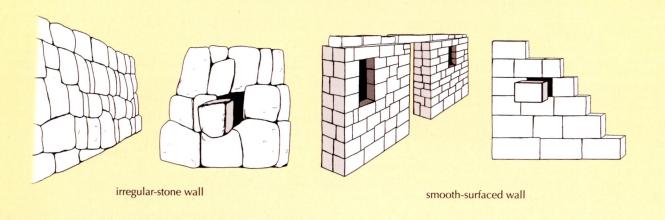

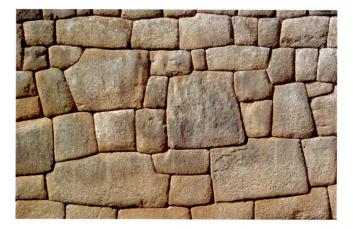

26-6 | INCA MASONRY, DETAIL OF A WALL IN MACHU PICCHU

Peru. Inca, 1450-1530.

Doors, windows, and niches were trapezoid shaped, narrower at the top than the bottom. The effort expended on stone construction by the Inca was prodigious.

MACHU PICCHU. MACHU PICCHU, one of the most spectacular archaeological sites in the world, provides an excellent example of Inca architectural planning (FIG. 26–7). At 9,000 feet above sea level, it straddles a ridge between two high peaks in the eastern slopes of the Andes and looks down on

the Urubamba River. Stone buildings, today lacking only their thatched roofs, occupy terraces around central plazas, and narrow agricultural terraces descend into the valley. The site, near the eastern limits of the empire, was the estate of the Inca Pachacuti (ruled 1438–71). Its temples and sacred stones—some, left natural, were erected in courtyard shrines—suggest that the site also had an important religious function.

Textiles

The production of fine textiles had been an important art in the Andes from the time of the Paracas culture (see Chapter 12), beginning about 1000 BCE. Among the Incas, textiles of cotton and camelid fibers (from llama, vicuna, and alpaca) were a primary form of wealth. One form of labor taxation required the manufacture of fibers and cloth, and textiles as well as agricultural products filled Inca storehouses. Cloth was deemed a fitting offering for the gods, so fine garments were draped around golden statues, and even three-dimensional images were constructed of cloth.

TUNICS. The patterns and designs on garments were not simply decorative but also carried symbolic messages, including indications of a person's ethnic identity and social rank. In the elaborate **TUNIC** in FIGURE 26–8, each square represents a miniature tunic, but the meanings of the individual patterns

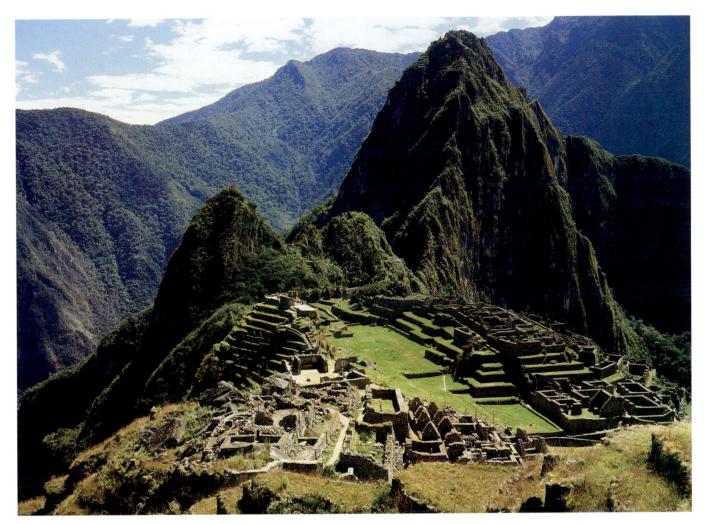

26–7 | **MACHU PICCHU** Peru. Inca, 1450–1530.

are not yet completely understood. The four-part motifs may refer to the Land of the Four Quarters. The diagonal key motif is often found on tunics with horizontal border stripes but its meaning is not known. The checkerboard patterns are thought to designate military officers and royal escorts. While we may not be sure what was meant in every case, patterns and colors appear to have been standardized like uniforms in order to convey information at a glance.

Metalwork

Following Cortés's example, Francisco Pizarro led an expedition to South America in 1532. He and his men seized the Inca ruler, Atahualpa, held him for ransom, and then treacherously strangled him. They marched on to Cuzco and seized it in 1533.

The Spanish were far less interested in Inca cloth than in their vast quantities of gold and silver. The Inca valued objects made of gold and silver not for their precious metal, but because they saw in them symbols of the sun and the moon. They are said to have called gold the "sweat of the sun" and silver the "tears of the moon." On the other hand, the

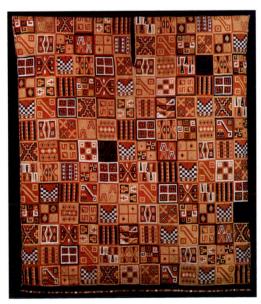

26–8 | TUNIC Peru. Inca, c. 1500. Wool and cotton, $35\% \times 30''$ (91 \times 76.5 cm). Dumbarton Oaks Research Library and Collections, Pre-Columbian Collection, Washington, D.C.

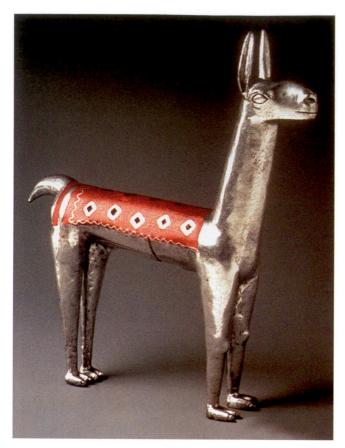

26–9 | **LLAMA** From Bolivia or Peru, found near Lake Titicaca, Bolivia. Inca, 15th century. Cast silver with gold and cinnabar, $9\times8\%\times1\%''$ (22.9 \times 21.6 \times 4.4 cm). American Museum of Natural History, New York.

Spanish exploration of the New World was propelled by feverish tales of native treasure. Whatever gold and silver objects the Spanish could lay their hands on, they melted down to enrich their royal coffers. Only a few small figures buried as offerings, like the little llama (FIG. 26–9), escaped the conquerors. The llama was thought to have a special connection with the sun, with rain, and with fertility, and a llama was sacrificed to the sun every morning and evening in Cuzco. A white llama was kept as the symbol of the Inca. Dressed in a red tunic and wearing gold jewelry, this llama passed through the streets of Cuzco during April celebrations. According to Spanish commentators, these processions included life-size gold and silver images of llamas, people, and gods.

The Aftermath of the Spanish Conquest

Native American populations in Mexico and Peru declined sharply after the conquest because of the exploitative policies of the conquerors and the ravages of smallpox and other diseases that spread from Europe and against which the indigenous people had no immunity. European missionaries suppressed local beliefs and practices and worked to spread Roman Catholicism throughout the Americas. While increas-

ing numbers of Europeans began to settle and dominate the land, native arts did not end with the Spanish conquest. Traditional arts, including fine weaving, continue to this day.

NORTH AMERICA

In America north of Mexico, from the upper reaches of Canada and Alaska to the southern tip of Florida, existed many different peoples with widely varying cultures. Much of their artwork was small, portable, fragile, and impermanent. In previous times these artworks were not appreciated for their aesthetic qualities, but were collected as anthropological artifacts or curiosities. As a consequence, one often must visit anthropology and natural history museums to view works of indigenous art. Today this attitude has changed, and Native American artworks have entered collections as art and are displayed in such prestigious places as the National Museum of the American Indian in Washington, D.C. Today work of an increasing number of young Native American artists can be seen alongside Euro-American artists in mainstream art galleries. We will look at art from only four North American cultural areas: the Eastern Woodlands, the Great Plains, the Northwest Coast, and the Southwest (SEE MAP 26-2).

The Eastern Woodlands

In the eastern woodlands, most tribes lived in stable villages, and they combined hunting, gathering, and agriculture for their livelihood. In the sixteenth century, skilled politicians appeared among them. The Iroquois formed a powerful confederation of five northeastern Native American nations, and they played a prominent military and political role until after the American Revolution. The Huron and Illinois also formed sizable confederacies.

The arrival in the seventeenth century on the Atlantic coast of a few boatloads of Europeans seeking religious freedom, land to farm, and a new life for themselves brought major changes. Trade with these settlers gave the Woodlands peoples access to things they valued, while on their part, the colonists learned native forms of agriculture, hunting, and fishing—skills they needed in order to survive. The arrival of the Europeans also had a negative impact, since they brought diseases, especially smallpox, with them. Disease wiped out entire Native populations. The lands seemed an untended wilderness to the Europeans, although in the first years of colonization some people remarked on the presence of abandoned fields and villages.

Native Americans traded furs for such useful items as metal tools, cookware, needles, and cloth, and they especially prized European glass beads and silver. They associated glass beads, and other shiny, reflective objects and materials, with ancient cultural values of self-knowledge, introspection, and understanding. These trade items largely replaced older materials, such as crystal, copper, and shell. The traditional meanings and values of

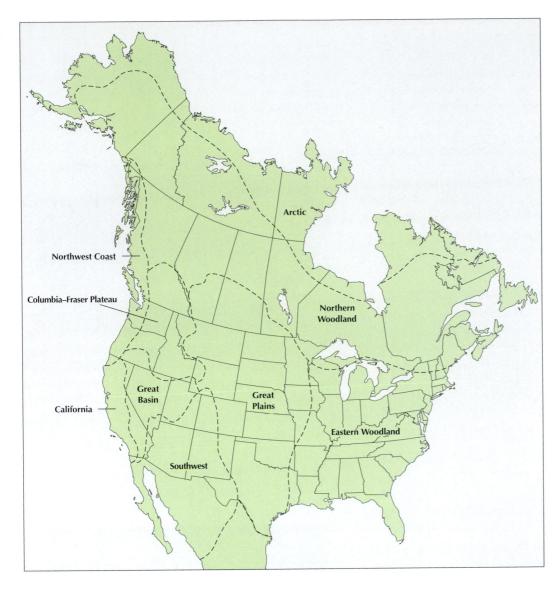

MAP 26-2 | NORTH AMERICAN CULTURAL AREAS

beads and similar items survive today from the ancestral mound-building civilizations of Eastern North America in contemporary celebratory and ceremonial powwow dress.

WAMPUM. Woodlands peoples made belts and strings of cylindrical purple and white shell beads called *wampum*. The

Iroquois and Delaware peoples used wampum to keep records (the purple and white patterns served as memory devices) and exchanged belts of wampum to conclude treaties (FIG. 26–10). Few actual wampum treaty belts have survived, so this one associated with an unwritten treaty when the land now comprising the State of Pennsylvania was

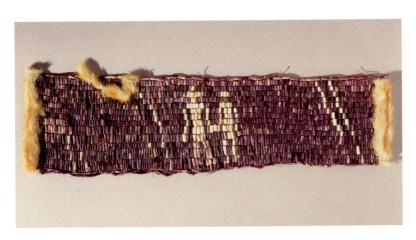

26–IO | WAMPUM BELT, TRADITIONALLY CALLED WILLIAM PENN'S TREATY WITH THE DELAWARE 1680's. Shell beads. Royal Ontario Museum, Canada. HD6364

Technique

BASKETRY

asketry is the weaving of reeds, grasses, and other plant materials to form containers. In North America the earliest evidence of basketwork, found in Danger Cave, Utah, dates to as early as 8400 BCE. Over the subsequent centuries, Native American women, notably in California and the American Southwest, developed basketry into an art form that combined utility with great beauty.

There are three principal basket-making techniques: coiling, twining, and plaiting. *Coiling* involves sewing together a spiraling foundation of rods with some other material. *Twining* is the sewing together of a vertical warp of rods. *Plaiting* employs weaving strips over and under each other.

The coiled basket shown here was made by the Pomo of California. According to Pomo legend, the Earth was dark until their ancestral hero stole the sun and brought it to Earth in a basket. He hung the basket first just over the horizon, but, dissatisfied with the light it gave, he kept suspending it in different places across the dome of the sky. He repeats this process every day, which is why the sun moves across the sky from east to west. In the Pomo basket, the structure of coiled willow and bracken fern root produces a spiral surface into which the artist worked sparkling pieces of clamshell, trade beads, and the soft

tufts of woodpecker and quail feathers. The underlying basket, the glittering shells, and the soft, moving feathers make this an exquisite container. Such baskets were treasured possessions, cremated with their owners at death.

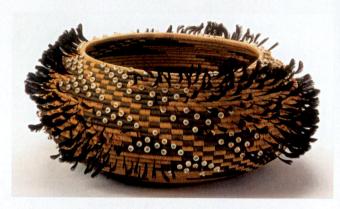

FEATHERED WEDDING BOWL

Pomo. c. 1877. Willow, bulrush, fern, feather, shells, glass beads. Height 5½" (14 cm), diameter 12" (36.5 cm). Philbrook © 2008 The Philbrook Museum of Art, Inc., Tulsa, Oklahoma. Clark Field Collection (1948.39.37)

ceded by the Delawares in 1682 is especially prized. The belt with two figures of equal size holding hands suggests the mutual respect enjoyed by the Delaware and Penn's Society of Friends (Quakers), a respect that later collapsed into land fraud and violence. In general, wampum strings and belts had the power of legal agreement and also symbolized a moral and political order.

QUILLWORK. Woodlands art focused on personal adornment-tattoos, body paint, elaborate dress-and fragile arts such as quillwork. Quillwork involved dyeing porcupine and bird quills with a variety of natural dyes, soaking the quills to soften them, and then working them into rectilinear, ornamental surface patterns on deerskin clothing and on birchbark items like baskets and boxes. A Sioux legend recounts how a mythical ancestor, Doublewoman ("double" because she was both beautiful and ugly, benign and dangerous), appeared to a woman in a dream and taught her the art of quillwork. As the legend suggests, quillwork was a woman's art form, as was basketry (see "Basketry," above). The Sioux BABY CARRIER (FIG. 26-11) is richly decorated with symbols of protection and well-being, including bands of antelopes in profile and thunderbirds—flying with their heads turned and tails outspread. The thunderbird was an especially beneficent symbol, thought to be capable of protecting against both human and supernatural adversaries.

26-II BABY CARRIER

The Upper Missouri River area. Eastern Sioux, 19th century. Board, buckskin, porcupine quill, length 31" (78.8 cm). Department of Anthropology, Smithsonian Institution Libraries, Washington, D.C. (Catalogue No. 7311)

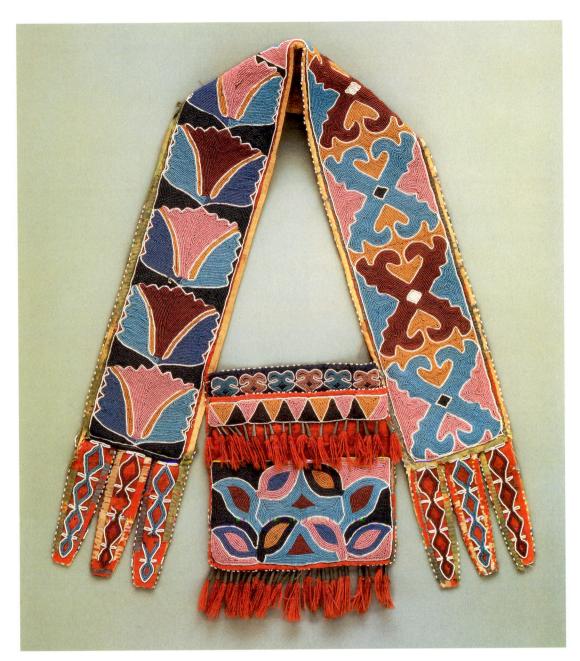

26–I2 | SHOULDER BAG Delaware people. Kansas. c. 1860. Wool fabric, cotton fabric and thread, silk ribbon, and glass beads, $23 \times 7 \frac{1}{4}$ " (58.5 \times 19.8 cm). The Detroit Institute of Arts. Founders Society Purchase (81.216)

BEADWORK. In spite of the use of shell beads in wampum, decorative beadwork did not become commonplace until after European contact. In the late eighteenth century, Native American artists began to acquire European colored-glass beads, and in the nineteenth century they favored the tiny seed beads from Venice and Bohemia. Early beadwork mimicked the patterns and colors of quillwork. In the nineteenth century it largely replaced quillwork and incorporated European designs. About 1830 Canadian nuns introduced the

young women in their schools to embroidered European floral motifs, and the native embroiderers began to adapt these designs as well as European needlework techniques and patterns from European garments into their own work. Functional aspects of garments might be transformed into purely decorative motifs; for example, a pocket would be replaced by an area of beadwork shaped like a pocket. A **shoulder Bag** from Kansas, made by a Delaware woman (FIG. 26–12), is covered with curvilinear plant motifs in contrast to the

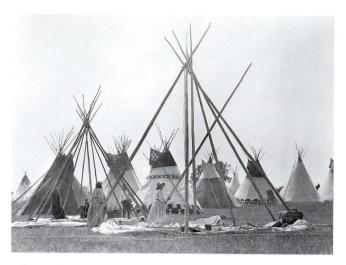

26–13 | BLACKFOOT WOMEN RAISING A TEPEE Photographed c. 1900. Montana Historical Society, Helena, Montana.

rectilinear patterns of traditional quillwork. White lines outline brilliant pink and blue leaf-shaped forms, heightening the intensity of the colors, which alternate within repeated patterns. The Delaware bag exemplifies the evolution of beadwork design.

The Great Plains

Between the Eastern Woodlands region and the Rocky Mountains to the west lay an area of prairie grasslands called the Great Plains. On the Great Plains, two differing ways of life developed, one a relatively recent and short lived (1700–1870) nomadic lifestyle—dependent on the region's great migrating herds of buffalo for food, clothing, and shelter—and the other, a much older sedentary and agricultural lifestyle. Horses, from wild herds descended from feral horses brought to America by Spanish explorers in the sixteenth and seventeenth centuries, made travel and a nomadic life easier for the dispossessed eastern groups that moved to the plains.

European settlers on the eastern seaboard put increasing pressure on the Eastern Woodlands peoples, seizing their farmlands and forcing them westward. Both Native Americans and backcountry settlers were living in loosely village-based, farming societies and thus were competing for the same resources. The resulting interaction of Eastern Woodlands artists with one another and with Plains artists led in some cases to the emergence of a new hybrid style, while other artists consciously fought to maintain their own cultures.

PORTABLE ARCHITECTURE. The nomadic Plains peoples hunted buffalo for food and hides from which they created clothing and a light, portable dwelling known as a **TEPEE** (FIG. 26–13). The tepee was well adapted to withstand the strong and constant wind, and the dust and violent storms of

the prairies. The framework of a tepee consisted of a stable pyramidal frame of three or four long poles, filled out with about twenty additional poles, in a roughly egg-shaped plan. The framework was covered with hides (or, later, with canvas) to form a conical structure. The hides were specially prepared to make them flexible and waterproof. A typical tepee required about eighteen hides; the largest, about thirty-eight hides. An opening at the top served as the smoke hole for a central hearth. The tepee leaned slightly into the prevailing west wind while the flap-covered door and smoke hole faced east, away from the wind. An inner lining covered the lower part of the walls and the perimeter of the floor to protect the occupants from drafts.

Tepees were the property and responsibility of women, who set them up at new encampments and lowered them when the group moved on. Blackfoot women could set up their huge tepees in less than an hour. Women painted. embroidered, quilled, and beaded tepee linings, backrests. clothing, and equipment. The patterns with which tepees were decorated, as well as their proportions and colors, varied from nation to nation, family to family, and individual to individual. In general, the bottom was covered with the traditional motifs of the people, and the center section held personal images. When disassembled and packed to be dragged by a horse to another location, the tepee served as a platform for transporting other possessions. The Sioux arranged their tepees in two half circles—one for the sky people and one for the earth people—divided along an east-west axis. When the Blackfoot people gathered in the summer for their ceremonial Sun Dance, their encampment contained hundreds of tepees in a circle a mile in circumference.

PLAINS INDIAN PAINTING. Plains men recorded their exploits in paintings on tepee linings and covers and on buffalo-hide robes. The earliest surviving painted buffalo-hide robe illustrates a battle fought in 1797 by the Mandan (of what is now North Dakota) and their allies against the Sioux (FIG. 26–14). The painter, trying to capture the full extent of a conflict in which five nations took part, shows a party of warriors in twenty-two separate episodes. The party is led by a man with a pipe and an elaborate eagle-feather headdress, and the warriors are armed with bows and arrows, lances, clubs, and flintlock rifles. Details of equipment and emblems of rank—headdresses, sashes, shields, feathered lances, powder horns for the rifles—are depicted carefully. Horses are shown in profile with stick legs, C-shaped hooves, and either clipped or flowing manes.

The figures stand out clearly against the light-colored background of the buffalo hide. The painter pressed lines into the hide, then filled in with black, red, green, yellow, and brown pigments. He drew the warriors as stick figures with rectangular torsos and tiny round heads. A strip of colored porcupine quills runs down the spine of the buffalo hide. The

robe would have been worn draped over the shoulders of the powerful warrior whose deeds it commemorates. As the wearer moved, the painted horses and warriors would seem to come alive, transforming the warrior into a living representation of his exploits.

Life on the Great Plains changed abruptly in 1869, when the Euro-Americans finished the transcontinental railway linking the east and west coasts of the United States and providing easy access to Native American lands. Between

Sequencing Events Cultures of the Americas

c. 1300

c. 1400-1519/21

c. 1438-1532

1700-1870

Eastern Woodlands Culture Height of the Aztec Empire Height of the Inca Empire

Plains Nomadic Culture

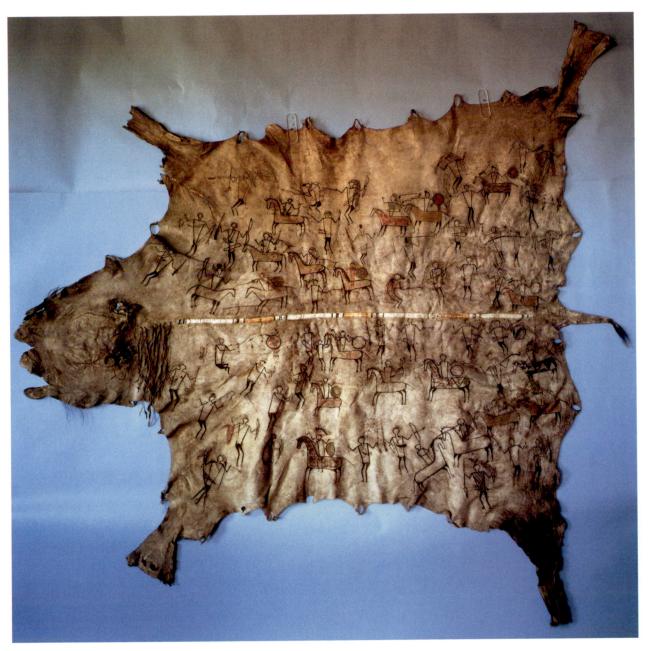

26-14 BATTLE-SCENE, HIDE PAINTING

Mandan. North Dakota. 1797–1800. Tanned buffalo hide, dyed porcupine quills, and black, red, green, yellow, and brown pigment, $7'10'' \times 8'6''$ (2.44 \times 2.65 m). Peabody Museum of Archaeology, Harvard University, Cambridge, Massachusetts.

(99-12-10/53121)

This robe, collected in 1804 by Meriwether Lewis and William Clark on their 1804-06 expedition into western lands acquired by the United States in the Louisiana Purchase, is the earliest documented example of Plains painting. It was one of a number of Native American artworks that Lewis and Clark sent to President Thomas Jefferson. Jefferson displayed the robe in the entrance hall of his home at Monticello, Virginia.

1871 and 1890, Euro-American hunters had killed off most of the buffalo, and soon ranchers and then farmers moved into the Great Plains. The U.S. government forcibly moved the outnumbered and outgunned Native Americans to reservations, land considered worthless until the later discovery of oil and, in the case of the Black Hills, gold.

The Northwest Coast

From southern Alaska to northern California, the Pacific coast of North America is a region of unusually abundant resources. Its many rivers fill each year with salmon returning to spawn. Harvested and dried, the fish could sustain large populations throughout the year. The peoples of the Northwest Coast—among them the Tlingit, the Haida, and the Kwakwaka'wakw (formerly spelled Kwakiutl)—exploited this abundance to develop a complex and distinctive way of life in which the arts played a central role.

ANIMAL IMAGERY. Northwest Coast people lived in extended family groups (clans) that claimed descent from a mythic animal or animal-human ancestor. A family derived its name and the right to use certain animals and spirits as totemic emblems, or crests, from its mythic ancestor. These emblems appeared prominently in Northwest Coast art, notably in carved cedar house poles and the tall, freestanding poles (mortuary poles) erected to memorialize dead chiefs. Chiefs, who were males in the most direct line of descent from the mythic ancestor, administered a family's spiritual and material resources. They validated their status and garnered prestige for themselves and their families by holding ritual feasts known as potlatches, during which they gave valuable gifts to the invited guests. Shamans, who were sometimes also chiefs, mediated between the human and spirit worlds. Some shamans were female, giving them unique access to specific aspects of the spiritual world.

The people lived in large, elaborately decorated communal houses made of massive timbers and thick planks. Carved and painted partition screens separated the chief's quarters from the rest of the house. The Tlingit screen illustrated here (FIG. 26–15) came from the house of Chief Shakes of Wrangell (d. 1916), whose family crest was the grizzly bear. The image of a rearing grizzly painted on the screen is itself made up of smaller bears and bear heads that appear in its ears, eyes, nostrils, joints, paws, and body. The images within the image enrich the monumental symmetrical design. The oval door opening is a symbolic vagina; passing through it reenacts the birth of the family from its ancestral spirit.

TEXTILES. Blankets and other textiles produced by the Chilkat Tlingit had great prestige among the Northwest Coast people (FIG. 26–16). Both men and women worked on the blankets. Men drew the patterns on boards, and women wove the patterns into the blankets, using shredded cedar

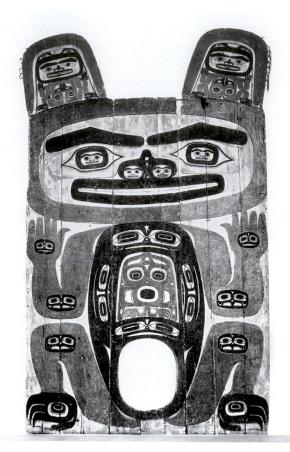

26–15 | GRIZZLY BEAR HOUSE-PARTITION SCREEN The house of Chief Shakes of Wrangell, Canada. Tlingit people. c. 1840. Cedar, native paint, and human hair, $15\times8'$ (4.57 \times 2.74 m). Denver Art Museum, Denver, Colorado.

bark and mountain-goat wool. The weavers did not use looms; instead, they hung cedar warp threads from a rod and twisted colored goat wool back and forth through them to make the pattern. The ends of the warp formed the fringe at the bottom of the blanket.

The small face in the center of the blanket shown here represents the body of a large stylized creature, perhaps a sea bear (a fur seal) or a standing eagle. Above the body are the creature's large eyes; below it and to the sides are its legs and claws. Characteristic of Northwest painting and weaving, the images are composed of two basic elements: the **ovoid**, a slightly bent rectangle with rounded corners, and the **formline**, a continuous, shape-defining line. Here, subtly swelling black formlines define shapes with gentle curves, ovoids, and rectangular C shapes. When the blanket was worn, its two-dimensional shapes would have become three-dimensional, with the dramatic central figure curving over the wearer's back and the intricate side panels crossing over his shoulders and chest.

MASKS. Many Native American cultures stage ritual dance ceremonies to call upon guardian spirits. The participants in Northwest Coast dance ceremonies wore elaborate cos-

tumes and striking carved and painted wooden masks. Among the most elaborate masks were those used by the Kwakwaka'wakw in their Winter Ceremony, in which they initiated members into the shamanistic Hamatsa society (see "Hamatsa Masks," page 888). The dance reenacted the taming of Hamatsa, a cannibal spirit, and his three attendant bird spirits. Magnificent carved and painted masks transformed the dancers into Hamatsa and the bird attendants who searched for victims to eat. Strings allowed the dancers to manipulate the masks so that the beaks opened and snapped shut with spectacular effect. Isolated in museums as "art," the masks doubtless lose some of the shocking vivacity they have in performance; nevertheless their bold forms and color schemes retain power and meaning that can be activated by the viewer's imagination.

The Southwest

The Native American peoples of the southwestern United States include, among others, the Pueblo (sedentary village-dwelling groups) and the Navajo. The Pueblo groups are heirs of the Ancestral Puebloans (Anasazi) and Hohokam cultures, which developed a fully settled, agricultural way of life

Sequencing Works of Art

c. 1500	Tunic, Peru
16th century	Founding of Tenochtitlan, from the Codex Mendoza
c. 1700	Wampum belt, William Penn's Treaty with the Delaware
1797-1800	Battle-scene hide painting, Mandan, North Dakota
c. 1840	Grizzly bear screen, House of Chief Shakes of Wrangell, Canada

around 700. Earlier societies had developed agriculture in the Southwest as early as 3500 BCE. The Ancestral Puebloans built apartmentlike villages and cliff dwellings whose ruins are found throughout the Four Corners region (New Mexico, Colorado, northern Arizona, and Utah) of the American Southwest. The Navajo, who arrived in the region sometime during the eleventh century or even later, developed a semi-sedentary way of life based on agriculture and (after the introduction of sheep by the Spanish) sheepherding. Being

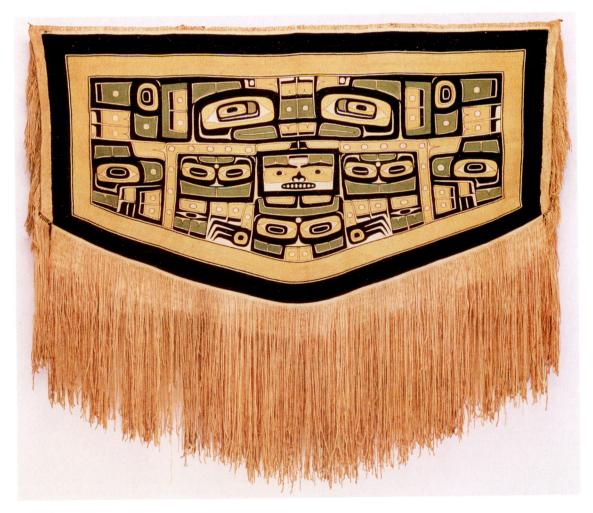

26-16 CHILKAT BLANKET

Tlingit people. Before 1928. Mountain-goat wool and shredded cedar bark, $55\% \times 63\%$ (140 \times 162 cm). American Museum of Natural History, New York.

THE OBJECT SPEAKS

HAMATSA MASKS

uring the harsh winter season. when spirits are thought to be most powerful, many northern people seek spiritual renewal through their ancient rituals-including the potlatch, or ceremonial gift giving, and the initiation of new members into the prestigious Hamatsa Society. With snapping beaks and cries of "Hap! Hap! Hap!" ("Eat! Eat! Eat!"), Hamatsa, the peopleeating spirit of the north, and his three assistants-horrible masked monster birds-begin their wild, ritual dance. The dancing birds threaten and even attack the Kwakwaka'wakw people who gather for the Winter Ceremony.

In the Winter Ceremony, youths are captured, taught the Hamatsa lore and rituals, and then in a spectacular theaterdance performance are "tamed" and brought back into civilized life. All the members of the community, including singers, gather in the main room of the great house, which is divided by a painted screen (SEE FIG. 26–15). The audience members fully participate in the performance; in early times, they brought containers of blood so that when the bird-

dancers attacked them, they could appear to bleed and have flesh torn away.

Whistles from behind the screen announce the arrival of the Hamatsa (danced by an initiate), who enters through the central hole in the screen in a flesh-craving frenzy. Wearing hemlock, a symbol of the spirit world, he crouches and dances wildly with outstretched arms as attendants try to control him. He disappears but returns again, now wearing red cedar and dancing upright. Finally tamed, a full member of society, he even dances with the women.

Then the masked bird-dancers appear—first Raven-of-the-North-End-of-the-World, then Crooked-Beak-of-the-End-of-the-World, and finally the untranslatable Huxshukw, who cracks open skulls with his beak and eats the brains of his victims. Snapping their beaks, these masters of illusion enter the room backward, their masks pointed up as though the birds are looking skyward. They move slowly counterclockwise around the floor. At each change in the music they crouch, snap their beaks, and let out their wild cries of "Hap! Hap!" Essential to

the ritual dances are the huge carved and painted wooden masks, articulated and operated by strings worked by the dancers. Among the finest masks are those by Willie Seaweed (1873–1967), a Kwakwaka'wakw chief, whose brilliant colors and exuberantly decorative carving style determined the direction of twentieth-century Kwakwaka'wakw sculpture.

The Canadian government, abetted by missionaries, outlawed the Winter Ceremony and potlatches in 1885, claiming the event was injurious to health, encouraged prostitution, endangered children's education, damaged the economy, and was cannibalistic. But the Kwakwaka'wakw refused to give up their "oldest and best" festival-one that spoke powerfully to them in many ways, establishing social rank and playing an important role in arranging marriages. By 1936, the government and the missionaries, who called the Kwakwaka'wakw "incorrigible," gave up. But not until 1951 could the Kwakwaka'wakw people gather openly for winter ceremonies, including the initiation rites of the Hamatsa Society.

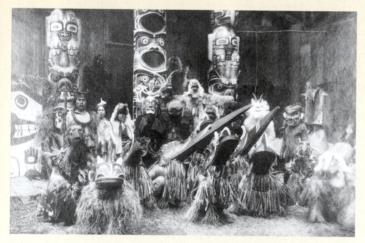

Edward S. Curtis HAMATSA DANCERS, KWAKWAKA'WAKW Canada. Photographed 1914. Smithsonian Institution Libraries, Washington, D.C.

The photographer Edward S. Curtis (1868–1952) devoted thirty years to documenting the lives of Native Americans. This photograph shows participants in a film he made about the Kwakwaka'wakw. For the film, his Native American assistant, Richard Hunt, borrowed family heirlooms and commissioned many new pieces from the finest Kwakwaka'wakw artists. Most of the pieces are now in museum collections. The photograph shows carved and painted posts, masked dancers (including those representing people-eating birds), a chief at the left (holding a speaker's staff and wearing a cedar neck ring), and spectators at the right.

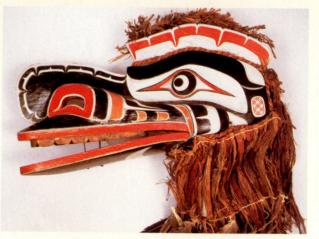

Attributed to Willie Seaweed
KWAKWAKA'WAKW BIRD MASK

Alert Bay, Vancouver Island, Canada. Prior to 1951. Cedar wood, cedar bark, feathers, and fiber, $10\times72\times15''$ (25.4 \times 183 \times 38.1 cm). Collection of the Museum of Anthropology, Vancouver, Canada. (A6120)

The name "Seaweed" is an anglicization of the Kwakwaka'wakw name *Siwid*, meaning "Paddling Canoe," "Recipient of Paddling," or "Paddled To"—referring to a great chief to whose potlatches guests paddled from afar. Willie Seaweed was not only the chief of his clan, but a great orator, singer, and tribal historian who kept the tradition of the potlatch alive during years of government repression.

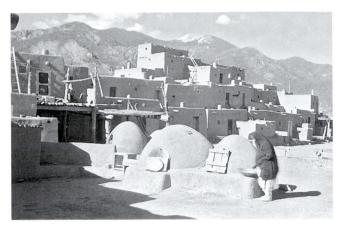

26–17 | Laura Gilpin TAOS PUEBLO
Tewa. Taos, New Mexico. Photographed 1947. Amon Carter
Museum, Fort Worth, Texas.
© 1979 Laura Gilpin Collection (neg. # 2528.1)

Laura Gilpin, photographer of the landscape, architecture, and people of the American Southwest, began her series on the Pueblos and Navajos in the 1930s. She published her work in four volumes of photographs between 1941 and 1968.

among the very few Native American tribal groups whose reservations are located on their actual ancestral homelands, both groups have managed to maintain the continuity of their traditions despite Euro-American pressure. Today, their arts reflect the adaptation of traditional forms to new technologies, new mediums, and the influences of the dominant American culture that surrounds them.

THE PUEBLOS. Some Pueblo villages, like those of their ancient ancestors, consist of multistoried dwellings of considerable architectural interest to today's environmentalists. One of these, TAOS PUEBLO, shown here in a photograph taken in 1947 by the American photographer of the Southwest, Laura Gilpin (1891–1979), is located in north-central New Mexico (FIG. 26-17). The northernmost of the surviving Pueblo communities, Taos once served as a trading center between Plains and Pueblo peoples. Taos burned in 1690 but was rebuilt about 1700 and has often been modified since. "Great Houses" (multifamily dwellings) stand on either side of Taos Creek. Bordering on a plaza that opens toward the neighboring mountains, they rise in a stepped fashion to provide a series of roof terraces that can serve as viewing platforms. The plaza and roof terraces are centers of communal life and ceremony, as can be seen in Pablita Velarde's painting of the winter solstice celebrations (SEE FIG. 26-19).

CERAMICS. Pottery traditionally was a woman's art among Pueblo peoples. Wares were made by coiling and other hand-building techniques, and then fired at low temperature in wood bonfires. The best-known twentieth-century Pueblo potter was Maria Montoya Martinez (1887–1980) of San Ildefonso Pueblo in New Mexico. Inspired by prehistoric blackware pottery that was unearthed at nearby archaeological excavations, she and her husband, Julian Martinez (1885–1943), developed a distinctive ceramics style decorated with matte (dull, nongloss) black forms on a lustrous black background (FIG. 26–18). Maria made pots covered with a slip that was then burnished. Using additional slip, Julian

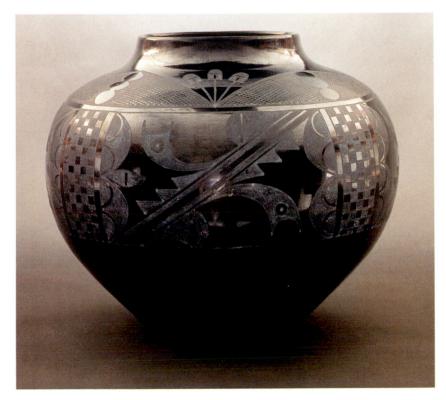

26–18 | Maria Montoya Martinez and Julian Martinez BLACKWARE STORAGE JAR San Ildefonso Pueblo, New Mexico. c. 1942. Ceramic, height 18½" (47.6 cm), diameter 22½" (57.1 cm). Museum of Indian Arts and Culture/Laboratory of Anthropology, Museum of New Mexico, Santa Fe.

Art and Its Context NAVAJO NIGHT CHANT

his chant accompanies the creation of a sand painting during a Navajo curing ceremony. It is sung toward the end of the ceremony and indicates the restoration of inner harmony and balance.

In beauty (happily) I walk. With beauty before me I walk. With beauty behind me I walk. With beauty below me I walk.
With beauty above me I walk.
With beauty all around me I walk.
It is finished (again) in beauty.
It is finished in beauty.

(Cited in Washington Mathews, American Museum of Natural History Memoir, no. 6. New York, 1902, page 145.)

painted the pots with designs that interpreted traditional Pueblo imagery in the then fashionable Art Deco style. After firing, the burnished ground became a lustrous black and the slip painting retained a matte surface. By the 1930s, production of blackware in San Ildefonso had become a communal enterprise. Family members and friends all worked making pots, and Maria signed all the pieces so that, in typical pueblo communal solidarity, everyone profited from the art market.

THE SANTA FE INDIAN SCHOOL. In the 1930s Anglo-American art teachers and dealers worked with Native Americans of the Southwest to create a distinctive, stereotypical "Indian" style in several mediums—including jewelry, pottery, weaving, and painting—to appeal to tourists and collectors. A leader in this effort was Dorothy Dunn (1903–91), who taught painting in the Santa Fe Indian School, an off-reservation government boarding school in New Mexico, from 1932 to 1937. Dunn inspired her students to create a painting style that combined the outline drawing and flat colors of folk art, the decorative qualities of Art Deco, and "Indian" subject matter. She and her students formed the Studio School. Restrictive as the school was, Dunn's success made painting a viable occupation for young Native American artists.

Pablita Velarde (1918–2006), from Santa Clara Pueblo in New Mexico and a 1936 graduate of Dorothy Dunn's school, was only a teenager when one of her paintings was selected for exhibition at the Chicago World's Fair in 1933. Thereafter, Velarde began to document Pueblo ways of life in a large series of murals for Bandelier National Monument. **KOSHARES OF TAOS (FIG. 26–19)** illustrates a moment during a ceremony celebrating the winter solstice when koshares, or clowns, take over the plaza from the Katsinas. Katsinas—the supernatural counterparts of animals, natural phenomena like clouds, and geological features like mountains—are central to traditional Pueblo religion. Katsinas manifest themselves in the human dancers who impersonate them during the winter

solstice ceremony, as well as in the small figures known as Katsina dolls that are given to children as educational aids in learning to identify the masks. Velarde's painting combines bold, flat colors and a simplified decorative line with European perspective. Her paintings, with their Art Deco abstraction, influenced the popular idea of the Indian style in art.

THE Navajos. Navajo women are renowned for their skill as weavers. According to Navajo mythology, the universe itself is a weaving, its fibers spun by Spider Woman out of sacred cosmic materials. Spider Woman taught the art of weaving to Changing Woman (a Mother Earth figure who changes through the seasons), and she in turn taught it to Navajo women. The earliest Navajo blankets have simple horizontal stripes, like those of their Pueblo neighbors, and are limited to the white, black, and brown colors of natural sheep's wool. Over time, the weavers developed finer techniques and introduced more intricate patterns. In the mid-nineteenth century, they began unraveling the colored fibers from commercially manufactured and dyed blankets and reusing the yarn in their own work. By 1870-90 they were weaving spectacular blankets that were valued as prestige items among the Plains peoples as well as Euro-American collectors.

SAND PAINTING. Another traditional Navajo art, sand painting, is the exclusive province of men. Sand paintings are made to the accompaniment of chants by shaman-singers in the course of healing and blessing ceremonies, and they have great sacred significance (see "Navajo Night Chant," above). The paintings depict mythic heroes and events; and as ritual art, they follow prescribed rules and patterns that ensure their power. To make them, the singer dribbles pulverized colored stones, pollen, flowers, and other natural colors over a hide or sand ground. The rituals are intended to cure by restoring harmony to the world. The paintings are not meant to be seen by the public and certainly not to be displayed in

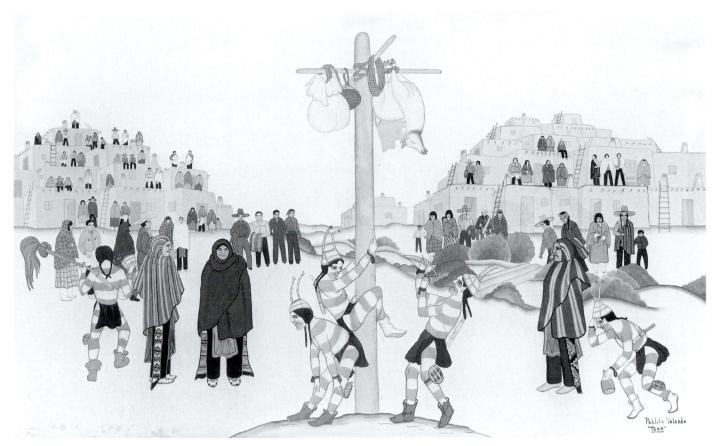

26–19 Pablita Velarde KOSHARES OF TAOS From Santa Clara Pueblo, New Mexico. 1946–47. Watercolor on paper, $13\% \times 22\%$ " (35.3 \times 56.9 cm). Museum Purchase 1947.37 © 2008 The Philbrook Museum of Art, Inc., Tulsa, Oklahoma.

museums. They are meant to be destroyed by nightfall of the day on which they are made.

In 1919 a respected shaman-singer named Hosteen Klah (1867–1937) began to incorporate sand-painting images into weaving, breaking with the traditional prohibitions. Many Navajos took offense at Klah both for recording the sacred images and for doing so in what was traditionally a woman's art form. Klah had learned to weave from his mother and sister. The Navajo traditionally recognize at least three genders and perhaps as many as five or more; Hosteen Klah was a *nadle*, or Navajo third-gender. Hence, he could learn both female and male arts; that is, he was trained both to weave and to heal. Hosteen Klah was not breaking artistic barriers in a conventional sense, but rather exemplifying the complexities of the traditional Navajo gender system. Klah's work was ultimately accepted because of his great skill and prestige.

The WHIRLING LOG CEREMONY sand painting, woven into tapestry (FIG. 26–20), depicts part of the Navajo creation myth. The Holy People create the Earth's Surface and divide it into four parts. They create humans, and bring forth corn, beans, squash, and tobacco—the four sacred plants. A malefemale pair of humans and one of the sacred plants stands in each of the four quarters, defined by the central cross. The four Holy People (the tall sticklike figures) surround the

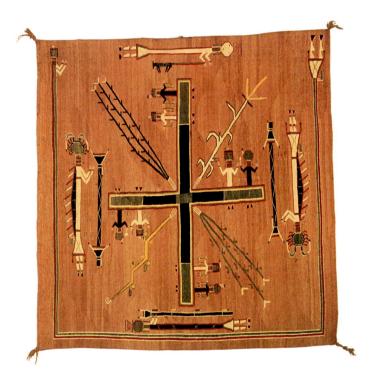

26–20 | Hosteen Klah WHIRLING LOG CEREMONY Sand painting; tapestry by Mrs. Sam Manuelito. Navajo, c. 1925. Wool, $5'5'' \times 5'10''$ (1.69 \times 1.82 m). Heard Museum, Phoenix, Arizona.

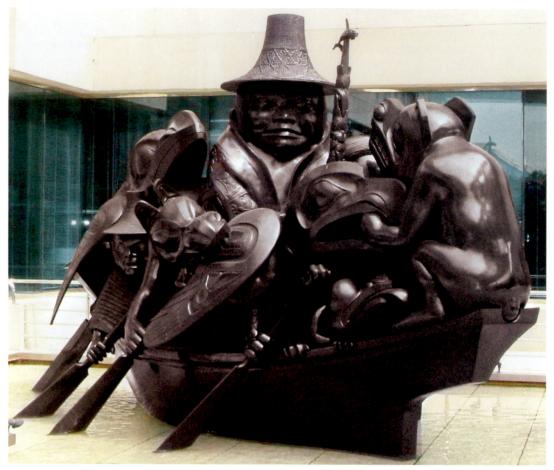

26–21 | Bill Reid THE SPIRIT OF HAIDA GWAII Haida, 1991. Bronze, approx. $13 \times 20'$ (4 × 6 m). Canadian Embassy, Washington, D.C.

image, and the guardian figure of Rainbow Maiden frames the scene on three sides. Since the open side represents the east, her head is in the northeast corner and her feet are in the southeast. Like all Navajo artists, Hosteen Klah hoped that the excellence of the work would make it pleasing to the spirits. Recently shaman-singers have made permanent sand paintings on boards for sale, but they usually introduce slight errors in them to render the paintings ceremonially harmless.

A NEW BEGINNING

The Institute of American Indian Arts (IAIA), founded in 1962 in Santa Fe and attended by Native American students from all over North America, supports Native American aspirations in the arts today just as Dorothy Dunn's Studio School had in the 1930s. Staffed by major Native American artists, the school encourages the incorporation of indigenous ideals in the arts without creating an official "style." As alumni achieved distinction and the IAIA museum in Santa Fe established a reputation for excellence, the institute has led Native American art into the mainstream of contemporary art (see Chapter 31).

Other artists, such as the Canadian Haida artist Bill Reid (1920–98), have sought to sustain and revitalize traditional art in their work. For example, trained as a woodcarver, painter, and jeweler, Reid revived the art of carving totem poles and dugout canoes in the Haida homeland of Haida Gwaii—"Islands of the People"—known on maps today as the Queen Charlotte Islands. Late in life he began to create large-scale sculpture in bronze. With their black patina, these works recall traditional Haida carvings in shiny black argillite.

An imposing piece, Reid's **THE SPIRIT OF HAIDA GWAII** now stands outside the Canadian Embassy in Washington, D.C. (FIG. 26–21). This sculpture, which Reid viewed as a metaphor for modern Canada's multicultural society, depicts a boatload of figures from the natural and mythic worlds struggling to paddle forward.

The dominant figure is a shaman in a spruce-root basket hat and Chilkat blanket holding a speaker's pole. On the prow, the place reserved for the chief in a war canoe, sits the Bear. He faces backward rather than forward, and is bitten by an Eagle, with formline-patterned wings. The Eagle, in turn, is bitten by the Seawolf. The Eagle and the Seawolf, together with the man behind them, nevertheless continue paddling.

At the stern, steering the canoe, is the Raven, the trickster in Haida mythology. The Raven is assisted by Mousewoman, the traditional guide and escort of humans in the spirit realms. According to Reid, the work represents a "mythological and environmental lifeboat," where "the entire family of living things ... whatever their differences, ... are paddling together in one boat, headed in one direction."

The National Museum of the American Indian. In 1989 Congress established the National Museum of the American Indian within the Smithsonian Institution. After many years of discussion and negotiation, the art of indigenous peoples is finally achieving full recognition by the museum establishment. Championed by curator/collectors such as Ralph T. Coe, exhibitions of contemporary as well as traditional Native American arts are held in major American and European museums. In September of 2004, the NATIONAL MUSEUM OF THE AMERICAN INDIAN finally opened on the Mall in Washington, D.C., directly below Capitol Hill and across from the National Gallery of Art (FIG. 26–22).

Inspired by the colors, textures, and forms of the American Southwest, the museum building establishes a new presence of Native Americans on the Mall. Symbolizing the Native ethic of environmental concern, the National Museum of the American Indian is surrounded by boulders ("Grandfather Rocks"), water, and plantings that recall the varied landscapes of North America, including wetlands, meadows, forest, and traditional cropland with corn, squash, and tomatoes. These are not gardens; rather they are intended to evoke indigenous environments. The entrance to the museum on the east side faces the morning sun and recalls the orientation of prairie tepees. Inside the building a Sun Marker of stained glass in the south wall throws its dagger of light across the vast atrium as the day progresses. Once again the great spirits of Earth and sky take form in a creation of the art of the Americas.

IN PERSPECTIVE

After 1492, the arrival of Europeans completely altered the destiny of the Americas. In Mesoamerica and South America the break with the past was sudden and violent; in North America the change took place more gradually, but the outcome was much the same. In both North and South America, natives succumbed to European disease to which they had no immunity, especially smallpox, leading to massive population loss and social disruption. Many present-day Native American ethnic groups, however, were formed by combinations of various survivor groups.

In the south, the Spanish came as conquerors to exploit the wealth of the New World. Aztecs, Incas, and others, who were heirs to long-established building traditions, had built huge ceremonial complexes and housing for substantial

Defining Art CRAFT OR ART?

n many world cultures, the distinction between "fine art" and "craft" does not exist. The traditional Western academic hierarchy of materials—in which marble, bronze, oil, and fresco are valued more than terra cotta and watercolor—and the equally artificial hierarchy of subjects—in which history painting, including religious history, stands supreme—are irrelevant to non-Western art.

The indigenous peoples of the Americas did not produce objects as works of art. In their eyes all pieces were utilitarian objects, adorned in ways necessary for their intended purposes. A work was valued for its effectiveness and for the role it played in society. Some, like a Sioux baby carrier (SEE FIG. 26-11), enrich mundane life with their aesthetic qualities. Others, such as Pomo baskets (see "Basketry," page 882), commemorate important events. The function of an Inca tunic may have been to identify or confer status on its owner or user through its material value or symbolic associations. And as with art in all cultures, many pieces have had great spiritual or magical power. Such works of art cannot be fully comprehended or appreciated when they are seen only on pedestals or encased in glass boxes in museums or galleries. They must be imagined, or better yet seen, as acting in their societies. How powerfully might our minds and emotions be engaged if we saw Kwakwaka'wakw (Kwakiutl) masks functioning in religious drama, changing not only the outward appearance, but also the very essence of the individual.

At the beginning of the twentieth century, European and American artists broke away from the academic bias that extolled the classical heritage of Greece and Rome. They found new inspiration in the art-or craft, if you will-of many different non-European cultures. Artists explored a new freedom to use absolutely any material or technique that effectively challenged outmoded assumptions and opened the way for a free and unfettered delight in, and understanding of, Native American art as well as the art of other non-Western cultures. The intellectual community as well as collectors, dealers, and critics have come to appreciate the non-Western aesthetics and to treasure forgotten and ignored arts on their own terms. And the more recent twentieth- and twentyfirst-centuries conception of art as a multimedia adventure has helped validate works of art once seen only in ethnographic collections and in the homes of private collectors. Today objects once called "primitive" are recognized as great works of art and acknowledged to be an essential dimension of a twenty-first-century worldview. The line between "art" and "craft" seems more artificial and less relevant than ever before.

26–22 | NATIONAL MUSEUM OF THE AMERICAN INDIAN
The Smithsonian Institution, Washington, D.C. Opened September, 2004. Architectural design: GBQC in association with Douglas Cardinal (Blackfoot). Architectural consultants: Johnpaul Jones (Cherokee-Choctaw) and Ramona Sakiestewa (Hopi). Landscape consultant: Donna House (Navajo-Oneida), ethno-botanist.

populations in cities. They had also performed feats of engineering in road networks and in drainage and irrigation works. Their monumental sculpture in stone and ceramic survived the Spanish onslaught, as did some examples of their magnificent textiles, but their plentiful objects in silver and gold were almost all melted down and carted off. Some traditional arts, especially in weaving and pottery, continue to the present day.

In North America, the Europeans came not as military men seeking riches to plunder, but as families seeking land to farm. Unlike the Spaniards, they found no large cities with urban populations to resist them. However, although they imagined that the lands they settled were an untended wilderness, in fact nearly all of North America was populated and possessed by indigenous peoples. Over the next 400

years, by means of violence, bribery, and treaties, the English colonies and, in turn, the United States displaced nearly all Native Americans from their ancestral homelands. What indigenous art Euro-Americans encountered they viewed as a curiosity, not art.

During the past century, the indigenous arts of the Americas have undergone a reevaluation that has renewed the conception of what constitutes "American art," especially as diverse artists continue to revive indigenous traditions, revisit native outlooks, and restate ancient truths in new ways. After being pushed to the brink of extinction, Native American cultures are now experiencing a revival in both North and South America, as Native Americans assert themselves politically, and as Euro-Americans come to appreciate the connections between native history and the land.

AZTEC, A VIEW OF THE WORLD
PAGE FROM CODEX FEJERVARY-MAYER
c.1400-1519/21

AZTEC, FEATHER HEADDRESS OF MONTEZUMA

BEFORE 1519

INCA, MACCHU-PICCHU
PERU
450-1530

BATTLE-SCENE, HIDE PAINTING
MANDAN, NORTH DAKOTA
1797–1800

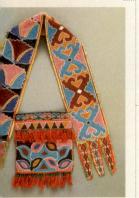

SHOULDER BAG DELAWARE, KANSAS c.1860

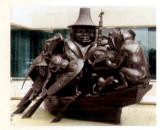

HAIDA, BILL REID

THE SPIRIT OF HAIDA GWAII

1991

ART OF THE AMERICAS AFTER 1300

Eastern Woodlands Culture c. 1300

Aztec Empire at Its Height c. 1400-1519/21

Inca Empire at Its Height c. 1438-1532

Cortés Conquers Aztec Empire
 c. 1519-24

✓ Pizarro Conquers Inca Empire c. 1532

✓ Plains Nomadic Culture 1700-1870

✓ Louisiana Purchase 1803

Transcontinental Railway Complete
 1869

■ Winter Ceremony Outlawed 1885–1951

1800

1600

1900

2000

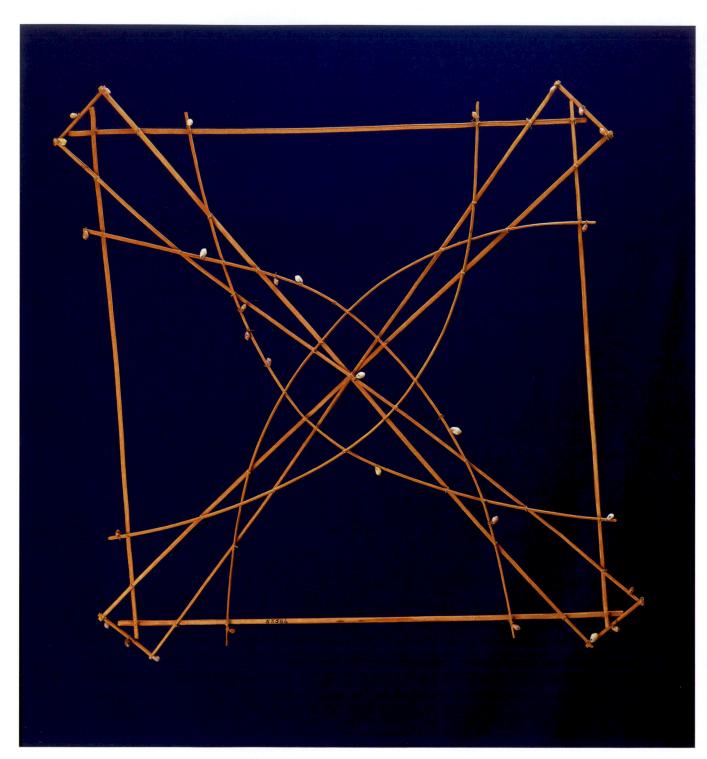

27–I | **WAPEPE NAVIGATION CHART** Marshall Islands, Micronesia. 19th century. Sticks, coconut fiber, shells. $29\% \times 29\%$ " (75 × 75 cm).

CHAPTER TWENTY-SEVEN

ART OF PACIFIC CULTURES

The low-lying coral atolls that make up the Marshall Islands of Micronesia are spaced like two strands of green pearls across the shimmering blue cloth of the Pacific (SEE MAP 27–1). Distances from island to island are not great; the

27

arrangement of sticks around a shell indicates a zone of distinctive waves shaped by the effect of an island deflecting the prevailing wind. Recognizing such refracted waves enables a navigator to sense the proximity of land without being able to see it, and to discern the least difficult course for

longest is not much more than 75 miles. But the low elevation of the shores means that a canoe traveling from one to the next is out of sight of land for most of the voyage. Renowned for their navigational skill, Marshallese sailors relied on celestial navigation (navigating by the sun and moon and stars) as well as a detailed understanding of the ocean currents and trade winds that prevail around their islands. To teach navigation to younger generations, Marshall Islands elders traditionally used "stick charts"—maps that included land, but also the path from one island to the next, the water a sailor would cross in his voyage.

encounter these ocean patterns in a particular way depending on its starting point and destination, each chart was applicable to one particular itinerary only. The charts were not taken out to sea, but were used as teaching devices to help memorize the ocean patterns between islands. Although such an object is primarily functional, its combination of clarity, simplicity, and abstraction have aesthetic impact. This *wapepe* was collected by the expedition of the USS *Albatross* in 1899–1900.

Every society has its own way of picturing the world.

making landfall. Since any given navigational course would

In common use until the 1950s, the stick chart (FIG. 27–1), called a *mattang* or *wapepe*, was a schematic diagram of the prevailing ocean currents and the characteristic wave patterns encountered on a journey from one island to another. The currents are represented by sticks held together by coconut fibers; the shells mark islands on the route. The

Every society has its own way of picturing the world. Born of an intimate familiarity with the sea, and constructed from simple materials readily at hand, the stick charts of the Marshall Islands envision a voyage in a conceptual diagram denoting the varying texture of wind and water between islands.

THE PEOPLING OF THE PACIFIC

- AUSTRALIA Arnhem Land
- MELANESIA New Guinea New Ireland
- MICRONESIA
- POLYNESIA Easter Island Marquesas Islands New Zealand Hawaiian Islands
- RECENT ART IN OCEANIA
- IN PERSPECTIVE

THE PEOPLING OF THE PACIFIC

On a map with the Pacific Ocean as its center, only the peripheries of the great landmasses of Asia and the Americas appear. More than one-third of the earth's surface is taken up by this vast expanse. The area of Oceania includes four distinct but connected cultural-geographic areas: Australia, Melanesia, Micronesia, and Polynesia (MAP 27-1). Australia includes the continent as well as the island of Tasmania to the southeast. Melanesia (meaning "black islands," a reference to the dark skin color of its inhabitants) includes New Guinea and the string of islands that extend eastward from it as far as Fiji and New Caledonia. Micronesia ("small islands"), to the north of Melanesia, is a region of small islands, including the Marianas. Polynesia ("many islands") is scattered over a huge, triangular region defined by New Zealand in the south, Easter Island in the east, and the Hawaiian Islands to the north. The last region on earth to be inhabited by humans, Polynesia covers some 7.7 million square miles, of which fewer than 130,000 square miles are dry land—and most of that is New Zealand. With the exception of temperate New Zealand, with its marked seasons and snow-capped mountains, Oceania is in the tropics, that is, between the Tropic of Cancer in the north and the Tropic of Capricorn to the south.

Australia, Tasmania, and New Guinea formed a single continent during the last Ice Age, which began some 2.5 million years ago. About 50,000 years ago, when the sea level was about 330 feet lower than it is today, people moved to this continent from Southeast Asia, making at least part of the journey over open water. Some 27,000 years ago humans were settled on the large islands north and east of New Guinea as far as San Cristobal, but they ventured no farther for another 25,000 years. By about 4000 BCE-possibly as early as 7000 BCE—the people of Melanesia were raising pigs and cultivating taro, a plant with edible rootstocks. As the glaciers melted, the sea level rose, flooding low-lying coastal land. By around 4000 BCE a 70-mile-wide waterway, now called the Torres Strait, separated New Guinea from Australia, whose aboriginal (native) people continued their hunting and gathering way of life into the twentieth century.

The settling of the rest of the islands of Melanesia and the westernmost islands of Polynesia—Samoa and Tonga coincided with the spread of the Lapita culture, named for a site in New Caledonia. The Lapita people spread throughout the islands of Melanesia beginning around 1500 BCE. They were farmers and fisherfolk who cultivated taro and yams and brought with them dogs, pigs, and chickens, animals that these colonizers needed for food. They also carried with them the distinctive ceramics whose remnants today enable us to trace the extent of their travels. Lapita potters produced dishes, platters, bowls, and jars. Sometimes they covered their wares with a red slip, and they often decorated them with bands of incised and stamped patterns-dots, lines, and hatching-heightened with white lime. Most of the decoration was entirely geometric, but some was figurative. The human face that appears in the example shown (FIG. 27-2) is among the earliest representations of a human being in Oceanic art. The Lapita people were skilled shipbuilders and

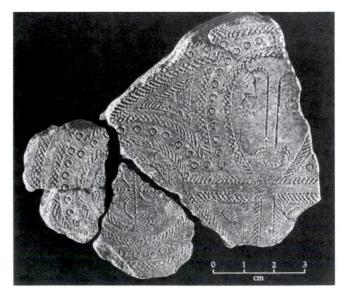

27–2 | FRAGMENTS OF A LARGE LAPITA JAR Venumbo Reef, Santa Cruz Island, Solomon Islands, Melanesia. c. 1200–1100 BCE. Clay, height of human face approx. 1/2" (4 cm).

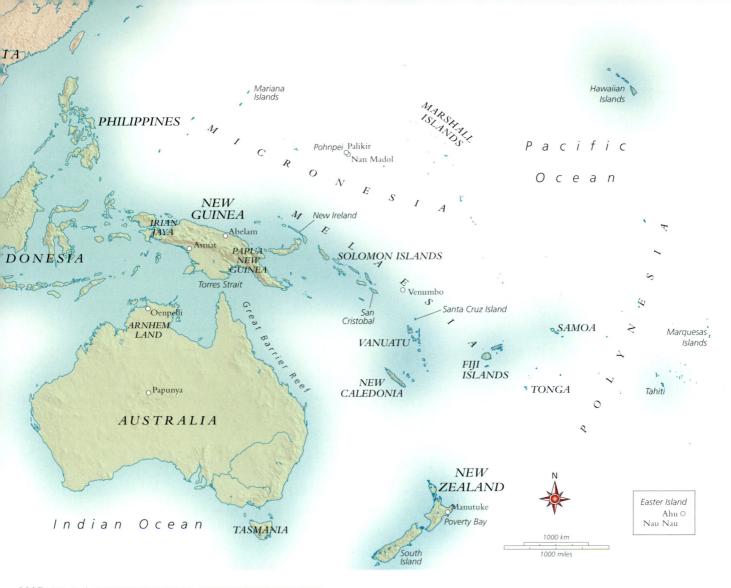

MAP 27-I | PACIFIC CULTURAL-GEOGRAPHIC REGIONS

The Pacific cultures are found in four vast areas: Australia, Melanesia, Micronesia, and Polynesia.

navigators and engaged in interisland trade. Over time the Lapita culture lost its widespread cohesion and evolved into various local forms. Its end is generally dated to the early centuries of the Common Era.

Polynesian culture emerged in the eastern Lapita region on the islands of Tonga and Samoa. Around the beginning of the first millennium CE, daring Polynesian seafarers, probably in double-hulled sailing canoes, began settling the scattered islands of Far Oceania and eastern Micronesia. Voyaging over open water, sometimes for thousands of miles, they reached Hawaii and Easter Island after about 500 CE and settled New Zealand around 800/900–1200 CE.

While the continued contact between eastern Melanesia (Vanuatu and the surrounding islands) and Polynesian peoples allowed for cross-cultural borrowings, there are distinctions between these areas and within the regions as well. The islands that make up Micronesia, Melanesia, and Polynesia include both low-lying coral atolls and the tall tops of vol-

canic mountains that rise from the ocean floor. Raw materials available to residents of these islands vary greatly, and islander art and architecture utilize these materials in different ways. The soil of volcanic islands can be very rich and thus can support densely populated settlements with a local diversity of plants and animals. On the other hand, coral atolls do not generally have very good soil and thus cannot support large populations. In a like manner, volcanic islands can provide good stone for tools and building (as at Nan Madol; SEE FIG. 27–8), while coral is sharp but not particularly hard, and the strongest tools on a coral atoll are often those made from giant clam shells. Generally, the diversity of both plants and animals decreases from west to east among the Pacific Islands.

The arts of this vast and diverse region display an enormous variety that is closely linked to a community's ritual and religious life. In this context, the visual arts were often just one strand in a rich weave that also included music, dance, and oral literature.

AUSTRALIA

The aboriginal inhabitants of Australia, or Aborigines, were nomadic hunter-gatherers closely attuned to the varied environments in which they lived until European settlers disrupted their way of life. They did not cultivate any crops, and their only modification of the landscape was regular controlled burning of the underbrush, which encouraged new plant life and attracted animals.

The Aborigines' traditional life is intimately connected with the concept of the Dreamtime, the period before humans existed. The world had begun as flat, but spirit beings shaped it into mountains, sand hills, creeks, and water holes. These spirits grew old and eventually went back to the sleep from which they had awoken at the Dreamtime, but their continuing influence is felt in climatic phenomena such as the monsoon season. Each animal and human is thought to have two souls, one mortal and one immortal, the latter associated with a particular ancestral spirit. These totemic ancestors are identified with specific places, which are honored as sacred sites. Social organization and mythology of the Aborigines are vividly represented in their arts. The goal of many aboriginal paintings is restoring contact with the Dreamtime.

Arnhem Land

While the Aborigines lived throughout the continent, some of their earliest remains are found in the north, in tropical Arnhem Land. In Arnhem Land the native people continued what was essentially a paleolithic lifestyle until well into the twentieth century. Their rich ceremonial life included ritual body painting as well as the ornamentation of implements and the interiors of bark houses. The rock paintings of Western Arnhem Land are particularly famous, and they illustrate images that are often associated with the Dreamtime.

X-RAY STYLE ROCK PAINTING. One of the most distinctive characteristics of traditional aboriginal imagery is the **x-ray style** depiction of animals. When depicting an x-ray style ani-

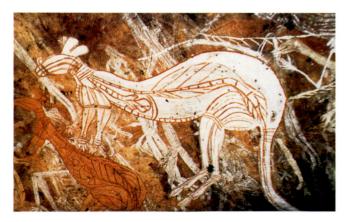

27–3 | MIMIS AND KANGAROO Prehistoric rock art, Oenpelli, Arnhem Land, Australia. Older painting 18,000–7000 BCE. Red and yellow ocher and white pipe clay.

mal, the artist would draw bones and internal organs—including the spinal column, the heart, and the stomach—over the silhouetted form. In the picture shown here (FIG. 27–3), all four of the kangaroo's legs have been drawn, and the ears have been placed symmetrically on top of its head. In some images both eyes appear in the head, which is shown in profile. The x-ray style was still prevalent in western Arnhem Land when European settlers arrived in the nineteenth century. This rock painting, however, dates much earlier, to perhaps as early as 18,000 years ago, roughly the same time as cave paintings were being produced in Western Europe. As here, frequently these rock paintings show a later image superimposed on an earlier one. The earlier painting is of skinny, sticklike humans that the Aborigines call *mimis* ("ancestral spirits").

BARK PAINTING. Eventually, as a means of communicating with outsiders and as an aid to education and memory, tribal elders recorded origin myths, rituals, and significant places and objects by painting on the bark stripped from eucalyptus trees. Bark painters from western Arnhem Land continued to use the x-ray style, but in eastern Arnhem Land, the bark painters, especially the Yolngu-speakers, developed a style based on ritual body painting.

The Yolngu rarely reveal the full meaning of a painting to outsiders, but in general they depict origin myths and ritual activities. A modern bark painting by Mithinarri Gurruwiwi (FIG. 27-4) represents a part of the origin myth of eastern Arnhem Land as interpreted by the Gälpu clan of the Yolngu people. The first humans—the Wäwilak Sisters—walked about with their digging sticks, singing, dancing, naming things, and populating the land with their children. But they offended the Wititj (Olive Serpent), who swallowed them but was then called before a council of serpents representing all the clans. Wititj had to admit wrongdoing and regurgitate the humans. This conference of snakes signifies both the origin of ritual activities and the spreading of the Wäwilak story to other clans. At the center of the bark painting, a dark rectangle represents Wititj's water hole, the Gälpu clan's ceremonial center and the home of the Yolngu people before and after their time on earth—both unborn souls and the dead. Wititj coils protectively around the water, slithering in and out of his hole. Wititi is represented twice again at the top of the painting among the water lilies, and at the bottom he attends the conference, with goannas (large lizards) and other serpents. The ancestral snakes are associated with water—rain, water holes, thunder and lightning—and fertility, so Wititj is covered with dots representing eggs. The dotted water lilies also remind us of the fertility of well-watered land. The Wäwilak sisters' story is sacred, and some Yolngus believe that only the initiated clan members should see such paintings. Ritual life and the meaning of ceremonial designs still remain private, and only designated artists have rights to reproduce clan narratives and designs.

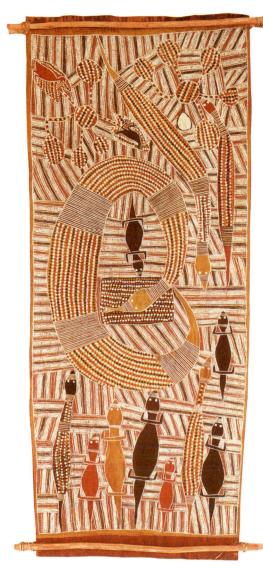

27–4 Mithinarri Gurruwiwi THE CONFERENCE OF SERPENTS FROM THE WÄWILAK MYTH
Eastern Arnhem Land, Australia. 1963. Natural pigments (ochers and clay) on eucalyptus bark, 53% × 22%" (137 × 58.5 cm). Kluge-Ruhe Aboriginal Art Collection, University of Virginia, Charlottesville.

The surface of the painting shimmers with brilliant dotting and cross-hatching. This characteristic cross-hatching, known as *rarrk*, originated in the designs painted on male chests and thighs as part of initiation ceremonies; consequently, what may appear to be simple decoration—the angle of the lines, their color, and the alternation of continuous and broken lines—has a more profound meaning for the Yolngu. In this painting, geometric forms represent abstract ideas as well as underlying structures and meanings, while recognizable figures are used to tell stories and to represent occurrences.

Aboriginal artists today may paint with acrylic paint on canvas instead of with ocher, clay, and charcoal on rock and eucalyptus bark, but their imagery has remained relatively constant, and their explanations of their work provide insight into the meaning of prehistoric images.

MELANESIA

In Melanesia the people usually rely at least partially on agriculture, and as a result they live in permanent settlements, many of which feature spaces set aside for ritual use. As in Australia, the arts were intimately involved with belief and provided a means for communicating with supernatural forces. Rituals and ritual arts were primarily the province of men, who devoted a great deal of time to both. In some societies most of the adult males were able to make ritual objects. Women, although barred from ritual arts, gained prestige for themselves and their families through their skill in the production of other kinds of goods, such as bark cloth. To be effective, ritual objects had to be well made, but they were often allowed to deteriorate after they had served their ceremonial function.

New Guinea

New Guinea, the largest island in the Pacific (and at 1,500 miles long and 1,000 miles wide, the second-largest island in the world), is today divided between two countries. The eastern half of the island is part of the modern nation of Papua New Guinea; the western half is Irian Jaya, a province of present-day Indonesia. Located near the equator and with mountains that rise to 16,000 feet, the island inhabitants utilize a variety of environments, from coastal mangrove marshes to grasslands, from dense rain forests to swampy river valleys. The population is equally diverse, with coastal fishermen, riverine hunters, slash-and-burn agriculturalists, and more stable farming communities in the highlands. Between New Guinea itself and the smaller neighboring islands more than 700 languages have been identified.

THE TAMBERAN HOUSE OF THE ABELAM OF PAPUA NEW GUINEA. The Abelam, who live in the foothills of the mountains on the north side of Papua New Guinea, raise pigs and cultivate yams, taro, bananas, and sago palms. In traditional Abelam society, people live in extended families or clans in hamlets. Wealth among the Abelam is measured in pigs, but men gain status from participation in a yam cult that has a central place in Abelam society and in the iconography of its art and architecture. The yams that are the focus of this cult-some of which reach an extraordinary 12 feet in length—are associated with clan ancestors and the potency of their growers. Village leaders renew their relationship with the forces of nature that vams represent during the Long Yam Festival, which is held at harvest time and involves processions, masked figures, singing, and the ritual exchange of the finest yams.

An Abelam hamlet includes sleeping houses, cooking houses, storehouses for yams, a central space for rituals, and a *tamberan* house. The term refers to something that the uninitiated are not allowed to view. In this ceremonial structure the images and objects associated with the yam cult and with

Art and Its Context

BOATS IN OCEANIA

mong island dwellers, boats are essential. In the Pacific their forms varied, depending on their purpose and the materials available. For example, a canoe for fishing in a calm lagoon would have different requirements from a battle canoe used for attacking across the open sea. Canoes ranged in size from simple dugouts and single outriggers (used throughout Polynesia) to double-hull canoes, which in Tahiti could carry up to 300 men. In the Gambier Islands of Polynesia, the Mangarevans did not traditionally build canoes at all; rather their ocean journeys were made on large rafts that could be fitted together to compose ocean-going platforms. Elsewhere in Polynesia, on coral atolls where plant life was limited, there were few large trees to use in canoe building. In the Tuamotu Islands, residents overcame this deficiency by making canoes out of small wooden planks sewn together with coconut fiber rope. Many canoes were paddled, but others had sails, or were powered by a combination of sail and paddle.

Some Melanesian and Polynesian canoes were relatively unornamented either because they were purely functional canoes and did not require ornamental elaboration to perform their task, or because of the circumstances of their use. For example, Hawaiian canoes tend to be uncarved because the oceans around the islands can be very violent and any carving would interfere with the streamlined form needed for safe control in high seas.

The most elaborate canoes were ocean-going sailing and war canoes. As the public political and martial face of the community, islanders wanted such boats to make a dramatic impression. Their prows and sterns were larger than needed to cut through the water, and they were often decorated with elaborate images of animals and humans as well as spirals and geometric shapes. In addition, many decorations were embellished with inlaid shell and painted designs. The most dramatic war canoes came from New Zealand and from the islands just north and east of New Guinea.

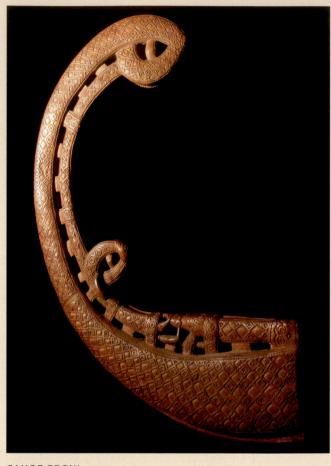

CANOE PROW
Kaniet Manus Province, Papua New Guinea.
Wood, length 18%" (46 cm). Otago Museum, Dunedin.

clan identity are kept hidden from women and uninitiated boys. Men of the clan gather in the *tamberan* house to organize rituals and conduct community business, and—in the past—to plan raiding parties. The prestige of a hamlet is linked to the quality of its *tamberan* house and the size of its yams. Constructed on a frame of poles and rafters and roofed with split cane and thatch, *tamberan* houses are built with a triangular floor plan, the side walls meeting at the back of the building. The façade is elaborately painted and carved (FIG. 27–5). In this example, built about 1961, red, ocher, white, and black faces of male spirits make up the bottom and middle rows on the façade, and at the top the figure is said to represent a female flying witch. This last figure is associated with the feminine power of the house itself. The projecting

pole at the top of the house is the only male element of the architecture, and is said to be the penis of the house. The small door at the lower right is a female element, a womb; entering and exiting the house is the symbolic equivalent to death and rebirth. The Abelam believe the paint itself has magical qualities. Regular, ritual repainting revitalizes the images and ensures their continued potency.

Every stage in the construction of a *tamberan* house is accompanied by ceremonies, which are held in the early morning while women and boys are still asleep. The completion of a house is celebrated with elaborate fertility rituals and an all-night dance. Women participate in these inaugural ceremonies and are allowed to enter the new house, which afterward is ritually cleansed and closed to them.

Ancestral Spirit Poles of the Asmat of Irian Jaya. The Asmat, who live in the grasslands on the southwest coast, were known in the past as warriors and headhunters. They identified trees with human beings, their fruit with human heads. Fruiteating birds were thus the equivalent of headhunters, and were often represented in war and mortuary arts, as was the praying mantis, because the female of the species bites off the head of the male while mating. To honor the dead the Asmat erected memorial poles covered with elaborate sculpture (FIG. 27–6). The poles are known as *mbis*, and the rituals surrounding them are intended to reestablish the balance between life and death. The Asmat believe that *mbis* house the souls of the recent dead, and they place them in front of the men's house of the village so the souls can observe the rituals there. After the *mbis* ceremonies, the poles are abandoned and allowed to deteriorate.

In the past, once the poles had been carved, villagers would organize a headhunting expedition so that they could place an enemy head in a cavity at the base of each pole. The base, with its abstract voids for enemy heads, represents the twisting roots of the banyan tree. Above the base, figures representing tribal ancestors support figures of the recent dead.

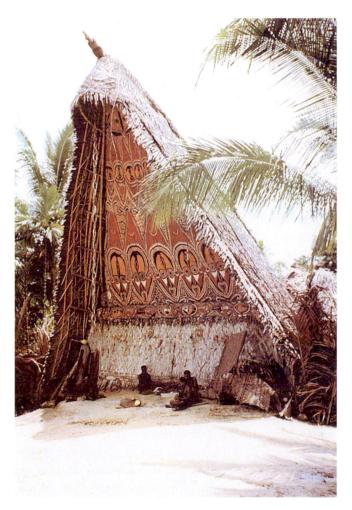

27–5 | EXTERIOR OF TAMBERAN HOUSE Kinbangwa village, Sepik River, Papua New Guinea, New Guinea. Abelam, 20th century. Carved and painted wood, with ocher pigments on clay ground.

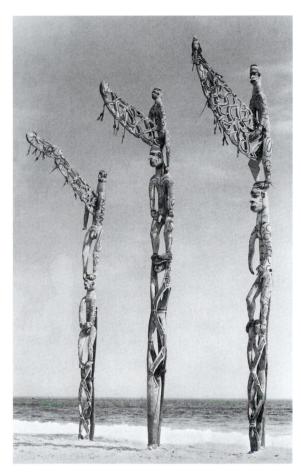

27–6 | ASMAT ANCESTRAL SPIRIT POLES (MBIS)
Faretsj River, Irian Jaya, Indonesia, New Guinea. c. 1960.
Wood, paint, palm leaves, and fiber, height approx. 18'
(5.48 m). Photograph in the Metropolitan Museum of Art,
New York.

The Michael C. Rockefeller Memorial Collection, Gift of Nelson A. Rockefeller and Mrs. Mary C. Rockefeller, 1965 (1978.412.1248-50)

The bent pose of the figures associates them with the praying mantis; birds are shown breaking open nuts. The large, lacy phalluses emerging from the figures at the top of the poles symbolize male fertility, and the surface decoration suggests tattoos and scarification (patterned scars), common body ornamentation in Melanesia.

New Ireland

New Ireland is one of the large eastern islands of the nation of Papua New Guinea. The northern people on the island practice a complex set of integrated cultural traditions known as *malanggan*, which are ceremonies that honor one's family and the family into which one marries. *Malanggan* are integral to honoring the dead, and one of the most important aspects of the traditions are elaborate funerary rituals for which striking painted carvings and masks are made. *Malanggan* involve an entire community as well as its neighbors and serve to validate social relations and property claims.

Although preparations are hidden from women and children, everyone participates in the actual ceremonies.

27–7 | DANCERS WEARING TATANUA MASKS Pinikindu Village, central New Ireland, Papua New Guinea, New Guinea. 1979. Masks: wood, vegetable fibers, trade cloth, and pigments, approx. 17 \times 13" (43 \times 33 cm).

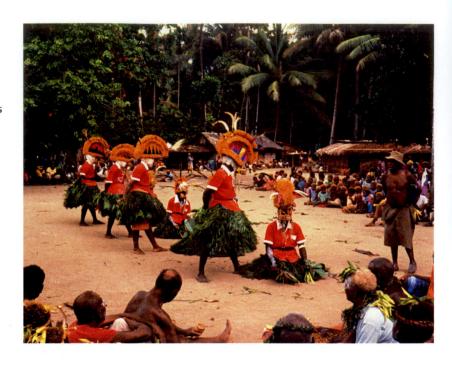

Arrangements begin with the selection of trees to be used for the *malanggan* carvings. In a ceremony marked by a feast of taro and pork, the logs are cut, transported, and ritually pierced. Once the carvings are finished, they are dried in the communal men's house, polished, and then displayed in a *malanggan* house in the village *malanggan* enclosure. Here the figures are painted and eyes made of sea-snail shell are inserted. The works displayed in a *malanggan* house include figures on poles and freestanding sculpture representing ancestors and the honored dead, as well as masks and ritual dance equipment.

TATANUA DANCE MASKS. One of the many ceremonies that make up the malanggan in New Ireland is a dance called tatanua that commemorates the dead. The term tatanua can be used to refer to the dance itself as well as the distinctive helmet masks worn by the male dancers. Tatanua masks represent one of the three souls of the dead (FIG. 27-7). They are carved and painted with simple, repetitive motifs such as ladders, zigzags, and stylized feathers. Traditional paint colors are applied in a ritually specified order: first lime white for magic spells; then red ocher to recall the spirits of those who died violently; then black from charcoal or burned nuts, a symbol of warfare; and finally yellow and blue from vegetable materials. The left and right sides of the magnificent crest of plant fiber are different colors, perhaps a reflection of a long-ago hairstyle in which the hair was cut short and left naturally black on one side and dyed yellow and allowed to grow long on the other. The contrasting sides of the masks allow dancers to present a different appearance by turning from side to side. A good performance of the tatanua dance is considered a demonstration of strength, while a mistake can bring laughter and humiliation.

MICRONESIA

The majority of Micronesia's inhabited islands are small, low-lying coral atolls. But in the western region several are volcanic in origin. The basalt cliffs of the island of Pohnpei provided the building material for one of the largest and most remarkable stone architectural complexes in Oceania.

Nan Madol. Nan Madol, on its southeast coast, consists of 92 artificial islands set within a network of canals covering about 170 acres (MAP 27–2). Seawalls and breakwaters 15 feet high and 35 feet thick protect the area from the ocean. When it was populated, openings in the breakwaters gave canoes access to the ocean and allowed seawater to flow in and out with the tides, flushing clean the canals. While other similar complexes have been identified in Micronesia, Nan Madol is the largest and most impressive, reflecting the importance of the kings who ruled from the site. The artificial islands and the buildings atop them were built between the early thirteenth and seventeenth centuries, until the dynasty's political decline. The site had been abandoned by the time Europeans discovered it in the nineteenth century.

Nan Madol was an administrative and ceremonial center as well as a home for as many as 1,000 people at one time. The powerful kings drew upon the labor force to construct a monumental city. Both the buildings and the underlying islands themselves are built of massive pieces of stone set in alternating layers of log-shaped stones and boulders of prismatic basalt. The largest of the artificial islets is more than 100 yards long, and one basalt cornerstone alone is estimated to have weighed about 50 tons. The stone logs were split from the cliffs by alternately heating the stone and dousing it with water. Most of the islands are oriented northeast-southwest, receiving the benefit of the cooling prevailing winds.

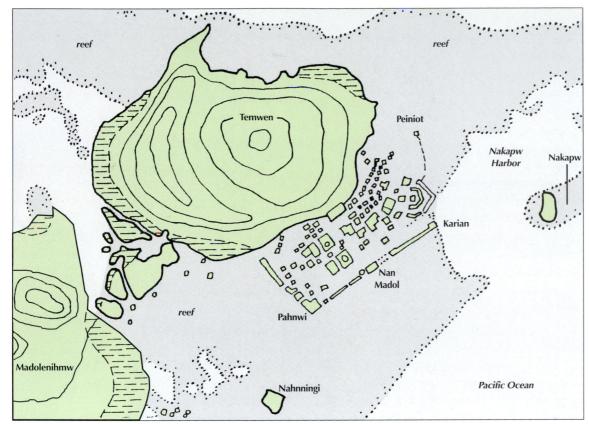

MAP 27–2 THE COMPLEX OF NAN MADOL
Pohnpei, Federated States of Micronesia. c. 1200/1300-c. 1500/1600.

The royal mortuary compound, which once dominated the southeast side of Nan Madol (FIG. 27–8), has walls rising in subtle upward and outward curves to a height of 25 feet. To achieve the sweeping, rising lines, the builders increased the number of stones in the header courses (those with the ends of the stones laid facing out along the wall) relative to the stretcher courses (those with the lengths of the stones laid parallel to the wall) as they came to the corners and entryways. The plan of the structure consists simply of progressively higher rectangles within rectangles—the outer walls leading by steps up to interior walls that lead up to a central courtyard with a small, cubical tomb.

POLYNESIA

The settlers of the far-flung islands of Polynesia developed distinctive cultural traditions but also retained linguistic and cultural affinities that reflect their common origin. Traditional Polynesian society was generally far more stratified than Melanesian society, and Polynesian art objects served as indicators of rank and status. Valued both as material objects and for the status they conferred, Polynesian artworks often were handed down as heirlooms from generation to generation.

In addition to being the last area of the Pacific to have been settled by humans, Polynesia was the last area mapped and colonized by Europeans. The most informative early explorations were led by the English captain James Cook, who made three voyages to the Pacific in the 1760s and 1770s. His expeditions mapped the Great Barrier Reef of

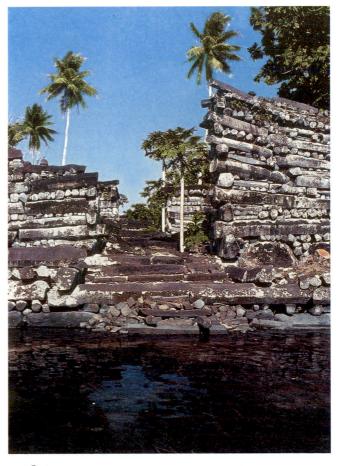

27–8 | ROYAL MORTUARY COMPOUND, NAN MADOL Pohnpei, Federated States of Micronesia. Basalt blocks, wall height up to 25^\prime (7.62 m).

Australia and both islands of New Zealand in addition to "finding" the Hawaiian Islands. These were voyages of discovery, and scientific study was a major activity and goal. In addition to astronomers, botanists, and other scientists, Cook brought artists to the Pacific to record visual images of the new plants, animals, places, and peoples that were encountered. Our earliest images of some of the peoples of the Pacific come from these artists.

European contact had a profoundly disruptive effect on society and art in Polynesia, as elsewhere in Oceania. Explorers, and later whalers, traded for or otherwise took objects of cultural importance, often misunderstanding the significance of the items they transported back to Europe and North America. The income derived from sales to European collectors quickly affected the production of such artworks, gradually debasing their original significance in their own cultural context and turning these artworks into mere commercial objects for the tourist trade.

Missionaries followed the explorers and their impact on the art of the Pacific Islands was just as dramatic. They encouraged the abandonment and even destruction of objects used in ritual context. They also promoted changes in the subject matter of religious art. Even attire changed significantly under the influence of Christian settlers, who insisted on much more coverage of the body than had been common previously, particularly in the case of women who had often gone bare-breasted before European contact.

Easter Island

Easter Island is the most isolated inhabited locale in Oceania, some 2,300 miles west of the coast of South America and 1,200 miles from Pitcairn Island, the nearest Polynesian outpost. Three volcanoes, one at each corner, make up the small triangular island. Originally known to its native inhabitants as Te Pito o te Henúa (Navel of the World) and now known as Rapanui, the name "Easter Island" was given by Captain Jacob Roggeveen, the Dutch explorer who first landed on the island on Easter Sunday in 1722.

MONUMENTAL MOAL. Easter Island is the site of Polynesia's most impressive sculpture. Stone temples, or *marae*, with stone altar platforms, or *ahu*, are common throughout Polynesia. Most of the *ahu* are built near the coast, parallel to the shore. About 900 CE, Easter Islanders began to erect huge stone figures on *ahu*, perhaps as memorials to dead chiefs. Nearly 1,000 of the figures, called *moai*, have been found, including some unfinished in the quarries where they were being made. Carved from tufa, a yellowish brown volcanic stone, most are about 36 feet tall, but one unfinished figure measures almost 70 feet. In 1978 several figures were restored to their original condition, with red tufa topknots on their heads and white coral eyes with stone pupils (FIG. 27–9). The heads have deep-set eyes under a prominent brow ridge; a

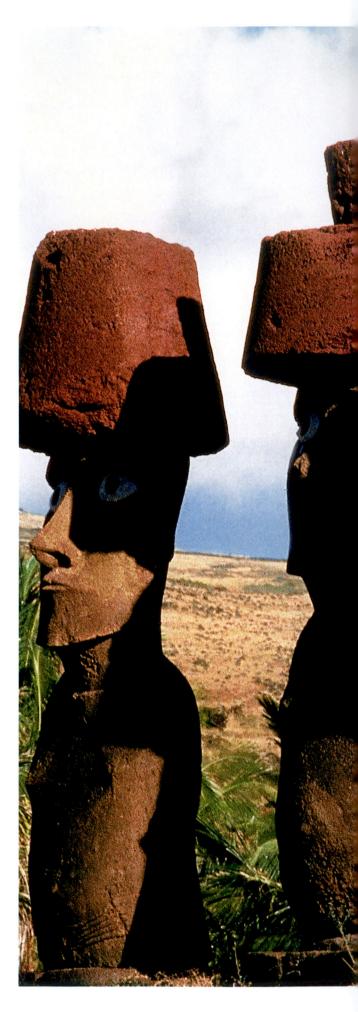

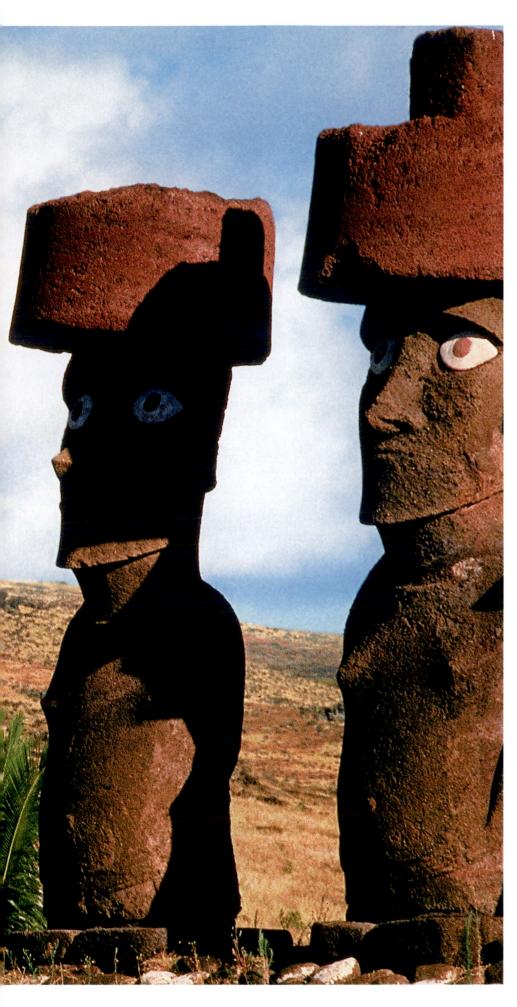

27–9 | MOAI ANCESTOR
FIGURES (?) Ahu Nau Nau,
Easter Island, Polynesia.
c. 1000–1500, restored 1978.
Volcanic stone (tufa), average
height approx. 36' (11 m).

THE OBJECT SPEAKS

FEATHER CLOAK

hen the Hawaiian King Kamehameha presented a feathered cape to the English explorer George Vancouver for King George III, it was a gift appropriate for a king. Like England, the stratified society of Polynesia had an elite social class to which people were born and from which they could not fall, no matter what events entangled them. The feathered cloak was an emblem of that status, and the right to wear it was restricted to members of the highest social level. The clothing is called 'Ahu 'ula ("red cloak"), which refers to the red color associated with royalty in Hawaii, much in the same way as purple was the color of royalty in the Byzantine Empire. Draped over the wearers' shoulders, such cloaks create a sensuously textured and colored abstract design. When the garment shown here is worn, the symmetrical arrangement of paired crescents join to create matching decorations on front and back.

Feathers were used for decorating not just cloaks, but also helmets, capes, blankets, and garlands (*leis*), all of which conferred status and prestige. Tall feather

pompons (kahili) mounted on long slender sticks were symbols of royalty. Even the effigies of gods that Hawaiian warriors carried into battle were made of light, basketlike structures covered with feathers. The feathered capes and cloaks worn by Hawaiian chiefs in war and ceremony indicated the relative status of the chief within the highly stratified Polynesian society. The most valuable capes and cloaks were full length and made with red, black, and yellow feathers. Shorter ones and capes using green feathers and feathers from less-desirable birds marked upper-class members of a lower rank.

The annual tribute paid to the king by his subjects included feathers. These went to the king who then redistributed them to his chiefs. Members of the upper class, while not guaranteed a feather cloak, had the right to accumulate feathers for making one. The greater a chief's prestige, the closer he was to the king, and thus the more access he had to the tribute feathers that were the king's to bestow. The yellow feathers used in cloaks were especially prized because they were particularly rare. While several birds in Hawaii had yellow

feathers, only the tail feathers of the mamo bird (now extinct) were considered desirable. These birds were snared, their tail feathers plucked, and then released. Each bird gave only a few feathers, usually no more than eight, in any given year. Thus the labor necessary to obtain them was intensive, and the limitation to a particular type of bird created an artificial scarcity of yellow feathers, making a fulllength cloak with wide areas of yellow even more valuable. At the same time, the use of red indicated featherwork as being the property of the highest social classes, so the feathered cloaks of red and yellow symbolically express both social and economic power.

The cloak's foundation consisted of coconut fiber netting onto which bundles of feathers were tied. Unlike tapa cloth, these cloaks were so closely associated with the spiritual power (mana) of the chief that they could be made only by men, who were surrounded by sacred protective objects as they worked. While they knotted the cloaks, the makers recited the chief's genealogy, imbuing the object with the power of the ancestors.

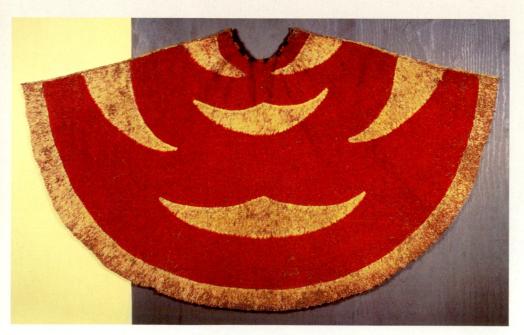

FEATHER CLOAK, KNOWN AS THE KEARNY CLOAK

Hawaii. c. 1843. Red, yellow, and black feathers, olona cordage, and netting, length 55½" (143 cm).
Bishop Museum, Honolulu.

King Kamehameha III (ruled 1825-54) presented this cloak to Commodore Lawrence Kearny, commander of the frigate USS Constellation.

long, concave, pointed nose; a small mouth with pursed lips; and an angular chin. The extremely elongated earlobes have parallel engraved lines that suggest ear ornaments. The figures have schematically indicated breastbones and pectorals, and small arms with hands pressed close to the sides, but no legs.

Easter Islanders stopped erecting *moai* around 1500 and entered a period of warfare among themselves, apparently because overpopulation was straining the island's available resources. Most of the *moai* were knocked down and destroyed during this period. The island's indigenous population, which may at one time have consisted of as many as 10,000 people, was nearly eradicated by Peruvian slave traders in the nineteenth century. The smallpox and tuberculosis they brought with them precipitated an epidemic that left only about 600 Easter Island inhabitants alive.

Marquesas Islands

The first inhabitants of Easter Island probably were voyagers from the Marquesas Islands, almost 2,000 miles to the west. The Marquesas are made up of several volcanic islands in two groups, one north of the other. Only six of the islands are inhabited. The natives were noted for their warfare, the culmination of which was often cannibalism. Contact with outsiders beginning in 1595 decimated the Marquesans. The worst century for declining population began in 1800, when there were an estimated 90,000 people living on the islands. By 1900 census figures show the population had dropped to about 3,500, and the native population reached its low of less than 2,000 by 1930. Even with their local traditions of violence and warfare, the greatest threat to the native way of life had come from outside, with diseases such as smallpox brought by visitors to the islands.

WAR CLUB. Traditional fighting in the Marquesas was hand-to-hand and warriors used elaborate regalia to convey their rank and status. A 5-foot-long ironwood war club (FIG. 27–IO) is lavishly decorated, with a Janus-like double face at the end. The high, arching eyebrows frame sunburst eyes whose pupils are tiny faces. Other patterns seem inspired by human eyes and noses. The overlay of low relief and engraved patterns suggests tattooing, a highly developed art in Polynesia (FIG. 27–II).

New Zealand

New Zealand was the last part of Polynesia to be settled. The first inhabitants had arrived by about the tenth century, and their descendants, the Maori, numbered in the hundreds of thousands by the time of European contact in the seventeenth and eighteenth centuries.

PORTRAIT OF A MAORI. Captain Cook's first expedition explored the coast of New Zealand in 1769. Sydney Parkinson (1745?–71), one of the artists on the voyage, documented aspects of Maori life and art at the time. An unsigned drawing

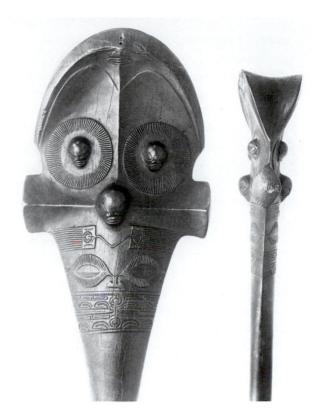

27–IO WAR CLUB
Marquesas Islands, Polynesia. Early 19th century.
Ironwood, length approx. 5' (1.52 m).
Peabody Essex Museum, Salem, Massachusetts.

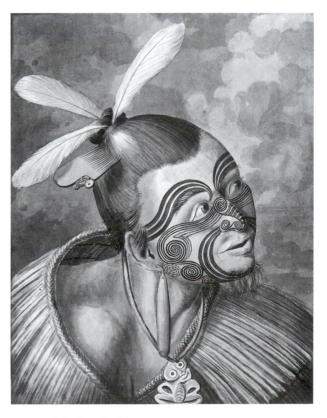

27–II | Sydney Parkinson PORTRAIT OF A MAORI 1769 Wash drawing, 15 $\frac{1}{2}$ × 11 $\frac{1}{8}$ " (39.37 × 29.46 cm), later engraved and published as plate XVI in Parkinson's *Journal*, 1773. The British Library, London.

by Parkinson (FIG. 27–11) shows a Maori with facial tattoos (moko) wearing a headdress with feathers, a comb, and a heitiki (a carved pendant of a human figure).

Combs similar to the one in the drawing can still be found in New Zealand. The long ear pendant is probably made of greenstone, a form of jade found on New Zealand's South Island that varies in color from off-white to very dark green. The Maori considered greenstone to have supernatural powers. The hei-tiki hanging on a cord around the man's neck would have been among his most precious possessions. Such tiki figures, which represented legendary heroes or ancestor figures, gained power from their association with powerful people. The tiki in this illustration has an almost embryonic appearance, with its large tilted head, huge eyes, and seated posture. Some tiki had large eyes of inlaid shell.

The art of tattoo was widespread and ancient in Oceania; bone tattoo chisels have even been found in Lapita sites. Both men and women were tattooed, and in modern traditional societies, both men and women do the tattooing on members of their own gender. Maori men generally had tattoos on the face and on the lower body between the waist and the knees. Women were tattooed around the mouth and on the chin. The typical design of men's facial tattoos, like the striking one shown here, consisted of broad, curving parallel lines from nose to chin and over the eyebrows to the ears. Small spiral patterns adorned the cheeks and nose. Additional spirals or other patterns were placed on the forehead and chin and in front of the ears. A formal, bilateral symmetry controlled the design. Maori men considered their moko designs to be so personal that they sometimes signed documents with them. Ancestor carvings in Maori meetinghouses also have distinctive moko. According to Maori mythology, tattooing, as well as weaving and carving, was brought to them from the underworld, the realm of the Goddess of Childbirth. Moko might thus have a birth-death symbolism that links the living with their ancestors.

CARVED LINTEL. The Maori are especially known for their wood carving, which is characterized by a combination of massive underlying form with delicate surface ornament. This combination is found in small works like the hei-tiki in Parkinson's drawing as well as in the larger-scale sculpture that adorned

storehouses and meetinghouses in Maori hilltop villages.

A carved lintel, probably collected on Captain Cook's second voyage in 1773, is one of the earliest surviving Maori sculptures in North America (FIG. 27–12). From its place over a doorway, the sculpture confirmed the power and prestige of its owners. The composition revolves around a central figure, a standing tiki. The fearsome square head glares at the world with glittering blue and green haliotis shell pupils set in triangular eyes under heavy eyebrows. Flaring nostrils and an open figure-eight shaped mouth with protruding tongue add to the terrifying aspect of the figure. The tongue gesture is defiant and aggressive. Massive arms and legs swell under a dense pattern of surface ornament and end in clawlike hands and feet. The tiki clutches a whale or fish. Glittering shell eyes help to sort out other fantastic, interlocking creatures, whose forms are nearly lost under the continuous spirals of surface ornament. The wood itself glows with a rich reddish-brown color, produced by rubbing the surface with a mixture of red clay and shark-liver oil, which colors and waterproofs the lintel.

MAORI MEETINGHOUSE. Only this lintel remains of what must have been an important building, but in the Museum of New Zealand in Wellington a meetinghouse carved by the master carver Raharuhi Rukupo in 1842-43 has been restored and re-erected.

This meetinghouse was built by Rukupo as a memorial to his brother (FIG. 27-13). Rukupo, who was an artist, diplomat, warrior, priest, and early convert to Christianity, built the house with a team of eighteen wood carvers. Although they used European metal tools, they worked in the technique and style of traditional carving done with stone tools. They finished the carved wood as usual, by rubbing it with a combination of red clay and shark-liver oil.

The whole structure symbolizes the sky father. The ridgepole is his backbone, the rafters are his ribs, and the slanting bargeboards—the boards attached to the projecting end of the gable—are his outstretched enfolding arms. His head and face are carved at the peak of the roof. The curvilinear patterns on the rafters were made with a silhouetting technique. Artists first painted the rafters white, then outlined the patterns, and finally painted the background red or black,

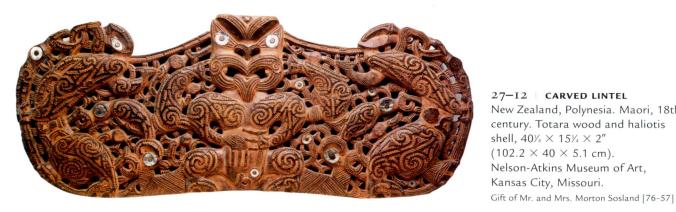

27-I2 CARVED LINTEL New Zealand, Polynesia. Maori, 18th century. Totara wood and haliotis shell, $40\frac{1}{4} \times 15\frac{3}{4} \times 2^{"}$ $(102.2 \times 40 \times 5.1 \text{ cm}).$ Nelson-Atkins Museum of Art, Kansas City, Missouri.

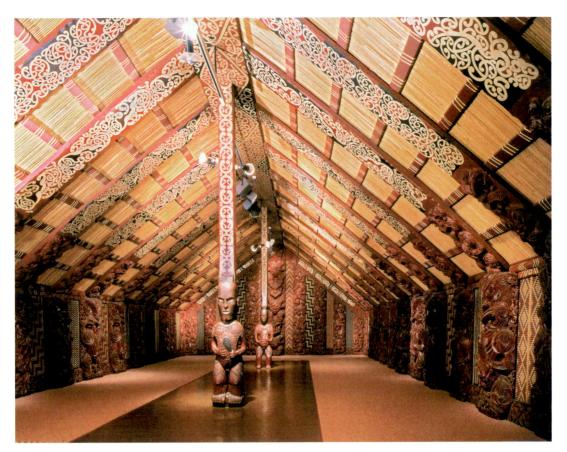

27–13 Raharuhi Rukupo, master carver TE-HAU-KI-TURANGA (MAORI MEETINGHOUSE) Manutuke Poverty Bay, New Zealand. 1842–43, restored in 1935. Wood, shell, grass, flax, and pigments. The Museum of New Zealand Te Papa Tongarewa, Wellington.

Neg. B18358

leaving the patterns in white. Characteristically Maori is the koru pattern, a curling stalk with a bulb at the end that is said to resemble the young tree fern.

Relief figures of ancestors—Raharuhi Rukupo included a portrait of himself among them—cover the support poles, wall planks, and the lower ends of the rafters. The ancestors, in effect, support the house. They were thought to take an active interest in community affairs and to participate in the discussions held in the meetinghouse. Like the *hei-tiki* in FIGURE 27–11, the figures have large heads. Flattened to fit within the building planks and covered all over with spirals, parallel and hatched lines, and tattoo patterns, they face the viewer head on with glittering eyes of blue–green inlaid shell. Their tongues stick out in defiance from their grimacing mouths, and they squat in the posture of the war dance.

Lattice panels made by women fill the spaces between the wall planks. Because ritual prohibitions, or taboos, prevented women from entering the meetinghouse, they worked from the outside and wove the panels from the back. They created the black, white, and orange patterns from grass, flax, and flat slats. Each pattern has a symbolic meaning: chevrons represent the teeth of the monster Taniwha; steps represent the stairs of heaven climbed by the hero-god Tawhaki; and diamonds represent the flounder.

Considered a national treasure by the Maori, this meetinghouse was restored in 1935 by Maori artists from remote areas who knew the old, traditional methods and is now preserved at the Museum of New Zealand.

Hawaiian Islands

Until about 1200 CE the Hawaiian Islands remained in contact with other parts of Polynesia; thereafter they were isolated, and the rigidly stratified Hawaiian society divided into several independent chiefdoms. Their isolation came to an end in 1778 with the arrival of the explorer Captain James Cook, who named them the Sandwich Islands after one of his patrons, the Earl of Sandwich. His first arrival coincided with a season of celebration in honor of the Hawaiian god Lono, and Captain Cook was regarded as a representative or emissary from that god. However his ship was damaged by a storm at sea shortly after leaving Hawaii and he went back for repairs. During the return visit relations with the Hawaiians were less cordial, and Cook was killed in a confrontation with them.

At the time of Cook's visit the islands were governed by several independent chiefdoms. In 1810 one ruler, Kamehameha I (c. 1758–1819), consolidated the islands into a unified kingdom. His family ruled until 1872, and the monarchy itself lasted until the dethronement of Queen

Lili'uokalani in 1893. Throughout the nineteenth century the influence of United States missionaries and economic interests increased, and Hawaii's traditional religion and culture declined. The United States annexed Hawaii in 1898, and the territory became a state in 1959.

When the Polynesians settled in Hawaii, they brought with them the production of bark cloth. This cloth, known as tapa or kapa, was usually made by women, sometimes with the assistance of men in obtaining the bark or in the decoration of the completed cloth. The bark used in the cloth was stripped from certain trees, particularly the "paper-mulberry" (not a true mulberry tree, but widely cultivated in the Pacific islands). It was washed in seawater, dried, and then softened by being soaked again in salt water and rinsed in fresh water. Layers of bark were folded over and beaten together, building up the cloth in a process of felting. In Hawaii the faces of the wooden mallets used for beating the cloth were incised with complex patterns, which left impressions in the cloth like watermarks, viewable when the cloth is held up to the light.

The traditional Hawaiian women's dress consisted of a sheet of bark cloth wrapped around the body either below or above the breasts. The example shown here (FIG. 27-14) belonged to Queen Kamamalu. Such garments were highly prized and considered to be an appropriate diplomatic gift. The queen took bark-cloth garments with her when she and King Kamehameha II made a state visit to London in 1823.

Bark cloth, with its easily available material and simple method of manufacture, is a common medium throughout Polynesia and Melanesia. Plain and decorated cloth was used

27-14 SKIRT ORIGINALLY BELONGING TO QUEEN KAMA-MALU Hawaii. 1823-24. Paper mulberry (wauke) bark, stamped patterns, $12'3'' \times 5'6''$ (3.77 × 1.7 m). Bishop Museum, Honolulu. Gift of Evangeline Priscilla Starbuck, 1927 (C.209)

for clothing, sails, mats, and ceremonial objects. Although there was great diversity in the islands of the Pacific, the restricted natural resources on any one archipelago and limited contact with outsiders meant that residents developed distinctive art styles for such products as tapa cloth even when the material used was essentially the same from one island to the next.

Various thicknesses and qualities of bark cloth were used for different purposes. Melanesians in one region of Vanuatu even made lightweight bark cloth for use as mosquito netting. Often the roughest, heaviest cloth would be used for mats, but clothing too was often quite rough. In Tikopia in the Solomon Islands, for example, a man's waist cloth was known to be uncomfortably scratchy for the first day or so.

The decoration of bark cloth varied. It could be dyed with turmeric or mud. It was sometimes exposed to smoke to turn it black or dark brown. Fine bark cloth was sometimes decorated in red or black with repeated geometric patterns made with tiny bamboo stamps or painted with freehand designs. The cloth could also be worked into a kind of appliqué, in which a layer of cutout patterns, usually in red, was beaten onto a light-colored backing sheet.

While bark cloth's most common use is functional, as clothing and for such items as mats and sails, tapa was also used for symbolic purposes, for example, to wrap wooden or wicker frames to make human effigies for display during festivals in the Marquesas and Easter Island. In addition to presenting clothing as a royal gift, pieces of bark cloth were exchanged for political advantage. In western Polynesia very large pieces, 7 to 10 feet across and hundreds of feet long, traditionally were given in ceremonial exchanges of valuables.

RECENT ART IN OCEANIA

Many contemporary artists in Oceania, in a process anthropologists call reintegration, have responded to the impact of European culture by adapting traditional themes and subjects to new mediums and techniques. The work of a Hawaiian quilt maker and an Australian aboriginal painter provide two examples of this process.

A QUILT FROM HAWAII. Missionaries encouraged women in the production of fiber arts, even though traditionally both men and women participated to varying extents in the making of such objects. Fabric patchwork and quilting were introduced to the Hawaiian Islands in 1820, and Hawaiian women were soon making distinctive, multilayered stitched quilts. Over time, as European-type cloth became increasingly available, the new arts replaced bark cloth in prestige, and today they are held in high esteem. Quilts are brought out for display and given as gifts to mark holidays and rites of passage, such as weddings, anniversaries, and funerals. They are also important gifts for establishing bonds between individuals and communities.

Royal Symbols, by contemporary quilter Deborah (Kepola) U. Kakalia, is a luxurious quilt with a two-color pattern reminiscent of bark-cloth design (FIG. 27-15). It combines heraldic imagery from both Polynesian and European sources to communicate the artist's proud sense of cultural identity. The crowns, the rectangular feather standards (kahili) in the corners, and the boldly contrasting red and yellow colors-derived from traditional featherwork—are symbols of the Hawaiian monarchy, even though the crowns have been adapted from those worn by European royalty. The kahili are ancient Hawaiian symbols of authority and rule, and the eight arches arranged in a cross in the center symbolize the uniting of Hawaii's eight inhabited islands into a single kingdom. The quilt's design, construction, and strong color contrasts are typically Hawaiian. The artist created the design the way children create paper snowflakes, by folding a piece of red fabric into eight triangular layers, cutting out the pattern, and then unfolding it. The red fabric was then sewn onto a yellow background and quilted with a technique known as contour stitching, in which the quilter follows the outlines of the design layer with parallel rows of tiny stitches. This technique, while effectively securing the layers of fabric and batting together, also creates a pattern that quilters liken to breaking waves.

Aborigine artists have adopted canvas and acrylic paint for rendering imagery traditionally associated with more ephemeral mediums like bark, body, and sand painting. Sand painting is an ancient ritual art form that involves creating large colored designs on bare ground. These paintings are done with red and yellow ochers, seeds, and feathers arranged on the ground in dots and other symbolic patterns. They are used to convey tribal lore to young initiates. Led by an art teacher named Geoffrey Bardon, a group of Aborigines

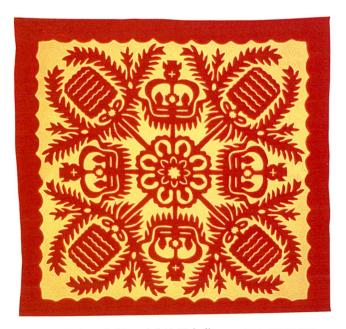

27–15 | Deborah (Kepola) U. Kakalia ROYAL SYMBOLS 1978. Quilt of cotton fabric and synthetic batting, appliqué, and contour stitching, $6'6\%'' \times 6'4\%'' (1.98 \times 1.96 \text{ m})$. Courtesy of Joyce D. Hammond, Joyce D. Hammond Collection

Sequencing Works of Art

c. 1000-1500	<i>Moai</i> ancestor figures (?) originally built, Easter Island
1842-43	Raharuhi Rukupo,.Te-Hau-ki- Turanga, New Zealand
c. 1960	Asmat ancestral spirit poles (mbis), New Guinea
1978	Deborah (Kepola) U. Kakalia, Royal Symbols
1978	Clifford Possum Tjapaltjarri, Man's Love Story

expert in sand painting formed an art cooperative in 1971 in Papunya, in central Australia. Their success in transforming their ephemeral art into a painted mural on the school wall encouraged community elders to allow others, including women, to try their hand at painting, which soon became an economic mainstay for many aboriginal groups in the central and western Australia desert.

Clifford Possum Tjapaltjarri (c. 1932–2002), a founder of the Papunya cooperative who gained an international reputation after an exhibition of his paintings in 1988, worked with his canvases on the floor, as in traditional sand painting, using ancient patterns and colors, principally red and yellow ochers as well as touches of blue. The superimposed layers of concentric circles and undulating lines and dots in a painting like *Man's Love Story* (FIG. 27–16) create an effect of shifting colors and lights.

The painting seems entirely abstract, but it actually conveys a narrative involving two mythical ancestors: One of these ancestors came to Papunya in search of honey ants; the white U shape on the left represents him seated in front of a water hole with an ants' nest, represented by the concentric circles. His digging stick lies to his right, and white sugary leaves lie to his left. The straight white "journey line" represents his trek from the west. The second ancestor, represented by the brownand-white U-shaped form, came from the east, leaving footprints, and sat down by another water hole nearby. He began to spin a hair string (a string made from human hair) on a spindle (the form leaning toward the upper right of the painting) but was distracted by thoughts of the woman he loved, who belonged to a kinship group into which he could not marry. When she approached, he let his hair string blow away (represented by the brown flecks below him) and lost all his work. Four women (the dotted U shapes) from the group into which he could marry came with their digging sticks and sat around the two men. Rich symbolism also fills other areas of the painting: The white footprints are those of another ancestral figure following a woman, and the wavy line at the top is the path of yet another ancestor. The black, dotted oval area indicates the site where young men were taught this story. The long horizontal bars are mirages. The wiggly shapes represent caterpillars, and the dots represent seeds, both forms of food.

27–16 | Clifford
Possum Tjapaltjarri
MAN'S LOVE STORY
1978. Synthetic polymer
paint on canvas,
6'11½" × 8'4½"
(2.15 × 2.57 m).
Art Gallery of South
Australia, Adelaide.
Visual Arts Board of the Australia
Council Contemporary Art
Purchase Grant, 1980

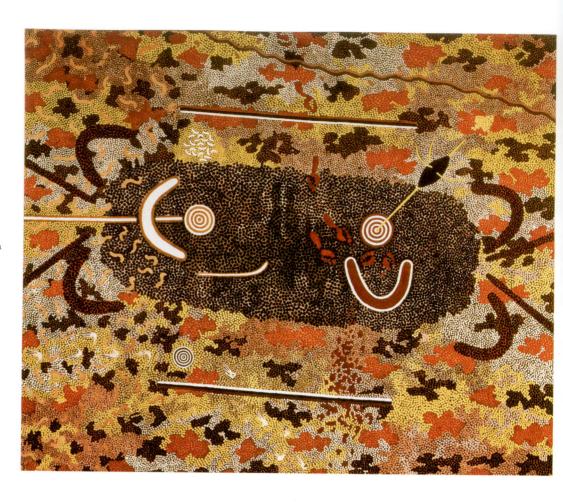

The point of view of this work may be that of someone looking up from beneath the surface of the earth rather than looking down from above. To begin the work Clifford Possum Tjapaltjarri first painted the landscape features and the impressions left on the earth by the figures—their tracks, direction lines, and the U-shaped marks they left when sitting. Then, working carefully, dot by dot, he captured the vast expanse and shimmering light of the arid landscape. The painting's resemblance to modern Western painting styles such as Abstract Expressionism, gestural painting, pointillism, or Color Field painting (Chapter 32) is accidental. Clifford Possum's work is rooted in the mythic, narrative traditions of his people. Although few artifacts remain from prehistoric times on the Pacific islands, throughout recorded history artists such as Possum have worked with remarkable robustness, freshness, and continuity. They have consistently created arts that express the deepest meanings of their culture.

IN PERSPECTIVE

Artists in the Pacific include the natives of Australia as well as the island groups of Melanesia, Micronesia, and Polynesia. The islands were the last region of the earth to be permanently settled, with some areas of Polynesia only inhabited during the last 1,000 years. There is great diversity among the cultures in these areas, reflecting the dramatic variation in the environment and resources available to native societies.

The small and sometimes isolated populations in the Pacific are intimately connected to their environment, utilizing the limited raw materials available to them to produce distinctive artworks closely linked to their religious lives and rituals. Clothing and body decorations such as body painting and tattooing are used to reflect social status and ethnic identity. Some of the scattered island groups of Micronesia and Polynesia produced dramatic stonework carved without metal tools, including monumental architecture and largescale stone sculpture. In parts of Australia, Aborigines lived as hunter-gatherers into the twentieth century. Their art reflects the continuity in their way of life and a deep spiritual connection to the landscape from antiquity through modern times. The largest island in Melanesia, New Guinea, has the most diverse environment in the Pacific. The combination of the environmental circumstances and the tens of thousands of years during which people lived there have allowed a wide variety of cultures to develop, each group speaking its own language and producing its own style of art.

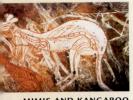

MIMIS AND KANGAROO 18,000-7000 BCE

FRAGMENTS OF A LARGE LAPITA JAR с. 1200-1100 все.

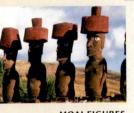

MOAI FIGURES c. 1000-1500 CE

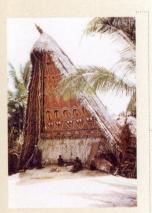

TAMBERAN HOUSE 20TH CENTURY

ART OF PACIFIC **CULTURES**

Farming Culture in Melanesia

c. 7000 BCE

 Australia Separates from Melanesia с. 4000 все

 Lapita Culture in Melanesia c. 1500 BCE

- Polynesians Settle Micronesia c. 1 CE
- Hawaii, Easter Island Settled After 500 CE
- New Zealand Settled c. 800/900-1200 CE

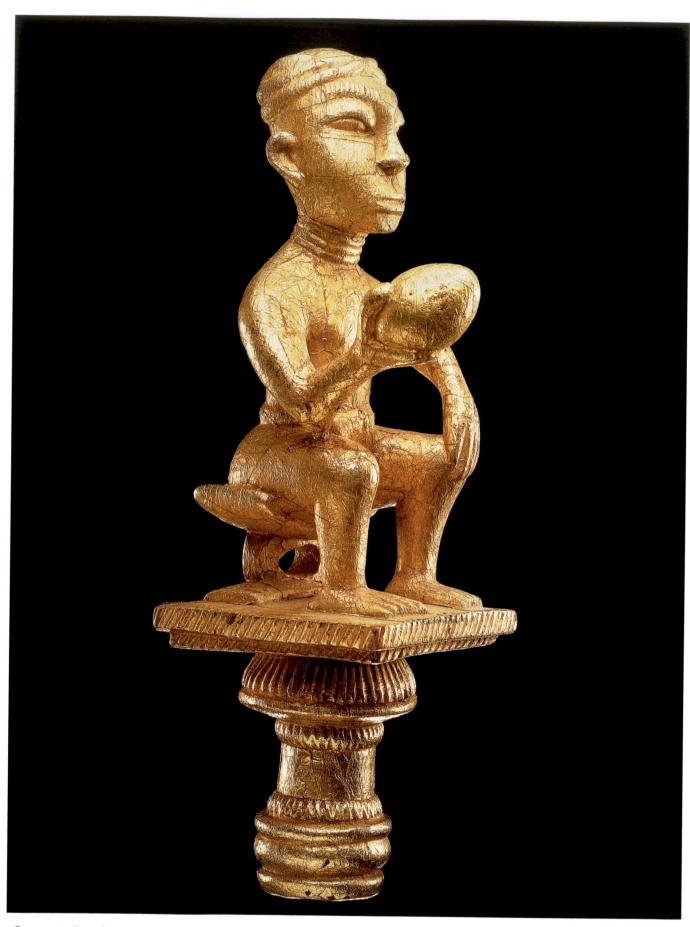

28–I | Attributed to Kojo Bonsu **FINIAL OF A SPOKESPERSON'S STAFF (***OKYEAME POMA***)** From Ghana. Ashanti culture. 1960s–70s. Wood and gold, height 11¼" (28.57 cm). Sarah Da Vanzo Collection, Johannesburg, South Africa.

CHAPTER TWENTY-EIGHT

ART OF AFRICA IN THE MODERN ERA

Political power is like an egg, says an Ashanti proverb. Grasp it too tightly and it will shatter in your hand; hold it too loosely and it will slip from your fingers. Whenever the *okyeame*, or spokesperson, for one twentieth-century

Ashanti ruler was conferring with that ruler or communicating the ruler's words to others, he held a staff with this symbolic caution on the use and abuse of power prominently displayed on the gold-leaf-covered finial (FIG. 28–1).

A staff or scepter is a nearly universal symbol of authority and leadership. Today in many colleges and universities a ceremonial mace is still carried by the leader of an academic procession, and it is often placed in front of the speaker's lectern, as a symbol of the speaker's authority. The Ashanti spokespersons who carry their image-topped staffs are part of this widespread tradition.

Since the fifteenth century, when the first Europeans explored Africa, objects such as this staff have been shipped

28

back to Western museums of natural history or ethnography, where they were catalogued as curious artifacts of "primitive cultures." Toward the end of the nineteenth century, however, changes in Western thinking about African cul-

ture gradually led more and more people to appreciate the inherent aesthetic qualities of these unfamiliar objects and at last to embrace them fully as art. In recent years scholars have further enhanced the appreciation of traditional African arts by exploring their meaning from the point of view of the people who made them.

If we are to understand African art such as this staff on its own terms, we must take it out of the glass case of the museum where we usually encounter it and imagine the artwork playing its vital role in a human community. Indeed, this is true of any work of art produced anywhere in the world. When we recognize in an artwork the true expression of values and beliefs, our imaginations cross a bridge to understanding.

- TRADITIONAL AND CONTEMPORARY AFRICA | Living Areas | Children and the Continuity of Life | Initiation | The Spirit World | Leadership | Death and Ancestors
- CONTEMPORARY ART
- IN PERSPECTIVE

TRADITIONAL AND CONTEMPORARY AFRICA

The second-largest continent in the world, Africa is a land of enormous diversity (MAP 28–1). Geographically, it ranges from vast deserts to tropical rain forest, from flat grasslands to spectacular mountains and dramatic rift valleys. Cultural diversity in Africa is equally impressive. More than 1,000 African languages have been identified and grouped by scholars into five major linguistic families. Various languages represent unique cultures, with their own history, customs, and art forms.

Before the nineteenth century, the most important outside influence to pervade Africa had been the religious culture of Islam, which spread gradually and largely peacefully through much of West Africa and along the East African coast (see "Foundations of African Cultures," page 921). The modern era, in contrast, begins with the European exploration during the nineteenth century and subsequent colonization of the African continent, developments that brought traditional African societies into sudden and traumatic contact with the "modern" world that Europe had largely created.

European ships first visited sub-Saharan Africa in the fifteenth century. For the next several hundred years, however, European contact with Africa was almost entirely limited to coastal areas, where trade, including the tragic slave trade, was carried out. Between the sixteenth and nineteenth centuries, over 10 million slaves were taken from Africa to colonies in North and South America and the Caribbean islands. Countries that participated in the Atlantic slave trade included Great Britain, Portugal, France, Spain, Denmark, Holland, and the United States.

During the nineteenth century, as the slave trade was gradually eliminated, European explorers began to investigate the unmapped African interior in earnest. They were soon followed by Christian missionaries, whose reports greatly fueled popular interest in the continent. Drawn by the potential wealth of Africa's natural resources, European governments began to seek territorial concessions from African rulers. Diplomacy soon gave way to force, and toward the end of the century, competition among rival European powers fueled the so-called scramble for Africa, during which England, France, Germany, Belgium, Italy, Spain, and Portugal raced to lay claim to whatever part of the continent they could. By 1914 virtually all of Africa had fallen under colonial rule.

In the years following World War I, nationalistic movements arose across Africa. Their leaders generally did not advocate a return to earlier forms of political organization but rather demanded the transformation of colonial divisions into modern nation–states governed by Africans. From the 1950s through the mid–1970s, one colony after another gained its independence, and the present–day map of Africa took shape. Today, the continent is composed of over fifty independent countries.

Change has been brought about by contact between one people and another since the beginning of time, and art in Africa has both affected and been affected by such contacts. During the early twentieth century, the art of traditional African societies played a role in revitalizing Western art. The formal inventiveness and expressive power of African sculpture were sources of inspiration for European artists trying to rethink strategies of representation. Conversely, contemporary African artists, who have come of age in the postcolonial culture that mingles European and African elements, can draw easily on influences from many cultures, both African and non-African. These artists have established a firm place in the lively international art scene along with their European, American, and Asian counterparts, and their work is shown as readily in Paris, Tokyo, New York, and Los Angeles as it is in the African cities of Abidjan, Johannesburg, Kinshasa, and Dakar.

From the time of the first European explorations and continuing through the colonial era, quantities of art from traditional African societies were shipped back to Western museums—not art museums, at first, but museums of natural history or ethnography, which exhibited the works as curious artifacts of "primitive" cultures. Toward the end of the nineteenth century, however, profound changes in Western thinking about art gradually led people to appreciate the aesthetic qualities of tradition–based African "artifacts" and finally to embrace them fully as art. Art museums, both in Africa and in the West, began to collect African art seriously and methodically. Together with the living arts of African peoples today, these collections afford us a rich sampling of African art in the nineteenth and twentieth centuries.

Numerous tradition-based societies persist in Africa, both within and across contemporary political borders, and art continues to play a vital role in the spiritual and social life of the community. This chapter explores African art in light

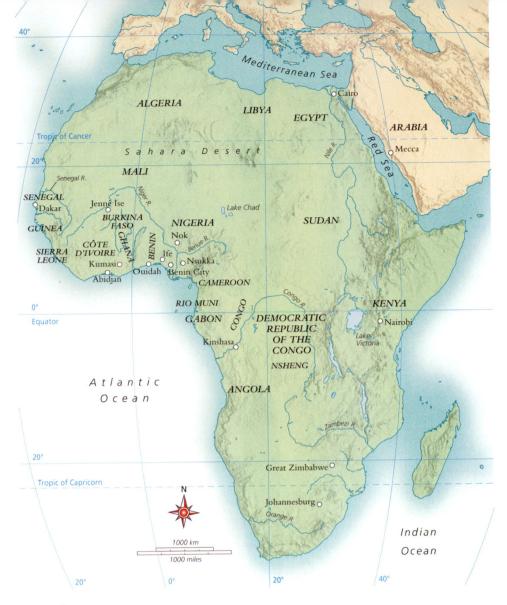

MAP 28-I PRESENT-DAY AFRICA

The vast continent of Africa is home to over fifty countries and innumerable cultures.

of how it addresses some of the fundamental concerns of human existence. Those concerns—rather than geographical region or time frame—form the backdrop against which we look at artworks in this chapter, as African art can be more fully understood within contexts of production and use.

Living Areas

Shelter is a basic human concern, yet each culture approaches it in a unique way that helps define that culture. The farming communities of the Nankani people in the border area between Burkina Faso and Ghana, in West Africa, have developed a distinctive painted adobe architecture. The mud and adobe buildings of their walled compounds are low and single storied with either flat roofs that form terraces or conical roofs. Each compound is surrounded by a defensive wall with a single entrance on the west side. Each building inside the enclosure is arranged so that it has a direct view of the entrance. Some buildings are used only by men, others only

by women. For example, Nankani men are in charge of the ancestral shrine near the entrance of the compound, the corral for cattle, and the granary; they have rectangular houses. The inner courtyards, outdoor kitchen, and round houses are women's areas (FIG. 28–2). Men build the compound; women paint the buildings inside and out.

The women decorate the walls with horizontal molded ridges called *yidoor*, meaning "rows in a cultivated field" and "long eye" (long life), to express good wishes for the family. They paint the walls with rectangles and squares divided diagonally to create triangular patterns that contrast with the curvature of the walls. The painted patterns are called "braided sling," "broken pottery," "broken gourd," and since the triangular motifs can be seen as pointing up or down, they are sometimes called "filed teeth." The same geometric motifs are used on pottery and baskets, and for scarification of the skin. When people decorate themselves, their homes, and their possessions with the same patterns, art serves to enhance cultural identity.

28–2 | NANKANI COMPOUND Sirigu, Ghana. 1972.

Among the Nankani people, creating living areas is a cooperative but gender-specific project. Men build the structures, women decorate the surfaces. The structures are also gendered. The round dwellings shown here are women's houses located in an interior courtyard; men occupy rectangular flatroofed houses. The bisected lozenge design on the dwelling to the left is called *zalanga*, the name for the braided sling that holds a woman's gourds and most treasured possessions.

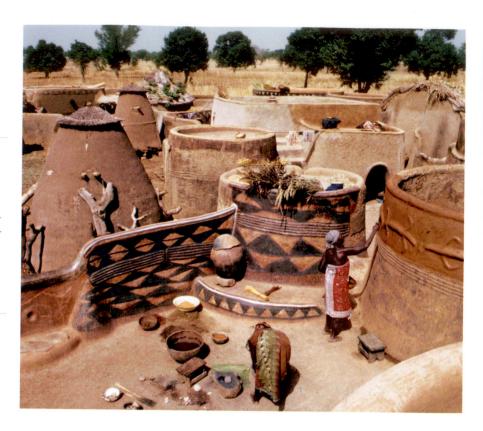

28–3 | DOLL (BIIGA)
Burkina Faso. Mossi culture. Mid-20th century. Wood, height 11¼" (28.57 cm).
Collection Thomas G. B. Wheelock.

Children and the Continuity of Life

Among the most fundamental of human concerns is the continuation of life from one generation to the next. In tradition-based societies children are especially important: Not only do they represent the future of the family and the community, but they also provide a form of "social security," guaranteeing that parents will have someone to care for them when they are old.

In the often harsh and unpredictable climates of Africa, human life can be fragile. In some areas half of all infants die before the age of 5, and the average life expectancy may be as low as 40 years. In these areas women bear many children in hopes that at least a few will survive into adulthood, and failure to have children is a disaster for a wife, her husband, and her husband's lineage. Women who have had difficulty bearing children appeal for help with special offerings or prayers, often involving the use of art.

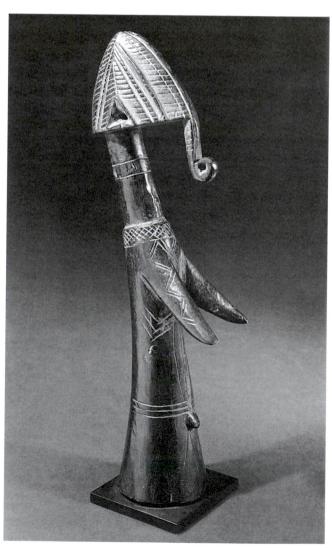

Art and Its Context

FOUNDATIONS OF AFRICAN CULTURES

frica was the site of one of the great civilizations of the ancient world—that of Egypt, which arose along the fertile banks of the Nile River over the course of the fourth millennium BCE and lasted for some 3,000 years. Egypt's rise coincided with the emergence of the Sahara, now the largest desert in the world, from the formerly lush grasslands of northern Africa. Some of the oldest known African art, images inscribed and painted in the mountains of the central Sahara beginning around 8000 BCE, bear witness to this gradual transformation as well as to the lives of the pastoral peoples who once lived in the region.

As the grassland dried, its populations migrated in search of pasture and arable land. Many probably made their way to the Sudan, the broad band of savanna south of the Sahara. During the sixth century BCE, knowledge of iron smelting spread across the Sudan, enabling larger and more complex societies to emerge. One such society was the iron-working Nok culture, which arose in present-day Nigeria around 500 BCE and lasted until about 200 CE. Terra-cotta figures created by Nok artists are the earliest known sculpture from sub-Saharan Africa.

Farther south in present-day Nigeria, a remarkable culture developed in the city of Ife, which rose to prominence around 800 CE. There, from roughly 1000 to 1400, a tradition of naturalistic sculpture in bronze and terra-cotta flourished. Ife was, and remains, the sacred city of the Yoruba people. According to legend, Ife artists brought the techniques of bronze casting to the kingdom of Benin to the southeast. From 1170 to the present century, Benin artists in the service of the court created numerous works in bronze, at first in the naturalistic style of Ife, then in an increasingly stylized and elaborate manner.

With the Arab conquest of North Africa during the seventh and eighth centuries, Islamic travelers and merchants became regular visitors to the Sudan. Largely through their writings, we know of the powerful West African empires of Ghana and Mali, which flourished successively from the fourth through the sixteenth centuries along the great bend in the Niger River. Both grew wealthy by controlling the flow of African gold and forest products into the lucrative trans-Sahara trade. The city of Jenné, in Mali, served not only as a commercial hub but also as a prominent center of Islam.

Peoples along the coast of East Africa, meanwhile, since before the Common Era had participated in a maritime trade network that ringed the Indian Ocean and extended east to the islands of Indonesia. Over time, trading settlements arose along the coastline, peopled by Arab, Persian, and Indian merchants as well as Africans. By the thirteenth century these settlements were important port cities, and a new language, Swahili, had developed from the longtime mingling of Arabic with local African languages. Peoples of the interior organized extensive trade networks to funnel goods to these ports. From 1000 to 1500 many of these interior routes were controlled by the Shona people from the site called Great Zimbabwe. The extensive stone palace compound there stood in the center of a city of some 10,000 at its height. Numerous cities and kingdoms, often of great wealth and opulence, greeted the astonished eyes of the first European visitors to Africa at the end of the fifteenth century.

Mossi BIIGA. The Mossi people of Burkina Faso carve a small wooden figure called biiga, or "child," as a plaything for little girls (FIG. 28–3). The girls feed and bathe the figures and change their clothes, just as they see their mothers caring for younger siblings. At this level the figures are no more than simple dolls. Like many children's dolls around the world, they show ideals of mature beauty, including elaborate hair-styles, lovely clothing, and developed breasts. The biiga shown here wears its hair just as little Mossi girls do, with a long lock projecting over the face. But the elongated breasts mark the doll as a mother of many children. Likewise, the scars on the belly mimic those applied to Mossi women following the birth of their first child. Thus, although the doll is called a child, it actually represents the ideal Mossi woman, one who has achieved the goal of motherhood.

Mossi girls do not outgrow their dolls as one would a childhood plaything. When a young woman marries, she brings the doll with her to her husband's home to serve as an aid to fertility. If she initially has difficulty bearing a child, she carries the doll on her back just as she would a baby. When she gives birth, the doll is placed on a new, clean mat just before the infant is placed there, and when she nurses, she places the doll against her breast for a moment before the newborn receives nourishment.

YORUBA TWIN FIGURES. The Yoruba people of Nigeria have one of the highest rates of twin births in the world. The birth of twins is a joyful occasion, yet it is troubling as well, for twins are more delicate than single babies, and one or both may well die. Many African peoples believe that a dead child continues its life in a spirit world and that the parents' care and affection may reach it there, often through the medium of art. When a Yoruba twin dies, the parents often consult a diviner, a specialist in ritual and spiritual practices, who may tell them that an image of a twin, or *ere ibeji*, must be carved to serve as a dwelling place for the deceased twin's spirit (FIG. 28–4).

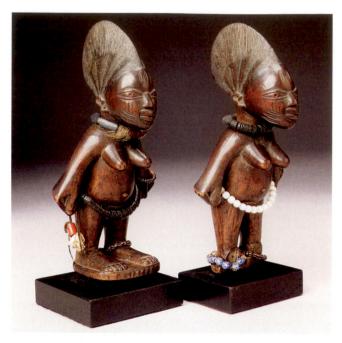

28–4 | TWIN FIGURES (ERE IBEJI)
Yoruba culture, from Nigeria. 20th century. Wood, height 71/8"
(20 cm). The University of Iowa Museum of Art, Iowa City.
The Stanley Collection (×1986.489 and ×1986.488).

As with other African sculpture, patterns of use result in particular signs of wear. The facial features of *ere ibeji* are often worn down or even obliterated by repeated feedings and washings. Camwood powder applied as a cosmetic builds to a thick crust in areas that are rarely handled, and the blue indigo dye regularly applied to the hair eventually builds to a thin layer of color.

When the image is finished, the mother brings the artist gifts. Then, carrying the figure as she would a living child, she dances home accompanied by the singing of neighborhood women. She places the figure in a shrine in her bedroom and lavishes care upon it, feeding it, dressing it with beautiful textiles and jewelry, anointing it with cosmetic oils. The Yoruba believe that the spirit of a dead twin, thus honored, is appeased and will look with favor on the surviving family members.

The twins in FIGURE 28–4 are female. They may be the work of the Yoruba artist Akiode, who died in 1936. Like most objects that Africans produce to encourage the birth and growth of children, the figures emphasize health and well-being. They have beautiful, glossy surfaces to suggest that they are well fed, as well as marks of adulthood, such as elaborate hair styles and scarification patterns, that will one day be achieved. They represent hope for the future, for survival, and for prosperity.

CHILDREN, ART, AND PERFORMANCE. In sub-Saharan Africa, as elsewhere, children from an early age are intensely interested in adult roles and activities including art making and the performative arts. In many societies a child's link to a particular artistic or craft activity is fixed. For example, in Africa, wood carving is universally a male-dominated activity, while women

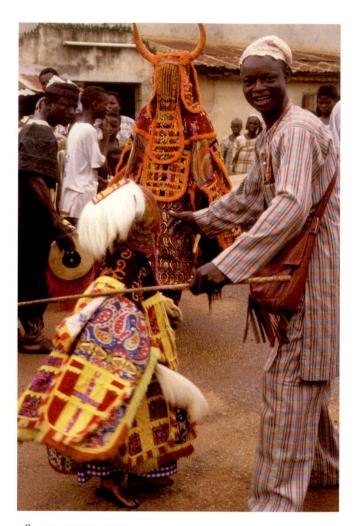

28–5 | ELDER GUIDING SMALL BOY IN EGUNGUN PERFORMANCE WHILE ADULT EGUNGUN PERFORMER LOOKS ON Yoruba culture, Nigeria. Photograph by Margaret Thompson Drewal. National Museum of African Art, Smithsonian Institu-

Eliot Elisofon Photographic Archive

tion, Washington, D.C.

are most often involved in pottery production, and individual children may be apprenticed to a wood carver or potter according to their gender. But, even beyond such formal apprenticeships, children are especially interested in the festive activities of community life, such as masquerade. While mask making and masquerade performance are usually controlled by adult associations, children are given space at the edges of events to experiment with their homemade masks and costumes. Yoruba masquerades such as Gelede or Egungun are often organized so that children perform first (FIG. 28-5). Some families even purchase or make elaborate costuming for their children in a similar style to that worn by adults. Adults view these early forays into masquerade as a training ground. As children perform, they are encouraged and gently corrected from the sidelines by family members. The Yoruba of Nigeria, especially place a significant value on the training of children into adult performance and aesthetic forms, and children are encouraged to perform from an early age.

Initiation

In contemporary Western societies, initiation into the adult world is extended over several years and punctuated by numerous rites, such as being confirmed in a religion, earning a driver's license, graduating from high school, and reaching the age of majority. All of these steps involve acquiring the knowledge society deems appropriate and accepting the corresponding responsibilities. In other societies, initiation can take other forms, and the acquisition of knowledge is usually supplemented by trials of endurance to prove that the candidate is equal to the responsibilities of adult life.

MASKS OF BWA INITIATION. The Bwa people of central Burkina Faso initiate young men and women into adulthood following the onset of puberty. The initiates are first separated from younger playmates by being "kidnapped" by older relatives, though their disappearance is explained in the community by saying that they have been devoured by wild beasts. The initiates remove their clothing and sleep on the ground without blankets. Isolated from the community, they are instructed about the world of nature spirits and about the masks that represent them. They learn of the spirit each mask

represents, and they memorize the story of each spirit's encounter with the founding ancestors of the clan. They learn how to construct costumes from hemp to be worn with the masks, and they learn the songs and instruments that accompany the masks in performance. Only boys wear each mask in turn and learn the dance steps that express the character and personality each mask represents. Returning to the community, the initiates display their new knowledge in a public ceremony. Each boy performs with one of the masks, while the girls sing the accompanying songs. At the end of the mask ceremony the young men and young women rejoin their families as adults, ready to marry, to start farms, and to begin families of their own.

Most Bwa masks depict spirits that have taken an animal form, such as crocodile, hyena, hawk, or serpent. Others represent spirits in human form. Among the most spectacular masks, however, are those that represent spirits that have taken neither human nor animal form. Crowned with tall, narrow planks (FIG. 28–6), these masks are covered in abstract patterns that are easily recognized by the initiated. The white crescent at the top represents the quarter moon, under which the initiation is held. The white triangles below represent bull

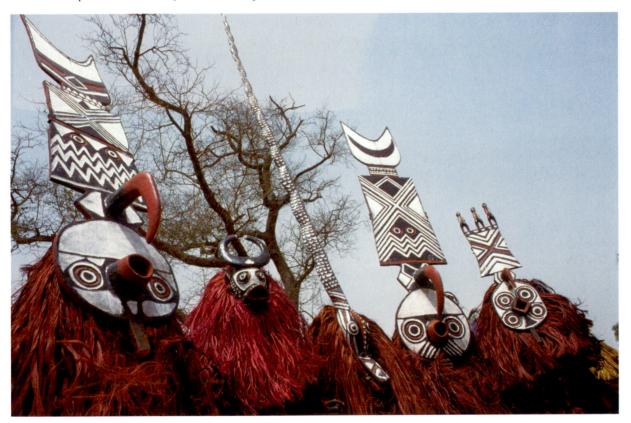

28–6 | MASKS IN PERFORMANCE Dossi, Burkina Faso, Bwa culture, 1984. Wood, mineral pigments, and fiber, height approx. 7' (2.13 m).

The Bwa have been making and using such masks since well before Burkina Faso achieved its independence in 1960. We might assume their use is centuries old, but in this case, the masks are a comparatively recent innovation. The elders of the Bwa family who own these masks state that they, like all Bwa, once followed the cult of the spirit of Do, who is represented by masks made of leaves. In the last quarter of the nineteenth century, the Bwa were the targets of slave raiders from the north and east. Their response to this new danger was to acquire wooden masks from their neighbors, for such masks seemed a more effective and powerful way of communicating with spirits who could help them. Thus, faced with a new form of adversity, the Bwa sought a new tradition to cope with it.

28-7 TEMNE NOWO MASQUERADE WITH ATTENDANTS
Photograph by Fred Lamp, 1980.
Sierra Leone.

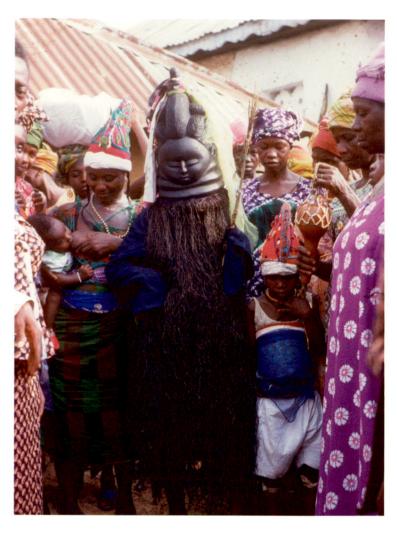

roarers—sacred sound makers that are swung around the head on a long cord to re-create spirit voices. The large central X represents the scar that every initiated Bwa bears as a mark of devotion. The horizontal zigzags at the bottom represent the path of the ancestors and symbolize adherence to ancestral ways. That the path is difficult to follow is clearly conveyed. The curving red hook that projects in front of the face is said to represent the beak of the hornbill, a bird associated with the supernatural world and believed to be an intermediary between the living and the dead. The mask thus proudly announces the initiate's passage to adulthood while encoding secrets of initiation in abstract symbols of proper moral conduct.

INITIATION TO WOMANHOOD IN WEST AFRICA. Among the Mende, Temne, Vai, and Kpelle peoples of Sierra Leone, the initiation of girls into adulthood is organized by a society of older women called Sande or Bondo. The initiation culminates with a ritual bath in a river, after which the initiated return to the village to meet their future husbands. At the ceremony, the Sande women wear black gloves and stockings, black costumes of shredded raffia fibers that cover the entire body, and black masks called *nowo* or *sowei* (FIG. 28–7).

With its glossy black surface, high forehead, elaborately plaited hairstyle decorated with combs, and refined facial features, the mask represents ideal female beauty. The mask is worn by a senior member of the women's Sande society whose responsibility is to prepare Sande girls for their adult roles in society including marriage and child rearing. The meanings of the mask are complex. One scholar has shown that the mask can be compared with the chrysalis of a certain African butterfly, with the creases at the base of the mask representing the segments of the chrysalis. Thus, the young woman entering adulthood is like a butterfly emerging from its cocoon. The comparison extends even further, for just as the butterfly feeds on the toxic sap of the milkweed to make itself poisonous to predatory birds, so the medicine of Sande is believed to protect the young women from danger. The creases may additionally refer to the concentric waves that radiate outward as the initiate emerges from the river to take her place as a member of the adult community.

BWAMI ASSOCIATION AMONG THE LEGA. A ceremony of initiation may accompany the achievement of other types of membership as well. Among the Lega people, who live in the dense forests between the headwaters of the Congo River and the

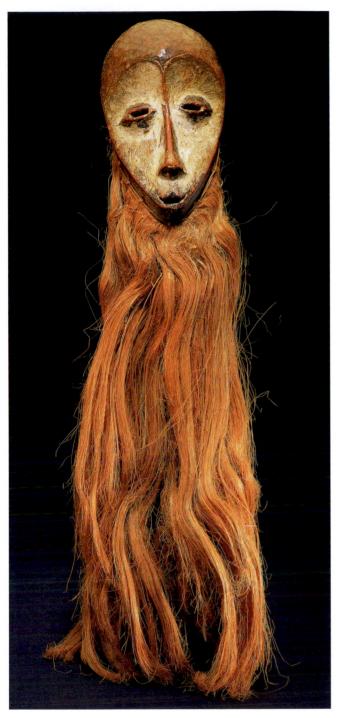

28–8 | BWAMI MASK (LUKWAKONGO)
Wood, plant fiber, and pigment, height: 22¾" (57.5 cm).
UCLA Fowler Museum of Cultural History, Los Angeles.

great lakes of East Africa, the political system is based on a voluntary association called *bwami*, which comprises six levels or grades. Some 80 percent of all male Lega belong to *bwami*, and all aspire to the highest grade. Women can belong to *bwami* as well, although not at a higher grade than their husbands.

Promotion from one grade of *bwami* to the next takes many years. It is based not only on a candidate's character but also on his or her ability to pay the initiation fees, which increase dramatically with each grade. No candidate for any

level of *bwami* can pay the fees alone; all must enlist the help of relatives to provide the necessary payment that may include cowrie shells, goats, wild game, palm oil, clothing, and trade goods. Thus, the ambition to move from one level of *bwami* to the next encourages a harmonious community, for all must stay on good terms with other members of the community if they are to advance.

Bwami initiations into advanced grades are held in the plaza at the center of the community in the presence of all members. Dances and songs are performed, and the values and ideals of the appropriate grade are explained through proverbs and sayings. These standards are illustrated by natural or crafted objects, which are presented to the initiate as signs of membership. At the highest two levels of bwami, such objects include exquisitely made small masks and sculpted figures.

The mask in FIGURE 28–8 is associated with *yananio*, the second-highest grade of *bwami*. Typical of Lega masks, the head is fashioned as an oval into which is carved a concave, heart-shaped face with narrow, raised features. The masks are often colored white with clay and fitted with a long beard made of plant fibers. Too small to cover the face, they are displayed in other ways—held in the palm of a hand, for example, or attached to a thigh. Each means of display recalls a different value or saying, so that one mask may convey a variety of meanings. Generally, the masks symbolize continuity between the ancestors and the living community and are thought to be direct links to deceased relatives and past members of bwami.

The Spirit World

While African religious beliefs have been influenced by Christianity and Islam for hundreds of years, many African peoples still rely on traditional customs and belief systems to find the answers to universal human problems. Why does one child fall ill and die while another remains healthy? Why does one year bring rain and a bountiful crop, while the next brings drought and famine? People everywhere confront these fundamental and troubling questions. In many African belief systems a supreme creator god is usually thought not to be fundamentally involved in the daily lives of humans. Instead, numerous subordinate spirit forces are said to be ever present and involved in human affairs. For instance, such spirits may inhabit agricultural fields, the river that provides fish, the forest that is home to game, or the land that must be cleared in order to build a new village. Families, too, may acknowledge the existence of ancestral spirits. These spirits control success and failure in life, and if a proper relationship is not maintained with the spirits, harm in the form of illness or misfortune can befall an individual, his family, or the entire community.

To communicate with these all-important spirits, many African societies rely on a specialist, such as a diviner who serves as a link between the supernatural and human worlds, opening the lines of communication through such techniques as prayer, sacrifice, offerings, ritual performance, and divination. Sometimes art plays a role in the diviner's dealings with the spirit world, giving visible identity and personality to what is imaginary and intangible.

Kongo Nkisi Nkonde. Among the most potent images of power in African art are the *nkisi*, or spirit figures that were made by the Kongo and Songye peoples of Congo. The best known are the large wooden *nkonde*, which bristle with nails, pins, blades, and other sharp objects (FIG. 28–9). An *nkisi nkonde* begins its life as a simple, unadorned wooden figure that may be purchased from a carver at a market or commissioned by a diviner on behalf of a client who has encountered some adversity or faces an important turning point. Drawing on specialized knowledge, the diviner prescribes magical/medicinal ingredients, called *bilongo*, specific to the client's problem. These *bilongo* are added to the figure, either mixed with white clay and plastered directly onto the body or suspended in a packet from the neck or waist.

The *bilongo* transform the *nkonde* into a powerful agent, ready to attack the forces of evil on behalf of a human client. *Bilongo* ingredients are drawn from plants, animals, and minerals, and may include human hair, nail clippings, and other materials. Each ingredient has a unique role. Some bring the figure to life by embodying the spirit of an ancestor or a soul trapped by a malevolent power. Others endow the figure with distinctive powers or focus the powers in a particular direction, often through metaphor. For example, the Kongo admire the quickness and agility of a particular species of mouse. Tufts of this mouse's hair included in the *bilongo* act as a metaphor for quickness, ensuring that the *nkisi nkonde* will act rapidly when its powers are activated.

To activate the powers, clients drive in a nail or other pointed object to get the *nkonde*'s attention and provoke it to action. An *nkisi nkonde* may serve many private and public functions. Two warring communities might agree to end their conflict by swearing an oath of peace in the presence of the *nkonde* and then driving a nail into it to seal the agreement. Two merchants might agree to a partnership by driving two small nails into the figure side by side and then make their pact binding by wrapping the nails together with a cord. Someone accused of a crime might swear his innocence and drive in a nail, asking the *nkonde* to destroy him if he has lied. A mother might invoke the power of the *nkonde* to heal her sick child.

The word *nkonde* shares a stem with *konda*, meaning "to hunt," for the figure is quick to hunt down a client's enemies and destroy them. The *nkonde* here stands in a pose called *pakalala*, a stance of alertness like that of a wrestler challenging an opponent in the ring. Other *nkonde* figures hold a knife or spear in an upraised hand, ready to strike or attack.

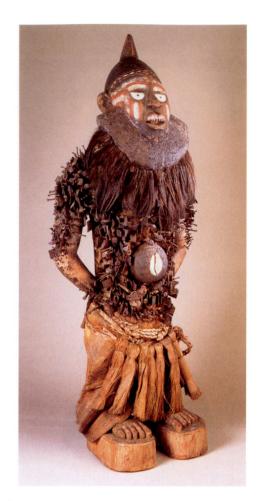

28–9 POWER FIGURE (NKISI NKONDE)

Democratic Republic of Congo (Zaire). Kongo culture,

19th century. Wood, nails, pins, blades, and other materials,
height 44" (111.7 cm). The Field Museum, Chicago.

Acquisition A109979c

Nkisi nkonde provide a dramatic example of the ways in which works of African sculpture are transformed by use. When first carved, the figure is "neutral," with no particular significance or use. Magical materials applied by a diviner transform the figure into a powerful being, at the same time modifying its form. Each client who activates that power further modifies the statue. Nails may also be added as part of a healing or oath-taking process. And when the figure's particular powers are no longer needed, the additions may all be stripped away to be replaced with different magical materials that give the same figure a new function. The result is that many hands play a role in creating the nkisi nkonde we see in a museum. The person we are likely to label as the "artist" is only the initial creator. Many others modify the work, and in their hands the figure becomes a visual document of the history of the conflicts and afflictions that have threatened members of the community.

Spirit Spouse of the Baule. Some African peoples conceive of the spirit world as a parallel realm in which spirits may have families, live in villages, attend markets, and possess personalities complete with faults and virtues. The Baule people in Côte d'Ivoire believe that each of us lived in the spirit world before we were born. While there, we had a spirit spouse, whom we left behind when we entered this life. A person who has difficulty assuming his or her gender-specific role as an adult Baule—a man who has not married or achieved his expected status in life, for example, or a woman who has not borne children—may dream of his or her spirit spouse.

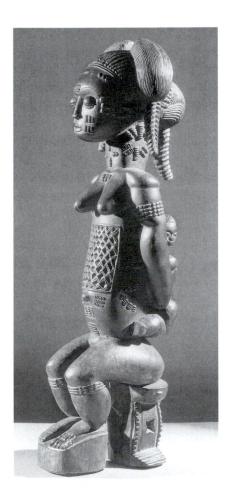

28–10 | SPIRIT SPOUSE (BLOLO BLA)
Côte d'Ivoire. Baule culture. Early 20th century.
Wood, height 17%" (43.5 cm). University of Pennsylvania
Museum of Archeology and Anthropology, Philadelphia.

For such a person, the diviner may prescribe the carving of an image of the spirit spouse (FIG. 28-10). A man has a blolo bla (otherworld wife) and a woman has a blolo bian (otherworld husband) carved. The figures display the most admired and desirable marks of beauty so that the spirit spouses may be encouraged to enter and inhabit them. Spirit spouse figures are broadly naturalistic, with swelling, fully rounded musculature and careful attention to details of hairstyle, jewelry, and scarification patterns. They may be carved standing in a quiet, dignified pose or seated on a stool. The owner keeps the figure in his or her room, dressing it in beautiful textiles and jewelry, washing it, anointing it with oil, feeding it, and caressing it. Over time, the surface of the figure softens as it takes on a glossy sheen indicating the attention it has been given. The Baule hope that by caring for and pleasing his or her spirit spouse a balance may be restored that will free the individual's human life to unfold smoothly.

YORUBA DIVINATION. While spirit beings are often portrayed in African art, major deities are generally considered to be far removed from the everyday lives of humans and are

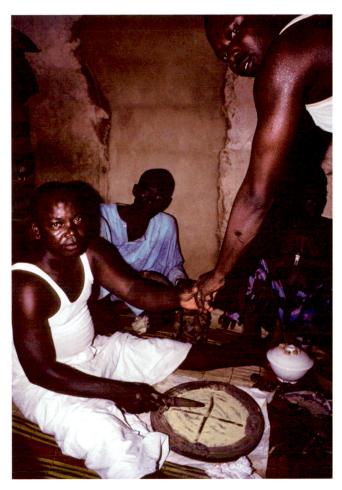

28–II | IFA DIVINATION SESSION
Yoruba culture, Nigeria. Photograph by Margaret Drewal.
National Museum of African Art, Smithsonian Institution,
Washington, D.C.
Eliot Elisofon Photographic Archives

thus rarely depicted. Such is the case with Olodumare, the creator god of the Yoruba people of southwestern Nigeria.

The Yoruba have a sizable pantheon of lesser, but still important, gods, or orisha. Two orisha are principal mediators: Orunmila who represents certainty, fate, order, and equilibrium; and his counterpart Eshu who represents uncertainty, disorder, and chance. Commonly represented in art, Eshu is a capricious and mischievous trickster who loves nothing better than to disrupt things that appear to be going well. The opposing forces of order and disorder are mediated through the agency of a diviner (babalawo) who employs a divination board (opon ifa) and its paraphernalia to reveal the causes of a client's problems (FIG. 28-11). The divination board is sprinkled with a white wood dust and the orisha Orunmila and Eshu are called to the divination by tapping the board with a special tapper. The babalawo throws sixteen palm nuts and after each toss the babalawo records the way the palm nuts have landed in the white wood dust on the divination board. Each configuration of the palm nuts relates to particular verses from a complex oral tradition also known as Ifa. As the selected verses are recited by the diviner, the client relates the verses to his or her own particular problems or concerns.

Eshu's image often appears on divination objects and in shrines employed by his worshipers. His image always appears at the top of the divination board, while other images along the edge of the board relate symbolically to the world of Ifa divination. Eshu is associated with two eternal sources of human conflict, sex and money, and is usually portrayed with a long hairstyle, because the Yoruba consider long hair to represent excess libidinous energy and unrestrained sexuality. Figures of Eshu are usually adorned with long strands of cowrie shells, a traditional African currency. Shrines to Eshu are erected wherever there is the potential for encounters that lead to conflict, especially at crossroads, in markets, or in front of banks. Eshu's followers hope that their offerings will persuade the god to spare them the pitfalls he places in front of others.

Leadership

As in societies throughout the world, art in Africa is used to identify those who hold power, to validate their right to their authority as representatives of the family or community, and to communicate the rules for moral behavior that must be obeyed by all members of the society. The gold-and-wood spokesperson's staff with which this chapter opened is an

example of the art of leadership (SEE FIG. 28–1). It belongs to the culture of the Ashanti peoples of Ghana, in West Africa. The Ashanti greatly admire fine language—one of their adages is, "We speak to the wise man in proverbs, not in plain speech"—and consequently their governing system includes the special post of spokesperson to the ruler. Since about 1900 these advisers have carried staffs of office such as the one pictured here. The carved figure at the top illustrates a story that may have multiple meanings when told by a witty owner. This staff was probably carved in the 1960s or 1970s by Kojo Bonsu. The son of Osei Bonsu (1900–76), a famous carver, Kojo Bonsu lives in the Ashanti city of Kumasi and continues to carve prolifically.

The Ashanti use gold not only for objects, such as the staff, that are reserved for the use of rulers, but also for jewelry, as do other peoples of the region. But for the Ashanti, who live in the middle of the richest gold fields of West Africa, gold was long a major source of power; for centuries, they traded it, first via intermediaries across the Sahara to the Mediterranean world, then later directly to Europeans on the West African coast.

KENTE CLOTH. The Ashanti are also renowned for the beauty of their woven textiles, called kente (FIG. 28–12).

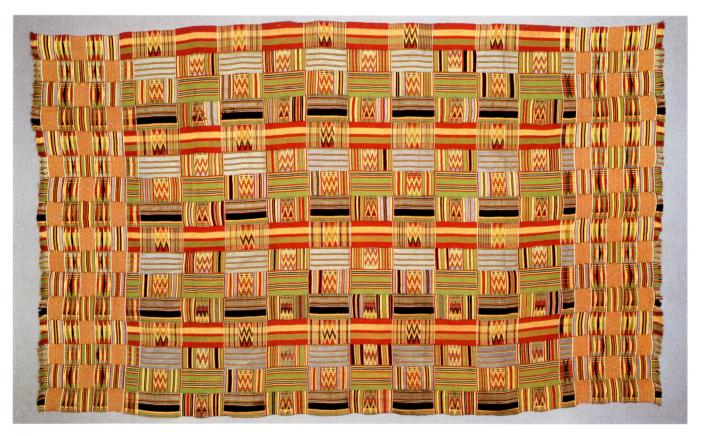

28-12 | KENTE CLOTH

Ashanti culture, Ghana. 20th century. Silk, $6'10\%'' \times 4'3\%'''$ (2.09 \times 130 m). National Museum of African Art and National Museum of Natural History, Smithsonian Institution, Washington, D.C. Purchased with funds provided by the Smithsonian Collections Acquisition Program, 1983–85, (EJ 10583)

Weaving was introduced in Ghana sometime during the seventeenth century from neighboring regions of West Africa. The weavers were, traditionally, men. Ashanti weavers work on small, light, horizontal looms that produce long, narrow strips of cloth. They begin by laying out the long warp threads in brightly colored stripes. Today the threads are likely to be rayon. Formerly, however, they were cotton and later silk, which the Ashanti first procured in the seventeenth century by unraveling silk cloth obtained through European trade. Weft threads are woven through the warp to produce complex patterns that are named after the warp-faced patterns or weft designs. The long strips produced by the loom are then cut to size and sewn together to form large rectangles of finished *kente* cloth.

Kente cloth was originally reserved for state regalia. A man wore a single piece, about 6 to 7 feet by 12 to 13 feet, wrapped like a toga with no belt and the right shoulder bare. Women wore two pieces—a skirt and a shawl. The kente cloth shown here began with a warp pattern that alternates red, green, and yellow. The pattern is known as oyokoman ogya da mu, meaning "there is a fire between two factions of the Oyoko clan," and refers to the civil war that followed the death of the Ashanti king Osei Tutu in about 1730. Tradition-

ally, only the king of the Ashanti was allowed to wear this pattern. Other complex patterns were reserved for the royal family or members of the court.

THE KUBA NYIM. The Kuba people of the Democratic Republic of Congo produce elaborate and sophisticated arts tied to leadership. At the pinnacle of the hierarchy sits the Kuba paramount ruler (nyim) whose residence was located approximately in the center of the Kuba region. The current nyim can trace his predecessors back to the founding of the kingdom in the seventeenth century. At the installation of a new monarch, a new capital city (Nsheng) is built including the residence of the nyim, his wives and children, as well as areas for other governmental functions, all surrounded by a high palisade.

Titled individuals will often lavish elaborate surface decoration on objects that belong to them to indicate their rank and prestige within the political and social hierarchy. This is exemplified in the geometric woven decoration on the walls of royal buildings (FIG. 28–13) and decorated mats, and on the intricate carved decoration of wooden drums, boxes, and other objects. It is also seen on the variety of embroidered textiles for men and women and on regalia such as

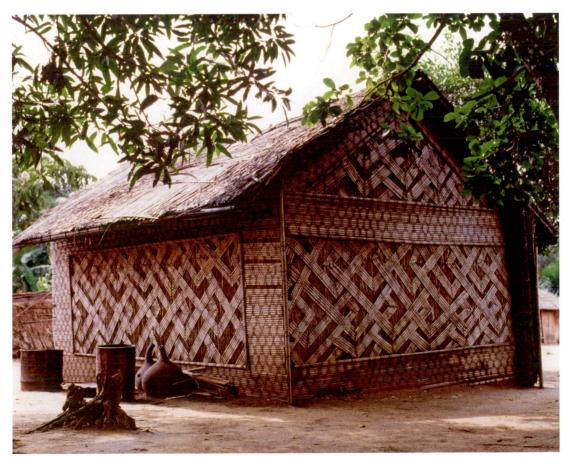

28 -- 13 $^{-}$ decorated building (sleeping room for $^{\it NYIM}$) in the royal compound of the kuba nyim

Nsheng, Democratic Republic of the Congo. Photograph by Angelo Turconi.

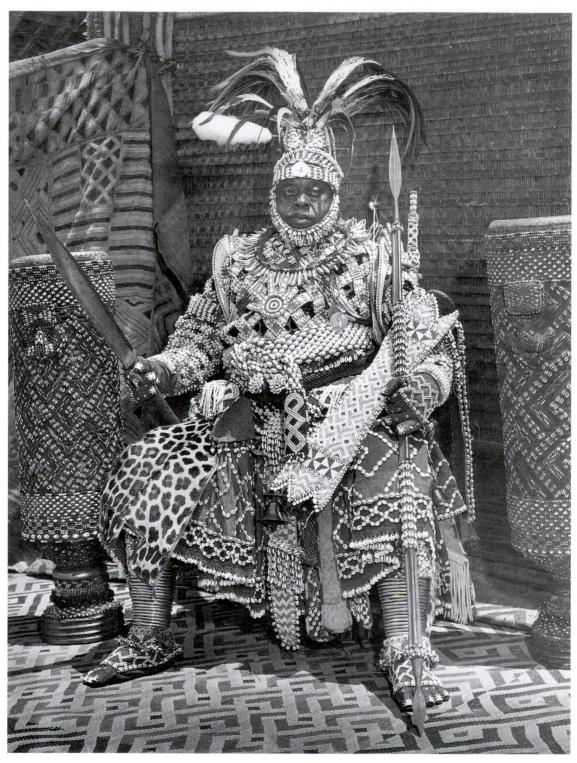

28–14 | MBOP MABIINC MAMBEKY

Paramount ruler (*nyim*) of Kuba peoples (reigned 1939-69). Prestige attire worn by the *nyim* for receiving important guests. The costume includes elements made from copper, brass, cowrie shells, beads, leopard skin, and eagle and parrot feathers. Photograph by Eliot Elisofon, 1947. National Museum of African Art, Smithsonian Institution, Washington, D.C.

Eliot Elisofon Photographic Archives

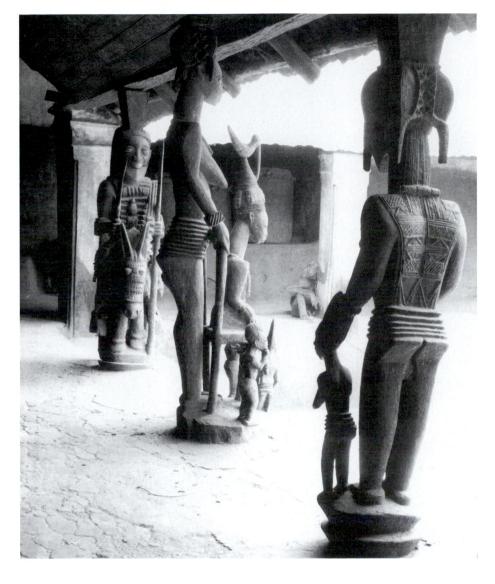

28–15 | Olowe of Ise

VERANDA POSTS

Ikere Palace, Ikere, Nigeria. 1910–14.

Wood and pigment. Photograph by

William Fagg, 1959. Royal Anthropological Institute of Great Britain and Ireland, London.

headdresses and jewelry that serve as prestige and festive attire for celebratory occasions. An eagle feather chief (*kumaphong*) displays sumptuous adornment at his investiture. Each element of regalia signifies a prerogative of an individual's titled position relative to the position of others within a complicated system of titleholding. Naturally the most extravagant adornment is worn by the paramount ruler, as can be seen in the photograph taken by Eliot Elisofon of the Kuba *nyim* in 1947 (FIG. 28–14). Textile display is also an essential aspect of funeral rituals where textiles are worn at celebratory dances and displayed on the body of the deceased. The textiles are subsequently buried with the deceased, where the Kuba believe an individual remains for a period of time before being reborn (see "Death and Ancestors," page 932).

YORUBA PALACE ART. The kings of the Yoruba people of Nigeria also manifested their authority and power through the large palaces in which they lived. In a typical palace plan,

the principal rooms opened onto a veranda with elaborately carved posts facing a courtyard (FIG. 28–15). Elaborate carving also covered the palace doors. Among the most important Yoruba artists of the early twentieth century was Olowe of Ise (d. 1938), who carved doors and veranda posts for the rulers of the Ekiti-Yoruba kingdoms in southwestern Nigeria.

The door of the royal palace in Ikere (FIG. 28–16) illustrates Olowe's artistry. Its asymmetrical composition combines narrative and symbolic scenes in horizontal rectangular panels. Tall figures carved in profile end in heads facing out to confront the viewer. Their long necks and elaborate hairstyles make them appear even taller, unlike typical Yoruba sculpture, which uses short, static figures. The figures are in such high relief that the upper portions are actually carved in the round. The figures move energetically against an underlying decorative pattern, and the entire surface of the doors is also painted.

28–16 Olowe of Ise DOOR FROM ROYAL PALACE IN IKERE, NIGERIA

Yoruba culture. c. 1925. Wood, pigment, height 72" (182.9 cm). The Detroit Institute of the Arts.

Gift of Bethea and Irwin Green in honor of the 20th anniversary of the Department of African, Oceanic, and New World Cultures (1997.80.A)

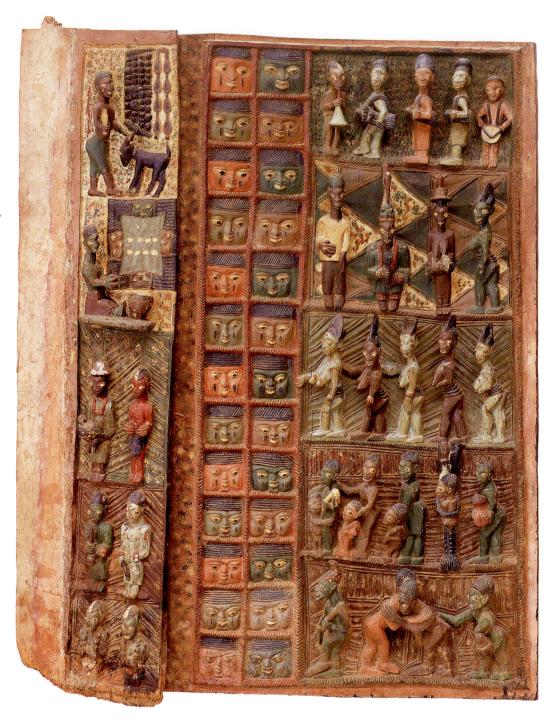

The doors commemorate celebrations honoring the *orisha* of divination, Orunmila. In the left-hand panel, the future will be foretold by reading oracles. At the top is a man with sacrificial animal and palm nuts. Below him, a diviner sits with a divination board and the ceremonial cup for the palm nuts and lower still are messengers and assistants. On the right, two rows of faces introduce the court. The king is represented in the second panel seated between his guard and two royal wives; the chief wife wears a European top hat, a symbol of power. Above the royals, musicians perform, while below royal wives dance. The bottom two registers depict the people—farm workers and a pair of wrestlers.

Olowe seems to have worked from the early 1900s until his death in 1938. Although he was famous throughout Yorubaland and called upon by patrons as distant as 60 miles from his home, few records of his activities remain, and only one European, Philip Allison, wrote of meeting him and watching him work. Allison described Olowe carving the ironhard African oak "as easily as [he would] a calabash [gourd]."

Death and Ancestors

In the view of many African peoples, death is not an end but a transition—the leaving behind of one phase of life and the beginning of another. Just as ceremonies mark the initiation of young men and women into the community of adults, so too they mark the initiation of the newly dead into the community of spirits. Like the rites of initiation into adulthood, death begins with a separation from the community, in this case the community of the living. A period of isolation and trial follows, during which the newly dead spirit may, for example, journey to the land of ancestors. Finally, the deceased is reintegrated into a community, this time the community of ancestral spirits. The living who preserve the memory of the deceased may appeal to his or her spirit to intercede on their behalf with nature spirits or to prevent the spirits of the dead from using their powers to harm.

DOGON FUNERARY DAMA. Among the Dogon people of Mali, in West Africa, a collective funeral rite with masks, called "dama," is held every twelve to thirteen years (FIG. 28–17). During *dama*, a variety of different masks perform to the sound of gunfire to drive the souls of the deceased from the village. Among the most common masks to perform is the *kanaga*, whose rectangular face supports a superstructure of planks that depict a woman, bird, or lizard with splayed legs.

For a deceased man, men from the community later engage in a mock battle on the roof of his home and participate in ritual hunts; for a deceased woman, the women of the community smash her cooking vessels on the threshold of her home. These portions of *dama* are reminders of human activities the deceased will no longer engage in. The *dama* may last as long as six days and include the performance of hundreds of masks. Because a *dama* is so costly, it is performed for several deceased elders at the same time. However, in certain Dogon communities frequented by tourists, *dama* performances have become more frequent as new masked characters are invented, including masks representing tourists

holding wooden cameras or anthropologists holding notebooks in their hands. In response to tourists, Dogon maskmakers produce additional masks that are offered for sale to tourists at the conclusion of the performance.

KUBA FUNERARY RITES. The Kuba people of the Democratic Republic of Congo do not hold elaborate rituals to honor ancestral spirits because the Kuba believe that after a generation or two individuals are reincarnated. Instead, they perform funerary masquerades to honor deceased members of the men's initiation society and high-ranking individuals who belonged to the community council of elders.

In the southern Kuba region, funeral rites for initiated men are often accompanied by the appearance of one or more masquerade figures on the day of interment of the deceased. For senior title holders, more elaborate preparations and the participation of the entire community is required. The most important masquerade figure in the southern Kuba region is Inuba, who appears at the funerals of senior title-holders (FIG. 28–18). Inuba's appearance requires the participation and attendance of all initiated men and community titleholders as well as the community to prepare for the masquerade on the day preceding and on the day of the funeral just prior to burial.

After touring the community on the day of the funeral, Inuba enters the shelter where the deceased has been placed into a coffin. The masked figure taps on top of the coffin to call the spirit of the deceased. Inuba speaks directly to the spirit and tells it that Inuba is performing to honor the deceased. At the same time Inuba admonishes the spirit not to be angry or harm anyone in the community because he has died. The recitation is believed to help lessen the anger of the deceased's spirit and to encourage it to leave the community peacefully. Once the recitation is concluded the deceased

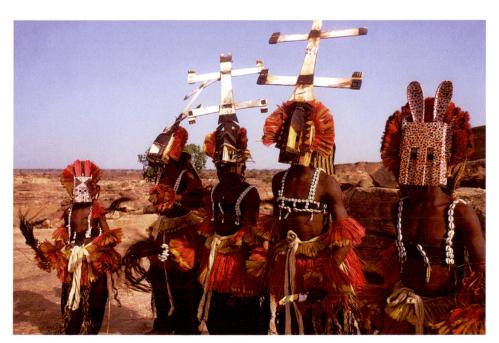

28–17 KANAGA AND RABBIT MASQUERADE FIGURES AT DAMA

Dogon culture, Mali. Performance photograph by Eliot Elisofon, 1959. National Museum of African Art, Smithsonian Institution, Washington, D.C. Eliot Elisofon Photographic Archives. (EEPA 3502)

THE OBJECT SPEAKS

AFRICAN ART CONFRONTING THE WEST

uring the late nineteenth and early twentieth century, Nkanu peoples residing in the Democratic Republic of the Congo and Angola created brightly painted figurative sculpture and decorated wall panels adorned with human and animal figures to celebrate the completion of initiation rites (nkanda). These artworks were displayed in a threesided roofed enclosure, called a kikaku, which was built at a crossroads nearby the initiation campground. These displays were made to reinforce the values taught during nkanda and to announce to the community that initiation was coming to a close and that their children would soon be home.

The kikaku resembled a stage. Wall panels were carved, painted, and attached to the back and sides of the kikaku, and sculpted figures were placed

in front of the wall panels on the floor of the structure. The *kikaku* wall panels were accentuated with brightly colored and symbolically charged patterns that conveyed specific meanings associated with the coming of age ritual. Nkanu initiation art was left to decay after the close of *nkanda*, and only a few individual pieces were collected during the colonial era—there is no extant example of an entire *kikaku* in any museum collection.

European colonial officials were a favorite subject in *kikaku*. Their depictions were considered "portraits" of specific individuals, and included distinguishing characteristics such as costume and hair style. Nkanu artists seem to have singled out specific colonial officials whom they especially despised for their cruelty or whom they wanted to ridicule because of

their dalliances with Nkanu women. These caricatures became a means of confronting colonial domination without openly attacking colonial officials, which would have undoubtedly led to severe repercussions.

In these wall panels, the central figure represents a colonial administrator. He is flanked by two figures representing Congolese men who are members of the "Force Publique," the Belgian colonial military force. One soldier is depicted wearing an ammunition belt, while the other assumes the awkward stance of an initiate who must balance on one leg. Both the stance and the painted patterns on the panels symbolically relate to the virility and procreative capacity of the initiate upon the successful completion of nkanda.

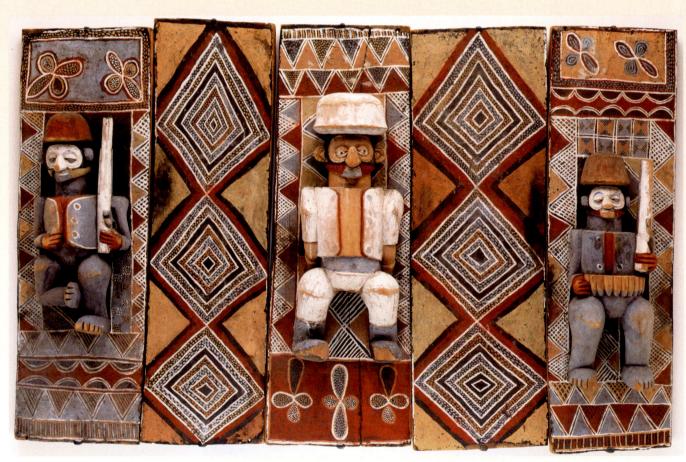

INITIATION WALL PANELS

Nkanu peoples. Democratic Republic of the Congo. Early 20th century. Wood, pigment, height 33%" (84.8 cm). National Museum of African Art, Smithsonian Institution, Washington, D.C. Museum purchase, 99-2-1

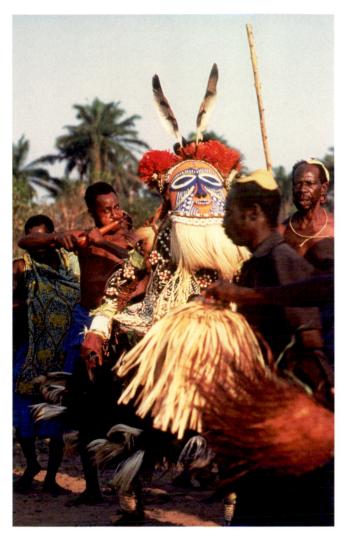

28–18 | INUBA ENTERING THE COMMUNITY FOR FUNERAL PERFORMANCE IN THE COMPANY OF SENIOR TITLEHOLDERS Southern Kuba peoples, Democratic Republic of the Congo. Photograph by David A. Binkley & Patricia J. Darish, 1981.

is immediately taken to the cemetery for burial while Inuba and initiated men dance for the assembled family members and visitors until dusk.

FANG ANCESTOR GUARDIAN. The Fang people, who live near the Atlantic coast from southern Cameroon through Rio Muni and into northern Gabon, followed an ancestral religion in which bones and skulls of ancestors who have performed great deeds are collected after burial and placed together in a cylindrical bark container called *nsekh o byeri*, which a family would carry when it migrated. Deeds thus honored include killing an elephant, being the first to trade with Europeans, bearing an especially large number of children, or founding a particular lineage or community. On top of the container the Fang place a wooden figure called *nlo byeri*, which represents the ancestors and which guards their relics from malevolent spirit forces (FIG. 28–19). *Nlo byeri* are often carved in a naturalistic style, with carefully arranged hairstyles, fully rounded torsos, and heavily muscled legs and

arms. Frequent applications of cleansing and purifying palm oil produce a rich, glossy black surface.

The strong symmetry of the statue is especially notable. The layout of Fang villages is also symmetrical, with pairs of houses facing each other across a single long street. At each end of the street is a large public meetinghouse. The Fang immigrated to the area they now occupy during the early nineteenth century. The experience was disruptive and disorienting, and Fang culture thus emphasizes the necessity of imposing order on a disorderly world. Many civilizations have recognized the power of symmetry to express permanence and stability.

Internally, the Fang strive to achieve a balance between the opposing forces of chaos and order, male and female, pure and impure, powerful and weak. They value an attitude of quiet composure, of reflection and tranquility. These qualities are embodied in the symmetry of the *nlo byeri*, which communicates the calm and wisdom of the ancestor while also instilling awe and fear in those not initiated into the Fang religion.

IRON MEMORIAL SCULPTURE OF THE FON. In the early twentieth century, Fon peoples living in coastal Ouidah, in the Republic of Benin, created a distinctive style of iron memorial sculpture (*asen*) that were kept in a special building located in a family's courtyard. The various figurative and

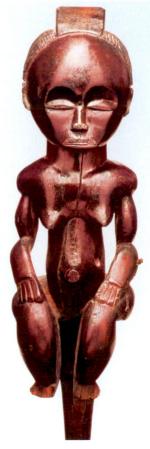

28–19 | RELIQUARY GUARDIAN (NLO BYERI)
Gabon. Fang culture. 19th century. Wood, height 16%"
(43 cm). Musée Dapper, Paris.

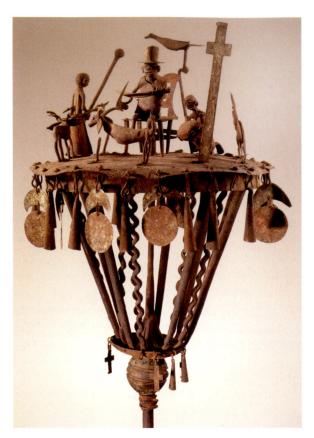

28–20 | ALTAR (ASEN)
Fon peoples, Ouidah, Republic of Benin. Iron, wood, paint traces, height 44½" (113 cm). National Museum of African Art, Smithsonian Institution, Washington D.C.
Gift of Monique and Jean Paul Barbier-Mueller 93-2-2.

other motifs placed on top of an *asen* related to the life and achievements of a particular ancestor. Each family maintained a number of *asen*. Collectively, the *asen* served as points of contact with the ancestral spirits during annual and periodic commemorative ceremonies. Through these ceremonies the ancestors were acknowledged and their aid was sought to help in the ongoing life of the family.

The asen in FIGURE 28–20 is a particularly complex example. The large disk supported by iron posts serves as a circular stage onto which are attached iron figures and animals. A central seated figure holding a sword presents the deceased as a person of authority. He is surrounded by figures who pay homage to him, including a kneeling female figure holding a lidded gourd that would contain an offering of water or food for the deceased. The images of animals such as the goat, chickens, bullock, and pig represent the animals that were sacrificed to honor the deceased at his funeral or at a commemorative ceremony. Other animals such as the bird on top of a millet stalk may refer to proverbs that acknowledge the responsibility of the living to honor their ancestors. The cross on the asen could be a Christian symbol or (more probably) a symbol of Mawu, who is considered the female half of the creator couple.

CONTEMPORARY ART

The photographs of rituals and ceremonies in this chapter show ways that African traditional arts have continued during the modern era. All of these photographs are somewhat dated, and yet, even today, performances are staged in which the same types of masks will most likely appear. Many African communities continue to re-create artforms according to their traditions. But Africa is ever-changing, and as new experiences pose new challenges and offer new opportunities, African art changes over time.

Perhaps the most obvious change in traditional African art has been in the adaptation of modern materials to traditional forms. Some Yoruba, for example, have used photographs and bright-colored, imported plastic children's dolls in place of the traditional *ere ibeji*, the images of twins shown in FIGURE 28–4. The Guro people of Côte d'Ivoire continue to commission delicate masks dressed with costly textiles and other materials, but now they paint them with brilliantly colored oil-based enamel paints. The Baule create brightly painted versions of spirit spouse figures dressed as businessmen or soccer players.

Throughout the colonial period and especially during the years following World War II, many African artists trained in the techniques of European art. In the postcolonial era, numerous African artists have studied in Europe and the United States, and many have become known internationally through exhibits of their work in galleries and museums. Yet, the diversity of influences on contemporary Africa makes it impossible to render a homogeneous view of what constitutes a contemporary African art. As the art historian and curator Salah Hassan (1999:224) writes: "The development of a modern idiom in African art is closely linked to modern Africa's search for identity. Most contemporary works have apparent ties to traditional African folklore, belief systems and imagery. The only way to interpret or understand these works is in the light of the dual experience of colonialism and assimilation into Western culture in Africa. They reflect the search for a new identity."

EL ANATSUI OF GHANA. This search for identity inspired a desire to affirm Africa's rich legacy of tradition-based art in the work of El Anatsui. Born in Ghana in 1944, Anatsui studied art in Kumasi where he took course work he describes as predominantly Western in orientation. He found the emphasis on Western traditions irrelevant while Ghana's own rich legacy was ignored and, following his own inclinations, he began to study Ghanaian surface design traditions as produced by Ewe and Asante textile artists. In 1975, Anatsui took a position in the Fine Arts Department of the University of Nigeria at Nsukka. There he found a like-minded spirit in Uche Okeke, who was intensely interested in revitalizing *uli*, an important Igbo surface design system. Anatsui began to create what would

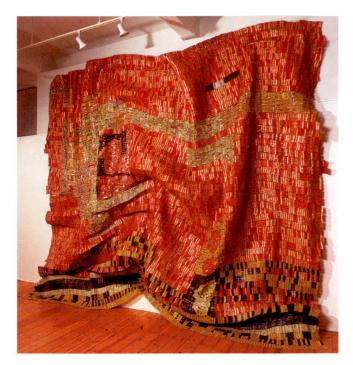

28–21 | El Anatsui FLAG FOR A NEW WORLD POWER 2004. Aluminum bottle tops, copper wire, 196 \times 177" (500 \times 450 cm). Courtesy October Gallery, London

become a large body of work inspired by *uli* and other graphic systems using tools such as chainsaws and blow torches. More recently, while still concerned with the survival and transmission of inherited traditions, Anatsui began to appropriate cast-off objects he found in and around Nsukka, including broken and discarded mortars, large coconut graters, and liquor-bottle caps, to create revelatory art forms in a variety of media. These include visually stunning immense wall sculptures that fold and undulate like textiles but are made from metal bottle caps sewn together with copper wire (FIG. 28–21).

While living in Nigeria, El Anatsui, like many contemporary African artists, also participates in international art events—including international workshops, symposia, biennial exhibitions, and art festivals that dramatically invigorate our global visual culture. On the other hand, many other African artists have moved permanently to major European and American cities, which offer them increased opportunities for exposure to art dealers, museum curators, art critics, and the expanding base of public and private collectors of African contemporary art.

Myth and Religion

DIVINATION AMONG THE CHOKWE

hokwe peoples of the Democratic Republic of the Congo and Angola consult diviners (nganga) to disclose the sources of problems such as death, illness, impotence, sterility, and theft. As the mediator between this world and the supernatural, the diviner's role is to ascertain the true meaning and underlying cause of an affliction or misfortune, and whether it is due to a conflict with human protagonists or with spirit forces. The diviner's ability to uncover the cause of a client's problems comes through the agency of powerful spirit forces and the efficacy of divinatory paraphernalia. A Chokwe nganga, utilizing a rattle to call the spirits to the divination, begins to shake a shallow covered basket (ngombo ya kusekula) containing a variety of natural objects including small antelope horns, seeds, and minerals. The basket also contains a number of carved wooden objects representing humans (in various symbolic poses), animals, and other objects such as small models of masks and masked figures. The objects in the basket are tossed about as the basket is shaken and when finished the cover is removed to reveal the arrangement of the objects as they came to rest below. The nganga interprets the results of multiple tosses to disclose the underlying cause of the client's problem and suggests what steps need to be taken to remedy the situation.

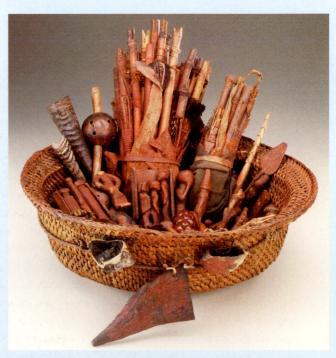

DIVINATION BASKET (NGOMBO)

Chokwe peoples, Democratic Republic of the Congo and Angola. Mid-19th-early 20th century. Plant fiber, seed, stone, horn, shell, bone, metal, feather, camwood, depth $12\frac{1}{16}$ (30.7 cm).

National Museum of African Art, Smithsonian Institution, Washington, D.C.

Museum purchase (86-12-17.1)

28–22 | Julie Mehretu DISPERSION 2002. Ink and acrylic on canvas, $90 \times 144''$ (228.6 \times 365.8 cm). Collection of Nicolas and Jeanne Greenberg Rohatyn, New York.

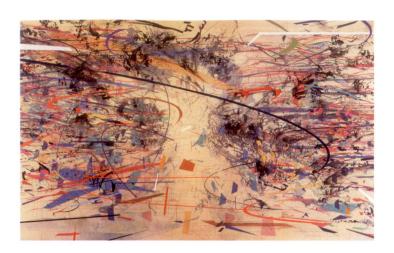

AFRICAN ARTISTS IN DIASPORA While many African artists are primarily influenced by their own culture and traditions, others—especially some who no longer live on the continent—seem entirely removed from African stylistic influences and yet still express the search for a new African identity in revelatory ways. Their experiences of movement, accommodation, and change often become important elements in their art making and form an additional basis for the interpretation of their work. Julie Mehretu (FIG. 28–22) is an eminent example of this kind of African artist.

Born in Ethiopia in 1970, but having lived as well in Senegal and the United States, and now in New York City, Julie Mehretu makes large-scale paintings and wall drawings that exude intense energy. Her works speak not only to her own history of movement and change, but also to the transnational movement of myriad others uprooted by choice or by force as they create new identities in this increasingly turbulent period of globalization and change.

The underpinnings of her intricately layered canvases are architectural plans of airports, passenger terminals, and other places where people congregate and pass through during their lives. Layered and at times obscuring these architectural elements are an immense inventory of signs and markings influenced by cartography, weather maps, Japanese and Chinese calligraphy, tattooing, graffiti, and various stylized forms suggesting smoke and explosions borrowed from cartoons, comic books, and anime. Occasionally architectural details such as arches, stairways, and columns reminiscent of Dürer or Piranesi can also be discerned. The ambiguous reading of the paintings as either implosion and chaos or explosion and regeneration gives the works visual and conceptual complexity. Mehretu explains that she is not interested in describing or mapping specific locations but "in the multifaceted layers of place, space, and time that impact the formation of personal and communal identity" (quoted in Fogle 2003:5). Mehretu's

concerns echo those of other contemporary African artists whose identification with the continent becomes increasingly complex as they move from Africa and enter a global arena.

IN PERSPECTIVE

Africans today create both tradition-based art and contemporary art. Tradition-based African art appears in an immense variety of forms, ranging from complete naturalism to total abstraction. These artworks are often directly related to the commemoration of significant rites of passage such as procreation and birth, initiation to adulthood, socialization in adult life, and death. In these contexts, art is often intended to help mediate aid and support from a supernatural world of ancestors and other spirit forces.

Generally, the full meaning of a tradition-based work of art can only be realized in the context of its use. For instance, when masked dancers perform within a specific ceremonial event, the mask itself (which we may later see as an artwork in a museum) is only a part of a process that most fully reveals its meaning in performance.

While political leaders throughout the world use art to express their authority and status, in Africa community leaders are thought to connect the living community with the spirit world. In this regard, African art often especially idealizes the spirits of community leaders and deceased persons, who are expected to mediate between the temporal and supernatural worlds to help achieve well-being both for themselves and for the entire community.

Increasingly, contemporary African artists are creating and exhibiting their work with an international art audience in mind. In searching for ways to express an African identity in art, some of these artists are continuing to draw inspiration from indigenous traditions, while others are seeking new meanings in radically modern forms.

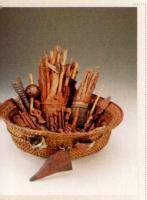

MID 19TH-EARLY 20TH CENTURY

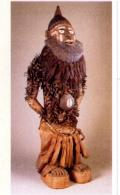

KONGO NKISI NKONDE 19TH CENTURY

VERANDAH POSTS 1910-14

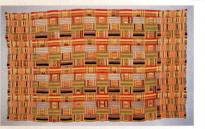

KENTE CLOTH 20TH CENTURY

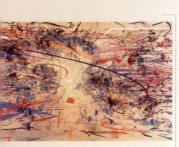

DISPERSION 2002

ART OF AFRICA IN THE MODERN ERA

Europeans Establish Contact with Coastal Sub-Saharan Africa c. 1400

- Portuguese First Encounter Congo Culture 1482
- Cordial Relations Established between Benin and Portugal 1485

1600

1800

- British Sack and Burn Benin Royal Palace 1897
- Oba of Benin Return from Exile 1914
- Most of Africa Under Foreign Control c. 1914
- Colonies Gain Independence 1950s-mid1970s

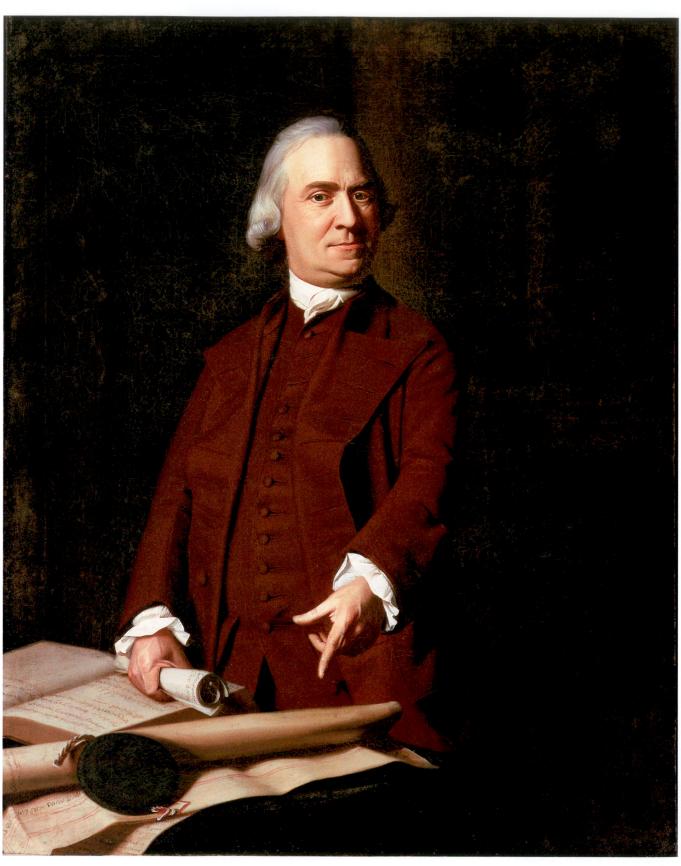

29–I | **John Singleton Copley SAMUEL ADAMS** c. 1770–72. Oil on canvas, $50 \times 40''$ (127 \times 102.2 cm). Museum of Fine Arts, Boston. Deposited by the City of Boston

CHAPTER TWENTY-NINE

EIGHTEENTH-CENTURY ART IN EUROPE AND THE AMERICAS

On March 5, 1770, a street fight broke out between several dozen residents of Boston and a squad of British soldiers. The British fired into the crowd, killing three men and wounding eight others, two of whom later died. Dubbed

the Boston Massacre by anti-British patriots, the event was one of many that led to the Revolutionary War of 1775–83, which won independence from Britain for the thirteen American colonies.

The day after the Boston Massacre, Samuel Adams, a member of the Massachusetts legislature, demanded that the royal governor, Thomas Hutchinson, expel British troops from the city—a confrontation that Boston painter John Singleton Copley immortalized in oil paint (FIG. 29–1). Adams, conservatively dressed in a brown suit and waistcoat, stands before a table and looks sternly out at the viewer, who occupies the place of Governor Hutchinson. With his left hand, Adams points to the charter and seal granted to Massachu-

29

setts by King William and Queen Mary; in his right, he grasps a petition prepared by the aggrieved citizens of Boston.

The vivid realism of Copley's style makes the life-size figure of Adams seem almost to be

standing before us. Adams's head and hands, dramatically lit, surge out of the darkness with a sense of immediacy appropriate to the urgency of his errand. The legislator's defiant stance and emphatic gesture convey the moral force of his demands, which are impelled not by emotion but by reason. The charter to which he points insists on the rule of law, and the faintly visible classical columns behind him connote republican virtue and rationality—important values of the Enlightenment, the major philosophical movement of eighteenth-century Europe as well as Colonial America. Enlightenment political philosophy provided the ideological basis for the American Revolution, which Adams ardently supported.

- THE ENLIGHTENMENT AND ITS REVOLUTIONS
- THE ROCOCO STYLE IN EUROPE | Architecture and Its Decoration in Germany and Austria | Painting and Sculpture in France
- ITALY AND THE CLASSICAL REVIVAL | Italian Portraits and Views | Neoclassicism in Rome: The Albani-Winckelmann Influence
- REVIVALS AND EARLY ROMANTICISM IN BRITAIN | Classical Revival in Architecture and Landscaping | Gothic Revival in Architecture and Its Decoration | Neoclassicism in Architecture and the Decorative Arts | Painting
- LATER EIGHTEENTH-CENTURY ART IN FRANCE | Architecture | Painting and Sculpture
- EIGHTEENTH-CENTURY ART OF THE AMERICAS | New Spain | North America
- IN PERSPECTIVE

THE ENLIGHTENMENT AND ITS REVOLUTIONS

The eighteenth century marks a great divide in Western history. When the century opened, the West was still semifeudal economically and politically. Wealth and power were centered in an aristocratic elite, who owned or controlled the land worked by the largest and poorest class, the farmers. In between was a small middle class composed of doctors, lawyers, shopkeepers, artisans, and merchants—most of whom depended for their livelihood on the patronage of the rich. Only those involved in overseas trade operated outside the agrarian system, but even they aspired to membership in the landed aristocracy.

By the end of the century, the situation had changed dramatically. A new source of wealth—industrial manufacture—was then developing, and social visionaries expected industry not only to expand the middle class but also to provide a better material existence for all classes, an interest that extended beyond purely economic concerns. What became known as the Industrial Revolution was complemented by a revolution in politics, spurred by a new philosophy that conceived of all white men (some thinkers included women and racial or ethnic minorities) as deserving of equal rights and opportunities. The American Revolution of 1776 and the French Revolution of 1789 were the seismic results of this dramatically new concept.

Developments in politics and economics were themselves manifestations of a broader philosophical revolution: the Enlightenment. The Enlightenment was a radically new synthesis of ideas about humanity, reason, nature, and God that had arisen during classical Greek and Roman times and during the Renaissance. What distinguished the Enlightenment proper from its antecedents was the late seventeenthand early eighteenth-century thinkers' generally optimistic view that humanity and its institutions could be reformed, if not perfected. Bernard de Fontenelle, a French popularizer of seventeenth-century scientific discoveries, writing in 1702, anticipated "a century which will become more enlightened

day by day, so that all previous centuries will be lost in darkness by comparison." At the end of the seventeenth and beginning of the eighteenth century, such hopes were expressed by a handful of people; after 1740, the number and power of such voices grew, so that their views increasingly dominated every sphere of intellectual life, including that of the European courts. The most prominent and influential of these thinkers, called *philosophes* (to distinguish their practical concerns from the purely academic ones of philosophers), included Jean-Jacques Rousseau, Denis Diderot, Thomas Jefferson, Benjamin Franklin, and Immanuel Kant.

The philosophes and their supporters did not agree on all matters. Perhaps the matter that most unified these thinkers was the question of the purpose of humanity. Rejecting conventional notions that men and women were here to serve God or the ruling class, the philosophes insisted that humans were born to serve themselves, to pursue their own happiness and fulfillment. The purpose of the state, they agreed, was to facilitate this pursuit. Despite the pessimism of some and the reservations of others, Enlightenment thinkers were generally optimistic that men and women, when set free from their political and religious shackles, could be expected to act both rationally and morally. Thus, in pursuing their own happiness, they would promote the happiness of others.

The new emphasis on rationality proceeded in part from new mathematical and scientific discoveries by such thinkers as René Descartes, Gottfried Wilhelm von Leibnitz, Blaise Pascal, and, perhaps most significantly, Isaac Newton. Newton brought a new emphasis on empirical proof to his scientific studies and rejected the supernatural realm as a basis for theory. Fellow Englishman John Locke transferred this empiricism to his consideration of human society, concluding that ideas and behavior are not inborn or predetermined by God but rather the result of perception and experience. Each individual was born a blank slate with certain basic rights that a government was obligated to protect.

Thus, most Enlightenment thinkers saw nature as both rational and good. The natural world, whether a pure mecha-

MAP 29-I | EUROPE AND NORTH AMERICA IN THE EIGHTEENTH CENTURY

During the eighteenth century, three major artistic styles—Rococo, Neoclassicism, and Romanticism—flourished in Europe and North America.

nism or the creation of a beneficent deity, was amenable to human understanding and, therefore, control. Once the laws governing the natural and human realms were determined, they could be harnessed for our greater happiness. From this concept flowed the inextricably intertwined industrial and political revolutions that marked the end of the century. Before the Enlightenment took hold, however, most of aristocratic Europe had a fling with the art style known as Rococo, a sensuous variation on the preceding Baroque.

THE ROCOCO STYLE IN EUROPE

The term *Rococo* was coined by critics who combined the Portuguese word *barroco* (which refers to an irregularly shaped pearl and may be the source of the word *baroque*) and the French word *rocaille* (the artificial shell or rock ornament popular for gardens) to describe the refined, fanciful, and often playful style that became fashionable in France at the end of the seventeenth century and spread throughout Europe in the eighteenth century. This was the favored style of an aristocracy that devoted itself to the enjoyment of superficial pleasures, including witty conversation, cultivated artifice, and playful sensuality. The Rococo style is

characterized by pastel colors, delicately curving forms, dainty figures, and a lighthearted mood. It may be seen partly as a reaction at all levels of society, even among kings and bishops, against the art identified with the formality and rigidity of seventeenth-century court life. The movement began in French architectural decoration at the end of Louis XIV's reign (ruled 1643-1715) and quickly spread across Europe (MAP 29-1). The Duke of Orléans, regent for the boy-king Louis XV (ruled 1715-74), made his home in Paris, and the rest of the court—delighted to escape the palace at Versailles—also moved there and built elegant town houses (in French, hôtel), whose smaller rooms dictated new designs for layout, furniture, and décor. They became the lavish settings for intimate and fashionable intellectual gatherings and entertainments, called salons, that were hosted by accomplished, educated women of the upper class whose names are still known today—Mesdames de Staël, de La Fayette, de Sévigné, and du Châtelet being among the most familiar. The SALON DE LA PRINCESSE in THE HÔTEL DE SOUBISE in Paris (FIG. 29-2), designed by Germain Boffrand (1667-1754) beginning in 1732, is typical of the delicacy and lightness seen in French Rococo hôtel design during the 1730s.

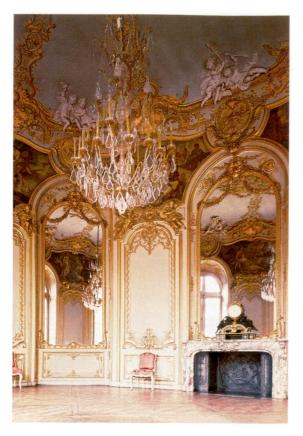

29-2 | Germain Boffrand SALON DE LA PRINCESSE, HÔTEL DE SOUBISE

Paris, France. Begun 1732. Library, Getty Research, Institute, Los Angeles. Wim Swaan Photograph Collection (96, p.21)

29–3 | Johann Balthasar Neumann KAISERSAAL (IMPERIAL HALL), RESIDENZ, WÜRZBURG

Bavaria, Germany. 1719-44. Fresco by Giovanni Battista Tiepolo. 1751-52 (SEE FIG. 29-4). Typical Rococo elements in architectural decoration were arabesques (characterized by flowing lines and swirling shapes), S-shapes, C-shapes, reverse—C-shapes, volutes, and naturalistic plant forms. The glitter of silver or gold against expanses of white or pastel color, the visual confusion of mirror reflections, delicate ornament in sculpted stucco, carved wood panels called *boiseries*, and inlaid wood designs on furniture and floors were all part of the new look. In residential settings, pictorial themes were often taken from classical love stories, and sculpted ornaments were rarely devoid of *putti*, cupids, and clouds.

Architecture and Its Decoration in Germany and Austria

After the end of the War of the Spanish Succession in 1714, rulers in central Europe felt the need to replace damaged buildings and display their power and wealth more impressively. Interior designs for some of these new palaces and churches, though based on traditional Baroque plans, were also animated by the Rococo spirit, especially in Germany and Austria. In occasional small-scale buildings, the Rococo style was successfully applied to architectural planning as well.

THE RESIDENZ AT WÜRZBURG. The first major architectural project influenced by the new Rococo style was the Resi-

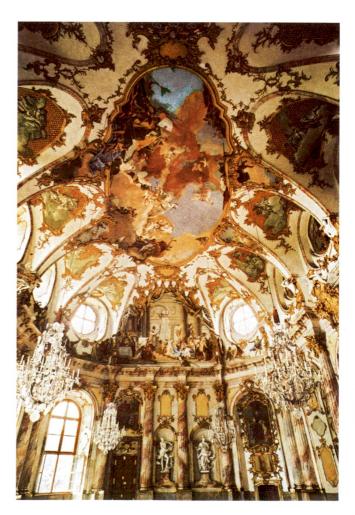

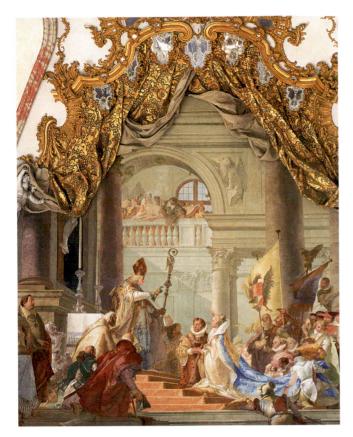

29–4 | Giovanni Battista Tiepolo THE MARRIAGE OF THE EMPEROR FREDERICK AND BEATRICE OF BURGUNDY Fresco in the Kaisersaal (Imperial Hall), Residenz. Würzburg, Germany. 1751–52.

denz, a splendid palace that Johann Balthasar Neumann (1687–1753) designed for the prince-bishop of Würzburg from 1719 to 1744. The oval KAISERSAAL, or Imperial Hall (FIG. 29–3), illustrates Neumann's great triumph in planning and decoration. Although the clarity of the plan, the size and proportions of the marble columns, and the large windows recall the Hall of Mirrors at Versailles (SEE FIG. 19–23), the decoration of the Kaisersaal, with its white-and-gold color scheme and its profusion of delicately curved forms, embodies the Rococo spirit. Here we see the earliest development of Neumann's aesthetic of interior design that culminated in his final project, the Church of the Vierzehnheiligen (Fourteen Auxiliary Saints) near Staffelstein (SEE FIG. 29–7).

Neumann's collaborator on the Residenz was the Venetian painter Giovanni Battista Tiepolo (1696–1770), who began to work there in 1750. Venice by the early eighteenth century had surpassed Rome as an artistic center, and Tiepolo gained international acclaim for his confident and optimistic expression of the illusionistic fresco painting pioneered by sixteenth-century Venetians such as Veronese (SEE PAGE 700). Tiepolo filled the niches in the Kaisersaal with frescoes—three scenes glorifying the twelfth-century crusader-emperor Frederick Barbarossa, who had been an early patron of the bishop of Würzburg—in a superb example of his architectural painting. THE MARRIAGE OF THE EMPEROR FREDERICK

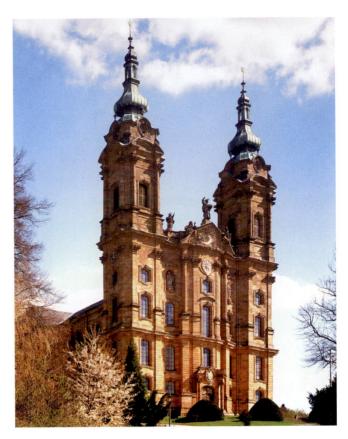

29–5 | Johann Balthasar Neumann CHURCH OF THE VIERZEHNHEILIGEN
Near Staffelstein, Germany. 1743–72.

were theater, with painted and gilded stucco curtains drawn back to reveal the sumptuous costumes and splendid setting of an imperial wedding. Like Veronese's grand conceptions, Tiepolo's spectacle is populated with an assortment of character types, presented in dazzling light and sun-drenched colors with the assured hand of a virtuoso. Against the opulence of their surroundings, these heroic figures behave with the utmost decorum and, the artist suggests, nobility of purpose. The pale colors and elaborately cascading draperies they wear foreshadow the emerging Rococo style.

ROCOCO CHURCH DECORATION. Rococo decoration in Germany was as often religious as secular. One of the many opulent Rococo churches still standing in Germany and Austria is that of the **CHURCH OF THE VIERZEHNHEILIGEN**, or "Fourteen Auxiliary Saints" (FIG. 29–5), which Neumann began in 1743. The exterior shows an early Rococo style, with its gently bulging central pavilion and delicately arched windows. The façade offers only a foretaste of the overall plan (FIG. 29–6), which is based on six interpenetrating oval spaces of varying sizes around a domed ovoid center. The plan recalls Borromini's Baroque design of the Church of San Carlo alle Quattro Fontane (SEE FIG. 22–10), but surpasses it in airy lightness. On the interior of the nave (FIG. 29–7), the Rococo love of undu-

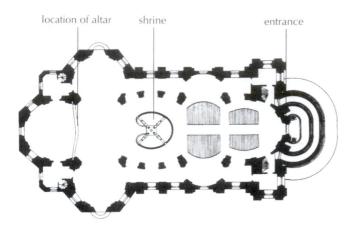

29–6 \perp plan of the church of the vierzehnheiligen c. 1743.

lating surfaces with overlays of decoration creates a visionary world where flat wall surfaces scarcely exist. Instead, the viewer is surrounded by clusters of pilasters and engaged columns interspersed with two levels of arched openings to the side aisles and large clerestory windows illuminating the gold and white of the interior. The foliage of the fanciful capitals is repeated in arabesques, wreaths, and the ornamented frames of the irregular panels that line the vault. What Neumann had begun in the Kaisersaal at Würzburg he brought to full fruition here in the ebullient sense of spiritual uplift achieved by the complete integration of architecture and decoration.

Rococo Painting and Sculpture in France

The death of the Sun King in 1715 brought important changes to French court life, and to art. The formality and seriousness that Louis XIV encouraged gave way to an increased devotion to pleasure, frivolity, and sensuality. As nobles forsook Versailles for pleasure palaces in the city such as the Hôtel de Soubise, artists decorated their salons with works that moved away from Academic precedent into realms redolent with casualness and fantasy. The Rococo style of painting and sculpture that French artists created reverberated across Europe until the rise of Neoclassicism in the 1760s brought Greece and Rome back in favor.

WATTEAU. The originator of the French Rococo style in painting, Jean-Antoine Watteau (1684–1721), was also its greatest exponent. Born in the provincial town of Valenciennes, Watteau around 1702 came to Paris, where he studied Rubens's Medici cycle (SEE FIG. 22–36), then displayed in the Luxembourg Palace, and the paintings and drawings of sixteenth-century Venetians such as Giorgione (SEE FIG. 20–23), which he saw in a Parisian private collection. After perfecting a graceful personal style informed by the fluent brushwork and rich colors of Rubens and the Venetians, Watteau created a new type of painting when he submitted his official examination canvas, PILGRIMAGE TO THE ISLAND OF CYTHERA

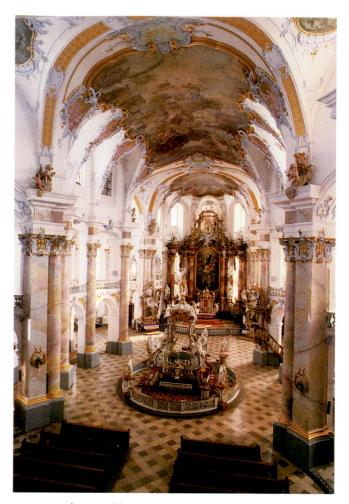

29—7 | Johann Balthasar Neumann INTERIOR, CHURCH OF THE VIERZEHNHEILIGEN 1743–72.

In the center of the nave of the Church of the Vierzehnheiligen (Fourteen Auxiliary Saints), an elaborate shrine was built over the spot where, in the fifteenth century, a shepherd had visions of the Christ Child surrounded by saints. The saints came to be known as the Holy Helpers because they assisted people in need.

(FIG. 29–8), for admission to membership in the Royal Academy of Painting and Sculpture in 1717 (see "Academies and Academy Exhibitions," page 948). The work so impressed the academicians that they created a new category of subject matter to accommodate it: the *fête galante*, or elegant outdoor entertainment. Watteau's painting depicts a dream world in which beautifully dressed couples, accompanied by *putti*, conclude their day's romantic adventures on the mythical island of love sacred to Venus, whose garlanded statue appears at the extreme right. The verdant landscape would never soil the characters' exquisite satins and velvets, nor would a summer shower ever threaten them. This kind of idyllic vision, with its overtones of wistful melancholy, had a powerful attraction in early eighteenth-century Paris and soon charmed most of Europe.

Tragically, Watteau died from tuberculosis when still in his thirties. During his final illness, while staying with the art dealer Edme-François Gersaint, he painted a signboard for Gersaint's shop (FIG. 29–9). The dealer later wrote that

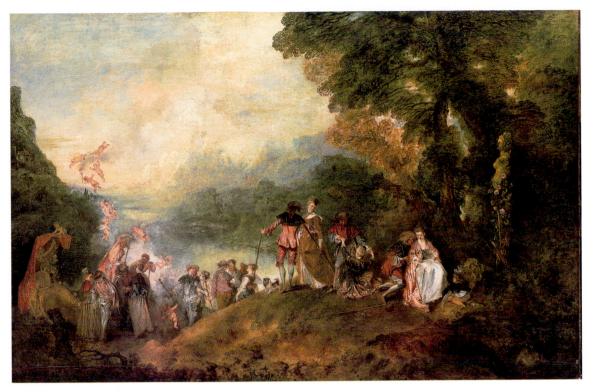

29–8 | Jean-Antoine Watteau PILGRIMAGE TO THE ISLAND OF CYTHERA 1717. Oil on canvas, $4'3'' \times 6'4\%''$ (1.3 \times 1.9 m). Musée du Louvre, Paris.

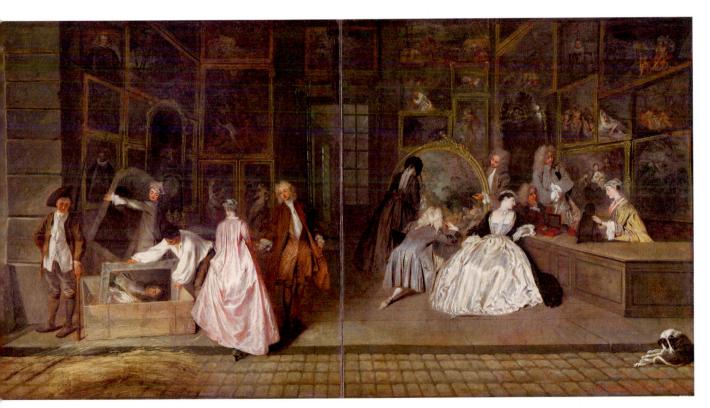

29–9 | Jean-Antoine Watteau | THE SIGNBOARD OF GERSAINT c. 1721. Oil on canvas, $5'4'' \times 10'1''$ (1.62 \times 3.06 m). Stiftung Preussische Schlössen und Gärten Berlin-Brandenburg, Schloss Charlottenburg.

Watteau's signboard painting was designed for the Paris art gallery of Edme-François Gersaint, who introduced to France the English idea of selling paintings by catalogue. The systematic listing of works for sale gave the name of the artist and the title, the medium, and the dimensions of each work of art. The shop depicted on the signboard is not Gersaint's but an ideal gallery visited by elegant and cultivated patrons. The sign was so admired that Gersaint sold it only fifteen days after it was installed. Later it was cut down the middle and each half was framed separately, which resulted in the loss of some canvas along the sides of each section. The painting was restored and its two halves reunited in the twentieth century.

Defining Art

ACADEMIES AND ACADEMY EXHIBITIONS

uring the seventeenth century, the French government founded a number of royal academies for the support and instruction of students in literature, painting and sculpture, music and dance, and architecture. In 1664, the Royal Academy of Painting and Sculpture began to mount occasional exhibitions of their members' recent work. These exhibitions came to be known as Salons because for much of the eighteenth century they were held in the Salon Carré in the Palace of the Louvre. Beginning in 1737, the Salons were held every other year, with a jury of members selecting the works to be shown. Illustrated here is a view of the Salon of 1787, with its typical floor-to-ceiling hanging of paintings. As the only public art exhibitions of any importance in Paris, the Salons were enormously influential in establishing officially approved styles and in molding public taste, and they helped consolidate the Royal Academy's dictatorial control over the production of art.

Among the most influential ideas promoted by the academy was that history painting (based on historical, mythological, or biblical narratives and generally conveying a high moral or intellectual idea) was the most important form of pictorial art, followed in prestige by landscape painting, portraiture, genre painting, and still life. As a result, most ambitious French artists of the later seventeenth and eighteenth centuries sought recognition as history painters, and devoted considerable effort to the creation of large-scale history paintings for the Salon. Several examples are visible in the upper registers of the illustrated view of the Salon of 1787, although the painting at the center is a portrait—Élisabeth Vigée-Lebrun's *Portrait of Marie Antoinette and Her Children* (SEE FIG. 29–38), doubtless given pride of place because it depicts members of the royal family.

In recognition of the importance of Rome as a training ground for artists—especially those aspiring to master history painting, which often treated subjects from ancient history or mythology—the French Royal Academy of Painting and Sculpture opened a branch there in 1666. The competitive Prix de Rome, or Rome Prize, was also established, which permitted the winners to study in Rome for three to five years. A similar prize was established by the French Royal Academy of Architecture in 1720.

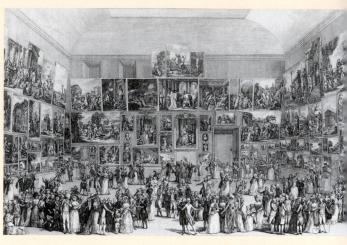

Piero Antonio Martini THE SALON OF 1787 1787. Engraving.

Many Western cultural capitals emulated the French model and opened academies of their own. Academies were established in Berlin in 1696, Dresden in 1705, London in 1768, Boston in 1780, Mexico City in 1785, and New York in 1802.

In France, the Revolution of 1789 brought a number of changes to the Royal Academy. In 1791, the jury system was abolished as a relic of the monarchy, and the Salon was democratically opened to all artists. In 1793, all of the royal academies were disbanded and, in 1795, reconstituted as the newly founded Institut de France, which was to administer the art school—the École des Beaux-Arts—and sponsor the Salon exhibitions. The number of would-be exhibitors was soon so large that it became necessary to reintroduce some screening procedure, and so the jury system was revived. In 1816, with the restoration of the monarchy following the defeat of Napoleon, the division of the Institut de France dedicated to painting and sculpture was renamed the Académie des Beaux-Arts, and thus the old academy was in effect restored.

Watteau had completed the painting in eight days, working only in the mornings because of his failing health. When the sign was installed, it was greeted with almost universal admiration, and Gersaint sold it shortly afterward.

The painting shows an art gallery filled with paintings from the Venetian and Netherlandish schools that Watteau admired. Indeed, the glowing satins and silks of the women's gowns pay homage to artists such as Gerard Ter Borch (SEE FIG. 22–51). The visitors to the gallery are elegant ladies and gentlemen, at ease in these surroundings and apparently

knowledgeable about paintings. Thus, they create an atmosphere of aristocratic sophistication. At the left, a woman in shimmering pink satin steps across the threshold, ignoring her companion's outstretched hand to look at the two porters packing. While one holds a mirror, the other carefully lowers into the wooden case a portrait of Louis XIV, which may be a reference to the name of Gersaint's shop, Au Grand Monarque ("At the Sign of the Great King"). It also suggests the passage of time, for Louis had died six years earlier. Other elements in the work also gently suggest transience. On the

left, the clock positioned directly over the king's portrait, surmounted by an allegorical figure of Fame and sheltering a pair of lovers, is a traditional *memento mori*, a reminder of mortality. The figures on it suggest that both love and fame are subject to the depredations of time. Well-established *vanitas* emblems are the straw (in the foreground), so easily destroyed, and the young woman gazing into the mirror (set next to a vanity case on the counter), for mirrors and images of young women looking at their reflections were time-honored symbols of the fragility of human life. Notably, the two gentlemen at the end of the counter also appear to gaze at the mirror, and are thus also implicated in the *vanitas* theme. The dying Watteau certainly knew how ephemeral life is, and no Western artist ever expressed the fleeting nature of human happiness with greater subtlety.

BOUCHER. The artist most closely associated today with Parisian Rococo painting at its height is François Boucher (1703–70). The son of a minor painter, Boucher in 1723 entered the workshop of an engraver. The young man's skill drew the attention of a devotee of Watteau, who hired Boucher to reproduce Watteau's paintings in his collection, an event that firmly established the direction of Boucher's career.

After studying at the French Academy in Rome from 1727 to 1731, Boucher settled in Paris and became an academician. Soon his life and career were intimately bound up with two women: The first was his artistically talented wife,

Marie-Jeanne Buseau, who was a frequent model as well as a studio assistant to her husband. The other was Louis XV's mistress, Madame de Pompadour, who became his major patron and supporter. Pompadour was an amateur artist herself and took lessons from Boucher in printmaking. After Boucher received his first royal commission in 1735, he worked almost continuously to decorate the royal residences at Versailles and Fontainebleau. In 1755, he was made chief inspector at the Gobelins Tapestry Manufactory, and he provided designs to it and to the Sèvres porcelain and Beauvais tapestry manufactories, all of which produced furnishings for the king. In 1765, Boucher became First Painter to the King. While he painted a number of fine portraits and scenes of daily life, Boucher is best known for his mythological scenes, in which gods, goddesses, and putti-generally nude except for strategically placed draperies-frolic or relax in natural settings. Among Boucher's most impressive mythological paintings is the TRIUMPH OF VENUS (FIG. 29–10). The goddess of love appears near the center of the composition, resting on silks and satins in a giant shell, pulled through the water by dolphins, and accompanied by burly Tritons and voluptuous sea nymphs, one of whom offers her a shell filled with pearls. In the sky above hover several putti, some of them carrying a shiny scarf that billows above Venus like a huge banner. In contrast to Watteau's wistful fêtes gallantes, Boucher's work creates a robust world of sensual pleasure recalling the style of Rubens (SEE FIG. 22-36), but Boucher's

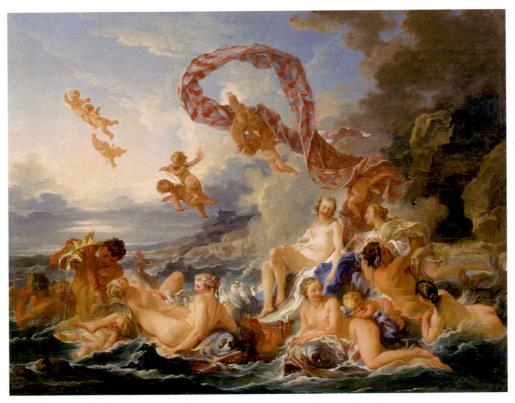

29–10 | François Boucher TRIUMPH OF VENUS 1740. Oil on canvas, $4'3\%'' \times 5'3\%''$ (1.3 × 1.62 m). Nationalmuseum, Stockholm.

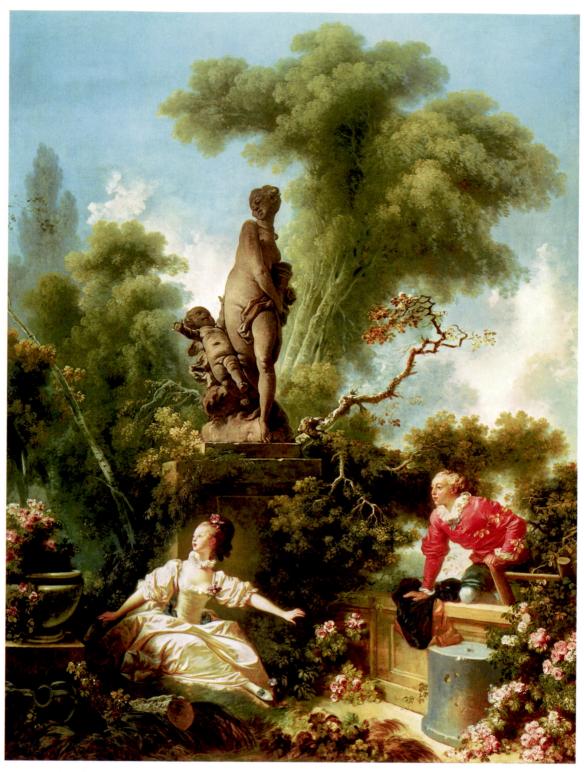

more charming and frivolous touches are distinctively Rococo.

FRAGONARD. The last noteworthy master of French Rococo painting, Jean-Honoré Fragonard (1732–1806) studied with Boucher, who encouraged Fragonard to enter the competition for the Prix de Rome, the three-to-five-year

scholarship awarded to the top students in painting and sculpture graduating from the French Academy's art school. Fragonard won the prize in 1752 and spent 1756–61 in Italy, but not until 1765 was he finally accepted as a member of the Royal Academy. Fragonard catered to the tastes of an aristocratic clientele, and he began to fill the vacuum left by Boucher's death in 1770 as a decorator of interiors.

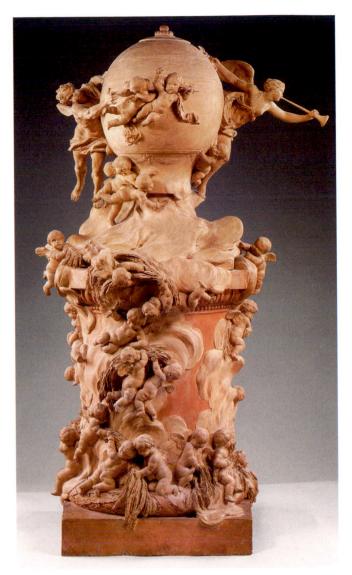

29–12 Clodion THE INVENTION OF THE BALLOON 1784. Terra-cotta model for a monument, height 43 ½" (110.5 cm). The Metropolitan Museum of Art, New York. Rogers Fund and Frederick R. Harris Gift, 1944 (44.21a b)

Clodion had a long career as a sculptor in the exuberant, Rococo manner seen in this work commemorating the 1783 invention of the hot-air balloon. During the austere revolutionary period of the First Republic (1792–95), he became one of the few Rococo artists to adopt successfully the more acceptable Neoclassical manner. In 1806, he was commissioned by Napoleon to provide the relief sculpture for two Paris monuments, the Vendôme Column and the Carrousel Arch near the Louvre.

Fragonard produced fourteen canvases commissioned around 1771 by Madame du Barry, Louis XV's last mistress, to decorate her château. These marvelously free and seemingly spontaneous visions of lovers explode in color and luxuriant vegetation. **THE MEETING** (FIG. 29–11) shows a secret encounter between a young man and his sweetheart, who looks anxiously over her shoulder to be sure she has not been followed, and clutches the letter that arranged the tryst. The rapid brushwork that distinguishes Fragonard's technique is at its freest and most lavish here. The entertaining subject mat-

Sequencing Works of Art

1717	Watteau, Pilgrimage to the Island of Cythera
1724	Plan of Chiswick House
c. 1730	Carriera, Charles Sackville, 2nd Duke of Dorset
1739	Chardin, The Governess
1770-72	Copley, Samuel Adams
1771-73	Fragonard, The Meeting
1781	Fuseli, The Nightmare
1787-93	Canova, Cupid and Psyche

ter, bright colors, and lush painting style typify the Rococo. Fragonard lived for more than thirty years after completing this work, long enough to see the Rococo lose its relevance in the newly complicated world of revolutionary France.

CLODION. In the last quarter of the eighteenth century, French art generally moved away from the Rococo style and toward Neoclassicism. But one sculptor who clung to Rococo up to the threshold of the French Revolution in 1789 was Claude Michel, known as Clodion (1738-1814). His major output consisted of playful, erotic tabletop sculpture, mainly in uncolored terra cotta. Typical of Clodion's Rococo designs is the terra-cotta model he submitted to win a 1784 royal commission for a large monument to the invention of the hot-air balloon (FIG. 29-12). Although Clodion's enchanting piece may today seem inappropriate to commemorate a technological achievement, hot-air balloons then were elaborately decorated with painted Rococo scenes, gold braid, and tassels. Clodion's balloon, decorated with bands of classical ornament, rises from a columnar launching pad in billowing clouds of smoke, assisted at the left by a puffing wind god with butterfly wings and heralded at the right by a trumpeting Victory. A few putti stoke the fire basket that provided the hot air on which the balloon ascended as others gather reeds for fuel and fly up toward them.

ITALY AND THE CLASSICAL REVIVAL

From the late 1600s until well into the nineteenth century, the education of a wealthy young northern European or American gentleman—and increasingly over that period, gentlewoman—was completed on the **Grand Tour**, a prolonged visit to the major cultural sites of southern Europe. Accompanied by a tutor and an entourage of servants, the young man

Art and Its Context

WOMEN AND ACADEMIES

Ithough several women were made members of the European academies of art before the eighteenth century, their inclusion amounted to little more than honorary recognition of their achievements. In France, Louis XIV had proclaimed in the founding address of the Royal Academy that its intention was to reward all worthy artists, "without regard to the difference of sex," but this resolve was not put into practice. Only seven women gained the title of Academician between 1648 and 1706, the year the Royal Academy declared itself closed to women. Nevertheless, four more women had been admitted to the cademy by 1770, when the men became worried that women members would become "too numerous," and declared four women members to be the limit at any one time. Young women were not admitted to the academy school nor allowed to compete for academy prizes, both of which were nearly indispensable for professional success.

Women fared even worse at London's Royal Academy. After the Swiss painters Mary Moser and Angelica Kauffmann were named as founding members in 1768, no other women were elected until 1922, and then only as associates. Johann Zoffany's 1771–72 portrait of the London academicians shows the men grouped around a male nude model, along with the academy's study collection of classical statues and plaster copies. Propriety prohibited the presence of women in this setting (women were not allowed to see or work from the male nude), so Zoffany painted Moser's and Kauffmann's portraits on the wall. In more formal portraits of the academy, however, the two women were included.

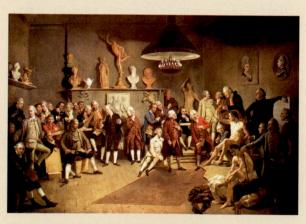

Johann Zoffany ACADEMICIANS OF THE ROYAL ACADEMY

1771-72. Oil on canvas, $47\frac{1}{2} \times 59\frac{1}{2}$ " (120.6 \times 151.2 cm). The Royal Collection, Windsor Castle, Windsor, England.

or woman began in Paris, moved on to southern France to visit a number of well-preserved Roman buildings and monuments there, then headed to Venice, Florence, Naples, and Rome. As repository of the classical and the Renaissance pasts, Italy was the focus of the Grand Tour and provided inspiration for the most characteristic style to prevail during the Enlightenment, Neoclassicism. Neoclassicism (neo means "new") presents classical subject matter—mythological or historical in a style derived from classical Greek and Roman sources. While some Neoclassical art was conceived to please the senses, most of it was intended to teach moral lessons. In its didactic manifestations—usually history paintings—Neoclassicism was an important means for conveying Enlightenment ideals such as courage and patriotism. It arose, in part, in reaction to the perceived frivolity and excess of the Rococo. Most Enlightenment thinkers held Greece and Rome in high regard as fonts of democracy and secular government, and the Neoclassical artists likewise revived classical stories and styles in an effort to instill those virtues.

Beginning in 1738, extraordinary archaeological discoveries made at two sites near Naples also excited renewed interest in classical art and artifacts. Herculaneum and Pompeii, two prosperous Roman towns buried in 79 CE by the sudden volcanic eruption of Mount Vesuvius, offered sensational new material for study and speculation. Numerous illustrated books on these discoveries circulated throughout Europe and America, fueling public fascination with the ancient world and contributing to a taste for the Neoclassical style.

Italian Portraits and Views

Most educated Europeans regarded Italy as the wellspring of Western culture, where Roman and Renaissance art flourished in the past and a great many artists still practiced. The studios of important Italian artists were required stops on the Grand Tour, and collectors avidly bought portraits and land-scapes that could boast an Italian connection.

CARRIERA. Wealthy northern European visitors to Italy often sat for portraits by Italian artists. Rosalba Carriera (1675-1757), the leading portraitist in Venice during the first half of the eighteenth century, began her career designing lace patterns and painting miniature portraits on the ivory lids of snuffboxes. By the early eighteenth century she was making portraits with pastels, crayons of pulverized pigment bound to a chalk base by weak gum water. A versatile medium, pastel can be employed in a sketchy manner to create a vivacious and fleeting effect or can be blended through rubbing to produce a highly finished image. Carriera's pastels earned her honorary membership in Rome's Academy of Saint Luke in 1705, and she later was admitted to the academies in Bologna and Florence. In 1720 she traveled to Paris, where she made a pastel portrait of the young Louis XV and was elected to the Royal Academy of Painting and Sculpture,

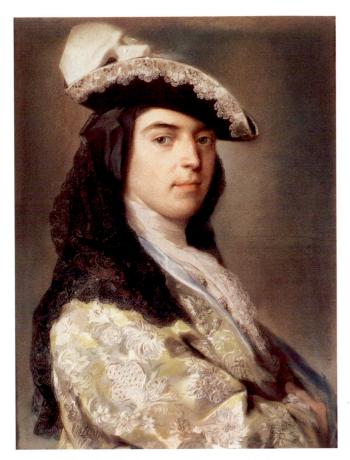

29–13 | Rosalba Carriera CHARLES SACKVILLE, 2ND DUKE OF DORSET c. 1730. Pastel on paper, $25 \times 19''$ (63.5 \times 48.3 cm). Private collection.

despite the 1706 rule forbidding the admission of any more women (see "Women and Academies," page 952). Returning to Italy in 1721, Carriera spent much of the rest of her career in Venice, where she produced sensitive portraits of distinguished sitters such as the British aristocrat Charles Sackville (FIG. 29–13).

CANALETTO. Even more than portraits of themselves, visitors to Italy on the Grand Tour desired paintings and prints of city views, which they collected largely as fond reminders of their travels. These city views were two types: the capriccio ("caprice;" plural capricci), in which the artist mixed actual features, especially ruins, into imaginatively pleasing compositions; and the veduta ("view;" plural vedute), a naturalistic rendering of a well-known tourist attraction, which often took the form of a panoramic view that was meticulously detailed, topographically accurate, and populated with a host of contemporary figures engaged in typical activities. The Venetian artist Giovanni Antonio Canal, called Canaletto (1697-1768), became so popular among British clients for his vedute that his dealer arranged for him to work from 1746 to 1755 in England, where he painted topographic views of London and the surrounding countryside, giving impetus to a school of English landscape painting.

In 1762, the English king George III purchased Canaletto's **SANTI GIOVANNI E PAOLO AND THE MONUMENT TO BARTOLOMMEO COLLEONI** (FIG. 29–14), painted probably in 1735–38. The Venetian square, with its famous fifteenth-century equestrian monument by Verrocchio (SEE FIG. 19–16),

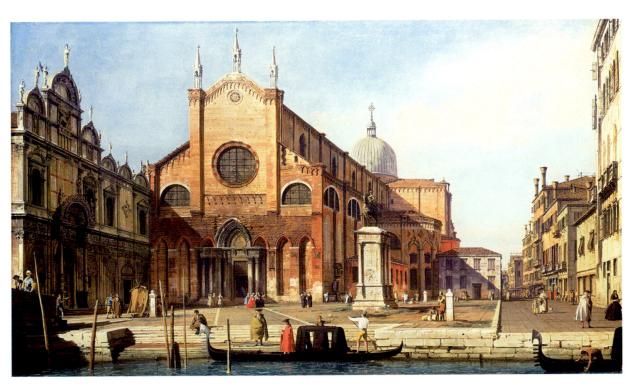

29–I4 | Canaletto SANTI GIOVANNI E PAOLO AND THE MONUMENT TO BARTOLOMMEO COLLEONI c. 1735–38. Oil on canvas, $18\% \times 30\%$ " (46×78.4 cm). The Royal Collection, Windsor Castle, Windsor, England.

is shown as if the viewer were in a gondola on a nearby canal. The roofline of the large church of Santi Giovanni e Paolo behind the monument creates a powerful orthogonal that draws the viewer's eye toward the vanishing point at the lower right. Many of Canaletto's views, like this one, are topographically correct. In others he rearranged the buildings to tighten the composition, even occasionally adding features to produce a *capriccio*.

PIRANESI. Very different are the Roman views of Giovanni Battista Piranesi (1720-78), one of the century's greatest printmakers. Trained in Venice as an architect, Piranesi went to Rome in 1740. After studying etching, he began in 1743 to produce portfolios of prints, and in 1761 he established his own publishing house. Piranesi created numerous vedute of ancient Roman ruins, crumbling and overgrown with vegetation, and exemplary of the new taste for the picturesque, which contemporary British theorists defined as a quality seen in a landscape (actual or depicted) with an aesthetically pleasing irregularity in its shapes, composition, and lighting. Piranesi's fame today rests primarily, however, on a series of capricci: his Carcerci d'invenzione (Imaginary Prisons), which he began etching in 1741 and published in their definitive form in 1761. Recent discoveries at Herculaneum and Pompeii stimulated Piranesi's and his patrons' interest in Roman ruins—a major source of inspiration for the Carceri.

Informed both by his careful study of ancient Roman urban architecture and his knowledge of Baroque stage set design, Piranesi's Carceri, such as THE LION BAS-RELIEF (FIG. 29-15), depict vast, gloomy spaces spanned by the remnants of monumental vaults and filled with mazes of stairways and catwalks traversed by tiny human figures. Throughout Piranesi's series, motifs such as barred windows, dangling ropes and tackle, and the occasional torture device generate a sinister mood, but the overall effect created by the immense interiors and dwarfed figures is that of the sublime, an awesome, nearly terrifying experience of vastness described by the British writer Edmund Burke in his influential essay A Philosophical Enquiry into the Origin of our Ideas of the Sublime and the Beautiful (1756). Through their evocation of the sublime, which would later engage Romantic painters such as Joseph Mallord William Turner, and more fundamentally due to their powerfully imaginative qualities, Piranesi's Carceri are an early manifestation of Romanticism.

Neoclassicism in Rome: The Albani-Winckelmann Influence

A notable sponsor of the classical revival was Cardinal Alessandro Albani (1692–1779), who amassed a huge collection of antique sculpture, sarcophagi, **intaglios** (objects in which the design is carved out of the surface), cameos, and vases. In 1760–61, he built a villa just outside Rome to house

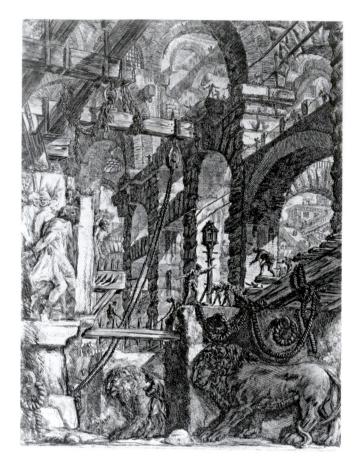

29–15 | Giovanni Battista Piranesi | THE LION BAS-RELIEF

Plate V from the series *Carceri d'invenzione (Imaginary Prisons)*. 1761. Etching and engraving, $21 \frac{1}{8} \times 16 \frac{1}{5}$ " (56.2 × 41.1 cm). The Fine Arts Museums of San Francisco.

Achenbach Foundation for the Graphic Arts purchase 1969.32.7.5

This print owes its name to the shadowy bas-reliefs of lions carved on the pedestals of a foreground stairway. At the left side of the composition is a brightly lit fragment of another ancient bas-relief showing a bound captive being paraded past spear-bearing Roman soldiers. Art historians have noted that this carved captive and another glimpsed to his right are the only prisoners actually pictured in Piranesi's print; the other human figures seem to be contemporary visitors to this fantastic ancient space, gesticulating with wonder at its sublime marvels.

and display his holdings, and the Villa Albani became one of the most important stops on the Grand Tour. The villa was more than a museum, however; it was also a kind of shop, where many of the items he sold to satisfy the growing craze for antiquities were faked or heavily restored by artisans working in the cardinal's employ.

Albani's credentials as the foremost expert on classical art were solidified when he hired as his secretary and librarian Johann Joachim Winckelmann (1717–68), the leading theoretician of Neoclassicism. The Prussian-born Winckelmann had become an advocate of classical art while working in Dresden, where the French Rococo style he deplored was fashionable. In 1755, he published a pamphlet, *Thoughts on the*

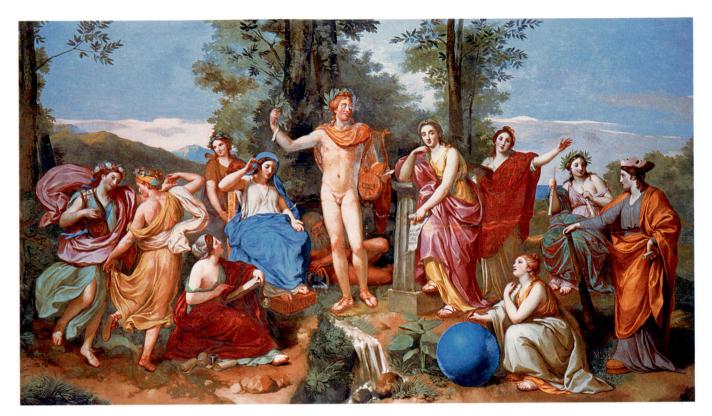

29–16 | Anton Raphael Mengs PARNASSUS Ceiling fresco in the Villa Albani, Rome. 1761.

Imitation of Greek Works in Painting and Sculpture, in which he attacked the Rococo as decadent and argued that only by imitating Greek art could modern artists become great again. Winckelmann imagined that the temperate climate and natural ways of the Greeks had perfected their bodies and made their artists more sensitive to certain general ideas of what constitutes true and lasting beauty. Shortly after publishing this pamphlet, Winckelmann moved to Rome, where in 1758 he went to work for Albani. In 1764 he published the second of his widely influential treatises, *The History of Ancient Art*, which many consider the beginning of modern art history. There he analyzed the history of art in terms of a logical succession of period styles, an approach which later became the norm for art history books (including this one).

MENGS. Winckelmann's closest friend and colleague in Rome was a fellow German, Anton Raphael Mengs (1728–79). Winckelmann's employer, Cardinal Albani, commissioned Mengs to create a painting for the ceiling of the great gallery in his new villa. The PARNASSUS ceiling (FIG. 29–16), from 1761, is usually considered the first true Neoclassical painting, though to most modern eyes the poses in the work seem forced and the atmosphere overly idealized. The scene takes place on Mount Parnassus in central Greece, which the ancients believed to be sacred to Apollo (the god of poetry, music, and the arts) and the nine Muses (female

personifications of artistic inspiration). At the center of the composition is Apollo, his pose modeled on that of the famous *Apollo Belvedere*, an ancient marble statue in the Vatican collection. Mengs's Apollo holds a lyre and a laurel branch, symbol of artistic accomplishment. Next to him, resting on a Doric column, is Mnemosyne, the mother of the Muses, who are shown in the surrounding space practicing the various arts. Inspired by relief sculpture he had studied at Herculaneum, Mengs arranged the figures in a generally symmetrical, pyramidal composition parallel to the picture plane. Winckelmann, not surprisingly, praised the work for achieving the "noble simplicity and calm grandeur" that he had found in Greek originals. Shortly after completing this work Mengs left for Spain, where he served as court painter until 1777.

CANOVA. The aesthetic ideals of the Albani-Winckelmann circle soon affected contemporary Roman sculptors, who remained committed to this paradigm for the next 100 years. The leading Neoclassical sculptor of the late eighteenth and early nineteenth centuries was Antonio Canova (1757–1822). Born near Venice into a family of stonemasons, Canova in 1781 settled in Rome, where under the guidance of the Scottish painter Gavin Hamilton (1723–98) he adopted the Neoclassical style and quickly became the most sought-after European sculptor of the period.

Canova specialized in two types of work: grand public monuments for Europe's leaders, and erotic mythological subjects, such as CUPID AND PSYCHE (FIG. 29-17), for the pleasure of private collectors. Cupid and Psyche illustrates the love story of Cupid, Venus's son, and Psyche, a beautiful mortal who had aroused the goddess's jealousy. Venus casts Psyche into a deathlike sleep; moved by Cupid's grief and love for her, the sky god Jupiter (the Roman name for the Greek Zeus) takes pity on the pair and gives Psyche immortality. In this sculpture, Canova chose the most emotional and tender moment in the story, when Cupid revives the lifeless Psyche with a kiss. Here Canova combined a Rococo interest in eroticism with a more typically Neoclassical appeal to the combined senses of sight and touch. Because the lovers gently caress each other, the viewer is tempted to run his or her fingers over the graceful contours of their cool, languorous limbs.

REVIVALS AND EARLY Romanticism in Britain

British tourists and artists in Italy became the leading supporters of Neoclassicism partly because they had been prepared for it by the architectural revival of Renaissance classicism in their homeland earlier in the century. While the terms Rococo and Neoclassicism identify distinct artistic styles—the one complex and sensuous, the other more simple and restrained—a third term applied to later eighteenth-century art, *Romanticism*, describes not only a style but also an attitude. Romanticism is chiefly concerned with imagination

and the emotions, and it is often understood as a reaction against the Enlightenment focus on rationality. Romanticism celebrates the individual and the subjective rather than the universal and the objective. The movement takes its name from the romances-novellas, stories, and poems written in Romance (Latin-derived) languages—that provided many of its themes. Thus, the term Romantic suggests something fantastic or novelistic, perhaps set in a remote time or place, infused by a poetic or even melancholic spirit. One of the best examples of early Romanticism in literature is The Sorrows of Young Werther by Johann Wolfgang von Goethe (1749-1832), in which a sensitive, outcast young man fails at love and kills himself. Goethe believed that the artist's principal duty was to communicate feeling to the audience, rather than to entertain or to recall ancient virtues; this soon became a basic precept of the Romantic movement.

Neoclassicism and Romanticism existed side by side in the later eighteenth and early nineteenth centuries. Indeed, because a sense of remoteness in time or place characterizes both Neoclassical and Romantic art, some scholars argue that Neoclassicism is a subcategory of Romanticism.

Classical Revival in Architecture and Landscaping

Just as the Rococo was emerging in France, a group of British professional architects and wealthy amateurs led by the Scot Colen Campbell (1676–1729) took a stance against what they saw as the immoral extravagance of the Italian Baroque. As a moral corrective, they advocated a return to the austerity and simplicity found in the architecture of Andrea Palladio.

29-17 | Antonio Canova CUPID AND PSYCHE 1787-93. Marble, 6'1" × 6'8" (1.55 × 1.73 m). Musée du Louvre, Paris.

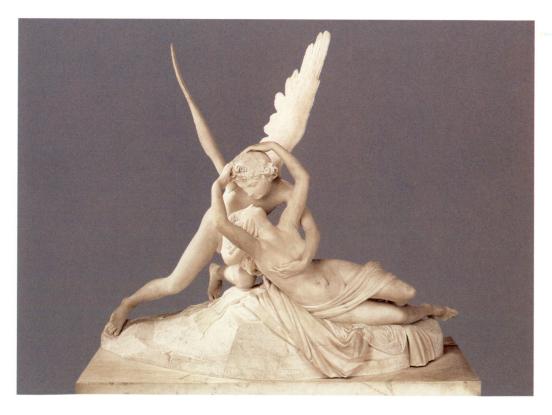

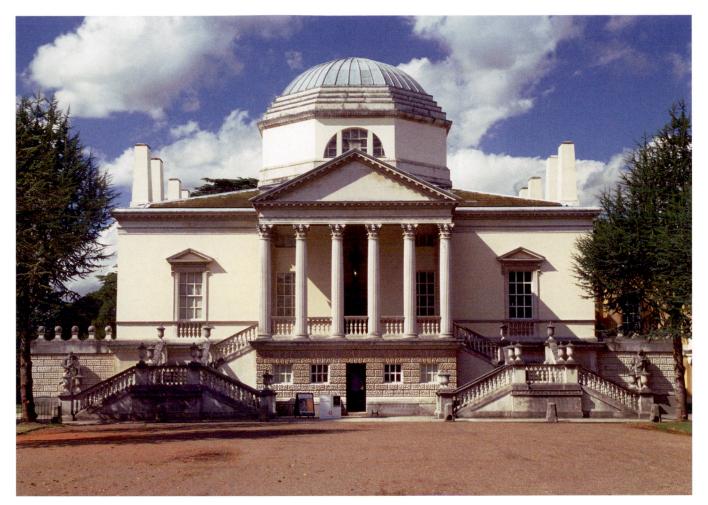

29–18 | Richard Boyle (Lord Burlington) CHISWICK HOUSE
West London, England. 1724–29. Interior decoration (1726–29) and new gardens (1730–40) by William Kent.

CHISWICK HOUSE. The most famous product of this group was **CHISWICK HOUSE** (FIG. 29–18), designed in 1724 by its owner, Richard Boyle, the third Earl of Burlington (1695–1753). Burlington sought out Palladio's architecture in Italy, especially his Villa Rotunda (SEE FIG. 20-47), which inspired Burlington's plan for Chiswick House. The building plan (FIG. 29-19) shares the bilateral symmetry of Palladio's villa, although its central core is octagonal rather than round and there are only two entrances. The main entrance, flanked now by matching staircases, is a Roman temple front, a flattering reference to the building's inhabitant. Chiswick's elevation is characteristically Palladian, with a main floor resting on a basement, and tall rectangular windows with triangular pediments. The result is a lucid evocation of Palladio's design, with few but crisp details that seem perfectly suited to the refined proportions of the whole.

In Rome, Burlington had persuaded the English expatriate William Kent (1685–1748) to return to London as his collaborator. Kent designed Chiswick's surprisingly ornate interior as well as the grounds, the latter in a style that became known throughout Europe as the English landscape

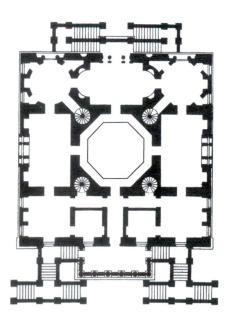

29–19 PLAN OF CHISWICK HOUSE 1724.

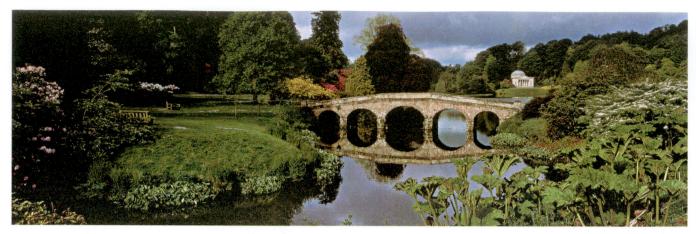

29–20 Henry Flitcroft and Henry Hoare THE PARK AT STOURHEAD Wiltshire, England. Laid out 1743; executed 1744–65, with continuing additions.

garden. Kent's garden, in contrast to the regularity and rigid formality of Baroque gardens (SEE FIG. 22–56), featured winding paths, a lake with a cascade, irregular plantings of shrubs, and other effects imitating the appearance of the natural rural landscape. The English landscape garden was another indication of the growing Enlightenment emphasis on the natural.

STOURHEAD. Following Kent's lead, landscape architecture flourished in the hands of such designers as Lancelot ("Capa-

bility") Brown (1716–83) (SEE FIG. 22–67) and Henry Flitcroft (1697–1769). In the 1740s the banker Henry Hoare began redesigning the grounds of his estate at Stourhead in Wiltshire (FIG. 29–20) with the assistance of Flitcroft, a protégé of Burlington. The resulting gardens at Stourhead carried Kent's ideas much further. Stourhead is, in effect, an exposition of the picturesque, with orchestrated views dotted with Greek- and Roman-style temples, grottoes, copies of antique statues, and such added delights as a rural cottage, a Chinese bridge, a Gothic spire, and a Turkish tent. In the view illustrated here, a

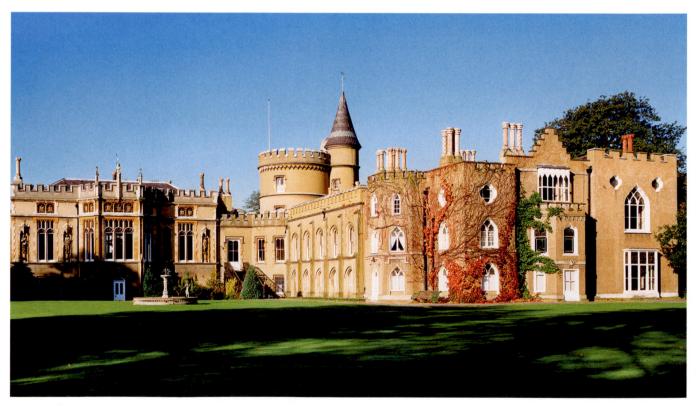

29–21 Horace Walpole and others **STRAWBERRY HILL** Twickenham, England. 1749–76.

replica of the Pantheon in Rome is just visible across a carefully placed lake. While the nostalgic evocation of an idyllic classical past recalls the work of the seventeenth-century French landscape painter Claude Lorrain (SEE FIG. 22-63), who had found a large market in Britain, the exotic elements here are an early indication of the Romantic taste for the strange and the novel. The garden is therefore an interesting mixture of the Neoclassical and the Romantic. For a wall inside the house, Hoare commissioned Mengs to paint *The Meeting of Antony and Cleopatra*, a work that similarly combines classical history with an exotic, Romantic subject.

Gothic Revival in Architecture and Its Decoration

Alongside the British classical revival of the mid-eighteenth century came a revival of the Gothic style, a manifestation of architectural Romanticism that spread to other nations after 1800. An early advocate of the Gothic revival was the conservative politician and author Horace Walpole (1717–97), who shortly before 1750 decided to remodel his house, called **STRAWBERRY HILL**, in the Gothic manner (FIG. 29–21). Gothic renovations were commonly performed in Britain before this date, but only to buildings that dated from the medieval period. Working with a number of friends and architects, Walpole spent nearly thirty years, from 1749 to 1776, transforming his home into a Gothic castle complete with **crenellated battlements** (alternating high and low sections of a wall, giving a notched appearance and creating permanent defensive shields), tracery windows, and turrets.

The interior, too, was totally changed. One of the first rooms Walpole redesigned, with the help of amateurs John Chute (1701-76) and Richard Bentley (1708-82), was the library (FIG. 29-22). Here the three turned for inspiration to illustrations in the antiquarian books that the library housed. For the bookcases, they adapted designs from London's old Saint Paul's Cathedral, which had been destroyed in the Great Fire of 1666. Prints depicting two medieval tombs inspired the chimneypiece. For the ceiling, Walpole incorporated a number of coats of arms of his ancestors—real and imaginary. The reference to fictional relatives offers a clue to Walpole's motives in choosing the medieval style. Walpole meant his house to suggest a castle out of the medievalizing Romantic fiction that he himself was writing. In 1764, he published The Castle of Otranto, a Romantic story set in the Middle Ages that helped launch the craze for the Gothic novel. Sir Walter Scott would later achieve fame as the best exponent of the genre in his novels Ivanhoe (1819) and Kenilworth (1821).

Neoclassicism in Architecture and the Decorative Arts

The vogue for classical things spread to most of the arts in late eighteenth-century England, as patrons regarded Greece and Rome as impeccable pedigree for their buildings, uten-

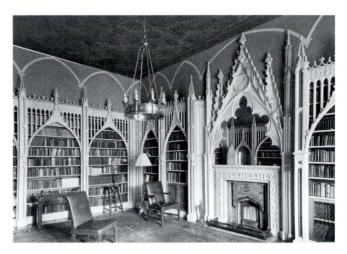

29–22 | Horace Walpole, John Chute, and Richard Bentley LIBRARY, STRAWBERRY HILL After 1754.

sils, poetry, and even clothing fashions. Alexander Pope translated Homer, and wrote his own poetry in iambic pentameter, a style based on the heroic couplets of Latin poets. Women often donned white muslin gowns in order to make themselves resemble classical statues.

ADAM: SYON HOUSE. The most important British contribution to Neoclassicism was a style of interior decoration developed by the Scottish architect Robert Adam (1728–92). On his Grand Tour in 1754-58, during which he joined Albani's circle of Neoclassicists, Adam largely ignored the civic architecture that had interested British classicists such as Burlington and focused instead on the applied ornament of Roman domestic architecture. When he returned to London to set up an architectural firm, he brought with him a complete inventory of decorative motifs, which he then modified in pursuit of a picturesque elegance. His stated aim to "transfuse the beautiful spirit of antiquity with novelty and variety" met with considerable opposition from the Palladian architectural establishment, but it proved ideally suited both to the evolving taste of wealthy clients and to the imperial aspirations of the new king, George III (ruled 1760-1820). In 1761, George appointed Adam and Adam's rival William Chambers (1723–96) as joint Architects of the King's Works.

Adam achieved wide renown for his interior renovations, such as those he carried out between 1760 and 1769 for the Duke of Northumberland at his country estate, Syon, near London. The opulent colored marbles, gilded relief panels, classical statues, spirals, garlands, rosettes, and gilded moldings in the anteroom (FIG. 29–23) are luxuriously profuse yet are restrained by the strong geometric order imposed on them and by the plain wall and ceiling surfaces. Adam's preference for bright pastel grounds and

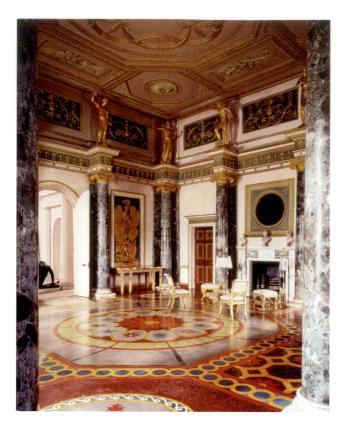

29–23 | Robert Adam ANTEROOM, SYON HOUSE Middlesex, England. 1760–69.

Adam's conviction that it was acceptable to modify details of the classical orders was generally opposed by the British architectural establishment. As a result of that opposition, Adam was never elected to the Royal Academy.

small-scale decorative elements derives both from the Rococo (SEE FIG. 29–5), and from the recently uncovered ruins of Pompeii.

WEDGWOOD. Such interiors were designed partly as settings for the art collections of British aristocrats, which included antiquities as well as a range of Neoclassical painting, sculpture, and decorative ware (see "Georgian Silver," page 962). The most successful producer of Neoclassical decorative art was Josiah Wedgwood (1730-95). In 1769, near his native village of Burslem, he opened a pottery factory called Etruria after the ancient Etruscan civilization in central Italy known for its pottery. This production-line shop had several divisions, each with its own kilns (firing ovens) and workers trained in individual specialties. In the mid-1770s Wedgwood, a talented chemist, perfected a fine-grained, unglazed, colored pottery, which he called jasperware. The most popular of his jasperware featured white figures against a blue ground, like that in THE APOTHEOSIS OF HOMER (FIG. 29-24). The relief on the front of the vase was designed by the sculptor John Flaxman, Jr. (1755-1826), who worked for Wedgwood from 1775 to 1787. Flaxman based the scene on a book illustration documenting a classical Greek vase in the

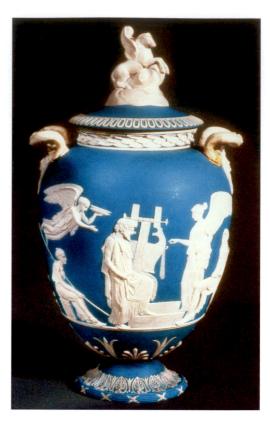

29–24 | Josiah Wedgwood | VASE: THE APOTHEOSIS OF HOMER

Made at the Wedgwood Etruria factory, Staffordshire, England. 1786. White jasper body with a mid-blue dip and white relief, height 18" (45.7 cm). Relief of *The Apotheosis of Homer* adapted from plaque by John Flaxman, Jr. 1778. Trustees of the Wedgwood Museum, Barlaston, Staffordshire, England.

collection of William Hamilton (1730–1803), a leading collector of antiquities and one of Wedgwood's major patrons. Flaxman's design simplified the original according to the prevailing idealized notion of Greek art and the demands of mass production.

The socially conscious Wedgwood—who epitomized Enlightenment thinking-established a village for his employees and cared deeply about every aspect of their living conditions. He was also active in the organized international effort to halt the African slave trade and abolish slavery. To publicize the abolitionist cause, Wedgwood asked the sculptor William Hackwood (c. 1757-1839) to design an emblem for the British Committee to Abolish the Slave Trade, formed in 1787. The compelling image Hackwood created was a small medallion of black-and-white jasperware, cut like a cameo in the likeness of an African man kneeling in chains, with the legend "Am I Not a Man and a Brother?" (FIG. 29-25). Wedgwood sent copies of the medallion to Benjamin Franklin, the president of the Philadelphia Abolition Society, and to others in the abolitionist movement. Later, those active in the women's suffrage movement in the United States adapted the image by representing a woman in chains with the motto "Am I Not a Woman and a Sister?"

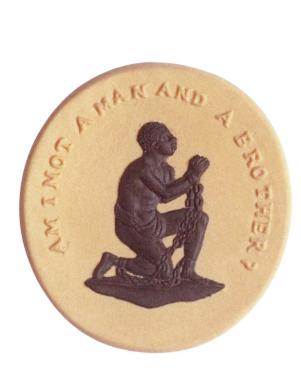

29–25 | William Hackwood for Josiah Wedgwood "AM I NOT A MAN AND A BROTHER?" 1787. Black and white jasperware, $1\% \times 1\%$ " (3.5 \times 3.5 cm). Trustees of the Wedgwood Museum, Barlaston, Staffordshire, England.

Painting

When the newly prosperous middle classes in Britain began to buy art, they first wanted portraits of themselves. But taste was also developing for other subjects, such as moralizing satire and caricature, ancient and modern history, the British landscape and people, and scenes from English literature. Whatever their subject matter, many of the paintings that emerged in Britain reflected Enlightenment values, including an interest in social progress, an embrace of natural beauty, and faith in reason and science.

THE SATIRIC SPIRIT. After the end of government censorship in 1695, a flourishing culture of literary satire emerged in Britain directed at a variety of political and social targets. John Gay's 1728 play The Beggar's Opera showed aristocrats as grasping and lazy, in contrast to the hardworking lower classes. Henry Fielding wrote in his Historical Register of the Year 1738 that he hoped to "expose the reigning follies in such a manner that men shall laugh themselves out of them."The first painter inspired by the work of these pioneering novelists and essayists was William Hogarth (1697-1764), a friend of Fielding who at times illustrated works by Gay. Trained as a portrait painter, Hogarth believed art should contribute to the improvement of society. About 1730, he began illustrating moralizing tales of his own invention in sequences of four to six paintings, which he then produced in sets of prints, both to maximize his profits and to influence as many people as possible.

Between 1743 and 1745, Hogarth produced the *Marriage* à la Mode suite, whose subject was inspired by Joseph Addison's 1712 essay in the *Spectator* promoting the concept of marriage based on love rather than aristocratic intrigue. The opening scene, **THE MARRIAGE CONTRACT** (FIG. 29–26), shows the gout-ridden Lord Squanderfield, at the right, arranging the marriage of his son to the daughter of a wealthy merchant. The merchant gains entry for his family into the aristocracy, while the lord gets the money he needs

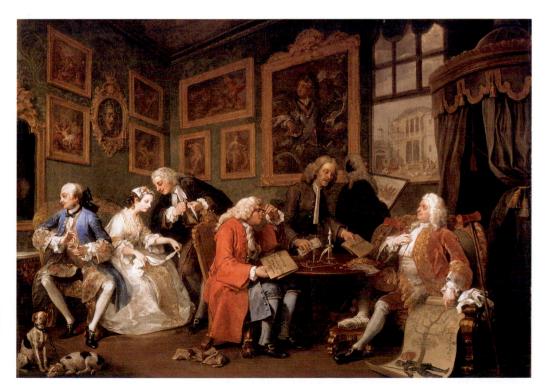

29–26 | William Hogarth THE MARRIAGE
CONTRACT
From Marriage à la Mode.
1743–45. Oil on canvas,
27½ × 35¾"
(69.9 × 90.8 cm).
The National Gallery,
London.
Reproduced by Courtesy of the
Trustees

THE OBJECT SPEAKS

GEORGIAN SILVER

ince ancient times, Europeans have prized silver for its rarity, reflectivity, and beautiful luster. At times, its use was restricted to royalty; at others, to liturgical applications such as statues of saints, manuscript illuminations, and chalices. But by the Georgian period—the years from 1714 to 1830, when Great Britain was ruled by four kings named George—wealthy British families filled their homes with a variety of objects made of fine silver—utensils and vessels that they collected not simply as useful, practical articles, but as statements of their own high social status.

British gentlemen employed finely crafted silver vessels, for example, to serve and consume punch, a potent alcoholic beverage that lubricated the wheels of Georgian society. Gentlemen took pride in their own secret recipes for punch, and a small party of drinkers might pass around an elegant punch bowl, consuming its contents as they admired its exterior. Larger groups would drink from cups or goblets, such as the simple yet elegant goblet by Ann and Peter Bateman, which has a gilded interior to protect the silver from the acid present in alcoholic drinks. (Hester Bateman's double beaker, also with a gilded interior, was made for use while traveling.) The punch would be poured into the goblets with a ladle such as the one shown here, by Elizabeth Morley, which has a twisted whalebone handle that floats, making it easy to retrieve from the bowl. Then, the filled goblets would be served on a flat salver like the one made by Elizabeth Cooke. Gentlemen also used silver containers to carry snuff, a pulverized tobacco that was inhaled by well-to-do members of both sexes. (The gentleman at the extreme left in William Hogarth's painting, The Marriage Contract (FIG. 29-26), is taking a pinch of snuff from a snuffbox.) The fairly flat snuffbox illustrated here, by Alice and George Burrows, has curved sides for easy insertion into the pockets of gentlemen's tightfitting trousers.

All of the objects shown here bear the marks of silver shops run either wholly or partly by women, who played a significant role in the production of Georgian silver. While some women served formal apprenticeships and went on to become members of the goldsmiths guild (which included silversmiths), most women became involved with silver through their

relation to a master silversmith—typically a father, husband, or brother—and they frequently specialized in a specific aspect of the craft, such as engraving, **chasing** (ornamentation made on metal by hammering or incising the surface), or polishing. The widows of silversmiths often took over their husbands' shops and ran them with the help of journeymen or partners.

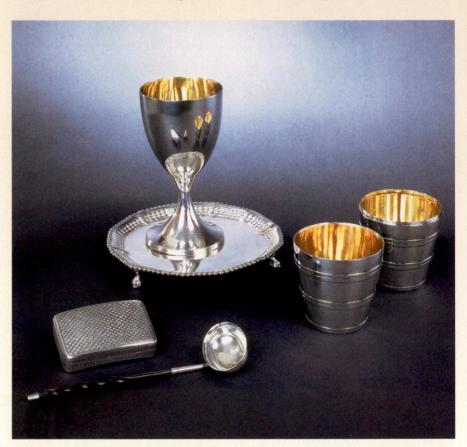

Elizabeth Morley, GEORGE III TODDY LADLE 1802; Alice and George Burrows, GEORGE III SNUFFBOX 1802; Elizabeth Cooke, GEORGE III SALVER 1767; Ann and Peter Bateman, GEORGE III GOBLET 1797; HESTER BATEMAN, GEORGE III DOUBLE BEAKER 1790. National Museum of Women in the Arts, Washington, D.C.

Silver Collection assembled by Nancy Valentine, purchased with funds donated by Mr. and Mrs. Oliver Grace and family

Hester Bateman (1708–94), the most famous woman silversmith in eighteenth-century Britain, inherited her husband's small spoon-making shop at the age of 52 and transformed it into one of the largest silver manufactories in the country. Adapting new technologies of mass production to the manufacture of silver, Bateman marketed her well-designed, functional, and relatively inexpensive wares to the newly affluent middle class, making no attempt to compete with those silversmiths who catered to the monarchy or the aristocracy. She retired when she was 82 after training her daughter-in-law Ann and her sons and grandson to carry on the family enterprise. Both Hester's double beaker and Ann and Peter's goblet show the restrained elegance characteristic of Bateman silver.

to complete his Palladian house, which is visible out the window.

The loveless couple who will be sacrificed to this deal sit on the couch at the left. While the young Squanderfield vainly admires himself in the mirror, his unhappy fiancée is already being wooed by lawyer Silvertongue, who suggestively sharpens his pen. The next five scenes show the progressively disastrous results of such a union, culminating in the young lord's murder of Silvertongue and the subsequent suicide of his wife.

Stylistically, Hogarth's works combine the additive approach of seventeenth-century Dutch genre painters with the elegance and casual poses of the Rococo. Hogarth wanted to please and entertain his audience as much as educate them. He also hoped to create a distinctively English style of painting, free of obscure mythological references and encouraging the self-improvement in viewers that would lead to the progress of society. In this way he opposed both the frivolous Rococo and the at-times abstruse and remote Neoclassicism. By at least one measure, he was a success: His work became so popular that in 1745 he was able to give up portraiture, which he considered a deplorable form of vanity.

PORTRAITURE. A generation younger than Hogarth, Sir Joshua Reynolds (1723–92) specialized in the very form of painting—portraiture—that the moralistic Hogarth despised. After studying Renaissance art in Italy, Reynolds settled in London in 1753 and worked vigorously to educate artists and patrons to appreciate classical history painting. In 1768 he was appointed the first president of the Royal Academy (see "Academies and Academy Exhibitions," page 948). Reynolds's Fifteen Discourses to the Royal Academy (1769–90) set out his theories on art: Artists should follow the rules derived from studying the great masters of the past, especially those who worked in the classical tradition; art should generalize to create the universal rather than the particular; and the highest kind of art is history painting.

Because British patrons preferred portraits of themselves to scenes of classical history, Reynolds attempted to elevate portraiture to the level of history painting by giving it a historical or mythological veneer. A good example of this ambitious type of portraiture, a form of Baroque classicism that Reynolds called the Grand Manner, is LADY SARAH BUN-BURY SACRIFICING TO THE GRACES (FIG. 29-27). Dressed in a classicizing costume, Bunbury plays the part of a Roman priestess making a sacrifice to the personifications of female beauty, the Three Graces. The figure is further aggrandized through the use of the monumental classical pier and arch behind her, the emphatic classical contrapposto (Italian for "set against"; used to describe the twisted pose resulting from parts of the body set in opposition to each other around a central axis), and the large scale of the canvas. Such works were intended for the public rooms, halls, and stairways of aristocratic residences.

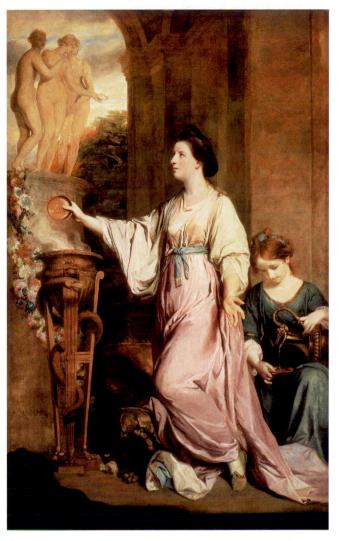

29–27 Joshua Reynolds LADY SARAH BUNBURY SACRIFICING TO THE GRACES

1765. Oil on canvas, $7'10'' \times 5'$ (2.42 \times 1.53 m). The Art Institute of Chicago.

Mr. and Mrs. W. W. Kimball Collection, 1922.4468

Lady Bunbury was one of the great beauties of her era. A few years before this painting was done, she turned down a request of marriage from George III.

A number of British patrons, however, remained committed to the kind of portraiture Van Dyck had brought to England in the 1620s, which had featured more informal poses against natural vistas. Thomas Gainsborough (1727–88) achieved great success with this mode when he moved to Bath in 1759 to cater to the rich and fashionable people who had begun going there in great numbers. A good example of his mature style is the **PORTRAIT OF MRS. RICHARD BRINSLEY SHERIDAN** (FIG. 29–28) which shows the professional singer (the wife of a celebrated playwright) seated informally outdoors. The sloping view into the distance and the use of a tree to frame the sitter's head appear borrowed directly from Van Dyck (SEE FIG. 22–38). But Gainsborough modernized the formula not simply through his lighter, Rococo palette and

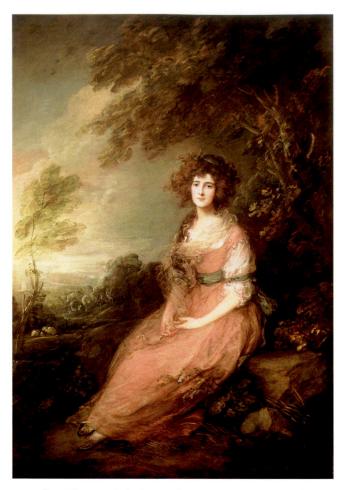

29–28 | Thomas Gainsborough PORTRAIT OF MRS. RICHARD BRINSLEY SHERIDAN 1785–87. Oil on canvas, $7'2\%'' \times 5'\%''$ (2.2 × 1.54 m). National Gallery of Art, Washington, D.C. Andrew W. Mellon Collection (1937.1.92)

feathery brushwork but also by integrating the woman into the landscape, thus identifying her with it. The effect is especially noticeable in the way her windblown hair matches the tree foliage overhead. The work thereby manifests one of the new values of the Enlightenment: the emphasis on nature and the natural as the sources of goodness and beauty.

THE ROMANCE OF SCIENCE. We see Enlightenment fascination with developments in the natural sciences in the dramatic depiction of AN EXPERIMENT ON A BIRD IN THE AIRPUMP (FIG. 29–29) by Joseph Wright of Derby (1734–97). Trained as a portrait painter, Wright made the Grand Tour in 1773–75 and then returned to the English Midlands to paint local society. Many of those he painted were the self-made entrepreneurs of the first wave of the Industrial Revolution, which was centered in the Midlands in towns such as Birmingham. Wright belonged to the Lunar Society, a group of industrialists (including Wedgwood), mercantilists, and progressive nobles who met in Derby. As part of the society's attempts to popularize science, Wright painted a series of "entertaining" scenes of scientific experiments.

The second half of the eighteenth century was an age of rapid technological advances (see "Iron as a Building Material," page 967), and the development of the air pump was among the many innovative scientific developments of the time. Although it was employed primarily to study the property of gases, it was also widely used to promote the public's interest in science because of its dramatic possibilities. In the experiment shown here, air was pumped out of the large glass bowl until the small bird inside collapsed from lack of oxy-

29–29 | Joseph Wright AN EXPERIMENT ON A BIRD IN THE AIR-PUMP 1768. Oil on canvas, $6\times8'$ (1.82 \times 2.43 m). The National Gallery, London.

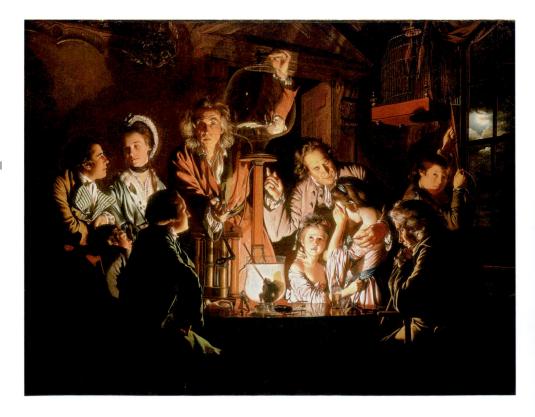

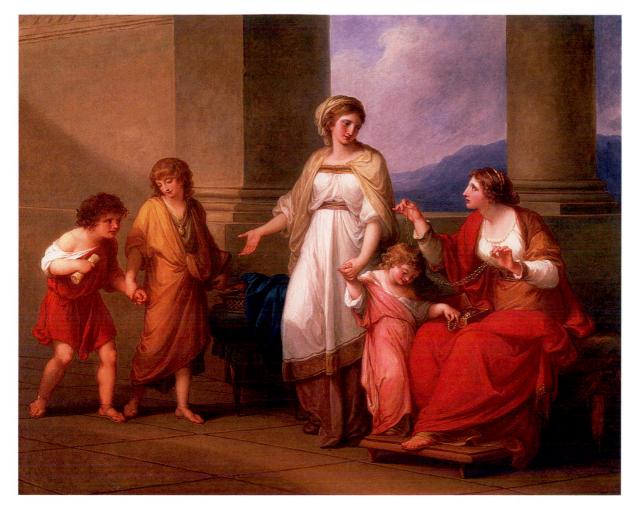

gen; before the animal died, air was reintroduced by a simple mechanism at the top of the bowl. In front of an audience of adults and children, a lecturer prepares to reintroduce air into the glass receiver. Near the window at right, a boy stands ready to lower a cage when the bird revives. (The moon visible out the window is a reference to the Lunar Society.) By delaying the reintroduction of air, the scientist has created considerable suspense, as the reactions of the two girls indicate. Their father, a voice of reason, attempts to dispel their fears. The dramatic lighting, stylistically derived from the Baroque religious paintings of Caravaggio and his followers (SEE FIG. 22–60) but here applied to a secular subject, not only underscores the life-and-death issue of the bird's fate but also suggests that science brings light into a world of darkness and ignorance.

HISTORY PAINTING. European academies had long considered history painting as the highest form of artistic endeavor, but British patrons were reluctant to purchase such works from native artists. Instead, they favored Italian paintings bought on the Grand Tour or acquired through agents in

Italy. Thus, the arrival in London in 1766 of the Italian-trained Swiss history painter Angelica Kauffmann (1741–1807) greatly encouraged those artists in London aspiring to success as history painters. She was welcomed immediately into Joshua Reynolds's inner circle and in 1768 was one of two women artists named among the founding members of the Royal Academy (see "Women and Academies," page 952).

Kauffmann had assisted her father on church murals and was already accepting portrait commissions at age fifteen. She first encountered the new classicism in Rome, where she painted Johann Winckelmann's portrait, and where she was elected to the Academy of Saint Luke. In a move unusual for a woman—most eighteenth-century women artists specialized in portraiture or still life—Kauffmann embarked on an independent career as a history painter. In London, where she lived from 1766 to 1781, she produced numerous history paintings, many of them with subjects drawn from classical antiquity. Kauffmann painted **CORNELIA POINTING TO HER CHILDREN AS HER TREASURES** (FIG. 29–30) for an English patron after returning to Italy. The story takes place in the

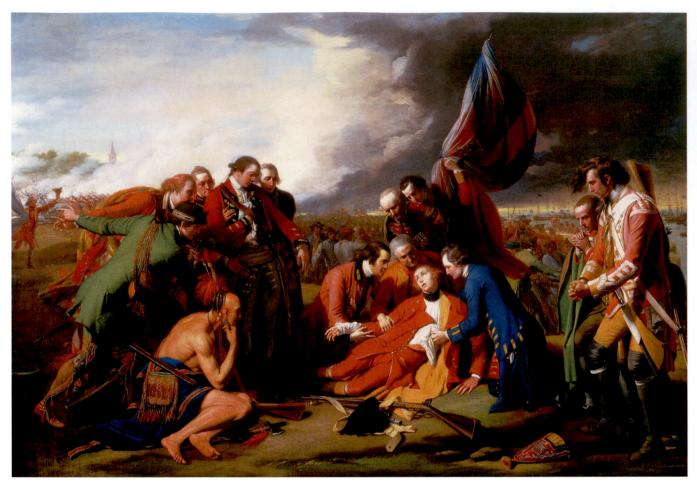

29–31 Benjamin West **THE DEATH OF GENERAL WOLFE**1770. Oil on canvas, $4'111_2'' \times 7'$ (1.51 \times 2.14 m). The National Gallery of Canada, Ottawa.

Transfer from the Canadian War Memorials, 1921 (Gift of the 2nd Duke of Westminster, Eaton Hall, Cheshire, 1918)

The famous Shakespearean actor David Garrick was so moved by this painting that he enacted an impromptu interpretation of the dying Wolfe in front of the work when it was exhibited by the Royal Academy. The mid-eighteenth-century revival of interest in Shakespeare's more dramatic plays, in which Garrick played a leading role, was both a manifestation of and a major factor in the rise of Romantic taste in Britain.

second century BCE, during the republican era of Rome. A woman visitor has been showing Cornelia her jewels and then requests to see those of her hostess. In response, Cornelia shows her daughter and two sons and says, "These are my most precious jewels." Cornelia exemplifies the "good mother," a popular subject among later eighteenth-century history painters who, in the reforming spirit of the Enlightenment, often depicted subjects that would teach lessons in virtue. The value of Cornelia's maternal dedication is emphasized by the fact that under her loving care, the sons, Tiberius and Gaius Gracchus, grew up to be political reformers. Although the setting of Kauffmann's work is as severely simple as the message, the effect of the whole is softened by the warm, subdued lighting and by the tranquil grace of the leading characters.

Kauffmann's devotion to Neoclassical history painting was at first shared by her American-born friend Benjamin

West (1738–1820), who, after studying in Philadelphia, left for Rome in 1759. There he met Winckelmann and became a student of Mengs. In 1763, West moved permanently to London, where he specialized in Neoclassical history paintings. In 1768, he became a founding member of the Royal Academy. Two years later, he shocked Reynolds and his other academic friends with his painting **THE DEATH OF GENERAL WOLFE** (FIG. 29–31) because rather than clothing the figures in ancient garb in accordance with the tenets of Neoclassicism, he chose to depict them in modern dress. When Reynolds learned what West was planning to do, he begged him not to continue this aberration of "taste." George III informed West he would not buy a painting with British heroes in modern dress.

West's painting glorifies the British General James Wolfe, who had died in 1759 in a British victory over the French for the control of Quebec during the Seven Years' War

(1756-63). West depicted Wolfe in his red uniform expiring in the arms of his comrades under a cloud-swept sky, rather than at the base of a tree, surrounded by two or three attendants—the actual situation of his death. Thus, though West's painting is naturalistic, it is not an objective document, nor was it intended to be; West employed the Grand Manner, which Reynolds promulgated in his Discourses, to celebrate the valor of the fallen hero, the loyalty of the British soldiers, and the justice of their cause. To indicate the North American setting, West also included at the left a Native American warrior who contemplates the fallen Wolfe-another fiction, since the Native Americans in this battle fought on the side of the French. The dramatic illumination increases the emotional intensity of the scene, as do the poses of Wolfe's attendants, arranged to suggest a Lamentation over the dead Christ. Extending the analogy, the British flag above Wolfe replaces the Christian cross. Just as Christ died for humanity, Wolfe sacrificed himself for the good of the State.

The Death of General Wolfe enjoyed such an enthusiastic reception by the British public that Reynolds apologized to West, and the king was among four patrons to commission replicas. West's innovative decision to depict a modern historical subject in the Grand Manner established the general format for the depiction of contemporary historical events for all European artists in the later eighteenth and early nineteenth centuries. And the emotional intensity of his image helped launch the Romantic movement in British painting.

ROMANTIC PAINTING. The Enlightenment's faith in reason and empirical knowledge, dramatized in such works of art as Joseph Wright's *An Experiment on a Bird in the Air-Pump* (SEE FIG. 29–29), was countered by Romanticism's celebration of the emotions and subjective forms of experience. Many Romantic artists glorified the irrational side of human nature that the Enlightenment sought to deny.

One such Romantic was John Henry Fuseli (1741–1825), who arrived in London from his native Switzerland in 1764. Trained in theology, philosophy, and the Neoclassical aesthetics of Winckelmann (whose writings he translated into English), Fuseli quickly became a member of the London intellectual elite. Joshua Reynolds encouraged Fuseli to become an artist, and in 1770 Fuseli left to study in Rome, where he spent most of the next eight years. Fuseli's encounter with ancient Roman sculpture and the painting of Michelangelo led him to develop a powerfully expressive style based on these sources rather than on the ancient Greek works admired by Winckelmann.

Back in London, Fuseli established himself as a history painter specializing in dramatic subjects drawn from such authors as Homer, Dante, Shakespeare, and Milton. Rejecting the Enlightenment emphasis on science and reason, Fuseli often depicted supernatural and irrational subjects, as in his

Elements of Architecture IRON AS A BUILDING MATERIAL

n 1779, Abraham Darby III built a bridge over the Severn River at Coalbrookdale in England-a town typical of the new industrial environment, with factories and workers' housing filling the valley. The bridge itself is important because it represents the first use of structural metal on a large scale, with iron replacing the heavy, hand-cut stone voussoirs used to construct earlier bridges. Five pairs of cast-iron, semicircular arches form a strong, economical hundred-foot span. In functional architecture such as this bridge, the available technology, the properties of the material, and the requirements of engineering in large part determine form and often produce an unintended and revolutionary new aesthetic. Here, the use of metal at last made possible the light, open, skeletal structure desired by builders since the twelfth century. Cast iron was quickly adopted by builders, giving rise to such architectural feats as the soaring train stations of the nineteenth century and leading ultimately to such marvels as the Eiffel Tower.

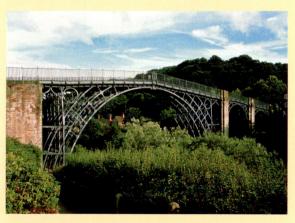

Abraham Darby III SEVERN RIVER BRIDGE Coalbrookdale, England. 1779.

Fuseli was not popular with the English critics. One writer said Fuseli's 1780 entry in the London Royal Academy exhibition "ought to be destroyed," and Horace Walpole called another painting in 1785 "shockingly mad, mad, mad, madder than ever." Even after achieving the highest official acknowledgment of his talents, Fuseli was called the Wild Swiss and Painter to the Devil. But the public appreciated his work, and *The Nightmare*, exhibited at the Academy in 1782, was repeated in at least three more versions and its imagery disseminated by means of prints published by commercial engravers. One of these prints would one day hang in the office of the Austrian psychoanalyst Sigmund Freud, who believed that dreams were manifestations of the dreamer's repressed desires.

most famous work, THE NIGHTMARE (FIG. 29-32). In this painting, Fuseli depicts a somnolent white-clad woman, sprawled across a divan, who is oppressed by an erotic dream caused by an incubus (or mara, an evil spirit), the gruesome demon sitting on her chest. According to legend, the incubus was believed to steal upon sleeping women and have intercourse with them—a subject Fuseli also depicted in other works. Adding to the erotic suggestiveness of The Nightmare is the horse with phosphorescent eyes that thrusts its head into the room through a curtain at the left. This was the first of at least four versions of the theme Fuseli would paint. His motives are perhaps revealed by the portrait on the back of the canvas, which may be that of Anna Landolt. Fuseli had met her in Zürich in the winter of 1778-79 and had fallen in love with her. Too poor to propose marriage to her, he did not declare his feelings, but after his return to London he wrote to her uncle that she could not marry another because they had made love in one of his dreams and she therefore belonged to him. The painting may be an illustration of that dream.

Also opposed to the Enlightenment emphasis on reason and artistically inspired by Michelangelo was Fuseli's friend William Blake (1757–1827), a highly original poet, painter, and printmaker. Trained as an engraver, Blake enrolled briefly at the Royal Academy, where he was subjected to the teachings of Reynolds. The experience convinced him that all rules hinder rather than aid creativity, and he became a lifelong advocate of unfettered imagination. For Blake, imagination offered access to the higher realm of the spirit, while reason could only provide information about the lower world of matter.

Deeply concerned with the problem of good and evil, Blake developed an idiosyncratic form of Christian belief and drew on elements from the Bible, Greek mythology, and British legend to create his own mythology. The "prophetic books" that he designed and printed in the mid-1790s combined poetry and imagery dealing with themes of spiritual crisis and redemption. Their dominant characters include Urizen ("your reason"), the negative embodiment of ratio-

nalistic thought and repressive authority; Orc, the manifestation of energy, both creative and destructive; and Los, the artist, whose task is to create form out of chaos.

Thematically related to the prophetic books are an independent series of twelve large color prints that Blake executed for the most part in 1795, including the awe-inspiring **ELOHIM CREATING ADAM** (FIG. 29–33). The sculpturesque volumes and muscular physiques of the figures reveal the influence of Michelangelo, whose works Blake admired in reproduction, and the subject invites direct comparison with Michelangelo's famous Creation of Adam on the ceiling of the Sistine Chapel (SEE FIG. 20–14). But while Michelangelo, with humanist optimism, viewed the Creation as a positive act, Blake presents it in negative terms. In Blake's print, a giant worm, symbolizing matter, encircles the lower body of Adam, who, with an anguished expression, stretches out on the ground like the crucified Christ. Above him, the winged Elohim (Elohim is one of the Hebrew names for God) appears anxious, even desperate—quite unlike the confident deity pictured by Michelangelo. For Blake, the Creation is tragic because it submits the spiritual human to the fallen state of a material existence. Blake's fraught and gloomy image challenges the viewer to recognize his or her fallen nature and seek to transcend it.

LATER EIGHTEENTH-CENTURY ART IN FRANCE

The late eighteenth century in France witnessed the fading fortunes of the Rococo under the impact of Enlightenment ideas, Neoclassicism, and the gathering clouds of revolution. These new currents led artists away from the Rococo's breezy if entertaining subjects and toward art that was more edifying or inspiring. Architects hewed a line closer to Roman sources, while painters and sculptors increasingly embraced either a down-to-earth naturalism or didactic narratives. The era also saw the rise of the most important exponent of Neoclassicism in painting, Jacques-Louis David.

Architecture

French architects of the late eighteenth century generally considered classicism not one of many alternative styles but *the* single, true style. In the increasingly secular, Enlightenment-oriented culture of the period, the Rococo seemed frivolous, the Baroque was associated (rightly or wrongly) with corrupt and scheming Roman Catholicism, while the Gothic called up the superstitions of the medieval period. In order to achieve greatness, many believed along with Winckelmann that "imitation of the ancients" was the key to success. He wrote in *Reflections on the Imitation of Greek Works*, "Good

29–33 † William Blake ELOHIM CREATING ADAM 1795. Color print finished in pen and watercolor, 17 \times 21½" (43.1 \times 53.6 cm). Tate Gallery, London.

Made through a monotype process, Blake's large color prints of 1795 combine printing with painting and drawing. To make them, the artist first laid down his colors (possibly oil paint) on heavy paperboard. From the painted board Blake then pulled a few impressions, usually three, on separate sheets of paper. These impressions would vary in effect, with the first having fuller and deeper colors than the subsequent ones. Blake then finished each print by hand, using watercolor and pen and ink.

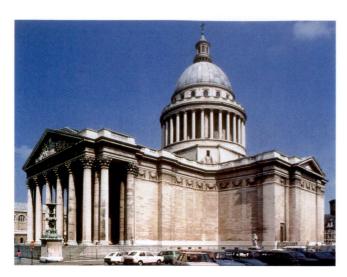

29–34 | Jacques-Germain Soufflot PANTHÉON (CHURCH OF SAINTE-GENEVIÈVE)
Paris. 1755–92.

This building has a strange history. Before it was completed, the Revolutionary government in control of Paris confiscated all religious properties to raise desperately needed public funds. Instead of selling Sainte-Geneviève, however, they voted in 1791 to make it the Temple of Fame for the burial of Heroes of Liberty. Under Napoleon I (ruled 1799-1814), the building was resanctified as a Catholic church and was again used as such under King Louis-Philippe (ruled 1830-48) and Napoleon III (ruled 1852-70). Then it was permanently designated a nondenominational lay temple. In 1851, the building was used as a physics laboratory. Here the French physicist Jean-Bernard Foucault suspended his now-famous pendulum on the interior of the high crossing dome and by measuring the path of the pendulum's swing proved his theory that the earth rotated on its axis in a counter-clockwise motion. In 1995, the ashes of Marie Curie, who had won the Nobel Prize in chemistry in 1911, were moved into this "memorial to the great men of France," making her the first woman to be enshrined there.

taste, which is becoming more prevalent throughout the world, had its origins under the skies of Greece." Original examples of Greek art were mostly inaccessible because the region was then dominated by the Ottoman Turks; but Roman art, its nearest equivalent, was close at hand.

The leading Neoclassical architect was Jacques-Germain Soufflot (1713-80); his Church of Sainte-Geneviève (FIG. 29-34), known today as the PANTHÉON, is the most typical Neoclassical building. Here Soufflot attempted to integrate three traditions: the kind of Roman architecture he had seen on his two trips to Italy; French and English Baroque classicism; and the Palladian style being revived at the time in England. The façade, with its huge portico, is modeled directly on ancient Roman temples. The dome, on the other hand, was inspired by several seventeenth-century examples, including Wren's Saint Paul's in London (SEE FIG. 22-66). Finally, the radical geometry of its plan (FIG. 29-35), a central-plan Greek cross, owes as much to Burlington's Chiswick House (SEE FIG. 29-19) as it does to Christian tradition. Note that he replaced the interlocking ovals and bulges of the Rococo with clear and pure rectangles, squares, and circles. Soufflot also seems to have been inspired by the plain, undecorated surfaces Burlington used in his home. The result is a building that attempts to maintain and develop the historical continuity of the classical tradition.

Painting and Sculpture

While French painters such as Boucher, Fragonard, and their followers continued to work in the Rococo style in the later decades of the eighteenth century, a strong reaction against the Rococo had set in by the 1760s. A leading detractor of the Rococo was Denis Diderot (1713–84), an Enlightenment figure whom many consider the founder of modern art criticism. In 1759, Diderot began to write reviews of the official Salon for a periodic newsletter for wealthy subscribers. Diderot believed that it was art's proper function to "inspire virtue and purify manners." He therefore criticized the adherents of the Rococo, whose characteristic works he con-

29-35 | SECTION AND PLAN OF THE PANTHÉON (CHURCH OF SAINTE-GENEVIÈVE)

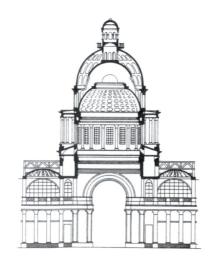

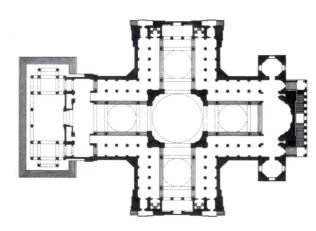

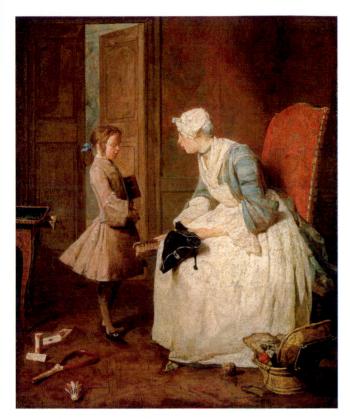

Purchase, 1956

Chardin was one of the first French artists to treat the lives of women and children with sympathy and to honor the dignity of women's work in his portrayals of young mothers, governesses, and kitchen maids. Shown at the Salon of 1739, *The Governess* was praised by contemporary critics, one of whom noted "the graciousness, sweetness, and restraint that the governess maintains in her discipline of the young man about his dirtiness, disorder, and neglect; his attention, shame, and remorse; all are expressed with great simplicity."

sidered frivolous at best and immoral at worst. Diderot's most notable accomplishment was editing, in collaboration with Jean le Rond d'Alembert, the *Encyclopédie* (1751–77), a thirty-two-volume compendium of knowledge and opinion that served as an archive of Enlightenment thought in fields as diverse as agriculture, aesthetics, and penology.

CHARDIN. Diderot found in Jean-Siméon Chardin (1699-1779) an artist to his liking. A painter whose output was limited essentially to still lifes and quiet domestic scenes, Chardin tended to work on a small scale, meticulously and slowly. As early as the 1730s, Chardin began to create moral genre pictures in the tradition of seventeenth-century Dutch genre paintings, which focused on simple, mildly touching scenes of everyday middle-class life. One such picture, THE GOVERNESS (FIG. 29-36), shows a finely dressed boy, with books under his arm, who listens to his governess as she prepares to brush his tricorn (three-cornered) hat. Scattered on the floor behind him are a racquet, a shuttlecock, and playing cards, evoking the childish pleasures that the boy leaves behind as he prepares to go to his studies and, ultimately, to a life of responsible adulthood. The work equally encourages benevolent exercise of authority, and willing submission to it.

GREUZE. Diderot's highest praise went to Jean-Baptiste Greuze (1725–1805)—which is hardly surprising, because Greuze's major source of inspiration came from the kind of middle-class drama that Diderot had inaugurated with his plays of the late 1750s. In addition to comedy and tragedy, Diderot thought the range of theatrical works should include a "middle tragedy" that taught useful lessons to the public with clear, simple stories of ordinary life. Greuze's domestic genre paintings, such as **THE DRUNKEN COBBLER** (FIG. 29–37),

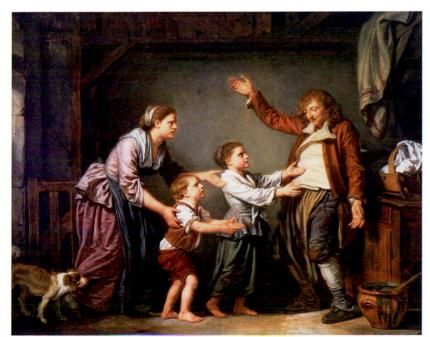

29–37 | Jean-Baptiste Greuze THE DRUNKEN COBBLER 1780–85. Oil on canvas, $29\% \times 36\%$ (75.2 \times 92.4 cm). Portland Art Museum, Portland, Oregon. Gift of Marion Bowles Hollis

In 1769, Greuze submitted a classical history painting to the Salon and requested the French Academy to change his official status from genre painter to the higher rank of history painter. The work was

the higher rank of history painter. The work was accepted but the request was refused. Greuze was so angry that he did not again exhibit at the Salon until 1800, preferring to show his works privately or in exhibitions sponsored by other organizations than the academy.

became the visual counterparts of that new theatrical form, which later became known as melodrama. On a shallow, stagelike space and under a dramatic spotlight, a drunken father returns home to his angry wife and hungry children. The gestures of the children make clear that he has spent the family's grocery money on drink. In other paintings, Greuze offered wives and children similar lessons in how not to behave.

VIGÉE-LEBRUN. French portrait painters before the Revolution of 1789 moved toward naturalistic poses and more everyday settings. Elegant informality continued to be featured, but new themes were introduced, figures tended to be larger and more robust, and compositional arrangements were more stable. Many leading portraitists were women. The

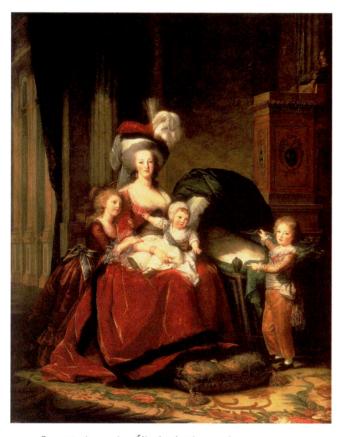

29–38 | Marie-Louise-Élisabeth Vigée-Lebrun PORTRAIT OF MARIE ANTOINETTE WITH HER CHILDREN 1787. Oil on canvas, $9' \frac{1}{2}'' \times 7' \frac{1}{8}''$ (2.75 \times 2.15 m). Musée National du Château de Versailles.

As the favorite painter to the queen, Vigée-Lebrun escaped from Paris with her daughter on the eve of the Revolution of 1789 and fled to Rome. After a very successful self-exile working in Italy, Austria, Russia, and England, the artist finally resettled in Paris in 1805 and again became popular with Parisian art patrons. Over her long career, she painted about 800 portraits in a vibrant style that changed very little over the decades.

most famous was Marie-Louise-Élisabeth Vigée-Lebrun (1755-1842), who in the 1780s became Oueen Marie Antoinette's favorite painter. In 1787, she portrayed the queen with her children (FIG. 29-38), in conformity with the Enlightenment theme of the "good mother," already seen in Angelica Kauffmann's painting of Cornelia (SEE FIG. 29-30). The portrait of the queen as a kindly, stabilizing presence for her offspring was meant to counter her public image as selfish, extravagant, and immoral. The princess leans affectionately against her mother, proof of the queen's natural goodness. In a further attempt to gain the viewer's sympathy, the little dauphin—the eldest son and heir to a throne he would never ascend—points to the empty cradle of a recently deceased sibling. The image also alludes to the well-known allegory of Abundance, suggesting the peace and prosperity of society under the reign of her husband, Louis XVI, who began his rule in 1774 but fell victim to revolutionary turmoil and was executed in 1792.

In 1783, Vigée-Lebrun was elected to one of the four places in the French Academy available to women. Also elected that year was Adélaïde Labille-Guiard (1749–1803), who in 1790 successfully petitioned to end the restriction on women. Labille-Guiard's commitment to increasing the number of women painters in France is evident in a selfportrait with two pupils that she submitted to the Salon of 1785. The monumental image of the artist at her easel (FIG. 29-39) was also meant to answer the sexist rumors that her paintings and those by Vigée-Lebrun had actually been painted by men. In a witty role reversal, the only male in this work is her muse—her father, whose bust is behind her. While the self-portrait flatters the painter's conventional feminine charms in a manner generally consistent with the Rococo tradition, a comparison with similar images of women by artists such as Fragonard (SEE FIG. 29-11) reveals the more monumental female type Labille-Guiard favored, in keeping with her conception of women as important contributors to national life, which is an Enlightenment impulse. The solid pyramidal arrangement of the three women adds to the effect.

DAVID. The most important French Neoclassical painter of the era was Jacques-Louis David (1748–1825), who dominated French art during the Revolution and subsequent reign of Napoleon. In 1774, David won the Prix de Rome and spent six years there, studying antique sculpture and assimilating the principles of Neoclassicism. After his return, he produced a series of severely undecorated, anti-Rococo paintings that extolled the antique virtues of stoicism, masculinity, and patriotism. In a career that rode the cresting waves of the Revolution, David was the dominant artist in France for over twenty years, creating memorable paintings and training the next generation.

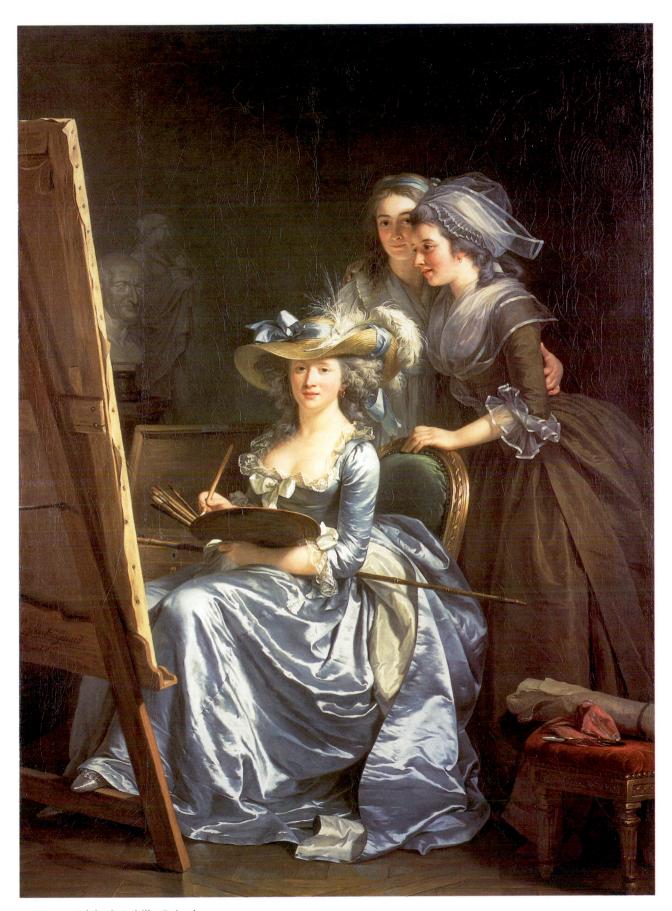

29–39 | Adélaïde Labille-Guiard SELF-PORTRAIT WITH TWO PUPILS 1785. Oil on canvas, $6'11''\times4'11\%''$ (2.11 \times 1.51 m). The Metropolitan Museum of Art, New York. Gift of Julia A. Berwind, 1953 (53.225.5)

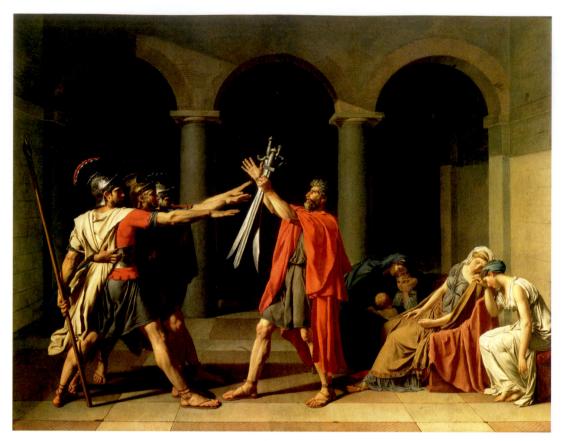

29–40 | Jacques-Louis David **OATH OF THE HORATII** 1784–85. Oil on canvas, $10'8\%''\times14'(3.26\times4.27~\text{m})$. Musée du Louvre, Paris.

The most famous and influential of these works was the **OATH OF THE HORATII** (FIG. 29–40), of 1784–85. A royal commission, the work reflects the taste and values of Louis XVI, who along with his minister of the arts, Count d'Angiviller, was sympathetic to the Enlightenment. Following Diderot's lead, d'Angiviller and the king believed art should improve public morals. Among his first official acts, d'Angiviller banned indecent nudity from the Salon of 1775 and commissioned a series of didactic history paintings. David's commission in 1784 was part of that general program.

This work was inspired by Pierre Corneille's seventeenth-century drama *Horace*, which was itself based on ancient Roman historical texts, although the patriotic oath-taking incident depicted by David is found in none of these sources and seems to have been his own invention. The story concerns an episode from the seventh century BCE when Rome and its rival Alba, a neighboring city-state, agreed to settle a border dispute and avert a war by means of a battle to the death between the three sons of Horace (the Horatii), representing Rome, and the three Curatii, representing Alba. In David's painting, which he set in an austere Roman interior, the triplet Horatii stand with arms outstretched toward their father, who holds up the swords on which the young men pledge to fight to the death for

Rome. In contrast to the upright, muscular angularity of the men is a group of limp and weeping women and frightened children at the right. The women are upset not simply because the Horatii might die but also because one of them (Sabina, in the center) is a sister of the Curatii, married to one of the Horatii, and another (Camilla, at the far right) is engaged to one of the Curatii. David's composition, which spatially separates the men from the women and children through the use of the framing background arches, effectively contrasts the men's stoic willingness to sacrifice themselves for the state with the women's emotional commitment to family ties.

David's painting soon became an emblem of the French Revolution of 1789, which, ironically, precipitated the downfall of the monarchy that had commissioned the work. The painting's lesson in the sacrifices required for the good of the state effectively captured the mood of the leaders of the new French Republic established in 1792, as the revolutionaries abolished the monarchy, extinguished titles of nobility, took education out of the hands of the Church, and wrote a declaration of human rights. David sympathized with all of these causes. He joined the leftist Jacobin party, and they in turn appointed him national minister of the arts when they achieved power in 1792.

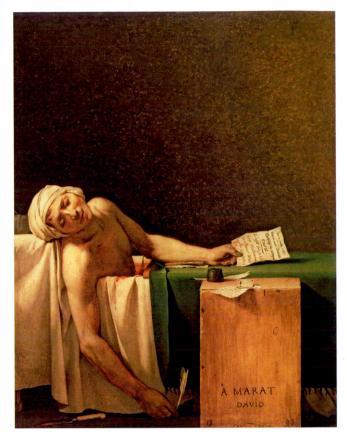

29–4I | Jacques-Louis David DEATH OF MARAT 1793. Oil on canvas, $5'5'' \times 4'2\frac{1}{2}''$ (1.65 \times 1.28 m). Musées Royaux des Beaux-Arts de Belgique, Brussels.

In 1793, David was elected a deputy to the National Convention and was named propaganda minister and director of public festivals. Because he supported Robespierre and the Reign of Terror, he was twice imprisoned after its demise in 1794, albeit under lenient circumstances that allowed him to continue painting.

David's greatest painting commemorates the death of one of the Jacobin leaders, Jean-Paul Marat (FIG. 29-41). A radical journalist, Marat lived simply among the packing cases that he used as furniture, writing pamphlets that urged the abolition of aristocratic privilege. A young supporter of an opposition party, Charlotte Corday, saw Marat as partly responsible for the 1792 riots in which hundreds of political prisoners deemed sympathetic to the king were killed. She decided that Marat should pay for his actions. Because Marat suffered from a painful skin ailment, he conducted his official business sitting in a medicinal bath. After using a ruse to gain entry to his house, Corday stabbed him, dropped her knife, and fled. Instead of handling the event in a sensational manner as Greuze might have, David played down the drama and showed us its quiet, still aftermath: the dead Marat slumped in his bathtub, a towel wrapped around his head, his right hand still holding a quill pen, his left hand grasping the letter Corday handed him on her entry. The simple wood block at the right, which Marat used as a desk, becomes his tombstone, inscribed with the painter's dedication. David combined his reductive Neoclassical style with a dramatic naturalism to liken Marat to a martyred saint. Marat's dangling right arm echoes that of Christ in both Michelangelo's Sistine *Pietà* and Caravaggio's *Entombment* (SEE FIGS. 20–9 AND 22–17), making Marat a Christ-like figure who has given his life for a greater cause—in this case not religious but political.

The Revolution degenerated into mob rule in 1793–94, as various political parties ruthlessly executed thousands of their opponents in what became known as the Reign of Terror. David himself, as a member of the Jacobins, served a two-week term as president, during which he signed several arrest warrants. When the Jacobins lost power in 1794, David was twice imprisoned, but he later emerged as a partisan of Napoleon and reestablished his career at the pinnacle of French art.

GIRODET-TRIOSON. A charismatic and influential teacher, David trained most of the important French painters who emerged in the 1790s and early 1800s. The lessons of David's teaching are evident, for example, in the **PORTRAIT OF JEAN-BAPTISTE BELLEY** (FIG. 29–42) by Anne-Louis Girodet-Trioson (1767–1824). Stylistically, the work combines a

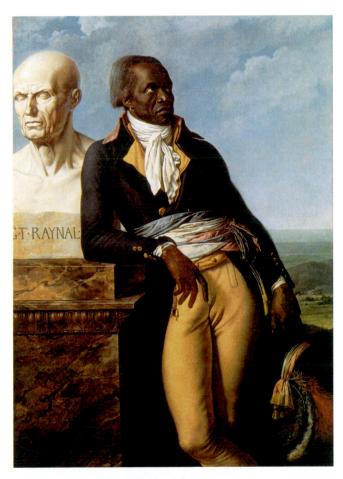

29–42 | Anne-Louis Girodet-Trioson PORTRAIT OF JEAN-BAPTISTE BELLEY 1797. Oil on canvas, $5'2\frac{1}{2}''\times3'8\frac{1}{2}''$ (1.59 \times 1.13 m). Musée National du Château de Versailles.

graceful pose recalling a classical sculpture with the kind of descriptive naturalism found in David's *Marat*. The work also has a significant political dimension. The Senegal-born Belley (1747?–1805) was a former slave sent by the colony of Saint-Domingue (now Haiti) as a representative to the French Convention. In 1794, he led the successful legislative campaign to abolish slavery in the colonies and grant black people full citizenship. Belley leans casually on a pedestal with the bust of the abbot Guillaume Raynal (1713–96), the French philosophe whose 1770 book condemning slavery had prepared the way for such legislation. (Unfortunately, in 1801 Napoleon reestablished slavery in the Caribbean Islands.) Girodet's portrait is therefore more of a tribute to the egalitarian principles of Raynal and Belley than it is a conventional portrait meant to flatter a sitter.

HOUDON. The heroes of the Enlightenment found their sculptor in Jean-Antoine Houdon (1741–1828), who combined naturalism with Neoclassicism in a way that influenced public monuments until the twentieth century. Houdon studied in Italy between 1764 and 1768 after winning the Prix de Rome. His commitment to a Neoclassical style began

during his stay in Rome, where he came into contact with some of the leading artists and theorists of the movement. Houdon carved busts and full-length statues of many important figures of his era, such as Diderot, Voltaire, Jean-Jacques Rousseau, Catherine the Great, Thomas Jefferson, Benjamin Franklin, Lafayette, and Napoleon. On the basis of his bust of Benjamin Franklin, Houdon was commissioned by the Virginia state legislature to do a portrait of its native son George Washington. Houdon traveled to the United States in 1785 to make a cast of Washington's features and a bust in plaster. He then executed a life-size marble figure in Paris (FIG. 29-43). For this work, Houdon combined contemporary naturalism with the new classicism that many were beginning to identify with republican politics. Although the military leader of the American Revolution of 1776 is dressed in his general's uniform, Washington's serene expression and relaxed contrapposto pose derive from sculpted images of classical athletes. Washington's left hand rests on a fasces, a bundle of rods tied together with an axe face, used in Roman times as a symbol of authority. The thirteen rods bound together are also a reference to the union formed by the original states. Attached to the fasces are a sword of war

29–43 | Jean-Antoine Houdon GEORGE WASHINGTON 1788–92. Marble, height 6′2″ (1.9 m). State Capitol, Richmond, Virginia.

The plow blade behind Washington alludes to Cincinnatus, a Roman soldier of the fifth century BCE who was appointed dictator and dispatched to defeat the Aequi, who had besieged a Roman army. After the victory, Cincinnatus resigned the dictatorship and returned to his farm. Washington's contemporaries compared him with Cincinnatus because, after leading the Americans to victory over the British, he resigned his commission and went back to farming rather than seeking political power. Just below Washington's waistcoat hangs the badge of the Society of the Cincinnati, founded in 1783 by the officers of the disbanding Continental Army who were returning to their peacetime occupations. Washington lived in retirement at his Mount Vernon, Virginia, plantation for five years before his 1789 election as the first president of the United States.

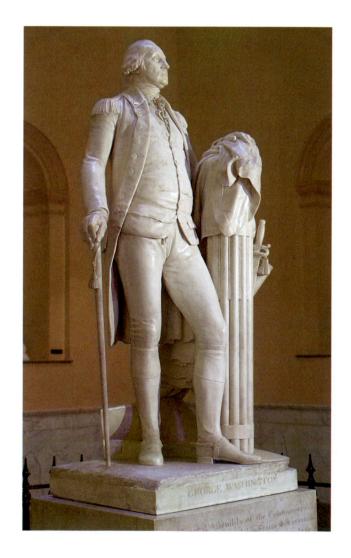

and a plowshare of peace. Houdon's studio turned out a regular supply of replicas of such works as part of the cult of great men promoted by Enlightenment thinkers as models for all humanity.

EIGHTEENTH-CENTURY ART OF THE AMERICAS

New Spain

In the wake of the Spanish conquest of central and south America, the conquerors suppressed local beliefs and practices and imposed Roman Catholicism throughout Spanish America. Native American temples were torn down, and churches were erected in their place. The early work of conversion fell to Franciscan, Dominican, and Augustinian religious orders. Several missionaries were so appalled by the conquerors' treatment of the people they called Indians that they petitioned the Spanish king to improve their conditions.

In the course of the Native Americans' conversion to Roman Catholicism, their own symbolism was to some extent absorbed into Christian symbolism. This process can be seen in the huge early colonial atrial crosses, so called because they were located in church atriums, where large numbers of converts gathered for education in the new faith. Missionaries recruited Native American sculptors to carve these crosses. One sixteenth-century ATRIAL CROSS, now in the Basilica of Guadalupe near Mexico City, suggests pre-Hispanic sculpture in its stark form and rich surface symbols in low relief, even though the individual images were probably copied from illustrated books that the missionaries brought (FIG. 29-44). The work is made from two large blocks of stone that are entirely covered with images known as the Arms of Christ, the "weapons" Christ used to defeat the devil. Jesus's Crown of Thorns hangs like a necklace around the cross bar, and with the Holy Shroud, which also wraps the arms, it frames the image of the Holy Face (the impression on the cloth Veronica used to wipe Jesus's face). Blood gushes forth where nails pierce the ends of the cross. Symbols of regeneration, such as winged cherub heads and pomegranates, surround the inscription at the top.

The cross itself suggests an ancient Mesoamerican symbol, the Tree of Life. The image of blood sacrifice also resonates with indigenous beliefs. Like the statue of the Aztec earth mother Coatlicue (SEE FIG. 26–4), the cross is composed of many individual elements that seem compressed to make a shape other than their own, the dense low relief combining into a single massive form. Simplified traditional Christian imagery is clearly visible in the work, although it may not yet have had much meaning or emotional resonance for the artists who put it there.

Converts in Mexico gained their own patron saint after the Virgin Mary was believed to have appeared as an Indian to an Indian named Juan Diego in 1531. Mary is said to have

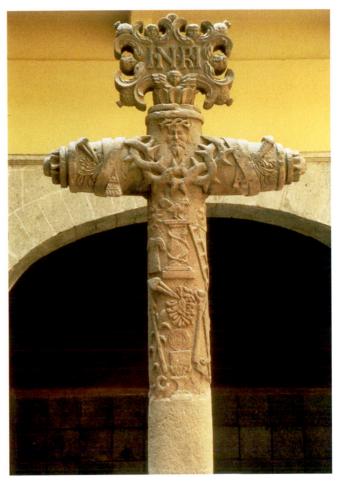

29–44 | ATRIAL CROSS
Before 1556. Stone, height 11′ 3″ (3.45 m). Chapel of the Indians, Basilica of Guadalupe, Mexico City.

asked that a church be built on a hill where an Aztec mother goddess had once been worshiped. As evidence of this vision, Juan Diego brought the archbishop flowers that the Virgin had caused to bloom, wrapped in a cloak. When Juan Diego opened his bundle, the cloak bore the image of a darkskinned Mary, an image that, light-skinned, was popular in Spain and known as the Virgin of the Immaculate Conception. The site of the vision was renamed Guadalupe after Our Lady of Guadalupe in Spain, and it became a venerated pilgrimage center. In 1754, the pope declared the Virgin of Guadalupe the patron saint of the Americas, seen here (FIG. 29–45) in a 1779 work by Sebastian Salcedo.

Spanish colonial builders quite naturally tried to replicate the architecture of their native country in their adopted lands. In the colonies of North America's Southwest, the builders of one of the finest examples of mission architecture, **SAN XAVIER DEL BAC**, near Tucson, Arizona (FIG. 29–46), looked to Spain for its inspiration. The Jesuit priest Eusebio Kino (1644–1711) began laying the foundations in 1700, using stone quarried locally by Native Americans of the Pima nation. The desert

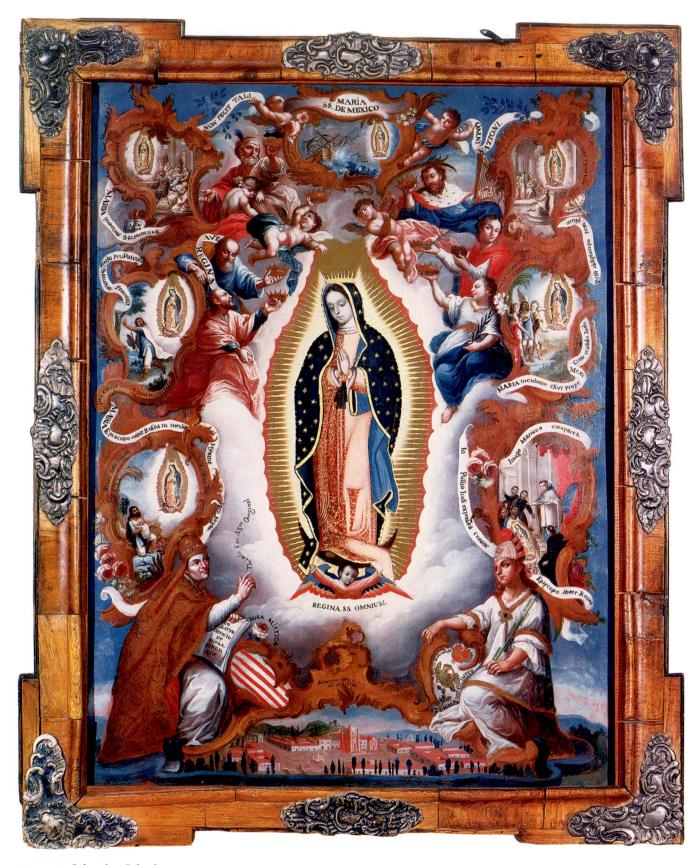

29–45 | Sebastian Salcedo OUR LADY OF GUADALUPE 1779. Oil on panel and copper, $25 \times 19''$ (63.5 \times 48.3 cm). Denver Art Museum.

At the bottom right is the female personification of New Spain (Mexico) and at the left is Pope Benedict XIV (papacy 1740-58), who in 1754 declared the Virgin of Guadalupe to be the patroness of the Americas. Between the figures, the sanctuary of Guadalupe in Mexico can be seen in the distance. The four small scenes circling the Virgin represent the story of Juan Diego, and at the top, three scenes depict Mary's miracles. The six figures above the Virgin represent Old Testament prophets and patriarchs and New Testament apostles and saints.

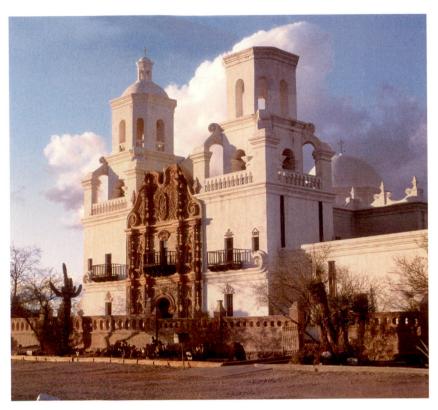

29–46 | MISSION SAN XAVIER DEL BAC Near Tucson, Arizona. 1784–97.

site had already been laid out with irrigation ditches, and Father Kino wrote in his reports that there would be running water in every room and workshop of the new mission, but the building never proceeded. The mission site was turned over to the Franciscans in 1768, after King Charles III ousted the Jesuit order from Spain and asserted royal control over Spanish churches. Father Kino's vision was realized by the Spanish Franciscan missionary and builder Juan Bautista Velderrain (d. 1790), who arrived at the mission in 1776.

The huge church, 99 feet long with a domed crossing and flanking bell towers, was unusual for the area since it was built of brick and mortar rather than adobe, which is made of earth and straw. The basic structure was finished by the time of Valderrain's death in 1790, and the exterior decoration was completed by 1797 under the supervision of his successor.

Although San Xavier is far from a copy, the focus on the central entrance area, with its Spanish Baroque decoration, is clearly in the tradition of the earlier work of Pedro de Ribera in Madrid. The mission was dedicated to Francis Xavier, whose statue once stood at the apex of the portal decoration. In the niches are statues of four female saints tentatively indentified as Lucy, Cecilia, Barbara, and Catherine of Siena. Hidden in the sculpted mass is one humorous element: a cat confronting a mouse, which inspired a local Pima saying: "When the cat catches the mouse, the end of the world will come" (cited in Chinn and McCarty, page 12).

North America

Eighteenth-century art by the white inhabitants of North America remained largely dependent on the styles of the European countries—Britain, France, and Spain—that had colonized the continent. Throughout the century, easier and more frequent travel across the Atlantic contributed to the assimilation of the European styles, but in general North American art lagged behind the European mainstream. In the early eighteenth century, the colonies grew rapidly in population, and rising prosperity led to an increased demand among the wealthy for fine works of art and architecture. (Apart from gravestone reliefs, sculpture was all but unknown.) Initially this demand was met by European immigrants who came to work in the colonies, but by the middle of the century a number of native-born American artists were also achieving professional success.

ARCHITECTURE. Professional architects, as we know them today, did not exist in the American colonies; rather, most fine houses and important public buildings were designed by amateur architects, sometimes called gentlemen-architects, who had the means and leisure to acquire and read books on architectural theory and the principles of design. These amateurs usually adapted, and sometimes copied outright, their building designs from the illustrated books of the sixteenth-century Italian architect Andrea Palladio (see Chapter 20) or the published designs of his English followers such as Inigo

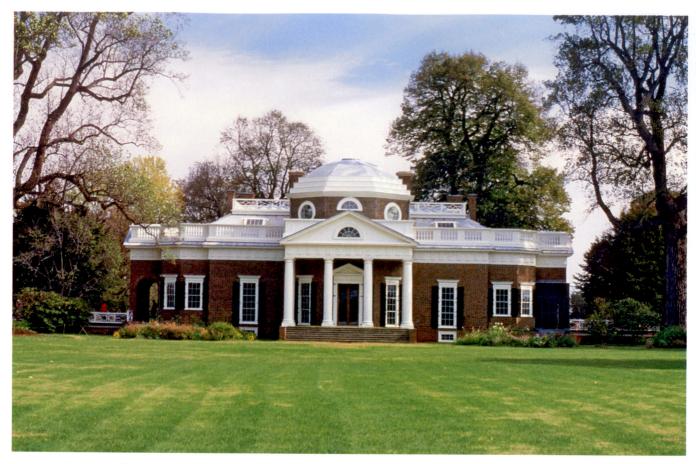

29–47 Thomas Jefferson MONTICELLO Charlottesville, Virginia. 1769–82, 1796–1809.

Jones, who had introduced the Palladian style to England in the seventeenth century.

The tremendously accomplished Thomas Jefferson (1743-1826), principal author of the Declaration of Independence, governor of Virginia (1779-81), American minister to France (1785-89), second vice president (1797-1801), and third president of the United States (1801-09), was also a gentleman-architect. While serving in France, Jefferson was asked by the Virginia legislature to procure a design for the new state capitol in Richmond. In consultation with the French archaeologist and Neoclassical architect Charles-Louis Clérisseau (1721-1820), Jefferson produced a design for the capitol based on an ancient Roman temple. Jefferson's political convictions led him to this choice: He felt that the United States, having won its independence from Britain, should also free itself from the influence of British architecture and turn for inspiration to the buildings of republican Rome, which provided an ancient example of a representative, rather than monarchical, form of government. Jefferson's Virginia State Capitol (1785-89) thus adapted the Roman temple form to symbolize the values of American democracy, republicanism, and humanism, and inaugurated Neoclassicism as the official style of governmental architecture in the United States. In

succeeding decades most other state and federal government buildings, such as the U. S. Capitol in Washington, D.C. (SEE FIG. 30–22), were built in the Neoclassical style.

Prior to his sojourn in France, Jefferson had between 1769 and 1782 designed and built, near Charlottesville, Virginia, a mountaintop home he called MONTICELLO (Italian for "little mountain") (FIG. 29-47), in a style based on eighteenth-century English Palladian models. In a second building campaign at Monticello (1796-1809) following his return from France, Jefferson enlarged the house and redesigned its brick and wood exterior so that its two stories would appear to be one, in the manner then fashionable for Parisian houses. He accented the entrance and garden façades by means of porticoes capped by triangular pediments, and he unified the exterior by means of a continuous Doric entablature and balustrade. Behind the garden portico rises a hexagonal drum, its walls pierced by white-framed oculi and supporting a saucer dome. The combination of pedimented portico fronting a domed space derives from the most famous of all ancient Roman temples, the Pantheon (second-century CE), also quoted in Palladio's Villa Rotonda and Burlington's Chiswick House (FIGS. 20-47, 29-18), and imparts to Monticello a distinctively Neoclassical note.

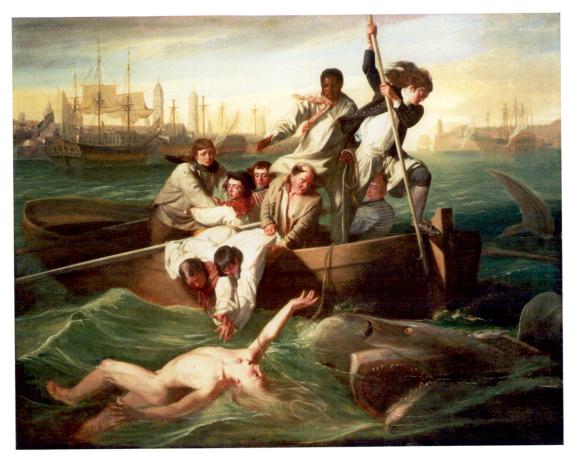

29–48 | John Singleton Copley | watson and the shark 1778. Oil on canvas, $5'10\frac{1}{4}''\times7'6\frac{1}{2}''$ (1.82 \times 2.29 m). National Gallery of Art, Washington, D.C.

Ferdinand Lammot Belin Fund.

PAINTING. Most painters in England's American colonies relied on native talents rather than formal training. Portraiture dominated the market in the increasingly prosperous colonies, and portraitists studied engravings to learn figure poses and backdrops. The American-born Benjamin West, a member of the Royal Academy in London from 1768, encouraged colonial artists to travel to Europe for study; the most ambitious artists accepted his invitation.

John Singleton Copley (1738–1815) grew up to be colonial America's first native-born artist of genius. Copley's sources of inspiration were meager—principally his stepfather's collection of engravings—but his work was already drawing attention when he was 15 years old. Key to Copley's success was his intuitive understanding of his upper-class clientele. They valued not only his excellent technique, which equaled that of European artists, but also his ability to dignify them while recording their features with unflinching realism, as seen in his powerful portrait of *Samuel Adams* (SEE FIG. 29–1).

Copley's talents so outdistanced those of his colonial contemporaries that the artist aspired to a larger reputation. In 1766, he sent a portrait of his half brother to an exhibition in London, where it received a favorable critical response.

Benjamin West, the expatriate artist from Pennsylvania, encouraged Copley to study in Europe. At that time, family ties kept him from following the advice, but the impending Revolutionary War soon caused him to reconsider. In 1773, rebellious colonists dressed as Native Americans boarded a ship and threw its cargo of tea into Boston Harbor to protest the British East India Company's monopoly and the tax imposed on tea by the colonial government—an event known as the Boston Tea Party.

The shipment of tea belonged to Copley's merchant father-in-law, Richard Clarke. Copley was thus torn between two circles: his affluent pro-British in-laws and clients, and his radical friends, including Paul Revere, John Hancock, and Samuel Adams. Reluctant to take sides, Copley sailed in June 1774 for Europe, visiting Italy and settling in London, where his family joined him. Like West, he never returned to his native country.

In London, Copley established himself as a portraitist and painter of modern history in the vein of West. His most distinctive effort in the latter arena was **WATSON AND THE SHARK** (FIG. **29–48**), commissioned by Brook Watson, a wealthy London merchant and Tory politician. Copley's 1778 painting dramatizes a 1749 episode during which the 14-year-old Watson, while swimming in the harbor of Havana,

was attacked by a shark and lost part of his right leg before being rescued by his comrades. Against the backdrop of a view of the Havana harbor, Copley deployed his foreground figures in a pyramidal composition inspired by classical prototypes. As the ferocious shark rushes on the helpless, naked Watson, a harpooner at the rescue boat's prow raises his spear for the kill. At the left, two of Watson's mates lean out and strain to reach him while the others in the boat look on in alarm. Prominent among these is a black man at the apex of the pyramid, who holds a rope that curls over Watson's extended right arm, connecting him to the boat and symbolizing his impending rescue.

While many have seen the black figure simply as a servant waiting to hand the rope to one of his white masters, art historians have also interpreted his presence in political terms. Watson's fateful swim in Havana Harbor occurred while he was working in the transatlantic shipping trade, one aspect of which involved the shipment of slaves from Africa to the West Indies. At the time Watson commissioned Copley's painting, a debate raged in Parliament not only over the Americans' recent Declaration of Independence, but also over the slave trade. Watson and other Tories opposed American independence and highlighted the hypocrisy of American calls for freedom from the British Crown while the colonists continued to deny freedom to African slaves. Furthermore, during the Revolutionary War the British used slavery to their advantage by promising freedom to every runaway American slave who joined the British army or navy.

Copley's painting, its subject doubtless dictated by Watson, therefore could be interpreted as a demonstration of Tory sympathy for the plight of the American slaves (though it should be noted that Watson ultimately did not support the outright abolition of slavery but rather gradual emancipation). In the context of Tory opposition to American independence, the shark-infested waters could symbolize the colonies themselves, a breeding ground of dangerous revolutionary ideas, while Watson's severed leg could stand for the dismemberment of the British Empire through the loss of its American colonies. Further connecting Watson, slavery, and the American colonies was the slavers' practice of throwing dead slaves overboard to the sharks during the journey from Africa to America. Yet Watson himself, through his involvement in the slave trade, had acted like a devouring shark and Copley represents him, metaphorically, as a victim of divine wrath (symbolized by the attacking shark) whose suffering redeems his guilty past. Significantly, Watson's arm reaches not toward his white comrades but toward the black man, whose reciprocal gesture seems to confer forgiveness.

The chaotic and uncertain mood of *Watson and the Shark* speaks of Romanticism, the movement that began in the late eighteenth century and would increasingly dominate the early nineteenth as the social forces unleashed by the Enlightenment and industrialization took hold across the Western world.

IN PERSPECTIVE

The eighteenth century in the West began under the sunny skies of the Rococo, as court artists decorated the salons of aristocrats with paintings that portrayed a life of ease. These works, whether by Tiepolo, Watteau, or Fragonard, generally took the aristocracy itself as subject matter, and depicted them in relaxed poses not based on classical norms, frolicking or relaxing in lush settings. The Rococo building style, initiated by Johan Balthasar Neumann in Bavaria, is a sensuous version of the Baroque. Spaces consist of complex, interpenetrating circles and ovals, with delicately scaled decoration.

The intellectual movement known as the Enlightenment influenced both society and art beginning in the middle years of the century. Based on scientific research rather than traditional belief, this movement led directly to the concept of universal human rights that many countries still aspire to today. Denis Diderot and others urged artists to work for the common good, and this encouraged artists such as Vigée–Lebrun to paint portraits in a down–to–earth style. Others, such as Wright, glorified science, and still others, such as Hogarth and Greuze, criticized aspects of the culture in the hope of improving it.

The discovery of the ruins of Pompeii and Herculaneum helped to set off the Neoclassical movement just after midcentury. Neoclassical painters such as David and Kauffmann, and sculptors such as Canova, rebelled against the entertaining Rococo and created art based on inspiring classical stories, with figure poses modeled after Roman reliefs in clear, evenly lit compositions. Neoclassicism also infused architecture with new, simpler designs based on Renaissance or Roman models. Leading architects included Jefferson, Boyle, Adam, and Soufflot.

Near the end of the century, the Romantic movement began to flower in England. Walpole redesigned Strawberry Hill to capture the flavor of the Middle Ages, Blake reinterpreted the Bible in his highly imaginative way, and John Henry Fuseli painted his nightmares. This movement, based on dreams, fantasies, and literature, would reach its height in the next century.

The eighteenth century ended in the smoke of the French Revolution, with Neoclassicism and incipient Romanticism the dominant movements.

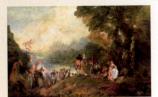

WATTEAU
PILGRIMAGE TO THE ISLAND
OF CYTHERA
1717

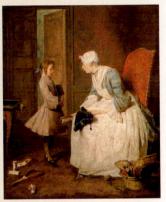

CHARDIN
THE GOVERNESS
1739

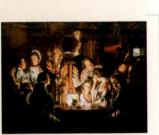

WRIGHT
AN EXPERIMENT ON A BIRD
IN THE AIR-PUMP
1768

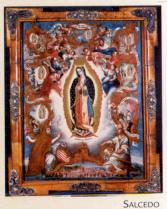

OUR LADY OF GUADALUPE

CHURCH OF THE VIERZEHNHEILIGEN 1743-72

WEDGWOOD VASE 1786

EIGHTEENTH-CENTURY ART IN EUROPE AND THE AMERICAS

1700

1720

1740

1760

1780

1800

- Louis XIV of France Dies 1715
- Louis XV Rules France 1715-74

- Seven Years' War 1756-63
- Women Were Founding Members of English Royal Academy 1768
- ✓ Louis XVI Rules France 1774-92
- American Revolution Begins 1776

◀ French Revolution Begins 1789

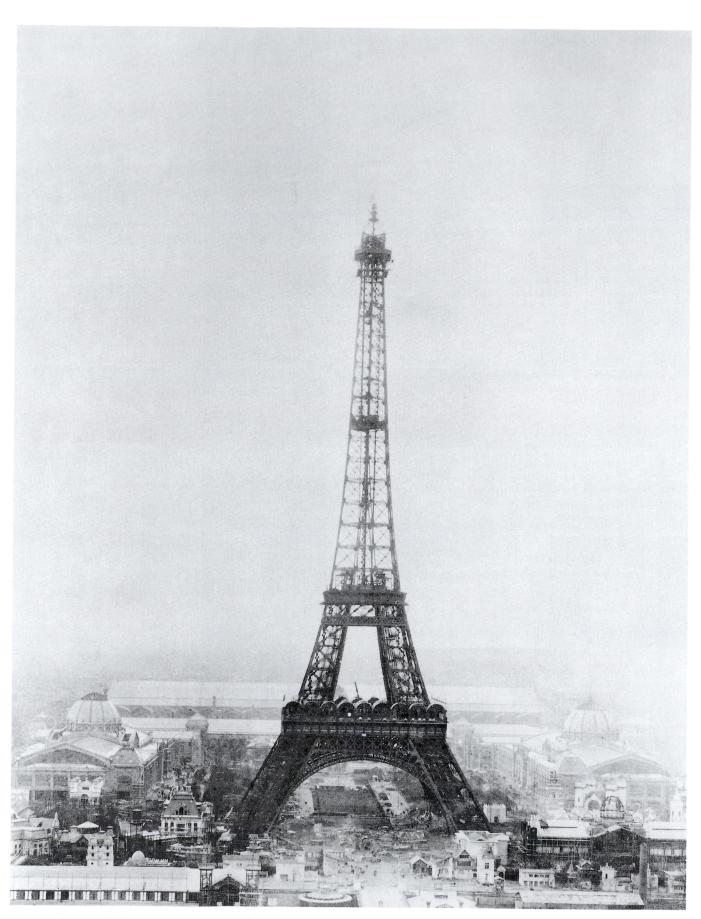

30-I Gustave Eiffel **EIFFEL TOWER** Paris. 1887-89.

CHAPTER THIRTY

NINETEENTH-CENTURY ART IN EUROPE AND THE UNITED STATES

"We writers, painters, sculptors, architects, and devoted lovers of the beauty of Paris . . . do protest with all our strength and all our indignation . . . against the erection, in the very heart of our capital, of the useless and monstrous

Eiffel Tower, which public spitefulness . . . has already baptized, 'the Tower of Babel.' "With these words, published in *Le Temps* on February 14, 1887, a group of conservative artists announced their strong opposition to the immense iron tower just beginning to be built on the River Seine. The work of the engineer Gustave Eiffel (1832–1923), the 300-meter (984-foot) tower would upon its completion be the tallest structure in the world, dwarfing even the Egyptian pyramids and Gothic cathedrals.

The EIFFEL TOWER (FIG. 30–1) was the main attraction of the 1889 Universal Exposition, one of several large fairs

30

staged in Europe and the United States during the late nineteenth century to showcase the latest international advances in science and industry, while also displaying both fine and applied arts. But because Eiffel's marvel lacked architec-

tural antecedents and did not conceal its construction, detractors saw it as an ugly, overblown work of engineering. For its admirers, however, it achieved a new kind of beauty derived from modern science and was an exhilarating symbol of technological innovation and human aspiration. One French poet called it "an iron witness raised by humanity into the azure sky to bear witness to its unwavering determination to reach the heavens and establish itself there." Perhaps more than any other monument, the Eiffel Tower embodies the nineteenth-century belief in the progress and ultimate perfection of civilization through science and technology.

- EUROPE AND THE UNITED STATES IN THE NINETEENTH CENTURY
- EARLY NINETEENTH-CENTURY ART: NEOCLASSICISM AND ROMANTICISM | Neoclassicism and Romanticism in France | Romantic Sculpture in France and Beyond | Romanticism in Spain: Goya | Romantic Landscape Painting | Orientalism | Revival Styles in Architecture Before 1850
- ART IN THE SECOND HALF OF THE NINETEENTH CENTURY | Early Photography in Europe | New Materials and Technology in Architecture at Midcentury | French Academic Art and Architecture | Realism | Late Nineteenth-Century Art in Britain | Impressionism
- THE BIRTH OF MODERN ART | Post-Impressionism | Symbolism in Painting | Late Nineteenth-Century French Sculpture | Art Nouveau | Late-Century Photography | Architecture
- IN PERSPECTIVE

EUROPE AND THE UNITED STATES IN THE NINETEENTH CENTURY

The Enlightenment set in motion powerful forces that would dramatically transform life in Europe and the United States during the nineteenth century. Great advances in manufacturing, transportation, and communications created new products for consumers and new wealth for entrepreneurs, fueling the rise of urban centers and improving living conditions for many (SEE MAP 30–1). But this so-called Industrial Revolution also condemned masses of workers to poverty and catalyzed new political movements for social reform. Animating these developments was the widespread belief in "progress" and the ultimate perfectibility of human civilization—a belief rooted deeply in Enlightenment thought (Chapter 29).

The Industrial Revolution had begun in eighteenth-century Britain, where the new coal-fired steam engine ran such innovations in manufacturing as the steam-powered loom. Increasing demands for coal and iron necessitated improvements in mining, metallurgy, and transportation. Subsequent development of the locomotive and steamship in turn facilitated the shipment of raw materials and merchandise, made passenger travel easier, and encouraged the growth of new cities.

Displaced from their small farms and traditional cottage industries by technological developments in agriculture and manufacturing, the rural poor moved to the new factory and mining towns in search of employment, and industrial laborers—many of them women and children—suffered miserable working and living conditions. Although new government regulations led to improvements during the second half of the nineteenth century, socialist movements condemned the exploitation of laborers by capitalist factory owners and advocated communal or state ownership of the means of production and distribution. The most radical of these movements was communism, which called for the abolition of private property.

Efforts at social reform reached a peak in 1848, as workers' revolts broke out in several European capitals. In that year, Karl Marx and Friedrich Engels also published the *Communist Manifesto*, which predicted the violent overthrow of the bourgeoisie (middle class) by the proletariat (working class) and the creation of a classless society. At the same time, the Americans Lucretia Mott and Elizabeth Cady Stanton organized the country's first women's rights convention, in Seneca Falls, New York. They called for the equality of women and men before the law, property rights for married women, the acceptance of women into institutions of higher education, the admission of women to all trades and professions, equal pay for equal work, and women's suffrage.

Continuing scientific discoveries led to the telegraph, telephone, and radio. By the end of the nineteenth century, electricity powered lighting, motors, trams, and railways in most European and American cities. Developments in chemistry created many new products, such as aspirin, disinfectants, photographic chemicals, and explosives. The new material of steel, an alloy of iron and carbon, was lighter, harder, and more malleable than iron, and replaced it in heavy construction and transportation. In medicine and public health, Louis Pasteur's purification of beverages through heat (pasteurization) and the development of vaccines, sterilization, and antiseptics led to a dramatic decline in death rates all over the Western world.

Some scientific discoveries challenged traditional religious beliefs and affected social philosophy. Geologists concluded that the earth was far older than the estimated 6,000 years sometimes claimed for it by biblical literalists. Contrary to the biblical account of creation, Charles Darwin proposed that all life evolved from a common ancestor and changed through genetic mutation and natural selection. Religious conservatives attacked Darwin's account of evolution, which seemed to deny the divine creation of humans and even the existence of God. Some of Darwin's supporters, however, suggested that "survival of the fittest" had advanced the human race, with certain types of people—particularly the

MAP 30-I | EUROPE AND THE UNITED STATES IN THE NINETEENTH CENTURY

Europe took the lead in industrialization, and France became the cultural beacon of the Western world.

Anglo-Saxon upper classes—achieving the pinnacle of social evolution. "Social Darwinism" provided a rationalization for the "natural" existence of a less "evolved" working class and a justification for British and American colonization of "underdeveloped" parts of the world.

The nineteenth century also witnessed the rise of imperialism. To create new markets for their products and to secure access to cheap raw materials and cheap labor, European nations established colonies in most of Africa and nearly a third of Asia. Colonial rule brought some technological improvements to non-Western regions but also threatened traditional native cultures and suppressed the economic development of the colonized areas.

As the power of both the Church and the Crown declined in the nineteenth century, so did their influence over artistic production. In their place, the capitalist bourgeoisie, nation–states, and national academies became major patrons of the arts. Large annual exhibitions in European and American cultural centers took on increasing importance as a means for artists to show their work, win prizes, attract buyers, and gain commissions. Art criticism proliferated in mass-printed periodicals, helping both to make and to break artis-

tic careers. And, in the later decades of the century, commercial art dealers gained in importance as marketers of both old and new art.

EARLY NINETEENTH-CENTURY ART: NEOCLASSICISM AND ROMANTICISM

Both Neoclassicism and Romanticism (see Chapter 29) remained vital in early nineteenth-century European and American art. Neoclassicism survived past the middle of the century in both architecture and sculpture, as patrons and creators held to the belief that recalling Greece and Rome ensured a connection to democracy. Neoclassical painters tended to dominate academies, where teachers urged students to learn from antique sculpture and great artists of the past such as Raphael. Most academicians regarded art as a repository of tradition in changing times, a way to access what was universal, abiding, and beautiful. They still hoped that art could inspire viewers to virtue and taste.

Romanticism took a variety of forms in the early decades, but the emphasis everywhere moved away from the

universal toward the personal, away from thought and toward feeling. Romantics respected the Enlightenment but regarded it as too narrowly focused on rationality, encouraging a certain coldness and detachment. Enlightenment rule by reason had, after all, led to the Reign of Terror in France. Humans are not only creatures of reason, the Romantics argued: Humans also possess deep and not always rational longings for self-expression, understanding, and identification with their fellows. The Romantic tools of feeling and imagination seemed the most appropriate aids to reach these goals. Thus Neoclassical art, embodied in the sandal-shod heroes of The Oath of the Horatii, seemed unconnected to the issues of the day. Many Romantic paintings and sculptures featured dramatic or emotional subject matter drawn from literature, the landscape, current events, or the artist's own imagination. In architecture, Romantics broadened the vocabulary of historical allusion that the Neoclassicists had pioneered: If recalling Rome instilled one set of feelings, then recourse to other periods could stimulate other kinds of sentiments. Ideally, each building type could use the style most appropriate to the personal wish of the patron.

Neoclassicism and Romanticism in France

The undisputed capital of the nineteenth-century Western art world was Paris. The École des Beaux-Arts attracted students from all over Europe and the Americas, as did the ateliers (studios) of Parisian academic artists who offered private instruction. Virtually every ambitious nineteenth-century artist aimed to exhibit in the Paris Salon, to receive positive reviews from the Parisian critics, and to find favor with the French art-buying public.

Conservative juries controlled the Salon exhibitions, however, and from the 1830s onward they routinely rejected paintings and sculpture that did not conform to the academic standards of slick technique, mildly idealized subject matter, and engaging, anecdotal story lines. As the century wore on, progressive and independent artists ceased submitting to the Salon and organized private exhibitions to present their work directly to the public without the intervention of a jury. The most famous of these was the first exhibition of the Impressionists, held in Paris in 1874.

DAVID AND HIS STUDENTS. With the rise of Napoleon, Jacques-Louis David reestablished his dominant position as chief arbiter of French painting. David saw in the general his best hope for realization of his Enlightenment-oriented political goals, and Napoleon saw in the artist a tested propagandist for revolutionary values. As Napoleon gained power and took his crusade across Europe, reforming law codes and abolishing aristocratic privilege, he commissioned David and his students to document his deeds. David's new artistic task, the glorification of Napoleon, appeared in an early, idealized portrait of Napoleon leading his troops across the Alps into

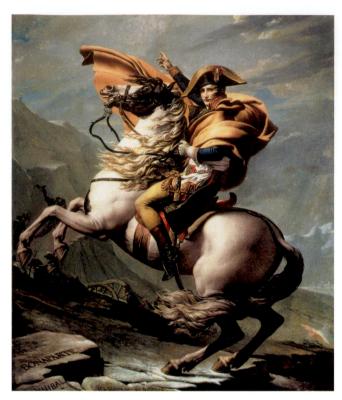

30−2 | Jacques-Louis David NAPOLEON CROSSING THE SAINT-BERNARD

1800–1801. Oil on canvas, $8'11''\times7'7''$ (2.7×2.3 m). Musée National du Château de la Malmaison, Rueil-Malmaison.

David flattered Napoleon by reminding the viewer of two other great generals from history who had accomplished this difficult feat—Charlemagne and Hannibal—by etching the names of all three in the rock in the lower left.

Italy in 1800 (FIG. 30–2). Napoleon—who actually made the crossing on a donkey—is shown calmly astride a rearing horse, exhorting us to follow him. His windblown cloak, an extension of his arm, suggests that Napoleon directs the winds as well. While Neoclassical in the firmness of its drawing, the work also takes stylistic inspiration from the Baroque—for example, in the dramatic diagonal composition used instead of the classical pyramid of the *Oath of the Horatii* (SEE FIG. 29–40). When Napoleon fell from power in 1814, David went into exile in Brussels, where he died in 1825.

Antoine-Jean Gros (1771–1835), who began to work in David's studio as a teenager, eventually vied with his master for commissions from Napoleon. Gros traveled with Napoleon in Italy in 1797 and later became an official chronicler of Napoleon's military campaigns. His painting NAPOLEON IN THE PLAGUE HOUSE AT JAFFA (FIG. 30–3) is an idealized account of an actual incident: During Napoleon's campaign against the Ottoman Turks in 1799, bubonic plague broke out among his troops. Napoleon decided to quiet the fears of the healthy by visiting the sick and dying, who were housed in a converted mosque in the Palestinian town of Jaffa (Palestine was then part of the Ottoman

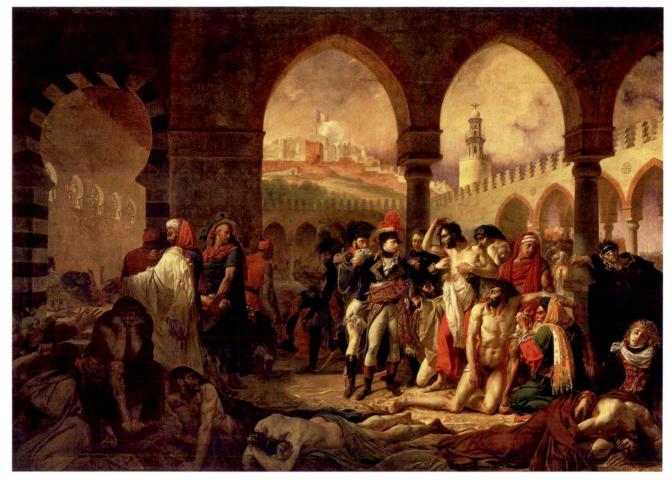

30–3 | Antoine-Jean Gros NAPOLEON IN THE PLAGUE HOUSE AT JAFFA 1804. Oil on canvas, $17'5'' \times 23'7''$ (5.32 \times 7.2 m). Musée du Louvre, Paris.

Empire). The format of the painting—a shallow stage and a series of arcades behind the main actors—is inspired by David's *Oath of the Horatii*. The overall effect is Romantic, however, not simply because of the dramatic lighting and the wealth of emotionally stimulating elements, both exotic and horrific, but also because the main action is meant to incite veneration rather than republican virtue. At the center of a small group of soldiers and a doctor, Napoleon calmly reaches toward the sores of one of the victims—the image of a Christ-like figure healing the sick with his touch is consciously intended to promote him as semidivine. Not surprisingly, Gros gives no hint of the event's cruel historical aftermath: Two months later, Napoleon ordered the remaining sick to be poisoned.

Jean-Auguste-Dominique Ingres (1780–1867) represents the Neoclassical wing of David's legacy, but Ingres significantly broadened both the sources and techniques of Neoclassicism. Inspired more by Raphael than by antique art, Ingres emulated the Renaissance artist's precise drawing, formal idealization, classical composition, and graceful lyricism, but interpreted them in a personal manner. Ingres won the

Prix de Rome and lived in Italy from 1806 to 1824, returning to serve as director of the French Academy in Rome from 1835 to 1841. As a teacher and theorist, Ingres became the most influential artist of his time.

Although Ingres, like David, fervently desired acceptance as a history painter, his paintings of literary subjects and contemporary history were less successful than his erotically charged portraits of women and female nudes, especially his numerous representations of the odalisque, a female slave or concubine in a sultan's harem. In LARGE ODALISQUE (FIG. 30-4), the cool gaze this odalisque levels at her master, while turning her naked body away from what we assume is his gaze, makes her simultaneously erotic and aloof. The cool blues of the couch and the curtain at the right heighten the effect of the woman's warm skin, while the tight angularity of the crumpled sheets accentuates the languid, sensual contours of her form. Although Ingres's commitment to fluid line and elegant postures was grounded in his Neoclassical training, he treated some Romantic themes, such as the odalisque, in an anticlassical fashion. Here the elongation of the woman's back (she seems to have several extra vertebrae), the widening of her hip, and her

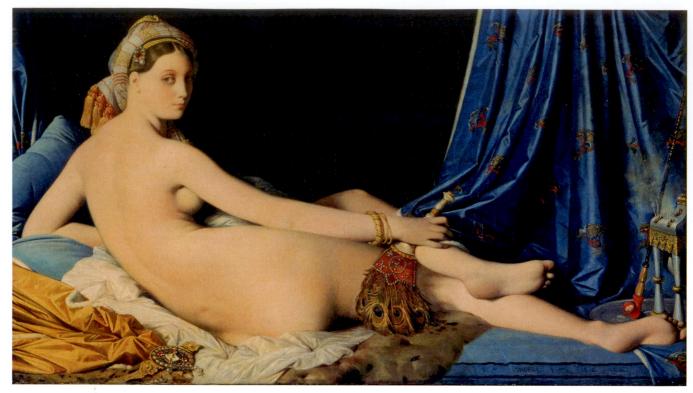

30–4 | Jean-Auguste-Dominique Ingres LARGE ODALISQUE 1814. Oil on canvas, approx. $35 \times 64''$ (88.9 \times 162.5 m). Musée du Louvre, Paris.

During Napoleon's campaigns against the British in North Africa, the French discovered the exotic Near East. Upper-middleclass European men were particularly attracted to the institution of the harem, partly as a reaction against the egalitarian demands of women of their class that had been unleashed by the French Revolution.

tiny, boneless feet are anatomically incorrect but aesthetically compelling.

Although Ingres complained that making portraits was a "considerable waste of time," he was unparalleled in rendering a physical likeness and the material qualities of clothing, hairstyles, and jewelry. In addition to polished life-size oil portraits, Ingres produced—usually in just a day—small portrait drawings that are extraordinarily fresh and lively. The exquisite POR-TRAIT OF MADAME DESIRÉ RAOUL-ROCHETTE (FIG. 30-5) is a flattering yet credible interpretation of the relaxed and elegant sitter. With her gloved right hand Madame Raoul-Rochette has removed her left-hand glove, simultaneously drawing attention to her social status (gloves traditionally were worn by members of the European upper class, who did not work with their hands) and her marital status (on her left hand is a wedding band). Her shiny taffeta dress, with its fashionably high waist and puffed sleeves, is rendered with deft yet light strokes that suggest more than they describe. Greater emphasis is given to her refined face and elaborate coiffure, which Ingres has drawn precisely and modeled subtly through light and shade.

FRENCH ROMANTIC PAINTING. Romanticism, already anticipated in French painting during Napoleon's reign, flowered during the royal restoration that lasted from 1815 to 1830.

French Romantic painters took further the innovations of David's pupils as they based their art more on imagination and feeling than on Neoclassical reason. The French Romantics painted literary subjects as expressions of imagination, and current events as vehicles of feeling. They depicted these subjects using loose, fluid brushwork, strong colors, complex and off-balance compositions, powerful contrasts of light and dark, and expressive poses and gestures.

Théodore Géricault (1791-1824) was the leading innovator of early French Romanticism, though his career was cut short by early death. After a brief stay in Rome in 1816-17, where he discovered Michelangelo, Géricault returned to Paris determined to paint a great contemporary history painting. He chose for his subject the scandalous and sensational shipwreck of the Medusa (see "Raft of the 'Medusa,"" page 992). In 1816, the ship of French colonists headed for Senegal ran aground near its destination; its captain was an incompetent aristocrat appointed by the newly restored monarchy for political reasons. Because there were insufficient lifeboats, a raft was hastily built for 152 of the passengers and crew, while the captain and his officers took the seaworthy boats. Too heavy to pull to shore, the raft was set adrift. When it was found thirteen days later, only fifteen people remained alive, having survived their last several days on

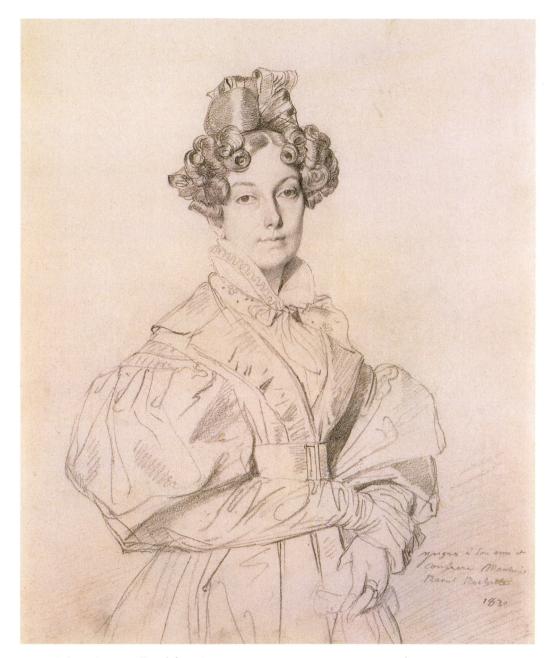

30–5 | Jean-Auguste-Dominique Ingres PORTRAIT OF MADAME DESIRÉ RAOUL-ROCHETTE 1830. Graphite on paper, $12\% \times 9\%''$ (32.2 × 24.1 cm). The Cleveland Museum of Art, Cleveland, Ohio.

Purchase from the J. H. Wade Fund (1927.437)

Madame Raoul-Rochette (1790–1878), née Antoinette-Claude Houdon, was the youngest daughter of the famous Neoclassical sculptor Jean-Antoine Houdon (SEE FIG. 29–43). In 1810, at the age of 20, she married Desiré Raoul-Rochette, a noted archaeologist, who later became the secretary of the Academy of Fine Arts and a close friend of Ingres. Ingres's drawing of Madame Rochette is inscribed to her husband, whose portrait Ingres also drew around the same time.

human flesh. Géricault chose to depict the moment when the survivors first spot their rescue ship.

At the Salon of 1819 the painting caused a great deal of controversy. Most contemporary French critics interpreted the painting as political commentary, with liberals praising it for exposing a difficult issue and royalists condemning it as closer to sensational journalism than art. Such a large, multifigured composition might normally be expected to portray a mythological

or historic subject with a recognizable hero; this work, in contrast, showed a recent sensational event with no hero except the anonymous sufferers who desperately plead for rescue. Rather than offering a heroic narrative, the work engages the sympathy of anyone who has ever felt lost. Because the monarchy refused to buy the canvas, Géricault exhibited it commercially on a two-year tour of Ireland and England, where the London exhibition attracted more than 50,000 paying visitors.

THE OBJECT SPEAKS

RAFT OF THE "MEDUSA"

héodore Géricault's monumental Raft of the "Medusa" is a history painting that speaks powerfully through a composition in which the victims' largely nude, muscular bodies are organized on crossed diagonals. The diagonal that begins in the lower left and extends to the waving figures registers their rising hopes. The diagonal that begins with the dead man in the lower right and extends through the mast and billowing sail, however, directs our attention to a huge wave. The rescue of the men is not yet assured. They remain tensely suspended between salvation and death. Significantly, the "hopeful" diagonal in Géricault's painting terminates in the vigorous figure of a black man, a survivor named Jean Charles, and it may therefore carry political meaning. By placing him at the top of the pyramid of sur-

vivors and giving him the power to save his comrades by signaling to the rescue ship, Géricault suggests metaphorically that freedom for all of humanity will only occur when the most oppressed member of society is emancipated.

Géricault's work was the culmination of extensive study and experimentation. An early pen drawing depicts the survivors' hopeful response to the appearance of the rescue ship on the horizon at the extreme left. Their excitement is in contrast with the mournful scene of a man grieving over a dead youth on the right side of the raft. A later pen-andwash drawing reverses the composition, creates greater unity among the figures, and establishes the modeling of their bodies through light and shade. These developments look ahead to the final composition of the *Raft of the "Medusa,"* but the

study still lacks the figures of the black man at the apex of the painting and the dead bodies at the extreme left and lower right, which fill out the composition's base.

Géricault also made separate studies of many of the figures, as well as studies of actual corpses, severed heads, and dissected limbs supplied to him by friends who worked at a nearby hospital. For several months, according to Géricault's biographer, "his studio was a kind of morgue. He kept cadavers there until they were half-decomposed, and insisted on working in this charnel-house atmosphere. ..." However, Géricault did not use cadavers directly in the Raft of the "Medusa." To execute the final painting, he traced the outline of his composition onto a large canvas, then painted each body directly from a living model, gradually

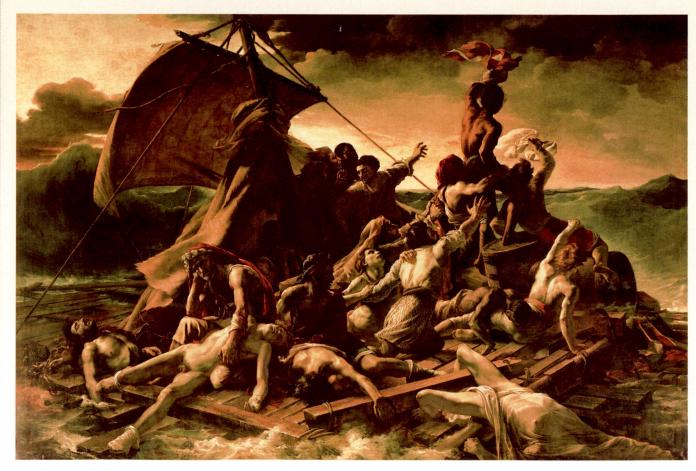

Théodore Géricault RAFT OF THE "MEDUSA" 1818–19. Oil on canvas, $16'1'' \times 23'6''$ (4.9×7.16 m). Musée du Louvre, Paris.

building up his composition figure by figure. He seems, rather, to have kept the corpses in his studio only to create an atmosphere of death that would provide him with a more authentic understanding of his subject.

Nevertheless, Géricault did not depict the actual physical condition of the survivors on the raft: exhausted, emaciated, sunburned, and close to death. Instead, following the dictates of the Grand Manner, he gave his men athletic bodies and vigorous poses, evoking the work of Michelangelo and Rubens (Chapters 20 and 22). He did this to generalize and ennoble his subject, elevating it above the particulars of a specific shipwreck so that it could speak to us of more fundamental conflicts: humanity against nature, hope against despair, life against death.

THE SIGHTING OF THE "ARGUS" (TOP) 1818.

Pen and ink on paper, $13\,\% \times 16\,\%$ (34.9 \times 41 cm). Musée des Beaux-Arts, Lille.

THE SIGHTING OF THE "ARGUS" (MIDDLE) 1818.

Pen and ink, sepia wash on paper, $8 \, \% \times 11 \, \%$ " (20.6 \times 28.6 cm). Musée des Beaux-Arts, Rouen.

STUDY OF HANDS AND FEET (BOTTOM) 1818–19.

Oil on canvas, $20 \frac{1}{2} \times 25^{\prime\prime}$ (52 × 64 cm). Musée Fabre, Montpellier.

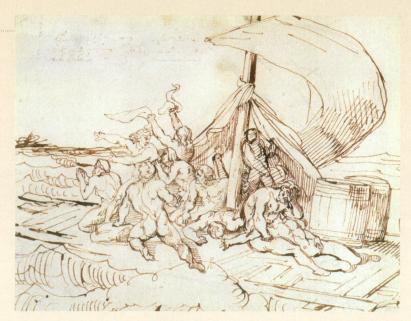

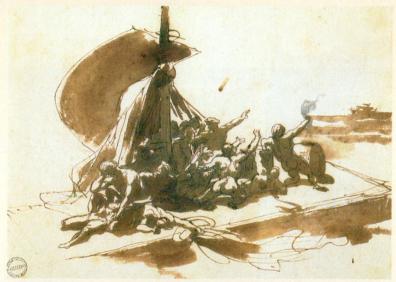

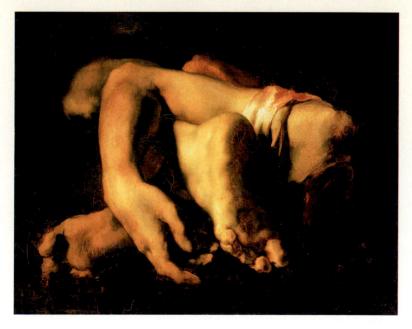

Technique LITHOGRAPHY

ithography, invented in the mid-1790s, is based on the natural antagonism between oil and water. The artist draws on a flat surface—traditionally, fine-grained stone—with a greasy, crayonlike instrument. The stone's surface is wiped with water, then with an oil-based ink. The ink adheres to the greasy areas but not to the damp ones. A sheet of paper is laid face down on the inked stone, which is passed through a flatbed press. Holding a scraper, the lithographer applies light pressure from above as the stone and paper pass under the scraper, transferring ink from stone to paper, thus making lithography a direct method of creating a printed image. Francisco Goya, Théodore Géricault, Eugène Delacroix, Honoré Daumier, and Henri de Toulouse-Lautrec used the medium to great effect.

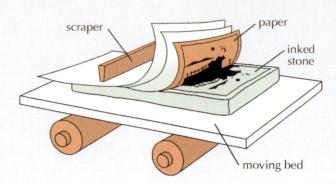

Diagram of lithographic press

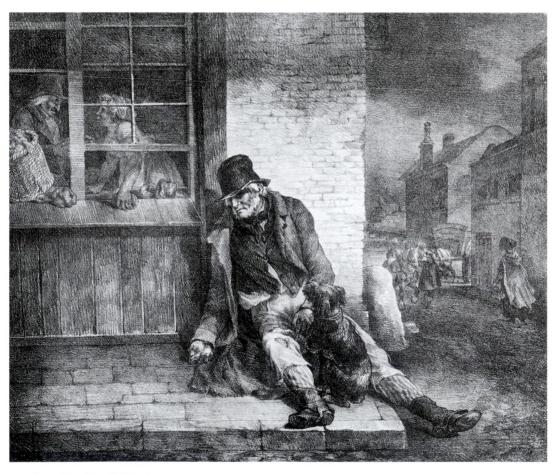

30–6 | Théodore Géricault PITY THE SORROWS OF A POOR OLD MAN 1821. Lithograph, $12.5 \times 14.8''$ (31.6×37.6 cm). Yale University Art Gallery, New Haven, Connecticut. Gift of Charles Y. Lazarus, B.A. 1936

One of the first artists to use the recently invented medium of lithography to create fine art prints, Géricault published his thirteen lithographs of *Various Subjects Drawn from Life and on Stone* in London in 1821. The title of *Pity the Sorrows of a Poor Old Man* comes from a popular English nursery rhyme of the period that began: "Pity the sorrows of a poor old man whose trembling limbs have borne him to your door."

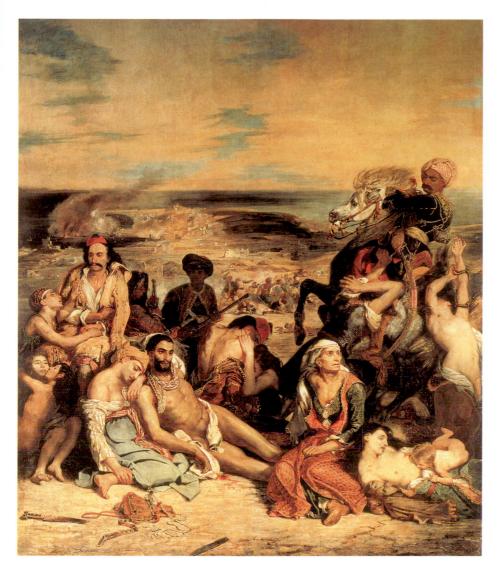

30-7 | Eugène Delacroix SCENES FROM THE MASSACRE AT CHIOS 1822-24. Oil on canvas, 13' 10" × 11' 7" (4.22 × 3.53 m). Musée du Louvre, Paris.

While in Britain, Géricault turned from Romantic history painting to the depiction of the urban poor in a series of lithographs (see "Lithography," page 994) entitled *Various Subjects Drawn from Life and on Stone.* PITY THE SORROWS OF A POOR OLD MAN (FIG. 30–6) depicts a haggard beggar, slumping against a wall and limply extending an open hand. Through the window above him, we see a baker who ignores the hungry man's plight and prepares to pass a loaf of bread to a paying customer. Although the subject's appeal to the emotions is Romantic, the print does not preach or sentimentalize. Viewers are invited to draw their own conclusions.

More insistent on the use of imagination was Eugène Delacroix (1798–1863), the most important Romantic after Géricault's early death. Stendhal (pen name of the French poet Henri Beyle) wrote, "Romanticism in all the arts is what represents the men of today and not the men of those remote, heroic times which probably never existed anyway." Delacroix fits the

description as well as any artist. Like Géricault, Delacroix depicted victims and antiheroes. One of his first paintings exhibited at a Salon was scenes from the massacre at **CHIOS** (FIG. 30-7), an event even more terrible than the shipwreck of the Medusa. In 1822, during the Greeks' struggle for independence from the Turks, the Turkish fleet stopped at the peaceful island of Chios and took revenge by killing about 20,000 of the 100,000 inhabitants and selling the rest into slavery in North Africa. Delacroix based his painting on journalistic reports, eyewitness accounts, and study of Greek and Turkish costumes. The painting is an image of savage violence and utter hopelessness—the entire foreground is given over to exhausted victims awaiting their fate—paradoxically made seductive through its opulent display of handsome bodies and colorful costumes. The Greek struggle for independence engaged the minds of many during that period, and it led the Romantic poet Lord Byron to enlist on the Greek side and give his life.

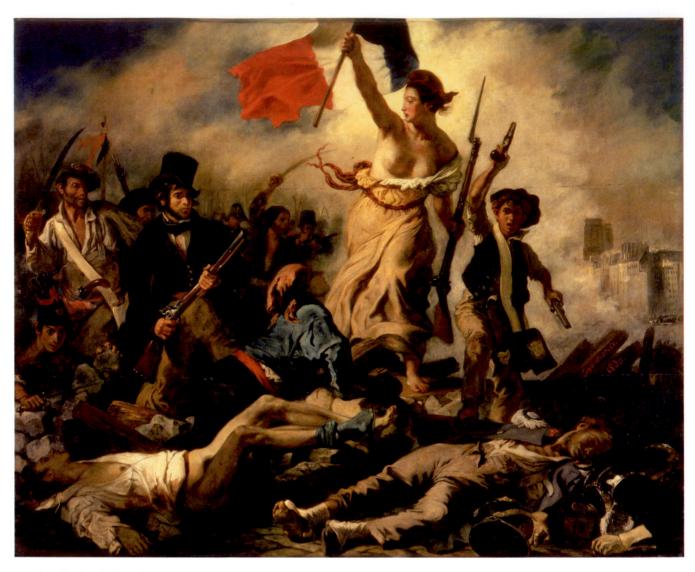

30–8 | Eugène Delacroix LIBERTY LEADING THE PEOPLE: JULY 28, 1830 1830. Oil on canvas, 8' $6\frac{1}{2}$ " \times 10' 8" (260 \times 325 cm). Musée du Louvre, Paris.

The work that brought Delacroix the most renown was LIBERTY LEADING THE PEOPLE: JULY 28, 1830 (FIG. 30-8), which summed up for many the destiny of France after the fall of Napoleon. When Napoleon was defeated in 1815, the victorious neighboring nations reimposed a monarchy on France under Louis XVIII, brother of the last pre-Revolutionary monarch. The king's power was limited by a constitution and a parliament, but the government became more conservative as years passed, and undid many of the Revolutionary reforms. Louis's successor Charles X reinstated press censorship, returned education to Catholic Church control, and limited voting rights. This led to a massive uprising over three days in July 1830 that overthrew the Bourbon monarchical line, replacing Charles with a more moderate king from the Orleanist line who promised to abide by a constitution. The term "July Monarchy" captures its initially mild-mannered character. Delacroix memorialized the revolt in this large painting a few months after it took place.

The work reports and departs from facts in ways that are typically Romantic. The Revolutionaries were indeed a motley crew of students, craft workers, day laborers, and even children and top-hatted lawyers. They stumble forward through the smoke of battle, crossing a barricade of refuse and dead bodies. This much of the work is plausibly accurate. Their leader, however, is the energetic flag-bearing allegorical figure of Liberty, personified by the muscular woman who carries the Revolutionary flag in one hand and a bayoneted rifle in the other. Delacroix took a classical allegorical figure and placed her, weapon and all, in the thick of battle. Like most Romantic paintings, the work is obviously not a mere transcription of an actual event. Rather, the artist applied his imagination to the story and created a work that, while not exactly faithful to fact, is indeed faithful to the emotional climate of the moment as the artist felt it. This was the essence of Romanticism.

Romantic Sculpture in France and Beyond

Romanticism gained general acceptance in France after the July Monarchy was established, bringing with it a new era of middle-class taste. This shift is most evident in sculpture, where a number of practitioners turned away from Neoclassical principles to more dramatic themes and approaches.

Early in the July Monarchy, the minister of the interior decided, as an act of national reconciliation, to complete the triumphal arch on the Champs-Elysées in Paris, which Napoleon had begun in 1806. François Rude (1784–1855) received the commission to decorate the main arcade to commemorate the volunteer army that had halted a Prussian invasion in 1792–93. Beneath the urgent exhortations of the winged figure of Liberty, the volunteers surge forward, some nude, some in classical armor (FIG. 30–9). Despite such Neoclassical elements, the effect is Romantic. The crowded, excited grouping so stirred the patriotism of French spectators that it quickly became known as **THE MARSEILLAISE**, the name of the French national anthem written in the same year, 1792.

Marble sculpture remained closer to Neoclassical norms until after 1850, when Romanticism began to infect it. The American sculptor Edmonia Lewis (1845–c. 1911) was a leader in this tendency. Born in New York State to a Chippewa mother and an African American father and originally named Wildfire, Lewis was orphaned at the age of four and raised by her mother's family. As a teenager, with the help of abolitionists, she attended Oberlin College, the first college in the United States to grant degrees to women, then moved to Boston. Her highly successful busts and medallions of abolitionist leaders and Civil War heroes financed her move to Rome in 1867.

Galvanized by the struggle of newly freed slaves for equality, Lewis created **FOREVER FREE** (FIG. 30–IO) as a memorial of the Emancipation Proclamation. The kneeling figure prays thankfully, while the standing man seems to dance on the ball that once bound his ankle as he raises the broken chain to the sky. In true Romantic fashion, Lewis's enthusiasm for the cause outran her financial abilities, so that she had to borrow money

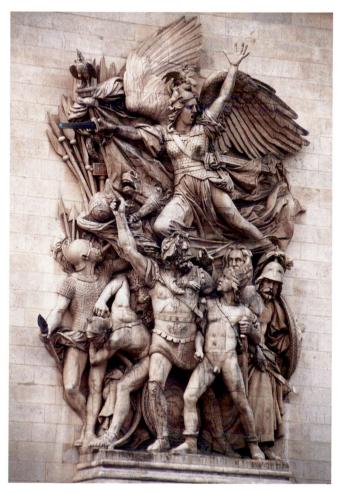

30–9 | François Rude | DEPARTURE OF THE VOLUNTEERS OF 1792 (THE MARSEILLAISE)

1833-36. Limestone, height approx. 42' (12.8 m). Arc de Triomphe, Place de l'Étoile, Paris.

30–10 | Edmonia Lewis FOREVER FREE 1867. Marble, $41\% \times 22 \times 17''$ (104.8 \times 55 \times 43.2 cm). Howard University Art Gallery, Washington, D.C.

to pay for the marble. Lewis sent this work back to Boston hoping that a subscription drive among abolitionists would redeem her loan. The effort was only partially successful, but her steady income from the sale of medallions eventually paid it off.

Romanticism in Spain: Goya

In the career of Francisco Goya v Lucientes (1746–1828), we see the birth of Romanticism in a single lifetime. In the 1770s and 1780s he was a court painter, making tapestry designs in a style based on the Rococo. The dawn of the French Revolution filled him with hope, as he belonged to an intellectual circle that was nourished by Enlightenment ideas. After the early years of the French Revolution, however, Spanish king Charles IV reinstituted the Inquisition, stopped most of the French-inspired reforms, and even halted the entry of French books into Spain. Goya responded to this new situation with Los Caprichos (The Caprices), a folio of eighty etchings produced between 1796 and 1798 whose overall theme is suggested by THE SLEEP OF REASON PRO-DUCES MONSTERS (FIG. 30-11). The print shows a slumbering personification of Reason, behind whom lurk the dark creatures of the night—owls, bats, and a cat—that are let loose when Reason sleeps. The rest of the Caprichos enumerate the specific follies of Spanish life that Goya and his circle considered monstrous. Goya hoped the series would show Spanish people the errors of their ways and reawaken reason. He even tried to sell the etchings, as Hogarth had done in England, but they only aroused controversy with his royal patrons. In order to deflect blame from himself, he made the metal plates an elaborate gift to the king. The disturbing quality of Goya's portrait of human folly suggests he was already beginning to feel the despair that would dominate his later work.

Goya's large portrait of the FAMILY OF CHARLES IV (FIG. 30–12) expresses some of the alienation that he felt. The work openly acknowledges the influence of Velázquez's earlier royal portrait Las Meninas (SEE FIG. 22-29) by placing the painter behind the easel on the left, just as Velázquez had. The artist somehow managed to make his patrons appear faintly ridiculous: The bloated and dazed king, chest full of medals, standing before another relative who appears to have seen a ghost; the double-chinned queen, who stares obliquely out (she was then having an open affair with the prime minister); her eldest daughter, to the left, stares into space next to another older relative who seems quizzically surprised by the attention. One French art critic described this frightened bunch as "The corner baker and his family after they have won the lottery." Yet the royal family seem to have been perfectly satisfied with Goya's realistic rather than flattering depiction of them. Indeed, if everyone was in fact posed in those positions, with the artist to one side, they must have all been admiring themselves in a huge mirror. As the authority of the Spanish aristocracy was crumbling, this complex rendition may have been the only possible type of royal portrait.

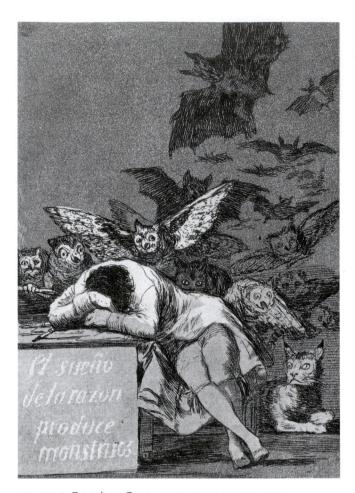

30–II | Francisco Goya | THE SLEEP OF REASON PRODUCES MONSTERS,

No. 43 from Los Caprichos (The Caprices). 1796-98; published 1799. Etching and aquatint, $8 \frac{1}{2} \times 6''$ (21.6 \times 15.2 cm). Courtesy of the Hispanic Society of America, New York.

After printing about 300 sets of this series, Goya offered them for sale in 1799. He withdrew them from sale two days later without explanation. Historians believe that he was probably warned by the Church that if he did not he might have to appear before the Inquisition because of the unflattering portrayal of the Church in some of the etchings. In 1803 Goya donated the plates to the Royal Printing Office.

In 1808 Napoleon conquered Spain and placed on its throne his brother Joseph Bonaparte. Many Spanish citizens, including Goya, welcomed the French at first because of the reforms they inaugurated, including a new, more liberal constitution. On May 2, 1808, however, a rumor spread in Madrid that the French planned to kill the royal family. The populace rose up, and a day of bloody street fighting ensued, followed by mass arrests. Hundreds of Spanish people were herded into a convent, and a French firing squad executed these helpless prisoners in the predawn hours of May 3. Goya commemorated the event in a painting (FIG. 30-13) that, like Delacroix's Massacre at Chios (SEE FIG. 30-7), focuses on victims and antiheroes, the most prominent of which is a Christ-like figure in white. Everything about this work is Romantic: the sensational current event, the loose brushwork, the poses based on reality, the off-balance composition, the dramatic lighting. But

Romantic Sculpture in France and Beyond

Romanticism gained general acceptance in France after the July Monarchy was established, bringing with it a new era of middle-class taste. This shift is most evident in sculpture, where a number of practitioners turned away from Neoclassical principles to more dramatic themes and approaches.

Early in the July Monarchy, the minister of the interior decided, as an act of national reconciliation, to complete the triumphal arch on the Champs-Elysées in Paris, which Napoleon had begun in 1806. François Rude (1784–1855) received the commission to decorate the main arcade to commemorate the volunteer army that had halted a Prussian invasion in 1792–93. Beneath the urgent exhortations of the winged figure of Liberty, the volunteers surge forward, some nude, some in classical armor (FIG. 30–9). Despite such Neoclassical elements, the effect is Romantic. The crowded, excited grouping so stirred the patriotism of French spectators that it quickly became known as **THE MARSEILLAISE**, the name of the French national anthem written in the same year, 1792.

Marble sculpture remained closer to Neoclassical norms until after 1850, when Romanticism began to infect it. The American sculptor Edmonia Lewis (1845–c. 1911) was a leader in this tendency. Born in New York State to a Chippewa mother and an African American father and originally named Wildfire, Lewis was orphaned at the age of four and raised by her mother's family. As a teenager, with the help of abolitionists, she attended Oberlin College, the first college in the United States to grant degrees to women, then moved to Boston. Her highly successful busts and medallions of abolitionist leaders and Civil War heroes financed her move to Rome in 1867.

Galvanized by the struggle of newly freed slaves for equality, Lewis created **FOREVER FREE** (FIG. 30–10) as a memorial of the Emancipation Proclamation. The kneeling figure prays thankfully, while the standing man seems to dance on the ball that once bound his ankle as he raises the broken chain to the sky. In true Romantic fashion, Lewis's enthusiasm for the cause outran her financial abilities, so that she had to borrow money

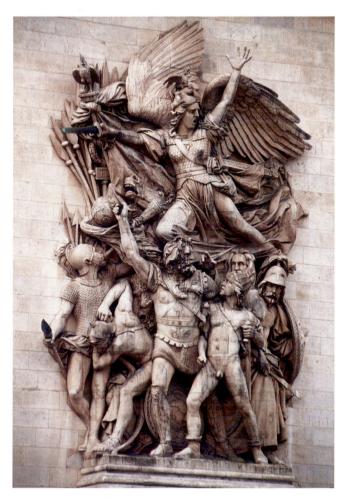

30-9 | François Rude DEPARTURE OF THE VOLUNTEERS
OF 1792 (THE MARSEILLAISE)

1833-36. Limestone, height approx. 42' (12.8 m). Arc de Triomphe, Place de l'Étoile, Paris.

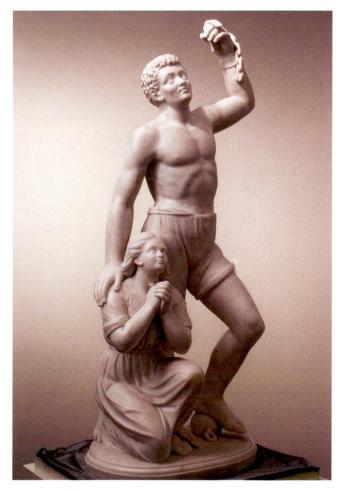

30–10 | Edmonia Lewis FOREVER FREE 1867. Marble, $41\% \times 22 \times 17''$ (104.8 \times 55 \times 43.2 cm). Howard University Art Gallery, Washington, D.C.

to pay for the marble. Lewis sent this work back to Boston hoping that a subscription drive among abolitionists would redeem her loan. The effort was only partially successful, but her steady income from the sale of medallions eventually paid it off.

Romanticism in Spain: Goya

In the career of Francisco Gova v Lucientes (1746–1828), we see the birth of Romanticism in a single lifetime. In the 1770s and 1780s he was a court painter, making tapestry designs in a style based on the Rococo. The dawn of the French Revolution filled him with hope, as he belonged to an intellectual circle that was nourished by Enlightenment ideas. After the early years of the French Revolution, however, Spanish king Charles IV reinstituted the Inquisition, stopped most of the French-inspired reforms, and even halted the entry of French books into Spain. Goya responded to this new situation with Los Caprichos (The Caprices), a folio of eighty etchings produced between 1796 and 1798 whose overall theme is suggested by THE SLEEP OF REASON PRO-DUCES MONSTERS (FIG. 30-II). The print shows a slumbering personification of Reason, behind whom lurk the dark creatures of the night—owls, bats, and a cat—that are let loose when Reason sleeps. The rest of the Caprichos enumerate the specific follies of Spanish life that Goya and his circle considered monstrous. Goya hoped the series would show Spanish people the errors of their ways and reawaken reason. He even tried to sell the etchings, as Hogarth had done in England, but they only aroused controversy with his royal patrons. In order to deflect blame from himself, he made the metal plates an elaborate gift to the king. The disturbing quality of Goya's portrait of human folly suggests he was already beginning to feel the despair that would dominate his later work.

Goya's large portrait of the FAMILY OF CHARLES IV (FIG. 30–12) expresses some of the alienation that he felt. The work openly acknowledges the influence of Velázquez's earlier royal portrait Las Meninas (SEE FIG. 22-29) by placing the painter behind the easel on the left, just as Velázquez had. The artist somehow managed to make his patrons appear faintly ridiculous: The bloated and dazed king, chest full of medals, standing before another relative who appears to have seen a ghost; the double-chinned queen, who stares obliquely out (she was then having an open affair with the prime minister); her eldest daughter, to the left, stares into space next to another older relative who seems quizzically surprised by the attention. One French art critic described this frightened bunch as "The corner baker and his family after they have won the lottery." Yet the royal family seem to have been perfectly satisfied with Goya's realistic rather than flattering depiction of them. Indeed, if everyone was in fact posed in those positions, with the artist to one side, they must have all been admiring themselves in a huge mirror. As the authority of the Spanish aristocracy was crumbling, this complex rendition may have been the only possible type of royal portrait.

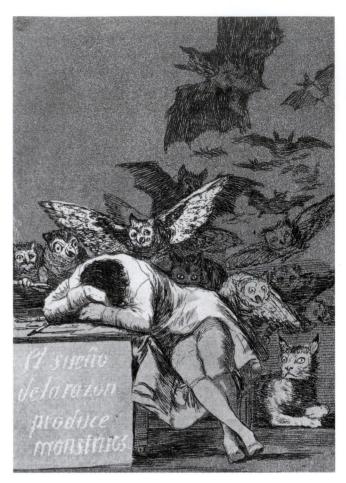

30—II | Francisco Goya | THE SLEEP OF REASON PRODUCES MONSTERS,

No. 43 from Los Caprichos (The Caprices). 1796–98; published 1799. Etching and aquatint, $8\frac{1}{2} \times 6^{\prime\prime}$ (21.6 \times 15.2 cm). Courtesy of the Hispanic Society of America, New York.

After printing about 300 sets of this series, Goya offered them for sale in 1799. He withdrew them from sale two days later without explanation. Historians believe that he was probably warned by the Church that if he did not he might have to appear before the Inquisition because of the unflattering portrayal of the Church in some of the etchings. In 1803 Goya donated the plates to the Royal Printing Office.

In 1808 Napoleon conquered Spain and placed on its throne his brother Joseph Bonaparte. Many Spanish citizens, including Goya, welcomed the French at first because of the reforms they inaugurated, including a new, more liberal constitution. On May 2, 1808, however, a rumor spread in Madrid that the French planned to kill the royal family. The populace rose up, and a day of bloody street fighting ensued, followed by mass arrests. Hundreds of Spanish people were herded into a convent, and a French firing squad executed these helpless prisoners in the predawn hours of May 3. Goya commemorated the event in a painting (FIG. 30-13) that, like Delacroix's Massacre at Chios (SEE FIG. 30-7), focuses on victims and antiheroes, the most prominent of which is a Christ-like figure in white. Everything about this work is Romantic: the sensational current event, the loose brushwork, the poses based on reality, the off-balance composition, the dramatic lighting. But

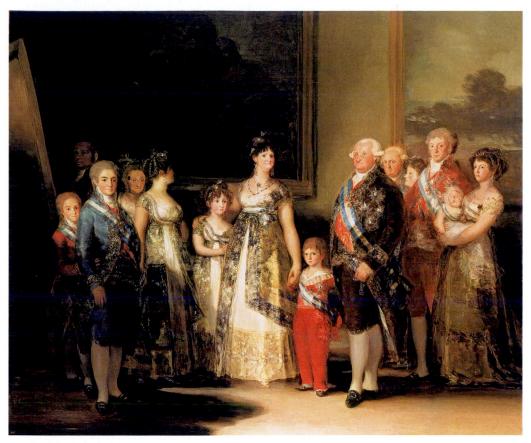

30–12 | Francisco Goya FAMILY OF CHARLES IV 1800. Oil on canvas, $9'12'' \times 11'$ (2.79 \times 3.36 m). Museo del Prado, Madrid.

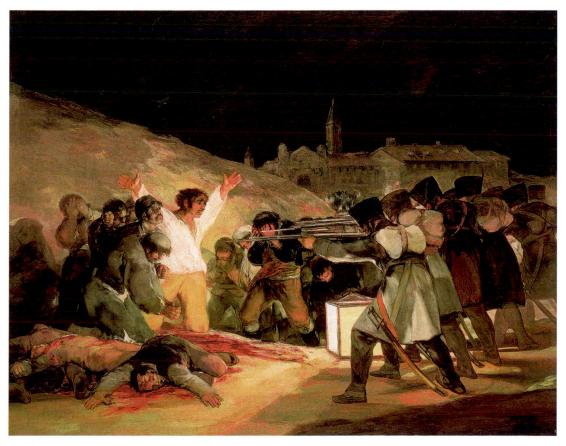

30–I3 | Francisco Goya | THIRD OF MAY, 1808 | 1814–15. Oil on canvas, 8'9" \times 13'4" (2.67 \times 4.06 m). Museo del Prado, Madrid.

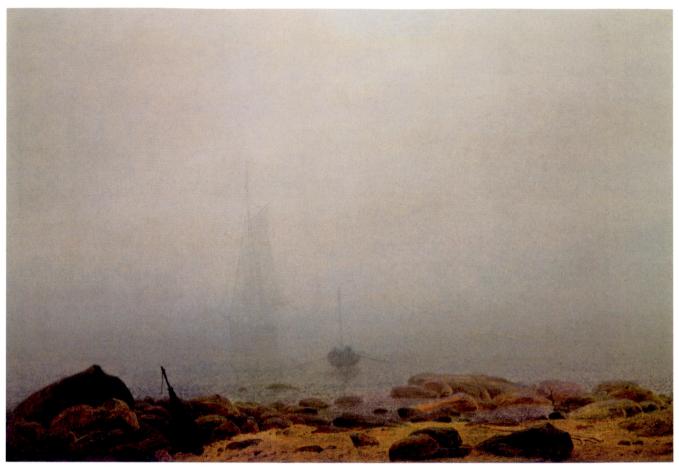

30–I4 | Caspar David Friedrich NEBEL (FOG) 1807. Oil on canvas, $13 \frac{1}{2} \times 20 \frac{1}{2}$ " (34.5 \times 52 cm). Neue Pinakothek, Munich.

Goya's work is less an indictment of the French than of the faceless and mechanical forces of war itself, blindly destroying defenseless humanity. When asked why he painted such a brutal scene, Goya responded: "To warn men never to do it again."

Soon after the Spanish monarchy was restored, Ferdinand VII (ruled 1808; 1814–33) abolished the new constitution and reinstated the Inquisition, which the French had banned. In 1815 Goya was himself called before the Inquisition for the alleged obscenity of an earlier painting of a female nude. Though found innocent, Goya gave up hope in human progress and retired to his home outside Madrid, where he vented his disillusionment in the series of nightmarish "black paintings" he did on its walls. He spent the last four years of his life in exile in France.

Romantic Landscape Painting

The Romantic vision of nature differed radically from that of the Enlightenment. Following the lead of Isaac Newton, most Enlightenment thinkers viewed nature as something orderly, predictable, and subject to laws that humans can discern by observation, and thus can control. It follows that the Enlightenment produced very few landscape artists. In contrast, most Romantics saw nature as ever-changing, unpredictable, more powerful than people, and even indifferent to them. Moreover, the many aspects of nature make an analog to the many types and moods of humans. Thus the Romantics found nature awesome, fascinating, or delightful; artists in many countries studied it in depth and put their feelings about it into works.

FRIEDRICH. The German Romantic painter Caspar David Friedrich (1774–1840) saw in nature a vehicle of intense personal feeling. He received early encouragement from poet Johann Wolfgang von Goethe to make landscape the principal subject of his art. In his early life Friedrich was also influenced by the writings and teachings of Gotthard Kosegarten, a Lutheran pastor and poet from his district who taught that we can see the divine in a personal experience of nature. If God's holy book was the Bible, just as important was God's "Book of Nature." Friedrich studied at the academies of Copenhagen and Dresden and settled in the latter city. Throughout his career, he not only sketched in nature, but also took long walks. Later, in the studio, he synthesized his sketches with his memories and feelings in order to create paintings such as NEBEL (FOG) (FIG. 30-14). Here we see a mysteriously quiet seacoast, where some passengers in a small

boat row out to a larger one. Fog has drawn a veil over most of the details of this landscape, but such facts matter much less to Friedrich than the overall mood, which is hushed and solemn. This place resembles none that we can visit, because the artist invented it based on his sketches and memories. He wrote, "Close your physical eyes in order that you may first see your painting with your spiritual eye. Then bring to the light of day what you have seen in the darkness so that it can affect others." We are left wondering about the possible reasons for this journey: Escape is one possibility; so is a more symbolic reading, such as death, or, in common parlance, passage to the other side.

Turner. Friedrich's English contemporary Joseph Mallord William Turner (1775–1851) devoted much of his early work to the Romantic theme of nature as a cataclysmic force that overwhelms human beings and their creations. Turner entered the Royal Academy in 1789, was elected a full academician at the unusually young age of twenty-seven, and later became a professor in the Royal Academy school. During the 1790s, Turner helped revolutionize the British watercolor tradition by rejecting underpainting and topographic accuracy in favor of a freer application of paint and more generalized atmospheric effects. By the late 1790s, Turner was also exhibiting large-scale oil paintings of grand natural scenes and historical subjects.

Turner's **snowstorm**: **Hannibal and His army cross- ING THE ALPS** (FIG. 30–15) epitomizes the Romantic view of awesome nature, as an enormous vortex of wind, mist, and

Sequencing Events The Beginnings of Modern France

1789	French Revolution begins
1792	Monarchy abolished, First Republic established
1804-1814	First Empire, rule of Napoleon I
1814–1830	Restoration of monarchy, reigns of Louis XVIII and Charles X
1830-1848	July Monarchy
1848-1852	Second Republic
1852-1870	Second Empire, reign of Napoleon III
1870	Third Republic established

snow threatens to annihilate the soldiers below it and even to obliterate the sun. Barely discernible in the distance is the figure of the Carthaginian general Hannibal, who, mounted on an elephant, led his troops through the Alps to defeat Roman armies in 218 BCE. Turner probably intended this painting as an allegory of the Napoleonic Wars—Napoleon himself had crossed the Alps, an event celebrated in Jacques-Louis David's *Napoleon Crossing the Saint-Bernard* (SEE FIG. 30–2). But while David's painting, which Turner saw in Paris in 1802, depicts Napoleon as a powerful figure who seems to command not only his troops but also nature itself, Turner reduced Hannibal to a speck on the horizon and showed his troops

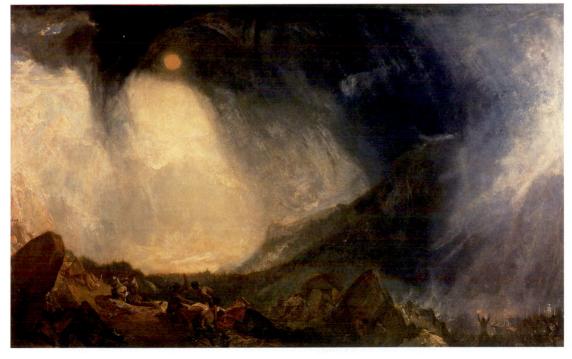

30–15 | Joseph Mallord William Turner SNOWSTORM: HANNIBAL AND HIS ARMY CROSSING THE ALPS 1812. Oil on canvas, $4'9'' \times 7'9'' (1.46 \times 2.39 \text{ m})$. The Tate Gallery, London.

threatened by a cataclysmic storm, as if foretelling their eventual defeat. In 1814, just two years after the exhibition of Turner's painting, Napoleon suffered a decisive loss to his European opponents and met final defeat at Waterloo in 1815.

Closer to home both physically and temporally, Turner based another thrilling work on a tragic fire that severely damaged London's ancient Parliament building, an important national monument. Most of the complex was erected in the eleventh century and had witnessed some of the most dramatic events in English history, but the fire that broke out on October 16, 1834, completely destroyed the House of Lords and left the Commons unusable because its roof fell in. Contemporary accounts tell of flames lighting the night sky, and hundreds of spectators gathering in boats on the Thames and along the shore to witness the cataclysm. Turner himself hurriedly sketched watercolors at the scene and within a few months made a large painting, THE BURNING OF THE HOUSE OF LORDS AND COMMONS, 16TH OCTOBER 1834 (FIG. 30–16).

More faithful to feeling than to fact, the work accurately depicts the crowds and the bridge but greatly exaggerates the size of the fire. Turner's main interest was in capturing the feelings attending the loss of one of England's most historic structures, and in order to do this he resorted to some of the loosest and most painterly brushwork ever seen in Western art up to that time. In those years, the Parliament was in the midst of reforming its electoral districts in order to broaden its political base and equalize representation. The Reform Bill of 1832 was a landmark in this democratic quest, but Turner's painting points out that Mother Nature often has the last word, thwarting or hindering even our most noble aspirations.

Both this work and *Hannibal Crossing the Alps* partake of the sublime, an aesthetic category beloved of some Romantic artists. According to Edmund Burke, who defined it in a 1756 essay (see Chapter 29), when we witness something that instills fascination mixed with fear, or if we stand in the presence of something far larger than ourselves, we may have sublime feelings. Turner focused his vision on this aspect of nature.

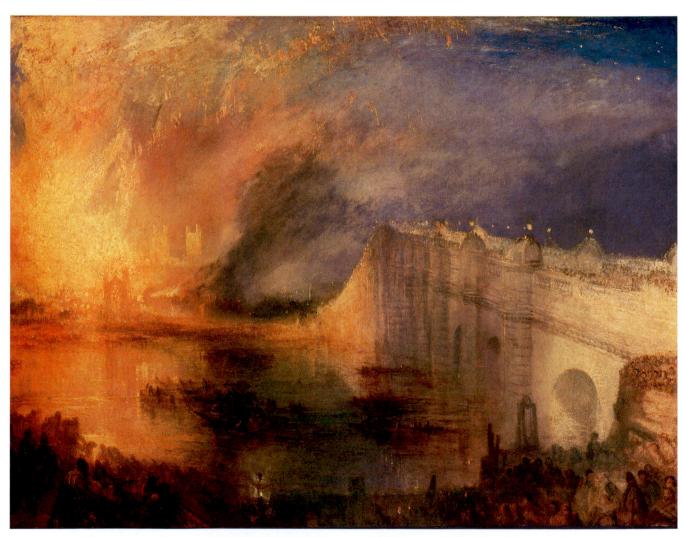

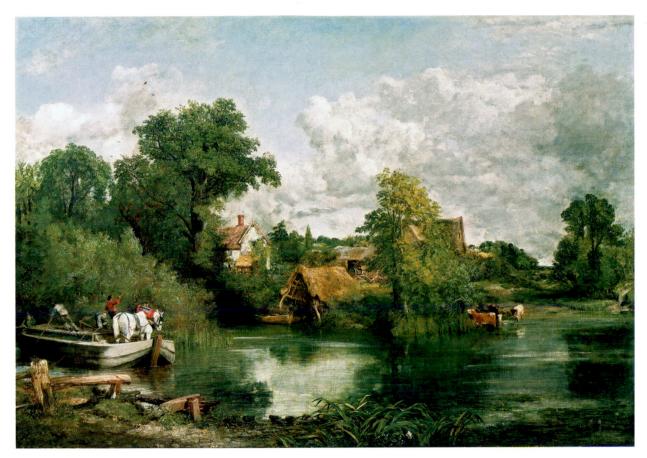

30–17 \parallel John Constable **THE WHITE HORSE** 1819. Oil on canvas, 4'3 $\frac{1}{4}$ " \times 6'2 $\frac{1}{8}$ " (1.31 \times 1.88 m). The Frick Collection, New York.

CONSTABLE. If Turner's works epitomize the theatrical side of Romantic landscape painting, those of his compatriot John Constable (1776-1837) capture a calmer mood with unprecedented spontaneity and freshness. The son of a successful miller, Constable declared that the landscape of his youth in southern England had made him a painter even before he ever picked up a brush. Although he was trained at the Royal Academy, he was most influenced by the British topographic watercolor tradition of the late eighteenth century and by the example of seventeenth-century Dutch landscapists (SEE FIG. 22-62). After moving to London in 1816, he dedicated himself to painting monumental views of the agricultural landscape of his youth. So convinced was he that artists should study nature afresh that he opposed the establishment of the English National Gallery of Art in 1832; he thought it might unduly distract painters.

THE WHITE HORSE (FIG. 30–17), a typical work of Constable's maturity, depicts a fresh early summer day in the Stour River valley after the passing of a storm. Sunlight glistens off the water and foliage, an effect Constable achieved through tiny dabs of white paint. In the lower left, a farmer and his helpers ferry a workhorse across the river. Such elements were never invented by Constable, who among the Romantics stays closest to fact. His goal was rather to capture the time of day, the humidity in the air, and the smell of wet

earth. He once said that he wanted to paint the landscape as if no one had ever painted it before. In order to capture faithfully his initial sensation, he frequently used unmixed dabs of pure color on his canvases, a technique which later influenced artists on both sides of the English Channel.

THE BARBIZON SCHOOL AND DAUBIGNY. Constable's first critical success came not in England but at the Paris Salon of 1824, where one of his landscapes won a gold medal. His example inspired a group of French landscape painters that emerged in the 1830s and became known as the Barbizon School because a number of them lived in the rural town of Barbizon in the forest of Fontainebleau, near Paris. One of these artists was Charles-François Daubigny (1817-78), whose close observations of nature helped pave the way for Impressionism later in the century. Daubigny loved to travel up and down the River Seine, where he was among the first to make an entire painting outdoors, on the spot (FIG. 30-18). He even bought a boat and made it into a floating studio in order to facilitate his quest. THE BARGES has yet more of the spontaneous look that Constable treasured, and indeed Daubigny was criticized for not filtering his art enough through the imagination. Or, as one critic tellingly wrote in 1861, "He should not content himself with a mere impression" of a scene.

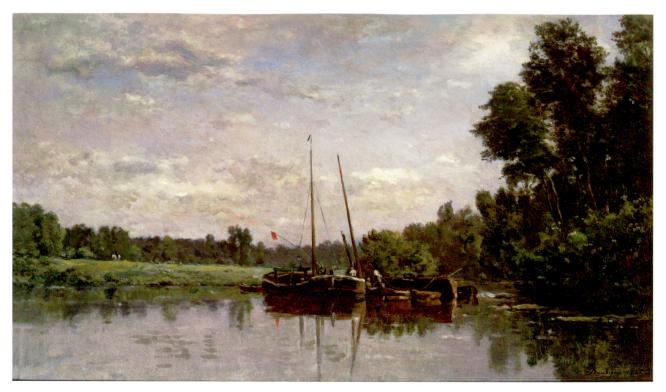

30–18 | Charles-François Daubigny LES PÉNICHES (THE BARGES) 1865. Oil on canvas, $15\times26''$ (38×67 cm). Musée du Louvre, Paris. Legs Thomy Thiery, 1902. R.F. 1362

COLE. If we place Romantic landscape artists on a continuum, with those favoring imagination and feeling at one end (Friedrich and Turner) and partisans of down-to-earth sensation on the other (Constable and the Barbizon School), we

will find the middle ground occupied by American painters such as Thomas Cole (1801–48). He emigrated from England to the United States at seventeen and by 1820 was working as an itinerant portrait painter. On trips around New York, Cole

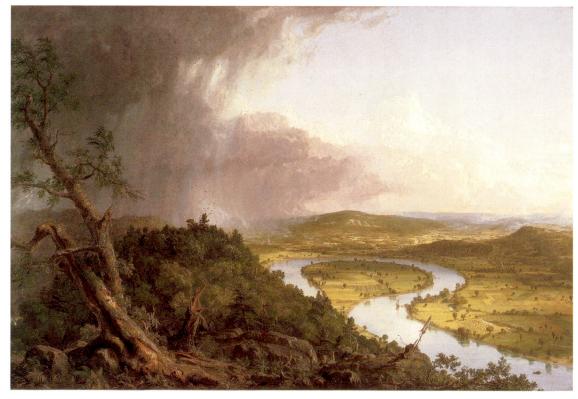

30–19 † Thomas Cole THE OXBOW 1836. Oil on canvas, 51½ \times 76″ (1.31 \times 1.94 m). The Metropolitan Museum of Art, New York. Gift of Mrs. Russell Sage, 1908 (08.228).

sketched and painted the landscape, which quickly became his chief interest, and his paintings launched what became known as the Hudson River School. With the help of a patron, Cole traveled in Europe between 1829 and 1832. In the mid-1830s, Cole went on a sketching trip that resulted in THE OXBOW (FIG. 30-19), which he painted for exhibition at the National Academy of Design in New York. He believed that a too-close focus on factual accuracy was murderous to art, so he made paintings months after his sketches were complete, the better, he said, for memory to "draw a veil" over the scene. Cole considered The Oxbow one of his "view" paintings, which were usually small, although this one is monumental. The scale suits the dramatic view from the top of Mount Holyoke in western Massachusetts across a spectacular oxbow-shaped bend in the Connecticut River. To Cole, such ancient geological formations constituted America's "antiquities." The work's title tells us that it depicts an actual spot, but the artist orchestrated the scene in order to convey his interpretation of its grandeur. He exaggerated the steepness of the mountain, and set the scene below a dramatic sky. Along a great sweeping arc produced by the departing dark clouds and the edge of the mountain, Cole contrasts the two sides of the American landscape: its dense, stormy wilderness and its congenial, pastoral valleys. The fading storm suggests that the wild will eventually give way to the civilized.

Orientalism

European art patrons during the Romantic period not only wanted landscapes depicting areas that they knew; part of the Romantic urge is to stimulate the imagination through escape to new places, the more exotic the better. Some artists traveled the world in order to fill this need. This Romantic fascination with foreign cultures dates as far back as Napoleon's 1798 invasion of Egypt, which had the goal not only of conquest but also of study of that culture. After Napoleon's fall, the Restoration government continued to send study missions to Egypt and the Mideast, and published between 1809 and 1822 the twenty-four volume Description de l'Egypte, which recorded copious information about the people, lands, and culture of that area. Artists soon began painting subjects set in those foreign lands, whether they had been there or not. Gros, for example, never went to Jaffa but still he painted Napoleon in the Plague House (SEE FIG. 30-3). Ingres likewise never ventured farther away than Italy but scored a great success with his Large Odalisque (SEE FIG. 30–4), a portrait of a harem girl. The vogue for Oriental subjects, as they were called, engaged artists of both Romantic and Neoclassical persuasions.

ROBERTS. One of the first professional European artists to actually travel to the Mideast was the Scottish landscape painter David Roberts (1796–1864), whose background is notable for a lack of academic training. Rather, he learned

Sequencing Works of Art

1830	Delacroix, Liberty Leading the People: July 28, 1830
1834	Turner, The Burning of the House of Lords and Commons, 16th October 1834
1836	Cole, The Oxbow
1836-60	Barry and Pugin, Houses of Parliament, London
1837	Daguerre, The Artist's Studio.

painting as an apprentice theater set designer. His wanderlust was probably awakened by an early assignment to paint sets for Mozart's comic opera set in Turkey, *The Abduction from the Seraglio*, in 1827. Roberts went to Spain and Morocco in 1832–33, returning to exhibit paintings, watercolors, and lithographs of the scenes he witnessed. (Eugène Delacroix also went to Morocco at the same time, though not in Roberts's company.) Emboldened by the success of that first trip, Roberts then set off for the Holy Land in 1838, and on his return he created a series of works, among them **GATEWAY TO THE GREAT TEMPLE AT BAALBEK** (FIG. 30–20).

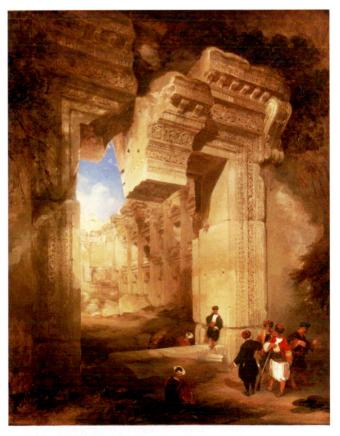

30–20 $\,\mid\,$ David Roberts GATEWAY TO THE GREAT TEMPLE AT BAALBEK 1841. Oil on canvas, 75×62 cm. Royal Academy of Arts, London.

This painting shows both the pleasures and pitfalls of the Orientalist movement. Views of ancient ruins fed the fashion for the picturesque in European viewers, and Roberts focused on those aspects of life in the lands he visited. Here we see a ruined Roman temple doorway in Lebanon, its keystone perched precariously. Later photographs document this curious feature of this most impressive building, which was later restored. Like most Orientalists, however, Roberts painted only "exotic" people in his works, not the Western members of his party. When this painting was turned into a lithograph for sale as part of a set, it was inscribed as follows: "These beautiful structures carry with them regret that such proud relics of genius should be in the hands of a people incapable of appreciating their merits and consequently heedless of their complete destruction."

GÉRÔME. The example of Roberts suggests that Orientalist paintings give us a selective view of the lands the artists visited, calculated to pique curiosity while allowing Western viewers to remain convinced of their cultural superiority, if indeed they felt it. Most Orientalists depicted either the spectacular sights or the carefully selected everyday scenes of the Mideast. The most prolific Orientalist in the latter category was Jean-León Gérôme (1824–1904). Gérôme went to Constantinople in 1853, the first of many trips to Asia Minor and Egypt. CAFE HOUSE, CAIRO (FIG. 30–21) shows the results of the artist's classical training under an academic master: The figures are tightly rendered, the poses believable, their scaling in space perfectly appropriate. Many Orientalist paintings tended to show Middle Eastern people as sultry and sexual (as in the *Odalisque* of Ingres) or prone to violence. This

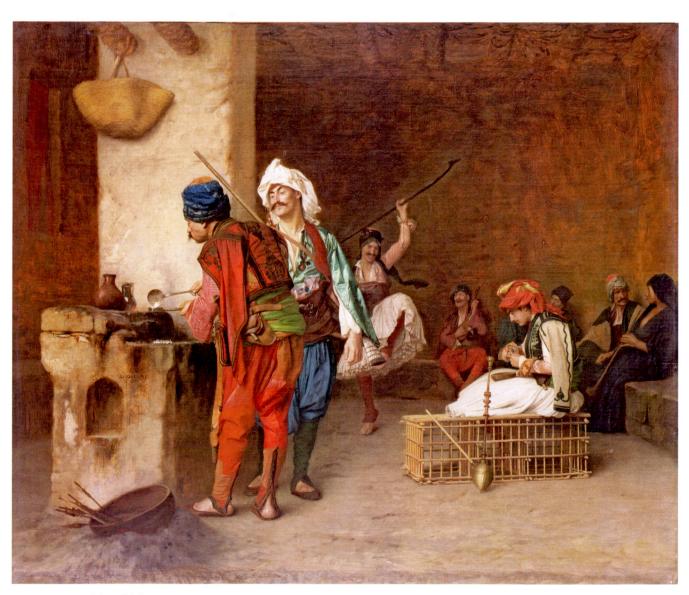

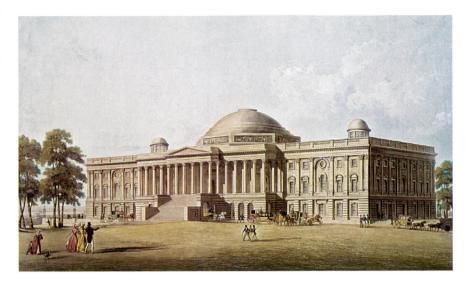

30–22 | Benjamin Henry Latrobe
U.S. CAPITOL
Washington, D.C. c. 1808. Engraving by
T. Sutherland, 1825. New York Public
Library. I. N. Phelps Stokes Collection, Myriam and
Ira Wallach Division of Art, Prints, and Photographs

work shows a group of mercenaries in a coffee house using the heat of the fireplace to melt metal for bullets. Orientalist subjects remained attractive to artists and patrons through most of the nineteenth century, as European nations colonized the Mideast and other parts of the world. In addition to his Orientalist scenes, Gérôme was an accomplished painter of Neoclassical subjects. He remained active until the end of the century.

Revival Styles in Architecture Before 1850

Both Neoclassicism and Romanticism motivated architects in the early nineteenth century, and many architects worked in either mode, depending on the task at hand. Neoclassicism, which evoked both Greek democracy and Roman republicanism, became the favored style for government buildings in the United States. In Europe, many different kinds of public institutions, including art museums, were built in the Neoclassical style.

NEOCLASSICAL STYLE. The most significant and symbolic Neoclassical edifice in Washington, D.C. was the U.S. Capitol, initially designed in 1792 by William Thornton (1759-1828), an amateur architect. His monumental plan featured a large dome over a temple front flanked by two wings to accommodate the House of Representatives and the Senate. In 1803, President Thomas Jefferson, also an amateur architect, hired a British-trained professional, Benjamin Henry Latrobe (1764–1820), to oversee the actual construction of the Capitol. Latrobe modified Thornton's design by adding a grand staircase and Corinthian colonnade on the east front (FIG. 30–22). After the British gutted the building in the War of 1812, Latrobe repaired the wings and designed a higher dome. Seeking new symbolic forms for the nation within the traditional classical vocabulary, Latrobe also created for the interior a variation on the Corinthian order by substituting indigenous plants—corn (FIG. 30-23) and tobacco-for the Corinthian order's acanthus leaves

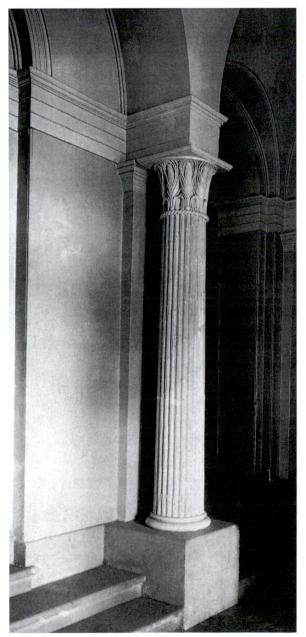

30–23 | Giuseppe Franzoni CORNCOB CAPITAL Sculpted for the U.S. Capitol. 1809.

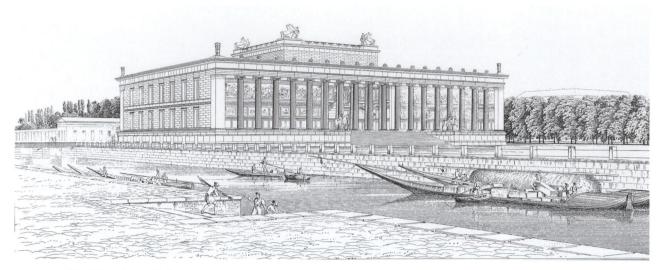

30–24 | Karl Friedrich Schinkel ALTES MUSEUM Berlin. 1822–30.

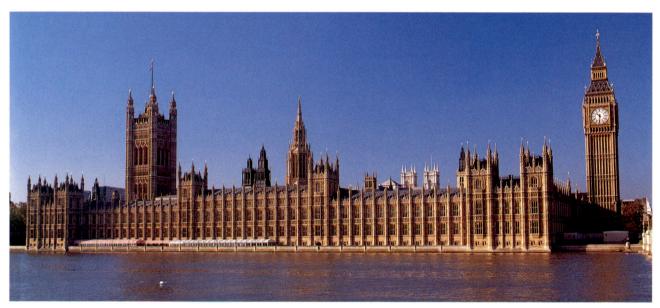

30–25 Charles Barry and Augustus Welby Northmore Pugin HOUSES OF PARLIAMENT London, England. 1836–60. Royal Commission on the Historical Monuments of England, London.

Pugin published two influential books in 1836 and 1841, in which he argued that the Gothic style of Westminster Abbey was the embodiment of true English genius. In his view, the Greek and Roman classical orders were stone replications of earlier wooden forms and therefore fell short of the true principles of stone construction.

(see Introduction, Fig. 3). Latrobe resigned in 1817, and the reconstruction was completed under Charles Bulfinch (1763–1844). A major renovation begun in 1850 brought the building closer to its present form.

Many European capitals in the early nineteenth century erected museums in the Neoclassical style—which, being derived chiefly from Greek and Roman religious architecture, positioned the new buildings as temples of culture. The most influential of these was the **ALTES** ("Old") **MUSEUM** in Berlin, designed in 1822 by Karl Friedrich Schinkel (1781–1841) and built between 1824 and 1830 (FIG. 30–24). Commissioned to

display the royal art collection, the Altes Museum was built on an island in the Spree River in the heart of the capital, directly across from the Baroque royal palace. The museum's imposing façade consists of a screen of eighteen Ionic columns, raised on a platform with a central staircase. Attentive to the problem of lighting artworks on both the ground and the upper floors, Schinkel created interior courtyards on either side of a central rotunda, tall windows on the museum's outer walls to provide natural illumination, and partition walls perpendicular to the windows to eliminate glare on the varnished surfaces of the paintings on display.

30–26 | Richard Upjohn TRINITY CHURCH New York City. 1839–46.

GOTHIC PRIDE. Schinkel also created numerous Gothic architectural designs, which many Germans considered an expression of national genius. Meanwhile, the British claimed the Gothic as part of *their* patrimony and erected a plethora of Gothic revival buildings in the nineteenth century, the most famous being the HOUSES OF PARLIAMENT (FIG. 30–25). After Parliament's Westminster Palace burned in 1834 in the fire so memorably painted by Turner, the government opened a competition for a new building designed in the English Perpendicular Gothic style, to be consistent with the neighboring Westminster Abbey, the thirteenth-century church where English monarchs are crowned.

Charles Barry (1795–1860) and Augustus Welby Northmore Pugin (1812–52) won the commission. Barry was responsible for the basic plan, whose symmetry suggests the balance of powers of the British system; Pugin provided the intricate Gothic decoration laid over Barry's essentially classical plan. The leading advocate of Gothic architecture in his era, Pugin in 1836 published *Contrasts*, which unfavorably compared the troubled modern era of materialism and mechanization with the Middle Ages, which he represented as an idyllic epoch of deep spirituality and satisfying handcraft. For Pugin, Gothic was not a style but a principle, like classicism. The Gothic, he insisted, embodied two "great rules" of architecture: "first that there should be no features about a build-

ing which are not necessary for convenience, construction or propriety; second, that all ornament should consist of enrichment of the essential structure of the building."

In nineteenth-century Europe and the United States, many architects used the Gothic style because of its religious associations, especially for Roman Catholic, Anglican, and Episcopalian churches. The British-born American architect Richard Upjohn (1802–78) designed many of the most important Gothic revival churches in the United States, including **TRINITY CHURCH** in New York (FIG. 30–26). With its tall spire, long nave, and squared-off chancel, Trinity quotes the early fourteenth-century British Gothic style particularly dear to Anglicans and Episcopalians. Every detail is historically accurate, although the vaults are of plaster, not masonry. The stained-glass windows above the altar were among the earliest in the United States.

ART IN THE SECOND HALF OF THE NINETEENTH CENTURY

The second half of the nineteenth century has been called the positivist age, an age of faith in the positive consequences of close observation of the natural and human realms. The term positivism was used by the French philosopher Auguste Comte (1798-1857) during the 1830s to describe what he saw as the final stage in the development of philosophy, in which all knowledge would derive from the objectivity of science and scientific methods. Just as scientists had determined through observation the laws of motion and gravity, so might social scientists—Comte invented this term—deduce the laws underlying human culture. Metaphysical and theological speculation were practically useless in this new era, he wrote in The Nature and Importance of Positive Philosophy. "The mind has given up the vain search after Absolute notions, the origin and destination of the universe, and the causes of phenomena, and applies itself to the study of their laws. . . . Reason and observation, duly combined are the means of this knowledge." In the second half of the century, the term positivism came to be applied widely to any expression of the new emphasis on objectivity.

In the visual arts, the positivist spirit is most obvious in the decline of Romanticism in favor of the accurate and apparently objective description of the ordinary, observable world. Positivist thinking is evident in the new movement of Realism in painting, and in many other artistic developments of the period after 1850—from the development of photography, capable of recording nature with unprecedented accuracy, to the highly descriptive style of academic art, to Impressionism's almost scientific emphasis on the optical properties of light and color. In architecture, the application of new technologies also led at the century's end to the abandonment of historical styles and ornamentation in favor of a more direct or "realistic" expression of structure and materials.

Early Photography in Europe

A prime expression of the new, positivist interest in descriptive accuracy spurred by Comte's philosophy was the development of photography. Photography as we know it emerged around 1840, but since the late Renaissance, artists and others had been seeking a mechanical method for exactly recording or rendering a scene. One early device was the camera obscura (Latin, meaning "dark chamber"), which consists of a darkened room or box with a lens through which light passes, projecting onto the opposite wall or box side an upside-down image of the scene, which an artist can trace. By the seventeenth century a small, portable camera obscura, or camera, had become standard equipment for many landscape painters. Photography developed essentially as a way to fix—that is, to make permanent—the images produced by a camera obscura on light-sensitive material.

30–27 | Louis-Jacques-Mandé Daguerre THE ARTIST'S STUDIO 1837. Daguerreotype, $6\frac{1}{2} \times 8\frac{1}{2}$ " (16.5 \times 21.6 cm). Société Française de Photographie, Paris.

STILL LIFE AND ALLEGORY. The first person to "fix" a photographic image was the painter Louis-Jacques-Mandé Daguerre (1787–1851), who guarded his patents so jealously that the earliest photographs are still called daguerreotypes. Using the most advanced lenses to project a scene onto a treated metal plate for twenty to thirty minutes yielded what seemed a perfect reproduction of the visible world. Daguerre's photograph of his studio tabletop (FIG. 30–27) retains the conventions of the still life that Daguerre practiced in his own painting, but the camera accurately captured the look of the drawing, the plaster cast, the curtain, and the wicker-covered bottle. Improvements in photography over the next twenty years gave better lenses, smaller cameras, and shorter exposure times, so that by the mid-nineteenth century portrait photography was widely practiced in many cities.

The acceptance of photography as an art form alongside painting or sculpture took much longer, however. Among the first photographers to argue for its artistic legitimacy was Oscar Rejlander (1813-75) of Sweden, who had studied painting in Rome before settling in England. He first took up photography in the early 1850s as an aid for painting but was soon attempting to create photographic equivalents of the painted and engraved moral allegories so popular in Britain since the time of Hogarth (SEE FIG. 29-26). In 1857 he produced his most famous work, THE TWO PATHS OF LIFE (FIG. 30-28), by combining thirty negatives. This allegory of Good and Evil, work and idleness, was loosely based on Raphael's School of Athens (SEE FIG. 20–6). At the center, an old sage ushers two young men into life. The serene youth on the right turns toward personifications of Religion, Charity, Industry, and other virtues, while his counterpart eagerly responds to the enticements of pleasure. The figures on the left Rejlander described as personifications of "Gambling, Wine, Licentiousness and other Vices, ending in Suicide, Insanity, and Death." In the lower center, with a drapery over her head, is the hopeful figure of "Repentance." Although Queen Victoria

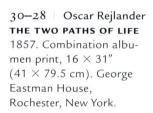

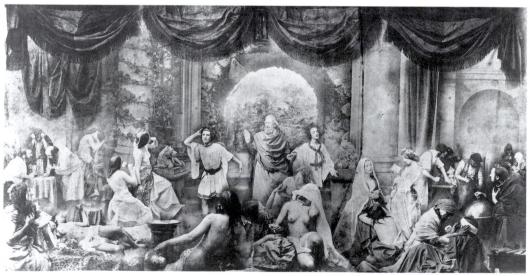

30–29 | Julia Margaret Cameron PORTRAIT OF THOMAS CARLYLE

1867. Silver print, $10\times8''$ (25.4 \times 20.3 cm). The Royal Photographic Society, Collection at National Museum of Photography, Film, and Television, England.

purchased a copy of *The Two Paths of Life* for her husband, it was not generally well received as art. One typical response was that "mechanical contrivances" could not produce works of "high art," a persistent criticism of photography.

PORTRAITURE. The most creative early portrait photographer was Julia Margaret Cameron (1815-79), who received her first camera as a gift from her daughters when she was forty-nine. Cameron's principal subjects were the great men and women of British arts, letters, and sciences, many of whom had long been family friends. Cameron's work was more personal and less dependent on existing forms than Rejlander's. Like many of Cameron's portraits, that of the famous British historian Thomas Carlyle is deliberately slightly out of focus (FIG. 30–29). Cameron was consciously rejecting the sharp stylistic precision of popular portrait photography, which she felt accentuated the merely physical attributes and neglected a subject's inner character. By blurring the details she sought to call attention to the light that suffused her subjects—a metaphor for creative genius—and to their thoughtful, often inspired expressions. In her autobiography Cameron said: "When I have had such men before my camera my whole soul has endeavored to do its duty towards them in recording faithfully the greatness of the inner as well as the features of the outer man."

The Frenchman Gaspard-Félix Tournachon, known as Nadar (1820–1910), applied photography to an even more ambitious goal, initially adopting the medium in 1849 as an aid in realizing the "Panthéon-Nadar," a series of lithographs

intended to include the faces of all the well-known Parisians of the day. Nadar quickly saw both the documentary and the commercial potential of the photograph, and in 1853 opened a portrait studio that became a meeting place for many of the great intellectuals and artists of the period. The first exhibition of Impressionist art was held there in 1874.

A realist in the tradition inaugurated by Daguerre, Nadar embraced photography because of its ability to capture people and their surroundings exactly: He took the first aerial photographs of Paris (from a hot-air balloon equipped with a darkroom), photographed the city's catacombs and sewers, produced a series on typical Parisians, and attempted to record all the leading figures of French culture. As we see in his portrait of the poet Charles Baudelaire (FIG. 30–30), Nadar avoided props and formal poses in favor of informal

30–30 | Nadar (Gaspard-Félix Tournachon)

PORTRAIT OF CHARLES BAUDELAIRE

1863. Silver print. Caisse Nationale des Monuments Historiques et des Sites, Paris.

The year this photograph was taken, Baudelaire published "The Painter of Modern Life," a newspaper article in which he called on artists to provide an accurate and insightful portrait of the times. The idea may have come from Nadar, who had been trying to do just that for some time. Although Baudelaire never wrote about the photographic work of his friend Nadar, he was highly critical of the vogue for photography and of its influence on the visual arts. In his Salon review of 1859 he said: "The exclusive taste for the True . . . oppresses and stifles the taste of the Beautiful. . . . In matters of painting and sculpture, the present-day *Credo* of the sophisticated is this: 'I believe in Nature . . . I believe that Art is, and cannot be other than, the exact reproduction of Nature. . . . 'A vengeful God has given ear to the prayers of this multitude. Daguerre is his Messiah."

30–31 | Joseph Paxton CRYSTAL PALACE London. 1850–51. Iron, glass, and wood.

ones determined by the sitters themselves. His goal was not so much an interpretation as a factual record of a sitter's characteristic appearance and demeanor.

New Materials and Technology in Architecture at Midcentury

The positivist faith in technological progress as the key to human progress spawned world's fairs that celebrated advances in industry and technology. The first of these fairs, the London Great Exhibition of 1851, introduced new building techniques that would eventually lead to the development of Modern architecture.

The revolutionary construction of the CRYSTAL PALACE (FIG. 30-31), created for the London Great Exhibition by Joseph Paxton (1803–65), featured a structural skeleton of cast iron that held iron-framed glass panes measuring 49 by 30 inches, the largest size that could then be mass-produced. Prefabricated wooden ribs and bars supported the panes. The triple-tiered edifice was the largest space ever enclosed up to that time—1,851 feet long, covering more than 18 acres, and providing for almost a million square feet of exhibition space. The central vaulted transept—based on the new cast-iron railway stations—rose 108 feet to accommodate a row of elms dear to Prince Albert, the husband of Queen Victoria. Although everyone agreed that the Crystal Palace was a technological marvel, most architects and critics, still wedded to Neoclassicism and Romanticism, considered it a work of engineering rather than legitimate architecture because it

made no clear allusion to any past style. Some observers, however, were more forward-looking. One visitor called it a revolution in architecture from which a new style would emerge.

We see a less reverent attitude toward technological progress in the first attempt to incorporate structural iron into architecture proper: the **BIBLIOTHÈQUE SAINTE-GENEVIÈVE** (FIG. 30–32), a library in Paris designed by Henri Labrouste (1801–75). Conventionally trained at the École des Beaux-Arts and employed as one of its professors, Labrouste was something of a radical in his desire to reconcile the École's conservative design principles with the technological innovations of industrial engineers. Although reluctant to promote this goal in his teaching, he clearly pursued it in his practice.

Because of the Bibliothèque Sainte-Geneviève's educational function, Labrouste wanted the building to suggest the course of both learning and technology. The window arches on the exterior have panels with the names of 810 important contributors to Western thought from its religious origins to the positivist present, arranged chronologically from Moses to the Swedish chemist Jöns Jakob Berzelius. The exterior's stripped-down Renaissance style reflects the belief that the modern era of learning dates from that period. The move from outside to inside subtly outlines the general evolution of architectural techniques. The exterior of the library features the most ancient of permanent building materials, cut stone, which was considered the only construction material "noble" enough for a serious building. The columns in the entrance

30-32 | Henri Labrouste READING ROOM, BIBLIOTHÈQUE SAINTE-GENEVIÈVE Paris. 1843-50.

hall are solid masonry with cast-iron decorative elements. In the main reading room, however, cast iron plays an undisguised structural role. Slender iron columns—cast to resemble the most ornamental Roman order, the Corinthian—support two parallel barrel vaults. The columns stand on tall concrete pedestals, a reminder that modern construction technology rests on the accomplishments of the Romans, who perfected the use of concrete. The design of the delicate floral cast-iron ribs in the vaults is borrowed from the Renaissance architectural vocabulary.

French Academic Art and Architecture

The Académie des Beaux-Arts and its official art school, the École des Beaux-Arts, exerted a powerful influence over the visual arts in France throughout the nineteenth century. Academic artists controlled the Salon juries, and major public commissions routinely went to academic architects, painters, and sculptors.

GARNIER: THE OPÉRA. Unlike Labrouste in the Bibliothèque Sainte-Geneviève, most later nineteenth-century architects trained at the École des Beaux-Arts worked in a style known as historicism, an elaboration on earlier Neoclassical and Romantic revivals. Historicists were expected to be aware of the whole sweep of architectural history. They often combined historical allusions to different periods in a single building. They typically used iron only as an internal support for conventional materials, as in the case of the OPÉRA, the Paris opera house (FIG. 30-33) designed by Charles Garnier (1825-98). The Opéra was a focal point of a thorough urban redevelopment plan begun under Napoleon III by Georges-Eugène Haussmann (1809-91) in the 1850s. After riots in 1848 devastated some of the city's central neighborhoods, the city leaders engaged Haussmann to rebuild the city and redraw the street map. Haussmann's project swept away the narrow, winding, medieval streets with their historic buildings, replacing them with new buildings

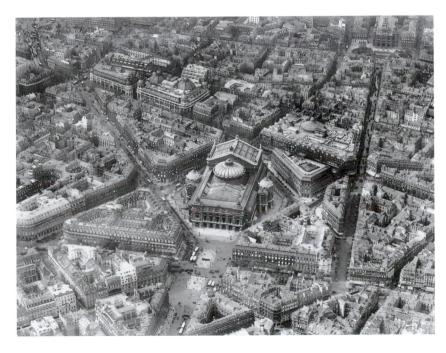

30–33 | Charles Garnier THE OPÉRA Paris, 1861–74.

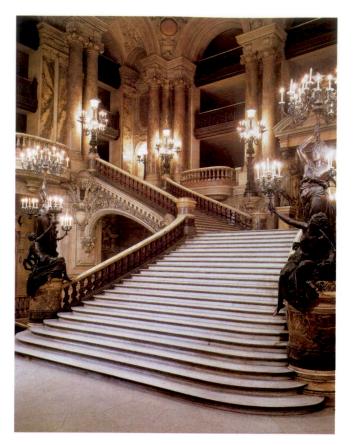

30-34 GRAND STAIRCASE, THE OPÉRA

The bronze figures holding the lights on the staircase are by Marcello, the pseudonym used by Adèle d'Affry (1836-79), the duchess Castiglione Colonna, as a precaution against the male chauvinism of the contemporary art world.

along wide, straight, tree-lined avenues that were more propitious for horse-drawn carriages, for strollers, and for suppressing future riots.

Set in one of these new intersections and carefully hiding its cast-iron frame, Garnier's design is a masterpiece of historicism based mostly on the Baroque style, here revived in order to recall that earlier period of France's greatness. The massive façade, featuring a row of paired columns above an arcade, is essentially a heavily ornamented, Baroque version of the seventeenth-century wing of the Louvre, an association meant to suggest the continuity of the French nation and to flatter Emperor Napoleon III by comparing him favorably with King Louis XIV. The luxuriant treatment of form, in conjunction with the building's primary function as a place of entertainment, was intended to celebrate the devotion to wealth and pleasure that characterized the period. The ornate architectural style was also appropriate for the home of that most flamboyant musical form, the opera.

The inside of what some critics called the "temple of pleasure" (FIG. 30–34) was even more opulent, with neo-Baroque sculptural groupings; heavy, gilded decoration; and a lavish mix of expensive, polychromed materials. The highlight of the interior was not the spectacle onstage so much as the

one on the great, sweeping Baroque staircase, where various members of the Paris elite—from old nobility to newly wealthy industrialists—could display themselves, the men in tailcoats accompanying women in bustles and long trains. As Garnier himself said, the purpose of the Opéra was to fulfill the most basic of human desires: to hear, to see, and to be seen.

CARPEAUX. Jean-Baptiste Carpeaux (1827–75), who had studied at the École des Beaux-Arts under the Romantic sculptor François Rude (SEE FIG. 30–9), was commissioned to carve one of the large sculptural groups for the façade of Garnier's Opéra (illustrated here in a plaster version). In this work, **THE DANCE** (FIG. 30–35), a winged personification of Dance, a slender male carrying a tambourine, leaps up joyfully in the midst of a compact, entwined group of mostly nude female dancers, embodying the theme of uninhibited Dionysian revelry. The erotic implication of this wild dance is revealed by the presence in the background of a satyr, a mythological creature known for its lascivious appetites.

Carpeaux's group upset many Parisians because he had not smoothed and generalized the bodies as Neoclassical

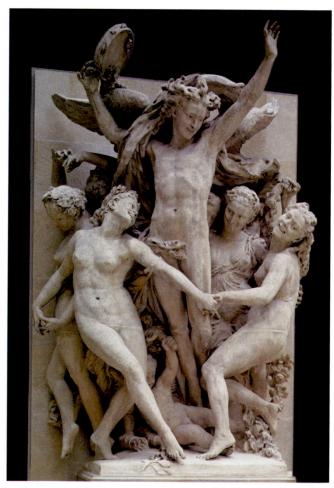

30−35 | Jean-Baptiste Carpeaux **THE DANCE** 1867–68. Plaster, height approx. 15′ (4.6 m). Musée de l'Opéra, Paris.

sculptors such as Canova had done (SEE FIG. 29–17). Although the figures are idealized, their detailed musculature and bone structure (observe the knees and elbows, for example) make them appear to belong more to the real world than to the ideal one. Carpeaux's handling of the body and its parts has therefore been labeled realistic.

Carpeaux's unwillingness to idealize physical details was symptomatic of an important shift in French academic art in the second half of the nineteenth century. Although the influence of photography on the taste of the period has sometimes been cited as the probable cause of this change, both photography and the new exactitude in academic art were simply manifestations of the increasingly positivist values of the era. These values were particularly evident among the bankers and businesspeople who came to dominate French society and politics in the years after 1830. As patrons, these practical leaders of commerce were generally less interested in art that idealized than in art that brought the ideal down to earth.

CABANEL. We see the effect of this new taste on painters in **THE BIRTH OF VENUS** by Alexandre Cabanel (1823–89), one of the leading academic artists (FIG. 30–36). He won the Prix de Rome in 1845 after studying with an academic master, and won top honors at the Salon three times in the 1860s and

1870s. The mythological subject of this work is venerable in Western art and engaged many artists as far back as Raphael. Cabanel depicted Venus borne along on the waves, accompanied by a group of putti, some of whom blow on conch shells. His ultra-skillful painting style is based on Neoclassical techniques and shows Cabanel's mastery of anatomy, flesh tones, and the surface of the sea. The image has a strong erotic charge, though, in the arched back and hooded eyelids of Venus. Thus is the goddess of love rendered as earthy as a pinup picture. This combination of mythological pedigree and physical appeal proved irresistible to Napoleon III, who bought The Birth of Venus for his private collection. Alert readers will notice that our illustration of this work is credited to more than one artist. This anomaly is explained in "How to Be a Famous Artist in the Nineteenth Century" (page 1016), which explores some ways in which successful artists bolstered their careers during that period.

Realism

The European national academies retained official control over both the teaching and the display of art in the second half of the nineteenth century. The academicians that populated the Salon juries in those years rewarded artists who painted in an acceptable style that showed the proper technical polish and appropriate subject matter. These artists all

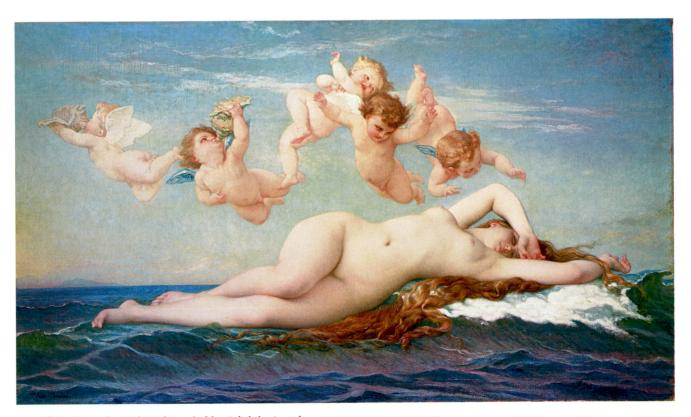

30–36 Alexandre Cabanel, copied by Adolphe Jourdan THE BIRTH OF VENUS c. 1864. Oil on canvas, $33 \times 53''$ (85.2×135.8 cm). Dahesh Museum of Art, New York. 2002.37

Technique

HOW TO BE A FAMOUS ARTIST IN THE NINETEENTH CENTURY

ince artists generally make unique, handcrafted objects, keeping their work visible to large numbers of people can be difficult, especially in modern times when most forms of entertainment are mass produced. Since at least the time of Hogarth in the eighteenth century, artists have resorted to engravings to disseminate large editions of their works. Hogarth did this with several print series, as we saw in Chapter 29. Francisco Goya sold many copies of his print series *Los Caprichos* (SEE FIG. 30-11) in both France and Spain. Both of these artists created prints because they wanted to send a message to the general public.

Works that won prizes or created controversy were often engraved for large-scale reproduction. Artists generally hired specialists to render their work in the new medium, and sold the prints at bookstores or magazine stands. J. M. W. Turner did this more often than most artists; he used a team of engravers to capture on paper the delicate tonal shadings of his works, such as HANNIBAL CROSSING THE ALPS, which was engraved by one of his favorites, John Cousen. Engraved editions might run

into the low hundreds before the repeated pressing took its toll on image quality. The arrival of steel plates in the 1820s made much larger editions possible: Those more durable surfaces could print up to 10,000 copies without loss of quality, though few artists experienced such demand.

One of the canniest self-marketers of the century was Alexandre Cabanel. After Napoleon III bought *The Birth of Venus*, the artist sold the reproduction rights to the art dealer Adolphe Goupil, who in turn hired artists to create at least two smaller-scale copies of the work (one of which is FIG. 30–36). After the original creator approved the copies and signed them, the dealer used them as models for engravers who cut the steel plates. The dealer then sold the smaller versions of the work.

The technological advances that made possible the mass reproduction of photographs changed this equation radically near the end of the century. The expense of hand-carving an engraving plate soon became prohibitive, and artists began to hope that publicity in newspapers or magazines might do for them what printed editions had done in the past.

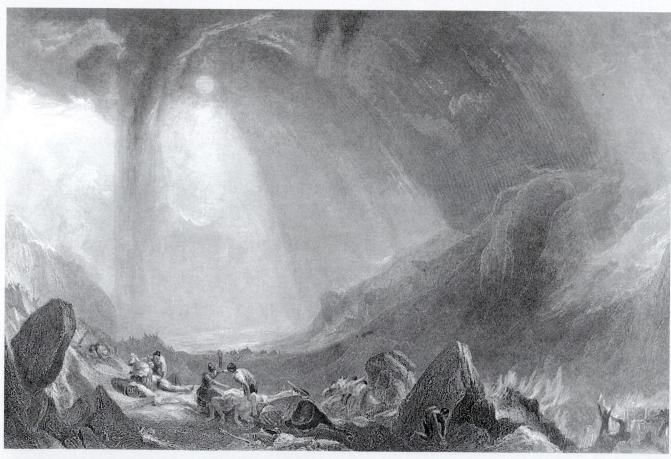

John Cousen, after J. M. W. Turner HANNIBAL CROSSING THE ALPS 1859. Engraving on paper. Tate Gallery, London. Transferred from British Museum. T06314

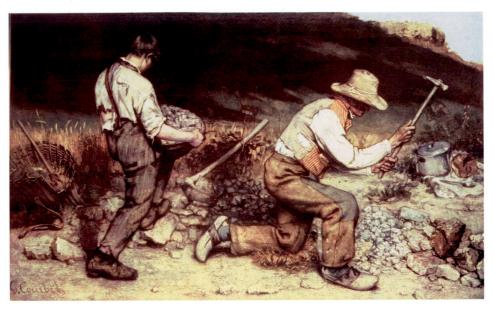

enjoyed successful careers during their day, creating works based on history, mythology, or picturesque genre, but they are mostly forgotten now because most of their work was simply not innovative. Rather, their art catered to the taste of most Salon visitors, who during the rapid social changes that transformed modern society looked to art for the reassurance of a comforting subject well painted.

In the middle nineteenth century, however, some artists rejected the precepts of the Salon in favor of a belief that art should faithfully record ordinary life. Most had not read Auguste Comte, but they joined in the new spirit of objectivity. In the years after 1850, some of the work produced by these independent-minded landscape and figure painters was labeled Realism, reflecting their positivist belief that art should show the "unvarnished truth." Some of these realists took up subjects that were generally regarded as not important enough for a serious work of art, and as a result they tended to get bad reviews in the press. But as we look back at the decades surrounding the middle of that century, we see that the realists were creating the most innovative and challenging work.

The political backdrop of the rise of Realism was defined by the Revolution of 1848 in France, when an uneasy coalition of socialists, anarchists, and workers overthrew the July Monarchy. The revolts began in February of that year, initially over government corruption and narrow voting rights, but they soon spread to a dozen major cities across Europe. The revolts led in France to the installation of Napoleon III (nephew of Bonaparte) as emperor under a new constitution with broadened suffrage rights, but still much social unease. Napoleon III soon acted to redraw the Paris street maps, as we have seen, to help prevent future revolts.

The Realist movement had a close parallel in literature of the time. Emile Zola, Charles Dickens, Honoré de Balzac, and others wrote novels that focused close attention on the urban lower classes. Zola, in particular, seemed to adhere to positivist beliefs in social science, as he said that he envisioned his novels as scientific experiments: He set his characters loose in an environment to see how they might interact with each other.

REALIST PAINTING IN FRANCE. The social radical Gustave Courbet (1819–77) was inspired by the events of 1848 to turn his attention to poor and ordinary people. Born and raised in Ornans near the Swiss border and largely self-taught as an artist, he moved to Paris in 1839. The street fighting of 1848 seems to have radicalized him. He told one newspaper in 1851 that he was "not only a Socialist but a democrat and a Republican: in a word, a supporter of the whole Revolution." Courbet proclaimed his new political commitment in three large paintings he submitted to the Salon of 1850–51.

One of these, **THE STONE BREAKERS** (FIG. 30–37), is a large painting showing two haggard men laboring to produce gravel used for roadbeds. In a letter he wrote while working on the painting, Courbet described its origins and considered its message:

[N]ear Maisières [in the vicinity of Ornans], I stopped to consider two men breaking stones on the highway. It's rare to meet the most complete expression of poverty, so an idea for a picture came to me on the spot. I made an appointment with them at my studio for the next day. . . . On the one side is an old man, seventy. . . . On the other side is a young fellow . . . in his filthy tattered shirt. . . . Alas, in labor such as this, one's life begins that way, and it ends the same way.

To contemporary viewers, this large painting of workers on the lowest social level seemed to dignify the revolutionaries of 1848. Courbet's friend, the anarchist philosopher Pierre-Joseph Proudhon, in 1865 called *The Stone Breakers* the first socialist picture ever painted, "a satire on our industrial civilization, which continually invents wonderful machines to perform all kinds of labor . . . yet is unable to liberate man from the most backbreaking toil." And Courbet himself, in a letter of the following year, referred to the painting as a depiction of "injustice."

Courbet's representation of The Stone Breakers on an 8½-foot-wide canvas testified in a provocative way to the painter's respect for ordinary people. In French art before 1848, such people usually had been shown only in modestly scaled paintings, while monumental canvases had been reserved for heroic subjects and pictures of the powerful. Immediately after completing The Stone Breakers, Courbet began work on an even larger canvas, roughly 10 by 21 feet, focusing on another scene of ordinary life: the funeral of an unnamed bourgeois citizen of Ornans. A BURIAL AT ORNANS (FIG. 30-38), also exhibited at the Salon of 1850-51, was attacked by conservative critics, who objected to its presentation of a mundane provincial funeral on a scale normally reserved for the depiction of a major historical event. They also faulted its disrespect for conventional compositional standards: Instead of arranging figures in a pyramid that would indicate a hierarchy of importance, Courbet lined them up in rows across the picture plane—an arrangement he considered more democratic. Critics also noted that the work contains no suggestion of an afterlife; rather it presents death and burial as mere physical facts, as a positivist might regard them. The painter's political convictions are especially evident in the individual attention and sympathetic treatment he accords the ordinary citizens of Ornans, many of them the artist's friends and family members. Courbet seems to have enjoyed the controversy: When some of his works were refused by the jury for a special Salon at the International Exposition of 1855, he rented a building near the fair's Pavilion of Art and installed a show of his own works which he called the Pavilion of Realism.

Similar accusations of political radicalism were made against Jean-François Millet (1814–75), though with less justification. The artist grew up on a farm and, despite living in Paris between 1837 and 1848, never felt comfortable in the city. The 1848 Revolution's preoccupation with ordinary people led Millet to focus on peasant life, only a marginal concern in his early work, and his support of the revolution earned him a state commission that allowed him to move from Paris to the village of Barbizon. After settling there in 1849, he devoted his art almost exclusively to the difficulties and simple pleasures of rural existence.

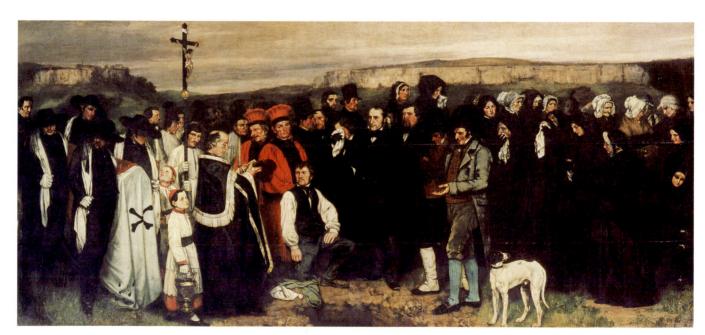

30–38 | Gustave Courbet A BURIAL AT ORNANS 1849. Oil on canvas, $10'3\frac{1}{2}'' \times 21'9''$ (3.1 × 6.6 m). Musée d'Orsay, Paris.

A Burial at Ornans was inspired by the 1848 funeral of Courbet's maternal grandfather, Jean-Antoine Oudot, a veteran of the Revolution of 1793. The painting is not meant as a record of that particular funeral, however, since Oudot is shown alive in profile at the extreme left of the canvas, his image adapted by Courbet from an earlier portrait. The two men to the right of the open grave, dressed not in contemporary but in late eighteenth-century clothing, are also revolutionaries of Oudot's generation, and their proximity to the grave suggests that one of their peers is being buried. Courbet's picture may be interpreted as linking the revolutions of 1793 and 1848, both of which sought to advance the cause of democracy in France.

Among the best known of Millet's mature works is **THE GLEANERS** (FIG. 30–39), which shows three women gathering grain at harvest time. The warm colors and slightly hazy atmosphere are soothing, but the scene is one of extreme poverty. Gleaning, or the gathering of the grains left over after the harvest, was a form of relief offered to the rural poor. It required hours of backbreaking work to gather enough wheat to produce a single loaf of bread. When the painting was shown in 1857, a number of critics thought Millet was

attempting to rekindle the sympathies and passions of 1848, and he was therefore labeled a realist and even a socialist. Although Millet did not harbor such beliefs, his works aroused suspicion and controversy.

The kind of work produced in the 1830s and 1840s by the Barbizon School (SEE FIG. 30–18) became increasingly popular with Parisian critics and collectors after 1850, largely because of the radically changed conditions of Parisian life. Between 1831 and 1851 the city's population doubled, then the massive renovations of the entire city led by Haussmann transformed Paris from a collection of small neighborhoods to a modern, crowded, noisy, and fast–paced metropolis. Another factor in the appeal of images of peaceful country life was the widespread uneasiness over the political and social effects of the Revolution of 1848, and fear of further disruptions.

Soothing images of the rural landscape became a specialty of Jean-Baptiste-Camille Corot (1796–1875), who during the early decades of his career had painted not only historical landscapes with subjects drawn from the Bible and classical history, but also ordinary country scenes similar to those depicted by the Barbizon School. Ironically, just as popular taste was beginning to favor the latter kind of work, Corot around 1850 moved on to a new kind of landscape painting that mixed naturalistic subject matter with Romantic, poetic effects. A fine example is **FIRST LEAVES, NEAR MANTES** (FIG. 30–40), an idyllic image of budding green foliage in a warm, misty wood.

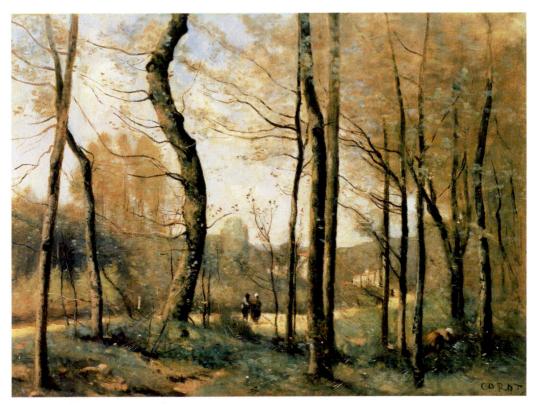

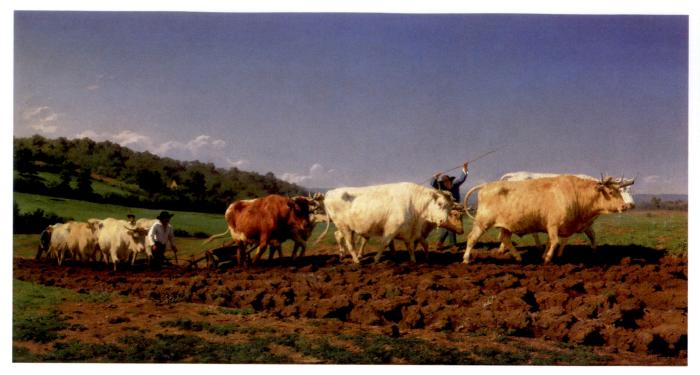

30–41 Rosa Bonheur PLOWING IN THE NIVERNAIS: THE DRESSING OF THE VINES 1849. Oil on canvas, $5'9'' \times 8'8''$ (1.8 × 2.6 m). Musée d'Orsay, Paris.

Bonheur was often compared with George Sand, a contemporary woman writer who adopted a male name as well as male dress. Sand devoted several of her novels to the humble life of farmers and peasants. Critics at the time noted that *Plowing in the Nivernais* may have been inspired by a passage in Sand's *The Devil's Pond* (1846) that begins: "But what caught my attention was a truly beautiful sight, a noble subject for a painter. At the far end of the flat ploughland, a handsome young man was driving a magnificent team [of] oxen."

The feathery brushwork in the grasses and leaves infuses the painting with a soft, dreamy atmosphere that is counterbalanced by the solidly modeled tree trunks in the foreground, which create a firm sense of structure. Beyond the trees, a dirt road meanders toward the village in the background. Two rustic figures travel along the road at the lower center, while another figure labors in the woods at the lower right. Corot invites us to identify with these figures and to share imaginatively in their simple and unhurried rural existence.

Among the period's most popular painters of farm life was Rosa Bonheur (1822–99), whose commitment to rural subjects was partly the result of her aversion to Paris, where she had been raised. Bonheur's success in what was then a male domain owed much to the socialist convictions of her parents, who belonged to a radical utopian sect founded by the Comte de Saint-Simon (1760–1825), which believed not only in the equality of women but also in a future female Messiah. Bonheur's father, a drawing teacher, provided most of her artistic training.

Bonheur devoted herself to painting her beloved farm animals with complete accuracy, increasing her knowledge by reading zoology books and making detailed studies in stockyards and slaughterhouses. (To gain access to these all-male preserves, Bonheur got police permission to dress in men's clothing.) Her professional breakthrough came at the Salon

of 1848, where she showed eight paintings and won a firstclass medal. Shortly after, she received a government commission to paint PLOWING IN THE NIVERNAIS: THE DRESSING OF THE VINES (FIG. 30-41), a monumental composition featuring one of her favorite animals, the ox. The powerful beasts, anonymous workers, and fertile soil offer a reassuring image of the continuity of agrarian life. The stately movement of people and animals reflects the kind of carefully balanced compositional schemes taught in the academy and echoes scenes of processions found in classical art. The painting's compositional harmony—the shape of the hill is answered by and continued in the general profile of the oxen and their handler on the right—as well as its smooth illusionism and conservative theme were very appealing to the taste of the times. Her workers are far less pathetic than those of Courbet or Millet. Bonheur became so famous that in 1865 she received France's highest award, membership in the Legion of Honor, becoming the first woman to be awarded its Grand Cross.

Millet, Courbet, Bonheur, and the other Realists who emerged in the 1850s are sometimes referred to as the "Generation of 1848." Because of his sympathy with working-class people, Honoré Daumier (1808–79) is also grouped with this generation. Unlike Courbet and the others, however, Daumier often depicted urban scenes, as in his famous early lith-

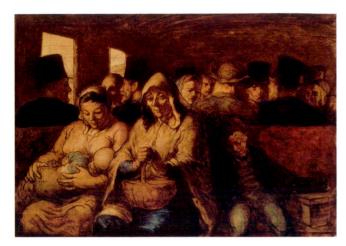

30–42 | Honoré Daumier THE THIRD-CLASS CARRIAGE c. 1862. Oil on canvas, $25\% \times 35\%$ " (65.4 \times 90.2 cm). The National Gallery of Canada, Ottawa. Purchase, 1946

Although he devoted himself seriously to oil painting during the later decades of his life, Daumier was known to the Parisian public primarily as a lithographer whose cartoons and caricatures appeared regularly in the press. Early in his career he drew antimonarchist caricatures critical of King Louis-Philippe, but censorship laws imposed in 1835 obliged him to focus on social and cultural themes of a nonpolitical nature.

ograph Rue Transnonain, Le 15 Avril 1834 (see Introduction, FIG. 13) and his later oil painting THE THIRD-CLASS CARRIAGE (FIG. 30–42). The painting depicts the interior of one of the large, horse-drawn buses that transported Parisians along one of the new boulevards Haussmann had introduced as part of the city's redevelopment. Daumier places the viewer in the poor section of the bus, opposite a serene grandmother, her daughter, and her two grandchildren. Although there is a great sense of intimacy and unity among these people, they are physically and mentally separated from the upper- and

middle-class passengers, whose heads appear behind them. By portraying the lower classes as hardworking and earnest, the work humanizes them in a way similar to that of the novels of Charles Dickens.

REALISM OUTSIDE FRANCE. Following the French lead, artists of other nations also embraced Realism in the period after 1850 as the social effects of urbanization and industrialization began to take hold in their countries. In Russia, Realism developed in relation to a new concern for the peasantry. In 1861 the czar abolished serfdom, emancipating Russia's peasants from the virtual slavery they had endured on the large estates of the aristocracy. Two years later a group of painters inspired by the emancipation declared allegiance both to the peasant cause and to freedom from the St. Petersburg Academy of Art, which had controlled Russian art since 1754. Rejecting what they considered the escapist, "art for art's sake" aesthetics of the Academy, the members of the group dedicated themselves to a socially useful Realism. Committed to bringing art to the people in traveling exhibitions, they called themselves the Wanderers. By the late 1870s members of the group, like their counterparts in music and literature, had also joined a nationalistic movement to reassert what they considered to be an authentic Russian culture rooted in the traditions of the peasantry, rejecting the Western European customs that had long predominated among the Russian aristocracy.

Ilya Repin (1844–1930), who attended the St. Petersburg Academy and won a scholarship to study in Paris, joined the Wanderers in 1878 after his return to Russia. Repin painted a series of works illustrating the social injustices then prevailing in his homeland, including **BARGEHAULERS ON THE VOLGA** (FIG. 30–43). The painting features a group of wretchedly dressed peasants condemned to the brutal work

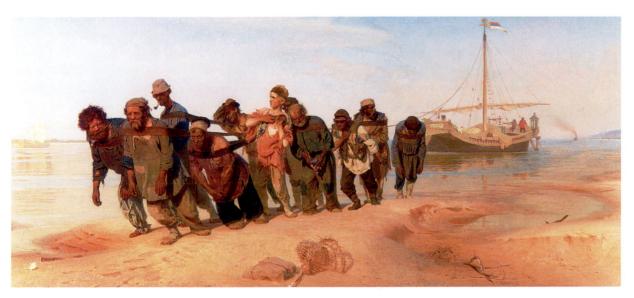

30–43 \perp Ilya Repin BARGEHAULERS ON THE VOLGA 1870–73. Oil on canvas, $4'3\%'' \times 9'3''$ (1.3 \times 2.81 m). State Russian Museum, St. Petersburg.

of pulling ships up the Volga River. To heighten our sympathy for these workers, Repin placed a youth in the center of the group, a young man who will soon look as old and tired as his companions unless something is done to rescue him. In this way, the painting is a cry for action.

The most uncompromising American Realist of the era, Thomas Eakins (1844-1916), was also criticized for selecting controversial subjects. Born in Philadelphia, Eakins trained at the Pennsylvania Academy of the Fine Arts, but since he regarded the training in anatomy as not rigorous enough lacking realism, as he might have put it—he supplemented his training at the Jefferson Medical College nearby. He later studied at the École des Beaux-Arts in Paris, then spent six months in Spain, where he encountered the profound realism of Jusepe de Ribera and Diego Velázquez (SEE FIGS. 22-25, 22-27). After he returned to Philadelphia in 1870, he specialized in frank portraits and scenes of everyday life whose lack of conventional charm generated little popular interest. But he was a charismatic and influential teacher, and was soon appointed director of the Pennsylvania Academy.

One work of his did attract attention of a negative kind: THE GROSS CLINIC (FIG. 30-44) was severely criticized and was refused exhibition space at the 1876 Philadelphia Centennial because the jury apparently did not regard surgery as a fit subject for art. The painting shows Dr. Samuel David Gross performing an operation with young medical students looking on. The representatives of science—a young medical student, the doctor, and his assistants—are all highlighted. This dramatic use of light, inspired by Rembrandt and the Spanish Baroque masters Eakins admired, is not meant to stir emotions but to make a point: Amid the darkness of ignorance and fear, modern science shines the light of knowledge. The light in the center falls not on the doctor's face but on his forehead—on his mind. The French poet and art critic Charles Baudelaire had called as far back as 1846 for artists to depict "The Heroism of Modern Life," and turn away from the historical or the imaginary. He wrote, "There are such things as modern beauty and modern heroism." Though Eakins most likely had not read Baudelaire's call, he did see Dr. Gross as a hero and depicted him memorably. For many years the painting hung not in an art gallery but at the Jefferson Medical College.

A few years later, Eakins's commitment to the unvarnished truth proved costly in his career. When he removed the loincloth from a male nude model in a mixed life-drawing class, the scandalized Academy board gave him the choice of changing his teaching methods or resigning. He resigned. This step did not remove Realism from the Academy curriculum, however, as we shall see in the next chapter.

His compatriot Winslow Homer (1836-1910) believed that unadorned realism was the most appropriate style for American-type democratic values. The Boston-born Homer began his career in 1857 as a freelance illustrator for popular

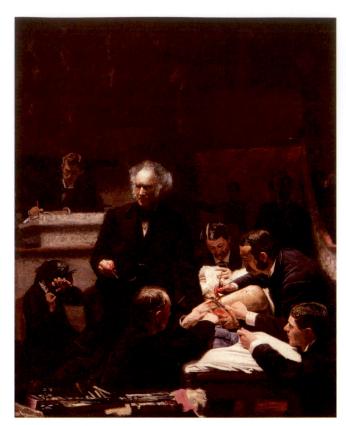

Thomas Eakins THE GROSS CLINIC 1875. Oil on canvas, $8' \times 6'5''$ (2.44 × 1.98 m). Jefferson Medical College of Thomas Jefferson University, Philadelphia.

Eakins, who taught anatomy and figure drawing at the Pennsylvania Academy of the Fine Arts, disapproved of the academic technique of drawing from plaster casts. In 1879 he said, "At best, they are only imitations, and an imitation of an imitation cannot have so much life as an imitation of nature itself." He added, "The Greeks did not study the antique . . . the draped figures in the Parthenon pediment were modeled from life, undoubtedly."

periodicals such as Harper's Weekly, which sent him to cover the Civil War in 1862. In 1866-67 Homer spent ten months in France, where the Realist art he saw may have inspired the rural subjects he painted when he returned. His commitment to depicting common people deepened after he spent 1881-82 in a tiny English fishing village on the rugged North Sea coast. The strength of character of the people there so inspired him that he turned from idyllic subjects to more dramatic themes involving the heroic human struggle against natural adversity. In England, he was particularly impressed with the breeches buoy, a mechanical apparatus used to rescue those aboard foundering ships. During the summer of 1883 Homer made sketches of a breeches buoy imported by the lifesaving crew in Atlantic City, New Jersey. The following year Homer painted THE LIFE LINE (FIG. 30-45), which depicts a coast guardsman using the breeches buoy to rescue an unconscious woman and is a testament not simply to human bravery but also to ingenuity.

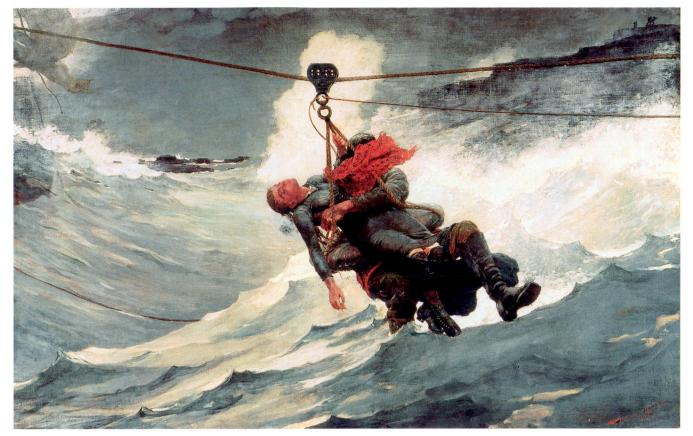

30–45 | Winslow Homer THE LIFE LINE 1884. Oil on canvas, $28\,\% \times 44\,\%$ " (73 × 113.3 cm). Philadelphia Museum of Art. The George W. Elkins Collection.

In the early sketches for this work, the man's face was visible. The decision to cover it focuses more attention not only on the victim but also on the true hero, the mechanical apparatus known as the breeches buoy.

Late Nineteenth-Century Art in Britain

The parliamentary reforms of the 1830s made England a more flexible society, better able to deal with the social pressures that industrialization and urbanization caused. Though it had its share of political agitation, the country was spared the worst violence of the 1848 revolts. Likewise, Realist currents were few, and they were tied to an effort to reform English art that looked back to the social concern of Hogarth. In 1848 seven young London artists formed the Pre-Raphaelite Brotherhood in response to what they considered the misguided practices of contemporary British art. Instead of the Raphaelesque conventions taught at the Royal Academy, the Pre-Raphaelites advocated the naturalistic approach of certain early Renaissance masters, especially those of northern Europe. They advocated as well a moral approach to art, in keeping with what they saw as a long tradition in Britain.

HUNT. The combination of didacticism and naturalism that characterized the first phase of the movement is best represented in the work of one of its leaders, William Holman Hunt (1827–1910), for whom moral truth and visual accuracy were synonymous. A well-known painting by this academically trained artist is **THE HIRELING SHEPHERD**

(FIG. 30–46). Hunt painted the landscape portions of the composition outdoors, an innovative approach at the time, leaving space for the figures, which he painted in his London studio. The work depicts a farmhand neglecting his duties to flirt with a woman while pretending to discuss a death's-head moth that he holds in his hand. Meanwhile, some of his

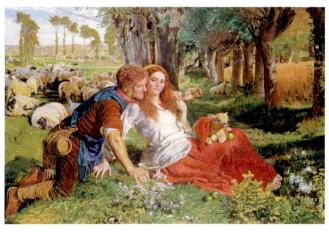

employer's sheep are wandering into an adjacent field, where they may become sick or die from eating green corn. Hunt later explained that he meant to satirize pastors who instead of tending their flock waste time discussing what he considered irrelevant theological questions. The work is certainly an allegory fashioned after one of the parables of Jesus about good and bad shepherds (John 10:11-13). The painting can also be seen as a moral lesson on the perils of temptation. The woman is cast as a latter-day Eve, as she feeds an apple—a reference to humankind's fall from grace—to the lamb on her lap and distracts the shepherd from his duty.

MORRIS AND THE ARTS AND CRAFTS MOVEMENT. socialist values of the Revolution of 1848 had their strongest impact on English arts in the field of interior design. William Morris (1834-1896) worked briefly as a painter under the influence of the Pre-Raphaelites before turning his attention to interior design and decoration. Morris's interest in handcrafts developed in the context of a widespread reaction against the gaudy design of industrially produced goods that began with the Crystal Palace exhibition of 1851. Unable to find satisfactory furnishings for his new home after his marriage in 1859, Morris designed and made them himself with the help of friends. He then founded a decorating firm to produce a full range of medieval-inspired objects. Although many of the furnishings offered by Morris & Company were expensive, one-of-a-kind items, others, such as the rushseated chair illustrated here (FIG. 30-47), were cheap and simple, intended to provide a handcrafted alternative to the vulgar excess characteristic of industrial furniture. Concerned with creating a "total" environment, Morris and his colleagues designed not only furniture but also stained glass, tiles, wallpaper, and fabrics, such as the PEACOCK AND **DRAGON CURTAIN** seen in the background of FIGURE 30–47.

Morris inspired what became known as the Arts and Crafts movement. His aim was to benefit not just a wealthy few but society as a whole. He rebelled against the common Western notion, in effect since the Renaissance, that art was a highly specialized product made by a uniquely gifted person for sale at a high price to a wealthy individual for a private possession. Rather, he hoped to usher in a new era of art by the people and for the people. As he said in the hundreds of lectures he began delivering in 1877, "I do not want art for a few, any more than education for a few, or freedom for a few." A socialist, Morris had serious doubts about mass production not only because he found its products ugly but also because of its deadening influence on the industrial worker, forced to work ten- to twelve-hour days at repetitive tasks. With craftwork, he maintained, the laborer retains the satisfaction of seeing a project through to completion. He was inspired by the popular and mostly anonymous artists of the Middle Ages, but he also dreamed of a Utopian future without class

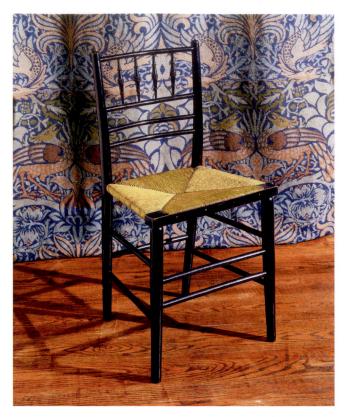

30–47 $\ \$ Foreground: Philip Webb $\ \$ Single Chair from the sussex range

In production from c. 1865. Ebonized wood with rush seat, $33 \times 16\% \times 14''$ ($83.8 \times 42 \times 35.6$ cm). Manufactured by Morris & Company. William Morris Gallery (London Borough of Waltham Forest).

BACKGROUND: William Morris PEACOCK AND DRAGON CURTAIN

1878. Handloomed jacquard-woven woolen twill, 12′10 ½″ \times 11′5 ½″ (3.96 \times 3.53 m). Manufactured at Queen Square and later at Merton Abbey. Victoria & Albert Museum, London.

Morris and his principal furniture designer, Philip Webb (1831–1915), adapted the Sussex Range from traditional rush-seated chairs of the Sussex region. The handwoven curtain in the background is typical of Morris's fabric design in its use of flat patterning that affirms the two-dimensional character of the textile medium. The pattern's prolific organic motifs and soothing blue and green hues—the decorative counterpart to those of naturalistic landscape painting—were meant to provide relief from the stresses of modern urban existence.

envy and where everyone embellished their lives with some form of art.

WHISTLER. Not all of those who participated in the revival of the decorative arts were committed to improving the conditions of modern life. Many saw in the Arts and Crafts revival simply another way to satisfy an elitist taste for beauty. Among these was the American expatriate James Abbott McNeill Whistler (1834–1903), who not only devoted attention to the rooms and walls where art is hung, but also participated in

controversies that laid important groundwork for the art of the next century. After flunking out of West Point in the early 1850s, Whistler studied art in Paris, where he came under the influence of the Realists, and painted seascapes with Courbet. After settling in London in 1859, his thought evolved away from Realism, and he began to conceive of aesthetic values as independent of any other social fact. That is, he believed that the mere arrangement of a room or a painting can be aesthetically pleasing in itself, no matter what it contains or depicts. He was among the first to hang his works in a gallery in a single row, rebelling against the "stacked" array of most art exhibitions since the seventeenth century. He also occasionally designed rooms to hold his works, mindful of the total harmony of a space.

His ideas about what makes a successful work of art proved equally revolutionary. He was among the first to collect Japanese art, finding there fascinating patterns of pure decoration that delighted his eye although he understood nothing of the subject matter. By the middle of the 1860s he was titling his works "Symphony" and "Arrangement," hinting that just as a symphony can be a pleasing composition of sound, so a painting can be a pleasing arrangement of form, regardless of its subject. He made several landscapes with the musical title "Nocturne," and when he exhibited some of these in 1877, he drew a negative review from England's leading art critic John Ruskin, a supporter of the Pre-Raphaelites who defended the moral intentions of those artists. Whistler's work seemed to have no such purpose, so Ruskin wondered in print how an artist could "demand 200 guineas for flinging a pot of paint in the public's face."

The most controversial painting in Whistler's show was NOCTURNE IN BLACK AND GOLD, THE FALLING ROCKET (FIG. 30-48), and it precipitated one of the most important court cases in Western art history. The work is a night scene painted in restricted tonalities that looks at first like a completely abstract painting, meaning that it does not represent observable aspects of nature. In fact, Whistler depicted a fireworks show over a lake at nearby Cremorne Gardens, with viewers dimly recognizable in the foreground. Calling the work a "Nocturne" recalled the piano pieces of Romantic composer Frederic Chopin, though Whistler was less interested in Romantic feeling than in pursuing the parallel between art and music. After reading Ruskin's review, Whistler sued the critic for libel and the case went to trial (see "Art on Trial in 1877"). On the witness stand, the artist defended his view that art has no higher purpose than creating visual delight; he further claimed that art need not have a subject matter at all in order to be successful. While Whistler never made a completely abstract painting, his theories became an important part of the justification for abstract art in the next century.

Defining Art

ART ON TRIAL IN 1877

his is a partial transcript of Whistler's testimony at the libel trial that he initiated against the art critic John Ruskin. Whistler's responses often provoked laughter, and the judge at one point threatened to clear the courtroom.

- Q: What is your definition of a Nocturne?
- A: I have, perhaps, meant rather to indicate an artistic interest alone in the work, divesting the picture from any outside sort of interest which might have been otherwise attached to it. It is an arrangement of line, form, and color first . . . The *Nocturne in Black and Gold* [SEE FIG. 30-48] is a night piece, and represents the fireworks at Cremorne.
- Q: Not a view of Cremorne?
- A: If it were called a view of Cremorne, it would certainly bring about nothing but disappointment on the part of beholders. It is an artistic arrangement. It was marked 200 guineas . . .
- Q: I suppose you are willing to admit that your pictures exhibit some eccentricities; you have been told that over and over again?
- A: Yes, very often.
- Q: You send them to the gallery to invite the admiration of the public?
- A: That would be such a vast absurdity on my part that I don't think I could.
- Q: Did it take you much time to paint the *Nocturne in Black and Gold*? How soon did you knock it off?
- A: I knocked it off in possibly a couple of days; one day to do the work, and another to finish it.
- Q: And that was the labor for which you asked 200 guineas?
- A: No, it was for the knowledge gained through a lifetime.

The judge ruled in Whistler's favor; Ruskin had indeed libeled him. But he awarded Whistler damages of only one half of one cent. Since in those days the person who brought the suit had to pay all the court costs, the case ended up bankrupting the artist.

30–48 | James Abbott McNeill Whistler NOCTURNE IN BLACK AND GOLD, THE FALLING ROCKET
1875. Oil on panel, $23\frac{1}{4} \times 18\frac{1}{6}$ " (60.2 × 46.7 cm). Detroit Institute of Arts, Detroit, Michigan.

46.309

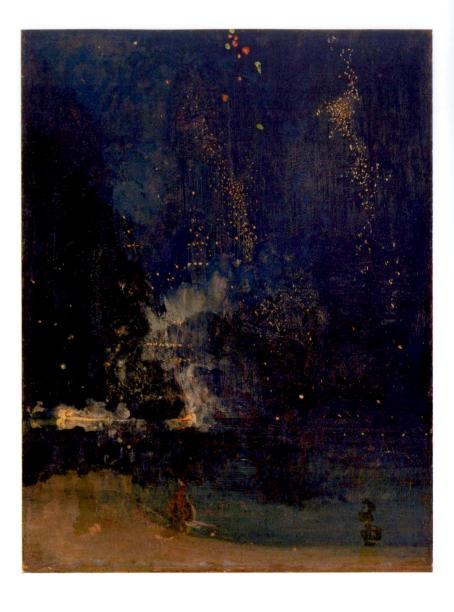

Impressionism

While the leading British artists were moving away from the naturalism advocated by the original Pre-Raphaelite Brotherhood, their French counterparts were pushing the French Realist tradition into new territory. The generation that matured around 1870 began as followers of Realism or the Barbizon School but soon moved to more modern subjects: leisure, the upper middle class, and the city. Although many of these artists specialized in paintings of the countryside, their point of view was usually that of a city person on holiday.

In April 1874, a number of these artists, including Paul Cézanne, Edgar Degas, Claude Monet, Berthe Morisot, Camille Pissarro, and Pierre-Auguste Renoir, exhibited together in Paris as the *Société Anonyme des Artistes Peintres, Sculpteurs, Graveurs, etc.* (Corporation of Artists Painters, Sculptors, Engravers, etc.). The mastermind of this arrangement was Pissarro, a devotee of anarchist philosophies. Anarchists such as Proudhon urged citizens to band together into

voluntary associations for mutual aid instead of relying on the state for such functions as banking and policing. Pissarro envisioned the Société as such a mutual aid group in opposition to the state-funded Salons. While the Impressionists became the best-known members that are remembered today, at the time the group consisted of artists who worked in various styles. All thirty participants agreed not to submit anything that year to the Salon, which had in the past often rejected their works; hence, their exhibition was a declaration of independence from the Academy and a bid to gain the attention of the public without the intervention of a jury. While the exhibition received some positive reviews, it was attacked by most critics. Louis Leroy, writing in the comic journal Charivari, seized on the title of a painting by Monet, Impression, Sunrise (1873), and dubbed the entire exhibition "impressionist." While Leroy used the word to attack the seemingly haphazard technique and unfinished look of some of the paintings, Monet and many of his colleagues were pleased to accept the label, which spoke to their concern for capturing an instantaneous impression of a scene in nature. Seven more Impressionist exhibitions followed between 1876 and 1886, with the membership of the group varying slightly on each occasion; only Pissarro participated in all eight shows. The exhibitions of the Impressionists inspired other artists to organize alternatives to the Salon, a development that by the end of the century ended the French Academy's centuries—old stranglehold on the display of art and thus on artistic standards.

MANET. Frustration among progressive artists with the exclusionary practices of the Salon jury had been mounting in the decades preceding the first Impressionist exhibition. Such discontent reached a fever pitch in 1863 when the jury turned down nearly 3,000 works submitted to the Salon, leading to a storm of protest. In response, Napoleon III tried to mediate in the dispute by ordering an exhibition of the refused work called the *Salon des Refusés* ("Salon of the Rejected Ones").

Featured in it was a painting by Édouard Manet (1832–83), LE DÉJEUNER SUR L'HERBE OF THE LUNCHEON ON THE GRASS (FIG. 30–49), which scandalized contemporary viewers and helped to establish Manet as a radical artist. Within a few years, many of the future Impressionists would gather around Manet and follow his lead in challenging academic conventions.

A well-born Parisian who had studied in the early 1850s with the progressive academician Thomas Couture (1815–79), Manet had by the early 1860s developed a strong commitment to Realism, largely as a result of his friendship with the poet Baudelaire (SEE FIG. 30–30). In his article "The Painter of Modern Life," Baudelaire called for an artist who would be the painter of contemporary manners, "the painter of the passing moment and all the suggestions of eternity that it contains." Manet seems to have responded to Baudelaire's call in painting *Le Déjeuner sur l'Herbe*, which proved deeply offensive to both the academic establishment and the average Salon-goer. Most disturbing to contemporary viewers was the "immorality" of Manet's theme: a suburban picnic

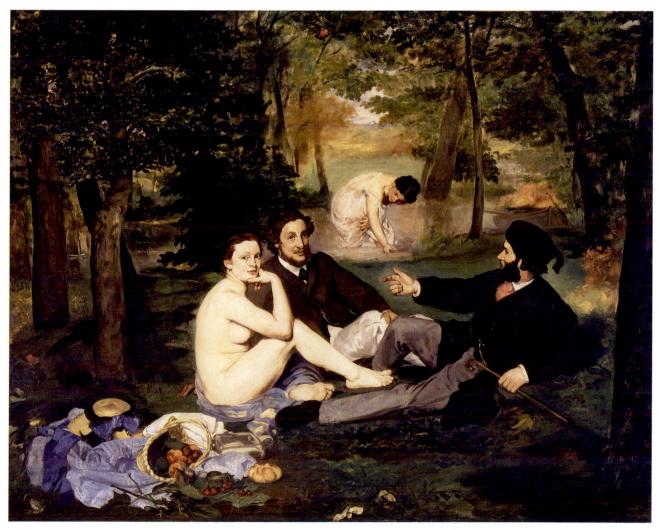

30–49 | Édouard Manet | LE DÉJEUNER SUR L'HERBE (THE LUNCHEON ON THE GRASS) 1863. Oil on canvas, $7' \times 8'8''$ (2.13 \times 2.64 m). Musée d'Orsay, Paris.

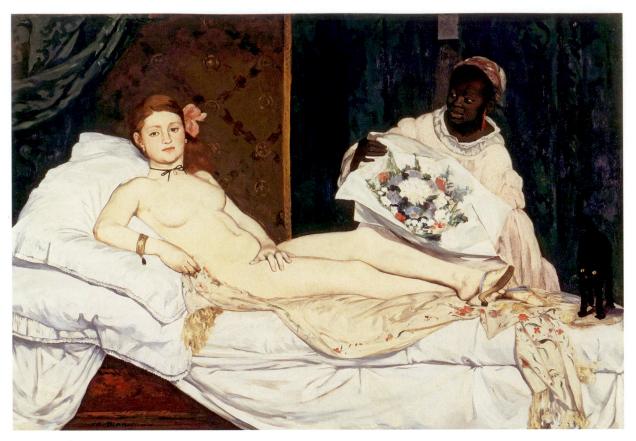

30–50 | Édouard Manet OLYMPIA 1863. Oil on canvas, 4'3" × 6'2½" (1.31 × 1.91 m). Musée du Louvre, Paris.

featuring a scantily clad bathing woman in the background and, in the foreground, a completely naked woman, seated alongside two fully clothed, upper-class men. Manet's scandalized audience assumed that these women were prostitutes and that the well-dressed men were their clients. What was most shocking about this work was its modernity, presenting nudity in the context of contemporary life. In contrast, one of the paintings that gathered most renown at the official Salon in that year was Alexandre Cabanel's *Birth of Venus* (SEE FIG. 30–36), which, because it presented nudity in a more acceptable classical environment, was favorably reviewed and quickly entered the collection of Napoleon III.

Manet apparently conceived of *Le Déjeuner sur l'Herbe* as a modern version of a famous Venetian Renaissance painting in the Louvre, the *Pastoral Concert*, then believed to be by Giorgione but now attributed to both Titian and Giorgione (SEE FIG. 20–24). Manet also adapted for his composition a group of river gods and a nymph from an engraving by Marcantonio Raimondi based on Raphael's *The Judgment of Paris*—an image that, in turn, looked back to classical reliefs. With its deliberate allusions to Renaissance artworks, Manet's painting addresses the history of art and Manet's relationship to it. To a viewer who has in mind the traditional perspective and the rounded modeling of forms of the two Renaissance works,

the stark lighting of Manet's nude and the flat, cutout quality of his figures become all the more shocking. In this way, Manet emphasized his own radical innovations.

The intended meaning of *Le Déjeuner* remains a matter of considerable debate. Some see it as a portrayal of modern alienation, for the figures in Manet's painting fail to connect with one another psychologically. Although the man on the right seems to gesture toward his companions, the other man gazes off absently, while the nude turns her attention away from them and to the viewer. Moreover, her gaze makes us conscious of our role as outside observers; we, too, are estranged. Manet's rejection of warm colors for a scheme of cool blues and greens plays an important role, as do his flat, sharply outlined figures, which seem starkly lit because of the near absence of modeling. The figures are not integrated with their natural surroundings, as in the *Pastoral Concert*, but seem to stand out sharply against them, as if seated before a painted backdrop.

Shortly after completing *Le Déjeuner sur l'Herbe*, Manet painted **OLYMPIA** (FIG. 30–50), whose title alluded to a socially ambitious prostitute of the same name in a novel and play by Alexandre Dumas *fils* (the younger). Like *Le Déjeuner sur l'Herbe*, Manet's *Olympia* was based on a Venetian Renaissance source, Titian's *Venus of Urbino* (SEE FIG. 20–26), which Manet had earlier copied in Florence. At first, Manet's paint-

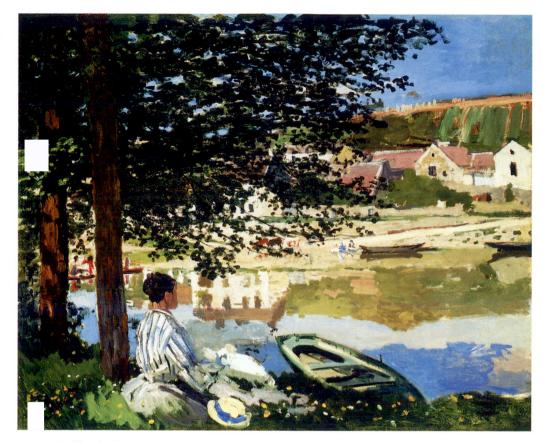

30–51 † Claude Monet ON THE BANK OF THE SEINE, BENNECOURT 1868. Oil on canvas, $32\times39\%''$ (81.5 \times 100.7 cm). Art Institute of Chicago. Potter Palmer Collection, 1922.427

ing appears to pay homage to Titian's in its subject matter (the Titian painting was then believed to be the portrait of a Venetian courtesan) and composition. However, Manet made his modern counterpart the very antithesis of the Titian. Whereas Titian's female is curvaceous and softly rounded, Manet's is angular and flattened. Whereas Titian's looks lovingly at the male spectator, Manet's appears coldly indifferent. Our relationship with Olympia is underscored by the reaction of her cat, who—unlike the sleeping dog in the Titian arches its back at us. Finally, instead of looking up at us, Olympia stares down on us, indicating that she is in the position of power and that we are subordinate, akin to the black servant at the foot of the bed who brings her a bouquet of flowers. In reversing the Titian, Manet in effect subverted the entire tradition of the accommodating female nude. Not surprisingly, conservative critics vilified the Olympia when it was displayed at the Salon of 1865.

Manet generally submitted his work to every Salon, but when he had a number of rejections in 1867, he did as Courbet had done in 1855: He rented a hall nearby and staged a solo exhibition. This made Manet the unofficial leader of a group of progressive artists and writers who gathered at the Café Guerbois in the Montmartre district of Paris. Among the artists who frequented the café were Degas,

Monet, Pissarro, and Renoir, who would soon exhibit together as the Impressionists. With the exception of Degas, who, like Manet, remained a studio painter, these artists began to paint outdoors, *en plein air* ("in the open air"), in an effort to record directly the fleeting effects of light and atmosphere. (*Plein air* painting was greatly facilitated by the invention in 1841 of tin tubes for oil paint.)

MONET. Claude Monet (1840–1926) was probably the purest exponent of Impressionism. Born in Paris but raised in the port city of Le Havre, Monet trained briefly with an academic teacher but soon forsook the studio to paint outdoors. He befriended the Barbizon School artist Daubigny (SEE FIG. 30-18), who urged him to "be faithful to his impression," and guided the younger artist to create his own floating studio on a boat. Many of Monet's early works include expanses of water, such as on the bank of the seine, bennecourt (FIG. 30-51). Monet's effort to capture the intense brightness of the sunlight led to the creation of this work, which one critic complained made his eyes hurt. Monet applied the flat expanses of pure color to the canvas unmixed, directly out of the tube, and he avoided underpainting his canvases in brown, as the academics taught. This is a solitary figure in a landscape, but it is not a Romantic vision. Monet visited

England in 1870 and saw the extremely painterly works by Turner, such as *The Burning of the Houses of Lords and Commons* (SEE FIG. 30–16). While Turner's brushwork may have influenced some of Monet's later landscapes, Monet did not share the older artist's commitment to feeling or to narrative. He said simply, "The Romantics have had their day." Instead he painted simple moments, capturing the play of light quickly before it changed.

In the 1870s, Monet moved further away from his Barbizon sources and began painting more urban subjects, such as the St. Lazare railway station (FIG. 30–52). This was a new structure, made of steel and glass, and Monet was fascinated by the way light descended through the glass ceiling and filtered through the steam from the trains parked beneath. He set up his easel in the station (to the consternation of the station manager), and painted twelve different views of the canopy under differing light conditions. The railroad was at that time a modern conveyance, bringing hordes of people from the countryside into the center of Paris. Monet had no interest in the human drama of the arrivals and departures, but rather he

focused on the evanescent qualities of the light in the context of modern urban haste.

Monet carried out his quest to record the shifting play of light on the surface of objects and the effect of that light on the eye without concern for the physical character or any symbolic importance of the objects he represented. The American painter Lilla Cabot Perry, who befriended Monet in his later years, recalled him telling her:

When you go out to paint, try to forget what objects you have before you—a tree, a house, a field, or whatever. Merely think, Here is a little square of blue, here an oblong of pink, here a streak of yellow, and paint it just as it looks to you, the exact color and shape, until it gives your own naive impression of the scene before you.

Perry also reported that Monet

said he wished he had been born blind and then had suddenly gained his sight so that he could have begun to paint in this way without knowing what the objects were that he saw before him. He held that the first real look at the motif was likely to be the truest and most unprejudiced one....

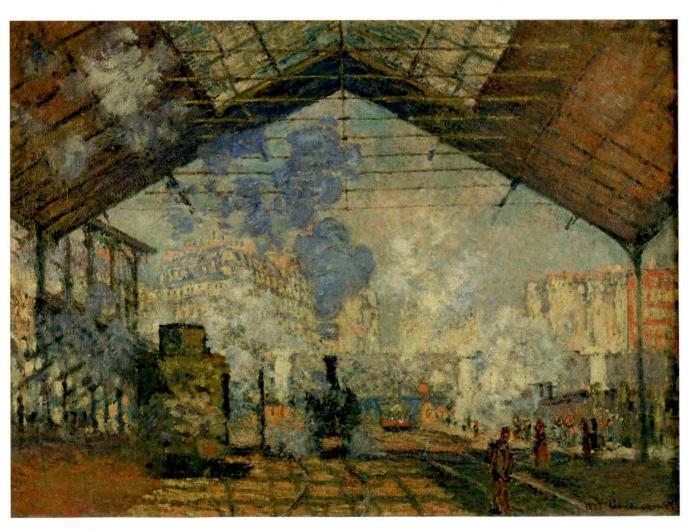

30–52 | Claude Monet GARE ST-LAZARE 1877. Oil on canvas, $29\% \times 50''$ (75.5 \times 104 cm). Musée d'Orsay, Paris. Photo: Erich Lessing/Art Resource, NY

Two important ideas are expressed here. One is that a quickly painted oil sketch most accurately records a landscape's general appearance. This view had been a part of academic training since the late eighteenth century, but such sketches were considered merely part of the preparation for a finished work. In essence Monet attempted to raise these traditional "sketch aesthetics" to the same level as a completed painting. As a result, the major criticism at the time was that his paintings were not "finished." The second idea is a more modern one, that an artist can see a subject freshly, without preconceptions or traditional filters. This was an inheritance of the Barbizon painters, and it led the Impressionists to paint subjects that had not been painted before. They sought subject matter that lacked the traditional markers of appropriateness: symbolic content, historical allusion, or narrative meanings. Instead they painted modern urban and suburban life in a way that captured its fastchanging character.

In the 1880s and 1890s, Monet focused his vision yet more intently, taking the idea of a series of works to other outdoor subjects: grain stacks, rows of poplar trees against the sky, and the cathedral at Rouen (FIG. 30–53). He painted the cathedral not because he suddenly discovered religion late in life, but because he found the church's undulating stone surface a laboratory of natural light effects, which he could paint without worrying much about perspective. He especially focused on the content of the shadows in the façade's deep niches, where he sometimes found iridescent overtones created by afterimages on his retina.

COUNTRY AND CITY IN PLEIN AIR. Although he painted during the 1870s in a style similar to Monet's, Camille Pissarro (1830–1903) identified more strongly with peasants and rural laborers. Born in the Danish West Indies to a French family and raised near Paris, Pissarro studied art in that city during the 1850s and early 1860s. After assimilating the influences of both Corot and Courbet, Pissarro embraced Impressionism in 1870, when both he and Monet were living in London to escape the Franco-Prussian War. There, they worked closely together, dedicating themselves, as Pissarro later recalled, to "plein air light and fugitive effects." The result, for both painters, was a lightening of color and a loosening of the way they handled paint.

Following his return to France, Pissarro settled in Pontoise, a small, hilly village northwest of Paris that retained a thoroughly rural character. There he worked for much of the 1870s in a style close to that of Monet, using high-keyed color and short brushstrokes to capture fleeting qualities of light and atmosphere. Rather than the vacationer's landscapes that Monet favored, however, Pissarro chose agrarian themes such as orchards and tilled fields. In the late 1870s his painting tended toward greater visual and material complexity.

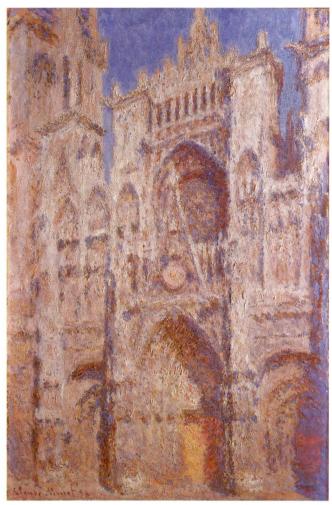

30–53 \perp Claude Monet ROUEN CATHEDRAL: THE PORTAL (IN SUN) 1894. Oil on canvas, $39\frac{7}{4}\times26^{\prime\prime}$ (99.7 \times 66 cm). The Metropolitan Museum of Art, New York. Theodore M. Davis Collection, Bequest of Theodore M. Davis, 1915 (30.95.250)

Monet painted more than thirty views of the façade of Rouen Cathedral. He probably began each canvas during two stays in Rouen in early 1892 and early 1893, observing his subject from a second-story window across the street. He then finished the whole series in his studio at Giverny. In these paintings Monet continued to pursue his Impressionist aim of capturing fleeting effects of light and atmosphere, but his extensive reworking of them in the studio produced pictures far more carefully orchestrated and laboriously executed than his earlier, more spontaneously painted *plein air* canvases.

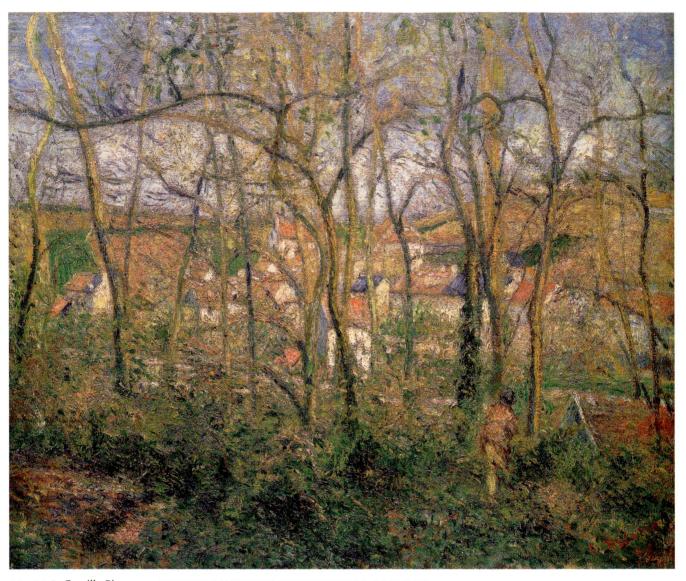

30–54 | Camille Pissarro WOODED LANDSCAPE AT L'HERMITAGE, PONTOISE 1878. Oil on canvas, $18\% \times 22\%$ " (46.5 \times 56 cm). The Nelson-Atkins Museum of Art, Kansas City, Missouri. Gift of Dr. and Mrs. Nicholas S. Pickard

wooded Landscape at L'Hermitage, pontoise (FIG. 30–54) reflects the continuing influence of Corot (SEE FIG. 30–40) in its composition of foreground trees that screen the view of a rural path and village and in its inclusion of a rustic figure at the lower right. Pissarro uses a brighter and more variegated palette than Corot, however, and he applies his paint more thickly, through a multitude of dabs, flecks, and short brushstrokes. One hostile critic remarked, accurately but painfully, "Corot, Corot, what crimes are committed in your name!"

More typical of the Impressionists in his proclivity for painting scenes of upper-middle-class recreation was Pierre-Auguste Renoir (1841–1919), who met Monet at the École des Beaux-Arts in 1862. Despite his early predilection for figure painting in a softened, Courbet-like mode, Renoir was encouraged by his more forceful friend Monet to create pleasant, light-filled landscapes, which were painted outdoors. By

the mid-1870s Renoir was combining Monet's style in the rendering of natural light with his own taste for the figure.

MOULIN DE LA GALETTE (FIG. 30–55), for example, features dancers dappled in bright afternoon sunlight. The Moulin de la Galette (the "Pancake Mill"), in the Montmartre section of Paris, was an old-fashioned Sunday afternoon dance hall, which during good weather made use of its open courtyard. Renoir has glamorized its working-class clientele by replacing them with his young artist friends and their models. Frequently seen in Renoir's work of the period, these attractive people are shown in attitudes of relaxed congeniality, smiling, dancing, and chatting. The innocence of their flirtations is underscored by the children in the lower left, while the ease of their relations is emphasized by the relaxed informality of the composition itself. The painting is knit together not by figural arrangement but by the overall mood, the sunlight falling through the

trees, and the way Renoir's soft brushwork weaves his blues and purples through the crowd and across the canvas. This idyllic image of a carefree age of innocence, a kind of paradise, nicely encapsulates Renoir's essential notion of art: "For me a picture should be a pleasant thing, joyful and pretty—yes pretty! There are quite enough unpleasant things in life without the need for us to manufacture more."

URBAN ANGLES. Subjects of urban leisure also attracted Edgar Degas (1834–1917), but he did not share the *plein air* Impressionists' interest in outdoor light effects. Instead, Degas composed his pictures in the studio from working drawings—a traditional academic procedure. Degas had in fact received rigorous academic training at the École des Beaux-Arts in the mid-1850s and subsequently spent three years in Italy studying the Old Masters. Firm drawing and careful composition remained central features of his art for the duration of his career, setting it apart from the more spontaneously executed pictures of the *plein air* painters.

The son of a Parisian banker, Degas was closer to Manet than to other Impressionists in age and social background. He was also the most well trained in a traditional sense, having studied with a pupil of Ingres and having made numerous copies of masterworks in museums (a typical way for students to learn in those days). After a period of painting psychologically probing portraits of friends and relatives, Degas became convinced that traditional painting had no future, so he turned in the 1870s to more modern subjects such as the racetrack, music hall, opera, and ballet. Composing his ballet scenes from carefully observed studies of rehearsals and performances, Degas, in effect, arranged his own visual choreography. THE REHEARSAL ON STAGE (FIG. 30–56), for example, is not a factual record of something seen but a careful contrivance, intended to delight the eye. The rehearsal is viewed from an opera box close to the stage, creating an abrupt foreshortening of the scene emphasized by the dark scrolls of the bass viols that jut up from the lower left. His work shows two new important influences: The angular viewpoint in this and many other works shows his knowledge of Japanese prints, which he collected, and the seemingly arbitrary cropping of figures (seen here at the left) shows the influence of photography, which he also practiced. His work diverges significantly

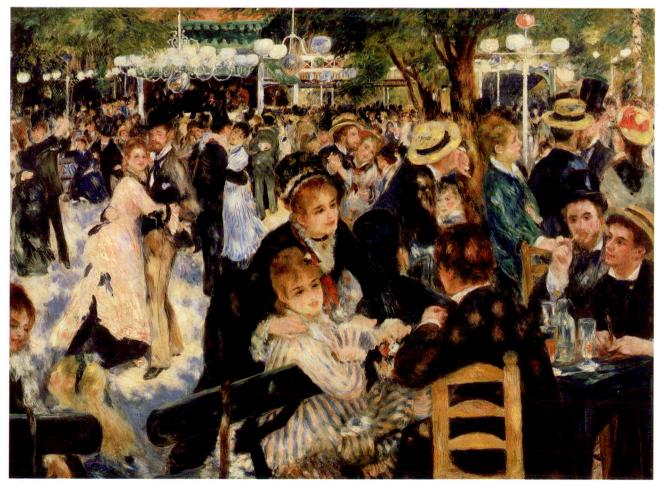

30–55 | Pierre-Auguste Renoir MOULIN DE LA GALETTE
1876. Oil on canvas, 4'3½" × 5'9" (1.31 × 1.75 m). Musée d'Orsay, Paris.

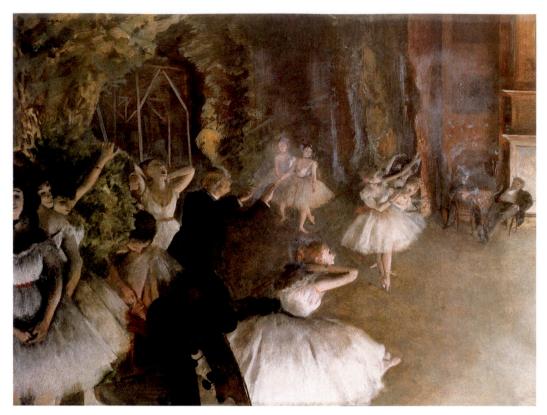

In the right background of Degas's picture sit two well-dressed, middle-aged men, each probably a "protector" (lover) of one of the dancers. Because ballerinas generally came from lower-class families and exhibited their scantily clad bodies in public—something that "respectable" bourgeois women did not do—they were widely assumed to be sexually available, and they often attracted the attentions of wealthy men willing to support them in exchange for sexual favors. Several of Degas's ballet pictures also include one or more of the dancers' mothers, who would accompany their daughters to rehearsals and performances in order to safeguard their virtue.

from that of the other Impressionists in these compositional techniques and also in his subjects, which are mostly indoors under artificial light. But the Realist novelist Edmond de Goncourt, a friend of most of the Impressionists, said that Degas was most able to capture "the soul of modern life."

We see similarly jarring angles in contemporary urban views in the art of Gustave Caillebotte (1848–1894), a friend of Degas who helped organize some of the Impressionist exhibitions and bought works from them when they needed financial assistance. Private study with an academic teacher qualified him for the École des Beaux-Arts, but he never attended. Rather, Caillebotte was fascinated by the new urban geometry that modern construction and Haussmann's new street grid produced. His **PARIS STREET, RAINY DAY** (FIG. 30–57) shows an unconventional and offhand composition similar to those of Degas, but with a gaping hole in the center where the street rushes away into seeming infinity. This is a typically open intersection that Haussmann's carving-up of Paris produced, here portrayed in somewhat exaggerated perspective. The figure at the right is cropped and crowded in

with two others in one half of the canvas, delineated by a lamppost; the other half is mostly building façades and a rain-soaked stone street. Caillebotte's painting technique owed little to Monet's pure colors, but his subjects and compositions remain jarringly modern.

UPPER-CLASS LIVES. Another artist who showed with the Impressionists was the American expatriate Mary Cassatt (1844–1926). Born near Pittsburgh to a well-to-do family, Cassatt studied at the Pennsylvania Academy of the Fine Arts in Philadelphia between 1861 and 1865 and then moved to Paris for further academic training. She lived in France for most of the rest of her life. The realism of the figure paintings she exhibited at the Salons of the early and middle 1870s attracted the attention of Degas, who invited her to participate in the fourth Impressionist exhibition, in 1879. Although she, like Degas, remained a studio painter, disinterested in plein air painting, her distaste for what she called the tyranny of the Salon jury system made her one of the group's staunchest supporters.

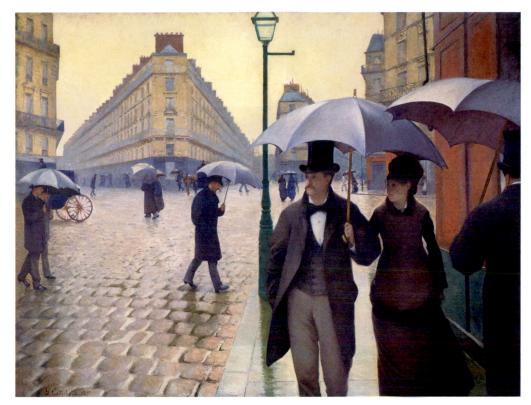

30–57 | Gustave Caillebotte PARIS STREET, RAINY DAY 1877. Oil on canvas, $83\frac{1}{2} \times 108\frac{3}{4}$ " (212.2 \times 276.2 cm). The Art Institute of Chicago. Part of the Charles H. and Mary F. S. Worcester Fund

Cassatt focused her work on the world to which she had access: the domestic and social life of well-off women. One of the paintings she exhibited in 1879 was **woman in a loge** (Fig. 30–58). The painting's bright and luminous color, fluent brushwork, and urban subject were no doubt chosen partly to demonstrate her solidarity with her new associates. (Renoir had exhibited a very similar image of a woman at the opera in 1874.) Reflected in the mirror behind the smiling woman are other operagoers, some with opera glasses trained not on the stage but on the crowd around them, scanning it for other elegant socialites. As Charles Garnier had noted, his new Opéra (SEE Fig. 30–34) made an ideal backdrop for just this kind of display.

30–58 | Mary Cassatt **WOMAN IN A LOGE** 1879. Oil on canvas, $31\% \times 23''$ (80.3×58.4 cm). Philadelphia Museum of Art. Bequest of Charlotte Dorrance Wright

Long known as *Lydia in a Loge*, *Wearing a Pearl Necklace*, this painting was believed to portray Cassatt's sister, Lydia, who came to live with her in 1877 and posed for many of her works. The young, redhaired sitter does not resemble the older, dark-haired Lydia, however, and was probably a professional model whose name has not been recorded. The painting is now known by the title it had when shown at the fourth Impressionist exhibition in 1879.

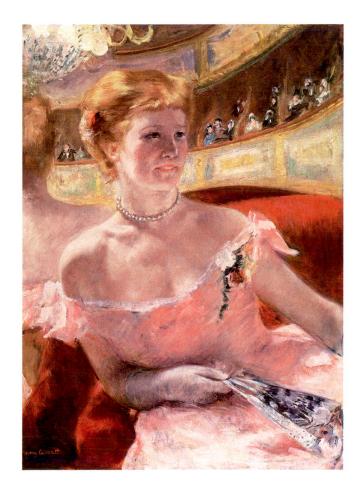

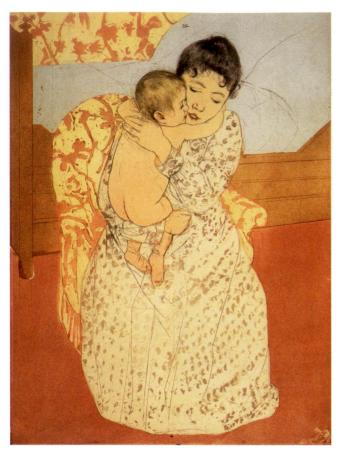

30–59 | Mary Cassatt MATERNAL CARESS 1891. Drypoint, soft-ground etching, and aquatint on paper, $14\frac{1}{4} \times 10\frac{1}{4}$ " (37.5 \times 27.3 cm). National Gallery of Art, Washington, D.C. Chester Dale Collection (1963.10.255)

Her later work shows the influence of Japanese prints, as the artist began endowing her compositions with more solid forms in off-balance compositions (FIG. 30–59). The clashing patterns in the mother's dress and the chair, with the tipped "horizon" line from the bed seen at an angle, testify to this influence. Though she lived as an expatriate, Cassatt retained her connections with upper-class society back in the United States, and when her friends and relatives came to visit she encouraged them to buy works by the Impressionists, thus creating a market for their work in the United States before one developed in France itself.

Cassatt decided early to have a career as a professional artist, but Berthe Morisot (1841–95) came to that decision only after years in the amateur role then conventional for women. Morisot and her sister, Edma, copied paintings in the Louvre and studied under several different teachers, including Corot, in the late 1850s and early 1860s. The sisters showed in the five Salons between 1864 and 1868, the year they met Manet. In 1869 Edma married and, following the traditional course, gave up painting to devote herself to domestic duties. Berthe, on the other hand, continued painting, even after her 1874 marriage to Manet's brother, Eugène, and the birth of

their daughter in 1879. Morisot sent nine works to the first exhibition of the Impressionists in 1874 and showed in all but one of their subsequent exhibitions.

Like Cassatt, Morisot dedicated her art to the lives of bourgeois women, which she depicted in a style that became increasingly loose and painterly over the course of the 1870s. In works such as **SUMMER'S DAY** (FIG. 30–60), Morisot pushed the "sketch aesthetics" of Impressionism almost to their limit, dissolving her forms into a flurry of feathery brushstrokes. Originally exhibited in the fifth Impressionist exhibition in 1880 under the title *The Lake of the Bois du Boulogne*, Morisot's picture is typically Impressionist in its depiction of modern urban leisure in a large park on the fashionable west side of Paris. As the women apparently ride in a ferry between tiny islands in the largest of the park's lakes, the viewer occupies a seat opposite them and is invited to share their enjoyment of the delicious weather and pleasant surroundings.

LATER MANET. Although he never exhibited with the Impressionists, preferring to submit his pictures to the official Salons where he had only limited success, Édouard Manet nevertheless in the 1870s followed their lead by lightening his palette, loosening his brushwork, and confronting modern life in a more direct manner than he had in *Le Déjeuner sur l'Herbe* and *Olympia*, both of which maintained a dialogue with the art of the past. But complicating Manet's apparent acceptance of the Impressionist viewpoint was his commitment, conscious or not, to counter Impressionism's essentially optimistic interpretation of modern life with a more pessimistic (we might say Realist) one.

Manet's last major painting, A BAR AT THE FOLIES-BERGÈRE (FIG. 30-61), for example, contradicts the happy aura of works such as Moulin de la Galette (SEE FIG. 30-55) and Woman in a Loge (SEE FIG. 30-58). In the center of the painting stands one of the barmaids at the Folies-Bergère, a large nightclub with bars arranged around a theater that offered circus, musical, and vaudeville acts. Reflected in the mirror behind her is some of the elegant crowd, who are entertained by a trapeze act. (The legs of one of the performers can be seen in the upper left.) On the marble bartop Manet has spread a glorious still life of liquor bottles, tangerines, and flowers, associated not only with the pleasures for which the Folies-Bergère was famous but also with the barmaid herself, whose wide hips, strong neck, and closely combed golden hair are echoed in the champagne bottles. The barmaid's demeanor, however, refutes these associations. Manet puts the viewer directly in front of her, in the position of her customer. She neither smiles at this customer, as her male patrons and employers expected her to do, nor gives the slightest hint of recognition. She appears instead to be self-absorbed and slightly depressed, perfunctory in the manner of the many shallow interactions that urban life enables. But in the mirror

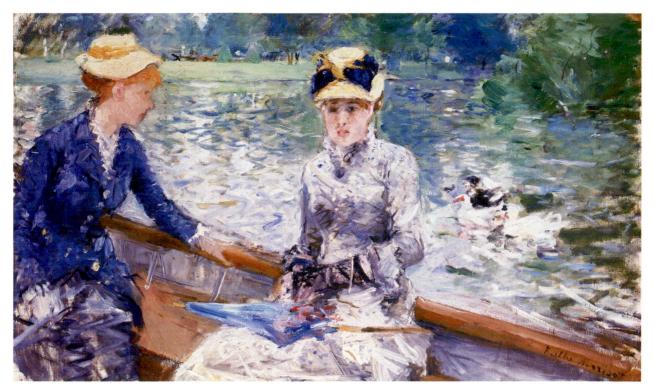

30–60 | Berthe Morisot SUMMER'S DAY 1879. Oil on canvas, 17 $^{13}\!\!/_{16} \times 29 \, ^{9}\!\!/_{16}$ " (45.7 \times 75.2 cm). The National Gallery, London. Lane Bequest, 1917

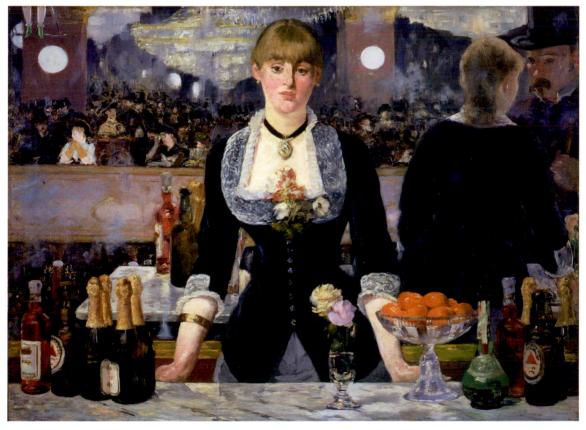

behind her, her reflection and that of her customer tell a different story. In this reflection, which Manet has curiously shifted to the right as if the mirror were placed at an angle, the barmaid leans toward the patron, whose intent gaze she appears to meet; the physical and psychological distance between them has vanished. Exactly what Manet meant to suggest by this juxtaposition has been much debated. One possibility is that he wanted to contrast the longing for happiness and intimacy, reflected miragelike in the mirror, with the disappointing reality of ordinary existence that directly confronts the viewer of the painting.

THE BIRTH OF MODERN ART

Manet and the Impressionists are generally regarded as the initiators of Modern art, a many-faceted movement that began probably in the 1860s and lasted for just over a hundred years. Rather than a cohesive movement with specific stylistic characteristics (such as the Rococo, for example), Modern art is distinguished primarily by a rejection of the traditions of art that had been handed down since the Renaissance. This traditional legacy came to artists in the form of customs, techniques, conventions, and rules. Custom dictated, for example, that artists paint with oil on canvas, using their brushes in certain ways, or that they cast public monuments in bronze. Techniques formed the principal subject of art instruction, such as one-point perspective and figure drawing from the nude. Conventions are the often unspoken agreements between artists and viewers, which, for example, lead Western viewers to see three-dimensional space in a painting's flat surface or to regard large works as more important than small ones. Rules are more stringent prohibitions, such as obscenity laws, which can invoke penalties. Far from being restrictive, this network of traditions defined Western art for about 400 years, giving artists a scope in which to operate and a set of values by which viewers could judge their products. Before Modern art, most innovation took place within the tradition.

Yet in the second half of the nineteenth century, artists began seriously and systematically to question that traditional legacy. They did this for various reasons, which some artists spoke about and others acted on unconsciously. Some thought that the tradition was simply used up and that nothing more could be said with it. Others regarded the tradition as irrelevant to the fast-changing world of urbanization and industrialization of that period. Claude Monet, for example, disregarded his academic teacher when he urged the class to think of Greek sculpture every time they saw a nude. Monet had serious doubts about the relevance of Greek sculpture to modern life. Some artists (probably a minority) were natural rebels who generally believed in opposing authority. The rise of photography was another important impetus to experimentation in art: Why perfect ancient methods of rendering

a subject when a machine could do it almost as well? Whatever the reason, Modern artists rejected not only the tradition but also the superstructure that came with it in the form of academic training, Salon exhibitions, and the taste of most of the art-viewing public. This choice was a costly one for many of them, who could have had much more lucrative careers if they had created their art in more acceptable modes.

A deeper cause of Modern art was the modernization of society. The Industrial Revolution created a new public for art in the urban middle classes who flocked to the Salons in search of culture. As we have seen, their taste was cautious and conservative, favoring Academic artists such as Bouguereau, Carpeaux, and Cabanel. Modern artists had little interest in catering to this clientele, and preferred to carry out and exhibit their experiments in realms outside the norm.

In place of the "official" art culture, Modern artists created what has been called an avant-garde. The term was initially used in a military context, designating the forward units of an advancing army that scouted territory which the rest of the troops would soon occupy. This term thus captures the forward-looking aspect of Modern art, and the belief that Modernists are working ahead of the public's ability to comprehend. As an art-world social group, the avant-garde consisted of Modern artists, along with a few collectors, art critics, and art dealers who followed the latest developments and found them stimulating. These two concepts, the rejection of tradition and the avant-garde, are most important for understanding Modern art.

Despite the angry protestations of conservative critics, the rejection of tradition did not happen all at once. In fact, the Modern art movement unfolded in a gradual and even logical way, as artists questioned and threw out one rule after another in succeeding decades. Modernism was not revolutionary but rather evolutionary. The Realists shunned traditional narrative content and properly "dignified" subject matter. The Impressionists also did that, and in addition they broke the convention that separated sketch from finished work. Although they seemed radical to some at the time, both of these movements left large parts of the tradition perfectly intact. After Impressionism began to run its course in the middle 1880s, other movements came along to challenge other aspects of the tradition. To these artists and movements we turn next.

Post-Impressionism

The English critic Roger Fry coined the term *Post-Impressionism* in 1910 to identify a broad reaction against Impressionism in avant-garde painting of the late nineteenth and early twentieth centuries. Art historians recognize Paul Cézanne (1839–1906), Georges Seurat (1859–1891), Vincent van Gogh (1853–1890), and Paul Gauguin (1848–1903) as the principal Post-Impressionist artists. Each of these painters moved through an Impressionist phase, and each continued to use in his mature work the bright Impressionist palette. But each came also to reject

Impressionism's emphasis on the spontaneous recording of light and color. Some sought to create art with a greater degree of formal order and structure; others moved further from Impressionism and developed more abstract styles that would prove highly influential for the development of Modern painting in the early twentieth century.

CÉZANNE. No artist had a greater impact on the next generation of Modern painters than Cézanne, who enjoyed little professional success until the last few years of his life, when younger artists and critics began to recognize the innovative qualities of his art. The son of a prosperous banker in the southern French city of Aix-en-Provence, Cézanne studied art first in Aix and then in Paris, where he participated in the circle of Realist artists around Manet. Cézanne's early pictures, somber in color and coarsely painted, often depicted Romantic themes of drama and violence, and were consistently rejected by the Salon.

In the early 1870s Cézanne changed his style under the influence of Pissarro and adopted the bright palette, broken brushwork, and everyday subject matter of Impressionism. Like the Impressionists, with whom he exhibited in 1874 and 1877, Cézanne now dedicated himself to the objective transcription of what he called his "sensations" of nature. Unlike the Impressionists, however, he did not seek to capture transi-

Sequencing Works of Art

1884	Homer, The Life Line
1884–86	Seurat , A Sunday Afternoon on the Island of La Grande Jatte
1884-89	Rodin, Burghers of Calais
1885-87	Cézanne, Mont Sainte-Victoire
1887-89	Eiffel, Eiffel Tower, Paris
1889	van Gogh, The Starry Night

tory effects of light and atmosphere but rather to create a sense of order in nature through a methodical application of color that merged drawing and modeling into a single process. His professed aim was to "make of Impressionism something solid and durable, like the art of the museums."

Cézanne's tireless pursuit of this goal is exemplified in his paintings of Mont Sainte-Victoire, a prominent mountain near his home in Aix that he depicted about thirty times in oil from the mid-1880s to his death. The version here (FIG. 30–62) shows the mountain rising above the Arc Valley, which is dotted with houses and trees and is traversed at the far right by an aqueduct. Framing the scene at the left is an

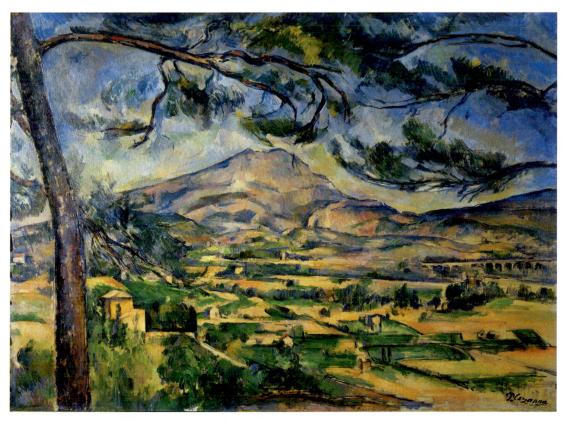

30–62 | Paul Cézanne MONT SAINTE-VICTOIRE c. 1885–87. Oil on canvas, $25\,\% \times 32''$ (64.8 \times 92.3 cm). Courtauld Institute of Art Gallery, London. (P.1934.SC.55)

evergreen tree, which echoes the contours of the mountains, creating visual harmony between the two principal elements of the composition. The even lighting, still atmosphere, and absence of human activity in the landscape communicate a sense of timeless endurance, at odds with the Impressionists' interest in capturing a momentary aspect of the everchanging world.

Cézanne's paint handling is more deliberate and constructive than the Impressionists' spontaneous and comparatively random brushwork. His strokes, which vary from short, parallel hatchings to sketchy lines to broader swaths of flat color, not only record his "sensations" of nature but also weave every element of the landscape together into a unified surface design. That surface design coexists with the effect of spatial recession that the composition simultaneously creates, generating a fruitful tension between the illusion of three dimensions "behind" the picture plane and the physical reality of its two-dimensional surface. On the one hand, recession into depth is suggested by elements such as the foreground tree, a **repoussoir** (French for "something that pushes back") that helps draw the eye into the valley and toward the distant mountain range, and by the gradual transition from the saturated greens and orange-yellows of the foreground to the softer blues and pinks in the mountain, which create an effect of atmospheric perspective. On the other hand, this illusion of consistent recession into depth is challenged by the inclusion of blues, pinks, and reds in the foreground foliage, which relate the foreground forms to the background mountain and sky, and by the tree branches in the sky, which follow the contours of the mountain, making the peak appear nearer and binding it to the foreground plane. Contemporary photographs of this same location reveal that Cézanne composed his paintings not according to how the scene looked. Nor did he alter the fact to fit his feeling, as a Romantic might. Rather, he depicted the scene in accordance with the harmony that the composition of the painting itself demanded. This proved a tremendously fruitful idea for future artists.

Spatial ambiguities of a different sort appear in Cézanne's late still lifes, in which many of the objects seem incorrectly drawn. In STILL LIFE WITH BASKET OF APPLES (FIG. 30-63), for example, the right side of the table is higher than the left, the wine bottle has two different silhouettes, and the pastries on the plate next to it are tilted upward while the apples below seem to be viewed head-on. Such apparent inaccuracies are not evidence of Cézanne's incompetence, however, but of his willful disregard for the rules of traditional scientific perspective. Although scientific perspective mandates that the eye of the artist (and hence the viewer) occupy a fixed point relative to the scene being observed (see "Brunelleschi, Alberti and Renaissance Perspective," page 622), Cézanne studies different objects in a painting from slightly different positions. Most of us, after all, when examining a scene, turn our head or move our bodies in order to take it all in. This composition as a whole, assembled from multiple sightings of its various elements, is complex and dynamic and even seems on the verge of collapse. The pastries look as if they could levitate, the bottle tilts precariously, the fruit basket appears ready to spill its contents, and only the folds and small tucks in the white cloth seem to prevent the apples from cascading to the floor. All of these physical improbabilities are designed, however, to serve the larger visual logic of the painting as a work of art, characterized by Cézanne as "something other than reality"—not a direct representation of nature but "a construction after nature." As with his landscapes, the distinction is a crucial one that later artists would exploit.

30–63 | Paul Cézanne

STILL LIFE WITH BASKET OF APPLES

1890–94. Oil on canvas, 24 ½ × 31"

(62.5 × 79.5 cm). The Art Institute of Chicago.

Helen Birch Bartlett Memorial Collection

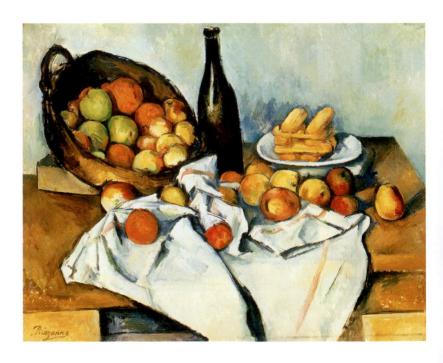

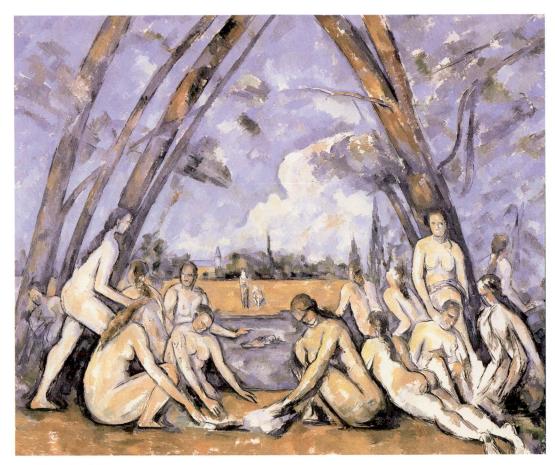

30–64 | Paul Cézanne | THE LARGE BATHERS
1906. Oil on canvas, $6'10'' \times 8'2''$ (2.08 \times 2.49 m). Philadelphia Museum of Art. The W. P. Wilstach Collection

Toward the end of his life, Cézanne's constructions after nature became increasingly abstract, as we see in the monumental THE LARGE BATHERS (FIG. 30-64), probably begun in the last year of his life, and left unfinished. This canvas, the largest Cézanne ever painted, culminated his involvement with the subject of nude bathers in nature, a theme he had admired in the Old Masters and had depicted on numerous earlier occasions. Unlike his predecessors, however, Cézanne did not usually paint directly from models but instead worked from earlier drawings, photographs, and memory. As a result, his bathers do not appear lifelike but have simplified, schematic forms. In The Large Bathers, the bodies cluster in two pyramidal groups at the left and right sides of the painting, beneath a canopy of trees that opens in the middle onto a triangular expanse of water, landscape, and sky. The figures assume motionless, statuesque poses (the crouching figure at the left quotes the Hellenistic Crouching Venus that Cézanne had copied in the Louvre) and seem to exist in a timeless realm, unlike the bathers of Manet (SEE FIG. 30-49), who clearly inhabit the modern world. Emphasizing the scene's serene remoteness from everyday life, the simplified yet resonant palette of blues and greens, ochers and roses, laid down in large patches over a white ground, suffuses the picture with light. Despite its unfinished state, The Large Bathers stands as a grand summation of Cézanne's art. His conception of the canvas as a separate realm from reality, requiring its own rules of composition, is his chief legacy to Modern art.

SEURAT. Georges Seurat was another artist who, like Cézanne, adapted Impressionist discoveries to the creation of an art of greater structure and monumentality. Born in Paris and trained at the École des Beaux-Arts, Seurat became devoted to classical aesthetics, which he combined with a rigorous study of optics and color theory, especially the "law of the simultaneous contrast of colors," first formulated by Michel-Eugène Chevreul in the 1820s. Chevreul's law holds that adjacent objects not only cast reflections of their own color onto their neighbors but also create in them the effect of their complementary color. Thus, when a blue object is set next to a yellow one, the eye will detect a trace of purple, the complement of yellow, and in the yellow object a trace of orange, the complement of blue.

The Impressionists knew of Chevreul's law but had not applied it systematically. Seurat, however, approached color as a scientist might. He calculated exactly which hues should be combined, in what proportion, to produce the effect of a particular color. He then set these hues down in dots of pure color, next to one another, in what came to be known by the

various names of *divisionism* (the term preferred by Seurat), *pointillism*, and *Neo-Impressionism*. In theory, these juxtaposed dots would merge in the viewer's eye to produce the impression of other colors, which would be perceived as more luminous and intense than the same hues mixed on the palette. In Seurat's work, however, this optical mixture is never complete, for his dots of color are large enough to remain separate in the eye, giving his pictures a grainy appearance the artist liked because it better showed the underlying order of his work.

Seurat's best-known work is **A SUNDAY AFTERNOON ON THE ISLAND OF LA GRANDE JATTE** (FIG. 30–65), which he first exhibited at the eighth and final Impressionist exhibition in 1886. The theme of weekend leisure is typically Impressionist, but the rigorous divisionist technique, the stiff formality of the figures, and the highly calculated geometry of the composition produce a solemn, abstract effect quite at odds with the casual naturalism of earlier Impressionism. Seurat's picture in fact depicts a contemporary subject in a highly formal style recalling much older art, such as that of the ancient Egyptians.

From its first appearance, A Sunday Afternoon on the Island of La Grande Jatte has generated conflicting interpretations. Contemporary accounts of the island indicate that on Sundays it was noisy, littered, and chaotic. By painting it the way he did, Seurat may have intended to show how tranquil it should be. It is more likely that he was satirizing the Parisian middle class, since like Pissarro he was a devotee of anarchist beliefs and made cartoons for anarchist magazines at that time.

VAN GOGH. Among the many artists to experiment with divisionism was the Dutch painter Vincent van Gogh, who took divisionism and Impressionism and made of them a highly expressive personal style. The oldest son of a Protestant minister, van Gogh worked as an art dealer, teacher, and evangelist before deciding in 1880 to become an artist. After brief periods of study in Brussels, The Hague, and Antwerp, he moved in 1886 to Paris, where he discovered the work of the Impressionists and Post-Impressionists. Van Gogh quickly adapted Seurat's divisionism, but rather than laying his paint

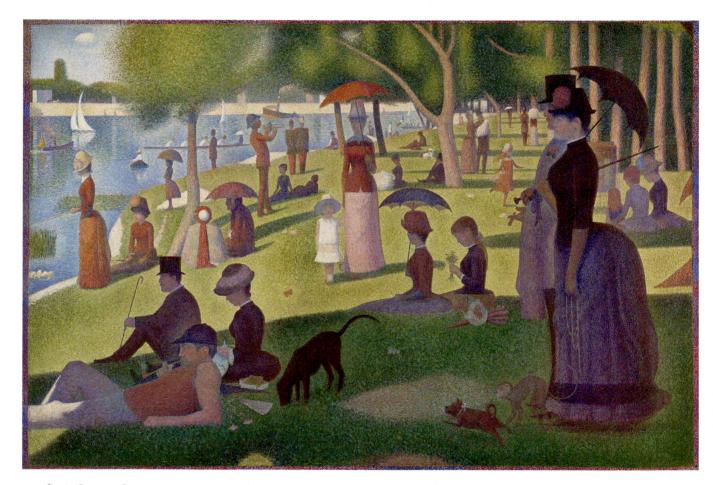

30–65 | Georges Seurat A SUNDAY AFTERNOON ON THE ISLAND OF LA GRANDE JATTE 1884–86. Oil on canvas, $6'9\%\%\times10'1\%\%$ (2.07 \times 3.08 m). The Art Institute of Chicago. Helen Birch Bartlett Memorial Collection

Although the painting is highly stylized and carefully composed, it has a strong basis in factual observation. Seurat spent months visiting the island, making small studies, drawings, and oil paintings of the light and the people he found there. All of the characters in the final painting, including the woman with the monkey, were based on his observations at the site.

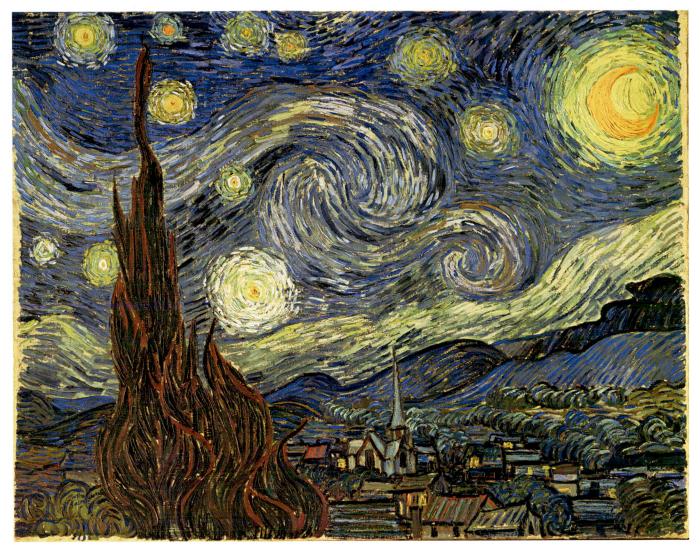

30–66 | Vincent van Gogh | THE STARRY NIGHT 1889. Oil on canvas, $28\,\% \times 36\,\%''$ (73 \times 93 cm). The Museum of Modern Art, New York. Acquired through the Lillie P. Bliss Bequest (472.1941)

down regularly in dots, he typically applied it freely in multidirectional dashes of impasto (thick applications of pigment), which gave his pictures a greater sense of physical energy and a palpable surface texture.

Van Gogh was a socialist who believed that modern life, with its constant social change and focus on progress and success, alienated people from each other and themselves (see "Modern Artists and World Cultures," page 1042). His own paintings are efforts to establish empathy between artist and viewer, thereby overcoming some of the emotional barrenness that he felt modern society created. In a steady and prolific output over ten years, he communicated his emotional state in paintings that contributed significantly to the emergence of the Expressionistic tradition, in which the intensity of an artist's feelings overrides fidelity to the actual appearance of things. For example, he once described his working method in a letter to his brother:

I should like to paint the portrait of an artist friend who dreams great dreams, who works as the nightingale sings, because it is his nature. This man will be fair-haired. I should like to put my appreciation, the love I have for him, into the picture. So I will paint him as he is, as faithfully as I can—to begin with. But that is not the end of the picture. To finish it, I shall be an obstinate colorist. I shall exaggerate the fairness of the hair, arrive at tones of orange, chrome, pale yellow. Behind the head—instead of painting the ordinary wall of the shabby apartment, I shall paint infinity, I shall do a simple background of the richest, most intense blue that I can contrive, and by this simple combination, the shining fair head against this rich blue background, I shall obtain a mysterious effect, like a star in the deep blue sky.

One of the earliest and most famous examples of Expressionism is **THE STARRY NIGHT** (FIG. 30–66), which van Gogh painted from imagination and memory as well as

Art in Its Context

MODERN ARTISTS AND WORLD CULTURES

on-Western art has been a constant influence on a great deal of Modern art. In some respects this is logical, because if artists regard their own tradition as outmoded or in need of reform, they may naturally look to other cultures for inspiration. Artistic interest in foreign cultures is certainly not new—the Orientalists, for example, visited many countries—but unlike previous cultural interactions, Modern artists were open to stylistic influence from nearly every inhabited continent.

The first wave of such influence was from Japan, beginning shortly after the U.S. Navy forcibly opened that country to Western trade and diplomacy in 1853.

Two years later, France, England, Russia, and the United States signed trade agreements that permitted regular exchange of goods. The first Japanese art to engage the attention of Modern artists was a sketchbook called *Manga* by Hokusai (1760–1849), which several Parisian artists eagerly passed around. Soon it became fashionable for people connected to the art world to collect Japanese objects for their homes. Édouard Manet, for example, painted a portrait of Emile Zola at his desk along with a Japanese screen and some prints that he owned. The Paris International Exposition of 1867 hosted the first exhibit of Japanese prints on the continent.

Soon, Japanese lacquers, fans, bronzes, hanging scrolls, kimonos, ceramics, illustrated books, and *ukiyo-e* (prints of the "floating world," the realm of geishas and popular entertainment) began to appear in Western European specialty shops, art galleries, and even some department stores. French interest in Japan and its arts reached such proportions by 1872 that the art critic Philippe Burty gave it a name: *japonisme*.

Japanese art profoundly influenced Western painting, print-making, applied arts, and eventually architecture. The tendency toward simplicity, flatness, and the decorative evident in much painting and graphic art in the West between roughly 1860 and 1900 is probably the most characteristic result of that influence. Nevertheless, its impact was extraordinarily diverse. What individual artists took from the Japanese depended on their own interests. Thus, Whistler found encouragement for his decorative conception of art, while Edgar Degas discovered both realistic subjects and interesting compositional arrangements, and those interested in the reform of late nineteenth-century industrial design found in Japanese objects both fine craft and a smooth elegance lacking in the West. Vincent van Gogh enjoyed the bold design and hand-crafted quality of Japanese prints. He both owned and copied Japanese prints, as the accompanying illustrations show.

Other artists saw in non-Western cultures not only new art styles, but also alternatives to Western civilization. Many Modern artists embraced preindustrial cultures, often naively, in a search for what was "primitive" and hence purer. Paul Gauguin's attitude was among the most enthusiastic of these, but primitivism remained an important influence on Modern art well into the twentieth century.

Hiroshige PLUM ORCHARD, KAMEIDO 1857. From *One Hundred Famous Views of Edo*. Woodblock print, $13\frac{7}{4} \times 8\frac{5}{8}$ " (33.6 \times 47 cm). The Brooklyn Museum, New York.

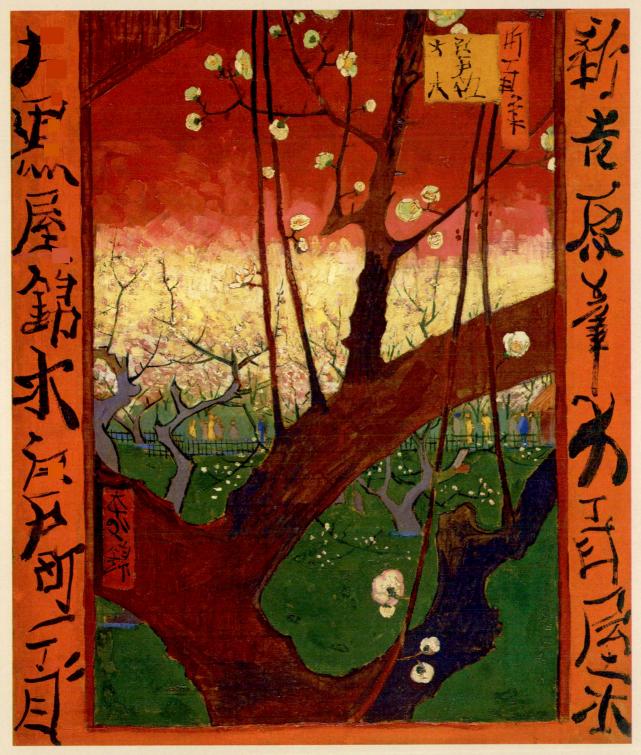

Vincent van Gogh JAPONAISERIE: FLOWERING PLUM TREE 1887. Oil on canvas, $21\frac{1}{2} \times 18^{\prime\prime}$ (54.6 \times 45.7 cm). Vincent van Gogh Museum, Amsterdam.

observation. Above the quiet town the sky pulsates with celestial rhythms and blazes with exploding stars. Van Gogh may have subscribed to the then-popular theory that after death people journey to a star, where they continue their lives. Contemplating immortality in a letter, van Gogh wrote: "Just as we take the train to get to Tarascon or Rouen, we take death to reach a star." The idea is given visible form in this painting by the cypress tree, a traditional symbol of both death and eternal life, which dramatically rises to link the terrestrial and celestial realms. The brightest star in the sky is actually a planet, Venus, which is associated with love. It is possible that the picture's extraordinary excitement also expresses van Gogh's euphoric hope of gaining the companionship that had eluded him on earth. The painting is a riot of brushwork, as rail-like strokes of intense color writhe across its surface. If the traditional function of brushwork is to describe a subject, van Gogh surpassed this and made brushwork more immediately expressive of the artist's feelings than any previous painter in the Western tradition. During the last year and a half of his life he experienced repeated psychological crises that lasted for days or weeks. While they were raging, he wanted to hurt himself and he heard loud noises in his head, but he could not paint. The stress and burden of these attacks led him into a mental asylum and eventually to his suicide in July 1890.

GAUGUIN. In painting from his imagination rather than from nature in The Starry Night, van Gogh was perhaps following the advice of his friend Gauguin, who had once counseled another colleague, "Don't paint from nature too much. Art is an abstraction. Derive this abstraction from nature while dreaming before it, and think more of the creation that will result." Gauguin's own mature work was even more abstract than van Gogh's, and, like Cézanne's, it laid important foundations for the development of nonrepresentational art in the twentieth century. Born in Paris to a Peruvian mother and a radical French journalist father, Gauguin lived in Peru from infancy until the age of seven; this experience, together with his service in the Merchant Marine in his youth, may have awakened in him the wanderlust that marked his artistic life. During the 1870s and early 1880s Gauguin enjoyed a comfortable bourgeois life as a stockbroker and painted in his spare time under the tutelage of Pissarro. Between 1880 and 1886, he exhibited in the final four Impressionist exhibitions. In 1883, Gauguin lost his job during a stock market crash; three years later he abandoned his wife and five children to pursue a full-time painting career. Gauguin knew firsthand the business-oriented culture of the day, and he came to despise it, at one point dismissing capitalism in a letter to a friend as "the European struggle for money." Disgusted by what he considered the corruption of urban civilization and seeking a more "primitive" existence,

Gauguin lived for extended periods in the French province of Brittany between 1886 and 1891, traveled to Panama and Martinique in 1887, spent two months in Arles with van Gogh in 1888, and then in 1891 sailed for Tahiti, a French colony in the South Pacific. After a final sojourn in France in 1893–95, Gauguin returned to the Pacific, where he died in 1903.

Gauguin's mature style was inspired by such nonacademic sources as medieval stained glass, folk art, and Japanese prints, and it featured simplified drawing, flattened space, and antinaturalistic color. Gauguin rejected Impressionism because it neglected subjective feelings and "the mysterious centers of thought." Gauguin called his anti-Impressionist style synthetism, because it synthesized observation of the subject in nature with the artist's feelings about that subject, expressed through abstracted line, shape, space, and color. Very much a product of such synthesis is MAHANA NO ATUA (DAY OF THE GOD) (FIG. 30-67), which, despite its Tahitian subject, was painted in France during one of his return trips home from the South Pacific. Gauguin had gone to Tahiti hoping to find an unspoiled paradise where he could live and work cheaply and "naturally." What he discovered, instead, was a thoroughly colonized country whose native culture was rapidly disappearing under the pressures of Westernization. In his paintings, Gauguin ignored this reality and depicted the Edenic ideal in his imagination, as seen in Mahana no atua, with its bright colors, stable composition, and appealing subject matter.

Gauguin divided Mahana no atua into three horizontal zones in styles of increasing abstraction. The upper zone, painted in the most realistic manner, centers around the statue of a god, behind which extends a beach landscape populated by Tahitians. This god was not local to Tahiti; it is Gauguin's version of a Javanese figure that he saw illustrated in a magazine. In the middle zone, directly beneath the statue, three figures occupy a beach divided into several bands of antinaturalistic color. The central female bather dips her feet in the water and looks out at the viewer, while on either side of her two figures recline in fetuslike postures—perhaps symbolizing birth, life, and death. Filling the bottom zone of the canvas is a strikingly abstract pool whose surface does not reflect what is above it but instead offers a dazzling array of bright colors, arranged in a puzzlelike pattern of flat, curvilinear shapes. By reflecting a strange and unexpected reality exactly where we expect to see a mirror image of the familiar world, this magic pool seems the perfect symbol of Gauguin's desire to evoke "the mysterious centers of thought." Gauguin's chief groundbreaking innovation was his use of color not to describe a subject, but to express his feelings. Like many of Gauguin's works, Mahana no atua is enigmatic and suggestive of unstated meanings that cannot be literally represented but only evoked indirectly through abstract pictorial means.

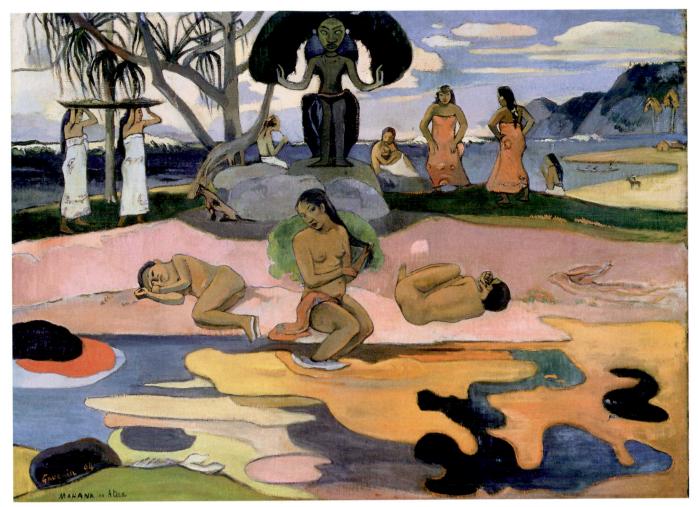

30–67 | Paul Gauguin MAHANA NO ATUA (DAY OF THE GOD) 1894. Oil on canvas, $27 \% \times 35 \%$ " (69.5 \times 90.5 cm). The Art Institute of Chicago. Helen Birch Bartlett Memorial Collection (1926.198)

Symbolism in Painting

Gauguin's suggestiveness is characteristic of Symbolism, an international movement in late nineteenth-century art and literature of which he was a recognized leader. Like the Romantics before them, the Symbolists opposed the values of rationalism and material progress that dominated modern Western culture and instead explored the nonmaterial realms of emotion, imagination, and spirituality. Ultimately the Symbolists sought a deeper and more mysterious reality than the one we encounter in everyday life, which they conveyed not through traditional iconography but through ambiguous subject matter and formal stylization suggestive of hidden and elusive meanings. Instead of objectively representing the world, they transformed appearances in order to give pictorial form to psychic experience, and they often compared their works to dreams. It seems hardly coincidental that Sigmund Freud, who compared artistic creation to the process of dreaming, wrote his pioneering The Interpretation of Dreams (1900) during the Symbolist period.

The Symbolist movement in painting closely parallels a similar one in literature, led by poets and art critics such as Maurice Maeterlinck, Jean Moréas, Joris-Karl Huysmans, and Paul Verlaine. Pronouncing themselves disgusted with the alleged materialism of contemporary society, they too retreated into fantasy worlds that they conjured from their imaginations. The purpose of a work of art, they wrote, was to serve as an evacuation hoist, lifting us out of our grimy present reality into a world of dreams and hallucinations. Maeterlinck wrote an extended poem about a forbidden medieval love affair, Pelleas and Melisande, in which the action takes place mostly at night, and Melisande's long yellow hair both illuminates some scenes and symbolizes her sexuality (composer Claude Debussy would turn this poem into a Symbolist opera in 1901). Huysmans' short novel Against the Grain (A Rebours) has a single character, an aristocrat named Des Esseintes, who locks himself away from the world because "Imagination could easily be substituted for the vulgar realities of things." Even nature was boring to the

Symbolists. Reversing Monet's criticism of the Romantics, Des Esseintes mused: "Nature had had her day, as he put it. By the disgusting sameness of her landscapes and skies, she had once and for all wearied the considerate patience of aesthetes." Instead, the truly sensitive person must take refuge in artworks "steeped in ancient dreams or antique corruptions, far removed from the manner of our present day."

EUROPEAN SYMBOLISTS. A dreamlike atmosphere pervades the later work of Gustave Moreau (1826–98), an older academic artist whom the Symbolists recognized as a precursor. The Symbolists particularly admired Moreau's renditions of the biblical Salome, the young Judaean princess who, at the instigation of her mother, Herodias, performed an erotic dance before her stepfather, Herod, and demanded in return the head of John the Baptist (Mark 6:21–28). In **THE APPARI**

TION (FIG. 30–68), exhibited at the Salon of 1876, the seductive Salome confronts a vision of the saint's severed head, which hovers open-eyed in midair, simultaneously dripping blood and radiating holy light. Moreau depicted this macabre subject and its exotic architectural setting in elaborate linear detail with touches of jewel-like color. His style creates an atmosphere of voluptuous decadence that amplifies Salome's role as the archetypal *femme fatale*, the "fatal woman" who tempts and destroys her male victim—a fantasy that haunted the imagination of countless male Symbolists, perhaps partly in response to late nineteenth-century feminism.

A younger artist who embraced Symbolism was Odilon Redon (1840–1916). Although he exhibited with the Impressionists in 1886, he diverged from their artistic goals by using nature as a point of departure for fantastic visions tinged with loneliness and melancholy. For the first twenty-

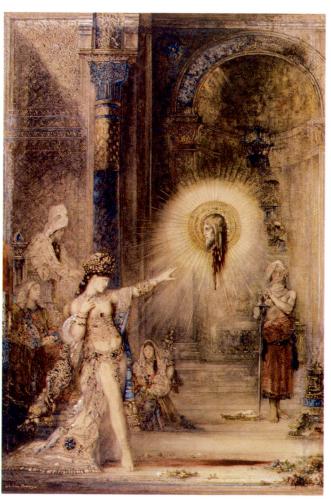

30–68 | Gustave Moreau THE APPARITION 1874–76. Watercolor on paper, $41\%6 \times 28\%6$ " (106 \times 72.2 cm). Musée du Louvre, Paris.

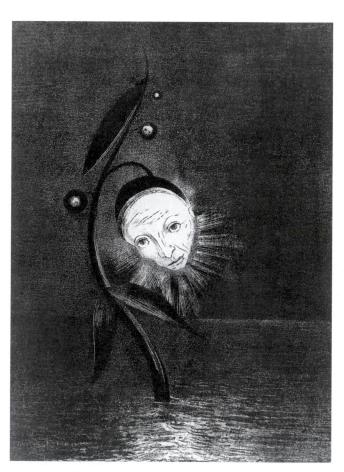

Plate 2 from Homage to Goya. 1885. Lithograph, $10\,\% \times 8'' \ (27.5 \times 20.3 \ cm)$. The Museum of Modern Art, New York. Abby Aldrich Rockefeller Purchase Fund

Fascinated by the science of biology, Redon based his strange hybrid creatures on the close study of living organisms. His aim, as he wrote in his journal, was "to make improbable beings live, like human beings, according to the laws of probability by putting . . . the logic of the visible at the service of the invisible."

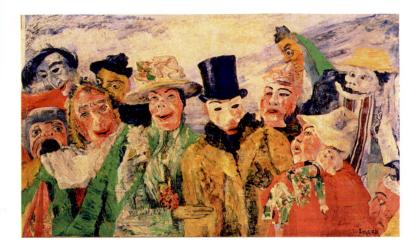

30–70 \mid James Ensor THE INTRIGUE 1890. Oil on canvas, $35 \frac{1}{2} \times 59''$ (90.3 \times 150 cm). Koninklijk Museum voor Schone Kunsten, Antwerp. © Ensor / Licensed by VAGA, New York, New York

five years of his career, Redon created moody images in black-and-white charcoal drawings that he referred to as *Noirs* ("Blacks"). He also made highly imaginative etchings and lithographs, such as **THE MARSH FLOWER**, A **SAD AND HUMAN FACE** (FIG. 30–69), one of many bizarre human-vegetal hybrids Redon invented. It should hardly surprise us that the fictional character Des Esseintes loved Redon, and in Huysmans' *Against the Grain* he spent an entire day looking at Redon's prints and dark charcoal drawings: "These designs were beyond anything imaginable; they leaped, for the most part, beyond the limits of painting and introduced a fantasy that was unique, the fantasy of a diseased and delirious mind."

Like the Impressionists, the Symbolists staged art exhibitions outside the normal venues of the day, but they cared less about attracting the general public. Instead of hiring a hall, printing a program, and charging a small admission fee as the Impressionists had done, the Symbolists showed modest exhibitions in more out-of-the-way places. For example, during the 1889 Universal Exposition, which marked the debut of the Eiffel Tower (SEE FIG. 30–1), they hung some works in a café a few blocks away from the grounds; the show passed almost unnoticed in the press.

Symbolism originated in France but had a profound impact on the avant-garde in other countries, where it often merged with Expressionist tendencies. Such a melding of Symbolism and Expressionism is evident in the work of the Belgian painter and printmaker James Ensor (1860–1949), who, except for four years of study at the Brussels Academy, spent his life in the coastal resort town of Ostend. Like Redon, Ensor derived his weird and anxious visions from the observation of the real world-often from the grotesque papier-mâché masks that his family sold during the annual pre-Lenten carnival, one of Ostend's main holidays. In paintings such as THE INTRIGUE (FIG. 30-70), these disturbing masks seem to come to life and reveal rather than hide the character of the people wearing them—comical, stupid, and hideous. The acidic colors increase the sense of caricature, as does the crude handling of form. The rough paint is both

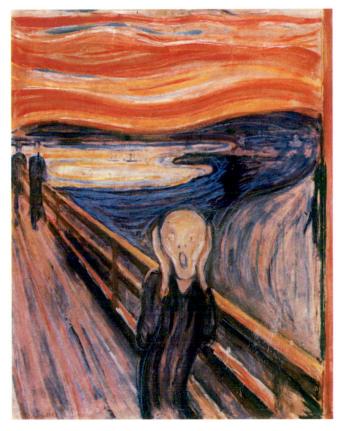

expressive and Expressionistic: Its lack of subtlety well characterizes the subjects, while its almost violent application directly records Ensor's feelings toward them.

The sense of powerful emotion that pervades Ensor's work is even more evident in that of his Norwegian contemporary Edvard Munch (1863–1944). Munch's most famous work, **THE SCREAM** (FIG. 30–71), is an unforgettable image of modern alienation that merges Symbolist suggestiveness with

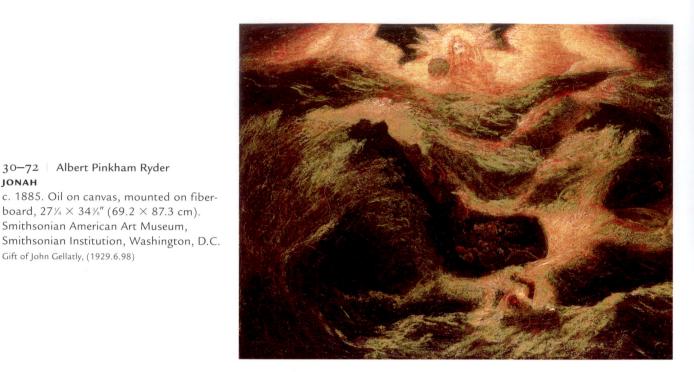

30-72 Albert Pinkham Ryder JONAH c. 1885. Oil on canvas, mounted on fiberboard, $27\frac{1}{4} \times 34\frac{3}{8}$ " (69.2 × 87.3 cm). Smithsonian American Art Museum,

Gift of John Gellatly, (1929.6.98)

Expressionist intensity of feeling. Munch recorded the painting's genesis in his diary: "One evening I was walking along a path; the city was on one side, and the fjord below. I was tired and ill. . . . I sensed a shriek passing through nature. . . . I painted this picture, painted the clouds as actual blood." In the painting itself, however, the figure is on a bridge and the scream emanates from him. Although he vainly attempts to shut out its sound by covering his ears, the scream fills the landscape with clouds of "actual blood." The overwhelming anxiety that sought release in this primal scream was chiefly a dread of death, as the sky and the figure's skull-like head suggest, but the setting of the picture also suggests a fear of open spaces. The expressive abstraction of form and color in the

painting reflects the influence of Gauguin and his Scandina-

vian followers, whose work Munch had encountered shortly

before he painted The Scream.

AMERICAN SYMBOLISTS. Some American artists of the late nineteenth century turned their backs on modern reality and, like their European Symbolist counterparts, escaped into the realms of myth, fantasy, and imagination. Some were also attracted to traditional literary, historical, and religious subjects, which they treated in unconventional ways to give them new meaning, as Albert Pinkham Ryder (1847-1917) did in his highly expressive interpretation of JONAH (FIG. 30–72).

Ryder moved from Massachusetts to New York City around 1870 and studied at the National Academy of Design. Although he traveled to Europe four times between 1877 and 1896, he seems to have been mostly unaffected by both the old and modern works he saw there. His mature painting style was an extremely personal one, as were his working methods. Ryder would paint and repaint the same canvas over a period of several years, loading glazes one on top of another to a depth of a quarter inch or more, mixing in with his oils such substances as varnish, bitumen, and candle wax. Due to chemical reactions between his materials and the uneven drying times of the layers of paint, most of Ryder's pictures have become darkened and severely cracked.

In Jonah, Ryder depicted the moment when the terrified Old Testament prophet, thrown overboard by his shipmates, was about to be consumed by a great fish. Appearing above in a blaze of holy light is God, shown as a bearded old man who holds the orb of divine power and makes a gesture of blessing, as if promising Jonah's eventual redemption. Both the subject—being overwhelmed by hostile nature—and its dramatic treatment through dynamic curves and sharp contrasts of light and dark are characteristically Romantic. The broad, generalized handling of the violent sea is particularly reminiscent of Turner (SEE FIGS. 30-15, 30-16), one of the few European artists whose work Ryder is known to have admired.

Vividly imagined biblical subjects became a specialty of Henry Ossawa Tanner (1859-1937), the most successful African American painter of the late nineteenth and early twentieth centuries. The son of a bishop in the African Methodist Episcopal Church, Tanner grew up in Philadelphia, sporadically studied art under Thomas Eakins at the Pennsylvania Academy of the Fine Arts between 1879 and 1885, then worked as a photographer and drawing teacher in Atlanta. In 1891 he moved to Paris for further academic training. In the early 1890s Tanner painted a few African American genre subjects but ultimately turned to biblical painting in order to make his art serve religion.

Tanner's **THE RESURRECTION OF LAZARUS** (FIG. 30–73) received a favorable critical reception at the Paris Salon of 1897 and was purchased by the Musée du Luxembourg, the museum for living artists. The subject is the biblical story in which Jesus went to the tomb of his friend Lazarus, who had been dead for four days, and revived him with the words "Lazarus, come forth" (John 11:1–44). Tanner shows the moment following the miracle, as Jesus stands before the amazed onlookers and gestures toward Lazarus, who begins to rise from his tomb. The limited palette of browns and golds, reminiscent of Rembrandt but more intense, is appropriate for the somber burial cave. It also has the expressive effect of unifying the astonished witnesses in their recognition that a miracle has indeed occurred.

Late Nineteenth-Century French Sculpture

RODIN. The most successful and influential European sculptor of the late nineteenth century was Auguste Rodin (1840–1917), whose work embodies some of the contemporary Symbolist and Expressionist currents. The public was much more prepared to accept his style, however, than that of the Symbolists. Born in Paris and trained as a decorative craftworker, Rodin failed on three occasions to gain entrance to the École des Beaux-Arts and consequently spent the first twenty years of his career as an assistant to other sculptors and

decorators. After an 1875 trip to Italy, where he saw the sculpture of Donatello and Michelangelo, Rodin developed his mature style of vigorously modeled figures in unconventional poses, which were simultaneously scorned by academic critics and admired by the general public.

Rodin's status as a major sculptor was confirmed in 1884, when he won a competition for the BURGHERS OF CALAIS (FIG. 30-74), commissioned to commemorate an event from the Hundred Years' War. In 1347 Edward III of England had offered to spare the besieged city of Calais if six leading citizens (or burghers)—dressed only in sackcloth with rope halters and carrying the keys to the city—would surrender to him for execution. Rodin shows the six volunteers preparing to give themselves over to what they assume will be their deaths. The Calais commissioners were not pleased with Rodin's conception of the event. Instead of calm, idealized heroes, Rodin presented ordinary-looking men in various attitudes of resignation and despair. He exaggerated their facial expressions, expressively lengthened their arms, greatly enlarged their hands and feet, and swathed them in heavy fabric, showing not only how they may have looked but how they must have felt as they forced themselves to take one difficult step after another. Rodin's willingness to stylize the human body for expressive purposes was a revolutionary move that opened the way for the more radical innovations of later sculptors.

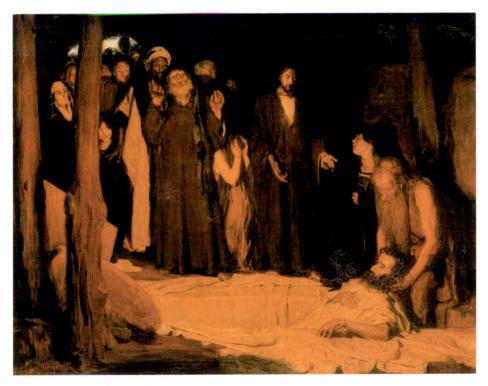

30–73 \perp Henry Ossawa Tanner THE RESURRECTION OF LAZARUS 1896. Oil on canvas, $37\% \times 47\%$ (94.9 \times 121.4 cm). Musée d'Orsay, Paris.

Tanner believed that biblical stories could illustrate the struggles and hopes of contemporary African Americans. He may have depicted the resurrection of Lazarus because many black preachers made a connection between the story's themes of redemption and rebirth and the Emancipation Proclamation of 1863, which freed black slaves and gave them a new life.

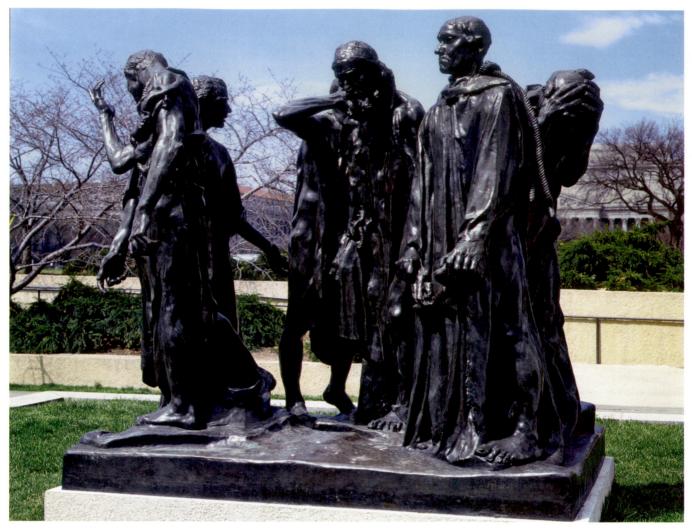

30–74 | Auguste Rodin BURGHERS OF CALAIS 1884–89. Bronze, $6'10\%'' \times 7'11'' \times 6'6''$ (2.1 \times 2.4 \times 2 m). Hirshhorn Museum and Sculpture Garden, Smithsonian Institution, Washington, D.C. Gift of Joseph H. Hirshhorn, 1966

Nor were the commissioners pleased with Rodin's plan to display the group on a low pedestal. Rodin felt that the usual placement of such figures on an elevated pedestal suggested that only higher, superior humans are capable of heroic action. By placing the figures nearly at street level, Rodin hoped to convey to viewers that ordinary people, too, are capable of noble acts. Rodin's removal of public sculpture from a high to a low pedestal would lead, in the twentieth century, to the elimination of the pedestal itself and to the presentation of sculpture in the "real" space of the viewer.

CLAUDEL. An assistant in Rodin's studio who worked on the *Burghers of Calais* was Camille Claudel (1864–1943), whose accomplishments as a sculptor were long overshadowed by the dramatic story of her life. Claudel began to study

sculpture in 1879 and became Rodin's pupil four years later. After she started working in his studio, she also became his mistress, and their often stormy relationship lasted fifteen years. Both during and after her association with Rodin, Claudel enjoyed independent professional success, but she also suffered from psychological problems that eventually overtook her, and she spent the last thirty years of her life in a mental asylum.

Among Claudel's most celebrated works is **THE WALTZ** (FIG. 30–75), which exists in several versions made between 1892 and 1905. The sculpture depicts a dancing couple, the man unclothed and the woman seminude, her lower body enveloped in a long, flowing gown. In Claudel's original conception, both figures were entirely nude, but she had to add drapery to the female figure after an inspector from the Ministry of the Beaux-Arts found the pairing of the nude

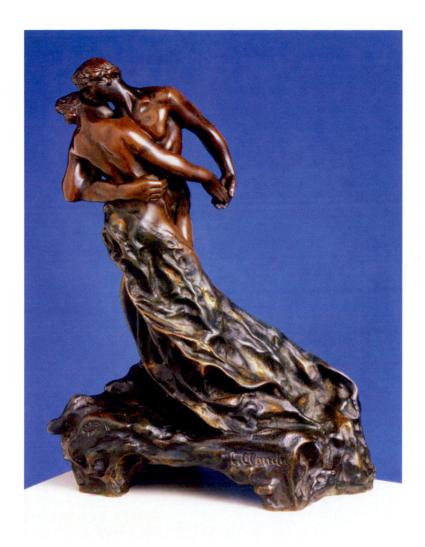

30-75 | Camille Claudel **THE WALTZ** 1892-1905. Bronze, 91/8" (25 cm). Neue Pinakothek, Munich.

French composer Claude Debussy, a close friend of Claudel, displayed a cast of this sculpture on his piano. Debussy acknowledged the influence of art and literature on his musical innovations.

bodies indecent and recommended against a state commission for a marble version of the work. After Claudel added drapery, the same inspector endorsed the commission, but it was never carried out. Instead, Claudel modified *The Waltz* further and had it cast in bronze.

In this work, Claudel succeeded in conveying an illusion of fluent motion as the dancing partners whirl in space, propelled by the rhythm of the music. The spiraling motion of the couple, enhanced by the woman's flowing gown, encourages the observer to view the piece from all sides, increasing its dynamic effect. Despite the physical closeness of the dancers there is little actual physical contact between them, and their facial expressions reveal no passion or sexual desire. After violating decency standards with her first version of *The Waltz*, Claudel perhaps sought in this new rendition to portray love as a union more spiritual than physical.

Art Nouveau

The swirling mass of drapery in Claudel's *Waltz* has a stylistic affinity with Art Nouveau (French for "new art"), a movement launched in the early 1890s that for more than a decade permeated all aspects of European art, architecture, and design. Like the contemporary Symbolists, the practitioners of Art Nouveau largely rejected the values of modern industrial society and sought new aesthetic forms that would retain a preindustrial sense of beauty while also appearing fresh and innovative. They drew particular inspiration from nature, especially from organisms such as vines, snakes, flowers, and winged insects, whose delicate and sinuous forms were the basis of their graceful and attenuated linear designs. Following from this commitment to organic principles, they also sought to harmonize all aspects of design into a beautiful whole, as found in nature itself.

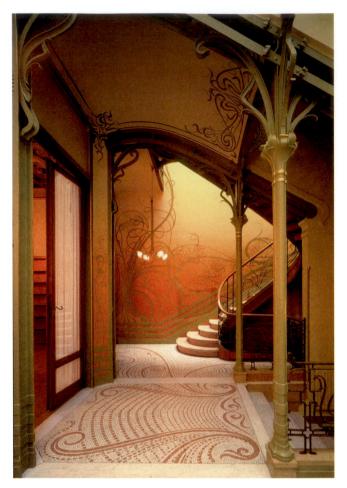

HORTA AND VAN DE VELDE. The artist most responsible for introducing the Art Nouveau style in architecture was the Belgian, Victor Horta (1861–1947). Trained at the academies in Ghent and Brussels, Horta worked in the office of a Neoclassical architect in Brussels for six years before opening his own practice in 1890. In 1892 he received his first important commission, a private residence in Brussels for a Professor Tassel. The result, especially the house's entry hall and staircase (FIG. 30-76), was strikingly original. The ironwork, wall decoration, and floor tile were all designed in an intricate series of long, graceful curves. Although Horta's sources are still a matter of debate, he apparently was much impressed with the stylized linear graphics of the English Arts and Crafts movement of the 1880s. Horta's concern for integrating the various arts into a more unified whole, like his reliance on a refined decorative line, derived largely from English reformers.

Horta's contemporary and compatriot Henry van de Velde (1863–1957) brought the Art Nouveau style into nearly all of the decorative arts. He studied at the Belgian National Academy in Antwerp, then went to Paris where he saw the Post-Impressionist art of Seurat and others. After a period making divisionist works in the late 1880s, his reading

of William Morris's socialist theories of art (see page 1022) convinced him that he should devote his creative energies toward art that everyone can see. From that moment he focused his efforts on useful objects. After designing a house for his family in 1895, he proceeded to create the rugs, furniture, utensils, wallpaper, and even his wife's dresses. He wrote in an exhibition catalogue near the same time, "The hope of a happy and egalitarian future lies behind these new decorative works." His design office in Brussels became a beehive of activity, and he argued against historicism in architecture and in favor of art for all. When the grocery firm Tropon approached him with a commission for a new advertising campaign, van de Velde created the first integrated marketing program in the history of design (FIG. 30-77). The abstract ovoid module that forms the center of this poster became the company's logo, and was featured on all of its products, as well as its stationery, advertising, and delivery vehicles.

GAUDÍ AND KLIMT. The application of graceful linear arabesques to all aspects of design, evident in the entry hall of the Tassel House, began a vogue that spread across Europe. In Spain, where the style was called *Modernismo*, the major practitioner was the Catalan architect Antonio Gaudí i Cornet

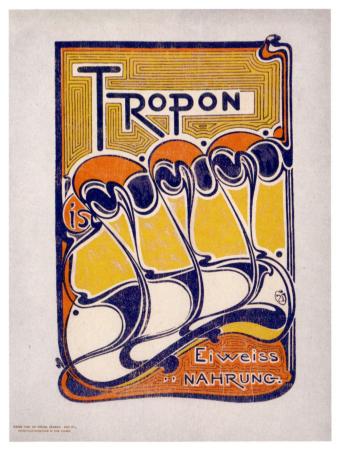

30–77 $^{||}$ Henry van de Velde **TROPON** 1898. Color lithograph, 12 $^{||}$ \times 8" (31 \times 20 cm). Fine Arts Museums of San Francisco.

Achenbach Foundation for the Graphic Arts Purchase, 1976.1.361

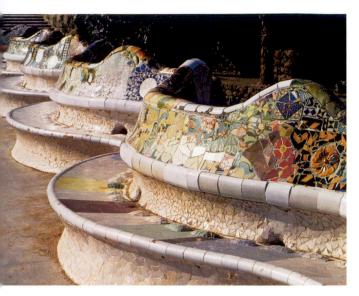

30–78 | Antonio Gaudí SERPENTINE BENCH, GÜELL PARK Barcelona. 1900–14.

(1852–1926). Gaudí attempted to integrate natural forms into his buildings and into daily life. For a public plaza on the outskirts of Barcelona, he combined architecture and sculpture in a continuous, serpentine bench that also is a boundary

wall (FIG. 30–78). Its surface is a glittering mosaic of broken pottery and tiles in homage to the long tradition of ceramic work in Spain.

In Austria, Art Nouveau was referred to as *Sezessionstil* because of its association with the Vienna Secession, one of several such groups formed in the late nineteenth century by progressive artists who seceded from conservative academic associations to form more liberal exhibiting bodies. The Vienna Secession's first president, Gustav Klimt (1862–1918), led a faction within the group dedicated to a richly decorative art and architecture that would offer an escape from the drab, ordinary world.

Between 1907 and 1908 Klimt perfected what is called his golden style, seen in **THE KISS** (FIG. 30–79), where a couple embrace in a golden aura. The representational elements here are subservient to the decorative ones, which are characteristically Art Nouveau in their intricate, ornamental quality. Not evident at first glance is the tension in the couple's physical relationship, most noticeable in the way that the woman's head is forced uncomfortably against her shoulder. That they kneel dangerously close to the edge of a precipice further unsettles the initial impression for those willing to look further into the beautiful surface.

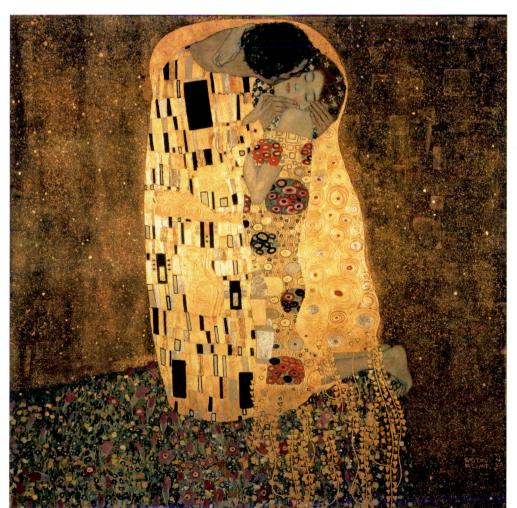

30–79 | Gustav Klimt THE KISS 1907-8. Oil on canvas, 5′ 10¾″ × 6′ (1.8 × 1.83 m). Österreichische Nationalbibliothek, Vienna.

The Secession was part of a generational revolt expressed in art, politics, literature, and the sciences. The Viennese physician Sigmund Freud, founder of psychoanalysis, may be considered part of this larger cultural movement, one of whose major aims was, according to the architect Otto Wagner, "to show modern man his true face."

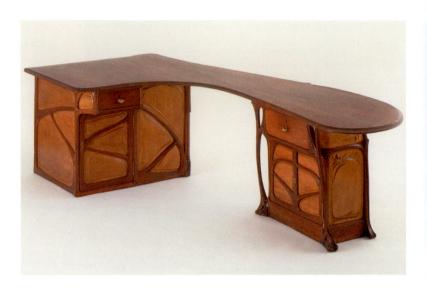

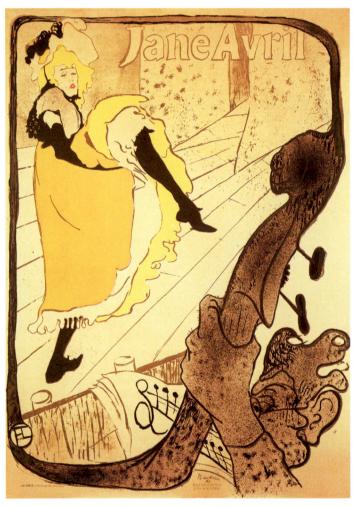

30–81 | Henri de Toulouse-Lautrec JANE AVRIL 1893. Lithograph, $50 \frac{1}{2} \times 37''$ (129 \times 94 cm). San Diego Museum of Art.

Gift of the Baldwin M. Baldwin Foundation (1987.32)

GUIMARD AND TOULOUSE-LAUTREC. In France, Art Nouveau was also sometimes known as *Style Guimard* after its leading French practitioner, Hector Guimard (1867–1942). Guimard worked in an eclectic manner during the early 1890s, but in 1895 he met and was influenced by Horta. He went on to design the famous Art Nouveau-style entrances for the Paris Métro (subway) and devoted considerable effort to interior design and furnishings, such as the desk he made for himself (FIG. 30–80). Instead of a static and stable object, Guimard handcrafted an asymmetrical, organic entity that seems to undulate and grow.

We see the influence of the Art Nouveau style on the century's best-known poster designer, Henri de Toulouse-Lautrec (1864–1901). Born into an aristocratic family in the south of France, Lautrec suffered from a genetic disorder and childhood accidents that left him physically handicapped and short in height. Extremely gifted artistically, he moved to Paris in 1882 and had private academic training before discovering the work of Degas, which greatly influenced his own development. He also discovered Montmartre, a lower-class entertainment district of Paris, and soon joined its population of bohemian artists. From the late 1880s Lautrec dedicated himself to depicting the social life of the Parisian cafés, theaters, dance halls, and brothels—many of them in Montmartre—that he himself frequented.

Among these images were thirty lithographic posters Lautrec designed between 1891 and 1901 as advertisements for popular night spots and entertainers. His portrayal of the café dancer Jane Avril (FIG. 30–81) demonstrates the remarkable originality that Lautrec brought to an essentially commercial project. The composition juxtaposes the dynamic figure of Avril dancing onstage at the upper left with the cropped image of a bass viol player and the scroll of his instrument at the lower right. The bold foreshortening of the stage and the prominent placement of the bass in the foreground both suggest the influence of Degas, who employed

similar devices (SEE FIG. 30–56). Lautrec departs radically from Degas's naturalism, however, particularly in his imaginative extension of each end of the bass viol's head into a curving frame that encapsulates Avril and connects her visually with her musical accompaniment. Also antinaturalistic are the radical simplification of form, suppression of modeling, flattening of space, and integration of blank paper into the composition, all of which suggest the influence of Japanese woodblock prints. Meanwhile, the emphasis on curving lines and the harmonization of the lettering with the rest of the design are characteristic of Art Nouveau.

Late-Century Photography

Despite the efforts of Rejlander, Cameron, and others to win recognition for photography as an art form (SEE FIGS. 30–28, 30–29), the medium was still generally regarded as a "handmaiden to the arts," as poet Charles Baudelaire put it. Painters such as Ingres, Delacroix, and Courbet had used photographs in place of posed models for some of their paintings, and photographers were widely accepted as portraitists or journalists, but dominant opinion still held back from accepting them as artists. Their efforts to gain legitimacy led to the rise of an international movement known as *Pictorialism*, in which photographers sought to create images whose aesthetic qualities matched those of Modern painting, drawing, and printmaking. The principal debate among Pictorialists was over

the degree of manipulation a photographer could engage in. Some photographers urged combining negatives into a print, as Rejlander had done, while others, who called themselves Naturalists or straight photographers, preferred composing a single negative while standing behind the camera and then printing it with minimal manipulation.

PHOTOGRAPHY AS ART. The leader of the Naturalist faction of Pictorialism was Peter Henry Emerson (1856-1936), though he later recanted some of his early positions. Born in Cuba, he lived there until age 13 when his family moved to London. He originally trained as a doctor and had a small medical practice until the lure of art overtook him in the middle 1880s. His early efforts at photographing the landscape convinced him that photography was an art form "superior to etching, woodcutting, and charcoal drawing," as he put it in his 1886 book Photography: A Pictorial Art. His work from this period shows him capturing poetic effects in interestingly off-balance compositions (FIG. 30-82). This work shows both his flair for composition and his devotion to print quality, which he regarded as crucial to photography's acceptance as an art form. He urged photographers to use the platinum process, in which the printing paper is coated with platinum dust, an exceptionally sensitive surface that can faithfully transmit very subtle tonal gradations. (Most art photographers used this process until World War I pushed

the price of platinum to impractical levels.) Ironically enough, a meeting with James McNeill Whistler in 1895 caused Emerson to radically alter his belief that photography was an art. After seeing Whistler's Nocturnes (SEE FIG. 30–48) and Japanese prints, Emerson came to believe that photography was only a mechanical process that could not equal the direct inspiration of an artist. However, before his resignation from the Photographic Society he gave a great deal of recognition to photographers, and his aesthetic of straight photography dominated the practice of art photographers until well into the next century.

PHOTOGRAPHY AS ACTIVISM. The urban photographs of Jacob Riis (1849–1914) offer a harsh contrast to the essentially aesthetic views of Emerson. A reformer who aimed to galvanize public concern for the unfortunate poor, Riis saw photography not as an artistic medium but as a means of bringing about social change. Riis immigrated to New York City from Denmark in 1870 and was hired as a police reporter for the *New York Tribune*. He quickly established himself as a maverick among his colleagues by actually investigating slum life himself rather than merely rewriting police reports. Riis's contact with the poor convinced him that crime, poverty, and ignorance were largely environmental problems that resulted from, rather than caused, harsh slum conditions. He believed that if Americans knew the truth about slum life, they would support reforms.

Riis turned to photography in 1887 to document slum conditions, and three years later published his photographs in a groundbreaking study, *How the Other Half Lives*. The illustrations were accompanied by texts that described their circumstances in matter-of-fact terms. Riis said he found the poor, immigrant family shown in **TENEMENT INTERIOR IN POVERTY GAP: AN ENGLISH COAL-HEAVER'S HOME** (FIG. 30–83) when he visited a house where a woman had been killed by her drunken, abusive husband:

The family in the picture lived above the rooms where the dead woman lay on a bed of straw, overrun by rats. . . . A patched and shaky stairway led up to their one bare and miserable room. . . . A heap of old rags, in which the baby slept serenely, served as the common sleeping-bunk of father, mother, and children—two bright and pretty girls, singularly out of keeping in their clean, if coarse, dresses, with their surroundings. . . . The mother, a pleasant-faced woman, was cheerful, even light-hearted. Her smile seemed the most sadly hopeless of all in the utter wretchedness of the place.

What comes through clearly in the photograph is the family's attempt to maintain a clean, orderly life despite the rats and the chaotic behavior of their neighbors. The broom behind the older girl implies as much, as does the caring way the father holds his youngest daughter. Riis shows that such slum dwellers are decent people who deserve better.

30–83 | Jacob Riis | TENEMENT INTERIOR IN POVERTY GAP: AN ENGLISH COAL-HEAVER'S HOME

c. 1889. Museum of the City of New York.

The Jacob A. Riis Collection

During the late nineteenth and early twentieth centuries, American social and business life operated under the British sociologist Herbert Spencer's theory of Social Darwinism, which in essence held that only the fittest will survive. Riis saw this theory as merely an excuse for neglecting social problems.

Architecture

The history of late nineteenth-century architecture is a story of the impact of modern conditions and materials on the still-healthy Beaux-Arts historicist tradition. Unlike painting and sculpture, where antiacademic impulses gained force after 1880, in architecture the search for modern styles occurred somewhat later and met with considerably more resistance. As the École des Beaux-Arts in Paris was rapidly losing its leadership in figurative art education, it was becoming the central training ground for both European and American architects. The center of innovation in late-century architecture was in the American Midwest.

WORLD'S COLUMBIAN EXHIBITION, CHICAGO. Richard Morris Hunt (1827–95) in 1846 became the first American to study architecture at the École des Beaux-Arts. Extraordinarily skilled in Beaux-Arts historicism and determined to raise the standards of American architecture, he built in every accepted style, including Gothic, French classicist, and Italian Renaissance. After the Civil War, Hunt built many lavish mansions emulating aristocratic European models for the growing class of wealthy Eastern industrialists and financiers.

Late in his career, Hunt participated in a grand project with more democratic aims: He was head of the board of architects for the 1893 World's Columbian Exposition in Chicago, organized to commemorate the 400th anniversary

Elements of Architecture

THE CITY PARK

arks originated during the second millennium BCE in China and the Near East as enclosed hunting reserves for kings and the nobility. In Europe from the Middle Ages through the eighteenth century, they remained private recreation grounds for the privileged. The first urban park intended for the public was in Munich, Germany, laid out by Friedrich Ludwig von Sckell in 1789–95 in the picturesque style of an English landscape garden (SEE FIG. 29–20), with irregular lakes, gently sloping hills, broad meadows, and paths meandering through wooded areas.

Increased crowding and pollution during the Industrial Revolution prompted outcries for large public parks whose greenery would help purify the air and whose open spaces would provide city dwellers of all classes with a place for healthful recreation and relaxation. Numerous municipal parks were built in Britain during the 1830s and 1840s and in Paris during the 1850s and 1860s, when Georges-Eugène Haussmann redesigned the former royal hunting forests of the Bois de Boulogne and the Bois de Vincennes in the English style favored by the emperor.

In American cities before 1857, the only outdoor spaces for the public were small squares found between certain intersections, and larger gardens, such as the Boston Public Garden. Neither kind of space filled the growing need for varied recreational facilities. For a time, naturalistically landscaped suburban cemeteries became popular sites for strolling, picnicking, and even horse racing—an incongruous use that strikingly demonstrated the need for urban recreation parks.

The rapid growth of Manhattan spurred civic leaders to set aside parkland while open space still existed. The city purchased an 843-acre tract in the center of the island and in 1857 announced a competition for its design as Central Park. The competition required that designs include a parade ground,

playgrounds, a site for an exhibition or concert hall, sites for a fountain and for a viewing tower, a flower garden, a pond for ice skating, and four east-west cross streets so that the park would not interfere with the city's vehicular traffic.

The latter condition was pivotal to the winning design, drawn up by architect Calvert Vaux (1824-95) and park superintendent Frederick Law Olmsted (1822-1903), who sank the crosstown roads in trenches hidden below the surface of the park and designed separate routes for carriages, horseback riders, and pedestrians.

Central Park contains some formal elements, such as the stately tree-lined Mall leading to the classically styled Bethesda Terrace and Fountain, but its designers believed that the "park of any great city [should be] an antithesis to its bustling, paved, rectangular, walled-in streets." Accordingly, Olmsted and Vaux followed the English tradition by designing Central Park in a naturalistic manner based on irregularities in topography and plantings. Where the land was low, they further depressed it, installing drainage tiles and carving out ponds and meadows. They planted clumps of trees to contrast with open spaces, and they emphasized natural outcroppings of schist to provide elements of dramatic, rocky scenery. They arranged walking trails, bridle paths, and carriage drives to provide a series of changing vistas. An existing reservoir divided the park into two sections. Olmsted and Vaux developed the southern half more completely and located most of the sporting facilities and amenities there, while they treated the northern half more as a nature preserve. Substantially completed by the end of the Civil War, Central Park was a tremendous success and launched a movement to build similar parks in cities across the United States and to conserve wilderness areas and establish national parks.

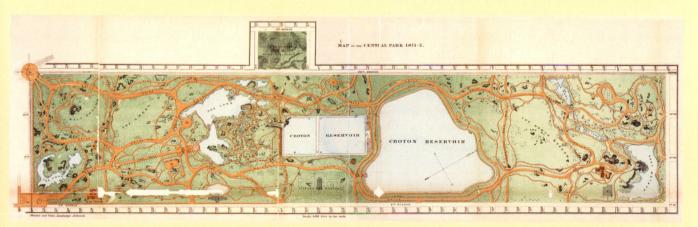

Frederick Law Olmsted and Calvert Vaux MAP OF CENTRAL PARK, NEW YORK CITY 1858–1880. Revised and extended park layout as shown in a map of 1873.

The rectangular water tanks in the middle of the park were later removed and replaced by a large, elliptical meadow known as the Great Lawn.

of Columbus's arrival in the Americas. The board abandoned the metal-and-glass architecture of earlier world's fairs (SEE FIG. 30-31) in favor of the appearance of what it called "permanent buildings—a dream city." (The buildings were actually temporary ones composed of staff, a mixture of plaster and fibrous materials.) To create a sense of unity for all the exposition's major buildings, the board designated a single, classical style associated with both the birth of democracy in ancient Greece and the imperial power of ancient Rome, reflecting the United States' pride in its democratic institutions and emergence as a world power. Hunt's design for the Administration Building at the end of the Court of Honor (FIG. 30-84) was in the Renaissance classicist mode used by earlier American architects for civic buildings (SEE FIG. 30-22).

The World's Columbian Exposition also provided a model for the American city of the future—reassurance that it could be clean, spacious, carefully planned, and classically beautiful, in contrast to the ill-planned, sooty, and overcrowded American urban centers rapidly emerging in the late nineteenth century. Frederick Law Olmsted, the designer of New York's Central Park (see "The City Park," page 1059), was principally responsible for the landscape design of the Chicago exposition. He converted the marshy lakefront into lagoons, canals, ponds, and islands, some laid out formally, as in the Court of Honor, others informally, as in the section containing national and state pavilions. After the fair closed and most of its buildings were taken down, Olmsted's landscape art remained for succeeding generations to enjoy.

THE CHICAGO SCHOOL: THE FIRST SKYSCRAPERS. The second American architect to study at the École des Beaux-Arts was Henry Hobson Richardson (1838-86). Born in Louisiana and schooled at Harvard, Richardson returned from Paris in 1865 and settled in New York. Like Hunt, he worked in a variety of styles, but he became famous for a simplified Romanesque style known as Richardsonian Romanesque. His best-known building was probably the MARSHALL FIELD WHOLESALE STORE in Chicago (FIG. 30-85). Although it is reminiscent of Renaissance palaces in form and of Romanesque churches in its heavy stonework and arches, it has no precise historical antecedents. Instead, Richardson took a fresh approach to the design of this modern commercial building. Applied ornament is all but eliminated in favor of the intrinsic appeal of the rough stone and the subtle harmony between the dark red granite facing of the base and the red sandstone of the upper stories. The solid corner piers, the vertical structural supports, give way to the regular rhythm of the broad arches of the middle floors, which are doubled in the smaller arches above, then doubled again in the rectangular windows of the attic. The integrated mass of the whole is completed in the crisp line of the simple cornice at the top.

Richardson's plain, sturdy building was a revelation to the young architects of Chicago then engaged in rebuilding the city after the disastrous fire of 1871 and helped shape a distinctly American architecture. About this time, new technology for making inexpensive steel (an alloy of iron, carbon, and other materials) brought architecture entirely new structural possibilities. The first structural use of steel in the internal skeleton of a building was made in Chicago by William Le Baron Jenney (1832-1907), and his example was soon followed by the younger architects who became known as the Chicago School. These architects saw in the stronger, lighter material the answer to both their search for an independent style and their clients' desire for taller buildings. The rapidly rising cost of commercial urban property made tall buildings more efficient; the first electric elevator, dating from 1889, made them possible.

Equipped with steel and with the improved passenger elevators, driven by new economic considerations, and inspired by Richardson's departure from Beaux-Arts historicism, the Chicago School architects produced a new kind of building—the skyscraper—and a new style of architecture. A fine early example of their work, and evidence of its rapid spread throughout the Midwest, is Louis Sullivan's WAIN-WRIGHT BUILDING in St. Louis, Missouri (FIG. 30-86). The Boston-born Sullivan (1856-1924) had studied for a year at the Massachusetts Institute of Technology (MIT), home of the United States' first architecture program, and equally briefly at the École des Beaux-Arts, where he seems to have developed his lifelong distaste for historicism. He settled in Chicago in 1875, partly because of the building boom there that had followed the fire of 1871, and in 1883 he entered into a partnership with the Danish-born engineer Dankmar Adler (1844-1900).

Sullivan's first major skyscraper, the Wainwright Building has a U-shaped plan that provides an interior light well for the illumination of inside offices. The ground floor, designed to house shops, has wide plate-glass windows for the display of merchandise. The second story, or mezzanine, also features large windows for the illumination of the shop offices. Above the mezzanine rise seven identical floors of offices, lit by rectangular windows. An attic story houses the building's mechanical plant and utilities. Forming a crown to the building, this richly decorated attic is wrapped in a foliate frieze of high-relief terra cotta, punctuated by bull's-eye windows, and capped by a thick cornice slab.

The Wainwright Building thus features a clearly articulated, tripartite design in which the different character of each of the building's parts is expressed through its outward appearance. This illustrates Sullivan's philosophy of functionalism, summed up in his famous motto, "Form follows function," which holds that the function of a building should dictate its design. But Sullivan did not design the Wainwright Building along strictly functional lines; he also took expres-

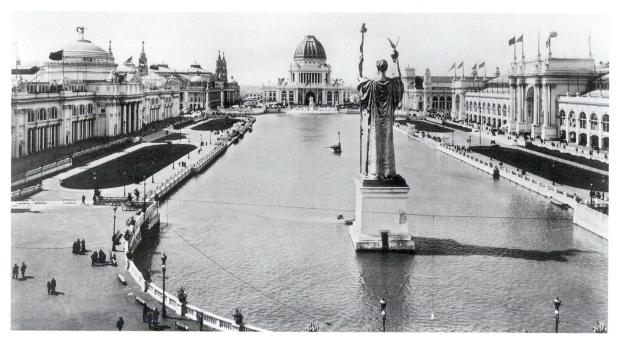

30-84 Court of Honor, world's columbian exposition Chicago. 1893. View from the east.

Surrounding the Court of Honor were, from left to right, the Agriculture Building by McKim, Mead, and White; the Administration Building by Richard Morris Hunt; and the Manufactures and Liberal Arts Building by George B. Post. The architectural ensemble was collectively called The White City, a nickname by which the exposition was also popularly known. The statue in the foreground is *The Republic* by Daniel Chester French.

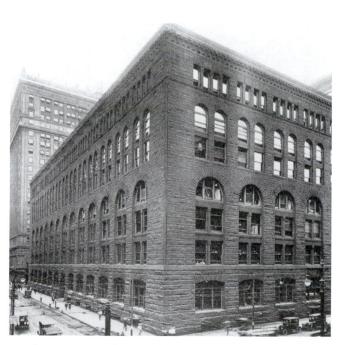

30–85 | Henry Hobson Richardson MARSHALL FIELD WHOLESALE STORE
Chicago. 1885–87. Demolished c. 1935.

sive considerations into account. The thick corner piers, for example, are not structurally necessary since the building is supported by a steel-frame skeleton, but they serve to emphasize its vertical thrust. Likewise, the thinner piers between the office windows, which rise uninterruptedly from the third

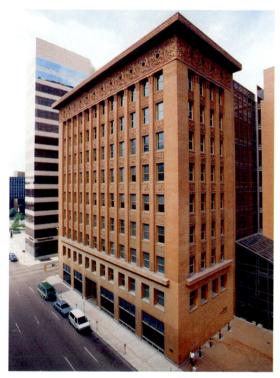

30–86 | Louis Sullivan WAINWRIGHT BUILDING St. Louis, Missouri. 1890–91.

story to the attic, echo and reinforce the dominant verticality. Sullivan emphasized verticality in the Wainwright Building not out of functional concerns but rather out of emotional ones. A tall office building, in his words, "must be every inch a proud and soaring thing, rising in sheer exultation."

In the Wainwright Building that exultation culminates in the rich vegetative ornament that swirls around the crown of the building, serving a decorative function very much like that of the foliated capital of a classical column. The tripartite structure of the building itself suggests the classical column with its base, shaft, and capital, reflecting the lingering influence of classical design principles even on an architect as opposed to historicism as Sullivan. It would remain for the Modern architects of the early twentieth century to break free from tradition entirely and pioneer an architectural aesthetic that was entirely new.

IN PERSPECTIVE

As the nineteenth century began, Neoclassicism and Romanticism were principal movements in Western art, with the former dominant in the academies and Salons, while the latter led the way in innovations. Romantics favored landscape, literature, or recent dramatic events as subjects, and rendered them in off-balance compositions that often featured loose, painterly brushwork.

The Realist movement that emerged in the late 1840s baffled most of the public with its deadpan renditions of common subjects such as rural labor. Yet the movement was the most innovative of the time, and its quasi-scientific accuracy led to Impressionism in the 1860s. Building on the Realism of Courbet and the Romantic-Realist landscapes of the Barbizon School, the Impressionists painted the landscape

in pure, unmixed colors and loose brushwork as they tried to capture the fleeting play of light over their subjects. Soon the Impressionists also painted the bustling urban life of the newly redesigned Paris streets. Both Realism and Impressionism partook of the spirit of positivism, the intellectual movement begun by Auguste Comte that favored direct observation over philosophical speculation and imaginative flights. The new art of photography also seemed to embody the positivist spirit, with its apparently seamless translation of reality onto a negative.

The Impressionists are generally regarded as the founders of Modern art, which generally rejected traditional rules. This earned them the scorn of much of the public: The Industrial Revolution had created an atmosphere of rapid social change that led the new middle-class art viewers to crave comforting, traditional subjects rendered with polished technique. Modern artists seceded from these demands, and functioned within a narrow social context of critics and collectors called the avant-garde.

As Impressionism reached its limits in the middle 1880s, Modern artists went in several directions. Post-Impressionists built directly on the preceding movement, taking it into greater formal organization or personal expression. Symbolists took refuge from the changing world in the misty realm of imagination, while Art Nouveau reinvested the design disciplines with organic shapes. In architecture, revivalism and historicism early in the century were displaced by technological innovations at midcentury that eventually led to the modern skyscraper.

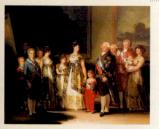

GOYA
FAMILY OF CHARLES IV
1800

Barry and Pugin houses of parliament 1836–60

PLOWING IN THE NIVERNAIS
1849

CAMERON
PORTRAIT OF THOMAS CARLYLE
1867

RODIN BURGHERS OF CALAIS 1884–89

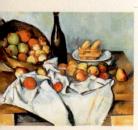

CÉZANNE IFE WITH BASKET OF APPLES 1890-94

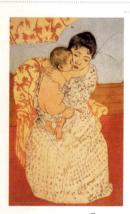

Cassatt **maternal caress** 1891

NINETEENTH-CENTURY ART IN EUROPE AND THE UNITED STATES

- Napoleon Crowned Emperor of France 1804
- Battle of Waterloo 1815

- ✓ July Monarchy 1830–48
- Beginning of Modern Photography
 c. 1840
- Revolution in France; Marx and Engels Publish Communist Manifesto; Women's Right Convention,
 Seneca Falls, NY 1848
- London Great Exhibition 1851
- American Civil War 1861-65

- Paris Universal Exposition 1889
- World's Columbian Exposition, Chicago 1893

1900

1800

1820

1840

1860

1880

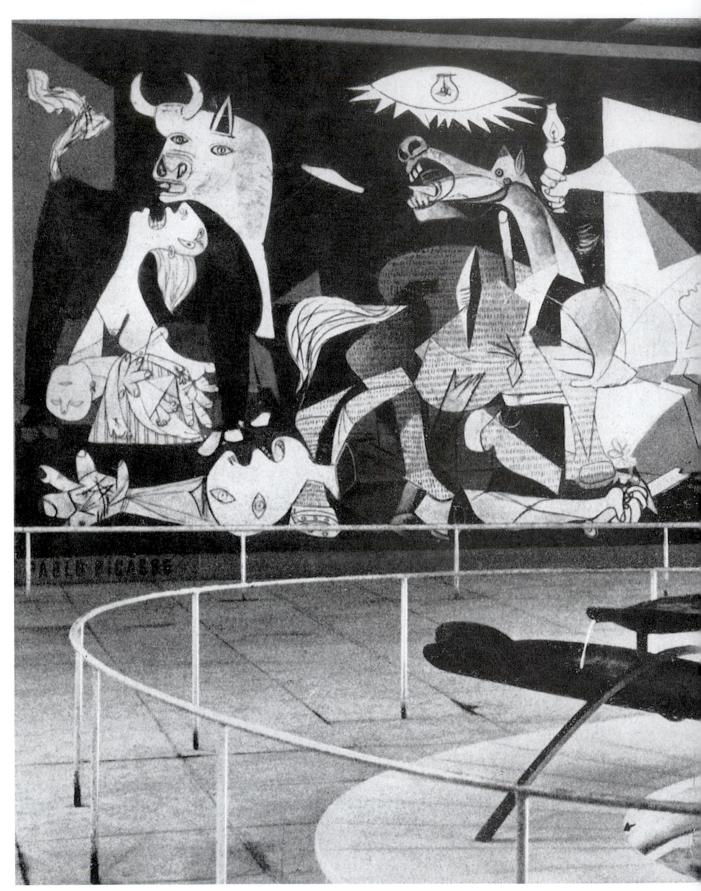

3I-I | Pablo Picasso GUERNICA 1937. Oil on canvas, $11'6'' \times 25'8''$ (3.5 \times 7.8 m). Museo Nacional Centro de Arte Reina Sofía, Madrid. On permanent loan from the Museo del Prado, Madrid. Shown installed in the Spanish Pavilion of the Paris Exposition, 1937. In the foreground: Alexander Calder's Fontaine de Mercure. 1937. Mercury, sheet metal, wire rod, pitch, and paint, $44 \times 115 \times 77''$ (122 \times 292 \times 196 cm). Fundacio Joan Miró, Barcelona.

CHAPTER THIRTY-ONE

MODERN ART IN EUROPE AND THE AMERICAS, 1900–1945

31

In April 1937, during the Spanish Civil War, German pilots flying for Spanish fascist leader General Francisco Franco targeted the Basque city of Guernica. This act, the world's first intentional mass bombing of civilians, killed more than 1,600 people and shocked

the world. The Spanish artist Pablo Picasso, living in Paris at the time, reacted to the massacre by painting **GUERNICA**, a stark, hallucinatory nightmare that became a powerful symbol of the brutality of war (FIG. 31–1).

Focusing on the victims, Picasso restricted his palette to black, gray, and white—the tones of the newspaper photographs that publicized the atrocity. Expressively distorted women, one holding a dead child and another trapped in a burning house, wail in desolation at the carnage. A screaming horse, an image of betrayed innocence, represents the suffering Spanish Republic, while a bull symbolizes either Franco or Spain. An electric light and a woman holding a lantern suggest Picasso's desire to reveal the event in all its horror.

The work excited widespread admiration when exhibited later that year in the Spanish Pavilion of the International Exposition in Paris because the artist used the language of Modern art to comment in a heartfelt manner on what seemed an international scandal. However, when World War II broke out a few years later, the tactic of bombing civilians became a common strategy that all sides adopted.

- EUROPE AND THE AMERICAS IN THE EARLY TWENTIETH CENTURY
- EARLY MODERN ART IN EUROPE | The Fauves: Wild Beasts Of Color | "The Bridge" and Primitivism | Independent Expressionists |

 Spiritualism of the Blue Rider | Cubism in Europe: Exploding the Still Life | Extensions of Cubism | Toward Abstraction in Sculpture | Dada
- EARLY MODERN ART IN THE AMERICAS | Modernist Tendencies in the United States | Modernism Breaks Out in Latin America | Canada
- EARLY MODERN ARCHITECTURE | European Modernism | American Modern Architecture
- ART BETWEEN THE WARS | Utilitarian Art Forms in Russia | Rationalism in the Netherlands | Bauhaus Art in Germany | Art and Politics | Surrealists Rearrange Our Minds
- IN PERSPECTIVE

EUROPE AND THE AMERICAS IN THE EARLY TWENTIETH CENTURY

Just as we ponder Guernica within the context of the Spanish Civil War, so too must we consider the backdrop of politics, war, and technological change to understand other twentieth-century art. As that century dawned, many Europeans and Americans believed optimistically that human society would "advance" through the spread of democracy, capitalism, and technological innovation. By 1906 representative governments existed in the United States and every major European nation (SEE MAP 31-1), and Western power grew through colonialism across Africa, Asia, the Caribbean, and the Pacific. The competitive nature of both colonialism and capitalism created great instability in Europe, however, and countries joined together in rival political alliances. World War I erupted in August 1914, initially pitting Britain, France, and Russia (the Allies) against Germany and Austria (the Central Powers). U.S. troops entered the war in 1917 and contributed to an Allied victory the following year.

World War I significantly transformed European politics and economics, especially in Russia, which became the world's first Communist nation in 1917 when a popular revolution brought the Bolshevik ("Majority") Communist Party of Vladimir Lenin to power. In 1922 the Soviet Union, a Communist state encompassing Russia and neighboring areas, was created. A revolution in Mexico (1910–1917) also overthrew an oppressive government.

The United States emerged from the war as the economic leader of the West, and economic recovery followed in Western Europe, but the 1929 New York stock market crash plunged the West into the Great Depression. In 1933, President Franklin D. Roosevelt responded with the New Deal, an ambitious welfare program meant to provide jobs and stimulate the American economy, and Britain and France also instituted state welfare policies during the 1930s. Elsewhere in Europe, the economic crisis brought to power right-wing totalitarian regimes: Benito Mussolini had already become

the fascist dictator of Italy in the mid-1920s; he was followed in Germany in 1933 by the Nazi leader Adolf Hitler. In Spain, General Francisco Franco consolidated his power by 1939 after his victory in the Spanish Civil War. Meanwhile, in the Soviet Union, Joseph Stalin (who had succeeded Lenin in 1924) established his authoritarian rule through the execution or imprisonment of millions of his political opponents.

The Western world of the early twentieth century was rocked by advances in technology, science, and psychology that undercut traditional beliefs and created new ways of seeing and understanding the world. Naming just a few of the technological innovations will help establish their reach: electrification, radio, automobiles, airplanes, movies, radar, and assembly-line production. Technology led both to better medicines for prolonging life and to more efficient warfare, which shortened it.

The stable and orderly Newtonian world of science was replaced with the more dynamic and unpredictable theory of relativity that German physicist Albert Einstein largely pioneered. His great innovation was to discover that matter is not stable at the atomic level. Rather, what we formerly took to be solid matter is only another form of energy, similar to gravity or light but much more powerful than either. He likewise altered our previous conceptions of space and time in a three-dimensional universe. After Einstein, it made more sense to see space and time as relative to each other: What time it is depends on where you are and how fast you are moving.

At the same time, new theories and discoveries in psychology altered how humans viewed themselves. In 1900, Austrian psychiatrist Sigmund Freud published *The Interpretation of Dreams*, which posited that our behavior is often motivated by powerful forces that are below our level of awareness. The human unconscious, as he described it, has strong urges for love and power that we simply cannot act upon if society is to remain peaceful and whole. Our psychic lives are not wholly, or even usually, guided by reason alone, but often by these urges that we may be unaware of. Thus we are always attempting to strike a balance between our rational

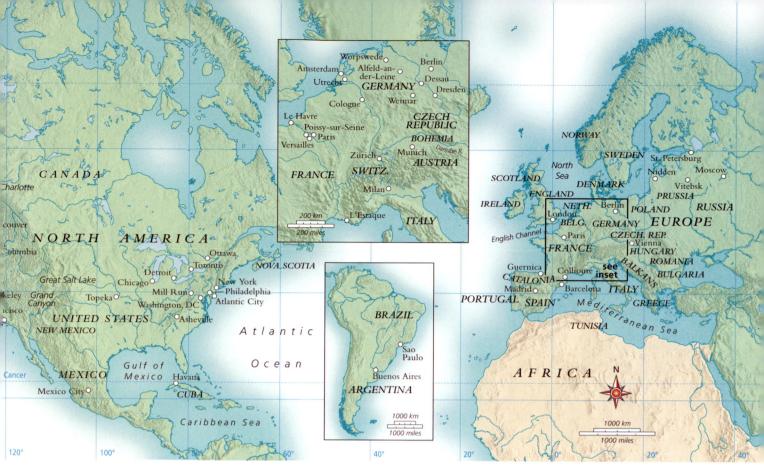

MAP 3I-I | EUROPE AND NORTH AMERICA, 1900-50

Through the end of World War II, Western Europe was home to the many forms of Modernism.

and irrational sides, often erring on one side or the other. Also in 1900, Russian scientist Ivan Pavlov began feeding dogs just after ringing a bell. Soon the dogs salivated not at the sight of food but at the sound of the bell. The discovery that these "conditioned reflexes" also exist in humans showed that if we manage the external stimuli we can control people's appetites. Political leaders of all stripes soon took advantage of this fact. As a consequence of all these events and discoveries, the old view that humans were created in the image of God took a severe beating.

EARLY MODERN ART IN EUROPE

Modern artists also invented myriad new ways of seeing our world. Most artists did not read physics or psychology, but they lived in the same world that was being transformed by these two fields. The Modernist urge to question and overthrow tradition was fertilized and encouraged by the constant change in the surrounding society. Modern art in the early twentieth century was still mostly controversial and much criticized for being either a publicity stunt, childish,

untrained, or politically subversive. Most often, none of these criticisms was true. Rather, Modern art is an outgrowth of modern society. Just as modern society valued innovation and invention, so did the art world. The plethora of new products that industry gave us is paralleled in the panoply of new styles of Modern art that we will be examining here.

The Fauves: Wild Beasts of Color

The Salon system still operated in France, but the ranks of artists dissatisfied with its conservative precepts swelled. These malcontents early in the century launched the Salon d'Automne ("Autumn Salon") in opposition to the official one that took place in the spring. The Autumn Salons had liberal juries where artists of all stripes exhibited, including Realists, Impressionists, Post-Impressionists, Symbolists, and even bad academic artists. The first Modern movement of the twentieth century made its debut in this salon's disorderly halls. Reviewing the 1905 Salon d'Automne, critic Louis Vauxcelles referred to some young painters as fauves ("wild beasts")—a term that captured the explosive colors and impulsive brushwork that characterized their pictures. Their

leaders—André Derain (1880–1954), Maurice de Vlaminck (1876–1958), and Henri Matisse (1869–1954)—advanced the colorist tradition in modern French painting, which they dated from the work of Eugène Delacroix (SEE FIGS. 30–7, 30–8) and which included that of the Impressionists and Post-Impressionists such as Gauguin and van Gogh. The Fauves took further the expressive power of color and brushwork that the latter two especially pioneered.

Among the first major Fauve works were paintings that Derain and Matisse made in 1905 in Collioure, a Mediterranean port. Derain's **MOUNTAINS AT COLLIOURE** (FIG. 31–2) exemplifies so-called mixed-technique Fauvism, in which short strokes of pure color, derived from the work of van Gogh and Seurat (SEE FIG. 30–65), are combined with curvilinear planes of flat color, inspired by Gauguin's paintings and Art Nouveau decorative arts (SEE FIG. 30–77). Derain's assertive colors, which he likened to "sticks of dynamite," do not record what he actually saw in the landscape but rather generate their own purely artistic energy as they express the artist's intense feeling about what he saw. The stark juxtaposi-

tions of complementary hues—green leaves next to red tree trunks, red-orange mountainsides against blue-shaded slopes—create what Derain called "deliberate disharmonies." Equally interested in such deliberate disharmonies was Matisse, whose **THE WOMAN WITH THE HAT** (FIG. 31–3) sparked controversy at the 1905 Salon d'Automne—not because of its fairly conventional subject, but because of the way its subject was depicted: with crude drawing, sketchy brushwork, and wildly arbitrary colors that create a harsh and dissonant effect.

Matisse soon settled into a style with less fevered brushwork but color regions just as vivid. **THE JOY OF LIFE (FIG. 31–4)** depicts nudes in attitudes close to traditional studio poses, but the landscape is intensely bright. He defended his aims in a 1908 pamphlet called *Notes of a Painter*: "What I am after, above all, is expression," he wrote. In the past, an artist might express feeling through the figure poses or facial expressions that the characters in the painting had. But now, he wrote, "The whole arrangement of my picture is expressive. The place occupied by figures or objects, the empty spaces around them, the proportions, everything plays a part."

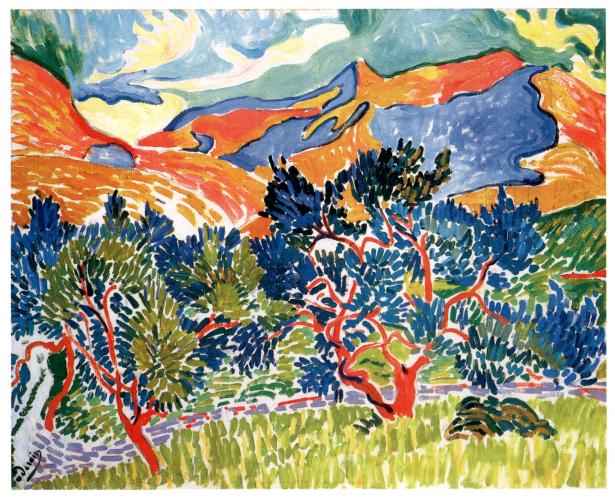

31–2 | André Derain MOUNTAINS AT COLLIOURE 1905. Oil on canvas, $32\times39\%''$ (81.5 \times 100 cm). National Gallery of Art, Washington, D.C. John Hay Whitney Collection

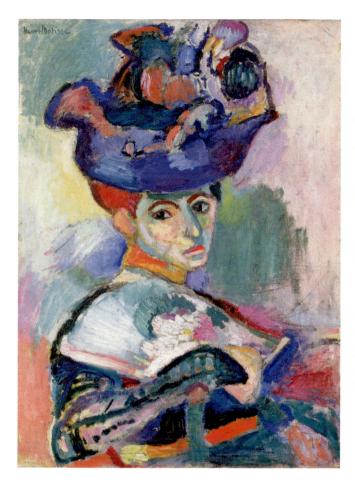

31–3 \parallel Henri Matisse THE WOMAN WITH THE HAT 1905. Oil on canvas, $31\frac{1}{4}\times23\frac{1}{2}$ " (80.6 \times 59.7 cm). San Francisco Museum of Modern Art.

Bequest of Elise S. Haas

Both *The Woman with the Hat* and *The Joy of Life* (FIG. 31-4) were originally owned by the brother and sister Leo and Gertrude Stein, important American patrons of European avant-garde art in the early twentieth century. They hung their collection in their Paris apartment, where they hosted an informal salon that attracted many leading literary, musical, and artistic figures, including Matisse and Picasso. In 1913 Leo moved to Italy while Gertrude remained in Paris, pursuing a career as a Modernist writer and continuing to host a salon with her companion, Alice B. Toklas.

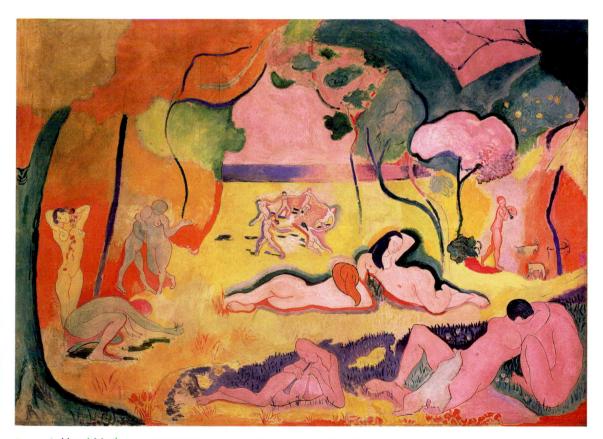

And the colors that he used? "The chief aim of color should be to serve expression as well as possible." We see in The Joy of Life that he also radically simplified the forms, both of the trees and of the bodies. The purpose of this step was to avoid overloading the viewer with excess details. A viewer may become absorbed in the leaves or the clouds, for example, and lose the overall feeling of the work. Matisse wrote, "All that is not useful in the picture is detrimental. A work of art must be harmonious in its entirety; for superfluous details would, in the mind of the beholder, encroach upon the essential elements." Far from the "wild beast" that his detractors saw, Matisse was a thoughtful innovator rather than a radical. The feelings that he communicated were mostly positive and pleasant, making his paintings, as he said, "something like a good armchair in which to rest from physical fatigue."

"The Bridge" and Primitivism

In northern Europe, the Expressionist tradition of artists such as van Gogh and Ensor expanded as younger artists used abstracted forms and colors to communicate more complicated emotional and spiritual states. Prominent in German Expressionist art was Die Brücke ("The Bridge"), which formed in Dresden in 1905 when four architecture students-Fritz Bleyl (1880-1966), Erich Heckel (1883-1970), Ernst Ludwig Kirchner (1880-1938), and Karl Schmidt-Rottluff (1884-1976)—decided to devote themselves to painting and to form an exhibiting group. Other German and European artists later joined the group, which endured until 1913. Die Brücke was named for a passage in Friedrich Nietzsche's Thus Spake Zarathustra (1883) that spoke of contemporary humanity's potential to be the evolutionary "bridge" to a more perfect being of the future.

The artists hoped that The Bridge would become a gathering place for "all revolutionary and surging elements," in opposition to the dominant culture, which they saw as "pale, overbred, and decadent," according to written testimony from one of the leaders. Among their favorite motifs were nudes in nature, such as we see in Schmidt-Rottluff's THREE NUDES-DUNE PICTURE FROM NIDDEN (FIG. 31-5), which shows three simplified female nudes formally integrated with their landscape. The style is purposefully simple and direct, and is a good example of Modernist Primitivism, which drew its inspiration from the non-Western arts of Africa, Pre-Columbian America, and Oceania. The bold stylization typical of such art offered a compelling alternative to the sophisticated illusionism that the Modern artists rejected, and it also provided them formal models to adapt. Many Modernists also believed that immersion in non-Western aesthetics gave them access to a more authentic state of being, uncorrupted by civilization and filled with primal spiritual energies. Nudism was also a growing cultural trend in Germany in those years, as city-dwellers forsook the urban environment to frolic outdoors and reconnect with nature.

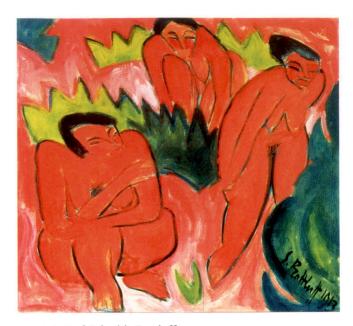

31-5 | Karl Schmidt-Rottluff THREE NUDES—DUNE PICTURE FROM NIDDEN 1913. Oil on canvas, $38\% \times 41\%$ (98 × 106 cm). Staatliche Museen zu Berlin, Preussischer Kulturbesitz, Nationalgalerie.

The group member most systematically committed to Primitivism was Emil Nolde (1867-1956), who was invited to join The Bridge in 1906. Originally trained in industrial design, he had studied with a private academic painting teacher in Paris for a few months in 1900, but he never painted as he was taught. Rather, Nolde regularly visited

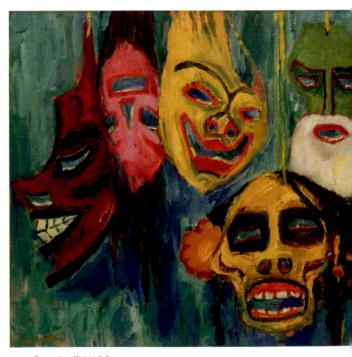

31-6 Emil Nolde MASKS 1911. Oil on canvas, $28\frac{3}{4} \times 30\frac{1}{2}$ " (73.03 × 77.47 cm). Nelson-Atkins Museum, Kansas City, Missouri. Gift of the Friends of Art, 5490. © Artists Rights Society (ARS), New York

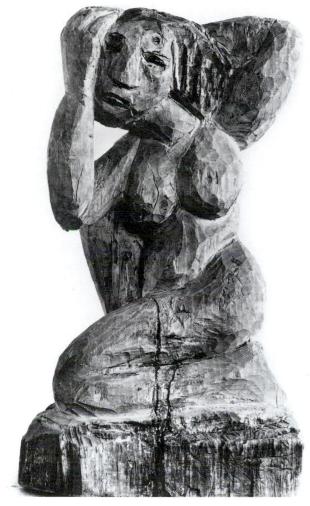

31–7 | Erich Heckel CROUCHING WOMAN 1912. Painted linden wood, $11\% \times 6\% \times 3\%$ " (30 × 17 × 10 cm). Estate of Erich Heckel, Hemmenhofen am Bodensee, Germany.

ethnographic museums to study the arts of tribal cultures from Africa and Oceania, and he was greatly stimulated by the radical simplifications and forceful presence of figural arts that he saw there. One result of his research was MASKS (FIG. 31-6). Here he used the garish colors and fevered brushwork of Expressionism to depict some of the masks that he sketched in the museum. If a traditional still life is a careful composition of pleasant items on a well-lit tabletop, surely this work is a brisk riposte. The masks hang in an indefinite pictorial space, presenting a lurid and grotesque appearance. On the eve of World War I, Nolde accompanied a German scientific expedition that traveled to New Guinea via Asia and the Palau Islands. In the preface to an unfinished book that he intended to write about his travels, he explained what attracted an artist from the supposedly "advanced" European civilization to the arts of Oceania: "Absolute originality, the

intense and often grotesque expression of power and life in very simple forms—that may be why we like these works of native art." Nolde was never exactly a joiner, so he stopped frequenting The Bridge studio in 1907 but remained on good terms with the members thereafter.

Several Bridge members also made their own "primitive" sculpture. Heckel's **CROUCHING WOMAN** (FIG. 31–7) is crudely carved in wood with hacking strokes, rejecting the classical tradition of marble and bronze and suggesting the desire to return to nature depicted in Schmidt-Rottluff's *Three Nudes*.

During the summers, members of The Bridge did return to nature, visiting remote areas of northern Germany, but in 1911 they moved to Berlin—perhaps preferring to imagine the simple life. Ironically, their images of cities, especially Berlin, offer powerful arguments against living there. Particularly critical of urban life are the street scenes of Kirchner, such as **STREET, BERLIN** (FIG. 31–8). Dominating the left half of the painting, two prostitutes—their professions advertised by their large feathered hats and fur-trimmed coats—strut past well-dressed bourgeois men, their potential clients.

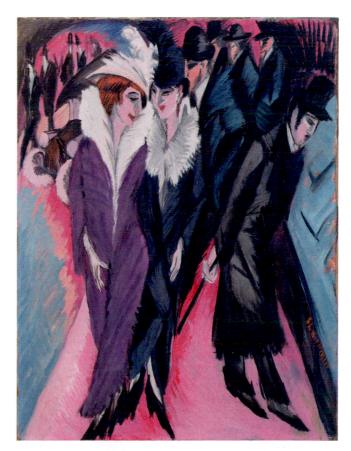

31–8 | Ernst Ludwig Kirchner STREET, BERLIN 1913. Oil on canvas, $47\% \times 35\%$ (120.6 \times 91 cm). The Museum of Modern Art, New York. Purchase (274.39)

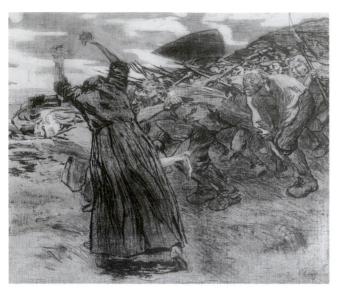

31–9 | Käthe Kollwitz | THE OUTBREAK From the *Peasants' War* series. 1903. Etching, $20 \times 23 \%$ " (50.7×59.2 cm). Kupferstichkabinett, Staatliche Museen zu Berlin, Preussischer Kulturbesitz.

The women and men appear as artificial and dehumanized figures, with masklike faces and stiff gestures. Their bodies crowd together, but they are psychologically distant from one another, victims of modern urban alienation. The harsh colors, tilted perspective, and angular lines register Kirchner's Expressionistic response to the subject.

Independent Expressionists

While the members of The Bridge sought to further their artistic aims collectively, many Expressionists in Germanspeaking countries worked independently. One, Käthe Kollwitz (1867–1945), was committed to causes of the working class and pursued social change primarily through printmaking because of its potential to reach a wide audience. Between 1902 and 1908 she produced the *Peasants' War* series, seven etchings that depict in an exaggerated and intense fashion events in a sixteenth-century rebellion. **THE OUTBREAK** (FIG. 31–9) shows the peasants' built-up fury from

31–10 Paula Modersohn-Becker SELF-PORTRAIT WITH AN AMBER NECKLACE

1906. Oil on canvas, $24 \times 19 \frac{1}{4}$ " (61 \times 50 cm). Öffentliche Kunstsammlung Basel, Kunstmuseum, Basel, Switzerland.

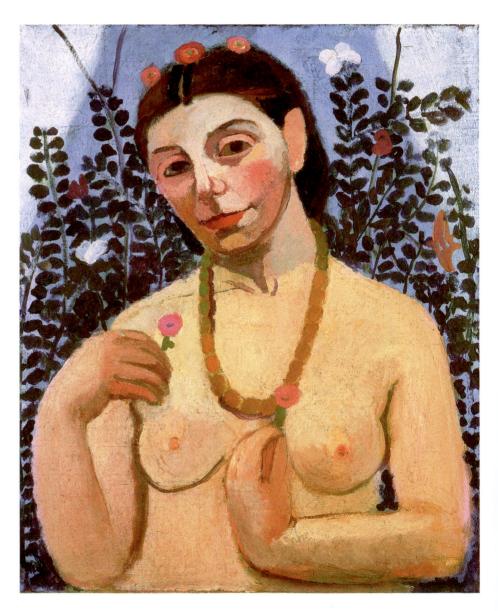

years of mistreatment exploding against their oppressors, a lesson in the power of group action. Kollwitz said that she herself was the model for the leader of the revolt, Black Anna, who raises her hands to signal the attack. Her arms silhouetted against the sky, and the crowded mass of workers with their farm tools, form a jumbled and chaotic picture of a time of upheaval.

Paula Modersohn-Becker (1876–1907), like Kollwitz, studied at the Berlin School of Art for Women, then moved in 1898 to Worpswede, a rustic artists' retreat in northern Germany. Dissatisfied with the Worpswede artists' naturalistic approach to rural life, after 1900 she made four trips to Paris to assimilate recent developments in Post-Impressionist painting. Her **SELF-PORTRAIT WITH AN AMBER NECKLACE** (FIG. 31–10) testifies to the inspiration she found in the work of Paul Gauguin (SEE FIG. 30–67). Her simplified shapes and crude outlines are similar to those in Schmidt-Rottluff's *Three Nudes* (FIG. 31–5), but her muted palette avoided his

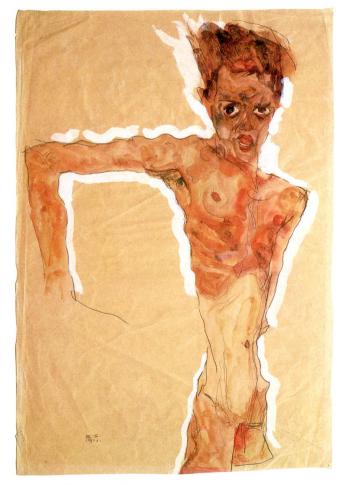

3I—II | Egon Schiele SELF-PORTRAIT NUDE 1911. Gouache and pencil on paper, $20\frac{1}{4} \times 13\frac{3}{4}$ " (51.4 \times 35 cm). The Metropolitan Museum of Art, New York. Bequest of Scofield Thayer, 1982 (1984.433.298)

intense colors. By presenting herself against a screen of flowering plants and tenderly holding a flower that echoes the shape and color of her breasts, she appears as a natural being in tune with her surroundings, as in the nudist paintings by members of The Bridge.

In contrast to Modersohn-Becker's gentle self-portrait, one by Austrian Egon Schiele (1890-1918) conveys physical and psychological torment (FIG. 31-11). Schiele's father had suffered from untreated syphilis and died insane when Egon was fourteen, leaving his son with an abiding link between sex, suffering, and death. In numerous drawings and watercolors, Schiele represented women in sexually explicit poses that emphasize the animal nature of the human body, and his self-portraits reveal deep ambivalence toward the sexual content of both his art and his life. In SELF-PORTRAIT NUDE, the artist stares at the viewer with an anguished expression, his emaciated body stretched into an uncomfortable pose. The absent right hand suggests amputation, and the unarticulated genital region, castration. The missing body parts have been interpreted as the artist's symbolic self-punishment for indulgence in masturbation, then commonly believed to lead to insanity.

Spiritualism of the Blue Rider

Members of *Der Blaue Reiter* ("The Blue Rider") harbored more spiritual intentions that led one member to produce some of the first completely abstract paintings. The group was named for a popular image of a blue knight, the Saint George on the city emblem of Moscow, which many believed would be the world's capital during Christ's 1,000-year reign on earth following the Apocalypse prophesied by Saint John. The Blue Rider formed in Munich around the painters Vasily Kandinsky (1866–1944), a Russian from Moscow, and Franz Marc (1880–1916), a native of Munich, who both considered blue the color of spirituality. Its first exhibition, in December 1911, featured fourteen very diverse artists, whose subjects and styles ranged widely, from naive realism to radical abstraction.

During the early years of his career, Franz Marc moved from a Barbizon-inspired landscape style to a colorful form of Expressionism influenced by the Fauves. By 1911 he was painting animals rather than people because he felt that animals enjoyed a purer, more spiritual relationship to nature than did humans; he rendered these animals in bold, near-primary colors. In his **THE LARGE BLUE HORSES** (FIG. 31–12), the animals merge into a homogenous unit, the fluid contours of which reflect the harmony of their collective existence and echo the lines of the hills behind them, suggesting that they are also in harmony with their surroundings. The pure, strong colors reflect their uncomplicated yet intense experience of the world as Marc enviously imagined it.

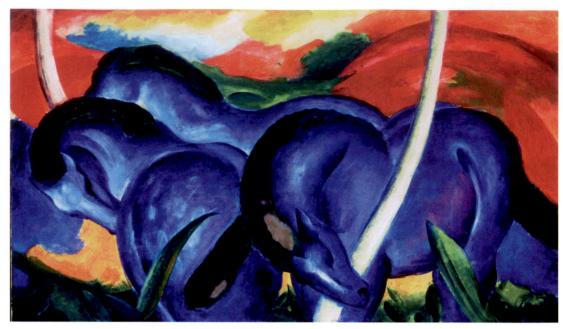

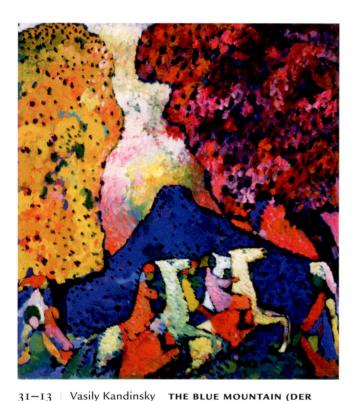

BLAUE BERG)

1908–09. Oil on canvas, 41¼ × 38" (106 × 96.6 cm).

Guggenheim Museum, New York.

Gift of Solomon R. Guggenheim, 1941.41.505. Vasily Kandinsky © 2007

© Artists Rights Society (ARS), New York/ADAGP, Paris

The most radical of the Expressionists was also the best read. Born into a wealthy family and trained originally as a lawyer, Kandinsky was headed for a career as a law school professor in Moscow when he began to frequent exhibitions of Modern art during trips to Germany. After procuring private art instruction, he threw over the idea of a conventional career, settled in Munich in 1896, and began painting.

His early works make frequent reference to Russian folk culture, a "primitive" type of society that inspired him. His 1909 work **THE BLUE MOUNTAIN** (FIG. 31–13) shows two horsemen, rendered in the style of Russian folk art, before a looming peak in his favorite color. The flatness of the work and the carefully parallel brushstrokes show influence from Gauguin and Cézanne. Many of his works feature riders; Kandinsky had in mind the horsemen of the Apocalypse who usher in the end of the world before its final transformation at the end of time.

Kandinsky's study of Whistler's work (SEE FIG. 30–48) also led him to see that the arts of painting and music were related: Just as the composer organizes sound, a painter organizes color and form. This insight was the most direct cause of Kandinsky's contribution to the history of Western art. His musical explorations led him to the work of the Austrian composer Arnold Schoenberg, who in the years surrounding 1910 was taking one of the most momentous steps in musical history. All Western music since antiquity was based on the arrangement of notes into scales, or modes (such as today's common major and minor), and composers could choose the scale they wanted for expressive reasons. Particularly since the Baroque period, each of the notes in any given scale had a role to play, and these roles operated in a clear hierarchy that served

to reinforce what became known as the "tonal center," a kind of home base or place of repose in the musical composition. Schoenberg's great departure was to eliminate the tonal center and treat all tones equally, denying the listener any place of repose and instead prolonging the tension (and thus, he felt, the expression) indefinitely. Kandinsky contacted the composer and was delighted to find out that he also painted in an Expressionist style. Kandinsky asked himself: If music can do without a tonal center, can art do without subject matter?

He found it difficult to paint a completely abstract painting, just as it is difficult to sing without a tonal scale. He gave his works musical titles, such as "Composition" and "Improvisation," and he made his paintings respond to his inner state rather than an external stimulus. Sometime in 1910, art historians generally agree, Kandinsky made his first abstract work. A typical work from this period is **IMPROVISATION 28** (FIG. 31–14). This work retains a vestige of the landscape; Kandinsky found references to nature the hardest to transcend. But the work takes us into a vortex of color, line, and shape. If we recognize buildings or mountains or faces in the work, then perhaps we are seeing in the old way, looking for correspondences between the painting and the world where

none are intended. Rather, the artist would have us look at the painting as if we were hearing a symphony, responding instinctively and spontaneously to this or that passage, and then to the total experience. Kandinsky further explained the musical analogy in a short book about his working methods called *Concerning the Spiritual in Art:* "Color directly influences the soul. Color is the keyboard, the eyes are the hammers, the soul is the piano with many strings. The artist is the hand that plays, touching one key or another purposively, to cause vibrations in the soul."

Kandinsky saw his art as part of a wider political program in opposition to the materialism of Western society. Art's traditional focus on accurate rendering of the physical world is a basically materialistic quest, he thought. Art should not depend so much on mere physical reality. He hoped that his paintings would lead humanity toward a deeper awareness of spirituality and the inner world.

The Swiss-born Paul Klee (1879–1940) participated in the second Blue Rider exhibition of 1912, but his involvement with the group was never more than tangential. A 1914 trip to Tunisia, rather than the Blue Rider, inspired Klee's interest in the expressive potential of color. On his return,

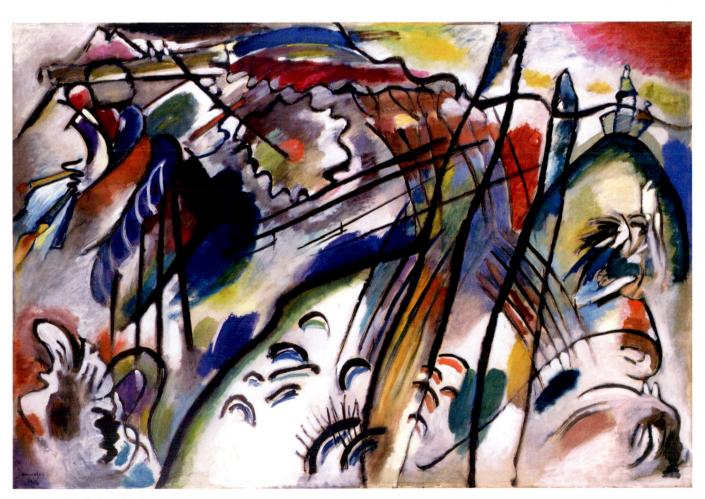

31–14 | Vasily Kandinsky IMPROVISATION 28 (SECOND VERSION) 1912. Oil on canvas, $43\% \times 63\%$ ". Guggenheim Museum, New York. Gift, Solomon R. Guggenheim. 37.239. Vasily Kandinsky © 2003 Artists Rights Society (ARS), New York/ADAGP, Paris

31–15 | Paul Klee

HAMMAMET WITH ITS MOSQUE
1914. Watercolor and pencil on
two sheets of laid paper mounted
on cardboard, 8 1/8 × 7 1/8"
(20.6 × 19.7 cm). The Metropolitan Museum of Art, New York.
The Berggruen Klee Collection, 1984
(1984.315.4)

Klee painted watercolors based on his memories of North Africa, including **HAMMAMET WITH ITS MOSQUE** (FIG. 31–15). The play between geometric composition and irregular brushstrokes is reminiscent of Cézanne's work, which Klee had recently seen. The luminous colors and delicate **washes**, or applications of dilute watercolor, result in a gently shimmering effect. The subtle modulations of red across the bottom, especially, are positively melodic. Klee, who played the violin and belonged to a musical family, seems to have wanted to use color the way a musician would use sound, not to describe appearances but to evoke subtle nuances of feeling.

Cubism in Europe: Exploding the Still Life

Of all Modern art movements created before World War I, Cubism probably had the most influence on later artists. The joint invention of Pablo Picasso (1881–1973) and Georges Braque (1882–1963), the Cubist style proved a fruitful launching pad for both artists, allowing each to comment on modern life and to investigate how we perceive the world.

Picasso's Early Art. Born in Málaga, Spain, Picasso was a child prodigy as an artist. During his teenage years at the National Academy in Madrid, he made highly polished works that portended a bright future, had he stayed on a conservative

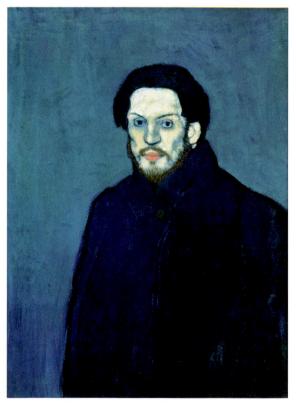

31–16 | Pablo Picasso SELF-PORTRAIT 1901. Oil on canvas, $31\% \times 23\%$ (81 \times 60 cm). Musée Picasso, Paris.

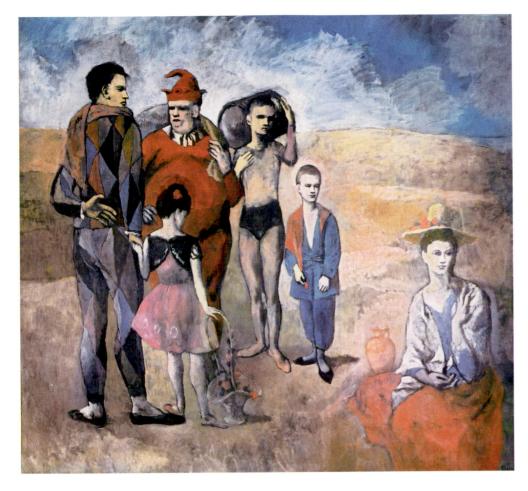

31–17 | Pablo Picasso

FAMILY OF SALTIMBANQUES

1905. Oil on canvas,
6′11¼″ × 7′6⅓″ (2.1 × 2.3 m).

National Gallery of Art,
Washington, D.C.

Chester Dale Collection

artistic path. But his restless temperament led him to Barcelona in 1899, where he involved himself in avant-garde circles.

During this time Picasso was attracted to the socially conscious nineteenth-century French painting that included Daumier (SEE FIG. 30–42) and Toulouse-Lautrec (SEE FIG. 30–81). In what is known as his Blue Period, he painted the outcasts of Paris and Barcelona in weary poses, using a coldly expressive blue, likely chosen for its associations with melancholy. These paintings seem to have been motivated by Picasso's political sensitivity to those he considered victims of modern capitalist society, which eventually led him to join the Communist Party. They also reflect his own unhappiness, hinted at in his 1901 **SELF-PORTRAIT** (FIG. 31–16), which reveals his familiarity with cold, hunger, and disappointment.

In search of a more vital art environment, Picasso moved to Paris in 1904. There his personal circumstances greatly improved. He gained a circle of supportive friends among the avant-garde, and his work attracted several important collectors. His works from the end of 1904 through 1905, known collectively as the Rose Period because of the introduction of that color into his palette, show the last vestiges of his earlier despair. During the Rose Period, Picasso was preoccupied with the subject of traveling acrobats, *saltimbanques*, whose rootless and insecure existence on the margins of society was

similar to the one he too had known. Picasso rarely depicted them performing but preferred to show them at rest, as in **FAMILY OF SALTIMBANQUES** (FIG. 31–17). In this mysterious composition, six figures inhabit a barren landscape painted in warm tones of beige and rose sketchily brushed over a blue ground. Five of the figures cluster together in the left two-thirds of the picture while the sixth, a seated woman, curiously detached, occupies her own space in the lower right. All of the *saltimbanques* seem psychologically withdrawn and uncommunicative, as silent as the empty landscape they occupy.

Soon his encounters with non-Western art in Paris museums would prove decisive in his career. In 1906 the Louvre installed a newly acquired collection of sixth- and fifth-century BCE sculpture from the Iberian Peninsula (present-day Spain and Portugal). Picasso identified these ancient Iberian figures with the stoic dignity of the villagers in the province of his birth. Even more important, he made repeated visits to the ethnographic museum where African art from France's colonies was displayed. While he never took the time to study the cultures where the art originated, Picasso was greatly stimulated by the expressive power and formal novelty of the African masks that he saw. Since African art was relatively inexpensive, he also bought several pieces and kept them in his studio.

31–18 | Pablo Picasso
LES DEMOISELLES D'AVIGNON
(THE YOUNG LADIES OF AVIGNON)
1907. Oil on canvas, 8' × 7'8"
(2.43 × 2.33 m). The Museum of
Modern Art, New York.
Acquired through the Lillie P. Bliss Bequest,
(333.1939)

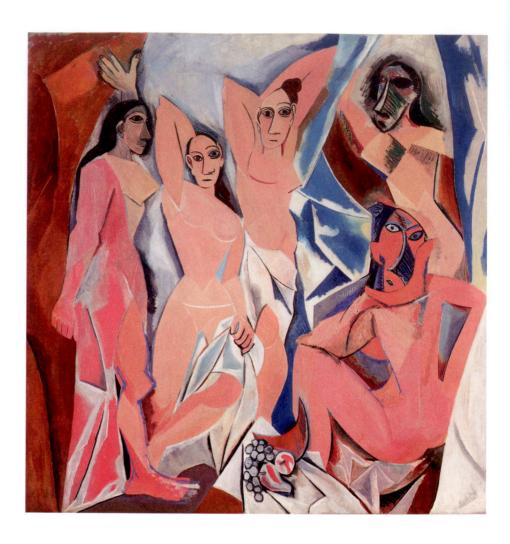

The result of these encounters burst into view in Picasso's large 1907 work LES DEMOISELLES D'AVIGNON (THE YOUNG LADIES OF AVIGNON) (FIG. 31-18). The Iberian influence is seen specifically in the faces of the three leftmost figures, with their simplified features and wide, almond-shaped eyes. The faces of the two right-hand figures, painted in a radically different style, were inspired by African art. Given the then-dominant condescending attitudes toward such allegedly "primitive" cultures, Picasso's wholesale adoption and adaptation of their styles for a large, multifigured painting—as opposed to a still life or a small genre work—was a culturally rebellious thing to do. Such sympathy with non-Western styles paralleled his political beliefs at the time, as he flirted with anarchist theories. Along with its bold embrace of non-Western art, the controversial subject matter of the work is prostitutes. The term demoiselles, meaning "young ladies," is a euphemism for prostitutes, and Avignon refers not to the French town but to a narrow street in the red-light district of Barcelona.

We see the African influence not only in their masklike faces, but also in the handling of their forms in space. The women in the painting are flattened and fractured into sharp curves and angles. The space they inhabit is equally fractured and convulsive. The central pair of *demoiselles* raise their arms

in a traditional gesture of accessibility but contradict it with their hard, piercing gazes and firm mouths. Even the fruit displayed in the foreground, a symbol of female sexuality, seems hard and dangerous. Women, Picasso suggests, are not the gentle and passive creatures that men would like them to be. With this viewpoint he contradicts practically the entire tradition of erotic imagery since the Renaissance. Likewise, his treatment of space shatters the orderly perspective also inherited from that period.

Most of Picasso's friends were horrified by his new work. Matisse, for example, accused Picasso of making a joke of Modern art and threatened to break off their friendship. But one artist, Georges Braque, responded positively, and he saw in Les Demoiselles d'Avignon a potential that Picasso probably had not fully intended. Picasso used broken and distorted forms expressionistically, to convey his view of women, which some feminists have derided as misogynist. But what secured Picasso's place at the forefront of the Parisian avant-garde was the revolution in form that Les Demoiselles d'Avignon inaugurated. Braque responded eagerly to Picasso's formal innovations and set out, alongside Picasso, to develop them. The work was the seedbed for the Cubist style, which came in two phases, Analytic and Synthetic.

ANALYTIC CUBISM. Georges Braque was born a year after Picasso, near Le Havre, France, where he trained to become a house decorator like his father and grandfather. In 1900 he moved to Paris. The Fauve paintings in the 1905 Salon d'Automne so impressed him that he began to paint brightly colored landscapes, but it was the 1907 Cézanne retrospective that established his future course. Picasso's *Demoiselles* sharpened his interest in altered form and compressed space and emboldened Braque to make his own advances on Cézanne's late direction.

Braque's 1908 **HOUSES AT L'ESTAQUE** (FIG. 31–19) reveals the emergence of early Cubism. Inspired by Cézanne's example, Braque reduced nature's many colors to its essential browns and greens and eliminated detail to emphasize basic geometric forms. Arranging the buildings into an approximate pyramid, he pushed those in the distance closer to the foreground, so the viewer looks *up* the plane of the canvas more than into it. The painting is less a Cézannesque study of nature than an attempt to translate nature's complexity into an independent, aesthetically satisfying whole.

Braque submitted *Houses at L'Estaque* to the 1908 Autumn Salon, but the jury, which included Matisse, rejected it—Matisse dismissively referring to Braque's "little cubes." Thus, the name *Cubism* was born.

Braque's early Cubist work helped point Picasso in a new artistic direction. By the end of 1908 the two artists had

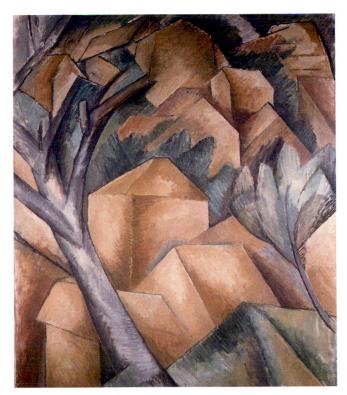

31–19 | Georges Braque HOUSES AT L'ESTAQUE 1908. Oil on canvas, $36\frac{1}{4} \times 23\frac{1}{6}$ " (73 × 59.5 cm). Kunstmuseum, Bern, Switzerland. Collection Hermann and Magrit Rupf-Stiftung

begun an intimate working relationship that lasted until Braque went off to war in 1914. "We were like two mountain climbers roped together," Braque later said. The move toward simplification begun in Braque's landscapes in 1908 continued in the moderately scaled still lifes the two artists produced over the next two and a half years. In Braque's VIOLIN AND PALETTE (FIG. 31–20), the gradual abstraction of deep

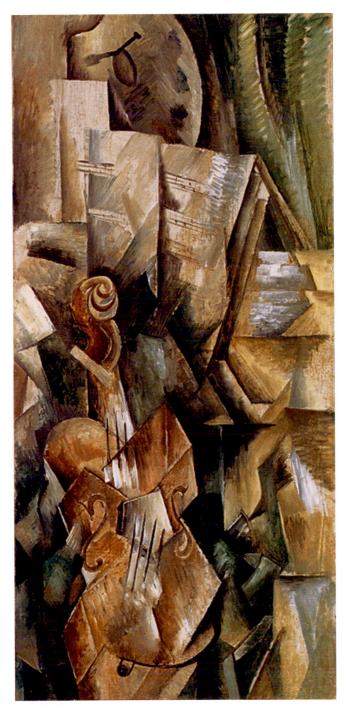

31–20 | Georges Braque VIOLIN AND PALETTE 1909–10. Oil on canvas, $36\% \times 16\%''$ (91.8 \times 42.9 cm). Solomon R. Guggenheim Museum, New York. (54.1412)

space and recognizable subject matter is well under way. The still-life items are not arranged in illusionistic depth but are pushed close to the picture plane in a shallow space. Braque knit the various elements together into a single shifting surface of forms and colors. In some areas of the painting, these formal elements have lost not only their natural spatial relations but their identities as well. Where representational motifs remain—the violin, for example—Braque fragmented them to facilitate their integration into the whole.

Braque's and Picasso's paintings of 1909 and 1910 initiated what is known as Analytic Cubism because of the way the artists broke objects into parts as if to analyze them. The works of 1911 and early 1912 are also grouped under the Analytic label, although they reflect a different approach to the breaking up of forms. Instead of simply fracturing an object, Picasso and Braque picked it apart and rearranged its elements. In this way, Analytic Cubism resembles the actual process of perception. When we look at an object, we are likely to examine it from various angles and then reassemble our glances into a whole in our brain. Picasso and Braque shattered their subjects into jagged forms analogous to momentary, partial glances, but they reassembled the pieces according not to the laws of reality but to those of aesthetic composition. Remnants of the subject Picasso worked from are evident throughout MA JOLIE (FIG. 31-21), for example, but any attempt to reconstruct that subject—a woman with a stringed instrument—would be misguided because the subject provided only the raw material for a formal arrangement.

The inscription of the title on the work offers a joke at the expense of baffled viewers (of which there were probably very many). *Ma Jolie* means "My Pretty One," which was also the name of a popular song. Our first impulse might be to wonder what exactly is pictured on the canvas, and to that unspoken question, Picasso provided a sarcastic answer: "It's My Pretty One!"

A subtle tension between order and disorder is maintained throughout this painting. For example, the shifting effect of the surface, a delicately patterned texture of grays and browns, is given regularity through the use of short, horizontal brushstrokes. Similarly, with the linear elements, strict horizontals and verticals dominate, although many irregular curves and angles are also to be found. The combination of horizontal brushwork and right angles firmly establishes a grid that effectively counteracts the surface flux. Moreover, the repetition of certain diagonals and the relative lack of details in the upper left and upper right create a pyramidal shape. Thus, what at first may seem a random assemblage of lines and muted colors turns out to be a well-organized unit. The aesthetic satisfaction of such a work depends on the way chaos seems to resolve itself into order.

Synthetic Cubism. Works such as *Ma Jolie* brought Picasso and Braque to the brink of total abstraction, but in the spring

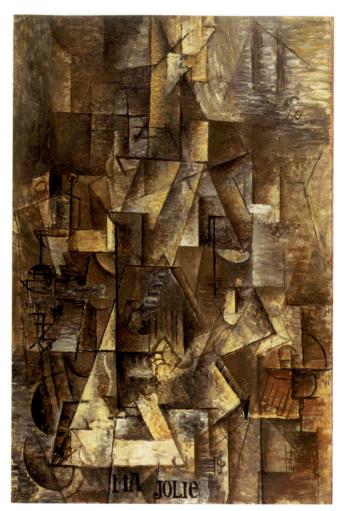

3I–2I | Pablo Picasso MA JOLIE 1911–12. Oil on canvas, $39\% \times 25\%''$ (100 \times 65.4 cm). The Museum of Modern Art, New York. Acquired through the Lillie P. Bliss Bequest (176.1945)

In 1923 Picasso said, "Cubism is no different from any other school of painting. The same principles and the same elements are common to all. The fact that for a long time Cubism has not been understood . . . means nothing. I do not read English, . . . [but] this does not mean that the English language does not exist, and why should I blame anybody . . . but myself if I cannot understand [it]?"

of 1912 they pulled back and began to create works that suggested more clearly discernible subjects. Neither artist wanted to break the link to reality; Picasso once said that there was no such thing as perfectly abstract art, because, he said, "You have to start somewhere." This second major phase of Cubism is known as Synthetic Cubism because of the way the artists created motifs by combining simpler elements, as in a chemical synthesis. Picasso's **GLASS AND BOTTLE OF SUZE** (FIG. 31–22), like many of the works he and Braque created from 1912 to 1914, is a *collage* (from the French *coller*, meaning "to glue"), a work composed of separate elements pasted together. At the center, newsprint and construction paper are assembled to suggest a

tray or round table supporting a glass and a bottle of liquor with an actual label. Around this arrangement Picasso pasted larger pieces of newspaper and wallpaper. The composition of this work is Cubist, as jagged shapes overlap in a shallow space. The elements together evoke not only a place—a bar—but also an activity: the viewer alone with a newspaper, enjoying a quiet drink. However, the newspaper clippings deal with the First Balkan War of 1912–13, which contributed to the outbreak of World War I. Picasso may have wanted to underline the disorder in his art by comparing it with the disorder then building in the world.

Picasso soon extended the principle of collage to produce revolutionary Synthetic Cubist sculpture, such as **MANDOLIN AND CLARINET** (FIG. 31–23). Composed of wood scraps, the sculpture suggests the typical Cubist subject of two musical instruments at right angles to each other. Sculpture has traditionally been either carved, modeled, or cast, but Picasso invented a new method here. In works such as this Picasso introduced the revolutionary technique of **assemblage**, giving sculptors the option not only of carving or modeling but also of constructing their works out of found

Sequencing Works of Art

1903	Stieglitz, The Flatiron Building
1905	Matisse, The Woman with the Hat
1906-1909	Wright, Robie House
1907	Picasso, Les Demoiselles d'Avignon Sloan, Election Night

1908–1912 Brancusi, The Magic Bird

objects and unconventional materials. Another innovative feature of assemblage was the introduction of space into the interior of the sculpture. We see how the parts of the sculpture do not fit perfectly together, leaving gaps and holes. Moreover, the white central piece describes a semicircle that juts outward toward the viewer. Thus the sculpture creates volume through contained space rather than mass alone. This innovation reversed the traditional conception of sculpture as a solid surrounded by a void.

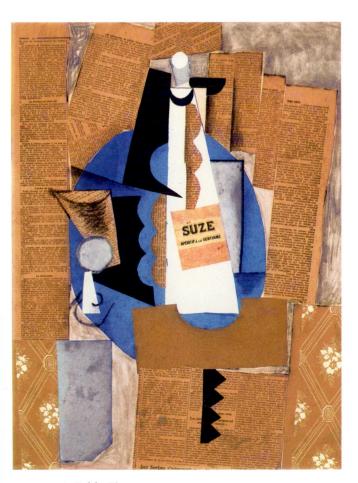

31–22 | Pablo Picasso GLASS AND BOTTLE OF SUZE 1912. Pasted paper, gouache, and charcoal, $25\% \times 19\%$ (65.4 \times 50.2 cm). Washington University Gallery of Art, St. Louis, Missouri.

University Purchase, Kende Sale Fund, 1946

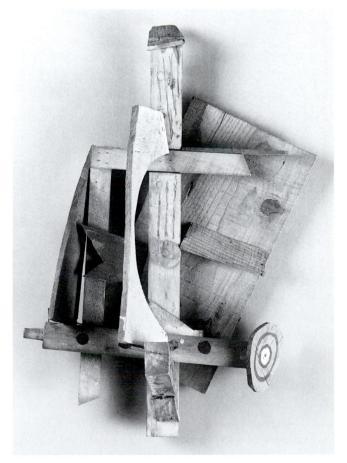

31–23 | Pablo Picasso MANDOLIN AND CLARINET 1913. Construction of painted wood with pencil marks, $22\% \times 14\% \times 9''$ (58 \times 36 \times 23 cm). Musée Picasso, Paris.

31–24 | Robert Delaunay

HOMAGE TO BLÉRIOT

1914. Tempera on canvas, 8'2½" × 8'3"
(2.5 × 2.51 m). Öffentliche

Kunstsammlung Basel, Kunstmuseum,
Basel, Switzerland.

Emanuel Hoffman Foundation

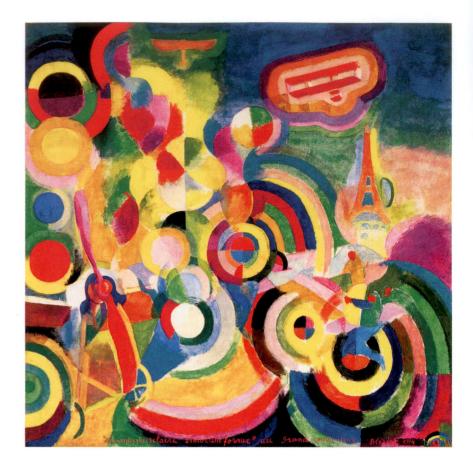

Extensions of Cubism

As the various phases of Cubism emerged from the studios of Braque and Picasso, it became clear to the art world that something of great significance was happening. Artists in many countries used various aspects of the Cubist style to create works that significantly broadened the message of Cubism beyond the studio-based aesthetic of its inventors.

FRENCH EXTENSIONS. Robert Delaunay (1885–1941) and his wife, the Ukrainian-born Sonia Delaunay-Terk (b. Sonia Stern, 1885-1979), took monochromatic, static, Analytic Cubism into a new, wholly different direction. Neo-Impressionism and Fauvism influenced Robert's early painting, and his interest in the spirituality of color led him to participate in Blue Rider exhibitions. Beginning in 1910, he fused Fauvist color with Analytic Cubist form in works celebrating the modern city and modern technology. One of these, HOMAGE TO BLÉRIOT (FIG. 31-24), pays tribute to the French pilot who in 1909 was the first to fly across the English Channel. One of Blériot's early airplanes, in the upper right, and the Eiffel Tower, below it, symbolized technological and social progress, and the crossing of the Channel expressed the hope of a new, unified world without national antagonisms. The brightly colored circular forms that fill the canvas suggest both the movement of the propeller on the left and the blazing sun,

as well as the great rose windows of Gothic cathedrals. By combining images of progressive science with those of divinity, Delaunay suggested that progress is part of God's divine plan. The ecstatic painting thus synthesizes not only Fauvist color and Cubist form but also religion and modern technology.

The critic Guillaume Apollinaire labeled Sonia and Robert's style Orphism for its affinities with Orpheus, the legendary Greek poet whose lute playing charmed wild beasts, implying an analogy between their painting and music. They preferred to think of their work in terms of "simultaneity," a complicated concept based on Michel-Eugène Chevreul's law of the simultaneous contrast of colors. *Simultaneity* for Sonia and Robert connoted the collapse of spatial distance and temporal sequence into the simultaneous "here and now" and the creation of harmonic unity out of elements normally considered disharmonious. The simultaneity that they envisioned captured the new, faster pace of life made possible by airplanes, telephones, and automobiles.

Sonia produced innovative paintings along with Robert, but she also devoted much of her career to fabric and clothing design. She pioneered new clothing patterns based on Modern painting and used them in garments that she called Simultaneous Dresses. Her greatest critical success came in 1925 at the International Exposition of Modern Decorative and Industrial Arts, for which she decorated a Citroën sports

31–25 | Sonia Delaunay-Terk
CLOTHES AND CUSTOMIZED CITROËN B-12
(EXPO 1925 MANNEQUINS AVEC AUTO)
From Maison de la Mode. 1925.

Delaunay-Terk's clothing and fabric designs were displayed at the 1925 International Exposition of Modern Decorative and Industrial Arts in Paris. The term *Art Deco* was coined to describe the kind of geometric style influenced by Cubism and abstract art evident in many of the works on display, which included clocks, furniture, and wallpaper.

car to match one of her ensembles (FIG. 31–25), suggesting that her bold geometric designs were an expression of the new automobile age. Sonia chose that particular car because it was produced cheaply for a mass market, and she had also recently brought out inexpensive ready-to-wear clothing. Moreover, the small three-seater was specifically designed to appeal to the "new woman," who, like the artist herself, was less tied to home and family and less dependent on men than her predecessors. Regrettably, only black-and-white photos exist of these creations.

Similarly fascinated by technology was Fernand Léger (1881–1955), who developed a version of Cubism based on machine forms. Léger painted in a nearly abstract Cubist style as early as 1911, but his artistic development was redirected by his wartime experience. Drafted into the French army, he was almost killed in a poison gas attack; the experience led him to see more beauty in everyday objects, even machine-made ones. **THREE WOMEN** (FIG. 31–26) is a machine-age version of the French odalisque tradition that dates back to Ingres (SEE FIG. 30–4). The picture space is shallow and compressed but less radically shattered than Analytic Cubist works. The women, arranged within a geometric grid, stare out blankly at us, embodying a quality of classical calm. Léger's women have identical faces, and their bodies seem assembled from

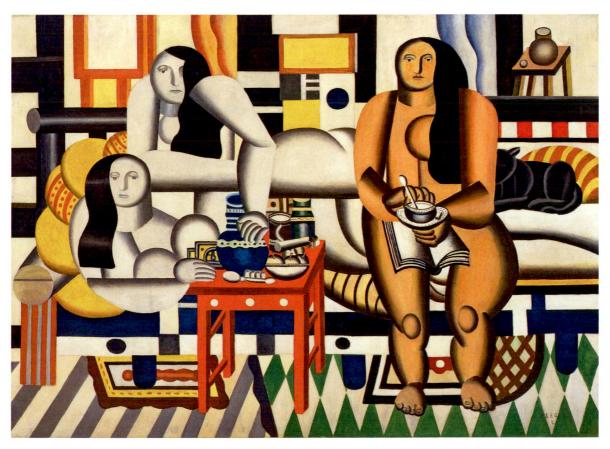

31–26 | Fernand Léger THREE WOMEN 1921. Oil on canvas, $6'1/2'' \times 8'3''$ (1.84 \times 2.52 m). The Museum of Modern Art, New York. Mrs. Simon Guggenheim Fund

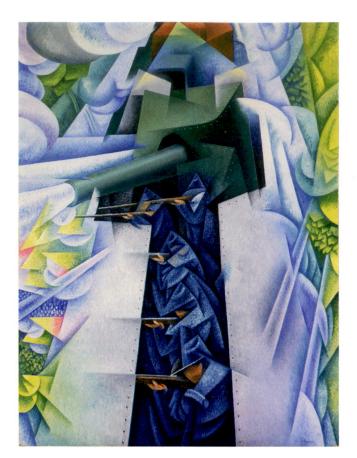

31–27 $^{\parallel}$ Gino Severini ARMORED TRAIN IN ACTION 1915. Oil on canvas, $45 \% \times 34 \%$ (115.8 \times 88.5 cm). The Museum of Modern Art, New York. Gift of Richard S. Zeisler. 287.86

standardized, interchangeable metal parts. The bright, exuberant colors and patterns that surround them suggest a positive vision of an orderly industrial society.

ITALIAN EXTENSIONS. Italian Futurism emerged on February 20, 1909, when the controversial Milanese poet and literary magazine editor Filippo Marinetti (1876–1944) published his "Foundation and Manifesto of Futurism" in a Paris newspaper. An outspoken attack against everything old, dull, "feminine," and safe, Marinetti's manifesto promoted the exhilarating "masculine" experiences of warfare and reckless speed. Futurism aimed both to free Italy from its past and to promote a new taste for the thrilling speed, energy, and power of modern technology and modern urban life.

In April 1911, five Milanese artists issued the "Technical Manifesto" of Futurist painting, in which they boldly declared that "all subjects previously used must be swept aside in order to express our whirling life of steel, of pride, of fever, and of speed." Some members of the group took a trip to Paris to prepare for a Futurist exhibition in 1912, and when they saw Cubist works there they realized that the style could be harnessed to express their love of machines, speed, and war.

Among the signers of the manifesto, Gino Severini (1883–1966) most consistently expressed the radical Futurist idea that war was a cleansing agent for humanity. He lived in Paris from 1906, where he focused special attention on the work of Seurat. Invited to sign the Technical Manifesto while living in Paris, he served as an intermediary between the Futurists based in Italy and the French avant–garde. In his 1915 work **ARMORED TRAIN IN ACTION** (FIG. 31–27), we see the artist's interest in Seurat's Post–Impressionism in the small strokes of bright color that enliven the surface of the work. He also uses the compressed picture space and jagged forms of Cubism to describe a tumultuous scene of smoke, violence, and cannon blasts issuing from the speeding train. The viewpoint in this painting is similarly dizzying, as if we are flying above in an airplane.

In 1912 the Futurist painter Umberto Boccioni (1882–1916) took up sculpture, and his "Technical Manifesto of Futurist Sculpture" called for a "sculpture of environment" in which closed outlines would be broken open and sculptural forms integrated with surrounding space. If traditional sculpture represented things at rest, Futurist sculpture should concern itself with motion. His major sculptural work, **UNIQUE FORMS OF CONTINUITY IN SPACE (FIG. 31–28)**, presents an armless nude figure in full, powerful stride. The contours of the muscular body flutter and flow into the surrounding space, expressing the figure's great velocity and vitality as it rushes forward, a stirring symbol of the brave new Futurist world. This brave new world included World War I, which the Futurists enthusiastically supported. Boccioni enlisted immediately, and lost his life in combat.

Russian Extensions. At the beginning of the century, art societies in St. Petersburg and Moscow began showing works by Impressionist and Post-Impressionist artists. In addition, some important Russian art collectors in both cities bought Modern artworks and opened their homes to artists. These two factors made it possible for Russians to be aware of most of the latest developments in the rest of Europe. By 1912, several Russians were painting in a style they called Cubo-Futurism for its combination of those two movements. Soon Russian artists took Cubism into completely abstract realms.

The leader in this new movement was Kazimir Malevich (1878–1935), who emerged after 1915 as the leading figure in the Moscow avant–garde. According to his later reminiscences, "in the year 1913, in my desperate attempt to free art from the burden of the object, I took refuge in the square form and exhibited a picture which consisted of nothing more than a black square on a white field." He used this large canvas as a backdrop for a performance of Mikhail Matiushin's new opera, *Victory Over the Sun*, in that year. Malevich exhibited thirtynine works in this radically new vein at the "Last Futurist Exhibition of Paintings: 0.10," held in St. Petersburg in the winter of 1915–16. One work, **SUPREMATIST PAINTING** (EIGHT RED RECTANGLES) (FIG. 31–29), consists simply of

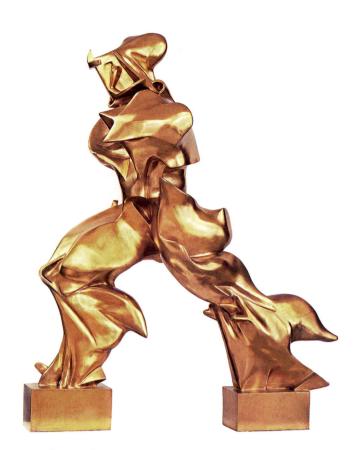

31–28 | Umberto Boccioni UNIQUE FORMS OF CONTINUITY IN SPACE 1913. Bronze, $43\% \times 34\% \times 15\%''$ (111 \times 89 \times 40 cm). The Museum of Modern Art, New York. Acquired through the Lillie P. Bliss Bequest, (231.1948)

Boccioni and the Futurist architect Antonio Sant'Elia were both killed in World War I. The Futurists had ardently promoted Italian entry into the war on the side of France and England. After the war Marinetti's movement, still committed to nationalism and militarism, supported the rise of fascism under Benito Mussolini, although a number of the original members of the group rejected this direction.

eight red rectangles arranged diagonally on a white painted ground. Malevich called this art Suprematism, short for "the supremacy of pure feeling in creative art" motivated by "a pure feeling for plastic [that is, formal] values." By eliminating objects and focusing entirely on formal issues, Malevich intended to "liberate" the essential beauty of all great art.

While Malevich was launching an art that transcended the present, Vladimir Tatlin (1885–1953) was opening a very different direction for Russian art, inspired by Synthetic Cubism. In April 1914, Tatlin went to Paris specifically to visit Picasso's studio. Tatlin was most impressed by the Synthetic Cubist sculpture he saw there, such as *Mandolin and Clarinet* (SEE FIG. 31–23), and began to produce innovative nonrepresentational relief sculptures constructed of various materials, including metal, glass, plaster, asphalt, wire, and wood. These "Counter-Reliefs," as he called them, were based on the conviction that each material generates its own repertory of forms and colors. Partly because he wanted to place "real

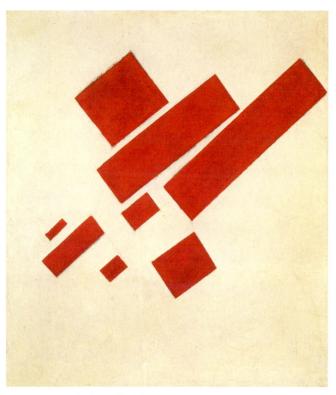

31–29 | Kazimir Malevich SUPREMATIST PAINTING (EIGHT RED RECTANGLES) 1915. Oil on canvas, $22\frac{1}{2} \times 18\frac{1}{6}$ " (57 \times 48 cm). Stedelijk Museum, Amsterdam.

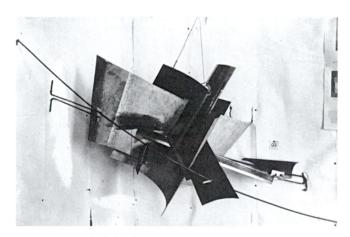

31–30 | Vladimir Tatlin CORNER COUNTER-RELIEF 1915. Mixed media, $31\% \times 59 \times 29\%''$ ($80 \times 150 \times 75$ cm). Present whereabouts unknown.

© Estate of Vladimir Tatlin/RAO Moscow/Licensed by VAGA, New York, NY

materials in real space" and because he thought the usual placement on the wall tended to flatten his reliefs, Tatlin began at the "0.10" exhibition of 1915–16 to suspend them across the upper corners of rooms (FIG. 31–30)—the usual location for the traditional Russian religious pictures known as icons. In effect, these Counter-Reliefs were intended to replace the old symbol of Russian faith with one dedicated to respect for modern and industrial materials.

3I-3I | Liubov Popova

ARCHITECTONIC PAINTING

1917. Oil on canvas, 29 ½ × 21"

(75.57 × 53.34 cm). Los Angeles County

Museum of Art.

Purchased with funds provided by the Estate of Hans G. M. de

Schulthess and the David E. Bright Bequest. 87.49

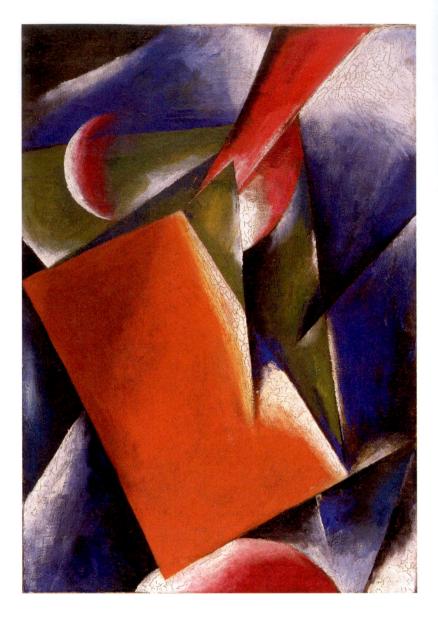

The Suprematist movement attracted many women, the most radical of whom was Liubov Popova (1889–1924). Born into a wealthy family, she studied Modern art in Paris in 1912–13. On her return to Russia she gravitated toward the Suprematists, and she made her first completely abstract Cubist works in 1916. She titled all of these works **ARCHITEC-TONIC PAINTING** (FIG. 31–31). They are more dynamic than those of Malevich, as their forms are modeled and seem to jut into our space. The title alludes to the combination of two-and three-dimensional forms that she attempted to capture in the shallow space of Cubism. The bright colors contribute to the dynamic space that the work creates: Warm colors, such as red and orange, seem to advance toward the viewer, while cool ones (blue and black) recede.

The Russian avant-garde enthusiastically supported the Russian Revolution when it broke out in 1917. They thought that their new form of art was appropriate for the new type of Russian citizen that would emerge from the ashes of the Czarist dictatorship.

Toward Abstraction in Sculpture

Sculpture underwent a revolution as profound as that of painting in the years prior to World War I. Some of the innovations were carried out by artists such as Erich Heckel (SEE FIG. 31–7), who gouged and chopped his sculptures in an Expressionist fashion, and Picasso (FIG. 31-23), who invented constructed sculpture. The sculptor most devoted to making abstract threedimensional objects was the Romanian Constantin Brancusi (1876-1957). Brancusi settled in Paris in 1904 and was immediately captivated by non-Western art. He admired the simplification of forms that he found in the art of many of those cultures because he thought that the artists who made them were intent on capturing the "essence" of the subject. This search for an essence seemed the opposite of the Western tradition after Michelangelo, which he thought focused too much attention on the superficial appearance. He wrote, "What is real is not the external form but the essence of things. Starting from this truth it is impossible for anyone to express anything essentially real by imitating its exterior surface."

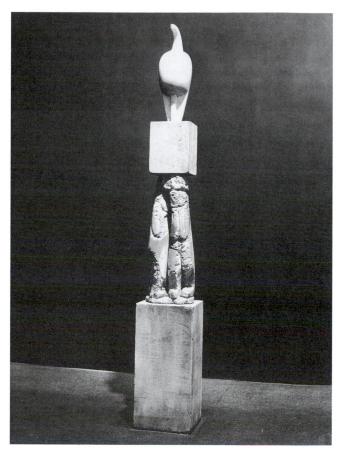

31–32 | Constantin Brancusi MAGIC BIRD 1908–12. White marble, height 22" (55.8 cm), on three-part limestone pedestal, height 5'10" (1.78 m), of which the middle part is the *Double Caryatid* (c. 1908); overall 7'8" \times 12 \times 4" \times 10 \times 8" (237 \times 32 \times 27 cm). The Museum of Modern Art, New York. Katherine S. Dreier Bequest

Brancusi's works tend to focus on two subjects, each of profound symbolic significance: the bird and the egg. The bird symbolized for him the human urge to transcend gravity and earthbound existence. We see in MAGIC BIRD (FIG. 31-32) that the avian form rises majestically above the figural masses below. The sculpture was inspired by Igor Stravinsky's orchestral piece The Firebird, a ballet based on a Russian folk tale that Brancusi saw in 1910. In the ballet, Prince Ivan rescues himself and a princess from an evil sorcerer and his monsters by waving one of the Firebird's feathers. The Firebird then leads Ivan to the hidden egg that holds the evil sorcerer's spirit, and she tells him to break it. When he does, the sorcerer vanishes. The upper part of the sculpture is the Firebird, who in the ballet has bright red plumage. Brancusi made her sleek and abstract. Below are struggling human masses that symbolize the sorcerer's assistants.

For Brancusi, the egg symbolized birth or rebirth and the potential for growth and development. He saw egg shapes as perfect, organic ovals that contain all possible life forms. In **THE NEWBORN** (FIG. 31–33), he charmingly conflated the egg shape with that of a shrieking infant's head. Both infants and eggs, after all, represent a life span in prototype. Perhaps its cry is the primal shout of the baby as it leaves the womb and enters a new (and for Brancusi, more problematic) level of existence.

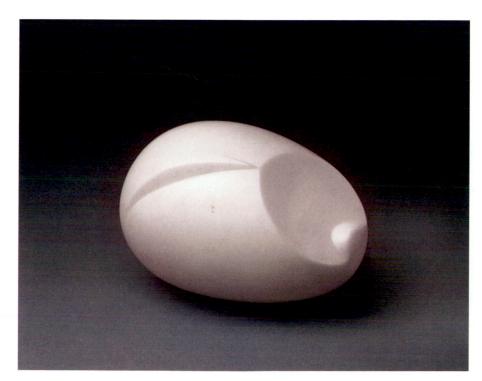

31–33 | Constantin Brancusi THE NEWBORN
1915. Marble, $5\% \times 8\% \times 5\%$ " (14.6 \times 21 \times 14.8 cm). Philadelphia Museum of Art.
Louise and Walter Arensberg Collection.
1950.134.10. Artists Rights Society

Dada

When the Great War broke out in August 1914, most European leaders thought it would be over by Christmas. Each side reassured its population that the efficiency and bravery of its soldiers would ensure a speedy resolution and that Europe could then resume its onward march of progress. Yet these hopes proved illusory in the extreme. World War I was by far the most brutal in human history up to that time, as the allegedly advanced societies hurled themselves at each other. A casualty list provides some indication of the human toll: Germany suffered 850,000 dead; France lost 700,000; Great Britain, 400,000. Large as they are, these numbers cover only the Western front, and only the single year 1916. The conflict, which was supposed to end quickly and gloriously, settled into a vicious stalemate on all fronts, as each side deployed the latest technology for killing: machine guns, flame throwers, fighter aircraft, poison gas. On the home front, governments assumed unheard-of powers over industry and labor in order to manage the war effort. Citizens saw propaganda campaigns, war profiteering masquerading as patriotism, and food rationing. Disgust with the

KARAWANE
jolifanto bambla o falli bambla
grossiga mpla habla horem
egiga goramen
higo bloiko russula huju
hollaka hollala
anlogo bung
blago bung
blago bung
boooo fataka
a na a
schampa wulla wussa olobo
hej tatta gorem
cschige Zunbada
mulubu ssubudu uluu ssubudu
tumba ba- umf
kusagauma
ba- umf

31-34 Hugo ball reciting the sound poem "Karawane"

Photographed at the Cabaret Voltaire, Zürich, 1916.

conflict would eventually spring up on many fronts, but the first artistic movement to react against the slaughter and its moral quandaries was Dada. If the goal of Modern art was questioning and overthrowing the traditions of art, the Dadaists went further and questioned art itself.

Hugo Ball and the Cabaret Voltaire. The movement began with the opening of the Cabaret Voltaire in Zürich, Switzerland, on February 5, 1916. The cabaret's founders, German actor and poet Hugo Ball (1886–1927) and his companion, Emmy Hennings (d.1949), a nightclub singer, had moved to neutral Switzerland after World War I broke out. Their cabaret was inspired by the bohemian artists' cafés they had known in Berlin and Munich, and it attracted avant-garde writers and artists of various nationalities who shared their disgust with contemporary culture, which they blamed for the war.

Ball's performance while reciting one of his sound poems, "KARAWANE" (FIG. 31-34), reflects the iconoclastic spirit of the Cabaret Voltaire. His legs and body encased in blue cardboard tubes, his head surmounted by a white-andblue "witch doctor's hat," as he called it, and his shoulders covered with a huge, gold-painted cardboard collar that flapped when he moved his arms, he slowly and solemnly recited the poem, which consisted of nonsensical sounds. As was typical of Dada, this performance involved two both critical and playful aims. One goal was to retreat into sounds alone and thus renounce "the language devastated and made impossible by journalism." Another end was simply to amuse his audience by introducing the healthy play of children back into what he considered overly restrained adult lives. The flexibility of interpretation inherent in Dada extended to its name, which, according to one account, was chosen at random from a dictionary. In German the term signifies baby talk; in French it means "hobbyhorse"; in Romanian and Russian, "yes, yes"; in the Kru African dialect, "the tail of a sacred cow." The name, and therefore the movement, could be defined as the individual wished.

DUCHAMP. French artist Marcel Duchamp (1887–1968) created the most shocking Dada works. He was also influential in spreading Dada to the United States after he moved to New York to escape the war in Europe. In Paris, Duchamp had experimented successfully with Cubism before abandoning painting, which he came to consider a mindless activity. By the time he arrived in New York, Duchamp believed that art should appeal to the intellect rather than the senses. Duchamp's cerebral approach is exemplified in his **readymades**, which were ordinary manufactured objects transformed into artworks simply through the decision of the artist. The most notorious readymade was **FOUNTAIN** (FIG. 31–35), a porcelain urinal turned 90 degrees and signed with the pseudonym "R. Mutt," a play on the name of the fixture's

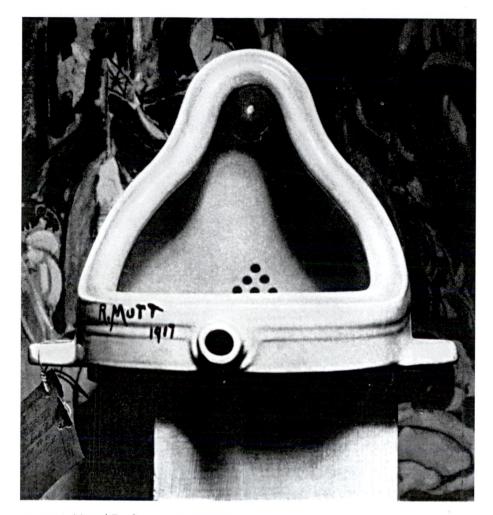

31–35 | Marcel Duchamp FOUNTAIN
1917. Porcelain plumbing fixture and enamel paint, height 24%" (62.5 cm). Photograph by Alfred Stieglitz. Philadelphia Museum of Art.
Louise and Walter Arensberg Collection (1998–74-1)

Stieglitz's photograph is the only known image of Duchamp's original *Fountain*, which mysteriously disappeared after it was rejected by the jury of the American Society of Independent Artists exhibition. Duchamp later produced several more versions of *Fountain* by simply buying new urinals and signing them "R. Mutt/1917."

manufacturer, the J. L. Mott Iron Works. Duchamp submitted *Fountain* anonymously in 1917 to the first annual exhibition of the American Society of Independent Artists, which was committed to staging a large, unjuried show, open to any artist who paid a \$6 entry fee. Duchamp, a founding member of the society and the head of the show's hanging committee, entered *Fountain* partly to test just how open the society was. A majority of the society's directors declared that *Fountain* was not a work of art, and, moreover, was indecent, so the piece was refused. The decision did not surprise Duchamp, who immediately resigned from the society.

A small journal that Duchamp helped to found published an unsigned editorial on the Mutt case refuting the charge of immorality and wryly noting: "The only works of art America has given are her plumbing and bridges." In a more serious vein, the editorial added: "Whether Mr. Mutt with his own hands made the fountain or not has no importance. He CHOSE it. He took an ordinary article of life, placed it so that its useful significance disappeared under the new title and point of view—created a new thought for that object." *Fountain* is a masterpiece of philosophical investigation, a conundrum on a tabletop that quietly explodes some

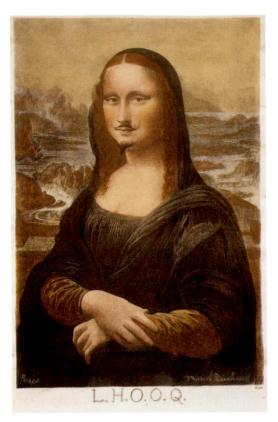

31–36 | Marcel Duchamp **L.H.O.O.Q.** 1919. Pencil on reproduction of Leonardo's *Mona Lisa*. $7\frac{1}{4} \times 4\frac{1}{4}$ " (19.7 × 12.1 cm). Philadelphia Museum of Art. Louise and Walter Arensberg Collection

of our most cherished notions. If a work of art is supposed to be a hand-made product, crafted (and signed) by the creator, this work is neither. If a work of art is supposed to have meaningful form, this work is formed to catch excretions. If a work of art is supposed to show the results of the artist's years of training and study, this work shows only the results of a trip to the hardware store. Duchamp's radical gesture was one of the most important advances of Modern art.

Equally challenging in a slightly different direction is L.H.O.O.Q. (FIG. 31-36). Duchamp bought a postcard reproduction of Leonardo's Mona Lisa (SEE FIG. 20-4), drew a mustache and beard on the famous face, and signed it with his name. He called this piece not a readymade but an "assisted readymade," in which the artist takes a common object and "assists" it with some alteration. Like Fountain, this work challenges preconceived notions with tremendous irreverence. Yet here the target is somewhat different. If one purpose of art is to contribute to civilization by creating objects of beauty, how can artists do this in the face of the unprecedented brutality of the war? Why would an artist want to contribute to the civilization that brought us such carnage? Duchamp's contribution to civilization is to ridicule its hypocrisies. One of the founders of the Dada movement put it succinctly: "Dada was born of disgust." In the face of poison gas attacks that caused thousands of casualties in a single day, perhaps the most reasonable response is one that scales similar heights of ridiculousness.

Duchamp made only a few readymades. In fact, he created very little art at all after about 1922, when he devoted himself mostly to chess. Asked his occupation, he usually said, "retired artist"; his influence, however, made itself felt in many other Modern art movements for the rest of the century.

BERLIN DADA. Dada soon spread to other countries. Early in 1917 Hugo Ball and the Romanian-born poet Tristan Tzara (1896–1963) organized the Galerie Dada. Tzara also edited the magazine *Dada*, which soon attracted the attention of like-minded men and women in various European capitals. The movement spread farther when members of Ball's circle returned to their respective homelands after the war. Richard Huelsenbeck (1892–1974) brought Dada to Germany, where he helped form the Club Dada in Berlin in April 1918.

One distinctive feature of Berlin Dada was the amount of visual art it produced, while Dada elsewhere tended to be

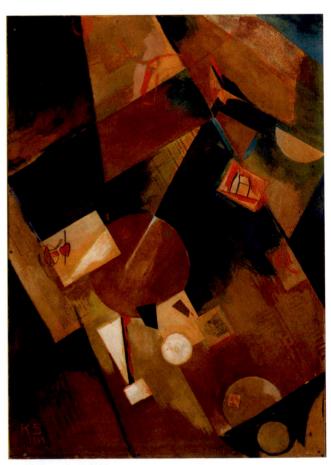

31–37 | Kurt Schwitters MERZBILD 5B (PICTURE-RED-HEART-CHURCH) April 26, 1919. Collage, tempera, and crayon on cardboard, 32% × 23% (83.4 × 60.3 cm). Guggenheim Museum. 52.1325. Kurt Schwitters © 2003 Artists Rights Society (ARS), New York/VG Bild-Kunst, Bonn

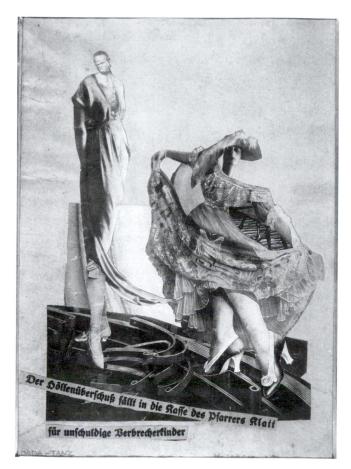

31-38 | Hannah Höch DADA DANCE 1922. Photomontage, $12\% \times 9\%$ (32×23 cm). Israel Museum, Jerusalem.

more literary. Berlin Dada members especially favored collage and photomontage (a photograph created from many smaller photographs arranged in a composition), one of whose leading practitioners was Kurt Schwitters (1887-1948). After study at the Dresden academy, Schwitters painted in an Expressionist style until an important 1919 meeting with Huelsenbeck and other Dadaists. Probably the best example of a Dada collage was created in 1918 by Jean Arp, who dropped torn scraps of paper on a canvas and glued them down where they fell; in contrast, Schwitters used pieces of trash that he found in streets and parks to make images of subtle poetry (FIG. 31-37). Schwitters called each of these works Merzbild, or Merz picture, using an invented term that he claimed meant "garbage" or "rejects." He layered items such as rail tickets, postage stamps, ration coupons, and beer labels together with painted or drawn surfaces, because, he said, refuse deserves equal rights along with paint. The detritus he used was the mass-produced refuse of modern society. In the present work we see several fragments of this type, along with a newspaper page of telling significance. It is a clipping from February 1919 that describes some of the postwar disorder of defeated Germany, as a short-lived socialist republic in Bremen was brutally overthrown by conservative forces. Schwitters thus took the collage of Synthetic Cubism and broadened its image vocabulary in order to make pointed political statements.

Hannah Höch (1889-1978) was among the best exponents of photomontage. Between 1916 and 1926, Höch worked for Berlin's largest publishing house, producing decorative border patterns and writing articles on crafts for a domestically oriented magazine, and many of her photomontages focus on women's issues. Although the status of women improved in Germany after the war, and the "new woman" was much discussed in the German news media, Höch's contribution to this discussion was largely critical. In works such as DADA DANCE (FIG. 31-38), she seems to ridicule the way changing fashions establish standards of beauty that women, regardless of their natural appearance, must observe. On the right is an odd composite figure, wearing high-fashion shoes and dress, in a ridiculously elegant pose. The taller figure, with a small, black African head, looks down on her with a pained expression. For Höch, as for many in the Modernist era, Africa represented what was natural, so Höch presumably meant to contrast natural elegance with its foolish, overly cultivated counterpart. The work's message is not immediately evident, however; nor is it spelled out clearly by the text, which reads: "The excess of Hell falls into the coffers of Pastor Klatt for innocent children of criminals." Many Dadaists valued such purposeful obscurity, a fact which made them good candidates for the Surrealist movement after it began in the mid-1920s.

EARLY MODERN ART IN THE AMERICAS

Artists in the United States were closest to the European innovations, adapting and adopting many of them within a few years of their appearance, but the penetration of Modern art elsewhere in the Americas was uneven. The reasons varied with each region: Canadians had few artistic contacts with Europe; many Mexicans were ideologically opposed to Modern art; South America was far enough away that a time lag took effect. In each case, Modern art took a form different from what unfolded in Europe. If there is a common thread uniting all these regions, it is self-exploration. That is, in many countries artists put the vocabulary of Modern art into the service of a search for cultural roots; they explored the new styles as they also searched for ways to embody their cultural identity.

Modernist Tendencies in the United States

When Modern art was first exhibited in the United States, it competed with a still-vital American Realist tradition that was fundamentally opposed to the abstract styles of painters such as Kandinsky, Delaunay, and Malevich. In the opening decade of the twentieth century, a vigorous Realist movement coalesced in New York City around the charismatic

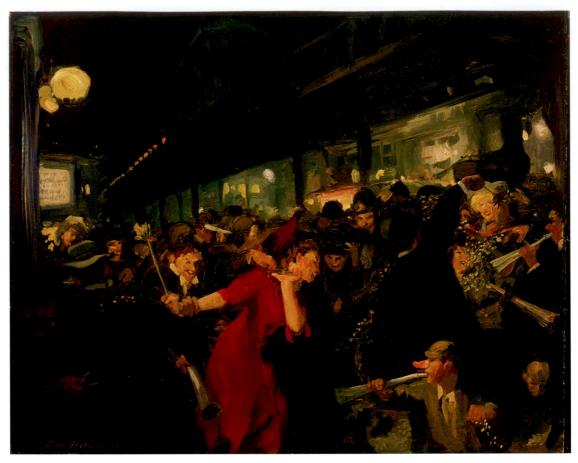

31–39 | John Sloan ELECTION NIGHT 1907. Oil on canvas, $26\% \times 32\%$ (67 × 82 cm). Memorial Art Gallery of the University of Rochester, Rochester, New York, Marion Stratton Gould Fund. 41.33.

painter and teacher Robert Henri (1865–1929). Speaking out against both the academic conventions of "beautiful" subject matter and the Impressionistic style then dominating American art, Henri told his students: "Paint what you see. Paint what is real to you."

THE ASHCAN SCHOOL. In 1908, Henri organized an exhibition of artists who came to be known as The Eight, four of whom were former newspaper illustrators. The show was a gesture of protest against the conservative exhibition policies of the National Academy of Design, the American counterpart of the French École des Beaux-Arts. Because they depicted scenes of often gritty urban life in New York City, five of The Eight became part of what was later dubbed the Ashcan School.

Several members of the Ashcan School studied at the Pennsylvania Academy, where a Realist tradition that Thomas Eakins established (SEE FIG. 30–44) remained active. Most characteristic of this school is John Sloan (1871–1951), whose **ELECTION NIGHT** (FIG. 31–39) embodies many of the group's concerns. The artist went out into the street during a postelection victory celebration and made a sheaf of quick drawings that he then turned into this painting. The work retains the feel of a spontaneous sketch, with its rough, painterly surface. Members

of the group were criticized, as the Impressionists had been before them, for exhibiting unfinished works. Sloan was an avid socialist who made illustrations for several leftist magazines in those years, but he used his painting for a broader purpose: to record the passing show of humanity in its beautiful as well as grimy aspects. This work seems to record the latter category, as some of the revelers look ridiculous in their false noses as they blow on huge trumpets. In the first decade of the twentieth century, the Ashcan School was the most Modern art movement in the United States.

STIEGLITZ'S GALLERY. The chief proponent of European Modern art in the United States was the photographer Alfred Stieglitz, who in the years before World War I worked to foster the American recognition of European Modernism and to support its independent development by Americans. Like Peter Emerson before him (SEE FIG. 30–82), Stieglitz sought recognition for photography as a creative art form on a par with painting, drawing, and printmaking. Born in New Jersey to a wealthy German immigrant family, Stieglitz was educated in the early 1880s at the Technische Hochschule in Berlin, where he discovered photography and quickly recognized its artistic potential. In 1890 Stieglitz began to photograph New York City street scenes with one of the new high-

speed, handheld cameras (the most popular of which, the Kodak, was invented in 1888), which permitted him to "await the moment when everything is in balance" and capture it. He sent one of his early photos to Emerson, who published it in his magazine. Stieglitz promoted his views through an organization called the Photo-Secession, founded in 1902, and two years later he opened a gallery at 291 Fifth Avenue, soon known simply as "291," which exhibited Modern art as well as photography to help break the barrier between the two. In the years around 1910, Stieglitz's gallery became the American focal point not only for the advancement of photographic art but also for the larger cause of European Modernism. Even more important, Stieglitz also exhibited young American artists beginning to experiment with Modernist expression.

In his own art, Stieglitz used his camera to capture poetic moments in the midst of urban life, as we see in **THE FLAT-IRON BUILDING** (FIG. 31–40). Usually Stieglitz's poetic moments were fascinating formal compositions that he framed, rather than documents of human interaction. The tree trunk in the right finds an echo in the grove farther back, and also in the wedge-shaped building that gave the work its title. An arc of chairs behind a low wall seems to encircle both the building and the trees. The entire scene is bathed in winter's cloudy light, which the artist finely controlled through careful exposure, exacting darkroom treatment, and handcrafted printing. Like Emerson, Stieglitz was a devotee of straight photography. Stieglitz's magazine *Camera Work*, where this image was published in 1903, was among the highest-quality art publications in existence at that time.

THE ARMORY SHOW. The turning point for Modern art in the United States was the 1913 exhibition known as the Armory Show. It was assembled by one of The Eight, Arthur B. Davies (1862-1928), to demonstrate how outmoded were the views of the National Academy of Design. Unhappily for the Ashcan School, the Armory Show also demonstrated how out of fashion their Realistic approach was. Of the more than 1,300 works in the show, only about a quarter were by Europeans, but those works drew all the attention. Critics claimed that Matisse, Kandinsky, Braque, Duchamp, and Brancusi were the agents of "universal anarchy." The academic painter Kenyon Cox called them mere savages. When a selection of works continued on to Chicago, civic leaders there called for a morals commission to investigate the show. Faculty and students at the School of the Art Institute were so enraged they hanged Matisse in effigy.

A number of younger artists, however, responded positively and sought to assimilate the most recent developments from Europe. The issue of Realism versus academicism, so critical before 1913, suddenly seemed inconsequential. For the first time in their history, American artists at home began fighting their provincial status.

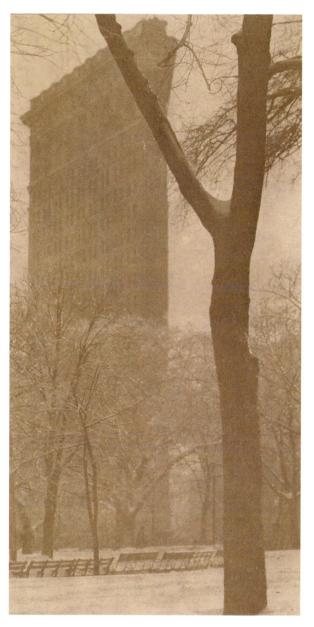

3I–40 | Alfred Stieglitz THE FLATIRON BUILDING 1903. Photogravure, $6\frac{1}{6} \times 3\frac{9}{6}$ " (17 \times 8.4 cm) mounted. Metropolitan Museum of Art, New York, Gift of J. B. Neumann, 1958 (58.577.37).

Among the pioneers of American Modernism who exhibited at the Armory Show was Marsden Hartley (1877–1943), who was also a regular exhibitor at Stieglitz's 291 gallery. Between 1912 and 1915 Hartley lived mostly abroad, first in Paris, where he discovered Cubism, then in Berlin, where he was drawn to the colorful, spiritually oriented Expressionism of Kandinsky. Around the beginning of World War I, Hartley merged these influences into the powerfully original style seen in his *Portrait of a German Officer* (see "*Portrait of a German Officer*," page 1094), a tightly arranged composition of boldly colored shapes and patterns, interspersed with numbers, letters, and fragments of German military imagery that refer symbolically to its subject.

THE OBJECT SPEAKS

PORTRAIT OF A GERMAN OFFICER

arsden Hartley's modernist painting Portrait of a German Officer does not literally represent its subject but speaks symbolically of it through the use of numbers, letters, and fragments of German military paraphernalia and insignia. While living in Berlin in 1914, the homosexual Hartley became enamored of a young Prussian lieutenant, Karl von Freyburg, whom he later described in a letter to his dealer, Alfred Stieglitz, as "in every way a perfect being-physically, spiritually and mentally, beautifully balanced-24 years young. . . . " Freyburg's death at the front in October 1914 devastated Hartley, and he mourned the fallen officer through painting.

The black background of *Portrait of a German Officer* serves formally to heighten the intensity of its colors and expressively to create a solemn, funereal mood. The symbolic references to Freyburg include his initials ("Kv.F"), his age ("24"), his regiment number ("4"), epaulettes, lance tips, and the Iron Cross he was awarded the day before he was killed. The cursive "E" may refer to Hartley himself, whose given name was Edmund.

Even the seemingly abstract, geometric patterns have symbolic meaning. The black-and-white checkerboard evokes Freyburg's love of chess. The blue-and-white diamond pattern comes from the flag of Bavaria. The black-and-white stripes are those of the historic flag of Prussia. And the red, white, and black bands constitute the flag of the German Empire, adopted in 1871.

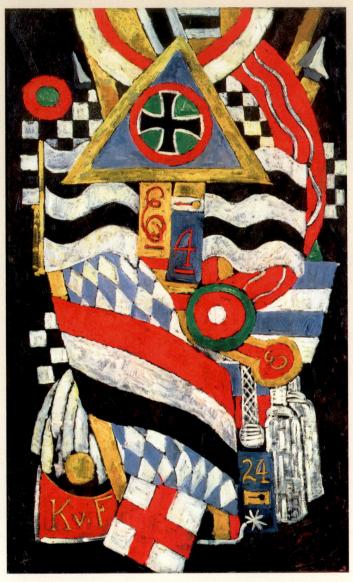

Marsden Hartley PORTRAIT OF A GERMAN OFFICER 1914. Oil on canvas, $68\% \times 41\%$ " (1.78 \times 1.05 m). The Metropolitan Museum of Art, New York. The Alfred Stieglitz Collection, 1949 (49.70.42)

HOME-GROWN MODERNISTS. In some ways the most original of the early Modernists in the United States was Arthur Dove (1880-1946). Dove went to Europe in 1907-09, where he studied the work of the Fauves and exhibited at the Autumn Salon. After returning home, he isolated himself and began making abstract studies from nature around the same time as Vasily Kandinsky, though the two were unaware of each other. His series of works called NATURE SYMBOLIZED (FIG. 31-41) is a remarkable set of small works in which the artist made visual equivalents for natural phenomena such as rivers, trees, and breezes. While Kandinsky focused on his inner life and tried to shut out the external world, Dove rendered in abstract terms his experience in the landscape. A reader of the American philosopher Ralph Waldo Emerson, Dove liked to say that he had "no background except perhaps the woods, running streams, hunting, fishing, camping, the sky." In 1912 he bought a chicken farm in Connecticut so that he could stay close to nature and not have to depend on art sales for his livelihood. Dove is a minor master, an American-type individualist even in an avant-garde context; he worked outside the mainstream and cared little for how his work was received.

Stieglitz reserved his strongest professional and personal commitment at 291 for Georgia O'Keeffe (1887–1986). Born in rural Wisconsin, O'Keeffe studied and taught art sporadically between 1905 and 1915, when a New York friend showed Stieglitz some of O'Keeffe's abstract charcoal drawings. On seeing them, Stieglitz is reported to have said, "At last, a woman on paper!" Stieglitz included O'Keeffe's work in a small group show at 291 in the spring of 1916 and gave her a solo exhibition the following year. One male critic wrote that O'Keeffe, with her organic abstractions, had "found expression in delicately veiled symbolism for 'what every woman knows' but what women heretofore kept to themselves." This was the beginning of much written criticism that focused on the artist's gender, to which O'Keeffe strongly objected. She wanted to be considered an artist, not a woman artist.

O'Keeffe went to New York in 1918, and she and Stieglitz married in 1924. In 1925 Stieglitz introduced O'Keeffe's innovative, close-up images of flowers, which remain among her best-known subjects (see Fig. 5, Introduction). That same year, O'Keeffe began to paint New York skyscrapers, which artists and critics of the period recognized as an embodiment of American inventiveness and productive energy. O'Keeffe's skyscraper paintings are not unambiguous celebrations of lofty buildings, however. She often depicted them from a low vantage point so that they appear to loom ominously over the viewer, as in CITY NIGHT (FIG. 31-42), whose dark tonalities, stark forms, and exaggerated perspective may produce a sense of menace or claustrophobia. The painting seems to reflect O'Keeffe's own growing perception of the city as too confining. In 1929, she began to spend her summers in New Mexico and moved there permanently after Stieglitz's death.

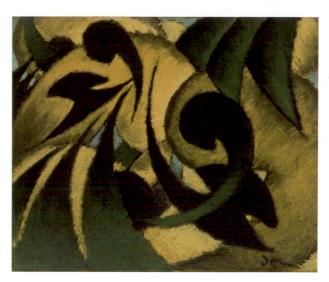

31–41 | Arthur Dove NATURE SYMBOLIZED NO. 2 c. 1911. Pastel on paper, $18 \times 21\%$ " (45.8×55 cm). The Art Institute of Chicago.

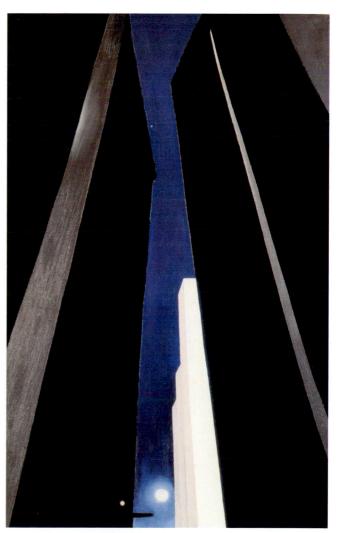

31–42 Georgia O'Keeffe CITY NIGHT 1926. Oil on canvas, $48 \times 30''$ (123 \times 76.9 cm). Minneapolis Institute of Arts.

Modernism Breaks Out in Latin America

Academic values dominated Latin American art during the nineteenth century, as artists and patrons mostly went to Paris in search of training or works to decorate their houses. At the time of World War I, the most radical artists in most countries practiced a pleasant form of Impressionism that focused on the local landscape or traditional customs. After the war, when artists who had studied abroad returned with visions of Cubism or Expressionism, they caused a jolt similar to that of the Armory Show in the United States. Yet Latin American Modernists did not merely imitate Europe-based Modern styles, as they might imitate clothing fashions or technology. Latin American artists put the Modern language to use in exploring ethnic, national, or continental identity.

BRAZIL. The year 1922 marked the centenary of Brazil's independence from Portugal, and the avant-garde in Sao Paulo celebrated with Modern Art Week. It was time for Brazil to declare its artistic independence as well, and so the event gathered avant-garde poets, dancers, and musicians as well as visual artists. The week had an undeniable confrontational character. Poets penned new lines making fun of their elders, and dancers enacted Modern versions of indigenous rituals. Composer Heitor Villa-Lobos (1887–1959) appeared on stage in a bathrobe and slippers to play new music based on Afro-Brazilian rhythms.

Sao Paulo poet Oswald de Andrade, a planner of Modern Art Week, wrote the *Anthropophagic Manifesto* in 1928 that proposed a radical solution to the most urgent problem: What would be Brazil's relationship to European culture? He wrote that Brazilians should do with European culture what the ancient Brazilian natives did to the arriving Portuguese explorers as often as they could: Eat them. The relationship of Brazil to Europe would be one of cannibalism, or *anthropophagia*. Brazilians would gobble up European culture, ingest it, and let it strengthen Brazilianness.

The painter who most closely embodies this irreverent ideal is Tarsila do Amaral (1887-1974), a daughter of the coffee-planting aristocracy who studied in Europe with Fernand Léger, among others (SEE FIG. 31-26). Her work ABA-PORÚ (THE ONE WHO EATS) shows what might happen if Léger were taken out into the fresh air (FIG. 31-43). The work also shows influence of Brancusi's smooth abstractions (SEE FIG. 31-33), which Tarsila collected. But she purposely inserted "tropical" clichés into this work, in the form of the cactus and the lemon-slice sun. The subject matter is a cannibal who seems to sit and reflect on life. If we Brazilians are cannibals, the work seems to say, well then, let us be cannibals. Or, as Andrade put it in one of his manifestos: "Carnival in Rio is the religious outpouring of our race. Richard Wagner yields to the samba. Barbaric but ours. We have a dual heritage: the jungle and the school."

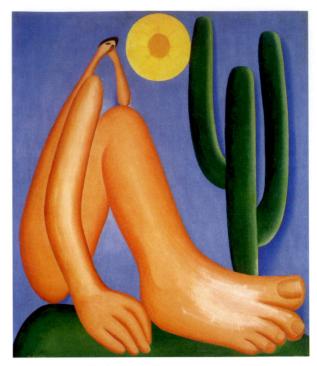

31–43 | Tarsila do Amaral

ABAPORÚ (THE ONE WHO EATS)

1928. Oil on canvas, 34" × 29" (86.4 × 73.7 cm).

Museo de Arte Latinoamericano, Buenos Aires.

Courtesy of Guilherme Augusto do Amaral / Malba-Coleccion Constantini,

Buenos Aires

ARGENTINA. In Argentina, the first exhibition of Cubist art in 1924 had a curious reception. On the first day of the show, the country's president came to visit, all by himself, to see the latest novelty. Later that evening at the official opening, a disturbance broke out that forced the gallery to close. These facts are signs of Argentina's "idiosyncratic modernity," wrote Xul Solar, the leading avant–garde artist. Argentina was at that time among the world's wealthiest nations, made rich on exports of beef and grain. It was also among the most cosmopolitan, with over 90 percent of the population of European descent, about half of them born in Europe. Buenos Aires saw itself as an outpost of Paris or Madrid.

Xul Solar (b. Alejandro Schultz Solari, 1887–1963) took the pseudonym in order to name himself after sunlight–Xul is the Latin *lux*, "light," spelled backward. He lived for twelve years in Europe, where he spent as much time studying art as the arcane mysticisms of the Jewish Kabbalah, the Chinese I Ching, tarot cards, and astrology. On his return in 1924, he altered his piano so that it showed colors instead of playing notes, and he invented two new languages that synthesized European and indigenous tongues. His paintings were little-known in his time because they are mostly small watercolors that he rarely exhibited (FIG. 31–44). The style of these works is most indebted to the Expressionist Paul Klee (SEE FIG. 31–15) but with important differences that reflect Xul's mystical proclivities. The central figure has catlike whiskers, lending it a mysterious air that the half-closed green eyes support.

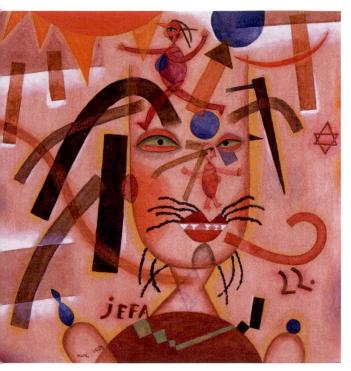

3I–44 \perp Xul Solar JEFA (PATRONESS) 1923. Watercolor on paper, set on cardboard, $10 \,\%'' \times 10 \,\%''$ (26 \times 26 cm). Museum of Fine Arts, Houston. Museum purchase with funds provided by the Latin American Experience Gala

and Auction 2005.343

The shallow composition is crisscrossed with lines of varying thickness which tend to go to or from the head, perhaps indicating directions of thought. An arrow at the top center connects the head to a blue orb symbolizing the universe, between a sun and crescent moon. Two smaller figures seem able to walk forward or backward with equal ease. A star of David at the right sits below a truncated Christian cross in the upper corner. This female feline is a mysterious but seemingly all-knowing being, which is now the artist regarded himself. Xul received the most support for his art from the literary magazine *Martín Fierro*, where the author Jorge Luis Borges worked. The magazine promoted avantgarde nationalism, Borges wrote, "believ[ing] in the importance of the intellectual contribution of the Americas, after taking a scissors to each and every umbilical cord."

CUBA. The avant-garde in Cuba in the 1920s was the most interdisciplinary, consisting of anthropologists, poets, composers, and even a few scientists. They gathered into a group in Havana that called itself "The Minority." Their 1927 manifesto pronounced itself opposed to government corruption, "Yankee imperialism," and dictatorships on any continent. Visual artists were urged to embrace not only new art, but, more important, popular art: to make Modern art that is rooted on Cuban soil. The artist who did this the most consistently over the years was Amelia Peláez (1896–1968). Shortly after the manifesto appeared, she had a seven-year stay in Paris where she studied with Alexandra Exter, a Russ-

ian artist allied with the Suprematists. On her return home in 1934, she joined the anthropologist Lydia Cabrera in studying Cuban popular and folk arts. Her paintings focus on the woman's realm of the Cuban domestic interior with a distinct national orientation (FIG. 31–45). The overall pictorial organization of this work is Cubist, as the flattened forms overlap in compressed pictorial space. We recognize in the work a mirror, a tabletop, and local hibiscus flowers, but these are embroidered by abstract patterns in pure color with heavy black outlining. This feature would be recognizable to any Cuban as a reinterpretation of the fan-shaped stained-glass windows that decorate a great many Cuban homes.

MEXICO. Art culture in Mexico was decisively shaped by the revolution of 1910–1917, which overthrew a dictatorship and established in his place a more democratic regime. Most postrevolutionary government officials believed that the more abstract forms of Modern art would not serve the people's needs because they are incomprehensible to the public. The Ministry of Education instead hired artists to paint murals in public buildings in a readily recognizable style. This movement of muralism will be discussed later, in the context of art for social change.

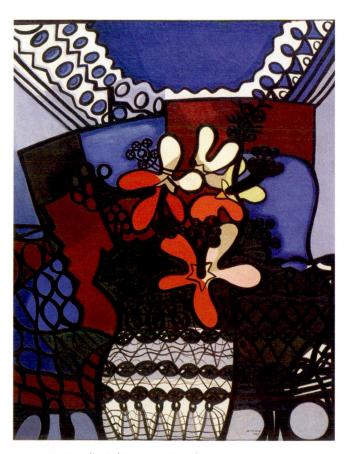

31–45 | Amelia Peláez MARPACÍFICO (HIBISCUS) 1943. Oil on canvas, $45\frac{1}{2} \times 35$ " (115.6 \times 88.9 cm). Art Museum of the Americas, Washington, D.C. Gift of IBM

31–46 | Frida Kahlo
THE TWO FRIDAS
1939. Oil on canvas.
5'8½" × 5'8½" (1.74 × 1.74 m).
Museo de Arte Moderno, Instituto
Nacional de Bellas Artes, Mexico
City.

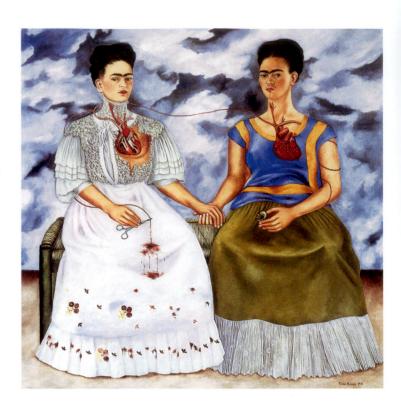

Some artists who did not participate in the mural program created highly individual styles with little or no connection to European Modernism. One of these was Frida Kahlo (1907-1954), who based her autobiographical art on traditional Mexican folk painting (FIG. 31-46). THE TWO FRIDAS shows a double image of the artist that expresses the split in her identity between European and Mexican (she was born of a German father and a part-indigenous Mexican mother). The European Frida on the left wears a Victorian dress while the Frida on the right wears Mexican peasant clothing. This latter Frida holds in her lap a piece of pre-Columbian sculpture, a small head of an indigenous god connected to a blood vessel that passes through the hearts of both Fridas. This vessel ends in the lap of the European Frida, who holds a forceps to try to stop its bleeding. The artist suffered a broken pelvis in a bus accident when she was 17, and faced a lifetime of surgical operations. The work alludes to that personal pain, as well as to the Aztec custom of human sacrifice by heart removal. The value of Kahlo's art, apart from its memorable self-expression, lies in how it investigates and lays bare larger issues of identity. This work focuses most on the mixed heritage of Latin America; others deal more directly with sexuality, feminine identity, and gender equality, all in the context of Kahlo's own life.

Canada

Canadian artists of the nineteenth century, like their counterparts in the United States, generally worked in styles derived from European art. A number of Canadians studied in Paris during the late nineteenth century, some of them mastering

academic realism and painting figurative and genre subjects, others developing tame versions of Impressionism and Post-Impressionism that they applied to landscape painting. Back in Canada, several of the most advanced painters in 1907 formed the Canadian Art Club, an exhibiting society based in Toronto, Ontario.

LANDSCAPE AND IDENTITY. In the early 1910s, a younger group of Toronto artists, many of whom worked for the same commercial art firm, became friends and began to go on weekend sketching trips together. They adopted the rugged landscape of the Canadian north as their principal subject and presented their art as an expression of Canadian national identity, despite its stylistic debt to European Post-Impressionism. A key figure in this development was Tom Thomson (1877-1917), who beginning in 1912 spent the warm months of each year in Algonquin Provincial Park, a large forest reserve 180 miles north of Toronto. There he made numerous small, swiftly painted, oil-on-board sketches that were the basis for full-size paintings he executed in his studio during the winter. A sketch made in the spring of 1916 led to THE JACK PINE (FIG. 31-47). The tightly organized composition features a stylized pine tree rising from a rocky foreground and silhouetted against a luminous background of lake and sky, horizontally divided by cold blue hills. The glowing colors and thick brushwork suggest the influence of Post-Impressionism, while the sinuous shapes and overall decorative effect reveal a debt to Art Nouveau. The painting's arresting beauty and reverential mood, suggesting a divine presence in the lonely northern landscape, have made

it an icon of Canadian art and, for many, a symbol of the nation itself.

NATIVE AMERICAN INFLUENCE. Three years after Thomson's tragic 1917 death by drowning in an Algonquin Park lake, several of his former colleagues formed an exhibiting society called the Group of Seven, which regularly invited other likeminded artists to exhibit with them. One was the West Coast artist Emily Carr (1871-1945), who first met members of the group on a trip to Toronto in 1927. Born in Victoria, British Columbia, Carr studied art in San Francisco (1890-93), England (1899-1904), and Paris (1910-11), where she assimilated the lessons of Post-Impressionism and Fauvism. Between 1906 and 1913 she lived in Vancouver, where she became a founding member of the British Columbia Society of Art. On a 1907 trip to Alaska she was taken with the monumental carved poles of Northwest Coast Native Americans and resolved to document these "real art treasures of a passing race." Over the next twenty-three years Carr visited more than thirty native village sites across British Columbia, making drawings and watercolors as the basis for oil paintings. After a commercially unsuccessful exhibition of her Native American subjects in 1913, Carr returned to Victoria and opened a boardinghouse. Running this business left little time for art, and for the next fifteen years she hardly painted. Her life changed dramatically in 1927 when she was invited to participate in an exhibition of West Coast art at the National Gallery of Canada in Ottawa, Ontario. It was on her trip east to attend the show's opening that she met members of the Group of Seven, whose example and encouragement rekindled her interest in painting.

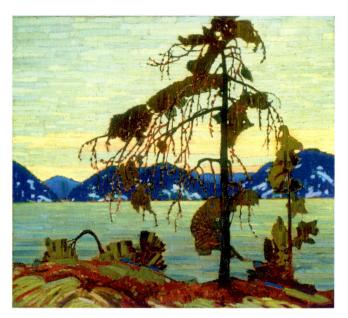

31–47 | Tom Thomson THE JACK PINE 1916–17. Oil on canvas, $49\% \times 54\%''$ (127.9 \times 139.8 cm). National Gallery of Canada, Ottawa, Ontario. Purchase, 1918.

Under the influence of the Group of Seven, Carr developed a dramatic and powerfully sculptural style full of dark and brooding energy. An impressive example of such work is **BIG RAVEN** (FIG. 31–48), which Carr based on a watercolor she made in 1912 in an abandoned village in the Queen Charlotte Islands. There she discovered a carved raven raised on a pole, the surviving member of a pair that had marked a mortuary house. While in her autobiography Carr described the raven as "old and rotting," in her painting the bird appears strong and majestic, thrusting dynamically above the swirling

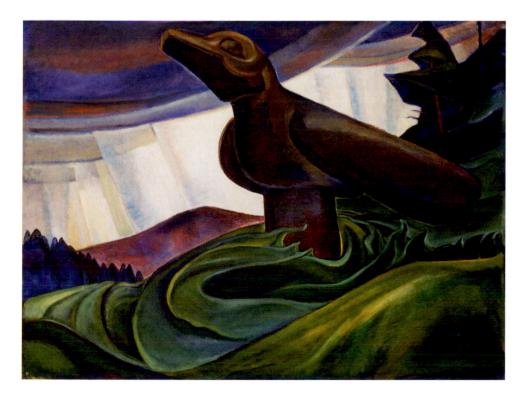

31–48 | Emily Carr
BIG RAVEN
1931. Oil on canvas, 34 × 44 %"
(87.3 × 114.4 cm).
The Vancouver Art Gallery,
Vancouver, B.C.
Emily Carr Trust (VAG 42.3.11)

vegetation, a symbol of enduring spiritual power. Through its focus on a Native American artifact set in a recognizably northwestern Canadian landscape, Carr's *Big Raven* may be interpreted, like the paintings of the Group of Seven, as an assertion of national pride.

EARLY MODERN ARCHITECTURE

New industrial materials and advances in engineering enabled twentieth-century architects to create unprecedented architectural forms that responded to the changing needs of society. Just as Modern artists set aside the traditions of painting and sculpture, Modern architects rejected historical styles and emphasized simple, geometric forms and plain, undecorated surfaces.

European Modernism

In Europe, a stripped-down and severely geometric style of Modern architecture arose, partly in reaction against the ornamental excesses of Art Nouveau. A particularly harsh critic of Art Nouveau (known in Austria as *Sezessionstil*) was the Viennese writer and architect Adolf Loos (1870–1933). In the essay "Ornament and Crime" (1913), he insisted, "The evolution of a culture is synonymous with the removal of ornament from utilitarian objects." For Loos, ornament was a sign of a degenerate culture.

Exemplary of Loos's aesthetic is his **STEINER HOUSE** (FIG. 31–49), whose stucco-covered, reinforced-concrete construc-

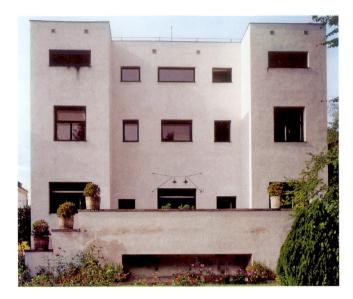

31–49 Adolf Loos STEINER HOUSE Vienna. 1910.

tion lacks embellishment. The plain, rectangular windows are placed only according to interior needs. For Loos, the exterior's only function was to provide protection from the elements. A curved roof behind allows rain and snow to run off but, unlike the traditional pitched roof, creates no wasted space.

The purely functional exteriors of Loos's buildings qualify him as a founder of European Modern architecture. Another was the German Walter Gropius (1883–1969), who

31-50 Walter Gropius and Adolf Meyer FAGUS SHOE FACTORY Alfeld-an-der-Leine, Germany. 1911-16.

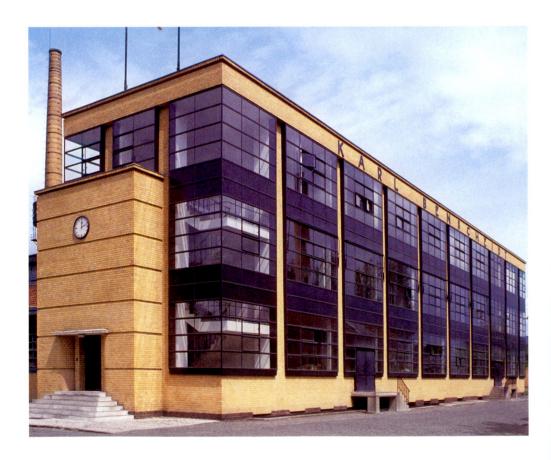

opened an office in 1910 with Adolf Meyer (1881–1929). Gropius's lectures on increasing workers' productivity by improving the workplace drew the attention of an industrialist who in 1911 commissioned him to design a factory for the **FAGUS SHOE COMPANY** (FIG. 31–50). This building represents the evolution of Modern architecture from the engineering advances of the nineteenth century. Unlike the Eiffel Tower or the Crystal Palace (SEE FIGS. 30–1, 30–31), it was conceived not to demonstrate advances or solve a problem but to function as a building. With it Gropius proclaimed that Modern architecture should make intelligent and sensitive use of what the engineer can provide.

To produce a purely functional building, Gropius gave the Fagus Factory façade no elaboration beyond that dictated by its construction methods. The slender brick piers along the outer walls mark the vertical members of the building's steel frame, and the horizontal bands of brickwork at the top and bottom, like the opaque panels between them, mark floors and ceilings. A curtain wall—an exterior wall that bears no weight but simply separates the inside from the outside—hangs over the frame, and it consists largely of glass. The corner piers standard in earlier buildings, here rendered unnecessary by the steel-frame skeleton, have been eliminated. The large windows both reveal the building's structure and flood the workplace with light. This building insists that good engineering is good architecture.

The most important French Modern architect was Le Corbusier (b. Charles-Édouard Jeanneret, 1887–1965), who developed several important concepts that influenced architects for the next half-century. His **VILLA SAVOYE** (FIG. 31–51), a private home outside Paris, is an icon of the

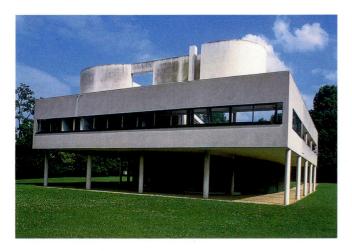

31–51 Le Corbusier VILLA SAVOYE Poissy-sur-Seine, France. 1929–30.

Located 30 miles outside of Paris, near Versailles, the Villa Savoye was designed as a weekend retreat. The owners, arriving from Paris, could drive right under the house, whose ground floor curves to accommodate the turning radius of an automobile and incorporates a three-car garage.

Sequencing Works of Art

1921	Léger, Le Grand Déjeuner
1922	Höch, <i>Dada Dance</i>
1926	O'Keeffe, City Night
1927	Mondrian, Composition with Yellow, Red, and Blue
1928	Tarsila do Amaral, <i>Abaporú</i>
1929-1930	Le Corbusier, Villa Savoye

International Style (see "The International Style," page 1109). It is the best expression of his domino construction system, first elaborated in 1914, in which slabs of ferroconcrete (concrete reinforced with steel bars) were floated on six freestanding steel posts, placed at the positions of the six dots on a domino playing piece. Over the next decade the architect explored the possibilities of this structure and in 1926 published "The Five Points of a New Architecture," which argued for elevating houses above the ground on *pilotis* (freestanding posts); making roofs flat for use as terraces; using partition walls slotted between supports on the interior and curtain walls on the exterior to provide freedom of design; and using ribbon windows (windows that run the length of the wall). All of these became features of Modern buildings.

Le Corbusier applied these motifs in a distinctive fashion that combined two apparently opposed formal systems: the simplified Doric architecture of classical Greece and the clear precision of machinery. He referred to his Villa Savoye as a "machine for living," meaning that it should be as rationally designed as a car or an appliance. Such houses could be effectively placed in nature, as here, but they were meant to transcend it, as the elevation off the ground and pure white coloring suggest. The building appears to be a cube, but behind the ribbon windows, the façade is hollow on its two southfacing sides, allowing natural light to penetrate throughout.

American Modern Architecture

Connection to the Land. Many consider Frank Lloyd Wright (1867–1959), a pioneer of architectural Modernism, the greatest American architect of the twentieth century. Summers spent working on his uncle's farm in Wisconsin gave him a deep respect for nature, natural materials, and agrarian life. After briefly studying engineering at the University of Wisconsin, Wright apprenticed for a year with a Chicago architect, then spent the next five years with the firm of Dankmar Adler and Louis Sullivan (SEE FIG. 30–86), eventually becoming their chief drafter. In 1893, Wright opened his own office, specializing in domestic architecture. Seeking better ways to integrate house and site, he turned away from the traditional boxlike design and by 1900 was creating "organic" architecture that integrated a building with its natural surroundings.

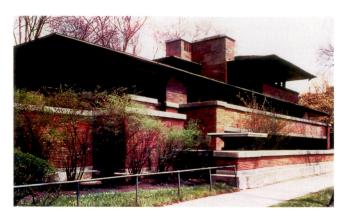

31–52 | Frank Lloyd Wright | FREDERICK C. ROBIE HOUSE Chicago. 1906–9.

This distinctive domestic architecture is known as the **Prairie style** because many of Wright's early houses were built in the Prairie States and were inspired by the horizontal character of the prairie itself. Its most famous expression is the **FREDERICK C. ROBIE HOUSE** (FIG. 31–52), which, typical of the style, is organized around a central chimney that marks the hearth as the physical and psychological center of the home. From the chimney mass, dramatically cantilevered (see "Space-Spanning Construction Devices," page xxix, Starter Kit) roofs and terraces radiate outward into the surrounding

environment, echoing the horizontality of the prairie even as they provide a powerful sense of shelter for the family within. The windows are arranged in long rows and deeply embedded into the brick walls, adding to the fortresslike quality of the building's central mass.

The horizontal emphasis of the exterior continues inside,

especially in the main living level—one long space divided into living and dining areas by a freestanding fireplace. The free flow of interior space that Wright sought was partly inspired by traditional Japanese domestic architecture, which uses screens rather than heavy walls to partition space (see "Shoin Design," page 860). In his quest to achieve organic unity among all parts of the house, Wright integrated lighting and heating into the ceiling and floor and designed built-in bookcases, shelves, and storage drawers. He also incorporated freestanding furniture of his own design, such as the dining room set seen in FIGURE 31-53. The chairs feature a strikingly modern, machine-cut geometric design that harmonizes with the rest of the house. Their high backs were intended to create around the dining table the intimate effect of a room within a room. Wright also designed the table with a view to promoting intimacy: Because he felt that candles and bouquets running down the center of the table formed a barrier between people seated on either side, he integrated lighting features and flower holders into the posts near each of the table's corners.

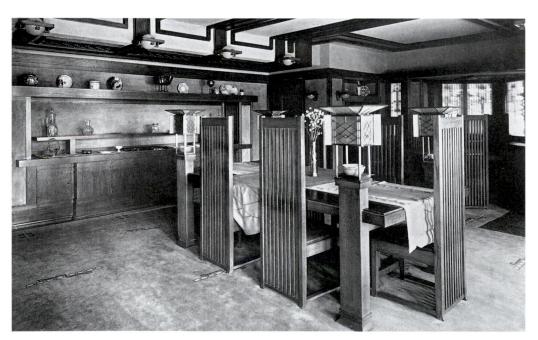

31-53 Frank Lloyd Wright DINING ROOM, FREDERICK C. ROBIE HOUSE

In 1897 Wright helped found the Chicago Arts and Crafts Society, an outgrowth of the movement begun in England by William Morris (Chapter 30). But whereas Morris's English predecessors looked nostalgically back to the Middle Ages and rejected machine production, Wright did not. He detested standardization, but he thought the machine could produce beautiful and affordable objects. The chairs seen here, for example, were built of rectilinear, machine-cut pieces. Wright, a conservationist, favored such rectilinear forms in part because they could be cut with a minimum of wasted lumber.

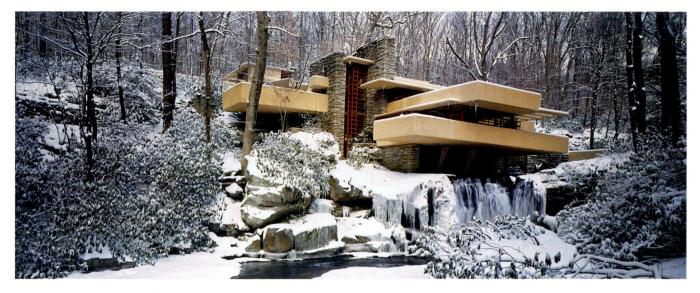

Wright had an uneasy relationship with Modernism as it developed in Europe. Though he routinely used modern building materials (concrete, glass, steel), he always sought ways to keep his buildings connected to the earth and organic realities. The machine aesthetic of Le Corbusier and Gropius held no interest for him. To keep this organic connection, he often used brick, wood, or local stone, items that more orthodox Modernists shunned because they spoke of the past.

FALLINGWATER (FIG. 31-54), in rural Pennsylvania, is perhaps the best-known expression of Wright's conviction that buildings ought to be not simply on the landscape but in it. The house was commissioned by Edgar Kaufmann, a Pittsburgh department store owner, to replace a family summer cottage, on a site that featured a waterfall into a pool where the children played. To Kaufmann's great surprise, Wright decided to build the house into the cliff over the pool, allowing the waterfall to flow around and under the house. A large boulder where the family had sunbathed was built into the house as the hearthstone of the fireplace. In a dramatic move that engineering experts questioned, Wright cantilevered a series of broad concrete terraces out from the cliffside, echoing the great slabs of rock below. The house is further tied to its site through materials. Although the terraces are poured concrete, the wood and stone used elsewhere are either from the site or in harmony with it. Such houses do not simply testify to the ideal of living in harmony with nature but declare war on the modern industrial city. When asked what could be done to improve the city, Wright responded: "Tear it down."

We see a still stronger connection to the land, in combination with a dose of Modernist Primitivism, in the architec-

ture of Mary Colter (1869–1958), which developed separately from that of Wright at about the same time. Born in Pittsburgh and educated at the California School of Design in San Francisco, she spent most of her career as architect and decorator for the Fred Harvey Company, a tourism firm active throughout the Southwest. Colter was an avid student of Native American arts, especially the architecture of the Hopi and Pueblo peoples, and her buildings quoted liberally from those traditions. She designed several visitor facilities at Grand Canyon National Park, of which the most dramatic is the **LOOKOUT STUDIO** (FIG. 31–55). The foundation of this building is natural rock, and most of the walls are built from stones quarried nearby. The building incorporates the edge of the canyon rim and natural rock outcrops into its design,

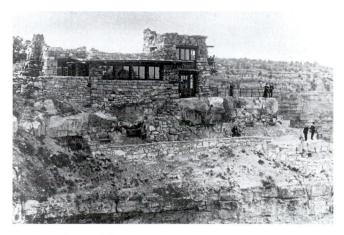

31–55 | Mary Colter LOOKOUT STUDIO Grand Canyon National Park, Arizona. 1914. Photo Grand Canyon National Park Museum Collection

Elements of Architecture

THE SKYSCRAPER

he evolution of the skyscraper depended on the development of these essentials: metal beams and girders for the structural-support skeleton; the separation of the building-support structure from the enclosing layer (the cladding); fireproofing materials and measures; elevators; and plumbing, central heating, artificial lighting, and ventilation systems. First-generation skyscrapers, built between about 1880 and 1900, were concentrated in the Midwest, especially in Chicago and St. Louis (SEE FIG. 30-86). Second-generation skyscrapers, with more than twenty stories, date from 1895. At first the tall buildings were freestanding towers, sometimes with a base, like the Woolworth Building of 1911-13 (SEE FIG. 31-56). New York City's Building Zone Resolution of 1916 introduced mandatory setbacks-recessions from the groundlevel building line-to ensure light and ventilation of adjacent elevator sites. Built in 1931, the 1,250-foot setback form of the Empire shafts State Building, diagrammed here, is thoroughly modern in hav-(layer two) ing a streamlined exterior-its cladding is in Art Deco style (SEE FIG. 31-25, caption)—that conceals the great complexity of the internal structure and mechanisms that make its height possible. The Empire State Building is still one of the tallest buildings stairwells in the world. (layer one) masonry wall beam girder cladding concrete slab flooring heat setbacks source

which is intended to facilitate contemplation of the spectacular view across the canyon. The roofline of the structure is also irregular, like the surrounding canyon wall. Inside, she used huge bare logs for most of the structural supports, between raw stone walls. All of these features can also be found in Hopi architecture. The sole concessions to modernity are in the liberal use of glass and a flat cement floor over the stone foundation. Her work on hotels and railroad sta-

tions throughout the Southwest helped to establish a distinctive identity for architecture of that region.

THE AMERICAN SKYSCRAPER. After 1900, New York City assumed leadership in the development of the skyscraper, whose soaring height was made possible by the use of the steel-frame skeleton for structural support and other advances in engineering and technology (see "The Skyscraper," above).

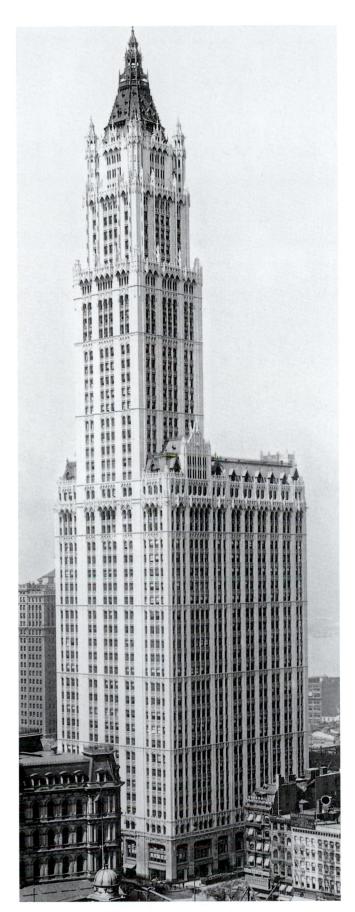

3I-56 | Cass Gilbert | woolworth building New York. 1911-13.

© Collection of the New York Historical Society, New York

New York clients rejected the innovative style of Louis Sullivan and other Chicago architects for the historicist approach still in favor in the East, as seen in the **woolworth building** (FIG. 31–56), designed by the Minnesota-based Cass Gilbert (1859–1934). When completed, at 792 feet and 55 floors, it was the world's tallest building. Its Gothic-style external details, inspired by the soaring towers of latemedieval churches, resonated well with the United States' increasing worship of business. Gilbert explained that he wished to make something "spiritual" of what others called his "Cathedral of Commerce."

ART BETWEEN THE WARS

World War I had a profound effect on Europe's artists and architects. While the Dadaists responded sarcastically to the unprecedented destruction, some sought in the war's ashes the basis for a new, more secure civilization. The onset of the Great Depression in 1929 also motivated many artists to try to find ways to serve society. In general, a great deal of art produced between 1919 and 1939 in Europe and North America is connected in some way with the hope for a better and more just world, rather than primarily serving self-expression or the investigation of aesthetics.

Utilitarian Art Forms in Russia

In the 1917 Russian Revolution, the radical socialist Bolsheviks overthrew the czar, took Russia out of the world war, and turned to winning an internal civil war that lasted until 1920. Most of the Russian avant-garde enthusiastically supported the Bolsheviks, who in turn supported them.

Constructivism. The case of Aleksandr Rodchenko (1891–1956) is fairly representative. An early associate of Malevich and Popova (SEE FIGS. 31–29, 31–31), Rodchenko initially used drafting tools to make abstract drawings. The Suprematist phase of his career culminated in a 1921 exhibition where he showed three large flat, monochromatic panels painted in red, yellow, and blue, which he titled *Last Painting* (they are unfortunately lost). After making this work, he renounced painting as a basically selfish activity and condemned self-expression as socially irresponsible.

In the same year he helped launch a group known as the Constructivists, who were committed to quitting the studio and going "into the factory, where the real body of life is made." In place of artists dedicated to expressing themselves or exploring aesthetic issues, politically committed artists would create useful objects and promote the aims of society. Rodchenko came to believe that painting and sculpture did not contribute enough to practical needs, so after 1921 he began to make photographs, posters, books, textiles, and theater sets that would promote the egalitarian ends of the new Soviet society.

In 1925 Rodchenko designed a model workers' club for the Soviet Pavilion at the Paris International Exposition of Modern Decorative and Industrial Arts (FIG. 31–57). Although Rodchenko said such a club "must be built for amusement and relaxation," the space was essentially a reading room dedicated to the proper training of the Soviet mind. Designed for simplicity of use and ease of construction, the furniture was made of wood because Soviet industry was best equipped for mass production in that material. The design of the chairs is not strictly utilitarian, however. Their high, straight backs were meant to promote a physical and moral posture of uprightness among the workers.

Not all Modernists in Soviet Russia were willing to give up traditional art forms. El Lissitzky (1890–1941), for one, attempted to fit the formalism of Malevich to the new imperative that art be useful to the social order. After the revolution, Lissitzky was invited to teach architecture and graphic arts at the Vitebsk School of Fine Arts and came

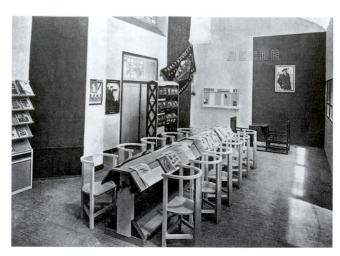

31–57 | Aleksandr Rodchenko
VIEW OF THE WORKERS' CLUB
Exhibited at the International Exposition of Modern
Decorative and Industrial Arts, Paris. 1925.
Rodchenko-Stepanova Archive, Moscow.
Art ©Estate of Aleksandr Rodchenko/RAO, Moscow / VAGA, New York

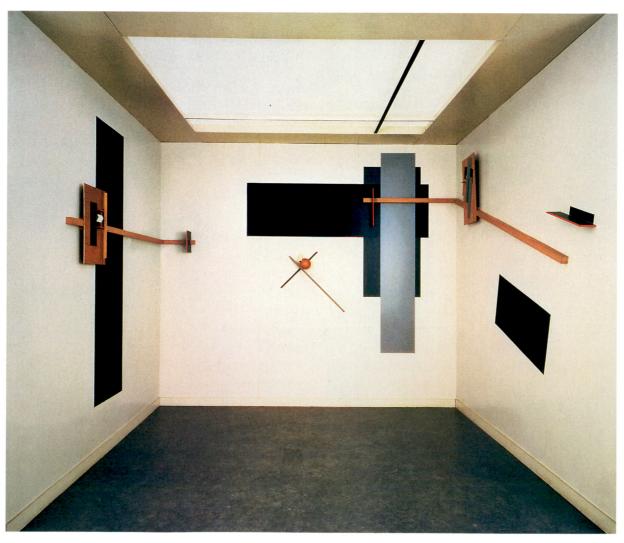

3I-58 | El Lissitzky PROUN SPACE Created for the Great Berlin Art Exhibition. 1923, reconstruction 1965. Stedelijk Van Abbemuseum, Eindhoven, the Netherlands.

under the influence of Malevich, who also taught there. By 1919 he was using Malevich's Suprematist vocabulary for propaganda posters and for the new type of art work he called the Proun (pronounced "pro-oon"), possibly an acronym for the Russian proekt utverzhdenya novogo ("project for the affirmation of the new"). Most Prouns were paintings or prints, but a few were spaces (FIG. 31-58) that qualify as early examples of installation art-artworks created for a specific site, especially a gallery or outdoor area, that create a total environment. Lissitzky rejected conventional painting tools as too personal and imprecise and produced his Prouns with the aid of mechanical instruments. Their engineered look was meant to encourage precise thinking among the public. Like many other Soviet artists of the late 1920s, Lissitzky grew disillusioned with the power of formalist art to communicate broadly and turned to more utilitarian projects—architectural design and typography, in particular and he began to produce, along with Rodchenko and others, propaganda photographs and photomontages.

Socialist Realism. The move away from abstraction was led by a group of Realists, deeply antagonistic to the avantgarde, who banded together in 1922 to form the Association of Artists of Revolutionary Russia (AKhRR) to promote a clear, representational approach to depicting workers, peasants, revolutionary activists, and, in particular, the life and history of the Red Army. Remembering fondly both the Realism and social radicalism of Gustave Courbet (SEE FIG. 30–37), they created huge, dramatic canvases and statues on heroic or inspirational themes in an effort to appeal to the people more directly than they thought Modern art could. By depicting workers and peasants in a heroic manner, they believed they could help build the Soviet state. Their work established the basis for the Socialist Realism instituted by Stalin after he took control of the arts in 1932.

One of the sculptors who worked in this official style was Vera Mukhina (1889–1953), who is best known for her **WORKER AND COLLECTIVE FARM WOMAN** (FIG. 31–59), a colossal stainless-steel sculpture made for the Soviet Pavilion at the Paris Universal Exposition of 1937. The powerfully built male factory worker and female farm laborer hold aloft their respective tools, a hammer and a sickle, to mimic the appearance of these implements on the Soviet flag. The two figures are shown as equal partners striding purposefully into the future, their determined faces looking forward and upward. The dramatic, windblown drapery and the forward propulsion of their diagonal poses enhance the sense of vigorous idealism.

Rationalism in the Netherlands

If Lissitzky's goal was nothing less than reform of human thought through art, a contemporary Dutch movement attempted the same thing using even more simplified means.

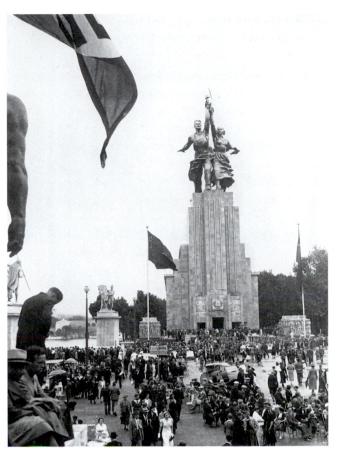

31–59 | Vera Mukhina
WORKER AND COLLECTIVE FARM WOMAN
Sculpture for the Soviet Pavilion, Paris Universal Exposition.
1937. Stainless steel, height approx. 78′ (23.8 m).
Art © Estate of Vera Mukhina / RAO, Moscow / VAGA, New York

The Dutch counterpart to Lissitzky's inspirational formalism was a group known as *de Stijl* ("The Style"), whose leading artist was Piet Mondrian (1872–1944). The turning point in Mondrian's life came in 1912, when he went to Paris and encountered Analytic Cubism. After assimilating its influence he gradually moved from radical abstractions of landscape and architecture to a simple, austere form of geometric art inspired by them. In the Netherlands during World War I, he met Theo van Doesburg (1883–1931), another painter who shared his artistic views. In 1917 van Doesburg started a magazine, *De Stijl*, which became the focal point of a Dutch movement of artists, architects, and designers. The title of the magazine is instructive: These artists did not work in a style, they worked in *The Style*.

Animating the de Stijl movement was the conviction that there are two kinds of beauty: a sensual or subjective one and a higher, rational, objective, "universal" kind. In his mature works, Mondrian sought the essence of the second kind, eliminating representational elements because of their subjective associations and curves because of their sensual appeal.

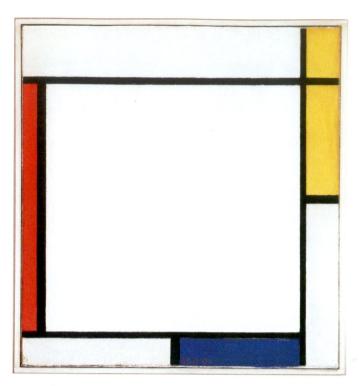

31–60 | Piet Mondrian (1872-1944)
COMPOSITION WITH YELLOW, RED, AND BLUE, 1927.
Oil on canvas, $14\% \times 13\%$ (37.8 \times 34.9 cm).
The Menil Collection, Houston. © 2008 Mondrian/Holtzman Trust c/o HCR International, Warrenton, VA, USA.

Mondrian so disliked the sight of nature, whose irregularities he held largely accountable for humanity's problems, that when seated at a restaurant table with a view of the outdoors, he would ask to be moved.

In this he was following the lead of the theosophist mystic and mathematician M. H. J. Schoenmaekers, who in the 1915 book *New Image of the World* urged thoughtful people "to penetrate nature in such a way that the inner construction of reality is revealed to us." That inner construction, Schoenmaekers wrote, consists of a balance of opposing forces, such as heat and cold, male and female, order and disorder. Moreover, he wrote, artists can help us visualize this inner construction by making completely abstract paintings out of horizontals, verticals, and primary colors only. These words found a ready audience in Mondrian, who had joined the Theosophical Society in 1909 and was already headed toward abstraction in his art. During the war, Mondrian and Schoenmaekers both lived in Amsterdam and shared many visits and conversations.

From about 1920 on, Mondrian's paintings, such as **com- POSITION WITH YELLOW, RED, AND BLUE** (FIG. 31–60), all employ the same essential formal vocabulary: the three primary hues (red, yellow, and blue), the three neutrals (white, gray, and black), and horizontal and vertical lines. The two linear directions are meant to symbolize the harmony of a series of opposites, including male versus female, individual versus society, and spiritual versus material. For Mondrian the essence of higher beauty was resolved conflict, what he called dynamic equilibrium. Here, in a typical composition, Mondrian achieved this equilibrium through the precise arrangement of color areas of different size, shape, and "weight," asymmetrically grouped around the edges of a canvas whose

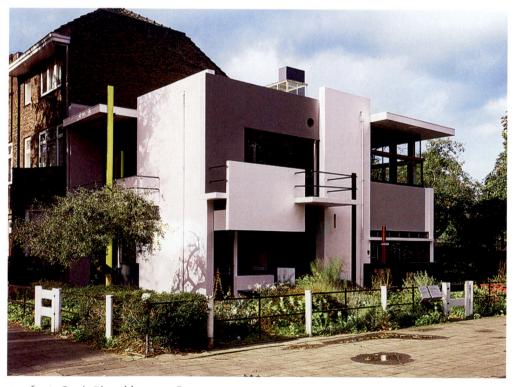

31–61 | Gerrit Rietveld **SCHRÖDER HOUSE** Utrecht, the Netherlands. 1925.

center is dominated by a large area of white. The ultimate purpose of such a painting is to demonstrate a universal style with applications beyond the realm of art. Like Art Nouveau, de Stijl wished to redecorate the world. But Mondrian and his colleagues rejected the organic style of Art Nouveau, believing that nature's example encourages "primitive animal instincts." If, instead, we live in an environment designed according to the rules of "universal beauty," we, like our art, will be balanced, our natural instincts "purified." Mondrian hoped to be the world's last artist: He thought that art had provided humanity with something lacking in daily life and that, if beauty were in every aspect of our lives, we would have no need for art.

The architect and designer Gerrit Rietveld (1888–1964) took de Stijl into the third dimension. His **schröder house** in Utrecht is an important example of the Modern architecture that came to be known as the International Style (see "The International Style," this page). Rietveld applied Mondrian's principle of a dynamic equilibrium to the entire house. The radically asymmetrical exterior (FIG. 31–61) is composed of interlocking gray and white planes of varying sizes, combined with horizontal and vertical accents in primary colors and black. His "RED-BLUE" CHAIR is shown here in the interior (FIG. 31–62), where sliding partitions allow modifications in the spaces used for sleeping, working, and entertaining. These innovative wall partitions were the idea of the patron, Truus Schröder-Schräder, a widowed interior designer. Though wealthy, Schröder-Schräder wanted her

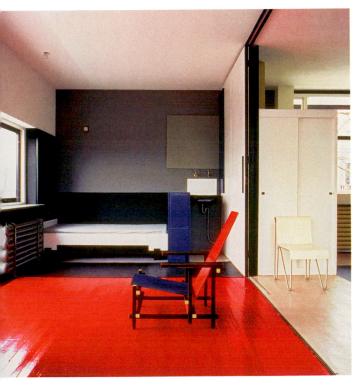

 $31-62 \perp$ interior, schröder house, with "red-blue" chair. 1925.

Elements of Architecture THE INTERNATIONAL

THE INTERNATIONAL STYLE

fter World War I, increased exchanges between Modern architects led to the development of a common formal language, transcending national boundaries, which came to be known as the International Style. The term gained wide currency as a result of a 1932 exhibition at the Museum of Modern Art in New York, "The International Style: Architecture since 1922," organized by the architectural historian Henry-Russell Hitchcock and the architect and curator Philip Johnson. Hitchcock and Johnson identified three fundamental principles of the style.

The first principle was "the conception of architecture as volume rather than mass." The use of a structural skeleton of steel and ferroconcrete made it possible to eliminate load-bearing walls on both the exterior and interior. The building could now be wrapped in a skin of glass, metal, or masonry, creating an effect of enclosed space (volume) rather than dense material (mass). Interiors could now feature open, free-flowing plans providing maximum flexibility in the use of space.

The second principle was "regularity rather than symmetry as the chief means of ordering design." Regular distribution of structural supports and the use of standard building parts promoted rectangular regularity rather than the balanced axial symmetry of classical architecture. The avoidance of classical balance also encouraged an asymmetrical disposition of the building's components.

The third principle was the rejection of "arbitrary applied decoration." The new architecture depended on the intrinsic elegance of its materials and the formal arrangement of its elements to produce harmonious aesthetic effects.

The style originated in the Netherlands, France, and Germany and by the end of the 1920s had spread to other industrialized countries. Important influences on the International Style included Cubism, the abstract geometry of de Stijl, the work of Frank Lloyd Wright, and the prewar experiments in industrial architecture of Germans such as Walter Gropius. The first concentrated manifestation of the trend came in 1927 at the Deutscher Werkbund's Weissenhofsiedlung exhibition in Stuttgart, Germany, directed by Mies van der Rohe, an architect who, like Gropius, was associated with the Bauhaus in Germany (see p. 1110). This permanent exhibition included modern houses by, among others, Mies, Gropius, and Le Corbusier. Its aim was to present models using new technologies and without reference to historical styles. All of the buildings featured flat roofs, plain walls, and asymmetrical openings, and almost all of them were rectilinear in shape.

The concepts of the International Style remained influential in architecture until the 1970s, particularly in the United States, where numerous European architects, including Mies and Gropius, settled in the 1930s. Even Frank Lloyd Wright, an individualist who professed to disdain the work of his European colleagues, adopted elements of the International Style in his later buildings, such as Fallingwater (SEE FIG. 31-54).

home to suggest not luxury but elegant austerity, with the basic necessities sleekly integrated into a meticulously restrained whole.

Bauhaus Art in Germany

The machine-made look of the buildings and furnishings of de Stijl proved anathema to the designers of the Bauhaus, who wanted to reinvigorate industry through craft. The Bauhaus ("House of Building") was the brainchild of Walter Gropius, an early devotee of the Arts and Crafts movement who believed that mass production destroyed art. He admired the spirit of the medieval building guilds—the *Bauhütten*—that had built the great German cathedrals, and he sought to revive and commit that spirit to the reconciliation of Modern art with industry by synthesizing the efforts of architects, artists, and designers and craft workers. The Bauhaus was formed in 1919, when Gropius convinced the authorities of Weimar, Germany, to allow him to combine the city's schools of art and craft. The Bauhaus moved to Dessau in 1925 and then to Berlin in 1932.

Although Gropius's "Bauhaus Manifesto" of 1919 declared that "the ultimate goal of all artistic activity is the building," the school offered no formal training in architecture until 1927. Gropius thought students would be ready for architecture only after they had completed the required preliminary course and received full training in the crafts taught in the Bauhaus workshops. These included making pottery, metalwork, textiles, stained glass, furniture, wood carvings, and wall paintings. In 1922 Gropius implemented a new emphasis on industrial design, and the next year brought on the Hungarian-born László Moholy-Nagy (1895–1946) to reorient the workshops toward the creation of sleek, func-

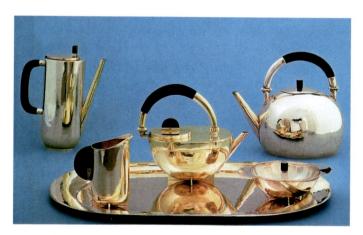

The lid of Marianne Brandt's sugar bowl is made of Plexiglas, reflecting the Bauhaus's interest in incorporating the latest advances in materials and technology into the manufacture of utilitarian objects.

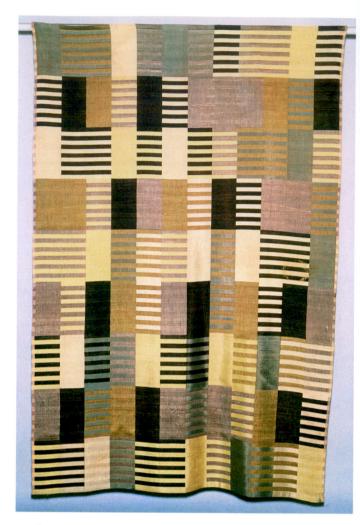

31–64 | Anni Albers **WALL HANGING** 1926. Silk, two-ply weave, $5'11\%'' \times 3'11\%'' (1.83 \times 1.22 \text{ m})$. Busch-Reisinger Museum, Harvard University, Cambridge, Massachusetts

Association Fund

Following the closure of the Bauhaus in 1933 by the Nazis, Anni Albers and her husband, Josef, immigrated to the United States, where they became influential teachers at the newly founded Black Mountain College in Asheville, North Carolina. Anni Albers exerted a powerful influence on the development of fiber art in the United States through her exhibitions, her teaching, and her many publications, including the books *On Designing* (1959) and *On Weaving* (1965).

tional designs suitable for mass production. The elegant tea and coffee service (FIG. 31–63) by Marianne Brandt (1893–1983), for example, though handcrafted in silver, was a prototype for mass production in a cheaper metal such as nickel silver. After the Bauhaus moved to Dessau, Brandt designed several innovative lighting fixtures and table lamps that went into mass production, earning much-needed revenue for the school. After Moholy-Nagy's departure in 1928 (the same year Gropius left), she directed the metal workshop for a year before leaving the Bauhaus herself.

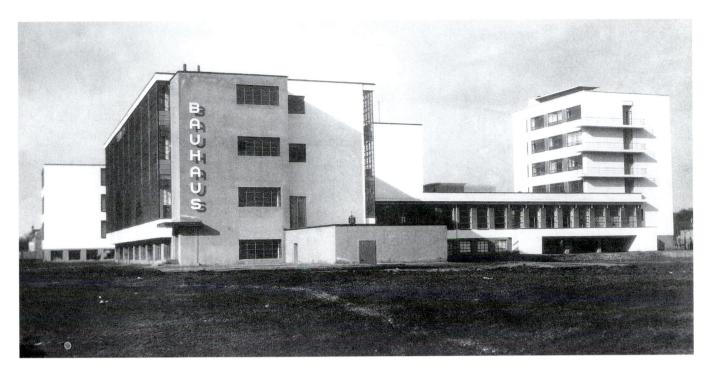

31–65 Walter Gropius BAUHAUS BUILDING Dessau, Germany. 1925–26. View from northwest.

One of the enduring contributions of the Bauhaus was graphic design. The sans-serif letters of the building's sign not only harmonize with the architecture's clean lines but also communicate the Bauhaus commitment to modernity. Sans-serif typography (that is, a typeface without serifs, the short lines at the end of the strokes of a letter) had been in use only since the early nineteenth century, and a host of new sans-serif typefaces was created in the 1920s.

As a woman holding her own in the otherwise all-male metals workshop, Brandt was an exceptional figure at the Bauhaus. Although women were admitted to the school on an equal basis with men, Gropius opposed their education as architects and channeled them into workshops that he deemed appropriate for their gender, namely pottery and textiles. One of the most talented members of the textile workshop was the Berlin-born Anni Albers (b. Annelise Fleischmann, 1899–1994), who arrived at the school in 1922 and three years later married Josef Albers (1888-1976), a Bauhaus graduate and professor. Obliged to enter the textiles workshop rather than the painting studio, Anni Albers set out to make "pictorial" weavings that would equal paintings as fine (as opposed to applied) art. Albers's wall hangings, such as the one shown in FIGURE 31-64, were intended to aesthetically enhance the interior of a modern building in the same way an abstract painting would. The decentralized, rectilinear design reflects the influence of de Stijl, while acknowledging weaving as a process of structural organization.

Albers's intention was "to let threads be articulate . . . and find a form for themselves to no other end than their own orchestration." Numerous other Bauhaus works reveal a similarly "honest" attitude toward materials, including Gropius's design for the new Dessau Bauhaus, built in 1925–26. The building frankly acknowledges the reinforced concrete, steel,

and glass of which it is built but is not strictly utilitarian. Gropius, influenced by de Stijl, used asymmetrical balancing of the three large, cubical structural elements to convey the dynamic quality of modern life (FIG. 31–65). The expressive glass-panel wall that wraps around two sides of the workshop wing of the building recalls the glass wall of the Fagus Shoe Factory (SEE FIG. 31–50) and sheds natural light on the workshops inside. The raised parapet below the workshop windows demonstrates the ability of modern engineering methods to create light, airy spaces unlike the heavy spaces of past styles.

After the Bauhaus moved to Berlin in 1932, it lasted only one more year before Adolf Hitler forced its closure (see "Suppression of the Avant-Garde in Nazi Germany," page 1112). Hitler objected to Modern art on two grounds: first, that it was cosmopolitan and not nationalistic enough; second, that it was unduly influenced by Jews. Only the first of these has a shred of truth; as grounds for censorship, neither is rational.

Art and Politics

Many art movements of the interwar period had a goal of improving the world somehow, but a few of them were more directly linked to political realities in their respective countries. These more politically oriented movements took a slightly different form in each region, in styles ranging from realism to abstraction.

Defining Art

SUPPRESSION OF THE AVANT-GARDE IN NAZI GERMANY

he 1930s in Germany witnessed a serious political reaction against avant-garde art and, eventually, a concerted effort to suppress it. One of the principal targets was the Bauhaus. Through much of the 1920s, the Bauhaus, where such luminaries as Paul Klee, Vasily Kandinsky, Josef Albers, and Ludwig Mies van der Rohe taught, had struggled against an increasingly hostile and reactionary political climate. As early as 1924 conservatives accused the Bauhaus of being not only educationally unsound but also politically subversive. To avoid having the school shut down by the opposition, Gropius moved it to Dessau in 1925, at the invitation of Dessau's liberal mayor, but he left the school soon after the relocation. His successors faced increasing political pressure, as the school was a prime center of Modernist practice, and the Bauhaus was again forced to move in 1932, this time to Berlin.

After Adolf Hitler came to power in 1933, the Nazi party mounted an aggressive campaign against Modern art. In his youth Hitler himself had been a mediocre landscape painter, and he had developed an intense hatred of the avant-garde. During the first year of his regime, the Bauhaus was forced to close for good. A number of the artists, designers, and architects who had been on its faculty—including Albers, Gropius, and Mies—migrated to the United States.

The Nazis also launched attacks against the German Expressionists, whose often intense depictions of German soldiers defeated in World War I and of the economic depression following the war were considered unpatriotic. Most of all, the treatment of the human form in these works, such as the Expression-

istic exaggeration of facial features, was deemed offensive. The works of these and other artists were removed from museums, while the artists themselves were subjected to public ridicule and often forbidden to buy canvas or paint.

As a final move against the avant-garde, the Nazi leadership organized in 1937 a notorious exhibition of banned works. The "Degenerate Art" exhibition was intended to erase Modernism once and for all from the artistic life of the nation. Seeking to brand all the advanced movements of art as sick and degenerate, it presented Modern artworks as specimens of pathology; the organizers printed derisive slogans and comments to that effect on the gallery walls (see illustration). The 650 paintings, sculpture, prints, and books confiscated from German public museums were viewed by 2 million people in the four months the exhibition was on view in Munich and by another million during its subsequent three-year tour of German cities.

By the time World War II broke out, the authorities had confiscated countless works from all over the country. Most were publicly burned, though the Nazi officials sold much of the looted art at public auction in Switzerland to obtain foreign currency.

The blindness of the Nazi regime even kept it from recognizing some of its friends. Expressionist Emil Nolde (SEE FIG. 31-6) joined the Danish section of the Nazi party in 1932, but still his works were confiscated and he was forbidden from painting. Among the other artists crushed by the Nazi suppression was Ernst Ludwig Kirchner, whose *Street, Berlin* (SEE FIG. 31-8) was included in the "Degenerate Art" exhibit. The state's open animosity was a factor in his suicide in 1938.

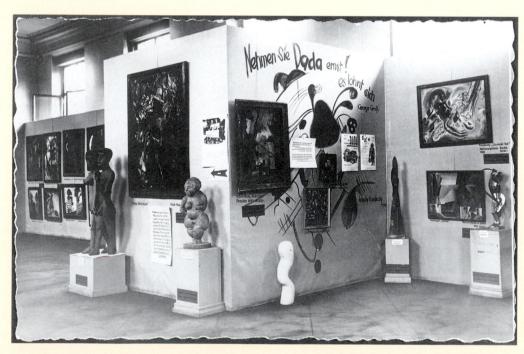

THE DADA WALL IN ROOM 3 OF THE "DEGENERATE ART" (ENTARTETE KUNST) EXHIBITION Munich. 1937.

Art © Estate of George Grosz/Licensed by VAGA, New York, N.Y.

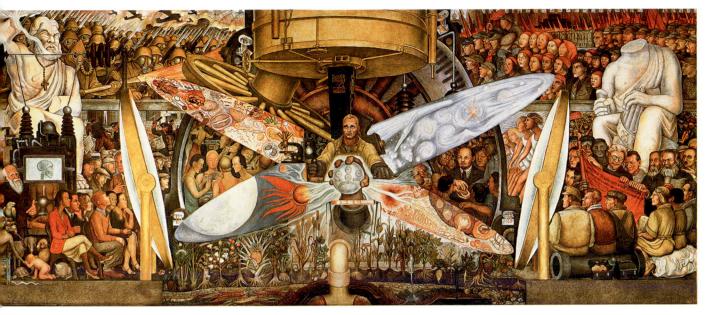

31–66 | Diego Rivera MAN, CONTROLLER OF THE UNIVERSE 1934. Fresco, $15'11'' \times 37'6''$ (4.85 \times 11.45 m). Museo del Palacio de Bellas Artes, Mexico City.

PAINTING FOR THE PEOPLE IN MEXICO. The Mexican Revolution of 1910 overthrew the thirty-five-year-long dictatorship of General Porfirio Díaz and was followed by ten years of political instability. In 1920 the reformist president Álvaro Obregón came to power and restored political order. As part of their revolt against the old regime, the leaders of the new government found ways to put art in the service of the people and the just-completed revolution. Obregón's government commissioned artists to decorate public buildings with murals celebrating the history, life, and work of the Mexican people.

Prominent in the new Mexican mural movement was Diego Rivera (1886–1957), a child prodigy who had enrolled in Mexico City's Academia de San Carlos at age 11. From 1911 to 1919 Rivera lived in Paris, where he befriended Picasso and worked in a Synthetic Cubist style. In 1919 he met David Siqueiros (1896-1974), another future Mexican muralist. They began to discuss Mexico's need for a national and revolutionary art. Siqueiros was violently opposed to Modern art, which he dismissed as "intellectual masturbation." It would be better, Rivera and Siqueiros thought, to make art in public places so that it could not be bought or sold, and to make it in a recognizable style. In this way, art could serve the people. In 1920-21 Rivera traveled in Italy to study its great Renaissance frescoes, then he visited ancient indigenous sites in Mexico that also had large mural paintings. The Mexican mural movement was indebted to both traditions.

One of Rivera's best murals (FIG. 31–66) was originally planned for New York City. Between 1930 and 1934 Rivera

worked in the United States, painting murals in San Francisco, Detroit, and New York. In 1933 the Rockefeller family commissioned him to paint a mural for the lobby of the RCA Building in Rockefeller Center, a fresco on the theme "Man at the Crossroads Looking with Hope and High Vision to the Choosing of a New and Better Future." When Rivera, a Communist, proposed including a portrait of Lenin in the mural, the Rockefellers objected. Rivera offered to add heads of Abraham Lincoln and some abolitionists, but the offer was refused. The Rockefellers canceled his commission, paid him his fee, and had the unfinished mural destroyed.

In response to what he called an "act of cultural vandalism," Rivera re-created the mural in the Palacio de Bellas Artes in Mexico City, under the new title MAN, CONTROLLER OF THE UNIVERSE. At the center of the mural, the clear-eyed young figure in overalls represents Man, who symbolically controls the universe through the manipulation of technology. Crossing behind him are two great ellipses that represent, respectively, the microcosm of living organisms as seen through the microscope at Man's right hand, and the macrocosm of outer space as viewed through the giant telescope above his head. Below, fruits and vegetables rise from the earth as a result of his agricultural efforts. To Man's left (the viewer's right), Lenin joins the hands of several workers of different races. To Man's right, decadent capitalists debauch themselves in a nightclub, directly beneath the disease-causing cells in the ellipse. (Rivera included in this section a portrait of the bespectacled John D. Rockefeller Jr.) The wings of the mural feature, to Man's left, the workers of the world embracing socialism, and, to Man's right, the capitalist world, which is cursed by militarism and labor unrest. The work of the muralists on government buildings in Mexico influenced art in the United States, as the Federal government also engaged in a program during the Depression to hire American artists to decorate public buildings with murals (see "Federal Patronage for American Art during the Depression," page 1116).

THE HARLEM RENAISSANCE. Between the two world wars, hundreds of thousands of African Americans migrated from the rural, mostly agricultural South to the urban, industrialized North, fleeing racial and economic oppression and seeking greater social and economic opportunity. This transition gave rise to the so-called New Negro movement, which encouraged African Americans to become politically progressive and racially conscious. The New Negro movement in turn stimulated a flowering of black art and culture known as the Harlem Renaissance, because its capital was in Manhattan's Harlem district, which had the country's largest concentration of African Americans. The cultural flowering encouraged musicians such as Duke Ellington, novelists such as Jean Toomer, and poets such as Langston Hughes. The intellectual leader of the Harlem Renaissance was Alain Locke (1886–1954), a critic and philosophy professor who argued that black artists should seek their artistic roots in the traditional arts of Africa rather than in the art of white America or Europe.

The first black artist to answer Locke's call was Aaron Douglas (1898–1979), a native of Topeka, Kansas, who moved to New York City in 1925 and rapidly developed an abstracted style influenced by African art. In paintings such as **ASPECTS OF NEGRO LIFE: FROM SLAVERY THROUGH RECONSTRUCTION** (FIG. 31–67), Douglas used schematic figures, sil-

houetted in profile with the eye rendered frontally as in ancient Egyptian reliefs and frescoes, and he limited his palette to a few subtle hues, varying in value from light to dark and sometimes organized abstractly into concentric bands that suggest musical rhythms or spiritual emanations. This work, painted for the Harlem branch of the New York Public Library under the sponsorship of the Public Works of Art Project, was intended to awaken in African Americans a sense of their place in history. At the right, Southern black people celebrate the Emancipation Proclamation of 1863, which freed the slaves. Concentric circles issue from the Proclamation, which is read by a figure in the foreground. At the center of the composition, an orator symbolizing black leaders of the Reconstruction era urges black freedmen, some still picking cotton, to cast their ballots in the box before him, while he points to a silhouette of the Capitol on a distant hill. Concentric circles highlight the ballot in his hand. In the left background, Union soldiers depart from the South at the close of Reconstruction, as the fearsome Ku Klux Klan, hooded and on horseback, invades from the left. Despite this negative image, the heroic orator at the center of Douglas's panel remains the focus of the composition, inspiring contemporary viewers to continue the struggle to improve the lot of African Americans.

The career of sculptor Augusta Savage (1892–1962) reflects the difficulties that many African Americans faced. She studied at Cooper Union in New York, but her first application for study in Europe in 1923 was turned down because of her race. Her letter of protest was eloquent but ultimately futile: "Democracy is a strange thing. My brother was good enough to be accepted in one of the regiments that

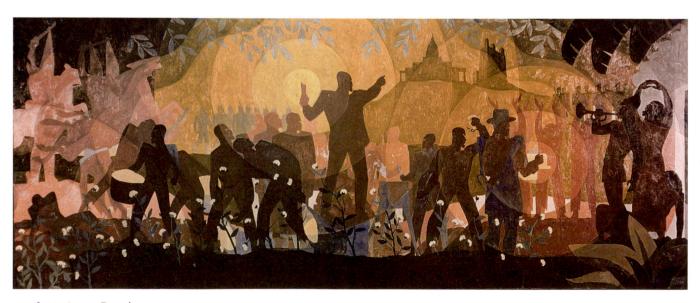

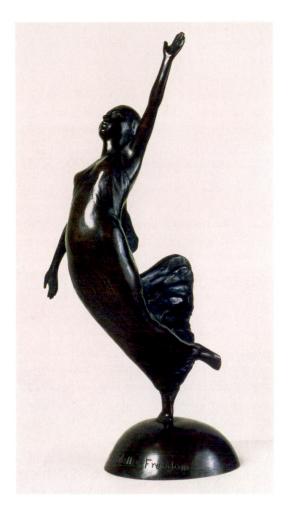

31–68 | Augusta Savage LA CITADELLE: FREEDOM 1930. Bronze, $14\frac{7}{2} \times 7 \times 6''$ (35.6 \times 17.8 \times 15.2 cm). Howard University Art Collection, Washington, D.C.

saw service in France during the war, but it seems his sister is not good enough to be a guest of the country for which he fought." On another occasion she was accepted but was unable to raise the money for passage. Finally in 1930 her efforts paid off, and she studied portraiture at La Grande Chaumière in Paris. On her return she sculpted portraits of many black leaders, such as Marcus Garvey and W. E. B. DuBois. Though she disagreed with Locke about the relevance of the tribal arts of Africa for contemporary artists, she devoted a great deal of time to the study of black history and was particularly stimulated by the story of Haiti, the black republic that achieved independence in 1804 after a slave revolt. One of her sculptures, LA CITADELLE: FREEDOM, combines her historical research with her interest in the human form (FIG. 31-68). La Citadelle is a castle that one of Haiti's first leaders erected, in imitation of the executive mansions of other countries. To her its very existence symbolized freedom and equality for blacks. Poised on the toes of one foot, the figure seems to fly through the air.

Sequencing Events WAR AND REVOLUTION IN THE EARLY 20TH CENTURY

1910-1918	Mexican Revolution
1911	Chinese Revolution; Republic founded under Sun Yat-sen
1914-1918	World War I
1917	Russian Revolution
1922	Soviet Union created
1933	Hitler becomes chancellor of Germany
1936	Outbreak of Spanish Civil War
1939-1945	World War II

The private art school that she established in a basement eventually received Federal funding in 1935 as part of the Works Progress Administration (see "Federal Patronage for American Art during the Depression," page 1116), and it became the Harlem Community Art Center, one of a hundred such centers across the country. Hers was the largest center, and it soon became much more than an art studio: poets, composers, dancers, and historians gathered there to discuss cultural issues and investigate and interpret black history.

The best-known artist to emerge from the Harlem Community Art Center was Jacob Lawrence (1917–2000). He devoted much of his early work to the depiction of black history, which he carefully researched and then recounted through narrative painting series comprising dozens of small panels, each accompanied by a text. He claimed that a single work was insufficient to capture the full import of the stories he researched. The themes of his painting series include the history of Harlem and the lives of abolitionist John Brown and Haitian revolutionary leader Toussaint L'Ouverture. In 1940-41, Lawrence created his most expansive set, THE MIGRATION OF THE NEGRO, whose sixty panels chronicle the exodus of African Americans from the rural South to the urban North-an exodus that had brought Lawrence's own parents from South Carolina to Atlantic City, New Jersey, where he was born. The first panel (FIG. 31-69), set in the South, depicts a train station filled with black migrants who stream through portals labeled with the names of Northern and Midwestern cities. The boldly abstracted style, with its simple shapes and bright, flat colors, suggests the influence of Cubism; but a more likely source is Lawrence's own study of the African art that also influenced Cubism. He later also illustrated books by Harlem Renaissance authors.

Art and its Context

FEDERAL PATRONAGE FOR AMERICAN ART DURING THE DEPRESSION

resident Franklin D. Roosevelt's New Deal, programs to provide relief for the unemployed and to revive the nation's economy during the Great Depression, included several initiatives to give work to American artists. The Public Works of Art Project (PWAP), set up in late 1933 to employ needy artists, was in existence for only five months but supported the activity of 4,000 artists, who produced more than 15,000 works. The Section of Painting and Sculpture in the Treasury Department, established in October 1934 and lasting until 1943, commissioned murals and sculpture for public buildings but was not a relief program; artists were paid only if their designs were accepted. These programs were influenced by the Mexican government's postrevolutionary mural painting program. The Federal Art Project (FAP) of the Works Progress Administration (WPA), which ran from 1935 to 1943, succeeded the PWAP in providing relief to unemployed artists. The most important work-relief agency of the Depression era, the WPA employed more than 6 million workers by 1943. Its programs to support the arts included the Federal Theater Project and the Federal Writers' Project as well as the Federal Art Project. About 10,000 artists participated in the FAP, producing a staggering amount of art, including about 108,000 paintings, 18,000 works of sculpture, 2,500 murals, and thousands of prints, photographs, and posters. Because it was paid for by the government, all this art became public property. The murals and large works of sculpture, commissioned for public buildings such as train stations, schools, hospitals, and post offices, reached a particularly wide audience.

To build public support for federal assistance to those in need, the government, through the Resettlement Agency (RA) and Farm Security Administration (FSA), hired photographers to document the problems of farmers, then supplied these photographs, with captions, free to newspapers and magazines. A leading RA/FSA photographer between 1935 and 1939 was the San Francisco-based Dorothea Lange (1895-1965). Many of her photographs document the plight of migrant farm laborers who had flooded California looking for work after fleeing the Dust Bowl conditions on the Great Plains. MIGRANT MOTHER, NIPOMO, CALIFORNIA pictures Florence Thompson, the 32year-old mother of seven children, who had gone to a pea-picking camp but found no work because the peas had frozen on the vines. The tired mother, with her knit brow and her hand on her mouth, seems to capture the fears of an entire population of disenfranchised people.

During the Depression, the Federal Art Project paid a generous average salary of about \$20 a week (a salesclerk at Woolworth's earned only about \$11), allowing painters and sculptors to devote themselves full-time to art and to think of themselves as professionals in a way few had been able to do before 1935. New York City's painters, in particular, began to develop a group identity, largely because they now had time to meet and discuss art in the bars and coffeehouses of Greenwich Village, the city's answer to the cafés that played such an important role in the life of artists in Paris. Finally, the FAP gave New York's art community a sense that high culture was important in the United States. The FAP's monetary support and its professional consequences would prove crucial to the artists later known as the Abstract Expressionists, who made important innovations after 1945.

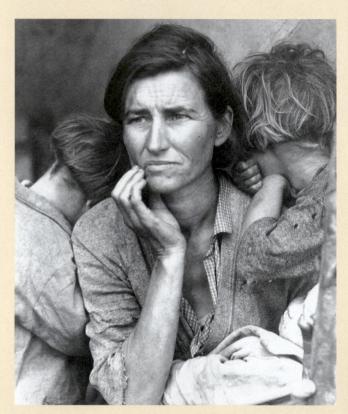

Dorothea Lange MIGRANT MOTHER, NIPOMO, CALIFORNIA February 1936. Gelatin-silver print. Library of Congress, Washington, D.C

Sculpture and Freedom. During the 1930s, totalitarian regimes increased pressure on Modern artists. In Russia, the leaders of the Communist Party promoted only Socialist Realism (SEE FIG. 31–59), and it became an official style early in the decade. Party leaders routinely denounced any sort of Modern tendencies in the arts, including music and drama,

on the grounds that Modern art was too individualistic and not understandable by the general public. Many of the pioneering Modernists, such as Popova and Rodchenko (SEE FIGS. 31–31, 31–57), were relatively unaffected by this, because they had already moved toward designing posters, furniture, and other useful objects. But Modernists who

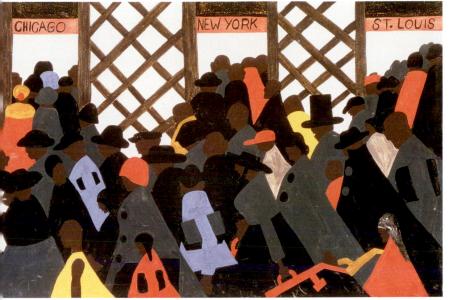

31—69 │ Jacob Lawrence DURING THE WORLD WAR THERE WAS A GREAT MIGRATION NORTH BY SOUTHERN NEGROES

Panel 1 from *The Migration of the Negro*. 1940–41. Tempera on masonite, $12\times18''$ (30.5 \times 45.7 cm). The Phillips Collection, Washington, D.C.

This is the first image in Lawrence's sixty-panel cycle that tells the story of the migration of Southern American blacks to the industrialized North in the decades between the two world wars. The Harlem writer Alain Locke brought the series to the attention of Edith Halpert, a white New York art dealer, who arranged for the publication of several of its panels in the November 1941 issue of Fortune magazine and who showed the entire series the same year at her Downtown Gallery. Thus, at age 23, Lawrence became the first African American artist to gain acclaim from whites in the segregated New York art world. The next year, the Migration series was jointly acquired by the Phillips Collection in Washington, D.C., and the Museum of Modern Art in New York, each of which purchased thirty paintings.

wanted to continue the Suprematist line, despite their continuing support of the Communist revolution, found themselves without opportunities to exhibit and at times were actively persecuted. Likewise, when the Nazi party took power in Germany, energetic suppression of Modernism in the arts followed shortly thereafter (see "Suppression of the Avant-Garde in Nazi Germany," page 1112).

European abstract artists had gathered in 1931 to form the Abstraction-Creation group, and two years later they announced opposition to totalitarian control as the central principle behind their union: "The second issue of Abstraction-Creation appears at a time when, under all regimes, in some countries more effectively than others, but everywhere, free thought is fiercely opposed. . . . We place this issue under the banner of a total opposition to all oppression, of whatever kind it may be." The group numbered about fifty active members and a few hundred more associates, working in many modes of Modern art from Cubism to Neo-Plasticism, but the most innovative of them were sculptors. These artists were investigating the allusive power of biomorphic forms, that is, forms based on or resembling forms found in nature. Picasso too embraced such forms in his anti-Fascist protest work Guernica (SEE FIG. 31-1).

An early leader in biomorphic sculpture was Barbara Hepworth (1903–1975). After study at the Leeds School of Art, she joined Abstraction–Creation in 1933, and she later helped to form Unit One, a similarly oriented group of English artists. Hepworth was among the first to pierce her sculpture with holes, so that air and light pass through (FIG. 31–70). This strategy differs from that of assemblage, in which the pieces assembled create spaces and voids (SEE FIG. 31–23).

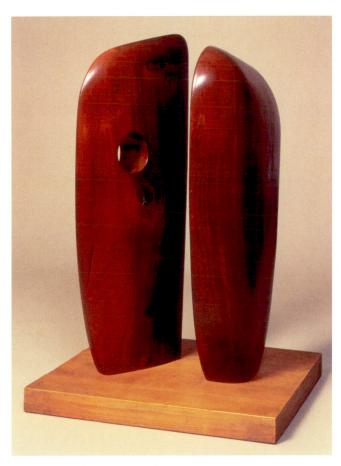

31–70 | Barbara Hepworth FORMS IN ECHELON 1938. Wood, $42\frac{1}{2} \times 23\frac{3}{3} \times 28^{\prime\prime}$ (108 \times 60 \times 71 cm). Tate Gallery, London.

Presented by the artist 1964 © Bowness, Hepworth Estate

FORMS IN ECHELON consists of two pieces whose shape, while not obviously representational, is highly suggestive of organic forms, perhaps weathered stones or fingers or the backs of insects. The artist rarely stated her intentions in creating these shapes, beyond merely saying that they are organic. She hoped that viewers would let their eyes play across them, letting imagination generate associations and meanings. The two parts stand in a relationship to each other that is similarly unstated but potentially full of significance.

Her compatriot Henry Moore (1898–1986) developed the idea of the pierced work in abstractions that were more obviously based on the human form. After serving in World War I, including being gassed at the battle of Cambrai, Moore studied sculpture at the Leeds School of Art and the Royal College of Art. The African, Oceanic, and Pre–Columbian art he saw at the British Museum had a more powerful impact on his developing aesthetic than the tradition–oriented curriculum at the college. In the simplified forms of these non–Western art works he discovered an intense vitality that interested him far more than the refinement of the Renaissance tradition. Moreover, he saw in non–Western art a respect for the inherent qualities of materials such as stone or wood. He

never joined Abstraction-Creation, but he was a founder of Unit One. In most of his own works of the 1920s and 1930s, Moore practiced direct carving in stone and wood and pursued the ideal of truth to material as he created new images of humans.

A central subject in Moore's art is the reclining female figure, such as **recumbent figure** (FIG. 31-71), whose massive, simplified forms recall Pre-Columbian art. Specifically, Moore was inspired by the chacmool, a reclining human form that occurs frequently in Toltec and Maya art (SEE FIG. 12-13). The carving reveals Moore's sensitivity to the inherent qualities of the stone, whose natural striations harmonize with the sinuous surfaces of the design. Moore sought out remote quarries and extracted stone from sites that interested him, always insisting that each work he created be labeled with the specific type of stone he used. While certain elements of the body are clearly defined, such as the head and breasts, and the supporting elbow and raised knee, other parts flow together into an undulating mass more suggestive of a hilly landscape than of a human body. An open cavity penetrates the torso, emphasizing the relationship of solid and void fundamental to Moore's art. The sculptor wrote in 1937,

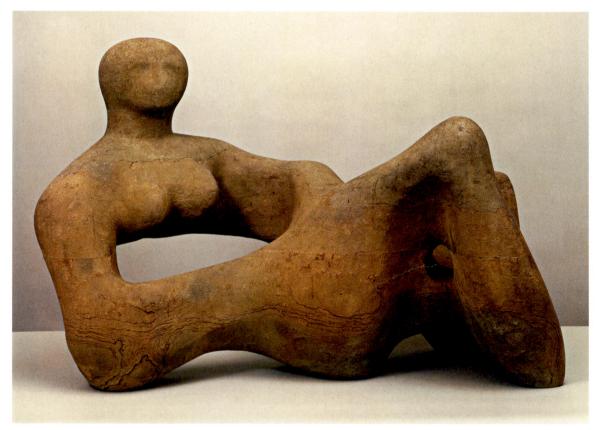

31–71 | Henry Moore RECUMBENT FIGURE 1938. Hornton stone, 35 \times 52 \times 29" (88.9 \times 132.7 \times 73.7 cm). Tate Gallery, London.

Originally carved for the garden of the architect Serge Chermayeff in Sussex, Moore's sculpture was situated next to a low-lying Modernist building with an open view of the gently rolling landscape. "My figure looked out across a great sweep of the Downs, and her gaze gathered in the horizon," Moore later recalled. "The sculpture had no specific relationship to the architecture. It had its own identity and did not *need* to be on Chermayeff's terrace, but it so to speak *enjoyed* being there, and I think it introduced a humanizing element; it became a mediator between modern house and ageless land."

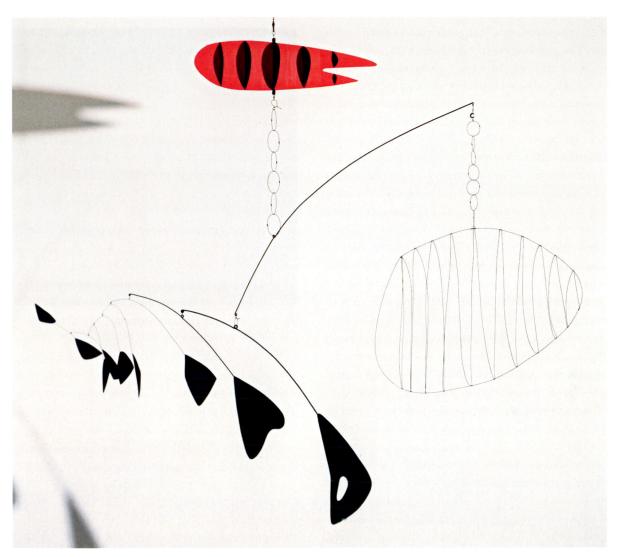

31–72 | Alexander Calder LOBSTER TRAP AND FISH TAIL 1939. Hanging mobile: painted steel wire and sheet aluminum, approx. $8'6'' \times 9'6''$ (2.6 \times 2.9 m). The Museum of Modern Art, New York. Commissioned by the Advisory Committee for the stairwell of the Museum (590.139.a-d)

"A hole can itself have as much shape-meaning as a solid mass." Moore also remarked on "the mystery of the hole—the mysterious fascination of caves in hillsides and cliffs," identifying the landscape as a source of inspiration for his hollowing out of the human body.

If the Italian Futurists suggested motion in their paintings and sculpture, Alexander Calder (1898–1976) made biomorphic works of sculpture that actually move. Calder's kinetic works, meaning works containing parts that move, unfix the traditional stability and timelessness of art and invest it with vital qualities of mutability and unpredictability. Born in Philadelphia and trained in both engineering and painting, Calder went to Paris in 1926 and became friendly with several abstract artists, joining Abstraction–Creation in time for the second issue of their journal. On a 1930 visit to Mondrian's studio, he had been impressed by the rectangles of colored paper that the painter had tacked up everywhere on the walls. What would it look like, Calder wondered, if the flat shapes were moving freely in space, interacting in not just

two but three dimensions? The question inspired Calder to begin creating sculpture with moving parts, known as mobiles. Calder's LOBSTER TRAP AND FISH TAIL (FIG. 31–72) features delicately balanced elements that spin and bob in response to shifting currents of air. At first, the work seems almost completely abstract, but Calder's title works on our imagination, helping us find the oval trap awaiting unwary crustaceans and the delicate wires at the right that suggest the backbone of a fish. The term *mobile*, which in French means "moving body" as well as "motive," or "driving force," came from Calder's friend Marcel Duchamp, who no doubt relished the double meaning of the word.

Surrealists Rearrange Our Minds

The entire history of the interwar period is the appropriate backdrop for the 1924 founding of the Surrealist movement. Led by French writer André Breton (1896–1966), the Surrealists attacked the rational emphasis of Western culture. They were as disillusioned as the Dadaists had been before them,

and indeed, many Surrealists had participated in that earlier movement. The problem, Breton wrote in 1934, is that "We still live under the rule of logic." European civilization emphasizes science, progress, comfort, and success. These values are not wrong in themselves, but in Europe they were pursued with blind fervor, and to the detriment of other values such as fantasy, imagination, and play. The results were obvious to the most casual observer: Europe experienced the unprecedented horrors of World War I, as science was applied to killing. And moreover, Europe was in danger again, they thought, from the rise of fascist regimes in Spain, Germany, and Italy, as those regimes intently snuffed out all opposition.

A participant in the Paris Dada movement, Breton became dissatisfied with the seemingly nonsensical activities of his colleagues and set out to make something more programmatic out of Dada's somewhat unfocused bitterness. In 1924 he published the first "Manifesto of Surrealism," outlining his view of Freud's theory that the human psyche is a battleground where the rational, civilized forces of the conscious mind struggle against the irrational, instinctual urges of the unconscious. The way to improve civilization, Breton argued, does not lie in strengthening the repressive forces of reason, but in freeing the individual to experience and safely express forbidden desires and urges. Artists are uniquely positioned to facilitate these explorations, because, he thought, coming face to face with one's inner demons in an art context may prevent our letting them loose in the real world. The Surrealists developed a number of techniques for liberating the unconscious, including dream analysis, free association, automatic writing, word games, and hypnotic trances. Their aim was to help people discover the more intense reality, or "surreality," that lay beyond the narrow rational notions of what is real.

AUTOMATISM. Surrealist painters employed a variety of manual techniques, known collectively as automatism, which were designed to release art from conscious control and thus produce new and surprising forms. Particularly inventive in his use of automatism was Max Ernst (1891–1976), a self-taught German artist who helped organize a Dada movement in Cologne and later moved to Paris, where he joined Breton's circle. In 1925 Ernst discovered the automatist technique of frottage, in which the artist rubs a pencil or crayon across a piece of paper placed on a textured surface. The resulting imprints stimulated Ernst's imagination, and he discovered in them fantastic creatures, plants, and landscapes, which he articulated through additional drawing. Ernst adapted the frottage technique to painting through grattage, creating patterns by scraping off layers of paint from a canvas laid over a textured surface. He then would extract representational forms from the patterns through overpainting. One result of this technique is **THE HORDE** (FIG. 31-73), a nightmarish scene of a group of monsters, seemingly made out of wood, who advance against some unseen opponent. Like

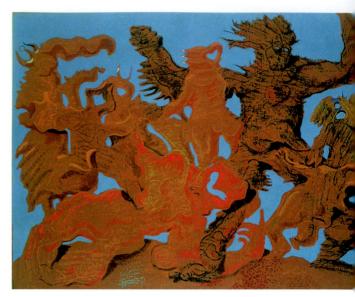

31–73 | Max Ernst **THE HORDE** 1927. Oil on canvas, $44\% \times 57\%$ (114 \times 146.1 cm). Stedelijk Museum, Amsterdam.

much of Ernst's work of the period, this frightening image seems to resonate with the violence of World War I—which he experienced firsthand in the German army—and also to foretell the coming of another terrible European conflict.

UNEXPECTED JUXTAPOSITIONS. Even more carefully executed are the paintings of Salvador Dalí (1904–89). Trained at the San Fernando Academy of Fine Arts in Madrid, where he mastered the traditional methods of illusionistic representation, Dalí traveled to Paris in 1928 where he met the Surrealists. By the next year Dalí had converted fully to the movement and was welcomed officially into it. Dalí's contribution to Surrealist theory was the "paranoid-critical method," in which the sane person cultivates the ability of the paranoid to misread ordinary appearances and become liberated from the shackles of conventional thought. He hoped that the paranoid-critical method would take an equal place in Western culture along with the scientific method for the analysis of reality.

Dalí's paintings generally deal with sexual urges of various kinds (FIG. 31–74). In the BIRTH OF LIQUID DESIRES, we see a woman in a white gown embracing a hermaphroditic figure (one which has both male and female organs). This figure half-kneels on a classical pedestal, its foot in a bowl that a partially hidden figure fills with a liquid, while on its head sits a long loaf of French bread. (Merely describing this piece provides a challenge to logic.) Out of the head a thick black cloud representing a dream emerges below a mysterious cabinet. In one of the recesses of the cloud, the artist inscribed in small print a nonsense phrase: "Consign: to waste the total slate?" The artist said that he arrived at his imagery by carefully writing down his nightmares and merely painting what his fantasy-laden mind conjured up. In this way, the work ful-

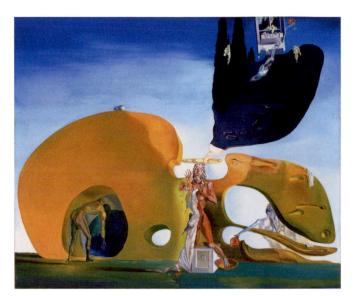

31–74 | Salvador Dalí BIRTH OF LIQUID DESIRES 1931–32. Oil and collage on canvas, $37\% \times 44\%$ (96.1 \times 112.3 cm). Guggenheim Museum, New York. Peggy Guggenheim Collection. 76.2553 PG 100. © 2003 Salvador Dalí, Gala-Salvador Dalí Foundation/Artists Rights Society (ARS), New York, N.Y.

fills the Surrealist goal, set out in the first "Manifesto of Surrealism," of expressing "the true process of thought, free from the exercise of reason and from any aesthetic or moral purpose." The composition is dominated by a large yellow bio-

morphic form whose shape might suggest a monster facing right, a painter's palette, or a violin (which might in turn suggest a woman's body). A shadow looms over the yellow form, which probably represents the artist's father, with whom Dalí had a tense relationship. There are many other ways to interpret this work, depending on the personality and mental state of the viewer. Others, for example, may see the cave at the left as the most significant motif. The half-shod figure who enters the cave may be regressing toward the womb, a metaphor for incest. Thus, perhaps, the central pair represents an incestuous union. Another line of analysis is to focus on the work's quotations from previous art. Some of these include, besides the classical pedestal and the palette, the pitcher pouring the liquid, a quote from a Dutch genre work by Vermeer (see Chapter 22), and the top of the cloud, which transcribes a portion of a work by the Swiss-German symbolist painter Arnold Böcklin. Dalí's tense relationship with his father is expressed in his uneasy juxtaposition of quotes from his artistic elders.

This absurd yet compelling work typifies the Surrealist interest in unexpected juxtapositions of disparate realities. When created with actual rather than represented objects and materials, the strategy produced disquieting assemblages such as **OBJECT (LE DÉJEUNER EN FOURRURE)** (FIG. 31–75), by Meret Oppenheim (1913–85), a Swiss artist who was one of the few female participants in the Surrealist movement.

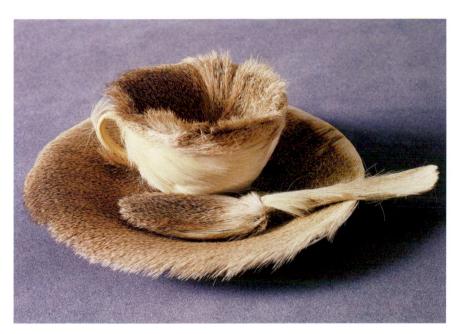

31–75 | Meret Oppenheim OBJECT (LE DÉJEUNER EN FOURRURE) (LUNCHEON IN FUR)

1936. Fur-covered cup, diameter 4%" (10.9 cm); fur-covered saucer, diameter 9%" (23.7 cm); fur-covered spoon, length 8" (20.2 cm); overall height, 2%" (7.3 cm). The Museum of Modern Art, New York.

Oppenheim's *Object* was inspired by a café conversation with Picasso about her designs for jewelry made of fur-lined metal tubing. When Picasso remarked that one could cover just about anything with fur, Oppenheim replied, "Even this cup and saucer."

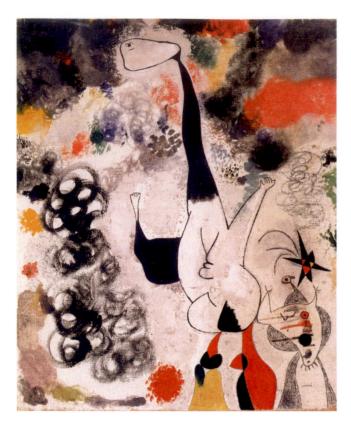

31–76 | Joan Miró SHOOTING STAR 1938. Oil on canvas, $25\% \times 21\%''$ (65.2 \times 54.4 cm). National Gallery of Art, Washington D.C.

Gift of Joseph H. Hazen (1970.36.1). Image © 2006 Board of Trustees, National Gallery of Art, Washington, D.C.

Consisting of a cup, saucer, and spoon covered with the fur of a Chinese gazelle, Oppenheim's work transforms implements normally used for drinking tea into a hairy ensemble that simultaneously attracts and repels the viewer.

BIOMORPHIC ABSTRACTION. The painter who made the most from biomorphic abstraction was Joan Miró, who exhibited with the Surrealists from the beginning of the movement. He arrived at his shapes by doodling, as shoot-ING STAR shows (FIG. 31-76). The Surrealists believed that through the accidents of doodling, we might relax our rational control and draw something that bubbles up from our unconscious. Miró usually doodled on the canvas, then examined his product to see what shapes it suggested, then applied more lines and colors to bring out what lay hidden. In an indefinite space influenced by Cubism, the star of the work's title seems to fly off toward the lower right, though the central figure could also be a deformed star. Other forms suggestive of birds' heads or flowers prance across the surface of this work, which looks improvised. Indeed, Miró painted in such a way that his forms appear to be taking shape before our eyes; their identity is in flux just as our thought process is itself always in flux. Miró was fascinated by the art of children, which he regarded as spontaneous and expressive; though he had been well-trained as an artist, he made it a goal to forget his learning in order to recover the freshness of childhood. We see that childlike quality here as well.

If the art world was full of schemes to improve civilization during the 1930s, obviously none of them functioned as the creators hoped; Europe hurtled once again toward war as the decade closed. A great many artists left Europe for the Americas, redrawing the map of artistic innovation.

IN PERSPECTIVE

The early twentieth century saw a systematic undermining of the traditional rules of Western art, as artists overthrew longheld conventions in a series of movements that flowered before 1920: Fauvists and Expressionists attacked traditional notions of pictorial representation through color and brushwork, culminating in completely abstract paintings by 1910. Cubists created influential new methods of composition in both painting and sculpture. Futurists embodied "the beauty of speed" in new ways, and Suprematists combined Cubist picture space with complete abstraction. During World War I, Dada asked the most radical questions about the nature of art itself. As part of a program of challenging the norms, many Modern artists looked to non-Western cultures for stylistic cues. Modern architecture also took definite form in buildings that used only the modern materials of concrete, glass, and steel, without decoration or reference to any past style.

Modern art arrived somewhat later to the Americas, but artists on those continents also pursued Modernist techniques, often coupling their experiments in form with efforts to uncover national or cultural identity.

In the period between the wars, many artists gave their art a deeper social relevance. Some reacted to the slaughter of World War I, others to social inequalities of various kinds, while still others combated fascism. Constructivists in Russia after the Communist Revolution united Modern styles with practical needs. Socialist Realists and Mexican muralists retreated from the more radical innovations of Modernism in order to communicate with the masses, often through art in public places. Bauhaus artists turned modern mass production toward a harmonious and beautiful home environment for consumers. Dutch painters and architects of de Stijl created art that they hoped would purify the human mind through use of pure colors and simple forms. Harlem Renaissance artists raised awareness of African American culture, some using Modernist techniques, and some looking past them back to African tribal arts. The Abstraction-Creation group used organic abstraction as part of a campaign against fascist regimes, which usually censored Modern art. Surrealists sought various ways to liberate the unconscious mind, based on their reading of Freud's psychology, in an effort to reorient Western culture toward fantasy.

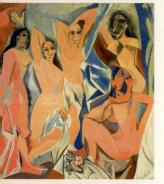

PICASSO

LES DEMOISELLES D'AVIGNON

1907

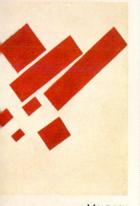

MALEVICH
SUPREMATIST PAINTING
1915-

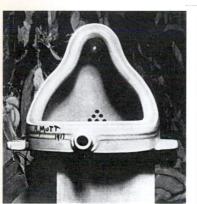

DUCHAMP FOUNTAIN 1917

GROPIUS

BAUHAUS

1925-26

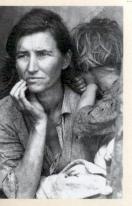

LANGE
MIGRANT MOTHER,
NIPOMO, CALIFORNIA

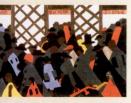

LAWRENCE
MIGRATION SERIES
1940-41...

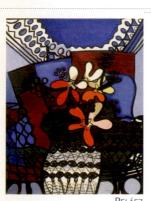

Peláez Marpacífico (Hibiscus) 1943

1900

1910

1920

1930

1940

1950

MODERN ART IN EUROPE AND THE AMERICAS, 1900–1945

■ Wright Brothers' First Flight 1903

- First Flight Across English Channel
- Messican Revolution 1910-17
- First Balkan War 1912-13
- World War I 1914-18
- Russian Revolution 1917
- Soviet Union Formed 1922
- Stalin Comes to Power 1924
- Great Depression Begins 1929
- New Deal in U.S.; Hitler Comes to Power in Germany 1933
- ▼ First Analog Computer 1935
- World War II 1939-45
- ▼ First Digital Computer 1939
- Atomic Bomb Dropped on Hiroshima and Nagasaki 1945

32–I | Jannis Kounellis UNTITLED (12 HORSES) 1969. Installation, Galleria L'Attico, Rome.

THE INTERNATIONAL SCENE SINCE 1945

32

Visitors to the 1969 Jannis Kounellis exhibition at the Galleria L'Attico in Rome did not see paintings, sculpture, drawings, or any other objects

made by the artist. Instead, they encountered twelve live horses of different breeds and colors tethered with halters to the gallery walls (FIG. 32–1). Following the example of Marcel Duchamp (SEE FIG. 31–36), Kounellis did not create a new object but took existing entities (in this case, living ones), placed them in an art context, and designated them a work of art. This particular work existed only as long as the horses remained "installed" in the gallery (three days) and could not be bought or sold. By placing unsalable works in the exhibition space, Kounellis, who harbored leftist political views, challenged "the ideological and economic interests that are the foundations of a gallery."

Kounellis did not intend simply to criticize the capitalist values of the art market; he also wanted to create a memorable work that would generate a rich variety of interpretations. He used horses because they evoke energy and strength and have art-historical associations with equestrian statuary and portraits of mounted heroes and rulers (SEE FIG. 19–14, 19–16, 30–2). One critic wrote that Kounellis's horses "had only to stand in place to confirm their stature as an attribute of Europe personified" and saw them as symbols of "the heritage accumulated over great distances of time, and of the

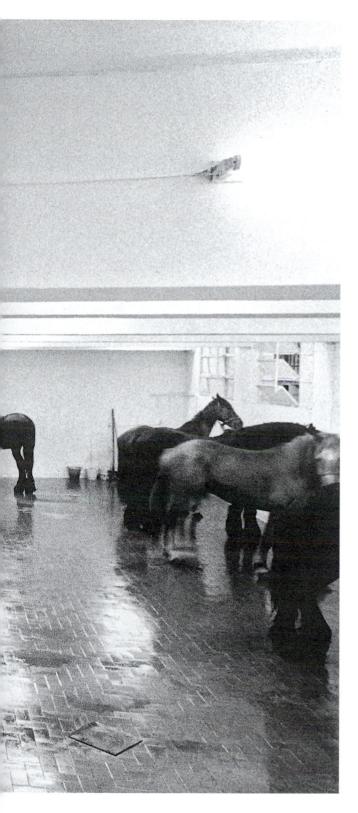

urgent need for freedom in the present moment." Another felt the installation conveyed "something of the quality of an anxiety dream." Still another suggested that Kounellis was actually mocking art by "treating the exhibition space as if it were a stable," which brought to mind one of the first-century emperor Caligula's "most insulting acts: making a horse a member of the Roman Senate."

However we interpret Kounellis's work, it stimulates our imaginations even as it defies our normal expectations of a work of art and—like much innovative art since World War II—causes us to question the nature of art itself.

CHAPTER-AT-A-GLANCE

- THE WORLD SINCE 1945
- POSTWAR EUROPEAN ART | Figural Artists | Abstraction and Art Informel
- ABSTRACT EXPRESSIONISM | The Formative Phase | Action Painting | Color Field Painting | Sculpture of the New York School
- **EXPERIMENTS WITH FORM IN BUENOS AIRES** | Concrete-Invention | Madí
- POSTWAR PHOTOGRAPHY | New Documentary Slants | The Modernist Heritage
- MOVING INTO THE REAL WORLD | Assemblage | Happenings | Pop Art
- THE FINAL ASSAULT ON CONVENTION, 1960-1975 | Op Art and Minimal Art | Arte Povera: Impoverished Art | Conceptual and Performance Art | Earthworks and Site-Specific Sculpture | Feminist Art
- ARCHITECTURE: FROM MODERN TO POSTMODERN | Midcentury Modernist Architecture | Postmodern Architecture
- POSTMODERN ART | The Critique of Originality | Telling Stories with Paint | Finding New Meanings in Shapes | High Tech and Deconstructive Architecture New Statements in New Media
- IN PERSPECTIVE

THE WORLD SINCE 1945

The United States and the Soviet Union emerged from World War II as the world's most powerful nations and soon were engaged in the "cold war." The Soviets set up communist governments in Eastern Europe and supported the development of communism elsewhere. The United States, through financial aid and political support, sought to contain the spread of communism in Western Europe, Japan, Latin America, and other parts of the developing world. A second huge communist nation emerged in 1949 when Mao Zedong established the People's Republic of China. The United States tried to prevent the spread of communism in Asia by intervening in the Korean War (1950-53) and in the Vietnam War (1965-75).

The United States and the Soviet Union built massive nuclear arsenals aimed at each other, effectively deterring either from attacking for fear of a devastating retaliation. The cold war ended in the late 1980s, when the Soviet leader Mikhail Gorbachev signed a nuclear-arms reduction treaty with the United States and instituted economic and political reforms designed to foster free enterprise and democracy. The dissolution of the Soviet Union soon followed and gave rise to numerous independent republics.

While the Soviet Union and the United States vied for world leadership, the old European states gave up their empires, often after massive resistance by the colonized peoples. The British led the way by withdrawing from India in 1947. Other European nations gradually granted independence to colonies in Asia and Africa, which entered the United Nations as a Third World bloc not aligned with either side in the cold war. Despite the efforts of the United Nations, deepseated ethnic and religious hatreds have continued to spark violent conflicts around the world—in countries such as Pakistan, India, South Africa, Somalia, Ethiopia, Rwanda, the former Yugoslavia, and states throughout the Middle East. Escalating the sense of tension around the globe were the devastating terrorist attacks of September 11, 2001, on the World Trade Center and the Pentagon in the United States, and the controversial U.S.-led wars in Afghanistan and Iraq that followed.

A great many Modern artists since 1945 have used their art to comment on the state of the world, and the growth and

MAP 32-I THE WORLD SINCE 1945

The distribution of cultural sites expands to cover the world.

proliferation of mass media after World War II made everyone better informed, including artists. In the decade following the war, many artists' reflections on the state of humanity paralleled the Existentialist philosophy developed primarily by Jean-Paul Sartre and Albert Camus. Existentialism started from the position that there was no God, no supreme being, no absolute, no "transpersonal entity." Modern science and the twentieth century's multiple disasters seemed to prove that God must be absent, leaving humans "condemned to be free," as Sartre put it. Existentialists reflected a great deal on the implications of this fact for each person. Since there is no God, the self is not a "soul" or even a stable entity but rather a process in constant evolution as each of us establishes an identity and responds to our world. Sartre's principal philosophical work, Being and Nothingness, postulated that human beings are responsible for the world they have created, yet they are also free to decide how to act in it. In this situation, the most valuable art offers sincere individual testimony about life, honest sharing of personal insight about existence.

The assault on tradition that has marked Modern art from its inception continued, but with a slightly different

focus. Most Modern artists thought less about questioning Renaissance-based rules because traditional styles of painting and sculpture had receded into the historical distance. Rather, many artists embraced a related quest: investigation of the nature of art. That is, they created works as experiments in form or challenges to the boundaries of art. What arose was a Tradition of the New, as Modern questioning grew more implanted in art institutions such as schools and museums and less controversial among the public.

The most important art-world watershed came sometime in the late 1970s, when the Modern movement seemed to exhaust the search for conventions to attack. The basic conditions and forces that undergirded Modern art also disappeared or evolved, leading to what we call the Postmodern period. Postmodern artists largely gave up the quest for formal novelty, and likewise the avant-garde lost its distinct identity as a social group. Instead there arose a plurality of styles in a more globalized art world, where artists found novel ways of exploring their identity and commenting about issues such as race, gender, the environment, and globalization itself.

POSTWAR EUROPEAN ART

The devastation of Europe in World War II far exceeded the toll of the first conflict: Defeated Germany lost 5 million dead, less than the 6 million Jews that Nazis had murdered in concentration camps, and far less than Russia's 20 million war casualties. Poland lost 20 percent of its population. At war's end, the total number of refugees and displaced persons across the continent amounted to 40 million. Two years after the end of hostilities, French industry was producing only 35 percent of its 1939 total. Looking at the condition of Europe in the same year, Winston Churchill described the extent of the catastrophe: "What is Europe now? A rubble heap, a charnel house, a breeding ground of pestilence and hate."

Most European artists in the immediate postwar period used their art to come to terms in some way with what they had experienced. There were many debates about how best to do this: Some urged figural styles, others proposed abstract art.

Figural Artists

For many artists, figuration was a way to keep one's art close to the human condition, to preserve a connection to humanity, or to express some kinship with the wounded, the displaced, and the dead. Swiss-born Alberto Giacometti (1901-1966) did this most memorably in sculpture (FIG. 32-2). He had worked in an abstract mode related to biomorphic Surrealism in the 1930s, but the war caused a crisis for him. Abstract art was merely "decorator stuff," he said, irrelevant to postwar humanity. So after the war he began sculpting in plaster from live models. The figures he produced were the antithesis of the classical ideal: thin, fragile, and lumpy, their surfaces rough and crude. Jean-Paul Sartre wrote that Giacometti's figures reminded him of "the fleshless martyrs of Buchenwald [concentration camp]." Yet they bravely occupy their limited space, and they even seem to ascend. Their frail nobility offers us a poignant vision of a way of "being in the world," to use a phrase dear to Existentialists. These slight individuals seemed to embody Sartre's view of the human condition. He wrote that Giacometti's figures are "between nothingness and being."

English artist Francis Bacon (1909–92) captured more of the horror and less of the ascent in his figural paintings. While working as an interior decorator, Bacon taught himself to paint in about 1930 but produced few pictures until the early 1940s, when the onset of World War II crystallized his harsh view of the world. He served as an air raid warden during the conflict, seeing that his neighbors got to safety during Nazi bombing attacks. His style draws on the Expressionist work of Vincent van Gogh (SEE FIG. 30–66) and Edvard Munch (SEE FIG. 30–71), as well as on Picasso's figure paintings. His subject matter comes from a wide variety of sources, including post-Renaissance Western art. **HEAD SURROUNDED BY SIDES OF BEEF** (FIG. 32–3), for example, is inspired by Diego

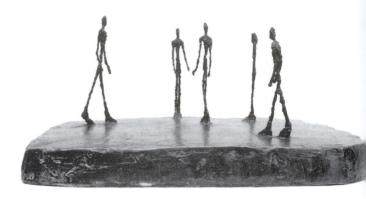

32–2 | Alberto Giacometti CITY SQUARE 1948. Bronze, $8\frac{1}{2} \times 25\frac{1}{8} \times 17\frac{1}{4}$ " (21.6 × 64.5 × 43.8 cm). The Museum of Modern Art, New York. Purchase (337.1949)

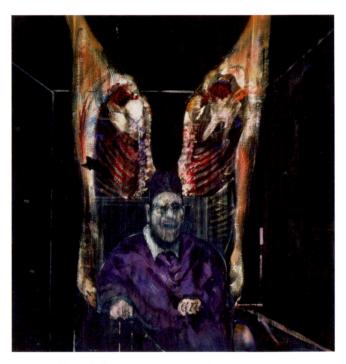

32–3 | Francis Bacon HEAD SURROUNDED BY SIDES OF BEEF 1954. Oil on canvas, $50\% \times 48\%$ (129 \times 122 cm). The Art Institute of Chicago.

Harriott A. Fox Fund

Velázquez's *Pope Innocent X* (1650), a solid and imperious figure that Bacon transformed into an anguished, insubstantial man howling in a black void. The feeling is also reminiscent of Munch's *The Scream*, but Bacon's pope is enclosed in a claustrophobic box that contains his frightful cries. The figure's terror is magnified by the sides of beef behind him, quoted from a Rembrandt painting. (Bacon said that slaughterhouses and meat brought to his mind the Crucifixion.) Bacon's pope seems to show that humanity's claim to a divine connection is illusory at best. The artist wrote, "I hope to make the best human cry in painting . . . to remake the violence of reality itself."

The French painter Jean Dubuffet (1901-85) developed a distinctive form of Expressionism inspired by what he called art brut ("raw art")—the work of children and the insane—which he considered uncontaminated by Western culture. The war provoked a crisis of values, he thought. Certain old beliefs—that humans are fit to be masters of nature, that the world responds to reason and analysis—have been proved wrong. In the 1951 lecture "Anticultural Positions," he expressed deep disillusionment with those traditional notions and urged artists to reject "civilization." In a postwar version of Modernist Primitivism, he embraced art by the insane and funded a society to study and collect it. In his own art, at times he applied paint mixed with tar, sand, and mud, using his fingers and ordinary kitchen utensils, in a deliberately crude and spontaneous style that imitated art brut. In the early 1950s, he began to mix oil paint with new, fast-drying industrial enamels, laying them over a preliminary base of still-wet oils. The result was a texture of fissures and crackles that suggests organic surfaces, like those of cow with the **SUBTILE NOSE** (FIG. 32–4). Dubuffet observed that "the sight of that animal affords me an inexhaustible feeling of wellbeing because of the aura of calm and serenity it gives off." The animal seems completely content and focused on its "subtile" nose, which appears to twitch just slightly, perhaps at the scent of some grassy morsel.

Abstraction and Art Informel

Dubuffet's celebration of crude, basic forms of self-expression, including graffiti, contributed to the emergence of the most distinctive postwar European artistic approach: Art Informel ("formless art"), which was sometimes also called tachisme (tache is French for "spot" or "stain"). Art Informel was promoted by French critic Michel Tapié (1909-87), who opposed geometric formalism as the proper response to the horrors of World War II. He insisted that Dada and the two world wars had discredited all notions of humanity as reasonable, thus clearing the way for a new and more authentic concept of the species that locates the origins of human expression in the simple, honest mark. Most practitioners of Art Informel worked abstractly, in part because the prewar totalitarian regimes despised abstraction. Moreover, many artists favored abstraction because it was cosmopolitan, not rooted in any of the nationalisms that had fueled the century's bloody conflicts.

The principal founder of *Art Informel* was Wolfgang Schulze, called Wols (1913–1951), who lived through some of Europe's dislocations. Born in Germany, the resolutely anti-Nazi artist left his homeland as soon as Hitler took power. He settled in Paris, where he knew many Modern artists, and took up a career as a photographer, with his work featured in international fashion magazines such as *Vogue* and *Harper's Bazaar*. When France was overrun in the Nazi invasion, he

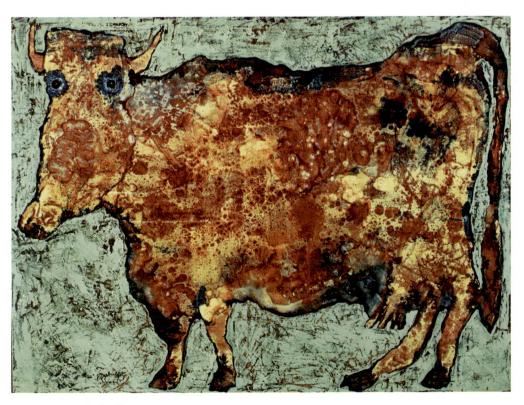

fled to Spain, where he was arrested and his passport confiscated. Deported from Spain in 1940, he lived the rest of the war as a stateless person in a refugee camp in southern France. When the war ended he settled in Paris and took up art again, painting in an abstract style (FIG. 32–5). He applied

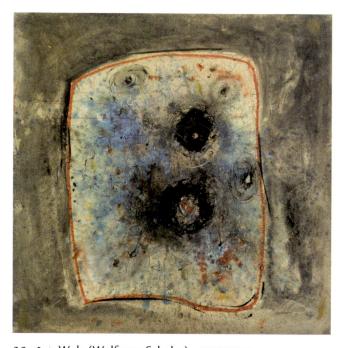

32–5 | Wols (Wolfgang Schulze) PAINTING 1944–45. Oil on canvas, 31% \times 32" (81 \times 81.1 cm). The Museum of Modern Art, New York. Gift of D. and J. de Menil Fund (29.1956) / Otto Wols © 2007 Artists Rights Society (ARS), New York

paint with whatever was at hand, sometimes allowing it to drip and run. Sometimes he threw paint at the canvas, then scraped the surfaces with a knife. These techniques are his own elaborations of Surrealist automatism. The resulting works often resemble cells or bacterial growths, with a disease-ridden or violent appearance. His experiences convinced him that humanity was no more noble than any other life form, however lowly or lofty. Sartre wrote about Wols and gave him money for his resettlement, but the artist's difficult history and complicated personal temperament led him to live carelessly, and he died of food poisoning in 1951.

If Art Informel expanded the range of materials that artists could apply to a canvas, Alberto Burri (1915–1995) used this more ample vocabulary in tellingly symbolic ways. A surgeon in the Italian army during the war, Burri was captured and spent most of the conflict in a POW camp in Texas. There he taught himself to paint with whatever was at hand, a trait that marked the rest of his career. Repatriated in 1945, he began to create works using red paint along with the burlap sacks that held donated foodstuffs that Italy received during its reconstruction (FIG. 32–6). The artist rarely spoke of his work, but the burlap seems to signify the bandages he used as a surgeon, and the red paint, the blood that flowed from unseen injuries. The English art critic Herbert Read, one of Burri's early supporters, wrote of him, "Burri is defiant in the face of chaos. He tries to face the wounds of Europe and heal them."

32–6 | Alberto Burri COMPOSITION (COMPOSIZIONE)
1953. Oil, gold paint, and glue on burlap and canvas, 33% × 39½" (86 × 100 cm). Solomon R.
Guggenheim Museum, New York.
FN53.1364

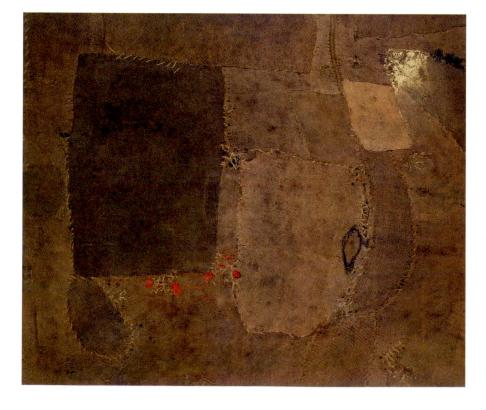

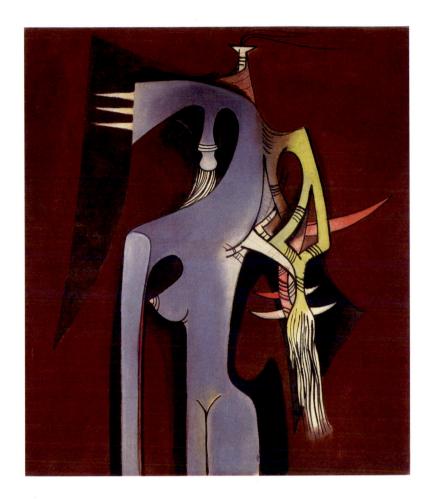

32–7 | Wifredo Lam ZAMBEZIA, ZAMBEZIA 1950. Oil on canvas, 49 % × 43 %" (125 × 110 cm). Solomon R. Guggenheim Museum, New York. Gift, Mr. Joseph Cantor, 1974.2095. Wifredo Lam © 2007 Artists Rights Society (ARS), New York / ADAGP, Paris

ABSTRACT EXPRESSIONISM

The rise of fascism and the outbreak of World War II led many leading European artists and writers to move to the United States. By 1941, André Breton, Salvador Dalí, Fernand Léger, Piet Mondrian, and Max Ernst were living in New York, where they had a strong impact on the art scene. American abstract artists were most deeply affected by the ideas of the Surrealists, from which they evolved Abstract Expressionism, a wide variety of work produced in New York between 1940 and roughly 1960. This movement pioneered many innovations, in materials used, methods of application, compositional structures, and the sizes of the resulting works. Abstract Expressionism is also known as the New York School, a more neutral label many art historians prefer.

The Formative Phase

The earliest Abstract Expressionists found inspiration in Cubist formalism and Surrealist automatism, two very different strands of Modernism. But whereas European Surrealists had derived their notion of the unconscious from Sigmund Freud, many of the Americans subscribed to the thinking of Swiss psychoanalyst Carl Jung (1875–1961). Jung's theory of the collective unconscious holds that beneath one's private memories lies a storehouse of feelings and symbolic associations common to all humans. Abstract Expressionists, dissatis-

fied with what they considered the provincialism of American art in the 1930s, sought the universal themes within themselves.

SPIRITUAL HERITAGE. One of the first artists to bring these influences together was Cuban artist Wifredo Lam (1902-1980), who turned them into art that supported the struggle against colonialism. Of mixed Chinese, Spanish, and African descent, he studied at the National Academy in Havana before settling in Paris. There he became friendly with both Picasso and the Surrealists, and his work began to reflect these influences. The Nazi invasion of France forced him to return to his homeland, on the same boat with Surrealist leader André Breton. While Breton continued on to New York, Lam remained in Havana and began investigating his Afro-Cuban heritage in the company of anthropologist Lydia Cabrera and novelist Alejo Carpentier. Lam's work from the late 1940s shows strong influence of Afro-Cuban art forms associated with santería, an indigenous form of polytheistic spirituality. Unlike European Primitivists, who adapted art forms foreign to them without necessarily studying their meanings, Lam reconnected with his own heritage and used it in works that often have an anticolonial subtext. ZAMBEZIA, ZAMBEZIA, for example (FIG. 32-7), shows overlapping planes and shallow spaces reminiscent of Joan Miró

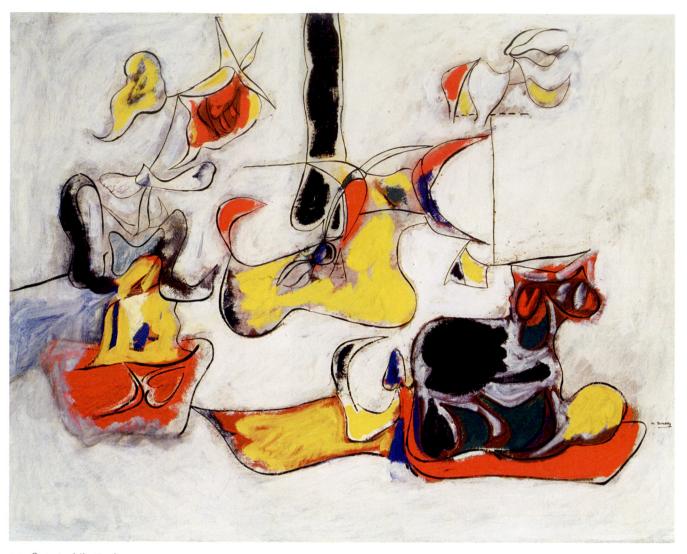

32–8 | Arshile Gorky GARDEN IN SOCHI c. 1943. Oil on canvas, $31\times39''$ (78.7 \times 99.1 cm). The Museum of Modern Art, New York. Acquired through the Lillie P. Bliss Bequest (492.1969)

Born Vosdanig Adoian in Turkish Armenia, Arshile Gorky adopted his new Russian-sounding name (*Gorky* is Russian for "bitter") after settling in New York in 1925. Insecure about his Armenian origins and hoping to impress his American colleagues, Gorky often gave his birthplace as Kazan, Russia, and on one occasion claimed to be a cousin of the famous Russian writer Maksim Gorky—apparently unaware that this was the pen name of Aleksey Peshkov. Related to Gorky's fabrication of a Russian background is his naming of *Garden in Sochi* for a Russian town rather than the Armenian village of Khorkom that actually inspired it.

(SEE FIG. 31–76), but here the forms are derived from Afro-Cuban religious implements used in rituals. The central figure is a composite deity of *santería*. The title is an early colonial name for Zimbabwe in East Africa. At that time this region was still a colony known as Rhodesia, but it was also a source for slaves brought to Cuba. Lam said, "I wanted with all my heart to paint the drama of my country . . . In this way I could act as a Trojan horse spewing forth hallucinating figures with the power to surprise, to disturb the dreams of the exploiters."

Arshile Gorky (1904–48) took the Cubist-Surrealist style further into spontaneous improvisation. He was born in Armenia and immigrated to the United States in 1920 fol-

lowing Turkey's brutal eviction of its Armenian population, which caused the death of Gorky's mother. Converging in Gorky's mature work were his childhood memories of Armenia, which provided his primary subject matter; his interest in Surrealism; and his attraction to Jungian ideas. These factors came together in the early 1940s in a series of paintings that Gorky called **GARDEN IN SOCHI** after the Russian resort on the Black Sea but that were actually inspired by Gorky's father's garden in his native Khorkom, Armenia (FIG. 32–8). According to Gorky, this garden was known as the Garden of Wish Fulfillment. It contained a rock upon which village women, including his mother, rubbed their bare breasts for the granting of wishes; above the rock stood a

"Holy Tree" to which people tied strips of clothing. Gorky's painting includes the highly abstracted images of a barebreasted woman at the left, a tree trunk at the upper center, and perhaps pennants of cloth at the upper right. The out-ofscale yellow shoes below the tree may refer to "the beautiful Armenian slippers" that Gorky and his father had worn in Khorkom. Knowledge of such autobiographical details is not necessary, however, to appreciate the painting's expressive effect, for the fluid, biomorphic forms—derived from Miró (SEE FIG. 31-76)—suggest vital life forces and signal Gorky's evocation of not only his own past but also an ancient, universal, unconscious identification with the earth. Despite their improvisational appearance, Gorky's paintings were based on detailed preparatory drawings—he wanted his paintings to touch his viewers deeply and to be formally beautiful, like the drawings of Ingres and Matisse.

PRIMORDIAL IMAGERY. Jackson Pollock (1912–56), the most famous of the Jung-influenced Abstract Expressionists, rejected this European tradition of aesthetic refinement what he referred to as "French cooking"-for cruder, rougher formal values identified with the Wyoming frontier country of his birth. Pollock went to New York in 1930 and studied at the Art Students League and later with the Mexican muralist David Siqueiros. Self-destructive and alcoholic, Pollock entered Jungian psychotherapy in 1939. Because Pollock was reluctant to talk about his problems, the therapist engaged him through his art, analyzing in terms of Jungian symbolism the drawings Pollock brought in each week.

The therapy had little apparent effect on Pollock's personal problems, but it greatly affected his art. He gained a new vocabulary of symbols and a belief in Jung's notion that artistic images that tap into primordial human consciousness can have a positive psychological effect on viewers, even if they do not understand the imagery. In paintings such as MALE AND FEMALE (FIG. 32-9), Pollock covered the surface of the painting with symbols he ostensibly retrieved from his unconscious through automatism. Underneath them is a firm compositional structure of strong vertical elements flanking a central rectangle—evidence, according to Pollock's therapist, of the healthy, stable adult psyche in which male and female elements are integrated. Such elements are balanced throughout the painting and within the forms suggesting two facing figures. Each figure combines soft, curving shapes suggestive of femininity with firmer, angular ones that connote masculinity. The sexual identity of both figures is therefore ambiguous; each seems to be both male and female. The painting and the two figures within it represent not only the union of Jung's anima (the female principle in the male) and animus (the male principle in the female) but also that of Pollock and his then lover, Lee Krasner (1908-84), a painter (SEE FIG. 32-12) with whom he had an intense relationship and whom he would marry in 1945.

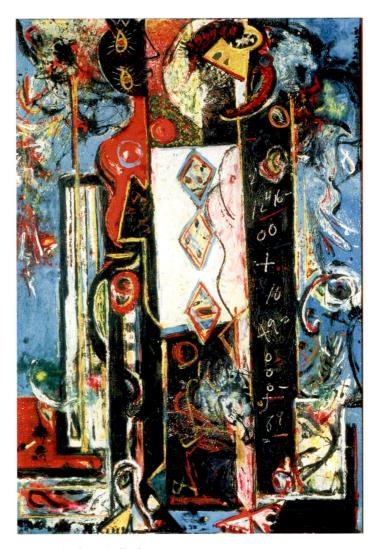

32-9 Jackson Pollock MALE AND FEMALE 1942. Oil on canvas, $6'1\frac{1}{4}'' \times 4'1''$ (1.86 × 1.24 m). Philadelphia Museum of Art.

Gift of Mr. and Mrs. Gates Lloyd

The reds and yellows used here, like the diamond shapes featured at the center, were inspired by Southwestern Native American art. Native Americans, like other so-called primitive peoples, were believed to have direct access to the collective unconscious and were therefore much studied by Surrealists and early members of the New York School, including Pollock and his psychiatrist.

Action Painting

In the late 1940s, Pollock liberated his earlier automatism in large canvases that evolved into a completely abstract welter that seemed to capture the controlled disorder of a frenzied dance. This forcefully improvisational style came to be known as action painting. The term was coined by art critic Harold Rosenberg (1906-78) in his 1952 essay "The American Action Painters," in which he claimed: "At a certain moment the canvas began to appear to one American painter after another as an arena in which to act—rather than a space in which to reproduce, redesign, analyze, or 'express' an object, actual or imagined. What was to go on the canvas was not a

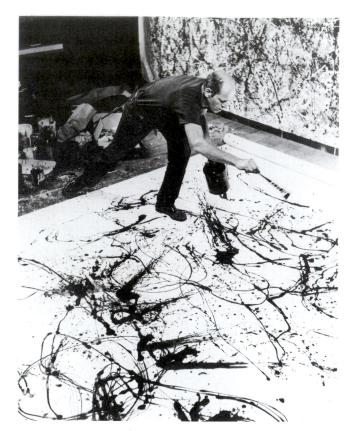

32–IO | Hans Namuth PHOTOGRAPH OF JACKSON POLLOCK PAINTING
The Springs, New York. 1950.

picture but an event." Although he did not mention them by name, Rosenberg was referring primarily to Pollock and to Pollock's chief rival for leadership of the New York School, Willem de Kooning (1904–97). It was Pollock, said de Kooning, who "broke the ice."

EXPLODING HIERARCHY. Beginning in the fall of 1946, Pollock worked in a renovated barn, where he placed his canvases on the floor so that he could work on them from all four sides. He also began to employ enamel house paints along with conventional oils, dripping them onto his canvases with sticks and brushes, using a variety of fluid arm and wrist movements (FIG. 32-10). As a student, he had experimented with spraying and dripping industrial paints during his studies with Siqueiros. He was also, according to his wife, a "jazz addict" who would spend hours listening to the explosively improvised bebop of Charlie Parker and Dizzy Gillespie. In addition, visits to the Natural History Museum allowed him to witness Navajo sand painting, a healing ritual in which a shaman pours colored sand on the floor in symbolic patterns. All of these sources help us to understand where Pollock's art came from, but they do not explain the power of the works he created from them, which engulf the viewer's entire field of vision (FIG. 32–11). AUTUMN RHYTHM and other works by Pollock from this period innovate in many ways. Besides the novel method of paint application shown in the photo, the works show no trace of the Cubist picture space, Picasso's chief legacy to Modern art. Following from this, the composition lacks hierarchical arrangement, as almost every area of the work is equally energized. In addition, the work shows

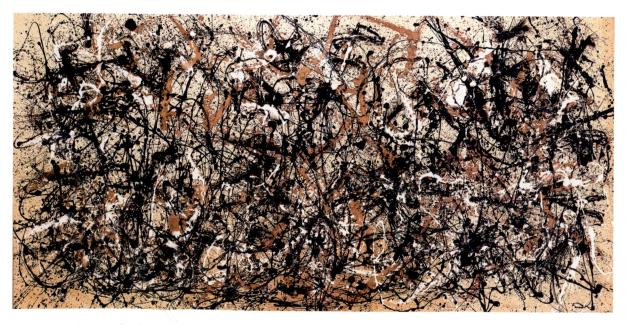

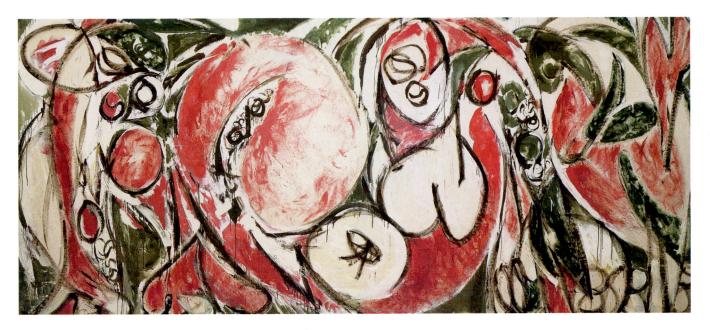

32—I2 | Lee Krasner THE SEASONS
1957. Oil on canvas, $7'8\frac{3}{4}'' \times 16'11\frac{3}{4}''$ (2.36 \times 5.18 m). Whitney Museum of American Art, New York.
Purchased with funds from Frances and Sydney Lewis (by exchange), the Mrs. Percy Uris Purchase Fund, and the Painting and Sculpture Committee (87.7)

clearly its process of making; we could literally retrace most of the artist's steps around the canvas. Finally, the work embodies a new level of physical involvement of the artist with his product. These paintings rank, along with certain works by Kandinsky (FIG. 31–14), Picasso (FIG. 31–18), and Duchamp (FIG. 31–36), among the most important breakthroughs of Modern art. As innovative as they are in a formal sense, these works also speak for the times. Pollock said in a radio interview that he was creating for "the age of the airplane, the atom bomb, and the radio," and the works do seem to embody something of the tensions of the Cold War period, as each side silently threatened the other with instant annihilation.

PAINTING FROM HARMONY, PAINTING FROM DOUBT. Lee Krasner (1908–84), who had studied in New York with the German expatriate teacher and abstract painter Hans Hofmann (1880–1966), produced fully nonrepresentational work several years before Pollock did. After she began living with him in 1942, however, she virtually stopped painting to devote herself to the conventional role of a supportive wife. Following the couple's move to Long Island in 1945, she set up a small studio in a guest bedroom, where she produced small, tight, gestural paintings similar in composition to Pollock's but lacking their sense of freedom. After Pollock's death in an automobile crash in 1956, Krasner took over his studio and produced large, dazzling gestural paintings, known as the Earth Green series, which marked her emergence from her husband's shadow. Works such as THE SEASONS (FIG. 32–12) feature bold, sweeping curves

that express not only her new sense of liberation but also her identification with the forces of nature in the bursting, rounded forms and springlike colors. "Painting, for me, when it really 'happens' is as miraculous as any natural phenomenon," said Krasner, suggesting an attitude similar to that of Pollock, who found "pure harmony" in the act of painting.

By contrast, Willem de Kooning insisted that "Art never seems to make me peaceful or pure." An immigrant from the Netherlands, de Kooning in the 1930s became friendly with several Modern painters but resisted the shift to Jungian Surrealism. For him it was more important to record honestly and passionately his sense of the world around him, which was never simple or certain. "I work out of doubt," he once remarked. During the 1940s he expressed his nervous uncertainty in the agitated way he handled paint itself. We see these autobiographical urges in action paintings such as ASHEVILLE (FIG. 32-13). De Kooning was less radical than Pollock in that he still used brushes and an easel, but the work shares the sense of urgent improvisation that typifies the style. The dominant rhythm of this work is controlled by the brushstrokes in black (including paint drips) that define jagged blocks. Some passages suggest fleshy body parts or eyes, but they are created by natural arm movements or gestures with the brush. The work's title is the name of the town in North Carolina near where Black Mountain College is located, a small college where de Kooning taught in the summer of 1948. Existentialist-oriented art critics see in these works an artist offering a rich glimpse of his own self, captured in a moment. If Sartre was correct in saying that there are no absolutes anymore,

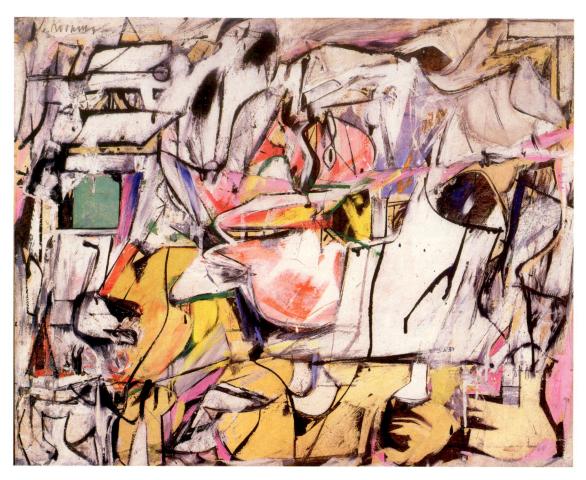

32–I3 | Willem de Kooning ASHEVILLE 1948. Oil and enamel on cardboard, $25\% \times 31\%$ (64.6 \times 80.7 cm). Phillips Collection, Washington, D.C. © The Willem de Kooning Foundation / Artists Rights Society (ARS), New York

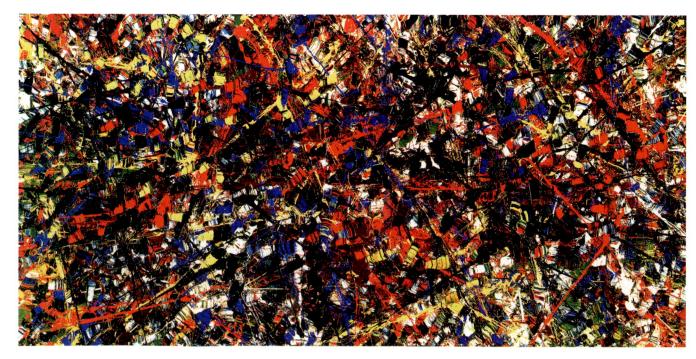

32–I4 | Jean-Paul Riopelle KNIGHT WATCH 1953. Oil on canvas, $38 \times 76\%''$ (96.6 \times 194.8 cm). The National Gallery of Canada, Ottawa, Ontario.

then all we really have is our selves as a reference point. Sartre held that people create their own identities through the decisions that they make, day by day, rather than through realization of some inner destiny or essence. If so, autobiographical works such as this are valuable because they offer us a condensation of the artist's self, built up in paint through a process of steps and decisions that this work makes obvious. Such was certainly the artist's goal.

ACTION PAINTING EXTENDS ITSELF. Action painting soon influenced artists in Canada and in Europe. One participant in this broad movement was the French Canadian painter Jean-Paul Riopelle (1923–2002), who settled in Paris in 1947. In his native Montreal, Riopelle had participated in the activities of *Les Automatistes* ("The Automatists"), who applied the Surrealist technique of automatism to the creation of abstract paintings. In the early 1950s, he began to squeeze blobs of paint directly onto the canvas and then spread them with a palette knife to create an "all-over" pattern of bright color patches, suggestive of broken shards of stained glass, and often traversed, as in KNIGHT WATCH (FIG. 32–14), by a network of spidery lines.

Helen Frankenthaler (b. 1928) visited Pollock's studio in 1951 and went on to create a more lyrical version of action painting that had an important influence on later artists. Like Pollock, she worked on the floor, but rather than flinging paint she poured it out in thin washes (FIG. 32–15). She also

used unprimed canvas, so that the paint soaked into the fabric rather than sitting on the surface. She typically began a work with some aesthetic question, but soon the process of creation became a self-expressive act as well. She described her working method in an interview (Artforum, October 1965): "I will sometimes start a picture feeling, What will happen if I work with three blues . . . ? And very often midway through the picture I have to change the basis of the experience. Or I add and add to the canvas....When I say gesture, my gesture, I mean what my mark is. I think there is something now that I am still working out in paint; it is a struggle for me to both discard and retain what is gestural and personal." In MOUN-TAINS AND SEA, she poured several colors, then outlined some of them in charcoal. The result reminded her of the coast of Nova Scotia where she frequently went to sketch, so the title of the work, applied later, alludes to this.

Color Field Painting

New York School artists used abstract means to express various sorts of emotional states, not all of them as urgent or improvisatory as that of the action painters. A group known as Color Field painters also developed out of the biomorphic Surrealism of Gorky and Lam, but they moved in a different direction. Responding in part to what they saw as a spiritual problem in modern society, they created works that use large, flat areas of color to evoke transcendent moods of contemplation.

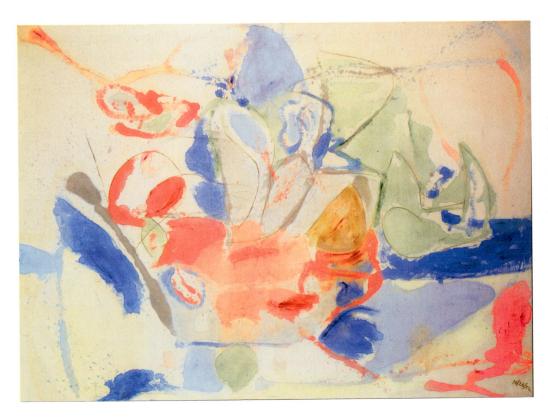

32–15 Helen Frankenthaler MOUNTAINS AND SEA
1952. Oil and charcoal on canvas, 7'2½" × 9'8½"
(2.2 × 2.95 m). Collection of the artist on extended loan to the National Gallery of Art, Washington, D.C.

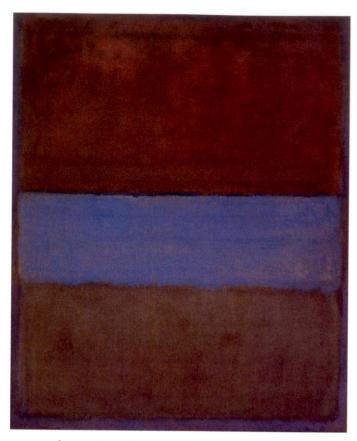

32–16 | Mark Rothko NO. 61, BROWN, BLUE, BROWN ON BLUE 1953. Oil on canvas, $9'7\%''\times7'7\%''$ (2.94 \times 2.32 m). The Museum of Contemporary Art, Los Angeles. The Panza Collection

THE DIVIDED INDIVIDUAL. Mark Rothko's (1903–1970) mature paintings typically feature two to four soft-edged rectangular blocks of color hovering one above another against a monochrome ground. In works such as BROWN, BLUE, BROWN ON BLUE (FIG. 32-16) Rothko sought to bring together the two divergent human tendencies that German philosopher Friedrich Nietzsche called the Dionysian and the Apollonian. The rich color represents the emotional, instinctual, or Dionysian element (after Dionysus, the Greek god of wine, the harvest, and inspiration), whereas the simple compositional structure is its rational, disciplined, or Apollonian counterpart (after Apollo, the Greek god of light, music, and truth). However, Rothko was convinced of Nietzsche's contention that the modern individual was "tragically divided," so his paintings are never completely unified but remain a collection of separate parts. What gives this fragmentation its particular force is that these elements offer an abstraction of the human form. In Brown, Blue, Brown on Blue, as elsewhere, the three blocks approximate the human division of head, torso, and legs. The vertical paintings, usually somewhat taller than the adult viewer, thus present the viewer with a kind of amplified mirror image of the divided self. The dark tonalities that Rothko increasingly featured in

his work emphasize the tragic implications of this division. The best of his mature paintings maintain a tension between the harmony they seem to seek and the fragmentation they regretfully acknowledge.

THE INDIVIDUAL AND THE SUBLIME. Barnett Newman also developed a distinctive nonrepresentational art to address modern humanity's existential condition, declaring his "subject matter" to be "[t]he self, terrible and constant." Newman specialized in monochrome canvases with one or more vertical lines, or "zips," dividing the surface, as in VIR HEROICUS SUBLIMIS (FIG. 32-17), whose Latin title means "Man, Heroic and Sublime." Newman often painted large works that engulf the viewer with color. He hoped to provide a modern experience of the sublime, as artists of the past such as Turner had done (SEE FIG. 30-15), but through abstract means which are not attached to any kind of scenery. Newman wondered whether modern science had demystified the world so much that people had lost the ability to sense the sublime. Jung wrote in Modern Man in Search of a Soul that the urge for the sublime was indeed frustrated in the modern era, and this led people to engage in war and slaughter as a perverse, negative substitute. Newman's own study of non-Western mythology convinced him that the sublime feelings are basic to most of the world's religions, yet modern Christianity seemed devoted to worldly goals such as material success and getting along well with others. The most popular minister of that period, the New York-based Dr. Norman Vincent Peale, achieved bestseller status with faith-based books such as The Power of Positive Thinking. Newman saw this as superficial. Writing about his art in the third person in an essay called "The Plasmic Image," he said: "The present painter is concerned not with his own feelings or with the mystery of his own personality but with the penetration into the world of mystery. His imagination is therefore attempting to dig into metaphysical secrets. To that extent his art is concerned with the sublime."

Sculpture of the New York School

Most sculptural media resist the spontaneous handling that painters such as Pollock developed, but some sculptors still took the New York School into the third dimension by using abstract means to transmit meanings and emotional states. The most important of these, David Smith (1906–1965) and Louise Nevelson (1899–1988), were first trained as painters, and their work retained important links to that medium.

WORKING WITH METAL. Smith gained metalworking skills at 19 as a welder and riveter at an automobile plant in his native Indiana. He first studied painting but turned to sculpture in the early 1930s after seeing reproductions of welded metal sculptures by Picasso and others. After World War II, Smith defied the traditional values of vertical, monolithic sculpture by welding horizontally formatted,

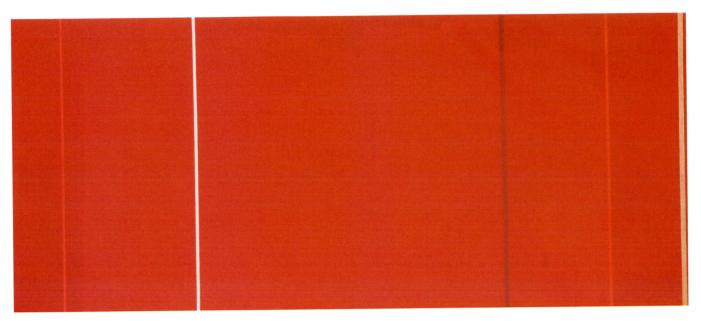

32–17 | Barnett Newman VIR HEROICUS SUBLIMIS 1950–51. Oil on canvas, $7'11\frac{1}{8}'' \times 17'9\frac{1}{4}''$ (2.42 \times 5.41 m). The Museum of Modern Art, New York. Gift of Mr. and Mrs. Ben Heller

open-form pieces that resemble drawings in space. A fine example is **HUDSON RIVER LANDSCAPE** (FIG. 32–18), whose fluent metal calligraphy, reminiscent of Pollock's poured lines of paint, was inspired by views from a train window of the rolling topography of upstate New York. Like many of his works from this period, the piece is meant to be seen from the front, like a painting.

During the last five years of his life, Smith turned from nature-based themes to formalism—a shift partly inspired by his discovery of the expressive properties of stainless steel. Smith explored both its relative lightness and the beauty of its polished surfaces in the *Cubi* series, monumental combinations of geometric units inspired by and offering homage to the formalism of Cubism. Like the Analytic Cubist works of

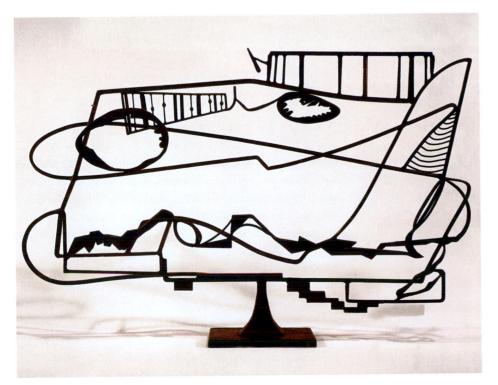

32–18 | David Smith

HUDSON RIVER LANDSCAPE

1951. Welded steel,

49 × 73½ × 16½"

(127 × 187 × 42.1 cm).

Whitney Museum of American Art,
New York.

Art © Estate of David Smith/Licensed by

VAGA, New York, N.Y.

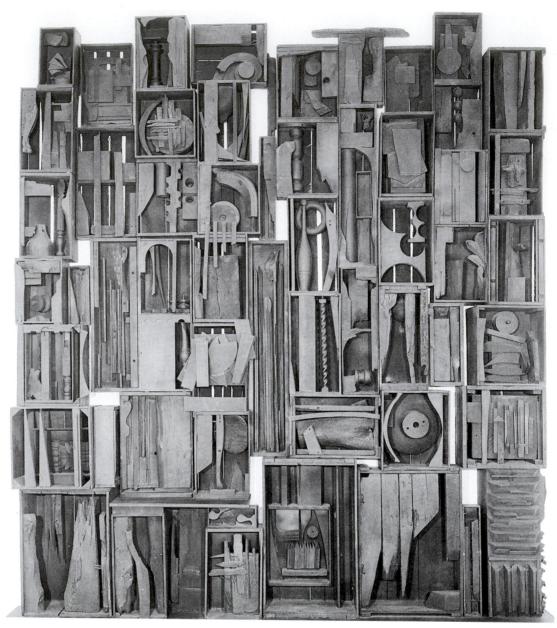

32–I9 | Louise Nevelson SKY CATHEDRAL 1958. Assemblage of wood construction, painted black, $11'3\%'' \times 10'\%'' \times 1'6''$ (3.44 \times 3.05 \times 0.46 m). The Museum of Modern Art, New York. Gift of Mr. and Mrs. Mildwoff

Braque and Picasso (SEE FIG. 31–21), *Cubi XIX* (see Fig. 6, Introduction) presents a finely tuned balance of elements that, though firmly welded together, seems ready to collapse at the slightest provocation. The viewer's aesthetic pleasure depends on this tension and on the dynamic curvilinear patterns formed by the play of light over the sculpture's burnished surfaces. The *Cubi* works were meant to be seen outdoors, not only because of the effect of sunlight but also because of the way natural shapes and colors complement the inorganic ones.

WORKING WITH WOOD. While many sculptors of the New York School shared Smith's devotion to welded metal, some

continued to work with more traditional materials, such as wood. Wood became the signature medium of Louise Nevelson (1899–1988), a Russian immigrant who gained intimacy with the material as a child in Maine, where her father ran a lumberyard. After studying painting with Hans Hofmann, who introduced her to the formal language of Cubism, Nevelson turned to sculpture around 1940, working first in a biomorphic mode reminiscent of Henry Moore (SEE FIG. 31–71) before discovering her talent for evoking ancient ruins, monuments, and royal personages through assemblage.

Nevelson's most famous works are the wall-scale assemblages she began to produce in the late 1950s out of stacked packing boxes, which she filled with carefully and

sensitively arranged Analytic Cubist-style compositions of chair legs, broom handles, cabinet doors, spindles, and other wooden objects. She painted her assemblages a matte black to obscure the identity of the individual elements, to formally integrate them, and to provide an element of mystery. One of her first wall assemblages was **SKY CATHEDRAL** (FIG. 32–19), which Nevelson believed could transform an ordinary space into another, higher realm—just as the prosaic elements she worked with had themselves been changed. To add a further poetic dimension, Nevelson first displayed *Sky Cathedral* bathed in soft blue light, like moonlight.

EXPERIMENTS WITH FORM IN BUENOS AIRES

Uruguayan and Argentine artists were as innovative as their counterparts from the New York School but in a completely different direction. Starting from the geometric abstraction of Mondrian (SEE FIG. 31–60), they pioneered a range of new techniques in abstract painting and sculpture. They gathered in Buenos Aires immediately after the war, where they formed the groups Arte Concreto-Invención and Madí. Like

the Abstraction-Creation group in Europe (see Chapter 31), the South Americans were also motivated by antifascism: Ruling Argentina at that time was Juan Perón, who admired Italian dictator Mussolini and professed a profound dislike of Modern art.

The forerunner of the Latin American experiments was the Uruguayan Joaquín Torres-García (1874-1949), who established what he called a "School of the South" in Montevideo, Uruguay's capital. He had spent forty-three years in Europe and participated in several abstract art groups. His own art was also rooted in Pre-Columbian indigenous art forms of the Inca, especially their masonry buildings (SEE FIG 26-6). He regarded ancient American cultures as a fertile bed of ideas similar to how Europeans might regard ancient Greek art: an important traditional source for later innovation. Torres-García also noticed that the patterns of stone in Inca architecture resembled the abstract paintings of Mondrian and others, a fact that he took as support for the universal validity of abstract art. His paintings (FIG. 32-20) combine ideas gleaned from Mondrian with Pre-Columbian patterns in a style he called Constructive Universalism. A tireless educator, he taught hundreds of students, formed several magazines, and even hosted a radio show.

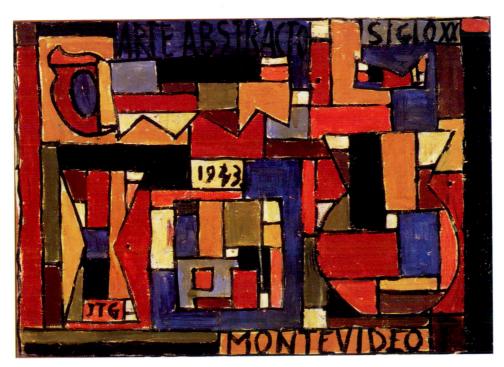

Gift of Mr. and Mrs. Armand J. Castellani, 1979 / Artists Rights Society (ARS), New York

Concrete-Invention

After visiting Torres-García and taking in his polemical materials in the years just after World War II, younger artists in Buenos Aires moved their art even further away from representation. Mondrian, after all, was still representing a cosmic order, and Torres-García owed some of his forms to ancient stone walls. They called their group "Concrete" in order to avoid the term abstract, which might mean that their art was abstracted from something else. Rather, they stressed their own "Invention" of new forms. Their first important discovery was the shaped canvas (FIG. 32-21), here in a version by Raúl Lozza (b. 1911). The artist's goal was not to picture or represent anything, nor was it to transcribe or symbolize his emotional state. The work should exist without reference to any other reality. Art with a representational agenda, even a hidden one, is harmful because it "tends to sap the mental strength of viewers, leaving them unaware of their true powers," according to one of the group's manifestos. Representational art makes viewers into passive spec-

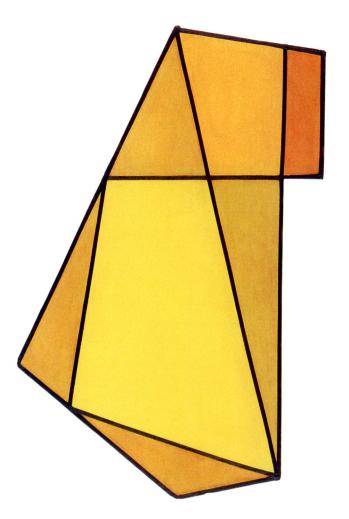

32–2I | Raul Lozza ANALYTICAL STRUCUTURE 1946. Oil and ribbon on wood, $20\frac{1}{2} \times 11\frac{1}{8}$ " (52.1 \times 32.5 cm). Galerie von Bartha, Basel. Artists Rights Society (ARS), New York

tators. Rather, Lozza invented these forms without any preconceived notion so that the viewer could experience the forms merely as forms. Conforming the creations to a rectangular format limits the artist's scope of invention. Moreover, a shaped canvas was necessary because a rectangular or square painting might still be readable as a "picture" of something. Straight edges are necessary because curved ones might remind viewers of some organic shape. The surface is completely smooth because showing brushwork would point the viewer's attention away from the work itself and toward the artist. Lozza, who made leftist political cartoons in the 1930s, hoped that viewers would grasp their "true powers" after seeing these works and be more inclined to invent something in their own lives.

Madí

The next aesthetic question follows logically from Lozza's work, and it led to another important innovation: If the artist's goal is to invent new forms, why limit oneself to paint on a flat surface? Can artists invent in entirely new media? These questions first occurred to Gyula Kosice (b. 1924), and they led him to split from Concrete-Invention and form Madí in 1946. (The name, pronounced "mah-DEE," is a nonsense word.) This group, which included poets and composers as well as painters, rejected many of the previous limitations of their media. Madí poets arranged words on the page in visual patterns rather than verses; composers threw out the Western harmonic system, as Schoenberg had done earlier (see Chapter 31). After painting shaped canvases and experimenting with sculpture that moved, Kosice in 1946 was the first to make a sculpture out of neon lights (FIG. 32-22). As in Lozza's analytical strucuture, the shapes are intended to be completely abstract, but here they are also immaterial, since they consist of neon gas agitated to a glow by electricity. Color is not something that the artist applied to the work, but rather it exists in the tube and in the air surrounding it. The artists of Madí and Concrete-Invention exhibited widely over the next two decades, and helped establish a strong current of geometric abstraction in Latin American art, which at times converged with later European and North American developments.

POSTWAR PHOTOGRAPHY

Documentary photography, which flourished under New Deal patronage in the 1930s (see page 1116), went into eclipse following the withdrawal of government support during World War II. Meanwhile, photojournalism, which burgeoned in the 1930s with the appearance of large-format picture magazines such as *Life*, grew in importance during the postwar decades. Fashion periodicals such as *Vogue* and *Harper's Bazaar* also provided work for professional photographers and stimulated the development of color photography.

32–22 | Gyula Kosice MADÍ LUMINOUS STRUCTURE "F" 1946. Neon gas tube, $20 \% \times 15 \% \times 7 \%$ " (55 \times 40 \times 18 cm). Collection of the artist.

New Documentary Slants

Many photographers took on commercial assignments to earn a living while producing independent work more expressive of their personal concerns and aesthetic interests. An important noncommercial trend that emerged in the 1950s was a new form of documentary photography that rejected traditional aesthetic standards to survey in a raw and unsentimental manner what one writer called the "social landscape." The founder of this mode was the Swiss-born Robert Frank (b. 1924). Frustrated by the pressure and banality of news and fashion assignments, Frank went to

Peru and Bolivia in 1948 to photograph the lives of poor people. Four years later he made another photo suite on Welsh coal miners at work. He applied successfully for a Guggenheim Fellowship in 1955 to finance a yearlong photographic tour of the United States. From more than 28,000 images, he selected 83 for a book published first in France as Les Américains in 1958 and a year later in an Englishlanguage edition as The Americans, with an introduction by the Beat writer Jack Kerouac (1922–69). Many of the images in the book combine unmistakable social comment with formal interest in composition. The perfect symmetry of

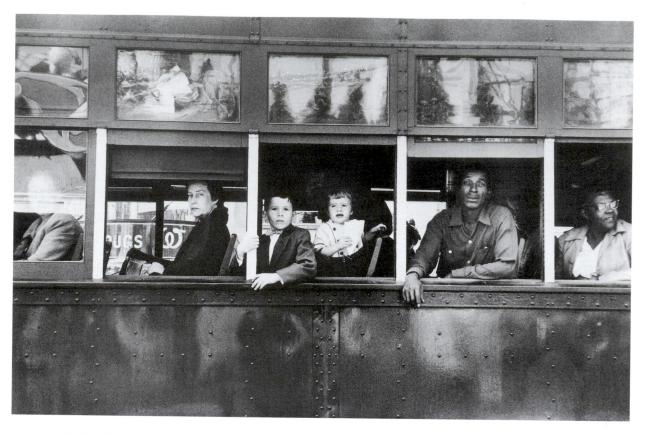

32–23 | Robert Frank TROLLEY, NEW ORLEANS 1955–56. Gelatin-silver print, $9\times13''$ (23 \times 33 cm). The Art Institute of Chicago.

trolley, New Orleans (FIG. 32–23), for example, ironically underscores the racial segregation that it documents: White passengers sit in the front of the trolley, African Americans in the back, according to the laws of many Southern states before the civil rights movement forced changes. At the same time, the rectangular frames of the trolley windows isolate the individuals looking through them, evoking a sense of urban alienation. The rectangles in various formats also echo the shape of the picture itself, and the top row presents ghostly reflections that could be photographs in themselves.

In her complete preoccupation with subject matter, Diane Arbus (1923–71), even more than Frank, rejected the concept of the elegant photograph, discarding the niceties of conventional art photography (FIG. 32–24). She developed this approach partly in reaction to her experience as a fashion photographer during the 1950s—she and her husband, Allan Arbus, had been *Seventeen* magazine's favorite cover photographers—but mostly because she did not want formal concerns to distract viewers from her compelling, often disturbing subjects. Her innovative treatment of the photographic process created some of the sense of unease. She moved beyond the boundaries of what had been acceptable subject matter, photographing nudists and people with physical deformities or people otherwise on the fringes of society.

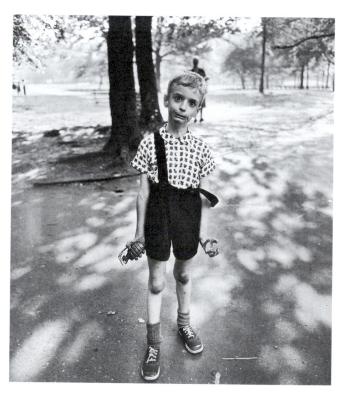

32–24 † Diane Arbus CHILD WITH TOY HAND GRENADE 1962. Gelatin-silver print, $8\frac{1}{4} \times 7\frac{1}{4}$ " (21 \times 18.4 cm). The Museum of Modern Art, New York.

32–25 | Minor White CAPITOL REEF, UTAH 1962. Gelatin-silver print. The Museum of Modern Art, New York. Purchase. Courtesy © The Minor White Archive, Princeton, New Jersey

She also usually allowed these subjects to sense the presence of the camera, allowing the subject to look back at us. This memorably broke down the distance between viewer and subject.

The Modernist Heritage

Other postwar photographers remained largely aloof from the social landscape and worked at expanding the Modernist line of Emerson and Stieglitz. A leading practitioner of this mode was Minor White (1908-76), whose aesthetically beautiful photographs were also meant to be forms of mystical expression, vehicles of self-discovery and spiritual enlightenment. Using a large-format camera, White focused sharply on weathered rocks (FIG. 32-25), swirling waves, frosted windowpanes, peeling paint, and similar "found" subjects that, as enigmatic photographic images, could serve as abstract visual equivalents for inner emotional states. In the late 1940s, White began showing his works in numbered sequences rather than as isolated individual images, thereby hoping to build a mood over a series of pictures. He experimented with infrared film in the middle 1950s, photographing light invisible to the naked eye in an effort to make his photos transcend physical reality. He also worked to advance photography as an art form, founding and then editing Aperture magazine from 1952 to 1975.

MOVING INTO THE REAL WORLD

The next generation of artists, who reached maturity in the 1950s, looked for new ways to link their art to the real world. One reason for this was a rebellion against their immediate forebears. New York School artists, after all, were studiobased. Despite their innovative techniques and formats, they used traditional media: paint, canvas, metal, wood. Perhaps the next goal should be to move beyond the studio. Moreover, younger artists saw the New York School as very serious, their brows darkened by the war and Existentialism, as they tried to flesh out their deeper selves in their work or heal a crisis of human spirituality. Members of the younger generation did not experience the war as adults, so it had less impact on their consciousness. Rather, as the Western world healed from the war's destruction, they saw growing waves of material prosperity that they grappled with in their creations. Thus, the most innovative European and North American artists in the 1950s and early 1960s reintroduced the real world into art and often worked in a less serious and sometimes even playful mode. The movements that resulted were Assemblage, Happenings, and Pop Art.

Assemblage

The most important early influence on the move toward the real world was the composer John Cage (1912-1992). Along with Dada poet Hugo Ball and Surrealist leader André Breton. Cage is one of the most important nonvisual artists to influence the course of Modern art history. He studied composition during the war years with Arnold Schoenberg, whose rejection of the major and minor musical scales earlier in the century paralleled the rise of completely abstract art (see page 1074). Cage's most important innovation in music was to open his works to the random sounds of noise that we all live with every day. For example, he created a piece for twelve radios, whose score consisted of instructions to twelve operators on how to turn their volume and tuning dials; naturally this piece sounded radically different at each new performance and in each new location. The composer did not express his own feelings in this work; rather, he set up a situation in which unpredictable events can happen. This method of creation was a logical outgrowth of his study of Zen Buddhism, which teaches that enlightenment can come at any time, from any sort of experience. Likewise, Assemblage artists gather seemingly random objects and put them together in unruly compositions, not in order to make a predetermined statement but rather to see what kind of meanings might emerge.

BETWEEN ART AND LIFE. Cage was teaching at Black Mountain College near Asheville, North Carolina, when he met his most precocious student, Robert Rauschenberg (b. 1925). Rauschenberg also studied painting with Willem de Kooning, who was on the faculty that year (see his *Asheville*, Fig. 32–13). Ever the

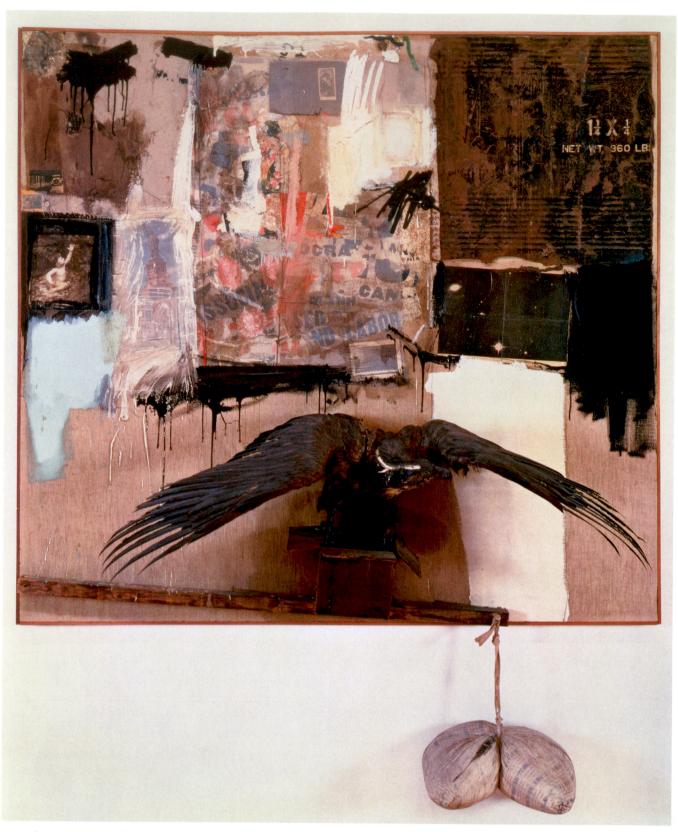

32–26 Robert Rauschenberg CANYON 1959. Combine painting: oil, pencil, paper, metal, photograph, fabric, wood on canvas, plus buttons, mirror, stuffed eagle, pillow tied with cord, and paint tube, $6'1'' \times 5'6'' \times 2' \%''$ (1.85 \times 1.68 \times 0.63 m). Courtesy Sonnabend Gallery, on infinite loan to the Baltimore Museum of Art, Baltimore, Maryland. Art © Robert Rauschenberg/Licensed by VAGA, New York, NY

irreverent prankster, Rauschenberg asked for a drawing by the action painter and expressed his feeling about the older generation by erasing it (with de Kooning's permission). After a trip to Europe in 1948–49, where he saw work by Alberto Burri, among others (SEE FIG. 32–6), Rauschenberg began finding ways to "work in the gap between art and life," as he put it. In 1951, he exhibited a series of blank white paintings, so that the lights in the room and the shadows cast by viewers became the content of the canvases. This closely parallels a similar work by Cage from the same period, 4' 33" (four minutes thirty-three seconds), which calls for a player or players to sit silently on the stage at their instruments for that length of time, allowing any random sounds to become the work.

Between 1955 and 1960, Rauschenberg created his most important pieces, which he called *Combines* because they combined painting and sculpture. **CANYON**, for example (FIG. 32–26), features an assortment of family photographs, public imagery (such as the Statue of Liberty), fragments of political posters (in the center), and various objects salvaged from trash (the flattened steel drum at upper right) or purchased (the stuffed eagle). This agglomeration shares space with various patches of paint. The rich disorder in this work challenges the viewer to make sense of it. In fact, Rauschenberg meant his work to be open to various readings, so he assembled mate-

rial that each viewer might interpret differently. One could, for example, see the Statue of Liberty as a symbolic invitation to interpret the work freely. Or perhaps, covered as it is with paint applied in the manner of action painting, it symbolizes that style. Following Cage's ideas, Rauschenberg created a work of art that was to some extent beyond his control—a work of iconographic as well as formal disarray. Rauschenberg cheerfully accepted the chaos and unpredictability of modern urban experience and tried to find artistic metaphors for it. "I only consider myself successful," he said, "when I do something that resembles the lack of order I sense."

BETWEEN ABSTRACTION AND REPRESENTATION. Jasper Johns (b. 1930) integrated the real world in his work in order to ask more direct questions about the nature of art. He came to New York from South Carolina in 1948 and met Rauschenberg six years later. Unlike Rauschenberg's works, Johns's are controlled, emotionally cool, and highly cerebral. Inspired by the example of Marcel Duchamp (SEE FIG. 31–36), Johns produced conceptually puzzling works that seemed to bear on issues raised in contemporary art. Art critics, for example, had praised the evenly dispersed, "nonhierarchical" quality of so much Abstract Expressionist painting, particularly Pollock's. The target in TARGET WITH FOUR FACES (FIG. 32–27), an

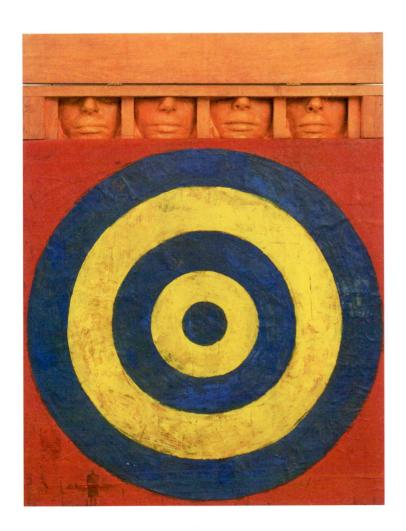

32–27 | Jasper Johns TARGET WITH FOUR FACES

1955. Assemblage: encaustic on newspaper and cloth over canvas, surmounted by four tinted plaster faces in wood box with hinged front; overall, with box open, $33\% \times 26 \times 3''$ (85.3 \times 66 \times 7.6 cm). The Museum of Modern Art, New York. Gift of Mr. and Mrs. Robert C. Scull, (8.1958) Art © Jasper Johns/Licensed by VAGA, New York, NY

emphatically hierarchical, organized image, can be seen as a critical comment on this discourse. The image also raises thorny questions about the difference between representation and abstraction. The target, although arguably a representation, is flat, whereas two-dimensional representational art usually creates the illusion of three-dimensional space. The target therefore occupies a troubling middle ground between the two kinds of painting then struggling for dominance in American art.

Johns, Cage, and Rauschenberg collaborated on several theatrical events in the late 1950s and early 1960s that may be the most perfect assemblages. Cage provided the music while Johns and Rauschenberg made sets and sometimes performed. Dancers came from the Merce Cunningham Dance Company, which specialized in making dance out of everyday actions such as waiting for a bus or reading a newspaper. Prior to the events, none of them informed the others of what they were going to do, or even for how long, so that the result was a multimedia evening of legendary unpredictability.

Happenings

Happenings resemble Assemblage in their incorporation of the real world, but Happenings are more scripted events that take place over a predetermined period of time. Many creators of Happenings acknowledged a debt to Jackson Pollock and his physical enactment of the work of art (SEE FIG. 32–10). If Pollock used his entire body with paint to create two-dimensional works, Happening artists used their bodies in the real world to create events.

THE GUTAI GROUP. The first Happenings took place in Japan, where recovery from war was closely supervised by American occupation. General Douglas MacArthur personally rewrote the Japanese constitution and directed a peaceful social revolution in order to transform postwar Japan into a Westernstyle nation. This naturally led to a radical collapse of old values that artists took advantage of. Some painters formed the Gutai group in 1954 to "pursue the possibilities of pure and creative activity with great energy," as their manifesto put it. Gutai organized outdoor installations, theatrical events, and dramatic displays of art making. The name of the movement means "embodiment," and most Gutai Happenings involved the artist performing some radical action. For example, one artist made paintings with his feet before an invited audience. Another made "drawings" by framing huge sheets of paper and walking through them. At the second Gutai Exhibition in 1956, Shozo Shimamoto (b. 1928) dressed in protective clothing and eyewear to produce **HURLING COLORS** (FIG. 32-28) by smashing bottles of paint on a canvas laid on the floor. This pushed Pollock's drip technique into the realm of a performance. Since there was practically no market for contemporary

32–28 | Shozo Shimamoto HURLING COLORS
1956. Happening at the second Gutai Exhibition, Tokyo.

art in Japan at that time, the artists often destroyed their works after the Happening was over.

KAPROW. The leading creator of Happenings in the United States was Allan Kaprow (1927–2006), like the Assemblagists a student of John Cage. Kaprow's Happenings usually involved simple scripts that invited guests acted out. A particularly ambitious Kaprow Happening of the early 1960s was THE COURT-YARD (FIG. 32-29), staged on three consecutive nights in the skylight-covered courtyard of a run-down Greenwich Village hotel. At the center of the courtyard stood a 30-foot-high tar paper-covered "mountain." Spectators were handed brooms by two workers and invited to help clean the courtyard, which was filled with crumpled newspaper and bits of tin foil, the latter dropped from the windows above. The workers ascended ladders to dump the refuse into the top of the mountain, while a man on a bicycle rode through the crowd, ringing his handlebar bell. After a few moments, wild noises were heard from the mountain, which then erupted in an explosion of black crepe-paper balls. This was followed by a shower of dishes that broke on the courtyard floor, while noises and activity were heard from the windows above. Mattresses and cartons were lowered to the courtyard, which the workers carried to the top of the mountain and fashioned into an "altar-bed." A young woman, wearing a nightgown and carrying a transistor radio, then climbed to the top of the mountain and reclined on the mattresses. Two photographers entered, searching for the young woman. They ascended the ladder, took flash pictures of her, thanked her, and left. The Happening concluded with an "inverse mountain" descending to cover the young woman.

Although Kaprow argued that Happenings lacked literary content, *The Courtyard* was for him richly symbolic: The young woman in the nightgown, for example, was the "dream girl," the "embodiment of a number of old, archetypal symbols. She is the nature goddess (Mother Nature) . . . and Aphrodite (Miss America)." Kaprow admitted that "very

32–29 ↑ Allan Kaprow THE COURTYARD 1962. Happening at the Mills Hotel, New York.

few of the visitors got these implications out of *The Court-yard*," but he believed that many sensed at some level "there was something like that going on."

HUMOR HAPPENS. Two Happenings by European artists from 1960 captured the movement's more humorous side. In Europe, Happenings were called New Realism, a term coined by art critic Pierre Restany in that year. Restany wrote that after the New York School and *Art Informel*, the art of painting was over; there was nothing left to be done with it (he was neither the first nor the last to say this; painting keeps coming back from the dead, as we shall see). After painting will come real life, Restany wrote: "The passionate adventure of the real, perceived in itself . . . The New Realists consider the world a painting: a large, fundamental work of which they appropriate fragments."

Sequencing Works of Art

1944-45	Wols, Painting
1947	Lozza, Painting No. 99
1950	Lam, Zambezia, Zambezia
	Pollock, Autumn Rhythm
1951	Smith, Hudson River Landscape
1952	Frankenthaler, Mountains and Sea
1953	Rothko, No. 61, Brown, Blue, Brown on Blue
1955	Johns, Target with Four Faces

The French artist Yves Klein (1928–1962) arrived at Happenings after experimenting with both *Art Informel* and monochromatic abstract art. For his Happening **ANTHRO-POMETRIES OF THE BLUE PERIOD** (FIG. 32–30), Klein invited members of the Paris art world to watch him direct three nude female models covered in blue paint to press their bodies against large sheets of paper. The accompaniment consisted of a string orchestra playing one constant note. This was meant, in part, as a satire on the pretentiousness of action painting, especially Pollock's work on the floor of his studio. Klein wrote, "I dislike artists who empty themselves into their paintings. They spit out every rotten complexity as if relieving themselves, putting the burden on their viewers." He offered instead a sensuous and diverting display, leading to a work that he created without actually touching it himself.

The Swiss-born Jean Tinguely (1925–1991) made comical Assemblages out of machinery that amounted to Happenings when activated. He studied art in Switzerland during the war, where he got to know several leading Dadaists, including Kurt Schwitters (SEE FIG. 31–37). Among Tinguely's most ingenious contraptions were his *Metamatics*,

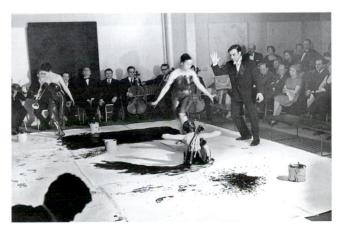

32–30 | Yves Klein ANTHROPOMÉTRIES OF THE BLUE PERIOD

1960. Performance at the Galerie Internationale d'Art Contemporain, Paris.

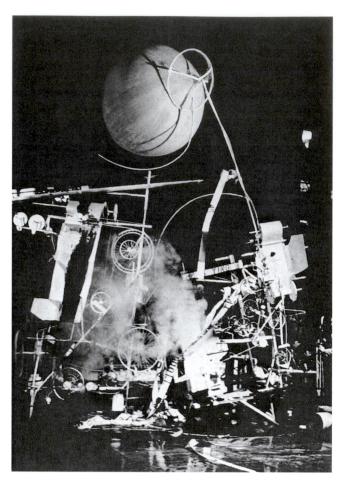

32–31 | Jean Tinguely HOMAGE TO NEW YORK
1960. Self-destroying sculpture in the garden of the Museum of Modern Art. New York.

machines with rolls of paper attached that produced abstract paintings by the yard. Viewers could turn on the machine, watch it run, and tear off the artworks it created. The satirical implication is that abstract art, which was supposed to powerfully express an artist's inner self, can be mass produced.

Happenings are generally scripted events, but when his largest machine once got out of control, it led to a Happening that made history. He designed HOMAGE TO NEW YORK (FIG. 32-31) for a special one-day exhibition in the sculpture garden of the Museum of Modern Art. He assembled the work from yards of metal tubing, several dozen bicycle and baby-carriage wheels, a washing-machine drum, an upright piano, a radio, several electric fans, a noisy old printing press, a bassinet, numerous small motors, two Metamatics, several bottles of chemical stinks, and various noisemakers—the whole ensemble painted white and topped by an inflated orange meteorological balloon. The machine was designed to destroy itself when activated. On the evening of March 17, 1960, before a distinguished group of guests, including New York governor Nelson A. Rockefeller, the work was plugged in. As smoke poured out of the machinery and covered the crowd, parts of the contraption broke free and scuttled off in

various directions, sometimes frightening the onlookers. The Metamatics blew abstract art in their direction. A device meant to douse the burning piano—which kept playing only three notes—failed to work, and firefighters had to be called in. They extinguished the blaze and finished the work's destruction—to boos from the audience, who, except for the museum officials, had been delighted by the spectacle. The artist said the event was better than any he could have planned.

Pop Art

Between about 1955 and 1965, some artists made the move into the real world by borrowing mass-produced imagery, or using mass-production techniques in their art, in response to the growing presence of mass media in the prosperous postwar culture. The movement was almost immediately given the name Pop Art to distinguish it from Assemblage, in which artists also used real objects, only some of them mass produced. The exclusive use of mass-produced imagery or techniques gives Pop Art a slicker look than the other contemporary movements. The emotional tone of Pop Art tends to show a more ironic, cynical, or detached attitude, compared with the irreverence or humor of Assemblage and Happenings.

Pop Art had its widest flowering in the United States after about 1962, but the movement originated in England years earlier. The immediate backdrop for Pop Art is wildly increasing prosperity brought on by a postwar economic boom. The Marshall Plan funneled \$9.4 billion to Europe for reconstruction, and the infusion brought about an industrial rebound. By 1950, industrial output for Europe as a whole was one-third higher than it had been in 1939. In 1955, European unemployment was only 2 percent. In most European countries, the average citizen benefited from an unprecedented level of government benefits, including social security, national health insurance, unemployment benefits, and company pensions. In 1958, for the first time, more people crossed the Atlantic by air than by sea. When English Prime Minister Harold Macmillan ran for reelection in 1959, his slogan was "You never had it so good!" In such an environment, lonely Existentialism seemed completely discredited.

HAMILTON. In this setting, younger artists wondered what they should do. Some Londoners formed the Independent Group to discuss the function of art in a comfortable industrial society which seemed to lack nothing. The group consisted of a critic, two architects, two artists, a photographer, and a writer, and they periodically staged exhibitions at London's Institute of Contemporary Arts. The artist-member generally credited with pioneering the Pop Art style was Richard Hamilton (b. 1922). An apprentice industrial designer during the war, he was thrown out of the Royal Academy for having "low standards." He reasoned, penetratingly and correctly, that the modern mass culture of televi-

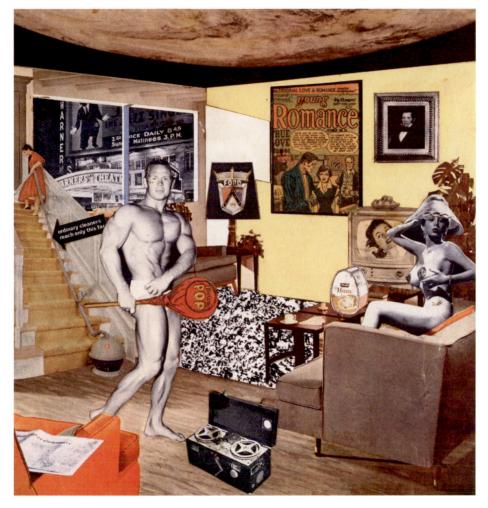

32–32 | Richard Hamilton JUST WHAT IS IT THAT MAKES TODAY'S HOMES SO DIFFERENT, SO APPEALING? 1955. Collage, $10\frac{1}{4} \times 9\frac{1}{4}$ " (26 × 24.7 cm). Kunsthalle Tübingen, Germany.

sion, movies, and media had taken over many of the previous functions of traditional art. For example, if in the past art showed us ideal beauty, today people see such things in advertising and pin-up photographs. If another function of art is to comment on society, then television news programs do that more vividly. If art has traditionally given us heroic narratives of larger-than-life figures, people today can see this at the movies. Finally, if art somehow symbolizes the times by its style, then car bodies and the latest consumer goods do this just as well.

ARS/DACS

Hamilton's answer was to make art that ironically used the same strategies as mass media. His 1955 collage has a long title borrowed from advertising slogans: JUST WHAT IS IT THAT MAKES TODAY'S HOMES SO DIFFERENT, SO APPEALING? (FIG. 32–32). Here we see a man and a woman—Hamilton called them Adam and Eve—in their domestic setting. To point out just a few of the details in this iconographically rich work: The home is populated with brand-name goods, most of them of American origin. Out the window is a movie theater showing *The Jazz Singer*, the 1927 film that was the first to integrate a spoken sound track. On the wall, occupying the

favored place above the TV set, is a portrait of John Ruskin, the moralistic art critic who had libeled James Whistler seventy years before (see "Art on Trial in 1877," page 1025). The central male figure holds the huge sucker that gave the style its name: Art critic Lawrence Alloway referred to that Tootsie Pop when he called Hamilton's collage a work of Pop Art. The work illustrates modern comfort, progress, and success, using the imagery of the mass media themselves. The historical antecedents for this work are the Dada collages of Hannah Höch and others (SEE FIG. 31-38), but Hamilton's work uses later imagery and is less bitter. Like other British Pop artists, Hamilton was not alienated from popular culture; he respected it and worked with it. He later designed an album cover for The Beatles ("White Album," 1968), as did his fellow Pop artist Peter Blake ("Sgt. Pepper's Lonely Hearts Club Band," 1967).

WARHOL. American artists soon found their way to a yet slicker and simpler Pop Art style that uses more layers of irony. Andy Warhol (1928–1987) is a giant of Pop Art if only because he created memorably in many media. Moreover, his

best works conceal important insights behind their mass-produced surfaces. Trained initially as a commercial artist, he decided in 1960 to pursue a career as an artist along the general lines suggested by the work of Johns and Rauschenberg. He took as subjects the iconic images of American mass culture, such as film star Marilyn Monroe (FIG. 32–33). MARILYN DIPTYCH is one of the first in which Warhol turned from conventional painting to the assembly-line technique of silk-screening photographic images onto canvas. The method was quicker than painting by hand and thus more profitable, and Warhol could also produce many versions of the subject—all of which he considered good business. He established a workshop in 1965 to make his pieces, and called it ironically The Factory.

The subject of this work is also telling. Like many Americans, Warhol was fascinated by movie stars such as Marilyn Monroe, whose persona became even more compelling after

her apparent suicide in 1962, the event that prompted Warhol to begin painting her. The strip of pictures in this work suggests the sequential images of film, the medium that made Monroe famous. Some of these are in black-and-white and some in color, like her movies. The face Warhol portrays, taken from a publicity photograph, is not that of Monroe the person but of Monroe the star, since Warhol was interested in her public mask, not in her personality or character. He borrowed the diptych format from the icons of Christian saints he recalled from the Byzantine Catholic church he had attended as a youth. By symbolically treating the famous actress as a saint, Warhol shed light on his own fascination with fame.

Warhol's most penetrating works take the mass media themselves as subject (FIG. 32–34). BIRMINGHAM RACE RIOT deals with the civil rights protests that characterized that period, but Warhol is typically noncommittal in this work. He

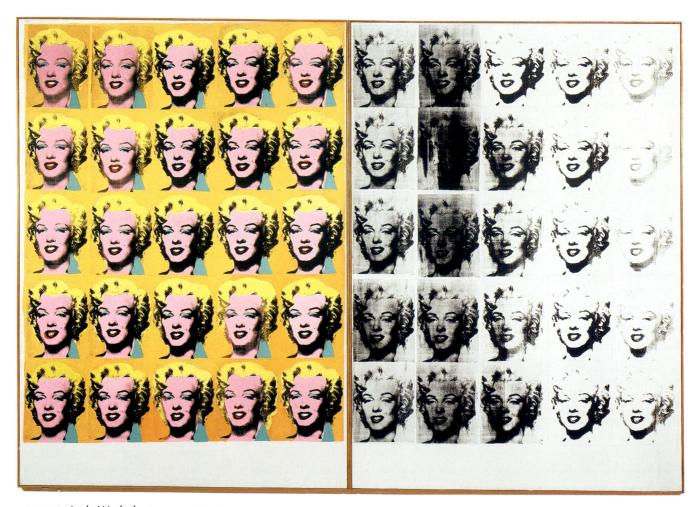

32–33 $^{\parallel}$ Andy Warhol MARILYN DIPTYCH 1962. Oil, acrylic, and silkscreen on enamel on canvas, two panels, each $6'10'' \times 4'9''$ (2.05 \times 1.44 m). Tate Gallery, London.

Warhol assumed that all Pop artists shared his affirmative view of ordinary culture. In his account of the beginnings of the Pop movement, he wrote: "The Pop artists did images that anybody walking down Broadway could recognize in a split second—comics, picnic tables, men's trousers, celebrities, shower curtains, refrigerators, Coke bottles—all the great modern things that the Abstract Expressionists tried so hard not to notice at all."

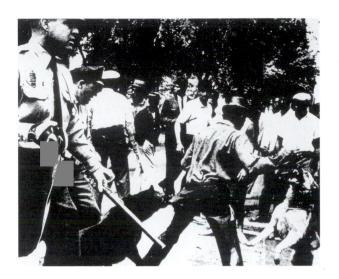

32–34 | Andy Warhol BIRMINGHAM RACE RIOT 1964. Serigraph on Bristol board, with Japan paper borders, $20\times24''$ (50.9×60.8 cm). National Gallery of Canada, Ottawa. (No. 17242) Purchased 1973 / © 2007 Andy Warhol Foundation for the Visual Arts / SODRAC, Montreal / Artists Rights Society (ARS), New York, NY

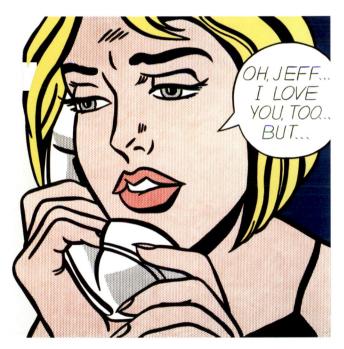

32–35 | Roy Lichtenstein OH, JEFF . . . I LOVE YOU, TOO . . . BUT . . . 1964. Oil and Magna on canvas, $48 \times 48''$ (122 \times 122 cm). Private collection.

took no position on the civil rights question but merely transcribed a media image from a popular magazine. Later versions of this work reproduced the photo dozens of times, as in the *Marilyn Diptych*. Warhol was among the first to notice that the mass media bring the whole world much closer to us, but they also enable us to observe the world in a detached fashion. Tragedies and disasters enter our living rooms every day,

but they come in a small box that we can turn on or off at will, making us voyeurs rather than participants. Moreover, the media repeat stories so often that we become desensitized to their impact. Warhol's works, through deadpan presentation and seemingly mindless repetition, make both of these points cogently. He also had a gift for aphorism that by itself might have guaranteed his fame. Nearly everyone has heard of his assertion that "In the future everybody will be worldfamous for fifteen minutes." He made a telling comment that speaks to a central dilemma of modern life: "All of my films are artificial, but then everything is sort of artificial. I don't know where the artificial stops and the real starts." Besides his art pieces and his films, Warhol also founded a magazine (Interview) and managed a highly influential rock band (The Velvet Underground). His influence outlasted Modern art itself, as we shall see.

LICHTENSTEIN. Roy Lichtenstein (1923–97) was among the first American artists to make art from the look as well as the subjects of popular culture. In 1961, while teaching at Rutgers University with Allan Kaprow, Lichtenstein began producing paintings whose imagery and style—featuring heavy black outlines, flat primary colors, and the Benday dots used to add tone in printing—were drawn from advertisements and cartoons. The most famous of these early works were based on panels from war and romance comic books, which Lichtenstein said he turned to for formal reasons. Although many assume that he merely copied from the comics, in fact he made numerous subtle yet important formal adjustments that tightened, clarified, and strengthened the final image. Nevertheless, most of the paintings retain a sense of the cartoon plots they draw on. OH, JEFF...I LOVE YOU, TOO...BUT... (FIG. 32-35), for example, compresses into a single frame the generic romance-comic story line, in which two people fall in love, face some sort of crisis that temporarily threatens their relationship, then live happily ever after. Lichtenstein's work plays an elaborate game with illusion and reality: We know that comic-book emotions are melodramatic and thus unreal, and yet he presents them vividly and almost reverently. He actually used a stencil to make sure that he got the Benday dots right. The issue of what is real and unreal in our media-saturated culture was just coming to awareness in the early 1960s; its increasing urgency since then has kept Pop Art relevant.

OLDENBURG. Swedish-born Claes Oldenburg (b. 1929) took both a more critical and a more humorous attitude toward his popular subjects than did Warhol and Lichtenstein. Oldenburg's humor is most evident in such large-scale public projects as his Lipstick Monument for his alma mater, Yale University (FIG. 32–36). Oldenburg created this work at the invitation of a group of graduate students in Yale's School of Architecture, who requested a monument to the "Second

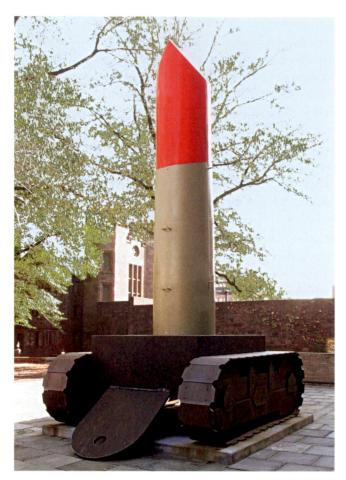

32–36 | Claes Oldenburg **LIPSTICK (ASCENDING) ON CATERPILLAR TRACKS** 1969, reworked 1974. Painted steel body, aluminum tube, and fiberglass tip, $21' \times 19' \ 5\%'' \times 10' 11''$ (6.70 \times 5.94 \times 3.33 m). Yale University Art Gallery, New Haven, Connecticut. Gift of Colossal Keepsake Corporation

American Revolution" of the late 1960s, which was marked by student demonstrations against the Vietnam War. By mounting a giant lipstick tube on tracks from a Caterpillar tractor, Oldenburg suggested a missile grounded in a tank, simultaneously subverting the warlike reference by casting the missile in the form of a feminine cosmetic with erotic overtones. Oldenburg thus urged his audience, in the vocabulary of the time, to "make love, not war." He also addressed the issue of "potency," both sexual and military, by giving the lipstick a balloonlike vinyl tip, which, after being pumped up with air, was meant to deflate slowly. (In fact, the pump was never installed and the drooping tip, vulnerable to vandalism, was soon replaced with a metal one.) Oldenburg and the students provocatively installed the monument on a plaza fronted by the Yale War Memorial and the president's office. The university, offended by the work's irreverent humor, had Oldenburg remove it the next year. In 1974 he reworked LIP- **STICK (ASCENDING) ON CATERPILLAR TRACKS** in the more permanent materials of fiberglass, aluminum, and steel and donated it to the university, which this time accepted it for the courtyard of Morse College.

THE FINAL ASSAULT ON CONVENTION, 1960–1975

If Pop artists happily engaged with the world of mass culture, other artists saw that movement as a distraction from the basic quest of Modern art: questioning and overthrowing the conventions of art itself. The era of 1960s and early 1970s was another period of intense experimentation, similar to the early twentieth century, when movements and styles proliferated and overlapped with each other. Various groups of artists on different continents attacked the rules from different angles. Though most of this art has no overt political dimension, the restless questioning by artists parallels the social upheavals that also marked that period. The years that saw the civil rights movement, massive rallies against the draft and the Vietnam War, and organized movements of environmentalism, feminism, and the Paris revolts of 1968, also saw artists making works that outdid the radicalism of even the Dadaists.

Op Art and Minimal Art

MATTER AS WAVE. Building on the Latin American tradition of geometric abstraction (SEE FIG. 32-21), some Venezuelan artists experimented with a new kind of motion in their art. We have already seen art that moves by Alexander Calder (SEE FIG. 31-72); Gyula Kosice in Argentina also made mobiles in the 1940s. Is it possible, some wondered, to have art that depends on motion by the spectator? In society, people are moving all the time, why not in the art gallery as well? Jesús Rafael Soto (1923-2005) created such works as far back as the 1950s (FIG. 32-37). TRANSFORMABLE HAR-MONY is a series of painted planes a few inches apart, attached together parallel to the wall. When a viewer passes by, the clashing lines set up patterns that seem to vibrate. Soto hoped that these vibrations generate enough interest on optical grounds alone, apart from any personal expression or symbolic meaning, to hold the viewer's contemplative attention. The moving patterns do not exist in the painted planes themselves but only on the viewer's retina; Soto said in 1965 that the form of his art is thus "dematerialized." Viewers passing by at different speeds, at different heights, will see somewhat different patterns. Every viewer with good enough eyesight will see the patterns, though, and their motion does not depend on the viewer's culture or level of education. Soto, a socialist, took pleasure in this egalitarian aspect of his art. Since the work depends primarily on optical phenomena, his art was dubbed (half in jest by a fan of Pop Art) "Op Art."

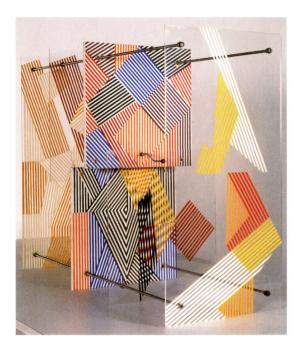

32−37 | Jesús Rafael Soto | **ARMONÍA TRANSFORMABLE** (TRANSFORMABLE HARMONY)

1956. Plexiglass and acrylic on wood, $39\% \times 15\% \times 39\%$ (100 \times 40 \times 100 cm). Art Museum of the Americas, Washington, D.C.

© Jesús Rafael Soto / Artists Rights Society (ARS), New York / ADAGP, Paris

English artist Bridget Riley (b. 1931) worked along a similar path in two-dimensional works (FIG. 32–38). **CURRENT** plays with the viewer's depth perception, as the narrow lines seem to describe wave patterns. Riley's art is based more on natural rhythms than that of Soto, and it also presumes a stationary viewer, but we soon discover as we look at this work that it is impossible to keep our eyes perfectly still. The lines seem to undulate, and the afterimages that develop in our retina create extraneous patterns. These optical phenomena create a new kind of visual immersion, perhaps admirably suited to a fast-paced existence.

MATTER AS MATTER. In its emphasis on hard-edged geometry, Op Art held a formal relationship to Minimalism, which emerged in the mid-1960s as the dominant mode of abstraction in New York. The Minimalists had no knowledge of the earlier Concrete-Invention group in Argentina, but they worked along a similar path. Minimalists sought to purge their art of everything that was not essential to art. They banished subjective gestures and personal feelings; negated representation, narrative, and metaphor; and focused exclusively on the artwork as a physical fact. They employed simple geometric forms with plain, unadorned surfaces and often used industrial techniques and materials to achieve an effect of complete impersonality. Canadian artist Jack Bush (1909–1977) once

said that his paintings are "something to look at, just with the eye, and react." This statement accurately describes part of the Minimalist program, but Bush retained something of a handmade look in his abstractions. Influenced by Helen Frankenthaler (SEE FIG. 32-15), he worked with thinned-down oils during the first half of the 1960s. Bush switched to acrylics in 1966, the year he painted TALL SPREAD (FIG. 32-39). In this large painting from Bush's Ladder series, a stack of color bars fills the right side of the canvas, held in place by a single green vertical stripe at the left. While the bands of the ladder alternate in value between dark and light, Bush chose their hues not according to any systematic logic but rather intuitively. Similarly, he avoided geometric regularity by varying the width of each band and leaning its top and bottom edges slightly off the horizontal. Bush's art retains the human touch in ways that American Minimalists worked hard to avoid.

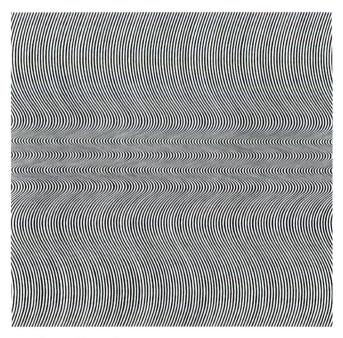

32–38 | Bridget Riley CURRENT 1964. Synthetic polymer on board, $58\%'' \times 58\%''$ (148 \times 149 cm). The Museum of Modern Art, New York. Philip Johnson Fund (576.1964)

While the American popular media loved Op Art, most avant-garde critics detested it. Lucy Lippard, for example, called it "an art of little substance," depending "on purely technical knowledge of color and design theory which, when combined with a conventional geometric . . . framework, results in jazzily respectable jumping surfaces, and nothing more." For Lippard and like-minded New York critics, Op Art was too involved with investigating the processes of perception to qualify as serious art.

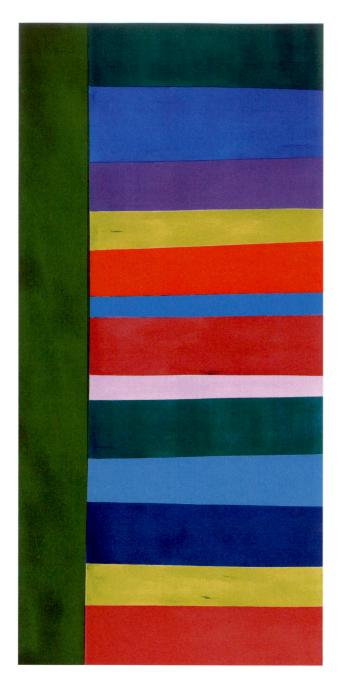

32–39 | Jack Bush TALL SPREAD 1966. Acrylic on canvas, $106\times50''$ (271 \times 127 cm). The National Gallery of Canada, Ottawa, Ontario. Purchase, 1966

The painter Frank Stella (b. 1936) inaugurated the Minimalist movement in the late 1950s through a series of large "Black Paintings," whose flat, symmetrical black enamel stripes, laid down on bare canvas with a house painter's brush, rejected the varied colors, spatial depth, asymmetrical compositions, and impulsive brushwork of action painters such as de Kooning. In 1960 Stella created a series of "Aluminum Paintings," using a metallic paint normally applied to radiators. He chose this paint because it "had a quality of repelling

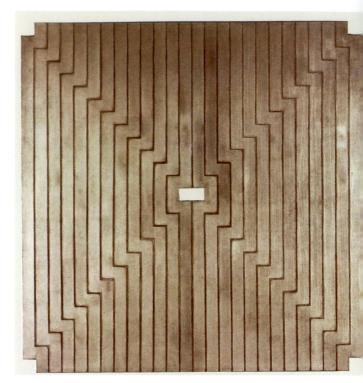

32–40 | Frank Stella AVICENNA 1960. Aluminum paint on canvas, $6'2\frac{1}{2}''\times6'$ (1.91 \times 1.85 m). The Menil Collection, Houston, Texas.

32–41 | Judd Foundation UNTITLED 1969. Anodized aluminum and blue Plexiglas, each $47\frac{1}{2} \times 59\frac{7}{6} \times 59\frac{7}{6}$ " (1.2 × 1.5 × 1.5 m); overall $47\frac{1}{2} \times 59\frac{7}{6} \times 278\frac{7}{2}$ " (1.2 × 1.5 × 7.7 m). The St. Louis Art Museum, St. Louis, Missouri. Purchase funds given by the Shoenberg Foundation, Inc. Art © Judd Foundation / Licensed by VAGA, New York, NY

the eye," and it created an even flatter, more abstract effect than had the "soft" black enamel. While the "Black Paintings" featured straight bands that either echoed the edges of the rectangular canvas or cut across them on the diagonal, in "Aluminum Paintings" such as AVICENNA (FIG. 32–40) Stella arrived at a more consistent fit between the shape of the support and the stripes painted on it by cutting notches out of the corners and the center of the canvas and making the stripes "jog" in response to these irregularities.

In these and subsequent series, Stella continually developed the possibilities of the shaped canvas that Argentine artists had pioneered. He used thick stretchers (the pieces of wood on which canvas is stretched) to give his works the appearance of slablike objects, which his friend Donald Judd (1928-94) recognized as suggesting sculpture. By the mid-1960s, Judd, trained as a painter, had decided that sculpture offered a better medium for creating the kind of pure, matter-of-fact art that he and Stella both sought. Rather than depicting shapes, as Stella did-which Judd thought still smacked of representation—Judd created actual shapes. In search of maximum simplicity and clarity, he evolved a formal vocabulary featuring identical rectangular units arranged in rows and constructed of industrial materials, especially galvanized iron, anodized aluminum, stainless steel, and Plexiglas. UNTITLED (FIG. 32-41) is a typical example of his mature work, which the artist did not make by hand but had fabricated according to his specifications. He faced the boxes with transparent Plexiglas to avoid any uncertainty about what might be inside. He arranged them in evenly spaced rows the most impersonal way to integrate them—and generally avoided sets of two or three because of their potential to be read as representative of something other than a row of boxes. Judd provided the viewer with a set of clear, self-contained

facts, setting the conceptual clarity and physical perfection of his art against the messy complexity of the real world.

Judd participated in protests against the Vietnam War and bought advertising space in newspapers to publicize that cause, but he felt that art should deal with aesthetic issues only. Some Minimalists struggled with the idea of banishing all personal meaning from their work, and in grappling with it they created innovative pieces. One of these is Eva Hesse (1936-1970), whose personal history kept influencing her creations. Born in Hamburg to German Jewish parents, Hesse narrowly escaped the Nazi Holocaust by immigrating with her family to New York City in 1939. After graduating from the Yale School of Art in 1959, she painted darkly Expressionistic self-portraits that reflected the emotional turbulence of her life. In 1964 she began to make completely abstract sculpture that adapted the vocabulary of Minimalism to a similarly self-expressive purpose. "For me . . . ," said Hesse, "art and life are inseparable. If I can name the content . . . it's the total absurdity of life." The "absurdity" that Hesse pursued in her last works was the complete denial of fixed form and scale, so vital to Minimalists such as Judd. Her ROPE PIECE (FIG. 32-42), for example, takes on a different shape and different dimensions each time it is installed. The work consists of several sections of rope, which Hesse and her assistant dipped in

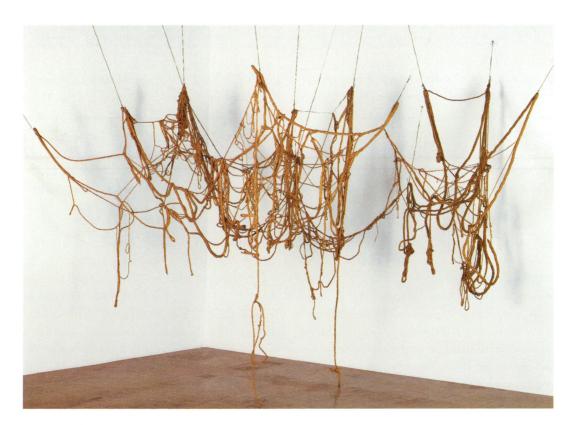

32–42 | Eva Hesse ROPE PIECE 1969–70. Latex over rope, string, and wire; two strands, dimensions variable. Whitney Museum of American Art, New York.

Purchase, with funds from Eli and Edythe L. Broad, the Mrs. Percy Uris Purchase Fund, and the Painting and Sculpture Committee (88.17 a-b)

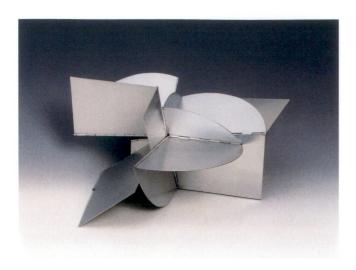

32–43 | Lygia Clark BICHO LC3 (PAN-CUBISME) 1970. Aluminum and metal, $9 \times 17 \frac{1}{4} \times 15 \frac{1}{4}$ " (23 × 45 × 40 cm). Daros-Latinamerica, Zurich, Switzerland. Artists Rights Society (ARS), New York

latex, knotted and tangled, and then hung from wires attached to the ceiling. The resulting linear web extends into new territory the tradition of "drawing in space" practiced by David Smith and others (SEE FIG. 32–18). Much more than a welded sculpture, Hesse's *Rope Piece* resembles a three-dimensional version of a poured painting by Jackson Pollock, and, like Pollock's work, it achieves a sense of structure despite its chaotic appearance. If the Minimal art of Judd and Stella is rigorously shaped by the artist, Hesse allowed the natural force of gravity a much larger role.

Brazilian artists also explored the physical properties of materials, but in ways that brought viewers into the creative process. Lygia Clark (1920-1988) began as an abstract painter, but under the influence of the Madí group (SEE FIG. 32–22), she wondered how she could change the relationship of artist to viewer so that the viewer is not the mere recipient of the artist's invention. She hoped to create work that empowered viewers to cooperate in actually shaping her artworks. In the 1960s she made a series of works called **BICHOS** ("Beasts") from irregular flanges of metal, attached together with hinges in asymmetrical ways (FIG. 32-43). The Bichos have no inside or outside, no upside down or right side up. At first they appear to be endlessly manipulable, but it soon becomes clear that the complex system of hinges that she installed limits the possibilities, as if the Bicho itself has desires that no one foresaw. The construction of the piece combines with gravity and the intent of the viewer to determine its shape. When a spectator asked her once how and in what ways she could move a Bicho, Clark replied, "I don't know, neither do you, but he does."

Arte Povera: Impoverished Art

Many artists in the late 1960s used natural processes in their work in an effort to expand art's vocabulary beyond tradi-

tional materials and reconnect viewers with organic realities. The most cohesive movement in this direction was Arte Povera, formed in Italy in 1967 by several artists who had been reading the American philosopher John Dewey. His 1934 book Art as Experience made several claims that later artists would adapt to their own ends. Dewey's principal insight was that the aesthetic experience of a work of art is not so very different from any experience of any object: Viewers select aspects of an object to look at, and they compare what they see with their own mental directory of experiences formed over their lifetimes. Thus the "aesthetic moment" that artists hope for is built in the viewer's mind by the viewer and not, strictly speaking, by the artist. Moreover, everyone's aesthetic experience will be different because the receiving minds are all different. The Italian artists who read this book (in a 1962 translation by Umberto Eco) wondered if viewers might respond aesthetically to visual stimuli that the artist did not exactly create, but merely set into motion. They were most interested in natural processes because they thought that modern life was becoming too prepackaged and mediated, and they also hoped to rebel against the art market by making items (or starting processes) that would be difficult to buy and sell.

The Greek-born Jannis Kounellis (b. 1933) made this approach gloriously visible in his UNTITLED (12 HORSES) that began this chapter (FIG. 32-1). Viewers to the gallery got a multisensory experience whose "richness" depended in part on how often the horses were washed and the floor was cleaned. Their experience could also include some of the many symbolic meanings that people attach to horses, and the artist need not specify or discourage any of them. The possibilities of such encounters could prove liberating for artist and viewer alike. The term Arte Povera was coined by art critic Germano Celant, who said that these artists are trying to "abolish their function as artists" and "discover the magic and the marvelous in natural elements." Works by Arte Povera artists are "impoverished" in at least two ways: first, the use of natural processes reduces the presence of the artist's ego or personality; second, employing everyday materials removes some of the specialness that artworks have enjoyed for centuries.

Gilberto Zorio (b. 1944) worked a more subtle way when he bought a piece of industrial pipe over nine feet long, sliced it in half, and filled it with cobalt chloride (FIG. 32–44). The compound is highly sensitive to humidity, changing from pink to blue and back again. In a gallery setting, the color changes over the course of a day. In addition, the segment was long enough so that the humidity (and thus the color) might even vary along the length of the pipe. Thus the piece looks different depending on atmospheric conditions, and perhaps it helps make viewers more aware of their sensory surroundings. Other pieces by Zorio involved slowly evaporating salt water during a month-long exhibition; as the pool shrank, a field of crystals grew.

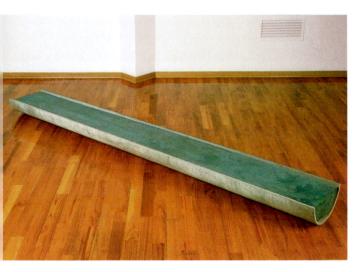

32–44 | Gilberto Zorio PINK-BLUE—PINK
1967. Semicylinder filled with cobalt chloride,
11% × 112% × 6" (30 × 285 × 15 cm). Galleria Civica d'Arte
Moderna e Contemporanea, Torino, Italy.
Purchased by the Fondazione Guido ed Ettore De Fornaris from Pier Luigi Pero,
Turin, 1985 / Artists Rights Society (ARS), New York / ADAGP, Paris

Mario Merz (1925–2003) was old enough to have experienced and rejected the expressive tendencies of *Art Informal*. He had participated in several shows as a painter, but his career as an abstract artist ended in 1962 when he bought every tube of paint at his local art store and applied them all to one canvas in a single day. His search for a more organic statement led him to the igloo, one of humanity's most prim-

Sequencing Works of Art

1962	Arbus, Child with Toy Hand Grenade
	Kaprow, The Courtyard
1964	Warhol, Birmingham Race Riot
	Riley, Current
1965	Kosuth, One and Three Chairs
1967	Zorio, Pink-Blue-Pink
1969	Judd, <i>Untitled</i>

itive structures. He made simple hemispheric frames out of metal, then covered them with what he called "shapeless" materials that lack substance: soil, glass, blobs of clay, or netting (FIG. 32-45). THE IGLOO symbolizes the human need for shelter and recalls how Eskimos live close to the earth. Merz also generally pierced his pieces with neon, in order, he said, to "energize them." The neon tubes might spell out political slogans of the day, or display simple mathematical facts such as 1 + 1 = 2. By such regressions, he hoped to arrive back at some originating point of thought, a degree zero of aesthetics. The Arte Povera artists were naturally accused of not making art; Merz's reply to this accusation was the most cogent and revealed their broader goal in terms derived from Dewey and Eco: "It is absurd to ask ourselves whether these forms are art or not: What we have to ask ourselves instead is whether they have some organic meaning or not."

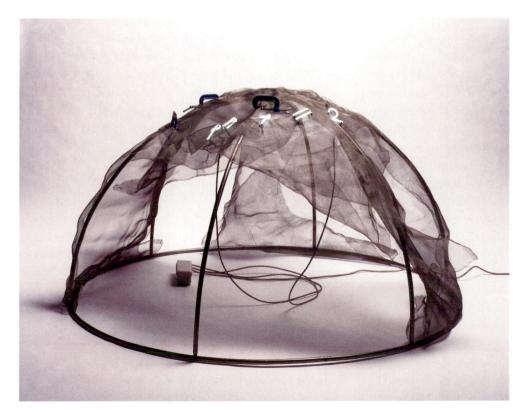

32–45 | Mario Merz IGLOO 1971. Steel tubes, neon tubing, wire mesh, transformer, C-clamps, $39\% \times 78\% \times 78\%$ ($100 \times 200 \times 200$ cm). Walker Art Center, Minneapolis T. B. Walker Acquisition Fund, 2001. (2001.64.1.19) / Artists Rights Society (ARS), New York

Conceptual and Performance Art

If the Minimalists and Arte Povera artists seemed radical, they were still at least making things: The artists who came to be known as Conceptualists pushed Minimalism to its logical extreme by eliminating the art object itself. Although the Conceptualists always produced something to look at, it was often only a printed statement, a set of directions, or a documentary photograph. The ultimate root of Conceptual art is Marcel Duchamp and his assertion that making art should be a mental, not a physical, activity. That is, every art object begins as an idea; carrying out the idea is a perfunctory affair. Conceptual art is based on the premise that if the idea is good, the art piece will also be good. This standard could apply to a great deal of art. For example, Michelangelo's work on the Sistine ceiling was very creative in envisioning the relationship between God and people in a new way. The idea of God reaching out to Adam was the masterpiece, and all he had to do was paint his idea. Many artists had a similar skill level at that time, but no one thought as creatively as Michelangelo did. By that reasoning, Michelangelo is a good Conceptual artist. In the 1960s, the Conceptual artist's quest was to do away with the valuable art object (to "dematerialize" it) while still exposing the artist's thought.

Deemphasizing the art object kept art from becoming simply another luxury item, a concern raised by the booming market for contemporary art that arose during the 1960s. Some artists did not want to make works that would sell in elite galleries and then decorate the homes of the wealthy. Others noticed that the governing boards of many museums consisted of corporate executives from companies that practiced discrimination or earned their money from warfare or exploiting natural resources. Artist groups picketed and protested outside most major museums in the late 1960s at one time or another. Making art that avoided the system became a priority for many.

The most prominent American Conceptual artist, Joseph Kosuth (b. 1945), abandoned painting in 1965 and began to work with language, under the influence of Duchamp and the linguistic philosopher Ludwig Wittgenstein (1889–1951). Kosuth believed that the use of language would direct art away from aesthetic concerns and toward philosophical speculation. His **ONE AND THREE CHAIRS** (FIG. 32–46) invites such speculation by presenting an actual chair, a full-scale black-and-white photograph of the same chair, and a dictionary definition of the word *chair*. The work thus leads the viewer from the physical chair to the purely linguistic ideal of "chairness" and invites the question of which is the most "real."

Many Conceptual artists used their bodies as an artistic medium and engaged in simple activities or performances that they considered works of art. Use of the body offered another alternative to object-oriented mediums like painting and sculpture, and it produced no salable artwork unless the artist's activity was recorded on film or video. One artist who

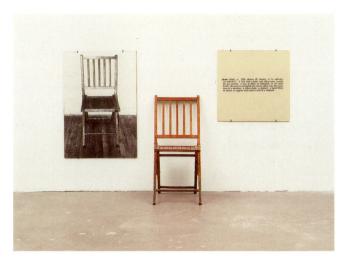

32–46 | Joseph Kosuth ONE AND THREE CHAIRS 1965. Wood folding chair, photograph of chair, and photographic enlargement of dictionary definition of chair; chair, $32\frac{1}{8} \times 14\frac{1}{8} \times 20\frac{1}{8}$ " (82.2 \times 37.8 \times 53 cm); photo panel, $36 \times 24\frac{1}{8}$ " (91.4 \times 61.3 cm); text panel $24\frac{1}{8} \times 24\frac{1}{2}$ " (61.3 \times 62.2 cm). The Museum of Modern Art, New York. Larry Aldrich Foundation Fund (383.1970 a-c)

used his body as an artistic medium in the late 1960s was the California-based Bruce Nauman (b. 1941). In 1966-67 he made a series of eleven color photographs based on wordplay and visual puns. In **SELF-PORTRAIT AS A FOUNTAIN** (FIG. 32–47), for example, the bare-chested artist tips his head back, spurts water into the air, and, in the spirit of Duchamp, designates himself a work of art. He is even a *Fountain*, naming himself after Duchamp's famous urinal.

Some of the most radical Conceptual and Performance art came out of Europe. As far back as 1960, Yves Klein helped initiate Performance art in his *Anthropometries of the Blue Period* (SEE FIG. 32–30). In the same year, Klein staged a more Conceptual show by leaving the gallery completely empty. He called this exhibition *The Void*, and art collectors could buy portions of the emptiness, parceled out in square meters. They had to pay with gold dust, which the artist threw into the Seine River. (There were several takers.)

Similarly subversive was the German artist Joseph Beuys, whose Performances had a ritualistic aspect and, often, a political message as well. Beuys met Happening artist Allan Kaprow in 1963 (SEE FIG. 32–29) and later testified to the importance of the encounter. Like a Happening, a Performance work is an event rather than an object, but Performance artists usually enact their pieces all alone. In 1965 Beuys swathed his head in honey and gold leaf, handicapped himself by attaching a large metal flange to one shoe, and hobbled around a gallery cradling a dead rabbit in his arms (FIG. 32–48). He stopped in front of each work in the gallery

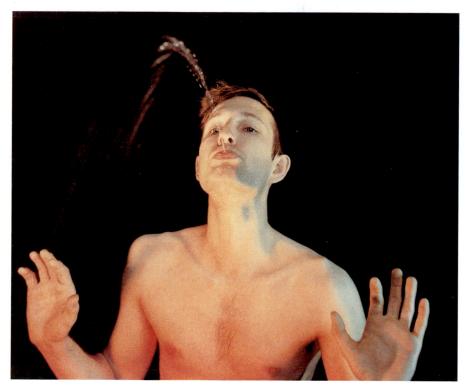

32–47 | Bruce Nauman SELF-PORTRAIT AS A FOUNTAIN 1966–67. Color photograph, $19\frac{3}{4} \times 23\frac{3}{4}$ " (50.1 \times 60.3 cm). Courtesy Leo Castelli Gallery, New York

Regarding his works of the later 1960s, Nauman observed, "I was using my body as a piece of material and manipulating it. I think of it as going into the studio and being involved in some activity. Sometimes it works out that the activity involves making something, and sometimes the activity itself is the piece."

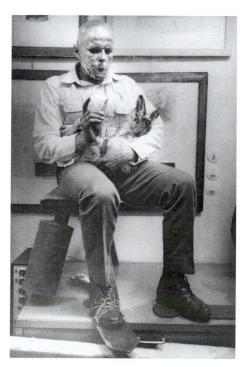

and whispered to the animal the meaning of each, then touched its lifeless paw to the glass-coated surface. His radiant head was intended to make him seem a magical figure or a wizard, while the metal flange made him frail at the same time. HOW TO EXPLAIN PICTURES TO A DEAD HARE targets endless attempts to explain art (including perhaps this book!). Beuys said, "Even a dead animal preserves more powers of intuition than some human beings." Beuys's later work was more political: Invited to show at the prestigious Documenta show of European contemporary art in 1972, he set up a table and passed out literature from a political party that he founded, the Organization for Direct Democracy Through Referendum. He was fired from his teaching position at the Düsseldorf Academy that year for admitting 172 students to his classes, because, he said, everyone is an artist. One of his 1976 performances was to run for the German Senate (he lost). His expression of mythic meanings combined with political activism made him hugely influential on later European art.

Earthworks and Site-Specific Sculpture

Conceptual and Performance artists seemed to take art to its limits, but most of their events happened in a gallery or

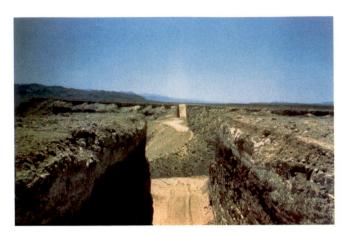

32–49 | Michael Heizer DOUBLE NEGATIVE 1969–70. 240,000-ton displacement at Mormon Mesa, Overton, Nevada. 1,500 \times 50 \times 30′ (457.2 \times 15.2 \times 9.1 m). Museum of Contemporary Art, Los Angeles. Gift of Virginia Dwan. Photograph courtesy the artist

museum. Some artists in the early 1970s wondered if art could do without those traditional settings entirely. Certainly art has been made in public places before, in ways that cannot be bought or sold, such as Mexican murals (SEE FIG. 31–66). But perhaps an artist could take the earth itself as a medium, and

shape a site or do something on it. Acting partly on the political impulse of getting away from the art market and partly on the Modern impulse to throw out conventions, a number of sculptors began to work outdoors, using raw materials found at the site to fashion Earthworks. They also pioneered a new category of art making called site-specific sculpture, which is designed for a particular location, often outdoors.

LARGE-SCALE EARTHWORKS. One of the leaders of the Earthworks movement was Michael Heizer (b. 1944), the California-born son of a specialist in Native American archaeology. Heizer moved to New York in 1966 but, disgusted by the growing emphasis on art as an investment, began to spend time in the Nevada desert and to create works there that could not easily be bought and sold and that required a considerable commitment of time from viewers. There, in 1969-70, Heizer hired bulldozers to produce his most famous work, DOUBLE NEGATIVE (FIG. 32-49). Using a simple Minimalist formal vocabulary, he made two gigantic cuts on opposite sides of a canyon wall at a remote location. To fully experience the work, the viewer needs to travel to Overton, Nevada, to walk into the 50-foot-deep channels and experience their huge scale, and to fly overhead to see the work from above.

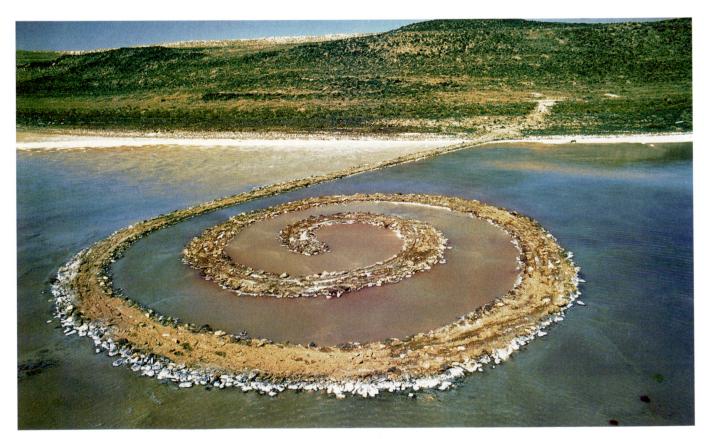

32–50 Robert Smithson SPIRAL JETTY
1969–70. Black rock, salt crystal, and earth spiral, length 1,500′ (457 m). Great Salt Lake, Utah.
Courtesy James Cohan Gallery, New York Art © Estate of Robert Smithson/Licensed by VAGA, New York, NY

More symbolic in intention was the work of another major Earthworks artist, Robert Smithson (1938-73), a New Jersey native who first traveled to the Nevada desert with Heizer in 1968. In his mature work, Smithson sought to illustrate the "ongoing dialectic" in nature between constructive forces-those that build and shape form-and destructive forces—those that destroy it. SPIRAL JETTY (FIG. 32-50), a 1,500-foot spiraling stone and earth platform extending into the Great Salt Lake in Utah, expresses these ideas. Smithson chose the lake because it recalls both the origins of life in the salty waters of the primordial ocean and also the end of life. One of the few organisms that live in the otherwise dead lake is an alga that sometimes gives it a red tinge, suggestive of blood. Smithson also liked the way the abandoned oil rigs that dot the lake's shores suggested both prehistoric dinosaurs and some vanished civilization. He used the spiral because it is the most fundamental shape in nature, appearing, for example, in galaxies, seashells, DNA molecules, and even salt crystals. Smithson also chose the spiral because, unlike Modernist squares, circles, and straight lines, it is a "dialectical" shape, one that opens and closes, curls and uncurls endlessly. It is an organic shape that also appears in rock art by various ancient peoples, where it transmits symbolic meanings unknown to us. More than any other shape, it suggested to him the perpetual coming and going of things. To allow the "ongoing dialectic" of construction and destruction to proceed, Smithson ordered that no maintenance be done on the work. Since he created it, the surrounding lake water has turned red and back to blue, risen up to drown the work, and revealed it again, covered with salt.

IMPERMANENT SITES. Strongly committed to the realization of temporary, site-specific artworks in both rural and urban settings are Christo and Jeanne-Claude, both born on June 13, 1935. Christo Javacheff (who uses only his first name) emigrated from his native Bulgaria to Paris in 1958, where he met Jeanne-Claude de Guillebon. His interest in "wrapping" (or otherwise defining) places or things in swaths of fabric soon became an obsession, and he began wrapping progressively larger items. Their first collaborative work, in 1961, was Stacked Oil Barrels and Dockside Packages at the port of Cologne, Germany. The pair moved to New York City in 1964. Four years later, Christo and Jeanne-Claude wrapped the Kunsthalle museum in Bern, Switzerland, and the following year they wrapped 1 million square feet of the Australian coastline. The artists pay all their own expenses, never accepting sponsors but rather raising funds through the sale of preparatory drawings of the intended project.

Their best-known work, **RUNNING FENCE** (FIG. 32–51), was a 24½-mile-long, 18-foot-high nylon fence that crossed two counties in northern California and extended into the Pacific Ocean. The artists chose the location in Sonoma and Marin counties for aesthetic reasons, as well as to call atten-

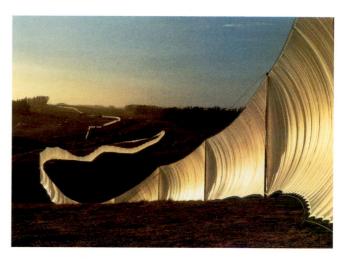

32–51 | Christo and Jeanne-Claude RUNNING FENCE 1972–76. Nylon fence, height 18' (5.50 m), length 24½ miles (40 km). Sonoma and Marin counties, California.

tion to the link between urban, suburban, and rural spaces. This concern with aesthetics is common to all their work, in which they reveal the beauty in various spaces. At the same time, the conflict and collaboration between the artists and various social groups open the workings of the political system to scrutiny and invest their work with a sense of social space. For example, Christo and Jeanne-Claude spent fortytwo months overcoming the resistance of county commissioners, half of whom were in favor of the project from the outset, as well as social and environmental organizations. before they could create Running Fence. Meanwhile, the project forged a community of supporters drawn from groups as diverse as college students, ranchers, lawyers, and artists. In a way, the fence broke down the social barriers among those people. The work remained in place for two weeks and then was taken down. Property owners whose land the work traversed could keep the materials.

Feminist Art

Feminist art emerged in the context of the Women's Liberation movement of the late 1960s and early 1970s, and it challenged one of the major unspoken conventions of the history of Western art including Modern art: the dominance of men. A major aim of feminist artists and their allies was increased recognition for the accomplishment of women artists, both past and present. As feminists examined the history of art, they found that women had contributed to most of the movements of Western art but were almost never mentioned in histories of art. Feminists also attacked the traditional Western hierarchy that placed "the arts" (painting, sculpture, architecture) at a level of achievement higher than "the crafts" (ceramics, textiles, jewelry-making). Since most craft media have been historically dominated by women, favoring art

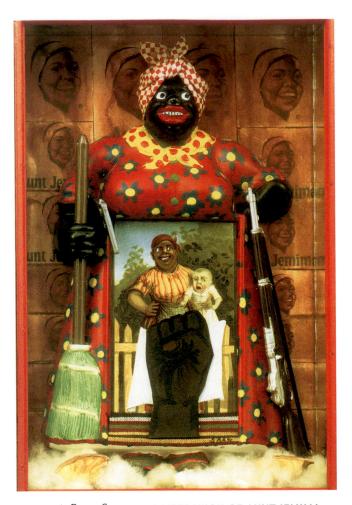

over craft tends to relegate women's achievements to secondclass status. Thus early feminist art tended to elevate craft media.

Women artists faced considerable discrimination at that time (and they still do). A 1970 survey revealed that although women constituted half of the nation's practicing artists, only 18 percent of commercial New York galleries carried works by women. Of the 143 artists in the 1969 Whitney Annual (now the Whitney Biennial), one of the country's most prominent exhibitions of the work of living artists, only eight were women. The next year, the newly formed Ad Hoc Committee of Women Artists, disappointed by the lukewarm response of the Whitney's director to their concerns, staged a protest at the opening of the 1970 Annual. To focus more attention on women in the arts, feminist artists began organizing women's cooperative galleries.

ATTACKING STEREOTYPES. As feminist art critics scanned the horizon for contemporary women who were creating with insufficient recognition, they found a wealth of neg-

lected talent, such as the Los Angeles-based African American sculptor Betye Saar (b. 1926). She had been making assemblages for years that showed a political militancy rare in postwar American art. Several of her works in this medium reflect both feminist interests and the aims of the civil rights movement. Saar's best-known work, THE LIBERATION OF AUNT JEMIMA (FIG. 32-52), appropriates (borrows for Saar's own purposes) the derogatory stereotype of the cheerfully servile "mammy" and transforms it into an icon of militant black feminist power. Set against a background papered with the smiling advertising image of Aunt Jemima stands a note pad holder in the form of an Aunt Jemima. She holds a broom (whose handle is actually the pencil for the note pad) and pistol in one hand and a rifle in the other. In the place of the note pad is a picture of another jolly mammy holding a crying child identified by the artist as a mulatto, or person of mixed black and white ancestry. In front of this pair is a large clenched fist—a symbol of Black Power signaling African Americans' willingness to use force to achieve their aims. Saar's armed Jemima liberates herself not only from racial oppression but also from traditional gender roles that had long relegated black women to such subservient positions as domestic servant or mammy.

COLLABORATION. A younger artist who assumed a leading role in the feminist movement of the 1970s was Judy Chicago (b. 1939), whose The Dinner Party is perhaps the best-known work of feminist art created in that decade (see "The Dinner Party," page 1168). Born Judy Cohen, she became Judy Gerowitz after her marriage and then in 1970 adopted the surname Chicago (from the city of her birth) to free herself from "all names imposed upon her through male social dominance." Originally a Minimalist sculptor, Chicago in the late 1960s began to make abstracted images of female genitalia designed to challenge the aesthetic standards of the male-dominated art world and to validate female experience. In 1970 she established the first feminist studio art course at Fresno State College (now California State University, Fresno). The next year, she moved to Los Angeles and joined with the painter Miriam Schapiro (b. 1923) to establish at the new California Institute of the Arts (CalArts) the Feminist Art Program, dedicated to training women artists.

During the first year of the program, Chicago and Schapiro led a team of twenty-one female students in the creation of *Womanhouse* (1971–72), a collaborative art environment set in a run-down Hollywood mansion, which the artists renovated and filled with installations that addressed women's issues. Schapiro's work for *Womanhouse*, created in collaboration with Sherry Brody, was *The Dollhouse*, a mixed-media construction featuring several miniature rooms adorned with richly patterned fabrics. Schapiro soon began to incorporate pieces of fabric into her acrylic paintings,

developing a type of work she called femmage (from female and collage). Schapiro's femmages, such as the exuberant PERSONAL APPEARANCE #3 (FIG. 32–53), celebrate traditional women's craftwork. After returning to New York from California in 1975, Schapiro became a leading figure in the Pattern and Decoration movement. Composed of both female and male artists, this movement sought to merge Modernist abstraction with ornamental motifs derived from women's craft, folk art, and a variety of non-Western sources in order to break down hierarchical distinctions among them.

RINGGOLD'S STORY QUILTS. African American artist Faith Ringgold (b. 1930) drew on the traditional American craft of quilt making and combined it with the rich heritage of African textiles to create memorable statements about American race relations. She began in the early 1970s to paint on soft fabrics rather than stretched canvases, and to frame her images with decorative quilted borders. Ringgold's mother, Willi Posey, a fashion designer and dressmaker, made these quilted borders until her death in 1981, after which Ringgold took responsibility for both the quilting and the painting. In 1977 Ringgold began writing her autobiography (We Flew Over the Bridge: The Memoirs of Faith Ringgold, 1995). Not immediately finding a publisher, she decided to write her stories on her quilts, and in the early 1980s inaugurated what became her signature medium: the story quilt.

Animated by a powerful feminist sensibility, Ringgold's story quilts are always narrated by women and usually address themes related to women's lives. A splendid example is TAR BEACH (FIG. 32-54), whose fictional narrator, 8year-old Cassie Louise Lightfoot, is based on the artist's childhood memories of growing up in Harlem. The "Tar Beach" of the title is the roof of the apartment building on which Ringgold's family, lacking air conditioning, would sleep on hot summer nights. Cassie describes sleeping on Tar Beach as a magical experience. As she lies on a blanket with her brother, she dreams that she can fly and possess everything over which she passes. Cassie can fly over the George Washington Bridge and make it hers; she can fly over the new union building and claim it for her father—a half-black, half-Native American man who helps construct skyscrapers but is prevented by his race from joining the union; she can fly over an ice cream factory to guarantee her mother "ice cream every night for dessert." Ringgold's colorful painting in the center of the quilt shows Cassie and her brother lying on a blanket at the lower right while their parents and two neighbors play cards at a table at center. Directly above the adults appears a second Cassie, magically flying over the George Washington Bridge against a star-dotted sky. Cassie's fantasy of achieving the impossible is charming but also delivers a serious message by remind-

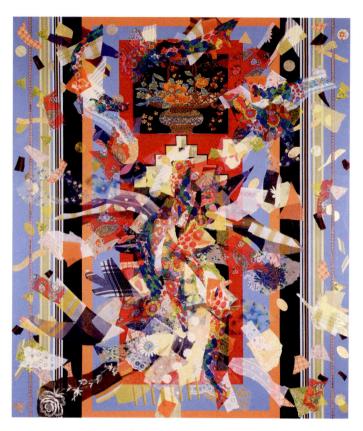

32–53 | Miriam Schapiro PERSONAL APPEARANCE #3 1973. Acrylic and fabric on canvas, $60 \times 50''$ (152.4 \times 127 cm). Private collection.

Schapiro championed the theory that women have a distinct artistic sensibility that can be distinguished from that of men and hence a specifically feminine aesthetic. During the late 1950s and 1960s she made explicitly female versions of the dominant Modernist styles, including reductive, hard-edged abstractions of the female form: large X-shapes with openings at their centers. In 1973 she created *Personal Appearance #3*, using underlying hard-edge rectangles and overlaying them with a collage of fabric and paper—materials associated with women's craftwork—the formal and emotional richness of which were meant to counter the Minimalist aesthetic of the 1960s, which Schapiro and other feminists considered typically male.

ing the viewer of the real social and economic limitations that African Americans have faced throughout American history.

Cuban-born Ana Mendieta (1948–85), celebrated the notion that women have a deeper identification with nature than do men. By 1972, Mendieta had rejected painting for Performance and body art. Influenced by Joseph Beuys but inspired by *santería*, the Afro-Cuban religion that Wifredo Lam had dealt with earlier (SEE FIG. 32–7), she produced ritualistic performances on film, as well as about 200 earth-and-body works, called *Silhouettes*, which she recorded in color photographs. Some were done in Mexico, and others, like the **TREE** OF LIFE series (FIG. 32–55), were set in Iowa, where she lived

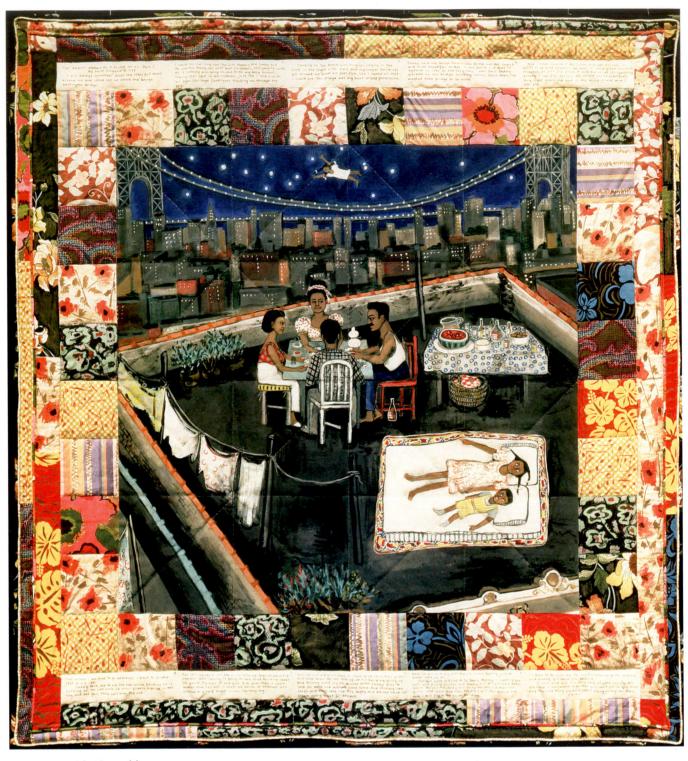

32–54 | Faith Ringgold TAR BEACH (PART I FROM THE WOMAN ON A BRIDGE SERIES) 1988. Acrylic on canvas, bordered with printed, painted, quilted, and pieced cloth, $74\% \times 68\%$ (190.5 \times 174 cm). Guggenheim Museum, New York. Gift, Mr. and Mrs. Gus and Judith Lieber, 1988 (88.362)

after completing graduate study. In this work, Mendieta stands covered with mud, her arms upraised like a prehistoric goddess, appearing at one with nature, her "maternal source." Reconnecting with the maternal source in this and other works was a compensation for a major disruption of her childhood: Along with 14,000 other unaccompanied chil-

dren, Mendieta was sent away from her native country by her parents in 1961 as part of Operation Peter Pan, a cold war mission to rescue Cuban children from communism after the 1959 revolution. The feeling of personal dislocation that this caused would always haunt her art, leading her to imprint her body by various means in several locations.

32–55 † Ana Mendieta UNTITLED WORK FROM THE TREE OF LIFE SERIES 1977. Color photograph, $20\times13\,\%$ (50.8 \times 33.7 cm). Courtesy of Galerie Lelong, New York and the Estate of Ana Mendieta

ARCHITECTURE: FROM MODERN TO POSTMODERN

As in painting and sculpture, Modernism endured in architecture until the 1970s. The International Style, with its plainly visible structure and rejection of historicism, dominated new urban construction in much of the world after World War II. Several important International Style architects, such as Walter Gropius (SEE FIG. 31–65), migrated to the United States and assumed important positions in architecture schools where they trained a generation of like-minded designers.

Midcentury Modernist Architecture

The best examples of postwar International Style buildings were designed by Ludwig Mies van der Rohe (1886–1969), a former Bauhaus staff member and refugee from Nazi Germany (see Chapter 31). Whether designing schools, houses, or office buildings, Mies used the same simple, rectilinear vocabulary that for many came to personify the modern, efficient culture of postwar capitalism. The differences among his

buildings are to be found in their details. Because he had a large budget for the **SEAGRAM BUILDING** in New York City (FIG. 32–56), for instance, he used custom-made bronze (instead of standardized steel) beams on the exterior, an example of his love of elegant materials. Mies would have preferred to leave the internal steel structural supports visible, but building codes required him to encase them in concrete. The ornamental beams on the outside thus stand in for the functional beams inside, much as the shapes on the surface of a Stella painting refer to the structural frame that holds the canvas (SEE FIG. 32–40).

The dark glass and bronze were meant to give the Seagram Company a discreet and dignified image. The building's clean lines and crisp design seemed to epitomize the efficiency, standardization, and impersonality that had become synonymous with the modern corporation itself—which, in part, is why this particular style dominated corporate architecture after World War II. Such buildings were also economical to build. Mies believed that the industrial preoccupation with streamlined efficiency was the dominant value of the day and that the only legitimate architecture was one that expressed this modern spirit. Criticized for building glass boxes, Mies pointed out the subtle mathematical relations that exist between the various rectangles on his buildings, and retorted, "Less is more."

32–56 | Ludwig Mies van der Rohe and Philip Johnson **SEAGRAM BUILDING**New York. 1954–58.

THE OBJECT SPEAKS

THE DINNER PARTY

complex, mixed-medium installation that fills an entire room, Judy Chicago's THE DINNER PARTY takes advantage of feminist art research and speaks powerfully of the accomplishments of women throughout history. Five years of collaborative effort went into the creation of the work, involving hundreds of women and several men who volunteered their talents as ceramists, needleworkers, and china painters to realize Chicago's designs. The Dinner Party is composed of a large, triangular table, each side stretching 48 feet, which rests on a triangular platform covered with 2,300 triangular porcelain tiles. Chicago saw the equilateral triangle as a symbol of the equalized world sought by feminism, and she also identified it as one of the earliest symbols of the feminine. The porcelain "Heritage Floor" bears the names of 999 notable women from myth, legend, and history. Along each side of the triangular table, thirteen place settings each represent a famous woman. Chicago chose the number thirteen because it is the number of men who were present at the Last Supper

and also the number of witches in a coven, and therefore a symbol of occult female power. The thirty-nine women honored through the place settings include mythical ancient goddesses such as Ishtar, legendary figures such as the Amazon, and historical personages such as the Egyptian queen Hatshepsut, the Roman scholar Hypatia, the medieval French queen Eleanor of Aquitaine, the medieval French author Christine de Pisan (SEE FIG. 21, Introduction), the Italian Renaissance noblewoman Isabella d'Este (see page 688), the Italian Baroque painter Artemesia Gentileschi (SEE FIG. 22-19), the eighteenth-century English feminist writer Mary Wollstonecraft (shown here), the nineteenth-century American abolitionist Sojourner Truth, and the twentieth-century American painter Georgia O'Keeffe (SEE FIG 31-42).

Each place setting features a 14-inchwide painted porcelain plate, ceramic flatware, a ceramic chalice with a gold interior, and an embroidered napkin, all set upon an elaborately decorated runner. The runners incorporate decorative motifs and techniques of stitching and weaving appropriate to the period with which each woman was associated. Most of the plates feature abstract designs based on female genitalia because, Chicago said, "that is all [the women at the table] had in common. . . . They were from different periods, classes, ethnicities, geographies, experiences, but what kept them within the same confined historical space" was the fact of their biological sex. Chicago thought it appropriate to represent the women through plates because they "had been swallowed up and obscured by history instead of being recognized and honored."

Chicago emphasized china painting and needlework in *The Dinner Party* to celebrate craft mediums traditionally practiced by women and to argue that they should be considered "high" art forms on a par with painting and sculpture. This argument complemented her larger aim of raising awareness of the many contributions women have made to history, thereby fostering women's empowerment in the present.

Judy Chicago **THE DINNER PARTY** 1974–79. Overall installation view. White tile floor inscribed in gold with 999 women's names; triangular table with painted porcelain, sculpted porcelain plates, and needlework, each side $48 \times 42 \times 3'$ ($14.6 \times 12.8 \times 1$ m). The Brooklyn Museum of Art. Gift of the Elizabeth A. Sackler Foundation (2002.10)

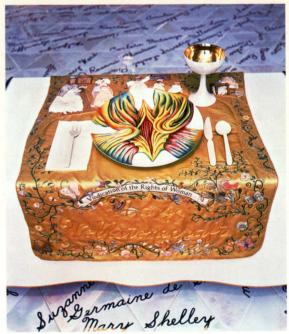

MARY WOLLSTONECRAFT
Place setting, detail of The Dinner Party

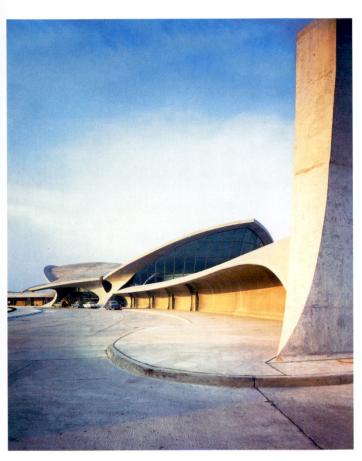

32–57 | Eero Saarinen TRANS WORLD AIRLINES TERMINAL, JOHN F. KENNEDY AIRPORT New York. 1956–62

In 2003 the National Trust for Historic Preservation added the TWA Terminal to its list of America's Eleven Most Endangered Historic Places due to plans by the building's owners, the Port Authority of New York and New Jersey, to demolish portions of the terminal and construct a large new terminal behind it, violating the integrity of Saarinen's design and rendering it useless as an aviation structure.

While Mies's pared-down, rectilinear idiom dominated skyscraper architecture into the 1970s, other building types invited more adventuresome Modernist designs that departed from the rational and impersonal principles of the International Style. A trend toward powerfully expressive, organic forms characterized the architecture of numerous buildings dedicated to religious or cultural functions. Such buildings remained Modernist in their unabashed use of massproduced materials and lack of historical references, but they showed a new exuberance in design. Expressive designs sometimes appeared also in commercial architecture, as in the remarkable trans world airlines (twa) terminal at John F. Kennedy Airport in New York City, by the Finnish-born American architect Eero Saarinen (1910-61). Seeking to evoke the excitement of air travel, Saarinen gave his building dynamically flowing interior spaces and covered it with two broad, winglike canopies of reinforced concrete that suggest a huge bird about to take flight (FIG. 32-57). Saarinen also designed all of the building's interior details-from ticket counters to telephone booths—to complement the gullwinged shell.

Modern architects of the post–World War II decades also sought fresh solutions to the persistent challenge of urban housing, which had engaged pioneers of the International Style such as Le Corbusier. The desire for economy led to an interest in the use of standard, prefabricated elements for the construction of both individual houses and larger residential complexes. An innovative example of the latter is HABITAT '67 (FIG. 32–58) by the Israeli-born Moshe Safdie (b. 1938). Built as a permanent exhibit for the 1967 World Exposition in Montreal, the complex consists of three stepped clusters of prefabricated concrete units attached to a zigzagging concrete frame that provides a series of elevated streets and shel-

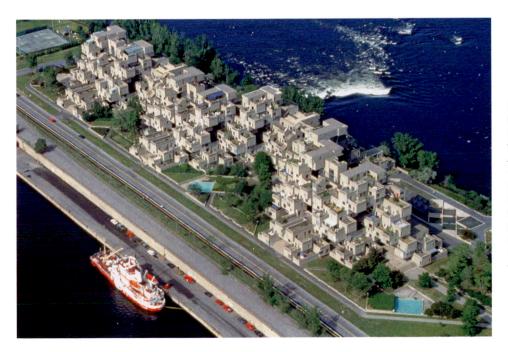

32–58 | Moshe Safdie

HABITAT '67

Montreal, Quebec, Canada. 1967

World Exposition.

Growing up in Israel, Safdie spent his summers on a kibbutz, or collective farm. This experience partly inspired his plans for Habitat, which adapts aspects of traditional communal living to the social, economic, and technological realities of industrial society.

tered courtyards. By stacking units that contained their own support system, Safdie eliminated the need for an external skeletal frame and allowed for expansion of the complex simply through the addition of more units. An inspired alternative to the conventional high-rise apartment block, Habitat '67 offers greater visual and spatial variety, increased light and air to individual apartments, and a sense of community not often found in a big city housing project.

Postmodern Architecture

Historians trace the origin of Postmodernism in architecture to the work of the Philadelphian Robert Venturi (b. 1925) and his associates, who rejected the abstract purity of the International Style by incorporating into their designs elements drawn from vernacular (meaning popular, common, or ordinary) sources. Parodying Mies van der Rohe's famous aphorism "Less is more," Venturi claimed "Less is a bore" in his pioneering 1966 book Complexity and Contradiction in Architecture. The problem with Mies and the other Modernists, he argued, was their impractical unwillingness to accept the modern city for what it is: a complex, contradictory, and heterogeneous collection of "high" and "low" architectural forms. Acting on these impulses, Venturi engaged in practices that Modernists thought heretical: He layered his buildings with references to past styles and at times even applied decoration to them. Such moves were controversial at first, but they pointed a way to innovation that many would follow.

While writing Complexity and Contradiction in Architecture, Venturi designed a house for his mother (FIG. 32–59) that illustrated many of his new ideas. The building is both simple and complex. The shape of the façade returns to the archetypal "house" shape—evident in children's drawings—that Modernists from Rietveld (SEE FIG. 31–61) to Safdie had rejected because of its historical associations. Its vocabulary of triangles, squares, and circles is also elementary, although the shapes are arranged in a complex asym-

metry that skews the restful harmonies of Modernist design. The round molding over the door has no structural function, and is thus—gasp!—a decoration. The most disruptive element of the façade is the deep cleavage over the door, which opens to reveal a mysterious upper wall (which turns out to be a penthouse) and chimney top. On the inside, too, complexity and contradiction reign. The irregular floor plan (FIG. 32–60), especially evident in the odd stairway leading to the second floor, is further complicated by the unusual ceilings, some of which are partially covered by a barrel vault.

The Vanna Venturi House makes reference to a number of older buildings, from Michelangelo's Porta Pia in Rome to a nearby house designed by Venturi's mentor, Louis Kahn (1901-74). Although such allusions to architectural history were lost on the general public, they provided many architects, including Philip Johnson (1906-2005), with a path out of Modernism. Johnson's major contribution to Postmodernism is the AT&T CORPORATE HEADQUARTERS (now the Sony Building) in New York City (FIG. 32-61), an elegant, granite-clad skyscraper whose thirty-six oversized floors reach the height of an ordinary sixty-story building. The skyscraper makes gestures of accommodation to its surroundings: Its smooth, uncluttered surfaces match those of its International Style neighbors, while the classically symmetrical window groupings between vertical piers echo those in more conservative Manhattan skyscrapers built in the early to mid-1900s. What critics focused on, however, was the building's resemblance to a type of eighteenth-century furniture: the Chippendale highboy, a chest of drawers with a long-legged base. Johnson seems to have intended a pun on the terms highboy and high-rise. In addition, the round notch at the top of the building and the arched entryway at the base recall the coin slot and coin return of old pay telephones. Many critics were not amused by Johnson's effort to add a touch of humor to high architecture. His purpose, however, was less to poke fun at his client or his profession than to create an architecture that would appeal to the public and at the same time, like a fine piece of furniture, meet its deeper aesthetic needs with a formal, decorative elegance.

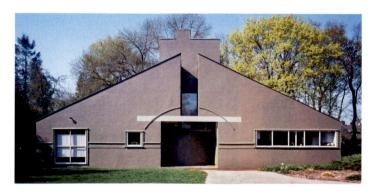

32–59 | Robert Venturi VANNA VENTURI HOUSE Chestnut Hill, Pennsylvania. 1961–64.

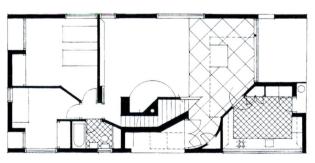

32–60 GROUND-FLOOR PLAN OF THE VANNA VENTURI HOUSE

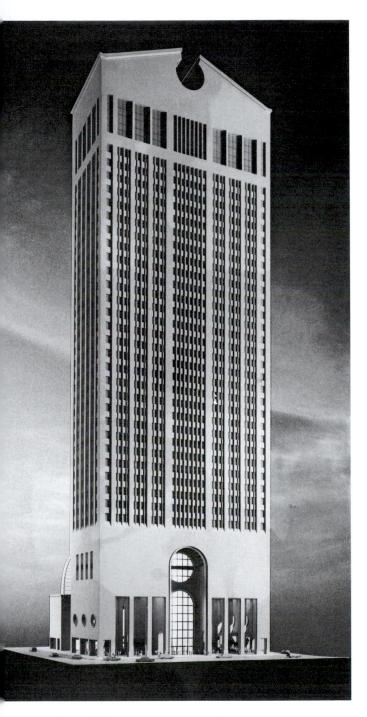

32–61 Philip Johnson and John Burgee MODEL, AT&T CORPORATE HEADQUARTERS New York. 1978–83.

After collaborating on the Seagram Building (SEE FIG. 32-56) with Mies, who had long been his architectural idol, Johnson grew tired of the limited Modernist vocabulary. During the 1960s he experimented with a number of alternatives, especially a weighty, monumental style that looked back to nineteenth-century Neoclassicism. At the end of the 1970s he became fascinated with the new possibilities opened by Venturi's Postmodernism, which he found "absolutely delightful."

POSTMODERN ART

Observers disagree about the exact date, but most agree that sometime during the 1970s, the impulses that created Modern art exhausted themselves. If we think back to the key concepts that defined Modern art (see p. 1038), we will see that they had evolved out of existence by the late 1970s. Moreover, the underlying social environment had evolved as well.

The quest to set aside conventions died a natural death when it seemed that all the rules had been broken. The radicalism of some Conceptual and site-specific works of the 1970s seemed to signal the end of an era. For example, an artist once announced a site-specific piece for a public park and unleashed tanks of colorless and odorless gases there; his piece was completely invisible. Another declared Lake Tahoe a work of art. Yet a third declared his own body a work of art and willed it to the Museum of Modern Art when he passes away (he is still alive). The Modernist questioning of conventions reached a point in the 1970s when there were no more conventions to question.

Likewise, the avant-garde has lost its distinctiveness as a source of innovation. In the past, it was a small group that cared about the innovations of a few artists, and it served as a support group for Modern artists such as Monet, Gauguin, Picasso, and Mondrian. As late as the 1950s, this group was still functioning much as it had in the 1880s. Helen Frankenthaler, in the same interview quoted earlier, described the scene in her day: "When we were all showing at Tibor de Nagy [Gallery] in the early fifties, none of us expected to sell pictures. A few people knew your work. There was a handful of people you could talk to in your studio, a small orbit." With the advent of Pop Art in the 1960s, the avant-garde came much more into the public eye. Andy Warhol was a celebrity (and he loved being one). Magazine coverage of contemporary art proliferated. Art schools began teaching Modern techniques instead of traditional ones. The spread of higher education (and the proliferation of art history courses) made the public for contemporary art much larger. All of these factors mean that innovation in the arts is not now confined to a small, select group; rather, a creative idea can now spring up almost anywhere.

Underlying the decline of the avant-garde is a larger social change: Just as Modern art arrived with the transition to an industrial society, Postmodern art is heralded by postindustrial society. Advanced capitalist societies today are based on information and services rather than industry, and these demand a relatively educated population that is flexible and tolerant. The values of Modern art (innovation, questioning of tradition, individual expression) have permeated this society. Most of us embrace the constant changes of our world. The media encourage this by treating each new consumer product as a revolution and rule-breaking as the norm. A telling moment came when a national chain of hamburger

stands adopted this slogan in the 1990s: "Sometimes you just gotta break the rules." In addition, Modern art itself is no longer controversial. The former rebels Gauguin, van Gogh, and Picasso are now the most expensive artists at auction. While the public still resists obscenity in art, most people tolerate what artists do, even when they do not understand it. Postmodern society has made the avant-garde a spent force by absorbing many of its values.

If the dominant tendency of Modern art was the questioning and rejection of tradition, finding a similar unifying concept for Postmodern art is difficult. In that sense, Postmodern art reflects our pluralistic and globalized society, in which innovation can happen anyplace. Since the demise of Modernism, the art world seems to be characterized much more by pluralism, in which a number of styles and trends coexist simultaneously. Postmodern artists generally avoid the Modernist goals of researching the qualities of their media or exploring aesthetic issues; first and foremost, they use art to comment on their world. Likewise, if Modern art was characterized by constant creation of new styles, Postmodern artists tend to revive previous styles and media, because they have discovered that referring to past art in a knowing fashion can add meaning to an artistic statement. Indeed, quotation of the past not only characterizes much Postmodern art and architecture; many of today's cultural products, such as movies, advertisements, and even political campaigns, make reference to past versions or even re-create them. We live in the age of the sequel, the knock-off, and the recycled character. In that sense, Andy Warhol's original insight ("I don't know where the artificial stops and the real starts") has become even more cogent. Though the definition of Postmodernism is still in dispute, we can point to a few trends that have motivated artists in this new period.

The Critique of Originality

Some of the first art to be called Postmodern questioned one of Modernism's basic notions, that an individual can create something totally original. If part of the heritage of Modern art is based on originality, Postmodern artists who criticize this notion ironically use the medium best known for truth and accuracy: the camera.

RECEIVED IDENTITY. Cindy Sherman (b. 1954), for example, made a series of works beginning in the late 1970s in which she posed her made-up self in settings that quote well-known plots of old movies (FIG. 32–62). In UNTITLED FILM STILL #21, she is the young girl who leaves the small town to find work in the big city. Other photos from the same series show her as the glamorous Southern belle, the hardworking housewife, or the teenager who waits by the phone for a call. All of these works examine the roles that our popular culture assigns to women, and Sherman shows that she understands them all very well and she plays them willingly. She seems to be saying

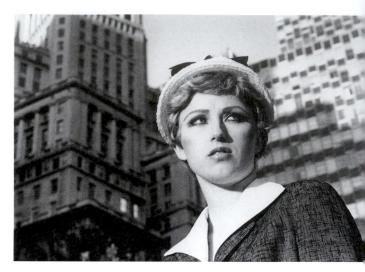

32–62 | Cindy Sherman UNTITLED FILM STILL #21 1978. Black-and-white photograph, $8\times10''$ (20.3 \times 25.4 cm). Courtesy of the artist and Metro Pictures, New York

32–63 | Barbara Kruger **WE WON'T PLAY NATURE TO YOUR CULTURE** 1983. Photostat $6'1'' \times 4'1''$ (1.85 × 1.24 m). Courtesy Mary Boone Gallery, New York

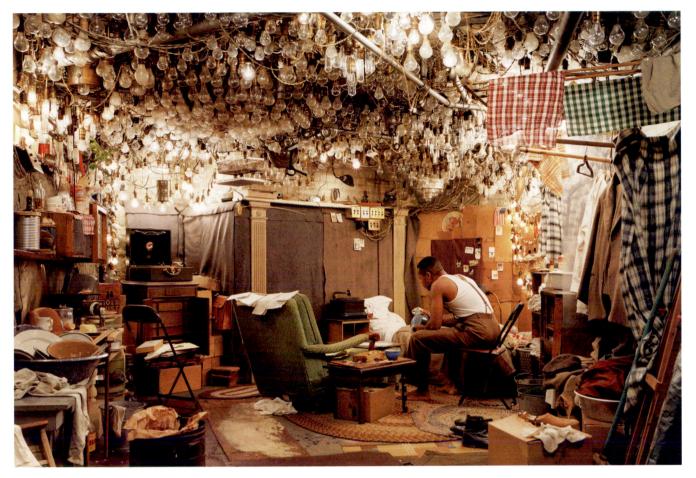

32–64 | Jeff Wall AFTER "INVISIBLE MAN" BY RALPH ELLISON, THE PREFACE 1999–2001. Edition of 2. Cibachrome transparency, aluminum light box, and fluorescent bulbs.

that her personality is the sum of all the movies that she has seen, and she does not know where the real Cindy Sherman starts and the one derived from movies stops. If this statement reminds us of Andy Warhol's confession about the real and the artificial, so much the better. The influence of popular culture on all of our identities has only intensified since he said it.

Barbara Kruger (b. 1945) makes a more militant point with slightly different media (FIG. 32–63). Her work quotes magazine advertising layouts, with a catchy photograph and a slogan inscribed, but the slogan talks back to the viewer with a confrontational sentence that sounds feminist. Women's curves have traditionally been seen as symbols for nature, but this work articulates a revolt against that role. This work is not an "original," but rather a piece of graphic design that can be reproduced. Kruger has worked in many other public media, including billboards and bus shelter posters, implanting her subversive messages directly in the flow of media and advertising.

CONSTRUCTED IDENTITY. If photography was traditionally a medium for the straightforward recording of reality ("The camera never lies"), many Postmodern photographers attack this notion by using the camera to photograph obviously set-

up situations. They show us that the camera can indeed be made to lie. Canadian artist Jeff Wall (b. 1946) creates detailed illusions that feel as if they could easily be documentary photographs, even as they seek to rival in visual impact large-scale history paintings from the past as well as glossy advertisements of the present. As an art history student in the 1970s, Wall was impressed by the way nineteenth-century artists such as Delacroix and Manet (see Chapter 30) adapted the conventions of history painting to the depiction of contemporary life. Since the late 1970s his own project has been to fashion a comparable grand-scale representation of the history of his own times, presented in the form of color transparencies mounted in large light boxes—a format borrowed from modern advertising and meant to give his art the same persuasive power.

Like a stage or movie director, Wall carefully designs the settings of his scenes and directs actors to play roles within them. He then shoots multiple photographs and combines them digitally to create the final transparency. To make **AFTER** "INVISIBLE MAN" BY RALPH ELLISON, THE PREFACE (FIG. 32–64), an especially elaborate composition, Wall spent eighteen months constructing the set and another three weeks shooting the single actor within it. The image vividly illustrates a well-known

passage from the classic 1952 novel by Ralph Ellison about a black man's search for fulfillment in modern America, which ends in disillusionment and retreat. Wall shows us the cellar room "warm and full of light," in which Ellison's narrator lives beneath 1,369 light bulbs. Powered by electricity stolen from the power company, these lights illuminate the truth of the character's existence: "Light confirms my reality, gives birth to my form. . . . Without light I am not only invisible but formless as well; and to be unaware of one's form is to live a death. . . . The truth is the light and the light is the truth." The artist mounts his work in large-scale light boxes the size of movie screens, to add yet another layer of quotation.

More recent photographers have continued the critique of originality by showing that photography is not merely a recorder of reality, but it also helps us construct our reality. There is no other way except through photography to establish the historical importance of Performance art or Earthworks, which are more remote for most viewers than famous museums. Likewise, photographs of artists at work also create mythology about them. The photographs of Jackson Pollock at work, for example, helped cement his reputation as a major

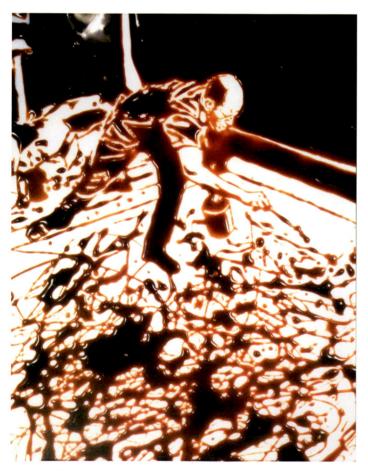

32-65 | Vik Muniz ACTION PHOTO I (FROM "PICTURES OF CHOCOLATE")

1997. Dye destruction print, 59% \times 46%" (152 \times 121 cm). Victoria & Albert Museum, London.

Art © Vik Muniz / Licensed by VAGA, New York, NY

Modern artist (SEE FIG. 32–10). Vik Muniz (b. 1961) re-creates famous photographs in surprising media and then photographs the result (FIG. 32–65). In **ACTION PHOTO 1**, Muniz splashed enough chocolate around so that he was able to make a passable copy of Hans Namuth's famous photo of Pollock at work. In order to make his version, Muniz had to develop the ability to match Pollock's famous drip technique of action painting (differing scales of the respective works complicated the task). After photographing his chocolate panel, he destroyed it, leaving the photograph as the completed work. The layers of reference in this work are numerous: It alludes to Muniz's skillful handling of the chocolate, the photo of Pollock, and to Pollock's actual painting. The latter is arguably the only "original" object in this work.

Andreas Gursky (b. 1955) photographs the spaces of contemporary society: stock exchanges, libraries, airports, designer stores, and, in the present example, a discount store (FIG. 32-66). This work may seem like a straight photograph, but in fact the artist shot several views and combined them with a digital photo editing program; he also altered the color scheme to give it more order. The store tried to create a perfect environment for shopping, and Gursky heightened the effect by smoothing out the dissonant shades, limiting the number of customers, and widening the perspective. He even placed the viewpoint high, as if we are "above the action," and added a reflective ceiling. All of these techniques are common in advertising photographs, which Gursky appropriates. An ironic fact about this particular work is that it belongs in the collection of a financial services company that invests in retail stores. A Postmodern method of discussing this work would be for the author to renounce originality and allow the owner of the work to speak in his place. Thus, let us invite the UBS publicity department to complete the story, from the company website: "Gursky's photographs refer to the structures and aesthetics of the consumerist world, in which context his series on the shop interior of the luxury brand Prada are, in their abstraction, as equally striking as the view into the interior of a 99 Cent store, one of Gursky's works in the UBS Art Collection. Whilst the Prada series could be linked to Color Field paintings, 99 Cent reminds one of pointillist or impressionist paintings, representing reality while melting light and color."

Telling Stories with Paint

Many in the art world thought that the art of painting was moribund in the last years of the Modern movement. Most innovations seemed to come from Performance, Conceptual, or feminist art, perhaps leaving painting as a historical relic. Such talk has proved completely untrue in the Postmodern period, as artists in many countries have gone back to the studio. There they have rediscovered the pleasures of storytelling through art. Principal influences include Joseph Beuys's political rituals and the self-examination that feminists practiced.

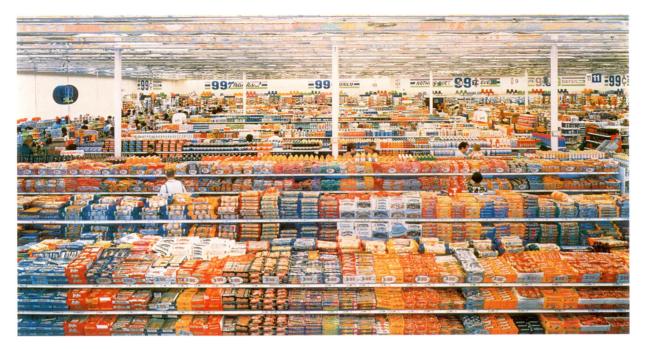

32–66 | Andreas Gursky 99 CENT 1999. C-print, $81\frac{1}{2} \times 132\frac{1}{8}$ " (207 × 336.7 cm). GURA.PH.9529. Courtesy Matthew Marks Gallery, New York. © 2001 Andreas Gursky / Artists Rights Society (ARS), New York, NY

NEO-EXPRESSIONISM. One of the first Postmodern movements to arise in the late 1970s was Neo-Expressionism, a return to the Expressionist styles in which the artist tries to render his or her inner self more than the outward appearance of the subject matter at hand. In Germany, the revival of Expressionism took on political connotations because the work of the original Expressionists had been labeled degenerate and banned by the Nazis during the 1930s (see "The

Suppression of the Avant-Garde in Nazi Germany," page 1112). The German Neo-Expressionist Anselm Kiefer (b. 1945) was born in the final weeks of World War II, and in his work he has sought to come to grips with his country's Nazi past—"to understand the madness." The burned and barren landscape in his **HEATH OF THE BRANDENBURG MARCH** (FIG. 32–67) evokes the ravages of war that the Brandenburg area, near Berlin, has frequently experienced, most recently in

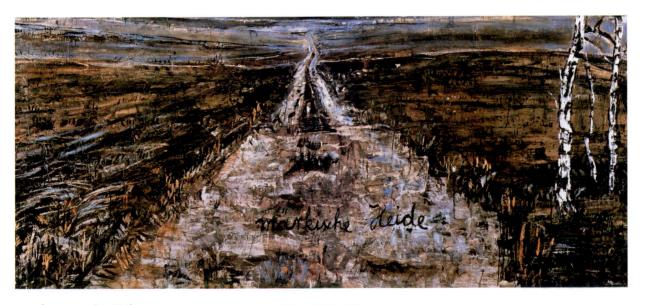

32–67 | Anselm Kiefer | HEATH OF THE BRANDENBURG MARCH 1974. Oil, acrylic, and shellac on burlap, $3'10\frac{1}{2}'' \times 8'4''$ (1.18 \times 2.54 m). Stedelijk Van Abbemuseum, Eindhoven, the Netherlands.

Kiefer often incorporates words and phrases into his paintings that amplify their meaning. Here, the words märkische Heide ("March Heath") evoke an old patriotic tune of the Brandenburg region, "Märkische Heide, märkische Sand," which Hitler's army adopted as a marching song.

32–68 | Sigmar Polke RAISED CHAIR WITH GEESE 1987–88. Artificial resin and acrylic on various fabrics, 9'5½" \times 9' 5½" (2.9 \times 2.9 m). The Art Institute of Chicago. Restricted gift in memory of Marshall Frankel; Wilson L. Mead Endowment (1990.81)

World War II. The road that lures us into the landscape, a standard device in nineteenth-century landscape paintings, here invites us into the region's dark past.

Kiefer's determination to deal with his country's troubled past was shaped in part by his study under Joseph Beuys (SEE FIG. 32-48) in the early 1970s. Another prominent Beuys student was Sigmar Polke (b. 1941), who grew up in Communist-controlled East Germany before moving at age 12 to West Germany. During the 1960s Polke made crude "capitalist realist" paintings that expressed a more critical view of consumer culture than did the generally celebratory work of the British and American Pop artists. Like them, Polke appropriated his images from the mass media. Polke later began to mix diverse images from different sources and paint them on unusual supports, such as printed fabrics, creating a complex, layered effect. RAISED CHAIR WITH GEESE (FIG. 32-68), for example, juxtaposes the silhouette of a watchtower with outlined figures of geese and a printed pattern of sunglasses, umbrellas, and folding chairs. The motif of the elevated hut generates many dark associations, ranging from the raised chair used by German fowl hunters (reinforced by the presence of the geese), to a sentry post for soldiers monitoring the border between East and West Germany, to a concentration camp watchtower. Set next to the decorative fabric

evocative of the beach, however, the tower also evokes the more pleasurable image of a raised lifeguard chair. Such lighter touches distinguish Polke's work in general from the unrelievedly serious efforts of Kiefer.

An American painter associated with the Neo-Expressionist movement was the tragically short-lived Jean-Michel Basquiat (1960-88), whose meteoric career ended with his death from a heroin overdose at age 27. The Brooklyn-born son of a Haitian father and a Puerto Rican mother, Basquiat was raised in middle-class comfort, against which he rebelled as a teenager. After quitting high school at 17, he left home to become a street artist, covering the walls of lower Manhattan with short and witty philosophical texts signed with the tag SAMO©. In 1980 Basquiat participated in the highly publicized "Times Square Show," which showcased the raw and aggressive styles of subway graffiti artists. The response to Basquiat's work encouraged him to begin painting professionally. Although he was untrained and wanted to make "paintings that look as if they were made by a child," Basquiat was a sophisticated artist. He carefully studied the Abstract

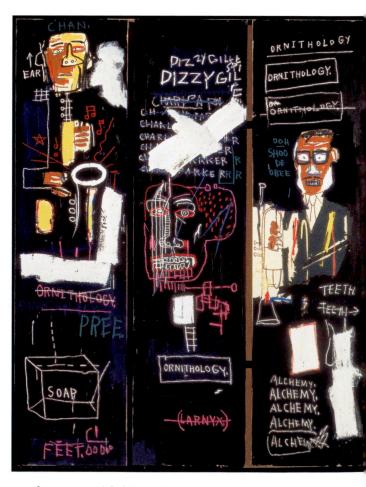

32–69 | Jean-Michel Basquiat HORN PLAYERS 1983. Acrylic and oil paintstick on canvas, three panels, overall $8'\times6'5''$ (2.44 \times 1.91 m). Broad Art Foundation, Santa Monica, California

Expressionists, the late paintings of Picasso, and Dubuffet (SEE FIG. 32–4), among others.

Basquiat's HORN PLAYERS (FIG. 32–69) portrays jazz musicians Charlie Parker (at the upper left) and Dizzy Gillespie (at center right) and includes numerous verbal references to their lives and music. The urgent paint handling and scrawled lettering seem genuinely Expressionist, conveying Basquiat's strong emotional connection to his subject (he avidly collected jazz records and considered Parker one of his personal heroes), as well as his passionate determination to make African American subject matter visible to his predominantly white audience. "Black people," said Basquiat, "are never portrayed realistically, not even portrayed, in Modern art, and I'm glad to do that."

NEW USES FOR OLD STYLES. In the Postmodern period, nearly every historical style is equally available for recycling by artists; Judith F. Baca (b. 1946) looked back to the Mexican mural movement (SEE FIG. 31–66) to recount from a new perspective the history of California (FIG. 32–70). Painted on a site controlled by the U.S. Army Corps of Engineers, Baca's **GREAT WALL OF LOS ANGELES** extends almost 2,500 feet along the wall of a drainage canal, making it the longest mural in the world. Its subject is the history of California,

Sequencing Works of Art

1978	Sherman, Untitled Film Stills
1981	Kapoor, As if to Celebrate
1982	Hammons, Higher Goals
1983	Basquiat, Horn Players
1986	Foster, Hong Kong and Shanghai Bank
1987-88	Polke, Raised Chair with Geese

with an emphasis on the role of ethnic minorities. The twentieth-century scenes include the deportation of Mexican American citizens during the Great Depression, the internment of Japanese American citizens during World War II, and residents' futile protests over the division of a Mexican American neighborhood by a new freeway. The mural concludes with more positive images of the opportunities minorities gained in the 1960s. Typical of Baca's public work, *The Great Wall of Los Angeles* was a group effort, involving professional artists and hundreds of young people who painted the mural under her direction.

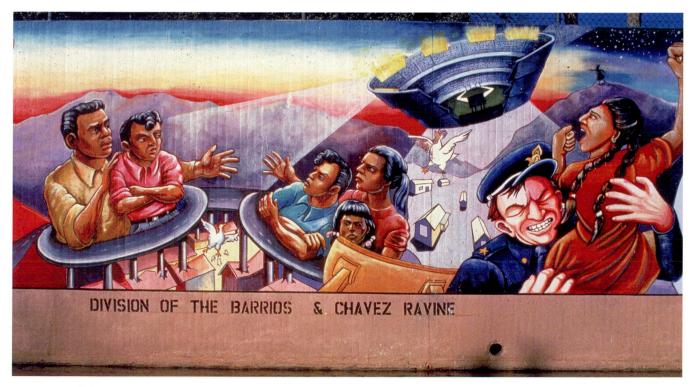

32–70 | Judith F. Baca | THE DIVISION OF THE BARRIOS |
Detail from *The Great Wall of Los Angeles*. 1976–83. Height 13′ (4 m), overall length approx. 2,500′ (762 m). Tujunga Wash Flood Control Channel, Van Nuys, California.

32-71 | Jaune Quick-to-See Smith | THE RED MEAN: SELF PORTRAIT

1992. Acrylic, newspaper collage, and mixed media on canvas, $90\times60''$ (228.6 \times 154.4 cm). Smith College Museum of Art, Northhampton, Massachusetts.

Part gift from Janet Wright Ketcham, class of 1953, and part purchase from the Janet Wright Ketcham, class of 1953, Fund © Jaune Quick-to-See Smith

Native American artist Jaune Quick-to-See Smith (b. 1940) borrowed a well-known image by Leonardo da Vinci for her work **THE RED MEAN** (FIG. 32–71). She describes the work as a self-portrait, and indeed the center of the work has

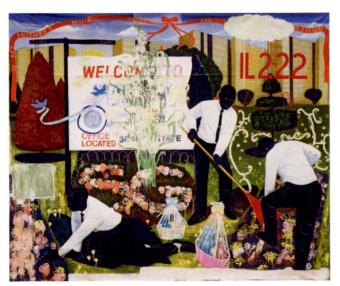

32–72 | Kerry James Marshall MANY MANSIONS 1994. Acrylic on paper mounted on canvas, $114\% \times 135\%$ " (290 \times 343 cm). Art Institute of Chicago.

Max V. Kohnstamm Fund, 1995.147 / Artists Rights Society (ARS), New York

a bumper sticker that reads "Made in the U.S.A." above an identification number. The central figure quotes Leonardo's *Vitruvian Man* (see "Vitruvian Man," page 665), but the message here is autobiographical. Leonardo inscribed the human form within perfect geometric shapes to emphasize the perfection of the human body, while Smith put her silhouette inside the red X that signifies nuclear radiation. This image alludes both to the uranium mines found on some Indian reservations and also to the fact that many have become temporary repositories for nuclear waste. The background of the work is a collage of Native American tribal newspapers. Her self-portrait thus includes her ethnic identity and life on the reservation as well as the history of Western art.

African American painter Kerry James Marshall (b. 1955) updates the pre-Modern genre of history paintings for the contemporary era. He grew up in public housing projects in Alabama and California, and in MANY MANSIONS (FIG. 32-72) he painted a visual essay on life in housing projects. In the background we see the huge buildings of Stateway Gardens, one of America's largest housing projects, located in Chicago. Many housing projects have the word "Gardens" in their names, and Marshall poses three well-dressed black men in the foreground, planting a garden in order to help create a sense of community. The three are arrayed in an off-center triangle that is based on Théodore Géricault's Raft of the "Medusa," a narrative work that Marshall admires (see "Raft of the 'Medusa,'" page 992). He told an interviewer from the PBS television network, "That whole genre of history painting, that grand narrative style of painting, was something that I really wanted to position my work in relation to." Thus he uses a reference to a past style to enrich his art. The work presents many sentimental touches as well, such as the red ribbon across the top with the altered quote from the Bible: "In my mother's house there are many mansions." Two bluebirds fly along at the left bearing another ribbon in their beaks. The overt cuteness of these features, together with the impossibly florid garden, lend the work an ironic touch. The inscription "IL2-22" is like an illustration number, reminding us that this work is only a version of its subject.

The paintings of Takashi Murakami (b. 1962) tie in closely with the popular culture of the artist's native Japan, but they are only one aspect of his voluminous output. EYE LOVE SUPERFLAT (FIG. 32–73) resembles at first glance a corporate logo. Four stylized eyes frame a monogram that symbolizes love on a field of stenciled floral patterns, all in garish colors. The eyes are rendered in a cute style that quotes the Japanese popular culture of manga (comics) and animated films. The Superflat of the title describes not only the lack of depth in this work but also Japanese culture as a whole, the artist says. Woodblock prints of the nineteenth century used flat patterns, as does much traditional Japanese art by painters such as Sesshu and Sotatsu (see Chapter 25). Murakami was trained in the traditional Japanese art techniques at Tokyo

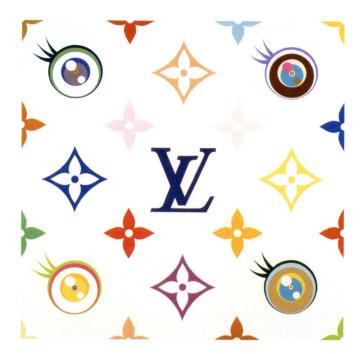

32–73 | Takashi Murakami EYE LOVE SUPERFLAT 2003. Acrylic on canvas mounted on wood, $23\% \times 23\%$ (59.7 \times 59.7 cm). Marianne Boesky Gallery, New York. © 2003 Takashi Murakami / Kaikai Kiki Co., Ltd. All rights reserved.

National University, where he earned a doctoral degree. He claims that Japanese culture today is still characterized by flatness, now of PDAs, flat-screen televisions, and digital bill-boards. *Eye Love Superflat* looks reproducible because it is. The artist, whom *Wired* magazine referred to in 2003 as "the next Andy Warhol," leads a workshop called the Hiropon Factory that employs 25 assistants who craft his images into videos,

T-shirts, handbags, and dolls. His career is an excellent example of how the paradigm for artistic success in the Postmodern era has evolved away from the archetypal solitary genius of Modernism.

Finding New Meanings in Shapes

Sculpture reached its limits under the impact of the Minimalist movement, as artists such as Judd and others (SEE FIG. 32–41) used the most elementary structures to see if they could remove all symbolic or personal meanings. Postmodern sculptors have gradually reinvested their work with some of these resonances, and thus the last twenty years have witnessed a flowering of three-dimensional art.

Martin Puryear (b. 1941) had an early interest in biology that would shape his mature aesthetic. As a Peace Corps volunteer in Sierra Leone on the west coast of Africa, Purvear studied the traditional, preindustrial woodworking methods of local carpenters and artisans. In 1966 he moved to Stockholm, Sweden, to study printmaking and learn the techniques of Scandinavian cabinetmakers. Two years later he began graduate studies in sculpture at Yale, where he encountered the work of a number of visiting Minimalist sculptors. By the middle of the 1970s he had combined these formative influences into a distinctive personal style reminiscent, in its organic simplicity, of Constantin Brancusi (SEE FIG. 31-33). Puryear's PLENTY'S BOAST (FIG. 32-74) does not represent anything in particular but suggests any number of things, including a strange sea creature or a fantastic musical instrument. Perhaps the most obvious reference is to the horn of plenty evoked in the sculpture's title. But the cone is empty, implying an "empty boast"—another phrase suggested by the

32–74 | Martin Puryear PLENTY'S BOAST 1994–95. Red cedar and pine, $68 \times 83 \times 118''$ (172.7 \times 210.8 \times 299.7 cm). The Nelson-Atkins Museum of Art, Kansas City, Missouri. Purchase of the Renee C. Crowell Trust (F95-16 A-C)

title. Whatever associations one prefers, the beauty of the sculpture lies in its superb craft and its idiosyncratic yet elegant organic forms. Sounding like an early twentieth-century Modernist, Puryear said, "The task of any artist is to discover his own individuality at its deepest."

If Puryear explores the territory of the self, Bombayborn Anish Kapoor (b. 1954) makes reference to the culture of his native India (FIG. 32–75). His pieces refer to the fleshy curves of traditional Indian sculpture and the tall shapes of Hindu temples (SEE FIGS. 23–4, 23–5), without exactly quoting either. He later sprinkles pigment powder on most of his works for two reasons: first, because such powders are the purest colors available since they are not mixed with binders as paint is; second, because such sprinkling has a ritualistic overtone, as if sanctifying the object. This work's long title has a diaristic quality that also suggests enlightenment.

In contrast to Kapoor's contemporary spirituality, Rachel Whiteread (b. 1963) urges us to take a fresh look at everyday things by making casts of them. She has cast the insides of a closet, the rectangle of space under a chair, and the contents of a water tower, turning all of these barely noticed negative spaces into solid blocks. Her aesthetic is based in part on the Arte Povera movement (SEE FIGS. 32-44, 32-45), which similarly found meaning in everyday things. For an exhibition in Venice she made a cast of the space behind the books on her library shelf. Over the years these castings have grown more ambitious, culminating in the 1993 work HOUSE (FIG. 32-76), in which she cast the entire inside of a three-story townhouse in concrete. The work took on a political dimension, because it was the last home remaining from a Victorian-era terrace that was being removed to create a new green space. Whiteread intended the work both as a monument to the idea of home and as a political statement about "the state of housing in England; the ludicrous policy of knocking down homes like this and building badly designed tower blocks which themselves have to be knocked down after 20 years." Immediately upon its completion, House became the focus of public debate over not just its

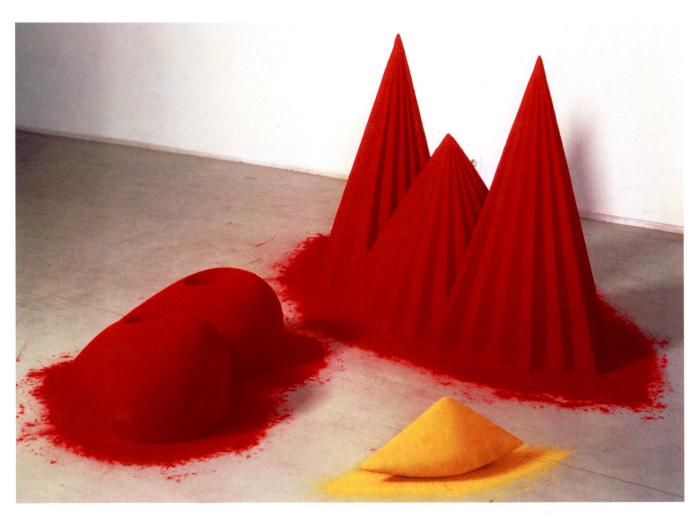

© Anish Kapoor

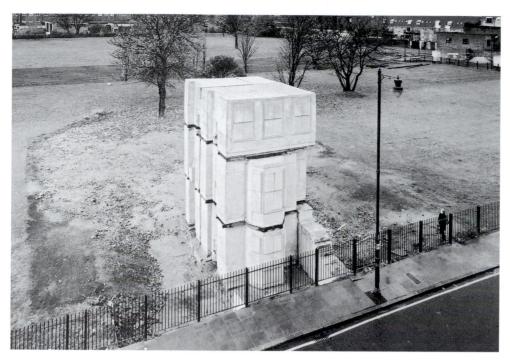

32–76 | Rachel Whiteread HOUSE
1993. Sprayed concrete. Corner of Grove and Roman roads, London; destroyed in 1994.
Commissioned by Artangel Trust and Beck's

artistic merits but also social issues such as housing, neighborhood life, and the authority of local planners. Intended to be temporary, Whiteread's work stood for less than three months before it, too, was demolished.

Modern sculpture since 1945 has generally neglected the human body, but many Postmodern sculptors have revived it because of its rich narrative possibilities. An important impetus for this renewed interest in the human form came with the AIDS crisis, which hit in the 1980s. The social agitation and medical controversy surrounding this disease gave many artists a new feeling that the human body is not only a means of storytelling but also a site of political struggle. The American sculptor Kiki Smith (b. 1954), who lost a sister to AIDS, has explored this territory in works such as **UNTITLED** (FIG. 32-77). This disturbing sculpture, made of red-stained, tissue-thin gampi paper, represents the flayed, bloodied, and crumpled skin of a male figure, torn into three pieces that hang limply from the wall. The body, once massive and vigorous, is now hollow and lifeless. This shattered, blood-red figure suggests a narrative too gruesome to contemplate but unfortunately not uncommon in present-day wars and terrorist attacks.

Postmodern sculptors may work in almost any medium that can be shaped in three dimensions. Ghana-born sculptor El Anatsui (b. 1944) was making wood carvings with a chain-saw when he began to notice the large quantities of liquor bottles in the trash in Nsukka, Nigeria, where he lives. He gathered several thousand of the aluminum tops, flattened

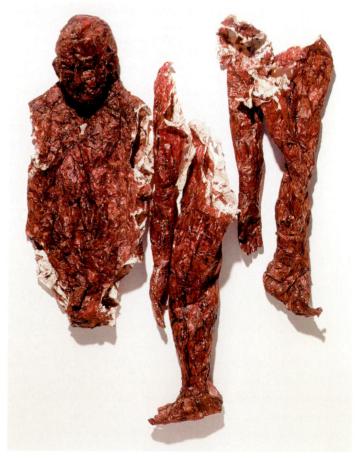

32–77 | Kiki Smith UNTITLED

1988. Ink on gampi paper, $48 \times 38 \times 7''$ (121.9 \times 96.5 \times 17.8 cm). The Art Institute of Chicago. Gift of Lannon Foundation (1997.121)

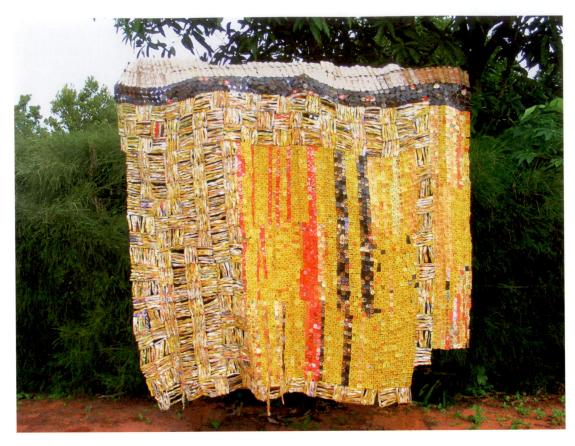

32–78 | El Anatsui AFTER KINGS
2005. Aluminum (liquor bottle tops) and copper wire, 88 × 70" (224 × 178 cm).
Private Collection, Washington, D.C. Courtesy Skoto Gallery, New York.
Artists Rights Society (ARS), New York

them, and stitched them together with copper wire to form large wall pieces such as **AFTER KINGS** (FIG. 32–78). The tops were chosen not only because they were plentiful but also because of symbolic meanings. He said, "To me, the bottle tops encapsulate the essence of the alcoholic drinks which were brought to Africa by Europeans as trade items at the time of the earliest contact between the two peoples. Almost all the brands I use are locally distilled. I now source the caps from around Nsukka, where I live and work. I don't see what I do as recycling. I transform the caps into something else." *After Kings* changes garbage into a form that resembles a traditional kente cloth from the Ashanti culture of Ghana (SEE FIG. 28–12). The kente cloth art form was originally for the nobility only, which helps to explain the title of the work.

The African tradition of making art from whatever is at hand also motivated the British-born Nigerian Chris Ofili (b. 1968) to attach elephant dung to the surface of a painting about Mary, the mother of Jesus. This work became highly controversial when the mayor of New York City tried to close a museum that exhibited it in 1999 (see "Recent Controversies Over Public Funding for the Arts," facing page).

High Tech and Deconstructive Architecture

Architecture has gone through a rebirth almost as dramatic as that of sculpture since the end of Modernism, as architects search restlessly for new support systems beyond the "glass box" of late Modernism (SEE FIG. 32–56). New three-dimensional digital graphics programs allow architects to visualize these new ideas quickly and easily, making possible many innovative building shapes.

HIGH TECH ARCHITECTURE. Even as Postmodernism flourished in the late 1970s and 1980s, High Tech challenged it as the dominant successor to an exhausted Modernism. Characterized by the use of advanced building technology and industrial materials, equipment, and components, High Tech architects experiment with new, more expressive ways of composing a building's mass and of incorporating service modules such as heating and electricity. Among the most spectacular examples of High Tech architecture is the HONG KONG & SHANGHAI BANK (FIG. 32-79) by Norman Foster (b. 1935). Invited by his client to design the most beautiful bank in the world, Foster spared no expense in the creation of this futuristic forty-seven-story skyscraper. The rectangular plan features service towers at the east and west ends, eliminating the central service core typical of earlier skyscrapers such as the Seagram Building. The load-bearing steel skeleton, composed of giant masts and girders, is on the exterior. The individual stories hang from this structure, allowing for uninterrupted façades and open working areas filled with natural

Defining Art

RECENT CONTROVERSIES OVER PUBLIC FUNDING FOR THE ARTS

hould public money support the creation or exhibition of art that some taxpayers might find indecent or offensive? This question became an issue of heated debate in 1989-90, when controversies arose around the work of the American photographers Robert Mapplethorpe and Andres Serrano (b. 1950), who had both received funding, directly or indirectly, from the National Endowment for the Arts (NEA). Serrano became notorious for a large color photograph, Piss Christ (1987), that shows a plastic crucifix immersed in the artist's urine. Although Serrano did not create that work using public money, he did receive a \$15,000 NEA grant in 1989 through the Southeastern Center for Contemporary Art (SECCA), which included Piss Christ in a group exhibition. Piss Christ came to the attention of the Reverend Donald Wildmon, leader of the American Family Association, who railed against it as "hate-filled, bigoted, anti-Christian, and obscene." Wildmon exhorted his followers to flood Congress and the NEA with letters of protest, and the attack on the NEA was quickly joined by conservative Republican politicians.

Amid the Serrano controversy, the Corcoran Gallery of Art in Washington, D.C., decided to cancel its showing of the NEA-funded Robert Mapplethorpe retrospective (organized by the Institute of Contemporary Art [ICA] in Philadelphia) because it included homoerotic and sadomasochistic images. Congress proceeded to cut NEA funding by \$45,000, equaling the \$15,000 SECCA grant to Serrano and the \$30,000 given to the ICA for the Mapplethorpe retrospective. It also added to the NEA guidelines a clause requiring that award decisions take into consideration "general standards of decency and respect for the diverse beliefs and values of the American public."

During the years of legal battle, the NEA underwent major restructuring under pressure from the Republican-controlled House of Representatives, some of whose members sought to eliminate the agency altogether. In 1996 Congress cut the NEA's budget by 40 percent, cut its staff in half, and replaced its seventeen discipline-based grant programs with four interdisciplinary funding categories. It also prohibited grants to individual artists in all areas except literature, making it impossible for visual artists in any medium to receive grants.

Another major controversy over the use of taxpayer money to support the display of provocative art erupted in the fall of 1999, when the Brooklyn Museum of Art opened the exhibition "Sensation: Young British Artists from the Saatchi Collection" in defiance of a threat from New York City mayor Rudolph Giuliani to eliminate city funding and evict the museum from its city-owned building if it persisted in showing work that he called "sick" and "disgusting." Giuliani and Catholic leaders took particular offense at Chris Ofili's THE HOLY VIRGIN MARY, a glittering painting of a stylized African Madonna with a breast made out of elephant dung, set against a background dotted with small photographic images of women's buttocks and genitalia. Ofili, a British-born black of Nigerian parentage who is himself Catholic, explained that he meant the painting to be a contemporary reworking of the traditional image of the Madonna surrounded

by naked *putti*, and that the elephant dung, used for numerous practical purposes by African cultures, represents fertility. Giuliani and his allies, however, considered the picture sacrilegious.

When in late September the Brooklyn Museum of Art refused to cancel the show, Giuliani withheld the city's monthly maintenance payment to the museum of \$497,554 and filed a suit in state court to revoke its lease. The museum responded with a federal lawsuit seeking an injunction against Giuliani's actions on the grounds that they violated the First Amendment. On November 1, the U.S. District Court for the Eastern District of New York barred Giuliani and the city from punishing or retaliating against the museum in any way for mounting the exhibition. While the mayor had argued that the city should not have to subsidize art that fosters religious intolerance, the court ruled that the government has "no legitimate interest in protecting any or all religions from views distasteful to them." Taxpayers, said the court, "subsidize all manner of views with which they do not agree," even those "they abhor."

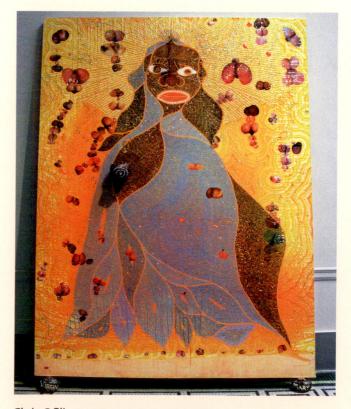

Chris Ofili THE HOLY VIRGIN MARY 1996. Paper collage, oil paint, glitter, polyester resin, map pins, and elephant dung on linen, $7'11'' \times 5'11\%''$ (2.44 \times 1.83 cm). The Saatchi Gallery, London.

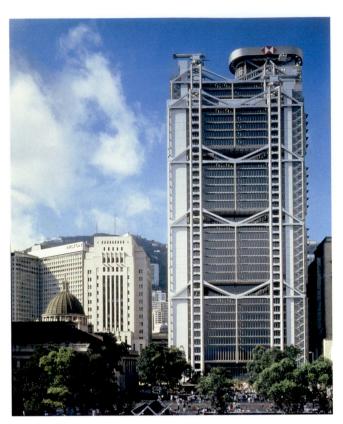

32–79 Norman Foster HONG KONG & SHANGHAI BANK Hong Kong. 1986.

light. The main banking hall, the lowest segment of the building, features a ten-story atrium space flooded by daylight refracted from motorized "sunscoops" at its apex, computer-programmed to track the sun and channel its rays into the building. The sole concession Foster's High Tech building makes to tradition are the two bronze lions that guard its public entrance—the only surviving elements from the bank's previous headquarters. A popular belief holds that touching the lions before entering the bank brings good luck.

DECONSTRUCTIVIST ARCHITECTURE. Deconstructivist architecture is a new tendency to disturb the traditional architectural values of harmony, unity, and stability through the use of skewed, distorted, and impure geometry. The principal influences on this movement are Suprematism and Constructivism, both Russian Modernist movements (SEE FIGS. 31–30, 31–58). Many architects since the 1980s have combined an awareness of these Russian sources with an interest in the theory of Deconstruction developed by French philosopher Jacques Derrida (1930–2004). Concerned mostly with the analysis of verbal texts, Derridean Deconstruction holds that no text possesses a single, intrinsic meaning. Rather, its meaning is always "intertextual"—a product of its relationship to other texts—and is always "decentered," or "dispersed" along

an infinite chain of linguistic signs, the meanings of which are themselves unstable. Deconstructivist architecture is, consequently, often "intertextual" in its use of design elements from other traditions, including Modernism, and "decentered" in its denial of a unified and stable form.

A prime example of Deconstructivist architecture is the **VITRA FIRE STATION** in Weil-am-Rhein, Germany (FIG. 32–80), by the Baghdad-born Zaha Hadid (b. 1950), who studied architecture in London and established her practice there in 1979. Stylistically influenced by the Suprematist paintings of Kasimir Malevich (SEE FIG. 31–29), the Vitra Fire Station features leaning, reinforced concrete walls that meet at unexpected angles and jut dramatically into space, denying any sense of unity while creating a feeling of dynamism appropriate to the building's function.

The Toronto-born, California-based Frank O. Gehry (b. 1929) creates unstable and Deconstructivist building masses using curved shapes far more exuberant than those of Modern architecture. He achieved his initial fame in the late 1970s with his inventive use of vernacular forms and cheap materials set into unstable and conflicted arrangements. After working during the 1980s in a more classically geometrical mode, in the 1990s Gehry developed a powerfully organic, sculptural style, most famously exemplified in his enormous GUGGENHEIM MUSEUM in Bilbao, Spain (FIG. 32-81). The building's complex steel skeleton is covered with a thin skin of silvery titanium that shimmers gold or silver depending on the light. Gehry's building resembles a living organism from most vantage points except the north, from which it resembles a giant ship, a reference to the shipbuilding so important to Bilbao. This building started a trend of adventurous design in art museums that continues today.

New Statements in New Media

The art of our own times is the most difficult to classify and analyze; we are still too close to the Postmodern trees to allow us to see the forest. Having pointed out in general terms a few trends that have developed in the last generation, we will close this book with a brief look at more recent art that is difficult to put into stylistic categories. The artists who created these seven works come from various continents and ethnic groups, reflecting today's globalized art world. Some of the creators focus on political issues; some are autobiographical or symbolic; some explore the new media that technology has given us.

SOCIAL CHANGE. A socially minded artist strongly committed to working in public is David Hammons (b. 1943), an outspoken critic of the gallery system. Lamenting the lack of challenging content in art shows, he says that the art world is "like Novocaine. It used to wake you up but now it puts you to sleep." Only street art, uncontaminated by commerce, he maintains,

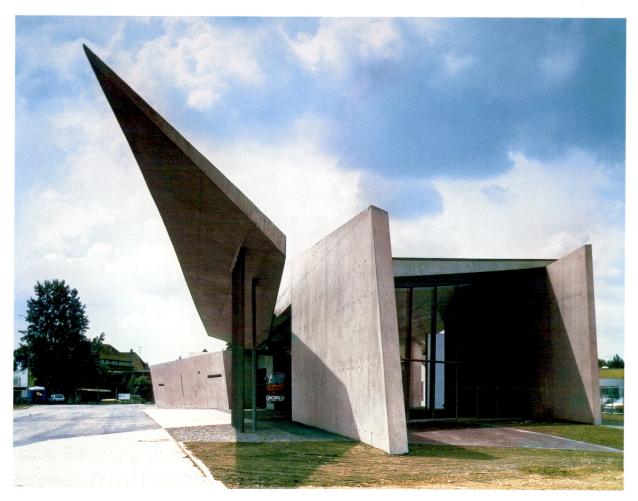

32-80 Zaha Hadid VITRA FIRE STATION Weil-am-Rhein, Germany. 1989-93.

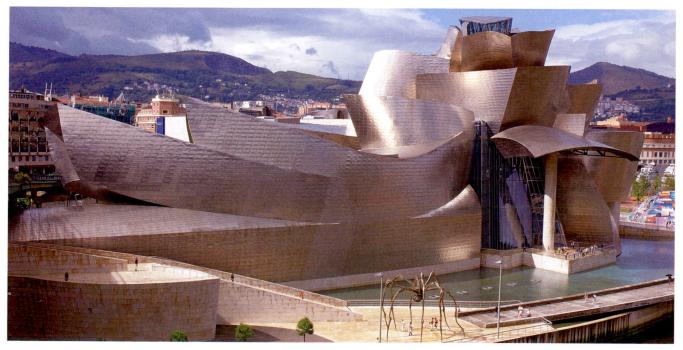

32–81 | Frank O. Gehry GUGGENHEIM MUSEUM Bilbao, Spain. 1993–97.

32–82 | David Hammons HIGHER GOALS 1982; shown installed in Brooklyn, New York, 1986. Five poles of mixed media, including basketball hoops and bottle caps, height of tallest pole 40' (11 m).

Courtesy of Artemis Greenberg Van Doren Gallery, New York

can still serve the function of jolting people awake. Hammons for the most part aims his work at his own African American community. His best-known creation is probably **HIGHER GOALS** (FIG. 32–82), which he produced in several versions between 1982 and 1986. This one, temporarily set up in a Brooklyn

park, has backboards and baskets set on telephone poles—a reference to communication—that rise as high as 35 feet. The poles are decorated with bottle caps, a substitute for the cowrie shells used not only in African design but also in some African cultures as money. Although the series may appear to honor the game of basketball, Hammons said it is "anti-basketball sculpture." "Basketball has become a problem in the black community because kids aren't getting an education. . . . It means you should have higher goals in life than basketball."

In their drive to bring about positive social change, some artists have created public works meant to provoke not only discussion but also tangible improvements. Notable examples are the REVIVAL FIELDS of Mel Chin (b. 1951), which are designed to restore the ecological health of contaminated land through the action of "hyperaccumulating" plants that absorb heavy metals from the soil. Chin created his first Revival Field near St. Paul, Minnesota, in the dangerously contaminated Pig's Eye Landfill (FIG. 32-83). He gave the work the cosmological form of a circle in a square (representing heaven and earth in Chinese iconography), divided into quarters by intersecting walkways. He seeded the inside of the circle with hyperaccumulating plants and the outside with nonaccumulating plants as a control. For three years the plants were harvested and replanted and toxic metals removed from the soil. Chin went on to create other Revival Fields elsewhere in the United States and Europe. "Rather than making a metaphorical work to express a problem," said Chin, "a work can . . . tackle a problem head-on. As an art form it extends the notion of art beyond a familiar objectcommodity status into the realm of process and public service." He has created a new kind of Earthwork (SEE FIGS. 32-49 to 32-51) that moves the focus away from aesthetic contemplation in favor of environmental activism.

32-83 | Mel Chin REVIVAL FIELD: PIG'S EYE LANDFILL

1991-93. St. Paul, Minnesota.

Although the *Revival Field* series serves the practical purpose of reclaiming a hazardous waste site through the use of plants that absorb toxic metals from the soil, Chin sought funding for his series not from the Environmental Protection Agency but from the National Endowment for the Arts. In 1990 his grant application, which had been approved by an NEA panel, was vetoed by NEA chair John E. Frohnmayer, who questioned the project's status as art. Frohnmayer reversed his decision after Chin eloquently compared *Revival Field* to a work of sculpture: "Soil is my marble. Plants are my chisel. Revived nature is my product. . . . This is responsibility and poetry."

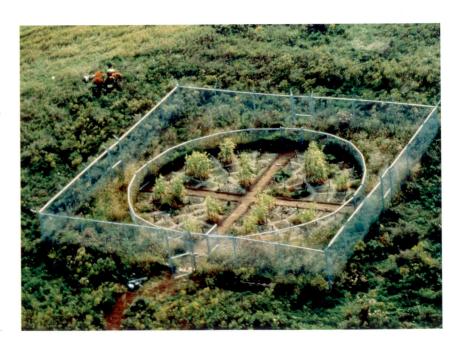

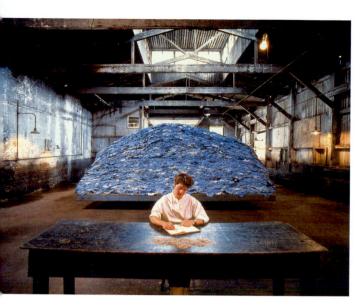

32–84 □ Ann Hamilton **INDIGO BLUE**1991. Installation for "Places with a Past," Spoleto Festival U.S.A., Charleston, South Carolina.

SOCIAL OBSERVATION. Visitors to the installation by Ann Hamilton (b. 1956) at the 1991 Spoleto Festival in Charleston, South Carolina, found an abandoned auto repair shop with a worker sitting at a table laboriously erasing pages from a book, before a huge pile of carefully folded blue clothing (FIG. 32-84). Taking a cue from the everyday aesthetics of John Dewey and Arte Povera, her installation allows historically specific readings that have a political subtext about aspects of American life neglected by most historians. The street outside was named for Eliza Lucas Pinckney, who in 1744 introduced to the American colonies the cultivation of indigo, the source of a blue dve used for blue-collar work clothes, among other things. The focal point of Hamilton's INDIGO BLUE was a pile of about 48,000 neatly folded work pants and shirts. However, Indigo Blue was more a tribute to the women who washed, ironed, and folded such clothes—in this case, Hamilton and a few women helpers, including her mother-than to the men who wore them. In front of the great mound of shirts and pants sat a performer erasing the contents of old history books-creating page space, Hamilton said, for the ordinary, working-class people usually omitted from conventional histories.

Landscape design has entered its Postmodern phase in the work of Ken Smith (b. 1953). When New York's Museum of Modern Art underwent an expansion in 2005, the curators decided to decorate some of the new roof space with landscape gardens. These spaces would not be accessible from inside the building, and hence the garden had to be maintenance-free. The concept was to decorate the roof so that the building would be less unsightly to the apartment dwellers living nearby. Smith created a humorously understated design

using plastic rocks, trees, and bushes set on gravel of various colors, all arranged in a camouflage pattern to "hide" the roof (FIG. 32–85). The curving plots also resemble the winding paths of New York's Central Park (see "The City Park," page 1059), but on a smaller scale responding to the needs of the site. When some neighbors objected that the garden was completely fake, Smith responded that Central Park is fake also, since Olmsted leveled the area before planting anything. The way this work alludes to the past, and makes a joke out of the confusion of the real and unreal, mark it as a highly original piece of garden design, creative in a Postmodern sense.

A number of contemporary artists create installations with video, either using the video monitor itself as a visible part of their work or projecting video imagery onto walls, screens, or other surfaces. The pioneer of video as an artistic medium was the Korean-born Nam June Paik (1931–2006), who proclaimed that just "as collage technique replaced oil paint, the cathode ray [television] tube will replace the canvas." Strongly influenced by John Cage, Paik made experimental music in the late 1950s and early 1960s. He began working with modified television sets in 1963 and bought his first video camera in 1965. Paik worked with live, recorded, and computer-generated images displayed on video monitors of varying sizes, which he often combined into sculptural

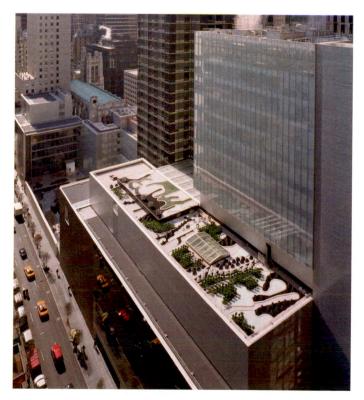

32–85 | Ken Smith, Landscape Architect MOMA ROOF GARDEN

2005. Outdoor garden at the Museum of Modern Art, New York. Photograph © Peter Mauss / ESTO / Artists Rights Society (ARS), New York

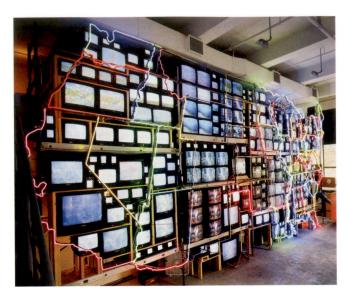

32–86 | Nam June Paik ELECTRONIC SUPERHIGHWAY: CONTINENTAL U.S.

1995. Forty-seven-channel closed-circuit video installation with 313 monitors, neon, steel structure, color, and sound; approx. 15 \times 32 \times 4′ (4.57 \times 9.75 \times 1.2 m).

Courtesy Holly Solomon Gallery, New York

ensembles such as **ELECTRONIC SUPERHIGHWAY: CONTINENTAL U.S.** (FIG. 32–86), a site-specific installation created for the Holly Solomon Gallery in New York. Stretching across an entire wall, the work featured a map of the continental United States outlined in neon and backed by video monitors perpetually flashing with color and movement and accompanied by sound. (Side walls featured Alaska and Hawaii.) The monitors within the borders of each state displayed images reflecting that state's culture and history, both past and recent. The only exception was New York State, whose monitors displayed live, closed-circuit images of the gallery visitors, placing them in the artwork and transforming them from passive spectators into active participants.

DIVISIONS, COMMONALITIES. The videos of Shirin Neshat (b. 1957) address universal themes within the specific context of present-day Islamic society. Neshat was studying art in California when revolution shook her native Iran in 1979. Returning to Iran in 1990 for the first time in twelve years, Neshat was shocked by the extent to which fundamentalist Islamic rule had transformed her homeland, particularly through the requirement that women appear in public veiled from head to foot in a *chador*, a square of fabric. Upon her return to the United States, Neshat began using the black *chador* as the central motif of her work.

In the late 1990s Neshat began to make visually arresting and poetically structured films and videos that offer subtle critiques of Islamic society. FERVOR (FIG. 32–87), in Neshat's words, "focuses on taboos regarding sexuality and desire" in Islamic society that "inhibit the contact between the sexes in

public. A simple gaze, for instance, is considered a sin. . . . "Composed of two separate video channels projected simultaneously on two large, adjoining screens, Fervor presents a simple narrative. In the opening scene, a black-veiled woman and jacket-wearing man, viewed from above, cross paths in an open landscape. The viewer senses a sexual attraction between them, but they make no contact and go their separate ways. Later, they meet again while entering a public ceremony where men and women are divided by a large curtain. On a stage before the audience, a bearded man fervently recounts (in Farsi, without subtitles) a story adapted from the Koran about Yusuf (the biblical Joseph) and Zolikha. Zolikha attempts to seduce Yusuf (her husband's slave) and then, when he resists her advances, falsely accuses him of having seduced her. The speaker passionately urges his listeners to resist such sinful desires with all their might. As his tone intensifies and the audience begins to chant in response to his exhortations, the male and female protagonists grow increasingly anxious, and the woman eventually rises and exits hurriedly. Fervor ends with the man and woman passing each other in an alley, again without verbal or physical contact.

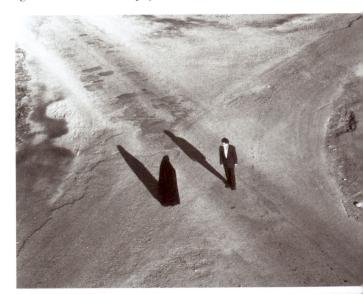

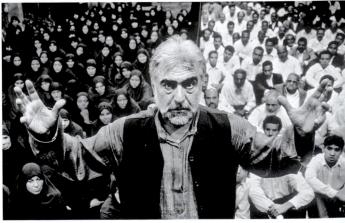

32–87 | Shirin Neshat PRODUCTION STILLS

2000. Video/sound installation with two channels of blackand-white video projected onto two screens, 10 minutes. Courtesy Barbara Gladstone Gallery, New York

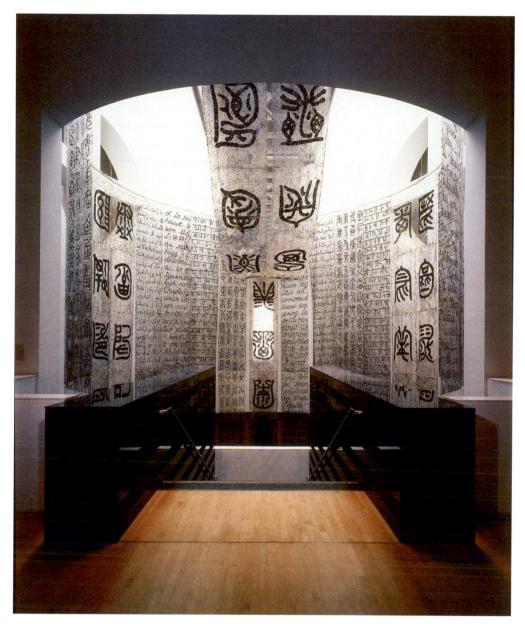

32–88 | Wenda Gu UNITED NATIONS—BABEL OF THE MILLENNIUM
1999. Site-specific installation made of human hair, height 75′ (22.9 m); diameter 34′ (10.4 m). San Francisco Museum of Modern Art.
Fractional and promised gift of Viki and Kent Logan

While Neshat concentrates on dualisms and divisions—between East and West, male and female, individual desire and collective law—the Shanghai-born artist Wenda Gu (b. 1955) dedicates his art to bringing people together. Trained in traditional ink painting at China's National Academy of Fine Arts, Gu in the 1980s began to paint pseudo-characters—fake, Chinese-looking ideograms of his own invention. Although he later claimed that his intent was simply to "break through the control of tradition," the Chinese authorities feared that his work contained hidden political messages and did not permit his first solo exhibition to open in 1986. The next year Gu emigrated to the United States and in 1992 began his *United Nations* series, which he describes as an ongoing worldwide

art project. The series consists of site-specific installations or "monuments" made of human hair, which Gu collects from barbershops across the globe and presses or weaves into bricks, carpets, and curtains. Gu's "national" monuments—installed in such countries as Poland, Israel, and Taiwan—use hair collected within that country, addressing issues specific to that country. His "transnational" monuments address larger themes and blend hair collected from different countries as a metaphor for the mixture of races that the artist predicts will eventually unite humanity into "a brave new racial identity." Many of Gu's installations, such as UNITED NATIONS—BABEL OF THE MILLENNIUM (FIG. 32–88), also incorporate invented scripts based on Chinese, English, Hindi, and Arabic characters

that, by frustrating viewers' ability to read them, "evoke the limitations of human knowledge" and help prepare them for entry into an "unknown world."

In its ambitious attempt to address in artistic terms the issue of globalism that dominates discussions of contemporary economics, society, and culture, Gu's work is remarkably timely. Yet, like all important art, it is meant to speak not only to the present but also to the future, which will recognize it as part of the fundamental quest of artists throughout history to extend the boundaries of human perception, feeling, and thought and to express humanity's deepest wishes and most powerful dreams. "A great 'Utopia' of the unification of mankind probably can never exist in our reality," admits Gu, "but it is going to be fully realized in the art world."

IN PERSPECTIVE

Shortly after the end of the World War II in 1945, artistic innovation in the Western world was centered in Paris, New York, and Buenos Aires. The Paris artists reacted to the meltdown of European civilization that witnessed millions of deaths. The New York School pioneered Abstract Expressionism and Color Field painting, while the Buenos Aires groups worked abstractly with shaped canvases and neon.

From about 1955 to 1965, artists experimented with new ways of bringing their art into contact with the real world. Some created Assemblages of real objects in chaotic compositions; others carried out Happenings that involved staging events. The third and most important outgrowth of this trend was Pop Art, in which artists borrowed the techniques of mass media to comment on popular culture.

In the 1960s and early 1970s, artists made the final assault on traditions that date from the Renaissance. As in the early twentieth century, movements followed each other in quick succession, each claiming to be more radical than the last. Minimal artists eliminated personal feeling and all social reference from their work. Conceptual artists eliminated the art object itself in favor of informational documentation of their ideas. Performance artists refused to produce anything permanent at all. Arte Povera artists made works that depended on natural processes rather than the artist's decision to determine their form. Earthwork artists worked in remote locations directly on the surface of the land. Feminists assaulted the mostly unspoken tradition of male dominance. Some of these movements were influenced by the activism of the 1960s, while others shared in the widespread questioning of social norms that marked the period.

By the mid- to late 1970s, there seemed to be no traditional rules of art left to break. In addition, the avant-garde had all but ceased to exist as a group separate from society at large. As a result, most art produced since then has been called Postmodern, as artists ceased focusing on formal innovation and devoted more energy to reflection on our world. Architecture underwent a similar transition as Postmodern architects began to use decoration and historical reference once again.

And the history of art still unfolds. As Modern art restlessly investigated the boundaries of art, the Postmodern period has opened new possibilities for interaction with the audience. If we viewers are aware of art of the past, we will be able to appreciate the many varieties of creativity that await us in the future.

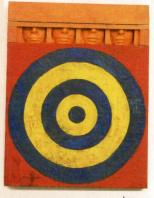

JOHNS TARGET WITH FOUR FACES 1955

Krasner **THE SEASONS**1957

RILEY CURRENT 1964

CHRISTO AND JEANNE-CLAUDE RUNNING FENCE 1972-76

FOSTER
NG KONG & SHANGHAI BANK
1986

Neshat
PRODUCTION STILLS
FROM "FERVOR"
2000

THE INTERNATIONAL SCENE SINCE 1945

1940

1950

1960

1970

1980

1990

2000

- World War II Ends 1945
- Britain Withdraws from India 1947
- People's Republic of China Established 1949
- Korean War 1950-53
- Civil Rights Movement Begins in U.S 1954
- USSR Launches First Satellite 1957
- Human First Orbits Earth 1961
- President John F. Kennedy Killed
 1963
- U.S. Enters Vietnam War 1965
- Montreal World Exposition 1967
- Robert F. Kennedy and Martin Luther King, Jr., Killed 1968
- ▼ First Moon Landing 1969
- Stephen Hawkings Proposes Black Hole Theory 1974

- Chernobyl Nuclear Power Plant
 Disaster 1986
- Germany Reunited 1990
- USSR Disssolved 1991
- Advent of World Wide Web 1994
- Human Genome Sequence Decoded 2000
- World Trade Center Attack 2001
- U.S. War in Iraq 2003

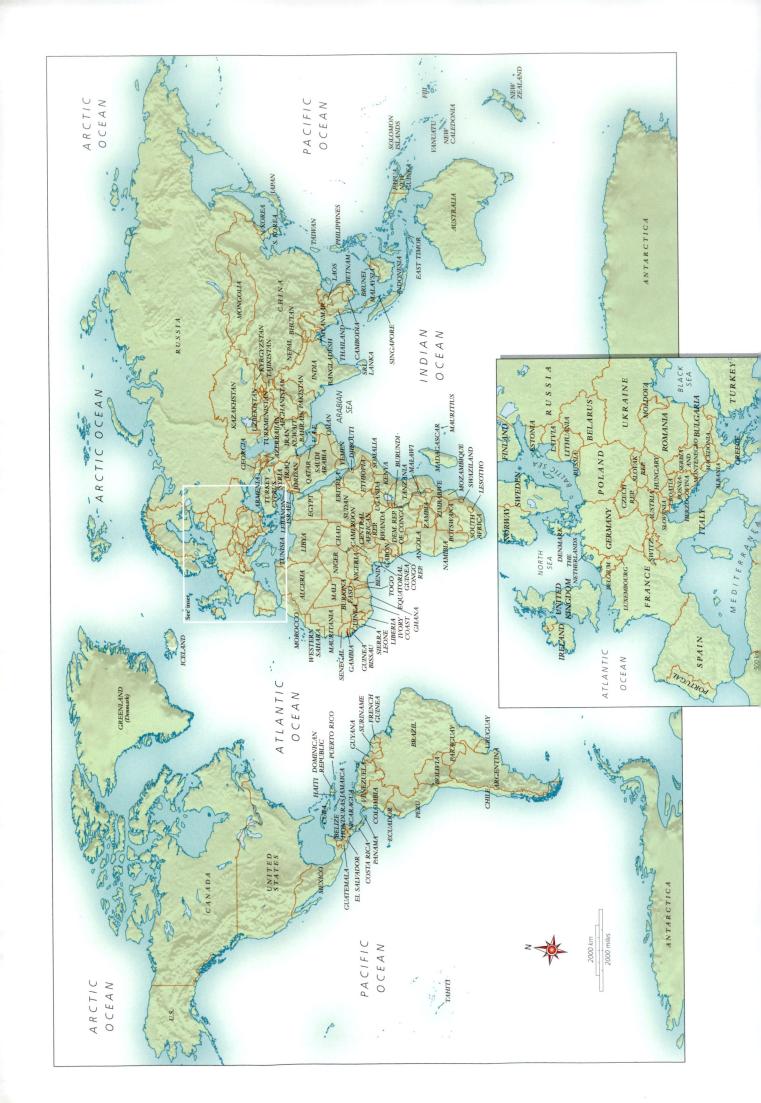

GLOSSARY

abacus The flat slab at the top of a **capital**, directly under the **entablature**.

absolute dating A method of assigning a precise historical date to periods and objects based on known and recorded events in the region as well as technically extracted physical evidence (such as carbon-14 disintegration). See also

radiometric dating, relative dating.

abstract, abstraction Any art that does not represent observable aspects of nature or transforms visible forms into a stylized image. Also: the formal qualities of this process.

acropolis The **citadel** of an ancient Greek city, located at its highest point and housing temples, a treasury, and sometimes a royal palace. The most famous is the Acropolis in Athens.

acroterion (acroteria) An ornament at the corner or peak of a roof.

adobe Sun-baked blocks made of clay mixed with straw. Also: the buildings made with this material.

adyton The back room of a Greek temple. At Delphi, the place where the **oracles** were delivered. More generally, a very private space or room.

aedicula (aediculae) A decorative architectural frame, usually found around a niche, door, or window. An aedicula is made up of a **pediment** and **entablature** supported by **columns** or **pilasters**.

agora An open space in a Greek town used as a central gathering place or market. See also forum.

aisle Passage or open corridor of a church, hall, or other building that parallels the main space, usually on both sides, and is delineated by a row, or **arcade**, of **columns** or piers. Called side aisles when they flank the **nave** of a church.

album A book consisting of a series of paintings or prints (album leaves) mounted into book form.

all'antica Meaning, "in the ancient manner." allegory In a work of art, an image (or images) that symbolically illustrates an idea, concept, or principle, often moral or religious.

alloy A mixture of metals; different metals melted together.

amalaka In Hindu architecture, the circular or square-shaped element on top of a spire (shikhara), often crowned with a finial, symbolizing the cosmos.

ambulatory The passage (walkway) around the **apse** in a basilican church or around the **central space in a central-plan building**.

amphiprostyle Term describing a building, usually a temple, with **porticoes** at each end but without **columns** along the other two sides.

amphora An ancient Greek jar for storing oil or wine, with an egg-shaped body and two curved handles.

aniconic A symbolic representation without images of human figures, very often found in Islamic art.

animal interlace Decoration made of interwoven animals or serpents, often found in Celtic and early medieval Northern European art.

ankh A looped cross signifying life, used by ancient Egyptians.

appropriation Term used to describe an artist's practice of borrowing from another source for a new work of art. While in previous centuries artists often copied one another's figures, motifs, or compositions, in modern times the sources for appropriation extend from material culture to works of art

apse, apsidal A large semicircular or polygonal (and usually vaulted) niche protruding from the end wall of a building. In the Christian church, it contains the altar. Apsidal is an adjective describing the condition of having such a space.

arabesque A type of linear surface decoration based on foliage and **calligraphic** forms, usually characterized by flowing lines and swirling shapes.

arcade A series of **arches**, carried by **columns** or **piers** and supporting a common wall or lintel. In a blind arcade, the arches and supports are engaged (attached to the wall) and have a decorative function.

arch In architecture, a curved structural element that spans an open space. Built from wedgeshaped stone blocks called voussoirs, which, when placed together and held at the top by a trapezoidal keystone, form an effective spacespanning and weight-bearing unit. Requires buttresses at each side to contain the outward thrust caused by the weight of the structure. Corbel arch: arch or vault formed by courses of stones. each of which projects beyond the lower course until the space is enclosed; usually finished with a capstone. Horseshoe arch: an arch of more than a half-circle; typical of western Islamic architecture. Ogival arch: a pointed arch created by S curves. Relieving arch: an arch built into a heavy wall just above a post-and-lintel structure (such as a gate, door, or window) to help support the wall above by transferring the load to the side walls.

archaic smile The curved lips of an ancient Greek statue, usually interpreted as an attempt to animate the features.

architrave The bottom element in an **entablature**, beneath the **frieze** and the **cornice**.

art brut French for "raw art." Term introduced by Jean Dubuffet to denote the often vividly expressionistic art of children and the insane, which he considered uncontaminated by culture. articulated Joined; divided into units; in architecture, divided intoparts tomake spatial organiza-

tion intelligible.

ashlar A highly finished, precisely cut block of stone. When laid in even **courses**, ashlar masonry creates a uniform face with fine joints. Often used as a facing on the visible exterior of a building, especially as a veneer for the **façade**. Also called **dressed stone**.

assemblage Artwork created by gathering and manipulating two and/or three-dimensional found objects.

astragal A thin convex decorative **molding**, often found on classical **entablatures**, and usually decorated with a continuous row of beadlike circles.

atelier The studio or workshop of a master artist or craftsperson, often including junior associates and apprentices.

atmospheric perspective See perspective.

atrial cross The cross placed in the atrium of a church. In Colonial America, used to mark a gathering and teaching place.

atrium An unroofed interior courtyard or room in a Roman house, sometimes having a pool or garden, sometimes surrounded by columns. Also: the open courtyard in front of a Christian church; or an entrance area in modern architecture.

automatism A technique whereby the usual intellectual control of the artist over his or her brush or pencil is foregone. The artist's aim is to allow the subconscious to create the artwork without rational interference.

avant-garde Term derived from the French military word meaning "before the group," or "vanguard." Avant-garde denotes those artists or concepts of a strikingly new, experimental, or radical nature for the time.

axis mundi A concept of an "axis of the world," which marks sacred sites and denotes a link between the human and celestial realms. For example, in Buddhist art, the axis mundi can be marked by monumental freestanding decorative pillars.

baldachin A canopy (whether suspended from the ceiling, projecting from a wall, or supported by columns) placed over an honorific or sacred space such as a throne or church altar.

bargeboards Boards covering the rafters at the gable end of a building; bargeboards are often carved or painted.

barrel vault See vault.

bar tracery See tracery.

bas-de-page French: bottom of the page; a term used in manuscript studies to indicate pictures below the text, literally at the bottom of the page.

base Any support. Also: masonry supporting a statue or the **shaft** of a **column**.

basilica A large rectangular building. Often built with a **clerestory**, side **aisles** separated from the center **nave** by **colonnades**, and an **apse** at one or both ends. Roman centers for administration, later adapted to Christian church use. Constantine's architects added a transverse aisle at the end of the nave called a **transept**.

bay A unit of space defined by architectural elements such as **columns**, **piers**, and walls.

beehive tomb A **corbel-vaulted** tomb, conical in shape like a beehive, and covered by an earthen mound

Benday dots In modern printing and typesetting, the individual dots that, together with many others, make up lettering and images. Often machine- or computer-generated, the dots are very small and closely spaced to give the effect of density and richness of tone.

bestiary A book describing characteristics, uses, and meaning illustrated by moralizing tales about real and imaginary animals, especially popular during the Middle Ages in western Europe.

bi A jade disk with a hole in the center.

biomorphic Adjective used to describe forms that resemble or suggest shapes found in nature.

black-figure A style or technique of ancient Greek pottery in which black figures are painted on a red clay ground. See also **red-figure**.

bodhisattva In Buddism, a being who has attained enlightenment but chooses to remain in this world in order to help others advance spiritually. Also defined as a potential Buddha.

boss A decorative knoblike element. Bosses can be found in many places, such as at the intersection of a Gothic vault rib. Also buttonlike projections in decorations and metalwork.

bracket, bracketing An architectural element that projects from a wall to support a horizontal part of a building, such as beams or the eaves of a roof.

brandea An object, such as a linen strip, having contact with a relic and taking on the power of the relic.

buon fresco See fresco.

hold the design together.

cairn A pile of stones or earth and stones that served both as a prehistoric burial site and as a marker of underground tombs.

calligraphy Handwriting as an art form. **calvx krater** See **krater**.

came (cames) A lead strip used in the making of leaded or **stained-glass** windows. Cames have an indented vertical groove on the sides into which the separate pieces of glass are fitted to

cameo Gemstone, clay, glass, or shell having layers of color, carved in **low relief** to create an image and ground of different colors.

camera obscura An early cameralike device used in the Renaissance and later for recording images of nature. Made from a dark box (or room) with a hole in one side (sometimes fitted with a lens), the camera obscura operates when bright light shines through the hole, casting an upside-down image of an object outside onto the inside wall of the box.

canon of proportions A set of ideal mathematical ratios in art based on measurements of the human body.

capital The sculpted block that tops a **column**. According to the conventions of the orders, capitals include different decorative elements. See **order**. Also: a historiated capital is one displaying a narrative.

capriccio A painting or print of a fantastic, imaginary landscape, usually with architecture.

capstone The final, topmost stone in a **corbel arch** or vault, which joins the sides and completes the structure.

cartoon A full-scale drawing used to transfer the outline of a design onto a surface (such as a wall, canvas,panel,or tapestry) to be painted, carved, or woven.

cartouche A frame for a **hieroglyphic** inscription formed by a rope design surrounding an oval space. Used to signify a sacred or honored name. Also: in architecture, a decorative device or plaque, usually with a plain center used for inscriptions or epitaphs.

caryatid A sculpture of a draped female figure acting as a column supporting an **entablature**.

catacomb A subterranean burial ground consisting of tunnels on different levels, having niches for urns and **sarcophagi** and often incorporating rooms (cubiculae).

celadon A high-fired, transparent **glaze** of pale bluish-green hue whose principal coloring agent is an oxide of iron. In China and Korea, such glazes typically were applied over a pale gray **stoneware** body, though Chinese potters some-

times applied them over **porcelain** bodies during the Ming (1368-1644) and Qing (1644-1911) dynasties. Chinese potters invented celadon glazes and initiated the continuous production of celadon-glazed wares as early as the third century CE.

cella The principal interior room at the center of a Greek or Roman temple within which the cult statue was usually housed. Also called the **naos**

cenotaph A funerary monument commemorating an individual or group buried elsewhere.

centering A temporary structure that supports a masonry **arch** and **vault** or **dome** during construction until the mortar is fully dried and the masonry is self-sustaining.

centrally planned building Any structure designed with a primary central space surrounded by symmetrical areas on each side. For example, **Greek-cross plan** (equal-armed cross).

ceramics A general term covering all types of wares made from fired clay, including **porcelain** and **terra cotta**.

chaitya A type of Buddhist temple found in India. Built in the form of a hall or **basilica**, a chaitya hall is highly decorated with sculpture and usually is carved from a cave or natural rock location. It houses a sacred shrine or stupa for worship.

chamfer The slanted surface produced when an angle is trimmed or beveled, common in building and metalwork.

chasing Ornamentation made on metal by incising or hammering the surface.

chattri (*chattris*) A decorative pavilion with an umbrella-shaped **dome** in Indian architecture.

 $\begin{tabular}{ll} \textbf{chevron} & A \ decorative \ or \ heraldic \ motif \ of \\ repeated \ Vs; \ a \ zigzag \ pattern. \end{tabular}$

chiaroscuro An Italian word designating the contrast of dark and light in a painting, drawing, or print. Chiaroscuro creates spatial depth and volumetric forms through gradations in the intensity of light and shadow.

chiton A thin sleeveless garment, fastened at waist and shoulders, worn by men and women in ancient Greece.

citadel A fortress or defended city, if possible placed in a high, commanding location.

clapboard Horizontal overlapping planks used as protective siding for buildings, particularly houses in North America.

clerestory The topmost zone of a wall with windows in a **basilica** extending above the **aisle** roofs. Provides direct light into the central interior space (the **nave**).

cloisonné An enamel technique in which metal wire or strips are affixed to the surface to form the design. The resulting areas (cloisons) are filled with enamel (colored glass).

cloister An open space, part of a monastery, surrounded by an arcaded or colonnaded walkway, often having a fountain and garden, and dedicated to nonliturgical activities and the secular life of the religious. Members of a cloistered order do not leave the monastery or interact with outsiders.

codex (codices) A book, or a group of **manuscript** pages (folios), held together by stitching or other binding on one side.

coffer A recessed decorative panel that is used to reduce the weight of and to decorate ceilings or **vaults**. The use of coffers is called coffering.

colonnade A row of **columns**, supporting a straight lintel (as in a **porch** or **portico**) or a series of arches (an **arcade**).

colophon The data placed at the end of a book listing the book's author, publisher, illuminator, and other information related to its production. Also, in East Asian handscrolls, the inscriptions which follow the painting are called colophons.

column An architectural element used for support and/or decoration. Consists of a rounded or polygonal vertical **shaft** placed on a **base** and topped by a decorative **capital**. In classical architecture, built in accordance with the rules of one of the architectural **orders**. Columns can be freestanding or attached to a background wall (**engaged**).

complementary color The primary and secondary colors across from each other on the color wheel (red and green, blue and orange, yellow and purple). When juxtaposed, the intensity of both colors increases. When mixed together, they negate each other to make a neutral graybrown.

Composite order See order.

cong A square or octagonal jade tube with a cylindrical hole in the center. A symbol of the earth, it was used for ritual worship and astronomical observations in ancient China.

connoisseurship A term derived from the French word connoisseur, meaning "an expert," and signifying the study and evaluation of art based primarily on formal, visual, and stylistic analysis. A connoisseur studies the style and technique of an object to deduce its relative quality and possible maker. This is done through visual association with other, similar objects and styles. See also **contextualism**; **formalism**.

contextualism An interpretive approach in art history that focuses on the culture surrounding an art object. Unlike **connoisseurship**, contextualism utilizes the literature, history, economics, and social developments (among other things) of a period, as well as the object itself, to explain the meaning of an artwork. See *also* **connoisseurship**.

contrapposto An Italian term mearing "set against," used to describe the twisted pose resulting from parts of the body set in opposition to each other around a central axis.

corbel, corbeling An early roofing and **arching** technique in which each course of stone projects slightly beyond the previous layer (a corbel) until the uppermost corbels meet. Results in a high, almost pointed **arch** or **vault**. A corbel table is a ledge supported by corbels.

corbeled vault See vault.

Corinthian order See order.

cornice The uppermost section of a Classical **entablature**. More generally, a horizontally projecting element found at the top of a building wall or **pedestal**. A raking cornice is formed by the junction of two slanted cornices, most often found in **pediments**.

course A horizontal layer of stone used in building.

crenellation Alternating high and low sections of a wall, giving a notched appearance and creating permanent defensive shields in the walls of fortified buildings.

crockets A stylized leaf used as decoration along the outer angle of spins, pinnacles, gables, and around **capitals** in Gothic architecture.

cuneiform An early form of writing with wedge-shaped marks impressed into wet clay with a stylus, primarily used by ancient Mesopotamians.

curtain wall A wall in a building that does not support any of the weight of the structure. Also: the freestanding outer wall of a castle, usually encircling the inner bailey (yard) and keep (primary defensive tower).

cyclopean construction or **masonry** A method of building using huge blocks of rough-hewn stone. Any large-scale, monumental building project that impresses by sheer size. Named after the Cyclopes (sing. Cyclops) one-eyed giants of legendary strength in Greek myths.

cylinder seal A small cylindrical stone decorated with incised patterns. When rolled across soft clay or wax, the resulting raised pattern or design (relief) served in Mesopotamian and Indus Valley cultures as an identifying signature.

dado (dadoes) The lower part of a wall, differentiated in some way (by a **molding** or different coloring or paneling) from the upper section.

daguerreotype An early photographic process that makes a positive print on a light-sensitized copperplate; invented and marketed in 1839 by Louis-Jacques-Mandé Daguerre.

demotic writing The simplified form of ancient Egyptian hieratic writing, used primarily for administrative and private texts.

dharmachakra Sanskrit for "wheel" (chakra) and "law" or "doctrine" (dharma); often used in Buddhist iconography to signify the "wheel of the law."

diptych Two panels of equal size (usually decorated with paintings or reliefs) hinged together.

dogu Small human figurines made in Japan during the Jomon period. Shaped from clay, the figures have exaggerated expressions and are in contorted poses. They were probably used in religious rituals.

dolmen A prehistoric structure made up of two or more large upright stones supporting a large, flat, horizontal slab or slabs.

dome A round vault, usually over a circular space. Consists of a curved masonry vault of shapes and cross sections that can vary from hemispherical to bulbous to ovoidal. May use a supporting vertical wall (drum), from which the vault springs, and may be crowned by an open space (oculus) and/or an exterior lantern. When a dome is built over a square space, an intermediate element is required to make the transition to a circular drum. There are two types: A dome on pendentives (spherical triangles) incorporates arched, sloping intermediate sections of wall that carry the weight and thrust of the dome to heavily buttressed supporting piers. A dome on squinches uses an arch built into the wall (squinch) in the upper corners of the space to carry the weight of the dome across the corners of the square space below. A half-dome or conch may cover a semicircular space.

domino construction System of building construction introduced by the architect Le Corbusier in which reinforced concrete floor slabs are floated on six freestanding posts placed as if at the positions of the six dots on a domino playing piece.

Doric order See order.

dressed stone See ashlar.

drum The wall that supports a **dome**. Also: a segment of the circular **shaft** of a **column**.

drypoint An **intaglio** printmaking process by which a metal (usually copper) plate is directly inscribed with a pointed instrument (**stylus**). The resulting design of scratched lines is inked, wiped, and printed. Also: the print made by this process.

earthenware A low-fired, opaque ceramic ware that is fired in the range of 800 to 900 degrees Celsius. Earthenware employs humble clays that are naturally heat resistant; the finished wares remain porous after firing unless glazed. Earthenware occurs in a range of earth-toned colors, from white and tan to gray and black, with tan predominating.

echinus A cushionlike circular element found below the abacus of a Doric capital. Also: a similarly shaped molding (usually with egg-and-dart motifs) underneath the volutes of an Ionic capital.

electron spin resonance techniques Method that uses magnetic field and microwave irradiation to date material such as tooth enamel and its surrounding soil.

emblema (emblemata) In a mosaic, the elaborate central motif on a floor, usually a self-contained unit done in a more refined manner, with smaller tesserae of both marble and semiprecious stones.

encaustic A painting technique using pigments mixed with hot wax as a medium.

engaged column A **column** attached to a wall. See also column.

engraving An intaglio printmaking process of inscribing an image, design, or letters onto a metal or wood surface from which a print is made. An engraving is usually drawn with a sharp implement (burin) directly onto the surface of the plate. Also: the print made from this process.

entablature In the Classical orders, the horizontal elements above the columns and capitals. The entablature consists of, from bottom to top, an architrave, a frieze, and a cornice.

entasis A slight swelling of the shaft of a Greek column. The optical illusion of entasis makes the column appear from afar to be straight.

exedra (exedrae) In architecture, a semicircular niche. On a small scale, often used as decoration, whereas larger exedrae can form interior spaces (such as an **apse**).

expressionism, expressionistic Terms describing a work of art in which forms are created primarily to evoke subjective emotions rather than to portray objective reality.

façade The face or front wall of a building. **faience** Type of **ceramic** covered with colorful, opaque glazes that form a smooth, impermeable surface. First developed in ancient Egypt.

fang ding A square or rectangular bronze vessel with four legs. The fang ding was used for ritual offerings in ancient China during the Shang dynasty.

fête galante A subject in painting depicting well-dressed people at leisure in a park or country setting. It is most often associated with eighteenth-century French Rococo painting.

filigree Delicate, lacelike ornamental work.

fillet The flat ridge between the carved out flutes of a **column shaft**. See also **fluting**.

finial A knoblike architectural decoration usually found at the top point of a spire, pinnacle, canopy, or gable. Also found on furniture; also the ornamental top of a staff.

fluting In architecture, evenly spaced, rounded parallel vertical grooves **incised** on **shafts** of **columns** or columnar elements (such as **pilasters**).

foreshortening The illusion created on a flat surface in which figures and objects appear to recede or project sharply into space. Accomplished according to the rules of **perspective**.

formal analysis See formalism.

formalism, formalist An approach to the understanding, appreciation, and valuation of art based almost solely on considerations of form. This approach tends to regard an artwork as independent of its time and place of making. See also **connoisseurship**.

four-iwan mosque See iwan and mosque.

fresco A painting technique in which waterbased pigments are applied to a surface of wet plaster (called **buon fresco**). The color is absorbed by the plaster, becoming a permanent part of the wall. **Fresco secco** is created by painting on dried plaster, and the color may flake off. Murals made by both these techniques are called frescoes.

fresco secco See fresco.

frieze The middle element of an **entablature**, between the **architrave** and the **cornice**. Usually decorated with sculpture, painting, or **moldings**. Also: any continuous flat band with **relief sculpture** or painted decorations.

frottage A design produced by laying a piece of paper over a textured surface and rubbing with charcoal or other soft medium.

fusuma Sliding doors covered with paper, used in traditional Japanese construction. Fusuma are often highly decorated with paintings and colored backgrounds.

galleria See gallery.

gallery In church architecture, the story found above the side **aisles** of a church, usually open to and overlooking the nave. Also: in secular architecture, a long room, usually above the ground floor in a private house or a public building used for entertaining, exhibiting pictures, or promenading. *Also*: a building or hall in which art is displayed or sold. Also: *galleria*.

garbhagriha From the Sanskrit word meaning "womb chamber," a small room or shrine in a Hindu temple containing a holy image.

genre A type or category of artistic form, subject, technique, style, or medium. See also genre painting.

gesso A ground made from glue, gypsum, and/or chalk forming the ground of a wood panel or the priming layer of a canvas. Provides a smooth surface for painting.

gilding The application of paper-thin **gold leaf** or gold pigment to an object made from another medium (for example, a sculpture or painting). Usually used as a decorative finishing detail.

giornata (giornate) Adopted from the Italian term meaning "a day's work," a giornata is the section of a **fresco** plastered and painted in a single day.

glaze See glazing.

glazing An outermost layer of vitreous liquid (**glaze**) that, upon firing, renders **ceramics** waterproof and forms a decorative surface. In painting, a technique particularly used with oil mediums in which a transparent layer of paint (**glaze**) is laid over another, usually lighter, painted or glazed area.

gloss A type of clay **slip** used in **ceramics** by ancient Greeks and Romans that, when fired, imparts a colorful sheen to the surface.

golf foil A thin sheet of gold.

gold leaf Paper-thin sheets of hammered gold that are used in **gilding**. In some cases (such as Byzantine **icons**), also used as a ground for paintings.

gopura The towering gateway to an Indian Hindu temple complex. A temple complex can have several different gopuras.

Grand Manner An elevated style of painting popular in the eighteenth century in which the artist looked to the ancients and to the Renaissance for inspiration; for portraits as well as history painting, the artist would adopt the poses, compositions, and attitudes of Renaissance and antique models.

Grand Tour Popular during the eighteenth and nineteenth centuries, an extended tour of cultural sites in southern Europe intended to finish the education of a young upper-class person from Britain or North America.

grattage A pattern created by scraping off layers of paint from a canvas laid over a textured surface. See also **frottage**.

Greek-cross plan See centrally planned building.

Greek-key pattern A continuous rectangular scroll often used as a decorative border. Also called a **meander pattern**.

grid A system of regularly spaced horizontally and vertically crossed lines that gives regularity to an architectural plan. Also: in painting, a grid enables designs to be enlarged or transferred easily. grisaille A style of monochromatic painting in shades of gray. Also: a painting made in this style. groin vault See vault.

guild An association of craftspeople. The medieval guild had great economic power, as it set standards and controlled the selling and marketing of its members' products, and as it provided economic protection, group solidarity, and training in the craft to its members.

hall church A church with a **nave** and **aisles** of the same height, giving the impression of a large, open hall.

handscroll A long, narrow, horizontal painting or text (or combination thereof) common in Chinese and Japanese art and of a size intended for individual use. A handscroll is stored wrapped tightly around a wooden pin and is unrolled for viewing or reading.

hanging scroll In Chinese and Japanese art, a vertical painting or text mounted within sections of silk. At the top is a semicircular rod; at the bottom is a round dowel. Hanging scrolls are kept rolled and tied except for special occasions, when they are hung for display, contemplation, or commemoration.

haniwa Pottery forms, including cylinders, buildings, and human figures, that were placed on top of Japanese tombs or burial mounds.

hemicycle A semicircular interior space or structure.

henge A circular area enclosed by stones or wood posts set up by Neolithic peoples. It is usually bounded by a ditch and raised embankment.

hieratic In painting and sculpture, a formalized style for representing rulers or sacred or priestly figures.

hieratic scale The use of different sizes for significant or holy figures and those of the everyday world to indicate importance. The larger the figure, the greater the importance.

high relief Relief sculpture in which the image projects strongly from the background. See also **relief sculpture**.

himation In ancient Greece, a long loose outer garment.

historicism The strong consciousness of and attention to the institutions, themes, styles, and forms of the past, made accessible by historical research, textual study, and archaeology.

history painting Paintings based on historical, mythological, or biblical narratives. Once considered the noblest form of art, history paintings generally convey a high moral or intellectual idea and are often painted in a grand pictorial style.

hollow-casting See lost-wax casting. hypostyle hall A large interior room characterized by many closely spaced columns that sup-

port its roof.

icon An image in any material representing a sacred figure or event in the Byzantine, and later in the Orthodox, Church. Icons were venerated by the faithful, who believed them to have miraculous powers to transmit messages to God.

iconoclasm The banning or destruction of images, especially icons and religious art. Iconoclasm in eighth– and ninth–century Byzantium and sixteenth– and seventeenth–century Protestant territories arose from differing beliefs about the power, meaning, function, and purpose of imagery in religion.

iconographic See iconography.

iconography The study of the significance and interpretation of the subject matter of art.

iconostasis The partition screen in a Byzantine or Orthodox church between the **sanctuary** (where the Mass is performed) and the body of the church (where the congregation assembles). The iconostasis displays **icons**.

idealism See idealization.

idealization A process in art through which artists strive to make their forms and figures attain perfection, based on pervading cultural values and/or their own mental image of beauty.

ideograph A written character or symbol representing an idea or object. Many Chinese characters are ideographs.

ignudi Heroic figures of nude young men.
illumination A painting on paper or parchment used as illustration and/or decoration for manuscripts or albums. Usually done in rich colors, often supplemented by gold and other precious materials. The illustrators are referred to as illuminators. Also: the technique of decorating manuscripts with such paintings.

impasto Thick applications of pigment that give a painting a palpable surface texture.

impost, impost block A block, serving to concentrate the weight above, imposed between the **capital** of a **column** and the springing of an arch above

in antis Term used to describe the position of columns set between two walls, as in a **portico** or a **cella**.

incising A technique in which a design or inscription is cut into a hard surface with a sharp instrument. Such a surface is said to be incised.

ink painting A monochromatic style of painting developed in China using black ink with gray washes

inlay To set pieces of a material or materials into a surface to form a design. *Also*: material used in or decoration formed by this technique.

installation art Artworks created for a specific site, especially a gallery or outdoor area, that create a total environment.

intaglio Term used for a technique in which the design is carved out of the surface of an object, such as an engraved seal stone. In the graphic arts, intaglio includes **engraving**, etching, and **drypoint**—all processes in which ink transfersto paper from incised, ink-filled lines cut into a metal plate.

intarsia Decoration formed through wood **inlay**.

intuitive perspective See perspective. Ionic order See order.

iwan A large, **vaulted** chamber in a **mosque** with a monumental arched opening on one side.

jamb In architecture, the vertical element found on both sides of an opening in a wall, and supporting an **arch** or lintel.

japonisme A style in French and American nineteenth-century art that was highly influenced by Japanese art, especially prints.

jasperware A fine-grained, unglazed, white **ceramic** developed by Josiah Wedgwood, often colored by metallic oxides with the raised designs ramaining white.

jataka tales In Buddhism, stories associated with the previous lives of Shakyamuni, the historical Buddha.

joined-wood sculpture A method of constructing large-scale wooden sculpture developed in Japan. The entire work is constructed from smaller hollow blocks, each individually carved, and assembled when complete. The joined-wood technique allowed the production of larger sculpture, as the multiple joints alleviate the problems of drying and cracking found with sculpture carved from a single block.

joggled voussoirs Interlocking voussoirs in an arch or lintel, often of contrasting materials for colorful effect.

kantharos A type of Greek vase or goblet with two large handles and a wide mouth.

key block A key block is the master block in the production of a colored **woodblock print**, which requires different blocks for each color. The key block is a flat piece of wood with the entire design carved or drawn on its surface. From this, other blocks with partial drawings are made for printing the areas of different colors.

keystone The topmost **voussoir** at the center of an **arch**, and the last block to be placed. The pressure of this block holds the arch together. Often of a larger size and/or decorated.

kiln An oven designed to produce enough heat for the baking, or firing, of clay.

kinetic art Artwork that contains parts that can be moved either by hand, air, or motor.

kondo The main hall inside a Japanese Buddhist temple where the images of Buddha are housed.

kore (korai) An Archaic Greek statue of a young woman.

kouros (kouroi) An Archaic Greek statue of a young man or boy.

krater An ancient Greek vessel for mixing wine and water, with many subtypes that each have a distinctive shape. **Calyx krater:** a bell-shaped vessel with handles near the base that resemble a flower calyx. Volute krater: a type of krater with handles shaped like scrolls.

kufic An ornamental, angular Arabic script.kylix A shallow Greek vessel or cup, used for drinking, with a wide mouth and small handles near the rim.

lacquer A type of hard, glossy surface varnish used on objects in East Asian cultures, made from the sap of the Asian sumac or from shellac, a resinous secretion from the lac insect. Lacquer can be layered and manipulated or combined with pigments and other materials for various decorative effects.

lakshana Term used to designate the thirtytwo marks of the historical Buddha. The lakshana include, among others, the Buddha's golden body, his long arms, the wheel impressed on his palms and the soles of his feet, and his elongated earlobes.

lamassu Supernatural guardian-protector of ancient Near Eastern palaces and throne rooms, often represented sculpturally as a combination of the bearded head of a man, powerful body of a lion or bull, wings of an eagle, and the horned headdress of a god, and usually possessing five legs.

lancet A tall narrow window crowned by a sharply pointed **arch**, typically found in Gothic architecture.

lantern A turretlike structure situated on a roof, **vault**, or **dome**, with windows that allow light into the space below.

lekythos (lekythoi) A slim Greek oil vase with one handle and a narrow mouth.

limner An artist, particularly a portrait painter, in England during the sixteenth and seventeenth centuries and in New England during the seventeenth and eighteenth centuries.

lingam shrine A place of worship centered on an object or representation in the form of a phallus (the lingam), which symbolizes the power of the Hindu god Shiva.

literati The English word used for the Chinese wenren or the Japanese bunjin, referring to well-educated artists who enjoyed literature, **calligraphy**, and painting as a pastime. Their painting are termed **literati painting**.

literati painting A style of painting that reflects the taste of the educated class of East Asian intellectuals and scholars. Aspects include an appreciation for the antique, small scale, and an intimate connection between maker and audience.

lithograph See lithography.

lithography Process of making a print (**lithograph**) from a design drawn on a flat stone block with greasy crayon. Ink is applied to the wet stone and adheres only to the greasy areas of the design.

loggia Italian term for a covered open-air. gallery. Often used as a corridor between buildings or around a courtyard, loggias usually have arcades or colonnades.

lost-wax casting A method of casting metal, such as bronze, by a process in which a wax mold is covered with clay and plaster, then fired, melting the wax and leaving a hollow form. Molten metal is then poured into the hollow space and slowly cooled. When the hardened clay and plas-

ter exterior shell is removed, a solid metal form remains to be smoothed and polished.

low relief Relief sculpture whose figures project slightly from the background. See also **relief sculpture**.

lunette A semicircular wall area, framed by an arch over a door or window. Can be either plain or decorated.

lusterware Ceramic pottery decorated with metallic **glazes**.

madrasa An Islamic institution of higher learning, where teaching is focused on theology and law.
 maenad In ancient Greece, a female devotee of the wine god Dionysos who participated in orgiastic rituals. She is often depicted with swirling drapery to indicate wild movement or dance. (Also called a Bacchante, after Bacchus, the Roman name of Dionysos.)

majolica Pottery painted with a tin glaze that, when fired, gives a lustrous and colorful surface.

mandala An image of the cosmos represented by an arrangement of circles or concentric geometric shapes containing diagrams or images. Used for meditation and contemplation by Buddhists

mandapa In a Hindu temple, an open hall dedicated to ritual worship.

mandorla Light encircling, or emanating from, the entire figure of a sacred person.

manuscript A handwritten book or document.

magsura An enclosure in a Muslim mosque,
near the mihrab, designated for dignitaries.

martyrium (martyria) In Christian architecture, a church, chapel, or shrine built over the grave of a martyr or the site of a great miracle.

mastaba A flat-topped, one-story structure with slanted walls over an ancient Egyptian underground tomb.

matte Term describing a smooth surface that is without shine or luster.

mausoleum A monumental building used as a tomb. Named after the tomb of Mausolos erected at Halikarnassos around 350 BCE.

meander See Greek-key pattern.

medallion Any round ornament or decoration. Also: a large medal.

megalith A large stone used in prehistoric building. Megalithic architecture employs such stones.

megaron The main hall of a Mycenaean palace or grand house, having a columnar **porch** and a room with a central fireplace surrounded by four **columns**.

memento mori From Latin for "remember that you must die." An object, such as a skull or extinguished candle, typically found in a **vanitas** image, symbolizing the transience of life.

memory image An image that relies on the generic shapes and relationships that readily spring to mind at the mention of an object.

menorah A Jewish lamp-stand with seven or nine branches; the nine-branched menorah is used during the celebration of Hanukkah.

Representations of the seven-branched menorah, once used in the Temple of Jerusalem, became a symbol of Judaism.

metope The carved or painted rectangular panel between the **triglyphs** of a **Doric frieze**. *mihrab* A recess or niche that distinguishes the wall oriented toward Mecca (*qibla*) in a **mosque**.

minaret A tall slender tower on the exterior of a mosque from which believers are called to prayer.

minbar A high platform or pulpit in a mosque.
 miniature Anything small. In painting, miniatures may be illustrations within albums or manuscripts or intimate portraits.

mirador In Spanish and Islamic palace architecture, a very large window or room with windows, and sometimes balconies, providing views to interior courtyards or the exterior landscape.

mithuna The amorous male and female couples in Buddhist sculpture, usually found at the entrance to a sacred building. The mithuna symbolize the harmony and fertility of life.

moat A large ditch or canal dug around a castle or fortress for military defense. When filled with water, the moat protects the walls of the building from direct attack

mobile A sculpture made with parts suspended in such a way that they move in a current of air.

modeling In painting, the process of creating the illusion of three-dimensionality on a two-dimensional surface by use of light and shade. In

sculpture, the process of molding a three-dimen-

module A segment or portion of a repeated design. Also: a basic building block.

sional form out of a malleable substance.

molding A shaped or sculpted strip with varying contours and patterns. Used as decoration on architecture, furniture, frames, and other objects.

monolith A single stone, often very large.

mortise-and-tenon joint A method of joining two elements. A projecting pin (tenon) on one element fits snugly into a hole designed for it (mortise) on the other. Such joints are very strong and flexible

mosaic Images formed by small colored stone or glass pieces (tesserae), affixed to a hard, stable surface.

mosque An edifice used for communal Muslim worship.

mudra A symbolic hand gesture in Buddhist art that denotes certain behaviors, actions, or feelings.

mullion A slender vertical element or **colon- nette** that divides a window into subsidiary sections

muqarnas Small nichelike components stacked in tiers to fill the transition between differing vertical and horizontal planes.

naos The principal room in a temple or church. In ancient architecture, the **cella**. In a Byzantine church, the **nave** and **sanctuary**.

narthex The vestibule or entrance porch of a church.

naturalism, naturalistic A style of depiction that seeks to imitate the appearance of nature. A naturalistic work appears to record the visible world.

nave The central space of a basilica, two or three stories high and usually flanked by aisles.necking The molding at the top of the shaft of the column.

necropolis A large cemetery or burial area; literally a "city of the dead."

nemes headdress The royal headdress of Egypt. niello A metal technique in which a black sulfur alloy is rubbed into fine lines engraved into a metal (usually gold or silver). When heated, the alloy becomes fused with the surrounding metal and provides contrasting detail.

nishiki-e A multicolored and ornate Japanese print.

nocturne A night scene in painting, usually lit by artificial illumination.

nonrepresentational art An **abstract** art that does not attempt to reproduce the appearance of objects, figures, or scenes in the natural world. Also called nonobjective art.

oculus (oculi) In architecture, a circular opening. Oculi are usually found either as windows or at the apex of a **dome**. When at the top of a dome, an oculus is either open to the sky or covered by a decorative exterior lantern.

ogee An S-shaped curve. See arch.
olpe Any Greek vase or jug without a spout.
one-point perspective See perspective.
opithodomos In greek temples, the entrance porch or room at the back.

oracle A person, usually a priest or priestess, who acts as a conduit for divine information. Also: the information itself or the place at which this information is communicated.

orant The representation of a standing figure praying with outstretched and upraised arms.

orchestra The circular performance area of an ancient Greek theater. In later architecture, the section of seats nearest the stage or the entire main floor of the theater.

order A system of proportions in Classical architecture that includes every aspect of the building's plan, elevation, and decorative system. Composite: a combination of the Ionic and the Corinthian orders. The capital combines acanthus leaves with volute scrolls. Corinthian: the most ornate of the orders, the Corinthian includes a base, a fluted column shaft with a capital elaborately decorated with acanthus leaf carvings. Its entablature consists of an architrave decorated with moldings, a frieze often containing sculptured reliefs, and a cornice with dentils. Doric: the column shaft of the Doric order can be fluted or smooth-surfaced and has no base. The Doric capital consists of an undecorated echinus and abacus. The Doric entablature has a plain architrave, a frieze with metopes and triglyphs, and a simple cornice. Ionic: the column of the Ionic order has a base, a fluted shaft, and a capital decorated with volutes. The Ionic entablature consists of an architrave of three panels and moldings, a frieze usually containing sculpted relief ornament, and a cornice with dentils. Tuscan: a variation of Doric characterized by a smooth-surfaced column shaft with a base, a plain architrave, and an undecorated frieze. A colossal order is any of the above built on a large scale, rising through several stories in height and often raised from the ground by a pedestal. orthogonal Any line running back into the represented space of a picture perpendicular to

orthogonal Any line running back into the represented space of a picture perpendicular to the imagined picture plane. In linear perspective, all orthogonals converge at a single **vanishing point** in the picture and are the basis for a **grid** that maps out the internal space of the image. An orthogonal plan is any plan for a building or city that is based exclusively on right angles, such as the grid plan of many modern cities.

pagoda An East Asian **reliquary** tower built with successively smaller, repeated stories. Each story is usually marked by an elaborate projecting roof.

palace complex A group of buildings used for living and governing by a ruler and his or her supporters, usually fortified.

palmette A fan-shaped ornament with radiating leaves.

parapet A low wall at the edge of a balcony, bridge, roof, or other place from which there is a steep drop, built for safety. A parapet walk is the passageway, usually open, immediately behind the uppermost exterior wall or battlement of a fortified building.

parchment A writing surface made from treated skins of animals. Very fine parchment is known as **vellum**.

parterre An ornamental, highly regimented flowerbed. An element of the ornate gardens of seventeenth–century palaces and châteaux.

pastel Dry pigment, chalk, and gum in stick or crayon form. Also: a work of art made with pastels

pedestal A platform or **base** supporting a sculpture or other monument. Also: the block found below the base of a Classical **column** (or **colonnade**), serving to raise the entire element off the ground.

pediment A triangular gable found over major architectural elements such as Classical Greek porticoes, windows, or doors. Formed by an entablature and the ends of a sloping roof or a raking cornice. A similar architectural element is often used decoratively above a door or window, sometimes with a curved upper molding. A broken pediment is a variation on the traditional pediment, with an open space at the center of the topmost angle and/or the horizontal cornice.

pendentive The concave triangular section of a **vault** that forms the transition between a square or polygonal space and the circular base of a **dome**.

peplos A loose outer garment worn by women of ancient Greece. A cloth rectangle fastened on the shoulders and belted below the bust or at the weight.

peripteral A term used to describe any building (or room) that is surrounded by a single row of columns. When such **columns** are engaged instead of freestanding, called pseudo-peripteral.

peristyle A surrounding **colonnade** in Greek architecture. A peristyle building is surrounded on the exterior by a colonnade. Also: a peristyle court is an open colonnaded courtyard, often having a pool and garden.

perspective A system for representing threedimensional space on a two-dimensional surface. Atmospheric perspective: A method of rendering the effect of spatial distance by subtle variations in color and clarity of representation. Intuitive perspective: A method of giving the impression of recession by visual instinct, not by the use of an overall system or program. Oblique perspective: An intuitive spatial system in which a building or room is placed with one corner in the picture plane, and the other parts of the structure recede to an imaginary vanishing point on its other side. Oblique perspective is not a comprehensive, mathematical system. One-point and multiple-point **perspective** (also called linear, scientific or mathematical perspective): A method of creating the illusion of three-dimensional space on a two-dimensional surface by delineating a horizon line and multiple orthogonal lines. These recede to meet at one or more points on the horizon (called vanishing points), giving the appearance of spatial depth. Called scientific or mathematical because its use requires some

knowledge of geometry and mathematics, as well as optics. **Reverse perspective:** A Byzantine perspective theory in which the orthogonals or rays of sight do not converge on a vanishing point in the picture, but are thought to originate in the viewer's eye in front of the picture. Thus, in reverse perspective the image is constructed with orthogonals that diverge, giving a slightly tipped aspect to objects.

photomontage A photographic work created from many smaller photographs arranged (and often overlapping) in a composition.

picture plane The theoretical spatial plane corresponding with the actual surface of a painting.

picture stone A medieval northern European memorial stone covered with figural decoration. See also **rune stone**.

picturesque A term describing the taste for the familiar, the pleasant, and the pretty, popular in the eighteenth and nineteenth centuries in Europe. When contrasted with the sublime, the picturesque stood for all that was ordinary but pleasant.

piece-mold casting A casting technique in which the mold consists of several sections that are connected during the pouring of molten metal, usually bronze. After the cast form has hardened, the pieces of the mold are disassembled, leaving the completed object.

pier A masonry support made up of many stones, or rubble and concrete (in contrast to a column shaft which is formed from a single stone or a series of drums), often square or rectangular in plan, and capable of carrying very heavy architectural loads.

pietra dura Italian for "hard stone." Semiprecious stones selected for color variation and cut in shapes to form ornamental designs such as flowers or fruit.

pietra serena A gray Tuscan limestone used in Florence.

pilaster An **engaged** columnar element that is rectangular in format and used for decoration in architecture.

pillar In architecture, any large, freestanding vertical element. Usually functions as an important weight-bearing unit in buildings.

plate tracery See tracery.

plinth The slablike **base** or **pedestal** of a **column**, statue, wall, building, or piece of furniture.

pluralism A social structure or goal that allows members of diverse ethnic, racial, or other groups to exist peacefully within the society while continuing to practice the customs of their own divergent cultures. Also: an adjective describing the state of having many valid contemporary styles available at the same time to artists.

podium A raised platform that acts as the foundation for a building, or as a platform for a speaker.

polychrome See polychromy.

polychromy The multicolored painted decoration applied to any part of a building, sculpture, or piece of furniture.

polyptych An altarpiece constructed from multiple panels, sometimes with hinges to allow for movable wings.

porcelain A high-fired, vitrified, translucent, white **ceramic** ware that employs two specific clays—kaolin and petuntse—and that is fired in the range of 1,300 to 1,400 degrees Celsius. The

relatively high proportion of silica in the body clays renders the finished porcelains translucent. Like **stonewares**, porcelains are glazed to enhance their aesthetic appeal and to aid in keeping them clean. By definition, porcelain is white, though it may be covered with a **glaze** of bright color or subtle hue. Chinese potters were the first in the world to produce porcelain, which they were able to make as early as the eighth century.

porch The covered entrance on the exterior of a building. With a row of **columns** or **colon-nade**, also called a **portico**.

portal A grand entrance, door, or gate, usually to an important public building, and often decorated with sculpture.

portico In architecture, a projecting roof or porch supported by columns, often marking an entrance. See also porch.

post-and-lintel construction An architectural system of construction with two or more vertical elements (posts) supporting a horizontal element (lintel).

potassium-argon dating Technique used to measure the decay of a radioactive potassium isotope into a stable isotope of argon, an inert gas.

potsherd A broken piece of ceramic ware.

Praire Style A style of architecture initiated by the American Frank Lloyd Wright (1867-1959), in which he sought to integrate his structures in an "organic" way into the surrounding natural landscape, often having the lines of the building follow the horizontal contours of the land. Since Wright's early buildings were built in the Prairie States of the Midwest, this type of architecture became known as the Prairie Style.

primitivism The borrowing of subjects or forms usually from non-Western or prehistoric sources by Western artists. Originally practiced by Western artists as an attempt to infuse their work with the naturalistic and expressive qualities attributed to other cultures, especially colonized cultures, primitivism also borrowed from the art of children and the insane.

pronaos The enclosed vestibule of a Greek or Roman temple, found in front of the **cella** and marked by a row of **columns** at the entrance.

proscenium The stage of an ancient Greek or Roman theater. In modern theater, the area of the stage in front of the curtain. Also: the framing **arch** that separates a stage from the audience.

psalter In Jewish and Christian scripture, a book containing the psalms, or songs, attributed to King David.

punchwork Decorative designs that are stamped onto a surface, such as metal or leather, using a punch (a handheld metal implement).

putto (putti) A plump, naked little boy, often winged. In classical art, called a cupid; in Christian art, a cherub.

pylon A massive gateway formed by a pair of tapering walls of oblong shape. Erected by ancient Egyptians to mark the entrance to a temple complex.

qibla The mosque wall oriented toward Mecca indicated by the mihrab.

quatrefoil A four-lobed decorative pattern common in Gothic art and architecture.

quincunx A building in which five **domed** bays are arranged within a square, with a central unit and four corner units. (When the central

unit has similar units extending from each side, the form becomes a **Greek cross**.)

quoin A stone, often extra large or decorated for emphasis, forming the corner of two walls. A vertical row of such stones is called quoining.

radiometric dating A method of dating prehistoric works of art made from organic materials, based on the rate of degeneration of radiocarbons in these materials. *See also* relative dating, absolute dating.

raigo A painted image that depicts the Amida Buddha and other Buddhist deities welcoming the soul of a dying worshiper to paradise.

raku A type of ceramic pottery made by hand, coated with a thick, dark glaze, and fired at a low heat. The resulting vessels are irregularly shaped and glazed, and are highly prized for use in the Japanese tea ceremony.

readymade An object from popular or material culture presented without further manipulation as an artwork by the artist.

realism In art, a term first used in Europe around 1850 to designate a kind of **naturalism** with a social or political message, which soon lost its didactic import and became synonymous with naturalism.

red-figure A style and technique of ancient Greek vase painting characterized by red clay-colored figures on a black background. (The figures are reversed against a painted ground and details are drawn, not engraved, as in black-figure style.) See also **black-figure**.

register A device used in systems of spatial definition. In painting, a register indicates the use of differing **groundlines** to differentiate layers of space within an image. In sculpture, the placement of self-contained bands of **reliefs** in a vertical arrangement. In printmaking, the marks at the edges used to align the print correctly on the page, especially in multiple-block color printing.

registration marks In Japanese **woodblock** printing, these were two marks carved on the blocks to indicate proper alignment of the paper during the printing process. In multicolor printing, which used a separate block for each color, these marks were essential for achieving the proper position or registration of the colors.

relief sculpture A three-dimensional image or design whose flat background surface is carved away to a certain depth, setting off the figure. Called high or low (bas) relief depending upon the extent of projection of the image from the background. Called sunken relief when the image is carved below the original surface of the background, which is not cut away.

reliquary A container, often made of precious materials, used as a repository to protect and display sacred relics.

repoussé A technique of hammering metal from the back to create a protruding image. Elaborate reliefs are created with wooden armatures against which the metal sheets are pressed and hammered.

reverse perspective See perspective.

rhyton A vessel in the shape of a figure or an animal, used for drinking or pouring liquids on special occasions.

rib vault See vault.

ridgepole A longitudinal timber at the apex of a roof that supports the upper ends of the rafters.rosette A round or oval ornament resembling a

rotunda Any building (or part thereof) constructed in a circular (or sometimes polygonal) shape, usually producing a large open space crowned by a **dome**.

round arch See arch.

roundel Any element with a circular format, often placed as a decoration on the exterior of architecture.

rune stone A stone used in early medieval northern Europe as a commemorative monument, which is carved or inscribed with runes, a writing system used by early Germanic peoples.

running spirals A decorative motif based on the shape formed by a line making a continuous spiral.

rustication In building, the rough, irregular, and unfinished effect deliberately given to the exterior facing of a stone edifice. Rusticated stones are often large and used for decorative emphasis around doors or windows, or across the entire lower floors of a building. Also, masonry construction with conspicuous, often beveled joints.

salon A large room for entertaining guests; a periodic social or intellectual gathering, often of prominent people; a hall or **gallery** for exhibiting works of art.

sanctuary A sacred or holy enclosure used for worship. In ancient Greece and Rome, consisted of one or more temples and an altar. In Christian architecture, the space around the altar in a church called the chancel or presbytery.

sarcophagus (sarcophagi) A stone coffin. Often rectangular and decorated with **relief sculpture**.

scarab In Egypt, a stylized dung beetle associated with the sun and the god Amun.

school of artists An art historical term describing a group of artists, usually working at the same time and sharing similar styles, influences, and ideals. The artists in a particular school may not necessarily be directly associated with one another, unlike those in a workshop or **atelier**.

scribe A writer; a person who copies texts.

scriptorium (scriptoria) A room in a monastery for writing or copying manuscripts.

scroll painting A painting executed on a rolled support. Rollers at each end permit the horizontal scroll to be unrolled as it is studied or the vertical scroll to be hung for contemplation or decoration.

seals Personal emblems usually carved of stone in intaglio or relief and used to stamp a name or legend onto paper or silk. They traditionally employ the archaic characters appropriately known as "seal script," of the Zhou or Qin. Cut in stone, a seal may state a formal given name, or it may state any of the numerous personal names that China's painters and writers adopted throughout their lives. A treasured work of art often bears not only the seal of its maker but also those of collectors and admirers through the centuries. In the Chinese view, these do not disfigure the work but add another layer of interest.

searification Ornamental decoration applied to the surface of the body by cutting the skin for cultural and/or aesthetic reasons.

seraph (seraphim) An angel of the highest rank in the Christian hierarchy.

serdab In Egyptian tombs, the small room in which the ka statue was placed.

sfumato Italian term meaning "smoky," soft, and mellow. In painting, the effect of haze in an image. Resembling the color of the atmosphere at dusk, sfumato gives a smoky effect.

sgraffito Decoration made by incising or cutting away a surface layer of material to reveal a different color beneath.

shaft The main vertical section of a column between the capital and the base, usually circular in cross section.

shaftgrave A deep pit used for burial.

shikhara In the architecture of northern India, a conical (or pyramidal) spire found atop a Hindu temple and often crowned with an *amalaka*.

shoji A standing Japanese screen covered in translucent rice paper and used in interiors.

sinopia The preparatory design or underdrawing of a **fresco**. Also: a reddish chalklike earth pigment.

site-specific sculpture A sculpture commissioned and/or designed for a particular spot.

slip A mixture of clay and water applied to a **ceramic** object as a final decorative coat. Also: a solution that binds different parts of a vessel together, such as the handle and the main body.

spandrel The area of wall adjoining the exterior curve of an arch between its **springing** and the **keystone**, or the area between two arches, as in an arcade

springing The point at which the curve of an arch or vault meets with and rises from its support.

squinch An **arch** or lintel built across the upper corners of a square space, allowing a circular or polygonal **dome** to be more securely set above the walls.

stained glass Molten glass is given a color that becomes intrinsic to the material. Additional colors may be fused to the surface (flashing). Stained glass is most often used in windows, for which small pieces of differently colored glass are precisely cut and assembled into a design, held together by **cames**. Additional painted details may be added to create images.

stele (stelae) A stone slab placed vertically and decorated with inscriptions or reliefs. Used as a grave marker or memorial.

stereobate A foundation upon which a Classical temple stands.

still life A type of painting that has as its subject inanimate objects (such as food, dishes, fruit, or flowers).

stoa In Greek architecture, a long roofed walkway, usually having columns on one long side and a wall on the other.

stoneware A high-fired, vitrified, but opaque ceramic ware that is fired in the range of 1,100 to 1,200 degrees Celsius. At that temperature, particles of silica in the clay bodies fuse together so that the finished vessels are impervious to liquids, even without glaze. Stoneware pieces are glazed to enhance their aesthetic appeal and to aid in keeping them clean (since unglazed ceramics are easily soiled). Stoneware occurs in a range of earth-toned colors, from white and tan to gray and black, with light gray predominating. Chinese potters were the first in the world to produce stoneware, which they were able to make as early as the Shang dynasty.

stucco A mixture of lime, sand, and other ingredients into a material that can be easily molded or modeled. When dry, produces a very durable surface used for covering walls or for architectural sculpture and decoration.

stupa In Buddhist architecture, a bell-shaped or pyramidal religious monument, made of piled earth or stone, and containing sacred relics.

stylobate In Classical architecture, the stone foundation on which a temple **colonnade** stands.

stylus An instrument with a pointed end (used for writing and printmaking), which makes a delicate line or scratch. Also: a special writing tool for **cuneiform** writing with one pointed end and one triangular wedge end.

sublime Adjective describing a concept, thing, or state of high spiritual, moral, or intellectual value; or something awe-inspiring. The sublime was a goal to which many nineteenth-century artists aspired in their artworks.

sunken relief See relief sculpture.

syncretism In religion or philosophy, the union of different ideas or principles.

taotie A mask with a dragon or animal-like face common as a decorative motif in Chinese art.

tapestry Multicolored pictorial or decorative weaving meant to be hung on a wall or placed on furniture.

tatami Mats of woven straw used in Japanese houses as a floor covering.

tempera A painting medium made by blending egg yolks with water, pigments, and occasionally other materials, such as glue.

tenebrism The use of strong **chiaroscuro** and artificially illuminated areas to create a dramatic contrast of light and dark in a painting.

terra cotta A medium made from clay fired over a low heat and sometimes left unglazed. Also: the orange-brown color typical of this medium.

tessera (tesserae) The small piece of stone, glass, or other object that is pieced together with many others to create a mosaic.

tetrarchy Four-man rule, as in the late Roman Empire, when four emperors shared power.

thatch A roof made of plant materials.

thermo-luminescence dating A technique that measures the irradiation of the crystal structure of material such as flint or pottery and the soil in which it is found, determined by luminescence produced when a sample is heated.

tholos A small, round building. Sometimes built underground, as in a Mycenaean tomb.

thrust The outward pressure caused by the weight of a vault and supported by buttressing. *See* **arch**.

tierceron In **vault** construction, a secondary rib that arcs from a **springing** point to the rib that runs lengthwise through the vault, called the ridge rib.

tokonoma A niche for the display of an art object (such as a screen, scroll, or flower arrangement) in a Japanese hall or tearoom.

tondo A painting or **relief sculpture** of circular shape.

torana In Indian architecture, an ornamented gateway arch in a temple, usually leading to the stupa.

toron In West African **mosque** architecture, the wooden beams that project from the walls. Torons are used as support for the scaffolding erected annually for the replastering of the building.

tracery Stonework or woodwork applied to wall surfaces or filling the open space of windows. In **plate tracery**, opening are cut through the wall. In **bar tracery**, **mullions** divide the space into vertical segments and form decorative patterns at the top of the opening or panel.

transept The arm of a cruciform church, perpendicular to the **nave**. The point where the nave and transept cross is called the crossing. Beyond the crossing lies the **sanctuary**, whether **apse**, choir, or chevet.

travertine A mineral building material similar to limestone, typically found in central Italy.

trefoil An ornamental design made up of three rounded lobes placed adjacent to one another.

triglyph Rectangular block between the **metopes** of a **Doric frieze**. Identified by the three carved vertical grooves, which approximate the appearance of the end of a wooden beam.

triptych An artwork made up of three panels. The panels may be hinged together so the side segments (**wings**) fold over the central area.

trompe Poeil A manner of representation in which the appearance of natural space and objects is re-created with the express intention of fooling the eye of the viewer, who may be convinced that the subject actually exists as three-dimensional reality.

trumeau A column, pier, or post found at the center of a large portal or doorway, supporting the lintel.

tugra A calligraphic imperial monogram used in Ottoman courts.

Tuscan order See order.

twisted perspective A convention in art in which every aspect of a body or object is represented from its most characteristic viewpoint.

ukiya-e A Japanese term for a type of popular art that was favored from the sixteenth century, particularly in the form of color woodblock prints. Ukiyo-e prints often depicted the world of the common people in Japan, such as courtesans and actors, as well as landscapes and myths.

urna In Buddhist art, the curl of hair on the forehead that is a characteristic mark of a buddha. The urna is a symbol of divine wisdom.

ushnisha In Asian art, a bulge on the top of the head which symbolizes the Buddha's enlightenment.

vanishing point In a perspective system, the point on the horizon line at which **orthogonals** meet. A complex system can have multiple vanishing points.

vanitas An image, especially popular in Europe during the seventeenth century, in which all the objects symbolize the transience of life. Vanitas paintings are usually of still lifes or genre subjects.

vault An arched masonry structure that spans an interior space. Barrel or tunnel vault: an elongated or continuous semicircular vault, shaped like a half-cylinder. Corbeled vault: a vault made by projecting courses of stone.

Groin or cross vault: a vault created by the intersection of two barrel vaults of equal size which creates four side compartments of identical size and shape. Quadrant or half-barrel vault: as the name suggests, a half-barrel vault. Rib vault: ribs (extra masonry) demarcate the junctions of a groin vault. Ribs may function to reinforce the groins or may be purely decorative. See also corbeling.

veduta (vedute) Italian for "vista" or "view."

Paintings, drawings, or prints often of expansive city scenes or of harbors.

vellum A fine animal skin prepared for writing and painting. See also parchment.

veneer In architecture, the exterior facing of a building, often in decorative patterns of fine stone or brick. In decorative arts, a thin exterior layer of finer material (such as rare wood, ivory, metal, and semiprecious stones) laid over the form.

verism A style in which artists concern themselves with capturing the exterior likeness of an object or person, usually by rendering its visible details in a finely executed, meticulous manner.

vihara From the Sanskrit term meaning "for wanderers." A vihara is, in general, a Buddhist monastery in India. It also signifies monks' cells and gathering places in such a monastery.

vimana The main element of a Southern Indian Hindu temple, usually in the shape of a pyramidal or tapering tower raised on a plinth.

volute A spiral scroll, as seen on an Ionic capital.votive figure An image created as a devotional offering to a god or other deity.

voussoirs The oblong, wedge-shaped stone blocks used to build an **arch**. The topmost voussoir is called a **keystone**.

warp The vertical threads in a weaver's loom. Warp threads make up a fixed framework that provides the structure for the entire piece of cloth, and are thus often thicker than weft threads. See also weft.

wash A diluted watercolor or ink. Often washes are applied to drawings or prints to add tone or touches of color.

wattle and daub A wall construction method combining upright branches, woven with twigs (wattles) and plastered or filled with clay or mud (daub).

weft The horizontal threads in a woven piece of cloth. Weft threads are woven at right angles to and through the warp threads to make up the bulk of the decorative pattern. In carpets, the weft is often completely covered or formed by the rows of trimmed knots that form the carpet's soft surface. See also warp.

white-ground A type of ancient Greek pottery in which the background color of the object is painted with a slip that turns white in the firing process. Figures and details were added by painting on or incising into this slip. White-ground wares were popular in the Classical period as funerary objects.

wing A side panel of a triptych or polyptych

(usually found in pairs), which was hinged to fold over the central panel. Wings often held the depiction of the donors and/or subsidiary scenes relating to the central image.

woodblock print A print made from one or more carved wooden blocks. In Japan, woodblock prints were made using multiple blocks carved in relief, usually with a block for each color in the finished print. See also woodcut.

woodcut A type of print made by carving a design into a wooden block. The ink is applied to the block with a roller. As the ink remains only on the raised areas between the carvedaway lines, these carved-away areas and lines provide the white areas of the print. Also: the process by which the woodcut is made.

x-ray style In Aboriginal art, a manner of representation in which the artist depicts a figure or animal by illustrating its outline as well as essential internal organs and bones.

yaksha, yakshi The male (yaksha) and female (yakshi) nature spirits that act as agents of the Hindu gods. Their sculpted images are often found on Hindu temples and other sacred places, particularly at the entrances.

ziggurat In Mesopotamia, a tall stepped tower of earthen materials, often supporting a shrine.

BIBLIOGRAPHY

Susan V. Craig

This bibliography is composed of books in English that are appropriate "further reading" titles. Most items on this list are available in good libraries, whether college, university, or public institutions. I have emphasized recently published works so that the research information would be current. There are three classifications of listings: general surveys and art history reference tools, including journals and Internet directories; surveys of large periods that encompass multiple chapters (ancient art in the Western tradition, European medieval art, European Renaissance through eighteenth-century art, modern art in the West, Asian art, and African and Oceanic art and art of the Americas); and books for individual chapters 1 through 32.

General Art History Surveys and Reference Tools

- Adams, Laurie Schneider. Art across Time. 2nd ed. New York: McGraw-Hill, 2002.
- Barnet, Sylvan. A Short Guide to Writing about Art. 8th ed. New York: Pearson/Longman, 2005.
- Boströöm, Antonia. *Encyclopedia of Sculpture*. 3 vols. New York: FitzroyDearborn, 2004.
- Broude, Norma, and Garrard, Mary D., eds. Feminism and Art History: Questioning the Litany. Icon Editions. New York: Harper & Row, 1982.
- Chadwick, Whitney. Women, Art, and Society. 3rd ed. New York: Thames and Hudson, 2002.
- Chilvers, Ian, ed. The Oxford Dictionary of Art. 3rd ed. New York: Oxford Univ. Press, 2004.
- Curl, James Stevens. A Dictionary of Architecture and Landscape Architecture. 2nd ed. Oxford: Oxford Univ. Press, 2006.
- Davies, Penelope J.E., et al. *Janson's History of Art: The Western Tradition*. 7th ed. Upper Saddle River, NJ: Prentice Hall, 2006.
- Dictionary of Art, The. 34 vols. New York: Grove's Dictionaries, 1996.
- Encyclopedia of World Art. 16 vols. New York: McGraw-Hill. 1972–83.
- Frank, Patrick, Duane Preble, and Sarah Preble. *Preble's Artforms.* 8th ed. Upper Saddle River, NJ: Prentice
 Hall, 2006.
- Gardner, Helen. Gardner's Art through the Ages. 12th ed. Ed. Fred S. Kleiner & Christin J. Mamiya. Belmont,
- CA: Thomson/Wadsworth, 2005. Gaze, Delia, ed. *Dictionary of Women Artists*. 2 vols. Lon-

don: Fitzroy Dearborn Publishers, 1997.

- Griffiths, Antony. Prints and Printmaking: An Introduction to the History and Techniques. 2nd ed. London: British Museum Press, 1996.
- Hadden, Peggy. The Quotable Artist. New York: Allworth Press, 2002.
- Hall, James. Illustrated Dictionary of Symbols in Eastern and Western Art. New York: Icon Editions. 1994.
- Holt, Elizabeth Gilmore, ed. A Documentary History of Art. 3 vols. New Haven: Yale Univ. Press, 1986.
- Honour, Hugh, and John Fleming. The Visual Arts: A History. 7th ed. Upper Saddle River, NJ: Prentice Hall, 2005
- Hults, Linda C. The Print in the Western World: An Introductory History. Madison: Univ. of Wisconsin Press, 1996. Johnson, Paul. Art: A New History. New York: Harper-
- Collins, 2003. Kaltenbach. G. E. *Pronunciation Dictionary of Artists' Names.* 3rd ed. Rev. Debra Edelstein. Boston: Little,
- Brown, and Co., 1993. Kemp, Martin. *The Oxford History of Western Art*. Oxford: Oxford Univ. Press, 2000.
- Kostof, Spiro. A History of Architecture: Settings and Rituals. 2nd ed. Rev. Greg Castillo. New York: Oxford Univ. Press. 1995.
- Mackenzie, Lynn. *Non-Western Art: A Brief Guide*. 2nd ed. Upper Saddle River, NJ: Prentice Hall, 2001.
- Marmor, Max, and Alex Ross, eds. Guide to the Literature of Art History 2. Chicago: American Library Association, 2005.
- Onians, John, ed. Atlas of World Art. New York: Oxford Univ. Press, 2004.
- Roberts, Helene, ed. Encyclopedia of Comparative Iconogra-

- phy: Themes Depicted in Works of Art. 2 vols. Chicago: Fitzroy Dearborn, 1998.
- Rogers, Elizabeth Barlow. Landscape Design: A Cultural and Architectural History. New York: Harry N. Abrams, 2001.
- Sayre, Henry M. Writing about Art. 5th ed. Upper Saddle River, NJ: Pearson/Prentice Hall, 2006.
- Sed-Rajna, Gabrielle. *Jewish Art*. Trans. Sara Friedman and Mira Reich. New York: Abrams, 1997.
- Slatkin, Wendy. Women Artists in History: From Antiquity to the Present. 4th ed. Upper Saddle River, NJ: Prentice Hall, 2000.
- Sutton, Ian. Western Architecture: From Ancient Greece to the Present. World of Art. New York: Thames and Hudson, 1999.
- Trachtenberg, Marvin, and Isabelle Hyman. Architecture: From Prehistory to Postmodernity. 2nd ed. Upper Saddle River, NJ: Prentice Hall, 2001.
- Tufts, Eleanor. Our Hidden Heritage: Five Centuries of Women Artists. New York: Paddington Press, 1974.
- West, Shearer. *Portraiture*. Oxford History of Art. Oxford: Oxford Univ. Press, 2004.
- Wilkins, David G., Bernard Schultz, and Katheryn M. Linduff. *Art Past, Art Present*. 5th ed. Upper Saddle River, NJ: Prentice Hall, 2005.
- Watkin, David. A History of Western Architecture. 4th ed. New York: Watson-Guptill Publications, 2005.

Art History Journals: A Select List of Current

- African Arts. Quarterly. Los Angeles: Univ. of California at Los Angeles, James S. Coleman African Studies Center. 1967-
- American Art: The Journal of the Smithsonian American Art Museum. 3/year. Chicago: Univ. of Chicago Press, 1987.
- American Indian Art Magazine, Quarterly. Scottsdale, AZ: American Indian Art Inc, 1975-
- American Journal of Archaeology. Quarterly. Boston: Archaeological Institute of America, 1885-
- Antiquity: A Periodical of Archaeology. Quarterly. Cambridge, UK: Antiquity Publications Ltd, 1927-
- Apollo: The International Magazine of the Arts. Monthly. London: Apollo Magazine Ltd, 1925-
- Architectural History. Annually. Farnham, UK: Society of Architectural Historians of Great Britain, 1958-
- Archives of American Art Journal. Quarterly. Washington, D.C.:Archives of American Art, Smithsonian Institution, 1960-
- Archives of Asian Art. Annually. New York: Asia Society, 1945-
- Ars Orientalis: The Arts of Asia, Southeast Asia, and Islam. Annually. Ann Arbor: Univ. of Michigan Dept. of Art History, 1954-
- Art Bulletin. Quarterly. New York: College Art Association, 1913-
- Art History: Journal of the Association of Art Historians. 5/year. Oxford: Blackwell Publishing Ltd, 1978-
- Art in America. Monthly. New York: Brant Publications Inc, 1913-
- Art Journal. Quarterly. New York: College Art Association, 1960-
- Art Nexus. Quarterly. Bogata, Colombia: Arte en Colombia Ltda, 1976-
- Art Papers Magazine. Bi-monthly. Atlanta: Atlanta Art Papers Inc, 1976-
- Artforum International. 10/year. New York: Artforum International Magazine Inc, 1962-
- Artnews. 11/year. New York: Artnews LLC, 1902– Bulletin of the Metropolitan Museum of Art. Quarterly. New York: Metropolitan Museum of Art, 1905–
- Burlington Magazine. Monthly. London: Burlington Magazine Publications Ltd, 1903-
- Dumbarton Oaks Papers. Annually. Locust Valley, NY: J. J. Augustin Inc, 1940-
- Flash Art International. Bimonthly. Trevi, Italy: Giancarlo Politi Editore, 1980-
- Gesta. Semiannually. New York: International Center of Medieval Art, 1963-
- History of Photography. Quarterly. Abingdon, UK: Taylor & Francis Ltd, 1976-

- International Review of African American Art. Quarterly. Hampton, VA: International Review of African American Art. 1976-
- Journal of Design History. Quarterly. Oxford: Oxford Univ. Press, 1988-
- Journal of Egyptian Archaeology. Annually. London: Egypt Exploration Society, 1914-
- Journal of Hellenic Studies. Annually. London: Society for the Promotion of Hellenic Studies, 1880-
- Journal of Roman Archaeology. Annually. Portsmouth, RI: Journal of Roman Archaeology LLC, 1988-
- Journal of the Society of Architectural Historians. Quarterly. Chicago: Society of Architectural Historians, 1940-
- Journal of the Warburg and Courtaild Institutes. Annually.
 London: Warburg Institute, 1937-
- Leonardo: Art, Science and Technology. 6/year. Cambridge, MA: MIT Press, 1968-
- Marg. Quarterly. Mumbai, India: Scientific Publishers,
- 1946-Master Drawings. Quarterly. New York: Master Drawings
- Association, 1963-October. Cambridge, MA: MIT Press, 1976-
- Oxford Art Journal. 3/year. Oxford: Oxford Univ. Press, 1978–
- Parkett. 3/year. Züürich, Switzerland: Parkett Verlag AG, 1984-
- Print Quarterly. Quarterly. London: Print Quarterly Publications, 1984-
- Simiolus: Netherlands Quarterly for the History of Art. Quarterly. Apeldoorn, Netherlands: Stichting voor Nederlandse Kunsthistorische Publicaties, 1966-
- Woman's Art Journal. Semiannually. Philadelphia: Old City Publishing Inc, 1980-

Internet Directories for Art History Information

ARCHITECTURE AND BUILDING

http://library.nevada.edu/arch/rsrce/webrsrce/contents.html

A directory of architecture websites collected by Jeanne Brown at the Univ. of Nevada at Las Vegas. Topical lists include architecture, building and construction, design, history, housing, planning, preservation, and landscape architecture. Most entries include a brief annotation and the last date the link was accessed by the compiler.

ART HISTORY RESOURCES ON THE WEB http://witcombe.sbc.edu/ARTHLinks.html

Authored by Christopher L. C. E. Witcombe of Sweet Briar College in Virginia since 1995, the site includes an impressive number of links for various art historical eras as well as links to research resources, museums, and galleries. The content is frequently updated.

ART IN FLUX: A DIRECTORY OF RESOURCES FOR RESEARCH IN CONTEMPORARY ART

http://www.boisestate.edu/art/artinflux/intro.html

Cheryl K. Shutleff of Boise State Univ. in Idaho has authored this directory, which includes sites selected according to their relevance to the study of national or international contemporary art and artists. The subsections include artists, museums, theory, reference, and links.

ARTCYCLOPEDIA: THE FINE ARTS SEARCH ENGINE

With over 2,100 art sites and 75,000 links, this is one of the most comprehensive web directories for artists and art topics.

The primary searching is by artist's name but access is also available by artistic movement, nation, timeline and medium.

MOTHER OF ALL ART HISTORY LINKS PAGES http://www.art-design.umich.edu/mother/

Maintained by the Dept. of the History of Art at the Univ. of Michigan, this directory covers art history departments, art museums, fine arts schools and departments as well as links to research resources. Each entry includes annotations.

VOICE OF THE SHUTTLE

http://vos.ucsb.edu

Sponsored by Univ. of California, Santa Barbara, this directory includes over 70 pages of links to humanities

and humanities-related resources on the Internet. The structured guide includes specific sub-sections on architecture, on art (modern & contemporary), and on art history. Links usually include a one sentence explanation and the resource is frequently updated with new information.

YAHOO! ARTS>ART HISTORY

http://dir.yahoo.com/Arts/Art_History/

Another extensive directory of art links organized into subdivisions with one of the most extensive being "Periods and Movements." Links include the name of the site as well as a few words of explanation.

Ancient Art in the Western Tradition, General

- Amiet, Pierre. Art in the Ancient World: A Handbook of Styles and Forms. New York: Rizzoli, 1981.
- Beard, Mary, and John Henderson. Classical Art: From Greece to Rome. Oxford History of Art. Oxford: Oxford Univ. Press, 2001.
- Boardman, John. Oxford History of Classical Art. New York: Oxford Univ. Press, 2001.
- Chitham, Robert. The Classical Orders of Architecture. 2nd ed. Boston: Elsevier/Architectural Press, 2005.
- Ehrich, Robert W., ed. Chronologies in Old World Archaeology. 3rd ed. 2 vols. Chicago: Univ. of Chicago Press, 1992.
- Gerster, Georg. The Past from Above: Aerial Photographs of Archaeological Sites. Ed. Charlotte Trüümpler. Trans.
- Stewart Spencer. Los Angeles: The J. Paul Getty Museum, 2005.
- Groenewegen-Frankfort, H. A., and Bernard Ashmole. Art of the Ancient World: Painting, Pottery, Sculpture, Architecture from Egypt, Mesopotamia, Crete, Greece, and Rome. Library of Art History. Upper Saddle River, NJ: Prentice Hall, 1972.
- Haywood, John. The Penguin Historical Atlas of Ancient Civilizations. New York: Penguin, 2005.
- Lloyd, Seton, and Hans Wolfgang Muller. Ancient Architecture. New York: Rizzoli, 1986.
- Milleker, Elizabeth J., ed. *The Year One: Art of the Ancient World East and West.* New York: Metropolitan Museum of Art, 2000.
- Nagle, D. Brendan. The Ancient World: A Social and Cultural History. 6th ed. Upper Saddle River, NJ: Pearson Prentice Hall, 2006.
- Romer, John, and Elizabeth Romer. The Seven Wonders of the World: A History of the Modern Imagination. New York: Henry Holt. 1995.
- Saggs, H. W. F. Civilization before Greece and Rome. New Haven: Yale Univ. Press, 1989.
- Smith, William Stevenson. Interconnections in the Ancient Near East: A Study of the Relationships between the Arts of Egypt, the Aegean, and Western Asia. New Haven: Yale Univ. Press. 1965.
- Tadgell, Christopher. Imperial Form: From Achaemenid Iran to Augustan Rome. New York: Whitney Library of Design, 1998.
- ———. Origins: Egypt, West Asia and the Aegean. New York: Whitney Library of Design, 1998.
- Trigger, Bruce G. Understanding Early Civilizations: A Comparative Study. New York: Cambridge Univ. Press, 2003.
- Winckelmann, Johann Joachim. History of the Art of Antiquity. Trans. Harry Francis Mallgrave. Texts & Documents. Los Angeles: Getty Research Institute, 2006.
- Woodford, Susan. *The Art of Greece and Rome*. 2nd ed. New York: Cambridge Univ. Press, 2004.

European Medieval Art, General

- Backman, Clifford R. *The Worlds of Medieval Europe*. New York: Oxford Univ. Press, 2003.
- Bennett, Adelaide Louise, et al. Medieval Mastery: Book Illumination from Charlemagne to Charles the Bold: 800-1475. Trans. Lee Preedy and Greta Arblaster-Holmer. Turnhout: Brepols, 2002.
- Benton, Janetta Rebold. Art of the Middle Ages. World of Art. New York: Thames & Hudson, 2002.
- Binski, Paul. *Painters*. Medieval Craftsmen. London: British Museum Press, 1992.
- Brown, Sarah, and David O'Connor. Glass-painters.

 Medieval Craftsmen. London: British Museum Press,
 1992.
- Calkins, Robert C. Medieval Architecture in Western Europe: From A.D. 300 to 1500. 1v. CD-ROM. New York: Oxford Univ. Press, 1998.
- Cherry, John F. Goldsmiths. Medieval Craftsmen. London: British Museum Press, 1992.
- Clark, William W., Medieval Cathedrals. Greenwood

- Guides to Historic Events of the Medieval World. Westport, CT: Greenwood Press, 2006.
- Coldstream, Nicola. Masons and Sculptors. Medieval Craftsmen. London: British Museum Press, 1991.
- . Medieval Architecture. Oxford History of Art. Oxford: Oxford Univ. Press, 2002.
- De Hamel, Christopher. Scribes and Illuminators. Medieval Craftsmen. London: British Museum Press, 1992.
- Duby, Georges. Art and Society in the Middle Ages. Trans.

 Jean Birrell. Malden, MA: Blackwell Publishers, 2000.

 ——. Sculpture: The Great Art of the Middle Ages from the

 Fifth to the Fifteenth Century. New York: Skira/Rizzoli,
- Eames, Elizabeth S. *English Tilers*. Medieval Craftsmen. London: British Museum Press, 1992.
- Fossier, Robert, ed. *The Cambridge Illustrated History of the Middle Ages*. Trans. Janet Sondheimer & Sarah Hanbury Tenison. 3 vols. Cambridge, U.K.: Cambridge Univ. Press, 1986–97.
- Hurlimann, Martin, and Jean Bony. French Cathedrals. Rev. & enlg. London: Thames and Hudson, 1967.
- Jotischky, Andrew, and Caroline Susan Hull. The Penguin Historical Atlas of the Medieval World. New York: Penguin, 2005.
- Kenyon, John. Medieval Fortifications. Leicester: Leicester Univ. Press, 1990.
- Labarge, Margaret Wade. A Small Sound of the Trumpet: Women in Medieval Life. London: Hamilton, 1990.
- Pfaffenbichler, Matthias. *Armourers*. Medieval Craftsmen. London: British Museum Press, 1992.
- Rebold Benton, Janetta. Art of the Middle Ages. World of Art. New York: Thames & Hudson, 2002.
- Sekules, Veronica. Medieval Art. Oxford History of Art. New York: Oxford Univ. Press, 2001.
- Snyder, James, Henry Luttikhuizen, and Dorothy Verkerk. Art of the Middle Ages. 2nd ed. Upper Saddle River, NJ: Prentice Hall, 2006.
- Staniland, Kay. Embroiderers. Medieval Craftsmen. London: British Museum Press, 1991.
- Stokstad, Marilyn. Medieval Art. 2nd ed. New York: Westview, 2004.
- —. Medieval Castles. Greenwood Guides to Historic Events of the Medieval World. Westport, CT: Greenwood Press, 2005.
- Wixom, William D., ed. Mirror of the Medieval World. New York: Metropolitan Museum of Art, 1999.

European Renaissance through Eighteenth-Century Art, General

- Black, C. F., et al. Cultural Atlas of the Renaissance. New York: Prentice Hall General Reference, 1993.
- Blunt, Anthony. Art and Architecture in France, 1500–1700. 5th ed. Rev. Richard Beresford. Pelican History of Art. New Haven: Yale Univ. Press, 1999.
- Brown, Jonathan. Painting in Spain: 1500–1700. Pelican History of Art. New Haven: Yale Univ. Press, 1998.
- Cole, Bruce. Italian Art, 1250–1550: The Relation of Renaissance Art to Life and Society. New York: Harper & Row, 1987.
- Graham-Dixon, Andrew. Renaissance. Berkeley: Univ. of California Press, 1999.
- Harbison, Craig. The Mirror of the Artist: Northern Renaissance Art in Its Historical Context. Perspectives. New York: Abrams. 1995.
- Harris, Ann Sutherland. Seventeenth-Century Art & Architecture. Upper Saddle River, NJ: Pearson Prentice Hall, 2005
- Harrison, Charles, Paul Wood, and Jason Gaiger. Aπ in Theory 1648–1815: An Anthology of Changing Ideas. Oxford: Blackwell, 2000.
- Hartt, Frederick, and David G. Wilkins. History of Italian Renaissance Art: Painting, Sculpture, Architecture. 6th ed. Unper Saddle River, NI: Prentice, Hall. 2007.
- Upper Saddle River, NJ: Prentice Hall, 2007. Jestaz, Bertrand. *The Art of the Renaissance*. Trans. I. Mark Paris. New York: Abrams, 1995.
- Levenson, Jay A., ed. Circa 1492: Art in the Age of Exploration. Washington: National Gallery of Art, 1991.
- McCorquodale, Charles. The Renaissance: European Painting, 1400–1600. London: Studio Editions, 1994.
- Minor, Vernon Hyde. Baroque & Rococo: Art & Culture. New York: Abrams, 1999.
- Murray, Peter. Renaissance Architecture. History of World Architecture. Milan: Electa, 1985.
- Paoletti, John T., and Gary M. Radke. Art in Renaissance Italy. 3rd ed. Upper Saddle River, NJ: Prentice Hall, 2006.
- Ripa, Cesare. Baroque and Rococo Pictorial Imagery: The 1758-60 Hertel Edition of Ripa's 'Iconologia.' Introd., transl., & commentaries Edward A. Maser. The Dover

- Pictorial Archives Series. New York: Dover Publications, 1991
- Smith, Jeffrey Chipps. The Northern Renaissance. Art & Ideas. New York: Phaidon Press, 2004.
- Stechow, Wolfgang. Northern Renaissance, 1400–1600: Sources and Documents. Upper Saddle River, NJ: Prentice Hall. 1966.
- Summerson, John. Architecture in Britain, 1530–1830. 9th ed. Yale Univ. Press Pelican History of Art. New Haven: Yale Univ. Press. 1993.
- Waterhouse, Ellis K. Painting in Britain, 1530 to 1790. 5th ed. Yale Univ. Press Pelican History of Art. New Haven: Yale Univ. Press. 1994.
- Whinney, Margaret Dickens. Sculpture in Britain: 1530–1830. 2nd ed. Rev. John Physick. Pelican History of Art. London: Penguin, 1988.

Modern Art in the West, General

- Arnason, H. Harvard. History of Modern Art: Painting, Sculpture, Architecture, Photography. 5th ed. Rev. Peter Kalb. Upper Saddle River, NJ: Prentice Hall, 2004.
- Ballantyne, Andrew, ed. Architectures: Modernism and After. New Interventions in Art History, 3. Malden, MA: Blackwell, 2004.
- Barnitz, Jacqueline. Twentieth- Century Art of Latin America. Austin: Univ. of Texas Press, 2001.
- Bjelajac, David. American Art: A Cultural History. Rev. & exp. ed. Upper Saddle River, NJ: Prentice Hall, 2005.
- Bowness, Alan. *Modern European Art*. World of Art. New York: Thames and Hudson, 1995.
- Brettell, Richard R. Modern Art, 1851–1929: Capitalism and Representation. Oxford History of Art. Oxford: Oxford Univ. Press, 1999.
- Chipp, Herschel Browning. Theories of Modern Art: A Source Book by Artists and Critics. California Studies in the History of Art. Berkeley: Univ. of California Press, 1984.
- Clarke, Graham. *The Photograph*. Oxford History of Art. Oxford: Oxford Univ. Press, 1997.
- Craven, David. Art and Revolution in Latin America, 1910-1990. New Haven: Yale Univ. Press, 2002.
- Craven, Wayne. American Art: History and Culture. Rev. ed. Boston: McGraw-Hill, 2003.
- Doordan, Dennis P. Twentieth-Century Architecture. New York: Abrams, 2002.
- Doss, Erika. Twentieth-Century American Art. Oxford: Oxford Univ. Press, 2002.
- Edwards, Steve, and Paul Wood, eds. Art of the Avant-Gardes. Art of the 20th Century. New Haven: Yale Univ. Press in assoc. with the Open Univ., 2004.
- Foster, Hal, et al. Art Since 1900: Modernism, Antimodernism, Postmodernism. New York: Thames & Hudson, 2004.
- Gaiger, Jason, ed. Frameworks for Modern Art. Art of the 20th Century. New Haven: Yale Univ. Press in assocwith the Open Univ., 2003.
- ——, and Paul Wood, eds. Art of the Twentieth Century: A Reader. New Haven: Yale Univ. Press, 2003
- Hamilton, George Heard. Painting and Sculpture in Europe, 1880–1940. 6th ed. Pelican History of Art. New Haven: Yale Univ. Press, 1993.
- Hammacher, A. M. Modern Sculpture: Tradition and Innovation. Enlg. ed. New York: Abrams, 1988.
- Harrison, Charles, and Paul Wood, eds. Art in Theory: 1900–2000: An Anthology of Changing Ideas. 2nd ed. Oxford: Blackwell, 2002.
- Hunter, Sam, John Jacobus, and Daniel Wheeler. Modern
 Art: Painting, Sculpture, Architecture, Photography. 3rd rev.
 & exp. ed. Upper Saddle River, NJ: Prentice Hall,
 2004.
- Krauss, Rosalinde. *Passages in Modern Sculpture*. Cambridge, MA: MIT Press, 1977.
- Mancini, JoAnne Marie. Pre-Modernism: Art-World Change and American Culture from the Civil War to the Armory Show, Princeton: Princeton Univ. Press, 2005.
- Marien, Mary Warner. Photography: A Cultural History. New York: Harry N. Abrams, 2002.
- Meecham, Pam, and Julie Sheldon. Modern Art: A Critical Introduction. 2nd ed. New York: Routledge, 2005.
- Newlands, Anne. Canadian Art: From Its Beginnings to 2000. Willowdale, Ont.: Firefly Books, 2000.
- Harris, Ann Sutherland, and Linda Nochlin. Women Artists: 1550–1950. Los Angeles: Los Angeles County Museum of Art, 1976.
- The Phaidon Atlas of Contemporary World Architecture. London: Phaidon, 2004.
- Powell, Richard J. Black Art: A Cultural History. 2nd ed. World of Art. New York: Thames and Hudson, 2002.
- Rosenblum, Naomi. A World History of Photography. 3rd ed. New York: Abbeville, 1997.

- Ruhrberg, Karl. Art of the 20th Century. Ed. Ingo F. Walther. 2 vols. New York: Taschen, 1998
- Scully, Vincent Joseph. Modern Architecture and Other Essays. Princeton: Princeton Univ. Press, 2003
- Stiles, Kristine, and Peter Howard Selz. Theories and Documents of Contemporary Art: A Sourcebook of Artists' Writings. California Studies in the History of Art, 35. Berkeley: Univ. of California Press, 1996.
- Tafuri, Manfredo. Modern Architecture. History of World Architecture. 2 vols. New York: Electa/Rizzoli, 1986
- Traba, Marta. Art of Latin America, 1900-1980. Washington, D.C.: Inter-American Development Bank, 1994. Upton, Dell. Architecture in the United States. Oxford His-
- tory of Art. Oxford: Oxford Univ. Press, 1998.
 Wood, Paul, ed. Varieties of Modernism. Art of the 20th
- Century. New Haven: Yale Univ. Press in assoc. with the Open Univ., 2004.
- Woodham, Jonathan M. Twentieth Century Design. Oxford History of Art. Oxford: Oxford Univ. Press, 1997.

Asian Art, General

- Addiss, Stephen, Gerald Groemer, and J. Thomas Rimer, eds. *Traditional Japanese Arts and Culture: An Illustrated Sourcebook.* Honolulu: Univ. of Hawai'i Press, 2006.
- Barnhart, Richard M. Three *Thousand Years of Chinese Painting*. New Haven: Yale Univ. Press, 1997.
- Blunden, Caroline, and Mark Elvin. Cultural Atlas of China. 2nd ed. New York: Checkmark Books, 1998.
- Brown, Kerry, ed. Sikh Art and Literature. New York: Routledge in collaboration with the Sikh Foundation, 1999.
- Bussagli, Mario. Oriental Architecture. History of World Architecture. 2 vols. New York: Electa/Rizzoli, 1989.
- Chang, Leon Long-Yien, and Peter Miller. Four Thousand Years of Chinese Calligraphy. Chicago: Univ. of Chicago Press, 1990.
- Chung, Yang-mo. Arts of Korea. Ed. Judith G. Smith. New York: Metropolitan Museum of Art. 1998.
- Clark, John. Modern Asian Art. Honolulu: Univ. of Hawaii Press, 1998.
- Clunas, Craig. Art in China. Oxford History of Art. Oxford: Oxford Univ. Press, 1997.
- Collcutt, Martin, Marius Jansen, and Isao Kumakura. Cultural Atlas of Japan. New York: Facts on File, 1988.
- Craven, Roy C. Indian Art: A Concise History. Rev. ed.
 World of Art. New York: Thames and Hudson, 1997.
- Dehejia, Vidya. *Indian Art*. Art & Ideas. London: Phaidon Press, 1997.
- Fisher, Robert E. Buddhist Art and Architecture. World of Art. New York: Thames and Hudson, 1993.
- Fu, Xinian. Chinese Architecture. Ed. & exp. Nancy S. Steinhardt. The Culture & Civilization of China. New Haven: Yale Univ. Press, 2002.
- Hearn, Maxwell K., and Judith G. Smith, eds. Arts of the Sung and Yüüan: Papers Prepared for an International Symposium. New York: Dept. of Asian Art, Metropolitan Museum of Art, 1996.
- Heibonsha Survey of Japanese Art. 31 vols. New York: Weatherhill, 1972–80.
- Hertz, Betti-Sue. Past in Reverse: Contemporary Art of East Asia. San Diego: San Diego Museum of Art, 2004.
- Japanese Arts Library. 15 vols. New York: Kodansha International, 1977–87.
- Kerlogue, Fiona. Arts of Southeast Asia. World of Art. New York: Thames & Hudson, 2004.
- Khanna, Balraj, and George Michell. Human and Divine: 2000 Years of Indian Sculpture. London: Hayward Gallery Pub., 2000.
- Lee, Sherman E. A History of Far Eastern Art. 5th ed. Ed. Naomi Noble Richards. New York: Abrams, 1994.
- China, 5000 Years: Innovation and Transformation in the Arts. New York: Solomon R. Guggenheim Museum, 1998.
- Liu, Cary Y., and Dora C.Y. Ching, eds. Arts of the Sung and Yüüan: Ritual, Ethnicity, and Style in Painting. Princeton: Art Museum, Princeton Univ., 1999.
- McArthur, Meher. The Arts of Asia: Materials, Techniques, Styles. New York: Thames & Hudson, 2005.
- —. Reading Buddhist Art: An Illustrated Guide to Buddhist Signs and Symbols. New York: Thames & Hudson, 2002.
- Mason, Penelope. *History of Japanese Art.* 2nd ed. Upper Saddle River, NJ: Pearson Prentice Hall, 2005.
- Michell, George. *Hindu Art and Architecture*. World of Art. London: Thames & Hudson, 2000.
- The Penguin Guide to the Monuments of India. 2 vols. New York: Viking, 1989.
- Mitter, Partha. *Indian Art*. Oxford History of Art. Oxford: Oxford Univ. Press, 2001.

- Nickel, Lukas, ed. Return of the Buddha: The Qingzhou Discoveries. London: Royal Academy of Arts, 2002.
- Pak, Youngsook, and Roderick Whitfield. Buddhist Sculpture. Handbook of Korean Art. London: Laurence King. 2003.
- Stanley-Baker, Joan. *Japanese Art.* Rev. & exp. ed. World of Art. New York: Thames and Hudson, 2000.
- Sullivan, Michael. *The Arts of China*. 4th ed., Exp. & rev. Berkeley: Univ. of California Press, 1999.
- Thorp, Robert L., and Richard Ellis Vinograd. Chinese Art & Culture. New York: Abrams, 2001.
- Topsfield, Andrew, ed. In the Realm of Gods and Kings: Arts of India. London: Philip Wilson, 2004.
- Tucker, Jonathan. The Silk Road: Art and History. Chicago: Art Media Resources, 2003.
- Tregear, Mary. Chinese Art. Rev. ed. World of Art. New York: Thames and Hudson, 1997.
- Vainker S.J. Chinese Pottery and Porcelain: From Prehistory to the Present. London: British Museum, 1991.
- Varley, H. Paul *Japanese Culture*. 4th ed., Updated & exp Honolulu: Univ. of Hawaii Press, 2000.

African and Oceanic Art and Art of the Americas, General

- Anderson, Richard L., and Karen L Field, eds. Art in Small-Scale Societies: Contemporary Readings. Englewood Cliffs, NJ: Prentice-Hall, 1993.
- Bacquart, Jean-Baptiste. *The Tribal Arts of Africa*. New York: Thames and Hudson, 1998.
- Bassani, Ezio, ed. Arts of Africa: 7000 Years of African Art. Milan: Skira, 2005.
- Benson, Elizabeth P. Retratos: 2,000 Years of Latin American Portraits. San Antonio: San Antonio Museum of Art, 2004
- Berlo, Janet Catherine, and Lee Ann Wilson. Arts of Africa, Oceania, and the Americas: Selected Readings. Upper Saddle River, NJ: Prentice Hall, 1993.
- Calloway, Colin G.. First Peoples: A Documentary Survey of American Indian History. Boston and New York: Bedford/St. Martin's, 2004.
- Coote, Jeremy, and Anthony Shelton, eds. Anthropology, Art, and Aesthetics. New York: Oxford Univ. Press, 1992.
- D'Azevedao, Warren L. The Traditional Artist in African Societies. Bloomington: Indiana Univ. Press, 1989.
- Drewal, Henry, and John Pemberton III. Yoruba: Nine Centuries of African Art and Thought. New York: Center for African Art, 1989.
- Evans, Susan Toby. Ancient Mexico & Central America: Archaeology and Culture History. New York: Thames & Hudson, 2004.
- ——, and David L. Webster, eds. Archaeology of Ancient Mexico and Central America: An Encyclopedia. New York: Garland Pub., 2001.
- ——, and Joanne Pillsbury, eds. Palaces of the Ancient New World: A Symposium at Dumbarton Oaks, 10th and 11th October, 1998. Washington, D.C.: Dumbarton Oaks Research Library and Collection, 2004.
- Geoffroy-Schneiter, Bééréénice. Tribal Arts. New York: Vendome Press, 2000.
- Guidoni, Enrico. Primitive Architecture. Trans. Robert Eric Wolf. History of World Architecture. New York: Rizzoli. 1987.
- Hiller, Susan, ed. & comp. The Myth of Primitivism:

 Perspectives on Art. London: Routledge, 1991.
- Mack, John, ed. Africa, Arts and Cultures. London: British Museum. 2000.
- Mexico: Splendors of Thirty Centuries. New York: Metropolitan Museum of Art, 1990.
- politan Museum of Art, 1990. Murray, Jocelyn, ed. *Cultural Atlas of Africa*. Rev. ed. New
- York: Facts on File, 1998. Nunley, John W., and Cara McCarty. *Masks: Faces of Culture*. New York: Abrams in assoc. with the Saint Louis
- Art Museum, 1999.
 Perani, Judith, and Fred T. Smith. The Visual Arts of Africa:
 Gender, Power, and Life Cycle Rituals. Upper Saddle.
- Gender, Power, and Life Cycle Rituals. Upper Saddle River, NJ: Prentice Hall, 1998.
- Phillips, Tom. Africa: The Art of a Continent. London: Prestel, 1996.Price, Sally. Primitive Art in Civilized Places. Chicago:
- Univ. of Chicago Press, 1989. Rabineau, Phyllis. Feather Arts: Beauty, Wealth, and Spiri
- Rabineau, Phyllis. Feather Arts: Beauty, Wealth, and Spirit from Five Continents. Chicago: Field Museum of Natural History, 1979.
- Schuster, Carl, and Edmund Carpenter. Patterns that Connect: Social Symbolism in Ancient & Tribal Art. New York: Abrams, 1996.
- Scott, John F. Latin American Art: Ancient to Modern. Gainesville: Univ. Press of Florida, 1999.

- Stepan, Peter. Africa. Trans. John Gabriel & Elizabeth Schwaiger. World of Art. London: Prestel, 2001.
- Visonàà, Monica Blackmun, et al. A History of Art in Africa. Upper Saddle River, NJ: Prentice Hall, 2000.

CHAPTER 1 Prehistoric Art in Europe

- Aujoulat, Norbert. Lascaux: Movement, Space, and Time. New York: H. N. Abrams, 2005.
- Bahn Paul G. The Cambridge Illustrated History of Prehistoric Art. Cambridge Illustrated History. Cambridge, U.K.: Cambridge Univ. Press, 1998.
- Bataille, Georges. The Cradle of Humanity: Prehistoric Art and Culture. Ed. and intro. Stuart Kendall. Trans. Michelle Kendall & Stuart Kendall. New York: Zone Books. 2005.
- Berghaus, Gunter. New Perspectives on Prehistoric Art. Westport, CT: Praeger, 2004
- Chippindale, Christopher. Stonehenge Complete. 3rd ed. New York: Thames and Hudson, 2004.
- Clottes, Jean. Chauvet Cave: The Art of Earliest Times. Salt Lake City: Univ. of Utah Press, 2003.
- World Rock Art. Trans. Guy Bennett. Los Angeles: Getty Conservation Institute, 2002.
- , and J. David Lewis-Williams. The Shamans of Prehistory: Trance and Magic in the Painted Caves. Trans. Sophie Hawkes. New York: Harry N. Abrams, 1998.
- Cunliffe, Barry W, ed. The Oxford Illustrated History of Prehistoric Europe. New York: Oxford Univ. Press, 2001.
- Forte, Maurizio, and Alberto Siliotti. Virtual Archaeology: Re-Creating Ancient Worlds. New York: Abrams, 1997. Freeman, Leslie G. Altamira Revisited and Other Essays on
- Freeman, Leshe G. Altamira Revisited and Other Essays on Early Art. Chicago: Institute for Prehistoric Investigation, 1987.
- Gowlett, John A. J. Ascent to Civilization: The Archaeology of Early Humans. 2nd ed. New York: McGraw-Hill, 1993.
- Guthrie, R. Dale. *The Nature of Paleolithic Art.* Chicago: Univ. of Chicago Press, 2005.
- Jope, E. M. Early Celtic art in the British Isles. 2 vols. New York: Oxford Univ. Press, 2000.
- Leakey, Richard E. and Roger Lewin. Origins Reconsidered: In Search of What Makes Us Human. New York: Doubleday, 1992.
- Leroi-Gourhan, Andréé. The Dawn of European Art: An Introduction to Paleolithic Cave Painting. Trans. Sara Champion. Cambridge, U.K.: Cambridge Univ. Press, 1982.
- Lewis-Williams, J. David. *The Mind in the Cave: Consciousness and the Origins of Art.* New York: Thames & Hudson. 2002.
- Marshack, Alexander. The Roots of Civilization: The Cognitive Beginnings of Man's First Art, Symbol, and Notation. New York: McGraw-Hill, 1972.
- Megaw, Ruth, and Vincent Megaw. Celtic Art: From Its Beginnings to the Book of Kells. Rev. and exp. ed. New York: Thames and Hudson, 2001.
- O'Kelly, Michael J. Newgrange: Archaeology, Art, and Legend. New Aspects of Antiquity. London: Thames and Hudson, 1982.
- Price, T. Douglas, and Gray M. Feinman. *Images of the Past*. 3rd ed. Mountain View, CA: Mayfield, 2000.
- Renfrew, Colin, ed. *The Megalithic Monuments of Western Europe*. London: Thames and Hudson, 1983.
- Ruspoli, Mario. The Cave of Lascaux: The Final Photographs. New York: Abrams, 1987.
- Sandars, N. K. Prehistoric Art in Europe. 2nd ed. Pelican
 History of Art. New Haven: Yale Univ. Press, 1992.
 Sura Ramos, Pedro A. The Cave of Altamira. Gen. Ed.
- Antonio Beltran. New York: Abrams, 1999. Sieveking, Ann. *The Cave Artists*. Ancient People and
- Places, vol. 93. London: Thames and Hudson, 1979. White, Randall. Prehistoric Art: The Symbolic Journey of Humankind. New York: Harry N. Abrams, 2003.

CHAPTER 2 Art of the Ancient Near East

- Akurgal, Ekrem. Ancient Civilizations and Ruins of Turkey: From Prehistoric Times until the End of the Roman Empire. 5th ed. London: Kegan Paul, 2002.
- Aruz, Joan, ed. Art of the First Cities: The Third Millennium B.C. from the Mediterranean to the Indus. New York: Metropolitan Museum of Art, 2003.
- Bahrani, Zainab. The Graven Image: Representation in Babylonia and Assyria. Archaeology, Culture, and Society Series. Philadelphia: Univ. of Pennsylvania Press, 2003.
- Boardman, John. Persia and the West: An Archaeological Investigation of the Genesis of Achaemenid Art. New York: Thames & Hudson, 2000.

- Bottero, Jean. Everyday Life in Ancient Mesopotamia. Trans. Antonia Nevill. Baltimore, MD.: Johns Hopkins Univ. Press. 2001.
- Charvat, Petr. Mesopotamia before History. Rev. & updated ed. New York: Routledge, 2002.
- Collon, Dominque. Ancient Near Eastern Art. Berkeley: Univ. of California Press, 1995.
- Crawford, Harriet. Sumer and the Sumerians. 2nd ed. New York: Cambridge Univ. Press, 2004.
- Curtis, J.E., and J. E. Reade, eds. Art and Empire: Treasures from Assyria in the British Museum. New York: Metropolitan Museum of Art, 1995.
- Curtis, John, and Nigel Tallis, eds. Forgotten Empire: The World of Ancient Persia. Berkeley: Univ. of California Press, 2005.
- Downey, Susan B. Mesopotamian Religious Architecture: Alexander through the Parthians. Princeton: Princeton Univ. Press, 1988.Ferrier, R. W., ed. Arts of Persia. New Haven: Yale Univ. Press, 1989.
- Frankfort, Henri. The Art and Architecture of the Ancient Orient. 5th ed. Pelican History of Art. New Haven: Yale Univ. Press, 1996.
- Haywood, John. Ancient Civilizations of the Near East and Mediterranean. London: Cassell, 1997.
- Lloyd, Seton. Ancient Turkey: A Traveller's History of Anatolia. Berkeley: Univ. of California Press, 1989.
- Meyers, Eric M., ed. The Oxford Encyclopedia of Archaeology in the Near East. 5 vols. New York: Oxford Univ. Press, 1997.
- Moorey, P. R. S. *Idols of the People: Miniature Images of Clay in the Ancient Near East.* The Schweich Lectures of the British Academy; 2001. New York: Oxford Univ. Press, 2003.
- Polk, Milbry, and Angela M. H. Schuster. The Looting of the Iraq Museum, Baghdad: The Lost Legacy of Ancient Mesopotamia. New York: Harry N. Abrams, 2005.
- Reade, Julian. Assyrian Sculpture. Cambridge, MA: Harvard Univ. Press, 1999.
- Roaf, Michael. Cultural Atlas of Mesopotamia and the Ancient Near East. New York: Facts on File, 1990.
- Roux, Georges. Ancient Iraq. 3rd ed. London: Penguin, 1992.
- Zettler, Richard L., and Lee Horne, ed. *Treasures from the Royal Tombs of Ur.* Philadelphia: Univ. of Pennsylvania, Museum of Archaeology and Anthropology, 1998.

CHAPTER 3 Art of Ancient Egypt

- Arnold, Dieter. Temples of the Last Pharaohs. New York: Oxford Univ. Press, 1999.
- Arnold, Dorothea. When the Pyramids Were Built: Egyptian Art of the Old Kingdom. New York: Metropolitan Museum of Art, 1999.
- Baines, John, and Jaromíír Máálek. Cultural Atlas of Ancient Egypt. Rev. ed. New York: Facts on File, 2000. Brier, Bob. Egyptian Munnnies: Unraveling the Secrets of an
- Ancient Art. New York: Morrow, 1994. Casson, Lionel. Everyday Life in Ancient Egypt. Rev. &
- exp. ed. Baltimore, Md.: Johns Hopkins Univ. Press, 2001.
- Egyptian Art in the Age of the Pyramids. New York: Metropolitan Museum of Art, 1999.
- The Egyptian Book of the Dead: The Book of Going Forth by Day: Being the Papyrus of Ani (Royal Scribe of the Divine Offerings). Trans. Raymond O. Faulkner. 2nd rev. ed. San Francisco: Chronicle, 1998.
- Freed, Rita E. Sue D'Auria, and Yvonne J Markowitz.

 Pharaohs of the Sun: Akhenaten, Nefertiti, Tutankhamen.

 Boston: Museum of Fine Arts in assoc. with Bulfinch
 Press/Little, Brown and Co., 1999.
- Hawass, Zahi A. Tutankhamun and the Golden Age of the Pharaohs. Washington, D.C.: National Geographic, 2005.
- Johnson, Paul. The Civilization of Ancient Egypt. Updated ed. New York: HarperCollins, 1999.
- Kozloff, Arielle P., and Betsy M. Bryan. Egypt's Dazzling Sun: Amenhotep III and His World. Cleveland: Cleveland Museum of Art, 1992.
- Lehner, Mark. The Complete Pyramids: Solving the Ancient Mysteries. New York: Thames and Hudson, 1997.
- Máálek, Jaromir. *Egypt: 4000 Years of Art.* London: Phaidon, 2003.
- Pemberton, Delia. Ancient Egypt. Architectural Guides for Travelers. San Francisco: Chronicle, 1992.
- Robins, Gay. The Art of Ancient Egypt. Cambridge, MA: Harvard Univ. Press, 1997.
- Roehrig, Catharine H., Renee Dreyfus, and Cathleen A. Keller. *Hatshepsut, from Queen to Pharaoh*. New York: The Metropolitan Museum of Art, 2005.

- Russmann, Edna R. Egyptian Sculpture: Cairo and Luxor. Austin: Univ. of Texas Press, 1989.
- Smith, Craig B. How the Great Pyramid Was Built. Washington, D.C.: Smithsonian Books, 2004.
- Smith, W. Stevenson. The Art and Architecture of Ancient Egypt. 3rd ed. Rev. William Kelly Simpson. Pelican History of Art. New Haven: Yale Univ. Press, 1999.
- Strudwick, Nigel, and Helen Studwick. Thebes in Egypt: A Guide to the Tombs and Temples of Ancient Luxor. Ithaca, NY: Cornell Univ. Press, 1999.
- Thomas, Thelma K. Late Antique Egyptian Funerary Sculpture: Images for this World and for the Next. Princeton: Princeton Univ. Press, 2000.
- Tiradritti, Francesco. Ancient Egypt: Art, Architecture and History. Trans. Phil Goddard. London: British Museum, 2002.
- The Treasures of Ancient Egypt: From the Egyptian Museum in Cairo. New York: Rizzoli, 2003.
- Wilkinson, Richard H. The Complete Temples of Ancient Egypt. New York: Thames & Hudson, 2000.
- Reading Egyptian Art: A Hieroglyphic Guide to Ancient Egyptian Painting and Sculpture. London: Thames and Hudson, 1992.
- Ziegler, Cristiane, ed. *The Pharaohs*. New York: Rizzoli, 2002.
- Zivie-Coche, Christiane. Sphinx: History of a Monument. Trans. David Lorton. Ithaca, NY: Cornell Univ. Press, 2002.

CHAPTER 4 Aegean Art

- Barber, R. L. N. *The Cyclades in the Bronze Age*. Iowa City: Univ. of Iowa Press, 1987.
- Castleden, Rodney. The Knossos Labyrinth: A New View of the
 "Palace of Minos" at Knossos. London: Routledge, 1990.

 Mycenaeans. New York: Routledge, 2005.
- Demargne, Pierre. *The Birth of Greek Art*. Trans. Stuart Gilbert & James Emmons. Arts of Mankind. New York: Golden, 1964.
- Dickinson. Oliver. The Aegean Bronze Age. Cambridge World Archaeology. Cambridge, U.K.: Cambridge Univ. Press, 1994
- Univ. Press, 1994.
 Doumas, Christos. *The Wall-Paintings of Thera*. 2nd ed.
- Trans. Alex Doumas. Athens: Kapon Editions, 1999. Fitton, J. Lesley. *Cycladic Art.* 2nd ed. London: British Museum, 1999.
- Getz-Gentle, Pat. Personal Styles in Early Cycladic Sculpture. Madison: Univ. of Wisconsin Press, 2001.
- Hamilakis, Yannis. ed. Labyrinth Revisited: Rethinking 'Minoan' Archaeology. Oxford: Oxbow, 2002.
- Higgins, Reynold. Minoan and Mycenean Art. Rev. ed. World of Art. New York: Thames and Hudson, 1997.
- Hitchcock, Louise. Minoan architecture: A Contextual Analysis. Studies in Mediterranean Archaeology and Literature, Pocket-Book, 155. Jonsered: P. ÅÅströöms Föörlag, 2000.
- Immerwahr, Sara Anderson. Aegean Painting in the Bronze Age. University Park: Pennsylvania State Univ. Press, 1990
- Preziosi, Donald, and Louise Hitchcock. Aegean Art and Architecture. Oxford History of Art. Oxford: Oxford Univ. Press, 1999.

CHAPTER 5 Art of Ancient Greece

- Barletta, Barbara A. The Origins of the Greek Architectural Orders. New York: Cambridge Univ. Press, 2001.
- Beard, Mary. *The Parthenon*. Cambridge, MA: Harvard Univ. Press, 2003.
- Belozerskaya, Marina, and Kenneth Lapatin. Ancient Greece: Art, Architecture, and History. Los Angeles: J. Paul Getty Museum, 2004.
- Boardman, John. Early Greek Vase Painting: 11th–6th Centuries B.C.: A Handbook. World of Art. London: Thames and Hudson, 1998.
- Greek Sculpture: The Archaic Period: A Handbook. World of Art. New York: Thames and Hudson, 1991.
- —. Greek Sculpture: The Classical Period: A Handbook. London: Thames and Hudson, 1985.
- —. Greek Sculpture: The Late Classical Period and Sculpture in Colonies and Overseas. World of Art. New York: Thames and Hudson, 1995.
- ——. The History of Greek Vases: Potters, Painters, and Pictures. New York: Thames & Hudson, 2001.
- Burn, Lucilla. Hellenistic Art: From Alexander the Great to Augustus. London: British Museum Press, 2004.
- Camp, John M. The Athenian Agora: Excavations in the Heart of Classical Athens. New York: Thames and Hudson, 1986.

- Carpenter, Thomas H. Art and Myth in Ancient Greece: A Handbook. World of Art. London: Thames and Hudson, 1991.
- Clark, Andrew J., Maya Elston, Mary Louise Hart. Understanding Greek Vases: A Guide to Terms, Styles, and Techniques. Los Angeles: J. Paul Getty Museum, 2002.
- De Grummond, Nancy T. and Brunilde S. R.idgway. From Pergamon to Sperlonga: Sculpture in Context. Berkeley: Univ. of California Press, 2000.
- Donohue, A. A. Greek Sculpture and the Problem of Description. New York: Cambridge Univ. Press, 2005.Fullerton, Mark D. Greek Art. Cambridge, U.K.: Cam-
- bridge Univ. Press, 2000. Hurwit, Jeffrey M. The Art and Culture of Early Greece
- 1100–480 B.C. Ithaca, NY: Cornell Univ. Press, 1985.
- ——, and Adam D. Newton. The Acropolis in the Age of Pericles. 1 v. & CD-ROM. New York: Cambridge Univ. Press, 2004.
- Karakasi, Katerina. Archaic Korai. Los Angeles: The J. Paul Getty Museum, 2003.
- Lagerlof, Margaretha Rossholm. The Sculptures of the Parthenon: Aesthetics and Interpretation. New Haven: Yale Univ. Press, 2000.
- Lawrence, A. W. Greek Architecture. 5th ed. Rev. R. A. Tomlinson. Pelican History of Art. New Haven: Yale Univ. Press, 1996.
- Martin, Roland. Greek Architecture: Architecture of Crete, Greece, and the Greek World. History of World Architecture. New York: Electa/Rizzoli, 1988.
- Osborne, Robin. Archaic and Classical Greek Art. Oxford History of Art. Oxford: Oxford Univ. Press, 1998.
- Palagia, Olga. ed. Greek Sculpture: Function, Materials, and Techniques in the Archaic and Classical Periods. New York: Cambridge Univ. Press, 2006.
- , and J.J. Pollitt., eds. Personal Styles in Greek Sculpture. Yale Classical Studies, v. 30. New York: Cambridge Univ. Press, 1996.
- Pedley, John Griffiths. *Greek Art and Archaeology*. 3rd ed. Upper Saddle River: Prentice-Hall, 2002.
- Pollitt, J. J. The Art of Ancient Greece: Sources and Documents. 2nd ed. Cambridge, U.K.: Cambridge Univ. Press. 1990.
- Ridgway, Brunilde Sismondo. The Archaic Style in Greek Sculpture. 2nd ed. Chicago: Ares, 1993.
- Fifth Century Styles in Greek Sculpture. Princeton: Princeton Univ. Press, 1981.
- Fourth Century Styles in Greek Sculpture. Wisconsin Studies in Classics. Madison: Univ. of Wisconsin Press, 1997.
- —. Hellenistic Sculpture 1: The Styles of ca. 331–200 B.C. Wisconsin Studies in Classics. Madison: Univ. of Wisconsin Press, 1990.
- Stafford, Emma J. Life, Myth, and Art in Ancient Greece. Los Angeles: J. Paul Getty Museum, 2004.
- Stewart, Andrew F. Greek Sculpture: An Exploration. 2 vols. New Haven: Yale Univ. Press, 1990.
- Whitley, James. The Archaeology of Ancient Greece. New York: Cambridge Univ. Press, 2001.

CHAPTER 6 Etruscan and Roman Art

- Bianchi Bandinelli, Ranuccio. Rome: *The Centre of Power: Roman Art to A.D. 200.* Trans. Peter Green. Arts of Mankind. London: Thames and Hudson, 1970.
- ——. Rome: The Late Empire: Roman Art A.D. 200–400. Trans. Peter Green. Arts of Mankind. New York: Braziller, 1971.
- Borrelli, Federica. The Etruscans: Art, Architecture, and History. Ed. Stefano Peccatori & Stefano Zuffi. Trans. Thomas Michael Hartmann. Los Angeles: J. Paul Getty Museum. 2004.
- Breeze, David John. *Hadrian's Wall*. 4th ed. London: Penguin, 2000.
- Brendel, Otto J. *Etruscan Art*. 2nd ed. Yale Univ. Press Pelican History Series. New Haven: Yale Univ. Press, 1995.
- Ciarallo, Annamaria, and Ernesto De Carolis, eds. *Pompeii: Life in a Roman Town*. Milan: Electa, 1999.
- Conlin, Diane Atnally. The Artists of the Ara Pacis: The Process of Hellenization in Roman Relief Sculpture.
 Studies in the History of Greece & Rome. Chapel Hill: Univ. of North Carolina Press, 1997.
- Cornell, Tim, and John Matthews. *Atlas of the Roman World*. New York: Facts on File, 1982.
- D'Ambra, Eve. Roman Art. Cambridge, U.K.: Cambridge Univ. Press, 1998.
- Elsner, Ja. Imperial Rome and Christian Triumph: The Art of the Roman Empire A.D. 100–450. Oxford History of Art. Oxford: Oxford Univ. Press, 1998.

- Gabucci, Ada. Ancient Rome: Art, Architecture, and History. Eds. Stefano Peccatori & Stephano Zuffi. Trans. T. M. Hart-man. Los Angeles, CA: J. Paul Getty Museum, 2002.
- ed. The Colosseum. Los Angeles, CA: J. Paul Getty Museum, 2002.
- Grant, Michael. Art in the Roman Empire. London: Routledge, 1995.
- Guillaud, Jacqueline, and Maurice Guillaud. Frescoes in the Time of Pompeii. New York: Potter, 1990.
- Haynes, Sybille. Etruscan Civilization: A Cultural History. Los Angeles: J. Paul Getty Museum, 2000.
- Holloway, R. Ross. Constantine & Rome. New Haven: Yale Univ. Press, 2004.
- L'Orange, Hans Peter. The Roman Empire: Art Forms and Civic Life. New York: Rizzoli, 1985.
- MacDonald, William L. The Architecture of the Roman Empire. An Introductory Study. Rev. ed. Yale Publications in the History of Art. New Haven: Yale Univ. Press, 1982.
- The Pantheon: Design, Meaning, and Progeny. Cambridge, MA: Harvard Univ. Press, 1976.
- —, and John A. Pinto. *Hadrian's Villa and Its Legacy*. New Haven: Yale Univ. Press, 1995.
- Mazzoleni, Donatella. *Domus: Wall Painting in the Roman House*. Los Angeles: J. Paul Getty Museum, 2004.
- Packer, James E., and Kevin Lee Sarring. The Forum of Trajan in Rome: A Study of the Monuments. California Studies in the History of Art, 31.2 vols., portfolio and microfiche. Berkeley: Univ. of California Press, 1997. Pollitt, J. J. The Art of Rome, c. 753 B.C.-337 A.D.: Sources
- Pollitt, J. J. The Art of Rome, c. 753 B.C.-337 A.D.: Source and Documents. Upper Saddle River, NJ: Prentice Hall, 1966.
- Ramage, Nancy H., and Andrew Ramage. Roman Art: Romulus to Constantine. 4th ed. Upper Saddle River, NJ: Prentice Hall, 2004.
- Spivey, Nigel. *Etruscan Art*. World of Art. New York: Thames and Hudson, 1997.
- Stamper, John W. The Architecture of Roman Temples: The Republic to the Middle Empire. New York: Cambridge Univ. Press, 2005.
- Stewart, Peter. Roman Art. New York: Oxford Univ. Press, 2004.
- Statues in Roman Society: Representation and Response. Oxford Studies in Ancient Culture and Representation. New York: Oxford Univ., 2003.
- Strong, Donald. Roman Art. 2nd ed. rev. & annotated. Ed. Roger Ling. Pelican History of Art. New Haven: Yale Univ. Press, 1995.
- Ward-Perkins, J. B. Roman Architecture. History of World Architecture. New York: Electa/Rizzoli, 1988.
- ——. Roman Imperial Architecture. Pelican History of Art. New Haven: Yale Univ. Press, 1981.
- Wilson Jones, Mark. Principles of Roman Architecture. New Haven: Yale Univ. Press, 2000.

CHAPTER 7

Jewish, Early Christian, and Byzantine Art

- Age of Spirituality: Late Antique and Early Christian Art, Third to Seventh Century. New York: Metropolitan Museum of Art, 1979.
- Beckwith, John. *The Art of Constantinople: An Introduction to Byzantine Art 330–1453*. 2nd ed. London: Phaidon, 1968.
- Early Christian and Byzantine Art. 2nd ed. Pelican History of Art. Harmondsworth, UK: Penguin, 1979.
- Carr, Annemarie Weyl. Byzantine Illumination, 1150–1250: The Study of a Provincial Tradition. Chicago: Univ. of Chicago Press, 1987.
- Cioffarelli, Ada. Guide to the Catacombs of Rome and Its Surroundings. Rome: Bonsignori, 2000.
- Cormack, Robin. Byzantine Art. Oxford History of Art. Oxford: Oxford Univ. Press, 2000.
- Cutler, Anthony. The Hand of the Master: Craftsmanship, Ivory, and Society in Byzantium (9th–11th Centuries). Princeton: Princeton Univ. Press, 1994.
- Demus, Otto. The Mosaic Decoration of San Marco, Venice. Ed. Herbert L. Kessler. Chicago: Univ. of Chicago Press. 1988
- Durand, Jannic. *Byzantine Art.* Paris: Terrail, 1999. Eastmond, Antony, and Liz James, ed. *Icon and Word : The*
- Eastmond, Antony, and Liz James, ed. Icon and Word: The Power of Images in Byzantium: Studies Presented to Robin Cormack. Burlington, VT: Ashgate, 2003.
- Evans, Helen C., ed. Byzantium: Faith and Power (1261-1557). New York: Metropolitan Museum of Art, 2004.
 ——, and William D.Wixom, eds. The Glory of Byzantium: Art and Culture of the Middle Byzantine era, A.D.
- Fine, Steven. Art and Judaism in the Greco-Roman World: Toward a New Jewish Archaeology. New York: Cambridge Univ. Press, 2005.

- Gerstel, Sharon E. J. Beholding the Sacred Mysteries: Programs of the Byzantine Sanctuary. Monograph on the Fine Arts, 56. Seattle: Published by College Art Association in assoc. with Univ. of Washington Press, 1999.
- Grabar, Andréé. Byzantine Painting: Historical and Critical Study. Trans. Stuart Gilbert. New York: Rizzoli, 1979. Jensen, Robin Margaret. Understanding Early Christian
- Art. New York: Routledge, 2000.
 Kitzinger, Ernst. Byzantine Art in the Making: Main Lines of Stylistic Development in Mediterranean Art, 3rd-7th Century. Cambridge, MA: Harvard Univ. Press, 1977.
- Krautheimer, Richard, and Slobodan Curcic. Early Christian and Byzantine Architecture. 4th ed. Pelican History of Art. New Haven: Yale Univ. Press, 1992.
- Levine, Lee I. and Zeev Weiss, eds. From Dura to Sepphoris: Studies in Jewish Art and Society in Late Antiquity. Journal of Roman Archaeology: Supplementary Series, no. 40. Portsmouth, R.I.: Journal of Roman Archaeology, 2000.
- Lowden, John. Early Christian and Byzantine Art. Art & Ideas. London: Phaidon, 1997.
- Maguire, Henry. The Icons of Their Bodies: Saints and their Images in Byzantium. Princeton: Princeton Univ. Press, 1996.
- Mainstone, R. J. Hagia Sophia: Architecture, Structure and Liturgy of Justinian's Great Church. London: Thames and Hudson, 1988.
- Mango, Cyril. Art of the Byzantine Empire, 312–1453: Sources and Documents. Upper Saddle River, NJ: Prentice Hall, 1972.
- Mathew, Gervase. Byzantine Aesthetics. London: J. Murray, 1963.
- Mathews, Thomas P. Byzantium: From Antiquity to the Renaissance. Perspectives. New York: Abrams, 1998.
- The Clash of Gods: A Reinterpretation of Early
 Christian Art. Rev. & exp. ed. Princeton: Princeton
 Univ. Press, 1999.
- Milburn, R. L. P. Early Christian Art and Architecture. Berkeley: Univ. of California Press, 1988.
- Olin, Margaret. The Nation without Art: Examining Modern Discourses on Jewish Art. Lincoln: Univ. of Nebraska Press. 2001.
- Olsson, Birger and Magnus Zetterholm, eds. The Ancient Synagogue from Its Origins until 200 C.E.: Papers Presented at an International Conference at Lund University, October 14-17, 2001. Conjectanca Biblica: New Testament Series, 39. Stockholm: Almqvist & Wiksell International. 2003.
- Ousterhout, Robert. Master Builders of Byzantium. Princeton: Princeton Univ. Press, 1999.
- Rodley, Lyn. Byzantine Art and Architecture: An Introduction. Cambridge, U.K.: Cambridge Univ. Press, 1994.
- Rutgers, Leonard Victor. Subterranean Rome: In Search of the Roots of Christianity in the Catacombs of the Eternal City. Leuven: Peeters, 2000.
- Tadgell, Christopher. Imperial Space: Rome, Constantinople and the Early Church. New York: Whitney Library of Design, 1998.
- Teteriatnikov, Natalia. Mosaics of Hagia Sophia, Istanbul: The Fossati Restoration and the Work of the Byzantine Institute. Washington, D.C.: Dumbarton Oaks Research Library and Collection, 1998.
- Tronzo, William. The Cultures of his Kingdom: Roger II and the Cappella Palatina in Palermo. Princeton: Princeton Univ. Press, 1997.
- Vio, Ettore. St. Mark's: The Art and Architecture of Church and State in Venice. New York: Riverside Book Co., 2003.
- Webb, Matilda. The Churches and Catacombs of Early Christian Rome: A Comprehensive Guide. Brighton, UK: Sussex Academic Press, 2001.
- Weitzmann, Kurt. Late Antique and Early Christian Book Illumination. New York: Braziller, 1977.
 ——. Place of Book Illumination in Byzantine Art. Prince-
- ton: Art Museum, Princeton Univ., 1975. Wharton, Annabel Jane. Refiguring the Post ClassicalCity: Dura Europe, Jerash, Jerusalem and Ravenna. New York: Cambridge Univ. Press, 1995.
- White, L. Michael. *The Social Origins of Christian Architecture*. 2 vols. Baltimore: Johns Hopkins Univ. Press, 1990.

CHAPTER 8 Islamic Art

- Al-Faruqi, Ismail R, and Lois Lamya'al Faruqi. *Cultural Atlas of Islam*. New York: Macmillan, 1986.
- Atasoy, Nurhan. Splendors of the Ottoman Sultans. Ed. and Trans. Tulay Artan. Memphis, TN: Lithograph, 1992.
- Atil, Esin. The Age of Sultan Suleyman the Magnificent. Washington, D.C.: National Gallery of Art, 1987.

- Baer, Eva. Islamic Ornament. New York: New York Univ. Press, 1998.
- Baker, Patricia L. Islam and the Religious Arts. New York: Continuum, 2004.
- Barry, Michael. Figurative Art in Medieval Islam and the Riddle of Bihzååd of Herååt (1465-1535). Paris: Flammarion, 2004.
- Blair, Sheila S., and Jonathan Bloom. The Art and Architecture of Islam 1250–1800. Pelican History of Art. New Haven: Yale Univ. Press, 1994.
- Carboni, Stefano, and David Whitehouse. Glass of the Sultans. New York: Metropolitan Museum of Art. 2001.
- Denny, Walter B. *I≈nik: The Artistry of Ottoman Ceramics*. New York: Thames & Hudson, 2004.
- Dodds, Jerrilynn D., ed. al-Andalus: The Art of Islamic Spain. New York: Metropolitan Museum of Art, 1992.
- Ecker, Heather. Caliphs and Kings: The Art and Influence of Islamic Spain. Washington, D.C.: Arthur M. Sackler Gallery, Smithsonian Institution, 2004.
- Ettinghausen, Richard, Oleg Grabar, and Marilyn Jenkins-Madina. *Islamic Art and Architecture*, 650–1250. 2nd ed. Yale Univ. Press Pelican History of Art. New Haven: Yale Univ. Press, 2001. Reissue ed. 2003.
- Frishman, Martin, and Hasan-Uddin Khan. The Mosque: History, Architectural Development and Regional Diversity. London: Thames and Hudson, 1994.
- Grabar, Oleg. *The Formation of Islamic Art*. Rev. ed. New Haven: Yale Univ. Press, 1987.
- —. The Great Mosque of Isfahan. New York: New York Univ. Press, 1990.
- Mostly Miniatures: An Introduction to Persian Painting.

 Princeton: Princeton Univ. Press, 2000.
- Mohammad al-Asad, Abeer Audeh, and Said
 Nuseibeh. The Shape of the Holy; Early Islamic
 legusalem. Princeton: Princeton Univ. Press. 1996
- Hillenbrand, Robert. *Islamic Art and Architecture*. World of Art. London: Thames and Hudson, 1999.
- Irwin, Robert. *The Alhambra*. Cambridge, MA: Harvard Univ. Press, 2004.
- Khatibi, Abdelkebir, and Mohammed Sijelmassi. The Splendour of Islamic Calligraphy. Rev. & exp. ed. New York: Thames and Hudson, 1996.
- Komaroff, Linda, and Stefano Carboni, eds. *The Legacy of Genghis Khan: Courtly Art and Culture in Western Asia, 1256-1353.* New York: Metropolitan Museum of Art. 2002.
- Lentz, Thomas W., and Glenn D. Lowry. Timur and the Princely Vision: Persian Art and Culture in the Fifteenth Century. Los Angeles: Los Angeles County Museum of Art. 1989.
- Necipo lu, Güülru. The Age of Sinan: Architectural Culture in the Ottoman Empire. Princeton: Princeton Univ. Press, 2005.
- Petruccioli, Attilio, and Khalil K. Pirani, eds. *Understanding Islamic Architecture*. New York: Routledge Curzon, 2002.
- Roxburgh, David J., ed. *Turks: A Journey of a Thousand Years*, 600-1600. London: Royal Academy of Arts, 2005.
 Sims Eleanor Boris I Marshak and Ernest I Grube.
- Sims, Eleanor, Boris I. Marshak, and Ernest J. Grube. Peerless Images: Persian Painting and Its Sources. New Haven: Yale Univ. Press, 2002.
- Stanley, Tim, Mariam Rosser-Owen, and Stephen Vernoit. Palace and Mosque: Islamic Art from the Middle East. London:V & A Publications, 2004.

 Steele, James. An Architecture for People: The Complete
- Works of Hassan Fathy. New York: Whitney Library of Design, 1997.
 Stierlin, Henri. Islamic Art and Architecture: From Isfahan to
- the Taj Mahal. New York: Thames & Hudson, 2002. Suhrawardy, Shahid. The Art of the Mussulmans in Spain.
- New York: Oxford Univ. Press, 2005.
 Tadgell, Christopher. Four Caliphates: The Formation and
- Development of the Islamic Tradition. London: Ellipsis, 1998. Ward, R. M. Islamic Metalwork. New York: Thames and Hudson, 1993.
- Watson, Oliver. Ceramics from Islamic Lands. New York: Thames & Hudson in assoc. with the al-Sabah Collection, Dar al-Athar al-Islamiyyah, Kuwait National Museum, 2004.

CHAPTER 9

Art of South and Southeast Asia before 1200

- Atherton, Cynthia Packert. *The Sculpture of Early Medieval Rajasthan*. Studies in Asian Art and Archaeology, v. 21. New York: Brill, 1997.
- Behl, Benoy K. The Ajanta Caves: Artistic Wonder of Ancient Buddhist India. New York: Abrams, 1998.
- Behrendt, Kurt A. *The Buddhist Architecture of Gandhara*. Handbook of Oriental Studies: Section Two: India, v. 17. Boston: Brill. 2004.

843-1261. New York: Abrams, 1997

- Berkson, Carmel. Elephanta: The Cave of Shiva. Princeton: Princeton Univ. Press, 1983.
- Chakrabarti, Dilip K. India, an Archaeological History: Palaeolithic Beginnings to Early Historic Foundations. New York: Oxford Univ. Press, 1999.
- Chandra, Pramod. The Sculpture of India, 3000 B.C.–1300 A.D. Washington, D.C.: National Gallery of Art, 1985.
- Craven, Roy C. Indian Art: A Concise History. Rev. ed. World of Art. New York: Thames and Hudson, 1997.
- Czuma, Stanislaw J. Kushan Sculpture: Images from Early India. Cleveland: Cleveland Museum of Art, 1985.
- Dehejia, Vidya. Art of the Imperial Cholas. New York: Columbia Univ. Press, 1990.
- The Sensuous and the Sacred: Chola Bronzes from South India. New York: American Federation of Arts, 2002
- Dessai, Vishakha N., and Darielle Mason, eds. Gods, Guardians, and Lovers: Temple Sculptures from North India, A.D. 700–1200. New York: Asia Society Galleries, 1993.
- Dhavalikar, Madhukar Keshav. Ellora. New York: Oxford Univ. Press, 2003.
- Girard-Geslan, Maud. Art of Southeast Asia. Trans. J.A. Underwood. New York: Harry N. Abrams, Inc., 1998.
- Huntington, Susan L. The Art of Ancient India: Buddhist, Hindu, Jain. New York: Weatherhill, 1985.
- Leaves from the Bodhi Tree: The Art of Pala India (8th–12th Centuries) and Its International Legacy. Dayton, OH: Dayton Art Institute, 1990.
- Hutt, Michael. Nepal: A Guide to the Art and Architecture of the Kathmandu Valley. Boston: Shambala, 1995.
- Knox, Robert. Amaravati: Buddhist Sculpture from the Great Stupa. London: British Museum, 1992.
- Khanna, Sucharita. Dancing Divinities in Indian Art: 8th-12th Century A.D. Delhi: Sharada Pub. House, 1999.
- Kramrisch, Stella. *The Art of Nepal*. New York: Abrams, 1964.
- ——. Presence of Siva. Princeton: Princeton Univ. Press, 1981.
- Meister, Michael, ed. *Encyclopedia of Indian Temple Architecture*. 2 vols. in 7. Philadelphia: Univ. of Pennsylvania Press, 1983.
- Michell, George. Hindu Art and Architecture. World of Art London: Thames & Hudson, 2000.
- Mitter, Partha. *Indian Art*. Oxford History of Art. Oxford: Oxford Univ. Press, 2001.
- Neumayer, Erwin. Lines on Stone: The Prehistoric Rock Art of India. New Delhi: Manohar, 1993.
- Pal, Pratapaditya, ed. The Ideal Image: The Gupta Sculptural Tradition and Its Influence. New York: Asia Society, 1978.
- Poster, Amy G. From Indian Earth: 4,000 Years of Terracotta Art. Brooklyn: Brooklyn Museum, 1986.
- Skelton, Robert, and Mark Francis. Arts of Bengal: The Heritage of Bangladesh and Eastern India. London: Whitechapel Gallery, 1979.
- Stierlin, Henri. Hindu India: From Khajuraho to the Temple City of Madurai. New York: Taschen, 1998.
- Tadgell, Christopher. India and South-East Asia: The Buddhist and Hindu Tradition. New York: Whitney Library of Design, 1998.
- Williams, Joanna G. Art of Gupta India, Empire and Province. Princeton: Princeton Univ. Press, 1982.

Chapter 10 Chinese and Korean Art before 1279

- Ciarla, Roberto, ed. The Eternal Army: The Terracotta Soldiers of the First Chinese Emperor. Vercelli: White Star, 2005.
- Fong, Wen, ed. Beyond Representation: Chinese Painting and Calligraphy, 8th–14th Century. Princeton Monographs in Art and Archaeology. New York: Metropolitan Museum of Art, 1992.
- Fraser, Sarah Elizabeth. Performing the Visual: The Practice of Buddhist Wall Painting in China and Central Asia, 618-960. Stanford, CA: Stanford Univ. Press, 2004.
- James, Jean M. A Guide to the Tomb and Shrine Art of the Han Dynasty 206 B.C.—A.D. 220. Chinese Studies, 2. Lewiston, NY: Edwin Mellen Press, 1996.
- Karetzky, Patricia Eichenbaum. Court Art of the Tang. Lanham, MD: Univ. Press of America, 1996.
- Kim, Kumja Paik. Goryeo Dynasty: Korea's Age of Enlightenment, 918-1392. San Francisco: Asian Art Museum—Chong-Moon Lee Center for Asian Art and Culture in cooperation with the National Museum of Korea and the Nara National Museum, 2003.
- Li, Jian, ed. The Glory of the Silk Road: Art from Ancient China. Dayton, OH: Dayton Art Institute, 2003.

- Little, Stephen, and Shawn Eichman. *Taoism and the Arts of China*. Chicago: Art Institute of Chicago, 2000.
- Liu, Cary Y., Dora C.Y. Ching, and Judith G. Smith. Character & Context in Chinese Calligraphy. Princeton: Art Museum, Princeton Univ., 1999.
- Luo, Zhewen. Ancient Pagodas in China. Beijing, China: Foreign Languages Press, 1994.
- Ma, Ch'eng-yuan. Ancient Chinese Bronzes. Ed. Hsio-Yen Shih. Hong Kong: Oxford Univ. Press, 1986.
- Murck, Alfreda. Poetry and Painting in Song China: The Subtle Art of Dissent. Harvard-Yenching Institute Monograph Series, 50. Cambridge, MA: Harvard Univ. Asia Center for the Harvard-Yenching Institute, 2000.
- Ortiz, Valéérie Malenfer. Dreaming the Southern Song Landscape: The Power of Illusion in Chinese Painting. Studies in Asian Art and Archaeology, v. 22. Boston: Brill, 1999.
- Paludan, Ann. Chinese Tomb Figurines. Hong Kong: Oxford Univ. Press, 1994.
- Portal, Jane. Korea: Art and Archaeology. New York: Thames & Hudson, 2000.
- Rawson, Jessica. Mysteries of Ancient China: New Discoveries from the Early Dynasties. London: British Museum Press, 1996.
- Rhie, Marylin M. Early Buddhist Art of China and Central Asia. 2 vols in 3. Handbuch der Orientalistik. Vierte Abteilung; China, 12. Leiden: Brill, 1999.
- Scarpari, Maurizio. Splendours of Ancient China. London: Thames & Hudson, 2000.
- So, Jenny F. ed. Noble Riders from Pines and Deserts: The Artistic Legacy of the Qidan. Hong Kong: Art Museum, the Chinese Univ. of Hong Kong, 2004.
- Sturman, Peter Charles. Mi Fu: Style and the Art of Calligraphy in Northern Song. New Haven: Yale Univ. Press, 1997.
- Wang, Eugene Y. Shaping the Lotus Sutra: Buddhist Visual Culture in Medieval China. Seattle: Univ. of Washington Press, 2005.
- 2000. Reissue ed. 2003. Watt, James C.Y. China: Dawn of a Golden Age, 200-750 AD. New York: Metropolitan Museum of Art, 2004.
- Whitfield, Susan, and Ursula Sims-Williams, eds. *The Silk Road: Trade, Travel, War and Faith.* Chicago: Serindia Publications, 2004.
- Wu Hung. Monumentality in Early Chinese Art and Architecture. Stanford: Stanford Univ. Press, 1995.
- Yang, Xiaoneng, ed. The Golden Age of Chinese Archaeology: Celebrated Discoveries from the People's Republic of China. Washington D.C.: National Gallery of Art, 1999

CHAPTER 11 Japanese Art before 1392

- Cunningham, Michael R. Buddhist Treasures from Nara. Cleveland: Cleveland Museum of Art, 1998.
- Fowler, Sherry D. Muroji: Rearranging Art and History at the Japanese Buddhist Temple. Honolulu: Univ. of Hawaii Press, 2005.
- Harris, Victor, ed. Shinto: The Sacred Art of Ancient Japan. London: British Museum, 2001.
- Izutsu, Shinry, and Shory œmori. Sacred Treasures of Mount Kÿ_ya: The Art of Japanese Shingon Buddhism.
 Honolulu: Koyasan Reihokan Museum, 2002.
- Kenrick, Douglas Moore. Jomon of Japan: The World's Oldest Pottery. New York: Kegan Paul International, 1995.
- Kurata, Bunsaku. Horyu-ji, Temple of the Exalted Law: Early Buddhist Art from Japan. New York: Japan Society,
- LaMarre, Thomas. Uncovering Heian Japan: An Archaeology of Sensation and Inscription. Asia-Pacific. Durham, NC: Duke Univ. Press, 2000.
- Miki, Fumio. *Haniwa*. Trans. and adapted by Gino Lee Barnes. Arts of Japan, 8. New York: Weatherhill, 1974.
- Mino, Yutaka. The Great Eastern Temple: Treasures of Japanese Buddhist Art from Todai-ji. Chicago: Art Institute of Chicago, 1986.
- Mizoguchi, Koji. An Archaeological History of Japan: 30,000 B.C. to A.D. 700. Philadelphia: Univ. of Pennsylvania Press, 2002.
- Nishiwara, Kyotaro, and Emily J. Sano. *The Great Age of Japanese Buddhist Sculpture, A.D. 60–1300.* Fort Worth, TX: Kimbell Art Museum, 1982.
- Pearson, Richard J. Ancient Japan. Washington, D.C.: Sackler Gallery, 1992.

- Rosenfield, John M. Japanese Arts of the Heian Period: 794–1185. New York: Asia Society, 1967.
- Soper, Alexander Coburn. Evolution of Buddhist Architecture in Japan. Princeton Monographs in Art and Archaeology, no. 22. New York: Hacker Art, 1978.
- The Tale of Genji: Legends and Paintings. Intro. Miyeko Murase. New York: G. Braziller, 2001.
- Washizuka, Hiromitsu, et al. Transmitting the Forms of Divinity: Early Buddhist Art from Korea and Japan. Ed. Naomi Noble Richard. New York: Japan Society, 2003.
- Yiengpruksawan, Mimi Hall. Hiraizumi: Buddhist Art and Regional Politics in Twelfth-Century Japan. Harvard East Asian Monographs, 171. Cambridge, MA: Harvard Univ. Asia Center, 1998

CHAPTER 12 Art of the Americas before 1300

- Baudez, Claude F., and Sydney Picasso. Lost cities of the Maya. Trans. Caroline Palmer. Discoveries. New York: Harry N. Abrams, 1992.
- Benson, Elizabeth P., and Beatriz de la Fuente. Olmec Art of Ancient Mexico. Washington, D.C.: National Gallery of Art, 1996.
- Berrin, Kathleen, ed. Feathered Serpents and Flowering Trees: Reconstructing the Murals of Teotihuacan. San Francisco: Fine Arts Museums of San Francisco. 1988.
- Cisco: Fine Arts Museums of San Francisco, 1988.

 Brody, J. J. Anasazi and Pueblo Painting. Albuquerque:
 Univ. of New Mexico Press, 1991.
- —, Catherine J. Scott, and Steven A. LeBlanc. Mimbres Pottery: Ancient Art of the American Southwest: Essays. New York: Hudson Hills Press in assoc. with The American Federation of Arts, 1983.
- Clark, John E., and Mary E. Pye, eds. Olmec Art and Archaeology in Mesoamerica. Studies in the History of Art, 58: Symposium Papers, 35. Washington, D.C.: National Gallery of Art, 2000.
- Clayton, Lawrence A., editor. The De Soto Chronicles: The Expedition of Hernando de Soto to North America, 1539-`1543. Tuscaloosa: University of Alabama Press, 1995.
- Coe, Michael D., and Rex Koontz. Mexico: From the Olmecs to the Aztecs. 5th ed. rev. & exp. New York: Thames & Hudson, 2002.
- Fagan, Brian M. Chaco Canyon: Archeologists Explore the Lives of an Ancient Society. New York: Oxford Univ. Press, 2005.
- Hall, Robert L. An Archaeology of the Soul: North American Indian Belief and Ritual. Urbana: Univ. of Illinois Press,
- Herring, Adam. Art and Writing in the Maya Cities, A.D. 600-800: A Poetics of Line. Cambridge, U.K.: Cambridge Univ. Press, 2005.
- Heyden, Doris, and Paul Gendrop. Pre-Columbian Architecture of Mesoamerica. Trans. Judith Stanton. History of World Architecture. New York: Electa/R.izzoli, 1988.
- Korp, Maureen. The Sacred Geography of the American Mound Builders. Native American Studies. Lewiston, NY: Edwin Mellen, 1990.
- Kubler, George. The Art and Architecture of Ancient America: The Mexican, Maya, and Andean Peoples. 3rd ed. Pelican History of Art. New Haven: Yale Univ. Press, 1990.
- Labbéé, Armand J. Shamans, Gods, and Mythic Beasts: Colombian Gold and Ceramics in Antiquity. New York: American Federation of Arts, 1998.
- Loendorf, Lawrence L., Christopher Chippindale, and David S. Whitley, eds. *Discovering North American Rock Art*. Tucson: Univ. of Arizona Press, 2005.
- Martin, Simon, and Nikolai Grube. Chronicle of the Maya Kings and Queens: Deciphering the Dynasties of the Ancient Maya. New York: Thames & Hudson, 2000.
- Miller, Mary Éllen. The Art of Mesoamerica: from Olmec to Aztec. 3rd ed. World of Art. London: Thames and Hudson, 2001.
- ——. Maya Art and Architecture. World of Art. London: Thames and Hudson, 1999.
- Miller, Mary Ellen, and Simon Martin. Courtly Art of the Ancient Maya. San Francisco: Fine Arts Museums of San Francisco, 2004.
- Milner, George R. The Moundbuilders: Ancient Peoples of Eastern North America. Ancient Peoples and Places. London: Thames & Hudson, 2004.
- Noble, David Grant. In Search of Chaco: New Approaches to an Archaeological Enigma. Santa Fe, NM: School of American Research Press, 2004.
 O'Connor, Mallory McCane. Lost Cities of the Ancient
- Southeast. Gainesville: Univ. Press of Florida, 1995. Pasztory, Esther. Pre-Columbian Art. Cambridge, U.K.:
 - Cambridge Univ. Press, 1998.

 —. Teotihuacan: An Experiment in Living.
 Norman: Univ. of Oklahoma Press, 1997.

- Pillsbury, Joanne, ed. Moche Art and Archaeology in Ancient Peru. Studies in the History of Art: Center for Advanced Study in the Visual Arts, 63: Symposium Papers, 40. Washington, D.C.: National Gallery of Art, 2001.
- Power, Susan C. Early Art of the Southeastern Indians: Feathered Serpents & Winged Beings. Athens: Univ. of Georgia Press, 2004.
- Rohn, Arthur H., and William M. Ferguson. Puebloan Ruins of the Southwest. Albuquerque: Univ. of New Mexico Press, 2006.
- Schobinger, Juan. The Ancient Americans: A Reference Guide to the Art, Culture, and History of Pre-Columbian North and South America. Trans. Carys Evans Corrales. 2 vols. Armonk, NY: Sharp Reference, 2001.
- Sharer, Robert J. and Loa P. Traxler. *The Ancient Maya*. 6th ed. Stanford, CA: Stanford Univ. Press, 2006.
- Stierlin, Henri, and Anne Stierlin, The Maya: Palaces and Pyramids of the Rainforest. London: Taschen, 2001.
- Stone-Miller, Rebecca. Art of the Andes: From Chavin to Inca. 2nd ed. World of Art. New York: Thames and Hudson, 2002.
- Townsend, Richard F. and Robert V. Sharp, eds. Hero, Hawk, and Open Hand: American Indian Art of the Ancient Midwest and South. Chicago: Art Institute of Chicago, 2004.
- Von Hagen, Adriana, and Craig Morris. The Cities of the Ancient Andes. New York: Thames and Hudson, 1998.

CHAPTER 13 Art of Ancient Africa

- Ben-Amos, Paula. *The Art of Benin*. Rev. ed. Washington, D.C.: Smithsonian Institution Press, 1995.
- Blier, Suzanne Preston. The Royal Arts of Africa: The Majesty of Form. New York: H.N. Abrams, 1998.
- Cole, Herbert M. Igbo Arts: Community and Cosmos. Los Angeles: Fowler Museum of Cultural History, Univ. of California, 1984.
- Connah, Graham. African Civilizations: An Archaeological Perspective. 2nd ed. Cambridge, U.K.: Cambridge Univ. Press, 2001.
- ———. Forgotten Africa: An Introduction to Its Archaeology. New York: Routledge, 2004.
- Coulson, David, and Alec Campbell. African Rock Art: Paintings and Engravings on Stone. New York: Harry N. Abrams, Inc., 2001.
- Darish, Patricia J. "Memorial Head of an Oba: Ancestral Time in Benin Culture," in Tempus Fugit, Time Flies. Ed. Jan Schall. Kansas City: The Nelson Atkins Museum of Art, 2000. Pgs. 290-97.
- Eyo, Ekpo, and Frank Willett. *Treasures of Ancient Nigeria*. Ed. Rollyn O. Kirchbaum. New York: Knopf, 1980.
- Ezra, Kate. Royal Art of Benin: The Perls Collection in the Metropolitan Museum of Art. New York: Metropolitan Museum of Art, 1992.
- Garlake, Peter S. Early Art and Architecture of Africa. Oxford History of Art. Oxford: Oxford Univ. Press, 2002.
- -----. The Hunter's Vision: The Prehistoric Art of Zimbabwe. Seattle: Univ. of Washington Press, 1995.
- Grunne, Bernard de. The Birth of Art in Africa: Nok Statuary in Nigeria. Paris: A. Biro, 1998.
- Huffman, Thomas N. Symbols in Stone: Unravelling the Mystery of Great Zimbabwe. Johannesburg: Witwatersrand Univ. Press, 1987.
- LaViolette, Adria Jean. Ethno-Achaeology in Jennéé, Mali: Craft and Status among Smiths, Potters, and Masons. Oxford: Archaeopress, 2000.
- Le Quellec, Jean-Loïïc. Rock Art in Africa: Mythology and Legend. Trans. Paul Bahn. Paris: Flammarion, 2004.
- M'Bow, Babacar, and Osemwegie Ebohon. Benin, a King-dom in Bronze: The Royal Court Art. Ft. Lauderdale, FL: African American Research Library and Cultural Center, Broward County Library, 2005.
- Phillipson, D.W. *African Archaeology*. 3rd ed. New York: Cambridge Univ. Press, 2005.
- Schäädler, Karl-Ferdinand. Earth and Ore: 2500 Years of African Art in Terra-Cotta and Metal. Trans. Geoffrey P. Burwell. Müünchen: Panterra, 1997.

CHAPTER 14 Early Medieval Art in Europe

- Alexander, J. J. G. Medieval Illuminators and Their Methods of Work. New Haven: Yale Univ. Press, 1992.
- The Art of Medieval Spain, A.D. 500–1200. New York: Metropolitan Museum of Art, 1993.
- Backhouse, Janet, D. H. Turner, and Leslie Webster. The Golden Age of Anglo-Saxon Art, 966–1066.
 Bloomington: Indiana Univ. Press, 1984.
 Bandman, Gunter. Early Medieval Architecture as Bearer

- of Meaning. New York: Columbia Univ. Press, 2005. Beckwith, John. Early Medieval Art: Carolingian, Ottonian, Romanesque. World of Art. New York: Oxford Univ. Press 1974
- Calkins, Robert G. Illuminated Books of the Medieval Ages. Ithaca, NY: Cornell Univ. Press, 1983.
- Carver, Martin. Sutton Hoo: A Seventh-Century Princely Burial Ground and Its Context. London: British Museum Press, 2005.
- Davis-Weyer, Caecilia. Early Medieval Art, 300–1150: Sources and Documents. Upper Saddle River, NJ: Prentice Hall. 1971.
- Diebold, William J. Word and Image: An Introduction to Early Medieval Art. Boulder, CO: Westview Press, 2000.
- Dodwell, C. R. *Pictorial Arts of the West 800–1200*. Yale Univ. Press Pelican History of Art. New Haven: Yale Univ. Press, 1993.
- Farr, Carol. The Book of Kells: Its Function and Audience. London: British Library, 1997.
- Fernie, E. C. The Architecture of the Anglo-Saxons. London: Batsford, 1983.
- Fitzhugh, William W., and Elisabeth I. Ward, eds. Vikings: The North Atlantic Saga. Washington, D.C.: Smithsonian Institution Press, 2000.
- Harbison. Peter. The Golden Age of Irish Art: The Medieval Achievement, 600–1200. London: Thames and Hudson, 1998
- Henderson, George. From Durrow to Kells: The Insular Gospel-Books, 650–800. London: Thames and Hudson, 1987.
- Horn, Walter W., and Ernest Born. Plan of Saint Gall: A Study of the Architecture and Economy of and Life in a Paradigmatic Carolingian Monastery. California Studies in the History of Art, 19. 3 vols. Berkeley: Univ. of California Press, 1979.
- Lasko, Peter. Ars Sacra, 800–1200. 2nd ed. Pelican History of Art. New Haven: Yale Univ. Press, 1994.
- McClendon, Charles B. The Origins of Medieval Architecture Building in Europe, A.D 600-900. New Haven: Yale Univ. Press, 2005.
- Mayr-Harting, Henry. Ottoman Book Illumination: An Historical Study. 2nd rev. ed. 2 vols. London: Harvey Miller, 1999.
- Mentréé, Mireille. *Illuminated Manuscripts of Medieval* Spain. New York: Thames and Hudson, 1996.
- Nees, Lawrence. Early Medieval Art. Oxford History of Art. Oxford: Oxford Univ. Press, 2002.
- Nordenfalk, Carl Adam Johan. Early Medieval Book Illumination. New York: Rizzoli, 1988.
- Richardson, Hilary, and John Scarry. An Introduction to Irish High Crosses. Dublin: Mercier, 1990.

 Stalley R. A. Farly Medical Architecture. Oxford History
- Stalley, R.A. Early Medieval Architecture. Oxford History of Art. Oxford: Oxford Univ. Press, 1999.
- Wickham, Chris. Framing the Early Middle Ages: Europe and the Mediterranean 400-800. New York: Oxford Univ. Press, 2005.
- Williams, John, ed. Imaging the Early Medieval Bible. The Penn State Series in the History of the Book. University Park: Pennsylvania State Univ. Press, 1999.
- Wilson, David M. Anglo-Saxon Art: From the Seventh Century to the Norman Conquest. London: Thames and Hudson, 1984.
- —, and Ole Klindt-Jensen. Viking Art. 2nd ed. Minneapolis: Univ. of Minnesota Press, 1980.

CHAPTER 15 Romanesque Art

- Armi, C. Edson. Design and Construction in Romanesque Architecture: First Romanesque Architecture and the Pointed Arch in Burgundy and Northern Italy. New York: Cambridge Univ. Press, 2004.
- Barral i Altet, Xavier. The Romanesque: Towns, Cathedrals and Monasteries. Taschen's World Architecture. New York: Taschen, 1998.
- Cahn, Walter. Romanesque Manuscripts: The Twelfith Century. A Survey of Manuscripts Illuminated in France. 2 vols. London: H. Miller, 1996.
- "Cloister Symposium, 1972" in Gesta, v.12 #1/2, 1973, pgs. v-132.
- Davis-Weyer, Caecilia. Early Medieval Art, 300–1150. Sources and Documents. Upper Saddle River, NJ: Prentice Hall, 1971.
- Dimier, Anselme. Stones Laid before the Lord: A History of Monastic Architecture. Trans. Gilchrist Lavigne. Cistercian Studies Series, no. 152. Kalamazoo, MI: Cistercian Publications, 1999.
- Evans, Joan. Cluniac Art of the Romanesque Period. Cambridge, U.K.: Cambridge Univ. Press, 1950.

- Fergusson, Peter. Architecture of Solitude: Cistercian Abbeys in Twelfth-Century England. Princeton: Princeton Univ. Press. 1984.
- Forsyth, Ilene H. The Throne of Wisdom: Wood Sculptures of the Madonna in Romanesque France. Princeton: Princeton Univ. Press. 1972.
- Gaud, Henri, and Jean-Franççois Leroux-Dhuys. Cistercian Abbeys: History and Architecture. Kööln: Köönnemann, 1998
- Hawthorne, John G. and Cyril S. Smith, eds. On Divers Arts: The Treatise of Theophilus. New York: Dover Press, 1979.
- Hearn, M. F. Romanesque Sculpture: The Revival of Monumental Stone Sculptures in the Eleventh and Twelfth Centuries. Ithaca, NY: Cornell Univ. Press, 1981.
- Hicks, Carola. The Bayeux Tapestry: The Life Story of a Masterpiece. London: Chatto & Windus, 2006
- Kubach, Hans Erich. Romanesque Architecture. History of World Architecture. New York: Electa/Rizzoli, 1988.
- Mââle, Emile. Religious Art in France, the Twelfth Century: A Study of the Origins of Medieval Iconography. Bollingen Series. Princeton: Princeton Univ. Press, 1978.
- Minne-Sèève, Viviane, and Hervéé Kergall. Romanesque and Gothic France: Architecture and Sculpture. Trans. Jack Hawkes & Lory Frankel. New York: Harry N. Abrams. 2000.
- O'Neill, John Philip, ed. *Enamels of Limoges: 1100-1350. Trans.* Sophie Hawkes, Joachim Neugroschel, & Patricia Stirneman. New York: Metropolitan Museum of Art, 1006.
- Petzold, Andreas, *Romanesque Art*. Perspectives. New York: Abrams, 1995.
- Radding, Charles M., and William W. Clark. Medieval Architecture, Medieval Learning: Builders and Masters in the Age of Romanesque and Gothic. New Haven: Yale Univ. Press, 1992.
- Schapiro, Meyer. The Romanesque Sculpture of Moissac. New York: Braziller, 1985.
- Seidel, Linda. Legends in Limestone: Lazarus, Gislebertus, and the Cathedral of Autun. Chicago: Univ. of Chicago Press. 1999.
- Stones, Alison, Jeanne Krochalis, Paula Gerson, and Annie Shaver-Crandell. *The Pilgrim's Guide: A Critical Edition*. 2 vols. London: Harvey Miller, 1998.
- Swanson, R. N. The Twelfth-Century Renaissance. Manchester: Manchester Univ. Press, 1999.
- Toman, Rolf,ed. Romanesque: Architecture, Sculpture, Painting. Trans. Fiona Hulse & Ian Macmillan. Kööln: Köönemann, 1997.
- The Year 1200. 2 vols. New York: Metropolitan Museum of Art, 1970
- Zarnecki, George, Janet Holt, and Tristam Holland, eds. English Romanesque Art, 1066–1200. London: Weidenfeld and Nicolson, 1984.

Chapter 16 Gothic Art of the Twelfth and Thirteenth Centuries

- Armi, C. Edson. The "Headmaster" of Chartres and the Origins of "Gothic" Sculpture. University Park: Pennsylvania State Univ. Press, 1994.
- Binding, Güünther. High Gothic: The Age of the Great Cathedrals. Taschen's World Architecture. London: Taschen, 1999.
- Binski, Paul. Becket's Crown: Art and Imagination in Gothic England, 1170-1350. New Haven: Yale Univ. Press, 2004.
- Bony, Jean. French Gothic Architecture of the 12th and 13th Centuries. California Studies in the History of Art. Berkeley: Univ. of California Press, 1983.
- Camille, Michael. Gothic Art: Glorious Visions. Perspectives. New York: Abrams, 1996.
- Cennini, Cennino. The Craftsman's Handbook (Il libro dell'arte). Trans. D.V. Thompson. New York: Dover, 1954.
- Crosby, Sumner McKnight. The Royal Abbey of Saint-Denis from Its Beginnings to the Death of Suger, 475–1151.Yale Publications in the History of Art. New Haven:Yale Univ. Press, 1987.
- Erlande-Brandenburg, Alain. Gothic Art. Trans. I. Mark Paris. New York: Abrams, 1989.
- —. Notre-Dame de Paris. New York: Abrams, 1998. Favier, Jean. The World of Chartres. Trans. Francisca Garvie. New York: Abrams, 1990.
- Frankl, Paul. Gothic Architecture. Rev. Paul Crossley. Yale Univ. Press Pelican History of Art. New Haven: Yale Univ. Press, 2000.
- Frisch, Teresa G. Gothic Art, 1140–c. 1450: Sources and Documents. Upper Saddle River, NJ: Prentice Hall, 1971.

- Grodecki, Louis, and Catherine Brisac. Gothic Stained Glass, 1200–1300. Ithaca, NY: Cornell Univ. Press, 1985.
- Kren, Thomas, and Mark Evans, eds. A Masterpiece Reconstructed: The Hours of Louis XII. Los Angeles: The J. Paul Getty Museum, 2005.
- Moskowitz, Ánita Fiderer. Nicola & Giovanni Pisano: The Pulpits: Pious Devotion, Pious Diversion. London: Harvey Miller Publishers, 2005.
- Murray, Stephen. Notre-Dame, Cathedral of Amiens: The Power of Change in Gothic. New York: Cambridge Univ. Press, 1996.
- Nussbaum, Norbert. German Gothic Church Architecture. Trans. Scott Kleager. New Haven: Yale Univ. Press, 2000.
- Panofsky, Erwin. Abbot Suger on the Abboy Church of St.-Denis and Its Art Treasures. 2nd ed. Ed. Gerda Panofsky-Soergel. Princeton: Princeton Univ. Press, 1979.
- Gothic Architecture and Scholasticism. Latrobe, PA: Archabbey 1951.
- Parry, Stan. Great Gothic Cathedrals of France. New York: Viking Studio. 2001.
- Sauerlander, Willibald. *Gothic Sculpture in France*, 1140–1270. Trans. Janet Sandheimer. London: Thames and Hudson, 1972.
- Scott, Robert A. The Gothic Enterprise: A Guide to Understanding the Medieval Cathedral. Berkeley: Univ. of California Press, 2003.
- Simsom Otto Georg von. The Gothic Cathedral: Origins of Gothic Architecture and the Medieval Concept of Order. 3rd ed. Bollingen Series. Princeton: Princeton Univ. Press, 1988.
- Smart, Alastair. The Dawn of Italian Painting, 1250–1400. Ithaca, NY: Cornell Univ. Press, 1978.
- Suckale, Robert, and Matthias Weniger. Painting of the Gothic Era. Ed. Ingo F. Walther. New York: Taschen, 1999.
- Villard, de Honnecourt. The Sketchbook of Villard de Honnecourt. Ed. Theodore Bowie. Bloomington: Indiana Univ., 1960.
- Wieck, Roger S. Time Sanctified: The Book of Hours in Medieval Art and Life. New York: Braziller, 1988.
- Williamson, Paul. Gothic Sculpture 1140–1300. Pelican History of Art. New Haven: Yale Univ. Press, 1995.

CHAPTER 17 Fourteenth Century Art in Europe

- Alexander, Jonathan, and Paul Binski, eds. Age of Chivalry: Art in Plantagenet England, 1200–1400. London: Royal Academy of Arts, 1987.
- Art from the Court of Burgundy: The Patronage of Philip the Bold and John the Fearless 1364-1419. Cleveland: The Cleveland Museum of Art, 2004.
- Backhouse, Janet. Illumination from Books of Hours. London: British Library, 2004.
- Boehm, Barbara Drake, and Jifiíí Fajt, eds. Prague: The Crown of Bohemia, 1347-1437. New York: Metropolitan Museum of Art, 2005.
- Bony, Jean. The English Decorated Style: Gothic Architecture Transformed, 1250-1350. The Wrightsman Lecture, 10th. Oxford: Phaidon Press Limited, 1979.
- Borsook, Eve. The Mural Painters of Tuscany: From Cimabue to Andrea del Sarto. 2nd ed. rev. & enlg. Oxford Studies in the History of Art and Architecture. Oxford: Clarendon Press 1980.
- Branner, Robert. St. Louis and the Court Style in Gothic Architecture. Studies in Architecture, v. 7. London, A. Zwemmer, 1965.
- Bruzelius, Caroline Astrid. The 13th-Century Church at St-Denis. Yale Publications in the History of Art, 33. New Haven: Yale University Press, 1985.
- Fajt, Jifiíí, ed. Magister Theodoricus, Court Painter to Emperor Charles IV: The Pictorial Decoration of the Shrines at Karlstejn Castle. Prague: National Gallery, 1998.
- Ladis, Andrew. ed, The Arena Chapel and the Genius of Giotto: Padua. Giotto and the World of Early Italian Art, 2. New York: Garland Pub., 1998.
- Moskowitz, Anita Fiderer. *Italian Gothic Sculpture: c. 1250-c. 1400.* New York: Cambridge Univ. Press, 2001.
- Norman, Diana, ed. Siena, Florence, and Padua: Art, Society, and Religion 1280-1400. 2 vols. New Haven: Yale Univ. Press in assoc. with the Open Univ., 1995.
- Paolucci, Antonio. The Origins of Renaissance Art: The Baptistry Doors, Florence. Trans. Franççoise Pouncey Chiarini. New York: George Braziller, 1996.
- Poeschke, Joachim. *Italian Frescoes, the Age of Giotto, 1280-1400*. New York: Abbeville Press, 2005.
- Welch, Evelyn S. Art in Renaissance Italy, 1350-1500. New Ed. Oxford: Oxford Univ. Press, 2000.

- White, John. Art and Architecture in Italy, 1250 to 1400.
 3rd ed. Pelican History of Art. Harmondsworth, UK: Penguin, 1993.
- Wieck, Roger S. Painted Prayers: The Book of Hours in Medieval and Renaissance Art. New York: George Braziller in assoc. with the Pierpont Morgan Library, 1997.

Chapter 18 Fifteenth-Century Art in Northern Europe and the Iberian Peninsula

- Baxandall, Michael. The Limewood Sculptors of Renaissance
- Germany. New Haven Yale Univ. Press, 1980. Blum, Shirley. Early Netherlandish Triptychs: A Study in Patronage. California Studies in the History of Art. Berkeley: Univ. of California Press, 1969.
- Borchert, Till-Holger. Age of Van Eyck: The Mediterranean World and Early Netherlandish Painting, 1430-1530. New York: Thames & Hudson, 2002.
- New York: Thames & Hudson, 2002.

 Cavallo, Adolph S. *The Unicorn Tapestries at the Metropolitan Museum of Art*. New York: The Museum, 1998.
- Chastel, Andrèè. French Art: The Renaissance, 1430–1620. Paris: Flammarion, 1995.
- Dhanens, Elisabeth. Van Eyck: The Ghent Altarpiece. New York: Viking Press, 1973.
- Flanders in the Fifteenth Century: Art and Civilization.
 Detroit: Detroit Institute of Arts, 1960.
- Füüssel, Stephan. Gutenberg and the Impact of Printing. Trans. Douglas Martin. Burlington, VT: Ashgate Pub., 2005.
- Kuskin, William, ed. Caxton's Trace: Studies in the History of English Printing. Notre Dame, IN: Univ. of Notre Dame Press, 2006.
- Lane, Barbara G. The Altar and the Altarpiece: Sacramental Themes in Early Netherlandish Painting. New York: Harper & Row, 1984.
- Marks, Richard, and Paul Williamson, eds. Gothic: Art for England 1400-1547. London: V & A, 2003.
- Meiss, Millard. French Painting in the Time of Jean de Berry: The Limbourgs and their Contemporaries. 2 vols. New York: G. Braziller, 1974
- Müüller, Theodor. Sculpture in the Netherlands, Germany, France, and Spain: 1400–1500. Trans. Elaine & William Robson Scott. Pelican History of Art. Harmondsworth, Eng.: Penguin, 1966.
- Päächt, Otto. Early Netherlandish Painting: From Rogier van der Weyden to Gerard David. Ed. Monika Rosenauer. Trans. David Britt. London: Harvey Miller, 1997.
- Panofsky, Erwin. Early Netherlandish Painting. Its Origins and Character. 2 vols. Cambridge, MA: Harvard Univ. Press. 1966.
- Parshall, Peter W. and Rainer Schoch. Origins of European Printmaking: Fifteenth-Century Woodcuts and their Public. Washington, D.C.: National Gallery of Art, 2005.
- Plummer, John. The Last Flowering: French Painting in Manuscripts, 1420–1530, from American Collections. New York: Pierpont Morgan Library, 1982.
- Scott, Kathleen L. Later Gothic Manuscripts, 1390–1490. A Survey of Manuscripts Illuminated in the British Isles, 6. 2 vols. London: H. Miller, 1996.
- Snyder, James. Northern Renaissance Art: Painting, Sculpture, the Graphic Arts from 1350 to 1575. 2nd.ed Rev. Larry Silver and Henry Luttikhuizen. Upper Saddle River, NJ: Prentice Hall, 2005.
- Vos, Dirk de. The Flemish Primitives: The Masterpieces. Princeton: Princeton Univ. Press, 2002.
- Zuffi, Stefano. European Art of the Fifteenth Century. Trans. Brian D. Phillips. Art through the Centuries. Los Angeles: J. Paul Getty Museum, 2005.

Chapter 19

Renaissance Art in Fifteenth-Century Italy

- Adams, Laurie Schneider. Italian Renaissance Art. Boulder, CO: Westview Press, 2001.
- Ahl, Diane Cole, ed. *The Cambridge Companion to Masac- cio*. New York: Cambridge Univ. Press, 2002.
- cto. New York: Cambridge Univ. Press, 2002.
 Alexander, J.J.G. The Painted Page: Italian Renaissance Book Illumination, 1450–1550. Munich: Prestel, 1994.
- Ames-Lewis, Francis. *Drawing in Early Renaissance Italy*. 2nd ed. New Haven: Yale Univ. Press, 2000.
- —. The Intellectual Life of the Early Renaissance Artist. New Haven: Yale Univ. Press, 2000.
- Baxandall, Michael. Painting and Experience in Fifteenth-Century Italy: A Primer in the Social History of Pictorial style. Oxford: Clarendon, 1972.
- Boskovits, Miklóós. Italian Paintings of the Fifteenth Century. The Collections of the National Gallery of Art. Washington, D.C.: National Gallery of Art, 2003.
- Botticelli and Filippino: Passion and Grace in Fifteenth-Century Florentine Painting. Milano: Skira, 2004.

- Brown, Patricia Fortini. Art and Life in Renaissance Venice. Perspectives. New York: Harry N. Abrams, 1997. Reissued. Upper Saddle River, NJ: Prentice Hall, 2006.
- Christianity and the Renaissance: Image and Religious Imagination in the Quattrocento. Syracuse, NY: Syracuse Univ. Press, 1990.
- Christiansen, Keith, Laurence B. Kanter, and Carl Brandon Strehlke. *Painting in Renaissance Siena*, 1420–1500. New York: Metropolitan Museum of Art, 1988.
- Christine, de Pisan. *The Book of the City of Ladies*. Trans. Rosalind Brown-Grant. London: Penguin Books, 1999.
- Gilbert, Creighton, ed. Italian Art, 1400–1500: Sources and Documents. Evanston: Northwestern Univ. Press, 1992
- Heydenreich, Ludwig Heinrich. Architecture in Italy, 1400–1500. Rev. Paul Davies. Pelican History of Art. New Haven: Yale Univ. Press, 1996.
- Hind, Arthur M. An Introduction to a History of Woodcut. New York: Dover, 1963.
- Huizinga, Johan. The Autumn of the Middle Ages. Trans. Rodney J. Payton & Ulrich Mammitzsch. Chicago: Univ. of Chicago Press, 1996.
- Hyman, Timothy. Sienese Painting: The Art of a City-Republic (1278-1477). World of Art. New York: Thames & Hudson, 2003
- King, Ross. Brunelleschi's Dome: How a Renaissance Genius Reinvented Architecture. New York: Walker & Co., 2000
- Lavin, Marilyn Aronberg, ed. Piero della Francesca and his Legacy. Studies in the History of Art, 48: Symposium Papers, 28. Washington, D.C.: National Gallery of Art, 1905.
- Levey, Michael. Early Renaissance. Harmondsworth, UK: Penguin, 1967.
- Päächt, Otto. Venetian Painting in the 15th Century: Jacopo, Gentile and Giovanni Bellini and Andrea Mantegna. Ed. Margareta Vyoral-Tschapka & Michael Päächt. Trans. Fiona Elliott. London: Harvey Miller Pub., 2003.
- Partridge, Loren W. The Art of Renaissance Rome, 1400-1600. Perspectives. New York: Harry N. Abrams, 1996. Reissue Ed. Upper Saddle River, NJ: Prentice Hall. 2006
- Poeschke, Joachim. Donatello and his World: Sculpture of the Italian Renaissance. Trans. Russell Stockman. New York: H. N. Abrams, 1993.
- Randolph, Adrian W. B., Engaging Symbols: Gender, Politics, and Public Art in Fifteenth-Century Florence. New Haven: Yale Univ. Press, 2002.
- Seymour, Charles. Sculpture in Italy 1400–1500. Pelican History of Art. Harmondsworth, UK: Penguin, 1966.
- Troncelliti, Latifah. The Two Parallel Realities of Alberti and Cennini: The Power of Writing and the Visual Arts in the Italian Quattrocento. Studies in Italian Literature, v. 14. Lewiston, N.Y: Edwin Mellen Press, 2004
- Turner, Richard. Renaissance Florence: The Invention of a New Art. Perspectives. New York: Abrams, 1997. Reissue ed. Upper Saddle River, NJ: Prentice Hall, 2006.
- Walker, Paul Robert. The Feud that Sparked the Renaissance: How Brunelleschi and Ghiberti Changed the Art World. New York: William Morrow, 2002.
- Welch, Evelyn S. Art and Society in Italy, 1350–1500.
 Oxford History of Art. Oxford: Oxford Univ. Press, 1997

Chapter 20 Sixteenth-Century Art in Italy

- Acidini Luchinat, Cristina, et al. The Medici, Michelangelo, & the Art of Late Renaissance Florence. New Haven: Yale Univ. Press, 2002.
- Andrews, Lew. Story and Space in Renaissance Art: The Rebirth of Continuous Narrative. New York: Cambridge Univ. Press, 1995.
- Bambach, Carmen. Drawing and Painting in The Italian Renaissance Workshop: Theory and Practice, 1330–1600. Cambridge, U.K.: Cambridge Univ. Press, 1999.
- Barriault, Anne B., ed. *Reading Vasari*. London: Philip Wilson in assoc. with the Georgia Museum of Art, 2005.
- Brown, Patricia Fortini. Art and Life in Renaissance Venice. Perspectives. New York: Abrams, 1997. Burroughs, Charles. The Italian Renaissance Palace Facade:
- Structures of Authority, Surfaces of Sense. Cambridge, U.K.: Cambridge Univ. Press, 2002.
- Cellini, Benvenuto. My Life. Trans. & notes Julia Conaway Bondanella & Peter Bondanella. Oxford World's Classics. New York: Oxford Univ. Press, 2002.

- Chastel, Andréé. *The Age of Humanism: Europe,* 1480–1530. Trans. Katherine M. Delavenay & E. M. Gwyer. London: Thames and Hudson, 1963.
- Chelazzi Dini, Giulietta, Alessandro Angelini, and Bernardina Sani. Sienese Painting: From Duccio to the Birth of the Baroque. New York: Abrams, 1998.
- Cole, Alison. Virtue and Magnificence: Art of the Italian Renaissance Courts. Perspectives. New York: Abrams, 1995. Reissue ed. Art of the Italian Courts. Prespectives. Upper Saddle River, NJ: Prentice Hall, 2006.
- Dixon, Annette, ed. Women Who Ruled: Queens, Goddesses, Amazons in Renaissance and Baroque Art. Ann Arbor: Univ. of Michigan Museum of Art, 2002.
- Franklin, David, ed. *Leonardo da Vinci, Michelangelo, and the Renaissance in Florence*. Ottawa: National Gallery of Canada in assoc. with Yale Univ. Press, 2005.
- Freedberg, S. J. Painting in Italy, 1500 to 1600. 3rd ed.

 Pelican History of Art. New Haven: Yale Univ. Press, 1993
- Goffen, Rona. Renaissance Rivals: Michelangelo, Leonardo, Raphael, Titian. New Haven: Yale Univ. Press, 2002.
- Gröössinger, Christa. Picturing Women in Late Medieval and Renaissance Art. New York: St. Martin's Press, 1997.
- Hall, Marcia B. After Raphael: Painting in Central Italy in the Sixteenth Century. New York: Cambridge Univ. Press, 1999.
- ——., ed. The Cambridge Companion to Raphael. New York: Cambridge Univ. Press, 2005.
- Hollingsworth, Mary. Patronage in Sixteenth Century Italy London: Murray, 1996.
- Hopkins, Andrew. Italian Architecture: From Michelangelo to Borromini. World of Art. New York: Thames & Hudson, 2002.
- Hughes, Anthony. Michelangelo. London: Phaidon, 1997.
 Huse, Norbert, and Wolfgang Wolters. Art of Renaissance Venice: Architecture, Sculpture and Painting, 1460–1590.
 Trans. Edmund Jephcott. Chicago: Univ. of Chicago Press, 1990.
- Jacobs, Fredrika Herman. Defining the Renaissance Virtuosa: Women Artists and the Language of Art History and Criticism. Cambridge, U.K.: Cambridge Univ. Press, 1997.
- Joannides, Paul. Titian to 1518: The Assumption of Genius. New Haven: Yale Univ. Press, 2001.
- King, Ross. Michelangelo & the Pope's Ceiling. New York: Walker & Company, 2003.
- Klein, Robert, and Henri Zerner. Italian Art, 1500–1600: Sources and Documents. Upper Saddle River, NJ: Prentice Hall, 1966.
- Kliemann, Julian-Matthias, and Michael Rohlmann, Italian Frescoes: High Renaissance and Mannerism, 1510-1600. Trans. Steven Lindberg. New York: Abbeville Press, 2004.
- Landau, David, and Peter Parshall. *The Renaissance Print:* 1470–1550. New Haven: Yale Univ. Press, 1994.
- Lieberman, Ralph. Renaissance Architecture in Venice, 1450–1540. New York: Abbeville, 1982.
- Lotz, Wolfgang. Architecture in Italy, 1500–1600. Rev. Deborah Howard. Pelican History of Art. New Haven: Yale Univ. Press, 1995.
- Manca, Joseph. Moral Essays on the High Renaissance: Art in Italy in the Age of Michelangelo. Lanham, MD: Univ. Press of America, 2001.
- Mann, Nicholas, and Luke Syson, eds. The Image of the Individual: Portraits in the Renaissance. London: British Museum Press, 1998.
- Meilman, Patricia, ed. *The Cambridge Companion to Titian*. New York: Cambridge Univ. Press, 2004
- Mitrovic, Branko. Learning from Palladio. New York: W. W. Norton, 2004.
- Murray Linda. The High Renaissance and Mannerism: Italy, the North and Spain, 1500–1600. World of Art. London: Thames and Hudson, 1995.
- Olson, Roberta J. M. Italian Renaissance Sculpture. World of Art. New York: Thames and Hudson, 1992.
- Partridge, Loren W. The Art of Renaissance Rome, 1400–1600. New York: Abrams, 1996.
- Pietrangeli, Carlo, et al. The Sistine Chapel: The Art, the History, and the Restoration. New York: Harmony, 1986.
- Pilliod, Elizabeth. Pontormo, Bronzino, Allori: A Genealogy of Florentine Art. New Haven: Yale Univ. Press, 2001.
- Poeschke, Joachim. Michelangelo and his World: Sculpture of the Italian Renaissance. Trans. Russell Stockman. New York: Harry N. Abrams, 1996.
- Pope-Hennessy, Sir John. Italian High Renaissance and Baroque Sculpture. 3rd ed. Oxford: Phaidon, 1986. —— Italian Renaissance Sculpture. 3rd ed. Oxford:
- Phaidon, 1986. Rosand, David. Painting in Cinquecento Venice: Titian,

- Veronese, Tintoretto. Rev. ed. Cambridge, U.K.: Cambridge Univ. Press, 1997.
- Rowe, Colin, and Leon Satkowski. Italian Architecture of the 16th Century. New York: Princeton Architectural Press, 2002.
- Rowland, Ingrid D. The Culture of the High Renaissance: Ancients and Moderns in Sixteenth Century Rome. Cambridge, U.K.: Cambridge Univ. Press, 1998.
- Shearman, John. *Mannerism*. Harmondsworth, UK: Penguin, 1967. Reissue ed. New York: Penguin Books, 1990.
- Vasari, Giorgio. *The Lives of the Artists*. Trans. Julia Conaway Bondanella & Peter Bondanella. New York: Oxford Univ. Press, 1991.
- Verheyen, Egon. The Paintings in the Studiolo of Isabella d'Este at Mantua. Monographs on Archaeology and Fine Arts. New York: New York Univ. Press, 1971.
- Williams, Robert. Art, Theory, and Culture in Sixteenth-Century Italy: From Techne to Metateche. Cambridge, U.K.: Cambridge Univ. Press, 1997.

Chapter 21 Sixteenth-Century Art in Northern Europe and the Iberian Peninsula

- Bartrum, Giulia. Albrecht Düürer and his Legacy: The Graphic Work of a Renaissance Artist. London: British Museum Press, 2002.
- Bartrum, Giulia. German Renaissance Prints 1490-1550. London: British Museum Press, 1995.
- Buck, Stephanie, and Jochen Sander. Hans Holbein the Younger: Painter at the Court of Henry VIII. Trans. Rachel Esner & Beverley Jackson. New York: Thames & Hudson, 2004.
- Chapuis, Julien. Tilman Riemenschneider: Master Sculptor of the Late Middle Ages. Washington, D.C.: National Gallery of Art, 1999.
- Cloulas, Ivan, and Michèèle Bimbenet-Privat. Treasures of the French Renaissance. Trans. John Goodman. New York: Harry N. Abrams, 1998.
- Davies, David, and John H. Elliott. El Greco. London: National Gallery, 2003.
- Dixon, Laurinda. Bosch. Art & Ideas. New York: Phaidon, 2003
- Foister, Susan. *Holbein and England*. New Haven: Published for Paul Mellon Centre for Studies in British Art by Yale Univ. Press, 2004.
- Hayum, Andréé. The Isenheim Altarpiece: God's Medicine and the Painter's Vision. Princeton Essays on the Arts. Princeton: Princeton Univ. Press, 1989.
- Hearn, Karen, ed. Dynasties: Painting in Tudor and Jacobean England, 1530-1630. New York: Rizzoli, 1996.
- Koerner, Joseph Leo. *The Reformation of the Image*. Chicago: Univ. of Chicago Press, 2004.
- Kubler, George. Building the Escorial. Princeton: Princeton Univ. Press, 1982.
- Osten, Gert von der, and Horst Vey. Painting and Sculpture in Germany and the Netherlands, 1500–1600. Pelican History of Art. Harmondsworth, UK: Penguin, 1969.
- Price, David Hotchkiss. Albrecht Düürer's Renaissance: Humanism, Reformation, and the Art of Faith. Studies in Medieval and Early Modern Civilization. Ann Arbor: Univ. of Michigan Press, 2003.
- Roberts-Jones, Philippe, and Francoise Roberts-Jones.

 Pieter Bruegel. New York: Harry N. Abrams, 2002.
- Smith, Jeffrey Chipps. Nuremberg, a Renaissance City, 1500–1618. Austin: Huntington Art Gallery, Univ. of Texas, 1983.
- Strong, Roy C. Artists of the Tudor Court: The Portrait Miniature Rediscovered, 1520–1620. London: Victoria and Albert Museum, 1983.
- The Word Made Image: Religion, Art, and Architecture in Spain and Spanish America, 1500-1600. Fenway Court, 28. Boston: Published by the Trustees of the Isabella Stewart Gardner Museum, 1998.
- Wheeler, Daniel. *The Chateaux of France*. New York: Vendome Press, 1979.
- Zerner, Henri. Renaissance Art in France: The Invention of Classicism. Paris: Flammarion, 2003.
- Zorach, Rebecca. Blood, Milk, Ink, Gold: Abundance and Excess in the French Renaissance. Chicago: Univ. of Chicago Press, 2005.

CHAPTER 22 Baroque Art

Adams, Laurie Schneider. Key Monuments of the Baroque Boulder, CO: Westview Press, 2000.

The Age of Caravaggio. New York: Metropolitan Museum of Art, 1985.

- Allen, Christopher. French Painting in the Golden Age. World of Art. New York: Thames & Hudson, 2003.
- Alpers, Svetlana. The Making of Rubens. New Haven: Yale Univ. Press, 1995.
- Barberini, Maria Giulia, et al. *Life and the Arts in the Baroque Palaces of Rome: Ambiente Barocco*. Eds. Stefanie Walker and Frederick Hammond. New Haven: Published for the Bard Graduate Center for Studies in the Decorative Arts, New York by Yale Univ. Press, 1999.
- Blankert, Albert. Rembrandt: A Genius and his Impact. Melbourne: National Gallery of Victoria, 1997.
- Boucher, Bruce. *Italian Baroque Sculpture*. World of Art. New York: Thames and Hudson, 1998.
- Brown, Beverly Louise, ed. *The Genius of Rome, 1592-1623*. London: Royal Academy of Arts, 2001.
- Careri, Giovanni. Baroques. Tran. Alexandra Bonfante-Warren. Princeton: Princeton Univ. Press, 2003.
- Chong, Alan, and Wouter Kloek. Still-Life Paintings from the Netherlands, 1550-1720. Zwolle: Waanders Publishers, 1999.
- Franits, Wayne E. Dutch Seventeenth-Century Genre Painting: Its Stylistic and Thematic Evolution. New Haven: Yale Univ. Press, 2004.
- Harbison, Robert. Reflections on Baroque. Chicago: Univ. of Chicago Press, 2000.
- Kiers, Judikje, and Fieke Tissink. Golden Age of Dutch Art: Painting, Sculpture, Decorative Art. London: Thames and Hudson, 2000.
- Lagerlof, Margaretha Rossholm. Ideal Landscape: Annibale Caracá, Nicolas Poussin, and Claude Lorrain. New Haven: Yale Univ. Press, 1990.
- McPhee, Sarah. Bernini and the Bell Towers: Architecture and Politics at the Vatican. New Haven: Yale Univ. Press, 2002.
- Millon, Henry A., ed. The Triumph of the Baroque: Architecture in Europe, 1600-1750. New York: Rizzoli, 1999.
- Morrissey, Jake. The Genius in the Design: Bernini, Borromini, and the Rivalry that Transformed Rome. New York: William Morrow, 2005.
- William Morrow, 2005.

 Slive, Seymour. Dutch Painting 1600–1800. Pelican History
- of Art. New Haven: Yale Univ. Press, 1995.
 Stratton, Suzanne L., ed. The Cambridge Companion to
- Veláázquez. New York: Cambridge Univ. Press, 2002. Summerson, John. Inigo Jones. New Haven: Published for the Paul Mellon Centre for Studies in British Art by Yale Univ. Press, 2000.
- Vlieghe, Hans. Flemish Art and Architecture, 1585–1700.Pelican History of Art. New Haven: Yale Univ. Press, 1998, Reissue ed. 2004.
- Wheelock Jr., Arthur K. Flemish Paintings of the Seventeenth Century. Washington, D.C.: National Gallery of Art, 2005.
- Wittkower, Rudolf. Art and Architecture in Italy, 1600 to 1750. 3 vols. 4th ed. Rev. Joseph Connors & Jennifer Montague. Pelican History of Art. New Haven: Yale Univ. Press, 1999.
- Zega, Andrew, and Bernd H. Dams. Palaces of the Sun King: Versailles, Trianon, Marly: The Chââteaux of Louis XIV. New York: Rizzoli, 2002.

CHAPTER 23 Art of India after 1200

- Asher, Catherine B. Architecture of Mughal India. New York: Cambridge Univ. Press, 1992.
- Beach, Milo Cleveland. Mughal and Rajput Painting. New York: Cambridge Univ. Press, 1992.
- Guy, John, and Deborah Swallow, eds. *Arts of India*, 1550–1900. London:Victoria and Albert Museum, 1990.
- Khanna, Balraj, and Aziz Kurtha. Art of Modern India. London: Thames and Hudson, 1998.
- Koch, Ebba. Mughal Art and Imperial Ideology: Collected Essays. New Delhi: Oxford Univ. Press, 2001.
- Michell, George. *Hindu Art and Architecture*. World of Art. London: Thames & Hudson, 2000.
- Moynihan, Elizabeth B., ed. *The Moonlight Garden: New Discoveries at the Taj Mahal*. Asian Art & Culture. Washington, D.C.: Arthur M. Sackler Gallery, Smithsonian Institution, 2000.
- Nou, Jean-Louis. *Taj Mahal*. Text by Amina Okada & M. C. Joshi. New York: Abbeville, 1993.
- Pal, Pratapaditya. Court Paintings of India, 16th-19th Centuries. New York: Navin Kumar, 1983.
- The Peaceful Liberators: Jain Art from India. New York: Thames and Hudson, 1994.
- Rossi, Barbara. From the Ocean of Painting: India's Popular Paintings, 1589 to the Present. New York: Oxford Univ. Press, 1998.
- Schimmel, Annemarie. The Empire of the Great Mughals: History, Art and Culture, Ed. Burzine K. Waghmar. Trans.

- Corinne Attwood. London: Reaktion Books, 2004. Stronge, Susan. *Painting for the Mughal Emperor: The Art of the Book*, 1560-1660. London: V&A, 2002.
- Tillotson, G. H. R. Mughal India. Architectural Guides for Travelers. San Francisco: Chronicle, 1990.
- ——, The Rajput Palaces: The Development of an Architectural Style, 1450–1750. New York: Oxford Univ. Press, 1999.
- —. The Tradition of Indian Architecture: Continuity, Controversy and Change since 1850. New Haven: Yale Univ. Press, 1989.
- Verma, Som Prakash. Painting the Mughal Experience. New York: Oxford Univ. Press, 2005.
- Welch, Stuart Cary. The Emperors' Album: Images of Mughal India. New York: Metropolitan Museum of Art, 1987.
- India: Art and Culture 1300–1900. New York: Metropolitan Museum of Art, 1985.

CHAPTER 24 Chinese and Korean Art after 1279

- Andrews, Julia Frances, and Kuiyi Shen. A Century in Crisis: Modernity and Tradition in the Art of Twentieth-Century China. New York: Guggenheim Museum, 1008
- Barnhart, Richard M. Painters of the Great Ming: The Imperial Court and the Zhe School. Dallas: Dallas Museum of Art, 1993.
- Barrass, Gordon S. The Art of Calligraphy in Modern China, London: British Museum, 2002
- Berger, Patricia Ann. Empire of Emptiness: Buddhist Art and Political Authority in Qing China. Honolulu: Univ. of Hawaii Press, 2003.
- Bickford, Maggie. Ink Plum: The Making of a Chinese Scholar-Painting. New York: Cambridge Univ. Press, 1996.
- Billeter, Jean Franççois. The Chinese Art of Writing. New York: Skira/Rizzoli, 1990.
- Bush, Susan, and Hsui-yen Shih, eds. Early Chinese Texts on Painting. Cambridge, MA: Harvard Univ. Press, 1985.
- Cahill, James. The Distant Mountains: Chinese Painting in the Late Ming Dynasty, 1580–1644. New York: Weatherhill, 1982.
- Hills beyond a River: Chinese Painting of the Y'uan Dynasty, 1279–1368. New York: Weatherhill, 1976.
 Parting at the Shore: Chinese Painting of the Early and Middle Ming Dynasty 1368–1580. New York: Weatherhill, 1978.
- Chung, Anita. Drawing Boundaries: Architectural Images in Qing China. Honolulu: Univ. of Hawaii Press, 2004.
- Clunas, Craig. Pictures and Visualities in Early Modern China. Princeton: Princeton Univ. Press, 1997.
- Fang, Jing Pei. Treasures of the Chinese Scholar: Form, Function and Symbolism. Ed. J. May Lee Barrett. New York: Weatherhill, 1997.
- Fong Wen C., and James C.Y. Watt. Possessing the Past: Treasures from the National Palace Museum, Taipei. New York: Metropolitan Museum of Art, 1996.
- Fong, Wen C. Between Two Cultures: Late-Nineteenth- and Twentieth-Century Chinese Paintings from the Robert H. Ellsworth Collection in the Metropolitan Museum of Art. New York: Metropolitan Museum of Art, 2001.
- Hearn, Maxwell K. and Judith G. Smith, eds. *Chinese Art: Modern Expressions*. New York: Dept. of Asian Art, the Metropolitan Museum of Art, 2001.
- Ho, Chuimei, and Bennet Bronson. Splendors of China's Forbidden City: The Glorious Reign of Emperor Qianlong. Chicago: Field Museum, 2004.
- Ho, Wai-kam. The Century of Tung Ch'i-ch'ang. 2 vols. Kansas City: Nelson-Atkins Museum of Art, 1992
- Kim, Hongnam. The Life of a Patron: Zhou Lianggong (1612-1672) and the Painters of Seventeenth-Century China. New York: China Institute in America, 1996.
- Knapp, Ronald G. China's Vernacular Architecture: House Form and Culture. Honolulu: Univ. of Hawaii Press, 1989.
- Lee, Sherman, and Wai-Kam Ho. *Chinese Art under the Mongols: The Y'uan Dynasty, 1279–1368.* Cleveland: Cleveland Museum of Art, 1968.
- Lim, Lucy. ed. Wu Guanzhong: A Contemporary Chinese Artist. San Francisco: Chinese Culture Foundation, 1989.
- Liu, Laurence G. Chinese Architecture. New York: Rizzoli, 1989.
- Moss, Paul. Escape from the Dusty World: Chinese Paintings and Literati Works of Art. London: Sydney L. Moss Ltd., 1999.
- Ng, So Kam. Brushstrokes: Styles and Techniques of Chinese Painting. San Francisco: Asian Art Museum of San Francisco, 1993.

- The Poetry [of] Ink: The Korean Literati Tradition, 1392-1910. Paris: Rééunion des Muséées Nationaux: Muséée National des Arts Asiatiques Guimet, 2005.
- Smith, Karen. Nine Lives: The Birth of Avant-Garde Art in New China. Zurich: Scalo, 2006.
- Till, Barry. The Manchu Era (1644-1912), Arts of China's Last Imperial Dynasty. Victoria, B.C: Art Gallery of Greater Victoria, 2004.
- Vainker, S. J. Chinese Pottery and Porcelain: From Prehistory to the Present. London: British Museum, 1991.
- Watson, William. *The Arts of China 900–1620*. Pelican History of Art. New Haven: Yale Univ. Press, 2000.
- Weidner, Marsha Smith. Views from Jade Terrace: Chinese Women Artists, 1300–1912. Indianapolis, IN: Indianapolis Museum of Art, 1988.

CHAPTER 25 Japanese Art after 1392

- Addiss, Stephen. The Art of Zen: Painting and Calligraphy by Japanese Monks, 1600–1925. New York: Abrams, 1989.
- Berthier, Franççois. Reading Zen in the Rocks: The Japanese Dry Landscape Garden. Trans. & essay Graham Parkes. Chicago: Univ. of Chicago Press, 2000.
- Brinker, Helmut, and Hiroshi Kanazawa. Zen, Masters of Meditation in Images and Writings. Trans. Andreas Leisinger. Artibus Asiae: Supplementum, 40. Züürich: Artibus Asiae, 1996.
- Calza, Gian Carlo. Ukiyo-e. New York: Phaidon, 2005.Carpenter, John T. ed. Hokusai and his Age: Ukiyo-e Painting, Printmaking and Book Illustration in Late Edo Japan.Amsterdam: Hotei, 2005.
- Clark, Timothy, et al. The Dawn of the Floating World, 1650-1765: Early Ukiyo-e Treasures from the Museum of Fine Arts, Boston. London: Royal Academy of Arts, 2001
- Guth, Christine. Art of Edo Japan: The Artist and the City 1615–1868. Perspectives. New York: Abrams, 1996.
- Hickman, Money L. Japan's Golden Age: Momoyama. New Haven: Yale Univ. Press, 1996.
- Jordan, Brenda G. and Victoria Weston, eds. Copying the Master and Stealing his Secrets: Talent and Training in Japanese Painting. Honolulu: Univ. of Hawaii Press, 2003.
- Levine, Gregory P.A. Daitokuji: The Visual Cultures of a Zen Monastery. Seattle: Univ. of Washington Press, 2005.
- McKelway, Matthew P. Traditions Unbound: Groundbreaking Painters of Eighteenth-Century Kyoto. San Francisco: Asian Art Museum—Chong-Moon Lee Center, 2005
- Miyajima, Shin''ichi, and Sato Yasuhiro. *Japanese Ink Painting*. Ed. George Kuwayama. Los Angeles: Los

 Angeles County Museum of Art, 1985.
- Munroe, Alexandra. *Japanese Art after 1945: Scream Against the Sky*. New York: Abrams, 1994.
- Murase, Miyeko, ed. *Turning Point: Oribe and the Arts of Sixteenth-Century Japan*. New York: Metropolitan Museum of Art, 2003.
- Newland, Amy Reigle, ed. *The Hotei Encyclopedia of Japanese Woodblock Prints*. 2 vols. Amsterdam: Hotei Publishing, 2005.
- Parker, Joseph D. Zen Buddhist Landscape Arts of Early Muromachi Japan (1336-1573), SUNY Series in Buddhist Studies. Albany: State Univ. of New York Press, 1999.
- Phillips, Quitman E. The Practices of Painting in Japan, 1475-1500. Stanford, CA: Stanford Univ. Press, 2000.
- Plutschow, Herbert E. Rediscovering Rikyu and the Beginnings of the Japanese Tea Ceremony. Folkestone: Global Oriental, 2003.
- Seo, Aubrey Yoshiko. The Art of Twentieth-Century Zen: Paintings and Calligraphy by Japanese Masters. Boston: Shambala, 1998.
- Singer, Robert T., and John T. Carpenter. Edo, Art in Japan 1615–1868. Washington, D.C.: National Gallery of Art. 1998.
- Till, Barry. The Arts of Meiji Japan, 1868–1912: Changing Aesthetics. Victoria, BC: Art Gallery of Victoria, 1995.

CHAPTER 26 Art of the Americas after 1300

- Bauer, Brian S. Ancient Cuzco: Heartland of the Inca. Joe R. and Teresa Lozano Long Series in Latin American and Latino Art and Culture. Austin: Univ.of Texas Press, 2004.
- Burger, Richard L. and Lucy C., eds. Machu Picchu: Unveiling the Mystery of the Incas. New Haven: Yale Univ. Press, 2004.

- Berlo, Janet Catherine, and Ruth B. Phillips. *Native North American Art*. Oxford History of Art. Oxford: Oxford Univ. Pres, 1998.
- Bingham, Hiram. Lost City of the Incas: The Story of Machu Picchu and Its Builders. London: Weidenfeld & Nicolson, 2002.
- Boone, Elizabeth Hill. *The Aztec World. Exploring the*Ancient World. Washington, D.C.: Smithsonian Books,
 1994.
- Broder, Patricia Janis. American Indian Painting and Sculpture. New York: Abbeville. 1981.
- Earth Songs, Moon Dreams: Paintings by American Indian Women. New York: St. Martin's Press, 1999.
- Brown, Steven C. Native Visions: Evolution in Northwest Coast Art from the Eighteenth through the Twentieth Century. Seattle: Seattle Art Museum in assoc. with the Univ. of Washington Press, 1998.
- Diaz del Castillo, Bernal. Discovery and Conquest of Mexico, 1517-1521. Ed. Genaro Garcíía. Trans. & notes A. P. Maudslay. New intro. Hugh Thomas. Originally published: New York: Farrar, Straus, and Cudahy, 1956. New York: DeCapo Press, 1996.
- Duffek, Karen, and Charlotte Townsend-Gault, eds. Bill Reid and Beyond: Expanding on Modern Native Art. Vancouver: Douglas & McIntyre, 2004.
- Feest, Christian F. Native Arts of North America. Updated ed. World of Art. New York: Thames and Hudson, 1992.
- Fields, Virginia M., and Victor Zamudio-Taylor. The Road to Aztlan: Art from a Mythic Homeland. Los Angeles: Los Angeles County Museum of Art, 2001.
- Griffin-Pierce, Trudy. Earth is my Mother, Sky is my Father: Space, Time, and Astronomy in Navajo Sandpainting. Albuquerque: Univ. of New Mexico Press. 1992.
- Holm, Bill. Northwest Coast Indian Art; An Analysis of Form. Thomas Burke Memorial Washington State Museum Monograph, 1. Seattle, Univ. of Washington Press, 1965.
- Hughes, Paul. Time Warps: Ancient Andean Textiles. London: Fine Textile Art, 1995.
- Kaufman, Alice, and Christopher Selser. The Navajo Weaving Tradition: 1650 to the Present. New York: Dutton. 1985.
- Macnair, Peter L., Robert Joseph, and Bruce Grenville.

 Down from the Shimmering Sky: Masks of the Northwest
 Coast. Vancouver: Douglas & McIntyre, 1998.
- Matos Moctezuma, Eduardo, and Felix R. Solíís Olguíín. Aztecs. London: Royal Academy of Arts, 2002.
- Moseley, Michael. The Incas and Their Ancestors: The Archaeology of Peru. London: Thames and Hudson, 1992
- Nabokov, Peter, and Robert Easton. *Native American Architecture*. New York: Oxford Univ. Press, 1989.
- Rushing III, W. Jackson, ed. Native American Art in the Twentieth Century: Makers, Meanings, Histories. New York: Routledge, 1999
- Shaw, George Everett. Art of the Ancestors: Antique North American Indian Art. Aspen, CO: Aspen Art Museum, 2004
- Solíís, Felipe R. *The Aztec Empire*. New York: Guggenheim Museum Publications, 2004.
- Taylor, Colin F. Buckskin & Buffalo: The Artistry of the Plains Indians. New York: Rizzoli, 1998.
- Townsend. Richard, ed. *The Aztess*. 2nd rev. ed. Ancient Peoples and Places. London: Thames and Hudson, 2000.
- Trimble, Stephen. Talking with the Clay: The Art of Pueblo Pottery. Santa Fe: School of American Research Press, 1987.
- Wood, Nancy C. Taos Pueblo. New York: Knopf, 1989.

CHAPTER 27 Art of Pacific Cultures

- Brandon, Reiko Mochinaga, and Loretta G. H. Woodard. Hawaiian Quilts: Tradition and Transition. Honolulu: Honolulu Academy of Arts, 2004.
- Caruana, Wally. *Aboriginal Art*. World of Art. New York: Thames and Hudson, 1996.
- D'Alleva, Anne. Arts of the Pacific Islands. Perspectives. New York: Abrams, 1998.
- Herle, Anita, ed. Pacific Art: Persistence, Change, and Meaning. Honolulu: Univ. of Hawai'i Press, 2002.
- Kaeppler, Adrienne Lois, Christian Kaufmann, and Douglas Newton. Oceanic Art. Trans. Nora Scott & Sabine Bouladon. New York: Abrams, 1997.
- Kirch, Patrick Vinton. The Lapita Peoples: Ancestors of the Oceanic World. The Peoples of South-East Asia and the Pacific. Cambridge, MA: Blackwell, 1997.

- Kjellgren, Eric. Splendid Isolation: Art of Easter Island. New York: Metropolitan Museum of Art, 2001.
- Küüchler, Susanne, and Graeme Were. Pacific Pattern. London: Thames & Hudson, 2005.
- Lilley, Ian, ed. Archaeology of Oceania: Australia and the Pacific Islands. Malden, MA: Blackwell, 2006.
- McCulloch, Susan. Contemporary Aboriginal Art: A Guide to the Rebirth of an Ancient Culture. Honolulu: Univ. of Hawaii Press, 1999.
- Moore, Albert C. Arts in the Religions of the Pacific: Symbols of Life. Religion and the Arts Series. New York: Pinter Publishers, 1995.
- Morwood, M. J. Visions from the Past: The Archaeology of Australian Aboriginal Art. Washington, D.C.: Smithsonian Institution Press, 2002.
- Neich, Roger, and Mick Pendergrast. *Traditional Tapa Tex*tiles of the Pacific. London: Thames and Hudson, 1997.
- Newton, Douglas, ed. Arts of the South Seas: Island Southeast Asia, Melanesia, Polynesia, Micronesia; The Collections of the Muséée Barbier-Mueller. Trans. David Radzinowicz Howell. New York: Prestel, 1999.
- Rainbird, Paul. The Archaeology of Micronesia. Cambridge World Archaeology. New York: Cambridge Univ. Press, 2004.
- Smidt, Dirk, ed. Asmat Art: Woodcarvings of Southwest New Guinea. New York: George Braziller in assoc. with Rijksmuseum voor Volkenkunde, Leiden, 1993.
- Starzecka, D. C., ed. *Maori Art and Culture*. London: British Museum Press, 1996.
- Taylor, Luke. Seeing the Inside: Bark Painting in Western Arnhem Land. Oxford Studies in Social and Cultural Anthropology. New York: Oxford Univ. Press, 1996.
- Thomas, Nicholas. *Oceanic Art.* World of Art. New York: Thames and Hudson, 1995.
- ——, Anna Cole and Bronwen Douglas, eds. Tattoo: Bodies, Art, and Exchange in the Pacific and the West. Durham: Duke Univ. Press, 2005.

CHAPTER 28 Art of Africa in the Modern Era

- Anatsui, El. El Anatsui Gawu. Llandudno, Wales, U.K.: Oriel Mostyn Gallery, 2003.
- Astonishment and Power. Washington, D.C.: National Museum of African Art, Smithsonian Institution, 1993.
- Beckwith, Carol, and Angela Fisher. *African Ceremonies*. 2 vols. New York: Harry N. Abrams, 1999.
- Binkley, David A. "Avatar of Power: Southern Kuba Masquerade Figures in a Funerary Context" in *Africa-Journal of the International African Institute*, v.57: 1, 1987. Pgs. 75-97.
- Cameron, Elisabeth L. Art of the Lega. Los Angeles: UCLA Fowler Museum of Cultural History, 2001.
- Cole, Herbert M., ed. I Am Not Myself: The Art of African Masquerade. Los Angeles: Fowler Museum of Cultural History, Univ. of California, 1985.
- —. Icons: Ideals and Power in the Art of Africa. Washington, D.C.: National Museum of African Art, Smithsonian Institution, 1989.
- A Fiction of Authenticity: Contemporary Africa Abroad. St. Louis: Contemporary Art Museum St. Louis, 2003.
- Fogle, Douglas, and Olukemi Ilesanmi. Julie Mehretu: Drawing into Painting. Minneapolis, MN: Walker Art Center, 2003.
- Gillow, John. African Textiles. San Francisco: Chronicle Books, 2003.
- Graham, Gilbert. Dogon Sculpture: Symbols of a Mythical Universe. Brookville, NY: Hillwood Art Museum, Long Island Univ., C.W. Post Campus, 1997.
- Hess, Janet Berry. Art and Architecture in Postcolonial Africa. Jefferson, NC: McFarland & Co., 2006.
- Jordáán, Manuel, ed. Chokwe! Art and Initiation Among the Chokwe and Related Peoples. Munich: Prestel-Verlag., 1998
- Kasfir, Sidney Littlefield. Contemporary African Art. World of Art. London: Thames and Hudson, 2000.
- Morris, James, and Suzanne Preston Blier. Butabu: Adobe Architecture of West Africa. New York: Princeton Architectural Press, 2004.
- Oguibe, Ole, and Okwui Enwezor. Reading the Contemporary: African Art from Theory to the Marketplace. Cambridge, MA: MIT Press, 1999.
- Pemberton III, John, ed. Insight and Artistry in African Divination. Washington, D.C.: Smithsonian Institution Press, 2000.
- Perrois, Louis, and Marta Sierra Delage. The Art of Equatorial Guinea: The Fang Tribes. New York: Rizzoli, 1990.
- Picton, John, et al. El Anatsui: A Sculpted History of Africa. London: Saffron Books in conjunction with the October Gallery, 1998.

- Roberts, Mary Nooter, and Allen F. Roberts, eds. Memory: Luba Art and the Making of History. New York: Museum for African Art, 1996.
- Roy, Christopher D. Art of the Upper Volta Rivers. Meudon, France: Chaffin, 1987.
- Schildkrout, Enid, and Curtis A. Keim. African Reflections: Art from Northeastern Zaire. Seattle: Univ. of Washington Press, 1990.
- Sieber, Roy, and Roslyn Adele Walker. African Art in the Cycle of Life. Washington, D.C.: National Museum of African Art, Smithsonian Institution, 1987.
- Stepan, Peter, and Iris Hahner-Herzog. Spirits Speak: A Celebration of African Masks. Munich. Prestel, 2005.
- Van Damme, Annemieke. Spectacular Display: The Art of Nkanu Initiation Rituals. Washington, D.C.: Smithsonian National Museum of African Art, 2001.
- Vogel, Susan Mullin. Baule: African Art, Western Eyes. New Haven: Yale Univ. Press, 1997.
- Walker, Roslyn Adele. O?_lo?_?_uve?_?_ of Ise?_?_:A Yoruba Sculptor to Kings. Washington, D.C.: National Museum of African Art, Smithsonian Institution, 1998.

Chapter 29 Eighteenth-Century Art in Europe and the Americas

- Bailey, Colin B., Philip Conisbee, and Thomas W. Gaehtgens. The Age of Watteau, Chardin, and Fragonard: Masterpieces of French Genre Painting. New Haven: Yale Univ. Press in assoc. with the National Gallery of Canada, Ottawa, 2003.
- Boime, Albert. Art in an Age of Revolution, 1750–1800. Chicago: Univ. of Chicago Press, 1987.
- Bowron, Edgar Peters, and Joseph J. Rishel, eds. Art in Rome in the Eighteenth Century. London: Merrell, 2000
- Craske, Matthew. Art in Europe, 1700–1830: A History of the Visual Arts in an Era of Unprecedented Urban Economic Growth. Oxford History of Art. Oxford: Oxford Univ. Press, 1997.
- Goodman, Elise, ed. Art and Culture in the Eighteenth Century: New Dimensions and Multiple Perspectives. Studies in Eighteenth-Century Art and Culture. Newark: Univ. of Delaware Press, 2001 Irwin, David G. Neoclassicism. Art & Ideas. London: Phaidon, 1997.
- Jarrasséé, Dominique. 18th-Century French Painting. Trans. Murray Wyllie. Paris: Terrail, 1999.
- Kalnein, Wend von. Architecture in France in the Eighteenth Century. Trans. David Britt. Pelican History of Art. New Haven: Yale Univ. Press, 1995.
- Levey, Michael. Painting in Eighteenth-Century Venice. 3rd ed. New Haven: Yale Univ. Press, 1994.
- Lewis, Michael J. *The Gothic Revival*. World of Art. New York: Thames & Hudson, 2002.
- Lovell, Margaretta M. Art in a Season of Revolution: Painters, Artisans, and Patrons in Early America. Early American Studies. Philadelphia: Univ. of Pennsylvania Press, 2005.
- Monneret, Sophie. David and Neo-Classicism. Trans. Chris Miller & Peter Snowdon. Paris: Terrail, 1999.
- Montgomery, Charles F., and Patrick E. Kane, eds. *American Art*, 1750–1800: Towards Independence. Boston: New York Graphic Society, 1976.
- Poulet, Anne L. Jean-Antoine Houdon: Sculptor of the Enlightenment. Washington, D.C.: National Gallery of Art, 2003.
- Summerson, John. Architecture of the Eighteenth Century. World of Art. New York: Thames and Hudson, 1986.
- Wilton, Andrew, and Ilaria Bignamini, eds. *Grand Tour: The Lure of Italy in the Eighteenth Century*. London:

 Tate Gallery, 1996.
- Young, Hilary, ed. The Genius of Wedgwood. London: Victoria & Albert Museum, 1995.

Chapter 30 Nineteenth-Century Art in Europe and the United States

- Adams, Steven. The Barbizon School and the Origins of Impressionism. London: Phaidon, 1994.
- Bajac, Quentin. The Invention of Photography. Discoveries. New York: Harry N. Abrams, 2002.
- Barger, M. Susan, and William B. White. The Daguerreotype: Nineteenth-Century Technology and Modern Science. Washington, D.C.: Smithsonian Institution, 1991.
- Benjamin, Roger. Orientalist Aesthetics: Art, Colonialism, and French North Africa, 1880-1930. Berkeley: Univ. of California Press, 2003.
- Bergdoll, Barry. European Architecture, 1750-1890. Oxford History of Art. New York: Oxford Univ. Press, 2000. Blakesley, Rosalind P. Russian Genre Painting in the

- Nineteenth Century. Oxford Historical Monographs. New York: Oxford Univ. Press, 2000.
- Blüühm, Andreas, and Louise Lippincott. Light!: The Industrial Age 1750-1900: Art & Science, Technology & Society. New York: Thames & Hudson, 2001.
- Boime, Albert. Art in an Age of Bonapartism, 1800–1815. Chicago: Univ. of Chicago Press, 1990.
- Boime, Albert. Art in an Age of Counterrevolution, 1815–1848. Chicago: Univ. of Chicago Press, 2004.
- Butler, Ruth, and Suzanne G. Lindsay. European Sculpture of the Nineteenth Century. The Collections of the National Gallery of Art Systematic Catalogue. Washington, D.C.: National Gallery of Art, 2000.
- Callen, Anthea. The Art of Impressionism: Painting Technique & the Making of Modernity. New Haven: Yale Univ. Press, 2000.
- Chu, Petra ten-Doesschate. Nineteenth Century European Art. New York: Abrams, 2003.
- Denis, Rafael Cardoso, and Colin Trodd. Art and the Academy in the Nineteenth Century. New Brunswick, NJ: Rutgers Univ. Press, 2000.
- Eisenman, Stephen. Nineteenth Century Art: A Critical History. 2nd ed. New York: Thames and Hudson, 2002.
- Eitner, Lorenz. Nineteenth Century European Painting: David to Cezanne. Rev. ed. Boulder: Westview Press, 2002.
- Frazier, Nancy. Louis Sullivan and the Chicago School. New York: Knickerbocker Press, 1998.
- Fried, Michael. Manet's Modernism, or, The Face of Painting in the 1860s. Chicago: Univ. of Chicago Press, 1996.
- Gerdts, William H. American Impressionism. 2nd ed. New York: Abbeville, 2001.
- Greenhalgh, Paul, ed. *Art nouveau*, 1890-1914. London: V&A Publications, 2000.
- Grigsby, Darcy Grimaldo. Extremities: Painting Empire in Post-Revolutionary France. New Haven: Yale Univ. Press, 2002.
- Groseclose, Barbara. Nineteenth-Century American Art.
 Oxford History of Art. Oxford: Oxford Univ. Press,
- Harrison, Charles, Paul Wood, and Jason Gaiger. Art in Theory 1815–1900: An Anthology of Changing Ideas. Oxford: Blackwell, 1998.
- Herrmann, Luke. Nineteenth Century British Painting. London: Giles de la Mare, 2000.
- Hirsh, Sharon L. Symbolism and Modern Urban Society. New York: Cambridge Univ. Press, 2004.
- Holt, Elizabeth Gilmore, ed. *The Expanding World of Art*, 1874–1902. New Haven: Yale Univ. Press, 1988.
- Kaplan, Wendy. The Arts & Crafts Movement in Europe & America: Design for the Modern World. New York: Thames & Hudson in assoc. with the Los Angeles County Museum of Art, 2004.
- Kapos, Martha, ed. *The Post-Impressionists: A Retrospective*. New York: Hugh Lauter Levin Associates, 1993.
- Kendall, Richard. *Degas: Beyond Impressionism.* London: National Gallery Publications, 1996.
- Lambourne, Lionel. *Japonisme: Cultural Crossings between Japan and the West.* New York: Phaidon, 2005.
- Lemoine, Bertrand. Architecture in France, 1800–1900.
 Trans. Alexandra Bonfante-Warren. New York: Harry N. Abrams, 1998.
- Lochnan, Katharine Jordan. *Turner Whistler Monet*. London: Tate Publishing in assoc. with the Art Gallery of Ontario, 2004.
- Noon, Patrick J. Crossing the Channel: British and French Painting in the age of Romanticism. London: Tate Pub., 2003.
- Pissarro, Joachim. Pioneering Modern Painting: Céézanne & Pissarro 1865-1885. New York: Museum of Modern Art, 2005
- Rodner, William S. J.M. W. Turner: Romantic Painter of the Industrial Revolution. Berkeley: Univ. of California Press, 1997.
- Rosenblum, Robert, and H. W. Janson. *19th Century Art*. Rev. & updated ed. Upper Saddle River, NJ: Pearson Prentice Hall, 2005.
- Rubin, James H. *Impressionism*. Art & Ideas. London: Phaidon, 1999.
- Rybczynski, Witold. A Clearing in the Distance: Frederick Law Olmsted and America in the Nineteenth Century. New York: Scribner, 1999.
- Smith, Paul. Seurat and the Avant-Garde. New Haven: Yale Univ. Press, 1997.
- Thomson, Belinda. Impressionism: Origins, Practice, Reception. Thames & Hudson World of Art. New York: Thames & Hudson, 2000.
- Twyman, Michael. Breaking the Mould: The First Hundred Years of Lithography. The Panizzi Lectures, 2000. London: British Library, 2001.

- Vaughan, William, and Francoise Cachin. Arts of the 19th Century. 2 vols. New York: Abrams, 1998.
- Werner, Marcia. Pre-Raphaelite Painting and Nineteenth-Century Realism. New York: Cambridge Univ. Press, 2005
- Zemel, Carol M. Van Gogh's Progress: Utopia, Modernity, and Late-Nineteenth-Century Art. California Studies in the History of Art, 36. Berkeley: Univ. of California Press, 1997.

CHAPTER 31 Modern Art In Europe And The Americas

- Ades, Dawn, comp. Art and Power: Europe under the Dictators, 1930-45. Stuttgart, Germany: Oktagon in assoc. with Hayward Gallery, 1995.
- Antliff, Mark, and Patricia Leighten. Cubism and Culture. World of Art. London: Thames & Hudson, 2001.
- Bailey, David A. Rhapsodies in Black: Art of the Harlem Renaissance. London: Hayward Gallery, 1997.
- Balken, Debra Bricker. Debating American Modernism: Stieglitz, Duchamp, and the New York Avant-Garde. New York: American Federation of Arts, 2003.
- Barron, Stephanie, ed. Degenerate Art: The Fate of the Avant-Garde in Nazi Germany. Los Angeles: Los Angeles County Museum of Art, 1991.
- Barron, Stephanie, and Wolf-Dieter Dube, eds. German Expressionism: Art and Society. New York: Rizzoli, 1997.
- Bochner, Jay. An American Lens: Scenes from Alfred Stieglitz's New York Secession. Cambridge, MA: MIT Press, 2005.
- Bohn, Willard. The Rise of Surrealism: Cubism, Dada, and the Pursuit of the Marvelous. Albany: State Univ. of New York Press, 2002.
- Bowlt, John E., and Evgeniia Petrova, eds. Painting Revolution: Kandinsky, Malevich and the Russian Avant-Garde. Bethesda, MD: Foundation for International Arts and Education, 2000.
- Bown, Matthew Cullerne. Socialist Realist Painting. New Haven: Yale Univ. Press, 1998.
- Brown, Milton. Story of the Armory Show: The 1913 Exhibition That Changed American Art. 2nd ed. New York: Abbeville, 1988.
- Chassey, Eric de, ed. American art: 1908-1947, from Winslow Homer to Jackson Pollock. Trans. Jane McDonald. Paris: Reunion des Musees Nationaux, 2001.
- Corn, Wanda M. The Great American Thing: Modern Art and National Identity, 1915–1935. Berkeley: Univ. of California Press, 1999.
- Curtis, Penelope. Sculpture 1900–1945: After Rodin. Oxford History of Art. Oxford: Oxford Univ. Press, 1999.
- Elger, Dietmar. Expressionism: A Revolution in German Art. Ed. Ingo F. Walther. Trans. Hugh Beyer. New York: Taschen. 1998.
- Fer, Briony. On Abstract Art. New Haven: Yale Univ., 1997.
- Fletcher, Valerie J. Crosscurrents of Modernism: Four Latin American Pioneers: Diego Rivera, Joaquíin Torres-Garcíía, Wifredo Lam, Matta. Washington, D.C.: Hirshhorn Museum and Sculpture Garden in assoc. with the Smithsonian Institution Press, 1992.
- Folgarait, Leonard. Mural Painting and Social Revolution in Mexico, 1920-1940: Art of the New Order. New York: Cambridge Univ. Press, 1998.
- Forgáács, Eva. The Bauhaus Idea and Bauhaus Politics. Trans. John Báátki. New York: Central European Univ. Press, 1995.
- Frank, Patrick. Los Artistas del Pueblo: Prints and Workers'
 Culture in Buenos Aires, 1917-1935. Albuquerque:
 Univ. of New Mexico Press, 2006.
- Grant, Kim. Surrealism and the Visual Arts: Theory and Reception. New York: Cambridge Univ. Press, 2005.
- Green, Christopher. Art in France: 1900–1940. Pelican History of Art. New Haven: Yale Univ. Press, 2000. Reissue ed. 2003.
- Haiko, Peter, ed. Architecture of the Early XX Century. Trans. Gordon Clough. New York: Rizzoli, 1989.
- Harris, Jonathan. Federal Art and National Culture: The Politics of Identity in New Deal America. Cambridge Studies in American Visual Culture. New York: Cambridge Univ. Press, 1995.
- Harrison, Charles, Francis Frascina, and Gill Perry. Primitivism, Cubism, Abstraction: The Early Twentieth Century. New Haven: Yale Univ. Press, 1993.
- Haskell, Barbara. The American Century: Art & Culture, 1900–1950. New York: Whitney Museum of American Art, 1999.

- Herbert, James D. Fauve Painting: *The Making of Cultural Politics*. New Haven: Yale Univ. Press, 1992.
- Hill, Charles C. The Group of Seven: Art for a Nation. Toronto: National Gallery of Canada, 1995.
- Karmel, Pepe. Picasso and the Invention of Cubism. New Haven: Yale Univ. Press, 2003.
- Lista, Giovanni. Futurism. Trans. Susan Wise. Paris: Terrail, 2001.
- McCarter, Robert, ed. On and by Frank Lloyd Wright: A Primer of Architectural Principles. New York: Phaidon Press, 2005.
- Moudry, Roberta, ed. *The American Skyscraper: Cultural Histories*. New York: Cambridge Univ. Press, 2005.
- Rickey, George. Constructivism: Origins and Evolution. Rev. ed. New York: G. Braziller, 1995.
- Taylor, Brandon. Collage: The Making of Modern Art. London: Thames & Hudson, 2004.
- Weston, Richard. *Modernism*. London: Phaidon, 1996. White, Michael. *De Stijl and Dutch Modernism*. Critical Perspectives in Art History. New York: Manchester Univ. Press, 2003.
- Whitfield, Sarah. Fauvism. World of Art. New York: Thames and Hudson, 1996.
- Whitford, Frank. Bauhaus. World of Art. London: Thames and Hudson, 1984.
- Zurier, Rebecca, Robert W. Snyder, and Virginia M. Mecklenburg. Metropolitan Lives: The Ashcan Artists and Their New York. Washington, D.C.: National Museum of American Art, 1995.

Chapter 32

The International Scene Since 1945

- Alberro, Alexander, and Blake Stimson, eds. Conceptual Art: A Critical Anthology. Cambridge, MA: MIT Press, 1999.
- Archer, Michael. Art Since 1960. 2nd ed. World of Art. New York: Thames and Hudson, 2002.
- Atkins. Robert. Artspeak: A Guide to Contemporary Ideas, Movements, and Buzzwords. 2nd ed. New York: Abbeville, 1997.
- Ault, Julie. Art Matters: How the Culture Wars Changed America. Ed. Brian Wallis, Marianne Weems, & Philip Yenawine. New York: New York Univ. Press, 1999.
- Battcock, Gregory. Minimal Art: A Critical Anthology. Berkeley: Univ. of California Press, 1995.
- Beardsley, John. Earthworks and Beyond: Contemporary Art in the Landscape. 3rd ed. New York: Abbeville, 1998.
- Bird, Jon, and Michael Newman, eds. Rewriting Conceptual Art. Critical Views. London: Reaktion, 1999.
- Bishop, Claire. *Installation Art: A Critical History*. New York: Routledge, 2005.
- Blais, Joline, and Jon Ippolito. At the Ege of Art. London: Thames & Hudson, 2006.
- Buchloh, Benjamin H. D. Neo-Avantgarde and Culture Industry: Essays on European and American Art from 1955 to 1975. Cambridge, MA: MIT Press, 2000.
- Carlebach, Michael L. American Photojournalism Comes of Age. Washington, D.C.: Smithsonian Institution Press, 1997.
- Causey, Andrew. Sculpture since 1945. Oxford History of Art. Oxford: Oxford Univ. Press, 1998.
- Corris, Michael, ed. Conceptual Art: Theory, Myth, and Practice. New York: Cambridge Univ. Press, 2004.
- Craven, David. Abstract Expressionism as Cultural Critique: Dissent during the McCarthy Period. Cambridge Studies in American Visual Culture. New York: Cambridge Univ. Press, 1999.
- Day, Holliday T. Crossroads of American Sculpture: David Smith, George Rickey, John Chamberlain, Robert Indiana, William T. Wiley, Bruce Nauman. Indianapolis, IN: Indianapolis Museum of Art, 2000.
- De Oliveira, Nicolas, Nicola Oxley, and Michael Petry.

 Installation Art in the New Millennium: The Empire of the

 Senses. New York: Thames & Hudson, 2003.
- De Salvo, Donna M., ed. *Open Systems: Rethinking Art* c. 1970. London: Tate, 2005.
- Fabozzi, Paul F. Artists, Critics, Context: Readings In and Around American Art Since 1945. Upper Saddle River, NJ: Prentice Hall, 2002.
- Fineberg, Jonathan David. Art Since 1940: Strategies of Being. 2nd ed. New York: Abrams, 2000.
- Flood, Richard, and Frances Morris. Zero to Infinity: Arte Povera, 1962-1972. Minneapolis, MN: Walker Art Center. 2001.
- Follin, Frances. Embodied Visions: Bridget Riley, Op Art and the Sixties. London: Thames & Hudson, 2004.
- Ghirardo, Diane. Architecture after Modernism. World of Art. New York: Thames and Hudson, 1996.

- Goldberg, Roselee. Performance Art: From Futurism to the Present. Rev. ed. World of Art. London: Thames and Hudson, 2001.
- Goldstein, Ann. A Minimal Future?: Art as Object 1958-1968. Los Angeles: Museum of Contemporary Art, 2004.
- Grande, John K. Art Nature Dialogues: Interviews with Environmental Artists. Albany: State Univ. of New York Press, 2004.
- Grosenick, Uta, and Burkhard Riemschneider, eds. Art at the Turn of the Millennium. New York: Taschen, 1999
- Grunenberg, Christoph, ed. Summer of Love: Art of the Psychedelic Era. London: Tate, 2005.
- Herskovic, Marika, ed. American Abstract Expressionism of the 1950s: An Illustrated Survey: With Artists' Statements, Artwork and Biographies. New York: New York School Press, 2003.
- Hitchcock, Henry Russell, and Philip Johnson. The International Style. New York: W.W. Norton, 1995.
- Hopkins, David. After Modern Art: 1945–2000. Oxford History of Art. Oxford: Oxford Univ. Press, 2000.
- Jencks, Charles. The New Paradigm in Architecture: The Language of Post-Modernism. New Haven: Yale Univ. Press, 2002.
- Jodidio, Philip. New Forms: Architecture in the 1990s. New York: Taschen, 2001.
- Johnson, Deborah, and Wendy Oliver, eds. Women Making Art: Women in the Visual, Literary, and Performing Arts Since 1960. Eruptions, vol. 7. New York: Peter Lang, 2001.
- Jones, Caroline A. Machine in the Studio: Constructing the Postwar American Artist. Chicago: Univ. of Chicago Press. 1996
- Joselit, David. American Art Since 1945. World of Art. London: Thames and Hudson. 2003.
- Katzenstein, Inéés, ed. Listen, Here, Now!: Argentine art of the 1960s: Writings of the Avant-Garde. New York: Museum of Modern Art, 2004.
- Legault, Rééjean, and Sarah Williams Goldhagen, eds.

 Anxious Modernisms: Experimentation in Postwar

 Architectural Culture. Montrééal: Canadian Centre for
 Architecture, 2000.
- Lucie-Smith, Edward. Movements in Art since 1945. World of Art. London: Thames and Hudson, 2001.
- Madoff, Steven Henry, ed. Pop Art: A Critical History. The Documents of Twentieth Century Art. Berkeley: Univ. of California Press, 1997.
- Moos, David, ed. *The Shape of Colour: Excursions in Colour Field Art*, 1950-2005. Toronto: Art Gallery of Ontario, 2005.
- Paul, Christiane. *Digital Art*. World of Art. London: Thames and Hudson, 2003.
- Phillips, Lisa. The American Century: Art and Culture, 1950–2000. New York: Whitney Museum of American Art, 1999.
- Ratcliff, Carter. The Fate of a Gesture: Jackson Pollock and Postwar American Art. New York: Farrar, Straus, Giroux, 1996.
- Reckitt, Helena, ed. Art and Feminism. Themes and Movements. London: Phaidon, 2001.
- Risatti, Howard, ed. Postmodern Perspectives: Issues in Contemporary Art. 2nd ed. Upper Saddle River, NJ: Prentice Hall, 1998.
- Robertson, Jean, and Craig McDaniel. *Themes of Contemporary Art: Visual Art after 1980.* New York: Oxford Univ. Press, 2005.
- Robinson, Hilary, ed. Feminism-Art-Theory: An Anthology, 1968-2000. Malden, MA: Blackwell Publishers, 2001.
- Rorimer, Anne. New Art in the 60s and 70s: Redefining Reality. New York: Thames & Hudson, 2001.
- Rush, Michael. New Media in Late 20th-Century Art.
 World of Art. London: Thames and Hudson, 1999.

 Video Art. New York: Thames & Hudson, 2003.
- Sandler, Irving. Art of the Postmodern Era: From the Late 1960s to the Early 1990s. New York: Icon Editions, 1996.
- Shohat, Ella. *Talking Visions: Multicultural Feminism* in a Transnational Age. Documentary Sources in Contemporary Art, 5. New York: New Museum of Contemporary Art, 1998.
- Sylvester, David. About Modern Art. 2nd ed. New Haven: Yale Univ. Press, 2001.
- Waldman, Diane. Collage, Assemblage, and the Found Object. New York: Abrams, 1992.
- Weintraub, Linda, Arthur Danto, and Thomas McEvilley. Art on the Edge and Over: Searching for Art's Meaning in Contemporary Society, 1970s–1990s. Litchfield, CT: Art Insights, 1996.

CREDITS

CREDITS AND COPYRIGHTS

Introduction

1 Roger Wood, London Corbis / Bettmann; 2 The Art Institute of Chicago. Wirt D. Walker Fund. 1949.585 Photograph © 2005, The Art Institute of Chicago. All Rights Reserved; 3 John Decopoulos; 4 University of Arizona, Museum of Art; 5 The University of Arizona Museum of Art. © 2007 The Georgia O'Keeffe Foundation / Artists Rights Society (ARS), New York; 6 Art Resource, NY; 7 Art Resource, NY; 8 Derechos reservados © Museo Nacional Del Prado - Madrid; 9 Spencer Museum of Art, The University of Kansas; 10 M. Sari / Musei Vaticani / SCALA Art Resource, NY; 11 Art Resource, NY; 12 SCALA Art Resource, NY; 13 Erich Lessing / Art Resource, NY; 14 Spencer Museum of Art, The University of Kansas; 15 The Nelson-Atkins Museum of Art, Kansas City, Missouri. Purchase, F83-55. Photograph by Mel McLean; 16 Spencer Museum of Art, The University of Kansas: Museum Purchase: Peter T. Bohan Art Acquisition Fund; 17 The J. Paul Getty Museum, Los Angeles; 18 Ghigo Roli / Index Ricerca Iconografica; 19 Robert Lehman Collection, 1975. (1975.1.794) Photograph © 1983 The Metropolitan Museum of Art; 20 Birmingham Museums and Art Gallery, Birmingham, England, U.K.; 21 By permission of The British Library; 22 Courtesy of the Freer Gallery of Art, Smithsonian Institution, Washington, D.C. F1904.61; 23 SCALA Art Resource, NY; 24 Victoria & Albert Museum, London / Art Resource, NY; BOX Catherine Ursillo / Photo Researchers, Inc.; BOX Frank Fournier.

Chapter 1

1-1 Ministere de la Culture et de la Communication. Direction Regionale des affaires Culturelles de Rhone Alpes. Service Regional de l'Archeologie; 1-2 National Geographic Image Collection. Jack Unruh / NGS Image Collection; 1-3 K. H. Augustin, Esslingen Ulmer Museum; 1-4 Naturhistorisches Museum, Vienna, Austria © Photography by Erich Lessing / Art Resource, NY; 1-5 Institute of Archeology ASCR Prague; 1-6 Sisse Brimberg / National Geographic Image Collection; 1-7 Michael Lorblanchet / San Heritage Centre / Rock Art Research Centre / University of the Witwatersrand, Johannesburg; 1-8 Sisse Brimberg National Geographic Image Collection; 1-9 Yvonne Vertut; 1-10 Sisse Brimberg / National Geographic Image Collection; 1-11 Yvonne Vertut; 1-12 Reunion des Musees Nationaux / Art Resource, NY; 1-13 Marilyn Stokstad; 1-15 © David Lyons / Alamy; 1-16 Department of the Environment, Heritage and Local Government; 01-17 Aerofilms; 1-18 National Museum, Copenhagen; 01-19 National Museum, Copenhagen; 1-20 National Museum, Copenhagen; 1-21 National Museum of Ireland; BOX Erich Lessing / Art Resource, NY; BOX Erich Lessing / Art Resource, NY.

Chapter 2

2-1 Image © The Metropolitan Museum of Art; 2-02 Folco Quilici; 2-3 Peter Dorrell, Stuart Laidlaw, Dr. Gary / Prof. Nasser D Khalili; 2-04 Dr. Brian F. Byrd; 2-05 World Tourism Organization: Iraq; 2-08 Courtesy of the Oriental Institute of the University of Chicago; 2-09 Corbis / Bettmann; 2-10 National Museum of Denmark, Copenhagen; 2-11 University of Pennsylvania Museum object # B17694, (image #150848); 2-12 Image © The Metropolitan Museum of Art; 2-13 Erich Lessing / Art Resource, NY; 2-14 Herve Lewandowski © Reunion des Musees Nationaux / Art Resource, NY; 2-15 D. Arnaudet / Louvre, Paris France / RMN / Art Resource, NY; 2-16 Dagli Orti / Picture Desk, Inc. Kobal Collection; 2-18 Courtesy of the Oriental Institute of the University of Chicago; 2-19 © The Trustees of the British Museum; 2-20 Courtesy of the Oriental Institute of the University of Chicago; 2-21 Art Resource/Bildarchiv Preussischer Kulturbesitz; 2-22 © Superstock; 2-23 © Gianni Dagli Orti / Corbis; 2-24 © Gianni Dagli Orgi / CORBIS. All Rights Reserved; 2-25 © Ashmolean Museum, Oxford, England, U.K.; BOX Ashmolean Museum, Oxford, England, U.K.; BOX John Simmons; BOX Herve Lewandowski / Reunion des Musees Nationaux / Art Resource, NY; BOX Herve Lewandowski / Reunion des Musees Nationaux / Art Resource, NY.

Chapter 3

3-1 The Egyptian Museum; 3-2a Art Resource, NY; 3-02b Art Resource, NY; 3-05 © Archivo Iconografico CORBIS / All Rights Reserved; 3-06 Free Agents Ltd. Corbis/Bettmann; 3-07 Harvard University Semitic Museum; 3-08 Werner Forman / Art Resource, NY; 3-09 Araldo de Luca / The Egyptian Museum, Cairo / Index Ricerca Iconografica; 3–10 Araldo de Luca Archives; 3–11 © 2006 Museum of Fine Arts, Boston Harvard University-Boston Museum of Fine Arts. All Rights Reserved; 3-12 The Brooklyn Museum of Art; 3-13 Herve Lewandowsk / Musee du Louvre / RMN Reunion des Musees Nationaux, France / Art Resource, NY; 3-14 Yvonne Vertut; 3-15 Photograph by Jamison Miller; 3-16 Yvonne Vertut; 3-17 Image @ The Metropolitan Museum of Art; 3-18 Image © The Metropolitan Museum of Art; 3-19 Araldo da Luca / Image © The Metropolitan Museum of Art; 3-20 Photograph © 1992 The Metropolitan Museum of Art; 3-22 Yann Arthus-Bertrand / Corbis / Bettmann; 3-25 Yvonne Vertut; 3-26 Image © The Metropolitan Museum of Art; 3-27 Petera A. Clayton; 3-30 Art Resource / Bildarchiv Preussischer Kulturbesitz; 3-31 Art Resource, NY; 3-32 Art Resource Bildarchiv Preussischer Kulturbesitz; 3-33 Araldo de Luca Studio / Index Ricerca Iconografica: 3-34 Guillermo Aldana / The Getty Conservation Institute; 3-35 © The British Museum; 3-36 © Copyright The British Museum; BOX © The British Museum; BOX Picture Desk, Inc. / Kobal Collection; BOX: Dagli Orti Giovanni; BOX: Werner Forman Archive / Art Resource, NY; BOX @ The British Museum; BOX: @ Fridmar Damm / Zefa / CORBIS All Rights Reserved; BOX: AKG-Images; BOX: Dagli Orti / Picture Desk, Inc. / Kobal Collection; BOX: Egyptian Tourist Authority.

Chapter 4

4-1 Nimatallah / National Archeological Museum, Athens Art Resource, NY; 4-2 Nicholas P. Goulandris Foundation; 4-3 Hellenic Republic Ministry of Culture; 4-4 McRae Books Srl; 4-5 © Georg Gerster / Photo Researchers, Inc.; 4-6 © Roger Wood / Corbis; 4-7 Studio Kontos Photostock: 4-8 Archeological Museum, Irklion, Crete / Studio Kontos Photostock; 4-9 Petros M. Nomikos / Courtesy of Thera Foundations, The Archaeological Society at Athens; 4-10 Studio Kontos Photostock; 4-11 Archeological Museum, Iraklion, Crete / Studio Kontos Photostock; 4-12 Erich Lessing; Art Resource, NY; 4-13 Nimtallah / Art Resource, NY; 4-14 Nimtallah / Art Resource, NY; 4-15 SCALA Art Resource, NY; 4-16 National Archaeological Museum, © Hellenic Ministry of Culture, Archaeological Receipts Fund; 4-17 Studio Kontos Photostock; 4-19 © The Trustees of the British Museum; 4-20 Studio Kontos Photostock; 4-21 © Vanni Archive / CORBIS All Rights Reserved; 4-23 Dagli Orti / Picture Desk, Inc. / Kobal Collection; 4-24 National Archaeological Museum, Athens / Hirmer Fotoarchiv, Munich, Germany; 4-25 Nimatallah / Art Resource, NY; 4-26 Nimtallah / Art Resource, NY; 4-27 Studio Kontos Photostock; BOX: Deutsches Archaologisches Institut, Athens; BOX: Studio Kontos Photostock; BOX: Studio Kontos Photostock.

Chapter 5

5-2 Dagli Orti / Picture Desk, Inc. / Kobal Collection; 5-3 Archeological Museum, Eretria, Greece / Hellenic Republic Ministry of Culture; 5-4 Photograph © 1996 The Metropolitan Museum of Art; 5-5 © Metropolitan Museum of Art; 5-6 Gérard Blot / C. Jean / Musee du Louvre / RMN Reunion des Musees Nationaux, France / SCALA/Art Resource, NY; 5-7 Marco Cristofori CORBIS-NY: 5-9 Gian Beerta Vanni / Archaelolgical Museum, Korkvra (Corfu) / Art Resource, NY; 5-11 Studio Kontos Photostock; 5-12 Vanni / Art Resource, NY; 5-13Vanni / Art Resource, NY; 5-14 Photograph © 1997 The Metropolitan Museum of Art; 5-15 SCALA / Art Resource, NY; 5-16 Bildarchiv Preubischer Kulturbesitz; 5-17 Studio Kontos Photostock; 5-18 Studio Kontos Photostock; 5-20 Bibliotheque Nationale de France 5-21 Photo Vatican Museums; 5-22 Chateau-Musee, Boulogne-su-Mer, France / Devos; 5-23 © The Metropolitan Museum of Art; 5-24

Scala / Art Resource, NY; 5-26 Studio Kontos Photostock; 5-27 Studio Kontos Photostock; 5-27 Studio Kontos Photostock; 5-28 Studio Kontos Photostock; 5-29 Bildarchiv Preussischer Kulturbesitz / Art Resource, NY; 5-30 Archeological Museum, Delphi/ Studio Kontos Photostock; 5-30 Studio Kontos Photostock; 5-31 SCALA / Museo Archeologico Naz, Italy / Art Resource, NY; 5-32 © 2005 Museum of Fine Arts, Boston. All Rights Reserved.; 5-33 © Georg Gerster / Photo Researchers Inc.; 5-34 With permission of the Royal Ontario Museum © ROM; 5-35 © Copyright The British Museum; 5-36 © The Trustees of the British Museum; 5-37 © The Trustees of the British Museum; 5-38 Reunions des Musees Nationaux / Art Resource, NY; 5-39 Studio Kontos Photostock; 5-40 Wolfgang Kaehler / CORBIS-NY; 5-40 De Agostini Editore Picture Library; 5-42 Akropolis Museum, Athens / Studio Kontos Photostock; 5-44 © 2005 Museum of Fine Arts, Boston. All Rights Reserved; 5-45 Nimatallah / National Museum Athens, Greece / Art Resource, NY; 5-48 Dagli Orti / Picture Desk, Inc. / Kobal Collection; 5-50 Archaeological Museum, Olympia / Studio Kontos Photostock; 5-51 P Zigrossi / Musei Vaticani / Vatican Museums, Rome, Italy; 5-52 © Copyright The British Museum; 5-53 Photo Vatican Museums; 5-54 Erich Lessing / Art Resource, NY; 5-55 © The Trustees of the British Museum; 5-56 © The Metropolitan Museum of Art; 5-57 SCALA / Alinari / Art Resource, NY; 5-58 Archeological Museum; 5-59 Studio Kontos Photostock; 5-60 Ruggero Vanni / CORBIS-NY; 5-61 Marvin Trachtenberg; 5-62 Araldo DeLuca / Museo Nazionale Romano, Rome / Index Ricerca Iconografica; 5-64 Bildarchiv Preussischer Kulturbesitz / Art Resource, NY; 5-65 Art Resource, NY; 5-66 Reunion des Musees Nationaux / Art Resource, NY; 5-67 Photograph © 1981 The Metropolitan Museum of Art; 5-68 Photograph © 1997 The Metropolitan Museum of Art; 5-69 Reunion des Musees Nationaux / Art Resource, NY; 5-69 Reunion des Musees Nationaux / Art Resource, NY; BOX: Ikona; BOX: Studio Kontos Photostock; BOX: The Antiquities of Athens / Gennadius Library / American School of Classical Studies at Athens; BOX: With permission of the Royal Ontario Museum © ROM; Box: Photograph by Gary Layda, The Parthenon, Nashville, Tennessee.

Chapter 6

6-1 Erich Lessing / Art Resource, NY; 6-2 © Maurizio Bellu / Ikona; 6-5 Museo Nazionale di Villa Giulia, Italy / Canali Photobank; 6-6 Nimatallah / Art Resource, NY; 6-7 SCALA Art Resource, NY; 6-8 Scala / Art Resource, NY; 60-9 Canali Photobank; 6-10 SCALA Art Resource, NY; 6-11 Scala / Art Resource, NY; 6-11 ScALA Art Resource, NY; 6-12 NY Carlsberg Glyptotek; 6-13 American Numismatic Society of New York; 6-14 Danita Delimont Photography; 6-15 Lazio/Soprintendenza Arc. Rome / Index Ricerca Iconografica

6-16 Canali Photobank; 6-18 Roy Rainford / Robert Harding World Imagery; 6-20 Photo Vatican Museums; 6-21 A. Jemolo / Ikona; 6-22 © Andrea Jemolo / Ikona; 6-22 Andrea Jemolo / IKONA; 6-23 Vincenzo Pirozzi / IKONA; 6-24 Kunsthistorisches Museum Wien / Kunsthistorisches Museum, Vienna, Austria; 6-25 George Gerster Photo Researchers, Inc.; 6-26 Soprintendenza Archeologica di Pompei / Ikona; 6-27 The Houses of Roman Italy 100BC-AF250: Ritual Space and Decoration, by John R. Clarke, figure 28, © 1991 The Regents of the University of California; 6-28 Alberti Index Ricerca Iconografica; 6-29 Fitzwilliam Museum, University of Cambridge, England; 6-30 Canali Photobank; 6-31 Canali Photobank; 6-32 Index Ricerca Iconografica; 6-34 © The Metropolitan Museum of Art, NY; 6-35 SCALA Art Resource, NY; 6-36 Erich Lessing / Art Resource, NY; 6-36 Erich Lessing / Art Resource, NY; 6-37 Scala / Art Resource, NY; 6-38 A. Vasari / Index Ricerca Iconografica; 6-39 © Achim Bednorz, Koln; 6-39 ◆© Achim Bednorz, Koln; 6-40 © Achim Bednorz, Koln; 6-42 Roman Architecture, Frank Sear, Cornell University Press, 1982; 6-43 Canali Photobank; 6-44 Araldo de Luca Archives / Index Ricerca Iconografica; 6-45 Ikona; 6-46 American Academy in Rome; 6-48 Dr. James E. Packer; 6-49 Scala / Art Resource, NY; 6-50 Robert Frerck /

Woodfin Camp & Associates; 6-51 SCALA Art

Resource, NY: 6-52 Canali Photobank: 6-54 Danita Delimont Photography: 6-56 Canali Photobank: 6-57 Biran Brake / John Hillelson Agency; 6-58 Art Resource / Bildarchiv Preussischer Kulturbesitz; 6-59 © IKONA Photo/FOTO VASARI ROMA; 6-60 Museo Capitolino / Canali Photobank; 6-61 Araldo De Luca/Musei Capitolini, Rome, Italy / Index Ricerca Iconografica; 6-62 Bildarchiv Preussischer Kulturbesitz / Art Resouce, NY; 6-63 Photograph © 1986 The Metropolitan Museum of Art; 6-66 Ikona; 6-67 Musei Vaticani, Braccio Nuovo, Citta del Vaticano, Rome / Art Resource, NY; 6-68 Fotostudio Rapuzzi; 6-69 Scala / Art Resource, NY; 6-71 © Achim Bednorz, Koln; 6-72 © Bildarchiv Monheim GmbH / Alamy; 6-73 Capitoline Museum / Canali Photobank; 6-74 Araldo de Luca Archives / Index Ricerca Iconografica; 6-75 IKONA; 6-77 © Copyright The British Museum; 6-78 V & A Images / Victoria and Albert Museum; 6-78 V & A Images / Victoria and Albert Museum; 6-79V & A Images / Victoria and Albert Museum; BOX: Musei Vaticani.

Chapter 7

7-1 Index Ricerca Iconografica; 7-2 © Soprintendenza Archeologica di Roma / Ikona; 7-3 Princeton University Press / Art Resource, NY; 7-4 Yale University Art Gallery; 7-5 Photo by David Harris, Jerusalem; 7 David Harris Photography; 7-7 The Cleveland Museum of Art, John L. Severance Fund. 1965.241; 7-8 Soprintendenza Archeologica di Roma / IKONA; 7-9 Yale University Art Gallery; 7-11 SCALA Art Resource, NY; 7-12 Vincenzo Pirozzi; 7-13 Nimatallah / Index Ricerca Iconografica; 7-14 Vincenzo Pirozzi / IKONA; 7-15 Canali Photobank; 7-17 © Achim Bednorz, Koln; 7-18 Scala / Art Resource, NY; 7-19 © Vanni Archive / Corbis; 7-20 Canali Photobank; 7-21 Canali Photobank; 7-24 Sonia Halliday Photographs; 7-25 @ Achim Bednorz, Koln; 7-27 Marvin Trachtenberg; 7-28 Scala; 7-30 Dagli Orti / Art Archive / Picture Desk, Inc. / Kobal Collec tion 7-31, 7-32 Canali Photobank; 7-33 SCALA Art Resource, NY; 7-34 © Arthur Hustwitt / eStock Photography LLC; 7-35 Bildarchiv der Osterreichische Nationalbibliothek; 7-36, 7-37 Donato Pineider, Florence / Biblioteca Medicea Laurenziana Firenze; 7-38 Studio Kontos Photostock; 7-39 SCALA / Tretyakov Gallery, Moscow / Art Resource, NY: 7-40 Bruce White © The Metropolitan Museum of Art, NY; 7-41 Dagli Orti / The Art Archive; 7-42 Bruce White / © 1997 The Metropolitan Museum of Art; 7-43 Studio Kontos Photostock; 7-44 Canali Photobank; 7-45 Musee du Louvre / RMN Reunion des Musees Nationaux, France / Daniel Arnaudet / Art Resource, NY; 7-46 © The British Museum; 7-47 Publifoto / Index Ricerca Iconografica; 7-48 Publifoto / Index Ricerca Iconografica; 7-49 Dr. Reha Gunay; 7-50 Dagli Orti / Picture Desk, Inc. / Kobal Collection / 7-51 Sovfoto / Eastfoto: BOX: Canali Photobank; BOX: Mario Carrieri Fotografo.

Chapter 8

8-1 © Kazuyoshi Nomachi / Corbis; 8-2 © Annie Griffiths Belt / Corbis; 8-4 Annie Griffiths Belt / Corbis; 8-5 Islamic Architecture, John Hoag, Harry N. Abrams, p. 308, 1977; 8-7 © Roger Wood / Corbis. All Rights Reserved; 8-8 Raffaello Bencini Fotografo; 8-9 Benini / Raffaello Bencini Fotografo; 8-10 Photograph © 1994 The Metropolitan Museum of Art, NY; 8-11 Bibliotheque Nationale de France; 8-12 Art Resource Reunion des Musees Nationaux; 8-13 Musee du Louvre / RMN Reunion des Musees Nationaux, France SCALA Art Resource, NY: 8-14 Werner Forman Archive Ltd; 8-15 Photograph © 1982 The Metropolitan Museum of Art; 8-16 Ronald Sheridan / The Ancient Art & Architecture Collection Ltd; 8-17 © Achim Bednorz, Koln; 8-18 Peter Sanders Photography; 8-19 Mario Carrieri Fotografo; 8-21 Photograph © 1982 The Metropolitan Museum of Art; 8-22 Museo de Telas Medievales, Monasterio de Santa Maria / Institut Amatller de Arte Hispanico; 8-23 Z. Perkins / James F. Ballard Collection / The Saint Louis Art Museum; 8-24 National Library, Egypt; 8-25, 8-26 British Library; 8-27 Sonia Halliday Photographs; 8-29 Photograph © 1980 The Metropolitan Museum of Art; 8-30 The Aga Khan Program for Islamic Architecture; BOX: Corning Museum of Glass; BOX: Library of Congress / Photo Courtesy of Gayle Garrett, Washington, D.C.

Chapter 9

9-1 By permission of The British Library; 9-2 Giraudon / The Bridgeman Art Library International; 9-3 J.M. Kenoyer / Harappa; 9-4 National Museum of Pakistan;

9-5 National Museum of New Delhi; 9-7 Jean-Louis Nou/Archaeological Museum, Sarnath / AKG-Images; 9-9 Marilyn Stokstad / Courtesy of Gene Markowski; 9-10, 9-16, 9-22, 9-23 University of Michigan / Asian Art Archives; 9-11 India Government Tourist Office / Architectural plan by Percy Brown, reproduced from Indian Architecture, Vol. 1 Bombay; 9-12 © Dinodia; 9-13, 9-15 Richard Todd / National Museum of New Delhi; 9-17 Benoy K. Behl; 9-18, 9-20 Jean-Louis Nou / akg-images; 9-24 © Robert Gill Papilio / Corbis; 9-25 © David Cumming, Eye Ubiquitous / Corbis; 9-26 © Dinodia; 9-27 Benoy K. Behl; 9-28 Photo Lynton Gardner; 9-29 The Norton Simon Foundation; 9-30 Borromeo / Art Resource, NY; 9-31 Scala; 9-33 akg-images; 09-35 Mrs. Holdsworth / Robert Harding.

Chapter 10

10-1 National Geographic Image Collection; 10-2 Banpo Museum; 10-5 The Institute of History and Philology, Academia Sinica, Taipei, Taiwan ROC; 10-6 Hunan Provincial Museum; 10-8 Cultural Relics Publishing House; 10-9 Cultural Relics Publishing House; 10-10 The Nelson-Atkins Museum of Art © Copyright The British Museum: 10-12, 10-20 National Palace Museum; 10-13 Wolfgang Kaehler / Corbis-NY; 10-14 Photograph © 2007 Museum of Fine Arts, Boston: 10-15 The Cultural Relics Bureau; 10-16 Cultural Relics Publishing House; 10-17 Cultural Relics Publishing House; 10-18 © 2005 Museum of Fine Arts, Boston. All Rights Reserved; 10-19, 10-23 Robert Newcombe The Nelson-Atkins Museum of Art; 10-22 Imperial Palace Museum; 10-24 Percival David Foundation; 10-25 National Museum of Korea; 10-26, 10-30 Photographic Services, Harvard University Art Museums; 10-27 National Museum of Korea; 10-28 Europhoto / AAA Collection; 10-29 TNM Image Archives; BOX: Cultural Relics Publishing House.

Chapter 11

11-1 Freer Gallery of Art/Smithsonian Institution; 11-3, 11-4 TNM Image Archives; 11-6 Kazuyoshi Miyoshi/Pacific Press Service; 11-6, 11-7, 11-10 Japan National Tourist Organization; 11-08 Tokyo National Museum DNP Archives.Com Co., Ltd / © Tori Busshi / Nara City Museum of Photography / Horyuji Temple; 11-09 Tokyo National Museum DNP Archives.Com Co., Ltd © Nara City Museum of Photography Horyuji Temple; 11-11 © Archivo Iconografico, S.A. / Corbis; 11-12 Japan National Tourist Organization Sakamoto Manschichi Photo Research Library, Tokyo; 11-13 The Tokugawa Reimeikai Foundation; 11-14 DNP Archives. Com Co., Ltd. 11-17 Japan National Tourist Organization / Asanuma Photo Studios, Kyoto, Japanl; 11-18 - Photograph courtesy of the Kyoto National Museum

BOX: © The Cleveland Museum of Art, John L. Seerance Fund. 1962.163

Chapter 12

12-1 © Corson Hirshfeld 1988; 12-02 © The Metropolitan Museum of Art, NY; 12-3 Werner Forman / Art Resource, NY; 12-4 Elizabeth Barrows Rogers / Mexican Government Tourism Office; 12-6 Picture Desk, Inc. /Kobal Collection; 12-7 The Cleveland Museum of Art; 12-8 Justin Kerr Associates; 12-9 The Museum of Modern Art / Licensed by SCALA Art Resource, NY; 12-10 SCALA Art Resource, NY; 12-11 © The Trustees of The British Museum; 12-12 Justin Kerr / © 2001 Trustees of The Art Museum, Princeton University, NJ; 12-13 Wim Swaan Collection / The Getty Research Institute for the History of Art and the Humanities; 12-14 John Bigelow Taylor; 12-16 © 2006 Museum of Fine Arts, Boston. All Rights Reserved; 12-17 Kevin Schafer / Corbis-NY; 12-18 Photograph (c)2006, The Art Institute of Chicago. All Rights Reserved; 12-1 UCLA Fowler Museum of Cultural History; 12-20 University of Pennsylvania Museum of Archaeology and Anthropology; 12-21 © Gilcrease Museum, Tulsa; 12-22 Tony Linck / Ohio Dept. of Natural Resources: 12-23 Cahokia Mounds Museum Society; 12-25 Richard A. Cooke / Corbis-NY; 12-26 Timothy O'Sullivan / National Archives and Records Administration / Presidential Library; 12-27 The Saint Louis Art Museum; BOX: Sucec /Craig Law; BOX: © Fred Hirshmann.

Chapter 13

13–1 Jerry Thompson; 13–2 Christopher Henshilwood / Centre for Development Studies, University of Bergen; 13–3 Robert Estall / Lajoux / Artephoto; 13–5 South

African Government Information Office; 13-6 Photograph © 1979 Dirk Bakker; 13-7 Museum of Ife Antiquities, Nigeria / Dirk Bakker; 13-8 Dirk Bakker; 13-9 Photograph by E.G. Schempt; 13-10 Eliot Elisofon / National Museum of African Art / Smithsonian Institution; 13-11 Photograph (c) 1995 The Metropolitan Museum of Art; 13-12 Franko Khoury / National Museum of African Art / Smithsonian Institution; 13-13 Image Bank / Getty Images, Inc.; 13-14 Vanderharst / Robert Harding; 13-15 Federal Information Department of Zimbabwe / Great Zimbabwe Site Museum, Zimbabwe; 13-16 Photo by Heini Schneebeli; 13-17 Courtesy of Royal Museum of Central Africa, Tervuren; BOX: Photograph by Jamison Miller; BOX: Neil Lee / Ringing Rocks Digitizing Laboratory / www.SARADA.co.za

Chapter 14

14-1, 14-7 The Board of Trinity College, Dublin / The Bridgeman Art Library International; 14-02 Werner Forman / Art Resource, NY; 14-03 Rapuzzi / Index Ricerca Iconografica; 14-04 Kit Weiss / National Museum of Denmark, Copenhagen; 14-5 © Copyright The British Museum; 14-6 Trinity College Library, Dublin; 14-8 Courtesy of Marilyn Stokstad, Private Collection; 14-9 Photo: © 1994 The Metropolitan Museum of Art; 14-10 Oronoz Archivo Archivo Fotographico Oronoz, Madrid; 14-11 Achim Bednorz; 14-13, 14-15, 14-17 Bibliotheque Nationale, Paris. RMN / Art Resource, NY; 14-16 Kunsthistorisches Museum. Vienna, Austria; 14-18 Central Museum, Utrecht: 14-19 Art Resource / The Pierpont Morgan Library: 14-20 Peter Schaelichli, Zurich; 14-20 © Museum of Cultural History, University of Oslo, Norway; 14-21 Eirik Irgens Johnsen; 14-22 © Carmen Redondo / Corbis. All Rights Reserved; 14-23 Werner Forman / Art Resource, NY; 14-25 Erich Lessing / Art Resource, NY; 14-26 Photograph © 1986 The Metropolitan Museum of Art; 14-28 C Achim Bednorz, Koln; 14-29 Cathedral of Cologne / Rheinisches Bildarchiv, Museen Der Stadt Koln; 14-30 Ann Munchow Fotografin; 14-31 Bayerische Staatsbibliothek; BOX: Hessisches Landes-und Hochschulebibliothek; BOX: Frank Tomio / Dom-Museum Hildesheim.

Chapter 15

15-1, 15-5, 15-11, 15-14, 15-16, 15-17, 15-21, 15-22, 15-23, 15-25, 15-26, 15-27 Achim Bednorz 15-2 Corpus Christi College; 15-3 Archivo Fotographico Oronoz, Madrid; 15-12 Studio Folco Quilici Produzioni Edizioni Srl; 15-13 Foto Vasari / Index Ricerca Iconografica; 15-15 Canali Photobank; 15-18 © Archivo Iconografico, S.A. / Corbis, 15-19 © Erich Lessing / Art Resource, NY; 15-20 Carolingian and Roman Architecture, figure 78, Kenneth John Conant, Yale University Press, 1959; 15-24 Ghigo Roli / Index Ricerca Iconografica; 15-29 Scala / Art Resource, NY;15-30 Giraudon The Bridgeman Art Library International; 15-31 © MNAC, 2001; 15-32 Photograph © 1999 The Metropolitan Museum of Art; 15-33 Constantin Beyer; 15-36 Ursula Seitz-Gray, Ffm. / Thuringer Universitats-und Landesbibliothek Jena; 15-37 The British Library; 15-38 Bibliotheque Municipale / Laboratoire Photographique, France; BOX: Wiesbaden Hessische Landesbibliothek; BOX: Centre Guillaume Le Conquerant; BOX: Achim Bednorz; BOX: Gemeinnutzige Stiftung Leonard von Matt; BOX: Musee de la Tapisserie de Bayeux.

Chapter 16

16-1 Archivo Iconografico, S.A. / Corbis. All Rights Reserved; 16-2 Yale University Press; 16-4 Corbis Royalty Free; 16-5 Herve Champollion / Caisse Nationale des Monuments Historique et des Sites; 16-6, 16-11, 16-15, 16-17, 16-18, 16-21, 16-22, 16-23, 16-24, 16-25, 16-32, 16-33, 16-36, 16-38, 16-42 Achim Bednorz; 16-7 Gian Berto Vanni / Art Resource, NY; 16-8 Sonia Halliday Photographs; 16-9 Pierpoint Morgan Library / Art Resource, NY; 16-12 Gothic Architecture, Louis Grodecki, Harry N. Abrams, p. 308, 1977; 16-13 Jean Bernard Photographe/Bordas Publication; 16-14 © Angelo Hornak / Corbis. All Rights Reserved; 16-19 Wim Swaan Collection / The Getty Research Institute; 16-20 Patric Muller / CMN Cenre des Monuments Nationaux; 16-25, 16-27 The Pierpont Morgan Library Art Resource, NY; 16-28 London Aerial Photo Library Corbis-NY; 16-30 Aerofilms; 16-31 © Nigel Corrie English Heritage Photo Library; 16-34 Erich Lessing Art Resource, NY; 16-35 Hirmer Fotoarchiv, Munich, Germany; 16-37 Constantin Beyer; 16-39 Nicola Pisano

Canali Photobank; 16-43 Canali Photobank; 16-44 SCALA Art Resource, NY; BOX: Art Resource, NY; BOX: Alessandra Tarantino / AP Wide World Photos; BOX: Alberto Pizzoli / Corbis / Sygma.

Chapter 17

17-1, 17-2, 17-3, 17-5 Achim Bednorz; 17-4 © Guide Gallimard Florence, Illustration by Pilippe Biard; 17-6 Tosi Index Ricerca Iconografica; 17-7 Cimabue (Cenni di Pepi) Index Ricerca Iconografica, 17-8 Galleria degli Uffizi; 17-9, 17-10 Alinari / Art Resource, NY; 17-11Piero Codato / Canali Photobank; 17-12 Canali Photobank: 17-13 Thames & Hudson International, Ltd; 17-14 Photograph © Board of Trustees, National Gallery of Art, Washington, D.C.; 17-14, 17-16, 17-17 Scala Art Resource, NY;17-15 Canali Photobank; 17-16 Mario Quattrone / IKONA; 17-18 M. Beck-Coppola / Art Resource / Musee du Louvre; 17-19 Photography © 1991 The Metropolitan Museum of Art; 17-20 The Walters Art Museum, Baltimore; 17-21 Photograph © 1981 The Metropolitan Museum of Art; 17-23 Jan Gloc; 17-24, 17-25 © Radovnn Bocek; BOX: Canali Photobank; BOX: Alinari / Art Resource, NY.

Chapter 18

18-1, 18-4, 18-12, 18-16 Erich Lessing / Art Resource, NY; 18-2 SCALA Art Resource, NY; 18-3 Reunion des Musees Nationaux / Art Resource, NY; 18-5L Giradon / Art Resource, NY; 18-5R SCALA Art Resource, NY; 18-6 R.G. Ojeda / Art Resource, NY; 18-7 Bildarchiv der Osterreichische Nationalbibliothek; 18-8 Photograph © 1998 The Metropolitan Museum of Art, NY; 18-9 Kunsthistorisches Museum, Vienna; 18-10 Photograph © 1996 The Metropolitan Museum of Art, NY; 18-11 © National Gallery, London; 18-12 Photograph © Board of Trustees, National Gallery of Art, Washington, D.C.; 18-13 © National Gallery, London; 18-14 © Museo Nacional Del Prado; 18-19 Photograph © 1993 The Metropolitan Museum of Art, NY; 18-19 Speltdoorn / Musees Royaux des Beaux-Arts de Belgique; 18-20 Galleria degli Uffizi; 18-22 Joerg P. Anders / Art Resource / Bildarchiv Preussischer Kulturbesitz; 18-23, 18-24, 18-25 Achim Bednorz; 18-26 SCALA Art Resource, NY; 18-27 Musee d'art et d'histoire, Geneve; 18-28 John Rylands University Library of Manchester; 18-30 Photograph © 1997 The Metropolitan Museum of Art, NY; 18-31 The Pierpont Morgan Library / Art Resource, NY; BOX: H. Martaans, Bruges / Brugge; BOX: Bibliotheque Nationale de France.

Chapter 19

19-1, 19-39 © National Gallery, London; 19-2Photo Nimitallah / Art Resource, NY; 19-6, 19-7, 19-9, 19-12, 19-13, 19-15, 19-30, 19-32, 19-40 Achim Bednorz; 19-8 Cantarelli / Index Ricerca Iconografica; 19-10 Canali Photobank; 19-11 Museo Nazionale del Bargello, Florence / Canali Photobank; 19-12 Nimatallah / Art Resource, NY; 19-14 © Piazza del Santo, Padua, Italy / The Bridgeman Art Library; 19-16, 19-21 Erich Lessing / Art Resource, NY; 19-16 Art Resource, NY; 19-17 SCALA Art Resource, NY; 19-18 Cincinnati Art Museum, Ohio; 19-19 Sta. Maria Novella, Florence / Canali Photobank; 19-20, 19-22 Studio Mario Quattrone: 19-23, 19-26, 19-27, 19-33, 19-37, BOX: Scala Art Resource, NY; 19-24 Canali Photobank; 19-25 Alinari /Art Resource, NY; 19-28, 19-29, BOX: Nicolo Orsi Battaglini / Art Resource, NY; 19-34 © Canali Photobank; 19-36 Orsi Battaglini / Index Ricerca Iconografica; 19-39 Galleria degli Uffizi, Florence / Canali Photobank; 19-41 Galleria Dell'Accademia, Venice / Cameraphoto Arte di Codato G.P. & C.snc; 19-44 Campolini / Art Resource, NY; 19-43 © The Frick Collection, NY; BOX: Art Resource / The Pierpont Morgan Library; BOX: The J. Paul Getty Museum; BOX: SCALA Art Resource, NY: BOX: Canali Photo-

Chapter 20

20-1, 20-6, 20-8 Musei Vaticani; 20-2 Studio Mario Quattrone; 20-3 © National Gallery, London; 20-4 Lewandowski / LeMage / Art Resource, NY; 20-5 Photograph © Board of Trustees, National Gallery of Art, Washington, D.C.; 20-7 Alinari / Art Resource, NY; 20-9, 20-14, 20-29, 20-34, 20-42 Canali Photobank; 20-10, 20-20, 20-21, 20-27, 20-31, BOX: SCALA Art Resource, NY; 20-11 Zigrossi Bracchetti / Vatican Musei / IKONA; 20-12 AKG-Images; 20-15Hirmer Fotoarchiv; 20-16 © Raffaello Bencini / Ikona; 20-17,

20-47, BOX; Achim Bednorz; 20-18, BOX; © Alinari / Ikona; 20-19 SuperStock, Inc.; 20-22 Ikona; 20-23 Cameraphoto / Art Resource, NY; 20-24 Musee du Louvre / RMN Reunion des Musees Nationaux / Erich Lessing / Art Resource, NY; 20-25 Embassy of Italy; 20-26 Summerfield / Galleria degli Uffizi, Florence / Index Ricerca Iconografica; 20-28 A. Braccetti - P. Zigrossi / Musei Vaticani; 20-30 Alinari / Art Resource, NY; 20-33 Index Ricerca Iconografica; 20-35 Galleria degli Uffizi; 20-36 Photograph © 1990 The Metropoligan Museum of Art; 20-37 © National Gallery, London; 20-38 Photo Joseph Zehavi / Art Resource, NY; 20-39 © 2005 Museum of Fine Arts, Boston. All Rights Reserved; 20-39 Photograph © 2007 Museum of Fine Arts, Boston; 20-40, 20-41, BOX: Kunsthistorisches

Museum, Vienna; 20-43 Cameraphoto / Art Resource, NY; 20-44 Erich Lessing / Art Resource, NY; 20-45 © Bildarchiv Monheim GmbH / Alamy.

Chapter 21

21-1 V & A Picture Library; 21-2, 21-3, 21-16, 21-22, 21-26 Erich Lessing / Art Resource, NY; 21-04 Photo O. Zimmermann; 21-5 Musee d'Unterlinden; 21-6 Germanisches Nationalmuseum Nurnberg; 21-7 SCALA Alte Pinakothek, Munich / Art Resource, NY; 21-8 Laurie Platt Winfrey, Inc. / The Metrpolitan Museum of Art, NY; 21-9 Los Angeles County Museum of Art / Culver Pictures, Inc.; 21-10, 21-12 Alte Pinakothek, Munich. Bayerische Staatsgemaldesammlungen, Neue Pinakothek, Munich; 21-11 Photograph © Board of Trustees, National Gallery of Art, Washington, D.C.; 21-13 Reunion des Musees Natinaux/Art Resource, NY; 21-14 © GlobalQuest Photography / L. B. Foy; 21-15 Giraudon / The Bridgeman Art Library International; 21-17 Musee du Louvre / RMN Reunion des Musees Nationaux / SCALA Art Resource, NY; 21-20 Photograph © 2007 The Metropolitan Museum of Art, NY; 21-21 Photo Oronoz. Derechos reservados © Museo Nacional Del Prado; 21-22, BOX: SCALA Art Resource, NY; 21-24 Martin Buhler / Kunstmuseum Basel; 21-25 Musees Royaux des Beaux-Arts de Belgique; 21-27 Index Ricerca Iconografica; 21-28 The Royal Collection © 2008, Her Majesty Queen Elizabeth II: 21-29 The Nelson-Atkins Museum of Art; 21-30 © Hardwick Hall, Derbyshire, UK / The Bridgeman Art Library; 21-31 A.F. Kersting; BOX: Photograph © 2007 The Metropolitan Museum of Art.

Chapter 22

22-1 Herve Lewandowski / Louvre, Paris / Reunion des Musees Nationaux / Art Resource, NY; 22-02 © Alinari Archives / Corbis; 22-3, 22-8, 22-9, 22-14 Achim Bednorz; 22-4 SCALA Art Resource, NY; 22-5 Adros Studio Fotografia; 22-6, 22-16, 22-17 Canali Photobank; 22-7 IKONA: 22-10 Allen Memorial Art Museum; 22-11 Joseph Martin / akg-images; 22-12 Vincenzo Pirozzi / IKONA; 22-13 Canali Photobank; 22-15 Dagli Orti The Art Archive; 22-18 Detroit Institute of Arts; 22-19 The Royal Collection © 2007, Her Majesty Queen Elizabeth II. Photo by A. C. Cooper Ltd.; 22-20 Casino Rospigliosi / Canali Photobank; 22-21 © The Cleveland Museum of Art, Dudley P. Allen Fund. 1943.265a; 22-22 Palazzo Barberini, Italy / Canali Photobank; 22-23 SCALA / Il Gesu, Rome, Italy / Art Resource, NY; 22-24 San Diego Museum of Art; 22-24 Markus Bassler / Bildarchiv Monheim GmbH / Alamy Images; 22-25 Bob Grove / Photograph © Board of Trustees, National Gallery of Art, Washington, D.C.; 22-26 Wadsworth Atheneum; 22-27 V & A Picture Library; 22-28, 22-29 Derechos reservados © Museo Nacional Del Prado; 22-30 The State Hermitage Museum; 22-31 Courtesy of Marilyn Stokstad, Private Collection; 22-32, 22-37, 22-54 Erich Lessing / Art Resource, NY; 22-33 Jakob Prandtauer / Achim Bednorz; 22-35 Institut Royal du Patrimoine Artistique (IRPA-KIK) © IRPA-KIK, Brussels; 22–36, 22–38 © Reunion des Musees Nationaux / Art Resource, NY; 22-39 Ashmolean Museum, Oxford, England; 22-41 Art Resource / Bildarchiv Preussischer Kulturbesitz; 22-42 Frans Hals Museum De Hallen; 22-43, 22-77 Photograph © Board of Trustees, National Gallery of Art, Washington, D.C.; 22-44, BOX: SCALA Art Resource, NY; 22-45, 22-46, 22-52 Rijksmuseum, Amsterdam; 22-47 Photograph © 2007 The Metropolitan Museum of Art; 22-48 Frick Art Reference Library The Frick Collection, NY; 22-49 Stichting Vrienden van Het Mauritshuis; 22-50, 22-51 Richard Carafelli / Photograph © Board of Trustees, National Gallery of Art, Washington, D.C.; 22-53 Detroit Institute of Arts; 22-55

The Toledo Museum of Art; 22-56, 22-67 Altitude Yann Arthus Bertrand; 22-57 Hugh Rooney / Eye Ubiquitos / Corbis-NY; 22-58 © Marc Deville / Corbis; 22-59 © Peter Willi / Superstock; 22-60 Photograph © 2000 Museum Associates/LACMA. All Rights Reserved: 22-61 Photo © 2004, Detroit Institute of Arts; 22-62 Photograph © 2007, The Art Institute of Chicago. All Rights Reserved; 22-63 © National Gallery, London; 22-64, 22-66 A.F. Kersting; 22-65 Inigo Jones / Historic Royal Palaces Enterprises Ltd; 22-68 Janet Urso @ bimmy.com; 22-69 Worcester Museum of Art. Gift of Mr. and Mrs. Albert W. Rice; BOX: National Museum of Women In the Arts.

Chapter 23

23-1 Steve Vidler / SuperStock, Inc; 23-2 Dirk Bakker; 23-5 Borromeo / Art Resource, NY; 23-6 Michael Flinn / Courtesy of Marilyn Stokstad; 23-7 Photo by Craig Smith; 23-8 V & A Picture Library; 23-09 Borromeo / Art Resource, NY; 23-11 © 2005 Museum of Fine Arts, Boston. All Rights Reserved; 23-12, 23-16 © David Ball / Alamy; 23-13 © 2007 Museum of Fine Arts, Boston. All Rights Reserved; 23-14 B.P. Mathur and Pierre / Dinodia Picture Agency; 23-15, 23-19 Photograph by Sexton / Dykes; 23-18 Craig Smith Phoenix Art Museum; BOX: Katherine Wetzel / © Virginia Museum of Fine Arts, Richmond; BOXES: Reunion des Musees Nationaux / Art Resource, NY.

Chapter 24

24-2, 24-3, 24-5, 24-6, 24-7, 24-12, 24-13 The National Palace Museum; 24-4, 24-11 The Cleveland Museum of Art; 24-8 Collection of the Palace Museum, Beijing; 24-9 Panorama Stock / Robert Harding; 24-10 The Nelson-Atkins Museum of Art; 24-14 Spencer Museum of Art; 24-15 Museum of Oriental Ceramics, Osaka; 24-16 Ewha Woman's University Museum, Seoul, Korea; 24-17 Photo Courtesy of Central Library, Tenri University, Tenri, Japan; 24-18 Samsung Museum, Lee'um, Seoul, Republic of Korea; 24-20 Whanki Foundation / Whanki Museum, Seoul, Korea; 24-24 Courtesy of the Oriental Institute of the University of Chicago; BOX: The Nelson-Atkins Museum of Art, Kansas City, Missouri.

Chapter 25

25-1 Tibor Franyo / Honolulu Academy of Arts; 25-2 © 2005 Museum of Fine Arts, Boston. All Rights Reserved; 25-3, 25-13, BOX: TNM Image Archives; 25-4, 25-9 Stephen Addiss; 25-5 Michael Yamashita; 25-6 Steve Vidler / SuperStock, Inc; 25-7, 25-11 Japan National Tourist Organization / Sakamoto Manschichi Photo Research Library, Tokyo; 25-8 Myoki-an / Pacific Press Service; 25-10 Freer Gallery of Art/Smithsonian; 25-12 Spencer Museum of Art; 25-14 Photograph © 2003 Museum Associates/LACMA; 25-15 Philadelphia Museum of Art; 25-16 © Shokodo, Ltd. & Japan Artists Association, Inc. 2006; 25-17 © Miyashita Zenji Spencer Museum of Art / University of Kansas, Kansas; 25-18 Dr. Tatsuo Yamamoto; 25-19 © 1999 Takashi Murakami / Kaikai Kiki Co., Ltd. All Rights Reserved; BOX: The Frank Lloyd Wright Archives

Chapter 26

26-1 National Museums and Galleries on Merseyside / Walker Art Gallery / World Museum Liverpool National Museums Liverpool; 26-2 Bodleian Library, University of Oxford; 26-3 Enrique Franco Torrijos, Mexico City / Embassy of Mexico; 26-4 Werner Forman / Art Resource, NY; 26-5 Dorling Kindersley Media Library / © Michel Zabe; 26-6 Chris Rennie / Robert Harding; 26-7 Dagli Orti / Picture Desk, Inc. / Kobal Collection; 26-8 Justin Kerr / Dumbarton Oaks, Byzantine Photograph and Fieldwork Archives, Washington, DC; 26-9 John Bigelow Taylor, NY / American Museum of Natural History; 26-10 With permission of the Royal Ontario Museum © ROM; 26-11 Smithsonian National Museum of Natural History; 26-12 Detroit Institute of Arts; 26-13 Montana Historical Society; 26-14 © 2006 Peabody Museum, Harvard University 99-12-10/53121 T4279; 26-15 Denver Art Museum, 26-16 Stephen S. Meyers / Courtesy Dept. of Library Services, American Museum of Natural History; 26-17 Amon Carter Museum / © Laura Gilpin Collection; 26-18 Museum of Indian Arts & Culture; 26-20 The Heard Museum; 26-21 Embassy of Canada; 26-22 J. Scott Applewhite / AP Photo; 26-29 The Philbrook Museum of Art; BOX: Courtesy Curtis Library, Northwestern University Library; BOX: Courtesy University of British Columbia Museum of Anthropology; BOX: The Philbrook Museum of Art.

Chapter 27

27-1 Jeffrey Dykes / Peabody Essex Museum; 27-2 Australian Tourist Commission; 27-3 E. Brandl / Courtesy AIATSIS Pictorial Collection; 27-4 Kluge-Ruhe / Aboriginal Art Collection / University of Virginia Library; 27-5 Marilyn Stokstad / Photo Courtesy Anthony Forge; 27-6 Photograph © 2007 The Metropolitan Museum of Art, NY; 27-7 R. Berle Clay; 27-8 Federated States of Micronesia; 27-9 James Balog / Black Star; 27-10 Peabody Essex Museum; 27-11 By permission of The British Library; 27-12 Robert Newcombe / The Nelson-Atkins Museum of Art; 27-13 Museum of New Zealand Te Papa Tongarewa; 27-14 Bishop Museum; 27-15 Dr. Joyce D. Hammond; 27-16 Art Gallery of South Australia; BOX: Bishop Museum MAP: Prehistoric Architecture in Micronesia, William N. Morgan , p. 60, ©1988. BOX: Otago Museum, Dunedin.

Chapter 28

28-1 Sarah DaVanzo Collection; 28-2 Margaret Courtney-Clarke / Corbis / Bettmann; 28-03 Igor Delmas; 28-4 University of Iowa Museum of Art; 28-5, 28-11 Margaret Thompson Drewal / Eliot Elisofon Photographic Archives / National Museum of African Art / Smithsonian Institution; 28-6 Charles & Josette Lenars Corbis-NY; 28-7 Frederick John Lamp; 28-8 Photo by Don Cole; 28-9 The Field Museum; 28-10 University of Pennsylvania Museum of Archaeology and Anthropology, Philadelphia; 28-12, 28-20, BOXES: Franko Khoury /National Museum of African Art / Smithsonian Institution; 28-13 @ Angelo Turconi; 28-14, 28-17 Eliot Elisofon / Eliot Elisofon Photographic Archives / National Museum of African Art / Smithsonian Institution; 28-15 Royal Anthropological Institute of Great Britain and Ireland; 28-16 Detroit Institute of Arts; 28-18 © David A. Binkley / Patricia Darish; 28-19 Hughes Dubois / Musee Dapper; 28-21 Photograph Courtesy October Gallery, London; 28-22 Courtesy The Project, New

Chapter 29

29-1 Photograph © 2007 Museum of Fine Arts, Boston; 29-2 Wim Swaan / The Getty Research; 29-3 Martin von Wagner Museum der Universitat Wurzburg / Antikensammlung; 29-4, 29-5, 29-18 © Achim Bednorz, Koln; 29-7 Picture Press Bild - und Textagentur GmbH, Munich, Germany; 29-8 Gerard Blott Reunion des Musees Nationaux / Art Resource, NY; 29-9 Erich Lessing / Art Resource, NY; 29-10 National Museum of Stockholm; 29-11 Frick Art Reference Library; 29-12 Photograph © 1990 The Metropolitan Museum of Art; 29-13 John Hammond / National Trust Photographic Library, England; 29-14 The Royal Collection © 2008, Her Majesty Queen Elizabeth II; 29-15 Fine Arts Museums of San Francisco; 29-16 IKONA; 29-17 C. Jean / Art Resource, NY; 29-20 Palazzo Barberini, Galleria Nazionale d' Arte Antica / Canali Photobank; 29-21 English Heritage / National Monuments Record / (c) Crown copyright; 29-22 A.F. Kersting; 29-23 Richard Bryant / Arcaid; 29-24, 29-25 Courtesy Wedgwood Museum Trust Limited, Barlaston, Staffordshire; 29-26, 29-29 © National Gallery, London; 29-27 Photograph © 2007, The Art Institute of Chicago. All Rights Reserved; 29-28 Photograph © Board of Trustees, National Gallery of Art, Washington, D.C.

29-30 Katherine Wetzel / Virginia Museum of Fine Arts, Richmond; 29-31, 29-36 National Gallery of Canada, Ottawa; 29-32 The Detroit Institute of Arts; 29-33 Tate; 29-34 French Government Tourist Office; 29-37 Portland Art Museum; 29-38 Caisse Nationale des Monuments Historique et des Sites, Paris; 29-39 Photograph © 1980 The Metropolitan Museum of Art; 29-40 © Reunion des Musees Nationaux, Paris, France / Art Resource, NY; 29-41 Cussac / Musees Royaux des Beaux-Arts de Belgique; 29-42 Musee National du Chateau de Versailles / Art Resource / Reunion des Musees Nationaux; 29-43 The Library of Virginia; 29-45 Denver Art Museum; 29-47 © David R. Frazier Photolibrary, Inc. / Alamy Images; 29–48 Photograph © 2006 Board of Trustees, National Gallery of Art, Washington, D.C.; BOX: National Museum of Women in the Arts, Washington, DC; BOX: Courtesy of Philip Pocock; BOX: The Royal Collection © 2006, Her Majesty Queen Elizabeth II; BOX: British Embassy.

Chapter 30

30-1 Lauros-Giraudon / Art Resource, NY; 30-2, 30-3, 30-4, 30-8 RMN Reunion des Musees Nationaux / Art Resource, NY; 30-5 The Cleveland Museum of Art: 30-6 Yale University Art Gallery; 30-7 Getty Images Stockbyte; 30-9 © Bernard Boutrit / Woodfin Camp and Associates, Inc; 30-10 Gregory; 30-11 Courtesy of the Hispanic Society of America; 30-12 © Museo Nacional Del Prado / Erich Lessing / Art Resource, NY; 30-13 Oronoz / © Museo Nacional Del Prado; 30-14 Osterreichische Galerie im Belvedere, Vienna; 30-15 Tate Gallery / Art Resource, NY; 30-16 Photo by Graydon Wood, 1988; 30-17 Frick Art Reference Library: 30-18, 30-32, 30-35, 30-52 Erich Lessing / Art Resource, NY; 30-19 Photograph © 1995 The Metropolitan Museum of Art; 30-20 © The Royal Academy of Arts; 30-21 Photograph © 1997 The Metropolitan Museum of Art, NY; 30-22, 30-24 The New York Public Library / Art Resource, NY; 30-26 © Leo Sorel; 30-27 Societe Française de Photographie; 30-28, 30-82 George Eastman House; 30-29 Science & Society Picture Library; 30-30 Caisse Nationale des Monuments Historique et des Sites, Paris; 30-31 V & A Images / Victoria and Albert Museum; 30-33 Roger-Viollet Agence Photographique, 30-34 Giraudon / Art Resource, NY: 30-36 © 2006 Dahesh Museum of Art, NY. All Rights Reserved; 30-37 Bridgeman Art Library; 30-38, 30-39, 30-49, 30-55, 30-73, BOXES: RMN Reunion des Musees Nationaux / Art Resource, NY; 30-40 The Carnegie Museum of Art, Pittsburgh; 30-41 Gerard Blot / Art Resource / Musee d'Orsay; 30-42 © 1922 The Metropolitan Museum of Art, NY; 30-43 © State Russian Museum / CORBIS. All Rights Reserved; 30-44 Thomas Jefferson University; 30-44 The Bridgeman Art Library; 30-45 Philadelphia Museum of Art; 30-46 Manchester City Art Galleries; 30-47 William Morris Gallery; 30-48 Photograph © 1988 The Detroit Institute of Arts; 30-50 RMN Reunion des Musees Nationaux/Art Resource, NY / © 2007 Edouard Manet/ARS,NY; 30-51 Photography © The Art Institute of Chicago; 30-53 Photograph © 2007 The Metropolitan Museum of Art; 30-53 Photograph © 1996 The Metropolitan Museum of Art; 30-54 The Nelson-Atkins Museum of Art; 30–56 © 1980 The Metropolitan Museum of Art; 30–57 Photography © The Art Institute of Chicago; 30-58 Philadelphia Museum of Art; 30-59 Dean Beasom / Photograph © Board of Trustees National Gallery of Art, Washington, D.C.; 30-60 © National Gallery, London; 30-61 John Webb / Courtauld Institute of Art; 30-62 The Samuel Courtauld Trust Courtauld Institute of Art Gallery; 30-63 Photograph © 2007, The Art Institute of Chicago. All Rights Reserved; 30-64 Philadelphia Museum of Art; 30-65 Photograph © 2006, The Art Institute of Chicago. All Rights Reserved. 30-66 Photograph © 2000 The Museum of Modern Art, New York / Art Resource, NY; 30-67 Photograph © 2007, The Art Institute of Chicago. All Rights Reserved; 30-68 J. G. Berizzi / Art Resource / RMN Reunion des Musees Nationaux, France; 30-69 The Museum of Modern Art / Licensed by Scala Art Resource, NY; 30-70 Koninklijk Museum voor Schone Kunsten, Antwerp / © 2007 ARS, NY / SABAM, Brussels; 30-71 J. Lathion / © Nasjonal galleriet / © 2007 ARS,NY / ADAGP, Paris; 30-72 Art Resource, NY / Smithsonian American Art Museum; 30-74 Hirshhorn / Smithsonian; 30-75 Bayerische Staatsgemaldesammlungen, Neue Pinakothek, Munich; 30-76 Ch. Bastin & J. Evrard / © ARS,NY / SOFAM, Brussels; 30-77 Fine Arts Museums of San Francisco; 30-78 Corbis/Bettmann; 30-79 Bildarchiv der Osterreichische Nationalbibliothek; 30-80 Digital image © The Museum of Modern Art / Licensed by SCALA Art Resource, NY; 30-81 San Diego Museum of Art; 30-83 Museum of the City of NY; 30-84 © Corbis. All Rights Reserved; 30-85 Library of Congress. 30-86 © Art on file / Louis H. Sullivan / Corbis-NY; BOX: Museo Fabre; BOX: City of NY, Department of Parks; BOX: Tate Gallery / Art Resource, New York; The Brooklyn Museum of Art / Central Photo Archive; BOX: Van Gogh Museum Enterprises.

Chapter 31

31-1 New York Public Library / Art Resource, NY; 31-2 Photograph © Board of Trustees, National Gallery of Art, Washington, D.C.; 31-3 San Francisco Museum of Modern Art / © Succession H. Matisse, Paris / ARS,NY / Photo: Ben Blackwell; 31-4 © 1995 the Barnes Foundation / 2008 Succession H. Matisse, Paris / ARS,NY;

31-5 Staatliche Museen zu Berlin, Preussischer Kulturbesitz, Nationalgalerie / Art Resource, NY: 31-6 Photograph by Jamison Miller; 31-8 Digital Image © The Museum of Modern Art / Licensed by SCALA Art Resource, NY; 31-9 © 2007 ARS, NY / Art Resource Bildarchiv Preussischer Kulturbesiz; 31-10 Martin Buhler / Kunstmuseum; 31-11 Photograph © 2007 The Metropolitan Museum of Art, NY: 31-12 Walker Art Center, Minneapolis; 31-13 The Solomon R. Guggenheim Museum, NY / © 2008 ARS, NY; 31-14 The Solomon R. Guggenheim Museum, NY / © 2008 ARS, NY; 31-15 Photograph © The Metropolitan Museum of Art / © ARS, NY / VG Bild-Kunst, Bonn; 31-16 RMN Reunion des Musees Nationaux / Art Resource, NY © 2008 Estate of Pablo Picasso / © ARS, NY; 31-17 Photograph © Board of Trustees, National Gallery of Art, Washington, D.C.; 31-18 Museum of Modern Art Licensed by SCALA Art Resource, NY / © 2007 Estate of Pablo Picasso / © ARS, NY; 31-19 Peter Lauri / Kunstmuseum Bern; 31-20 The Solomon R. Guggenheim Museum / George Braque © 2002 ARS, NY ADAGP, Paris; 31-21 Art Resource, NY / © 2007 Estate of Pablo Picasso / ARS, NY; 31-22 @ 2007 Estate of Pablo Picasso / ARS, NY; 31-23 RMN Reunion des Musees Nationaux / Art Resource, NY / © 2008 Estate of Pablo Picasso / ARS, NY; 31-24, 31-25 Emanuel Hoffman Foundation. Kunstsammlung Basel, Switzerland / © L & M Services, B.V. Amsterdam, 20031010; 31-26 Museum of Modern Art / Licensed by SCALA Art Resource, NY; 31-27 Digital Image © The Museum of Modern Art / Licensed by Scala / Art Resource, NY; 31–28 Art Resource, NY; 31–29 Stedelijk Museum Amsterdam; 31-30 © Estate of Vladimir Tatlin / RAO Moscow / Licensed by VAGA, NY: 31-30 Annely Juda Fine Art; 31-31 Photograph ©2006 Museum Associates / LACMA; 31-35 © Philadelphia Museum of Art: The Louise and Walter Arensberg Collection, 1950. 1998-74-1 / © 2007 ARS, NY / ADAGP, Paris / Succession Marcel Duchamp; 31-36 Lynn Rosenthal, 1998 / Philadelphia Museum of Art / © 2006 ARS, NY; 31-37 Solomon R. Guggenheim Museum, NY / © 2008 ARS, NY; 31-39 Photo by James Via; 31-40 Photograph © 2000 The Metropolitan Museum of Art, NY; 31-41 Photography © The Art Institute of Chicago; 31-42 The Minneapolis Institute of Arts / © 2008 The Georgia O'Keeffe Foundation / ARS, NY; 31-43 Guilherme Augusto do Amaral / Malba-Coleccion Costanini, Buenos Aires; 31-44 The Museum of Fine Arts, Houston; 31-45 Art Museum of the Americas; 31-46 Bob Schalkwijk / © 2001 Banco de Mexico Diego Rivera & Frida Kahlo Museums Trust. Av. Cinco de Mayo No. 2, Col. Centro, Del. Cuauhtemoc 06059, Mexico, D.F. Reproduction authorized by the Instituto Nacional de Bellas Artes y Literatura / Art Resource, NY; 31-47 National Gallery of Canada; 31-48 Trevor Mills / Vancouver Art Gallery; 31-49 Gerald Zugmann Fotographie KEG; 31-50 Vanni / Art Resource, NY; 31-51 Anthony Scibilia / Art Resource, NY / © 2001 ARS, NY ADAGP, Paris / FLC; 31-52 Heidrich Blessing Chicago Historical Society; 31-53 David R. Phillips / Chicago Architecture Foundation; 31-54 Fallingwater; 31-55 Sante Fe Railroad; 31-56 Cass Gilbert / The New-York Historical Society; 31-57 © Estate of Aleksandr Rodchenko / RAO Moscow Licensed by VAGA, NY; 31-58 Van Abbemuseum; 31-59 Estate of Vera Mukhina; 31-60 Hickey-Robertson / The Menil Collection, Houston. © 2008 Mondrian / Holtzman Trust c/o HCR International, Warrenton, VA; 31-61 Florian Monheim / Artur Architekturbilder Agentur GmbH; 31-62 Jannes Linders Photography; 31-63 Fred Kraus Bauhausarchiv-Museum fur Gestaltung; 31-64 Michael Nedzweski / The Busch-Reisinger Museum / © President and Fellows of Harvard College, Massachusetts; 31-65 The Museum of Modern Art/Licensed by SCALA Art Resource, NY; 31-66 @ Banco de Mexico Trust Reproduction authorized by the Instituto Nacional de Bellas Artes y Literatura. Palacio de Bellas Artes, Mexico City; 31-67 Schomburg Center for Research in Black Culture, New York Public Library / Art Resource, NY; 31-68 Howard University Libraries; 31-69 © 2007 ARS, NY; 31-70 Tate Gallery, London / Art Resource, NY; 31-71 The Henry Moore Foundation / Tate Picture Gallery; 31-72 The Museum of Modern Art / Licensed by SCALA Art Resource, NY / © 2007 ARS, NY; 31-73 Stedelijk Museum, Amsterdam; 31-74 The Solomon R. Guggenheim Foundation, NY / © 2008 ARS, NY; 31-75 The Museum of Modern Art / Licensed by SCALA Art Resource, NY / © 2006 ARS, NY; 31-76

Image © 2006 Board of Trustees, National Gallery of Art, Washington; BOX: Photograph © 1986 The Metropolitan Museum of Art; BOX: Akademie der Kunste/Archiv Bildende Kunst; BOX: Courtesy of the Library of Congress;

Chapter 32

32-1 Claudio Abate / Index Ricerca Iconografica; 32-4, 32-24 Museum of Modern Art / Licensed by SCALA Art Resource, NY; 32-5 Digital Image © The Museum of Modern Art / Licensed by SCALA Art Resource, NY; 32-6 Solomon R. Guggenheim Museum, NY; 32-7 Solomon R. Guggenheim Museum, NY / © 2008 ARS, NY; 32-8 Art Resource, NY; 32-9 © ARS, NY; 32-10 Hans Namuth Ltd; 32-11 Photograph © 1998 The Metropolitan Museum of Art, NY / © 2007 The Pollock-Krasner Foundation / ARS, NY; 32-12 Geoffrey Clements / © 1997 Whitney Museum of American Art, NY / © 2007 ARS, NY; 32-13 © The Phillips Collection, Washington, DC; 32-14 National Gallery of Canada; 32-15 Photograph © Board of Trustees, National Gallery of Art, Washington, DC; 32-16 Valerie Walker / Museum of Contemporary Art, Chicago / © ARS, NY; 32-17 The Museum of Modern Art Licensed by SCALA Art Resource, NY / © 2007 ARS, NY; 32-18 Whitney Museum of American Art, NY / © Estate of David Smith / Licensed by VAGA, NY; 32-20 Albright-Knox Art Gallery / © 2008 ARS, NY; 32-21 Galerie von Bartha; 32-22 Gyula Kosice; 32-23 Photograph © 2004, The Art Institute of Chicago. All Rights Reserved; 32-25 © The Minor White Archive, Princeton, NI / Museum of Modern Art / Licensed by SCALA Art Resource, NY; 32-26 Sonnabend Gallery /

Art © Robert Rauschenberg / Licensed by VAGA, NY; 32-27 Digital Image © The Museum of Modern Art Licensed by SCALA Art Resource, NY / © Jasper Johns / Licensed by VAGA, NY; 32-28 Marilyn Stokstad / Courtesy of Shozo Shimamoto; 32-29 Marilyn Stokstad / Lawrence Shustack; 32-30 Harry Shunk; 32-31 Digital Image © Museum of Modern Art / Licensed by SCALA Art Resource, NY / © 2003 ARS, NY / ADAGP, Paris; 32-32 Kunsthalle Tubingen, Sammlung G.F. Zundel / © 2007 ARS, NY / DACS, London; 32-33 © 2003 Andy Warhol Foundation for the Visual Arts / ARS, New York / (TM)2002 Marilyn Monroe LLC under license authorized by CMG Worldwide Inc., Indianapolis, Indiana 46256 USA www.MarilynMonroe.com; 32-34 photo © National Gallery of Canada, Ottawa / © 2008 Andy Warhol Foundation for the Visual Arts / ARS, NY / SODRAC Montreal; 32-35 © Estate of Roy Lichtenstein; 32-36 Yale University Art Gallery; 32-37 Art Museum of the Americas; Art © Estate of Jesus Rafael Soto / Licensed by VAGA, NY; 32-38 Philip Johnson Fund / Museum of Modern Art / Licensed by SCALA Art Resource, NY; 32-39 National Gallery of Canada; 32-40 The Menil Collection, Houston / © ARS, NY; 32-42 Geoffrey Clements / Collection of the Whitney Museum of American Art, NY; 32-43 Photo by Peter Schaelchli, Zurich; 32-44 Gongella / Ikona; 32-45 Walker Art Center, T.B. Walker Acquisition Fund, 2001; 32-46 Museum of Modern Art /Licensed by SCALA Art Resource, NY / © 2006 ARS, NY; 32-47 Eric Pollitzer / Leo Castelli Gallery, NY / © 2007 ARS, NY; 32-48 © Ute Klophaus / VG Bild-Kunst, Bonn / © ARS, NY; 32-49 Venuri, Scott Brown & Associates, Inc; 32-50 Gianfranco Gorgoni / VAGA; 32-51 Wolfgang Volz; 3252 Benjamin Blackwell / University of CA / Berkeley Art Museum; 32-53 Robert Hickerson; 32-54 Solomon R. Guggenheim Museum, NY / Photo © Faith Ringgold; 32-55 Galerie Lelong; 32-56 Andrew Garn; 32-57 Ezra Stoller / Esto Photographics, Inc; 32-58 Courtesy Moshe Safdie and Associates; 32-59 Matt Wargo / VSBA; 32-61 Richard Payne, FAIA; 32-62 Cindy Sherman Metro Pictures; 32-63 Mary Boone Gallery; 32-64 Jeff Wall / Marian Goodman Gallery; 32-65 V & A Images © Vic Muniz and the Estate of Hans Namuth / VAGA. NY / DACS, London 2006; 32-66 Matthew Marks Gallery, NY / Monika Spruth Galerie, Cologne / © 2001 Andreas Gursky; 32–67 Van Abbemuseum / © 2007 The Estate of Anseim Kiefer / ARS, NY; 32-68 Photograph © 2007, The Art Institute of Chicago. All Rights Reserved: 32-69 © 2007 ARS, NY / ADAGP, Paris; 32-70 Tujunga Wash Flood Control Channel SPARC Social and Public Art Resource Center; 32-71 Smith College Museum of Art; 32-72 Photography © The Art Institute of Chicago; 32-73 KaiKai Kiki Co., Ltd; 32-74 Robert Newcombe / Nelson-Atkins Museum of Art; 32-75 Tate Gallery, London / Art Resource, NY; 32-77 Susan Einstein / © 2000, The Art Institute of Chicago; 32-78 Skoto Gallery; 32-79 Ian Lambot / Foster and Partners; 32-80 Richard Bryant / Esto Photographics, Inc; 32-81 © AAD Worldwide Travel Images / Alamy; 32-82 Jack Tilton Gallery, NY; 32-83 Mel Chin; 32-84 William H. Struhs; 32-85 © Peter Mauss / Esto; 32-86 Holly Solomon Gallery; 32-87 © 2000 Shirin Neshat. Photo: Larry Barns / Barbara Gladstone Gallery; 32-88 San Francisco Museum of Modern Art; BOX: Photograph © Donald Woodman / © 2005 Judy Chicago / ARS, NY.

INDEX

Acts of the Apostles series, 668, 668 Italic page numbers refer to illustrations Kongo spirit figure (nkisi nkonde), Democratic Republic of the Congo, 926, 926 Adam, Robert, Anteroom, Syon House, England, and maps. 959–960, *960* Kuba, Democratic Republic of the Congo, Adam and Eve (Dürer), 716, 716 929, 929, 930, 931, 933, 935, 935 A Adams, Samuel, 940, 941 Lega bwami masks, Democratic Republic of Aachen, Palace Chapel of Charlemagne, 451, 452, Adelaide, queen, 464 the Congo, 924-925, 925 Adena, 412 Mende masks, Sierra Leone, 924, 924 Aachen (Liuthar) Gospels, 469-470, 469, 470 Adler, Dankmar, 1060, 1101 Abacus, 117, 118, 318 Mossi dolls (biiga), Burkina Faso, 920, 921 Admonitions of the Imperial Instructress to Court Abaporú (The One Who Eats) (Amaral), 1096, 1096 Nankani compound, Ghana, 919-920, 920 Ladies (Gu Kaizhi), 355-356, 355 Nok, 425-427, 427 Abbasid dynasty, 285-286, 290, 294 Adobe, 433 Olowe of Ise, door of palace, Yoruba, Nigeria, Adyton, 116 931-932, 932 SEE ALSO under name of Aedicula, 635 Saharan rock art, 424-425, 425 list of, during Romanesque period, 489 Aegean spirit world, 925-928, 926, 927 Abd-al-Rahman I, 290 Bronze Age in, 84 Abd-al-Rahman III, 291 twin figures (ere ibeji), Yoruba, Nigeria, Cycladic Islands in the Bronze Age, 84-86 Abelam, 901-902 921-922, 922 map of, 85 Abelard, Peter, 514 Yoruba of Ife, 420, 421, 429-430, 429, 430. Minoan civilization on Crete, 86-95 Aborigines, Australia, 900-901, 900, 901, 921-922, 922, 927-928, 927, 931-932, 931 Mycenaean (Helladic) culture, 95-104 After "Invisible Man" by Ralph Ellison, the Preface 913-914, 914 Abraham, Sarah, and the Three Strangers, Psalter of New Palace period, 89-95 (Wall), 1173-1174, 1173 Old Palace period, 86–88 Saint Louis, 537-538, 537 After Kings (Anatsui), 1182, 1182 timeline, 95 Agamemnon, 98 Absolute dating, 13 Aeneid (Virgil), 179 Abstract art, xxxv funerary mask of, 93, 99, 102-103, 102 Aerial (atmospheric) perspective, 195, 586 art informel, 1129-1130 Agora Aeschylus, 159 biomorphic forms, 1117-1119, 1117, 1118, Athenian Agora, 145-147, 146 Aesop, 115 1119, 1122, 1122 use of term, 145 Aesthetics, xxxvii-xxxviii Neolithic, 12-13, 13 Agriculture Paleolithic, 6 Near East Fertile Crescent, 26 cradle of art and civilization, 422-424 patterns in Bwa maks, 923-924, 923 Neolithic, 12 cultures in 921 Neolithic China, 344 sculpture, 1086-1087, 1087 historical view of, 918-919 Abstract Art in Five Tones and Complementaries (Tor-New World, 396, 399, 408 maps of, 423, 919 Agrippa, Marcus Vipsanius, 184, 210 other countries attracted to, 422, 918 García), 1141, 1141 Agrippina, 198 timelines, 937 Abstract Expressionism, 1131-1141, 1131-1140 Ah Hasaw, 403 Abstraction-Creation group, 1117 African American artists Ahmose, queen, 71 Douglas, Aaron, 1114, 1114 Abu Simbel, Rameses II temples at, 75-78, 76, 77 Ain Ghazal, Jordan, 28-29, 29 Academicians of the Royal Academy (Zoffany), 952, Harlem Renaissance, 1114-1116, 1114, 1115, Aisles, 242, 287 952 Ajax, The Suicide of Ajax (Exekias), 126, 126 Académie des Beaux-Arts, 948, 1013 Lawrence, Jacob, 1115, 1117 Akbar, Indian ruler, 817–818 Academies, 793, 948, 952 Lewis, Edmonia, 997-998, 997 Akbarnama, Akbar inspecting construction of Acanthus, 118 Marshall, Kerry James, 1178, 1178 Fatehpur Sikri, 819, 819 Achaemenes, 42 Puryear, Martin, 1179-1180, 1179 Akhenaten, 72-74 Ringgold, Faith, 1165, 1166 Achaemenids, 42-43 colossal statue of, 72, 72 Achala, Tangka painting, Tibet, 813, 813 Saar, Betye, 1164, 1164 Akhenaten and His Family, 73, 73 Achilles and Ajax Playing a Game (Exekias), 126, Savage, Augusta, 1114–1115, 1115 Akiode, Twin figures (ere ibeji), Yoruba culture, Tanner, Henry Ossawa, 1050-1051, 1051 Nigeria, 921-922, 922 Achilles Painter, Woman and Maid, 148, 148 African art Akkad (Akkadians), 36-37 Achilles (Spear Bearer or Doryphoros) (Polykleitos), Akrotiri, "Flotilla" fresco, Thera, 82-83, 82, 90 Ashanti Kente cloth, Ghana, 928-929, 928 128, 128 Ashanti staff, Ghana, 916, 917, 928 Albani, Alessandro, 954 Acropolis, Athens Baule spirit figure (blolo bla), Côte d'Ivoire, Albarello, Renaissance jar, 634, 634 Athenian Agora, 145-147, 146 926-927 927 Albers, Anni, Wall hanging, 1110, 1111 description of, 136 Benin, 428, 428, 430-432, 430, 432 Albers, Josef, 1111 Erechtheion, 142-144, 143 Blombos Cave, South Africa, 422-423, 423 Alberti, Leon Battista, 624 Kritian Boy, 131, 132 Bwa masks, Burkina Faso, 923-924, 923 On Architecture, 677 model of, 137 children, art, and performance, 922, 922 On Painting, 622 Parthenon, 116, 136-142, 138, 139, 140, 141, contemporary, 936-938, 937, 938 Palazzo Rucellai, 627-628, 627 divination, 927-928, 927, 937, 937 Sant'Andrea church, 644-645, 645, 647 Peplos Kore, 123-124, 124 Album leaves, 833, 837 Dogon dama mask, Mali, 933, 933 Temple of Athena Nike, 144-145, 144 Fang, Nlo byeri guardian, Gabon, 935, 935 Alcuin of York, 455 Acropolis, use of term, 136 Fon, iron memorial scupture, 935-936, 936 Aldobrandini, Pietro, 756 Acroterion, 118 funerary, 932–933, 935–936, 933, 935, 936 Alexander II, pope, 518 Actaeon, Artemis Slaying (Pan Painter), 134-135, Alexander VI, pope, 671 Great Zimbabwe and the Shona, 433-435, 135 434, 435, 436 Alexander the Great, 46, 80, 128, 149, 157 Action painting (gesturalism), 1133-1137, Igbo-Ukwu, 427, 427, 429, 429 on a coin, 154, 155 1133-1137 initiation, 923-925, 923, 924, 925 Alexander the Great (Lysippos), 154, 155

Jenné, 433, 433, 434

Kongo, 436-437, 437, 438

Action Photo I (from "Pictures of Chocolate")

(Muniz), 1174, 1174

Alexander the Great Confronts Darius III at the Battle

of Issos, Pompeii, 155, 156, 157

architecture, Gothic Revival, 1009, 1009 Angelico, Fra (Guido di Pietro da Mugello), Alexandria, Egypt, 149 architecture, Modern, 1101-1105, Annunciation, 638, 639 Alfonso VI, 474, 483 Angilbert, 453 1102-1105, 1167, 1169-1170, 1167, 1169 al-Hakam II, 291 Angkor Vat, Cambodia, 338–339, 339, 340 architecture, Neoclassicism, 979-980, 980, Alhambra, Granada, Spain Anglo-Saxons, 446 1007-1008, 1007 Court of the Lions, Alhambra, 298, 299-300 See also Normans architecture, nineteenth century, 1058, Palace of the Lions, Alhambra, 299, 300 Anguissola, Sofonisba, Self-Portrait, 696-697, 697 1060-1062, 1061 Ali, 284 architecture, Postmodern, 1170, 1170 An Gyeon, Dream Journey to the Peach Blossom Allegory, 650 Allegory of Good Government in the City and in the Land, 846, 846 Armory Show, 1093 Ashcan School, 1092 Aniconism, 284 Country (A. Lorenzetti), 571-572, 571 Harlem Renaissance, 1114-1116, 1114, 1115, Animals Allegory of Peace, 188-189, 188 cave art, 0, 1, 6-11, 7, 9, 10, 11, 424-425, 425 Allegory of Sight, from Allegories of the Five Senses landscape painting, 1004–1005, 1004 domesticated, 12, 21, 396 (Brueghel and Rubens), 778, 780, 780 Allegory with Venus and Cupid (Bronzino), Modern art, 1091-1095, 1092-1095 Native American use of imagery, 886 Neolithic, 12-13, 12 New York School, 1131-1141, 1131-1140 695-696, 695 painting, early, 806, 806 New World, 396, 408 Alloy, 20 Animal style, 445 Alma-Tadema, Lawrence, Pheidias and the Frieze of painting, Neoclassicism, 981-982, 981 Ankh, 52, 64 painting, Neo-Expressionism, 1176-1177, the Parthenon, Athens, xliii, xliii Ankhnesmeryra, queen, 61 1176 al-Sadi, 433 Annunciation (Angelico), 638, 639 Altamira cave, Spain, Bison, 6, 7, 10, 10 painting, Realism, 1022, 1022, 1023 painting, Romantic landscape, 1004-1005, Annunciation, Book of Hours of Jeanne d'Evreux Altar from Pergamon, 162-163, 162 (Pucelle), 572-573, 573 Altar of Augustan Peace (Ara Pacis Augustae), Annunciation, Ghent Altarpiece (Jan and Hubert van painting, Symbolists, 1050-1051, 1050, 1051 187-188, 187, 188 Pop art, 1150–1154, 1151–1154 Evck), 584, 585 Altarpiece of the Holy Blood (Riemenschneider), sculpture, Neoclassicism, 997-998, 997 Annunication, Mérode Altarpiece, Triptych of the 710, 710 (Campin), 587, 588, 597-598, 597 skyscrapers, 1060, 1104-1105, 1104, 1105, Altars and altarpieces Annunciation, Reims Cathedral, Notre-Dame 1167, 1167, 1170, 1170 Chartreuse de Champmol (Broederlam), cathedral, 533-536, 535 American Revolution, 941, 942 588-590, 589, 590 Annunciation and Virgin of the Rosary (Stoss), 711, Fon, iron memorial scupture, Benin, 935-936, Americans, The (Frank), 1143 711 Americas Ansquetil, abbot, 496 SEE ALSO Central America; Mesoamerica; Ghent Altarpiece (Jan and Hubert van Eyck), Anta, 116 584, 585, 598, 599 North America; South America Anthemius of Tralles, Hagia Sophia church, Istanmaps of, 397, 875 Isenheim Altarpiece (Grünewald), 711-712, 712, bul, 255, 255, 256, 257, 259, 305 timelines, 406, 411, 413 713 714 Amida Buddha, Heian period, Japan, 386, 386 Anthropométries of the Blue Period (Klein), 1149, Last Judgment Altarpiece (Weyden), 602-603, 1149 Amida Buddha, Nara period, Japan, 382-383, 382 603 Anthropomorphs, Great Gallery, Horseshoe Maestà Altarpiece (Duccio di Buoninsegna), Amiens Cathedral, Notre-Dame cathedral, 528, 530-531, 530, 532-533, 533, 534, 535 Canyon, Utah, 414, 414 567, 567, 568, 569, 570 Anthropophagic Manifesto (Andrade), 1096 Mérode Altarpiece (Triptych of the Annunication) Amitabha Buddha Antigonus, 157 (Campin), 587, 588, 597-598, 597 altar to, Sui dynasty, China, 358, 358 Western Paradise of Amitabha Buddha, Tang Antoninus Pius, 204 Portinari Altarpiece (Goes), 606-607, 607, 609, Antwerp, sixteenth century, 731-734 dynasty, China, 358, 359 609 Anubis, 52 terminology, 591, 591 Amorites, 37 Anu Ziggurat (White Temple), Uruk, 30, 30 Altdorfer, Albrecht, Danube Landscape, 718, 719 Amphiprostyle temple, 116 Altes Museum (Schinkel), Berlin, 1008, 1008 Amphitheaters, Colosseum (Flavian Amphithe-Apadana (audience hall), 44-45, 44, 45 Aphaia, temple of (Aegina), 120-121, 120 ater), Rome, 202-204, 202, 203 Altneuschul, Prague, 542, 543 Aphrodite, 109, 110 Amphora, 125 Amadou, Sekou, 433 Aphrodite of Knidos (Praxiteles), 152-153, 152 Amalakas, 320, 327, 333 Amun, 52, 71 Aphrodite of Melos (Venus de Milo), 165, 166 Great Temple of, 67-69, 68, 69 Amaral, Tarsila do, Abaporú (The One Who Eats), Analytic Cubism, 1078-1080, 1079, 1080 Apollinaire, Guillaume, 1082 1096, 1096 Anasazi. See Ancestral Puebloans Apollo, 109, 110, 128 Amaravati school, 324-325, 324 sanctuary of, 110-111, 111, 132-133, 133 Anastaise, illuminator, 592, 593 Amarna period, 72–75 Anastasis, Church of the Monastery of Christ, temple of, 111 Amasis Painter, Dionysos with Maenads, 125-126, Temple of Zeus, 130-131, 130, 131 Chora, Constantinople, 278, 279 125 Apollo (Vulca), 173-174, 175 Ambulatories, 247, 287 Anatolia, 37, 39 Apollo Attended by the Nymphs of Thetis (Girardon), Chatal Huyuk, 28, 28 Amenemhat I, 63, 65-66, 65 796-797, 797 Anatomy Lesson of Dr. Nicolaes Tulp, The (Rem-Amenhotep III, 69, 74 Apollodorus of Damascus, 205 brandt), 784, 784 Amenhotep IV, 72 Apollo with Battling Lapiths and Centaurs, 130-131, Anatsui, El, 1181 America After Kings, 1182, 1182 federal patronage of art, 1116 Flag for a New World Power, 936-937, 937 Apotheosis of Homer, The (Flaxman), 960, 960 Gothic Revival in, 1009, 1009 Apparition (Moreau), 1048, 1048 Industrial Revolution, 986-987 Anavysos Kouros, Athens, 122, 122 Ancestral Puebloans, Pueblo Bonito, Chaco Apple Cup, silver (Krug?), 714, 714 map of, in the nineteenth century, 987 Canyon, New Mexico, 394-395, 395-396, Apse, 242, 322 Modern art in, 1091-1095, 1092-1095 Aqueducts, Pont du Guard, Roman bridge, 182, 416, 417-418, 417, 418 Neoclassicism in, 979-982, 980, 981, Ancient Ruins in the Cañon de Chelley, Arizona 997-998, 997 Aguinas, Thomas, 514, 515, 524 twentieth century in, 1066-1067 (O'Sullivan), 417, 417 Arabesques, 284, 818, 944 Andachtsbilder, 580 American art Abstract Expressionism, 1131-1141, Andean textiles, 409, 409, 410, 410 Ara Pacis Augustae (Altar of Augustan Peace), 187-189, 187, 188 Andhra dynasty, 319, 322-323 1131-1140 Arbus, Allan, 1144 Andrade, Oswald de, 1096 architecture, early, 805-806, 806

Arbus, Diane, Child with Toy Hand Grenade, 1144, French Baroque, 793-797, 794-797 Ottonian, 464-465, 465, 468 1144 French Gothic, 516-532, 517-532 Paleolithic, 2-4, 3 Arcades, 172, 183, 287 French Neoclassicism, 969-970, 970 Postmodern, 1170, 1170 Arc de Triomphe, Paris, Departure of the Volunteers German Gothic, 541-542, 542, 543 Prairie style, 1102 of 1792 (The Marseillaise) (Rude), 997, 997 German Neoclassicism, 1008, 1008 Pueblo Bonito, Chaco Canyon, New Mexico, Archaic period of Greek art. See Greek art, German Rococo, 944-946, 944, 945, 946 394-395, 395-396, 416, 417-418, 417, 418 Gothic, English, 539-541, 540, 541 Pueblos, 887, 889, 889 Archaic smile 122 174 Gothic, French, 516-532, 517-532 Renaissance, early, 621-628, 622-627, Archangel Michael diptych, Byzantine, 263-264, Gothic, German (Holy Roman Empire) 640-642, 641, 642, 644-647, 645, 646, 263 541-542, 542, 543 653 654 Archangel Michael icon, Byzantine, 273, 276, 276 Gothic, Italian, 546, 546 Renaissance, English, 738, 739 Arches Gothic Revival, American, 1009, 1009 Renaissance, French, 720-723, 721, 722, 723 corbel 171 576 Gothic Revival, English, 959, 959, 1008, 1009 Renaissance, High, 677-680, 678, 679, 680 horseshoe, 291, 292 Great Zimbabwe and the Shona, 433-435, Renaissance, Spanish, 725, 725 Islamic, 292 434, 435, 436 Rococo, 944-946, 944, 945, 946 nodding agee, 576 Greek (Archaic period), 116, 117-119, 117 Roman books on, 179 pointed, 292, 485 Greek city plans, orthogonal, 149-150, 149 Roman Colosseum (Flavian Amphitheater), round, 171, 172 Greek Parthenon, Acropolis, 136-144, 138, 202-204, 202, 203 transverse, 488 Romanesque, 480–493, 480, 481, 483–494 139, 143 Architectonic Painting (Popova), 1086, 1086 French nineteenth century, 1012–1013, 1013 Roman Imperial, 205-212, 206-213, Architecture French Renaissance, 720-723, 721, 722, 723 219-220, 219, 220, 223-224, 223, 226-228, Abelam tamberan houses, 901–902, 903 Hellenistic, 158-160, 158, 159 226, 227, 228 Ain Ghazal, Jordan, 28, 29 High Tech, 1182, 1184, 1184 Roman Pantheon, 210, 210, 211, 212 American, early, 805-806, 805 Hindu northern temples, 327-329, 327, 328, Roman Republic, 181-185, 182, 183, 184, American Gothic Revival, 1009, 1009 329, 333-334, 334 199, 200, 201-204, 201, 202, 203 American Modern, 1101-1105, 1102-1105. Hindu southern temples, 333, 333, 335-336, skyscrapers, 1060, 1104-1105, 1104, 1105, 1167, 1169–1170, 1167, 1169 1167, 1167, 1170, 1170 American Neoclassicism, 979-980, 980, Hindu temples in India, 812, 814 Spanish Baroque, 770-771, 771 1007-1008, 1007 Holy Roman Empire, Gothic, 541-542, 542, Spanish Renaissance, 725, 725 American nineteenth century, 1058, 543 Sumerian, 30, 30, 33, 33 1060-1062, 1061 Incas, 877-878, 878, 879 Teotihuacan, 399-401, 400, 401 American Postmodern, 1170, 1170 Indian (Mughal period), 808-809, 809, use of term, 2 Art Nouveau, 1054, 1054 817-818, 818, 819 Viking timber, 461, 462, 463, 463 Assyrian, 40-41, 42 Indian temples, 320, 327-329, 327, 328, 329, Architecture, elements of Baroque, Austrian, 771-772, 772, 773 333-336, 333, 334, 335 arches, vaults, and domes, 172, 172 Baroque, English, 801-804, 802, 803, 804 International style, 1109, 1167 arches and mugarnas, Islamic, 292, 292 Baroque, French, 793-797, 794-797 Islamic, 286–292, 286–292, 295, 297–300, basilica-plan churches, 242, 243, 242, 243 Baroque, Italian, 745-754, 747-754 297, 298, 300 Byzantine multiple-dome plan, 275 Baroque, Spanish, 770-771, 771 Italian, Baroque, 745-754, 747-754 central-plan churches, 242, 242 bridges, 967, 967 Italian, fourteenth century, 557-559, 557, 558, Gothic church, 522, 522 Byzantine, early, 254-263, 255, 256, 258, 559 Greek orders, 117, 118, 118, 158-159, 158 260-262 Italian, Gothic, 546, 546 Greek temple plans, 116, 116 Byzantine, late, 278, 279 Italian, Renaissance, 621-628, 622-627, Inca masonry, 878, 878 Byzantine, middle, 267-273, 268-272 640-642, 641, 642, 644-647, 645, 646, International style, 1109 Carolingian, 451-455, 452, 453, 454 653, 654, 677–680, 678, 679, 680 iron, use of, 967 Chatal Huyuk, Anatolia, 28, 29 Japanese, Asuka period, 379–380, 380 Japanese shoin design, 860, 860 Chichen Itza, 406-407, 407 Japanese, Heian period, 384-385, 384-385 mastaba to pyramid, 56 Chinese, 839, 839 Japanese, Momoyama period, 857, 857 mosque plans, 289, 289 Chinese, Han dynasty, 353-354, 354 Japanese, Yayoi period, 378, 378 pagodas, 359-360, 360, 361 Chinese, pagodas, 359-360, 360, 361 Jenné, 433, 434 parks, 1059, 1059 Chinese, Six Dynasties Buddhist, 356-357 Khmer, 338-339, 339 pendentives and squinches, 257, 257 Chinese, Tang dynasty Buddhist, 358-360, landscape, 956-959, 957, 958, 1187, 1187 post-and-lintel and corbel construction, 14 359, 360 Maori, 910-911, 911 rib vaulting, 521, 521 Christian, early, 242-249, 242-249 Mayan, 402-404, 403, 404 Roman orders, 174, 174, 203 Deconstructivist, 1184, 1185 Micronesia, 904-904, 905 Roman techniques, 181-182 de Stijl, 1108, 1109 Minoan, 86-88, 87, 88 Saint Peter's basilica plans, 679, 679 Egyptian pyramids and mastabas, 55-59, 56, Modern, 1100-1105, 1100-1105, 1167, skyscrapers, 1104, 1104 57, 58 1169-1170, 1167, 1169 stupas and temples, Indian, 319-321, 319, 320 Egyptian rock-cut tombs, 63, 63 Mycenaean, 95-102, 96-102 Tuscan order, 173, 174, 203 Egyptian temples, 67-72, 68, 69, 71, 75-78, Nankani compound, Ghana, 919, 920 wood, 462, 462 76, 77 Neo-Babylonian, 42, 42, 43 Architraves, 119 English Baroque, 801-804, 802, 803, 804 Neoclassicism, American, 979-980, 980, Archivolts, 495 English Classical Revival, 956-959, 957, 958 1007-1008, 1008 Arch of Constantine, Rome, 226-227, 226 English fourteenth century, 576-578, 577 Neoclassicism, English, 959-960, 960 Arch of Titus, Rome, 199, 200, 201, 201 English Gothic, 539-541, 540, 541 Neoclassicism, French, 969-970, 970 Arena, 202-203 English Gothic Revival, 959, 959, 1008, 1009 Neoclassicism, German, 1008, 1008 Ares, 109, 110 English Neoclassicism, 959-960, 960 Neolithic, 13-17, 14, 15, 16, 17 Argentina, Cubism in, 1096-1097, 1097 English Renaissance, 738, 739 nineteenth century use of new materials and Arianism, 249 Etruscan, 170-171, 173-174, 173 methods, 1012-1013 Aristotle, xxxiv, 128, 149, 515, 659, 666 European Modern 1100-1101, 1100, 1101 Olmec, Great Pyramid, 398, 398 Ark of the Covenant, 236, 236 flamboyant-style, 610-611, 611

Ottoman, 305-306, 306, 307

Armonía Transformable (Transformable Harmony)

Baca, Judith F., Division of the Barrios, from Great Assurbanipal and His Queen in the Garden, 41, 41 (Soto), 1154, 1155 Wall of Los Angeles, 1177, 1177 Assurnasirpal II, palace of Armor Bacchus, 110, 194, 229 for English royal games, 737, 737 Assurnasirpal II Killing Lions, 40, 40 Samurai, 389, 389 Human-Headed Winged Lion (lamassu), 24, 25 Bacchus (Caravaggio), 757, 757 Assyria (Assyrians), 25, 40-41 Bacci Chapel, San Francesco church, Arezzo, Armored Train in Action (Severini), 1084, 1084 642-643, 642 Armory Show, 1093 Astragal, 118 Bacon, Francis, 746 Astronomy, or Venus Urania (Giovanni da Arnhem Land, Australia, 900-901 Arnolfini, Giovanni, 599-600, 601 Bologna), 698, 698 Bacon, Francis (20th century artist), Head Surrounded by Sides of Beef, 1128, 1128 Arp, Jean, 1091 Asturians, 449 Asuka period, Japan, 378-382, 379, 380, 854 Baerze, Jacques de, 589 Arruda, Diogo de, Convent of Christ, Tomar, Bailey, 493 Portugal, 724, 724 AT&T Corporate Headquarters (Johnson and Burgee), New York City, 1170, 1171 Balbilla, Julia, 198 Art Baldacchino, 550, 747 Ateliers, 819, 988 brut, 1129 Baldacchino (Bernini), 747-748, 748 Aten, 72 conceptual art, 1160-1161, 1160, 1161 Baldachin, 488, 747 Athanadoros, Laocoön and His Sons, xxxvii, craft versus, 893 Ball, Hugo, 1090, 1145 xxxvii, 163-164 criticism, 987 "Karawane," 1088, 1088 Athena, 109, 110 defined, xxxiii Ball game, Mesoamerican, 405 Athena, Herakles, and Atlas, 131, 131 history, xlvi-xlvii Banker and His Wife, The (Van Reymerswaele), Athena Attacking the Giants, 162, 163 human figure as beauty and ideal, 731-732, 731 Athena Nike, temple of, 116, 144-145, 144 xxxvi-xxxvii Banner of Las Navas de Tolosa, Islamic, 302, 302 Athena Parthenos, 136 impoverished (povera), 1158-1159, 1159 Banqueting House (Jones), Whitehall Palace, Lon-Athena Pronaia, sanctuary of, 150-151, 150 informel, 1129-1130 don, 802, 802, 803 Athenian Agora, 145-147, 146 modes of representation, xxxiii-xxxviii Baptismal font (Reiner of Huy), Notre-Dame-Athens, 108-109, 114-115, 125, 130, 135-136, nature of, xxxiii Aux-Fonts, Liege, France, 506-507, 507 patrons and collectors, role of, xliii-xlvi Baptistry of the Arians, Ravenna, 249 performance, 1160-1161, 1160, 1161 SEE ALSO Acropolis Baptistry of the Orthodox, Ravenna, 249, 250 Atlas, Athena, Herakles, and, 131, 131 reasons for having, xxxviii-xl Bar at the Folies-Bergère, A (Manet), 1036, 1037, Atmospheric (aerial) perspective, 195, 586 search for meaning and, xxxviii Atrial crosses, 977, 977 social context and, xxxix-xl Barberini palace and square (Cruyl), 761, 762 Atrium, 170, 192, 242 sociopolitical intentions, xl Barbieri Giovanni Francesco, 760 Attack on the Castle of Love, jewelry box lid, 574, viewers, responsibilities of, xlvii Barbizon School, 1003 574 Art as Experience (Dewey), 1158 Attalos I, 160 Bardon, Geoffrey, 913 Art Deco, use of term, 1083 Bargeboards, 910 Arte Concreto-Invención, 1141 Attila, 442 Augustan sculpture, 186-190, 186, 187, 188, 189 Bargehaulers on the Volga (Repin), 1021-1022, 1021 Artemis, 109, 110, 134-135, 135 Ara Pacis Augustae (Altar of Augustan Peace), Barges, The (Daubigny), 1003, 1004 Artemis, temple of (Corfu), 119, 119 Bark clothing, 912, 912 187-189, 187, 188 Artemis Slaying Actaeon (Pan Painter), 134-135, Bark painting, Australian, 900-901, 901 Gemma Augustea, 189-190, 189 Augustine, Saint, 442, 446 Baroque, use of term, 744 Arte povera, 1158-1159, 1159 Baroque art Art for art's sake theory, xlvi Augustus, 185, 205 Augustus of Primaporta, Roman, 186-187, 186 architecture, Austrian, 771-772, 772, 773 Artists architecture, English, 801-804, 802, 803, 804 copy with color restored, 186, 186 how to be famous nineteenth century, 1016 architecture, French, 793-797, 794-797 Aulus Metellus (The Orator), Roman, 180, 181 who are, xl-xliii architecture, Italian, 745-754, 747-754 Aurora (Reni), 761, 761 Artist's Studio, The (Daguerre), 1010, 1010 architecture, Spanish, 770-771, 771 Art Nouveau, 1053-1057, 1054, 1055, 1056 Australia, 900-901, 900, 901, 913-914, 914 Flemish, 774-779, 774-779 Austria Arts and Crafts movement, 1024 painting, Dutch, 779, 781-793, 781-793 architecture, Baroque, 771-772, 772, 773 Aryans, 315-316 painting, French, 797-800, 798-801 architecture, Rococo, 944-945, 944, 945, 946 Ascension, Rabbula Gospels, 265, 265 painting, Italian, 754-764, 755-763 Art Nouveau in, 1055, 1055 Ascension of Elijah, 245, 245 painting, Spanish, 764-770, 764-770 Steiner House (Loos), 1100, 1100 Asen (altar), Fon, iron memorial scupture, Benin, sculpture, Italian, 745, 748, 749-751, 749 Woman from Willendorf, 4, 5 935-936 936 Automatism, 1120, 1137 Baroque period Ashanti, Ghana in the colonies in North America, 805-806 Autumn Colors on the Qiao and Hua Mountains Kente cloth, 928-929, 928 description of, 744 (Zhao Mengfu), 833, 834 staff, 916, 917, 928 in England, 801-804 Autumn Rhythm (Number 30) (Pollock), Ashcan School, 1092 in Flanders, 774-779 1134-1135, 1134 Asheville (de Kooning), 1135, 1136, 1137 in France, 793-800 Autumn Salons, 1067-1068 Ashikaga (Muromachi) period, 856-859 Autun, Burgundy, France, Saint-Lazare cathedral, in Italy, 745-764 Ashlar, 102 map of Europe and North America in, 745 Ashoka, king of India, 311, 317, 319, 815 497-498, 497, 498 in the Netherlands/United Dutch Republic, Avalokiteshvara, 810, 812 Ashokan pillars, India, 310, 311, 317 779-793 Avant-garde, use of term, 1038 As If to Celebrate, I Discovered a Mountain Blooming science and worldview in, 746 Avicenna (Stella), 1156-1157, 1156 with Red Flowers (Kapoor), 1180, 1180 Axis mundi, 317, 320, 327, 361, 381 in Spain, 764-772 Asmat spirit poles (mbis), Irian Jaya, 903, 903 style of, 744 Aspects of Negro Life: From Slavery through Recon-Aztecs, 872-873, 873, 874-876 Barozzi, Giacomo. See Vignola struction (Douglas), 1114, 1114 Barrel vaults, 172, 322, 488 Assemblage, 1145-1148, 1146, 1147 Barry, Charles, Houses of Parliament, London, Assisi, Church of St. Francis, 546, 546 1008.1009 Association of Artists of Revolutionary Russia Barry, Madame du, 951 Baby carrier, Sioux, 882-883, 882 (AKhRR), 1107 Bartolomeo, Michelozzo di. See Michelozzo di Babylon (Babylonians), 31, 37, 38 Assumption of the Virgin (Correggio), 680-681, 681 Bartolomeo neo-, 42

Assurbanipal, 29, 42

Bar tracery, 531 Bells, Zhou dynasty bronze, China, 348-349, 349 Blackware storage jar (Martinez and Martinez), Bas-de-page, 573 Benday dots, 1153 889-890, 889 Bases, of columns, 118 Benedictine Abbey of Melk (Prandtauer), Austria, Blake, William, 968 Basil I. 267 771-772, 772, 773 Elohim Creating Adam, 969, 969 Basil II, 268 Benedictine plan, 479 Blanche of Castile, 528, 536, 537 Basilica, Trier, Germany, 223-224, 223 Blenheim Palace (Vanbrugh), England, 803-804, Benedictines, 451, 477, 488 Basilica of Maxentius and Constantine (Basilica Benedict of Nursia, 451 804 Nova), Rome, 227-228, 227, 228 Beni Hassan, Egypt, rock-cut tombs, 63, 63 Bleyl, Fritz, 1070 Basilica-plan churches, 242, 243, 242, 243 Benin, Nigeria Blind arcades, 818 Basilicas, defined, 205-206 heads, 430-432, 430, 432 Blombos Cave, South Africa, 422-423, 423 Basilica Ulpia, Rome, 205-206, 207 Plaque: Warrior Chief Flanked by Warriors and Bloodletting ritual, Teotihuacan, 401, 402 Basilica Ulpia, Rome, 206, 207 Attendants, 428, 428 Blue Mountain (Kandinsky), 1074, 1074 Basil the Great of Cappadocia, 266 Benin, Republic of, Fon iron memorial scupture, Blue Rider (Der Blaue Reiter), 1073-1076, 1074, Basketry, 882, 882 935-936, 936 1075, 1076 Basquiat, Jean-Michel, Horn Players, 1176-1177, Bentley, Richard, 959 Boccaccio, Giovanni 1176 Concerning Famous Women, 591, 592, 592 Beowulf, 446 Bateman, Ann, 962 Berlin The Decameron, 561 Bateman, Hester, 962 Altes Museum (Schinkel), Berlin, 1008, 1008 Boccioni, Umberto, Unique Forms of Continuity in Bateman, Peter, 962 Dadaism, 1090-1091, 1090, 1091 Space, 1084, 1085 Baths of Caracalla, Rome, 219, 219 Berlin Kore, Athens, 122-123, 123 Bodhidharma Meditating (Hakuin), 864-865, 864, Baths of Diocletian, 220 Bernard of Clairvaux, abbot, 477, 484, 489 Bodhisattvas, 358 Battista Sforza and Federico da Montefeltro (Piero Bernini, Gianlorenzo Avalokiteshvara, 810, 812 della Francesca), 643-644, 643, 644 Baldacchino, 747-748, 748 Bodhisattva, Gupta period, India, 326-327, 326 Battle between the Gods and the Giants, Treasury of Cornaro Chapel, Santa Maria della Vittoria Bodhisattva Seated in Meditation, Three Kingthe Siphnians, Delphi, 120, 120 church, 749-750, 749 doms, Korea, 368, 368 Battle between the Romans and the Barbarians, 222, David, 748, 749 Descent of the Amida and the Twenty-five Bod-Fountain of the Four Rivers, 753, 754, 754 hisattvas, Kamakura period, Japan, 391, 392 Battle of Centaurs and Wild Beasts, Hadrian's Villa, Saint Peter's Basilica piazza design, 747-749, Maitreya, 337, 337 Tivoli, 213, 213, 215 Seated Guanyin Bodhisattva, Liao dynasty, Battle of San Romano, The (Uccello), 618-619, Saint Teresa of Ávila in Ecstasy, 750-751, 750 China, 361-362, 362 619-620 Bernward, Bishop, doors of Saint Michael Seated Willow-branch Gwanse'eum Bosal (Bod-Battle of the Bird and the Serpent (Emeterius and Church, Germany, 466, 466, 467, 469 hisattva Avalokiteshvara), Goryeo dynasty, Ende), copy of Commentary on the Apoca-Berrettini, Pietro, See Pietro da Cortona Korea, 370, 370 lypse (Beatus), 450, 451 Bertoldo di Giovanni, 669 Boffrand, Germain, Salon de la Princesse, Hôtel Battle of the Nudes (Pollaiuolo), 634, 634 Bestiary, 594 de Soubise, Paris, 943, 944 Battle scene on buffalo-hide, 884-885, 885 Betrayal and Arrest of Christ, Book of Hours of Jeanne Bohier, Thomas, 720, 722 Baudelaire, Charles, 1011-1012, 1011, 1027 d'Evreux (Pucelle), 572-573, 573 Bonanno, 486 Bauhaus art, 1110-1111, 1110, 1111, 1112 Beuys, Joseph, How to Explain Pictures to a Dead Bonheur, Rosa, Plowing in the Nivernais: The Dress-Bauhaus Building (Gropius), Dessau, Germany, Hare, 1160-1161, 1161 ing of the Vines, 1020, 1020 1111. 1111. 1112 Bonheur de Vivre, Le (The Joy of Life) (Matisse), Bhagavad Gita, 336 Baule spirit figure (blolo bla), Côte d'Ivoire, Bhakti movement, 336, 336, 821 1068, 1069, 1070 926-927. 927 Bharat Mata (Mother India) (Tagore), 825, 826 Boniface IV, pope, 212 Bautista de Toledo, Juan, El Escorial, Madrid, 725, Bi. 351 Bonsu, Kojo, Staff (Ashanti), Nigeria, 916, 917. 725 Bible 928 Bawa, Manjit, Dharma and the God, 826, 828 Gutenberg, 615 Bonsu, Osei, 928 Bayeux Tapestry, Normandy, France, 504-505, 504, Queen Blanche of Castile and Louis IX mor-Book of Genesis, 264, 264 505 alized, 536, 537 Book of Homilies (Guda), 508, 508 Bays, 172, 358-359, 860 Vulgate, 243, 455 Book of Hours of Jeanne d'Evreux (Pucelle), BCE (before the Common Era) designation, 2 Bibliothèque Sainte-Geneviève (Labrouste), Paris, 572-573, 573 Beadwork, 883-884, 883 1012-1013, 1013 Book of Kells, Iona, Scotland, 440, 441, 448, 449 Beatus, 449-450 Bicho LC3 (Pan-Cubisme) (Clark), 1158, 1158 Book of the City of Ladies, The (Christine de Pizan), Beau Dieu, Amiens Cathedral, Notre-Dame Big Raven (Carr), 1099-1100, 1099 cathedral, 532-533, 535 Bihzad, Kamal al-Din, 304, 305 Book of the Courtier, The (Castigione), 640 Beautiful style, 577-578, 613 Bilbao, Spain, Guggenheim Museum, Solomon R. Books "Beautiful" Virgin and Child, Sternberk, 580, 581 (Gehry), 1184, 1185 early forms of, 251 Biomorphic forms, 1117–1119, 1117, 1118, Beauvais, Vincent de, 515, 524 printing of, 615-616, 652 Beaver effigy platform pipe, Hopewell culture, 1119, 1122, 1122 Books of the Dead, 78-79, 79 412, 413 Bird-Headed Man with Bison, Lascaux cave, 9-10, 9 Borgund stave church, Norway, 462, 463, 463 Bede, 441 Bird on top of monolith, Great Zimbabwe, 435, Borobudur, Java, 338, 338 Beehive tombs, 99 436 Borromini, Francesco Beijing, Forbidden City, 839, 839 San Carlo alle Quattro Fontane church, Birmingham Race Riot (Warhol), 1152-1153, 1153 Belgium, Art Nouveau in, 1054, 1054 Birth of Liquid Desires, The (Dalí), 1120-1121, 1121 751-752, 751, 752, 753 Bellini, Gentile, Procession of the Relic of the True Birth of Venus, The (Botticelli), 651-652, 651 Sant'Agnese church, 753, 753 Cross before the Church of Saint Mark, 654, 654 Birth of Venus, The (Cabanel), 1015, 1015 Bosch, Hieronymus, Garden of Earthly Delights, Bellini, Giovanni Bishop Odo Blessing the Feast, Bayeux Tapestry, Nor-728-729, 729 Saint Francis in Ecstasy, 655, 656 man, 504, 504, 505 Bosses, 449, 576 Virgin and Child Enthroned with Saints Francis, Bison, Altamira cave, Spain, 6, 7, 10, 10 Boston Massacre, 941 John the Baptist, Job, Dominic, Sebastian, and Bison, Le Tuc d'Audoubert, France, 10, 11 Boston Tea Party, 981 Louis of Toulouse, 654-655, 655 Black Death, 554, 556, 575 Böttger, Friedrich, 840 Bellini, Jacopa, 654 Black-figure painted vases, 114, 115, 125-126, Botticello, Sandro Bellori, Giovanni, 757 125, 126 The Birth of Venus, 651-652, 651

Brunelleschi, Filippo, 622 Burgundy The Mystic Nativity, 652-653, 653 abbey at, 482, 483 Capponi chapel, Santa Felicità church, Flo-Primavera (Spring), 650-651, 650 Boucher, François, Triumph of Venus, 949-950, 949 dukes of, dates for, 593 rence, 692, 693 Saint-Lazare cathedral, Autun, Burgundy, Florence Cathedral dome, 558, 558, 559, Bourgot, illuminator, 592 France, 497-498, 497, 498 623-624, 623 Bouts, Dirck Burial at Ornans, A (Courbet), 1018, 1018 Justice of Otto III, 605-606, 606 Foundling Hospital, 624, 626, 626 San Lorenzo church, 624-625, 624, 625 Burial customs. See Funerary customs; Tombs Wrongful Execution of the Count, 605-606, 606 Bowl, Painted Pottery, Neolithic Chinese, Brutus, Lucius Junius, 178, 178 Burial of Count Orgaz (El Greco), 726, 727 Burial ships 344-345, 345 Buddha, 316, 318 Amida Buddha, Heian period, Japan, 386, 386 Sutton Hoo, England, 446, 447 Bowl with kufic border, Samarkand ware, 294, Viking, 459-460, 459, 460 Amida Buddha, Nara period, Japan, 382-383, Burins, 615 382 BP (before present) designation, 2 Burke, Edmund, 954 Bracketing, 353-354, 361 Amitabha Buddha, altar to, Sui dynasty, China, Burkina Faso 358, 358 Brahma, 318 Bwa masks, 923-924, 923 Buddha and Attendants, Mathura school, 324, Bramante, Donato, 666 Mossi dolls (biiga), 920, 921 Saint Peter's basilica, plan for, 679, 679 Burlington, Lord (Richard Boyle), Chiswick Tempietto, San Pietro church, Rome, Buddha Calling the Earth to Witness, 815-816, House, England, 957-958, 957 677-678, 678 Burma, Theravada Buddhism in, 814-815, 814 Brancacci Chapel, Santa Maria del Carmine Parinirvana of the Buddha, Sri Lanka, 339, 340 Burning of the House of Lords and Commons, 16th Seated Buddha in Cave, Six Dynasties, China, church, Florence, 636-638, 637, 638, 639 October 1834, The (Turner), 1002, 1002 357, 357 Brancusi, Constantin, 1086 Burri, Alberto, Composition, 1130, 1130 Seated Shakyamuni Buddha, Seokguram, Korea, Magic Bird, 1087, 1087 Burrows, Alice, 962 368, 369 Newborn, 1087, 1087 Shakyamuni, Thailand, 337, 337 Burrows, George, 962 Brandt, Marianne, 1111 Burty, Philippe, 1044 Siddhartha in the Palace, Nagarjunakonda, India, Coffee and tea service, 1110, 1110 Buseau, Marie-Jeanne, 949 324-325, 324 Braque, Georges Standing Buddha, Gandhara school, 323, 323 Bush, Jack, Tall Spread, 1155, 1156 Analytic Cubism, 1078-1080, 1079, 1080 Houses at L'Estaque, 1079, 1079 Standing Buddha, Gupta style, 326, 326 Busketos, 486 Buttresses, 172, 479, 492, 518 Violin and Palette, 1079-1080, 1079 Buddhism Buxheim Saint Christopher, woodcut, 614, 614 Brazil, Modern art in, 1096, 1096 in Burma and Thailand, 814-816 Bwa masks, Burkina Faso, 923-924, 923 in China, 356 Breton, André, 1119-1120, 1131, 1145 Bwami masks, Lega, Democratic Republic of the in India, 317, 810 Breuil, Abbé Henri, 6 in Japan, 373, 378-392, 852-856 Congo, 924-925, 925 Briconnet, Catherine, 722 Byodo-in temple, Heian period, Japan, 395-396, Bridge (Die Brücke), 1070-1072, 1070, 1071 in Korea, 368, 370 395 symbols, 381 Bridges, iron, 967, 967 Brinkmann, Vincenz, 187 Buddhist art Byzantine art, early Constantinople, churches in, 254-259, 255, architecture, Six Dynasties Buddhist, 356-357 architecture, Tang dynasty Buddhist, 358-360, 256, 258 SEE ALSO England; English art dates for, 254 colonial period, 825 359, 360 icons and iconoclasm, 266-267, 266, 267 in Cambodia, 338-339, 339, 340 Hadrian's wall, 212, 213 objects of veneration and devotion, 263-265, in India, 810, 812 Brody, Sherry, The Dollhouse, 1164 263, 264, 265 in Japan, Asuka period, 379-382, 379, 380 Broederlam, Melchior, Champmol Altarpiece, Ravenna, churches in, 259-263, 260, 261, 262 in Japan, esoteric, 383, 383 589-590, 589 Byzantine art, late in Japan, Nara period, 382-383, 382 Bronze Age in Japan, Pure Land, 384-386, 384-385, 386, architecture, 278, 279 Aegean, 84 dates for, 254 389, 391, 391 in China, 346-349, 347, 349 objects of veneration and devotion, 278-279, in Japan, Zen, 390, 390, 391-392, 392 prehistoric, 20-21, 21 280 in Java, 338, 338 Bronze Foundry, A (Foundry Painter), 132, 132 in Korea, 368, 368, 370, 370 Byzantine art, middle Bronze work architecture and mosaics, 267-273, 268-272 rock-cut halls, 321-322, 322 bells, 348-349, 349 sculpture, 326, 326, 337, 337, 357, 357 dates for, 254 Etruscan, 168-169, 169-170, 177-178, 178 objects of veneration and devotion, 273-274, in Sri Lanka, 339, 340 fang ding, 347, 347 273, 274 in Thailand, 337, 337 Hildesheim bronze doors, 466, 466, 467, 469 in Sicily, 274-278, 277, 278 Buenos Aires, experiments with form in, hollow-casting, 132 1141-1142, 1141, 1142, 1143 Byzantine Empire, map of, 235 low-wax casting, 346, 347 Buffalmacco(?), The Triumph of Death, Cam-Byzantium, 254 piece-mold casting, 346, 347 posanto, Pisa, 556, 556 Renaissance, 629-631, 630, 631 sculpture, Classical Greek, 131-134, 133, 134 Buland Darvaza (The Lofty Gate), Fatehpur Sikri, C Bronzino (Agnolo di Cosimo), 694 818, 818 Bull and Puppy (Rosetsu), 865-866, 865 Cabanel, Alexandre, 1016 Allegory with Venus and Cupid, 695-696, 695 Bull Leaping, Knossos, Crete, 91-92, 92 The Birth of Venus, 1015, 1015 Portrait of a Young Man, 694, 695 Bull's-head rhyton, Knossos, Crete, 93, 94, 94 Cabaret Voltaire, 1088 Brooklyn Museum of Art, "Sensation" exhibition, Buncheong ceramics, 845-846, 845 Ca D'Oro (House of Gold), Contarini Palace, 1183 Venice, 653, 654 Bunsei, Landscape, 852-853, 852 Brown, Blue, Brown on Blue (Rothko), 1138, 1138 Caen, Normandy, Saint-Étienne church, Caen, Buon fresco, 90, 569 Brown, Lancelot, 958 Buontalenti, Bernardo, The Great Grotto, Boboli 492-493, 492, 493 Bruegel the Elder, Pieter, 728, 732 Gardens, Florence, 677, 677 Caesar, Julius, 185 The Fall of Icarus, 733, 733 Return of the Hunters, 733-734, 734 Burgee, John, AT&T Corporate Headquarters, denarius of, 181, 181 New York City, 1170, 1171 Cafe House, Cairo (Casting Bullets) (Gérôme), Brueghel, Jan, 734 Burghers of Calais (Rodin), 1051-1052, 1052 1006-1007, 1006 Allegory of Sight, from Allegories of the Five

Burgundians, 442

Cage, John, 1145

Senses, 778, 780, 780

Cahokia, 413, 415, 415 Caracalla, 210, 218-219 rock-shelter art, 12-13, 12 Caillebotte, Gustave, Paris Street, Rainy Day, 1034, Caracalla, 218, 219 Saharan rock art, 424-425, 425 Caracalla, Baths of, 219, 219 sculptures, 10-11, 11 Caravaggio (Michelangelo Merisi), 797 Cairn, 15 techniques used, 8 Cairo, Egypt, Madrasa-mausoleum-mosque Bacchus, 757, 757 Cave-Temple of Shiva, Elephanta, India, 330, 330, complex, 298, 299 Calling of Saint Matthew, 758, 758 332, 332 Calchas, 177 Death of the Virgin,774 Caxton, William, 615-616 Calder, Alexander, Lobster Trap and Fish Tail, 1119, Entombment, 759, 759 CE (Common Era) designation, 2 1119 Carbon-14 dating, 13, 413, 415 Celadon-glazed ceramics, 368-370, 369 Calendar, Mayan, 402, 403 Carducho, Vincente, 757 Celant, Germano, 1158 Caliph Harun al-Rashid Visits the Turkish Bath Carlyle, Thomas, 1011, 1011 Cella, 114, 116 (Bihzad), 304, 305 Carolingian Empire, 450 Cellini, Benvenuto, Saltcellar of King Francis I, Calligraphy architecture, 451-455, 452, 453, 454 697-698, 697 Chinese, 832 goldwork, 457-459, 458 Celtic art, 441, 446 Chinese, Six Dynasties, 356, 356 manuscripts, 455-459, 455, 456, 457, 458 Openwork box lid, 22, 22 Islamic, 292-293, 293 Carpeaux, Jean-Baptiste, The Dance, 1014-1015, Cenami, Giovanna, 599-600, 601 Japanese, 386-388, 855, 855 1014 Cenotaphs, 817 Sanskrit, 811 Centaur, Greece, 112, 112 Carpet making, Islamic, 303 Calligraphy Couplet (Ikkyu), 855, 855 SEE ALSO Textiles Centering, 172 Calling of Saint Matthew, The (Caravaggio), 758, Carr, Emily, Big Raven, 1099-1100, 1099 Central America, 407-408 758 Carracci, Agostino, 755 Central Park (Olmsted and Vaux), New York City, Calvin, John, 708, 720 Carracci, Annibale 1059. 1059 Calyx krater, 127-128 Landscape with Flight into Egypt, 756-757, 756 Central-plan churches, 242, 242 Cambio, Arnolfo di, Florence Cathedral, 558, 558, Palazzo Farnese, Rome, 755-757, 755, 756 Central-plan mosques, 289, 305-306 Carracci, Ludovico, 755, 760 Ceramics Carriera, Rosalba, Charles Sackville, 2nd Duke of Cambodia, Angkor Vat, 338-339, 339, 340 SEE ALSO Pottery Camel Carrying a Group of Musicians, Tang dynasty, Dorset, 952-953, 953 Aegean (Minoan), 88-89, 89, 94, 94 China, 350, 350 Carter, Howard, 49 Buncheong, 845-846, 845 Cameos, 954, 960 Carthage, 179 celadon-glazed, 368-370, 369 in the Middle Ages, 444 Carthusians, 588-589 Chinese Song (southern) dynasty, 366, 366 Camera obserra, 1010 Cartoon, 664, 668 Chinese Tang dynasty, 350, 350 Camera Picta, Ducal Palace, Mantua, Italy, 646, Cartouches, 64, 203, 678 Cycladic Islands, 84-86, 85, 86 Caryatids, 119-120, 119 Greek, 112-113, 113 Cameron, Julia Margaret, Portrait of Thomas Carlyle, Casa y Nóvoas, Fernando, 771 Islamic, 294, 294, 301-302, 301 1011, 1011 Cassatt, Mary, 1034 Italian Renaissance, 634, 634 Cames, 528 Maternal Caress, 1036, 1036 Japanese, Jomon period, 374-376, 374, 375 Campbell, Scot Colen, 956 Woman in a Loge, 1035, 1035 Japanese, modern, 869, 869 Campin, Robert Castagno, Andrea del, The Last Supper, 638, 640, Japanese, tea ceremony, 858-860, 858, 859 Flemish City, A, 587, 588 Joseon, 845-846, 845, 846 Mérode Altarpiece (Triptych of the Annunication), Castiglione, Baldassare, The Book of the Courtier, Korean, 367-370, 367, 369, 845-846, 845, 587, 588, 597-598, 597 846 Canada Castle of Otranto, The (Walpole), 959 Moche, 411, 411 Habitat '67 (Safdie), Montreal, 1169-1170, Castles Mycenaean, 104, 104 Dover Castle, England, 493, 494 Neolithic, 18, 18, 19-20, 20 modern art in, 1098-1100, 1099 Stokesay Castle, England, 541, 541 Pueblos, 889-890, 889 Canaletto (Giovanni Antonio Canal), Santi Gio-Catacomb of Commodilla, Rome, 232, 233-234, use of term, 19, 20 vanni e Paolo and the Monument to Bartolommeo 239 Vietnamese, 816, 816 Colleoni, 953-954, 953 Catacombs, 233-234, 236 Cerberus, 177 Canoe prow, Oceania, 902, 902 paintings, 238-240, 239 Ceremonial architecture, Neolithic, 15-17, 16, Canon of proportions, 54, 54 Catharina Hooft and Her Nurse (Hals), 782, 782 Canon (Polykleitos), 129 Cathedrals. See under name of Ceremonial stand with snake, Three Kingdoms, Canopic jars, 55 Catholicism, 734 Korea, 367-368, 367 Canopus, Hadrian's Villa, Tivoli, 212, 212 Cats and Mice with Host, Chi Rho Iota, page from Ceres, 110 Canova, Antonio, 955 Book of Kells, Iona, Scotland, 448, 449 Cernavoda, Romania, figures of a man and Cupid and Psyche, 956, 956 Cattle Being Tended, Tassili-n-Ajjer, Algeria, woman, 18, 18, 19 Canterbury Tales, The (Chaucer), 561, 575, 616, 616 424-425, 425 Cerveteri, Etruscan tombs, 176–177, 176, 177 Cantley: Wherries Waiting for the Turn of the Tide Cave art Cézanne, Paul, 1026 (Emerson), 1057, 1057 Altamira, 6, 7, 10, 10 The Large Bathers, 1041, 1041 Canvas painting, 682 Australian, 900, 901 Mont Sainte-Victoire, 1039-1040, 1039 Canyon (Rauschenberg), 1146, 1147 Blombos, South Africa, 422-423, 423 Still Life with Basket of Apples, 1040, 1040 Capitals, column, 117, 118, 174, 317, 318 Chauvet, 0, 1, 7 Chacmools, 1118 historiated, 498-499, 498 dating techniques, 13 Chaco Canyon, New Mexico, Pueblo Bonito, Capitoline Hill, 688 La Mouthe, 11, 11 394-395, 395-396, 416, 417-418, 417, 418 Capitol Reef, Utah (White), 1145, 1145 Lascaux, 8-10, 9 Chaitya rock-cut halls, Karla, India, 322, 322 Capponi chapel, Santa Felicità church, Florence, meaning of, 6-7 Chakra, 323, 324, 381 692, 693 painting, Tang dynasty, Dunhuang, 358, 359 Chambers, William, 959 Capriccio, 953 Paleolithic, 0, 1, 6-11, 7, 9, 10, 11 Chamfered, 818 Caprichos (Caprices), Los (Goya), 998, 998 Pech-Merle, 7-8, 7 Champollion, Jean-François, 78 Capstones, 15, 320 rock-cut, Six Dynasties, 357, 357 Chan Buddhism, 366 Captain Frans Banning Cocq Mustering His Comrock-cut halls, Gupta period, India, 321-322, Chandella dynasty, 333-334 pany (The Night Watch) (Rembrandt), 785, 785

322

Chardin, Jean-Siméon, The Governess, 971, 971

Christ in Majesty, San Climent church, Tahull, Spain, Neolithic, 344-346 Charioteer, Sanctuary of Apollo, 132-133, 133 500, 501 pictographs and writing, 348 Charlemagne, 450, 455, 456 Christo (Christo Javacheff), Running Fence, 1163, Qin dynasty, 342-343, 343, 349 Palace Chapel of, 451, 452, 453 Qing (Manchu) dynasty, 835, 843-844 1163 Charles I, king of England, 775, 776, 777-778, Christus, Petrus, A Goldsmith (Saint Eligius?) in His 801.802 Shang dynasty, 346-347 Six Dynasties, 354–357, 355, 356, 357 Shop, 604, 605 Charles I at the Hunt (Van Dyck), 777-778, 779 Christ Washing the Feet of His Disciples, Liuthar Charles II, king of Spain, 764 Song dynasty, 361-366, 362-366 (Aachen) Gospels, 469-470, 470 Sui dynasty, 356-361, 358 Charles IV, Holy Roman emperor, 578, 579, 582 Churches Tang dynasty, 349, 350, 356-361, 359, 360 Charles IV, king of France, 572, 578 timelines, 369, 841 SEE ALSO under name of Charles IV, king of Spain, 998, 999 basilica-plan, 242, 243, 242, 243 Yuan dynasty, 832-835 Charles V, Holy Roman emperor, 660, 661, 685, Byzantine, in Constantinople, 255, 255, 256, Zhou dynasty, 348-349, 349 708, 764 257, 259 Charles V, king of France, 587, 592, 593 Chinese art Byzantine, in Greece, 269, 269, 270, 271 architecture and city planning, 839, 839 Charles V Triumphing Over Fury (Leoni), Byzantine, in Kiev, 268-269, 268 furniture, 840-841, 840 xxxvi-xxxvii, xxxvi, 708 Byzantine, in late period, 278-279, 279, 280 painting, individualist, 844, 844 Charles VI, Holy Roman emperor, 771 Byzantine, multiple-dome plan, 275 painting, literati, 841-843, 841, 842 Charles VI, king of France, 609 Byzantine, in Ravenna, 258, 259-262, 260, painting, Ming dynasty, 836-838, 836, 838 Charles VII, king of France, 609 painting, modern, 844-845, 845 Charles Martel, 449 Byzantine, in Sicily, 274-275, 277-278, 277, painting, orthodox, 843-844, 843 Charles Sackville, 2nd Duke of Dorset (Carriera), painting, Yuan dynasty, 832-833, 834, 835 952-953, 953 porcelain, 838-839, 839, 840 Byzantine, in Venice, 271, 272, 273 Charles the Bald, 458, 518 central-plan, 242, 242 Chartres cathedral, Notre-Dame cathedral, Chinese art before 1280 Gothic, French, 516-532, 517-532 architecture, Han dynasty, 353-354, 354 518-521, 519, 520, 523, 525, 526, 527-528, architecture, Six Dynasties Buddhist, 356-357 Greek-cross plan, 242, 275, 679 Latin-cross plan, 645, 645, 647, 679 architecture, Tang dynasty Buddhist, 358-360, Chartreuse de Champmol, Dijon, France, in the Middle Ages, 453-454, 453 359, 360 588-590, 589, 590 Bronze Age, 346-349, 347, 349 organization of, 239 Chasing, 962 Romanesque, 480-493, 480, 481, 483-494 Chatal Huyuk, Anatolia, 28, 28 calligraphy, Six Dynasties, 356, 356 stave, 462, 463, 463 ceramics, Song (southern) dynasty, 366, 366 Château of Chenonceau, 720-721, 721, 722 ceramics, Tang dynasty, 350, 350 Church of the Monastery of Christ, Chora, Con-Châtelet, Madame du, 943 stantinople, 278, 279 Chaucer, Geoffrey, The Canterbury Tales, 561, 575, figure painting, 360, 361 Chute, John, 959 Liangzhu culture, 345-346, 346 616, 616 Ciborium, 244 Neolithic, 344-346 Chauvet cave, 0, 1, 7 Ci'en Temple, Great Wild Goose Pagoda, Tang Chavin de Huantar, 408-409 painted pottery, 344-345, 345 painting, Six Dynasties, 354-356, 355 dynasty, China, 359-360, 360 Chenonceau, Château of, 720-721, 721, 722 painting, Song (northern) dynasty, 362-365, Cimabue (Cenni di Pepi), Virgin and Child Chevreul, Michel-Eugène, 1041 Enthroned, 561, 562 363, 364 Chevrons, 102 painting, Song (southern) dynasty, 365-366, Cione, Berici di, Palazzo della Signoria, Florence, Chiaroscuro, 664 557, 557 Chicago painting, Tang dynasty, 358, 359, 360, 361 Cistercians, 477, 484-485, 509 Frederick C. Robi House (Wright), Chicago, rock-cut caves, Six Dynasties, 357, 357 Citadels 1102-1103, 1102 Assyrian, 40-41, 41 sculpture, Liao dynasty, 361-362, 362 Marshall Field Wholesale Store (Richardson), Mohenjo-Daro, Indus Valley, 313-314, 314 sculpture, Sui dynasty, 358, 358 1060, 1061 Chi Rho Iota, page from Book of Kells, Iona, Scot-Mycenae, 96-97, 96, 97 World's Columbian Exposition (Hunt), 1058, City Night (O'Keeffe), 1095, 1095 land, 440, 441, 448, 449 1060, 1061 City of God, The (Augustine), 442 Chiswick House (Lord Burlington), England, Chicago, Judy, The Dinner Party, 1164, 1168, 1168 City plans 957-958, 957 Chicago School, 1060-1062 Chinese, 839, 839 Chichen Itza, 406-407, 407 Chiton, 125 Chinese, Neolithic, 344 Chokwe, Divination basket, Democratic Republic Chichester-Constable chasuble, 575-576, 576 Egyptian, 66-67, 67 of the Congo, 937, 937 Chihuly, Dale, Violet Persian Set with Red Lip Etruscan, 170 Chola dynasty, 335 Wraps, xli, xli Christ and Disciples on the Road to Emmaus, Santo Greek orthogonal, 149-150, 149 Child with Toy Hand Grenade (Arbus), 1144, 1144 Roman, Republic, 190-192, 190, 191, 192 Domingo abbey, Silos, 472, 473 Chilkat blanket, 886, 887 Teotihuacan, 399-400, 400 Christian art Chin, Mel, Revival Fields, 1186, 1186 architecture, 242-249, 242-249 Cityscape, House of Publius Fannius Synistor, China Bronze Age, 346-349, 347, 349 Boscoreale, 196, 197 basilica-plan churches, 242, 243, 242, 243 central-plan churches, 242, 242 City Square (Giacometti), 1128, 1128 Buddhism, 356-357, 358-360 City-states house-churches, 241, 241 Confucianism, 352-353, 355 first, 26, 28 culture, 834 iconography of the life of Jesus, 252-253 paintings, catacomb, 238-240, 239 Greek, 108, 130 Daoism, 351-352 Claesz, Pieter, Still Life with a Watch, 791-792, 791 sculpture, 240-241, 240, 241, 250, 251, 254 dynasties, dates for, 351, 835 Clapboard, 805 Han dynasty, 343, 349, 351-354, 351, 352, Christianity Clark, Lygia, Bicho LC3 (Pan-Cubisme), 1158, early, 234, 238-239 353, 354 in the Middle Ages, early, 446-449 1158 map of, after 1280, 833 Classic, use of term, 128 schisms, 249, 554, 647 map of, before 1280, 345 Classical, use of term, 129 Middle Kingdom, 344 symbols of, 238 Classical period of Greek art. See Greek art, classi-Christine de Pizan, 592 Ming dynasty, 835-843 The Book of the City of Ladies, 561 cal modern period, 835, 844-845 Classical Revival Christine de Pizan Presenting Her Book to the Queen Mongol invasions, 832 in England, 956-959 of France, xlv, xlv Neo-Confucianism, 362

in Italy, 952-956, 953, 954, 955 Concerning Famous Women (Boccaccio), 591, 592, Courbet, Gustave Classicism, French architecture, 969-970, 970 A Burial at Ornans, 1018, 1018 Claude Lorrain. See Lorrain, Claude (Claude Concerning the Spiritual in Art (Kandinsky), 1075 The Stone Breakers, 1017-1018, 1017 Gellé) Concrete, Roman use of, 182-183 Cour Carré, Louvre (Lescot), Paris, 723, 723 Claudel, Camille, The Waltz, 1052-1053, 1053 Conference of Serpents from the Wäwilak Myth, The Courses, 102, 434 Clement VI, pope, 578 (Gurruwiwi), 900-901, 901 Courtly Attendants, Borobudur, Java, 338, 338 Clement VII, pope, 661, 667, 668, 671, 687 Confucianism, 352-353, 355 Courtly love, 574 Cleopatra VII, 71, 80 Neo-, 362, 859 Court (Rayonnant) style, 535-537, 572 Clerestory, 70, 206, 242, 453 Confucius, 348, 352, 355, 356, 834 Courtyard, The (Kaprow), 1148-1149, 1149 Clifford, George, 3rd Earl of Cumberland, 737, Cong, 346, 346 Cousen, John, Hannibal Crossing the Alps, 1016, 737, 738, 738 Conical Tower, Great Zimbabwe, 434, 435 Clodion (Claude Michel), The Invention of the Bal-Connoisseurship, xlvi Couture, Thomas, 1027 loon, 951, 951 Constable, John, The White Horse, 1003, 1003 Cow with the Subtile Nose (Dubuffet), 1129, 1129 Cloisonné, 274, 446 Constantina, 246, 247 Cox, Kenyon, 1093 Cloister, 453 Constantine the Great, 225-230, 242, 243, 246, Craft, art versus, 893 Cloister crafts, Romanesque, 502-510, 502-510 249, 254, 442 Cranach the Elder, Lucas, Nymph of the Spring, Clouet, Jean, Francis I, 720, 720 arch of, 226-227, 226 717–718, 718 Clovio, Giulio, Farnese Hours, 696, 696 Basilica of Maxentius and Constantine, Rome, Creation and Fall (Wiligelmus), 495, 495 Clovis, 442 227-228, 227, 228 Creation of Adam (Michelangelo), 671, 674, 674 Cluny, 477 Crenellated battlements, 959 Constantine the Great, Rome, 224, 225-226 abbey at, 482, 483 Constantinople, 225, 254 Crenellations, 42 Cluny III church, 482-484, 483 Hagia Sophia, 255, 255, 256, 257, 259, 305 Crete, Minoan civilization, 86-95 Code of Hammurabi, 38 walls of, 254-255, 254 Crockets, 576, 610 Codex, 251, 264, 406 Constantius Chlorus, 223 Croesus, king, 45, 46 Codex Colbertinus, 507, 508 Constructive Universalism, 1141 Cro-Magnons, 2 Codex Fejervary-Mayer (Aztec), 872-873, 873 Constructivism, 1105-1107, 1106 Cromwell, Oliver, 744 Codex Mendoza (Aztec), 874-875, 874 Contarini, Marino, 653 Cross, Christian symbol, 238 Coeur, Jacques, 611 Contextualism, xlvi–xlvii Crosses Coffee and tea service (Brandt), 1110, 1110 Contrapposto, 129, 963 Irish high crosses, 449, 449 Coffers, 210, 636 Convent of Christ, Tomar, Portugal, 724, 724 Lombards, 444, 445 Cogul, Spain, People and Animals, 12-13, 12 Cook, James, 905-906, 909, 911 Crouching Woman (Heckel), 1071, 1071 Coiling, 882 Cooke, Elizabeth, 962 Crown, Three Kingdoms, Korean, 367, 367 Coins Cope of the Order of the Golden Fleece, Flemish, Crucifix (Coppo di Marcovaldo), 549-550, 549 denarius of Julius Caesar, 181, 181 596, 596 Crucifixion, Dormition church, Daphni, Greece, making of, 46, 46 Copernicus, Nicolaus, 746 Persian Daric, 45, 45, 46 Copley, John Singleton Crucifixion, Rabbula Gospels, 264-265, 265 Colbert, Jean-Baptiste, 793 Samuel Adams, 940, 941, 981 Crucifixion with Angels and Mourning Figures, Lindau Cole, Thomas, 1004 Watson and the Shark, 981-982, 981 Gospels, 458-459, 458 The Oxbow, 1004, 1005 Coppo di Marcovaldo, Crucifix, 549-550, 549 Crucifix (Majestat Batilló), Catalunya, Spain, 502, Collage, 1080, 1091 Corbel arch, 171, 576 503 Colleoni, Bartolommeo, 633, 633 Corbel construction, 14 Cruciform, 248 Colonna, Francesco de, Hypnerotomachia Poliphili, Corbel vaults, 14, 102 Cruck construction, 462 Garden of Love page, 652, 652 Córdoba, Spain, Great Mosque of, 290-291, 290, Crusades, 475-478, 515 Colonnades, 116, 183 Cruyl, Lieven, 779 Colophons, 448, 450, 837 Core glass, 70 Barberini palace and square, 761, 762 Color, complementary, 1041 Corinth, Greece, 108, 114 Crypt, 244 Color field painting, 1137-1138, 1138, 1139 Cornithian capital, xxxiv, xxxiv Crystal Palace (Paxton), London, 1012, 1012 Corinthian order, 117, 118, 118, 158-159, 158 Colossal head, Olmec, 399, 399 Cuba, Modern art in, 1097, 1097 Colosseum (Flavian Amphitheater), Rome, Cormont, Renaud de, 530 Cubicula, 239 202-204, 202, 203 Cormont, Thomas de, 530, 531 Cubiculum of Leonis, Catacomb of Commodilla, Colter, Mary, Lookout Studio, Grand Canyon Cornaro Chapel (Bernini), Santa Maria della Vit-Rome, 232, 233-234, 239 National Park, Arizona, 1103-1104, 1103 toria church, Rome, 749-750, 749 Cubism Column Cille, 441 Corncob Capital, U.S. Capitol (Franzoni), analytic, 1078-1080, 1079 Column of Trajan, Rome, 208-209, 208, 209 1007-1008, 1007 French, 1082-1084, 1082, 1083 Columns, 118, 287 Cornelia Pointing to Her Children as Her Treasures Italian, 1084, 1084, 1085 Commentary on the Apocalypse (Beatus), 449-450, (Kauffmann), 965-966, 965 Picasso, work of, 1076-1078, 1076, 1077, Corner Counter-Relief (Tatlin), 1085, 1085 450, 451 1078, 1080-1081, 1080, 1081 Commodus, 205, 217 Cornices, 118, 174, 333 Russian, 1084-1086, 1085, 1086 Commodus as Hercules, 217-218, 217 Coronation Gospels, 456, 456 synthetic, 1080-1081, 1080, 1081 Communist Manifesto (Marx and Engels), 986 Corot, Jean-Baptiste-Camille, First Leaves, Near Cubi XIX (Smith), xxxv, xxxv, 1139-1140 Comnenian dynasty, 267 Mantes, 1019-1020, 1019 Cubo-Futurism, 1084 Complementary color, 1041 Correggio (Antonio Allegri), Assumption of the Vir-Cuneiform, Sumerian, 29-30, 32, 32 Complexity and Contradiction in Architecture (Vengin, 680-681, 681 Cupid, 110 turi), 1170 Cortés, Hernán, 873, 874 Cupid and Psyche (Canova), 956, 956 Composite capitals, 174 Cossutius, 158 Current (Riley), 1155, 1155 Composite order, 174 Côte d'Ivoire, Baule spirit figure (blolo bla), Curtain wall, 1101 Composition (Burri), 1130, 1130 926-927, 927 Cuzco, Peru, (Inca), 876-878, 878 Composition with Yellow, Red, and Blue (Mondrian), Coucy, Robert de, 531 Cybele, 179 1108-1109, 1108 Council of Trent, 687, 745 Cycladic Islands, 84-86 Comte, Auguste, 1009 Counter-Reformation, 660, 687-692, 744, Cyclopean construction, 96 Conceptual art, 1160-1161, 1160, 1161 745-746

Cylinder seals, 35, 35

Smoking Flame, 797, 798 Melun Diptych (Fouguet), 609-610, 610 Cylindrical vessel, Mayan, 406, 406 Delaunay, Robert, Homage to Blériot, 1082, 1082 Diquis, 407-408 Cyrus II, 42-43 Discus Thrower (Diskobolos) (Myron), 106, 107 Delaunay-Terk, Sonia, Clothes and customized Cyrus the Great, 129, 235 Czech Republic, Woman from Ostrava Petrkovice, 5, Citroën, 1082-1083, 1083 Dish from Mildenhall, 229, 229 Delaware, 881-882, 883-884 Dispersion (Mehretu), 938, 938 Delivery of the Keys to Saint Peter (Perugino), 622, Divination basket, Chokwe, Democratic Republic 622, 647-648, 648 of the Congo, 937, 937 D Divisionism, 1042 Della Porta, Giacomo, 690 Dada Dance (Höch), 1091, 1091 Djoser's funerary complex at Saqqara, 55-56, 56, fountain, 753, 754 Dadaism, 1088-1091. 1088-1091 Il Gesù church, 691-692, 691 Daddi, Bernardo, 567 de l'Orme, Philibert, 721 Dogon dama mask, Mali, 933, 933 Madonna and Child, 552, 553 Dogu, Jomon period, Japan, 375-376, 375 Delphi Dado, 194 Dollhouse, The (Schapiro and Brody), 1164 Sanctuary of Apollo, 110-111, 111, 132-133, Dagger blade, Mycenae, 93, 103, 103 Dolmen, 15 Daguerre, Louis-Jacques-Mandé, The Artist's Stu-Dome of the Rock, Jerusalem, 236, 286-287, Sanctuary of Athena Pronaia, 150-151, 150 dio, 1010, 1010 Treasury of the Siphnians, 116, 119-120, 120 286, 287 Daguerreotypes, 1010 Domes, 172 Demeter, 110 Dai Jin, Returning Late from a Spring Outing, 837, Byzantine multiple, 275 Democratic Republic of the Congo 838 Chokwe divination basket, 937, 937 of Florence Cathedral, 558, 558, 559, Dalí, Salvador, 1131 initiation wall panels, Nkanu, 934, 934 623-624, 623 The Birth of Liquid Desires, 1120-1121, 1121 hemispheric, 172, 320 Kongo, 436-437, 437, 438 Dama, Dogon mask, Mali, 933, 933 Kongo spirit figure (nkisi nkonde), Democraof the Pantheon, 210, 211 Damascus, 286 tic Republic of the Congo, 926, 926 pendentive, 248 Dance, The (Carpeaux), 1014-1015, 1014 Dominicans, 514, 524, 555 Kuba, 929, 929, 930, 931, 933, 935, 935 Danube Landscape (Altdorfer), 718, 719 Lega bwami masks, 924-925, 925 Dominicus, abbot, 450 Daoism, 351-352 Domino construction system, 1101 Demoiselles d'Avignon, Les (Picasso), 1078, 1078 Darby, Abraham III, Severn River Bridge, Eng-Domitian, 199, 204, 210 Demotic writing, 78 land, 967, 967 Denarius of Julius Caesar, 181, 181 Domna, Julia, 218 Daric, 45, 45 Donatello Denmark Darius I, 43-45, 45 David, 631-632, 631 Gummersmark brooch, 445-446, 446 Darius III, 46 Horse and Sun Chariot, Trundholm, 21, 21 equestrian monument of Erasmo da Narni, Darius and Xerxes Receiving Tribute, Persepolis, 45, 45 Neolithic vessels, 18-20, 20 631.632-633 Darwin, Charles, 986–987 Mary Magdalen, 632, 633 rune stones, 460, 461 Dating art Departure of the Volunteers of 1792 (The Marseillaise) real name of, 629 problem with Aegean objects, 84 Saint George, 629, 629 (Rude), Arc de Triomphe, Paris, 997, 997 types and techniques for, 13 Dong Qichang, 863 Deposition (Weyden), 600-602, 602 Daubigny, Charles-François, The Barges, 1003, The Qingbian Mountains, 841, 841, 843 Depression of 1929, 1066, 1116 1004 Donjon, 493 Derain, André, Mountains at Collioure, 1068, 1068 Daumier, Honoré Doors of Bishop Bernward, Saint Michael Der Blaue Reiter, 1073-1076, 1074, 1075, 1076 Rue Transonain, Le 15 Avril 1834, xl, xl, 1020 Derrida, Jacques, xlvii, 1184 Church, Germany, 466, 466, 467, 469 Third-Class Carriage, 1021, 1021 Doorway panels, parish church, Urnes, Norway, Descartes, René, 746, 942 David, Jacques-Louis, 972 Descent of the Amida and the Twenty-five Bodhisattvas, 461 461 Death of Marat, 975, 975 Kamakura period, Japan, 391, 392 Doric order, 117, 118, 118 Napoleon Crossing the Saint-Bernard, 988, 988 Dormition church, Daphni, Greece, 271, 271 Desiderius, 444, 486, 489, 501 Oath of the Horatii, 974, 974 Dormition of the Virgin, Strasbourg, France, 544, de Stiil, 1107-1110, 1108, 1109 David (Bernini), 748, 749 Devi, 318 David (Donatello), 631-632, 631 Double Negative (Heizer), 1162, 1162 Dewey, John, 1158 David (Michelangelo), 670, 671 Douglas, Aaron, Aspects of Negro Life: From Slavery De Witte, Emanuel, Portuguese Synagogue, Amster-David the Psalmist, Paris Psalter, Byzantine manuthrough Reconstruction, 1114, 1114 dam, 790, 790 script, 274, 274 Dharma and the God (Bawa), 826, 828 Dove, Arthur, Nature Symbolized No. 2, 1095, 1095 Davies, Arthur B., 1093 Dove (Christian symbol), 238 Dharmachakra, 383 Death masks. SEE Funerary masks Dover Castle, England, 493, 494 Dharmaraja Ratha, Mamallapuram, India, 333, Death of General Wolfe (West), 966-967, 966 Drawing Lesson, The (Steen), xli, xlii, 790 Death of Marat (David), 975, 975 Dream Journey to the Peach Blossom Land (An Diamond Mountains (Geumgang-san) (Jeong Seon), Death of Sarpedon (Euphronios), 127-128, 127 Gyeon), 846, 846 847, 847 Decameron, The (Boccaccio), 561 Dressed stone, 87, 320, 434 Diana, 110 Deconstructivist architecture, 1184, 1185 Drums, column, 118, 287 Diary (Shimomura), xl, xl Decorated style, 576 Drums, octagonal base, 623, 818 Diderot, Denis, 942, 970-971 Deesis, 273, 598 Die Brücke (the Bridge), 1070-1072, 1070, 1071 Drums, wall, 172, 257 Degas, Edgar, 1026 Drunken Cobbler (Greuze), 971–972, 971 Dietrich II, 545 The Rehearsal on Stage, 1033-1034, 1034 Drypoint technique, 785-786 Dijon, France, Chartreuse de Champmol, Degenerate Art exhibition, Munich, 1112 588-590, 589, 590 Dubuffet, Jean, Cow with the Subtile Nose, 1129, Deir el-Bahri, funerary temple of Hatshepsut at, 1129 Dinner Party, The (Chicago), 1164, 1168, 1168 70-72, 70, 71 Ducal Palace, Mantua, Italy, 646, 647 Diocletian, 222, 225 Deir el-Medina, workers' village, 66-67, 67 Ducal Palace, Urbino, Italy, 640-642, 641, 642 baths of, 220 De Kooning, Willem, 1134 Duccio di Buoninsegna, Maestà Altarpiece, 567, Dionysos, 110, 159 Asheville, 1135, 1136, 1137 Dionysos with Maenads (Amasis Painter), 125-126, 567, 568, 569, 570 Delacroix, Eugène 125 Duchamp, Marcel, 1119 Liberty Leading the People, July 28, 1830, 996, Fountain, 1088-1090, 1089 Diptychs, 229, 230, 591 LHOOQ, 1090, 1090 Archangel Michael, Byzantine, 263-264, 263

Marilyn Diptych (Warhol), 1152, 1152

Duke of Berry at Table, from Très Riches Heures

Scenes from the Massacre at Chios, 995, 995

De La Tour, Georges, Mary Magdalen with the

(Limbourg brothers), 587, 588 sculpture, xxxii, 59-64, 59, 60, 61, 63, 64, Dover Castle, 493, 494 Dunhuang, China, cave paintings, 358, 358 73-74, 73, 74 Durham Castle and cathedral, 490, 491, 492 Dunn, Dorothy, 890 symbols, 52 embroidery, fourteenth century, 575-576, 576 Dura-Europus, 234, 236-237, 236, 237 temples, 67-72, 68, 69, 71, 75-78, 76, 77 Georgian silver, 962, 962 Dürer, Albrecht, 714, 785 tombs, 55-56, 56 landscape garden, 956-959, 958 Adam and Eve, 716, 716 Eiffel, Gustave, Eiffel Tower, Paris, 984, 985 manuscripts, Gothic illuminated, 538, 539 Four Apostles, 716-717, 717 Eight, The, 1092 painting, late nineteenth century, 1023-1024, Four Horsemen of the Apocalypse, 715, 715 Einhard, 453 1023 Melencolia I, 706, 707-708 Einstein, Albert, 1066 painting, Neoclassicism, 961, 963-969, 961, Self-Portrait, 715, 715 Eitoku, Kano, Fusuma, 857–858, 858 963-969 Durga as Slayer of the Buffalo Demon, Mamallapu-Ekkehard and Uta, Naumburg Cathedral, Gerpainting, Renaissance, 735-738, 735, 736, 738 ram, India, 332-333, 332 many, 545, 545, 547 painting, Romanticism, 967-969, 968, 969 Durham Castle and cathedral, England, 490, 491, Elam, 26, 28 painting, Romantic landscape, 1001-1003, Eleanor of Aquitaine, 516, 517, 538 1001-1003 Dur Sharrukin, 40-41, 41 Election Night (Sloan), 1092, 1092 Stonehenge, 16, 17, 17, 19 Dutch art, Baroque painting, 779, 781-793, Electronic Superhighway: Continental U.S. (Paik), wedgwood, 960, 960, 961 781-792 1187-1188, 1188 Engravings, 615 Dutch Visitors to Rome Looking at the Farnese Her-Electron spin resonance techniques, 13 Enlightenment cules (Goltzius), xlvii, xlvii El Escorial (Bautista and Herrera), Madrid, 725, description of, 942-943 Dvaravati style, 337, 337 map of Europe and North America, 943 Dying Gallic Trumpeter (Epigonos), 160, 161, 162 El Greco (Domenikos Theotokopoulos), 726 science and, 964 Dying Warrior, pediment of Temple of Aphaia, 121, Burial of Count Orgaz, 726,727 Ensor, James, The Intrigue, 1049, 1049 121 View of Toledo, 727-728, 727 Entablature, 117, 118, 400 Elizabeth, countess of Shrewsbury, 738, 739 Entombment (Caravaggio), 759, 759 Elizabeth I, queen of England, 734, 736, 737 Entombment (Pontormo), 693, 693 F Elohim Creating Adam (Blake), 969, 969 Epic of Gilgamesh, 29-30, 35 Eagle brooches, Visigoths, 443-444, 444 Embarkation of the Queen of Sheba, (Lorrain), 800, Epidauros, theater in, 159-160, 159 Eakins, Thomas, The Gross Clinic, 1022, 1022 Corinthian capital from, xxxiv, xxxiv Earspool, Moche, 411-412, 412 Emblemata, 215 Epigonos, Dying Gallic Trumpeter, 160, 161, 162 Earthenware, 377 Embroidery Equestrian monument of Bartolommeo Colleoni Earthworks Bayeux Tapestry, Normandy, France, 504-505, (Verrocchio), 633, 633 Great Serpent Mound, Mississippian Period, 504. 505 Equestrian monument of Erasmo da Narni 413, 413 opus anglicanum, 575-576, 576 (Donatello), 631, 632-633 Equestrian statue of Marcus Aurelius, 216, 217 Mississippian Period, 412-416, 413 technique, 505 modern, 1161-1163, 1162, 1163 Emerson, Peter Henry, 1057-1058 Erasmo da Narni, 631, 632 Cantley: Wherries Waiting for the Turn of the Tide, Monk's Mound, Cahokia, 413, 415, 415 Erasmus, Desiderius, 708 Nazca, 410, 411 1057, 1057 Erechtheion, Acropolis, 142-144, 144 Poverty Point, Louisiana, 412 Photography: A Pictorial Art, 1057 Eriksson, Leif, 459 Emeterius, copy of Commentary on the Apocalypse Woodland Period, 412 Ernst, Max, 1131 Easter Island, 906, 906-907, 909 (Batus), 450, 450, 451 The Horde, 1120, 1120 Eastern Woodlands, 880-884 Emperor Justinian and His Attendants, San Vitale Eros, 110 Ebbo, 456-457 church, Ravenna, 260, 261 Esoteric Buddhist art, 383, 383 Ecclesius, 259 Empress Theodora and Her Attendants, San Vitale Eternal Shiva, Cave-Temple of Shiva, Elephanta, Echinus, 117, 118 church, Ravenna, 260, 261 India, 332, 332 Eco, Umberto, 1158 Encaustic, 80 Étienne Chevalier and Saint Stephen (Fouquet), École des Beaux-Arts, 948, 988, 1012, 1013, 1058 Encyclopédie (Diderot), 971 609-610, 610 Edict of Milan, 225, 242 Ende, 592 Etruscans Edict of Nantes, 720 copy of Commentary on the Apocalypse (Beatus), architecture, 170-171, 173-174, 173 Edo culture, 431 450, 451 bronze work, 168-169, 169-170, 177-178, Edo period, 859-868 Engaged columns, 183-184 Edward I, king of England, 575 Engels, Friedrich, 986 cities, 170 Edward III, king of England, 575, 1051 England civilization, 170 Edward VI, king of England, 734 Baroque period in, 801-804 temples and their decoration, 171, 173-174, Egypt, 921 Classical Revival in, 956-959 173, 175 creation myths, 51-52 Gothic, 538-541 tombs, 174, 176-177, 176, 177 Madrasa-mausoleum-mosque complex in Gothic Revival in, 959 Eumenes II, 163 Cairo, 298, 299 Industrial Revolution, 986-987 Euphronios, Death of Sarpedon, 127-128, 127 map of ancient, 51 National Gallery of Art, 1003 Euripides, 159 timelines, 53, 65, 73 Neoclassicism in, 959-969 Europe Egyptian art Renaissance in, 734-739 SEE ALSO under specific country Early Dynastic, 50-56 English art map of, in Baroque period, 745 glassmaking, 70, 70, 74-75 architecture, Baroque, 801-804, 802, 803, 804 map of, in the Enlightenment, 943 Late Period, 79–80 architecture, fourteenth century, 576-578, 577 map of, in the fourteenth century, 555 Middle Kingdom, 62-67 architecture, Gothic, 539-541, 540, 541 map of, in the Gothic era, 515 mummification, 55 architecture, Gothic Revival, 959, 959, 1008, map of, in the Middle Ages (early), 443 Neolithic and Predynastic, 50 map of, in the nineteenth century, 987 New Kingdom, 67-79 architecture, Neoclassicism, 959-960, 960 map of, prehistoric, 3 Old Kingdom, 56-62 architecture, Renaissance, 738, 739 map of, in the Renaissance, 587, 661, 709 map of, in the Romanesque period, 475 painting, 64 architecture and landscape architecture, Classipyramids and mastabas, 55-59, 56, 57, 58 cal Revival, 956-959, 957, 958 map of, in the twentieth century, 1067 rock-cut tombs, 63, 63 armor for royal games, 737, 737

postwar art, 1128-1130

painting, Renaissance, 634-640, 635-640 Baule spirit figure (blolo bla), Côte d'Ivoire, twentieth century in, 1066-1067 Palazzo della Signoria (Cione and Talenti), 926-927, 927 Eusebius, 243 Evans, Arthur, 84, 86, 87, 88 Cycladic, 84-86, 85, 86 Palazzo Medici-Riccardi, 625, 625, 627, 627 Fang, Nlo byeri guardian, Gabon, 935, 935 Exedrae, 183, 212, 257 Palazzo Rucellai, 627-628, 627 Exekias Greek, 113 San Giovanni baptistry, 558-559, 560, Achilles and Ajax Playing a Game, 126, 126 Indus Valley, 314 629-631, 630 The Suicide of Ajax, 126, 126 Japanese dogu, Jomon period, 375-376, 375 Exeter Cathedral, England, 576-578, 577 Japanese, Kofun period, 377, 377 San Lorenzo church, 624-625, 624, 625 sculpture, Renaissance, 628-634, 628-633 Experiment on a Bird in the Air-Pump, An (Wright), Kongo spirit figure (nkisi nkonde), Democra-Florida Glades culture, Key Marco, 415-416, 416 tic Republic of the Congo, 926, 926 964-965, 964 Expressionism, 162, 1043, 1072-1073, 1072, 1073 Moai ancestor figures, Easter Island, 906, "Flotilla" fresco, Thera, 82-83, 82, 90 Flower Piece with Curtain (Van der Spelt and Van 906-907, 909 Abstract, 1131-1141, 1131-1140 Mossi dolls (biiga), Burkina Faso, 920, 921 Mieris), xxxiii, xxxiii Neo-, 1175-1177, 1175, 1176 Flower Still Life (Ruysch), 792, 793 Expulsion from Paradise (Masaccio), 636, 638 naming, 5 Fluted shafts, 118 Eyck, Jan van. See Van Eyck, Jan Paleolithic, 4-6, 4, 5, 6 Flying buttresses, 518 Eye Love Superflat (Murakami), 1178-1179, 1179 Soldiers, mausoleum of Emperor Shihuangdi, China, 342-343, 343, 349 Flying gallop, 13 Fon, iron memorial scupture, Benin, 935-936, twin figures (ere ibeji), Yoruba culture, Nige-Facade, 114 ria, 921-922, 922 Fagus Shoe Company (Gropius and Meyer), Ger-Fontainebleau, France, Chamber of the Duchess votive, 32-33, 33, 37, 37, 171 many, 1100-1101, 1100 of Étampes, 721-722, 722 Filigree, 93 Faience, 64, 70 Fontana, Domenico, 745 Fillets, 118 Fallingwater, Kaufmann House (Wright), Mill Fontana, Lavinia, Noli Me Tangere, 698-699, 699 Finding of the Baby Moses, The, Dura-Europos, 237, Run, Pennsylvania, 1103, 1103 Fontenay, Notre-Dame abbey church, Burgundy, 237 Fall of Icarus, The (Bruegel the Elder), 733, 733 France, 484-485, 485 Finials, 327, 360, 433, 437, 438, 818 Fall of the Giants (Romano), 680, 680 Fiorentino, Rosso, 721 Fontenelle, Bernard de, 942 Family of Charles IV (Goya), 998, 998 Forbidden City, Beijing, Ming dynasty, 839, 839 Firmans, 306 Family of Saltimbanques (Picasso), 1077, 1077 Foreshortening, 128, 622 First Leaves, Near Mantes (Corot), 1019-1020, Family of Vunnerius Keramus (Family Group), Forever Free (Lewis), 997–998, 997 1019 Roman, 221, 221 Fish (Christian symbol), 238 Formline, 886 Fang, Nlo byeri guardian, Gabon, 935, 935 Fishing in a Mountain Stream (Xu Daoning), Forms in Echelon (Hepworth), 1117-1118, 1117 Fang ding, Shang dynasty, China, 347, 347 Forstermann, Ernst, 403 Song (northern) dynasty, 364-365, 364 Fan Kuan, Travelers among Mountains and Streams, Fish-shaped bottle, Egyptian, 70, 70 Fortuna Primigenia, sanctuary of, 183, 183 Song (northern) dynasty, 363, 363 5-iv-71 (Gim Hwangi), 848, 848 Forum, Roman Farnese, Alessandro, 678, 687, 691, 696 Augustus, 185, 205 Five Pillars of Islam, 299 Farnese Hercules, xlvi, xlvii Flag for a New World Power (Anatsui), 936-937, of Trajan, 205-206, 206, 207, 208, 208 Farnese Hours (Clovio), 696, 696 937 view of, 185 Fathy, Hasan Foster, Norman, Hong Kong & Shanghai Bank, Flamboyant-style architecture, 610-611, 611 Mosque at New Gourna, 307, 308 Flame ware (kaen-doki) vessel, Jomon period, Hong Kong, 1182, 1184, 1184 New Gourna Village, 307 Foundling Hospital (Brunelleschi), 624, 626, 626 Japan, 374, 374 Fauvism, 1067-1070, 1068, 1069 Flanders, 586, 774-779, 774-779 Foundry Painter, A Bronze Foundry, 132, 132 Fayum portraits, 80 Fountain (Duchamp), 1088-1090, 1089 Flashing, 528 Feast in the House of Levi (Veronese), 700, 701 Flatiron Building, The (Stieglitz), 1093, 1093 Fountain Mosaic, Pompeii, 193, 193 Feather cloak (Kearny Cloak), Hawaiian, 908, 908 Fountain of the Four Rivers (Bernini), 753, 754, Flavian Amphitheater (Colosseum), Rome, Feathered Wedding Basket, Pomo, 882, 882 202-204, 202, 203 754 Feather headdress of Moctezuma, 876, 877 Fouquet, Jean Flavians, 199-204 Federal Art Project (FAP), 1116 Étienne Chevalier and Saint Stephen, Melun Dip-Flaxman, John, Jr., 960 Federico da Montefeltro, 620, 640-644, 643, 666 tych, 609-610, 610 Flemish art Felix, Julia, 198 Virgin and Child, Melun Diptych, 609-610, 610 fiber arts, 594-596, 595, 596 Feminist art, 1163-1166, 1164-1167 Four Apostles (Dürer), 716-717, 717 manuscripts, illuminated, 588, 590-594, 592, Femmage, 1165 Four Crowned Martyrs, The (Nanni di Banco), Feng Ju (Wang Xizhi), 356, 356 painting, 596-609, 597, 599, 600-609 Orsanmichele church, 628-629, 628 Fenollosa, Ernest, 868 painting, Baroque, 774-779, 774-779 Four Horsemen of the Apocalypse (Dürer), 715, 715 Ferdinand VII, king of Spain, 1000 tapestry, 594-595, 595 Four-iwan mosque, 289, 295, 299 Ferdinand of Aragon, 725 Four Winds publishing house, 728, 732 Flitcroft, Henry, Stourhead park, Wiltshire, Eng-Fertile Crescent, 26, 27, 28 Fra Angelico. See Angelico, Fra (Guido di Pietro land, 958-959, 958 Fervor (Neshat), 1188, 1188 da Mugello) Floating Lights (Taikan), 868, 868 Fête galante, 946 Florence, 621 Fragonard, Jean-Honoré, 950 Feudalism, 443, 474 architecture, Renaissance, 623-628, 623-627 The Meeting, 950, 951 Fiber arts Brancacci Chapel, Santa Maria del Carmine France Flemish, 594-596, 595, 596 church, 636-638, 637, 638, 639 Baroque period in, 793-800 Neolithic, 17 ducal courts, 587-596 Capponi chapel, Santa Felicità church, Flo-Fifteen Discourses to the Royal Academy (Reynolds), rence, 692, 693 Gothic era, 515-538 963 Neoclassicism in, 969-977, 988-990 Cathedral, 558, 558, 559 Fifty-Three Stations of the Tokaido (Hiroshige), 866 Cathedral Dome, 623-624, 623 Renaissance in, 609-611, 720-723 Figural art, 1128-1129, 1128 Foundling Hospital, 624, 626, 626 Rococo style in, 946-951 Figure painting, Tang dynasty, China, 360, 361 Romanticism in, 990-996 Great Grotto (Buontalenti), Boboli Gardens, Figures, Neolithic depiction of, 12-13, 12, 18, 18, 677, 677 Francis, saint, 524 19 Orsanmichele Tabernacle, 552, 553-554, Francis I, king of France, 697, 720, 721, 722, 723 **Figurines** Francis I (Clouet), 720, 720 628-629, 628 Ain Ghazal, Jordan, 28-29, 29 Franciscans, 514, 524, 555 painting, 559, 561-567, 562, 563, 565, 566

Franco, Francisco, 1065, 1066 Sala della Pace, Siena, 570, 571 Chinese, 830-831, 831 Frank, Robert Scrovegni (Arena) Chapel, Padua, 563-566, English landscape, 957-958, 957 The Americans, 1143 565, 566 French Baroque, 796, 796 Trolley, New Orleans, 1144, 1144 secco, 90, 569 French Renaissance, 723 Frankenthaler, Helen, Mountains and Sea, 1137, technique, 401, 569 Great Grotto (Buontalenti), Boboli Gardens, 1137 Freud, Sigmund, xlvi, 1047, 1066, 1120 Florence, 677, 677 Franklin, Benjamin, 942, 960 Friedrich, Caspar David, Nebel (Fog), 1000-1001, Islamic chahar bagh, 299-300 Franks, 442, 450 Japanese Zen dry, 855-856, 856 Franzoni, Giuseppe, Corncob Capital, U.S. Capi-Frieze, 117, 118, 287 landscape, 1187, 1187 tol, 1007-1008, 1007 Frigidarium, 220 Roman, 192-193, 193 Frederick C. Robi House (Wright), Chicago, Frolicking Animals (Toba Sojo), Heian period, Garden Scene, Primaporta, 192, 194, 195 1102-1103, 1102 Japan, 387-388, 388 Gare St. Lazare (Monet), 1030-1031, 1030 Frederick II, Holy Roman Emperor, 541, 547 Frottage, 1120 Garnier, Charles, Opéra, Paris, 1013-1014, 1013, Freeman, Leslie G., 7 Fry, Roger, 1038 Freer, Charles Lang, xlv-xlvi Fujii, Chuichi, Untitled '90, 869, 869 Gates of Paradise, San Giovanni baptistry, Flo-Freestanding sculpture Funerary architecture. See Tombs rence, 629-630, 630 Greek Archaic, 121-125, 122, 123, 124 Funerary customs Gateway to the Great Temple at Baalbek (Roberts), Greek Classical, 131, 132 SEE ALSO Burial ships 1005-1006, 1005 Fremont people, 414 Asmat spirit poles, 903, 903 Gaudí i Cornet, Antonio, Serpentine bench, French art Chinese cong, 346, 346 1054-1055, 1055 academic, 1013-1015 Egyptian mummification, 55 Gauguin, Paul, 1038 Etruscan, 174, 176–177, 176, 177 academies, 793, 799, 948 Mahana no atua (Day of the God), 1046, 1046 architecture, Baroque, 793-797, 794-797 Greek, 112-113 Gaulli, Giovanni Battista, The Triumph of the Name architecture, Gothic, 516-532, 517-532 Japanese Kofun period, 377, 377 of Jesus and the Fall of the Damned, 763-764, architecture, Modern, 1101, 1101 Kuba, 933, 935, 935 763 architecture, Neoclassicism, 969-970, 970 New Ireland malanggan, 903-904 Gauls, 160, 442 architecture, nineteenth century, 1012-1013, Viking picture and rune stones, 460, 461 Geese Aslant in the High Wind (Gyokudo), 863, 863 1013 Funerary masks Gehry, Frank, Guggenheim Museum, Solomon architecture, Renaissance, 720-723, 721, 722, of Agamemnon, 93, 99, 102-103, 102 R., Bilbao, Spain, 1184, 1185 Dogon dama mask, Mali, 933, 933 Geisha as Daruma Crossing the Sea (Harunobu), Art Nouveau, 1056-1057, 1056 of Tutankhamun, 48, 49 866 866 Chauvet cave 0.1.7 Funerary sculpture, Roman, 222, 222 Gemma Augustea, 189-190, 189, 442 Cubism, 1082-1084, 1082, 1083 Funerary vases, Greek, 112-113, 113 Genghis Khan, 294, 366, 832 flamboyant style, 610-611 Furniture Genre, 744, 836, 789-790 garden design, Baroque, 796, 796 Art Nouveau, 1054-1055, 1055, 1056, 1056 Gentileschi, Artemisia La Mouthe cave, 11, 11 Chinese, 840-841, 840 Judith and Maidservant with the Head of Lascaux cave, 8-10, 9 Morris & Company, 1024, 1024 Holofernes, 759, 760 manuscripts, fourteenth century illuminated, Neolithic, 14-15 Self-Portrait as the Allegory of Painting, 760, 760 572-573, 573 Fuseli, John Henry (Füssli, Johann Heinrich), Geoglyphs manuscripts, Gothic illuminated, 536, The Nightmare, 967-968, 968 SEE ALSO Earthworks 537-538, 537 Fusuma (Kano Eitoku), 857-858, 858 Nazca, 410, 411 painting, Baroque, 797-800, 798-801 Fusuma, sliding doors, 857-858, 858, 860 Geometric period of Greek art, 111, 112-114 painting, Fauvism, 1067-1070, 1068, 1069 Futurism, in Italy, 1084, 1084, 1085 George III, king of England, 908, 953, 959, 966 painting, fifteenth century, 609-610, 610 George Clifford, 3rd Earl of Cumberland (Hilliard), painting, Neoclassicism, 971-976, 971-975, 738, 738 988-990, 988-991 G George Washington (Houdon), 976-977, 976 painting, Realism, 1017-1021, 1017-1021 Gabon, Fang, Nlo byeri guardian, 935, 935 Georgian silver, 962, 962 painting, Renaissance, 720, 720 Gainsborough, Thomas, Portrait of Mrs. Richard Gerald of Wales, 441 painting, Rococo, 946, 947, 948-951, 949, 951 Brinsley Sheridan, 963-964, 964 Géricault, Théodore, 990-991 painting, Romanticism, 990-996, 992-996 Galileo Galilei, 746 Pity the Sorrows of a Poor Old Man, 994, 995 Pech-Merle cave, 7-8, 7 Galla Placidia, 442 Raft of the "Medusa," 990, 992-993, 992, 993 Romanesque, 482-485, 501, 502 Mausoleum of, 247-249, 248, 249 German art Salons, 943, 948, 988 Galleria, 755 SEE ALSO Holy Roman Empire sculpture, fourteenth century, 573-574, 574, Galleries, 257 architecture, Gothic, 541-542, 542, 543 Gallic Chieftain Killing His Wife and Himself, 160, architecture, Modern, 1100-1101, 1100 sculpture, Gothic, 532-537, 533-536 160, 162 architecture, Neoclassicism, 1008, 1008 sculpture, Neoclassicism, 976-977, 976 Galmeton, Richard de, 576 architecture, Rococo, 944-946, 944, 945, 946 sculpture, nineteenth century, 1014-1015, Gandhara school, 323, 323 Bauhaus art, 1110-1111, 1110, 1111, 1112 1015, 1051-1053, 1052, 1053 Gandhi, Mahatma, 825 Dadaism, 1090-1091, 1090, 1091 sculpture, Paleolithic, 10, 11 Gandhi Bhavan, Punjab University (Mathur and Der Blaue Reiter, 1073-1076, 1074, 1075, sculpture, Rococo, 951, 951 Jeanneret), India, 825-826, 826 sculpture, Romanticism, 997, 997 Garamante, 425 Die Brücke, 1070-1072, 1070, 1071 Woman from Brassempouy, 5-6, 6 Garbhagriha, 320, 327, 328, 333 metalwork, 714, 714 French Revolution, 942, 974-975 Garden in Sochi (Gorky), 1132-1133, 1132 Nazi suppression of, 1112 French Royal Academy of Painting and Sculpture, Garden of Earthly Delights (Bosch), 728-729, 729 Neo-Expressionism, 1175-1176, 1175, 1176 948 Garden of Love page from, Hypnerotomachia Poliphili painting, expressionism, 1072-1073, 1072, Frescoes (Colonna), 652, 652 1073 buon, 90, 569 Garden of Love (Rubens), 777, 777 painting, Renaissance, 711-719, 712-719 "Flotilla" fresco, Thera, 82-83, 82 Garden of the Cessation of Official Life, Ming painting, Romantic landscape, 1000-1001, Italian Renaissance, 635-640, 636-640 dynasty, China, 830-831, 831 Minoan, 90-92, 90, 91, 92 Gardens sculpture, Gothic, 543-545, 544, 545, 547

Goths, 442, 514 Glaze technique, 42, 350, 501, 839 sculpture, Renaissance, 709-711, 710, 711 Goujon, Jean, 723 sculpture, Rococo, 945-946, 946 Gleaners, The (Millet), 1019, 1019 Speyer cathedral, 488-490, 490 Glorification of the Papacy of Urban VIII Governess, The (Chardin), 971, 971 (Pietro da Cortona), 762, 762 Goya, Francisco Germany Caprichos (Caprices), Los, 998, 998, 1016 SEE ALSO Holy Roman Empire Gloss, 114 Family of Charles IV, 998, 999 Bauhaus Building, Dessau, 1111, 1111, 1112 Glykera, 156 The Sleep of Reason Produces Monsters, 998, 998 Fagus Shoe Company (Gropius and Meyer), Gnosis, Stag Hunt, 156-157, 156 Goddess Coatlicue, Aztec, 876, 876 Third of May, 1808, 998, 999, 1000 1100-1101, 1100 Graffiti, 1176 Nazis, 1066, 1112 Godescalc Gospel Lectionary, 455-456, 455 Goes, Hugo van der, Portinari Altarpiece, 606-607, Granada, Spain Renaissance in, 709-719 Gero Crucifix, Ottonian, 468, 469 607, 609, 609 Court of the Lions, Alhambra, 298, 299-300 Palace of the Lions, Alhambra, 299, 300 Gérôme, Jean-León, Cafe House, Cairo (Casting Goethe, Johann Wolfgang von, 956 Grand Canyon National Park, Arizona, Lookout Gold foil, 93 Bullets), 1006-1007, 1006 Studio (Colter), 1103-1104, 1103 Gold leaf, 93, 94, 94 Ghana Grand Déjeuner, Le (The Large Luncheon) (Léger), Goldsmith (Saint Eligius?) in His Shop, A (Christus), Ashanti Kente cloth, 928-929, 928 1083-1084, 1083 604, 605 Ashanti staff, 916, 917, 928 Grand Manner, 963, 967 Gold work contemporary art, 936-937, 937 Grand Tour, 951-956 Aegean (Minoan), 93-94, 93, 94 Nankani compound, 919-920, 920 Graphic arts Ghent Altarpiece (Jan and Hubert van Eyck), 584, Carolingian, 457-459, 458 Art Nouveau, 1053-1057, 1054, 1055, 1056 Diquis, 407-408, 407 Renaissance, 614–616 Greek, 155, 155 Gherardini del Giocondo, Lisa, 664 Inca, 879-880, 880 Grattage, 1120 Ghiberti, Lorenzo, San Giovanni baptistry, door Grave Stele of Hegeso, Greek, 147-148, 147 Korean, 367, 367 panels, 629-631, 630 Mannerism, 697-698, 697, 698 Great Friday Mosque, Jenné, 433, 434 Ghirlandaio, Domenico, 669 Great Gallery, Horseshoe Canyon, Utah, 414, 414 frescoes for Sassetti Chapel, 648, 649-650. Moche, 411-412, 412 Great Grotto (Buontalenti), Boboli Gardens, Flo-Roman, 221, 221 Goltzius, Hendrick, 728, 779 rence, 677, 677 The Nativity and Adoration of the Shepherds, Great Lyre with Bull's Head, Ur, 34-35, 34 649-650, 649 Dutch Visitors to Rome Looking at the Farnese Great Mosque of Córdoba, Spain, 290-291, 290, Hercules, xlvii, xlvii real name of, 648 Gonçalves, Nuño, Saint Vincent with the Portuguese Giacometti, Alberto, City Square, 1128, 1128 Great Mosque of Isfahan (Masjid-i Jami), Iran, Royal Family from Altarpiece of Saint Vincent, Gilbert, Cass, Woolworth Building, New York 295, 297, 297 City, 1105, 1105 612-613, 613 Gonzaga, Federigo II, 680 Great Mosque of Kairouan, Tunisia, 288, 290, 290 Gilding, 93 Great Plains, 884-886 Gilgamesh, 29-30, 35 Gonzaga, Lodovico, 644, 647 Great Pyramid (Aztec), 875 Good Shepherd, Orants, and Story of Jonah, Gilpin, Laura, Taos Pueblo, 889, 889 239-240, 239 Great Pyramid, La Venta, Olmec, 398, 398 Gim Hwangi, 5-iv-71, 848, 848 Great Schism, 554, 647 Giorgione (Giorgio da Castelfranco) Good Shepherd (lunette), 248-249, 249 Great Serpent Mound, Mississippian Period, 413, Good Shepherd (sculpture), 240, 240 The Pastoral Concert, 684, 684 The Tempest, 682-683, 683 Gopuras, of the Minakshi-Sundareshvara Temple, 413 Great Sphinx, Egypt, xxxii, xxxii, 59 Giornata, 569, 638 India, 812, 814 Gorgons, pediment on Temple of Artemis, Cofru, Great Stupa, Sanchi, India, 319-321, 319, 321 Giotto di Bondone, 554 Great Tower, Dover Castle, England, 493, 494 frescoes, Scrovegni (Arena) Chapel, Padua, 119, 119 Great Wall of Los Angeles, The Division of the Barrios 563-564, 565, 566, 567 Gorky, Arshile, Garden in Sochi, 1132-1133, 1132 Goryeo dynasty, 368-370, 845 (Baca), 1177, 1177 Lamentation, 564, 566, 567 Great Wave, The (Hokusai), 850-851, 851, 866, 868 Marriage at Cana, Raising of Lazarus, Resurrec-Gospels Great Wild Goose Pagoda, Tang dynasty, China, Coronation Gospels, 456, 456 tion and Noli Me Tangere and Lamentation, of Ebbo, 456-457, 456 359-360, 360 Scrovegni (Arena) Chapel, Padua, 564, 566 Great Zimbabwe and the Shona, 433-435, 434, Godescalc Gospel Lectionary, 455-456, 455 Virgin and Child Enthroned, 561-562, 563 Gospel Book of Durrow, Iona, Scotland, 435 436 Giovane, Palma, 687 Greco, El (Domenikos Theotokopoulos), 726 447-448, 447 Giovanni da Bologna (Jean de Boulogne or Lindau Gospels, 458-459, 458 Burial of Count Orgaz, 726, 727 Giambologna), Astronomy, or Venus Urania, 698, View of Toledo, 727-728, 727 Liuthar (Aachen) Gospels, 469-470, 469, 470 Gossaert, Jan, 728, 729 Girardon, François, Apollo Attended by the Nymphs of Byzantine art in, 269, 269, 270, 271 Saint Luke Painting the Virgin Mary, 730-731, Thetis, 796-797, 797 emergence of civilization, 108-112 730 Girodet-Trioson, Anne-Louis, Portrait of Jean-Baptiste Belley, 975–976, 975 historical background, 108-109 Gothic, use of term, 514 map of ancient, 109 Gothic art Last Judgment, 497–498, 497 architecture, American Gothic Revival, 1009, religious beliefs and sacred places, 109-111 timelines, 113, 117 The Suicide of Judas, 498-499, 498 architecture, English Gothic Revival, 959, Greek art, archaic Gita Govinda, India, 821, 823, 823 sculpture, freestanding, 121-125, 122, 123, 959, 1008, 1009 Giuliani, Rudolph, 1183 Giza, pyramids at, 57-59, 57, 58 in England, 538-541 sculpture, pediment, 119-121, 119, 120, 121 in France, 515-538 Glaber, Radulphus, 479 temples, 116, 116, 117–119, 117, 118 in Holy Roman Empire and Germany, vases, painted, 114, 125-128, 125, 126, 127 541-545, 547 millefiore, 446 international, 588, 592-593, 613 Greek art, classical, 111-112 stained, 527-528, 527, 529 Acropolis, 116, 136-142, 138, 139, 140, 141, Glass and Bottle of Suze (Picasso), 1080-1081, in Italy, 546, 547-550 Gothic era 1081 Athenian Agora, 145-147, 146 description of, 514-515 Glassmaking map of Europe in, 515 city plans, 149-150, 149 Egyptian, 70, 70, 74-75 dates for, 128 timelines, 527, 537 Islamic, 296, 296

early, 128, 129-135 Gu Kaizhi, Admonitions of the Imperial Instruc-Hanging scrolls, 833, 837 goldsmiths, work of, 155, 155 tress to Court Ladies, 355-356, 355 Haniwa, Kofun period, Japan, 377, 377 high, 128, 135-148 Gummersmark brooch, Norse, Denmark, Hannibal Crossing the Alps (Cousen), 1016, 1016 late, 148-157 445-446 446 Happenings, 1148-1150, 1148, 1149, 1150 monumental tombs, 151 Gupta period, 325-327 Harald Bluetooth, Danish king, 460, 461 murals and mosaics, 155-157, 156 Guro, Côte d'Ivoire, 936 Haram al-Sharif, 236, 286, 286 painting, 148, 148 Gurruwiwi, Mithinarri, The Conference of Serpents Harappan civilization, 312-315, 313, 314, 315 Parthenon, 116, 136-142, 138, 139, 140, 141, from the Wäwilak Myth, 900-901, 901 Harbaville Triptych, Byzantine, 273, 273 Gursky, Andreas, 99 Cent, 1174, 1175 Hardouin-Mansart, Jules, Palais de Versailles, 793, Polykleitos, canon of, 128-129 Gutai group, 1148 794, 795–797, 795, 796, 797 sculpture, bronze, 131-134, 133, 134 Gutenberg, Johann, 615 Hardwick Hall (Smythson), Shrewsbury, England, sculpture, freestanding, 131, 132 Guti, 37 738, 739 sculpture, in late period, 151-155, 151, 152, Guzman, Domenico, 524 Harlem Renaissance, 1114-1116, 1114, 1115, Gyokudo, Uragami, Geese Aslant in the High Wind, sculpture, pediment, 130-131, 131 Harmony in Blue and Gold, Peacock Room, for sculpture, stele, 147-148, 147 Frederick Leyland (Whistler), xlv-xlvi, xlv tholos, 150-151, 150 Hartley, Marsden, Portrait of a German Officer, vases, 134-135, 135, 148, 148 1093, 1094, 1094 women as artists, 157 Habitat '67 (Safdie), Montreal, Canada, Harunobu, Suzuki, Geisha as Daruma Crossing the Greek art periods Sea, 866, 866 1169-1170, 1169 Archaic, 111, 114-128 Habsburg Empire, 464, 764 Harvester Vase, Crete, 93-94, 93 Classical, 111-112, 128-157 Hackwood, William, "Am I Not a Man and a Harvesting of Grapes, Santa Costanza church, Geometric, 111, 112-114 Rome, 247, 247 Brother?" jasperware, 960, 961 Hellenistic, 112, 157-166 Hades, 110 Hassan, Salah, 936 historical divisions, 111-112 Hadid, Zaha, 307 Hatshepsut Orientalizing, 111, 114 Enthroned, 70, 71 Vitra Fire Station, Germany, 1184, 1185 Greek-cross plan churches, 242, 275, 679 Hadrian, 158, 204, 205 as a sphinx, 71 Greek gods and heroes, description of, 110 temple of, 71-72, 71 Pantheon, 210, 210, 211, 212 Greek manner, 559, 561 Villa, Tivoli, 212, 212, 213, 213 Hattusha, 39 Gregory VII, pope, 476, 489 Haussmann, Georges-Eugène, 1013, 1019, 1059 Wall, Britain, 212, 213 Gregory of Nazianzus, 230 Hawaiian Islands, 908, 908, 911-913, 912, 913 Hadrian Hunting Boar and Sacrificing to Apollo, Gregory the Great, pope, 446 Hawass, Zahi, 50 215-216 215 Greuze, Jean-Baptiste, The Drunken Cobbler, Hagenauer, Nikolaus, Saint Anthony Enthroned Head, colossal Olmec, 399, 399 971-972, 971 Head, Nok, 426-427, 427 between Saints Augustine and Jerome, 711, 712 Grid, 44 Hagesandros, Laocoön and His Sons, xxxvii, xxxvii, Headdress Griffin, Islamic, 300, 301 163-164 gold, Three Kingdoms, Korean, 367, 367 Grisaille, 528, 564, 572, 577, 603 Hagia Sophia church, Istanbul, 255, 255, 256, nemes, 52, 72 Grizzly bear house partition screen, Tlingit, 886, 257, 259, 305 Head of a king, Yoruba, 429-430, 429 886 Haida, 886, 892, 892 Head of a man, Akkadian, 36, 36 Groin vaults, 172, 488, 521, 521 Hakuin Ekaku, 863 Head of a man (known as Brutus), Roman, Gropius, Walter, 1110 Bodhidharma Meditating, 864-865, 864 177-178, 178 Bauhaus Building, Dessau, Germany, 1111, Halder, Jacob, Armor of George Clifford, 737, 737 Head of Senusret III, 63, 63 Halikarnassos, mausoleum at, 153, 153 Head of Usurper Lajuwa, Yoruba, 430, 430 Fagus Shoe Company, 1100-1101, 1100 Hall of Bulls, Lascaux cave, 8, 9 Heads, Benin, 430-432, 430, 432 Gros, Antoine-Jean, Napoleon in the Plague House at Hall of Mirrors (Le Brun and Hardouin-Mansart), Head Surrounded by Sides of Beef (Bacon), 1128, Jaffa, 988-989, 989 Versailles, 793, 795, 795 Gross Clinic, The (Eakins), 1022, 1022 Hall of the Abencerrajes, Alhambra, 300, 300 Heath of the Brandenburg March (Kiefer), Grottos, French, 723 1175-1176, 1175 Hals, Frans, 781 Groundlines, 54 Catharina Hooft and Her Nurse, 782, 782 Heckel, Erich, Crouching Woman, 1071, 1071 Group of Seven, 1099 Officers of the Haarlem Militia Company of Saint Heian period, Japan, 373, 383-388, 383-388, 854 Grünewald, Matthias, Isenheim Altarpiece, 711-712, Adrian, 782, 782 Heizer, Michael, Double Negative, 1162, 1162 712, 713, 714 Hamatsa masks, Kwakwaka'wakw, 888, 888 Helladic, use of term, 95 Gu, Wenda, United Nations-Babel of the Millen-Hamilton, Ann, Indigo Blue, 1187, 1187 Hellenistic art, 112 nium, 1189-1190, 1189 Hamilton, Gavin, 955 architecture, 158-160, 158, 159 Guan ware vase, Song (southern) dynasty, 366, 366 sculpture, 160, 160, 161, 162-165, 162, 163, Hamilton, Richard, 1150 Güas, Juan, San Juan de Los Reyes church, Toledo, 164, 165, 166 Just What Is It that Makes Today's Home so Dif-Spain, 612, 612 ferent, so Appealing?, 1151, 1151 Helen of Egypt, 155, 157 Guda, 592 Hamilton, William, 960 Hemicycles, 690 Book of Homilies, 508, 508 Hammamet with its Mosque (Klee), 1076, 1076 Hemispheric domes, 172, 320 Gudea, 37, 37 Hammons, David, Higher Goals, 1184, 1186, 1186 Hendrick III of Nassau, 728, 729 Guercino (Giovanni Francesco Barbieri), Saint Henges, 17 Hammurabi, 37 Hennings, Emmy, 1088 code of, 38 Displaying a Painting of the Virgin, xli, xli, 760 Henri, Robert, 1092 Stele of Hammurabi, 38, 38 Guernica (Picasso), 1064-1065, 1065 Hampton, James, Throne of the Third Heaven of the Henry I, king of England, 475 Guggenheim Museum, Solomon R. (Gehry), Bil-Nations' Millennium General Assembly, xxxviii, Henry II, king of England, 516, 538 bao, Spain, 1184, 1185 Henry II, king of France, 720 Guido di Pietro. See Angelico, Fra (Guido di Hamzanama, 819, 821 Henry II, Ottonian king, 469 Pietro da Mugello) Henry III, king of England, 538, 575 Hamza's Spies Scale the Fortress, 819, 821 Guilds, 514, 555, 596 Handscrolls, 356, 388-389, 388, 389, 833, 837 Henry III, king of France, 720 women in, 592 Han dynasty, 343, 349-354, 834 Henri IV, king of France, 720, 793 Guimard, Hector, Desk, 1056, 1056 Henri IV Receiving the Portrait of Marie de' Medici Hanging Gardens, 42

House of the Vettii, Pompeii, 192, 193, 193 (Rubens), 776, 776 Hofmann, Hans, 1135 Hogarth, William, 1016 Henry VI, king of England, 609 Houses at L'Estaque (Braque), 1079, 1079 Henry VIII, king of England, 708, 734, 735-736 The Marriage Contract, from Marriage à la Mode, Houses of Parliament (Barry and Pugin), London, Henry VIII (Holbein), 735-736, 735 961, 961, 963 1008.1009 Henry of Blois, 508 Hohlenstein-Stadel, Germany, Lion-Human figurine, House-synagogue, 236-237, 236, 237 Hephaistos, 110 4-5.4 Housing Hepworth, Barbara, Forms in Echelon, Hohokam culture, 416, 887 Ain Ghazal, Jordan, 28-29, 29 1117-1118, 1117 Hoi An Hoard, ceramics from, Vietnam, 816, 816 Chinese, Han dynasty, 353, 354 Hera, 109, 110 Hokke, Totoya, Raiko Attacks a Demon Kite, 867 Egyptian, 66-67, 67 Hera I, temple of, 116, 117, 117, 119 Great Zimbabwe and the Shona, 433-435, Hokusai, Katsushika The Great Wave, 850-851, 851, 866, 868 434, 435, 436 Hera II, temple of, 117 Herakleitos, The Unswept Floor, 214, 214 Manga, 1044 Japanese, Yayoi period, 377, 378 Herat, 304 Thirty-Six Views of Fuji, 851, 866 Nankani compound, Ghana, 919, 920 Herculaneum, 952 Holbein the Younger, Hans, Henry VIII, 735-736, Neolithic, 13-17, 14, 15, 16, 17 Paleolithic, 3-4, 3 Hercules (Herakles), 121 Pueblo Bonito, Chaco Canyon, New Mexico, Athena, Herakles, and Atlas, 131, 131 Hollow-casting bronze, 132 394-395, 395-396, 416, 417-418, 417, 418 Hercules and Antaeus (Pollaiuolo), 633-634, 633 Holy Cross church, Schwäbisch Gmünd, Germany, 578-579, 578 Pueblos, 887, 889, 889 Hermes, 110, 127 Roman, Republic, 190-192, 190, 191, 192 Hermes and the Infant Dionysos (Praxiteles), Holy Roman Empire, 464, 474 SEE ALSO Germany tepees, 884, 884 151-152, 151 architecture, fourteenth century, 578-579, 578 How the Other Half Lives (Riis), 1058 Herodotus, 50, 51, 55, 425 Herod the Great, 236 architecture, Gothic, 541-542, 542, 543 How to Explain Pictures to a Dead Hare (Beuys), Herrad of Lndsberg, 499 fifteenth century, 613, 614 1160-1161, 1161 metalwork, 714, 714 Hudson River Landscape (Smith), 1139, 1139 Herrera, Juan de, El Escorial, Madrid, 725, 725 Huelsenbeck, Richard, 1090 Hesse, Eva, Rope Piece, 1157-1158, 1157 painting, fourteenth century, 579-580, 580, Hugh de Semur, 482, 489 Hestia, 110 painting, Renaissance, 711-719, 712-719 Huineng, 841 Het Schilderbock (The Painter's Book) (Van Mander), sculpture, Gothic, 543-545, 544, 545, 547 Huizong, emperor of China, Ladies Preparing 728 sculpture, Renaissance, 709-711, 710, 711 Newly Women Silk, 360, 361 Hiberno-Saxon 446 Renaissance (early) in, 613 Human development, 2 Hideyoshi, Toyotomi, 856 Holy Virgin Mary (Ofili), 1182, 1183, 1183 Human figures, Egyptian representation of, Hierakonpolis, Egypt, 50 Palette of Narmer, 53-54, 53 Homage to Blériot (Delaunay), 1082, 1082 52-53, 54, 54 Hieratic scale, 36-37, 53, 464 Homage to New York (Tinguely), 1150, 1150 Human-Headed Winged Lion (lamassu), Nimrud, 24, Homer, 84, 98, 103, 127, 959 Hieratic writing, 78 Homer, Winslow, The Life Line, 1022, 1023 Humanism, 554-555, 586-587, 620-621 Hieroglyphs, 53, 78, 78, 86 Hundreds of Birds Admiring the Peacocks (Yin Higher Goals (Hammons), 1184, 1186, 1186 Hong Kong & Shanghai Bank (Foster), Hong Kong, 1182, 1184, 1184 Hong), 836, 836 High relief. See Sculpture, relief High Tech architecture, 1182, 1184, 1184 Honnecourt, Villard de, 525 Hundred Years' War, 554, 572, 575, 1051 Hunefer, 78–79, 79 Honorius, 247 Hildegard, 455, 499 Hilliard, Nicholas, George Clifford, 3rd Earl of Cum-Hopewell, 412 Hungry Tigress Jataka, Asuka period, Japan, 380, berland, 738, 738 Horace, 180 380 Horde, The (Ernst), 1120, 1120 Huns, 442 Himation, 125 Himeji Castle, Osaka, Japan, 857, 857 Hunt, Richard Morris, World's Columbian Expo-Horemheb, tomb of, 64, 64 Horn Players (Basquiat), 1176-1177, 1176 sition, Chicago, 1058, 1060, 1061 Hindu art Horse and Sun Chariot, Trundholm, Denmark, 21, Hunt, William Holman, The Hireling Shepherd, monumental narrative reliefs, 329-333, 330, 331, 332 1023-1024, 1023 northern temples, 320, 327-329, 327, 328, Horseman, Jenné, 432, 433 Hunter's Mural, Nine Mile Canyon, Utah, 414, 414 Horsemen, Parthenon, 141, 142 Hunt of the Unicorn tapestry, 594-595, 595 329, 333-334, 334 Horseshoe arches, 291, 292 southern temples, 320, 333, 333, 335-336, Hurling Colors (Shimamoto), 1148, 1148 Horta, Victor, Stairway, Tassel House, Brussels, Hus, John, 554, 582 temples in India, 812, 814 1054, 1054 Hyksos, 67 Hortus Deliciarum (The Garden of Delights) (Her-Hypnerotomachia Poliphili (Colonna), 652, 652 Hinduism, 318, 811 Hippodamos, 149, 150 rad), 499 Hypostyle hall, 68, 288, 289 Huysmans, Joris-Karl, 1047 Hippopotamus, Egyptian, 64-65, 65 Horus, 52, 53, 54 Horyu-ji, temple, Japan, 379-380, 379, 380 Hireling Shepherd, The (Hunt), 1023-1024, 1023 Hosios Loukas, monastery of, Greece, 269, 269, Hiroshige, Utagawa, 851 Fifty-Three Stations of the Tokaido, 866 270, 271 Ibn Muqla, 292 One Hundred Views of Edo: Plum Orchard, Houdon, Jean-Antoine, George Washington, Ice Age, 11 976-977, 976 Kameido, 1044, 1044 Ichi, 429 Hour of Cowdust, India, 823-825, 824 Historiated capitals, 498-499, 498 Iconoclasm, 266, 709 Hours of Mary of Burgundy (Mary of Burgundy Historicism, 1013 Iconography, xxxviii, 35, 266-267 History of Ancient Art, The (Winckelmann), 955 Painter), Mary at Her Devotions from, 593-594, Han dynasty, 353 History paintings of the life of Jesus, 252-253 House (Whiteread), 1180-1181, 1181 defined, 948 of Tantric Bodhisattva, 810 English Neoclassicism, 965-967, 965, 966 House-churches, 241, 241 Iconologia (Ripa), 759-760 Hitchcock, Henry-Russell, 1109 House of Jacques Coeur, Bourges, France, 611, Iconostasis, 259, 266 Icons, Byzantine, 259, 266-267, 266, 269, Hitler, Adolph, 1066, 1111, 1112 Hittites, 37, 39, 75 House of M. Lucretius Fronto, Pompeii, 197-198, 273-274, 273, 276, 276, 278-279, 280 Hoare, Henry, Stourhead park, Wiltshire, England, Idealism, xxxiv, 430 House of Publius Fannius Synistor, Boscoreale, 958-959, 958 Ideographs, 348 Höch, Hannah, Dada Dance, 1091, 1091 195, 195, 196, 197 Ieyasu, Tokugawa, 856

Ife, Nigeria, 921 culture of, 429–430, 429, 430 ritual vessel, 420, 421	328, 329, 333–334, 334 Hindu southern temples, 320, 333, 333, 335–336, 335	Isidorus of Miletus, Hagia Sophia church, Istanbul, 255, 255, 256, 257, 259, 305
Ife, Yoruba of. See Yoruba of Ife, Nigeria Igbo-Ukwu, 427, 427, 429, 429	Indus Valley (Harappan) civilization, 312–315, 313, 314, 315, 815	Isis, 51–52, 179 Islam, 234, 283–284 Five Pillars of, 299
Igloo (Merz), 1159, 1159	Kushan and later Andhra periods, 322-327	Islamic art
Ignatius of Loyola, 688, 690 Ignudi, 671, 674, 756	Mathura school, 323–324, <i>324</i> Maurya period, 316–319, <i>316</i> , <i>318</i>	architecture, 286–292, 286–292, 295, 297–300, 297, 298, 300
Ikkyu, 854 Calligraphy Pair, 855, 855	painting, 326–327, 326, 336, 336 rock-cut halls, 321–322, 322	calligraphy, 292–293, 293 ceramics, 294, 294, 301–302, 301
Iktinos, 136, 137, 138–139	Shungas and early Andhra periods, 319–322	glass, 296, 296
Il Gesù church (Vignola and della Porta), 690–692, 691	stupas, 319–321, <i>319</i> , <i>321</i> temples, 320, 327–329, <i>327</i> , <i>328</i> , <i>329</i> ,	manuscripts, 303–304, <i>304</i> , <i>305</i> metalwork, 300–301, <i>301</i>
Iliad (Homer), 84, 98, 103, 127	333–336, 333, 334, 335	textiles, 294, 295, 302–303, 302, 303
Illuminated manuscripts. See Manuscripts, illuminated	Vedic period, 315–316 India gate (Lutyens), New Delhi, 825, <i>825</i>	Islamic world
Imba Huru, Great Zimbabwe, 434	Indigo Blue (Hamilton), 1187, 1187	early society, 283–285 map of, <i>285</i>
Imhotep, 55	Individualists, 844	Shi'ites versus Sunni, 284
Immaculate Conception, The (Murillo), 769–770, 770	Indonesia, sculpture, 817, <i>817</i> Industrial Revolution, 942	in Spain, 449 Italian art
Impasto, 744	description of, 986–987	architecture, Baroque, 745-754, 747-754
Imperial Procession, Ara Pacis, 188, 188 Impost blocks, 624	map of Europe and America in the nineteenth century, 987	architecture, fourteenth century, 557–559, 557, 558, 559
Impoverished (povera) art, 1158-1159, 1159	Indus Valley (Harappan) civilization, 312–315,	architecture, Gothic, 546, <i>546</i>
Impressionism angles, 1033–1034, <i>1034</i>	313, 314, 315, 815 Ingres, Jean-Auguste-Dominique	architecture, Renaissance (early), 621–628, 622–627, 640–642, 641, 642, 644–647,
Cassatt, 1034–1036, 1035, 1036	Large Odalisque, 989–990, 990	645, 646, 653, 654
exhibitions, 1026 Manet, 1027–1029, <i>1027</i> , <i>1028</i> , 1036, <i>1036</i> ,	Portrait of Madame Desiré Raoul-Rochette, 990, 991	architecture, Renaissance (High), 677–680,
1038	Initiation art, 923–925, <i>923</i> , <i>924</i> , <i>925</i>	678, 679, 680 ceramics, 634, 634
Monet, 1029–1031, 1029, 1030, 1031	Initiation Rites of the Cult of Bacchus, Pompeii,	Cubism and Futurism, 1084, 1084, 1085
Morisot, 1036, <i>1037</i> plein air, 1031–1033	194–195, <i>194</i> Initiation wall panels, Nkanu, Democratic	Gothic, 547–550 painting, Baroque, 754–764, 755–763
Post-, 1038–1046, 1039–1047	Republic of the Congo, 934, 934	painting, fourteenth century, 559, 561-567,
use of word, 1026–1027 Improvisation No. 28 (Second Version) (Kandinsky),	Ink painting, 852–855, <i>852</i> , <i>855</i> , 864 Inlaid, 30, 93	562, 563, 565, 566 painting, Gothic, 549–550, 549, 550
1075, 1075	Innocent X, pope, 753	painting, Neoclassicism, 952-956, 953, 954,
In antis, 116 Incas, 876–880	Installation art, 1107 Institute of American Indian Arts (IAIA), 892	955 painting, Renaissance (early), 634–640,
Incense burner, Han dynasty, China, 352, 352	Intaglios, 615, 954	636–640, 642–644, 642, 643, 644,
Increase ceremonies, 6	Intarsia, 641 International Gothic art, 588, 592–593, 613	647–653, 648–653, 654–655, 654, 655, 656
India	International style, 1109, 1167	painting, Renaissance (High), 662, 663, 664–669, 664–668, 671–674, 672, 673, 67
architecture, Mughal, 808–809, 809, 817–818,	Interpretation of Dreams, The (Freud), 1047, 1066	Romanesque, 486–490
818, 819 Buddhism, 317	Intonaco, 663 Intrigue, The (Ensor), 1049, 1049	sculpture, Baroque, 745, 748, 749–751, 749 sculpture, Gothic, 547–549, <i>547</i> , <i>548</i>
Buddhist art, 810, 812	Intuitive perspective, 197, 586	sculpture, Neoclassicism, 955–956, 956
colonial rule, 825 culture of, 815	Invention of the Balloon, The (Clodion), 951, 951 Iona, Scotland	sculpture, Renaissance (early), 628–634, 628–633
Hinduism, 318	Book of Kells, 440, 441, 448, 449	sculpture, Renaissance (High), 669–671, 669
Hindu temples, 811–812, <i>814</i> Jain art, 810–811, <i>812</i>	Gospel Book of Durrow, 447–448, 447	670, 674–677, 675, 676, 677, 680–686,
luxury arts, 827, 827	Ionic order, 117, 118 Iran, Great Mosque of Isfahan (Masjid-i Jami),	<i>680–687</i> Italy
map of, after 1200, 811	Iran, 295, 297, <i>297</i>	Baroque period in, 745–764
map of, before 1200, <i>313</i> modern, 825–826, <i>826</i> , <i>828</i>	Ireland high (monumental) crosses, 449, 449	Grand Tour, 951–956 maps of, in Renaissance, 621, 661
Mughal period, 809, 817–825	Iron Age, 22, 22	Neoclassicism in, 952-956, 953, 954, 955,
painting, Mughal, 818–821, 819, 821, 822 painting, Rajput, 821, 823–825, 823, 824	New Grange, tomb interior, 15–16, <i>16</i> Openwork box lid, 22, <i>22</i>	956 Itza, 406
painting on paper, 820	Irian Jaya, 903, <i>903</i>	Ivory
Taj Mahal, <i>808–809</i> , 809, 818, <i>819</i> timelines 319	Iron Age, 21–22 Iron bridges, 967, <i>96</i> 7	box panel, Nayak period, India, 827, 827 Byzantine, 273, <i>273</i>
India, art before 1200	Iroquois, 880	French fourteenth century, 574, 574
Amaravati school, 324–325, <i>324</i> Bhakti movement, 336, <i>336</i>	Isabella, queen of Castile, 611–612, 725 Isabella d'Este, 685, 688	Ottonian, 464, 464 iwans, four-, 289, 295, 299, 809, 818
Buddhist sculpture, 326, 326	Isabella d'Este (Titian), 688, 688	, , , , ,
Gandhara school, 323, 323 Gupta period, 325–327	Isenheim Altarpiece (Grünewald), 711–712, 712, 713, 714	J
Hindu monumental narrative reliefs, 329-333,	Ise shrine, Yayoi period, Japan, 378, 378	Jack Pine (Thomson), 1098–1099, 1099
330, 331, 332 Hindu northern temples, 320, 327–329, 327,	<i>Ishiyama-gire,</i> Heian period, Japan, <i>372</i> , <i>373</i> , <i>386 Ishtar Gate, 31</i> , <i>42</i> , <i>42</i> , <i>43</i>	Jacob and Esau, Gates of Paradise (Ghiberti), 630–631, 630
		000 001, 000

Jahan, shah of India, 809, 817, 818 Jasperware, 960, 961 Joseph and Potiphar's Wife (Properzia de' Rossi), Jahangir, 817, 820 Jataka tales, 321, 380 682, 682 Jahangir in Darbar, 820–821, 822 Iava Josephus, Flavius, 179 Jain art, 810-811, 812 Borobudur, 338, 338 Joy of Life, The (Le Bonheur de Vivre) (Matisse), Jainism, 316, 810-811, 812 Ramayana scene 817 817 1068, 1069, 1070 Jambs, 532 Jean, duke of Berry, 590 Judaism, early, 234-235 James I, king of England, 777, 801, 802 Jean de Marville, 590 Judd, Donald, Untitled, 1156, 1157 Jane Avril (Toulouse-Lautrec), 1056-1057, 1056 Jean le Noir, 592 Judgment of Hunefer before Osiris, 79, 79 Jan van Eyck. See Van Eyck, Jan Jeanne-Claude (de Guillebon), Running Fence, Judith and Maidservant with the Head of Holofernes Japan 1163, 1163 (Gentileschi), 759, 760 Asuka period, 378-382, 379, 380, 854 Jeanne d'Evreux, 572-573, 574 Julia Domna, 218 Buddhism in, 373, 378-392, 854 Jeanneret, Charles-Édouard. See Le Corbusier Julio-Claudians, 189–190 Buddhism, Zen, 852-856 Jeanneret, Pierre, Gandhi Bhavan, Punjab Univer-Julius II, pope, 659, 660, 666, 671, 677, 678, 679 culture, 854 sity, India, 825-826, 826 Jung, Carl, 1131, 1138 Jefa (Patroness) (Xul Solar), 1096-1097, 1097 Edo period, 859-868 Juno, 110 Heian period, 373, 383-388, 383-388, 854 Jefferson, Thomas, 184-185, 942, 1007 Jupiter, 110 Jomon period, 374-375, 374, 375, 854 Monticello, Virginia, 980, 980 Justice of Otto III (Bouts), 605-606, 606 Kamakura period, 388-392, 388-392, 854 Jelling, Denmark, rune stones, 460, 461 Justinian I, 254, 255, 260, 261 Kofun period, 376-378, 377, 854 Jenghiz Khan, 294, 366, 832 Just What Is It that Makes Today's Home so Different, map of, after 1392, 853 Jenné, 433, 433, 434 so Appealing? (Hamilton), 1151, 1151 Jenné-Jeno, 433, 433, 434 map of, before 1392, 375 K Meiji period, 868 Jenney, William Le Baron, 1060 Modern, 868-870 Jeong Seon, Diamond Mountains (Geumgang-san), Ka, 55 Momoyama period, 856-859 847.847 Kaaba, 282-283, 284 Muromachi (Ashikaga) period, 852-856 Jericho, 27, 27, 28 Kabuki, 866 Nara period, 382-383, 382, 854 Jerusalem Kahlo, Frida, The Two Fridas, 1098, 1098 periods in, dates for, 379, 855 Dome of the Rock, 236, 286-287, 286, 287 Kahun, Egyptian town, 66 prehistoric, 374-378 First Temple of Solomon, 235-236 Kai, 61-62, 61 Shinto, 377-378 Haram al-Sharif, 236, 286, 286 Kairouan, Tunisia, Great Mosque of, 288, 290, 290 timelines, 391, 859 Second Temple Solomon, 201, 201, 235-236 Kaisersaal (Imperial Hall), Residenz (Neumann), Yayoi period, 376-378, 378, 854 Jesuits, 688, 690-691 Germany, 944-945, 944, 945 Jesus of Nazareth, 238-239 Japanese art Kakalia, Deborah (Kepola) U., Royal Symbols, architecture, 857, 857, 860 iconography of the life of, 252-253 912-913. 913 ceramics, 858-860, 858, 859, 869, 869 **Jewelry** Kahn, Louis, 1170 Gutai group, 1148 Aegean (Minoan), 89, 89 Kakuzo, Okakura, 868 ink painting, 852-855, 852, 854, 864 Egyptian, 64, 64 Kalhu, 40 Greek, 155, 155 kabuki, 866 Kallikrates Kano decorative painting, 857-858, 858 Moche, 411-412, 412 Parthenon, 136-142 Maruyama-Shijo school painting, 865-866, Norse, 445-446, 446 Temple of Athena Nike, 144-145, 144 865 Visigoths, 443-444, 444 Kalpa Sutra, 810-811, 812 Modern, 868-870, 869, 870 Jewish art, early Kamakura period, Japan, 388-392, 388-392, 854 Nanga school painting, 863, 863 Ark of the Covenant, 236, 236 Kamamalu, queen of Hawaii, skirt of, 912, 912 Rimpa school painting, 860-861, 861, 863 menorahs, 201, 236, 236 Kamares ware jug, Crete, 88-89, 89 sculpture, 869, 869 Solomon, First Temple, 235-236 Kamehameha I, king of Hawaii, 908, 909 tea ceremony, 858-860, 858, 859 Solomon, Second Temple, 201, 201, 235-236 Kamehameha II, king of Hawaii, 912 ukiyo-e (woodblocks), 866, 867, 867 synagogues, 236-238, 236, 542, 543, 790, 790 Kana, Japanese writing, 376 Zen dry gardens, 855-856, 855 Jewish Cemetery, The (Ruisdael), 790-791, 791 Kandariya Mahadeva temple, Khajuraho, India, Zen painting, 863-865, 864 Jewish War (Josephus), 179 333-334, 334 Japanese art, before 1392 Joan of Arc, 609 Kandinsky, Vasily, 1073 architecture, Asuka period, 379-380, 380 Jocho, Amida Buddha, Heian period, Japan, 386, Blue Mountain, 1074, 1074 architecture, Heian period, 384-385, 384-385 386 Concerning the Spiritual in Art, 1075 architecture, Yayoi period, 378, 378 Joggled voussoirs, 299 Improvisation No. 28 (Second Version), 1075, Buddhist art, Asuka period, 379-382, 379, 380 John, duke of Berry, 587, 588, 591 1075 Buddhist art, esoteric, 383, 383 John of Damascus, 266 Kanishka, 322 Buddhist art, Nara period, 382-383, 382 John of Worcester, Worcester Chronicle, 474-475, Kano decorative painting, 857-858, 858 Buddhist art, Pure Land, 384-386, 384-385, 476 Kant, Immanuel, 942 386, 389, 391, 391 Johns, Jaspar, Target with Four Faces, 1147-1148, Kao Ninga, Monk Sewing, Kamakura period, Japan, Buddhist art, Zen, 390, 390, 391-392, 392 1147 390. 390 calligraphy and painting, 386-388, 387, 388 Johnson, Philip, 1109 Kapa, 912 painting, Heian period, 386-388, 387, 388 AT&T Corporate Headquarters, New York Kapoor, Anish, As If to Celebrate, I Discovered a painting, Nara period, 382-383, 382 City, 1170, 1171 Mountain Blooming with Red Flowers, 1180, painting, raigo, 391, 392 Seagram Building, New York City, 1167, 1167 Samurai armor, 389, 389 Joined-wood method, 386, 387 Kaprow, Allan, The Courtyard, 1148-1149, 1149 sculpture, Heian period, Japan, 386, 386 Jomon period, 374-376, 374, 375, 854 "Karawane" (Ball), 1088, 1088 Jonah (Ryder), 1050, 1050 sculpture, Nara period, Japan, 382-383, 382 Karnak, temples at, 68, 69-70, 69 culpture, portrait, Kamakura period, 389, 391, Jones, Inigo, 801 Katholikon, Monastery of Hosios Loukas, Greece, 391 Banqueting House, Whitehall Palace, London, 269, 269, 270, 271 Japonaiserie: Flowering Plum Tree (Van Gogh), 1044, 802, 802, 803 Katsinas 418 1045 Joseon ceramics, 845-846, 845, 846 Kauffmann, Angelica, 952 Japonisme, 851, 1044 Joseon dynasty, 845 Cornelia Pointing to Her Children as Her Trea-Jashemski, Wilhelmina, 192 Joseon painting, 846-848, 846, 847, 848 sures, 965-966, 965

363, 364 Kaufmann, Edgar, 1103 Kouros (kouroi) statues, 122, 122, 123 Chinese, Song (southern) dynasty, 365-366, Kaufmann House (Wright), Mill Run, Pennsylva-Krasner, Lee, The Seasons, 1135, 1135 Krater, 104 364-365 nia, 1103, 1103 Dutch, 790-791, 791 Kearny Cloak, Hawaiian, 908, 908 Greek Geometric style, 112-113, 113 English, 1001-1003, 1001-1003 Keep, 493 Krishna and the Gopis, Gita Govinda, India, 823, Kent, William, 957-958 French, 797-800, 800, 801 German, 718, 719, 1000-1001, 1000 Kritian Boy, Acropolis, Athens, 131, 132 Kente cloth, Ashanti, Ghana, 928-929, 928 Kepler, Johannes, 746 Kritias, 148 Japanese, 850-851, 851, 866, 868 inoan, 91, 91 Kerouac, Jack, 1143 Kritios, 131 Krug, Hans, Apple Cup, 714, 714 Romantic, 1000-1005, 1000-1004 Key block, 867 Keystone, 172 Kruger, Barbara, We Won't Play Nature to Your Cul-Landscape with Flight into Egypt (Carracci), 756–757, 756 Khafre, 57-58 ture, 1172, 1173 Kuba, Democratic Republic of the Congo, 929, Landscape with Saint John on Patmos (Poussin), sculpture of, xxxii, 59-60, 59, 60 797-798, 800, 800 Khajuraho, India, Kandariya Mahadeva temple, 929, 930, 931, 933, 935, 935 Lange, Dorothea, Migrant Mother, Nipomo, Califor-Kublai Khan, 294, 366, 832, 836 333-334, 334 Khamerernebty II, 60-61, 60 Kufic script, 292-293, 293, 294, 294, 295 nia, 1116, 1116 Khamsa (Five Poems) (Nizami), 304, 305 Kushans, 321, 322 Lantern, 624 Laocoön and His Sons (Hagesandros, Polydoros, and Khmer, 338-339 Kuya, 389 Khufu, 57-58 Kuya Preaching (Kosho), 389, 391, 391 Athanadoros), xxxvii, xxxvii, 163-164 Kiefer, Anselm, Heath of the Brandenburg March, Kuyunjik, Iraq, 41 Laozi, 348, 352 Lapita, 898-899, 898 1175-1176, 1175 Kwakwaka'wakw (Kwakiutl), 886, 888, 888 Kiev. Byzantine art in, 268-269, 268 Kylix, 132, 132 Lapith Fighting a Centaur, Parthenon, 140, 141 Kilns, 20, 114, 838, 960 Kyoto, Japan Large Bathers, The (Cézanne), 1041, 1041 Kinetic works, 1119 fusuma, sliding doors, 857-858, 858, 860 Large Blue Horses, The (Marc), 1073, 1074 Kino, Eusebio, 977, 979 Large Odalisque (Ingres), 989-990, 990 Ryoan-ji, Zen dry garden, 855-856, 855 Ki no Tsurayuki, 373 Tai-an tearoom (Rijyu), 858-859, 858 Lascaux cave, 8-10, 9 Las Meninas (The Maids of Honor) (Velázquez), Kirchner, Ernst Ludwig, 1112 Street, Berlin, 1071-1072, 1071 L 768. 769 Kiss, The (Klimt), 1055, 1055 Labille-Guiard, Adélaïde, Self-Portrait with Two Last Judgment, tympanum (Gislebertus), Saint-Lazare cathedral, Autun, Burgundy, France, Klah, Hosteen, Whirling Log Ceremony, 891-892, Pupils, 972, 972 497-498, 497 Labrouste, Henri, Bibliothèque Sainte-Geneviève, Last Judgment (Michelangelo), 688, 689, 690 Klee, Paul, 1075 Paris, 1012-1013, 1013 Hammamet with its Mosque, 1076, 1076 Labyrinth, 86, 89-90 Last Judgment Altarpiece (Weyden), 602-603, 603 Lastman, Pieter, 784 Klein, Yves La Citadelle: Freedom (Savage), 1115, 1115 Last Supper, The (Castagno), 638, 640, 640 Anthropométries of the Blue Period, 1149, 1149 Lacquer, 862 The Void. 1160 Lacquer box for writing implements (Korin), 862, Last Supper, The (Leonardo), xlii, xlii, 662, 663, 664 Klimt, Gustav, The Kiss, 1055, 1055 Last Supper, The (Rembrandt), xlii-xliii, xliii Last Supper, The (Tintoretto), 700-701, 701 Knights of Christ, Tomar, Portugal, 724, 724 Lactantius, 243 Ladies Preparing Newly Women Silk (Huizong), 360, Knight Watch (Riopelle), 1136, 1137 Last Supper from Altarpiece of the Holy Blood (Riemenschneider), 710, 710 Knossos, palace at Old Palace period, 86–89, 87, 88 Latin American art. See Mesoamerica; Mexico; Lady Murasaki, 383, 386 Second Palace period, 89-95 Lady Sarah Bunbury Sacrificing to the Graces under name of country Latin-cross plan churches, 645, 645, 647, 679 Koetsu, Hon'ami, Mount Fuji teabowl, 859-860, (Reynolds), 963, 963 Latrobe, Benjamin Henry, U.S. Capitol, Lady Xok's Vision of a Giant Snake (Accession Cer-Kofun period, Japan, 376-378, 377, 854 emony), Mayan, 405-406, 405 1007-1008, 1007 Laurana, Luciano, Ducal Palace, 640-642, 641, Koi Konboro, 433 La Fayette, Madame de, 943 642 Kollwitz, Käthe Schmidt, The Outbreak, Lagash, 37 La Venta, Olmec 1072-1073, 1072 Lakshana, 323 Colossal Head, 399, 399 Kondo, 379 Lam, Wifredo, Zambezia, Zambezia, 1131-1132, Great Pyramid, 398, 398 Kongo, 436-437, 437, 438 1131 Kongo spirit figure (nkisi nkonde), Democratic Lawrence, Jacob, The Migration of the Negro, 1115, Lamassus, 24, 25 Republic of the Congo, 926, 926 Lamb (sheep) (Christian symbol), 238 1117 Lamentation (Giotto di Bondone), 564, 566, 567 Leaning Tower of Pisa, 486, 486 Korea (Korean art) ceramics, 367-370 367, 369, 845-846, 845, Le Bonheur de Vivre (The Joy of Life) (Matisse), Laming-Emperaire, Annette, 6 846 La Mouthe cave, 11, 11 1068, 1069, 1070 Le Brun, Charles, Hall of Mirrors, Versailles, 793, Goryeo dynasty, 368-370 Lamps, Paleolithic, 11, 11 795, 795 map of, 345 Lamp with ibex design, La Mouthe cave, France, painting, 370, 370, 846-848, 846, 847, 848 Le Corbusier, 139 11, 11 sculpture, 368, 369 Villa Savoye, France, 1101, 1101 Lancets, 527, 528, 529 Le Déjeuner sur l'Herbe (Manet), 1027-1028, 1027 Three Kingdoms period, 366-368 Landscape Leeuwenhoek, Antoni van, 746 unified Silla period, 368 English garden, 956-959, 957, 958 Lega bwami masks, Democratic Republic of the Kore (korai) statues, 122-125, 123, 124 French Baroque, 796, 796 Congo, 924-925, 925 Korin, Ogata, Lacquer box for writing imple-Landscape (Bunsei), 852-853, 852 ments, 862, 862 Landscape (Shitao), 844, 844 Léger, Fernand, 1131 Le Grand Déjeuner (The Large Luncheon), Koshares of Taos (Velarde), 890, 891 Landscape architecture, 956-959, 957, 958, 1187, Kosho, Kuya Preaching, 389, 391, 391 1187 1083-1084, 1083 Leibnitz, Gottfried Wilhelm von, 942 Kosice, Gyula, Madí Luminous Structure "F," 1142, Landscape painting American, 1004-1005, 1004 Lekythos, 148 Le Nain, Antoine, The Village Piper, 797, 799 Kosuth, Joseph, One and Three Chairs, 1160, 1160 Canadian, 1098-1099, 1099 Le Nain, Louis, 797 Chinese, Six Dynasties, 354-356, 355 Kounellis, Jannis, 1158

Chinese, Song (northern) dynasty, 362-365,

Untitled (12 Horses), 1124-1125, 1125-1126

Le Nain, Mathieu, 797

Lenin, Vladimir, 1066 Livia, 185, 189 Madí, 1141, 1142 Le Nôtre, André, 793, 796 Villa of Livia, Primaporta, 192, 194, 195 Madí Luminous Structure "F" (Kosice), 1142, Leo III, emperor, 266 Llama, Inca, 880, 880 1143 Leo III, pope, 451 Lobster Trap and Fish Tail (Calder), 1119, 1119 Madonna and Child (Daddi), 552, 553 Leo X, pope, 666–668, 668, 671, 720 Locke, Alain, 1114 Madonna with the Long Neck (Parmigianino), 694, Leonardo da Vinci, xxxv, 799 Locke, John, 942 The Last Supper, xlii, xlii, 662, 663, 664 Loculi, 239 Madrasa-mausoleum-mosque complex in Cairo, Mona Lisa, 664-665, 664 Loggia, 553, 627 298, 299 Virgin and Saint Anne with the Christ Child and of the Lancers, 557, 557, 649 Madrasas, 295, 297, 297 the Young John the Baptist, 664, 664 Lombards, 444 Madrid, El Escorial (Bautista and Herrera), 725, Vitruvian Man, 665, 665 Leoni, Leone, Charles V Triumphing Over Fury, Banqueting House (Jones), Whitehall Palace, Madurai, temple at, 812, 814 xxxvi-xxxvii, xxxvi, 708 802. 802. 803 Maebyeong bottle with decoration, Goryeo Leroi-Gourhan, André, 6 Crystal Palace (Paxton), 1012, 1012 dynasty, Korea, 369-370, 369 Leroy Louis 1026 Great Exhibition of 1851, 1012-1013 Maenads, 125 Lescot, Pierre, Louvre, palais du, 723, 723 Houses of Parliament (Barry and Pugin), Maestà Altarpiece (Duccio di Buoninsegna), 567, Les Demoiselles d'Avignon (The Young Ladies of Avi-1008, 1009 567, 568, 569, 570 gnon) (Picasso), 1078, 1078 Royal Academy, 952 Magadha, 325 Saint Paul's Cathedral (Wren), 802-803, 804 Lessing, xxxviii Magdeburg Cathedral, Saint Maurice, Germany, Lesyngham, Robert, 577 Lookout Studio, Grand Canyon National Park, 544-545, 545 Le Tuc d'Audoubert, France, Bison, 10, 11 Arizona (Colter), 1103-1104, 1103 Magdeburg ivories, 464, 464 Le Vau, Louis, Palais de Versailles, 793, 794, Loos, Adolf, Steiner House, Vienna, 1100, 1100 Magic Ball (Positive) (Murakami), 869-870, 870 795–797, 795, 796, 797 Lorblanchet, Michel, 8 Magic Bird (Brancusi), 1087, 1087 Lewis, Edmonia, Forever Free, 997-998, 997 Lorenzetti, Ambrogio, 556 Mahana no atua (Day of the God) (Gauguin), 1046, Leyland, Frederick, xlv Allegory of Good Government in the City and in 1047 Leyster, Judith, Self-Portrait, 783, 783 the Country, 571-572, 571 Mahavira, 316, 810 LHOOQ (Duchamp), 1090, 1090 Sala della Pace, fresco series, 570, 571 Mahayana Buddhism, 322 Liangzhu culture, 345-346, 346 Lorenzo the Magnificent. See Medici, Lorenzo Maison Carrée (Square House), Roman temple, Liao dynasty, 361-362, 362 de' (the Magnificent) 184-185, 184 Liberation of Aunt Jemima (Saar), 1164, 1164 Lorrain, Claude (Claude Gellé), 797 Majestat Batilló (crucifix), Catalunya, Spain, 502, Liber Scivias (Hildegard of Bingen and Volmar), Embarkation of the Queen of Sheba, 800, 801 499 499 Lost-wax casting, 93, 155, 347, 348, 407, 427 Majolica, 597 Liberty Leading the People, July 28, 1830 Louis VI, king of France, 513 Ma Jolie (Picasso), 1080, 1080 (Delacroix), 996, 996 Louis VII, king of France, 513, 515, 516, 517 Malanggan carvings, New Ireland, 903-904, 904 Lichtenstein, Roy, Oh Jeff...I Love You, Too...But..., Louis IX, king of France, 536, 536, 537 Male and Female (Pollock), 1133, 1133 1153, 1153 Louis XI, king of France, 609 Malevich, Kazimir, Suprematist Painting (Eight Red Life Line, The (Homer), 1022, 1022 Louis XIII, king of France, 793, 797 Rectangles), 1084-1085, 1085 Life of John the Baptist (A. Pisano), panel doors, Louis XIV, king of France, 743, 793, 800, 943, Mali 921 558-559, 560 946, 952, 1014 Dogon dama mask, 933, 933 Lili'uokalani, queen of Hawaii, 911 Louis XIV (Rigaud), 742, 743, 800 Great Friday Mosque, Jenné, 433, 434 Limbourg brothers, 591 Louis XV, king of France, 796, 943, 949, 951, 952 Mamallapuram, India January, The Duke of Berry at Table, Très Riches Louis XVI, king of France, 972, 974 Dharmaraja Ratha, 333, 333 Heures, 587, 588 Louis of Anjou, 587 Durga as Slayer of the Buffalo Demon, 332-333, February, Life in the Country, Très Riches Heures, Louis the German, 464 332 592-593, 593 Louis the Pious, 456 Mambeky, Mbop Mabiinc, Kuba ruler, 930, 931 Limners, 806 Loup, Jean le, 531 Mamluk dynasty, 294 Lin, Maya Ying, Vietnam Veterans Memorial, xliv, Louvre, palais du (Lescot), Paris, 723, 723 Mamluk glass oil lamp, 296, 296 Low-relief, 318, 346 Mammoth-bone houses, 3-4, 3 Lindau Gospels, 458-459, 458 Lozza, Raúl, Painting #99, 1142, 1142 Man, Controller of the Universe (Rivera), Linear perspective (one-point or mathematical), Ludovisi Battle Sarcophagus, 222, 222 1113-1114, 1113 619, 621, 622, 647 Luncheon on the Grass (Manet), 1027-1028, 1027 Man and Centaur, Greece, 113-114, 113 Mandalas, 319, 328, 330, 333, 381, 383, 383 Lingam, 330 Lunettes, 239, 598 Lintel, carved, Maori, 910, 910 Lusterware, 301-302, 301 Mandapas, 320, 334 Lion Bas-Relief, The (Piranesi), 954, 954 Luther, Martin, 708, 716, 717 Mandolin and Clarinet (Picasso), 1081, 1081 Lion capital, Maurya period, India, 318-319, 318 Lutyens, Edwin, India gate, New Delhi, 825, 825 Manet, Édouard Lion Gate, Hattusha, 39, 39 Luzarches, Robert de, 530 A Bar at the Folies-Bergère, 1036, 1037, 1038 Lion Gate, Mycenae, 96, 100, 100, 101 Lydians, 45, 46 Le Déjeuner sur l'Herbe (Luncheon on the Grass), Lion-Human figurine, Hohlenstein-Stadel, Ger-Lyre with Bull's Head, Ur, Great, 34-35, 34 1027-1028, 1027 many, 4-5, 4 Olympia, 1028-1029, 1028 Lysippos Lippi, Filippino, Brancacci Chapel, Santa Maria Alexander the Great, 154-155, 154 Manetho, 51 del Carmine church, 636 The Man Scraping Himself (Apoxyomenos), 153, Man in a Red Turban (Jan van Eyck), 598-599, 600 Lipstick (Ascending) on Caterpillar Tracks (Olden-154 Mannerism burg), 1154, 1154 defined, 692-693 M Lissitzky, El, 1106 goldwork, 697-698, 697, 698 Proun space, 1107, 1107 Maat. 73 manuscripts, 696, 696 Literati painting, 833, 841-843, 841, 842, 853 Macedonia, 130, 149 ainting, 693-696, 693, 694, 695, 697, Lithography, 994 Macedonian dynasty, 267 698-699, 699 Liu Sheng, prince, 352 Machu Picchu, Peru (Inca), 878, 879 Mansart, François, 793 Liuthar (Aachen) Gospels, 469-470, 469, 470 Macy Jug Islamic lusterware, 301-302, 301 Mansart, Jules. See Hardouin-Mansart, Jules

Maderno, Carlo, Saint Peter's basilica, plan for,

679, 679, 747, 747

Man Scraping Himself (Apoxyomenos), The (Lysip-

pos), 153, 153

Lives of the Most Excellent Italian Architects, Painters,

and Sculptors (Vasari), xlvi, 620, 661, 728

Man's Love Story (Possum Tjapaltjarri), 913-914, of Pacific cultures, 899 of Agamemnon, funerary, 93, 99, 102-103, of Roman Republic, 171 914 of the world, since 1945, 1127 Benin, 430-432, 430, 432 Mantegna, Andrea, 654 frescoes in Camera Picta, Ducal Palace, Man-Maqsura, 290 Bwa, Burkina Faso, 923-924, 923 tua. Italy, 646, 647 Marat, Jean-Paul, 975, 975 Dogon dama mask, Mali, 933, 933 Hamatsa masks, Kwakwaka'wakw, 888, 888 Mantle with bird impersonators (Paracas culture), Marathon, 129-130 Marc, Franz, The Large Blue Horses, 1073, 1074 Lega bwami, Democratic Republic of the 409.410 Mantua, Italy Marco Polo, 832, 836 Congo, 924-925, 925 Mende, Sierra Leone, 924, 924 architecture in, 644-647 Marcus Aurelius, 204, 216 Ducal Palace, 646, 647 Equestrian statue of Marcus Aurelius, 216, 217 Native American, 886-887, 888, 888 tatanua, New Ireland, 904, 904 Palazzo del Tè (Romano), 680, 680 Marduk, 42 Sant'Andrea church, 644-645, 645, 647 of Tutankhamun, funerary, 48, 49 Marduk Ziggurat, 42, 42 Margaret of Austria, 688 Masks (Nolde), 1070-1071, 1070 Manuel I, king of Portugal, 724 Masolino, Brancacci Chapel, Santa Maria del Manueline style, 724 Marie Antoinette, queen of France, 972, 972 Marilyn Diptych (Warhol), 1152, 1152 Carmine church, 636, 637 Manuscripts Beatus, 449-450 Marine style ceramics, 94, 94 Masonry Carolingian, 455-459, 455, 456, 457, 458 Marinetti, Filippo, 1084 Gothic masters, 525 Mannerism, 696, 696 Markets of Trajan, Roman, 206, 208, 208 Inca, 877-878, 878 Ottonian, 469-470, 469, 470 Mark the Evangelist, Godescalc Gospel Lectionary, Mastaba, 55, 56, 56 Master of Flémalle. See Campin, Robert Manuscripts, illuminated, 251 455-456, 455 Byzantine, 264-265, 264, 265, 274, 274 Marpacífico (Hibiscus) (Peláez), 1097, 1097 Master Theodoric, Saint Luke, 579-580, 580 Flemish, 588, 590-594, 592, 593, 594 Marquesas Islands, 909, 909 Maternal Caress (Cassatt), 1036, 1036 Marriage at Cana, Raising of Lazarus, Resurrection Mathematical perspective (one-point or linear), fourteenth century, French, 572-573, 573 Gothic, English, 538, 539 619, 621, 622, 635, 647 and Noli Me Tangere and Lamentation (Giotto di Gothic, French, 536, 537-538, 537 Bondone), 564, 566 Mathur, B. P., Gandhi Bhavan, Punjab University, Islamic, 303-304, 304, 305 Marriage Contract, from Marriage à la Mode (Hoga-India, 825-826, 826 Middle Ages, 440, 441, 447-449, 447. 449 rth), 961, 961, 963 Mathura school, 323-324, 324, 326 Ottoman, 306-307, 307 Marriage of the Emperor Frederick and Beatrice of Bur-Matisse, Henri Renaissance, 614-616, 652 gundy, The (Tiepolo), 945, 945 Le Bonheur de Vivre (The Joy of Life), 1068, 1069, 1070 Romanesque, 507-509, 508, 509, 510 Mars, 110, 179 The Woman with the Hat, 1068, 1068 Marseillaise, Departure of the Volunteers of 1792 scriptoria, 263, 447, 448, 450, 455, 469-470, (Rude), Arc de Triomphe, Paris, 997, 997 Matsushima screens (Sotatsu), 860, 861, 863 502, 507-510, 539 Marshall, Kerry James, Many Mansions, 1178, 1178 Maurya period, 316-319, 316, 318 Manuzio, Aldo (Aldus Manutius), 652 Marshall Field Wholesale Store (Richardson), Mausoleum. See Tombs Many Mansions (Marshall), 1178, 1178 Chicago, 1060, 1061 Mausoleum of Emperor Shihuangdi, China, Manyoshu (Japanese poetry), 382 Maori, New Zealand, 909-911, 909, 910, 911 Marshall Islands, stick charts, 896, 897 342-343, 343, 349 Mausoleum of Galla Placidia, 247-249, 248, 249 Marshals and Young Women, Parthenon, 142, 142 Mapplethorpe, Robert, 1183 Marsh Flower, a Sad and Human Face, The (Redon), Mausolos, 151 Maps of the Aegean, 85 1048-1049, 1048 Maxentius, 225 Basilica of Maxentius and Constantine of Africa, 423, 919 Martinez, Julian, Blackware storage jar, 889-890, (Basilica Nova), 227-228, 227, 228 of America in the nineteenth century, 987 Maya, 402-407 of the Americas, 397, 875 Martinez, Maria Montoya, Blackware storage jar, 889-890, 889 Maya, Mother of Buddha, Holding a Tree Branch, of Byzantine empire, 235 of China after 1280, 833 Martyrdom of Saint Bartholomew (Ribera), 765-766, Nepal, 813, 813 Mazarin, Cardinal, 793 of China before 1280, 345 765 Martyrdom of Saint Ursula (Memling), 608, 608 Mbis (spirit poles), Asmat, Irian Jaya, 903, 903 of Egypt, ancient, 51 Martyria, 286, 679 Meander, 189 of Europe in Baroque period, 745 Maruyama-Shijo school painting, 865-866, 865, Mecca, 283, 286 of Europe in Enlightenment, 943 of Europe in fourteenth century, 555 866, 868 Medallion, 239, 626, 626 of Europe in Gothic period, 515 Marx, Karl, xlvi, 986 Medallion rug, Ushak, 302, 302 f Europe in the Middle Ages, 443 Mary I, queen of England, 734 Medes, 42 Mary at Her Devotions from Hours of Mary of Burof Europe in the nineteenth century, 987 Medici, Catherine de, 720, 721, 722, 775, 776, gundy (Mary of Burgundy Painter), 593-594, 793 of Europe prehistoric, 3 594 Medici, Cosimo de' (the Elder), 623, 625, 627, of Europe in the Renaissance, 587, 621, 661, Mary Magdalen (Donatello), 632, 633 Medici, Giovanni de Bicci de', 624, 666-668, 668 of Europe in the Romanesque period, 475 Mary Magdalen with the Smoking Flame, (De La of Europe in the twentieth century, 1067 Tour), 797, 798 Medici, Giulio de', 667, 668, 675 Mary of Burgundy Painter, Mary at Her Devotions Medici, Lorenzo de' (the Magnificent), 620, 621, of Greece, ancient, 109 from Hours of Mary of Burgundy, 593-594, 594 651, 669, 675 of India after 1200, 811 of India before 1200, 313 Mary of Hungary, 688, 732 Medici Chapel, 675-677, 676 Medici family, 621, 623, 650, 675 of Islamic world, 285 Masaccio of Italy in the Renaissance, 621 Brancacci Chapel, Santa Maria del Carmine Medici Palace Courtyard, 627, 627 Medici-Riccardi palace, 625, 625, 627, 627 of Japan after 1392, 853 church, 636-638, 637, 638, 639 of Japan before 1392, 375 Medici Venus, statue, xxxvi, xxxvi Expulsion from Paradise, 636, 638 of Korea, 345 real name of, 635 Medina, 283, 286 Tribute Money, 636-638, 639 of Mesoamerica, after 1300, 875 Medusa, pediment on Temple of Artemis, Cofru, 119, 119 of Near East, 27 Trinity with the Virgin, Saint John the Evangelist, of North America in Baroque period, 745 and Donors, 635-636, 636 Meeting, The (Fragonard), 950, 951 of North America in Enlightenment, 943 Masjid-i Jami, (Great Mosque of Isfahan), Iran, Meetinghouse (Rukupo), Maori, 910-911, 911 295, 297, 297 Megalithic architecture, Neolithic, 15-17, 16, 17 of North America in the twentieth century,

Masks

1067

Megaron, 95, 96-97

Mehmed II, 279 Metamorphoses (Ovid), 179 Miracle of the Crib at Greccio (Saint Francis Master), Mehretu, Julie, Dispersion, 938, 938 Metopes, 117, 118 550, 550 Meiji period, 868 Mexican art Miraculous Draft of Fishes (Raphael), 668-669, 668 Meketre, 66, 66 Aztecs, 872-873, 873, 874-876 Miraculous Draft of Fishes (Witz), 613, 614 Melanesia, 901-904, 903, 904 interwar years, 1113-1114, 1113 Miradors, 300 Melencolia I (Dürer), 706, 707-708 Modern art, 1097-1098, 1098 Miró, Joan, Shooting Star, 1122, 1122 Melos, Aphrodite of (Venus de Milo), 165, 166 Meyer, Adolf, Fagus Shoe Company, 1100-1101, Mirror, Etruscan, 177, 178 Melun Diptych (Fouquet), 609-610, 610 Mississippian Period, 412-416 Memento mori, 949 Michelangelo Buonarroti, 220, 799 Mithras, 179 Memling, Hans Creation of Adam, 671, 674, 674 Mithuna couples, 322, 325, 328 Martyrdom of Saint Ursula, 608, 608 David, 670, 671 Mnesikles Saint Ursula reliquary, 608, 608, 609 Last Judgment, 688, 689, 690 Erechtheion, Acropolis, 142-144, 143 Memory images, 6, 54 Medici Chapel, 675-677, 676 Propylaia, 142 Memphis, 80 Moai ancestor figures, Easter Island, 906, Moses, 675, 675 Mende masks, Sierra Leone, 924, 924 Pietà, 669-671, 669 906-907, 909 Mendieta, Ana Rondanini Pietà, 690, 691 Moats, 254, 490, 493, 541 Silhouettes, 1165 Saint Peter's basilica, plan for, 679, 679, 690, Mobiles, 1119 Untitled work from the Tree of Life series, Moche culture, 411-412 1165-1166, 1167 Sistine Chapel, 671, 672, 673, 674, 674 Moche Lord with a Feline, 411, 411 Michelozzo di Bartolomeo Moctezuma, feather headdress of, 876, 877 Mengs, Anton Raphael, Parnassus, 955, 955 Cathedral Dome, 624, 625 Modeling, 10 Menkaura, 58, 60-61, 60 Palazzo Medici-Riccardi, 625, 625, 627, 627 Modena Cathedral, Creation and Fall (Wiligelmus), Menkaura and a Queen, 60-61, 60 Micronesia, 904-905, 905 Italy, 495, 495 Menorahs, 201, 236, 236 Middle-Aged Flavian Woman, 204, 205 Modern art Mentuhotep, Nebhepetre, 62 Middle Ages American, 1091-1095, 1092-1095 Mercury, 110 British Isles, 446-448 in architecture, 1100-1105, 1100-1105, 1167, Merian, Maria Sibylla, Wonderful Transformation of Carolingian Europe, 450-459 1169-1170, 1167, 1169 Caterpillars and (Their) Singular Plant Nourishdefined, 444 Argentina, 1096-1097, 1097 ment, 746, 746 description of, 442-443 Art Nouveau, 1053-1057, 1054, 1055, 1056 Mérode Altarpiece (Triptych of the Annunication) Lombards, 444 Bauhaus art in Germany, 1110-1111, 1110, (Campin), 587, 588, 597-598, 597 map of Europe in, 443 1111, 1112 Meryeankhnes, queen, 61, 61 Ottonian Europe, 464–470 birth of, 1038 Merz, Mario, Igloo, 1159, 1159 Scandinavia, 444–446 Blue Rider (Der Blaue Reiter), 1073-1076, Merzbild 5B (Picture-Red-Heart-Church) (Schwit-Spain, 449-450 1074, 1075, 1076 ters), 1090, 1091 timelines 457, 465 Brazilian, 1096, 1096 Mesoamerica Vikings, 459-464 Canadian, 1098-1100, 1099 SEE ALSO Mexican art; Native American art Visigoths, 443–444 Constructivism, 1105-1107, 1106 aztecs, 872-873, 873, 874-876 Mies van der Rohe, Ludwig, 1112 Cuban, 1097, 1097 ball game, cosmic, 405 Seagram Building, New York City, 1167, 1167 Cubism, 1076-1086, 1076-1086 European conquest of, 880 Migrant Mother, Nipomo, California (Lange), Dadaism, 1088-1091, 1088-1091 Incas, 876-880 1116, 1116 expressionism, 1072-1073, 1072, 1073 map of, after 1300, 875 Migration of the Negro, The (Lawrence), 1115, Fauvism, 1067-1070, 1068, 1069 Maya, 402-407 International style, 1109 Olmec, 398-399 Mihrab, 288, 289, 291, 297, 297, 298, 299, 433 Mexican, 1097-1098, 1098 periods of, 398 Milan 247 Nazi suppression of, 1112 range of, 397 Sant' Ambrogio church, Milan, 488, 489 primitivism and the Bridge (Die Brücke), Spanish art, influence of, 977, 977, 978, 979, Santa Maria delle Grazie monastery, 662, 663, 1070-1072, 1070, 1071 Rationalism, 1107-1110, 1108, 1109 Teotihuacan, 399-402 Miletos, 129 sculpture, abstraction, 1086-1087, 1087 timeline, 406 city plans, 149-150, 149 Socialist Realism, 1107, 1107 Mesolithic period. See Neolithic period Millet, Jean-François, 1018 Surrealism, 1119-1122, 1120, 1121, 1122 Mesopotamia. See Near East The Gleaners, 1019, 1019 Modernismo, 1054 Metalwork Mill Run, Pennsylvania, Fallingwater, Kaufmann Modersohn-Becker, Paula, Self-Portrait with an Aegean (Minoan), 89, 89, 93, 94, 94–95 House (Wright), 1103, 1103 Amber Necklace, 1072, 1073 Byzantine, 273-274 Mimbres/Mogollon culture, 416 Modules, 359, 624, 860 English armor for royal games, 737, 737 Mimis and Kangaroo, prehistoric cave art, Australia, Mohenjo-Daro, citadel in, 313-314, 314 engraving, 615 900, 900 Moholy-Nagy, László, 1110 Georgian silver, 962, 962 Minamoto Yoritomo, 389, 854 Moissac, France, Saint-Pierre priory church, German, 714, 714 Minarets, 288, 818 496-497, 496 Greek, 113-114, 113, 131-134, 133, 134 Minbar, 290, 298, 299 Momoyama period, 856-859 Inca, 879-880, 880 Minerva, 110 Mona Lisa (Leonardo), 664-665, 664 Islamic, 300-301, 301 Ming dynasty, 835-843 Monasteries, 446 Lombards, 444, 445 Miniatures, 251, 304 Benedictines, 451, 477 Mycenaean, 93, 102-103, 102, 103 Minimalism, 1154-1158 of Centula, France, 453-454, 453 New York School, 1138-1140, 1139 Minoan civilization of Christ in Chora, 278, 279 Norse, 445-446, 446 development of, 86 Cistercians, 477, 484-485, 509 Romanesque, 506-507, 506, 507 New Palace period, 89-95 Cluny, 477, 482, 483 Samurai armor, 389, 389 Old Palace period, 86-89 Dominicans, 514, 524 Sumerian, 34-35, 34 origin of name, 86 Franciscans, 514, 524 Minos, king, 84, 86 techniques, 93 of Hosios Loukas, Greece, 269, 269, 270, 271 Visigoths, 443-444, 444 Minotaur, legend of, 86, 94 of Saint Gall, 454-455, 454

Mondrian, Piet, 1107, 1131 Napoleon in the Plague House at Jaffa (Gros), Mrs Freake and Baby Mary (anonymous), 806, 806 Composition with Yellow, Red, and Blue, Mshatta, Jordan, palace at, 288, 288 988-989, 989 1108-1109, 1108 Muawiya, 284 Naram-Sin, 36-37, 36 Monet, Claude, 1026 Mudras, 324, 325, 816 Nara period, Japan, 382-383, 382, 854 Gare St. Lazare, 1030-1031, 1030 Mughal period, India, 809, 817-825 Narmer Palette, 53-54, 53 On the Bank of the Seine, Bennecourt, Muhammad, 283-284, 285 Narthex, 237, 242, 451 1029-1030, 1029 Muhammad V. 299 Naskhi, 293 Rouen Cathedral: The Portal (in Sun), 1031, 1031 Mukhina, Vera, Worker and Collective Farm Woman, Nasrids, 299 Mongols, 294, 832, 833, 839 1107, 1107 National Academy of Design, 1092 Monk Sewing (Kao Ninga), Kamakura period, Mullions, 531 National Endowment for the Arts (NEA), 1183 Japan, 390, 390 Mummies, 80, 80 National Museum of the American Indian, 893, Monograms (Christian symbol), 238 preserving, 55 894 Monoliths, Great Zimbabwe, 435, 436 Munch, Edvard, The Scream, 1049-1050, 1049 Native American art Montbaston, Jeanne de, 592 Muniz, Vik, Action Photo I (from "Pictures of Choco-Aztecs, 872-873, 873, 874-876 Montefeltro, Federico da, 620, 640-644, 643, 666 late"), 1174, 1174 contemporary, 892-893, 892, 894 Monticello (Jefferson), Virginia, 980, 980 early cultures, 412-418, 413-418 Muqarnas, 292, 295, 300, 300 Montreal, Canada, Habitat '67 (Safdie), Eastern Woodlands, 880-884, 880-883 Murakami, Takashi 1169-1170, 1169 Eye Love Superflat, 1178-1179, 1179 European conquest of, 880 Great Plains, 884-886, 884, 885 Mont Sainte-Victoire (Cézanne), 1039-1040, Magic Ball (Positive), 869-870, 870 1039 Incas, 876–880 Murals Monumental sculpture. See Sculpture, monumeninfluence on Emily Carr, 1099, 1099 SEE ALSO Cave art Modern, 1178, 1178 Greek, Classical 148, 148, 155-156, 156 Moon Goddess Coyolxauhqui, Aztec, 875, 876 Navajo, 887, 890-892, 891 Italian Renaissance, 635-640, 636-640 Moore, Henry, Recumbent Figure, 1118-1119, Northwest Coast, 886-887, 886, 887 Japanese, Nara period, 382-383, 382 1118 Pueblos, 887, 889-890, 889 Minoan, 90-92, 90, 91, 92 Moors, 449 Southwest, 887, 889-892, 889, 891 Rajarajeshvara Temple to Shiva, Thanjavur, Moreau, Gustave, Apparition, 1048, 1048 Spanish art, influence of, 977, 977, 978, 979, India, 336, 336 Morisot, Berthe, 1026 Roman, Republic, 193–198, 193–199 Summer's Day, 1036, 1037 Nativity and Adoration of the Shepherds, The Romanesque, 499, 500, 501, 504 Morisot, Edma, 1036 (Ghirlandaio), 649-650, 649 Murasaki, Lady, 383, 386 Morley, Elizabeth, 962 Nativity pulpit (G. Pisano), 548-549, 548 Murillo, Bartolomé Esteban, The Immaculate Con-Morris, William, Peacock and Dragon curtain, 1024, Nativity pulpit (N. Pisano), 547-548, 548 ception, 769-770, 770 Nativity with Prophets Isaiah and Ezekiel, Maestà Muromachi (Ashikaga) period, 852-856 Altarpiece (Duccio di Buoninsegna), 569, 570 Morris & Company, 1024, 1024 Museum of Modern Art, New York City Mortise-and-tenon joints, 19, 840 Naturalism, xxxiii-xxxiv, 350, 421 International style, 1109 Mosaics Nature and Importance of Positive Philosophy, The landscape architecture, 1187, 1187 Byzantine, 262, 262, 269, 271, 271 (Comte), 1009 Musical instruments Christian, 245-246, 246 Nature Symbolized No. 2 (Dove), 1095, 1095 Chinese zither (qin), 863 Greek, 155-157, 156 Nauman, Bruce, Self-Portrait as a Fountain, 1160, Great Lyre with Bull's Head, Ur, 34-35, 34 Islamic, 287, 297, 297 Paleolithic 7 Roman, Imperial, 213-215, 213, 214 Naumburg Cathedral, Germany, 545, 545, 547 Muslims. See Islam Roman, Republic, 193, 193 Navajo, 887, 890-892, 891 Mussolini, Benito, 1066 Romanesque, 499, 500, 501, 504 Navajo Night Chant, 890 Mycenaeans synagogue floor, 237-238, 237 Nave, 206, 242, 526 architecture, 95-102, 96-102 techniques, 215 Naxos, 84 ceramics, 104, 104 Moscow, Byzantine icons, 278-279, 280 Navaks, 812 metalwork, 102-103, 102, 103 Moser, Mary, 952 Nazca, 410-411 sculpture, 103-104, 103 Moses (Michelangelo), 675, 675 Nazis, 1066, 1112 Myron, Discus Thrower (Diskobolos), 106, 107 Mosque at New Gourna (Fathy), 307, 308 Neanderthal, 2 Mysticism, 580, 582, 582 Mosques Near East Mystic Nativity (Botticelli), 652-653, 653 central-plan, 289, 289, 305-306 Akkad, 36-37 defined, 285 Assyria, 25, 40–41 Great Friday Mosque, Jenné, 433, 434 Babylon, 37, 38 Great Mosque of Córdoba, Spain, 290-291, Nadar (Gaspard-Félix Tournachon), Portrait of Elam 26 290. 291 Charles Baudelaire, 1011-1012, 1011 fertile crescent, 26, 27, 28-29 Great Mosque of Isfahan (Masjid-i Jami), Iran, Naming works of art. 5 first cities, 26, 27, 28 295, 297, 297 Namuth, Hans, Photograph of Jackson Pollock paint-Hittites of Anatolia, 37, 39 Great Mosque of Kairouan, Tunisia, 288, 290, ing, 1134, 1134 Lagash, 37 290 Nanchan Temple, Tang dynasty, China, 358-359, map of, 27 plans, 289, 289 359 neo-Babylonia, 42 of Sultan Selim (Sinan), Turkey, 306, 306, 307 Nanga school painting, 863, 863 Persia, 42-46 Mossi dolls (biiga), Burkina Faso, 920, 921 Nankani compound, Ghana, 919-920, 920 Sumer, 29-35 Mott, Lucretia, 986 Nan Madol, 904-905, 905 timelines, 35, 39 Moulin de la Galette (Renoir), 1032-1033, 1033 Nanna Ziggurat, Ur, 33, 33 Nebel (Fog) (Friedrich), 1000-1001, 1000 Mound builders, 413 Nanni di Banco, The Four Crowned Martyrs, Orsan-Nebuchadnezzar II, 42 Mountains and Sea (Frankenthaler), 1137, 1137 michele church, 628-629, 628 Necking, 118 Mountains at Collioure (Derain), 1068, 1068 Naos, 114, 116, 242, 257 Mount Fuji teabowl (Koetsu), 859-860, 859 Napoleon, 998 Necropolises, 55-59, 233-234 Nefertari Mouth of Hell, Winchester Psalter, 508-509, 509 Napoleon III, 1013, 1014, 1015, 1017, 1027 Mozarabic art, 449-450, 450 Making an Offering to Isis, 75, 79 Napoleon Crossing the Saint-Bernard (David), 988, Mozi, 348 988 temples of, 75-78, 76, 77

skyscrapers, 1104-1105, 1104, 1105, 1167, map of, in the twentieth century, 1067 Nefertiti, 72, 73, 73, 74, 74, 84 1167, 1170, 1170 Mississippian Period, 412-416 Nemes headdress, 52, 72 Trans World Airlines Terminal (Saarinen), John Northwest Coast, 886-887, 886, 887, 888, Neo-Babylonia, 42 F. Kennedy Airport, 1169, 1169 Neoclassicism Southwest, 416-418, 887, 889-892, 889, 891 Trinity Church (Upjohn), 1009, 1009 architecture, American, 979-980, 980, 1007-1008 1007 Woolworth Building, 1105, 1105 timeline, 413 Woodland Period, 412 architecture, English, 959-960, 960 New York School, 1131-1141, 1131-1140 New Zealand, 909-911, 909, 910, 911 North American art. See American art; Native architecture, French, 969-970, 970 architecture, German, 1008, 1008 Nicholas of Verdun, Shrine of the Three Kings, American art defined, 899, 987 543-544, 544 Northwest Coast Native Americans, 886-887, in the nineteenth century, 987 Nicomachus Flavianus, Virius, 229 886, 887, 888, 888 painting, American, 981-982, 981 Niello, 93, 506 Norway burial ship, Oseberg, 459-460, 459, 460 painting, English, 961, 961, 963-969, 963-969 Nietzsche, Friedrich, 1138 painting, French, 988-990, 988-991 timber architecture, 461, 462, 463, 463 Nigeria Urnes, church portal, 461, 462 painting, Italian, 952-956, 953, 954, 955 Benin, 428, 428, 430-432, 430, 432 Notre-Dame abbey church, Fontenay, Burgundy, Igbo-Ukwu, 427, 427, 429, 429 in Rome, 954-956, 955, 956 sculpture, American, 997-998, 997 Nigeria, Yoruba of Ife France, 484-485, 485 children, performances by, 922, 922 Notre-Dame cathedral sculpture, Italian, 955-956, 956 divination sessions, 927-928, 927 Amiens, 528, 530-531, 530, 532-533, 533, Neo-Confucianism, 362, 859 534, 535 Neo-Expressionism, 1175-1177, 1175, 1176 heads, 429-430, 429, 430 Chartres, 518-521, 519, 520, 523, 525, 526, Olowe of Ise, door of palace, 931-932, 931, Neo-Impressionism, 1042 527-528, 527, 529 Neolithic period ritual vessel, 420, 421 Paris, 517-518, 518 architecture, 13-17, 14, 15, 16, 17, 19 Reims, 531-532, 531, 532, 533-535, 535 twin figures (ere ibeji), 921-922, 922 in China, 344-346 Nubians, 79-80 Night Attack on the Sanjo Palace, Kamakura period, description of, 11-12 Japan, 388-389, 388, 389 Nymph of the Spring (Cranach the Elder), in Egypt, 50 Nightmare, The (Fuseli), 968, 968 717-718, 718 rock-shelter art, 12-13, 12 sculpture and ceramics, 18-20, 18, 20 Nike, 110 Nike (Victory) Adjusting Her Sandal, Acropolis, 144, Neoplatonists, 623 Nepal, Tantric influence, 813, 813 Oath of the Horatii (David), 974, 974 Neptune, 110 Nike (Victory) of Samothrace 163, 164 Object (Le Déjeuner en fourrure) (Luncheon in Fur) Neri, Filippo, 757 Nile, 50 Nero, 189, 199 (Oppenheim), 1121-1122, 1121 Nimrud, 25 Nerva, 204 Assurnasirpal II Killing Lions, 40, 40 Octavian, 185 Human-Headed Winged Lion (lamassu), 24, 25 Octopus Flask, Crete, 94, 94 Neshat, Shirin, Fervor, 1188, 1188 Nine Mile Canyon, Utah, 414, 414 Oculus, 172, 210, 527, 624 Netherlands Baroque painting, 779-793, 781-793 99 Cent (Gursky), 1174, 1175 Odalisque, 989 Odyssey (Homer), 84, 98 Nineveh, 36, 41 Rationalism, 1107-1110, 1108, 1109 Renaissance painting, 728-734, 729-734 Nizami, Khamsa (Five Poems), 304, 305 Officers of the Haarlem Militia Company of Saint Schröder House (Rietveld), 1108, 1109-1110, Ni Zan, The Rongxi Studio, 835, 835 Adrian (Hals), 782, 782 Nkanu, Initiation wall panels, Democratic Ofili, Chris, Holy Virgin Mary, 1182, 1183, 1183 1109 Republic of the Congo, 934, 934 Oh Jeff...I Love You, Too...But..., (Lichtenstein), Neumann, Johann Balthasar Church of the Vierzehnheiligen, 945-946, Nkisi nkonde, Kongo spirit figure, Democratic 1153, 1153 Republic of the Congo, 926, 926 O'Keeffe, Georgia 945.946 Nobunaga, Oda, 856 City Night, 1095, 1095 Kaisersaal (Imperial Hall), Residenz, Germany, Nocturne in Black and Gold, the Falling Rocket Red Canna, xxxv, xxxv 944-945, 944, 945 (Whistler), 1025, 1026 Okyo, Maruyama, Pine Tree in Snow, 865, 865 Nevelson, Louise, 1138, 1140 Sky Cathedral, 1140, 1141 Nocturnes, 1025 Oldenburg, Claes, 1153 Nok culture, 425-426, 427, 921 Newborn (Brancusi), 1087, 1087 Lipstick (Ascending) on Caterpillar Tracks, 1154, New Delhi, 825 Nolde Emil 1112 1154 Masks, 1070-1071, 1070 Old Sacristy, San Lorenzo Church (Brunelleschi), New Grange, Ireland, tomb interior, 15-16, 16 Noli Me Tangere (Fontana), 698-699, 699 New Guinea, 901 Florence, 624, 624 Old Saint Peter's basilica, Rome, 243-244, 243, New Ireland, 903-904, 904 Normandy Bayeux Tapestry, 504-505, 504, 505 Newman, Barnett, Vir Heroicus Sublimis, 1138, Saint-Étienne church, Caen, 492-493, 492, Old Testament Trinity (Three Angels Visiting Abraham) (Rublyov), 278-279, 280 New Mexico, Sun Dagger, Pueblo Bonito, Chaco Canyon, 394-395, 395-396, 416, 417-418, Saint-Maclou church, 610-611, 611 Old Woman, Greece, 164-165, 165 Norman Palace (King Roger), Palermo, Sicily, Olga, princess, 268 417, 418 277-278, 278 Olmec, 398-399 New Negro movement, 1114 Normans, 274-275, 459, 476 Olmsted, Frederick Law New Realism, 1149 Newton, Isaac, 942 SEE ALSO Normandy Central Park, New York City, 1059, 1059 Norse, 445-446 World's Columbian Exposition, Chicago, 1060 New York City North America Olowe of Ise, door of palace, Yoruba, Nigeria, SEE ALSO Museum of Modern Art Abstract Expressionism, 1131-1141, SEE ALSO America; Americas 931-932, 931, 932 cultures, 412-418, 881 1131-1140 Olpe, 114, 115 Ashcan School, 1092 East, 412 Eastern Woodlands, 880-884, 880-883 AT&T Corporate Headquarters (Johnson and Hera I, temple of, 116, 117, 117, 119 Burgee), 1170, 1171 Great Plains, 884-886, 884, 885 Zeus, temple of, 130-131, 130, 131 Central Park (Olmsted and Vaux), 1059, 1059 Hamatsa masks, Kwakwaka'wakw, 888, 888 Olympia (Manet), 1028-1029, 1028 Olympic Games, 107 Seagram Building (Mies van der Rohe and map of, in Baroque period, 745

map of, in Enlightenment, 943

One and Three Chairs (Kosuth), 1160, 1160

Johnson), New York City, 1167, 1167

One Hundred Views of Edo: Plum Orchard, Kameido peopling of, 898-899 Florentine fourteenth century, 559, 561-566, (Hiroshige), 1044, 1044 Polynesia, 905–912 562, 563, 565, 566 One-point perspective (linear or mathematical), recent art in Oceania, 912-914, 913, 914 French Baroque, 797-800, 798-801 619, 621, 622, 635, 647 timeline, 913 French Neoclassicism, 971–976, 971–975, On the Bank of the Seine, Bennecourt (Monet), Padua, Italy, frescoes, Scrovegni (Arena) Chapel, 988-990, 988-991 1029-1030, 1029 563-567, 565, 566 French Realism, 1017-1021, 1017-1021 Op Art, 1154-1158 Paestum, Italy, temple of Hera I, 116, 117, 117, French Renaissance, 720, 720 Openwork box lid, Ireland, 22, 22 French Rococo, 946, 947, 948-951, 949, 951 Opéra (Garnier), Paris, 1013-1014, 1013, 1014 French Romanticism, 990-996, 992-996 Pagodas, 359-360, 360, 361, 379 Opithodomos, 116 Genre, 744, 836, 789-790 Paik, Nam June, 848 Oppenheim, Meret, Object (Le Déjeuner en fourrure) German expressionism, 1072-1073, 1072, Electronic Superhighway: Continental U.S., (Luncheon in Fur), 1121-1122, 1121 1187-1188, 1188 Opus anglicanum, 575-576, 576 German Renaissance, 711-719, 712-719 Painted banner, Han dynasty, China, 349, 351, Oracle bones, 346-347 Harlem Renaissance, 1114-1116, 1114, 1117 Orant figures, 239, 239 history, 948 Painted Pottery, Neolithic Chinese, 344-345, 345 Orator, The (Aulus Metellus), Roman, 180, 181 Impressionism, 1026-1038, 1027-1037 Painted vases Orbais, Jean d', 531 Indian, Gupta period, 326-327, 326 black-figure, 114, 115, 125-126, 125, 126 Orcagna (Andrea di Cione) Indian, Mughal, 818-821, 819, 821, 822 Greek, Archaic, 114, 125-128, 125, 126, 127 Florence Cathedral, 558, 558, 559 Indian, Rajput, 821, 823-825, 823, 824 Greek, Classical, 134-135, 135, 148, 148 Orsanmichele Tabernacle, 552, 553-554 ink, 852-855, 852, 855, 864 Greek, Geometric, 112-113, 113 Orchestra, 160 Islamic miniatures, 304, 304 Mayan, 406, 406 Orgaz, Count, 726, 727 Italian Baroque, 754-764, 755-763 red-figure, 114, 126-128, 127 Orientalism, 1005-1007, 1005, 1006 Italian Neoclassicism, 952-956, 953, 954, 955 standard shapes, 125 Orientalizing period of Greek art, 111, 114 Italian Renaissance, 634-640, 634-640. techniques for, 114 Orsanmichele, 553, 628-629 642-644, 642, 643, 644, 647-653, white-ground, 114, 148, 148 Orthogonal city plans, 149-150, 149 Painting 648-653, 654-655, 654, 655, 656, 662, Orthogonals, 622 663, 664-669, 664-668, 671-674, 672, SEE ALSO Cave art; Landscape painting; Osberg ship, Norway, 459-460, 459, 460 673, 674 Mosaics; Murals; Portraiture Osiris, 51-52, 78-79, 79, 179 Abstract Expressionism, 1131-1138, Japanese Heian period, 386-388, 387, 388 Osman, 305 1131-1139 Japanese ink, 852-855, 852, 855 Ostrogoths, 247, 442 Action (gesturalism), 1133-1137, 1134, 1135, Japanese Kamakura period, raigo, 391, 392 O'Sullivan, Timothy H., Ancient Ruins in the apanese Kano decorative, 857-858, 858 1136, 1137 American early, 806, 806 Cañon de Chelley, Arizona, 417, 417 Japanese Maruyama-Shijo school, 865-866, 865 Otto I, Holy Roman emperor, 464 American Neoclassicism, 981-982, 981 apanese Modern, 868-870, 869, 870 Otto I Presenting Magdeburg Cathedral to Christ, Japanese Nanga school, 863, 863 American Realism, 1022, 1022, 1023 464, 464 Japanese Rimpa school, 860-861, 861, 863 Australian Aborigine, 900-901, 900, 901, Japanese Zen, 863–865, 864 Otto II, Holy Roman emperor, 464 913-914, 914 Otto III, Holy Roman emperor, 456, 464, 469, bark painting, Australian, 900-901, 901 Korean, 370, 370, 846-848, 846, 847, 848 470, 479, 605, 606 Baroque, Flemish, 774-779, 774-779 literati, 833, 841-843, 841, 842, 853 Otto III Enthroned, Liuthar (Aachen) Gospels, 469, lithography, 994 Baroque, French, 797-800, 798-801 Mannerism, 693–696, 693, 694, 695, 697, 469 Baroque, Italian, 754-764, 755-763 Ottoman Empire Baroque, Spanish, 764-770, 764-770 698-699, 699 architecture, 305-306, 306, 307 Mayan, 406, 406 on canvas, 682 illuminated manuscripts and tugras, 306-307, catacomb, 238-240, 239 Navajo sand, 890-892, 891 307 Chinese, Ming dynasty, 836-838, 836, 838, Neoclassicism, American, 981-982, 981 Ottonian Empire Neoclassicism, English, 961, 963-969, 961, 841-843, 841, 842 architecture, 464-465, 465, 468 Chinese, modern, 844-845, 845 963-969 ivories, 464, 464 Chinese, Qing dynasty, 843-844, 843, 844 Neoclassicism, French, 971-976, 971-975, anuscripts, 469-470, 469, 470 988-990, 988-991 Chinese, Six Dynasties, 354-356, 355 sculpture, 466, 466, 467, 468-469, 468 Chinese, Song (northern) dynasty, 362-365, Neoclassicism, Italian, 952-956, 953, 954, 955 Our Lady of Guadalupe (Salcedo), 977, 978 363, 364 Neo-Expressionism, 1175-1177, 1175, 1176 Outbreak, The (Kollwitz), 1072-1073, 1072 Chinese, Song (southern) dynasty, 365-366, Netherlands, Renaissance, 728-734, 729-734 Oval plate (Palissy), 723, 723 New Zealand, 909-910, 909 364-365 Ovid, 179, 198 Chinese, Tang dynasty, 358, 359, 360, 361 oil and tempera, 596, 634-640, 636-640, 662, Ovoid, 886 682-686, *683-687* Chinese, Tang dynasty figure, 360, 361 Oxbow, The (Cole), 1004, 1005 Chinese, Yuan dynasty, 832-833, 834, 835 oil painting in Venice, 699-702, 700, 701 Orientalism, 1005-1007, 1005, 1006 color field, 1137-1138, 1138, 1139 Cubism, 1076-1086, 1076-1086 on paper, 820 Pachacuti, 878 pastels, 952 Der Blaue Reiter, 1073-1076, 1074, 1075, Plains Indian, 884-885, 885 Pacific cultures and art Australia, 900-901, 900, 901, 913-914, 914 Die Brücke, 1070-1072, 1070, 1071 plein air, 1031-1033 Easter Island, 908, 909, 911-913, 912, 913 Post-Impressionism, 1038-1046, 1039-1047 English late nineteenth century, 1023-1024, Hawaiian Islands, 867-868, 867, 868 primitivism, 1070-1072, 1070, 1071 Irian Jaya, 903, 903 Realism, American 1022, 1022, 1023 English Neoclassicism, 961, 963-969, 961, map of regions, 899 963-969 Realism, French, 1017-1021, 1017-1021 Marquesas Islands, 909, 909 English Renaissance, 735-738, 735, 736, 738 Realism, Russian, 1021-1022, 1021 Melanesia, 901-904, 903, 904 English Romanticism, 967-969, 968, 969 Renaissance, early, 634-640, 636-640. Micronesia, 904-905, 905 Expressionism, 162, 1043, 1072-1073 642-644, 642, 643, 644, 647-653, 648-653, New Ireland, 903-904, 904 Fauvism, 1067-1070, 1068, 1069 654-655, 654, 655, 656 New Zealand, 909-911, 909, 910, 911 Flemish, 596-609, 597, 599, 600-609 Renaissance, English, 735-738, 735, 736, 738

Flemish Baroque, 774-779, 774-779

Papua New Guinea, 901-903, 903

Renaissance, French, 720, 720

Norman Palace, 277-278, 278 Parterres, 796 Renaissance, German, 711-719, 712-719 Parthenon, Acropolis Renaissance, High, 662, 663, 664-669, Palatine Chapel, 277, 277 description of, 116, 136-142, 138, 139, 140, 664-668, 671-674, 672, 673, 674 Palestrina, Sanctuary of Fortuna Primigenia, 183, Renaissance, Netherlands, 728-734, 729-734 141, 142 183 Doric frieze, 140-141, 140 Renaissance, Spanish, 725-728, 726, 727 Palissy, Bernard, 723, 723 Palladio (Andrea di Pietro della Gondola), 956, pediments, 137, 140 rock painting, Australian, 900, 900 processional frieze, 141-142, 141, 142 rock-shelter, 12-13, 12 Four Books of Architecture, 704, 801 Parting of Lot and Abraham, mosaic, Rome, 246, Rococo, French, 946, 947, 948-951, 949, 951 Roman, 198, 198 San Giorgio Maggiore church, Venice, 702, Pascal, Blaise, 942 703, 703 Romanticism, English, 967-969, 968, 969 Romanticism, French, 990–996, 992–996 Villa Rotunda, 704, 704 Passage grave, 15-16 Romanticism, Spanish, 998, 998, 999, 1000 Pallavas, 333, 335 Pastels, 952 Pastoral Concert, The (Giorgione and Titian), 684, Russian Realism, 1021-1022, 1021 Palmettes, 146 Pan, 110 684 sand, 890-892, 891 Spanish Baroque, 764-770, 764-770 Panofsky, Erwin, 707 Patrons of art SEE ALSO under name of Pan Painter, Artemis Slaying Actaeon, 134-135, 135 Spanish Renaissance, 725-728, 726, 727 Spanish Romanticism, 998, 998, 999, 1000 American government, 1116 Panthéon (Soufflot), Sainte-Geneviève, Paris, 970, Symbolism, 1047-1051, 1048-1051 aroque period and, 744, 775 collectors and museums as, xlvi Pantheon, Rome, 210, 210, 211, 212 Tangka, 813, 813 controveries over public funding, 1183 Painting (Wols), 1130, 1130 Papacy Painting #99 (Lozza), 1142, 1142 SEE ALSO under name of pope defined, xliiii in England, 538 list of popes during Romanesque period, 489 Pakal, Lord, palace and tomb of, Mayan, 403-404, in France, 609, 720, 722 list of popes who were patrons of the arts, 404 individuals as, xlv-xlvi, 675, 763, 778, 912 Palace(s) in Italy, 547, 620, 623, 634, 661, 675 Assurnasirpal II, 24, 25, 40, 40 Paper first manufactured, 292-293 in the Netherlands, 728 Banqueting House (Jones), Whitehall Palace, popes who were, 661, 671 London, 802, 802, 803 Indian painting on, 820 Papua New Guinea, 901-903, 903 in Spain, 725 Blenheim (Vanbrugh), England, 803-804, 804 women as, 688, 722 Ca D'Oro (House of Gold), Contarini Palace, Paracas, 410-411 Pattern and Decoration movement, 1165 Venice, 653, 654 Parapets, 145 Paul III, pope, 671, 678, 687, 688, 690, 691 Chapel of Charlemagne, 451, 452, 453 Parchment, 251, 292, 448, 450 Parinirvana of the Buddha, Sri Lanka, 339, 340 Paul V, pope, 747 Château of Chenonceau, 720-721, 721, 722 Pausanias, 100, 179, 212 della Signoria (Cione and Talenti), Florence, Bibliothèque Sainte-Geneviève (Labrouste), Pausias, 156 557. 557 Paxton, Joseph, Crystal Palace, London, 1012, Ducal Palace, Mantua, Italy, 646, 647 1012-1013, 1013 Departure of the Volunteers of 1792 (The Marseil-Ducal Palace, Urbino, Italy, 640-642, 641, 642 Dur Sharrukin, 40-41, 41 laise) (Rude), Arc de Triomphe, Paris, 997, Peacock and Dragon curtain (Morris), 1024, 1024 Pech-Merle cave, Spotted Horses and Human Hands, El Escorial (Bautista and Herrera), Madrid, École des Beaux-Arts, 948, 988, 1012, 1013, 725, 725 Farnese, Rome, 678, 678, 680, 755-757, 755, Pectoral, of Senusret II, 64, 64 Pedestals, 174 756 Eiffel Tower, Paris, 984, 985 Fontainebleau, France, Chamber of the Louvre, palais du (Lescot), 723, 723 Duchess of Étampes, 721–722, 722 Notre-Dame cathedral, 517-518, 518 Peeters, Clara, Still Life with Flowers, Goblet, Dried Fruit, and Pretzels, 778-779, 779 Opéra, (Garnier), 1013-1014, 1013, 1014 of Inscriptions, Mayan, 403-404, 404 Peláez, Amelia, Marpacífico (Hibiscus), 1097, 1097 Panthéon, Sainte-Geneviève (Soufflot), 970, Knossos, 86-95, 87, 88 Pelican Figurehead, Florida Glades culture, Key Louvre (Lescot), Paris, 723, 723 Marco, 415-416, 416 Medici-Riccardi, 625, 625, 627, 627 Sainte-Chapelle, 536-537, 536 Pen box (Shazi), 300-301, 301 Salon de la Princesse (Boffrand), Hôtel de Minoan, 86-88, 87 Mshatta, Jordan, 288, 288 Soubise, 943, 944 Pendentive domes, 248 Pendentives, 248, 257 Nebuchadnezzar II, 42, 42, 43 Paris Psalter, Byzantine manuscript, 274, 274 People and Animals, Cogul, Spain, 12-13, 12 Paris Street, Rainy Day (Caillebotte), 1034, 1035 Pylos, 97, 97, 98, 99 Parkinson, Sydney, Portrait of a Maori, 909-910, Peplos, 123 Residenz (Neumann), Germany, 944-945, 944, 945 909 Peplos Kore, Acropolis, Athens, 123-124, 124 Pepv II, 61 Parks Rucellai, Florence, 627-628, 627 Pepy II and His Mother, Queen Meryeankhnes, 61, Central Park, New York City, 1059, 1059 Sargon II, 40-41, 41 61 Versailles, 793, 794, 795-797, 795, 796, 797 early designs, 1059 Stourhead park (Flitcroft and Hoare), Wilt-Performance art, 1160-1161, 1160, 1161 Pala dynasty, 810 shire, England, 958-959, 958 Pergamene style, 163-164, 163, 164 Palatine Chapel, Palermo, Sicily, 277, 277 Palazzo della Signoria (Cione and Talenti), Flo-Parler, Heinrich, Church of the Holy Cross, Pergamon, 160 altar from, 162-163, 162 578-579, 578 rence, 557, 557 Parler, Peter Perikles (Pericles), 135, 136, 142 Palazzo del Tè (Romano), Mantua, 680, 680 Church of the Holy Cross, 578-579, 578 Peripteral temple, 116 Palazzo Farnese, Rome, 678, 678, 680, 755-757, Saint Wenceslas Chapel, 579, 579 Peristyle court, 68, 116, 117, 192 755, 756 Palazzo Medici-Riccardi, 625, 625, 627, 627 Parmigianino (Francesco Mazzola), Madonna with Perpendicular style, 576–578 Perry, Lilla Cabot, 1030 Palazzo Rucellai, Florence, 627-628, 627 the Long Neck, 694, 694 Parnassus (Mengs), 955, 955 Persephone, 110, 123 Palenque, 403-404, 404 Persepolis, 43–45, 43, 149 Paleolithic period Paros, 84 Persia (Persians), 42-46, 128, 129-130, 149 Parrhasios, xxxiii architecture, 2-4, 3 Personal Appearance #3 (Schapiro), 1165, 1165 Parsa, 42 cave art, 6-11 7, 9, 10, 11 Parson Capen House, Massachusetts, 805-806, culpture, 4-6, 4, 5, 6, 10-11, 11 atmospheric (aerial) perspective, 195, 586 805 Palermo

intuitive, 197, 586 Piece-mold casting, 346, 347 Polke, Sigmar, Raised Chair with Geese, 1176, 1176 one-point (linear or mathematical), 619, 621, Piero della Francesca Pollaiuolo, Antonio del, 170 622, 635, 647 Bacci Chapel, San Francesco church, Arezzo, Battle of the Nudes, 634, 634 reverse, 262 642-643, 642 Hercules and Antaeus, 633-634, 633 wisted, 8, 54 Battista Sforza and Federico da Montefeltro, Pollock, Jackson, 1174 Peru 643-644, 643, 644 Autumn Rhythm (Number 30), 1134-1135, Andean cultures, 408-412 Recognition and Proving of the True Cross, 642, Incas, 876-880 643 Male and Female, 1133, 1133 Moche, 411-412, 411, 412 Piers, 287, 453 Namuth's photograph of Pollock painting, Nazca, 410-411, 410 Pietà (Michelangelo), 669-671, 669 1134 Paracas, 410, 410 Pietà (Titan and Giovane), 686, 686 Polycrome, 867 Perugia, 171 Pietra dura, 818 Polydoros, Laocoön and His Sons, xxxvii, xxxvii, Perugino Pietra serena, 624, 626, 676 163-164 Delivery of the Keys to Saint Peter, 622, 622, Pietro da Cortona (Pietro Berrettini), 761 Polygnotos of Thasos, 148 647-648, 648 Glorification of the Papacy of Urban VIII, 762, Polykleitos, 128, 151 real name of, 647 762 The Canon, 129 Pesaro, Jacopo, 684 Pilasters, 171 Spear Bearer (Doryphoros or Achilles), 128, 128 Pesaro Madonna (Titian), 684-686, 685 Piles, Roger de, 744 Polynesia, 905–912 Peter of Illyria, 244 Principles of Painting, 799 Polyptych, 591 Petrarch, 554, 561, 586, 644 Pilgrimages, 475, 480 Pomo, Feathered Wedding Basket, 882, 882 Petroglyphs, 414 Pilgrimage to the Island of Cythera, The (Watteau), Pompadour, Madame de, 949 Petronius, Satyricon, 214 946, 947 Pompeii, 952 Pharaoh, origin of term, 67 city plan, 190-192, 190, 191, 192 Pillars, 116 Pheidias, 136, 137, 151 Ashokan pillars, India, 310, 311, 317 gardens, 192-193, 193 Pheidias and the Frieze of the Parthenon, Athens Five Pillars of Islam, 299 House of M. Lucretius Fronto, 197-198, 197 (Alma-Tadema), xliii, xliii House of Publius Fannius Synistor, 195, 195, Pine Spirit (Wu Guanzhong), 844-845, 845 Philip II, king of Macedon, 149 Pine Tree in Snow (Okyo), 865, 865 Philip II, king of Spain, 708, 725, 726, 764 Pink-Blue-Pink (Zorio), 1158, 1159 House of the Vettii, 192, 193, 193 Philip III, king of Spain, 764 Piranesi, Giovanni Battista, The Lion Bas-Relief, Villa of Livia, Primaporta, 192, 194, 195 Philip IV, king of Spain, 764, 766, 768, 775 954, 954 Villa of the Mysteries, 192, 192, 194-195, 194 Philip V, King of Spain, 743 Pisa, Italy Young Woman Writing, 198, 199 Philip Augustus, 515 cathedral complex, 486, 486 Pompey the Great, portrait of, 181, 181 Philip the Arab, Roman, 220, 221 Leaning Tower of, 486, 486 Pont du Guard, Roman bridge, 182, 182 Philip the Bold, duke of Burgundy, 587, 588, 590 Pisano, Andrea, 556 Pontormo, Jacopo da, Entombment, 693, 693 Philip the Fair, 531, 728 Life of John the Baptist, panel doors, 558-559, Poore, Richard, 539 Philip the Good, duke of Burgundy, 585, 587, 596 Pop art, 1150-1154, 1151-1154 Philosophical Enquiry into the Origin of Our Ideas of Pisano, Giovanni, Nativity pulpit, Pisa, 548-549, Pope, Alexander, 959 the Sublime and the Beautiful, A (Burke), 954 548 Pope Leo X with Cardinals Giulio de' Medici and Philostratus, 221 Pisano, Nicola Luigi de' Rossi (Raphael), 667-668, 668 Phoebus, 110 Nativity pulpit, Pisa, 547-548, 548 Popova, Liubov, Architectonic Painting, 1086, Phonograms, 32, 78 Pulpit, Pisa, 547-548, 547 1086 Photography Pissarro, Camille, 1026, 1027, 1031 Porcelain early, 1010-1012, 1010, 1011 Wooded Landscape at l'Hermitage, Pontoise, 1032, Chinese, 838–839, 839, 840 late nineteenth century, 1057-1058, 1057, 1032 Korean painted, 846, 846 1058 Piss Christ (Serrano), 1183 technique for making, 840 Modernism, 1093, 1093 Pitcher, Corinth, 114, 115 postwar, 1142-1145, 1144, 1145 Pity the Sorrows of a Poor Old Man (Géricault), Porch of the Maidens, Erechtheion, Acropolis, Photography: A Pictorial Art (Emerson), 1057 994, 995 143-144, 143 Photojournalism, 1142 Pizarro, Francisco, 879 Porta Augusta, Perugia, Italy, 170, 173 Photomontages, Dadaism, 1090, 1091, 1091 Plaiting, 882 Portals, 242 Photo-Secession, 1093 Plaque: Warrior Chief Flanked by Warriors and Atten-Porticos, 116 Piazza Navona, Rome, 753–754, 753 dants, Benin, Nigeria, 428, 428 Portinari Altarpiece (Goes), 606-607, 607, 609, Picasso, Pablo, 1076 Plate tracery, 527 609 Analytic Cubism, 1078-1080, 1080 Plato, xxxiv, 128, 149, 623, 659, 666 Portrait of a German Officer (Hartley), 1093, 1094, Blue Period, 1077 Plein air painting, 1031–1033 Family of Saltimbanques, 1077, 1077 Plenty's Boast (Puryear), 1179-1180, 1179 Portrait of a Lady (Weyden), 604, 604 Glass and Bottle of Suze, 1080-1081, 1081 Plinth, 174 Portrait of a Maori (Parkinson), 909-910, 909 Guernica, 1064-1065, 1065 Pliny the Elder, 153, 155, 157, 162, 163, 179, 181, Portrait of a Young Man (Bronzino), 694, 695 Iberian Period, 1077-1078 Portrait of Charles Baudelaire (Nadar), 1011-1012, Les Demoiselles d'Avignon (The Young Ladies of Pliny the Younger, 179 Plowing in the Nivernais: The Dressing of the Vines Avignon), 1078, 1078 Portrait of Giovanni Arnolfini and His Wife, Giovanna Ma Jolie, 1080, 1080 (Bonheur), 1020, 1020 Cenami (Jan van Eyck), 599-600, 601 Mandolin and Clarinet, 1081, 1081 Pluralism, 1172 Portrait of Jean-Baptiste Belley (Girodet-Trioson), Rose Period, 1077 Plutarch, 55, 155, 179 975-976, 975 Self-Portrait, 1076, 1077 Pluto, 110 Portrait of Khusrau Shown to Shirin, Khamsa, 304, Synthetic Cubism, 1080-1081, 1081 Podium, 145, 173 Picnic at the Lotus Pond (Sin Yunbok), 847, 847 Poesie (painted poems), 682 Portrait of Lord Pakal, Mayan, 404, 405 Pictographs, 32, 78, 348, 414 Poet on a Mountaintop (Shen Zhou), 842, 842 Portrait of Madame Desiré Raoul-Rochette (Ingres), Pictorialism, 1057 Pointed arch, 292, 485 990, 991 Picturesque, 954 Pointillism, 1042 Portrait of Marie Antoinette with Her Children Picture stones, 460 Pointing, 225

(Vigée-Lebrun), 948, 972, 972

Portrait of Mrs. Richard Brinsley Sheridan	Prandtauer, Jakob, Benedictine Abbey of Melk,	Pylons, 68
(Gainsborough), 963–964, 964	Austria, 771–772, 772, 773	Pylos, palace at, 97, 97, 98, 99 Pyramids
Portrait of Pompey the Great, 181, 181	Praxiteles	Chichen Itza, 406–407, 407
Portrait of Thomas Carlyle (Cameron), 1011, 1011	Aphrodite of Knidos, 152–153, 152 Hermes and the Infant Dionysos, 151–152, 151	constructing, 58–59
Portrait sculpture Italian Neoclassicism, 952–956, 953, 954, 955	Predella, 569, 591	at Giza, 57–59, <i>57</i> , <i>58</i>
Japanese, Kamakura period, 389, 391, 391	Prehistoric art	Great Pyramid (Aztec), 875
Mayan, 404, 405	Bronze Age, 20–21	Great Pyramid, La Venta, Olmec, 398, 398
Roman Imperial, 216-217, 217, 220, 220,	Iron Age, 21–22	Itza, 406–407, 407
222–223, 223, 224, 225–226	in Japan, 374–378	Mayan, 403–404, 403, 404
Roman Republic, 204, 204, 205	Neolithic period, 11–20	of the Moon, 399, 400, 411
Portraiture	Paleolithic period, 2–11	stepped, at Saqqara, 55–56, 56, 57
Baroque, 777–778, 778	timeline, 7, 19 Prehistoric Europe, map of, 3	of the Sun, 399–400, 400, 411 Teotihuacan, 399–400, 400
Dutch Baroque, 781–782, 782, 783 English, 735–737, 735, 736	Priam Painter, Women at a Fountain House,	Pythian Games, 111
English, 753–757, 755, 756 English Neoclassicism, 963–964, 963, 964	145–146, <i>146</i>	- /
Flemish, 598–599, 600, 604, 604	Priene city plan, 150	Q
French, 720, 720	Priestess of Bacchus, 229, 230	Qibla, 288, 289, 298, 299
photography, 1011-1012, 1011	Priest-king, Indus Valley, 314–315, 314	Qin dynasty, 343, 349, 834
Roman, 198, 199	Primaporta, Garden Scene, 192, 194, 195	Qingbian Mountains (Dong Qichang), 841, 841,
Portugal, Renaissance in, 611-613, 724	Primaticcio, Francesco, Chamber of the Duchess	843
Portuguese Synagogue, Amsterdam (de Witte), 790,	of Étampes, Fontainebleau, France, 721–722,	Qing (Manchu) dynasty, 835, 843–844 Qiu Ying, Spring Dawn in the Han Palace,
790	722	837–838, <i>838</i>
Portunus, 183, 184	Primavera (Botticelli), 650–651, 650	Quadrant vaults, 481
Poseidon, 109, 110	Primitive art, use of term, 424 Primitivism, 1070–1072, 1070, 1071	Quadratura, 761
Positivism, 1009 Possum Tjapaltjarri, Clifford, Man's Love Story,	Princess Elizabeth (Teerlinc), 736, 737	Quadro riportato, 761
913–914, <i>914</i>	Princess from the Land of Porcelain (Whistler), xlv	Quatrefoils, 532, 534
Post-and-lintel construction, 14, 14, 15, 334, 462	Printing, 615–616, 652, 660	Queen Nefertari Making an Offering to Isis, 75, 79
Post-Impressionism	Printmaking, 614, 714–717	Queen's ship, Osberg, Norway, 459-460, 459, 460
Cézanne, 1039–1041, 1039, 1040, 1041	Prix de Rome, 948	Queen Tiy, portrait, 74, 74
Gauguin, 1046, 1047	Procession of the Relic of the True Cross before the	Quillwork, 882–883, 882
Seurat, 1041–1042, 1042	Church of Saint Mark (Gentile Bellini), 654,	Quiltwork, 912–913, 913
an Gogh, 1042–1043, 1043, 1046	654	Quincunx, 275 Quire, 251
use of term, 1038	Procopius of Caesarea, 255	Quoins, 678
Postmodern art, 1171 architecture, 1170, <i>1170</i>	Pronaos, 114, 116 Properzia de' Rossi, Joseph and Potiphar's Wife, 682,	Qur'an, 283, 284, 287
architecture, Deconstructivist, 1184, 1185	682	frontispiece, 304, 304
architecture, High Tech, 1182, 1184, 1184	Propylaia, Acropolis, 142	page from, 292, 293
European art, 1128–1130, 1128–1130	Proscenium, 160	
identity, 1172-1174, 1172, 1173, 1174	Proserpina, 110	R
Neo-Expressionism, 1175-1177, 1175, 1176	Protestantism, 687, 708, 720, 728	Ra (Re), 51, 52
new types of media, 1184, 1186-1190,	Proto-Geometric, 112	Ra-Atum, 51
1186–1189	Proto-historic Iron Age, 21–22	Rabbula Gospels, 264–265, 265
new uses for old styles, 1177–1179, 1177,	Proun space (Lissitzky), 1107, 1107	Radiometric dating, 13, 415 Raft of the "Medusa," (Géricault), 990, 992–993,
1178, 1179	Psalm I, Windmill Psalter, England, 538, 539 Psalters	992, 993
shapes, new meanings in, 1179–1182, 1179–1182	Paris, Byzantine manuscript, 274, 274	Raigo painting, Kamakura period, Japan, 391, 392
use of term, 1127	Psalter of Saint Louis, 537–538, 537	Raiko Attacks a Demon Kite (Hokke), 867
Potassium-argon dating, 13	Utrecht, 457, 457	Raimondi Stone, Chavin de Huantar, 408, 409
Potsherds, 20	Winchester, 508-509, 509	Raised Chair with Geese (Polke), 1176, 1176
Potter's wheel, 20	Windmill, 538, 539	Raising of the Cross, The (Rubens), 775
Pottery	Pseudo-Dionysius, 513	Rajaraja I, 335, 336
SEE ALSO Ceramics; Painted vases	Ptolemies, 157	Rajaraja I and His Teacher, 336
Chinese Neolithic painted, 344–345, 345	Ptolemy, 80	Rajarajeshvara Temple to Shiva, Thanjavur, India,
formation of, 20	Ptolemy V, 78 Pucelle, Jean, Book of Hours of Jeanne d'Evreux,	335–336, <i>335</i> , 336 Rajput, India, 821, 823–825, 823, <i>824</i>
Japanese Jomon period, 374–376, <i>374</i> , <i>375</i> Lapita, 898–899, <i>898</i>	572–573, <i>573</i>	Raku, 860
Pueblo, 889–890, <i>889</i>	Pueblo Bonito, Chaco Canyon, New Mexico,	Ramayana scene, Java, 817, 817
Sumerian, 31, <i>33</i>	394–395, 395–396, 416, 417–418, 417, 418	Ramses II, 69
use of term, 20	Pueblos, 416, 887, 889–890, 889	temples of, 75–78, 76, 77
Wedgwood, 960, 960	Pugin, Augustus Welby Northmore, Houses of	Raphael
Poussin, Nicolas, Landscape with Saint John on Pat-	Parliament, London, 1008, 1009	Miraculous Draft of Fishes, 668–669, 668
mos, 797–798, 800, 800	Punchwork, 569	Pope Leo X with Cardinals Giulio de' Medici and
Poussinistes, 799	Pure Land Buddhist art, 384–386, 384–385, 386,	Luigi de' Rossi, 666–668, 668 School of Athens, 659, 666, 667
Program	389, 391, <i>391</i> Purse cover, Sutton Hoo burial ship, England,	The Small Cowper Madonna, 666, 666
Prague Altneuschul, 542, <i>543</i>	446, 447	Stanza della Segnatura, 658–659, 659–660,
Saint Wenceslas Chapel, 579, 579	Puryear, Martin, Plenty's Boast, 1179-1180, 1179	666
Prairie style, 1102	Putti, 247, 644, 647, 671, 684, 695, 776, 777, 944,	Rationalism, 1107-1110, 1108, 1109
Prakhon Chai style, 337, 337	946, 949, 1015	Rauschenberg, Robert, 1145

Canyon, 1146, 1147	Remus, 169, 179	Revival Fields (Chin), 1186, 1186
Ravenna Ravenna Anima 240	Renaissance	Reynolds, Joshua, Lady Sarah Bunbury Sacrificing to
Baptistry of the Arians, 249 Baptistry of the Orthodox, 249, 250	artists, changing status of, 661–662	the Graces, 963, 963
Mausoleum of Galla Placidia, 247–249, 248,	book printing, 652 ceramics, 634, <i>634</i>	Rhytons, 93–94, 93 Prince Warriors 133, 135, 134
249	development and meaning of, 586	Riace Warriors, 133–135, 134 Ribera, Jusepe de, Martyrdom of Saint Bartholomew,
San Vitale church, 258, 259–262, 260, 261	in England, 734–740	765–766, 765
Rayonnant (Court) style, 535–537, 572	fiber arts, 594–596, 595, <i>596</i>	Rib vaulting, 488, 492, 521, <i>521</i>
Read, Herbert, 1130	in Flanders, 596–609	Richardson, Henry Hobson, Marshall Field
Readymades, 1088, 1090	in France, 609–611, 720–723	Wholesale Store, Chicago, 1060, 1061
Realism	in Germany, 709–719	Richelieu, Cardinal, 793
American, 1022, 1022, 1023	graphic arts, 614–616	Ridgepole, 13
French, 1017-1021, 1017-1021	in Holy Roman Empire, 613	Riemenschneider, Tilman, 709
New, 1149	in Italy, 618-655, 662-686	Altarpiece of the Holy Blood, 710, 710
in the nineteenth century, 1015, 1017	Mannerism, 692–699	Rietveld, Gerrit, Schröder House, Netherlands,
Russian, 1021–1022, 1021	manuscripts, illuminated, 584-586, 602-604	<i>1108</i> , 1109–1110, <i>1109</i>
Socialist, 1107, 1107	maps of Europe in, 587, 621, 661, 709	Rigaud, Hyacinthe, Louis XIV, 742, 743, 800
use of term, xxxiii–xxxiv, 1009	metalwork, 737, 737	Rikyu, Sen no, Tai-an tearoom, Kyoto, Japan,
Rebecca at the Well, Book of Genesis, 264, 264	in the Netherlands, 728–734	858–859, <i>858</i>
Recognition and Proving of the True Cross (Piero	patrons of the arts, 547, 620, 623, 634, 661,	Riley, Bridget, Current, 1155, 1155
della Francesca), 642, 643	671, 675, 720, 722	Rimpa school painting, 860, 861, 863
Recumbent Figure (Moore), 1118–1119, 1118	in Portugal, 611-613, 724	Riis, Jacob
Red Canna (O'Keeffe), xxxv, xxxv	printmaking, 614-616, 714-717	How the Other Half Lives, 1058
Red-figure painted vases, 114, 126–128, 127	in Spain, 611–613, 723–728	Tenement Interior in Poverty Gap: An English
Red Mean: Self Portrait (Smith), 1178, 1178	tapestry, 594–595, <i>595</i>	Coal-Heaver's Home, 1058, 1058
Redon, Odilon, The Marsh Flower, a Sad and	timelines, 693, 731	Ringgold, Faith, Tar Beach, 1165, 1166
Human Face, 1048–1049, 1048	women artists, 592, 662	Riopelle, Jean-Paul, Knight Watch, 1136, 1137
Redwald, 446	Renaissance architecture	Ripa, Cesare, 759–760
Reformation, 660, 708–709, 721, 728	early, 621–628, 622–627, 640–642, 641, 642,	Rivera, Diego, Man, Controller of the Universe,
Registers, 31, 564	644–647, 645, <i>646</i> , 653, <i>654</i>	1113–1114, 1113
Registration marks, 867	English, 738, 739	Robbia, Andrea della, 626
Rehearsal on Stage, The (Degas), 1033–1034, 1034	French, 720–723, 721, 722, 723	Robbia, Luca della, 634
Reid, Bill, <i>Spirit of Haida Gwaii</i> , 892–893, <i>892</i> Reims, Gaucher de, 531	High, 677–680, 678, 679, 680	Roberts, David, Gateway to the Great Temple at
Reims, Gatteller de, 351 Reims Cathedral, Notre-Dame cathedral,	Spanish, 725, 725	Baalbek, 1005–1006, 1005
531–532, <i>531</i> , 532, 533–535, <i>535</i>	Renaissance painting early, 634–640, 636–640, 642–644, 642, 643,	Robin, Pierre (?), Saint-Maclou church, Nor-
Reinach, Salomon, 6		mandy, France, 610–611, 611
Reiner of Huy, Baptismal font, Notre-Dame-	644, 647–653, 648–653, 654–655, 654, 655, 656	Robusti, Jacopo. See Tintoretto Robusti, Marietta, 702
Aux-Fonts, Liege, France, 506–507, 507	English, 735–738, 735, 736, 738	Rock art
Reintegration, 912	French, 720, 720	Australian, 900, 900
Rejlander, Oscar, The Two Paths of Life,	German, 711–719, 712–719	Saharan, 424–425, <i>425</i>
1010–1011, 1010	High, 662, 663, 664–669, 664–668, 671–674,	South African, 426, 426
Relative dating, 13	672, 673, 674	technique, 414
Relief. See Sculpture, relief	Netherlands, 728-734, 729-734	Rock-cut caves, Six Dynasties, 357, 357
Religious beliefs	one-point perspective (linear or mathemati-	Rock-cut halls, Buddhist, 321–322, 322
SEE ALSO under name of religion	cal), 619, 621, 622, 635, 647	Rock-cut tombs, Beni Hasan, Egypt, 63, 63
African spirit world and divination, 925-928,	Spanish, 725-728, 726, 727	Rockefeller family, 1113
926, 927, 937, 937	Renaissance sculpture	Rock painting, Australian, 900, 900
ancient Near East, 26	early, 628–634, <i>628–633</i>	Rock-shelter art, 12-13, 12
Aztec, 874	German, 709-711, 710, 711	Rococo
Chinese, Neolithic, 345–346, 346	High, 669–671, 669, 670, 674–677, 675, 676,	academies, 948, 952
Chinese, Shang dynasty, 346–347	<i>677</i> , <i>680–686</i> , <i>680–687</i>	in Germany and Austria, 944–946
Diquis, 408	Portuguese, 724, 724	Grand Tour, 951–956
Egyptian, 51–52	Reni, Guido, Aurora, 761, 761	in France, 946–951
Greek, 109–111	Renoir, Pierre-Auguste, 1026	Salons, 943, 948
Mayan, 406	Moulin de la Galette, 1032–1033, 1033	timeline, 951
Olmec, 399	Repin, Ilya, Bargehaulers on the Volga,	use of term, 943
Paleolithic, 9–10	1021–1022, 1021	Rococo style
Pueblo, 418 Roman, 179	Repoussé (embossing), 93, 95, 458	architecture, 944–946, <i>944</i> , <i>945</i> , <i>946</i>
Sumerian, 32–33, <i>33</i>	Repoussoir, 1040	defined, 943, 944
Teotihuacan, 400–401	Residenz, Kaisersaal (Imperial Hall) (Neumann),	painting, French, 946, 947, 948–951, <i>949</i> , 950
Reliquaries, 319, 443, 484, 484	Germany, 944–945, <i>944</i> , <i>945</i> Restany, Pierre, 1149	
Rembrandt van Rijn, xli, 783, 799	Restoration work, <i>Warriors</i> , Riace, Italy, 135	painting, German, 945, <i>945</i> sculpture, French, 951, <i>951</i>
The Anatomy Lesson of Dr. Nicolaes Tulp, 784,	Resurrection of Lazarus, The (Tanner), 1051, 1051	Rodchenko, Aleksandr, Workers' Club,
784	Returning Late from a Spring Outing (Dai Jin), 837,	1105–1106, <i>1106</i>
Captain Frans Banning Cocq Mustering His	838	Rodin, Auguste, Burghers of Calais, 1051–1052,
Company (The Night Watch), 785, 785	Return of the Hunters, The (Bruegel the Elder),	1052
The Last Supper, xlii–xliii, xliii	733–734, 734	Roger, abbot, 496
Self-Portrait, 786, 787	Reverse perspective, 262	Roger II, king of Sicily, 274–275
Three Crosses, 786, 786	Revett, Nicholas, 138	Roggeveen, Jacob, 906

Ruskin, John, 1025 Neoclassicism in, 954-956, 955, 956 Rogier van der Weyden. See Weyden, Rogier Palazzo Farnese, 678, 678, 680, 755-757, 755, Russian art van der Byzantine icons, 278-279, 280 Rolin, Nicolas, 602, 603 Constructivism, 1105-1107, 1106 Pantheon, 210, 210, 211, 212 Roman Empire Constantine the Great, 225–230 Cubism and Futurism, 1084-1086, 1085, Piazza Navona, 753-754, 753 emperors, list of with dates, 199 in the Renaissance, 647 painting, Realism, 1021-1022, 1021 Flavians, 199-204 sack of, 442, 661 Socialist Realism, 1107, 1107 San Carlo alle Quattro Fontane church (Borgods and heroes, description of, 110, 179 romini), 751-752, 751, 752, 753 Rusticated stone blocks, 627 Julio-Claudians, 189-190 San Clemente church, 486-488, 487, 501 Ruysch, Rachel, Flower Still Life, 792, 793 origins of, 178-179 Ryder, Albert Pinkham, Jonah, 1050, 1050 Tempietto, San Pietro church, 677-678, 678 religion, 179 Ryoan-ji, Kyoto, Japan, Zen dry garden, 855-856, Rome Imperial Severan dynasty, 218-220 Tetrarchs, 222-224 architecture, 205-212, 206-213, 219-220, 219, 220, 223-224, 223, 226-228, 226, 227, third century, 220-222 women, 198, 199 writers on art, 179 mosaics, 213-215, 213, 214 S sculpture, 215-218, 215, 216, 217 Romanesque, defined, 475, 477 Saar, Betye, Liberation of Aunt Jemima, 1164, 1164 sculpture, funerary, 222, 222 Romanesque period Saarinen, Eero, Trans World Airlines Terminal, architecture, 480-493, 480, 481, 483-494 sculpture, portrait, 216-217, 217, 220, 220, 222-223, 223, 224, 225-226 John F. Kennedy Airport, New York City, church, 475-476 1169, 1169 cloister crafts, 502-510, 502-510 Romulus, 169, 179 Rondanini Pietà (Michelangelo), 690, 691 Safdie, Moshe, Habitat '67, Montreal, Canada, intellectual life, 476-477 1169-1170, 1169 Rongxi Studio, The (Ni Zan), 835, 835 manuscripts, 507-509, 508, 509, 510 Roosevelt, Franklin D., 1066, 1116 Saharan rock art, 424-425, 425 map of, 475 Saint Anthony Enthroned between Saints Augustine metalwork, 506-507, 506, 507 Rope Piece (Hesse), 1157-1158, 1157 mosaics and murals, 499, 500, 501, 504 and Jerome (Hagenauer), 711, 712 Rosenberg, Harold, 1133-1134 political and economic life, 474-475 Rosetsu, Nagasawa, Bull and Puppy, 865-866, 865 Sainte-Chapelle, Paris, 536-537, 536 Saint Cyriakus church, Gernrode, Germany, 465, sculpture, 472, 473, 495-499, 495-498 Rosetta Stone, 31, 78, 78 Rosettes, 114, 115, 288 465, 468 timelines, 489, 497, 507 Rose windows, 528, 529 Saint-Denis, abbey church, France, 512, 513, Romania (Cernavoda), figures of a man and Rossellino, Bernardo, 627 516-517, 517, 574, 574 woman, 18, 18, 19 Romano, Giulio, 721 Rossi, Luigi de', 667, 668 Saint Elizabeth church, Marburg, Germany, 542, Palazzo del Tè, Mantua, 680, 680 Rothko, Mark, Brown, Blue, Brown on Blue, 1138, Saint-Étienne church, Caen, Normandy, 492-493, 1138 Roman Republic architecture, 181-185, 182, 183, 184, 199, Rotunda, 242, 453 492, 493 200, 201-204, 201, 202, 203 Rouen Cathedral: The Portal (in Sun) (Monet), Saint Faith (Sainte Foy), reliquary statue of, 484, 1031, 1031 484 cities and homes, 190-193, 190, 191, 192 early empire, 179-180, 185-204 Round arch, 171, 172 Saint Francis, 546 Roundels, 171, 215-216 Saint Francis, church of, Assisi, Italy, 546, 546 gardens, 192-193, 193 Rousseau, Jean-Jacques, 942 Saint Francis in Ecstasy (Giovanni Bellini), 655, 656 map of, 171 murals, 193-198, 193-199 Royal mortuary compound, Nan Madol, Pohn-Saint Francis Master, Miracle of the Crib at Greccio, pei, Micronesia, 904–905, 905 550 550 painting, still life and portraits, 198, 198, 199 Saint Gall monastery, Switzerland, 454-455, 454 Royal rune stone, 460, 461 sculpture, 180-181, 180, 181 Royal Symbols (Kakalia), 912-913, 913 Sainte-Geneviève, Panthéon (Soufflot), Paris, 970, sculpture, Augustan, 186-190, 186, 187, 188, 970 189 Rubénistes, 799 sculpture, portrait, 204, 204, 205 Rubens, Peter Paul, 799 Saint George (Donatello), 629, 629 Allegory of Sight, from Allegories of the Five Saint Isidore, 443 Romans Crossing the Danube and Building a Senses, 778, 780, 780 Saint James cathedral, Santiago de Compostela, Fort, Column of Trajan, 209, 209 Garden of Love, 777, 777 Spain, 479-484, 479, 481, 482, 770-771, 771 Romanticism Henri IV Receiving the Portrait of Marie de' Saint-Lazare cathedral, Autun, Burgundy, France, English painting, 967-969, 968, 969 Medici, 776, 776 French painting, 990-996, 992-996 497-498, 497, 498 St. Louis, Missouri, Wainwright Building (Sulli-French sculpture, 997, 997 house of, 774-775, 774 landscape painting, 1000-1005, 1000-1005 The Raising of the Cross, 775, 775 van), 1060-1062, 1061 Saint Luke (Master Theodoric), 579-580, 580 Rublyov, Andrey, Old Testament Trinity (Three in the nineteenth century, 987-988 Spanish painting, 998, 998, 999, 1000 Angels Visiting Abraham), 278-279, 280 Saint Luke Displaying a Painting of the Virgin (Guercino), xli, xli, 760 Rucellai, Giovanni, 620, 627 use of term, 956 Rude, François, Departure of the Volunteers of 1792 Saint Luke Painting the Virgin Mary (Gossaert), Rome (The Marseillaise), Arc de Triomphe, Paris, 997, 730-731, 730 SEE ALSO Saint Peter's basilica; Vatican Saint-Maclou church, Normandy, France, Arch of Constantine, 226-227, 226 Rudolf of Swabia, tomb effigy, 506, 506 610-611, 611 Arch of Titus, 199, 200, 201, 201 Rue Transonain, Le 15 Avril 1834 (Daumier), xl, xl, Saint Mark cathedral, Venice, 271, 272, 273 Basilica of Maxentius and Constantine, 227-228, 227, 228 Saint Matthew, from the Codex Colbertinus, 507, 1020 Ruisdael, Jacob van, The Jewish Cemetery, 790-791, Capitoline Hill, 688 508 Saint Matthew the Evangelist, Coronation Gospels, Colosseum (Flavian Amphitheater), 202-204, 202, 203 Rukupo, Raharuhi, Maori Meetinghouse, New Saint Matthew the Evangelist, Ebbo Gospels, Zealand, 910-911, 911 Column of Trajan, 208-209, 208, 209 Cornaro Chapel (Bernini), Santa Maria della 456-457, 456 Rules for Monasteries (Benedict of Nursia), 451 Vittoria church, 749-750, 749 Rune stones, 460, 461 Saint Maurice, 464 Saint Maurice, Magdeburg, Germany, 544-545, Running Fence (Christo and Jeanne-Claude), 1163, Forum of Trajan, 205-206, 206, 207, 208, 208 Il Gesù church (Vignola and della Porta), Saint Michael Church, doors of Bishop Bern-

Running spirals, 102

690-692, 691

ward, Hildesheim, Germany, 466, 466, 467, Sand painting, 890-892, 891 Schiele, Egon, Self-Portrait Nude, 1073, 1073 San Francesco church, Bacci Chapel, Arezzo, Schinkel, Karl Friedrich, Altes Museum, Berlin, Saint Paul's Cathedral (Wren), London, 802-803, 642-643, 642 1008 1008 804 Sangallo the Younger, Antonio da, Palazzo Far-Schliemann, Heinrich, 84, 88, 98, 100, 100. Saint Peter, abbey church of, 482-484 nese, Rome, 678, 678, 680 102 Saint Peter's basilica Schliemann, Sophia, 100, 100 San Giorgio Maggiore church, Venice, 702, 703, Bernini's plan, 747-749, 747, 749 703 Schmidt-Rottluff, Three Nudes-Dune Picture from Bramante's plan, 679, 679 San Giovanni baptistry, Florence, 558-559, 560, Nidden, 1070, 1070 Maderno's plan, 679, 679, 747, 747 629-631, 630 Scholasticism, 515 Michelangelo's plan, 679, 679, 690, 690 San Juan de Los Reyes church, Toledo, Spain, 612, Schongauer, Martin, Temptation of Saint Anthony, old, 243-244, 243, 244, 679, 679 612 614-615, 615 Saint-Pierre priory church, Moissac, 496-497, San Lorenzo, Olmec, 398 School of Athens (Raphael), 659, 666, 667 San Lorenzo church, Florence, 624-625, 624, 625 Schröder House (Rietveld), Netherlands, 1108, Saint Riquier church, Monastery of Centula, San people, rock art, 426, 426 1109-1110, 1109 France, 453-454, 453 San Pietro church, Rome, 677-678, 678 Schröder-Schräder, Truus, 1109-1110 Saint-Savin-sur-Gartempe abbey church, Poitou, Sant'Agnese church, Rome, 753, 753 Schulze, Wolfgang. See Wols France, 488, 488, 501, 502 Sant' Ambrogio church, Milan, 488, 489 Schwitters, Kurt, Merzbild 5B (Picture-Red-Heart-Saint Sebastian Tended by Saint Irene Sant'Andrea church, Mantua, Italy, 644-645, 645, Church), 1090, 1091 (Ter Brugghen), 779, 781 647 Science Saint Serapion (Zurbarán), 766, 766 Santa Costanza church, Rome, 246-247, 246, 247 Baroque period and, 746 Saint-Simon, comte de, 1020 Sant'Elia, Antonio, 1085 Enlightenment and, 942, 986 Saint Teresa of Ávila, 749 Santa Fe Indian School, 890 Sckell, Ludwig von, 1059 Saint Teresa of Ávila in Ecstasy (Bernini), 750-751, Santa Felicità church, Florence, 692, 693 Scott, Walter, 959 Santa Maria Degi Angeli, 220, 220 Scream, The (Munch), 1049-1050, 1049 Saint Ursula reliquary (Memling), 608, 608, 609 Santa Maria del Carmine church, Brancacci Scribes, 263 Saint Vincent (Sant Vincenc) Church, Cardona, Chapel, Florence, 636-638, 637, 638, 639 Scriptoria, 263, 447, 448, 450, 455, 469-470, 502, Santa Maria della Vittoria church, Rome, 749, 749 507-510, 539 Saint Vincent with the Portuguese Royal Family from Santa Maria delle Grazie monastery, Milan, Italy, Scrolls, 251 Altarpiece of Saint Vincent (Gonçalves), 662, 663, 664 Scrovegni (Arena) Chapel, Padua, 563-567, 565, 612-613, 613 Santa Maria Maggiore church, Rome, 245-246, 566 Saint Wenceslas Chapel (P. Parler), Prague, 579, Sculpture 579 Santa Sabina church, Rome, 244-245, 244, 245 SEE ALSO Figurines Sala della Pace, fresco series (Lorenzetti), Siena, Santa Sophia cathedral, Kiev, 268, 269 Abstract, 1086-1087, 1087 570, 571 Santi Giovanni e Paolo and the Monument to Bar-Ain Ghazal, Jordan, 28-29, 29 Salcedo, Sebastian, Our Lady of Guadalupe, 977, tolommeo Colleoni (Canaletto), 953-954, 953 Akkadian, 36-37, 36 San Vitale church, Ravenna, 258, 259-262, 260, American Neoclassicism, 997-998, 997 Salimbeni, Lionardo Bartolini, 619-620, 623 Aztec, 875-876, 876 Salisbury Cathedral, England, 539-540, 540 San Xavier del Bac mission, Arizona, 977, 979, Baroque, Italian, 745, 748, 749-751, 749 Salisbury Plain, England, Stonehenge, 16, 17, 17, Benin, 430-432, 430, 432 19 Sappho, 115 biomorphic forms, 1117-1119, 1117, 1118, Saljuqs, 294 Saggara 1119 Salon d'Automne, 1067-1068 Djoser's funerary complex at, 55-56, 56, 57 Bronze Age, 20-21, 21 Salon de la Princesse (Boffrand), Hôtel de Seated Scribe, 61-62, 61 Buddhist, 326, 326, 357, 357, 358, 358, 810, Soubise, Paris, 943, 944 Ti Watching a Hippopotamus Hunt, 62, 62 812 Salon des Refusés, 1027 Sarcophagi, 55 Chinese, Liao dynasty, 361-362, 362 Salon of 1787 (Martini), 948, 948 from Cerveteri, 176-177, 177 Chinese, Six Dynasties, 357, 357 Salons, 943, 948, 988 of the Church of Santa Maria Antiqua, Chinese, Sui dynasty, 358, 358 Saltcellar of King Francis I (Cellini), 697-698, 697 240-241, 241 Christian, early, 240-241, 240, 241, 250, 251, Samarkand ware, 294, 294 of Junius Bassus, 250, 251, 254 Samoa, 899 Lord Pakal palace and tomb, Mayan, 403-404, Egyptian, xxxii, 59-64, 59, 60, 61, 63, 64, Samuel Adams (Copley), 940, 941, 981 73-74, 73, 74 Samurai, 388, 852, 854 Ludovisi Battle Sarcophagus, 222, 222 French fourteenth century, 573-574, 574, 575 Samurai armor, 389, 389 Sargon I 36 French Gothic, 532-537, 533-536 San Carlo alle Quattro Fontane church (Borro-Sargon II, 40-41 French Neoclassicism, 976-977, 976 mini), 751-752, 751, 752, 753 Sarnath, 326 French nineteenth century, 1014-1015, 1014, Sánchez Cotán, Juan, Still Life with Quince, Cab-Sarsen, 17 1051-1053, 1052, 1053 bage, Melon, and Cucumber, 764-765, 764 Sartre, Jean-Paul, 1126, 1127 French Rococo, 951, 951 San Clemente church, Rome, 486-488, 487 Sassetti Chapel, Florence, 648, 649-650, 649 French Romanticism, 997, 997 mosaics of, 501 Satyricon (Petronius), 214 German (Holy Roman Empire) Gothic, San Climent church, Tahull, Catalunya, Spain, Saussure, Ferdinand de, xlvii 543-545, 544, 545, 547 500, 501 Savage, Augusta, 1114 German Renaissance, 709-711, 710, 711 Sanctuaries, 109-110 La Citadelle: Freedom, 1115, 1115 German Rococo, 945-946, 946 Sanctuary of Apollo, Delphi, 110-111, 111 Savonarola, Girolamo, 652, 669 Gothic, French, 532-537, 533-536 Charioteer, 132-133, 133 Scandinavia, in the Middle Ages, 444-446 Gothic, German (Holy Roman Empire), Treasury of the Siphnians, 116, 119-120, 120 Scarab beetle, 52, 64, 84 543-545, 544, 545, 547 Sanctuary of Athena Pronaia, Delphi, 150-151, Scarification, 429 Gothic, Italian, 547-549, 547, 548 150 Scenes from the Massacre at Chios, (Delacroix), 995, Greek bronze, 131-134, 133, 134 Sanctuary of Fortuna Primigenia, Palestrina, Italy, Greek freestanding (Archaic), 121-125, 122, 183, 183 Schapiro, Miriam 123. 124 Sanctuary of Zeus, 110 The Dollhouse, 1164 Greek freestanding (Classical), 131, 132,

Personal Appearance #3, 1165, 1165

Sande, 924

151–155, *151*, *152*, *153*

Sévigné, Madame de, 943 sunken, 73, 73 Greek pediment (Archaic), 119-121, 119, Sezessionstil, 1055, 1100 Scythians, 42 120, 121 Seagram Building (Mies van der Rohe and John-Sforza, Battista, 642, 643-644, 643 Greek pediment (Classical), 130-131, 131 Sforza, Ludovico, 662, 663, 664 son), New York City, 1167, 1167 Greek stele (Classical), 147-148, 147 Sfumato, 665, 681, 754 Haida, 892-893, 892 on hanging scrolls or handscrolls, 837 Sgraffito, 627 Harlem Renaissance, 1114-1115, 1115 impressions, Indus Valley, 312, 313, 314 Shaft graves, 99 Hellenistic, 160, 160, 161, 162-165, 162, 163, Shafts, of columns, 117, 118, 317 Sumerian cylinder, 35, 35 164, 165, 166 Shaka Triad (Tori Busshi), Asuka period, Japan, 380, hollow-cast, 36, 36 Seascape and Coastal Towns, Villa Farnesina, Rome, 195, 195 380, 382 Holy Roman Empire, Gothic, 543-545, 544, 545, 547 Seasons, The (Krasner), 1135, 1135 Shamans Diquis, 408 Seated Buddha in Cave, Six Dynasties, China, Italian Baroque, 745, 748, 749-751, 749 Native American, 886 357, 357 Italian Gothic, 547-549, 547, 548 Olmec 399 Seated Guanyin Bodhisattva, Liao dynasty, China, Italian Neoclassicism, 955-956, 956 361-362, 362 Paleolithic, 9-10 Italian Renaissance, 628-634, 628-633, Seated Harp Player, Cyclades, 86, 86 Shaman singers, 891 669-671, 669, 670, 674-677, 675, 676, 677, Shaman with Drum and Snake, Diquis, 407-408, Seated Scribe, Saqqara, 61-62, 61 680-686, 680-687 Seated Shakyamuni Buddha, Seokguram, Korea, Japanese, Heian period, Japan, 386, 386 Shangdi, Shang diety, 346 368. 369 Japanese, Nara period, Japan, 382-383, 382 Shang dynasty, 346-347, 834 Seated Willow-branch Gwanse'eum Bosal (Bodhisattva Jenné, 433, 433 Shazi, pen box, 300-301, 301 Avalokiteshvara), Goryeo dynasty, Korea, 370, joined-wood method, 386, 387 Shen Zhou, 840 Maori wood, 910, 910 Poet on a Mountaintop, 842, 842 Seaweed, Willie, Kwakwaka' wakw Bird Mask, 888, Mayan, 404-406, 405 Sherman, Cindy, Untitled Film Still #21, 888 Minoan, 92-93, 92 1172-1173, 1172 Mycenaean, 103-104, 103 Secco, 90, 569 She-Wolf, Etrucsan/Roman, 168-169, 169-170 Neoclassicism, American, 997-998, 997 Seed jar, Pueblo Bonito, 418, 418 Shihuangdi, emperor of China, 349 Neoclassicism, French, 976-977, 976 Seleucus, 157 Soldiers from the mausoleum of, 342-343, Self-Portrait (Anguissola), 696-697, 697 Neoclassicism, Italian, 955-956, 956 343 349 Neolithic, 18, 18, 19-20, 20 Self-Portrait (Dürer), 715, 715 Shikharas, 320, 327 Self-Portrait (Leyster), 783, 783 Nepal inlaid devotional, 813, 813 Shimamoto, Shozo, Hurling Colors, 1148, 1148 Self-Portrait (Picasso), 1076, 1077 New York School, 1138-1140, 1139, 1140 Shimomura, Roger, Diary, xl, xl Self-Portrait (Rembrandt), 786, 787 Nok, 426-427, 427 Shinto, 377-378 Ottonian, 466, 466, 467, 468-469, 468 Self-Portrait (Van Hemessen), 732, 732 Shitao, Landscape, 844, 844 Self-Portrait as a Fountain (Nauman), 1160, 1161 Paleolithic, 4-6, 4, 5, 6, 10-11, 11 Shiva, 318, 329 Self-Portrait as the Allegory of Painting (Gentileschi), Persian, 45, 45 Cave-Temple of Shiva, Elephanta, India, 330, Portuguese, Renaissance, 724, 724 760, 760 330, 332, 332 Renaissance, early, 628-634, 628-633 Self-Portrait Nude (Schiele), 1073, 1073 Self-Portrait with an Amber Necklace (Modersohn-Kandariya Mahadeva temple, Khajuraho, Renaissance, German, 709-711, 710, 711 Becker), 1072, 1073 Renaissance, High, 669-671, 669, 670, India, 333-334, 334 Rajarajeshvara Temple to Shiva, Thanjavur, Self-Portrait with Two Pupils (Labille-Guiard), 972, 674-677, 675, 676, 677, 680-686, 680-687 India, 335-336, 335, 336 Rococo, French, 951, 951 973 Shiva Nataraja (Dancing Shiva) Thanjavur, Selim II, 306 Rococo, German, 945-946, 946 India, 331, 331 Roman Augustan, 186-190, 186, 187, 188, Senbi, 65, 65 Shogun, 852 Senior, copy of Commentary on the Apocalypse Romanesque, 472, 473, 495-499, 495-498, (Beatus), 450, 450 Shoin design, 860 Shoii screens, 860 502-503, 502, 503, 506 Senusret I. 63 Shona, from Great Zimbabwe, 433-435, 434, 435, Senusret II, 64, 64, 66 Roman Imperial, 215-218, 215, 216, 217 436, 921 Roman Imperial, funerary, 222, 222 Senusret III, 63, 63 Shooting Star (Miró), 1122, 1122 Roman Imperial, portrait, 216-217, 217, 220, Seokguram, 368, 369 Septimius Severus, Julia Domna, and Their Children, Shotoku, prince, 379 220, 222-223, 223, 224, 225-226 Shoulder bag, Delaware, 883–884, *883* Roman Republic, 180-181, 180, 181 Geta and Caracalla, 218, 218 Shrewsbury, England, Hardwick Hall (Smythson), Roman Republic, portrait, 204, 204, 205 Seraphim, 655 738, 739 Serdab, 55, 56 Romanticism, French, 997, 997 Serlio, Sebastiano, 738 Shrine of the Three Kings (Nicholas of Verdun), site-specific, 1161-1163, 1162, 1163 Serpentine bench (Gaudí i Cornet), 1054-1055, 543-544, 544 Sumerian, 30-33, 30, 33 Shroud of Saint Josse, Khurasan, 294, 295 1055 Yoruba of Ife, 420, 421, 429-430, 429, 430, Shubun, 852 Serrano, Andres, Piss Christ, 1183 921-922, 922, 931-932, 931, 932 Sesshu, 853 Shunga dynasty, 319 Sculpture, monumental Shute, John, 738 Winter Landscape, 854, 855 Irish high crosses, 449, 449 Shwe-Dagon Stupa, Burma, 814, 815 Moai ancestor figures, Easter Island, 906, Seth, 51 Sicily, Byzantine art in, 274-275, 277-278, 277, 906-907, 909 Sety I, 69 Seurat, Georges, 1038, 1041 Olmec, 399, 399 A Sunday Afternoon on the Island of La Grande Siddhartha in the Palace, Nagarjunakonda, India, Sculpture, relief 324-325, 324 Akkadian, 36-37, 36 Jatte, 1042, 1042 Siena Cathedral, facade, Siena, 548, 549 Seven Years' War, 966 Chavin de Huantar, 408, 409 Severan dynasty, 218–220 Sienese painting, 567, 567, 568, 569, 570, Egyptian, 59-64, 59, 60, 61, 63, 64, 73-74, Severini, Gino, Armored Train in Action, 1084, 1084 571-573, 571 73, 74 Sierra Leone, Mende masks, 924, 924 Severn River Bridge (Darby III), England, 967, high, 10 Signboard of Gersaint (Watteau), 946, 947, 948-949 low, 318, 346 Silhak movement, 847 Severus, Alexander, 222 modeling, 10 Silk, 294, 295, 349, 350 Severus, Septimius, 210, 218, 219 Paleolithic, 4-5, 4, 10, 11

Silla kingdom, 368 Incas, 876-880 Stele of Naram-Sin, 31, 36-37, 36 Silver, Georgian, 962, 962 South Cross of Ahenny, Ireland, 449, 449 Stele sculpture Sinan, 305-306, 306, 307 Spain Greek classical, 147-148, 147 Sinopia, 569 Baroque period in, 764-771 Mathura school, 324, 324 Sin Yunbok, Picnic at the Lotus Pond, 847, 847 Civil War in, 1065 Stella, Frank, Avicenna, 1156-1157, 1156 Sioux, 882-883, 884 colonies in America, 977-979 Stereobate, 116 Siphnians, Treasury of the, Delphi, 116, 119-120, Guggenheim Museum, Solomon R. (Gehry), Stieglitz, Alfred, 1092, 1095 Bilbao, Spain, 1184, 1185 The Flatiron Building, 1093, 1093 Siqueiros, David Alfaro, 1113, 1133 Renaissance in, 611-613, 725-728 Still Life, Herculaneum, 198, 198 Sistine Chapel, Vatican Romanticism in, 998, 998, 999, 1000 Still life, Roman, 198, 198 Delivery of the Keys to Saint Peter (Perugino), Spandrels, 172, 818 Still Life with a Watch (Claesz), 791-792, 791 622, 622, 647-648, 648 Spanish art Still Life with Basket of Apples (Cézanne), 1040, Last Judgment, 688, 689, 690 Alhambra, 298, 299-300, 300 Michelangelo's work on, 671, 672, 673, 674, Altamira cave, 6, 7, 10, 10 Still Life with Flowers, Goblet, Dried Fruit, and Pretarchitecture, Baroque, 771-772, 772, 773 zels (Peeters), 778-779, 779 Site-specific sculpture, 1161-1163, 1162, 1163 architecture, Renaissance, 725, 725 Still Life with Quince, Cabbage, Melon, and Cucumber Sithathoryunet, 64, 64 Art Nouveau (Modernismo), 1054-1055, (Sánchez Cotán), 764-765, 764 Six Dynasties, 354-357 1055 Stoa. 145 Sixtus III, pope, 245, 246 Flemish art, 611-612 Stokesay Castle, England, 541, 541 Sixtus IV, pope, 170, 647, 650 Great Mosque of Córdoba, 290-291, 290, 291 Stone Age, 2 Sixtus V, pope, 671, 745, 746, 751 in the Middle Ages, 449-450 Stone Breakers, The (Courbet), 1017-1018, 1017 Skara Brae, Orkney Islands, Scotland, 13-15, 14, painting, Baroque, 764-770, 764-770 Stonehenge, England, 16, 17, 17, 19 15 painting, Renaissance, 725-728, 726, 727 Stoneware, 367 Skopas, 153, 153 painting, Romanticism, 998, 998, 999, 1000 Stoss, Veit, Annunciation and Virgin of the Rosary, Sky Cathedral (Nevelson), 1140, 1141 rock-shelter, 12-13, 12 711, 711 Skyscrapers, 1060, 1104-1105, 1104, 1105, 1167, Romanesque, 481-482 Stourhead park (Flitcroft and Hoare), Wiltshire, 1167, 1170, 1170 Sparta, 108, 130, 135, 148-149 England, 958-959, 958 Sleep of Reason Produces Monsters, The (Goya), 998, Spear Bearer (Doryphoros or Achilles) (Polykleitos), Strabo, 115 998 128, 128 Strasbourg Cathedral, Dormition of the Virgin, Slip, 112, 114 Speyer cathedral, Germany, 488-490, 490 France, 544, 544 Sloan, John, Election Night, 1092, 1092 Sphinx Strawberry Hill (Walpole), England, 958, 959, 959 Sluter, Claus, Well of Moses, 590, 590 Great Sphinx, Egypt, xxxii, xxxii, 59 Street, Berlin (Kirchner), 1071-1072, 1071 Small Cowper Madonna, The (Raphael), 666, 666 Hatshepsut as, 71 Stringcourses, 492 Smith, David, 1138 Spiral Jetty (Smithson), 1162, 1163 Stuart, James, 138 Cubi XIX, xxxv, xxxv, 1139–1140 Spirit figure (nkisi nkonde), Kongo, Democratic Stucco, 176 Hudson River Landscape, 1139, 1139 Republic of the Congo, 926, 926 Studiolo (study) of Federico da Montefeltro, Smith, Jaune Quick-to-See, The Red Mean: Self Spirit of Haida Gwaii (Reid), 892-893, 892 Ducal Palace, Urbino, Italy, 641-642, 642 Portrait, 1178, 1178 Spirit spouse, Baule, Côte d'Ivoire, 926-927, 927 Stupas, 319-321, 319, 320, 360, 361 Smith, Ken, Landscape Architect, 1187, 1187 Spoils from the Temple of Solomon, Jerusalem, 201, Style Guimard, 1056 Smith, Kiki, Untitled, 1181, 1181 Stylobate, 116, 118 Smithson, Robert, Spiral Jetty, 1162, 1163 Spotted Horses and Human Hands, Pech-Merle Stylus, 29, 32, 114 Smythson, Robert, Hardwick Hall, Shrewsbury, cave, France, 7-8, 7 Sublime, 954 England, 738, 739 Spring Dawn in the Han Palace (Qiu Ying), Succulent (Weston), xxxiv, xxxiv Snowstorm: Hannibal and His Army Crossing the Alps 837-838, 838 Suger of Saint-Denis, abbot, 513, 516-517 (Turner), 1001-1002, 1001 Spring Festival on the River (Zhang Zeduan), Song Suicide of Ajax (Exekias), 126, 126 Sobekneferu, 71 (northern) dynasty, 364, 365 Suicide of Judas, The, capital at Saint-Lazare cathe-Socialist Realism, 1107 Springings, 172 dral, Autun, Burgundy, France, 498-499, 498 Société Anonyme des Artistes Peintres, Sculpteurs, Squinches, 257, 300 Sui dynasty, 357-361, 834 Graveurs, Etc., 1026 Suitor's Visit, The (Ter Borch), 789-790, 789 Stadiums, Colosseum (Flavian Amphitheater), Society of Jesus, 687-688 Rome, 202-204, 202, 203 Suleyman the Magnificent, 306 Soissons, Bernard de, 531 Staël, Madame de, 943 Sullivan, Louis, 1101 Soldiers, mausoleum of Emperor Shihuangdi, Wainwright Building, St. Louis, Missouri, Staff, Ashanti, 916, 917, 928 China, 342-343, 343, 349 Staff finial, Kongo, 437, 438 1060-1062, 1061 Solomon Stag Hunt (Gnosis), 156-157, 156 Sulpicia, 198 First Temple, 235-236 Stained glass, 527-528, 527, 529 Sultan Hasan, 299 Second Temple, 201, 201, 235-236 Stairway (Horta), Tassel House, Brussels, 1054, Sumer (Sumerians), 29-35 Song dynasty, 361-366, 831, 832, 834 1054 Summer's Day (B. Morisot), 1036, 1037 Sophocles, 128, 159 Stalin, Joseph, 1066 Sun Dagger, Pueblo Bonito, Chaco Canyon, New Sorel, Agnès, 609 Standing Buddha, Gandhara school, 323, 323 Mexico, 394-395, 395-396, 416, 417-418, Sotatsu, Tawaraya, Matsushima screens, 860, 861, Standing Buddha, Gupta style, 326, 326 417, 418 Standing Youth (kouros), 122, 122 863 Sunday Afternoon on the Island of La Grande Jatte, A Soto, Jesús Rafael, Armonía Transformable (Trans-Stanton, Elizabeth Cady, 986 (Seurat), 1042, 1042 formable Harmony), 1154, 1155 Stanza della Segnatura, 658-659, 659-660, 666 Sunken relief, 73, 73 Soufflot, Jacques-Germain, Panthéon, Sainte-Starry Night, The (Van Gogh), 1043, 1043, 1046 Suprematism, 1086 Geneviève, Paris, 970, 970 Suprematist Painting (Eight Red Rectangles) (Male-Statues. See Sculpture Stave church, Borgund, Norway, 462, 463, 463 South Africa vich), 1084-1085, 1085 Blombos Cave, 422-423, 423 Steel, early use of, 1060 Surrealism, 1119-1122, 1120, 1121, 1122 rock art, 426, 426 Steen, Jan, The Drawing Lesson, xli, xlii, 790 Surrender at Breda (Velázquez), 766-768, 768 South America Steiner House (Loos), Vienna, 1100, 1100 Suryavaman II, 339 SEE ALSO under name of country Stele of Amenemhat I, 65-66, 65 Susa, 28, 31, 43, 44 Andean cultures, 407-412 Stele of Hammurabi, 38, 38 Sussex chair (Webb), 1024, 1024

Thatch, 13 of Amun, 67-69, 68, 69 Sutton Hoo burial ship, England, 446, 447 of Aphaia, 120-121, 120 Theaters Switzerland, 613 of Apollo, 111 Colosseum (Flavian Amphitheater), Rome Symbolism, 1047-1051, 1048-1051 202-204, 202, 203 of Artemis, 119, 119 Symmachorum, 229, 230 Hellenistic, 159-160, 159 of Athena Nike, 116, 144-145, 144 Symmachus, Quintus Aurelius, 229 Byodo-in, Japan, 384-385, 384-385 Japanese kabuki, 866 Sympathetic magic, 6 Thebes, 80 Synagogues, 236-238, 236 Ci'en, Tang dynasty, China, 359-360, 360 Theft of art, 31 complexes, Egyptian, 67-72 Altneuschul, Prague, 542, 543 Theodora, empress, 254, 255, 260, 261, 266 Portuguese Synagogue, Amsterdam, 790, 790 of the Divine Trajan, 208 Etruscan, 171, 173-174, 173, 175 Theodore Metochites, 278 Syncretism, 239 Synthetic Cubism, 1080-1081, 1081 of the Feathered Serpent, Teotihuacan, Theodoros, 150 Theodosius I, 107, 247 Synthetism, 1046 400-401, 401 Greek (Archaic period), 116, 117-119, 117 Theodosius II, 254 Syon House (Adam), England, 959-960, 960 Theophilus, 477 Greek (first ones), 114 Thermo-luminescence dating, 13 of Hatshepsut, 71-72, 71 of Hera I, 116, 117, 117, 119 Theseus, 86 Tablinum, 192 Third-Class Carriage (Daumier), 1021, 1021 of Hera II, 117 Tachisme 1129 Third of May, 1808 (Goya), 998, 999, 1000 Hindu, in India, 812, 814 Tagore, Abanindranath, Bharat Mata (Mother India), Thirty-Six Immortal Poets (Japanese), 373 Hindu northern, 320, 327-329, 327, 328, 825, 826 Thirty-Six Views of Fuji, Great Wave, The, (Hoku-329, 333-334, 334 Tagore, Rabindranath, 825 Hindu southern, 320, 333, 333, 335-336, 335 sai), 850-851, 851, 866 Tai-an tearoom (Rikyu), Kyoto, Japan, 858-859, Tholos, 145, 149, 150-151, 150, 246 Horyu-ji, temple, Japan, 379-380, 379, 380 858 Treasury of Atreus, 99, 99, 102 Indian, 320, 327-329, 327, 328, 329, Taikan, Yokoyama, Floating Lights, 868, 868 Thomas of Witney, Exeter Cathedral, England, 333-336, 333, 334, 335 Taj Mahal, 808-809, 809, 818, 819 of Inscriptions, Mayan, 403-404, 404 576-578, 577 Talenti, Francesco, Florence Cathedral, 558, 558, Thomson, Tom, Jack Pine, 1098-1099, 1099 at Karnak, 69-70, 69 Thornton, William, United States Capitol, Wash-Nanchan, Tang dynasty, China, 358-359, 359 Talenti, Simone, Palazzo della Signoria, Florence, ington, D.C., 1007, 1007 of Nefertari, 75-78, 76, 77 557, 557 Thoughts on the Imitation of Greek Works in Painting of the Olympian Zeus, 158-159, 158, 212 Tale of Genji, The, Heian period paintings, and Sculpture (Winckelmann), 954-955, Pantheon, Rome, 210, 210, 211, 212 386-388, 387 969-970 of Ramses II, 75-78, 76, 77 Tall Spread (Bush), 1155, 1156 Thousand Peaks and Myriad Ravines, A (Wang Roman Republic, 183-185, 184 Tamamushi Shrine, Japan, 379-380, 379 Hui), 843-844, 843 Seokguram, Korea, 368, 369 Tamberan houses, Abelam, Papua New Guinea, Three Crosses (Rembrandt), 786, 786 of Solomon, First Temple, 235-236 901-902 903 Three Nudes-Dune Picture from Nidden (Schmidtof Solomon, Second Temple, 201, 201, Tang dynasty, 350, 357-361, 831, 833, 834 235-236 Rottluff), 1070, 1070 Tangka painting, 813, 813 Throne of the Third Heaven of the Nations' Millenof Zeus, 130-131, 130, 131 Tanka, 373 nium General Assembly (Hampton), xxxviii, Temptation of Saint Anthony (Schongauer), Tanner, Henry Ossawa, 1050 xxxix 614-615, 615 Resurrection of Lazarus, The, 1051, 1051 Thutmose I, 69, 71 Ten Books of Architecture (Vitruvius), 179, 185 Tantric Buddhism, 810 Tenement Interior in Poverty Gap: An English Coal-Thutmose II, 71 Tao Qian, 846 Thutmose III, 67, 69, 71 Heaver's Home (Riis), 1058, 1058 Taos Pueblo, 889, 889 Tian (Heaven), 348 Tenochtitlan, Mexico, 873, 874-876 Taotie, 346 Teotihuacan, 399-402 Tiberius, 189 Tapa, 912 Tibet, Tantric influence, 813, 813 Tepees, 884, 884 Tapestry Tiepolo, Giovanni Battista, The Marriage of the Ter Borch, Gerard, The Suitor's Visit, 789-790, 789 Andean, 409, 409, 410, 410 Emperor Frederick and Beatrice of Burgundy, 945, Ter Brugghen, Hendrick, Saint Sebastian Tended by Bayeux Tapestry, 504-505, 504, 505 Saint Irene, 779, 781 Flemish, 594-595, 595 Tiercerons, 576 Terra-cotta, 314, 421, 634 Islamic, 303 Tikal, 402-403, 403 Tesserai, 155, 213, 215, 291 Renaissance, 668-669, 668 Timber architecture, Viking, 461, 462, 463, 463 Tetrarchs, 222-224 Tapié, Michel, 1129 Timurid dynasty, 304 Tetrarchs, 222-223, 223 Target with Four Faces (Johns), 1147-1148, 1147 Tinguely, Jean Textiles Tassel House, Stairway (Horta), Brussels, 1054, Homage to New York, 1150, 1150 Andean, 409, 409, 410, 410 1054 Metamatics, 1149–1150 Chilkat blanket, 850, 851 Tatami mats, 859, 860 Tintoretto (Jacopo Robusti), Last Supper, The, Flemish, 594-596, 595, 596 Tatanua masks, New Ireland, 904, 904 701-702, 701 Inca, 878-879, 879 Tatlin, Vladimir, Corner Counter-Relief, 1085, Titian (Tiziano Vecelli), 683, 799 Islamic, 294, 295, 302-303, 302, 303 1085 Isabella d'Este, 688, 688 Kente cloth, Ashanti, Ghana, 928-929, 928 Tattooing, New Zealand, 909-910, 909 Pastoral Concert, The, 684, 684 Kongo, 436-437, 437 Tausret, 71 techniques for making, 44, 409 Pesaro Madonna, 684-686, 685 Teabowl called Mount Fuji (Koetsu), 859-860, Pietà, 686, 687 Thailand Dvaravati style, 337, 337 Venus of Urbino, 686, 686 Tea ceremony, 858-860, 858, 859 Prakhon Chai style, 337, 337 Titus, 202, 236 Tearoom (Rikyu), Kyoto, Japan, 858-859, 858 Arch of, Rome, 199, 200, 201, 201 Theravada Buddhism in, 815-816, 816 Teerlinc, Levina Bening, Princess Elizabeth, 736, Thamyris from Concerning Famous Women (Boccac-Tivoli, Hadrian's Villa at, 212, 212, 213, 213 737 Ti Watching a Hippopotamus Hunt, 62, 62 cio), 592, 592 Tempera, 148, 596, 662 Tiy, queen, 74, 74 Thanjavur, India Tempest, The (Giorgione), 682-683, 683 Tlingit, 886, 886, 887 Rajarajeshvara Temple to Shiva, 335–336, 335, Tempietto, San Pietro church, Rome, 677-678, Toba Sojo, Frolicking Animals, Heian period, Japan, 387-388, 388 Shiva Nataraja (Dancing Shiva) 331, 331 Temples

Tokonoma, 858-859, 860 Treasury of Atreus, Mycenae, 99, 99, 102 Tokugawa Ieyasu, 859 Treasury of the Siphnians, Delphi, 116, 119-120, Uccello, Paolo, The Battle of San Romano, Toledo, Spain, San Juan de Los Reyes church, 612, 618-619, 619-620 612 Tree of Jesse, Chartres Cathedral, 527-528, 527 Ukiyo-e (woodblocks), 866, 867, 867 Tomb of the Reliefs, 176, 176, 177 Tree of Jesse, Saint Jerome's Commentary on Isaiah, Ulu Burun, ship wreck at, 84 Tomb of the Triclinium, 174, 176, 176 Burgundy, France, 509, 510 Umayyad dynasty, 284-285, 286, 288, 290 Tombe Trefoils, 531 Underglaze painting, 840 beehive, 99 Très Riches Heures (Limbourg brothers) Unicorn Is Found at the Fountain from Hunt of the catacombs, 233-234, 236 January, The Duke of Berry at Table, 587, 588 Unicorn tapestry, 594-595, 595 Chinese, mausoleum of Emperor Shihuangdi, February, Life in the Country, 592-593, 593 Unique Forms of Continuity in Space (Boccioni), 342-343, 343, 349 Tribute Money (Masaccio), 636-638, 639 1084, 1085 Chinese, Shang dynasty, 346-347 Trier, Germany, Basilica, 223-224, 223 United Nations—Babel of the Millennium (Gu), Chinese, Zhou dynasty, 348-349, 349 Triglyphs, 117, 118 1189-1190, 1189 Etruscan, 174, 176-177, 176, 177 Trilithons, 17 United States. See American art of Galla Placidia, 247-249, 248, 249 Trinity Church (Upjohn), New York City, 1009, United States Capitol (Latrobe), Washington, at Halikarnassos, 153, 153 1009 D.C., 1007-1008, 1007 Igbo-Ukwu, 427, 427, 429, 429 Trinity with the Virgin, Saint John the Evangelist, and Unit One, 1117, 1118 Japanese, Kofun period, 377, 377 Donors (Masaccio), 635-636, 636 Universal Exposition (1889), 985 Korean, 367-368, 367 Triptych, 591 Unswept Floor, The (Herakleitos), 220, 214, 214 of Marquis Yi of Zeng, 348-349, 349, 351, Garden of Earthly Delights (Bosch), 728-729, Untitled (Judd), 1156, 1157 351 729 Untitled (Smith), 1181, 1181 Moche, 411-412 Harbaville, Byzantine, 273, 273 Untitled Film Still #21 (Sherman), 1172-1173, model of a house, Han dynasty, 353-354, 354 Mérode Altarpiece (Triptych of the Annunication) Mycenaean, 99, 99, 102, 102 (Campin), 587, 588, 597-598, 597 Untitled (12 Horses) (Kounellis), 1124–1125, Neolithic, 15-17, 16, 17 Portinari Altarpiece (Goes), 606-607, 607, 609, 1125-1126, 1158 of Pakal, Lord, Mayan, 403-404, 404 Untitled '90 (Fujii), 869, 869 Roman, 222, 222 The Raising of the Cross (Rubens), 775, Untitled work from the Tree of Life series (Mendiroyal mortuary compound, Nan Madol, Pohneta), 1165-1166, 1167 pei, Micronesia, 904-905, 905 Triumphal Procession, Titus in Chariot, 201, 201 Upanishads, 315 shaft, 99 Triumph of Death (Buffalmacco?), Camposanto, Upjohn, Richard, Trinity Church, New York City, Taj Mahal, 808-809, 809, 818, 819 Pisa, 556, 556 1009, 1009 tholos, 99, 145, 149, 150-151, 150 Triumph of the Name of Jesus and the Fall of the Ur, 33-35 Tombs, Egyptian Damned, The (Gaulli), 763-764, 763 Urban II, pope, 478, 483, 489 complex at Saggara, Djoser's, 55-56, 56, 57 Triumph of Venus (Boucher), 949-950, 949 Urban VIII, pope, 747, 748 construction of, 58-59 Triumph of Venice (Veronese), xxxix-xl, xxxix Urbino, Italy Triumphs, The (Petrarch), 561, 644 decorations, 62, 62, 63-66, 64, 65 architecture in, 640-642 mastabas, 55-56, 56 Trojan War, 98 Ducal Palace, 640-642, 641, 642 pyramids at Giza, 57-59, 57, 58 Trolley, New Orleans, (Frank), 1144, 1144 painting, 642-644, 642, 643, 644 rock-cut at Beni Hasan, 63, 63 Trompe l'oeil, 278, 635, 641, 666, 671, 680, 712 Urna, 323 of Tutankhamun, 75, 75 Tropon (Van de Velde), 1054, 1054 Urnes, Norway, church portal, 461, 461 Tondo, 198, 249 Troy, 84, 98 Uruk, 29, 30-31 Tonga, 899 Trumeau, 495, 496, 532 Vase, 31, 33 Toranas, 320, 321, 321 Trundholm, Denmark, Horse and Sun Chariot, 21, Ushnisha, 323 Tori Busshi, Shaka Triad, Asuka period, Japan, 380, 21 Utamaro, Kitagawa, Woman at the Height of Her 380, 382 Tugras, Ottoman, 306-307, 307 Beauty, xxxvii, xxxvii Torons, 433 Tunic, Inca, 878-879, 879 Uthman, 284 Torres-García, Joaquín, Abstract Art in Five Tones Tunisia, Great Mosque of Kairouan, 288, 290, 290 Utrecht Psalter, 457, 457 and Complementaries, 1141, 1141 Turkey, Mosque of Sultan Selim (Sinan), 306, 306, Torso figures, Indus Valley, 314-315, 314, 315 307 Totemistic rites, 6 Turner, Joseph Mallord William, 1016 Toulouse-Lautrec, Henri de, Jane Avril, 1056-1057, The Burning of the House of Lords and Commons, Valley of the Golden Mummies, 49 16th October 1834, 1002, 1002 Valley of the Kings, 49-50 Tower of Babel, Saint-Savin-sur-Gartempe abbey Snowstorm: Hannibal and His Army Crossing the Valley of the Kings and Queens, 70-72 church, Poitou, France, 501, 502 Alps, 1001-1002, 1001 Vanbrugh, John, Blenheim Palace, England, Towns Tuscan order, 173, 174, 203 803-804, 804 Egyptian, 66-67, 67 Tutankhamun Vandals, 442 Neolithic, 12, 13-17, 19 funerary mask of, 48, 49 Van der Spelt, Adriaen, Flower Piece with Curtain, Tracery, plate, 527 tomb, 75, 75 xxxiii, xxxiii Trajan, 204 Tutankhaten, 75 Van de Velde, Henry, Tropon, 1054, 1054 Column of Trajan, 208-209, 208, 209 Twelve Views from a Thatched Hut (Xia Gui), Song Van Doesburg, Theo, 1107 forum of, 205-206, 206, 207, 208, 208 (southern) dynasty, 365-366, 364-365 Van Dyck, Anthony, Charles I at the Hunt, Transepts, 242, 244, 479 Twin figures (ere ibeji), Yoruba culture, Nigeria, 777-778, 778 Transfiguration of Christ with Saint Apollinaris, Sant' 921-922, 922 Van Eyck, Hubert, Ghent Altarpiece, 584, 585, 598, Apollinare church, Classe, 262-263, 262 Twining, 882 599 Transformable Harmony (Soto), 1154, 1155 Twisted perspective, 8, 54 Van Eyck, Jan Trans World Airlines Terminal (Saarinen), John F. Two Fridas, The (Kahlo), 1098, 1098 Ghent Altarpiece, 584, 585, 598, 599 Kennedy Airport, New York City, 1169, Two Paths of Life, The (Rejlander), 1010-1011, Man in a Red Turban, 598-599, 600 Portrait of Giovanni Arnolfini and His Wife, Gio-Traoré, Ismaila, 433 Two Women with a Child, Mycenae, 103-104, 103 vanna Cenami, 599-600, 601 Travelers among Mountains and Streams, Fan Kuan, Tympanum, 495, 496, 497-498 Van Gogh, Vincent, 1038, 1042 Song (northern) dynasty, 363, 363 Tzara, Tristan, 1090 Japonaiserie: Flowering Plum Tree, 1044, 1045

Virgin and Child Enthroned (Giotto di Bondone), The Starry Night, 1043, 1043, 1046 Saint Mark cathedral, 271, 272, 273 561-562, 563 Van Hemessen, Caterina, Self-Portrait, 732, 732 Venturi, Robert Virgin and Child Enthroned with Saints Francis, John Vanishing point, 622, 637 Complexity and Contradiction in Architecture, Van Mander, Carel, 728 1170 the Baptist, Job, Dominic, Sebastian, and Louis of Toulouse (Giovanni Bellini), 654-655, 655 Van Mieris, Frans, Flower Piece with Curtain, xxxiii, Vanna Venturi House, 1170, 1170 Virgin and Child in Majesty, Maestà Altarpiece (Ducxxxiii Venus, god, 110 Vanna Venturi House (Venturi), 1170, 1170 Venus de Milo (Aphrodite of Melos), 165, 166 cio di Buoninsegna), 567, 567, 568 Virgin and Child with Saints and Angels, icon, Van Reymerswaele, Marinus, The Banker and His Venus of Urbino (Titian), 686, 686 Wife, 731-732, 731 Monastery of Saint Catherine, Egypt, 266, Venus Urania (Giovanni da Bologna), 698, 698 Vapheio Cup, Sparta, Greece, 93, 94-95, 95 Venus (Woman) from Willendorf, Austria, 4, 5 Virgin and Saint Anne with the Christ Child and the Vasari, Giorgio, xlvi, 562, 562, 620, 625, 661, 682, Verism, 181 Vermeer, Jan (Johannes) Young John the Baptist (Leonardo), 664, 664 696,728 Virgin of Vladimir, Constantinople, 266-267, 267 Vase Painter and Assistants Crowned by Athena and View of Delft, 787, 787 Vir Heroicus Sublimis (Newman), 1138, 1139 Woman Holding a Balance, 788-789, 788 Victories, A, Greek, 157, 157 Veronese (Paolo Caliari), 699 Vishnu, 318 Vases and vessels Vishnu Narayana on the Cosmic Waters, Vishnu Tem-Chinese, Shang dynasty, 347, 347 Feast in the House of Levi, 700, 701 ple, Deogarh, India, 329, 329 The Triumph of Venice, xxxix-xl, xxxix Chinese, Song (southern) dynasty, 366, 366 Vishnu Temple at Deogarh, India, 327-329, 327, Greek painted (Archaic), 114, 125-128, 125, Verrocchio, Andrea del, 662 328, 329 Equestrian monument of Bartolommeo 126, 127 Visigoths, 290, 291, 442, 443-444 Greek painted (Classical), 134-135, 135, 148, Colleoni, 633, 633 Visitation, Reims Cathedral, Notre-Dame cathe-Versailles, palais de (Le Vau and Hardouin-148 Mansart), 793, 794, 795-797, 795, 796, dral, 533-535, 535 Greek painted (Proto-Geometric), 112-113, Vitra Fire Station (Hadid), Germany, 1184, 1185 112.113 Japanese, Jomon period, 374-376, 374, 375 Hall of Mirrors (Le Brun and Hardouin-Vitruvian Man (Leonardo), 665, 665 Mansart), 793, 795, 795 Minoan, 93-94, 93, 94 Vitruvius, 171, 173, 179, 185, 665, 677 Vladimir, grand prince, 268-269 Moche, 411, 411 plan of, 796, 796 Vlaminck, Maurice de, 1068 Mycenaean, 104, 104 Vespasian, 189, 202 Neolithic, 19-20, 20 Vesperbild, Germany, 580, 582, 582 Void, The (Klein), 1160 Volmar, monk, 499 painted techniques, 114 Vessels. See Vases and vessels Volutes, 118 Pueblo Bonito seed jar, 418, 418 Vesta, 110 Victor III, pope, 486, 501 Votive figures, 32-33, 33, 171 Sumerian, 31, 33 Victoria, queen of England, 1012 Votive statue of Gudea, 37, 37 Wedgwood, 960, 960 Voussoirs, 171, 172, 291, 299, 967 Vienna, Steiner House (Loos), 1100, 1100 Yoruba, 420, 421 Vienna Genesis (Book of Genesis), 264, 264 Vulca, Apollo, 173-174, 175 Vatican Pietà (Michelangelo), 669-671, 669 Vierzehnheiligen church (Neumann), Germany, Vulcan, 110 945-946, 945, 946 Saint Peter's basilica, 679, 679, 690, 690, 747-749, 747, 749 Vietnam, ceramics, 816, 816 W Stanza della Segnatura, 658-659, 659-660, Vietnam Veterans Memorial (Lin), xliv, xliv Wainwright Building (Sullivan), St. Louis, Mis-View of Delft (Vermeer), 787, 787 666 souri, 1060-1062, 1061 View of Toledo (El Greco), 727-728, 727 Vatican, Sistine Chapel Wall, Jeff, After "Invisible Man" by Ralph Ellison, the Delivery of the Keys to Saint Peter (Perugino), Vigée-Lebrun, Marie-Louise-Élisabeth, Portrait of Preface, 1173-1174, 1173 622, 622, 647-648, 648 Marie Antoinette with Her Children, 948, 972, Wall hanging (Albers), 1110, 1111 Last Judgment, 688, 689, 690 Wall paintings. See Murals Michelangelo's work on, 671, 672, 673, 674, Vignola (Giacomo Barozzi), Il Gesù church, Walpole, Horace, Strawberry Hill, England, 958, 690-691, 691 674 Vaults Viharas, 320, 322, 327 959, 959 Walter of Memburg, 576 barrel, 172, 322, 488 Vijayanagar, 812 Vikings, 268-269, 441 Waltz, The (Claudel), 1052-1053, 1053 corbel, 14, 102 burial ship, Oseberg, 459-460, 459, 460 Wampum belts, 881-882, 881 groin, 172, 488, 521, 521 Wang Hui, A Thousand Peaks and Myriad Ravines, picture and rune stones, 460, 461 quadrant, 481 843-844, 843 rib, 488, 492, 521, 521 timber architecture, 461, 462, 463, 463 Wang Xizhi, Feng Ju, 356, 356 Vaux, Calvert, Central Park, New York City, 1059, Urnes, church portal, 461, 462 Wapepe navigation chart, Marshall Islands, 896, 1059 Villa at Tivoli, Hadrian's, 212, 212, 213, 213 897 Vauxcelles, Louis, 1067 Villa Farnesina, Rome, 195, 195 War, art as spoils of, 31 Village Piper, The (A. Le Nain), 797, 799 Vedas, 315-316 War club, Marquesas Islands, 909, 909 Vedute, 953, 954 Villanovans, 170 Villa of Livia, Primaporta, 192, 194, 195 Warhol, Andy, 1151 Veiled and Masked Dancer, Greece, 164, 164 Birmingham Race Riot, 1152-1153, 1153 Velarde, Pabilita, Koshares of Taos, 890, 891 Villa of the Mysteries, 192, 192, 194-195, 194 Marilyn Diptych, 1152, 1152 Villa Rotunda (Palladio), 704, 704 Velázquez, Diego Warka Head, Uruk, 30, 30, 31, 31 Las Meninas (The Maids of Honor), 768, 769 Villa Savoye (Le Corbusier), France, 1101, 1101 Warp, 303, 929 Surrender at Breda, 752-753, 753 Vimanas, 320, 333, 335, 812 Water Carrier of Seville, 766-768, 768 Violet Persian Set with Red Lip Wraps (Chihuly), Warrior Chief Flanked by Warriors and Attendants, Benin, Nigeria, 428, 428 Velderrain, Juan Bautista, 979 xli, xli Vellum, 251, 292, 448, 450 Violin and Palette (Braque), 1079-1080, 1079 Warrior Priest, tomb of, 411-412 Warriors, Riace, Italy, 133-135, 134 Veneer, 183 Viollet-le-Duc, Eugène-Emmanuel, 518 Warrior Vase, Mycenae, 104, 104 Virgil, 179 Venice Virgin and Child, Auvergne, France, 503, 503, 506 Washington, D.C., United States Capitol architecture, 653-654, 654, 702, 703-704, (Latrobe), 1007-1008, 1007 703, 704 Virgin and Child (Fouquet), 609-610, 610 oil painting in, 699-702, 700, 701 Washington, George, 976, 976 Virgin and Child, Saint-Denis, abbey church, France, 574, 574 Water Carrier of Seville (Velázquez), 766, 767 Renaissance oil painting, 654-655, 654, 655, Water jar, Igbo-Ukwu, 429, 429 682-686, *683*-687 Virgin and Child Enthroned (Cimabue), 561, 562

Watson and the Shark (Copley), 981-982, 981 Watteau, Jean-Antoine The Pilgrimage to the Island of Cythera, 946, 947 The Signboard of Gersaint, 946, 947, 948-949 Wattle and daub, 13, 462, 805-806 Weaving SEE ALSO Textiles Chilkat blanket, 886, 887 Kente cloth, Ashanti, Ghana, 928-929, 928 Navajo, 890 Webb, Philip, Sussex chair, 1024, 1024 Wedgwood, Josiah, pottery, 960, 960, 961 Weeks, Kent R., 49-50 Weft, 303, 929 Well of Moses (Sluter), 590, 590 West, Benjamin, The Death of General Wolfe, 966-967, 966 Western Paradise of Amitabha Buddha, Tang dynasty, China, 358, 359 Weston, Edward, Succulent, xxxiv, xxxv Westwork, 451, 465 We Won't Play Nature to Your Culture (Kruger), 1172, 1173 Weyden, Rogier van der Deposition, 600-602, 602 Last Judgment Altarpiece, 602-603, 603 Portrait of a Lady, 604, 604 Whirling Log Ceremony (Klah), 891-892, 891 Whistler, James Abbott McNeill, 1024 Harmony in Blue and Gold, Peacock Room, for Frederick Leyland, xlv-xlvi, xlv lawsuit, 1025 Nocturne in Black and Gold, the Falling Rocket, 1025, 1026 Princess from the Land of Porcelain, xlv White, Minor, Capitol Reef, Utah, 1145, 1145 White-ground painted vases, 114, 148, 148 Whitehall Palace, Banqueting House (Jones), London, 802, 802, 803 White Horse (Constable), 1003, 1003 Whiteread, Rachel, House, 1180-1181, 1181 White Temple, Uruk, 30, 30 Wildom, Donald, 1183 Wiligelmus, Creation and Fall, 495, 495 Willelmus, 513 William I, 277 William of Orange, 772, 801 William the Conqueror, 474, 492, 504 Winchester Psalter, 508-509, 509 Winckelmann, Johann Joachim, 954-955, 966, 969-970 Wind, ceramic vessel (Zenji), 869, 869 Windmill Psalter, England, 538, 539 Winter Landscape (Sesshu), 854, 855 Wittgenstein, Ludwig, 1160 Witz, Konrad, Miraculous Draft of Fishes, 613, 614 Wols (Wolfgang Schulze), 1129 Painting, 1130, 1130 Woman and Maid (Achilles Painter), 148, 148 Woman at the Height of Her Beauty (Utamaro), xxxvii, xxxvii Woman from Brassempouy, France, 5-6, 6 Woman from Ostrava Petrkovice, Czech Republic, 5, Woman from Willendorf, Austria, 4, 5 Woman Holding a Balance (Vermeer), 788-789, 788 Womanhouse, 1164 Woman in a Loge (Cassatt), 1035, 1035 Woman or Goddess with Snakes, Knossos, Crete, 92-93.92 Woman Spinning, Susa, 44, 44

Woman with the Hat, The (Matisse), 1068, 1069 Womb World mandala, Heian period, Japan, 383, 383 Women academies and, 952 African American artists, 997-998, 997. 1164-1165, 1164, 1166 African artists, 924, 924, 938, 938 Baroque artists, 746, 746, 759-760, 760, 778-779, 779, 783, 783, 792, 793 Egyptian, 67, 70-72, 73, 73, 74, 74, 75-78, 77, 79 feminist art, 1163-1166, 1164-1167 Georgian silver artists, 962, 962 Greece artists, 157 in guilds, 592 Japanese, 386 Mayan, 405–406 Mende masks, Sierra Leone, 924, 924 Native American artists, 882-884, 882, 883 Neolithic, 12-13, 17 Neolithic period and depiction of, 12-13, 12, 18, 18, 19 as patrons of the arts, 688, 722 Renaissance artists, 592, 662, 695-699 Roman, 198, 199 in the Romanesque period, 499 salons and role of, 943 Viking, 459-460 Women artists Albers, Anni, 1110, 1111 Amaral, Tarsila do, 1096, 1096 Anastaise, 592, 593 Anguissola, Sofonisba, 696-697, 697 Arbus, Diane, 1144-1145, 1144 Baca, Judith F., 1177, 1177 Bateman, Ann. 962 Bateman, Hester, 962 Bonheur, Rosa, 1020, 1020 Bourgot, 592 Brandt, Marianne, 1110-1111, 1110 Brody, Sherry, 1164 Burrows, Alice, 962 Cameron, Julia Margaret, 1011, 1011 Carr, Emily, 1099-1100, 1099 Carriera, Rosalba, 952-953, 953 Cassatt, Mary, 1034-1036, 1035, 1036 Chicago, Judy, 1164, 1168, 1168 Christine de Pizan, xlv, xlv, 561, 592 Clark, Lygia, 1158, 1158 Claudel, Camille, 1052-1053, 1053 Colter, Mary, 1103-1104, 1103 Cooke, Elizabeth, 962 Delaunay-Terk, Sonia, 1082-1083, 1083 Ende, 450, 451, 592 Fontana, Lavinia, 698-699, 699 Frankenthaler, Helen, 1137, 1137 Gentileschi, Artemisia, 759-760, 760 Girodet-Trioson, Anne-Louis, 975-976, 975 Guda, nun, 508, 508, 592 Hamilton, Ann, 1187, 1187 Hepworth, Barbara, 1117-1118, 1117 Hesse, Eva, 1157-1158, 1157 Hildegard of Bingen, 499, 499 Höch, Hannah, 1091, 1091 Kahlo, Frida, 1098, 1098 Kauffmann, Angelica, 952, 965-966, 965 Kollwitz, Käthe Schmidt, 1072-1073, 1072 Krasner, Lee, 1135, 1135 Kruger, Barbara, 1172, 1173

Labille-Guiard, Adélaïde, 972, 973

Lady Murasaki, 383, 386 Lewis, Edmonia, 997-998, 997 Leyster, Judith, 783, 783 Lin, Maya Ying, xliv, xliv Mehretu, Julie, 938, 938 Mendieta, Ana, 1165-1166, 1167 Merian, Maria Sibvlla, 746, 746 Modersohn-Becker, Paula, 1072, 1073 Montbaston, Jeanne de, 592 Morisot, Berthe, 1026, 1036, 1037 Morisot, Edma, 1036 Morley, Elizabeth, 962 Moser, Mary, 952 Mukhina, Vera, 1107, 1107 Neshat, Shirin, 1188, 1188 Nevelson, Louise, 1138, 1140-1141, 1140 O'Keeffe, Georgia, xxxv, xxxv, 1095, 1095 Oppenheim, Meret, 1121-1122, 1121 Peeters, Clara, 778-779, 779 Peláez, Amelia, 1097, 1097 Pompadour, Madame de, 949 Popova, Liubov, 1086, 1086 Properzia de' Rossi, 682, 682 Riley, Bridget, 1155, 1155 Ringgold, Faith, 1165, 1166 Robusti, Marietta, 702 Ruysch, Rachel, 792, 793 Saar, Betye, 1164, 1164 Savage, Augusta, 1114-1115, 1115 Schapiro, Miriam, 1164-1165, 1165 Sherman, Cindy, 1172-1173, 1172 Smith, Jaune Quick-to-See, 1178, 1178 Smith, Kiki, 1181, 1181 Teerlinc, Levina Bening, 736–737, 736 Van Hemessen, Caterina, 732, 732 Vigée-Lebrun, Marie-Louise-Élisabeth, 948, 972, 972 Whiteread, Rachel, 1180-1181, 1181 Women at a Fountain House (Priam Painter), 145-146, 146 Wonderful Transformation of Caterpillars and (Their) Singular Plant Nourishment, (Merian), 746, 746 Wood, New York School, 1140-1141, 1140 Woodblocks, 615 Japanese ukiyo-e, 866, 867, 867 prints, 866, 867 Woodcuts, 615, 652, 715-717, 715, 716, 717 Wooded Landscape at l'Hermitage, Pontoise (Pissarro), 1032, 1032 Woodland Period, 412 Woolworth Building (Gilbert), New York City, 1105, 1105 Worcester Chronicle (John of Worcester), 474-475, Worker and Collective Farm Woman (Mukhina), 1107, 1107 Workers' Club (Rodchenko), 1105-1106, 1106 World, since 1945, 1126-1127 map of, 1127 World's Columbian Exposition (Hunt), Chicago, 1058, 1060, 1061 World War I, 1066, 1088 World War II, 1066 Wren, Christopher, Saint Paul's Cathedral, London, 802-803, 804 Wright, Frank Lloyd, 1101 Fallingwater, Kaufmann House, Mill Run, Pennsylvania, 1103, 1103 Frederick C. Robi House, Chicago, 1102-1103, 1102 Wright, Joseph, Experiment on a Bird in the Air-

Pump, An, 964-965, 964 Writing calligraphy, Chinese, 832 calligraphy, Islamic, 292–293, 293 calligraphy, Japanese, 386-388, 855, 855 calligraphy, Sanskrit, 811 calligraphy, Six Dynasties, 356, 356 Chinese, 347, 348, 356, 356, 376 Egyptian demotic, 78 Egyptian hieratic, 78 Egyptian hieroglyphics, 53, 78, 78 Greek alphabetic, 108 Han'geul (Korean alphabet), 845 Incas and method of, 877 Japanese calligraphy, 386-388, 855, 855 Japanese kana, 376 Mayan, 402, 403 Minoan hieroglyphic and Linear A and B, 86 Sumerian cuneiform, 29-30, 32, 32 Wrongful Execution of the Count (Bouts), 605-606, Wudi, Han emperor of China, 353 Wu family of China, 353, 353 Wu Guanzhong, Pine Spirit, 844-845, 845 Würzburg, Germany, Kaisersaal (Imperial Hall), Residenz (Neumann), 944-945, 944, 945 X Xerxes I, 44, 45, 45, 46

Xia Gui, Twelve Views from a Thatched Hut, Song

(southern) dynasty, 365-366, 364-365

Xia dynasty, 346, 834

Xiuhtecutli, 872, 873

Xie He, 354

(Patroness), 1096-1097, 1097 Yakshas, 321, 324 Yakshi bracket figure, Great Stupa, Sanchi, India, 321, 321 Yakshi Holding a Fly Whisk, Maurya period, India, 316-317, 316 Yangsaho culture, 344 Yaroslav, grand prince, 269 Yayoi period, Japan, 376-378, 378, 854 Yi dynasty, 845 Yin Hong, Hundreds of Birds Admiring the Peacocks, 836, 836 Yi Seonggye, 845 Yolngu, 900-901, 901 Yongle, emperor of China, 839 Yoritomo, Minamoto, 389, 854 Yoruba of Ife, Nigeria children, performances by, 922, 922 divination sessions, 927-928, 927 heads, 429-430, 429, 430 Olowe of Ise, door of palace, 931-932, 931, 932 ritual vessel, 420, 421 twin figures (ere ibeji), 921-922, 922

X-ray style, 900

Xuanzang, 360

Young, Thomas, 78

Young Flavian Woman, 204, 204

Young Girl Gathering Saffron Crocus Flowers,

Xuande, emperor of China, 839

Xu Daoning, Fishing in a Mountain Stream, Song

(northern) dynasty, 364–365, 364 Xul Solar (Alejandro Schultz Solari), *Jefa* Akrotiri, Thera, 90–91, 90 Young Woman Writing, Pompeii, 198, 199 Yuan dynasty, 366, 832–835

Z

Zahir-ud-Din, Muhammad, Mughal emperor, Zambezia, Zambezia (Lam), 1131-1132, 1131 Zen Buddhism, 852-856 Zen Buddhist art, 390, 390, 391-392 Zen dry garden, 855-856, 856 Zenji, Miyashita, Wind, ceramic vessel, 869, 869 Zen painting, 863-865, 864 Zeus, 109, 110-111 temple of, 130-131, 130, 131 temple of the Olympian Zeus, 158-159, 158, 212 Zeuxis, xxxiii Zhang Xuan, 361 Zhang Zeduan, Spring Festival on the River, Song (northern) dynasty, 364, 365 Zhao Mengfu, Autumn Colors on the Qiao and Hua Mountains, 833, 834 Zhou dynasty, 348-349, 834 Zhuangzi, 352, 834 Ziggurats Assyrian, 41, 41 Marduk, 42, 42

Zoffany, Johann, Academicians of the Royal Academy, 952, 952 Zorio, Gilberto, Pink-Blue-Pink, 1158, 1159

Zurbarán, Francisco de, Saint Serapion, 766, 766

Zimbabwe, Great, 433-435, 434, 435, 436

Sumerian, 30, 30, 33, 33